CONCISE
DICTIONARY
OF
AMERICAN
BIOGRAPHY

CONCISE
DICTIONARY
OF
AMERICAN
BIOGRAPHY

FIFTH EDITION
COMPLETE THROUGH 1980

Volume 2

CHARLES SCRIBNER'S SONS
Macmillan Library Reference USA
NEW YORK

Simon & Schuster and Prentice Hall International
LONDON MEXICO CITY NEW DELHI SINGAPORE SYDNEY TORONTO

Library of Congress Cataloging-in-Publication Data

Concise Dictionary of American biography.—5th ed. complete to 1980.
 p. cm.
 Published under the auspices of the American Council of Learned
Societies.
 Includes index.
 Contents: v. 1. A–N—v. 2. O–Z.
 ISBN 0-684-80549-9 (alk. paper)
 1. United States—Bibliography—Dictionaries. I. American Council
of Learned Societies. II. Dictionary of American biography.
E176.C73 1997
920.073—dc21
[B] 97-34104
 CIP

1 3 5 7 9 11 13 15 17 20 18 16 14 12 10 8 6 4 2
Printed in the United States of America

Charles Scribner's Sons
An imprint of Simon & Schuster Macmillan
1633 Broadway
New York, New York 10019

CONCISE
DICTIONARY
OF
AMERICAN
BIOGRAPHY

O

OAKES, GEORGE WASHINGTON OCHS (*b. Cincinnati, Ohio, 1861; d. 1931*), editor. Son of Julius Ochs; brother of Adolph S. Ochs. Served in several editorial capacities on the *Chattanooga Daily Times*, 1880–ca. 1888; after engaging in magazine work, returned to the *Times*, 1896, as general manager. A civic leader in Chattanooga, he served as mayor, 1893–97. *Post* 1900, he was employed in a number of editorial and managerial capacities on his brother's publications and others, including editorship of *Current History* and *The Times Mid-Week Pictorial*.

OAKES, THOMAS FLETCHER (*b. Boston, Mass., 1843; d. Seattle, Wash., 1919*), railroad executive. Director, 1881–88, president, 1888–93, and general receiver, 1893–95, of Northern Pacific Railroad.

OAKES, URIAN (*b. probably London, England, ca. 1631; d. Massachusetts, 1681*), Congregational clergyman, poet. Immigrated to New England as a boy; graduated Harvard, 1649. A dissenting minister and teacher in England, 1653–71, Oakes served thereafter as pastor of the church in Cambridge, Mass. A ringleader among those who drove Leonard Hoar out of the presidency of Harvard, he was acting president of the college *post* 1675 and received formal election as president in February 1679/ 80.

OAKIE, JACK (*b. Lewis Delaney Offield, Sedalia, Mo., 1903; d. Northridge, Calif., 1978*), actor. Began professional stage career in the chorus of George M. Cohan's *Little Nellie Kelly* in 1922; by 1927 he had achieved headliner status on Broadway. In Los Angeles from 1927, he moved into films and became identified with a series of collegiate comedies through the mid–1930's. From 1936 to 1938 he hosted the radio variety show "Jack Oakie College." He also had major roles in such films as *Call of the Wild* with Clark Gable (1935), *The Affairs of Annabel* (1938) with Lucille Ball, *The Great Dictator* (1940) with Charlie Chaplin, and *Lover Come Back* (1962) with Rock Hudson and Doris Day. From the 1950's he made various television appearances on variety shows and in guest roles on dramatic series.

OAKLEY, ANNIE (*b. Darke Co., Ohio, 1860; d. Greenville, Ohio, 1926*), markswoman. A notable attraction in vaudeville and the circus, Annie Oakley starred in Buffalo Bill's "Wild West" show *post* 1885; the use of her name to denote punch-marked complimentary tickets derived from her ability to perforate a playing card with rifle bullets while it fluttered to the ground.

OAKLEY, THOMAS JACKSON (*b. Beekman, N.Y., 1783; d. New York, N.Y., 1857*), lawyer, politician, New York legislator. Congressman, Federalist, from New York, 1813–15; congressman, Clinton Democrat, 1827–28. In high repute as an advocate, Oakley was judge of the superior court of New York City, 1828–47, and chief justice of that court, 1847–57.

OATES, WILLIAM CALVIN (*b. Bullock Co., Ala., 1835; d. Montgomery, Ala., 1910*), Confederate soldier, lawyer, Alabama legislator. Congressman, Democrat, from Alabama, 1881–94; sound-money governor of Alabama, 1894–96.

OATMAN, JOHNSON (*b. near Medford, N.J., 1856; d. Norman, Okla., 1922*), gospel hymn writer.

OBER, FREDERICK ALBION (*b. Beverly, Mass., 1849; d. Hackensack, N.J., 1913*), ornithologist. Explored Lesser Antilles, 1876–78 and 1880, discovering 22 new species of birds.

OBERHOFFER, EMIL JOHANN (*b. Munich, Bavaria, 1867; d. San Diego, Calif., 1933*), musician. Immigrated to New York City, 1885; removed to Minnesota, 1897, where he taught music, conducted, and was one of the prime movers in the establishment of the Minneapolis Symphony Orchestra, 1903. *Post* 1923, he was active in the musical life of Los Angeles, Calif.

OBERHOLSER, HARRY CHURCH (*b. Brooklyn, N.Y., 1870; d. Cleveland, Ohio, 1963*), ornithologist. Attended Columbia and George Washington University (Ph.D., 1916). Began a career in government service with the Bureau of Biological Survey (now Fish and Wildlife Service) in 1895; retired as senior biologist in 1941. An expert identifier of birds, he reported 11 new families and subfamilies of birds, 99 new genera and subgenera, and 560 new species and subspecies. Taught at Biltmore Forest Summer School, 1904–10, and American University, 1920–35. Curator of ornithology at Cleveland Museum of Natural History, 1941–47.

OBERHOLTZER, ELLIS PAXSON (*b. Cambria Station, Pa., 1868; d. Philadelphia, Pa., 1936*), journalist, historian. Author, among other serious studies, of *History of the United States since the Civil War* (1917–37).

OBERHOLTZER, SARA LOUISA VICKERS (*b. Uwchlan, Pa., 1841; d. Philadelphia, Pa., 1930*), poet, advocate of school savings banks to promote thrift.

OBERNDORF, CLARENCE PAUL (*b. New York, N.Y., 1882; d. New York, 1954*), psychoanalyst. Studied at Cornell University, M.D., 1906. A pioneer analyst, Oberndorf helped to found the New York Psychoanalytic Society in 1911. Joined the American Psychoanalytic Association shortly thereafter; president, 1924 and 1936. Taught at Cornell medical school from 1914 to 1920, and at Columbia University, 1936–49. Helped to reorganize the American Psychoanalytic Association into a highly restricted group that set strictly Freudian standards in the training and practice of analysts. Published *A History of Psychoanalysis in America* (1953).

OBERON, MERLE (*b. Estelle Merle O'Brien Thompson, Port Arthur, Tasmania, Australia, 1911; d. Los Angeles, Calif., 1979*), actress. Moved to London at age sixteen and worked as a dancer before she appeared in several British films directed by Alexander Korda (whom she married in 1939), including *The Private Life of Henry VIII* (1933) and *The Scarlet Pimpernel* (1935). She became a star with such American–British films as *The Dark Angel* (1935) and *These Three* (1936) but is best known for her role as

Cathy in *Wuthering Heights* (1939). She made occasional appearances in films and more frequent appearances in television roles before retiring in the late 1950's; she attempted a comeback in 1972, starring in and producing the film *Interval.*

O'BRIAN, JOHN LORD (*b. Buffalo, N.Y., 1874; d. Buffalo, 1973*), lawyer and public official. Graduated University of Buffalo Law School (1898). He was elected to the New York State Assembly (1907) and appointed U.S. attorney in western New York (1909). In 1919, while with the War Emergency Division of the Department of Justice, O'Brian argued *Schenck* v. *United States*, which established the "clear and present danger" test to justify the denial of first amendment rights. In 1936, as special counsel for the Tennessee Valley Authority, he won a landmark decision that allowed the government to proceed with the project. During World War II he was general counsel for the War Production Board; with emergency powers and the assistance of a formidable legal staff, he oversaw the efficient awarding of U.S. military contracts. After the war he continued to practice law, working with a Washington, D.C., firm and a Buffalo, N.Y., firm that he had joined in 1917.

O'BRIEN, EDWARD CHARLES (*b. Fort Edward, N.Y., 1860; d. Montevideo, Uruguay, 1927*), merchant, public official, shipping expert. U.S. minister to Uruguay and Paraguay, 1905–09.

O'BRIEN, FITZ-JAMES (*b. Co. Limerick, Ireland, ca. 1828; d. Cumberland, Md., 1862*), journalist. Came to America *ca.* 1852. Sponsored by George P. Morris and others, he quickly became prominent in New York City's literary and Bohemian Circles. Enlisting in the Union Army at the outbreak of the Civil War, O'Brien died of the effects of a wound. His *Poems and Stories* (posthumously published, 1881) reprints his best work of which "The Diamond Lens" is probably the best-known example.

O'BRIEN, FREDERICK (*b. Baltimore, Md., 1869; d. Sausalito, Calif., 1932*), journalist. Author of *White Shadows in the South Seas* (1919), *Atolls of the Sun* (1922), and other accounts of travel.

O'BRIEN, JEREMIAH (*b. Kittery, Maine, 1744; d. Machias, Maine, 1818*), Revolutionary patriot, naval officer. At the head of about forty volunteers, O'Brien seized the sloop *Unity* in the harbor of Machias and with her engaged and captured the armed schooner *Margaretta*, commanded by an officer of the Royal Navy, June 12, 1775. Thereafter he cruised with success in the service of the Massachusetts Navy until the fall of 1776, when he became a privateersman. Captured in 1780 with his vessel the *Hannibal*, he was imprisoned at New York and later in Mill Prison, England, whence he escaped; on returning to America, 1781, he commanded successively the *Hibernia* and the *Tiger.*

O'BRIEN, JUSTIN (*b. Chicago, Ill., 1906; d. New York, N.Y., 1968*), translator and scholar. Attended University of Chicago and Harvard (Ph.D., 1936). Taught at Harvard, 1929–31, and Columbia, 1931–65. Translated *Journals of André Gide* (1947–51) and wrote *Portrait of André Gide* (1953), the latter illustrating his ability to combine analysis with a sympathetic and intuitive understanding of a subtle and controversial writer. He had his greatest impact on English-language readers through his translation of Albert Camus's works.

O'BRIEN, MATTHEW ANTHONY (*b. Co. Tipperary, Ireland, 1804; d. Louisville, Ky., 1871*), Roman Catholic clergyman, Dominican missionary and provincial. Came to Canada, 1826; ordained in Kentucky, 1839. A magnetic preacher and able administrator.

O'BRIEN, MORGAN JOSEPH (*b. New York, N.Y., 1852; d. New York, 1937*), lawyer, jurist. Graduated, St. John's College (Fordham), 1872; Columbia Law School, 1875. Justice, New York supreme court, 1887–95; appellate division, 1895–1906. Resigning to reenter private practice, O'Brien rose in his profession and engaged in extensive public service; the 1936 New York City Charter revision was owing in great part to his efforts.

O'BRIEN, RICHARD (*b. Maine, ca. 1758; d. Washington, D.C., 1824*), mariner, privateersman. An Algerian captive, 1785–95, O'Brien served as U.S. consul general to Algiers, 1797–1803. Prior to this he had helped conclude treaties of peace with Algiers and Tripoli, 1796.

O'BRIEN, ROBERT DAVID ("DAVEY") (*b. Dallas, Tex., 1917; d. Dallas, 1977*), athlete. A star quarterback for his Dallas high school football team, he also played for Texas Christian University (B.A., 1939), winning the Heisman Trophy and leading his team to victory in the Sugar Bowl in 1938. He played professional football for the Philadelphia Eagles (1939–40), throwing for 2,600 yards and eleven touchdowns with thirty-four interceptions. At five feet, seven inches, and 150 pounds, he was known as "The Mighty Mite." He left football in 1940 and joined the Federal Bureau of Investigation, leaving in 1951 to enter oil business. Elected to Professional Football Hall of Fame in 1955.

O'BRIEN, ROBERT LINCOLN (*b. Abington, Mass., 1865; d. Washington, D.C., 1955*), journalist, editor, tariff expert. Graduated from Harvard, B.A., 1891. Personal stenographer and executive clerk to President Grover Cleveland, 1892–95. Became Washington correspondent for the *Boston Evening Transcript*, 1895; editor, 1906–10. Editor of the *Boston Herald*, 1910–28. Head of the U.S. Tariff Commission, 1931–37; strongly endorsed the reciprocal tariff agreements of Secretary of State Cordell Hull.

O'BRIEN, THOMAS JAMES (*b. Jackson Co., Mich., 1842; d. Grand Rapids, Mich., 1933*), lawyer, Republican politician. U.S. minister to Denmark, 1905–07; ambassador to Japan, 1907–11; ambassador to Italy, 1911–13.

O'BRIEN, WILLIAM SHONEY (*b. Queen's Co., Ireland, ca. 1826; d. San Rafael, Calif., 1878*), capitalist, Nevada silver-mine operator. Came to America *ante* 1845; removed to California, 1849. Associated with John W. Mackay, James G. Fair, and others in highly successful mine operations.

O'BRIEN, WILLIS HAROLD (*b. Oakland, Calif., 1886; d. Hollywood, Calif., 1962*), film animator. He pioneered the use of pliable, miniature figures of clay over wood framing, exposing each film frame individually and then slightly altering the position of each model, thereby simulating movement. His first film, *The Dinosaur and the Missing Link* (1915), was purchased by the Edison Company, for whom he later worked (1916–17) on their "Conquest Programs." *The Lost World* (1925) combined animation and live action and is considered a cinema landmark. His best-known films were *King Kong* (1933) and *Mighty Joe Young* (1949); he received an Academy Award for the latter.

O'CALLAGHAN, EDMUND BAILEY (*b. Mallow, Ireland, 1797; d. 1880*), physician, historian. Removed to Albany, N.Y., from Canada, 1837; practiced medicine until 1848; devoted full time to editing early records of New York State, 1848–70. Among the important works which he produced were *History of New Netherland* (1846–48); *Documentary History of the State of New York* (1849–51); and *Documents Relative to the Colonial History of the State of New York* (Volumes I–XI, 1853–61).

O'CALLAGHAN, JEREMIAH (*b. Co. Cork, Ireland, 1780; d. Holyoke, Mass., 1861*), Roman Catholic clergyman, author. Or-

daincd, 1805, in Ireland, O'Callaghan early became an opponent of the taking of interest on money loans, an anticapitalist position which involved him in difficulties with his ecclesiastical superiors for many years. Immigrating to America, 1823, he was unable to win acceptance in any diocese until 1830; at that time, accepted by the diocese of Boston, he was assigned to missionary and pastoral work in Vermont where he worked with great zeal and success. His book *Usury, or Interest, Proved . . . Destructive to Civil Society* (New York, 1824) went through several editions and had a strong influence on the English radical writer William Cobbett.

O'CALLAHAN, JOSEPH TIMOTHY (*b. Roxbury, Mass., 1905; d. Worcester, Mass., 1964*), Jesuit priest, educator, and navy chaplain. Attended Weston (M.A., 1929) and Georgetown. Taught at Boston College (1931), Weston (1936), and Holy Cross (1938–39, 1946–49). Enlisted in the navy in 1939 and in 1944 was assigned to the carrier *Franklin*, which was attacked by a Japanese dive bomber in March 1945. Fighting raging flames and without regard for his safety, although wounded by shrapnel, he organized and led firefighting crews and inspired crew members with his courage and faith in the face of almost certain death; he was awarded the Medal of Honor. He wrote *I Was Chaplain on the Franklin* (1956), which became a best-seller.

OCCIDENTE, MARIA DEL *See* BROOKS, MARIA GOWEN.

OCCOM, SAMSON (*b. near New London, Conn., 1723; d. 1792*), Indian Presbyterian clergyman, missionary, First Indian to be trained (1743–47) by Eleazar Wheelock. Occom was ordained in 1759. He accompanied Nathaniel Whitaker to England to secure money for Wheelock's Indian Charity School, 1766–68. An active missionary among the New England tribes and the Oneida, he opposed as best he could the white encroachment upon Indian lands.

OCCONOSTOTA *See* OCONOSTOTA.

OCHS, ADOLPH SIMON (*b. Cincinnati, Ohio, 1858; d. Chattanooga, Tenn., 1935*), newspaper publisher. Son of Julius Ochs. Began work, 1869, as office boy on the Knoxville, Tenn., *Chronicle*; tried various occupations in various places during his early youth but always came back to Knoxville and the newspaper business. Removing to Chattanooga, Tenn., at the age of 19, he began his publishing career by purchasing the *Chattanooga Times* with borrowed money, 1878. After developing the *Times* with great success as a newspaper "clean, dignified and trustworthy," he purchased the once-prosperous *New York Times*, 1896. He applied to his new purchase without compromise the principles he had practiced in Chattanooga; it was to be a strictly "news" paper in which editorial opinion was subordinate and the news was treated with freedom from personal and partisan bias. He also excluded advertising which seemed to him fraudulent or improper. Refusing to make any concessions to yellow journalism, Ochs brought the *Times* along slowly but steadily; after it began to succeed, he put most of his profits back into expansion of plant and services. From time to time he held interests in other papers, but came eventually to the conclusion that running the *Times* was job enough for any man. The excellence of the *Times's* coverage of war news, 1914–18, raised the paper to preeminence. Ochs never held nor sought public office; in his later years, he gave much time to philanthropies and public causes.

OCHS, JULIUS (*b. Fürth, Bavaria, 1826; d. Chattanooga, Tenn., 1888*), merchant. Father of Adolph S. Ochs and George W. Oakes. Came to America, 1845. Resided successively in Kentucky, Ohio, and Tennessee; served in Union Army; was active in politics and civic affairs.

OCHS, PHIL (*b. El Paso, Tex., 1940; d. Far Rockaway, N.Y., 1976*), singer and songwriter. Attended Ohio State University (1958–62) and moved to Greenwich Village in New York City, then the center of a folk music revival. He began performing original songs in clubs and cafes, earning a reputation as a leading protest singer. In albums such as *All the News That's Fit to Sing* (1964), *I Ain't Marching Anymore* (1965), and *Pleasures of the Harbor* (1967), he addressed themes of pacifism, politics, public apathy, and civil rights. He was strongly identified with the antiwar movement during the Vietnam War; his song "The War Is Over" became a peace-movement anthem. His notable concert appearances included those at New York's Carnegie Hall in 1966 and 1970 and the Felt Forum in 1974. He committed suicide by hanging.

OCHSNER, ALBERT JOHN (*b. Baraboo, Wis., 1858; d. 1925*), surgeon. Graduated Rush Medical College, 1886; studied also in Vienna and Berlin. Practiced in Chicago *post* 1889; taught at Rush Medical College and at University of Illinois; was chief surgeon, Augustana Hospital, 1891–1925, and at St. Mary's Hospital, 1896–25.

OCKERSON, JOHN AUGUSTUS (*b. Skane Province, Sweden, 1848; d. St. Louis, Mo., 1924*), engineer. Came to America as a child; graduated University of Illinois, C.E., 1873. Associated *post* 1879 with the Mississippi River Commission, he became an international authority on river and harbor improvement and navigation. Among his individual achievements was the construction of levees (1910) to control flood waters of the Colorado River.

O'CONNELL, WILLIAM HENRY (*b. Lowell, Mass., 1859; d. Brighton, Mass., 1944*), Roman Catholic clergyman, archbishop and cardinal. Graduated Boston College, 1881; pursued theological studies at North American College, Rome; ordained to priesthood, June 1884. After service in parishes in Medford and Boston, Mass., he was rector of the North American College, 1895–1901. A strong proponent of papal authority, and of the autonomy of bishops within their dioceses, he was named bishop of Portland, Maine, 1901, and succeeded to the archbishopric of Boston in 1907. He was made a cardinal in 1911. In full control of the archdiocese until his death, he centralized its finances and all other institutional activities, imposing clear and firm policy guidelines on his clergy and on the administration of parishes and schools. Generally conservative on social issues, he strove consciously to improve relations between Roman Catholics and Protestants; he did not hesitate, however, to speak out on public issues which to his mind constituted a threat to Catholic interests. He gave encouragement to education, charitable activities, and the foreign missions, was frequently critical of errant politicians of his own faith, and took a lifelong interest in liturgical music.

O'CONNOR, EDWIN GREENE (*b. Providence, R.I., 1918; d. Boston, Mass., 1968*), novelist. Attended Notre Dame (B.A., 1939). Began a career as a radio announcer (1940) in Providence, R.I., and later worked at stations in Palm Beach, Fla.; Buffalo, N.Y.; and Boston, Mass. He left radio in 1946 to become a freelance writer. Under the name Roger Swift, he wrote for the *Boston Herald* and the *Atlantic Monthly*. His first novel, *The Oracle* (1951), shows his gift for satire, comedic insight into human folly and the grace and humor of his objective style. *The Last Hurrah* (1956) was a best-seller and is called the best American novel on urban politics. *The Edge of Sadness* (1961) won a Pulitzer Prize. Other works include *I Was Dancing* (1964), *All in the Family* (1966), and *Benjy: A Ferocious Fairy Tale* (1957).

O'CONNOR, JAMES (*b. Cobh, Ireland, 1823; d. 1890*), Roman Catholic clergyman. Brother of Michael O'Connor. Came to

America *ca.* 1839. Ordained in Rome, 1848, he served in the dioceses of Pittsburgh and Philadelphia until 1876 when he was consecrated vicar-apostolic of Nebraska. Appointed first bishop of Omaha, 1885, he served until his death.

O'CONNOR, MARY FLANNERY (*b. Savannah, Ga., 1925; d. Milledgeville, Ga., 1964*), novelist and short-story writer. Attended Georgia State College for Women and University of Iowa (M.F.A., 1947). Published her first story, "The Geranium," in *Accent* (1946); between 1946 and 1952 published stories and portions of her first novel, *Wise Blood* (1952), in *Accent, Sewanee Review, Mademoiselle,* and other magazines. "The Life You Save May Be Your Own" was selected for publication in *O. Henry Prize Stories* of 1954; later stories appeared regularly in that collection and others. Her work has been described as "southern gothic" and is in the grotesque tradition in American literature. O'Connor's writing was also influenced by her devout Catholicism.

O'CONNOR, MICHAEL (*b. near Cork, Ireland, 1810; d. Woodstock, Md., 1872*), Roman Catholic clergyman. Brother of James O'Connor. Educated in France and in Rome, Italy, he was ordained, 1833, and came to America *ca.* 1839 as rector of the Seminary of St. Charles, Philadelphia. Consecrated bishop of Pittsburgh, 1843, he served there with distinguished success until his resignation, 1860. Thereafter, having become a Jesuit, he traveled extensively throughout the United States as a missionary.

O'CONNOR, WILLIAM DOUGLAS (*b. Boston, Mass., 1832; d. Washington, D.C., 1889*), journalist, civil servant, friend and champion of Walt Whitman. Author of *The Good Gray Poet* (1866).

O'CONOR, CHARLES (*b. New York, N.Y., 1804; d. 1884*), lawyer. Admitted to the bar, 1824, he practiced with phenomenal success and appeared as counsel in most of the outstanding cases heard in his time. Among them were the Jumel Will case, the Roosevelt Hospital case, the Tilden-Hayes election contest, the Tweed case, and the Forrest divorce case. A Democrat, he ran unsuccessfully a number of times for public office; he was nominated for president of the United States by the "Straight-out" Democrats, 1872.

OCONOSTOTA (*d. 1785*), Cherokee Indian chief. Lived at Great Echota in present Monroe Co., Tenn. Imprisoned at Fort Prince George (S.C.), 1759, by Governor W. H. Lyttelton after proffering friendship, Oconostota was soon released; thereafter he devoted himself to repaying treachery with equal treachery. Unsuccessfully attempting to capture Fort Prince George, 1760, he led Cherokee in raids against the frontier settlements; later he commanded the Indians in the taking of Fort Loudoun and was responsible for the massacre of its defenders. Apparently reconciled to the superiority of the white forces, he led the Cherokee delegation at the treaty of peace with the Iroquois at Johnson Hall, 1768; he opposed sale of Cherokee lands at Sycamore Shoals, 1775. During the Revolution he fought for the British, resigning his leadership, 1782.

OCTACITE *See* OUTACITY.

O'DANIEL, WILBERT LEE ("PAPPY") (*b. Malta, Ohio, 1890; d. Dallas, Tex., 1969*), businessman, radio musician, and politician. During a successful career in the flour-milling industry, organizing his own companies, he created, with Bob Wills, the radio program "Light Crust Doughboys" (1930); he wrote over 150 songs and programs on religion, families, morals, and Americanism. The song "Them Hillbillies are Politicians Now" resulted in a grass-roots letter campaign encouraging him to enter

and later win the Texas gubernatorial race in 1938; he was reelected in 1940. A U.S. senator, 1942–48, he served without distinction; his election successes are often attributed to showmanship and radio.

ODELL, BENJAMIN BARKER (*b. Newburgh, N.Y., 1854; d. 1926*), businessman, New York State Republican politician and leader. Suggested Theodore Roosevelt's candidacy for governor, 1898; elected governor himself in 1900 and again in 1902, he served with efficiency and economy. A realist in politics, he was the first "machine" Republican to defy the rule of Thomas C. Platt.

ODELL, GEORGE CLINTON DENSMORE (*b. Newburgh, N.Y., 1866; d. New York, N.Y., 1949*), educator, theater historian. Brother of Benjamin B. Odell. B.A., Columbia University, 1889; M.A., 1890; Ph.D., 1892. Taught in English department at Columbia, 1895–1939; appointed professor of dramatic literature, 1924. Author of *Shakespeare from Betterton to Irving* (1920), and of the encyclopedic, fifteen-volume *Annals of the New York Stage* (1927–49).

ODELL, JONATHAN (*b. Newark, N.J., 1737; d. Fredericton, N.B., Canada, 1818*), Loyalist, physician, poet, Episcopal clergyman. Played important role in negotiations between Benedict Arnold and British headquarters in New York, 1779–80; was author of Tory satirical verses in Rivington's *Royal Gazette* and other newspapers; registrar and clerk of New Brunswick province, *ca.* 1784–1812.

ODENBACH, FREDERICK LOUIS (*b. Rochester, N.Y., 1857; d. Cleveland, Ohio, 1933*), Roman Catholic clergyman, Jesuit, meteorologist. Graduated Canisius College, Buffalo, N.Y., 1881; entered the Society of Jesus, 1881; made his subsequent studies in the Netherlands and England. Taught scientific studies at the present John Carroll University in Cleveland, 1892–1933, supervising and in large measure constructing the meteorological observatory there. He designed and built the first ceraunograph (an adaptation of the coherer to the detection and recording of static disturbances), 1899; in 1900, he began a seismological observatory and was the founder of Jesuit activity in that field in the United States.

ODENHEIMER, WILLIAM HENRY (*b. Philadelphia, Pa., 1817; d. Burlington, N.J., 1879*), Episcopal clergyman. Bishop of New Jersey, 1859–74, and of Northern New Jersey (later Newark), 1874–79.

ODETS, CLIFFORD (*b. Philadelphia, Pa., 1906; d. New York, N.Y., 1963*), dramatist, screenwriter, and actor. Acted on radio and in theater, 1923–30, including the Group Theatre, for which he wrote in 1935 *Waiting for Lefty, Awake and Sing!, Till the Day I Die,* and *Paradise Lost;* other plays for the Group were *Golden Boy* (1937), *Rocket to the Moon* (1938), and *Night Music* (1940). He later wrote the plays *The Big Knife* (1949), *The Country Girl* (1950), and *The Flowering Peach* (1954). His plays were sociological in theme and are distinguished by his concerns for individual loneliness in the modern world. Worked as a screenwriter in Hollywood (1936–38, 1943–47, 1955–61), writing *The General Died at Dawn* (1936) and *None But the Lonely Heart* (1944). Received Award of Merit Medal for Drama (1961) from the American Academy of Arts and Letters.

ODIN, JOHN MARY (*b. Ambierle, France, 1801; d. Ambierle, 1870*), Roman Catholic clergyman, Vincentian. Came to New Orleans, La., with Bishop Dubourg, 1822; served as missionary in Arkansas and Texas *post* 1923; consecrated vicar apostolic of Texas, 1842. Appointed bishop of Galveston, 1847, he was raised to the archbishopric of New Orleans, 1861.

O'DONNELL, EMMETT ("ROSY"), JR. (*b. Brooklyn, N.Y., 1906; d. McLean, Va., 1971*), air force general. Graduated U.S. Military Academy (1928) and entered pilot training school. During World War II he served as an operations officer in Java and India. As a brigadier general (1944), he commanded the B-29 bombing raids on Tokyo that began in November 1944. He was promoted to major general in 1948, and in 1950, as head of the Far East Bomber Command, he directed U.S. bombing operations over North Korea. His opposition to restrictions on U.S. bombing missions in North Korea and China led to his reassignment to the United States in 1951. In 1959 he was promoted to full general and named commander in chief, Pacific Air Forces; he retired in 1963.

O'DONNELL, KENNETH PATRICK (*b. Worcester, Mass., 1924; d. Boston, Mass., 1977*), presidential adviser. Graduated Harvard University (B.A., 1949), where he was a roommate of Robert F. Kennedy, brother of future president John F. Kennedy. O'Donnell worked on John Kennedy's congressional campaign in 1946 and emerged as a key organizer in Kennedy's 1960 presidential bid. O'Donnell, officially an appointments secretary in the White House, was a trusted and loyal confidant of President Kennedy; scholars dispute, however, whether his pro-New Deal positions influenced the president's policy decisions. Simultaneously a friend of Robert Kennedy and a special assistant to President Lyndon Johnson, O'Donnell helped smooth over tensions between the two men. He ran unsuccessfully for governor of Massachusetts in 1965 and 1970.

O'DONNELL, THOMAS JEFFERSON (*b. Mendham Township, N.J., 1856; d. 1925*), lawyer. Removing to Denver, Colo., 1879, he spent the remainder of his life there in the practice of law and as a power in the Democratic party. Opposed to Grover Cleveland's financial policies, he was many times an unsuccessful seeker for public office.

O'DONOVAN, WILLIAM RUDOLF (*b. Preston Co., Va., now W. Va., 1844; d. New York, N.Y., 1920*), sculptor, painter, Confederate soldier.

O'DOUL, FRANCIS JOSEPH ("LEFTY") (*b. San Francisco, Calif., 1897; d. San Francisco, 1969*), baseball player and manager. Began professional career in baseball in 1917 with San Francisco Seals of the Pacific Coast League. During 1919–34, he was optioned or traded thirteen times by different major league clubs, first with the New York Yankees, 1919–22, and later the New York Giants, Boston Red Sox, Brooklyn Dodgers, and Philadelphia Phillies. Played in the first all-star game, 1933, and appeared in the 1933 World Series. Managed in the Pacific Coast League, 1935–57, and was a batting coach for the Giants in San Francisco. Among his protégés were Joe Di Maggio and Willie McCovey.

ODUM, HOWARD WASHINGTON (*b. near Bethlehem, Ga., 1884; d. Chapel Hill, N.C., 1954*), sociologist. Studied at Emory College; the University of Mississippi; Clark University, Ph.D., 1909; and Columbia University, Ph.D., 1910. Taught at the University of North Carolina, 1920–54. A scholar of folk cultures, especially black cultures, Odum wrote many works about black music. Urged government involvement in the social welfare programs that he espoused; in 1929, he joined William F. Ogburn in coordinating the study published as *Recent Trends In the United States* (1933), which marked a new departure in the relations between the federal government and the social sciences. A proponent of the concept of regionalism in the social welfare programs of his time, Odum sought unity through diversity. President of the American Sociological Society, 1930; president of the Southern Regional Council, 1944–46.

O'DWYER, JOSEPH (*b. Cleveland, Ohio, 1841; d. 1898*), physician. Graduated N.Y. College of Physicians and Surgeons, 1866; practiced thereafter in New York City. Successfully demonstrated value of intubation in treatment of diphtheria at New York Foundling Asylum *post* 1872; his findings, first attacked and later enthusiastically approved by the medical profession, were published first in the *New York Medical Journal*, Aug. 8, 1885. He was also among the first to recognize the value of diphtheria serum.

O'DWYER, WILLIAM (*b. Bohola, Co. Mayo, Ireland, 1890; d. New York, N.Y., 1964*), lawyer and mayor of New York City. Arrived in New York in 1910; became U.S. citizen, 1916, and next year joined New York City police force. Studied law in the evening at Fordham (LL.B., 1923). Following service in several city judicial positions, he was elected Kings County district attorney (1940) and smashed the crime ring "Murder, Inc." Elected mayor of New York City in 1945; reelected in 1949. A probe into gambling and police corruption led to his resignation in 1950, after he handed out $125,000 in raises to friends on the city's payroll. He appeared before the Senate Crime Committee, headed by Estes Kefauver, in 1951, while serving as U.S. ambassador to Mexico; although no charges of wrongdoing were made, it was evident that he had dealings with criminal elements; resigned as ambassador in 1952. The stereotype of the affable Irish politician, his rise in politics was due as much to hard work as to an understanding of machine politics. His accomplishments as mayor include bringing the United Nations headquarters to the city and the selection of Robert Moses as the city's construction coordinator.

OEHMLER, LEO CARL MARTIN (*b. Pittsburgh, Pa., 1867; d. Pasadena, Calif., 1930*), musician, piano teacher, composer. Teacher of Charles W. Cadman.

OEMLER, ARMINIUS (*b. Savannah, Ga., 1827; d. Savannah, 1897*), physician, agriculturist, Confederate soldier. Among the first to introduce scientific diversified farming into the South, Oemler anticipated by two years (1888) the German discovery of the presence of nitrogen-fixing bacteria in the nodules of leguminous plants. He started the first commercial oyster-packing plant in the South *ca.* 1883 and was thereafter a promoter of that industry.

OERTEL, JOHANNES ADAM SIMON (*b. Fürth, Bavaria, 1823; d. Vienna, Va., 1909*), Episcopal clergyman, artist. Came to America, 1848, after studying at Munich. Active in the ministry *post* 1867, he is remembered chiefly as the painter of the very popular "Rock of Ages," although he did much excellent work in church decoration and was a superior woodcarver.

O'FALLON, BENJAMIN (*b. probably Lexington, Ky., 1793; d. Jefferson Co., Mo., 1842*), Indian agent, trader. Son of James O'Fallon; nephew of William and George Rogers Clark; brother of John O'Fallon. As U.S. Indian agent at Prairie du Chien, O'Fallon made treaties with the Oto and Ponca, 1817. Appointed agent for the upper Missouri, 1819, he served until 1927 with great success owing to his honesty and courage and his remarkable knowledge of Indian customs, habits, and characteristics. He was a principal in the Missouri Fur Co.

O'FALLON, JAMES (*b. Ireland, 1749; d. 1794*), physician, Revolutionary soldier, adventurer. Immigrated to North Carolina, 1774; after the Revolution, removed to Charleston, S.C. Appointed general agent of the South Carolina Yazoo Company, he associated himself with James Wilkinson and with Esteban Miró in intrigues connected with the institution of an independent government for the West. A proclamation by President

Washington, March 1791, proved disastrous to O'Fallon's plans. He married a sister of William and George Rogers Clark in 1791 and was the father of Benjamin and John O'Fallon.

O'FALLON, JOHN (*b. Louisville, Ky., 1791; d. St. Louis, Mo., 1865*), soldier, merchant. Son of James O'Fallon; nephew of William and George Rogers Clark; brother of Benjamin O'Fallon. After able army service at Tippecanoe and in the War of 1912, O'Fallon resigned his commission, 1818, and engaged in trade at St. Louis, Mo., where he became a wealthy and public-spirited citizen.

O'FERRALL, CHARLES TRIPLETT (*b. Frederick Co., Va., 1840; d. Richmond, Va., 1905*), lawyer. Confederate cavalry colonel, Virginia legislator. Congressman, Democrat, from Virginia, 1884–93. A strict constructionist and supporter of Grover Cleveland, O'Ferrall made a determined effort to wipe out lynching as governor of Virginia, 1894–98.

OFFLEY, DAVID (*b. Philadelphia, Pa., d. Smyrna, Turkey, 1838*), merchant. Removing to Smyrna, 1811, he founded there the first American commercial house in the Levant. He served as consular commercial agent, 1823–32, and as U.S. consul, 1832–38.

OFTEDAL, SVEN (*b. Stavanger, Norway, 1844; d. 1911*), Lutheran clergyman, Minneapolis civic leader. Came to America, 1873. Professor of theology, 1873–1904, and president of trustees, 1874–1911, of Augsburg Seminary, Minneapolis.

OGBURN, WILLIAM FIELDING (*b. Butler, Ga., 1886; d. Tallahassee, Fla., 1959*), sociologist, statistician, educator. Studied at Mercer University and Columbia University, Ph.D., 1912. Professor of sociology at Columbia, 1919–27, and at the University of Chicago, 1927–51. Ogburn played a major role in converting the social sciences into quantitative empirical disciplines by introducing statistical techniques into research. Works include *Social Change: With Respect to Culture and Original Nature* (1922), in which he introduced the term, "cultural lag," and *Recent Social Trends in the United States* (1933). President of the American Association for the Advancement of Science, 1932; president of the Society for the History of Technology, 1959.

OGDEN, AARON (*b. Elizabeth, N.J., 1756; d. Jersey City, N.J., 1839*), Revolutionary soldier, lawyer, pioneer steamboat operator. Graduated College of New Jersey (Princeton), 1773. Entering practice after the Revolution, he became a leader of the New Jersey bar, served as U.S. senator, Federalist, 1801–03, and was elected governor of New Jersey in the fall of 1812 on a peace ticket. After commanding the New Jersey militia during the War of 1812, he undertook operation of a steamboat between Elizabeth and New York City which occasioned the legal conflicts concluded in the celebrated U.S. Supreme Court case of *Gibbons vs. Ogden*, 1824. Ruined by this litigation, he became collector of customs at Jersey City in 1829 and served until his death.

OGDEN, DAVID (*b. Newark, N.J., 1707; d. Whitestone, N.Y., 1798*), lawyer, New Jersey councilor and jurist, Loyalist.

OGDEN, DAVID BAYARD (*b. Morrisania, N.Y., 1775; d. Staten Island, N.Y., 1849*), lawyer. Son of Samuel Ogden. Practicing in New York City *post* 1803, Ogden's chief fame arose from the clarity of his presentations before the U.S. Supreme Court. The most celebrated of the many cases in which he participated was *Cohens vs. Virginia* (1821) in which he appeared for Cohens.

OGDEN, FRANCIS BARBER (*b. Boonton, N.J., 1783; d. Bristol, England, 1857*), engineer. Nephew of Aaron Ogden. A pioneer in designing steamboat engines, Ogden resided in England *post* 1830 where he served in several consular posts. He financed the work of John Ericsson and promoted his interests in England and in the United States.

OGDEN, HERBERT GOUVERNEUR (*b. New York, N.Y., 1846; d. Fortress Monroe, Va., 1906*), cartographer, topographer. Appointed an aid in the U.S. Coast and Geodetic Survey, 1863, Ogden remained with that service until his death, serving as cartographer and topographer and as director of publication of three editions of the U.S. *Coast Pilot* (1899, 1903, 1904). He also made original explorations in Alaska.

OGDEN, PETER SKENE (*b. Quebec, Canada, 1794; d. Oregon City, Oreg., 1854*), fur trader, explorer. Grandson of David Ogden. Entered employ of the North West Company *ca.* 1815. Transferred to the Columbia district beyond the Rockies *ca.* 1818, he spent the remainder of his life there. His work took him into almost every valley in southern Idaho and eastern Oregon and into Montana; he was one of the first white men to visit the Great Salt Lake region (Ogden, Utah, was named in his honor), and he was the first to traverse the Humboldt River valley in northern Nevada. Assigned to the Fraser River region *ca.* 1836, he was stationed at Fort Vancouver *post* 1844. A man of great cultivation and urbanity, he was author of *Traits of American Indian Life* (London, 1853).

OGDEN, ROBERT CURTIS (*b. Philadelphia, Pa., 1836; d. Kennebunkport, Maine, 1913*), merchant, promoter of education in the South.

OGDEN, ROLLO (*b. Sand Lake, N.Y., 1856; d. 1937*), Presbyterian clergyman, newspaper editor. Graduated Williams, 1877. Leaving the ministry, 1887, on conscientious grounds, Ogden joined the staff of the N.Y. *Evening Post*, 1891; he became editor-in-chief, 1903, and served until 1920, simultaneously controlling the editorial policy of the *Nation*. A champion of anti-imperialism, low tariffs, civil service reform, black rights, woman suffrage, and international action for peace, he at the same time opposed any wide expansion of governmental powers. Ogden served as associate editor of the *New York Times*, 1920–22, and as editor, 1922–37. Remaining a staunch internationalist, he approved of some parts of the New Deal but was hostile to its augmentation of federal power.

OGDEN, SAMUEL (*b. Newark, N.J., 1746; d. New York, N.Y., 1810*), iron founder, land promoter. Son of David Ogden.

OGDEN, THOMAS LUDLOW (*b. probably Morristown, N.J., 1773; d. 1844*), lawyer. Grandson of David Ogden; nephew of Samuel Ogden. Graduated Columbia, 1792; admitted to New York bar, 1796. Specializing in trusts and will and equity jurisprudence, Ogden became one of the most active corporation lawyers in New York City and was identified with many of its cultural and civic activities.

OGDEN, UZAL (*b. Newark, N.J., 1744; d. Newark, 1822*), Episcopal clergyman. Made theological studies under Thomas B. Chandler; was ordained in London, England, 1773. Rector of Trinity Church, Newark, 1788–1805, Ogden was elected first bishop of New Jersey, 1798, but was refused consecration. Suspended from the Episcopal ministry, 1805, as the final step in a long controversy over his broad views on order and doctrine, he became a Presbyterian.

OGDEN, WILLIAM BUTLER (*b. Walton, N.Y., 1805; d. New York, N.Y., 1877*), businessman. After early success as a land developer in New York, Ogden removed to Chicago, Ill., 1835, made a fortune in real estate operations there, and was elected

the city's first mayor, 1837. After his term, he devoted himself to railroad construction east and west from Chicago; among the roads which he headed were the Galena & Chicago; the Pittsburgh, Fort Wayne & Chicago; the Chicago & Northwestern. He presided over the National Pacific Railway Convention, 1850, and was first president of the Union Pacific, 1862.

OGG, FREDERIC AUSTIN (*b. Solsberry, Ind., 1878; d. Madison, Wis., 1951*), political scientist, author, editor, educator. Studied at DePauw College (Ph.B., 1899), Indiana University, and Harvard, Ph.D., 1908. Taught history at Simmons College, 1909–14. Professor of political science at the University of Wisconsin, 1914–50. A pioneer in the field of political science, Ogg wrote many widely used texts: *Introduction to American Government* (1922) and *Essentials of American Government* (1932). Served on the editorial board of *American Political Science Review*, 1916–26; managing director, 1926–49. President of the American Political Science Association, 1941.

OGILVIE, JAMES (*b. Aberdeen, Scotland, date unknown; d. Aberdeen, 1820*), teacher, lecturer. An eccentric pseudo-philosopher, Ogilvie conducted several schools in Virginia *ante* 1809; thereafter, he became a wandering professor of oratory. Failing in his ambitions, he returned to Scotland where he committed suicide.

OGILVIE, JOHN (*b. probably New York, N.Y., 1724; d. New York, 1774*), Anglican clergyman. Graduated Yale, 1748. After ordination in London, England, 1749, Ogilvie returned to America with an appointment as missionary in Albany, N.Y., and to the Mohawk Indians. He served with zeal in this work, was a military chaplain, 1756–60, and in 1764 was appointed assistant minister of Trinity Church, New York City, where he served until his death.

OGLE, SAMUEL (*b. Northumberland Co., England, ca. 1702; d. Annapolis, Md., 1752*), British officer, colonial official. Proprietary governor of Maryland, 1732, 1733–42, and 1747–52, Ogle successfully resolved the question of the validity of English legal statutes in Maryland; he also regulated the tobacco trade.

OGLESBY, RICHARD JAMES (*b. Oldham Co., Ky., 1824; d. 1899*), lawyer, politician, Union major general. Republican governor of Illinois, 1865–69, also for a very brief period in 1873, and 1885–89; U.S. senator, 1873–79.

OGLETHORPE, JAMES EDWARD (*b. London, England, 1696; d. England, 1785*), soldier, philanthropist, founder of the colony of Georgia. Educated at Eton and Oxford; early gained military reputation in service under Prince Eugene against the Turks. Briefly involved in Jacobite activity abroad, he returned to England in 1719 to manage family estate. Entering Parliament as a mild High Tory, he held his seat, 1722–54, advocating naval preparedness, an expanding imperial commerce, improved penal conditions for debtors, and abolition of both impressment and slavery. He conceived the idea of sending newly freed and unemployed debtors to America at about the time when concern over the exposed position of Carolina to Indian and Spanish raids led the British government to seek expansion and defense of that colony by a buffer zone to the south. After a long period of many trials, Oglethorpe and 19 associates received a charter in 1732 to establish the colony of Georgia. His energetic publicity efforts and royal favor having brought both money and settlers for the venture, he landed at Charleston, 1733. Pursuing a conciliatory policy with the Indians, he secured a site at Savannah. Fortifications were at once erected and a rigorous system of military training established. Salzburger Lutherans were persuaded to migrate to the colony, 1734. Need for more money brought Ogle-

thorpe back to England, 1734; he pressed successfully for new regulations banning sale of rum, prohibiting slavery, and setting up a licensing system for the Indian trade. Groups of Scotch Presbyterian and Moravian settlers were induced to join the colony between 1735 and 1738. Rumors of insurrection caused Oglethorpe to return to Georgia in 1735, accompanied by Charles and John Wesley, who did not find their stay congenial and soon left. An effective but expensive southern military outpost against the Spaniards, Fort Frederica, was founded in 1736.

Complaints by Carolina against the licensing of trade, Spanish resentment of Frederica, the tales reported to England by malcontent settlers, and increasing debts drew Oglethorpe back to London, 1736–37. Most difficulties were smoothed over, but trouble with Spain continued. Persisting in his efforts to strengthen the colony for both humanitarian and imperial reasons, Oglethorpe returned once more to Georgia in 1738, this time with a regiment of 700 men. Henceforth, a dragging war with Spain was his principal concern. Georgians attacked St. Augustine in 1740, and Frederica in turn was besieged by the Spanish in 1742. Oglethorpe borrowed heavily on his English holdings to conduct a successful defense of his colony, but internal discontents and serious charges by a subordinate forced his return to London in 1743. He was acquitted by a court martial but his administrative powers and vigor had diminished; his colonizing days were over and he lived uneventfully thereafter in England. He was promoted to the rank of full general, 1765.

O'GORMAN, THOMAS (*b. Boston, Mass., 1843; d. Sioux Falls, S. Dak., 1921*), Roman Catholic clergyman, Paulist, educator. Second bishop of Sioux Falls, 1896–1921; assisted William H. Taft in settlement of Philippine friar question, 1902.

O'HARA, JAMES (*b. Ireland, 1752; d. Pittsburgh, Pa., 1819*), Revolutionary soldier, manufacturer, land speculator. Early Pittsburgh banker and glass manufacturer; associated with John H. Hopkins in Ligonier iron works.

O'HARA, JOHN HENRY (*b. Pottsville, Pa., 1905; d. Princeton, N.J., 1970*), novelist and short-story writer. American master of short fiction, began work as a reporter for the *New York Herald Tribune* in 1928, the year his first short story appeared in the *New Yorker*. Held a series of journalistic jobs, most of which he lost due to drinking. His novel *Appointment in Samarra* (1934) established his literary reputation. He practiced the novel of manners, and his principal themes were the cruelty of human conduct and the pain of loneliness. *The Doctor's Son* (1935) was his first short-story collection and led to his being credited with perfecting the subgenre "the New Yorker story." *Butterfield 8*, his second novel (1935), led to work in Hollywood as a script polisher. His stories about "Pal Joey" began appearing in the *New Yorker* in 1938 and were collected in 1940, when the musical, for which he wrote the book, appeared on Broadway. During the 1940's he published stories, commuted to Hollywood, and wrote a column for *Newsweek*. *A Rage to Live* (1949) became a bestseller; other novels include *Ten North Frederick* (1955), *From the Terrace* (1958), and *Ourselves to Know* (1960). In the 1960's he wrote short stories and novellas for the *New Yorker* and published thirteen volumes of fiction.

O'HARA, THEODORE (*b. Danville, Ky., 1820; d. Guerryton, Ala., 1867*), soldier, journalist. Officer in both Mexican and Civil wars; author of "The Bivouac of the Dead," commemorating Kentuckians killed at Buena Vista.

O'HARE, KATE (RICHARDS) CUNNINGHAM (*b. Ottawa County, Kans., 1877; d. Benicia, Calif., 1948*), socialist lecturer and organizer. Apprenticed as a machinist; joined Socialist Labor party,

1899, leaving it for the Socialist party of America, 1901. Married F. P. O'Hare, 1902, with whom she worked as party organizer and as editor-publisher of the *National Rip-Saw* (later renamed *Social Revolution*). Imprisoned 1919–20 for opposition to U.S. involvement in World War I. With her husband, founded Commonwealth College in Leesville, La., 1922; removed with college to Mena, Ark., 1925. Divorced in 1928, she married C. C. Cunningham and resided thereafter in California, where she was active in prison reform and in support of Upton Sinclair's EPIC movement and his campaign for governor.

O'HIGGINS, HARVEY JERROLD (*b. London, Ontario, Canada, 1876; d. 1929*), novelist, journalist. Helped introduce literary use of psychoanalytic method in 1920's; was long associated with work of the Authors' League.

OHLMACHER, ALBERT PHILIP (*b. Sandusky, Ohio, 1865; d. Detroit, Mich., 1916*), physician, pathologist. M.D., Northwestern, 1890. Pioneered in study of the pathology of epilepsy.

OHRBACH, N(ATHAN) M. (*b. Vienna, Austria, 1885; d. New York City, 1972*), retailer. Opened several specialty clothing shops in New York City in the 1910's, including Bon Marché, and launched a low-priced clothing store in Manhattan in 1923. He later expanded the stores, known as "Ohrbach's," to suburban sites in New York and California. He was a pioneer of low-cost, high-volume selling and introduced copies of Paris designer fashions at low prices.

O'KELLY, JAMES (*b. Ireland or America, ca. 1735; d. 1826*), Methodist preacher, opponent of slavery. Prominent as preacher in North Carolina and Virginia *post* 1778, he opposed authority, especially that of Bishop Francis Asbury, insisting that General Conferences should have a larger role in direction of church affairs. Seceding from the Methodist Episcopal Church, 1792, he set up his own group, called Republican Methodists and later simply "Christians." This group was congregational in policy and regarded the Scriptures as the only authority on faith and practice.

OKEY, JOHN WATERMAN (*b. Monroe Co., Ohio, 1872; d. Columbus, Ohio, 1885*), lawyer. Prominent common-pleas and supreme court jurist in Ohio. Co-author of *Digest of Ohio Reports* (1867) and *The Municipal Code of Ohio* (1869).

O'LAUGHLIN, MICHAEL See BOOTH, JOHN WILKES.

OLCOTT, CHANCELLOR JOHN See OLCOTT, CHAUNCEY.

OLCOTT, CHAUNCEY (*b. Buffalo, N.Y., 1860; d. Monte Carlo, Monaco, 1932*), actor, singer. Popular Irish–American tenor; wrote "My Wild Irish Rose."

OLCOTT, EBEN ERSKINE (*b. New York, N.Y., 1854; d. New York, 1929*), mining engineer. Graduated Columbia School of Mines, 1874. Pioneered development of Cerro de Pasco copper fields in Peru; managed Hudson River Day Line *post* 1895.

OLCOTT, HENRY STEEL (*b. Orange, N.J., 1832; d. 1907*), lawyer, president-founder of the Theosophical Society. Led a bizarre life as Helena Blavatsky's partner; was conciliator of Japanese and Ceylonese Buddhist sects, and editor of the *Theosophist*.

OLDEN, CHARLES SMITH (*b. near Princeton, N.J., 1799; d. Princeton, 1876*), businessman, farmer, New Jersey legislator and jurist. Anti-Democrat coalition governor of New Jersey, 1860–63.

OLDER, FREMONT (*b. near Appleton, Wis., 1856; d. near Stockton, Calif., 1935*), printer, editor, reformer. Removed to San Francisco, Calif., 1873; worked on a number of California and Nevada newspapers; settled in San Francisco, 1884, where he became managing editor of the *Bulletin*, 1895. He built up the paper's circulation and attracted national attention by journalistic crusades against the Southern Pacific Railroad, the Abraham Ruef political machine, and the domination of the state by special interests; he also worked for penal reform, encouraged labor unions, and demanded the acquittal of Thomas J. Mooney and others after the Preparedness Day bombings, 1916. Leaving the editorship of the *Bulletin*, he became editor of the San Francisco *Call*, 1918, and a loyal defender of his employer William R. Hearst. As an editor, he was forceful and successful; as a person, he was full of contradictions and difficult to analyze.

OLDFATHER, WILLIAM ABBOTT (*b. Urumiah, Persia, 1880; d. Homer Park, Ill., 1945*), classicist. Child of Presbyterian missionary parents. A.B., Hanover (Ind.) College, 1899. A.B., Harvard, 1901; A.M., 1902, Ph.D., University of Munich, 1908. Taught at Northwestern University, 1903–06, 1908–09; was associate professor and later professor of classics at University of Illinois, 1909–45. He headed the classics department at Illinois *post* 1926.

OLDFIELD, ("BARNEY") BERNA ELI (*b. near Wauseon, Ohio, 1878; d. Beverly Hills, Calif., 1946*), automobile racer. Known as "Barney" Oldfield. Began as a bicycle racer. Famous as the first man to break the one-minute mile, which he did driving Henry Ford's "999" at the Indiana State Fair, Indianapolis, June 15, 1903.

OLDHAM, JOHN (*b. probably Lancashire, England, ca. 1600; d. Block Island, R.I., 1636*), colonist, trader. Came to America, 1623; resided in both Plymouth and Massachusetts Bay colonies. His murder by Indians near Block Island helped to start Pequot War.

OLDHAM, WILLIAM FITZJAMES (*b. Bangalore, India, 1854; d. Glendale, Calif., 1937*), Methodist clergyman. A convert to Methodism, he was licensed to preach in India, 1876. After serving as pastor and teacher in the U.S., 1890–1904, he was bishop and supervisor of missions in southern Asia, 1904–12, and in South America, 1916–28.

OLDHAM, WILLIAMSON SIMPSON (*b. Franklin Co., Tenn., 1813; d. Houston, Tex., 1868*), Arkansas legislator and jurist. Removed to Texas, 1849. Confederate senator from Texas, 1861–65. Opposed both conscription and suspension of *habeas corpus* by Confederate government on states' rights grounds.

OLDS, IRVING SANDS (*b. Erie, Pa., 1887; d. New York, N.Y., 1963*), lawyer and corporation executive. Attended Yale and Harvard Law (graduated, 1910). Joined New York law firm White and Case (1911) and became a partner in 1917. Elected to the board and finance committee of U.S. Steel (1936); chairman of the board (1940–52). He expanded the company's facilities, breaking all production records during World War II. Despite severe postwar labor strife in the steel and coal industries, production exceeded records set during the war; his negotiation of a strike settlement in 1947 with United Steel Workers set an industrywide pattern for labor negotiations. Remained a director of U.S. Steel until 1960, then served as one of three voting trustees (1960–62) of TWA stock to protect the airline from bankruptcy.

OLDS, LELAND (*b. Rochester, N.Y., 1890; d. Bethesda, Md., 1960*), economist, public official. Studied at Amherst College, Harvard, Columbia, and the Union Theological Seminary. Industrial editor, 1922–29, for the Federated Press, a news service with an assortment of clients among labor journals. An expert in the field of public utilities, Olds was head of the New York State Power Authority, 1931–39. A member of the Federal Power Com-

mission, 1939–49, he was involved in the controversial regulation of the natural gas industry. Appointed to a third term in 1949, he failed to receive ratification in the Senate. Attacked by such figures as Lyndon Johnson for his leftist writings in the 1920's and 1930's, Olds became a victim of the "red scare" of the Cold War.

OLDS, RANSOM ELI (*b. Geneva, Ohio, 1864; d. Lansing, Mich., 1950*), inventor, automobile manufacturer. Began as bookkeeper in his father's Lansing, Mich., machine shop, 1883; became a partner, 1885. Encouraged by his successful manufacture of a small engine heated by ordinary gasoline stove burners, Olds built a three-wheel self-propelled vehicle in 1887. Increasingly interested in the internal combustion engine, Olds adopted it for another vehicle, completed in 1896. The following year he formed the Olds Motor Vehicle Company and, to supersede the family machine shop, the Olds Gasoline Machine Works. In 1899 the assets of the motor vehicle company were incorporated into a new company, the Olds Motor Works, and operations transferred to Detroit. In 1904 Olds resigned and formed the Reo Motor Car Company (a name derived from his initials) in Lansing. To ensure a nearby and steady source of parts, he organized several subsidiary firms. He played a lesser role in Reo's affairs after 1915 and gave increasing time to other ventures, including the Ideal Power Lawn Mower Company to manufacture a mower he had invented, the Capital National Bank (forerunner of the Michigan National Bank), and R. E. Olds Company, an investment firm. His most ambitious project was Oldsmar, a Florida community on Tampa Bay.

OLDS, ROBERT EDWIN (*b. Duluth, Minn., 1875; d. Paris, France, 1932*), lawyer, Red Cross official. Assistant U.S. secretary of state, 1925–27; under secretary of state, 1927–28. A loyal and self-effacing subordinate to Frank B. Kellogg.

OLDSCHOOL, OLIVER See SARGENT, NATHAN.

O'LEARY, DANIEL (*b. Clonakilty, Ireland, 1846[?]; d. Los Angeles, Calif., 1933*), pedestrian. Set many records for walking; twice winner of the Astley Belt.

OLIN, STEPHEN (*b. Leicester, Vt., 1797; d. Middletown, Conn., 1851*), Methodist clergyman, educator. President of Randolph-Macon College (1834–37) and Wesleyan University (1842–51); tried to prevent denominational split over slavery in 1840's.

OLIPHANT, HERMAN (*b. near Forest, Ind., 1884; d. Washington, D.C., 1939*), lawyer. Teacher of law at University of Chicago, 1914–21; at Columbia, 1921–28; at Johns Hopkins, 1928–33. U.S. treasury department adviser, 1933–39, he was influential in shaping New Deal fiscal policies.

OLIVER, ANDREW (*b. Boston, Mass., 1706; d. Boston, 1774*), Massachusetts provincial legislator. Brother of Peter Oliver. Graduated Harvard, 1724. Married Governor Thomas Hutchinson's sister-in-law, 1734, and thereafter consistently acted with Hutchinson in colonial policies. Appointed secretary of the province, 1756, he held this position until 1771 when he was appointed lieutenant governor. He was hated by the popular or patriot party because of his appointment as stamp officer under the Stamp Act, and the revolution in 1773 of letters which Governor Hutchinson and he had earlier written to England describing unsettled conditions in the colonies and prescribing remedies. On both occasions mobs threatened him and his family and attacked his home.

OLIVER, ANDREW (*b. Boston, Mass., 1731; d. Salem, Mass., 1799*), Massachusetts legislator and jurist, scientist. Son of Andrew Oliver (1706–1774). Graduated Harvard, 1749. His most significant scientific contribution was *An Essay on Comets* (1772).

OLIVER, CHARLES AUGUSTUS (*b. Cincinnati, Ohio, 1853; d. Philadelphia, Pa., 1911*), ophthalmologist. Coauthor with William F. Norris of *A Textbook of Ophthalmology* (1893) and *System of Diseases of the Eye* (1897–1900).

OLIVER, FITCH EDWARD (*b. Cambridge, Mass., 1819; d. Boston, Mass., 1892*), physician, historian. Edited diaries of Benjamin Lynde and William Pynchon; author of other studies of Massachusetts history.

OLIVER, GEORGE TENER (*b. Co. Tyrone, Ireland, 1848; d. Pittsburgh, Pa., 1919*), steel manufacturer, lawyer. Brother of business associate of Henry W. Oliver. Publisher of *Pittsburgh Gazette Times*; steadfast proponent of protective tariff; U.S. senator, Republican from Pennsylvania, 1909–17.

OLIVER, HENRY KEMBLE (*b. Beverly, Mass., 1800; d. Salem, Mass., 1885*), teacher, musician, cotton-mill superintendent. Massachusetts state treasurer, 1860–65; organized pioneer Massachusetts Bureau of Statistics of Labor, 1869, and headed it until 1873.

OLIVER, HENRY WILLIAM (*b. Co. Tyrone, Ireland, 1840; d Pittsburgh, Pa., 1904*), ironmaster. Brother of George T. Oliver. Came to America as a child. Helped organize a firm in Pittsburgh to manufacture nuts and bolts, 1863; it grew steadily after the Civil War and was incorporated as the Oliver Iron & Steel Co., 1888. Oliver branched out into many phases of the ferrous metal industry; his chief distinction was in early (1892) recognizing the potential of Mesabi range iron ore. Organizing a mining company and building a feeder railroad, Oliver began the ore traffic from the lake ports to Pittsburgh.

OLIVER, JAMES (*b. Liddesdale, Scotland, 1823; d. South Bend, Ind., 1908*), cooper, foundryman, inventor. Came to America as a boy. Began experimenting with chilled iron for making hard-faced plows, *ca.* 1865; obtained two patents in 1868 for mould board processes. He went on to more important inventions, one (1869) to prevent castings from cooling too rapidly, others (1871–76) which guaranteed a hard, smooth surface on the face of the mould board. His Oliver Chilled Plow Works, employing his discoveries, was by the time of his death producing 200,000 plows annually.

OLIVER, JOSEPH (*b. in or near New Orleans, La., ca. 1885; d. Savannah, Ga., 1938*), cornetist, jazz composer, orchestra leader, known as "King" Oliver. A black, Oliver pioneered in bringing New Orleans jazz to a wide audience.

OLIVER, "KING" See OLIVER, JOSEPH.

OLIVER, PAUL AMBROSE (*b. aboard ship in English Channel, 1830; d. 1912*), merchant. Union soldier. Raised in Germany; returned to America, 1849. Invented blasting powder manufacturing processes; headed powder plant in Wilkes-Barre, Pa., 1868–1903.

OLIVER, PETER (*b. Boston, Mass., 1713; d Birmingham, England, 1791*), Loyalist, Massachusetts provincial jurist, and iron manufacturer. Brother of Andrew Oliver (1706–1774). Graduated Harvard, 1730. Judge of superior court, 1756–74; chief justice, 1771–74. Departed with British army to Halifax, N.S., 1776; later settled in England with a British pension.

OLMSTEAD, ALBERT TEN EYCK (*b. Troy, N.Y., 1880; d. Chicago, Ill., 1945*), orientalist, historian of the pre-Islamic civiliza-

tions of the Near East. A.B., Cornell University, 1902; A.M., 1903; Ph.D., 1906. Taught ancient history at University of Missouri, 1909–17; professor of history and curator of the Oriental Museum, University of Illinois, 1917–29; professor of oriental history, University of Chicago, 1929–45. Author of *Assyrian Historiography* (1916), in which he established the principles of source interpretation for the royal annals of Assyria; author also, among other works, of *History of Assyria* (1923) and *History of Palestine and Syria* (1931).

OLMSTEAD, GIDEON *See* OLMSTED, GIDEON.

OLMSTED, DENISON (*b. near East Hartford, Conn., 1791; d. New Haven, Conn., 1859*), scientist, inventor, teacher. Graduated Yale, 1813. Held chairs of mathematics and natural philosophy at Yale, 1825–59; won fame for meteor shower investigations; was author of widely used textbooks.

OLMSTED, FREDERICK LAW (*b. Hartford, Conn., 1822; d. Waverly, Mass., 1903*), landscape architect. Son of a prosperous merchant; attended Yale; studied engineering, 1837–40. An unhappy period in a New York dry goods importing firm was followed by a year's voyage to China, 1843. He next turned to farming on Staten Island acreage given him by his father and became friendly with Andrew J. Downing. During the 1850's he turned to writing noteworthy travel studies. His *Walks and Talks of an American Farmer in England* (1852) and articles in the *Horticulturist* were followed by a commission from the *New York Times* to report on economic and social conditions in the South. His travels through the Southeast and Texas and a lengthy journey from New Orleans to Richmond were recorded first in letters to the *Times*, then in separate volumes and finally in *The Cotton Kingdom* (2 vols., 1861). This work remains a classic picture and analysis of the planter-slavery system in the *ante bellum* South. His continuing interest in landscaping led to his appointment in 1857 as superintendent of Central Park in New York City; in 1858, he became the park's chief architect. Olmsted and a young English architect, Calvert Vaux, had entered a competition to provide a new design for the park. Their plan won and the two men set out to make the first American park not only a work of art but a successful municipal enterprise. Olmsted took leave of absence, 1861, to become general secretary of the U.S. Sanitary Commission, which he organized successfully. Political opposition in New York and failing health led Olmsted to go to California, 1863; there he superintended John C. Frémont's Mariposa estate, led the move to make Yosemite a state reservation, and made designs for the grounds of the new University of California, Berkeley. Returning to New York, he resumed work on Central Park and set up with Vaux (1865) a firm for the practice of landscape architecture. For thirty years he did a richly varied business in city parks, city planning, private estates, historical sites, and university designs. Frequent visits to Europe and a succession of talented associates helped Olmsted to gain a towering reputation. His tenacity in seeking to protect quiet, sylvan retreats to be used by busy urban residents led to much political opposition. Central Park and Brooklyn's Prospect Park were his most spectacular New York City projects, but he also made the plans for the Riverside and Morningside parks. The Boston park system with the famed Arnold Arboretum, Chicago's South Park, Detroit's Belle Isle Park, and Mount Royal Park in Montreal were other major projects. Representative of his firm's varied designs were those for the Capitol grounds at Washington, D.C., and Albany, N.Y., for Stanford University, for the suburban development at Riverside near Chicago, the Niagara Reservation, George W. Vanderbilt's vast estate "Biltmore" near Asheville, N.C., and a crowning achievement, the design of the grounds of the "White City" at the 1893 Chicago World's Fair.

OLMSTED, FREDERICK LAW (*b. Staten Island, N.Y., 1870; d. Malibu, Calif., 1957*), landscape architect, planner, conservationist. Graduated from Harvard University, B.A., 1894. The son of America's most famous landscape architect, Frederick Olmsted, Sr., young Olmsted apprenticed with his father in laying out the plans for the campus of Stanford University and working on the grounds of the Vanderbilt estate, Baltimore, in Asheville, N.C. Landscape projects of the firm of Olmsted Brothers, founded in 1895, include Fort Tryon Park, the Cloisters, and Forest Hills Gardens in New York City; and the White House grounds, Lafayette Park, Washington Monument Gardens, the Jefferson Memorial, and Washington Cathedral. Helped found the American Society of Landscape Architects and the American Institute of Planners.

OLMSTED, GIDEON (*b. East Hartford, Conn., 1749, d. East Hartford, 1845*), sea captain, privateersman. Celebrated, but only nominally successful, as commander of various privateers, 1776–95. The case of the sloop *Active* resulted from one of his captures.

OLMSTED, JOHN CHARLES (*b. Geneva, Switzerland, 1852; d. Brookline, Mass., 1920*), landscape architect. Nephew, stepson, and pupil of Frederick L. Olmsted whose work he continued; first president of the American Society of Landscape Architects.

OLMSTED, MARLIN EDGAR (*b. Potter Co., Pa., 1847; d. New York, N.Y., 1913*), corporation lawyer. Orthodox Republican congressman from Pennsylvania, 1897–1913; chairman, Committee on Insular Affairs, *post* 1909. A master of parliamentary procedure.

OLNEY, JESSE (*b. Union, Conn., 1798; d. Stratford, Conn., 1872*), teacher, elementary school textbook writer. His *Practical System of Modern Geography* (1828) and *A New and Improved School Atlas* (1829) became standard works because of the simplicity and novelty of their method.

OLNEY, RICHARD (*b. Oxford, Mass., 1835; d. 1917*), lawyer, statesman. Graduated Brown, 1856; Harvard Law School, 1858. Practiced successfully in Boston as specialist in will cases and corporation law. Appointed U.S. attorney general, 1893, he took prompt action against seizure of trains by Coxey's Army (1894). In the summer of that year he enjoined the American Railway Union and its president, Eugene V. Debs, from interfering with the U.S mails by halting railroad operations as a gesture of sympathy with the Pullman Company strikers; in 1895, he directed the argument in the U.S. Supreme Court which successfully upheld his action and declared the union officials in contempt. Thereafter, however, he urged recognition of the rights of organized labor and supported the movement which brought about the arbitration act of 1898. As U.S. secretary of state, 1895–97, Olney drafted the famous threatening declaration to Great Britain in the Venezuela boundary dispute, arguing that "the United States is practically sovereign on this continent." Successful in securing arbitration, he then sought to persuade Spain to more humane measures in Cuba but resisted pressure to recognize Cuban rebels as belligerents.

OLSEN, JOHN SIGVARD ("OLE") (*b. Peru, Ind., 1892; d. Albuquerque, N.Mex., 1963*), and **HAROLD OGDEN JOHNSON** (*"CHIC"*) *b. Englewood, Ill., 1891; d. Las Vegas, Nev., 1962*), comedians and partners for nearly fifty years in vaudeville, on Broadway, in movies and nightclubs, and on radio and television. Teamed up as a vaudeville act in 1914 and starred in their own review, *Monkey Business*, in 1926. They made their Broadway debut in *Take a Chance* (1933), then began one-night stands when the vaudeville circuits began to disintegrate. Their most famous show, *Hellzapoppin*, opened in New York in 1938 and

was a sellout, despite unenthusiastic reviews, winning over audiences with its zany antics; it closed in 1941 after 1,400 performances. Further productions included *Sons o' Fun* (1941), *Laffing Room Only* (1944), *Pardon Our French* (1950), and *Hellzasplashin* (1959), their last appearance as a team. Began a radio career in the late 1930's and presented "Comedy News" with limited success. Signed by NBC television as a summer replacement for Milton Berle (1949). Resumed a nightclub career in 1956, but the novelty of their act was gone.

OLSON, FLOYD BJERSTJERNE (*b. Minneapolis, Minn., 1891; d. Rochester, Minn., 1936*), lawyer, Farmer-Labor leader. Governor of Minnesota, 1931–36, he was more radical in his pronouncements than in his policies as an executive.

OLYPHANT, DAVID WASHINGTON CINCINNATUS (*b. Newport, R.I., 1789; d. Cairo, Egypt, 1851*), merchant. Engaged profitably in the China trade *post* 1820; supported and directed Presbyterian mission activity in China.

OLYPHANT, ROBERT MORRISON (*b. New York, N.Y., 1824; d. New York, 1918*), merchant. Son of David W. C. Olyphant. Engaged in China trade, 1844–73. Active in affairs of the Delaware & Hudson Co., he served as its president, 1884–1903.

O'MAHONEY, JOSEPH CHRISTOPHER (*b. Chelsea, Mass., 1884; d. Bethesda, Md., 1962*), journalist and U.S. senator. Attended Columbia and Georgetown (LL.B., 1920). Reporter and editor (1907–17), then practiced law in Cheyenne, Wyo., where he became active in Democratic politics. U.S. senator (1933–52, 1954–61); major assignments were to the Appropriations, Judiciary, and Interior committees, serving as chairman of the latter (1949–52). His greatest impact was as a crusading antimonopolist; he introduced the resolution that established the Temporary National Economic Committee (chairman, 1938–41), and cosponsored the Employment Act of 1946, which established the Joint Economic Committee (chairman for three congresses) and the Council of Economic Advisers.

O'MAHONY, JOHN (*b. Co. Cork, Ireland, 1816; d. New York, N.Y., 1877*), Fenian leader. Came to America, 1853. Headed American branch, Irish Republican Brotherhood, 1858–66 and 1872–77.

O'MALLEY, FRANK WARD (*b. Pittston, Pa., 1875; d. Tours, France, 1932*), journalist, author. Outstanding reporter on *New York Sun*, 1906–20.

O'MALLEY, WALTER FRANCIS (*b. New York City, 1903; d. Rochester, Minn., 1979*), major league baseball executive. Graduated University of Pennsylvania (1926) and Fordham University (LL.B., 1930). He established a lucrative law practice that specialized in bankruptcies. In 1950 he became the principal owner of the Brooklyn Dodgers; he emerged as baseball's leading policymaker while serving on the baseball owners' executive council and oversaw the negotiations for national television contracts. O'Malley's decision to move the Dodgers to Los Angeles in 1958 sparked a fierce controversy that forced him to justify his action before a congressional committee. The westward move of the franchise, however, helped expand the national presence of major league baseball. In the 1962 season, the club set an attendance record of 2.7 million spectators at the newly opened Dodger Stadium. He retired from the Dodger presidency in 1970 but remained chairman until his death.

OÑATE, JUAN DE (*b. Mexico, ca. 1549; d. Spain, ca. 1624*), colonizer of New Mexico. Son of a wealthy Spanish official in New Spain, he early engaged in military and mining operations in northern Mexico. Receiving an official contract to explore and colonize New Mexico, he led a well-equipped expedition up the Rio Grande, 1597–98. Establishing a capital at San Juan, he promoted missionary activities, and forced Indians of the upper Rio Grande pueblos to submit. He also sent expeditions to present-day Kansas (1601) and the Gulf of California (1605). After his resignation as chief of the colony, 1607, he returned to Mexico. Convicted of having mistreated his soldiers and the Indians, 1614, he was sentenced to banishment. He returned to Spain *ante* 1624.

ONDERDONK, BENJAMIN TREDWELL (*b. New York, N.Y., 1791; d. New York, 1861*), Episcopal clergyman. Brother of Henry U. Onderdonk. Consecrated bishop of New York, 1830. Suspended from office after a celebrated ecclesiastical trial, 1845.

ONDERDONK, HENRY (*b. Manhasset, N.Y., 1804; d. 1886*), teacher, local historian. Collected and published many valuable original documents of early Long Island history, especially Revolutionary War incidents.

ONDERDONK, HENRY USTICK (*b. New York, N.Y., 1789; d. 1858*), physician, Episcopal clergyman. Brother of Benjamin T. Onderdonk. Outstanding as a theological scholar and controversialist, he was consecrated assistant bishop of Pennsylvania, 1827, and succeeded as bishop, 1836. He was suspended at his own request from office and from the ministry for alcoholism (1844–56).

O'NEAL, EDWARD ASBURY (*b. Madison Co., Ala., 1818; d. Florence, Ala., 1890*), lawyer, Confederate officer, Democratic governor of Alabama, 1882–86.

O'NEAL, EDWARD ASBURY, III (*b. Florence, Ala., 1875; d. Florence, 1858*), agricultural leader. Studied at Washington and Lee University and at the University of Illinois. President of the Alabama chapter of the American Farm Bureau Federation; national vice president, 1924–31; president, 1931–46. A New Deal supporter, O'Neal helped Roosevelt draft the Agricultural Adjustment Administration legislation. Important during the transition of American agriculture from small family farms to modern scientific conglomerates.

O'NEALE, MARGARET L. (*b. Washington, D.C., 1796; d. Washington, 1879*), Daughter of a tavern-keeper, Peggy O'Neale led a varied, colorful, and dramatic life. First married to a navy purser, she charmed President Andrew Jackson's firm friend John H. Eaton, whom she met in 1818 and married soon after her husband's death in 1828. Washington society was scandalized. Jackson stood by his friend and newly appointed secretary of war, despite the consequent dramatic rift in Jackson's cabinet which led to mass resignation, 1831. After sharing her husband's position as governor of Florida and U.S. minister to Spain, Mrs. Eaton returned with him to Washington in 1840 where she resided thereafter.

O'NEALL, JOHN BELTON (*b. Newberry District, S.C., 1793; d. near Newberry, S.C., 1863*), South Carolina jurist and legislator. Held judicial posts, 1828–63. Chief justice of the state, 1859–63; opposed nullification and secession.

O'NEILL, C. WILLIAM ("BILL") (*b. Marietta, Ohio, 1916; d. Columbus, Ohio, 1978*), judge and governor. Graduated Marietta College (1938) and Ohio State University Law School (LL.B., 1942). Elected to the Ohio state legislature at age twenty-two, he became Ohio's youngest attorney general in 1950. He ran successfully as a Republican for governor of Ohio in 1956, though he lost his reelection bid two years later. While in office, he oversaw the expansion of the public education system and initi-

ated a highway construction program. He was elected to the Ohio supreme court in 1960 and oversaw a reform of the state judicial system and wrote several noted opinions upholding media access to trial proceedings; he was appointed chief justice in 1970.

O'NEILL, EUGENE (*b. New York, N.Y., 1888; d. Boston, Mass., 1953*), playwright. Studied briefly at Princeton and Harvard. His first play, *Bound East for Cardiff* (1916), produced at Provincetown, Mass., gave birth to the Provincetown Players and launched O'Neill's career. Awarded the Pulitzer Prize for *Beyond the Horizon* (1919) and *Anna Christie* (1920). His one-act play, *The Emperor Jones* (1920), was unique at the time for providing a serious dramatic role for a black actor. Other plays of this period include *The Hairy Ape* (1921), *The Great God Brown*, which used masks and monologues, and *Desire Under the Elms* (1924), based on themes from Greek tragedy.

Received third Pulitzer Prize for *Strange Interlude* (1926–27), which ran for several hours and brought O'Neill international fame. *Mourning Becomes Electra* (1929–31), was another long play based on the Orestes legend. *Ah! Wilderness* (1932), his only comedy, starred George M. Cohan and was made into a successful motion picture.

Stricken with a nervous disorder similar to Parkinson's disease, O'Neill had great problems writing in the years between 1935 and 1943. He produced his finest works during this period: *The Iceman Cometh* (1939); *Long Day's Journey Into Night* (1941), *A Touch of the Poet* (1942), and *A Moon for the Misbegotten* (1943).

O'Neill died almost forgotten. The posthumous productions of his plays restored his reputation as perhaps America's greatest playwright. *Long Day's Journey Into Night*, finally staged on Broadway in 1956, won O'Neill his fourth Pulitzer Prize. Awarded the Nobel Prize for Literature in 1936.

O'NEILL, JAMES (*b. Kilkenny, Ireland, 1849; d. New London, Conn., 1920*), actor. Came to America as a child. Early played varied roles; *post* 1882 was identified with "Edmond Dantes" in *Monte Cristo*, which he played more than 6000 times. Father of Eugene G. O'Neill.

O'NEILL, JOHN (*b. Co. Monaghan, Ireland, 1834; d. Omaha, Nebr., 1878*), Union soldier, Fenian leader. Immigrated to America as a youth. Attacked Canada three separate times (1866–71) with small forces which were easily repulsed.

O'NEILL, MARGARET L. *See* O'NEALE, MARGARET.

O'NEILL, ROSE CECIL (*b. Wilkes-Barre, Pa., 1874; d. Springfield, Mo., 1944*), illustrator, author. Creator of the Kewpie doll (patented March, 1913), which was based on her sketches in the *Ladies' Home Journal* and other magazines.

ONSAGER, LARS (*b. Oslo, Norway, 1903; d. Coral Gables, Fla., 1976*), theoretical physical chemist. Graduated Norges Tekniske Hogskole in Norway (1925) and came to the United States in 1928 (naturalized 1945) to teach at Johns Hopkins University. He taught at Brown University (1929–33), then joined the faculty in chemistry at Yale University, where he received his Ph.D. in 1935. His research merged physics, chemistry, and mathematics in the study of the mobility of ions in electrolyte solutions. He drew extensively on statistical models to explore the influence of electrical fields on ionic activity in solutions. His work led to the theory known as Onsager's reciprocal relations. He won the Nobel Prize in chemistry in 1968.

OPDYKE, GEORGE (*b. Hunterdon Co., N.J., 1805; d. 1880*), clothing merchant, municipal and currency reformer. Mayor of New York City during the Draft Riots (1863).

OPPENHEIM, JAMES (*b. St. Paul, Minn., 1882; d. 1932*), poet, novelist. Raised in New York City. Author, among other books, of *Songs for the New Age* (1914) and *The Golden Bird* (1923); edited *The Seven Arts*, 1916–17.

OPPENHEIMER, JULIUS ROBERT (*b. New York, N.Y., 1904; d. Princeton, N.J., 1967*), theoretical physicist. Attended Harvard; Cavendish Laboratory in Cambridge, England; and University of Göttingen (Ph.D., 1927). Taught at University of California and California Institute of Technology (1927–41, 1946–47); director of Institute for Advanced Study (1947–66), where under his leadership Princeton became the world center of theoretical physics. Played a major role in the emergence of an American school of physics by training outstanding members of a new generation. Although he predicted the positron in a 1930 paper (it was discovered in 1932) and in 1936 explained why electron-positron pairs required a new cosmic-ray particle (the meson was found the next year), no major breakthrough bears his name. Became involved in atomic bomb developments in 1941; in May 1942 appointed director of the central laboratory for bomb design and development at Los Alamos, N. Mex. Exhausted and deeply troubled in the aftermath of the bombings of Hiroshima and Nagasaki, he resigned in 1945. Drafted a proposal (1946) for the U.S. State Department for the international control of atomic energy, which provided the tone and substance of the Acheson-Lilienthal plan. Served on numerous committees, most importantly the Atomic Energy Commission's General Advisory Committee, of which he was chairman. In late 1953 his security clearance was suspended; rather than accept the implication of disloyalty, he appeared before a secret appeals board in 1954, but despite testimony on his behalf from distinguished scientists and public servants, the board recommended against continuation of his clearance. Received the Enrico Fermi Award for outstanding contributions to atomic energy (1963).

OPPER, FREDERICK BURR (*b. Madison, Ohio, 1857; d. New Rochelle, N.Y., 1937*), pioneer comic strip artist. Creator of "Happy Hooligan" (1899), "Alphonse and Gaston," "Maude the Mule," and others; drew political cartoons for the Hearst newspapers.

OPTIC, OLIVER *See* ADAMS, WILLIAM TAYLOR.

ORCUTT, HIRAM (*b. Acworth, N.H., 1815; d. Boston, Mass., 1899*), educator. Graduated Dartmouth, 1842. Won reputation as principal of Thetford (Vt.) Academy, 1843–55; thereafter headed a succession of New England academies; associate editor, *New England Journal of Education*.

ORD, EDWARD OTHO CRESAP (*b. Cumberland, Md., 1818; d. Havana, Cuba, 1883*), soldier. Graduated West Point, 1839. Served against Seminole Indians, also in California and Oregon. Appointed brigadier general of volunteers, Union army, 1861, he was promoted major general, 1862, after good service in Virginia. Assigned to the Army of the Tennessee, he distinguished himself at Iuka and Corinth; during the Vicksburg campaign, he commanded the XIII Corps. He directed the campaign against Staunton, Va., 1864, in association with General George Crook, and later headed the VIII and XVIII Corps in the operations before Richmond. In January 1865, he took command of the Army of the James. He retired as regular major general, 1880.

ORD, GEORGE (*b. probably Philadelphia, Pa., 1781; d. Philadelphia, 1866*), naturalist, philologist. Friend and associate of Alexander Wilson; completed Wilson's *American Ornithology* (volumes 8 and 9) and reissued the work, augmented, in 1824–25. Loyalty to Wilson caused attacks by Ord upon J.J. Audubon and the famous "Audubon-Wilson" controversy which began af-

ter Wilson's death. Ord accompanied Thomas Say and William Maclure on an extensive field trip through Georgia and Florida, 1818. He was a proud, reserved man of profound learning.

ORDRONAUX, JOHN (*b. New York, N.Y., 1830; d. Glen Head, N.Y., 1908*), lawyer, physician, teacher. First New York State commissioner in lunacy, 1874–82; specialist in medical jurisprudence.

ORDWAY, JOHN (*b. Bow, N.H., ca. 1775; d. probably Missouri, ca. 1817*), explorer, sergeant in Lewis and Clark Expedition. His important journal was first published in *Wisconsin Historical Collections* (Vol. 22, 1916).

O'REILLY, ALEXANDER (*b. Co. Meath, Ireland, 1722; d. Bonete, Spain, 1794*), Spanish lieutenant general. Joined Spanish army at age of ten. A leader in army reform and reorganization, he successfully put down the 1768 uprising against Ulloa, first Spanish governor of Louisiana, and swiftly integrated the colony into the Spanish colonial system. His regulations for administration of Louisiana were in effect until the end of Spanish rule.

O'REILLY, HENRY (*b. Carrickmacross, Ireland, 1806; d. 1886*), editor, pioneer telegraph line builder. Came to New York, N.Y., as a boy. Became editor of the *Rochester* (N.Y.) *Daily Advertiser*, 1826, and was a leading citizen of that city. Agitated for enlargement and rebuilding of the Erie Canal; remained a leading exponent of the canal against railroad interests up to the Civil War. Entering into contract, 1845, with Amos Kendall and S. F. B. Morse for financing and construction of telegraph from Pennsylvania to St. Louis and the Great Lakes, he erected 8000 miles of line. Resulting litigation and money difficulties led him to abandon the enterprise.

O'REILLY, JOHN BOYLE (*b. near Drogheda, Ireland, 1844; d. Hull, Mass., 1890*), poet, editor. Came to America, 1869, after an adventures career as an Irish rebel and consequent deportation to Australia. Became part owner and editor of the Boston *Pilot*, 1876. Author of *Songs, Legends and Ballads* (1878), *Moondyne* (1879), and other books.

O'REILLY, ROBERT MAITLAND (*b. Philadelphia, Pa., 1845; d. Washington, D.C., 1912*), surgeon general, U.S. Army, 1902–09. Personal physician to President Cleveland. Reformed medical corps practices after Spanish–American War and recommendations of Dodge Commission.

O'RIELLY, HENRY *See* O'REILLY, HENRY.

ORMSBY, WATERMAN LILLY (*b. Hampton, Conn., 1809; d. Brooklyn, N.Y., 1883*), banknote engraver.

ORNE, JOHN (*b. Newburyport, Mass., 1834; d. Cambridge, Mass., 1911*), Orientalist, teacher. Graduated Amherst, 1855. Curator of Arabic manuscripts, Semitic Museum of Harvard University, 1889–1911.

ORR, ALEXANDER ECTOR (*b. Strabane, Ireland, 1831; d. 1914*), grain merchant. Came to New York, N.Y., 1851. Active in many civic and business organizations, Orr served as president, Rapid Transit Commission of New York City, 1894–1907. The first subways were efficiently built under his strict supervision. He reorganized the New York Life Insurance Co. after the Hughes investigation, 1905.

ORR, GUSTAVUS JOHN (*b. Orrville, S.C., 1819 d. 1887*), educator. Graduated Emory, 1844. Reforming pioneer school commissioner of Georgia, 1872–87; agent for Peabody Fund in Georgia.

ORR, HUGH (*b. Lochwinnoch, Scotland, 1715; d. 1798*), toolmaker, Revolutionary patriot, manufacturer. Came to Massachusetts, 1740; settled in East Bridgewater and prospered as maker of edged tools. Produced first musket made in the colonies, 1748; during the Revolution, made great numbers of muskets and cannon, using advanced techniques, and produced quantities of cannon shot. Under state direction and encouragement, Orr induced English mechanics skilled in textile machine manufacture to immigrate to Massachusetts, but the sample machines produced by them in his shop (*ca. 1786–87*) were not practical.

ORR, JAMES LAWRENCE (*b. Craytonville, S.C., 1822; d. St. Petersburg, Russia, 1873*), lawyer, South Carolina legislator. Brother of Jehu A. Orr. Congressman, Democrat, from South Carolina, 1849–59; speaker of the House, 1857–59. Antisecessionist and supporter of Stephen A. Douglas's policies, Orr reversed himself in 1860, advocated secession, and served as a Confederate States senator, 1861–65. Espousing President Johnson's policies, he was elected governor of South Carolina and served 1866–68, advising the whites to accept the Reconstruction acts. Losing the confidence of the people, he joined the Radical party, 1868, and was elected to the circuit bench. He supported U.S. Grant in 1872, and was appointed U.S. minister to Russia after Grant's election.

ORR, JEHU AMAZIAH (*b. Anderson Co., S.C., 1828; d. Columbus, Miss., 1921*), Mississippi legislator, lawyer. Brother of James L. Orr. Moderate Democrat in Mississippi politics before and after Civil War.

ORRY-KELLY, (*b. Orry George Kelly, Kiama, Australia, 1897; d. Hollywood, Calif., 1964*), costume designer. Designed sets and costume for the theater in the 1920's, including costumes for Ethel Barrymore and Katherine Hepburn. Hired by Warner Brothers as a costume designer; his first picture, *The Rich Are Always with Us* (1932), featured Bette Davis, and he continued to design for her for more than a decade. Other actresses he designed for were Ingrid Bergman (*Casablanca*, 1942), Rosalind Russell (*Auntie Mame*, 1958), and Marilyn Monroe (*Some Like It Hot*, 1959). He won Academy Awards for his costumes for *Les Girls* (1957) and *Some Like It Hot*, and shared the award for *An American in Paris*.

ORTH, GODLOVE STEIN (*b. near Lebanon, Pa., 1817; d. Lafayette, Ind., 1882*), politician, lawyer. Pursued long career in Indiana as Whig, Know-Nothing, and Republican legislator and congressman. U.S. minister to Austria–Hungary, 1875–76. Orth never hesitated to sacrifice principle for party solidarity; no unpopular measure ever received his vote.

ORTHWEIN, CHARLES F. (*b. near Stuttgart, Germany, 1839; d. St. Louis, Mo., 1898*), grain merchant. Immigrated to America, 1854; began grain commission business in St. Louis during Civil War. Sent first grain shipment to Europe via Mississippi River, 1866; worked generally to encourage St. Louis export trade.

ORTON, EDWARD FRANCIS BAXTER (*b. Deposit, N.Y., 1829; d. Columbus, Ohio, 1899*), geologist, educator. State geologist of Ohio, 1882–99; brought out last three volumes of state geological survey begun by John S. Newberry. Opposed reckless waste of natural gas and advocated conservation of state resources.

ORTON, HARLOW SOUTH (*b. Madison Co., N.Y., 1817; d. Madison, Wis., 1895*), lawyer, Wisconsin jurist and legislator. Dean of University of Wisconsin law school, 1869–74; justice of Wisconsin supreme court, 1878–94, and chief justice, 1894–95.

ORTON, HELEN FULLER (*b. near Pekin, N.Y., 1872; d. Queens, N.Y., 1955*), author. Orton's first book, *Prince and Rover of Clov-*

erfield Farm (1921), contained children's stories about farm and nature experiences. Wrote books about early American history, including *The Treasure in the Little Trunk* (1932), and mysteries for children, including *Mystery at the Little Red Schoolhouse* (1941).

ORTON, JAMES (*b. Seneca Falls, N.Y., 1830; d. Peru, 1877*), Presbyterian clergyman, zoologist, explorer, educator. Made three productive expeditions to the Amazon-equatorial Andes region (1867, 1873, and 1876); wrote *The Andes and the Amazons* (complete edition, 1876). Professor of natural history at Vassar *post* 1869.

ORTON, WILLIAM (*b. near Cuba, N.Y., 1826; d. 1878*), lawyer, telegraph executive. Instrumental in negotiations leading to creation of Western Union Telegraph Co. as a monopoly, 1866; served as its president, 1867–78.

ORTYNSKY, STEPHEN SOTER (*b. Galicia, Austria, 1866; d. Philadelphia, Pa., 1916*), Catholic prelate. Greek Catholic bishop for the United States *post* 1907; ministered to Americans of Ukrainian and Ruthenian extraction.

ORY, EDWARD ("KID") (*b. La Place, La., 1886; d. Honolulu, Hawaii, 1973*), musician. An accomplished Dixieland slide trombonist, in 1911 he moved to New Orleans and emerged as a popular bandleader, playing with such luminaries as King Oliver, Johnny Dodds, and Louis Armstrong. In the 1920's and 1930's, he performed Dixieland music both as a sideman and bandleader. In 1926 he recorded his most famous composition, "Muskrat Ramble." After the 1940's Ory's band toured extensively in the United States and abroad, and he appeared in the films *New Orleans* (1946) and *The Benny Goodman Story* (1955).

OSBORN, CHARLES (*b. Guilford Co., N.C., 1775; d. Porter Co., Ind., 1850*), Quaker minister, Abolitionist. Led abolition movements in Tennessee, Ohio, and Indiana; published the *Philanthropist* (Mt. Pleasant, Ohio), 1817–18.

OSBORN, CHASE SALMON (*b. Huntington County, Ind., 1860; d. Poulan, Ga., 1949*), journalist, prospector, politician. Attended Purdue University. Worked on newspapers in Lafayette, Ind.; Chicago, Ill.; and Milwaukee, Wis. Owned and edited a paper in Florence, Wis., 1883–87, at the same time prospecting for iron ore in the Menominee range. Settled in Sault Ste. Marie, Mich.; became wealthy through discovery of an iron deposit in Ontario, 1901; held half interest in the Saginaw, Mich., *Courier-Herald*, 1902–12. Early involved in Michigan politics as a Republican, he served on the state railroad commission, 1899–1903; his experience on the commission and his regard for Theodore Roosevelt made him progressive. Elected governor of Michigan, 1910, he instituted a strong program of reform, including a workmen's compensation act; in the presidential campaign of 1912 he supported Theodore Roosevelt. Pledged to a single term as governor, he did not seek reelection in 1912; he continued, however, to support liberal policies, backing Robert La Follette's candidacy in 1924 and Franklin D. Roosevelt's in 1940. He gave away much of his fortune to various institutions before his death.

OSBORN, HENRY FAIRFIELD (*b. Princeton, N.J., 1887; d. New York, N.Y., 1969*), naturalist and conservationist. Attended Princeton (B.A., 1909) and Trinity College, Cambridge. Following a career in business, from which he retired in 1935, he devoted his time and energy to his passion for animals. A trustee and member of the executive board of the New York Zoological Society from 1923, he became president of the organization in 1940. Under his direction the Bronx Zoo and the New York

Aquarium developed new facilities for animals and promoted better opportunities for public education and scientific research. His work in conservation made his reputation; he warned of a depletion of forests, soils, and water resources that would threaten human existence and developed that argument in *Our Plundered Planet* (1948) and *The Limits of the Earth* (1953).

OSBORN, HENRY FAIRFIELD (*b. Fairfield, Conn., 1857; d. Garrison, N.Y., 1935*), paleontologist. Son of William H. Osborn. Graduated Princeton, 1877; made special studies in biological sciences at several New York City medical schools and also at Cambridge and London, England. Taught natural sciences at Princeton, 1881–91; organized department of biology at Columbia, 1891, and taught there until *ca.* 1907. Also in 1891, Osborn organized a department of mammalian paleontology for the American Museum of Natural History, New York. His connection with the museum continued for 45 years; he served as its president, 1908–33. During his association with it, the museum became a world leader, its collection of fossil vertebrates became second to none, and its displays, made under his direction, were effective in providing direct and interesting instruction for laymen. A prolific writer of papers and books, he popularized paleontology; among his more influential books were *The Age of Mammals* (1910) and *Men of the Old Stone Age* (1925). An evolutionary theorist, he originated a number of descriptive principles (such as that of "adaptive radiation") which were of value.

OSBORN, HENRY STAFFORD (*b. Philadelphia, Pa., 1823; d. Oxford, Ohio, 1894*), Presbyterian clergyman, mapmaker, metallurgist. Taught at Lafayette College and Miami University. Author, among other books, of *New Descriptive Geography of Palestine* (1877) and *Metallurgy, Iron and Steel* (1869).

OSBORN, LAUGHTON (*b. New York, N.Y., ca. 1809; d. New York, 1878*), poet, dramatist. Graduated Columbia, 1827. Prolific writer of limited talents and eccentric habits; spent much time attacking critics. Among his books were *The Vision of Rubeta* (1838) and *Arthur Carryl* (1841).

OSBORN, NORRIS GALPIN (*b. New Haven, Conn., 1858; d. New Haven, 1932*), editor, civil service and prison reformer. Influential editor of the *New Haven Evening Register* (1884–1907) and *New Haven Journal-Courier* (1907–32).

OSBORN, SELLECK (*b. Trumbull, Conn., ca. 1782; d. Philadelphia, Pa., 1826*), Democratic journalist, poet. Editor of *The Witness* (Litchfield, Conn.,) 1805–08; the *American Watchman* (Wilmington, Del.,) 1817–20; the *New York Patriot*, 1823–24. A collection of his poems was published in Boston, Mass., 1823.

OSBORN, THOMAS ANDREW (*b. Meadville, Pa., 1836; d. Meadville, 1898*), lawyer, businessman, Kansas legislator. Settled in Kansas, 1857. Republican governor of Kansas, 1873–77; U.S. minister to Chile and Brazil, 1877–85.

OSBORN, THOMAS OGDEN (*b. Jersey, Ohio, 1832; d. Washington, D.C., 1904*), Chicago lawyer, Union soldier. U.S. minister to Argentine Republic, 1874–85; helped adjust Patagonian boundary dispute with Chile (1881). Promoted South American railroads.

OSBORN, WILLIAM HENRY (*b. Salem, Mass., 1820; d. New York, N.Y., 1894*), merchant, railroad promoter and president, philanthropist. Controlled Illinois Central Railroad, 1855–82.

OSBORNE, JAMES WALKER (*b. Charlotte, N.C., 1859; d. New York, N.Y., 1919*), lawyer, reformer. Admitted to New York bar, 1885; was outstanding assistant district attorney, 1891–1902. Ex-

posed seamy social and political conditions in Albany, N.Y., 1911; investigated abuses at Sing Sing prison, 1913.

OSBORNE, THOMAS BURR (*b. New Haven, Conn., 1859; d. New Haven, 1929*), biochemist. Grandson of Eli W. Blake. Graduated Yale, 1881; Ph.D., 1885. Staff member, Connecticut Agricultural Station, 1886–1928. Foremost expert on the proteins of plants. His first work was on proteins of the oat-kernel (1891), followed in the next decade by descriptions of the proteins in 32 other seeds. In 1906 he began a series of hydrolytic decompositions of purified proteins that led *post* 1909 to studies of their nutritive properties. He isolated and demonstrated dietary value of substance since known as vitamin A; later did similar work with what became known as vitamin B. His monograph *The Vegetable Proteins* (1909, extensively revised 1924) remains a biochemical classic.

OSBORNE, THOMAS MOTT (*b. Auburn, N.Y., 1859; d. Auburn, 1926*), prison reformer. Graduated Harvard, 1884; worked in, and later headed, father's prosperous agricultural machinery factory. Appointed chairman of the New York commission for prison reform, 1913, he began his tenure by "serving" a week's term in the Auburn prison, later recorded in his *Within Prison Walls* (1914). He pioneered in introducing a sense of corporate responsibility among prisoners with the Mutual Welfare League plan; he also founded the Welfare League Association (an aid society for discharged prisoners) and the National Society of Penal Information, which merged in the Osborne Association. He served as warden of Sing Sing, 1914–16, and as commandant of Portsmouth Naval Prison, 1917–20.

OSCEOLA (*b. among the Creek Indians on Tallapoosa River, Ga., ca. 1800; d. Charleston S.C., 1838*), leader in the Second Seminole War. Although not born to high rank or elected a chief, Osceola (also known as Powell) became influential among the Seminole and opposed the treaty of Payne's Landing (1832), at which some Seminole chiefs agreed to removal across the Mississippi. Vigorously rejecting all efforts to make the Seminole move from their land in 1835, he precipitated war, hiding Seminole women and children in the swamps and commencing effective harassing tactics against the U.S. forces sent to put down the uprising. Under a flag of truce, Osceola was treacherously arrested, October 1837, and imprisoned in Fort Moultrie where he died.

OSGOOD, FRANCES SARGENT LOCKE (*b. Boston, Mass., 1811; d. New York, N.Y., 1850*), poet. Prolific author of rather thin poetry; remembered mainly for love affair with Edgar Allan Poe, 1845.

OSGOOD, GEORGE LAURIE (*b. Chelsea, Mass., 1844; d. Godalming, England, 1922*), singer, composer, conductor, teacher. A leader in Boston musical life; organized and conducted Boston Singers' Society, 1890; author of a *Guide in the Art of Singing* (1874).

OSGOOD, HERBERT LEVI (*b. Canton, Maine, 1855; d. 1918*), historian. Graduated Amherst, 1877; studied also at Yale and Berlin; Ph.D., Columbia, 1889. Taught at Columbia *post* 1890. His seven-volume study of American colonial history (1904–24) was a pioneer scientific documentation of the struggle between British executive authorities and the colonial assemblies.

OSGOOD, HOWARD (*b. Plaquemines Parish, La., 1831; d. Rochester, N.Y., 1911*), Baptist clergyman, author. Learned, orthodox professor of Old Testament interpretation at Rochester Theological Seminary, 1875–1901.

OSGOOD, JACOB (*b. South Hampton, N.H., 1777; d. 1844*), founder of the Osgoodites. Opposed paid ministers, law courts, magistrates, abolitionists, and military training. Love of God and neighbor was the only theological principle accepted by Osgood and his sect.

OSGOOD, SAMUEL (*b. Andover, Mass., 1747/48; d. New York, N.Y., 1813*), Revolutionary soldier, Massachusetts and New York legislator. Able member of finance committees in Continental Congress, 1781–84; opposed Constitution as leading to excessive consolidation. First U.S. postmaster general, 1789–91; supported Jefferson *post* 1800.

OSGOOD, WILLIAM FOGG (*b. Boston, Mass., 1864; d. Belmont, Mass., 1943*), mathematician. A.B., Harvard, 1886; A.M., 1887. Studied at the University of Göttingen with Felix Klein; Ph.D., Erlangen, 1890. Joined department of mathematics at Harvard, 1890, where he remained until retirement in 1933 (professor *post* 1903); taught at National University of Peking, China, for two years after leaving Harvard. Devoted much of his research to the theory of functions; was author, among other works, of *Lehrbuch der Funktionentheorie* (Vol. 1, 1906–07; Vol 2, 1924–32).

O'SHAUGHNESSY, MICHAEL MAURICE (*b. Limerick, Ireland, 1864; d. San Francisco, Calif., 1934*), hydraulic engineer. Graduated Royal University, Dublin, 1884; immigrated to California, 1885. The most important of his many undertakings was the construction of the Hetch Hetchy water supply system, 1912–34.

O'SHAUGHNESSY, NELSON JARVIS WATERBURY (*b. New York, N.Y., 1876; d. Vienna, Austria, 1932*), diplomat. Entered U.S. diplomatic service, 1904. Made second secretary of the U.S. Embassy at Mexico City, 1911, he acted as chargé d'affaires, July 1913–April 1914, during the crisis of that period. He was later a severe critic of President Wilson's policy with respect to Huerta.

O'SHEA, MICHAEL VINCENT (*b. LeRoy, N.Y., 1866; d. Madison, Wis., 1932*), educator, author. Professor of education, University of Wisconsin, *post* 1897. Popular lecturer on educational techniques and practices; wrote *Newer Ways with Children* (1929).

OSLER, WILLIAM (*b. Bond Head, Upper Canada, 1849; d. Oxford, England, 1919*), physician. At the time of his death Osler was probably the greatest figure in the medical world. After attending grammar schools in Dundas and Barie, Ontario, he entered Trinity College School at Weston with the intention of becoming a minister. Influenced by teachers there, he decided to become a physician and entered the Toronto Medical School, 1868. After two years he went on to McGill Medical School where he graduated, 1872. At McGill he was particularly influenced by Dr. Robert Howard, a scholarly and thorough teacher by Edinburgh School methods. Osler next spent two years visiting the great clinics in England, Berlin, and Vienna; he gave much time to study of histology, physiology, and experimental pathology at University College Hospital, London. There he observed in circulating blood, before anyone else, the presence of what were later called "blood-platelets." In 1875 he was appointed professor of medicine at McGill. He took a wide interest in all medical activities in Montreal, writing for medical journals, delivering inspiring addresses, and enlivening interest in medical associations. He organized a demonstration course in pathology at the Montreal General Hospital, modeled on methods he had observed in Berlin. His continuing interest in clinical medicine while at Montreal led to a revolution in technique; patients were given little medicine but much encouragement and interest. A sharp rise in recoveries attended this method. By 1884 Osler had come to recognize the possibilities of medical school work on a

university basis where teachers would be largely released from the harassment of practice. This recognition led him to leave Montreal and accept appointment as professor of clinical medicine in the University of Pennsylvania (1884), the beginning of a 21-year period of residence and work in the United States.

In Philadelphia, Osler's rare traits of personality together with thorough professional methods made him popular as teacher, clinician, and consultant. His many contributions to medical literature included *The Gulstonian Lectures on Malignant Endocarditis* (1885), and the Cartwright Lectures, *On Certain Problems of the Blood Corpuscles* (1886). In September 1888, Osler was appointed physician-in-chief to the new Johns Hopkins Hospital, Baltimore, and there he remained for 16 years, probably the most eventful and most influential period of his life. For the first four years Osler devoted much of his time to organizing the clinical staff and to the institutional work of the Johns Hopkins Medical School which opened in 1893. Organized upon the unit system with a graded resident staff as used in German universities, the school employed teaching methods which accorded with those in Great Britain and France. The teaching program included instruction of small groups of students who served in the wards as clinical clerks and surgical dressers, practical work in clinical laboratories, amphitheater clinics, and work in the outpatient clinics. Osler did everything he could to arouse in his students a love of thoroughness and orderliness, an appreciation of medical knowledge for its own sake, and a desire to make original contributions of their own. Through his pupils he may be said to have created an American school of internal medicine. In 1891 he published his classic *Principles and Practice of Medicine*. Although his main contribution in the Johns Hopkins period lay in his stimulation and insemination of the minds of others, Osler also did important research into typhoid fever, malaria, pneumonia, cardiovascular disease, and tuberculosis. Further, he found time to be an active propagandist in the field of public health, to make Johns Hopkins Hospital a place of refuge for the sick poor of Baltimore, to build up medical libraries there, and to deliver effective occasional addresses of lasting value, such as *Aequanimitas* (1889), which remains a powerful and affecting work, *The Master Word in Medicine* (1903), and *The Student Life* (1905).

Because he was slowly being overwhelmed by patients who came from near and far to seek his aid, and for reasons of health, Osler accepted the Regius Professorship of Medicine in the University of Oxford, 1905; he held it until his death. He became a curator of the Bodleian Library, helped develop the Oxford Medical School, and took an active part in setting up the Royal Society of Medicine and launching the *Quarterly Journal of Medicine*. Although Osler was a competent and productive investigator and researcher, most of his contemporaries placed highest emphasis upon his ability to inspire others, to lend friendly counsel, and to mediate disputes in the profession.

OSSOLI, MARGARET FULLER *See* FULLER, SARAH MARGARET.

OSTENACO *See* OUTACITY.

OSTEN SACKEN, CARL ROBERT ROMANOVICH VON DER (*b. St. Petersburg, Russia, 1828; d. Heidelberg, Germany, 1906*), entomologist, diplomat. Came to America, 1856, as secretary to Russian legation; was consul general in New York City, 1862–71. Wrote a critical catalogue for the Smithsonian Institution of described diptera in North America (1858 and 1878); was coauthor of *Monographs of the Diptera of North America* (1862–73).

OSTERHAUS, PETER JOSEPH (*b. Coblenz, Germany, 1823; d. Duisburg, Germany, 1917*), Union major general, U.S. consular official.

OSTERHOUT, WINTHROP JOHN VANLEUVEN (*b. Brooklyn, N.Y., 1871; d. New York, N.Y., 1964*), physiologist. Attended Brown, Bonn, and University of California at Berkeley (Ph.D., 1899). His interest in biology led to his discovery that plants require sodium and the study of osmotic pressure of cells. Taught at Berkeley, Harvard (1909–29), and Rockefeller Institute. His *Experiments with Plants* (1905) is an excellent textbook. Confounded the *Journal General of Physiology* (1928) and was editor for forty-five years. Elected to National Academy of Sciences (1919).

OSTROMISLENSKY, IWAN IWANOWICH (*b. Moscow, Russia, 1880; d. New York, N.Y., 1939*), chemist. Came to America, 1922. Pioneer in development of polystyrene and synthetic rubber.

O'SULLIVAN, JOHN LOUIS (*b. Gibraltar, 1813; d. New York, N.Y., 1895*), lawyer, journalist, diplomat. Helped found, and edited, *United States Magazine and Democratic Review* (1837–46), a leading Democratic and nationalist organ. Probably coined term "Manifest Destiny" (1845).

O'SULLIVAN, MARY KENNEY (*b. Hannibal, Mo., 1864; d. West Medford, Mass., 1943*), labor organizer, reformer. Working as a bookbinder and bindery forewoman in Keokuk, Iowa, and Chicago, Ill., she was appalled by urban poverty and squalor and after organizing the Chicago Women's Bindery Workers' Union became a leader in the Chicago Trades and Labor Assembly. In 1892 she was appointed a national organizer by the American Federation of Labor, the first woman to hold such a post. After marriage to John F. O'Sullivan, labor editor of the *Boston Globe*, 1894, she continued to speak and organize; with William E. Walling she drafted the essential structure of the National Women's Trade Union League (1903), becoming its first secretary. Active in support of the Lawrence, Mass., textile workers' strike in 1912, she served as a factory inspector for the industrial safety division of the Massachusetts department of labor, 1914–34. A proponent of woman suffrage, international peace, and liberal politics, she never lost her commitment to reform.

OSWALD, LEE HARVEY (*b. New Orleans, La., 1939; d. Dallas, Tex., 1963*), assassin of President John F. Kennedy. An unstable, violence-prone malcontent, he went to Moscow in 1959, where he renounced his U.S. citizenship and worked as a metalworker. He went to Texas in 1962 and in early 1963 purchased a rifle by mail, equipping it with a telescopic sight. He took a job at the Texas School Book Depository in Dallas, and on Nov. 22, from a window on the sixth floor of the depository, shot and killed Kennedy and wounded Gov. John B. Connally; less than an hour later, he shot and killed Patrolman J. D. Tippit, then was apprehended by police in the Texas Theater. On Nov. 24, as he was being transferred from city jail to county jail, he was shot and killed by Dallas nightclub operator Jack Ruby.

OTACITE *See* OUTACITY.

OTERMÍN, ANTONIO DE (*fl. 1678–1683*), Spanish governor of New Mexico. Leader of settlers in retreat from Santa Fe to present Juárez (opposite El Paso, Texas) after Pueblo Indian uprising and massacre, 1680.

OTEY, JAMES HERVEY (*b. Bedford Co., Va., 1800; d. Memphis, Tenn., 1863*), Episcopal clergyman. Consecrated bishop of Tennessee, 1834; served until his death. Helped found University of the South.

OTIS, ARTHUR SINTON (*b. Denver, Colo., 1886; d. St. Petersburg, Fla., 1964*), psychologist. Attended Stanford (Ph.D., 1920). While working toward his doctorate, he helped devise the psychological tests used during World War I. In 1921 he became

editor of tests and mathematics at World Book Company. His reputation rests on the development, publication, administration, and revision of various forms of the Otis Group Intelligence Scale, a test used in U.S. schoolbooks until 1963. During World War II he was a psychological consultant to the Navy Bureau of Aeronautics and then for the Civil Aeronautics Administration (1945–48).

OTIS, BASS (*b. Bridgewater, Mass., 1784; d. Philadelphia, Pa., 1861*), portrait painter, engraver, pioneer in American lithography.

OTIS, CHARLES EUGENE (*b. Barry Co., Mich., 1846; d. St. Paul, Minn., 1917*), Minnesota jurist.

OTIS, CHARLES ROLLIN (*b. Troy, N.Y., 1835; d. Summerville, S.C., 1927*), inventor, elevator manufacturer. Son of Elisha G. Otis.

OTIS, ELISHA GRAVES (*b. Halifax, Vt., 1811; d. Yonkers, N.Y., 1861*), mechanic, inventor. Engaged in constructing a bedstead factory at Yonkers, N.Y. 1852, Otis devised some unique features for an elevator in the structure, among them a safety appliance that prevented the elevator from falling if the lifting chain or cable broke. His invention attracted notice and he began a small manufactory at Yonkers. Orders came slowly, but in 1861 he established a firm foundation for his business by inventing and patenting a steam elevator; his sons carried on his work with great success.

OTIS, ELWELL STEPHEN (*b. Frederick, Md., 1838; d. Rochester, N.Y., 1909*), lawyer, Union soldier Established command school at Fort Leavenworth, 1881; commanded all American forces in Philippines at outbreak of Aguinaldo's insurrection, 1899; retired as major general, 1902.

OTIS, FESSENDEN NOTT (*b. Ballston Springs, N.Y., 1825; d. New Orleans, La., 1900*), physician. Graduated N.Y. Medical College, 1852; taught at N.Y. College of Physicians and Surgeons, 1862–90. Concentrated on genitourinary diseases; first established curability of urethral stricture though his theory of cure is no longer accepted.

OTIS, GEORGE ALEXANDER (*b. Boston, Mass., 1830; d. Washington, D.C., 1881*), U.S. Army surgeon. Editor, *The Medical and Surgical History of the War of the Rebellion* (surgical volumes, 1870, 1876).

OTIS, HARRISON GRAY (*b. Boston, Mass., 1765; d. Boston, 1848*), lawyer, statesman. Nephew of James Otis and Mercy Otis Warren. Graduated Harvard, 1783; read law with John Lowell. Rose to leading place at the Boston bar and earned a large income, partly by successful land speculations in the decade 1785–95. Early became a leading Federalist politician through skill in oratory, and served in U.S. Congress, 1797–1801; supported President Adams in reconciliation with France, 1799. Represented Boston for many years in the Massachusetts legislature; helped plan, and was a leading figure at, the Hartford Convention in which he consistently threw his influence against proposals to force a break with the national government. U.S. senator from Massachusetts, 1817–22; mayor Boston, 1829–31. Deprecated the abolition movement but defended freedom of speech on the slavery question. A Whig in later life.

OTIS, HARRISON GRAY (*b. Marietta, Ohio, 1837; d. Hollywood, Calif., 1917*), Union soldier, journalist. Removed to California, 1876; active manager of the Times-Mirror Co. in Los Angeles, *post* 1886. A conservative Republican, of great influence in Southern California.

OTIS, JAMES (*b. West Barnstable, Mass., 1725; d. Andover, Mass., 1783*), politician, publicist. Born of a lawyer father, Otis prepared for Harvard with the minister in West Barnstable and graduated in 1743. Studying law under Jeremiah Gridley, he was admitted to the bar in Plymouth County, 1748, and two years later moved to Boson. He married Ruth Cunningham, well-dowered daughter of a Boston merchant, 1755. By painstaking study Otis became learned in the common, civil, and admiralty law and legal theory. A supple mind coupled with brilliant and captivating pleading made him early known in all parts of the province. This reputation led to his appointment by Governor Pownall as king's advocate general of the vice admiralty court at Boston, a lucrative post. In 1760, Pitt ordered the Sugar Act of 1733 to be strictly enforced. The royal customs collectors applied to the superior court of the province for writs of assistance in order to help them in searches for evidence of violation. Otis, in his official capacity, was expected to argue for the writs. Instead he resigned and undertook, for the Boston merchants, to oppose issuance. Circumstances were such as to cause his motives to be questioned. At this time, Otis's father was speaker of the House and had great influence among country members. When Chief Justice Stephen Sewall died in 1760, the elder Otis expected to be appointed to the court with the prospect of becoming chief justice. His ambition was thwarted, however, when Thomas Hutchinson was appointed to the chief justiceship. Since this occurred just before James Otis resigned his post and began to oppose issuance of the writs of assistance, many suggested that his actions stemmed from his father's disappointment. Otis vehemently denied the charge, but the Loyalists ever afterwards insisted that Otis's entire political course was determined by frustrated family ambition.

In February 1761, Otis argued the illegality of writs of assistance before the superior court. What he said is not precisely known, but his general line of attack was based upon the presumed existence of a fundamental law which embodied the principles of the natural law and was superior to acts of Parliament. The slogan "Taxation without representation is tyranny" appears in John Adams's 1820 expansion of his notes of the proceedings. Otis claimed that acts against the Constitution and national equity should be declared void. He lost the case but Attorney General de Grey ruled in 1766 that the act of Parliament in question did not authorize writs of assistance in the colonies. Otis's speech, however, provided the base for continuing attacks upon acts of Parliament which regulated colonial commerce and taxation. Soon after his speech, Otis was elected one of Boston's representatives to the General Court where he helped to rouse sentiment against the Crown officials. In his first political pamphlet, *A Vindication of the Conduct of the House of Representatives* (1762), Otis summarized the rights of Englishmen. Later, in a notable speech in Faneuil Hall, he declaimed at length on the proposition that settlers in the colonies should enjoy all the rights, privileges, and duties of Englishmen living in the mother country and asserted that the difficulties of the time had been caused by illegal attempts to extend the royal prerogative.

From 1761 to 1769 Otis was the recognized political leader of Massachusetts Bay. Rumors of *rapprochement* with Governor Hutchinson often affected his standing with the popular party, but his speeches and pamphlets in these years indicate a consistent defense of the colonists' rights as against alleged royal and Parliamentary encroachments. His pamphlet *The Rights of the British Colonies Asserted and Proved* (1764) reasserted his position on natural rights as developed in the writs of assistance speech and defined the constitutional position of the colonies in the single commonwealth which he believed the British Empire to be.

One of three Massachusetts delegates to the Stamp Act Congress convened in New York City (1765), he was a leading figure there. The Congress accepted his constitutional position but rejected his argument in the *Rights* pamphlet that the colonies should have representation in Parliament. Otis, however, continued to urge his idea in another pamphlet, *Considerations on behalf of the Colonists, in a Letter to a Noble Lord* (1765). Otis's pamphlets had a profound effect in the colonies and in England, but he failed to see the possibility of a federal solution to the problem and never faced the choice between submission and revolution. He disapproved of violent action, recommending peaceful remonstrances. In 1768 Otis helped to adopt the Non-importation declaration in the House as the colonial response to the Townshend Act. Struck on the head during an altercation with a Crown official, 1769, he was insane save for short intervals thereafter. His subsequent political opinions and actions are unimportant. He died as the result of a stroke of lightning.

Ott, Isaac (*b. Northamptonn Co., Pa., 1847; d. Easton, Pa., 1916*), physician, neurologist. Credited with discovery of the hormone of milk secretion; demonstrated that injury in the corpus striatum causes body temperature rise.

Ott, Melvin Thomas ("Mel") (*b. Gretna, La., 1909; d. New Orleans, La., 1958*), baseball player. Right fielder and legendary batter for the New York Giants, 1926–47. Ott's lifetime average was .304; he hit 511 home runs, exceeded only by Babe Ruth and Jimmy Foxx. Manager of the Giants, 1941–48. Ott left baseball in 1955 but returned as broadcaster for the Detroit Tigers. Elected to the Baseball Hall of Fame, 1951.

Ottassite *See* Outacity.

Ottendorfer, Anna Behr Uhl (*b. Würzburg, Germany, 1815; d. 1884*), journalist, philanthropist. Came to America *ca.* 1837; married Oswald Ottendorfer, 1859. Owner and manager *post* 1852 of the *New-Yorker Staats-Zeitung*, which she made prosperous and influential.

Ottendorfer, Oswald (*b. Zwittau [Moravia], Austria–Hungary, 1826; d. 1900*), journalist, philanthropist. Came to America, 1850; married Anna B. U. Ottendorfer, 1859. Editor of the *New-Yorker Staats-Zeitung, post* 1858; influential anti-Tammany Democrat and reformer.

Otterbein, Philip William (*b. Dillenburg, Prussia, 1726; d. Baltimore, Md., 1813*), clergyman. Educated for Reformed ministry in Germany; arrived in New York, 1752, to serve as missionary in Pennsylvania. Although he always considered himself a minister of the Reformed Church, he promoted a nonsectarian religious movement, which shortly before his death he made an independent denomination, the Church of the United Brethren in Christ. It was organized on the Wesleyan model with a strong evangelistic strain. Otterbein, a zealous and effective minister, labored to bring organized religion to scattered German settlements in Pennsylvania and Maryland.

Ottley, Roi (*b. New York, N.Y., 1906; d. Chicago, Ill., 1960*), author, journalist. Studied at St. Bonaventure College and at the University of Michigan. Worked for the *Amsterdam News* in New York (1932–37); joined the Federal Writers Project of the Works Progress Administration. Wartime and postwar correspondent for *Liberty* and *Pittsburgh Courier*. Wrote feature articles for the *Chicago Defender, Ebony*, and the *Chicago Tribune*. Author of *New World A-Coming* (1943), *No Green Pastures* (1951), and *The Lonely Warrior* (1955).

Otto, Bodo (*b. Hanover, Germany, 1711; d. Reading, Pa., 1787*), physician. Came to America, 1755; practiced in New Jersey and Pennsylvania. Appointed senior surgeon of the Middle Department of the Continental hospitals, 1776, he served devotedly and effectively until 1782.

Otto, John Conrad (*b. near Woodbury, N.J., 1774; d. Philadelphia, Pa., 1844*), physician. Grandson of Bodo Otto; pupil and friend of Benjamin Rush whom he succeeded as physician to the Pennsylvania Hospital, 1813–34. Gave first adequate description of hemophilia (1803) and noted its peculiar hereditary nature.

Otto, William Tod (*b. Philadelphia, Pa., 1816; d. Philadelphia, 1905*), Indiana jurist. Son of John C. Otto. Assistant U.S. secretary of the interior, 1863–71.

Ouconnastote *See* Oconostota.

Ouimet, Francis Desales (*b. Brookline, Mass., 1893; d. Newton, Mass., 1967*), golfer and stockbroker. Winner of the Greater Boston Interscholastic Championship at age sixteen and the U.S. Open in 1913, beating Harry Vardon and Ted Ray. He became a stockbroker in 1919. Other championships included U.S. Amateur (1914, 1931), French Amateur (1914), Massachusetts Amateur (1914, 1919, 1922, 1925), Western Amateur (1917), North and South Amateur (1920), St. George's Challenge Cup (1923), Crump Memorial (1924, 1927), and Massachusetts Open (1932). Played on or captained the U.S. Walker Cup Team from 1922 to 1949. First American elected captain of the Royal and Ancient Golf Club of St. Andrews (1951).

Ouray (*b. probably Taos, N.Mex., ca. 1833; d. Los Piños Reservation, Colo., 1880*), Ute Indian chief. Born of an Uncompahgre father and an Apache mother, Ouray spent much of his childhood among Mexican rancheros, from whom he learned to speak Spanish correctly. Became chief of the Uncompahgre, 1860; was appointed an interpreter at Los Piños Reservation, 1862; in 1863 signed a treaty by which he was recognized by the United States as head chief for all the Western Ute. Thereafter he helped put down occasional uprisings and negotiated with the government in defense of his tribe's interests.

Oursler, (Charles) Fulton (*b. Baltimore, Md., 1893; d. New York, N.Y., 1952*), writer, editor. Self-educated, Oursler became editor for the publications of Bernarr Macfadden, the physical health popularizer, in 1922. Macfadden's companies published the magazines *Physical Culture, True Story, True Romance*, and *True Detective*. Author of *Behold This Dreamer!* (1924) and *The World's Delight* (1929). Best remembered for his religious stories, Oursler wrote *The Greatest Story Ever Told* (1949), *The Greatest Book Ever Written* (1951), and *The Greatest Faith Ever Known* (1953). Resigned from the Macfadden enterprises, 1942; became a senior editor of the *Reader's Digest*, 1944. Despite his involvement in the sensationalistic journalism of the Macfadden magazines, Oursler was a respected conservative, known for his piety and patriotism.

Outacity (*fl. 1756–1777*), Cherokee chief, known also as "Judd's Friend" and "Mankiller." Visited London, 1762, under tutelage of Henry Timberlake. He and his family were received by the King and sat for a Reynolds portrait.

Outcault, Richard Felton (*b. Lancaster, Ohio, 1863; d. Flushing, N.Y., 1928*), comic artist. Inaugurated the "funny paper" in November 1894 as cartoonist for the New York *World*. Created the "Yellow Kid" and "Buster Brown."

OUTERBRIDGE, ALEXANDER EWING (*b. Philadelphia, Pa., 1850; d. Philadelphia, 1928*), metallurgist, official of the U.S. Mint. Developed method for obtaining thin films of metal for microscopic studies, 1876; made notable studies of molecule mobility in cast iron, 1894–96.

OUTERBRIDGE, EUGENIUS HARVEY (*b. Philadelphia, Pa., 1860; d. 1932*), merchant. Brother of Alexander E. Outerbridge. In business in New York City *post* 1878, he is regarded as the "father of the Port of New York Authority."

OVERMAN, FREDERICK (*b. Elberfeld, Germany, ca. 1803; d. Philadelphia, Pa., 1852*), metallurgist, authority on metallurgy of iron. Came to America, 1842. Wrote *The Manufacture of Steel* (1851) and *A Treatise on Metallurgy* (1852).

OVERMAN, LEE SLATER (*b. Salisbury, N.C., 1854; d. 1930*), lawyer, North Carolina legislator. U.S. senator, Democrat, 1903–30. Vigorously supported Clayton Act (1914); is remembered for the 1918 Overman Law which widened the president's power to transfer functions of one government department to another.

OVERSTREET, HARRY ALLEN (*b. San Francisco, Calif., 1875; d. Falls Church, Va., 1970*), philosopher, social psychologist, and adult educator. Attended University of California (B.A., 1899) and Oxford (B.S., 1901). Ideologically interested in the working poor. Taught at University of California at Berkeley, 1901–11, City College of New York, 1911–39, and the continuing-education program of the New School for Social Research, 1924–36. Instrumental in the development of radio program "America's Town Meeting of the Air" (1938). His concern for the industrial worker was later supplemented by a solicitude for black Americans, victims of world hunger, and underprivileged children. By the end of the 1950's, he had become preoccupied with Communism as a domestic and foreign menace to American society. His first book was *Influencing Human Behavior* (1925). The pinnacle of his success was with *The Mature Mind* (1949), which discussed how the mature individual copes with the forces of politics, economics, family life, and religion.

OVERTON, JOHN (*b. Louisa Co., Va., 1766; d. Nashville, Tenn., 1833*), Tennessee jurist, politician. Early business partner and independent-minded political supporter of Andrew Jackson.

OWEN, DAVID DALE (*b. near New Lanark, Scotland, 1807; d. 1860*), geologist. Son of the British social reformer Robert Owen; brother of Robert D. Owen. Immigrated to New Harmony, Ind., 1828; attended lectures in geology and chemistry in London, England, 1831–32; graduated Ohio Medical College, 1836. Began his career of geological surveying, 1836, with a trip through Tennessee; was state geologist of Indiana, 1837. Conducted for the federal government a geological survey of mineral deposits in the Dubuque, Iowa, and Mineral Point, Wisconsin, area, 1839. He followed this by extensive surveys in Wisconsin, Minnesota, and Iowa, which he described in a *Report* (1852), and he served successively thereafter as state geologist of Kentucky, Arkansas, and Indiana for each of which he published valuable survey reports.

OWEN, EDWARD THOMAS (*b. Hartford, Conn., 1850; d. Madison, Wis., 1931*), educator. University of Wisconsin teacher of Romance languages, 1878–1914. Pioneered in effort to rationalize grammar through a radical revision of method and nomenclature based on analysis of the antecedent psychological states that prompt expression.

OWEN, GRIFFITH (*b. near Dolgelly, Wales, ca. 1647; d. Philadelphia, Pa., 1717*), Quaker preacher, surgeon. Leader of the Welsh Quakers who settled (1684) in Lower Merion Township near Philadelphia. Member of Provincial Council, 1690–1717.

OWEN, ROBERT DALE (*b. Glasgow, Scotland, 1801; d. Lake George, N.Y., 1877*), social reformer, author. Son of Robert Owen, British industrialist and social reformer; brother of David D. Owen. Helped set up New Harmony community in Indiana, 1826–27; thereafter joined Frances Wright in a coterie known as the "Free Enquirers," formed to advocate liberal divorce laws, widespread industrial education, and a more nearly equal distribution of wealth. Owen continued to pursue these objectives long after the coterie disbanded. Resuming residence in Indiana ca. 1833, he served in the legislature (1836–38) and in the U.S. Congress (1843–47). A resolution introduced by him in 1844 became basis for solution of the Oregon boundary dispute. He also helped establish the Smithsonian Institution. Later he became an influential advocate of emancipation. His autobiography, *Threading My Way*, was published in 1874.

OWEN, ROBERT LATHAM (*b. Lynchburg, Va., 1856; d. Washington, D.C., 1947*), lawyer, politician. Graduated Washington and Lee University, 1877. Removed with his widowed mother (who was part Cherokee) to Salina, Indian Territory, 1879; there he became a citizen of the Cherokee Nation, served as secretary of the Cherokee board of education, studied law, and began practice in Tahlequah in 1880. He was federal agent for the Five Civilized Tribes, 1885–89, and thereafter represented the Choctaw and the Cherokee in several important court cases in Washington, D.C. He organized the First National Bank of Muskogee in 1890 and was its president until 1900. In 1901 he was influential in securing the congressional act that gave citizenship to Indians in the Territory. A leader in organizing the Democratic party in Indian Territory, he was elected to the U.S. Senate by the first legislature of the new state of Oklahoma, 1907, and served until 1925, declining to run again in 1924. Identified throughout his career with progressivism and popular democracy, he was one of the most consistent backers of Woodrow Wilson's "New Freedom" program; a money reformer, he was cosponsor with Carter Glass of the Federal Reserve Act (1913). He was also a champion of liberal labor laws, and cosponsor of the Palmer-Owen and Keating-Owen child labor bills. After leaving the Senate he resumed the practice of law in Washington, D.C.

OWEN, STEPHEN JOSEPH (*b. Cleo Springs, Okla., 1898; d. Oneida, N.Y., 1964*), football coach. Began professional football career with the Kansas City Cowboys, 1924–25. The 1926 season marked the beginning of a long career with the New York Giants: captained the 1927 team, which won the NFL championship; was made a player-coach in 1930; became permanent head coach in 1931; led the team to world championships in 1934 and 1938; resigned as coach in 1953. Coached the Philadelphia Eagles (1956–57) and in the Canadian Football League (1958–62). Rehired by the Giants as a scout (1963). Pioneer of the A formation, the "one-way" performer, and the "umbrella" defense; elected to the Pro Football Hall of Fame in 1966.

OWEN, THOMAS McADORY (*b. Jefferson Co., Ala., 1866; d. Montgomery, Ala., 1920*), lawyer, archivist, historian. Established and later directed the Alabama Department of Archives, first state department of its kind, 1901.

OWEN, WILLIAM FLORENCE (*b. Limerick, Ireland, 1844; d. 1906*), actor. Made debut at Salem, Ohio, 1867; associated with Madame Modjeska, Augustin Daly, and Mrs. Fiske, he gained fame in such comic roles as "Falstaff" and "Touchstone."

OWENS, JAMES CLEVELAND ("JESSE") (*b. Oakville, Ala., 1913; d. Tucson, Ariz., 1980*), track athlete. From a family of Alabama

947

sharecroppers, he excelled as a high-school track competitor in Cleveland, Ohio, and won a work-study scholarship to Ohio State University (1933–36), where he set Big Ten and national records in track and field events. At the 1936 Olympic Games, held in Berlin, Owens won gold medals and broke world records in the 100– and 200–meter dashes and 400–meter relay, in addition to winning the broad jump competition. His spectacular performance made him a national celebrity and the American press touted Owens as a national hero standing up against German fascism.

Capitalizing on his celebrity status in the late 1930's and 1940's, Owens started businesses and made fee-paying appearances at public events. In the 1950's he spoke frequently to civic groups and schools concerning patriotism and athletics. Under the auspices of the State Department, he traveled internationally extolling American culture. In 1960 he helped found the sales and promotional agency Owens–West, which benefited from his public profile. A political conservative who advocated moderate remedies for racial discrimination, he viewed the civil rights movement of the 1960's as too confrontational. In *Blackthing: My Life as Black Man and White Man* (1970), Owens criticized "pro-Negro bigots" and contended that black poverty resulted from a failure of discipline and morality. During the 1970's, he won lucrative promotional contracts and in 1976 received the Medal of Freedom.

Owens, John Edmond (*b. Liverpool, England, 1823; d. near Baltimore, Md., 1886*), actor, theatrical manager. Came to America as a child; was raised in Philadelphia, Pa., where he made debut, 1840. Excelled in standard comic roles, particularly Yankee characters.

Owens, Michael Joseph (*b. Mason Co., Va., now W. Va., 1859; d. Toledo, Ohio, 1923*), inventor. Developed and perfected the first automatic bottle-blowing machine (patented 1895, 1904); was associated with Edward D. Libbey in glass manufacturing *post* 1888.

Owre, Alfred (*b. Hammerfest, Norway, 1870; d. 1935*), physician, dentist, educator. D.D.S., University of Minnesota, 1894. As professor and dean of the college of dentistry, University of Minnesota, *post* 1902, and as dean of the school of dentistry at Columbia, 1927–34, Owre fought for reforms in dental education which were bitterly opposed in his time but in many cases adopted after his death.

Owsley, Frank Lawrence (*b. Montgomery County, Ala., 1890; d. Winchester, England, 1956*), historian. Studied at Alabama Polytechnic Institute and at the University of Chicago, Ph.D., 1924. Professor of history at Vanderbilt University, 1920–49, and at the University of Alabama, 1949–56. Defended and sought to correct many misconceptions about the Confederacy through such works as *State Rights in the Confederacy* (1925), *King Cotton Diplomacy* (1931), and *Plain Folk of the Old South* (1949).

Owsley, William (*b. Virginia, 1782; d. near Danville, Ky., 1862*), Kentucky jurist, politician. Member and vigorous supporter of the "Old Court" in the dispute of the 1820's; Whig governor, 1844–48.

Oxnam, Garfield Bromley (*b. Sonora, Calif., 1891; d. White Plains, N.Y., 1963*), Methodist bishop, author, and social reformer. Attended University of Southern California (B.A., 1913), Boston (B.S.T., 1915), Harvard, and Massachusetts Institute of Technology. Ordained in Methodist Episcopal church (1916). Taught social ethics at USC (1919–23) and Boston University's School of Theology (1927–28); named president of DePauw University (1928). Elected bishop in 1936. The social creed he espoused was the solidarity of the human race, supremacy of the common good, and equal rights for all. A leader in postwar Protestant ecumenism, he served on the Federal Council of Churches, the World Council of Churches, and the National Council of Churches. As bishop of Washington, D.C., he questioned the competence of the House Un-American Activities Committee and struck a crucial blow against Sen. Joseph McCarthy.

P

PACA, WILLIAM (*b. near Abingdon, Md., 1740; d. Talbot Co., Md., 1799*), Maryland legislator, signer of the Declaration of Independence, jurist. Active in political opposition to the proprietor of the colony. Elected to First and Second Continental Congresses (served 1774–79), Paca devoted his energy and much of his fortune to winning the Revolution. He participated in drawing up the first state constitution, served in the state senate, was elected three times governor of Maryland, 1782–85, and served as federal district judge, 1789–99.

PACE, EDWARD ALOYSIUS (*b. Starke, Fla., 1861; d. Washington, D.C., 1938*), Roman Catholic clergyman, educator. Graduated St. Charles College, Maryland, 1880; D.Th., Rome, 1886; Ph.D., Leipzig, 1891. A pioneer in scientific psychology and modern scholastic philosophy, he was professor of psychology, 1891–94, and of philosophy, 1894–1935, at Catholic University of America.

PACHECO, ROMUALDO (*b. Santa Barbara, Calif., 1831; d. Oakland, Calif., 1899*), California legislator and official, diplomat. Republican governor of California, 1875–76; performed valuable service in helping to unite native Californians with American settlers.

PACK, CHARLES LATHROP (*b. Lexington, Mich., 1857; d. New York, N.Y., 1937*), pioneer forest conservationist. Cofounder, National Conservation Association and American Tree Association; president, 1930–37, Charles Lathrop Pack Forestry Foundation.

PACKARD, ALPHEUS SPRING (*b. Chelmsford, Mass., 1798; d. Squirrel Island, Maine, 1884*), educator. Brother of Joseph Packard. Served in many academic capacities at Bowdoin, 1819–84.

PACKARD, ALPHEUS SPRING (*b. Brunswick, Maine, 1839; d. Providence, R.I., 1905*), entomologist, teacher. Son of Alpheus S. Packard (1798–1884); grandson of Jesse Appleton. Graduated Bowdoin, 1861; M.D., Maine Medical School, 1864. Early interested and trained in geology, Packard soon found his lifework in entomology and first gained notice as author of *Guide to the Study of Insects* (1869). An ardent evolutionist, Packard had taxonomic skills, but his principal contribution lay in the biological aspects of his field. His most important later publications were *Insects Injurious to Forest and Shade Trees* (1881), *Text-Book of Entomology* (1898), and his monumental *Monograph of the Bombycine Moths* (1895–1914), which was finished by T. D. A. Cockerell. At his death he was generally recognized as the most learned and accomplished entomologist in America. *Post* 1878, he taught at Brown University.

PACKARD, FREDERICK ADOLPHUS (*b. Marlboro, Mass., 1794; d. Philadelphia, Pa., 1867*), editor, writer. Editorial secretary of American Sunday School Union, 1828–67; persistently attacked exclusion of orthodox religion from public educational systems.

PACKARD, JAMES WARD (*b. Warren, Ohio, 1863; d. Cleveland, Ohio, 1928*), engineer, manufacturer, inventor. Graduating from Lehigh University, 1884, Packard worked as an engineer in an incandescent lamp company where he took out several patents for bulb manufacturing processes. After heading his own successful electrical company, 1890–1900, he began manufacture of Packard automobiles, 1900. Having little interest in the business side of the company, Packard spent most of his time inventing mechanical improvements, such as superior ignition and carburetion systems, braking mechanisms, and chassis construction methods.

PACKARD, JOHN HOOKER (*b. Philadelphia, Pa., 1832; d. Philadelphia, 1907*), surgeon. Son of Frederick A. Packard. Surgeon to the Pennsylvania Hospital, 1884–96; writer of medical treatises, including *A Hand-book of Operative Surgery* (1870).

PACKARD, JOSEPH (*b. Wiscasset, Maine, 1812; d. Virginia, 1902*), Episcopal clergyman, biblical scholar. Brother of Alpheus S. Packard (1798–1884). Professor, Theological Seminary of Virginia, 1836–95, dean, *post* 1874.

PACKARD, SILAS SADLER (*b. Cummington, Mass., 1826; d. 1898*), pioneer in business education. Founded Packard's Business College, New York City, 1858; successfully promoted training and use of women in office work.

PACKER, ASA (*b. Groton, Conn., 1805; d. Philadelphia, Pa., 1879*), carpenter, railroad builder, politician, philanthropist. Removed to Pennsylvania, 1822; began career by buying and operating a coal boat from Mauch Chunk to Philadelphia via the Lehigh Valley canal. Investing his earnings in coal land and contracting to construct canal locks, Packer added to his fortune by founding the Lehigh Valley Railroad Co., 1853, and by further purchases of coal lands; by the 1870's he was accounted the richest man in Pennsylvania. He established and endowed Lehigh University 1866.

PACKER, WILLIAM FISHER (*b. Centre Co., Pa., 1807; d. Williamsport, Pa., 1870*), editor, politician. Publisher of the *Lycoming Gazette*, 1829–36; joint publisher of the *Keystone*, 1836–41; Democratic governor of Pennsylvania, 1857–61.

PADDOCK, ALGERNON SIDNEY (*b. Glens Falls, N.Y., 1830; d. 1897*), lawyer. Secretary and acting governor of Nebraska Territory, 1861–67; U.S. senator, Republican, from Nebraska, 1875–81 and 1887–93. Fought excessive railroad freight rates.

PADDOCK, BENJAMIN HENRY (*b. Norwich, Conn., 1828; d. 1891*), Episcopal clergyman. Brother of John A. Paddock. As bishop of Massachusetts, 1873–91, he lessened the discord between High and Low Church factions.

PADDOCK, JOHN ADAMS (*b. Norwich, Conn., 1825; d. near Santa Barbara, Calif., 1894*), Episcopal clergyman. Brother of Benjamin H. Paddock. Active in the Northwest *post* 1880 as missionary bishop of Washington Territory and bishop of Olympia.

PADILLA, JUAN DE (*b. Andalusia, Spain, ca. 1500; d. "Quivira," in northern Texas or Kansas, ca. 1544*), Franciscan missionary. Came to Mexico *ca.* 1528. Accompanied Coronado's expedition; established first mission in Southwest at Quivira; martyred attempting to extend his ministry to a hostile Indian tribe.

PAGE, CHARLES GRAFTON (*b. Salem, Mass., 1812; d. Washington, D.C., 1868*), physician, electrical pioneer. Graduation from Harvard, 1832, and medical studies in Boston preceded practice in Salem; Page, however, early devoted most of his time to electrical experiments. Starting with Joseph Henry's calorimotor, Page developed, 1836, an induction apparatus of greater intensity than Henry's; with Ruhmkorff's improvements, it is the induction coil of today. Page also discovered the superior effect of substituting bundles of iron wires for solid iron bars as cores in induction coils and invented a self-acting circuit breaker. He experimented with reciprocating electromagnetic engines, 1846, but failed in practical tests of his battery-powered locomotive, 1851. Page worked as examiner in the U.S. Patent Office from 1861 until his death.

PAGE, DAVID PERKINS (*b. Epping, N.H., 1810; d. 1848*), educator. Successful principal of first (1844) normal school in New York at Albany; author of *The Theory and Practice of Teaching* (1847).

PAGE, JOHN (*b. Gloucester Co., Va., 1743; d. Virginia, 1808*), Revolution patriot, planter, Virginia legislator. Grandson of Mann Page. Congressman, Democratic-Republican, from Virginia, 1789–97; governor of Virginia, 1802–05. Lifelong friend and political supporter of Jefferson.

PAGE, JOSEPH FRANCIS ("JOE") (*b. Cherry Valley, Pa., 1917; d. Latrobe, Pa., 1980*), baseball player. In 1940 he signed with the New York Yankees farm system and moved up to the majors in 1944, pitching successfully for the Yankees that season before injuries and his flamboyant off-field activities sidetracked his career. After moving to the bullpen in 1947, he was used consistently in game-saving situations. Page had his finest season in 1949 with a 13–8 won-loss record, 27 saves, and a 2.59 earned run average. He notched a save and a victory during the 1949 World Series and won the series' outstanding player award. After retiring from baseball in 1954, he operated several taverns in Pennsylvania.

PAGE, LEIGH (*b. South Orange, N.J., 1884; d. Randolph, N.H., 1952*), physicist and educator. Studied at Yale University (Ph.B., 1904; Ph.D., 1913), Yale faculty member from 1912 to 1952, he was professor of mathematical physics from 1922. Page's main contribution to physics was the emission theory of electromagnetism. Starting from a postulate regarding the emission of particles from charged bodies, he formulated the basic equations of electromagnetic theory from Einstein's relativity theory of 1905. Books include *An Introduction to Electrodynamics from the Standpoint of Electron Theory* (1922), and *Electrodynamics* (1940) written with N. I. Adams, Jr.

PAGE, MANN (*b. Virginia, 1691; d. 1730*), Virginia planter and councillor. Son-in-law of Robert Carter (1663–1732). Considered second largest landowner in Virginia; built huge, luxurious house, "Rosewell."

PAGE, ORAN THADDEUS ("LIPS") (*b. Dallas, Tex., 1908; d. New York, N.Y., 1954*), trumpet player, singer, and bandleader. Page began his career with the bands that accompanied such singers as "Ma" Rainey, Bessie Smith, and Ida Cox. From 1930 to 1935 he played with Bennie Moten's Kansas City Band; he later played with Count Basie, Artie Shaw, and the band that accompanied Ethel Waters. After playing at the Paris Jazz Festival in 1949, he worked New York as a single. His most famous recording was "Baby, It's Cold Outside," with singer Pearl Bailey in 1949.

PAGE, RICHARD LUCIAN (*b. Clarke Co., Va., 1807; d. Blueridge Summit, Pa., 1901*), Confederate naval and army officer. Nephew of "Light-Horse Harry" Lee. Commanded at Fort Morgan, Ala., 1864, during Union land and sea attack upon Mobile.

PAGE, THOMAS JEFFERSON (*b. Matthews Co., Va., 1808; d. Rome, Italy, 1899*), naval officer, explorer. Grandson of John Page and Thomas Nelson. Commanded a surveying and exploratory expedition, 1853–56, about which he wrote *La Plata: The Argentine Confederation and Paraguay* (1859). Commanded Confederate cruiser *Stonewall*, 1865.

PAGE, THOMAS NELSON (*b. "Oakland," Hanover Co., Va., 1853; d. Hanover Co., 1922*), diplomat, author, lawyer. Great-grandson of John Page, U.S. ambassador to Italy, 1913–19. *In Ole Virginia* (1887) established his reputation and helped establish (with his later books) the myth of a pre–Civil War feudal utopia in the South.

PAGE, THOMAS WALKER (*b. Albemarle Co., Va., 1866; d. Charlottesville, Va., 1937*), economist. Cousin of Thomas N. Page. Ph.D., Leipzig, 1896. Taught at universities of California, Texas, and Virginia. Member and vice-chairman, U.S. Tariff Commission, 1918–22; 1930–37.

PAGE, WALTER HINES (*b. Cary, N.C., 1855; d. Pinehurst, N.C., 1918*), journalist, diplomat. Educated at Trinity College (now Duke), Randolph-Macon, and Johns Hopkins. Successful as editor-director of *Forum* and *Atlantic Monthly*; became partner in Doubleday, Page and Co., 1899; founded *The World's Work*, a journal of politics and practical affairs, 1900. During these years Page campaigned for educational, agricultural, industrial, and sanitary improvements, particularly in the South. Appointed U.S. ambassador to Great Britain, 1913, Page pressed for immediate American intervention against Germany in World War I. Disappointed with Wilson's neutrality policy, he threatened to resign many times. *Post* 1917 Page worked effectively to cement the Allied powers into an effective partnership.

PAGE, WILLIAM (*b. Albany, N.Y., 1811; d. Tottenville, N.Y., 1885*), portrait painter. Pupil of James Herring and S. F. B. Morse; studied in Italy, 1849–60. Consciously imitated Titian.

PAINE, ALBERT BIGELOW (*b. New Bedford, Mass., 1861; d. New Smyrna, Fla., 1937*), journalist, biographer, writer of light fiction for children and adults. Literary executor of Mark Twain, whose authorized biography he published in 1912.

PAINE, BYRON (*b. Painesville, Ohio, 1827; d. 1871*), lawyer, states' rights advocate. Wisconsin Supreme Court judge, 1859–64 and 1867–71.

PAINE, CHARLES (*b. Williamstown, Vt., 1799; d. Waco, Tex., 1853*), woolen manufacturer, Vermont railroad promoter. Son of Elijah Paine; brother of Martyn Paine. Whig governor of Vermont, 1841–43.

PAINE, CHARLES JACKSON (*b. Boston, Mass., 1833; d. Weston, Mass., 1916*), Union brigadier general, capitalist, yachtsman. Brother of Robert T. Paine (1835–1910). Owned and successfully raced *Puritan, Mayflower,* and *Volunteer* in international competition.

PAINE, ELIJAH (*b. Brooklyn, Conn., 1757; d. 1842*), farmer, woolen manufacturer, Vermont legislator Among first settlers of Williamstown, Vt., 1784. Justice of Vermont Supreme Court, 1791–93; U.S. senator, Federalist, from Vermont, 1795–1801.

PAINE, HALBERT ELEAZER (*b. Chardon, Ohio, 1826; d. 1905*), lawyer. Union officer. Early law partner of Carl Schurz. Congressman, Radical Republican, from Wisconsin, 1865–71; U.S. commissioner of patents, 1878–80. Wrote authoritative *Treatise on the Law of Elections to Public Offices* (1888).

PAINE, HENRY WARREN (*b. Winslow, Maine, 1810; d. Cambridge, Mass., 1893*), lawyer, leader of Boston, Mass., bar *post* 1854; lecturer, Boston University Law School, 1872–85.

PAINE, JOHN ALSOP (*b. Newark, N.J., 1840; d. Tarrytown[?], N.Y., 1912*), archaeologist, botanist.

PAINE, JOHN KNOWLES (*b. Portland, Maine, 1839; d. Cambridge, Mass., 1906*), composer, teacher, organist. Studied music, particularly the organ, in Germany, 1857–61; returning to America, he gave distinguished recitals and joined the Harvard faculty, 1862. Among his best compositions were his Symphony no. 2 (1880) and music for Sophocles' *Oedipus Tyrannus* (1881). As a teacher Paine developed at Harvard, 1862–1905, the first noteworthy music school in America, in which he stressed music as art and not as a trade.

PAINE, MARTYN (*b. Williamstown, Vt., 1794; d. New York, N.Y., 1877*), physician. Son of Elijah Paine; brother of Charles Paine. Graduated Harvard, 1813; Harvard Medical, 1816. Helped found, and taught at, University of the City of New York medical college; a leading professor of therapeutics, he advocated vivisection and wrote *Institutes of Medicine* (1847).

PAINE, RALPH DELAHAYE (*b. Lemont, Ill., 1871; d. Concord, N.H., 1925*), journalist, war correspondent. Author of excellent stories for boys and historical studies such as *The Old Merchant Marine* (1919) and *The Fight for a Free Sea* (1920).

PAINE, ROBERT (*b. Person Co., N.C., 1799; d. Aberdeen, Miss., 1882*), bishop of the Methodist Episcopal Church, South, 1846–82. Instrumental in peaceable division of Methodist church, 1844–45; strengthened his denomination's financial position during Reconstruction.

PAINE, ROBERT TREAT (*b. Boston, Mass., 1731; d. Boston, 1814*), signer of the Declaration of Independence, Massachusetts legislator and jurist. Graduated Harvard, 1749. After brief career in Congregational ministry, Paine settled in legal practice at Taunton, Mass., 1761. He early joined the patriot cause, acted as associate prosecuting attorney in the "Boston Massacre" trial, was elected to the legislature, and then served as delegate to Continental Congress, 1774–76. During the Revolution, Paine worked principally in Massachusetts, was elected the first state attorney general, 1777, and earned a lasting reputation as a zealous and effective patriot. Instrumental in suppressing Shays's Rebellion, Paine became a state supreme court justice, 1790. He continued active politics as a Federalist until his retirement from the bench in 1804.

PAINE, ROBERT TREAT (*b. Taunton, Mass 1773; d. Boston, Mass., 1811*), editor, satirist, poet. Son of Robert T. Paine (1731–1814). Wrote "Adams and Liberty," 1798; edited the *Federal Orrery*, 1794–96. An early bohemian wit in proper Boston.

PAINE, ROBERT TREAT (*b. Boston, Mass., 1835; d. Waltham, Mass., 1910*), philanthropist. Brother of Charles J. Paine.

Founder, and president, 1879–1907, of Associated Charities of Boston; a leading authority on philosophy and implementation of modern philanthropy.

PAINE, THOMAS (*b. Thetford, England, 1737; d. New York, N.Y., 1809*), pamphleteer, agitator, deist. Son of a Quaker corset maker, Paine attended school until he was 13 when poverty compelled his apprenticeship to the paternal trade. Serving briefly as a privateer, 1756, he returned to his home and spent the years 1757–74 working successively and in many towns as a corset maker, exciseman, schoolteacher, exciseman again, tobacconist, and grocer. He experienced two brief, childless marriages. He was deeply, lastingly affected by the monotony of his occupation, the ugliness of his poverty, and the frustration produced by the gap, existing in his mind, between his abilities and his apparent destiny. However, he read widely in contemporary social, political, and scientific literature, and so educated himself.

Armed with letters of introduction from Benjamin Franklin, whom he had met in London when he was agitating to get salaries of excisemen increased, Paine immigrated to Philadelphia, arriving in October 1774. There he fell naturally into journalism, supporting himself largely by contributions to the *Pennsylvania Magazine* on a number of subjects, from recent inventions to slavery. Refreshed by what seemed the unlimited potentialities of the New World and deeply imbued with current rationalist theories on the nature of society, Paine quickly took up the patriot cause. His celebrated *Common Sense* was published as an anonymous pamphlet in Philadelphia on Jan. 10, 1776. It urged an immediate declaration of independence as the fulfillment of America's moral obligation to the world. The colonies, Paine reasoned, must fall away eventually. If they separated from a debasing monarchy while they were still uncorrupt, natural, and democratic, human destiny could be altered by their example, and America's mission would be served. The pamphlet enjoyed a phenomenal success; 120,000 copies were sold in three months and some 500,000 in all.

Paine joined Washington's army during the New Jersey retreat, November–December 1776, during which he wrote the first number of the *Crisis*. Beginning with the famous words "These are times that try men's souls," it appeared in the *Pennsylvania Journal* on Dec. 19, 1776, and in pamphlet form four days later. Eleven further numbers and four supernumerary ones appeared during the war. Urging vigorous action and sacrifice, they were widely read both in the army and the country at large. Appointed secretary of the congressional committee on foreign affairs, April 1777, Paine served efficiently, but was drawn into the Beaumarchais affair and engaged in public dispute with Silas Deane. Pressure from the French minister in Washington forced his resignation, whereupon he was appointed clerk to the Pennsylvania Assembly. After the war Paine lived in Bordentown, N.J., and in New York City, 1783–87; he was mildly lionized and worked on his cherished invention, an iron bridge. He had been given a confiscated Loyalist farm at New Rochelle, N.Y.

Despairing of getting his bridge adopted in America, Paine went to Europe in 1787, living in England and France and passing the time pleasantly as a favorite in liberal circles. Stirred by the onset of the French Revolution, he acted as self-appointed missionary of the world revolution, 1789–92. He hoped England would follow France's course, and after Edmund Burke published his quickly popular condemnation of events in France, 1790, Paine replied with the first part of his *Rights of Man* in 1791; the second part appeared in 1792. This pamphlet was a defense of specific measures taken by the French revolutionists and an exposition of the "natural rights" philosophy; Paine argued that man's rights to liberty, property, security, and resistance to oppression could only be guaranteed by a republican form of government with a written constitution, manhood suffrage, and

an absence of artificial distinctions of birth and rank. Paine hoped his pamphlet would stimulate a revolution in England. Pitt's ministry suppressed it, however, and declared Paine, safe in France, an outlaw. Made a French citizen by the National Assembly and elected to the revolutionary convention in France (Pas de Calais Department, 1792), Paine served for a year, attaching himself to the moderate Gironde group. Imprisoned in December 1793 for being a national of a country at war with France, he was not released until the following November. Until 1802 he lived in Paris, supported in part by solicitous friends. His principal work of this period, *The Age of Reason* (1794, 1796), was a defense of deism and a rationalist attack upon literal acceptance of the Bible.

Before his return to America in 1802, Paine had become a central figure in the partisan dispute between Jeffersonians and Federalists, largely because Thomas Jefferson had commented favorably upon his deistic treatise and had offered Paine passage to America on a public vessel. The last seven years of his life were marked by poverty, declining health, and social ostracism, and were spent in Bordentown, in New York City, and in New Rochelle. He was buried in a corner of his New Rochelle farm, but in 1819 his bones were removed and taken to England by William Cobbett. In addition to the major works already cited, Paine was author of a number of minor pamphlets. A revolutionary by temperament and something of a professional radical, Paine was always pleading a cause; his books, lucid and studded with apt epithets, are arguments rather than expositions. He was essentially a propogandist through whom the ideas of more-original men were transmitted to the crowd.

PAINTER, GAMALIEL (*b. New Haven, Conn., 1743; d. 1819*), Revolutionary soldier, Vermont pioneer and legislator. Promoted settlement and development of Middlebury, Vt.; a founder of Middlebury College, and a fellow of the college, 1800–19.

PAINTER, WILLIAM (*b. Triadelphia, Md., 1838; d. Baltimore, Md., 1906*), engineer. Devised, patented (1892), and produced the "Crown Cork" single-use bottle cap, the basis of extensively used bottle sealers today.

PAL, GEORGE (*b. Cegléd, Hungary, 1908; d. Beverly Hills, Calif., 1980*), film producer. As a film producer in Europe in the 1930's, he mastered special-effects animation techniques and created several hundred short movies featuring animated puppets, known as Puppetoons. In 1939 he immigrated to the United States (naturalized about 1949), where he headed an animation studio for Paramount Pictures. He soon turned to feature-length movies, receiving Academy Awards for his special-effects work on *Destination Moon* (1949), *When Worlds Collide* (1951), and *War of the Worlds* (1953). He also directed several films, including *Tom Thumb* (1958), *The Time Machine* (1960), and *The 7 Faces of Dr. Lao* (1964). Pal's movies helped raise the quality of the science-fiction film genre.

PALEY, BARBARA CUSHING ("BABE") (*b. Boston, Mass., 1915; d. Long Island, N.Y., 1978*), socialite. Moved to New York City in 1929 and worked at a low-level position at *Glamour* Magazine. During the 1930's, she and her two older sisters were popular in New York high society, earning the title the "Fabulous Cushing Sisters." In 1939 she became fashion editor at *Vogue*, and her influence in the fashion industry continued after her 1947 marriage to William S. Paley, founder of Columbia Broadcasting System.

PALEY, JOHN (*b. Russia, 1871; d. 1907*), editor, author. Came to America, 1888. Made the New York *Jewish Daily News* a powerful influence on Yiddish-speaking people as its editor *post ca.*

1893. His vigorous, conservative articles brought him a personal following and bitter abuse from the Yiddish socialist press.

PALFREY, JOHN CARVER (*b. Cambridge, Mass., 1833; d. Boston, Mass., 1906*), Union soldier, engineer. Son of John G. Palfrey. Graduated Harvard, 1853; West Point, 1857. Specialist in military fortifications; helped save Union gunboat fleet during Red River campaign, 1864, by raising level of the water, thus permitting passage over the rapids.

PALFREY, JOHN GORHAM (*b. Boston, Mass., 1796; d. Boston, 1881*), Unitarian clergyman, editor, historian. Graduated Harvard, 1815. Minister of Brattle Square Church, Boston, 1818–31; Dexter professor of sacred literature, Harvard, 1831–39. Contributed important articles to *North American Review*, and managed it between 1835 and 1843; served as congressman, Whig, 1847–49. Author of a number of books on religious topics which were largely made up of his successful public lectures. His most important work was his *History of New England* (5 vols., 1858–90), the product of vast research, painstakingly and accurately undertaken. It remained the standard work for decades afterward in spite of its bias in favor of New England Puritans and anti-English animus.

PALLADINO, LAWRENCE BENEDICT (*b. Dilecto, Italy, 1837; d. Missoula, Mont., 1927*), Roman Catholic missionary, Jesuit. Came to California, 1863; served in Montana area principally, 1867–1925. Author of *Indian and White in the Northwest* (1894).

PALLEN, CONDÉ BENOIST (*b. St. Louis, Mo., 1858; d. 1929*), editor, lecturer, author. Graduated Georgetown University, 1880; Ph.D., St. Louis University, 1885. A founder and managing editor, 1904–20, of the *Catholic Encyclopedia*.

PALMER, ALBERT MARSHMAN (*b. North Stonington, Conn., 1838; d. 1905*), theatrical manager. Managed Union Square Theatre, New York City, 1872–83; later managed Madison Square Theatre and Wallack's. Encouraged American authors to deal with native American material; helped found Actor's Fund, 1882.

PALMER, ALEXANDER MITCHELL (*b. Moosehead, Pa., 1872; d. Washington, D.C., 1936*), lawyer. Graduated Swarthmore, 1891; practiced law in Stroudsburg, Pa., *post* 1893. Congressman, progressive Democrat, from Pennsylvania, 1909–15; active supporter of Woodrow Wilson, 1912. As alien property custodian, 1917–19, he was widely criticized for his handling of some $600 million worth of enemy property; as U.S. attorney general, 1919–21, he was denounced in liberal circles for his onslaught on domestic radicalism, particularly his raids on private homes and deportation of aliens.

PALMER, ALICE ELVIRA FREEMAN (*b. Colesville, N.Y., 1855; d. Paris, France, 1902*), educator. Wife of George H. Palmer. Graduated University of Michigan, 1876; became head of Department of History at Wellesley College, 1879. Manifest administrative abilities led to her appointment, 1881–82, as president of Wellesley, which she developed into a first-rate women's college by the time of her resignation, 1888. In 1889 she was appointed to the Massachusetts Board of Education; she served as dean of women at the University of Chicago, 1892–95.

PALMER, ALONZO BENJAMIN (*b. Richfield, N.Y., 1815; d. 1887*), physician, teacher. Dean of medical department, University of Michigan, 1875–87. Wrote *Treatise on the Science and Practice of Medicine* (1882) and *Epidemic Cholera* (1866).

PALMER, BENJAMIN MORGAN (*b. Charleston, S.C., 1818; d. New Orleans, La., 1902*), Presbyterian clergyman. Pastor in New

Orleans *post* 1856; helped found *Southern Presbyterian Review* and *Southwestern Presbyterian.*

PALMER, BERTHA HONORÉ (*b. Louisville, Ky., 1849; d. Osprey, Fla., 1918*), Chicago hostess and social leader. Married Potter Palmer, 1871.

PALMER, DANIEL DAVID (*b. near Toronto, Canada, 1845; d. Los Angeles, Calif., 1913*), founder of chiropractic. Started Palmer School of Chiropractic, Davenport, Iowa, 1898. Coauthor, *Science of Chiropractic* (1906); author, *Textbook of the Science, Art and Philosophy of Chiropractic* (1910).

PALMER, ELIHU (*b. Canterbury, Conn., 1764; d. Philadelphia, Pa., 1806*), militant deist. Graduated Dartmouth, 1787; served as Presbyterian and Universalist minister; practiced law. Founded formal deist organizations *ca.* 1795, known as the Philosophical Society (Columbian Illuminati) in New York City and as the Theophilanthropists in Philadelphia and Baltimore, Md.

PALMER, ERASTUS DOW (*b. Pompey, N.Y., 1817; d. Albany, N.Y., 1904*), cameo-cutter, sculptor. First American sculptor to exhibit lyric charm in his work; created *White Captive* (1858) and other ideal pieces; excelled as portraitist.

PALMER, GEORGE HERBERT (*b. Boston, Mass., 1842; d. Cambridge, Mass., 1933*), philosopher, teacher, man of letters. Married Alice F. F. Palmer, 1887. Graduated Harvard, 1864; Andover Theological Seminary, 1870. Appointed to the Harvard faculty, 1870, he continued to teach until retirement, 1913. Professor of philosophy *post* 1873, his professional interest was in the theory of ethics; a man of the middle ground, he criticized the extreme positions of Puritanism and Hegelianism. *The Odyssey of Homer* (1884), *The Field of Ethics* (1901), *The Problem of Freedom* (1911), and his edition of *The English Works of George Herbert* (3 vols., 1905) were among his best-known writings and indicate the range of his interests.

PALMER, HENRY WILBUR (*b. Clifford, Pa., 1839; d. Wilkes-Barre, Pa., 1913*), lawyer. Congressman, Republican, from Pennsylvania, 1901–07 and 1909–11. Often in controversy, he championed the established order, rugged individualism, and puritan reforms.

PALMER, HORATIO RICHMOND (*b. Sherburne, N.Y., 1834; d. Yonkers, N.Y., 1907*), musician, director of music. Dean of music at Chautauqua, 1877–91. Organized successful Church Choral Union, New York City, 1881; composed "Just for Today" and other popular hymns.

PALMER, INNIS NEWTON (*b. Buffalo, N.Y., 1824; d. Chevy Chase, Md., 1900*), soldier. Graduated West Point, 1846. Served with distinction in Mexican War; held Union army divisional command in Civil War, chiefly in North Carolina; commanded 2nd Cavalry in expanding West, 1865–79.

PALMER, JAMES CROXALL (*b. Baltimore, Md., 1811; d. Washington, D.C., 1883*), naval surgeon. Brother of John W. Palmer. Served with Wilkes Expedition, 1838–42; with West Gulf blockade squadron, 1863–65. Surgeon general of the navy, 1872–73.

PALMER, JAMES SHEDDEN (*b. New Jersey, 1810; d. St. Thomas, Virgin Islands, 1867*), naval officer. Led Union fleet in first passage of Vicksburg; succeeded in Farragut in command of Union forces on the Mississippi; commanded West Gulf squadron in fall, 1864; aided Virgin Islanders after earthquake, 1866.

PALMER, JOEL (*b. Ontario, Canada, 1810; d. Dayton, Oreg., 1881*), Oregon legislator and pioneer. Author of *Journal of Travels over the Rocky Mountains* (1847); successful and diligent superintendent of Indian affairs for Oregon Territory, 1853–57.

PALMER, JOHN MCAULEY (*b. Scott Co., Ky., 1817; d. Springfield, Ill., 1900*), lawyer, Union major general. Removed to Illinois, 1831; helped found Republican party there. Republican governor of Illinois, 1869–73. Palmer, a Democrat *post* 1872, served as U.S. senator, 1891–97. In 1896, he was the presidential nominee of the National, or "Gold," Democrats.

PALMER, JOHN MCAULEY (*b. Carlinville, Ill., 1870; d. Washington, D.C., 1955*), army officer. Graduated West Point, 1892. Served on the army general staff, 1911–12 and 1916–17. In 1917 he became Pershing's assistant chief of staff for operations for the American Expeditionary Force in France. Promoted brigadier general in 1922, he retired in 1926. Recalled during World War II as an adviser on reserve forces, he retired again in 1946. An advocate of universal military training during peacetime, he was the author of the National Defense Act of 1920 and helped frame the Selective Service Act of 1940.

PALMER, JOHN WILLIAMSON (*b. Baltimore, Md., 1825; d. Baltimore, 1906*), physician, author. Brother of James C. Palmer. Southern correspondent for *New York Tribune* during Civil War; wrote ballad "Stonewall Jackson's Way."

PALMER, JOSEPH (*b. Devonshire, England, 1716; d. Dorchester, Mass., 1788*), manufacturer, Revolutionary brigadier general. Immigrated to Massachusetts, 1746. Commanded unsuccessful attack on British at Newport, R.I., October 1777; lost most of his fortune during Revolution.

PALMER, NATHANIEL BROWN (*b. Stonington, Conn., 1799; d. San Francisco, Calif., 1877*), sea captain, explorer. In search of new seal rookeries in the South Atlantic, Palmer discovered Palmer Land on Antarctica, 1820. A respected packet and China clipper captain in later life, he made many valuable suggestions for improved clipper design.

PALMER, POTTER (*b. Albany Co., N.Y., 1826; d. Chicago, Ill., 1902*), Chicago merchant, real estate promoter. Removed to Chicago, 1852. Married Bertha H. Palmer, 1871. Founder of present Marshall Field stores, State Street business center, "Palmer system" of retailing, Palmer House hotel.

PALMER, MRS. POTTER *See* PALMER, BERTHA HONORÉ.

PALMER, RAY (*b. Little Compton, R.I., 1808; d. Newark, N.J., 1887*), Congregational clergyman, hymnist. Author of "My Faith Looks Up to Thee" (*ca.* 1831); published *Hymns and Sacred Pieces* (1865), *Voices of Hope and Gladness* (1881), and other books.

PALMER, THOMAS WITHERELL (*b. Detroit, Mich., 1830; d. Detroit, 1913*), businessman, philanthropist. U.S. senator, Republican, from Michigan, 1883–89; U.S. minister to Spain, 1889–91. President, Chicago World's Fair Commission, 1892–93.

PALMER, WALTER LAUNT (*b. Albany, N.Y., 1854; d. Albany, 1932*), landscape, figure, and still-life painter. Son of Erastus D. Palmer. Studied with Frederick E. Church and, in Paris, with Carolus Duran. Achieved success and popularity with delicately shaded winter scenes.

PALMER, WALTER WALKER (*b. Southfield, Mass., 1882; d. Tyringham, Mass., 1950*), physician, medical educator. Graduated Amherst College, 1905. M.D., Harvard Medical School, 1910. His early research, much of it in collaboration with Lawrence J. Henderson at Harvard, was devoted to studies of acid-base bal-

ance in diabetes and nephritis; he continued this research as a staff member of the Rockefeller Institute, New York City, 1915–17, and also developed the first reliable quantitative method for hemoglobin determination. He later concerned himself principally with the physiology of the thyroid gland. He built up one of the world's renowned departments of internal medicine at Columbia University, where he served as associate professor, 1917–19, and Bard professor of medicine, 1921–47, and as director of the medical service at Presbyterian Hospital.

PALMER, WILLIAM ADAMS (*b. Hebron, Conn., 1781; d. Danville, Vt., 1860*), lawyer, Vermont legislator and jurist. U.S. senator, Democrat, from Vermont, 1818–25; anti-Masonic leader and governor 1831–35.

PALMER, WILLIAM HENRY (*b. England, ca. 1830; d. Philadelphia, Pa., 1878*), entertainer, known on stage as Robert Heller. Achieved success in America *post* 1864 with acts using magic, puppets, and piano numbers.

PALMER, WILLIAM JACKSON (*b. near Leipsic, Del., 1836; d. near Colorado Springs, Colo., 1909*), Union soldier, railroad executive. Served with distinction throughout the Civil War as a cavalry officer. After the war, he served as an official of the Union Pacific Railroad's Eastern Division, which became the Kansas Pacific and later merged into the Union Pacific. In 1870, he became first president of the Denver and Rio Grande and completed its line westward by 1883. During the 1880's, he organized and constructed Mexican railroads, two lines from Mexico City to the border being completed by 1890. He was an organizer and first president of the Colorado Coal and Iron Co. and helped develop Colorado Springs.

PALMORE, WILLIAM BEVERLY (*b. Fayette Co., Tenn., 1844; d. Richmond, Va., 1914*), clergyman of the Methodist Episcopal Church, South. Owner-editor *post* 1890 of the influential *St. Louis Christian Advocate.*

PALÓU, FRANCISCO (*b. Mallorca, ca. 1722; d. Mexico, ca. 1789*), Franciscan missionary, historian. Accompanied Junípero Serra to Mexico, 1749; served as Serra's associate and independently on missions in Lower and Upper California; founded Mission Dolores (San Francisco), 1776. Author of monumental chronicles of the Franciscan work in California and a biography of Junípero Serra (1787).

PAMMEL, LOUIS HERMANN (*b. LaCrosse, Wis., 1862; d. Nevada, 1931*), botanist, educator, conservationist. Author of *The Grasses of Iowa* (1901), *Ecology* (1903), *Weed Flora of Iowa* (1913)

PANCOAST, HENRY KHUNRATH (*b. Philadelphia, Pa., 1875; d. Merion, Pa., 1939*), pioneer radiologist. Son of Seth Pancoast. M.D., University of Pennsylvania, 1898; headed Department of Radiology there *post* 1902.

PANCOAST, JOSEPH (*b. near Burlington, N.J., 1805; d. Philadelphia, Pa., 1882*), anatomist, surgeon. University of Pennsylvania, M.D., 1828; taught at Jefferson Medical College, 1838–74; accomplished spectacular surgical feats. Wrote *Treatise on Operative Surgery* (1844).

PANCOAST, SETH (*b. Darby, Pa., 1823; d. Philadelphia, Pa., 1889*), physician, anatomist, student of the occult.

PANGBORN, CLYDE EDWARD (*b. Bridgeport, Wash., 1894; d. New York, N.Y., 1958*), aviator. After studying briefly at the University of Idaho and receiving flight training in the army during World War I, Pangborn became a civilian aviator, working in flying circuses and barnstorming for a living. In 1931, with Hugh Herndon, he completed the first nonstop flight across the Pacific, flying from Japan to Washington state. In 1934, with Colonel Roscoe Turner, he flew a record flight from London to Australia.

PANOFSKY, ERWIN (*b. Hannover, Germany, 1892; d. Princeton, N.J., 1968*), art historian. Attended universities of Freiburg (Ph.D., 1914), Berlin, and Munich. Taught at University of Hamburg (1921–33), until dismissed by the Nazi regime, by which time he was well known for his theoretical and historical studies of medieval and Renaissance art. Immigrated to the United States in 1934 and taught at New York University (1934), Princeton (1934–46, 1948–68), Harvard (1947–48), and was a visiting member of the Institute for Advanced Study (1935). Called the most influential art historian of the twentieth century, he is best remembered as the deviser of an approach to analyzing works of visual art that depends on a well-thought-out theory of the relation of mind to world. His most frequently cited practical studies are *Albrecht Dürer* (1943), *Early Netherlandish Painting* (1947–48), *Renaissance and Renascences in Western Art* (1960), and *Problems in Titian, Mostly Iconographic* (1969). *Preface to Studies in Iconology* (1939) systematized his iconological method.

PANSY See ALDEN, ISABELLA MACDONALD.

PANTON, WILLIAM (*b. Aberdeenshire, Scotland, ca. 1742; d. at sea near Nassau, Bahamas, 1801*), Indian trader. Immigrated to Charleston, S.C., ca. 1770; formed a trading partnership at Savannah, Ga.; spent most of 1775–84 in East Florida organizing trade relations with Creek Indians. His Loyalist sentiments led to confiscation of his Georgia property. From 1784 to 1801, he lived mostly in West Florida, where he carried on far-flung trading operations with the Creek, Choctaw, Chickasaw, and Cherokee; the Spanish authorities sponsored his operations in order to keep the Indians friendly to Spain. Trading as Panton, Leslie and Co. and successor firms, with headquarters at Pensacola, Panton prospered until American companies began to cut into his business.

PAPANICOLAOU, GEORGE NICHOLAS (*b. Kyme, Greece, 1883; d. Miami, Fla., 1962*), anatomist and oncologist. Attended universities of Athens (M.D., 1904), Jena, Freiburg, and Munich (Ph.D., 1910). Arrived in the United States in 1913 and taught at New York Hospital (1913) and Cornell Medical College (1914–49); director of the Miami Cancer Institute (1961; later renamed Papanicolaou Cancer Research Institute). His systematic study of the cytology of human vaginal secretions and the observation of distinctive neoplastic cells in the vaginal fluid of women with cancer of the cervix led to the development of the Papanicolaou smear ("Pap" test), a means of cancer diagnosis; widespread application of the test was followed by a sharp reduction in the death rate from cancer of the uterus and cervix.

PARDEE, ARIO (*b. Chatham, N.Y., 1810; d. Ormond, Fla., 1892*), engineer, Pennsylvania coal operator, philanthropist. Benefactor and trustee of Lafayette College.

PARDEE, DON ALBERT (*b. Wadsworth, Ohio, 1837; d. Atlanta, Ga., 1919*), Union soldier, Louisiana jurist. Settled in legal practice at New Orleans, 1865. A Republican, yet respected in the South, Pardee was U.S. circuit court judge, fifth circuit, 1881–1919.

PARDOW, WILLIAM O'BRIEN (*b. New York, N.Y., 1847; d. 1909*), Roman Catholic clergyman, Jesuit educator. Provincial

of Jesuit New York–Maryland province, 1893–97; widely known for pulpit eloquence.

PARIS, WALTER (*b. London, England, 1842; d. Washington, D.C., 1906*), architect, watercolor painter. Resident in America *post ca.* 1872; a founder of the Tile Club.

PARISH, ELIJAH (*b. Lebanon, Conn., 1762; d. Byfield, Mass., 1825*), Congregational clergyman. Pastor at Byfield *post* 1787; associate of Jedidiah Morse in authorship of geographies.

PARK, EDWARDS AMASA (*b. Providence, R.I., 1808; d. Andover, Mass., 1900*), Congregational clergyman, theologian. Last outstanding exponent of the "New England theology"; taught at Andover Theological Seminary, 1836–81; was an editor of *Bibliotheca Sacra*, 1844–84.

PARK, JAMES (*b. Pittsburgh, Pa., 1820; d. Allegheny, Pa., 1883*), iron and steel manufacturer. Encouraged introduction of new industrial processes, including Bessemer process; instrumental in increase of tariff schedules which gave steel a position of special privilege, 1882–83.

PARK, MAUD WOOD (*b. Boston, Mass., 1871; d. Melrose, Mass., 1955*), suffragist and social worker. Studied at Radcliffe College. After founding the College Equal Suffrage League in 1900, she toured the country and rallied college women to the cause of feminism. At the same time she was a social worker in Boston. In 1916 she joined the National American Woman Suffrage Association as head of the lobbying efforts for the right-to-vote amendment. After ratification in 1920, she headed the National League of Women Voters from 1920 to 1924. She established the Women's Joint Congressional Committee which brought about the right of independent citizenship for women in 1922. After her health failed she began to write plays about the women's movement.

PARK, ROBERT EZRA (*b. Harveyville, Pa., 1864; d. Nashville, Tenn., 1944*), sociologist. Raised in Red Wing, Minn. Ph.B., University of Michigan, 1887. After working as a journalist in Minneapolis, Detroit, Denver, and New York City, he was moved to resume studies in philosophy and psychology by his growing interest in the relation between "news" and social change. After receiving the M.A. from Harvard, 1899, he spent the next four years at the universities of Berlin, Strasbourg, and Heidelberg, which granted him the Ph.D., 1904. That same year he became secretary of the Congo Reform Association after his return to the United States; in the course of his work he met Booker T. Washington, for whom he acted as press agent, ghostwriter, and general assistant in the affairs of Tuskegee Institute. In 1913 he joined the sociology department at the University of Chicago, where he remained until 1929 (professor *post* 1923). After retirement he journeyed and lectured in the Orient, taught at University of Hawaii and at Yenching University, and was on the staff of Fisk University, 1935–37. Insistent on accuracy in data-gathering, and on the conduct of investigations with empathy as well as detachment, he excelled as a teacher of advanced students. He never produced a systematic treatise of sociology. In his widely used *Introduction to the Sciences of Sociology* (1921, with E. W. Burgess), he emphasized processes of social interaction rather than the study of institutions. Among his lasting contributions were his concepts of "collective behavior" and the "marginal man." He ranks with Franz Boas and William I. Thomas as a pioneer in the modern study of race and ethnic relations, but he was skeptical of the value of attempts to "engineer" social change.

PARK, ROSWELL (*b. Lebanon, Conn., 1807; d. Chicago, Ill., 1869*), educator, army officer, Episcopal clergyman. Established, and was first president of Racine College, Wisconsin, 1852–63.

PARK, ROSWELL (*b. Pomfret, Conn., 1852; d. Buffalo, N.Y., 1914*), surgeon, pathologist. Son of Roswell Park (1807–69). M.D., Northwestern, 1876. Popularized Lister's antiseptic technique; founded Institute for Malignant Diseases, New York; published *The Principles and Practice of Modern Surgery* (1907), and other works on the practice and history of medicine and surgery.

PARK, TRENOR WILLIAM (*b. Woodford, Vt., 1823; d. at sea, 1882*), lawyer, financier. Son-in-law of Hiland Hall. Removed to California, 1852; was land-title specialist in law firm of Henry W. Halleck and Frederick Billings, San Francisco. Sharp-trading manipulator of stocks in John C. Frémont's Mariposa estate, Vermont and Panama railroads, and the notorious Utah Emma mine.

PARK, WILLIAM HALLOCK (*b. New York, N.Y., 1863; d. New York, 1939*), bacteriologist, public health officer. Graduated College of the City of New York, 1883; M.D., New York College of Physicians and Surgeons, 1886. Began practice as a nose-and-throat specialist, simultaneously working on the bacteriology of diphtheria in New York City's Board of Health laboratory. Corroborating, supplementing, and applying the achievements of European scientists in isolating the diphtheria bacillus, developing an antitoxin and later an immunity test, Park pioneered in mass immunization. His program, widely followed in the United States and abroad, virtually eliminated diphtheria as a cause of death. As director of New York City's health laboratories, Park investigated many other infectious diseases and was a leader in milk sanitation.

PARKE, BENJAMIN (*b. New Jersey, 1777; d. Indiana, 1835*), soldier, jurist. Removed to Kentucky *ca.* 1797; settled to Vincennes, Ind., 1801. Negotiated treaty securing central Indiana for whites, 1818; served as a judge of the territorial court, 1808–17, and thereafter as U.S. district judge.

PARKE, JOHN (*b. Dover, Del., 1754; d. Kent Co., Del., 1789*), Revolutionary soldier, poet. Author of *Lyric Works of Horace . . . by a Native of America* (1786).

PARKE, JOHN GRUBB (*b. near Coatesville, Pa., 1827; d. Philadelphia, Pa., 1900*), Union soldier. Graduated West Point, 1849. A distinguished engineer officer and field commander, Parke served in almost all Civil War theaters, most notably at Vicksburg, 1863, and Fort Steadman, 1865. He retired as colonel, 1889.

PARKER, ALTON BROOKS (*b. Cortland, N.Y., 1852; d. New York, N.Y., 1926*), jurist. Graduating from Albany (N.Y.) Law School, 1873, Parker began practice at Kingston; thereafter he was elected and appointed to increasingly important judicial posts in the state, rising to chief justice, New York Court of Appeals, 1897. A consistent Democrat, Parker's judicial record, particularly on labor cases, was generally liberal. Party managers selected him to be Democratic presidential nominee, 1904, playing down his liberalism and presenting him as a safe, conservative candidate. In contrast to Theodore Roosevelt. His campaign, accordingly, was colorless and he was badly defeated.

PARKER, ALVIN PIERSON (*b. near Austin, Tex., 1850; d. Oakland, Calif., 1924*), clergyman of the Methodist Episcopal Church, South. Missionary to China, 1875–1923; editor, *Chinese Christian Advocate*.

PARKER, AMASA JUNIUS (*b. Sharon, Conn., 1807; d. 1890*), New York lawyer, jurist. Active in Democratic politics and a founder of Albany (N.Y.) Law School, 1851.

PARKER, ARTHUR CASWELL (*b. Iroquois, N.Y., 1881; d. Naples, N.Y., 1955*), anthropologist, archaeologist, and museum administrator. Part Seneca, Parker fulfilled his lifelong interest in Indians and Indian affairs through the study of anthropology. He became ethnologist with the New York State Library at Albany in 1904; from 1906 to 1925 he was archaeologist for the New York State Museum; and from 1925 to 1946 he was director of the Rochester Municipal Museum (later the Rochester Museum of Arts and Sciences). Parker distinguished himself for the quantity of his writings about the Iroquois nation.

PARKER, CARLETON HUBBELL (*b. Red Bluff, Calif., 1878; d. 1918*), economist, labor conciliator. His report on the Wheatland, Calif., hop-field riot, 1912, became a model for similar injuries. He was author of *The Casual Laborer and Other Essays* (1920).

PARKER, CHARLIE ("BIRD") (*b. Kansas City, Kans., 1920; d. New York, N.Y., 1955*), jazz musician. An alto saxophonist, Parker was a leader in the development of improvisational jazz. He was a soloist with Jay McShann, Billy Eckstine, Red Norvo, Dizzy Gillespie, and accompanied Sarah Vaughan. In 1947 he formed the best of his small groups, the Quintet, with Max Roach and Miles Davis. One of the greatest jazz improvisors of his time, Parker, in the opinion of some critics, brought jazz to its highest level of achievement.

PARKER, CORTLANDT See PARKER, JOHN CORTLANDT.

PARKER, DOROTHY ROTHSCHILD (*b. West End, N.J., 1893; d. New York, N.Y., 1967*), short-story writer, poet, dramatist, and critic. Hired by *Vanity Fair* in 1916, she became drama critic in 1918, but was fired in 1920 for an acerbic theater review. One of the Algonquin Wits, known for their puns, gibes, and gossip, she wrote a theater column for *Ainslee's Magazine*, and her essays, short stories, and character sketches appeared in *Saturday Evening Post, Ladies Home Journal, Everybody's,* and *Smart Set.* She collaborated with Elmer Rice on the play *Close Harmony, or The Lady Next Door* (1924); with Robert Benchley on the one-act play *Nero* (1924); with George S. Kaufman on her first filmscript, *Business is Business* (1925); and with her husband Alan Campbell on twenty-two filmscripts (1934–49). Unhappy in her personal life, she collected her sardonic poems in *Enough Rope* (1926), which became a best-seller. She also contributed occasionally to the *New Yorker* and began a weekly book-review column (1927–31). Her radical leftist activities in the 1930's led to her being blacklisted in Hollywood in 1949 for "un-American activities." Her best play during this difficult period was *The Ladies of the Corridor* (1953), written with Arnaud D'Usseau. In later years she taught at California State College at Los Angeles, wrote lyrics for Leonard Bernstein's musical *Candide* (1958), and wrote a book-review column for *Esquire* (1957–63).

PARKER, EDWARD PICKERING (*b. Salem, Mass., 1912; d. Salem, Mass., 1974*), games manufacturer. Graduated Harvard University (B.A., 1934) and joined his family's board game company, Parker Brothers. In 1934, after a period of decline, the company purchased the rights to the board game Monopoly; by 1974 the company had sold more than 70 million sets of the game. Parker Brothers was sold to General Mills for $47.5 million in 1967, and Edward Parker was named company president in 1968.

PARKER, EDWIN BREWINGTON (*b. Shelbina, Mo., 1868; d. Washington, D.C., 1929*), Texas lawyer, international jurist. Priorities commissioner, War Industry Board, 1917–18. Chairman of the Liquidation Commission immediately following World War I, he was adjudicator in many war claims actions as Mixed Claims Commission umpire *post* 1923.

PARKER, EDWIN POND (*b. Castine, Maine, 1836; d. Hartford, Conn., 1920*), Congregational clergyman. Pastor of Second Church, Hartford, *post* 1860.

PARKER, EDWIN WALLACE (*b. St. Johnsbury, Vt., 1833; d. Naini Tal, India, 1901*), Methodist missionary and bishop. Active in development of Methodist church and educational enterprises in northern India, 1859–1901.

PARKER, ELY SAMUEL (*b. Indian Falls, N.Y., 1828; d. Fairfield, Conn., 1895*), Seneca sachem, engineer, Union brigadier general. Aided Lewis H. Morgan in research; attended Rensselaer Polytechnic Institute. As U. S. Grant's military secretary, 1864–65, Parker wrote the official copies of the surrender terms at Appomattox. After the Civil War, he rose rapidly in rank during service with the regular army. Commissioner of Indian affairs, 1869–71, he resigned after being unjustly accused of fraud; thereafter he made and lost a small fortune on Wall St.

PARKER, FOXHALL ALEXANDER (*b. New York, N.Y., 1821; d. Annapolis, Md., 1879*), naval officer. Brother of William H. Parker. Author of *The Naval Howitzer Afloat* (1866) and *Fleet Tactics Under Steam* (1870). Died as superintendent of the U.S. Naval Academy.

PARKER, FRANCIS WAYLAND (*b. Bedford, N.H., 1837; d. 1902*), educator. Introduced progressive classroom teaching *post* 1875 in Quincy, Mass., Boston, and Chicago schools; first director, School of Education, University of Chicago, 1901–02.

PARKER, GEORGE HOWARD (*b. Philadelphia, Pa., 1864; d. Cambridge, Mass., 1955*), zoologist. Studied at Harvard University (D.Sc., 1891). Taught at Harvard from 1894 until retirement. Director of the Harvard Zoological Laboratories, 1921–34. A specialist in the nervous systems of lower animals, Parker was elected to the National Academy of Sciences in 1913.

PARKER, HENRY TAYLOR (*b. Boston, Mass., 1867; d. 1934*), journalist. After experience on a number of newspapers, he served *post* 1905 as music and drama editor of the *Boston Transcript* and made the paper notable for care and originality in dealing with the arts.

PARKER, HORATIO WILLIAM (*b. Auburndale, Mass., 1863; d. Cedarhurst, N.Y., 1919*), musical composer, teacher, choral director. Received principal training in Munich, Germany, 1882–85, under Joseph Rheinberger. An accomplished organist, he wrote many compositions, principally works for orchestra and chorus, and collaborated in writing two operas. He was professor of music at Yale, 1894–1919. His style was marked by conservatism and a natural feeling for religion, both clearly present in his best-known work, *Hora Novissima* (1893).

PARKER, ISAAC (*b. Boston, Mass., 1768; d. 1830*), jurist. Graduated Harvard, 1786. Esteemed for decisions showing a broad social sensitivity while justice of Massachusetts Supreme Court, 1806–30 (chief justice, *post* 1814). Drew up plan for Harvard Law School, 1817, at which he was first Royall professor.

PARKER, ISAAC CHARLES (*b. Belmont Co., Ohio, 1838; d. Fort Smith, Ark., 1896*), lawyer. Congressman, Republican, from Missouri, 1871–75; federal judge, western district of Arkansas, 1875–96. A hard and fearless frontier jurist.

PARKER, JAMES (*b. Woodbridge, N.J., ca. 1714; d. Burlington, N.J., 1770*), printer, journalist. Apprenticed to William Bradford in New York, 1727; entered partnership with Benjamin Franklin, 1742, to carry on a New York printing business. As public printer of New York, 1743–60, Parker had a number of disputes with the government of the colony over printing antiadministration items. Parker published several New York newspapers and periodicals in addition to sermons, almanacs, and histories; he set up the first permanent printing office in New Jersey at Woodbridge, 1751, and entered also into partnerships for operation of other printing shops in New York and in New Haven, Conn.

PARKER, JAMES (*b. Hunterdon Co., N.J., 1776; d. 1868*), New Jersey landowner, official, and legislator. Father of John C. Parker. Originally a Federalist, he supported Andrew Jackson, 1824–37, thereafter becoming a Whig and finally a Republican. He was a principal factor in the promotion of the Delaware and Raritan Canal; served as congressman, 1833–37; and twice mayor of Perth Amboy; and was active in the cultural and religious life of his state.

PARKER, JAMES CUTLER DUNN (*b. Boston, Mass., 1828; d. Brookline, Mass., 1916*), composer, organist, music teacher. Nephew of Richard G. Parker. Organist, Trinity Church, Boston; teacher, New England Conservatory.

PARKER, JANE MARSH (*b. Milan, N.Y., 1836; d. Los Angeles, Calif., 1913*), author, essayist.

PARKER, JOEL (*b. Jaffrey, N.H., 1795; d. 1875*), jurist, legislator. Chief justice, New Hampshire superior court, 1838–48; Royall professor of Law, Harvard, 1848–68. Vigorously opposed Radical Republican tinkering with U.S. Constitution *post* 1862.

PARKER, JOEL (*b. Bethel, Vt., 1799; d. New York, N.Y., 1873*), Presbyterian clergyman. Vigorous and popular preacher; held prominent pastorates in New York City, New Orleans, Philadelphia, and Newark, N.J. President, Union Theological Seminary, New York, 1840–42.

PARKER, JOEL (*b. near Freehold, N.J., 1816; d. Philadelphia, Pa., 1888*), jurist, politician. Democratic governor of New Jersey, 1863–66 and 1872–75; state supreme court justice, 1880–88. Supported Civil War but defended states' rights against so-called "military necessities."

PARKER, JOHN (*b. Lexington, Mass., 1729; d. 1775*), Revolutionary soldier. Captain of the minuteman company which defended Lexington, Apr. 19, 1775.

PARKER, JOHN CORTLANDT (*b. Perth Amboy, N.J. 1818; d. Newark, N.J., 1907*), lawyer. Son of James Parker (1776–1868). Graduated Rutgers, 1836; studied law in Newark office of Theodore Frelinghuysen. President, American Bar Association, 1883–84, Parker was at the time of his death the acknowledged leader of the New Jersey bar. Prominent in organization of the New Jersey Republican party, he enthusiastically supported Lincoln in 1860 and 1864 and helped secure New Jersey's ratification of the 14th Amendment. He served on the U.S. commission to investigate Louisiana's electoral vote in 1876 and on various state legal commissions, but declined several high diplomatic appointments. His work as advisory master of the New Jersey Court of Chancery resulted in opinions which were landmarks in the state's corporate law.

PARKER, JOHN JOHNSTON (*b. Monroe, N.C., 1885; d. Washington, D.C., 1958*), jurist. Received LL.B. from the University of North Carolina, 1908. After practicing law in North Carolina and serving in Republican politics (member of the Republican National Committee, 1924), Parker was appointed appellate judge for the U.S. Court of Appeals for the Fourth Circuit in 1925 by President Coolidge; he served until his death. In 1930, President Hoover appointed him to the Supreme Court, but he failed to win ratification. As appellate judge, he heard more than 4,000 arguments and made over 1,500 decisions. He was against laissez-faire in economic matters, and heard many cases concerning race relations; his decision in *Briggs v. Elliott* (1951) ruled in favor of school segregation, later struck down by the Supreme Court in 1954. Parker was a member of the U.S. Judicial Conference from 1930 to 1958; in 1945, President Truman appointed him as alternate U.S. member of the International Military Tribunal at Nuremberg, Germany.

PARKER, JOHN MILLIKEN (*b. Bethel Church, Miss., 1863; d. Pass Christian, Miss., 1939*), cotton factor, leader in Progressive and Democratic parties. Democratic governor of Louisiana, 1920–24.

PARKER, JOSIAH (*b. Isle of Wight Co., Va., 1751; d. Isle of Wight Co., 1810*), Revolutionary soldier, politician. Antifederalist member of Congress from Virginia, 1789–1801.

PARKER, PETER (*b. Framingham, Mass., 1804; d. Washington, D.C., 1888*), Presbyterian medical missionary to China, 1834–40 and 1842–57. Served as secretary to Caleb Cushing in treaty negotiations, 1844; thereafter was ad interim U.S. representative in China at various times and U.S. minister, 1855–57.

PARKER, QUANAH *See* QUANAH.

PARKER, RICHARD ELLIOT (*b. Westmoreland Co., Va., 1783; d. Clarke Co., Va., 1840*), War of 1812 soldier, Virginia legislator and U.S. senator. Judge of Virginia general court, 1817–36; judge, supreme court of appeals, 1837–40.

PARKER, RICHARD GREEN (*b. Boston, Mass., 1798; d. Boston, 1869*), Boston public school teacher, textbook writer.

PARKER, SAMUEL (*b. Ashfield, Mass., 1779; d. 1866*), Congregational clergyman, missionary, explorer. Selected sites for Oregon Indian missions during stay there, 1835–36; published *Journal of an Exploring Tour Beyond the Rocky Mountains* (1838).

PARKER, SAMUEL CHESTER (*b. Cincinnati, Ohio, 1880; d. Chicago, Ill., 1924*), educator. Graduated University of Cincinnati, 1901; a pupil also of John Dewey and E. L. Thorndike. Teacher of education, University of Chicago, 1909–24. His successful textbooks included *Methods of Teaching in High Schools* (1915).

PARKER, THEODORE (*b. Lexington, Mass., 1810; d. Florence, Italy, 1860*), theologian, Unitarian clergyman, publicist and author. Grandson of John Parker. Self-educated in the main, he graduated from Harvard Divinity School, 1836, and became minister in West Roxbury, Mass., 1837. Grown skeptical of orthodoxy, he believed that religious truths were drawn from individual intuition and feeling rather than from revelation. An immensely popular lecturer and essayist, Parker demanded a new theology based upon the immanence of God in nature and human experience. An associate of the Channings, F. H. Hedge, R. W. Emerson, and Bronson Alcott, he quickly became a figure of intense controversy in religious circles; resigning his pastorate, 1845, he became minister of a new free church in Boston. Here, he dealt largely with social questions, was a violent supporter of abolition, and exercised great influence on politics.

PARKER, THEODORE BISSELL (*b. Roxbury, Mass., 1889; d. Wellesley, Mass., 1944*), civil engineer. B.S., Massachusetts Institute of Technology, 1911. A specialist in waterway and hydroelectric engineering, he served with the U.S. Army Corps of Engineers and in civilian employment principally with Stone and Webster. Appointed state engineer and acting director for Massachusetts of the Federal Emergency Administration of Public Works, 1933, he was named chief engineer of construction of the Tennessee Valley Authority, 1935, and chief engineer in 1938. He resigned in 1943 to become professor of civil engineering and chairman of the department at MIT.

PARKER, THOMAS (*b. Wiltshire, England, 1595; d. Newbury, Mass., 1677*), minister at Newbury, 1635–77. An orthodox Calvinist in doctrine, he advocated the Presbyterian, rather than the Congregational, ecclesiastical polity.

PARKER, WILLARD (*b. Lyndeborough, N.H., 1800; d. 1884*), surgeon. Graduated Harvard, 1826; served medical apprenticeship with John C. Warren and S. D. Townsend in Boston; M.D., Harvard, 1830. Taught at a number of schools; was professor of surgery, New York College of Physicians and Surgeons, 1839–70. A courageous and successful operator, he pioneered in surgical techniques for appendicitis.

PARKER, WILLIAM HARWAR (*b. New York, N.Y., 1826; d. Washington, D.C., 1896*), naval officer, author. Brother of Foxhall A. Parker. Graduated U.S. Naval Academy, 1865.

PARKHURST, CHARLES (*b. Sharon, Vt., 1845; d. 1921*), Methodist clergyman. Edited *Zion's Herald*, 1888–1919; promoted temperance and reunion of Methodism, North and South.

PARKHURST, CHARLES HENRY (*b. Framingham, Mass., 1842; d. New York, N.Y., 1933*), Presbyterian clergyman, reformer. Graduated Amherst, 1866; held New York City pastorate, 1880–1918. Launched furious attack upon alliance between Tammany Hall and organized vice, 1892, which led to Lexow Investigation, 1894.

PARKHURST, JOHN ADELBERT (*b. Dixon, Ill., 1861; d. Williams Bay, Wis., 1925*), businessman, astronomer. Did valuable photometric research at Yerkes Observatory, particularly in determining magnitude ranges and color indices.

PARKINSON, THOMAS IGNATIUS (*b. Philadelphia, Pa., 1881; d. New York, N.Y., 1959*), lawyer and insurance executive. Received LL.B. from the University of Pennsylvania, 1902. Taught at the Columbia University Law School from 1917 to 1935. In 1933 Parkinson was offered the post of secretary of the treasury by Roosevelt; he declined and became a critic of the New Deal. In 1920 he joined the Equitable Life Insurance Company of America; serving as vice president, 1925–27, president, 1927–53, and chairman of the board, 1954 until his death.

PARKMAN, FRANCIS (*b. Boston, Mass., 1823; d. Boston, 1893*), historian. Son of a New England family of wealth, social standing, and culture, Parkman developed as a boy a taste for outdoor life and nature study; during college vacations, he took long trips through New England, partly on foot and partly by canoe. At Harvard, he excelled in subjects that interested him and gave much time to outside reading. After graduation in 1844, he entered Harvard Law School, received a law degree, but never bothered to take the bar examinations.

In 1846 Parkman set out from St. Louis, Mo., on a journey over the Oregon Trail to study the Indians and to improve his health. He returned in poor physical condition, but a result of the trip was his first major writing, *The California and Oregon Trail* (first published in *Knickerbocker* magazine, 1847; book publication, 1849). In 1848 he began to write the *History of the Conspiracy of Pontiac*; it was the first of a sequence of books detailing the history of the struggles between the English and the French for control of the North American continent which he had planned to be his life task. Parkman estimated that it would take about 20 years to finish his project, but because of serious and crippling physical ailments the work took much longer. He suffered from a malady affecting the nervous system; its symptoms were extreme weakness of sight, an inability to concentrate upon any intellectual pursuit for more than brief periods at a time, and continual exhaustion. For most of his historical research Parkman had to employ copyists and readers and to write with a special frame in which parallel wires were strung across the page to guide his hand. His prodigious research under these circumstances was a remarkable achievement. Parkman also found time to become an accomplished horticulturist, to help found the Archaeological Society of America, and to keep up an extensive and active social intercourse. He was author also of a negligible novel, *Vassall Morton* (1856).

His great series of historical works began with publication of the work on Pontiac's conspiracy (1851). Thereafter came *Pioneers of France in the New World* (1865); *The Jesuits in North America* (1867); *The Discovery of the Great West* (1869, better known as retitled in 1879, *La Salle and the Discovery of the Great West*); *The Old Régime in Canada* (1874); *Count Frontenac and New France Under Louis XIV* (1877); *Montcalm and Wolfe* (1884); and, to complete the series, *A Half-Century of Conflict* (1892). Long before ending his work, his fame as America's leading historian was well established. Parkman was a careful scholar, insisting upon working from original manuscript material, which he sought out at home and abroad, but he was equally an artist. Diligent scholarship was joined with a flowing and evocative prose style, a profound feeling for the wildness and spaciousness of the continent on which the struggle took place, and a poet's sense of the overarching drama of the conflict.

PARKS, LARRY (*b. Samuel Lawrence Klausman Parks, Olathe, Kans., 1914; d. 1975*), actor. Graduated University of Illinois (B.S.) and moved to New York City, working at various jobs until he appeared in the play *Golden Boy* (1937). Parks was a low-paid contract film actor in Hollywood in the early 1940's before starring in the hit film *The Jolson Story* (1946). In 1951, during testimony before the House Committee on Un-American Activities, Parks was the first Hollywood celebrity to admit that he had joined the Communist party (in 1941); his testimony, in which he named twelve other party members, outraged many in the entertainment industry, both on the left and the right, and effectively ended his acting career.

PARKS, WILLIAM (*b. probably Shropshire, England, ca. 1698; d. at sea, 1750*), printer, newspaper publisher. Public printer of Maryland, 1727–37; established and operated press at Williamsburg, Va., 1730–50. Founded the *Maryland Gazette*, 1727; also the *Virginia Gazette*, 1736. Distinguished as a typographer, Parks published a number of books of literary and historical importance.

PARLEY, PETER *See* GOODRICH, SAMUEL GRISWOLD.

PARMENTIER, ANDREW (*b. Enghien, Belgium, 1780; d. Brooklyn, N.Y., 1830*), horticulturist, landscape gardener. Came to America, 1824; established a botanical garden and nursery in Brooklyn, N.Y., 1825; was an advocate of the naturalistic, rather than the formal, treatment of gardens.

PARMLY, ELEAZAR (*b. Braintree, Vt., 1797; d. New York, N.Y., 1874*), dentist. Beginning as student assistant to his eldest brother, Parmly practiced as an itinerant dentist in the Midwest, 1817–19; from 1819 to 1821 he studied and practiced in London and Paris. Returning to New York City, he began a lifelong practice there. Striving constantly to improve professional standards of dentistry, he helped found the New York Society of Surgeon Dentists, 1834, and helped establish the *American Journal of Dental Science*, 1839. He became first president of the New York College of Dentistry, 1866.

PARR, SAMUEL WILSON (*b. Granville, Ill., 1857; d. Urbana, Ill., 1931*), chemist, inventor. Graduated University of Illinois, 1884; M.S., Cornell University, 1885. Professor of chemistry, University of Illinois, 1891–1926. Parr's principal scientific contributions were made with respect to the physical and chemical properties, classification, and utilization of coal. He developed three types of calorimeters for determining heat value of coal and other solids, and an alloy mixture, which he named "illium," for lining calorimeters. His method of low-temperature coking was another important contribution, as were his studies of the embrittlement of boiler plate.

PARRINGTON, VERNON LOUIS (*b. Aurora, Ill., 1871; d. Gloucestershire, England, 1929*), teacher, philologist, historian. Educated at College of Emporia (Kans.) and at Harvard (graduated, 1893). Taught English and French at Emporia and at University of Oklahoma; was professor of English at University of Washington, 1908–29. An effective teacher, he developed a notable and popular series of courses in the history of American literature and thought. He published *The Connecticut Wits* (1926) and *Sinclair Lewis, Our Own Diogenes* (1927); his fame rests, however, on his *Main Currents in American Thought* (1927–30), an original interpretation of American literature in its relation to the full life of the nation. His principal theme was the rise of the idea of democratic idealism and the struggle to make it prevail in every dimension of American society.

PARRIS, ALBION KEITH (*b. Hebron, Maine, 1788; d. 1857*), Maine legislator and jurist. Democratic governor of Maine, 1821–26; U.S. senator, 1827–28; Maine Supreme Court justice, 1828–36; second comptroller of federal treasury, 1836–49.

PARRIS, ALEXANDER (*b. Hebron, Maine, 1780; d. Pembroke, Mass., 1852*), builder, architect. Worked extensively *post* 1815 in Boston area; served as consultant to Loammi Baldwin and as superintendent of construction for Charles Bulfinch. Designed David Sears House, 1816; St. Paul's Church, 1819; and Faneuil Hall Market area, 1825.

PARRIS, SAMUEL (*b. London, England, 1653; d. Sudbury, Mass., 1719/20*), clergyman. Came to Massachusetts *ante* 1674; was pastor at Salem Village, 1689–96. Prominent in ferreting out and condemning "witches" during the delusion of 1692–93.

PARRISH, ANNE (*b. Philadelphia, Pa., 1760; d. Philadelphia, 1800*), philanthropist. Sister of Joseph Parrish. Founded Philadelphia school for poor girls, 1796, and House of Industry for employment of poor women, 1795.

PARRISH, CELESTIA SUSANNAH (*b. near Swansonville, Va. 1853; d. Clayton, Ga., 1918*), educator. Greatly advanced public education in Georgia, particularly among rural children and adult illiterates.

PARRISH, CHARLES (*b. Dundaff, Pa., 1826; d. Philadelphia, Pa., 1896*), coal operator. Managed a varied industrial and commercial empire around Wilkes-Barre *post* 1856. The Lehigh & Wilkes-Barre Coal Co. was his principal holding.

PARRISH, EDWARD (*b. Philadelphia, Pa., 1822; d. Fort Sill, Indian Territory [now Oklahoma], 1872*), pharmacist, teacher. Son of Joseph Parrish. A principal founder, and president, 1868–71, of Swarthmore College.

PARRISH, JOSEPH (*b. Philadelphia, Pa., 1779; d. Philadelphia, 1840*), physician, abolitionist, teacher. Brother of Anne Parrish. M.D., University of Pennsylvania, 1805. Held numerous hospital staff appointments; was president of board of managers of Wills Eye Hospital, 1833–40.

PARRISH, MAXFIELD (*b. Philadelphia, Pa., 1870; d. Plainfield, N.H., 1966*), artist. Attended Haverford College, Pennsylvania Academy of Fine Arts, and Drexel Institute. Opened his own studio (1894) to pursue commercial illustration and received national recognition with a cover design for *Harper's Weekly* (1895). For the next several decades his work appeared on the covers of *Scribner's Magazine, Century Magazine, Ladies' Home Journal*, and *National Weekly*. Illustrated L. Frank Baum's *Mother Goose in Prose* (1897) and was established firmly as a master of fantasy and romance with illustrations for such children's classics as Eugene Field's *Poems of Childhood* (1904), *Arabian Nights* (1909), and Nathaniel Hawthorne's *Wonder Book and Tanglewood* (1910). He is best known for his color prints, which hung over the mantels of millions of middle-class homes. In the mid-1930's he retired from illustration to paint rural landscapes for calendars and greeting cards.

PARROTT, ENOCH GREENLEAFE (*b. Portsmouth, N.H., 1815; d. 1879*), naval officer. Cousin of Robert P. Parrott. Made first Union capture of a Confederate privateer, June 3, 1861; was senior officer during much of blockade off Charleston; commanded monitor *Monadnock* during attacks on Fort Fisher, 1864–65.

PARROTT, ROBERT PARKER (*b. Lee, N.H., 1804; d. Cold Spring, N.Y., 1877*), ordnance inventor, manufacturer. Graduated West Point, 1824. Resigning from the army, 1836, he became superintendent of Gouverneur Kemble's West Point Foundry at Cold Spring, N.Y., makers of ordnance. Parrott invented two important devices: a rifled cast-iron cannon in several calibers strengthened by wrought iron hoops around the breech (patented 1861) and an explosive projectile to fit his cannon's rifling. These were extensively used on land and at sea during the Civil War and were probably the most efficient and effective ordnance of their type in the world.

PARRY, CHARLES CHRISTOPHER (*b. Admington, England, 1823; d. Davenport, Iowa, 1890*), botanist. Came to America as a boy. Graduated Union College, 1842; M.D., Columbia, 1846. Settling in Davenport, Iowa, 1846; Parry began his lifelong study of flora in the western states, devoting his summers to wide exploration. As member of organized expeditions or on his own, he made many important contributions to knowledge *post* 1848; his studies of plants along the U.S.–Mexican border, of Alpine flora of the Colorado Rockies, of California chaparral and California manzanitas are particularly notable. He discovered hundreds of new plant forms, among them the *Lilium parryi*, the Torote bush, and the Ensenada buckeye.

PARRY, CHARLES THOMAS (*b. Philadelphia, Pa., 1821; d. Beach Haven, N.J., 1887*), locomotive builder. General superintendent in charge of construction at Baldwin Locomotive Works *post* 1855; partner *post* 1867. Introduced scientific management techniques and fair labor policies.

PARRY, JOHN STUBBS (*b. Lancaster Co., Pa., 1843; d. Jacksonville, Fla., 1876*), obstetrician, gynecologist. M.D., University of Pennsylvania, 1865. Made important studies of rachitis; reorganized obstetrical and gynecological departments at Philadelphia Hospital; wrote *Extra-Uterine Pregnancy* (1875).

PARSONS, ALBERT RICHARD (*b. Montgomery, Ala., 1848; d. Illinois, 1887*), printer, Confederate soldier, anarchist. Settled in Chicago, 1873; edited anarchist newspaper *The Alarm,* 1884–86; executed for alleged complicity in Haymarket Riot.

PARSONS, ALBERT ROSS (*b. Sandusky, Ohio, 1847; d. Mount Kisco, N.Y., 1933*), musician. Dean of New York piano teachers; ardent advocate of Wagner; wrote *The Science of Pianoforte Practice* (1886).

PARSONS, ELSIE WORTHINGTON CLEWS (*b. New York, N.Y., 1875; d. New York, 1941*), sociologist, anthropologist. Daughter of Henry Clews. Graduated Barnard College, 1896. M.A., Columbia University, 1897; Ph.D., 1899. Her early writings were much concerned with the role of women in society and the cramping effect of conventions; influenced by Franz Boas and Pliny E. Goddard, she devoted herself *post* 1915 to field research in ethnology, primarily among the Pueblo Indians of the Southwest. She interested herself also in folklore and the collection of folktales. Among her books were *Mitla, Town of the Souls* (1936), *Pueblo Indian Religion* (1939), and *Folk-Lore of the Antilles, French and English* (1933–43).

PARSONS, FRANK (*b. Mount Holly, N.J., 1854; d. Boston, Mass., 1908*), lawyer, teacher, political scientist. Urged currency and municipal government reforms in *Rational Money* (1898), *The City for the People* (1900), and other works; did pioneer work in vocational guidance.

PARSONS, JOHN EDWARD (*b. New York, N.Y., 1829; d. 1915*), corporation lawyer, advocate of industrial combination. Organized American Sugar Refining Co., 1891; successfully defended it in *U.S. v. E. C. Knight Co.*

PARSONS, LEWIS BALDWIN (*b. Perry, N.Y., 1818; d. Flora, Ill., 1907*), lawyer, railroad manager. Director of rail and river transportation for Union army in Department of the Mississippi 1861–64; for all departments, 1864–66. Received brevet of major general, 1866, for exceptional service.

PARSONS, LEWIS ELIPHALET (*b. Lisle, N.Y., 1817; d. Talladega, Ala., 1895*), lawyer, Alabama Unionist and legislator. Settled in Talladega *ca.* 1840. Provisional governor of Alabama, 1865; supported President Andrew Johnson; was Speaker of lower house in Alabama legislature, 1872–73.

PARSONS, LOUELLA ROSE OETTINGER (*b. Freeport, Ill., 1881; d. Santa Monica, Calif., 1972*), columnist. A story editor and scenario writer in Chicago in the 1910's, she then worked as a motion picture editor for the *Morning Telegraph* (1919) and the *New York American* (1923). In 1926 she was hired as the motion picture editor for William Randolph Hearst's Universal News Service; during the 1930's and 1940's, she emerged as a powerful Hollywood figure. Her column provided "inside" information on the film industry and provocative gossip on celebrities. In the 1930's Parson's column ran in more than 600 newspapers.

PARSONS, SAMUEL BROWNE (*b. Flushing, N.Y., 1819; d. 1906*), horticulturist, nurseryman. Made first successful importation of Italian honeybees, 1860, and of Valencia oranges, 1870; specialized in Japanese maples and rhododendrons; wrote *The Rose: Its History, Poetry, Culture, and Classification* (1847).

PARSONS, SAMUEL HOLDEN (*b. Lyme, Conn., 1737; d. Big Beaver River, Ohio, 1789*), lawyer, Connecticut legislator, Revolutionary major general. Directed Connecticut's defense *post* 1778, after active service at Boston and Long Island and on the Hudson. A promoter and director of the Ohio Co., he served *post* 1787 as first judge of the Northwest Territory.

PARSONS, TALCOTT (*b. Colorado Springs, Colo., 1902; d. Munich, Germany, 1979*), sociological theorist. Graduated Amherst College (1924) and attended London School of Economics and Heidelberg University (Ph.D., 1927). He taught at Amherst (1927), then joined the faculty of Harvard University (1927–73), where he emerged as a leading figure in American sociology. Parsons, whose ideas were influenced by the European thinkers Emile Durkheim and Max Weber, founded the "structural functional" school. In such works as *Structure and Process in Modern Societies* (1960), Parsons put forth a general and somewhat conservative theory of human social activity. He argued that society consisted of four generally stable, interrelated systems: the behavioral system (biology), personality system (psychology), the social system (sociology), and the cultural system (anthropology).

PARSONS, THEOPHILUS (*b. Byfield, Mass., 1750; d. Boston, Mass., 1813*), jurist. Graduated Harvard, 1769; was aided in study of law by Edmund Trowbridge; practiced in Newburyport, Mass., and *post* 1800 in Boston. Chief justice of the Massachusetts supreme court, 1806–13. In a pamphlet, *The Essex Result* (1778), Parsons outlined a plan for a government which greatly influenced John Adams' state constitution adopted in 1780. Leading member of the Essex Junto, a Federalist political clique in Massachusetts, Parsons enjoyed a towering reputation as lawyer and judge. He was instrumental in preserving the substance of common-law doctrines in American jurisprudence by restating them in intelligible form to suit American needs. In giving his decisions, he drew rules of general application from the English common law, much unwritten colonial law, and distinctive local usages.

PARSONS, THEOPHILUS (*b. Newburyport, Mass., 1797; d. 1882*), lawyer. Son of Theophilus Parsons (1750–1813). Professor at Harvard Law School, 1848–69; author of *The Law of Contracts* (1853–55), *A Treatise on Maritime Law* (1859), and many other treatises, both legal and philosophical.

PARSONS, THOMAS WILLIAM (*b. Boston, Mass., 1819; d. Scituate, Mass., 1892*), dentist, poet. Translated first ten cantos of Dante's *Inferno* (1843), the first extensive translation published in America. His able but incomplete version of the whole of the *Divine Comedy,* together with his original poems were issued in a collected edition, 1893.

PARSONS, USHER (*b. Alfred, Maine, 1788; d. Providence, R.I., 1868*), physician, surgeon. Commissioned surgeon's mate, July 1812, after private study of medicine, Parsons won fame for brilliant work in treating American wounded after battle of Lake Erie, 1813. He received M.D. degree from Harvard, 1818; in 1822 he became professor of anatomy and surgery at Brown University. An idealist in medicine and a scholar, he won the Bolyston Prize four times for professional writings.

PARSONS, WILLIAM BARCLAY (*b. New York, N.Y., 1859; d. New York, 1932*), engineer. Graduated Columbia, 1879; C.E., Columbia School of Mines, 1882. His early interest was in railway construction. As chief engineer of the New York City Transit Commission, 1894–98 and 1899–1904, he planned and oversaw construction of the first subway, developing lasting standards of design for such work. Thereafter he became engineering consultant on a wide range of projects, which included the Isthmian

Canal Commission, the London Traffic Commission, and the Chicago Transit Commission. He designed the Cape Cod Canal, served with the United States Engineers during World War I, and designed the Detroit-Windsor vehicular tunnel.

PARTINGTON, MRS. *See* SHILLABER, BENJAMIN PENHALLOW.

PARTON, ARTHUR (*b. Hudson, N.Y., 1842; d. Yonkers, N.Y., 1914*), landscape painter. Followed traditional English practices as modified by Hudson River school.

PARTON, JAMES (*b. Canterbury, England, 1822; d. Newburyport, Mass., 1891*), journalist, biographer. Came to America as a child. Staff member of New York *Home Journal*, 1848–55. Thereafter highly successful as author of carefully researched and well-organized lives of Horace Greeley (1855), Aaron Burr (1857), Andrew Jackson (1859–60), and other major American figures.

PARTON, SARA PAYSON WILLIS (*b. Portland, Maine, 1811; d. New York, N.Y., 1872*), author. Daughter of Nathaniel Willis; sister of N. P. Willis; married James Parton, 1856. Under pen name of "Fanny Fern," Parton turned out quantities of frothy but popular chitchat on homey subjects.

PARTRIDGE, ALDEN (*b. Norwich, Vt., 1785; d. Norwich, 1854*), military educator. Originator of preparatory military academies of elementary and secondary grade; founded Norwich University (1819).

PARTRIDGE, JAMES RUDOLPH (*b. Baltimore, Md., ca. 1823; d. Alicante, Spain, 1884*), lawyer, politician, diplomat. Influential Maryland Unionist and Republican; U.S. minister to a number of Latin American countries, 1862–83.

PARTRIDGE, RICHARD (*b. Portsmouth, N.H., 1681; d. London, England, 1759*), merchant, colonial agent. Removed to England, 1701. Agent for New York, New Jersey, Massachusetts, and Pennsylvania at various times; was agent for Rhode Island, 1715–59, during which time he secured a favorable settlement of boundary questions; he served also as agent for Connecticut, 1750–59. He played an active part in making the Molasses Act, 1733, less offensive to New England interests.

PARTRIDGE, WILLIAM ORDWAY (*b. Paris, France, 1861; d. New York, N.Y., 1930*), sculptor. His equestrian General Grant in New York, 1896, and his marble Pietà in St. Patrick's Cathedral are perhaps his best-known works.

PARVIN, THEODORE SUTTON (*b. Cedarville, N.J., 1817; d. 1901*), lawyer, teacher, librarian. Raised in Cincinnati, Ohio; removed to Iowa, 1838, where he practiced law and held numerous judicial and civil offices. President, Iowa State Teachers' Association, 1867; principal founder, Masonic Library at Cedar Rapids.

PARVIN, THEOPHILUS (*b. Buenos Aires, Argentina, 1829; d. Philadelphia, Pa., 1898*), obstetrician, gynecologist. Grandson of Caesar A. Rodney. Graduated Indiana University, 1847; M.D., University of Pennsylvania, 1852. Wrote *Science and Art of Obstetrics* (1886).

PASCALIS-OUVERIÈRE, FELIX (*b. France, ca. 1750; d. New York, N.Y., 1833*), physician. Immigrated from Santo Domingo, 1793; practiced in Philadelphia, and after 1810, in New York. Author of accounts of yellow fever outbreaks in Philadelphia, 1796 and 1798.

PASCHAL, GEORGE WASHINGTON (*b. Skull Shoals, Ga., 1812; d. Washington, D.C., 1878*), jurist, author, journalist. Removed to Arkansas, 1837; to Texas, 1848. Prominent Texas Unionist. Compiled notable digest of Texas Supreme Court decisions (1872–75).

PASCO, SAMUEL (*b. London, England, 1834; d. 1917*), Florida politician. Came to America as a boy; was raised in Charlestown, Mass.; removed to Florida, 1859. A Democratic leader in Florida after service in Confederate army, he served as U.S. senator, 1887–99, and on the Isthmian Canal Commission, 1899–1904.

PASQUIN, ANTHONY *See* WILLIAMS, JOHN

PASSAVANT, WILLIAM ALFRED (*b. Zelienople, Pa., 1821; d. Pittsburgh, Pa., 1894*), Lutheran clergyman, editor. Devoted life to home missionary movement and establishing institutions of mercy; was responsible for introduction of Lutheran deaconesses into the United States, 1849.

PASTOR, ANTONIO (*b. New York, N.Y., 1837; d. Elmhurst, N.Y., 1908*), New York theater manager, actor, better known as "Tony Pastor." Played prominent role in developing vaudeville format and in encouraging young performers.

PASTORIUS, FRANCIS DANIEL (*b. Franconia, Germany, 1651; d. Germantown, Pa., 1719/20*), lawyer, author, schoolmaster. Laid out settlement of Germantown, 1683, as agent for colony of Quakers from Frankfurt am Main; signed first Quaker protest against slavery in America, 1688.

PASVOLSKY, LEO (*b. Pavlograd, Russia, 1893; d. Washington, D.C., 1953*), economist, journalist, foreign policy adviser. Studied at the College of the City of New York and at Columbia University. Wrote many books and articles about communism and economics in the Soviet Union, mainly under the auspices of the Institute of Economics (later the Brookings Institution), which he joined in 1922. Author of influential economic papers for the World Monetary and Economic Conference in London, 1932–33. Joined the Division of Trade Agreements of the Department of State, 1935. Appointed special assistant to Secretary of State Cordell Hull, 1936, and became his most trusted adviser; forwarded the reciprocal trade agreements program and supplied memoranda on international questions. Became chief of the Division of Special Research and director of the Committee on Postwar Problems, 1941, and began his major work in formulating the concept and charter of the United Nations. At the San Francisco Conference, 1945, Pasvolsky was instrumental in negotiating many aspects of the organization's need for the veto in the Security Council and broad security provisions in the charter. As chairman of the Coordinating Committee, he was responsible for the final wording of the U.N. Charter. Explained the Charter to Congress and to national organizations, 1945. Attended the Bretton Woods Conference, 1945, before leaving the State Department to become director of international studies of the Brookings Institution.

PATCH, ALEXANDER McCARRELL (*b. Fort Huachuca, Arizona Territory, 1889; d. San Antonio, Tex., 1945*), army officer. Raised in Pennsylvania. Graduated West Point, 1913; commissioned in the infantry. When the United States entered World War I, he went to France, where in 1917 his unit became a part of the new 1st Division. Machine guns were new to the division, and he was among the first Americans to be schooled by the British in their use. During the next two decades he alternated between regimental duty and assignments as a military student and instructor. In 1924 he attended the Command and General Staff School and in 1931 entered the Army War College. Six weeks after Pearl

Harbor, General George C. Marshall selected Patch to command the task force destined to defend New Caledonia. On Mar. 1, 1944, Patch was given command of the U.S. 7th Army, which invaded southern France in concert with an Allied advance from a northern beachhead in Normandy. On Aug. 15 he began his landings along the Riviera. During January 1945 he met and repelled Hitler's last major offensive on the western front. Marshall ordered him home in June to ready the 4th Army for Pacific duty. When Japan capitulated, Patch headed a board to study the army's postwar structure. Posthumously, in 1954, he was made a general.

PATCH, SAM (*b. Rhode Island, ca. 1807; d. Rochester, N.Y., 1829*), daredevil. Gained national reputation diving into rivers from great heights, including Niagara River from ledge on Goat Island. Killed in a dive into the Genesee River.

PATCHEN, KENNETH (*b. Niles, Ohio, 1911; d. Palo Alto, Calif., 1972*), poet, novelist, and painter. Attended University of Wisconsin and Commonwealth College in Mena, Ark., then worked at various jobs around the country before settling in Greenwich Village in New York City (1934), where he wrote the critically acclaimed *Before the Brave* (1936), a collection of poetry that detailed life in a Midwestern steel town. In the 1940's Patchen published more than twenty volumes of writing, including the experimental, antiwar novel *The Journal of Albion Moonlight* (1940). He also wrote *Albion Moonlight: Memoirs of a Shy Pornographer* (1945), *Sleepers Awake* (1946), *Orchards, Thrones, and Caravans* (1952), and *Glory Never Guesses* (1955), a folio of silkscreens, poems, and drawings.

PATE, MAURICE (*b. Pender, Nebr., 1894; d. New York, N.Y., 1965*), businessman and United Nations official. Attended Princeton (B.S., 1915). Following work with several U.S. relief agencies during World Wars I and II, he accompanied Herbert Hoover (1948) on a world food survey that helped spur the UN to establish its children's fund (UNICEF); he was appointed its first executive director, a post he held for life. Under his direction UNICEF provided emergency aid, then shifted its focus to the worldwide problem of chronic starvation and disease among children. In 1960 he refused to allow his nomination for the Nobel Peace Prize, claiming the honor belonged to UNICEF.

PATERSON, JOHN (*b. Wethersfield, Conn., 1744; d. Lisle, N.Y., 1808*), lawyer, Revolutionary brigadier general, public official. Helped organize the Ohio Co.; was a proprietor of the "Boston Purchase" in upper New York State.

PATERSON, WILLIAM (*b. Co. Antrim, Ireland, 1745; d. Albany, N.Y., 1806*), politician, U.S. Supreme Court justice. Taken to America as a child; was raised in New Jersey. Graduated to College of New Jersey (Princeton), 1763; studied law with Richard Stockton. Elected deputy to New Jersey Provincial Congress, 1775; served as attorney general of New Jersey, 1776–83. Appointed delegate to the Constitutional Convention, 1787, Paterson presented the "New Jersey Plan," which represented the views of small states. U.S. senator, 1789, and governor of New Jersey, 1790–92, Paterson then became an associate judge of the U.S. Supreme Court and served until his death. He collected and collated the laws of New Jersey (published 1800) and also drafted remodeled rules for practice and procedure in the state courts which were adopted in 1799. Paterson, N.J., which he helped promote, bears his name.

PATILLO, HENRY (*b. Scotland, 1726; d. Dinwiddie Co., Va., 1801*), Presbyterian clergyman. Came to Virginia as a child. Removed to North Carolina, 1765; presided over first synod of the Carolinas; was an active patriot and delegate to North Carolina Provincial Congress, 1775.

PATMAN, JOHN WILLIAM WRIGHT (*b. Patman's Switch, Tex., 1893; d. Bethesda, Md., 1976*), politician. Graduated Cumberland University in Lebanon, Tenn. (LL.B., 1916) and in 1920 became a Texas state legislator, leading campaigns against the Ku Klux Klan and agricultural corporations. As a Democratic congressman from Texas from 1929 until his death, Patman emerged as a powerful supporter of small merchants and independent farmers. His activism on behalf of his poor constituents ultimately earned him the title of the House's last "populist." During the depression, he led legislative campaigns to protect independent grocers from national chains, which resulted in the Patman–Robinson Act. During World War II, he helped create the Small Business Administration and, later, as the chairman of House Banking Committee, oversaw legislation that created a national system of credit unions for the savings of ordinary workers.

PATON, LEWIS BAYLES (*b. New York, N.Y., 1864; d. 1932*), Congregational clergyman, Old Testament scholar, archaeologist. Taught at Hartford (Conn.) Theological Seminary, 1892–1932.

PATRI, ANGELO (*b. Piaggine, Salerno, Italy, 1876; d. Danbury, Conn., 1965*), educator and columnist. Attended City College of New York and Columbia (M.A., 1904). Teacher (from 1898) and principal (from 1908) in New York City public schools. His philosophy of liberal education promoted the teaching of subjects that promoted creative learning; developed a closer understanding between teachers and parents, and gained the participation of parents in school activities. He presented his ideas through radio, child guidance books, and his syndicated column, "Our Children." Author of *A Schoolmaster of the Great City* (1917) and books for children, such as *Pinocchio in Africa* (1911).

PATRICK, EDWIN HILL ("TED") (*b. Rutherford, N.J., 1901; d. New York, N.Y., 1964*), magazine editor. Copywriter for Young and Rubicam (beginning in 1928); writer for World Peaceways (mid-1930's), an organization of American businesses, publishers, and advertisers seeking to promote peace; with the Office of War Information (1942–44), then Compton Advertising (1944–46). He joined Curtis Publishing in 1946 and took over the editorship of the recently launched *Holiday* magazine. Under his direction the magazine became consistently profitable by attracting top authors and paying handsomely for articles; the inclusion of high-quality visual material; and "special issues" on individual countries. Elected chairman of the American Society of Magazine Editors and Magazine Publishers Association (both in 1963).

PATRICK, HUGH TALBOT (*b. New Philadelphia, Ohio, 1860; d. Chicago, Ill., 1939*), neurologist. M.D., Bellevue Hospital Medical School, 1884. Pioneered in neurology in the Middle West; was professor of nervous and mental diseases at Northwestern University and Chicago Polyclinic.

PATRICK, MARSENA RUDOLPH (*b. near Watertown, N.Y., 1811; d. 1888*), Union major general, agriculturist. Graduated West Point, 1835. After service in Seminole and Mexican wars, Patrick engaged in farming and agricultural education, 1850–61. During the Civil War, he held field commands up to Antietam (September 1862); he was provost marshal general for the Army of the Potomac until 1864 and thereafter for all Union armies operating against Richmond. He died while in command of the soldiers' home in Dayton, Ohio.

PATRICK, MARY MILLS (*b. Canterbury, N.H., 1850; d. Palo Alto, Calif., 1940*). First president of American College for Girls, Istanbul, Turkey, 1890–1924.

PATRICK, MASON MATHEWS (*b. Lewisburg, W.Va., 1863; d. Washington, D.C., 1942*), army officer. Graduated West Point, 1886; commissioned in the Corps of Engineers. After three decades of various and exemplary service, which included duty as chief engineer of the army of pacification in Cuba, he went to France in World War I as colonel commanding the 1st Engineers. He later had charge of all engineering construction for the American Expeditionary Forces in France. In May 1918, now a major general, he was assigned by General John J. Pershing to the task of bringing order out of confusion as commander of all Air Service units, which were plagued by bickering and poor organization. He returned to the United States in 1919 to resume his duties with the Corps of Engineers. Appointed chief of the Army Air Service in October 1921, he served until 1927; although convinced of the importance of air power, unlike his chief assistant, Col. William Mitchell, he was moderate in his approach to gaining some degree of autonomy for the Air Service. After retirement in 1927 he continued active and was public utilities commissioner for the District of Columbia, 1929–33.

PATTEN, GILBERT (*b. Corinna, Maine, 1866; d. Vista, Calif., 1945*), author. Christened George William Patten. In a 60-year career as a writer he published under his own name and a dozen pen names at least 1,500 works of fiction, principally for the dime-novel trade and the pulp magazines. Of these, more than 800 stories dealt with the fantastic career of "Frank Merriwell," a schoolboy and college athlete of impossible skill, strength, and virtue. Published as by "Burt L. Standish," the Merriwell stories appeared from 1896 until Patten abandoned the series in 1913.

PATTEN, JAMES A. (*b. Freeland Corners, Ill., 1852; d. Chicago, Ill., 1928*), grain merchant, capitalist. A successful speculator in grain futures, he held virtual corners in corn, oats, and wheat, 1908–09.

PATTEN, SIMON NELSON (*b. DeKalb Co., Ill., 1852; d. Brown's-Mills-in-the-Pines, N.J., 1922*), economist. Ph.D., Halle, 1878; was strongly influenced by German thought and economic example. Professor at University of Pennsylvania, 1888–1917, and an outstanding teacher, Patten was an economic optimist, holding that man by proper application of intelligence could better his economic condition. He opposed the gloomy view of the classical economists as being derived from an exploitative economic environment, contrasting with it the limitless social improvement which must follow on economic conservation. He believed that Americans were wasteful consumers and recommended a theory of prosperity based on a wisely managed consumption and on a philosophy of spending, rather than saving, in an era of growing abundance. *The Development of English Thought* (1899) and *The New Basis of Civilization* (1907) are representative of his writing but are no measure of his thought or influence.

PATTEN, WILLIAM (*b. Watertown, Mass., 1861; d. 1932*), zoologist, paleontologist. B.S., Harvard, 1883; Ph.D., Leipzig, 1884. Taught at University of North Dakota, and at Dartmouth *post* 1893.

PATTERSON, ALICIA (*b. Chicago, Ill., 1906; d. New York, N.Y., 1963*), editor and publisher. Raised in a journalistic family, she moved to New York where her father left the *Chicago Tribune* to launch the *New York Daily News*; she worked in the promotion department of the *Daily News* (1927–38) and later as literary critic (1932–43). Acquired the defunct *Nassau County Journal* on Long Island (1940) and renamed it *Newsday*. The newspaper won quick acceptance and was awarded the N. W. Ayer and Son award for excellence in typography, makeup, and printing (1955). Editorially, she supported internationlist positions in foreign affairs; called for the recognition of Communist China; and denounced Sen. Joseph McCarthy. A series of articles by Alan Hathway on corruption at racetracks received the 1954 Pulitzer Prize for meritorious public service.

PATTERSON, DANIEL TODD (*b. Long Island, N.Y., 1786; d. Washington, D.C., 1839*), naval officer. Conducted successful raid against Jean Laffite at Barataria Bay, La., 1814; provided Andrew Jackson with invaluable naval support on Lake Borgne in battle of New Orleans.

PATTERSON, ELEANOR MEDILL ("CISSY") (*b. Chicago, Ill., 1881; d. near Marlboro, Md., 1948*), newspaper editor and publisher. Granddaughter of Joseph Medill; sister of Joseph M. Paterson; niece of Robert S. McCormick. Served as editor-publisher of W. R. Hearst's Washington, D.C. *Herald*, 1930–37, doubling its circulation; leased the paper from Hearst, along with his evening paper, the *Times*, 1937, and in January 1939 exercised options to buy them. She then combined them into a single all-day paper with six editions, the *Washington Times-Herald*, which shortly had the largest circulation in the city and was as lively and spiteful as its owner.

PATTERSON, JAMES KENNEDY (*b. Glasgow, Scotland, 1833; d. 1922*), educator. Came to America as a boy; was raised in Indiana. President and ardent advocate of State College of Kentucky, later University of Kentucky, from 1869 to 1910.

PATTERSON, JAMES WILLS (*b. Henniker, N.H., 1823; d. Hanover, N.H., 1893*), educator, politician. Graduated Dartmouth, 1848; taught there, 1852–65. Congressman, Republican, from New Hampshire, 1863–67; U.S. senator, 1867–73. Implicated in Crédit Mobilier scandals. State superintendent of education, New Hampshire, 1881–93.

PATTERSON, JOHN HENRY (*b. near Dayton, Ohio, 1844; d. 1922*), salesman, manufacturer. Bought a small, failing company, 1884, and built it into the highly successful National Cash Register Co., by using aggressive modern sales techniques and direct mail advertising.

PATTERSON, JOSEPH MEDILL (*b. Chicago, Ill., 1879; d. New York, N.Y., 1946*), newspaper publisher. Grandson of Joseph Medill; brother of Eleanor M. Patterson; nephew of Robert S. McCormick. B.A., Yale, 1901. Joined the *Chicago Tribune* staff as a reporter, rising to assistant editor; resigned on learning that his father had used the paper's influence to aid him in a successful campaign for election to the Illinois legislature, 1903. A nonconformist and a reformer, he joined the Socialist party and devoted himself to writing, 1906–10; in 1908 he published a novel, *A Little Brother of the Rich*. Disillusioned with socialism, he joined his cousin Robert M. McCormick as coeditor of the *Chicago Tribune*. More interested in reporting than editing, he personally covered the Mexican border incident, 1914, and the start of World War I in Europe. After serving with credit as an artillery officer in France, he returned home to bring out on June 26, 1919, in New York City, a mass appeal tabloid, the *Illustrated Daily News* (soon called simply the *Daily News*, which under his close superintendence became the widest-selling newspaper in the United States.

PATTERSON, MORRIS (*b. Philadelphia, Pa., 1809; d. Philadelphia, 1878*), merchant, philanthropist. Pioneer in developing anthracite coal trade.

PATTERSON, RICHARD CUNNINGHAM, JR. (*b. Omaha, Nebr., 1886; d. New York, N.Y., 1966*), engineer, ambassador, and corporate executive. Attended Nebraska and Columbia (engineer of mines degree, 1912). Engineering inspector for New York City (1913) and secretary of the city's Fire Department (1917). With J. G. White Engineering (1920) and E. I. du Pont de Nemours (1921–27). As New York City's commissioner of corrections, 1927–32, he improved conditions in the city's eighteen prisons. Resigned to become executive vice president of the National Broadcasting Company. Assistant U.S. secretary of commerce (1938–39); chairman of the board of R.K.O. (1939–45); and a trustee of the Import-Export Bank. Appointed ambassador to Yugoslavia (1944–47) and to Guatemala (1948–50); minister to Switzerland (1951–53). Head of New York City's Department of Commerce (1954–66).

PATTERSON, ROBERT (*b. near Hillsborough, Ireland, 1743; d. Philadelphia, Pa., 1824*), Revolutionary soldier, mathematician. Came to America, 1768. Professor of mathematics, University of Pennsylvania, 1779–1814; director of U.S. Mint, 1805–24.

PATTERSON, ROBERT (*b. Co. Tyrone, Ireland, 1792; d. Philadelphia, Pa., 1881*), soldier, industrialist. Came to America as a boy; served in War of 1812; was successful as a commission grocery merchant in Philadelphia. Major general of volunteers in the Mexican War, Patterson gained honors at Cerro Gordo and Jalapa. *Post* 1848 he became prominent in the Louisiana sugar industry, came to own 30 cotton mills in Pennsylvania, and was a promoter of the Pennsylvania Railroad. Made a major general of volunteers, 1861, he was given command of the military department composed of Pennsylvania, Delaware, Maryland, and the District of Columbia. His failure to check Confederate forces under General J. E. Johnston in July 1861 and his noncooperation with McDowell in first Bull Run led to much controversy and to his retirement from service.

PATTERSON, ROBERT MAYNE (*b. Philadelphia, Pa., 1832; d. Philadelphia, 1911*), Presbyterian clergyman, editor. Associate editor, *The Presbyterian*, 1870–80; editor, *The Presbyterian Journal*, 1880–93; authority on ecclesiastical law.

PATTERSON, ROBERT PORTER (*b. Glens Falls, N.Y., 1891; d. Elizabeth, N.J., 1952*), lawyer, judge, and statesman. Studied at Union College and Harvard University. He served in France during World War I, winning the Distinguished Service Cross. Practiced law in New York until 1930, when President Hoover appointed him judge of the U.S. District Court of the Southern New York District. President Roosevelt appointed him to the Second Circuit Court of Appeals in 1939; and in 1940, under secretary of war. During World War II he was influential in overseeing the military production necessary for winning the war. In 1945 he refused Truman's offer to appoint him to the Supreme Court, but accepted the appointment as secretary of war. He resigned in 1947 and returned to private law practice; serving as president of the Bar Association of New York City and of the Council on Foreign Relations.

PATTERSON, RUFUS LENOIR (*b. Salem, N.C., 1872; d. New York, N.Y., 1943*), inventor, businessman. Attended University of North Carolina; grandson of Francis Fries. Developed a machine for weighing, packing, stamping, and labeling smoking tobacco (patented March 1897) which brought him to the notice of James B. Duke. Becoming a close ally of Duke, he was made a vice president of the American Tobacco Co. in 1901, and was a founder of the American Machine and Foundry Co. President of that company *post* 1900 (chairman of the board, 1941–43), he was probably more responsible for the mechanization of the tobacco industry than any other individual. Under his guidance the company and its subsidiaries became the world's largest suppliers of tobacco manufacturing equipment, and expanded into many other fields.

PATTERSON, THOMAS HARMAN (*b. New Orleans, La., 1820; d. Washington, D.C., 1889*), naval officer. Son of Daniel T. Patterson. Served during Civil War on Union Atlantic blockade duty; retired as rear admiral, 1882.

PATTERSON, THOMAS MACDONALD (*b. Co. Carlow, Ireland, 1839; d. 1916*), lawyer, editor. Came to America as a boy; settled in Denver, Colo., 1872; was Democratic territorial delegate and congressman from Colorado, 1875–79. Controlled Denver *Rocky Mountain News*, 1892–1913; was a consistent friend of labor, reform, and popular control of government. U.S. senator, Populist Democrat, 1901–07.

PATTERSON, WILLIAM (*b. Co. Donegal, Ireland, 1752; d. Baltimore, Md., 1835*), merchant. Father of Elizabeth P. Bonaparte. Came to America, 1766. Imported supplies and munitions for patriot army and made fortune during Revolution; later a successful shipowner and industrialist, he was an incorporator and director of the Baltimore & Ohio Railroad and of the Canton Company.

PATTERSON, WILLIAM ALLAN ("PAT") (*b. Honolulu, Hawaii, 1899; d. Glenview, Ill., 1980*), airline executive. Working in San Francisco in banking jobs from 1914, he became involved in 1927 with the mail carrier Pacific Air Transport (PAT). When Boeing Airplane purchased PAT in 1929, Patterson emerged as an assistant to Boeing president Philip Johnson. In 1931 he was made vice-president of United Air Lines, a new Boeing subsidiary that oversaw its airline interests. In 1934 federal regulations regarding mail carriers forced the company to sever ties with Boeing. Patterson, promoted to president of United, soon directed the mergers of several smaller air carriers into the largest single airline in the nation. He oversaw United's steady growth, enacted harmonious labor policies, and pursued conservative market strategies. In 1961 he acquired Capital Airlines, making United the largest airline in the Western world.

PATTIE, JAMES OHIO (*b. Bracken Co., Ky., 1804; d. ca. 1850*), trapper, author. Published *Personal Narrative* (1831, 1833; ed. Timothy Flint), a dramatic, semifictional account of travels as far west as California.

PATTISON, GRANVILLE SHARP (*b. Glasgow, Scotland ca. 1791; d. New York, N.Y., 1851*), anatomist. Came to America, 1819; taught at University of Maryland, 1820–26. Brought great prestige to Jefferson Medical College as professor of anatomy, 1832–41; held chair of anatomy thereafter at University of the City of New York.

PATTISON, JAMES WILLIAM (*b. Boston, Mass., 1844; d. Asheville, N.C., 1915*), Union soldier, painter, lecturer on art. Popularized serious art and promoted art museums and schools in Illinois and Missouri, notably at Chicago and St. Louis; served for many years as secretary of the Chicago Municipal Art League.

PATTISON, JOHN M. (*b. near Owensville, Ohio, 1847; d. Milford, Ohio, 1906*), lawyer, insurance executive, Ohio legislator. Congressman, Democrat, 1891–93; Democratic governor of Ohio, 1906.

PATTISON, ROBERT EMORY (*b. Quantico, Md., 1850; d. Philadelphia, Pa., 1904*), lawyer, banker, politician. As Democratic governor of Pennsylvania, 1883–87 and 1891–95, stressed econ-

omy and reform; wrote distinguished minority report for U.S. Pacific Railway Commission (1887).

PATTISON, THOMAS (*b. Troy, N.Y., 1882; d. New Brighton, N.Y., 1891*), naval officer. Appointed midshipman, 1839. Retired as rear admiral, 1883, after varied and distinguished service.

PATTON, FRANCIS LANDEY (*b. Warwick, Bermuda, 1843; d. Bermuda, 1932*), Presbyterian clergyman, theologian. Graduated Princeton Theological Seminary, 1865; attained wide experience in New York and Chicago as pastor, lecturer, and writer for the religious press. He returned to Princeton Seminary as Stuart professor, 1881, teaching also in the College of New Jersey and specializing in Christian ethics. Patton was chosen president of the college (*post* 1896 called Princeton University), 1888. His administration was marked by financial success and academic progress; a trend toward appointing faculty members who had had formal graduate training in their subjects rather than men trained only as ministers was begun by him and he introduced electives to the curriculum. Patton retired in 1902, after nominating Woodrow Wilson as his successor. He continued, however, as professor of ethics, and as president of the Princeton Seminary until 1913.

PATTON, GEORGE SMITH (*b. San Gabriel, Calif., 1885; d. Heidelberg, Germany, 1945*), army officer. Great-grandson of John Mercer Patton; grandson and son of graduates of Virginia Military Institute. In 1903, after six years of study at Dr. Clark's Classical School for Boys in Pasadena, he entered the Virginia Military Institute. The following year he transferred to the U.S. Military Academy at West Point. Upon graduation in 1909, he was commissioned a second lieutenant of cavalry. In 1912, he represented the United States in the Stockholm Olympic Games, where he placed fifth in the military pentathlon. The next year, he spent the summer at Saumur, France, studying instructional methods for the cavalry saber. As an unofficial aide to General John J. Pershing, Patton participated in the punitive expedition to Mexico in 1916. In 1917, now a captain and still on Pershing's staff, he sailed for France. Detailed to the Tank Corps, Patton attended courses at the French tank school and observed British training methods. As a major, he organized and directed the American Tank Center at Langres, France (later at Bourg), and formed the 304th Brigade of the Tank Corps. He participated in the Meuse-Argonne offensive with his brigade. Ending the war as a colonel, Patton was awarded the Distinguished Service Medal for his contributions to tank warfare and the Distinguished Service Cross. In 1932 he participated, under General Douglas MacArthur, in the forcible ejection from Washington of the "Bonus Army."

In July 1940 Patton took command of a brigade of the 2nd Armored Division at Fort Benning, Ga. In April 1941, as a major general, he became the division commander and, on Jan. 19, 1942, commanding general of the I Armored Corps. That October, in command of the Western Task Force, Patton sailed from Norfolk, Va. He directed the amphibious operations near Casablanca, French Morocco, Nov. 8.

In March 1943, after the Germans inflicted a severe defeat on American units at Kasserine Pass in Tunisia, Patton was appointed commanding general of the II Corps. On July 11, 1943, with Patton (now lieutenant general) in command of the U.S. 7th Army, the Allies invaded Sicily. The island was conquered in a lightning campaign of 38 days, and under Patton's leadership American combat performance was brought into maturity. On Aug. 10, 1943, while touring military hospitals in Sicily, he impetuously slapped and verbally abused two soldiers suffering from combat exhaustion; the incident incurred the wrath of his superiors and nearly ended his career. In March 1944, assigned to

the European theater of operations and transferred to England, he trained the U.S. 3rd Army for its role as the major American follow-up force after the cross-channel invasion of Normandy.

When the Germans launched their Ardennes counteroffensive in December—the "Battle of the Bulge"—Patton, in one of the most remarkable movements in military history, took only a few days to turn his army from an eastward to a northward orientation and bring it into position to shore up the southern shoulder of the Bulge. When his troops linked up with the encircled defenders of Bastogne, the failure of the German offensive was sealed. The 3rd Army crossed the Rhine in March 1945 at Mainz and Oppenheim, and drove through the heart of Germany into Czechoslovakia and Austria. The discovery of Ohrdruf, the first of the Nazi concentration camps to be liberated, filled him with the deepest revulsion. In charge of the "denazification" program in Bavaria, he was upset by the wholesale dismissal of former Nazis from governmental positions, believing this would pave the way for a Communist coup. He also urged the employment of "more former members of the Nazi party in administrative jobs and as skilled workmen." For expressing these opinions he was removed from command of the 3rd Army and given command of the 15th Army, a largely paper force. Deeply religious yet often violently profane in his language, irascible yet given to mawkish sentimentality, identified by the ivory-handled pistols that became his trademark, "Blood and Guts" Patton was the outstanding American field commander of World War II.

PATTON, JOHN MERCER (*b. Fredericksburg, Va., 1797; d. Richmond, Va., 1858*), lawyer, Virginia legislator. Grandson of Hugh Mercer. Congressman, independent Democrat, from Virginia, 1830–38; coauthor, *Code of Virginia* (1849), a superior digest and revision of the civil and criminal codes.

PATTON, WILLIAM (*b. Philadelphia, Pa., 1798; d. New Haven, Conn., 1879*), Presbyterian and Congregational clergyman, author. A founder of Union Theological Seminary, New York, 1836.

PAUGER, ADRIEN DE (*b. France, date unknown; d. New Orleans, La., 1726*), engineer. Came to Louisiana, 1720, as assistant to Le Blond de la Tour; surveyed and laid out original town of New Orleans, 1721.

PAUL, ALICE (*b. Moorestown, N.J., 1885; d. Moorestown, 1977*), women's rights activist. Graduated Swarthmore College (B.S., 1905), New York School of Philanthropy (M.A., 1907), and University of Pennsylvania (Ph.D., 1912). While working in London as a caseworker (1907–10), she joined the militant wing of the British suffrage movement. She returned to the United States in 1910 and emerged as a prominent figure in the campaign for woman's voting rights, leading a branch of the women rights movement known as the "New Suffragists," which advocated nonviolent civil disobedience and a federally oriented lobbying strategy. The National Woman's Party, which she founded in 1916, was instrumental in the passage of the Nineteenth Amendment in 1920. In 1923 Paul wrote the Equal Rights Amendment (ERA), which encountered opposition from activists who favored protective legislation for women. Paul continued to work in the National Woman's Party for the remainder of her career.

PAUL, ELLIOT HAROLD (*b. Malden, Mass., 1891; d. Providence, R.I., 1958*), novelist, journalist, and editor. Studied briefly at the University of Maine. As the literary editor of the European editions of the *Chicago Tribune* and the *New York Herald* in the 1920's and 1930's, Paul became an important figure in the literary world of Paris. He wrote the first serious evaluation of Ger-

trude Stein's work. In 1927 he founded the literary magazine *transitions*, publishing works by Stein and James Joyce. His many books include *The Life and Death of a Spanish Town* (1937) and *The Last Time I Saw Paris* (1942), both of which became minor classics.

PAUL, FATHER *See* FRANCIS, PAUL JAMES.

PAUL, HENRY MARTYN (*b. Dedham, Mass., 1851; d. 1931*), astronomer, engineer, teacher. Graduated Dartmouth, 1873; C.E., 1875. Did important work at Washington Naval Observatory on variable stars and eclipses; professor of mathematics, U.S. Naval Academy, 1905–12.

PAUL, JOHN *See* WEBB, CHARLES HENRY.

PAUL, JOSEPHINE BAY (*b. Anamosa, Iowa, 1900; d. New York, N.Y., 1962*), investment executive. Attended Colorado College (1916–17); later ran, with her sister, a flourishing greeting card business (1928–33). Following the death of her husband, wealthy broker and investor Charles Ulrick Bay (in 1955), she assumed many of his directorships and became chairman of American Export Lines, making her the first woman to control a major steamship company in the United States. Named president and chairman of the board of A. M. Kidder (1956), becoming the first woman to head a member firm of the New York Stock Exchange. Named woman of the year in business by Associated Press (1956).

PAUL, WILLIAM DARWIN ("SHORTY") (*b. New York City, 1900; d. Iowa City, Iowa, 1977*), inventor of buffered aspirin and sports and rehabilitation medicine pioneer. Graduated University of Cincinnati with undergraduate and medical degrees and took his medical residency in 1930 at the University of Iowa, where he remained for his entire career, overseeing a pathbreaking clinical medical practice. During the 1940's Paul developed buffered aspirin from a mixture of antacid and the pain-suppressing compound. He later collaborated to develop a buffered compound for antacid tablets, which became known as Rolaids. Paul was also a pioneer in sports medicine, post-polio rehabilitation, electrocardiography, the oral administration of penicillin, and the treatment of diabetes with insulin.

PAULDING, HIRAM (*b. Westchester Co., N.Y., 1797; d. near Huntington, N.Y., 1878*), naval officer. Appointed midshipman, 1811; served as acting lieutenant aboard *Ticonderoga* in battle of Lake Champlain; graduated from Alden Partridge's military academy at Norwich, Vt., 1823. Paulding spent his entire active life on sea and shore duty, making frequent cruises in the Atlantic, Pacific, and Mediterranean. As captain, commanding the Home Squadron in the Caribbean, 1857, he seized William Walker with 150 filibusters at Grey Town, Nicaragua. President Buchanan, however, set Walker free and relieved Paulding of command. Head of the New York Navy Yard through much of the Civil War, Paulding, now rear admiral, did much to advance construction of Ericsson's monitors by advocating the design and expediting their actual building.

PAULDING, JAMES KIRKE (*b. Putnam Co., N.Y., 1778; d. near Hyde Park, N.Y., 1860*), author, naval official. Despite scanty schooling, he developed literary interests, an aesthetic appreciation of nature, and keen powers of social observation. Related by marriage to Washington Irving, he was associated with Irving in the first series of *Salmagundi*, 1807–08. Much of his subsequent writing was made up of caustic criticism of English ways and enthusiastic praise of his own homeland; his *Diverting History of John Bull and Brother Jonathan* (1812), *The United States and England* (1815), and *John Bull in America* (1825) were in

this vein. Appointed secretary of the Board of Navy Commissioners, 1815, he became U.S. navy agent in New York, 1824. He served ably in Van Buren's cabinet as secretary of the navy, 1838–41. Liberal, tolerant in all but his view of the English, thoroughly American, Paulding was author of more than 70 short tales, a mass of miscellaneous prose (including a second series of *Salmagundi*, 1819–20), some unsuccessful efforts in verse (e.g., *The Backwoodsman*, 1818). The others were *Koningsmarke* (1823); *Westward Ho!* (1832); *The Old Continental* (1846); *The Puritan and His Daughter* (1849). Like the contemporaries, he wrote too much and revised too little, but the unsentimental tone of his stories in an age of sentiment and the versatility and range of his interests give him a place in American literary history.

PAVY, OCTAVE (*b. New Orleans, La., 1844; d. 1884*), Arctic explorer. Physician and naturalist for A. W. Greely's Lady Franklin Bay expedition, 1881–84; died of exposure at Cape Sabine.

PAWNEE, BILL *See* LILLIE, GORDON WILLIAM.

PAYNE, BRUCE RYBURN (*b. Mull's Grove, N.C., 1874; d. Nashville, Tenn., 1937*), educator. Graduated Duke, 1896; Ph.D., Teachers College, Columbia, 1904. President, George Peabody College for Teachers, 1911–37.

PAYNE, CHRISTOPHER HARRISON (*b. near Red Sulphur Springs, Va., 1848; d. St. Thomas, Virgin Islands, 1925*), Baptist clergyman, lawyer, black leader. U.S. consul, St. Thomas, Danish West Indies, 1903–17; thereafter a prosecuting attorney and a police judge.

PAYNE, DANIEL ALEXANDER (*b. Charleston, S.C., 1811; d. 1893*), bishop of the African Methodist Episcopal Church, educator. President of Wilberforce University, 1863–76; wrote history of his church.

PAYNE, HENRY B. (*b. Hamilton, N.Y., 1810; d. Cleveland, Ohio, 1896*), lawyer, politician. Removed to Cleveland, 1833, where he practiced with great success and engaged also in railroad promotion. A leader in the Democratic party and a consistent supporter of business interests, he was congressman from Ohio, 1875–85, and U.S. senator, 1885–91.

PAYNE, HENRY CLAY (*b. Ashfield, Mass., 1843; d. Washington, D.C., 1904*), railroad and public utilities executive, politician. Settled in Milwaukee, Wis., 1863. Executive officer, Milwaukee Street Railway Co., 1890–95; receiver, Northern Pacific Railroad, 1893–95; U.S. postmaster general, 1902–04.

PAYNE, JOHN BARTON (*b. Pruntytown, Va. [now W.Va.], 1855; d. Washington, D.C., 1935*), lawyer. Winning reputation as lawyer and jurist in Chicago, Ill., *post* 1882, he was active in that city's civic affairs and held a number of national offices under the administration of President Wilson, including a brief period as U.S. secretary of the interior. He served as chairman of the American Red Cross *post* 1921 with great efficiency and without compensation.

PAYNE, JOHN HOWARD (*b. New York, N.Y., 1791; d. Tunisia, 1852*), actor, dramatist, editor, diplomat. Produced first play, *Julia, or The Wanderer*, in New York, 1806. Made professional stage debut in *Douglas* at Park Theatre, New York, 1809; for two years was a theatrical sensation in New York and Boston; was first American to play Hamlet (Boston, 1809). Resided in Europe, principally in France and England, 1813–32, attaining occasional success as an actor and active playwright. *Charles the Second; or, The Merry Monarch* (1824), a play in which Washington Irving collaborated, won favor, as did others, but he was con-

stantly in debt. Returning to America, he projected a number of unsuccessful schemes and was concerned, in an effort to obtain justice for the Cherokee, 1835. He served as U.S. consul in Tunis, 1842–45 and 1851–52. He is remembered principally today as author of the song "Home, Sweet Home!" which he had written for his operetta *Clari* (1823).

PAYNE, OLIVER HAZARD (*b. Cleveland, Ohio, 1839; d. 1917*), Union soldier, oil refiner, capitalist. Son of Henry B. Payne. Partner in notorious South Improvement Co. and treasurer of the Standard Oil Co. until 1884. Thereafter engaged in other industries, he was a dominant figure in American Tobacco Co. and influential in Tennessee Coal and Iron Co. He was a benefactor of Cornell Medical College and other institutions.

PAYNE, SERENO ELISHA (*b. Hamilton, N.Y., 1843; d. Washington, D.C., 1914*), lawyer, Republican politician. Nephew of Henry B. Payne. Congressman from New York, 1883–87 and 1891–1914; chairman, House Ways and Means Committee, 1899–1914. A friend of high tariffs, he gave his name to the Payne-Aldrich Tariff, 1909.

PAYNE, WILLIAM HAROLD (*b. Ontario Co., N.Y., 1836; d. Ann Arbor, Mich., 1907*), educator. Occupied first chair of education in the United States at University of Michigan, 1879–87 and 1901–04; wrote many textbooks.

PAYNE, WILLIAM MORTON (*b. Newburyport, Mass., 1858; d. Chicago, Ill., 1919*), teacher, translator, literary critic. Associate editor of the *Dial*, 1892–1915; wrote *American Literary Criticism* (1904) and *Leading American Essayists* (1910).

PAYNE-GAPOSCHKIN, CECELIA HELENA (*b. Wendover, England, 1900; d. Cambridge, Mass., 1979*), astronomer. Graduated Newnham College, Cambridge University (B.A., 1923) and Radcliffe College (Ph.D., 1925). In the early 1920's she joined the Harvard College Observatory, but, because of restrictions on career advancement of female scientists, she did not become a full professor until 1956. A pioneer in the technique of determining stellar magnitudes using photographic plates, she was the first to establish the prevalence of hydrogen and helium in the cosmos. She also contributed significantly to the scientific understanding of supernovae. *Variable Stars* (1938) and *Galactic Novae* (1957) are among her noted works.

PAYSON, EDWARD (*b. Rindge, N.H., 1783; d. Portland, Maine, 1827*), Congregational clergyman. Son of Seth Payson. Pastor at Second Church, Portland, *post* 1811; an intense, unhealthily introspective preacher.

PAYSON, SETH (*b. Walpole, Mass., 1758; d. Rindge, N.H., 1820*), Congregational clergyman. Father of Edward Payson. Pastor at Rindge, *post* 1782; author of *Proofs of the Real Existence and Dangerous Tendency of Illuminism* (1802).

PEABODY, ANDREW PRESTON (*b. Beverly, Mass., 1811; d. 1893*), Unitarian clergyman, educator, author. Editor and proprietor, *North American Review*, 1853–63; Plummer professor of Christian morals, Harvard, 1860–81.

PEABODY, CECIL HOBART (*b. Burlington, Vt., 1855, d. Boston, Mass., 1934*), educator. Son of Selim H. Peabody. Graduated Massachusetts Institute of Technology, 1877. After teaching in Japan and at the University of Illinois, he was associated *post* 1884 with his alma mater as teacher of steam engineering and *post* 1893 as head of the Department of Naval Architecture and Marine Engineering. He was author of pioneering textbooks

such as *Thermodynamics of the Steam Engine* (1889) and *Naval Architecture* (1904). He retired as professor emeritus, 1820.

PEABODY, ELIZABETH PALMER (*b. Billerica, Mass., 1804; d. Jamaica Plain, Mass., 1894*), educator, author. Granddaughter of Joseph Palmer; sister-in-law of Nathaniel Hawthorne and Horace Mann. Conducted several private schools around Boston; acted as W. E. Channing's secretary, 1825–34; was A. Bronson Alcott's assistant in his Temple School, Boston. An early member of the Transcendental Club, she was friend of R. W. Emerson, Hawthorne, Thoreau. Her bookshop in Boston, opened 1839, carried a unique selection of European books and became a center for transcendentalists; plans for the Brook Farm community were drawn there, and she was publisher of Margaret Fuller's translations from the German, several of Hawthorne's books, and of the *Dial*, 1842–43. She established the first kindergarten in America, 1860, and published the *Kindergarten Messenger*, 1873–75.

PEABODY, ENDICOTT (*b. Salem, Mass., 1857; d. Groton, Mass., 1944*), Episcopal clergyman, educator. Great-grandson of Joseph Peabody; distantly related to George Peabody. Attended Cheltenham School in England; graduated Trinity College, Cambridge University, 1878. After returning to the United States, he spent three years in business and then began studies at the Episcopal Theological School in Cambridge, Mass. Ordained in 1884, he opened Groton School that same year as an Episcopal school for boys; he served as headmaster until 1940. Emphasizing hard work, physical fitness, self-discipline, and social responsibility, he strove to arouse a sense of moral leadership in his students, most of whom were from financially secure families.

PEABODY, FRANCIS GREENWOOD (*b. Boston, Mass., 1847; d. Cambridge, Mass., 1936*), Unitarian clergyman, writer. Professor of theology and Christian morals, 1881–1913, and founder of the Department of Social Ethics, Harvard Divinity School, 1906.

PEABODY, GEORGE (*b. South Danvers, Mass., 1795; d. London, England, 1869*), merchant, financier, philanthropist. Apprenticed at 11 to a Danvers grocer, he subsequently secured positions in Newburyport, Mass., and Georgetown, D.C. Made manager of a wholesale dry-goods warehouse, 1814, he moved to Baltimore with his employer, 1815, and became senior partner of the firm, Riggs & Peabody, 1829. In 1835 he negotiated in England without charge a loan of $8 million for the state of Maryland, then on the verge of bankruptcy; in 1836, as incorporator and president of the Eastern Railroad, he again demonstrated his talent for securing English funds for investment in America. He settled permanently in London, 1837, where he had previously established the firm of George Peabody & Co., specializing in foreign exchange and American securities in direct competition with the Barings and Rothschilds. In 1854 he took Junius S. Morgan into partnership. During the years 1837–41, when American credit in Europe was much shaken, Peabody used his name and funds to restore confidence. He made a gift of $15,000 to sponsor an American exhibit at the Crystal Palace exhibition, 1851; granted $10,000 to outfit an expedition to search for Sir John Franklin, the Arctic explorer; and gave elaborate Fourth of July dinners where English nobility met American visitors to England.

Peabody's philanthropic activities, however, were principally directed toward America. As his fortune mounted he made increasingly generous gifts to a wide range of projects. Notable among these were $1.5 million to found the Peabody Institute at Baltimore, which provided a free library, an academy of music, and an art gallery; $250,000 to found the Peabody Institute in Peabody, Mass., with its library and lecture fund; $150,000 to

establish the Peabody Museum of Natural History at Yale; $140,000 to found the Peabody Academy of Science in connection with the Essex Institute, Salem, Mass.; and $3.5 million to the Peabody Education Fund for the promotion of education in the South. His foremost benefaction in England was a grant of $2.5 million for the erection of workingmen's tenements in London. After a funeral service in Westminster Abbey, his body was brought home for burial in Danvers, Mass.

Peabody, George Foster (*b. Columbus, Ga., 1852; d. Warm Springs, Ga., 1938*), banker. Partner in Spencer Trask & Co., 1881–1906. An active philanthropist, he was especially interested in southern education.

Peabody, Joseph (*b. Middleton, Mass., 1757; d. Salem, Mass., 1844*), Revolutionary privateersman, merchant ship powner. Became most prominent and wealthiest shipowner in Salem, employing about 7,000 seamen; traded principally with the Far East.

Peabody, Josephine Preston (*b. Brooklyn, N.Y., 1874; d. 1922*), poet, dramatist. Her best-known plays, *The Piper* (1909), *The Wings* (1912) and *Harvest Moon* (1916), kept alive the tradition of poetic drama in America.

Peabody, Lucy Whitehead (*b. Belmont, Kans., 1861; d. Beverly, Mass., 1949*), leader in Baptist and interdenominational organizations for support of foreign missions. Served with first husband, Rev. Norman Waterbury, on Baptist mission to India, 1881–86; returned to the United States after his death and concerned herself with a great number of Protestant missionary enterprises. Married Henry W. Peabody, 1906.

Peabody, Nathaniel (*b. Topsfield, Mass., 1741; d. Exeter, N.H., 1823*), physician. Revolutionary patriot. Prominent member, New Hampshire Committee of Safety; organizer, New Hampshire Medical Society, 1791.

Peabody, Oliver William Bourn (*b. Exeter, N.H., 1799; d. Burlington, Vt., 1848*), lawyer, Unitarian clergyman. Brother of William B. O. Peabody. Graduated Harvard, 1816; contributed to *North American Review*; supervised Boston, 1836, edition of Shakespeare's works. Pastor at Burlington, Vt., 1845–48.

Peabody, Robert Swain (*b. New Bedford, Mass., 1845; d. Marblehead, Mass., 1917*), architect. Graduated Harvard, 1866; studied at École des Beaux Arts, Paris; partner in Peabody and Stearns *post* 1870. Designed State House at Concord, N.H., and (old) Union League Club, New York; worked mainly in Italian Renaissance style.

Peabody, Selim Hobart (*b. Rockingham, Vt., 1829; d. St. Louis, Mo., 1903*), educator. Graduated University of Vermont, 1852. Secured first legislature grant for Illinois Industrial University, which became University of Illinois in 1885; served there as regent (president), 1880–91.

Peabody, William Bourn Oliver (*b. Exeter, N.H., 1799; d. Springfield, Mass., 1847*), Unitarian clergyman, man of letters. Brother of Oliver W. B. Peabody. Pastor at Springfield *post* 1820.

Peale, Anne Claypoole (*b. Philadelphia, Pa., 1791; d. 1878*), painter of miniatures. Daughter of James Peale; niece of Charles W. Peale; sister of Sarah M. Peale. Worked mainly in Philadelphia and Baltimore.

Peale, Charles Willson (*b. Queen Anne Co., Md., 1741; d. Philadelphia, Pa., 1827*), portrait painter, naturalist, patriot. Peale's father, a native of Rutlandshire, England, became master of the Free School near Centerville, Md., 1740, and of the Kent County School at Chestertown, 1742; he died in 1750. Charles Peale received rudiments of schooling until his thirteenth year when he was apprenticed to a saddler. Released from his indenture, 1761, he set up his own saddlery, but his Loyalist creditors put him out of business when he joined the Sons of Freedom during the Stamp Act crisis. At this point he found that an amateur interest in portraiture could win him valuable commissions and he sought instruction, first from John Hesselius, then from John Singleton Copley in Boston. Several interested patrons advanced him money to obtain further training in England, where he studied under Benjamin West, 1767–69. On his return to Annapolis, Md., his work brought him recognition in several of the colonies; in 1776 he removed to Philadelphia, where he at once found subjects among delegates to the Continental Congress and distinguished visitors. Elected a first lieutenant in the city militia, he saw service during the engagements at Trenton and Princeton, and as a captain continued in active service during the campaign that resulted in the evacuation of Philadelphia. In 1779 he was elected one of Philadelphia's representatives to the General Assembly of Pennsylvania.

During his many encampments with the army he had painted miniatures of his fellow officers which served as nucleus of the portrait collection subsequently formed as his record of the war; after the Revolution he engraved mezzotint plates from this collection. An amateur naturalist, he decided to exhibit natural curiosities as well as paintings in his museum or gallery in Philadelphia, which he opened to the public and for which he was later granted use of rooms at the American Philosophy Society, 1794, and at Independence Hall, 1802. Subsequently, the collections were incorporated as the Philadelphia Museum, and managed after 1810 by his sons. Peale helped to found the Philadelphia Academy of Fine Arts, 1805, and left several notable writings, among them *An Essay on Building Wooden Bridges* (1797) and *Introduction to a Course of Lectures on Natural History* (1800). He married three times and raised 12 children, many of whom became distinguished painters or naturalists. (*See* entries for Raphael, Rembrandt, and Titian R. Peale.) He was brother of James Peale.

Peale's early portraits were large canvasses in the classic English style. His fingers were formally placed with the faces solidly and tightly painted, though the eyes were generally oversmall and the lips almost uniformly thin. He left scores of paintings depicting a wide cross section of the distinguished men and families of his day. He will always be known for his portraits of Washington, of which he painted 60 in all, 7 of them from life (one of the latter being the first portrait of him — a three-quarter length in uniform of a colonel of Virginia militia, 1772). The 6 other life studies generally accredited are a three-quarter length in Continental uniform (1776); a miniature on ivory (1777); a bust portrait begun at Valley Forge in 1777; a full-length portrait showing Washington with his left hand resting upon a cannon, with Nassau Hall, Princeton, and marching Hessian prisoners in the background (1779); a bust portrait painted during the Constitutional Convention in 1787; and a bust portrait of Washington when president (painted at Philadelphia, 1795). His representations of the first president, though perhaps uninspired, faithful to life.

Peale, James (*b. Chestertown, Md., 1749; d. Philadelphia, Pa., 1831*), Revolutionary soldier, portrait painter in miniature and oils. Brother of Charles W. Peale; father of Anne C. and Sarah M. Peale. His miniatures *post* 1795 are his best work.

Peale, Raphael (*b. Annapolis, Md., 1774; d. 1825*), painter. Son and pupil of Charles W. Peale; brother of Rembrandt and Titian R. Peale. Produced miniature portraits and still lifes which are adequate but undistinguished.

PEALE, REMBRANDT (*b. near Richboro, Bucks Co., Pa., 1778; d. Philadelphia, Pa., 1860*), portrait and historical painter. Son of Charles W. Peale; brother of Raphael and Titian R. Peale. Attended private schools in Philadelphia; early exhibited a talent for painting. Besides studying under his father and copying the paintings in his father's Philadelphia museum gallery, he practiced in the school of design which his father and others attempted to form in 1795; in that same year he made a portrait from life of Washington. Between 1796 and 1800, he worked in Charleston, S.C., and Baltimore, Md. When the elder Peale successfully recovered the skeletons of two mastodons, the son assisted in mounting them and was sent to Europe to exhibit one of the skeletons, 1802–03; while abroad, he studied under Benjamin West and had two portraits accepted for exhibition at the Royal Academy, 1803. Returning home, he was commissioned by his father to add further portraits to the Peale gallery and did several, the most noted being that of Thomas Jefferson. Study in France, 1808–10, was followed by an unsuccessful attempt to establish a museum and gallery of his own in Baltimore. After the failure of his Baltimore venture Peale established himself successively in New York, Philadelphia, and again in New York, where he was elected president of the American Academy of Fine Arts. *Post* 1828 he traveled in Italy and England, resided briefly in New York, and made his home in Philadelphia *post* 1834. His *Notes on Italy* (1831) and *Graphics: A Manual of Drawing and Writing* (1835) received some attention, and he lectured extensively. He became obsessed in later life with the idea of exploiting his 1823 portrait of Washington (a composite from his father's and his own sketches) as an "ideal" representation. He did his best painting in the period 1808–20, largely in encaustic, which presented a fine, enamel-like texture. His large canvas *The Court of Death* was exhibited *post* 1820 and brought favorable notice.

PEALE, SARAH MIRIAM (*b. Philadelphia, Pa., 1800; d. Philadelphia, 1885*), portrait painter. Daughter of James Peale; sister of Anna C. Peale.

PEALE, TITIAN RAMSAY (*b. Philadelphia, Pa., 1799; d. Philadelphia, 1885*), naturalist, artist, mechanician. Son of Charles W. Peale; brother of Raphael and Rembrandt Peale. Accompanied William Maclure on trip to Georgia and Florida to study and collect fauna, 1818; accompanied Stephen H. Long's expedition to the upper Missouri, 1819–20. Appointed assistant manager of the Philadelphia Museum, 1821, he built up its collection of Lepidoptera and published *Lepidoptera Americana* (1833). He contributed many colored plates to Charles Bonaparte's *American Ornithology* and Thomas Say's *American Entomology*. A member of the Wilkes Exploring Expedition to the South Pacific, 1838–42, Peale collected a notable selection of Polynesian ethnica for the Academy of Natural Sciences of Philadelphia. He was an examiner in the U.S. Patent Office, Washington, D.C., 1849–72.

PEARCE, CHARLES SPRAGUE (*b. Boston, Mass., 1851; d. Anvers-sur-Oise, France, 1914*), painter. Grandson of Charles Sprague. Studied in Paris; resided *post* 1885 in France.

PEARCE, JAMES ALFRED (*b. Alexandria, Va., 1805; d. Chestertown, Md., 1862*), lawyer, Maryland politician. Grandson of Elisha Dick. Congressman, Whig, from Maryland, 1835–39 and 1841–43; U.S. senator, 1843–62. An able and industrious committee worker of superior intelligence; urged reasonable settlement of the secession crisis.

PEARCE, RICHARD (*b. Cornwall, England, 1837; d. London, England, 1927*), metallurgist. Devised important and successful techniques for reduction of precious ores in Colorado and Montana, 1873–1902. President, American Institute of Mining Engineers, 1889. Retired to England, 1902.

PEARCE, RICHARD MILLS (*b. Montreal, Canada, 1874; d. 1930*), pathologist, medical educator. M.D., Tufts, 1894; M.D., Harvard, 1897; studied also at Leipzig. Professor of pathology at Albany Medical College and Bellevue Medical College, he went to University of Pennsylvania, 1910, appointed to the first U.S. chair or research medicine. His great contribution to medical education came during his directorship of the Division of Medical Education, Rockefeller Foundation, 1920–30. He collected data throughout the world on the state of medical education, directed expenditure of substantial sums in various medical centers, and established the annual publication *Methods and Problems of Medical Education* (1924).

PEARCE, STEPHEN AUSTEN (*b. Brompton, Kent, England, 1836; d. Jersey City, N.J., 1900*), musician, musical editor. D.Mus., Oxford, 1864. Settled in New York, N.Y., 1872; held position of organist at a number of city churches and was widely known as lecturer and recitalist.

PEARL, RAYMOND (*b. Farmington, N.H., 1879; d. Hershey, Pa., 1940*), biologist, statistician. Graduated Dartmouth, 1899; Ph.D., University of Michigan, 1902. Worked at University of Maine, 1907–18; at Johns Hopkins, 1918–40. Early exponent of the application of statistics to study of biology and medicine.

PEARSE, JOHN BARNARD SWEET (*b. Philadelphia, Pa., 1842; d. Georgeville, Canada, 1914*), metallurgist. Noted *post* 1870 for design and improvement of Bessemer steel plants and their products; wrote history of iron manufacture in America (1876).

PEARSON, DREW (*b. Evanston, Ill., 1897; d. Washington, D.C., 1969*), journalist. Attended Swarthmore (B.A., 1919). Foreign editor of the *United States Daily*, predecessor of *U.S. News and World Report* (1926–29), and diplomatic correspondent for the *Baltimore Sun* (1929–31). Coauthored anonymously with Robert S. Allen the best-selling *Washington Merry-Go-Round* (1931), a book containing Washington, D.C., gossip and attacks on President Herbert Hoover and Congress; it was followed by *More Merry-Go-Round* (1932), with indictments of Gen. Douglas MacArthur and the Supreme Court. These books displayed Pearson's unique style of slashing and partisan political observation mixed with titillating revelations about the private lives of Washington higher-ups. Began "Washington Merry-Go-Round," a syndicated column, in 1932, which became the most widely read daily newspaper column in the country, and had a weekly radio program on ABC (1938–55). His politics were liberal and left of center; he encouraged closer relations with the Soviet Union, and aimed at exposing corruption and incompetence in government and the private lives of public figures. He was the first to reveal that Germany was about to invade Russia in 1941 and that Gen. George Patton had slapped a soldier. His muckraking in the area of fiscal corruption led to the retirement of Congressman Adam Clayton Powell and Sen. Thomas J. Dodd; later, one of his targets was Sen. Joseph McCarthy. He was sued for libel scores of times, but lost only one lawsuit.

PEARSON, EDMUND LESTER (*b. Newburyport, Mass., 1880; d. New York, N.Y., 1937*), librarian, author. Notable for the literary distinction of his writing on crime in *Studies in Murder* (1924) and other books.

PEARSON, EDWARD JONES (*b. Rockville, Ind., 1863; d. Baltimore, Md., 1928*), engineer. Graduated Cornell University, 1883. As president, New York, New Haven & Hartford Railroad, 1917–28, restored it to sound financial and physical condition.

PEARSON, ELIPHALET (*b. Newbury, Mass., 1752; d. Greenland, N.H., 1826*), educator. Graduated Harvard, 1773. First principal, Phillips Academy, Andover, 1778–86; thereafter taught at Harvard, 1786–1806, and was instrumental in founding Andover Theological Seminary to combat Unitarianism.

PEARSON, FRED STARK (*b. Lowell, Mass., 1861; d. at sea aboard Lusitania, 1915*), engineer. Graduated Tufts, 1883. Became an authority on design and construction of electrified street railway systems and electric power plants. His first major project, 1889–93, was electrifying the West End Street Railway in Boston, which required generators of unprecedented size. He went on to introduce electric streetcars in Brooklyn, N.Y., and to devise an underground conduit system for the Metropolitan Street Railway Co. of New York City. For the latter he constructed a power station of 70,000 horsepower, in 1896 the largest in the country. *Post* 1899, Pearson built large power plants for Mexico City, Rio de Janeiro, and Toronto.

PEARSON, LEONARD (*b. Evansville, Ind., 1868; d. Newfoundland, Canada, 1909*), veterinarian. Graduated Cornell University, 1888; D.V.M., University of Pennsylvania, 1890. Professor of veterinary medicine at University of Pennsylvania, *post* 1891. Learning of tuberculin studies of Koch and Gutmann whereby tuberculosis could be diagnosed in cattle before physical signs were apparent, he made the first tuberculin test in the western hemisphere, 1892; through speeches and writings he led in bringing about general acceptance of the test. As state veterinarian of Pennsylvania, he guided activities of the State Livestock Sanitary Board. His system of suppressing bovine tuberculosis became model for other states; his work in collaboration with associates on relation of bovine to human tuberculosis attracted worldwide attention. He was brother of Edward J. and Raymond A. Pearson.

PEARSON, RAYMOND ALLEN (*b. Evansville, Ind., 1873; d. Hyattsville, Md., 1939*), agricultural administrator, educator. Brother of Edward J. and Leonard Pearson. President, Iowa State A. & M., 1912–26; University of Maryland, 1926–35.

PEARSON, RICHMOND MUMFORD (*b. Rowan Co., N.C., 1805; d. Winston, N.C., 1878*), jurist. Chief justice, North Carolina Supreme Court, 1858–78; opposed conscription under Confederacy; supported Grant in 1868 campaign.

PEARSON, THOMAS GILBERT (*b. Tuscola, Ill., 1873; d. New York, N.Y., 1943*), ornithologist, wildlife conservationist. Raised in Indiana and Florida. Graduated Guilford (N.C.) College, 1896. B.S., University of North Carolina, 1899. Associated *post* 1902 with the Audubon Society movement, serving as secretary of the National Association of Audubon Societies from its incorporation in 1905, and as president, 1920–34. He campaigned successfully for protective measures and the maintenance of favorable environment for birds and other wildlife, both in the United States and abroad.

PEARSONS, DANIEL KIMBALL (*b. Bradford, Vt., 1820; d. 1912*), physician, financier, philanthropist. Removed to Chicago, Ill., 1860. Acquired great wealth as land agent and investor in Michigan pine lands; donated $5 million to educational institutions, especially Beloit College.

PEARY, JOSEPHINE DIEBITSCH (*b. Washington, D.C., 1863; d. Maine, 1955*), writer and arctic explorer. The wife of Robert E. Peary, Josephine Peary accompanied her husband on many of his expeditions to the arctic regions. In 1893 she was the first white woman to give birth in the Arctic. She wrote *My Arctic Journal* and *Snow Baby* about her experiences. In 1955 she was awarded the Gold Medal of the National Geographic Society.

PEARY, ROBERT EDWIN (*b. Cresson, Pa., 1856; d. Washington, D.C., 1920*), Arctic explorer. Graduated Bowdoin, 1877. Served in U.S. Coast and Geodetic Survey as a cartographic draughtsman, 1879–81; thereafter in U.S. Navy corps of civil engineers until his retirement as rear admiral, 1911. During the summer and fall of 1866 he made the first of his seven expeditions to the Far North, trudging with a Danish friend about 100 miles inland from the foot of the Greenland icecap. On his return home, he tried to win financial support for a larger expedition to cross the icecap, but his hopes of being the first to do so were blighted by Nansen's expedition in 1889. In 1891, however, he set out to explore the unknown northern extremity of Greenland, and in the next year became the first to reach the island's northeast coast. He also made important meteorological, tidal, and ethnological observations.

Peary next determined to explore north of the coast of Greenland and to reach the North Pole, if possible. Bad weather and ice conditions were encountered during the expedition of 1893–95 and the pole was not attained, but Peary was back on the west coast of Greenland for scientific work the next year. He published an account of his expeditions to this point, *Northward over the Great Ice* (1898). Failing in a dash for the pole, 1899, he remained in the Arctic until 1902, in the spring of that year reaching latitude 84°17' N. With a new ship, the *Roosevelt*, Peary tried again in 1905–06, but reached only 87°6' N. On his return, he published *Nearest the Pole* (1907) and made preparations for yet another expedition, which left New York in July 1908. By September the *Roosevelt* had reached 82°30' N., a record for northern penetration by a vessel. Peary spent the next few months establishing his base camp at Cape Columbia on Ellesmere Island. Adopting Eskimo methods of dress and travel, he set out over the sea ice on Mar. 1, 1909, with 6 whites, a black, 17 Eskimos, 19 sledges, and 133 dogs. His plan was to let the trail-blazing sledges gradually drop off and return to base, leaving the best dogs for the polar dash. Near the 88th parallel the last supporting party dropped off, leaving Peary, the black, 4 Eskimos, and 40 dogs. Nearly exhausted, Peary finally reached the North Pole on Apr. 6, 1909, spent 30 hours making astronomical observations, and then returned to camp under favorable conditions in 16 days. An ugly controversy at once broke out, however, when his cable announcing victory came 5 days after Dr. Frederick A. Cook's claim that he had reached the pole the preceding year. The American public generally sided with Cook, but careful scientific examination of data showed Cook's story to be false and Peary's substantiated.

PEASE, ALFRED HUMPHREYS (*b. Cleveland, Ohio, 1838; d. St. Louis, Mo., 1882*), pianist, composer. Prominent concert pianist, best remembered for songs "Hush Thee, My Baby" and "Stars of the Summer Night."

PEASE, CALVIN (*b. Suffield, Conn., 1776; d. Warren Ohio, 1839*), jurist. Brother-in-law of Gideon Granger, with whom he studied law. Removed to Ohio, 1800. Upheld right of jury trial against legislative act giving jurisdiction in civil suits to justices of the peace, 1806; state supreme court justice, 1816–30.

PEASE, ELISHA MARSHALL (*b. Enfield, Conn., 1812; d. Lampasas, Tex., 1883*), politician, lawyer. Removing to Texas, 1835, he was chosen secretary of the provisional government and helped draft the new republic's constitution. Thereafter he served the Texas government in a number of official positions. After Texas entered the Union he served in the legislature and was Democratic governor, 1853–57. During his administration

the state debt was paid, a school fund of $2 million created, and an endowment for a state university established. A Unionist, Pease became a Republican and was provisional governor, 1867–70. His administration, though sane and moderate, arrayed a majority of Texans against him.

PEASE, JOSEPH IVES (*b. Norfolk, Conn., 1809; d. near Salisbury, Conn., 1883*), line engraver. Made charming and popular engravings for gift-book annuals and fashion plates for *Godey's Lady's Book*.

PEASLEE, EDMUND RANDOLPH (*b. Newton, N.H., 1814; d. New York, N.Y., 1878*), physician, gynecologist. Graduated Dartmouth, 1836; M.D., Yale, 1840. An esteemed teacher at many medical schools; wrote *Ovarian Tumors: Their Pathology, Diagnosis and Treatment, Especially by Ovariotomy* (1872).

PEATTIE, DONALD CULROSS (*b. Chicago, Ill., 1898; d. Santa Barbara, Calif., 1964*), botanist and writer. Attended University of Chicago and Harvard (B.A., 1922). Began work as a scientific botanist in the Bureau of Foreign Seed and Plant Introduction and became a free-lance writer in 1924. He established a wide readership for his mixture of history, biography, and description of nature through his column on the seasons in the *Washington Star* (1925–34); through the books *Almanac for Moderns* (1935), *Green Laurels* (1936), and *Prairie Grove* (1938); and as *Reader's Digest* roving editor (beginning in 1943). He also wrote the scientific study *Flora of the Indiana Dunes* (1930) for the Field Museum and fiction with his wife, including *Sons of the Martian* (1932), *Port of Call* (1932), and *A Wife to Caliban* (1934).

PEAVEY, FRANK HUTCHINSON (*b. Eastport, Maine, 1850; d. Chicago, Ill., 1901*), industrialist. Removed to Iowa, 1867. Built up a grain elevator empire centered in Minneapolis; organized Peavey Steamship Co., 1899, for freighting on Great Lakes.

PEAY, AUSTIN (*b. near Hopkinsville, Ky., 1876; d. Nashville, Tenn., 1927*), lawyer, Tennessee politician. Reform Democratic governor, 1923–27; grudgingly signed antievolution bill, which was basis for Scopes trial.

PECK, CHARLES HORTON (*b. Rensselaer Co., N.Y., 1833; d. Menands, N.Y., 1917*), pioneer mycologist. Graduated State Normal School, Albany, N.Y., 1852; Union College, 1859. Appointed to staff of New York State Cabinet of Natural History, 1867, he made a notable series of botanical studies, known as Peck's Reports (1868–1912) to the regents of the University of the State of New York. Appointed New York State botanist, 1883, he built up a state herbarium; he also made investigations of fungi native to America and Canada which resulted in descriptions of 2,500 species new to science, and wrote excellent synoptical studies of the agarics and other groups.

PECK, CHARLES HOWARD (*b. Newtown, Conn., 1870; d. 1927*), surgeon. M.D., New York College of Physicians and Surgeons, 1893; taught surgery there *post* 1900. Best known for gastrointestinal operations; senior consultant in general surgery, American Expeditionary Forces, 1918.

PECK, GEORGE (*b. Middlefield, N.Y., 1797; d. Scranton, Pa., 1876*), Methodist clergyman, editor, author. Grandfather of Stephen Crane.

PECK, GEORGE RECORD (*b. near Cameron, N.Y., 1843; d. Chicago, Ill., 1923*), Union soldier, railroad attorney. General solicitor, Santa Fe Railroad, 1882–84 and 1886–95; general counsel, Chicago, Milwaukee & St. Paul, 1895–1911.

PECK, GEORGE WASHINGTON (*b. Rehoboth, Mass., 1817; d. Boston, Mass., 1859*), lawyer, journalist, music critic. Author, among other books, of the California Gold Rush fantasy *Aurifodina* (under pseudonym "Cantell A. Bigly," 1849).

PECK, GEORGE WILBUR (*b. Henderson, N.Y., 1840; d. Milwaukee, Wis., 1916*), humorist, journalist. Raised in Wisconsin; founder-editor, Milwaukee *Sun*; Democratic governor of Wisconsin, 1891–95. Author of *Peck's Bad Boy and His Pa* (1883), *The Grocery Man and Peck's Bad Boy* (1883), and others.

PECK, HARRY THURSTON (*b. Stamford, Conn., 1856; d. 1914*), classical philologist, editor, literary critic. Taught Latin at Columbia University, 1882–1910; edited the *Bookman*, 1895–1902; headed staffs of encyclopedias and was prolific in literary journalism. Committed suicide after a long period of mental aberration.

PECK, JAMES HAWKINS (*b. present Jefferson Co., Tenn., ca. 1790; d. St. Charles, Mo., 1836*), jurist. As federal district judge in Missouri *post ca.* 1822, he was impeached but acquitted for alleged misuse of contempt powers, 1830–31.

PECK, JESSE TRUESDELL (*b. Middlefield, N.Y., 1811; d. 1883*), Methodist bishop, educator, author. Won notice for an antislavery speech at the 1844 General Conference which split the church; a founder of Syracuse University.

PECK, JOHN JAMES (*b. Manlius, N.Y., 1821; d. Syracuse, N.Y., 1878*), Union major general, railroad and insurance executive.

PECK, JOHN MASON (*b. Litchfield, Conn., 1789; d. Rock Spring, Ill., 1858*), Baptist clergyman. Missionary in Illinois, Indiana, and Missouri *post* 1817. Author of *Guide for Emigrants* (1831), *Gazetteer of Illinois* (1834), *The Traveller's Directory for Illinois* (1840), and other works.

PECK, LILLIE (*b. Gloversville, N.Y., 1888; d. New York, N.Y., 1957*), settlement-house leader. Attended Simmons College. Beginning in Boston settlement-house work, Peck helped found the International Federation of Settlements in 1922; served as president from 1947. Executive secretary of the National Federation of Settlements from 1930 to 1947, Peck organized an integrated conference of the National Settlements in the South in 1936, using TVA facilities. During the Berlin Blockade in 1949, she worked with the U.S. military authorities in setting up community centers in Berlin. She was the representative of International Settlements to the U.N. Economic and Social Council in 1952.

PECK, THOMAS EPHRAIM (*b. Columbia, S.C., 1822; d. Richmond, Va., 1893*), Presbyterian clergyman. Professor at Union Theological Seminary in Virginia, 1869–93; strictly orthodox interpreter of the Scriptures.

PECK, TRACY (*b. Bristol, Conn., 1838; d. Rome, Italy, 1921*), Latinist, scholar. Graduated Yale, 1861; taught Latin at Cornell University, 1871–80, and at Yale, 1880–1908. Devoted his profound learning to effective teaching rather than writing.

PECK, WILLIAM DANDRIDGE (*b. Boston, Mass., 1763; d. Cambridge, Mass., 1822*), naturalist. Graduated Harvard, 1782. Professor of natural history, Harvard, 1805–22; first teacher of entomology in U.S.; described bark beetles, lepidopterous borers, and other parasites in pioneer scholarly papers.

PECKHAM, GEORGE WILLIAMS (*b. Albany, N.Y., 1845; d. Milwaukee, Wis., 1914*), teacher, librarian, entomologist. With wife published valuable study, *On the Instincts and Habits of Solitary*

Wasps (1898). Superintendent, public schools of Milwaukee, 1891–97; director, Milwaukee Public Library, 1897–1910.

PECKHAM, RUFUS WHEELER (b. *Albany, N.Y., 1838; d. near Albany, 1909*), U.S. Supreme Court justice. Brother of Wheeler H. Peckham. Judge, New York Supreme Court, 1883–86; New York Court of Appeals, 1886–95. Throughout his life as Democrat, Peckham often stood against his party organization but was unopposed by Democratic leaders when President Cleveland appointed him to the U.S. Supreme Court, 1896. Distinguished for learning and industry, he commanded the respect of fellow judges and lawyers. His opinions in *U.S.* v. *Trans-Missouri Freight Association, Addyston Pipe & Steel Co.* v. *U.S.*, and *Lochner* v. *New York* may especially be noted.

PECKHAM, STEPHEN FARNUM (b. *near Providence, R.I., 1839; d. 1918*), Union soldier, chemist, educator. Expert on petroleum and bitumens; wrote, among many other treatises, *Report on the Production, Technology, and Uses of Petroleum and Its Products* (1885); taught at a number of colleges in the East and Midwest.

PECKHAM, WHEELER HAZARD (b. *Albany, N.Y., 1833; d. New York, N.Y., 1905*), lawyer. Brother of Rufus W. Peckham. Prominent among prosecution counsel in conviction of William Tweed, 1873; a founder of New York City bar association, 1869.

PECORA, FERDINAND (b. *Nicosia, Sicily, 1882; d. New York City, 1971*), lawyer and jurist. Graduated New York Law School (1906) and worked for Progressive Theodore Roosevelt in the 1912 presidential campaign and Democrat Woodrow Wilson in 1916. He became an assistant district attorney in New York in 1918 and then chief assistant (1922–30). In 1933 he was appointed chief counsel for the Senate Banking and Currency Committee's inquiry into the 1929 stock market crash; in a high profile investigation, he uncovered wrongdoing by Wall Street investment banks and financiers, including J. P. Morgan. Pecora's work increased public support for the passage of such financial reforms as the Glass–Steagall Banking Act of 1933 and the Securities Exchange Act of 1934. He next served on the New York State Supreme Court (1935–50).

PEDDER, JAMES (b. *Isle of Wight, England, 1775; d. Roxbury, Mass., 1859*), agriculturist, author. Came to America, 1832. Editor of the *Farmers' Cabinet*, Philadelphia, 1840–43, and the *Boston Cultivator*, 1848–59.

PEEK, FRANK WILLIAM (b. *Calaveras Co., Calif., 1881; d. Port Daniels, Canada, 1933*), electrical engineer. Graduated Stanford, 1905. Associated with General Electric Co. *post* 1906. Specialist in high-voltage generators and transmission; built a 10 million-volt lightning generator, 1931.

PEEK, GEORGE NELSON (b. *Polo, Ill., 1873; d. Rancho Santa Fe, near San Diego, Calif., 1943*), businessman, farm leader. Successful in the farm machinery business, he served on the War Industries Board, 1917–19, leaving federal service to become president of the Moline Plow Co. In an effort to lift the depression in agriculture which followed World War I, he and Hugh S. Johnson worked out a plan for federal help in removing price-depressing surpluses from the domestic market; resigning his business post in 1924, he gave all his time to organizing support for his farm relief program. His ideas were incorporated in the successive McNary-Haugen bills, which failed of enactment, 1924–28. Leaving the Republican party, he acted as adviser on farm problems to Franklin D. Roosevelt in the presidential campaign of 1932 and was named head of the Agricultural Adjustment Administration in May 1933. Immediately at odds with Secretary of Agriculture Henry A. Wallace over acreage restriction and other policy matters, he was shifted in December to a post as special adviser on foreign trade. Resigning two years later because he disapproved of the administration's reciprocal trade policies, he became a bitter and vocal critic of the New Deal.

PEERS, BENJAMIN ORRS (b. *Loudoun Co., Va., 1800; d. Louisville, Ky., 1842*), Episcopal clergyman, educator, advocate of Pestalozzi's principles. Acting president, Transylvania University, 1833–34; editor, *The Journal of Christian Education, post* 1838.

PEERSON, CLENG (b. *Norway, 1783; d. Bosque Co., Tex., 1865*), immigrant leader and organizer. Arrived in New York, 1821, as agent for Norwegian Quaker settlers and others; arranged land purchase and erection of houses near Rochester, N.Y.; guided first body of Norwegian immigrants to his settlement, 1825. Journeying west in 1833 to find a new site, he chose the Fox River Valley of Illinois to which he guided the first contingent of Norwegians to Illinois, 1834; many other Norwegian settlements in the West emanated therefrom. In 1850 he led settlers to Dallas and Bosque counties in Texas.

PEET, HARVEY PRINDLE (b. *Bethlehem, Conn., 1794; d. New York, N.Y., 1873*), educator of the deaf. Studied and worked with Thomas H. Gallaudet, 1822–30; director, New York Institution for the Instruction of the Deaf and Dumb, 1831–67.

PEET, ISAAC LEWIS (b. *Hartford, Conn., 1824; d. New York, N.Y., 1898*), educator of the deaf. Son and pupil of Harvey P. Peet; director, New York Institution for the Instruction of the Deaf and Dumb, 1867–92.

PEET, STEPHEN DENISON (b. *Euclid, Ohio, 1831; d. Salem, Mass., 1914*), Congregational clergyman, archaeologist. Pioneer student of ancient American Indian culture; editor, *American Antiquarian and Oriental Journal*, 1878–1910.

PEFFER, WILLIAM ALFRED (b. *Cumberland Co., Pa., 1831; d. Grenola, Kans., 1912*), journalist, politician. Settled successively in California, Indiana, Missouri, and Illinois, 1849–62. Having read law during Civil War service, he practiced in Tennessee, 1865–69. Removing to Kansas, he edited two small newspapers and became editor of the *Kansas Farmer*, 1881, later the most powerful farm journal in Kansas. First allied with the Republican party, he later sided with the conservative wing of the Farmer's Alliance. U.S. senator from Kansas, 1891–97, his odd appearance and dry, statistical speeches made him a symbol of Populism, if not a caricature. By 1900 he had drifted back to the Republicans.

PEGLER, WESTBROOK (b. *Minneapolis, Minn., 1894; d. Tucson, Ariz., 1969*), journalist. Worked for the United Press (1916–25) as a war correspondent and sportswriter, then for the *Chicago Tribune* as a sports editor (1925–33). His columns for the *Tribune* showed traits that later characterized his political columns: a cynical pose, a sustained irreverence toward national heroes and institutions, and a sure instinct for uncovering hypocrisy in the righteous. He wrote the column "Fair Enough" for Scripps-Howard newspapers (beginning 1933) and moved to the Hearst chain in 1944, where he wrote "As Pegler Sees It" until 1962. He won a Pulitzer Prize in 1941 for his articles on labor racketeering; later became an ardent supporter of Sen. Joseph McCarthy. Remembered after his death for hurling tirades and vituperative epithets at Franklin and Eleanor Roosevelt, Henry A. Wallace, Dwight D. Eisenhower, John F. Kennedy, the New Deal, and the Fair Deal.

PEGRAM, GEORGE BRAXTON (b. *Trinity, N.C., 1876; d. Swarthmore, Pa., 1958*), physicist. Studied at Trinity College (now

Duke University) and at Columbia University (Ph.D., 1903). Taught at Columbia from 1905 until his death; dean of the School of Mines, Engineering and Chemistry, 1918–1930; chairman of the physics department, 1913–1945; vice president of the university, 1949–1950. Helped found the American Institute of Physics in 1931; secretary from 1938 to 1956. Remembered for his role in the development of atomic power, Pegram hired Enrico Fermi in 1938 and headed the Columbia division of the Manhattan Project. In 1941 he became head of the uranium section of the project under the Office of Scientific Research and Development. He was responsible for the assemblage and operations coordination of the staff and responsible for the engineering aspects of the Manhattan Project. Pegram was the main founder of the Brookhaven Laboratory, a direct outgrowth of the Manhattan Project.

PEI, MARIO ANDREW (*b. Rome, Italy, 1901; d. Glen Ridge, N.J., 1978*), educator and philologist-linguist. Immigrated to New York City in 1908 (naturalized 1925) and graduated City College of New York (B.A., 1925) and Columbia University (Ph.D., 1932). He was a faculty member at Columbia (1933–69) and, during World War II, developed language courses and material for the U.S. government that assisted global war effort. He wrote *Languages for War and Peace* (1943), which was a reference and guide book for thirty-seven languages. In the postwar era, Pei emerged as an influential linguistics scholar and commentator on public issues. He envisioned language as a potential unifying force in a global community and founded the academic field of geolinguistics, which explored economic, political, and cultural aspects of contemporary languages. Pei wrote several noted works, including *One Language for the World and How to Achieve It* (1958) and *The Story of Language* (1949). In several books he sought to make the technical field of linguistics accessible to nonspecialists.

PEIRCE, BENJAMIN (*b. Salem, Mass., 1809; d. 1880*), mathematician, astronomer. Father of Charles S. and James M. Peirce. While a student at the Salem Private Grammar School, Peirce came to know Nathaniel Bowditch, who stimulated him to undertake mathematical studies. He graduated from Harvard College in 1829; taught at Bancroft's Round Hill School, Northampton, Mass., for two years; and then joined the faculty at Harvard. He was professor of mathematics and astronomy from 1833 until his death. His first major work was revising and correcting Bowditch's translation of Laplace's work on celestial mechanics, 1829–39; he then undertook to write a series of textbooks on trigonometry, algebra, geometry, and calculus, creditable but hardly original works. *A System of Analytic Mechanics* (1855), however, included a masterly discussion of determinants and functional determinants. Pierce took an active part in founding the Harvard Observatory, and he made remarkably accurate computations of the general perturbations of Uranus and Neptune. From 1849 until 1867 he was consulting astronomer to the *American Nautical Almanac* office established in Cambridge by Congress. In 1847 he was one of a committee of five appointed to organize the Smithsonian Institution. He was director of the longitude determinations of the U.S. Coast Survey, 1852–67, and superintendent of the survey, 1867–74. It was Peirce who determined upon extending coastal survey to a general geodetic survey, which would provide a general map of the country independent of local surveys. While superintendent, Peirce took personal charge of the American expedition to Sicily to observe a solar eclipse, 1870, and probably organized the two expeditions in 1874 to observe the transit of Venus. From his work with the survey he formulated in 1852 what is called "Peirce's criterion." His most original and able mathematical contribution was his *Linear Associative Algebra* (1870, 1881).

About three-quarters of his published works related to questions in astronomy, geodesy, and mechanics, and one-quarter to pure mathematics. He was generally acknowledged to be the leading mathematician in America and exerted great influence upon the progress of mathematical science in the United States through encouragement of young and talented men and through his inspiring teaching at Harvard.

PEIRCE, BENJAMIN OSGOOD (*b. Beverly, Mass., 1854; d. Cambridge, Mass., 1914*), mathematician, physicist. Graduated Harvard 1876; Ph.D., Leipzig, 1879; studied with Weidemann and Helmholtz. As instructor and professor at Harvard *post* 1882, he helped develop a remarkable course on the Newtonian potential function and Fourier series, and taught graduate courses in pure mathematics and mathematical physics. His researches on the thermal conductivity of stone and its variation of temperature, and on magnetism were brilliant mathematical demonstrations. His most noteworthy publications were *Elements of the Theory of the Newtonian Potential Function* (1886, later expanded, 1902), *Short Table of Integrals* (1910), and *Mathematical and Physical Papers, 1903–1913* (1926).

PEIRCE, BRADFORD KINNEY (*b. Royalton, Vt., 1819; d. Newton Center, Mass., 1889*), Methodist clergyman, social worker. Wrote *A Half Century with Juvenile Delinquents* (1869); edited *Zion's Herald*, 1872–88.

PEIRCE, CHARLES SANDERS (*b. Cambridge, Mass., 1839, d. 1914*), philosopher, logician, scientist, founder of pragmatism. Son of Benjamin Peirce; brother of James M. Peirce. His father supervised his education with the hope of making him a mathematician. Young Peirce mastered Whately's *Elements of Logic* at age 13, and conducted quantitative analysis experiments in a laboratory which he set up. The elder Peirce trained his son in the art of concentration, encouraged in him the power of sensuous discrimination, and constantly presented him with mathematical problems, tables, and examples to the end that he discover the principles for himself. In spite of obvious brilliance, Peirce did poorly at Harvard, 1855–59. In 1861 he joined the U.S. Coast Survey staff, with which he remained for 30 years. He lectured at Harvard on the philosophy of science, 1864–65; gave the university lectures on philosophy, 1869–70; and worked as an assistant at the Harvard Observatory, where he did research leading to the only book he published during his lifetime, *Photometric Researches* (1878). For the Coast Survey, Peirce made important pendulum investigations and researches in gravity theory; he also made the first attempt to use the wavelength of a light ray as a standard unit of measure.

Peirce always called himself a logician and became the foremost logician in the United States, tending to see philosophy and other subjects almost entirely from a logical perspective. He first gained notice by bringing attention to the work of George Boole, the founder of modern logic, Peirce went on to make a number of vital and permanent improvements in Boole's system, many of them incorporated in a long series of technical papers completed between 1867 and 1885. Many of these papers were difficult and might never have been noticed if Ernst Schröder had not based a large part of his work on Peirce's contributions. Peirce modified, extended, and transformed the Boolean algebra, making it applicable to propositions, relations, probability, and arithmetic. Practically single-handedly, Peirce laid the foundations of the logic of relations, the instrument for the logical analysis of mathematics. He invented the copula of inclusion, the most important symbol in the logic of classes, two new logical algebras, and two new systems of logical graphs, and was the first to give the fundamental principle for the logical development of mathematics. Oddly, he never tried to get some of his most im-

portant logical papers published, though an elaborate work on logic was turned down by publishers as being too abstruse. Peirce published only a few important papers on pure mathematics. He clearly anticipated the method for the derivation and definition of number which Bertrand Russell and Alfred North Whitehead announced later. He showed too that every associative algebra can be represented by one whose elements are matrices. Further, Peirce made contributions to the theory of aggregates, transfinite arithmetic, and analysis situs.

Pragmatism, Peirce's creation, had its origin in the Cambridge discussions of a fortnightly "metaphysical club" founded in the 1870's and including among its members Oliver Wendell Holmes, Chauncey Wright, William James, and Nicholas St. John Green. Through his study of the history of logic, Peirce had discovered Duns Scotus and was by 1871 a convert to Scotist realism in opposition to Berkeley's nominalism. In a paper published that year in the *North American Review* (October 1871), in which Pierce criticized Berkeley, he outlined the pragmatic position, but his first definite statement of it was made in an article, originally written in French in 1877, which appeared in the *Popular Science Monthly* for January 1878 under the title "How to Make Our Ideas Clear." It was the second of a series of six articles on logic. In that article appeared this famous formula: "Consider what effects, which might conceivably have practical bearings, we conceive the object of our conception to have. Then, our conception of these effects is the whole of our conception of the object."

Peirce received no recognition for his work until William James in 1898 first publicly used the term "pragmatism" and acknowledged Peirce's priority. Peirce's pragmatism, however, was different from James's, having more in common with the idealism of Josiah Royce and the later views of John Dewey. Peirce, for example, believed in the idea of an absolute and in universals, but shared with the pragmatic school a belief in the dependence of logic on ethics, a critical attitude toward individualism and egoism, and a defense of the reality of absolute chance and the principle of continuity. He developed his own formulation of the last idea and considered it his main contribution to philosophy.

In spite of his formidable intellectual achievements, Peirce was given the opportunity to teach for only eight years of his life. He was a lecturer on logic at John Hopkins, 1879–84, and gave occasional lectures elsewhere in addition to his early Harvard career. His lectures were generally difficult, appealing only to the brightest students, but the chief hurdle was his general personality and personal habits. He was vain, sloppy in dress, forgetful, uncivil, highly emotional, and suffered socially and professionally from the circumstances of his divorce from his first wife in 1883. Having inherited some money, he retired in 1887 to a remote and wild section of Pennsylvania near Milford, where he wrote indefatigably on many subjects, and as poverty overtook him, eked out a living writing book reviews and articles for encyclopedias.

PEIRCE, CYRUS (*b. Waltham, Mass., 1790; d. West Newton, Mass., 1860*), Congregational clergyman, educator. Graduated Harvard, 1810; Harvard Divinity School, 1815. Principal of the first state normal school established in Massachusetts, at Lexington and West Newton, 1839–42 and 1844–49.

PEIRCE, HENRY AUGUSTUS (*b. Dorchester, Mass., 1808; d. San Francisco, Calif., 1885*), merchant, diplomat. As partner of James Hunnewell and Charles Brewer, made fortune in Pacific trade; U.S. minister to the Hawaiian Kingdom, 1869–77. Expansionist.

PEIRCE, JAMES MILLS (*b. Cambridge, Mass., 1834; d. Cambridge, 1906*), educator, mathematician. Son of Benjamin

Peirce; brother of Charles S. Peirce. Graduated Harvard, 1853. Professor of mathematics at Harvard, *post* 1861; first dean of Harvard graduate school, 1890–95.

PEIRCE, WILLIAM (*b. probably England, ca. 1590; d. off New Providence, Bahamas, 1641*), shipmaster. Made many trips conveying emigrants to New England and Virginia, 1625–35; author of *An Almanac for . . . 1639. Calculated for New England* (Cambridge, Mass., printed by Stephen Day), the earliest almanac compiled in English America.

PEIXOTTO, BENJAMIN FRANKLIN (*b. New York, N.Y., 1834; d. 1890*), lawyer, diplomat, journalist. As consul to Romania, 1870–76, was influential in abating persecution of Jews there; founded (1886) and edited *The Menorah*, important Jewish periodical; was active official of B'nai B'rith.

PELHAM, HENRY (*b. Boston, Mass., 1748/9; d. Ireland, 1806*), painter, miniaturist, engraver, cartographer. Son of Peter Pelham; half brother of John S. Copley. A Loyalist, he removed to London, England, 1776.

PELHAM, JOHN (*b. present Calhoun Co., Ala., 1838; d. Kelly's Ford, Va., 1863*), Confederate soldier. Resigned from West Point, 1861, to join Confederate army. Became romantic hero in command of famed Stuart Horse Artillery; served brilliantly during Seven Days' Battles and at Antietam.

PELHAM, PETER (*b. England, ca. 1695; d. Boston, Mass., 1751*), limner, engraver. Learned mezzotint engraving in London and was well trained in portrait painting before he immigrated to Boston *ante* 1728. As the practice of his art did not produce a living for him, he opened a school in Boston at which he taught dancing, arithmetic, and other subjects. In 1748 he married Mary Singleton Copley, a widow, and it was in his household that John Singleton Copley was raised, as was Pelham's own son, Henry, who also became an engraver and painter.

PELHAM, ROBERT A. (*b. near Petersburg, Va., 1859; d. Washington, D.C., 1943*), journalist, politician, government official. Child of free black parents, he was raised in Detroit, Mich. Employed *post* 1877 by the *Detroit Post*, he and his brother Benjamin distributed the paper as independent contractors, 1884–91. They also published and edited (in association with others) a weekly, the *Plaindealer*, which soon became the leading newspaper under black management in the Midwest. Active in Republican politics, Robert Pelham gave up the management of the *Plaindealer* in 1891 to accept appointment as a special agent of the U.S. General Land Office. In 1900 he was appointed to the U.S. Census Bureau and removed to Washington, D.C.; serving until his retirement in 1937, he made important contributions as an inventor of tabulating machines for bureau use and as a statistician.

PELLEW, HENRY EDWARD (*b. Canterbury, England, 1828; d. Washington, D.C., 1923*), philanthropist. Brother-in-law of John Jay (1817–94); settled in the United States *post* 1873. Helped organize Charity Organization Society in New York; aided tenement house reform and night refuge movements.

PELOUBET, FRANCIS NATHAN (*b. New York, N.Y., 1831; d. Auburndale, Mass., 1920*), Congregational clergyman, author. Pioneer in the American Sunday school movement and writer of widely used teaching aids for use with the International Lessons.

PELZ, PAUL JOHANNES (*b. Seitendorf, Silesia, 1841; d. Washington, D.C., 1918*), architect. Came to America, 1858; studied

with Detlef Leinau. With John L. Smithmeyer, submitted winning design for the Library of Congress building, 1873.

PEMBERTON, BROCK (*b. Leavenworth, Kans., 1885; d. New York, N.Y., 1950*), theatrical producer, director. Cousin of Victor Murdock. B.A., University of Kansas, 1908. Worked as reporter and play reviewer on a number of newspapers, including the *Emporia Gazette* and the New York *Evening Mail*, *World*, and *Times*. He made his start as an independent producer with *Enter Madame* by Gilda Varesi and Dolly Byrne, 1920; after producing a number of artistic successes that lost money (including the first American performance of Luigi Pirandello's plays), he resolved to devote himself to plays that "would sell to an audience." Among these were *Strictly Dishonorable* (1929), *Personal Appearance* (1934), and *Harvey* (1944).

PEMBERTON, ISRAEL (*b. Philadelphia, Pa., 1715; d. 1779*), Quaker merchant, philanthropist. Brother of James and John Pemberton. One of the wealthiest merchants of his day; promoted friendly relations with Indians. Was imprisoned for refusing allegiance oath to Commonwealth of Pennsylvania, 1777.

PEMBERTON, JAMES (*b. Philadelphia, Pa., 1723; d. 1809*), Quaker, merchant, philanthropist. Brother of Israel and John Pemberton. A founder of Society for the Relief of Free Negroes, 1775; president, Pennsylvania Society for Promoting the Abolition of Slavery, 1790–1803.

PEMBERTON, JOHN (*b. Philadelphia, Pa., 1727; d. Pyrmont, Germany, 1795*), Quaker preacher. Brother of Israel and James Pemberton. Preached in Great Britain, 1750–53 and 1781–86; imprisoned in 1777–78 for opposing armed resistance to Great Britain.

PEMBERTON, JOHN CLIFFORD (*b. Philadelphia, Pa., 1814; d. Penllyn, Pa., 1881*), soldier. Great-grandson of Israel Pemberton. Graduated West Point, 1837. Served ably in Florida Indian wars in 1837–39, in the Mexican War, and in the West. Commissioned Confederate brigadier general, June 1861, he was made major general early in 1862, in charge of the southeastern department. He built Fort Wagner and Battery "B" for defense of Charleston during 1862. Appointed lieutenant general, October 1862, he commanded the department embracing Tennessee Mississippi, and eastern Louisiana. He took direct charge of the defense of Vicksburg against Grant, surrendering only when heavily outnumbered and totally without food on July 4, 1863.

PEÑALOSA BRICEÑO, DIEGO DIONISO DE (*b. Lima, Peru, ca. 1622; d. Paris, France[?], ca. 1687*), soldier. Governor of New Mexico, 1661–65; banished by the Inquisition from New Spain for misconduct, 1668; sold military information to England and France.

PENDER, WILLIAM DORSEY (*b. Edgecombe Co., N.C., 1834; d. Staunton, Va., 1863*), Confederate soldier. Graduated West Point, 1854. Commanded North Carolina brigade in General A. P. Hill's division from the Seven Days' Battles through Chancellorsville. Promoted major general, May 1863, he was mortally wounded while leading a division at Gettysburg.

PENDERGAST, THOMAS JOSEPH (*b. St. Joseph, Mo., 1872; d. Kansas City, Mo., 1945*), political boss. Resident in Kansas City post 1890, he succeeded his older brother as Democratic party leader in several of the city wards, 1910. By the mid-1920's he had secured political control of the entire city and of Jackson County, of which the city was a part, through manipulation of franchises, construction contracts, tax deductions to friends and other conventional, old-fashioned devices of city bosses. Grateful for the support of the Pendergast machine in the Democratic national convention, 1932, President Franklin D. Roosevelt put him in charge of considerable federal patronage in the state, which vastly implemented his power. A federal investigation conducted by a political enemy and the mobilization of public sentiment against the machine resulted in his trial and conviction for income tax evasion, 1939.

PENDLETON, EDMUND (*b. Caroline Co., Va., 1721; d. Caroline Co., 1803*), lawyer, jurist, Revolutionary patriot. Admitted to local bar, 1741, he was admitted to practice before the general court, 1745. Elected to the House of Burgesses, 1752, he was by 1765 a leader of the conservative Cavalier party, opposed to Patrick Henry and violent measures. On the approach of crisis, 1773, Pendleton emerged was one of Virginia's leading men. He represented Virginia in the first Continental Congress, was president of the two Virginia revolutionary conventions which met in 1775, presided over the Committee of Safety, and was president of the Virginia convention of 1776 which recommended a declaration of independence. He also helped draw up Virginia's constitution and was first Speaker of the Virginia House of Delegates, 1776. President of Virginia Supreme Court of Appeals, 1779–1803. He vigorously supported adoption of the federal Constitution.

PENDLETON, EDMUND MONROE (*b. Eatonton, Ga., 1815; d. 1884*), physician, agricultural chemist. Organized in Augusta, Ga., ca. 1867, a firm to manufacture commercial fertilizers on large scale, was among the first to use cotton seed for fertilizer.

PENDLETON, ELLEN FITZ (*b. Westerly, R.I., 1864; d. Newton, Mass., 1936*), educator. Graduated Wellesley, 1886; served on its staff thereafter, and was president, 1911–36.

PENDLETON, GEORGE HUNT (*b. Cincinnati, Ohio, 1825; d. Brussels, Belgium, 1889*), lawyer, Ohio legislator, diplomat. Congressman, Democrat, from Ohio, 1857–65; Democratic candidate for vice-presidency, 1864. Sponsored "Ohio idea" to pay U.S. bonds in greenbacks, 1867; served as U.S. senator from Ohio, 1879–85, and advocated civil service reform.

PENDLETON, JAMES MADISON (*b. Spotsylvania Co., Va., 1811; d. Bowling Green, Ky., 1891*), Baptist clergyman, editor. Strong Unionist as pastor at Bowling Green, Ky., and Murfreesboro, Tenn.

PENDLETON, JOHN B. (*b. New York, N.Y., 1798; d. New York, 1866*), lithographer. After study of process in Paris, and with aid of two French workmen, produced first commercial lithographs in United States at Boston, 1825.

PENDLETON, JOHN STROTHER (*b. Culpeper Co., Va., 1802; d. Culpeper Co., 1868*), lawyer, Virginia legislator. U.S. chargé d'affaires in Chile, 1841–44. Congressman, Whig, from Virginia, 1845–49. Concluded treaty of commerce, 1853, as U.S. chargé d'affaires to Argentine Confederation, 1851–54.

PENDLETON, WILLIAM KIMBROUGH (*b. Yanceyville, Va., 1817; d. Bethany, W.Va., 1899*), minister of the Disciples of Christ, educator. President Bethany College, 1866–86; edited *Millennial Harbinger*, 1865–70; superintendent, West Virginia public schools, 1873–80.

PENDLETON, WILLIAM NELSON (*b. Richmond, Va., 1809; d. Lexington, Va., 1883*), Episcopal clergyman, educator, Confederate soldier. Graduated West Point, 1830. Pastor of Grace Church, Lexington, Va., 1853–83. As brigadier general, 1862--

65, he was distinguished chief of artillery in the Army of Northern Virginia.

PENFIELD, EDWARD (*b. Brooklyn, N.Y., 1866; d. Beacon, N.Y., 1925*), illustrator, painter, author. Inaugurator of the brief but golden age of American poster art; art editor for *Harper's Magazine*, *Weekly*, and *Bazar* (sic), 1890–1901.

PENFIELD, FREDERIC COURTLAND (*b. Wast Haddam, Conn., 1855; d. New York, N.Y., 1922*), journalist, diplomat. Able, tactful, U.S. ambassador to Austria–Hungary, 1913–17.

PENFIELD, WILLIAM LAWRENCE (*b. Dover, Mich., 1846; d. Washington, D.C., 1909*), jurist. As solicitor, U.S. Department of State, 1897–1905, Penfield made valuable contributions to U.S. policy and to promotion of international arbitration.

PENFOLD, JOSEPH WELLER (*b. Marinette, Wis., 1907; d. 1973*), conservationist. Graduated Yale University (1930) and began his career in conservation in 1949 as the western representative for the Izaak Walton League of America. As the conservation director of the league after 1957, he emerged as a prominent lobbyist for conservation legislation. He served on the master plan team for the Yellowstone and Teton National Parks and conceived legislation, enacted by Congress in 1958, that created the Outdoor Recreation Resources Review Commission. He also served as an officer of the National Resources Council of America (1957–69).

PENHALLOW, SAMUEL (*b. Cornwall, England, 1665; d. Portsmouth, N.H., 1726*), merchant, judge, historian. Immigrated to New England, 1686. Treasurer, province of New Hampshire, 1699–1726; chief justice, superior court, 1717; held numerous other offices. Author of *The History of the Wars of New-England* (1726), a valuable account of the Indian wars of 1702–25.

PENICK, CHARLES CLIFTON (*b. Charlotte Co., Va., 1843; d. Baltimore, Md., 1914*), Episcopal clergyman. Missionary bishop of Cape Palmas, Liberia, 1877–83.

PENINGTON, EDWARD (*b. Amersham, England, 1667; d. Philadelphia, Pa., 1701*), colonial official. Author of several tracts in defense of Quakers against attacks by Thomas Crisp and George Keith, 1695–96, he came to Pennsylvania as surveyor general, 1698, and served until his death.

PENINGTON, EDWARD (*b. Bucks Co., Pa., 1726; d. Philadelphia, Pa., 1796*), Quaker merchant. Grandson of Edward Penington (1667–1701). Member, Philadelphia Committee of Correspondence, 1774; delegate, first Continental Congress, 1774. Opposed armed resistance and independence.

PENN, JOHN (*b. England, 1729; d. Philadelphia, Pa., 1795*), Pennsylvania provincial official. Grandson of William Penn; brother of Richard Penn. Inherited life use of a quarter of the proprietary rights in Pennsylvania, 1771. A resident of the province and member of the provincial council, 1752–55, Penn attended the Albany Congress on Indian Affairs, 1754. He was again in residence as lieutenant governor of the province, 1763–71, and from 1773 to the end of proprietary rule on Sept. 26, 1776. He handled difficult boundary claims with Connecticut, Virginia, and Maryland, and tried to mediate between disgruntled Indians and revengeful frontiersmen. Yielding gracefully to the turn of events in 1776, he made his principal residence in or near Philadelphia until his death.

PENN, JOHN (*b. Caroline Co., Va., 1740; d. 1788*), lawyer, Revolutionary patriot. Removed to Granville Co., N.C., 1774. Member of the Continental Congress, 1775–77, 1778–80; signer, Declaration of Independence; member, North Carolina Board of War, 1780–81.

PENN, RICHARD (*b. England, 1735; d. England, 1811*), Pennsylvania provincial official. Grandson of William Penn; brother of John Penn (1729–95). Lieutenant governor of Pennsylvania, 1771–73; conveyed Congress's "olive branch" petition to the king, 1775; remained in England thereafter.

PENN, THOMAS (*b. Bristol, England, 1702; d. England, 1775*), Pennsylvania provincial official. Son of William Penn; uncle of John and Richard Penn. His father, on his death in 1718, left the proprietary interests in Pennsylvania to his widow as executrix for their four sons. Thomas acquired a one-fourth interest, 1727, and in 1746 an additional half interest. From 1732 to 1741 he managed the province's affairs in Philadelphia; thereafter, he lived in England and conducted business by correspondence. He was never well liked, either by colonists or Indians. The Indians were particularly incensed by his "Walking Purchase" of the forks of the Delaware in 1737. Penn was only a nominal Quaker for most of his life.

PENN, WILLIAM (*b. London, England, 1644; d. England, 1718*), Quaker statesman, founder of Pennsylvania. Son of Adm. Sir William Penn, a wealthy and influential Anglican, and Margaret Jasper Penn. Religiously inclined even in childhood, Penn came early under Puritan influences, which caused his expulsion in 1662, after two years' study, from Christ Church College, Oxford. Resident on the Continent for the next three years, he had a glimpse of naval service during the Dutch War of 1665, studied at Lincoln's Inn for about a year, and then, 1666, went to Ireland to take charge of several estates owned by his father. There came the great turning point of his life. Hearing the powerful preaching of Thomas Loe, an early Quaker apostle, he began to attend meetings of Friends and was soon in trouble with the authorities, who put him in jail for a time. Released, he was recalled to England by his father. He then became an avowed and active Friend, writing a number of powerful pamphlets—among them *The Sandy Foundation Shaken* (1668) and *No Cross, No Crown* (1669)—directed against luxury, economic oppression, and curbs on religious freedom and rights of free Englishmen. He was again imprisoned for his writings, but in 1670 won an outstanding legal victory for freedom of speech and juries by acting as his own pleader in the noted Bushell's Case. He made missionary tours through Holland, Germany, and England, 1670–80.

Meanwhile, by a series of transactions the American province of West Jersey had come into the hands of Friends, and Penn became one of the trustees to manage the property. The 200 settlers who arrived to found the town of Burlington, 1677, brought with them a statement of "Concessions and Agreements" for their government; this charter was written largely by Penn. It guaranteed the right of petition and jury trial, provided against imprisonment for debt, permitted no capital punishment, and guaranteed religious freedom. Further, it provided for fair treatment of the Indians; and it also announced itself as fundamental law, preeminent over subsequent statutes. The Assembly, which was to dominate the government, was to be freely elected by the settlers each year; its debates were to be public. The proprietors were to appoint the executive, but there was no provision for an executive veto.

Penn's next venture into practical politics was Pennsylvania. He had inherited from his father, besides a considerable fortune immediately available, a large claim for funds loaned to King Charles II. On petition, Penn received in payment, 1681, a great tract of land north of Maryland. The king insisted that it be called

Pennsylvania in honor of the grantee's father. In 1682, Penn received from his friend the duke of York the territory of Delaware, which was first joined to Pennsylvania but later became a separate province. Penn called his new property a "Holy Experiment" and at once set to work to develop it. He sent over his cousin, William Markham, to act as his deputy, 1681, and himself followed the next year. He broadcast proposals to settlers, especially among his converts on the Continent. His terms for purchase or rental of land were very liberal and soon attracted many settlers. Penn's first Frame of Government for his province was dated Apr. 25, 1682, and appended to it a few days later (May 5) were the Laws Agreed Upon in England. The government was not so strikingly democratic as that for West Jersey. Large powers were granted to the Governor's Council as compared with those given the Assembly, yet both were elective and the governor was assigned a rather minor place. Murder and treason were the only capital crimes and complete religious freedom was permitted. The preface stated, "Any Government is free to the People under it (whatever be the Frame) where the Laws rule, and the People are a Party to those Laws." The Pennsylvania Assembly soon became sensitive in claiming its rights. Penn usually acquiesced, though at times he became exasperated by the insistent claims. Penn's brightest record is that of his dealings with the Indians. He took stern measures to protect them against rum and the rapacity of white traders and to ensure fairness in land transactions. The Indians consequently were intensely loyal to him; not until his descendants and successors had betrayed and defrauded them did Pennsylvania know the terrors of frontier warfare. Tradition has fused his several treaties made with the Indians into one great one, "under the elm tree at Shackamaxon," as made famous by Benjamin West's painting. Penn's first stay in Pennsylvania lasted only from 1682 to August 1684, but he accomplished much, looking after affairs of government, superintending the laying out of Philadelphia, building his mansion at Pennsbury, visiting other colonies, preaching, trying to settle the difficult Maryland boundary dispute, and writing a memorable description of the colony (letter to the Free Society of Traders in England, August 1683).

Returning to England, Penn secured from King James II the release of 1,300 Friends from jail, and made a third missionary tour to Holland and Germany. His close friendship with James II made him suspect after the Revolution of 1688, and for the years 1692–94 his governorship of Pennsylvania was forfeited; it was restored when suspicions had abated. During these troubled years he continued to supervise his interests in the New World. He secured a partial settlement of his dispute with Lord Baltimore over boundaries and gave orders in 1689 for establishment of a public grammar school in Philadelphia (the William Penn Charter School). In 1697 he presented to the Board of Trade a plan for uniting the American colonies which included a central congress with limited powers.

Religious and governmental problems arose that demanded his presence in Pennsylvania. His second and last trip, 1699–1701, was marked by a change in the form of government, embodied in the Charter of Privileges, 1701. Separate legislatures were created for Pennsylvania and Delaware; the Council, made appointive, was to be practically an advisory board of the governor; the Assembly, annually elected on a wide suffrage, was to be unicameral legislature and was empowered to convene on its own call. After 1701, Penn, in spite of troubles and disappointments in his personal affairs and with his appointed officials, retained his active proprietorship until apoplexy rendered him incapable ca. 1712.

PENNELL, JOSEPH (*b. Philadelphia, Pa., 1857; d. Brooklyn, N.Y., 1926*), artist, etcher, lithographer. After study at Pennsylvania School of Industrial Art and the school of the Pennsylvania Academy (where he rebelled against the unsympathetic criticisms of Thomas Eakins), Pennell commenced ca. 1880 a long, colorful career as illustrator in Europe and the United States. By precept and example, he fought to raise standards of magazine and book illustration; his own expert draftsmanship and high artistic integrity lent authority to his waspish criticisms of shoddy work by others. Between 1884 and 1912, he was primarily engaged in familiarizing America with the picturesqueness of Europe; thereafter he interpreted the beauty of his own country, in particular the drama of skyscraper cities and great industrial enterprises. His lithographs of the Panama Canal, done in 1912, were among his best work. Returning permanently to the United States in 1917, he pictured the industrial effort of World War I as he had previously lithographed the war work in British plants. His immense output comprised over 900 plates in etching and mezzotint, some 621 lithographs, and innumerable sketches and watercolors. He was the first to make the varied aspects of modern industry recognized subjects for art. He was also author as well as illustrator of a number of books, wrote treatises on illustration and lithography, and published a highly individual autobiography, *The Adventures of an Illustrator* (1925).

PENNEY, J(AMES) C(ASH) (*b. Hamilton, Mo., 1875; d. New York City, 1971*), businessman. In 1902 he opened a dry goods store in a Wyoming mining town and soon expanded the business regionally; in 1912, with thirty-four stores in eight western states, he renamed the chain the J. C. Penney Company. He emphasized low-priced and high quality merchandise, and established an innovative partnership agreement with store managers. By the 1920's he had over 500 stores. Penney lost much of his $40 million personal fortune in the stock market crash, but his chain survived.

PENNIMAN, JAMES HOSMER (*b. Alexandria, Va., 1860; d. Philadelphia, Pa., 1931*), educator, textbook author, bibliophile. Donor of special educational reference libraries to Pennsylvania, Yale, and Brown universities.

PENNINGTON, JAMES W. C. (*b. Maryland, 1809; d. Jacksonville, Fla., 1870*), Congregational and Presbyterian clergyman, teacher. An escaped slave, he gained fame as a learned and eloquent preacher; he was author of *The Fugitive Blacksmith* (1849) and of works on black history.

PENNINGTON, WILLIAM (*b. Newark, N.J., 1796; d. Newark, 1862*), New Jersey lawyer and politician. Son of William S. Pennington. Whig governor of New Jersey, 1837–43; chief figure in Broad Seal War, 1838; congressman, and controversial Speaker of the House, 1859–61.

PENNINGTON, WILLIAM SANDFORD (*b. Newark, N.J., 1757; d. 1826*), lawyer, Revolutionary soldier. New Jersey legislator. Judge, state supreme court, 1804–13; Democratic-Republican governor, 1813–15; federal district judge, 1815–26.

PENNOCK, ALEXANDER MOSELY (*b. Norfolk, Va., 1814; d. Portsmouth, N.H., 1876*), naval officer. Won reputation for executive ability as commander of federal naval base at Cairo, Ill., 1862–64, serving Mississippi gunboat flotilla; promoted rear admiral, 1872.

PENNOYER, SYLVESTER (*b. Groton, N.Y., 1831; d. Portland, Oreg., 1902*), lawyer, businessman. As Democratic governor of Oregon, 1887–95, he advocated compulsory arbitration of labor disputes, a graduated income tax, and a general liberalization of government. He became a Populist in 1892, subsequent to his reelection, and bitterly opposed President Cleveland.

PENNYPACKER, ELIJAH FUNK (*b. Chester Co., Pa., 1804; d. 1888*), farmer. Pennsylvania legislator, abolitionist. President, state antislavery society; made his house near Phoenixville an important Underground Railroad station.

PENNYPACKER, GALUSHA (*b. Chester Co., Pa., 1844; d. Philadelphia, Pa., 1916*), Union soldier. Nephew of Elijah F. Pennypacker. Rose to major general of volunteers; won Congressional Medal for gallantry at Fort Fisher, 1865. Commanded U.S. 16th Infantry, 1869–83.

PENNYPACKER, SAMUEL WHITAKER (*b. Phoenixville, Pa., 1843; d. near Schwenskville, Pa., 1916*), lawyer, jurist, bibliophile, historian. Republican reform governor of Pennsylvania, 1903–07.

PENROSE, BOIES (*b. Philadelphia, Pa., 1860; d. Washington, D.C., 1921*), Pennsylvania Republican politician and legislator. Grandson of Charles B. Penrose; brother of Richard A. F. Penrose and Spencer Penrose. Graduated Harvard, 1881. After writing a scholarly treatise, *The City Government of Philadelphia* (1887), he commenced a long career as a tough, resourceful, often ruthless political boss in Pennsylvania, apparently motivated by a desire for power rather than money. Serving in the U.S. Senate from 1897 until his death, he was chairman of the Senate Finance Committee *post* 1911, and succeeded Matthew S. Quay as leader of the state Republican machine, 1904. He was a consistent supporter of a high protective tariff.

PENROSE, CHARLES BINGHAM (*b. Philadelphia, Pa., 1798; d. Harrisburg, Pa., 1857*), lawyer, politician. Anti-Masonic Whig state senator, 1833–41; solicitor, U.S. treasury, 1841–45; respected member of Philadelphia bar.

PENROSE, RICHARD ALEXANDER FULLERTON (*b. Philadelphia, Pa., 1863; d. Philadelphia, 1931*), geologist. Brother of Boies Penrose and Spencer Penrose. Graduated Harvard, 1884; Ph.D., 1886. Professor of economic geology, University of Chicago, 1892–1911; a founder of Commonwealth Mining and Milling Co. and of Utah Copper Co.

PENROSE, SPENCER (*b. Philadelphia, Pa., 1865; d. Colorado Springs, Colo., 1939*), Colorado mine operator, promoter, philanthropist. Brother of Boies and Richard A. F. Penrose.

PENTECOST, GEORGE FREDERICK (*b. Albion, Ill., 1842; d. Philadelphia, Pa., 1920*), Baptist clergyman, evangelist and author.

PEPPER, GEORGE SECKEL (*b. Philadelphia, Pa., 1808; d. Philadelphia, 1890*), philanthropist. Brother of William Pepper (1810–64). Benefactor of local cultural and charitable institutions; a legacy from his estate was first grant to Free Library of Philadelphia.

PEPPER, GEORGE WHARTON (*b. Philadelphia, Pa., 1867; d. Devon, Pa., 1961*), lawyer and U.S. senator. Attended University of Pennsylvania Law School (LL.B., 1889). For the next twenty-eight years he developed a successful law practice and taught at Pennsylvania while editing and writing legal material. U.S. senator, 1922–27, serving on the Military Affairs, Naval Affairs, and Foreign Relations committees and chairing the committees on Banking and Currency and the Library of Congress. Argued the congressional side in *Myers* v. *United States* (1926), involving the right of the president to remove a postmaster without the approval of Congress, and represented the defendants in *United States* v. *Butler* (1936), which resulted in the invalidation of the Agricultural Adjustment Act.

PEPPER, WILLIAM (*b. Philadelphia, Pa., 1810; d. 1864*), physician, teacher. Brother of George S. Pepper. M.D., University of Pennsylvania, 1832. Physician to the Pennsylvania Hospital, 1842–58, where he took prominent teaching role; professor of medicine, University of Pennsylvania, 1860–64.

PEPPER, WILLIAM (*b. Philadelphia, Pa., 1843; d. Pleasanton, Calif., 1898*), physician, educator, public benefactor. Son of William Pepper (1810–64). Graduated University of Pennsylvania, 1862; M.D., 1864. His early experience was as pathologist to the Pennsylvania Hospital. Beginning as a lecturer on morbid anatomy at the Medical School of the University of Pennsylvania, 1868, he continued to teach there until 1895, becoming professor of clinical medicine, 1876, and professor of the theory and practice of medicine, 1884. Through his efforts, there was founded at Pennsylvania, 1874, the first teaching hospital in the United States closely associated with a university medical school and in which the faculty acted as staff; in 1887 he founded the University Hospital nurses' training school. He outlined his principles of reform in medical education in two notable addresses delivered in 1877 and 1893. In honor of his father, he established and endowed the William Pepper Laboratory of Clinical Medicine, 1894, the first in America to promote advanced clinical studies to the causation of disease. Pepper was one of the first to describe malarial parasites, to call attention to the involvement of the bone marrow in pernicious anemia, and to outline the modern therapeutics of tuberculosis. Among his better-known works were the editorship of *A System of Practical Medicine* (1885–86) and his *Text-Book of the Theory and Practice of Medicine* (1893–94).

In 1880 he was appointed provost of the University of Pennsylvania and soon showed administrative abilities of a high order. In 14 years he raised the university from a loosely organized group of schools to an integrated, modern university, highly esteemed in academic circles. He reorganized the faculties and curricula of the college, the dental school, the law school, and the Towne Scientific School. Further, he was instrumental in founding the Wharton School of Finance, the veterinary school, the school of architecture, the Wistar Institute of Anatomy and Biology, and the Bennett School for the graduate education of women. He built a new library, started departments of hygiene, biology, and physical education, and further developed the graduate school of philosophy. A notable contribution was his creation of the University Extension Lectures, a widely influential experiment in adult education.

PEPPER, WILLIAM (*b. Philadelphia, Pa., 1874; d. Philadelphia, 1947*), physician. Son of William Pepper (1843–98). B.A., University of Pennsylvania, 1894; M.D., 1897. Taught clinical pathology at the school of medicine, University of Pennsylvania, 1907–19; served with distinction and a special gift for harmonious leadership as dean of the school of medicine, 1912–45.

PEPPERRELL, SIR WILLIAM (*b. Kittery Point, Maine, 1696; d. 1759*), baronet, merchant, colonial official, soldier. Pepperell's father, after apprenticeship to the captain of a fishing vessel sailing to the New England coast, became a merchant on the Isle of Shoals and later at Kittery Point. He prospered and took his son into partnership. Thereafter their business grew constantly; they built ships, engaged in trade with the Indies, the southern colonies, and the Mediterranean, and acquired extensive tracts of real estate in Maine, then part of Massachusetts. The younger Pepperell spent much of his time in Boston managing business affairs, became known in the upper social circles, and married a granddaughter of Samuel Sewell, 1723. He was made colonel in charge of the Maine militia, 1726, became a lifelong member

of the Governor's Council the next year, and for 18 years was its president. In 1730, Governor Jonathan Belcher appointed him chief justice of the province. When Governor William Shirley conceived the idea of attacking the French fortress at Louisbourg on Cape Breton, 1744, Pepperell was chosen to command the expedition. Under protection of a British fleet, some 4,000 provincial troops arrived at Cape Breton on Apr. 30, 1745. Although Pepperell had no experience investing a fortress, the troops landed in good style and the inefficient French garrison promptly gave up its main battery. The siege went on amidst much confusion and occasional merriment until the French surrendered on June 17. Pepperell was acclaimed a hero, receiving a baronetcy in 1746, the first granted to an American. He raised troops during the French and Indian War, was made major general, 1755, and lieutenant general, 1759, but did not take part in any battles.

PERABO, JOHANN ERNST (*b. Wiesbaden, Germany, 1845; d. West Roxbury, Mass., 1920*), pianist, composer. Came to America as a child. Studied at Leipzig Conservatory, 1862–65. Especially noted for playing of Beethoven and Shubert, and as a teacher.

PERALTA, PEDRO DE (*b. Spain, ca. 1584; d. Madrid, Spain, 1666*), colonial official. Appointed governor of New Mexico, 1609; founded the settlement of Santa Fe. Engaged in serious disputes with Franciscan missionaries. Returned to Mexico, *ca.* 1613.

PERCHÉ, NAPOLEON JOSEPH (*b. Angers, France, 1805; d. New Orleans, La., 1883*), Roman Catholic clergyman. Came to America, 1837, as missionary in Kentucky; served in New Orleans, La., from 1842; archbishop from 1870. Edited *Le Propogateur Catholique*, 1842–57.

PERCIVAL, JAMES GATES (*b. Kensington, Conn., 1795; d. Hazel Green, Wis., 1856*), poet, geologist. Graduated Yale, 1815; M.D., 1820. Regarded as the ranking American poet until Bryant's *Poems* appeared in 1832. After *Poems* (1821), Percival published *Clio I and II* (1822), *Prometheus Part II with Other Poems* (1822), *Clio III* (1827), and *The Dream of a Day, and Other Poems* (1843). In 1827–28 he aided Noah Webster in revising his dictionary. He was state geologist of Connecticut, 1835–38, and of Wisconsin, 1854–56, publishing reports of his work. Eccentric and impractical, he was one of the most learned men of his time.

PERCIVAL, JOHN (*b. West Barnstable, Mass., 1779; d. 1862*), merchant mariner, naval officer. Called "Roaring Jack." Sailing master of *Peacock* in victory over *Epervier*, 1813; commanded *Constitution* on world cruise, 1844–46.

PERCY, GEORGE (*b. England, 1580; d. England, 1632*), colonial official. Son of Henry Percy, 8th earl of Northumberland. Joined Virginia voyage of December 1606; incapacitated by illness as governor of Virginia, 1609–10; author of two accounts of early Virginia. He left the colony in April 1612.

PERCY, WILLIAM ALEXANDER (*b. Greenville, Miss., 1885; d. Greenville, 1942*), lawyer, planter, author. A representative of the traditional attitudes of enlightened white people in the South, he published, among other works, *Selected Poems* (1930) and an autobiography, *Lanterns on the Levee* (1941). His collected poems were issued posthumously in 1943.

PERDUE, ARTHUR WILLIAM (*b. Whitesburg, Md., 1885; d. Salisbury, Md., 1977*), businessman. Graduated Eastern Shore College (1908) and worked as a miller and railroad man before entering the poultry business in 1917. With the help of his wife,

Pearl Parsons, he built his first hatchery in 1925. Perdue's strict standards for sanitation, feed, and breeding helped him establish a thriving business. He ventured into the broiler business in 1940. His son, Franklin, assumed control of the family business in 1948 and built it into an integrated system in which all aspects of broiler production, including hatching, preparation, processing, and distribution were conducted in-house.

PERELMAN, SIDNEY JOSEPH (*b. New York City, 1904; d. New York City, 1979*), humorist and author. Attended Brown University (1921–24) and worked as a cartoonist and humorist writer for magazines in New York City. In the 1930's he collaborated on two Marx Brothers films and started writing for the *New Yorker*. Perelman's comic essays, which featured his acerbic wit and skilled word play, parodied popular culture. He published several collections of his magazine pieces, including *The Road to Miltown or, Under the Spreading Atrophy* (1957). He also wrote several Broadway plays, including a collaboration for the hit musical *One Touch of Venus* (1943). Perelman despised the Hollywood film industry but won an Academy Award for the script of *Around the World in Eighty Days* (1956).

PEREZ, LEANDER HENRY (*b. Plaquemines Parish, La., 1891; d. Plaquemines Parish, 1969*), politician and segregationist leader. Attended Louisiana State and Tulane Law School, and in 1919 was appointed judge of the Twenty-ninth Judicial District, comprising Plaquemines and St. Bernard parishes. Earned a lasting reputation as a flamboyant, ruthless partisan; elected district attorney for the two parishes (1924), using the post for thirty-six years to enrich himself, manipulate election returns, and perpetuate segregation. An early ally of Huey Long, he was chief defense strategist in Long's successful attempt to avoid impeachment. Broke with the Democratic party in 1948 to form the Dixiecrat party, and founded the White Citizens Council (1954), in the wake of the Supreme Court's desegregation decision, to thwart integration. He resigned in 1960, but continued to battle the civil rights movement as it gained momentum in the 1960's.

PERHAM, JOSIAH (*b. Wilton, Maine, 1803; d. East Boston, Mass., 1868*), showman, railroad executive. First to persuade railroads to issue cheap round-trip excursion fares; first, but unsuccessful, president of Northern Pacific Railroad, 1864.

PERIAM, JONATHAN (*b. Newark, N.J., 1823; d. 1911*), horticulturist, agricultural writer. Removed to Cook Co., Ill., 1838. Edited the *Prairie Farmer*, 1876–84 and 1887–93; wrote or compiled a number of farm reference books.

PERIN, CHARLES PAGE (*b. West Point, N.Y., 1861; d. New York, N.Y., 1937*), geologist, steel engineer. Chiefly associated, *post* 1902, with the Tata Iron and Steel Co., India's first modern steel plant.

PERKINS, CHARLES CALLAHAN (*b. Boston, Mass., 1823; d. near Windsor, Vt., 1886*), art critic, organizer of cultural activities. President, Boston Handel and Haydn Society, 1850–51 and 1875–86; largest subscriber toward Boston Music Hall and benefactor of Museum of Fine Arts.

PERKINS, CHARLES ELLIOTT (*b. Cincinnati, Ohio, 1840; d. Westwood, Mass., 1907*), railroad executive. Son of James H. Perkins; cousin of John Murray Forbes. President, Chicago, Burlington & Quincy Railroad, 1881–1901; added many subsidiary lines and strengthened the road financially.

PERKINS, DWIGHT HEALD (*b. Memphis, Tenn., 1867; d. Lordsburg, N.Mex., 1941*), architect, conservationist. Raised in Chicago, Ill. Attended Massachusetts Institute of Technology,

1885–86; served as instructor in architecture there before returning to Chicago in 1888 to join the firm of Burnham and Root; took charge of the office while Daniel Burnham was serving as chief of construction of the Chicago World's Fair, 1891–93. Opening his own office, 1894, he played a leading role in the movement known as the Chicago school of architecture. As architect to the Chicago Board of Education, 1905–10, he virtually created the modern style of architecture for educational buildings by applying to them the Chicago principles of functionalism and organic design. He continued to work with high distinction until his retirement from active practice in 1936; the most impressive of his later buildings was the Evanston Township High School, 1924.

PERKINS, ELI *See* LANDON, MELVILLE DE LANCEY.

PERKINS, ELISHA (*b. Norwich, Conn., 1741; d. New York, N.Y., 1799*), medical quack. Invented curative "metallic tractors," which were pieces of metal to be drawn over affected areas of the body. "Perkinism" enjoyed international celebrity, 1795–1800.

PERKINS, FRANCES (*b. Boston, Mass., 1880; d. New York, N.Y., 1965*), labor reformer and secretary of labor. Attended Mount Holyoke, New York School of Philanthropy, and Columbia (M.A., 1910). Executive secretary of New York City Consumers' League (1910); executive secretary of the Committee on Safety of the City of New York (1912); and member of N.Y. Industrial Commission (1918–22) and N.Y. Industrial Board (1923–33). She scored a notable success in settling a violent strike of copper workers in Rome, N.Y. (1919), expanded the state's employment agencies, and made herself an expert on unemployment insurance. As U.S. secretary of labor (1933–45), she revived the somnolent Department of Labor, cleaned out the corrupt Bureau of Immigration, strengthened job-placement services, created the Division of Labor Standards to provide guidance to state labor departments, and played a crucial role in achieving the Social Security Act (1935) and Fair Labor Standards Act (1938). Her restraining hand prevented federal intervention in the San Francisco general strike of 1935, but the event gave rise to rumors linking her to radical leader Harry Bridges. The House Un-American Activities Committee launched a campaign to impeach her, but the House tabled the impeachment resolution after a unanimous report from the Judiciary Committee. During World War II she helped protect labor standards and defended her department's cost-of-living index against charges that it discriminated against labor. Her memoir (with Howard Taubman), *The Roosevelt I Knew* (1946) is an enduring contribution to Roosevelt scholarship. She served on the Civil Service Commission (1946–53) and was a visiting professor at the School of Industrial Relations, from 1957.

PERKINS, FREDERIC BEECHER (*b. Hartford, Conn., 1828; d. Morristown, N.J., 1899*), editor, author, and pioneer in library science. Librarian at Boston and San Francisco public libraries, among others.

PERKINS, GEORGE CLEMENT (*b. Kennebunkport, Maine, 1839; d. Oakland, Calif., 1923*), shipowner, banker, California legislator. Removed to California, 1855; incorporated Pacific Coast Steamship Co. Republican governor of California, 1880–83; U.S. senator, 1893–1915.

PERKINS, GEORGE DOUGLAS (*b. Holley, N.Y., 1840; d. 1914*), printer, newspaper publisher and editor. Associated with *Sioux City* (Iowa) *Journal*, 1869–1914; noted for his "lay sermons." Congressman, Republican, from Iowa, 1891–99.

PERKINS, GEORGE HAMILTON (*b. Hopkinton, N.H., 1836; d. Boston, Mass., 1899*), naval officer. Commanded monitor *Chickasaw* during forcing of Mobile Bay forts, successfully engaging Confederate ram *Tennessee*. Promoted commodore after retirement, 1891.

PERKINS, GEORGE HENRY (*b. Cambridge, Mass., 1844; d. 1933*), geologist, educator. Graduated Yale, 1867; Ph.D., 1869. Professor of natural sciences University of Vermont, 1869–1933; dean of the college, *post* 1907. State entomologist, 1880–95; state geologist, 1898–1933.

PERKINS, GEORGE WALBRIDGE (*b. Chicago, Ill., 1862; d. Stamford, Conn., 1920*), banker. Rose from office boy to first vice president of New York Life Insurance Co.; devised an improved agency system and extended firm's business in Europe. Joining J. P. Morgan & Co. in 1901, he took leading part in organizing International Harvester, International Mercantile Marine, Northern Securities Co., and U.S. Steel Corporation. Believed in cooperation and combination rather than competition of small business units. Leaving Morgan, 1910, he joined the Progressive party in 1912 and became chairman of its national executive committee. As chairman of a YMCA finance committee, he raised $200 million for World War I welfare work.

PERKINS, JACOB (*b. Newburyport, Mass., 1766; d. London, England, 1849*), inventor. Devised steel-plate method for printing bank notes, *ca.* 1805; successfully employed process in partnership in London with Gideon Fairman and others *post* 1819; produced first penny postage stamps, 1840. Perkins also patented an innovating high-pressure boiler and engine, and other devices for ships.

PERKINS, JAMES BRECK (*b. St. Croix Falls, Wis., 1847; d. Washington, D.C., 1910*), New York lawyer and politician, historian of France. Congressman, Republican, from New York, 1901–10. Author of a number of deservedly popular and useful surveys of 16th- and 17th-century French history.

PERKINS, JAMES HANDASYD (*b. Boston, Mass., 1810; d. near Cincinnati, Ohio, 1849*), Unitarian clergyman, author, social worker. Nephew of Thomas H. Perkins; father of Charles E. Perkins. Worked with poor of Cincinnati; president, Cincinnati Relief Union, 1841–49.

PERKINS, JAMES HANDASYD (*b. Milton, Mass., 1876; d. Mount Kisco, N.Y., 1940*), banker. Brother of Thomas N. Perkins. President, Farmers Loan and Trust Co., New York, and successor, 1921–33; board chairman, National City Bank, 1933–40.

PERKINS, JUSTIN (*b. Holyoke, Mass., 1805; d. Chicopee, Mass., 1869*), Congregational clergyman. Missionary to Persia *post* 1833; prominent Syriac scholar, author and translator.

PERKINS, MARION (*b. Marche, Ark., 1908; d. Chicago, Ill., 1961*), sculptor. In the late 1930's learned to use clay models, molds, and the mallet and chisel at the South Side Community Art Center in Chicago. Inspired by the art forms of Africa, he was an exponent of black pride through art. His most famous piece, *Man of Sorrows* (1950), is a powerful depiction of a black Christ; other sculptures include *John Henry* (1943), *Ethiopia Awaking* (1948), and *Jean Baptiste Point du Sable*. Although he gained fame from his sculpting, he was never able to support himself through his art, and had to continue working as a freight handler.

PERKINS, MAXWELL EVARTS (*b. New York, N.Y., 1884; d. Stamford, Conn., 1947*), editor. Grandson of Charles C. Perkins and

of William Maxwell Evarts. Graduated Harvard, 1907. After work as a reporter on the *New York Times*, he joined the staff of Charles Scribner's Sons, publishers, as book advertising manager, 1910. As editor of the firm *post* 1914, he sponsored many of the talented writers who expressed the new spirit in American letters that followed on the close of World War I; he was particularly skillful in handling writers of fiction. Among those whom he encouraged and aided were F. Scott Fitzgerald, Ring Lardner, Ernest Hemingway, James Boyd, Marjorie Kinnan Rawlings, and Thomas Wolfe.

PERKINS, SAMUEL ELLIOTT (*b. Brattleboro, Vt., 1811; d. 1879*), jurist, legal writer. Justice, Indiana Supreme Court, 1847–64, 1876–79; wrote *A Digest of the Decisions of the Supreme Court of Indiana* (1858).

PERKINS, THOMAS HANDASYD (*b. Boston, Mass., 1764; d. Boston, 1854*), merchant, philanthropist, Massachusetts Federalist legislator. Commenced profitable trade chiefly with China *ca.* 1790; remained as principal partner in firm until 1838, extending ventures wherever a profit seemed likely. His public and private benefactions were numerous and generous.

PERKINS, THOMAS NELSON (*b. Milton, Mass., 1870; d. Westwood, Mass., 1937*), lawyer, public servant. Brother of James H. Perkins (1876–1940). Practiced in Boston as skilled adviser in corporate reorganizations; participant in formulation of the Dawes and Young plans.

PERLEY, IRA (*b. Boxford, Mass., 1799; d. Concord, N.H., 1874*), lawyer, jurist. Chief justice, New Hampshire Supreme Judicial Court, 1855–59 and 1864–69; wrote *Trial by Jury* (1867).

PERLMAN, PHILIP BENJAMIN (*b. Baltimore, Md., 1890; d. Washington, D.C., 1960*), attorney and government official. Studied at Johns Hopkins University and at the University of Maryland (LL.B., 1911). After serving in Maryland government as secretary of state and state attorney, Perlman was appointed U.S. solicitor general by President Truman in 1947, serving until 1952. He served briefly as U.S. attorney general in 1952. As solicitor general, Perlman argued sixty-one cases before the Supreme Court, winning forty-one. He represented the government in the dispute over Truman's seizure of the steel industry in 1952 (which the government lost) and many cases concerned with racial discrimination.

PERLMAN, SELIG (*b. Bialystok, Poland, 1888; d. Philadelphia, Pa., 1959*), labor economist. Immigrated to the U.S. in 1908. Studied at the University of Naples and the University of Wisconsin (Ph.D., 1915). Taught at the University of Wisconsin from 1919 to 1959. A student and protégé of John Rogers Commons, Perlman helped write sections of the *History of Labor in the United States* (1918). A theorist on the origins of the labor movement, Perlman believed that the greatest enemy of labor was manipulation by intellectuals. He wrote *A Theory of the Labor Movement* in 1928, a work which established him as the leading labor scholar of his generation.

PERRIN, BERNADOTTE (*b. Goshen, Conn., 1847; d. Saratoga, N.Y., 1920*), classical scholar. Graduated Yale, 1869; Ph.D., 1873. Professor of Greek at Western Reserve, 1881–93; of Greek studies at Yale, 1893–1909; made excellent annotated translation of *Plutarch's Lives*.

PERRINE, CHARLES DILLON (*b. Steubenville, Ohio, 1867; d. Villa General Mitre, Argentina, 1951*), astronomer. Privately educated, Perrine became secretary of Lick Observatory in Mount Hamilton, Calif. in 1893; in 1895, assistant astronomer. He dis-

covered nine comets between 1895 and 1902, and in 1905, the sixth and seventh satellites of Jupiter. From 1909 to 1936 he was the director of the Argentine National Observatory at Córdoba. There he attempted to chart the positions of the stars in the southern skies. Although removed from the directorship of the Córdoba Observatory in 1936, his plans for Argentinian astronomy were eventually realized by the Argentinian government.

PERRINE, FREDERIC AUTEN COMBS (*b. Manalapan, N.J., 1862; d. Plainfield, N.J., 1908*), electrical engineer, consultant. Graduated Princeton, 1883; D.Sc., 1885. Organized Department of Electrical Engineering at Stanford as professor, 1893–1900. Designed first long 60-kilovolt transmission line.

PERRINE, HENRY (*b. Cranbury, N.J., 1797; d. Indian Key, Fla., 1840*), physician, U.S. consul, plant explorer. Introduced sisal and henequen from Mexico to southern Florida, 1833.

PERROT, NICOLAS (*b. France, 1644; d. ca. 1718*), explorer. Among first French fur traders to Algonquian tribes at Green Bay, Wis., 1668–70. Won great influence over western tribes and preserved their friendship for France; traded and built forts along the upper Mississippi, 1685–96. He has been called the ablest Indian diplomat of his time.

PERRY, ANTOINETTE (*b. Denver, Colo., 1888; d. New York, N.Y., 1946*), actress, stage director. Best remembered for her gifted and versatile stage direction, principally in association with the productions of Brock Pemberton, and for her encouragement of younger members of the profession. Among many other services, she was a founder and chairman, 1941–44, of the American Theatre Wing War Service and a trustee of the Actors' Fund. The annual "Tony" awards for distinguished work in the theater are made in memory of her.

PERRY, ARTHUR LATHAM (*b. Lyme, N.H., 1830; d. Williamstown, Mass., 1905*), economist, apostle of free trade, text-book writer. Graduated Williams, 1852; taught there, 1854–91.

PERRY, BENJAMIN FRANKLIN (*b. Pendleton District, S.C., 1805; d. 1886*), lawyer, South Carolina legislator, Unionist. Consistently opposed secession, 1832–60, but stood by his state, 1861–65. Appointed provisional governor, 1865, he effected many democratic reforms with tact and wisdom. *Post* 1866, he bitterly opposed congressional Reconstruction.

PERRY, BLISS (*b. Williamstown, Mass., 1860; d. Exeter, N.H., 1954*), professor, author, and editor. Studied at Williams College. Taught at Williams, 1881–1892; at Princeton University, 1893–1900. Editor of the *Atlantic Monthly*, 1900–1909. Professor at Harvard, 1909–1930. Remembered as one of Harvard's best literature teachers.

PERRY, CHRISTOPHER RAYMOND (*b. South Kingstown, R.I., 1761; d. Newport, R.I., 1818*), merchant mariner, naval officer. Father of Matthew C. and Oliver H. Perry.

PERRY, CLARENCE ARTHUR (*b. Truxton, N.Y., 1872; d. New Rochelle, N.Y., 1944*), social worker. B.S., Cornell University, 1899. After a decade of teaching and work with the U.S. Immigration Commission, he joined the staff of the Russell Sage Foundation in 1909. Appointed associate director of the foundation's Department of Recreation, 1913, he remained in that post (except for two years' army service during World War I) until his retirement in 1937. Believing that the public school should serve as a stimulus to neighborhood social cohesion and regeneration, he was active in the community center movement for after-hours use of the school plant for recreational, social, civic,

and adult-educational purposes. His major contribution was in his promotion of the idea and his practice techniques for its implementation. *Post* 1921 he turned to housing and neighborhood unit planning as bases for encouraging cooperative citizenship and transcending the depersonalization of urban society. His ideas were expressed in his *The Neighborhood Unit: A Scheme of Arrangement for the Family Community* (1929).

PERRY, EDWARD AYLESWORTH (*b.* Richmond, Mass., 1831; *d.* Kerrville, Tex., 1889), lawyer, Confederate brigadier general, Democratic governor of Florida, 1885–89.

PERRY, EDWARD BAXTER (*b.* Haverhill, Mass., 1855; *d.* Camden, Maine, 1924), blind concert pianist, author. Studied with Clara Schumann and Liszt. Gave more than 3000 lecture recitals, 1885–1917.

PERRY, ENOCH WOOD (*b.* Boston, Mass., 1831; *d.* New York, N.Y., 1915), portrait and genre painter.

PERRY, MATTHEW CALBRAITH (*b.* Newport, R.I., 1794; *d.* New York, N.Y., 1858), naval officer. Son of Christopher R. Perry; brother of Oliver H. Perry. Entering the navy as midshipman, 1809, he served aboard the *President* and the *United States* during the War of 1812. After varied service, 1820–33, which included convoying settlers to Liberia, destroying pirates in the West Indies, and helping extinguish a conflagration at Smyrna, he was assigned to the Navy Yard at New York.

Serving chiefly ashore, 1833–41, he agitated for a naval apprenticeship system (adopted in 1837); organized, 1833, the U.S. Naval Lyceum to promote learning among naval officers; sponsored the *Naval Magazine*; and was a member of the board of examiners which established the first course of instruction at Annapolis. His continuing interest in better naval equipment led him to advocate steam warships; he is sometimes called the father of the steam navy. Promoted captain in 1837, he was given command of the *Fulton*, a pioneer naval steamship. Later he organized the naval engineer corps and in 1839–40 conducted aboard the *Fulton* at Sandy Hook the first U.S. naval school of gun practice. Perry commanded the American squadron sent to Africa to help suppress the slave trade, 1843, and the naval forces operating on the east coast of Mexico, 1846–47, sharing with General Winfield Scott credit for the capitulation of Veracruz, 1847.

Selected in January 1852, to negotiate a treaty with Japan, a country at that time closed to the West, Perry entered on his most famous work. State Department instructions included as objects of the mission protection of American seamen and property in Japan, and the opening of one or more Japanese ports to American commerce. Perry was requested first to use persuasion, but if this failed, to use "more vigorous methods." Provided with a letter from President Fillmore to the Emperor of Japan, he sailed from Norfolk on Nov. 24, 1852, and in late May 1853, arrived at Napa, Ryukyu Islands, which he made a base. He sailed for Edo (now Tokyo), the Japanese capital, on July 2, with his flagship *Susquehanna* and three other vessels. Deliberately surrounding himself with an aura of mystery, he refused to see a minor official at Edo Bay, insisting upon delivering President Fillmore's letter to a representative of the highest rank. When directed to go to Nagasaki, where foreign business was ordinarily conducted, he refused and threatened to land with an armed force. Finally, on July 14, he delivered the letter and other documents to the princes Idzu and Iwami, representatives of the emperor. Perry said he would return later to receive a reply. The Japanese were conciliatory when he returned to Edo Bay in February 1854, and on Mar. 31 a treaty of peace and commerce was signed at Yokohama, which granted American trading rights at Hakodate and Shimoda. Perry later reported on the mission in *Narrative of the Expedition of an American Squadron to the China Seas and Japan* (1856).

PERRY, NORA (*b.* Dudley, Mass., 1831; *d.* Dudley, 1896), poet, journalist, author of juvenile stories. Best known for the poems "Tying Her Bonnet Under Her Chin" and "After the Ball."

PERRY, OLIVER HAZARD (*b.* South Kingstown, R.I., 1785; *d.* Venezuela, 1819), naval officer. Son of Christopher R. Perry; brother of Matthew C. Perry. Entered service as midshipman, April 1799; saw action during naval war with France aboard the *General Greene*, commanded by his father. During the war with Tripoli he served on the *Adams* and the *Constellation*. Promoted lieutenant, 1807, and master commandant, 1812, he requested duty on the Great Lakes under Commodore Isaac Chauncey. Ordered on Feb. 8, 1813, to proceed to Sackett's Harbor, N.Y., he was assigned to command the naval forces on Lake Erie. Making his own headquarters at Erie, Pa., Perry spent the spring and summer building, equipping, and manning a small fleet, an arduous task because many materials had to be brought overland from the seaboard. By August he was ready with a ten-ship fleet, the largest being two sister brigs of 480 tons, *Lawrence* and *Niagara*. The British naval force commander, Barclay, was blockading the harbor, but at one point relaxed surveillance and Perry escaped over the Erie bar, sailed up the lake, and made a base at a Put-in-Bay, north of Sandusky, Ohio. Barclay's force lay at a station at Amherstburg on the Detroit River. Deciding to force an action for control of Lake Erie, Barclay weighed anchor on Sept. 9; on the following day at sunrise he was sighted by Perry, who sailed from Put-in-Bay to engage the British fleet. Barclay's flagship, *Detroit*, was roughly comparable to Perry's *Lawrence*, and his other main ship, *Queen Charlotte*, to Perry's *Niagara*. The battle was joined late in the morning of Sept. 10. The weather gauge slightly favored Perry, whose fleet also enjoyed superiority in weight of metal. The fleets were roughly equal in number of effective men available. Perry's plan was for his flagship, the *Lawrence*, to engage the *Detroit*; the *Niagara*, the *Queen Charlotte*; and his smaller vessels, their opposite numbers in the British line. The *Lawrence* (flying a battle flag with the words "Don't give up the ship") bore the brunt of the battle for over two hours. When all its guns were disabled and 83 of her 103-man crew were casualties, Perry transferred his flag to the *Niagara*. After a brief further action, the British commander surrendered and Perry sent General W. H. Harrison the famous dispatch "We have met the enemy and they are ours." The victory secured control of Lake Erie, helped in the later invasion of Upper Canada, and also helped the United States to make good its claim to the Northwest at the Treaty of Ghent. Perry died while descending the Orinoco River after concluding negotiations with Venezuela.

PERRY, PETTIS (*b.* Marion, Ala., 1897; *d.* Moscow, Soviet Union, 1964), Communist party functionary. Forced to leave a life of deprivation and racial prejudice in the South (1917), he joined the Communist party in 1932. He rose steadily within the party, heading its National Negro Work Commission (1948) and being elected to its National Committee (1950). Arrested (1951) and tried and found guilty (1952) for attending Communist party meetings, he resumed an active role in party activities after his release from prison (1955), but was never successful in recruiting a mass black following for the party. He died in Moscow while receiving medical treatment for a lung ailment and heart disease.

PERRY, RALPH BARTON (*b.* Poultney, Vt., 1876; *d.* Cambridge, Mass., 1957), philosopher. Educated at Princeton University and at Harvard (Ph.D., 1899). Perry taught at Harvard from 1902

until 1948. Remembered for his editing and scholarship on William James, Perry wrote *The Thought and Character of William James* (1935), for which he received the Pulitzer Prize in 1936. The author of some two dozen books and 200 essays, Perry is remembered as being one of the "Six Realists" in contemporary American philosophy. *The Approach to Philosophy* (1905), *General Theory of Value* (1926) and *Realms of Value*, (1954) are among his best-known works. From 1940 to 1945 Perry was chairman of the Committee of American Defense.

PERRY, RUFUS LEWIS (*b. Smith Co., Tenn., 1834; d. Brooklyn, N.Y., 1895*), Baptist clergyman, black leader, journalist. Editor of the *Sunbeam*, the *People's Journal*, the *American Baptist*, and the *National Monitor* (1872–95).

PERRY, STUART (*b. Newport, N.Y., 1814; d. 1890*), businessman, inventor. Patented, 1846, an improved noncompression gas engine using explosive rosin vapor within the engine cylinder, ignited by an incandescent platinum element.

PERRY, THOMAS SERGEANT (*b. Newport R.I., 1845; d. Boston, Mass., 1928*), author, scholar. Grandson of Oliver H. Perry.

PERRY, WALTER SCOTT (*b. Stoneham, Mass., 1855; d. Stoneham, 1934*), educator, artist. First director, Pratt Institute art school, Brooklyn, N.Y., 1887–1928.

PERRY, WILLIAM (*b. Norton, Mass., 1788; d. Exeter, N.H., 1887*), physician. Devised process for producing potato starch as substitute for imported cotton sizing and manufactured it *post 1824*.

PERRY, WILLIAM FLAKE (*b. Jackson Co., Ga., 1823; d. Bowling Green, Ky., 1901*), educator. First state superintendent of public education in Alabama, 1854–58; built efficient school organization, despite widespread indifference.

PERRY, WILLIAM STEVENS (*b. Providence, R.I., 1832; d. Iowa, 1898*), Episcopal clergyman, historiographer. Consecrated bishop of Iowa, 1876, he served until death. Author of *Historical Collections Relating to the American Colonial Church* (1870–78) and *History of the American Episcopal Church* (1885).

PERSHING, JOHN JOSEPH (*b. near Laclede, Mo., 1860; d. Washington, D.C., 1948*), soldier. Son of a small-town storekeeper, he spent his early childhood amid the alarms of the Civil War. Following graduation in 1886, he joined the 6th Cavalry at Fort Bayard, N. Mex., in the wake of Geronimo's capture, just in time for little skirmishes with a disappearing foe. In 1891 the 6th Cavalry joined in General Nelson A. Miles's campaign to prevent a great Sioux war; although not in the fight at Wounded Knee Creek, Pershing participated in mopping up after the battle. A brief stay at Fort Niobrara, Nebr., ended with his appointment, on Sept. 25, 1891, as professor of military science and tactics, commandant of the university battalion, and teacher of fencing at the University of Nebraska in Lincoln. He also used his time at the university to take a law degree in 1893.

Pershing went to West Point as instructor of tactics in June 1897. He became disliked as a "tac," or instructor, and the cadets nicknamed him "Black Jack." The epithet stemmed from his service with the black 10th Cavalry in Montana and his obvious devotion to the regiment. Unhappy at West Point, Pershing joined a regiment at Chickamauga, Ga., in 1898, and went with it to Cuba, where he took a prominent part in the battle of San Juan and Kettle hills and in operations around Santiago. Upon his return to the United States, he took charge of the Bureau of Insular Affairs, a new division within the War Department. He

then served, 1899–1903, in the Philippines, commanding in the campaign against the Moros on Mindanao.

Called home for service with the General Staff, Pershing attended the Army War College in 1904–05. In February 1905 he was named military attaché in Japan and hence became official American observer of the Russo-Japanese War. In 1906 he was promoted to brigadier general, over more than 800 superiors in the army. Promotion took him again to the Philippines, where he remained, with some time out for home and European service, until 1914. As commander of the Department of Mindanao and governor of the Moro Province, he fought hard battles, but he also encouraged internal improvements and agricultural innovations. When he was recalled to permanent assignment in the United States in 1914, the Moros mourned his departure.

After being stationed briefly in San Francisco, Pershing was assigned to Fort Bliss, Tex., and became entangled in Mexican border problems. From Mar. 16, 1916, until Feb. 6, 1917, he led troops against Pancho Villa, who was never caught, but the relentless quest broke Villa's power. When the United States entered World War I, Pershing was made commander of the American Expeditionary Forces (AEF), with authority to use them as he saw fit, with one restriction: They were to constitute a separate American army. On Sept. 12, 1918, the U.S. 1st Army successfully launched an attack against the powerful Saint-Mihiel salient. Pershing then shifted his army to join the Allied offensive in the Meuse-Argonne — a logistical triumph. The Allied forces struggled on until the German line collapsed. With the armistice on Nov. 11, 1918, active fighting ended.

In September 1919 Pershing returned to the United States as America's most famous general. Rank had come swiftly (major general, Sept. 26, 1916; general, Oct 6, 1917); on Sept. 3, 1919, he was named General of the Army. When, on July 1, 1921, he became chief of staff, his military achievements exceeded those of anyone before him. In 1931 he published *My Experiences in the World War*, which won the Pulitzer Prize for history.

PERSON, THOMAS (*b. Brunswick Co., Va., 1733; d. Franklin Co., N.C., 1800*), surveyor, landowner, North Carolina patriot and legislator.

PERSONS, WARREN MILTON (*b. West De Pere, Wis., 1878; d. Cambridge, Mass., 1937*), economist, statistician. Graduated University of Wisconsin, 1899; Ph.D., 1916. Taught at Wisconsin, Dartmouth, and Colorado, and at Harvard, 1919–28. Innovator in analysis and measurement of business fluctuations.

PETER, HUGH (*b. Cornwall, England, 1598; d. London, England, 1660*), clergyman, B.A., Trinity College, Cambridge, 1617/8; M.A., 1622. A Puritan in sympathy, he left England *ca.* 1629 and was associated with an English congregation at Rotterdam for which he drafted a covenant embodying Congregational principles. Leaving John Davenport in charge of his Rotterdam group, Peter immigrated to New England, 1635, and succeeded Roger Williams as pastor at Salem, Mass., December 1636. A firm supporter of nonseparating Congregationalism, he was active in public affairs and helped settle the differences between John Winthrop and Thomas Dudley. Concerned in the drafting of a legal code for the colony, 1636–37, and in the founding of Harvard, he was appointed one of the three agents from Massachusetts sent to further church reformation in England, 1641. Returning to England, he rose high in the councils of Parliament and Cromwell, was active in the trial of King Charles I, and was executed after the Restoration.

PETER, JOHN FREDERICK (*b. Herrndyck, Holland, 1746; d. Bethlehem, Pa., 1813*), musician, schoolmaster, preacher. Trained as a Moravian minister in Holland, Peter also received

instruction in music, including harmony and musical composition. Arriving at Nazareth, Pa., 1769, he served as a teacher, then became organist at the Brethren's House in Bethlehem, 1770. Leading organizer of musical activities there, he expanded the Collegium Musicum, where works of Mozart, Haydn, and Handel were performed with a full orchestra. He composed more than 30 anthems for chorus, solo, and orchestra which reflected Haydn and showed a tendency toward modern chromatic alteration. He was probably the first composer of serious concerted music in America. Under his direction, Haydn's *Creation* was first performed in full in America, 1811.

PETER, ROBERT (*b. Launceston, Cornwall, England, 1805; d. Winton, Ky., 1894*), physician, chemist. Came to America as a boy; attended the Rensselaer School, Troy, N.Y. Removed to Kentucky, 1832; became professor of chemistry at Morrison College, Lexington, 1833. In 1838 he was elected to the chair of chemistry and pharmacy at Transylvania University, which he held until 1857. As chemist of the Kentucky geological survey of 1854, Peter first noted that the productivity of the bluegrass soils was due to their high phosphorus content and gave excellent descriptions of the phosphatic limestone which underlies these soils. He was chemist also to David D. Owen's surveys of Arkansas and Indiana, and professor at Kentucky University, 1865–87.

PETER, SARAH WORTHINGTON KING (*b. Chillicothe, Ohio, 1800; d. Cincinnati, Ohio, 1877*), philanthropist. Daughter of Thomas Worthington. Converted to Catholicism, 1855, she brought many charitable groups, including Sisters of Mercy and Franciscan Sisters, to work in the Cincinnati area.

PETERKIN, GEORGE WILLIAM (*b. Clear Spring, Md., 1841; d. 1916*), Episcopal clergyman, Confederate soldier. First bishop of West Virginia, 1878–1916; established southern Brazil mission, 1893–99.

PETERKIN, JULIA MOOD (*b. Laurens County, S.C., 1880; d. Orangeburg, S.C., 1961*), writer. Attended Columbia (S.C.) College and Converse College (M.A., 1897). The wife of a plantation owner, she began to write sketches of plantation life that were published in H. L. Mencken's magazine *Smart Set* (1921) and Emily Clark's *Reviewer*. Her first book was *Green Thursday* (1924), a collection of sketches and short stories, and her first novel, *Black April* (1927), made her a leader in the southern literary renaissance. Her best novel, *Scarlet Sister Mary* (1928), won a Pulitzer Prize. After 1939 she devoted herself to the management of the family Lang Syne Plantation.

PETERS, ABSALOM (*b. Wentworth, N.H., 1793; d. New York, N.Y., 1869*), Presbyterian clergyman, editor. A principal founder of American Home Missionary Society, 1826, and of the Union Theological Seminary, New York.

PETERS, CHRISTIAN HENRY FREDERICK (*b. Coldenbüttel, Schleswig, 1813; d. 1890*), astronomer. Study at the University of Berlin and at Göttingen was followed by scientific work in Sicily and Turkey. Arriving in America in 1854, he became director of the observatory at Hamilton College and in 1867 professor of astronomy. There his solar observations were noteworthy, especially his descriptions of sun spots. While engaged in making comprehensive zodiacal charts he discovered 48 new asteroids. About 1876 he undertook to prepare a new edition of the star catalogue in Ptolemy's *Almagest*; it was published in 1915 by a collaborator, Edward Knobel.

PETERS, EDWARD DYER (*b. Dorchester, Mass., 1849; d. Dorchester, 1917*), mining and metallurgical engineer, physician, educator.

PETERS, JOHN ANDREW (*b. Ellsworth, Maine, 1822; d. Bangor, Maine, 1904*), lawyer, Maine legislator. Congressman, Republican, 1867–73; associate justice, state supreme judicial court, 1873–83; chief justice, 1883–1900. Noted for legal learning, fairness, and liberal decisions.

PETERS, JOHN CHARLES (*b. New York, N.Y., 1819; d. Williston, N.Y., 1893*), physician, medical writer. Became prominent homeopathist; was joint editor, *North American Journal of Homeopathy*, 1855–61; dramatically renounced the method, 1861.

PETERS, JOHN PUNNETT (*b. New York, N.Y., 1852; d. 1921*), Episcopal clergyman, archaeologist. Graduated Yale, 1873; Ph.D., 1876. Led University of Pennsylvania expedition to site of ancient Nippur, Babylonia, 1888–90; wrote *Nippur* (1897).

PETERS, MADISON CLINTON (*b. Lehigh Co., Pa., 1859; d. 1918*), clergyman. After holding Reformed, Baptist, and Presbyterian pastorates, he attempted *post* 1907 to reach unorganized religious-minded people in cities through lectures and syndicated newspaper articles.

PETERS, PHILLIS WHEATLEY *See* WHEATLEY, PHILLIS.

PETERS, RICHARD (*b. Liverpool, England, ca. 1704; d. Philadelphia, Pa., 1776*), Church of England, clergyman, provincial official. Immigrated to Philadelphia *ca.* 1735; was secretary of province land office, 1737–60, and prospered in Indian trade. Served Pennsylvania's proprietors as provincial secretary, 1742/3–62, and as provincial councillor, 1749–76; attended Albany Congress, 1754, and Fort Stanwix conference, 1768. Rector of Christ and St. Peter's churches, 1762–75.

PETERS, RICHARD (*b. Philadelphia, Pa., 1744; d. Philadelphia, 1828*), lawyer, Revolutionary patriot, jurist, agriculturist. Nephew of Richard Peters (*ca.* 1704–76). Graduated College of Philadelphia, 1761. Elected secretary of the Board of War by the Continental Congress in June 1776, he served as a leading member of the board until 1781. He was Speaker of the Pennsylvania Assembly, 1789–90, and served in the state senate, 1791–92. As federal district judge for Pennsylvania, 1792–1828, Peters vigorously upheld the powers of the federal government, made important contributions to maritime law, and laid the legal foundations for suits for libel against those attacking the federal government before passage of the Sedition Act of 1798. Wrote *A Discourse on Agriculture: Its Antiquity* (1816), a plea for scientific farming.

PETERS, RICHARD (*b. Germantown, Pa., 1810; d. Atlanta, Ga., 1889*), civil engineer, railroad superintendent, agriculturist, financier. Grandson of Richard Peters (1744–1828). An early and successful promoter of Atlanta, Ga.; built a large flour mill and street railways in that city.

PETERS, SAMUEL ANDREW (*b. Hebron, Conn., 1735; d. New York, N.Y., 1826*), Anglican clergyman, Loyalist. Graduated Yale, 1757. Rector at Hebron, 1760–74. Forced to flee New England by Sons of Liberty, 1774, he resided in England, returning to America in 1805 as agent for land claims of heirs of Jonathan Carver. Author of *A General History of Connecticut* (1781), in which appeared his famous account of the "blue laws."

PETERS, WILLIAM CUMMING (*b. Woodbury, England, 1805; d. Cincinnati, Ohio, 1866*), music publisher, musician. Published Stephen Foster's "Susanna," "Old Uncle Ned," and others.

PETERSON, CHARLES JACOBS (*b. Philadelphia, Pa., 1819; d. Philadelphia, 1887*), editor, publisher, author. Cousin of Henry

Peterson. Founded *Lady's World,* 1840 (known *post* 1848 as *Peterson's Magazine,* a successful imitator of *Godey's Lady's Book.*

PETERSON, HENRY (*b. Philadelphia, Pa., 1818; d. Germantown, Pa., 1891*), editor, publisher, poet. Cousin of Charles J. Peterson. Major owner and chief editor of *Saturday Evening Post,* 1848–73; increased its content of fiction and verse.

PETIGRU, JAMES LOUIS (*b. Abbeville District, S.C., 1789; d. Charleston, S.C., 1863*), lawyer, politician. Graduated South Carolina College, 1809; was admitted to the bar, 1812; served as state attorney general, 1822–30. An outstanding and eloquent opponent of secession and nullification, he remained all his life an intense nationalist and Unionist. Opposing John C. Calhoun's program by pamphlet and speech, he was by 1832 the leader of the Union party. Thereafter he held no judicial or political office (save a two-year term as federal district attorney, 1851–53), but as a superb advocate, he was undisputed head of the state bar. He opposed secession in 1860, but was grieved by Lincoln's policy of coercion. He has been described as "the greatest private citizen that South Carolina has ever produced."

PETRI, ANGELO (*b. Marseilles, France, 1883; d. San Francisco, Calif., 1961*), vintner and businessman. Arrived in the United States in 1895. While he served as president (1912–44) of the family-owned Petri Cigar Company, Marca Petri cigars became known nationally, and by the mid-1920's the firm was the largest cigar manufacturer west of Chicago. After Prohibition he began to revive the family's Petri Wine Company, established in the San Joaquin Valley, by acquiring several wineries in Napa Valley and selling his wine in bulk to bottlers. When his sons took over the two businesses, he acted mainly in an advisory capacity as chairman (until 1956). In 1949 Petri Wine acquired K. Arakelian, the second largest winery in the nation, and the firm was renamed United Vintners, which, with the Italian Swiss Colony label acquired in 1953, became the largest wine-making organization in the world.

PETTENGILL, SAMUEL BARRETT (*b. Portland, Oreg., 1886; d. Springfield, Vt., 1974*), congressman. Graduated Middlebury College (B.A., 1908) and Yale University (LL.B., 1911) and established a law practice in South Bend, Ind. As a Democratic member of the U.S. House of Representatives (1933–39), he was an outspoken opponent of President Franklin Roosevelt. In *Jefferson: The Forgotten Man* (1938), Pettengill warned of the concentration of power in the federal government and espoused the principles of Jeffersonian liberalism.

PETTIGREW, CHARLES (*b. Chambersburg, Pa., 1743; d. Tyrrell Co., N.C., 1807*), Episcopal clergyman. Chief organizer and administrator of his church in North Carolina, 1775–1807; a leading founder of the University of North Carolina.

PETTIGREW, JAMES JOHNSTON (*b. Tyrrell Co., N.C., 1828; d. 1863*), lawyer. Confederate brigadier general. Grandson of Charles Pettigrew. Killed in action on retreat after Gettysburg, where he had succeeded to command of General Henry Heth's division.

PETTIGREW, RICHARD FRANKLIN (*b. Ludlow, Vt., 1848; d. 1926*), lawyer. Raised in Wisconsin. Settled in Sioux Falls, Dakota Territory, 1870; became a prominent member of the territorial legislature. Territorial delegate to Congress, 1881–83; he was U.S. senator from South Dakota, 1889–1901. A nonconformist Republican, he worked to reserve federal forest lands from sale; he also favored government ownership of railroads and telegraph lines, advocated unlimited silver coinage, and opposed

annexation of Hawaii and the Philippines. He was indicted, but never tried, for opposing American entrance into World War I.

PETTIT, CHARLES (*b. near Amwell, N.J., 1736; d. Philadelphia, Pa., 1806*), merchant, New Jersey and Pennsylvania official, fiscal expert, patriot. Assistant quartermaster general, Continental army, 1778–81; instrumental in effecting Pennsylvania's adoption of U.S. Constitution; president, Insurance Co. of North America *post* 1796.

PETTIT, THOMAS MCKEAN (*b. Philadelphia, Pa., 1797; d. Philadelphia, 1853*), Pennsylvania jurist, Democratic politician. Grandson of Charles Pettit and Thomas McKean. Associate and presiding judge of district court for city and county of Philadelphia, 1833–45.

PETTUS, EDMUND WINSTON (*b. Limestone Co., Ala., 1821; d. Hot Springs, N.C., 1907*), lawyer, Confederate brigadier general, Alabama politician. U.S. senator, Democrat, from Alabama, 1897–1907.

PEW, JOHN HOWARD (*b. Bradford, Pa., 1882; d. Ardmore, Pa., 1971*), business executive. Graduated Grove City College (B.S., 1900) and attended Massachusetts Institute of Technology, then joined his family's business, the Sun Oil Company, in 1901. As company president (1912–47) and chairman (1963–71), he oversaw Sun Oil's growth from a small regional firm into a multinational corporation with more than 28,000 employees by the 1970's. He employed a business strategy of vertical integration that saw Sun Oil assume control of most of the steps of oil production and distribution. He also directed the company's technological breakthroughs in high octane gasoline and synthetic rubber.

PEW, JOSEPH NEWTON, JR. (*b. Pittsburgh, Pa., 1886; d. Philadelphia, Pa., 1963*), industrialist and political leader. Attended Cornell (engineering degree, 1908), then entered the family-owned business, Sun Oil Company, serving as vice president (1912–47) and chairman, and as president and chairman of Sun Shipbuilding and Dry Dock Company (from 1917). His contributions to those firms include the "custom blending" pump that delivered gas in nine octane ratings and a gyroscopic instrument that aided in achieving record drilling depths in oil exploration. Known outside the oil industry as a behind-the-scenes strategist of the conservative wing of the Republican party; his massive contributions to campaign funds gave him a major role in party affairs.

PEYTON, JOHN LEWIS (*b. near Staunton, Va., 1824; d. 1896*), lawyer, Confederate agent, author. North Carolina state agent in England, 1861–65, he was critical of Confederate foreign policy, expressing his views in several volumes of reminiscences.

PFAHLER, GEORGE EDWARD (*b. Numidia, Pa., 1874; d. Philadelphia, Pa., 1957*), radiologist. Studied at Bloomsburg State Normal School and at the Medico-Chirurgical College (later part of the University of Pennsylvania School of Medicine). Taught there from 1902. One of the first experimenters and practitioners of radiology in the U.S., Pfahler was the first president of the American College of Radiology, 1922–23.

PFISTER, ALFRED (*b. Zurich, Switzerland, 1880; d. New York, N.Y., 1964*), chemical manufacturer. Attended Chemical Institute of the University of Basel (Ph.D., 1903). With Jacques Wolf and Company in New Jersey (1914–32); under his presidency the company developed new lines of textile chemicals and captured a share of the lucrative U.S. market for synthetic organic chemicals. Started Pfister Chemical in 1932, producing chemi-

cals for use in bactericides, fungicides, and cancer chemotherapy; during World War II produced napalm for the Chemical War Service.

PFUND, AUGUST HERMAN (*b. Madison, Wis., 1879; d. Baltimore, Md., 1949*), physicist. B.S., University of Wisconsin, 1901; Ph.D., Johns Hopkins University, 1906. Taught at Johns Hopkins *post* 1906; appointed professor, 1927; headed physics department from 1938 until his retirement in 1947. His innovative and exacting research established a firm foundation for the subsequent development of infrared technology.

PHELAN, DAVID SAMUEL (*b. Sydney, Nova Scotia, 1841; d. St. Louis, Mo., 1915*), Roman Catholic clergyman, journalist. Edited the *Western Watchman*, a militant newspaper published at St. Louis, 1868–1915; scored American Protective Association; upheld liberal point of view in politics and church polity; bluntly criticized hierarchy.

PHELAN, JAMES (*b. Queen's Co., Ireland, 1824; d. San Francisco, Calif., 1892*), merchant, capitalist. Came to America as a child; prospered in New York; established himself as general merchant in San Francisco, 1849. Organized First National Gold Bank, 1870, and other banks and insurance companies.

PHELAN, JAMES (*b. Aberdeen, Miss., 1856; d. Nassau, Bahamas, 1891*), lawyer, author. Ph.D., Leipzig, 1878. Published *Memphis Avalanche*, 1881–91; wrote *History of Tennessee* (1888). As congressman, Democrat, from Tennessee, 1887–91, Phelan opposed traditional Southern views on the tariff and black rights.

PHELAN, JAMES DUVAL (*b. San Francisco, Calif., 1861; d. Saratoga, Calif., 1930*), California politician, banker. Son of James Phelan (1824–92). Elected mayor of San Francisco in 1897 and reelected twice as a reform candidate, he vigorously attacked the corrupt board of supervisors and provided leadership in drafting and adopting a new city charter. He was also responsible for the beautifying of the city and for the "Burnham Plan," from which came San Francisco's present civic center. At his own expense he took steps to secure the city's water supply in the Hetch Hetchy Valley. As a Democrat in the U.S. Senate, 1915–21, he supported Wilson, but favored separation of the League of Nations Covenant from the Versailles Treaty.

PHELPS, ALMIRA HART LINCOLN (*b. Berlin, Conn., 1793; d. Baltimore, Md., 1884*), educator. Sister of Emma H. Willard. Author of popular elementary science textbooks, among them *Botany for Beginners* (1833) and *Lectures on Chemistry* (1837).

PHELPS, ANSON GREENE (*b. Simsbury, Conn., 1781; d. New York, N.Y., 1853*), metals merchant, philanthrophist. Senior partner of Phelps, Dodge & Co., *post* 1832; important in development of Pennsylvania iron and Lake Superior copper mines.

PHELPS, AUSTIN (*b. West Brookfield, Mass., 1820; d. Bar Harbor, Maine, 1890*), Congregational clergyman. Professor of sacred rhetoric and homiletics at Andover Seminary, 1848–79; aligned himself with conservatives at Andover.

PHELPS, CHARLES EDWARD (*b. Guilford, Vt., 1833; d. Baltimore, Md., 1908*), lawyer, jurist, Union soldier, Maryland congressman. Son of Almira H. L. Phelps. Judge of supreme bench of Baltimore, 1882–1908; wrote *Juridical Equity* (1894).

PHELPS, EDWARD JOHN (*b. Middlebury, Vt., 1822; d. New Haven, Conn., 1900*), lawyer. Graduated Middlebury College, 1840. Kent Professor of Law at Yale, 1881–85 and 1889–1900.

U.S. ambassador to Great Britain, 1885–89; U.S. counsel in 1893 fur-seal arbitration with Great Britain.

PHELPS, ELIZABETH STUART *See* WARD, ELIZABETH STUART PHELPS.

PHELPS, GUY ROWLAND (*b. Simsbury, Conn., 1802; d. Hartford, Conn., 1869*), physician. Founded Connecticut Mutual Life Insurance Co., 1846; did much to popularize mutual system of insurance.

PHELPS, JOHN SMITH (*b. Simsbury, Conn., 1814; d. 1886*), lawyer, Missouri legislator, Union soldier. Removed to Missouri, 1837. Congressman, Democrat, 1845–63; governor of Missouri, 1877–81. A consistent Unionist, and a faithful, honest public servant.

PHELPS, OLIVER (*b. Poquonock, Conn., 1749; d. Canandaigua, N.Y., 1809*), merchant Massachusetts legislator. Speculated on credit, 1788–96, in millions of acres of western lands, mostly in western New York. Partner of Nathaniel Gorham.

PHELPS, THOMAS STOWELL (*b. Buckfield, Maine, 1822; d. New York, N.Y., 1901*), naval officer. Made careful surveys of waterways preparatory to military operations during Civil War, especially of Potomac and York rivers and Pamlico Sound in 1861. Retired as rear admiral, 1884.

PHELPS, WILLIAM FRANKLIN (*b. Auburn, N.Y., 1822; d. St. Paul, Minn., 1907*), educator. Headed normal schools in New Jersey, Minnesota, and Wisconsin. First president, American Normal School Association, 1858–63.

PHELPS, WILLIAM LYON (*b. New Haven, Conn., 1865; d. New Haven, 1943*), educator, literary critic, lecturer. B.A., Yale, 1887; M.A., Harvard, 1891; Ph.D., Yale, 1891. As teacher of English literature at Yale, 1892–1933 (professor *post* 1901), he led the movement for informality and geniality in the classroom and for the inclusion of contemporary fiction and drama in the curriculum of study. An unashamed popularizer of literature, he championed the joys of reading in his courses of public lectures, his monthly essay column in *Scribner's Magazine* entitled "As I Like It," in a syndicated newspaper feature, and in radio addresses. Typical of his books, which were made up largely of his magazine essays and lectures, was *Essays on Modern Novelists* (1910).

PHELPS, WILLIAM WALTER (*b. Dundaff, Pa., 1839; d. Englewood, N.J., 1894*), lawyer. Congressman, Republican from New Jersey, 1873–75 and 1883–89. U.S. minister to Austria–Hungary, 1881; to Germany, 1889–93.

PHILIP (*d. Bristol, R.I., 1676*), Indian leader, known also as King Philip, Po-Metacom, and Metacomet. Son of Massassoit, he became sachem of the Wampanoag in 1662, and for nine years behaved peaceably. From 1671 to 1675 he was suspected of plotting against the settlers, and when the latter executed three Wampanoag for killing Sassamon, Philip's former secretary who had revealed his alleged plots, the conflict known as King Philip's War began in June 1675. With his allies, the Nipmuck, he killed many colonists and burned several towns after ineffectual resistance. He again fell upon the Massachusetts towns in 1676, but the colonial troops now turned to a policy of capturing Indian women and children, destroying Indian crops, and offering immunity to deserters. After the dwindling away of his forces, Philip sought refuge in a swamp near Mount Hope, where he was shot by an Indian serving under Capt. Benjamin Church.

PHILIP, JOHN WOODWARD (*b. Kinderhook, N.Y., 1840; d. 1900*), naval officer. Graduated U.S. Naval Academy, 1861. As captain of USS *Texas* during battle of Santiago Bay, 1898, he ordered, "Don't cheer, men, those poor devils are dying." Promoted rear admiral, 1899, he commanded the Brooklyn (N.Y.) Navy Yard at his death.

PHILIPP, EMANUEL LORENZ (*b. Sauk Co., Wis., 1861; d. 1925*), businessman, transportation expert. Served with distinction as governor of Wisconsin, 1915–21; although a "regular" Republican, he respected previous Progressive legislation.

PHILIPS, JOHN FINIS (*b. Boone Co., Mo., 1834; d. 1919*), lawyer, Union soldier. One of "Big Four" Democratic leaders of Missouri *post* 1874. Served as congressman, 1875–77 and 1880–81; as federal district judge, 1888–1910.

PHILIPS, MARTIN WILSON (*b. Columbia, S.C., 1806; d. Oxford, Miss., 1889*), Mississippi agriculturist, reformer. Urged introduction of fruit trees and use of improved agricultural implements.

PHILIPSE, FREDERICK (*b. Friesland, Holland, 1626; d. 1702*), merchant, New York colonial official. Immigrated to New Amsterdam, probably 1647. Acquired fortune through Indian trade, manufacture of wampum, importation of slaves, and Madagascar trade. Assembled extensive Hudson River landholdings, erected into manor of Philipsburgh, 1693.

PHILIPSON, DAVID (*b. Wabash, Ind., 1862; d. Boston, Mass., 1949*), rabbi, leader in American Reform Judaism. Raised in Dayton and Columbus, Ohio. Graduated University of Cincinnati, B.A., 1883; graduated in the same year from Hebrew Union College and was ordained a rabbi; D.D., Hebrew Union, 1886. Served at Har Sinai Temple, Baltimore, Md., 1884–88, and at Bene Israel, Cincinnati, Ohio, 1888–1938. A prolific writer, translator, and editor, he stressed two themes in his works and his ministry: liberal Judaism and Americanism. A man of ecumenical goodwill, he held the firm conviction that the bond of Judaism was religious, not political, national, or racial; he was strongly opposed to Zionism.

PHILLIPS, DAVID GRAHAM (*b. Madison, Ind., 1867; d. New York, N.Y., 1911*), novelist, journalist. Author of muckraking magazine exposés; also of a number of "problem" novels, of which the most ambitious was *Susan Lenox: Her Fall and Rise* (1917).

PHILLIPS, FRANCIS CLIFFORD (*b. Philadelphia, Pa., 1850; d. Ben Avon, Pa., 1920*), chemist. Professor of chemistry, Western University of Pennsylvania, 1875–1915; worked on standardization and improvement of methods of analysis.

PHILLIPS, FRANK (*b. Scotia, Greeley Co., Nebr., 1873; d. Atlantic City, N.J., 1950*), oil industry executive. Successful in both oil production and banking in and about Bartlesville, Okla., *post* 1903, he and his brother Lee E. Phillips organized and incorporated Phillips Petroleum Co., June 1917. Under his guidance as president (chairman of the board *post* 1938), the company pioneered in new production techniques and grew into the ninth largest oil corporation in the United States. He was a generous patron of educational institutions and the founder of the Woolaroc Museum.

PHILLIPS, GEORGE (*b. probably South Rainham, England, 1593; d. Watertown, Mass., 1644*), clergyman. An original settler of Watertown, 1630, he drafted covenant of the church there, and was pastor, 1630–44. First Massachusetts minister to practice congregational form of church polity.

PHILLIPS, HARRY IRVING (*b. New Haven, Conn., 1889; d. Milford, Conn., 1965*), journalist. Began as a cub reporter for New Haven Register; became a copy boy at the *New York Globe* (1917); and started a syndicated column (1918). The *Globe* was sold to the *New York Sun* (1923), and he became the *Sun's* star columnist (until 1950). His column was written with a gentle touch more typical of rural philosophers than the sophisticated cynicism of New York columnists. Evils, in his opinion, were the national debt, income taxes, fireside chats, and Eleanor Roosevelt. Prior to World War II, he wrote radio sketches, skits for Broadway musicals, and several books, including *The Globe Trotter* (1924) and *On White or Rye* (1941). During the war he introduced the character "Private Oscar Purkey," and the Purkey columns appeared in several book collections. Later he wrote for Bell McClure Syndicate.

PHILLIPS, HENRY (*b. Philadelphia, Pa., 1838; d. 1895*), numismatist, philologist, translator. Author of, among numerous other works, *Historical Sketches of the Paper Currency of the American Colonies* (1865) and *Continental Paper Money* (1866).

PHILLIPS, JOHN (*b. Andover, Mass., 1719; d. 1795*), land speculator, moneylender, philanthropist. Uncle of Samuel Phillips. Graduated Harvard, 1735. After making liberal gifts to Dartmouth College, he incorporated and endowed Phillips Exeter Academy, 1781; it opened in 1783. Phillips patterned his new school after Phillips Academy, Andover, but reserved to himself much power over the school's affairs.

PHILLIPS, JOHN SANBURN (*b. Council Bluffs, Iowa, 1861; d. Goshen, N.Y., 1949*), magazine editor and publisher. Raised in Galesburg, Ill., B.A., Knox College, 1882; B.A., Harvard, 1885; studied also at University of Leipzig. Associated *post* 1886 with Samuel S. McClure as working editor and general manager of the McClure Syndicate, of *McClure's Magazine*, 1893–1906, and of the publishing firm of McClure, Phillips and Co., 1900–06. Differing over company policy with McClure, he left him in 1906 to join with various staff writers of *McClure's Magazine* in purchasing the *American Illustrated Magazine*, which was renamed the *American Magazine*. After its sale to the Crowell Publishing Co., 1911, he continued on as editor of the *American* until 1915, serving thereafter as consulting editor until 1938. Much of the success of *McClure's* was owing to Phillips' practical editorial talents and day-to-day thoroughness.

PHILLIPS, LENA MADESIN (*b. Nicholasville, Ky., 1881; d. Marseilles, France, 1955*), lawyer and women's organization leader. Studied at Women's College of Baltimore (later Goucher), at the University of Kentucky Law School (LL.B., 1917), and at New York University (LL.M., 1923). Founder of the National (1919) and International (1930) Federation of Business and Professional Women's Clubs. President of the national organization, (1926–29), and of the international, (1930–47). President of the National Council of Women, 1931–35. After World War II, she was consultant to the U.N. Economic and Social Council and chairwoman of the First International Conference on Public Information.

PHILLIPS, PHILIP (*b. Cassadaga, N.Y., 1834; d. Delaware, Ohio, 1895*), singing evangelist, composer, and compiler of hymns.

PHILLIPS, SAMUEL (*b. Northern Andover, Mass., 1752; d. Andover, Mass., 1802*), educator, public official. Nephew of John Phillips. Graduated Harvard, 1771. Delegate to Massachusetts

Provincial Congress, 1775, and to state constitutional convention, 1779–80; served in state senate, 1780–1801. Securing financial aid from his uncle and father, he established, 1777, at Andover a unique endowed academy, controlled by a board of trustees, the majority of whom were laymen. The first object of Phillips Academy was "the promotion of true Piety and Virtue," that is, character, which emphasis showed the influence of John Locke and English nonconformist academies. The school opened in April 1778 with Eliphalet Pearson as principal.

PHILLIPS, THOMAS WHARTON (*b. near Mount Jackson, Pa., 1835; d. New Castle, Pa., 1912*), oil producer. Republican congressman, religious writer. Leading member of U.S. Industrial Commission, 1898–1902.

PHILLIPS, ULRICH BONNELL (*b. La Grange, Ga., 1877; d. 1934*), educator, historian. Graduated University of Georgia, 1897; Ph.D., Columbia, 1902. Taught history at Wisconsin, at Tulane, and at Michigan, 1911–29; thereafter, he was professor of history at Yale. Phillips's many articles and books were pioneering studies in the history of the South up to the Civil War; he was especially concerned with establishing the facts about the plantation system and slavery. His *Life and Labor in the Old South* (1929) was the first volume in a projected history of the South, which he did not live to complete.

PHILLIPS, WALTER POLK (*b. near Grafton, Mass., 1846; d. Vineyard Haven, Mass., 1920*), telegrapher, journalist. Devised Phillips Telegraphic Code for news transmission, 1879. Became managerial head of the United Press organization early in the 1880's; utilized independent wires, made alliances with foreign news agencies, and led the United Press forces during their "war" with the Associated Press, 1893–97. Thereafter, on the collapse of the United Press, he was prominent in the Columbia Graphophone Co.

PHILLIPS, WENDELL (*b. Boston, Mass., 1811; d. Boston, 1884*), lawyer, orator, reformer. Graduated Harvard, 1831. Becoming a rabid abolitionist, he first gained notice for a passionate speech in Faneuil Hall, 1837, at a meeting called to protest the murder of Elijah P. Lovejoy. A fairly consistent disciple of William L. Garrison, Phillips traveled extensively on the lyceum circuit. His language on the subject of slavery became increasingly intemperate through the 1840's and 1850's; he assailed the Constitution as a protector of reaction and ultimately called for secession by the North. After the Civil War he turned to a succession of other causes, among them prohibition and fair treatment for the Indians. His zeal for the labor movement led him to denounce the profit-and-wage system vehemently; he wrote *The Labor Question* (1884).

PHILLIPS, WILLARD (*b. Bridgewater, Mass., 1784; d. Cambridge, Mass., 1873*), lawyer, insurance executive, author. Zealous advocate of protective tariffs; wrote *Manual of Political Economy* (1828) and *Propositions Concerning Protection and Free Trade* (1850).

PHILLIPS, WILLIAM (*b. Beverly, Mass., 1878; d. Sarasota, Fla., 1968*), diplomat who served under every president from Theodore Roosevelt to Harry Truman. Attended Harvard (B.A., 1900) and Harvard Law. During a forty-four-year career, alternated between appointments in the Foreign Service and the State Departments; positions he held included ambassador to Belgium and Luxembourg (1924–27), Italy, (1936–40), and India (1942–44); resident director of the Office of Strategic Services; and ambassador to Supreme Headquarters, Allied Expeditionary Force (1940), working closely with Gen. Dwight Eisenhower. He officially retired in 1944. Assigned (1946) to the twelve-man

Anglo-American Committee on Palestine, which reviewed the problem of Jewish refugees still detained in Europe. During a long retirement, wrote his memoir, *Ventures in Diplomacy* (1952).

PHILLIPS, WILLIAM (*b. Boston, Mass., 1750/1; d. Boston, 1827*), merchant, philanthropist, Federalist politician. Cousin of Samuel Phillips. Lieutenant governor of Massachusetts, 1812–23; generous benefactor of Phillips Academy, Andover; president, American Bible Society.

PHILLIPS, WILLIAM ADDISON (*b. Paisley, Scotland, 1824; d. 1893*), lawyer, Union soldier, journalist. Immigrated to Illinois as a boy. Won reputation as New York *Tribune* correspondent in Kansas, 1855; served in Kansas legislature. As Republican congressman from Kansas, 1873–79, he advocated then radical economic and reform policies.

PHINIZY, FERDINAND (*b. Oglethorpe Co., Ga., 1819; d. Athens, Ga., 1889*), cotton merchant, financier.

PHIPPS, HENRY (*b. Philadelphia, Pa., 1839; d. Great Neck, N.Y., 1930*), bookkeeper, steel manufacturer, philanthropist. From 1867 to 1901, Phipps was a close business associate of Andrew Carnegie, serving principally as a conservative financial adviser in Carnegie's operations.

PHIPPS, LAWRENCE COWLE (*b. Amityville, Pa., 1862 d. Santa Monica, Calif., 1958*), industrialist and politician. With only a high school education, Phipps went to work for the Carnegie Steel Company in 1879, rising eventually to vice president and treasurer. After the company was sold in 1901, Phipps took his earnings and moved to Colorado, becoming active in local Republican politics. He was elected to the U.S. Senate in 1918 and served until 1930. A conservative, Phipps supported President Coolidge, was for restrictive immigration and protective trade measures, and was chairman of the Committee on Education. He was forced from politics when it was learned that he received the support of the Ku Klux Klan.

PHIPS, WILLIAM (*b. Maine frontier of Massachusetts, 1650/1; d. London, England, 1694/5*), baronet, colonial official. Apprenticed early to a ship's carpenter in Boston, he followed that trade there. Successful in command of an expedition to raise a Spanish treasure ship off Haiti, he was knighted in 1687. *Post* 1688, he worked with Increase Mather for restoration of the old charter rule in the colony; in 1690, he won a spectacular victory over the French by capturing Port Royal in Nova Scotia. When William III granted a new charter to Massachusetts, Phips, on the nomination of Increase Mather, was made the first royal governor. Arriving at his post in May 1692, he abruptly halted the witchcraft trials. He alienated important political factions in the colony by highhanded actions, and the crown by refusing to enforce customs regulations and by failing to protect the colony's frontiers.

PHISTERER, FREDERICK (*b. Stuttgart, Germany, 1836; d. Albany, N.Y., 1909*), soldier. Immigrated to America, 1855; joined U.S. Army in that year. Rose from private to captain, winning fame at Stone's River, 1862. Resigning regular commission, 1870, he rose to brevet major general in New York National Guard.

PHOENIX, JOHN See DERBY, GEORGE HORATIO.

PHYFE, DUNCAN (*b. Scotland, 1768; d. New York, N.Y., 1854*), cabinetmaker. After apprenticeship to a cabinetmaker in Albany, N.Y., he moved to New York City and was established in his own

shop at 2 Broad St. by 1792. Combining the talents of an artist with those of a businessman, he soon built up a prosperous concern in which his sons eventually joined him as partners. Critics believe that he was the equal of the famous 18th-century English masters; his work in mahogany is unsurpassed. Starting with indebtedness to English contemporaries, he developed a unique style influenced strongly by the French Directoire and early Empire styles. Phyfe did his best work early in his career, afterward succumbing to the demand for so-called American Empire, which degenerated into heavy, commonplace forms called "butcher furniture" by Phyfe himself.

PHYSICK, PHILIP SYNG (*b. Philadelphia, Pa., 1768; d. 1837*), surgeon. Grandson of Philip Syng. Graduated University of Pennsylvania, 1785. Studied medicine with Adam Kuhn, in London with John Hunter, and at Edinburgh, M.D., 1792. Returning to Philadelphia, he slowly built a solid practice, helped by his close friendship with Benjamin Rush and Stephen Girard. Elected to the staff of Pennsylvania Hospital in 1794, he served there until 1816; he also lectured on surgery at the University of Pennsylvania, 1801–19. Among his advances in surgery were the invention of the needle forceps for tying deeply placed blood vessels, a snare for tonsillectomy, and new forms of catheters in surgery of the urinary tract.

PIATIGORSKY, GREGOR (*b. Ekaterinoslav, Ukraine, 1903; d. Los Angeles, Calif., 1976*), violoncellist. Received cello instruction from his father and in 1917 secured the first cello chair with the Imperial Opera orchestra in Moscow. He fled the Bolshevik regime in 1921 and later performed with the Berlin Symphony. In 1928 Piatigorsky started touring internationally as a cello virtuoso, delivering a celebrated performance with the New York Philharmonic at Carnegie Hall in 1929. In the ensuing decades he played with practically every major symphony orchestra and conductor in the world. He became a U.S. citizen in 1942. From 1961 to 1976 he performed chamber music throughout the United States with violinist Jascha Heifetz; the duet won several Grammy awards for its recordings. Piatigorsky taught at the University of Southern California from 1962 until his death, and his influence as a teacher and performer helped transform the cello into a versatile solo musical instrument.

PIATT, DONN (*b. Cincinnati, Ohio, 1819; d. near West Liberty, Ohio, 1891*), journalist, Union soldier. Founder and editor of the weekly *Capital*, published at Washington, D.C., 1871–80; exposed weaknesses and corruption of both Republicans and Democrats.

PIATT, JOHN JAMES (*b. James' Mills, Ind., 1835; d. Cincinnati, Ohio, 1917*), poet, U.S. consul, journalist. Coauthor with William Dean Howells of *Poems of Two Friends* (1860); author of a number of volumes of later work, 1866–97.

PIATT, SARAH MORGAN BRYAN (*b. Lexington, Ky., 1836; d. Caldwell, N.J., 1919*), poet. Wife of John J. Piatt.

PICCARD, JEAN FELIX (*b. Basel, Switzerland, 1884; d. Minneapolis, Minn., 1963*), organic chemist and aeronautical engineer. Attended University of Basel, Swiss Institute of Technology (D.Sc., 1909), and Munich. Taught at Munich, Lausanne, Chicago, and Massachusetts Institute of Technology, from 1914 to 1929. Formed Hercules Powder Company (1919); became head of the chemical service department (1929–32). Was naturalized in 1931. Interested in the scientific uses of balloons, and while at Bartol Research Foundation, he ascended over 57,000 feet, returning with data on radiation at various levels (1934). At the University of Minnesota (1936–52), he pioneered the use of blasting caps to sever mooring ropes and release ballast; developed the prototype of the "Skyhook" balloons (1946–47) used for meteorological research; and produced a frost-resistant window and a gas valve to prevent explosions of hydrogen gas.

PICK, LEWIS ANDREW (*b. Brookneal, Va., 1890; d. Washington, D.C., 1956*), army officer and engineer. Studied at Virginia Polytechnic Institute. Commissioned in the army during World War I, Pick remained in the Army Corps of Engineers until his retirement in 1953. He served in the Philippines, taught at various army colleges, and was appointed Missouri River engineer in 1942–43 and 1945–49. During World War II Pick gained international fame for constructing the famous Ledo Road from India into Burma, one of the great engineering feats of military history which enabled the Allies to reenter Burma.

PICKARD, SAMUEL THOMAS (*b. Rowley, Mass., 1828; d. Amesbury, Mass., 1915*), printer, author. Coeditor of *Portland* (Me.) *Transcript*, 1855–95; author of *Life and Letters of John Greenleaf Whittier* (1894).

PICKENS, ANDREW (*b. near Paxtang, Pa., 1739; d. Tomassee, S.C., 1817*), Revolutionary soldier. Defeated Loyalist force at Kettle Creek, Ga., 1779; took prominent part in battles of Cowpens and Eutaw Springs.

PICKENS, FRANCIS WILKINSON (*b. Colleton District, S.C., 1805; d. near Edgefield Court House, S.C., 1869*), lawyer, politician. Grandson of Andrew Pickens. Studied at Franklin College, Georgia, and South Carolina College. Passionately attached to Thomas Cooper's states' rights doctrines, he wrote extensively under pen names "Sydney" and "Hampden" urging South Carolina to implement nullification principles, 1827–30; he replied forcefully, 1832, to Jackson's nullification proclamation. As a congressman, Democrat, 1834–43, he led in protecting acceptance of abolitionist petitions. A leader of the secession movement growing out of dissatisfaction with the Compromise of 1850, he later became more moderate. After Lincoln's election, however, he urged immediate secession and served as Confederate governor of South Carolina, December 1860–1862.

PICKENS, ISRAEL (*b. near Concord, N.C., 1780; d. near Matanzas, Cuba, 1827*), lawyer. Congressman, Democrat, from North Carolina, 1811–17. Removed to Alabama, 1818, where he was anti-Crawford governor, 1821–25. First opposed, then tolerated, a state-owned banking system; helped found University of Alabama.

PICKENS, WILLIAM (*b. Anderson County, S.C., 1881; d. at sea, 1954*), educator and government administrator. Studied at Talladega College, Ala., at Yale University (B.A., 1904), where he was the first black elected to the Yale chapter of Phi Beta Kappa, and at Fisk University (M.A., 1908). After several years of teaching, he became dean and, later, vice president of Morgan State College, Baltimore, Md. Pickens was a member of the original Committee of 100 of the NAACP; in 1920, he became field director of the organization, a position he held until 1940. In 1941, he became chief of the Inter-racial Section of the Savings Bond Division of the U.S. Treasury. Although he was charged by Martin Dies as being a communist, he worked to become an effective head of the bond sales program. He retired in 1952.

PICKERING, CHARLES (*b. Susquehanna Co., Pa., 1805; d. 1878*), physician, naturalist. Chief zoologist, Wilkes South Seas Exploring Expedition, 1838–42; author of reports on geographical distribution of men, animals, and plants based on the expedition's findings and on later research.

PICKERING, EDWARD CHARLES (*b. Boston, Mass., 1846; d. 1919*), astronomer. Graduated Lawrence Scientific School, Harvard, 1865; taught physics at Massachusetts Institute of Technology, 1866–77. Director of the Harvard Observatory, 1877–1919, where he pioneered in using methods of physics to extend knowledge of stellar structure and evolution. Using Harvard's large instruments, Pickering developed the art of photometry, using the meridian photometer to establish the magnitudes of stars by instrumental rather than visual means. He thus catalogued the magnitudes of 80,000 stars and further compiled a photographic library of about 300,000 plates, which captured all stars down to the eleventh magnitude. He also pioneered in stellar spectroscopy.

PICKERING, JOHN (*b. Newington, N.H., ca. 1738, d. 1805*), New Hampshire legislator and jurist. Appointed U.S. district court judge for New Hampshire, 1795, he was impeached and removed in 1804 for partisan reasons, although actually suffering from mental collapse.

PICKERING, JOHN (*b. Salem, Mass., 1777; d. Boston, Mass., 1846*), lawyer, philologist. Son of Timothy Pickering. Graduated Harvard, 1796. Author of the first collection of American word usages (1816) and the outstanding *Comprehensive Lexicon of the Greek Language* (1826, 1829, 1846). Authority on American Indian languages.

PICKERING, TIMOTHY (*b. Salem, Mass., 1745; d. Salem, 1829*), soldier, administrator, politician. Graduated Harvard, 1763. An early supporter of the independence movement, he displayed great ability as a newspaper controversialist and pamphleteer. As colonel of Massachusetts militia, he took part in the operations of April 1775, was assigned to coast defense operations, then joined Washington's army in the 1776–77 campaign. He served as adjutant general of the army in 1777, was a member of the board of war, 1777–80, and quartermaster general, 1780–83. Much criticized for his work in the latter post, Pickering clearly served with energy and determination. After the Revolution, he engaged in mercantile business in Philadelphia, but in 1787 moved his family into the Wyoming Valley region of Pennsylvania, where he represented Pennsylvania's interest in the dispute with Connecticut settlers and demonstrated talent in negotiating with the Indians. A supporter of the federal Constitution, he was appointed agent to deal with the Seneca in 1790 and U.S. postmaster general in 1791. He continued to act as an Indian negotiator, supporting an enlightened policy. Appointed U.S. secretary of war, 1795, Pickering also had jurisdiction over naval affairs and pushed construction of the famous frigates that served so well in the War of 1812. He was a fervent Federalist and used his talents for controversy against fellow Federalists whom he suspected of deviation just as heartily as he used them against Jeffersonians. Alexander Hamilton was his special hero, and he came to believe that the French Revolution was the cause of all that was damnable in the world. On the resignation of Edmund Randolph, Pickering succeeded to the post of secretary of state in August 1795, serving until Adams dismissed him in 1800. As secretary, Pickering tried desperately to widen the breach with France and looked forward eagerly to hostilities. Frustration of these hopes, 1798–99, brought him to hate President Adams with a fine passion; he acted indiscreetly in corresponding with Adams' enemies and intriguing against him at every opportunity, thus helping to wreck his own party. Pickering later served in the U.S. Senate, 1803–11, and in the House of Representatives, 1813–17, where he continued to support "high-toned" Federalist principles and virulently opposed the War of 1812.

PICKET, ALBERT (*b. 1771; d. 1850*), teacher, author. Pupil of Noah Webster; taught in New York City *ca.* 1794–1826 and thereafter in Cincinnati, Ohio. Prepared widely adopted series of elementary English texts; edited early educational periodical, *The Academician*, 1818–20; formed Western Literary Institute and College of Professional Teachers, which was active from 1829 to 1845.

PICKETT, ALBERT JAMES (*b. Anson Co., N.C., 1810; d. 1858*), planter, historian. Removed to Autauga Co., Ala., as a child. Author of *History of Alabama and Incidentally of Georgia and Mississippi from the Earliest Period* (1851).

PICKETT, GEORGE EDWARD (*b. Richmond, Va., 1825; d. Norfolk, Va., 1875*), Confederate soldier. Graduated West Point, 1846. Went directly to the Mexican War, where he gained distinction at Contreras and Churubusco, and was first to cross the parapet of Chapultepec. After frontier service in the Northwest, he resigned from the U.S. Army, 1861, and was commissioned Confederate colonel. Made brigadier general in February 1862, he served gallantly at Seven Pines and Gaines's Mill and was given command of a Virginia division with rank of major general in October. At Gettysburg, Lee ordered Pickett with 4,500 effectives to assault the Union center on July 3, 1863. His command advanced half a mile, with parade precision, over ground raked by rifle and artillery fire; repulsed, a scant quarter of them returned from the charge. Pickett made the greatest fight of his career at Five Forks on Apr. 1, 1865.

PICKETT, JAMES CHAMBERLAYNE (*b. Fauquier Co., Va., 1793; d. Washington, D.C., 1872*), War of 1812 soldier, Kentucky legislator, diplomat. Arranged treaty with Republic of Ecuador, 1839 (proclaimed in 1842); negotiated convention with Peru, 1841.

PICKFORD, MARY (*b. Gladys Louise Smith, Toronto, Canada, 1892; d. Santa Monica, Calif., 1979*), actress and film producer. Began performing on stage at age six, landed a starring role in the hit touring show *The Warrens of Virginia* in 1907. She entered the nascent film industry in 1909, working with director D. W. Griffith. With a captivating film presence and trademark golden curls, she endeared herself to the American public in a series of roles as a preteen and adolescent. In the mid–1910's, in collaboration with producer Adolph Zukor, Pickford starred in such films as *Tess of the Storm Country* (1914). By 1917 she was a film industry superstar, earning more than $1 million per year. In 1918 she founded the Mary Pickford Company, which released the popular film *Daddy Long Legs* (1919). The following year she joined with Griffith, Charlie Chaplin, and Douglas Fairbanks (whom she married in 1920) to form the distribution organization United Artists (UA). Pickford made sixteen films for UA, including the hits *Pollyanna* (1920) and *My Best Girl* (1927). She retired from acting in 1933 and sold her share of UA in 1951.

PICKNELL, WILLIAM LAMB (*b. Hinesburg, Vt., 1853; d. Marblehead, Mass., 1897*), landscape painter. Encouraged by George Innes; studied in Paris with J. L. Gérôme.

PICTON, THOMAS (*b. New York, N.Y., 1822; d. New York, 1891*), soldier of fortune, journalist. Served in Lopez' 1850–51 filibustering expedition against Cuba and William Walker's invasion of Nicaragua. Frequently wrote under pen name "Paul Preston."

PIDGIN, CHARLES FELTON (*b. Roxbury, Mass., 1844; d. Melrose, Mass., 1923*), statistician. Inventor of methods and instru-

ments for mechanical tabulation of statistics. Author of best selling *Quincy Adams Sawyer* (1900) and other novels.

PIEPER, FRANZ AUGUST OTTO (*b. Carwitz, Germany, 1852; d. St. Louis, Mo., 1931*), Lutheran theologian. Came to America, 1870. Leader in Missouri Synod; president, Concordia Seminary, 1887–1931.

PIERCE, BENJAMIN (*b. Chelmsford, Mass., 1757; d. Hillsborough, N.H., 1839*), farmer, Revolutionary soldier, New Hampshire legislator. Father of Franklin Pierce. An avid Jeffersonian, he was elected governor of New Hampshire, 1827 and 1829, on basis of Revolutionary record and agrarian appeal.

PIERCE, EDWARD ALLEN (*b. Orrington, Maine, 1874; d. New York City, 1974*), businessman. Attended Bowdoin College briefly and joined the brokerage firm A. A. Housman and Company in 1901. In a bold plan to increase the firm's business, Pierce oversaw the creation of network of branch offices around the nation that were connected by private telegraph wires. The company grew into the largest wire investment house in the nation in the 1920's. In 1927 the firm was renamed E. A. Pierce and Company. In 1938 after the depression led to financial losses, Pierce merged his company with Merrill Lynch. The two investment houses shared a common business strategy, as Charles Merrill put it, to "bring Wall Street to Main Street."

PIERCE, EDWARD LILLIE (*b. Stoughton, Mass., 1829; d. Paris, France, 1897*), lawyer. Brother of Henry L. Pierce. Author of scrupulously honest *Memoir* of Charles Sumner (1877, 1893).

PIERCE, FRANKLIN (*b. Hillsborough, N.H., 1804; d. Concord, N.H., 1869*), lawyer, president of the United States. Son of Benjamin Pierce. Graduated Bowdoin, 1824. First elected to the New Hampshire lower house in 1829, he became Speaker in 1831 and 1832. He next served in the U.S. House of Representatives, 1833–37, and the U.S. Senate, 1837–42; he was a consistent, loyal Jacksonian Democrat. He respected southern rights and developed a settled antipathy for political abolitionists. During a decade of legal practice in New Hampshire, 1842–52, he gained a commanding reputation for effective jury pleading and was personally popular. From 1842 to 1847 he managed most of the local Democratic campaigns, enforcing strict party discipline. Enlisting for the Mexican War as a private, he rose to brigadier general, but did not participate in any battles. He took the lead in enforcing New Hampshire Democratic support for the Compromise of 1850, and his friends worked to secure for him the presidential nomination in 1852 as a compromise candidate. The convention, hopelessly deadlocked, turned to Pierce at last as a candidate who would satisfy the southern bloc. He carried all but four states in November, although his popular majority was less than 50,000.

Pierce selected his cabinet from all sections of the country and from among all factions that had supported him. He set his administration to a policy of complete respect for states' rights, economy, honesty, and a vigorous foreign policy aimed at acquiring more territory. One project dear to his heart was the acquisition of Cuba. American diplomats in Europe were working to this end, but news of their activity leaked prematurely and was publicized in the so-called Ostend Manifesto. Northern opposition followed and the project failed. Pierce succeeded in making the Gadsden Purchase of land from Mexico, 1853, and in persuading the British to agree to retire from Central America except Honduras. Pierce's chief political problem, however, was Kansas. Induced by a group of powerful Senate Democrats to support the Kansas-Nebraska Act in return for favorable action on his patronage appointments and his foreign policy program,

he thereafter became engulfed in a political storm. Determined to enforce the act fairly, he selected appointees to office in the territories equally from the North and South, but his choice of men was generally unfortunate, notably in the case of Governor A. H. Reeder of Kansas. On the appearance of civil war in Kansas between Free-Soilers supporting a local government of their own choosing and Missouri forces threatening to disperse them by force, Pierce supported the technically legal proslavery government, a fact which further alienated Northern Democratic leaders. Pierce's second choice as Kansas governor, Wilson Shannon, proved ineffective, and not until the summer of 1856 were law and order restored under Governor John W. Geary. In his effort to be impartial an "legal," Pierce had helped to split his party and to lay the groundwork for organization of the Republican party. He had honestly tried to do his duty, but was without adequate experience or temperamental fitness and had failed utterly to estimate the depth of northern feeling against the South. Refused renomination in 1856, he became increasingly unpopular in New Hampshire and particularly so after later intemperate attacks upon Lincoln.

PIERCE, GEORGE FOSTER (*b. Greene Co., Ga., 1811; d. Sparta, Ga., 1884*), bishop of the Methodist Episcopal Church, South, educator. President, Emory College, 1848–54; appointed bishop, 1854.

PIERCE, GILBERT ASHVILLE (*b. East Otto, N.Y., 1839; d. Chicago, Ill., 1901*), lawyer, Union soldier, journalist, author. Dakota territorial governor, Republican, 1884–86; U.S. senator from North Dakota, 1889–91.

PIERCE, HENRY LILLIE (*b. Stoughton, Mass., 1825; d. 1896*), cocoa manufacturer, Massachusetts legislator, philanthropist. Brother of Edward L. Pierce. Managed and later owned Walter Baker and Co.; Boston mayor, 1872 and 1877; independent and liberal Republican congressman from Massachusetts, 1873–77. A man of outstanding integrity.

PIERCE, JOHN DAVIS (*b. Chesterfield, N.H., 1797; d. Medford, Mass., 1882*), Congregational clergyman, educator. Removed to Marshall Mich., 1831. Drafted plan for organization of primary schools and state university as Michigan superintendent of public instruction, 1836–41.

PIERCE, ROBERT WILLARD (*b. Fort Dodge, Iowa, 1914; d. Los Angeles, Calif., 1978*), evangelist and humanitarian. Attended the Pasadena Nazarene College, Los Angeles, after which he served as an itinerant evangelist for the Church of the Nazarene on the West Coast; he was ordained by the First Baptist Church of Wilmington, Calif., in 1940. He was named vice-president of the Youth for Christ organization in 1945 and became committed to missionary work during a brief trip to China in 1947. During the Korean War, as a war correspondent for the *Christian Digest*, Pierce launched fund-raising drives for humanitarian projects in Asia. He founded World Vision (1950), which grew into the world's largest voluntary relief organization and was noted for its orphan sponsorship program; Pierce resigned in 1967.

PIERCE, WILLIAM LEIGH (*b. probably Georgia, ca. 1740; d. 1789*), Revolutionary soldier, Savannah, Ga., businessman. As a delegate to the Constitutional Convention, 1787, he made notes on its debates and also wrote character sketches of fellow delegates which are especially useful for information on the less prominent persons present.

PIERPONT, FRANCIS HARRISON (*b. near Morgantown, Va., [now W. Va.], 1814; d. Pittsburgh, Pa., 1899*), lawyer, Virginia Unionist. Helped organize West Virginia and was provisional

governor, 1861–63; served as governor of the "restored" state of Virginia (i.e., those counties under federal control but not included in West Virginia), 1863–65, and of Virginia, 1865–68.

PIERPONT, JAMES (*b. Roxbury, Mass., 1659/60; d. New Haven, Conn., 1714*), Congregational clergyman. Graduated Harvard, 1681. Pastor, First Church, New Haven, 1685–1714; leading founder and an original trustee of Yale College.

PIERPONT, JOHN (*b. Litchfield, Conn., 1785; d. Medford, Mass., 1866*), Unitarian clergyman, poet, reformer. Grandfather of John Pierpont Morgan. Minister of Hollis Street Church, Boston, 1819–45. Author of *Airs of Palestine* (1816); edited *American First Class Book* (1823) and *The National Reader* (1827).

PIERREPONT, EDWARDS (*b. North Haven, Conn., 1871; d. New York N.Y., 1892*), New York lawyer, influential Union Democrat. U.S. attorney general, 1875–76; U.S. ambassador to England, 1876–77.

PIERSON, ABRAHAM (*b. Yorkshire, England, 1609; d. Newark, N.J., 1678*), clergyman. Graduated Trinity College, Cambridge, 1632. Strongly Puritan, he immigrated to Massachusetts, 1640, and became pastor of a group at Lynn who settled in December of that year at Southampton, Long Island. Believing strongly that church and state should act in unison and that only church members should be freemen, he opposed Southampton's union with Connecticut, 1644, and left in 1647 to organize a new church at Branford, New Haven Colony, where his views prevailed. There he remained pastor for 20 years. When New Haven in turn joined Connecticut, he departed with most of his congregation to found a new church at Newark, N.J., 1667.

PIERSON, ABRAHAM (*b. Southampton, N.Y., ca. 1645; d. Killingworth [Clinton], Conn., 1707*), Congregational clergyman. Son of Abraham Pierson (1609–78). Named one of ten trustees upon organization of Yale College; elected first rector of Yale, 1701.

PIERSON, ARTHUR TAPPAN (*b. New York, N.Y., 1837; d. Brooklyn, N.Y., 1911*), Presbyterian clergyman, promoter of missionary activities. Wrote *The Crisis of Missions* (1886); editor, *Missionary Review*, 1890–1911.

PIERSON, HAMILTON WILCOX (*b. Bergen, N.Y., 1817; d. Bergen, 1888*), Presbyterian clergyman, author. Served as traveling agent for American Bible Society; ministered to freedmen in Virginia and Georgia, 1863–69.

PIERZ, FRANZ (*b. near Kamnik, Carniola, Austria, 1785; d. Austria, 1880*), Roman Catholic missionary. Worked among Chippewa Indians in Michigan and Minnesota, 1835–71; promoted German settlement in Minnesota. Author of *Die Indianer in Nord-Amerika* (1855).

PIEZ, CHARLES (*b. Mainz, Germany, 1866; d. Washington, D.C., 1933*), manufacturer, engineer. Director of the Emergency Fleet Corp., 1917–19.

PIGGOT, ROBERT (*b. New York, N.Y., 1795; d. Sykesville, Md., 1887*), stipple engraver, Episcopal clergyman. Apprentice to David Edwin; partner of Charles Goodman. Held pastorates in Pennsylvania, Delaware, and Maryland *post* 1824.

PIGGOTT, JAMES (*b. Connecticut, ca. 1739; d. East St. Louis, Ill., 1799*), Revolutionary soldier, pioneer. Settled in Illinois, ca. 1780; served as judge of various courts at Cahokia during 1790's; organized ferry service at East St. Louis, 1797.

PIKE, ALBERT (*b. Boston, Mass., 1809; d. Washington, D.C., 1891*), lawyer, soldier, author, prominent Freemason. From 1833 to the Civil War, Pike lived principally in Arkansas, where he taught school, edited the *Arkansas Advocate*, 1835–37, and became one of the Southwest's most respected lawyers. He was the first reporter of the Arkansas Supreme Court, 1840–45, commanded a cavalry troop in the war with Mexico, was a prominent Whig, and later a promoter of the Know-Nothing party. Made brigadier general and commander of the Indian country west of Arkansas by the Confederate government in 1861, he recruited Indians into the army who committed some atrocities at Pea Ridge, 1862, for which Pike was unjustly accused. His quarrels with General T. C. Hindman, his superior, led to his arrest, 1863, and brief imprisonment. After the war he practiced law and directed the Southern Jurisdiction of Scottish Rite Masonry. His *Hymns to the Gods* were first published in *Blackwood's Magazine* for June 1839, and republished with additional poems in 1872 and subsequent editions. He was also author of *Prose Sketches and Poems* (1834), *Nugae*, (1854), and Masonic writings.

PIKE, JAMES SHEPHERD (*b. Calais, Maine, 1811; d. Calais, 1882*), journalist, author. Wrote vivid and colorful accounts of official life in the capital as Washington correspondent of the *New York Tribune*, 1850–60. Served as U.S. minister to The Hague, 1861–66.

PIKE, MARY HAYDEN GREEN (*b. Eastport, Maine, 1824; d. Baltimore, Md., 1908*), novelist, abolitionist. Published *Ida May* (1854) and *Caste* (1856), melodramatic antislavery novels.

PIKE, NICOLAS (*b. Somersworth, N.H., 1743; d. 1819*), teacher, arithmetician. Graduated Harvard, 1766. Master for many years of the grammar school at Newburyport, Mass. His fame rests chiefly upon his well-organized and admirable treatise, *A New and Complete System of Arithmetick, Composed for the Use of the Citizens of the United States* (1788), and an abridgement thereof (1793). He was the first American arithmetician to attain wide popularity in the field of school textbooks.

PIKE, ROBERT (*b. Wiltshire, England, ca. 1616; d. 1708*), colonial official. Immigrated to New England, 1635; was an original settler of Salisbury, Mass., 1639; served almost continuously as a Massachusetts elected official, 1648–96. Denounced curtailing of rights of Baptists and Quakers; stressed invalidity of specter testimony in Salem witch trials.

PIKE, ZEBULON MONTGOMERY (*b. Lamberton, now part of Trenton, N.J., 1779; d. York, Canada, 1813*), soldier, explorer. Commissioned first lieutenant, U.S. Army, 1799; served on frontier; was ordered by General James Wilkinson, 1805, to lead party from St. Louis, Mo., to the headwaters of the Mississippi. He reached what he mistakenly thought was the river's source in the winter of 1805–06. Returning to St. Louis, he was sent to explore the source of the Arkansas and Red rivers and to reconnoiter the Spanish settlements in New Mexico. Setting out from St. Louis on July 15, 1806, he moved up the Arkansas and reached the site of the present Pueblo, Colo. Here on a side trip he attempted unsuccessfully to reach the summit of the peak which bears his name. Turning south, seeking the source of the Red River, he crossed the Sangre de Cristo Mountains and built a fort on the Conejos branch of the Rio Grande. The Spaniards, hearing of his incursion, sent a force to bring him to Santa Fe. He yielded without a struggle and was taken eventually to Chihuahua for questioning. Returning to the United States, he found his name coupled in some quarters with the Burr-Wilkinson scheme for erecting a separate empire in the Southwest. These charges were probably without foundation. Promoted major, 1808, and colo-

nel, 1812, he was advanced in rank to brigadier general and put in command of troops attacking York (present Toronto), Canada, in April 1813. His mission was successful, but he was killed in the assault.

PILAT, IGNAZ ANTON (*b. St. Agatha, Austria, 1820; d. New York, N.Y., 1870*), landscape gardener. Came to America, 1848. Made comprehensive botanical survey of New York Central Park site; directed planting operations for Calvert Vaux and Frederick L. Olmsted.

PILCHER, JOSHUA (*b. Culpeper Co., Va., 1790; d. St. Louis, Mo., 1843*), fur trader, Indian agent. President, Missouri Fur Co., 1820–31; U.S. superintendent of Indian affairs, 1839–41.

PILCHER, LEWIS STEPHEN (*b. Adrian, Mich., 1845; d. 1934*), surgeon, Union soldier. Father of Paul M. Pilcher. Graduated University of Michigan, 1862; M.D., 1866. Practiced and taught in Brooklyn, N.Y., *post* 1872 until 1918. As editor of *Annals of Surgery*, from 1885, Pilcher exercised wide influence upon surgical thought in the English-speaking world.

PILCHER, PAUL MONROE (*b. Brooklyn, N.Y., 1876; d. 1917*), surgeon, urologist. Son of Lewis S. Pilcher. M.D., New York College of Physicians and Surgeons, 1900. Author of *Practical Cystoscopy and the Diagnosis of Surgical Diseases of the Kidneys and Urinary Bladder* (1911).

PILKINGTON, JAMES (*b. Cavendish, Vt., 1851; d. New York, N.Y., 1929*), New York policeman, contractor. Amateur champion boxer, wrestler, and oarsman during the 1880's.

PILLING, JAMES CONSTANTINE (*b. Washington D.C., 1846; d. Olney, Md., 1895*), ethnologist. Author of an outstanding bibliography of the languages of American Indian tribes.

PILLOW, GIDEON JOHNSON (*b. Williams Co., Tenn., 1806; d. Helena, Ark., 1878*), lawyer, politician, soldier. Close political friend of James K. Polk; served as general officer in Mexican War and attempted to exalt his own importance at expense of General Winfield Scott. A conservative opponent of extremist measures up to the Civil War, he accepted rank of Confederate brigadier general, 1861. Second in command at Fort Donelson, he escaped capture when the post was surrendered in February 1862, by passing his responsibility off on General Simon B. Buckner. He was given no important command during the remainder of the war.

PILLSBURY, CHARLES ALFRED (*b. Warner, N.H., 1842; d. Minneapolis, Minn., 1899*), flour miller. Nephew of John S. Pillsbury. Removed to Minneapolis, 1869; bought a share in a small local flour mill. Quick to recognize the importance of new technological advances, he installed the La Croix purifying process, which permitted use of Northwest spring wheat for highgrade bread flour, and later adopted the roller process. His firm, C. A. Pillsbury and Co., prospered, partly because of highly favorable railroad freight rates which he helped secure and maintain, partly because of his extensive system of grain elevators, and partly because of his effective advertising techniques based upon brand names. His incursions into the grain market were spectacular though not often profitable. *Post* 1889, he was managing director of Pillsbury-Washburn. Ltd.

PILLSBURY, HARRY NELSON (*b. Somerville, Mass., 1872; d. Frankford, Pa., 1906*), chess player. Among top international masters, 1894–1904; first American professional chess player; specialized in simultaneous blindfold play.

PILLSBURY, JOHN ELLIOTT (*b. Lowell, Mass., 1846; d. Washington, D.C., 1919*), naval officer, oceanographer. Graduated U.S. Naval Academy, 1867. Served with U.S. Coast Survey 1876–91; invented current meter; determined axis of Gulf Stream; wrote *The Gulf Stream* (1891).

PILLSBURY, JOHN SARGENT (*b. Sutton, N.H., 1828; d. Minneapolis, Minn., 1901*), flour miller, Minnesota legislator. Uncle of Charles A. Pillsbury. Settled in present Minneapolis, 1855. Partner in C. A. Pillsbury and Co. Republican governor of Minnesota, 1876–82; retrieved University of Minnesota from bankruptcy, 1864.

PILLSBURY, PARKER (*b. Hamilton, Mass., 1809; d. Concord, N.H., 1898*), reformer, Garrisonian abolitionist. Lecture agent, antislavery societies, 1840–61; edited *Herald of Freedom*, 1840 and 1845–46; ardent advocate of woman's rights.

PILMORE, JOSEPH (*b. Tadmouth, England, 1739; d. Philadelphia, Pa., 1825*), Episcopal clergyman. Trained by John Wesley, Pilmore went to America, 1769, and was first Methodist preacher in Philadelphia; he returned to England, 1774. Abandoning Methodism, 1784, he came back to America and was ordained, 1785, by Samuel Seabury. He served thereafter as rector in New York and the Philadelphia area.

PILSBURY, AMOS (*b. Londonderry, N.H., 1805; d. Albany, N.Y., 1873*), pioneer professional prison administrator.

PINCHBACK, PINCKNEY BENTON STEWART (*b. Macon, Ga., 1837; d. Washington, D.C., 1921*), Union soldier, politician. Son of a white father and a free black mother. Louisiana Radical legislator and official during Reconstruction.

PINCHOT, AMOS RICHARDS ENO (*b. Paris, France, 1873; d. New York, N.Y., 1944*), lawyer, politician, reformer. Brother of Gifford Pinchot. B.A., Yale, 1897. Served in Spanish-American War. Admitted to the New York bar after attending Columbia Law School and New York Law School, he devoted most of his time to managing the family estate until 1908, when he became active in politics as his brother's aide and adviser in the Ballinger controversy. Convinced that industrial monopolies were dictating national policy, he helped organize the Progressive party, 1912, and aligned himself with its "radical nucleus" in favor of public ownership of forests, waterpower, and all sources of energy; he also advocated the breaking-up of private monopolies. Disillusioned with the Progressives' failure to press for reforms, he supported President Wilson's reelection in 1916 but soon opposed him because of domestic policies, especially curtailment of civil rights during World War I. In 1917 he helped found what was to become the American Civil Liberties Union, serving on its executive committee until his death. At first a supporter of Franklin D. Roosevelt, he broke with him in 1933 over monetary policy and the growth of federal power, which he considered as great a threat to the individual citizen as business monopolies.

PINCHOT, CORNELIA ELIZABETH BRYCE (*b. Newport, R.I., 1881; d. Washington, D.C., 1960*), social reformer. Socially prominent and the wife of two-time governor of Pennsylvania, Gifford Pinchot, Cornelia Pinchot advocated women's and children's rights in industry and the home. A colorful figure, her activities in support of important social legislation, her prolabor stands, and her positions on women's rights were widely reported in the press. She sought, but never attained, political office.

PINCHOT, GIFFORD (*b. Simsbury, Conn., 1865; d. New York, N.Y., 1946*), forester, conservationist, federal and state official. Member of a well-to-do New York merchant family, he was ed-

ucated in a succession of private schools in New York and Paris and at Phillips Exeter Academy. He entered Yale University in 1885, determined to pursue a career in forestry. After receiving the B.A. degree in 1889, he enrolled for a year in the French National Forestry School at Nancy and then in 1892 took charge of the forests at Biltmore, the North Carolina estate of George W. Vanderbilt.

In 1896 Pinchot was appointed to the National Forest Commission of the National Academy of Sciences, created to make recommendations on the national forest reserves in the western states. The commission's study helped bring about passage of the Forest Management Act of 1897. In 1898 he was named chief of the tiny Division of Forestry in the U.S. Department of Agriculture. He induced Congress in 1905 to transfer the forest reserves from the General Land Office of the Interior Department to his own division in the Department of Agriculture. He quickly became a close companion and adviser in Roosevelt's select circle. In several ways Pinchot acted as a catalyst to the emerging conservation movement. In 1903 he served on the Committee of the Organization of Government Scientific Work. His work on the Public Lands Commission, which he initiated in 1903, led eventually to the systematic classification of the nation's natural resources by the U.S. Geological Survey, as well as to sweeping land-law reform. In 1908 the movement flowered in the proposals of the Inland Waterways Commission.

When Roosevelt was succeeded by William Howard Taft, who did not admit Pinchot to his inner circle of advisers, Taft appointed Richard A. Ballinger, onetime commissioner of the General Land Office, as secretary of the interior. Ballinger began to attack conservation policies on many fronts. He moved directly against the Forest Service. The struggle that developed between Ballinger and Pinchot split the Taft administration down the middle. In the end, Taft upheld Ballinger, and in 1910 Pinchot was dismissed from government service. The controversy contributed significantly to the estrangement between Taft and Roosevelt.

In January 1911, Pinchot helped found the National Progressive Republican League. He initially supported the presidential ambitions of Robert M. La Follette, but shifted his allegiance once Roosevelt became a candidate early in 1912. When the Republican party renominated Taft, Pinchot bolted and helped from the Progressive party, which nominated Roosevelt. Twice governor of Pennsylvania, 1923–27 and 1931–35, Pinchot drafted a new administrative code and grappled strenuously with economic problems caused by the Great Depression. Perhaps his most important accomplishment was the construction of thousands of miles of rural roads. He maintained his interest in forestry, serving as nonresident lecturer and professor at the Yale School of Forestry, established in 1900 by a grant from his father, and as a founder and president, 1900–08 and 1910–11, of the Society of American Foresters. Pinchot's autobiography, *Breaking New Ground*, was published posthumously in 1947.

PINCKNEY, CHARLES (*b. Charleston, S.C., 1757; d. 1824*), planter, lawyer, Revolutionary soldier. Second cousin of Charles C. and Thomas Pinckney. As congressman from South Carolina, 1784–87, he led in movement to amend the Articles of Confederation; a prominent delegate to the Constitutional Convention, 1787, he submitted a plan for a constitution (the "Pinckney draught") now known only in a reconstructed form. It is probable that he had an important share in determining the final form and content of the U.S. Constitution, but his egoistic claims for credit have made historians doubtful of his real achievements. He served as Federalist governor of South Carolina, 1789–92. Alienated from his party on personal and intellectual grounds, he became a Democratic-Republican and, as such, was governor in 1797–99 and 1807–09. While U.S. senator, 1799–1801, he

was leader in attacks on the Adams administration and was the manager of Thomas Jefferson's campaign in South Carolina. Appointed U.S. minister to Spain, March 1801–1805, he succeeded in winning Spanish assent to the cession of Louisiana, but his attempt to secure a cession of the Floridas exceeded his instructions and failed. As congressman from South Carolina, 1819–21, he delivered one of his finest addresses in opposition to the Missouri Compromise.

PINCKNEY, CHARLES COTESWORTH (*b. Charleston, S.C., 1746; d. Charleston, 1825*), lawyer, Revolutionary soldier, statesman. Son of Elizabeth L. Pinckney; brother of Thomas Pinckney; second cousin of Charles Pinckney. Served in South Carolina colonial and state legislatures; was prominent as a delegate to Constitutional Convention, 1787. Between 1791 and 1795, he was offered and declined the command of the army, a seat on the U.S. Supreme Court, and the secretaryships of war and state. Accepting the post of U.S. minister to France, July 1796, he was refused official recognition by the Directory when he arrived at Paris in December. Appointed to serve with Elbridge Gerry and John Marshall on a special mission in France, 1797, he gave an indignant refusal to suggestions that a bribe to French officials might ease matters (the XYZ Affair). As major general, 1798–1800, he commanded all U.S. military posts and forces south of Maryland as well as those in Kentucky and Tennessee. A lifelong Federalist, he was his party's nominee for vice president in 1800 and for president in 1804 and 1808.

PINCKNEY, ELIZABETH LUCAS (*b. probably Antigua, ca. 1722; d. Philadelphia, Pa., 1793*), introducer of indigo into colonial South Carolina. Mother of Charles C. and Thomas Pinckney. Educated in England, she was brought to her father's plantation, "Wappoo," near Charleston in 1738 and left to manage the affairs of three plantations, her father returning to Antigua. Searching about for a profitable crop she experimented with indigo seeds, 1741; after three years' trial, she succeeded in raising a crop and, with help from a Montserrat man, prepared it for market. Her husband, Charles Pinckney, further developed the industry, which became a very profitable one. Upon the death of her husband in 1758, she again became manager of extensive plantation properties.

PINCKNEY, HENRY LAURENS (*b. Charleston., S.C., 1794; d. Charleston, 1863*), editor, South Carolina legislator and congressman. Son of Charles Pinckney; brother-in-law of Robert Y. Hayne. Proprietor and principal editor of *Charleston Mercury*, 1823–32; made it the leading state daily and an uncompromising advocate of nullification. Mayor of Charleston, 1829 and 1837–39.

PINCKNEY, THOMAS (*b. Charleston, S.C., 1750; d. Charleston, 1828*), soldier, diplomat, politician. Son of Elizabeth L. Pinckney; brother of Charles C. Pinckney. Educated in England and called to the English bar in 1774, he returned to South Carolina, 1774. He served with credit, 1775–81, in the Southern campaigns of the Revolution and was severely wounded at Camden. Entering successful legal practice at Charleston, he was governor of his state, 1787–89, and president of the South Carolina ratifying convention, 1788. He served fruitlessly as U.S. minister to Great Britain, 1792–95, but as special envoy to Spain he concluded the advantageous treaty of San Lorenzo, 1795. Unsuccessful candidate for the U.S. vice-presidency, 1796, he was a Federalist congressman from South Carolina, 1797–1801.

PINCUS, GREGORY GOODWIN ("GOODY") (*b. Woodbine, N.J., 1903; d. Boston, Mass., 1967*), biologist. Attended Cornell and Harvard (Sc.D., 1927). Taught at Harvard (1930–37), but later

could not secure a regular academic position, believing himself to be a victim of scientific conservatism and anti-Semitism. Studied the effects of pH on mammalian sperm, the problems of developing in vitro fertilization and artificial parthenogenesis, and the role of hormones in embryonic maintenance. Founded (with Hudson Hoagland) the Worcester Foundation for Experimental Biology (1944), dedicated to biological engineering; he became a scientific entrepreneur and served as liaison between academic scientists and commercial interests. His most important achievement was the development of the first oral contraceptive, which was marketed in 1961. Elected to National Academy of Science (1965).

PINE, ROBERT EDGE (*b. London, England, 1730; d. Philadelphia, Pa., 1788*), portrait and subject painter. Came to America, 1784; painted many of the celebrities of the time (including Washington and members of his family). Proposed a series of paintings illustrative of the Revolution, but died before attempting more than one.

PIÑEROJIMÉNEZ, JESÚS TORIBIO (*b. Carolina, Puerto Rico, 1897; d. Canóvanas, Puerto Rico, 1952*), politician. Studied at Xavier College in Baltimore, Md., at the University of Puerto Rico, and the University of Pennsylvania. In 1937, with his friend Muñoz Marín, he formed the Popular Democratic Party of Puerto Rico; in 1940 he was elected to the legislature of Puerto Rico; in 1944 to the post of resident commissioner of Puerto Rico in the U.S. Congress. In 1946 President Truman appointed him the first native-born governor of Puerto Rico. He served until 1948, when he was succeeded by Marín.

PINGREE, HAZEN STUART (*b. Denmark, Maine, 1840; d. England, 1901*), manufacturer, Michigan politician, Union soldier. Settling in Detroit, 1865, he became partner in a shoe-manufacturing enterprise which prospered. Elected reform mayor of Detroit under Republican auspices, 1889, he found that a group of private vested interests controlled municipal affairs. After bitter fights he established a municipal power plant, removed toll gates, forced reductions in gas and telephone rates, and made the street railway monopoly give better service. During the panic of 1893 he inaugurated a plan of gardens for the unemployed ("Pingree's potato patches"). Elected governor of Michigan, 1896, he served until 1901. The chief target of his fight against special privilege while governor was the railroads, but his administration was only moderately successful.

PINKERTON, ALLAN (*b. Glasgow, Scotland, 1819; d. 1884*), detective. Settling in Illinois early in the 1840's, he first engaged in the cooper's trade. After uncovering a gang of counterfeiters, he was made deputy sheriff of Kane Co., Ill., 1846; he later held the same post in Cook Co. Named first detective of the Chicago police force, 1850, he established a private agency in the same year, one of the first in the United States. Successful in solving a number of train and express robberies, he learned through his operatives of a Southern plot against Abraham Lincoln's life, February 1861, and was responsible for the circuitous route followed by the president on his way to inauguration. Later in the year, on invitation of General George B. McClellan, Pinkerton organized a secretservice and counterespionage department for the army and conducted it until November 1862. Thereafter, he engaged in a wide variety of detective work, including antistrike activity and labor espionage; he was also author of a number of "real life" detective narratives based on his agency's experiences.

PINKERTON, LEWIS LETIG (*b. Baltimore Co., Md., 1812; d. 1875*), physician, Disciples of Christ clergyman, editor, educator.

Prominent *post* 1839 in the activities and controversies of his denomination in Kentucky.

PINKHAM, LYDIA ESTES (*b. Lynn, Mass., 1819; d. Lynn, 1883*), reformer, manufacturer of patent medicine. Began producing her famous and widely advertised "Vegetable Compound" in 1875.

PINKNEY, EDWARD COOTE (*b. London, England, 1802; d. Baltimore, Md., 1828*), poet, lawyer, editor. Son of William Pinkney. His small but distinguished body of poetry appeared in *Rodolph* (1823) and *Poems* (1825); he edited *The Marylander*, a newspaper in support of J. Q. Adams' campaign for reelection, 1827–28.

PINKNEY, NINIAN (*b. Annapolis, Md., 1811; d. Easton, Md., 1877*), surgeon. Nephew of William Pinkney. Graduated St. John's, Annapolis, 1830; M.D., Jefferson Medical College, 1833. Served with distinction in U.S. Navy, 1834–73; was surgeon of the fleet in D. D. Porter's squadron, 1862–65.

PINKNEY, WILLIAM (*b. Annapolis, Md., 1764; d. Washington, D.C., 1822*), lawyer, Maryland legislator, diplomat. Father of Edward C. Pinkney. Studied law with Samuel Chase; was admitted to the bar, 1786. Pinkney rose rapidly to a commanding position in his profession and was considered the most talented advocate of his time, despite his personal affectations and the flamboyant character of his oratory. Inordinately vain, he wished to excel in everything and concealed his profound researches into precedents behind a screen of affected carelessness and haste of preparation. He appeared in 72 cases before the U.S. Supreme Court.

He served as joint commissioner with Christopher Gore in England, 1796–1804, working to adjust maritime claims under the seventh article of the Jay Treaty. Returning home, he was briefly attorney general of Maryland. Joint commissioner with James Monroe to treat with the British over reparations for ship seizures and impressment, 1806–07, he was concerned in the formulation of a proposed treaty which Jefferson angrily repudiated. He then engaged in frustrating and futile negotiations with the British over the *Leopard-Chesapeake* affair and the issue of the orders in council while serving as U.S. minister to Great Britain, 1807–11. He was an able U.S. attorney general, 1811–14; served in the militia, 1814; and sat in Congress from Maryland, 1815–16. Effective as U.S. minister to Russia, 1816–18, he became U.S. senator from Maryland in 1819 and served until his death. Here he performed his greatest work for his country as an interpreter of the Constitution. His speeches in opposition to Rufus King during the debates over the Missouri Compromise were an important factor in bringing the compromise about. Meanwhile, he reached the heights of his forensic career in the Supreme Court in his arguments in *McCulloch* v. *Maryland* (1818–19) and *Cohens* v. *Virginia* (1821).

PINNEY, NORMAN (*b. Simsbury, Conn., 1804; d. New Orleans, La., 1862*), clergyman, educator. Organized the Mobile (Ala.) Institute, a classical school for boys, 1836, and headed it for many years.

PINO, JOSÉ *See* SON OF MANY BEADS.

PINTARD, JOHN (*b. New York, N.Y., 1759; d. New York, 1844*), merchant, philanthropist. Helped organize both the Massachusetts and New-York Historical societies; served as president of New York City's first savings bank, 1828–41.

PINTARD, LEWIS (*b. New York, N.Y., 1732; d. Princeton, N.J., 1818*), New York merchant. Served as American commissary for prisoners in New York City during most of the Revolution.

PINTO, ISAAC (*b. 1720; place unknown; d. New York, N.Y., 1791*), merchant, scholar, patriot. A Sephardic Jew, he appears first in New York records, 1740; he lived from time to time in various places including Charleston, S.C. He was best known as the translator into English of the first Jewish prayerbook printed in America, the *Evening Service of Roshashanah and Kippur* (1761), and *Prayers for Shabbath, Rosh-Hashanah, and Kippur* (1766). He was probably also translator of *The Form of Prayer . . . for a General Thanksgiving . . . for the Reducing of Canada* (1760) and may have been author of letters appearing under the pseudonyms "A.B." and "Philalethes" in New York newspapers, 1750–75.

PINZA, EZIO (*b. Rome, Italy, 1892; d. Stamford, Conn., 1957*), opera singer. Studied at the University of Ravenna and the Rossini Conservatory in Bologna. He made his debut as King Mark in *Tristan and Isolde* in Rome in 1920. After achieving success at Milan's La Scala, he came to the Metropolitan Opera in 1926 and was the reigning basso until his retirement in 1948. Operatic roles there include the title roles in *Don Giovanni, Faust, The Marriage of Figaro,* and *Boris Godunov.* After retirement he turned to Broadway where he succeeded in the role of Émile de Becque in *South Pacific* (1949).

PIPER, CHARLES VANCOUVER (*b. Victoria, British Columbia, Canada, 1867; d. 1926*), agronomist. Graduated University of Washington, 1885; Harvard, M.S., 1900. Taught botany and zoology at State College of Washington, 1893–1903; was employed thereafter by U.S. Department of Agriculture, having charge *post* 1905 of the Office of Forage Crops. His most important achievement was finding Sudan grass, a useful cousin of the Johnson grass of the South, which he discovered under a mistaken classification. He published *Sudan Grass, a New Drought-Resistant Hay Plant* (1913), which started culture of a commercially important product. He also wrote *Forage Plants and Their Culture* (1914) and other special studies.

PIPER, WILLIAM THOMAS (*b. Knapp Creek, N.H., 1881; d. Lock Haven, Pa., 1970*), oil company executive and airplane manufacturer. Attended Harvard (B.S., 1903). Founded (1914) Dallas Oil Company; bought C. G. Taylor aircraft (1931) and became dedicated to the idea of an inexpensive airplane for the average person. His Cub aircraft was licensed in 1931. Opened the Piper Aircraft Company (1937) and soon dominated the private-airplane industry. During World War II he sold 7,000 L-4's ("puddle jumpers") to the army; he began producing the SuperCub and Pacer in 1948; and the twin-engine Apache, the first all-metal Piper plane, went on the market in 1954. By 1970 the company was producing 12,000–15,000 planes a year.

PIPPIN, HORACE (*b. West Chester, Pa., 1888; d. West Chester, 1946*), artist. Wounded and partially disabled in World War I army service; began painting *ca.* 1929. After receiving enthusiastic critical praise for a showing of his work in 1937, he continued to paint with both critical and material success. He can properly be placed among the great "naive" painters, such as Henri Rousseau and Hector Hyppolite. Historically, he was the first black American to produce an important body of work not limited by defensive attitudes or emulation of supposedly "superior" models. His art conveyed a vision of the American scene — its history and folklore, its exterior splendors and interior pathos — which was uniquely his own.

PIRSSON, LOUIS VALENTINE (*b. Fordham, N.Y., 1860; d. 1919*), geologist. Graduated Sheffield Scientific School, Yale, 1882; studied also at Heidelberg and Paris. Became interested in igneous geology after serving with U.S. Geological Survey party in Yellowstone Park, 1889–90. Teacher at Yale *post* 1892, in 1893 he gave the first graduate course there in petrology. Associate editor of the *American Journal of Science,* 1899–1919, he was one of four authors of *Quantitative Classification of Igneous Rocks* (1903), a landmark in petrology. He was the sole author of *Rocks and Rock Minerals* (1908); and of Part 1 of the *Text Book of Geology* by Pirsson and Schuchert.

PISE, CHARLES CONSTANTINE (*b. Annapolis, Md., 1801; d. Brooklyn, N.Y., 1866*), Roman Catholic clergyman, author. Educated at Georgetown and at Mount St. Mary's, Emmitsburg, Md., he was ordained in 1825 and served parishes in Baltimore, Washington, D.C., New York City, and Brooklyn. He was the only Catholic priest ever to serve as chaplain to the U.S. Senate, 1832–33. Among his many books is the early novel *Father Rowland* (1829).

PISTON, WALTER HAMOR (*b. Rockland, Maine, 1894; d. Belmont, Mass., 1976*), composer and teacher. Graduated Normal School of Art in Boston (1916) and Harvard University (1924), where he accepted a teaching position in 1926, becoming a full professor in 1944. Piston wrote several musical textbooks but is best known for his compositions, which include eight symphonies. The Boston Symphony Orchestra premiered eleven of his works between 1927 and 1971. A neoclassicist, he also explored modern harmonic and rhythmic themes, including jazz and folk music, within classical music structures.

PITCAIRN, JOHN (*b. Dysart, Scotland, 1722; d. Boston, Mass., 1775*), British major of marines. Commanded British force at Lexington battle, April 1775; was mortally wounded at Bunker Hill.

PITCAIRN, JOHN (*b. near Paisley, Scotland, 1841; d. Bryn Athyn, Pa., 1916*), railroad executive, manufacturer, philanthropist. Came to the United States as a child. Helped organize Pittsburgh Plate Glass Co., 1883; was its president, 1897–1905.

PITCHER, MOLLY See MCCAULEY, MARY LUDWIG HAYS.

PITCHER, ZINA (*b. near Fort Edward, N.Y., 1797; d. Detroit, Mich., 1872*), physician, naturalist. Settled in Detroit, 1836. Initiated medical department, University of Michigan, 1850; developed public schools while mayor of Detroit, 1840–41 and 1843.

PITCHLYNN, PETER PERKINS (*b. Noxubee Co., Miss., 1806, d. Washington, D.C., 1881*), Choctaw chief. Selected western lands for Choctaw resettlement, 1828; removed to Indian Territory after 1830 treaty; elected principal chief of tribe, 1860.

PITKIN, FREDERICK WALKER (*b. Manchester, Conn., 1837; d. Pueblo, Colo., 1886*), lawyer. Settled in Colorado, 1874. An able and honest Republican governor of the state, 1879–83, he was responsible for driving out the Ute and for suppressing the Leadville miners' strike, 1880.

PITKIN, TIMOTHY (*b. Farmington, Conn., 1766; d. New Haven, Conn., 1847*), lawyer, Connecticut legislator, historian. Grandson of William Pitkin (1694–1769). Congressman, Federalist, from Connecticut, 1805–19; author of an important statistical account of American commerce (1816).

PITKIN, WALTER BOUGHTON (*b. Ypsilanti, Mich., 1878; d. Palo Alto, Calif., 1953*), writer and educator. Studied briefly at the University of Michigan, at Hartford Theological Seminary, and at the universities of Munich and Berlin. Taught at Columbia University, 1905–43; professor in the School of Journalism from 1912. Editor of *Parents' Magazine* (1927–30), American

editor of the *Encyclopaedia Britannica* (1927–28), and editorial director of the *Farm Journal* (1935–38). Pitkin's blend of iconoclasm and utopianism was part of the social history of the Great Depression; he wrote over thirty books that were optimistic in their appeal to the masses, including *The Psychology of Happiness* (1929), *Let's Get What We Want* (1935), and his most famous work, *Life Begins at Forty* (1932).

PITKIN, WILLIAM (*b. probably Marylebone, England, 1635; d. Hartford, Conn., 1694*), lawyer, jurist. Immigrated to Hartford, 1659. Became Connecticut's chief prosecutor, 1664; championed colony's right to control own militia and maintain independence of royal interference in local government.

PITKIN, WILLIAM (*b. Hartford, Conn., 1694; d. Hartford, 1769*), jurist, colonial administrator. Grandson of William Pitkin (1635–94). Member of committee to draw up confederation plan at Albany Congress, 1754; governor of Connecticut, 1765–69; held many other offices.

PITKIN, WILLIAM (*b. Hartford, Conn., 1725; d. Hartford, 1789*), jurist, manufacturer. Son of William Pitkin (1694–1769). Established first powder mill in Connecticut, 1776; judge of superior court, 1769–89; member, Revolutionary Council of Safety.

PITMAN, BENN (*b. Trowbridge, England, 1822; d. Cincinnati, Ohio, 1910*), phonographer. Came to America, 1852, to popularize his brother Isaac's system of shorthand; established Phonographic Institute in Cincinnati.

PITNEY, MAHLON (*b. Morristown, N.J., 1858; d. Washington, D.C., 1924*), New Jersey Republican legislator and congressman, U.S. Supreme Court justice. As associate justice, U.S. Supreme Court, 1912–22, he delivered a long series of painstaking opinions which were marked by conservatism and antilabor feeling.

PITTMAN, KEY (*b. Vicksburg, Miss., 1872; d. Reno, Nev., 1940*), lawyer. Began practice in Seattle, Wash., 1892. Moving to the Yukon, 1897, and to Nome, Alaska, 1899, he settled in 1901 in Tonopah, Nev. After a decade of mining, legal, and political activities, he was elected U.S. senator, Democrat, from Nevada, 1912. Unwaveringly loyal to mining interests, he won advantages by his abilities as a negotiator and by exploiting the bloc powers of the seven silver-mining states. The so-called Pittman Act, 1918; the silver agreement of the World Economic Conference, 1933; and the Silver Purchase Act, 1934, testify to his ingenuity in maintaining silver prices through large annual purchases by the U.S. government.

PITTOCK, HENRY LEWIS (*b. London, England, 1836; d. Portland, Oreg., 1919*), printer, newspaper publisher, paper manufacturer. Came to America as a child; removed from Pittsburgh, Pa., to Oregon *ca.* 1852. Published *Morning Oregonian post* 1861, Portland *Evening Telegram post* 1877, and *Sunday Oregonian post* 1881; enjoyed Portland newspaper monopoly by 1902.

PITTS, HIRAM AVERY (*b. ca. 1800; d. Chicago, Ill., 1860*), inventor. Raised in Maine; was blacksmith by trade. Patented chain-band for horsepower treadmill, 1834; improved thresher and fanning mill, 1837. Manufactured Chicago-Pitts threshers in Chicago *post* 1852.

PITTS, ZASU (*b. Parsons, Kans., 1898; d. Los Angeles, Calif., 1963*), actress. She used her fragile appearance, fluttering hands, wide-eyed countenance, and wistful demeanor to good effect in comedy and melodrama. Appeared opposite Mary Pickford in *The Little Princess* (1917) and reached the pinnacle of her art with *Greed* (1924) and *The Wedding March* (1928). She had a string of comedy hits in 1929–33 and made a memorable comic performance in *Ruggles of Red Gap* (1935). Appeared frequently on television (1954–63) and was best-known to television audiences for her role on "The Gale Storm Show" (1956–60).

PLACIDE, HENRY (*b. probably Charleston, S.C., 1799; d. Babylon, N.Y., 1870*), actor. Made debut in Augusta, Ga., 1808. After his first appearance in an important role at New York's Park Theatre, 1823, he occupied first rank in popularity as a comedian, ranging from dialect farce to high comedy, until his retirement from the stage, 1865. He played for 20 years at the Park; thereafter, he was a member of the company of Burton's Theatre and made extended tours throughout the United States. His brother and his three sisters all had stage careers.

PLAISTED, HARRIS MERRILL (*b. Jefferson, N.H., 1828; d. Bangor, Maine, 1898*), lawyer, Union major general by brevet. Commanded "Iron Brigade," 1863–65; was attorney general of Maine, 1873–75, and Republican congressman from Maine, 1876–77. Becoming a Greenbacker, 1879, he was elected Democrat-Greenback governor, 1880, but failed of reelection in 1883; thereafter he edited *The New Age* in support of bimetallism.

PLANT, HENRY BRADLEY (*b. Branford, Conn., 1819; d. 1899*), express company executive, railroad and steamship operator. Bought Atlantic and Gulf Railroad and Charleston and Savannah Railroad at foreclosure sales, 1879–80; using these as nucleus, he built up the "Plant System" of transportation lines along the southern Atlantic seaboard. He was also operator of several steamship lines and the builder of a number of hotels in the area served by his system. Providing Florida fruit growers a quicker and cheaper access to markets, he became rich and powerful as Florida and other states dependent on his roads grew in population and were developed. He was associated in the Plant Investment Co., holding company for his properties, with H. M. Flagler, M. K. Jesup, and W. T. Walters.

PLATER, GEORGE (*b. near Leonardtown, Md., 1735; d. 1792*), lawyer, Maryland colonial legislator, Revolutionary patriot. Member of Continental Congress, 1778–80; presided over Maryland ratifying convention, 1788; governor of Maryland, 1791–92.

PLATH, SYLVIA (*b. Boston, Mass., 1932; d. London, England, 1963*), poet. Attended Smith (A.B., 1955) where, despite publication of poems and short stories, suffered a nervous breakdown, attempted suicide, and underwent psychiatric treatment; those events form the material for her autobiographical novel, *The Bell Jar* (1963, 1971). Her poetry written while at Newnham College at Cambridge (B.A., 1957) appeared in her first published volume, *The Colossus* (1962). Taught at Smith (1957), then devoted herself entirely to writing; in 1959 received a fellowship to Yaddo, the writers' colony in Saratoga Springs, N.Y. Her bestknown poems were published posthumously in *Ariel* (1965, 1966). She has been endowed with an unfortunate notoriety because of her suicide and the dark subjects of her poems.

PLATNER, SAMUEL BALL (*b. Unionville, Conn., 1863; d. 1921*), classical scholar. Graduated Yale, 1883; Ph.D., 1885. Taught Latin at Adelbert College, Western Reserve University, *post* 1885; was author of a number of scholarly books, including *A Topographical Dictionary of Ancient Rome* (published posthumously, 1929).

PLATT, CHARLES ADAMS (*b. New York, N.Y., 1861; d. 1933*), architect, landscape architect, painter, etcher. Studied in New

York and in Paris under Boulanger and Lefebvre; after publication of his *Italian Gardens* (1894), he moved into the practice of architecture. He designed the Freer Gallery, among other buildings in Washington, and is responsible for buildings at the University of Illinois, the University of Rochester, Dartmouth, Johns Hopkins, and the Deerfield, Mass., Academy. The Leader-News building, Cleveland, Ohio, is his most significant commercial structure. His most characteristic work, combining architecture and landscaping, is Phillips Academy, Andover, Mass.

PLATT, ORVILLE HITCHCOCK (*b. Washington, Conn., 1827; d. Meriden, Conn., 1905*), lawyer, Connecticut legislator. Pupil of Frederick W. Gunn; studied law under Gideon H. Hollister. After a short, early career in teaching and successful practice of law in Meriden, he won the hotly contested Republican nomination for U.S. senator, 1879; he served in the Senate thereafter until his death. In 1881 he became chairman of the Patents Committee (a position he held intermittently for ten years); his name became associated with practically every patent law passed during his long career. Advocate of liberal copyright relations with Europe, he was successful in securing an international copyright bill (passed 1891) which effectively ended literary piracy. Chairman of the Committee on Territories, 1887–93, he was associated with the admission of six Far West states. In fiscal and tariff legislation, however, he found his main interest. He believed in silver as a medium of exchange but opposed free coinage at 16-to-1 except under international agreement; his influence with the West led that section to accept the compromise Silver Purchase Act of 1890. In international relations Platt stood consistently with the administration in office. Cleveland received his support in the Venezuelan dispute with Great Britain; he was one of the props of the McKinley administration during the difficulties over Cuba. Almost overnight he became an expansionist in 1898, voting for the annexation of Hawaii and strongly urging the retention of the Philippines. As chairman of the Committee on Cuban Relations, he composed and introduced the famous Platt Amendment to the army appropriation bill, 1901. Following the death of McKinley, Platt became a valued supporter of Theodore Roosevelt. His last chairmanship was that of the judiciary committee. A "stand-pat" conservative, he was respected for his high character and unselfish service. He was several times mentioned for the vice presidential nomination, but his own political ambitions never went beyond the senatorship from Connecticut.

PLATT, THOMAS COLLIER (*b. Owego, N.Y., 1833; d. 1910*), businessman, politician. Began career as druggist in Owego; was elected county clerk on the Republican ticket, 1859, but soon returned to business as president of the Tioga County National Bank and a speculator in Michigan timberlands He served on various state and county Republican committees during the 1860's, but his political career really began in 1870 when he became the close friend of Roscoe Conkling, helping to organize the "southern tier" counties against Horace Greeley and Senator Reuben E. Fenton. Thereafter he was consulted by Conkling on practically every phase of New York politics. As congressman from New York, 1875–79, Platt made little impression in the House, but remained an indispensable behind-the-scene "Stalwart" Republican worker in state politics. Deeply distrustful of James A. Garfield in 1880, he supported him for the presidency only in return for a promise of recognition and rewards if Garfield were elected. As chairman of the state committee, he did much to conciliate the outraged Senator Conkling and to organize the campaign in New York; his reward was election to the U.S. Senate in 1881. Having promised Chauncey M. Depew his unreserved support of the Garfield administration, Platt was faced with a dilemma when Garfield appointed a "Half-Breed,"

or reform, Republican as collector of the Port of New York. Both Platt and Conkling resigned their Senate seats in protest and were defeated when they sought reelection in the legislature. Conkling's active career was thus ended; Platt's was eclipsed for over six years. In 1888 Platt gave Benjamin Harrison his New York support for the presidential nomination in return for a supposed promise of the post of U.S. secretary of the treasury. When Harrison failed to fulfill his promise, Platt became angry; he also resented the starvation fare allotted him in federal patronage. His token support of Harrison was responsible for Grover Cleveland's sweep of New York in 1892. He continued, however, to perfect the New York Republican machine, to which he had fallen heir on Conkling's retirement. After the election of Levi P. Morton as governor, 1894, his power became almost irresistible; its chief agency was patronage, local, state, and federal. Year after year, New York State conventions carried out his preordained program, and the legislature docilely obeyed his commands. As Theodore Roosevelt's power grew, Platt's declined; he tried to shunt Roosevelt into obscurity as vice president in 1900, but found that with Roosevelt's accession as president and B. B. Odell's as New York's governor his power politics would no longer work. He continued to hold his seat in the Senate but was shorn of party authority. Industrious and patient, he was, however, the very type of ruthless, unprincipled party boss.

PLEASANTS, JAMES (*b. Goochland Co., Va., 1769; d. Goochland Co., 1836*), lawyer, Virginia legislator. Congressman, 1811–19; U.S. senator, 1819–22; governor of Virginia, 1822–25. A cousin of Thomas Jefferson, a Democrat and advocate of social reform, he opposed the rising dominance of Andrew Jackson.

PLEASANTS, JOHN HAMPDEN (*b. Goochland Co., Va., 1797; d. 1846*), journalist, Whig politician. Son of James Pleasants. Founder and editor of the Richmond *Whig*, 1824–46. Killed in a duel with Thomas Ritchie, Jr., an editor of the Richmond *Enquirer*.

PLEASONTON, ALFRED (*b. Washington, D.C., 1824; d. Washington, D.C., 1897*), Union major general, brilliant cavalry leader. Graduated West Point, 1844; was distinguished in Mexican War and in western and southern Indian campaigns. Averted complete disaster at Chancellorsville, 1863, by checking General T. J. Jackson's advance against the Union right flank; commanded all Union cavalry at Gettysburg; routed General Sterling Price near Marais des Cygnes River, Kansas, October 1864. Resigned commission in dispute over rank, 1868.

PLIMPTON, GEORGE ARTHUR (*b. Walpole, Mass., 1855; d. Walpole, 1936*), publisher, book collector. Graduated Amherst, 1876. Associated *post* 1877 with Ginn and Co. and its predecessor firms, he served as chairman of the firm, 1914–31, and greatly expanded its activities.

PLOTZ, HARRY (*b. Paterson N.J., 1890; d. Washington, D.C., 1947*), bacteriologist, physician. M.D., College of Physicians and Surgeons, Columbia University, 1913. After developing an antityphus vaccine, 1914–15, which involved him in controversy, he served in Europe with the American Red Cross Sanitary Commission, 1915–16, and as a major on the staff of the U.S. Army surgeon general, 1916–19. Medical adviser to the Jewish Joint Distribution Committee's relief expedition to eastern Europe in 1921, he was with the Institut Pasteur in Paris from 1922 until 1940, becoming *chef de service* in 1931 and publishing extensively on bacteriologic, virologic, and immunologic subjects. In 1941 he rejoined the U.S. Army as lieutenant colonel and directed the division of virus and rickettsial diseases at the Army

Medical Center, Washington, D.C., until 1945. Thereafter, he continued work as a consultant to the U.S. secretary of war until his death.

PLOWMAN, GEORGE TAYLOR (*b. Le Sueur, Minn., 1869; d. Cambridge, Mass., 1932*), architect, etcher.

PLUMB, GLENN EDWARD (*b. Clay, Iowa, 1866; d. Washington, D.C., 1922*), lawyer. Specialist in railroad law and traction problems. Advocated plan for cooperative government ownership of railroads, with operating managers and employees sharing in profits.

PLUMB, PRESTON B. (*b. Berkshire, Ohio, 1837; d. Washington, D.C., 1891*), journalist, Union soldier, lawyer. Established *Kanzas* (sic) *News*, 1857, at Emporia. Prominent as an independent Republican in Kansas politics, Plumb was U.S. senator from 1877 until his death. As chairman of the Public Lands Committee *post* 1881, he was responsible for the reforming land law of 1891 which inaugurated reclamation and conservation.

PLUMBE, JOHN (*b. Wales, 1809; d. Dubuque, Iowa, 1857*), railroadman, publicist, photographer. Came to America as a boy. Plumbe appears to have been the first (1836) responsible and effective advocate of a railroad to the Pacific, continuing his efforts to this end as late as 1851. Active as a photographer *post* 1840, he established studios and equipment shops in over a dozen cities. His special claim to distinction is his unpatented Plumbeotype process, a method for reproducing daguerreotypes on paper.

PLUMER, WILLIAM (*b. Newburyport, Mass., 1759; d. Epping, N.H., 1850*), lawyer. Served as a Federalist in the New Hampshire legislature at various periods, 1785–1800; was a Speaker of the House, 1791 and 1797. A member of the state constitutional convention of 1791–92, he was U.S. senator, 1802–07. The foreign policy difficulties of Jefferson's second administration led to Plumer's repudiation of Federalism and his support of Madison in 1808. Soon an active Democratic-Republican, he served as New Hampshire governor, 1812–13 and 1816–19, pressing for reforms, which included revising the Dartmouth College charter; this action led to a memorable controversy and Supreme Court action. After retirement he devoted himself to writing for the press.

PLUMER, WILLIAM SWAN (*b. Griersburg, now Darlington, Pa., 1802; d. Baltimore, Md., 1880*), Presbyterian clergyman, professor of theology, author. An "old school" leader, he was twice elected moderator of the General Assembly, 1838 and 1871.

PLUMLEY, FRANK (*b. Eden, Vt., 1844; d. Northfield, Vt., 1924*), jurist, Vermont Republican leader and congressman. Umpire for the Mixed Claims Commissions of British, Dutch, and French claims against Venezuela, 1903.

PLUMMER, HENRY (*d. Bannack, Mont., 1864*), bandit. Nothing is known of his early life. He began his public career in Nevada City, Calif., 1856, when he was elected town marshal. Convicted of murdering a man with whose wife he was involved, he escaped prison on the assumption that he was dying of tuberculosis, but lived to establish a record of seduction, brawling, murder, and jailbreaking for which he was never punished. Fleeing to Washington Territory, 1861, he soon removed to Lewiston, Idaho, where he led a gang of bandits. At the end of 1862, he settled in Bannack, where he managed to be elected sheriff and organized a band of outlaws who terrified all southern Montana and were responsible for killing over 100 men within a few months. His double life ended when the townspeople organized a committee of vigilantes who rounded up his gang, exposed him, and hanged him.

PLUMMER, HENRY STANLEY (*b. Hamilton, Minn., 1874; d. Rochester, Minn., 1936*), physician. M.D., Northwestern, 1898. A staff member of the Mayo Clinic *post* 1901, Plummer developed a number of mechanical aids to medical practice and on the basis of clinical observation proposed a new classification for thyroid diseases, which encouraged worldwide activity in their study. The Mayo concept of private group medical practice was greatly influenced by Plummer's thinking.

PLUMMER, JONATHAN (*b. Newbury, Mass., 1761; d. Newburyport, Mass., 1819*), peddler, ballad-monger. Poet laureate to "Lord" Timothy Dexter, 1793–1806.

PLUMMER, MARY WRIGHT (*b. Richmond, Ind., 1856; d. Dixon Ill., 1916*), librarian, teacher, poet. Headed library schools at Pratt Institute, 1894–1911, and New York Public Library; president, American Library Association, 1915–16.

PLUNKETT, CHARLES PESHALL (*b. Washington, D.C., 1864; d. Washington, 1931*), naval officer. Graduated Annapolis, 1884. Commanded batteries of 14-inch naval guns on railway mounts in Layon-Longuyon sector, Western Front, 1918; held important sea and shore commands until retirement as rear admiral, 1928.

POCAHONTAS, (*b. Virginia, ca. 1595; d. Gravesend, England, 1617*), Indian "princess." Alternative name of Matoaka, daughter of Powhatan. Mentioned in Capt. John Smith's *True Relation* as a "child of ten" in 1607; saved Smith by her intervention when he was captured by Powhatan, 1608. The truth of this famous story is still a matter of controversy. In the spring of 1613 Pocahontas fell into the hands of Samuel Argall, who brought her to Jamestown, where she was received graciously by the acting governor, Sir Thomas Dale, and was subsequently converted to Christianity. Her marriage in April 1614 at Jamestown to John Rolfe, an English gentleman, acted as a bond between the English and the Indians and brought a peace which aided establishment of the colony. In 1616 she accompanied her husband to England, where she was received by the king and queen.

POE, EDGAR ALLAN (*b. Boston, Mass., 1809; d. Baltimore, Md., 1849*), poet, critic, short-story writer. Son of David and Elizabeth (Arnold) Poe, actors; brother of William H. L. Poe and Rosalie Poe. Orphaned in 1811, the Poe children were parceled out among foster parents; Edgar went to live with Mr. and Mrs. John Allan of Richmond, Va. In 1815, he was taken to Great Britain (where Allan, a merchant, planned to establish a branch of his firm), attended for a short period a school in Irvine, Scotland, and was later at the boarding school of the Misses Dubourg in Chelsea and at the Manor House School, Stoke Newington. On the failure of Allan's venture, 1820, they all returned to Richmond, where Poe attended the school of Joseph H. Clarke and began to write verse. Here he met Rob Stanard, to whose mother, Jane Stith Stanard, "To Helen" is addressed.

By 1824 the relation between John Allan and Poe was strained because of Poe's knowledge of Allan's infidelity to his wife. The young man, up to this point, had done well in school, read widely in contemporary literature, and was considered a very able swimmer. Secretly but transiently engaged to a neighbor's daughter, Sarah Elmira Royster, he was sent to the University of Virginia, 1826. He remained for only one term. Allan refused to pay his charges. In order to maintain himself Poe tried gambling, which got him heavily into debt; the situation was further complicated by Poe's drinking. It was plain, even at this time, that a very little liquor was disastrous to him. Allan, refusing to pay the gambling debts, proposed that Poe take up the reading of law; Poe insisted

on a literary career. The violent quarrel that ensued drove Poe from Allan's house to seek his fortune under an assumed name. Arriving in Boston sometime in April 1827, he published in that year his first volume, *Tamerlane and Other Poem*. The verse, although it gave hints of the poet's power, was undistinguished and went unnoticed. In desperate circumstances, he enlisted in the U.S. Army under the assumed name "Edgar A. Perry." Assigned to Battery H, 1st U.S. Artillery, at Fort Independence, Boston, he was ordered to South Carolina in October 1827 and served at Fort Moultrie until the end of 1828. Promoted sergeant major, he corresponded with Allan about going to West Point. Allan consented, partly because of Mrs. Allan's dying wishes, and Poe set off with letters of recommendation to the secretary of war in April 1829, requesting an appointment. It was not soon forthcoming. Proceeding in May to Baltimore, Md., he lived on a pittance sent him by Allan. He now first saw his blood relatives — his grandmother Mrs. David Poe, his aunt Mrs. Maria Clemm, and Mrs. Clemm's daughter Virginia, his future wife. For a time he lived with Mrs. Clemm and his elder brother William. His second volume of poetry, *Al Aaraaf, Tamerlane, and Minor Poems*, was published in Baltimore in December 1829. In January 1830 he returned to Richmond where he quarreled further with Allan. Receiving an appointment to West Point, he passed the examinations and entered the U.S. Military Academy on July 1, 1830.

Poe had hoped to win back his foster father's favor; however, a letter of his containing an unfortunate remark fell into Allan's hands, and Poe was definitely disowned. He now determined to leave the army and deliberately neglected his duties, for which he was dismissed in March 1831. His third volume, *Poems by Edgar A. Poe*, appeared in 1831; it contained three of his most famous lyrics, "To Helen," "Israfel," and "The Doomed City," but attracted little attention. Removing to Baltimore *ca.* March 1831, he took up residence with Mrs. Clemm and Virginia and stayed in that city until the summer of 1835. Beginning to write prose extensively, he first attracted notice in October 1833 on the publication in the *Baltimore Saturday Visiter* of "A MS. Found in a Bottle." An important outcome of this publication was the friendship of John P. Kennedy, who became his patron and introduced him to T. W. White, editor of the *Southern Literary Messenger*, to which Poe began to contribute. In midsummer of 1835 he joined the staff of the *Messenger* in Richmond and, through brilliant editing and critical writing, increased the circulation sevenfold. This success was offset by Poe's increased drinking, which caused a temporary separation between him and White. In September, Poe took out a license to marry his 13-year-old cousin Virginia; they were publicly married in Richmond, May 1836.

Discontented with the limited scope of the *Messenger*, Poe took his child bride and Mrs. Clemm to New York in January 1837. Unable to make a living there, in the summer of 1838 he moved to Philadelphia, where he edited a pirated textbook on conchology (1839), but supported himself mainly by free-lance writing. In May 1839 he was employed by William E. Burton as coeditor of Burton's *Gentleman's Magazine*, continuing in this capacity until June 1840. His prose *Narrative of Arthur Gordon Pym* had been published in book form, July 1838; the end of 1839 brought the publication of his sixth volume, *Tales of the Grotesque and Arabesque*. Quarreling with Burton, Poe set about the establishment of his own magazine in January 1841, but dropped the project to be literary editor of *Graham's Lady's and Gentleman's Magazine*. Once again Poe's talent increased the circulation as well as his own fame, but lapses into drink and general ill health ended this employment in May 1842. The remainder of Poe's sojourn in Philadelphia was a period of great poverty, visionary schemes to publish his own magazine (to be

called "The Stylus"), and abortive attempts to obtain government employ. His wife was now advanced in tuberculosis, and only Mrs. Clemm's efforts kept the family together and alive. However, in 1843 Poe wrote and published "The Gold Bug" (*Dollar Newspaper*, June 21, 28), issued a pamphlet of stories (part of a proposed series) which contained "The Murders in the Rue Morgue," and composed the early version of "The Raven."

Poe left Philadelphia with Virginia and returned to New York in April 1844. "The Raven" was cast in final form and appeared first in the New York *Evening Mirror* (Jan. 29, 1845) to great applause; in June 1845, Poe found himself sole editor of the *Broadway Journal*. Later in that year, two more volumes of his work appeared: *Tales* and *The Raven and Other Poems*. Now famous, Poe through pressure of a number of circumstances gave up the *Broadway Journal*, January 1846. In the spring, he moved his family to Fordham, where he wrote a series of journalistic critical articles known as "The Literati of New York City" for *Godey's Lady's Book*. Virginia Poe died in January 1847 during a winter in which the family sounded the depths of misery. Poe now sought female sympathy ardently; among those whom he courted with an erratic, abnormal persistence were Mary Louise Shew, Sarah Helen Whitman, and Annie Richmond. During this time he published *Eureka: A Prose Poem* (1848) and composed some of his best-known lyrics: "The Bells," "Ulalume," "Annabel Lee," and "El Dorado." His time was occupied mainly in trips to Philadelphia, Richmond, and Fordham and by bouts of drinking. Arriving in Richmond almost dead in July 1849, he joined a lodge of teetotalers and began to court his old love Sarah Royster, now widowed. The marriage day was set, and Poe left Richmond to bring back Mrs. Clemm. Stopping in Baltimore five days before the election of 1849, Poe disappeared; he was found semiconscious in a tavern by an old friend, Dr. James E. Snodgrass, on Oct. 3. Four days later he died in great mental agony and was buried in the churchyard of the Westminster Presbyterian Church, Baltimore.

In the practical affairs of everyday life, in many of the common amenities, in the domestic circle, and in the general give-and-take of earthly existence, Poe was greatly lacking and frequently a complete failure. His relations with women, at least during the latter part of his life, were fantastic and nothing more. He certainly at various times resorted to opiates and he was the victim of alcohol. Combined with all this was an undoubted charm and fascination, a magnetism and reverse power of antagonism which caused him to be greatly loved by a few, hated by many, and memorable to everybody. He practiced literature in a time and place when what he had to say and his way of saying it were little appreciated, was constantly ground down by poverty and disappointments, and was victim of a succession of tragedies which cannot all be attributed to his own failings. All of this can be summed up by saying that as a man Poe was abnormal, and as a genius, unique.

His reputation as artist in the United States from 1845 on, contrary to the belief of foreign critics, has always been assured. At his death he was already in his native country a famous man. In France, owing largely to the early and brilliant translations of Baudelaire, Poe has exerted a very great literary influence. His fame rests on a small bulk of exquisite lyrical poetry, on a few of his stories, and on his contribution to the methods of writing certain types of short prose fiction. He is commonly considered to be the originator of the "detective story," or tale of logical deduction. His style in prose is a product of his own peculiar genius, unusually effective when used by him, but not to be imitated. His characters are either grotesques or the inhabitants of another world than this. As a critic there is much to be learned from him, but his dicta should be carefully compared with the sources from which he took them, principally Coleridge.

POE, ORLANDO METCALFE (*b. Navarre, Ohio, 1832; d. Detroit, Mich., 1895*), soldier, engineer. Graduated West Point, 1856. Commissioned brigadier general, 1862; received regular army brevet of that rank, 1865. A successful field officer, 1861–63, he was chief engineer under General W. T. Sherman, 1864–65. Thereafter he was active in railroad construction and in river and harbor improvement work in the Great Lakes region.

POINDEXTER, GEORGE (*b. Louisa Co., Va., 1779; d. Jackson, Miss., 1853*), lawyer. Removed to Mississippi, 1802; served as attorney general, delegate to Congress, and district judge of the territory; was congressman, Democrat, from Mississippi, 1817–19, and governor of the state, 1820–21. His able codification of the laws of Mississippi was published in 1824. As U.S. senator, 1830–35, he was an outspoken opponent of Andrew Jackson.

POINDEXTER, MILES (*b. Memphis, Tenn., 1868; d. Greenlee, Va., 1946*), lawyer, politician. Grandnephew of Joseph R. Anderson. LL.B., Washington and Lee University, 1891. Removed to the state of Washington, 1891, where he practiced law, first in Walla Walla and then in Spokane; entering politics as a Democrat, he was repelled by the populism of that party locally and became a Republican, 1897. After service as assistant prosecuting attorney for Spokane County, 1899–1904, and as judge of the superior court, 1904–08, he was elected to the U.S. House of Representatives, 1908. A progressive reformer and one of the "insurgent" group in Congress, he swept the Republican senatorial primary in 1910 and was elected to the U.S. Senate by the state legislature. Continuing his advocacy of reform during his first term, he was a member of the Progressive party, 1912–15, backed President Wilson's domestic policies, and was sympathetic to labor; by 1916, however, he had become critical of the president's international idealism and handling of foreign policy. Reelected in 1916 by popular vote, he strongly supported U.S. intervention in World War I, but was a bitter opponent of the Versailles Treaty and the League of Nations; during the postwar years he also opposed federal aid for farmers, which alienated his constituents and cost him election in 1922. He served as U.S. ambassador to Peru, 1923–28; thereafter, he practiced law in Washington, D.C.

POINSETT, JOEL ROBERTS (*b. Charleston, S.C., 1779; d. near Statesburg, S.C., 1851*), diplomat, statesman. Educated at Timothy Dwight's school, Greenfield Hill, Conn., and in England; studied law with Henry W. De Saussure; made extended tour of Europe and western Asia, 1801–08. Returning home hoping for high military appointment, he accepted in 1810 a post as special agent to Rio de la Plata (now Argentina) and Chile and supported the movement there to gain independence from Spain. On his return, 1815, he became interested in politics, served in the South Carolina legislature, and was congressman, Democrat, 1821–25. First U.S. minister to Mexico, 1825–30, he was recalled at request of the Mexicans for meddling in local politics. As U.S. secretary of war, 1837–41, he was distinguished for energy and ability. He was a strong Unionist. The poinsettia was developed by him from a Mexican flower.

POLAK, JOHN OSBORN (*b. Brooklyn, N.Y., 1870; d. Brooklyn, 1931*), obstetrician, gynecologist. Associated as consultant and teacher with many hospitals, in particular the Long Island College Hospital, from which he had graduated in 1891.

POLAND, LUKE POTTER (*b. Westford, Vt., 1815; d. Waterville, Vt., 1887*), Vermont jurist. U.S. senator, Republican, from Vermont, 1865–67; congressman, 1867–75. Chairman of House committees investigating Ku Klux Klan and Crédit Mobilier, he was also on committee which rejected the carpetbag régime in Arkansas, 1875. Poland was largely responsible for the revision

of U.S. statutes, 1867–1875, as chairman of a House committee instituted for that purpose.

POLING, DANIEL ALFRED (*b. Portland, Oreg., 1884; d. Philadelphia, Pa., 1968*), Protestant minister and author. Attended Oregon's Dallas College (B.A., 1904) and was licensed to preach by the United Evangelical Church. A staunch prohibitionist, he was nominated by the Prohibition party for governor of Ohio (1912), drawing a record "dry" vote. He rejected pacifism and took a leading role by organizing a front-line Chaplain Corps in France during World War I. His wartime experiences were the basis for *Huts in Hell* (1918), his first popular book. In 1920 went to the New York Marble Collegiate Reformed Church and served as minister, 1923–30. Pastor of the Baptist Temple in Philadelphia (1936–48). Edited the *Christian Herald*, 1926–63, and in 1927 became head of the World's Christian Endeavor Union.

POLK, FRANK LYON (*b. New York, 1871; d. New York, 1943*), lawyer, diplomat, municipal, reformer. Son of William M. Polk. B.A., Yale, 1894; LL.B., Columbia University Law School, 1897. Resuming legal practice in New York City after service in the Spanish-American War, he also took on various civic and political responsibilities, including membership on the city board of education and the presidency of the Municipal Civil Service Commission. An independent Democrat, he effected a number of reforms in administration of the civil service and organized opposition to the Tammany Hall machine. A supporter of Woodrow Wilson in the presidential contest, 1912, Polk was appointed to the U.S. Department of State as second to Secretary Robert Lansing, 1915. In this post, he handled the diplomatic problems incident to the Mexican border crisis, advised on the problems of neutral rights arising out of World War I, and coordinated the intelligence gathering agencies of the federal government, 1917–18. In 1919 he was appointed first U.S. under secretary of state, a new position. He resigned in June 1920 and returned to the practice of law, but continued to act as adviser to Democratic governors and in general favored the New Deal.

POLK, JAMES KNOX (*b. Mecklenburg Co., N.C., 1795; d. Nashville, Tenn., 1849*), lawyer, eleventh president of the United States. Scotch-Irish in ancestry; moved in 1806 with his family to the valley of Duck River, Tenn. After preparation in Tennessee academies, he graduated from University of North Carolina with first honors in mathematics and classics, 1818. He read law in Tennessee with Felix Grundy; was admitted to the bar, 1820. Starting practice at Columbia, Tenn., in less than a year he was a leading practitioner. During two years in the state legislature he won notice as businessman and debater; he also became a friend of Andrew Jackson. He married Sarah Childress of Murfreesboro, 1824, a woman of ability and culture.

Entering the U.S. House of Representatives in 1825, he opposed the policies of President J. Q. Adams on political principle and because of loyalty to Jackson. After Jackson became president, 1829, Polk was a recognized leader of administration forces in the House. Owing to Polk, Jackson was able to triumph over the Bank of the United States. Polk, as a member of the House Ways and and Means Committee, submitted a strong minority report in favor of executive action when the bank issue was joined in 1832; as chairman of that committee post December 1833, he was chief defender of the president's action in withdrawing federal funds from the bank. Polk defeated John Bell for the speakership of the House in 1835, but was bitterly heckled and denounced as Jackson's "slave" during his brilliant four-year administration of the post. Contrary to his preferences he was drafted by the Democrats as candidate for governor of Tennessee and was elected, 1839. His administration was satisfactory but

uneventful; he was defeated for reelection in 1841 and again in 1843.

The Whigs had gained control of the federal government in 1840, but the Democrats began early to prepare for victory in 1844. Henry Clay would surely be the Whig candidate. Martin Van Buren was favored as the Democratic candidate, and Polk and Richard M. Johnson were being considered for the vice presidential nomination. Not until Van Buren wrote a letter in late April 1844 opposing the annexation of Texas was Polk's name suggested for the presidency. Jackson, as head of the Democratic party, declared that Van Buren had committed political suicide and directed Polk's nomination as a "dark horse." After the defeat of Clay in the election, Polk announced that his principles and policy were to be found in the Democratic platform and in his inaugural address. He advised prospective cabinet members to devote their time and energy to supporting his administration and not to possible candidacy as his successor. Politely but firmly, he made it clear that his decisions would be his own, although he would seek and accept advice from his party's elder statesmen.

Polk was younger than any of his predecessors, but few presidents have had more definite plans for their administrations, and none has been more successful in accomplishing his plans. In a conversation with George Bancroft, his secretary of the navy, a few days after inauguration he stated, "There are four great measures which are to be the measures of my administration: one, a reduction of the tariff; another, the independent treasury; a third, the settlement of the Oregon boundary question; and lastly, the acquisition of California." Before he left office in 1849, he had accomplished each of these measures. The Walker tariff law of 1846 placed import duties substantially on a revenue basis and substituted ad valorem for specific duties. The independent treasury bill of 1846 reestablished a financial system which continued, with slight modifications, until supplemented by the Federal Reserve system. The Oregon question was resolved also in 1846 by Polk's firmness in dealing with Great Britain and according to his own compromise plan of dividing the area between Alaska and California along the 49th parallel. Polk's plan for gaining California and New Mexico by forcing their cession as payment of Mexico's long-standing damage-claims debt to the United States led to the Mexican War. The charge that Polk wantonly provoked the war to extend slavery is unfounded. Polk was the first president to change the fundamental character of the Monroe Doctrine, opposing not only the use of foreign force but interference of any kind in American affairs. Opposed to "pork barrel" legislation, he indicated Clay's "American system" in his brilliant last annual message. Although a consistent party man, he had a supreme contempt for the spoils system. His expansion policy gave the United States a vast increase in territory and free access to the Pacific. He favored the course of extending the Missouri Compromise line to the Pacific and opposed all extremist views on the question of slavery; thus, he was disliked by both sides in that great controversy and has been given scant credit for his outstanding public services.

POLK, LEONIDAS (*b. Raleigh, N.C., 1806; d. near Marietta, Ga., 1864*), Episcopal clergyman, Confederate lieutenant general. Son of William Polk. Educated at University of North Carolina and West Point. Converted by Charles P. McIlvaine, he resigned his commission late in 1827, attended Virginia Theological Seminary, and was ordained in May 1831. Appointed missionary bishop of the Southwest, 1838, and bishop of Louisiana, 1841, he was a principal agent in the founding of the University of the South. Suspending his episcopal work, 1861, he accepted a commission as major general in the Confederate army and served conscientiously as a corps commander under Generals A. S. Johnston and Braxton Bragg. He fought bravely at Shiloh, Perryville, and Murfreesboro, but blundered at Chick-

amauga and was often in conflict with Bragg, whose removal he recommended to President Jefferson Davis. Meanwhile, he had been promoted to lieutenant general, October 1862. He was killed at Pine Mountain. An evangelical in his religious point of view, he was gifted as an executive; as a soldier, he was distinguished for organizing ability and as a disciplinarian.

POLK, LEONIDAS LAFAYETTE (*b. Anson Co., N.C., 1837; d. 1892*), farmer, newspaper editor, president of the National Farmers' Alliance and Industrial Union *post* 1889.

POLK, LUCIUS EUGENE (*b. Salisbury, N.C., 1833; d. Columbia, Tenn., 1892*), planter, Confederate officer. Nephew of Leonidas Polk. Valued subordinate to General P. R. Cleburne at Shiloh and later battles.

POLK, THOMAS (*b. Cumberland Co., Pa., ca. 1732; d. Charlotte, N.C., 1794*), Revolutionary soldier, North Carolina colonial legislator. Father of William Polk; great-uncle of James K. Polk.

POLK, TRUSTEN (*b. Sussex Co., Del., 1811; d. St. Louis, Mo., 1876*), lawyer, Confederate soldier. Governor, anti-Benton Democrat, of Missouri, 1856–57; U.S. senator, 1857–61. Responsible for education and tax reform in Missouri; prominent spokesman for Southern cause, 1861.

POLK, WILLIAM (*b. near Charlotte, N.C., 1758; d. Raleigh, N.C., 1834*), Revolutionary soldier, North Carolina businessman and legislator. Son of Thomas Polk. Unsuccessful Federalist gubernatorial candidate in several elections; later supported Andrew Jackson.

POLK, WILLIAM MECKLENBURG (*b. Ashwood, Tenn., 1844; d. Atlantic City, N.J., 1918*), Confederate soldier, gynecologist. Son of Leonidas Polk. Graduated New York College of Physicians and Surgeons, 1869. Dean, Cornell Medical School, 1898–1918.

POLK, WILLIS JEFFERSON (*b. near Frankfort, Ky., 1867; d. San Mateo, Calif., 1924*), architect. Studied with various architects, including Stanford White; entered Chicago office of Daniel H. Burnham and assisted in plan to adorn San Francisco, 1903. Practiced independently in San Francisco, *post* 1904; was chairman of architectural commission, Panama-Pacific Exposition, 1915. His buildings in San Francisco after the earthquake and fire of 1906 were mainly in a monumental, conservative style. Later buildings showed fresh handling of new materials and recognition of changes demanded by new functions, as in the Hallidie Building and the Central Pumping Station of Spring Valley Water Co. Restorer of the Mission Dolores, he is considered one of the creators of the "California style" of domestic architecture.

POLLAK, GUSTAV (*b. Vienna, Austria, 1849; d. Cambridge, Mass., 1919*), editor, critic. Came to America, 1866. Son-in-law of Michael Heilprin. Wrote on foreign politics and literary criticism for New York *Nation* and *Evening Post*; worked on encyclopedias.

POLLAK, WALTER HEILPRIN (*b. Summit, N.J., 1887; d. New York, N.Y., 1940*), lawyer. Son of Gustav Pollak; grandson of Michael Heilprin. Practicing in New York City, Pollak was active in the protection of the public interests and in defense of civil liberties, serving as counsel for Earl Browder, Benjamin Gitlow, and other individuals and groups of whose opinions he personally disapproved.

POLLARD, EDWARD ALFRED (*b. Albemarle Co., Va., 1831; d. Lynchburg, Va., 1872*), journalist, author. Edited *Daily Richmond Examiner*, 1861–67; was ablest and most prolific Southern writer of the period; bitterly opposed Jefferson Davis. Author of *The Lost Cause* (1866) and numerous other biased historical accounts of the Civil War.

POLLARD, JOSEPH PERCIVAL (*b. Greifswald, Pomerania, Germany, 1869; d. Baltimore, Md., 1911*), literary and dramatic critic. Reviewer for *Town Topics*, 1897–1911.

POLLOCK, CHANNING (*b. Washington, D.C., 1880; d. Shoreham, N.Y., 1946*), playwright, lecturer, reformer. Served as reporter, drama editor, and critic on Washington, D.C., newspapers, and as press agent for theatrical producers in New York City. After writing a successful dramatization of Frank Norris' novel *The Pit* (1903), he did a great deal of theatrical journeywork as playwright and librettist; in 1919, a melodrama by him, *The Sign on the Door*, was a success in both New York and London. He is best remembered for two subsequent plays that expressed Pollock's serious ethical and religious purpose as a writer: *The Fool* (1922) and *The Enemy* (1925).

POLLOCK, JAMES (*b. Milton, Pa., 1810; d. Lock Haven, Pa., 1890*), lawyer. Congressman, Whig, from Pennsylvania, 1844–49. As Whig and Know-Nothing governor, 1855–58, he materially reduced state debt by selling state-owned canals and railroads to Pennsylvania Railroad and other systems. Served as director of U.S. Mint at Philadelphia, 1861–66 and 1869–73; thereafter was its superintendent.

POLLOCK, OLIVER (*b. near Coleraine, Ireland, ca. 1737; d. Pinckneyville, Miss., 1823*), trader, planter, financier. Immigrated to Pennsylvania ca. 1760; removed to New Orleans, 1768. His generosity in feeding Alexander O'Reilly's army, 1769, gained him freedom of trade in Louisiana. He helped the American army get needed ammunition, 1776, through friendship with Unzaga, O'Reilly's successor as governor of Louisiana. By the close of 1777, Bernardo de Galvez, Unzaga's successor, had advanced to American frontier posts some $70,000 worth of ammunition and provisions, for which sum Pollock was personally responsible. George Rogers Clark's requests for aid were similarly financed by Pollock as U.S. commercial agent *post* 1778. His advances totaled $300,000. His credit exhausted, Pollock was imprisoned in 1783 but soon released. His claims against Virginia and the federal government were eventually paid.

POLLOCK, (PAUL) JACKSON (*b. Cody, Wyo., 1912; d. East Hampton, N.Y., 1956*), painter. The acknowledged master of the school of abstract expressionist painting, Pollock's training was with the academic painter Thomas Hart Benton at the Art Students League in New York. In the late 1930's, he came under the influence of European refugee painters. In 1942 he showed his first major painting, *Stenographic Figure*. His first one-man show was in 1943 and included the work *She Wolf*; from this time on, Pollock's works became less totemic and more abstract. In 1945, he moved to East Hampton, N.Y., where he immersed himself in developing his most innovative works of totally abstract, frequently large-scale, freely dripped, overall images that suggest limitless space. By 1950 he was called by many the greatest living American painter and the most influential.

POLOCK, MOSES (*b. Philadelphia, Pa., 1817; d. 1903*), publisher, rare-book dealer, bibliophile.

POMERENE, ATLEE (*b. Berlin, Ohio, 1863; d. Cleveland, Ohio, 1937*), lawyer, politician. Graduated Princeton, 1884. An active liberal Democrat and holder of local offices, Pomerene was elected lieutenant governor of Ohio, 1910, but was chosen almost immediately by the legislature as U.S. senator and served until 1923. A moderate progressive, he opposed woman suffrage, and in the debates over the League of Nations was one of the small group of Democrats willing to accept the Lodge reservations. He was cosponsor of the Bill of Lading Act, 1916, and the Webb-Pomerene Act, 1918. His best-known service was as special counsel, with Owen J. Roberts, to the prosecutor in the Teapot Dome scandal during the Harding administration. Appointed chairman of the Reconstruction Finance Corporation, July 1932, he did not receive Senate confirmation in the post. He later became one of Franklin D. Roosevelt's severest critics.

POMEROY, JOHN NORTON (*b. Rochester, N.Y., 1828; d. California, 1885*), legal author and educator. Associated *post* 1878 with Hastings College of Law. Among eight major treatises which he wrote, his *Equity Jurisprudence* (1881–83) was outstanding.

POMEROY, MARCUS MILLS (*b. Elmira, N.Y., 1833; d. Brooklyn, N.Y., 1896*), printer, newspaper editor and publisher, politician. Known as "Brick" Pomeroy. Gained national fame as editor of the La Crosse (Wis.) *Democrat, post* 1860. He engaged in railroad promotion and was an active "Greenbacker."

POMEROY, SAMUEL CLARKE (*b. Southampton, Mass., 1816; d. Whitinsville, Mass., 1891*), businessman, Kansas politician. As financial agent for New England Emigrant Aid Co., he went with the second group of settlers to Kansas in 1854; while chairman of public safety committee at Lawrence, 1856, he failed to prevent the town's ruin by "border ruffians." Delegate to the first Republican National Convention, he received eight votes for vice president. When Kansas was admitted to the Union, Pomeroy was elected to the U.S. Senate; serving 1861–73, he joined Radicals in opposition to Lincoln and was responsible for the "Pomeroy Circular," in favor of candidacy of Salmon P. Chase, 1864. His reelection to the Senate, 1867, was investigated by a committee of Kansas legislature which made charges of bribery against Pomeroy; the charges were repeated, 1873. Although cleared by a U.S. Senate committee, the incident ended his political career.

POMEROY, SETH (*b. Northampton, Mass., 1706; d. Peekskill, N.Y., 1777*), gunsmith, soldier. Fought in wars with French and Indians, 1745–59; distinguished at Lake George, September 1755. Raised and drilled troops in western Massachusetts, 1775–76; appointed first Continental brigadier general, June 1775.

PONCE DE LEÓN, JUAN (*b. San Servos, Spain, ca. 1460; d. Cuba, 1521*), Spanish explorer, discoverer of Florida. Said to have shipped with Columbus on second voyage to Hispaniola, 1493, where he fought under Nicolas de Ovando in conquest of Higuey and was made governor of that province. Learning from an Indian of gold in unexplored Puerto Rico, he subjugated that island and was made its governor, 1509, he was replaced by Diego Columbus, son of Christopher, 1512. Although now a rich man, enticed by Indian tales of gold and of a spring whose waters made the aged young again, he set forth in search of the island called Bimini, where all these were said to be found. Sailing from Puerto Rico in March 1513, he made the coast of Florida in true latitude 27°30', explored the coast southward to the Tortugas, and made other explorations, returning to repacify Puerto Rico. On his second trip to Florida, 1521, he was wounded by an Indian arrow, which led to his death.

POND, ALLEN BARTLIT (*b. Ann Arbor, Mich., 1858; d. Chicago, Ill., 1929*), architect, humanitarian. Designer of Hull House group in Chicago; was long associated with its work.

POND, ENOCH (*b. Wrentham, Mass., 1791; d. Bangor, Maine, 1882*), Congregational clergyman, professor and official in Bangor Theological Seminary.

POND, FREDERICK EUGENE (*b. Packwaukee, Wis., 1856; d. Brooklyn, N.Y., 1925*), writer on field sports, better known by his pen name of "Will Wildwood."

POND, GEORGE EDWARD (*b. Boston, Mass., 1837; d. Como, N.J., 1899*), journalist. Editor-correspondent of *Army and Navy Journal*, 1861–68; at various times on staffs of *New York Times*, Philadelphia *Record*, and New York *Sun*.

POND, IRVING KANE (*b. Ann Arbor, Mich., 1857; d. Washington, D.C., 1939*), architect, structural engineer. Graduated University of Michigan, C.E., 1879. After working for several Chicago architectural firms, Pond established a partnership with his brother Allen B. Pond, 1886. Participating in Chicago's great architectural renaissance, the firm for nearly 50 years designed every kind of structure, most notably public and educational buildings. A conservative member of the Chicago group dominated by Louis Sullivan, Pond stressed structure and function but with strong emphasis on formal, plastic, and decorative elements.

POND, JAMES BURTON (*b. Cuba, N.Y., 1838; d. 1903*), lecture manager. Successful in managing celebrity tours. Among his clients were Henry Ward Beecher, Ann Eliza Young (nineteenth wife of Brigham), Mark Twain, and Henry M. Stanley.

POND, PETER (*b. Milford, Conn., 1740; d. Boston, Mass., 1807*), soldier, fur trader, explorer. Entered fur trade at Detroit, 1765; was one of first to explore the Athabaska. Made important maps, *ca.* 1784, of his travels through the Northwest.

POND, SAMUEL WILLIAM (*b. New Preston, Conn., 1808; d. Shakopee, Minn., 1891*), Congregational missionary to the Dakota Indians. Composed a Dakota grammar and dictionary; published various works for and about the Indians.

PONS, LILY (*b. Alice Josephine Pons, Draguignan, France, 1898; d. Dallas, Tex., 1976*), coloratura soprano. Attended the Paris Conservatory to study piano and during World War I sang and played piano in French hospitals for wounded soldiers. After studying with the famed Spanish voice teacher Alberti di Gorostiaga, she made her operatic debut in France in 1928. She began a lengthy association with the Metropolitan Opera in New York City (1931–58), during which time she emerged as a leading star of the opera house; she was renowned for the beauty and clarity of her high tones. She also appeared in several movie musicals, including *That Girl from Paris* (1936), and conducted yearly national and international concert tours. She became a U.S. citizen in 1941.

PONTIAC (*d. 1769*), Ottawa chief, identified through Francis Parkman's *The History of the Conspiracy of Pontiac* (1851) with the French and Indian War in the Old Northwest. Accounts of his early life are largely legendary. Parkman claims that he was born on the Maumee River in 1720 and that he influenced the Chippewa as well as the Ottawa tribes. He may have been the "Sachem of the Outawawas" encountered in Robert Rogers' *Concise Account of North America* (1765); he may also have been present at the conference between the Detroit Indians and Sir William Johnson on Sept. 3, 1761. Pontiac's claim to fame lies in his activities during the siege of Detroit in 1763–64, although his importance at that time was much less than Parkman supposed. He attempted to surprise the garrison by treachery, and during the long siege, he was the greatest local menace. When other tribes made offers of peace, Pontiac's group seemed bent on breaking the truce; yet copies exist of a letter dated Oct. 30, 1763, from Pontiac to Henry Gladwin suing for peace. He was probably not responsible for starting the 1764 uprising which Parkman named "Pontiac's conspiracy"; he merely took up opposition at Detroit. The other tribes involved came to terms, but Pontiac and his band held out until a conference at Fort Ontario in July 1766. Having accepted peace with the English, he abode by it thereafter. The accounts of his death in 1769 are contradictory. Instead of being a great organizer, Pontiac was more likely only a local villein. The reports of his resistance appealed to popular imagination, however, so that he gained, even during his own lifetime, a reputation more romantic than he deserved.

POOL, JOE RICHARD (*b. Fort Worth, Tex., 1911; d. Houston, Tex., 1968*), attorney and politician. Attended University of Texas and Southern Methodist (LL.B., 1937). Democratic representative in Texas legislature, 1952–58, and U.S. congressman, 1962–68. Opposed the programs of Presidents John Kennedy and Lyndon Johnson; in 1960 he recommended the creation of a lake near Dallas to control Mountain Creek (Joe Pool Lake was created after his death). He became a national figure in 1966 when he chaired a subcommittee that held hearings to make it a federal crime to aid anyone engaged in armed conflict against the United States; after tumultuous hearings, to which he subpoenaed leaders of organizations resisting the Vietnam War, the bill passed the House but died in the Senate.

POOL, JOHN (*b. Pasquotank Co., N.C., 1826; d. Washington, D.C., 1884*), lawyer, North Carolina legislator and Unionist. U.S. senator, Republican, from North Carolina, 1868–73. Instrumental in introducing national anti–Ku Klux Klan legislation.

POOL, MARIA LOUISE (*b. Rockland, Mass., 1841; d. Rockland, 1898*), writer of sketches of New England life.

POOLE, ERNEST COOK (*b. Chicago, Ill., 1880; d. New York, N.Y., 1950*), novelist, journalist, social critic. B.A., Princeton University, 1902. Author of a number of novels *post* 1906 which dealt with successive problems of the times and reflected both his own idealism and the too fast pace of change in American Life, he is remembered best for *The Harbor* (1915) and *His Family* (1917). The latter was awarded the first Pulitzer Prize offered in fiction. Poole had won distinction, meanwhile, as an investigative reporter and foreign correspondent for *McClure's* and other magazines. After the mid-1920's his novels declined in popularity; late in life he tapped with success a new vein of regional New England material in *The Great White Hills of New Hampshire* (1946) and *The Nancy Flyer* (1949).

POOLE, FITCH (*b. South Danvers, now Peabody, Mass., 1803; d. 1873*), journalist, humorist. Librarian of Peabody Institute *post* 1856. Author of witty satires published in newspapers of Peabody and Salem, Mass., 1836–71.

POOLE, WILLIAM FREDERICK (*b. Salem, Mass., 1821; d. Evanston, Ill., 1894*), librarian, historian. Graduated Yale, 1849. Served as assistant to John Edmands; expanded an indexing project of Edmands to later-titled *Poole's Index to Periodical Literature*. Served as assistant in Boston Athenaeum, as librarian of Boston Mercantile Library Association, and then as librarian of the Athenaeum, 1856–69. Helped establish libraries at U.S. Naval Academy and at Cincinnati. Librarian of Chicago Public

Library, 1874–87; organized and headed the Newberry Library, Chicago, 1887–94. An outstanding leader in the progress of librarians to professional rank, he made pioneer contributions to the theory of library administration.

POOR, CHARLES HENRY (b. *Cambridge, Mass., 1808; d. Washington, D.C., 1882*), naval officer.

POOR, DANIEL (b. *Danvers, Mass., 1789; d. Mampy, India, 1855*), Congregational missionary.

POOR, ENOCH (b. *Andover, Mass., 1736; d. Paramus, N.J., 1780*), Revolutionary soldier. Settled in Exeter, N.H., ca. 1760. As colonel, 2nd New Hampshire, he served in the campaign of 1776 around Ticonderoga and in battles of Trenton and Princeton. Promoted brigadier general, 1777, he fought well at Saratoga and in Sullivan's expedition against the Six Nations.

POOR, HENRY VARNUM (b. *East Andover, Maine, 1812; d. Brookline, Mass., 1905*), railroad journalist, economist. Brother of John A. Poor. Author of many works on railways and economics, he was noted for compiling and publishing annual *Poor's Manual of Railroads* (first issued 1868).

POOR, JOHN (b. *Plaistow, N.H., 1752; d. York Haven, Pa., 1829*), educator. Graduated Harvard, 1775. Headed Young Ladies' Academy, Philadelphia, Pa., 1787–1809, an important early venture in female education.

POOR, JOHN ALFRED (b. *East Andover, Maine, 1808; d. 1871*), lawyer, railroad official. Brother of Henry V. Poor. Projected railway lines connecting Portland, Maine, with Halifax, Nova Scotia, and Montreal; served as director, Atlantic and St. Lawrence Railroad Co. Published *American Railroad Journal* and was president of the York and Cumberland (later the Portland and Rochester) Railroad. He resigned these positions to devote himself to international railway expansion, securing the charter of the European and North American Railway Co. (completed in 1871), connecting Maine railroads with those of lower Canada. Poor was also author of *English Colonization in America: A Vindication of the Claims of Sir Ferdinando Gorges* (1862) and other works. He was a tireless promoter of Maine interests.

POORE, BENJAMIN PERLEY (b. *near Newburyport, Mass., 1820; d. 1887*), journalist, author. Noted as Washington, D.C., correspondent of *Boston Journal* and other papers *post* 1854; edited and published useful catalogues of U.S. public documents.

POPE, ALBERT AUGUSTUS (b. *Boston, Mass., 1843; d. Cohasset, Mass., 1909*), Union soldier, manufacturer. Pioneer maker of bicycles at Hartford, Conn., *post ca.* 1878; developed "Columbia" and "Hartford" brands. He popularized the bicycle, financing legal test cases over their use, advocating better-roads movement, and publishing *The Wheelman* and *Outing*. He began manufacturing electric phaetons and runabouts through the Columbia Electric Vehicle Co., 1896. Progressing to production of gasoline automobiles, he turned out the Pope-Toledo and the Pope-Hartford at Toledo, Ohio, and Hartford, Conn., respectively; the Pope-Waverly electric was made at a plant in Indianapolis, Ind. Decline in the bicycle trade and a lull in the development of the automobile forced his company into receivership.

POPE, FRANKLIN LEONARD (b. *Great Barrington, Mass., 1840; d. Great Barrington, 1895*), electrician, inventor, author. Active in development of telegraphy *post* 1865; partner of Thomas A. Edison, 1869–70; made practical adaptation of the railway block signal invented by Thomas S. Hall.

POPE, JAMES PINCKNEY (b. *Vernon, La., 1884; d. Alexandria, Va., 1966*), lawyer and U.S. senator. Attended Louisiana Polytechnic and University of Chicago (LL.B., 1909). Founded Pope and Barnes law firm (1910) and aligned himself with the Democratic party. Served in various positions in Boise, Idaho, including city attorney (1916–17) and mayor (1929–32). Leader of the progressive, "dry" segment of the state's party. U.S. senator, 1932–38, and an ardent supporter of the New Deal and President Franklin Roosevelt's "court-packing" plan. Cosponsored the second Agricultural Adjustment Act (1938). As one of three directors of the Tennessee Valley Authority (1939–51), he defended the agency from attacks by conservatives and private industry.

POPE, JOHN (b. *Louisville, Ky., 1822; d. Sandusky, Ohio, 1892*), soldier. Son of Nathaniel Pope. Graduated West Point, 1842; was assigned to topographical engineers. Served with General Taylor in Mexican War; performed survey work in Southwest and West. Commanded Army of the Mississippi under Halleck and opened up the river almost to Memphis, March–April 1862. Because of this success and efficiency in moves against Corinth. Miss., he was appointed in June to command of the (Union) Army of Virginia, ordered to protect Washington. His inept handling of personalities subsequent to his assumption of larger responsibilities on the failure of the Union peninsular campaign in July and his total failure at the second battle of Bull Run (Aug. 27–30, 1862), led to his removal and replacement by General G. B. McClellan. Pope was no longer employed in field operations, but distinguished himself as head of various military departments until his retirement, 1886.

POPE, JOHN RUSSELL (b. *New York, N.Y., 1874; d. New York, 1937*), architect. Graduated Columbia, School of Mines, 1894; attended the American School of Architecture (later the American Academy) in Rome, and the École des Beaux Arts in Paris. Practicing independently in New York *post* 1903, Pope set a new standard in domestic architecture, combining elegance, beauty, and livability with archaeological correctness in a variety of styles. Pope believed above all else in the reposeful serenity of the monumental classic. His monumental buildings, of which he designed more than any other architect of his generation, included the National Archives, the National Gallery of Art, and the Jefferson Memorial, all in Washington, D.C.

POPE, NATHANIEL (b. *Louisville, Ky., 1784; d. St. Louis, Mo., 1850*), territorial secretary, 1809–16, and delegate, 1816–18, from Illinois. Cousin of Ninian Edwards; father of John Pope. Influential in establishing laws, northern boundary, and educational policy of Illinois. U.S. district judge *post* 1819.

POPHAM, GEORGE (d. *Maine, 1608*), Maine colonist. Sailed from Plymouth, England, in May 1607 to colonize for Sir Ferdinando Gorges in "Northern Virginia"; settled, Aug. 18, on western side of mouth of Kennebec. The colony was abandoned soon after Popham's death in the following February.

PORCHER, FRANCIS PEYRE (b. *St. John's, S.C., 1825; d. Charleston, S.C., 1895*), physician, botanist. Practiced in Charleston. Author of, among other works, *The Resources of the Southern Fields and Forests* (1863).

PORMORT, PHILEMON (b. *Grimsby, England, ca. 1595; d. Boston, Mass., ca. 1656*), educator. Immigrated to New England, 1634; appointed master of first public school in Boston, 1635; an adherent of Anne Hutchinson.

PORTER, ALBERT GALLATIN (b. *Lawrenceburg, Ind., 1824; d. Indianapolis, Ind., 1897*), Indiana lawyer and congressman. Law

partner of Benjamin Harrison. Republican governor of Indiana, 1881–85; U.S. minister to Italy, 1889–91.

PORTER, ALEXANDER (*b. Co. Donegal, Ireland, 1785; d. "Oak Lawn," St. Mary Parish, La., 1844*), Louisiana legislator, jurist, sugar planter. Came to America, 1801; settled in Louisiana, 1809. U.S. senator, Whig, 1833–37 and 1843.

PORTER, ANDREW (*b. Montgomery Co., Pa., 1743; d. Harrisburg, Pa., 1813*), teacher, Revolutionary artillery and ordnance officer, surveyor. Father of James M. and David R. Porter. Surveyor general of Pennsylvania, 1809–13.

PORTER, ARTHUR KINGSLEY (*b. Stamford, Conn., 1883; d. Ireland, 1933*), archaeologist. Graduated Yale, 1904. Taught history of art at Yale, 1915–19; professor of fine arts, Harvard, 1920–33. The leading American medieval archaeologist of his day, Porter was author of *Medieval Architecture: Its Origins and Development* (1909), *Lombard Architecture* (1915), *Romanesque Sculpture of the Pilgrimage Roads* (1923), *Spanish Romanesque Sculpture* (1928), and other works equally distinguished for originality and brilliance in research.

PORTER, BENJAMIN CURTIS (*b. Melrose, Mass., 1845; d. New York, N.Y., 1908*), portrait and figure painter.

PORTER, COLE (*b. Peru, Ind., 1891; d. Santa Monica, Calif., 1964*), composer and lyricist. Attended Yale (B.A., 1913), where he wrote more than 300 songs, some of which became Yale classics. His first major hit song, written for the Broadway musical *Paris*, was "Let's Do It, Let's Fall in Love" (1928), which like many of his song elegantly combines graceful melody and rhyming ingenuity with a mixture of sexual innuendoes, offbeat humor, and colloquialisms. Hit songs came regularly after that: "What Is This Thing Called Love?" (1929), "You Do Something to Me" (1929), "Night and Day" (1932), and several from the Broadway musical *Anything Goes* (1934). Wrote the scores for numerous films, such as *High Society* (1956) and *Les Girls* (1957), and the scores for such Broadway shows as *Kiss Me, Kate* (1948), *Can-Can* (1953), and *Silk Stockings* (1955).

PORTER, DAVID (*b. Boston, Mass., 1780; d. near Constantinople, Turkey, 1843*), naval officer. Father of David D. Porter; foster father of David G. Farragut. Son of a Revolutionary naval officer, he saw service in the naval war with France, 1798–99, and was made prisoner aboard the *Philadelphia* at Tripoli. Commanding the *Essex*, 1811–13, he took her on a remarkable cruise in the Pacific, raiding British commerce. Captured by the British at Valparaiso, Chile, after a desperate defense, he was paroled and participated in the operations on the Potomac in September 1814. Appointed commissioner of Navy Board, 1815, he served until 1823. As commander of the West India Squadron, 1823–25, he suppressed piracy, but was court-martialed because of retaliation against Puerto Rico, where one of his officers had been mistreated. Resigning, he accepted command of the Mexican navy, 1826–29. He returned home, broken in health and fortune, and spent the remainder of his life in minor U.S. diplomatic posts.

PORTER, DAVID DIXON (*b. Chester, Pa., 1813; d. Washington, D.C., 1891*), naval officer. Son of David Porter; cousin of Fitz-John Porter. Served under father as midshipman in Mexican navy; appointed midshipman, U.S. Navy, 1829. Commanded merchant ships, 1849–55. Porter achieved great prominence during the Civil War. Promoted commander, 1861, he was responsible for the preliminary planning of the New Orleans expedition, 1862, and commanded the mortar flotilla which ably supported Farragut's fleet. Appointed to command of the Missis-

sippi Squadron as rear admiral, October 1862, he received congressional commendation for his part in the surrender of Arkansas Post and Vicksburg; he received a similar compliment for his work in the reduction of Fort Fisher, 1864–65. He was superintendent of the U.S. Naval Academy, which he successfully reformed and expanded, 1865–69; he was named vice admiral, 1866. Appointed adviser to secretary of the navy, 1869, he virtually ran the department through 1870. Succeeding Farragut as full admiral, August 1870, he was head of the Board of Inspection *post* 1877.

PORTER, DAVID RITTENHOUSE (*b. near Norristown, Pa., 1788; d. Harrisburg, Pa., 1867*), iron manufacturer. Son of Andrew Porter. After long service in the Pennsylvania legislature, he served as Democratic governor, 1839–45; he opposed debt repudiation and upheld the state's credit, but was in conflict with his party's views on the protective tariff question.

PORTER, EBENEZER (*b. Cornwall, Conn., 1772; d. Andover, Mass., 1834*), Congregational clergyman. Graduated Dartmouth, 1792. A conservative in theology, he taught at Andover Theological Seminary *post* 1812 and was its president, 1827–34.

PORTER, EDWIN STANTON (*b. Connelsville, Pa., 1870; d. New York, N.Y., 1941*), pioneer motion-picture director. After working as a sign painter, telegraph operator, and, during a three-year hitch in the U.S. Navy, an electrician, he entered motion-picture work in 1896 as a projectionist. Soon after joining the Edison Co. in 1899, he took charge of production at Edison's New York studio, operating the camera, directing the actors, and editing the final print. During the next decade he became the most influential moviemaker in the United States and made a number of important innovations in technique, including the dissolve, the close-up, and side lighting, which were to become the basic modes of visual communication through film. His most important film was *The Great Train Robbery* (1903). He left Edison in 1909 and was one of the organizers of Rex, an independent company; he was chief director of Famous Players Film Co., 1912–16. Thereafter, he was concerned mainly with mechanical aspects of the industry.

PORTER, FITZ-JOHN (*b. Portsmouth, N.H., 1822; d. Morristown, N.J., 1901*), soldier. Cousin of David D. Porter. Graduated West Point, 1845. Assigned to the artillery, he served with credit in the Mexican War; he was an instructor at West Point, 1849–55, and was assistant adjutant general in the Mormon expedition, 1857–59. Becoming brigadier general of volunteers, 1861, he rose to command of the V Corps during the peninsular campaign, 1862. Blamed for the Union defeat in the second battle of Bull Run, August 1862, Porter was court-martialed and cashiered in January 1863. Claiming injustice, he continued to fight the case for many years and in 1886 was reappointed colonel of infantry and retired.

PORTER, GENE STRATTON (*b. Wabash Co., Ind., 1863; d. Los Angeles, Calif., 1924*), author. One of the most popular American novelists of the years 1903–24, Mrs. Porter produced, among other romances of idealism, sentimentality, nature lore and uplift, *Freckles* (1904), *A Girl of the Limberlost* (1909), *Laddie* (1913), and *The Keeper of the Bees* (1925).

PORTER, HOLBROOK FITZ-JOHN (*b. New York, N.Y., 1858; d. 1933*), engineer. Son of Fitz-John Porter. Graduated Lehigh, 1878. Highly reputed as a consulting engineer, Porter was interested as well in the social and humanitarian aspects of industry; while working with the Westinghouse Co., 1902–05, he installed the first shop committee with employee representation to function in the United States.

PORTER, HORACE (*b. Huntingdon, Pa., 1837; d. 1921*), Union brigadier general, railroad executive, diplomat. Son of David R. Porter. Graduated West Point, 1860. Served in Civil War as artillery and ordnance officer; received Congressional Medal for gallantry at Chickamauga; was aide-de-camp to General U. S. Grant, 1864–65, later serving as one of Grant's military secretaries until 1872. A noted orator and prominent figure in Republican politics, Porter was U.S. ambassador to France, 1897–1905; he served as a U.S. delegate to the Hague Conference, 1907.

PORTER, JAMES DAVIS (*b. Paris, Tenn., 1828; d. Paris, 1912*), lawyer, Confederate soldier, Tennessee jurist. Democratic governor of Tennessee, 1875–79; later served as an assistant U.S. secretary of state, and as U.S. minister to Chile, 1893–94. A principal factor in the founding of the George Peabody College for Teachers while governor, he served as president of the college, 1902–09.

PORTER, JAMES MADISON (*b. near Norristown, Pa., 1793; d. 1862*), Pennsylvania jurist and politician. Son of Andrew Porter; brother of David R. Porter. First president of the Lehigh Valley Railroad; principal founder of Lafayette College, 1826.

PORTER, JERMAIN GILDERSLEEVE (*b. Buffalo, N.Y., 1852; d. 1933*), astronomer. Director, Cincinnati Observatory, 1884–1930.

PORTER, JOHN ADDISON (*b. Catskill, N.Y., 1822; d. New Haven, Conn., 1866*), chemist. Graduated Yale, 1842; studied also in Germany. Taught chemistry at Yale *post* 1852; was first dean of Sheffield Scientific School.

PORTER, JOHN LUKE (*b. Portsmouth, Va., 1813; d. Portsmouth, 1893*), naval constructor. In Confederate service, 1861–65, Porter was associated with John M. Brooke in the design of the ironclad *Virginia* (*Merrimack*); he also designed a number of other ironclad steam sloops and rams, but was handicapped by lack of iron and adequate engines.

PORTER, KATHERINE ANNE (*b. Callie Russell Porter, Indian Creek, Tex., 1890; d. Silver Spring, Md., 1980*), writer. Worked for newspapers in Fort Worth and Denver before moving in 1919 to New York City, where she became active in anarchist political causes. While traveling as a magazine correspondent, Porter developed an interest in the culture and politics of Mexico. Her experiences during the Mexican Revolution provided the basis for several short stories, including "The Flowering Judas" (1930), which helped her establish a national reputation as a short-story writer. After the publication of the critically acclaimed book *Pale Horse, Pale Rider* (1939), she was offered teaching posts at several universities and appointed a fellow at the Library of Congress. Porter won the Pulitzer Prize and the National Book award for the best-selling novel *Ship of Fools* (1962).

PORTER, NOAH (*b. Farmington, Conn., 1811; d. 1892*), Congregational clergyman, educator. Graduated Yale, 1831. A noted conservative scholar. After holding several pastorates he was associated with Yale *post* 1846 and served as president of the college, 1871–86. He succeeded Chauncey A. Goodrich as editor of Webster's *American Dictionary*.

PORTER, PETER BUELL (*b. Salisbury, Conn., 1773; d. Niagara Falls, N.Y., 1844*), lawyer, New York politician and congressman. Rose to major general of militia for effective service at Chippewa, Lundy's Lane, and Fort Erie in War of 1812. U.S. secretary of war, 1828–29. Influential in development of locality of present Buffalo, N.Y.

PORTER, ROBERT PERCIVAL (*b. Norwich, England, 1852; d. 1917*), journalist, statistician. Administered the eleventh census, 1889–93; *post* 1904, was associated as an editor of special supplements and as a correspondent with the London *Times*.

PORTER, RUFUS (*b. Boxford, Mass., 1792; d. New Haven, Conn., 1884*), inventor. Founded the *Scientific American*, August 1845.

PORTER, RUSSELL WILLIAMS (*b. Springfield, Vt., 1871; d. Pasadena, Calif., 1949*), Arctic explorer, architect, astronomer, telescope maker. A man of many talents, he assisted *post* 1928 in the design and construction of the great Palomar Mountain observatory and of the astrophysical laboratory at California Institute of Technology.

PORTER, SAMUEL (*b. Farmington, Conn., 1810; d. Farmington, 1901*), teacher of the deaf. Brother of Noah and Sarah Porter.

PORTER, SARAH (*b. Farmington, Conn., 1813; d. Farmington, 1900*), educator. Sister of Noah and Samuel Porter. Founded Miss Porter's School for Girls at Farmington, 1843.

PORTER, STEPHEN GEYER (*b. near Salem, Ohio, 1869; d. 1930*), lawyer. Raised in Pennsylvania, he served as a Republican congressman from that state, 1911–30; he became chairman of the House Committee on Foreign Affairs, 1919, and came to be one of the most influential figures in determination of American foreign policy.

PORTER, THOMAS CONRAD (*b. Alexandria, Pa., 1822; d. Easton, Pa., 1901*), German Reformed clergyman, botanist. Graduated Lafayette College, 1840; Princeton Theological Seminary, 1843. Taught science at Franklin and Marshall College and at Lafayette; did pioneer botanical work in the Rocky Mountains as aide to John M. Coulter and Joseph Leidy; wrote extensively on literature as well as the sciences.

PORTER, WILLIAM SYDNEY (*b. Greensboro, N.C., 1862; d. New York, N.Y., 1910*), short-story writer, better known by pseudonym "O. Henry." Left school at 15; worked in a drugstore; removed to Texas, 1882, settling in Austin. After holding various jobs, he was teller in a bank, 1891–94. After failure of a humorous weekly, the *Rolling Stone*, which he edited, Porter removed to Houston, 1895, where he wrote a column for the *Daily Post*. Accused of embezzlement of funds from the Austin bank in which he had been teller, he fled to New Orleans and thence to Honduras; returning to Austin, 1897, he was sentenced in March 1898 to five years in the federal penitentiary in Columbus, Ohio. Released July 1901 after reduction of his term for good behavior, Porter felt the disgrace intensely. Meanwhile, having written and published several stories while in prison under various pseudonyms, of which "O. Henry" eventually displaced all others, he went to New York City, 1902. Nowhere else in his varied experience of life had Porter encountered such a range and diversity of humanity as New York offered him, and he soon put this new material to work. Almost immediately successful as a writer for the magazines, he was essentially an observer and a teller of tales marked by compassion and irony. He employed a few formulas and introduced minor variations into them with great ingenuity, but his success owed less to his technique than to his view of life. His work was of uneven merit and was often trivial. Among the many collected volumes of his stories, *Cabbages and Kings* (1904), *The Four Million* (1906), *Heart of the West* (1907), and *The Gentle Grafter* (1908) are outstanding.

PORTER, WILLIAM TOWNSEND (*b. Plymouth, Ohio, 1862; d. Framingham, Mass., 1949*), physiologist. M.D., St. Louis Medi-

cal College (later Washington University School of Medicine), 1885; postgraduate studies at universities of Kiel, Breslau, and Berlin. Taught physiology at St. Louis Medical College, 1887–93; as professor of physiology at Harvard Medical School *post* 1893 (professor of comparative physiology, 1906–28), introduced use of laboratory experiments as part of instruction. He also established the Harvard Apparatus Co. to supply specialized laboratory equipment at minimum cost to educational institutions. In 1897 he founded the *American Journal of Physiology*, which he edited until 1914.

PORTER, WILLIAM TROTTER (*b. Newbury, Vt., 1809; d. New York, N.Y., 1858*), journalist, promoter of sporting literature. Established *Spirit of the Times*, New York, December 1831; was helped by the young Horace Greeley. Published *American Turf Register*, 1839–44. Losing ownership of *Spirit*, 1842, Porter continued in an editorial capacity until 1858. Sketches of southern and western life which had been contributed to the *Spirit* by various writers were gathered by Porter into *The Big Bear of Arkansas* (1845) and *A Quarter Race in Kentucky* (1847).

PORTIER, MICHAEL (*b. Montbrison, France, 1795; d. 1859*), Roman Catholic clergyman. Came to America as missionary, 1817; ordained at St. Louis, Mo., 1818. Consecrated vicar apostolic of Florida and Alabama, 1826; bishop of Mobile, 1829–59.

PORTOLÁ, GASPAR DE (*b. Balaguer, Spain, ca. 1723; d. post 1784*), soldier, first governor of Upper California, His contribution to U.S. history consists in his march, 1769–70, from Velicatá in Lower California to Monterey, Upper California, a distance of about 1,000 miles of untrod country, and in his founding of the missions and presidios of San Diego and Monterey. With the Portolá expedition were Juan Crespi (who kept a diary of the enterprise) and Junípero Serra.

PORY, JOHN (*b. Thompston, Norfolk, England, 1572; d. Sutton St. Edmund, England, 1635*), geographer, traveler. Secretary to the Virginia Council at Jamestown, 1619–21, and Speaker of the first Virginia Assembly, July 30, 1619.

POSEY, ALEXANDER LAWRENCE (*b. Eufaula, Okla., 1873; d. in North Canadian River near Eufaula, 1908*), Creek Indian journalist, poet. Influential in Indian affairs and delegate to virtually every convention called in Indian Territory in his time. Editor of the *Indian Journal*.

POSEY, THOMAS (*b. Fairfax Co., Va., 1750; d. Shawneetown, Ill., 1818*), soldier. Fought in Dunmore's War, and as officer in 7th Virginia Regiment during Revolution; was brigadier general, 1793, under Wayne. A Kentucky legislator *ca.* 1805–10, he was U.S. senator from Louisiana, 1812–13, and governor of Indiana Territory, 1813–16.

POST, AUGUSTUS (*b. Brooklyn, N.Y., 1873; d. New York, N.Y., 1952*), pioneer aviator and automobilist. Studied at Amherst College and at Harvard Law School. One of the first automobile owners in New York City, Post established the first public garage for autos. He founded in 1905 the Aero Club of America, which announced the intention of Raymond Orteig to award a $25,000 prize to the first person to cross the Atlantic in a heavier-than-air craft. The award went to Lindbergh in 1927. Post wrote *Problems of Flying at High Altitudes* with W. Kasperowicz; *Glenn Hammond Curtiss* (1912), and the *Curtiss Aviation Book* (1912) with Curtiss.

POST, CHARLES WILLIAM (*b. Springfield, Ill., 1854; d. Santa Barbara, Calif., 1914*), breakfast-food manufacturer, advertising expert. Producer of Postum. Waged fierce battles against trade unions.

POST, CHRISTIAN FREDERICK (*b. Conitz, East Prussia, ca. 1710; d. Germantown, Pa., 1785*), Moravian lay missionary. Came to Bethlehem, Pa., 1742. Evangelized Indians in New York, Wyoming Valley, and Ohio country; won Ohio Valley tribes to alliance with British, 1758, which resulted in French loss of Fort Duquesne. Later worked among Indians of Nicaragua.

POST, EMILY PRICE (*b. Baltimore, Md., 1873; d. New York, N.Y., 1960*), author and columnist. The social arbiter of the middle class in America, Emily Post wrote *Emily Price Post's Etiquette* in 1922; the book sold over 500,000 copies, and, along with her newspaper columns and her radio program, made Emily Post a household word on matters of etiquette. Post's guiding principle was the other person's comfort, not adherence to rigid rules of behavior. Other works include the novel *The Flight of a Mother* (1904), *The Personality of a House* (1930), and *Motor Manners* (1950).

POST, GEORGE ADAMS (*b. Cuba, N.Y., 1854; d. Somerville, N.J., 1925*), lawyer, journalist, manufacturer of railroad supplies.

POST, GEORGE BROWNE (*b. New York, N.Y., 1837; d. Bernardsville, N.J., 1913*), Union soldier, architect. Graduated New York University, 1858; studied in office of Richard M. Hunt. Interested primarily in the engineering side of architecture, he was uncritically eclectic in design. His first important work was the Williamsburgh Savings Bank, New York, 1874; among other important New York buildings which he designed were the Western Union Building, Produce Exchange, Cotton Exchange, original Times Building, Pulitzer Building, St. Paul Building, and the earlier buildings of the College of the City of New York. He was responsible for many of the largest residences of his time, was particularly effective in his plan for the Wisconsin State Capitol (begun in 1904), and was a pioneer in modern hotel design.

POST, GEORGE EDWARD (*b. New York, N.Y., 1838; d. 1909*), physician, missionary to Syria. Professor of surgery, Syrian Protestant College, Beirut, *post* 1868; later became dean of the medical school.

POST, ISAAC (*b. Westbury, N.Y., 1798; d. Rochester, N.Y., 1872*), abolitionist, spiritualist. Converted to spiritualism by Margaret Fox, 1848.

POST, LOUIS FREELAND (*b. near Danville, N.J., 1849; d. 1928*), lawyer, reformer, journalist. As leading protagonist of Henry George's "single tax" philosophy; editor of the *Public*, Chicago, *post* 1898; assistant U.S. secretary of labor, 1913–21.

POST, MARJORIE MERRIWEATHER (*b. Springfield, Ill., 1887; d. Washington, D.C., 1973*), businesswomen and philanthropist. In 1914 Post inherited several million dollars and ownership of the Postum Cereal Company. Postum, renamed General Foods in 1929, grew into the largest food business in the nation. Post's second husband, E. F. Hutton, helped engineer the company's expansion in the 1920's. Post was director of General Foods from 1935 to 1958. Post had a lavish lifestyle and highly popular public personae and was a major benefactor of the Red Cross, Salvation Army, National Symphony Orchestra, and the Boy Scouts.

POST, MELVILLE DAVISSON (*b. near Clarksburg, W.Va., 1871; d. Clarksburg, 1930*), short-story writer, novelist, lawyer. Author of superior detective stories (*The Strange Schemes of Randolph*

Mason, 1896; *The Nameless Thing*, 1912; and others) characterized by skill in plotting.

POST, TRUMAN MARCELLUS (*b. Middlebury, Vt., 1810; d. St. Louis, Mo., 1886*), educator, Congregational clergyman, Missouri Unionist. Taught at Illinois College, 1833–47; thereafter pastor in St. Louis of one of the first Congregational churches west of the Mississippi.

POST, WILEY (*b. near Grand Plain, Tex., 1899; d. northern Alaska, 1935*), aviator. Winner of Bendix Trophy race, 1930. Made record-breaking circumnavigation of the world, June 23–July 1, 1931, with Harold Gatty as navigator; flying solo, broke his own record, 1933. Died with Will Rogers in a crash while flying to the Orient by way of Siberia.

POST, WRIGHT (*b. North Hempstead, N.Y., 1766; d. 1828*), New York surgeon. Studied under Richard Bayley and in England. As professor of surgery at Columbia, 1792–1813, collected specimens for anatomical museum; was professor at New York College of Physicians and Surgeons *post* 1813 and its president, 1821–26. Did much to introduce Hunterian principles of surgical procedure in America.

POSTL, CARL See SEALSFIELD, CHARLES.

POSTON, CHARLES DEBRILL (*b. Hardin Co., Ky., 1825; d. Phoenix, Ariz., 1902*), lawyer, explorer, author. First delegate from Arizona Territory to Congress, 1864–65; advocated irrigation works.

POTAMIAN, BROTHER (*b. Co. Cavan, Ireland, 1847; d. 1917*), Christian Brother, scientist. Name in religion of Michael Francis O'Reilly. Came to New York City as a child; entered congregation of Brothers of the Christian Schools at Montreal, 1859. Graduated University of London, D.Sc., 1883. After distinguished career as teacher and scientist in England and Ireland, he taught at Manhattan College, New York City, 1896–1917; he was particularly learned in electricity and magnetism.

POTOFSKY, JACOB SAMUEL (*b. Radomyshl, Russia, 1894; d. New York City, 1979*), labor leader. Immigrated with his family to the United States in 1905, worked in the garment industry in New York City at age fourteen, and emerged as an activist in the labor movement. In 1914 he and Sidney Hillman formed the Amalgamated Clothing Workers (ACW). Potofsky was a key figure in the Committee for Industrial Organization (CIO) when it was formed in 1935. A socialist as a young man, he later moderated his views and helped align the CIO in support of President Franklin Roosevelt's New Deal policies and the Democratic party. As president of the ACW (1946–72), he oversaw organizing campaigns that recruited union members from southern textile workers and among African–American, Hispanic–American, and Native American groups.

POTT, FRANCIS LISTER HAWKS (*b. New York, N.Y., 1864; d. Shanghai, China, 1949*), Episcopal clergyman, missionary, educator. L.H.B., Columbia College, 1883; B.D., General Theological Seminary, New York City, 1886. President of St. John's College (later University) in Shanghai, 1888–1940.

POTT, JOHN (*b. England, date unknown, d. probably Virginia, bef. 1642*), physician. Came to Virginia, 1621. In course of a checkered career, was deputy governor of the colony, 1629–30.

POTTER, ALONZO (*b. Beekman, N.Y., 1800; d. San Francisco, Calif., 1865*), Episcopal clergyman. Brother of Horatio Potter. Graduated Union, 1818; taught mathematics and natural philosophy there. Ordained, 1824, he served as rector of St. Paul's Church, Boston, 1826–31, then as professor of philosophy at Union until 1845 when he was chosen bishop of Pennsylvania. Broad-minded and tolerant toward those of differing opinions, he upheld the doctrine of the Muhlenberg Memorial of 1853. He opposed slavery and wrote in confutation of the claim that it was justified by the Bible.

POTTER, CHARLES EDWARD (*b. Lapeer, Mich., 1916; d. Washington, D.C., 1979*), U.S. senator. Graduated Michigan State Normal College (B.A., 1938) and was severely wounded in combat during World War II, losing both his legs. He was elected as a Michigan Republican to the U.S. House of Representatives (1946) and the U.S. Senate (1952). He was a member of the Senate Interstate and Foreign Commerce Committee and a member of the subcommittee that held hearings (1954) on charges brought by the U.S. Army against anti-Communist crusader Sen. Joseph McCarthy after the army hearings in 1954. Potter later relayed his experience in the Army–McCarthy hearings in *Days of Shame* (1965). He failed in his 1958 reelection bid and founded a real estate and brokerage firm, also acting as a fund-raiser for the Republican party. In 1972 he was an official in the reelection campaign of President Richard Nixon.

POTTER, CHARLES FRANCIS (*b. Marlboro, Mass., 1885; d. New York, N.Y., 1962*), clergyman. Attended Bucknell, Brown, and Newton Theological Seminary (S.T.M., 1916); ordained in 1908. While serving at the West Side Unitarian Church in New York City (1919–25), he emerged as the leading advocate of the modernist side in the fundamentalist-modernist conflict of the 1920's. He achieved national attention in a series of radio debates (1924) with John Roach Straton; served as Bible expert for Clarence Darrow's defense in the Scopes "monkey trial" (1925). Taught at Antioch (1925–27), then returned to the ministry as pastor of the Church of the Divine Paternity (1927–29), where he aligned himself with the Social Gospel movement. Wrote fifteen books, including *The Story of Religion* (1929) and *The Lost Years of Jesus Revealed* (1958). Campaigned against capital punishment and was an early advocate of birth control and euthanasia.

POTTER, EDWARD CLARK (*b. New London, Conn., 1857; d. New London, 1923*), sculptor. Studied with Daniel C. French and in Paris. Collaborated with French in work for Chicago World's Fair, 1893, and on numerous equestrian statues. Among his own best-known works are the celebrated New York Public Library lions and the Slocum statue at Gettysburg.

POTTER, ELIPHALET NOTT (*b. Schenectady, N.Y., 1836; d. Mexico City, 1901*), Episcopal clergyman, educator. Son of Alonzo Potter; grandson of Eliphalet Nott. Reorganized and expanded Union College as president, 1871–84; was president of Hobart College, 1884–97.

POTTER, ELISHA REYNOLDS (*b. South Kingston, R.I., 1811; d. 1882*), lawyer, Rhode Island legislator and congressman, writer. As state commissioner of public schools, 1849–54, he did much to promote efficient administration of education in Rhode Island. State supreme court justice, 1868–82.

POTTER, ELLEN CULVER (*b. New London, Conn., 1871; d. Philadelphia, Pa., 1958*), physician, social worker. Studied at the Women's Medical College of Pennsylvania (M.D., 1903). A public health official in Pennsylvania and New Jersey, Potter was secretary of welfare under Pennsylvania Governor Pinchot (1923–27), the first woman to serve on the state's cabinet. From 1930 to 1949, she was medical director and, from 1946, deputy

commissioner of the New Jersey Department of Institutions and Agencies.

POTTER, HENRY CODMAN (b. Schenectady, N.Y., 1835; d. Cooperstown, N.Y., 1908), Episcopal clergyman. Son of Alonzo Potter. Rector of St. John's, Troy, N.Y., 1859–66, and Grace Church, New York City, 1868–83, he made his parishes centers for Christian work of every sort. In 1883 he was elected assistant bishop of New York, succeeding his uncle Horatio Potter. By training an evangelical, he adopted a moderate Broad Church position. As bishop he dealt wisely with many party disputes within the church, in particular the cases of R. Heber Newton, J. O. S. Huntington, and Charles A. Biggs; he also expanded the religious work of the diocese and was a strong force for civic reform. The Cathedral of St. John the Divine was begun by him.

POTTER, HORATIO (b. Beekman, N.Y., 1802; d. 1887), Episcopal clergyman. Brother of Alonzo Potter. Elected bishop of New York, 1854, he healed the breach in the church caused by the suspension of Bishop Benjamin T. Onderdonk and brought the diocese to flourishing condition before his virtual retirement in 1883.

POTTER, JAMES (b. Co. Tyrone, Ireland, 1729; d. Pennsylvania, 1789), farmer, Revolutionary soldier, one of the earliest settlers in Penn's Valley region of Pennsylvania (ca. 1774).

POTTER, LOUIS MCCLELLAN (b. Troy, N.Y., 1873; d. Seattle, Wash., 1912), sculptor. Studied in Paris. Interested in universal brotherhood of man, he did vividly realistic studies of primitive and exotic types, which were of ethnological rather than aesthetic interest.

POTTER, NATHANIEL (b. Easton, Md., 1770; d. Baltimore, Md., 1843), physician, surgeon. M.D., University of Pennsylvania, 1796. Practiced in Baltimore; taught at Maryland Medical College post 1807. Rendered great service as epidemiologist, particularly of yellow fever; established noncontagiousness of that disease, 1797–98.

POTTER, PAUL MEREDITH (b. Brighton, England, 1853; d. 1921), journalist, dramatist. Came to America ante 1876. Facile and competent adapter for the stage of successful novels such as Du Maurier's *Trilby* (1895).

POTTER, PLATT (b. Galway, N.Y., 1800; d. Schenectady, N.Y., 1891), jurist. Justice of New York Supreme Court, 1857–73.

POTTER, ROBERT (b. Granville Co., N.C., ca. 1800; d. Texas, 1842), lawyer, North Carolina legislator and Democratic congressman, Texas pioneer.

POTTER, ROBERT BROWN (b. Schenectady, N.Y., 1829; d. 1887), lawyer, Union major general. Son of Alonzo Potter; grandson of Eliphalet Nott. Displayed extraordinary skill and gallantry, notably at South Mountain and Antietam, 1862, as colonel of the 51st New York. He won equal distinction as a division commander at Knoxville, 1863, and at Petersburg, Va., 1864.

POTTER, WILLIAM BANCROFT (b. near Northfield, Conn., 1863; d. 1934), electrical engineer. Entered employ of Thomson-Houston Co., 1887, as machinist on electrical equipment; gained extensive experience in installation of electric traction and lighting systems; invented series-parallel controller for electric railway motors, 1892. Worked thereafter at General Electric Co. supervising operations of the railway department; held more than 130 patents.

POTTER, WILLIAM JAMES (b. North Dartmouth, Mass., 1829; d. Boston, Mass., 1893), clergyman, editor. Left Unitarian fold, 1867, to join in founding the Free Religious Associations; was pastor in New Bedford, Mass., 1859–93.

POTTS, BENJAMIN FRANKLIN (b. Carroll Co., Ohio, 1836; d. 1887), Union brigadier general, lawyer. Territorial governor of Montana, Republican, 1870–83.

POTTS, CHARLES SOWER (b. Philadelphia, Pa., 1864; d. 1930), physician, neurologist, teacher.

POTTS, JONATHAN (b. Colebrookdale, Pa., 1745; d. Reading, Pa., 1781), physician, Revolutionary patriot. M.D., College of Philadelphia (University of Pennsylvania), 1768. Served as medical officer at Lake George, 1776; appointed deputy director general of the hospitals of the Northern Department, 1777, directed Middle Department hospitals as deputy, 1778–80.

POTTS, RICHARD (b. Upper Marlborough, Md., 1753; d. Frederick, Md., 1808), legislator, jurist. U.S. senator, Federalist, from Maryland, 1793–96.

POU, EDWARD WILLIAM (b. Tuskegee, Ala., 1863; d. Washington, D.C., 1934), lawyer, North Carolina official. Congressman, Democrat, from North Carolina, 1901–34. As chairman of the House Rules Committee, 1917–21 and 1933–34, he played a leading part in furthering the legislative programs of Presidents Wilson and F. D. Roosevelt.

POULSON, NIELS (b. Horsens, Denmark, 1843; d. Brooklyn, N.Y., 1911), architect, philanthropist, designer and manufacturer of ornamental metalwork. Came to America, 1864. Left fortune to American-Scandinavian Foundation.

POULSON, ZACHARIAH (b. Philadelphia, Pa., 1761; d. Philadelphia, 1844), printer, publisher, philanthropist. Edited the *American Daily Advertiser*, 1800–39.

POUND, CUTHBERT WINFRED (b. Lockport, N.Y., 1864; d. Ithaca, N.Y., 1935), jurist. Professor of law, Cornell University, 1895–1904. Judge, New York Supreme Court for 8th judicial district, 1906–15; associate judge, New York Court of appeals, 1915–34; (chief justice post 1932). A legal liberal and vigorous defender of civil liberties, Pound wrote the first American judicial opinion upholding validity of a workman's compensation act (*Ives* v. *South Buffalo Railway Co.*) and was author of a number of other opinions evidencing a broad tolerance of legislative discretion in cases involving constitutionality of statutes.

POUND, EZRA LOOMIS (b. Hailey, Idaho, 1885; d. Venice, Italy, 1972), poet and critic. Graduated Hamilton College (1905) and University of Pennsylvania (M.A., 1906). In 1908 he moved to Europe where he joined the literary community in London. He worked as a literary editor, in which position he helped publish such emerging authors as T. S. Eliot and James Joyce. Pound also released several collections of verse, including *Exultations* (1909) and *Hugh Selwyn Mauberley* (1920), that established him as a leading figure in the emerging modernist school of poetry. He rejected what he considered were the ornateness and elitism of traditional poetry in favor of terse, direct, and vital expression. In 1925 Pound moved to Italy where he concentrated on *The Cantos*, a series of poems that he released periodically. In this allusive and dense work, Pound explored themes of beauty and order in history.

During World War II, Pound, an admirer of the Italian fascist dictator Mussolini, broadcast anti-American tracts on Rome Radio, for which he was convicted of treason after the war. Follow-

ing his incarceration in Italy in 1945, he was held at St. Elizabeth's Hospital, a mental institution in Washington, D.C. During this period Pound wrote some of his most poignant and personal verse in *Pisan Cantos* (1948). He was awarded the Bollingen Prize in Poetry in 1948, which sparked a controversy in part because of the poet's outspoken anti-Semitism. After his release from St. Elizabeth's in 1958, Pound returned to Italy.

POUND, (NATHAN) ROSCOE (*b. Lincoln, Nebr., 1870; d. Cambridge, Mass., 1964*), law professor, jurist, and botanist. Attended University of Nebraska and Harvard Law. First developed an interest in botany, and his *Phytogeography of Nebraska* (1898) is considered a pioneering work. In the 1890's he practiced trial and appellate litigation; by 1899 botany became crowded out, and he channeled his energies into teaching law and the fusion of scholarship and "progressive" law reform. Taught at Nebraska Law School (1898–1907; dean, 1903–07), Northwestern (1907–09), Chicago (1909–10), Harvard Law (1910–47; dean, 1916–36), and University of California at Los Angeles (1949–53). Developed a theory of "sociological jurisprudence," stressing the dependency of legal rules on changing social conditions, and procedure, from which he developed a philosophy by which local rules were seen as embodiments of fundamental features of social organization. From this work came his famous 1906 address to the American Bar Association, "The Causes of Popular Dissatisfaction with the Administration of Justice," which launched his national career. The address combined traditional criticism of the legal profession and suggestions for reform. His rise was one of the most meteoric in the history of academic law. After 1910 he made his philosophy of professional reform more explicit; his approach, embodied in the phrases "sociological jurisprudence" and "social engineering," complemented his earlier work and expanded upon it. By 1916 he was regarded as the creator and architect of an approach to common-law decision making that favored the adjustment of legal principles and doctrines to the human condition they are to govern. He published at an extraordinary rate, including *Interpretations of Legal History* (1923) and *Law and Morals* (1924), but his scholarship eventually became repetitious and synthetic, and by 1936 he had lost his scholarly standing. Cultivating alumni who were anti-Communist and anti-Semitic, he gradually cast off the features of sociological jurisprudence: administrative agencies became a threat to private enterprise; social sciences, alien subjects; and academic freedom, invitation to Communism. His five-volume *Jurisprudence* appeared in 1959. He became opposed to curriculum reform and experimental research programs seeking to integrate law with social sciences; rejected the Realist movement in legal education, which had borrowed from his work; and rejected the New Deal, which he called the "service state."

POUND, THOMAS (*b. probably England, ca. 1650; d. Isleworth, England, 1703*), pirate, cartographer, captain in Royal Navy. Made first (*ca.* 1691) map of Boston harbor to be engraved and offered for sale.

POURTALÈS, LOUIS FRANÇOIS DE (*b. Neuchâtel, Switzerland, 1823; d. Beverly Farms, Mass., 1880*), marine zoologist. Associated with U.S. Coast Survey, 1848–73; pupil of J. L. R. Agassiz, whom he assited in Switzerland *ante* 1846 and at Harvard *post* 1870. He specialized in collecting and studying animal life at great depths.

POWDERLY, TERENCE VINCENT (*b. Carbondale, Pa., 1849; d. Washington, D.C., 1924*), labor leader, government official. Machinist by trade, he joined the Machinists' and Blacksmiths' Union, 1871, and the Knights of Labor, 1874. Rising in the Knights through various official posts, he headed the organization, 1879–93, during the period of its rise and fall as a powerful labor group, showing himself an idealist and reformer, but not an aggressive leader. To him the Knights of Labor was a great educational organization, destined to reform the world by encouraging the working people to demand government ownership of public utilities, regulation of trusts and monopolies, reform of the currency and of the land system, and such measures as the abolition of child labor. Personally sober, he denounced drink as one of the great evils under which workingmen suffered. He opposed the trade form of organization because he believed skilled workers should assist the unskilled. He laid little stress on immediate demands, such as higher wages and shorter hours, and opposed strikes as an outmoded industrial weapon which should be superseded by arbitration. His ultimate ideal was the abolition of the wage system, not through revolution but through producers' cooperatives in which every man would be his own employer.

Before his retirement from the Knights of Labor he had begun to study law, and on Sept. 24, 1894, he was admitted to the bar in Lackawanna Co., Pa. In 1897 he was admitted to practice before the Pennsylvania Supreme Court and in 1901 before the U.S. Supreme Court. He served as U.S. commissioner general of immigration, 1897–1902, and as chief of the Division of Information of the Bureau of Immigration, 1907–21.

POWDERMAKER, HORTENSE (*b. Philadelphia, Pa., 1896; d. Berkeley, Calif., 1970*), anthropologist. Attended Goucher College and London School of Economics (Ph.D., 1928). Pioneer woman anthropologist who did fieldwork in exotic places: her data on the Bismarck archipelago village of Lesu helped update and further the ethnology of Melanesia (*Life in Lesu*, 1933); in Indianola, Miss. (1933–34) to study blacks and whites; in Hollywood (1946–47) to study the values and practices of the film industry (*Hollywood, the Dream Factory*, 1950); in Zambia (1953–54) to study culture change and the media (*Copper Town and Changing Africa*, 1962). Important works include *After Freedom* (1939), "The Channeling of Negro Aggression by the Cultural Process" (*American Journal of Sociology*, 1943), and *Probing Our Prejudices* (1944).

POWEL, JOHN HARE (*b. Philadelphia, Pa., 1786; d. Newport, R.I., 1856*), War of 1812 soldier, agriculturist, author. Brother of Robert Hare. Introduced improved breeds of Durham shorthorn cattle and Southdown sheep to America.

POWELL *See OSCEOLA.*

POWELL, ADAM CLAYTON SR. (*b. Martin's Mill, Va., 1865; d. New York, N.Y., 1953*), clergyman. Studied at Wayland Seminary in Washington, D.C., and at the Yale Divinity School (1895–96). Pastor of the Abyssinian Baptist Church in New York from 1908 to 1937. Moved the church from midtown New York to Harlem in 1923. A founder of the Urban League and a member of the first board of directors of the NAACP. The father of congressman Adam Clayton Powell, Jr., Powell Sr. provided the political and cultural base for his son's political career.

POWELL, ADAM CLAYTON, JR. (*b. New Haven, Conn., 1908; d. Miami, Fla., 1972*), congressman. After graduating from Colgate University (1926), he studied for the ministry and later preached in Harlem in New York City. In the 1930's he led demonstrations against racial discrimination by businesses and city agencies. In 1941 he became the city's first African–American councilman and in 1944 was elected to the U.S. House of Representatives, where he served a twenty-six-year term fraught with controversy. Among his accomplishments, Powell, as chairman of the Committee on Education and Labor, helped secure passage of much of President John Kennedy's New Frontier and President Lyndon

Johnson's Great Society programs. An outspoken and maverick legislator, he also garnered substantial opposition while in Congress. In 1967 the House of Representatives voted not to seat Powell for various improprieties. Among other financial irregularities, Powell had his wife on the staff payroll although she performed no work. Powell also faced a $211,000 libel judgment that he refused to settle. A 1969 U.S. Supreme Court ruling reinstated Powell, though he lost his reelection bid the following year.

POWELL, ALMA WEBSTER (*b. Elgin, Ill., 1874; d. Mahwah, N.J., 1930*), operatic soprano, singing teacher.

POWELL, EDWARD PAYSON (*b. Clinton, N.Y., 1833; d. Sorrento, Fla., 1915*), teacher, Congregational and Unitarian clergyman. Influenced by Darwinism; friend and associate of Jenkin L. Jones. Author of *Our Heredity from God* (1887).

POWELL, GEORGE HAROLD (*b. Ghent, N.Y., 1872; d. Pasadena, Calif., 1922*), horticulturist. Authority on preservation and transportation of perishable fruits; held important positions in U.S. Department of Agriculture, 1901–11, and with the California Fruit Growers' Exchange.

POWELL, JOHN BENJAMIN (*b. near Palmyra, Mo., 1886; d. Washington, D.C., 1947*), editor, correspondent, writer on Asia. Graduated from University of Missouri's school of journalism; rose to city editor of *Hannibal* (Mo.) *Courier-Post*, 1910–13; instructor in journalism, University of Missouri, 1913–16. Resident in China from 1917 until his repatriation after imprisonment by the Japanese during World War II, he represented, among other papers, the *Chicago Tribune*, the *Manchester Guardian*, and the London *Daily Herald*. He was also editor *post* 1917, and for many years proprietor, of *Millard's Review of the Far East* (renamed *China Weekly Review* in 1922), an English-language weekly report of developments in politics, economics, society, and religion, which strongly supported unification of China and gave early warning of Japanese aggressive designs.

POWELL, JOHN WESLEY (*b. Mount Morris, N.Y., 1834; d. Haven, Maine, 1902*), Union soldier, geologist, teacher. Under auspices of the Smithsonian Institution and with aid of appropriations from Congress, Powell first explored the gorges of the Green and Colorado rivers by boat, 1869, traversing the Grand Canyon; he continued his explorations of the Rocky Mountain region in 1871 and 1874–75. Appointed director of the U.S. Geological survey, 1880, after serving as director of its Rocky Mountain division *post* 1875, he administered the Survey with marked success until 1894. He was also director of the Bureau of Ethnology (under the Smithsonian), 1879–1902. He was especially notable for the quality of the reports made by him and issued under his supervision (in particular his *Explorations of the Colorado River of the West*, 1875) and for his encouragement of his subordinates to attain distinction on their own. He retired from the survey, partly for reasons of health, partly because of antagonism to his projects for forest preservation and irrigation.

POWELL, LAZARUS WHITEHEAD (*b. Henderson Co., Ky., 1812; d. near Henderson, Ky., 1867*), lawyer, planter. Democratic governor of Kentucky, 1851–55. As U.S. senator, 1859–65; he fought for neutrality of his state and was an advocate of the Crittenden propositions; throughout the Civil War, he opposed military interference in civic affairs.

POWELL, LUCIEN WHITING (*b. near Upperville, Va., 1846; d. Washington, D.C., 1930*), landscape painter. Student of Thomas Morgan; influenced strongly by the English artist J. M. W. Turner.

POWELL, MAUD (*b. Peru, Ill., 1868; d. Uniontown, Pa., 1920*), violinist. Niece of John W. Powell; daughter of William Bramwell Powell. Made studies in Chicago; also at the Paris Conservatory and in Leipzig. She then toured a year in England, playing before Queen Victoria. In 1885, after further study with Joseph Joachim, she made her debut with the Berlin Philharmonic. Returning to New York, she appeared with the New York Philharmonic, 1885, and made annual concert tours, 1886–92. Organizing the Maud Powell Quartet, 1894, she appeared with it until 1898. Thereafter, she continued as a successful solo artist in America and Europe, winning praise for her technical mastery and deep interpretive insight.

POWELL, RICHARD EWING ("DICK") (*b. Mountain View, Ark., 1904; d. Hollywood, Calif., 1963*), actor. Beginning as a singer and musician in his teens, he was signed (1932) to a long-term contract by Warner Brothers and made more than thirty film musicals, including *42nd Street* (1933), *Broadway Gondolier* (1935), *On the Avenue* (1937), and *Going Places* (1940). A handsome, curly-haired tenor, he became the epitome of the actor-singer of the 1930's. Tired of musicals, he bought his release from Warners and won critical acclaim for serious roles in *Murder, My Sweet* (1945) and *Pitfall* (1948). In the 1950's he founded the Four Star Television Company.

POWELL, SNELLING (*b. Carmarthen, Wales, 1758; d. Boston, Mass., 1821*), actor, manager. Came to America, 1793. Prominent on the Boston stage as an actor *post* 1794, he was very successful as manager of the Boston Theatre, 1806–21.

POWELL, THOMAS (*b. England, 1809; d. Newark, N.J., 1887*), poet, dramatist, journalist. Came to America, 1849, after establishing himself as an industrious literary workman in London; was associated thereafter with the Frank Leslie publications. Author of a number of books, including the useful *Living Authors of England* (1849) and *Living Authors of America* (1850).

POWELL, THOMAS REED (*b. Richford, Vt., 1880; d. Boston, Mass., 1955*), constitutional lawyer. Studied at the University of Vermont, Harvard Law School (LL.B., 1904), and Columbia (Ph.D., 1913). Taught at Columbia (1906–25); at Harvard University (1925–49). Rejecting abstract and absolute principles, Powell concentrated on concrete criticisms and observations of the law; his special interest was the area of conflicts between national and state power in a federal system. His book *Vagaries and Varieties in Constitutional Law* was published posthumously in 1956.

POWELL, WILLIAM BRAMWELL (*b. Castile, N.Y., 1836; d. Mount Vernon, N.Y., 1904*), educator. Brother of John W. Powell; father of Maud Powell. Superintendent of schools in Peru and Aurora, Ill.; supervisor of District of Columbia schools, 1885–1900. Advocated progressive methods.

POWELL, WILLIAM BYRD (*b. Bourbon Co., Ky., 1799; d. Covington, Ky., 1866*), eclectic physician, phrenologist. Investigated relations between temperament and cranial conformation, evolving theory of phrenology — that human temperament could be read from examination of the cranium alone.

POWELL, WILLIAM HENRY (*b. New York, N.Y., 1823; d. New York, 1879*), historical and portrait painter. Pupil of James H. Beard and Henry Inman. Commissioned, 1847, to paint *De Soto* panel for rotunda in U.S. Capitol; painted *Battle of Lake Erie* for Ohio Capitol (completed 1863).

POWER, FREDERICK BELDING (*b. Hudson, N.Y., 1853; d. Washington, D.C., 1927*), pharmacist, chemist. Ph.D., Strass-

burg, 1800. Taught at Philadelphia College of Pharmacy and at University of Wisconsin; engaged in industrial research here and in England, 1892–1916; headed phytochemical laboratory, U.S. Department of Agriculture, 1916–27. Made major contributions to knowledge of plant constituents and distribution of organic compounds in plants; investigated chaulmoogra seeds and derivatives.

POWER, FREDERICK DUNGLISON (*b. Yorktown, Va., 1851; d. Washington, D.C., 1911*), Disciples of Christ clergyman. Pastor, *post* 1875, of Vermont Ave. Christian Church, Washington, D.C.

POWER, FREDERICK TYRONE (*b. London, England, 1869; d. California, 1931*), actor. Came to America as a boy; went on stage *ca.* 1886; was member of Augustin Daly's company. Later supporting Henry Irving. Mrs. Fiske, and others, he was famous in England and America for playing heroic and poetic roles in romantic drama.

POWER, JOHN (*b. Roscarberry, Ireland, 1792; d. 1849*), Roman Catholic clergyman. Came to America, 1819; served thereafter as pastor of St. Peter's Church, New York City, and was active in the social and political advancement of the Irish-Americans.

POWER, TYRONE (*b. 1869*) See POWER, FREDERICK TYRONE.

POWER, TYRONE (*b. Cincinnati, Ohio, 1914; d. Madrid, Spain, 1958*), actor. Self-trained, Power was a member of an old theatrical family. He began acting after high school, and after working in plays in Chicago, he was seen in *Romeo and Juliet* and *Saint Joan* (1936). That year, he signed a seven-year contract with Twentieth Century-Fox under the producer Darryl Zanuck. His first film was *Lloyd's of London* (1936); other films include *Suez* (1938), *The Rains Came* (1939), and *A Yank in the RAF* (1941). Power served in the marines during World War II and was discharged a first lieutenant. Other films include *The Razor's Edge* (1946), *The Sun Also Rises* (1957), and, his last film, *Witness for the Prosecution* (1958). He appeared on Broadway in the play *Mr. Roberts* (1950), and *John Brown's Body* (1953).

POWERS, DANIEL WILLIAM (*b. near Batavia, N.Y., 1818; d. Rochester, N.Y., 1897*), banker. Promoted civic and commercial interests of Rochester.

POWERS, FRANCIS GARY (*b. Burdine, Ky., 1929; d. Santa Barbara, Calif., 1977*), pilot and espionage agent. Graduated Milligan College in Tennessee (1950) and joined the U.S. Air Force. He was recruited in 1955 to join the Central Intelligence Agency and trained to fly advanced reconnaissance aircraft. In 1960 his U-2 plane was shot down near the Russian city of Sverdolovsk. Despite denials by the U.S. government, Russian authorities deduced the espionage nature of Powers' flight, after which an outraged Soviet premier Nikita Khrushchev ended a summit conference with President Dwight Eisenhower. Powers eventually provided a comprehensive account of his mission before a Soviet tribunal and was exchanged in a spy swap in 1962. He worked as an instructor for the CIA and as a traffic reporter for several Los Angeles radio stations. He died in a helicopter crash.

POWERS, HIRAM (*b. near Woodstock, Vt., 1805; d. Florence, Italy, 1873*), sculptor. Began career in Cincinnati, Ohio, *ca.* 1829, making wax figures of celebrities and mechanized monsters for a local "Chamber of Horrors"; worked briefly with Kirke Brown and Shobal Vail Clevenger. Removing to Washington, D.C., 1834, He made busts from life of such prominent figures as John Marshall, Andrew Jackson, John C. Calhoun, and Daniel Webster. Three benefactors — Nicholas Longworth, W. C. Pres-

ton, and John S. Preston — lent him the means of removing with his family to Florence, Italy, 1839, where he remained for the rest of his life. He was early befriended there by the sculptor Horatio Greenough. Soon after his arrival in Italy, he set up in clay a life-size figure called *Eve Before the Fall*, later carved in marble. This was a precursor of his *Greek Slave*, a nude female figure, finished in marble in 1843 and thereafter reproduced in at least six marble copies. It was without doubt the most celebrated single statue of its day, owing in part to the emotional appeal of the current Greek struggle for independence. Among others, Elizabeth Barrett Browning, Edward Everett, and Nathaniel Hawthorne wrote about it, and it received acclaim on exhibition at the Crystal Palace, London, 1851. In 1853 there was a movement to commission Powers to decorate the Capitol at Washington, but he declined to submit designs in competition with other artists. He made about 150 portrait busts, nearly all of men, which are now considered his strongest work. At the height of his successful career he built himself a fine house in Florence and there entertained many famous personages from America. The *Greek Slave* has historical importance as the first sculpture by an American to attract general public notice.

POWHATAN (*d. 1618*), Indian chief. His personal name was Wa-hun-sen-a-cawh or Wa-hun-son-a-cock, and he was chief, or "emperor," of the Powhatan federation, which at the beginning of the 17th century extended over Tidewater Virginia. His father was of a southern tribe, said to have been driven north by the Spaniards; upon his arrival in Virginia, he had conquered five of the local tribes. His son and successor, known to the Jamestown settlers at Powhatan, extended his sway over many more. He ruled with an iron hand, being excessively cruel to prisoners and malefactors. Despite frequent protestations of goodwill, he annoyed the English settlers by ambushing small parties, murdering workers in the field, and refusing to sell them corn when their provisions fell low, but with the marriage of his daughter Pocahontas to John Rolfe, he concluded a peace to which he steadily adhered thereafter. Powhatan died in April 1618 and was succeeded by his brother Itopatin, or Opitchapam.

POWNALL, THOMAS (*b. Lincolnshire, England, 1722; d. Bath, England, 1805*), colonial governor. Pownall deserves more than any other Englishman of his time to be called a student of colonial administration. He came to America in 1753 as secretary to Sir Danvers Osborn, governor of New York, who committed suicide two days after arrival. Pownall, however, remained in America as an observer for Lord Halifax and the Board of Trade until 1756, making the acquaintance of, among other notables, William Shirley and Benjamin Franklin. Appointed lieutenant governor of New Jersey in May 1755 to assist the aged Jonathan Belcher, he continued his close study of colonial trade and defense problems. Returning to England early in 1756, he presented a scheme for the unification of the military command of the colonies and stressed the importance of control of inland waterways. Offered the governorship of Pennsylvania, he declined it in order to accompany to America the new commander in chief, Lord Loudoun. He went back to England in October 1756 to present Loudoun's case against William Shirley, governor of Massachusetts. The favorable impression which he made on the newly formed Pitt ministry caused him to be offered the governorship of Massachusetts, which he accepted. He reached Boston on Aug. 3, 1757, and took up his work with vigor, using conciliation in order to get maximum cooperation in the war against the French and Indians. He defended the constitutional authority of the civil government against the war powers claimed by the military and was almost too able and too independent. The Board of Trade recalled him in November 1759, offering him several lucrative positions, which he declined. Pownall's

chief claim to remembrance is his book *The Administration of the Colonies* (1764), in which he discussed the reorganization in administration, in law, and in the status of the colonies necessary to maintain the union with England. His policies were far ahead of the views of his contemporaries. Pownall never returned to America, but was in essential sympathy with the colonists until their final measures of resistance. As member of Parliament, he introduced in 1780 a bill favoring a conclusion of the war by royal negotiation, which was defeated.

POYDRAS, JULIEN DE LALANDE (*b. Rezé, near Nantes, France, 1746; d. Pointe Coupée Parish, La., 1824*), poet, public servant, planter, merchant, philanthropist. Came to New Orleans, 1768.

POZNANSKI, GUSTAVUS (*b. Storchnest, Poland, 1804; d. New York, N.Y., 1879*), Jewish religious leader and reformer. Came to America, 1831. Rabbi, Congregation Beth Elohim, Charleston, S.C., 1836–47. Instituted radical alterations in creed and ritual.

PRALL, DAVID WRIGHT (*b. Saginaw, Mich., 1886; d. Berkeley, Calif., 1940*), philosopher. Graduated University of Michigan, 1909; Ph.D., University of California, 1918. After teaching at Amherst and Harvard, he was on the faculty of the University of California, 1921–30. Again at Harvard *post* 1930, he became professor, 1938. A notable teacher, he was author of *A Study in the Theory of Value* (1921), *Aesthetic Judgment* (1929) and *Aesthetic Analysis* (1936).

PRANG, LOUIS (*b. Breslau, Prussian Silesia, 1824; d. California, 1909*), Boston lithographer. Immigrated to America, 1850. Publisher of prints and school drawing-books, he popularized "chromos," color reproductions of art.

PRANG, MARY AMELIA DANA HICKS (*b. Syracuse, N.Y., 1836; d. Melrose, Mass., 1927*), art teacher, author. Edited art manuals for the firm of Louis Prang, whom she later married.

PRATT, BELA LYON (*b. Norwich, Conn., 1867; d. Boston, Mass., 1917*), sculptor. Studied at Yale School of Fine Arts and Art Students League, New York City; served as assistant to Augustus Saint-Gaudens. Taught *post* 1893 at Boston Museum School. Excelled in decorative groups, portrait bas-reliefs, busts of noted men, ideal nudes of women and children, and youthful soldierly figures.

PRATT, CHARLES (*b. Watertown, Mass., 1830; d. Brooklyn, N.Y., 1891*), oil merchant, philanthropist. Foreseeing growth of petroleum industry upon discovery of oil in Pennsylvania, he established with Henry H. Rogers a refinery at Greenpoint, N.Y., 1867, and marketed Pratt's Astral Oil, a high-quality illuminant, which became world famous. Merging with Standard Oil, 1874, Pratt assumed a leading position in that firm and grew very wealthy. His philanthropies included a model tenement for workingmen and substantial gifts to Amherst College, University of Rochester, and Adelphi Academy, Brooklyn. He also founded Pratt Institute in Brooklyn, 1887, and the Pratt Institute Free Library.

PRATT, DANIEL (*b. Temple, N.H., 1799; d. 1873*), carpenter, cotton mill operator, industrialist. Removed to Georgia, 1819; to Alabama, 1833. Founded Prattville, Ala., 1838, where he engaged in cotton and wool milling. Financed Henry F. De Bardeleben in development of Birmingham, Ala., industries.

PRATT, DANIEL (*b. Chelsea, Mass., 1809; d. Boston, Mass., 1887*), vagrant. Under delusion that he had been elected president of the United States, he used to visit New England college campuses to "lecture" *post ca. 1837*.

PRATT, ELIZA ANNA FARMAN (*b. Augusta, N.Y., 1837; d. Warner, N.H., 1907*), writer of juvenile stories. Edited *Wide Awake*, 1875–93.

PRATT, ENOCH (*b. North Middleborough, Mass., 1808; d. 1896*), iron merchant, capitalist, philanthropist. Removed to Baltimore, Md., 1831; established firm of E. Pratt and Brothers in iron trade; later branched out into transportation, banking, and fire insurance. The most important of his philanthropies was the Enoch Pratt Free Library in Baltimore (opened 1886), which was first to embody idea of "branch" libraries. He was also greatly interested in the improvement of the condition of blacks and gave much to hospitals and educational institutions.

PRATT, FRANCIS ASHBURY (*b. Woodstock, Vt., 1827; d. 1902*), pioneer toolmaker, inventor. Began career as a machinist, eventually working at the Colt armory, Hartford, Conn., 1852–54. Here he met his future partner, Amos Whitney. Pratt and Whitney began doing machine work on their own, 1860; in 1864 both gave up positions with the Phoenix Iron Works to give full time to their own firm. Pratt was a promoter of the use of interchangeable parts, inaugurating that system in his own factory while making firearms during the Civil War. The establishment of a standard system of gauges for Europe and America was owing largely to Pratt's efforts.

PRATT, JAMES BISSETT (*b. Elmira, N.Y., 1875; d. Williamstown, Mass., 1944*), philosopher, student of Oriental religions. Graduated Williams College, 1898; studied at Columbia University Law School and at University of Berlin. Ph.D., Harvard, 1905. Taught philosophy at Williams College, 1905–43 (Mark Hopkins professor *post* 1917). Author of, among other works, *The Psychology of Religious Belief* (1907), *The Religious Consciousness* (1920), *Matter and Spirit* (1922), and *The Pilgrimage of Buddhism* (1928).

PRATT, JOHN (*b. Unionville, S.C., 1831; d. ca. 1900*), journalist. Patented the "ptereotype," 1866–68, forerunner of the Hammond typewriter.

PRATT, JOHN LEE (*b. Aspen Grove, Va., 1879; d. near Aspen Grove, 1975*), businessman. Graduated University of Virginia (1905) and joined E. I. du Pont de Nemours Chemical Company; during World War I he oversaw the production of armaments. In 1919 he joined General Motors (GM), advancing to vice-president by 1922. He proved to be an outstanding executive for GM; he oversaw the expansion of the firm's diesel motor business and helped develop the financial plans that steered the company through the depression. In 1939 he was appointed to the War Resources Board. He served as chief of staff for the entire GM corporation after the war and resigned from the GM board in 1968.

PRATT, MATTHEW (*b. Philadelphia, Pa., 1734; d. 1805*), portrait painter. A friend and pupil of Benjamin West, Pratt painted many of the leading Americans of his time in a superior style; his color was refined and delicate, and he ranks with the best of his contemporaries as a technician.

PRATT, ORSON (*b. Hartford, N.Y., 1811; d. Salt Lake City, Utah, 1881*), Mormon leader. Brother of Parley P. Pratt. Converted by his brother, Orson rose rapidly in the Mormon hierarchy and was ordained one of the apostles of that church, 1835. He supported the Brigham Young faction on the death of Joseph Smith and was in the first company to enter the Salt Lake Valley,

1847. After a long career in missionary and administrative work both in the United States and in Europe, he was appointed historian of the church, 1874. He was also active in Utah politics and served seven terms as Speaker of the lower house of the territorial legislature. His philosophical vagaries occasionally irritated the more practical Brigham Young, but Pratt profoundly influenced Mormon theology.

PRATT, PARLEY PARKER (*b. Burlington, N.Y., 1807; d. 1857*), apostle of the Latter-Day Saints. Brother of Orson Pratt. Joined Mormons, 1830; ordained apostle, 1835. Author of an *Autobiography* (1874). Killed by the husband of a convert.

PRATT, RICHARD HENRY (*b. Rushford, N.Y., 1840; d. San Francisco, Calif., 1924*), soldier, Indian educator. Raised in Indiana. After Union army service in Civil War and regular army service in Indian campaigns, 1867–75, he had remarkable success as a teacher of Indian prisoners at Fort Marion, Fla., 1875–78. Continuing his work on a larger scale at Hampton Institute, 1878–79, he then founded the famous Indian school at Carlisle, Pa., and served as its superintendent until 1904. He was promoted to brigadier general shortly before his retirement.

PRATT, SERENO STANSBURY (*b. Westmoreland, N.Y., 1858; d. Troy, N.Y., 1915*), journalist, specialist in finance and commerce. Editor in chief, *Wall Street Journal*, 1905–08; author of *The Work of Wall Street* (1903); secretary, New York State Chamber of Commerce, 1908–15.

PRATT, SILAS GAMALIEL (*b. Addison, Vt., 1846; d. Pittsburgh, Pa., 1916*), pianist, composer.

PRATT, THOMAS GEORGE (*b. Georgetown, D.C., 1804; d. 1869*), lawyer, Maryland legislator. Restored state credit as Whig governor of Maryland, 1844–47; was U.S. senator, 1850–57. During Civil War period, he became a Democrat and was a strong Confederate sympathizer.

PRATT, THOMAS WILLIS (*b. Boston, Mass., 1812; d. Boston, 1875*), civil engineer, railroad construction and operation expert. Invented and patented the type of bridge and roof truss bearing his name, 1844; also patented improvements to steam boilers, ship hull construction, and the propulsion of ships.

PRATT, WALDO SELDEN (*b. Philadelphia, Pa., 1857; d. Hartford, Conn., 1939*), musicologist.

PRATT, WILLIAM VEAZIE (*b. Belfast, Maine, 1869; d. Charleston, Mass., 1957*), naval officer. Graduated from the U.S. Naval Academy in 1889. Pratt's early assignments included action in the Spanish-American War and the Philippine Insurrection; more routine was his teaching at the Naval Academy and the Naval War College. By 1921, he was promoted to the rank of rear admiral after serving as an assistant to Admiral William S. Benson, the Chief of Naval Operations during World War I. Pratt attended many international naval conferences including the Washington Conference (1921–22) and the London Conference in 1930, becoming an expert and proponent of naval limitations, a policy which he believed reduced the chances of war. By 1930, he was commander in chief of the U.S. Fleet. He retired in 1933 and during World War II was a naval specialist for *Newsweek*, a position he held until 1946.

PRATT, ZADOCK (*b. Stephentown, N.Y., 1790; d. Bergen, N.J., 1871*), tanner, New York Democratic legislator and congressman.

PRATTE, BERNARD (*b. Ste. Genevieve, Mo., 1771; d. 1836*), merchant, fur trader. Leading citizen of St. Louis, Mo., *post ca.* 1795.

PRAY, ISAAC CLARK (*b. Boston, Mass., 1813; d. 1869*), journalist, dramatist, actor. Graduated Amherst, 1833. Author of, among other works, *Prose and Verse from the Portfolio of an Editor* (1836) and *Memoirs of James Gordon Bennett* (1855).

PREBER, CHRISTIAN See PRIBER, CHRISTIAN.

PREBLE, EDWARD (*b. Falmouth, now Portland, Maine, 1761; d. Portland, 1807*), naval officer. Shipped aboard a privateer, 1777; appointed midshipman, Massachusetts navy, 1779. *Post* 1783, served aboard merchant ships. Appointed lieutenant in the reorganized U.S. Navy, 1798, he was commissioned captain, 1799, and commanded the *Essex* on convoy duty. In the war with Tripoli, Preble sailed aboard the *Constitution* in command of the squadron which blockaded that state, 1803–04. In the face of numerous difficulties, Preble made an unsuccessful attempt to capture Tripoli in August–September 1804, and was soon after superseded as commodore by Samuel Barron. Preble was particularly effective as a trainer of the young officers who served under him, many of whom later distinguished themselves during the War of 1812.

PREBLE, GEORGE HENRY (*b. Portland, Maine, 1816; d. 1885*), naval officer, author. Nephew of Edward Preble. Appointed midshipman, 1835, he served in a variety of capacities until the Civil War when he was given command of the *Katahdin*. He fought under Farragut at New Orleans, and was actively engaged in operations up to Vicksburg. As commander of the sloop *Oneida*, he was severely censured for allowing the Confederate cruiser *Florida* (*Oreto*) to break through the blockade of Mobile, September 1862. Reinstated, he served thereafter with distinction and retired as rear admiral, 1878.

PREBLE, WILLIAM PITT (*b. York, Maine, 1783; d. 1857*), jurist, railroad executive. Active in achieving separation of Maine from Massachusetts. Aided Albert Gallatin in preparation of northeastern boundary case, 1828, and continued to act in this matter up to the Webster-Ashburton Treaty signing, 1842. He was associated with John A. Poor in the building of the Atlantic and St. Lawrence Railroad.

PREETORIUS, EMIL (*b. Alzey, Rhenish Hesse, Germany, 1827; d. 1905*), journalist. Settled in St. Louis, Mo., 1853. Early active in the Republican party, he was a friend and partner of Carl Schurz in the *Westliche Post*, editing it *post* 1864.

PREFONTAINE, STEVE ROLAND ("PRE") (*b. Coos Bay, Oreg., 1951; d. Eugene, Oreg., 1975*), track athlete. While attending the University of Oregon (B.A., 1973), he was the National Collegiate Athletic Association cross-country champion (1970–73). He refused to turn professional after graduation, preferring to train for the Montreal Olympic Games in 1976, but was killed in an automobile accident. In his short career, he set fourteen U.S. track records.

PRENDERGAST, MAURICE BRAZIL (*b. Roxbury, Mass., 1861; d. New York, N.Y., 1924*), painter. Studied in Boston and in Paris, France, 1887–89. Beginning as a painter of gay and sparkling studies of street life and holiday scenes, he changed his style radically *post* 1914 in the direction of a more abstract and purely decorative art, which won enthusiastic approval from contemporary critics.

PRENTIGE, GEORGE DENNISON (*b. New London Co., Conn., 1802; d. 1870*), journalist. Removed to Kentucky, 1830, as editor of the *Louisville Daily Journal*. Within a short time he made his paper the most influential Whig organ in the South and West. A Unionist, he was largely responsible for Kentucky's refusal to secede. A collection of his witty editorials appeared as *Prenticeana* (1860).

PRENTICE, SAMUEL OSCAR (*b. North Stonington, Conn., 1850; d. 1924*), jurist. Graduated Yale, 1873; Yale School of Law, 1875. Connecticut superior court judge, 1889–1901; justice, supreme court of errors, 1901–20 (chief justice, 1913–20). Taught at Yale School of Law, 1896–1915.

PRENTIS, HENNING WEBB, JR. (*b. St. Louis, Mo., 1884; d. Lancaster, Pa., 1959*), business executive. Studied at the University of Missouri and the University of Cleveland. Prentis joined the Armstrong Cork Company in 1907, becoming vice president in 1926 and president in 1934. Under his leadership, Armstrong became one of America's leading corporations; through astute use of marketing and advertising, Prentis led the company to a prominent position by World War II. He was chairman of the National Association of Manufacturers in 1941.

PRENTISS, BENJAMIN MAYBERRY (*b. Belleville, Va., 1819; d. Bethany, Mo., 1901*), Union soldier, lawyer. Distinguished at Shiloh; promoted major general, 1862. Commanded at battle of Helena, Ark., July 1863, winning victory over superior force.

PRENTISS, ELIZABETH PAYSON (*b. Portland, Maine, 1818; d. Dorset, Vt., 1878*), writer of religious and juvenile fiction. Among her many books the most popular were *Stepping Heavenward* (1869) and the "Little Susy" books (1853 and later).

PRENTISS, GEORGE LEWIS (*b. West Gorham, Maine, 1816; d. 1903*), Congregational and Presbyterian clergyman, educator. Brother of Seargent S. Prentiss. Graduated Bowdoin, 1835. After holding a number of pastorates, he organized the New School Church of the Covenant, New York City, 1862, and served there until 1873. Taught a variety of subjects at Union Theological Seminary *post* 1871.

PRENTISS, SAMUEL (*b. Stonington, Conn., 1782; d. Montpelier, Vt., 1857*), Vermont jurist. U.S. senator, FederalistWhig from Vermont, 1831–42; thereafter, U.S. judge, Vermont district.

PRENTISS, SEARGENT SMITH (*b. Portland, Maine, 1808; d. Natchez, Miss., 1850*), lawyer, orator, Whig congressman from Mississippi. Brother of George L. Prentiss. Removed to Mississippi *ca.* 1828; practiced at Natchez, Vicksburg, and, *post* 1845, New Orleans.

PRESBREY, EUGENE WILEY (*b. Williamsburg, Mass., 1853; d. California, 1931*), stage manager, dramatist. Successful as an adapter of popular novels into plays.

PRESCOTT, ALBERT BENJAMIN (*b. Hastings, N.Y., 1832; d. Ann Arbor, Mich., 1905*), chemist. M.D., University of Michigan, 1864. Taught at Michigan *post* 1865; took a major part in establishment of the university's school of pharmacy, serving as its dean, 1874–1905. Did notable work in sanitary and food chemistry and in toxicology; was author of influential treaties and papers.

PRESCOTT, GEORGE BARTLETT (*b. Kingston, N.H., 1830; d. New York, N.Y., 1894*), telegraph engineer. Chief electrician of Western Union, 1866–82; author of a number of works on the telegraph, the telephone, and other electrical subjects.

PRESCOTT, OLIVER (*b. Groton, Mass., 1731; d. Groton, 1804*), physician, Revolutionary soldier. Brother of William Prescott. Held a number of Massachusetts military and civic appointments.

PRESCOTT, SAMUEL (*b. Concord, Mass., 1751; d. Halifax, Nova Scotia, ca. 1777*), physician, Revolutionary patriot. Successfully completed the "midnight ride" of Apr. 18, 1775, after capture of Paul Revere; gave alarm at Concord. Died in prison after capture aboard a privateer.

PRESCOTT, SAMUEL CATE (*b. South Hampton, N.H., 1872; d. Boston, Mass., 1962*), bacteriologist. Attended Massachusetts Institute of Technology (S.B., 1894); joined the faculty (1895), retiring as dean of science (1942). Discovered the scientific method for making canned food entirely sanitary (1895–97) by boiling, which killed all microorganisms. Founded the Boston Biochemical Laboratory (1904) and directed a laboratory (1914–17) for United Fruit in Costa Rica. Chief of the U.S. Department of Agriculture dehydration division (1918–19), directing vital studies for the war effort. During and after World War II served as consultant to the government and various food industry corporations.

PRESCOTT, WILLIAM (*b. Groton, Mass., 1726; d. Pepperell, Mass., 1795*), farmer, Revolutionary soldier. Brother of Oliver Prescott. Colonel of minutemen, 1775; arrived too late for fight at Concord; appointed to council of war at siege of Boston. Ordered to fortify Bunker Hill, June 16, 1775, he decided after consultation with his officers to fortify Breed's Hill, since it commanded Boston more effectively. It is not known for certain whether he or Israel Putnam was in general command on the field of battle, June 17, but Prescott did command at a vital point in the line. He later took part in the evacuation of New York and the Saratoga campaign, but age and an injury forced him to retire from active service.

PRESCOTT, WILLIAM HICKLING (*b. Salem, Mass., 1796; d. Boston, Mass., 1859*), historian. Grandson of William Prescott; born to wealth and social position. Graduated Harvard, 1814. While in his junior year at college, a blow on his left eye permanently destroyed its sight; two years later an inflammation of the right eye impaired his vision, so that at periods he was practically blind. Deciding to follow a literary career despite these difficulties, he toured Europe, 1815–17; on his return to Boston he began an intensive study of the history and literature of the principal countries of western Europe with the aid of paid secretaries who read to him. He contributed reviews and articles to the *North American Review*, 1821–36, the best of which were collected as *Biographical and Critical Miscellanies* in 1845. At work since 1826 on the first of his masterpieces, he published *The History of the Reign of Ferdinand and Isabella the Catholic* late in 1837 (title-page date, 1838). The book was an immediate success, and Prescott was hailed on both sides of the Atlantic. The year after the publication of *Ferdinand and Isabella* was one of physical pain and enforced idleness, but he devoted much thought to the next of his endeavors—the history of the conquests of Mexico and Peru. He began research for the *History of the Conquest of Mexico* in April 1839; so well had he learned to handle his materials that he was able to publish the three volumes in 1843. The *History of the Conquest of Peru* was written at an even more rapid rate; two years apparently sufficed for actual composition, though the work was not published until March 1847. Despite the appearance of much new material, these books remain standard authorities on the two greatest achievements of the Spanish conquistadores in the New World. Prescott's fame was now so great that on a trip to England in

1850 he was entertained and honored as no other private American citizen. He had contemplated a history of the reign of Philip II as early as 1838; to this task he devoted the rest of his life. Only three of the projected ten volumes appeared, two in 1855 and the last in 1858. He also prepared a new edition of William Robertson's *History of the Reign of the Emperor Charles the Fifth* (1857).

Prescott's outstanding merit, in addition to courage, was the scrupulous care and integrity with which he used his materials, and it is a tribute to his skill as a historian that what was intended for the casual reader is now the material of the professional historical student. He was also a master of narrative. Although his inherited prejudices did not color his interpretation of facts to the extent displayed by J. L. Motley, they were dominant enough to deprive him of wholehearted sympathy with the 16th century. As a man, he possessed great gaiety and charm; his generosity was proverbial.

PRESLEY, ELVIS ARON (b. Tupelo, Miss., 1935; d. Memphis, Tenn., 1977), singer and actor. Presley's spectacular rise to stardom began with the single "That's All Right, Mama," recorded for Sam Phillip's Sun Records; released in July 1954, the song was an immediate hit on Memphis radio. Presley signed with impresario Colonel Thomas A. Parker and began touring the South and appeared on the "Grand Ole Opry" radio program. Phillips sold Presley's contract to RCA Victor in 1956, and their first release, "Heartbreak Hotel," was an unprecedented number one on the country, pops, and rhythm and blues charts. He appeared on all the major television variety shows, most notably his appearance on "The Ed Sullivan Show" in January 1957, when cameras showed him only from the waist up to hide Presley's gyrations during his performance. More hit songs followed in 1957–58, including "Blue Suede Shoes," "Hound Dog," "Love Me Tender," "All Shook Up," and "Jailhouse Rock." His film career began in 1956 with *Love Me Tender*, followed by *Jailhouse Rock* (1957) and *King Creole* (1958). Presley's music popularized African–American rhythm and blues. His energetic, irreverent, and sexually suggestive stage performances appealed to the emerging youth culture of the 1950's.

After serving in the U.S. Army from 1958 to 1960, Presley starred in a series of twenty-seven formula movies in the 1960's, such as *Blue Hawaii* (1961), *Fun in Acapulco* (1963), and *Speedway* (1968), and his singing career declined. He made a legendary television special in December 1968, his first television appearance in eight years, and the song "If I Can Dream" became his first hit in years; a hit album, *From Elvis in Memphis*, followed, as did more hit singles, such as "In the Ghetto" and "Suspicious Minds." He signed a contract to appear in a pair of month-long shows each year at the International (now Hilton) Hotel in Las Vegas, which began in July 1970 and continued until his death; the shows featured lavish stage performances and a full orchestra. Around 1973, following his divorce, he began a period of self-indulgence, including binge eating and abuse of prescription drugs, and his obesity made his Vegas shows grotesque, although his magnificent voice was still awe-inspiring. He died of heart failure at Graceland, his mansion in Memphis. After his death, his tomb in Graceland became the most visited grave in the nation.

PRESSER, THEODORE (b. Pittsburgh, Pa., 1848; d. Philadelphia, Pa., 1925), music teacher and publisher, philanthropist, editor. Founded *Etude* magazine, 1883.

PRESSMAN, LEE (b. New York, N.Y. 1906; d. Mount Vernon, N.Y., 1969), lawyer. Attended New York University, Cornell, and Harvard Law (LL.B., 1929). Appointed assistant general counsel for the Agricultural Adjustment Administration (1933–35), then general counsel for relief programs and the Resettlement Administration. Joined the Communist party, then left in 1935, but did not reject its ideology. Hired in 1936 as general counsel for the Steelworkers Organizing Committee and later for the Congress of Industrial Organizations (CIO). Met frequently with Communists in the CIO, but at the 1940 convention, he dutifully moved for denouncing communism and fascism. His involvement with communism became an issue during the onset of the cold war, and he was forced to resign his position in the CIO in 1948.

PRESTON, ANN (b. Westgrove, Pa., 1813; d. 1872), physician. One of first (1852) graduates from Female Medical College of Pennsylvania, at which she became a professor. Helped found Woman's Hospital of Philadelphia.

PRESTON, HARRIET WATERS (b. Danvers, Mass., 1836; d. Cambridge, Mass., 1911), author. Noted for translations of Provençal and Roman classical poets.

PRESTON, JOHN SMITH (b. near Abingdon, Va., 1809; d. Columbia, S.C., 1881), lawyer, planter, orator. Brother of William C. Preston. Supported states' rights as South Carolina legislator; was effective superintendent, Confederate Bureau of Conscription, 1863–65.

PRESTON, JONAS (b. Chester, Pa., 1764, d. Philadelphia, Pa., 1836), physician, Pennsylvania legislator, philanthropist.

PRESTON, MARGARET JUNKIN (b. Milton, Pa., 1820; d. Baltimore, Md., 1897), poet. Daughter of George Junkin; sister-in-law of Thomas J. Jackson.

PRESTON, THOMAS SCOTT (b. Hartford, Conn., 1824; d. 1891), Roman Catholic clergyman, devotional and controversial writer. A convert from the Episcopal ministry, 1849, Monsignor Preston served in New York as chancellor of the diocese post 1855 and as vicar general, 1873–91. He was an uncompromising conservative.

PRESTON, WILLIAM (b. near Louisville, Ky., 1816; d. 1887), lawyer, soldier, Kentucky Whig legislator and congressman. A Democrat post 1854, he was U.S. minister to Spain, 1858–60; he returned to serve as Confederate brigadier general and minister to Mexico.

PRESTON, WILLIAM BALLARD (b. Montgomery Co., Va., 1805; d. 1862), lawyer, Virginia Whig legislator and congressman, U.S. secretary of the navy, 1849–50. Nephew of John Floyd. Opposed Virginia secession but presented secession ordinance; served as Confederate senator from Virginia, 1861–62.

PRESTON, WILLIAM CAMPBELL (b. Philadelphia, Pa., 1794; d. Columbia, S.C., 1860), lawyer, South Carolina legislator. Brother of John S. Preston; friend of Hugh S. Legaré and of Washington Irving. An intense advocate of states' rights and of slavery, Preston was elected to the U.S. Senate, 1833, as a Democrat from South Carolina. Opposing Jackson, he became a Whig and resigned from the Senate, 1842, rather than accept dictation from the legislature. He was president of South Carolina College, 1846–51.

PREUS, CHRISTIAN KEYSER (b. Spring Prairie, Wis., 1852; d. 1921), Lutheran clergyman. Taught at Luther College, Decorah, Iowa, post 1898; was president of the college post 1902.

PREVOST, FRANÇOIS MARIE (b. Pont-de-Cé, France, ca. 1764; d. Donaldsonville, La., 1842), surgeon. Graduated in medicine at Paris; settled in Donaldsonville ca. 1800. Distinguished as one

of the earliest successful performers of the cesarean section in the United States.

PRIBER, CHRISTIAN (*b. possibly Saxony, date unknown; d. Frederica, Ga., post 1744*), utopian community builder. Immigrated to South Carolina *ca.* 1734; two years later, went to live among the Cherokee. Labored to draw all southern Indians into a great independent confederation which would be administered along communist lines, somewhat anticipating the doctrine of Saint-Simon.

PRICE, BRUCE (*b. Cumberland, Md., 1845; d. Paris, France, 1903*), architect. Began career in Baltimore, Md., 1869; removed to New York City, 1877. Price laid out Tuxedo Park, N.Y., 1885–86, and designed many of the individual houses there; his largest and most lavish domestic work was "Georgian Court," 1898–1900, at Lakewood, N.J. He also did a great deal of work in Canada, including the Château Frontenac at Quebec.

PRICE, ELI KIRK (*b. East Bradford, Pa., 1797; d. 1884*), Philadelphia lawyer, law reformer. Was responsible as Pennsylvania legislator for passage of Consolidation Act, 1854, giving Philadelphia a new charter and unifying that city.

PRICE, ELI KIRK (*b. Philadelphia, Pa., 1860; d. 1933*), lawyer, Philadelphia civic leader. Grandson of Eli K. Price (1797–1884). Devoted himself to the growth and development of Fairmount Park and to the construction of the Philadelphia Museum of Art.

PRICE, GEORGE EDWARD MCCREADY (*b. Havelock, New Brunswick, Canada, 1870; d. Loma Linda, Calif., 1963*), fundamentalist advocate and geologist. Attended Battle Creek College and taught in Canada (1897–1904), then taught nursing and medical students in the College of Medical Evangelists in California (1906–12), which granted him a B.A.; taught at other Adventist institutions (1912–38). Led a spirited crusade against evolution and advocated the "new catastrophism." In the mid-1920's he was described as the principal scientific authority of the fundamentalists. Wrote *The New Geology* (1923), his most comprehensive and systematic book.

PRICE, GEORGE MOSES (*b. Poltava, Russia, 1864; d. New York, N.Y., 1942*), physician, public health worker. Child of Jewish parents, he immigrated to the United States in 1882. After working as a New York City sanitary inspector and as an inspector for the Tenement Commission, he took his degree in medicine at New York University, 1895. Until 1913 he combined a career in private practice with continued activity in the field of public health. His major accomplishments came as an outgrowth of his association *post* 1910 with the International Ladies' Garment Workers Union; he served as director of the garment industry's Joint Board of Sanitary Control, 1910–25, and was responsible for investigations and legislation that corrected flagrant abuses in factory sanitary conditions and safety. After 1913 he gave his full professional time to the work of the Union Health Center, which he had founded; this was the first attempt by a trade union to provide medical services for its members and was a model for later union clinics. Price was author of, among other works, *The Modern Factory: Safety, Sanitation, and Welfare* (1914).

PRICE, HIRAM (*b. Washington Co., Pa., 1814; d. 1901*), banker, railroad builder. Removed to Davenport, Iowa, 1844. Congressman, Republican, from Iowa, 1863–69 and 1877–81; U.S. commissioner of Indian affairs, 1881–85.

PRICE, JOSEPH (*b. Rockingham Co., Va., 1853; d. Philadelphia, Pa., 1911*), physician, surgeon, gynecologist. M.D., University of Pennsylvania, 1877. After working as a ship's doctor,

he began work at the Philadelphia Dispensary and made its clinic for women one of the best known and largest in the country. Working thereafter in three private hospitals in Philadelphia (among them the present Joseph Price Memorial), Price had vast influence as clinical teacher in the forming of gynecology and abdominal surgery as specialties. He revolutionized surgical practices in maternity and abdominal operations.

PRICE, RODMAN MCCAMLEY (*b. Sussex Co., N.J., 1816; d. 1894*), naval officer, politician. Played active role in U.S. occupation of California, 1846; as alcalde of Monterey, was said to be first American to exercise judicial authority in California. Congressman, Democrat, from New Jersey, 1851–53; governor, 1854–57.

PRICE, STEPHEN (*b. New York, N.Y., 1782; d. 1840*), theatrical manager. Purchased share in Park Theatre, New York City, 1808; became sole manager and lessee *ca.* 1815. Price began the practice of importing European stars for performances at his theater and for road tours under his direction.

PRICE, STERLING (*b. Prince Edward Co., Va., 1809; d. Missouri, 1867*), lawyer, farmer, Missouri legislator, soldier. Removed to Missouri *ca.* 1831; settled in Chariton Co. After rising to rank of brigadier general in the Mexican War, he was anti-Benton Democratic governor of Missouri, 1852–56. Chosen president of the Missouri convention of 1860 as a conditional Union man, he took command of the state troops by appointment of Governor C. F. Jackson after the convention adjourned. The aggressive policies of Unionists such as Frank P. Blair and Nathaniel Lyon drove him into support of the Southerners. Displaying high military ability at the battles of Wilson's Creek and Lexington, 1861, he retreated with his forces into Arkansas, where they joined the Confederate army, 1862. His subsequent campaigns in Mississippi and Arkansas, gave him great reputation and made him perhaps the leading secession figure west of the Mississippi.

PRICE, THEODORE HAZELTINE (*b. New York, N.Y., 1861; d. New York, 1935*), cotton merchant and broker. Founded and edited *Commerce and Finance*, 1912–35; compiled trade handbooks.

PRICE, THOMAS FREDERICK (*b. Wilmington, N.C., 1860; d. Hong Kong, China, 1919*), Roman Catholic clergyman, cofounder of Maryknoll. Graduated St. Charles College, Maryland, 1881; St. Mary's Seminary, Baltimore, Md. Ordained, 1886, the first native North Carolinian to become a Catholic priest, he worked in his own state and was editor of an apologetics magazine, *Truth*, 1896–1911. Together with Rev. James A. Walsh, Price established the Catholic Foreign Mission Society of America (Maryknoll), 1910–11.

PRICE, THOMAS LAWSON (*b. near Danville, Va., 1809; d. 1870*), businessman, railroad builder, politician. Removed to Missouri and settled in Jefferson City, 1831; was a leader in development of Missouri railroads. A pro-Benton Democrat and state officeholder, he became an unconditional Unionist and a War Democrat congressman, serving ably as an opponent of Radical measures through the year 1862. He was later prominent in the reorganization of the Democratic party in Missouri.

PRICE, THOMAS RANDOLPH (*b. Richmond, Va., 1839; d. 1903*), philologist, Confederate soldier. Taught Greek and English at University of Virginia, 1870–82; professor of English, Columbia University, 1882–1903.

PRICE, WILLIAM CECIL (*b. probably Russell Co., Va., 1818; d. Chicago, Ill., 1907*), lawyer. Removed as a young man to Missouri, where he held various offices and served as a Democratic legislator. For 20 years before the Civil War, he agitated for repeal of the Missouri Compromise and the removal of restrictions upon slavery. A fanatical secessionist, he served briefly in the Confederate army.

PRICE, WILLIAM THOMPSON (*b. Jefferson Co., Ky., 1846; d. 1920*), dramatic critic. Founded American School of Playwriting, New York, 1901; was regarded within the profession as an authority on dramatic construction.

PRIEST, EDWARD DWIGHT (*b. Northfield, Mass., 1861; d. 1931*), electrical engineer. Graduated present Worcester Polytechnic, 1884. Specialist in railway electrification problems; designed special type of motor for use on elevated railroads.

PRIEST, IVY MAUDE BAKER (*b. Kimberly, Utah, 1905; d. Santa Monica, Calif., 1975*), politician. In the 1930's became active in Salt Lake City Republican politics and served as cochairman of the Young Republican organization for eleven western states. In the late 1940's she was at the forefront of Republican party efforts to organize women voters. As a leader of the "Young Turks," she lobbied for the selection of Dwight Eisenhower as the Republican presidential nominee in 1952. President Eisenhower subsequently appointed her treasurer of the United States (1953–61); she was also elected treasurer of California (1966–74).

PRIESTLEY, JAMES (*b. probably Virginia, date unknown; d. Nashville, Tenn., 1821*), educator. Studied at Liberty Hall Academy (forerunner of Washington and Lee); was principal or director of a great number of academies and colleges *post* 1788, including Cumberland College at Nashville.

PRIESTLEY, JOSEPH (*b. near Leeds, England, 1733; d. Northumberland, Pa., 1804*), scientist, educator, Unitarian theologian. Attended a local grammar school where he learned Latin, Greek, and shorthand; studied Hebrew with John Kirkby, a Congregational clergyman. When ill health forced him to leave school, he taught himself modern languages, the rudiments of Chaldee, Syriac, Arabic, and also natural history. Entered Daventry, a dissenting academy, 1751, where his tendencies to Arianism took firm root. Unsuccessful as a pastor, 1755–61, he went as tutor in belles lettres to Warrington, the chief dissenting academy in England, where he found learned associates and adequate channels of expression for his many interests. He preached, wrote, and published, among others, *A Chart of Biography* (1765), for which he received a doctorate from Edinburgh. He was the first teacher to give formal instruction in modern history, and his teaching of the sciences was entirely new in secondary education. In 1767, because of his wife's poor health and his need for a larger salary, he took charge of the Mill Hill congregation in Leeds, which he held until 1772 when he became librarian to Lord Shelburne. In 1780 he removed to Birmingham and was minister of the New Meeting there until the 1791 riots when his expressed sympathies with the French Revolution resulted in the burning of his house, his books, and all his effects. Deciding to immigrate to America, he arrived in New York City, June 4, 1794. His arrival caused much public comment and he was visited by the leading New York dignitaries; two weeks later in Philadelphia he again received public acclaim. Averse to the distractions of Philadelphia, he made his home in Northumberland, Pa., but made frequent trips to Philadelphia to address the American Philosophical Society and continued to write and perform scientific experiments.

Although his scientific interests had been manifested early, he had not begun active experimentation until 1766. In February 1767, he published *The History and Present State of Electricity*, to which he appended an account of experiments performed between June 1766 and the beginning of 1767. In this work he stated, but did not fully prove, the inverse-square law of electrostatics, explained the formation of the (Priestley) rings occurring as a result of electrical discharges on metallic surfaces, attempted to measure electrical resistance and impedance, and proposed an explanation of the oscillatory nature of the discharge from a Leyden jar. More important perhaps is his isolation of oxygen (before November 1771) and description of its basic properties (1774). His discovery was confirmed by Lavoisier, 1775. He also isolated and described eight other gases, including ammonia and carbon monoxide, and wrote a notable study of optics, *The History and Present State of Discoveries Relating to Vision, Light and Colours* (1772).

Priestley's versatility and his peculiar qualities of mind were more clearly manifested in his theological and political writings than in his science. He left Daventry Academy an Arian; by the time he went to Warrington he had rejected the Atonement and the inspiration of the sacred text. In 1775 he put forward the doctrine of the homogeneity of man, which brought upon him the charge of atheism. His principal theological works were written in America, and he was the chief protagonist of the Unitarian movement here. His books in this field include *A General History of the Christian Church* (1790–1802) and *A General View of the Arguments for the Unity of God . . .* (1793, 1812). In politics he was a utilitarian and a republican, but he prided himself on never having joined a political party. His *Essay on the First Principles of Government* (1768) strongly influenced Jeremy Bentham. In two anonymous pamphlets (1769 and 1774) he rebuked the British government for its treatment of the colonies. Prior to 1783 he was intimate with Edmund Burke, but Priestley's republican leanings estranged them, and their differences were brought to a dramatic climax by the French Revolution. Priestley's *Letters to the Right Honourable Edmund Burke* (1791) led more or less directly to the riots which destroyed his house in Birmingham. He was also opposed to slavery. In American politics he sided with the Democratic-Republicans against the Federalists. By 1797 or earlier he had become acquainted with Thomas Jefferson, who turned to him for counsel about the projected University of Virginia and wrote of his "affectionate respect" for Priestley.

PRIMA, LUIGI ("LOUIS") (*b. New Orleans, La., 1911; d. New Orleans, 1978*), jazz trumpeter, singer, and composer. Began his career in the 1930's on the New Orleans nightclub circuit with his own band and performed in New York, Chicago, and Los Angeles. Prima gave high-energy stage performances that featured comedy and slapstick. He appeared in numerous commercial films, including *Swing It* (1936), *The Benny Goodman Story* (1956), and *The Jungle Book* (1967). Prima recorded several popular hits, including "Sing, Sing, Sing" and "That Old Black Magic." He continued to tour successfully with his big band through the 1960's.

PRIME, BENJAMIN YOUNGS (*b. Huntington, N.Y., 1733 o.s.; d. Huntington, 1791*), physician. Graduated College of New Jersey, 1751; M.D., University of Leiden, 1764; studied also in England and Scotland. Practiced *post* 1764 in New York City and in Huntington. Author of *The Patriot Muse* (London, 1764) and a number of writings in support of the American cause subsequent to the passage of the Stamp Act. His *Columbia's Glory; or British Pride Humbled* (1791) reviewed the events of the Revolutionary War.

PRIME, EDWARD DORR GRIFFIN (*b. Cambridge, N.Y., 1814; d. New York, N.Y., 1891*), Presbyterian clergyman. Grandson of Benjamin Y. Prime; brother of William C. and Samuel I. Prime.

PRIME, SAMUEL IRENAEUS (*b. Ballston, N.Y., 1812; d. 1885*), Presbyterian clergyman, author. Grandson of Benjamin Y. Prime; brother of Edward D. G. and William C. Prime. Assistant editor, *New York Observer*, 1840–49; editor in chief, 1851–85. During his editorship the *Observer* was a leading Presbyterian organ and a strong force in American life. He was author also of a number of popular books and was the conductor *post* 1853 of the "Editor's Drawer" in *Harper's Magazine*.

PRIME, WILLIAM COWPER (*b. Cambridge, N.Y., 1825; d. New York, N.Y., 1905*), journalist, educator. Grandson of Benjamin Y. Prime; brother of Edward D. G. and Samuel I. Prime. Graduated College of New Jersey (Princeton), 1843. After practicing law in New York City, 1846–61, Prime served as editor of the N.Y. *Journal of Commerce*, 1861–69, and remained a partner in the paper thereafter. An authority on numismatics and old porcelain, he was a principal promoter of the Metropolitan Museum of Art and was professor of the history of art at Princeton *post* 1884. He was author also of a number of books, including *Owl Creek Letters* (1848), *The Old House by the River* (1853), *Boat Life in Egypt and Nubia* (1857), and *Pottery and Porcelain* (1878).

PRINCE, FREDERICK HENRY (*b. Winchester, Mass., 1859; d. Biarritz, France, 1953*), investment banker and society figure. Studied at Harvard (1878–80). Prince turned a modest inherited fortune into a financial empire mostly through the acquisition of railroads. By the 1930's, he was worth $250 million. In 1933, Prince sponsored a plan to consolidate all major trunk lines in the nation into seven major lines; President Roosevelt was at first in favor of this plan, but was forced to back down because of the cost. After 1933, Prince concentrated on the meat packing industry in Chicago, acquiring the chairmanship of the executive committee of Armour and Company in 1934, and restoring that company to solvency. An avid sportsman, Prince remained active as a sailor and polo player into his seventies.

PRINCE, LE BARON BRADFORD (*b. Flushing, N.Y., 1840; d. Flushing, 1922*), lawyer, jurist. Son of William R. Prince. Prominent as a New York Republican politician, Prince served as chief justice of New Mexico Territory, 1879–82; he compiled and published *The General Laws of New Mexico* (1880). As governor of New Mexico, 1889–93, he was responsible for the adoption of the territory's first public school code and for the creation of the University of New Mexico.

PRINCE, MORTON (*b. Boston, Mass., 1854, d. 1929*), physician, psychologist. Graduated Harvard, 1875; Harvard Medical School, 1879. Becoming early interested in abnormal psychology, he made further studies at Vienna, Strasbourg, Paris, and Nancy, and was encouraged by S. Weir Mitchell to specialize in neurology and psychotherapy. From 1885–1913, he was physician for diseases of the nervous system at Boston City Hospital and taught at Harvard and at Tufts. He founded the *Journal of Abnormal Psychology*, 1906, and edited it up to the time of his death. Among his books the most famous is *The Dissociation of a Personality* (1906). He developed a psychology of the abnormal which integrates neurology, general psychology, and allied subjects effectively and with great benefit to them all. In addition to his professional work, he was active in civic projects in Boston.

PRINCE, THOMAS (*b. Sandwich, Mass., 1687; d. Boston, Mass., 1758*), theologian, scholar, bibliophile. Graduated Harvard, 1709. Became associate minister at Old South Church, Boston, 1718, and served in this connection until his death. An early collector and preserver of colonial documentary material, in particular the Mather papers, he was author of, among many other writings, *A Chronological History of New England in the Form of Annals* (1736), a pioneer attempt at accurate recording of the New England past. A supporter of George Whitefield, Prince was a vital factor in sustaining the evangelist's popularity. He collected a remarkable library of Americana, which was left to Old South; some of the books were destroyed during the British occupation at Boston, but many of them are now preserved in Boston Public Library.

PRINCE, WILLIAM (*b. probably Flushing, N.Y., ca. 1725; d. Flushing, 1802*), nurseryman. American pioneer in selling budded or grafted stock and in breeding new varieties, particularly of the plum.

PRINCE, WILLIAM (*b. Flushing, N.Y., 1766; d. 1842*), nurseryman. Son of William Prince (*ca. 1725–1802*). Continued his father's work and introduced the Isabella grape *ca.* 1816, once important in New York wine culture.

PRINCE, WILLIAM ROBERT (*b. Flushing, N.Y., 1795; d. Flushing, 1869*), nurseryman. Son of William Prince (*1766–1842*). Associated with his father in business and coauthor with him of *A Treatise on the Vine* (1830) and *The Pomological Manual* (1831). He was author also of *Prince's Manual of Roses* (1846) and of many articles for gardening and horticultural publications.

PRING, MARTIN (*b. Devonshire, England, ca. 1580; d. Bristol, England, 1626*), naval commander, explorer. Made a successful trading voyage in command of the *Speedwell* and the *Discoverer* to the Cape Code area, 1603; made a chart of the coast of Virginia, 1606. Active in Far East waters, 1613–21, he was made a freeman of the Virginia Co. and given 200 acres of Virginia land, 1621.

PRINGLE, CYRUS GUERNSEY (*b. East Charlotte, Vt., 1838; d. 1911*), plant breeder and collector. Made important botanical explorations *post* 1880 in the Pacific states and Mexico. Built up herbarium at the University of Vermont.

PRINGLE, HENRY FOWLES (*b. New York, N.Y., 1897; d. Washington, D.C., 1958*), journalist and biographer. Studied at Cornell University. Through the 1920's, Pringle worked for various New York newspapers before turning to biography. In 1931, he published *Theodore Roosevelt*, which won the Pulitzer Prize. From 1932 to 1943, he taught at the School of Journalism at Columbia University. His other major work was *The Life and Times of William Howard Taft* (1939).

PRINGLE, JOEL ROBERTS POINSETT (*b. Georgetown Co., S.C., 1873; d. San Diego, Calif., 1932*), naval officer. Graduated Annapolis, 1892. Performed distinguished service as chief of staff to Admiral Sims, 1917–19, and as liaison with the British command at Queenstown, Ireland, having charge of destroyer refitting. After holding a number of other important appointments, he died while serving as commander, battleships, U.S. Fleet, with the rank of vice admiral.

PRINGLE, JOHN JULIUS (*b. Charleston, S.C., 1753; d. 1843*), lawyer, planter, South Carolina legislator and federal official. Attorney general of South Carolina, 1792–1808.

PRINTZ, JOHAN BJÖRNSSON (*b. Bottnaryd, Sweden, 1592; d. 1663*), soldier, colonial governor. After an adventurous career as a mercenary soldier and officer in the Swedish army, he was appointed governor of New Sweden, 1642, and arrived at Fort

Christina (Wilmington, Del.), Feb. 15, 1643. He was handicapped from the outset by a shortage of men and supplies, and during the last five years of his administration, 1648–53, the Swedish government left him to shift for himself. Reputed to weigh 400 pounds and famous for severity and profanity, he was amply qualified for his work, making the colony a prosperous enterprise for his country. His harshness as a ruler, however, created conflicts between him and his settlers, which came to a head in July 1653, when a group of them petitioned to send two men to present their grievances to the home government. Printz regarded this move as rebellion and hanged the leader of the dissidents. Resigning the governorship to his son-in-law in September, he returned to Sweden.

PRINZE, FREDDIE (*b. New York City, 1954; d. Los Angeles, Calif., 1977*), comedian and actor. Performed stand-up comedy routines in Manhattan nightclubs while still in high school; his comic material drew on his upbringing in a poor, Puerto Rican neighborhood of New York City. After a successful appearance on "The Tonight Show" in 1973, Prinze assumed the starring role in the new television series *Chico and the Man*, which soon became a hit. Prinze made numerous televisions appearances during his career, including the made-for-television movie *The Million Dollar Ripoff* (1976). Suffering an addiction to prescription and illegal drugs, he shot himself in 1977.

PRITCHARD, FREDERICK JOHN (*b. Camanche, Iowa, 1874; d. Washington, D.C., 1931*), plant breeder. Graduated University of Nebraska, 1904. Did important work on the sugar beet and on disease-resistant tomatoes for the U.S. Department of Agriculture *post* 1910.

PRITCHARD, JETER CONNELLY (*b. Jonesboro, Tenn., 1857; d. 1921*), lawyer, legislator. U.S. senator, Republican, from Tennessee, 1894–1903. An able progressive, he became a U.S. circuit judge, 1904, and presiding judge of the circuit court of appeals (4th Circuit), 1913.

PRITCHETT, HENRY SMITH (*b. Fayette, Mo., 1857; d. Santa Barbara, Calif., 1939*), astronomer. Studied at the U.S. Naval Observatory under Asaph Hall; Ph.D., University of Munich, 1895. President, Massachusetts Institute of Technology, 1900–05; first president, Carnegie Foundation for Advancement of Teaching, 1905–30.

PROCTER, JOHN ROBERT (*b. Mason Co., Ky., 1844; d. Washington, D.C., 1903*), geologist, civil service reformer. Director of the Kentucky geological survey, 1879–93; U.S. Civil Service Commission member and president, 1893–1903.

PROCTER, WILLIAM (*b. Baltimore, Md., 1817; d. 1874*), pharmacist, teacher. Ran a drugstore in Philadelphia, Pa., *post* 1844. Professor at Philadelphia College of Pharmacy, 1846–66; editor, *American Journal of Pharmacy*, 1850–71; a founder of the American Pharmaceutical Association, 1852.

PROCTOR, FREDERICK FRANCIS (*b. Dexter, Maine, ca. 1851; d. Larchmont, N.Y., 1929*), vaudeville theater owner and manager.

PROCTOR, HENRY HUGH (*b. near Fayetteville, Penn., 1868; d. 1933*), Congregational clergyman, black leader. Graduated Fisk University, 1891, Yale Divinity School, 1894. Became prominent as pastor of First Congregational Church, Atlanta, Ga., 1894–1919; it became the first institutional church for blacks in the South and through its various agencies served some 10,000 persons. He was pastor of the Nazarene Congregational Church, Brooklyn, N.Y., *post* 1920. A pioneer in all interracial movements, he was elected moderator of the New York City Congregational Church Association, 1926.

PROCTOR, JOSEPH (*b. Marlboro, Mass., 1816; d. 1897*), actor, manager. Made professional debut at Boston, 1833; enjoyed early success playing principal character in *Nick of the Woods* (an adaptation of the novel by Robert M. Bird). Playing in support of many star actors in classic dramas, he was distinctly a "strong" actor of the Edwin Forrest school.

PROCTOR, LUCIEN BROCK (*b. Hanover, N.H., 1823; d. Albany, N.Y., 1900*), lawyer, writer of New York legal history and biography.

PROCTOR, REDFIELD (*b. Proctorsville, Vt., 1831; d. Washington, D.C., 1908*), businessman, lawyer, Union soldier. Republican governor of Vermont, 1878–80; able and efficient U.S. secretary of war, 1889–91; U.S. senator from Vermont, 1891–1908. Proctor was particularly interested as a senator in the committees on agriculture and military affairs. His speech on Cuba, delivered in March 1898, helped condition the United States for the war with Spain.

PROCTOR, WILLIAM COOPER (*b. Glendale, Ohio, 1862; d. Cincinnati, Ohio, 1934*), soap manufacturer, philanthropist. President of Procter & Gamble *post* 1907. Instituted employee profit-sharing plans, stock ownership, and pensions; guaranteed employees 48 workweeks in each calendar year, 1923.

PROFACI, JOSEPH (*b. Villabati, Sicily, 1897; d. Bay Shore, N.Y., 1962*), organized crime leader. Came to the United States in 1921; by 1929 he controlled crime in Staten Island, N.Y., and by 1930 was head of one of New York City's five crime families, a position he retained for life. He used mob money from numbers, narcotics, and prostitution to establish about twenty legitimate businesses, including the importation of olive oil. Found guilty of obstructing justice (1957), but the conviction was overturned on appeal. His citizenship was revoked in 1958, a decision also reversed on appeal. Estimated revenues from his Brooklyn rackets were between $100 million and $200 million over a twenty-five-year period.

PROKOSCH, EDUARD (*b. Eger, Austria–Hungary, 1876; d. near New Haven, Conn., 1938*), Germanic philologist. Came to America, 1898. M.A., University of Chicago, 1901; Ph.D., University of Leipzig, 1905. Taught at University of Wisconsin, 1905–13; University of Texas, 1913–19; Bryn Mawr, 1920–27; New York University, 1927–28; and Yale, *post* 1929.

PROPHET *See* TENSKWATAWA.

PROSSER, CHARLES SMITH (*b. Columbus, N.Y., 1860; d. Columbus, Ohio, 1916*), educator, geologist. After serving in a number of government and teaching positions, he was head of the Department of Historical Geology at Ohio State, 1901–16. His published work dealt mainly with the stratigraphy and paleontology of the Paleozoic formations of New York, Kansas, Maryland, and Ohio.

PROUD, ROBERT (*b. Yorkshire, England, 1728; d. Philadelphia, Pa., 1813*), educator, historian. Immigrated to Philadelphia, 1759; was master of the Friends Public School for many years. Author of *The History of Pennsylvania in North America* (1797–98), a valuable work based on original research.

PROUTY, CHARLES AZRO (*b. Newport, Vt., 1853; d. Newport, 1921*), lawyer. Member of Interstate Commerce Commission, 1896–1914; supported Theodore Roosevelt's railroad policy. *Post*

1914, he served as director of the commission's Bureau of Valuation, organizing it and shaping its policies and philosophy of value.

PROUTY, CHARLES TYLER (*b. Washington, D.C., 1909; d. Fort Lauderdale, Fla., 1974*), Shakespearean scholar. Graduated Dartmouth College (B.A., 1931) and Cambridge University (B.A., 1933; M.A., 1938; Ph.D., 1939). He taught at Lehigh University (1936–38), was a research fellow at the Folger Shakespeare Library (1939–40), taught at the University of Missouri (1940–48), then joined the faculty at Yale University in 1948. He wrote works on Elizabethan theater, such as *The Sources of* Much Ado About Nothing (1950) and *The Contention and Shakespeare's 2 Henry VI* (1954). In *An Early Elizabethan Playhouse* (1953), he detailed his research discoveries on Trinity Hall, a late-eighteenth-century London playhouse. Prouty helped found and was director of the Yale Summer Shakespeare Institute (1955–62).

PROUTY, OLIVE HIGGINS (*b. Worcester, Mass., 1882?; d. Brookline, Mass., 1974*), writer. Graduated Smith College (1904). Her first of twelve novels, *Stella Dallas* (1922), served as the basis for a popular radio serial and was adapted for the film of the same name (1937). The novel *Now, Voyager* (1941) was also made into a motion picture. She was a financial benefactor and confidante to writer Sylvia Plath and an active supporter of Smith College.

PROVOOST, SAMUEL (*b. New York, N.Y., 1742 o.s.; d. 1815*), Episcopal clergyman. Graduated King's College (Columbia), 1758; studied at Peterhouse, Cambridge; ordained in London, 1766. Returning to New York as assistant minister of Trinity Church, his Whig sympathies caused conflict with Loyalist members of the parish and he resigned, 1771. In 1784 he was chosen rector of St. Paul's, New York City, and served in the following year as chaplain of Congress. He was consecrated first bishop of New York, February 1787, by the Archbishop of Canterbury in the chapel of Lambeth Palace, London, and officiated until 1801 when private reasons caused him to offer his resignation. The resignation was refused, but thereafter the work of the diocese was done by a coadjutor. Bishop Provoost was chairman of the committee which drafted the constitution of the Episcopal church and was responsible for the necessary changes in the Book of Common Prayer following the creation of a distinctly American Episcopal church.

PROVOST, ETIENNE (*b. Canada, ca. 1782; d. St. Louis, Mo., 1850*), hunter, guide. Associated at times with William Ashley and the American Fur Co., he is supposed to have been the first white man to visit the Great Salt Lake and was possibly the discoverer of South Pass. He was guide for J. J. Audubon on his western expedition, 1843.

PROVOSTY, OLIVIER OTIS (*b. Pointe Coupée Parish, La., 1852; d. New Orleans, La., 1924*), jurist, Louisiana legislator. Justice, Louisiana Supreme Court *post* 1901; chief justice, 1922. He retired from public life at the end of 1922.

PRUDDEN, THEOPHIL MITCHELL (*b. Middlebury, Conn., 1849; d. 1924*), pathologist, bacteriologist. Graduated Sheffield Scientific School, Yale, 1872; Yale Medical School, 1875. Studied also in Heidelberg, Vienna, Berlin. Taught histology and pathology at New York College of Physicians and Surgeons. The first to make diphtheria antitoxin in the United States, he was for years adviser to Hermann M. Biggs of the New York health department. He was coauthor with Francis Delafield in the writing of the great standard textbook *Hand-book of Pathological Anatomy and Histology* (1885). In 1901, he became one of the scientific directors of the Rockefeller Institute.

PRUD'HOMME, JOHN FRANCIS EUGENE (*b. St. Thomas, Virgin Islands, 1800; d. Georgetown, D.C., 1892*), engraver, banknote designer. Came to New York City as a child. Long active in his profession, he was with the U.S. Bureau of Engraving and Printing, 1869–85.

PRUYN, JOHN VAN SCHAICK LANSING (*b. Albany, N.Y., 1811; d. Clifton Springs, N.Y., 1877*), lawyer. Official and general counsel of New York Central Railroad *post* 1853, he was directly or indirectly connected with many of the leading financial and railroad enterprises in the United States. Active also in politics and philanthropy, he was chancellor of the University of the State of New York, 1862–77, and was responsible for the establishment of the state board of charities.

PRUYN, ROBERT HEWSON (*b. Albany, N.Y., 1815; d. 1882*), lawyer. Graduated Rutgers, 1833. After service as a Whig New York State legislator and officeholder, he followed W. H. Seward into the Republican party and was commissioned U.S. minister resident in Japan, October 1861, serving in that post with great tact and ability until 1865.

PRYBER, CHRISTIAN See PRIBER, CHRISTIAN.

PRYOR, ARTHUR W. (*b. St. Joseph, Mo., 1870; d. West Long Branch, N.J., 1942*), musician. Member of a family of professional musicians, he was a master of the trombone. His rise to national fame began in 1892, when he became a featured soloist with John Philip Sousa's newly formed band. Forming his own band in 1903, Pryor was successful on tour, in seasonal engagements at resorts, and as a recording artist. Among his many compositions, the most popular was a novelty, "The Whistler and His Dog." He retired in 1933.

PRYOR, NATHANIEL (*b. probably Amherst Co., Va., ca. 1775; d. Osage Agency, Indian Territory, 1831*), soldier, trader. Sergeant in Lewis and Clark expedition; served with distinction in the battle of New Orleans.

PRYOR, ROGER ATKINSON (*b. near Petersburg, Va., 1828; d. New York, N.Y., 1919*), soldier, Confederate brigadier general, jurist. Graduated Hampden-Sydney College, 1845. Practiced law at Petersburg; was associated at various times with the *Southside Democrat*, the Washington *Union*, and the *Richmond Enquirer*; founded *The South*, 1857, as an ultrasouthern newspaper. Congressman, Democrat, from Virginia, 1859–61. Visiting Charleston, S.C., with other Virginians, 1861, he urged the attack on Fort Sumter, but declined the honor of firing the first shot in favor of Edmund Ruffin. After serving gallantly through the Civil War, he removed to New York City, September 1865, was admitted to the New York bar and practiced successfully. He was a justice of the New York Supreme Court, 1896–99.

PUGET, PETER RICHINGS See RICHINGS, PETER.

PUGH, ELLIS (*b. Dolgelley, North Wales, 1656; d. 1718*), Quaker preacher and writer. Resident in or near Philadelphia, 1687–1706, and *post* 1708. Author of *Annerch ir Cymru* (Philadelphia, 1721), the first book in Welsh known to have been printed in America.

PUGH, EVAN (*b. Jordan Bank, Pa., 1828; d. 1864*), chemist. Studied at Leipzig and Heidelberg; Ph.D., Göttingen, 1856; studied also in England. Organizer and president, Agricultural College of Pennsylvania (present Pennsylvania State College), 1859–64.

PUGH, GEORGE ELLIS (*b. Cincinnati, Ohio, 1822; d. Cincinnati, 1876*), lawyer, Ohio legislator. U.S. senator, Democrat, from Ohio, 1855–61. Opposed extreme Southern position; active in urging acceptance of Crittenden Compromise. Ran for lieutenant governor of Ohio on ticket with C. L. Vallandigham, 1863; assisted Charles O'Conor as defense counsel in case of Jefferson Davis.

PUJO, ARSÈNE PAULIN (*b. Calcasieu Parish, La., 1861; d. New Orleans, La., 1939*), lawyer. Congressman, Democrat, from Louisiana, 1903–13. An active member of the National Monetary Commission, 1908–12, Pujo in 1911 became chairman of the House Banking and Currency Committee, and in 1912 headed a subcommittee whose investigations of the money trusts (including J. P. Morgan & Co.) led to important reforms.

PULASKI, CASIMIR (*b. Podolia, Poland, ca. 1748; d. off Savannah, Ga., 1779*), Polish patriot, Revolutionary cavalry leader. Joined father in active rebellion against foreign domination of Poland, 1768; after defeat, fled to Turkey, 1772; arrived in Paris, France, 1775. Introduced by Benjamin Franklin and Silas Deane, Pulaski arrived in Boston, July 1777, and was recommended by George Washington to Congress for command of all the Continental cavalry. After service at Brandywine and Germantown, he commanded cavalry during the winter of 1777–78 and acted with General Anthony Wayne in foraging for the troops at Valley Forge. Refusing to serve under Wayne, he resigned his command, March 1778. After ill success with an independent cavalry corps of his own and guard service at Minisink on the Delaware River, he was ordered in February 1779 to South Carolina. Defeated in an attempt to block the British advance northward from Savannah, Ga., he joined forces with General Benjamin Lincoln in Georgia. During the siege of Savannah, he was mortally wounded while charging the enemy lines.

PULITZER, JOSEPH (*b. Mako, Hungary, 1847; d. in harbor of Charleston, S.C., 1911*), journalist. Obtained passage to America by enlisting in Union army at Hamburg, Germany; arrived in Boston, 1864; served for a year with the 1st New York (Lincoln) Cavalry. Removing to St. Louis, Mo., he performed all sorts of menial labor until he became in 1868 a reporter on the German daily *Westliche Post*. He soon became a prominent figure in local journalism and held important civic positions, 1869–72. He campaigned on behalf of Horace Greeley, 1872, and disappointment over the defeat of the Liberal Republican movement brought him to the Democratic party, to which he remained loyal for the rest of his life. In 1874 he bought the bankrupt St. Louis *Staats-Zeitung*, whose membership in the Associated Press he sold to the *St. Louis Daily Globe* for a good profit. This gave him leisure to study law and he was admitted to the bar, 1876.

He settled finally on a career in journalism in 1878 when he bought the *St. Louis Dispatch* and merged it with the *Post*. The new daily, the *St. Louis Post-Dispatch*, was a huge success and a leader in fighting municipal and political corruption. In 1883 he bought the New York *World* from Jay Gould and converted it into a profitable venture and a great national political force. The program which Pulitzer announced on acquiring control made him immediately popular with labor. The *World* declared that it opposed the aristocracy of money, but that it wished to become the organ of the true American aristocracy, "the aristocracy of labor." Main items in its program were the taxation of luxuries, inheritances, large incomes, monopolies, and large and privileged corporations; the enactment of a tariff for revenue only; the reform of the civil service; the punishment of corrupt officials and purchasers of votes at elections; and the punishment of employers who coerced their employees at election times. Success was immediate, owing to this policy and to the sensa-

tional methods and "stunts" which Pulitzer employed. In 1887 he founded the *Evening World*.

Early in 1896 the morning *World* resorted to extreme "yellow journalism" in its rivalry with the rising dailies of William Randolph Hearst and was only redeemed by the personal supervision of Pulitzer, who had retired from direct management in 1887. Although ill and blind, he impressed upon the *World* its subsequent high character as an internationally minded, extremely well-informed daily, with a remarkably able editorial page, no longer an organ of the working classes but of all who favored liberal and democratic policies. The influence of the *World* upon the political life and the press of the country was very great after it abandoned its career of sensationalism and vulgarity. It opposed jingoism and special privilege; it was the fearless scourge of political corruption; it was completely free of domination by advertisers. After Pulitzer's death the papers passed to his sons, who failed to keep them profitable and sold them to the Scripps-Howard newspaper group. His will provided for the establishment of a school of journalism at Columbia University and for the annual awards known as the Pulitzer Prizes.

PULITZER, JOSEPH, JR. (*b. New York, N.Y., 1885; d. St. Louis, Mo., 1955*), newspaper editor and publisher. Studied at Harvard University (1904–06). Sent by his father as an apprentice to the *St. Louis Post-Dispatch* in 1906, Joseph Jr. acquired the newspaper in 1912. By expanding into radio (1922) and television (1947), the Pulitzer Publishing Co. became a major force in the communications industries. An ardent defender of the freedom of the press, Pulitzer often defended his reporters and cartoonists in court. He was conservative in politics and supported Landon and Dewey in their bids for the presidency. He stayed at the *Post-Dispatch* until his death.

PULITZER, MARGARET LEECH (*b. Newburgh, N.Y., 1893; d. New York City, 1974*), historian and writer. Graduated from Vassar College (B.A., 1915) and worked for Condé Nast publishing in New York City. She launched her writing career with the novel *The Back of the Book* (1924). In 1927 she collaborated with Heywood Broun on the noted biography *Anthony Comstock: Roundsman of the Lord*. She won Pulitzer Prizes for two historical studies: *Reveille in Washington, 1860–1865* (1941) and *In the Days of McKinley* (1959).

PULITZER, RALPH (*b. St. Louis, Mo., 1879; d. New York, N.Y., 1939*), journalist, publisher. Son of Joseph Pulitzer. Graduated Harvard, 1900. Editor-publisher of the New York *World*, 1911–30, he gave primary attention to news and a liberal editorial policy.

PULLER, LEWIS BURWELL ("CHESTY") (*b. West Point, Va., 1898; d. Huntington, Va., 1971*), Marine Corps officer. Dropped out of the Virginia Military Institute in 1918 to join the marines; he served as boot camp instructor at Parris Island, S.C. He served in Haiti (1919–24), Nicaragua (1928–33), and Peking, China (1933). During World War II Puller commanded the First Battalion, Seventh Marine Regiment, in bloody fighting on Peleliu (1944). In the Korean War he directed the amphibious Marine landing at Inchon (1951) and the subsequent march on Seoul. When he retired in 1955 as a lieutenant general, he was the most decorated individual in the history of the Marine Corps.

PULLMAN, GEORGE MORTIMER (*b. Brocton, N.Y., 1831; d. 1897*), inventor, industrialist. Removed to Chicago, Ill., 1855, where he became a successful contractor. By 1858, he had brought his earlier-formulated idea for improved railroad sleeping accommodations to the point of remodeling several coaches of the Chicago & Alton Railroad into sleeping cars. On failure

of railroads generally to adopt his cars, Pullman removed to Colorado, 1859, where he conducted a general store and worked on plans for improvement of his scheme. Returning to Chicago, 1863, he and an associate completed plans and secured a patent for the basic idea of a folding upper berth in April 1864 and a second patent covering the lower berth arrangement, September 1865. Their first car, *Pioneer*, was enthusiastically received. Pullman and his partner constructed a number of other similar cars and in 1867 organized the Pullman Palace Car Co. Pullman's business ability made it the greatest car-building organization in the world.

PULTE, JOSEPH HIPPOLYT (*b. Meschede, Westphalia [Prussia], 1811; d. Cincinnati, Ohio, 1884*), homeopathic physician, author. M.D., University of Marburg, 1833; came to America, 1834. Practiced mainly in Cincinnati.

PUMPELLY, RAPHAEL (*b. Owego, N.Y., 1837; d. Newport, R.I., 1923*), geologist, explorer. Attended Royal School of Mines, Freiberg, Saxony. Began work as mining engineer in southern Arizona, 1859. Worked in Japan with William P. Blake, 1861–63, as government geologist; traveled in Asia until 1865. His reputation as a mining geologist rests chiefly on his work in association with Thomas B. Brooks in the copper and iron districts of Michigan and the Lake Superior area. Restlessly active, he served at various times as state geologist of Missouri, as head of the New England division of the U.S. Geological Survey, and in other professional assignments. In 1903 and 1904 under auspices of the Carnegie Institution, he organized and conducted expeditions into central Asia seeking traces of prehistoric civilization and evidences of geological and climatic changes. His most important technical achievements were his studies of the loess of China and his discovery of the secondary nature of the iron ores of Michigan, together with his work on the paragenesis of the copper deposits there.

PUPIN, MICHAEL IDVORSKY (*b. Idvor, Banat, Austria–Hungary, 1858; d. New York, N.Y., 1935*), physicist. Born of illiterate but highly intelligent Serbian parents, he received his early education in Idvor and Panchevo, a nearby town. He studied at schools in Prague and during a trip to Vienna was befriended by an American couple who stirred his desire to study in America. In 1874, he arrived at Castle Garden, New York City, with five cents capital. Working at odd jobs in New York, he spent his spare time in the library of Cooper Union. A German theological student taught him Greek and Latin as preparation for his admission to Columbia University. Passing the examinations with honor, 1879, he graduated in 1883 and secured his citizenship papers. He went to Cambridge University for study of physics and mathematics, and then on to Berlin to study under Helmholtz; he received the Ph.D. degree from Berlin, 1889. Returning to Columbia, 1889, as teacher of mathematical physics in the Department of Electrical Engineering, he was promoted to professor of electromechanics, 1901, a position which he held until his retirement in 1931.

His teaching brought him in contact with many practical engineering problems. Henry A. Rowland, for example, had reported distortions in an alternating current when it was magnetizing iron in electrical power apparatus. It consisted of addition of higher harmonics to the normal harmonic changes in current. Recollecting Helmholtz' work in analyzing complex sound waves by means of resonators. Pupin developed an analogous method for electrical waves and invented the electrical resonator, consisting of a circuit having a variable condenser and inductance akin to the tuning unit in a radio. When this direct method was applied to the current under study, its harmonics were readily obtained. Many later applications of this method were developed.

In 1894 he became interested in the theoretical problem of the propagation of waves in a vibrating string and applied his findings to solving the problem of attenuation of electrical currents in conveying speech in long-distance telephony. He had found that a disturbance set up in a string which was loaded with weights at equal intervals did not die out as quickly as in a string which was not loaded. Others had shown that transmission efficiency of long telephone or telegraph circuits could be improved by increasing the "uniformly distributed inductance," but no one had found a way of doing it. Pupin's study of the analogous string problem showed him the proper spacing for inductance coils along the telephone circuit. Coils inserted at about one for every four or five miles on overhead wires and at one to two miles in cables resulted in reduction of both attenuation and distortion. When the discovery of X rays was announced in 1895, Pupin constructed a tube and obtained the first X-ray photograph in America on Jan. 2, 1896. He also discovered secondary X-radiation.

After a long period of recuperation from the loss of his wife, 1896, and the effects of illness, he returned to Columbia to work on problems of radio transmission. E. H. Armstrong was one of his pupils. After World War I he ceased personal research; in 1919, he acted as an adviser to the Yugoslav delegation to the Paris Peace Conference.

An eloquent speaker with a poetic imagination. Pupin never failed to stress idealism in science and life. There is also much evidence of his deeply religious nature in his autobiography *From Immigrant to Inventor* (1923), which in 1924 received a Pulitzer Prize. Other of his works were a book on thermodynamics (1894), *Serbian Orthodox Church* (1918), *Yugoslavia* (1919), *The New Reformation* (1927), *Romance of the Machine* (1930), and 65 articles of scientific interest. He received 34 patents for his inventions.

PURCELL, JOHN BAPTIST (*b. Mallow, Ireland, 1800; d. 1883*), Roman Catholic clergyman. Came to America, 1818; attended the seminary at Mount St. Mary's College, Emmitsburg, Md., 1820–23; completed theological studies in Paris, where he was ordained, 1826. After a brief period as professor of moral philosophy and as president of Mount St. Mary's, Purcell was consecrated bishop of Cincinnati, 1833. An able and tactful administrator with a strong interest in education, he was, with the exception of John Hughes, the most influential figure in the American hierarchy of his time and was named archbishop, July 1850. His more than 50 years of distinguished service to the church were unfortunately shadowed in 1879 by the failure of a private bank for which he was nominally responsible and he was succeeded by his coadjutor, William H. Elder.

PURDUE, JOHN (*b. Huntingdon Co., Pa., 1802; d. Lafayette, Ind., 1876*), merchant, philanthropist. Principal benefactor of Purdue University.

PURDY, CORYDON TYLER (*b. present Wisconsin Rapids, Wis., 1859; d. Melbourne, Fla., 1944*), structural engineer. C.E., University of Wisconsin, 1886. Originally a designer of bridges, he was quick to see the possibilities of steel framing for high-building construction; in partnership with Lightner Henderson, 1893–1916 (*post* 1917 as chairman of the board of the corporation that succeeded the partnership), he displayed a mastery of the structural design of large and complex buildings. The first of his works with a frame constructed entirely of steel was the Marquette Building in Chicago, 1894; his best-known New York City skyscrapers were the Flatiron Building, 1903, and the Metropolitan Tower, 1909.

PURDY, LAWSON (*b. Hyde Park, N.Y., 1863; d. Port Washington, N.Y., 1959*), tax and zoning expert. Studied at Trinity College and New York Law School. Purdy achieved a national reputation while serving as secretary of the N.Y. Tax Reform Association (1896–1906); president of the N.Y. City Department of Taxes and Assessments (1906–17); vice president of the National Tax Association (1907–12); and president of the National Municipal League (1916–19). His main achievement was the enactment of legislation for New York City that required publication of assessment rolls (1902) and the separate listing of land and total value of an assessed property (1906). Purdy was also involved in the enactment of the first comprehensive zoning law in 1916.

PURNELL, BENJAMIN (*b. Mayville, Ky., 1861; d. 1927*), founder of an eccentric religious sect, the House of David.

PURNELL, WILLIAM HENRY (*b. Worcester Co., Md., 1826; d. 1902*), lawyer, politician. Graduated Delaware College (present University of Delaware), 1846. Active in Maryland politics as a Whig and Know-Nothing, later as chairman of the Union party, 1864–66. President of Delaware College, 1870–85; served thereafter as principal of Frederick Female Seminary (present Hood College) and as president of New Windsor College.

PURPLE, SAMUEL SMITH (*b. Lebanon, N.Y., 1822; d. 1900*), physician, editor. Practiced in New York City *post* 1844; was a founder and benefactor of the New York Academy of Medicine, whose library was formed around the nucleus of books bequeathed to the academy by him.

PURRY, JEAN PIERRE (*b. Neuchâtel, Switzerland, 1675; d. ca. 1736*), colony promoter. Proposed settlement of European Protestants in Carolina, 1724–26; established Purrysburgh, S.C., with a group of Swiss immigrants, 1732–34.

PURSH, FREDERICK (*b. Grossenhain, Saxony, 1774; d. Montreal, Canada, 1820*), botanist, horticulturist, explorer. Came to America, 1799. Aided by Benjamin S. Barton, Pursh made two memorable journeys of botanical exploration in 1806 and 1807: the first through the mountains from western Maryland to the North Carolina border and back along the coast, the second across the Pocono region of Pennsylvania to central New York and thence east to the Vermont Green Mountains. He was author of *Flora Americae Septentrionalis* (1814), the first complete flora of America north of Mexico, and of a posthumously published journal of his explorations.

PURTELL, WILLIAM ARTHUR (*b. Hartford, Conn., 1897; d. West Hartford, Conn., 1978*), U.S. senator and manufacturer. In 1929 he launched the Holo–Krome Screw Corporation, using several of his inventions to produce high-quality screws; he was involved with several successful manufacturing firms in Connecticut. After his appointment to a vacant U.S. Senate seat in 1952, he ran successfully that year for the state's other senate position. He was a committed conservative who opposed the New Deal and President Harry Truman's domestic initiative, the Fair Deal. He lobbied successfully to add an amendment to the Social Security law that limited government spending for child welfare services in urban areas that were adequately covered by voluntary agencies. In 1954 he refused to censure the anti-Communist Sen. Joseph McCarthy. Purtell served on a Senate select committee in 1956 to investigate lobbying, campaign contributions, and corrupt political practices. After losing his reelection bid in 1958, he returned to his manufacturing interests.

PURVIANCE, DAVID (*b. Iredell Co., N.C., 1766; d. Preble Co., Ohio, 1847*), frontier preacher and legislator in Tennessee, Kentucky, and Ohio. A founder of the so-called Christian denomination.

PURYEAR, BENNET (*b. Mecklenberg Co., Va., 1826; d. Madison Co., Va., 1914*), educator. Professor of chemistry, Richmond College (present University of Richmond), 1850–58 and 1865–95. A pioneer in applying chemistry to Virginia agriculture, he had a wide influence among farmers.

PUSEY, CALEB (*b. Berkshire, England, ca. 1650; d. Chester Co., Pa., 1727 o.s.*), miller, Pennsylvania provincial legislator, Quaker controversial writer. Immigrated to Pennsylvania, 1682; erected Chester Mills near Upland, 1683, which he managed until 1717.

PUSEY, WILLIAM ALLEN (*b. Elizabethtown, Ky., 1865; d. Chicago, Ill., 1940*), dermatologist, authority on syphilis. Graduated Vanderbilt University, 1885; M.D., New York University, 1888. Practiced in Chicago.

PUSHMATAHA (*b. probably present Noxubee Co., Miss., ca. 1765; d. Washington, D.C., 1824*), Choctaw chief. Opposed Tecumseh's efforts to form an Indian confederacy; led Choctaw warriors against the Creek in campaign under Andrew Jackson, 1813–14.

PUTNAM, ARTHUR (*b. Waveland, Miss., 1873; d. near Paris, France, 1930*), sculptor. Patronized by Willis Polk and E. W. Scripps, he was particularly effective in bronzes of western animals.

PUTNAM, CHARLES PICKERING (*b. Boston, Mass., 1844; d. 1914*), physician. Brother of James J. Putnam; grandson of James Jackson. A noted specialist in pediatrics and orthopedics in Boston *post* 1871, he was also the most important leader in charitable and social work in that city *post* 1875.

PUTNAM, EBEN (*b. Salem, Mass., 1868; d. Wellesley Farms, Mass., 1933*), editor, genealogist, historian. Son of Frederic W. Putnam.

PUTNAM, FREDERIC WARD (*b. Salem, Mass., 1839; d. Cambridge, Mass., 1915*), archaeologist, naturalist. Strongly influenced by J. L. R. Agassiz while studying at Harvard, Putnam began his long career as a museum administrator at the Essex Institute. Influential in the founding of the Peabody Academy of Science, Salem, he served as its director, 1869–73. As curator of the Peabody Museum at Harvard *post* 1874, he revolutionized the methods of museum administration; *post* 1894, he served also as curator of anthropology, American Museum of Natural History, New York City. To these activities and many other advisory posts, Putnam added that of teaching, for he was appointed Peabody professor of archaeology at Harvard in 1887. In the rise and development of anthropology in America, Putnam played a leading, perhaps the foremost, part and was largely responsible for its acceptance as a university study.

PUTNAM, GEORGE HAVEN (*b. London, England, 1844; d. New York, N.Y., 1930*), Union soldier, publisher. Son of George P. Putnam, he succeeded his father as head of the firm of G. P. Putnam & Son, 1872, and remained its active head until 1930. He played a prominent part in securing the copyright act of 1909.

PUTNAM, (GEORGE) HERBERT (*b. New York, N.Y., 1861; d. Quissett, Mass., 1955*), librarian and lawyer. Studied at Harvard and at Columbia Law School. In 1884, he became head of the Minneapolis Athenaeum (later the Minneapolis Public Library). In 1895, he was appointed librarian of the Boston Library. In 1899, director of the Library of Congress in Washington. He

remained in that position until 1939, when he became librarian emeritus. As chief of the Library of Congress, Putnam increased the collection sevenfold, added the annex, and acquired the funding for the Library of Congress Trust Fund (donated by Elizabeth Sprague Coolidge) which established the Library as a major center of chamber music, and raised the library to the level of one of the greatest centers of learning and research in the world. Putnam was president of the American Library Association in 1898 and 1904.

PUTNAM, GEORGE PALMER (*b. Brunswick, Maine, 1814; d. New York, N.Y., 1872*), publisher. Became partner in Wiley & Putnam, 1840; after a number of vicissitudes, established firm of G. P. Putnam & Son, 1866. Maintained close working relations with the British book trade, was an early advocate of international copyright.

PUTNAM, GIDEON (*b. Sutton, Mass., 1763; d. 1812*), developer of Saratoga Springs, N.Y., as a spa and resort, 1802–12.

PUTNAM, HELEN CORDELIA (*b. Stockton, Minn., 1857; d. Providence, R.I., 1951*), physician and health educator. Studied at Vassar College and the Women's Medical College of Pennsylvania (M.D., 1889). Practiced medicine in Providence, R.I. from 1892. Vice president of the American Academy of Medicine, 1894 and 1897; president, 1908. A specialist in child care, Putnam focused on physical education and sanitary conditions in schools. Helped found the American Association for the Study and Prevention of Infant Mortality; this became the Child Health Organization in 1923, and, later, the American Academy of Pediatrics.

PUTNAM, ISRAEL (*b. Salem Village, present Danvers, Mass., 1718; d. Brooklyn [earlier Pomfret, Conn.], 1790*), soldier. Served throughout French and Indian War with Connecticut forces and with Robert Rogers as one of his rangers; promoted major of colony forces, 1758, and lieutenant colonel, 1759. In 1764, he campaigned with Bradstreet's expedition in Pontiac's War. Active in the organization of the Sons of Liberty at the time of the Stamp Act troubles, he served in the General Assembly, 1766–67. After an exploring trip to the Gulf of Mexico and up the Mississippi River, 1773, he became chairman of the committee of correspondence of his home town, 1774, and in the same year was made lieutenant colonel of the 11th Regiment, Connecticut Militia. Appointed major general in the Continental army, 1775, he was a leading spirit in planning for the battle of Bunker Hill and was everywhere during the whole of that fight, although he seems not to have been in supreme command. Ordered to New York after the siege of Boston was ended in March 1775, he played a controversial part in the battle of Long Island and thereafter sunk steadily in the regard of George Washington and the other generals. His dilatoriness as commander of the forces in the Hudson Highlands brought him a sharp rebuke; a court of inquiry, however, exonerated him, but in December 1779 a stroke of paralysis ended his military career. Active, brave, and disinterested, he failed through incapacity in the superior commands to which his popularity advanced him.

PUTNAM, JAMES JACKSON (*b. Boston, Mass., 1846; d. 1918*), neurologist. Brother of Charles P. Putnam. Graduated Harvard, 1866; Harvard Medical School, 1870. After making special studies in Leipzig, Vienna, and London, he returned to Boston, where he practiced, and taught at Harvard Medical School, 1874–1912. In 1872, he started one of the first neurological clinics in the United States at Massachusetts General Hospital; he was the author of many important papers in the fields of structural and functional neurology.

PUTNAM, JAMES OSBORNE (*b. Attica, N.Y., 1818; d. 1903*), lawyer, Whig and Republican public servant and diplomat. Maintained a lifelong interest in the educational and cultural institutions of Buffalo, N.Y.; was a founder of University of Buffalo, 1846, and its chancellor, 1895–1902.

PUTNAM, NINA WILCOX (*b. New Haven, Conn., 1885; d. Cuernavaca, Mexico, 1962*), author. From the acceptance of a short story by *Ainslee's* magazine in 1907, she had continuing success as a popular author of romances, high comedy, and colloquial humor. Introduced her most popular character, Marie La Tour, in a story for *Saturday Evening Post*, where she published regularly for two decades. Wrote twenty-two books, including *In Search of Arcady* (1912), *Sunny Bunny* (1917), and *Paris Love* (1931). Wrote more than 1,000 short stories, and twelve were made into movies, including "Sitting Pretty" (1933). She wrote the syndicated column "I and George" for North American Newspaper Alliance (1928–38).

PUTNAM, RUFUS (*b. Sutton, Mass., 1738; d. 1824*), soldier, Ohio pioneer. Cousin of Israel Putnam. A self-taught surveyor and millwright, Putnam fought in the French and Indian War and rose to rank of brigadier general in the Continental service during the Revolution, serving with credit as an engineer and as a field commander. Active in the organization of the Ohio Co. Putnam became superintendent of the new colony and was with the first party of settlers to arrive at Marietta, April 1788. Commissioned brigadier general, U.S. Army, 1792, he made the Treaty of Vincennes, September 1792, with the lower Wabash tribes. As surveyor general of the United States, 1796–1803, he surveyed the military tract (inaccurately). As delegate to the Ohio constitutional convention, 1802, he exerted strong influence against the admission of slavery.

PUTNAM, RUTH (*b. Yonkers, N.Y., 1856; d. Geneva, Switzerland, 1931*), author. Daughter of George P. Putnam; sister of George H. Putnam and Mary C. P. Jacobi. Specialist in the history of the Netherlands.

PUTNAM, WILLIAM LE BARON (*b. Bath, Maine, 1835; d. 1918*), jurist, diplomat, expert in equity. Judge, U.S. Circuit Court of Appeals (1 st Circuit), 1892–1917.

PYE, WATTS ORSON (*b. near Faribault, Minn., 1878; d. 1926*), Congregational clergyman. As missionary to China *post* 1907, he directed pioneer activity in the provinces of Shansi and Shensi from headquarters at Fenchow.

PYLE, ERNEST TAYLOR (*b. near Dana, Ind., 1900; d. Ie Shima, Ryukyu Islands, Japan, 1945*), newspaper columnist, war correspondent. Popularly known as Ernie Pyle. Attended Indiana University. After serving in various capacities on several newspapers, he had risen by 1932 to be managing editor of the Washington, D.C., *Daily News*. In 1935 he was given an assignment as roving correspondent by the Scripps-Howard management and wrote a syndicated column of informal, chatty commentary, which was very well received. At the outbreak of World War II he went overseas. His reporting from the successive fronts was truthful and graphic, and had a special quality of sincerity that resulted from his concern with the combat infantryman whose perils and feelings he shared. After covering the liberation of Paris, he went home for a brief rest; he then returned to the battlefront, this time in the Pacific area, where he was killed by enemy machine-gun fire. In 1944 he had been awarded the Pulitzer Prize for his war correspondence.

PYLE, HOWARD (*b. Wilmington, Del., 1853; d. Florence, Italy, 1911*), artist, author, teacher. Educated in Quaker schools; stud-

ied art with a Flemish teacher (Van der Weilen) in Philadelphia and briefly at the Art Students League, New York City. Removing to New York, 1876, he developed his own style and technique through patient labor and experiment, encouraged by Edwin Abbey, A. B. Frost, F. S. Church, and others. Successful *post* 1878 as a magazine illustrator, he returned to Wilmington, where he set up his studio. Accurate in delineation of the characters and events of early American history, he was most effective in pen-and-ink work, but was one of the first in the field when the new process for reproducing pictures in color came into being. Important as are the illustrations which he did for the work of other men, his reputation really rests upon his own tales and the pictures he made for them. Outstanding among them are *The Merry Adventures of Robin Hood* (1883), *The Wonder Clock* (1888), *Otto of the Silver Hand* (1888), *Men of Iron* (1892), and *The Story of Jack Ballister's Fortunes* (1895); he also wrote and illustrated a variety of books which dealt with pirates, appealing as much to adults as to children. He taught illustration at Drexel Institute, Philadelphia, 1894–1900, and thereafter in his own school at Wilmington. By somewhat unorthodox methods of instruction, he developed such artists as Maxfield Parish, N. C. Wyeth, and Frank Schoonover.

PYLE, ROBERT (*b. London Grove, Pa., 1877; d. West Chester, Pa., 1951*), nurseryman and authority on roses. Studied at Swarthmore College. Pyle acquired his own mailorder nursery specializing in roses in 1907. One of the nation's leading authorities on roses, he was president of the American Rose Society from 1923 to 1932; founder of the American Association of Botanical Gardens and Arboretums; a member of the Advisory Council of the National Arboretum in Washington, D.C.; president of the American Horticultural Society from 1932 to 1935; and trustee and vice president of All-American Rose Selections. Trustee of Swarthmore College from 1910.

PYLE, WALTER LYTLE (*b. Philadelphia, Pa., 1871; d. 1921*), ophthalmologist, medical writer.

PYNCHON, JOHN (*b. Springfield, Essex, England, ca. 1626; d. 1702/3*), colonial industrialist, public servant. Son of William Pynchon. Came to New England with his father as a child. Conducted the family trading business *post* 1652 and exercised a controlling influence in and about Springfield, Mass.

PYNCHON, THOMAS RUGGLES (*b. New Haven, Conn., 1823; d. New Haven, 1904*), Episcopal clergyman. Graduated Washington College (present Trinity), Hartford, 1841; was professor of science there, 1855–77, and professor of moral philosophy, 1877–1902. President of the college, 1874–83.

PYNCHON, WILLIAM (*b. England, ca. 1590; d. near Windsor, England, 1662*), trader, colonial official. Immigrated from Springfield, Essex, England, 1630; settled first at Dorchester and started fur-trading operations at Roxbury, Mass., where he was first signer of the church covenant. He had brought considerable capital to the colony and served it as assistant, 1630–36, and as treasurer, 1632–34. Active in the immigration to the Connecticut River valley, he was appointed one of the commissioners to govern the new settlement, March 1635/6. He was at Springfield, May 1636, when, with seven others, he signed an agreement concerning land allotments and settling a minister. Falling out with Thomas Hooker, Pynchon severed connections with the River Colony and supported the claim of Massachusetts to Springfield, which took no further part in the Connecticut government after 1638. Largest landowner in Springfield, Pynchon virtually ruled the community and was successful as a trader, shipping furs direct to London down the Connecticut River. Reelected a Massachusetts assistant, 1642, he was elected annually thereafter until 1651. He returned to England probably in the spring of 1652 after deeding his property at Springfield to his son John Pynchon and to his sons-in-law. Shortly before his departure he had written a tract critical of the orthodox view of the Atonement which the Massachusetts clergy denounced as heretical.

Q

QUACKENBUSH, STEPHEN PLATT (b. Albany, N.Y., 1823; d. Washington, D.C., 1890), naval officer. Retired as rear admiral, 1885, after 45 years of valuable service, particularly with the Civil War blockade forces off Virginia and North Carolina.

QUANAH (b. probably northern Texas, ca. 1845; d. near Fort Sill, Oklahoma, 1911), Comanche chief. Son of a Kwahadi chief and a white captive, Cynthia Parker. Refusing to accept the Medicine Lodge treaty of 1867, he terrorized the frontier settlements in Texas until he was badly defeated at the fight at Adobe Walls in present Hutchinson Co., Texas, June 1874. Adapting himself to the white man's way after his surrender, 1875, he fostered building and agriculture among his tribesmen, popularized education, and discouraged extravagance.

QUANTRILL, WILLIAM CLARKE (b. Canal Dover, Ohio, 1837; d. Louisville, Ky., 1865), guerrilla chief. Settled in Kansas, 1857. Journeyed to Utah, 1858; worked as gambler. Returning to Kansas, he taught school in the winter of 1859–60, and thereafter engaged in horse-stealing, escaping arrest by fleeing to Missouri. Irregularly connected with the Confederate Army at the start of the Civil War, he soon appeared as the chief of a guerrilla band which operated in Missouri and Kansas, robbing mail coaches, raiding and sacking Unionist communities and farms. Formally outlawed in 1862, he mustered his troop into Confederate service and was given the rank of captain. In August 1863, he destroyed the town of Lawrence, Kans. Dissension arising among his followers, they broke up into smaller bands. He made a raid into Kentucky early in 1865 and in May of that year was fatally wounded near Taylorsville.

QUARTER, WILLIAM (b. King's Co., Ireland, 1806; d. 1848), Roman Catholic clergyman. Immigrated to Canada, 1822, where he was denied admission to seminaries because of his youth. Accepted by Dr. John Dubois at Mount St. Mary's, Emmitsburg, Md., he made his theological studies and was ordained, September 1829. After serving as a New York pastor, he was consecrated first bishop of Chicago, 1844

QUARTLEY, ARTHUR (b. Paris, France, 1839; d. New York, N.Y., 1886), painter of seascapes. Came to New York as a boy; was taught to draw by his father, an engraver. Worked in Baltimore, Md., 1862–75, thereafter, in New York and in summers at Isle of Shoals, N.H.

QUAY, MATTHEW STANLEY (b. Dillsburg, Pa., 1833; d. Beaver, Pa., 1904), politician, lawyer, Union soldier. Rose to prominence in Pennsylvania politics by success in promoting gubernatorial campaign of Andrew G. Curtin, 1860. Reentering politics on his return from distinguished service in the Civil War, he served as secretary of Pennsylvania, 1872–78, and as recorder of Philadelphia; he was also chairman of the Republican state committee. Unable to gain control of the political machine in Philadelphia, he resigned the position of recorder and was again appointed commonwealth secretary, 1879, holding this position until 1882.

Elected state treasurer in 1885, from this time until his death he held undisputed political control of Pennsylvania and was U.S. senator post 1887 with the exception of a hiatus in 1899–1900. Quay's influence was decisive in matters connected with tariff legislation, but he is chiefly to be remembered for his genius as a political maneuverer. He always had a machine to work with, but he would build up a new one for each major contest and by aligning his enemies against one another was able to triumph over them all. His break with Benjamin Harrison and his failure to take an active part in the campaign of 1892 was a prime factor in the Democratic victory of that year. An educated man with a passion for literature, he displayed an utter contempt for ordinary political ideals and he was one of the best-hated men in politics.

QUAYLE, WILLIAM ALFRED (b. Parkville, Mo., 1860; d. Baldwin, Kans., 1925), Methodist clergyman, educator, bishop.

QUEEN, WALTER W. (b. Washington, D.C., 1824; d. Washington, 1893), naval officer. Retired as rear admiral, 1886, after varied sea and shore service, notably in Civil War blockade of North Carolina.

QUELCH, JOHN (b. London, England, ca. 1665; d. Boston, Mass., 1704), pirate. Unlawfully in command of the Boston brigantine *Charles*, Quelch plundered a number of Portuguese ships off the coast of Brazil, November 1703–February 1704. On the return of the *Charles* to Marblehead, Mass., Quelch and some of his crewmen were arrested, tried, and hanged on June 30. The speed and questionable procedures of the trial, together with the eagerness of Boston authorities to confiscate and divide the loot, have caused the case to be characterized as "judicial murder."

QUESNAY, ALEXANDRE-MARIE (b. Saint-Germain-en-Viry, France, 1755; d. Saint-Maurice, France, 1820), soldier, educator. Came to Virginia, April 1777; served as captain in Revolutionary army until autumn 1778. Taught school in Virginia, Philadelphia, New York, 1780–86. Returning to France, in the spring of 1787 he presented a plan for an Academy of the United States of America to Thomas Jefferson, then U.S. minister to France. His plan called for an extensive system of schools and universities throughout the United States centering around an establishment at Richmond. On Jefferson's statement that America was too poor to support such undertakings, the project failed.

QUEZON, MANUEL LUIS (b. Baler, Tayabas [now Quezon Province], Luzon, Philippine Islands, 1878; d. Saranac Lake, N.Y., 1944), lawyer, statesman. After serving as an officer in Emilio Aguinaldo's insurrection against the U.S. takeover in the Philippines, 1899–1901, he resumed his interrupted studies at the University of Santo Tomás (Manila) and received the LL.B. degree in 1903. Later that year he returned to his native province to practice. He was elected governor of Tayabas, 1906, running on a platform advocating immediate independence; the next year he was elected to the first Philippine Assembly, where he became floor leader of the majority party, the Nacionalista. By vote of the

Assembly, he served as one of the two Philippine resident commissioners to the United States, 1909–16. In public, a fiery partisan of independence, he realized that his people had much to gain in the material way from its postponement and so cooperated with the United States in many matters that might otherwise have become open issues. He helped draft the second Jones Bill, which provided for some autonomy but deferred independence until a stable government and economy had been well established. When the bill was passed in 1916, he returned to the Philippines as a national hero. Elected president of the new Philippine Senate, he shared leadership with Sergio Osmeña, speaker of the Assembly, rivaling him in building up a personal political machine or power bloc, as a process of Filipinization of government and industry got under way. The arrival of Leonard Wood as U.S. governor general in 1921 put a stop to Filipinization, and by opportunistic maneuvering Quezon put himself forward as the symbol of opposition to colonial status as reasserted by General Wood's governing policies. When his rivals Osmeña and Manuel Roxas on a mission in 1932–33 obtained from the U.S. Congress legislation that provided for Philippine independence after ten years, he saw to it that the proposal was rejected by the Philippine legislature. He then led a new mission to the United States and secured from Congress the Tydings-McDuffie Act (1934), which differed little from the previous legislation but which was ratified unanimously by his legislature. Forming a new coalition with Osmeña and his followers, Quezon was elected president of the Commonwealth — the transitional government that was to precede full independence — in 1935. Giving lip service to democratic forms and reforming principles, and hampered by agrarian and labor discontent, he steadily concentrated power in his own hands. In 1940 the Assembly granted him emergency powers and amended the constitution to permit his continuance in office. At the outbreak of war with Japan he went first to Corregidor, and then to the United States where, with Osmeña, he maintained a war cabinet.

QUICK, JOHN HERBERT (*b. Grundy Co., Iowa, 1861; d. Columbia, Mo., 1925*), lawyer, Iowa politician, author. His best work as a writer is contained in a trilogy of Iowa novels, *Vandemark's Folly* (1921), *The Hawkeye* (1923), and *The Invisible Woman* (1924), vivid, truthful pictures of pioneer life.

QUIDOR, JOHN (*b. Tappan, N.Y., 1801; d. Jersey City, N.J., 1881*), portrait and figure painter. Pupil of John W. Jarvis. Best known for paintings illustrative of scenes from the works of Washington Irving.

QUIGG, LEMUEL ELY (*b. near Chestertown, Md., 1863; d. 1919*), journalist, press agent, politician. Congressman, Republican, from New York, 1894–99; a political lieutenant of Thomas C. Platt. Ousted from Republican leadership of New York County by Benjamin B. Odell, 1900, he became a promoter of the traction interests of Thomas Fortune Ryan.

QUIGLEY, JAMES EDWARD (*b. Oshawa, Canada, 1854; d. Rochester, N.Y., 1915*), Roman Catholic clergyman. Raised in Rochester, N.Y.; graduated St. Joseph's College, Buffalo, N.Y., 1872; made theological studies in Buffalo, at the University of Innsbruck, and at Rome. Bishop of Buffalo, 1897–1903; archbishop of Chicago thereafter.

QUILL, MICHAEL JOSEPH (*b. Kilgarvan, Co. Kerry, Ireland, 1905; d. New York, N.Y., 1966*), labor leader. Immigrated to New York in 1926; worked for the Interborough Rapid Transit Company; in 1934 was a charter member of the Transport Workers Union at its founding and elected its president in 1935, a post he held for life. He was a militant unionist prone to theatrical gestures and extravagant rhetoric who won contracts for tens of thousands of workers in New York, Philadelphia, and Chicago. Elected to New York City Council (1937–39, 1943–49) and vice president of the Congress of Industrial Organizations (1950); he was the only head of a major CIO union to oppose merger with the American Federation of Labor. Under his leadership, the TWU reached a membership of 135,000 by 1966. He led transit strikes in several cities and died shortly after a major strike against the New York City system in 1966, which paralyzed the city for twelve days.

QUIMBY, PHINEAS PARKHURST (*b. Lebanon, N.H., 1802; d. Belfast, Maine, 1866*), founder of mental healing in America. Trained as a clockmaker, he took up mesmerism, 1838, abandoning it in 1847 for mental healing which he practiced *post* 1859 in Portland, Maine. Mary Baker Eddy was a patient of his, 1862 and 1864, and derived her basic ideas from his teaching.

QUINAN, JOHN RUSSELL (*b. Lancaster, Pa., 1822; d. Baltimore, Md., 1890*), physician, medical historian. Practiced in Calvert, Co., Md., and in Baltimore.

QUINBY, ISAAC FERDINAND (*b. Morris Co., N.J., 1821; d. Rochester, N.Y., 1891*), soldier, professor of mathematics and natural science. Graduated West Point, 1843; served in Mexican War. He was associated with the University of Rochester, 1851–85, except for a period of distinguished Civil War service as colonel, 13th New York Volunteers, in 1861, and as a brigade and division commander under General U. S. Grant from March 1862 until resignation because of ill health in December 1863. He led the Yazoo Pass expedition, March 1863.

QUINCY, EDMUND (*b. Boston, Mass., 1808; d. 1877*), reformer, author. Son of Josiah Quincy (1772–1864). Graduated Harvard, 1827. An active associate of William L. Garrison and other Abolitionists, he held office in a number of radical antislavery societies but was personally devoid of fanaticism.

QUINCY, JOSIAH (*b. Boston, Mass., 1744; d. at sea, off the harbor of Gloucester, Mass., 1775*), lawyer, Revolutionary patriot. Graduated Harvard, 1763. Author, *post* 1767, of a number of essays strongly urging the patriot side in the difficulties with England; these were published in the Boston newspapers under several pseudonyms. He was associated with John Adams as counsel for the British soldiers on trial for the Boston massacre, 1770. Developing tubercular symptoms, he made a trip to Charleston, S.C., 1773, during which he met many of the prominent Southern patriots. In May 1774, he published his chief political work, *Observations of the Act of Parliament Commonly Called the Boston Port-Bill*. In the hope that he might present the case of the colonies correctly in England, he proceeded to London late in 1774 where he had interviews with Lord North, Lord Dartmouth, and other leading men without result.

QUINCY, JOSIAH (*b. Braintree, now Quincy, Mass., 1772; d. Boston, 1864*), politician, municipal reformer, educator. Son of Josiah Quincy (1744–1775); nephew of William Phillips. Graduated Phillips Andover in 1786; Harvard, 1790. Congressman, Federalist, from Massachusetts, 1805–13. Becoming a friend of John Randolph of Roanoke and minority leader in Congress, he opposed the Embargo and nonintercourse system as cowardly, futile, and unconstitutional. He also maintained that admission of any territory by majority vote without consent of all the original federators would virtually dissolve the Union. Advocating preparedness for war in the congressional session beginning November 1811 (hoping thereby to restore the Federalists to power by exposing the administration's supposed hypocrisy in this matter), he changed his position completely early in 1812 and opposed

war legislation. After leaving Congress, he entered the Massachusetts senate where he continued his campaigns against the war, slave representation, and Southern dominance until 1820, when the Federalists dropped him for insurgency. Elected to the Massachusetts lower house and chosen its speaker, he resigned, 1821, to take a place on the Boston municipal bench. As mayor of Boston, 1823–27, he instituted a great program of city improvement and reform. His administration of Harvard as its president, 1829–45, was able and businesslike but not particularly distinguished for academic initiative, although he showed a genius for choosing good faculty members—among them, Jared Sparks, Henry Wadsworth Longfellow, and Benjamin Peirce. Deeply interested in the law school, he reformed it and made it into an academic professional school with the aid of Joseph Story. He was author of a number of books of which *The History of Harvard University* (1840) is probably best remembered.

QUINCY, JOSIAH PHILLIPS (*b. Boston, Mass., 1829; d. 1910*), author, historian. Grandson of Josiah Quincy (1772–1864). Graduated Harvard, 1850. Assisted his uncle Edmund Quincy in antislavery work; contributed fiction to periodicals; author of a variety of historical material in *Proceedings* of Massachusetts Historical Society.

QUINE, WILLIAM EDWARD (*b. St. Ann, Isle of Man, 1847; d. Chicago, Ill., 1922*), physician, educator. Came to America as a boy; graduated from Chicago Medical College, 1869. *Post* 1870, he taught with distinction at the Chicago Medical College and at the Chicago College of Physicians and Surgeons (*post* 1897 University of Illinois).

QUINN, ARTHUR HOBSON (*b. Philadelphia, Pa., 1875; d. Philadelphia, 1960*), educator, literary historian, biographer. Studied at the University of Pennsylvania (Ph.D., 1899); taught at the University of Pennsylvania (1894–1945). One of the first teachers of American literature and drama, Quinn was instrumental in making the study of native writers academically acceptable. His best work was a biography of *Edgar Allan Poe* (1941). Author of *A History of the American Drama from the Beginning to the Civil War* (1923) and *Literature of the American People* (1951).

QUINN, EDMOND THOMAS (*b. Philadelphia, Pa., 1868; d. New York, N.Y., 1929*), sculptor, painter. Studied at Pennsylvania Academy of Fine Arts under Thomas Eakins, and in France and Spain. Attained distinction as a portraitist and as a sculptor of ideal figures. Notable among his works are the reliefs for the battle monument at King's Mountain, S.C. (1908) and the statue of Edwin Booth as Hamlet in Gramercy Park, New York City.

QUINTARD, CHARLES TODD (*b. Stamford, Conn., 1824; d. 1898*), physician, Episcopal clergyman. Brother of George W. Quintard. After practicing medicine in Georgia and Tennessee, he was ordained in 1856 and became rector of Calvary Church, Memphis, Tenn., and a little later rector in Nashville. After distinguished service in the Confederate Army as chaplain and surgeon, he was elected bishop of Tennessee, 1865. As educator, his most important work was the "second founding" of the University of the South at Sewanee, 1866–72.

QUINTARD, GEORGE WILLIAM (*b. Stamford, Conn., 1822; d. New York, N.Y., 1913*), manufacturer of marine engines. Brother of Charles T. Quintard.

QUITMAN, JOHN ANTHONY (*b. Rhinebeck, N.Y., 1798; d. near Natchez, Miss., 1858*), lawyer, soldier. Settled in practice at Natchez, 1821. Quitman's activity as a Freemason contributed a great deal to his professional political progress. Chancellor of Mississippi, 1827–35, he became identified in 1834 with the political group known as "Nullifiers." Although the opinions of this group were not then popular in Mississippi, he was elected to the state senate, 1835, but was defeated in a campaign for Congress, 1836. Having recruited and led a company to the relief of the Texans (which took no part in the fighting), he was appointed brigadier general of Mississippi militia and served with ability in the Mexican War. As governor of Mississippi, 1850–51, he opposed the Compromise measures of 1850 and caused the legislature to protest their adoption by Congress. He was also concerned in a Cuban movement for independence which brought about his indictment at New Orleans by a federal grand jury. As congressman, 1855–58, he continued to act as a champion of the states' rights proslavery cause.

R

RABY, JAMES JOSEPH (b. Bay City, Mich., 1874; d. near Midway, Ga., 1934), naval officer. Graduated Annapolis, 1895. Commanded the cruiser *Albany*, June 1917–April 1918, escorting a larger number of ships in convoy to Europe than any other American naval vessel. Promoted rear admiral, 1927, he was for some time the only commissioned naval aviator in this grade. At the time of his death, he was commandant of all naval activities in the South.

RACHFORD, BENJAMIN KNOX (b. Alexandria, Ky., 1857; d. Cincinnati, Ohio, 1929), physiologist, pediatrician, philanthropist. M.D., Medical College of Ohio, 1882. After study at Berlin, he published a classic paper "The Influence of Bile on the Fat-Splitting Properties of the Pancreatic Juice" (*Journal of Physiology*, April 1891). Practicing in Cincinnati, Ohio, *post* 1894, he taught at the Medical College of Ohio (later University of Cincinnati), continued to make physiological experiments, and published several books on children's diseases. Elected director of pediatrics, Cincinnati General Hospital, 1897, he established a children's ward and one of the first outdoor wards in America for the treatment of tuberculosis of children. He initiated the Babies Milk Fund, 1909, and was associated with a number of other charities.

RACHMANINOFF, SERGEI VASILYEVICH (b. estate of Oneg, near Novgorod, Russia, 1873; d. Beverly Hills, Calif., 1943), composer, pianist, conductor. Cousin of Alexander Siloti. Studied at St. Petersburg Conservatory, 1882–85; at Moscow Conservatory, graduating as a pianist, 1891, and in composition, 1892. On the latter occasion he received the gold medal for his one-act opera *Aleko*, and in the same year composed his celebrated Prelude in C-sharp Minor. Earning his living as a piano teacher, he continued to compose; in 1901 he produced his very popular Second Piano Concerto. He turned next to conducting with outstanding success at the Moscow Bolshoi Theater, 1904–06. Desiring more time to compose, he lived for the next three years in Dresden, Germany. He made his American debut in the fall of 1909 at Smith College, and on Nov. 28 was soloist in the world premiere of his Third Piano Concerto in New York City. Residing in Moscow, 1910–17, he was conductor for part of that period of the Moscow Philharmonic Society orchestra. A steadfast opponent of the Soviet state, he left Russia at the time of the revolution and never returned. At this time, he deliberately set out on a career as a virtuoso pianist, traveling all over America and Europe and playing with incredible technical skill and startlingly original but convincing interpretation. He also continued to compose with great success and complete disregard of the work and theories of the musical revolutionaries of his time. He wrote four operas, one of which he left unfinished; three symphonies and two symphonic poems; a small but fine body of chamber music; impressive choral settings for the liturgy of the Russian Orthodox Church; more than seventy songs; and nearly a hundred piano pieces. Although he was at home in the United States, he remained loyal to the Czar; he did not become a U.S. citizen until 1943.

RADCLIFF, JACOB (b. Rhinebeck, N.Y., 1764; d. Troy, N.Y., 1844), lawyer, New York legislator and jurist. A founder (1804–05) of Jersey City, N.J. Federalist mayor of New York City, 1810 and 1815–17.

RADCLIFFE, GEORGE LOVIC PIERCE (b. Lloyds, Md., 1877; d. Baltimore, Md., 1974), lawyer, businessman, and U.S. senator. Graduated Johns Hopkins University (B.A., 1897; Ph.D., 1900) and University of Maryland (LL.B., 1903) and joined American Bonding Company in 1903; following a merger with Fidelity and Deposit Company in 1913, he became executive vice-president of Fidelity and friends with Franklin D. Roosevelt, then a firm vice-president. Active in Democratic politics beginning in 1923, he joined the Roosevelt administration as a director for the Public Works Administration in 1933. He was elected to the U.S. Senate (1934–46), where he was only moderately supportive of Roosevelt's New Deal programs; he broke with Roosevelt over the latter's Supreme Court reorganization plan. His major Senate activity was in behalf of the shipping industry; he cowrote the Merchant Marine Act of 1936, which established the U.S. Maritime Commission. His absences from Washington to tend to Fidelity business led to his reelection defeat in 1946. He also served as president (1931–65) and chairman (1965–74) of the Maryland Historical Society.

RADEMACHER, HANS (b. Wandsbeck, Germany, 1892; d. Haverford, Pa., 1969), mathematician and educator. Attended University of Göttingen (Ph.D., 1917). During 1917–19 published five papers on mathematical mapping and differentiability, including a paper that introduced the term "total differentiability." Taught at University of Berlin (1919–22), where he published a paper (1922) that introduced a type of orthogonal functions now known as Rademacher functions; at University of Hamburg (1922–25), where he turned his attention to number theory, a subject in which he made his most outstanding contributions; and at University of Breslau (1925–34), where he produced numerous studies in analytic number theory and mathematical functions. He achieved his most singular result at the University of Pennsylvania (1934–62): an expression for, and a means of calculating, the partition function $p(n)$, which enables one to determine in how many ways integers can be added together to yield a given integer. He became a naturalized citizen in 1943.

RADFORD, ARTHUR WILLIAM (b. Chicago, Ill., 1896; d. Washington, D.C., 1973), naval officer. Graduated U.S. Naval Academy (1916), entered flight training in 1920, and was assigned to the new Bureau of Aeronautics (1921–23). In 1929 he was assigned to the aircraft carrier *Saratoga*, becoming skipper of its crack Fighting Squadron 1B. In December 1941 he returned to the Bureau of Aeronautics with the task of expanding the navy's wartime aviation training; he was promoted to rear admiral in July 1943 and given command of a fast carrier division in the Pacific. In 1949 he became commander in chief of the Pacific Fleet, with the rank of full admiral. He led the "revolt of the admirals" in 1949 against preferential funding for air force bomb-

ers over naval aviation, directed naval operations during the Korean War, and in August 1953 became chairman of the Joint Chiefs of Staff; he retired in 1957.

RADFORD, WILLIAM (*b. Fincastle, Va., 1809; d. 1890*), naval officer. Won particular distinction as commodore commanding ironclads in attacks on Fort Fisher, December 1864–January 1865; promoted rear admiral, 1866.

RADIN, MAX (*b. Kempen, Poland, 1880; d. Berkeley, Calif., 1950*), lawyer, philologist, educator. Son of a rabbi; came to the United States with parents, 1884. A.B., College of the City of New York, 1899. LL.B., New York University, 1902. Ph.D., Columbia University, 1909. Taught in the public schools of New York City, at the City College, and at Columbia, 1900–19. Professor of law, University of California at Berkeley, 1919–48; he was thereafter a member of the Institute for Advanced Study at Princeton. Author of a number of books and many contributions to journals, he is especially remembered for his historical and philosophical studies of the legal sources of the U.S. Constitution.

RADIN, PAUL (*b. Lodz, Poland, 1883; d. New York, N.Y., 1959*), anthropologist, linguist. Immigrated to the United States in 1884. Studied at the City College of New York and Columbia University (Ph.D., 1911). Taught at Mills College, the University of California, Oxford and Cambridge universities, and Black Mountain College. Studied primitive peoples, in particular the Indians of North America. Works include *Primitive Man As Philosopher* (1927), *Primitive Religion* (1937), and *The World of Primitive Man* (1953), and *The Trickster* (1956).

RADISSON, PIERRE ESPRIT (*b. France, 1636; d. ca. 1710*), explorer. Came to Canada *ca.* 1651; was captured by Iroquois, 1652, and adopted by them. Escaping, he returned to France, 1654, but came back to Canada in that same year. On westward journeys with his brother-in-law, the Sieur des Groseilliers, he became aware of the importance of the fur trade of inland North America and of the need to control either or both of the main exits for that trade—New York and Hudson's Bay. Angered by an injustice done them by the governor of Canada, Radisson and Groseilliers entered English service, and their reports led to the founding of the Hudson's Bay Co. (chartered 1670). Resuming his French connection, 1674, Radisson "passed over to England for good" *ca.* 1683. His own accounts of his voyages, valuable for vivid portrayal of the life of the early *coureurs de bois* in the north country, were edited as *Voyages of Peter Esprit Radisson* (Prince Society, 1885).

RAE, JOHN (*b. near Aberdeen, Scotland, 1796; d. Staten Island, N.Y., 1872*), economist, scientist. Immigrated to Canada, 1821. A wandering scholar, he resided thereafter in Canada, New York, Massachusetts, California, and the Hawaiian Islands. His criticism of the doctrines of Adam Smith appeared as *Statement of Some New Principles on the Subject of Political Economy, etc.* (Boston, 1834). In the broad sense a collectivist, he was in the narrow sense a nationalist and protectionist; he worked out the time discount theory of interest long in advance of its better known expositors.

RAFFEINER, JOHN STEPHEN (*b. Walls, Tyrol, Austria, 1785; d. Brooklyn, N.Y., 1861*), Roman Catholic clergyman. Came to America, 1833, to be a missionary among German emigrants; served as vicar general for the Germans under Bishop John Hughes in New York and as vicar general of the Brooklyn diocese.

RAFINESQUE, CONSTANTINE SAMUEL (*b. near Constantinople, Turkey, 1783; d. Philadelphia, Pa., 1840*), naturalist. Of French and German parentage, he early showed a keen interest in natural history. Educated by private tutors, he never developed the orderly methods and mental attitudes of the trained scientist. Resident in Philadelphia, Pa., 1802–04, he worked in a merchant's counting-house but found time for considerable travel and made the acquaintance of President Jefferson and prominent scientists of the day. Journeying to Italy with his botanical collections, he lived at Palermo, was secretary to the U.S. consul, made an unhappy marriage, and conducted extensive research on the ichthyology of Sicilian waters. Engaging in the medical drug business, 1808, he set forth to settle in the United States, 1815, taking with him a stock of drugs and all his personal belongings. He arrived naked and penniless, for his ship was wrecked off Fisher's Island, and he narrowly escaped drowning. Befriended by Samuel L. Mitchill, he found work as a tutor in the Livingston family at Clermont. He then explored the Hudson Valley, Lake George, Long Island, and other regions, and in Philadelphia enjoyed the friendship of Zaccheus Collins, the Quaker naturalist. In 1818 he went to Lexington, Ky., to visit an old friend, John D. Clifford, through whose influence he was appointed professor of botany, natural history, and modern languages at Transylvania University. He traveled extensively in Kentucky and Tennessee and visited many points in Ohio, Indiana, and Illinois. After leaving Transylvania in 1826, he resided in Philadelphia but continued to make field trips.

No other American naturalist traveled so widely. He wrote and published incessantly but the eccentric manner in which he issued his works matched the general irregularity of his way of life. Botany and ichthyology continued to be his chief interests, but he wrote also on banking, economics, the Bible, and even produced verse. His descriptions of plants and fishes are often vague or inaccurate, and he had a passion for announcing new species. Behind this passion, however, lay the conviction, expressed more than once in his writings, that "every variety is a deviation which becomes a species as soon as it is permanent by reproduction. Deviations in essential organs may then gradually become new genera." He thus had a glimpse, if no more than a glimpse, of the later development of biological thought. He was ahead of his generation in the United States, also, in advocating Jussieu's method of classification. During his last years he suffered from dire poverty, neglect, and ill-health, and some of his later schemes and activities indicate that he was not entirely sane, yet he was one of the great pioneers of natural science in America.

RAFT, GEORGE (*b. George Ranft, New York City, 1895; d. Los Angeles, Calif., 1980*), actor. Worked as a professional dancer on the vaudeville circuit and in New York City nightclubs before his Hollywood breakthrough in the 1932 film *Scarface: Shame of Nation*, in which he had a memorable supporting role as a gangster. Raft's performance, which he later claimed was inspired by organized crime figures he knew personally, led to a number of typecast roles as a suave and elegant criminal. Raft appeared in about sixty movies, including *Bolero* (1934), *Souls at Sea* (1937), *They Drive by Night* (1940), and *Some Like It Hot* (1959), in which he played a self-parody role. Later in his career Raft returned to nightclub acts and worked for several hotels and casinos.

RAFTER, GEORGE W. (*b. Orleans, N.Y., 1851; d. Karlsbad, Austria, 1907*), civil engineer, specialist in water supply and control, and sewage disposal. Collaborated with William T. Sedgwick on a method of water analysis.

RAGUET, CONDY (*b. Philadelphia, Pa., 1784; d. Philadelphia, 1842*), lawyer, economist, U.S. consul and chargé d'affaires in

Brazil, 1822–27. Active in journalism in Philadelphia and Washington, D.C., *post* 1827, he set forth acute analyses of tariff and currency questions in his *Free Trade Advocate, Banner of the Constitution,* and *The Examiner* which, with his other writings, give him a place among early students of the business cycle.

RAHT, AUGUST WILHELM (*b. Dillenburg, Germany, 1843; d. San Francisco, Calif., 1916*), metallurgist. Came to the United States, 1867; established a professional reputation in lead-silver smelting in Utah, Colorado, New Mexico, and Montana. He served as metallurgical expert for the Guggenheims, 1891–1910.

RAHV, PHILIP (*b. Ivan Greenberg, Kupin, Ukraine, 1908; d. Cambridge, Mass., 1973*), critic, editor, and educator. Immigrated to the United States in 1922; joined the Communist party in 1932; published essays, reviews, and poems under the literary sponsorship of the party; and cofounded in 1934 the *Partisan Review,* which became a prestigious forum for the intelligentsia of the Western world. Rahv was coeditor and the journal's dominant voice until 1969; his significant contributions on literature to the *Review* include "Paleface and Redskin" and "The Death of Ivan Ilyich and Joseph K" (1940). He also taught at Brandeis University (1957–73).

RAINES, JOHN (*b. Canandaigua, N.Y., 1840; d. Canandaigua, 1909*), lawyer, New York legislator, Union soldier. Congressman, Republican, from New York, 1889–93. As New York State senator, he was responsible for the "Raines Law" (1896) controlling the liquor traffic.

RAINEY, GERTRUDE MALISSA NIX PRIDGETT (*b. Columbus, Ga., 1886; d. Rome, Ga., 1939*), black blues singer, known as "Ma" Rainey The first, and to some critics, the greatest of the blues singers, "Ma" Rainey sang what has come to be known as "country" blues.

RAINEY, HENRY THOMAS (*b. near Carrollton, Ill., 1860; d. St. Louis, Mo., 1934*), lawyer. Graduated Amherst, 1883. Congressman, Democrat, from Illinois, 1903–34, with the exception of the years 1921–23. A consistent progressive and ardent supporter of Presidents Wilson and F. D. Roosevelt, he was elected speaker of the House, March 1933, and pushed through the first New Deal measures with great efficiency.

RAINEY, JOSEPH HAYNE (*b. Georgetown, S.C., 1832; d. Georgetown, 1887*), first black to serve in the U.S. House of Representatives. Came into political prominence, 1867, as member of Republican executive committee in South Carolina. As congressman, 1870–79, he served with ability and tact and was particularly effective in speaking for civil rights. He later served as an agent for the U.S. Treasury Department.

RAINEY, "MA" *See* RAINEY, GERTRUDE MALISSA NIX PRIDGETT.

RAINS, CLAUDE (*b. London, England, 1889; d. Sandwich, N.H., 1967*), actor. Appeared in his first play at age eleven and by age eighteen was a stage manager set on an acting career. Performed in numerous productions in England, Australia, and the United States (1911–20), then began teaching at the Royal Academy of Dramatic Art. He achieved astounding success on Broadway in *The Constant Nymph* (1926) and signed with the Theatre Guild's repertory company. His first film was *The Invisible Man* (1933), one of many character roles in which he tended to be cast as madman or villain, such as the roguish prefect of police in *Casablanca* (1942). Signed a long-term contract with Warner Brothers (1936) and played in numerous starring and supporting roles: *Anthony Adverse* (1936); *The Adventures of*

Robin Hood (1938); *Mr. Smith Goes to Washington* (1939); *Mr. Skeffington* (1944); and *Notorious* (1946). Nominated for Academy Awards for *Mr. Smith, Casablanca, Mr. Skeffington,* and *Notorious.* Returned to the stage in 1950–51 and won six stage awards, including a Tony, for his role in *Darkness at Noon.*

RAINS, GABRIEL JAMES (*b. Craven Co., N.C., 1803; d. Aiken, S.C., 1881*), Confederate brigadier general. Brother of George W. Rains. Graduated West Point, 1827; served in the Seminole wars and in the war with Mexico. Commissioned in the Confederate Army, 1861, he served as explosives expert after holding field commands, 1861–62. He was particularly notable as the deviser of land mines and torpedoes and was engaged in much controversy over the ethics of their use.

RAINS, GEORGE WASHINGTON (*b. Craven Co., N.C., 1817; d. near Newburgh, N.Y., 1898*), soldier, Confederate munitions expert, inventor. Brother of Gabriel J. Rains. Graduated West Point, 1842; served with credit in the war with Mexico. Resigning from the army, 1856, he became president of an iron works at Newburgh, N.Y. Immediately upon his commissioning as major in the Confederate artillery, 1861, he was assigned to the procurement of gun powder and was placed in charge of all munitions operations, 1862, at Augusta, Ga. After the war, he was professor of chemistry and dean of the Medical College of Georgia until his retirement, 1894.

RAINSFORD, WILLIAM STEPHEN (*b. near Dublin, Ireland, 1850; d. New York, N.Y., 1933*), Episcopal clergyman. Ordained in England and beginning his ministry there, he became rector of St. George's Church, New York, N.Y., January 1883, and served there until 1904. Strongly individual, he built up St. George's as an "institutional church" with the constant support of his senior warden, J. Pierpont Morgan, who disagreed with Rainsford's increasing theological and political liberalism. He later developed a naturalistic theology of his own and in 1912 was released from the priesthood at his own request.

RÂLE, SÉBASTIEN (*b. Pontarlier, France, 1654 or 1657; d. Norridgewock, Maine, 1724*), Jesuit missionary. Ministered to Indians near Quebec, 1689–91; served on the mission to the Illinois, 1691–93. Recalled to Canada, he was sent to the Abenaki mission in what is now the state of Maine; he worked with success among that branch of the tribe which lived on the Kennebec River but on the outbreak of Queen Anne's War, 1702, his efforts to keep the Indians from ravaging the Massachusetts frontier were relatively ineffective. In 1705, an English expedition came up the Kennebec and burned the Abenaki village and its chapel. *Post* 1713, after the English claimed sovereignty over the region, the raiding was intensified and the English blamed Râle for inciting the Indians. The mission at Norridgewock was attacked again in 1721 by the English but Râle escaped. In 1724, he was shot down at the door of his house by a British war party and his scalp taken to Boston "to the great joy and exultation of the people of Massachusetts." He was an able missionary, a fine linguist, and a courageous champion of French policy.

RALPH, JAMES (*b. probably New Jersey, ca. 1695; d. Chiswick, England, 1762*), poet, political writer. Accompanied Benjamin Franklin to London, December 1724; was distinguished as a poet by Alexander Pope in the second edition of *The Dunciad.* Turning to work for the theatre, he produced (among other plays) *The Fashionable Lady* (1730), the first play by a born American to be produced in London, and was associated in management with Henry Fielding. Thereafter, he was employed as an able political writer in the interest of Frederick, Prince of Wales, and others, but renounced political writing ca. 1754 on receipt of a pension

from the Pelham–Duke of Newcastle ministry. He aided Franklin in preparing for the press *An Historical Review of the Constitution and Government of Pennsylvania* (1759) and was author of an interesting essay, *The Case of Authors by Profession* (1758), a defense of professional writers.

RALPH, JULIAN (*b. New York, N.Y., 1853; d. 1903*), journalist, foreign correspondent. Made his reputation as one of Charles A. Dana's reportorial staff on the N.Y. *Sun*, 1876–95, and as correspondent in the Greco-Turk and Boer wars, 1897–1900.

RALSTON, SAMUEL MOFFETT (*b. near New Cumberland, Ohio, 1857; d. 1925*), lawyer. Began practice in Lebanon, Ind., 1886. Democratic governor of Indiana, 1913–17; U.S. senator, 1923–25. Refused possible Democratic presidential nomination, 1924.

RALSTON, WILLIAM CHAPMAN (*b. Wellsville, Ohio, 1826; d. 1875*), banker. Beginning as a clerk on a Mississippi River steamboat, 1842, he rose in eight years to be a steamship agent at Panama City for Garrison and Morgan, removing to San Francisco, Calif. (1854) as a partner in the firm. Quickly realizing the future of the city as a center of trade and finance, he was instrumental in the establishment of the banking firm of Garrison, Morgan, Fretz and Ralston, 1856; during the panic of 1857 his courage and ability won him the complete confidence of the business community of San Francisco. With D. O. Mills, he organized the Bank of California, 1864; it soon became the leading financial institution of the Far West and Ralston became its president, 1872. Meanwhile, having engaged himself in widespread and vast plans of imperial expansion, he used the resources of the bank to aid his enterprises, some of them of an extremely dubious character. Living lavishly and becoming further involved in a network of speculation, he was able to continue deceiving his directors and political supporters until August 1875 when the bank suspended payment. On August 27, when his resignation was demanded, he was found drowned.

RAMAGE, JOHN (*b. probably Dublin, Ireland, ca. 1748; d. Montreal, Canada, 1802*), painter of miniatures. Mentioned as a goldsmith and painter of miniatures in Boston as early as 1775. A Loyalist, Ramage followed the fortunes of the British arms, removing to Halifax in March 1776 and settling in New York City at some time in 1777. Remaining in New York after the British left, he was successful in his profession until 1794 when he removed to Montreal to escape involvement in debt. His miniatures are small, accurately painted in the line manner, delicately colored, and done with scrupulous care.

RAMBAUT, MARY LUCINDA BONNEY (*b. Hamilton, N.Y., 1816; d. Hamilton, 1900*), educator, reformer. Established Chestnut Street Female Seminary, Philadelphia, 1850; moved the school to Ogontz, Pa., 1883, changing its name to the Ogontz School.

RAMÉE, JOSEPH JACQUES (*b. Charlemont, France, 1764; d. near Noyon, France, 1842*), architect, landscape architect. Resident in America, 1811–16, Ramée did his most important American work on the layout and first buildings of Union College, Schenectady, N.Y. (1812–13).

RAMSAY, ALEXANDER (*b. in or near Edinburgh, Scotland ca. 1754; d. Parsonsfield, Maine, 1824*), anatomist. Came to America, 1801, and with the exception of the years, 1810–16, when he returned to Europe, led a wandering life as an itinerant lecturer and teacher. A man of immense learning, vanity, and illtemper, he was constantly at odds with his contemporaries. He was author of *Anatomy of the Heart, Cranium and Brain* (1812; second edition, 1813).

RAMSAY, DAVID (*b. Lancaster Co., Pa., 1749; d. Charleston, S.C., 1815*), physician, Revolutionary patriot, South Carolina legislator, historian. Author of *History of the Revolution of South Carolina* (1785), *History of the American Revolution* (1789), *History of South Carolina* (1809), which are still of value for what they contain of his own eyewitness experience but were drawn to a large extent from the work of others.

RAMSAY, ERSKINE (*b. Six Mile Ferry, Pa., 1864; d. Birmingham, Ala., 1953*), mining engineer, inventor. Studied at St. Vincent's College (1882–83). Inventor, along with his father, Robert Ramsay, of most of the important inventions for coalmining technology of the late nineteenth- and early twentieth-centuries. Holder of over 40 patents. Pioneer in the use of coal by-products. Founder of the Pratt Consolidated Coal Company, 1904, and the Alabama By-Products Corporation, 1924.

RAMSAY, FRANCIS MUNROE (*b. Washington, D.C., 1835; d. Washington, 1914*), naval officer. Served with great credit in the Mississippi River campaigns of the Civil War under David D. Porter. Promoted captain, 1877, he was superintendent of the U.S. Naval Academy, 1881–86. He retired as rear admiral, 1897.

RAMSAY, GEORGE DOUGLAS (*b. Dumfries, Va., 1802; d. 1882*), soldier. Graduated West Point, 1820. Assigned to the artillery, he became an expert in ordnance and was in command at numerous U.S. arsenals. Promoted brigadier general, 1863, he served as chief of ordnance of the Union army until September 1864 when he was retired for age.

RAMSAY, NATHANIEL (*b. Lancaster Co., Pa., 1741; d. Maryland, 1817*), lawyer, Revolutionary soldier. Served, 1776–81, with Maryland troops; won particular distinction at Monmouth, 1778, where he played a decisive part in checking the American retreat.

RAMSEUR, STEPHEN DODSON (*b. Lincolnton, N.C., 1837; d. Winchester, Va., 1864*), Confederate major general. Graduated West Point, 1860. Resigning from the U.S. Army, 1861, he commanded a North Carolina battery. Rising rapidly for conspicuous merit, he was wounded successively at Malvern Hill, Chancellorsville, and Spotsylvania. He was mortally wounded while rallying his men against Sheridan's counterattack at Cedar Creek.

RAMSEY, ALEXANDER (*b. near Harrisburg, Pa., 1815; d. 1903*), lawyer. Congressman, Whig, from Pennsylvania, 1843–47. Removing to Minnesota, 1849, as newly appointed territorial governor, he opened an immense area in the south of the territory to settlement by negotiating treaties with the Sioux, 1851. At the end of his term, 1853, he entered business in St. Paul, Minn., and served as governor of the state, 1859–63. As U.S. senator, Republican, from Minnesota, 1863–75, he made important contributions to postal reform. He was U.S. secretary of war, 1879–81, in President R. B. Hayes's cabinet.

RAMSEY, JAMES GETTYS McGREADY (*b. near Knoxville, Tenn., 1797; d. Knoxville, 1884*), physician, banker, railroad promoter. Author of *The Annals of Tennessee to the End of the 18th Century* (1853).

RAMSPECK, ROBERT C. WORD ("BOB") (*b. Decatur, Ga., 1890; d. Castor, La., 1972*), congressman and business executive. Graduated Atlanta Law School (LL.B., 1920) and became solicitor of the city court of Decatur (1923–27) and city attorney (1927–29). Elected to the U.S. House of Representatives (1929–45), he was an outspoken opponent of spoils politics, an advocate of civil service reform and fair labor legislation, and a champion of legislation to provide pensions of members of Con-

gress; he was House Democratic whip from 1942 to 1945. He became chairman of the U.S. Civil Service Commission (1951–53) and vice–president of Eastern Air Lines (1953–61).

RAND, ADDISON CRITTENDEN (*b. Westfield, Mass., 1841; d. New York, N.Y., 1900*), manufacturer of rock drills. Organized Rand Drill Co., 1871; was leader in inducing mining companies to substitute rock drills and air compressors for handwork.

RAND, BENJAMIN (*b. Canning, N.S., Canada, 1856; d. Canning, 1934*), bibliographer, educator. Graduated Acadia University, 1875; Ph.D., Harvard, 1885. Associated thereafter with the Harvard philosophical department as instructor and librarian until 1933, Rand made his principal contribution as a painstaking bibliographer in the field of philosophy.

RAND, EDWARD KENNARD (*b. Boston, Mass., 1871; d. Cambridge, Mass., 1945*), classicist, medievalist. A.B., Harvard, 1894. Ph.D., University of Munich, 1900. Studied also at Harvard Divinity School, the Episcopal Theological School, and University of Chicago. Appointed instructor in Latin at Harvard, 1901, he was made professor in 1909 and held the Pope Professorship of Latin, 1931–42. He was author of many technical studies in Latin paleography and textual criticism, and of *Founders of the Middle Ages* (1928) and *The Building of Eternal Rome* (1943). He was a founder and first president of the Mediaeval Academy of America (1925), and first editor of *Speculum*.

RAND, EDWARD SPAGUE (*b. Newburyport, Mass., 1782; d. 1863*), merchant, New England woolen manufacturer, Massachusetts legislator.

RAND, JAMES HENRY (*b. Tonawanda, N.Y., 1859; d. North Falmouth, Mass., 1944*), inventor, businessman. Devised *ca.* 1880 a system of dividers and colored signal strips and tabs for organizing and indexing business files, which he later extended to include other devices for efficient record keeping. His firm, originally the Rand Ledger Company, enjoyed great success. *Post* 1925, when his son, James Henry Rand, Jr., became president and general manager, the Library Bureau and other firms were acquired and merged; after a merger with the Remington Typewriter Company, 1927, the firm was restyled the Remington-Rand Company.

RAND, SALLY (*b. Helen Gould Beck, Elkton, Mo., 1904; d. Glendora, Calif., 1979*), dancer and actress. Worked as a chorus girl, vaudeville dancer, and acrobatic dancer before gaining minor roles in several silent films during the 1920's. In 1932 in New York City, she first appeared in her famed "fan dance," which featured a naked Rand with a pair of twenty-one-inch-stem, double-willowed ostrich fans. In 1933 Rand was arrested four times in one day on a charge that her "costume" failed to meet decency standards. She performed her routine, which consisted of a six-minute dance to classical music, at fairs, nightclubs, carnivals, and theaters through the 1970's.

RANDALL, ALEXANDER WILLIAMS (*b. Ames, N.Y., 1819; d. Elmira, N.Y., 1872*), lawyer. Removed to Wisconsin Territory, 1840. Originally a Whig, then a Free-Soil Democrat, he served as Republican governor of Wisconsin, 1857–61; his drill in mobilizing the state's resources for the Civil War was outstanding. As assistant postmaster general, he helped reelect Abraham Lincoln, 1864, and was U.S. postmaster general, 1866–69.

RANDALL, BENJAMIN (*b. New Castle, N.H., 1749; d. 1808*), founder and organizer of the Free Will Baptists.

RANDALL, BURTON ALEXANDER (*b. Annapolis, Md., 1858; d. Philadelphia, Pa., 1932*), ophthalmologist, otologist. Brother of Wyatt W. Randall. M.D., University of Pennsylvania, 1880. Practiced and taught in Philadelphia; coauthor of *American Text-Book of Diseases of the Eye, Ear, Nose and Throat* (1899).

RANDALL, CLARENCE BELDEN (*b. Newark Valley, N.Y., 1891; d. Ishpeming, Mich., 1967*), industrialist. Attended Harvard (LL.B., 1915); admitted to Michigan bar (1915). Joined Inland Steel Company (1925), becoming its president (1949) and chairman of the board (1953–56). Under his leadership the firm expanded its basic resources of iron and coal; in the area of labor relations, he believed in collective bargaining and that it was unfair for the federal government to intervene in dealing with the United Steelworkers. Steel consultant to the Economic Cooperation Administration in Paris (1948); member of the Department of Commerce Business Advisory Council (1951–57); and special assistant to the president on foreign economic policy (1956–61). Received the Presidential Medal of Freedom (1963).

RANDALL, HENRY STEPHENS (*b. Brookfield, N.Y., 1811; d. Cortland, N.Y., 1876*), agriculturist, educator. Author of numerous books and articles dealing with agricultural subjects and of *The Life of Thomas Jefferson* (1858) for which he had the use of family manuscripts no longer accessible as a unit.

RANDALL, JAMES GARFIELD (*b. Indianapolis, Ind., 1881; d. Urbana, Ill., 1953*), historian and professor. Studied at Butler College and the University of Chicago (Ph.D., 1911). Taught at the University of Illinois, 1920–53. Authority on the Civil War and Lincoln biographer. Wrote *The Civil War and Reconstruction* (1937) and *Lincoln the President* (1945–55), which stresses the political, constitutional, and diplomatic developments, rather than the conventional military history of the Civil War.

RANDALL, JAMES RYDER (*b. Baltimore, Md., 1839; d. Augusta, Ga., 1908*), journalist, poet. Attended Georgetown College, Washington, D.C. Wrote "Maryland, My Maryland" on hearing of the attack on the 6th Massachusetts regiment as it marched through Baltimore, April 1861. The poem appeared first in the Sunday edition of the New Orleans *Delta* on April 26 and was immediately reprinted all over the South. Set to the music of an old German song, it became a battle song of the South. Randall's collected poems were published posthumously in 1910.

RANDALL, ROBERT RICHARD (*b. possibly New Jersey, ca. 1750; d. New York, N.Y., 1801*), merchant, privateersman, philanthropist. Bequeathed the bulk of his property to provide an asylum for seamen, Sailors Snug Harbor, Staten Island, N.Y. Moved in 1796 to Sea Level, N.C.

RANDALL, SAMUEL (*b. Sharon, Mass., 1778; d. 1864*), Rhode Island jurist, journalist. Graduated Brown, 1804. Notable for his authorship of two farces: *The Miser* and *The Sophomore*, both printed as pamphlets in Warren, R.I., 1812, but probably written by him while in college.

RANDALL, SAMUEL JACKSON (*b. Philadelphia, Pa., 1828; d. Washington, D.C., 1890*), businessman, politician. Congressman, Democrat, from Pennsylvania, 1863–90; speaker of the House, 1876–81; powerful chairman of the appropriations committee, 1883–87. Highly regarded by labor and small business, Randall gained national prominence during Reconstruction by uncovering scandals in the Grant administration and supplying the Democrats with the battle cry of "Retrenchment and Reform." In 1880 under his guidance the rules of procedure of the House were pruned and condensed. Falling out with President Cleveland in December 1887, Randall was deserted by his po-

litical friends and lost the federal patronage which had given him control of the Democrats in Pennsylvania.

RANDALL, SAMUEL SIDWELL (*b. Norwich, N.Y., 1809; d. 1881*), educator. Deputy superintendent of New York public schools, 1841–46, 1849–52; superintendent of New York City public schools, 1854–70. In a report to the legislature, Jan. 1, 1852, Randall made a series of recommendations for the control and financing of the public schools which were adopted and established public school education in New York State on a more efficient basis.

RANDALL, WYATT WILLIAM (*b. Annapolis, Md., 1867; d. Baltimore, Md., 1930*), chemist. Brother of Burton A. Randall. Graduated St. Johns, Annapolis, 1861; Ph.D., Johns Hopkins, 1890. Associated with the Maryland State Department of Health, 1911–30; taught biochemistry at Johns Hopkins, 1921–30. He was also consultant to the U.S. Department of Agriculture and to various agricultural associations.

RANDOLPH, ALFRED MAGILL (*b. near Winchester, Va., 1836; d. 1918*), Episcopal clergyman. Graduated William and Mary, 1855; Virginia Theological Seminary, 1858. After serving in several pastorates and as a Confederate chaplain, he was rector of Emmanuel Church, Baltimore, Md., 1867–83. A vigorous advocate of Low Church principles, he served as coadjutor bishop of Virginia, 1883–92, and as bishop of Southern Virginia, 1892–1918.

RANDOLPH, A(SA) PHILIP (*b. Crescent City, Fla., 1889; d. New York City, 1979*), labor and civil rights leader. Moved to New York City and studied social economics and Marxist socialism at several colleges. In 1917 he helped found the *Messenger*, a magazine in which he spoke out against racist employers and unions and U.S. participation in World War I. In 1925 he became the leader of efforts to organize the Brotherhood of Sleeping Car Porters union (BSCP), of which he became president. After New Deal legislation improved the legal standing of unions, he secured improved wages and better conditions for the BSCP in 1937. By that time he was a major spokesmen on behalf of blacks and was participating in a range of labor and civil rights activities. In 1941 he organized the March on Washington Movement, which sought to address racial discrimination. As estimates of the protest grew to 100,000 marchers, President Franklin Roosevelt signed Executive Order 8802, which barred racial discrimination by companies and unions doing business with the government. In 1959, seeking to promote the standing of African–Americans in national unions, Randolph formed the Negro American Labor Council, under whose auspices he organized another march on Washington in 1963. Randolph stepped down as president of the BSCP in 1968.

RANDOLPH, EDMUND (*b. near Williamsburg, Va., 1753; d. Clarke Co., Va., 1813*), lawyer, Virginia legislator, statesman. Grandson of Sir John Randolph; son of John Randolph (1727/8–84); nephew of Peyton Randolph. Briefly an aide-de-camp to George Washington, 1775, he became attorney general of Virginia, 1776, was a delegate to the Continental Congress, 1779–82, and in 1786, was elected governor of Virginia, holding that office until 1788. He was a delegate to the Annapolis Convention and to the Federal Convention of 1787 in which he proposed the Virginia Plan and also drew a draft (perhaps the first) of the work of the committee of detail of which he was a member. Declining to sign the finished Constitution because he thought it insufficiently republican, he wrote a *Letter . . . on the Federal Constitution* (1787) expressing his criticism. However, he advocated ratification in the Virginia ratification convention, 1788,

on the grounds of practical expediency. First U.S. attorney general, 1789–93, he endeavored to remain nonpartisan in the conflict between Jefferson and Hamilton. Appointed U.S. secretary of state, Jan. 2, 1794, he was troubled by Hamilton's active interference in foreign affairs, but endeavored to maintain a truly American policy despite public inclination to sympathize either with France or Great Britain in the European struggle then raging. He approved sending a special envoy to Great Britain to clarify relations there, but opposed the appointment of John Jay and in particular opposed giving him the right to negotiate a commercial treaty. When Jay had accomplished his mission and when the contents of the so-called Jay Treaty were known, the French government protested that it violated treaty obligations of the United States to France. In fact, the treaty as negotiated by Jay came far short of carrying out the detailed instructions which had been given him and was unsatisfactory to the Senate and to Randolph unless it were modified. President Washington apparently supported Randolph's position in this matter up to the time when the British minister to the United States released some intercepted communications from Fauchet, the French minister at Philadelphia, to his home government. These seemed to imply that Randolph had made indiscreet revelations of information to him and appeared to suggest that French bribes would be welcome. Called to account by Washington under humiliating circumstances, Randolph resigned as secretary of state in August 1795. Later, Fauchet denied that he meant what had been said and Randolph himself wrote his own *Vindication*, published in 1795. Withdrawing to Richmond, Va., Randolph entered again upon the practice of law and became a leading legal figure; he was senior counsel for Aaron Burr in the famous treason trial of 1807.

RANDOLPH, EDMUND (*b. Richmond, Va., 1819; d. California, 1861*), lawyer. Grandson of Edmund Randolph (1753–1813). Settled in San Francisco, Calif., 1849, where he practiced with great success. He was leading counsel for the United States along with Edwin M. Stanton in the Alameden Quicksilver Mine case. A staunch defender of slavery, he somewhat inconsistently opposed secession and upheld the Union, yet his last public address (1861) was a stinging attack on President Lincoln.

RANDOLPH, EDWARD (*b. Canterbury, England, ca. 1632; d. 1703*), British commercial and political agent. Came to Boston, Mass., in June 1676, with orders requiring the colonial government to answer complaints of the Mason and Gorges heirs with respect to occupation of Maine and New Hampshire. Received with scant courtesy and informed that the laws of England did not apply to Massachusetts, he returned home and made a scathing report on the colonists. In consequence, Maine and New Hampshire were withdrawn from Massachusetts administration and the colony was ordered to enforce the navigation acts, to repeal all laws repugnant to English law, and to cease discrimination against non-church-members in public life. Appointed to take full charge of customs collections throughout New England, 1678, Randolph settled in Boston early in 1680; receiving no help in his task from the local government, he set himself to have the Massachusetts charter annulled. Commissioned secretary of the Dominion of New England, 1685, after the charter had been declared forfeit, he became a councilor in the government under Joseph Dudley and later under Sir Edmund Andros. Imprisoned on the fall of Andros, 1689, and sent to England, he was appointed surveyor of customs for all North America, 1691. Frequently returning to England to push his plans for reorganization of colonial administration, he was in America *post* 1702. He encountered everywhere a contempt for the laws of trade and was virtually powerless to enforce them in the face of constant opposition from local judges, juries, and governments. The Brit-

ish government acted absurdly in expecting one man to enforce the laws of trade, and Randolph's career illustrates the lack of understanding at home which eventuated in the final breakdown of imperial administration.

RANDOLPH, EPES (*b. Lunenberg, Va., 1856; d. Tucson, Ariz., 1921*), railroad executive. Early associated with Collis P. Huntington interests, especially Southern Pacific and Kentucky Central railroads; built and operated Pacific Electric Railway. Supervised Colorado River control project, 1905–07, which saved the Imperial Valley.

RANDOLPH, GEORGE WYTHE (*b. "Monticello," Virginia, 1818; d. "Edgehill," Virginia, 1867*), lawyer, Confederate brigadier general. Grandson of Thomas Jefferson; son of Thomas M. Randolph; brother of Thomas J. Randolph. Served as Confederate secretary of war, March to November, 1862; resigned because of ill health and Jefferson Davis's dominance in the department.

RANDOLPH, ISHAM (*b. New Market, Va., 1848; d. Chicago, Ill., 1920*), civil engineer. Highly reputed as consultant in railroad, canal, and land reclamation work. Supervised construction of Chicago Drainage Canal as chief engineer of Chicago Sanitary District, 1893–1907.

RANDOLPH, JACOB (*b. Philadelphia, Pa., 1796; d. 1848*), Philadelphia surgeon. M.D., University of Pennsylvania, 1817. A generally conservative operator and teacher, he introduced lithotripsy in America at the Pennsylvania Hospital.

RANDOLPH, SIR JOHN (*b. "Turkey Island," Henrico Co., Va., ca. 1693; d. 1736/7*), lawyer, scholar, Virginia legislator. Son of William Randolph, father of John Randolph (1727–84) and Peyton Randolph. Attended Gray's Inn, London; was called to bar, 1717. Clerk of the House of Burgesses, 1718–34; served as substitute for the Crown attorney general, 1727; represented the College of William and Mary and the Assembly on missions to King and Parliament, 1728 and 1732; was knighted, 1732. Speaker of the House of Burgesses, 1734–36/7. The most learned Virginia lawyer of his time.

RANDOLPH, JOHN (*b. Williamsburg, Va., 1727 or 1728; d. Brompton, England, 1784*), lawyer, Loyalist. Son of Sir John Randolph; brother of Peyton Randolph. Served as clerk of the House of Burgesses; succeeded his brother as attorney general for the Crown, 1766. After aiding Lord Dunmore in his struggle with the revolutionary party and seeking in vain to reconcile the differences between the King's government and the people, he fled to England, 1775, where he lived on a small pension.

RANDOLPH, JOHN (*b. "Cawsons," Prince George Co., Va., 1773; d. Philadelphia, Pa., 1833*), statesman, orator. Greatgrandson of William Randolph; nephew of Theodorick Bland (1742–90). Best known as John Randolph "of Roanoke," after his residence in Charlotte Co., he adopted the designation *ca.* 1810, in order to distinguish himself from a detested distant kinsman. Capricious, thin-skinned, and passionate even as a boy, he received his early education under direction of his stepfather, St. George Tucker, and at schools in Orange Co. and Williamsburg. He attended the College of New Jersey (Princeton) for a brief period, studied for a short time in New York City, and in September 1790 went to study law with Edmund Randolph in Philadelphia. After several further desultory trials of formal education, he settled at "Bizarre," Cumberland Co., 1794, and distinguished himself mainly for horsemanship, restlessness, and impudent self-confidence.

From the outset of his career a Jeffersonian, or at least an opponent of the Federalists (above all things he cherished personal liberty), he was elected to Congress from Virginia in 1799. Attracting considerable attention for his extraordinary powers as a speaker and for his audacity in debate, he became chairman of the ways and means committee, 1801, and was in effect the administration leader of the House until 1805. Booted and spurred, whip in hand, he swaggered and sneered, but he was undeniably a tireless worker and a master parliamentarian. Somewhat inconsistently supporting the Louisiana Purchase, he returned to his character as a states' rights and strict construction man in the attack on the federal judiciary. He failed in his management of the impeachment of Justice Samuel Chase, however, and suffered a loss of reputation. Prior to this, he had become disillusioned with the administration's action in the Yazoo claims matter; by his fierce denunciation of all who favored compromise, he alienated Gallatin and Madison as well as the more unscrupulous of the party leaders. He came to a definite break with his party over Jefferson's secretive efforts to acquire Florida and ranged himself in open opposition with his "Decius" letters (beginning in the Richmond *Enquirer*, August 15, 1806).

A scrupulous precisian, unwilling to make the least concession of principle to suit the exigencies of politics, Randolph continued to pour out his scorn on his opponents in Congress until 1813. He opposed the Embargo; he opposed the War of 1812. However, with the appearance on the scene of Henry Clay, John C. Calhoun, and Daniel Webster, he ceased to be preeminent as an orator. Defeated for the 13th Congress by John W. Eppes, he returned to the House in 1815 and denounced the chartering of the second Bank of the United States, the tariff, and other nationalistic measures. Refusing to stand for the 15th Congress because of ill health, he served continuously from 1819 until 1825. With the rise of the Missouri question, he became a sectional leader, standing firmly on strict construction of the Constitution and opposing compromise as of old. He was hostile to John Q. Adams and suspicious of Henry Clay with whom he fought a duel in April 1826.

As a U.S. senator, 1825–27, he suffered from mental disorder during the first session and refrained from speaking during the second after John Tyler had been brought forward as a candidate against him. Returned to the House, 1827–29, he was leader of the opposition to John Q. Adams. As delegate to the Virginia convention of 1829–30, he opposed any significant constitutional change. Accepting appointment as U.S. minister to Russia, 1830, he was obliged to resign because of ill health when he had been less than a month at his post. After a long period of sickness and mental alienation, he died while waiting to take ship for England and was buried at "Roanoke" with his face to the West — to keep an eye on Henry Clay, it is said.

Randolph at the age of thirty already looked like an old man. He suffered from insomnia and rheumatism and died, probably, of tuberculosis. He was also impotent for the great part of his life. *Post* 1818, he was on several occasions clearly demented. A constitutional purist, a merciless hater of iniquity, a master of vituperation, and an incomparable orator, he comes down in history as a champion of lost causes, one of the most pathetic as well as one of the most brilliant figures ever to appear in our national public life.

RANDOLPH, LILLIAN (*b. Knoxville, Tenn., 1914; d. Oakland, Calif., 1980*), entertainer. Emerged as a popular nightclub singer in Los Angeles in the late 1930's and in the 1940's and 1950's won roles on radio comedies, often playing the stereotypical role of the African–American maid. Her most famous character was that of Birdie Lee Coggins in "The Great Gildersleeve," a role that she reprised in several movies and on television. Randolph appeared in more than thirty films, often as a maid, including *The Adventures of Mark Twain* (1944), *Hush, Hush, Sweet Charlotte* (1964), and *The Onion Field* (1979). She also appeared on

such television shows as "The Bill Cosby Show" (1969–70) and *Roots* (1977).

RANDOLPH, PEYTON (*b. probably "Tazewell Hall," Williamsburg, Va., ca. 1721; d. Philadelphia, Pa., 1775*), lawyer, statesman. Son of Sir John Randolph; brother of John Randolph (1727–84). Educated at William and Mary; studied law in London at the Middle Temple; called to bar, 1744 n.s. Appointed King's attorney for Virginia in 1748; served in the House of Burgesses almost continuously, 1748–75. Resigning his post as King's attorney, 1766, he became speaker of the House and held office until the Revolution. A conservative by temperament, Randolph opposed Governor Dinwiddie on several occasions in the interest of the colonials and between 1765 and 1774 moved steadily with the current of Virginia rebel sentiment. He presided over every important Revolutionary assemblage, was appointed to the first Continental Congress, and served as its president in 1774 and 1775.

RANDOLPH, SARAH NICHOLAS (*b. Albemarle Co., Va., 1839; d. Baltimore, Md., 1892*), teacher, author. Daughter of Thomas J. Randolph. Wrote lives of Thomas J. (Stonewall) Jackson (1876) and of her great-grandfather (*Domestic Life of Thomas Jefferson*, 1871).

RANDOLPH, THEODORE FITZ (*b. New Brunswick, N.J., 1826; d. 1883*), industrialist. Conservative Democratic governor of New Jersey, 1869–72; U.S. senator, 1875–81.

RANDOLPH, THOMAS JEFFERSON (*b. "Monticello," Va., 1792; d. "Edgehill," Va., 1875*), planter, financier, Virginia legislator. Grandson of Thomas Jefferson; son of Thomas M. Randolph. Served as chief executor of his grandfather's estate; edited first published collection of his grandfather's writings, *Memoir, Correspondence, and Miscellanies from the Papers of Thomas Jefferson* (1829).

RANDOLPH, THOMAS MANN (*b. Goochland Co., Va., 1768; d. 1828*), Virginia planter and legislator. Son-in-law of Thomas Jefferson; father of Thomas J. Randolph and George W. Randolph. Brilliant but impractical and rash, he represented Virginia in Congress, 1803–07, and was governor of the state, 1819–22. He enjoyed some repute as a botanist.

RANDOLPH, WILLIAM (*b. Warwickshire, England, ca. 1651; d. 1711*), planter, merchant, colonial official. Father of Sir John Randolph; grandfather of John Randolph (1727–84) and Peyton Randolph. Came to Virginia *ca.* 1673. By 1705, he had acquired vast tracts of land and had become one of the leading planters in the colony. Among the many civil and military posts which he held were those of speaker of the House of Burgesses, 1696 and 1698, and attorney general for the Crown, 1694–98.

RANEY, GEORGE PETTUS (*b. Apalachicola, Fla., 1845; d. 1911*), lawyer, Confederate soldier, Florida Democratic legislator. State attorney general, 1877–85; associate justice, state supreme court, 1885–89, and chief justice, 1889–94.

RANGER, HENRY WARD (*b. Syracuse, N.Y., 1858; d. New York, N.Y., 1916*), landscape painter, of interest for his experiments with pigments and varnishes.

RANKIN, JEANNETTE PICKERING (*b. Missoula, Montana Territory, 1880; d. Carmel, Calif., 1973*), first woman in Congress. Graduated University of Montana (B.S., 1902), attended New York School of Philanthropy (1908–09), and studied social legislation at the University of Washington. She returned to Montana in 1910 to work for passage of women's suffrage (granted 1914). In 1916 she was elected to the U.S. House of Representatives, where she sponsored women's health education legislation and supported President Woodrow Wilson's prosecution of World War I. She lost her reelection bid in 1918 and devoted herself to the pacific cause, helping to found the Women's International League for Peace and Freedom in 1919. She was reelected to the House in 1940 as an isolationist Republican and cast the lone vote in December 1941 against war with Japan, which ended her electoral career.

RANKIN, JEREMIAH EAMES (*b. Thornton, N.H., 1828; d. Cleveland, Ohio, 1904*), Congregational clergyman. Graduated Middlebury College, 1848; Andover Seminary, 1854. President of Howard University, 1889–1903; author, among other hymns, of "God be with you till we meet again."

RANKIN, JOHN ELLIOT (*b. Bolanda, Miss., 1882; d. Tupelo, Miss., 1960*), congressman. Attended the University of Mississippi (LL.B., 1910). Democratic congressman from 1921 to 1952. Cosponsored the legislation that created the Tennessee Valley Authority (TVA) in 1933. He helped formulate the postwar G.I. Bill of Rights and served on the House Committee on Un-American Activities (1945–48). Closely identified with white supremacy, antisemitism, and union baiting.

RANKIN, MCKEE (*b. Sandwich, Ontario, Canada, 1844; d. 1914*), actor, theatrical manager. Played *post* 1865 with leading stock companies; was particularly effective in melodrama. Managed, and played leads to, Nance O'Neill.

RANKINE, WILLIAM BIRCH (*b. Owego, N.Y., 1858; d. 1905*), lawyer, "father of Niagara power." Gave full time *post* 1890 to the development of the Niagara Falls power project; was head executive of its operating department *post* 1897.

RANNEY, AMBROSE LOOMIS (*b. Hardwick, Mass., 1848; d. 1905*), physician. Graduated Dartmouth, 1868; M.D., University of the City of New York, 1871. Taught anatomy at his *alma mater* and at New York Post-Graduate. Author of authoritative papers on eye strain as the cause of functional nervous disease and other disorders.

RANNEY, RUFUS PERCIVAL (*b. Blandford, Mass., 1813; d. Cleveland, Ohio, 1891*), Ohio jurist, Democratic politician. State supreme court judge, 1851–56 and 1862–64.

RANNEY, WILLIAM TYLEE (*b. Middletown, Conn., 1813; d. West Hoboken, N.J., 1857*), historical and genre painter of the life of the American frontier, notably of the old Southwest.

RANSOHOFF, JOSEPH (*b. Cincinnati, Ohio, 1853; d. Cincinnati, 1921*), surgeon. M.D., Medical College of Ohio, 1874; studied also in England, France, and Germany and was made fellow of the Royal College of Surgeons, 1877. Taught at the Medical College of Ohio *post* 1877; was among first in America to operate on gall bladder and kidney; contributed prolifically to professional journals.

RANSOM, JOHN CROWE (*b. Pulaski, Tenn., 1888; d. Gambier, Ohio, 1974*), poet and literary critic. Graduated Vanderbilt University (B.A., 1909) and accepted a Rhodes scholarship to Christ Church College, Oxford (B.A., 1913). He joined the Vanderbilt faculty in 1914 and became a professor of English (1927–37). In 1915 he began meeting with an informal group, the Fugitives, to discuss American life and letters; they began publishing a literary journal, *Fugitive* (1922–25), which ushered in the new literary movement Agrarianism and announced the theory of New Criticism, which insisted that the work of art be evaluated

as an object in and of itself, independent of outside influences. Ransom's first poetry collection, *Poems About God*, was published in 1919; like their successors, these poems are obsessed with mutability, decay, and death and the disparity between expectation and reality. Later collections of poetry include *Grace After Meat* and *Chills and Fever* (both 1924) and *Selected Poems* (1964), which won the National Book Award. He taught poetry at Kenyon College (1937–58) and founded the *Kenyon Review* (1939), serving as its editor until 1959, then lectured at more than 200 colleges and universities. His first book of literary criticism was *The World's Body* (1938).

RANSOM, MATT WHITAKER (b. *Warren Co., N.C., 1826; d. 1904*), lawyer, Confederate soldier, North Carolina official and legislator. A Whig before the Civil War, he was a Democrat after it and served as U.S. senator from North Carolina, 1873–95. He was a leader in securing the compromise of 1876–77 by which the disputed presidential election was peacefully settled and in the defeat of the Lodge "Force Bill," 1890. As U.S. minister to Mexico, 1895–97, he arbitrated disputes between that country and Guatemala.

RANSOM, THOMAS EDWARD GREENFIELD (b. *Norwich, Vt., 1834; d. near Rome, Ga., 1864*), Union soldier, civil engineer. Removed to Illinois *ca.* 1851. At outbreak of Civil War he became lieutenant colonel, 11th Illinois Infantry, and brought the regiment to a high state of discipline and training; it served with particular distinction at Fort Donelson and Shiloh. Appointed brigadier general, he distinguished himself in the Vicksburg campaign and in an expedition against Natchez so as to win the particular praise of General Grant. After service in Texas and Arkansas, he was assigned to command the 4th Division, XVI Corps, under Sherman and was again outstanding in the Atlanta campaign. He died while in command of the XVII Corps, after pursuing the army of Confederate General John Hood across north Georgia. He was reputed one of the most capable volunteer soldiers developed in the Civil War.

RANSOME, FREDERICK LESLIE (b. *Greenwich, England, 1868; d. Pasadena, Calif., 1935*), geologist. Immigrated to California as a small child. Graduated University of California, 1893; Ph.D., 1896. An active staff member of the U.S. Geological Survey, 1897–1923, Ransome taught thereafter at the University of Arizona and at the California Institute of Technology. He was author of a veritable library of monographs on important mining districts and on problems of water control.

RANSON, STEPHEN WALTER (b. *Dodge Center, Minn., 1880; d. Chicago, Ill., 1942*), neurologist, anatomist. A.B., University of Minnesota, 1902. Ph.D., University of Chicago (under Henry H. Donaldson), 1905. M.D., Rush Medical College, 1907. Assistant in anatomy, Northwestern University Medical School, 1908–10; professor, and chairman of the department, 1911–24. After serving as professor of neuroanatomy and histology at Washington University Medical School, 1924–28, he returned to Northwestern to organize and direct the research of the Institute of Neurology and remained there for the rest of his life. Among other research he studied the degeneration and regeneration of nerve fibers, the structure of the vagus nerve, and the functional role of spinal ganglia; perhaps his most significant contributions were his studies of the function of the hypothalamus as control center for the sympathetic nervous system.

RANTOUL, ROBERT (b. *Salem, Mass., 1778; d. Beverly, Mass., 1858*), apothecary, public official, reformer. Father of Robert Rantoul (1805–52). Opposed the growth of corporations as in-

imical to liberty and equality; advocated temperance, international peace, and abolition of capital punishment.

RANTOUL, ROBERT (b. *Beverly, Mass., 1805; d. 1852*), lawyer, reformer. Son of Robert Rantoul (1778–1858). Graduated Harvard, 1826. A Jacksonian Democrat and a liberal Unitarian, he furthered a number of humanitarian causes as a Massachusetts legislator; these included the abolition of the death penalty, the extension of the public school system, and control of the liquor interests. The Massachusetts supreme court upheld in 1842 his reasoning in defense of journeymen bootmakers charged with unlawful conspiracy in organizing to compel collective bargaining (*Commonwealth* v. *Hunt and Others*); he also served as counsel for Rhode Islanders indicted in connection with the Dorr rebellion. Elected to Congress, 1851, by a coalition between Free-Soilers and Democrats, he was chosen to the U.S. Senate in the same year to fill out Daniel Webster's term. His early death was a great loss to the antislavery Democrats and to liberal reform.

RAPAPORT, DAVID (b. *Munkács, Hungary, 1911; d. Stockbridge, Mass., 1960*), psychoanalyst. Studied at the University of Budapest and the Royal Hungarian University (Ph.D., 1938). Immigrated to the United States in 1938. Director of research at the Karl Menninger Clinic at Topeka, Kans. (1940–48). Researcher at the Austin Riggs Center in Stockbridge, Mass., from 1948. Rapaport worked on systematizing psychoanalytic theory, in particular its metapsychology, the abstract level of theorizing in psychoanalysis, allegedly explanatory of its clinical theory. His works contain an extensive translation of psychoanalysis into the idiom of contemporary psychology. Works include *Emotions and Memory* (1942), *Diagnostic Psychological Testing* (1945–46), and *Organization and Pathology of Thought* (1951).

RAPHALL, MORRIS JACOB (b. *Stockholm, Sweden, 1798; d. 1868*), rabbi, author. Raised in Denmark and England; rabbi of Birmingham Hebrew Congregation, 1841–49. Came to New York, 1849, as preacher to Congregation B'nai Jeshurun and officiated until 1865. He was the first Jew to open a session of the House of Representatives with prayer (Feb. 1, 1860), and a champion of orthodox Judaism in America against the growing encroachments of reform.

RAPP, GEORGE (b. *Iptingen, Württemberg, 1757; d. Economy, Pa., 1847*), religious leader, founder of the Harmony Society. A student of the Bible and of the German mystics, Rapp became leader of a group of separatists in Germany which for a number of years was subject to much petty persecution. Purchasing unimproved land in Butler Co., Pa., 1803, Rapp and some of his followers built the town of Harmony where early in 1805 the rest of his group joined them. The Harmony Society was a communistic theocracy under Rapp as dictator; it was one of the most successful of the more than 200 communistic societies that have sprung up in the United States. Established at Harmony, Ind., 1814–24, the community returned to Pennsylvania and made their last settlement at Economy on the Ohio River below Pittsburgh.

RAPP, WILHELM (b. *Perouse, Württemberg, 1827; d. Chicago, Ill., 1907*), German language journalist. Came to America, 1852, after involvement in German revolutionary activity; worked as editor of several newspapers, notably of *Der Wecker*, Baltimore, Md., and the *Illinois Staats-Zeitung*.

RAREY, JOHN SOLOMON (b. *Groveport, Ohio, 1827; d. 1866*), horse tamer of international celebrity.

RASKOB, JOHN JAKOB (*b. Lockport, N.Y., 1879; d. near Centerville, Md., 1950*), financier, politician. Studied stenography and accounting. Beginning as secretary to Pierre S. du Pont, 1900, he worked closely with him and his cousins, A. I. and T. C. du Pont, in their expansion of E. I. du Pont de Nemours and Company *post* 1902, and pioneered in developing many useful techniques in modern corporate finance. Raskob was *de facto* treasurer of the firm *post* 1909, receiving the title officially in 1914. Interested in the General Motors Corporation as an investor, he worked with William C. Durant on the complicated finances of that firm and secured its financial control by the du Pont interests, resigning as treasurer of the Du Pont Company and becoming chairman of the finance committee of General Motors in March 1918. He introduced modern accounting and auditing practices and formed the General Motors Acceptance Corporation (1919); his funding of the firm's postwar expansion program, however, ran into difficulties during the business recession of 1920 and he had a relatively minor role in the massive reorganization that brought General Motors to its peak of success in a few years' time. Turning increasingly to outside investment and speculation, he also entered politics through his association and friendship with Alfred E. Smith. He resigned from General Motors to become national chairman of the Democratic party after Smith's nomination for the presidency in 1928. He continued to maintain a headquarters for the party's national committee in Washington, D.C., subsequent to Smith's defeat. With the aid of Charles Michelson and others, he kept President Herbert Hoover's administration under constant attack, 1929–32; hopeful of securing a renomination for Smith, he sought to block the candidacy of Franklin D. Roosevelt but was outmaneuvered at the 1932 Democratic national convention. He was replaced as national chairman by James A. Farley. In 1934 he helped found the American Liberty League, an anti-New Deal organization.

RASLE, SÉBASTIEN See RÂLE, SÉBASTIEN.

RATHBONE, BASIL (*b. Johannesburg, South Africa, 1892; d. New York, N.Y., 1967*), actor. Began a career on the British stage in 1911, which he resumed after World War I. Appeared in New York in *The Czarina* (1922) and *The Dark* (1925), but embarked on a long film career in Hollywood in 1924. Tall and handsome, with finely chiseled features and an excellent profile, he made a vivid impression on the screen in about 150 films, ranging from classics to low-grade horror films: *Captain Blood* (1935), *A Tale of Two Cities* (1935), *The Adventures of Robin Hood* (1938), *Sons of Frankenstein* (1939), *The Mark of Zorro* (1940), *The Heiress* (1947), and *The Last Hurrah* (1958). Best remembered for his portrayal of Sherlock Holmes on radio and in thirteen films, the first being *The Hound of the Baskervilles* (1939).

RATHBONE, JUSTUS HENRY (*b. Deerfield, N.Y., 1839; d. Lima, Ohio, 1889*), teacher, government clerk. Founded fraternal order of the Knights of Pythias in Washington, D.C., 1864.

RATHBONE, MONROE JACKSON ("JACK") (*b. Parkersburg, W.Va., 1900; d. Baton Rouge, La., 1976*), oil company executive. Graduated Lehigh University (1921) and joined Standard Oil Company of Louisiana, advancing to company president by 1936. In 1944 Standard Oil Company (New Jersey) appointed him president of affiliate Esso Standard Oil; he became president of Standard Oil in 1954 and then chief executive officer (1960–65) and chairman (1963–65), during which time he directed the consolidation of Standard's domestic affiliates into Humble Oil and Refining Company (now Exxon Corporation). Rathbone also oversaw an initiative, which ultimately did not prove commercially viable, to manufacture an inexpensive fertilizer from petrochemicals under the auspices of the United Nations Greening of the Earth Program.

RATHBUN, RICHARD (*b. Buffalo, N.Y., 1852; d. 1918*), zoologist. Served on Geological Commission of Brazil and on U.S. Fish Commission; was on staff of National Museum and the Smithsonian. Rathbun wrote copiously on marine invertebrates and on the economic aspects of marine biology.

RATTERMANN, HEINRICH ARMIN (*b. near Osnabrück, Germany, 1832; d. 1923*), insurance executive, historian, man of letters. Came to Cincinnati, Ohio, as a boy. Established German Mutual Fire Insurance Co., 1858. Promoted musical and cultural activities in Cincinnati; became authority on pioneer German settlers in the United States.

RAU, CHARLES (*b. Verviers, Belgium, 1826; d. Washington, D.C., 1887*), archaeologist. Came to America, 1848; was associated *post* 1875 with the U.S. National Museum, acting as curator of the department of archaeology, 1881–87. Considered the foremost American archaeologist of his time, he was the first in America to recognize the importance of the study of aboriginal technology and was the author of many contributions to scholarly journals.

RAUCH, FREDERICK AUGUSTUS (*b. Kirchbracht, Prussia, 1806; d. Mercersburg, Pa., 1814*), philosopher, educator. Educated at Marburg, Giessen, and Heidelberg. Came to America as a political refugee, 1831; was ordained to German Reformed ministry, 1832; after seminary teaching at York, Pa., he was organizer and first president of Marshall College, 1836–41. Author of *Psychology or a View of the Human Soul* (1840), an important work.

RAUCH, JOHN HENRY (*b. Lebanon, Pa., 1828; d. Lebanon, 1894*), physician. M.D., University of Pennsylvania, 1849. Practiced in Iowa, 1850–56, and thereafter (excepting Civil War service) in Chicago. Promoted higher medical education and standards of practice as first president of Illinois State Board of Health and member, 1877–91.

RAUE, CHARLES GOTTLIEB (*b. near Loebau, Saxony, 1820; d. Philadelphia, Pa., 1896*), homeopathic physician.

RAULSTON, JOHN TATE (*b. Marion County, Tenn., 1868; d. South Pittsburg, Tenn., 1956*), lawyer, legislator, judge. Studied at Tennessee Wesleyan College and the University of Chatanooga. Practiced law until he was elected judge for the Eighteenth District in Tennessee (1918–26). Remembered as the presiding judge for the famed 1925 Scopes Trial in Dayton, Tenn., Raulston upheld the right of the state to determine the school curriculum. In 1926 Raulston resumed his law practice until his retirement in 1952.

RAUM, GREEN BERRY (*b. Golconda, Ill., 1829; d. Chicago, Ill., 1909*), Union soldier, lawyer, Illinois Republican congressman and politician.

RAUSCHENBUSCH, WALTER (*b. Rochester N.Y., 1861; d. Rochester, 1918*), Baptist clergyman, educator. Graduated University of Rochester, 1864; Rochester Theological Seminary, 1886. Pastor, Second German Baptist Church, New York City 1886–97. Influenced by the sufferings of his parishioners during a time of depression and by the ideas of the Fabian socialists, he became an influential figure in the development in the United States of what has been called the "social gospel." Professor of New Testament interpretation at Rochester Seminary, 1897–1902, he was professor of church history thereafter until his death. Among his

books, his *Christianity and the Social Crisis* (1907) was outstanding.

RAUTENSTRAUCH, WALTER (*b. Sedalia, Mo., 1880; d. Palisade, N.J., 1951*), industrial engineer, educator. Studied at the University of Missouri (M.S., 1903) and at Cornell University. Taught at Columbia University School of Engineering from 1906; headed the nation's first department of industrial engineering, 1919–45; professor emeritus from 1945. A disciple of Frederick W. Taylor's scientific management theories, he achieved fame through involvement with the technocracy movement of the early 1930's. Believed that social engineering, led by industrial engineers, could help rebuild society. Founded the Committee on Technocracy in 1932. In 1933 he resigned from the committee because of disenchantment; this signaled the end of the movement.

RAVALLI, ANTONIO (*b. Ferrara, Italy, 1811; d. 1884*), Roman Catholic clergyman, Jesuit missionary. Came to work among the Indians of the region that is now Montana, 1844, in response to an appeal of Father P.-J. De Smet. A skilled mechanic and builder as well as an artist, and also a physician, he worked until his death among the Indians and settlers of Montana with the exception of the years 1860–63.

RAVENEL, EDMUND (*b. Charleston, S.C., 1797; d. Charleston, 1871*), physician, planter, naturalist. M.D., University of Pennsylvania, 1819. Made a remarkable collection of marine shells of which he issued a catalogue, 1834, said to have been the first in the United States. Author of *Echinidae . . . of South Carolina* (1848) and other studies.

RAVENEL, HARRIOTT HORRY RUTLEDGE (*b. Charleston, S.C., 1832; d. Charleston, 1912*), author. Granddaughter of William Lowndes; married St. Julien Ravenel, 1851. Published *Eliza Pinckney* (1896), *Charleston, the Place and the People* (1906), and other works.

RAVENEL, HENRY WILLIAM (*b. Berkeley Co., S.C., 1814; d. Aiken, S.C., 1887*), planter, botanist, agricultural writer. Leading authority on American fungi; collected an extensive herbarium of fungi, mosses, and lichens.

RAVENEL, MAZYCK PORCHER (*b. Pendleton, S.C., 1861; d. Columbia, Mo., 1946*), bacteriologist, hygienist, public health authority. Graduated University of the South, 1881; Medical College of South Carolina, 1884. Studied hygiene at University of Pennsylvania with John S. billings; studied also at the Pasteur Institute, Paris, and at the Institute of Hygiene in Halle, Germany. Taught bacteriology at the medical and veterinary schools, University of Pennsylvania, 1896–1904, serving also as bacteriologist of the Pennsylvania State Livestock Sanitary Board; made notable investigations of the relation of animal diseases to illness in man, especially bovine tuberculosis. As bacteriologist and assistant director of the Henry Phipps Institute (1904–07), and as professor of bacteriology, University of Wisconsin (1907–14), he continued his studies of tuberculosis, and made important investigations of typhoid fever, rabies, and diphtheria, largely in their public health aspects. *Post* 1914, he was professor of preventive medicine and bacteriology at University of Missouri, and director of its public health laboratory. He was editor of the *American Journal of Public Health*, 1921–11, and author (among other works) of *A Half Century of Public Health* (1921).

RAVENEL, ST. JULIEN (*b. Charleston, S.C., 1819; d. 1882*), physician, Confederate soldier and surgeon, and agricultural chemist. Nephew of Edmund Ravenel. Originated process for manufacture of ammoniated and acid fertilizers from phosphate deposits along Ashley and Cooper rivers, South Carolina, ca. 1867. Worked on soil-restoration problems.

RAVENSCROFT, JOHN STARK (*b. near Petersburg, Va., 1772; d. Raleigh, N.C., 1830*), planter, Episcopal clergyman. Ordained, 1817, after a late conversion; consecrated first bishop of North Carolina, 1823; built up a strong conservative body of clergy and laity before resigning his charge, 1828.

RAVOUX, AUGUSTIN (*b. Langeac, France, 1815; d. St. Paul, Minn., 1906*), Roman Catholic clergyman. Volunteered for mission work, 1838; came to Dubuque, Iowa, and was ordained there, 1840. Served Sioux missions on the St. Peter's (present Minnesota) River, 1841–44; was pastor for entire area on Mississippi River headwaters, 1844–51. Worked thereafter in many capacities in the diocese of St. Paul.

RAWLE, FRANCIS (*b. probably Plymouth, England, ca. 1662; d. Philadelphia, Pa., 1726/7*), merchant, political economist. After imprisonment as a Quaker, he immigrated to Pennsylvania, 1686. Member of the Assembly, 1704–09 and 1719–26/7, Rawle was a leader in the antiproprietary party. A mercantilist in theory, he was author of *Some Remedies Proposed for the Restoring the Sunk Credit of the Province of Pennsylvania* (1721) and *Ways and Means for the Inhabitants of Delaware to Become Rich* (1725).

RAWLE, FRANCIS (*b. Freedom Forge, Pa., 1846; d. 1930*), Philadelphia lawyer. Grandson of William Rawle. A founder of the American Bar Association, 1878; edited revisions of Bouvier's *Law Dictionary* (1883, 1897, 1914).

RAWLE, WILLIAM (*b. Philadelphia, Pa., 1759; d. Philadelphia, 1836*), lawyer, philanthropist. Great-grandson of Francis Rawle (*ca.* 1662–1726/7). A Loyalist, he studied law at the Middle Temple, London. Returning to Philadelphia after the Revolution, he served as U.S. attorney for Pennsylvania, 1791–99, and practiced in the city thereafter. He was active in many civic and cultural enterprises, advocated abolition of slavery, and was a devout Quaker; among his many writings, his *View of the Constitution of the United States* (1825) was outstanding. He was a member of the commission to revise the Pennsylvania statutes, 1830–34.

RAWLE, WILLIAM HENRY (*b. Philadelphia, Pa., 1823; d. 1889*), Philadelphia lawyer, Union soldier, legal author and editor. Grandson of William Rawle.

RAWLINGS, MARJORIE KINNAN (*b. Washington, D.C., 1896; d. St. Augustine, Fla., 1953*), novelist. Studied at the University of Wisconsin (B.A., 1918). Her books include *South Moon Under* (1933); *Golden Apples* (1935); *The Yearling* (1939), which won the Pulitzer Prize; *When the Whippoorwill* (1940); *Cross Creek* (1942); and *The Sojourner* (1953). Discovered by Scribners' Maxwell Perkins, she wrote with candid realism about poor whites in exotic settings. Work displays little of the prevailing pessimism and social consciousness of her time, or the naturalistic resort to sex, violence, and sensation. Her books give fresh expression to pastoral themes of central importance to the American cultural tradition.

RAWLINS, JOHN AARON (*b. Galena, Ill., 1831; d. Washington, D.C., 1869*), lawyer, Union soldier. Appointed aide-de-camp to General U.S. Grant, 1861, he remained constantly with him as principal staff officer and intimate adviser, exercising his influence with great tact and ability. Promoted brigadier general, 1863, he was made brevet major general and chief of staff of the

army, 1865. Long in failing health, he served briefly as U.S. secretary of war, 1869.

RAWLINSON, FRANK JOSEPH (*b. Langham, England, 1871; d. Shanghai, China, 1937*), Baptist and Congregational clergyman. Immigrated to America, 1889. Graduated Bucknell, 1899; Rochester Theological Seminary, 1902. Missionary to China, 1902–22, as a Baptist. He served thereafter as a Congregational missionary at large and editor.

RAY, CHARLES BENNETT (*b. Falmouth, Mass., 1807; d. 1886*), Methodist and Congregational clergyman, pioneer black journalist, antislavery worker. Published and edited the *Colored American*, 1838–42; was Congregational pastor and missionary in New York City *post* 1846.

RAY, ISAAC (*b. Beverly, Mass., 1807; d. Philadelphia, Pa., 1881*), psychiatrist. M.D., Bowdoin, 1827. Headed Butler Hospital, Providence, R.I., 1846–66; practiced thereafter in Philadelphia. A leader in his specialty, he was author of *A Treatise on the Medical Jurisprudence of Insanity* (1838), *Mental Hygiene* (1863), and many other works.

RAY, MAN See MAN RAY.

RAYBURN, SAMUEL TALIAFERRO ("SAM") (*b. Roane County, Tenn., 1882; d. Bonham, Tex., 1961*), Democratic party leader and Speaker of the House of Representatives in every Democratic-controlled Congress from 1940 until his death. Attended Mayo Normal School (now East Texas State) and University of Texas; passed the state bar in 1908. Elected speaker of the Texas House in 1911. As U.S. congressman (1912–61) served on the Committee on Interstate and Foreign Commerce (chairman, 1930). He was a typical southern progressive of the period, devoted to free trade, aid to farmers, and states' rights and was indifferent to organized labor and hostile toward concentrated wealth. During the New Deal, he forged a close working relationship with President Franklin Roosevelt and helped develop and pilot through Congress some of the most significant New Deal legislation. Never an important influence in state politics after his election to Congress, he increasingly was only a revered symbol in the Texas Democratic party. He was among the foremost supporters of the internationalist-interventionist foreign policies of Roosevelt, Harry Truman, and Dwight Eisenhower, but was more comfortable with the moderate conservatism of Eisenhower in domestic affairs than with Truman's Fair Deal or John Kennedy's New Frontier. A quiet opponent of civil rights measures for most of his career, in 1957 and 1960 he finally lent his active support to civil rights legislation designed to facilitate exercise of the right to vote. During the 1950's he and Lyndon Johnson worked as a team with substantial control of Congress; they committed the Democratic party to a policy of "moderation" that fit both the requirements of their home constituency and what they perceived as the national mood. The Rayburn-Johnson approach drew heavy fire from liberal Democrats. Rayburn was vocal and consistent in his assertions that there could be no higher honor than leadership in what he considered the "popular branch" of the national government.

RAYMOND, ALEXANDER GILLESPIE (*b. New Rochelle, N.Y., 1909; d. Westport, Conn., 1956*), cartoonist. Studied at the Grand Central School of Art. Creator of strips such as "Flash Gordon" and "Jungle Jim" in 1934, he is considered the finest cartoonist of the golden age of the comics. Other series include "Secret Agent X-9" (1935), done in collaboration with writer Dashiell Hammett, and "Rip Kirby" (1946). Served in the Marines in World War II and was president of the National Cartoonists So-

ciety, 1950–51. Radio, film, comic book, and television series were made from most of his strips.

RAYMOND, BENJAMIN WRIGHT (*b. Rome, N.Y., 1801; d. 1883*), Chicago merchant and capitalist. Removed to Chicago, Ill., 1836. As mayor, 1839 and 1842, he brought the city through effects of depression of 1837–39 and donated his salary to the unemployed. Active in many businesses *post* 1843, including real estate, railroad promotion and watch manufacturing, he laid out the town of Lake Forest.

RAYMOND, CHARLES WALKER (*b. Hartford, Conn., 1842; d. 1913*), military engineer. Brother of Rossiter W. Raymond. Graduated West Point, 1865; retired as brigadier general, 1904. Made survey and map of Yukon River, 1869; supervised many important river and harbor improvements; was chairman, board of engineers for constructing Pennsylvania Railroad tunnels under Hudson River.

RAYMOND, DANIEL (*b. in or near New Haven, Conn., 1786; d. 1849[?]*), lawyer, economist. Studied law under Tapping Reeve. Settled in Baltimore, Md., *ca.* 1814; removed to Cincinnati, Ohio, *post* 1840. Author of *Thoughts on Political Economy* (1820, supplemented in the fourth edition, 1840, by *Elements of Constitutional Law*, *The Missouri Question* (1819), and *The American System* (1828). Opposing classical *laissez-faire* in principle, Raymond distinguished between individual wealth, i.e., the sum of individual riches, and national wealth which he considered the development of economic capacities; he believed that political economy was concerned less with property than with productive power and that national prosperity required a liberal measure of deliberate economic control. Convinced that social principles are always relative to place and time, he based his thought on the American economic environment; it is probable that Georg F. List and John Rae were influenced by him.

RAYMOND, GEORGE LANSING (*b. Chicago, Ill., 1839; d. 1929*), Presbyterian clergyman, educator. Son of Benjamin W. Raymond. Graduated Williams, 1862; Princeton Theological Seminary, 1865. Taught rhetoric at Williams; professor of aesthetics and oratory at Princeton, 1880–1905; professor of aesthetics at George Washington University, 1905–12. Author of a number of studies, issued in a uniform edition as *Comparative Aesthetics* (1909).

RAYMOND, HARRY HOWARD (*b. Yarmouth, N.S., Canada, 1864; d. 1935*), steamship line executive. Came to the United States, 1884; was long associated with the Mallory and Clyde companies and with the Atlantic, Gulf & West Indies lines.

RAYMOND, HENRY JARVIS (*b. Lima, N.Y., 1820; d. 1869*), editor, politician. Graduated University of Vermont, 1840. Removing to New York City, he worked for Horace Greeley on the *New Yorker* and became his chief assistant on the *New York Tribune*, 1841. Shifting to the *Morning Courier*, 1843, he grew in professional reputation. Also a Whig politician, he was elected to the N.Y. Assembly, 1849, and chosen speaker, 1851. His alignment with the Free-Soil group led by W. H. Seward and Thurlow Weed cost him his post with the *Courier*. In association with George Jones (1811–1891), with whom he had become friendly at the *Tribune*, he established the *New York Daily Times* (so-called until 1857). In its first issue (Sept. 18, 1851), he declared that "we do not mean to write as if we were in passion — unless that shall really be the case; and we shall make it a point to get into a passion as rarely as possible." This substitution of moderation and reason for intemperate partisanship brought the *Times* immediate success at the *Tribune's* expense. Through irked by the Whig refusal to face the realities of the slavery issue, Ray-

mond could not bring himself to leave the party until 1856. Meanwhile his nomination for lieutenant governor of New York, 1854, had mortally offended Greeley and made that formidable editor the political enemy of W. H. Seward.

Raymond wrote the Republican statement of principles at the founding of the national party, 1856; thereafter the *Times* was Republican. He discussed the crucial issues of 1860 in a notable series of open letters to W. L. Yancey (published as *Disunion and Slavery*) and was a steadfast supporter of Abraham Lincoln. As active in politics as in journalism, he was again speaker of the New York Assembly, 1862. In 1864 he played a chief part in Andrew Johnson's nomination for the vice presidency at Baltimore and was named Republican national chairman; he also ran for Congress and was elected.

As administration leader in the House, Raymond was a complete failure. Championing the moderate Reconstruction policies of President Johnson, he was completely outgeneraled by Thaddeus Stevens and the Radicals and acted with hesitation and inconsistency. When the president tried to organize a National Union coalition of conservative Republicans and War Democrats, Raymond supported its purposes in the *Times* but opposed formation of a new party as such. He attended the National Union Convention at Philadelphia, August 1866, pleading for harmony and intelligent action, but the Radicals carried the day and he was their first victim. Expelled from the national committee, he declined renomination for Congress. After the failure of an attempt by him and Weed to form a Union bloc of moderates in New York State, he ceased to struggle against the inevitable. In the campaign of 1868, the *Times* supported the Republicans but the tendency of the paper was increasingly less partisan. Raymond began the *Times* campaign (later brilliantly concluded by George Jones) against the "Tweed Ring" and advocated sound money, tariff reduction and civil-service reform.

Raymond's contribution to journalism was the substitution of decency for personal invective and fairness for black-and-white partisanship. He was one of the earliest and greatest of local reporters, with a prodigious speed and accuracy that became legendary. His editorials were lucid and persuasive, but they usually lacked the smashing force that some of his contemporaries derived from conviction of their own utter rightness and the wickedness of those who held divergent views. He once said that when he wrote a sentence he could not help seeing before he got to the end how only partially true it was. This trait and lack of a realistic appraisal of public opinion were his fatal weaknesses as a politician. His misfortune was not only that he was a temperamental nonpartisan in an age of bitter partisanship, but that he was a temperamental nonpartisan incurably addicted to party politics.

RAYMOND, JOHN HOWARD (*b. New York, N.Y., 1814; d. Poughkeepsie, N.Y., 1878*), educator. Graduated Union, 1832; Madison University (present Colgate) Seminary 1838. Taught at Madison and at Rochester. First president, Brooklyn Polytechnic, 1855–64; thereafter president and academic organizer of Vassar College, for the success of which he was largely responsible.

RAYMOND, JOHN T. (*b. Buffalo, N.Y., 1836; d. Evansville, Ind., 1887*), comedian. Stage name of John O'Brien. Relied for effects on facial and physical eccentricities; was identified with role of Col. Mulberry Sellers in *The Gilded Age, post 1873*.

RAYMOND, MINER (*b. New York, N.Y., 1811; d. 1897*), Methodist clergyman, theologian. Principal of Wesleyan Academy (Wilbraham, Mass.), 1848–64; professor, Garrett Biblical Institute, Evanston, Ill., 1864–95. Author of *Systematic Theology* (1877).

RAYMOND, ROSSITER WORTHINGTON (*b. Cincinnati, Ohio, 1840; d. Brooklyn, N.Y., 1918*), mining engineer, editor. Brother of Charles W. Raymond. U.S. commissioner of mining statistics, 1868–76; was long associated with *American Journal of Mining* and with Cooper, Hewitt & Co. Secretary, American Institute of Mining Engineers, 1884–1911.

RAYNER, ISIDOR (*b. Baltimore, Md., 1850; d. Washington, D.C., 1912*), lawyer, legislator. Congressman, Democrat, from Maryland, 1887–89, 1891–95. After attracting national attention as counsel for Adm. W. S. Schley in the Santiago inquiry, he was U.S. senator from Maryland, 1905–12.

RAYNER, KENNETH (*b. Bertie Co., N.C., ca. 1810; d. 1884*), planter, North Carolina legislator and Whig congressman. An enthusiastic Know-Nothing in the middle 1850's, he verged from aggressive Unionism to whole-hearted secessionism between 1855 and 1861; by 1863, he was engaging in secret moves for peace. Removing to Tennessee, 1869, and later to Mississippi, he became a Republican. He was a judge of the *Alabama* claims commission, 1874–77, and solicitor of the U.S. treasury thereafter until his death.

RAZAF, ANDY (*b. Andrea Paul Razafkeriefo, Washington, D.C., 1895; d. Los Angeles, Calif., 1973*), lyricist and composer. Dropped out of high school and held various jobs while struggling to establish himself as a songwriter. He sold his first song in 1913, then worked with blues and jazz musicians, and sold several popular and enduring songs, including "S'posin'" (1929), "Ain't Misbehavin'" (1929), and "Honeysuckle Rose" (1929). He collaborated with Eubie Blake on the revue *Blackbirds* (1930), then wrote the music and memorable lyrics for the songs "That's What I Like 'Bout the South" (1933), "Stompin' at the Savoy" (1936), and "In the Mood" (1939).

REA, SAMUEL (*b. Hollidaysburg, Pa., 1855; d. Gladwyne, Pa., 1929*), civil engineer, expert in railroad construction and finance. President, Pennsylvania Railroad, 1913–25.

REACH, ALFRED JAMES (*b. London, England, 1840; d. Atlantic City, N.J., 1928*), baseball player, sporting-goods manufacturer.

READ, CHARLES (*b. Philadelphia, Pa., ca. 1713; d. Martinburg, N.C., 1774*), colonial New Jersey lawyer, land speculator, ironmaster, and official. A powerful figure in New Jersey, 1747–71, Read came on evil days and died as a small shopkeeper. He was notable as an agricultural experimenter and as a pioneer in the bog-iron industry and held a dominant position in New Jersey politics.

READ, CHARLES WILLIAM (*b. Yazoo Co., Miss., 1840; d. Meridian, Miss., 1890*), Confederate naval officer. Graduated U.S. Naval Academy, 1860; entered Confederate service, April 1861. As junior officer in Mississippi River campaigns, 1861–62, and as lieutenant commanding several commerce raiders, 1863–65, Read made a record of active service unsurpassed by any of his rank, North or South.

READ, CONYERS (*b. Philadelphia, Pa., 1881; d. 1959*), historian. Attended Harvard University (Ph.D., 1908), Oxford University (B. Litt., 1909). Taught at the University of Chicago, 1911 until World War I when he served with the Red Cross. After the war, Read worked in his family textile business until 1933. Professor at the University of Pennsylvania, 1934–51. An expert on Tudor history, Read wrote *Mr. Secretary Walsingham and the Policy of Queen Elizabeth* (1925), *Bibliography of British History, Tudor Period* (1933), and *The Tudors* (1936). Served as a British

specialist for the Office of Strategic Services in World War II. President of the American Historical Association in 1949.

READ, DANIEL (*b. Rehoboth, present Attleboro, Mass., 1757; d. New Haven, Conn., 1836*), musician, composer. Partner in publishing business of Amos Doolittle. Author of *The American Singing Book* (1785), *An Introduction to Psalmody* (1790), *The Columbian Harmonist* (1793), and others; edited *The American Musical Magazine*, 1786–87, first periodical of its kind.

READ, DANIEL (*b. near Marietta, Ohio, 1805; d. Keokuk, Iowa, 1878*), educator. Graduated Ohio University, 1824. Taught at Ohio, Indiana State, and University of Wisconsin; modernized and expanded University of Missouri as president, 1867–76.

READ, GEORGE (*b. near North East, Md., 1733; d. 1798*), lawyer, statesman. Raised in New Castle, Del., where he practiced law *post* 1754; served as attorney general for the Lower Counties, 1763–74, and as a provincial assemblyman. A moderate Whig, much like his friend John Dickinson, he was a member of the First Continental Congress and of the Second Congress until 1777. Refusing to vote for the resolution of independence on July 2, 1776, he signed the Declaration and upheld it following its adoption. Dominant in the Delaware constitutional convention, 1776, he was elected to the legislative council and became its speaker and vice president of the state; he was acting president, November 1777 to March 1778. Resigning in 1779, he returned to the council, 1782–88. Jealous of the power that might be exerted by the larger states, he disapproved of some provisions of the Articles of Confederation; later, as a delegate to the federal convention, he was outspoken in defence of the rights of the smaller states. He finally accepted the compromise on representation, however, and largely through his efforts Delaware was the first state to ratify the U.S. Constitution. U.S. senator, Federalist, 1789–93, he was thereafter chief justice of Delaware.

READ, GEORGE CAMPBELL (*b. Ireland, 1787; d. Philadelphia, Pa., 1862*), naval officer. Served with credit aboard *Constitution* and *United States* in War of 1812; bombarded Quallah Battoo, Sumatra, 1838, in reprisal for plunder of an American merchant ship by the natives.

READ, GEORGE WINDLE (*b. Indianola, Iowa, 1860; d. Washington, D.C., 1934*), army officer. Graduated West Point, 1883. Showed marked abilities as a colonial administrator in Cuba and the Philippines; organized and commanded the II Army Corps in World War I; retired as major general, 1924.

READ, JACOB (*b. "Hobcaw," Christ Church Parish, S.C., 1752; d. Charleston, S.C., 1816*), Revolutionary soldier, lawyer, South Carolina legislator and congressman. Speaker of South Carolina House of Representatives, 1787–94; U.S. senator, Federalist, 1795–1801. One of the "midnight" judges of 1801.

READ, JOHN (*b. Fairfield, Conn., 1679/80; d. 1749*), lawyer. Graduated Harvard, 1697. After an early trial of the ministry, he was admitted to the Connecticut bar, 1708; he removed to Boston, Mass., 1721. Elected attorney general of the province repeatedly *post* 1721, he served only in 1723, 1726, and 1734 because of a dispute between governor and legislature over the right to appoint to this office. First lawyer to represent Boston in the General Court (1738) under the second charter, Read served on the Governor's Council, 1741–42. Outstanding as a counsel in his time, he had a great influence on the development of New England legal practices and in particular on the modernizing and simplifying of forms. He also engaged in extensive real-estate transactions.

READ, JOHN (*b. New Castle, Del., 1769; d. Trenton, N.J., 1854*), lawyer. Son of George Read; father of John M. Read (1797–1874). Practiced in Philadelphia *post* 1792; was active in the city's political and social life.

READ, JOHN MEREDITH (*b. Philadelphia, Pa., 1797; d. 1874*), jurist. Grandson of George Read; son of John Read; father of John M. Read (1837–96). U.S. district attorney for eastern Pennsylvania, 1837–41; attorney general of Pennsylvania, 1846; Pennsylvania supreme court justice, 1858–73 (chief justice, 1872–73). Opposed extension of slavery; was an early adherent of the Republican party.

READ, JOHN MEREDITH (*b. Philadelphia, Pa., 1837; d. Paris, France, 1896*), lawyer, diplomat. Son of John M. Read (1797–1874). U.S. consul general at Paris, 1869–73; U.S. minister resident in Greece, 1873–79.

READ, NATHAN (*b. Warren, Mass., 1759; d. Belfast, Maine, 1849*), iron manufacturer. Graduated Harvard, 1781; taught there, 1783–87. Settling as an apothecary in Salem, Mass., he conducted experiments on the application of the steam engine to land and water transportation. Having designed a multitubular steam boiler and an improved double-acting engine and also a form of paddle wheel, he petitioned Congress in 1790 for a patent on these plans for a steamboat, and also for a steam road carriage. In August 1791 he was granted a patent for the boiler and the engine and for a chain wheel method of propelling boats which he had added to his earlier application. Unable to secure financial help in building a vessel, he dropped his plans and engaged in iron manufacturing and farming.

READ, OPIE POPE (*b. Nashville, Tenn., 1852; d. Chicago, Ill., 1939*), author, humorist. After experience as a journalist in Tennessee, Arkansas, and Kentucky, Read founded the *Arkansaw Traveler* in Little Rock, 1882, a humorous weekly which became one of the most widely quoted papers in America. Relinquishing editorship, 1891, he concentrated on fiction, turning out some forty novels and collections of humorous stories and was in his later years a great favorite on the Chautauqua and lecture circuits. His work enjoyed great success, 1890–1900; one of his books, *The Jucklins* (1896), was said to have sold over a million copies.

READ, THOMAS (*b. Newcastle Co., Del., ca. 1740; d. Fieldsboro, N.J., 1788*), naval officer. Brother of George Read. Served with ability in both the Pennsylvania and the Continental navies, 1775–79, and as a privateer; sailed the frigate *Alliance* from Philadelphia to Canton, China, 1787–88, in a remarkably fast voyage by a new route.

READ, THOMAS BUCHANAN (*b. near Guthriesville, Pa., 1822; d. New York, N.Y., 1872*), painter, poet. Assisted Shobal V. Clevenger in Cincinnati, Ohio; worked as an itinerant portrait painter; was helped by Nicholas Longworth. Won success in Boston *post* 1841; removed to Philadelphia, 1846; resided in Florence, Italy, 1853–55, and in Rome, Italy, 1866–72. He published a number of volumes of verse which were extravagantly praised at the time, but his work was derivative and unpolished; of his shorter pieces, "Drifting" and "Sheridan's Ride" are alone remembered. His work as a painter was merely competent.

READE, EDWIN GODWIN (*b. Mount Tirzah, N.C., 1812; d. 1894*), lawyer, North Carolina supreme court justice, banker.

REAGAN, JOHN HENNINGER (*b. Sevier Co., Tenn., 1818; d. 1905*), surveyor, lawyer, Texas jurist, Confederate official. Congressman, moderate Democrat, from Texas, 1857–61. Member

of the secession convention of Texas, 1861, and of the provisional Congress of the Confederacy, he was appointed Confederate postmaster general, March 1861, and served until the close of the Civil War. Advising Texans to accept the results of the war, acknowledge the extinction of slavery, and admit blacks to civil rights lest the state suffer the evils of military government, he lost political standing in the state but by 1875 had recovered his position and was returned to Congress. In the House of Representatives, 1875–87, he stood for orthodox Democratic policies and was for ten years chairman of the committee on commerce. He was U.S. senator, 1887–91, and in the latter year accepted the chairmanship of the Texas railroad commission which he held until 1903. His greatest service in Congress was the joint authorship and advocacy of the bill to establish the Interstate Commerce Commission (1887).

REALF, RICHARD (*b. Framfield, England, 1834; d. Oakland, Calif., 1878*), Abolitionist, Union soldier, journalist, poet. Came to America, 1854; was a newspaper correspondent in Kansas, 1856. Associated with John Brown (1800–1859), he was a prominent member of Brown's convention at Chatham, Canada, May 1858, and was chosen secretary of state in the mysterious scheme of government which Brown hoped to establish. A tragic figure, he died a suicide; his poems were collected and published as a book in 1898.

REAM, NORMAN BRUCE (*b. Somerset Co., Pa., 1844; d. 1915*), capitalist. Settling in Chicago, Ill., 1871, he became a successful speculator in livestock and grain. Removing to New York City, 1895, he was an associate of the elder J. P. Morgan and others in corporate reorganizations and mergers, notably of the Baltimore & Ohio Railroad, the National Biscuit Co., and the Federal Steel Co.

RECORD, SAMUEL JAMES (*b. Crawfordsville, Ind., 1881; d. New Haven, Conn., 1945*), forester. B.A., Wabash College, 1903; M.A., 1906. Master of Forestry, Yale, as of 1905. Associated with the U.S. Forest Service, 1904–10, he then joined the Yale faculty as instructor in forestry; he was made professor in 1917, and dean of the School of Forestry, 1939. Early interested in study of the systematic anatomy of woods throughout the world, he was author, among other works, of *Identification of the Economic Woods in the United States* (1912), *The Mechanical Properties of Wood* (1914), and *Timbers of Tropical America* (1924, in collaboration with C. D. Mell).

RECTOR, HENRY MASSEY (*b. Louisville, Ky., 1816; d. 1899*), planter, lawyer. Removed to Arkansas ca. 1835 where he served in the legislature and as a judge of the supreme court. An active secessionist, he was Democratic governor of Arkansas, 1860–62.

RED CLOUD (*b. Blue Creek, Nebr., 1822; d. Pine Ridge, S. Dak., 1909*), chief of the Oglala Sioux. A noted warrior, Red Cloud took his band of hostile Sioux and Cheyenne on the war path, 1866, in protest against the opening of the Bozeman Trail and the building of forts along it in Sioux territory. He commanded the Indian forces at the Fetterman massacre, December 1866, and at the Wagon Box fight, August 1867. His able and resolute campaign induced the government to yield. The trail was closed by the treaty of 1868 and the three forts abandoned. Although a persistent critic of the government and of its Indian agents whom he charged with fraud, he was an advocate of peace thereafter.

RED EAGLE See WEATHERFORD, WILLIAM.

RED JACKET (*b. probably Canoga, present Seneca Co., N.Y., ca. 1758; d. 1830*), Seneca chief. Indian name, Sagoyewatha.

Skilled in oratory and political trickery, he played for popularity in his tribe, 1779–90, by attacking the unsuccessful policy of Cornplanter and other leaders and by haranguing against the whites and peace. Once his position as a chief among the Iroquois was assured, he worked for peace with the United States and avoidance of trouble with the British, hoping thus to maintain the independence of his people. Bitterly opposed to any encroachment of white civilization, he was at the height of his power, 1815–25. As the Christian party among the Seneca grew and because of his own increasing addiction to drink, he gradually lost influence.

RED WING (*b. probably near present Red Wing, Minn., ca. 1750; d. place unknown, ca. 1825*), chief of the Khemnichan band of Mdewakanton Sioux. Outstanding as a warrior, he adopted a policy of peace *post* 1814.

REDFIELD, AMASA ANGELL (*b. Clyde, N.Y., 1837; d. Farmington, Conn., 1902*), lawyer. Practiced *post* 1862 in New York City; was an authority on surrogate practice and on negligence. Author, among other works, of *Law and Practice of Surrogates' Courts* (1875) and *A Treatise on the Law of Negligence* (with T. G. Shearman, 1869).

REDFIELD, ISAAC FLETCHER (*b. Weathersfield, Vt., 1804; d. Charlestown, Mass., 1876*), lawyer. Vermont supreme court justice, 1835–60 (chief justice, 1852–60). Author of *Practical Treatise upon the Law of Railways* (1858), *The Law of Wills* (1864–70), *The Law of Carriers* (1869), and other works. He was associated with Caleb Cushing, 1867–69, as a special U.S. counsel in Civil War claims cases against Great Britain.

REDFIELD, JUSTUS STARR (*b. Wallingford, Conn., 1810; d. Florence, N.J., 1888*), publisher. A successful printer and general publisher in New York City, 1841–60, he brought out collected editions of authors, among them W. G. Simms, and the 1850–56 edition of Edgar A. Poe.

REDFIELD, ROBERT (*b. Chicago, Ill., 1897; d. Chicago, Ill., 1958*), anthropologist. Attended the University of Chicago (Ph.B., 1920; Ph.D. in anthropology, 1928). Taught at the University of Chicago, 1927–53; dean of the Division of Social Sciences, 1934–46. His early research in Mexico helped develop social anthropology in Mexico and was a starting point of modern research on contemporary peasant societies. Works include *Tepoztlán* (1930), *The Folk Culture of Yucatán* (1941), *A Village that Chose Progress* (1950), and *The Primitive World and Its Transformations* (1953). Redfield's expertise was in the confrontation of primitive societies with the forces of technology. Was president of the American Anthropological Association in 1944.

REDFIELD, WILLIAM C. (*b. Middletown, Conn., 1789; d. New York, N.Y., 1857*), saddler, meteorologist, transportation promoter. Observing the "great September gale," 1821, in western Massachusetts, Redfield explained the nature of such storms in a meteorological classic "Observations on the Hurricanes and Storms of the West Indies and the Coast of the United States" (*American Journal of Science and Arts*, October 1833). This article and a previous one in the same periodical, 1831, were the first of any importance on their subject. He also proposed and put into successful operation between New York and Albany the tow method of conveying freight in barges and wrote a number of pamphlets advocating railroad construction.

REDFIELD, WILLIAM COX (*b. Albany, N.Y., 1858; d. New York, N.Y., 1932*), machinery manufacturer, statesman. Congressman, Democrat, from New York, 1911–13; U.S. secretary of commerce, 1913–19. A strong factor in Woodrow Wilson's election

as president, 1912, Redfield reorganized and enlarged the commerce department, strengthened the Bureau of Standards, and, as a keen student of economic tendencies, was of great value in the cabinet during World War I.

REDMAN, BEN RAY (b. *Brooklyn, N.Y., 1896; d. Hollywood, Calif., 1961*), author, editor, and critic. Attended Columbia, 1914–15. Literary editor of the *Spur* (1922–29), managing editor of *Travel* (1923), and editorial and advertising manager for G. P. Putnam and Sons (1924–26). A prolific and diverse free-lance writer, his book reviews for the *New York Herald-Tribune* (1926–37) and the *Saturday Review of Literature* (1925–61) suggest the extensive and persistent influence he exerted on American literary taste. Also composed short stories, a volume of poetry (*Masquerade*, 1923), and several mysteries, including *The Bannerman Case* (1935) and *Sixty-Nine Diamonds* (1940).

REDMAN, JOHN (b. *Philadelphia, Pa., 1722; d. 1808*), physician. Studied medicine with John Kearsley; studied also at Edinburgh, London, and Paris and was graduated M.D., University of Leyden, 1748. An ardent follower of Boerhaave and Sydenham, he practiced and taught in Philadelphia, was a consulting physician to the Pennsylvania Hospital, and was president of the College of Physicians of Philadelphia, 1786–1804. Among his pupils were John Morgan, Benjamin Rush, and Caspar Wistar.

REDPATH, JAMES (b. *Berwick-on-Tweed, Scotland, 1833; d. New York, N.Y., 1891*), journalist, editor. Immigrated to Michigan ca. 1850; became associated with the *New York Tribune*, 1852; attracted wide attention for articles on the political troubles in Kansas, slavery in the Southern states, and John Brown. An ardent abolitionist, he aided Haiti in securing recognition of its independence and helped ex-slaves to immigrate there from the United States. He established the Redpath Lyceum Bureau in Boston, 1868.

REDWOOD, ABRAHAM (b. *Antigua, W. I., 1709; d. 1788*), merchant, philanthropist. Brought to Philadelphia as a child; removed to Newport, R. I., 1726. Interested in the cultural and literary activity of colonial Newport, Redwood made the principal contribution towards the founding of a public library there, 1747.

REECE, BRAZILLA CARROLL (b. *Johnson County, Tenn., 1889; d. Bethesda, Md., 1961*), U.S. congressman from Tennessee (1920–30, 1932–46, 1950–61). Attended Carson-Newman College, New York University (M.A., 1916), and University of London. Emerged as one of the leading critics of the Roosevelt and Truman administrations, and by 1946 was considered to be the leading Republican politician in the South. Member of the House Rules, Interstate Commerce, and Military Affairs committees. Chairman of a special committee (1954) that issued a controversial report chastising large foundations for "directly supporting subversion" and dodging taxes on large fortunes. Was Republican national committeeman from Tennessee, 1939 until his death, and chairman of the Republican National Committee, 1946–48.

REED, DANIEL ALDEN (b. *Sheridan, N.Y., 1875; d. Washington, D.C., 1959*), congressman. Studied at Cornell University (LL.B., 1898). Elected as a Republican to the U.S. Congress from 1918. Served on the House Ways and Means Committee from 1933 and was chairman, 1953–54. An ardent advocate of tax reduction legislation, he clashed with the Eisenhower administration. Resigned his chairmanship in 1955.

REED, DAVID (b. *Easton, Mass., 1790; d. 1870*), Unitarian clergyman. Founder, publisher, and editor of the *Christian Register*, 1821–66.

REED, DAVID AIKEN (b. *Pittsburgh, Pa., 1880; d. Sarasota, Fla., 1953*), lawyer, U.S. senator. Studied at Princeton University and the University of Pittsburgh law school. Practiced law in Pittsburgh, often appearing before the U.S. Supreme Court, before serving in the army in France during World War I. A protégé of Andrew Mellon, he was appointed to fill a vacancy in the U.S. Senate, 1922, and was elected later that year as conservative Republican. Author of the Reed-Johnson Immigration Act (1924), which sought to preserve the racial status quo by apportioning quotas to each "national stock" according to its representation in the population in 1920. This practice was especially prejudicial to the peoples of southern Europe and the Orient, while favoring the populations of northern Europe. The effects of this policy, especially on Japan, were considered one of many important factors leading to World War II. Lost his seat in the Senate, 1934, and returned to private law practice in Pittsburgh.

REED, EARL HOWELL (b. *Geneva, Ill., 1863; d. 1931*), author, etcher. Son of Elizabeth A. Reed; brother of Myrtle Reed.

REED, ELIZABETH ARMSTRONG (b. *Winthrop, Maine, 1842; d. 1915*), writer on Oriental literature. Mother of Earl H. and Myrtle Reed.

REED, HENRY HOPE (b. *Philadelphia, Pa., 1808; d. at sea, aboard steamer Arctic, 1854*), educator. Grandson of Joseph Reed; brother of William B. Reed. Graduated University of Pennsylvania, 1825; was professor of rhetoric and English literature there, 1835–54. Author and editor of a number of works in belles lettres, Reed was the first American exponent of William Wordsworth and did more than anyone else to secure Wordsworth's fame in America.

REED, JAMES (b. *Woburn, Mass., 1722 o.s.; d. Fitchburg, Mass., 1807*), soldier in the French and Indian War and in the Revolution. Serving as colonel of the 2nd Continental regiment at Ticonderoga, July 1776, he was stricken with an illness that destroyed his sight; he retired in September as brigadier general. He was an original proprietor of Fitzwilliam, N.H.

REED, JAMES (b. *Boston, Mass., 1834; d. Boston, 1921*), minister of the Church of the New Jerusalem. Son of Sampson Reed. Graduated Harvard, 1855; ministered in Boston *post* 1860.

REED, JAMES ALEXANDER (b. *near Mansfield, Ohio, 1861; d. near Fairview, Mich., 1944*), lawyer, politician. Raised in Linn County, Iowa, was admitted to the bar, 1885; removed to Kansas City, Mo., 1887. Reed's first public post was city counselor (1897–98), followed by election as prosecuting attorney of Jackson County, which included Kansas City. He swept into the mayor's chair in 1900 as a reform candidate. Leading a consumers' war on street railway, electric, and telephone utilities, he won reelection in 1902. He was elected to the U.S. Senate in 1910, and was reelected by statewide vote, with increasing majorities, in 1916 and 1922.

In the Senate, Reed generally supported the Wilson administration's New Freedom legislation and its foreign policies, including the declaration of war against Germany in 1917. But he soon turned against wartime measures, especially economic controls. Reed's criticism of the conduct of the war paled beside his utterly uncompromising stand against the Versailles peace treaty and in particular against the covenant of the League of Nations. He likewise opposed the war's debt settlements and the four-

power treaty proposed by the Washington Conference on arms limitation in 1921.

Reed made a serious bid for the Democratic presidential nomination in 1928, and consequently did not run for reelection to the Senate. Upon leaving Washington he resumed his law practice in Kansas City. Increasingly opposed to government "paternalism" and "socialist or regulatory schemes," he became a foe of the New Deal and of President Franklin D. Roosevelt. In 1936 he organized the National Jeffersonian Democrats and stumped for Alfred M. Landon; four years later he again supported the Republican nominee, Wendell L. Willkie.

REED, JAMES HAY (b. Allegheny, Pa., 1853; d. Pittsburgh, Pa., 1927), lawyer. Partner in practice of corporation law with Philander C. Knox until 1901, Reed was counsel to Andrew Carnegie, to the Vanderbilt interests in the Pittsburgh district, and to many other large business concerns.

REED, JOHN (b. Hesse-Cassel, Germany, 1757; d. Cabarrus Co., N.C., 1845), Hessian soldier, farmer, gold miner. Settling in Mecklenburg, present Cabarrus Co., N.C., after the Revolution, Reed began successful placer mining operations on his farm ca. 1803 which set off activity in an industry soon second in economic importance only to agriculture in the state. Post 1831, he worked his mine with shafts and steam power; the total yield between 1803 and 1845 has been estimated at ten million dollars.

REED, JOHN (b. Portland, Oreg., 1887; d. Russia, 1920), journalist. Graduated Harvard, 1910. His interest in the problems of society aroused ca. 1913 by Lincoln Steffens and Ida Tarbell, he took up a far more radical position than theirs. He joined staff of The Masses and engaged actively on behalf of the Paterson, N.J., silk strikers, 1914. Brilliant but biased articles on the Mexican revolution brought him national reputation as a war correspondent and he covered World War I successively with the armies of Germany, Serbia, Bulgaria, Romania, and Russia. His reports were published as The War in Eastern Europe (1916). An enthusiastic observer of the October revolution in Petrograd, 1917, Reed became a close friend of Lenin and wrote much of the Bolshevist propaganda dropped over the German lines. Returning to America, he published Red Russia and Ten Days that Shook the World (both in 1919) and was expelled with other left-wingers from the National Socialist Convention, August 1919. When the left-wing groups split into two bitterly hostile factions known as the Communist party and the Communist Labor party, Reed headed the latter. Indicted for sedition, he left America by means of a forged passport, was imprisoned briefly in Finland, and at last reached Russia where he died of typhus.

REED, JOSEPH (b. Trenton, N.J., 1741; d. Philadelphia, Pa., 1785), lawyer, Revolutionary soldier and statesman. Graduated College of New Jersey (Princeton), 1757; studied law with Richard Stockton and at the Middle Temple, London. Engaging in legal practice and also in the iron trade and real-estate business, he was appointed deputy secretary of New Jersey, 1767; he removed his practice to Philadelphia ca. 1770. Appointed a member of the committee of correspondence for Philadelphia, November 1774, he served as president of the second Provincial Congress early in 1775 and gradually shifted from a belief in accommodation with England to a feeling that independence was essential. On Washington's appointment as commander-in-chief, Reed became his military secretary and was later adjutant general of the Continental Army with the rank of colonel. He was of great service to Washington in the campaign of Trenton and Princeton and served with credit at the battles of Brandywine, Germantown and Monmouth. Delegate to the Continen-

tal Congress, 1777–78, he served on important committees, and in December 1778 was chosen president of the Supreme Executive Council of Pennsylvania, serving until 1781. The many attacks made on his reputation as a soldier and patriot were without foundation.

REED, LUMAN (b. Austerlitz, N.Y., 1781; d. 1836), New York merchant. Remembered as one of the earliest patrons of American painting, he encouraged, among others, A. B. Durand, Thomas Cole and W. S. Mount.

REED, MARY (b. Lowell, Ohio, 1854; d. Chandag, Kumaon District, India, 1943), Methodist Episcopal missionary to India post 1884. Headed the leper asylum at Chandag near Almora, 1891–1943.

REED, MYRTLE (b. Norwood Park, Ill., 1874; d. 1911), writer. Daughter of Elizabeth A. Reed; sister of E. H. Reed. Author of a number of deftly written and popular romances of which the most successful was Lavender and Old Lace (1902).

REED, RICHARD CLARK (b. near Soddy, Tenn., 1851; d. Columbia, S.C., 1925), Presbyterian clergyman, educator, author. Professor of church history, Columbia Theological Seminary, 1898–1925.

REED, SAMPSON (b. West Bridgewater, Mass., 1800; d. Boston, Mass., 1880), Swedenborgian writer, wholesale drug merchant. Author of several works of which Observations on the Growth of the Mind (1826) exerted great influence on R. W. Emerson.

REED, SIMEON GANNETT (b. East Abington, Mass., 1830; d. 1895), merchant, steamboat operator. Settled in Portland, Oreg., ca. 1852; was partner in the Oregon Steam and Navigation Co. and other successful enterprises. His fortune was used to found Reed College, opened 1911.

REED, STANLEY FORMAN (b. Minerva, Ky., 1884; d. Long Island, N.Y., 1980), Supreme Court justice. Graduated Kentucky Wesleyan College (B.A., 1902) and Yale College (B.A., 1906) and attended University of Virginia Law School and Columbia Law School. Established a law practice in Kentucky and in the 1930's was counsel for several federal government agencies and served briefly as solicitor general. He was appointed to the Supreme Court in 1935. Reed, who exhibited no overriding judicial philosophy, was viewed as a swing vote in Supreme Court rulings. He generally supported the rights of labor and government agencies, though he voted against President Harry Truman's seizure of the steel mills in 1952. Reed wrote several highly regarded opinions concerning civil rights, including a 1944 opinion in Smith v. Allwright, which abolished the whites-only Democratic primary in Texas. He retired from the Court in 1957.

REED, THOMAS BRACKETT (b. Portland, Maine, 1839; d. Washington, D.C., 1902), lawyer, Maine legislator, parliamentarian. Graduated Bowdoin, 1860. As congressman, Republican, from Maine, 1877–99, Reed became famous for the sarcasm and invective which he employed in debate and in his committee work. Appointed to the committee on rules, 1882, he began a long fight for reform of the rules of the House, proposing that procedural checks be removed in order that the majority party might actually govern. Elected speaker, December 1889, he forced adoption in February of the famous "Reed Rules," whereby he was able to expedite passage of the Republican legislative program. He was also a noted exponent of protectionism. Replaced as speaker and his rules voided, 1891, he labored to rehabilitate the Republican party after its defeats in 1890 and 1892; he supported President Cleveland's sound-money policy

but opposed all tariff reforms. Serving again as speaker, 1895–99, he brought about the return of the "Reed Rules." Resenting failure of the Republicans to nominate him for the presidency, 1896, he supported the McKinley administration until 1898 when he expressed bitter opposition to expansionism. Following the war with Spain and the annexation of Hawaii, Reed resigned in disgust and returned to the practice of law in New York City. His epigrams have become part of American political tradition. "A statesman," he once said, "is a successful politician who is dead."

REED, WALTER (*b. Belroi, Va., 1851; d. Washington, D.C., 1902*), physician, head of the U.S. Army Yellow Fever Commission. M.D., University of Virginia, 1869; M.D., Bellevue Hospital Medical College, New York City, 1870. Commissioned in the U.S. Army medical corps, 1875, he spent a number of years on frontier garrison duty. Requesting leave of absence for postgraduate work, 1890, he made specialized studies in bacteriology at Johns Hopkins Hospital; in 1893, he was detailed as professor of bacteriology and microscopy at the Army Medical School with James Carroll as assistant. Interested especially in the bacteriology of erysipelas and diphtheria, he served also as chairman of a committee to investigate causes and mode of transmission of typhoid fever. In 1900, having some experience with the problems involved, he was put at the head of a commission of U.S. Army medical officers to investigate cause and mode of transmission of yellow fever in Havana, Cuba. Reed was to have general superintendence of the investigation, James Carroll was bacteriologist, Jesse W. Lazear was entomologist, and other distinguished officers also served. The commission established by experimentation on human subjects (which resulted in the crippling of Dr. Carroll and the death of Dr. Lazear) that the disease was transmitted by mosquitoes, later definitely classified as the *Aëdes aegypti*. The commission worked from June 1900 to February 1901, and as a result of its findings and subsequent limitation of the carrier, yellow fever has virtually ceased to be a hazard in the United States.

REED, WILLIAM BRADFORD (*b. Philadelphia, Pa., 1806; d. New York, N.Y., 1876*), lawyer. Brother of Henry H. Reed; grandson of Joseph Reed. Originally a Whig, Reed became a Democrat in 1856, supported Buchanan in the campaign of that year, and was appointed U.S. minister to China. Serving in China from November 1857 until 1859, he concluded the treaty of Tientsin, 1858. His bitter and open opposition to the Civil War cost him his social and professional standing.

REEDER, ANDREW HORATIO (*b. Easton, Pa., 1807; d. 1864*), lawyer. Unsuccessful Democratic governor of Kansas Territory, 1854–55, Reeder became a Free State spokesman after his removal from the governorship for incapacity and land speculation.

REEDY, WILLIAM MARION (*b. St. Louis, Mo., 1862; d. San Francisco, Calif., 1920*), journalist. Editor of *Reedy's Mirror* (St. Louis), *post* 1893. Beginning as a society journal, the paper became under Reedy a link between the cultures of the East Coast and the Middle West and introduced in its pages many writers who became famous in the 1920's.

REES, JAMES (*b. Wales, 1821; d. 1889*), steamboat builder. Came to America as a child; was raised near present Wheeling, W. Va. Founder of a successful engine and boat-works at Pittsburgh, Pa., he popularized the "stern-wheeler" and invented a number of improvements in steamboat construction. He was an early advocate of the ten-hour day.

REES, JOHN KROM (*b. New York, N.Y., 1851; d. 1907*), geodesist, astronomer. Graduated Columbia, 1872; Columbia School

of Mines, 1875. Director of the observatory at Columbia *post* 1881, he also taught astronomy; as secretary, American Meteorological Society, he advocated introduction of standard time.

REESE, ABRAM (*b. Llanelly, South Wales, 1829; d. Pittsburgh, Pa., 1908*), iron and machinery manufacturer. Brother of Isaac and Jacob Reese. Came to America as a child. Held a number of patents, issued *post* 1859, for perfection and improvement of machinery for rolling iron and steel; patented a universal rolling mill, 1892.

REESE, CHARLES LEE (*b. Baltimore, Md., 1862; d. Florida, 1940*), chemist. Graduated University of Virginia, 1884; Ph.D. Heidelberg, 1886. Chief chemist and director of research laboratory, Du Pont Company, 1902–31, he was one of the outstanding industrial chemists of his day.

REESE, HELOISE BOWLES (*b. Fort Worth, Tex., 1919; d. San Antonio, Tex., 1977*), columnist and author. Started writing a column in the *Honolulu Advertiser* in 1959 that offered time- and money-saving housekeeping tips. "Hints from Heloise" was syndicated by King Features in 1961 and eventually appeared in more than 600 U.S. and foreign newspapers. She published six books, including *Heloise's Kitchen Hints* (1963) and *Heloise's Hints for the Working Woman* (1970), and made frequent radio and television appearances.

REESE, ISAAC (*b. Llanelly, South Wales, 1821; d. Pittsburgh, Pa., 1908*), brick manufacturer. Brother of Abram and Jacob Reese. Came to America as a child. Among other inventions he produced the "Reese Silica Brick," 1882, which was capable of withstanding very high temperatures with practically no shrinkage or expansion.

REESE, JACOB (*b. Llanelly, South Wales, 1825; d. near Philadelphia, Pa., 1907*), metallurgist. Brother of Abram and Isaac Reese. Came to America as a child. Among a great number of inventions useful in the manufacture of iron and steel, Reese perfected the basic open-hearth steel process *ca.* 1877, although his claim as inventor was not favorably decided by the Patent Office until 1881.

REESE, JOHN JAMES (*b. Philadelphia, Pa., 1818; d. Atlantic City, N.J., 1892*), toxicologist. Graduated University of Pennsylvania, 1836; M.D., 1839. Author of *A Text Book of Medical Jurisprudence and Toxicology* (1884), a standard work.

REESE, LIZETTE WOODWORTH (*b. near Baltimore, Md., 1856; d. 1935*), poet, educator. Educated chiefly in private schools; taught for many years in the public schools of Baltimore. Her lyrics, intensely felt and inspired by a keen sense of the beauty of common things, were uninfluenced in technique by fashionable poetic fads. Her first volume, *A Branch of May*, appeared in 1887; after the appearance of her *Selected Poems* (1926), she published *Little Henrietta* (1927), *White April and Other Poems* (1930), and several other volumes both in verse and prose.

REEVE, TAPPING (*b. Brookhaven, N.Y., 1744; d. Litchfield, Conn., 1823*), jurist, teacher of law. Graduated College of New Jersey (Princeton), 1763. Admitted to the Connecticut bar, 1772, he settled in Litchfield where he began the practice of his profession. After teaching law informally for some time Reeve formally opened the Litchfield Law School in 1784. With exception of the department of law at William and Mary under George Wythe, it was the first school of its kind in the United States. Appointed a judge of the superior court, he associated James Gould with the school as a teacher. Under Gould's direction the school developed and flourished, numbering among its gradu-

ates some of the most prominent men in the public life of the next generation. Reeve was made chief justice of the supreme court of errors of Connecticut, 1814, and served until his retirement, 1816.

REEVES, ARTHUR MIDDLETON (*b. Cincinnati, Ohio, 1856; d. near Hagerstown, Ind., 1891*), philologist, historian, authority on Old Norse.

REEVES, DANIEL F. (*b. New York City, 1912; d. New York City, 1971*), sports entrepreneur. Attended Georgetown University and worked in his family's grocery store chain until its merger with Safeway Stores in 1941, when he acquired two-thirds of the National Football League's Cleveland Rams franchise; that same year he purchased the New Jersey Giants of the American Professional Football Association. In 1946 he moved the Rams from Cleveland to Los Angeles, the first major league team of any sport to move to the West Coast, and hired the first black halfback, Kenny Washington, which lowered the color bar in professional sports. He also created a scouting network for the evaluation of college players that was copied by every other NFL team. He was inducted into the Football Hall of Fame in 1967.

REEVES, JOSEPH MASON (*b. Tampico, Ill., 1872; d. Bethesda, Md., 1948*), naval officer. Graduated U.S. Naval Academy, 1894; served in Spanish-American War aboard USS *Oregon* as engineer; transferred to the line, 1899. After a number of varied assignments, including command of the battleship *North Dakota* (1921–23), he took command in 1925 of Aircraft Squadrons, Battle Fleet, based at San Diego, Calif., and in three years' hard training shaped them into an effective striking arm. Promoted rear admiral, 1927, he was responsible for the training of flight crews for the *Saratoga* and the *Lexington*, thus contributing to the evolution of the carrier task force. In 1933 he became commander, Battle Fleet, and then for two years before his retirement in 1936 was commander in chief, U.S. Fleet, conducting peacetime exercises with a realism never before attained. Recalled to duty, 1940, he served on the lendlease and munitions assignment boards.

REGAN, AGNES GERTRUDE (*b. San Francisco, Calif., 1869; d. Washington D.C., 1943*), educator, social reformer. Executive secretary, National Council of Catholic Women, *post* 1920; assistant director, National Catholic School of Social Service, *post* 1925; authority in the field of social legislation.

REHAN, ADA (*b. Limerick, Ireland, 1860; d. New York, N.Y., 1916*), actress. Came to America as a child; was raised in Brooklyn, N.Y., After making her stage debut at Newark, N.J., 1873, she joined the Arch St. company, Philadelphia. Although her name was properly Ada Crehan, she was billed by a printer's error as Ada C. Rehan for her Philadelphia debut and preserved the mistake throughout her subsequent career. Playing in support of Fanny Devenport, Edwin Booth, Lawrence Barrett, John T. Raymond, and others, she joined Augustin Daly's company, 1879, and remained under Daly's management until he died, 1899. The leading woman of his company, she was a popular idol in New York and London and was considered the perfect mistress of the classic, artificial style of playing. Famous in many parts, her performance as Katherine in Shakespeare's *Taming of the Shrew* is considered her outstanding role. Her last public appearance was at a New York benefit for Madame Modjeska 1905

REID, FRANK KNOX MORTON (*b. Philadelphia, Pa., 1848; d. 1914*), artist, specialist in marines.

REICHEL, CHARLES GOTTHOLD (*b. Hermsdorff, Silesia, 1751; d. Niesky, Silesia, 1825*), Moravian bishop and educator. Prin-

cipal of the academy at Nazareth, Pa., 1785–1801; bishop of the southern province, 1801–11, and of the northern province, 1811–18. He was sent to Germany, 1818.

REICHEL, WILLIAM CORNELIUS (*b. Salem, N.C., 1824; d. 1876*), Moravian clergyman, educator. Grandson of Charles G. Reichel. Author of a number of historical studies on the Moravian Church in America.

REICHENBACH, HANS (*b. Hamburg, Germany, 1891; d. Los Angeles, Calif., 1953*), educator, philosopher of science, logician. Studied at the Technische Hochschule of Stuttgart, and the universities of Berlin, Munich, and Göttingen. Taught at the Technische Hochschule of Stuttgart, 1920–25. One of the first students to attend Einstein's seminar on relativity at the University of Berlin. Taught at the University of Berlin, 1925–33. From 1933 to 1938, having fled Hitler, he taught at the University of Istanbul. Immigrated to the United States in 1938 and remained at the University of California at Los Angeles until his death. Reichenbach's detailed technical knowledge of mathematics and physics, combined with profound philosophical penetration, made him a seminal philosopher of science and the preeminent champion of empiricism in philosophy of science in the twentieth century. Works include *Philosophie der Raum-Zeit-Lehre* (1928), *Experience and Prediction* (1938), and *The Direction of Time* (1956).

REICK, WILLIAM CHARLES (*b. Philadelphia, Pa., 1864; d. 1924*), journalist. As city editor, *New York Herald*, 1889–1903, he became known as one of America's ablest journalists. Holding the presidency of the New York Herald Co., 1903–07, he resigned, and after working for the *New York Times* and the Philadelphia *Public Ledger*, bought a controlling interest in the N.Y. *Sun*, 1911. He was afterwards president of the company which published the *New York Journal of Commerce*.

REID, CHRISTIAN *See* TIERNAN, FRANCES CHRISTINE FISHER.

REID, DAVID BOSWELL (*b. Edinburgh, Scotland, 1805; d. Washington, D.C., 1863*), chemist, educator, ventilation engineer. Resident in the United States, 1855–63.

REID, DAVID SETTLE (*b. Rockingham Co., N.C., 1813; d. 1891*), lawyer, North Carolina legislator. Congressman, Democrat, from North Carolina, 1843–47; governor, 1851–54; U.S. senator, 1854–59. A conservative pro-Southern man, Reid was considered the wisest and most resourceful Democratic leader in North Carolina between the day of Nathaniel Macon and the Civil War.

REID, GILBERT (*b. Laurel, N.Y., 1857; d. Shanghai, China, 1927*), Presbyterian clergyman, newspaper correspondent, missionary to China. Founded International Institute of China *ca.* 1897.

REID, HELEN MILES ROGERS (*b. Appleton, Wis., 1882; d. New York, N.Y., 1970*), newspaper executive. Attended Barnard (B.A., 1903), then was hired as social secretary to Elisabeth Mills Reid, wife of Whitelaw Reid, the owner of the *New York Tribune*. Married Ogden Mills Reid, their son, and became the *Tribune's* advertising director (1918); in her first two years the paper's advertising revenues more than doubled, As vice president of the paper (since 1922) she helped arrange the purchase of the *New York Herald* (1924); the expanded paper was renamed *Herald Tribune* and became one of the nation's best newspapers. Succeeded her husband as president (1947) and brought such noted columnists and writers as Walter Lippmann, Dorothy Thompson, and Clementine Paddleford to the paper. In the late 1930's the paper began to lose circulation and advertising revenues to the *New*

York Times because of her higher advertising prices; she sold the paper in 1958. Trustee of Barnard (1914–56) and chairman (1947–70).

REID, IRA DE AUGUSTINE (*b. Clifton Forge, Va., 1901; d. Bryn Mawr, Pa., 1968*), sociologist and educator. Attended Morehouse College, universities of Chicago and Pittsburgh, and Columbia (Ph.D., 1939). As industrial secretary of the New York Urban League, 1925–28, he surveyed the living conditions of low-income black families. Gathered data for the National Interracial Conference (1928), which yielded the landmark *The Negro in American Civilization* (1930). Became director of research and investigations for the league (1928) and published one of the first reliable studies of blacks in the work force, *Negro Membership in American Labor Unions* (1930). Taught at Atlanta University (1934–44), New York University School of Education (1945–47), and Haverford College (1946–66).

REID, JAMES L. (*b. near Russellville, Ohio, 1844; d. 1910*), corn breeder. Raised in Illinois where, after a number of experiments, he produced the corn variety known as Reid's Yellow Dent *ante* 1880.

REID, JOHN MORRISON (*b. New York, N.Y., 1820; d. New York, 1896*), Methodist clergyman. President of Genesee College (nucleus of present Syracuse University), 1858–64; did valuable work as corresponding secretary, Methodist Missionary Society, 1872–88.

REID, MAYNE See REID, THOMAS MAYNE.

REID, MONT ROGERS (*b. near Oriskany, Va., 1889; d. Cincinnati, Ohio, 1943*), surgeon. A.B., Roanoke College, 1908. M.D., Johns Hopkins, 1912. Worked at Johns Hopkins Hospital under William S. Halstead, becoming chief resident in surgery, 1918. Associate professor of surgery, University of Cincinnati, 1922–31, and chairman of the department thereafter, he made it one of the great U.S. training centers for surgeons. His chief research contributions were his experimental and clinical studies of surgery of the thyroid and of the large blood vessels, also his work in surgical treatment of angina pectoris and cancer.

REID, OGDEN MILLS (*b. New York, N.Y., 1882; d. New York, 1947*), newspaper editor and publisher. Son of Whitelaw Reid. B.A., Yale, 1904; LL.B., 1907. Joining the staff of the *New York Tribune*, 1908, he was named editor early in 1913 and held that post until his death. In 1924 he acquired the *New York Herald*; thereafter the combined papers were published as the *Herald Tribune*.

REID, ROBERT (*b. Stockbridge, Mass., 1862; d. Clifton Springs, N.Y., 1929*), portrait, figure and mural painter.

REID, ROSE MARIE (*b. Cardston, Canada, 1906; d. Provo, Utah, 1978*), bathing suit designer. Began designing women's bathing suits utilizing cotton instead of wool, then the traditional suit fabric, in the 1930's, and her innovation significantly improved the comfort and utility of bathing suits. In 1946 she moved her firm from Canada to California, where she developed a thriving business; by 1960 her firm enjoyed annual sales of $18.4 million. Reid helped transform the woman's bathing suit into a fashion item, developing bathing suit lines for such settings as recreation and summer cruises. In the 1960's she refused to design bikinis, terming them "vulgar."

REID, SAMUEL CHESTER (*b. Norwich, Conn., 1783; d. New York, N.Y., 1861*), sea captain. Distinguished for his heroic conduct as commander of the privateer *General Armstrong*, 1814.

Putting in at the harbor of Fayal (Azores) in September of that year, Reid defended his vessel against a series of attacks by armed boats from the British men of war *Carnation, Rota,* and *Plantagenet* which were en route to join the British forces concentrating at Jamaica against New Orleans. Reid eventually scuttled and abandoned his ship, but the delay he caused the British squadron indirectly aided Jackson's defense of New Orleans.

REID, THOMAS MAYNE (*b. Ballyroney, Ireland, 1818; d. London, England, 1883*), novelist, journalist. Came to America *ca.* 1838. After traveling widely in the South and West, hunting, trapping and trading with the Indians, he worked for a time as a tutor and at other occupations. Early in 1843 he went to Philadelphia where he lived for about three years, worked as a journalist and playwright, and established friendship with Edgar Allan Poe. He served with distinction as a U.S. Army officer in the Mexican War. Sailing from New York, 1849, to help in the German and Hungarian revolution, he found on arrival in Europe that they had collapsed and lived in England thereafter, with the exception of the years 1867–70 which he spent mainly in Newport, R.I., and New York City. Reid was author of more than seventy novels of romance and adventure; a number of these are based on his American experiences, notably *The Rifle Rangers* (London, 1850). His book *The Quadroon* (1856) was the basis for Dion Boucicault's sensational play *The Octoroon*.

REID, WHITELAW (*b. near Xenia, Ohio, 1837; d. London, England, 1912*), journalist, diplomat. Son-in-law of Darius O. Mills. Graduated Miami University, 1856; edited the *Xenia News* and was active in Republican politics. War correspondent of the *Cincinnati Gazette*, 1861–65, he showed marked ability although his combination of reserve with unusual ambition and selfassertiveness led some to regard him as a selfish careerist. After attempting to run cotton plantations in Louisiana and Alabama, 1865–67, he returned briefly to the *Cincinnati Gazette* and in the fall of 1868 joined the *New York Tribune* as Horace Greeley's editorial assistant; he became managing editor, 1869. Loyal in support of Greeley's bid for the presidency as a Liberal Republican, 1872, Reid played as disinterested a part as could have been expected when Greeley's collapse brought about a crisis in the affairs of the *Tribune*. A brief struggle for the vacant editorship with Schuyler Colfax ended in Reid's victory and he became head of the most powerful newspaper in America. Maintaining the paper at a high level of competence, Reid increased the circulation of the daily, and though still devoted to Republican principles, fought the Grant administration and shared in exposing its corruption. After the election of James A. Garfield, a close friend, to the presidency, 1880, Reid encouraged the new president in measures which resulted in the resignation of Roscoe Conkling and the downfall of the "Stalwart" Republicans. Reid was the first to install the linotype in a newspaper composing room, believed in spending money liberally for talent, and, with E.L. Godkin, performed a valuable service to journalism by maintaining an important newspaper based on brains and character when others were depending upon sensationalism. An enthusiastic backer of James G. Blaine, Reid considered Cleveland's election a calamity. After stumping for Harrison in the campaign of 1888, he served as U.S. minister to France, 1889–92, and was nominated for the vice presidency, 1892. Generally supporting Grover Cleveland's chief policies during his second term, Reid gave early and ardent support to McKinley and vehemently denounced W.J. Bryan. He was an ardent expansionist and acted on his beliefs while serving as a member of the U.S. commission to negotiate peace with Spain, 1898. A first distrustful of Theodore Roosevelt, Reid soon warmed to him and was particularly pleased by his seizure of Panama. On his appoint-

ment as U.S. ambassador to Great Britain, 1905, he gave up active editorship of the *Tribune*.

REID, WILLIAM SHIELDS (*b. Chester Co., Pa., 1778; d. Lynchburg, Va., 1853*), Presbyterian clergyman, Virginia educator.

REID, WILLIAM WHARRY (*b. Argyle, N.Y., 1799; d. 1866*), surgeon. Graduated Union College, 1825. Practiced in Rochester, N.Y., 1828–ca. 1864; is credited with the first (1844) reduction of hip dislocation by flexion.

REIERSEN, JOHAN REINERT (*b. Vestre Moland, Norway, 1810; d. Prairieville, Tex., 1864*), journalist, editor. Traveled in the United States, 1843; published *Pathfinder for Norwegian Emigrants to the United North American States and Texas* (Norway, 1844). Established first Norwegian settlement in Texas at Brownsboro, 1845.

REIK, THEODOR (*b. Vienna, Austria, 1888; d. New York, N.Y., 1969*), psychoanalyst. Attended University of Vienna (Ph.D., 1912). Met Sigmund Freud in 1910 and began a profesional and personal relationship that survived Reik's later deviations from Freud's teachings. Practiced psychoanalysis in Europe, 1918–38, then established a thriving practice in New York City (1938) and a clinic for people who could not afford the high fees of most psychoanalysts. Major themes in his work include the importance of intuition in psychoanalysis and the unconscious "duet" of patient and therapist. Disagreed with some orthodox Freudian emphases and criticized the sexual nature of the psychoanalytic view of human nature. His fullest exploration of psychoanalysis appeared in *Listening with the Third Ear* (1948).

REILLY, MARION (*b. Altoona, Pa., 1879; d. Philadelphia, Pa., 1928*), educator, suffrage leader, philanthropist. Dean of Bryn Mawr College, 1907–16.

REINAGLE, ALEXANDER (*b. Portsmouth, England, 1756; d. Baltimore, Md., 1809*), musician. Came to America, 1786; was successful as teacher and pianist and director of concerts in Philadelphia, New York City, and Baltimore. Served as musical director of the New Theatre, Philadelphia, from its opening in 1793 until 1809 and adapted many current English ballad operas to the American stage. His own four piano sonatas, written 1786–94, are the finest surviving American instrumental productions of the eighteenth century.

REINER, FRITZ (*b. Budapest, Hungary, 1888; d. New York, N.Y., 1963*), conductor. Attended Budapest Academy of Music (1898–1908). Began his music career as a coach at the Budapest Komishe Oper (1909) and was conductor and/or director of the Landestheater in Ljubljana, Yugoslavia (1910); the Budapest Volkoper (1911–13); State Orchestra in Dresden (1914–21); Cincinnati Symphony Orchestra (1922–30); Philadelphia Grand Opera (1934–35); San Francisco Opera (1936–38); Pittsburgh Symphony (1938–48); Metropolitan Opera (1949–53); and Chicago Symphony Orchestra (1953–62). Taught at the Curtis Institute of Music (1931–41). He became a U.S. citizen in 1928. His major contributions include the transmission of the best European conducting methods; his supreme musicianship that upgraded the quality of his orchestras; and his recordings of prominent classical and contemporary works.

REINHARDT, AD (*b. Buffalo, N.Y., 1913; d. New York, N.Y., 1967*), painter. Attended Columbia (B.A., 1915) and studied painting and art history at Teachers College, Columbia's Graduate School of Fine Arts, National Academy of Design, American Artists School, and New York University's Institute of Fine Arts. Eight of his paintings were shown at the 1939 New York World's Fair. Consistently nonobjective in his painting after 1940, he is grouped with the New York school of abstract expressionism, but by 1952 he was revolting against cubism, and his canvases appeared as monochrome color fields. His first one-man gallery exhibition was in 1944, and the first of many exhibitions at the Betty Parsons Gallery took place in 1946. Taught at Brooklyn College, 1946–67, and intermittently at California School of fine Arts, University of Wyoming, Yale School of Fine Arts, and Syracuse.

REINHARDT, AURELIA ISABEL HENRY (*b. San Francisco, Calif., 1877; d. Palo Alto, Calif., 1948*), educator. B.Litt., University of California at Berkeley, 1898. Ph.D. in English, Yale, 1905. Dynamic and successful president of Mills College, 1916–43.

REINHART, BENJAMIN FRANKLIN (*b. near Waynesburg, Pa., 1829; d. 1885*), historical, genre, and portrait painter. Uncle of Charles S. Reinhart.

REINHART, CHARLES STANLEY (*b. Pittsburgh, Pa., 1844; d. 1896*), genre painter, illustrator. Nephew of Benjamin F. Reinhart. An excellent draftsman, he ranks high among American illustrators of his time.

REINSCH, PAUL SAMUEL (*b. Milwaukee, Wis., 1869; d. Shanghai, China, 1923*), political scientist, diplomat. Graduated University of Wisconsin, 1892; LL.B., 1894, Ph.D., 1898. Taught political science at Wisconsin, 1898–1913; was among first to develop systematic courses in world politics; wrote a number of books and articles opposing excessive nationalism and imperialism. As U.S. minister to China, 1913–19, he tried to obtain that country's entrance into World War I on the basis of specific guarantees of financial assistance and other aids.

REISINGER, HUGO (*b. Wiesbaden, Germany, 1856; d. Langenschwalbach, Germany, 1914*), import and export merchant. Resident in the United States *post* 1884, Reisinger collected and exhibited modern American and German art as a means of providing a cultural interchange between the countries.

REISNER, GEORGE ANDREW (*b. Indianapolis, Ind., 1867; d. Giza, Egypt, 1942*), Egyptologist. A.B., Harvard, 1889; Ph.D. in Semitics, 1893. In 1894 Reisner was appointed a scientific assistant in the Egyptian department of the Berlin Museum. He returned to Harvard in 1896–97 as an instructor in the Semitic department. In 1897 he went to Egypt as American member of an international commission designated to catalog the Khedivial Museum in Cairo. He began excavating in 1898 at Quft in Upper Egypt. In 1903 he excavated the valley temples and tombs near the great pyramids at Giza. In 1905 a Harvard University-Boston Museum of Fine Arts Egyptian Expedition was created, of which Reisner was director until his death in 1942. Although he left Egypt only infrequently, Reisner was a member of the Harvard faculty, as assistant professor of Semitic archaeology, 1905–10, assistant professor of Egyptology, 1910–1914, and professor of Egyptology, 1914–42. From 1910 to 1942 he was also curator of the department of Egyptian art of the Boston Museum of Fine Arts.

During the years 1908–10 Reisner was director of Harvard's Palestinian Expedition. At Giza he excavated progressively from 1899 to 1938 large portions of the cemetery west of the Great Pyramid; the entire royal family cemetery to the east, including the intact tomb of Queen Hetep-heres; and the temples of the Third Pyramid of Mycerinus. In 1907–09, during construction to raise the height of the Aswan Dam, Reisner was in charge of the Egyptian government's archaeological survey in Lower Nubia. He also worked extensively in the Sudan. Suffering from increasing blindness in the final years, he returned to the United

States in 1939 to receive the honorary degree of Doctor of Letters from Harvard.

REITZEL, ROBERT (*b. Weitenau, Baden, Germany, 1849; d. Detroit, Mich., 1898*), German-American poet, editor. Immigrated to the United States, 1870. Issued the weekly *Der arme Teufel* at Detroit *post* 1884.

RELLSTAB, JOHN (*b. Trenton, N.J., 1858; d. Lake Placid, N.Y., 1930*), journeyman potter, New Jersey lawyer, official, and jurist. Judge of the U.S. district court for New Jersey, 1909–30.

REMEY, GEORGE COLLIER (*b. Burlington, Iowa, 1841; d. Washington, D.C., 1928*), naval officer. Graduated U.S. Naval Academy, 1859. Commanded naval base at Key West, Fla., during war with Spain, 1898; appointed rear admiral in that year, he commanded the Asiatic station, 1900, during the Philippine warfare and Boxer uprising in China.

REMINGTON, ELIPHALET (*b. Suffield, Conn., 1793; d. 1861*), iron forger, manufacturer. Father of Philo Remington. Founded celebrated firm for the manufacture of rifles, pistols, and agricultural implements at Ilion, N.Y., *ca.* 1828.

REMINGTON, FREDERIC (*b. Canton, N.Y., 1861; d. Ridgefield, Conn., 1909*), painter, sculptor, author, illustrator. Studied at Yale School of Fine Arts, 1878–80; studied also at the N.Y. Art Students League. Excelling as a delineator of outdoors men, preferably with horses, Remington is considered unsurpassed in his studies of Western Indians, cowboys and frontiersmen, soldiers in the field, and in general the human figure in action. In his later work, his ability to state by suggestion the character of land, the season of the year, and the state of the weather greatly improved. His sculpture was essentially illustration in bronze with his usual accent on character and action. His books include *Pony Tracks* (1895), *Crooked Trails* (1898), *Stories of Peace and War* (1899), *Done in the Open* (1902), and *The Way of an Indian* (1906). He wrote them in a fresh, journalistic style and illustrated them with the closest attention to accuracy of detail.

REMINGTON, JOSEPH PRICE (*b. Philadelphia, Pa., 1847; d. 1918*), pharmacist. Graduated Philadelphia College of Pharmacy, 1866; taught there *post* 1871 and was made dean, 1893. Author of *Practice of Pharmacy* (1885). Chairman of the committee to revise the *Pharmacopoeia of the Unites States*, 1901–18.

REMINGTON, PHILO (*b. Litchfield, N.Y., 1816; d. Silver Springs, Fla., 1889*), manufacturer. Son of Eliphalet Remington. President *post* 1865 of arms and agricultural equipment manufacturing firm founded by his father, he actively developed the pistolmaking branch of the business, perfected the Remington breech-loader, marketed sewing machines, and introduced the Remington typewriter (developed from Sholes and Glidden prototype) in 1876.

REMINGTON, WILLIAM WALTER (*b. New York, N.Y., 1917; d. Lewisburg, Pa., 1954*), economist, federal government employee. Studied at Dartmouth College and at Columbia University (M.A., 1940). Economist with the National Resources Planning Board (1940–41); Office of Price Administration (1941–42); and War Production Board (1942–44). Appointed to the staff of the President's Council of Economic Advisers (1946–48). In 1948 he headed the division of the Department of Commerce that cleared export licenses to trade with Soviet bloc nations. Accused by Elizabeth Bentley in 1945 of having been a source for secrets during the war (Bentley had been a Communist courier). Subsequently accused of having belonged to the Communist party

in 1937. In 1953 he was convicted of perjury and sentenced to prison, where he was murdered by two fellow inmates.

REMOND, CHARLES LENOX (*b. Salem, Mass., 1810; d. Boston, Mass., 1873*), black leader. The first black to address public gatherings on behalf of abolition, Remond was appointed agent of the Massachusetts Anti-Slavery Society, 1838, and achieved his greatest success on a lecture tour through Great Britain and Ireland, 1840–41.

REMSEN, IRA (*b. New York, N.Y., 1846; d. Carmel, Calif., 1927*), chemist, educator. Attended New York schools and the New York Free Academy (later College of the City of New York); M.D., N.Y. College of Physicians and Surgeons, 1867; Ph.D., University of Göttingen, 1870. A research student in organic chemistry under some of the best German authorities of the time, Remsen returned to America, 1872, won recognition for his *Principles of Theoretical Chemistry* (1877), and taught for a short time at Williams College. Chosen first professor of chemistry at Johns Hopkins, 1876, he soon surrounded himself with a group of brilliant students who in their later careers strongly influenced the development of chemistry in the United States. Also of great influence in the development of chemical research were the *American Chemical Journal* which Remsen established, 1879, and a series of notable textbooks which he wrote. Appointed president of Johns Hopkins, 1901, he served until 1913, meanwhile continuing his active direction of the department of chemistry.

RÉMY, HENRI (*b. Agen, France, ca. 1811; d. New Orleans, La., 1867*), Louisiana editor, lawyer. A political refugee from France, Rémy came to New Orleans *ca.* 1836 where he studied law in the office of Pierre Soulé. He was later an associate of William Walker in the seizure of Nicaragua, 1855–57.

RENALDO, DUNCAN (*b. Casile Dumitree Cughienas, Romania, 1904; d. Santa Barbara, Calif., 1980*), actor. Arrived in Baltimore in the 1920's and broke into the motion picture business in New York City, starring in his first film, *Fifty–Fifty*, in 1925. He also starred in the combination silent-talkie *The Bridge of San Luis Rey* (1929). His next film was the hit *Trader Horn* (1931). In the 1930's Renaldo was imprisoned for eighteen months for falsifying information on his passport; President Franklin Roosevelt pardoned Renaldo, allowing him to remain in the country. In 1945–50 he made eight films as the Cisco Kid and appeared in the successful television series "Cisco Kid" (1951–56). Injuries from performing his own stunts on the series ended his acting career.

RENICK, FELIX (*b. Hardy Co., Va., 1770; d. near Chillicothe, Ohio, 1848*), Ohio pioneer, cattleman. Settled in Ross Co., Ohio, 1801; became an outstanding agricultural leader in south central Ohio; improved cattle herd by importing English shorthorns, 1834–36.

RENNIE, MICHAEL (*b. Bradford, Yorkshire, England, 1900; d. London, England, 1971*), actor. Graduated Cambridge University (B.A., 1931) and briefly worked in a film studio before joining a stock company and honing his talents with classical theater training. His first starring role was in *I'll Be Your Sweetheart* (1945), and his first U.S. film was the cult classic *The Day the Earth Stood Still* (1950). He appeared in almost one hundred films, but his greatest success was as the debonair amateur detective Harry Lime in "The Third Man," the hit NBC and BBC television series (1959–62). He became a U.S. citizen in 1960 and made his Broadway debut in *Mary, Mary* (1961).

RENO, JESSE LEE (*b. Wheeling, Va., present W. Va., 1823; d. 1862*), Union major general. Graduated West Point, 1846. After service in the Mexican War, he was active principally as an ord-

nance expert until the Civil War when he was commissioned brigadier general, 1861. Serving principally in General Burnside's commands, he was killed at the battle of South Mountain. The city of Reno, Nev., was named in his honor.

RENO, MILO (*b. Wapello Co., Iowa, 1866; d. Excelsior Springs, Mo., 1936*), farm leader. President (1921–30) of the Iowa Farmers' Union; organizer of the Farmers' Holiday Association, which struck in 1932 for higher farm prices and spurred remedial legislation.

RENWICK, EDWARD SABINE (*b. New York, N.Y., 1823; d. Short Hills, N.J., 1912*), engineer, patent expert. Son of James Renwick (1792–1863); brother of Henry B. and James Renwick (1818–1895). Among his many inventions the most important was a series of ten covering incubators and chicken brooders, 1877–86; he also patented a grain harvester and binder, 1851–53, from which he never profited commercially although his ideas were widely used by manufacturers of harvesting machinery after his patents expired.

RENWICK, HENRY BREVOORT (*b. New York, N.Y., 1817; d. New York, 1895*), engineer, patent expert. Son of James Renwick (1792–1863); brother of Edward S. and James Renwick (1818–1895).

RENWICK, JAMES (*b. Liverpool, England, 1792; d. New York, N.Y., 1863*), educator, engineer. Father of Edward S., Henry B. and James Renwick (1818–1895). Came to the United States as a child. Graduated Columbia, 1807; traveled abroad with Washington Irving; A.M., Columbia, 1810. Professor of natural philosophy and experimental chemistry at Columbia, 1820–53, Renwick was until his death a recognized authority on every branch of engineering of that day. Among many projects on which he was consultant was the Morris Canal for which he devised a system of inclined planes or railways for transporting boats; he served also as a commissioner for the survey of the Northeast Boundary, 1840. The more important of his original scientific works were *Outlines of Natural Philosophy* (1822–23) and *Treatise on the Steam-Engine* (1830).

RENWICK, JAMES (*b. New York, N.Y., 1818; d. 1895*), engineer, architect. Son of James Renwick (1792–1863); brother of Edward S. and Henry B. Renwick. Graduated Columbia, 1836; served on engineering staff of Erie Railroad and Croton Aqueduct. Entirely self-trained in architecture, Renwick won a competition for design of Grace Church, New York City, 1843; thereafter he developed a large practice as an ecclesiastical and general architect. Working at first either in the Gothic or Romanesque style, he early accepted the trend towards eclecticism with sometimes incoherent results; technically, his work was not only careful but advanced, and he was full of imagination. Among his principal works were St. Patrick's Cathedral, New York City (1853–87), the Smithsonian Institution in Washington, D.C. (1846 and after), the Vassar College building (1865), and the Corcoran Gallery, Washington, D.C. An inspiring teacher, he trained among others William W. Root and Bertram G. Goodhue.

REPPLIER, AGNES (*b. Philadelphia, Pa., 1855; d. Philadelphia, 1950*), author, lecturer. Attended Eden Hall, a school conducted by the Sisters of the Sacred Heart, and a school in Philadelphia directed by Agnes Irwin; began to write professionally, 1871. Encouraged by the Rev. Isaac Hecker, she became a regular contributor to the *Catholic World* and later to the *Atlantic Monthly*, winning national prominence as a writer of essays on all manner of topics, marked by wit, irony, erudition, and stylistic distinction. Her books included *Books and Men* (1888); *The Fireside Sphinx*

(1901); *A Happy Half-Century* (1908); an autobiography, *In Our Convent Days* (1905); and biographies of Pére Marquette and Junipero Serra.

REQUA, MARK LAWRENCE (*b. Virginia City, Nev., 1865; d. Los Angeles, Calif., 1937*), mining engineer. Associate and political adviser of Herbert Hoover.

REQUIER, AUGUSTUS JULIAN (*b. Charleston, S.C., 1825; d. New York, N.Y., 1887*), poet, South Carolina and Alabama jurist, New York City lawyer.

RESE, FREDERICK (*b. Weinenburg, Hanover, Germany, 1791; d. Hildesheim, Germany, 1871*), Roman Catholic clergyman. After working as a journeyman tailor, he made theological studies in Rome and was ordained there, 1822. A volunteer for mission work, he came to Cincinnati, Ohio, *ca.* 1824, the first German priest in the old Northwest. Instrumental in founding the Leopoldine Society of Vienna and in bringing the Redemptorists to the United States, he was bishop of Detroit *post* 1833; he took no active part in the running of the diocese, however, subsequent to 1841.

RESOR, STANLEY BURNET (*b. Cincinnati, Ohio, 1879; d. New York, N.Y., 1962*), advertising executive. Attended Yale (B.A., 1901). Joined Proctor and Collier Advertising (1904), then became manager of the Cincinnati office of J. Walter Thompson (1908); moved to New York headquarters as vice president and general manager (1912); purchased the firm (1916); became its president (until 1955) and then chairman (until 1961). During his presidency the firm became the largest advertising agency in the world. He relied heavily on market research and the compilation of statistical data, and his chief accomplishment was to make advertising part of broader marketing strategies. Named Advertising Man of the Year (1948) by *Advertising and Selling* magazine.

RESTARICK, HENRY BOND (*b. Holcombe, England, 1854; d. 1933*), Episcopal clergyman. Immigrated to Canada *ca.* 1871; settled in Iowa, 1873. A rector for many years in San Diego, Calif., he served as bishop of the district of Honolulu, Hawaii, 1902–20.

REULING, GEORGE (*b. Romrod, Germany, 1839; d. 1915*), ophthalmologist. M.D., University of Giessen, 1865; studied also in Wiesbaden and at Vienna, Berlin, and Paris. Immigrated to Baltimore, Md., 1868; conducted Maryland Eye and Ear Infirmary *post* 1869. Professor of ophthalmology and otology at Washington University, Baltimore, and at Baltimore Medical College.

REUTER, DOMINIC (*b. Coblenz, Germany, 1856; d. Syracuse, N.Y., 1933*), Roman Catholic clergyman, Franciscan. Came to America as a child; entered Friars Minor Conventual at Syracuse, N.Y., 1875. Educated at St. Francis College, Trenton, N.J., and at the University of Innsbruck, he held a number of teaching and other positions in his order and served as minister general, 1904–10.

REUTERDAHL, HENRY (*b. Malmö, Sweden, 1871; d. Washington, D.C., 1925*), illustrator, painter, author. Settled in the United States, 1893. A specialist in depicting naval life and operations, he came to hold a semi-official status as artist to the U.S. Navy.

REUTHER, WALTER PHILIP (*b. Wheeling, W.Va., 1907; d. Pellston, Mich., 1970*), labor leader. Employed at the Ford automobile plant, 1927–32, then worked at Gorki auto works in the Soviet Union, 1933–35. Played a prominent role at the 1936

South Bend, Ind., convention of the United Auto Workers and was elected to the general executive board. Became president of UAW Local 174 and led a strike at Kelsey-Havers Corporation that started an influx of recruits into the local. Appointed director of UAW's General Motors Department (1939) and, through a series of strikes and pullouts, forced GM to recognize the UAW as the bargaining agent for the company's tool and die makers; reorganization of GM production workers quickly followed, as it did elsewhere in the industry. In 1940 he argued that auto plants could be converted to aircraft production, and a succession of other proposals established his reputation as the ablest of a new generation of trade-union leaders. Became UAW president (1946) and purged the union hierarchy of his opponents. He went on the offensive against Communists in the Congress of Industrial Organizations, of which the UAW was a member, and became a prominent figure in the anti-Communist left. A consistent supporter of Franklin Roosevelt, after Harry Truman's victory (1948) came to accept the Democratic party as the only viable instrument for labor politics in America. A brilliant practitioner of collective bargaining, his strategy was to single out one firm for strike actions and then to extend the gains achieved there to the rest of the industry. Became president of the CIO in 1952 and played a crucial part in the merger with the American Federation of Labor in 1955. He found himself increasingly at odds with AFL–CIO president George Meany, and the UAW left the AFL–CIO in 1968. Founded the Alliance for Labor Action (1969), which included only the UAW and the Teamster's Brotherhood, which Reuther had helped expel from the AFL–CIO in 1957 for corruption.

REVEL, BERNARD (*b. Pren, Russia, 1885; d. New York, N.Y., 1940*), Jewish scholar, educator. Came to America, 1906. As president, *post* 1915, of the Rabbi Isaac Elchanan Theological Seminary (the Yeshiva), New York, N.Y., Revel labored devotedly to develop it as a college of liberal arts and sciences which would produce enlightened rabbis, teachers, and laymen for the American Jewish community.

REVELL, FLEMING HEWITT (*b. Chicago, Ill., 1849; d. 1931*), publisher of religious books and Sunday-school materials. Brother-in-law of Dwight L. Moody.

REVELL, NELLIE MACALENEY (*b. Springfield, Ill., 1872; d. New York, N.Y., 1958*), journalist, publicist, radio personality. After working as a reporter for various midwestern and western newspapers, Revell became the first woman reporter for the *New York World* in the 1890's. She left journalism to become publicist for such notables as Al Jolson, Lillie Langtry, Lillian Russell, and Will Rogers, as well as for six circuses. In 1919 a paralyzing spinal ailment interrupted her career. She wrote several books about her illness. Upon partial recovery, she became an interviewer of stage, sports, and political personalities for NBC (1930–47).

REVELS, HIRAM RHOADES (*b. Fayetteville, N.C., 1822; d. Aberdeen, Miss., 1901*), Methodist clergyman, Mississippi legislator and educator. Of mixed African and Indian descent, Revels was U.S. senator, Republican, from Mississippi, 1870–71; thereafter, he served as president of Alcorn University. He was active in behalf of the Democrats in the 1875 campaign which led to the overthrow of the Carpetbag government.

REVERE, JOSEPH WARREN (*b. Boston, Mass., 1812; d. Hoboken, N.J., 1880*), naval officer, Union brigadier general. Grandson of Paul Revere. Appointed midshipman, 1828; served in a variety of capacities until 1845 when he was assigned to the Pacific and played a part in the conquest of California. Resigning from the navy, 1850, he became a rancher and trader, and in

1851 reorganized the artillery branch of the Mexican army. Removing to New Jersey, 1852, he became colonel of the 7th New Jersey Volunteers, 1861, and was promoted brigadier general, October 1862. Relieved of command and court-martialed and dismissed for his conduct at Chancellorsville, May 1863, he was reinstated by President Lincoln, 1864. He was author of *A Tour of Duty in California* (1849) and *Keel and Saddle* (1872).

REVERE, PAUL (*b. Boston, Mass., 1735; d. Boston, 1818*), patriot, silversmith, engraver. A successful craftsman, Revere came into close contact with John Hancock, Samuel Adams, and Joseph Warren through his leadership of the patriotic mechanic class of Boston. When the North End Caucus, most influential of all the patriotic political clubs, voted to oppose the selling of tea by the East India Co., Revere was one of three committeemen chosen to suggest a course of action and along with fifty other Boston workingmen shared in the famous Tea Party. Journeying to New York in the winter of 1773 to apprise the Sons of Liberty there of developments in Boston, he rode out again in the following spring to carry the news of the Boston Port Bill to New York and Philadelphia and to make an appeal for help. In September 1774 he rode to Philadelphia with the "Suffolk Resolves." He then was made official courier for the Massachusetts Provincial Assembly to Congress. Two days before his famous ride to Lexington, he rode with the important purpose of warning the patriots to move their military stores from Concord. On the 18th of April 1775, he rode again to warn Hancock and Adams that the British were out to capture them and to alert the countryside to the fact that the royal troops were on the march. Mounted on a stout work-horse, he eluded British patrols, reached Lexington, saw his two chiefs on the way, and then set out with William Dawes and Samuel Prescott to warn Concord. Stopped by British troopers, Revere was detained a little and then released to make his way back to Lexington without his horse. Anxious for action, he received no military command in the Continental Army. He designed and printed the first issue of Continental money; he made the first official seal for the colonies and the Massachusetts state seal. Learning the process of manufacturing gunpowder, he for a time directed a mill at Canton, Mass.; in 1779 he participated in the ill-fated Penobscot expedition. A master silversmith but a rather amateurish engraver of political cartoons, Revere later entered the foundry business and was the discoverer of a process for rolling sheet copper.

REVSON, CHARLES HASKELL (*b. Somerville, Mass., 1906; d. New York City, 1975*), founder and chief executive of Revlon. After working as a nail polish salesman in New York City in 1931, he and his brother Joseph founded Revlon in 1932; their nail polish business grew and in 1939 lipstick was added to the product line. He promoted products in magazines, which were appearing in color for the first time, and his "Fire and Ice" campaign (1951) further increased Revlon's position in the cosmetics field, as did the company's sponsorship of the television show "The $64,000 Question" (1955). The company went public in 1955 at $12 per share, rising to $30 per share in three months. He introduced different lines, such as Ultima II, Marcella Borghese, and Moon Drops, to appeal to different markets. In 1966 he acquired a profitable pharmaceutical firm and obtained rights to seventeen drugs. By 1974 Revlon was marketing 3,500 products in 85 countries.

REYNOLDS, ALEXANDER WELCH (*b. Clarke Co., Va., 1817; d. Alexandria, Egypt, 1876*), Confederate brigadier general. Graduated West Point, 1838. Served in the Seminole War and on extensive Western frontier duty. After the Civil War, in which he was engaged principally in the Western campaigns, he re-

moved to Egypt, took a commission in the Egyptian army and served as chief of staff to William W. Loring.

REYNOLDS, CHARLES ALEXANDER (*b. probably near Stephensburg, Ky., 1842[?]; d. near the Little Big Horn, Montana Territory, 1876*), Union soldier, hunter, scout, known as "Lonesome Charley." Generally ranked as the greatest of the Western scouts, Reynolds was raised in Illinois and Kansas. After Civil War service, he left home and became a hunter in the Dakota country, furnishing game to military posts. He served as a scout for the Yellowstone expedition under David S. Stanley, 1873, was the guide for Custer's Black Hills expedition, 1874, and in the following year was hunter and chief scout for, among other military expeditions, that of William Ludlow. Employed as a scout for the Big Horn expedition which left Fort Abraham Lincoln, May 17, 1876, he was assigned to Reno's battalion and was shot at the beginning of the retreat from the Little Big Horn valley.

REYNOLDS, EDWIN (*b. Mansfield, Conn., 1831; d. Milwaukee, Wis., 1909*), engineer. As plant superintendent for the Corliss Steam Engine Co., Providence, R.I., Reynolds built the giant engine displayed at the 1876 Exhibition. Associated *post* with the Edward P. Allis Co. and Allis-Chalmers, he incorporated many of his inventions and improvements in the machinery manufactured by those companies. He built the first triple expansion pumping engine for waterworks service in the United States, 1888, and in the same year patented a blowing engine for blast furnaces which was a radical departure from accepted design practice. In 1893 he designed and built a four-cylinder compound steam engine for the Manhattan Railway power house, New York, N.Y.

REYNOLDS, GEORGE MCCLELLAND (*b. Panora, Iowa, 1865; d. Pasadena, Calif., 1940*), banker. Protégé of J. Ogden Armour, Reynolds served as president of the Continental National Bank of Chicago and its subsequent consolidations, 1906–33. He was associated with Nelson W. Aldrich in the investigations which produced the Aldrich Plan.

REYNOLDS, JOHN (*b. probably England, 1713; d. 1788*), British admiral, first royal governor of Georgia, 1754–57. In constant struggle with the Assembly over financial problems and procedures, Reynolds regarded the colonists as "lawless, antimonarchal people" who required government by military force.

REYNOLDS, JOHN (*b. Montgomery Co., Pa., 1788; d. Belleville, Ill., 1865*), lawyer, Illinois legislator, Democratic politician. Raised in Tennessee, and near Kaskaskia, Ill. Undistinguished as a lawyer but a glib and able cultivator of the electorate, Reynolds was governor of Illinois, 1830–34, and congressman from that state, 1834–37, 1839–43. He was author of a colorful autobiography, *My Own Times* (1855). He was later a strong Confederate sympathizer.

REYNOLDS, JOHN FULTON (*b. Lancaster, Pa., 1820; d. Gettysburg, Pa., 1863*), Union soldier. Graduated West Point, 1841. An artillery officer, he served with particular distinction in the Mexican War and in the Far West, 1854–60. Made brigadier general of volunteers, 1861, he was active in the Peninsular campaign, directed the Pennsylvania militia, and in November 1862 was promoted major general. He was most effective as the I Corps commander at Fredericksburg and Chancellorsville. Ordered to occupy Gettysburg on June 28, 1863, Reynolds set the I, III, and XI Corps in motion and arrived at the town on the morning of July 1. Marching at the head of the 2nd Wisconsin Regiment, he was killed by a sharpshooter.

REYNOLDS, JOSEPH JONES (*b. Flemingsburg, Ky., 1822; d. Washington, D.C., 1899*), Union soldier. Graduated West Point, 1843. Served as artillery officer with General Zachary Taylor's army in the Mexican War; taught at West Point, 1846–55; resigned from the army, 1857. Appointed brigadier general, 1861, he served under General Rosecrans in western Virginia and on promotion to major general, 1862, commanded a division in the Army of the Cumberland. After the battle of Chickamauga, 1863, he became chief of staff of the Army of the Cumberland; *post* July 1864, he headed the XIX Corps. After postwar duty in Texas and Louisiana and in the Far West, he retired, 1877.

REYNOLDS, JULIAN SARGEANT (*b. New York City, 1936; d. New York City, 1971*), politician. Attended Princeton University and University of Pennsylvania and graduated Wharton School of Finance (1958) and joined the family business, Reynolds Metals Corporation. He was elected to the Virginia Senate (1967) and as lieutenant governor (1969) as a Democrat and supported compliance with court rulings on racial questions. His popularity within both political parties led to shock when he announced he had a brain tumor.

REYNOLDS, MILTON (*b. Albert Lea, Minn., 1892; d. Chicago, Ill., 1976*), industrialist. A high-school dropout, Reynolds became a millionaire by age twenty-five as a tire dealer and became a stock market speculator in the 1920's. He underwent several successes and bankruptcies, including a printing shop and the import of cigarette lighters. In 1945, after learning of a similar device in Argentina, Reynolds launched production of a ballpoint pen that used a patented gravity flow method to deliver ink. The pen was one of the most successful product introductions in American history. Reynolds sold 2 million pens in three months, but his success was diminished by increasing competition from other firms in the ballpoint pen market.

REYNOLDS, QUENTIN JAMES (*b. Bronx, N.Y., 1902; d. Travis Air Force Base, Calif., 1965*), author and war correspondent. Attended Brown and Brooklyn Law (LL.B., 1931). Obtained a job with the International News Service (1931) and was its feature writer in Berlin by early 1933. Returned to New York to work for *Collier's* (1933–48) and was sent to Europe as war correspondent in 1940, covering the fall of France and the Battle of Britain, after which he wrote *The Wounded Don't Cry* (1941), a bestselling book. His radio broadcasts for British Broadcasting and his risktaking coverage of combat in Italy, North Africa, and the southwest Pacific helped establish his reputation as one of America's leading war correspondents.

REYNOLDS, RICHARD SAMUEL, SR. (*b. Bristol, Tenn., 1881; d. Richmond, Va., 1955*), aluminum executive. Studied briefly at Columbia University and at the University of Virginia Law School. Worked for the Reynolds family-owned tobacco company (1902–12), then resigned and formed his own business, the Reynolds Corporation. Founded the U.S. Foil Company in 1919, which became the Reynolds Metals Company in 1928. A pioneer in the manufacture of aluminum, Reynolds guided the company through the Depression and World War II until it was the nation's second largest producer of aluminum in 1955. President of the Reynolds Metals Company until 1948; chairman of the board, 1948–55. Published *War Enthroned and Other Poems* (1936) and *Crucible: Poems* (1950).

REYNOLDS, ROBERT RICE (*b. Asheville, N.C., 1884; d. Asheville, 1963*), U.S. senator. Attended University of North Carolina (B.A., 1906) and its law school; began practicing law in 1909 and was elected prosecuting attorney for the state's Fifteenth Judicial District (1910–14). As U.S. senator (1932–45) advocated im-

migration restriction and opposed U.S. entry into World War II; created the Vindicators Association to further those causes in 1939. A colorful if uninfluential member of the Senate.

REYNOLDS, SAMUEL GODFREY (*b. Bristol, R.I., 1801; d. Bristol, 1881*), tanner, inventor of improved machinery for making nails, pins and spikes.

REYNOLDS, WILLIAM (*b. Lancaster, Pa., 1815; d. Washington, D.C., 1879*), naval officer. Brother of John F. Reynolds. Retired as rear admiral, 1877.

REYNOLDS, WILLIAM NEAL (*b. Patrick County, Va., 1863; d. Winston-Salem, N.C., 1951*), tobacco manufacturer, sportsman, philanthropist. Studied from 1882 to 1884 at Trinity College (now Duke University). Joined the family business, forming the R. J. Reynolds Tobacco Company in 1888; vice president and member of the board of directors (1889–1918); president (1918–24); chairman of the board (1924–31). His company produced the first modern mass-marketed cigarette, Camel, in 1913. Owner of one of the three largest tobacco companies in the nation, Reynolds was also an avid sportsman; he bred and raced horses. Endowed Wake Forest College, North Carolina State College, and was a trustee of Duke University.

REZANOV, NIKOLAI PETROVICH (*b. St. Petersburg, Russia, 1764; d. Krasnoyarsk, Siberia, 1807*), Russian civil service official, Alaskan colonizer. A founder of the Russian-American Co. for the exploitation of Alaska, Rezanov set out in 1803 to investigate the resources of the territory and to test the possibility of supplying the colonies there by sea. After many difficulties, he landed at New Archangel (Sitka), 1805; in search of food for the starving community, he visited the port of San Francisco, Calif., April–May 1806. He died on his way back to Russia.

RHEA, JOHN (*b. Co. Donegal, Ireland, 1753; d. 1832*), lawyer. Immigrated to America, 1769; settled in eastern Tennessee, 1778. Congressman, Democrat, from Tennessee, 1803–15, 1817–23; a friend and supporter of Andrew Jackson; opposed slavery.

RHEES, MORGAN JOHN (*b. Glamorganshire, Wales, 1760; d. 1804*), Baptist clergyman, reformer. Came to America, 1794. After traveling widely in the United States, Rhees collaborated with Benjamin Rush in land developments in central Pennsylvania where he also preached and organized Baptist churches among the Welsh settlers.

RHEES, RUSH (*b. Chicago, Ill., 1860; d. Rochester, N.Y., 1939*), Baptist clergyman, educator. Great-grandson of Morgan J. Rhees. Graduated Amherst, 1883; Hartford Theological Seminary, 1888. President, University of Rochester, 1900–35.

RHEES, WILLIAM JONES (*b. Philadelphia, Pa., 1830; d. Washington, D.C., 1907*), bibliographer, official and archivist of Smithsonian Institution.

RHETT, ROBERT BARNWELL (*b. Beaufort, S.C., 1800; d. Louisiana, 1876*), lawyer, statesman. Changed name from Smith to Rhett, 1837. Elected to the legislature, 1826, he quickly became prominent for his passionate and eloquent advocacy of an extreme states' rights doctrine; as congressman from South Carolina, 1837–49, he advanced to the forefront of the followers of J. C. Calhoun, accepting Calhoun's belief that the Constitution, rightly interpreted, would protect the South. After Calhoun's failure to secure the presidential nomination and the abandonment by Northern Democrats of the Southern position on the tariff, Rhett moved more and more towards secession, and *post* 1850

was its open advocate. Succeeding Calhoun as U.S. senator, 1850, he resigned his seat, 1852, when a South Carolina convention passed an ordinance merely declaratory of the right of secession which Rhett chose to regard as a "submission" to the Union over the Compromise of 1850. Continuing to work for his declared aim of Southern Confederacy, he met with William L. Yancey and other Southern radicals in 1858 but was forced with them to the conclusion that the only hope for secession lay in a Republican victory in 1860. Through his newspaper mouthpiece, the *Charleston Mercury*, Rhett worked to undermine Southern confidence in the Democratic party and was the principal architect of secession when the crisis arose in South Carolina in late 1860. At the Southern Congress in Montgomery, Ala., he failed to secure the Confederate presidency and was ignored in the cabinet appointments. Welcoming the Civil War because in his view it would stop any chance of a reconstruction of the Union, he was a vigorous critic of President Jefferson Davis's administration and opposed Davis's "usurpations" as vigorously as he had opposed the Union. He died still serenely confident in his faith that the South would be "separate and free." His character and the motivation of his career as well as his statesmanship are subjects on which historians are as little likely to reach agreement as were his contemporaries.

RHIND, ALEXANDER COLDEN (*b. New York, N.Y., 1821; d. New York, 1897*), naval officer. Son of Charles Rhind. Acquired a reputation for insubordination during his early years of service; performed a number of highly hazardous individual exploits during the Civil War, in particular at Charleston, S.C., April 1863, and at the first attack on Fort Fisher, 1864. Retired as rear admiral, 1883.

RHIND, CHARLES (*b. Aberdeen, Scotland, date unknown; d. probably New York, N.Y., post 1846*), merchant, diplomatic agent. Father of Alexander C. Rhind. First appears in New York City directory, 1810, as a ship chandler. U.S. commissioner with David Offley and James Biddle to negotiate treaty of commerce with Turkey, 1830.

RHINE, JOSEPH BANKS (*b. Waterloo, Pa., 1895; d. Hillsborough, N.C., 1980*), psychologist. Graduated University of Chicago (B.S., 1922; M.S., 1923; Ph.D., 1925), was an botany instructor at West Virginia University (1924–26), and began his interest in psychic research with William McDougall at Harvard University in 1926. In 1930 Rhine and McDougall created the Parapsychology Laboratory at Duke University, which conducted the first systemic study of psychic activity. Rhine and his associates claimed that the human mind could transcend the normal parameters of space and time, a phenomenon he termed extrasensory perception (ESP); his controversial research faced strident criticism from many scientists. In 1937 he founded the *Journal of Parapsychology*, and his book *New Frontiers of the Mind* reached the best-seller lists. During the 1940's he expanded his research into psychokinesis; he continued his research at Duke until retirement in 1965.

RHOADS, CORNELIUS PACKARD (*b. Springfield, Mass., 1898; d. Stonington, Conn., 1959*), scientist, physician, administrator. Attended Bowdoin College (B.A., 1920), Harvard Medical School (M.D., 1924). Was an instructor at Harvard (1926); staff member of the Rockefeller Institute for Medical Research (1928–39). Became chief of the Medical Division of the Army Chemical Warfare Service during World War II. Rhoads is chiefly remembered as the country's foremost cancer researcher. Director of the newly formed Sloan-Kettering Institute for Cancer Research, from 1948. A proponent of chemotherapy in cancer treatment, he guided the foundation to international prominence.

RHOADS, JAMES E. (*b. Marple, Pa., 1828; d. Bryn Mawr, Pa., 1895*), physician, Quaker editor, philanthropist. President of Bryn Mawr College, 1883–94.

RHODES, EUGENE MANLOVE (*b. Tecumseh, Nebr., 1869; d. 1934*), cowboy, novelist. Raised in Kansas and New Mexico; worked as a cowpuncher and rancher, 1882–1906, with a short interval for study at the University of the Pacific. Author of a number of excellent fictional studies of the cattle kingdom which include *Good Men and True* (1910), *The Desire of the Moth* (1916), *West Is West* (1917), *Stepsons of Light* (1921), *Beyond the Desert* (1934), and *The Proud Sheriff* (1935). His books have been described as the only body of fiction devoted to the cattleman and his life that is both true to the subject and written by an artist in prose.

RHODES, JAMES FORD (*b. Cleveland, Ohio, 1848; d. Brookline, Mass., 1927*), businessman, historian. Brother-in-law of Marcus A. Hanna. Retiring from business, 1885, he wrote a *History of the United States from the Compromise of 1850* which is marked by good judgment and, for its day, notable fairmindedness. Somewhat pedestrian in style, it still stands as a landmark in American historiography and is distinguished for the thoroughness and skill with which it handles vast materials. The first two volumes were published in 1893 and were greeted by competent critics with immediate and practically unanimous approval; five subsequent volumes (Vol. 3, 1895; Vol. 4, 1899; Vol. 5, 1904; Vols. 6 and 7, 1906) served to enhance the author's fame. He had originally intended to carry the history to 1855 but wisely decided to end it with the restoration of Southern home rule in 1877. He was author also of several other works, but his fame rests upon his major history and especially on the first five volumes.

RIBAUT, JEAN (*b. Dieppe, France, ca. 1520; d. Florida, 1565*), French mariner. A trusted captain under Admiral Coligny, Ribaut was chosen to establish a French colony and asylum for Huguenots on the coast of Florida, 1562. After making his landfall in late spring near St. John's River, he settled his colonists at the present Port Royal, S.C., which he called Charlesfort, and returned to France. Becoming embroiled there in the Wars of Religion, he fled to England where he was for a time imprisoned. After his release he set out with a reinforcement for his colony in 1565, but was taken prisoner by the Spaniards under Pedro Menéndez de Avilés and executed.

RICCA, PAUL (*b. Felice DeLucia, Naples, Italy, 1898; d. Chicago, Ill., 1972*), racketeer. After killing two men and serving two years in prison, he fled the United States but returned in 1920 under his new name and became a naturalized citizen in 1928. He was hired by Al Capone in Chicago and rose in the criminal world; by 1943 he was considered the top man in the Chicago Mafia (the "Outfit"). He provided capital for criminal ventures through loan sharking and gambling but had an aversion to drug dealing. He was imprisoned in 1944 for extortion of $2 million from Hollywood movie studios and was paroled in 1947. He invoked the Fifth Amendment before Senate committees investigating organized crime in the 1950's. In 1957 his citizenship was revoked and deportation proceedings began in 1959, but neither Italy nor any other country would accept him. By the early 1960's he was considered the Outfit's older statesman, and his protege, Sam Giancana, became his successor.

RICE, ALEXANDER HAMILTON (*b. Newton Lower Falls, Mass., 1818; d. Melrose, Mass., 1895*), paper manufacturer, Boston councilman and mayor. Congressman, Republican, from Massachusetts, 1859–67; governor of Massachusetts, 1876–78.

RICE, ALICE CALDWELL HEGAN (*b. Shelbyville, Ky., 1870; d. Louisville, Ky., 1942*), author. Married Cale Y. Rice, 1902. Author of numerous short stories and twenty novels, of which the first, *Mrs. Wiggs of the Cabbage Patch* (1901), was extraordinarily successful.

RICE, CALVIN WINSOR (*b. Winchester, Mass., 1868; d. New York, N.Y., 1934*), engineer. Promoter of national and international engineering societies.

RICE, CHARLES (*b. Munich, Bavaria, 1841; d. 1901*), chemist, philologist, Sanskrit scholar. Came to America, 1862. After service in U.S. Navy, was associated with the pharmacy department of Bellevue Hospital, New York City, and became eventually its superintendent. Chairman, revision committee, *U.S. Pharmacopoeia*, 1880–1901.

RICE, CHARLES ALLEN THORNDIKE (*b. Boston, Mass., 1851; d. New York, N.Y., 1889*), journalist. Publisher and editor, *North American Review*, post 1876, he made that moribund periodical a financial and literary success by persuading leaders of world opinion to write for it on contemporary public questions.

RICE, DAN (*b. New York, N.Y., 1823; d. Long Branch, N.J., 1900*), circus clown, showman. Remembered as one of the greatest of American clowns, Rice (born McLaren) was also famous as a crackerbox philosopher and commentator on public affairs.

RICE, DAVID (*b. Hanover Co., Va., 1733; d. 1816*), Presbyterian clergyman, active as a missionary and church organizer in Kentucky post 1783.

RICE, EDGAR CHARLES ("SAM") (*b. near Morocco, Ind., 1890; d. Rossmor, Md., 1974*), baseball player. Signed with the Petersburg team in the Virginia League in 1914, and his contract was sold in 1915 to the Washington Senators, for whom he played as a pitcher then as a right fielder. He served in World War I and returned to the Senators in 1919, batting .321; in 1920 he led the American League in steals and putouts. The Senators won the pennant in 1924, when Rice led the league in hits and had a thirty-one game hitting streak. In 1925 Rice set a league record for singles (182), not broken until 1985, and the Senators won the World Series. He was released from Washington in 1934 and played one more year, with Cleveland. He was elected into the Baseball Hall of Fame in 1963.

RICE, EDMUND (*b. Waitsfield, Vt., 1819; d. White Bear Lake, Minn., 1889*), lawyer, railroad executive, and promoter. Brother of Henry M. Rice. Settling in St. Paul, Minn., 1849, he was prominent in developing railroads of that state. Twice mayor of St. Paul, he was a Democratic member of Congress, 1887–89.

RICE, EDWIN WILBUR (*b. Kingsborough, present Gloversville, N.Y., 1831; d. 1929*), Congregational clergyman and missionary. Official of the American Sunday School Union.

RICE, EDWIN WILBUR (*b. La Crosse, Wis., 1862; d. 1935*), electrical engineer. Son of Edwin W. Rice (1831–1929). A longtime associate as pupil and assistant to Elihu Thomson, Rice served as technical director of the General Electric Co. and as its president, 1913–22. Patents issued to him cover practically the entire field of electrical operations; he was responsible for the addition of Charles P. Steinmetz to the company's staff.

RICE, ELMER (*b. New York, N.Y., 1892; d. Southampton, England, 1967*), playwright, director, and novelist. Attended New York Law School; admitted to the bar in 1913. His first play, *On Trial* (1914), was a sensation, and was followed by about fifty

others, including *Wake Up Jonathan*, with Hatcher Hughes (1921); *The Adding Machine* (1923); *Close Harmony*, with Dorothy Parker (1924); *Street Scene* (1929), which won a Pulitzer Prize; *Counsellor-at-Law* (1931); and *Dream Girl* (1945). With other playwrights formed the Playwrights' Producing Company to produce and direct their own plays; in 1933 he directed Robert E. Sherwood's *Abe Lincoln in Illinois*. Also wrote three novels: *A Voyage to Purilia* (1930); *Imperial City* (1937); and *The Show Must Go On* (1949). One of the first dramatists to use the American stage as a vehicle for social criticism, he had little impact on the American theater after World War II.

RICE, FENELON BIRD (b. Greensburg, Ohio, 1841; d. Oberlin, Ohio, 1901), music teacher. Grandson of David Rice. Graduated Boston Music School, 1863; studied also in Leipzig. Director of the school of music at Oberlin College, 1871–1901.

RICE, GEORGE SAMUEL (b. Claremont, N.H., 1866; d. Takoma Park, Md., 1950), mining engineer. Graduated School of Mines, Columbia University, 1887. After attaining marked success in private engineering practice, he began in 1908 a long crusade for mine safety, which brought him international reputation. He served as chief mining engineer, U.S. Bureau of Mines, 1910–37; during his tenure the Bureau became a world leader in research and promotion of safe mining techniques and procedures.

RICE, (HENRY), GRANTLAND (b. Murfreesboro, Tenn., 1880; d. New York, N.Y., 1954), sports journalist. Studied at Vanderbilt University (B.A., 1901). One of America's most famous sportswriters, Rice contributed to the *New York Tribune* (1914–30) and had nationwide distribution of his columns through syndication. Helped build the reputations of such figures as Babe Ruth, Red Grange, and Bobby Jones. Joined the North American Newspaper Alliance in 1930.

RICE, HENRY MOWER (b. Waitsfield, Vt., 1816; d. San Antonio, Tex., 1894), Indian trader, Minnesota pioneer. Brother of Edmund Rice. Resident in Minnesota *post* 1847, he was influential in establishment of the Territory, served as territorial delegate to Congress, and was U.S. senator, Democrat, from the State of Minnesota, 1858–63.

RICE, ISAAC LEOPOLD (b. Wachenheim, Bavaria, 1850; d. 1915), New York lawyer, financier, chess expert. Came to America as a child. LL.B., Columbia Law School, 1880. Prominent as a railroad lawyer and as a promoter of electrical inventions, he was also the inventor of the "Rice gambit" and was founder (1886) and chief proprietor of the *Forum*.

RICE, JOHN ANDREW (b. Lynchburg, S.C., 1888; d. Silver Spring, Md., 1968), educator. Attended Tulane (B.A., 1911), Oxford as a Rhodes Scholar (B.A., 1914), and University of Chicago. Taught at the University of Nebraska (1919–28), Rutgers (1928–30), New Jersey College for Women (1928–30), and Rollins College (1930–33), from which he was fired for his outspoken criticism of the curriculum system. With a few colleagues and little money, he founded Black Mountain College in rural North Carolina, where a steady stream of innovative faculty gave the school an unsurpassed reputation for creative work in literature and the arts; the college closed in 1956. Rice had resigned in 1940 and later contributed short stories to the *New Yorker* and *Saturday Evening Post*.

RICE, JOHN HOLT (b. Bedford Co., Va., 1777; d. 1831), Presbyterian clergyman, educator. Nephew of David Rice. Active in establishing the theological seminary at Hampden-Sydney, he served as professor of theology there *post* 1824; he was also a strong controversial writer and a promoter of Presbyterian missionary activities.

RICE, LUTHER (b. Northboro, Mass., 1783; d. 1836), Baptist clergyman and educational promoter. Devoted his life to the organization of American Baptists in support of missionary work and higher education for the clergy.

RICE, NATHAN LEWIS (b. Garrard Co., Ky., 1807; d. Chatham, Ky., 1877), Presbyterian clergyman, editor. Held numerous pastorates in the East and Middle West; helped influence Cyprus H. McCormick to become patron of what is now known as McCormick Theological Seminary. President of Westminster College, Fulton, Mo., 1869–74, and professor of theology in Danville (Ky.) Seminary, 1874–77. He was most famous as a controversialist for his debates with Alexander Campbell in Kentucky, 1843.

RICE, RICHARD HENRY (b. Rockland, Maine, 1863; d. 1922), engineer. Graduated Stevens Institute of Technology, 1885. After wide experience as an engine and machine designer, Rice was associated with the General Electric Co. *post* 1903 for which he directed work on the development of the steam turbine. He designed the first turbo-blower for blast furnaces to be installed in America.

RICE, THOMAS DARTMOUTH (b. New York, N.Y., 1808; d. New York, 1860), father of the American minstrel show. Introduced the "Jim Crow" song and dance at the Southern Theatre, Louisville, Ky., 1828; as prepared for publication by William C. Peters, the song became a hit in America and England. In addition to making successful tours in the character of "Jim Crow," Rice wrote numerous extravaganzas known as "Ethiopian Opera." Although he was not the first blackface comedian, Rice, by his phenomenal success, created a vogue for them.

RICE, VICTOR MOREAU (b. Mayville, N.Y., 1818; d. 1869), educator. Graduated Allegheny College, 1841. First superintendent and organizer of the New York State Department of Public Instruction, 1854–57 and 1862–68. His most conspicuous accomplishment was abolition of the rate bill and final establishment of free schools on the principle that the property of the state should educate the children of the state.

RICE, WILLIAM MARSH (b. Springfield, Mass., 1816; d. 1900), merchant, philanthropist. Removed to Houston, Texas, 1838, where he prospered as a trader, investor, and landowner; left his large fortune for the foundation of Rice Institute, Houston.

RICE, WILLIAM NORTH (b. Marblehead, Mass., 1845; d. Delaware, Ohio, 1928), geologist. Graduated Wesleyan University, 1865; Ph.D., Yale, 1867. Professor of geology and natural history at Wesleyan, 1867–84; thereafter taught only geology. Promoted a reconciliation of science and religion in his writing and teaching.

RICH, ISAAC (b. Wellfleet, Mass., 1801; d. 1872), Boston fish merchant and real estate owner. A leading benefactor of Methodist educational institutions, Rich left practically his whole estate to Boston University.

RICH, OBADIAH (b. Truro, Mass., 1783; d. London, England, 1850), bibliographer, bookseller. After serving as U.S. consul at Valencia, Spain, 1816–ca. 1829, he moved to London, England, where he established himself as a bookseller and specialized in manuscripts and early printed books relating to America. His generosity with his stock and personal library won him the gratitude of such historians as Washington Irving, W. H. Prescott,

George Bancroft, and others. He was author of a number of catalogues of items which he had for sale which are still useful in bibliographical research.

RICH, ROBERT (*b. Woolrich, Pa., 1883; d. Jersey Shore, Pa., 1968*), businessman and U.S. congressman. Attended Williamsport Commercial College and Dickinson College. Began work with the family-owned Woolrich Woolen Mills in 1896 and was its general manager by 1930. Appointed to complete a congressional term (1930), he was elected from that Pennsylvania district for the next six congresses. Vociferously opposed to the New Deal, he was alone among House Republicans to vote against extending the National Industrial Recovery Act. He called for the eradication of many New Deal agencies and was an archisolationist who opposed U.S. defense buildup and foreign assistance, including the Marshall Plan. Returned to Woolrich Mills in 1951 and was its chairman, 1964 to 1966.

RICHARD, GABRIEL (*b. Saintes, France, 1767; d. Detroit, Mich., 1832*), Roman Catholic clergyman, educator, Sulpician. Fleeing France during the Revolution, he came to Baltimore, June 1792, and was assigned by Bishop John Carroll to work among the French and Indians out of Kaskaskia and Cahokia. Settling in Detroit, June 1798, he succeeded as pastor of St. Anne's Church there and became vicar general of the region. A zealous, austere, and able man, he ministered to whites and Indians, fought the evils of liquor, and organized some of the earliest educational institutions in Detroit. Obtaining from Baltimore a printing press and a printer, he issued the first paper printed in Detroit, the *Essai du Michigan*, 1809, and also published a number of books. In an effort to stimulate local industry, he imported carding machines, spinning wheels, and looms. Imprisoned as an American during the War of 1812, on his return to Detroit he engaged in relief work there and together with John Monteith, a minister, founded the University of Michigania, 1817. Elected delegate to Congress, 1822, he served a single term. Returning to his church work in Detroit, he died ministering to victims of a cholera epidemic.

RICHARD, JAMES WILLIAM (*b. near Winchester, Va., 1843; d. 1909*), Lutheran clergyman, theologian, educator, Author of *The Confessional History of the Lutheran Church* (1909).

RICHARDS, CHARLES BRINCKERHOFF (*b. Brooklyn, N.Y., 1833; d. New Haven, Conn., 1919*), mechanical engineer. Trained as practical mechanic, Richards devised a steam-engine indicator which facilitated high-speed engine design. While an official at the Colt Armory, 1861–80, he devised the platformscale testing machine for testing the strength of metals and became a recognized authority on heating and ventilation. He headed the department of mechanical engineering at Sheffield Scientific School, Yale, 1884–1909.

RICHARDS, CHARLES HERBERT (*b. Meriden, N.H., 1839; d. 1925*), Congregational clergyman, official of the Congregational Church Building Society, lecturer on ecclesiastical architecture.

RICHARDS, DICKINSON WOODRUFF (*b. Orange, N.J., 1895; d. Lakeville, Conn., 1973*), physician and Nobel laureate. Graduated Yale University (B.A., 1917) and College of Physicians and Surgeons, Columbia University (M.A., 1922; M.D., 1923). He began his teaching career at the college and Columbia–Presbyterian Medical Center in 1929. In 1931 he began a thirty-year association with fellow teacher André Cournand, and they perfected techniques of cardiac catheterization, used to measure the efficacy of cardiac drugs, diagnosis of so-called blue babies, and in the study of chronic pulmonary disease; they and Werner Forssmann were awarded the 1956 Nobel Prize for physiology

and medicine. He became head of Columbia University's First Medical Division at Bellevue Hospital (1945) and Lambert Professor of Medicine at the College of Physicians and Surgeons (1947), positions he held until retirement in 1961.

RICHARDS, ELLEN HENRIETTA SWALLOW (*b. Dunstable, Mass., 1842; d. Jamaica Plain, Mass., 1911*), chemist, home economist. Graduated Vassar, 1870; B.S., Massachusetts Institute of Technology, 1873. Taught sanitary chemistry at Massachusetts Institute *post* 1884; was a leader in the home economics movement.

RICHARDS, JOHN KELVEY (*b. Ironton, Ohio, 1856; d. 1909*), jurist, Ohio legislator and official. U.S. solicitor general, 1897–1903; judge, U.S. circuit court (6th circuit), 1903–09. Gained high reputation for handling of Insular Cases and others before the U.S. Supreme Court, 1897–1903.

RICHARDS, JOSEPH WILLIAM (*b. Oldbury, England, 1864; d. 1921*), metallurgist. Came to America as a boy. Graduated Lehigh, 1866; Ph.D., the first to be granted by the university, 1893. An outstanding teacher at Lehigh *post* 1887, he was a recognized authority on the metallurgy of aluminum, electro-metallurgy, and metallurgical-chemical calculations.

RICHARDS, LAURA ELIZABETH HOWE (*b. Boston, Mass., 1850; d. Gardiner, Maine, 1943*), author. Daughter of Julia Ward Howe and Samuel Gridley Howe; married Henry Richards, an architect and paper mill manager, 1871. Author of more than seventy books, including jingles and nonsense verse (*Sketches & Scraps*, 1881, and others), humorous stories for children (*The Joyous Story of Toto*, 1885), and a number of books for young girls, of which the most popular was *Captain January* (1890). She also wrote juvenile biographies of famous people, and several books relating to her parents, collaborating with her sister on *Julia Ward Howe* (1915), which won a Pulitzer Prize.

RICHARDS, ROBERT HALLOWELL (*b. Gardiner, Maine, 1844; d. Natick, Mass., 1945*), mining engineer. Grandson of Robert Hallowell Gardiner. B.S., Massachusetts Institute of Technology, 1868. Appointed instructor in chemistry at M.I.T., he stressed laboratory work; in 1871 he organized the institute's mining and metallurgical laboratories, devising special equipment for practical illustration and testing of processes under actual mill conditions. He served as professor of mining engineering and head of that department, 1873–1914. He invented or improved a number of machines for ore dressing (which was his speciality) and was author of more than a hundred technical papers and of two books on ore dressing.

RICHARDS, THEODORE WILLIAM (*b. Germantown, Pa., 1868; d. Cambridge, Mass., 1928*), chemist. Son of William T. Richards. Graduated Haverford, 1885; Ph.D., Harvard, 1888. As a graduate student he came under the influence of Josiah P. Cooke who at the time was interested in atomic weights and because of his distrust of their current values had undertaken the revision of some of them. Cooke entrusted Richards with the experimental determination of the relation of the atomic weights of hydrogen and oxygen. In this extremely exacting problem Richards showed the qualities which made him the foremost experimental chemist of his time. After completion of his graduate work he spent one year as a traveling fellow in Europe. On his return he was appointed to the Harvard faculty, becoming a full professor in 1901 and obtaining the Erving Professorship of Chemistry in 1912. Richards always believed that only through measurements of precision was progress to be made in chemistry. Beginning with copper he redetermined the atomic weights of barium, strontium, and zinc, and, with the help of his students, twenty

additional elements. In the course of his work many new analytical processes were devised and perfected. His determination of atomic weights brought to light many previous inaccuracies.

During the last half of his career his interest turned to various fields of physical chemistry, in particular, thermochemistry and thermodynamics. He devoted much energy to the perfecting of thermochemical measurements and devised the "adiabatic calorimeter." New and highly accurate data were obtained in this way, covering heats of solution of metals in acids, heats of combustion of organic substances, heats of neutralization, specific heats of liquids, specific heats of solids at low temperatures, and heats of evaporation of liquids. The study of the data thus obtained led Richards to the discovery that the magnitude of the difference between "total energy change" and "free energy change" depends upon change in heat capacity of a system during chemical change and that this difference gradually disappears as the absolute zero is approached. His work in thermochemistry led him into the field of thermometry and to the exact determination for the first time of the inversion temperatures of hydrated compounds for use as fixed points.

Richards's chief interest in the latter part of his life lay in the consideration of the relation between the physical properties of the various elements and their compounds, especially those connected with atomic volumes and compressibilities. He devised new forms of apparatus for determining exactly the compressibilities of the elements and their compounds, as well as certain related properties such as surface tension and heat of evaporation. This work led to the discovery of the periodicity of atomic volume and compressibility and the close parallelism between these properties, as well as to the fact that increase or decrease in volume during a chemical change depends on the one hand upon the compressibilities of the substances involved and on the other upon their chemical affinities. The latest aspect of this work was an attempt to compute from compressibilities and other data the actual internal pressures which hold matter together. Richards published nearly 300 papers covering a far wider field than indicated here. While many of the theoretical results which he reached have been and will be of the greatest importance, his contribution to the technique of precise physico-chemical investigation will undoubtedly always stand out as being equally important. Indeed he may well be said to have inaugurated a new era in the accuracy of analytical an physico-chemical experimentation. He received the Nobel prize of 1914 for his work on atomic weights.

RICHARDS, THOMAS ADDISON (b. *London, England, 1820; d. Annapolis, Md., 1900*), landscape painter, art teacher. Came to America as a boy. Studied at N.Y. National Academy of Design in which he became an associate and an official. His work as a painter belongs with the Hudson River school and his romantic enthusiasm for natural scenery may be considered the keynote of his career. He was professor of art in the present New York University, 1867–87. Among the books he wrote and illustrated were *The American Artist* (1838), *Georgia Illustrated* (1842), *American Scenery* (1854), and *Appletons' Illustrated Handbook of American Travel* (1857).

RICHARDS, VINCENT (b. *New York, N.Y., 1903; d. New York, 1959*), tennis player. Studied at Fordham University (1920–22), Columbia University (1922). Won twenty-seven national tennis titles in singles, doubles, and mixed doubles competition. Played and took the title in the national doubles championship with William Tilden in 1918. Represented the United States on five winning Davis Cup teams and won the men's singles and doubles titles at the 1924 Olympics. In 1927 he helped organize the Professional Lawn Tennis Association of the United States. Last title, again with Tilden, was the national professional doubles title in 1945. Was the first commissioner of the World Professional Tennis League, in 1947. Generally, he was instrumental in making professional tennis a successful sport.

RICHARDS, WILLIAM (b. *Plainfield, Mass., 1793; d. 1847*), Congregational clergyman, missionary to the Hawaiian Islands. Richards spent the great part of his life *post* 1838 as a Hawaiian government official and played a great but unobtrusive part in liberalizing the Hawaiian economic and political system.

RICHARDS, WILLIAM TROST (b. *Philadelphia, Pa., 1833; d. Newport, R.I., 1905*), painter. Father of Theodore W. Richards. Specialized in accurate, realistic seascapes.

RICHARDS, ZALMON (b. *Cummington, Mass., 1811; d. Washington, D.C., 1899*), educator. Graduated Williams, 1836. An organizer and first president (1857) of the National Teachers' Association which later became the National Education Association.

RICHARDSON, ALBERT DEANE (b. *Franklin, Mass., 1833; d. New York, N.Y., 1869*), journalist, Civil War correspondent for the *New York Tribune*. Author of two books immensely popular in their time, *The Secret Service* (1865) and *Beyond the Mississippi* (1866).

RICHARDSON, ANNA EURETTA (b. *Charleston, S.C., 1883; d. Washington, D.C., 1931*), home economist, educator.

RICHARDSON, CHARLES FRANCIS (b. *Hallowell, Maine, 1851; d. Sugar Hill, N.H., 1913*), educator. Graduated Dartmouth, 1871. Professor of English at Dartmouth, 1882–1911. Author, among other works, of two pioneer studies: *A Primer of American Literature* (1878) and *American Literature: 1607–1885* (1887, 1888). Despite their shortcomings, these works supplied a need and were for a time of considerable influence.

RICHARDSON, CHARLES WILLIAMSON (b. *Washington, D.C., 1861; d. Boston, Mass., 1929*), physician, specialist in diseases of the throat, nose, and ear.

RICHARDSON, EDMUND (b. *Caswell Co., N.C., 1818; d. Jackson, Miss., 1886*), cotton planter, factor, manufacturer. Removed to Mississippi, 1833, where he prospered as a merchant and plantation owner; he also engaged in factoring at New Orleans, La. Heavily in debt at the end of the Civil War, he rebuilt his fortune in a very short time, began the manufacture of cotton in addition to his other concerns, and was at the time of his death the largest cotton planter in the world.

RICHARDSON, HENRY HOBSON (b. *St. James Parish, La., 1838; d. Boston, Mass., 1886*), architect. Great-grandson of Joseph Priestley. Educated in Louisiana and at Harvard where he graduated, 1859. Accepted in the fall of 1860 at the École des Beaux Arts, Paris, he worked under L. J. André and got some of his first practical experience under French architects who were imbued with the doctrines of Néo-Grec rationalism. At the end of the Civil War, he was urged to remain in France where his brilliance had been widely recognized, but he returned to America and won his first recognition in an 1866 competition for design of the First Unitarian Church, Springfield, Mass. His American reputation grew swiftly. His success in the Brattle Street Church competition (Boston, 1870) was followed by his winning the competition for plans for Trinity Church, Boston, in 1872. He achieved a nationwide reputation for his Trinity design, and in 1876 shared with Leopold Eidlitz and Frederick L. Olmsted the work of completing the building and grounds of the New York State Capitol. Removing his home to Brookline, Mass., 1874,

and his office there four years later, he continued on a successful course until his death, living well, enjoying life, and happy in his friendships.

The long list of Richardson's work includes buildings in Boston, Chicago, Pittsburgh, and Cincinnati. Beginning as an ecclesiastical architect, he turned increasingly to more modern problems; he is quoted as saying that he would have liked to have designed a grain elevator. His earlier churches are in a simplified Victorian Gothic style, but the Brattle Street Church tower strikes a new note, and in Trinity Church he first employed his own style of modified French and Spanish Romanesque. His larger houses betray a struggle between prevalent fashion and his own desire to be daringly new; his libraries, despite their Romanesque style, show the development of a rationalism not unlike that of the contemporary French. The Cincinnati Chamber of Commerce (1885) is grand in scale, but its roof shows the exaggeration into which the architect's gusto occasionally led him; his Pittsburgh Jail and Court House show his facility in handling materials and bringing out their special beauties, and achieve a grim, powerful magnificence that was new in American architecture. Richardson created outstanding innovations in his commercial buildings, notably in the Marshall Field Building, Chicago (1885). Almost equally revolutionary was the series of stations he designed in Massachusetts for the Boston & Albany Railroad.

Richardson's influence was enormous; he set an architectural fashion that dominated the eastern United States from 1880 until 1893. His imitators, however, copied his mannerisms only and failed to realize the deep foundations of his art. In consequence, Richardson's style fell into disrepute soon after his death, although his care in handling materials, the brilliance of his planning, and his rationalism were all marked in the early work of Charles F. McKim and Stanford White who had served in his office. A lover of the decorative arts, he employed only the best men of his time in creating interior richness for his buildings, and his ideal of architecture and the sister arts as one unity persisted long after his death. A measure of his remarkable talents is the fact that to successive groups of architects from his own day to the present, each with varying demands, he has seemed to be the first great American example of the qualities that they each seek.

RICHARDSON, ISRAEL BUSH (*b. Fairfax, Vt., 1815; d. Sharpsburg, Md., 1862*), Union soldier. Graduated West Point, 1841. Served with great gallantry as an infantry officer in the Seminole and Mexican wars; after garrison duty in the Southwest, he resigned from the army, 1855. Organized and commanded the 2nd Michigan Regiment at the outbreak of the Civil War; covered Union retreat at first battle of Bull Run. Promoted brigadier general and major general, he led his division in the struggle for the "Bloody Lane" at Antietam and was mortally wounded there.

RICHARDSON, JAMES DANIEL (*b. Rutherford Co., Tenn., 1843; d. Murfreesboro, Tenn., 1914*), lawyer, Confederate soldier. Tennessee legislator, Masonic leader. Congressman, Democrat, from Tennessee, 1885–1905.

RICHARDSON, JOSEPH (*b. Philadelphia, Pa., 1711; d. 1784*), colonial silversmith. Member of the board of the Pennsylvania Hospital, 1756–70.

RICHARDSON, MAURICE HOWE (*b. Athol, Mass., 1851; d. 1912*), surgeon. Graduated Harvard, 1873; M.D., Harvard Medical School, 1877. Practiced in Boston; taught anatomy and surgery at Harvard Medical and served as Moseley Professor of Surgery, 1907–12. Wrote with great ability on the development of the operation for appendicitis (1892–98).

RICHARDSON, ROBERT (*b. Pittsburgh, Pa., 1806; d. Bethany, W. Va., 1876*), physician, educator. A notable convert to the Disciples of Christ, 1829, he was a close associate of Alexander Campbell.

RICHARDSON, RUFUS BYAM (*b. Westford, Mass., 1845; d. 1914*), Greek scholar and archeologist. Graduated Yale, 1869; Ph.D., 1878; B.D., 1883. Taught Greek at Yale, Indiana University, and Dartmouth; director, American School of Classical Studies at Athens, 1893–1903.

RICHARDSON, SID WILLIAMS (*b. Athens, Tex., 1891; d. Saint Joseph's Island, Tex., 1959*), oil executive, philanthropist. Studied briefly at Baylor University and Simmons College (now Hardin-Simmons University). Became an independent oil producer in 1919; owned his first oil field in 1932; by 1935 he was an established multimillionaire. A friend of President Dwight D. Eisenhower, Richardson assiduously shunned publicity. At his death he probably controlled more oil reserves than any other individual in the United States and more than several of the major petroleum companies. His philanthropic activities were kept from public view until after his death, when the Sid Richardson Foundation made numerous grants to educational and charitable institutions.

RICHARDSON, TOBIAS GIBSON (*b. Lexington, Ky., 1827; d. New Orleans, La., 1892*), surgeon. M.D., University of Louisville, 1848; was a private pupil of S. D. Gross. Taught anatomy and surgery at Louisville and Pennsylvania; professor of anatomy, University of Louisiana (now Tulane), 1858–62. After service on the Confederate medical staff, he returned to New Orleans and continued to teach anatomy at Tulane until 1872 when he became professor of surgery and so continued until 1889. He was also dean, 1865–85, and was elected president of the American Medical Association, 1877.

RICHARDSON, WILDS PRESTON (*b. Hunt Co., Tex., 1861; d. Washington, D.C., 1929*), army officer. Graduated West Point, 1884. Supervised building of Richardson Highway from Valdez to Fairbanks, Alaska; commanded U.S. forces in northern Russia, 1919; retired as colonel, Regular Army, 1920.

RICHARDSON, WILLARD (*b. Massachusetts, 1802; d. 1875*), journalist. Graduated South Carolina College, 1828; immigrated to Texas, 1837. As editor-owner of the *Galveston News, post* 1843, Richardson advocated states'-rights doctrines, remorselessly opposed Sam Houston, and was a Southern pioneer in independent journalism.

RICHARDSON, WILLIAM ADAMS (*b. Tyngsborough, Mass., 1821; d. 1896*), jurist. Graduated Harvard, 1843. After attending the law school and admittance to the bar, 1846, he practiced in Lowell, Mass., and was a probate judge. Accepting an assistant secretaryship of the U.S. treasury under G. S. Boutwell, 1869, he succeeded to the secretaryship, 1873. After a short term marked by weakness and ineptitude, he was made a judge of the Court of Claims, June 1874, and became chief justice of that court, 1885.

RICHARDSON, WILLIAM LAMBERT (*b. Boston, Mass., 1842; d. 1932*), obstetrician. Graduated Harvard, 1864; M.D., Harvard Medical School, 1867. Reopened the Boston Lying-In Hospital, 1873, and made it one of the outstanding hospitals of its type in the United States. Taught obstetrics at Harvard, 1871–1907, and was dean of the medical faculty *post* 1893.

RICHARDSON, WILLIAM MERCHANT (*b. Pelham, N.H., 1774; d. 1838*), jurist, congressman, New Hampshire official. As chief

justice, New Hampshire superior court, 1816–38, he played a leading part in shaping the jurisprudence of that state.

RICHBERG, DONALD RANDALL (*b. Knoxville, Tenn., 1881; d. Charlottesville, Va., 1960*), lawyer, government official. Attended the University of Chicago (B.A., 1901), Harvard Law School (LL.B., 1904). Served as counsel for the Illinois Progressive Party, various labor unions, and the city of Chicago in a suit against public utilities. Member of the New Deal; was appointed general counsel to the National Recovery Administration (NRA) in 1933. President Franklin D. Roosevelt appointed him director of the Industrial Emergency Committee and of the National Emergency Council in 1934. The next year, when the Supreme Court found the NRA unconstitutional, Richberg's influence ended. Taught at the University of Virginia Law School from the late 1930's. Became an opponent of the New Deal and the welfare state; helped draft parts of the Taft-Hartley Act.

RICHINGS, PETER (*b. probably London, England, 1798; d. Media, Pa., 1871*), actor, opera singer. Immigrated to New York, 1821; made his debut there at the Park Theatre in September. Achieving success by hard work rather than outstanding talent, he remained active in the profession until 1867.

RICHMOND, CHARLES WALLACE (*b. Kenosha, Wis., 1868; d. Washington, D.C., 1932*), ornithologist. M.D., Georgetown University, 1897. Associated for much of his life with the U.S. National Museum in curatorial capacities, Richmond was a recognized authority in problems of avaian nomenclature and bibliography.

RICHMOND, DEAN (*b. Barnard, Vt., 1804; d. New York, N.Y., 1866*), businessman, railroad president, political leader in New York State. Starting as a leader of the "Barnburner" movement, he was chairman of the New York State Democratic committee, 1850–66, and was a dominating factor in his party's councils. *Post ca.* 1852, he was a "Soft" Democrat, or favorer of compromise on the slavery issue; in 1860, he was a leader among the supporters of Stephen A. Douglas. With Thurlow Weed, he helped arrange the National Union Convention at Philadelphia, 1866, in an endeavor to unite Democrats and Conservative Republicans in opposition to the Republican Radicals.

RICHMOND, JOHN LAMBERT (*b. near Chesterfield, Mass., 1785; d. Covington, Ind., 1855*), Baptist clergyman, physician. Graduated Medical College of Ohio, 1822. While in practice at Newton, Ohio, he performed first successful Caesarean operation (1827) to be reported in the U.S. medical press.

RICHMOND, JOHN WILKES (*b. Little Compton, R.I., 1775; d. Philadelphia, Pa., 1857*), physician. Practiced in Providence, R.I., *post* 1815; is chiefly remembered for his endeavors to compel the payment of the Revolutionary War debt of Rhode Island after virtual repudiation in 1844.

RICHMOND, MARY ELLEN (*b. Belleville, Ill., 1861; d. 1928*), pioneer social worker, teacher. Beginning her career with the Charity Organization Society of Baltimore, 1889, she became general secretary of the Society for Organizing Charity in Philadelphia, 1900; *post* 1909, she was director of the Charity Organization Department, Russell Sage Foundation. Among her books were *Social Diagnosis* (1917) and *Marriage and the State* (with F. S. Hall, 1929).

RICHTER, CONRAD MICHAEL (*b. Pine Grove, Pa., 1890; Pottsville, Pa., 1968*), writer. His family's association with the Lutheran ministry influenced his writing and figures directly in two of his best novels: the National Book Award-winning *The Waters of Kronos* (1960) and *A Simple Honorable Man* (1962). Other novels include *The Sea of Grass* (1937) and the Pulitzer Prize-winning *The Town* (1950), which was the third part of the trilogy *The Awakening Land* (published as a set in 1966). His first acclaimed short story, "Brothers of No Kin," appeared in *Forum* (1914) and became the title piece of his first collection of stories (1924). In his work he employed quiet humor and clarity and economy of expression to depict what he called the "small authenticities" of daily life. Other collections include *Smoke Over the Prairie and Other Stories* (1947) and *The Rawhide Knot and Other Stories* (1948).

RICHTMYER, FLOYD KARKER (*b. Cobleskill, N.Y., 1881; d. Ithaca, N.Y., 1939*), physicist. Graduated Cornell, 1904; Ph.D., 1910. Taught physics at Cornell *post* 1906 and served *post* 1931 as dean of the graduate school. A pioneer in photometry and in the use of photoelectric cells, also in X-ray research.

RICKARD, CLINTON (*b. Tuscarora Indian Reservation, Lewiston, N.Y., 1882; d. Buffalo, N.Y., 1971*), Indian tribal leader. He learned tribal history from his maternal grandmother and joined the army in 1901. In 1904 he returned to New York State and in 1905 purchased land on the reservation and became a farmer. In 1920 he was made a chief of the Tuscarora tribe; in 1926 he formed the Six Nations Defense League and successfully obtained border-crossing rights for Canadian and U.S. Indians; in 1928 he renamed the group the Indian Defense League, which remains a watchdog organization. He successfully lobbied for additional funds for reservation schools and for the right of Indians to attend public high schools. President of the Chiefs' Council (the Tuscarora Nation governing body) from 1930, he testified before the Senate in 1948 but did not prevent passage of legislation that placed state governments over tribal ones. He also failed in efforts to prevent New York State from seizing more than half the Tuscarora Reservation for a reservoir in 1958.

RICKARD, GEORGE LEWIS (*b. Kansas City, Mo., 1871; d. Miami Beach, Fla., 1929*), gambler, prizefight promoter, better known as "Tex" Rickard.

RICKENBACKER, EDWARD VERNON ("EDDIE") (*b. Columbus, Ohio, 1890; d. Zurich, Switzerland, 1973*), fighter pilot and airline executive. In 1911 he began a career as a racing driver, competing in three Indianapolis 500s and setting a world speed record of 134 miles per hour at Daytona. During World War I he was a driver on Gen. John Pershing's staff then entered pilot training; he became a combat pilot in March 1918 and downed his first German plane in April. By the end of the war he had flown 134 missions and scored twenty-six victories, earning him the Medal of Honor in 1931.

During the 1920's he bought the Indianapolis Speedway, which he managed for almost two decades; founded Florida airways (later Eastern Air Transport); joined the Cadillac division of General Motors (1927); and became vice-president of sales for Fokker Aircraft Corporation (1929). He became vice-president of American Airways in 1932 and returned to GM in 1933, becoming vice-president of its newly acquired North American Aviation, which included Eastern Air Transport (renamed Eastern Air Lines), of which he became general manager in 1934 and president in 1938. During World War II he undertook special assignments, including secret missions, then returned to Eastern in 1945. Poor decisions and competition from Delta led to Eastern's decline; in 1959 he was replaced as president and made chairman; he retired in 1964.

RICKERT, MARTHA EDITH (*b. Dover, Ohio, 1871; d. Chicago, Ill., 1938*), philologist. Graduated Vassar, 1891; Ph.D., Univer-

sity of Chicago, 1899. Professor of English, University of Chicago, *post* 1924, Miss Rickert made her principal contribution to scholarship in association with John M. Manly as editor of the monumental *The Text of the Canterbury Tales* (1940). She was author also of a number of others works.

RICKETSON, DANIEL (*b.* New Bedford, Mass., 1813; *d.* New Bedford, 1898), poet, local historian. Friend and associate of H. D. Thoreau, R. W. Emerson, the Alcotts, and other leading literati.

RICKETTS, CLAUDE VERNON (*b.* Greene County, Mo., 1906; *d.* Bethesda, Md., 1964), naval officer. Graduated from U.S. Naval Academy (1929) and received his pilot's wings in 1932. Served as an officer aboard various vessels, beginning in 1938, and held key administrative posts in the navy. During World War II took part in the capture of the Gilbert, Marshall, and Marianas Islands and of Iwo Jima and Okinawa (1943–45). Promoted to rear admiral (1956) and full admiral (1961), then was made vice chief of naval operations.

RICKETTS, HOWARD TAYLOR (*b.* Findlay, Ohio, 1871; *d.* Mexico City, Mex., 1910), pathologist. Graduated University of Nebraska, 1894; M.D., Northwestern, 1897; studied also in Vienna and at the Pasteur Institute in Paris. Joining the department of pathology, University of Chicago, 1902, he began a program in the new field of immunology and in 1906 began his brilliant studies of Rocky Mountain spotted fever. In the course of his investigations, he discovered in the blood of patients and in the communicating ticks and their eggs a small organism which he rightly assumed to be the cause of the disease; this and related organisms responsible for many important diseases are now known as *Rickettsia* in the memory of the man who first identified them. Struck by the resemblance of Rocky Mountain fever to typhus, he undertook a successful investigation of that disease, demonstrating in a short time that the agent of transmission is chiefly the louse, and again finding micro-organisms which were later established as the true cause of the disease. He died of typhus himself in the midst of his successful work.

RICKETTS, JAMES BREWERTON (*b.* New York, N.Y., 1817; *d.* Washington, D.C., 1887), Union soldier. Graduated West Point, 1839. After service with the artillery in the Mexican War and in various posts throughout the United States, he was appointed brigadier general, 1862, and held divisional command at Cedar Mountain, second Bull Run, South Mountain, and Antietam. Disabled by many wounds, he left the field until March 1864 when he again commanded a division in the Wilderness campaign and under Sheridan in the Shenandoah Valley. He retired as major general in 1867.

RICKETTS, PALMER CHAMBERLAINE (*b.* Elkton, Md., 1856; *d.* Baltimore, Md., 1934), engineer, educator. Graduated Rensselaer Polytechnic, 1875. Engaged in engineering practice for many years, his reputation rests principally upon his educational work at Rensselaer and his development of that school materially and academically as teacher (*post* 1875), director (1892–1901), and president, 1901–34.

RICKEY, WESLEY BRANCH (*b.* Lucasville, Ohio, 1881; *d.* Columbia, Mo., 1965), major-league baseball executive. Attended Ohio Wesleyan and University of Michigan (LL.B., 1911). Played for the Cincinnati Reds (1904) and the St. Louis Browns (1905–07); became executive assistant to the Browns' owner (1913) and managed the team, reviving the farm system and enabling the Browns to compete with wealthy rivals in recruiting players. As manager and president of the St. Louis Cardinals (1916–42) he built a network of minor-league farm clubs; by

1940 he had over thirty teams in the chain, almost cornering the market in young players. Became president and general manager of the Brooklyn Dodgers (1942) and co-owner (1945). Won public support for admitting blacks to major-league baseball, selecting Jackie Robinson (1945) as a test case. Forced to sell his Dodgers stock, he became executive vice president of the Pittsburgh Pirates (1951–55). President (1959) of the Continental League, a rival league that, although it failed, forced major-league baseball to undertake continental expansion. Voted into the Baseball Hall of Fame (1967).

RICORD, FREDERICK WILLIAM (*b.* Guadeloupe, French West Indies, 1819; *d.* Newark, N.J., 1897), librarian, New Jersey public official and jurist. Nephew of Philippe Ricord.

RICORD, PHILIPPE (*b.* Baltimore, Md., 1800; *d.* Paris, France, 1889), physician, world-wide authority on venereal diseases. Uncle of Frederick W. Ricord. Removed to France, 1820, for medical study and practiced there, principally in Paris; his *Traité pratique des maladies vénériennes* (Paris, 1838) was an epical document in the history of medicine.

RIDDELL, JOHN LEONARD (*b.* Leyden, Mass., 1807; *d.* 1865), physician, botanist. M.D., Cincinnati Medical College, 1836. Professor of chemistry, Medical College of Louisiana (later Tulane), New Orleans, 1836–65. Author of a pioneer botany text, *Synopsis of the Flora of the Western States* (1835). Riddell was active in the medical and civic life of Louisiana, but is particularly noted for his invention of the binocular microscope which he devised in 1851, put in form in 1852, and displayed before the American Association for the Advancement of Science in July 1853.

RIDDER, BERNARD HERMAN (*b.* New York City, 1883; *d.* West Palm Beach, Fla., 1975), publisher. Graduated Columbia University (B.A., 1903) and began his newspaper career with the *Brooklyn Eagle* (1905); in 1909 he joined the *Staats–Zeitung*, the New York German-language paper of which his father was founder and publisher, and became publisher in 1915, when he and his brothers inherited the paper. He built the family businss by merging with other German-language newspapers and served as president of the publishing company until it was sold in 1930. In 1926 the brothers acquired the *Jamaica Long Island Press*, their first venture into English-language press. In 1927 they acquired the *New York Journal of Commerce*, *St. Paul Pioneer Press*, and the *St. Paul Dispatch*; Ridder served as president of all three until 1931. The brothers continued to acquire small-town papers, and Bernard rejoined the two Minnesota papers as editor (1938–46) and publisher (1938–50). In 1974 Ridder Publications merged with Knight Newspapers to form Knight–Ridder Newspapers, Inc., with Ridder remaining chairman emeritus of the the board of Ridder Publishing.

RIDDER, HERMAN (*b.* New York, N.Y., 1851; *d.* 1915), newspaper publisher. Established the *Catholic News* (N.Y.), 1886. After managing the *New-Yorker Staats-Zeitung*, he bought it from Oswald Ottendorfer *post* 1890 and directed it until his death. Active in German-American affairs and as an independent Democrat, he also held office in trade associations and in the Associated Press.

RIDDLE, ALBERT GALLATIN (*b.* Monson, Mass., 1816; *d.* Washington, D.C., 1902), lawyer, Ohio legislator and congressman. A bitter anti-slavery Whig, Riddle issued the 1848 call for a mass meeting at Chardon which inaugurated the Ohio Free-Soil party.

RIDDLE, GEORGE PEABODY (*b. Charlestown, Mass., 1851; d. Boston, Mass., 1910*), actor, reader, able director of Greek play revivals.

RIDDLE, MATTHEW BROWN (*b. Pittsburgh, Pa., 1836; d. Edgeworth, Pa., 1916*), Reformed Dutch clergyman, biblical scholar. Taught New Testament exegesis at Hartford (Conn.) and Western Theological seminaries.

RIDDLE, SAMUEL DOYLE (*b. Glen Riddle, Pa., 1861; d. Glen Riddle, 1951*), sportsman. Graduated from Pennsylvania Military College (later Widener College) in 1879. Owner and trainer of the racehorse Man o'War, a famous American racehorse that broke track records almost every time he ran and set three world's records. Riddle bred some of the nation's most successful racehorses including War Admiral, Battleship, Crusader, War Glory, and Scapa Flow.

RIDEING, WILLIAM HENRY (*b. Liverpool, England, 1853; d. Brookline, Mass., 1918*), journalist, miscellaneous writer. Came to America, 1869. Associated *post* 1881 with editorial staff of *Youth's Companion*; also an editor of *North American Review*.

RIDEOUT, HENRY MILNER (*b. Calais, Maine, 1877; d. at sea, en route for Europe, 1927*), Harvard instructor, writer. Author of several textbooks in association with Charles T. Copeland, and of popular fiction.

RIDGAWAY, HENRY BASCOM (*b. Talbot Co., Md., 1830; d. 1895*), Methodist clergyman, theologian. Professor at Garrett Biblical Institute, 1882–95; president of the Institute *post* 1885.

RIDGE, MAJOR (*b. probably Hiwassee, in present Polk Co., Tenn., ca. 1771; d. near Van Buren, Okla., 1839*), Cherokee Indian leader. After first supporting John Ross in opposition to land cession, he signed a treaty at New Echota, Ga., December 1835, whereby all Cherokee lands east of the Mississippi were ceded and westward removal accepted. The tragic westward migration of the Cherokee followed, and Ridge was murdered in revenge for his part in causing it.

RIDGELY, CHARLES GOODWIN (*b. Baltimore, Md., 1784; d. Baltimore, 1848*), naval officer. Appointed midshipman, 1799. Saw varied service in the wars with the Barbary powers, the War of 1812, and in campaigns against the West Indian pirates.

RIDGELY, DANIEL BOWLY (*b. near Lexington, Ky., 1813; d. Philadelphia, Pa., 1868*), naval officer. Commended, 1865, for energetic action against Confederate blockade runners throughout the Civil War; promoted commodore, 1866.

RIDGELY, NICHOLAS (*b. Dover, Del., 1762; d. 1830*), Delaware legislator and jurist. State attorney general, 1791–1801; chancellor of Delaware, 1802–30.

RIDGWAY, ROBERT (*b. Mount Carmel, Ill., 1850; d. 1929*), ornithologist. A protégé of Spencer F. Baird, Ridgway assumed care of the bird collections of the Smithsonian Institution, and in 1880 was designated curator of birds, U.S. National Museum, in which post he continued until his death. He did important field work and was author of a number of books; among these were *Color Standards and Nomenclature* (1886), *The Birds of North and Middle America* (1901–19), and several works written in collaboration with Spencer F. Baird and Thomas M. Brewer. At the height of his career, Ridgway was considered the leading American ornithologist; his writings were models of accuracy.

RIDGWAY, ROBERT (*b. Brooklyn, N.Y., 1862; d. Fort Wayne, Ind., 1938*), civil engineer, expert in subway construction and deep tunnel work.

RIDPATH, JOHN CLARK (*b. Putnam Co., Ind., 1840; d. New York, N.Y., 1900*), educator, author of popular historical works.

RIEFLER, WINFIELD WILLIAM (*b. Buffalo, N.Y., 1897; d. Sarasota, Fla., 1974*), economist. Graduated Amherst College (B.A., 1921) and Robert Brookings Graduate School (Ph.D., 1927); in 1923 he joined the staff of the Federal Reserve Board in Washington, D.C. He became an economic adviser to the Franklin D. Roosevelt administration in 1933 and drafted the margin provision in the Securities and Exchange Act (1934). He joined the faculty at the Institute for Advanced Study, Princeton (1935–48), and helped organize and served as director of the National Bureau of Economic Research. He was sent to London in 1942 to oversee lend-lease operations. In 1948 he became assistant to the chairman of the Federal Reserve Board, where in the 1950's he worked on adjusting monetary policy to fight the inflationary impact of large military budgets. He retired in 1959.

RIEGER, JOHANN GEORG JOSEPH ANTON (*b. Aurach, Bavaria, 1811; d. Jefferson City, Mo., 1869*), German Evangelical missionary in Illinois, Iowa, and Missouri *post* 1836.

RIEGGER, WALLINGFORD (*b. Albany, Ga., 1885; d. New York, N.Y., 1961*), composer. Attended Cornell, Institute of Musical Art (now Juilliard), and Berlin Hochschule für Musik. Made conducting debut (1910) with the Blüthner Orchestra in Berlin. His first mature composition, *Trio in B minor* (1920), received the Paderewski Prize. His music was occasionally romantic, occasionally impressionistic, utilizing traditional harmonic and melodic procedures within formal structures. Broke with conservatism to embrace atonality with *Rhapsody for Orchestra* (1925). From atonality went on to the twelve-tone system: *Dichotomy* (1932), *String Quartet No. 1* (1938–39), and *Duos for Three Woodwinds* (1943). Taught at Drake University (1918–22), Institute of Musical Art (1924–25), Ithaca Conservatory (1926–28), and Metropolitan Music School (from 1936).

RIGDON, SIDNEY (*b. Piny Fork, Pa., 1793; d. Friendship, N.Y., 1876*), early Mormon leader. A Campbellite preacher in the Western Reserve *post* 1828, Rigdon announced a public conversion to Mormonism, 1830, and played an important role in the new movement until the death of Joseph Smith. Outmaneuvered in his attempt to be selected as "Guardian" of the church by Brigham Young and the other apostles, Rigdon was excommunicated at Nauvoo, 1844. In the following year, he was voted by a group of followers the president of a new sect. He was probably the author of the "Lectures on Faith," although Smith published them as his own.

RIGGE, WILLIAM FRANCIS (*b. Cincinnati, Ohio, 1857; d. Omaha, Nebr., 1927*), Roman Catholic clergyman, Jesuit, astronomer. Director of the observatory, Creighton University, 1896–1927. Author of *Harmonic Curves* (1926) and other contributions to the literature of mathematics and astronomy.

RIGGS, ELIAS (*b. New Providence, N.J., 1810; d. probably Constantinople, Turkey, 1901*), missionary in the Near East *post* 1832, linguist, author.

RIGGS, GEORGE WASHINGTON (*b. Georgetown, D.C., 1813; d. Prince George's Co., Md., 1881*), banker. Entered partnership with William W. Corcoran in Washington, D.C., 1840–48; purchased Corcoran's interest in Corcoran & Riggs, 1854. Thereafter he continued the firm as Riggs & Co. until his death.

RIGGS, JOHN MANKEY (*b. Seymour, Conn., 1810; d. Hartford, Conn., 1885*), dentist. Studied under Horace Wells. A strong advocate of hygienic care of the mouth, he gained wide repute as a specialist in treatment of pyorrhea. On Dec. 11, 1844, at Hartford, he performed an outstanding operation in the history of modern anesthesia, extracting a tooth from the mouth of Horace Wells while the latter was under the influence of nitrous oxide gas.

RIGGS, STEPHEN RETURN (*b. Steubenville, Ohio, 1812; d. Beloit, Wis., 1883*), Presbyterian clergyman. Missionary to the Sioux *post* 1837; authority on Siouan languages.

RIGGS, WILLIAM HENRY (*b. New York, N.Y., 1837; d. 1924*), art collector. Resident in Paris, France, *post ca.* 1857, Riggs made a remarkable collection of art and armor which he was influenced by his friend J. Pierpont Morgan to present to the Metropolitan Museum of Art.

RIIS, JACOB AUGUST (*b. Ribe, Denmark, 1849; d. Barre, Mass., 1914*), journalist, reformer. Immigrated to New York City, 1870; was employed as a police reporter on the *New York Tribune* and the *Evening Sun.* Offering evidence based on his personal observation of the degradation of the tenement districts of the city, Riis effected massive reforms in housing through his vivid writings and countless lectures. Opposed by politicians and landlords, he found a powerful friend and abettor in Theodore Roosevelt. Among his books were *How the Other Half Lives* (1890), *The Children of the Poor* (1892), *Out of Mulberry Street* (1898), and *The Making of an American* (1901).

RIIS, MARY PHILLIPS (*b. Memphis, Tenn., 1877; d. New York, N.Y., 1967*), stockbroker. As the widow of social reformer Jacob Riis, she was a lifelong supporter of the Jacob A. Riis Neighborhood House. She began selling bonds (1917) for Bonbright and Company, and in 1919 headed a Bonbright branch that specialized in serving women customers. She attributed her success in the securities business to her ability to evaluate facts unemotionally. Remained active as a broker until she was eighty, having evolved an investment philosophy that consisted of investing 20 percent of available funds in safe, income-oriented instruments, 60 percent in major growth stocks, and 20 percent in speculative capital gains.

RILEY, BENJAMIN FRANKLIN (*b. near Pineville, Ala., 1849; d. Birmingham, Ala., 1925*), Baptist clergyman, educator.

RILEY, BENNET (*b. St. Mary's Co., Md., 1787; d. Buffalo, N.Y., 1853*), soldier, Indian fighter. Entered U.S. Army as ensign of riflemen, 1813. After varied service in the War of 1812 and against the Western Indians, he became colonel of the 2nd Infantry at the outbreak of the Mexican War but was quickly advanced to brigade command. He received the brevet of major general for his outstanding charge at the battle of Contreras, August 1847. Transferred to California, 1848, he served as provisional governor and convened the assembly at Monterey, September 1849, which drew up the first constitution for California and applied for admission to the Union.

RILEY, CHARLES VALENTINE (*b. London, England, 1843; d. 1895*), entomologist. Immigrated to the United States *ca.* 1860; was associated with the *Prairie Farmer* (Chicago) as reporter and was named as entomologist to the State of Missouri, 1868–77. His reports of his Missouri investigations established his reputation; many authorities date modern economic entomology from their publication. Through his efforts, the U.S. Entomological Commission was established, 1877, of which he became chief; he served as entomologist to the U.S. Department of Agriculture,

1878–79 and 1881–94. He was an able investigator and a prolific writer, his work showing an unusual sense of economic proportion combined with scientific accuracy.

RILEY, ISAAC WOODBRIDGE (*b. New York, N.Y., 1869; d. 1933*), philosopher, educator. Graduated Yale, 1892; Ph.D., 1902. Professor of philosophy, Vassar College, 1908–33. Author of the notable *American Philosophy: The Early Schools* (1907), *American Thought from Puritanism to Pragmatism* (1915), and other works.

RILEY, JAMES WHITCOMB (*b. Greenfield, Ind., 1849; d. Indianapolis, Ind., 1916*), poet. Leaving school at 16, Riley worked as a sign painter and as a small town journalist. His popularity dates from his employment on the *Indianapolis Journal,* 1877–85, during which time the verses which he contributed to the paper were widely copied. The series of verses signed "Benj. F. Johnson, of Boone" were particularly noticed and were published as a book in 1883 with the title *The Old Swimmin' Hole and 'Leven More Poems.* Riley was truly a Hoosier poet, for the whimsical and eccentric characters in his verses together with their dialect and the scene against which they moved were all drawn from his local observations. Oversentimental as he may be, he made an original contribution to American literature in portraying the special characteristics of his time and place. Among the long list of books, the most popular were *Afterwhiles* (1887), *Pipes o' Pan at Zekesbury* (1888), *Rhymes of Childhood* (1890), and *Poems Here at Home* (1893).

RILEY, WILLIAM BELL (*b. Greene County, Ind., 1861; d. Golden Valley, Minn., 1947*), Baptist clergyman, evangelist. B.A., Hanover (Ind.) College, 1885; M.A., 1888. Graduated Southern Baptist Theological Seminary, Louisville, Ky., 1888. Served small churches in Kentucky, Indiana, and Illinois; pastor of Calvary Baptist Church, Chicago, 1893–97, and of First Baptist Church in Minneapolis, Minn., 1897–1942. Founded Northwestern Bible Training School in Minneapolis, 1902; headed the World's Christian Fundamentals Association, 1919–29. A leader in the defense and propagation of fundamentalism.

RIMMER, WILLIAM (*b. Liverpool, England, 1816; d. 1879*), sculptor, painter. Came to Nova Scotia as a child; was raised in Hopkinton, Mass., and Boston. Worked at a number of trades and professions including shoemaking, medicine, and itinerant portrait painting; he was also a musician and a teacher of music. Encouraged to concentrate on sculpture *post* 1860, he won reputation but little income and was obliged to teach art anatomy in Boston and at Cooper Union, New York City. Unable to work with a group or with others at all, Rimmer was a man of extraordinary gifts, too widely lavished. However, William M. Hunt admired his genius and John La Farge and Daniel C. French were gladly his pupils.

RINDGE, FREDERICK HASTINGS (*b. Cambridge, Mass., 1857; d. Yreka, Calif., 1905*), philanthropist, California land developer. Donated a number of public buildings to Cambridge, Mass.

RINEHART, MARY ROBERTS (*b. Pittsburgh, Pa., 1876; d. New York, N.Y., 1958*), novelist, mystery writer. Graduated from the Pittsburgh Training School for Nurses in 1896. Married to a physician, Rinehart began selling stories in 1903 to help support her family. Her first mystery novel, *The Circular Staircase* (1908), was later made into a successful play, *The Bat.* As a European correspondent for the *Post,* she was the first woman to report from the front. Founded the publishing firm of Farrar and Rinehart. Immensely popular at the time, several of Rinehart's sixty-two books are still some of the finest mysteries in American literature.

RINEHART, STANLEY MARSHALL, JR. (*b. Pittsburgh, Pa., 1897; d. South Miami, Fla., 1969*), publisher. Attended Harvard (1915–17). Took a job in the advertising department of George H. Doran Company (1919) and, after buying an interest, eventually became director of the company. After the company merged with Doubleday, Page (1927), Rinehart, his brother Frederick, and John Farrar formed Farrar and Rinehart; in 1931 that company bought Cosmopolitan Book Corporation, acquiring such writers as Philip Wylie, Upton Sinclair, and Stephen Vincent Benét. The house's greatest success was with Hervey Allen's *Anthony Adverse* (1933), which sold over a million copies. As president of the firm, Rinehart exemplified the willingness of new young publishers to treat books as commodities. Rinehart bought out Farrar and established Rinehart and Company (1946), which published in the late 1940's Norman Mailer's *The Naked and the Dean* and Charles Jackson's *The Lost Weekend*. He sold the firm to Henry Holt and Company (1960), but stayed on as a director of Holt, Rinehart and Winston until 1963.

RINEHART, WILLIAM HENRY (*b. near Union Bridge, Md., 1825; d. Rome, Italy, 1874*), sculptor. Began work as a stonecutter and letter in Baltimore, Md.; studied at the Maryland Institute. Under the patronage of several local merchants including W. T. Walters, Rinehart visited Italy, 1855–57. Finding it impossible to practice sculpture at home, he returned to Italy in 1858, and kept a studio in Rome for the rest of his life. Throughout his career, Walters remained his chief patron. Rinehart's best work was done in a sensitive and refined neo-classic style. Among his works his "Clytie" (Peabody Institute) is perhaps his masterpiece, but his massive seated figure of Roger B. Taney (Annapolis, Md.; copy in Baltimore) remains one of the most successful public monuments in the United States.

RINGGOLD, CADWALADER (*b. Washington Co., Md., 1802; d. New York, N.Y., 1867*), naval officer. Grandson of John Cadwalader. Appointed midshipman, 1819; promoted lieutenant, 1828, and commander, 1849. During this period he was employed against the pirates of the West Indies and cruised in the Mediterranean and the Pacific; he commanded the *Porpoise* in the Wilkes Exploring Expedition, 1838–42. Engaged in surveys on the California coast, 1849–50, he published *A Series of Charts. . . to the Bay of San Francisco* (1851) and subsequently commanded a surveying expedition in the North Pacific, 1853–54. Ordered home as insane by Commodore Matthew C. Perry, Ringgold resented the action bitterly, as a medical survey upon his return to America declared him fully competent. Promoted captain, 1857, he later served with great distinction in the Civil War and retired as commodore, 1864.

RINGLING, CHARLES (*b. McGregor, Iowa, 1863; d. Sarasota, Fla., 1926*), circus proprietor. Joined four of his brothers in a concert company, 1882. Organizing their first circus, 1884, the brothers by 1900 had one of the largest shows on the road and began absorbing other circuses; they acquired the Barnum & Bailey Circus, 1907. Charles Ringling was also a prominent factor in the real-estate developments along Florida's West Coast.

RIORDAN, PATRICK WILLIAM (*b. Chatham, N.B., Canada, 1841; d. 1914*), Roman Catholic clergyman. Raised in Chicago; graduated Notre Dame, 1858; studied for priesthood in North American College, Rome. Consecrated coadjutor to Archbishop Alemany of San Francisco, 1883, he succeeded almost immediately to the see and administered it prudently until his death.

RIPLEY, EDWARD HASTINGS (*b. Center Rutland, Vt., 1839; d. Rutland, Vt., 1915*), Union brigadier general, financier. Brother of Julia C. R. Dorr. Commanding the first federal infantry to enter Richmond, Va., 1865, he restored order, suppressed the mob, and extinguished the fire which was raging in the Confederate capital.

RIPLEY, EDWARD PAYSON (*b. Dorchester, Mass., 1845; d. Santa Barbara, Calif., 1920*), railroad executive. Notable in particular for his skill and integrity in restoring the Atchison, Topeka & Santa Fe Railway during his presidency, 1896–1920.

RIPLEY, ELEAZAR WHEELOCK (*b. Hanover, N.H., 1782; d. West Feliciana, La., 1839*), lawyer, soldier. Grandson of Eleazar Wheelock. Served in War of 1812 as colonel of the 21st (present 5th) Infantry and as brigadier general in the Niagara campaign. Resigning from the army, 1820, he practiced law at New Orleans, La., and was congressman, Democrat, from Louisiana, 1835–39.

RIPLEY, EZRA (*b. Woodstock, Conn., 1751; d. 1841*), Unitarian clergyman. Graduated Harvard, 1776. Pastor, First Church, Concord, Mass., 1778–1841. Abandoned Trinitarianism and orthodox Calvinism *ca.* 1772, but was a fervent evangelical.

RIPLEY, GEORGE (*b. Greenfield, Mass., 1802; d. 1880*), Unitarian clergyman, editor, reformer, literary critic. Graduated Harvard, 1823; Harvard Divinity School, 1826. Minister of Purchase Street Church, Boston, 1826–41. Ripley was strongly influenced by German theology, and with F. H. Hedge edited *Specimens of Foreign Standard Literature* (1838 and *post*), translations of Cousin, Jouffroy, Schleiermacher, and others which were of profound influence on New England intellectual life. He resumed a previous controversy with Andrews Norton over the philosophy of religion in 1839, defending his own views as well as those of R. W. Emerson in *Letters on the Latest Form of Infidelity* (1840). An associate of Emerson, Hedge, A. B. Alcott, Theodore Parker, Margaret Fuller, and others in the so-called "Transcendental Club," Ripley aided Fuller in editing the *Dial* (founded 1840) and assumed charge of the Brook Farm colony (1841) which was to be a practical application of what he and William E. Channing considered the New Testament social order. Although he disliked the regimentation involved in socialism, Ripley, as president, along with others of the group, accepted the new constitution which made Brook Farm a Fourierite Phalanx, January 1844, and edited the *Harbinger*, post 1845. Heavily involved in debt on the final collapse of Brook Farm, August 1847, Ripley removed to New York City and in 1849 succeeded Margaret Fuller as literary critic of the *New York Tribune*. For more than 20 years he labored to pay off the debts of Brook Farm. In his 31 years as critic for the *Tribune*, hardly a single important American book escaped his intelligent criticism. In 1850 he was a founder of *Harper's New Monthly Magazine* and edited its literary department. Success with *A Hand-Book of Literature and the Fine Arts* (edited with Bayard Taylor, 1852) was followed by a further success as editor (with Charles A. Dana) of the *New American Cyclopoedia* (1858–63).

RIPLEY, JAMES WOLFE (*b. Windham Co., Conn., 1794; d. Hartford, Conn., 1870*), soldier. Graduated West Point, 1814. After varied service in the artillery, 1814–33, Ripley transferred to the ordnance corps. In command of the armory at Springfield, Mass., 1841–54, he rebuilt and modernized the plant. Chief of ordnance, U.S. Army, 1861–63, he fought favoritism, fraud, and political influence.

RIPLEY, ROBERT LEROY (*b. Santa Rosa, Calif., 1893; d. New York, N.Y., 1949*), newspaper sports cartoonist and feature artist. Creator of the "Believe It or Not!" feature, which first appeared in the December 19, 1918, issue of the New York *Globe*. Widely syndicated, and the basis of movie shorts, radio programs, and a chain of museums of oddities, the feature made him a fortune.

RIPLEY, ROSWELL SABINE (*b. Worthington, Ohio, 1823; d. New York, N.Y., 1887*), soldier. Nephew of James W. Ripley. Graduated West Point, 1843. Author of *The War with Mexico* (1849). Resigning from the army, 1853, he engaged in business in South Carolina. As a state militia officer, he commanded and reconditioned Forts Moultrie and Sumter after their evacuation and fall, 1861. Thereafter, as a brigadier general in the South Carolina and Confederate forces, he was continually in disagreement with his superiors and subordinates although he was reputed an excellent officer and a wise, if unheeded, counselor.

RIPLEY, WILLIAM ZEBINA (*b. Medford, Mass., 1867; d. Boothbay, Maine, 1941*), economist. Graduated Massachusetts Institute of Technology, 1890, with degree in civil engineering. Ph.D., Columbia University, in political economy, 1893. Taught political science, sociology, and economics at M.I.T., 1893–1901; simultaneously taught physical geography, anthropology, and sociology at Columbia. Professor of political economy at Harvard, 1902–33. Author of early writings on anthropological topics, which gave support to nativists and advocates of immigration restriction, he devoted most of his time *post* 1900 to economics; he was an authority on transportation and undertook many public service assignments in this field. He was author, among other works, of *Railroads: Rates and Regulation* (1912); *Railroads: Finance and Organization* (1915); and *Main Street and Wall Street* (1927), a critique of contemporary developments in corporate practices, especially holding companies.

RISING, JOHAN CLASSON (*b. Risingé Parish, Östergötland, Sweden, 1617; d. 1672*), scholar, Swedish official. Succeeded Johan B. Printz as governor of New Sweden, 1654; surrendered Fort Christina to the Dutch under Peter Stuyvesant, August 1655.

RISTER, CARL COKE (*b. Hayrick, Tex., 1889; d. 1955*), historian. Studied at Hardin-Simmons and at George Washington University (Ph.D., 1925). Taught at Hardin-Simmons intermittently, 1919–29; and at the University of Oklahoma, 1929–51. Books include *The Southern Frontier* (1928), *The Greater Southwest*, with R. N. Richardson (1934), and *Oil! Titan of the Southwest* (1949).

RITCHARD, CYRIL (*b. Cyril Trimmnel–Richard, Sydney, Australia, 1898; d. Chicago, Ill., 1977*), actor and director. Attended St. Aloysius College and University of Sydney and established a reputation as an actor, singer, and director in Australia. He debuted on the London stage in 1925 and in New York in 1947 (*Love for Love*). His trans-Atlantic career reached its pinnacle when he starred in *The Millionairess* (1952). His greatest role was as Captain Hook in the Broadway musical *Peter Pan* (1954); he won a Tony Award for best supporting actor and reprised the role in two popular live productions (1955, 1956). He appeared in several other television productions, including *Visit to a Small Planet* (1957), and directed several critically acclaimed Broadway hits, including *The Reluctant Debutante* (1956) and *The Jockey Club Stakes* (1973). Other stage roles were in the musicals *The Roar of the Greasepaint, the Smell of the Crowd* (1965) and *Sugar* (1972).

RITCHEY, GEORGE WILLIS (*b. Tuppers Plains, Meigs County, Ohio, 1864; d. Azusa, Calif., 1945*), astronomer, optical expert. Attended University of Cincinnati; taught woodworking in Chicago Manual Training School; served as head of optical laboratory and superintendent of instrument construction at Yerkes Observatory. Superintended construction of Mount Wilson Observatory, 1904–09; headed the optical shop there, 1909–19. Thereafter, he held posts at the Paris Observatory and at the Naval Observatory, Washington, D.C. A perfectionist, Ritchey made important contributions to the design of large telescopes and to the development of celestial photography.

RITCHIE, ALBERT CABELL (*b. Richmond, Va., 1876; d. Baltimore, Md., 1936*), lawyer, Maryland public official. Greatgrandson of William H. Cabell. Graduated Johns Hopkins, 1896; LL.B., University of Maryland, 1898. A strong fighter in the public interest against the public utility companies, Ritchie served as Maryland attorney general, 1915–19, and as governor of Maryland, 1919–34. A masterful tactician, he achieved many administrative reforms in the state and was frequently mentioned as a Democratic presidential prospect.

RITCHIE, ALEXANDER HAY (*b. Glasgow, Scotland, 1822; d. New Haven, Conn., 1895*), engraver, painter. Came to America, 1841. Engraved a number of popular reproductions of historical paintings, including "The Death of Lincoln" after one of his own paintings, and "The Republican Court" after Daniel Huntington.

RITCHIE, ANNA CORA *See* MOWATT, ANNA CORA OGDEN.

RITCHIE, THOMAS (*b. Tappahannock, Va., 1778; d. 1854*), journalist, politician. Cousin of Spencer Roane. Published and edited the *Richmond Enquirer*, 1804–45, and the Washington *Union*, 1845–51. Making his newspaper the "Democratic Bible" of its time, he favored public schools and state internal improvements. Supporting the "Virginia principles of '98," he opposed Henry Clay and the divisive tactics of John C. Calhoun.

RITNER, JOSEPH (*b. Berks Co., Pa., 1780; d. 1869*), farmer, Pennsylvania legislator. Governor, Whig and anti-Mason, of Pennsylvania, 1835–39, Ritner contended as best he could against financial panic, canal and railroad lobbying, and antiabolitionist riots; he obtained a large increase in the permanent school appropriation and the number of common schools.

RITTENHOUSE, DAVID (*b. Paper Mill Run, near Germantown, Pa., 1732; d. 1796*), instrument-maker, astronomer, mathematician. Great-grandson of William Rittenhouse. Despite lack of formal schooling, Rittenhouse as a boy showed extraordinary mathematical and mechanical ability and by his own efforts acquired a sound knowledge of physical science. He opened an instrument shop on his father's farm chiefly for clock-making *ca.* 1751. His first public service was a province boundary survey to settle a dispute with Lord Baltimore, 1763–64. He designed his celebrated orrery which gave him much contemporary fame, 1767; he also experimented on the compressibility of water and invented a metallic thermometer. In 1768 he presented to the American Philosophical Society his calculations on the transit of Venus that was to occur in 1769. To observe that event, he built an observatory and its equipment, including a transit telescope now considered the first telescope made in America. His observations (aided by William Smith, 1727–1803, and others) are regarded as among the best that were made. Removing to Philadelphia, 1770, he continued to work at an observatory there and in 1785 invented the collimating telescope; he also made a plane transmission grating, 1786, anticipating Fraunhofer. In 1792, he solved the problem of finding the sum of the several powers of the sines by demonstration to the second power, by infinite series to the sixth, and by the law of commutation for higher powers. He was frequently engaged on boundary surveys and commissions for over half the British colonies in America and conducted canal and river surveys as well. As engineer of the Committee of Safety, 1775, he supervised the casting of cannon and the manufacture of saltpeter; in 1777, he was president of the Council of Safety, serving also as a member of the General Assembly and of the Board of War, and as state treasurer. Professor of astronomy

at University of Pennsylvania, he was on the commission to organize the United States Bank and was appointed first director of the Mint, 1792, serving until 1795. He was president of the American Philosophical Society, 1791–96.

RITTENHOUSE, JESSIE BELLE (*b. Mount Morris, N.Y., 1869; d. Detroit, Mich., 1948*), poet, critic, lecturer. Active in the American poetic "renaissance" of the first third of the 20th century, she was editor of a number of influential and successful anthologies and was a major factor in the founding of the Poetry Society of America, 1910. Among her books were *The Younger American Poets* (1904); *The Little Book of Modern Verse* (1913); and an autobiography, *My House of Life* (1934).

RITTENHOUSE, WILLIAM (*b. Mülheim-am-Ruhr, Rhenish Prussia, 1644; d. Germantown, Pa., 1708*), Mennonite minister, pioneer paper manufacturer. Immigrated to America, 1688. In partnership with William Bradford (1663–1752) and others, he built the first paper mill to be erected in the colonies on Paper Mill Run near Wissahickon Creek (Roxborough Township, Pa.), 1690.

RITTER, FRÉDÉRIC LOUIS (*b. Strasbourg, Alsace, 1834; d. 1891*), musical composer and historian, educator. Came to America, 1856; founded Cecilia Society and Philharmonic Orchestra, Cincinnati, Ohio. Professor of music, Vassar College, 1867–91.

RITTER, JOSEPH ELMER (*b. New Albany, Ind., 1892; d. St. Louis, Mo., 1967*), Roman Catholic cardinal and reform leader. Attended St. Meinrad's seminary and was ordained in 1917. At the Cathedral of Saint Peter and Paul in Indianapolis, he began a lifelong career as diocesan administrator and leader. He was made bishop of Indianapolis (1934) and headed the see until 1946, serving the last two years as archbishop. He opened five catechetical centers for black children and ordered full integration of the parochial schools. Named archbishop of St. Louis (1946), he created a national stir by ordering the integration of its Catholic schools. Became a cardinal in 1961 and played a major role at Vatican II (1962–65); he authorized the first English-language mass, held in St. Louis in 1965.

RITTER, WILLIAM EMERSON (*b. near Hampden, Wis., 1856; d. Berkeley, Calif., 1944*), naturalist, science administrator. Graduated State Normal School at Oshkosh (Wis.), 1884. B.S., University of California, 1888. A.M., Harvard, 1891; Ph.D., 1893. Taught biology at University of California *post* 1891, becoming professor in 1902, and emeritus in 1923. With aid of E. W. Scripps and Ellen B. Scripps, he established three important institutions: the Scripps Institution of Oceanography at La Jolla; the Foundation for Population Research at Miami University in Ohio; and the news agency Science Service in Washington, D.C.

RITTER, WOODWARD MAURICE ("TEX") (*b. Murvaul, Panola County, Tex., 1905; d. Nashville, Tenn., 1974*), singer and actor. Attended University of Texas, Austin (1922–27), and began touring as "The Texas Cowboy and His Songs." He went to New York in 1929 and through the 1930's performed on such radio shows as "The Lone Ranger" and "Death Valley Days" and appeared in plays, including *Green Grow the Lilacs* (1931). He was Capital Records' first country singer (signed in 1942), and his big hits included "Rock & Rye Rag" and "High Noon." In the 1960's his hit singles included "Wayward Wind," "Have I Told You Lately That I Love You," and "You Are My Sunshine." His first film was *Song of the Gringo* (1936) and until 1964 made seventy-eight Westerns; he also appeared in the television series "Ranch Party" (1959–62) and in 1964 became a regular on the

"Grand Ole Opry." He helped establish the Country Music Association and was one of the first six inductees into its Hall of Fame (1964).

RIVERA, LUIS MUÑOZ See MUÑOZ-RIVERA, LUIS.

RIVERS, LUCIUS MENDEL (*b. Gumville, N.C., 1905; d. Birmingham, Ala., 1970*), U.S. congressman. Attended College of Charleston and University of South Carolina Law School. Elected to South Carolina legislature (1933–36), then worked for the U.S. Department of Justice (1936–40). Elected U.S. congressman (1940); reelected fifteen times. The stereotype of the flamboyant southern politician, his unquestioning and unswerving support of the military brought him power and attention. He pressed for more sophisticated weapons and an expansion of the armed forces, but was an opponent of the all-volunteer army. One consequence of his power was the proliferation of military installations in his congressional district around Charleston.

RIVERS, THOMAS MILTON (*b. Jonesboro, Ga., 1888; d. New York, N.Y., 1962*), physician and virologist. Attended Emory and Johns Hopkins Medical School (M.D., 1915). At Johns Hopkins (1915–17, 1919) and at Rockefeller Institute for Medical Research, 1922–37 director, 1937–56. His work and that of his colleagues made Rockefeller Institute a leading center of virus research in the 1930's and 1940's. Chairman of the National Foundation for Infantile Paralysis committee on research (1933) and its vaccine advisory committee, which conducted the clinical trials of Jonas Salk's vaccine; medical director of the foundation (1956–58) and vice president for medical affairs (1958–62). Directed the formation of Naval Medical Research Unit Number 2 (1943), which conducted antivirus programs in the Pacific.

RIVERS, WILLIAM JAMES (*b. Charleston, S.C., 1822; d. Baltimore, Md., 1909*), educator. Professor of ancient languages at South Carolina College (later University of South Carolina), 1856–73. President of Washington College, Chestertown, Md., 1873–87. Author of the important *A Sketch of the History of South Carolina to the Close of the Proprietary Government, . . .* (1856).

RIVES, GEORGE LOCKHART (*b. New York, N.Y., 1849; d. Newport, R.I., 1917*), lawyer. Grandson of William C. Rives. Graduated Columbia, 1868; Trinity College, Cambridge, 1872. LL.B., Columbia Law School, 1873. Noted for his extensive and able public-service activity in New York City as trustee and officer of Columbia and of the Astor and Lenox libraries, as counsel and member of the Rapid Transit Commission, as president of the charter revision commission (1900), and in many other posts. Author, among other books, of *The United States and Mexico, 1821–1848* (1913).

RIVES, HALLIE ERMINIE (*b. Post Oak Plantation, Ky., 1876; d. New York, N.Y., 1956*), novelist. Wife of diplomat Post Wheeler, Rives wrote many popular novels including *Smoking Flax* (1897), *Hearts Courageous* (1902), with Patrick Henry as the hero, *Satan Sanderson* (1907), *The Kingdom of Slender Swords* (1910), and *The Magic Man* (1927). Writing was characterized by fast-moving narratives, vivid imagination, and shallow personalities. Although not a critical success, Rives achieved fame in the genre of romantic fiction.

RIVES, JOHN COOK (*b. probably Franklin Co., Va., 1795; d. 1864*), journalist. Partner of Francis P. Blair in management of the Washington *Daily Globe*, 1833–49; reported debates impartially in the *Congressional Globe*, 1833–64.

RIVES, WILLIAM CABELL (*b. Amherst Co., Va., 1793; d. "Castle Hill," near Charlottesville, Va., 1868*), Virginia political leader, diplomat. Grandson of William Cabell. Graduated William and Mary, 1809; was schooled in law and politics by Thomas Jefferson. Congressman, Jacksonian Democrat, from Virginia, 1823–29, U.S. minister to France, 1829–32. Elected to the U.S. Senate, 1832, he resigned in 1834 rather than obey instructions from the Virginia Assembly to take a stand against Jackson's removal of federal deposits from the U.S. Bank. Failing in a bid for the vice presidential nomination with Martin Van Buren, he was reelected to the Senate, 1836–39, replacing John Tyler. Heading the Virginia conservatives who insisted that federal money should be deposited in state banks, he came out squarely against Van Buren's sub-treasury system. Returning to the Senate, 1841, he stood with Tyler in his struggle with Henry Clay on the bank question; in 1844 he became a full-fledged Whig. On the expiration of his term, 1845, he retired to private life for several years, serving again as U.S. minister to France, 1849–53. In 1861, he opposed secession but declared that Virginia would join the Southern group if the government should attempt to coerce seceded states; he was a member of the peace convention which met in Washington that year at the insistence of Virginia. He sat as a member of the Confederate Provisional Congress and as a member of the first regular Confederate Congress.

RIVINGTON, JAMES (*b. London, England, 1724; d. New York, N.Y., 1802*), bookseller, printer, journalist. Came to America, 1760; opened book shops in Philadelphia, New York, and Boston, but confined his business interests to New York *post* 1766. Bankrupt several times through high living and free spending, he steadied himself *post* 1769 and his business prospered. On April 22, 1773, he put out the first regular issue of *Rivington's New-York Gazetteer*, a newspaper which proposed to print both sides of questions. The successful paper soon became offensive to the Sons of Liberty in New York because of its neutral policy, and in November 1775 a party of patriots from Connecticut destroyed Rivington's printing plant. Securing a new plant from abroad, he resumed publication in October 1777, this time in the Loyalist interest, and issued the paper through December 1783. Allowed to remain in the United States after the British departure, allegedly because of secret aid given to Washington's spies, Rivington failed to thrive and died poor.

RIX, JULIAN WALBRIDGE (*b. Peacham, Vt., 1850; d. New York, N.Y., 1903*), landscape painter, etcher. Became celebrated for his atmospheric renderings of California scenery; worked in Paterson, N.J., and New York, N.Y., *post* 1888.

ROACH, JOHN (*b. Mitchelstown, Co. Cork, Ireland, 1813; d. New York, N.Y., 1887*), shipbuilder. Came to America *ca.* 1829. Prospering as a foundryman and engine builder, Roach was among the first to recognize the importance of the shift from wooden to iron vessels and in 1868 began planning for development of an iron shipbuilding industry in the United States. Removing from New York to Chester, Pa., 1871, he launched 126 iron vessels there between 1872 and 1886 and was active in awakening public opinion in favor of an American merchant marine.

ROANE, ARCHIBALD (*b. Lancaster, present Dauphin Co., Pa., 1759; d. 1819*), lawyer, Tennessee jurist. An associate of Andrew Jackson in pioneer eastern Tennessee, Roane became attorney general for the district of Hamilton when a territorial government was instituted, 1790. He served as Democratic governor of the State of Tennessee, 1801–03, and was twice a judge of the superior court of errors and appeals.

ROANE, JOHN SELDEN (*b. Wilson Co., Tenn., 1817; d. 1867*), planter, lawyer, Mexican War and Confederate officer. Removed as a young man to Arkansas, settling at Pine Bluff. Democratic governor of Arkansas, 1849–52.

ROANE, SPENCER (*b. Essex Co., Va., 1762; d. Warm Springs, Va., 1822*), jurist, Virginia legislator. Attended William and Mary; admitted to the bar, 1782, after attendance at the lectures of George Wythe. An admirer of the political thought of Patrick Henry and George Mason, Roane became a judge of the Virginia general court, 1789, and was elected to the supreme court of appeals, 1794. During his 27 years' service on this bench, his opinions were generally sound but inclined to the side of liberty rather than property; mindful of precedents, he was also alert to the public policies of his own time. A strict constructionist and supporter of Jefferson, he joined his cousin Thomas Ritchie in founding the *Richmond Enquirer* and contributed to it a series of articles (May and June 1819, May 1821) in opposition to what he regarded as the usurping tendencies of the U.S. Supreme Court under John Marshall. Heartily approved by Democratic-Republican leaders including Jefferson, these articles reinvigorated the extreme states' rights theory.

ROARK, RURIC NEVEL (*b. Greenville, Ky., 1859; d. Cincinnati, Ohio, 1909*), Kentucky educator.

ROBB, INEZ EARLY CALLAWAY (*b. Middletown, Calif., 1900; d. Tucson, Ariz., 1979*), journalist. Graduated University of Missouri (B.A., 1924) and worked as a reporter in Tulsa, Okla., and as an assistant editor for the *New York Daily News* before becoming the society reporter and editor for the *Daily News* in 1928. Robb, who treated society events as "real news," set a standard for subsequent society columnists with her eyewitness and in-depth reporting of high-society activities. In 1938 she launched a general news column for the International News Service (INS) that ran nationally. One of the first women to be accredited as a war correspondent, she covered the North African invasion during World War II. After 1953 she wrote a daily opinion column for the Scripps–Howard newspapers and United Features Syndicate, which appeared in 140 newspapers in North America at her retirement in 1969.

ROBB, JAMES (*b. Brownsville, Pa., 1814; d. Cheviot, Ohio, 1881*), banker. Active in New Orleans, La., commerce, public utilities, and railroad promotion, 1838–59, and also subsequent to the Civil War.

ROBB, WILLIAM LISPENARD (*b. Saratoga, N.Y., 1861; d. Troy, N.Y., 1933*), electrical engineer, educator. Graduated Columbia, 1880; Ph.D., University of Berlin, 1883. Professor of physics, Trinity College, Hartford, Conn., 1885–1902; professor of electrical engineering and physics, Rensselaer Polytechnic, 1902–33.

ROBBINS, CHANDLER (*b. Lynn, Mass., 1810; d. Weston, Mass., 1882*), Unitarian clergyman, local historian. Pastor, Second Church, Boston, Mass., 1833–74.

ROBBINS, THOMAS (*b. Norfolk, Conn., 1777; d. Colebrook, Conn., 1856*), Congregational clergyman, antiquarian. Librarian, Connecticut Historical Society, 1844–54.

ROBERDEAU, DANIEL (*b. St. Christopher, British West Indies, 1727; d. Winchester, Va., 1795*), Philadelphia merchant, Revolutionary patriot. Father of Isaac Roberdeau.

ROBERDEAU, ISAAC (*b. Philadelphia, Pa., 1763; d. Washington, D.C., 1829*), engineer. Son of Daniel Roberdeau. Studied

in London; assisted Pierre C. L'Enfant in work on the new city of Washington, 1791–92. Practicing as an engineer in Pennsylvania until 1812, he was appointed major in the newly organized topographical engineer corps of the U.S. Army, April 1813. He survived the temporary abolition of the corps in 1815, and in 1818 became its chief. He was given brevet rank of lieutenant colonel, 1823.

ROBERT, CHRISTOPHER RHINELANDER (*b. Suffolk Co., N.Y., 1802; d. Paris, France, 1878*), New York merchant, Presbyterian layman, philanthropist. Founded Robert College, Constantinople, Turkey, 1863.

ROBERT, HENRY MARTYN (*b. Robertville, S.C., 1837; d. Hornell, N.Y., 1923*), Union Army engineer, parliamentarian. Author of *Pocket Manual of Rules of Order* (1876), generally known as "Robert's Rules."

ROBERTS, BENJAMIN STONE (*b. Manchester, Vt., 1810; d. Washington, D.C., 1875*), railroad engineer, lawyer, inventor of a breech-loading rifle. Graduated West Point, 1835; resigned from army, 1839, to enter railroad work and assisted George W. Whistler in Russian railroad construction, 1842. Reentering the army, he gave distinguished service in the Mexican War and on the frontier. As a Union officer in the Civil War, he won brevets for gallantry in New Mexico and rose to rank of major general in later service in Virginia, Tennessee, and Louisiana.

ROBERTS, BENJAMIN TITUS (*b. Gowanda, N.Y., 1823; d. Cattaraugus, N.Y., 1893*), Methodist clergyman. An organizer and first general superintendent of the Free Methodist Church, 1860–93.

ROBERTS, BRIGHAM HENRY (*b. Warrington, England, 1857; d. 1933*), Mormon leader. Immigrated to Salt Lake City as a child. Author of A *Comprehensive History of the Church of Jesus Christ of Latter Day Saints* (1930).

ROBERTS, EDMUND (*b. Portsmouth, N.H., 1784; d. Macao, China, 1836*), merchant. As special agent of the United States, Roberts negotiated treaties of commerce with Siam and Muscat, 1833.

ROBERTS, ELIZABETH MADOX (*b. Perryville, Ky., 1881; d. Orlando, Fla., 1941*), author. Raised in Springfield Ky.; graduated from high school in Covington, Ky., 1900. Between 1900 and 1910 she conducted private classes at home in Springfield, and then taught in the public schools. Suffering from respiratory ailments including incipient tuberculosis, she spent much time after 1910 in Colorado. Verses that she composed to accompany photographs of mountain flowers by Kenneth Hartley appeared in a booklet issued in Colorado Springs for the tourist trade: *In the Great Steep's Garden* (1915). In 1917 she enrolled at the University of Chicago. She was elected to Phi Beta Kappa and in 1921 received the Ph.B. degree in English, with honors. The fruits of her college literary activity were published in *Under the Tree* (1922; enlarged edition, 1930). Roberts then returned to Springfield. Her first novel, *The Time of Man* (1926), won international acclaim; *My Heart and My Flesh* (1927) and *Jingling in the Wind* (1928) followed. Her second major success was *The Great Meadow* (1930), a re-creation of pioneer life in Kentucky during the period of the Revolutionary War. A *Buried Treasure* (1931) is Roberts' most vivid excursion into the life of the Kentucky folk. In 1932 she published her first collection of short stories, *The Haunted Mirror*. Her next novel, *He Sent Forth a Raven* (1935), was an allegorical work, the theme of which was the same as that in her next novel, *Black is My Truelove's Hair* (1938). A second volume of poems, *Song in the Meadow*, ap-

peared in 1940, and a second volume of short stores, *Not by Strange Gods*, in 1941, shortly after her death. Although her novels are graphic portrayals of Kentucky life, they are most impressive for their timeless qualities. Her strongest characters have an authentic life on the soil, and her work is memorable for its depiction of the intimate relationships that exist between man and nature.

ROBERTS, ELIZABETH WENTWORTH (*b. Philadelphia, Pa., 1871; d. Concord, Mass., 1927*), painter, leader in work of the Concord (Mass.) Art Assn.

ROBERTS, ELLIS HENRY (*b. Utica, N.Y., 1827; d. Utica, 1918*), journalist, financier. Congressman, Republican, from New York, 1871–75; treasurer of the United States, 1897–1905. A "Half-Breed," a sound money man, and a protectionist.

ROBERTS, GEORGE BROOKE (*b. near Bala, Pa., 1833; d. near Bala, 1897*), railroad executive, engineer. President of the Pennsylvania Railroad Co., 1880–97.

ROBERTS, HOWARD (*b. Philadelphia, Pa., 1843; d. Paris, France, 1900*), sculptor.

ROBERTS, ISSACHAR JACOB (*b. Summer Co., Tenn., 1802; d. Upper Alton, Ill., 1871*), Baptist clergyman and missionary in China, 1837–52. Independent in status from 1852 until his return to America in 1866, he was deeply implicated in the Taiping Rebellion.

ROBERTS, JOB (*b. near Gwynedd, Pa., 1756; d. Gwynedd, 1851*), pioneer scientific agriculturist, inventor of farm machinery, leader in the Society of Friends.

ROBERTS, JONATHAN (*b. near Norristown, Pa., 1771; d. Montgomery Co., Pa., 1854*), farmer, Pennsylvania legislator. As congressman, (Democrat) Republican, from Pennsylvania, 1811–14, Roberts defended the policies of Albert Gallatin; as U.S. senator, 1814–21, and afterwards in the Pennsylvania legislature, he fought against Andrew Jackson and Jacksonian policies, later becoming a Whig.

ROBERTS, JOSEPH JENKINS (*b. Petersburg, Va., 1809; d. Monrovia, Liberia, 1876*), statesman. Born of free, colored parents, he migrated to Liberia, 1829, and became a merchant there. Appointed governor of Liberia, 1842, he mollified the hostile native chiefs, adjusted a difficult financial situation and, in 1847, called the conference at which the new republic of Liberia was proclaimed. Elected as first president, he served with wisdom and distinction through 1855; thereafter until his death he was president of the College of Liberia. Reelected to the presidency of the republic, 1871, to quell a domestic crisis, he served until January 1876.

ROBERTS, KENNETH LEWIS (*b. Kennebunk, Maine, 1885; d. Kennebunkport, Maine, 1957*), novelist and journalist. Studied at Cornell University. The author of many historical novels, Roberts began his career as a journalist, working for the *Boston Post* and the *Saturday Evening Post* through World War I. In 1930, he published his first novel, *Arundel*, an apology of Benedict Arnold; other works include *Rabble in Arms* (1933), *Northwest Passage* (1937), *Oliver Wiswell* (1940), an apology for American Tories during the Revolution, and *Lydia Bailey* (1947). An iconoclast and disciplined historian, Roberts was often criticized for his unpopular historical views. His books received favorable criticism.

ROBERTS, MARSHALL OWEN (*b. New York, N.Y., 1814; d. Saratoga Springs, N.Y., 1880*), capitalist. Starting as a shipchandler, Roberts came into prominence, 1847, when with George Law and others he took up a government contract for mail steamship service from New York to New Orleans and to the Isthmus of Panama. The California gold rush *post* 1849 tremendously increased business for their U.S. Mail Steamship Co. (incorporated April 1850), but later competition from Cornelius Vanderbilt and other factors ended the company's prosperity. Roberts's chartering and selling of steamships during the Civil War forms an interesting chapter in the history of profiteering; the success of his operations was in no way hindered by his activity in New York politics as an anti-Seward Whig and as a Republican. For many years president of the North River Bank in New York City, he was one of the group which financed Cyrus Field's cable venture, 1854.

ROBERTS, NATHAN S. (*b. Piles Grove, N.J., 1776; d. 1852*), civil engineer. Worked on surveys for the Erie Canal, 1816–22; had charge of construction from Lockport to Buffalo, 1822–25. Thereafter he served as consulting engineer for canals in New York, Pennsylvania, and elsewhere in the United States.

ROBERTS, ORAN MILO (*b. Laurens District, S.C., 1815; d. Austin, Tex., 1898*), lawyer. Admitted to the Alabama bar, 1837. Removing to Texas, 1841, he prospered in practice, served as district attorney and district judge, and was a justice of the Texas supreme court, 1857–61. Colonel of the 11th Texas Infantry, 1862–64, he was briefly chief justice of Texas under Confederate rule. Reappointed chief justice of the supreme court, 1874, he won repute for learning. Elected governor of Texas, 1878, while still chief justice, he was reelected, 1880, and during his terms improved the state's financial condition and established the University of Texas. Elected professor of law in the University, 1883, he served until 1893.

ROBERTS, OWEN JOSEPHUS (*b. Philadelphia, Pa., 1875; d. Chester Springs, Pa., 1955*), associate justice of the U.S. Supreme Court. Studied at the University of Pennsylvania; after receiving his law degree, he taught at the University of Pennsylvania until 1918, when he entered private practice. After serving as a special prosecutor to investigate the oil scandals of the Harding administration (the Teapot Dome scandals), Roberts was appointed to the Supreme Court by President Hoover in 1930; he served until retirement in 1945.

Along with Chief Justice Charles Evans Hughes, Roberts played a key role in the transition of a hands-off policy in government to the social service state. In the case of *Nebbia* v. *New York* (1934), he sustained a New York statute regulating the price of milk, helped cast aside Supreme Court-created limitations on the power to govern and furnished doctrinal foundations for legitimating the New Deal.

But in 1936, in the case of *U.S.* v. *Butler*, Roberts put New Deal legislation beyond the constitutional pale of the taxing and spending power in a case involving the Agricultural Adjustment Act (AAA). Roberts reasoned, going against his earlier decisions, that the Tenth Amendment places certain subject matter, including agriculture, absolutely beyond national control.

In 1937, Roosevelt, stymied by the Court's intransigence (in particular, that of Roberts) threatened to "pack" the court. Roberts then shifted his views and supported the minimum wage legislation of 1937, an obvious reversal of his decision in the AAA case. Roberts went on to support many other positions of the New Deal, including Social Security and eventually endorsing the Agricultural Adjustment Act of 1938.

Worried that the concept of precedent was being ignored in favor of instant decisions subject to the short-term needs of the times, Roberts became increasingly alienated from the other justices. He resigned in 1945.

ROBERTS, ROBERT RICHFORD (*b. Frederick Co., Md., 1778; d. Lawrence Co., Ind., 1843*), Methodist clergyman. Raised in frontier Westmoreland Co., Pa., he was one of the earliest settlers in present Mercer Co. (the Shenango settlement), 1797. A pastor and circuit rider *post* 1802, he was elected bishop, 1816, and served until his death, removing in 1819 to Indiana.

ROBERTS, SOLOMON WHITE (*b. Philadelphia, Pa., 1811; d. Atlantic City, N.J., 1882*), civil engineer, canal and railroad expert. Inspired construction of the first successful anthracite furnace for iron smelting in the Lehigh Valley, 1839–40.

ROBERTS, THEODORE (*b. San Francisco, Calif., 1861; d. Los Angeles, Calif., 1928*), actor, player of "heavy" roles on stage and in motion pictures.

ROBERTS, WILLIAM CHARLES (*b. Galltmai, Wales, 1832; d. Danville, Ky., 1903*), Presbyterian clergyman, educator. Immigrated to New York, N.Y., 1849. Graduated College of New Jersey (Princeton), 1855; Princeton Theological Seminary, 1858. President, Lake Forest College, Ill., 1886–93; Centre College, Danville, Ky., 1898–1903. Served many other colleges as trustee.

ROBERTS, WILLIAM HENRY (*b. Holyhead, Wales, 1844; d. Philadelphia, Pa., 1920*), Presbyterian clergyman. Came to America as a boy. Held a number of pastorates; served as stated clerk of the General Assembly *post* 1884. A dynamic administrator, he worked especially for unity among Presbyterians.

ROBERTS, WILLIAM MILNOR (*b. Philadelphia, Pa., 1810; d. Soledade, Brazil, 1881*), civil engineer, canal and railroad expert. Chief engineer, Northern Pacific Railroad, 1869–79; chief engineer of all public works in Brazil, 1879–81.

ROBERTS, WILLIAM RANDALL (*b. Mitchelstown, Ireland, 1830; d. New York, N.Y., 1897*), merchant, Fenian leader. Immigrated to New York, N.Y., 1849. Succeeded John O'Mahony as president of the Fenian Brotherhood, 1865; with T. W. Sweeny, organized invasion of Canada, 1866. Congressman, Democrat, from New York, 1871–75; U.S. minister to Chile, 1885–89.

ROBERTSON, ABSALOM WILLIS (*b. Martinsburg, W. Va., 1887; d. Lexington, Va., 1971*), politician. Graduated University of Richmond (B.A., 1907; LL.B., 1908), served in the Virginia senate (1916–22), and was elected to the U.S. House of Representatives in 1932, where he helped establish the Select Committee on Conservation of Wildlife Resources (1934); as chair of the committee he sponsored the Pittman–Robertson Act (1937), which returned millions in federal taxes on guns and ammunition to the states for game and conservation programs. He served in the U.S. Senate (1946–66), where he was a member of the Appropriations Committee, opposing all expansion of federal power and spending (except defense), and chairman of the Banking and Currency Committee (1959–66). A conservative Democrat, he challenged the banning of school prayer (1962), civil rights legislation, and social-welfare spending.

ROBERTSON, ALICE MARY (*b. Tullahassee Mission, Indian Territory, 1854; d. 1931*), educator, social worker. Granddaughter of Samuel A. Worcester; daughter of William S. Robertson. Engaged *post* 1880 mainly in Indian education in Oklahoma, she served as member of Congress, Republican, from Oklahoma, 1921–23.

ROBERTSON, ARCHIBALD (*b. Monymusk, Scotland, 1765; d. probably New York, N.Y., 1835*), painter of miniatures. Studied in Edinburgh and at the Royal Academy in London. Came to America, 1791; with his brother, Alexander, opened the Columbian Academy of Painting in New York City, 1792; was associated with American Academy of Fine Arts *post* 1816. Author of *Elements of the Graphic Arts* (1802). He continued active as a painter until 1828. In addition to portraits, he executed many watercolor views of New York City.

ROBERTSON, ASHLEY HERMAN (*b. Ashmore, Ill., 1867; d. San Diego, Calif., 1930*), naval officer. Graduated Annapolis, 1888. Commanded battleships *California* and *Colorado*, 1914–16, and transport *Mount Vernon*, 1917. After holding a number of high and responsible commands *post* 1918, he died as vice admiral commanding the 11th Naval district.

ROBERTSON, GEORGE (*b. near Harrodsburg, Ky., 1790; d. Lexington, Ky., 1874*), Kentucky jurist and legislator. As congressman, Whig, from Kentucky, 1817–21, he initiated legislation passed in 1820 which liberalized the purchase of government land. Chief justice of the state court of appeals, 1829–43, he was an associate justice, 1864–70, and again chief justice, 1870–71. He was a Unionist during the Civil War.

ROBERTSON, JAMES (*b. Edinburgh, Scotland, 1740; d. probably Edinburgh, date of death unknown*), printer, journalist, Loyalist. Came to America *ante* 1766. Published *New-York Chronicle*, 1769; *Albany Gazette*, 1771–72; co-publisher of *Norwich Packet* (Conn.), 1773–76. Removing to New York City, 1776, Robertson and his brother published the *Royal American Gazette*, 1777–83, and also, in Philadelphia (March-May 1778), the *Royal Pennsylvania Gazette*. In Charleston, S.C., he published the *Royal South Carolina Gazette*, 1780–82. After the British evacuation of New York, he removed with his brother to Nova Scotia.

ROBERTSON, JAMES (*b. Brunswick Co., Va., 1742; d. Chickasaw Bluffs, Tenn., 1814*), Tennessee frontier leader, Indian fighter, and treaty negotiator.

ROBERTSON, JAMES ALEXANDER (*b. Corry, Pa., 1873; d. Annapolis, Md., 1939*), editor, librarian, historian. Graduated Adelbert College of Western Reserve, 1896. Expert in the collection and editing of documents, Robertson made many contributions to the history of the Hispanic world; he held research appointments at the U.S. Department of Commerce, Florida State Historical Society, and Stetson University, and was archivist of Maryland.

ROBERTSON, JEROME BONAPARTE (*b. Woodford Co., Ky., 1815; d. Tex., 1891*), physician, Texas pioneer, Confederate brigadier general. Graduated in medicine, Transylvania, 1835. Practiced in Washington Co., Texas, *post* 1838; succeeded John Hood in command of the Texas brigade, 1862.

ROBERTSON, JOHN (*b. near Petersburg, Va., 1787; d. Mount Athos, Va., 1873*), lawyer, Virginia legislator and official. Brother of Thomas B. and Wyndham Robertson. An uncompromising critic of Jackson, he was congressman, Whig, from Virginia, 1835–41. A justice of the Virginia circuit court *post* 1841, he urged moderation when the Civil War threatened, but became and remained an active supporter of the Confederacy after secession.

ROBERTSON, MORGAN ANDREW (*b. Oswego, N.Y., 1861; d. Atlantic City, N.J., 1915*), merchant seaman, author of sea stories. Among his books were *Where Angels Fear to Tread* (1899), *Ship-*mates (1901), and *Sinful Peck* (1903); his work was distinguished for its adventurous spirit and fast-paced action.

ROBERTSON, THOMAS BOLLING (*b. near Petersburg, Va., 1779; d. White Sulphur Springs, Va., 1828*), lawyer, Louisiana official. Brother of John and Wyndham Robertson. Secretary of the territory of Orleans, 1807–12; congressman, (Democrat) Republican, from the state of Louisiana, 1812–18; governor of Louisiana, 1820–24; U.S. district judge for Louisiana, 1824–28.

ROBERTSON, WILLIAM HENRY (*b. Bedford, N.Y., 1823; d. Katonah, N.Y., 1898*), lawyer, New York politician and legislator. His appointment as collector of the port of New York by President Garfield precipitated the fight over federal appointments and patronage, 1880–81, which resulted in the resignation from the U.S. Senate of Roscoe Conkling and Thomas C. Platt.

ROBERTSON, WILLIAM JOSEPH (*b. Culpeper Co., Va., 1817; d. Charlottesville, Va., 1898*), Virginia lawyer and jurist, the leading corporation lawyer in his section *post* 1865.

ROBERTSON, WILLIAM SCHENCK (*b. Huntington, N.Y., 1820; d. 1881*), Presbyterian missionary to the Indians. Father of Alice M. Robertson. Worked as teacher among the Creeks at Tullahassee, Indian Territory, 1849–61 and *post* 1866.

ROBERTSON, WILLIAM SPENCE (*b. Glasgow, Scotland, 1872; d. Urbana, Ill., 1955*), historian. Studied at the University of Wisconsin and at Yale University (Ph.D., 1903). Taught at the University of Illinois (1909–45). An expert and pioneer in the field of South American history, Robertson wrote many books on his subject, concentrating on the wars for independence throughout Latin America: *Rise of the Spanish American Republics as Told in the Lives of Their Liberators* (1918), *The Life of Miranda* (1929), and *France and Latin-American Independence* (1939).

ROBERTSON, WYNDHAM (*b. near Richmond, Va., 1803; d. Abingdon, Va., 1888*), lawyer, Virginia legislator. Brother of John and Thomas B. Robertson. Whig governor of Virginia (acting), 1836–37. Opposed both secession and the coercion of seceded states.

ROBESON, GEORGE MAXWELL (*b. Oxford Furnace, N.J., 1829; d. Trenton, N.J., 1897*), lawyer, New Jersey official. As U.S. secretary of the navy, 1869–77, he was severely criticised for extravagance and favoritism. He was congressman, Republican, from New Jersey, 1879–83.

ROBESON, PAUL LEROY (*b. Princeton, N.J., 1898; d. Philadelphia, Pa., 1976*), singer, actor, and political activist. Graduated Rutgers University (1919), where he was an All-American in football, and Columbia Law School (1923) and embarked on a performance career. That year he had a critically acclaimed role in the play *All God's Children*. In 1925 he formed a duet and toured nationally, singing black spirituals and folk songs with musician Lawrence Bound. In 1928 his reputation as an actor grew with his performance in a London production of *Show Boat*. The musical, which featured his rendition "Ol' Man River," made Robeson a celebrity in England. Robeson starred in several films for British studios, including *King Solomon's Mines* (1937) and *Jericho* (1937). In the 1930's he became active in political causes, working for the anti-fascist Republican government during the Spanish Civil War. He also traveled to Russia, where he was impressed with the Soviet national arts program and the country's apparent absence of racism. He reached stardom in the United States upon returning to the country in 1939. His rousing, patriotic rendition of "Ballad for Americans" was a staple of radio programming during World War II. In 1944 and

1945 Robeson starred in a well-received national production of *Othello* and conducted a successful concert tour.

His political activism soon undermined his career, particularly as Cold War tensions mounted. During the 1940's he spoke out extensively on such issues as working class rights, racial discrimination, and peaceful policies with the Soviet Union. After a spate of lynchings of African Americans in the South after the war, he amplified his calls for federal antilynching legislation. In 1949, riots apparently instigated by veterans' groups broke out at his performances in Peekskill, N.Y. He was soon blacklisted by the entertainment industry and denounced by the mainstream civil rights establishment. Robeson was also denied a visa by the U.S. government to leave the country until 1958, when he was finally allowed to return to England. In the early 1960's, he was placed in sanatoriums in England and later East Berlin for physical and emotional problems. After 1965, he spent the final years of his life in seclusion in Philadelphia.

ROBIDOU, ANTOINE (*b. St. Louis, Mo., 1794; d. St. Joseph, Mo., 1860*), trapper, trader. Possibly traded to Taos, N.M., 1822; established home in New Mexico, 1828. Established, *ca.* 1832, Fort Robidou or Fort Uinta, famous trappers' rendezvous in northeastern Utah; removed his home to St. Joseph, Mo., 1845. Interpreter with General S. W. Kearny, 1846, he was badly wounded at the battle of San Pascual.

ROBINS, HENRY EPHRAIM (*b. Hartford, Conn., 1827; d. Greenfield, Mass., 1917*), Baptist clergyman, educator. President of present Colby College, 1873–82.

ROBINS, MARGARET DREIER (*b. Brooklyn, N.Y., 1868; d. Hernando County, Fla., 1945*), social reformer. Active in New York City and state reform movements *post* 1902, she removed to Chicago on her marriage in 1905 to Raymond Robins, who was head of the Northwestern University Settlement. Already engaged in the work of the National Women's Trade Union League, she served as its president, 1907–22; at her instigation the League established in 1914 a school to train working women for trade union leadership, a pioneering effort in the U.S. labor movement. She also worked for woman suffrage and for municipal reform.

ROBINS, RAYMOND (*b. Staten Island, N.Y., 1873; d. near Brooksville, Fla., 1954*), religious activist, social reformer, and politician. Received law degree from Columbian (now George Washington) Law School in 1896. Practiced law in San Francisco until he went to Alaska to search for gold in 1897. He returned to the mainland and eventually settled in Chicago, becoming a reform worker in settlement houses and a member of the Chicago Board of Education (1906–09). A supporter of Theodore Roosevelt, he was chairman of the Bull Moose Convention of 1916; in 1917, he traveled to Russia with the Red Cross in an attempt to keep the Kerensky government in power and Russia in the war. He returned to Russia in 1933 and was instrumental in persuading Roosevelt to recognize the Soviet government.

ROBINSON, ALBERT ALONZO (*b. South Reading, Vt., 1844; d. 1918*), civil engineer. Brother of Stillman W. Robinson. Supervised development and construction of the Atchison, Topeka & Santa Fe Railroad, 1871–93, becoming chief engineer and general manager; was president, Mexico Central Railway Co., 1893–1906.

ROBINSON, BENJAMIN LINCOLN (*b. Bloomington, Ill., 1864; d. Jaffrey, N.H., 1935*), botanist. Brother of James H. Robinson. Graduated Harvard, 1887; Ph.D., University of Strassburg, 1889. As curator of the Gray Herbarium at Harvard *post* 1892, Robin-son increased its endowment, housed it in a building of his own design, and maintained its high standards. He was editor of an additional volume of Asa Gray's *Synoptical Flora of North America* (1895–97), coeditor of the 7th edition of Gray's *Manual of the Botany of the Northern United States* (1908), and author of *Flora of the Galapagos Islands* (1902) and many other studies.

ROBINSON, BEVERLEY (*b. Middlesex Co., Va., 1722 o.s.; d. England, 1792*), landowner, New York colonial official. Brother of John Robinson; brother-in-law of Roger Morris. Wealthy through marriage to a Philipse heiress and through his own trading ventures, Robinson was an ardent Loyalist in the Revolution and served as colonel of the Loyal Americans and other Tory units; he was particularly effective as a director of British spy and intelligence work. He removed to England on the downfall of British rule.

ROBINSON, BILL (*b. Richmond, Va., 1878; d. New York, N.Y., 1949*), dancer, actor. Christened Luther; nicknamed "Bojangles." In 1891, at the age of twelve, he joined a traveling company in *The South Before the War*, and in 1905 he worked with George Cooper as a vaudeville team. Robinson began working as a solo act in nightclubs, and was featured in *Blackbirds of 1928*, a black revue for white audiences. From then on his public role was that of a dapper, smiling, plaid-suited ambassador to the white world, maintaining a tenuous connection with black show-business circles. After 1930 black revues waned in popularity, but he remained a vogue with white audiences for more than a decade in motion pictures. His most frequent role was that of an antebellum butler opposite Shirley Temple or Will Rogers in such films as *The Little Colonel, The Littlest Rebel*, and *In Old Kentucky* (all released in 1935). In a small vignette in *Hooray for Love* (1935) he played a mayor of Harlem modeled on his own ceremonial honors; in *One Mile From Heaven* (1937) he played a policeman; and in the war-time musical *Stormy Weather* (1943) he played a romantic lead. He appeared in one film for black audiences, *Harlem Is Heaven* (1931), a financial failure. In 1939 he returned to the stage in *The Hot Mikado*, a jazz version of the Gilbert and Sullivan operetta produced at the New York World's Fair. His next appearance, in *All in Fun* (1940), failed to attract audiences. His last theatrical project was to have been *Two Gentlemen From the South* with James Barton, but the show did not open.

ROBINSON, BOARDMAN (*b. Somerset, Nova Scotia, 1876; d. Stamford, Conn., 1952*), artist. Studied at the Massachusetts Normal Art School in Boston and at the École des Beaux Arts in Paris. An illustrator for newspapers (*The New York Morning Telegraph*, 1907–10) and several magazines, Robinson turned to book illustration in the 1920's and 1930's, including *The Idiot, Moby Dick* and *Leaves of Grass*. He painted murals which included the fresco panels at the Department of Justice in 1937. Taught at the New York Art Students' League (1919–22 and 1924–30). Director of the Colorado Springs Fine Arts Center (1936–46). Works can be seen at the Metropolitan Museum of Art in New York, the Denver Art Museum, and the Detroit Institute of Art.

ROBINSON, CHARLES (*b. Hardwick, Mass., 1818; d. near Lawrence, Kans., 1894*), physician, California pioneer and legislator, agent of the New England Emigrant Aid Co. Cautious and calculating, Robinson was the balance wheel of the Free-State party in Kansas, 1855–59, and was a leader in uniting antislavery factions in the territory. An opponent of James H. Lane, he was elected governor of Kansas under the Topeka constitution, January 1856, but was soon indicted for usurpation and imprisoned by a proslavery grand jury. When the Republican

party supplanted the Free-State organization, 1859, he was nominated for governor and elected, taking office on the admission of the state, 1861. His two years in office were filled with difficulties, including an attempt at impeachment because of alleged irregularities in sale of state bonds. Engaging in politics only sporadically thereafter, he was by turns a Liberal Republican, a Democratic candidate for Congress, and a Greenback-Populist-Democratic candidate for governor.

ROBINSON, CHARLES MULFORD (*b. Ramapo, N.Y., 1869; d. Albany, N.Y., 1917*), journalist, author, city planner. Professor of civic design, University of Illinois, 1913–17.

ROBINSON, CHARLES SEYMOUR (*b. Bennington, Vt., 1829; d. New York, N.Y., 1899*), Presbyterian clergyman, hymnologist, editor. Author of *Songs for the Sanctuary* (1865), *Laudes Domini* (1884), and other hymnals.

ROBINSON, CHRISTOPHER (*b. Providence, R.I., 1806; d. Woonsocket, R.I., 1889*), lawyer, diplomat, Rhode Island attorney general and congressman. U.S. minister to Peru, 1861–65.

ROBINSON, CLAUDE EVERETT (*b. Portland, Oreg., 1900; d. New York, N.Y., 1961*), public opinion research specialist. Attended University of Oregon and Columbia (Ph.D., 1932). As associate director of George Gallup's American Institute of Political Opinion (1936), he and Gallup were pioneers in the area of scientific public opinion research. He formed the Opinion Research Corporation (1938), serving as president until 1957 and chairman until 1960. Began *Public Opinion Index for Industry* (1943) and founded Gallup and Robinson, an advertising research company (1948).

ROBINSON, CONWAY (*b. Richmond, Va., 1805; d. Philadelphia, Pa., 1884*), lawyer. Brother of Moncure Robinson. Author of a number of scholarly works on history and legal institutions; worked with John M. Patton on revision of the Virginia codes, 1846–52.

ROBINSON, EDWARD (*b. Southington, Conn., 1794; d. New York, N.Y., 1863*), philologist, geographer. Husband of Therese A. L. von J. Robinson. Graduated Hamilton College, 1816; was influenced by Moses Stuart to specialize in Hebrew; studied in Germany, 1826–30. Professor of biblical literature at Andover Theological Seminary and later at Union Theological Seminary, New York City, Robinson was founder of the *American Biblical Repository*, 1831 (editor, 1831–35), and of the *Bibliotheca Sacra*, 1843. His principal book was *Biblical Researches in Palestine, Mount Sinai and Arabia Petraea* (London, 1841). His work is now recognized as marking an epoch in the development of historical geography and related fields.

ROBINSON, EDWARD (*b. Boston, Mass., 1858; d. New York, N.Y., 1931*), museum administrator, classicist. Associated with Boston Museum of Fine Arts, 1885–1905; director, Metropolitan Museum of Art, New York City, 1910–31.

ROBINSON, EDWARD G. (*b. Emmanuel Goldenburg, Bucharest, Romania, 1893; d. 1973*), actor. Immigrated to New York City in 1902 and attended City College of New York (1910–11) and American Academy of Dramatic Arts. His first principal role was in *Kismet* (1914), which toured Canada. He returned to New York, appeared in a string of critical hits, and landed a starring role in *The Racket* (1927). He began his film career in *A Hole in the Wall* (1929); in *Night Ride* (1929), he first played a gangster on screen. Superstardom followed after his role as gangster Rico Bandillo in *Little Caesar* (1931). In 1937 he began the weekly radio series "Big Town," in which he played a crusading reporter. His leading-man career broadened in the 1940's, especially in *Double Indemnity* and *The Woman in the Window* (both 1944), *The Stranger* (1946), and *Key Largo* (1948). He was accused of Communist affiliations during the Red Scare of the 1950's but was cleared and resumed his career in the epic *The Ten Commandments* (1956) and on stage in *Middle of the Night* (1956). In the 1950's and 1960's he had starring roles in most of television's live theatrical series. His film career began to wind down, and he parodied his gangster roles in *Robin and the Seven Hoods* (1964) and played a suave elderly gent in *The Cincinnati Kid* (1965); his last film was *Soylent Green* (1973). He was presented with an Oscar for his lifetime contributions just before his death.

ROBINSON, EDWARD MOTT (*b. Philadelphia, Pa., 1800; d. New York, N.Y., 1865*), New Bedford (Mass.) merchant. Father of Hetty H. R. Green.

ROBINSON, EDWARD STEVENS (*b. Lebanon, Ohio, 1893; d. New Haven, Conn., 1937*), psychologist. Graduated University of Cincinnati, 1916; Ph.D., University of Chicago, 1920. Taught at Chicago and Yale; made contributions to study of learning and memory, work and fatigue, and the development of a social psychology of the law.

ROBINSON, EDWARD VAN DYKE (*b. Bloomington, Ill., 1867; d. 1915*), economist. Graduated University of Michigan, 1890; Ph.D., University of Leipzig, 1895. Taught at University of Minnesota and at Columbia University.

ROBINSON, EDWIN ARLINGTON (*b. Head Tide, Maine, 1869; d. 1935*), poet. Descended collaterally from Anne Bradstreet, Robinson attended Harvard. His young manhood was clouded by family misfortunes. Unable to get magazine publication for his poems, he published them at his own expense in *The Torrent and the Night Before* (1896); with additional poems, they were republished in *The Children of the Night* (1897). After abortive attempts in Gardiner, Maine, and in Boston, Mass., to earn a living while remaining free to write, he removed to New York City, 1899. His *Captain Craig and Other Poems* (1902) received scant attention, but in 1905 his work was reviewed with intelligent praise in the *Outlook* by President Theodore Roosevelt. Thereafter, with the assistance of friends, he continued his career in more or less material security. His most distinguished early book *The Town Down the River* appeared in 1910; *The Man Against the Sky* (1916) won wide recognition. In 1917 he brought out *Merlin*, the first of his long poems on Arthurian themes. His *Collected Poems* (1921) was awarded the 1922 Pulitzer Prize; he received a second Pulitzer Prize for *The Man Who Died Twice* (1924), and a third for *Tristram* (1927). He was by this time in general critical esteem and *Tristram* enjoyed a large sale. Subsequent to *Avon's Harvest* (1921), he wrote a number of psychological studies in verse which included *Cavender's House* (1929), *Matthias at the Door* (1931), and *King Jasper* (1935); these had a mixed critical reception as contrasted with the general acclaim given his purely narrative and lyrical work.

A careful technician, particularly in blank verse, Robinson reflected himself in his poetry; like him, it was reticent, sincere, unposed, and rooted in essential New Englandism. Whether he wrote of Yankees or the dwellers in Camelot, he concentrated his insight on the fundamentals of human nature. His greatest defect was that of obscurity. In his Arthurian poems, however, his fusion of psychological insight with dramatic force and richness of language showed forth to greatest advantage. A well-worn story took on new life under his hands, as in *Tristram*, where the rush and passion of the tale itself simplified his thoughts and permitted his a perfect balance of intellect and feeling.

ROBINSON, EZEKIEL GILMAN (*b. S. Attleboro, Mass., 1815; d. Boston, Mass., 1894*), Baptist clergyman, educator. Graduated Brown, 1838; Newton Theological Institution, 1842. Professor of biblical theology. Rochester Theological Seminary, 1853–72, and its president *post* 1860, he became president of Brown University, 1872. His stern but efficient rule ended in 1889, leaving the University far richer in equipment and further advanced in educational policy.

ROBINSON, FREDERICK BYRON (*b. near Hollandale, Wis., 1855; d. 1910*), surgeon, anatomist. Graduated University of Wisconsin, 1878; M.D., Rush Medical College, 1882. Settling in Chicago, Ill., 1891, he taught gynecology and abdominal surgery at several Chicago medical schools and held a number of hospital staff posts. His chief claim to distinction rests upon his researches and voluminous writings in the field of the anatomy of the abdomen and pelvis.

ROBINSON, GEORGE CANBY (*b. Baltimore, Md., 1878; d. Greenport, N.Y., 1960*), physician and educator. Studied at Johns Hopkins University (M.D., 1903). Robinson's academic appointments included Washington University (1913–20), dean of the medical school from 1917; Vanderbilt University, dean (1920–28); and Cornell University Medical College, director (1928–34). Robinson's speciality was organizing medical departments. His books include *The Patient as a Person* (1939) and *Adventures in Medical Education* (1957).

ROBINSON, HARRIET JANE HANSON (*b. Boston, Mass., 1825; d. Malden, Mass., 1911*), woman suffrage leader. Wife of William S. Robinson.

ROBINSON, HENRY CORNELIUS (*b. Hartford, Conn., 1832; d. Hartford, 1900*), corporation lawyer, Connecticut Republican legislator and judicial reformer, leading Congregational layman.

ROBINSON, HENRY MORTON (*b. Boston, Mass., 1898; d. New York, N.Y., 1961*), author. Attended Columbia (M.A., 1924). Author of the novels *Children of Morningside* (1924), *The Perfect Round* (1945), and *The Cardinal*; the verse collections *Buck Fever* and *The Second Wisdom*; and the nonfiction works *John Erskine* (1928), *Science Versus Crime* (1935), and *Fantastic Interim* (1943). Contributed to *Century*, *Bookman*, and *North American Review* while teaching at Columbia (1924–27), and held three editorial positions with Reader's Digest (1935–45). He is remembered for his versatility as a teacher, editor, critic, essayist, scholar, novelist, and journalist.

ROBINSON, JAMES HARVEY (*b. Bloomington, Ill., 1863; d. New York, N.Y., 1936*), historian. Brother of Benjamin L. Robinson. Educated in the Bloomington public schools, and at the State Normal School where he developed a lifelong interest in biology, he traveled abroad and engaged in business before entering Harvard. Graduating in 1887, he took a master's degree the following year and received a doctorate from the University of Freiburg, 1890. He taught at University of Pennsylvania, 1891–95. Professor of European history at Barnard College and Columbia, 1895–1919, he helped found the New School for Social Research (New York City), 1919, and remained with it until 1921. Author of a best-selling work, *The Mind in the Making* (1921), which he had written in the hope of persuading the educated many to think critically about human behavior, he was author also of a number of textbooks and of *The New History* (1912) which advocated "totality" in historical study, viz., the employment of all the social and behavioral sciences in examining the record of man considered as an animal in a state of evolution. Filled with a sense of mission against organized Christianity, he rejected all forms of supernaturalism and considered that the

principal task of the historian and his scientific allies must be to show ordinary men how to overcome the burden of the past and its precedents by understanding how that burden arose and grew. An outstanding teacher and lecturer, Robinson exercised great influence in shifting public secondary school teaching of history from its traditional political emphasis to consideration of how human beings came to be what they are.

ROBINSON, JOHN (*b. Virginia, 1704; d. Virginia, 1766*), Virginia colonial legislator and official. Brother of Beverley Robinson. Speaker of the House of Burgesses and treasurer of Virginia, 1738–66. A report after his death, based on an investigation by Richard Henry Lee and others, showed his accounts short by more than 100,000 pounds.

ROBINSON, JOHN CLEVELAND (*b. Binghamton, N.Y., 1817; d. Binghamton, 1897*), soldier. Attended West Point, 1835–38, leaving to study law. After Mexican War service, he remained in the army and was engaged principally in Western frontier duty. Commanding Fort McHenry, Baltimore, Md., in April 1861, he discouraged any attempt on the part of rioters to attack the post. Thereafter in continuous service with the Army of the Potomac, he distinguished himself particularly at Gettysburg. He rose to rank of major general, retiring in 1869.

ROBINSON, JOHN MITCHELL (*b. Tuckahoe Neck, Caroline Co., Md., 1827; d. Annapolis, Md., 1896*), Maryland circuit and appeals court judge, *post* 1864; chief justice court of appeals, 1893–96.

ROBINSON, JOHN ROOSEVELT ("JACKIE") (*b. Cairo, Ga., 1919; d. Stamford, Conn., 1972*), baseball player and business executive. A standout athlete in high school, he attended Pasadena Junior College, playing football, basketball, and baseball, and University of California at Los Angeles, becoming UCLA's finest-ever all-around athlete, but left in 1946 to join a National Youth Administration camp. Because blacks could not play professional football in the United States, he played halfback for the semi-professional Honolulu Bears. During World War II he was able to attend Officers Candidate School, after boxer Joe Louis had the ban against blacks lifted; he became a morale officer for black troops. While awaiting discharge in November 1944, he met a member of the Kansas City Monarchs of baseball's Negro American League, and he seized the opportunity to join the team.

Meanwhile, Branch Rickey, co-owner of the Brooklyn Dodgers, was seeking new baseball talent and widened his search to Latin American and black players. He decided that Robinson would be the perfect choice to break baseball's color barrier. In 1946 Robinson began play with a Dodger farm team and in 1947 moved up to the majors and was selected Rookie of the Year; in 1949 he led the league in batting with a .342 average and was named Most Valuable Player. In his ten seasons with the Dodgers, he was noted for his clutch hitting, daring base running, and stealing home nineteen times. During his tenure the Dodgers won the National League pennant six times and the World Series in 1955. Rather than be traded to the New York Giants in 1957, he retired and entered the business world. He was elected to the Baseball Hall of Fame in 1962.

ROBINSON, JOSEPH TAYLOR (*b. near Lonoke, Ark., 1872; d. Washington, D.C., 1937*), lawyer. Congressman, Democrat, from Arkansas, 1903–13, he was elected governor of Arkansas in 1912, but resigned to fill a seat in the U.S. Senate, where he served, 1913–37. Robinson became Senate Democratic leader in 1923 and received his party's vice presidential nomination in 1928. As Senate majority leader, 1933–37, he supported President F.D. Roosevelt on almost every issue, including the unpop-

ular Supreme Court reorganization bill. An able parliamentarian and an effective behind-the-scenes worker, he played an important role in two progressive Democratic administrations.

ROBINSON, MONCURE (b. Richmond, Va., 1802; d. Pennsylvania, 1891), civil engineer. Brother of Conway Robinson. Built original line of Philadelphia & Reading Railroad, 1834–36.

ROBINSON, MOSES (b. Hardwick, Mass., 1742; d. Bennington, Vt., 1813), Revolutionary soldier, Vermont political leader. Chief justice of the supreme court, 1778–89; governor of Vermont, 1789–90; U.S. senator, 1791–96. Strongly opposed the Jay Treaty, 1794–95.

ROBINSON, ROWLAND EVANS (b. Ferrisburg, Vt., 1833; d. Ferrisburg, 1900), Author of a number of books of sketches in prose, depicting rural Vermont life and people.

ROBINSON, RUBY DORIS SMITH (b. Atlanta, Ga., 1942; d. Atlanta, 1967), civil rights activist. While attending Atlanta's Spellman College (1958–65), she joined the Student Nonviolent Coordinating Committee, participated in sit-ins and freedom rides, and became administrative secretary of SNCC in 1962. She visited Guinea in 1964 with other SNCC leaders and began to appreciate the economic as well as racial dimensions of exploitation. A hardworking, efficient, and determined volunteer, she was elected executive secretary of SNCC (1966) and endorsed the call for "black power"; she insisted that black women historically had to play strong roles for the survival of their families and formally protested the limited roles allotted to women in SNCC. Died of cancer.

ROBINSON, SOLON (b. Tolland, Conn., 1803; d. Jacksonville, Fla., 1880), Indiana pioneer, agriculturist, author. With James M. Garnett, Henry L. Ellsworth, and others, Robinson was advocating formation of a national agricultural society as early as 1838; his activities paved way for forming of the U.S. Agricultural Society, 1852. Writing in the New York Tribune (for which he was agricultural editor, 1853–ca. 1868), the American Agriculturist, and other journals, he produced a body of travel sketches which are trustworthy historical records of rural life of his time. He was author also of a number of books of more general interest which include *The Will: a Tale of the Lake of the Red Cedars* (1841) and *Hot Corn: Life Scenes in New York* (1854).

ROBINSON, STILLMAN WILLIAMS (b. near South Reading, Vt., 1838; d. Columbus, Ohio, 1910), engineer, educator. Brother of Albert A. Robinson. C. E., University of Michigan, 1863. Established department of mechanical engineering at present University of Illinois, where he taught from 1870–78; professor of physics and mechanical engineering at Ohio State, 1878–95. A pioneer in experimental instruction in engineering education, he was also author of several outstanding textbooks and the holder of a number of profitable patents.

ROBINSON, STUART (b. Strabane, Ireland, 1814; d. Louisville, Ky., 1881), Presbyterian clergyman, editor, educator. Came to America as a child. Pastor in Louisville post 1858; aggressive editor of denominational journals; Confederate sympathizer.

ROBINSON, THEODORE (b. Irasburg, Vt., 1852; d. New York, N.Y., 1896), artist. Passed early life in the Midwest and West; settled in New York City, 1874, where he was an organizer of the Art Students League whose name he suggested; studied in Paris, France, under Carolus-Duran and J. L. Gérôme post 1877. Returning home, he became a member of the Society of American Artists, 1881. During subsequent journeys to France, 1884–92, he came under influence of the Impressionists and

subsequently was important as pioneer and spokesman for the new movement in America. His work occupies a unique and outstanding place in American painting.

ROBINSON, THERESE ALBERTINE LOUISE VON JAKOB (b. Halle, Germany, 1797; d. Hamburg, Germany, 1870), philologist, novelist, translator. Wife of Edward Robinson (1794–1863). Resided in America, 1830–37, 1840–63. Wrote scholarly works on a wide variety of subjects, also several novels; employed pen name "Talvj."

ROBINSON, WILLIAM (b. Coal Island, Ireland, 1840; d. Brooklyn, N.Y., 1921), engineer. Came to America as a child. Graduated Wesleyan University, 1865. Specializing in electrical work, Robinson was the inventor and basic patentee (1872) of the railroad block-signal; he also devised the bond wire system for connecting adjacent rails electrically, patented the radial car truck used on electric railways, and made important improvements in steam turbines.

ROBINSON, WILLIAM CALLYHAN (b. Norwich, Conn., 1834; d. 1911), legal educator and author. Graduated Dartmouth, 1854. Assisted in reorganization of Yale Law School, where he taught, 1869–96; thereafter headed department of law, Catholic University of America, Washington, D.C. Author of *Notes on Elementary Law* (1875, 1882, 1910), *Elements of American Jurisprudence* (1900), a scholarly edition of Horne's *Mirrour of Justices* (1903), and other works.

ROBINSON, WILLIAM ERIGENA (b. Unagh, Ireland, 1814; d. Brooklyn, N.Y., 1892), lawyer, journalist, politician. Immigrated to America, 1836. Graduated Yale, 1841; studied at Yale Law School. Contributed the "Richelieu" dispatches from Washington to the New York Tribune, 1844–48. An ardent Irish patriot, he held a number of minor federal offices in New York; he served as congressman, Democrat, from New York, 1867–69 and 1881–85.

ROBINSON, WILLIAM STEVENS (b. Concord, Mass., 1818; d. Malden, Mass., 1876), Massachusetts journalist, antislavery advocate. Whig, Free-Soil, and Republican political leader. Clerk of Massachusetts House of Representatives, 1862–73, he was known as the "Warwick" of state politics and successfully led opposition to Benjamin F. Butler's bids for the governorship.

ROBINSON-SMITH, GERTRUDE (b. Mamaroneck, N.Y., 1881; d. New York, N.Y., 1963), civic worker and music patron. President of the American Woman's Association (1911–28) and creator of the Ice Flotilla Committee, which provided ice-making machines for advance field hospitals in World War I. Organizer of the French Theater at the Barbizon Plaza Hotel in New York (1937). Formed the Berkshire Symphony Festival (1934) in Stockbridge, Mass., and was president until 1955. Convinced Serge Koussevitzky, conductor of the Boston Symphony, to bring the orchestra to Stockbridge in 1936, and donated her estate, "Tanglewood," to the festival. The Berkshire Music Center opened in 1940. Appointed to the advisory committee of the National Culture Center in Washington, D.C., in 1963.

ROBOT, ISIDORE (b. Tharoiseau, France, 1837; d. Dallas, Tex., 1887), Roman Catholic clergyman, Benedictine. Came to America, 1871; founded monastery at Sacred Heart, Okla., 1875; became prefect-apostolic of Indian Territory, 1876, and served until 1886.

ROBSON, MAY (b. Wagga Wagga, New South Wales, Australia, 1858; d. Beverly Hills, Calif., 1942), actress. Stage name of Mary Jeannette Robinson. Raised in a suburb of Melbourne, Australia,

and in England, she came to the United States on her marriage to C. L. Gore, 1877. Left destitute and with a son to support when her husband died in New York City, she turned on impulse to the stage. She made her debut in a character part at the Grand Opera House, Brooklyn, on Sept. 17, 1883, with great success; between 1884 and 1901 she was a member of three famous New York stock companies: A. M. Palmer's, Daniel Frohman's (Lyceum), and Charles Frohman's (Empire). A specialist in playing eccentrics, she won additional renown as a make-up expert. After leaving the Empire company, she played featured roles. She first starred in *The Rejuvenation of Aunt Mary* (1907), in which she toured for almost ten years. Experienced as a film actress since 1911, she resumed film work in the late 1920's; her greatest single success came in 1933, when she played "Apple Annie" in *Lady for a Day*.

ROBSON, STUART (*b. Annapolis, Md., 1836; d. New York, N.Y., 1903*), actor. Stage-name of Henry Robson Stuart. Partner of William H. Crane in a celebrated comedy team, 1877–89.

ROCHAMBEAU, JEAN BAPTISTE DONATIEN DE VIMEUR, COMTE DE (*b. Vendôme, France, 1725; d. Thoré, France, 1807*), French soldier. Entering the army as a junior officer of cavalry, 1740, he was given command of a troop, 1743, and by 1747 had risen to colonel. After a period of retirement in the Vendômois, 1749–56, he shared in the brilliant campaign against Minorca, and after distinguishing himself at Crefeld, June 1758, rose to command of an infantry regiment in the next year. His skill in maneuver and his personal bravery saved the French from a disaster at Klostercamp, October 1760; early in 1761 he was made brigadier general and inspector of cavalry. He was noted for his introduction of a number of tactical improvements and for his unusual interest in the welfare of his soldiers. Appointed to command the French expeditionary army in America, he sailed with his force from Brest on May 1, 1780, and arrived off Rhode Island on July 11. The splendid discipline of his army together with the tact and charm of the officers removed many old American prejudices against the French. Unwilling to make a major move until the French had command of the sea, he discouraged the idea of an attack on New York which was favored by Lafayette and Washington, requested reinforcement from France, and put his army into winter quarters in Rhode Island. Informed in May 1781 that no more troops were to be expected but that the French West India fleet under command of the Comte de Grasse would cooperate with him and with Washington, he held a conference with the American general at Wethersfield, Conn., May 21. Washington still favored an attempt against New York, but Rochambeau urged that combined operations be undertaken with the fleet against Cornwallis in Virginia. The French army then moved from Newport and united with Washington's troops near White Plains, N.Y. The Franco-American force now numbered some 10,000 men and awaited news from de Grasse before it determined on its next move. When it was learned on August 14 that the French fleet was sailing for the Chesapeake, Rochambeau once again advised a march southward against Cornwallis who was being harassed by Lafayette's force in Virginia. The march southward began on August 19; an army group under General Wm. Heath was left to threaten New York so as to deceive the British. Until August 29 the joint movement might well have been an attack in force on New York and so the British considered it; thereafter the speed with which the united army traveled to join Lafayette at Williamsburg, Va., was as extraordinary as the efficiency with which de Grasse (aided by the arrival of the French supporting fleet from Newport) repelled the efforts of the English fleet under Admiral Graves to prevent the sealing-off of the mouth of the Chesapeake. The combined armies arrived at Williamsburg, Va., on September 14 to find the British en-

camped at Yorktown in a hopeless position with no longer any chance of rescue by sea. After 17 days of formal siege, Yorktown was surrendered on Oct. 19, 1781. Rochambeau embarked for France, Jan. 11, 1783. Thereafter he held important district commands at home, commanded the northern military department in 1790–91, and was created a marshal of France, December 1791. Narrowly escaping death under the Terror, he was honored by Napoleon and received the Legion of Honor.

ROCHE, ARTHUR SOMERS (*b. Somerville, Mass., 1883; d. Florida, 1935*), popular novelist and storywriter. Son of James J. Roche.

ROCHE, JAMES JEFFREY (*b. Mountmellick, Ireland, 1847; d. Berne, Switzerland, 1908*), journalist. Immigrated as a child to Charlottetown, P.E.I.; removed to Boston, Mass., 1866. Assistant to John B. O'Reilly on the Boston *Pilot*, leading Irish Catholic journal in the United States, Roche became editor of the paper, 1890. He was U.S. consul at Genoa, Italy, 1904, and later at Berne.

ROCHE, JOSEPHINE ASPINWALL (*b. Neligh, Nebr., 1886; d. Bethesda, Md., 1976*), coal operator, government official, and labor leader. Graduated Vassar College (B.A., 1908) and Columbia University (M.A., 1910) and did settlement work in New York City before becoming Denver's first policewoman in 1912. Committed to social activism and government-sponsored welfare policies, she served on the Commission for Relief in Belgium (1915) and in 1923 was a director for the U.S. Children's Bureau. In 1927 she inherited minority holdings in the Rocky Mountain Fuel Company and acquired a majority interest; she angered stockholders by inviting the United Mineworkers of America (UMW) to unionize company workers. In 1934 she was appointed assistant secretary of the treasury in the Franklin Roosevelt administration. Beginning in 1939, she chaired the Interdepartmental Committee to Coordinate Health and Welfare Activities and lobbied for universal access to basic health care. From 1947 to 1971 she managed the welfare and retirement fund of the UMW.

ROCHESTER, NATHANIEL (*b. Westmoreland Co., Va., 1752; d. Rochester, N.Y., 1831*), merchant, Revolutionary soldier. After making several land purchases in the newly opened Genesee country of New York, he removed there from Hagerstown, Md., *post* 1803, and in 1818 settled in Rochester which had already been founded by him.

ROCK, JOHN (*b. Lauter, Hesse-Darmstadt, Germany, 1836; d. 1904*), nurseryman. Immigrated to New York City as a boy. Served in Union Army, 1861–65; removed to California, 1866, starting a nursery at Santa Clara. Established California Nursery Co. at Niles, 1884.

ROCKEFELLER, ABBY GREENE ALDRICH (*b. Providence, R.I., 1874; d. New York, N.Y., 1948*), philanthropist, art patron. Daughter of Nelson W. Aldrich; married John D. Rockefeller, Jr., Oct. 9, 1901. Shared in planning the restoration of Colonial Williamsburg and initiated the unique collection of American folk art housed there; was a founder and generous patron of the Museum of Modern Art, New York City. She was active as well in organizing and advancing numerous projects for social welfare.

ROCKEFELLER, JOHN DAVISON (*b. Richford, N.Y., 1839; d. Ormond, Fla., 1937*), industrialist, philanthropist. Brother of William Rockefeller. His father, a trader in lumber, salt, and other commodities, had a farm, first at Richford, later at Moravia, N.Y., where John first attended school. A year's further schooling at

Owego, N.Y., and two years of high school in Cleveland, Ohio, where the family moved in 1853, comprised Rockefeller's formal education. After three-and-a-half years with a Cleveland firm of commission merchants, Rockefeller and a young Englishman, Maurice B. Clark, formed (1859) a successful partnership, dealing in grain, hay, meats, and miscellaneous goods. Inheriting his mother's religious bent, Rockefeller became the leading layman in the Erie Street Baptist Church, and began contributing at least a tenth of his modest income to charities. In 1864 he married Laura Celestia Spelman, by whom he had four children, Bessie, Alta, Edith, and John D., Jr.

In 1863 Rockefeller, sensing the commercial possibilities in the recent linking of Cleveland by a railroad to the new "Oil Regions" in northwestern Pennsylvania, had joined in building a refinery, which in two years was the largest in Cleveland. Buying out his partners, 1865, Rockefeller, his brother William, and one of his original partners, Samuel Andrews, built a second refinery, the Standard Works, and William went to New York to develop the export and eastern trade. Rockefeller's special talent for enlisting brains brought him Henry M. Flagler as a partner in 1867; Flagler undertook in the firm's behalf an expert negotiation of lower freight rates, then unstandardized. Rockefeller's efficiency and foresight in the intensely competitive oil business soon effected further economies in operation. The firm made its own barrels, built warehouses, obtained fleets of lighters and tankers. Meticulous about details, he instituted a cost-accounting system accurate to the third decimal. In 1870 the firm became a joint-stock corporation, the Standard Oil Company of Ohio. Rockefeller, now convinced that solvency depended upon organization to end or abate destructive competition, pressed forward to acquire all other Cleveland refineries, and then refineries in other cities. Ownership or control of pipelines was the next step, accompanied by the purchase or lease of oil-terminal facilities in New York, and the beginning of an elaborate marketing system. Within seven years Standard Oil, holding a position close to monopoly, dominated the American oil industry. A few years later it also dominated the foreign oil market.

The organization of this vast combination became perplexing. The Ohio company, nucleus of the group, had no legal right to own property or stock outside Ohio. The solution, in 1881, was the establishment of a board of trustees which took over all stock and issued certificates of interest in the trust estates. Thus was the modern "Trust" born, soon followed by antitrust laws as a result of public hostility against Standard Oil and similar trusts. Although it was never Rockefeller's intent to obtain absolute control of refining, the Standard's ruthless competitive practices gave great offense, and general American opinion refused to accept any excuses for monopoly. In 1892 Standard of Ohio's trust agreement was dissolved by court order. Management was subsequently controlled by interlocking directorates of various state companies and finally (1899) by a holding company, Standard Oil (New Jersey), which was disbanded after a federal suit and a dissolution decree in 1911.

Ironically, as public criticism of him rose to a climax, Rockefeller was only the nominal head of the combination. *Post* 1897 he was wholly occupied with the distribution of his vast fortune, but the "tainted money" controversy of 1905 threatened to interfere with acceptance of his benefactions. In philanthropy, however, as in business, he was a conspicuous innovator and organizer. By employing able publicity agents and mitigating his own policy of silence about his affairs, he effected an eventual change in public opinion. Frederick T. Gates, an able and imaginative Baptist clergyman whom Rockefeller had met when founding (1889) the University of Chicago, was his principal aide in philanthropy *post* 1891; he was joined in 1897 by John D. Rockefeller, Jr. The Rockefellers established four principal philanthropic institutions: the Rockefeller Institute for Medical Research (1901); the General Education Board (1902); the Rockefeller Foundation (1913), "to promote the wellbeing of mankind throughout the world"; and the Laura Spelman Rockefeller Memorial Foundation (1918), later absorbed by the Rockefeller Foundation. Rockefeller's benefactions during his lifetime totaled $550 million and the endowment of his foundations continued to multiply.

Rockefeller gained a preeminent place, both in industry and in philanthropy, as an organizing genius. Alike in rationalizing the chaotic oil industry as in exploring new fields in education, health, and social welfare, he contributed a powerful initial impulse, intense application to detail, great penetration in solving difficult problems, and a rare tact in welding together talented groups of men to implement his ideas. In industry he gave his associates the fullest latitude and in philanthropy a complete freedom, with the result that their loyalty never flagged. Rockefeller had neither great breadth of mind nor notable cultivation. His greatest failure was in public relations, which he never understood. His chief defect was his tardiness in comprehending the steady advance of business ethics and the necessity of squaring business practices with new demands by government. His dominant passion was neither money-getting nor power-seeking, but a hatred of disorder and waste.

ROCKEFELLER, JOHN DAVISON JR. (*b. Cleveland, Ohio, 1874; d. Tucson, Ariz., 1960*), industrialist and philanthropist. Studied at Brown University. The heir of the Rockefeller Standard Oil fortune, Rockefeller's first major business experience was his adamant handling of a strike of the Colorado Fuel and Iron Co. in Ludlow, Colo. The strike ended in violence known as the Ludlow Massacre for which Rockefeller was blamed. Later Rockefeller became a champion of the rights of labor without abrogating his responsibilities to management. After World War I, he devoted his life to philanthropic pursuits: the endowment of Riverside Church, Rockefeller University in New York, Ft. Tryon Park, the restoration of Williamsburg, and the donation of the land for the permanent home of the United Nations. His major business venture turned out to be the development of Rockefeller Center in New York City.

ROCKEFELLER, JOHN DAVISON, III (*b. New York City, 1906; d. Mount Pleasant, N.Y., 1978*), philanthropist. Graduated Princeton University (1929) and, as an heir to the Standard Oil fortune, continued his family's extensive philanthropy. In the early 1950's he oversaw cultural exchanges with Japan that helped normalize relations with the United States. In 1953 he founded Population Control, which emerged as an influential research group on population growth issues in the 1960's. In 1970 he was appointed to chair the Commission on Population Growth and the American Future. President Richard Nixon publicly disassociated himself from Rockefeller's group after its recommendations for sex education and abortion rights. He was a driving force in creating Lincoln Center for the Performing Arts in New York City, beginning in 1955; he resigned from the center's board in 1969.

ROCKEFELLER, MARTHA BAIRD (*b. Madera, Calif., 1895; d. New York City, 1971*), concert pianist and philanthropist. Graduated Occidental College, Los Angeles (1916) and New England Conservatory of Music (1917) and studied piano in Berlin with Arthur Schnabel. She made her British debut with the London Symphony (1926) and played with the Boston Symphony under Serge Koussevitzky; she retired from the concert stage in 1931. She remained active in music as a philanthropist, serving as a trustee of the New England Conservatory and contributing generously to Lincoln Center for the Performing Arts, the Metro-

politan Opera, and the Boston Symphony. In 1962 she founded the Martha Baird Rockefeller Fund for Music to assist the careers of young musicians and music scholars.

ROCKEFELLER, NELSON ALDRICH (*b. Bar Harbor, Maine, 1908; d. New York City, 1979*), businessman and public official. Graduated Dartmouth College (B.A., 1930) and became interested in Latin America, where his family had numerous investments. Concerned with the spread of Communism among the region's poor, he at one point pressured Standard Oil Company, which his family owned, to improve Venezuela's social welfare. During World War II, he was an assistant secretary of state for Latin American affairs (1944–45). In the 1950's he chaired an advisory committee that helped fashion the Department of Health, Education, and Welfare (HEW) and later served briefly as its under secretary.

In 1958 he became governor of New York; his bid benefited from the family fortune that financed his campaign. Republican Rockefeller's pro-New Deal, liberal positions were popular in the traditionally Democratic state. As governor until 1974, he directed state initiatives regarding housing, education, and the environment. Toward the end of his governorship, he emphasized lower taxes and anticrime legislation, which appealed to the changing concerns of his constituency. He was a national leader of the moderate wing of the Republican party. With his committed anti-Communism, support for a global U.S. foreign policy, and championing of activist government programs on domestic issues, Rockefeller held a centrist, liberal ideology that was shared by many Americans, including Democrats. The early favorite for the 1964 Republican presidential nomination, Rockefeller was damaged by publicity surrounding his 1963 marriage to a younger woman, which angered moral traditionalists in the Republican party. The following year at the Republican National Convention, he denounced right-wing extremism in his party. He served as vice-president of the United States under President Gerald Ford (1974–76).

ROCKEFELLER, WILLIAM (*b. Richford, N.Y., 1841; d. Tarrytown, N.Y., 1922*), financier, industrialist. Brother of John D. Rockefeller whom he assisted in his oil operations, managing Standard Oil's export selling functions in New York. An able salesman and commercial diplomat, he was active in bringing Henry H. Rogers, Charles Pratt, and others into the Standard Oil mergers and later, in association with Rogers and with James Stillman, carried on a number of adventurous speculations in Wall Street securities, chief of which was the Amalgamated Copper deal. *Post* 1911 and the dissolution of the Standard Oil trust, he withdrew from an active part in the oil industry and devoted himself to his investments.

ROCKEFELLER, WINTHROP (*b. New York City, 1912; d. Palm Springs, Calif., 1973*), philanthropist and politician. Attended Yale University (1931–34) and went to work for the family's Standard Oil subsidiary Humble Oil to learn the business from the bottom up. He was recalled to New York City in 1937 to participate in family business and philanthropic and public service endeavors, including service on the board of Colonial Williamsburg and as vice-chairman of the Greater New York Fund. After army service and several years as a playboy, he moved to Arkansas (1953) and befriended Gov. Orval Faubus, who appointed him to the new Arkansas Industrial Development Commission in 1955. By 1960 he began working to put life into Arkansas's moribund Republican party in the traditionally Democratic state. In 1966 he defeated a rabid segregationist to become governor (1967–71) and secured passage of laws to reform the state's prison system and improve education and social services.

ROCKHILL, WILLIAM WOODVILLE (*b. Philadelphia, Pa., 1854; d. Honolulu, Hawaii, 1914*), orientalist, diplomat. Educated in France; was official in American legations at Peking, China, and Seoul, Korea, 1884–87. Made scientific expeditions for the Smithsonian Institution in Mongolia and Tibet, 1888–89, 1891–92. Returning to the diplomatic service, 1893, he made his most notable contribution as special agent in China for settlement of the problems raised by the Boxer insurrection, 1900. He was also director of the International Bureau of the American Republics, 1899–1905, and thereafter U.S. minister to China and ambassador successively to Russia and Turkey. He presented a large library of rare Chinese works to the Library of Congress and was author of a number of important Far Eastern studies.

ROCKNE, KNUTE KENNETH (*b. Voss, Norway, 1888; d. southeast Kansas, 1931*), football coach. Came to America as a child; was raised in Chicago, Ill. Graduated Notre Dame, 1914. As head football coach at Notre Dame *post* 1918, Rockne developed colorful and highly trained teams whose play featured speed and deception. Many of the players trained by him became football coaches in colleges all over the country, further popularizing the so-called "Rockne System."

ROCKWELL, ALPHONSO DAVID (*b. New Canaan, Conn., 1840; d. 1933*), physician, Union Army surgeon. M.D., Bellevue Hospital Medical School, N.Y., 1864. In association with George M. Beard, Rockwell placed electrotherapeutics on a scientific and professional basis.

ROCKWELL, GEORGE LINCOLN (*b. Bloomington, Ill., 1918; d. Arlington, Va., 1967*), organizer and leader of the American Nazi party. Attended Brown University (1938–40) and Pratt Institute. Founded the fascist American Nazi Party (1958), whose membership probably never exceeded 100. A white supremacist, he advocated the sterilization or extermination of all Jews, who, he insisted, were responsible for the world-wide Communist movement. He also called for the deportation of all blacks to Africa and for the hanging of all "traitors," including former Presidents Harry Truman and Dwight Eisenhower and Chief Justice Earl Warren. He staged numerous provocative demonstrations, where his "storm troopers" were provided with Nazi uniforms and swastika armbands; his own presence at rallies often led to violence and arrests. He was shot to death by a former member of the party who had been expelled.

ROCKWELL, KIFFIN YATES (*b. Newport, Tenn., 1892; d. near Thann, Alsace, 1916*), aviator. Enlisted in French Foreign Legion, 1914; after pilot training, became member of Escadrille Lafayette, April 1916. Killed in action.

ROCKWELL, NORMAN PERCEVAL (*b. New York City, 1894; d. Stockbridge, Mass., 1978*), illustrator. Studied at the Art Students League in New York City and began illustrating children's books and magazines in 1912. In 1916 he began drawing covers for the *Saturday Evening Post*, the best-selling magazine in the nation. In his famed illustrations, Rockwell meticulously depicted commonplace scenes from American life. One of his many famous covers, "The Doctor and The Doll" (1929), showed a kindly doctor listening to the "heartbeat" of a young girl's doll. By the 1920's Rockwell's illustrations were coveted and valuable commodities, and he was sought after to draw covers for popular journals and by advertising agencies to depict products attractively before the advent of commercial photography. In 1943 the *Post* published Rockwell's "The Four Freedoms," a series considered his artistic masterpieces and basis for a successful war bond drive. In the 1950's, at the height of his popularity, he participated in major advertising campaigns. He continued to

provide material to the *Post*; an extra 250,000 copies were sold of the magazine every time a Rockwell cover appeared. Over his lifetime, Rockwell's illustrations appeared in virtually every commercial art market, including posters for movies, calendars, Christmas cards, and U.S. postage stamps.

ROCKWELL, WILLARD FREDERICK (*b. Dorchester, Mass., 1888; d. Pittsburgh, Pa., 1978*), industrialist, engineer, and inventor. Graduated Massachusetts Institute of Technology (B.S., 1909); in 1919 he purchased a small axle company, Wisconsin Parts, and the business thrived after he patented a double-reduction gear for axles, an invention that became integral in truck production. Beginning in the 1920's he initiated an aggressive campaign to acquire and merge with related axle and automotive parts companies. In 1958 he was chairman of Rockwell Standard, one of the largest suppliers of auto parts, which merged with North American Aviation to form North American–Rockwell in 1967.

RODDEY, PHILIP DALE (*b. Moulton, Ala., 1820; d. London, England, 1897*), Confederate brigadier general, merchant. Developed great abilities as cavalry scout leader under Generals Braxton Bragg, Joseph Wheeler, and Nathan B. Forrest.

RODENBOUGH, THEOPHILUS FRANCIS (*b. Easton, Pa., 1838; d. New York, N.Y., 1912*), Union cavalry colonel, author. Awarded Congressional Medal of Honor for gallantry at Trevilian Station, Va., 1864.

RODES, ROBERT EMMETT (*b. Lynchburg, Va., 1829; d. Winchester, Va., 1864*), civil engineer, Confederate major general. Graduated Virginia Military Institute, 1848. Starting in the Civil War as colonel, 5th Alabama Infantry, he distinguished himself at first Bull Run, Fair Oaks, Gaines's Mill, South Mountain, and Antietam. Leading the flank march at Chancellorsville, his division launched the surprise attack which gave the Confederates the victory. Rodes was an outstanding officer in the Eastern campaigns, 1863–64, and died on the battlefield while counterattacking Union forces under General P. H. Sheridan.

RODGERS, CHRISTOPHER RAYMOND PERRY (*b. Brooklyn, N.Y., 1819; d. Washington, D.C., 1892*), naval officer. Son of George W. Rodgers (1787–1832). Served with high efficiency in Seminole, Mexican, and Civil wars; as superintendent, U.S. Naval Academy, 1874–78, he attempted with fair success to raise standards of studies and behavior.

RODGERS, GEORGE WASHINGTON (*b. Cecil Co., Md., 1787; d. Buenos Aires, Argentina, 1832*), naval officer. Brother of John Rodgers (1773–1838); father of Christopher R. P. and George W. Rodgers (1822–1863). Warranted midshipman, 1804; served in War of 1812 abroad USS *Wasp* in engagement with HMS *Frolic* and later aboard USS *Macedonian*. Died while in command of the Brazil Squadron protecting American rights in present Argentina.

RODGERS, GEORGE WASHINGTON (*b. Brooklyn, N.Y., 1822; d. in action off Charleston, S.C., 1863*), naval officer. Son of George W. Rodgers (1787–1832); brother of Christopher R. P. Rodgers. Ordnance specialist.

RODGERS, JOHN (*b. Boston, Mass., 1727; d. New York, N.Y., 1811*), Presbyterian clergyman, Revolutionary chaplain, evangelist. Held pastorates for many years in New Castle Co., Del., and in New York City.

RODGERS, JOHN (*b. near present Havre de Grace, Md., 1773; d. Philadelphia, Pa., 1838*), naval officer. Father of John Rodgers (1812–1882); brother of George W. Rodgers (1787–1832). After merchant marine service in which he rose to master, Rodgers was appointed second lieutenant abroad the *Constellation*, March 1798, soon rising to first lieutenant and executive officer under Thomas Truxtun. Promoted captain a year later, he cruised in command of the *Insurgente* and later of the *Maryland*. Returning briefly to the merchant marine, 1801, he was recalled to the navy and served in the Mediterranean against the Barbary pirates, 1802–06. As senior officer under Commodores Morris and Barron, he commanded the blockading fleet off Tripoli with great success and played a great part in the treaty negotiations with Morocco, Tripoli, and Tunis. Commanding the northern division of coast defense, 1810–11, while cruising in the frigate *President* he engaged the British sloop *Little Belt* off Cape Henry, May 16, 1811. Ranking officer in active service in the War of 1812, Rodgers operated principally against British commerce, performing feats which although they were not as brilliant as some of the famous sea duels of the war were much more useful. On shore duty with a detachment of sailors and marines, he harassed the British on the retreat down the Potomac after the expedition against Washington, D. C. He also helped defend Baltimore, Md., when it was menaced by the enemy. He became senior naval officer, 1821, and in 1823 served briefly as U.S. secretary of the navy.

RODGERS, JOHN (*b. near Havre de Grace, Md., 1812; d. Washington, D.C., 1882*), naval officer. Son of John Rodgers (1773–1838). Appointed midshipman, 1828; was active in surveys, principally with the North Pacific Exploring and Surveying Expedition, 1852–56. He began his Civil War service at Cincinnati, Ohio, where he purchased and fitted out three small steamships, the nucleus of the Mississippi Flotilla. Aide to Admiral Du Pont in operations against South Carolina late in 1861 and later in actions on the James River, he became captain of the monitor *Weehawken*. He distinguished himself particularly in the attack on Fort Sumter, April 1863, and later against the Confederate ironclad *Atlanta*. At the time of his death he was senior rear admiral.

RODGERS, JOHN (*b. Washington, D.C., 1881; d. near Philadelphia, Pa., 1926*), naval officer. Great-grandson of John Rodgers (1773–1838). Graduated Annapolis, 1903. The second naval officer to be licensed as an aviator, Rodgers commanded the Naval Air Station, Pearl Harbor, Hawaii, 1922–25. He won particular notice for heroism as commander of the San Francisco-Hawaii flight, September 1925.

RODGERS, RICHARD CHARLES (*b. Long Island, N.Y., 1902; d. New York City, 1979*), composer. Attended Columbia University (1919–21) and formed a collaboration with lyricist Lorenz Hart. They enjoyed their first success with *The Garrick Gaieties* (1925), followed by a series of musical productions, including *Simple Son* (1930), which included the song "Ten Cents a Dance," and *Babes in Arms* (1937). During the 1930's, Rodgers and Hart also produced songs for several Hollywood films. In the 1940's, after Hart's death, Rodgers formed a partnership with lyricist Oscar Hammerstein II. After their first hit stage production, *Oklahoma!* (1943), they collaborated in several spectacularly successful musicals, including *Carousel* (1945), *South Pacific* (1949), and *The King and I* (1951). They also produced *The Sound of Music*, which ran from 1959 to 1963 and won the Tony Award for best musical. After Hammerstein's death in 1960, Rodgers continued to compose musicals, including *I Remember Mama* (1979). Over his lifetime, Rodgers helped write and produce forty-two Broadway musicals.

RODMAN, ISAAC PEACE (*b. South Kingston, R.I., 1822; d. near Sharpsburg, Md., 1862*), businessman, Rhode Island legislator, Union brigadier general. Commanding the 4th Division of the IX Corps, he was killed at the battle of Antietam.

RODMAN, THOMAS JACKSON (*b. near Salem, Ind., 1815; d. Rock Island, Ill., 1871*), soldier, ordnance expert. Graduated West Point, 1841. Invented process for casting cannon upon a hollow core, cooling inner surface by a flow of water so that each successive layer of metal was compressed by the shrinkage of outer layers; also developed an improved powder for artillery. His inventions were finally approved and adopted by the U.S. government, 1859, and were also adopted by the governments of Russia, Great Britain, and Prussia. During the Civil War, he commanded the arsenal at Watertown, Mass., where he supervised casting of the celebrated "Columbiad" and other heavy guns, both smoothbore and rifled, for use by the army and navy.

RODNEY, CAESAR (*b. near Dover, Del., 1728; d. Dover, 1784*), statesman, jurist. Brother of Thomas Rodney. Serving almost continuously, 1761–76, as Kent Co. delegate of the legislature at New Castle, Rodney was elected speaker in 1769, 1773–74, and 1775–76. He was an associate of Thomas McKean and George Read in patriotic activity and was a delegate to the First Continental Congress. Reelected to Congress, 1775, he was also made brigadier general of the Kent Co. militia. In the late afternoon of July 2, 1776, his vote committed the Delaware delegation to acceptance of independence and he also voted with McKean for the adoption of the Declaration. Rejected by the conservatives of Kent Co. because of his action, he failed to obtain any political office in the fall of 1776, but as a member of the Council of Safety busied himself in raising troops for Washington's army. In 1777 he was reelected to the Continental Congress, and in the spring of 1778 he was chosen president of Delaware; he served with ability until November 1781. He was regarded by his contemporaries as a man of wit and high courage.

RODNEY, CAESAR AUGUSTUS (*b. Dover, Del., 1772; d. Buenos Aires, Argentina, 1824*), lawyer, statesman, diplomat. Son of Thomas Rodney; nephew of Caesar Rodney. Congressman, (Democrat) Republican, from Delaware, 1803–05; was a House manager in impeachment proceedings against John Pickering and Samuel Chase. U.S. attorney general, 1807–11, he served in the Delaware militia during the War of 1812. After service, 1817–18, as a U.S. commissioner investigating the political status of the newly established South American republics, he was congressman again very briefly in 1821, and U.S. senator, 1822. Appointed first U.S. minister to the Argentine Republic, he arrived in Buenos Aires, November 1823, but soon fell dangerously ill and died in office.

RODNEY, THOMAS (*b. Kent Co., Del., 1744; d. Natchez, Miss., 1811*), farmer, Revolutionary soldier, jurist. Brother of Caesar Rodney; father of Caesar A. Rodney. Judge, supreme court of Delaware, 1802–03; U.S. judge for Mississippi Territory, 1803–11.

RODZINSKI, ARTUR (*b. Spalato, Dalmatia [now Split, Yugoslavia], 1892; d. Boston, Mass., 1958*), conductor. Studied at the University of Lvov and at the Vienna Academy of Music. While he was a conductor at the Teatr Wielki Opera House in Warsaw, he was heard by a touring conductor, Leopold Stokowski, and was hired as the assistant conductor of the Philadelphia Orchestra (1926–29). From 1929 to 1933, he was conductor of the Los Angeles Philharmonic; from 1933 to 1943, he directed the Cleveland Orchestra; from 1943 to 1947, the New York Philharmonic; and from 1947 to 1948, the Chicago Symphony Orchestra. Remembered for his Wagner, Tchaikovsky, and Brahms interpretations, Rodzinski also championed twentieth-century composers such as Richard Strauss. In 1935, Rodzinski premiered Shostakovich's *Lady Macbeth of Mzensk* with the Cleveland Orchestra; in Florence, he conducted the Western premier of Prokofiev's *War and Peace*.

ROE, EDWARD PAYSON (*b. present New Windsor, N.Y., 1838; d. Cornwall-on-Hudson, N.Y., 1888*), Presbyterian clergyman, popular novelist. Author of *Barriers Burned Away* (1872), *A Knight of the Nineteenth Century* (1877), and other moralistic novels which were all best sellers.

ROE, FRANCIS ASBURY (*b. Elmira, N.Y., 1823; d. Washington, D.C., 1901*), naval officer. Performed outstanding Civil War service in the taking of New Orleans and later on the Atlantic Coast blockade where he commanded the *Sassacus* in action against the Confederate ironclad *Albemarle*, May 1864. He retired as rear admiral, 1885.

ROE, GILBERT ERNSTEIN (*b. Oregon, Wis., 1865; d. New York, N.Y., 1929*), lawyer, legal author. Political and legal adviser of Robert M. LaFollette. Practiced in New York, N.Y., *post* 1899.

ROEBLING, JOHN AUGUSTUS (*b. Mühlhausen, Germany, 1806; d. Brooklyn, N.Y., 1869*), engineer, bridge builder. Father of Washington A. Roebling. Graduated Royal Polytechnic Institute, Berlin; came to America, 1831. Settling in a German colony in Butler Co., Pa., Roebling soon abandoned his efforts to be a farmer and went to work for the State of Pennsylvania as an engineer on canal projects. Observing the greater utility of twisted wire cables over ropes made of hemp in hauling canal boats upon inclined planes, he designed machinery for fabrication of wire rope and in 1841 manufactured the first wire rope made in America. He moved his factory from Saxonburg, Pa., to Trenton, N.J., *ca.* 1848. Interested from youth in bridge-building, in 1844–45 he designed and built a wooden aqueduct for the Pennsylvania Canal, which was carried on two continuous wire cables; in 1846 he completed his first suspension bridge over the Monongahela River at Pittsburgh. Among his many successful bridge constructions thereafter, the most striking was his pioneer railroad suspension bridge at Niagara Falls, built 1851–55. As early as 1857, Roebling had suggested to the New York City authorities the possibility of a bridge over the East River between Manhattan and Brooklyn which would not interfere with navigation. Appointed chief engineer of the project ten years later, he perfected plans which were approved early in 1869. While making observations at the site of the proposed bridge in June 1869, he received the injury from which he died.

ROEBLING, WASHINGTON AUGUSTUS (*b. Saxonburg, Pa., 1837; d. Trenton, N.J., 1926*), civil engineer, industrialist. Son of John A. Roebling. Graduated Rensselaer Polytechnic Institute; served as assistant to his father until 1861. An officer of engineers in the Union Army, 1861–65, he received several commendations for gallant, efficient service, leaving the army as brevet colonel of volunteers. Returning to his post as assistant to his father, he succeeded the elder Roebling as chief engineer of the Brooklyn Bridge project in 1869 and saw it through to its successful conclusion, 1883. Seriously ill *post* 1872, Roebling had directed a great part of the work from his home, at the same time maintaining an active part in the family business at Trenton, John A. Roebling's Sons Co., of which he became president, 1876. He virtually retired from active professional work *ca.* 1888.

ROEDING, GEORGE CHRISTIAN (*b. San Francisco, Calif., 1868; d. 1928*), horticulturist, nurseryman. Established the

Smyrna fig culture in California by demonstrating necessity of pollination by the Blastophaga wasp.

ROEMER, KARL FERDINAND (*b. Hildesheim, Germany, 1818; d. Breslau, Germany, 1891*), German geologist. Visited America, 1845, to study condition of German colonists in Texas and to report upon natural resources in the country. Three of his works resulted from this journey: *Texas Mit besondere Rücksicht . . .* (Bonn, 1849), *Die Kreidbildungen von Texas . . .* (Bonn, 1852), and a work on the fossils of western Tennessee published in 1860.

ROETHKE, THEODORE HUEBNER (*b. Saginaw, Mich., 1908; d. Bainbridge Island, Wash., 1963*), poet and teacher. Attended Harvard and University of Michigan (M.A., 1936). Known for his writing and public reading of poetry and brilliant teaching, his first significant publications were in *Commonweal* (1931), *New Republic*, and *Sewanee Review* (1932). Began to build his reputation as a teacher at Lafayette College (1931), while making headway as a poet, publishing in *Saturday Review of Literature*, *Nation*, and *Atlantic Monthly*. Taught (1935) at Michigan State College, where he suffered the first attack of a manic-depressive disorder that afflicted him periodically, and at Pennsylvania State College (1936–43). His work appeared in thirty American publications, including the *New Yorker, Harpers, Yale Review*, and the *American Scholar*. The poems in his first volume, *Open House* (1941), were exercises in traditional styles, forms, and rhymes. He reached a new peak in teaching at Bennington (1943–45), but also suffered his second major manic episode. Taught at the University of Washington (from 1947 until his death); given the title of poet in residence (1962). His major work was *The Lost Sea and Other Poems* (1949), in which traditional forms yielded to a rich experimentation in rhythms, line lengths, and groupings, and introduced the long poem, or "sequence," ranging between 50 and 175 lines, a continuing feature of his work. The new style continued with elaborations and variations in *Praise to the End!* (1951) and *The Waking* (1953), which won a Pulitzer Prize. He also received the Bollingen Prize (1958), the National Book Award (1959), and many other prizes.

ROGERS, CLARA KATHLEEN BARNETT (*b. Cheltenham, England, 1844; d. Boston, Mass., 1931*), opera and concert soprano. Made American debut in New York, 1871; settled in Boston. Professor of singing at New England Conservatory of Music *post* 1902.

ROGERS, EDITH NOURSE (*b. Saco, Mass., 1881; d. Boston, Mass., 1960*), politician. From experience she had in France during World War I, Rogers became interested in disabled veterans, becoming the personal representative of presidents Harding, Coolidge, and Hoover for veterans' affairs. She was elected as a Republican to Congress in 1925, filling her husband's seat; she served until her death. In the House, she was active in veterans' rights, being a prime supporter of the G.I. Bill of Rights. In 1942, she introduced legislation establishing the Women's Army Corps.

ROGERS, EDWARD STANIFORD (*b. Salem, Mass., 1826; d. 1899*), horticulturist, developer of the Rogers hybrid grape.

ROGERS, HARRIET BURBANK (*b. N. Billerica, Mass., 1834; d. 1919*), teacher of the deaf, pioneer in use of the oral method. Principal, Clarke School for the Deaf, 1867–86.

ROGERS, HENRY DARWIN (*b. Philadelphia, Pa., 1808; d. Glasgow, Scotland, 1866*), geologist, educator. Brother of James B., Robert E., and William B. Rogers. An early associate of Robert D. Owen, Rogers taught at the University of Pennsylvania, worked on surveys of New Jersey and Pennsylvania ca. 1835–ca.

1847, and was professor of natural history in the University of Glasgow *post* 1855. His report on the Pennsylvania survey (published, 1858) was a most important document, in particular for findings regarding the structures of the Appalachian Mountains.

ROGERS, HENRY HUTTLESTON (*b. Mattapoisett, Mass., 1840; d. New York, N.Y., 1909*), capitalist. Partner of Charles Pratt in oil refining, Rogers devised the machinery by which naphtha was first successfully separated from crude oil (patented, 1871). An executive of the Standard Oil Co. *post* 1874, he devoted much of his time to the Wall Street operations of that trust in association with William Rockefeller. Active in public utilities promotion and in such controversial deals as Amalgamated Copper (1899), he worked with E. H. Harriman in the latter's extensive railroad operations, and also in the insurance operations which led to the Mutual Life investigation, 1905. He was a friend and financial counselor of Mark Twain.

ROGERS, HENRY J. (*b. Baltimore, Md., 1811; d. Baltimore, 1879*), inventor, telegraph pioneer. An early associate of Samuel F. B. Morse.

ROGERS, HENRY WADE (*b. Holland Patent, N.Y., 1853; d. Pennington, N.J., 1926*), educator, jurist. Graduated University of Michigan, 1874. Professor of law, University of Michigan *post* 1882; dean of the law school, 1886–90. President of Northwestern University, 1890–1900. Professor, Yale Law School, 1901–21; dean, 1903–16. Judge, U.S. circuit court of appeals, sitting in New York City, 1913–26. Did outstanding work in raising standards at Yale Law School.

ROGERS, ISAIAH (*b. Marshfield, Mass., 1800; d. probably Cincinnati, Ohio, 1869*), architect. After apprenticeship to a carpenter, Rogers worked in the office of Solomon Willard and started his own practice ca. 1826. Called the father of the modern hotel, he planned the Tremont in Boston (1828–29) and Astor House in New York (1834–36); also Clinton Hall (1847) and the New York Merchants' Exchange (1836–42). He designed other important buildings throughout the country with great taste and success; these included the second St. Charles Hotel, New Orleans, La. (ca. 1851), and the Burnet House, Cincinnati, Ohio (1850). *Post* 1862, he was supervising architect of the U.S. Treasury Department.

ROGERS, JAMES BLYTHE (*b. Philadelphia, Pa., 1802; d. Philadelphia, 1852*), chemist, educator. Brother of Henry D., Robert E., and William B. Rogers. M.D., University of Maryland, 1822. Taught chemistry in many institutions and was associated with his brothers in their survey and other work; professor of chemistry, University of Pennsylvania, 1847–52.

ROGERS, JAMES GAMBLE (*b. Bryants Station, near Louisville, Ky., 1867; d. New York, N.Y., 1947*), architect. B.A., Yale, 1889. Began career in office of William Le B. Jenney, Chicago, Ill.; studied at École des Beaux Arts, Paris, 1893–99, and was awarded diploma *par excellence*. Practiced in Chicago and New York; founded his own firm in New York, 1908, and in the following quarter-century established himself as the leading U.S. designer of college and university buildings. A master of the modern collegiate Gothic style, he designed the principal buildings erected at Yale and at Northwestern universities between 1920 and 1932, as well as Columbia University's Butler Library and extensive parts of the campuses of Southern Baptist College, Colgate-Rochester Divinity School, and Sophie Newcomb College.

ROGERS, JAMES HARRIS (*b. Franklin, Tenn., 1856; d. Hyattsville, Md., 1929*), inventor. Among the many devices on which

he held patents, probably the most valuable was his system of printing telegraphy (1887–94).

ROGERS, JAMES HARVEY (*b. Society Hill, S.C., 1886; d. Rio de Janeiro, Brazil, 1939*), economist. Studied at universities of South Carolina, Chicago, and Geneva (under Vilfredo Pareto), and at Yale (Ph.D., 1916). Taught at University of Missouri, at Cornell, and at Yale, 1931–39. Rogers combined a keen capacity for abstract mathematical analysis with concern for concrete social problems. One of President Franklin D. Roosevelt's early advisers, he undertook in 1933 with George F. Warren a revision of U.S. government fiscal policies. Among other recommendations, he urged that abandonment of the gold standard and devaluation of currency be accompanied by large-scale public works and expanded foreign lending and trade in cooperation with other governments. He was author of *Stock Speculation and the Money Market* (1927), *The Process of Inflation in France, 1914–1927* (1929), *America Weights Her Gold* (1931), and *Capitalism in Crisis* (1938).

ROGERS, JOHN (*b. Milford, Conn., 1648; d. New London, Conn., 1721*), founder of the Rogerene sect.

ROGERS, JOHN (*b. Salem, Mass., 1829; d. New Canaan, Conn., 1904*), sculptor, creater of the "Rogers groups." While employed as a machinist, he spent leisure hours moulding in clay; he studied ways of reproducing clay groups in plaster form during a short stay in Rome, 1858–59. Conceiving the idea of producing statuary which told a story of immediate popular interest, he made a sensation in New York with his "Slave Auction," 1859. The sale of copies of his original models continued brisk until the 1890's by which time critics began to patronize his sincere and almost photographic renderings. His Civil War groups have historical importance and contain some of Rogers's best portraits, for example, the Abraham Lincoln in the "Council of War." His genre groups, most popular of his works, are often exquisite and catch something of the movement and mass of monumental sculpture.

ROGERS, JOHN ALMANZA ROWLEY (*b. Cromwell, Conn., 1828; d. Woodstock, Ill., 1906*), Congregational clergyman, antislavery advocate, one of the original founders of Berea (Ky.) College.

ROGERS, JOHN IGNATIUS (*b. Philadelphia, Pa., 1843; d. Denver, Colo., 1910*), Pennsylvania corporation and real-estate lawyer, professional baseball executive.

ROGERS, JOHN RANKIN (*b. Brunswick, Maine, 1838; d. Olympia, Wash., 1901*), druggist, farmer, Populist, writer, Washington legislator. Settled in the State of Washington, 1890. Liberal coalition governor of Washington, 1897–1901; author of the "Barefoot Schoolboy Law."

ROGERS, JOHN RAPHAEL (*b. Roseville, Ill., 1856; d. Brooklyn, N.Y., 1934*), inventor. Son of John A. R. Rogers. Patented a machine for making stereotype matrices (1888) and devised a double-wedge space band. After legal difficulties with Ottmar Mergenthaler, Rogers merged his own company with the Mergenthaler Linotype Co., 1895, and served the combined companies as engineer and chief of the experimental department thereafter. He patented more than 400 devices in the field of composing machines for printing.

ROGERS, MARY JOSEPHINE (*b. Roxbury, Mass., 1882; d. New York, N.Y., 1955*), religious worker. Studied at Smith College and Boston Normal School. In 1912, she joined the Catholic Foreign Mission Society of America, later known as Maryknoll, near Ossining, N.Y. Rogers became Mother Mary Joseph and was elected mother general from 1925 until her retirement in 1947. The Maryknoll Sisters opened their first mission in Los Angeles in 1920, an orphanage and school for Japanese-American children. By the time of her death in 1955, there were 1,160 Maryknoll Sisters serving eighty-four missions in seventeen countries in Latin America, the Orient, Africa, the Pacific Islands, and the U.S.

ROGERS, MOSES (*b. New London, Conn., ca. 1779; d. Georgetown, S.C., 1821*), early steamboat captain. Commanded the *Phoenix*, 1809, in earliest ocean voyage of a steam vessel; fitted out the *Savannah*, 1818, and commanded her on her voyage to Liverpool, 1819.

ROGERS, RANDOLPH (*b. Waterloo, N.Y., 1825; d. Rome, Italy, 1892*), sculptor. Studied in Florence, Italy, 1848–51; resided principally in Rome, Italy, *post* 1855. A neo-classic whose modeling approaches realism, Rogers worked with great success and was an honored figure in his adopted Italian home. He is known principally for his "Columbus doors" of the U.S. Capitol at Washington, D.C., and for his heroic figure of "Michigan" on the top of the Detroit monument.

ROGERS, ROBERT (*b. Methuen, Mass., 1731 o.s.; d. London, England, 1795*), soldier. Reared on a farm near Rumford, present Concord, N.H. Raised recruits for Shirley's expedition to Nova Scotia, 1755; entered the New Hampshire regiment and became a captain on the Crown Point expedition. Noticed for his boldness and skill in scouting, he was appointed captain of an independent company of rangers, March 1756; he was promoted to be major of nine such companies, 1758. Famous in England and the colonies alike for rash courage, hardiness, and prankishness, he was constantly in the field; he was at Crown Point, 1759, when he destroyed the Saint Francis Indians in a daring raid, and in the final campaign about Montreal. Late in 1760, he went west as far as Detroit and Shawneetown to receive the surrender of all French posts. Unable to adjust to peace and civilization and quite lacking in principle in his dealings, he was a consistent failure in his employments, 1760–75. Returning to America from England, 1775, he courted both the Americans and the British and was imprisoned as a spy by Washington in 1776. Escaping to the British, he raised the Queen's American rangers but was soon deprived of his command. Employed thereafter in recruiting, his dishonesty and dissipation rendered him next to useless and in 1780 he returned to England. During a brief period as commander at Michilimackinac, 1766–67, he commissioned Jonathan Carver to undertake an exploratory journey into the present Minnesota. He was author of *A Concise Account of North America* and *Journals* (both London, 1765) and a crude tragedy *Ponteach* (1766), one of the first dramas written by a native New Englander.

ROGERS, ROBERT EMPIE (*b. Baltimore, Md., 1813; d. 1884*), chemist, educator. Brother of James B., Henry D., and William B. Rogers. M.D., University of Pennsylvania, 1836. Active with his brothers in research work. Professor of chemistry, University of Virginia, 1842–52; at medical school, University of Pennsylvania, 1852–77; at Jefferson Medical College, *post* 1877. He was also employed as a metals expert by the U.S. Mint.

ROGERS, ROBERT WILLIAM (*b. Philadelphia, Pa., 1864; d. near Chadds Ford, Pa., 1930*), Orientalist. A.B., University of Pennsylvania, 1886; A.B., Johns Hopkins, 1887; Ph.D., Haverford, 1890; Ph.D., Leipzig, 1895. Taught at Drew Theological Seminary and at Princeton. A student of Assyriology, Hebrew, and the Old Testament, Rogers made contributions to knowledge in

all three fields. He was author, among other books, of *A History of Babylonia and Assyria* (1900, rewritten and reissued, 1915).

ROGERS, STEPHEN (*b. Tyre, N.Y., 1826; d. Valparaiso, Chile, 1878*), surgeon. Largely self-educated; M.D., New York Medical College, 1856. Practiced in Panama, 1849–55; and in Santiago, Chile, 1856–65, as surgeon to railroad companies. Returned to Chile, 1875, after successful practice in New York City.

ROGERS, THOMAS (*b. Groton, Conn., 1792; d. New York, N.Y., 1856*), inventor, locomotive builder. Built the "Sandusky," first locomotive to operate west of the Allegheny Mountains, at Paterson, N.J., 1837, improving on English models. In 1842 he produced the "Stockbridge" with cylinders outside of the frame; in 1844 he designed and built the locomotive type which was subsequently adopted generally throughout the United States. This had two pairs of coupled driving wheels and was the first example of the use of equalizing beams between the drivers and the front swiveling truck. He also introduced the shifting link valve motion and was the first (1850) to apply the wagon top boiler.

ROGERS, WILL (*b. near Oologah, Indian Territory, present town of Claremore, Okla., 1879; d. near Point Barrow, Alaska, 1935*), humorist, actor, news commentator. Of Cherokee extraction on both his paternal and maternal side, he enjoyed a comfortable frontier youth on his father's ranch and became an expert roper of calves. After brief attendance at Kemper Military School 1897–98, he worked as a cowboy in Texas, traveled to the Argentine and to South Africa, worked as rope artist and rough rider with a Wild West show in Australia, and returned home in 1904. He made his New York debut at Madison Square Garden, April 1905, with Colonel Zach Maulhall's show; in the same year he discovered by chance that informal joking with the audience, often at the expense of his own skill with a lariat, improved his act. Projecting an essentially American image of a man playing his "natchell self," he rose to star rank in *Hands Up* (1915) and was a star of the *Ziegfeld Follies* in 1916–18, 1922, and 1924–25. Bringing news highlights into unexpected focus as part of his patter, he deflated rhetorical bunk and group smugness. A contributor of syndicated articles to newspapers *post* 1922, he began in 1926 a syndication of a single daily paragraph which dealt mainly with politics; ultraconservative at heart, he joked at whatever program, fad, or party was uppermost. He reached the height of his acting fame in a series of talking pictures, 1929–35, in which he played himself, whether the costume was top-hat, overalls, or medieval armor. A cowboy philosopher with a cool brain and a warm heart, he was held in popular affection as much for his personal qualities of decency and generosity as for his abilities as a performer. He was killed while attempting a flight north to the Orient with his fellow-Oklahoman, Wiley Post.

ROGERS, WILLIAM ALLEN (*b. Springfield, Ohio, 1854; d. Washington, D.C., 1931*), cartoonist, illustrator of stories by James Otis, Kirk Munroe, and other authors of children's books.

ROGERS, WILLIAM AUGUSTUS (*b. Waterford, Conn., 1832; d. 1898*), mathematician, astronomer, physicist. Graduated Brown, 1857. A teacher at Alfred and Harvard universities and at Colby College, Rogers made important researches on the value of the yard and the meter and changes therein. He was closely associated with Albert A. Michelson and Edward W. Morley in application of optical methods to determination of minute changes in length.

ROGERS, WILLIAM BARTON (*b. Philadelphia, Pa., 1804; d. Cambridge, Mass., 1882*), geologist, educator. Brother of Henry D., James B., and Robert E. Rogers. Educated at College of William and Mary, he served there as professor of natural history

and chemistry, 1828–35; he was professor of natural philosophy, University of Virginia, 1835–53. State geologist of Virginia, 1835–42, he worked jointly with his brother Henry on theory of structure of the Appalachians. An early advocate of the founding of Massachusetts Institute of Technology, he was elected its first president, serving 1862–70 and 1878–81.

ROGERS, WILLIAM CROWNINSHIELD (*b. Salem, Mass., 1823; d. London, England, 1888*), sea captain. Grandson of Jacob Crowninshield. Master of the clipper *Witchcraft* on her record run from Rio to San Francisco, 1851; served in Union Navy during Civil War; occupied himself thereafter with finance.

ROHDE, RUTH BRYAN OWEN (*b. Jacksonville, Ill., 1885; d. Copenhagen, Denmark, 1954*), congresswoman, diplomat. The daughter of William Jennings Bryan, she studied at the Monticello Seminary and the University of Nebraska. Secretary-treasurer of the American Woman's Relief Fund in London, 1914–15. Became the first congresswoman from the Deep South, representing Florida's Fourth District as a Democrat, 1929–33. Nominated envoy extraordinary and minister plenipotentiary to Denmark and Iceland, 1933, she was the first woman to hold a post in the U.S. Foreign Service. Published *Look Forward, Warrior*, 1943, a plan for a United Nations of the World. Alternate to the American delegation to the U.N., 1949, and served as chairman of the executive committee of the Speakers Research Committee.

ROHÉ, GEORGE HENRY (*b. Baltimore, Md., 1851; d. New Orleans, La., 1899*), medical educator, psychiatrist. M.D., University of Maryland, 1873; studied also under Edward Wigglesworth. Taught and practiced in Baltimore principally; was active in modernizing treatment of the insane.

ROHEIM, GEZA (*b. Budapest, Hungary, 1891; d. New York, N.Y., 1953*), anthropologist and psychoanalyst. Studied at the University of Budapest (Ph.D., 1914). Taught at the University of Budapest from 1919; member of the Budapest Institute of Psychoanalysis. Immigrated to the U.S. in 1938. Roheim survives less as the author of specific works than as a controversial pioneer in the convergence of psychoanalysis and anthropology. In 1925, his study, *Australian Totemism*, based on the primal horde theory won the Freud Prize as the best work of applied psychoanalysis. Books include *The Origin and Function of Culture* (1943) and *The Eternal Ones of the Dream* (1945).

ROHLFS, ANNA KATHARINE GREEN (*b. Brooklyn, N.Y., 1846; d. 1935*), author. Graduated Green Mountain Junior College, 1866. Author of *The Leavenworth Case* (1878), pioneer work in modern detective fiction, and some thirty other mystery novels distinguished for technical skill.

ROLETTE, JEAN JOSEPH (*b. Canada, 1781; d. 1842*), fur trader. Worked out of Prairie du Chien along the Upper Mississippi and the Wisconsin, *post* 1806; was American Fur Co. agent *post* 1820. Served as chief justice of Crawford County, Wis., *post* 1830.

ROLF, IDA PAULINE (*b. New York City, 1896; d. Bryn Mawr, Pa., 1979*), biochemist and physiologist. Graduated Barnard College (1916) and College of Physicians and Surgeons, Columbia University (Ph.D., 1920) and joined Rockefeller Institute (now University) during studies at Columbia. In 1940 she adapted techniques from yoga exercises to develop a physical therapy that involved physical manipulation of the connective tissues surrounding the body's bones and muscles; she termed the therapy "structural integration" and it eventually became known as Rolf-

ing. She lectured extensively and held workshops on the method and formed the Guild for Structural Integration in 1973.

ROLFE, JOHN (*b. Heacham, Norfolk, England, 1585; d. probably Bermuda Hundred, Va., 1622*), colonist, Virginia official. Sailed in the *Sea Adventure*, 1609; settled in Virginia after stranding in Bermuda for some months; successfully adapted native tobacco to European taste. His marriage to Pocahontas in April 1614 brought an eight-year peace with the Indians in the neighborhood of Jamestown.

ROLFE, ROBERT ABIAL ("RED") (*b. Penacook, N.H., 1908; d. Gilford, N.H., 1969*), baseball player, manager, and coach. Graduated Dartmouth (B.A., 1931) and signed with the New York Yankees, playing in their minor leagues until 1934, when he established himself as one of the top third basemen in baseball. His best year was 1939, when he batted .329 and led the American League in runs scored (139), base hits (213), and doubles (46). Scored more than 100 runs in seven consecutive seasons. Selected for the American League all-star team (1937, 1939); retired after the 1942 season. After coaching at Yale (1943–46), he became supervisor of scouting for the Detroit Tigers (1949), then field manager; he was voted manager of the year in 1950, but was fired in 1952. He returned to Dartmouth as athletic director, 1954–67.

ROLFE, WILLIAM JAMES (*b. Newburyport, Mass., 1827; d. Martha's Vineyard, Mass., 1910*), teacher, philologist, textbook author and editor. Introduced regular instruction in English literature into Massachusetts high-school curricula.

ROLLINS, ALICE MARLAND WELLINGTON (*b. Boston, Mass., 1847; d. Bronxville, N.Y., 1897*), author, book reviewer.

ROLLINS, EDWARD HENRY (*b. Rollinsford, N.H., 1824; d. Isles of Shoals, N.H., 1889*), Whig, Know-Nothing, and Republican politician. Elected to the lower house of the New Hampshire legislature, 1855, he became speaker in 1856; he took a vital part in the formation and subsequent success of the Republican party in his state. A congressman, 1861–67, he opposed reform in any guise and supported harsh measures of Reconstruction; thereafter he continued to operate the state Republican machine as its chairman, 1868–72. Treasurer of the Union Pacific Railroad, 1871–76 (with which he had been associated *post* 1869), he was U.S. senator from New Hampshire, 1877–83.

ROLLINS, FRANK WEST (*b. Concord, N.H., 1860; d. Boston, Mass., 1915*), banker. Son of Edward H. Rollins. Republican governor of New Hampshire, 1899–1901. Initiated "Old Home Week," 1898; promoted conservation.

ROLLINS, JAMES SIDNEY (*b. Richmond, Ky., 1812; d. 1888*), lawyer, Missouri legislator. Originally a Whig, Rollins served in Congress, from Missouri, as a Conservative-Unionist, 1861–65. Thereafter, as a member of the Missouri legislature, he assisted in the reorganization of the University of Missouri and opposed radical Republican policies. With Carl Schurz and Benjamin G. Brown, he was a leader in the Liberal Republican movement.

ROLLINSON, WILLIAM (*b. Dudley, England, 1762; d. 1842*), engraver. Came to America, 1789. Working thereafter in New York City in both line and stipple, he became eventually a bank note engraver and made several improvements in the technique of bank-note manufacture.

ROLPH, JAMES (*b. San Francisco, Calif., 1869; d. Santa Clara Co., Calif., 1934*), businessman, public official. Successful in shipping and banking, Rolph served as nonpartisan mayor of San Francisco for 19 consecutive years *post* 1911 and dedicated himself to the expansion and physical improvement of the city. Elected governor of California as a Republican, 1930, he was ineffectual in dealing with the problems raised by the depression.

ROLSHOVEN, JULIUS (*b. Detroit, Mich., 1858; d. New York, N.Y., 1930*), painter. Studied at Cooper Union, New York City, and in Düsseldorf and Munich, Germany. Influenced by Frank Duveneck.

RÖLVAAG, OLE EDVART (*b. Island of Dönna, Helgeland, Norway, 1876; d. Northfield, Minn., 1931*), author, educator. Came to America, 1896. Graduated St. Olaf College, 1905; studied also at University of Oslo, Norway. Professor of Norwegian at St. Olaf College, ca. 1907–26, 1927–31. Among his many books, marked by creative realism and brooding imagination, *Giants in the Earth* (translated and published in America, 1927) achieved an outstanding artistic and popular success. It has been called the most powerful novel ever written about pioneer life in America.

ROMAN, ANDRÉ BIENVENU (*b. St. Landry Parish, La., 1795; d. probably New Orleans, La., 1866*), planter, Louisiana legislator. Outstanding Whig governor of Louisiana, 1831–35 and 1839–43; fostered efforts at flood control, public schools, internal improvements.

ROMANOFF, MICHAEL ("PRINCE MIKE") (*b. either Vilna, Lithuania, or Brooklyn, N.Y., 1893?; d. Hollywood, Calif., 1971*), restaurateur and pretender to the Russian nobility. Raised in New York City orphanages, he began assuming names and various backgrounds at an early age; he first attracted the attention of the press around 1922 when he announced he was a close relative of the late Tsar Nicholas II and began a ten-year battle with U.S. immigration authorities about his U.S. citizenship. In the 1930's he continued his career as a con artist, begun as a youth, criss-crossing the United States. In 1939 he opened Romanoff's with the backing of admiring Hollywood friends, and he and the restaurant became Hollywood institutions; among the filmmaking community, the restaurant, which closed in 1962, was the place to see and be seen.

ROMANS, BERNARD (*b. Netherlands, ca. 1720; d. probably at sea, ca. 1784*), civil engineer, naturalist, cartographer, soldier. Came to America ca. 1757; appointed deputy surveyor of Georgia, 1766; ran surveys in East and West Florida, engaging also in botanical study. Variously active after journeying north in 1773, he was employed by the N.Y. committee of safety, 1775, to construct fortifications on the Hudson River. Resenting interference with his work, he resigned. Commissioned captain of Pennsylvania artillery, February 1776, he served under General Horatio Gates in part of the northern campaign. Ordered to South Carolina ca. July 1780, he was captured at sea and imprisoned in Jamaica until the end of the Revolutionary War. Among his books the most noted is *A Concise Natural History of East and West Florida* (Vol. I, New York, 1775, second edition, 1776; the second volume was never published). Maps made by him appear in a number of publications of the time.

ROMAYNE, NICHOLAS (*b. New York, N.Y., 1756; d. New York, 1817*), physician, medical educator. M.D., Edinburgh, 1780. Practiced and taught in New York; associated his private school with Queen's College, present Rutgers, 1792–93. After a somewhat checkered career *post* 1794, he returned to New York, 1806, and served as president and professor at the College of Physicians and Surgeons (later affiliated again with Queen's College) until 1816.

ROMBAUER, IRMA LOUISE (*b. St. Louis, Mo., 1877; d. St. Louis, 1962*), cookbook author. As a wife, mother, and hostess, she taught herself to cook by trial and error, using recipes and techniques from relatives, friends, and chefs, and culled from newspapers and books; she took copious notes on her successes and failures, recording precise weights and measurements, oven temperatures, and cooking times in a manner similar to that of a scientist. In 1922 she distributed copies of recipes to a cooking class, and in 1931 elaborated on the handout in the self-published book *The Joy of Cooking*. An enlarged edition was published by Bobbs-Merrill in 1936; rewritten in 1943, the book was a hefty tome that quickly became the best-selling cookbook in publishing history. The fourth edition, *The New Joy of Cooking*, appeared in 1951, with Rombauer's daughter cited as coauthor.

ROMBERG, SIGMUND (*b. Nagykanizsa, Hungary, 1887; d. New York, N.Y., 1951*), composer. Studied engineering briefly in Vienna. Immigrated to the U.S. in 1909. Composer of numerous operettas in the turn-of-the-century style of Vienna, including *Blossom Time* (1921), *The Student Prince* (1924), *The Desert Song* (1926), and *The New Moon* (1928). Discovered by the Shubert brothers, Romberg enjoyed enormous success on Broadway in the 1920's; his works include some of the best-known popular songs of the twentieth century.

ROMBRO, JACOB (*b. probably Zuphran, Russia, 1858; d. New York, N.Y., 1922*), editor, socialist leader, Yiddish author. Best known under pen name "Philip Krantz." Active here *post* 1890.

ROMEIKE, HENRY (*b. Riga, Russia, 1855; d. 1903*), originator of the press-clipping service. Resident in the United States *post ca.* 1885.

ROMER, ALFRED SHERWOOD (*b. White Plains, N.Y., 1894; d. Cambridge, Mass., 1973*), paleontologist. Graduated Amherst College (1917) and Columbia University (Ph.D., 1921); taught at Bellevue Hospital Medical College (1921–23); joined the faculty of the University of Chicago (1923–34), teaching geology; and joined Harvard University in 1934, where he taught zoology and was curator of vertebrate paleontology at the Museum of Comparative Zoology (its director from 1946 to 1961). He is best known for his work with fossil animals, particularly reptiles and amphibians, and his contribution to the understanding of vertebrate evolutionary history. He published more than 200 papers and books, including *Vertebrate Paleontology* (1933), an indispensable text for over fifty years, and two popular books widely used in college courses, *Man and the Vertebrates* (1933) and *The Vertebrate Body* (1949).

ROMMEL, EDWIN AMERICUS ("EDDIE") (*b. Baltimore, Md., 1897; d. Baltimore, 1970*), baseball pitcher and umpire. He began his nearly fifty years in professional baseball as a batboy for the Baltimore Orioles. His playing career started in the Peninsula and International leagues (1916–19), and in 1920 he signed with the Philadelphia Athletics. Known for his knuckle ball, he was with the Athletics when they won the 1929 and 1930 World Series and the American League pennant in 1931. Released as a player in 1932, but remained until 1935 as a coach and batting-practice pitcher. He turned to umpiring and worked the 1943 and 1947 World Series and five all-star games. He retired from baseball in 1959.

ROMNES, H(AAKON) I(NGOLF) (*b. Stoughton, Wis., 1907; d. Sarasota, Fla., 1973*), business executive. Graduated University of Wisconsin (1928) and joined AT&T's Bell Laboratories in New York City as a circuit designer. He transferred to the AT&T engineering division (1935–55); as vice–president of AT&T (1952–59), he oversaw the design of direct dialing for long--distance calls. He became president of Western Electric (1959–63), AT&T's manufacturing subsidiary, and AT&T president (1965–72) and chairman (1967–72). As head of AT&T, he oversaw removal of the company's monopoly over long distance service and equipment, development of new policies in response to competition, and regulatory battles with the Federal Communications Commission.

RONDTHALER, EDWARD (*b. near Nazareth, Pa., 1842; d. 1931*), bishop of the Moravian Church. Held pastorates in Brooklyn, N.Y., Philadelphia, Pa., and Salem, N.C.; consecrated bishop, 1891. As Salem developed into Winston-Salem, largest industrial city in the state, Rondthaler played a leading part in its community life.

ROOD, OGDEN NICHOLAS (*b. Danbury, Conn., 1831; d. New York, N.Y., 1902*), physicist, specialist in physiological optics. Grandson of Uzal Ogden. Graduated College of New Jersey (Princeton), 1852; did post-graduate work at Sheffield Scientific School and at Berlin and Munich. Professor of physics, Columbia *post* 1864, he was a master at devising and improving physical apparatus and instruments. He was author of an influential book on the physics of color sensations, *Modern Chromatics* (1879); among other devices, he developed the flicker photometer.

ROONEY, PAT (*b. New York, N.Y., 1880; d. New York, 1962*), dancer, actor, and songwriter. With his wife, Marion Bent, they formed a memorable vaudeville and musical comedy dance team; in 1919 he introduced a waltz clog to the tune of "The Daughter of Rosie O'Grady" that identified him throughout his career. Teamed with Herman Timberg when Bent retired (1932), forming one of the popular Jewish-Irish pairs of vaudeville. Wrote several popular songs, including "You Be My Ootsie, I'll Be Your Tootsie," and appeared in the stage production of *Guys and Dolls* (1950).

ROOSA, DANIEL BENNETT ST. JOHN (*b. Bethel, N.Y., 1838; d. 1908*), physician. M.D., University of the City of New York (present New York University), 1860. Professor at his *alma mater* and also at the University of Vermont, he was responsible for the founding (1883) of the New York Post-Graduate Medical School and was its president, 1883–1908.

ROOSEVELT, (ANNA) ELEANOR (*b. New York, N.Y., 1884; d. New York, 1962*), humanitarian, United Nations diplomat, and social reformer. Niece of Theodore Roosevelt and wife of Franklin D. Roosevelt, whom she married in 1905. It was not until America's entry into World War I and her assumption of duties with the Red Cross that her organizational abilities found a public focus. She began to cultivate women associated with the trade unions, politics, and the successful suffrage movement. With the vote, women became more important in politics, and she was at her husband's side during his race for the vice-presidency in 1920. During the campaign she began to appreciate the qualities of Louis Howe, her husband's secretary, with whom she formed a deep and abiding friendship. She became her husband's proxy and surrogate in Democratic party politics after his polio attack in 1921 left his lower limbs useless. She began to define her identity as a publicist, politician, and organizer, and headed the women's division of the Democratic party when Franklin ran for governor of New York (1928). After Franklin became president (1932), her views and actions as first lady became as much a feature of New Deal Washington as her husband's. She took under her wing such New Deal projects as subsistence homesteads, the National Youth Administration, and services that involved women. She was adept on the radio and began to write the daily column "My Day" for United Features Syndicate

(1935). Supported Franklin's efforts to rearm the nation at the time of the fall of France, and was cochairman of the Office of Civilian Defense (1941–42), which became the whipping boy of Congress and the press. During the war she toured Britain and the South Pacific, visiting field hospitals and front-line installations. Following Franklin's death in 1945, her public career entered a new phase. In December 1945 President Harry Truman appointed her one of five delegates to the first UN General Assembly in London and to the UN Human Rights Commission, whose first job was to draft an international bill of rights. As a UN delegate she vigorously advocated the establishment of a Jewish state; she resigned in 1952 and went to work for the American Association for the UN and was an unofficial ambassador at large, visiting the Middle East, Asia, and Europe. President John Kennedy named her to the U.S. delegation to the UN (1961); also giving up her forty-year opposition to the Equal Rights Amendment, she presided over the Commission on the Status of Women appointed by Kennedy. She wrote *This Is My Story* (1937), *Ladies of Courage* (1954), and *Tomorrow Is Now* (1963). She remained a political power within the Democratic party until her death.

ROOSEVELT, FRANKLIN DELANO (*b. Hyde Park, N.Y., 1882; d. Warm Springs, Ga., 1945*), thirty-second president of the United States. Roosevelt was the only son of James Roosevelt, the vice president of the Delaware and Hudson Railroad, and Sara Delano Roosevelt, a handsome strong-minded woman. In 1896, at fourteen, Franklin was plunged into the Spartan rigors of Groton School, Groton, Mass. He continued at Harvard, where he was president (editor) of the *Harvard Crimson*. He next entered the Columbia Law School. His work was fairly good, but after passing his bar examinations in the spring of the third year, he did not bother to finish his courses and take his LL.B. degree. In his final year at Harvard, Roosevelt had become engaged to Anna Eleanor Roosevelt, a distant cousin and the niece of Theodore Roosevelt. On Mar. 17, 1905, President Theodore Roosevelt came to New York City to give away his niece at her wedding. Franklin had long admired Theodore Roosevelt, and it was to a considerable extent the example of Theodore Roosevelt that impelled him toward politics and public service.

Roosevelt's entrance into politics came in 1910 when Democratic leaders in heavily Republican Dutchess County, where Hyde Park is located, invited him to run for the state senate. Despite the odds against him, he won the election. In the New York senate Roosevelt assumed leadership of Democratic insurgents blocking the election in the legislature of the Tammany Hall candidate for U.S. Senator, William F. Sheehan. Roosevelt, firmly established as a progressive on the basis of his opposition to Tammany, went on to champion the interests of the upstate farmers, conservationists, and advocates of good government. When he ran for reelection in 1912, typhoid fever kept him from campaigning. At this point, a newspaperman from Saratoga, Louis McHenry Howe worked for him so effectively that Roosevelt not only won but ran ahead of the Democratic candidates for president and governor.

Early in 1912 Roosevelt projected himself into presidential politics as a spokesman for New York progressive anti–Tammany Democrats who favored Woodrow Wilson, and he continued his strong advocacy both before and after the Democratic convention. His reward was an appointment, in March 1913, as assistant secretary of the navy. He was soon established in Washington as one of a handful of promising young progressive Democrats. In 1914, when Roosevelt campaigned for the nomination for U.S. Senator in the New York Democratic primary, Tammany easily defeated him. He learned his lesson. Thereafter, he and the Tammany leaders kept an uneasy peace. He managed to survive as assistant secretary and did much to help prepare the navy for war.

During World War I he achieved a reputation as one of the most capable young administrators in the capital. He visited Europe in the winter of 1918–19 to supervise the disposal of navy property. In Paris he was able to observe the peace conference and he returned on the *George Washington* with President Wilson, who transformed him into an ardent public supporter of the League of Nations.

Late in 1918 the Roosevelts underwent a serious family crisis. Eleanor Roosevelt discovered that her husband was romantically involved with her social secretary, Lucy Mercer. She offered him a divorce; he refused and, according to one account, told her not to be foolish. Although the Roosevelts remained married, their relationship was altered. Mrs Roosevelt, deeply and permanently hurt, developed a public and personal life of her own. In 1920 Roosevelt received the Democratic nomination for vice president as the running mate of Governor James M. Cox of Ohio. After a Republican landslide, Roosevelt became a vice president in New York City for a surety bonding concern, the Fidelity and Deposit Company of Maryland. He also entered into a law partnership in which he was not very active; in 1924 he left it to form a new partnership with Basil O'Connor. Suddenly, in August 1921, while vacationing at his summer home at Campobello Island, New Brunswick, Roosevelt fell ill with poliomyelitis. It was a severe attack which left him never again able to walk without braces and a cane. There followed grim years in which he doggedly worked at trying to regain the use of his legs and to remain a national political figure. Substantial recuperation began when he discovered the warm, buoyant mineral waters at Warm Springs, a rundown resort in Georgia which he first visited in the fall of 1924. Each year he spent part of his time at Warm Springs, gradually rebuilding muscles until in 1928 he could with difficulty walk with leg braces and two canes.

For Eleanor Roosevelt, a shy woman, Roosevelt's illness completed the transition she had already begun toward public activity. Whatever her personal feelings may have been, she remained intensely loyal to Roosevelt. When polio immobilized him, in order to keep him active in politics and thus bolster his morale, she began to act as his substitute at meetings. With the aid of Mrs. Roosevelt and Howe, Roosevelt succeeded in continuing without a break as a significant Democratic figure in both state and national politics. In New York he tied himself to the popular Alfred E. Smith, who had risen from the ranks of Tammany to become an outstanding governor. When Smith became a contender for the Democratic presidential nomination of 1924, he asked Roosevelt to manage his campaign. Smith regarded Roosevelt as attractive but ineffectual and wanted no more than his name and national contacts. Although Smith was not nominated at the 1924 convention, Roosevelt again made the speech nominating Smith at the 1928 convention; this time his candidate was chosen on the first ballot. Both before and after the nomination, Roosevelt peppered Smith with suggestions which were ignored. Roosevelt felt out of the campaign, and in September 1928 was at Warm Springs, trying to strengthen his leg muscles. Repeatedly Roosevelt had declined suggestions that he run for governor that year to strengthen Smith in New York, but during the state convention he unexpectedly gave in to Smith's pleas over the telephone. In high spirits Roosevelt undertook a four-week campaign for governor for New York. While Smith was losing New York by 100,000 votes, Roosevelt carried it by the narrow margin of 25,000 votes out of four-and-a-quarter million. Even before he took office, he was being discussed as a likely Democratic nominee for president in 1932.

Roosevelt undertook to become an outstanding governor in his own right. Cautiously he moved out from the shadow of Al Smith. In his first two-year term as governor he established himself as a moderate progressive, an effective administrator, and an

extraordinarily able political leader. The Great Depression, which had steadily become more and more disastrous in the years after the stock market crash of 1929, had transformed both state and national politics. In response to it, Roosevelt gradually changed from a cautious progressive whose policies were scarcely distinguishable from those of President Herbert Hoover into a daring innovator, the prime challenger of the President. As governor, Roosevelt mobilized the resources of his state to provide at least minimum security for those in distress. Several of his proposals and agencies foreshadowed the New Deal. In August 1931 he obtained legislation establishing a Temporary Emergency Relief Administration, which under Harry Hopkins provided aid to 10 percent of the state's families. In 1930 he won reelection by an unprecedented plurality of 725,000 votes. Immediately the state Democratic chairman, James A. Farley, proclaimed that Roosevelt would be the next presidential nominee of his party. At the 1932 Democratic convention, a "stop Roosevelt" movement almost succeeded, as the combination of urban Smith followers and rural supporters of John Nance Garner, together with the delegates of "favorite sons," controlled more than one-third of the votes through three ballots. At that point Garner, realizing that continued deadlock would aid the urban forces rather than bring his own nomination, released his delegates, and Roosevelt was nominated on the fourth ballot.

Roosevelt campaigned cautiously in 1932 in order not to alienate any of the numerous groups of voters disillusioned with Hoover. Early in 1932 Roosevelt had assembled a group of campaign advisers and speech writers, for the most part Columbia University professors. Newspapermen labeled this group the "brain trust." Roosevelt not only assailed Hoover for deficit spending, but proposed familiar progressive solutions for recovery and reform. In the election of 1932 Roosevelt overwhelmingly defeated Hoover. Democrats also elected such substantial majorities to each house of Congress that Roosevelt could expect ready enactment of his recovery program. Carefully he set about planning administrative appointments and recovery and reform measures. Roosevelt for the first time appointed a woman to cabinet rank, Frances Perkins, who became secretary of labor. Four months of acute depression intervened before the new president could take office; the Norris "lame duck" amendment had not yet gone into effect, and Roosevelt was not to be inaugurated until Mar. 4. It was a time of bewilderment and despair. Industrial production was far below levels of the 1920's, a quarter of the wage earners were unemployed, and a quarter of the farmers had lost their land. While he was preparing to take office, tragedy almost intervened. In Miami on the night of Feb. 15, 1933, Roosevelt barely missed being shot by a would-be-assassin.

The effect of Roosevelt's powerful, positive inaugural address on Mar. 4, 1933, was in consequence electric. Speaking solemnly and forcefully, he sought to reassure the American people. "This great Nation will endure as it has endured, will revive and prosper," he declared. "So, first of all, let me assert my firm belief that the only thing we have to fear is fear itself." With few restraints upon him, Roosevelt asserted energetic leadership, and the nation was in a mood to follow. His overall plan was basically twofold. He hoped through a series of emergency measures to bring about rapid recovery. Next, through reforms he wished to eliminate the shortcomings and evils in the American economy that might bring future depressions.

The banking crisis forced Roosevelt to act even more speedily than he had planned. He issued a proclamation on Mar. 6, 1933, closing all banks and stopping gold transactions; and on Apr. 19, 1933, he officially took the nation off the gold standard. Economy had been a major theme of Roosevelt's campaign for election, and during his first few weeks in office he further gladdened

conservatives with his insistence upon cutting governmental expenses.

Between March and May of 1933 Roosevelt sent to Congress in rapid succession a number of messages and draft bills. By June 16 Congress had enacted every one of these measures. The legislation of Roosevelt's "first hundred days" emphasized recovery and relief. In the recovery program, the key measures were the farm recovery bill Roosevelt submitted to Congress on Mar. 16, leading to the Agricultural Adjustment Administration, and the industrial recovery bill of May 17, proposing the National Recovery Administration and the Public Works Administration. As he signed the National Industrial Recovery Act in June 1933, Roosevelt called it "the most important and far-reaching legislation ever enacted by the American Congress." It created the National Recovery Administration, rather analogous to the War Industries Board of World War I. The NRA sought to bring prosperity through limiting production and through placing a floor under prices. The NRA floundered during the first two years of the New Deal, suffering from the lack of purchasing power, the unwillingness of desperate businessmen to give up competitive undercutting, and the basic unenforceability of a multiplicity of code regulations. Roosevelt's achievement was more substantial through the Agricultural Adjustment Administration, which put into effect the crop restriction program that the Farm Bureau Federation had favored. He also succeeded in bringing a modicum of quick relief to millions who were hungry and in danger of losing their homes and farms. Congress in May 1933 created the Federal Emergency Relief Administration. Roosevelt appointed Harry Hopkins, who had been New York administrator, to head it; and Hopkins quickly funneled an initial half-billion dollars into state relief administrations.

Human erosion and loss of moral values among the unemployed worried Roosevelt. At the outset of the New Deal he persuaded Congress to establish the Civilian Conservation Corps to enlist unemployed men, mostly youths, in projects for forestation and flood control. This program was popular and continued through the New Deal. The devaluation of the dollar may have helped foreign trade; major competing nations had already devalued their currencies. It achieved little within the United States, and in January 1934 Roosevelt ended currency manipulation, setting the gold content of the dollar at 59.06 percent of its earlier level.

Through his first two terms in office, Roosevelt sought to reconcile two rather contradictory aims, to alleviate suffering and stimulate the economy through large-scale spending, and to prevent the federal deficit from soaring to dangerous heights. Of the two conflicting pressures upon Roosevelt, that from the dispossessed was the greater and the more sustained. Roosevelt responded to it with continued but cautious spending. The breakdown of Roosevelt's first economic recovery program by late spring of 1935 was forcing him into major readjustments. The NRA had not worked well, so in some respects the adverse Supreme Court decision to invalidate the NRA code system (May 1935) was a mercy killing. But while conservatives rejoiced, Roosevelt fumed, declaring to reporters that the Supreme Court was taking a horse-and-buggy view of the power of the government to regulate the economy. Yet what was most viable in the NRA program continued. Just before the court's decision, Roosevelt had finally accepted Senator Robert F. Wagner's bill establishing strong federal protection for collective bargaining, and in July this became the National Labor Relations Act.

Much of the failure of the earlier recovery program resulted, Roosevelt believed, from bad business practices and from the refusal of business to cooperate with the government. Increasingly he sought to reform business, in part as a means of achieving recovery. The Securities Exchange Act of 1934 had placed

the stock market under federal regulation. In March 1935 Roosevelt proposed to Congress legislation prohibiting the pyramiding of public utility holding companies, and in June he recommended restructuring federal taxes to increase substantially the levies on wealthy individuals and corporations. The outcry against the holding company and tax bills further helped convince the underprivileged that Roosevelt was their champion. Nonetheless, national politics continued to be polarized sharply for and against Roosevelt. He was the lone issue in the 1936 campaign. The Republicans nominated Governor Alfred M. Landon of Kansas, who made constructive criticisms of the New Deal; but the result was a sweeping victory for Roosevelt, who received the electoral votes of every state except Maine and Vermont.

A single conservative bulwark seemed to stand between Roosevelt and his reform objectives — the Supreme Court. The Court had invalidated his initial industrial and agricultural recovery programs and several other New Deal measures. Without warning, in February 1937, he suddenly proposed to Congress an overhauling of the federal judiciary, purportedly to help the courts keep up with their growing dockets. At the heart of Roosevelt's bill was the proposal that he be empowered to name as many as six new Supreme Court justices. Roosevelt's plan shocked Congress and alarmed a large number of those who had voted for him in 1936. The Supreme Court itself affected the political battle when, by 5-to-4 decisions, it upheld both the National Labor Relations Act and the Social Security Act. There seemed no longer to be any need for Roosevelt's proposal, and in the end it was defeated.

Under the authority of the Reorganization Act of 1939, Roosevelt established the Executive Office of the President, placing within it the Bureau of the Budget and the National Resources Planning Board, and also providing for an office for emergency management, to be set up in the event of a national crisis. He was further empowered to appoint administrative assistants. Numerous pieces of legislation aided one or another group of Americans. For workers, there was the Fair Labor Standards Act of 1938, which made a start toward establishing minimum wages. For city people there was a beginning of slum clearance and public housing, through the Public Works Administration. In 1937 the New Deal seemed to be bringing such a substantial degree of recovery that Roosevelt feared a dangerous, unhealthy boom would result. Upon the advice of Secretary of the Treasury Morgenthau, he drastically cut back government spending, furloughing large numbers of WPA workers. Defenders of the status quo were alarmed not only by the increase in the national deficit, but also by the growing labor strife, as the rival C.I.O. and A.F. of L., under the protection of the Wagner Act, sought to organize mass production industries. The sit-down strikes of 1937, which many middle-class people regarded as labor preemption of employers' property, were especially frightening. Opponents placed the blame upon Roosevelt.

In the Congressional election of 1938, for the first time since 1932, the Republicans gained a number of seats in both houses of Congress. The election seemed to be another serious political setback for Roosevelt. Contrary to his earlier policy, he had openly intervened in several Democratic primaries in opposition to conservatives. By this time, 1939, Europe was on the brink of war, and increasingly Roosevelt was turning his attention toward foreign dangers and American defense.

Foreign affairs always interested Roosevelt, and even during the domestic crisis of the first month of his administration he had given a good bit of attention to them. His initial major decision in the realm of foreign affairs was a fundamental economic one: that the United States should seek recovery through a nationalistic program rather than one involving international economic cooperation. Before the end of 1933 Roosevelt recognized the Soviet Union, primarily in the hope of stimulating foreign trade, and in 1934 he gave his backing to a reciprocal trade program. Throughout the Western Hemisphere, Roosevelt projected himself as a smiling, benign "good neighbor." He and Secretary of State Cordell Hull pledged to Latin American nations that the United States would not intervene with armed force, and they held to the new policy even in 1938 when Mexico expropriated American oil holdings. Gradually, as military threats became more serious in both Europe and East Asia, Roosevelt began to change the Good Neighbor program into a mutual security arrangement foreshadowing the post-World War II Pan-American pacts.

Toward Japan's expansionism in East Asia, Roosevelt brought some of the views he had acquired during his years in President Wilson's Navy Department. At one of his first cabinet meetings he discussed the possibility of war with Japan, and within several months he was channeling some of the public works funds into naval construction. In 1934 he obtained passage of a measure which began the rebuilding of the U.S. fleet.

Europe was another matter. There Roosevelt proceeded cautiously, and with good reason, since he could easily arouse acute criticism in Congress and among the electorate. Mussolini seemed to Roosevelt to have been a stabilizing force in Italy, and for several years the President looked upon him with favor. It was different with Hitler. He came into power a few months before Roosevelt, who in private immediately spoke of him as a menace. While the European dictatorships and Japan strengthened their armies and fleets and threatened weaker nations, Roosevelt long kept the nation on a neutral course. In 1935, as he saw Mussolini preparing to conquer Ethiopia, Roosevelt signed a Neutrality Act imposing restrictions. When the President proclaimed that a state of war existed, it became illegal for Americans to sell munitions to belligerents on either side, and Americans could travel on the vessels of belligerents only at their own risk. During the gathering crisis in Europe, Congress enacted, and Roosevelt signed, further neutrality measures.

In the fall of 1937, as the Japanese armies advanced into north China, Roosevelt made a first tentative proposal looking toward collective security, stating that peace-loving nations should act in concert to quarantine war as they would a contagion. Public sentiment was so opposed to a strong stand against Japan that at the end of 1937 when Japanese aviators sank the U.S. gunboat *Panay* in Chinese waters, Roosevelt quickly accepted Japanese offers of apology and indemnity. Throughout the Spanish Civil War he pursued a neutral course. Toward Hitler he shared with the leaders of France and England feelings of apprehension. When Hitler threatened war in 1938 over Czechoslovakia, Roosevelt urged him to accept a peaceful solution, but the President's message was not a factor of any significance in the Munich settlement. Apprehension turned to alarm during the next few months as Hitler began to put pressure upon Poland.

When war broke out in Europe in 1939, Roosevelt called Congress into special session and obtained modification of the Neutrality Act to allow belligerents to purchase arms on a "cash and carry" basis, an arrangement favoring the British and French. Hitler's triumphs in 1940 led Roosevelt to enlist the full backing of the United States, short of armed intervention, for the beleaguered British. With strong popular support, he moved the United States from neutrality to an active nonbelligerency. On June 10, 1940, as France was about to fall before Hitler's onslaught, Mussolini declared war on the French. Speaking that evening, Roosevelt bluntly declared, "The hand that held the dagger has struck it into the back of its neighbor."

There had been indications before the war crisis became intense that Roosevelt intended to retire at the end of his second

term, in keeping with American tradition. In the national emergency following the fall of France, however, he accepted the Democratic nomination for a third term. Despite the repugnance of many Democratic politicians, Roosevelt insisted upon the nomination for vice president of Henry A. Wallace. The Republicans had responded to the national emergency by nominating the personable Wendell L. Willkie. It was a relatively close election, Roosevelt winning by 27 million votes to 22 million.

In the year between his reelection and Pearl Harbor, Roosevelt established defense organizations, stimulated the building of plants to produce enormous quantities of war matériel, gave massive aid to Britain, and tightened economic pressure upon Japan. Early in 1941, since the British were reaching the end of funds with which to buy munitions, Roosevelt pushed through Congress a new measure of aid, the Lend-Lease Act. This was a means of circumventing existing legislation prohibiting cash loans to nations which had not paid their World War I debts. Roosevelt proposed lending goods instead of money, and explained that the goods could be returned after the war. He met with Prime Minister Winston Churchill of England in the summer of 1941 and issued with him a statement of idealistic war aims, the Atlantic Charter. Step by step Roosevelt had moved toward war against Germany. When the attack came it was from Japan, not Germany. On Dec. 7 the Japanese launched their attack upon Pearl Harbor. It was an angry president addressing a united Congress and nation who called on Dec. 8 for a declaration of war against Japan. Three days later, Germany and Italy declared war on the United States. With the country fully involved in global war, Roosevelt assumed the role of commander in chief of the American nation and sought to head the coalition of nations arrayed against the Axis. As the war proceeded, Roosevelt also became increasingly the foe of colonialism and the advocate of a new world organization, the United Nations. The United States and its allies were to suffer one acute setback after another, yet even before hostilities began, the nation was well on its way toward winning the battle of production. To mobilize the country's resources, Roosevelt set up a variety of war agencies. In 1941 he established the Office of Price Administration, which set price ceilings and handled a rationing program for scarce commodities, and in January 1942, the War Production Board. Like President Wilson, Roosevelt tried to adjourn politics during the war. Congress voted the war measures Roosevelt wished, but he had to pay the price of acquiescing in the dismantling of several New Deal agencies, including the national Resources Planning Board. The electorate, now more prosperous and more conservative, in the 1942 election still further reduced the Democratic majorities in both houses.

At one press conference Roosevelt remarked that in place of "Dr. New Deal" he had brought in "Dr. Win-the-War," but it soon became apparent that with victory Roosevelt would bring back "Dr. New Deal." He continued to advocate long-range humane goals, even though during the war neither he nor Congress did much to implement them. For returning veterans, Congress did provide financing for further education, for a start in business or farming, or for the purchase of a house, through the Servicemen's Readjustment Act of 1944, popularly called the "G.I. Bill of Rights." The commander in chief varied from the president in little except that he was able to cloak many of his moves in wartime secrecy. He depended heavily upon his military commanders, especially General George C. Marshall and Adm. Ernest J. King. At a series of summit meetings to determine grand strategy, Roosevelt demonstrated his skill as a compromiser, making concessions first to the British and later to the Russians in order to hold together the alliance until final victory. In mid-January 1943 he and Churchill met, without Stalin, at Casa-

blanca, Morocco, to plan the next stage in the war. Churchill again was persuasive. Roosevelt announced at a press conference that the Allied policy toward the Axis would be one of unconditional surrender. (Roosevelt had earlier broached the topic with Churchill.) By 1943 the balance of armed power had shifted perceptibly from Churchill to Roosevelt. At a conference in Washington they agreed upon May 1, 1944, as a tentative date for a cross-Channel invasion.

The key to postwar peace, Roosevelt believed, would be American-Russian amity. He long sought a face-to-face meeting with Marshal Stalin. The first such meeting came when Churchill, Stalin, and Roosevelt conferred at Teheran, Iran, in November 1943. Roosevelt tried to win over Stalin, and returned from the conference feeling that indeed he had done so. The 1944 invasion of France (on June 6) was a success, and when Stalin, Churchill, and Roosevelt met for a second time at Yalta, in the Crimea, early in 1945, the war was close to an end. In subsequent years Roosevelt has been harshly criticized for the agreements he made there with the Russians.

In his thinking about the postwar world, Roosevelt came to accept the concept of a United Nations as an international peacekeeping organization. His hope was that, within the framework of the United Nations, the Americans and the Russians could cooperate to maintain world order. At the time of his death he was preparing to go to San Francisco to address the opening session of the conference that would found the United Nations.

Even though the war was rapidly drawing to a close in Europe and Roosevelt was thinking seriously about peace-keeping, Japan was continuing its stubborn resistance. In the summer of 1939 Albert Einstein had sent a letter to Roosevelt warning him that German physicists had achieved atomic fission with uranium and might succeed in constructing such a device. After further warnings, Roosevelt authorized a small research program which in time became the mammoth Manhattan Project. By 1945 it was apparent that the Germans were not even close to producing a bomb but that the United States might soon have a workable one.

Despite deteriorating health, Roosevelt in 1944 ran for a fourth term as president and was reelected. Roosevelt accepted Senator Harry S. Truman of Missouri as his running mate. Roosevelt's Republican opponent was the youthful governor of New York, Thomas E. Dewey, who charged that the Roosevelt administration had "grown tired, old, and quarrelsome in office." At the end of September, Roosevelt threw himself into the campaign with his earlier zest, and by a popular vote of 25.6 million to 22 million he won the election. In the months after the 1944 election, Roosevelt's health continued to decline. He went to Warm Springs, Ga., for a vacation. It was there, on Apr. 12, 1945, that he died of a massive cerebral hemorrhage.

Many contemporaries and some later writers have considered Roosevelt an enigmatic, contradictory figure. He polarized American society; both ardent admirers and vehement haters were united in their feeling that they could not always understand him. Outwardly he was jovial, warm, and capable of seeming most indiscreet in his candor when he was not being indiscreet at all, and sometimes far from candid. He seldom talked about his thinking or his plans until he had firmly made up his mind. In not sharing his thought processes, he helped build an aura of mystery and authority, and he kept power firmly to himself. Roosevelt's merits as an administrator have also been frequently debated. On the surface he was haphazard in his handling of affairs. He liked to draw elaborate organization charts, but they seldom counted for much. His real interest was less in agencies than in men who could be loyal to him and effective. The surprising thing is how many administrators of widely varying views and talents, with little in common except their will-

ingness to work for Roosevelt, continued over the years to render important service. Measured by these public servants and their contributions, Roosevelt ranks well as an administrator.

At the time of his death, Roosevelt was eulogized as one of the greatest figures of modern times. In the next few years, as conservatives in Congress sought to obliterate New Deal domestic programs and blamed the travail of the cold war upon Roosevelt's mistaken policies, his reputation declined. Despite adverse judgments concerning some of his policies and actions, he remains a major figure in modern history. The day before his death, he worked on the draft of a speech ending, "The only limit to our realization of tomorrow will be our doubts of today." Roosevelt added in his own hand, "Let us move forward with strong and active faith."

ROOSEVELT, HILBORNE LEWIS (b. *New York, N.Y., 1849; d. 1886*), organ builder, electrical experimenter. Cousin of Theodore Roosevelt.

ROOSEVELT, KERMIT (b. *Oyster Bay, L.I., N.Y., 1889; d. Alaska, 1943*), explorer, army officer, shipping executive. Son of Theodore Roosevelt (1858–1919). A.B., Harvard, 1912. Served in World War I with British forces in Mesopotamia, and with U.S. 1st Division in France; with brother Theodore, conducted exploring expeditions in eastern Turkestan (1925) and China (1928–29). In World War II, served with British army (1939–41), and as major in U.S. Army from April 1942 until his death.

ROOSEVELT, NICHOLAS J. (b. *New York, N.Y., 1767; d. Skaneateles, N.Y., 1854*), engineer. Operated an engine-building works at present Belleville, N.J., *post ca.* 1794. Entered partnership, 1797, with Robert R. Livingston and John Stevens to build a steamboat for which the engines were to be constructed at Roosevelt's works. The resulting vessel, *Polacca*, made a trial trip, 1798, attaining a speed of some three miles an hour under its own steam. Compelled to abandon his works because of financial difficulties, Roosevelt became associated with Robert Fulton, 1809, in introducing steamboats on Western rivers; in 1811 he built at Pittsburgh the steamboat *New Orleans* which descended the Ohio and Mississippi in 14 days. He also received a patent (1814) for the use of vertical paddle wheels.

ROOSEVELT, ROBERT BARNWELL (b. *New York, N.Y., 1829; d. Sayville, N.Y., 1906*), political reformer, conservation pioneer, author. Uncle of Theodore Roosevelt (1858–1919).

ROOSEVELT, THEODORE (b. *New York, N.Y., 1858; d. Sagamore Hill, Oyster Bay, N.Y., 1919*), statesman, author, president of the United States. Born in a well-to-do family long identified on the paternal side with mercantile pursuits in Manhattan, Roosevelt was on his mother's side a descendant of Archibald Bulloch of Georgia. Handicapped as a child by asthma, he built up his body by sheer determination, teaching himself to ride, box, and shoot; his early intellectual interests centered on natural history. Graduated Harvard, 1880. Finding that law failed to interest him, he turned to the writing of history, produced *The Naval War of 1812* (1882), and so entered on a literary career which made up one phase of his life and of which he never tired. As an independent Republican assemblyman for New York's 21st district, 1882–84, Roosevelt won acceptance in politics on his merits. An irritant to his elders and supposed betters, he attacked misconduct as he chaw, saw to it that the newspapers had his side of every story, and zestfully supported laws for the relief of labor and for better government. After an experiment in ranching in Dakota Territory, and the untimely deaths in 1884 of his wife (he had married Alice Hathaway Lee in 1880) and of his mother, he threw himself into active work and in quick succession wrote

Hunting Trips of a Ranchman (1885), *Thomas Hart Benton* (1886), *Gouverneur Morris* (1888), *Ranch Life and the Hunting-Trail* (1888), *Essays on Practical Politics* (1888), and the first two volumes of *The Winning of the West* (1889). Meanwhile he had returned to practical politics, running for mayor of New York (1886) in a hopeless contest against Abram S. Hewitt and Henry George. Marrying again (Edith Kermit Carow) in London, 1886, he continued active in Republican politics; he supported the winning presidential ticket in 1888 and was made a U.S. civil service commissioner, May 1889.

A firm believer in reform, Roosevelt brought a glare of happy publicity over civil service as the politicians tried to evade the specific requirements of the Pendleton Act of 1883. Happy in Washington, Roosevelt was accepted in the circle of Henry Adams and John Hay and made an on-the-spot study of high policy and backstage intrigue. Ethical to the core, Roosevelt wrote and spoke like a lay evangelist, keeping the crooks out of offices and protecting competent officeholders. Returning to New York City, 1895, he completed *The Winning of the West* (published 1894–96) and accepted the presidency of the board of police commissioners. Overzealous, he accomplished relatively little, but with Jacob A. Riis as his Boswell he studied the lowest levels of city life; observed the unholy alliance of graft, politics, and crime; and succeeded as before in turning his daily routine into pungent, front-page news. Laborious wire-pulling persuaded President McKinley to make Roosevelt assistant secretary of the navy, 1897, a post in which he served with his usual gusto until resigning in May 1898 to take active service in the field during the war with Spain.

As convinced as any jingo of the merits of war over Cuba, he and his friend Leonard Wood organized the first volunteer cavalry regiment (Rough Riders), equipped it, and secured its inclusion in the force mobilizing at Tampa. The Rough Riders, dismounted, took Kettle Hill before Santiago, July 1, 1898; when Wood was promoted to higher rank, Roosevelt became colonel. He later chronicled the unit's glories in *The Rough Riders* (1899), coming home an authentic hero of the war. His sudden popularity upset the plans of Republican Boss Thomas C. Platt for the approaching campaign for governor of New York. Roosevelt, nominated, campaigned with an escort of Rough Riders and was elected by a small majority. He pushed practical reforms as much as possible without breaking with Platt, but two years of him in Albany made Platt ready for promotion to any office outside the state. Unacceptable to President McKinley and Mark Hanna, Roosevelt was nevertheless nominated for the vice-presidency at Philadelphia in June 1900 and the *brio* of his campaign made it possible for McKinley to remain at home in dignity and safety. The Republican ticket was victorious.

Looking forward to a life on the political shelf as vice president, Roosevelt became 26th president of the United States through the assassination of McKinley; he took the oath of office in Buffalo, N.Y., Sept. 14, 1901. Sensing that there was a chance for a flexible president to place himself at the head of national movement for reorganization of the American pattern, and aware also that more was needed for reform than an ethical approach to government, Roosevelt bided his time and during his first term announced no change in administration doctrine. An able administrator, he brought a new virility to the job of president and a new technique to the office; red tape of any kind was abhorrent to him and with insatiable curiosity he strove for personal contact with as many kinds of human beings as was possible. Decisions flowed swiftly from his desk, more often right than wrong. The new sophistication in Washington, D.C., was marked abroad, and foreign nations altered the character of their diplomatic representatives in America, sending men of letters and wit rather than political factotums. Taking over the presidency in the midst

of readjustments caused by the war with Spain, Roosevelt directed negotiation of the Hay-Herran Treat (ratified, 1903, but rejected by Colombia) in an effort to expedite building of the Panama Canal. Enraged at the tactics of Colombia, Roosevelt in effect encouraged the secession of the Panama territory from its mother country and its institution as a new republic which, within a month, agreed in its own name to the treaty that Colombia had rejected. Thereafter he guided every step in the construction of the canal. Acting with complete freedom in foreign affairs, he brought about settlement of a European intervention in Venezuela that bore on both the Monroe Doctrine and canal strategy in 1902. When the Dominican Republic was threatened with intervention because of a similar situation arising out of economic default, 1904, Roosevelt persuaded that country to invite him to set up a financial receivership with an American comptroller to collect and disburse its revenues. He also settled the old Alaska boundary dispute on his own terms, 1903, and his cautious pressure upon both Russia and Japan resulted in the Peace of Portsmouth, September 1905. As he did not recognize arbitration as any substitute for preparedness, he continued to encourage army reforms (which included formation of a general staff, 1903) and the strengthening of the navy. Subsequent to some difficulties with Japan over the social position of Orientals in the United States, he openly soothed that country and then sent the modernized battle fleet on a tour around the world (December 1907–February 1909), which was a triumph of administration and policy. "Speak softly," he liked to say, "and carry a big stick, you will go far." In Latin America, however, recent events seemed to have set a pattern of North American aggression inconsistent with the Monroe Doctrine. To explain away the illusion of a menace from the north, Elihu Root, now secretary of state after John Hay's death, was sent on tour among the southern neighbors.

Congress, meanwhile, resented these high-handed executive actions but was left no option but to pay the bills and to limit the president's reform activities at home. The "Ananias Club," numbering all those who had been called liars by the president, grew apace; Roosevelt's hard-hitting methods sometimes made it difficult for his friends to work with him and embittered his enemies more than was necessary. Behind these costly quarrels lay the fact that Roosevelt was trying to dominate a government of checks and balances in which the coordinate branches were as constitutional as he was himself. Since Thomas Jefferson, no president had ranged his mind over so broad a field; since Andrew Jackson, none had been so certain that he had a special mandate from the people. As Roosevelt appeared to be swerving cautiously towards the left, Republicans of the school of McKinley feared and fought him while radicals tried to steal his glory. The struggle involved a new hypothesis of the control of an industrial society in order to save individual economic freedom. There was no effective Democratic opposition in the Roosevelt congress, but the key positions were held by Republican conservatives who distrusted Roosevelt's applications of the "Square Deal." On the death of Marcus A. Hanna, 1904, the conservative Republicans were left leaderless. After renomination at Chicago without opposition, Roosevelt took over the Republican national committee, naming G. B. Cortelyou as chairman. Following his easy victory in the 1904 election, Roosevelt disclaimed a third term. Among specific domestic problems that confronted him, revision of the tariff was recognized as necessary but nothing was ever done about it. Anticipating the "muckrakers" in their attacks upon the trusts, Roosevelt had demanded at Pittsburgh, July 4, 1902, that trusts be subjected to public control, a policy popular in both parties. With the dissolution of the Northern Securities Co., 1904, the addition to the Cabinet of a secretary of commerce and labor, the Elkins Law, and the Expedition Act, further

progress in trust control was made but there was more enthusiasm than certainty in the process. The Interstate Commerce Act was strengthened, 1906, and sweeping laws were passed for the protection of food and drug buyers. But by 1906 the fervor of the "muck-rake" period had begun to die out and the president was left unpopular with business and the Republican party stalwarts. The Wall Street panic of 1907 was called the Roosevelt panic. Among the most memorable of Roosevelt's national services were his efforts for conservation of national forest and land reserves; in these he was strenuously opposed by Congress on a number of grounds both worthy and unworthy.

When he sponsored his secretary of war, William H. Taft, for the presidential nomination in 1908, Roosevelt hoped that his administrative team would be held together, but Taft preferred to select his own Cabinet after his election. Out of office, Roosevelt worked at writing and engaged in extensive travels, returning to America in June 1910 and receiving a triumphant reception. It was not in his nature to abstain from political activity and he was dissatisfied with President Taft's favoring of conservative policies. By the summer or early autumn of 1911 he became completely estranged from the president. Having allowed himself to be persuaded that Roosevelt policies were lost unless he returned to politics, he entered the race for the nomination in 1912, but since the administration controlled the party machinery, the Republican convention renominated Taft. Roosevelt's delegation to the convention of 1912 became the nucleus of the Progressive party which met on August 5 and nominated Roosevelt for president and Hiram Johnson of California for vice president on a platform of liberal reform. His candidacy, however, only succeeded in providing opportunity for the victory of Woodrow Wilson. In 1914 Roosevelt went on an expedition to the Brazilian wilderness, where he discovered the "River of Doubt"; he returned with a tropical infection from which he never fully recovered. A neutral in World War I until his old suspicions of Germany were revived, he became an enthusiastic support of the Allies and denounced the diplomatic courses of President Wilson, seeking with tongue and pen to arouse the country. Disappointed of his wish for military command after the United States entered the war, he entertained hopes that he might run for the presidency again in 1920, but died peacefully in his sleep early in 1919. His career had personified America's recognition of a changing world; his flaws were on the surface but his human values were timeless.

ROOSEVELT, THEODORE (*b. Oyster Bay, L.I., N.Y., 1887; d. Cherbourg, France, 1944*), soldier, public official, businessman. Son of Theodore Roosevelt (1858–1919). A.B., Harvard, 1908. After distinguished service with the 1st Division, U.S. Army in France in World War I, he served in the New York Assembly (1919–21), and as assistant secretary of the navy, 1921–24. He ran as Republican candidate for governor of New York, 1924, and was defeated by Alfred E. Smith. With his brother Kermit, he conducted exploring expeditions in eastern Turkestan and the Yunnan and Szechuan provinces of China, 1925 and 1928–29. Returning to public life, he showed himself an able administrator and an intelligent reformer as governor of Puerto Rico (1929–32) and as governor general of the Philippines, 1932–33. An opponent of New Deal domestic policies, he supported the foreign policies of his kinsman Franklin D. Roosevelt. Returning to the army in 1941, he was promoted brigadier general and took part in the Tunisian and Italian campaigns of World War II; he led the 4th Division ashore on Utah Beach in the Normandy invasion, June 6, 1944. He died the next month of a heart attack while military governor of Cherbourg. Posthumously awarded the Medal of Honor, he held every combat decoration of the U.S. Army ground forces.

Root, Amos Ives (*b. near Medina, Ohio, 1839; d. 1923*), apiarist, pioneer in commercial beekeeping.

Root, Elihu (*b. Clinton, N.Y., 1845; d. New York, N.Y., 1937*), lawyer, statesman. Graduated Hamilton College, 1864; New York University Law School, 1867. Within a year he established his own law firm in New York City and began a career which made him the acknowledged leader of the American bar. His success was due to a phenomenal memory, capacity for hard work, mastery of detail, logical conciseness and clarity of argument, and ever-present wit. Court work was his specialty. No contemporary opprobrium attached to his serving (1873) as assistant to one of the defense counsel in the prosecution of Boss Tweed, or to later representation of large corporate interests, but these aspects of his practice were later magnified by his detractors, especially the Hearst press.

Root resigned his cabinet post in 1903 but returned in 1905 as U.S. secretary of state. Among his notable accomplishments (for which he received the Nobel Peace Prize, 1912) were the reestablishment of friendly relations with Latin America and Japan, and the conclusion of a series of arbitration treaties. He also settled the North Atlantic fisheries controversy and established the U.S. consular service on a career basis.

From 1909 to 1915 Root served as U.S. senator from New York. Committed to William H. Taft before Theodore Roosevelt "threw his hat in the ring," Root sorrowfully but doggedly presided over the 1912 Republican National Convention which led to the Bull Moose bolt and a lasting breach between him and Roosevelt. Critical of Wilson and neutrality, he wholeheartedly supported the Allied cause. His position in the League of Nations fight was that the treaty should be accepted with reservations; he believed Article X impracticable as a permanent commitment. Active in framing the statute for the Permanent Court of International Justice, he strongly advocated American membership in the Court. As friend and adviser of Andrew Carnegie, he helped establish a number of Carnegie benefactions and served as president or chairman of the board of the Carnegie Endowment for International Peace, the Carnegie Institution, and the Carnegie Corporation. Wise in counsel, skilled in advocacy, he was a distinguished elder statesman throughout his later years and remained active to the last in matters affecting the bar.

Root, Elisha King (*b. Ludlow, Mass., 1808; d. Hartford, Conn., 1865*), mechanic, inventor. As superintendent (later president) of the Colt Armory, 1849–65, Root designed and built the Armory as well as most of the machinery used in it. His drophammer (invented, 1853, 1858) put the art of die-forging on its modern basis.

Root, Erastus (*b. Hebron, Conn., 1773; d. New York, N.Y., 1846*), lawyer. Began practice at Delhi, N.Y.; served several terms in state legislature and was lieutenant governor of New York, 1823–24. Originally an anti–Clinton Democrat, he refused to support Andrew Jackson in 1832 and later became a Whig. He was congressman from New York, 1803–05, 1809–11, 1815–17, and 1831–33.

Root, Frank Albert (*b. Binghamton, N.Y., 1837; d. 1926*), Kansas newspaper publisher. Author of *The Overland Stage to California* (with W. E. Connelley, 1901).

Root, Frederic Woodman (*b. Boston, Mass., 1846; d. Chicago, Ill., 1916*), music teacher, composer, organist. Son of George F. Root.

Root, George Frederick (*b. Sheffield, Mass., 1820; d. 1895*), music educator, composer. Father of Frederic W. Root. Established New York Normal Institute, 1853, to train music teachers; followed example of Lowell Mason in holding "musical conventions" to explain class instruction methods in singing. Removed to Chicago, 1859, where he engaged in music publishing until 1871 and continued teaching until his death. Among his many popular songs were "The Battle Cry of Freedom," "Tramp, Tramp, Tramp, the Boys are Marching," "Just Before the Battle, Mother," and "The Vacant Chair."

Root, Jesse (*b. Coventry, Conn., 1736 o.s.; d. Coventry, 1822*), Revolutionary soldier, Connecticut legislator and jurist. Member of the Continental Congress, 1778–82. Judge of the superior court of Connecticut, 1789–1807 (chief justice *post* 1798).

Root, John Wellborn (*b. Lumpkin, Ga., 1850; d. 1891*), architect. C.E., University of the City of New York (present New York University), 1869. Worked in office of James Renwick (1818–1895); at invitation of Peter B. Wight, became head draftsman in Chicago for Carter, Drake & Wight, 1871. Entered partnership with Daniel H. Burnham, 1873. The rise of the firm was rapid and owed much to Root's creative engineering mind; his designs, although superficially based on the popular Romanesque of H. H. Richardson, were all essentially personal and structurally true, especially his designs for business buildings. The Monadnock Building was a high point in his work. Appointed consulting architect for the World's Columbian Exposition, 1890, Root requested that his partner be included, an example of the superb cooperation between them throughout their careers. While Burnham deserves credit for the formation of the board of architects and the generalship of the work at the Exposition, to Root must go much of the credit for the final choice of site and the settlement of the basic plan.

Root, Joseph Pomeroy (*b. Greenwich, Mass., 1826; d. Wyandotte, Kans., 1885*), physician, antislavery advocate, Kansas territorial legislator. Republican lieutenant governor of the State of Kansas, 1859–61, Root served in the Civil War as surgeon of the 2nd Kansas Cavalry. He was U.S. minister to Chile, 1870–73.

Roper, Daniel Calhoun (*b. Marlboro County, S.C., 1867; d. Washington, D.C., 1943*), businessman, lawyer, public official. B.A., Trinity College (now Duke University), 1888. A Populist at heart who chose to remain within the Democratic party, he served briefly in the South Carolina legislature and held several federal appointments, of which the most important was with the Bureau of the Census, 1900–11. In course of this, he became an expert in the economics of the cotton trade. Active in support of President Woodrow Wilson's campaigns for the presidency, 1912 and 1916, he was appointed to high offices in the Post Office (1913–16), the U.S. Tariff Commission (1917), and was made Commissioner of Internal Revenue (1917–21). Chiefly engaged in the practice of law in Washington, 1921–32, he had a significant role in the nomination of Franklin D. Roosevelt, 1932. President Roosevelt named Roper to his cabinet as secretary of commerce, 1933, but despite his earlier liberalism, Roper was a generally conservative influence within the New Deal and resigned in 1938.

Roper, Elmo Burns, Jr. (*b. Hebron, Nebr., 1900; d. Norwalk, Conn., 1971*), public opinion analyst. Attended University of Minnesota and University of Edinburgh, began a career in sales, and gave it up in 1933 to begin market research in New York City; his firm was engaged in 1935 to conduct public opinion surveys for *Fortune* magazine. His reputation grew with the successful prediction of a landslide victory of Franklin D. Roosevelt in 1936; his market surveys were designed to uncover consumer buying habits and preferences and reactions to advertising. In 1940 he initiated the analysis of voting trends over the air, and

in 1944 began his semiweekly newspaper column "What People Are Thinking." He retired from market research in 1966.

ROPES, JAMES HARDY (*b. Salem, Mass., 1866; d. 1933*), Congregational clergyman, New Testament scholar. Graduated Harvard, 1889; Andover Theological Seminary, 1893. After extensive further study in Europe, he taught at Harvard *post* 1895 and was Hollis Professor of Divinity *post* 1910. He is remembered principally for his work in reorganizing Phillips Academy, Andover, for his editorship of the *Harvard Theological Review* (1921–33), and for his scholarly work *The Text of Acts* (1926).

ROPES, JOHN CODMAN (*b. St. Petersburg, Russia, 1836; d. 1899*), Boston lawyer, military historian. Author, among other works, of *The Story of the Civil War* (1894–98).

ROPES, JOSEPH (*b. Salem, Mass., 1770; d. 1850*), merchant, War of 1812 privateersman.

RORER, DAVID (*b. Pittsylvania Co., Va., 1806; d. 1884*), lawyer. Removed to Little Rock, Ark., 1826; after practicing there and holding public office, he settled in pioneer Burlington, Iowa (then in Michigan Territory), 1836. Rorer plotted the town, drafted the charter, and suggested the name "Hawkeyes" for Iowans. He was for many years one of the most active members of the Iowa bar, especially in fugitive slave cases and railroad litigation.

RORIMER, JAMES JOSEPH (*b. Cleveland, Ohio, 1905; d. New York, N.Y., 1966*), art scholar and museum administrator. Graduated from Harvard (1927), then joined the Metropolitan Museum of Art. He was a central figure in the planning of the Cloisters, completed in 1938, which owed its authentically medieval architectural character to Rorimer. Became full curator of the Metropolitan's Department of Medieval Art in 1934 and director of the museum in 1955; among his notable acquisitions were Raphael's *Madonna of the Meadows* and Rembrandt's *Aristotle Contemplating the Bust of Homer.*

RORTY, JAMES HANCOCK (*b. Middletown, N.Y., 1890; d. Sarasota, Fla., 1973*), poet, editor, and author. Graduated Tufts College in Medford, Mass. (B.A., 1913), and attended New York University and New School for Social Research. He moved to San Francisco in 1920, working in advertising by day and writing verse at night; his 1922 poem "When We Dead Waken" won *The Nation's* poetry prize. His radical political career led to his arrest in 1927 for protesting the execution of Nicola Sacco and Bartolomeo Vanzetti; in 1932 he promoted the election of Communist party candidates; and in 1934 he joined the American Workers' Party. In the area of consumer affairs, he published *Our Master's Voice* (1934), an exposé of advertising, and *American Medicine Mobilizes* (1939), an attack on the American Medical Association. During the 1940's he moved to the center politically and worked with several government agencies; in the 1950's he was an avowed anti-Communist; in 1962 a mental breakdown left him unable to write.

ROSA, EDWARD BENNETT (*b. Rogersville, N.Y., 1861; d. Washington, D.C., 1921*), physicist. Graduated Wesleyan University, 1886; Ph.D., Johns Hopkins, 1891. Taught physics at Wesleyan, 1891–1903; was in charge of electrical work of National Bureau of Standards *post* 1902. Jointly with Wilbur O. Atwater, Rosa devised apparatus and made measurements which showed that the physical law of conservation of energy also applied to animal processes, thus giving a scientific basis for study of nutrition problems. While with the Bureau of Standards, he did fundamental work on electrical measurements which included precise determination of the value of the ampere as measured by mechanical forces exerted between coils carrying current; he also determined relation between electrical units derived from magnetic effects and those derived from electrostatic forces. He later made studies of engineering problems arising in the operation and regulation of public-utility services.

ROSATI, JOSEPH (*b. Sora, Naples, 1789; d. Rome, Italy, 1843*), Roman Catholic clergyman, Vincentian. Came to America as volunteer for missions, 1816; worked in Kentucky; began St. Mary's Seminary, Perryville, Mo., 1818, teaching and also acting as pastor. Consecrated coadjutor to the bishop of Louisiana, 1824, he became bishop of St. Louis, 1827. Continuing to administer Lower Louisiana as well, he did not settle permanently in his own see until 1830. After attending the provincial Council of Baltimore, 1840, he proceeded to Rome whence he was sent as Apostolic Delegate to negotiate an agreement between the republic of Haiti and the Holy see.

ROSE, ALEX (*b. Olesh Royz, Warsaw, Russian Poland, 1898; d. New York City, 1976*), labor union official and political leader. Immigrated to the United States in 1913 and emerged as a union activist in the Cloth Hat, Cap, and Millinery Workers' International Union in 1916; he 1950 he became president of the merged and enlarged United Hatters. In 1936 he helped found the American Labor Party, which supported President Franklin Roosevelt's campaign bid. As a union leader, Rose opposed the influence of organized crime in the labor movement and promoted moderate, pro-industry labor policies. He was a central figure in the Liberal party and advanced the political fortunes of such figures as New York City mayors Richard F. Wagner and John V. Lindsay and Sen. Daniel Patrick Moynihan.

ROSE, AQUILA (*b. England, ca. 1695; d. 1723*), printer, ferryman, poet. Immigrated to Philadelphia *ante* 1717. The best versifier that Philadelphia could show before the younger Thomas Godfrey, Rose produced translations from Ovid and other poems which appeared posthumously in *Poems on Several Occasions* (1740).

ROSE, BILLY (*b. New York, N.Y., 1899; d. Montego Bay, Jamaica, 1966*), producer, songwriter, and theater and nightclub owner. Published his first song, "Ain't Nature Grand," in 1921 and had his first hit, "Barney Google," in 1923. Of the nearly 400 songs for which he wrote lyrics, 41 were hits, including "Me and My Shadow" and "It's Only a Paper Moon." Founded the Song-writers Protective Association (1931) and became its first president. Owner of the Back Stage Club, which attracted underworld figures during and after Prohibition, he found it lucrative to work with mobsters. He managed the first theater-restaurant, the Casino de Paree, and his Billy Rose Music Hall for them, but he stopped being a front in 1934. His first musical, *Corned Beef and Roses* (1930) failed, but after some tinkering, it reopened (1931) as *Crazy Quilt* and was a success. Although *Jumbo* (1935) lost money, more than a million people saw the production, which brought the circus and the eponymous elephant to Broadway. In 1937 he coined the word "aquacade" for his first aquatic musical review; other aquacades he produced were for the 1939 New York World's Fair and the Golden State Exposition in San Francisco (1940). His most renowned nightclub, the Diamond Horseshoe (1939–52) became a top New York tourist attraction. Of the eleven Broadway shows he produced, *Carmen Jones* (1943) is the most memorable. Signed newspaper ads for that production and others evolved into his syndicated column, "Pitching Horseshoes" (1947–50). He organized the Billy Rose Foundation, to which he bequeathed almost all of his $54 million estate.

ROSE, CHAUNCEY (*b. Wethersfield, Conn., 1794; d. Terre Haute, Ind., 1877*), financier, railroad builder, philanthropist. Settled in Terre Haute, 1825. He was the principal benefactor of Rose Polytechnic Institute (formally opened, 1883).

ROSE, EDWARD (*fl. 1811–1834*), guide, interpreter. Child of a white trader and a part Cherokee and part black mother, Rose was engaged by Wilson P. Hunt at the Arikara village as hunter, guide, and interpreter, 1811; in May 1812, Rose joined Manuel Lisa's expedition to the upper Missouri. Living for some years among the Crow and the Arikara, in 1823 he was interpreter to William H. Ashley whom he vainly warned against the Arikara before the defeat of June 2. Rose was also interpreter to Henry Atkinson on his treaty-making expedition up the Missouri, 1825. In 1832, Zenas Leonard met him in a Crow village at the mouth of Stinking River where he ranked as a chief. Although Rose bore a bad reputation among his contemporaries, everything which is definitely known of him is creditable.

ROSE, ERNESTINE LOUISE SIISMONDI POTOWSKI (*b. Piotrkow, Russian Poland, 1810; d. Brighton, England, 1892*), reformer, advocate of woman's rights. Resided and worked in the United States, 1836–69.

ROSE, JOHN CARTER (*b. Baltimore, Md., 1861; d. Atlantic City, N.J., 1927*), Maryland jurist, reformer, member of Theodore Roosevelt's "tennis cabinet." U.S. district judge, 1910–22; judge, U.S circuit court of appeals for the fourth circuit, *post* 1922.

ROSE, JOSEPH NELSON (*b. near Liberty, Ind., 1862; d. Washington, D.C., 1928*), botanist. Graduated Wabash College, 1885; Ph.D., 1889. Influenced in choice of a career by John M. Coulter, Rose served *post* 1888 as botanist in the U.S. Department of Agriculture, in curatorial posts in the National Herbarium (U.S. National Museum), and as a research associate of the Carnegie Institution of Washington. He was an authority on Mexican flora generally, and made particular studies of the *Crassulaceae* and *Cactaceae*.

ROSE, MARY DAVIES SWARTZ (*b. Newark, Ohio, 1874; d. Edgewater, N.Y., 1941*), nutritionist. Litt.B., Shepardson College, 1901. B.S., Teachers College, Columbia University, 1906. Ph.D. in physiological chemistry, Yale, 1909. Taught nutrition and dietetics at Teachers College, 1904–40 (professor of nutrition *post* 1923); author, among other works, of *Feeding the Family* (1916) and *The Foundations of Nutrition* (1927).

ROSE, URIAH MILTON (*b. Bradfordsville, Ky., 1834; d. 1913*), Arkansas jurist, legal writer.

ROSE, WALTER MALINS (*b. Toronto, Canada, 1872; d. Los Angeles, Calif., 1908*), legal annotator. Author, among other works, of an innovating 12-volume study *Notes on the U.S. Reports* (1899–1901) which treated cases reported from 2 *Dallas* to 172 *U.S.*, showing their value as authority by listing subsequent citations in state and federal courts.

ROSE, WICKLIFFE (*b. Saulsbury, Tenn., 1862; d. Vancouver Island, Canada, 1931*), public health and educational administrator. After teaching at Peabody College for Teachers where he became dean, and at the University of Nashville, he served as general agent of the Peabody Education Fund, 1907–14. Director of the Rockefeller Commission for Education of Hookworm *post* 1910, he was made director of the International Health Board, 1913, and widened the scope of the enterprise to include malaria and yellow fever; the program later was expanded to a worldwide attack on all preventable disease. Retiring in 1923, he was made president of the General Education Board and of the International Education Board, supervising in the latter capacity a vast program of aid in the teaching of science and in fostering research.

ROSEBURY, THEODOR (*b. London, England, 1904; d. Conway, Mass., 1976*), bacteriologist. Graduated New York University (1924) and University of Pennsylvania School of Dental Medicine (D.D.S., 1928). He was on the faculty of Columbia University (1930–51) and Washington University (1951–66), researched biological warfare for the U.S. government during World War II, and wrote several books, including *Peace and Pestilence* (1949), which discussed the danger of germ warfare. He also wrote *Microorganisms Indigenous to Man* (1962), a valuable reference work on microbiota associated with humans; in his noted book *Life on Man* (1969), he discussed harmless microbes.

ROSECRANS, SYLVESTER HORTON (*b. Homer, Ohio, 1827; d. 1878*), Roman Catholic clergyman. Brother of William S. Rosecrans. Influenced by his brother's conversion to Catholicism and by the instructions of Father John B. Lamy, he entered the Catholic Church and was graduated from St. John's (Fordham) College, N.Y., 1846. Ordained priest, 1852, he was consecrated co-adjutor bishop of Cincinnati, 1862, and made bishop of the new see of Columbus, Ohio, 1868.

ROSECRANS, WILLIAM STARKE (*b. Delaware Co., Ohio, 1819; d. near Los Angeles, Calif., 1898*), soldier. Brother of Sylvester H. Rosecrans. Graduated West Point, 1842; was a convert to Catholicism while a cadet. After engaging in fortification work and four years' duty as instructor at West Point, he resigned his commission, 1854, and entered business as engineer-architect and head of an oil refining company. Volunteering for the Union Army at the outbreak of the Civil War, he was almost immediately commissioned regular brigadier general, commanded a brigade in McClellan's campaign in western Virginia, and won the battle of Rich Mountain, July 1861, one of the first battles of the war. Succeeding McClellan as commanding general, department of the Ohio, and later as chief of the department of western Virginia, he continued the operations which ended late that fall in complete expulsion of Confederate forces and formation of the State of West Virginia. He commanded the left wing of Pope's Army of the Mississippi, May 1862, during the movement upon Corinth and succeeded Pope in command a month later. After his defeat of the Confederate counterattack against Corinth under Price and Van Dorn, Oct. 3, 1862, he was promoted major general and ordered to relieve Buell in Kentucky. Reorganizing Buell's forces as the Army of the Cumberland, he advanced to Nashville.

In December, he moved against the Confederates under General Braxton Bragg who had concentrated at Murfreesboro. The two armies met on Stone River just west of Murfreesboro on Dec. 29, 1862; after a first Confederate success, Rosecrans established a new defensive line. Fighting continued, Bragg lost his nerve, and on Jan. 3, 1863, retreated to Shelbyville. For six months the armies engaged in only minor operations. On June 23 Rosecrans began to advance and in nine days maneuvered Bragg out of his positions at Shelbyville and Tullahoma back into Chattanooga. By this time, Rosecrans' openly expressed resentment of interference from Washington had brought him into disfavor there. Prodded into advancing by General Halleck, Rosecrans on August 16 made a feint up the Tennessee River above Chattanooga, then crossed below that place, and maneuvered Bragg out of it. Owing to the overextension of his lines, Rosecrans was badly defeated in the bloody battle of Chickamauga on Sept. 19–20, 1863, when the reinforced Bragg turned to face him. Relieved of command on October 19, Rosecrans was assigned to com-

mand the department of the Missouri and was later detached to await orders. He resigned his commission in the regular army, March 1867. Generally regarded as an able officer, and even called the greatest strategist of the war, he was handicapped by a hot temper and a hasty tongue. In later life he was U.S. minister to Mexico, 1868–69, and a Democratic congressman from California, 1881–85.

ROSELIUS, CHRISTIAN (*b. near Bremen, Germany, 1803; d. New Orleans, La., 1873*), lawyer, teacher of law. Immigrated to New Orleans, 1823; studied law in office of Auguste D'Avezac; attained first rank at the Louisiana bar, ranking with Pierre Soulé and Edward Livingston. Expert in the French civil law and its background, he taught for many years at the University of Louisiana (Tulane) and was dean of its law department.

ROSEN, JOSEPH A. (*b. Moscow, Russia, 1878; d. New York, N.Y., 1949*), agronomist, resettlement expert. Came to the United States, 1903, after escape from exile to Siberia and residence for several years in Germany. Graduated Michigan Agricultural College, 1908; introduced high-yield Russian rye seeds to cultivation in Midwest; headed Baron de Hirsch Agricultural School in Woodbine, N.J. Believing that the emancipation of Russian Jews could be best achieved by their integration into the larger society of the nation, he joined Herbert Hoover's relief mission to Russia in 1921 as representative of the Joint Distribution Committee (J.D.C.) of the American Jewish Committee. Success in rehabilitating destroyed Jewish farms encouraged him to think that the mass of destitute, petit-bourgeois Jews could be transformed into a self-reliant peasantry through resettlement and special training. With financial aid from the J.D.C., he worked (1924–36) within the Russian socialist context and established a quarter-million Jews on farms in the Ukraine and in Crimea, which were models of productivity and organization. Returning to the United States, 1937, he worked on resettlement projects for German Jewish refugees.

ROSENAU, MILTON JOSEPH (*b. Philadelphia, Pa., 1869; d. Chapel Hill, N.C., 1946*), epidemiologist. Child of Jewish immigrant parents from Germany. M.D., University of Pennsylvania, 1889; studied at later periods in Berlin, Vienna, and at the Institut Pasteur, Paris. Associated with the present U.S. Public Health Service, 1890–1909 (director of its research laboratory, 1899–1909), he presided over the laboratory's rapid expansion and made important contributions to medicine. In collaboration with J. F. Anderson, he pioneered in the study of anaphylaxis; with Joseph Goldberger, he established the official unit for standardization of diphtheria antitoxin; he also made studies of the epidemiology of typhoid fever and acute respiratory infections; studies of malaria, botulism, and other diseases; and important contributions to milk supply sanitation. While professor of preventive medicine, Harvard Medical School, 1909–35, he was instrumental in establishing the first U.S. school for public health officers (1913); *post* 1922, he was its professor of epidemiology. Retiring from Harvard, 1935, he spent the rest of his life at the University of North Carolina, where he taught his specialty in the medical school and developed a school of public health.

ROSENBACH, ABRAHAM SIMON WOLF (*b. Philadelphia, Pa., 1876; d. Philadelphia, 1952*); **ROSENBACH, PHILIP HYMAN** (*b. Philadelphia, Pa., 1863; d. Los Angeles, Calif., 1953*), antique and rare book dealers. Abraham studied at the University of Pennsylvania and received a Ph.D. in 1901; he then joined his brother Philip's antique business, introducing the selling of rare books, and the famed Rosenbach Co. was begun (1903). While Philip ran the antique business, his brother, Dr. Rosenbach, was

in charge of the rare book division. One of the world's greatest collectors of rare books, the Dr. was responsible for the collection of the Widener family that became the Widener Memorial Library at Harvard. He also collected most of the volumes in the Huntington Library; the Folger Shakespeare Library; the collection given by the Harkness family to the Library of Congress; and the Elkins collection which went to the Free Library of Philadelphia.

Manuscripts include the Shakespeare First Folios, the Gutenberg Bible, first edition of Carroll's *Alice in Wonderland*, and Joyce's *Ulysses*.

ROSENBERG, ABRAHAM HAYYIM (*b. Karlin, Russia, 1838; d. 1925*), author, biblical scholar. A distinguished rabbi in Pinsk, Nikolayev, and Poltava, Rosenberg came to the United States in 1891. He was author of a number of works in both Hebrew and Yiddish which include his life-work *Ozar ha-shemoth*, a Hebrew cyclopedia of Biblical literature (published, 1898–99 and 1923).

ROSENBERG, ETHEL (*b. New York, N.Y., 1915; d. Ossining, N.Y., 1953*); **ROSENBERG, JULIUS** (*b. New York, N.Y., 1918; d. Ossining, N.Y., 1953*), spies. Julius studied at the City College of New York, graduating in 1939. He was employed as a junior engineer for the Army Signal Corps (1940–45). He was fired in 1945 for lying about his membership in the Communist party. Involved in a spy ring that included such figures as Claus Fuchs, a physicist employed at Los Alamos, and Ethel's brother, David Greenglass, also employed at Los Alamos. The Rosenbergs were arrested in 1950 during the "red scare" that was sweeping the nation. They were implicated by the testimonies of Greenglass and his wife, Ruth. Both were sentenced to be executed; the other members of the ring were all given prison terms. Despite numerous pleas for commutation of the sentences, the couple was executed at Sing Sing in 1953. Many arguments have been given as to their innocence, but none thus far that could clear their names of the charges brought against them. Their deaths stand as a monument even for many who accept their guilt, to the degree to which anti-Communist hysteria at the height of the Cold War prevented some Americans from tempering the demands of justice with an equally full measure of mercy.

ROSENBERG, HENRY (*b. Bilten, Switzerland, 1824; d. 1893*), merchant, banker. Immigrated to Galveston, Texas, 1843. Prospering there in the dry-goods business and many other enterprises, he was a benefactor of the city during life and on his death left a great part of his estate for charitable purposes in Galveston.

ROSENBERG, PAUL (*b. Paris, France, 1881; d. Paris, 1959*), art dealer and collector. Sharing art galleries in Paris with his father, and opening a gallery in London on his own, Rosenberg, after World War I opened a gallery in Paris that was to become the home of some of the most famous artists of this century: Picasso, with whom Rosenberg had an exclusive contract from 1918 to 1940, Braque, Léger, and Henri Matisse. Rosenberg fled the Nazis in 1940 and opened a gallery in New York where he remained the rest of his life, never reestablishing his business ties in France.

ROSENBLATT, BERNARD ABRAHAM (*b. Grodek, Poland, 1886; d. New York, N.Y., 1969*), Zionist leader. Arrived in the United States in 1892. Interested in Zionism as a youth, he organized the Zionist Literary Society for high school students (1902). At Columbia (M.A., 1908) he established the first Columbia University Zionist Society; also attended Columbia Law (LL.B., 1909). In 1911 he served as honorary secretary of the Federation of American Zionists, thus moving into the inner circle of the small American Zionist movement. His efforts helped establish the nucleus of Hadassah, the American women's Zionist orga-

nization. His first book, *The Social Commonwealth* (1914), combined socialist ideals of cooperation and the regulation of economic life with the benefits of competition and a voluntary democracy. In 1915 he incorporated the American Zion Commonwealth to purchase land in Palestine for Jewish settlement. Attended the World Zionist Convention in 1920 and rallied behind Chaim Weizmann and his program of colonization in Palestine. During 1925–55, he divided his time between Haifa and New York. In the late 1930's organized a committee in Haifa to advocate partition and federation; the establishment of the state of Israel brought an end to his Zionist activity.

ROSENBLATT, JOSEPH (*b. Biélaya Tzerkov, near Kiev, Russia, 1882; d. Jerusalem, 1933*), cantor, concert tenor. Celebrated professionally in Europe, he came to America, 1912, where his natural vocal virtuosity and faultless pitch made him a musical celebrity. A concert artist exclusively *post* 1926, he died while on a visit to Palestine.

ROSENFELD, MORRIS (*b. Bokscha, Russian Poland, 1862; d. 1923*), tailor, poet. Immigrated to America, 1886. After a miserable existence in New York City sweatshops for some 14 years, Rosenfeld was enabled to devote himself entirely to literature and became editor and contributor to several Yiddish papers. He published his first collection of folk and revolutionary songs, *Die Glocke* (1888); other collections appeared in 1890 and 1917. His talent was made generally known by publication of *Songs from the Ghetto* in English (1898).

ROSENFELD, PAUL LEOPOLD (*b. New York, N.Y., 1890; d. New York, 1946*), critic of music, art, and literature. B.A., Yale, 1912. Litt.B., School of Journalism, Columbia University, 1913. Associated before World War I with the New York cultural circle that included Van Wyck Brooks, Leo Ornstein, Waldo Frank, and Randoph Bourne, he devoted himself to interpreting the modern movement in the arts to the American public. His first work appeared in the *New Republic* and *Seven Arts* (1916). He was music critic of the *Dial* and a regular contributor to the *Nation*, *Vanity Fair*, and other journals throughout the 1920's. Among his books were *Musical Portraits* (1920) and *Port of New York* (1924), a collection of essays on those of his contemporaries who, in his view, best represented the new art of the time.

ROSENMAN, SAMUEL IRVING (*b. San Antonio, Tex., 1896; d. New York City, 1973*), lawyer, jurist, and political adviser. Attended City College of New York and graduated Columbia College (1915) and Columbia Law School (1919) and was elected a Democratic state assemblyman (1921–26); he authored the Rosenman Act (1923), which strengthened rent-control laws. In 1926 he joined the Legislative Bill Drafting Commission. He began a lifelong association with Franklin D. Roosevelt during the latter's 1928 gubernatorial campaign, first as speechwriter and then as counsel to the governor. He was appointed to the New York State Supreme Court (1932–43), while also serving as President Roosevelt's speechwriter and adviser; he became special counsel to the president in 1943 and took up private practice of law in 1946.

ROSENSTEIN, NETTIE ROSENCRANS (*b. Vienna, Austria, 1893; d. New York City, 1980*), fashion designer. Immigrated to New York City in 1800 and in 1917 opened a dressmaking business, which was soon selling high fashion, ready-to-wear dresses to leading stories around the nation. She launched a wholesale design firm in 1931, concentrating on evening dresses, and generated more than $1 million in annual sales by 1937. Rosenstein emphasized understated designs and is credited with popularizing the "little black dress" as the staple fashion wear for American women.

ROSENSTIEL, LEWIS SOLON (*b. Cincinnati, Ohio, 1891; d. Miami Beach, Fla., 1976*), industrialist and philanthropist. Worked for his uncle's distillery in Kentucky until Prohibition began in 1920; during the ensuing decade, he purchased several distilleries and the distribution rights for various liquors and wine. When Prohibition was repealed in 1933, he owned an array of liquor industry assets. By the end of World War II, his firm, Schenley Industries, which specialized in bourbon, was one of the major distilleries in the nation. The firm struggled, however, as Americans' liquor tastes shifted from whiskey to vodka. He sold the distillery in 1968.

ROSENTHAL, HERMAN (*b. Friedrichsstadt, Courland, Russia, 1843; d. 1917*), author. After establishing a literary reputation at home, Rosenthal came to America, 1881, and with Michael Heilprin became a pioneer in founding agricultural colonies of Russian Jews in this country. Employed as a statistician and economic surveyor for a time, he became chief of the Slavonic division, New York Public Library, 1898, and remained in this post until his death. He was an important member of the editorial board of the *Jewish Encyclopedia*.

ROSENTHAL, MAX (*b. Turck, Russian Poland, 1833; d. 1918*), lithographer, mezzotint engraver. Came to America, 1849, after apprenticeship in Paris, France; was engaged principally in chromolithography until about 1870. Thereafter, he won fame as an etcher and mezzotinter of portraits of distinguished Americans, principally of the colonial and Revolutionary War periods.

ROSENTHAL, TOBY EDWARD (*b. New Haven, Conn., 1848; d. Munich, Germany, 1917*), genre and portrait painter.

ROSENWALD, JULIUS (*b. Springfield, Ill., 1862; d. Chicago, Ill., 1932*), merchant, philanthropist. Associated with Sears, Roebuck & Co., *post* 1895, he was president of the company, 1910–25, and thereafter until his death, chairman of the board. After building up a great business through sensing the possibilities of mailorder, appreciating his own limitations, and surrounding himself with expert help, he turned to a wide range of philanthropies which transcended race, creed, and nationality. His benefactions were made principally through the Julius Rosenwald Fund which he created in 1917. His work for the advancement of the black was doubtless the outstanding feature of his philanthropy.

ROSENWALD, LESSING JULIUS (*b. Chicago, Ill., 1891; d. Jenkintown, Pa., 1979*), business executive and art collector. Attended Cornell University (1910–11) and joined Sears, Roebuck and Company, of which his father was president and largest shareholder, as a shipping clerk. He served as chairman of the board of directors from 1932 to 1939 and then retired to devote his life to philanthropy and art collecting. Rosenwald amassed a formidable collection in art, prints, and rare books. Over his lifetime, he donated some 25,000 prints and drawings and nearly 8,000 rare books to public institutions, including the Library of Congress and the National Gallery of Art.

ROSEWATER, EDWARD (*b. Bukowan, Bohemia, Austria–Hungary, 1841; d. Omaha, Nebr., 1906*), Nebraska journalist and legislator, Union soldier. Came to the United States, 1854. Founded the *Omaha Daily Bee*, 1871, which he managed actively until shortly before his death.

ROSEWATER, VICTOR (*b. Omaha, Nebr., 1871; d. Philadelphia, Pa., 1940*), journalist, politician. Son of Edward Rosewater.

Graduated Columbia, 1891; Ph.D., 1893. Associated with the *Omaha Bee* until 1920, he served it as managing editor, editor, and publisher. A dominant influence in the Republican party in Nebraska by 1908, he presided as chairman of the National Republican Committee over the stormy opening session of the convention of 1912. By ruling out of order a motion by Theodore Roosevelt's floor leader to substitute Roosevelt delegates for those approved by the committee, Rosewater made it possible for Elihu Root to become temporary chairman and was thus a major factor in Roosevelt's withdrawal from the convention.

Ross, Abel Hastings (*b. Winchendon, Mass., 1831; d. Port Huron, Mich., 1893*), Congregational clergyman, authority on the history and polity of that denomination.

Ross, Alexander (*b. Nairnshire, Scotland, 1783; d. present Winnipeg, Canada, 1856*), fur trader, explorer. Immigrated to Canada, 1804; worked as schoolteacher. Engaged by Wilson P. Hunt at Montreal, 1810, as a clerk in Astor's Pacific Fur Co., he sailed in September on the *Tonquin* and aided in the building of Fort Astoria and later of Fort Okanogan. He was a member of the expedition that founded Fort Walla Walla, July 1818, and remained in charge there until the fall of 1823. Starting east, he was persuaded to lead an expedition into the Snake River country, and in 1824 penetrated present Idaho as far as the mouth of the Boise River. In the spring of 1825, he started east again but halted at the Red River colony where he resided for the remainder of his life. He was author of important historical works of firsthand authority, *Adventures of the First Settlers on the Oregon or Columbia River* (London, 1849), *The Fur Hunters of the Far West* (1855), and *The Red River Settlement* (1856).

Ross, Alexander Coffman (*b. Zanesville, Ohio, 1812; d. Zanesville, 1883*), jeweler, song writer. Remembered principally for his authorship of the famous "Tippecanoe and Tyler, Too" for the presidential campaign of 1840.

Ross, Araminta *See* Tubman, Harriet.

Ross, Betsy (*b. Philadelphia, Pa., 1752; d. 1836*), seamstress, upholsterer, legendary maker of the first United States flag.

Ross, Charles Griffith (*b. Independence, Mo., 1885; d. Washington, D.C., 1950*), journalist. Graduated University of Missouri, 1905. Rose to editorial rank on various newspapers in St. Louis, Mo., and elsewhere; taught at University of Missouri's school of journalism, 1908–18. Washington correspondent of the St. Louis *Post-Dispatch*, 1918–34, he was distinguished for thoroughness of investigation, accurate and lucid writing, and thoughtful analysis; he won the Pulitzer Prize for newspaper correspondence in 1932. After serving as editor of the editorial page of the *Post-Dispatch*, 1934–39, he returned to Washington as contributing editor and writer of a signed column of opinion. *Post* 1945, at considerable personal sacrifice, he was the widely respected press secretary of his friend and high school schoolmate, President Harry S. Truman.

Ross, Denman Waldo (*b. Cincinnati, Ohio, 1853; d. London, England, 1935*), artist, educator. Graduated Harvard, 1875; did further work under Henry Adams and Charles E. Norton, receiving the doctorate, 1880, for a study of early German land tenure. Shifting his field to art, he taught at Harvard *post* 1899 in the departments of architecture and fine arts. His theories were set forth in *A Theory of Pure Design* (1907) and *On Drawing and Painting* (1912). Working with precise and clear-cut formulae, he cut at the root of Ruskinian vagueness and brought his master Norton's aesthetics to earth. Associated with Ernest Fenollosa, Edward S. Morse, and William S. Bigelow as a donor of Oriental

art to the Boston Museum, he was also a benefactor of the Fogg Museum at Harvard.

Ross, Edmund Gibson (*b. Ashland, Ohio, 1826; d. Albuquerque, N.Mex., 1907*), journalist, antislavery advocate, Union soldier. A free-state leader in Kansas *post* 1856, he edited and published the Topeka *Kansas Tribune*, and the Topeka *Kansas State Record*, 1857–62. He became editor of the Lawrence *Tribune*, 1865, and served as U.S. senator, Republican, from Kansas, 1866–71. Entering the Senate an intense radical and opponent of Andrew Johnson, he insisted that Johnson have a fair trial after the president's impeachment. His vote against conviction on grounds of lack of evidence destroyed his political career. Leaving the Republican party, 1872, because of his dislike of the protective system and of the character of Grant's administration, he continued active in Kansas journalism until 1882 when he moved to New Mexico. He was governor of that territory, 1885–89.

Ross, Edward Alsworth (*b. Virden, Ill., 1866; d. 1951*), sociologist. Studied at Coe College in Iowa, and at Johns Hopkins (Ph.D. in political economy). Taught at Stanford University from 1893 to 1900; while there, he shifted his interests from economics to sociology. Widely acknowledged as a founder of American sociology, Ross coupled this discipline with an active interest in progressive politics and reform; as a result, he was asked to resign his tenured position at Stanford. Taught at the University of Nebraska from 1901 to 1906 and at the University of Wisconsin from 1906 until retirement in 1937.

Rejecting the prevalent philosophies of Darwinism and laissezfaire in social planning, Ross believed that a system of social control was possible that would enable Americans to keep the rugged individualism of the past as well as adapt to the corporate state they were creating for the future. His books include *Social Control: A Survey of the Foundations of Order* (1901), Ross's most creative contribution to social thought; *The Foundations of Sociology* (1905); *Social Psychology* (1908); and *The Principles of Sociology* (1920). Ironically, Ross was a racist, believing in the inferiority of the non-white races and working for a restricted immigration policy for the U.S.

Ross, Erskine Mayo (*b. Belpré, Va., 1845; d. Los Angeles, Calif., 1928*), California jurist. Began practice in Los Angeles, 1868. Appointed judge, U.S. district court of the southern district of California, 1887, he was advanced in 1895 to the U.S. circuit court and served there until his resignation, 1925.

Ross, George (*b. New Castle, Del., 1730; d. Philadelphia, Pa., 1779*), Pennsylvania jurist, signer of the Declaration of Independence. Practiced at Lancaster, Pa., *post* 1750; member of provincial Assembly, 1768–75. A Tory as a member of the First Continental Congress, 1774, he became a Whig, 1775; as a member of the Second Continental Congress, he worked tirelessly for the patriot cause in Pennsylvania. Vice president of the Pennsylvania constitutional convention of 1776 and a strong factor in its deliberations, he was returned to Congress in July but withdrew because of illness in January 1777. Commissioned judge of the admiralty court of Pennsylvania, 1779, he defied Congress for attempting to review his judgment in the case of the sloop *Active*.

Ross, Harold Wallace (*b. Aspen, Colo., 1892; d. Boston, Mass., 1951*), publisher and editor. Founder of the *New Yorker* magazine in 1925. Self-educated, Ross began his editing work in Paris during World War I with the army newspaper *Stars and Stripes* and in New York, he edited the publication of the new American Legion. With the backing of a friend, Raoul Fleisch-

mann, he founded the *New Yorker* and was its editor until his death in 1951. The magazine became a success and attracted such writers as Dorothy Parker, Robert Benchley, Corey Ford, E. B. White, James Thurber, John O'Hara, Jean Stafford, and John Cheever. Artists included Peter Arno, Alan Dunn, Whitney Darrow, Jr., and Charles Addams.

Ross, James (*b. near Delta, Pa., 1762; d. Allegheny City, Pa., 1847*), lawyer. Encouraged in his study of law by Hugh H. Brackenridge, he practiced at first in Washington Co., Pa., removing to Pittsburgh, 1795. A Federalist, he served as a commissioner to treat with the insurgents during the Whiskey Insurrection, 1794, and was largely responsible for the amicable settlement. He was U.S. senator from Pennsylvania, 1794–1803.

Ross, James Delmage McKenzie (*b. Chatham, Ontario, Canada, 1872; d. Rochester, Minn., 1939*), electrical engineer. Settled in Seattle, Wash., 1901; headed Seattle municipal power plant, 1911–39; was a principal architect of the public power program instituted during administrations of President F. D. Roosevelt.

Ross, John (*b. near Lookout Mountain, Tenn., 1790; d. Washington, D.C., 1866*), Cherokee Chief. Indian name, Cooweescoowe. Son of a Scottish Loyalist and a mother of one-fourth Cherokee blood. Served under Andrew Jackson in War of 1812. President, National Council of the Cherokee, 1819–26; principal chief of the eastern Cherokee, 1828–39. A leader in the opposition to westward removal of his tribe, he led his people to present Oklahoma, 1838–39, and helped make the constitution of 1839 which united the eastern and western Cherokee under a single government. Chosen chief of the united nation, 1839, he held office until his death. Failing to keep the Cherokee nation neutral at the outbreak of the Civil War, he signed a treaty of alliance with the Confederacy in October 1861 which was repudiated two years later.

Ross, Lawrence Sullivan (*b. Bentonsport, Iowa, 1838; d. 1898*), planter, Texas legislator, Confederate brigadier general. Raised in Texas, Ross was captain of a ranger company operating against the Comanche, 1859–60. Entering Confederate service, 1861, he was particularly distinguished for skill in covering Van Dorn's retreat from Corinth, Miss., 1862. As Democratic governor of Texas, 1887–91, he led the legislature in passing laws which prohibited dealing in cotton futures and closed the sale of public lands to corporations. He was president, Agricultural and Mechanical College of Texas, *post* 1891.

Ross, Martin (*b. Martin Co., N.C., 1762; d. Bethel, N.C., 1827*), Revolutionary soldier, Baptist clergyman.

Ross, Nellie Tayloe (*b. St. Joseph, Mo., 1876; d. 1977*), governor of Wyoming and government official. In 1924, following the death of her husband, the governor of Wyoming, the state Democratic party chose Ross as its gubernatorial candidate. She won the general election, becoming the first woman governor in U.S. history. She battled a hostile Republican-dominated state government and failed in her reelection bid in 1926. After 1928, as a national official in the Democratic party, Ross coordinated activities to recruit female voters. She was director of the U.S. Mint (1933–53).

Ross, Thomas Joseph (*b. Brooklyn, N.Y., 1893; d. Rye, N.Y., 1975*), public relations counsel. Graduated St. Francis Xavier College, New York (B.A., 1913), and worked as a reporter for the *New York Sun* and *New York Tribune*. In 1919 he joined the public relations firm Lee, Harris and Lee, one of the first in the industry. In 1933 he was a senior partner and the firm was re-named Ivy Lee and T. J. Ross, which developed the concept of corporations aligning with public interests. In 1961 he became chairman of the newly named T. J. Ross & Associates.

Rossen, Robert (*b. New York, N.Y., 1908; d. New York, 1966*), film writer, director, and producer. Attended New York University and began a career in the theater in 1930, acting in and directing off-Broadway and summer stock companies. Offered a contract by Warner Brothers (1936–43), his filmscripts include *Marked Woman* (1937), *The Sea Wolf* (1941), and *A Walk in the Sun* (1946). Became a film director with *Johnny O'Clock* (1947) and is best remembered for directing *Body and Soul* (1947). Established his own film-producing unit (1947), and in 1949 produced, directed, and wrote *All the King's Men*, which received the Academy Award for best picture. Blacklisted for a period because of his admission before the House Un-American Activities Committee (1951) of one-time membership in the Communist party, he later wrote *The Hustler* (1961) and *Lilith* (1964).

Rosser, Thomas Lafayette (*b. Campbell Co., Va., 1836; d. near Charlottesville, Va., 1910*), Confederate major general, engineer. Raised in Texas, Rosser attended West Point, 1856–61, resigning before graduation to enter Confederate service. A brilliant artillerist and cavalryman, Rosser served after the Civil War as chief engineer of the Northern Pacific Railroad and later of the Canadian Pacific, retiring in 1886 to become a gentleman farmer.

Rossiter, Clinton Lawrence, III (*b. Philadelphia, Pa., 1917; d. Ithaca, N.Y., 1970*), political scientist, historian, lecturer, and writer. Attended Cornell and Princeton (Ph.D., 1942); his thesis brought him wide professional acclaim when published as *Constitutional Dictatorship: Crisis Government in the Modern Democracies* (1948). Taught at University of Michigan (1946) and Cornell (1946–70). The award-winning *Seedtime of the Republic* (1953) established his reputation as a diligent and meticulous scholar. *The American Presidency* (1956) was an enormous success in both the scholarly world and popular paperback market. Before his death he had lectured or given seminars at fifty colleges or universities on every continent.

Rossiter, Thomas Prichard (*b. New Haven, Conn., 1818; d. Cold Spring, N.Y., 1871*), historical and portrait painter, associate of J. F. Kensett, J. W. Casilear, and Thomas Cole.

Rossiter, William Sidney (*b. Westfield, Mass., 1861; d. Concord, N.H., 1929*), official of the Census Bureau, statistician. Author of *A Century of Population Growth . . . 1790–1900* (1909). Managed and later headed the Rumford Press.

Rostovtzeff, Michael Ivanovitch (*b. Zhitomir, Ukraine, 1870; d. New Haven, Conn., 1952*), historian and archaeologist. Studied at the University of Kiev and the University of St. Petersburg (Ph.D., 1903). Immigrated to the U.S. in 1920 where he taught at the University of Wisconsin from 1920 to 1925. Professor of ancient history and archaeology at Yale University (1925–39), continuing as director of archaeological research until 1944. Recognized as one of the leading ancient historians of his time, Rostovtzeff placed emphasis on the social and economic histories in his interpretations of the ancient civilizations. Books published in this country include *A History of the Ancient World* (1926), *The Social and Economic History of the Roman Empire* (1926), and *The Social and Economic History of the Hellenistic World* (1941). President of the American Historical Society, 1935.

Rotch, Abbott Lawrence (*b. Boston, Mass., 1861; d. Boston, 1912*), meteorologist. Great-great grandson of William

Rotch; grandson of Abbott Lawrence; brother of Arthur Rotch. Graduated Massachusetts Institute of Technology, 1884. Instituted and maintained the Blue Hill Observatory, 1884–1912; was a pioneer in American aeronautics. Coauthor of *Charts of the Atmosphere for Aeronauts and Aviators* (1911), a first attempt at mapping conditions of the upper air.

ROTCH, ARTHUR (*b. Boston, Mass., 1850; d. Beverly, Mass., 1894*), architect. Great-great-grandson of William Rotch; grandson of Abbott Lawrence; brother of Abbott L. Rotch. Graduated Harvard, 1871; studied architecture at Massachusetts Institute of Technology and at the École des Beaux Arts, Paris, France. Benefactor of architectural departments of M.I.T. and Harvard.

ROTCH, THOMAS MORGAN (*b. Philadelphia, Pa., 1849; d. 1914*), pediatrician. Cousin of Abbott L. and Arthur Rotch. Graduated Harvard, 1870; Harvard Medical School, 1874; studied also in Berlin, Vienna, and Heidelberg. Began practice of pediatrics at Boston, 1876; founded and became medical director of the West-End Infants' Hospital, 1881. A teacher of pediatrics at Harvard Medical School *post* 1878, he was professor of pediatrics *post* 1893. Devising a "percentage" method of artificial feeding based on a careful estimation of the caloric value of milk, he placed the feeding of infants on a scientific basis. His book, *Pediatrics: the Hygiene and Medical Treatment of Children* (1896), was one of the first to be written on that branch of medicine.

ROTCH, WILLIAM (*b. Nantucket, Mass., 1734 o.s.; d. 1828*), whaling merchant.

ROTH, LILLIAN (*b. Boston, Mass., 1910; d. New York City, 1980*), actress and singer. Began acting at age seven and had a breakthrough role on Broadway in *Shavings* (1910); she signed with Paramount Pictures in 1929 and achieved fame with her vivacious on-screen personality, starring in such films as *The Vagabond King* (1930). In the 1930's she suffered from alcohol dependence, from which she did not recover until the late 1940's. In 1954 she released the popular autobiography *I'll Cry Tomorrow*, which was made into a film the following year. She enjoyed a successful return to Broadway in the 1962 musical comedy *I Can Get It for You Wholesale*.

ROTH, SAMUEL (*b. Carpathian Mountains, Austria–Hungary, 1894; d. New York City, 1974*), publisher. Immigrated to New York City in 1903 and, mostly self-educated, in 1914 published his first book of poems, *New Songs for Zion*, which attracted Columbia University professors and earned him a faculty scholarship. He opened the Poetry Bookshop in Greenwich Village in 1917, which became a haunt for noted poets and writers, and published his second book of poem, *First Offering*. After World War I he began publishing the quarterly magazine *Two Worlds*, which published unauthorized excerpts of James Joyce's *Finnegans Wake* and *Ulysses*. He was arrested in 1928 for publication of the latter because it was deemed obscene; this was the first of nine arrests and six convictions for violating anti-obscenity laws. His appeal to the U.S. Supreme Court in *Roth* v. *United States* (1957) was turned down but liberalized the definition of obscenity according to "community standards."

ROTHAFEL, SAMUEL LIONEL (*b. Stillwater, Minn., 1881; d. New York, N.Y., 1936*), showman, motion-picture theatre operator. Better known as "Roxy," he was raised in Brooklyn, N.Y. He made his first innovations in showing of motion-pictures while manager of the Lyric Theatre, Minneapolis, Minn., 1912. Coming to New York in the following year, he became in a short time the most successful motion-picture theatre operator in the world, successively directing the Strand, Rialto, Rivoli, and Capitol theaters in New York City. His formula included presenta-

tion of an excellent orchestra, famous singers and musicians, and precision dancing, along with important feature films. He was a pioneer also in surrounding his productions with a luxurious décor. His radio program known as "Roxy and His Gang" was a popular feature in the mid- and late-1920's.

ROTHERMEL, PETER FREDERICK (*b. Nescopeck, Pa., 1817; d. near Linfield, Pa., 1895*), artist. Painter, among much other somewhat photographic work, of "The Battle of Gettysburg" (1871), which now hangs in the Capitol at Harrisburg, Pa.

ROTHKO, MARK (*b. Dvinsk, Russia, 1903; d. New York, N.Y., 1970*), painter. Arrived in the United States in 1913, and in the 1920's attended Yale and the Arts Students League. His early work consisted primarily of representational landscapes, still lifes, and nudes; participated in his first exhibition in 1928. During the following decade his subjects expanded to include cityscapes and genre scenes. Participated in the Works Progress Administration Federal Art Project (1936–37). One of "the Ten," a group that rebelled against the regional style prevailing in contemporary American art and that admired the innovative works of Milton Avery and European modernists. His work of the late 1930's reflects the social and political climate of the decade; a disquieting mood prevails in these works, coupled with a simplicity of composition. Explored ancient and Christian myths as subject matter for works, 1938–43. In 1944 he became interested in surrealists and painted Miró-like fantasies. By the mid-1940's his work was frequently included in major museum exhibitions. Began painting in a purely abstract style in 1947. By 1950 he was painting in the style for which he is best known; his brilliant-colored vertical canvases usually bore two or three frontally situated rectangles balanced one above the other. These works were primarily in red, orange, yellow, and violet. During the late 1950's and 1960's he worked primarily in a dark or muted palette; he reintroduced brilliant colors in his final works.

ROTHROCK, JOSEPH TRIMBLE (*b. McVeytown, Pa., 1839; d. West Chester, Pa., 1922*), physician, Union soldier, botanist. M.D., University of Pennsylvania, 1867. After practicing at Wilkes-Barre, Pa., he served as botanist and surgeon to the government survey of Colorado, New Mexico, and California under Lt. G. N. Wheeler, describing many new plants in his report (published 1878). Professor of botany, University of Pennsylvania, 1877–1904, he was a leader in the forest conservation movement and the first Pennsylvania commissioner of forestry.

ROTHWELL, RICHARD PENNEFATHER (*b. Oxford, Ontario, Canada, 1836; d. 1901*), mining engineer, editor. Worked in the United States *post* 1864 mainly as consultant to operators of anthracite mines; was a co-founder of the American Institute of Mining Engineers, 1871. Coeditor with Rossiter W. Raymond of the *Engineering and Mining Journal post* 1874 and sole editor *post* 1890.

ROULSTON, MARJORIE HILLIS (*b. Peoria, Ill., 1890; d. New York City, 1971*), writer. Joined *Vogue* magazine as a production editor (1918) and became executive editor (1932–36); she left *Vogue* to begin three decades of writing. Her best-selling *Live Alone and Like It* (1936), advice for single women, reflected her humorous and lyrical prose writing. She was also a popular lecturer and wrote a monthly column, "On Petting," for *Good Housekeeping*. After her husband's death, she wrote *You Can Start Over* (1951). A member of the Authors Guild from 1953, she created and edited the Guild's *Bulletin* in 1956.

ROULSTONE, GEORGE (*b. Boston, Mass., 1767; d. 1804*), printer. Accompanied Governor William Blount to Tennessee; issued first number of the *Knoxville Gazette* at Hawkins Court

House (Rogersville), Nov. 5, 1791, continuing publication (except for a brief period in 1798) until his death. As territorial and later state printer, Roulstone produced a number of volumes of official papers and a few general publications. His most important production was the *Laws of the State of Tennessee* (1803).

ROUND, WILLIAM MARSHALL FITTS (*b. Pawtucket, R.I., 1845; d. Acushnet, Mass., 1906*), journalist, prison reformer. Corresponding secretary. Prison Association of New York, 1882–1900; introduced cottage system at Burnham Industrial Farm, Canaan, N.Y., as director *ca.* 1888.

ROUQUETTE, ADRIEN EMMANUEL (*b. New Orleans, La., 1813; d. New Orleans, 1887*), Roman Catholic clergyman, missionary to the Choctaw, poet. Brother of François D. Rouquette. Author, among other works, of *Les Savanes* (1841) which won him the title of "the Lamartine of America," *La Thébaïde en Amérique* (1852), and *La Nouvelle Atala* (1879).

ROUQUETTE, FRANCOIS DOMINIQUE (*b. Bayou Lacombe, La., 1810; d. Louisiana, 1890*), poet. Brother of Adrien E. Rouquette. An eccentric genius, he was author of a number of works of which *Meschacébéennes* (1839) and *Fleurs d'Amérique* (1856) received very high praise from notable French critics.

ROURKE, CONSTANCE MAYFIELD (*b. Cleveland, Ohio, 1885; d. Grand Rapids, Mich., 1941*), folklorist, cultural historian. A.B., Vassar College, 1907. Taught English at Vassar, 1910–15; concentrated thereafter on research and writing in the areas of American folklore and social history. She was author, among other books, of *Trumpets of Jubilee* (1927), *Troupers of the Gold Coast* (1928), *American Humor* (1931), *Davy Crockett* (1934), *Audubon* (1936), and *The Roots of American Culture* (1942).

ROUS, FRANCIS PEYTON (*b. Baltimore, Md., 1879; d. New York, N.Y., 1970*), medical researcher. Attended Johns Hopkins University and Medical School (M.D., 1905). Joined Rockefeller Institute for Medical Research (1909); became a full member of the institute (1920) and a member emeritus (1945). He published the findings of his most famous discovery — that a virus is the causative agent of a chicken sarcoma — in 1911; in 1966 he received the Nobel Prize in medicine for his discovery of tumor-inducing viruses. Editor of *Journal of Experimental Medicine* for almost fifty years. Elected to the National Academy of Sciences (1927); received the Albert Lasker Award (1958), the National Medal of Science (1966), and other prestigious awards.

ROUSSEAU, HARRY HARWOOD (*b. Troy, N.Y., 1870; d. at sea, en route to Panama, 1930*), naval officer, engineer. Served on Isthmian Canal Commission under George W. Goethals, 1907–14, in special charge of design and construction of the Panama Canal terminals; later as rear admiral, held important navy administration posts and headed the shipyard division under the Shipping Board during World War I.

ROUSSEAU, LOVELL HARRISON (*b. near Stanford, Ky., 1818; d. New Orleans, La., 1869*), lawyer, Kentucky and Indiana legislator, Union major general. Received formal cession of Alaska from the Russians, 1867, as U.S. representative there.

ROVENSTINE, EMERY ANDREW (*b. Atwood, Ind., 1895; d. New York, N.Y., 1960*), physician and anesthesiologist. Studied at Wabash College, Indiana University (M.D., 1928), and at the University of Wisconsin. Taught at the University of Wisconsin from 1931 to 1935. Headed the anesthesia department at Bellevue Hospital and New York University from 1935. Instrumental in making anesthesiology a regulated speciality, Rovenstine helped found The American Board of Anesthesiology in 1937. Member

of the National Research Council (1941–46). Full recognition for the legitimacy of anesthetists came with the creation of the American Board of Anesthesia in 1941.

ROVERE, RICHARD HALWORTH (*b. Jersey City, N.J., 1915; d. Poughkeepsie, N.Y., 1979*), political journalist. Graduated Bard College (1917), where he joined the Communist party (he abandoned his radicalism in the late 1930's) and worked as an editor and free-lance writer covering political affairs for such magazines as *The Nation, Common Sense,* and *Harper's.* He joined the *New Yorker* in 1944 and from 1948 until his death, he wrote the regular column "Letter from Washington," in which he commented on politics, economics, and foreign policy with a generally critical, liberal perspective. He eschewed "insider" government contacts in favor of documentary sources for his columns. His influential books include *Senator Joe McCarthy* (1959), which portrayed the anti-Communist figure as a dangerous demagogue. In the 1960's, much to his amusement, his satirical and comical depiction of American elites as the sinister "American Establishment," which first appeared in an *Esquire* article in 1957, was taken seriously by many commentators and became a standard part of political debate.

ROWAN, JOHN (*b. near York, Pa., 1773; d. Louisville, Ky., 1843*), Kentucky jurist, legislator, and congressman. A liberal leader in the fight against the Kentucky judiciary, 1823–24, he served as U.S. senator, Democrat, 1825–31. He worked for reform of the federal judiciary and abolition of imprisonment for debt.

ROWAN, STEPHEN CLEGG (*b. near Dublin, Ireland, 1808; d. Washington, D.C., 1890*), naval officer. Raised in Ohio. Appointed midshipman, 1826; commended for gallant service in the Seminole War; was particularly distinguished in war with Mexico. Executive officer of the *Cyane,* he shared in the capture of Montrey, Calif., July 1846, and, in command of a battalion of seamen and marines, fought with the army in the retaking of Los Angeles and the relief of San José. His Civil War service was outstanding. In February 1862, he cooperated with General Burnside in the capture of Roanoke Island and later in the capture of New Bern, N.C. He performed outstanding service also at Charleston, S.C., July — September 1863. Promoted rear admiral, 1866, he retired as vice admiral, 1889.

ROWE, LEO STANTON (*b. McGregor, Iowa, 1871; d. Washington, D.C., 1946*), political economist, diplomat. Raised in Philadelphia, Pa. Ph.B., Wharton School, University of Pennsylvania, 1890. Ph.D., University of Halle, 1892. LL.B., University of Pennsylvania, 1895. While teaching political science at Pennsylvania, 1896–1917 (professor *post* 1904), he accepted a number of diplomatic assignments concerning U.S.-Latin American relations, culminating in his secretaryship of the U.S.-Mexico Mixed Claims Commission, 1916–17. Impressed with knowledge and tact, President Wilson appointed him to supervise Latin American affairs as assistant secretary of the treasury, 1917–19, and as chief of division in the State Department, 1919–20. Thereafter until his death, he was director general of the Pan American Union.

ROWE, LYNWOOD THOMAS (*b. Waco, Tex., 1912; d. El Dorado, Ark., 1961*), baseball pitcher. Signed by the Detroit Tigers (1932) and played in three World Series (1934, 1935, and 1940), winning the world championship in 1935. Sold to the Brooklyn Dodgers (1942), then to the Philadelphia Phillies (1943); in 1949 he asked for his release. Managed an Eastern League farm club at Williamsport, Pa. (1951), served as pitching coach for Detroit (1954–55), and in 1957 became a scout for Detroit.

ROWELL, CHESTER HARVEY (*b. Bloomington, Ill., 1867; d. Berkeley, Calif., 1948*), journalist, politician. Ph.B., University of Michigan, 1888; studied also at universities of Halle and Berlin; taught languages at several colleges and at University of Illinois between 1894 and 1898. Editor and manager of the *Fresno* (Calif.) *Republican*, 1898–1920; editor, 1932–35, and editorial columnist, 1935–47, of the *San Francisco Chronicle*. He was a leader in founding the Lincoln–Roosevelt League, 1907, and in the struggle to convert the California Republican party to progressivism and independence of the Southern Pacific Railroad. A close friend and adviser of Hiram Johnson, he parted company with him on the question of U.S. entry into the League of Nations, which Rowell favored.

ROWELL, GEORGE PRESBURY (*b. Concord, Vt., 1838; d. Poland Springs, Maine, 1908*), advertising agent. Devised the "list system" *ca.* 1865; founded *Printers' Ink*, July 1888.

ROWLAND, HENRY AUGUSTUS (*b. Honesdale, Pa., 1848; d. 1901*), physicist. Graduated Rensselaer Polytechnic, 1870. Taught science and physics at Wooster University and at Rensselaer; was chosen first professor of physics, Johns Hopkins, 1875. Rowland's principal contributions to physics were of three kinds: those which involved original concepts, those concerned with accurate measurement of physical constants, and those in which engineering talent was most conspicuous. His first important investigation resulted in "On Magnetic Permeability, and the Maximum of Magnetism of Iron, Steel, and Nickel" (*Philosophical Magazine*, August 1873) and provided the basis for subsequent study of both permanent and induced magnetization; it was the starting point for calculations for the design of dynamos and transformers. A second important experiment, performed during the winter of 1875–76, answered in the affirmative the question whether a moving charged conductor would have an effect upon a magnet similar to that of an electric current; this was of great significance in connection with the modern theory of electrons. For his study of spectra, he combined the principle of the grating with that of the concave mirror, eventually producing gratings ruled on concave surfaces thus obviating many of the difficulties inherent in the use of plane gratings. In order to produce gratings more accurate than any previously known, he designed a ruling machine which virtually eliminated errors. In the field of measurements, he obtained values for the mechanical equivalent of heat, the ohm, the ratio of the electric units, and the wavelengths of various spectra. Teaching less by precept than by example, Rowland was a severe taskmaster in the laboratory.

ROWLAND, HENRY COTTRELL (*b. New York, N.Y., 1874; d. Washington, D.C., 1933*), physician, traveler and adventurer, author.

ROWLAND, THOMAS FITCH (*b. New-Haven, Conn., 1831; d. New York, N.Y., 1907*), boat builder, engine designer. President of the Continental Iron Works *post* 1860, Rowland built the original *Monitor* for John Ericsson, and upon its completion built the monitors *Montauk*, *Catskill* and *Passaic* and also the double-turret monitor *Onondaga*.

ROWLANDS, WILLIAM (*b. London, England, 1807; d. Utica, N.Y., 1866*), Calvinistic Methodist clergyman, editor. Came to America, 1836; ministered mainly in New York City and in Oneida Co., N.Y. Founded and edited Y *Cyfaill*, influential Welsh language periodical (first number, January 1838).

ROWLANDSON, MARY WHITE (*b. probably England, ca. 1635; d. ca. 1678*), Indian captive, author. Daughter of one of the original proprietors of Lancaster, Mass., she was married to the minister there *ca.* 1656 and on Feb. 10, 1675/6, was carried into captivity when the Indians attacked and burnt Lancaster. Remaining in captivity for 11 weeks, she was ransomed and returned with her two surviving children; in 1677, she removed with her family to Wethersfield, Conn. Her narrative of her captivity entitled *The Soveraignty & Goodness of God, Together with the Faithfulness of His Promises Displayed, etc.* was first published in Cambridge, Mass., 1682, and became one of the most widely read pieces of 17th-century American prose.

ROWSE, SAMUEL WORCESTER (*b. Bath, Maine, 1822; d. Morristown, N.J., 1901*), painter, illustrator, lithographer. Gained wide reputation for his delicate, well-characterized crayon portraits of contemporary celebrities.

ROWSON, SUSANNA HASWELL (*b. Portsmouth, England, ca. 1762; d. Boston, Mass., 1824*), novelist, actress, educator. Cousin of Anthony Haswell. Raised in Massachusetts, daughter of an English officer, she returned to England, 1778; her first novel, *Victoria*, was published, 1786, and received favorable London notice. Later in the year, she married William Rowson. Three works which she published in 1788 and 1789 added little to her reputation, but early in 1791 she produced, and published in London, a novel which was to make her famous — *Charlotte, a Tale of Truth*. Sentimental and didactic, supposedly based on an actual affair of Col. John Montrésor, the book captivated the American fancy when it was reprinted in Philadelphia, 1794; it became the chief American "best seller" before *Uncle Tom's Cabin*. On the business failure of her husband, 1792, the family turned for support to the stage and were recruited in England by Thomas Wignell for his Philadelphia company. They acted mostly in minor parts in Philadelphia, Baltimore and Annapolis, 1793–96, and Mrs. Rowson wrote and adapted plays for the company. The Rowsons went to the Federal Street Theatre, Boston, in 1796; in the spring of 1797, Mrs. Rowson left the stage to devote the rest of her life to conducting a school for girls in or near Boston. She served as editor of the *Boston Weekly Magazine*, 1802–05, and continued to write for its successor *The Boston Magazine*; she also wrote for *The Monthly Anthology* and *The New England Galaxy*. Among other books which she published were *Reuben and Rachel* (1798), *Miscellaneous Poems* (1804), *Sarah, the Exemplary Wife* (1813) and a sequel to *Charlotte (Temple)* entitled *Charlotte's Daughter* (1828).

"ROXY." *See* ROTHAFEL, SAMUEL LIONEL.

ROYALL, ANNE NEWPORT (*b. Maryland, 1769; d. Washington, D.C., 1854*), author. Of uncertain parentage, she was raised in the house of William Royall, an eccentric Virginia farmer and scholar who undertook her education and married her in 1797. Engaged in a long litigation over his property after his death, she started out to earn her own living in 1824 by traveling over the United States and publishing accounts of her journeys. Vigorous, straightforward, truly liberal in her reforming zeal but indiscreet and often amateurish, she made herself the terror of the national capital and was noted especially for her ability to uncover graft. Her attacks against Presbyterians led to her trial and conviction in 1829 on the trumped-up charge of being a common scold. Her paper *Paul Pry* ran from December 1831 to November 1836; *The Huntress* began in December 1836 and was continued until just before her death. Among her ten volumes of travel and comment were *Sketches of History, Life and Manners in the United States* (1826), *The Black Book* (1828–29), and *Mrs. Royall's Southern Tour* (1830–31). These and her other works deserve to survive as valuable sources for study of U.S. social history in her time.

ROYCE, JOSIAH (*b. Grass Valley, Calif., 1855; d. Cambridge, Mass., 1916*), philosopher, educator. Child of a pioneer California family, Royce was indebted to his mother for his early education, both religious and secular. The family settled in San Francisco *ca.* 1866, where he attended school and spent many of his leisure hours in the Mercantile Library. The intellectual and moral influence of the California environment was lifelong in him and was effective in two of his later books, *California . . . A Study of American Character* (1886) and *The Feud of Oakfield Creek* (1887). Shy and sensitive, he felt a wistful need of social relations. The belief that a man's fullest development can be found only in the life of the "community" became a major topic in his philosophizing. His philosophical development consists essentially in the interaction of his instinctive Protestantism and moral individualism with the pantheistic, aesthetic doctrines which he acquired from Lotze, Schelling, Schopenhauer, Fichte, and Hegel. Graduating from the University of California, 1875, he spent the next year mainly at Göttingen and Leipzig; in 1876 he was invited to be one of the first twenty fellows appointed at the new Johns Hopkins University. A fellow in literature, he received the Ph.D. degree, 1878, for study in the history of philosophy and German literature in the 18th and 19th centuries.

While teaching English literature at the University of California, 1878–82, he schooled himself in the technicalities of philosophy by continuous reading and thinking. He reexamined Kant and Hegel and made a study of contemporary writers such as William James, Charles S. Peirce, and the psychologists Wundt and Bain. In an article of January 1882 he announced his adhesion to the school of post-Kantian idealism. Encouraged by William James to venture into philosophy, Royce went to Harvard to substitute for James in the fall and winter term, 1882–83; he remained at Harvard during the balance of his days. Soon earning the good opinion of students, colleagues, and President Eliot, he became assistant professor, 1885, professor, 1892, and in 1914, received the Alford Professorship of Natural Religion and Moral Philosophy. During the earlier years of his career, Royce's development was greatly influenced by association with William James, and he did extensive work in psychology, publishing *Outlines of Psychology* (1903). Although his friendship with James was lifelong, Royce soon manifested a divergence of view from James. As early as 1883 Royce noted in his diary a criterion of truth which he often reaffirmed. A given statement is true, he said, when "the contradictory of this statement would involve this statement itself." The mind thinks what (if it is to think at all) it cannot avoid thinking without contradicting itself. Under this dialectical compulsion, the mind escapes the skepticism of the passing moment and the relativities of a merely human experience — all of which is widely removed from James both in matter and doctrine. Royce, as the protagonist of monism, and James, as the friend of pluralism, became symbolic of a good-humored philosophical controversy.

Royce's first major philosophical work was *The Religious Aspect of Philosophy* (1885), in which he set forth a religious view of the world which does not imply but is consistent with a positive creed. The method of the book is a variant of the method of doubt and the argument falls into two main parts. The first part is an appeal to the thinker to postulate what is not given in experience and asks why should religion not be permitted to postulate a goodness at the heart of things which satisfies the highest moral needs, as science postulates the simplicity and orderliness of nature. In the second part of the argument, Royce supports postulate by proof and arrives at his famous "Absolute," or universal knower. The general metaphysical implications are evident. They are idealistic and monistic. In *The Conception of God* (1897) Royce attempts to reconcile the human prerogatives of freedom and responsibility with his metaphysical Absolute by insisting that the principle of individuation is choice or preference, that the Absolute is an individual consisting ultimately in a sheer act of will, and that this Absolute Will is parceled out among human beings, each of which wills independently within its own province. In *The Spirit of Modern Philosophy* (1892), Royce treats his subject with humor and eloquence and handles his beloved Romanticists together with Kant, Hegel, and Schopenhauer with tenderness and insight. *The World and the Individual* (1900, 1901) is the most important of his systematic works. In the first volume Royce argues an unqualified idealism; the constructive portion of the book gives to this characteristic doctrine, however, a new and significant development. In *The Religious Aspect of Philosophy* Royce had used the term "thought" to designate the processes of the Absolute, while in *The Conception of God* the emphasis had been shifted to "will." In the present book the term "purpose" plays a mediating role. Thought is essentially purposive. The key to its nature is found in the double meaning of ideas. An idea's "internal meaning" consists of the universals or ideal possibilities which constitute *what* is judged; its "external meaning" consists in the particular object to which it refers, and which constitutes that which is judged *about*. This object, while it lies beyond the idea, is embraced within mind as the experience to which the idea points as its own "fulfilment." The second volume of *The World and the Individual* is devoted to cosmological and practical applications.

Post 1900, Royce's interests developed in opposite but complementary directions toward a more technical and specialized treatment of logic, and toward a more popular treatment of moral, social, and religious problems; he was one of the first Americans after Charles S. Peirce to enter the field of symbolic logic and the philosophical foundations of mathematics. In *The Philosophy of Loyalty* (1908) he outlines a basis for ethical action; in *The Problem of Christianity* (1913) he gives his final interpretation of the Christian faith and also his most thorough treatment of the subject of religion. He selected as the three central Christian ideas, the Pauline Church, the "lost" state of the natural man, and atonement. These ideas he interpreted in terms of the "community," as being the supreme object of the individual's loyalty, by estrangement from which man is lost, and by whose spirit and service he is restored. The effect of these ethical and religious studies was to bring the metaphysical Absolute into nearer relation to man. The Absolute assumes the form of a personified "Beloved Community," to which the individual man was bound by a sort of patriotic fervor, or blend of self-sacrifice and self-aggrandizement. Interpretations are triadic, involving a sign, an interpreter, and a second mind to which the interpretation is communicated. Thus, Royce argues, interpretation involved a *community* of two or more minds. Knowledge is creative of being, but knowledge is now construed as a social affair — a community of interpretation.

After the death of William James, Royce was the most influential American philosopher of his day and the leading exponent in America of post-Kantian idealism of which he represented the voluntaristic wing. He may be said to stand close to Fichte, but he was distinguished from German neo-Fichteans not only by his profound metaphysical passion but also by the English and American strains in his inheritance. Any mere doctrinal classification of Royce is inadequate, for he was a man of rich experience and varied talents. His defects as a thinker and writer flowed from a tendency to prolixity. His processes of mind were powerful, massive but laborious.

ROYCE, RALPH (*b. Marquette, Mich., 1890; d. Homestead Air Force Base, Fla., 1965*), U.S. Air Force officer. Graduated from the U.S. Military Academy (1913) and attended the Signal Corps Aviation School (1915–16). Assigned to the First Aero Squadron,

assuming command of the squadron with U.S. entry into World War I; his dash and intrepidity during missions in France won him the Croix de Guerre. After the war he held several commands, and in 1941 became military attaché for air in London and was promoted to brigadier general. World War II commands included the Northeast Sector of the Allied Air Forces in Australia and U.S. Air Forces in the Middle East, headquartered in Cairo (1943); he was air officer aboard the cruiser *Augusta* on D day. He retired as a major general in 1946.

ROYE, EDWARD JAMES (*b. Newark, Ohio, 1815; d. at sea, off Liberia, 1872*), schoolteacher, businessman. Leading merchant of Liberia, *post ca.* 1848. Inaugurated fifth president of Liberia, January 1871, he was deposed in October on charges of mishandling a loan and boundary dispute with England.

ROYSTER, JAMES FINCH (*b. Raleigh, N.C., 1880; d. Richmond, Va., 1930*), philologist, educator. Graduated Wake Forest College, 1900; Ph.D., University of Chicago, 1907. Taught at Universities of North Carolina and Texas. Dean of college of liberal arts, University of North Carolina, 1922–25; dean of graduate school, 1925–29.

RUARK, ROBERT CHESTER (*b. Southport, N.C., 1915; d. London, England, 1965*), journalist and novelist. Attended University of North Carolina (B.A., 1935). Copyboy for the Washington, D.C., *Daily News* (1937), becoming assistant city editor by 1942. Washington correspondent for the Newspaper Enterprise Association Service (1942–45) and for Scripps-Howard Newspaper Alliance (1945). In 1946 he became a columnist for Scripps-Howard and United Feature Service in New York. Author of the novels *Something of Value* (1955), *The Old Man and the Boy* (1957), and *Uhuru* (1962).

RUBEY, WILLIAM WALDEN (*b. Moberly, Mo., 1898; d. Santa Monica, Calif., 1974*), geologist. Graduated University of Missouri (B.A., 1920), attended Johns Hopkins University (1921–22) and Yale University (1922–24), and joined the U.S. Geological Survey in 1920; he worked full-time for the survey from 1924 to 1960. He did fieldwork in the overthrust-fault area of southwestern Wyoming for over fifty years, prepared a landmark report on the geological history and structure of Illinois, studied the geology of the flat midcontinent and Great Plains region, and investigated mineral resources at the site of the Hoover Dam. In 1960 he became a professor at the University of California, Los Angeles, and continued to advise the U.S. Geological Survey and other government science agencies.

RUBICAM, RAYMOND (*b. Brooklyn, N.Y., 1892; d. Scottsdale, Ariz., 1978*), advertising agency executive. Entered the advertising industry in 1916, working for F. Wallis Armstrong and then N. W. Ayer, where he developed the slogan "The Instrument of the Immortals" for Steinway pianos. With John Orr Young, he formed Young & Rubicam in 1923 in Philadelphia. In 1924 Y&R won a contract with General Foods to promote the languishing product, Postum; the success of their campaign led to promotional contracts for other company brands, including Sanka Coffee and Jell-O. Y&R later developed accounts with such clients as Gulf Oil, Parke Davis drugs, and Travelers Insurance, following what came to be known as the image school of advertising, which emphasized the personality of a product rather than the traditional claim and reason-why basis for ads. Rubicam retired in 1944; Y&R grew to be the largest advertising agency in the country during the 1970's.

RUBIN, ISIDOR CLINTON (*b. Vienna, Austria, 1883; d. London, England, 1958*), gynecologist. Studied at the City College of New York and at Columbia University (M.D., 1905). Working at New York's Mt. Sinai and Beth Israel Hospitals and teaching at Columbia and New York University, Rubin was the foremost gynecologist of his generation, specializing in fertility. He discovered that the ovum was conveyed to the uterus by the peristaltic waves of the fallopian tubes. In 1919, Rubin performed the first successful test to determine the patency of the fallopian tubes; this work brought him international fame.

RUBINOW, ISAAC MAX (*b. Grodno, Russia, 1875; d. New York, N.Y., 1936*), physician, social worker, economic statistician, Jewish leader. Came to America, 1893. Graduated Columbia, 1895; M.D., New York University, 1898. Practicing among the poor, Rubinow became convinced that ill health was as much an economic as a medical problem. In 1903 he gave up medical practice to become an expert in economics and statistics in the U.S. Department of Agriculture, the first of a succession of posts he held in the federal government. His report of European legislation on industrial accidents (1911) helped lay the foundation for state workmen's compensation laws passed, 1911–20. Leaving federal service, he worked for a time on studies of insurance for private companies and associations, but he is particularly remembered as a pioneer in the American social security movement. He was author of, among other books, *The Care of the Aged* (1931) and *The Quest for Security* (1934).

RUBINSTEIN, HELENA (*b. Cracow, Poland, 1870; d. New York, N.Y., 1965*), beauty expert and cosmetics manufacturer. Attended the medical school of the University of Cracow and was sent by her family to Australia in 1890. She took with her a supply of a special face cream that had long been used by her family and established (1902) the country's first beauty salon in Melbourne. Within a few years she amassed a small fortune from the sale of the cream; she subsequently invented and sold a wide variety of other preparations. In 1915 she moved to the United States and began to build a worldwide corporation. By the 1920's she had salons throughout Europe. World War II forced the closing of most European salons, and she contributed to the war effort by creating cosmetics for disfigured servicemen. In the 1940's she opened salons in Latin America, and in the 1950's, in Japan. She was also widely known as a collector of art, jewelry, and antiques.

RUBLEE, GEORGE (*b. Madison, Wis., 1868; d. New York, N.Y., 1957*), lawyer and statesman. Studied at Harvard University (LL.B., 1895). Rublee entered public life in 1913 as Louis D. Brandeis' liaison with Congress; in 1914, he wrote the key provision of the Federal Trade Commission Act which was a "decisive event in the history of the antitrust program." In 1918–19, President Wilson sent Rublee to the London Conference of the Allied Maritime Transport Council, which pooled and allocated shipping for war use. In 1938, Roosevelt appointed him director of the Intergovernmental Committee on Refugees. He served until 1939, when he resigned because of the unwillingness of governments to accept Jewish refugees.

RUBLEE, HORACE (*b. Berkshire, Vt., 1829; d. Milwaukee, Wis., 1896*), editor, diplomat. Raised in Wisconsin. Editorial writer and co-proprietor, *Wisconsin State Journal*, 1853–68, Rublee was active in the Republican party from its birth. After serving as U.S. minister to Switzerland, 1869–76, he returned to journalism, and was associated *post* 1881 with the *Daily Milwaukee Republican* and the *Milwaukee Sentinel*.

RUBY, JACK L. (*b. Chicago, Ill., 1911; d. Dallas, Tex., 1967*), assassin of Lee Harvey Oswald. A quick-tempered, disobedient, and incorrigible youth, he engaged in commercial ventures on Chicago streets until 1947, from which time until 1963 his main

source of income was the operation of nightclubs and dance halls in Dallas. On Nov. 24, 1963, two days after Oswald assassinated President John Kennedy, as Oswald was being transferred to another jail, Ruby shot and killed him while a national television audience witnessed the event. Ruby maintained he shot Oswald to spare Mrs. Kennedy the ordeal of returning to Dallas to testify in a trial. He was convicted of murder and sentenced to death, but his conviction was reversed on appeal (1966); he died in jail while awaiting a second trial. Various theories attempted to link Ruby and Oswald with a conspiracy to kill President Kennedy, but none of several official investigations found any proof for these allegations.

RUCKER, GEORGE ("NAP") (b. Crabapple, Ga., 1884; d. Crabapple, 1970), major-league baseball player. First played professionally in 1904 with the Atlanta Crackers, then joined Augusta's South Atlantic League team (1905–06). He signed with the Brooklyn Dodgers in 1907 as a pitcher and quickly established himself as the best left-handed pitcher in the major leagues. Despite the weakness of the Dodgers of his time, he pitched a perfect game in 1908 and had thirty-eight shutouts in his career; his sixteen strikeouts against the Cardinals in 1909 was his greatest performance, giving him the National League's single-game strikeout record until 1933. He retired as a player in 1916, then became a Dodger scout.

RUCKSTULL, FREDERICK WELLINGTON (b. Breitenbach, Alsace, France, 1853; d. New York, N.Y., 1942), sculptor. Immigrated with parents to the United States, 1855; raised in St. Louis, Mo. Studied at Washington University art school, and in Paris with G. Boulanger and C. Lefèvre; had his studio in New York City post 1892. Dedicated to the neo-Baroque classicism of his time, he practiced with success and was especially gifted as an organizer and coordinator of large sculpture projects, e.g., the Dewey Arch in New York City, and the Appellate Court Building, also in New York.

RUDGE, WILLIAM EDWIN (b. Brooklyn, N.Y., 1876; d. 1931), printer, typographer. Influential in the encouragement of good design and fine printing post 1912.

RUDITSKY, BARNEY (b. London, England, 1898; d. Los Angeles, Calif., 1962), policeman and private detective. Joined New York City police force in 1921; promoted to detective in 1924. Working with Detective Johnny Broderick, they became leaders of a special antigangster squad assigned to combat organized crime in New York City. His exploits as a detective during Prohibition became the basis for the television series "The Lawless Years." Became a private detective after World War II and moved to Los Angeles (1948), where he worked for and against Hollywood stars. His most famous and bizarre episode involved his being hired by Joe Di Maggio to spy on his then-wife, Marilyn Monroe.

RUDKIN, MARGARET FOGARTY (b. New York, N.Y., 1897; d. New Haven, Conn., 1967), business executive. In 1937, after a doctor suggested that chemical additives in commercially baked goods were aggravating her son's asthmatic condition, she began baking her own whole wheat bread with stone-ground flour; when her son's condition improved, the allergist asked her to make the bread for other patients, which generated a sizable mail-order business. From that small beginning, she established Pepperidge Farm, a business that provided bakery products for people who wanted the quality of homemade goods and were willing to pay for them. Through favorable local and then national publicity, the business grew at a phenomenal rate; 1960 profits were $1.3 million on annual sales of $32 million. In 1960

she sold the company to Campbell Soup Company for $28 million in Campbell stock.

RUEF, ABRAHAM (b. San Francisco, Calif., 1864; d. San Francisco, 1936), lawyer. Graduated University of California, 1883; Hastings College of Law, 1886. Rose to political power through control of the Union Labor party post 1901 and became boss of his native city. Engaged in numerous corrupt practices, he was exposed by, among others, Fremont Older, Francis J. Heney, and James D. Phelan. After trial and conviction, he was in prison, 1911–15.

RUFFIN, EDMUND (b. Prince George Co., Va., 1794; d. Amelia Co., Va., 1865), agricultural experimenter and writer, farmer. After making trial of the use of marl on his worn-out fields (adopting a suggestion from Sir Humphrey Davy's Elements of Agricultural Chemistry, he concluded that soils once fertile but reduced by harmful cultivation had lost their power to retain manures. He believed that this condition could be corrected by the application of calcareous earths and that a fertility equal to or greater than the original could be acquired by the use thereafter of fertilizers, crop rotation, drainage, and good plowing. Presenting his theories and results in written form on several occasions, he issued them in 1832 in a volume entitled An Essay on Calcareous Manures which had wide influence. Active in the organization of agricultural societies, he became agricultural surveyor of South Carolina, 1842, publishing a report in the next year which became a landmark in the agricultural history of that state. He was a prolific writer on other topics as well as agriculture, especially in defense of slavery and states' rights. Originally a Whig, he became a Democrat as the struggle over states' rights developed and was one of the first secessionists in Virginia. He originated the League of United Southerners, was invited to sit in three secession conventions, and as a volunteer with the Charleston Palmetto Guard, fired the first shot from Morris Island against Fort Sumter. On the collapse of the Confederacy, he ended his own life.

RUFFIN, THOMAS (b. King and Queen Co., Va., 1787; d. Hillsboro, N.C., 1870), jurist. Graduated College of New Jersey (Princeton), 1805; studied law in Petersburg, Va., and in North Carolina under Archibald D. Murphey; practiced in Hillsboro post 1808. After holding several minor court posts, he served as associate justice of the North Carolina supreme court, 1829–33, and as chief justice, 1833–52; in 1858 he was called back to the supreme court, but served for only one year. An ardent Unionist, he denied any constitutional right of secession, but after the failure of a compromise which he offered the North Carolina secession convention, he voted for the ordinance and supported the Confederate war effort. In constitutional law, the authorities rank him with John Marshall and Lemuel Shaw. He was equally noted in common law and equity.

RUFFNER, HENRY (b. Shenandoah Co., Va., 1790; d. 1861), Presbyterian clergyman, educator. Graduated Washington College, Lexington, Va., 1813. Taught at Washington College, 1819–48, at times acted as president, and was president in fact, 1836–48. In his Address to the People of West Virginia (1847), he argued for confinement of slavery to the region east of the Blue Ridge and its gradual abolition there on broad grounds of public policy.

RUFFNER, WILLIAM HENRY (b. Lexington, Va., 1824; d. Asheville, N.C., 1908), Presbyterian clergyman, educator. Son of Henry Ruffner. Graduated Washington College, 1842. As Virginia state superintendent of public education, 1870–82, Ruffner drew a school law which became a model for other Southern

states and secured its enactment by the legislature. For his services to the schools, especially for his solution of the problem of the relation of church and state in the educational field, he has been called the "Horace Mann of the South."

RUGER, THOMAS HOWARD (*b. Lima, N.Y., 1833; d. Stamford, Conn., 1907*), lawyer, Union soldier. Graduated West Point, 1854. Commissioned colonel of the 3rd Wisconsin Infantry early in the Civil War, he distinguished himself at Antietam. Promoted brigadier general, 1862, he succeeded to divisional command at Gettysburg; in October 1863 he was transferred to brigade command in the West, took part in all of Sherman's operations, and won brevet of major general of volunteers for service at the battle of Franklin, November 1864. Remaining in the army, he was superintendent at West Point, 1871–76, and saw a variety of service in the West and Northwest. He retired as regular major general, 1897.

RUGG, ARTHUR PRENTICE (*b. Sterling, Mass., 1862; d. Sterling, 1938*), lawyer, jurist. Graduated Amherst, 1883. Appointed associate judge of the supreme judicial court of Massachusetts, 1906, he was made chief justice in 1911 and retained this position until his death. His almost 3,000 opinions were uniformly excellent and affected very nearly the entire body of the law of the commonwealth.

RUGG, HAROLD ORDWAY (*b. Fitchburg, Mass., 1886; d. Woodstock, N.Y., 1960*), educator and author. Studied at Dartmouth College and the University of Illinois (Ph.D., 1915). A social reconstructionist with a speciality in curriculum design, Rugg taught at Columbia University's Teachers College from 1920 to 1951. His major publications were fourteen pamphlets entitled "Man and His Changing Society" published between 1929 and 1945. Controversial, these works were critiques of American society that were termed subversive by 1940, and precipitated one of the most sensational cases of textbook censorship in American educational history.

RUGGLES, SAMUEL BULKLEY (*b. New Milford, Conn., 1800; d. Fire Island, N.Y., 1881*), lawyer, New York canal commissioner, 1839–58. Practiced in New York City *post* 1821; developed Gramercy Park, New York City, 1831, and was also active in promoting creation of Union Square. He was a strong influence in the liberalization of Columbia College and its development into a university.

RUGGLES, TIMOTHY (*b. Rochester, Mass., 1711; d. Wilmot, N.S., Canada, 1795*), Massachusetts provincial legislator and jurist, soldier, Loyalist. Graduated Harvard, 1732. Rose to rank of brigadier general in the French and Indian War. Elected president of the Stamp Act Congress, 1765, over James Otis, Ruggles would not sign the petitions which were drawn up, alleging scruples of conscience. A supporter of Governor Thomas Hutchinson, he was made a Mandamus Councilor, 1774, and late in that year strove to form an association of Loyalists pledged not to acknowledge or submit to the pretended authority of any congress. Appointed to command three companies of Tory volunteers to be called the Loyal American Associators, November 1775, Ruggles was for a brief time with the British on Long Island. Banished from Massachusetts, 1778, his estates were confiscated and he removed to Nova Scotia, 1783.

RUHL, ARTHUR BROWN (*b. Rockford, Ill., 1876; d. Queens, N.Y., 1935*), journalist, foreign correspondent, dramatic critic. Author, among other books, of *White Nights and other Russian Impressions* (1917).

RUHRÄH, JOHN (*b. Chillicothe, Ohio, 1872; d. 1935*), pediatrician. Studied at present University of Maryland and at Johns Hopkins; practiced *post* 1894 in Baltimore, Md., and taught at University of Maryland, with intervals of study abroad. Made first collective investigation of actinomycosis in United States, 1899–1900; introduced use of soybean in infant dietetics, 1909. Author of *Pediatrics of the Past* (1925) and other works, he contributed articles on his specialty to most of the modern encyclopedias and systems of medicine.

RUKEYSER, MURIEL (*b. New York City, 1913; d. New York City, 1980*), poet, author, and social activist. Attended Vassar College (1930–32) and Columbia University and worked as literary editor for *New Theater* magazine and contributed poems to such periodicals as *Poetry*. Her writing featured social commentary and highlighted her activist politics. Her second volume of poems, *U.S. 1* (1938), included the series of poems "The Book of the Dead," which detailed a West Virginia mining town dying of silicosis. Rukeyser released numerous collections, including *Wake Island* (1942) and *The Outer Banks* (1967). She also wrote several books for children, including *Come Back Paul* (1955). She served on the faculty of Sarah Lawrence College from 1956 to 1967.

RUMFORD, BENJAMIN THOMPSON, COUNT *See* THOMPSON, BENJAMIN.

RUML, BEARDSLEY (*b. Cedar Rapids, Iowa, 1894; d. Danbury, Conn., 1960*), publicist. Studied at Dartmouth College and at the University of Chicago (Ph.D., 1917). Ruml successfully combined academic, business, and government service in his career. From 1921 to 1930, he was director of the Laura Spelman Rockefeller Memorial; from 1931 to 1934, he was dean of the social science division at the University of Chicago; and from 1934 to 1951, he was treasurer, chairman, and director of Macy's Department Store in New York while at the same time serving as director of the New York Federal Reserve Bank (1937–47). But Ruml is especially remembered for his "pay-as-you-go" income tax plan. Because of the difficulties most American servicemen encountered in paying taxes for their civilian earnings when they were earning minimal wages in the armed forces, Ruml devised what is essentially the withholding tax plan we know today, passed in 1943 as the Tax Payment Act.

RUMMEL, JOSEPH FRANCIS (*b. Steinmauern, Germany, 1876; d. New Orleans, La., 1964*), Roman Catholic archibishop. Attended St. Anselm's College, St. Joseph's Seminary ("Dunwoodie"), North American College in Rome, and Pontifical Urban University; ordained in 1902. Served as a curate, pastor, and vicar in various churches in New York State, 1903–28, when he was named ordinary of Omaha. Promoted to the New Orleans archbishopric (1935); his jurisdiction covered 13,200 square miles in twenty-three Louisiana parishes. He was a staunch defender of human rights, especially of racial justice, and was the first Catholic bishop to publicize a resolution upholding the Supreme Court decision in *Brown v. Board of Education* (1954).

RUMSEY, CHARLES CARY (*b. Buffalo, N.Y., 1879; d. 1922*), sculptor, polo player. Rumsey's bronzes depicting polo ponies and their riders were particularly effective; notable among his monumental works is an equestrian "Pizarro" now in the city of Lima, Peru. His compositions attained a rhythm and dynamic power which gave them individuality in spite of the evident influences of Rodin, Bourdelle, and Maillol.

RUMSEY, JAMES (*b. Bohemia Manor, Md., 1743; d. London, England, 1792*), inventor. Encouraged by George Washington and others in his efforts to produce a boat propelled by steam,

Rumsey exhibited on the Potomac River in December 1787 a vessel propelled by streams of water forced out through its stern; the force pump was operated by a steam engine. He also developed an improved steam boiler, an improved grist mill and saw mill, and a plan for raising water by means of a steam engine. Securing English patents on his boiler and steamboat, and U.S. patents in 1791, he was unable to raise sufficient capital for manufacture.

RUMSEY, MARY HARRIMAN (*b. New York, N.Y., 1881; d. 1934*), leader in public welfare. Daughter of Edward H. Harriman; wife of Charles C. Rumsey. Graduated Barnard College, 1905. Conceived idea of organizing New York Junior League for public and social service, 1901; served five years as its president. Active as a cattle breeder, sportswoman, and art patron, she was also an advocate of cooperative movements and a worker for many civic and charitable enterprises, private and public.

RUMSEY, WILLIAM (*b. Bath, N.Y., 1841; d. 1903*), Union soldier, lawyer. Judge, New York State supreme court, 1880–1901. Author of one-time standard work on New York State practice.

RUNCIE, CONSTANCE FAUNT LE ROY (*b. Indianapolis, Ind., 1836; d. Winnetka, Ill., 1911*), composer, pianist. Niece of David and Robert D. Owen.

RUNKLE, JOHN DANIEL (*b. Root, N.Y., 1822; d. 1902*), mathematician, educator. Graduated Lawrence Scientific School, Harvard, 1851. Professor of mathematics, Massachusetts Institute of Technology, 1865–68, 1880–1902. Appointed acting president of the Institute, 1868, he held the title of president, 1870–78. He established the Lowell School of Practical Design, 1872, and was associated with the work of the *Nautical Almanac*, 1849–84.

RUNYON, DAMON (*b. Manhattan, Kans., 1880; d. New York, N.Y., 1946*), journalist, short story writer. After working on a number of small-town newspapers in Colorado, where he was raised, he became star reporter of the Denver *Rocky Mountain News*. Joining the staff of the *New York American*, 1911, he made a success as a writer of colorful sports news; thereafter, he was a war correspondent in Mexico and France, a reporter of crimes and trials, and the top feature writer of the Hearst organization. He is remembered in particular for a number of magazine short stories, written in and after 1929, of which *Guys and Dolls* (1931) was the first of several collections in book form. Well plotted and told in a special style of picturesque slang, they dealt with a cast of Broadway characters that never were in life but were wonderfully entertaining to read about. Many of the stories were adapted for the stage and screen.

RUPP, ADOLPH FREDERICK (*b. Halstead, Kans., 1901; d. Lexington, Ky., 1977*), college basketball coach. Graduated University of Kentucky (B.A., 1923) and Columbia University (M.A., 1930) and became head coach of the University of Kentucky basketball team (1930–72), during which time he won four national collegiate championships. Rupp's legendary teams featured an up-tempo, fast-breaking offense and pressure man-to-man defense. In 1952 the Kentucky team was penalized after investigators discovered illegal cash payments to Kentucky players and point shaving by team members. In a celebrated match in 1966, Rupp, who refused to recruit African–American players until the late 1960's, lost the national championship game to a Texas Western University team that featured five African–American starters. He retired in 1972 and was elected to the Basketball Hall of Fame.

RUPP, ISRAEL DANIEL (*b. Cumberland Co., Pa., 1803; d. Philadelphia, Pa., 1878*), schoolmaster, historian. Author of *History of Lancaster County* (1844) and other volumes devoted to the county history of Pennsylvania.

RUPP, WILLIAM (*b. Lehigh Co., Pa., 1839; d. 1904*), German Reformed clergyman, professor of theology, editor. Taught at his denomination's seminary in Lancaster, Pa., *post* 1894.

RUPPERT, JACOB (*b. New York, N.Y., 1867; d. New York, 1939*), brewer, New York Democratic congressman. Co-owner (1914–23) and sole owner thereafter of the New York Yankees baseball club.

RUSBY, HENRY HURD (*b. Franklin, present Nutley, N.J., 1855; d. Sarasota, Fla., 1940*), pharmacognosist, botanical explorer. M.D., New York University, 1884. Traveling as pharmacognosist for Parke, Davis & Co., 1884–88, Rusby made extensive investigations in North and South America and collected specimens of some 45,000 species of plants, many of them hitherto unknown to botany; among the new drugs which resulted was cocillana. Appointed professor of materia medica at New York College of Pharmacy, 1889, he became dean in 1901 and remained so until 1930 after the college was affiliated with Columbia University. He also taught at other institutions in New York and made further botanical collections in South America. By teaching, research, and writings, he established beneficial standards for pharmaceutical education and for American pharmacy at large. He was one of the foremost early exponents in America of the study of medicinal plants on a truly scientific basis and gave much knowledge and time to the formulation of legal standards for crude plant drugs.

RUSH, BENJAMIN (*b. Byberry, near Philadelphia, Pa., 1745 o.s.; d. Philadelphia, Pa., 1813*), physician, Revolutionary patriot. Graduated College of New Jersey (Princeton), 1760. Studied medicine with John Redman and attended first lectures of William Shippen and John Morgan at the College of Philadelphia; completing his medical education at the University of Edinburgh, he received its doctorate in 1768. Returning to Philadelphia, 1769, Rush began to practice medicine and to teach chemistry at the College of Philadelphia. He published the first American chemistry text, *A Syllabus of a Course of Lectures on Chemistry* (1770), and attracted attention by his unusual ability as practitioner of a new system of treatment taught by his Edinburgh master, the great William Cullen. He also wrote at length on medical, social, and political topics, and, as the quarrel between the colonies and the mother country mounted, he became the associate of patriot leaders like John Adams and Thomas Jefferson. Elected to the Continental Congress, 1776, he was a singer of the Declaration of Independence.

Appointed surgeon general of the Middle Department in the medical service of the Continental Army, 1777, he accused Dr. William Shippen, his superior, of maladministration and resigned when a decision was given against him. Association in the Conway Cabal and General Washington's recognition of his part in it (1778) ended Rush's military career and he returned to his practice in Philadelphia. Becoming a member of the staff of the Pennsylvania Hospital, 1783, he served in that capacity for the rest of his life. Sponsor of a number of ameliorative movements which went to remold America in the ensuing century, he was active against slavery and capital punishment and advocated temperance, an improved educational system, and prison reform. His ideas on social reform may be found in his *Essays, Literary, Moral and Philosophical* (1798). In the Pennsylvania convention for ratifying the new U.S. Constitution, he and James Wilson led the successful movement for adoption; in 1789, they inaugurated

a campaign which secured a more liberal and effective state constitution for Pennsylvania. After the creation of the University of Pennsylvania, 1791, Rush became professor of the institutes of medicine and clinical practice in the university (1792) and in 1796 succeeded Dr. Adam Kuhn as professor of theory and practice as well. He was treasurer of the U.S. Mint, 1797–1813.

It is impossible to describe Rush's system of theory and practice briefly without oversimplification, but it might be called a logical extension of John Brown's reformulation (1788) of Cullen's theory. The essential principle was that all diseases were due to one "proximate" cause—a state of excessive excitability or spasm in the blood vessels. Hence, in most cases but one treatment was called for, namely, "depletion" through bleeding and purging. He confidently proclaimed his system when the initial volume of his *Medical Inquiries and Observations* was published in 1789, but critics declared that Rush's fondness for depletion led him to dangerous extremes in practice. In the epidemic of yellow fever which descended upon Philadelphia, 1793, Rush worked with desperation and devotion in the stricken city, but it was pointed out that there was an obvious correlation between increasing employment of Rush's treatment and an increasing mortality rate. Although Rush's treatment was not the only variable involved, yet it was impossible to reconcile his claims with the stark fact of the mortality tables, and he may be considered the victim of a credulity about diagnoses and cures which characterized much of his work. Also, his view that the "remote" cause of the epidemic was unsanitary conditions in the city antagonized many citizens. Despite all this, his published account of the epidemic and of those which followed it won him recognition both at home and abroad. His chief essay on the subject is *An Account of the Bilious Remitting Yellow Fever . . . 1793* (1794). Dr. Rush was an observant man but not a good observer. However, there is reason to believe that he was the pioneer worker in experimental physiology in the United States, and he was the first American to write on *cholera infantum* and the first to recognize focal infection in the teeth. His contributions to psychiatry were also notable, and his *Medical Inquiries and Observations upon the Diseases of the Mind* (1812) shows some appreciation of what would today be known as mental healing and even of psychoanalysis.

RUSH, JAMES (*b. Philadelphia, Pa., 1786; d. Philadelphia, 1869*), physician, psychologist. Son of Benjamin Rush; brother of Richard Rush. Graduated College of New Jersey (Princeton), 1805; M.D., University of Pennsylvania, 1809. Founder of the Ridgway Branch Library Company of Philadelphia.

RUSH, RICHARD (*b. Philadelphia, Pa., 1780; d. Philadelphia, 1859*), lawyer, statesman, diplomat. Son of Benjamin Rush; brother of James Rush. Graduated College of New Jersey (Princeton), 1798. Admitted to the Philadelphia bar, 1800, he grew in reputation as a speaker and made important political contacts as defense counsel for William Duane when Thomas McKean sued that editor for libel, 1808. An ardent Democratic-Republican, Rush became attorney general of Pennsylvania, 1811, and was appointed comptroller of the U.S. treasury in November of that year. Appointed U.S. attorney general, February 1814, he edited *Laws of the United States* (1815), and in a brief period as U.S. secretary of state just after the inauguration of President Monroe, negotiated the Rugh-Bagot convention (April 1817) establishing limitation of naval armament on the Great Lakes. Appointed U.S. minister to Great Britain, October 1817, he was one of the most efficient and best-liked of American representatives in that post. Tactful, well-bred and with wide intellectual interests, he moved with ease in British society and succeeded in settling a number of disputes subsequent to the War of 1812. He negotiated a treaty of joint occupation of Oregon which served as a basis of understanding for nearly thirty years, and in 1819 handled wisely the issues raised by Andrew Jackson's invasion of Florida and the execution of Ambrister and Arbuthnot. Rush played a very important role in the preliminaries of the Monroe Doctrine, and his dispatches of August — September 1823 were an important factor in persuading President Monroe and John Quincy Adams to take a strong stand. Accepting the post of U.S. secretary of the treasury, 1825, he favored a mild protectionist policy. Candidate for vice president of the United States, 1828, he was badly defeated in the Jacksonian triumph. As a private citizen, he continued active in the public interest, supported Andrew Jackson in the 1832 struggle over the Bank, and in 1835 served on a commission to settle the Ohio–Michigan boundary dispute. In 1836–38 he secured the Smithson bequest, then in chancery, which was used to establish the Smithsonian Institution. U.S. minister to France, 1847–49, he acted with his usual intelligence and tact during the revolutionary days of 1848 in Paris. Returning home, he continued interested in public affairs until his death. He was author of the important *Memoranda of a Residence at the Court of London* (1833, 1845) and *Occasional Productions . . .* (1860).

RUSH, WILLIAM (*b. Philadelphia, Pa., 1756; d. 1833*), carver of ship's figureheads, first native American sculptor. Worked in Philadelphia; co-founder, with Charles W. Peale and others, of the Pennsylvania Academy of the Fine Arts, 1805.

RUSHING, JAMES ANDREW (*b. Oklahoma City, Okla., 1903; d. New York City, 1972*), singer and musician. His first significant job as a jazz pianist was in Los Angeles in 1925 with the band of Jelly Roll Morton; he next joined, as a singer, the Blue Devils, led by bassist Walter Page and including William ("Count") Basie on piano. Basie and Rushing performed together with other bands, until Basie formed his own band in 1936 with Rushing as lead singer; this partnership was one of the most famous in the history of popular music and jazz. Rushing left Basie in 1950 to form his own group and in 1952 began a career as a predominantly solo singer. He enjoyed limited success until the 1970's.

RUSK, JEREMIAH MCCLAIN (*b. Morgan Co., Ohio, 1830; d. 1893*), farmer, businessman, Union soldier. Settled in Vernon Co., Wis., 1853. As Republican governor of Wisconsin, 1882–89, he gave the state a strong and effective government, earning the affectionate title "Uncle Jerry"; in quelling strike riots in Milwaukee, May 1886, he uttered a much-quoted remark, "I seen my duty and I done it." While U.S. secretary of agriculture, 1889–93, he secured inspection of all American meat exports and engaged the interest of the press in the activities and policies of his new department.

RUSK, THOMAS JEFFERSON (*b. Pendleton District, S.C., 1803; d. Nacogdoches, Tex., 1857*), Texas pioneer, soldier, jurist. Removed to Texas *ca.* 1835. Took active part in the convention of 1836, signed declaration of independence for Texas, aided in drafting of Texas constitution, and was elected secretary of war in the provisional government. Rusk fought at San Jacinto, commanding the Texas army after that battle. Appointed secretary of war in Sam Houston's cabinet, he soon resigned to practice law but led an active campaign against hostile Indians in East Texas Supreme Court, 1838, he presided over its first session, January–June 1840. A supporter of annexation of Texas to the United States, he served as U.S. senator, Democrat, *post* 1846, giving full support to the administration in the war with Mexico and working consistently for improvement of transportation. Choice of many delegates for the presidential nomination, 1856, he refused to have his name entered.

RUSS, JOHN DENNISON (*b. Essex, Mass., 1801; d. Pompton, N.J., 1881*), physician, penologist, pioneer teacher of the blind. Graduated Yale, 1823; M.D., Yale, 1825. Associated with Samuel G. Howe in support and relief of Greek revolutionaries, 1827–30; practiced in New York City *post* 1830. Cofounder of New York Institution for the Blind which he served as manager, 1832–35.

RUSSELL, ANNIE (*b. Liverpool, England, 1864; d. Winter Park, Fla., 1936*), actress, noted for ingenue roles. Made debut as a child actress in Montreal, Canada, 1872; made New York debut in a juvenile performance of *H.M.S. Pinafore* at the Lyceum Theatre, 1879; established herself in popular favor in title role of *Esmeralda*, 1881. Among her later important parts were the title role in *Hazel Kirke* and in Shaw's *Major Barbara*; she was effective also in Shakespearean repertory.

RUSSELL, BENJAMIN (*b. Boston, Mass., 1761; d. 1845*), journalist. Learned to set type in office of Isaiah Thomas to whom he was apprenticed. Founded *The Massachusetts Centinel* (first issued, March 24, 1784) which he edited and published until his retirement, 1828; *post* 1790 the paper was known as the *Columbian Centinel*. A vigorous writer, Russell took an active part in politics and made his Federalist paper the most enterprising and influential in Massachusetts. He held many public offices both honorary and elective.

RUSSELL, CHARLES EDWARD (*b. Davenport, Iowa, 1860; d. Washington, D.C., 1941*), journalist, socialist, reformer. Held various newspaper posts in the Midwest and New York City, including city editor of the New York *World* (1894–97), managing editor of the *New York American* (1897–1900), and publisher of the *Chicago American* (1900–02); he also lectured on free trade and worked for the Populists. Following a period of poor health, he wrote a series of articles on the Beef Trust for *Everybody's Magazine* (1905), which established him as a leading muckraker. He continued this line of activity in magazine articles and a number of books, exposing the evils of child labor, railroad finance, electoral frauds, and the concentration of wealth. Active in the right wing of the Socialist party, 1908–17, he was expelled from the party for his advocacy of U.S. participation in World War I, but continued to hold socialist views and lent his support to countless campaigns for social justice and civil liberties. An idealist, a gradualist, more interested in facts than in theories, and ever optimistic, he refused to be forced either into disappointed apathy or the advocacy of violence. Among his many books were *The American Orchestra and Theodore Thomas* (1927, a winner of the Pulitzer Prize) and an autobiography, *Bare Hands and Stone Walls* (1933).

RUSSELL, CHARLES ELLSWORTH ("PEE WEE") (*b. Maple Wood, Mo., 1906; d. Alexandria, Va., 1969*), jazz musician. Became a full-time professional clarinetist in 1922; for the next five years he worked as an itinerant player of a music that was increasingly being called "jazz." He apprenticed with numerous bands that included instrumentalists of major reputation of the burgeoning art form. In 1925 he often worked with Bix Beiderbecke and fell under the influence of what was later called the Chicago style of jazz. He emulated the tone of Frank Teschemaker, evident on Russell's first recording, "Ida," made with Red Nichols and His Five Pennies (1927). In the late 1930's he joined Louis Prima's band. From 1938 to 1950 he did his best-remembered work with the "Condon mob," a group of musicians who played for Eddie Condon. In 1950 he organized his own group, then rejoined Condon in 1955, remaining with him until 1961. He captured the *Downbeat* readers' poll for clarinet in 1942–44 and the critics' poll, 1962–68.

RUSSELL, CHARLES TAZE (*b. Pittsburgh, Pa., 1852; d. Tex., 1916*), religious leader. Commonly known as "Pastor Russell," founder of a millennial sect now known as Jehovah's Witnesses.

RUSSELL, CHARLES WELLS (*b. Wheeling, present W. Va., 1856; d. Washington, D.C., 1927*), lawyer, government official, diplomat. Prepared an important report on peonage in the South, 1907; was U.S. envoy extraordinary to Persia, 1909–14.

RUSSELL, DAVID ALLEN (*b. Salem, N.Y., 1820; d. Winchester, Va., 1864*), Union soldier. Graduated West Point, 1845. Commended for Mexican War service, he was active in Northwest Indian fighting until the outbreak of the Civil War. After hard and outstanding service in brigade command (notably at Rappahannock Station, Va., November 1863), he rose to divisional command, May 1864, and was killed in a critical moment of the battle of Winchester.

RUSSELL, HENRY NORRIS (*b. Oyster Bay, N.Y., 1877; d. Princeton, N.J., 1957*), astronomer. Studied at Princeton University (Ph.D., 1900), and at King's College, Oxford, England. Taught at Princeton from 1905; chairman of the astronomy department from 1912. Russell noted his own career could be briefly summed up: 1. The development of methods for calculating the orbits of eclipsing binary stars, and various practical applications. 2. The determination of dynamical parallaxes and the investigation of the masses of the binary stars. 3. The application of physical principles to the study of the spectra of the sun, sunspots, and stars. 4. The application of these principles to a quantitative analysis of the atmospheres of the sun and stars. 5. The term-analysis of complex atomic spectra. Known as "the dean of American astronomy," Russell had awesome power within the discipline. He spent summers working in various observatories, but preferred to return to Princeton and pursue theoretical studies.

RUSSELL, IRWIN (*b. Port Gibson, Miss., 1853; d. New Orleans, La., 1879*), poet. A pioneer in black dialect poetry, Russell was author of a single volume published posthumously, *Poems* (1888).

RUSSELL, ISRAEL COOK (*b. Garrattsville, N.Y., 1852; d. Ann Arbor, Mich., 1906*), geologist. Graduated in engineering, University of the City of New York (present New York University), 1872; attended Columbia School of Mines. After extensive field experience in government survey work under John J. Stevenson, G. K. Gilbert, and others, he served as professor of geology, University of Michigan, 1892–1906. An authority on North American geography, particularly that of Alaska and the North-west, and a specialist in glaciology, Russell was author, among other works, of *Geological History of Lake Lahontan* (1885) which remains a classic of geological science.

RUSSELL, JAMES EARL (*b. near Hamden, N.Y., 1864; d. Trenton, N.J., 1945*), educator. A.B., Cornell University, 1887. After six years of experience as teacher and headmaster in secondary schools, he grew dissatisfied with their formalism and went abroad to study foreign educational systems and theories. His major studies were made in Germany; after work with Wilhelm Rein at Jena, he went to Leipzig and was awarded the Ph D there in 1894. He returned home, convinced that the subjects taught and the methods used in public education should reflect the underlying philosophy and pragmatic needs of a country; that in a democracy, education should assist all citizens to realize their highest intellectual and occupational capacities; and that a high degree of professional training was necessary and desirable for teachers. Achieving national reputation through his publications while professor of philosophy and pedagogy at University

of Colorado, 1895–97, he became dean of Teachers College, Columbia University, late in 1897. When he retired in 1927, he had, with the aid of an outstanding faculty, made Teachers College the center of the progressive education movement in the United States and one of the most influential and successful university schools of education in the world.

RUSSELL, JAMES SOLOMON (*b. Palmer's Springs, Va., 1857; d. Lawrenceville, Va., 1935*), Episcopal clergyman, educator. Born of slave parents, he attended Hampton Institute and St. Stephen's School, Petersburg, Va.; he was ordained deacon in 1882 and priest, 1887. Principal and founder of St. Paul Normal and Industrial School (1888–1930), he was twice elected to the episcopal bench but declined to leave his school work.

RUSSELL, JOHN HENRY (*b. Frederick, Md., 1827; d. 1897*), naval officer. Graduated U.S. Naval Academy, 1848. Led force which burned the Confederate privateer *Judah*, Pensacola, Fla., September 1861; commanding *Kennebec*, he served ably in Admiral D. G. Farragut's operations at New Orleans and Mobile.

RUSSELL, JONATHAN (*b. Providence, R.I., 1771; d. Milton, Mass., 1832*), orator, diplomat, merchant. A prominent Democratic-Republican, Russell served as U.S. chargé d'affaires at Paris and London, and was U.S. minister to Sweden and Norway, 1814–18; in 1814 he was one of the peace commissioners at Ghent. Accused by John Quincy Adams of employing a false document against him, 1822, Russell retired from public life.

RUSSELL, JOSEPH (*b. Township of Dartmouth, Mass., 1719 o.s.; d. 1804*), New Bedford merchant, shipowner. A Russell vessel, the *Rebecca*, made the first whaling voyage around Cape Horn to the Pacific hunting grounds, 1791–93.

RUSSELL, LILLIAN (*b. Clinton, Iowa, 1861; d. Pittsburgh, Pa., 1922*), comic opera singer, internationally famous beauty. Stage name of Helen Louise Leonard. Raised in Chicago, Ill. After studying singing in New York under Leopold Damrosch, she made her first stage appearance, 1879, in the chorus of a company of *Pinafore*. In November 1880, she made her first appearance under her stage name at Tony Pastor's Theatre, New York. Beauty of face and figure, an excellent natural voice, and a great flair for publicity contributed to her success in a number of comic operas which featured her voice and appearance but required little dramatic ability.

RUSSELL, MOTHER MARY BAPTIST (*b. Newry, Ireland, 1829; d. California, 1898*), founder of the Sisters of Mercy in California. Name in religion of Katherine Russell. Raised in a family of remarkable distinction, Mother Russell joined the Institute of Mercy at Kinsale, 1848. As superior of a group of her order who had volunteered for work in San Francisco, Calif., she arrived there in December 1854 and established a convent and school. Early hostility to the nuns ended in gratitude after their work in the county hospital during an epidemic of cholera. Thereafter until her death she engaged in all works of charity, building and staffing hospitals, orphanages, homes for the aged, and schools throughout the state.

RUSSELL, OSBORNE (*b. probably Hallowell, Maine, 1814; d. Placerville, Calif., ca. 1865*), trapper, Oregon and California pioneer. Author of the important *Journal of a Trapper, Or Nine Years in the Rocky Mountains*, 1834–1843 (published Boise, Idaho, 1914).

RUSSELL, RICHARD BREVARD, JR. ("DICK") (*b. Winder, Ga., 1897; d. Washington, D.C., 1971*), governor of Georgia and U.S. senator. Graduated University of George (LL.B., 1918) and entered law practice with his father. He was elected to the Georgia house of representatives (1920–31) and became governor at the age of thirty-three (1931–33). As governor he was involved in a controversy over the extradition from New Jersey of an escaped chain-gang convict that translated into weakness on race relations. He was elected to the U.S. Senate as a Democrat in 1932 and served until his death; he was president pro tempore of the Senate from 1969. In the Senate he supported family farms as the center of agricultural life, including legislation for rural electrification and farm loans; he opposed easing immigration laws and fought against civil rights legislation, including the antilynching law of 1935, and introduced a bill to provide financial incentives for African Americans to relocate from the South. He was chairman of the Armed Services Committee (1951–69) and a strong supporter of national defense, although he opposed escalation during the Vietnam War

RUSSELL, ROSALIND (*b. Waterbury, Conn., 1912; d. Beverly Hills, Calif., 1976*), actress. Graduated from the American Academy of Dramatic Arts in 1929. After working for several theater companies in New England, she launched a Hollywood film career in 1934, eventually earning a reputation for her versatile acting skills and professionalism. She gained her first starring role in *Craig's Wife* (1936) and had noted roles in *His Girl Friday* (1940), *Sister Kenny* (1946), *Picnic* (1955), and *Gypsy* (1962). After 1950 Russell appeared more frequently in stage productions, including the touring hit *Bell, Book, and Candle* (1951). She won a Tony award for her role as Ruth in the musical *Wonderful Town* (1953), a performance she reprised for a television production. In her most celebrated role, Russell starred in the Broadway hit *Auntie Mame* (1956) and in the screen version (1958).

RUSSELL, SOL SMITH (*b. Brunswick, Mo., 1848; d. Washington, D.C., 1902*), actor. Nephew by marriage of Sol Smith. Celebrated throughout the country *post ca.* 1867 as a comedian, he had a dry, crackling manner that was irresistible in its appeal to contemporary audiences.

RUSSELL, WILLIAM (*b. Glasgow, Scotland, 1798; d. Lancaster, Mass., 1873*), educator. Immigrated to Georgia, 1817–18; taught at and conducted schools in many towns along the eastern seaboard. As principal of the New England Normal Institute, 1853–55, he made it an important center of Pestalozzianism in the United States. First editor of the *American Journal of Education* (1826), he was the author of a number of textbooks.

RUSSELL, WILLIAM EUSTIS (*b. Cambridge, Mass., 1857; d. St. Adelaide, Quebec, Canada, 1896*), lawyer, politician. Democratic governor of Massachusetts, 1891–94.

RUSSELL, WILLIAM HENRY (*b. Nicholas Co., Ky., 1802; d. Washington, D.C., 1873*), lawyer, Kentucky legislator, California pioneer. An associate of John C. Frémont in the early government of California, Russell later practiced law there. A large, expansive, bombastic man, he bore the nickname of "Owl" Russell.

RUSSELL, WILLIAM HEPBURN (*b. Burlington, Vt., 1812; d. Palmyra, Mo., 1872*), freighter, stagecoach operator. Joined Alexander Majors in partnership (December 1854) which later became Russell, Majors & Waddell. Persuaded the reluctant Majors to join him in operation of the Pony Express, starting April 1860. Involved with John B. Floyd, U.S. secretary of war, in a celebrated embezzlement scandal, Russell was indicted in January 1861, but action on the case was postponed because of the Civil War. Failure of the Pony express venture led to failure

of Russell's firm, and he transferred his interest in the freighting part of it to Majors.

RUSSWURM, JOHN BROWN (*b. Port Antonio, Jamaica, B.W.I., 1799; d. Liberia, 1851*), educator, government official. Probably the first person of African descent to graduate from an American college (Bowdoin, 1826), Russwurm established one of the first newspapers for blacks in the United States, *Freedom's Journal*, 1827. Immigrating to Liberia, 1829, he served as superintendent of public schools and as colonial secretary. He was governor of the Maryland Colony at Cape Palmas, 1836–51.

RUST, JOHN DANIEL (*b. Necessity, Tex., 1892; d. Pine Bluff, Ark., 1954*), inventor. Studied briefly at Western College in Artesia, N.Mex. With his brother Mack, Rust invented the first cotton-picking machine in 1931. Because of the displacement their invention would cause in migrant workers, manufacture of the machine was put off until after World War II. John Rust established the World Foundation in 1944, which received the profits from the machine, then being manufactured by the Allis-Chalmers Manufacturing Company.

RUST, RICHARD SUTTON (*b. Ipswich, Mass., 1815; d. Cincinnati, Ohio, 1906*), Methodist clergyman, advocate of education for blacks.

RUTER, MARTIN (*b. Charlton, Mass., 1785; d. Tex., 1838*), Methodist clergyman, educator, missionary to Texas.

RUTGERS, HENRY (*b. near New York, N.Y., 1745; d. New York, 1830*), landowner, Revolutionary officer, philanthropist. A principal benefactor of New York educational institutions, Rutgers was a trustee of Princeton University and Queen's College; the latter institution changed its name to Rutgers in his honor.

RUTH, GEORGE HERMAN ("BABE") (*b. Baltimore, Md., 1895; d. New York, N.Y., 1948*), baseball player. Legally committed to St. Mary's Industrial Home for Boys, Baltimore, at age seven, he became the school's star baseball player. In 1914 Ruth joined the Baltimore club of the International League, but because of a financial squeeze, he was sold the same year to the major-league Boston Red Sox. With a brilliant overall record for 1914, his major-league career was launched. Over the next four years, as a regular Red Sox pitcher, Ruth helped Boston win three American League pennants and three World Series titles. Overall, his six years as a Boston pitcher showed eighty-nine victories and forty-six losses, a pace which, if continued, would surely have ranked him as one of baseball's greatest pitchers.

But Ruth's versatility ended his pitching. His exceptional abilities as a hitter prompted Boston manager Ed Barrow in 1918 to place him full-time in the outfield, where he played thereafter. In 1918 he batted .300 and hit eleven homers; a year later he astounded the baseball world by clubbing a record twenty-nine homers on a .322 batting average. In 1919 Ruth was sold to the New York Yankees. He was the dominant figure in American baseball from 1920 to 1935, leading the Yankees to seven league pennants and five World Series championships. In 1925, he was hospitalized and underwent surgery for an intestinal abscess. After engaging a trainer to help him lose weight, he effected a comeback and over the seasons of 1926–1928 led the Yankees to three straight pennants. In 1927, after hitting his all-time seasonal high of sixty homers, Ruth toured the Far West.

In a fifteen-year career as a Yankee, Ruth set many records. His overall performance was the more remarkable since he had spent a quarter of his big-league career as a pitcher. In 1935 the Yankees released him to the Boston Braves; disillusioned, Ruth quit in midseason. In 1936 he was elected a charter member of the Baseball Hall of Fame. Two years later he accepted a coach-

ing offer from the Brooklyn Dodgers, but resigned before the end of the season. In 1948, shortly before his death, he saw himself portrayed in a Hollywood film, *The Babe Ruth Story*.

RUTHERFORD, JOSEPH FRANKLIN (*b. near Boonville, Mo., 1869; d. San Diego, Calif., 1942*), lawyer, second president of Jehovah's Witnesses. Succeeded Charles Taze Russell as president in January 1917.

RUTHERFURD, LEWIS MORRIS (*b. Morrisania, N.Y., 1816; d. 1892*), astrophysicist, pioneer in astronomical photography and spectroscopy. Great-grandson of Lewis Morris (1726–1798). Graduated Williams College; studied law under William H. Seward. Began serious work in science, 1856; secured first photographs of the moon, 1858. Following up observational work of Fraunhofer, he attempted a classification of stellar spectra which was published in the *American Journal of Science*, January 1863. Inventor of a number of devices for improving the efficiency of his work, he built during 1870 a machine with which he succeeded in ruling interference gratings superior to all others down to the time of Henry A. Rowland. Rutherfurd took a leading part in establishing the department of geodesy and practical astronomy at Columbia, 1881.

RUTLEDGE, EDWARD (*b. Charleston, S.C., 1749; d. Charleston, 1800*), lawyer, statesman. Brother of John Rutledge. Member of the First Continental Congress, 1774, and of the Second Continental Congress, 1775–76, he seconded the opinions of his brother. At first opposing independence, he influenced the South Carolina delegation to vote for it and was a signer of the Declaration. Returning home in November 1776 to serve in the defense of the state, he was taken prisoner at the fall of Charleston but was exchanged in time to take his seat in the legislature in January 1782. Although he drew up the bill proposing confiscation of Loyalist property, he was influential in moderating its effect. An active member of the legislature, 1782–98, he was a stiffly conservative Federalist. Elected governor, 1798, he served until his death.

RUTLEDGE, JOHN (*b. Charleston, S.C., 1739; d. 1800*), statesman, jurist. Brother of Edward Rutledge. After studying law at the Middle Temple, London, he was called to the English bar, 1760, and returned to an immediate and brilliant success in Charleston. A provincial legislator *post* 1761, he was sent as a delegate to the First Continental Congress in which, like Joseph Galloway, he favored maintaining self-government without breaking up the empire. In the Second Continental Congress, his efforts for establishment of regular governments in the colonies culminated in the advice of Congress to South Carolina (November 1775) to take such action if it should seem necessary. Returning to his native state, he was elected to the Council of Safety. He was one of the committee which wrote the South Carolina constitution of 1776 and served as president of the General Assembly until his resignation (1778) in protest against a revision of the state constitution which he considered dangerously democratic.

When the state faced invasion in January 1779, Rutledge was elected governor and worked tirelessly to support the efforts of American military forces during a calamitous period. Despite the fall of Charleston and the defeat at Camden, 1780, he did not despair and, while he begged Congress for help, encouraged Thomas Sumter, Francis Marion, and other partisans to wage detached warfare against the British. In August 1781 he set about a restoration of civil government, working to a large extent through the militia officers. Laying down his office at the end of the year, he reentered the legislature, served for a brief time in Congress, 1782–83, and in 1784 was elected to the South Caro-

lina chancery court. Chairman of the committee of detail in the Federal Convention, 1787, he fought for wealth to be made part of the basis of representation, for assumption of state debts, and against restrictions on the slave trade; also for election of the president by Congress and of Congress by the legislatures. Elected chief justice of South Carolina, February 1791, he was offered the chief justiceship of the U.S. Supreme Court, 1795. His nomination was rejected by the Senate because of the bitterness of his attacks against Jay's Treaty. He embodied perhaps more perfectly than any other man of his time the ideas of the ruling class of 18th-century South Carolina.

RUTLEDGE, WILEY BLOUNT (*b. Cloverport, Ky., 1894; d. York, Maine, 1949*), legal educator, associate justice of the U.S. Supreme Court. B.A., University of Wisconsin, 1914. After a period of schoolteaching and of recovery from tuberculosis in New Mexico and Colorado, he took his LL.B. degree at University of Colorado, 1922. Associate professor of law at Colorado, 1924–26, he then became professor at Washington University (St. Louis, Mo.) law school, advancing to deanship of the school in 1931. In 1935 he became dean of the law school at the State University of Iowa; in 1939 he was appointed to the U.S. Court of Appeals for the District of Columbia, from which he was elevated to the Supreme Court four years later. Painstaking and unsparing of his time and energy, he was a "lawyer's judge," expert in disputed technical points. His opinions, which were not numerous, tended to be long and encyclopedic. He summarized his liberal philosophy in his book, *A Declaration of Legal Faith* (1947).

RYAN, ABRAM JOSEPH (*b. Hagerstown, Md., 1838; d. Louisville, Ky., 1886*), Roman Catholic clergyman, Confederate chaplain, poet of the Confederacy. Father Ryan's collected poems, including "The Conquered Banner" and "The Sword of Robert E. Lee," were published in book form, 1879.

RYAN, ARTHUR CLAYTON (*b. Grandview, Iowa, 1879; d. Scarsdale, N.Y., 1927*), Congregational clergyman, missionary to Turkey. General secretary, American Bible Society, *post* 1924.

RYAN, CORNELIUS JOHN ("CONNIE") (*b. Dublin, Ireland, 1920; d. New York City, 1974*), journalist and author. His first reporting job was in London in 1941 with the Reuters News Agency; he joined the *London Daily Telegraph* as a war correspondent in 1943. In 1945 he opened the Tokyo Bureau of the *Telegraph*, then moved on to the Middle East bureau (1946) and acted as a stringer for *Time* magazine and the *St. Louis Post Dispatch*. In 1947 *Time* brought him to New York City; in 1950 he became a U.S. citizen and joined the "Newsweek" television program as a reporter. In 1959 he joined *Reader's Digest*, where he remained until his death. His three international best-sellers were *The Longest Day* (1959), *The Last Battle* (1966), and *A Bridge Too Far* (1974).

RYAN, EDWARD GEORGE (*b. near Enfield, Ireland, 1810; d. Madison, Wis., 1880*), jurist. Came to America, 1830; settled in Milwaukee, Wis., 1848. Chief justice of Wisconsin, 1874–80, he ruled in important cases involving the power of the state legislature to regulate railway rates and to prescribe conditions upon which foreign corporations might do business in the state.

RYAN, HARRIS JOSEPH (*b. Matamoras, Pa., 1866; d. 1934*), electrical engineer. M.E., Cornell University, 1887. Taught at Cornell, 1888–1905; headed department of electrical engineering at Leland Stanford, 1905–31. Authority on power transmission at high voltages; a pioneer in engineering use of the cathode-ray tube.

RYAN, JOHN AUGUSTINE (*b. Vermillion Township, Minn., 1869; d. St. Paul, Minn., 1945*), Roman Catholic clergyman, economist, social reformer. Attended a school conducted by the Christian Brothers in St. Paul; entered St. Thomas Seminary (called after 1893 St. Paul Seminary), from which he graduated as valedictorian in 1892. Ordained to the priesthood in 1898, Ryan began graduate work in theology at the Catholic University of America in Washington, D.C., where he received his degree as S.T.B. and his licentiate in sacred theology (S.T.L.). He received his doctorate in sacred theology (S.T.D.) from Catholic University in 1906. His thesis, *A Living Wage: Its Ethical and Economic Aspects,* was published that same year. For thirteen years (1902–15) he taught at St. Paul Seminary. In 1909 he put together (and published in the *Catholic World*) a full program of social reform. Six years later he transferred to Catholic University, at first as associate professor of political science, then successively as associate professor of theology (1916), professor of theology (1917), and dean of the School of Sacred Sciences (1919). He published *Distributive Justice: The Right and Wrong of Our Present Distribution of Wealth* (1916). In 1917 he founded the *Catholic Charities Review*. When the bishops set up the National Catholic Welfare Council (later Conference) in 1919, Ryan was the obvious man to serve as the Washington director of its Social Action Department, created in 1920. In 1922 he was coauthor of the book *The State and the Church*, followed by the revised edition, *Catholic Principles of Politics* (1940). Ryan welcomed the New Deal as the triumphant realization of his lifetime struggle for social justice.

RYAN, JOHN DENNIS (*b. Hancock, Mich., 1864; d. New York, N.Y., 1933*), capitalist. Dominating figure *post* 1909 in the Anaconda Copper Mining Co. which he made one of the greatest industrial enterprises in the world; active also in public utilities and railroads.

RYAN, PATRICK JOHN (*b. Thurles, Ireland, 1831; d. 1911*), Roman Catholic clergyman. Immigrated to St. Louis, Mo., 1852, where he was ordained, 1853. A leading preacher and orator of his time, he was consecrated coadjutor bishop of St. Louis, 1872, and in 1884 succeeded to the see of Philadelphia.

RYAN, ROBERT BUSHNELL (*b. Chicago, Ill., 1909; d. New York City, 1973*), actor. Graduated Dartmouth College (1932), where he won a prize for his one-act play *The Visitor*. He held a variety of jobs before signing a film contract in 1939 with Paramount, where he was used in several B-films. His contract up in 1940, he concentrated on the stage and appeared on Broadway in *Clash by Night* (1941). He returned to film in 1942 and received an Oscar nomination for best supporting actor for his role in *Crossfire* (1947). Many of his films were in the film noir genre and his understated acting style was shown to special advantage. He appeared in three or four films annually, including the Westerns *The Proud Ones* (1956) and *The Wild Bunch* (1969); among his best performances were those in *Bad Day at Black Rock* (1955), *Billy Budd* (1962), and *The Iceman Cometh* (1973). He continued with stage plays, including Shakespearean plays and *The Front Page* (1969) and *Long Day's Journey into Night* (1971).

RYAN, STEPHEN VINCENT (*b. near Almonte, Ontario, Canada, 1825; d. 1896*), Roman Catholic clergyman, Vincentian. Raised in Pennsylvania. Completed theological studies in Missouri and was ordained in St. Louis, 1849. Elected visitor general of his order in America, 1857, he was named against his will bishop of Buffalo, 1868; and served until his death. A strong liberal, Bishop Ryan found himself in continual disagreement with Bishop Bernard McQuaid of Rochester.

RYAN, THOMAS FORTUNE (*b. Lovingston, Va., 1851; d. 1928*), promoter, financier. Beginning as an errand boy in a Baltimore, Md., dry-goods commission house, Ryan removed to New York City, 1872, and prospered as a stockbroker, 1873–83. His first exploit in high finance was the organization of the New York Cable Railroad, 1883, a paper corporation with which, in association with William C. Whitney and Peter A. B. Widener, he eventually controlled practically every street railway line in New York City. His Metropolitan Traction Co., organized 1886, manipulated the securities of the various traction companies held by Ryan's syndicate and is considered to have been the first holding company in the United States. Threatened by the competition of the new subway system, 1905, Ryan bludgeoned the interests behind the Interborough Rapid Transit Co. into consolidating with his firm and engaging in a scheme of overcapitalization which left New York City traction in a state of financial collapse, 1906–07. Called "the most adroit, suave and noiseless man" in American finance, Ryan extended his power into banking, insurance, public utilities, and general industry by methods which were constantly under fire as prejudicial to the public interest.

RYAN, WALTER D'ARCY (*b. Kentville, N.S., Canada, 1870; d. Schenectady, N.Y., 1934*), illuminating engineer, developer of flood lighting and high-intensity streetlighting.

RYBNER, MARTIN CORNELIUS (*b. Copenhagen, Denmark, 1853; d. 1929*), composer, pianist, music teacher. Came to America as professor of music at Columbia University, 1904; resigned, 1919, to devote his time to composition and recital work.

RYDBERG, PER AXEL (*b. Odh, Sweden, 1860; d. New York, N.Y., 1931*), botanist. Came to America, 1882. Graduated University of Nebraska, 1891; Ph.D., Columbia, 1898. On staff of New York Botanical Garden *post* 1899; was author, among other books, of *Catalogue of the Flora of Montana* (1900), *Flora of Colorado* (1906), and *Flora of the Rocky Mountains* (1917, 1922).

RYDER, ALBERT PINKHAM (*b. New Bedford, Mass., 1847; d. Elmhurst, N.Y., 1917*), painter. Studied under William E. Marshall and at National Academy of Design. Living principally in New York City *post* 1868, and a virtual recluse not because of misanthropy but owing to his deep absorption in his work, Ryder produced hardly more than 150 pictures throughout his career. Not one of these is perfunctory and all are of the rarest kind of poetic painting; his best work was produced between 1873 and 1898, and his small marines are most representative of his highest technical and structural achievement. Ryder's work reveals a mastery of design and possesses a charm that is wholly spontaneous and original.

RYERSON, MARTIN ANTOINE (*b. Grand Rapids, Mich., 1856; d. 1932*), capitalist. Raised in Chicago, Ill., where he engaged in business until the early 1890's, Ryerson was identified with many philanthropies, notably as a benefactor to the Chicago Art Institute, the Field Museum, and the University of Chicago.

RYLAND, ROBERT (*b. King and Queen Co., Va., 1805; d. 1899*), Baptist clergyman, educator. Headed Virginia Baptist Seminary, Richmond, Va. (later Richmond College), from 1832 until the Civil War; thereafter was active in Kentucky education.

RYNNING, OLE (*b. Ringsaker, Norway, 1809; d. Iroquois Co., Ill., 1838*), immigrant leader. Immigrated to Beaver Creek region in Illinois, 1837; author of a remarkable guide book for Norwegians proposing to come to America (published at Christiania, 1838).

S

SAARINEN, EERO (*b. Kirkkonummi, Finland, 1910; d. Ann Arbor, Mich., 1961*), architect. Arrived in the United States in 1923. Graduated from Yale with honors (1934) and joined the architectural firm of his father, noted architect Eliel Saarinen, in Bloomfield Hills, Mich. Served as an instructor at Cranbrook (1939–49), a center of high culture and serious environmental thought. Collaborated with Charles Eames (1940) on the design of furniture using rubber-bonded plywood and metal and won first prize in the Organic Design Competition. Became a designer in the firm of Saarinen, Swanson and Associates (1941–47); his early works include the Kleinhans Music Hall in Buffalo (1938–40) and the Des Moines Art Center (1944–48). The firm reorganized as Saarinen, Saarinen and Associates and was commissioned for the General Motors Technical Center at Warren, Mich.; his technical innovations for that project included development of a thin, porcelain-faced "sandwich" panel serving as both exterior skin and interior finish and use of neoprene "zipper gaskets" for window glazing. Collaborated with Eames on a demonstration house sponsored as Case Study Houses by *California Arts and Architecture* (1945). Prepared plans for universities and colleges undergoing postwar expansion; many involved variations in a curtain-wall aesthetic, such as Noyes House at Vassar (1954–58) and the Kresge Auditorium and the interdenominational chapel at MIT (1953–56). His systematic, almost engineer-like insistence on analyzing the nature of a project suggested the possibility of an autonomous architecture for each building. He made dramatic use of mirror glass in the Bell Laboratories in New Jersey (1957–62) and self-rusting Cor-Ten steel at Deere and Company in Illinois (1957–63). Other projects were the U.S. embassy at Grosvenor Square, London (1955–60), the Gateway Arch in St. Louis (1959–64), the CBS Building in New York City (1960–64), and Dulles International Airport at Chantilly, Virginia (1958–62).

SAARINEN, GOTTLIEB ELIEL (*b. Rantalsami, Finland, 1873; d. Bloomfield Hills, Mich., 1950*), architect, educator, city planner. Studied at Polytechnic Institute, Helsinki. Pre-1914, his major works were the monumental Helsinki railroad station and his redesign of the city of Reval, Estonia. Through contacts made while teaching at the School of Architecture, University of Michigan, 1923, he was chosen to supervise the building of the school complex and academy of arts and crafts projected by George G. Booth for his estate at Cranbrook, Bloomfield Hills, Mich. He directed the academy until his death and was active in architectural practice as well as partner of his gifted son, Eero Saarinen.

SABATH, ADOLPH J. (*b. Zabori, Bohemia [now Czechoslovakia], 1866; d. Bethesda, Md., 1952*), congressman. Immigrated to the United States in 1881. Studied at Lake Forest University (LL.B., 1891). Elected Democratic congressman from Chicago's Fifth District, he served in the House until his death. A champion of immigrants' rights, Sabath was opposed to any restriction on immigration. He was a member of the Immigration and Naturalization Committee, chairman of the House Steering Committee (1936) and of the Rules Committee (1938). A liberal, Sabath was a supporter of Wilson, Roosevelt, and Truman. He backed the proposals of the New Deal, the formation of the State of Israel, and the Marshall Plan.

SABIN, CHARLES HAMILTON (*b. Williamstown, Mass., 1868; d. Shinnecock Hills, N.Y., 1933*), banker. President, Guaranty Trust Co., 1915–21; thereafter chairman of the board.

SABIN, FLORENCE RENA (*b. Central City, Colo., 1871 d. Denver, Colo., 1953*), anatomist. Studied at Smith College and at Johns Hopkins University. A member of the Johns Hopkins faculty, she became the first woman professor at the university in 1917. A specialist in the development of the lymphatic vessels in the embryo, and, later, of blood cells in embryos, Sabin made important contributions to anatomy. She was a researcher at the Rockefeller Institute from 1925 to 1938. In 1947, at age seventy-six, she was appointed the manager of the Department of Health and Welfare of the city of Denver. President of the American Association of Anatomists, 1924–26. Elected to the National Academy of Sciences in 1925, the first woman to be so honored.

SABIN, JOSEPH (*b. probably Braunston, Northamptonshire, England, 1821; d. 1881*), bookseller, bibliographer. Came to America, 1848. Dealer and cataloguer of rare books and prints in Philadelphia and New York, Sabin is particularly remembered as the compiler of *Dictionary of Books Relating to America* (1868–84, issued in parts), an outstanding reference work which he left unfinished. The work was brought to a conclusion by later scholars in the 19th and 20th centuries.

SABINE, LORENZO (*b. Lisbon, N.H., 1803; d. Boston Highlands, Mass., 1877*), historian, businessman, public official. Author of, among other works, the valuable *The American Loyalists* (1847; second and enlarged edition under title *Biographical Sketches of Loyalists*, 1864).

SABINE, WALLACE CLEMENT WARE (*b. Richwood, Ohio, 1868; d. 1919*), physicist. Graduated Ohio State, 1886; M.A., Harvard, 1888. Taught physics at Harvard *post* 1889; appointed dean of Lawrence Scientific School, 1906; dean, Harvard Graduate School of Applied Science, 1908–16. Authority on architectural acoustics and aerial warfare.

SACAGAWEA (*b. probably near present Lemhi, Idaho, ca. 1787; d. Fort Manuel, present N.Dak., 1812*), Shoshone woman, interpreter of the Lewis and Clark expedition. Sacagawea was of the greatest service to the explorers; without the aid she obtained for them from the Shoshone it is possible that the expedition could not have proceeded beyond the headwaters of the Salmon River. The details of her life are the subject of much controversy.

SACCO, NICOLA (*b. Torre Maggiore, Foggia, Italy, 1891; d. Massachusetts, 1927*), anarchist and a principal with Bartolomeo Vanzetti, who was a native of Piedmont, in a celebrated judicial controversy, 1920–27, which culminated in the execution of

both men for murder. The mobilization of liberal and left-wing forces in favor of the defense lent emotional overtones to the case.

Sachs, Alexander (*b. Rossien, Lithuania, 1893; d. New York City, 1973*), economist. Graduated Columbia University (B.S., 1912). After working as an economist for Lehman Brothers, in 1933 Sachs became an administrator in the National Recovery Administration, opposing its extensive regulatory practices; he returned to Wall Street in 1936. In 1939, at the urging of scientists Albert Einstein and Leo Szilard, Sachs counseled President Franklin D. Roosevelt on atomic weapons and informed him that Nazi Germany had a fledgling atomic program. Sachs later criticized the dropping the atomic bombs on Japan, arguing that the weapons should not have been used against civilian populations.

Sachs, Bernard (*b. Baltimore, Md., 1858; d. New York, N.Y., 1944*), neurologist. Brother of Julius Sachs. B.A., Harvard, 1878. M.D., University of Strasbourg, 1882; studied also in Berlin, Vienna, Paris, and London. Practiced in New York *post* 1884; professor of mental and nervous diseases, New York Polyclinic, 1888–1905; served also as professor of clinical neurology at College of Physicians and Surgeons, Columbia University. Appointed consulting neurologist at New York's Mount Sinai Hospital, 1893, he was a major figure in the developing field of organic neurology. He published some 200 articles and several books, including *Nervous Diseases of Childhood* (1895). He was editor of the *Journal of Nervous and Mental Disease*, 1886–1911, and played a principal role in establishing international collaboration in the field of neurology. All through his career, he adhered to his belief in neuropsychiatry as a single practice; he was tolerant of Freudians, but viewed their generalizations with skepticism, particularly when made by people without training and experience in organic neuropathology, neurophysiology, and clinical medicine.

Sachs, Hanns (*b. Vienna, Austria, 1881; d. Boston, Mass., 1947*), psychoanalyst. An early associate of Freud. Came to the United States, 1932; practiced in Boston and taught at Harvard. Founded (1938) and edited *The American Imago*.

Sachs, Julius (*b. Baltimore, Md., 1849; d. 1934*), educator. Graduated Columbia, 1867; Ph.D., University of Rostock, 1871. Principal, Sachs Collegiate Institute, New York City, 1871–1901; professor of secondary education, Teachers College, Columbia, 1902–17; author of scholarly studies on Greek and educational topics.

Sachs, Paul Joseph (*b. New York, N.Y., 1878; d. Cambridge, Mass., 1965*), art educator and philanthropist. Graduated from Harvard (1900) and joined the family firm of Goldman, Sachs and Company, investment bankers; elected a partner in 1904. Joined the Fogg Art Museum (1912) and became associate director (1923). Taught at Harvard's Fine Arts Department (1917–48). His most notable contribution as a teacher was his graduate seminar in museum administration (first offered in 1921). In 1948 he assumed a major administrative role in incorporating into Harvard two international research foundations: Dumbarton Oaks in Washington, D.C., and I Tatti at Settignano, near Florence, Italy. His publications include *Early Italian Engravings* (1915) and *Great Drawings* (1951).

Sachs, Theodore Bernard (*b. Dinaberg, Russia, 1868; d. Naperville, Ill., 1916*), physician, specialist in treatment of tuberculosis. Came to America *ca.* 1891. M.D., Chicago College of Physicians and Surgeons, 1895. Practicing in Chicago and vicinity, he was a leader in the establishment of the Chicago Municipal Tuberculosis Sanitarium, 1909–15.

Sachse, Julius Friedrich (*b. Philadelphia, Pa., 1842; d. Philadelphia, 1919*), businessman, antiquarian, photographer, writer on Pennsylvania German history.

Sack, Israel (*b. Kaunas, Lithuania, 1883; d. Brookline, Mass., 1959*), antiques dealer. Immigrated to the U.S. in 1903. A cabinetmaker, Sack opened a shop in Boston in 1905. There he built a following for American antiques that was to culminate in his gathering the collection that became part of the permanent collection at the American Wing of the Metropolitan Museum of Art, given by Mrs. Russell Sage in 1924; in 1928, Sack was commissioned by John D. Rockefeller to furnish Colonial Williamsburg. Sack moved his business to New York in 1934 and remained active in the trade until 1955.

Sackett, Henry Woodward (*b. near Ithaca, N.Y., 1853; d. 1929*), lawyer, authority on libel, benefactor of Cornell University.

Sadlier, Denis (*b. Co. Tipperary, Ireland, 1817; d. Wilton, N.Y., 1885*), book publisher. Came to America as a boy. Established with his brother the Catholic publishing firm of D. & J. Sadlier & Co. in New York City, 1836.

Sadlier, Mary Anne Madden (*b. Cootehill, Ireland, 1820; d. Montreal, Canada, 1903*), author. Sister-in-law of Denis Sadlier. Immigrated to Montreal, 1844; resided in New York City *post* 1860. Writer of popular fiction for Catholic readers.

Sadtler, John Philip Benjamin (*b. Baltimore, Md., 1823; d. Atlantic City, N.J., 1901*), Lutheran clergyman, educator. Graduated present Gettysburg College, 1842. Son-in-law of Samuel S. Schmucker. President, Muhlenberg College, 1877–85.

Sadtler, Samuel Philip (*b. Pinegrove, Pa., 1847; d. 1923*), chemist, educator. Son of John P. B. Sadtler; grandson of Samuel S. Schmucker. Graduated present Gettysburg College, 1867; S.B., Harvard, 1870; Ph.D., Göttingen, 1871. Taught chemistry at Gettysburg College, University of Pennsylvania and Philadelphia College of Pharmacy; chemical editor, *Dispensatory of the United States*, 1883–1923. Author of textbooks.

Saenderl, Simon (*b. Malgerzdorf, Bavaria, 1800; d. Gethsemane, Ky., 1879*), Roman Catholic clergyman, Redemptorist and Trappist. Came to America, 1832, as first Redemptorist superior in the United States; worked as a missionary in Wisconsin, Michigan, New York, and Pennsylvania. Entered the Trappists, 1852.

Safford, James Merrill (*b. Zanesville, Ohio, 1822; d. Dallas, Tex., 1907*), geologist, educator. Graduated Ohio University, 1844. Taught sciences at Cumberland University, University of Nashville, and Vanderbilt; state geologist of Tennessee, 1854–60 and 1871–1900.

Safford, Truman Henry (*b. Royalton, Vt., 1836; d. Newark, N.J., 1901*), astronomer, mathematician. A mathematical prodigy as a child, Safford graduated from Harvard, 1854. A staff member of Harvard Observatory 1854–66, he taught at University of Chicago, 1866–71, and was professor of astronomy at Williams College, 1876–1901.

Safford, William Edwin (*b. Chillicothe, Ohio, 1859; d. 1926*), ethnobotanist, ethnologist, philologist. Graduated U.S. Naval Academy, 1880; made postgraduate studies at Yale and Harvard. Resigning from the navy, 1902, he served thereafter as

botanist in the U.S. Department of Agriculture. Among his many works, *The Useful Plants of the Island of Guam* (1905) is particularly notable. It established Safford's reputation as an ethnobotanist and was followed by a number of other important studies of food plants.

SAGE, BERNARD JANIN (*b. near New Haven, Conn., 1821; d. New Orleans, La., 1902*), lawyer, planter, Confederate agent. Author of *Davis and Lee* (London, 1865, later issued as *The Republic of Republics*, a defense of the Confederate leaders on the grounds of history and international law.

SAGE, HENRY WILLIAMS (*b. Middletown, Conn., 1814; d. Ithaca, N.Y., 1897*), merchant, lumber manufacturer, benefactor of Cornell University and Yale Divinity School.

SAGE, MARGARET OLIVIA SLOCUM (*b. Syracuse, N.Y., 1828; d. New York, N.Y., 1918*), philanthropist. Wife of Russell Sage. Inheriting practically the whole of her husband's fortune on his death in 1906, she distributed it over a wide range of charitable activities, including hospitals, social agencies, learned societies, museums, and 18 colleges. She established the Russell Sage Foundation, 1907.

SAGE, RUSSELL (*b. Oneida Co., N.Y., 1816; d. Long Island, N.Y., 1906*), financier, Whig congressman from New York. An associate in business of Jay Gould, Sage was one of the shrewdest and most conservative money manipulators of his time. Active *post* 1856 in railroad and other promotions, he was best known as a moneylender during the last quarter-century of his life. At his death his fortune was estimated at about $70 million. He is credited with invention of the Wall Street practice of "puts and calls."

ST. ANGE DE BELLERIVE, LOUIS (*b. Montreal, Canada, ca. 1698; d. St. Louis, Mo., 1774*), frontier soldier. Captain of the French post on the Wabash River, 1736–64; conducted evacuation of Fort Chartres, 1764–65. Commanded at St. Louis as acting governor of Upper Louisiana, 1765–70.

ST. CLAIR, ARTHUR (*b. Thurso, Scotland, 1736 o.s.; d. Chestnut Ridge, present Greensburg, Pa., 1818*), soldier. Appointed ensign in the British army, 1757, he served with Amherst in Canada, and in 1760 married a niece of James Bowdoin. Resigning from the army, 1762, he purchased an estate in western Pennsylvania and was the largest resident property-owner west of the mountains in that province. An enlightened agent of government in the frontier country, he opposed the influx of Virginians there, but was unable to prevent Virginia's domination of the Pittsburgh area. Member of the Committee of Safety of Westmoreland Co., he served as colonel in the retreat after the Canadian invasion, 1775, and was with Washington at Trenton and Princeton, 1776–77. Ordered to defend Fort Ticonderoga in the spring of 1777, he was obliged to surrender it and was recalled by Congress from service in the field. Active *post* 1778 in Pennsylvania politics, he was a delegate to the Confederation Congress, 1785–87, and president, 1787. Appointed governor of the Northwest Territory, 1787, he served until 1802. His attempts to maneuver the Indian tribes of the area into acceptance of the Treaty of Fort Harmar, 1789, led to a war in which he as major general and commander of the federal army was overwhelmingly defeated near present Fort Wayne, Ind., Nov. 4, 1791, by a confederated Indian army under Little Turtle. In governing the Northwest Territory he tried to enforce both the spirit and the letter of the Ordinance of 1787. Overbearing and paternalistic, he sought to prevent the Territory's progress to statehood and was removed from office by President Jefferson.

ST. DENIS (DENYS), LOUIS JUCHEREAU DE (*b. Beauport, Quebec, Canada, 1676; d. Natchitoches, La., 1744*), French explorer, colonizer. Accompanied Iberville on expedition for founding Louisiana; accompanied Bienville on exploration to Red River, 1700. Founded French trading post at Natchitoches, where he resided *post* 1719. A man of great influence with the Indians of Texas and Louisiana.

ST. DENIS, RUTH (*b. New Jersey, 1879; d. Hollywood, Calif., 1968*), modern-dance pioneer. Appeared with David Belasco's theatrical company (1900–04), then assembled a company of East Indian immigrants and choreographed the dance *Radha*, performed at the New York Theatre in 1906, which made her famous; *Radha* was a blend of exotic spectacle and morality tale and established the basic form, theme, and exotic trappings of her choreography. In 1915 she opened the Ruth St. Denis School of Dancing in Los Angeles with her husband and dance partner, Edwin Myers ("Ted") Shawn, and called it Denishawn. The Denishawn company toured the country (1915–29), creating an American audience for dance and pioneering a modern dance style. With the publication of her autobiography, *An Unfinished Life*, and the revival of her historical dances (both 1939), she created for herself a new role as matriarch of American modern dance. She made her last public dance appearance in 1966, at the age of eighty-seven.

SAINT-GAUDENS, AUGUSTUS (*b. Dublin, Ireland, 1848; d. Cornish, N.H., 1907*), sculptor. Of French and Irish descent, Saint-Gaudens was brought to America as an infant and raised in New York City. Trained as a cameo-cutter, he worked at his trade while studying at Cooper Union and at the National Academy of Design and also trusted to his trade for support during the decade he spent in France and Italy *post* 1867. At the Beaux-Arts in Paris he received a good grounding under Jouffroy, but he did not allow his talent to be fixed in any one mold either in Paris or, *post* 1870, in Rome. It is significant that he began his work in Rome not with an Apollo or a Venus but with a study of Hiawatha. He worked with great industry and in the highest spirits, drawing upon unusual stores of perseverance. The story of his success is not one of swift growth and facile triumph but one of persistent effort and study. Side by side with his gift for portraiture and taste for it ran his interest in imaginative design. The early *Hiawatha* in marble (Saratoga, N.Y.) and the *Silence* (Masonic Temple, New York City) attest to this. Commissioned *ca.* 1877 to do full-lengths of Admiral Farragut (Madison Square, New York City) and Captain Randall (Sailors' Snug Harbor, Staten Island, N.Y.), he returned to America and became a particular friend of John La Farge. The *Farragut*, unveiled 1881, was a landmark in Saint-Gaudens' life and in the history of American sculpture; it established him as a master. The subject was placed realistically before the world, a living embodiment, a public monument with the stamp of creative art on it. Stanford White designed the pedestal, and so began a long association with Saint-Gaudens.

Progressing in his line as interpreter of major American historical figures, Saint-Gaudens continued to reveal himself as a master of characterization and of plastic design. His research into the lives and backgrounds of his subjects and the long thought which he gave to his work account for its remarkable conviction much more than any supposed clairvoyance. *Sherman* (New York City) of 1903 is probably the greatest equestrian monument of modern times, and his two statues of Lincoln in Chicago, Ill., are eloquently expressive. His low reliefs show simple, charming composition and subtle modeling and were enhanced, as were all his works, by lettering which was made part of the design. Among his imaginative works, the *Amor Caritas* (1887); *Diana* (1892), which he made for the original Madison Square Garden;

the Phillips Brooks monument; and the unfinished symbolic groups for the Boston Public Library are evidence of his deep sense that beauty must mean at least some goodness. Simplicity is the keynote to his art, even in his one essay in the grand style, the great Adams Monument in Rock Creek Cemetery, Washington, D.C. (1891). This enigmatic figure, displaying creative energy and originality, spiritual force, and the sure fusion of dramatic purpose with technical authority, is his bid for immortality. He played an important part in the general development of artistic matters. He was active in the National Academy of Design, was a founder of the Society of American Artists, and aided Charles F. McKim in establishing the American Academy in Rome; he also collaborated with Theodore Roosevelt in a proposed reform of American coinage. Generously appreciative of younger artists when he felt that they were on the right track, he never failed to stress the discipline of rigorous training; he was as devoted to craftsmanship as to beauty.

ST. JOHN, CHARLES EDWARD (*b. Allen, Mich., 1857; d. 1935*), astronomer, educator. Graduated Michigan Agricultural College, 1887; Ph.D., Harvard, 1896. Taught at University of Michigan and at Oberlin; served on staff of Mount Wilson Observatory *post* 1908, marking special study of the sun. Probably his most important investigation was a test of the validity of Einstein's relativity theory through comparison of solar and terrestrial spectra (published in *Astrophysical Journal*, April 1928).

ST. JOHN, ISAAC MUNROE (*b. Augusta, Ga., 1827; d. White Sulphur Springs, W.Va., 1880*), civil engineer, Confederate brigadier general. Commissary general of the Confederate army, 1865.

ST. JOHN, JOHN PIERCE (*b. Brookville, Ind., 1833; d. Olathe, Kans., 1916*), prohibitionist, Union soldier. Republican governor of Kansas, 1879–83; presidential nominee, National Prohibition party, 1884.

ST. LUSSON, SIMON FRANÇOIS DAUMONT, SIEUR DE (*b. France, date unknown; d. probably Canada, 1674*), soldier, explorer. Served in Canada, 1663–68, 1670–73. While on an expedition to explore for mines near Lake Superior, St. Lusson presided over a formal ceremony of annexation to France of the Great Lakes area at Sault Ste. Marie, June 14, 1671.

SAINT-MÉMIN, CHARLES BALTHAZAR JULIEN FEVRET DE (*b. Dijon, France, 1770; d. Dijon, 1852*), artist, engraver. Resident in the United States, 1793–1814. Saint-Mémin produced more than 800 portraits of distinguished Americans of that time. Securing an exact profile of the sitter in crayon by means of a physionotrace, he reduced the profile with a pantograph to a miniature about two inches in diameter and recorded it directly on copper with graver and roulette. He also engraved topographical sketches of New York. A principal collection of his work is in the Corcoran Gallery, Washington, D.C.

SAINT-MÉRY, MOREAU DE *See* MOREAU DE SAINT-MÉRY, MÉDÉRIC-LOUIS-ELIE.

ST. VRAIN, CERAN DE HAULT DE LASSUS DE (*b. near St. Louis, Mo., 1802; d. Mora, N.Mex., 1870*), pioneer merchant in the Southwest, soldier. Entered the fur trade at an early age; journeyed to Taos, N.Mex., 1824–25; traded out of Santa Fe, 1826. In partnership with Charles Bent, 1831–47, St. Vrain developed a business surpassed in importance only by the American Fur Co.; he also held large tracts of land under grant from the Mexican government. During the Mexican War, he organized and led a company of volunteers and later served against raiding Apache and Ute. Appointed colonel, 1st New Mexico Cavalry,

1861, he resigned because of age and was succeeded by Kit Carson.

SAJOUS, CHARLES EUCHARISTE DE MÉDICIS (*b. at sea, 1852; d. Philadelphia, Pa., 1929*), physician. Began medical studies at University of California; M.D., Jefferson Medical College, 1878. Practiced in Philadelphia and was lecturer and professor at several medical schools there, including Temple University and the postgraduate school of University of Pennsylvania. Authority on endocrinology and laryngology.

SAKEL, MANFRED JOSHUA (*b. Nadvorna, Austria [now Nadvornaya, Ukrainian S.S.R.], 1900; d. New York, N.Y., 1957*), psychiatrist. Immigrated to the U.S. in 1936. Studied at the First State College in Brno and at the University of Vienna (M.D., 1925). Worked at the Lichterfelde Hospital in Berlin from 1927 to 1933. The first to use insulin coma therapy as a treatment for mental disorders, Sakel propagated his technique in the U.S. after immigration. Published *The Pharmacologic Shock Treatment of Schizophrenia* in 1938.

SALISBURY, ALBERT (*b. Lima, Wis., 1843; d. 1911*), educator, Union soldier. President, Whitewater (Wis.) Normal School, 1885–1911.

SALISBURY, EDWARD ELBRIDGE (*b. Boston, Mass., 1814; d. 1901*), orientalist, educator. Graduated Yale, 1932; made postgraduate studies there in Hebrew and cognate languages, and at Paris, Bonn, and Berlin. A pioneer teacher of Arabic and Sanskrit at Yale, 1843–56, Salisbury opened the field of Oriental studies in the United States. He was author of a number of learned studies published principally in *Journal of American Oriental Society*.

SALISBURY, JAMES HENRY (*b. Scott, N.Y., 1823; d. Dobbs Ferry, N.Y., 1905*), physician, chemist, plant pathologist. A precursor of the germ theory of disease in works published, 1862–68.

SALISBURY, ROLLIN D. (*b. Spring Prairie, Wis., 1858; d. 1922*), geologist, educator. Graduated Beloit College, 1881. Succeeded his mentor, Thomas C. Chamberlin, as professor of geology at Beloit, 1882–91. After teaching briefly at the University of Wisconsin, 1891, he became professor of geographic geology, University of Chicago, serving there as teacher (and dean of the Graduate School of Science *post* 1899) for the rest of his life. He was a leading authority on glacial and Pleistocene deposits.

SALMON, DANIEL ELMER (*b. Mount Olive, N.J., 1850; d. Butte, Mont., 1914*), veterinarian. Graduated Cornell, 1872; D.V.M., 1876. Outstanding as chief, Bureau of Animal Industry, U.S. Department of Agriculture, 1883–1905, he succeeded in bringing contagious pleuropneumonia and Texas fever among cattle under complete control. He also made investigations into the cause and prevention of fowl cholera, contagious diseases of swine, and nodular diseases of sheep. He was responsible for the inauguration of a nationwide system of meat inspection, for a quarantine system for imported livestock, and for inspection of export cattle and the ships which carried them.

SALMON, LUCY MAYNARD (*b. Fulton, N.Y., 1853; d. 1927*), educator. Graduated University of Michigan, 1876; M.A., 1883; fellow in history, Bryn Mawr, 1886–87. Taught history at Vassar, 1887–1927.

SALMON, THOMAS WILLIAM (*b. Lansingburg, N.Y., 1876; d. 1927*), physician, pioneer in mental hygiene.

SALM-SALM, AGNES ELISABETH WINONA LECLERQ JOY (*b. Franklin Co., Vt., or possibly Philipsburg, Quebec, 1840; d. Karlsruhe, Germany, 1912*), princess, adventuress. Princess Salm-Salm is principally remembered for her heroic role during the fall of Maximilian's regime in Mexico, 1867, when she attempted the emperor's rescue, and for her relief work with the German army, 1870.

SALOMON, HAYM (*b. Lissa, Poland, ca. 1740; d. Philadelphia, Pa., 1785*), merchant, Revolutionary patriot. An advocate of Polish independence, he fled to England, 1772, and thence to New York City, where he began business as a broker and commission merchant. Twice imprisoned by the British as an active Whig, 1776 and 1778, he removed to Philadelphia and within the next few years became a leading broker in that city. His liberal advances of cash to officers of the government and his equally liberal investments in Revolutionary paper, *ca.* 1780–84, constitute an outstanding example of devotion to the American cause; he contributed much in other ways to maintain the bankrupt government's credit.

SALTER, WILLIAM (*b. Brooklyn, N.Y., 1821; d. 1910*), Congregational clergyman. Removed to Iowa, 1843. At first an itinerant pastor, he served as minister of the First Church of Burlington, 1846–1910. He was author of a number of religious books and several works on Iowa history.

SALTER, WILLIAM MACKINTIRE (*b. Burlington, Iowa, 1853; d. 1931*), Ethical Culture lecturer, philosopher. Son of William Salter. Authority on the thought of Nietzsche.

SALTONSTALL, DUDLEY (*b. New London, Conn., 1738; d. Mole St. Nicolas, Haiti, 1796*), naval officer. Grandson of Gurdon Saltonstall. Served as a privateersman in the French and Indian War; commanded merchant ships before the Revolution. Given command of the *Alfred*, flagship of Commodore Esek Hopkins, 1775, he was in the expedition which captured New Providence, 1776. He is best remembered for his connection with the Penobscot expedition, 1779, during which he commanded the naval forces employed. He was dismissed from the navy for failure to support army operations against the fort and the British vessels which were protecting Castine (Bagaduce) harbor and for the eventual loss of his entire fleet. He was subsequently successful in privateering and afterward returned to the merchant service.

SALTONSTALL, GORDON (*b. Haverhill, Mass., 1666 o.s.; d. 1724 o.s.*), Congregational clergyman, colonial statesman. Great-grandson of Nathaniel Ward; grandson of Richard Saltonstall. Graduated Harvard, 1684. Ordained minister of the church at New London, Conn., 1691; became confidant and adviser of Fitz-John Winthrop. Closely associated with public affairs during Winthrop's governorship, 1698–1707, Saltonstall succeeded him as governor of Connecticut at the request of the Connecticut Assembly and was reelected annually until his death. His adroit and conservative management of the colony's affairs fully justified the confidence placed in him. He was a leader in the approval by the Assembly of the Saybrook platform of 1708 and was active in the permanent settlement of Yale College at New Haven.

SALTONSTALL, LEVERETT (*b. Boston, Mass., 1892; d. Dover, Mass., 1979*), governor and U.S. senator. Graduated Harvard University (B.A., 1914; LL.B., 1917) and joined his father's law firm in 1920. He was elected to the board of aldermen in Newton, Mass.; won the Republican seat in the Massachusetts legislature (1922–36), serving as speaker in 1929–36; and won the governorship in 1938. As governor, he trimmed waste in the state government and lowered taxes while securing social reforms,

such as unemployment insurance and old-age insurance. He was elected to the U.S. Senate (1944–66), where he served on the Naval Affairs and Armed Services committees; he helped secure passage of the National Security Act of 1947, backed the Roosevelt–Truman policy of internationalism, and collaborated with Sen. John F. Kennedy on establishing the Cape Cod National Seashore and gaining federal insurance for flood-stricken communities. He took stands unpopular with the Republican right in the 1950's; he was the only Republican leader to vote for censure of Sen. Joseph McCarthy and endorsed President Harry Truman's recall of General Douglas MacArthur from command in Korea.

SALTONSTALL, RICHARD (*b. Woodsome, Yorkshire, England, ca. 1610; d. Hulme, Lancashire, England, 1694*), Massachusetts colonist. Grandfather of Gurdon Saltonstall. Came with his father to Massachusetts Bay, 1630, where they established the settlement of Watertown. After studying law in England, 1631–35, he returned to New England and settled in Ipswich. His residence there was interrupted by three stays in England, 1649–63, 1672–80, and 1686–94. A colonial officeholder and magistrate, he served also in the militia and was a member of the liberal group which included Simon Bradstreet and Nathaniel Ward.

SALTUS, EDGAR EVERTSON (*b. New York, N.Y., 1855; d. 1921*), novelist, essayist. Author of *The Philosophy of Disenchantment* (1885) and other works expressive of rebellion against contemporary main currents in American literature, Saltus wrote in a style which strained after effect and was more bizarre than original. He is to be studied at his best in an account of the Roman emperors, *Imperial Purple* (1892); his fiction was marked by weakness of characterization and melodramatic situations.

SAMAROFF, OLGA (*b. San Antonio, Tex., 1882; d. New York, N.Y., 1948*), pianist, teacher. Christened Lucie Mary Olga Agnes Hickenlooper. Studied at Paris Conservatory, where in 1896 she was first American girl to win a scholarship; studied also in Berlin. Debut at Carnegie Hall, New York City, January 1905, as "Olga Samaroff," the name of a remote ancestor. Successful in European and American concert tours, she married Leopold Stokowski, 1911, from whom she was divorced in 1923. Taught at Juilliard School, New York City, *post* 1925, and at Philadelphia Conservatory of Music *post* 1928; organized Schubert Memorial, 1928, to provide debut opportunities for young American artists; created Layman's Music Courses, *ca.* 1930.

SAMPSON, MARTIN WRIGHT (*b. Cincinnati, Ohio, 1866; d. 1930*), educator, editor. Stimulating teacher of English composition and literature at University of Iowa, Stanford, Indiana, and Cornell, 1908–30.

SAMPSON, WILLIAM (*b. Londonderry, Ireland, 1764; d. New York, N.Y., 1836*), Irish patriot, lawyer. Imprisoned for activity with the United Irishmen at the end of the 18th century, Sampson was exiled in 1799 and settled in the United States, 1806. Admitted to the bar almost immediately, he won high rank through his eloquence and his advocacy of personal rights. He was counsel in one of the earliest American labor cases (the Journeymen Cordwainers Case in New York, 1809–10) and in 1813 was successful as amicus curiae in the Kohlmann Case. His *Memoirs* (1807) were in fact a denunciation of the British policy toward Ireland. He was also author of an early (1823) plea for the codification of American law.

SAMPSON, WILLIAM THOMAS (*b. Palmyra, N.Y., 1840; d. Washington, D.C., 1902*), naval officer. Graduated U.S. Naval Academy, 1861. After service with the Union naval forces, he performed several tours of duty as an instructor at Annapolis and

was superintendent of the Naval Academy, 1886–90. As chief of the ordnance bureau, 1893–97, he was credited with making great advances in guns, explosives, and gunnery practice. President of the board of inquiry on the *Maine* disaster, he was selected to command the North Atlantic Squadron in the war with Spain; he supervised the entire blockade of Cuba and was responsible for cooperation with the army. His absence from the mouth of Santiago Harbor when the Spanish squadron issued forth to defeat on the morning of July 3, 1898, led to a celebrated controversy with Adm. Winfield S. Schley over credit for the victory. He was made permanent rear admiral, 1899.

SAMUELS, EDWARD AUGUSTUS (*b. Boston, Mass., 1836; d. Fitchburg, Mass., 1908*), ornithologist, sportsman, authority on the natural history of New England.

SAMUELS, SAMUEL (*b. Philadelphia, Pa., 1823; d. Brooklyn, N.Y., 1908*), master mariner. Celebrated for his 78 fast voyages as captain of the New York and Liverpool packet *Dreadnought*, 1854–62. Author of an interesting autobiography *From the Forecastle to the Cabin* (1887).

SANBORN, EDWIN DAVID (*b. Gilmanton, N.H., 1808; d. New York, N.Y., 1885*), educator. Graduated Dartmouth 1832. Taught Latin and Greek at Dartmouth, 1835–37, and in 1837 became professor of Latin. Removing to Washington University, St. Louis, Mo., 1859, he taught there until 1863; he then returned to Dartmouth as professor of oratory and belles letters, resigning in 1882. A teacher of the old school, brimful of learning, he inspired generations of undergraduates with some measure of his own enthusiasm for letters.

SANBORN, FRANKLIN BENJAMIN (*b. Hampton Falls, N.H., 1831; d. Plainfield, N.J., 1917*), author, journalist, reformer. Graduated Harvard, 1855. Influenced by Theodore Parker and Ralph Waldo Emerson, he conducted a school at Concord, Mass., and was soon in the thick of the abolition movement. New England agent for John Brown, he was arrested in April 1860 for refusing to testify before the U.S. Senate on Brown's intentions, but was almost immediately released on a writ of habeas corpus. Thereafter he devoted the greater part of his time to newspaper work and to activity with the Massachusetts state board of charities. A lecturer at many schools and colleges, he joined with William T. Harris in establishing the Concord School of Philosophy. He had known intimately the men and women who had made Concord famous and served as their loyal, intelligent editor and biographer after their deaths. Among his books are *Henry D. Thoreau* (1882), *The Life and Letters of John Brown* (1885 and later editions), *Ralph Waldo Emerson* (1901), and *Recollections of Seventy Years* (1909).

SANBORN, KATHERINE ABBOTT (*b. Hanover, N.H., 1839; d. 1917*), teacher, lecturer, journalist. Daughter of Edwin D. Sanborn, she published most of her writing under the name of Kate Sanborn. Among her books are *Adopting an Abandoned Farm* (1891), *A Truthful Woman in Southern California* (1839), and *Memories and Anecdotes* (1915).

SANBORN, WALTER HENRY (*b. Epsom, N.H., 1845; d. 1928*), jurist. Removed to St. Paul, Minn., ca. 1870. Judge, U.S. circuit court of appeals (8th Circuit), 1892–1928; presiding judge of the circuit post 1903. A man of deep learning, he was especially skilled in cases dealing with personal injury.

SANDBURG, CARL AUGUST (*b. Galesburg, Ill., 1878; d. Flat Rock, N.C., 1967*), poet, biographer, journalist, and folklorist. Attended Lombard College in Illinois and published his first book of poems, *In Reckless Ecstasy*, in 1904. Was drawn into Chicago's radical circles, and in 1907 joined the Socialist party and became a professional organizer; but broke with the party in 1917. A number of his poems, including "Chicago," were published in *Poetry: A Magazine of Verse* in 1912, and their free verse in vigorous colloquial rhythms established him as an outstanding figure among Chicago writers. Published *Chicago Poems* (1916), *Cornhuskers* (1918), *Smoke and Steel* (1920), and *Slabs of the Sunburnt West* (1922). In 1918 he went to Stockholm, Sweden, to report on the Finnish Revolution for the Newspaper Enterprise and smuggled Lenin's "Letter to American Workingmen" into the United States. His first book for children was *Rootabaga Stories* (1922). He made frequent public appearances before college groups and literary audiences, and his platform appearances increased his popularity and the sale of his books. He brought together nearly 300 songs and ballads in *The American Songbag* (1927). His two-volume *Abraham Lincoln: The Prairie Years* (1926) won critical acclaim, and his four-volume *Abraham Lincoln: The War Years* (1939) won a Pulitzer Prize. His one novel *Remembrance Rock* (1948), and his *Complete Poems* (1950) won him another Pulitzer. He received the Presidential Medal of Freedom in 1964.

SANDE, EARL (*b. Groton, S.Dak., 1898; d. Jacksonville, Oreg., 1968*), jockey and horse trainer. Began his professional career in 1918 in New Orleans and rode 158 winners that first season. He was the leading money-winning jockey in 1921, 1923, and 1927, winning the Kentucky Derby on Flying Ebony in 1925 and on Zev in 1927. He was suspended in 1927 for a foul at Pimlico, but was reinstated in 1928. Returned as a jockey in 1930 and rode Gallant Fox to the Triple Crown of racing; he rode thirteen winners in 1932, the year he retired. Was a trainer for Col. Maxwell Howard, 1932–44, then took over the Howard stable, and also trained for Clifford Mooers until 1949.

SANDEMAN, ROBERT (*b. Perth, Scotland, 1718; d. Danbury, Conn., 1771*), preacher. Promoter in the American colonies of the sect which came to be known as Sandemanians, 1764–71. He and his followers were vigorously opposed by leading New England ministers for their rejection of the Covenant of Grace and of the doctrine of justification by faith as an act of regeneration. Sandeman taught that "every one who obtains a just notion of the person and work of Christ . . . is justified . . . simply by that notion."

SANDERS, BILLINGTON McCARTER (*b. Columbia Co., Ga., 1789; d. Penfield, Ga., 1854*), Baptist minister. Graduated South Carolina College, 1809. First principal of Mercer Institute, 1832–39, he has been justly called the real founder of Mercer University.

SANDERS, CHARLES WALTON (*b. Newport, N.Y., 1805; d. New York, N.Y., 1889*), educator. Author of elementary school textbooks in reading and spelling.

SANDERS, DANIEL CLARKE (*b. Sturbridge, Mass., 1768; d. Medfield, Mass., 1850*), educator, Congregational clergyman. Graduated Harvard, 1788. First president of University of Vermont, 1800–14, Sanders managed its finances, supervised erection of its first building, and for some time carried the entire burden of instruction. Pastor of the First Church, Medfield, Mass., 1815–29.

SANDERS, DANIEL JACKSON (*b. near Winnsboro, S.C., 1847; d. 1907*), Presbyterian clergyman, educator. Born in slavery, Sanders graduated from Western Theological Seminary, Allegheny, Pa., 1874. A leader in educational work and a pastor in Wilmington, N.C., he was editor of the *Africo-American Presbyterian*,

post 1879, and president of Biddle (later Johnson C. Smith) University, *post* 1891.

SANDERS, ELIZABETH ELKINS (*b. Salem, Mass., 1762; d. Salem, 1851*), author, reformer. Advocate of justice for the American Indian and opponent of foreign-mission activity.

SANDERS, FRANK KNIGHT (*b. Batticotta, Ceylon, 1861; d. Rockport, Mass., 1933*), Congregational clergyman, biblical scholar. Son of missionary parents, he graduated Ripon College, 1882. Influenced by the teaching of William R. Harper at Yale Divinity School, he turned to graduate work in Semitic languages, Ph.D., 1889. Instructor and professor at Yale, 1889–1905, and dean of its Divinity School, 1901–05, he was active thereafter in church administrative positions and was author of a number of books.

SANDERS, GEORGE (*b. St. Petersburg, Russia, 1906; d. Barcelona, Spain, 1972*), actor. After a lackluster career on British radio and stage, in 1936 he appeared in his first British motion picture, *Find the Lady*, and first American film, *Lloyds of London*. He moved to Hollywood, where he played in over ninety films, often cast as a suave and cruel villain. His most memorable performances were in *Lancer Spy* (1937), *The Picture of Dorian Gray* (1945), *All About Eve* (1950), and *A Shot in the Dark* (1964). He also starred in the "The Saint" and "The Falcon" detective film series.

SANDERS, GEORGE NICHOLAS (*b. Lexington, Ky., 1812; d. 1873*), financial promoter, lobbyist, revolutionist. Grandson of George Nicholas. Led "Young America" movement, 1851–53, as means of furthering revolutionary republicanism in Europe. As U.S. consul in London, 1853, he plotted recklessly with Kossuth, Mazzini, and other exiled rebels and was refused Senate confirmation in the post. During the Civil War, he was a Confederate agent in Europe and Canada. Half-idealist, half-charlatan.

SANDERS, HARLAND DAVID ("COLONEL") (*b. Henryville, Ind., 1890; d. 1980*), restaurateur and entrepreneur. Took correspondence courses in law from Southern University and represented clients from the mid–1910's to early 1920's. In 1929 he opened a filling station with an adjacent restaurant, locally famous for its fried chicken, in Corbin, Ky. He failed in his attempt in 1937 to start a chain of restaurants, but by 1952 "Colonel" Sanders had perfected a "secret recipe of eleven herbs and spices" for a unique process of frying chicken. In 1956 he sold the Corbin business and traveled the nation to promote his chicken and sell franchises; by 1960 he had franchised more than 200 outlets. By 1963 Colonel Sanders Kentucky Fried Chicken was the largest fast-food chain in the United States. He sold the firm for $2 million in 1964 and remained a salaried director and goodwill ambassador.

SANDERS, JAMES HARVEY (*b. Union Co., Ohio, 1832; d. Memphis, Tenn., 1899*), agricultural journalist. Founded *Western Stock Journal*, May 1869, the first periodical devoted to animal husbandry; was a noted breeder of horses; wrote the *Norman Stud Book* (1876) and other studies in animal heredity.

SANDERS, THOMAS (*b. South Danvers, Mass., 1839; d. Derry, N.H., 1911*), financier. Advanced money to Alexander Graham Bell for development of the telephone; later served as an official and director of the Bell Telephone Co.

SANDERS, WILBUR FISK (*b. Leon, N.Y., 1834; d. 1905*), Montana pioneer lawyer. Nephew of Sidney Edgerton, with whom he removed to what was then eastern Idaho, 1863. An organizer of vigilantes and successful in his practice, he was a leader in the movement to form a separate territory from eastern Idaho. After organization of Montana Territory, 1864, he promoted the Republican party there, and on Montana's admission as a state, he was elected U.S. senator, serving January 1890–March 1893.

SANDERSON, EZRA DWIGHT (*b. Clio, Mich., 1878; d. Ithaca, N.Y., 1944*), entomologist, rural sociologist. B.S., Michigan Agricultural College, 1897; B.S., Cornell University, 1898; Ph.D., University of Chicago, 1921. Worked in the field of economic entomology in Maryland, Delaware, Texas, New Hampshire, and West Virginia; headed Department of Rural Sociology, Cornell University, 1918–43.

SANDERSON, JOHN (*b. near Carlisle, Pa., 1783; d. Philadelphia, Pa., 1844*), educator, author. Teacher of classical languages and English in Philadelphia, Sanderson was a popular contributor to periodicals and for a brief time edited the *Aurora* newspaper. He was author of *Sketches of Paris, by an American Gentleman* (1838), which was widely read, and with his brother published the first two volumes of the *Biography of the Signers to the Declaration of Independence* (1820, completed by Robert Waln, 1823–27).

SANDERSON, ROBERT (*b. England, 1608; d. Boston, Mass., 1693*), silversmith. Immigrated to America as a young man; was among first settlers in Hampton, N.H., 1638; resided in Watertown, Mass., 1639–53. Removed to Boston in 1653, after appointment (with John Hull) to manage the colony mint. A craftsman in the front rank of New England silversmiths, he was probably Hull's first teacher.

SANDERSON, SIBYL (*b. Sacramento, Calif., 1865; d. Paris, France, 1903*), dramatic soprano. Studied at Paris Conservatory, 1886–88. Made debut at The Hague in Massenet's *Manon*, 1888; made Paris debut at the Opéra Comique, 1889; created role of *Thaïs* at Paris, 1894. Despite her tremendous popularity on the Continent, she was received coldly in England and America.

SANDHAM, HENRY (*b. Montreal, Canada, 1842; d. London, England, 1910*), portrait painter, landscapist, illustrator. Worked in Boston, Mass., 1880–1901. Illustrated many books, including H. H. Jackson's *Ramona* (1900 ed.); painted several large historical studies, among them *The Dawn of Liberty*, now in Lexington, Mass., town hall.

SANDLER, JACOB KOPPEL (*b. Bialozerkove, Russia, 1856; d. 1931*), composer. Immigrated to New York City, 1888. After working as a shirtmaker and as a peddler, he became director of a synagogue choir and eked out a precarious living by acting also as chorus director in a Yiddish theater. As incidental music for a long-forgotten play, he composed the celebrated hymn "Eili, Eili"; it was first performed in April 1896 at the Windsor Theatre in the Bowery.

SANDOZ, MARI (*b. Sheridan County, Nebr., 1896; d. New York, N.Y., 1966*), historian and novelist. With only four and a half years of formal schooling, she taught in rural schools in Nebraska, 1913–22, then attended the University of Nebraska as a special student. *Old Jules* (1935), a biography of her father, a Swiss immigrant who had become a rancher and horticulturist, won the Atlantic Monthly Prize for nonfiction; it was the first book in her Trans-Missouri Series, which recounts the history of the Great Plains from the Stone Age to modern times. Taught fiction writing at Wisconsin, 1947–55. Her two highly regarded short novels on Indian themes are *The Horsecatcher* (1956) and *The Story Catcher* (1962). The best and least allegorical of her novels is *Miss Morissa* (1955).

SANDS, BENJAMIN FRANKLIN (*b. Baltimore, Md., 1812; d. Washington, D.C., 1883*), naval officer. Raised in Kentucky; entered navy as midshipman, 1828. After varied service, principally in survey and hydrographic work, he became chief of the Bureau of Construction and served, 1858–61. Promoted captain, 1862, he was senior officer on the North Carolina coast blockade until October 1864, when he was assigned to operations against Fort Fisher. Commander of the second division, West Gulf Squadron, 1865, he hoisted the flag at Galveston, Tex., on June 5 after receiving the surrender of the last Confederate troops. Superintendent of the Naval Observatory, 1867–74, he retired as rear admiral.

SANDS, COMFORT (*b. present Sands' Point, N.Y., 1748; d. Hoboken, N.J., 1834*), New York merchant, Revolutionary patriot and fiscal official. A founder of the Bank of New York, 1784, he was president of the New York Chamber of Commerce, 1794–98.

SANDS, DAVID (*b. present Sands' Point, N.Y., 1745; d. Cornwall-on-the-Hudson, N.Y., 1818*), Quaker preacher, abolitionist, merchant.

SANDS, DIANA PATRICIA (*b. New York City, 1934; d. New York City, 1974*), actress. Appeared in several off-Broadway shows in the 1950's and in 1959 won rave reviews for her performance in *A Raisin in the Sun* and the film version in 1961. She starred in such Broadway productions as *Blues for Mister Charlie* (1964) and *The Owl and the Pussycat* (1964). In 1967 she toured internationally as the female lead in *Caesar and Cleopatra* and appeared in the television series "East Side, West Side" and "I Spy."

SANDS, JOSHUA RATOON (*b. Brooklyn, N.Y., 1795; d. Baltimore, Md., 1883*), naval officer. Nephew of Comfort Sands. Entering the navy, June 1812, he retired as rear admiral, 1872, after a career of active service which included the War of 1812, the Mexican War, and the Civil War.

SANDS, ROBERT CHARLES (*b. New York, N.Y., 1799; d. Hoboken, N.J., 1832*), journalist, author. Son of Comfort Sands. Graduated Columbia, 1815. Projected and edited minor literary periodicals; assisted William Cullen Bryant in editorship of *New York Review*, 1825–26; was on editorial staff of *New-York Commercial Advertiser*, 1827–32. Joined with Bryant and Gulian C. Verplanck in publication of *The Talisman*, an annual to which he contributed some of his best work. His collected writings were published, 1834, including his principal poetic work, *Yamoyden* (previously published, 1820).

SANDYS, GEORGE (*b. Bishopsthorpe, near York, England, 1577/8; d. Boxley Abbey, near Maidstone, Kent, England, 1643/4*), poet, Virginia colonist. A shareholder in the Virginia Co., he was appointed treasurer of the colony of Virginia, 1621. Removing to Virginia in the autumn of that year, he remained there until 1628 or later. An industrious and able administrator, he is best remembered for his verse translation of the *Metamorphoses* of Ovid which he completed in Virginia (1626; 2nd ed., 1632).

SANFORD, EDMUND CLARK (*b. Oakland, Calif., 1859; d. 1924*), psychologist, educator. Graduated University of California, 1883; Ph.D., Johns Hopkins, 1888. Taught at Clark University post 1889, president of Clark College, 1909–20; professor of psychology and education, Clark University, 1920–24.

SANFORD, EDWARD TERRY (*b. Knoxville, Tenn., 1865; d. 1930*), lawyer. Judge, U.S. district court in Tennessee, 1908–23; associate justice, U.S. Supreme Court, 1923–30. Considered slow in making decisions as a district judge, Sanford wrote a number of important opinions while on the Supreme Court. Probably his most important opinion was in what is known as the Pocket Veto Case, 1929.

SANFORD, ELIAS BENJAMIN (*b. Westbrook, Conn., 1843; d. 1932*), Congregational clergyman. A leader in the forming of the Federal Council of the Churches of Christ in America, he served it for many years as secretary and also wrote its history.

SANFORD, HENRY SHELTON (*b. Woodbury, Conn., 1823; d. Healing Springs, Va., 1891*), diplomat, developer of Sanford, Fla.

SANFORD, NATHAN (*b. Bridgehampton, N.Y., 1777; d. Flushing, N.Y., 1838*), lawyer, New York State legislator and public official. U.S. senator, Democrat, from New York, 1815–21 and 1826–31, he confined his attention to administration and to measures for improvement of government organization. He advocated creation of a department of the interior and expansion of the attorney general's office into a department of justice.

SANGER, CHARLES ROBERT (*b. Boston, Mass., 1860; d. Cambridge, Mass., 1912*), chemist. Son of George P. Sanger. Graduated Harvard, 1881; Ph.D., 1884. Associated in research work with Henry B. Hill, Sanger succeeded him as professor of chemistry at Harvard, 1903. His most important research was concerned with detection of arsenic and antimony and with the chemistry of pyromucic acid and its derivatives. His work confirmed the dangers suspected in the use of arsenic in wallpaper.

SANGER, GEORGE PARTRIDGE (*b. Dover, Mass., 1819; d. 1890*), Boston lawyer, Massachusetts public official. First president, John Hancock Mutual Life Insurance Co. (organized 1863).

SANGER, MARGARET HIGGINS (*b. Corning, N.Y., 1879; d. Tucson, Ariz., 1966*), birth control advocate. In 1911, professing the twin goals of sexual and political revolution, she joined the Socialist party, wrote articles for the Socialist *Call*, and participated in the Lawrence, Mass., textile mills strikes. As a visiting nurse on Manhattan's Lower East Side she encountered many women whose health had been broken by excessive childbearing or botched abortions. Began to publish *Woman Rebel* (1914), a belligerently radical sheet, but its postal privileges were almost immediately suspended for violating federal antiobscenity statutes. She fled to Europe to avoid prosecution, and remained there until 1915; charges were dropped in 1916. She opened the first birth control clinic in the United States in Brooklyn, N.Y., in 1916, and within weeks was arrested and served a thirty-day sentence. In 1917 she launched *Birth Control Review*, which served as link for birth control organizations springing up around the country. By the 1920's she had abandoned her radical associates and fallen in with upper-class woman reformers. Organized the first American Birth Control Conference and founded the American Birth Control League in 1921, over which she presided until 1928. She prodded the American Medical Association in 1937 to declare its support for prescribing contraception and for conducting research into improved contraceptive techniques; that research, with Sanger's quiet financial backing, led to the development of the birth control pill in the 1950's. In 1938 the American Birth Control League and her Clinical Research Bureau joined to form the Birth Control Federation of America, later the Planned Parenthood Federation of America.

SANGSTER, MARGARET ELIZABETH MUNSON (*b. New Rochelle, N.Y., 1838; d. Maplewood, N.J., 1912*), journalist. Editor of, among other periodicals, *Hearth and Home* and *Harper's Bazaar*; author of a number of volumes in prose and verse compiled from her magazine articles and of several novels, cheerful, practical, and religious in tone.

SANKEY, IRA DAVID (*b. Edinburg, Pa., 1840; d. Brooklyn, N.Y., 1908*), singing evangelist. Associated *post ca.* 1870 with the work of Dwight L. Moody. Collections of the songs used in the Moody and Sankey revivals gained almost worldwide popularity.

SANTAYANA, GEORGE (*b. Madrid, Spain, 1863; d. Rome, Italy, 1952*), philosopher and poet. Immigrated to the U.S. in 1872. Studied at Harvard (Ph.D., 1889) and Berlin. Taught at Harvard (1889–1912). Lived abroad after 1912. One of America's foremost philosophers, Santayana published many works: *Sonnets and Other Verses* (1894), *The Sense of Beauty* (1896), *Interpretations of Poetry and Religion* (1900), *The Life of Reason: or the Phases of Human Progress* (1905–06), *The Realm of Being* (1927–40), *Scepticism and Animal Faith* (1923), and a bestselling novel, *The Last Puritan* (1935). Santayana believed that nature is ultimately man's source and destiny and that nature manifests itself in man in his urge to make existence as reasonable and beautiful as possible. Man's moral task is to move towards reason and harmony through appreciation and action informed by critical and constructive effort.

SAPIR, EDWARD (*b. Lauenburg, Germany, 1884; d. New Haven, Conn., 1939*), anthropologist, linguist. Came to America as a child. Graduated Columbia, 1904; Ph.D., 1909. Influenced by Franz Boas, whose anthropological approach to the study of language opened up vistas for him, Sapir began the study of American Indian languages and cultures, the field in which much of his work was done. Chief of the anthropology division, Canadian National Museum, 1910–25, he was Sterling professor of anthropology and linguistics at Yale, 1925–39. A pioneer in the phonemic method of linguistic analysis, he was also much interested in general culture and its relation to personality. He was author of many specialized papers and of *Language* (1921).

SAPPINGTON, JOHN (*b. Maryland, 1776; d. 1856*), physician. Raised in Tennessee; removed to Missouri, 1817, where he practiced in Howard and later Saline counties. Soon after quinine (isolated 1820) became available in the United States, he strongly advocated its use in treatment of malaria without recourse to bleeding and purging. Author of *Theory and Treatment of Fevers* (1844), he distributed quinine wholesale, *post* 1832, as Dr. Sappington's Anti-Fever Pills.

SARDI, MELCHIORRE PIO VENCENZO ("VINCENT") (*b. San Marzano Oliveto, Italy, 1885; d. Saranac Lake, N.Y., 1969*), restaurateur. An adventurous boy, he worked on a coastal schooner and then in London gained experience as waiter in plush hotels. After arrival in New York (1907), he refined his skills in food service at several of the city's finest restaurants, such as Knickerbocker Hotel's dining room, the Palais Royale, and the Bartholdi Inn. In 1921 he opened Sardi's, a small forty-seat restaurant in the theater district; it soon attracted a steady stream of actors, producers, and writers. In 1926 he had to close to make way for the St. James Theater; he opened a new Sardi's in 1927 in the same area, but customers were slow in returning. He hired Alex Gard to do caricatures of his clientele, and soon hundreds of them covered the walls from floor to ceiling. By 1930's the restaurant was more popular than ever. Syndicated columnists, such as Walter Winchell, made the dining room their home base; following opening night performances on Broadway, it became a tradition to gather at Sardi's to wait for reviews. In 1946 Sardi's became the setting for the daily radio program "Luncheon at Sardi's." He retired in 1947.

SARG, TONY (*b. Coban, Guatemala, 1880; d. New York, N.Y., 1942*), illustrator, author, puppeteer. Son of a German coffee and sugar planter and his English wife; graduated Prussian military academy at Lichterfelde, 1899. Resigned army commission, 1905, and worked as an artist in England, 1905–15. Immigrated to New York City, 1915, where he worked as a designer and illustrator, and created highly original marionette shows, which toured with great success, 1920–30. Among his most notable creations were the giant animal balloons, featured in Macy's Thanksgiving Day parade in New York City.

SARGENT, AARON AUGUSTUS (*b. Newburyport, Mass., 1827; d. San Francisco, Calif., 1887*), printer, journalist, lawyer. Removed to California, 1849. Starting in politics as a Know-Nothing assemblyman, he was active in organization of the Republican party in California and served as congressman, 1861–63 and 1869–73. He was author, with Theodore D. Judah, of the first Pacific railroad bill to pass Congress. U.S. senator, 1873–79, he was U.S. minister to Germany, 1882–84. Closely identified with the railroad interests, he was a masterful machine politician.

SARGENT, CHARLES SPRAGUE (*b. Boston, Mass., 1841; d. 1927*), arboriculturist, Union soldier. Graduated Harvard, 1862. Professor of horticulture at Harvard, 1872–73; professor of arboriculture, 1879–1927. Directed the Arnold Arboretum *post* 1873. Author of *Report on the Forests of North America* (1884) and the notable *Silva of North America* (1891–1902), among other works. Advocated conservation and national parks.

SARGENT, DUDLEY ALLEN (*b. Belfast, Maine, 1849; d. 1924*), physician, physical culture expert. Developed programs of physical training at Bowdoin, Yale, and Harvard; organized a training school for physical education teachers at Cambridge, Mass., 1881.

SARGENT, EPES (*b. Gloucester, Mass., 1813; d. 1880*), journalist, poet, spiritualist. Brother of John O. Sargent. His numerous anthologies composed for school use gave him a wide contemporary celebrity. Among his plays, *Velasco* (published 1839) was the most successful; his best volume of verse was *Songs of the Sea* (1847), which contains the well-known "A Life on the Ocean Wave." *Post* 1865, he devoted most of his energy to the exposition of his new faith in spiritualism.

SARGENT, FITZWILLIAM (*b. Gloucester, Mass., 1820; d. Bournemouth, England, 1889*), ophthalmologist, surgeon. Practiced in Philadelphia, 1843–52; lived principally in Europe thereafter. Father of John Singer Sargent.

SARGENT, FRANK PIERCE (*b. East Orange, Vt., 1854; d. Washington, D.C., 1908*), labor leader. Headed Brotherhood of Locomotive Firemen, 1885–1902. As U.S. commissioner general of immigration *post* 1902, he helped initiate methods for the prevention of fraud against immigrants, for the exclusion of undesirable elements, and for the prevention of smuggling of Chinese across the borders.

SARGENT, FREDERICK (*b. Liskeard, England, 1859; d. Glencoe, Ill., 1919*), electrical engineer. Came to America, 1880. Consulting engineer for the Chicago Edison Co. and many other concerns, he was a specialist in the design and construction of central electric generating stations. He was among the first to recognize the advantages of the steam turbine.

SARGENT, GEORGE HENRY (*b. Warner, N.H., 1867; d. Warner, 1931*), journalist. City editor, *St. Paul* (Minn.) *Daily Pioneer Press*, 1890–95; staff member, *Boston Evening Transcript*, 1895–1931. Conducted "The Bibliographer" department for the *Transcript*.

SARGENT, HENRY (*b. Gloucester, Mass., ca. 1770; d. 1845*), painter. Brother of Lucius M. Sargent. Encouraged by John Trumbull, he studied in London with Benjamin West. Diligent and gifted, he fell short of genius; he is best represented by *The Tea Party* and *The Dinner Party* in the Boston Museum of Fine Arts.

SARGENT, HENRY WINTHROP (*b. Boston, Mass., 1810; d. 1882*), horticulturist, landscape gardener. Son of Henry Sargent.

SARGENT, JAMES (*b. Chester, Vt., 1824; d. 1910*), lock expert. Formed partnership of Sargent and Greenleaf in Rochester, N.Y., 1869, to manufacture the "nonpickable" lock which he had devised; perfected a time lock *ca.* 1873. He was also inventor and manufacturer of a number of other devices, including railway semaphore signals, automatic fire alarms, and glass-lined steel tanks.

SARGENT, JOHN OSBORNE (*b. Gloucester, Mass., 1811; d. 1891*), lawyer, journalist. Brother of Epes Sargent. Author of, among other works, the posthumous *Horatian Echoes* (1893).

SARGENT, JOHN SINGER (*b. Florence, Italy, 1856; d. London, England, 1925*), painter. Son of Fitz-William Sargent. Encouraged in art by his mother (who had been responsible for the family's expatriation to Europe shortly before his birth), Sargent received lessons at the Academy in Florence and continued to sketch from nature as the family wandered through southern Italy, France, and Germany. Beginning formal study at the Beaux-Arts in Paris, 1874, he acquired in the atelier of Carolus-Duran a facile and fluent technique quite suited to his temperament and a dexterity in seizing instantaneous effects. After a brief visit to the United States, 1876, he returned to France, where he painted his *Gitana* and *Rehearsal at the Cirque d'Hiver*; in 1877 he sent his first picture, a portrait of Miss Watts, to the Salon. Following productive visits to Italy, Spain, and Morocco, 1878–80, he entered on a period of activity to which belong some of his finest portraits, including the famous *Madame Gautreau*, which roused a tempest of abuse when it was first exhibited in Paris. The artist was entirely serious in his work and devoid of malice; he had depicted the lady in a costume of her own choosing and he was astonished and hurt at the outcry of disparagement. Removing from Paris to London, he encountered further harsh criticism from the press, his portraits of Mrs. White and the Misses Vickers being declared hard, tasteless, and raw in color. His exotic style and brilliance, however, offering a contrast to the academic manner of British portrait painters of the time, brought him all the patrons he could desire. Establishing himself in a studio in Tite St., London, 1885, he produced the first of a long series of pictures of children in which he revealed the most lovable side of his nature in work of remarkable delicacy and beauty. His *Carnation, Lily, Lily, Rose*, exhibited at the Royal Academy, 1887, was a great success.

Resident in Boston, Mass., 1887–88, Sargent was first accorded the American appreciation which was so great a source of satisfaction to him throughout his career. Henceforward, Boston became his American headquarters and the goal of a long series of visits. On his second trip to America, 1890, he painted *Carmencita*, considered his masterpiece by many critics, and portraits of Edwin Booth, Joseph Jefferson, and Lawrence Barrett. Commissioned by the trustees of the Boston Public Library to paint mural decorations for that building, he welcomed the change. Beginning preliminary work, 1891, he completed the first part, 1894, and went to Boston, 1895, to see to its emplacement. Meanwhile, his portrait work continued and culminated in the appearance of the Wertheimer family portraits (1898, 1901, 1902). Made a Royal Academician, 1897, he showed forth all the finest qualities of his art in his diploma picture, *A Venetian Interior* (1900). Crossing and recrossing the Atlantic almost every year, he enjoyed on these voyages the only real rest periods he ever allowed himself to take. In 1916 he returned to America to install the last of the Boston Public Library decorations, and that summer went sketching in the Canadian Rockies and Glacier National Park. On completion of the library decorations he undertook to decorate the rotunda of the Art Museum, Boston, and while preparing studies for this work went to the war front in France during 1918 to record impressions for the Imperial War Museum, London. The Sargent exhibition in New York, 1924, was harshly reviewed by the modernists and was indicative of the change of taste which was soon to depreciate Sargent's worth as an artist.

As a portrait painter Sargent ranks beneath the greatest masters but rates as the equal of the best painters of the British school, Reynolds and Gainsborough. His genre paintings are original, objective, and possess great charm of style, but he was not so effective in landscape. Much may be said pro and con about his mural paintings. As he violated the accepted canons which ban relief and perspective, his walls do not have the vertical aspect demanded by sound architectonic principles; also, the want of flatness of modeling is matched by overwhelming complexity of detail. His Boston Library work, however, presents a splendid effect. His fertility of invention is undeniable, and if his work has little of the impassioned conviction of the ages of faith, this can hardly be imputed to the artist as a serious fault, for he was of his own time.

SARGENT, LUCIUS MANLIUS (*b. Boston, Mass., 1786; d. Boston, 1867*), antiquary, temperance advocate. Brother of Henry Sargent. Author of *Hubert and Ellen* (1812), *The Temperance Tales* (1848), *Dealings with the Dead* (1856), and other works.

SARGENT, NATHAN (*b. Putney, Vt., 1794; d. 1875*), Whig and Republican journalist, lawyer. Washington correspondent under pseudonym "Oliver Oldschool" for many Northern newspapers *post* 1842.

SARGENT, WINTHROP (*b. Gloucester, Mass., 1753; d. near New Orleans, La., 1820*), Revolutionary soldier, Ohio pioneer. Graduated Harvard, 1771. A secretary of the Ohio Co., he aided Manasseh Cutler in the purchase of land and took an active part in the planning of the new colony at Marietta. Appointed by Congress the secretary of Northwest Territory, 1787, he assumed charge during the frequent, prolonged absences of Governor Arthur St. Clair and was acting governor of the territory after St. Clair's defeat by the Indians, November 1791. Resigning his secretaryship, 1798, he became the first governor of Mississippi Territory, but failed of reappointment in 1801. Unpopular because of his Federalism, he was a conscientious public servant and a man of wide intellectual interests.

SARGENT, WINTHROP (*b. Philadelphia, Pa., 1825; d. Paris, France, 1870*), author. Grandson of Winthrop Sargent (1753–1820). A talented historical researcher, Sargent was author of *The History of an Expedition Against Fort Du Quesne in 1755* (1855) and *Life and Career of Major John André* (1861); he also edited *The Loyal Verses of Joseph Stansbury and Doctor Jonathan Odell* (1860).

SARNOFF, DAVID (*b. Uzlian, Russia, 1891; d. New York City, 1971*), communications executive. Joined the Marconi Wireless Telegraph Company of America in 1906, advancing to commercial manager in 1917. After the British-owned company was sold to General Electric in 1919, Sarnoff became an executive for the new Radio Corporation of American (RCA). He led RCA

efforts to create a radio network to broadcast entertainment and information into the homes of Americans. The National Broadcasting Company (NBC), a subsidiary of RCA, launched radio service in 1927. By 1929, when Sarnoff was made chairman of RCA Victor, radio sales exceeded $800 million. That year Sarnoff also helped form the motion-picture company Radio–Keith–Orpheum (RKO) and hired Vladimir Zworykin, the inventor who developed an all-electronic television. In 1941 NBC started commercial telecasting. During World War II Sarnoff led efforts to coordinate the Allied broadcast facilities, for which he was promoted to brigadier general in 1944. He later supported U.S. intelligence agencies during the Cold War with RCA facilities and expertise. As an executive at RCA, Sarnoff stressed innovation and technological advances and strongly supported investment in research efforts, claiming that "the heart of RCA is its scientific laboratories." He retired in 1968.

SARPY, PETER A. (*b. St. Louis, Mo., 1805; d. Plattsmouth, Nebr., 1865*), fur trader, probably first white resident of Nebraska. Headed trading post at Bellevue, Nebr., *post ca.* 1823; assisted the Mormons on their first expedition westward; played large part in negotiation of land-cession treaties with Omaha and Oto Indians, 1854.

SARTAIN, EMILY (*b. Philadelphia, Pa., 1841; d. Philadelphia, 1927*), painter, engraver, educator. Daughter of John Sartain; sister of Samuel and William Sartain. Principal of the School of Design for Women, Philadelphia, 1886–1919.

SARTAIN, JOHN (*b. London, England, 1808; d. Philadelphia, Pa., 1897*), engraver, publisher. Came to America, 1830. Executed engraved plates for the periodicals of the day and was associated, 1841–48, principally with *Graham's Magazine*. Published *Sartain's Union Magazine*, 1849–52, a literary and artistic success but a financial failure. A versatile artist in all types of work, Sartain was particularly distinguished for his facility in mezzotint. Of his eight children, Emily, Samuel, and William had distinguished careers. He was author of an autobiography, *Reminiscences of a Very Old Man* (1899).

SARTAIN, SAMUEL (*b. Philadelphia, Pa., 1830; d. Philadelphia, 1906*), engraver. Son of John Sartain.

SARTAIN, WILLIAM (*b. Philadelphia, Pa., 1843; d. 1924*), painter. Son of John Sartain. Studied with Christian Schüssele and in France with Léon Bonnat. Particularly effective as a landscape painter, he was also active as a teacher and in artists' associations.

SARTON, GEORGE ALFRED LÉON (*b. Ghent, Belgium, 1884; d. Cambridge, Mass., 1956*), historian of science. Studied at the University of Ghent (D.Sc., 1911). Founder of the history of science journal *Isis* (1912) and its companion journal *Osiris* (1936). Sarton immigrated to the U.S. in 1915. *Isis*, which included Poincaré, Arrhenius, Durkheim, and Ostwald on the editorial board, was to become the mainspring for the study and legitimation of the history of science. An associate at the Carnegie Institution in Washington, D.C., Sarton lived in Cambridge. He completed three volumes of his monumental, *Introduction to the History of Science* by 1948. *Isis* became the official journal of the History of Science Society in 1924. Sarton was elected to the American Philosophical Society in 1934. President, International Union of History of Science (1950–56). Considered the chief catalyst in America for the formation of history of science as a distinct discipline. Father of novelist May Sarton.

SARTWELL, HENRY PARKER (*b. Pittsfield, Mass., 1792; d. Penn Yan, N.Y., 1867*), physician, botanist. Author of, among other works, *Carices Americae Septentrionalis Exsiccatae* (1848–50).

SASLAVSKY, ALEXANDER (*b. Kharkov, Russia, 1876; d. San Francisco, Calif., 1924*), violinist, conductor. Studied in Kharkov and Vienna; came to America *ca.* 1893. A first violinist of the New York Symphony Society, 1893–1918, and concertmaster and assistant conductor *post* 1903, Saslavsky became concertmaster of the Philharmonic Orchestra of Los Angeles, 1919. Throughout his career he was important as a teacher and for his work in introducing chamber music to a larger public.

SASSACUS (*b. probably near Groton, Conn., ca. 1560; d. 1637*), chief sachem of the Pequot. Killed by the Mohawk while fleeing westward after defeat of Pequot by John Mason, 1637.

SATTERLEE, HENRY YATES (*b. New York, N.Y., 1843; d. 1908*), Episcopal clergyman. Graduated Columbia, 1863; studied at General Theological Seminary, New York. Minister at Wappinger Falls, N.Y., 1865–82; rector of Calvary Parish, New York City, 1882–96. Elected bishop of the diocese of Washington, D.C., 1896, he projected and outlined plans for the National Cathedral, which was later developed in accord with his vision of it.

SATTERLEE, RICHARD SHERWOOD (*b. Fairfield, N.Y., 1798; d. 1880*), army surgeon. Practiced in Seneca Co., N.Y., and in Detroit, Mich., 1818–22; entered the U.S. Army as assistant surgeon, 1822; served in Middle West frontier posts and in Seminole War. Senior surgeon of General Worth's division in the Mexican War, he supervised the general hospital in Mexico City after its fall. Appointed medical purveyor, 1853, he served in this capacity throughout the Civil War, retiring as lieutenant colonel, 1869.

SAUER, CARL ORTWIN (*b. Warrenton, Mo., 1889; d. Berkeley, Calif., 1975*), geographer. Graduated Central Wesleyan College (1908) and University of Chicago (Ph.D., 1915) and held faculty positions at the University of Michigan in Ann Arbor (1916–23) and the University of California at Berkeley (1923–57). His scholarship on geography, which emphasized historical, ecological, and humanistic factors, helped transform the academic discipline. He also pioneered research on the environmental problems of erosion and pollution. Among his noted works are *The Morphology of Landscape* (1925), *Handbook of South American Indians* (1950), and *Sixteenth Century North America: The Land and the People as Seen by North Americans* (1971).

SAUGANASH (*b. Canada, ca. 1780; d. near present Council Bluffs, Iowa, 1841*), Potawatomi subchief. Also known as Billy Caldwell or Englishman. An associate of Tecumseh, 1807–13, he swore allegiance to the United States *ca.* 1820 when he took up residence at present, Chicago, Ill. He migrated with his people to Iowa in 1836.

SAUGRAIN DE VIGNI, ANTOINE FRANÇOIS (*b. Paris, France, 1763; d. St. Louis, Mo., 1820*), physician, naturalist, philosopher. Visited the United States, 1787–88, when he became a friend of Benjamin Franklin. Resided in Gallipolis, Ohio, 1790–96; resided in St. Louis, *post* 1800, where he practiced, performed scientific experiments, and introduced the first smallpox vaccine virus brought there, 1809.

SAULSBURY, ELI (*b. Kent Co., Del., 1817; d. Dover, Del., 1893*), lawyer, Delaware legislator. Brother of Gove and Willard Saulsbury (1820–92). U.S. senator, Democrat, from Delaware, 1871–89.

SAULSBURY, GOVE (*b. Kent Co., Del., 1815; d. 1881*), physician, politician. Brother of Eli and Willard Saulsbury (1820–92). M.D., University of Pennsylvania, 1842. A recognized Democratic leader in the Delaware legislature, he became acting governor of the state in March 1865 and served until 1871. He opposed all constitutional amendments growing out of the Civil War and characterized Reconstruction as a flagrant usurpation of power.

SAULSBURY, WILLARD (*b. Kent Co., Del., 1820; d. 1892*), lawyer, politician. Brother of Gove and Eli Saulsbury; father of Willard Saulsbury (1861–1927). Attorney general of Delaware, 1850–55. As U.S. senator, Democrat, from Delaware, 1859–71, he supported the Crittenden Resolutions and later opposed military interference in elections and the suspension of the writ of habeas corpus by the administration. He was chancellor of Delaware, 1873–92.

SAULSBURY, WILLARD (*b. Georgetown, Del., 1861; d. Wilmington, Del., 1927*), lawyer, businessman. Son of Willard Saulsbury (1820–92). U.S. senator, Democrat, from Delaware, 1913–19. A leading supporter of Woodrow Wilson's policies and a useful member of the Committee on Foreign Relations, he gave special attention to Chinese affairs.

SAUNDERS, ALVIN (*b. near Flemingsburg, Ky., 1817; d. Omaha, Nebr., 1899*), businessman, Iowa legislator. Chairman of the Iowa delegation to the Republican convention, 1860, he was active during the campaign in behalf of Abraham Lincoln. Appointed governor of Nebraska Territory, 1861, he served with ability until March 1867 when Nebraska became a state. U.S. senator, Republican, from Nebraska, 1877–83, he was particularly interested in the development of inland waterways and Indian affairs.

SAUNDERS, CLARENCE (*b. Amherst County, Va., 1881; d. Memphis, Tenn., 1953*), merchant. Self-educated, Saunders founded the first modern supermarket, the Piggly Wiggly grocery store (1916), which grew into the chain. Saunders lost heavily in Wall Street maneuverings in the 1920's and never regained his early successes after many tries at new marketing techniques. Regarded as the inventor of modern supermarket stores.

SAUNDERS, FREDERICK (*b. London, England, 1807; d. 1902*), librarian, author, journalist. Came to America, 1837; made a pioneer appeal to Congress for protection of the copyright of English authors against American pirating. Failing in his effort, he remained in the United States, wrote a number of useful books, and was librarian of the Astor Library *post* 1859 and chief librarian, 1876–96.

SAUNDERS, PRINCE (*b. either Lebanon, Conn., or Thetford, Vt., date unknown; d. Port-au-Prince, Haiti, 1839*), black reformer, author. After teaching school in Boston, Saunders went to England, where he became concerned with William Wilberforce in educational plans for Haiti. Agent in London for Henri Christophe, emperor of Haiti, 1816–18, he lived for a while in Philadelphia and, after Christophe's overthrow, 1820, returned to Haiti. At the time of his death he was referred to as attorney general of the country.

SAUNDERS, ROMULUS MITCHELL (*b. Caswell Co., N.C., 1791; d. 1867*), lawyer, North Carolina legislator and official. Congressman, Democrat, from North Carolina, 1821–27 and 1841–45, Saunders was an active partisan and a tireless seeker after public office; John Quincy Adams said of him, "There is not a more cankered or venomous reptile in the country." Un-

distinguished as U.S. minister to Spain, 1846–49, he served as judge of the state superior court, 1852–67.

SAUNDERS, WILLIAM (*b. St. Andrews, Scotland, 1822; d. 1900*), horticulturist, landscape gardener. Came to America, 1848; formed partnership with Thomas Meehan in Philadelphia, 1854. Appointed superintendent of the experimental gardens of the U.S. Department of Agriculture, 1862, he designed the grounds of the department at Washington and had charge of their development until his death. He was designer of the national cemetery at Gettysburg and selected the site and designed the grounds for the Lincoln monument at Springfield, Ill. Organizer and director of the exhibits of the Department of Agriculture at numerous fairs and expositions, he was also a pioneer in the introduction of foreign plants to the United States. The Washington navel orange, brought by him from Brazil, 1871, became the leading commercial variety in California. Among his more than 3,000 published papers was the first bulletin of the Department of Agriculture (1862).

SAUNDERS, WILLIAM LAURENCE (*b. Raleigh, N.C., 1835; d. Raleigh, 1891*), lawyer, newspaper editor. Confederate soldier, Democratic politician. Edited and caused to be published *The Colonial Records of North Carolina* (1886–90).

SAUNDERS, WILLIAM LAWRENCE (*b. Columbus, Ga., 1856; d. Tenerife, Canary Islands, 1931*), engineer, inventor of rock-drill devices. President and chairman of the board, Ingersoll-Rand Co., *post* 1905, he was active as a Democrat in New Jersey politics.

SAUR, CHRISTOPHER See SOWER, CHRISTOPHER.

SAUVEUR, ALBERT (*b. Louvain, Belgium, 1863; d. Boston, Mass., 1939*), metallographer, metallurgist. Graduated Massachusetts Institute of Technology, 1889. A teacher at Harvard, 1899–1935, Sauveur introduced metallography (the microscopic study of metal structure) into U.S. industrial practice.

SAVAGE, EDWARD (*b. Princeton, Mass., 1761; d. Princeton, 1817*), painter, engraver. Painted a celebrated portrait of George Washington, 1789–90; practiced his art in Boston, Philadelphia, and New York and was engaged, *post* 1809, in the manufacture of cotton at Lancaster, Mass.

SAVAGE, HENRY WILSON (*b. New Durham, N.H., 1859; d. 1927*), real estate operator, theatrical producer. Assumed management of Castle Square Theater, Boston, 1895, and organized there a famous light-opera company. He later produced, among other successes, *The Sultan of Sulu* (1902), *The Prince of Pilsen* (1903), *The College Widow* (1904), and *The Merry Widow* (1907).

SAVAGE, JAMES (*b. Boston, Mass., 1784; d. Boston, 1873*), antiquary, lawyer, civic worker. Author of *Genealogical Dictionary of the First Settlers of New England* (1860–62). Encouraged founding of Provident Institution for Savings, 1816, one of the first savings banks incorporated in the United States.

SAVAGE, JOHN (*b. Dublin, Ireland, 1828; d. near Spragueville, Pa., 1888*), journalist. Came to America, 1848. Engaging for a while in free-lance work, he became leading editorial writer for the Washington, D.C., *States*, 1857–61. He served in the Union army during the Civil War, worked for a brief time on the *New Orleans Times*, and in 1867 became chief executive of the Fenian Brotherhood in America.

SAVAGE, JOHN LUCIAN ("JACK") (*b. Cooksville, Wis., 1879; d. Englewood, Colo., 1967*), civil engineer. Attended University of Wisconsin (B.S., 1903). Worked for the newly created Bureau of Reclamation in Idaho, 1903–08, then joined Andrew J. Wiley's consulting practice (1908–16). Designed several important projects, including the Salmon River Dam, the Swan Falls Power Plant, and the Oakley Reservoir Dam. Rejoined the Reclamation Service in 1916 and was promoted in 1924 to chief designing engineer, a position he held until he retired from government work in 1945. Headed the design work on such massive dams as Hoover, Grand Coulee, Shasta, Parker, and Imperial, as well as hundreds of smaller engineering works. Retained by the TVA to help with designing the Norris, Wheeler, and Pickwick dams, and assisted in the design of the Madden Dam for the Panama Canal Zone.

SAVAGE, MINOT JUDSON (*b. Norridgewock, Maine, 1841; d. Boston, Mass., 1918*), Unitarian clergyman, lecturer. Principal pastorates at Church of the Unity, Boston, and the Church of the Messiah, New York City; author of *The Religion of Evolution* (1876).

SAVAGE, PHILIP HENRY (*b. North Brookfield, Mass., 1868; d. Boston, Mass., 1899*), poet. Son of Minot J. Savage. Graduated Harvard, 1893. Author of *First Poems and Fragments* (1895) and *Poems* (1898).

SAVAGE, THOMAS STAUGHTON (*b. present Cromwell, Conn., 1804; d. Rhinecliff, N.Y., 1880*), Episcopal clergyman, physician, naturalist. Graduated Yale, 1825; M.D., 1833. First missionary sent to Africa by his church, Savage served in Liberia and its neighborhood at intervals between 1836 and 1847; he wrote several pioneer papers on the behavior of chimpanzees.

SAVERY, WILLIAM (*b. place unknown, 1721; d. Philadelphia. Pa., 1787*), cabinetmaker. Father of William Savery (1750 o.s.–1804). Believed to have settled in Philadelphia ca. 1740. Savery worked there until his death. His designs reveal his indebtedness to English 18th-century design books, but his furniture displays his ability to naturalize and interpret his models in an original manner. There is considerable carving in his mahogany pieces, but for the most part his furniture has simple and pure lines. He excelled as a maker of chairs.

SAVERY, WILLIAM (*b. Philadelphia, Pa., 1750 o.s.; d. Philadelphia, 1804*), tanner, Quaker preacher in the United States and Europe. Son of William Savery (1721–87).

SAVILLE, MARSHALL HOWARD (*b. Rockport, Mass., 1867; d. New York, N.Y., 1935*), archaeologist. Trained in fieldwork by Frederic W. Putnam; was associated successively with the Peabody Museum, Harvard; the American Museum of Natural History; and the Museum of the American Indian, New York. First $$Word$$ professor of American archaeology at Columbia University, designated 1903. Studied ruins at Copan, Honduras, 1891–92; secured important collections at Maya ruins of Palenque, Mexico. 1897; excavated at Mitla, Monte Albán, and Xochicalco, Mexico, 1899–1904; later extended collecting excursions to Colombia and Ecuador. Primarily interested in museum specimens, Saville was apt at securing patrons for his work and was an authority on the literature of his special field. He took no interest in theoretical anthropology nor did he greatly advance field-research technique.

SAWYER, LEICESTER AMBROSE (*b. Pinckney, N.Y., 1807; d. Whitesboro, N.Y., 1898*), Presbyterian and Independent clergyman, newspaper editor. Biblical scholar and exponent of the "higher criticism."

SAWYER, LEMUEL (*b. Camden Co., N.C., 1777; d. Washington, D.C., 1852*), lawyer, author. Congressman, Jefferson and Jackson Democrat, from North Carolina, 1807–13, 1817–23, and 1825–29. Author of a number of works including *Blackbeard, A Comedy* (published, Washington, D.C., 1824; staged New York City, 1833); a novel, *Printz Hall: A Record of New Sweden* (1839); and *A Biography of John Randolph of Roanoke* (1844).

SAWYER, LORENZO (*b. Leray, N.Y., 1820; d. San Francisco, Calif., 1891*), California pioneer and jurist. Studied law in Columbus, Ohio, with Noah H. Swayne; removed first to Chicago, Ill., then to Wisconsin; removed to California, 1850. After terms as judge of the California district and supreme courts, Sawyer was named a U.S. circuit judge (9th Circuit), 1870, and served until his death; his best-known decision was in the case *In re Neagle* (1889). He was first president of the board of trustees of Leland Stanford University.

SAWYER, PHILETUS (*b. near Rutland, Vermont, 1816; d. Oshkosh, Wis., 1900*), lumberman, Wisconsin legislator. Removed to the vicinity of Oshkosh ca. 1847. Long a leader in Wisconsin Republican politics, he served as congressman, 1865–75, and as U.S. senator, 1881–93, contributing to the reputation of the Senate as a millionaire's club. Compelled, ca. 1891, to make good on bonds of Republican state treasurers who had failed to account for interest received on public deposits, he was also the principal target in the campaign against boss rule and corruption waged by Robert M. La Follette.

SAWYER, SYLVANUS (*b. Templeton, Mass., 1822; d. Fitchburg, Mass., 1895*), inventor of machinery for splitting and dressing rattan (patented 1849, 1851, 1854, 1855) and other mechanical devices.

SAWYER, THOMAS JEFFERSON (*b. Reading, Vt., 1804; d. 1899*), Universalist clergyman, editor, educator. Held principal pastorate at the Grand Street (Orchard St.) Universalist Society, New York City; professor of theology, Tufts Divinity School, 1869–92 (dean, 1882–92).

SAWYER, WALTER HOWARD (*b. Middletown, Conn., 1867; d. Auburn, Maine, 1923*), engineer, hydraulic and sanitary expert. Supervised waterpower development at Lewiston. Maine, and the Androscoggin River storage system *post* 1902; invented a number of devices for furthering this work.

SAWYER, WILBUR AUGUSTUS (*b. Appleton, Wis., 1879; d. Berkeley, Calif., 1951*), public health administrator. Studied at the University of California and at Harvard (M.D., 1906). After working for the California State Board of Health, Sawyer joined the International Health Board of the Rockefeller Foundation. As director of the West African Yellow Fever Commission (1926–27), he was responsible for the isolation of the yellow fever virus. Discovered methods of immunity by inoculation in 1931. Director of health for the U.N. Relief and Rehabilitation Administration from 1944.

SAXE, JOHN GODFREY (*b. Highgate, Vt., 1816; d. Albany, N.Y., 1887*), lawyer, humorist. Less a poet than a humorist using verse as his medium, Saxe enjoyed wide popularity in his time. He was author of, among other books, *Progress: A Satirical Poem* (1846), *The Money-King and Other Poems* (1860), and *Leisure-Day Rhymes* (1875).

SAXTON, EUGENE FRANCIS (*b. Baltimore, Md., 1884; d. New York, N.Y., 1943*), editor. B.A., Loyola College, Baltimore, 1904. Headed book editorial department, Harper & Brothers. *post*

1925, after earlier experience with Doubleday, Page & Co., 1910–17, and George H. Doran Co.

SAXTON, JOSEPH (*b. Huntington, Pa., 1799; d. 1873*), watchmaker, constructor of scientific apparatus, inventor. Curator of standard weighing apparatus, U.S. Mint, 1837–43; superintendent of weights and measures, U.S. Coast Survey, 1843–73.

SAY, BENJAMIN (*b. Philadelphia, Pa., 1755; d. Philadelphia, 1813*), physician, apothecary, philanthropist. Father of Thomas Say.

SAY, THOMAS (*b. Philadelphia, Pa., 1787; d. New Harmony, Ind., 1834*), entomologist, conchologist. Son of Benjamin Say. Interested in natural history by William Bartram, his mother's uncle, Say devoted nearly all his time to its study *post* 1812. He visited Georgia and Florida with George Ord, William Maclure, and T. R. Peale, 1818. The next year, as zoologist, he accompanied Stephen H. Long's expedition to the Rocky Mountains; also as zoologist, he went with Long's second expedition, 1823, to the sources of the Minnesota River. Holder of a nominal curatorship at the American Philosophical Society, also nominally professor of natural history at the University of Pennsylvania, 1822–28, he worked on his *American Entomology* (planned and begun, 1816), bringing out the first two volumes in 1824 and 1825. In 1825 also he prepared for the press the first volume of Charles Bonaparte's *American Ornithology*. Resident in the community and village of New Harmony *post* 1825 (except for a visit to Mexico during late 1827 and early 1828), he continued to work industriously. In 1828 he completed the third volume of *American Entomology* and between 1830 and 1834 published the six numbers of his *American Conchology*. Say's work was almost wholly taxonomic and his writings were almost entirely descriptive. The excellence of his work was early acknowledged by European zoologists and nearly all his species have been recognized. His complete writings on entomology were edited by J. L. LeConte and published (1859) with a biographical memoir by George Ord.

SAYLES, JOHN (*b. Ithaca, N.Y., 1825; d. Tex., 1897*), lawyer. Removed to Texas, 1845. Practiced law at Brenham and Abilene; wrote extensively on Texas law and taught law at Baylor University.

SAYPOL, IRVING HOWARD (*b. New York City, 1905; d. New York City, 1977*), lawyer and judge. Attended St. Lawrence University and took night courses at Brooklyn Law School. Admitted to the New York bar in 1928 and became an attorney for New York City (1929–34) and assistant U.S. attorney for the Southern District of New York (1945). As United States attorney (1949–52), he was the chief prosecutor for the federal government in Manhattan and the central figure in controversial trials involving national security issues. He guided federal prosecution of alleged Communist spy Alger Hiss (1949), securing Hiss's conviction for perjury (1950), and the prosecution of Julius and Ethel Rosenberg for passing atomic secrets to the Soviet Union, although he was accused of manipulating the jury and conspiring with the trial judge in persuading the Justice Department to ask for the death sentence for the Rosenbergs. He was elected a trial-level judge of the New York Supreme Court (1952–77); in 1976 he was indicted but cleared of charges of influence peddling.

SAYRE, LEWIS ALBERT (*b. present Madison, N.J., 1820; d. 1900*), orthopedic surgeon. M.D., New York College of Physicians and Surgeons, 1842. Practiced in New York City; played large part in organization of Bellevue Hospital Medical College, 1861, occupying there the first chair of orthopedic surgery in America. As resident physician of New York City, 1860–66, he

bettered sanitary conditions in tenements. In his own specialty, he was acknowledged leader, developing among other techniques a treatment of lateral curvature that became known the world over as the Sayre method. He was father of Reginald H. Sayre.

SAYRE, REGINALD HALL (*b. New York, N.Y., 1859; d. 1929*), surgeon. Son of Lewis A. Sayre. Graduated Columbia, 1881. M.D., Bellevue Hospital Medical College, 1884. The trusted associate of his father, he became assistant to the professor of surgery at Bellevue, 1885, and afterward was lecturer and orthopedic surgeon there. He succeeded his father as clinical professor of orthopedic surgery at Bellevue, 1898, and served as consultant to numerous hospitals.

SAYRE, ROBERT HEYSHAM (*b. Columbia Co., Pa., 1824; d. South Bethlehem, Pa., 1907*), civil engineer, railroad official. Directing force in the building and development of the Lehigh Valley Railroad system, 1852–82 and 1885–98.

SAYRE, STEPHEN (*b. Southampton, N.Y., 1736; d. "Brandon," Middlesex Co., Va., 1818*), merchant, banker, diplomatic agent. Graduated College of New Jersey (Princeton), 1757. Removing to London, he became a member of the mercantile firm of Dennys De Berdt and organized his own banking house in 1770. An outspoken friend of the colonies (author of *The Englishman Deceived*, 1768), Sayre was arrested and lodged in the Tower, 1775, charged with conspiracy to overthrow the government. Discharged for lack of evidence, he went to Paris and was appointed secretary to Arthur Lee in May 1777. Quarreling with Lee after Lee's Berlin mission failed, Sayre attempted to promote commercial treaties for the United States in Copenhagen and Stockholm but accomplished nothing. Returning home at the end of the Revolution, he became a partisan of the South American liberator Francesco Miranda.

SAYRE, WALLACE STANLEY (*b. Point Pleasant, W.Va., 1905; d. New York City, 1972*), political scientist. Graduated Marshall College (B.A., 1927; M.A., 1928) and New York University (Ph.D., 1930) and joined the faculty at NYU (1931–38). From 1938 to 1942 he headed the New York City Civil Service Commission. He held faculty positions at Cornell University (1946–49), City College of New York (1949–54), and Columbia University (1954–68). He collaborated on the noted work on municipal politics, *Governing New York City* (1960).

SCAMMELL, ALEXANDER (*b. present Milford, Mass., 1747; d. Williamsburg, Va., 1781*), Revolutionary soldier. Staff officer under General John Sullivan at Boston and in the Long Island campaign. Promoted colonel, 3rd New Hampshire Continental Battalion, December 1776, he was at Ticonderoga and Saratoga. Appointed adjutant general of the Continental army, January 1778, he served through 1780, resigning to take command of the 1st New Hampshire Regiment.

SCAMMON, JONATHAN YOUNG (*b. Whitefield, Maine, 1812; d. Chicago, Ill., 1890*), lawyer, Chicago businessman and civic leader. Settled in Chicago, 1835; helped establish free schools there and was instrumental in founding many societies and charitable institutions, most of which he served as president. He founded, among other newspapers, the *Chicago Journal* (1844) and the *Inter Ocean* (1872).

SCANLAN, LAWRENCE (*b. Co. Tipperary, Ireland, 1843; d. 1915*), Roman Catholic clergyman. Served in the diocese of San Francisco, Calif., after ordination in Ireland, June 1868; removed to Salt Lake City, 1873, as missionary to Utah and a great part of Nevada. Bishop of Salt Lake City, *post* 1891.

SCARBOROUGH, DOROTHY (*b. Mt. Carmel, Tex., 1878; d. New York, N.Y., 1935*), educator, student of folklore. Graduated Baylor, 1896; Ph.D., Columbia, 1917. Taught at Baylor and Columbia; specialized in short-story technique and folk songs of the South.

SCARBOROUGH, LEE RUTLAND (*b. Colfax, La., 1870; d. Amarillo, Tex., 1945*), Southern Baptist clergyman, educator. B.A., Baylor University, 1892; B.A., Yale, 1896. Abandoned study of law for the ministry; held pastorates in Texas, 1896–1908. Professor of evangelism *post* 1908 and president, 1915–42, of Southwestern Baptist Theological Seminary.

SCARBOROUGH, WILLIAM SAUNDERS (*b. Macon, Ga., ca. 1852; d. 1926*), educator, author. Born in slavery, Scarborough attended Atlanta University and graduated from Oberlin, 1875. Appointed professor of classics, Wilberforce University, Wilberforce, Ohio, 1877, he remained there until his death, serving as president of the university, 1908–20. He had an unusual aptitude for the study of languages.

SCARBROUGH, WILLIAM (*b. South Carolina, 1776; d. New York, N.Y., 1838*), planter, Savannah, Ga., merchant. In association with Moses Rogers and others, Scarbrough was backer of the pioneer transatlantic steamship *Savannah*, which voyaged to Europe and back in 1819.

SCATTERGOOD, THOMAS (*b. Burlington, N.J., 1748; d. Philadelphia, Pa., 1814*), tanner, Quaker preacher, traveler. Displayed a quietist tendency reflecting the influence of John Woolman.

SCHADLE, JACOB EVANS (*b. near Raunchtown, Pa., 1849; d. St. Paul, Minn., 1908*), laryngologist. M.D., Jefferson Medical College, 1881; did postgraduate study with Charles E. Sajous. Removing to St. Paul, Minn., 1887, he became the leading practitioner of laryngology in that section of the country and was professor of his specialty at the University of Minnesota. His chief professional interests were the investigation of the causes and treatment of hay fever and asthma and of the effects of postnasal adenoid growths upon the health of children.

SCHAEBERLE, JOHN MARTIN (*b. Württemberg, Germany, 1853; d. Ann Arbor, Mich., 1924*), astronomer. Taught at University of Michigan and served in the observatory there; was a member of original staff of the Lick Observatory.

SCHAEFFER, CHARLES FREDERICK (*b. Germantown, Pa., 1807; d. Philadelphia, Pa., 1879*), Lutheran clergyman, theologian, author. Son of Frederick D. Schaeffer; brother of David F. and Frederick C. Schaeffer. A conservative, he left his professorship at Gettysburg Theological Seminary to become professor and chairman of the faculty of the Philadelphia Seminary in 1864, and taught there until 1878.

SCHAEFFER, CHARLES WILLIAM (*b. Hagerstown, Md., 1813; d. Germantown, Pa., 1896*), Lutheran clergyman. Grandson of Frederick D. Schaeffer; nephew of Frederick C. Schaeffer. Held pastorates at Whitemarsh, Harrisburg, and Germantown; taught church history and pastoral theology at Philadelphia Seminary. Author of *Family Prayer for Morning and Evening* (1861) and other books

SCHAEFFER, DAVID FREDERICK (*b. Carlisle. Pa., 1787; d. Frederick, Md., 1837*), Lutheran clergyman. Son of Frederick D. Schaeffer; brother of Charles F. and Frederick C. Schaeffer. Pastor at Frederick, Md., *post* 1808. An organizer of the Maryland Synod, 1820, he was also one of the most active in formation of the General Synod.

SCHAEFFER, FREDERICK CHRISTIAN (*b. Germantown, Pa., 1792; d. New York, N.Y., 1831*), Lutheran clergyman. Son of Frederick D. Schaeffer; brother of Charles F. and David F. Schaeffer. Pastor at Harrisburg, Pa., and New York City; organized St. James's Church in New York, *ca.* 1826, of which he was pastor until his death.

SCHAEFFER, FREDERICK DAVID (*b. Frankfurt am Main, Germany, 1760; d. Frederick, Md., 1836*), Lutheran clergyman. Father of Charles F., David F., and Frederick C. Schaeffer; grandfather of Charles W. Schaeffer. Came to America *ca.* 1774. Pastor at Carlisle, Pa., 1786–90; at Germantown, 1790–1812; at St. Michael's and Zion's, Philadelphia, 1812–34.

SCHAEFFER, NATHAN CHRIST (*b. near Kutztown, Pa., 1849; d. 1919*), educator, lecturer, German Reformed clergyman. Pennsylvania superintendent of public instruction, 1893–1919.

SCHAFF, PHILIP (*b. Chur, Grisons, Switzerland, 1819; d. New York, N.Y., 1893*), church historian. Studied at universities of Tübingen and Halle; was a pupil of Neander at the University of Berlin, 1840–41; made licentiate in theology, 1841. Invited by the Eastern Synod of the German Reformed church to succeed F. A. Rauch on the theological faculty at Mercersburg (Pa.) Seminary, 1843, he was ordained to the ministry, April 1844, and in July arrived in the United States. His inaugural address, *The Principle of Protestantism* (1845), portrayed the Reformation not as a revolution but as a development out of the good forces in the Catholic church and looked forward to the possibility of ultimate union of Protestantism and Catholicism. It was vigorously criticized, and during the years he remained at Mercersburg, he remained subject to opposition, which was strengthened by his association with John W. Nevin in development of the so-called Mercersburg theology. Schaff grew in reputation as a church historian and came to be recognized as the mediator between the theology of Germany and American scholarship. He was editor of *A Commentary on the Holy Scriptures* (1865–80, based on work of John P. Lange) and of the *Religious Encyclopaedia* (1882–84, based on work of Herzog, Plitt, and Hauck). Resigning his position at Mercersburg, 1865, he joined the faculty of Union Theological Seminary, New York City, 1870, transferring his denominational affiliation to the Presbyterian church. Active in ecumenical activities, he also rendered valuable service in the work revising the English Bible, 1881–85, arranging for the organization of the American committee, selecting its members, and acting as president. His most ambitious work was his *History of the Christian Church* (5th ed. rev., 1882–92).

SCHALK, RAYMOND WILLIAM ("CRACKER") (*b. Harvel, Ill., 1892; d. Chicago, Ill., 1970*), baseball player. Began his career as a catcher in 1911 with the class-D Illinois-Missouri League. In 1912 he signed with the Milwaukee Brewers, then the Chicago White Sox. His forte was defense; he revolutionized the art of major-league catching and was the first catcher to back up first and third base on infield ground balls. He caught four no-hitters, including a perfect game by Charley Robertson in 1922. He played in the World Series of 1917 and 1919, the latter being the series that involved the "Black Sox" scandal. Schalk was not part of the White Sox faction that threw the series, and he testified (1920) at a grand jury of the suspicious behavior of the defendants; he maintained a public silence about the scandal all his life and emerged from the episode unscathed. He was a player-manager for the White Sox (1927–29); a player-coach for the New York Giants (1929); coach and scout for the Chicago Cubs (1929–31); a minorleague manager (1932–40); and assistant baseball coach at Purdue (1947–63). Elected to the Baseball Hall of Fame (1955).

SCHALL, THOMAS DAVID (*b. near Reed City, Mich., 1877; d. 1935*), lawyer, politician. Beginning practice in Minneapolis, Minn., ca. 1904, after an early life of extreme difficulty, he became blind in 1907, but continued his career with his wife's aid. Congressman from Minnesota, at first Progressive and later Republican, 1915–25, he was U.S. senator thereafter until his death. A grim political fighter and a fluent, bombastic orator, he was a bitter critic of the New Deal.

SCHAMBERG, JAY FRANK (*b. Philadelphia, Pa., 1870; d. 1934*), dermatologist, authority on syphilis.

SCHARF, JOHN THOMAS (*b. Baltimore, Md., 1843; d. 1898*), Confederate soldier, lawyer, historian, collector of Americana. Among his numerous studies in local history, the most valuable is his *History of Maryland* (1879).

SCHARY, DORE (*b. Isidore Schary, Newark, N.J., 1905; d. New York City, 1980*), producer and writer. Began his playwriting career in the late 1920's and landed bit parts on Broadway, playing opposite Paul Muni (1927) and Spencer Tracy (1928); he moved to Hollywood in 1932 and established a reputation as a reliable and speedy craftsman writer. He was hired by MGM and his script for *Boys' Town* (1938) won an Academy Award. He became an executive producer and gained a reputation for choosing good scripts, directors, and actors. He left MGM in 1944 to join RKO, where he became executive vice-president of production and made such profitable movies as *The Farmer's Daughter* (1947) and *The Spiral Staircase* (1946). An outspoken liberal, he came under attack for his testimony before the House Un–American Activities Committee (1947), stating that he would hire "communists and noncommunists alike on the basis of ability," but he fell in with the blacklisting policies of the 1950's. He produced more than 250 pictures at MGM (1948–56), including *Battleground* (1949), *Show Boat* (1951), *An American in Paris* (1951), and *Seven Brides for Seven Brothers* (1964). He also wrote the successful Broadway play *Sunrise at Campobello* (1957), which won five Tony awards and was named best play of 1958.

SCHAUFFLER, HENRY ALBERT (*b. Constantinople, Turkey, 1837; d. 1905*), Congregational clergyman. Son of William G. Schauffler. Graduated Williams, 1859. Ordained in Constantinople, 1865, he served as a Protestant missionary in Turkey and Austria and worked *post* 1882 among Slavic immigrants to the United States.

SCHAUFFLER, WILLIAM GOTTLIEB (*b. Stuttgart, Germany, 1798; d. 1883*), Congregational clergyman. Father of Henry A. Schauffler. Raised in southern Russia, he came to America, 1826, and received his ministerial education at Andover Theological Seminary. Ordained, 1831, in Boston, he worked thereafter as a missionary among the Jews in Turkey and elsewhere until 1856; thereafter he addressed himself to the Armenians and Turks.

SCHECHTER, SOLOMON (*b. Fokshan, Romania, 1850; d. 1915*), Hebraist, author. Studied at Lemberg, Vienna, and Berlin; removed to England, 1882; was appointed reader in Talmud and rabbinical literature at Cambridge University, 1890. Identifying a fragment of manuscript in 1896 as part of the lost original Hebrew of Ecclesiasticus, he attracted worldwide notice; shortly thereafter, excavating the Genizah at Cairo, he brought back to Cambridge some 50,000 Hebrew and Arabic manuscripts, among them many of the remaining chapters of Ecclesiasticus. He was author of *The Wisdom of Ben Sira* (1899), based on his findings. Unhappy in England, he welcomed appointment in 1901 as president of the Jewish Theological Seminary in New York and was within a short time the acknowledged leader of Jewish scholarship in America. He was author of a number of publications, some of them based upon the Cairo manuscripts, of which the most important was his *Documents of Jewish Sectaries* (1910). His *Some Aspects of Rabbinic Theology* (1909) was the first approach to a methodical presentation of Jewish theology.

SCHEEL, FRITZ (*b. Lübeck, Germany, 1852; d. 1907*), violinist, conductor. Came to America, 1893. First conductor of the San Francisco Symphony, he removed to Philadelphia, Pa., 1899, and in 1901 became conductor of the Philadelphia Orchestra Association, a post which he held until his death.

SCHELE DE VERE, MAXIMILIAN (*b. Wexiö, Sweden, 1820; d. Washington, D.C., 1898*), philologist. Holder of several German doctorates, he came to America, 1843, and served as professor of modern languages, University of Virginia, 1844–95. Inaugurator of systematic study of Anglo-Saxon, he also offered courses in comparative philology at a time when few American colleges recognized the value of the comparative method. He was author of a number of books, including *Americanisms: The English of the New World* (1871) and was associated with the work of the *Standard Dictionary* (1893–95).

SCHELL, AUGUSTUS (*b. Rhinebeck, N.Y., 1812; d. 1884*), lawyer, New York politician and businessman. An associate of Cornelius Vanderbilt (1794–1877) in his New York Central Railroad operations and in his fight for the Erie, Schell held numerous directorates in railroads, banks, and insurance companies. A heavy stock market operator, with Horace F. Clark and Jay Gould he engineered the post–Civil War corner in Chicago & Northwestern stock, which was one of Wall Street's notable episodes. Steadfast in support of the Tammany Democratic organization, he was collector of the Port of New York, 1857–61, and succeeded William M. Tweed as Grand Sachem of Tammany, 1872. Also in 1872 he served as Horace Greeley's financial banker and campaign manager. Interested in many of the clubs, societies, and institutions of New York City, he was twice president of the New-York Historical Society and a benefactor of the New York Institution for the Blind.

SCHELLING, ERNEST HENRY (*b. Belvidere, N.J., 1876; d. New York, N.Y., 1939*), pianist, conductor, composer. Studied with a long series of European masters, including Moszkowski and Paderewski. Successful as a concert artist and as composer of a number of piano and orchestral compositions, including *A Victory Ball* (1923), Schelling turned chiefly *post* 1925 to the conducting of children's orchestral concerts, at which he won his audiences over to music with an infectious enthusiasm.

SCHELLING, FELIX EMANUEL (*b. New Albany, Ind., 1858; d. Mount Vernon, N.Y., 1945*), educator, scholar. Brother of Ernest H. Schelling. B.A., University of Pennsylvania, 1881; LL.B., 1883; M.A., 1884. Taught English language and literature at Pennsylvania, 1886–1934 (professor *post* 1893), and was the principal creator of an English department in the modern sense at that university. Author of, among other works, *A Book of Elizabethan Lyrics* (1895); *Elizabethan Drama 1558–1642* (1908); *English Literature During the Lifetime of Shakespeare* (1910); and *The English Lyric* (1913).

SCHEM, ALEXANDER JACOB (*b. Wiedenbrück, Germany, 1826; d. Hoboken, N.J., 1881*), encyclopedia editor, statistician, journalist.

SCHENANDOA See SKENANDOA.

SCHENCK, FERDINAND SCHUREMAN (*b. Plattekill, N.Y., 1845; d. White Plains, N.Y., 1925*), Reformed Church clergyman, educator. Professor of theology, New Brunswick Theological Seminary, 1899–1924; lectured also at New York University, Rutgers, and Princeton Theological Seminary.

SCHENCK, JAMES FINDLAY (*b. Franklin, Ohio, 1807; d. 1882*), naval officer. Brother of Robert C. Schenck. Appointed midshipman, 1825; active in conquest of California, 1846; commended for excellence as division commander in Civil War attacks on Fort Fisher. Retired as rear admiral, 1869.

SCHENCK, NICHOLAS MICHAEL (*b. Rybinsk, Russia, 1881; d. Miami Beach, Fla., 1969*), motion-picture and theater executive. Immigrated to the United States in the early 1890's. With his brother Joseph offered vaudeville shows at Fort George in Manhattan, where around 1908 they established Paradise Park. Marcus Loew offered them partnerships in some of his theatrical ventures, beginning with the acquisition of the Lyric Theater in Hoboken, N.J.; in 1912 they established Palisades Amusement Park in Fort Lee, N.J., which they owned until 1935. Nicholas became president of Loew's, Inc. (1927), and its motion-picture subsidiary, MGM. After World War II the fortunes of Loew's and MGM declined, and for almost a decade Schenk delayed compliance with a 1946 court order requiring the division of Loew's into separate theatrical and motion-picture firms. He retired as president in 1955.

SCHENCK, ROBERT CUMMING (*b. Franklin, Ohio, 1809; d. Washington, D.C., 1890*), lawyer, Ohio legislator, Union major general. Brother of James F. Schenck. Congressman, Whig, from Ohio, 1843–51, he served as U.S. minister to Brazil, 1851–53. After two years' hard service in the Civil War, late in 1863 he returned, as a Republican, to the House of Representatives, where he distinguished himself by violent attacks on the Copperheads and by opposition to President Andrew Johnson. He was chairman of the Committee on Military Affairs and later of the Ways and Means Committee. Leaving Congress, 1871, he succeeded John L. Motley as U.S. minister to Great Britain. His connection with a fraudulent mine promotion in the West forced him to resign in 1876.

SCHERESCHEWSKY, SAMUEL ISAAC JOSEPH (*b. Tauroggen, Russian Lithuania, 1831; d. Tokyo, Japan, 1906*), Episcopal clergyman, a convert from Judaism. Came to America, 1854; served as a missionary in China and Japan for the greater part of his life *post* 1859; was Episcopal bishop of Shanghai, 1877–83. Naturally gifted as a linguist, he translated the Bible and the Book of Common Prayer into several forms of classical Chinese.

SCHERMAN, HARRY (*b. Montreal, Canada, 1887; d. New York, N.Y., 1969*), publishing entrepreneur. Moved to Philadelphia in 1889; attended Wharton School of Finance of the University of Pennsylvania. Worked in New York at newspaper jobs and various advertising agencies, specializing in writing copy for book publishers. With Max Sackheim and Albert and Charles Boni formed a partnership (1916) to publish inexpensive leather-bound literary classics; 48 million books were sold over eight years. He began the Book-of-the-Month Club in 1926; through his clever offers of bonuses and advertising, the club had more than 40,000 members by the end of the year. By 1931, was president of the BOMC and in 1950 became chairman of the board.

SCHEVE, EDWARD BENJAMIN (*b. Herford, Westphalia, Germany, 1865; d. Longmont, Colo., 1924*), musician. Came to America, 1888. Professor of music, Grinnell (Iowa) College, *post* 1906.

SCHEVILL, RUDOLPH (*b. Cincinnati, Ohio, 1874; d. Berkeley, Calif., 1946*), professor of Spanish. B.A., Yale, 1896; Ph.D., University of Munich, 1898. Taught French and German at Bucknell University, 1899–1900; German, French, and Spanish at Yale, 1900–10. Professor of Romance languages, University of California in Berkeley, 1910–19, and chairman of separate department of Spanish, 1919–44 (including Portuguese *post* 1931). Editor of complete works of Cervantes (1914–41, 18 vols.); author of studies of Cervantes and Lope de Vega.

SCHICKILLEMY *See* SHIKELLAMY.

SCHIEREN, CHARLES ADOLPH (*b. Neuss, Germany, 1842; d. 1915*), leather-belting manufacturer. Came to America as a boy. Secured patents, 1887–88, for improvements in belting design for high-speed work. Reform mayor of Brooklyn, N.Y., 1893–95; rescued that city from bankruptcy.

SCHIFF, JACOB HENRY (*b. Frankfurt am Main, 1847; d. New York, N.Y., 1920*), financier, philanthropist. Coming to New York City, 1865, Schiff entered business as a broker and became an American citizen. After residence in Germany, 1872–74, he returned to the United States as a partner in Kuhn, Loeb & Co., and 1885 became head of that firm. He was concerned with financing important railroads in the East, in particular, the Pennsylvania Railroad and the Louisville & Nashville; in the great struggle for control of the Northern Pacific, he was allied with E. H. Harriman against J. J. Hill and J. P. Morgan & Co. He was also interested in the great insurance companies, particularly the Equitable. Schiff's philanthropies were many and varied and included the American Red Cross, hospitals, settlement houses, and libraries. He was benefactor of several Jewish seminaries and was one of the founders of the American Jewish Committee, 1906.

SCHILDKRAUT, JOSEPH (*b. Vienna, Austria, 1896; d. New York, N.Y., 1964*), actor. Studied at the American Academy of Dramatic Arts (1910–13). Appeared on the New York stage with the Theatre Guild (1920–24) and Eva Le Gallienne's Civic Repertory (1932–33); his several dozen plays include a memorable performance in *The Diary of Anne Frank* (1955). His first important movie was *Orphans of the Storm* (1921); others of his more than sixty films include *The King of Kings* (1927), *Tenth Avenue* (1928), *Show Boat* (1929), *Cleopatra* (1934), and *The Life of Emile Zola* (1937), for which he won an Academy Award for his portrayal of Captain Dreyfus. He appeared in more than eighty television productions and hosted his own series (1953–54).

SCHILLING, HUGO KARL (*b. Saalfeld, Germany, 1861; d. 1931*), philologist. Ph.D., Leipzig, 1885. Immigrating to America, 1886, he taught at Wittenberg College and at Harvard, and was professor of German at the University of California, 1901–29.

SCHILLINGER, JOSEPH (*b. Kharkov, Russia, 1895; d. New York, N.Y., 1943*), composer and musical theorist. Graduated Imperial Conservatory of Music, Petersburg, 1918. Taught at State Academy of Music, Kharkov, 1918–22, becoming dean; lectured thereafter at various institutions in Leningrad and was associated with modernist circles there. Came to the United States 1928, and settled in New York City, where he taught, and continued to develop his theories of modern composition. These found their most characteristic expression in his application of strict mathematical principles and formulas to the writing of music. His method was fully developed in two posthumous books: *The Schillinger System of Musical Composition* (1946) and *The Mathematical Basis of the Arts* (1948). Several popular composers be-

came his students, of whom the most famous was George Gershwin.

SCHINDLER, KURT (*b. Berlin, Germany, 1882; d. New York, N.Y., 1935*), musician, composer, music editor, authority on folk music. Came to New York, 1905. Assistant conductor at the Metropolitan Opera, 1905–08, he organized the MacDowell Chorus in 1909. Known as the Schola Cantorum *post* 1912, the organization remained under his direction until 1926 and became outstanding among choral groups. Schindler wrote a number of songs and choruses and edited 11 collections of Russian, Spanish and other music.

SCHINDLER, RUDOLPH MICHAEL (*b. Vienna, Austria, 1887; d. Los Angeles, Calif., 1953*), architect. Studied at the Imperial Institute of Engineering and at the Vienna Academy of Fine Arts. Came to the U.S. in 1914. Joined Frank Lloyd Wright (1917) to work on designs for the Imperial Hotel in Tokyo. Set up own firm in 1922. Schindler is remembered for his innovative styles of domestic architecture in California. He designed houses that were of a natural feeling—usually of wood and stucco and consisting of principal spaces oriented around outdoor living areas.

SCHINDLER, SOLOMON (*b. Neisse, Germany, 1842; d. 1915*), rabbi. Came to America, 1871. A radical reformer, Schindler held his principal pastorate in Boston, Mass., 1874–94, and was engaged thereafter in social work.

SCHINZ, ALBERT (*b. Neuchâtel, Switzerland, 1870; d. Iowa City, Iowa, 1943*), educator, scholar. Licentiate in both letters and theology, University of Neuchâtel; Ph.D., Tübingen, 1894; studied also at universities of Berlin and Paris. Immigrated to the United States, 1897. Taught French at University of Minnesota; Bryn Mawr College, 1899–1913; Smith College, 1913–28; and University of Pennsylvania, 1928–41. Author of a number of books and articles on many phases of French literature, he was a recognized authority on Jean-Jacques Rousseau; among his studies on this topic, *La Pensée de Jean-Jacques Rousseau* (1929) is probably the most important.

SCHIPPERS, THOMAS (*b. Kalamazoo, Mich., 1930; d. New York City, 1977*), conductor. Graduated Curtiss Institute of Music (1947) and studied piano and composition with Olga Samaroff. Hired by Gian Carlo Menotti as supervisor of his opera company, Schippers conducted the New York premiere of Menotti's opera *The Consul* (1950) and directed the television premiere of Menotti's *Amahl and the Night Visitors* (1951). He was resident conductor of the New York City Opera (1952–55) and began a long association with the New York Philharmonic and Metropolitan Opera in 1955. He was the first American conductor to open a Metropolitan Opera season (1960) and led the American premiere of Menotti's *The Last Savage* (1964) at the Met. He was named music director of the Cincinnati Symphony (1970) and a professor of music at the college's Conservatory of Music (1972). His greatest success was leading the Met's production of Mussorgsky's *Boris Godunov* (1974).

SCHIRMER, GUSTAV (*b. Königsee, Saxony, 1829; d. Eisenach, Germany, 1893*), music publisher. Came to America as a boy. Established the house of G. Schirmer in New York City, 1866; was among the original patrons of Bayreuth; encouraged native musical talent in America.

SCHIRMER, RUDOLPH EDWARD (*b. New York, N.Y., 1859; d. Santa Barbara, Calif., 1919*), lawyer, music publisher. Son of Gustav Schirmer, whom he succeeded as president of G. Schirmer, Inc.

SCHLATTER, MICHAEL (*b. St. Gall, Switzerland, 1716; d. Philadelphia, Pa., 1790*), German Reformed clergyman, educator. Came to Pennsylvania as a missionary, 1746; organized Reformed parishes throughout Pennsylvania, Maryland, Virginia, and New Jersey. Chaplain of the Royal American Regiment, 1757–59, and of the 2nd Pennsylvania Battalion in Bouquet's expedition, 1764, he was an ardent patriot during the Revolution.

SCHLESINGER, ARTHUR MEIER (*b. Xenia, Ohio, 1883; d. Cambridge, Mass., 1965*), historian. Attended Ohio State and Columbia (Ph.D., 1917). Taught at Ohio State (1912–19); University of Iowa (1919–24), where he offered what he believed to be the first course in the "social" and "cultural" aspects of U.S. history; and Harvard (1924–54). Published collections of his essays in *New Viewpoints in American History* (1922), *Paths to the Present* (1949), and *The American as Reformer* (1950). Also wrote *The Political and Social History of the United States* (1925), with Homer C. Hockett; the provocative historical study of American etiquette books, *Learning How to Behave* (1946); and *Prelude to Independence: The Newspaper War on Britain, 1764–1776* (1957). Helped found the Social Science Research Council (1924) and was its chairman (1930–33); cofounder of the *New England Quarterly* (1928). His central importance to the writing of American history lies in his rejection of the unarticulated premises that had constricted much of the writing and teaching of that history to what had been "politically important." His "social history" was a liberating influence among American historians.

SCHLESINGER, BENJAMIN (*b. Krakai, Lithuania, 1876; d. Colorado Springs, Colo., 1932*), labor leader. Immigrated to Chicago, Ill., 1891; became a leading spirit in the Jewish labor movement. An able organizer and administrator, he was at various times business manager of the *Jewish Daily Forward* and president of the International Ladies' Garment Workers' Union.

SCHLESINGER, FRANK (*b. New York, N.Y., 1871; d. Old Lyme, Conn., 1943*), astronomer. B.S., College of the City of New York, 1890; M.A., Columbia University, 1897; Ph.D., 1898. The leading authority in his time on photographic astrometry, he was associated with the Yerkes Observatory, directed the Allegheny Observatory at University of Pittsburgh, 1905–20, and was director of the observatory at Yale University, 1920–41.

SCHLEY, WINFIELD SCOTT (*b. Frederick Co., Md., 1839; d. New York, N.Y., 1909*), naval officer. Graduated U.S. Naval Academy, 1860. After an active career on land and sea which included effective Civil War service, several tours of duty on the staff of the U.S. Naval Academy, and the command of the 1884 Arctic expedition to rescue the survivors of A. W. Greely's ill-fated party, Schley was selected to command the Flying Squadron at the opening of the Spanish-American War. After considerable friction with the commander of the Atlantic Squadron, William T. Sampson, Schley was in active command at the battle of Santiago, 1898, owing to Sampson's temporary absence from the station outside that port, a circumstance which left credit for the victory in doubt. Retiring as rear admiral, 1901. Schley demanded a court of inquiry to decide on the merits of the dispute. This was held late in 1901 and reached a judgment in general adverse to Schley, although Admiral George Dewey, on the question of command, rendered a minority opinion in his favor.

SCHMAUK, THEODORE EMANUEL (*b. Lancaster, Pa., 1860; d. Philadelphia, Pa., 1920*), Lutheran clergyman, historian. An uncompromising advocate of confessionalism, he was pastor at Lebanon, Pa., 1883–1920.

SCHMIDT, ARTHUR PAUL (*b. Altona, Germany, 1846; d. 1921*), music publisher. Immigrated to America *ca.* 1866; founded his own firm in Boston, Mass., 1876. Gave great encouragement to American composers by publishing works in larger forms which had no possibility of immediate commercial success.

SCHMIDT, CARL LOUIS AUGUST (*b. Brown County, S. Dak., 1885; d. Berkeley, Calif., 1946*), biochemist. B.S., University of California in Berkeley, 1908; M.S., 1910; Ph.D., 1916. Taught at University of California *post* 1915, becoming professor of biochemistry, 1924. Served as dean of the college of pharmacy, 1937–44, and as acting dean of the medical school, 1938–39. Principal research in the biochemistry of bile, the physical chemistry of proteins and amino acids, and applications of the data of biochemistry to immunology.

SCHMIDT, FRIEDRICH AUGUST (*b. Leutenberg, Germany, 1837; d. 1928*), Lutheran theologian, educator. Immigrated to St. Louis, Mo., as a child. A graduate of Concordia Theological Seminary, 1857, he taught theology in a number of midwestern seminaries. He figured extensively in the predestination controversy during and after the 1880's as an opponent of what he considered the new Calvinism.

SCHMIDT, NATHANIEL (*b. Hudiksvall, Sweden, 1862; d. Ithaca, N.Y., 1939*), orientalist, historian. Professor of Semitic languages and Oriental history, Cornell University, 1896–1932.

SCHMUCKER, BEALE MELANCHTHON (*b. Gettysburg, Pa., 1827; d. near Phoenixville, Pa., 1888*), Lutheran clergyman. Son of Samuel S. Schmucker. A pastor in present West Virginia and Pennsylvania, Schmucker opposed his father's theological tendencies and became a leader of the extreme churchly party among Lutherans. He was distinguished as a liturgical scholar.

SCHMUCKER, JOHN GEORGE (*b. Michelstadt, Germany, 1771; d. Williamsburg, Pa., 1854*), Lutheran clergyman. Father of Samuel S. Schmucker. Came to Pennsylvania as a boy; was raised in western Virginia. Pastor at Hagerstown, Md., 1794–1809, and at York, Pa., and its neighborhood, 1809–52.

SCHMUCKER, SAMUEL SIMON (*b. Hagerstown, Md., 1799; d. 1873*), Lutheran clergyman, theologian. Son of John G. Schmucker. Graduated University of Pennsylvania, 1819; Princeton Theological Seminary, 1820. Pastor at New Market, Va., 1820–26. As a founder of, and professor at, Gettysburg Theological Seminary, 1826–64, he exercised a liberal, Americanizing influence and for many years led the thought of the General Synod. A classical school which he started at Gettysburg, 1827, became Pennsylvania College, 1832, and is now known as Gettysburg College; he served as its president, 1832–34. Author of *Elements of Popular Theology* (1834) and a number of other works. He precipitated the doctrinal battle between "American" and "Old" Lutheranism with the publication of his *Definite Platform . . . for Evangelical Lutheran District Synods* (1855). He was the father of Beale M. Schmucker.

SCHNABEL, ARTUR (*b. Lipnik, Austria, 1882; d. Axenstein, Switzerland, 1951*), pianist and composer. After studying privately in Vienna, Schnabel lived in Berlin from 1910 to 1933; taught at the High School for Music, 1925–33. The foremost interpreter of Beethoven of his time, Schnabel toured extensively in Europe and the U.S. (first U.S. tour, 1921); immigrated to the U.S. in 1939. An arch-conservative, traditional pianist, Schnabel played only eighteenth- and nineteenth-century composers — Beethoven, Schubert, Bach, Mozart, and Brahms. He composed many works of his own but refused to play them in public. The first pianist to record all of the Beethoven sonatas, 1931–35.

SCHNAUFFER, CARL HEINRICH (*b. Heimsheim, near Stuttgart, Germany, 1823; d. probably Baltimore, Md., 1854*), poet, editor. Influenced in Germany by Gustav Struve and Friedrich K. F. Hecker, Schnauffer fought in the Baden revolution, 1848–49. Immigrating to Baltimore, Md., 1851, he joined in the "Turner" movement and founded the *Baltimore Wecker*, 1851.

SCHNEIDER, ALBERT (*b. Granville, Ill., 1863; d. Portland, Oreg., 1928*), bacteriologist. M.D., Chicago College of Physicians and Surgeons, 1887; Ph.D., Columbia, 1897. Professor at Northwestern, University of California, University of Nebraska; also dean of pharmacy, North Pacific College, 1922–28.

SCHNEIDER, BENJAMIN (*b. New Hanover, Pa., 1807; d. Boston, Mass., 1877*), Presbyterian missionary to Turkey, 1834–*ca.* 1875.

SCHNEIDER, GEORGE (*b. Pirmasens, Rhenish Bavaria, 1823; d. Colorado Springs, Colo., 1905*), journalist, banker. Came to America, 1849. As managing editor of the *Illinois Staats-Zeitung*, 1851–62, Schneider bitterly opposed Stephen A. Douglas and did much to consolidate the German vote in support of Abraham Lincoln. He was president, National Bank of Illinois, 1871–97.

SCHNEIDER, HERMAN (*b. Summit Hill, Pa., 1872; d. Cincinnati, Ohio, 1939*), engineer. Graduated Lehigh University, 1894. Taught engineering at Lehigh, 1899–1903; dean of College of Engineering at University of Cincinnati, 1906–39, serving for four years of this period also as president. Inaugurated at Cincinnati the "cooperative system" of technological education, in which theoretical studies were alternated with practical shop experience.

SCHNEIDER, THEODORE (*b. Geinsheim, Rhenish Palatinate, 1703; d. 1764*), physician, Roman Catholic clergyman, Jesuit. Highly distinguished as a professor at Liège and as rector of the University of Heidelberg, 1738–40, Schneider came to Philadelphia, 1741, assigned to act as missionary to German immigrants. He aided Robert Harding in eastern Pennsylvania and in New Jersey, founded a number of chapels, and built a large church at Goshenhoppen, Pa.

SCHNEIDERMAN, ROSE (*b. Saven, Poland, 1882; d. New York City, 1972*), labor organizer. Immigrated in 1890 to New York City, where she worked in the garment industry beginning at age thirteen; in 1902 she organized the first women's local of the Jewish Socialist cap makers' union. She emerged as a prominent labor organizer during the wave of garment industry strikes from 1909 to 1914. She was the first president of the International Ladies Garment Workers' Union, and as president of the national Women's Trade Union League (1926–50) she lobbied for maximum hour and minimum wage legislation for women. Beginning in the 1920's, she opposed the Equal Rights Amendment, arguing it would undermine protective legislation for women. In 1933 she was appointed to the National Recovery Administration's Labor Advisory Board and in 1937–44 was secretary of the New York State Department of Labor.

SCHNELLER, GEORGE OTTO (*b. Nürnberg, Germany, 1843; d. 1895*), inventor. Immigrated to America *ca.* 1860. Patented, 1880–1884, machinery for the manufacture and insertion of brass corset eyelets.

SCHNERR, LEANDER (*b. Gommersdorf, Baden, Germany, 1836; d. 1920*), Roman Catholic clergyman, Benedictine. Immigrated to Pittsburgh, Pa., as a child. Archabbot of St. Vincent's, Latrobe, Pa., *post* 1892.

SCHOCKEN, THEODORE (*b. Zwickau, Germany, 1914; d. White Plains, N.Y., 1975*), publisher. Graduated Harvard University (M.B.A., 1951). In 1933 became head of Schocken Verlag, the family's publishing house in Germany, which was devoted to Judaica, and fled to the United States in 1938. He headed the American branch of Schocken Books from 1946 to 1949, then pursued other business interests. In 1965 he reassumed the firm's presidency, at which time he oversaw the firm's successful expansion into the fields of social science and women's studies and benefits from a renewed interest in Judaica on colleges campuses.

SCHODDE, GEORGE HENRY (*b. Allegheny, Pa., 1854; d. 1917*), Lutheran clergyman, conservative biblical scholar. Professor at Capital University, Columbus, Ohio, *post* 1880.

SCHOENBERG, ARNOLD (*b. Vienna, Austria, 1874; d. Los Angeles, Calif., 1951*), composer. The most innovative and revolutionary of twentieth-century composers, Schoenberg's music evolved from a post-Romantic, Wagnerian style to the exploration of atonal and twelve-tone systems. His post-Romantic piece for orchestra and choruses, *Gurrelieder* (composed 1901; premiere 1913), was followed in 1907–08 by the String Quartet no. 2 in F-sharp Minor, the finale of which was the first piece of completely atonal music ever written. Dividing his time between Berlin and Vienna, Schoenberg was the leader of a school of composers that produced Alban Berg and Anton von Webern. Along with perfecting his use of the atonal medium, he introduced the concept of *Sprechstimme*, which became the fundamental use of the human voice in the new music. After World War I, he decided that atonalism gave anarchy instead of freedom and changed to the twelve-tone scale. His first entirely twelve-tone piece was the Suite for Piano (1924). Other works in this medium were the third and fourth String Quartets (1926; 1936), the Violin Concerto, (1936), and the opera *Moses und Aron* (1930–32).

Schoenberg immigrated to the U.S. in 1933; he taught at the University of California, Los Angeles, from 1936 to 1944. During this period, he returned to his Jewish origins for inspiration: *Kol Nidre* (1938), *A Survivor From Warsaw* (1947), and *Psalm 130* (1950).

SCHOENHEIMER, RUDOLF (*b. Berlin, Germany, 1898; d. Yonkers, N.Y., 1941*), biochemist. M.D., University of Berlin, 1922; studied at the University of Leipzig with Karl Thomas, 1923–26; worked in the Pathological Institute, University of Freiburg, 1926–33, becoming head of the Department of Pathological Chemistry and continuing his studies of sterols. Dismissed from his post because he was a Jew, he came to the United States in 1933 to teach in the biochemistry department of the College of Physicians and Surgeons, Columbia University. In addition to making a number of important further findings in his special field of research, he developed the methodology for use of isotopic tracers in the study of metabolic processes.

SCHOENHOF, JACOB (*b. Oppenheim, Germany, 1839; d. New York, N.Y., 1903*), lace merchant, free-trade advocate, economist. Immigrated to America, 1861. Author of, among other books, *The Industrial Situation and the Question of Wages* (1885) and *The Economy of High Wages* (1892), in which he forecast the doctrine later associated with the name of Henry Ford.

SCHOEPPEL, ANDREW FRANK (*b. Claflin, Kans., 1894; d. Bethesda, Md., 1962*), lawyer and politician. Attended universities of Kansas and Nebraska (LL.B., 1922); admitted to Kansas bar in 1923. As Kansas Republican governor (1942–47) he modernized the school systems, permitted the first executions of criminals since 1870, and launched an investigation that led to the state's repeal of prohibition (1949). Was U.S. senator, 1948–62, serving on the Interstate and Foreign Commerce, the Appropriations, and the Agricultural and Forestry committees.

SCHOFF, STEPHEN ALONZO (*b. Danville, Vt., 1818; d. Norfolk, Conn., 1904*), engraver. Employed professionally in bank-note work, Schoff produced, among other artistic plates, *Caius Marius on the Ruins of Carthage* after Vanderlyn, and *Bathers* after William M. Hunt.

SCHOFIELD, HENRY (*b. Dudley, Mass., 1866; d. 1918*), law teacher. Graduated Harvard, 1887; LL.B., 1890. Practiced principally in Chicago; was professor of law, Northwestern University *post* 1902. Authority on Chicago's relations to local traction systems. Author of a number of comments on important decisions which were later collected as *Essays on Constitutional Law and Equity* (1921).

SCHOFIELD, JOHN McALLISTER (*b. Gerry, N.Y., 1831; d. St. Augustine, Fla., 1906*), soldier. Graduated West Point, 1853. Commissioned in the artillery, he served as professor of natural philosophy at West Point. 1855–60. In Missouri at the outbreak of the Civil War, he became chief of staff to General Nathaniel Lyon and served until Lyon's death at the battle of Wilson's Creek, August 1861. Promoted brigadier general of volunteers in November, he was engaged in field operations in Missouri and later commanded the Department of the Missouri as major general. Assuming command of the XXIII Corps in February 1864, he took part in Sherman's Atlanta campaign as one of the three army commanders and badly shattered Hood's Confederate force at the fierce battle of Franklin, Tenn. Moving the XXIII Corps to the mouth of the Cape Fear River, he occupied Wilmington, N.C., and effected a junction with Sherman at Goldsboro, Mar. 23, 1865, for the final moves against General J. E. Johnston. After serving as confidential agent for the U.S. State Department in France, 1865–66, he commanded the Department of the Potomac, and in the spring of 1868 served briefly as U.S. secretary of war. Promoted major general, regular army, 1869, he commanded several departments successively and made the recommendations that led to the acquisition of Pearl Harbor, Hawaii, as a naval base. Superintendent at West Point, 1876–81, he became commanding general of the army, 1888, and retired as lieutenant general, 1895.

SCHOFIELD, WILLIAM HENRY (*b. Brockville, Ontario, Canada, 1870; d. Peterboro, N.H., 1920*), educator. Graduated Victoria College, 1889; Ph.D., Harvard, 1895. Expert in Scandinavian studies, Schofield taught English at Harvard, 1897–1906, and was thereafter professor of comparative literature.

SCHOLTE, HENDRIK PETER (*b. Amsterdam, Netherlands, 1805; d. Pella, Iowa, 1868*), Dutch Reformed and Independent clergyman, colonist. Seceding from the Netherlands state church, 1834, Scholte with other like-minded pastors urged emigration as a means of escape for their followers from persecution at home. Immigrating to the United States, 1847, he founded the settlement of Pella in Marion Co., Iowa, and was its principal citizen until his death.

SCHOMER, NAHUM MEIR (*b. Nesvizh, Russia, 1849; d. 1905*), Yiddish novelist and playwright. Prolific writer of popular works which helped develop the habit of reading among the Yiddish-speaking masses. Immigrated to New York City, 1889.

SCHOOLCRAFT, HENRY ROWE (*b. Albany Co., N.Y., 1793; d. 1864*), ethnologist. Attended Union and Middlebury colleges, where he favored the study of geology and mineralogy. Began

explorations in 1817–18 with a trip which resulted in *A View of the Lead Mines of Missouri* (1819). A member of the Cass exploring expedition, 1820, he reported on it in *Narrative Journal of Travels through the Northwestern Regions of the United States . . . to the Sources of the Mississippi River* (1821). He described a later expedition to the sources of the Mississippi in his *Narrative of an Expedition . . . to Itasca Lake* (1834, 1855). Schoolcraft's wide acquaintance with the Indians led to his appointment as Indian agent for the Lake Superior tribes, 1822; he served as superintendent of Indian affairs for Michigan, 1836–41. A constant promoter of the study of Indian ethnology, he was author of *Algic Researches* (1839), which concerned Indian mental characteristics, and of other valuable works. His principal production was *Historical and Statistical Information Respecting the History, Condition and Prospects of the Indian Tribes of the United States* (six parts, 1851–57, illustrated with engravings from paintings by Seth Eastman).

SCHÖPF, JOHANN DAVID (*b. Wunsiedel, Germany, 1752; d. 1800*), physician, traveler. After service as a surgeon with a German regiment in the British service, 1777–83, Schöpf made a scientific tour from New Jersey to Florida before returning to his home in Bayreuth. He wrote a number of articles and monographs on his studies and an excellent travel book and historical source entitled *Reise durch einige der mittlern und südlichen vereinigten nordamerikanischen Staaten nach Ost-Florida und den Bahama-Inseln* (Erlangen, 1788; translated as *Travels in the Confederation*, 1911).

SCHORER, MARK (*b. Marcus Robert Schorer, Sauk City, Wis., 1908; d. Oakland, Calif., 1977*), writer. Attended University of Wisconsin (B.A., 1929) and Harvard University (M.A.; Ph.D., 1936). In the 1930's, he published his first short stories in magazines and his first novel, *A House Too Old* (1935). He taught at Dartmouth College (1936–40), Harvard (1940–45), and University of California, Berkeley (1945–60). He was fascinated by critical theory and the problem of the novel and was a leader of the New Criticism literary theory. His last novel was *The Wars of Love* (1954), and he wrote the authorized biography *Sinclair Lewis: An American Life* (1961). Other works include *Colonel Markesan and Less Pleasant People; D. H. Lawrence; The World We Imagine*, a collection of essays, prefaces, and lectures; and the posthumous short-story collection *Pieces of Life* (1977).

SCHOTT, CHARLES ANTHONY (*b. Mannheim, Germany, 1826; d. Washington, D.C., 1901*), geodesist. Came to America, 1848. Chief of computing division, U.S. Coast Survey, 1855–1900, Schott made his principal contributions to science in the fields of geodesy and terrestrial magnetism. He also wrote on meteorology and climatology, especially of the Arctic regions.

SCHOULER, JAMES (*b. present Arlington, Mass., 1839; d. 1920*), lawyer, historian. Son of William Schouler. Graduated Harvard, 1859. Schouler is principally remembered as the author of *History of the United States of America Under the Constitution* (7 vols., 1880–1913). This was the first attempt to cover in a scholarly way the period from the Revolution to the Civil War. It appeared almost contemporaneously, however, with the work of John B. McMaster. Schouler's interpretation was primarily political and constitutional and was based on an industrious exploration of sources. To a large extent, his history and McMaster's supplement each other.

SCHOULER, WILLIAM (*b. near Glasgow, Scotland, 1814; d. 1872*), editor. Massachusetts legislator. Father of James Schouler. Came to America, 1816. Active as an editor of Whig and Republican papers in Massachusetts and Ohio, Schouler served as adjutant general of Massachusetts, 1860–66, revealing remarkable executive ability and winning the lasting admiration of Governor John A. Andrew. He was author of *A History of Massachusetts in the Civil War* (1868–71) and of personal reminiscences.

SCHRADIECK, HENRY (*b. Hamburg, Germany, 1846; d. Brooklyn, N.Y., 1918*), violinist, conductor, teacher. After a brilliant career in Europe, he came to America, 1883, and was a teacher in Cincinnati, Philadelphia, and New York City. Among his pupils were Maud Powell and Theodore Spiering.

SCHREMBS, JOSEPH (*b. Wurzelhofen, near Regensburg, Bavaria, Germany, 1866; d. Cleveland, Ohio, 1945*), Roman Catholic clergyman. Came to the United States, 1877; studied at St. Vincent's Archabbey, Latrobe, Pa., and at the Grand Séminaire, Montreal, Canada; ordained to the priesthood, June 1889. After service as curate and pastor of several parishes in the diocese of Grand Rapids, Mich., he was named auxiliary bishop in 1911; later that year he was appointed first bishop of Toledo, Ohio. An administrator of the National Catholic War Council, he played a crucial role in its continuation after 1920 as the National Catholic Welfare Council (Conference) and directed its department of lay organization. In 1921 he was appointed bishop of Cleveland, Ohio, and held that post until his death; *post* 1939, he had a personal title of archbishop.

SCHRIECK, LOUISE VAN DER (*b. Bergen op Zoom, Holland, 1813; d. Cincinnati, Ohio, 1886*), founder of the Sisters of Notre Dame de Namur in America. Came to Cincinnati, Ohio, 1840, as one of a group of volunteer nuns; was named superior of the convent, 1845. As superior provincial *post* 1848, she founded 26 convents of teaching sisters in Washington, D.C., Philadelphia, Pa., and through Ohio and Massachusetts.

SCHRIVER, EDMUND (*b. York, Pa., 1812; d. 1899*), soldier, railroad executive. Graduated West Point, 1833. Employed mainly in staff work, Schriver was brevetted major general, 1865, for effective service during the Civil War. Thereafter he served principally on inspection duty until retirement, 1881.

SCHROEDER, JOHN FREDERICK (*b. Baltimore, Md., 1800; d. 1857*), Episcopal clergyman. A skillful preacher, he was assistant at Trinity Church, New York City, 1823–39, having immediate charge of St. Paul's Chapel. He served thereafter as principal of a girl's school and as rector of several churches successively in Flushing, New York City, and Brooklyn, N.Y. He was a moderate evangelical.

SCHROEDER, RUDOLPH WILLIAM (*b. Chicago, Ill., 1886; d. Maywood, Ill., 1952*), pioneer aviator and aviation executive. One of the first men to enter the stratosphere, Schroeder successfully piloted a plane to an altitude of 33,113 ft. in 1920. A member of the Aviation Section of the Army Signal Corps (1916–20); special accident investigator for the Air Commerce Bureau (1933–37). Manager of operations and vice president of safety for United Air Lines (1937–42). A pioneer in aviation safety, Schroeder helped develop many devices for flight safety: night landing flares, instrument flying, and controllable pitch propellers.

SCHROEDER, SEATON (*b. Washington, D.C., 1849; d. 1922*), naval officer. Graduated Annapolis, 1868. An efficient officer of wide experience, Schroeder was author of treatises on torpedoes and torpedo boats, assisted in perfecting the Driggs-Schroeder gun, and retired as rear admiral, 1911. Earlier in his career he had assisted Henry H. Gorringe in transporting the Cleopatra's Needle obelisk, now in Central Park, from Egypt to New York City, 1879.

SCHUCHERT, CHARLES (*b. Cincinnati, Ohio, 1858; d. New Haven, Conn., 1942*), paleontologist. Assistant to Edward O. Ulrich, 1885–88, and to James Hall, 1889–91; worked with Newton H. Winchell on studies of Minnesota brachiopods; served as a preparator at Peabody Museum, Yale. Joining the U.S. Geological Survey, 1893, he became assistant curator of invertebrate paleontology at the National Museum, 1894. In 1904 he was appointed curator of geological collections at Peabody Museum, Yale, and professor of historical geology. He retired from teaching in 1925, but remained at the museum for the rest of his life. Highly effective as a teacher of graduate students, he made Yale an outstanding training ground for invertebrate paleontologists and stratigraphers.

SCHUESSELE, CHRISTIAN *See* SCHUSSELE, CHRISTIAN.

SCHULTZ, DUTCH *See* FLEGENHEIMER, ARTHUR.

SCHULTZ, HENRY (*b. Szarkowszczyzna, Russian Poland, 1893; d. near San Diego, Calif., 1938*), mathematical economist. Came to America as a boy. Graduated College of the City of New York, 1916; Ph.D., Columbia, 1925. Studied also at London School of Economics and at Galton Laboratory of University of London. Taught at University of Chicago, *post* 1926; was author of *The Theory and Measurement of Demand* (1938).

SCHULTZE, AUGUSTUS (*b. near Potsdam, Prussia, 1840; d. Bethlehem, Pa., 1918*), Moravian clergyman, editor, author. Professor of classics at Moravian College, Bethlehem, Pa., *post* 1870; president of the college, 1885–1918.

SCHUMANN-HEINK, ERNESTINE (*b. Lieben, near Prague, Bohemia, 1861; d. Hollywood, Calif., 1936*), singer. An outstanding contralto, she made her first professional appearance in Graz, Austria, 1876; after a somewhat difficult career with various German opera companies, she won success with the Hamburg Opera, 1888. Thereafter her European reputation grew and she was invited to join the Metropolitan Opera Co.: she made her American debut in Chicago, November 1898, in *Lohengrin*. Leaving the Metropolitan, 1903, to undertake work in concert and operetta, she returned to grand opera in 1905 and continued active on both sides of the Atlantic until *ca.* 1914. Displaying strong American patriotism during World War I, she made concert work her principal activity during the 1920's and the early 1930's; she also sang on the radio and in vaudeville. At its prime, her voice was remarkable for its compass as well as for its quality and power.

SCHUMPETER, JOSEPH ALOIS (*b. Triesch, Moravia, now Czechoslovakia, 1883; d. Cambridge, Mass., 1950*), economist. Educated at the University of Vienna. Precocious, with Napoleonic aspirations, and always a showman, he was a member of the Department of Economics at Harvard subsequent to his arrival in the United States, 1932. He brought with him a reputation as the enfant terrible of the Austrian school of economics; he had taught at Czernowitz and Graz, served as finance minister in the post–World War I socialist government of Austria, 1919–20, and occupied the chair of public finance at Bonn, 1925–32. It is probable, despite all his early brilliance, that the work he did in the last dozen years of his life is his most valuable contribution. He was author of, among other books, *Business Cycles* (1939), *Capitalism, Socialism and Democracy* (1942), *History of Economic Doctrines* (1951), and *History of Economic Analysis* (1954, incomplete and edited by his widow). A number of his earlier books have been translated from the German, e.g., *The Theory of Economic Development* (originally published in 1911).

SCHURMAN, JACOB GOULD (*b. Freetown, Prince Edward Island, Canada, 1854; d. New York, N.Y., 1942*), philosopher, educator, diplomat. Descended from New York Loyalists of Dutch extraction who had moved to Canada during the American Revolution. He attended the University of London, where he received a B.A. degree in 1877 from University College. He next studied philosophy for a year at Edinburgh, while simultaneously studying for an M.A. at London, and earned a D.Sc. with distinction in 1878. Schurman went to Cornell in 1886 for the professorship of Christian ethics and mental philosophy, recently endowed by Henry W. Sage. In 1890 Sage endowed the School of Philosophy at Cornell, with Schurman as its dean.

Schurman had already established himself as a philosopher of some distinction with *Kantian Ethics and the Ethics of Evolution* (1881), the first English-language critique of Kant's ethical system. He also wrote *The Ethical Import of Darwinism* (1888) and two books comprising his popular lectures, *Belief in God* (1890) and *Agnosticism and Religion* (1896). The objective idealism espoused by Schurman, who emphasized the totality of human experience in its social, historical, and institutional aspects, held sway at the Sage School of Philosophy. In 1892 the first general scholarly journal devoted to philosophy in America, the *Philosophical Review*, began publication at Cornell under his editorship. Schurman became president of Cornell in 1892. During his 28-year regime he created the Veterinary College, the College of Agriculture, the Medical College, and the ill-fated College of Forestry. Under his presidency Cornell changed from a privately endowed to a mixed public and private institution.

In the recently conquered Philippines. Schurman was chairman of a government commission to investigate local conditions, 1899. In 1902 he was publicly arguing (in his lecture and book *Philippine Affairs*) for Philippine independence. He also served as minister to Greece and Montenegro, 1912–13; minister to China, 1921–25, his most important diplomatic post; and ambassador to Germany, 1925–30.

SCHURZ, CARL (*b. Liblar, near Cologne, Germany, 1829; d. New York, N.Y., 1906*), German revolutionary. Union soldier, lawyer, diplomat, statesman. A leader of the student revolutionary movement at the University of Bonn. Schurz was profoundly influenced by Gottfried Kinkel and followed him in the abortive move upon Siegburg, May 1849. Thereafter he became a lieutenant and staff officer of the revolutionary army, fought in several engagements during June, and managed to escape from the fortress of Rastatt before its capture by the Prussians. After a brief refuge in Switzerland, he returned to Germany to rescue Kinkel, who had been sentenced to life imprisonment and was confined at Spandau. Achieving this purpose on the night of Nov. 6, 1850, he accompanied Kinkel to England. Thence, after a brief residence, he immigrated to the United States, August 1852. Settling on a small farm in Watertown, Wis., 1856, he espoused the antislavery cause and was drawn into Republican politics. Speaking in German, he campaigned for Frémont, 1856, and in 1858 spoke in Illinois for Abraham Lincoln. An able orator in both German and English, he was soon in demand for one campaign after another and was particularly effective during the campaign of 1860. His speech at Cooper Union, New York City, in September, a merciless criticism of Stephen A. Douglas, was regarded as his principal oratorical effort. Appointed U.S. minister to Spain by Lincoln, Schurz remained only a brief time in that post and returned to urge immediate emancipation of the slaves as a means of securing European sympathy for the North.

Appointed brigadier general of volunteers, June 1862, he took his military duties seriously. Commended as a division commander at the second battle of Bull Run, August 1862, he and his division were soon held up to scorn because of their flight during the battle of Chancellorsville. Schurz blamed the disaster

on the improper placement of his division by General O. O. Howard and a long controversy ensued. Commanding the XI Corps at Gettysburg, Schurz was again unsuccessful in stemming an attack of the Confederates, and once again there were charges that his German troops had failed to stand their ground. Promoted to major general, Schurz and his corps were transferred to the west. After the battle of Chattanooga the depleted XI Corps was merged into a new unit and its general was appointed to an inactive post at Nashville. The end of the Civil War found Schurz serving as chief of staff to General Slocum in Sherman's army. Throughout his military service he had been in an anomalous situation because of his constant correspondence with President Lincoln; despite this, he won the regard of Sherman, Hancock, and other able Northern generals.

Traveling through the Southern states, July–September 1865, Schurz wrote a lenghty report on his observations which has value to this day, although President Johnson tried his best to suppress it. Briefly the Washington correspondent of the *New York Tribune* and the editor of the Detroit *Post*, he became coeditor, with Emil Preetorius, of the St. Louis *Westliche Post*, 1867. He delivered the keynote address at the Republican National Convention, 1868. As U.S. senator, Republican, from Missouri, 1869–75, Schurz soon found himself among the anti-Grant members; he opposed the president's spoils-loving and domineering partisans, introduced a bill to create a permanent civil service merit system, 1869, and made incessant attacks upon public corruption. Failing of reelection, he returned once again to journalism and lecturing. Having done more than any other leader to promote the Liberal Republican movement, he was permanent president of the Cincinnati convention, 1872, and was active in Horace Greeley's campaign. Supporting R. B. Hayes for the presidency, 1876, he served with enlightened ability as U.S. secretary of the interior, 1877–81. Coeditor of the New York *Evening Post* and the *Nation*, 1881–83, he resigned because of friendly differences over methods and policies with Edwin L. Godkin. He contributed the leading editorials to *Harper's Weekly*, 1892–98. Opposed to the war with Spain and later to expansionist policies, he held in his last years a unique position as a veteran statesman and political philosopher. Among his books are *A Life of Henry Clay* (1887) and *Reminiscences* (1907–08).

SCHUSSELE, CHRISTIAN (*b. Guebviller, Alsace, 1826; d. Merchantville, N.J., 1879*), painter, teacher, lithographer. Immigrated to Philadelphia, Pa., *ca.* 1849. Established reputation as a painter with *Clear the Track*, engraved by John Sartain, 1854. Among other of his well-known paintings are *Franklin Before the Lords in Council* (1856) and *Washington at Valley Forge* (1862). In the latter part of his life he served as professor of drawing and painting at the Pennsylvania Academy of the Fine Arts.

SCHUSTER, MAX LINCOLN (*b. Kalusz, Austria, 1897; d. New York, N.Y., 1970*), editor and publisher. Brought by his parents to New York City when he was several weeks old; attended Pulitzer School of Journalism at Columbia (B.Litt., 1917). In late 1923 he and Richard L. Simon started a publishing business and published their first project, a crossword puzzle book, in 1924. In 1926 they contracted Will Durant to write *The Story of Philosophy*, which sold over a half million copies. Many of their publications sold in the millions, including Dale Carnegie's *How to Win Friends and Influence People* (1938). In 1939 he, Simon, and Leon Shimkin joined Robert Fair De Graff in establishing Pocket Books, a company specializing in the publication of paperbound books; it soon became an outstanding success. Simon and Schuster and Pocket Books were sold to Field Enterprises in 1944, and until 1957 Schuster and Simon alternated as president and board chairman. In 1957 Shimkin and Schuster

bought back the firm, and nine years later Schuster sold his interest to Shimkin.

SCHUTTLER, PETER (*b. Wachenheim, Hesse-Darmstadt, Germany, 1812; d. Chicago, Ill., 1865*), wagon maker. Came to America, 1834. In business in Chicago *post* 1843, Schuttler produced a lightweight easy-running wagon which displaced the old prairie schooner type for westward emigration.

SCHUYLER, EUGENE (*b. Ithaca, N.Y., 1840; d. Italy, 1890*), diplomat. Son of George W. Schuyler. Graduated Yale, 1859; Ph.D., 1861; LL.B., Columbia, 1863. A consular and diplomatic officer principally in Russia *post* 1867, Schuyler became widely known for a report on Turkish atrocities in Bulgaria (1876). Subsequently holding posts as diplomatic representative to Romania, Greece, Serbia, and Egypt, he was an outstanding figure during an era of mediocrity in the American foreign service. Among his literary works were translations from Turgenev and Tolstoy and a biography of Peter the Great (1884).

SCHUYLER, GEORGE WASHINGTON (*b. Stillwater, N.Y., 1810; d. 1888*), businessman, New York State official. Father of Eugene Schuyler. Author of *Colonial New York: Philip Schuyler and His Family* (1885).

SCHUYLER, JAMES DIX (*b. Ithaca, N.Y., 1848; d. Ocean Park, Calif., 1912*), hydraulic and railroad engineer, expert in dam building and water-supply systems.

SCHUYLER, LOUISA LEE (*b. New York, N.Y., 1837; d. 1926*), welfare-work leader. Great-granddaughter of Philip J. Schuyler and of Alexander Hamilton. Worked with U.S. Sanitary Commission through the Civil War; organized State Charities Aid Association, 1872; secured opening of nurses' training school at Bellevue Hospital, the first in America (*ca.* 1874).

SCHUYLER, MARGARITA (*b. Albany, N.Y., 1701; d. Albany, 1782*). Daughter-in-law of Peter Schuyler; aunt of Philip J. Schuyler. Celebrated as a hostess and as the subject of A. M. Grant's *Memoirs of an American Lady* (1808).

SCHUYLER, MONTGOMERY (*b. Ithaca, N.Y., 1843; d. New Rochelle, N.Y., 1914*), journalist, critic of architecture. Attended Hobart College. Served on the staff of the New York *World*, 1865–83; of the *New York Times*, 1883–1907. Meanwhile he had been managing editor, *Harper's Weekly*, 1885–87, and was a literary adviser to Harper & Brothers. He was author of *American Architecture: Studies* (1892), but the bulk of his writing on this topic is scattered through the files of periodicals, notably the *Architectural Record*, of which he was one of the founders, 1891.

SCHUYLER, PETER (*b. Beverwyck, present Albany, N.Y., 1657; d. 1724*), soldier and official of colonial New York. Elected first mayor of Albany, 1686, and head of the board of Indian commissioners, Schuyler acted with energy and efficiency as protector of the frontier against the French threat from Canada and possessed a remarkable influence over the Iroquois. Active in opposition to Jacob Leisler, he was made a judge of common pleas by Governor Sloughter, 1691, and appointed to the council in 1692 by Governor Fletcher. Acting governor of New York, July 1719–September 1720, he was removed from the council on the arrival of Governor Burnet, who feared him as a potential leader of the opposition. A trader and merchant, Schuyler owned numerous land grants, of which the most extensive was in the Saratoga patent.

SCHUYLER, PHILIP JOHN (*b. Albany, N.Y., 1733; d. Albany, 1804*), soldier, statesman, landowner. Commanded a company

in the 1755 expedition against Crown Point; served in John Bradstreet's expedition to Oswego, 1756. Returned to service, 1758, as deputy commissary under Lord Howe and was again with Bradstreet at the taking of Fort Frontenac. Collected and forwarded provisions from Albany to Amherst's forces, 1759–60. Living as a country gentleman thereafter until the outbreak of the Revolution, Schuyler developed his estates. Although he opposed the De Lancey-Colden royalist coalition, he withheld his sympathy from the radicals among the Sons of Liberty. Accepting membership in the New York delegation to the second Continental Congress, he was appointed on June 15, 1775, one of four major generals under Washington and assigned to command in northern New York. With only halfhearted support from New England he recruited and provisioned an army, strengthened garrisons at Ticonderoga and Crown Point, maintained the neutrality of the Iroquois, and organized the expedition of 1775–76 against Canada. Yielding the field command to General Richard Montgomery because of ill health, he was nevertheless held responsible for the failure of the expedition by New Englanders, who disliked him as a severe disciplinarian and as a symbol of the mutual antagonism between "Yorker" and "Yankee." Except for his indecision over defending Ticonderoga, which ended in St. Clair's abandonment of that fort, July 1777, Schuyler handled the difficult situation in northern New York with considerable skill. Retreating before the British in such a way as to permit levies of militia to harass the advancing General Burgoyne, he upset another part of the British strategy by relieving Fort Stanwix and so wrecking the efforts of the British general St. Leger to approach from the west. Congress, however, alarmed by the loss of Ticonderoga, superseded him with General Horatio Gates, Aug. 4, 1777. Demanding a court-martial, he was acquitted with honor, October 1778, and in the following spring resigned from the Continental service. He continued, however, to assist Washington with advice and served briefly in Congress, 1779–80. Holder of a number of public offices, 1780–98, Schuyler gave particular attention to problems of finance; he was a strong supporter of the movement which culminated in the Constitutional Convention of 1787 and served as U.S. senator, Federalist, from New York, 1789–91 and 1797–98. He was intimately associated with the career of his son-in-law, Alexander Hamilton.

SCHUYLER, ROBERT LIVINGSTON (*b. New York, N.Y., 1883; d. Rochester, N.Y., 1966*), historian, educator, and editor. Attended Columbia (Ph.D., 1909). Taught at Yale (1906) and Columbia (1910–51). Drew up the syllabus for the courses in American history and modern European history (1912–13). Author of *The Constitution of the United States* (1923); *Parliament and the British Empire* (1929), which demolished the old contention that the acts against which American colonists protested were without legal authority; *Josiah Tucker* (1931); and, his last major book, *The Fall of the Old Colonial System* (1945). Had a distinguished career as an editor, of *Political Science Quarterly* (1919–21), *Columbia Studies in History, Economics, and Public Law* (1923–29, 1944–48), and *American Historical Review* (1936–41), and the second supplement (1958) of the *Dictionary of American Biography*.

SCHWAB, CHARLES MICHAEL (*b. Williamsburg, Pa., 1862; d. New York, N.Y., 1939*), industrialist. Beginning work in the steel industry at the Carnegie-owned Edgar Thomson Steel plant an iii engineer helper, Schwab advanced swiftly, owing in great part to his genius in dealing with people and his openmindedness toward technological, production, and laborsaving innovations. Appointed president of Carnegie Steel Co., 1897, he served as go-between in the sale of the Carnegie properties to the J. P. Morgan interests and in formation of the U.S. Steel Corporation, 1901. President of the new corporation, 1901–03, he

built up the Bethlehem Steel Co., *post 1904*, into principal rival of U.S. Steel. To the operation of Bethlehem, Schwab brought daring, energy, and the skills of a great salesman. He set up an executive profit-sharing system, put essentially all wages on an incentive basis, and gave his associates a free hand. During World War I he was the principal factor in Bethlehem's success with war-contract work and became in time a sort of senior spokesman for the steel industry. Dying insolvent because of unwise investment outside the steel industry and the effects of the Great Depression, he stands as an almost perfect specimen of the great entrepreneur in the heyday of American capitalism.

SCHWAB, JOHN CHRISTOPHER (*b. New York, N.Y., 1865; d. New Haven, Conn., 1916*), economist, librarian. Graduated Yale, 1886; Ph.D., Göttingen, 1889. Taught political economy at Yale *post 1891*. Author of *The Confederate States of America, 1861–1865; A Financial and Industrial History* (1901).

SCHWARTZ, DELMORE DAVID (*b. Brooklyn, N.Y., 1913; d. New York, N.Y., 1966*), writer. Attended University of Wisconsin, New York University (B.A., 1935), and Harvard. His masterpiece, "In Dreams Begin Responsibilities," appeared in *New Directions in Prose and Poetry* (1937). His first book (1935) was a collection of poetry and prose under that title and brought him instant critical attention and fame. Published the autobiographical play *Shenandoah* in 1941; the best of his short stories were collected in *The World Is a Wedding* (1948). *Summer Knowledge* (1959), which contains the best of his early work and his later, long-line poems, won the Bollingen Prize. Taught at Harvard (1940–47), Princeton (1949–50), Kenyon (1950). Indiana (1951), Chicago (1954), and Syracuse (1962–65). Editor of the *Partisan Review* (1943–55) and poetry editor and film critic for *New Republic* (1955–57). Suffered from paranoia and marital problems, and died in a seedy New York hotel. His life was depicted in Saul Bellow's novel *Humboldt's Gift* (1975).

SCHWARTZ, MAURICE (*b. Sudilkov, Russia, 1889; d. Tel Aviv, Israel, 1960*), actor. Born Avrom Moishe Schwartz. One of the leading figures in the Yiddish theater in America. Schwartz began acting with the Delancey Street Dramatic Club. By 1911, he was working in the David Kessler Theater on Second Avenue in New York. In 1920 took over the Yiddish Art Theater, dedicated to presenting plays of quality in Yiddish, including non-Jewish classics. The troupe included such actors as Paul Muni, Celia Adler, Lazar Fried, and Samuel Goldenberg. The repertory included works by Sholem Aleichem, Sholem Asch, and Osip Dymov, as well as Yiddish translations of Tolstoy, Ibsen, Chekhov, Molière, and Shaw. Schwartz is remembered as a great theater organizer as well as a fine actor. He was responsible for guiding the Yiddish theater to its heights.

SCHWARZ, EUGENE AMANDUS (*b. Liegnitz, Silesia, Germany, 1844; d. 1928*), entomologist. Came to America, 1872. In U.S. Department of Agriculture service *post 1879*, Schwarz was considered to be the most learned coleopterist of his time and also excelled as a field investigator.

SCHWATKA, FREDERICK (*b. Galena, Ill., 1849; d. Portland, Oreg., 1892*), explorer. Graduated West Point, 1871; M.D., Bellevue Hospital Medical College, New York, 1876. In association with William H. Gilder, Schwatka journeyed to the Arctic, 1878, and after a search of more than two years resolved all doubts concerning the fate of the famous expedition of Sir John Franklin. Resigning from the army, 1885, he devoted himself thereafter to travel and to writing and lecturing.

SCHWEINITZ, EDMUND ALEXANDER DE (*b. Bethlehem, Pa., 1825; d. 1887*), Moravian bishop, historian. Son of Lewis D. von Schweinitz.

SCHWEINITZ, EMIL ALEXANDER DE (*b. Salem, N.C., 1866; d. 1904*), biochemist. Grandson of Lewis D. von Schweinitz. Graduated University of North Carolina, 1882; Ph.D., 1885; Ph.D. in chemistry, Göttingen, 1886. Engaged *post* 1888 in research in the U.S. Department of Agriculture (*post* 1890 as chief of research in biochemistry, Bureau of Animal Industry), he specialized in the study of disease-producing bacteria and the production of means of immunity to them. In addition to his work for the government, he was dean and professor of chemistry at the medical school, present George Washington University.

SCHWEINITZ, GEORGE EDMUND DE (*b. Philadelphia, Pa., 1858; d. Philadelphia, 1938*), opthalmologist. Son of Edmund A. de Schweinitz; grandson of Lewis D. von Schweinitz. Graduated Moravian College, 1876; M.D., University of Pennsylvania, 1881. Taught ophthalmology at Philadelphia Polyclinic and at Jefferson Medical College; professor of ophthalmology, University of Pennsylvania, 1902–24, and at its Graduate School of Medicine thereafter. Long regarded as the American leader in his specialty, de Schweinitz was coauthor and editor of numerous textbooks and author of hundreds of articles; his principal work was *Diseases of the Eye* (1892), for many years the most admired textbook in its field.

SCHWEINITZ, LEWIS DAVID VON (*b. Bethlehem, Pa., 1780; d. Bethlehem, 1834*), Moravian clergyman, botanist, pioneer mycologist. Father of Edmund A. and grandfather of Emil A. and George E. de Schweinitz. Author of *The Fungi of Lusatia* (1805), *The Fungi of North Carolina* (1818), *A Synopsis of North American Fungi* (published in *Transactions of the American Philosophical Society*, 1834), and other works.

SCHWELLENBACH, LEWIS BAXTER (*b. Superior, Wis., 1894; d. Washington, D.C., 1948*), lawyer, politician. Raised in Spokane, Wash. LL.B., University of Washington, 1917. After World War I army service, he practiced in Seattle. Active in politics as a Democrat, he was elected to the U.S. Senate, 1934. A consistent supporter of the New Deal and especially interested in the problems of labor, he left the Senate in December 1940 to accept appointment as a federal judge for the eastern district of the state of Washington. In 1945 President Truman chose him to be U.S. secretary of labor, a post in which he served with considerable ability, despite increasing ill health.

SCHWIDETZKY, OSCAR OTTO RUDOLF (*b. Konitz, Germany [now Chojnice, Poland], 1874; d. Ramsey, N.J., 1963*), medical instrument maker. Immigrated to the United States in 1900 and became an importer of surgical supplies. Created the Ace bandage and invented devices to provide access to the bloodstream to control and fight disease, including the first glass-barrel and rubber-bulb syringe (1910), which evolved into the Asepto model; the standard syringe for injecting fluids into the genito-urinary system (1916); the syrette syringe, used on wounded soldiers in World War I to inject morphine; and the caudal needle for the continuous administration of anesthesia into the spinal column. His lifelong association with Becton-Dickinson Company began in 1913.

SCHWIMMER, ROSIKA (*b. Budapest, Hungary, 1877; d. Winnetka, Ill.[?], 1948*), feminist, peace advocate, writer, lecturer. Conceived idea of Peace Ship, which Henry Ford underwrote, 1915; served as minister from Hungary to Switzerland during Mihály Károlyi's regime (November 1918–March 1919); center of controversy after her immigration to the United States, 1921, and denied right of citizenship. Her chief concern in later life was the establishment of an all-inclusive, democratic, nonmilitary federation of nations under a world government.

SCIDMORE, ELIZA RUHAMAH (*b. Madison, Wis., 1856; d. 1928*), journalist, traveler, lecturer.

SCOLLARD, CLINTON (*b. Clinton, N.Y., 1860; d. Kent, Conn., 1932*), poet. Author of *Pictures in Song* (1884) and of a number of other volumes of lyrics marked by painstaking care in versification.

SCOPES, JOHN THOMAS (*b. Paducah, Ky., 1900; d. Shreveport, La., 1970*), teacher and geologist. In 1925 the Tennessee legislature enacted a law making it a misdemeanor to teach evolution in the state's public schools, and the American Civil Liberties Union advertised that it would pay the expenses of anyone who would test the law's constitutionality. Scopes agreed to do so and was arrested for teaching evolution at Central High School in Dayton, Tenn. The case developed into the nation's biggest news story when William Jennings Bryan and Clarence Darrow volunteered to oppose each other in trying the case. At issue were the rights of religion and government to decide what should or should not be taught. The jury found Scopes guilty; Judge John Raulston fined him $100. Darrow argued the appeal before the Tennessee Supreme Court, which overturned the sentence, ruling that the jury, not the judge, should have set the fine. Scopes returned to teaching and relative obscurity. In 1960 he reemerged to promote the film version of the play *Inherit the Wind*, based on his trial.

SCOTT, ALLEN CECIL (*b. Omaha, Nebr., 1882; d. Omaha, 1964*), businessman. Developed the idea of a pilot chute that popped out of an individual parachute when the pilot pulled the ripcord and dragged the main chute free; the patent granted (1921) covered the packing of the main chute, the harness and release, and the pilot chute, which became the basic design of all later chutes.

SCOTT, AUSTIN (*b. Maumee, Ohio, 1848; d. Granville Centre, Mass., 1922*), educator. Graduated Yale, 1869; M.A., University of Michigan, 1870; Ph.D., Leipzig, 1873. Served as editorial assistant to George Bancroft. Taught history at Johns Hopkins, 1875–82, and at Rutgers College, *post* 1883, later becoming professor of political science. President of Rutgers, 1891–1906.

SCOTT, CHARLES (*b. present Powhatan Co., Va., ca. 1739; d. Clark Co., Ky., 1813*), colonial soldier. Revolutionary major general by brevet, Kentucky legislator. Removing to Kentucky, 1785, he served under General Josiah Harmar in the 1790 expedition against the Indians. In 1791 he led an expedition against the Indians on the Wabash River and was with General St. Clair at the disastrous defeat of Nov. 4. He led the mounted Kentucky volunteers at the battle of Fallen Timbers, August 1794. Governor of Kentucky, 1808–12.

SCOTT, COLIN ALEXANDER (*b. Ottawa, Canada, 1861; d. Boston, Mass., 1925*), psychologist, educational reformer. Author of *Social Education* (1908).

SCOTT, DRED (*b. in slavery, Southampton Co., Va., ca. 1795; d. St. Louis, Mo., 1858*). Nominal plaintiff in the famous legal process, 1846–57, which led to the Dred Scott decision by the U.S. Supreme Court.

SCOTT, EMMETT JAY (*b. Houston, Tex., 1873; d. Washington, D.C., 1957*), educator and publicist. Studied at Wiley University in Texas. In 1891, Scott became a reporter for the *Houston Post;*

by 1894 he was the editor for the *Texas Freeman,* an influential black newspaper. It was as private secretary to Booker T. Washington (1897–1915) that Scott gained influence in black politics and social organization. In 1900, he helped Washington organize the National Negro Business League, serving as secretary until 1922. Secretary, Tuskegee Institute (1912–17), and secretary-treasurer (1919–38), Howard University. During World War I, was advisor to the secretary of war on black soldiers. Served on public relations staff of Republican national conventions (1924–48); assistant publicity director, Republican National Committee (1939–42).

SCOTT, FRED NEWTON (*b. Terre Haute, Ind., 1860; d. San Diego, Calif., 1931*), educator. Taught at University of Michigan *post* 1889; headed departments of rhetoric and journalism. Author of a number of works on style, he was coauthor with C. M. Gayley of *An Introduction to the Methods and Materials of Literary Criticism* (1899).

SCOTT, GUSTAVUS (*b. probably Prince William Co., Va., 1753; d. Washington, D.C., 1800*), lawyer, Maryland legislator, Revolutionary patriot.

SCOTT, HARVEY WHITEFIELD (*near Groveland, Ill., 1838; d. Baltimore, Md., 1910*), journalist. Brother of Abigail J. S. Duniway. Editor of the Portland *Morning Oregonian,* 1866–72; editor and part owner, 1877–1910. A conservative Republican, he won national recognition for his newspaper and made it the strongest journal in the Pacific Northwest.

SCOTT, HUGH LENOX (*b. Danville, Ky., 1853; d. Washington, D.C., 1934*), army officer. Grandson of Charles Hodge. Graduated West Point, 1876. Served with cavalry, chiefly in the Dakotas and Oklahoma, 1876–97; became specialist in language, history, and "sign talk" of the Plains Indians. On staffs of General William Ludlow and General Leonard Wood in Cuba, 1899–1902, he was governor of Sulu Archipelago in the Philippines, 1903–06. Promoted colonel, he served as superintendent of West Point, 1906–10. As brigadier general, he commanded on the Mexican border, 1913–14. Appointed chief of staff, November 1914, he laid the basis for raising, training, and equipping the American forces in World War I. Retired as major general, 1917, he remained on active duty for two years and commanded the 78th Division at Camp Dix, N.J.

SCOTT, IRVING MURRAY (*b. Hebron Mills, Md., 1837; d. San Francisco, Calif., 1903*), shipbuilder, foundryman. Removed to San Francisco, 1860; was long associated with the Union Iron Works and its predecessor firm. Constructed U.S. warships *Charleston, Olympia, San Francisco, Oregon, Wisconsin,* and *Ohio,* 1889–1901.

SCOTT, JAMES BROWN (*b. Kincardine, Ontario, Canada, 1866; d. Wardour, Md., 1943*), international lawyer, foundation executive, advocate of international arbitration and conciliation. Raised in Philadelphia, Pa., B.A., Harvard, 1890; M.A., 1891; Doctor of Civil and Canon Law, Heidelberg, 1894. Organized Los Angeles Law School, serving as dean, 1896–99; dean, college of law of University of Illinois, 1899–1903; professor of law, Columbia University, 1903–06; solicitor (chief legal officer), U.S. Department of State, 1906–11; permanent secretary and director of the division of international law, Carnegie Endowment for International Peace, 1911–40. Influenced in his theories of international law by the work of Francisco de Vitoria and Hugo Grotius, he believed that warfare would give way to legal principles and practices if governments could be educated to accept an international tribunal for conciliation of disputes. Over

the years, he continued to hold academic posts at George Washington University, Johns Hopkins, and Georgetown University.

SCOTT, JAMES WILMOT (*b. Walworth Co., Wis., 1849; d. New York, N.Y., 1895*), journalist. Associated with Chicago, Ill., newspapers *post* 1875, he made his *Chicago Herald* a conservative force for reform, 1881–95.

SCOTT, JOB (*b. Providence, R.I., 1751; d. Ballitore, Ireland, 1793*), Quaker preacher. An outstanding example of quietism, Scott advanced views on biblical interpretation which anticipated modernist tenets.

SCOTT, JOHN (*b. probably Ashford, Kent, England, ca. 1630; d. England, 1696*), adventurer, swindling land speculator, spy. Nefariously active in New York and New England, 1654–64.

SCOTT, JOHN ADAMS (*b. Fletcher, Ill., 1867; d. Augusta, Mich., 1947*), classicist. Graduated Northwestern University, 1895; Ph.D., Johns Hopkins University, 1897. Taught Greek at Northwestern, 1897–1938 (professor *post* 1901; chairman of Department of Classical Languages *post* 1904); author of *The Unity of Homer* (1921), and other works.

SCOTT, JOHN MORIN (*b. New York, N.Y., ca. 1730; d. New York, 1784*), lawyer. Graduated Yale, 1746; studied law in office of William Smith (1697–1769). An active practitioner and a ready speaker, Scott was associated with William Livingston *post* 1752 in support of the Whig Presbyterian cause in New York and was an organizer of the New York Sons of Liberty. He was a leader of the radical party in the New York provincial congress, 1775–77, and ran against George Clinton for the governorship of New York, 1777. He was New York secretary of state, 1778–84, and was also a state legislator and a member of the Continental Congress. He served as brigadier general in the battle of Long Island, August 1776.

SCOTT, JOHN PRINDLE (*b. Norwich, N.Y., 1877; d. 1932*), composer, baritone, hymnist.

SCOTT, LEROY (*b. Fairmount, Ind., 1875; d. Chateaugay Lake, N.Y., 1929*), journalist, settlement worker. Author of *The Walking Delegate* (1905), *Counsel for the Defense* (1912), and other mediocre fiction; magazine writer on social questions and on crime and its detection.

SCOTT, ORANGE (*b. Brookfield, Vt., 1800; d. Newark, N.J., 1847*), Methodist clergyman, abolitionist. Led a secession from his church on the issue of slavery, 1841; presided over convention at Utica, N.Y., May 1843, at which the Wesleyan Methodist Connection of America was formed.

SCOTT, ROBERT KINGSTON (*b. Armstrong Co., Pa., 1826; d. Henry Co., Ohio, 1900*), businessman, Union major general by brevet. Chief, South Carolina branch of Freedmen's Bureau, 1865–68. As governor, Union Republican, of South Carolina, 1868–72, Scott was largely responsible for the scandals and disorder that characterized Republican rule in the state; his policies trebled the public debt, and he was leader in conspiracies to further fraudulent contracts and stock issues.

SCOTT, SAMUEL PARSONS (*b. Hillsboro, Ohio, 1846; d. Hillsboro, 1929*), lawyer. Hispanic scholar. Author of, among other works, *History of the Moorish Empire in Europe* (1904).

SCOTT, THOMAS ALEXANDER (*b. Fort Loudoun, Pa., 1823; d. near Darby, Pa., 1881*), railroad executive. Proposed plan for President-elect Lincoln's surreptitious entry into Washington, D.C., 1861; was assistant U.S. secretary of war in charge of gov-

ernment railways and transport, August 1861–June 1862; supervised removal of General Hooker's force from Virginia to Chattanooga, 1863. As first vice president of the Pennsylvania Railroad, 1860–74, Scott ably seconded the efforts of J. Edgar Thomson to strengthen the Pennsylvania system and continued that work as president, 1874–80.

Scott, Thomas Fielding (*b. Iredall Co., N.C., 1807; d. New York, N.Y., 1867*), Episcopal clergyman. Missionary bishop in Oregon and Washington Territory *post* 1854.

Scott, Walter (*b. Moffat, Scotland, 1796; d. Mason Co., Ky., 1861*), religious reformer, schoolteacher. Came to America, 1818. As a Disciples of Christ preacher *post* 1826, Scott established the evangelistic pattern and the form and method of propaganda to which the rapid growth of that sect was largely due.

Scott, Walter Dill (*b. Cooksville, Ill., 1869; d. Evanston, Ill., 1955*), applied psychologist and educator. Studied at Illinois State Normal University, Northwestern University, McCormick Theological Seminary, and the University of Leipzig (Ph.D., 1900). Taught at Northwestern (1900–16). Became the first professor of applied psychology in the nation at Carnegie Institute of Technology, 1916. During World War I, developed the first tests for personnel classification for the army. President of Northwestern (1920–39). Built the university into one of the leading institutions in the country, establishing several new departments and schools. A pioneer in the application of psychology in advertising.

Scott, Walter Edward (*b. Cynthiana[?], Ky., 1870[?]; d. Stovepipe Wells, Calif., 1954*), eccentric mining prospector. Performed at one time for "Buffalo Bill's Wild West" show. Known as "Death Valley Scotty," Scott perpetrated a series of hoaxes, claiming to have found a rich gold mine in Death Valley. A Chicago millionaire, A. M. Johnson, financed his escapades on a lark, building him a mansion, Scotty's Castle, in Death Valley in the 1920's. Scott ended his days showing tourists through the castle.

Scott, William (*b. Warrenton, Va., 1804; d. near Jefferson City, Mo., 1862*), jurist. Removed to Missouri, 1826. Appointed to the state circuit bench, 1835, he was advanced to the state supreme court, 1841; with the exception of a two-year interval, he served until his death. Conservative and competent, he wrote many opinions in cases involving master and slave, including those in the state actions in the Dred Scott Case. An ardent Democrat, he was an opponent of Thomas H. Benton and a sympathizer with the Confederate cause.

Scott, William Anderson (*b. Bedford Co., Tenn., 1813; d. San Francisco, Calif., 1885*), Presbyterian clergyman. Grew prominent as pastor at the First Presbyterian Church, New Orleans, La., 1842–54; formed Calvary Church, San Francisco, Calif., 1854, and St. John's Church in the same city, 1870. Helped found, 1871, and taught at, San Francisco Theological Seminary.

Scott, William Berryman (*b. Cincinnati, Ohio, 1858; d. Princeton, N.J., 1947*), geologist, paleontologist. Grandson of Charles Hodge; brother of Hugh Lenox Scott. B.A., College of New Jersey (Princeton), 1877; Ph.D., Heidelberg, 1880. Taught geology at Princeton, 1880–1930 (professor *post* 1884 and chairman of department *post* 1909). One of the most important vertebrate paleontologists of his era, he was preeminent in descriptive and taxonomic studies of fossil vertebrates and in the mammalian paleontology of the Tertiary period. Of his more than 170 publications, perhaps the most important was *A History of Land Mammals in the Western Hemisphere* (1913; 2nd. ed., 1937).

Scott, W(illiam) Kerr (*b. Haw River, N.C., 1896; d. Burlington, N.C., 1958*), politician. Studied at the North Carolina State College of Agriculture and Mechanic Arts (B.S., 1917). A Jeffersonian farmer who was active in agricultural affairs in North Carolina, Scott became state commissioner of agriculture (1936–48). Elected Democratic governor, 1948, he was instrumental in improving rural life through roadbuilding, electrification, and better health care facilities. He appointed first black to state board of education and first woman to the Superior Court. Elected to the U.S. Senate in 1954, Scott was an outspoken liberal — opposing Senator Joseph R. McCarthy and advocating equal rights for women.

Scott, William Lawrence (*b. Washington, D.C., 1828; d. 1891*), railroad and coal operator. Grandson of Gustavus Scott. A type of the individualistic capitalist of his time, he supervised his various and far-flung interests from home offices in Erie, Pa.

Scott, Winfield (*b. "Laurel Branch," in neighborhood of Petersburg, Va., 1786; d. West Point, N.Y., 1866*), soldier, statesman. Attended College of William and Mary; studied law in Petersburg. Commissioned captain of light artillery, May 1808, Scott recruited a company and embarked for New Orleans, La., arriving Apr. 1, 1809. Put on trial and suspended for a year from the army for stating that General James Wilkinson, his commander, had been as great a traitor as Aaron Burr, Scott rejoined his command, 1811, serving as a staff officer in New Orleans until February 1812. Promoted lieutenant colonel, he reported at Buffalo, N.Y., in October 1812, and was taken prisoner at the battle of Queenstown. Exchanged later in the year, he was sent to Philadelphia early in 1813 as adjutant general with rank of colonel.

Detailed for duty on the northern front, he planned and executed the successful attack on Fort George on the Niagara River in May 1813. Commanding an infantry battalion in the advance guard of General Jacob Brown's force, he defeated the British in an engagement on Uphold's Creek late in the year. Almost alone among American officers in the realization that adequate training and knowledge were prerequisites of victory, Scott was ordered by President Madison and Secretary Monroe to Albany, N.Y., to supervise preparations for another offensive on the Niagara, but, in fact, was left to supervise munitions at the arsenal. Promoted a regular brigadier general, March 1814, he returned to Buffalo, where he played the chief part in training the only American troops who gave a good account of themselves on land during the War of 1812. On July 4–5, he drove the enemy in a running fight for 16 miles to the Chippewa, and he and his brigade bore the brunt of the fighting at Lundy's Lane on July 25. He became overnight the idol of the United States and a hero abroad. Brevetted major general, he was prevented by wounds received at Lundy's Lane from joining Jackson at New Orleans.

Performing routine duties, 1815–32, Scott gave much of his time to study of military methods in Europe and to constructive writing. He headed the board which produced the first standard set of American drill regulations, 1815, and was the sole author of the revised *Infantry Tactics* (1835), which remained standard down to the Civil War. Passed over in favor of Alexander Macomb for appointment as commanding general of the army, 1828, Scott protested the appointment vainly. Employed briefly in the Black Hawk War, 1832, he was personally commissioned by President Jackson in that same year to watch the South Carolina nullifiers, and by his tact and wisdom did much to preserve the peace during the nullification crisis. Commissioned in 1835 to prosecute war against the Seminole and Creek Indians in Flor-

ida and adjacent states, he was denied adequate means for making a campaign and unreasonably relieved of the duty. Examined before a court of inquiry for his alleged failure, he was fully exonerated. During 1838 he performed with brilliance as a soldier-diplomat in settling difficulties raised by a rebellion in Canada, by the removal of the Cherokee Indians beyond the Mississippi, and by a dispute and a possible war with Great Britain over the Maine boundary question. Appointed general in chief of the army, 1841, he instituted reforms, outlawed cruel punishments for soldiers, and aided officers to become well schooled. *Post* 1839 he was mentioned as a possible Whig candidate for the presidency.

As war with Mexico approached, Scott endorsed the appointment of Zachary Taylor to command the army of occupation at Corpus Christi and supplied him with able officers as subordinates. When the fruitlessness of the campaign was demonstrated (despite the tactical victories which were gained), Scott proposed a strategic plan that would, as he put it, "conquer a peace." President Polk, inimical to anything that might advance Scott's political prestige, opposed it, but was forced to acquiesce in it by Secretary W. L. Marcy, Senator Thomas H. Benton, and others. Setting out with full powers for the seat of war, Scott managed by tireless effort to land 10,000 men below Veracruz, Mar. 9, 1847. Advised by senior officers to take the city by assault, he chose to invest it from the rear and took it Mar. 26 with less than 20 dead. No reinforcements were sent him, and it became plain that the administration was hedging on fulfillment of his plan; nevertheless, Scott pushed forward in April toward Mexico City. Winning a victory at Cerro Gordo, despite inefficiency on the part of his senior officers, he was halted at Jalapa when a large part of his force left in a body because of the expiration of their enlistments. His urgent demands for money and men brought him no response until midsummer. On Aug. 5, when his force had been raised by incoming recruits to about 10,000 effectives, he set off once more from Puebla. After a series of actions at Contreras, Churubusco, Molino del Rey, and Chapultepec, Scott marched into Mexico City on Sept. 14, and entered on the difficult task of putting his army to work at the government of an occupied territory. In this effort he was so successful that a deputation of Mexicans asked him to be their dictator. The administration at Washington, however, saw an opportunity to undercut the victorious general politically when his troublesome subordinate, Gideon J. Pillow, distributed his own personal version of Scott's battles to the newspapers at home. Scott protested Pillow's actions and also those of General Worth, but President Polk upheld the offenders and ordered the victorious commander himself before a handpicked court of inquiry. On Apr. 22, 1848, Scott returned to the United States. In the words of Robert E. Lee, an engineer officer on his staff, he had been "turned out as an old horse to die"; yet in the sequel, Scott was completely vindicated and received unprecedented honors from the people of New York and other cities. He ran as Whig candidate for the presidency in 1852 and was overwhelmingly defeated by Franklin Pierce after an exceptionally scurrilous campaign. In 1852, he was raised to rank of lieutenant general.

Foreseeing the Civil War, Scott pleaded with President Buchanan in October and December 1860, to reinforce the Southern forts and armories against seizure. In January 1861, with headquarters at Washington, he actively oversaw recruiting and training of the defenders of the capital and personally commanded Lincoln's bodyguard at the inauguration. Rendering all aid in his power to the president, he drew up a general plan for the conduct of the federal forces which might well have curtailed the war; it was disregarded on the ground he was too old to give advice. Retiring in November 1861, he continued active and in 1865 presented to General U. S. Grant, who had been one of

his subalterns in the Mexican War, a gift bearing the inscription "from the oldest to the greatest general."

In his prime a bulky and immensely strong man, six feet, five inches in height, Scott possessed a whimsical egotism, was inclined to flourishes of unfortunate rhetoric, and was too outspoken for his own advancement; his exactness in dress and behavior won him the nickname "Fuss and Feathers." In his public career of nearly half a century he had been a main factor in ending two wars, in saving the country from several others, and in acquiring a large portion of its western territory.

SCOVEL, HENRY SYLVESTER (*b.* Denny Station, Pa., 1869; *d.* Havana, Cuba, 1905), engineer, journalist. Aggressive correspondent in Cuba for several U.S. newspapers, 1895–99.

SCOVEL, SYLVESTER *See* SCOVEL, HENRY SYLVESTER.

SCOVELL, MELVILLE AMASA (*b.* Belvidere, N.J., 1855; *d.* 1912), agricultural chemist, educator. Patented processes for clarifying juice of sugar-producing plants and for manufacturing glucose, sugar, and syrup from sorghum; was director, Kentucky Agricultural Experiment Station *post* 1885; made notable contributions as chemist, agronomist, pure-food exponent, and administrator.

SCOVILLE, JOSEPH ALFRED (*b.* Woodbury, Conn., 1815; *d.* New York, N.Y., 1864), journalist. Secretary and biographer of John C. Calhoun. Scoville edited several New York newspapers *post* 1850 and is particularly remembered for his five volumes of commercial reminiscence entitled *The Old Merchants of New York City* (1863–66, published under pseudonym "Walter Barrett").

SCRANTON, GEORGE WHITFIELD (*b.* Madison, Conn., 1811; *d.* Scranton, Pa., 1861), iron manufacturer, railroad president, developer of transportation in the Lackawanna Valley. Founded city of Scranton, 1840.

SCREWS, WILLIAM WALLACE (*b.* Jernigan, Ala., 1839; *d.* Coosada, Ala., 1913), Confederate soldier, journalist. Editorowner of the *Montgomery* (Ala.) *Advertiser*, 1866–1913, he led opposition to Reconstruction, fought the Farmers' Alliance, and directed the policies of the Democratic party in the state.

SCRIBNER, CHARLES (*b.* New York, N.Y., 1821; *d.* Lucerne, Switzerland, 1871), publisher. Father of Charles Scribner (1854–1930). Graduated College of New Jersey (Princeton), 1840. Gave up practice of law to found publishing firm of Baker & Scribner, 1846; on death of his partner, 1850, continued the firm in his own name.

SCRIBNER, CHARLES (*b.* New York, N.Y., 1854; *d.* New York, 1930), publisher. Son of Charles Scribner (1821–71); grandson of John I. Blair. Graduated College of New Jersey (Princeton), 1875. Entering the publishing house established by his father (known *post* 1878 as Charles Scribner's Sons), he served it as president, 1879–1928, and was thereafter chairman of the board. He was active also as a banker and as a benefactor of Princeton University and Skidmore College.

SCRIBNER, CHARLES (*b.* New York, N.Y., 1890; *d.* New York, 1952), publisher. Studied at St. Paul's School and at Princeton University (B.A., 1913). Joined the family publishing firm, Charles Scribner's Sons, in 1913; secretary, 1918; vice president, 1926; and president from 1932. Instrumental in the liberalization of the firm. Along with editor Maxwell Perkins, Scribner backed the publication of many of the century's most influential authors: F. Scott Fitzgerald, Ernest Hemingway, Thomas Wolfe, Taylor Caldwell, John Galsworthy, Alan Paton, Aubrey Menen, and

James Jones. *Scribner's Magazine,* under the editorship of A. S. Dashiell, also included many leading authors but failed to make the transition from a conservative magazine to a more timely publication. Scribner expanded the reference book department, continuing the publication of the *Dictionary of American Biography,* begun by his father, and bringing out the *Dictionary of American History* in 1940. The children's book department was also expanded and many new children's authors attracted to the firm. Scribner also assisted the Princeton University Press, serving as president from 1940 until 1948.

SCRIPPS, EDWARD WYLLIS (*b. near Rushville, Ill., 1854; d. Monrovia Bay, Liberia, 1926*), newspaper publisher. Half brother of James E. and Ellen B. Scripps. Entering newspaper work in Detroit, Mich., 1872, he founded the Cleveland, Ohio, *Penny Press,* 1878, first link of a chain of cheap daily papers extending from the Middle West to the Pacific. In partnership with Milton A. McRae *post* 1889, he organized, 1897, an independent news service to cover the field west of Pittsburgh; in 1907 it became known as the United Press Association, the first such agency to operate in connection with a chain of daily papers. He was also organizer of the NEA syndicate. Editorially, the Scripps papers were independent in politics, sympathetic with union labor, and liberal in their general attitude.

SCRIPPS, ELLEN BROWNING (*b. London, England, 1836; d. 1932*), journalist, philanthropist. Sister of James E. Scripps; half sister of Edward W. Scripps. Playing a large part in the success of the newspaper ventures of her brother and half brother, she also made a fortune in California real estate. Founded Scripps College at Claremont, Calif., and the present Scripps Institution of Oceanography.

SCRIPPS, JAMES EDMUND (*b. London, England, 1835; d. Detroit, Mich., 1906*), newspaper publisher. Brother of Ellen B. Scripps; half brother of Edward W. Scripps. Came to America as a boy; was raised near Rushville, Ill. Began newspaper career, 1857, as reporter on the Chicago *Democratic Press;* served as business manager and editor of *Detroit Tribune;* founded Detroit *Evening News,* August 1873. Helped finance founding of the Cleveland, Ohio, *Penny Press* by his half brother, Edward W. Scripps, 1878, and later joined with him in the formation of his chain of newspapers. Conservative in temperament, he disagreed with his partners over questions of management and gradually withdrew from the combination; by 1903 he had relinquished his holdings in all but the *Evening News,* later called the *Detroit News.* He purchased the *Detroit Tribune,* 1891.

SCRIPPS, ROBERT PAINE (*b. San Diego, Calif., 1895; d. near Santa Margarita Island, Magdalena Bay, Lower California, 1938*), newspaper publisher. Son of Edward W. Scripps. Headed the Scripps-Howard newspaper chain, 1926–38.

SCRIPPS, WILLIAM EDMUND (*b. Detroit, Mich., 1882; d. Oakland County, Mich., 1952*), newspaper publisher. Inheriting an interest in the *Detroit Evening News,* founded by his father, Scripps declined to accept the position of publisher, deferring to a relative. Instead he concentrated his energies on radio communications, aviation, and inventions. Eventually accepting the post of publisher in the 1930's he left the running of the paper to others and turned to agriculture, animal husbandry, conservation, and philanthropy.

SCRUGGS, WILLIAM LINDSAY (*b. near Knoxville, Tenn., 1836; d. Atlanta, Ga., 1912*), journalist, Tennessee Unionist, diplomat. Agent of Venezuela in the United States, 1894–98, during crisis over boundary difficulties with Great Britain.

SCRYMSER, JAMES ALEXANDER (*b. New York, N.Y., 1839; d. New York, 1918*), capitalist, Union soldier. Promoted and developed cable and telegraph lines to Cuba, Mexico, and Central and South American points.

SCUDDER, HORACE ELISHA (*b. Boston, Mass., 1838; d. Cambridge, Mass., 1902*), editor, author. Brother of Samuel H. Scudder. Graduated Williams, 1858. Editor with Houghton, Mifflin & Co. and its predecessor firms *post ca.* 1864; editor, *Riverside Magazine for Young People,* 1867–70; editor, *Atlantic Monthly,* 1890–98. Author of a number of books, which included eight juvenile "Bodley Books" of travel (1876–1884) and biographies of Noah Webster, Bayard Taylor, George Washington, and James Russell Lowell.

SCUDDER, JOHN (*b. Freehold, N.J., 1793; d. Wynberg, South Africa, 1855*), physician, Reformed Dutch clergyman. Missionary to Ceylon and India, 1819–42 and 1846–54.

SCUDDER, JOHN MILTON (*b. Harrison, Ohio, 1829; d. Daytona, Fla., 1894*), eclectic physician. Graduated Eclectic Medical Institute, Cincinnati, Ohio, 1856. Taught at his alma mater throughout his professional life and devoted much of his time and energy to its development and improvement. He served as dean *post* 1861 and as editor of the *Eclectic Medical Journal,* 1861–94.

SCUDDER, (JULIA) VIDA DUTTON (*b. Madura, India, 1861; d. Wellesley, Mass., 1954*), writer, professor, and Christian socialist. Studied at Smith College (B.A., 1884; M.A., 1889) and Oxford University. Taught English at Wellesley College (1887–1928). A member of the Socialist party, Scudder sought to reconcile Marxist theory with the Christian ideal of community. She founded the Women's Trade Union League in 1903 and helped establish a settlement house, Denison House, in Boston in 1890. Important works include *Social Ideals in English Letters* (1898).

SCUDDER, NATHANIEL (*b. either Huntington, N.Y., or near Freehold, N.J., 1733; d. near Shrewsbury, N.J., 1781*), physician, New Jersey Revolutionary patriot and colonel of militia. Member of Continental Congress, February 1778–December 1779. He was killed in a skirmish with Loyalist refugees three days before the surrender at Yorktown.

SCUDDER, SAMUEL HUBBARD (*b. Boston, Mass. 1837; d. Cambridge, Mass., 1911*), entomologist. Brother of Horace E. Scudder. Graduated Williams, 1857; studied at Lawrence Scientific School under Agassiz, whom he also served as assistant. Scudder's bibliography comprises 791 scientific titles. Outside the field of entomology he was author of *Catalogue of Scientific Serials . . . 1633–1876* (1879) and *Nomenclator Zoologicus* (1882–84), both important works. His true lifework, however, dealt with American diurnal Lepidoptera, the Orthoptera, and fossil insects. Among his numerous writings on butterflies, his *Butterflies of the Eastern United States and Canada, with Special References to New England* (1888–89) stands out as monumental. He was the greatest American orthopterist of his time, and his work on fossil insects was profound, extensive, and pioneer. His style of writing possessed great charm.

SCULL, JOHN (*b. Reading, Pa., 1765; d. near present Irwin, Pa., 1828*), newspaper editor. Partner with Joseph Hall in establishment at Pittsburgh, Pa., 1786, of the first newspaper published west of the Alleghenies, the Pittsburgh *Gazette.* Also a civic leader in Pittsburgh, he continued publication of the *Gazette* until 1816.

SCULLIN, JOHN (*b. near Helena, N.Y., 1836; d. St. Louis, Mo., 1920*), railroad builder, St. Louis street-railway operator, steel manufacturer. Contract or builder of many midwestern railroads, he constructed the major portion of the Missouri-Kansas-Texas system, 1869–74.

SEABURY, GEORGE JOHN (*b. New York, N.Y., 1884; d. New York, 1909*), chemist, pharmacist. Founded Seabury and Johnson, pioneer manufacturers of surgical dressings, of which he was president *post* 1885.

SEABURY, SAMUEL (*b. Groton, Conn., 1729; d. New London, Conn., 1796*), Episcopal clergyman, Loyalist, writer. Graduated Yale, 1748; studied medicine at University of Edinburgh; ordained by the bishop of London, 1753. Sent by the Society for the Propagation of the Gospel as missionary to New Brunswick, N.J., 1754, he was transferred to Jamaica, N.Y., 1757, and was inducted as rector at Westchester, N.Y., 1767. A

leader in the campaign of the New York Anglican clergy to secure bishops for America, he was one of the authors of the articles "A Whip for the American Whig," published in Gaine's *New York Gazette*, April 1768–July 1769. Just before the outbreak of the Revolution, he produced several important pamphlets signed "A. W. Farmer" in which, with clear, homely language and arguments, he tried to convince Americans that their greatest freedom lay in submitting to the British government and securing desired change through peaceful appeals to that government. These pamphlets (which were answered by Alexander Hamilton) were *Free Thoughts on the Proceedings of the Continental Congress; The Congress Canvassed; A View of the Controversy Between Great Britain and Her Colonies* (published November and December 1774); and *An Alarm to the Legislature of the Province of New York* (January 1775). After entering actively into the Loyalist campaign to prevent election of delegates to provincial and Continental congresses, Seabury went into hiding, April 1775. In November, Connecticut soldiers under Isaac Sears took him prisoner at Westchester, and he suffered a brief confinement at New Haven, Conn. In the fall of 1776 he entered the British lines on Long Island, later serving as a guide to the British both on Long Island and in Westchester County. Holding several chaplaincies under the British, he lived comfortably in New York City throughout the Revolution. Presented by the Episcopal clergy of Connecticut as a candidate for consecration as bishop in the now independent colonies, 1783, he was refused consecration by Anglican authorities, who believed themselves legally debarred from performing the rite. He then proceeded to Scotland and, on Nov. 14, 1784, was consecrated by the nonjuring Scottish prelates. Returning to America in the early summer of 1785, he became rector of St. James's Church, New London, Conn., and served as bishop of Connecticut and Rhode Island until his death. Working strenuously to revive and reorganize the churches in his diocese, he stood for unity in essentials and liberty in nonessentials, but had little sympathy for the prevailing liberalizing ideas of his American brethren.

SEABURY, SAMUEL (*b. New London, Conn., 1801; d. 1872*), Episcopal clergyman. Grandson of Samuel Seabury (1729–96). A High Churchman of the old school, he served as editor of *The Churchman*, 1833–49, supporting Tractarianism and Bishop Benjamin T. Onderdonk. He served also as a teacher in the General Theological Seminary, and was rector of the Church of the Annunciation, New York, 1838–68.

SEABURY, SAMUEL (*b. New York, N.Y., 1873; d. New York, 1958*), lawyer, jurist, special investigator. Studied at New York Law School. Elected to city court of New York as judge, and from 1914 to 1916 served as judge on Court of Appeals. Defeated

for governor in 1916 and returned to private practice. In 1930 appointed by Governor Franklin D. Roosevelt to conduct investigation of the magistrates' court. In 1931 formed the Joint Legislative Committee to Investigate the Affairs of the City of New York. Seabury became the symbol of the fight against corruption in New York County and the investigation resulted in the resignation of Mayor Jimmy Walker. Instrumental in the election of Fiorello H. La Guardia as mayor, he served as his advisor for twelve years.

SEAGER, HENRY ROGERS (*b. Lansing, Mich., 1870; d. Kiev, Russia, 1930*), economist. Graduated University of Michigan, 1890; Ph.D., University of Pennsylvania, 1894. Taught at Wharton School, 1894–1902, and at Columbia thereafter. A conservative and a believer in progress, Seager engaged in many meliorative activities with the purpose of bettering social conditions within the framework of laissez-faire. Among his works, *Principles of Economics* (1913) is the most considerable.

SEAGRAVE, GORDON STIFLER (*b. Rangoon, Burma, 1897; d. Namkham, Burma, 1965*), medical missionary. Attended Denison University and Johns Hopkins Medical School (M.D., 1921) and had additional surgical training at Columbia and Vienna universities. Appointed a missionary by the American Baptist Foreign Mission Society (1920). He was assigned to the Namkham Hospital in Burma (1922); his books on service in Burma are *Waste-Basket Surgery* (1930) and *Tales of a Waste-Basket Surgeon* (1938). In 1940 he ran a 400-bed hospital at Prome and jungle hospitals along the Burma Road and the Burma-China border. His Army Medical Corps unit of fifteen ran the only hospital for the remnants of Chiang Kai-shek's Fifth and Sixth armies (1942). He became famous with the publication of *Burma Surgeon* (1943). He amicably severed relations with the Baptist Foreign Mission Society in 1946; they retained ownership of the Namkham Hospital but leased it to Seagrave for $1 a year. His location embroiled him in Burma's civil war, and he was arrested in 1950, charged with treason, and sentenced to six years imprisonment. After appeals the High Court of Burma released him in 1951.

SEALSFIELD, CHARLES (*b. Poppitz. Moravia, Austria, 1793; d. near Solothurn, Switzerland, 1864*), novelist. Pen name of Karl Anton Postl, who abandoned the monastic life in Prague, fled Austria, and appeared as Charles Sealsfield in New Orleans, La., 1823. After traveling through the Southern states, Texas, and Mexico and a brief residence near Pittsburgh, he returned to Europe. His *The United States As They Are . . . by the Author of Austria As It Is* was published anonymously in English, 1828; it had appeared the previous year in German. After further travels and residence in the United States, the then Mexican Southwest and Mexico proper, he retired to Switzerland, 1832, where he continued to reside except for occasional visits to the United States. Sealsfield attempted to create a new type of fiction, the ethnographical novel in which a whole people figured as protagonist. He exemplified his theory in six books published in German and English between 1834 and 1843; in these the people of the United States and Mexico were portrayed in every possible social relation.

SEAMAN, ELIZABETH COCHRANE (*b. Cochran Mills, Pa., 1867; d. New York, N.Y., 1922*), journalist, known as "Nellie Bly." Famous for a tour around the world, 1889–90, in which she beat the time of Jules Verne's fictional "Phileas Fogg" by eight days.

SEARING, LAURA CATHERINE REDDEN (*b. Somerset Co., Md., 1840; d. San Mateo, Calif., 1923*), journalist. Civil War correspondent in Washington, D.C., for the *St. Louis (Mo.) Repub-*

lican; later on staff of New York City newspapers. Deaf and mute, she was taught speech by Alexander G. Bell.

SEARLE, ARTHUR (*b. London, England, 1837; d. Cambridge, Mass., 1920*), astronomer. Graduated Harvard, 1856. Associated with the Harvard Observatory *post* 1868, he became Phillips professor of astronomy, 1887, and was made emeritus, 1912: he also taught astronomy at Radcliffe, 1891–1912.

SEARLE, JAMES (*b. probably New York, N.Y., 1733; d. Philadelphia, Pa., 1797*), merchant, Revolutionary patriot. Prospering as a merchant in Philadelphia *post ca.* 1762, he took part in all early protests against British policy. Elected to the Continental Congress, November 1778, he allied himself with the radical group, seconding James Lovell and Richard H. Lee in their hostility to Silas Deane. Appointed special envoy to float Pennsylvania state loan in Europe, July 1780, he failed in his efforts at Paris, Amsterdam, and Lyons, and on his return *ca.* 1781 found that much of his fortune had been dissipated by unwise actions of his partners.

SEARLE, JOHN PRESTON (*b. Schuylerville, N.Y., 1854; d. 1922*), Dutch Reformed clergyman, educator. Graduated Rutgers, 1875; New Brunswick Theological Seminary, 1878. Held principal pastorate at Somerville, N.J. Professor of theology at New Brunswick Seminary *post* 1893, he served also as president of the faculty *post* 1902.

SEARS, BARNAS (*b. Sandisfield, Mass., 1802; d. Saratoga, N.Y., 1880*), Baptist clergyman, educator. Graduated Brown, 1825. Taught at Hamilton (N.Y.) Literary Institution, 1829–33 and 1835. Professor of theology, Newton Theological Institution, 1836–48; president Newton, 1839–48. Succeeding Horace Mann in 1848 as the secretary of the Massachusetts Board of Education, he gave permanence to Mann's reforms; in 1855 he left to become president of Brown University, remaining there until 1867. Thereafter, until his death, he was general agent of the Peabody Education Fund and the principal architect of its purpose and methods.

SEARS, EDMUND HAMILTON (*b. Sandisfield, Mass., 1810; d. Weston, Mass., 1876*), Unitarian clergyman. Held principal pastorates at Wayland, Mass., and Weston, Mass.; was author of a number of once-popular spiritual books and of the hymns "It Came Upon a Midnight Clear" and "Calm on the Listening Ear of Night."

SEARS, ISAAC (*b. West Brewster, Mass., 1730; d. Canton, China, 1786*), merchant, mariner, Revolutionary patriot. A leader of resistance to the Stamp Act in New York City, he was the head of nearly every mob demonstration in New York City *post* 1765, including the jettisoning of tea cargoes in 1774. After Lexington and Concord, he and his followers dispossessed the Loyalist leaders and officials and were virtually dictators in New York until the spring of 1776. Sears was especially noted for severe treatment of the Long Island Tories, January–August 1776. In Boston, 1777–83, he promoted privateering; after the war he resumed his general merchandise business in New York City, served in the state legislature, and died while promoting a business venture in China.

SEARS, RICHARD DUDLEY (*b. Boston. Mass., 1861; d. Boston, 1943*), businessman, tennis champion. Graduated Harvard, 1883. Won first U.S. national amateur lawn tennis championship at Newport, R.I., 1881; won also in succeeding years through 1887. Doubles champion (with James Dwight or Joseph S. Clark), 1882–87. First U.S. national court tennis champion, New York City, 1892.

SEARS, RICHARD WARREN (*b. Stewartville, Minn., 1863; d. Waukesha, Wis., 1914*), mail-order merchant, advertising expert. Beginning as a distributor of watches by mail order, 1886, he established the firm of Sears, Roebuck & Co., and served as its president and principal advertising writer until 1909. The company entered on its major phase of prosperity after its removal from Minneapolis to Chicago, 1893.

SEARS, ROBERT (*b. St. John, New Brunswick, Canada, 1810; d. Toronto, Canada, 1892*), printer, publisher. Resided in the United States *ca.* 1831–60. His illustrated Bibles and other works of reference had wide sale because of the excellence of their wood engravings. He was also editor and publisher of several gazetteers.

SEASHORE, CARL EMIL (*b. Mörlunda, Sweden, 1866; d. Lewiston, Idaho, 1949*), psychologist. His father, who came to the United States, 1869, and settled in Boone County, Iowa, anglicized the family name from Sjöstrand. B.A., Gustavus Adolphus College, Minnesota, 1891; Ph.D., Yale, 1895. Taught at State University of Iowa, 1897–1937 (professor *post* 1902, chairman of Department of Philosophy and Psychology *post* 1905, dean of the Graduate College in 1908–37 and 1942–46). Built his department into one of the first large-scale psychology departments in the Midwest; developed methods for measurement of musical aptitude and talent. Author of, among other works, *The Psychology of Musical Talent* (1919) and *Psychology of Music* (1937).

SEATON, WILLIAM WINSTON (*b. King William Co., Va., 1785; d. 1866*), journalist. Brother-in-law of Joseph Gales (1786–1860), with whom he was associated as editor of the official administration newspaper, the *National Intelligencer*, Washington, D.C., *post* 1812. Gales and Seaton were exclusive reporters of the debates of Congress, 1812–29, Seaton covering the Senate. Their firm published the well-known *Annals of Congress* (1834–56) and the monumental *American State Papers* (1832–61). A civic leader in Washington, Seaton was mayor of the city, 1840–50, led the movement for the Washington Monument, and was treasurer of the Smithsonian Institution *post* 1846.

SEATTLE (*b. in neighborhood of present Seattle, Wash., ca. 1786; d. 1866*), chief of the Dwamish, Suquamish, and allied Indian tribes. A friend to the white settlers, he did not want his name to be given to their settlement.

SEAWELL, MOLLY ELLIOT (*b. Gloucester Co., Va., 1860; d. Washington, D.C. 1916*), author. A prolific and skillful writer, she produced a number of books for juvenile and adult readers, which include *Little Jarvis* (1890), *Midshipman Paulding* (1891), and *The Lively Adventures of Gavin Hamilton* (1899).

SEBASTIAN, BENJAMIN (*b. ca. 1745, place uncertain; d. probably Grayson Co., Ky., 1834*), lawyer, Revolutionary soldier. Removed to Kentucky from Virginia *ca.* 1784; was implicated as early as 1787 in the pro-Spanish intrigues of James Wilkinson. A judge of the state appellate court, 1792–1806, he served as intermediary in 1795 in F. L. H. de Carondelet's attempts to win over the Kentuckians and carried proposals of a seditious character to Harry Innes and George Nicholas. Exposed as a paid agent of Spain, 1804, he was forced to resign his office and was no longer a factor in political life *post* 1806.

SEBERG, JEAN DOROTHY (*b. Marshalltown, Iowa, 1938; d. Paris, France, 1979*), actress. In her freshman year at the University of Iowa, she won a worldwide casting competition for the title role in Otto Preminger's film *Saint Joan* (1957), which opened to unfavorable reviews. Her other films include *Bonjour Tristesse* (1958), *The Mouse That Roared* (1959), and *Let No*

Man Write My Epitaph (1960). She became a star of the French New Wave with Jean–Luc Godard's *A Bout de Souffle* (*Breathless*, 1961). Her strongest performance in an American film was in *Lilith* (1964). An active supporter of black nationalist causes, she was emotionally devastated by the FBI fabrication and planting of a story that she was carrying the baby of a Black Panther leader; she committed suicide in 1979.

SECCOMB, JOHN (*b. Medford, Mass., 1708; d. Chester, Nova Scotia, Canada, 1792*), Congregational clergyman, writer of humorous verse. Pastor at Harvard, Mass., 1733–63, he served thereafter as minister in Nova Scotia.

SEDDON, JAMES ALEXANDER (*b. Fredericksburg, Va., 1815; d. Goochland Co., Va., 1880*), lawyer. Congressman, Democrat, from Virginia, 1845–47 and 1849–51. An ardent follower of John C. Calhoun, he was later active in the secession movement in Virginia and was elected to the first Confederate Congress. He served as the somewhat dilatory Confederate secretary of war, November 1862–1865.

SEDELLA, ANTOINE. *See* ANTOINE, PÈRE.

SEDGWICK, ANNE DOUGLAS (*b. Englewood, N.J., 1873; d. Hampstead, England, 1935*), novelist. Resident chiefly in London and Paris *post* 1882, she married Basil de Sélincourt in 1908, residing thereafter in Oxfordshire. Primarily studies of character, her novels were based on intimate knowledge of British society and international contrasts. Winning wide readership first with *Tante* (1911), a study of feminine egotism, she produced a number of other successful books, including *Adrienne Toner* (1922), *The Little French Girl* (1924), and *Dark Hester* (1929).

SEDGWICK, ARTHUR GEORGE (*b. New York, N.Y., 1844; d. 1915*), lawyer, journalist. Son of Theodore Sedgwick (1811–59); brother-in-law of Charles E. Norton. Associated in editorial capacity with the *Nation*, 1872–1905, he was also author or editor of a number of legal treatises.

SEDGWICK, CATHARINE MARIA (*b. Stockbridge, Mass., 1789; d. West Roxbury, Mass., 1867*), author. Daughter of Theodore Sedgwick (1746–1813); sister of Theodore Sedgwick (1780–1839). A pioneer in the creation of the American domestic novel, she wrote because of her belief that the safety of the Republic depended upon the domestic virtues of its people and so tried to make unaffected goodness and wholesome living appear attractive. Her novels and tales, although marked by romanticism and her declared didactic purpose, also contain realistic presentations of domestic scenes and were extremely popular in their time. She was also author of a number of "self-help" books. Among her novels (which were praised by W. C. Bryant and Nathaniel Hawthorne) were *A New England Tale* (1822), *Redwood* (1824), *Hope Leslie* (1827), and *The Linwoods; or Sixty Years Since* (1835).

SEDGWICK, ELLERY (*b. New York, N.Y., 1872; d. Washington, D.C., 1960*), editor and publisher. Studied at Harvard (B.A., 1894). Owner and editor of the *Atlantic Monthly* from 1908 to 1938, Sedgwick moved the magazine from insolvency to one of the nation's most prosperous and respected periodicals. Published Ernest Hemingway, Robert Frost, Randolph Bourne, H. C. Wells, Felix Frankfurter, and William E. Ripley.

SEDGWICK, JOHN (*b. Cornwall Hollow, Conn., 1813; d. Spotsylvania, Va., 1864*), soldier. Graduated West Point, 1837. Commissioned in the artillery, he saw service in the Seminole and Mexican wars and was with the cavalry in the West and Southwest, 1857–60. Commissioned brigadier general of volunteers at the outbreak of the Civil War, Sedgwick held brigade and divisional command in the Army of the Potomac. Promoted major general, 1862, he took a prominent part in the battles of Antietam and Chancellorsville and led the V and VI Corps against Marye's Heights, Fredericksburg, Va. Distinguished also for his conduct at Gettysburg and in the operations at Mine Run, he was killed in action subsequent to the battle of the Wilderness. Although a strict disciplinarian, he was admired and trusted by his soldiers, who called him "Uncle John."

SEDGWICK, ROBERT (*b. Woburn, England, ca. 1613; d. Jamaica, British West Indies, 1656*), colonist, soldier. Settled in Charlestown, Mass., 1636. He was active in training the militia officers of the colony and was also successful in business; he was granted a monopoly of the colony's Indian trade, 1644. Deputy to the General Court from Charlestown and holder of a number of local offices, he was elected major general of the colony, 1652. After successfully harassing the French settlements in Maine and eastern Canada, he died while on a military expedition against Spain in the West Indies.

SEDGWICK, THEODORE (*b. West Hartford, Conn., 1746; d. Boston, Mass., 1813*), lawyer, Massachusetts jurist and legislator. Father of Catharine M. Sedgwick and Theodore Sedgwick (1780–1839). Practiced law in Berkshire Co., Mass., *post* 1766, first at Sheffield and later at Stockbridge. Early active in the struggle against Great Britain, he served as military secretary to General John Thomas in the invasion of Canada, 1776. An active legislator for most of the years 1780–88, he was Speaker of the Massachusetts House, 1788, and also sat in Congress, 1785–88. A strenuous opponent of Shays's Rebellion, he aided ratification by Massachusetts of the U.S. Constitution; while a Federalist member of Congress from Massachusetts, 1789–96, he was chairman of important committees. U.S. senator, June 1796–March 1799, he returned to the House of Representatives and was its Speaker, 1799–1801. In 1802 he was appointed for life to the supreme judicial court of Massachusetts.

SEDGWICK, THEODORE (*b. Sheffield, Mass., 1780; d. 1839*), lawyer, Massachusetts legislator, railroad advocate, reformer. Son of Theodore Sedgwick (1746–1813); brother of Catharine M. Sedgwick.

SEDGWICK, THEODORE (*b. Albany, N.Y., 1811; d. Stockbridge, Mass., 1859*), lawyer. Son of Theodore Sedgwick (1780–1839); nephew of Catharine M. Sedgwick; father of Arthur G. Sedgwick. Graduated Columbia, 1829. In extensive practice in New York City, 1834–50, he was hampered thereafter by ill health. A lifelong student of legal, judicial, and political problems, he wrote extensively on these subjects; his most important book was *A Treatise on the Measure of Damages* (1847), which was for years the only work in English on the subject.

SEDGWICK, WILLIAM THOMPSON (*b. West Hartford, Conn., 1855; d. Boston, Mass., 1921*), biologist, epidemiologist. Graduated Sheffield Scientific School, 1877; Ph.D., Johns Hopkins, 1881. Influences by Henry N. Martin, whom he served as an associate, 1881–83, Sedgwick was called in 1883 to teach biology at the Massachusetts Institute of Technology. Appointed full professor there in 1891, for the next 30 years he headed the departments of biology and public health. Among students trained by him were many of the leading sanitarians in the United States and abroad. He engaged also in extensive public service as consulting biologist to the Massachusetts State Board of Health. Among his works is the classic *Principles of Sanitary Science and the Public Health* (1902).

SEDLEY, WILLIAM HENRY. *See* SMITH, WILLIAM HENRY.

SEE, HORACE (*b. Philadelphia, Pa., 1835; d. New York, N.Y., 1909*), naval architect. Associated with William Cramp & Sons, 1870–89, he was designer and superintending engineer, 1879–89, and in that decade was responsible for the first vessels of the "New Navy." In private practice thereafter, he invented a great number of important devices for use in ship construction.

SEED, MILES AINSCOUGH (*b. Preston, England, 1843; d. Pelham, N.Y., 1913*), photographer, manufacturer of photography supplies. Came to America, 1865; settled in St. Louis, Mo. After perfecting process for manufacture of a photographic dry plate, he formed a company and began production, 1882. Overcoming prejudice against his revolutionary improvement by constant travel and personal demonstration, he opened up large markets. In 1902 the Eastman Kodak Co. purchased his business and formula.

SEEGER, ALAN (*b. New York, N.Y., 1888; d. near Belloy-en-Santerre, France, 1916*), poet. Graduated Harvard, 1910. Removing to Paris, France, in the autumn of 1912, he resided there until the beginning of World War I, at which time he enlisted in the French Foreign legion. He died in action. His best-known poem, "I Have a Rendezvous with Death," and other works were collected in *Poems* (1916).

SEELYE, JULIUS HAWLEY (*b. Bethel, Conn., 1824; d. 1895*), clergyman, educator. Brother of L. Clark Seelye. Graduated Amherst, 1849; Auburn Theological Seminary, 1852. After serving as pastor, First Dutch Reformed Church, Schenectady, N.Y., 1853–58, he became professor of philosophy at Amherst and began service there that lasted, except for one short interval, until his death. An exponent of the philosophical views of Laurens P. Hickock, he was an effective teacher and became acknowledged leader of an able faculty. Appointed president of Amherst, 1876, he devised the "Amherst Plan," a system of student self-government, doubled the college income, and raised academic standards.

SEELYE, LAURENUS CLARK (*b. Bethel, Conn., 1837; d. Northampton, Mass., 1924*), Congregational clergyman, educator. Brother of Julius H. Seelye. Graduated Union, 1857; studied theology at Andover, Berlin, and Heidelberg. After a brief pastorate in Springfield, Mass., he became professor of rhetoric at Amherst and served 1865–73. Thereafter, as president of Smith College until 1910, he carried that institution to success, despite an original poverty of means. The growth of the college in equipment and endowment was due more to his skillful management than to the generosity of outsiders.

SEEVERS, WILLIAM HENRY (*b. Shenandoah Co., Va., 1822; d. 1895*), Iowa legislator, jurist. Resident in Oskaloosa, Iowa, *post* 1846, he held a number of public offices and served as chief justice of the state supreme court, 1876, 1882, and 1887–88.

SEGHERS, CHARLES JEAN (*b. Ghent, Belgium, 1839; d. Yukon country, Alaska, 1886*), Roman Catholic clergyman, missionary. Served in British Columbia, 1863–78; was bishop of Victoria *post* 1873. Named coadjutor bishop of Oregon City (Portland), 1878, he succeeded to that see two years later as archbishop, but resigned in 1884 to resume his duties in British Columbia and to develop the missions in Alaska.

SEGUIN, EDOUARD (*b. Clamecy, France, 1812; d. 1880*), psychiatrist, pioneer in education of the retarded. Immigrated to America *ca.* 1850.

SEGUIN, EDWARD CONSTANT (*b. Paris, France, 1843; d. 1898*), neurologist. Son of Edouard Seguin. Came to America as a boy.

M.D., New York College of Physicians and Surgeons, 1864; made special studies of nervous diseases in Paris under Brown-Sequard and Charcot. Ranking in his profession with S. W. Mitchell and William A. Hammond, he practiced in New York City until 1894 and taught diseases of the nervous system at the College of Physicians and Surgeons, 1868–87.

SEIBERLING, FRANK AUGUSTUS (*b. Summit County, Ohio, 1859; d. Akron, Ohio, 1955*), manufacturer, inventor, and promoter. Attended Heidelberg College in Ohio. Founded the Goodyear Tire and Rubber Co. in 1898; by 1915, it was the world's largest producer of automobile tires. The company prospered, acquiring railroads and foreign plants until the post–World War I recession. In 1921 Seiberling was forced to resign from Goodyear. He promptly founded the Seiberling Rubber Co. Helped reorganize Goodyear in 1927. Remained active until 1950.

SEIBOLD, LOUIS (*b. Washington, D.C., 1863; d. Washington, 1945*), journalist. A talented reporter, he was associated with the New York *World* through most of his working life; he was close to President Woodrow Wilson and gained a reputation as a launcher of the president's trial balloons of information on policy.

SEIDEL, GEORGE LUKAS EMIL (*b. Ashland, Pa., 1864; d. Milwaukee, Wis., 1947*), woodcarver, socialist politician. Raised in Prairie du Chien, Madison, and Milwaukee, Wis. Apprenticed at 13 after completing elementary school. Early interested in trade union activity, he was converted to the radical wing of socialist thought while resident in Germany, 1886–92. Returning to Milwaukee, he worked at his trade and was associated with Victor L. Berger, joining, 1897, the Milwaukee Branch of the Social Democracy of America formed by Berger and Eugene V. Debs. In 1904 and 1906 he was elected to the Milwaukee Common Council; in 1909 he became the first Social Democratic alderman-at-large. In 1910 he was elected mayor of Milwaukee by a wide margin, his party making a sweep of city elective offices and also winning control of the county board. The first socialist mayor of a principal American city, he stressed scientific methods of government, strict economy, and social service programs. For a variety of reasons, the Social Democrats lost public confidence, and Seidel was defeated for reelection in 1912 by a nonpartisan candidate. In 1912 also, he was the Socialist party's candidate for vice president of the United States, running on the ticket with Eugene V. Debs. He was again elected alderman-at-large in 1916, but failed in bids for the Wisconsin governorship, 1918, and for city treasurer of Milwaukee, 1920. From 1920 to 1923, as state secretary for his party, he toured Wisconsin in a vain effort to revive the prewar Socialist momentum. After a breakdown in health, he returned to public life as a member of the Milwaukee City Service Commission, 1926–32. Failing in his campaign for a U.S. Senate seat, 1932, he served once again on the common council, 1932–36.

SEIDENSTICKER, OSWALD (*b. Göttingen, Germany, 1825; d. Philadelphia, Pa., 1894*), philologist, historian of the Germans in Pennsylvania. Came to America, 1846. Taught German at University of Pennsylvania, 1867–94.

SEIDL, ANTON (*b. Pesth, Hungary, 1850; d. 1898*), musician. Studied at the Leipzig Conservatory; worked with Richard Wagner, 1872–78. Celebrated as a conductor of Wagnerian opera in Europe, he debuted at the Metropolitan Opera, New York City, 1885, and conducted there until German opera was temporarily dropped in 1891. Becoming conductor of the New York Philharmonic Society in succession to Theodore Thomas, he con-

tinued so for the rest of his life. resuming his work with German opera at the Metropolitan, 1895–97. Seidl exercised a great influence on American musical life and because of his association with Wanger was able to give a special authenticity to his interpretations of the Wagnerian music dramas.

SEILER, CARL (*b. Switzerland, 1849; d. Reading, Pa., 1905*), laryngologist. Began study of medicine in Vienna and Heidelberg; he received the M.D. degree at University of Pennsylvania, 1871, and was a special pupil and assistant of Jacob da Silva Solis Cohen. A teacher of his specialty at his alma mater, 1877–95, he was author of several books and the deviser of the widely used Seiler's tablets.

SEIP, THEODORE LORENZO (*b. Easton, Pa., 1842; d. Allentown, Pa., 1903*), Lutheran clergyman. Long a teacher at Muhlenberg College, he served with great ability as its president, 1885–1903.

SEISS, JOSEPH AUGUSTUS (*b. near Graceham, Md., 1823; d. Philadelphia, Pa., 1904*), Lutheran clergyman. Held chief pastorates in Baltimore and Philadelphia, notably at Church of the Holy Communion, Philadelphia, 1874–1904. An admired preacher and prolific author, he was one of the founders of the General Council of the Evangelical Lutheran Church in North America.

SEITZ, DON CARLOS (*b. Portage, Ohio, 1862; d. Brooklyn, N.Y., 1935*), journalist. On staff of *Brooklyn Eagle*, 1880–91. After a brief period as assistant publisher of the New York *Recorder*, he went with the New York *World*, of which he was first an editor, then advertising manager, and finally business manager from 1898 to 1923. A liberal and witty man of complete independence and fearlessness, he believed that a newspaper was an institution for public service; during his tenure, the *World* became one of the nation's powerful liberal voices; and he was in no way responsible for the decline and disappearance of the Pulitzer properties in New York. Retiring in 1926 from daily journalism, he served on the staffs of the *Outlook* and the *Churchman*. He was also author of many books, including biographies of John Paul Jones, Artemus Ward, Braxton Bragg, Joseph Pulitzer, and Horace Greeley.

SEITZ, WILLIAM CHAPIN (*b. Buffalo, N.Y., 1914; d. Charlottesville, Va., 1974*), museum curator and art historian. Graduated University of Buffalo (B.A., 1946; M.A., 1952) and Princeton University (Ph.D., 1955). His study *Claude Monet* (1960) established him as a prominent scholar of the abstract expressionist art movement. While a curator at the Museum of Modern Art in New York City (1960–65), he organized several exhibits that helped fuel the popularity and foster the public's understanding of modern art. He was a professor at Brandeis University (1965–70) and University of Virginia (1971–74).

SEIXAS, GERSHOM MENDES (*b. New York, N.Y., 1746; d. New York, 1816*), Chosen rabbi of the Spanish and Portuguese synagogue of New York (Shearith Israel), 1768, he was for many years New York's chief professor of Hebrew and through a great portion of his 50-year ministry one of the principal spokesmen of American Jewry. The first rabbi to preach sermons in English in an American synagogue, he constantly advocated the full participation by Jews in the life of the new democratic American state. He was, on the evidence of his public statements and prayers, a strong supporter of the American cause. He served as regent and trustee of Columbia College. 1784–1815.

SÉJOUR, VICTOR (*b. New Orleans, La., 1817; d. Paris, France, 1874*), dramatist. Born of black parents, Séjour was educated in New Orleans and Paris and in 1841 achieved celebrity with a heroic poem. *La Retour de Napoléon*. Influenced by Émile Augier, he became a writer of immediately popular dramatic spectacles; among his 21 plays which were produced in Paris, his greatest successes were *Richard III* (1852), *Les Noces Vénitiennes* (1855), *Le Fils de la Nuit* (1856), and *Les Volontaires de 1814* (1862). He died of tuberculosis after experiencing a decline in his fortunes.

SELBY, WILLIAM (*b. probably England, ca. 1739; d. Boston, Mass., 1798*), musician, composer. Immigrated to Boston *ante* October 1771; was at various times organist of King's Chapel. Three choral concerts organized and directed by him, 1782, 1786, and 1787, encouraged a taste for cantatas and oratorios in Boston and undoubtedly influenced the movement which led to formation of the Handel and Haydn Society more than 15 years after his death. Selby's only extant compositions are a few songs.

SELDEN, GEORGE BALDWIN (*b. Clarkson, N.Y., 1846; d. Rochester, N.Y., 1922*), patent attorney, inventor. After developing a lightweight high-speed three-cylinder gasoline compression engine employing hydrocarbon liquid fuels, 1877, Selden then designed a so-called road locomotive which was virtually an automobile. Having applied for a U.S. patent, May 1879, he tried without success to secure financial help in building his machine; he therefore delayed the issue of a patent to him until November 1895. Meanwhile, the automobile had made rapid strides, but the assignees of Selden's basic patent (who were obliged to pay him royalty) required all other persons manufacturing automobiles to pay for the privilege by licensing. The first successful action to compel payment was brought against the Winton Motor Co., 1900. A suit against the Ford Motor Co. initiated in 1903 came to final adjudication in January 1911 when it was held that Selden had a true and valid patent only with respect to the use of a two-cylinder type of engine as designated in the patent. Inasmuch as all manufacturers were by this time using a four-cycle engine, no further royalties were required to be paid.

SELDES, GILBERT VIVIAN (*b. Alliance, N.J., 1893; d. New York, N.Y., 1970*), journalist and critic. Graduated from Harvard (1914) and worked briefly as a reporter for the *Pittsburgh Sun* and as music critic and editorial writer for the *Philadelphia Evening Ledger* (1914–16); left for England as a free-lance war correspondent. Became associate editor (1919) of *Collier's Weekly*; managing editor (1919–23) and dramatic critic (1923–29) of *Dial*; and contributed reviews and critical essays to the *New Republic*, *Freeman*, and *Nation*. He regularly gave notice to art forms not generally considered serious, such as movies, vaudeville, and the popular theater of song and dance. Wrote *The Seven Lively Arts* (1924), a survey of nearly all the then-popular entertainment arts. His most ambitious social criticism of the depression years was *Mainland* (1936). Columnist for the *New York Journal* (1931–37) and in the late 1950's for the *Village Voice*; also wrote for radio and television and was a program director for Columbia Broadcasting System (1937–45). Taught at and was dean of the Annenberg School of Communications (1959–63).

SELFRIDGE, THOMAS OLIVER (*b. Charlestown, Mass., 1836; d. 1924*), naval officer. Graduated U.S. Naval Academy, 1854. Cited for conspicuous gallantry during the Civil War. Surveyed Isthmus of Darien for an interoceanic canal, 1869–70; later surveyed the Amazon and Madeira rivers. Commissioned rear admiral, 1896, he retired, 1898.

SELIG, WILLIAM NICHOLAS (*b. Chicago, Ill., 1864; d. Los Angeles, Calif., 1948*), early motion-picture producer. Developed

and marketed a projection machine (the Selig Polyscope, 1896) and other devices; gave his principal attention to film production after about 1904. Established in 1909 what has been called the first permanent motion-picture studio in the Los Angeles area, but soon removed to Edendale. Made and released several hundred pictures under the Diamond-S name, 1912–17; contracted with popular authors for story material, his 1914 film of Rex Beach's *The Spoilers* making him a small fortune. One of his early discoveries was the cowboy star Tom Mix.

SELIGMAN, ARTHUR (*b. Santa Fe, N.Mex., 1871; d. 1933*), merchant, banker, Democratic politician. Governor of New Mexico, 1931–33.

SELIGMAN, EDWIN ROBERT ANDERSON (*b. New York, N.Y., 1861; d. Lake Placid, N.Y., 1939*), economist. Son of Joseph Seligman; brother of Isaac N. Seligman. Graduated Columbia, 1879; LL.B., 1884; Ph.D., 1885. Beginning his teaching career at Columbia as a lecturer, he was promoted to full professor, 1891, and was the first McVickar professor of political economy, 1904–31. A unique combination of scholar and public figure, Seligman was author of *The Economic Interpretation of History* (1902) and *Principles of Economics, with Special Reference to American Conditions* (1905), two important and influential works; he was also editor in chief of the *Encyclopaedia of the Social Sciences* (1930–35) and was principally responsible for raising the funds needed for this monumental project. He was best known, however, for his pioneering achievements in public finance, in which field he was author of a number of significant books, which included *On the Shifting and Incidence of Taxation* (1892). *Progressive Taxation in Theory and Practice* (1894), *Essays in Taxation* (1895), and *The Income Tax* (1911). The theoretical core of his work was the marginal economics of which John Bates Clark was one of the leading formulators, yet Seligman allowed in his own work for considerable qualification in the theory. Conservative by nature, he was respected by enlightened members of the business community and frequently served the government as an adviser in matters of taxation; his writings and personal testimony helped shape the Transportation Act of 1920, and he was also active in the campaign for an effective central banking system that eventuated in the Federal Reserve Act. A worker for honest municipal government, for conservation of natural resources, and for a fair policy toward labor, Seligman was probably the first eminent American economist to advocate the doctrine of the living wage.

SELIGMAN, ISAAC NEWTON (*b. Staten Island, N.Y., 1855; d. New York, N.Y., 1917*), banker, civic leader. Son of Joseph Seligman. President of the family banking house of J. & W. Seligman & Co. post 1894.

SELIGMAN, JESSE (*b. Baiersdorf, Bavaria, 1827; d. Coronado. Calif., 1894*), banker, philanthropist. Brother of Joseph Seligman. Immigrated to America as a boy; was in dry-goods business with a brother at Watertown, N.Y., 1848–50. Removing to California, he prospered as a merchant in San Francisco and served on the Vigilance Committee of 1851 and later on the Committee of Twenty-one. Removing to New York City, 1857, he joined his brother Joseph's clothing firm and later became a partner in the banking firm of J. & W. Seligman & Co. (organized 1862). He succeeded his brother Joseph as head of the firm, 1880, and was for a generation one of the leading financiers of the United States.

SELIGMAN, JOSEPH (*b. Baiersdorf, Bavaria, 1819; d. New Orleans, La., 1880*), financier, civic leader. Brother of Jesse Seligman; father of Isaac N. Seligman. Immigrating to America, 1837,

he served for some time as secretary to Asa Packer. He founded a clothing firm with his brothers, including Jesse, 1857, which was transformed early in 1862 into the banking house of J. & W. Seligman & Co. Strong supporters of the Union, the Seligmans promoted large sales of U.S. bonds in Frankfurt at a time when it was almost impossible to sell the national securities in England or France. During the presidency of U. S. Grant, Joseph Seligman was one of his confidential financial advisers, and throughout the 1870's the firm figured prominently in the conversion and refunding of the obligations of the United States. Joseph Seligman was also active in New York City civic affairs and was a member of the Committee of Seventy, which ousted the Tweed Ring.

SELIJNS, HENRICUS (*b. Amsterdam, Holland, 1636; d. New York, N.Y., 1701*), Dutch Reformed clergyman, poet. Pastor in present Brooklyn, N.Y., 1660–64, and in New York City post 1682. A cultured and tolerant man and a popular preacher, he secured for the Dutch Reformed church the first church charter granted in the colony, 1696.

SELIKOVITSCH, GOETZEL (*b. Rietavas. Lithuania, 1863; d. 1926*), orientalist, journalist. Graduated École des Hautes Études, Paris, France, 1884. After traveling widely in the Near East and Africa, he came to America in 1887. Taking up Yiddish journalism as a profession, he served on the staff of the *Jewish Daily News* in New York City from 1901 until his death. He was author of a number of scholarly works in Hebrew and French.

SELLERS, COLEMAN (*b. Philadelphia, Pa., 1827; d. Philadelphia, 1907*), engineer. Grandson of Charles W. Peale. While chief engineer of William Sellers & Co., 1856–86, he patented a number of inventions, notably the Sellers coupling. Conducting a consulting practice thereafter, he was important in the design and construction of the hydroelectric power development at Niagara Falls.

SELLERS, ISAIAH (*b. Iredell, Co., N.C., ca. 1802; d. Memphis, Tenn., 1864*), pioneer steamboat pilot. An authority on Mississippi River navigation, he made a number of noteworthy record runs and was first to use the pseudonym "Mark Twain" in contributions to the New Orleans *Daily Picayune*.

SELLERS, MATTHEW BACON (*b. Baltimore, Md., 1869; d. Ardsley-on-Hudson, N.Y., 1932*), patent lawyer, pioneer in aerodynamics. Served on Naval Consulting Board, 1915–18 and post 1919. Patented a quadroplane, 1911, and secured other patents for airplane gear; was technical editor of *Aeronautics post* 1911.

SELLERS, WILLIAM (*b. Upper Darby, Pa., 1824; d. 1905*), machine-tool builder. President of William Sellers & Co. and predecessor firms in Philadelphia, Pa, post 1848; also headed Edge Moor Iron Co. post 1868, and Midvale Steel Co. post 1873. Sellers held about 90 U.S. patents for machine tools of all kinds; the most original of his inventions was the spiral geared planer, patented 1862; he was one of the first designers to make the form of a machine follow the function to be performed. He was also author of the present system of standard screw threads (first proposed by him, 1864).

SELLSTEDT, LARS GUSTAF (*b. Sundsvall, Sweden, 1819; d. Buffalo, N.Y., 1911*), seaman, portrait painter, organizer and president of Buffalo Fine Arts Academy.

SELYNS, HENRICUS See SELIJNS, HENRICUS.

SELZNICK, DAVID O. (*b. Pittsburgh, Pa., 1902; d. Beverly Hills, Calif., 1965*), movie producer. His early profitable and important

films include *Dinner at Eight* (1933), *King Kong* (1933), *Viva Villa!* (1934), *David Copperfield* (1935), and *A Tale of Two Cities* (1935). In Hollywood since 1925, he introduced several great stars, such as Katharine Hepburn, Fred Astaire, Ingrid Bergman, and Joan Fontaine. Formed Selznick International Studios (1936), and some of the finest films in Hollywood history began to appear: *A Star Is Born* (1937), which received eight Academy Award nominations; *Gone With the Wind* (1939), which received ten Oscars; and *Rebecca* (1940), with eleven Oscar nominations. Further successes in the 1940's and 1950's include *I'll Be Seeing You* (1945) and *Spellbound* (1945) and several starring wife Jennifer Jones, such as *Duel in the Sun* (1947) and *A Farewell to Arms* (1958).

SEMBRICH, MARCELLA (b. *Wisnieczyk, Galicia, 1858; d. New York, N.Y., 1935*), soprano. Professional name of Praxede Marcelline Kochanska, who married Wilhelm Stengel, 1877. Urged by Franz Liszt to devote herself principally to singing, Sembrich was a versatile instrumentalist as well as a soprano of extraordinary range and brilliance. She made her début at Athens, Greece, in *I Puritani*, 1877; her début at the Metropolitan Opera, New York, 1883, was in the role of *Lucia*. After singing in the leading opera houses of Europe, she rejoined the Metropolitan, with which she sang, 1898–1909. *Post* 1917, she was active as a teacher.

SEMMES, ALEXANDER JENKINS (b. *Georgetown, D.C., 1828; d. New Orleans, La., 1898*), physician, Confederate surgeon, Roman Catholic clergyman. Cousin of Raphael Semmes; brother of Thomas J. Semmes. Served in the priesthood, principally in Georgia, *post* 1878.

SEMMES, RAPHAEL (b. *Charles Co., Md., 1809; d. Point Clear, Ala., 1877*), naval officer. Cousin of Alexander J. Semmes and Thomas J. Semmes. Appointed midshipman, 1826, he served in routine posts at sea until his promotion to lieutenant, 1837; thereafter, until the outbreak of the Mexican War, he was on survey duty on the southern coast and in the Gulf of Mexico. Commanding the brig *Somers* on the Mexican blockade, 1846, he lost the vessel in a tropical storm, but was exonerated of any blame. He served thereafter on shore at Veracruz and in the march to Mexico City, receiving several citations for gallantry. On awaiting-order status for a great part of the time, 1847–61, he practiced law, settling near Mobile, Ala., 1849. Promoted commander, 1855, he resigned from the U.S. Navy, 1861, and entered the navy of the Confederacy. He rebuilt and commissioned the *Sumter*, formerly a packet vessel, and took it to sea in June as a commerce raider. Highly successful in operations in Caribbean waters and off the South African coast, he sailed to Gibraltar, where he was blockaded by Union forces; laying up the *Sumter*, April 1862, he discharged its crew and sold it later to a British firm. Promoted captain and ordered to command the *Alabama*, nearing completion at Liverpool, England, he took the ship to the Azores, where he armed it and set about his old business of destroying Union commerce. He ranged from the Atlantic whaling grounds and the Grand Banks to the coast of Brazil, taking 44 merchantmen. Sailing for Africa, he arrived at Capetown, August 1863, and then went on a long cruise across the Indian Ocean and contiguous waters, returning up the Atlantic to Cherbourg, France, June 1864. He had by then captured a total of 82 merchantmen and had also defeated and sunk the USS *Hatteras*. At Cherbourg, awaiting French permission to overhaul, Semmes was challenged by the USS *Kearsarge*, which had appeared on the morning of June 19, 1864, and fought in a circle of less than onehalf mile in diameter. Heavily battered by the Union man-of-war, the *Alabama* sank shortly after noon. Rescued by an English yacht from the water, Semmes was taken to England and

returned to the Confederacy by way of Mexico. Assigned as rear admiral to command of the James River squadron, January 1865, he burned his ships on the evacuation of Richmond and turned his men into a naval brigade, which was surrendered at Greensboro, N.C., as part of General J. E. Johnston's army. Paroled, Semmes was arrested in December 1865 and held for a short time in prison but released by presidential order. Hounded out of one employment after another, he engaged in the practice of law at Mobile until his death. He was author of *Service Afloat and Ashore* (1851) and *Memoirs of Service Afloat During the War Between the States* (1869).

SEMMES, THOMAS JENKINS (b. *Georgetown, D.C., 1824; d. 1899*), lawyer, Louisiana legislator. Brother of Alexander J. Semmes; cousin of Raphael Semmes. Graduated Georgetown (D.C.), 1842; Harvard Law School, 1845. Removed to New Orleans, La., 1850, where he practiced thereafter. Attorney general of Louisiana, 1859–61; Confederate senator from Louisiana, 1862–65. The most notable part of his career followed the Civil War. He was a guiding influence in the Louisiana constitutional convention of 1879, and for years his name appeared as counsel in nearly every case before civil courts in the state. He was also professor of civil law at the University of Louisiana (later Tulane University).

SEMPLE, ELLEN CHURCHILL (b. *Louisville. Ky., 1863; d. West Palm Beach, Fla., 1932*), anthropogeographer. Graduated Vassar, 1882; studied at Leipzig under Friedrich Ratzel. Taught at University of Chicago and at Clark University; was president of the Association of American Geographers. 1921, the only woman ever to hold that position. Among her books, all of which are outstanding, *Influences of Geographic Environment* (1911) was said to have shaped the whole trend and content of geographic thought in the United States.

SENEY, GEORGE INGRAHAM (b. *Astoria. N.Y., 1826; d. New York, N.Y., 1893*), banker, art collector, philanthropist.

SENN, NICHOLAS (b. *Buchs, St. Gall. Switzerland, 1844; d. Chicago, Ill., 1908*), surgeon. Came to America as a boy. Graduated Chicago Medical College, 1868; M.D., University of Munich, 1878. Practiced principally in Milwaukee. Wis., 1874–93, and thereafter in Chicago, where he taught surgery at several schools, including Chicago Polyclinic and University of Chicago. He maintained a lifelong interest in military medicine.

SENNETT, GEORGE BURRITT (b. *Sinclairville, N.Y., 1840; d. Youngstown, Ohio, 1900*), manufacturer of oil-well machinery, ornithologist. Made prolonged and important studies in birdlife of the lower Rio Grande region of southern Texas. The materials gathered by him were utilized and described, however, by others.

SENNETT, MACK (b. *Richmond, Quebec, Canada, 1880; d. Los Angeles, Calif., 1960*), film director. producer, and actor. Sennett, after an unsuccessful career on the stage, made his first film in 1908. In 1912, he formed the Keystone Film Co., and began making the comedies, with the famous Keystone Cops and Bathing Beauties, which remain standards for cinema comedy today. Using such talents as "Fatty" Arbuckle, Mack Swain, Gloria Swanson, Harry Langdon, and Ben Turpin, he was brilliantly successful during the era of silent films. When sound was introduced, he directed W. C. Fields and Bing Crosby. But his distributor and parent company, Paramount-Publix went bankrupt in the early 1930's, and Sennett, suffering great financial losses, retired from films in 1935.

SEQUOYAH (b. *Taskigi, Tenn., ca. 1770; d. possibly Tamaulipas, Mexico, 1843*), inventor of the Cherokee syllabary. Crippled

for life in a hunting accident, he began his efforts to reduce his tribal language to characters *ca.* 1809 and, after much ridicule and opposition, completed his table of 85 or 86 characters in 1821. A tribal council approved his work and in a short time thousands of Cherokee had learned to read and write. Sequoyah has been called the ablest intelligence produced among the American Indians.

SERGEANT, HENRY CLARK (*b. Rochester, N.Y., 1834; d. Westfield, N.J., 1907*), machinist. After securing a number of patents for useful inventions, 1854–68, he established a machine shop in New York City for development of crude ideas brought to him by other inventors. After working with Simon Ingersoll *ca.* 1870 in development of the idea of a rock drill, he was associated with Ingersoll in at least one patent and was responsible for the organization of the original Ingersoll Rock Drill Co., also adapting the device to use of compressed air rather than steam. Selling out his interest, 1883, he patented a new rock drill, 1884; after manufacturing it for a short time, he joined his company with the Ingersoll company. Among his other notable inventions of a later date were several types of valves for air compressors, the "tappet" drill, and the Sergeant release rotation.

SERGEANT, JOHN (*b. Newark, N.J., 1710; d. 1749*), Congregational clergyman, missionary to the Housatonic Indians. Graduated Yale, 1729. Entered permanently upon his work among Indians, 1735. Ministered principally in vicinity of present towns of Sheffield and Stockbridge, Mass.

SERGEANT, JOHN (*b. Philadelphia, Pa., 1779; d. 1852*), lawyer, Pennsylvania official. Son of Jonathan D. Sergeant; brother of Thomas Sergeant. Graduated College of New Jersey (Princeton), 1795; studied law with Jared Ingersoll. Practicing in Philadelphia *post* 1799, he became a leader of the bar and was a member of the intellectual group led by Joseph Dennie and Nicholas Biddle. Elected to Congress from Pennsylvania, he served in that body, 1815–23, 1827–29, and 1837–41, successively as a Federalist, as a National Republican, and as a Whig. A supporter of the "American system," he opposed the Missouri Compromise and was for many years the chief legal and political adviser to the Second Bank of the United States; he is credited with having had major influence in inducing Biddle to apply for renewal of the bank's charter. President of Pennsylvania constitutional convention, 1837–38, he took the lead in the fight over the judiciary. Sergeant's great strength was as a forensic legalist, less eloquent than intellectual. In his cases before the Supreme Court (*Osborn v. United States Bank, Worcester v. Georgia,* and the like) he advocated national powers as opposed to states' rights. His stature may be measured by the offices which he declined, these included a justiceship of the U.S. Supreme Court, a cabinet office under Harrison, and the embassy to England under Tyler.

SERGEANT, JONATHAN DICKINSON (*b. Newark, N.J., 1746; d. Philadelphia, Pa., 1793*), lawyer, Revolutionary patriot. Nephew of John Sergeant (1710–49); grandson of Jonathan Dickinson. Graduated College of New Jersey (Princeton), 1762. As member of the New Jersey Provincial Congress, 1776, he led in forming a state constitution; he was also member of the Continental Congress, 1776–77, representing New Jersey. After removing to Pennsylvania, he engaged in politics there and was attorney general of that state, 1777–80. His zeal for democratic principles led him to support the French Revolution, and he was prominent during the Edmond Genêt episode as a friend of France. Among his children were John Sergeant (1779–1852) and Thomas Sergeant.

SERGEANT, THOMAS (*b. Philadelphia, Pa., 1782; d. 1860*), Pennsylvania official and jurist, legal author. Son of Jonathan D. Sergeant; brother of John Sergeant (1779–1852). Graduated College of New Jersey (Princeton), 1798; studied law under Jared Ingersoll; was associate justice, Pennsylvania Supreme Court, 1834–46. Strongly opposed amendment of state constitution, 1837–38, which provided for popular election of judges. Excelled as a legal writer.

SERLING, ROD(MAN) EDWARD (*b. Syracuse, N.Y., 1924; d. Rochester, N.Y., 1975*), television writer and producer. Graduated Antioch College (B.A., 1950) and worked as a script writer for radio stations in Cincinnati. His free-lance writing efforts paid off in 1951, when he sold his first of ten scripts for a television drama to "Lux Video Theatre." He won his first Emmy award for "Patterns," which aired on NBC's "Kraft Television Theatre" in 1955. The following year he signed with CBS–TV and won acclaim for "Requiem for a Heavyweight," which inaugurated the "Playhouse 90" series. In 1959, with his own Hollywood production firm, Serling launched the offbeat and popular television series "The Twilight Zone." He was narrator of the show, which ran until 1964; he wrote 89 of the 151 scripts and won three Emmys. He was also coauthor of the screenplay for the motion picture *Planet of the Apes* (1968).

SERRA, JUNÍPERO (*b. Petra, Mallorca, 1713; d. Mission San Carlos, near Monterey, Calif., 1784*), Roman Catholic clergyman, Franciscan. After winning early distinction as professor of philosophy and preacher, he volunteered for mission work and arrived in Mexico City with Francisco Palóu, January 1750. After mission work among Indians northeast of Querétaro and parish duties in the capital city, he was sent as *presidente* of the new Franciscan mission field in Lower California, 1767. Having engaged to cooperate with the government by founding missions in Upper California, Father Serra, with five companions, accompanied the expedition of Gaspar de Portolá northward and founded Mission San Diego in July 1769, the first of the 21 missions eventually erected on the California coast. During Father Serra's presidency, nine of these missions were founded: San Diego, San Carlos, San Antonio, San Gabriel, San Luis Obispo, San Francisco de Asisi, San Juan Capistrano, Santa Clara, and San Buenaventura. In his differences with the military authorities, no one could question his partiotism as a Spaniard or his sense of justice as a spiritual leader and protector of the rights of Indians. He traveled constantly on foot from mission to mission, aiding his associates by his counsel and encouragement.

SERRELL, EDWARD WELLMAN (*b. London, England, 1826; d. New York, N.Y., 1906*), civil and military engineer. Came to America as a child. An expert in railroad and bridge design and construction, Serrell organized and commanded the 1st New York Engineers at the outbreak of the Civil War; he later became chief engineer of the X Corps and chief engineer and chief of staff of the Army of the James. During the siege of Charleston, S.C., he devised and personally supervised construction of the famous "Swamp Angel" battery.

SERVICE, ROBERT WILLIAM (*b. Preston, England, 1874; d. Lancieux, France, 1958*), poet. After working in a bank in Scotland, Service immigrated to Canada and the U.S. in the mid 1890's. By the early 1900's, he was working in Dawson in the Yukon. It was there that he wrote his famous folk poems, published first in 1907 as *The Spell of the Yukon,* and, in 1909, as *Ballads of a Cheechako.* These books included his most famous poems, "The Shooting of Dan McGrew," and "The Cremation of Sam McGee." Other successful books include *Rhymes of a Rolling Stone* (1912) and *Rhymes of a Red Cross Man* (1916).

He lived in France after 1913 except during World War II. Although only a popular poet, Service left his mark on the folklore of the North American frontier experience.

SERVOSS, THOMAS LOWERY (*b. Philadelphia, Pa., 1786; d. New York, N.Y., 1866*), merchant, shipowner. Active in trade at Natchez, Miss., and New Orleans, La., 1810–25, Servoss was representative of those northerners who made threefold profits in the cotton belt by selling northern goods, shipping back cotton in return, and transporting the goods in both directions. He operated a profitable line of sailing packet ships between New York and New Orleans, 1827–31, and later engaged in banking in New York.

SESSIONS, HENRY HOWARD (*b. Madrid, N.Y., 1847; d. Chicago, Ill., 1915*), railroad-car builder, inventor, 1887, of the passenger car "vestibule."

SESTINI, BENEDICT (*b. Florence, Italy, 1816; d. Frederick, Md., 1890*), Roman Catholic clergyman, Jesuit, mathematician, astronomer. Came to America, 1848. At the observatory of Georgetown University, Washington, D.C., he made observations of sunspots, 1850, which he sketched and which were later engraved and published, 1853. These are rated as among the best studies of the sun's maculae antedating the application of photography. Father Sestini was also an architect, and in 1866 founded the widely read Catholic publication *Messenger of the Sacred Heart*, which he edited until 1885.

SETCHELL, WILLIAM ALBERT (*b. Norwich, Conn., 1864; d. Berkeley, Calif., 1943*), botanist. B.A., Yale, 1887; Ph.D., Harvard, 1890. Taught biology at Yale, 1891–95; professor of botany, University of California at Berkeley, 1895–1934. For more than 40 years, the major subject of his research was the marine algal flora of the Pacific Coast, during much of the time in collaboration with Nathaniel L. Gardner. In one of his most significant investigations, he helped determine the role of algae in the formation of coral reefs. He was largely responsible for building his department at Berkeley into one of the world's principal botanical centers.

SETH, JAMES (*b. Edinburgh, Scotland, 1860; d. 1924*), philosopher. While professor of philosophy at Brown 1892–96, he completed his most important work, *A Study of Ethical Principles* (1894). In this work he sought to mediate between utilitarianism and the Kantian and other rationalistic systems, finding in "personality" a concept that unites the truth of both. Sage professor of moral philosophy at Cornell University, 1896–98, he returned to the University of Edinburgh as professor of moral philosophy and continued in that post until the end of his life. He was a strong force for social and other reforms in Scotland.

SETON, ELIZABETH ANN BAYLEY (*b. New York, N.Y., 1774; d. Emmitsburg, Md., 1821*), founder of the American Sisters of Charity, known as Mother Seton. Daughter of Richard Bayley, she was educated principally by her father and in 1794 married William Magee Seton, a New York merchant. In 1797, with Isabella M. Graham and others, she founded a society for relief of widows, the first charitable organization in New York City. Accompanying her husband to Italy, she made her first contact with Catholicism there, and on returning home after his death in December 1803, she became a convert in 1805. Estranged from her family and friends, she began a school for girls in Baltimore, Md., 1808, and there in the spring of 1809 with four companions formed a community which took the name Sisters of St. Joseph. Removing to Emmitsburg, Md., that summer, they took, with some modifications, the rule of the Daughters of Charity of St. Vincent de Paul; *post* 1812 they were known as the

Sisters of Charity of St. Joseph and constituted the first native American religious community. Mother Seton served for the rest of her life as the first superior and, in spite of the poverty that threatened her community's existence, formed her associates into effective teachers and model religious. Her cause for canonization was introduced at Rome by Cardinal Gibbons *ca.* 1907. She was the grandmother of Robert and William Seton and the aunt of James R. Bayley.

SETON, ERNEST THOMPSON (*b. South Sheilds, Durham, England, 1860; d. near Santa Fe, N.Mex., 1946*), illustrator, author, naturalist, lecturer. Raised in Canada. Successful as writer and illustrator of a number of books about animals and nature, of which some were professedly scientific; his most popular works, however, were outdoor stories that depended for their effect on evocation of wonder and excitement and reader identification, rather than on accuracy or plausibility. He was a zealous propagandist for conservation, for the American Indian, and for preservation of woodcraft skill. Among his books were *The Birds of Manitoba* (1891); *Life Histories of Northern Animals* (1909); and *Lives of Game Animals* (1925–28)—which were representative of his work as a naturalist-scientist. His popular works included *Wild Animals I Have Known* (1898) and *Animal Heroes* (1905); he was author also of a number of books for children and of a Boy Scouts' *Handbook* (1910).

SETON, GRACE GALLATIN THOMPSON (*b. Sacramento, Calif., 1872; d. Palm Beach, Fla., 1959*), author and book designer. Studied at Packer Collegiate Institute. The wife of artist and naturalist Ernest Thompson Seton, Grace Seton wrote *A Woman Tenderfoot in the Rockies* (1900) and *Nimrod's Wife* (1907). She then designed her husband's books and managed publicity for his lectures and his business affairs. During World War I she directed the Women's Motor Unit of La Bientre du Blessé in France, for which she received three French decorations. In 1933 she organized a woman writers' conference at the Century of Progress Exhibition, which later became the core of the Biblioteca Feminina at Northwestern University. Other books include *A Woman Tenderfoot in Egypt* (1923), *Chinese Lanterns* (1924), and *Yes, Lady Saheb* (1925).

SETON, ROBERT (*b. Pisa, Italy, 1839; d. 1927*), Roman Catholic clergyman. Grandson of Elizabeth A. B. Seton; brother of William Seton. A brilliant student at several Roman colleges *post* 1857, he was ordained in 1865 and gave up the chance of a notable ecclesiastical career to serve as chaplain to St. Elizabeth's Convent near Madison, N.J., and as a pastor in Jersey City. Returning to Rome, 1902, he served until 1914 as an unofficial link between the Vatican and America. He passed the remainder of his life in virtual retirement, principally at Emmistburg, Md., and Madison, N.J.

SETON, WILLIAM (*b. New York, N.Y., 1835; d. New York, 1905*), lawyer, Union soldier, author. Grandson of Elizabeth A. B. Seton; brother of Robert Seton.

SETTLE, THOMAS (*b. Rockingham Co., N.C., 1831; d. 1888*), politician, jurist. North Carolina legislator. Participated in meeting which organized the North Carolina Radical party, 1865, and introduced resolution which identified it with the Republican party. Associate judge, North Carolina Supreme Court, 1868–71 and 1872–76. He served also briefly as U.S. minister to Peru and was a U.S. district judge for Florida *post* 1877.

SEVERANCE, CAROLINE MARIA SEYMOUR (*b. Canadaigua, N.Y., 1820; d. 1914*), founder of women's clubs in Cleveland, Ohio, Boston, Mass., and Los Angeles, Calif.

SEVERANCE, FRANK HAYWARD (*b. Manchester, Mass., 1856; d. 1931*), Buffalo, N.Y., journalist, historian. Secretary, Buffalo Historical Society, *post* 1901; authority on the history of the Niagara frontier.

SEVERANCE, LOUIS HENRY (*b. Cleveland, Ohio, 1838; d. Cleveland, 1913*), capitalist. Engaged in oil production at Titusville, Pa., *post* 1864, he became associated with the Standard Oil Co. of Ohio and served as its treasurer, 1876–94. In association with Herman Frasch and others, he was a founder of the Union Sulphur Co. His principal benefactions were made to the Presbyterian church and to its missions.

SEVIER, AMBROSE HUNDLEY (*b. Greene Co., Tenn., 1801; d. near Little Rock, Ark., 1848*), lawyer, Arkansas legislator, planter. Settled in Arkansas, 1821; became associated by marriage with a powerful, political family headed by Richard M. Johnson. Territorial delegate from Arkansas to Congress, Democrat, 1828–36, he took a prominent part in achieving statehood for Arkansas and served as U.S. senator, 1836–48. An expansionist, he warmly supported the Mexican War and served with Nathan Clifford in the conclusion of negotiations for peace under the Treaty of Guadalupe Hidalgo, 1848.

SEVIER, JOHN (*b. near present New Market, Va., 1745; d. Alabama, 1815*), pioneer, soldier. Immigrated to the remote frontier that is now East Tennessee, 1773. Continuing to move down the Holston River valley as settlement advanced, he lived on the Nolachucky River, 1783–90. *post* 1790, he resided in or near Knoxville. An acknowleged leader of the backwoodsmen, he was a member of the local committee of safety, 1776, and a representative in the Provincial Congress of North Carolina. As an officer of the militia, he led a body of the Tennesseeans across the Smokies to join in the victory over the British at King's Mountain, 1780, and later set out upon an expedition against the Cherokee. During 1781 and 1782 he continued raiding against the Indians. At the end of the Revolution he joined with William Blount and others in a project for colonizing at Muscle Shoals. At first opposing the movement for organization of a separate state of Franklin, he later put himself at the head of it and was elected governor. Concerting a military expedition against the Indians with the state of Georgia, he alienated many liberals among the pioneers and lost prestige when Georgia failed to give aid. The defeat of Sevier's faction in a so-called battle, February 1788, resulted in the virtual extinction of the state of Franklin. Denounced as a reckless disturber of the public peace, he sought refuge on the extreme frontier with a group of followers and sank to the level of a bushwhacker, defying the efforts of Congress and entering into dubious correspondence with Spanish agents. Taking advantage of a new trend in public affairs, Sevier came forth as an advocate of the new U.S. Constitution and with the aid of William Blount succeeded in winning a full pardon and election to the North Carolina Senate, 1789. After a brief term in Congress, 1789–91, he devoted most of his attention during the territorial period of Tennessee to his plantation and his business concerns; he took no part in the Genêt affair or in the conspiracies of Blount and Aaron Burr. Elected first governor of the state of Tennessee, he served 1796–1801 and 1803–09. Engaged in a bitter feud with Andrew Jackson from about 1796 to the end of his life, he served again in the state senate. 1809–11, and was a congressman, 1811–15, serving on several committees and supporting the administration.

SEWALL, ARTHUR (*b. Bath, Maine, 1835; d. near Bath, 1900*), shipbuilder. Brother of Frank Sewall; father of Harold M. Sewall. Launching the first of his 80 vessels, 1855, Sewall and his partners did much to keep the wooden sailing vessel alive in its period of decline. During the 1890's he built the *Rappahannock*, *Shenandoah*, *Susquehanna*, and *Roanoke*, largest and last of the great American full-rigged wooden ships.

SEWALL, FRANK (*b. Bath, Maine, 1837; d. Washington, D.C., 1915*), Swedenborgian clergyman, author, educator. Brother of Arthur Sewall. Made his chief contribution to the life of his church in the development of its forms of worship.

SEWALL, HAROLD MARSH (*b. Bath, Maine, 1860; d. New York, N.Y., 1924*), diplomat, Maine legislator. Son of Arthur Sewall. Opposed German coup d'état at Apia, Samoa, 1887, while U.S. consul general there. As U.S. minister to Hawaii, 1897–98, he received transfer of sovereignty of the islands and remained in Hawaii as U.S. speical agent until establishment of regular territorial government, 1900.

SEWALL, JONATHAN (*b. Boston, Mass., 1728; d. St. John, New Brunswick, Canada, 1796*), lawyer, Loyalist. Graduated Harvard, 1748. Originally the intimate friend of John Adams, he became an adherent of the crown *ca.* 1761 because of opposition by James Otis to a request made by him to the Massachusetts General Court. Successively solicitor general and attorney general of Massachusetts, and *post* 1768 a judge of the vice admiralty court, he sailed for England early in 1775, whence he immigrated to Canada, 1788. A witty man, Sewall was a frequent and able contributor to the press.

SEWALL, JONATHAN MITCHELL (*b. Salem, Mass., 1748; d. Portsmouth, N.H., 1808*), lawyer, occasional poet. Grandnephew of Samuel Sewall. Author of *Miscellaneous Poems* (1801).

SEWALL, JOSEPH ADDISON (*b. Scarboro, Maine, 1830; d. 1917*), physician, educator. As first president of the University of Colorado, 1877–87, he developed that institution under most adverse conditions; he later taught at the University of Denver, where he was also dean of the school of pharmacy and acted as chemist for the city of Denver.

SEWALL, MAY ELIZA WRIGHT (*b. Milwaukee, Wis., 1844; d. 1920*), teacher, feminist. Principal for many years to the Girls' Classical School, Indianapolis, Ind., Sewall served as chairman of the executive committee of the National Suffrage Association and was a prominent figure in the International Council of Women. In 1889, when the Federation of Women's Clubs was formed, she became its first president.

SEWALL, SAMUEL (*b. Bishopstoke, England, 1652; d. Boston, Mass., 1730*), merchant, colonial magistrate. Born of New England parents, he returned with his family to Boston *ca.* 1661 and graduated from Harvard, 1671. Active in politics and the holder of many legislative and judicial offices in the colony throughout his life, he was particularly noteworthy for his service in 1692 as a special commissioner to try the cases of witchcraft at Salem. Sewall was the only one of the judges who ever publicly admitted that he had been in error in this matter; he made his confession of error in Old South Church, Boston, 1697. His tract *The Selling of Joseph* (1700) was one of the earliest appeals in the antislavery cause. He was also author of several tracts on religious subjects, on the Indians, and on politics, and wrote verses which circulated in manuscript form. As a writer he is remembered chiefly for his diary, which covers the period 1674–1729, with a gap at 1677–85. This work, which was first published in *Massachusetts Historical Society Collection* (1878–82), is an incomparable picture of the mind and life of a New England Puritan of the transition period. Sewall, as unwittingly portrayed by himself, emerges as mercenary, average in mentality, conventional, and introspective, yet also affectionate, honorable,

strong, and fearless. Other American diaries possess higher importance from a political point of view, but none so vividly reproduces the diarist's entire world.

SEWALL, STEPHEN (*b. York, Maine, 1734; d. Cambridge, Mass., 1804*), classicist, Hebraist. Graduated Harvard, 1761. Succeeding Judah Monis as teacher of Hebrew at Harvard, 1761, he was first Hancock professor of Hebrew and Oriental languages, 1765–85. His interests also included science and politics, and he was an early supporter of the Revolution.

SEWARD, FREDERICK WILLIAM (*b. Auburn, N.Y., 1830; d. 1915*), journalist, diplomat, New York legislator. Son of William H. Seward, served as his father's secretary and associate, 1849–72. Author-editor of *Autobiography of William H. Seward* (1877) and other works.

SEWARD, GEORGE FREDERICK (*b. Florida, N.Y., 1840; d. 1910*), diplomat. Nephew of William H. Seward. In the consular service, 1861–76, he was appointed U.S. minister to China, 1876; he resigned, 1879, after criticism of his record by the Democrats in Congress. He was president of Fidelity and Casualty Co., 1893–1910.

SEWARD, THEODORE FRELINGHUYSEN (*b. Florida, N.Y., 1835; d. East Orange, N.J., 1902*), musician, teacher, hymnologist. Studied in Boston, Mass., with Lowell Mason, George F. Root, and Thomas Hastings (1784–1872). Edited a collection of spirituals, *Jubilee Songs* (1872), and a number of other collections of songs and hymns; was coauthor with Lowell Mason of *The Pestalozzian Music Teacher* (1871). In helping to preserve spirituals, he made his most distinctive contribution.

SEWARD, WILLIAM HENRY (*b. Florida, N.Y., 1801; d. Auburn, N.Y., 1872*), statesman. Father of Frederick W. Seward; uncle of George F. Seward. Graduated Union College, 1820; was admitted to the bar, 1822; established himself in Auburn, N.Y., 1823. Moved by distrust of the Southern Jeffersonians and by his great interest in internal improvements, he supported DeWitt Clinton for governor and John Quincy Adams for president, 1824; the enthusiasm he then felt for Adams had a part in forming his political ideals. Drawn by expediency and conviction into the Anti-Masonic movement, he became a close friend of Thurlow Weed and through Weed's influence was elected to the New York State Senate, 1830. After four years' service he ran for governor as a Whig, but was defeated by William L. Marcy. Devoting himself to the practice of law, he acquired a small competence as agent for the Holland Land Co. in handling disputes with its settlers. Nominated, with Weed's assistance, by the Whigs for governor, 1838, he was forced for the first time to face the slavery issue and expressed a cautious opposition to that institution.

As governor of New York, 1839–43, he revealed an optimistic temper, strong humanitarian sympathies, impulsiveness, and a tendency to challenge majority opinion. Urging internal improvements upon the legislature in the midst of a depression, he brought about impairment of the state's credit. His declaration that the New York City public schools should be staffed by teachers of the same faith and racial extraction as the Catholic immigrant children brought down on him a nativist storm of criticism, and he was forced to retreat from this position. While he was governor, he took an advanced ground on the matter of slavery and won the support of the growing abolitionist element. In the belief that he was too far in advance of public opinion to prosper politically, he declined renomination in 1842 and returned to legal practice as a chancery court and patent specialist. He continued to take part in almost every campaign, however,

and by championing the Irish cause won the support of Irish-American voters.

In 1848 he was elected to the U.S. Senate, many Democrats and all the Whigs in the legislature voted for him. In the debates over the proposed Compromise of 1850, Seward opposed all compromise and asserted that the Fugitive Slave Law was impossible to enforce in the North. In a speech of Mar. 11, 1850, he declared that the slave system would either be ended "by gradual voluntary effort and with compensation" within the framework of the Union, or the Union would be itself dissolved and a civil war ensue. In the same speech he used the famous phrase "a higher law than the Constitution," which was widely misunderstood as a threat of action outside the American charter. An intense Whig partisan, he had in common with Weed a great interest in party politics and party victory, so he curbed, for a time, his dislike of compromise and tolerated a party policy which would raise as few perplexing questions of principle as possible. Meantime, in the Senate, he expressed an ardent nationalism and republicanism with such recklessness as to lay him open to the charge of demagogy. He played a leading part in the welcome to Kossuth, protested against Russian intervention in Hungary, and once again championed the Irish cause. In the debates on the Kansas-Nebraska bill, Seward showed greater caution than in the discussions of 1850, although he spoke vigorously against the bill and warned the South of the conflict to which he felt it would inevitably give rise. *Post* 1854, the rise of the Republican party in the West and the Know-Nothing party in the East and South created embarrassment for him as a Whig party leader; however, with Weed, he was able to negate the efforts of the Know-Nothings and secure reelection to the Senate. After the merger of the old Whig party with the rising Republican organization in the fall of 1855, Seward's speeches on slavery became of the most forthright character, and from that time until 1860 he embodied the growing antislavery sentiment of the North as much as any man. He advocated admission of Kansas under the Topeka Constitution, denounced the Dred Scott decision as the product of a conspiracy, and in October 1858 made at Rochester, N.Y., the famous speech in which he declared that the slavery struggle was "an irrepressible conflict." Perhaps for tactical reasons, however, he supported the Douglas idea of decision by popular sovereignty in Kansas, 1858, and in a later speech minimized the effect of the "irrepressible conflict" speech by praising the moderation of the slaveholders and blaming the free Democrats of the North for the events of the past few years.

Passed over expediently in 1856 by the Republicans, who favored John C. Frémont, for the presidential nomination, he was undoubtedly the leading candidate when the Republican National Convention met in Chicago, June 1860. The hostility of Horace Greeley, the opposition of the Know-Nothings, and Seward's own radical utterances, however, conspired to deprive him of the nomination. With his usual outward calm and very real generosity, he campaigned for the Republican ticket throughout the North and, in the crisis following the election, employed conciliatory language and methods advocating, among other things, a constitutional convention to settle outstanding difficulties.

Appointed U.S. secretary of state by Lincoln, he accepted, although he was displeased at the choice of Salmon P. Chase and Blair for the cabinet. He took office believing that he would be the dominant figure in the administration, and during March and April 1861 conducted himself in a manner which hardly represented him at his best. His "Some Thoughts for the President's Consideration" of April 1861 advocated embroiling the United States with most of Europe and waging actual war on Spain and France as a means of preserving the Union; he also virtually suggested that the president abdicate his power to the

secretary of state. He engaged in maneuvers behind Lincoln's back by which the reinforcement of Fort Pickens was delayed and the expedition to Fort Sumter weakened. His conduct of his office during the four years of war, however, deserves high praise, for he abandoned his early truculence toward other nations and expressed the views of the United States with dignity and force. His handling of the seizure of Mason and Slidell on board the *Trent* was masterly. He proved able to avert the possibility of European intervention in the Civil War and to check anti-Northern agitation in France and England by the self-confident optimism of his dispatches and the skillful use of the question of slavery. Seward's steady pressure (together with the diplomatic skill of Charles Francis Adams) led to British action against outfitting of Confederate cruisers in British ports. Seward was even more adroit in his management of the matter of French intervention in Mexico.

When the war was over, his strong instinct for expansionism revived. In 1867 he negotiated the cession of Alaska to the United States by Russia and secured prompt ratification of the treaty by the U.S. Senate. He was unsuccessful in maneuvers to acquire islands of the Danish West Indies. In addition to his normal duties, he served as a sort of political liaison officer, and his interest in patronage problems was continuous. After suffering serious injury in a carriage accident in the spring of 1865, he had been brutally attacked on the night of Lincoln's assassination; yet, despite the fact that he was partially crippled, he transacted the public business with as much skill and coolness as ever. In the administration of Andrew Johnson he was a central figure. He advocated a conciliatory policy toward the South, wrote some of Johnson's most important veto messages, and supported the president up to the very end, even though by so doing he lost both popularity and influence. Leaving office on President Grant's accession, he made a tour around the world and returned to his home in Auburn late in 1871.

SEWELL, WILLIAM JOYCE (*b. Castlebar, Ireland, 1835; d. Camden, N.J., 1901*), Union soldier, railroad executive, politician. Came to America, 1851. Prominent in management of the Pennsylvania Railroad system's New Jersey lines, Sewell became in time virtual Republican boss of New Jersey. He served in the state senate, 1872–81, and was U.S. senator, 1881–87 and 1895–1901.

SEXTON, ANNE GRAY HARVEY (*b. Newton, Mass., 1928; d. Weston, Mass., 1974*), poet. Began writing at age twenty-nine initially as a form of therapy for her depression. Within three years she had completed the collection of poems *To Bedlam and Part Way* (1960). She developed a large following, particularly among women, and won a Pulitzer Prize for *Live or Die* (1966); later collections were *Love Poems* (1969) and *Transformations* (1971). She became a professor of creative writing at Boston University in 1972 and committed suicide in 1974.

SEYBERT, ADAM (*b. Philadelphia, Pa., 1773; d. Paris, France, 1825*), physician. Studied with Caspar Wistar; M.D., University of Pennsylvania, 1793. After continuing his studies at London, Edinburgh, and Göttingen, and making special studies in mineralogy in Paris, he returned to Philadelphia, 1797, where he practiced and ran an apothecary shop. An expert in the analysis of minerals, he also manufactured, it is claimed, the first mercurials in America. While a congressman, Democratic-Republican, from Pennsylvania, 1809–15 and 1817–19, he interested himself in government revenues and expenditure and was author of *Statistical Annals . . . of the United States* (1818). An active member and official of the American Philosophical Society, he was one of the leading pioneer American chemists and mineralogists.

SEYBERT, HENRY (*b. Philadelphia, Pa., 1801; d. Philadelphia, 1883*), mineralogist, philanthropist. Son of Adam Seybert. Endowed a chair of philosophy at the University of Pennsylvania; left a great part of his estate to Pennsylvania for relief of poor children.

SEYBERT, JOHN (*b. Manheim, Pa., 1791; d. near Bellevue, Ohio, 1860*), bishop of the Evangelical Association. Itinerant missionary among German immigrants in Pennsylvania and Ohio.

SEYFFARTH, GUSTAVUS (*b. near Torgau, Germany, 1796; d. New York, N.Y., 1885*), archaeologist, Lutheran theologian, classical and Oriental philologist. Opposed school of Champollion. Resigned professorship of archaeology at University of Leipzig, 1854; immigrated to America, 1856. Erudite, but afflicted with a speculative dogmatic mentality, Seyffarth contended throughout his whole life that hieroglyphic signs were phonograms or syllabic writing and that Egyptian literature was based on ancient Coptic, related by him to Hebrew.

SEYMOUR, CHARLES (*b. New Haven, Conn., 1885; d. Chatham, Mass., 1963*), diplomat and historian. Studied at Kings College, Cambridge, England, and Yale (Ph.D., 1911). Joined the Yale faculty in 1911 and was president, 1937–50. His *Diplomatic Background of the War, 1870–1914* (1916) established his reputation as a diplomatic historian and expert on World War I. Invited in 1917 by Col. Edward M. House, President Woodrow Wilson's adviser, to join the Inquiry, a group of "experts" who prepared background information for the forthcoming peace conference; after the war he accompanied Wilson to the Paris Peace Conference. Back at Yale he concentrated on writing the diplomatic history of the war and became editor of Colonel House's papers (published 1926–28).

SEYMOUR, GEORGE FRANKLIN (*b. New York, N.Y., 1829; d. Springfield, Ill., 1906*), Episcopal clergyman. An ardent Anglo-Catholic, he served as professor and dean at the General Theological Seminary, New York; he was consecrated bishop of Springfield, 1878

SEYMOUR, HORATIO (*b. Pompey Hill, N.Y., 1810; d. 1886*), lawyer, New York politician. Brother-in-law of Roscoe Conkling. Early a henchman of the Albany Regency, Seymour was a long-time political lieutenant of William L. Marcy. As a New York assemblyman, 1842 and 1844–45, he forced expansion measures of his famous "Report of the Committee on Canals" through the legislature against the strongest opposition and was elected Speaker of the assembly, 1845. His skill in effecting working compromises between the Democratic "Hunker" and "Barnburner" factions made him an important figure. Although an advocate *post* 1845 of "free soil" in any southwestern territory which might be gained from Mexico and opposed to federal meddling with slavery where it then existed, he expressed a strong dislike for both abolitionists and Southern extremists. A true Jeffersonian, he insisted on the supreme importance of local government. He served the first of his terms as governor of New York, 1853–55, showing himself industrious and conscientious, improving the penal system and opposing prohibition and anti-Catholicism. Defeated for reelection, he devoted himself for a while to private business. Considered a possible compromise candidate at the Charleston, S.C., Democratic convention, 1860, Seymour supported Stephen A. Douglas, but on Lincoln's election urged loyal acceptance of the constitutional fact and favored the Crittenden Compromise. Although he considered an armed conquest of the South unwise, he helped the Union war effort and, as governor, 1863–65, was tireless in supplying the state's army quotas. He found himself pushed, however, into a position as

national leader of the opposition to the Republicans and was a constant critic of the extraconstitutionalpowers assumed by the Lincoln administration. Although he was denounced by Horace Greeley and others as a temporizing Copperhead during the draft riots in New York City, July 1863, the verdict of time has been in his favor. Defeated as Democratic candidate for the presidency after a vigorous campaign, 1868, he became an elder statesman of the party, assisted in driving Boss Tweed from power and lived to see his disciple, Grover Cleveland, in the White House. A man of dignity and integrity, he failed practically as a statesman, largely because of his gentlemanly scorn for extreme opinions.

SEYMOUR, HORATIO WINSLOW (*b. Cayuga Co., N.Y., 1854; d. New York, N.Y., 1920*), journalist. Raised in Wisconsin. Served as editor on *Milwaukee Daily News, Chicago Times, Chicago Herald, Chicago Chronicle,* and New York *World;* was noted for his innovating use of startling and effective headlines. A liberal Democrat, he opposed Republican money and tariff policies.

SEYMOUR, THOMAS DAY (*b. Hudson, Ohio, 1848; d. New Haven, Conn., 1907*), classicist. Grandnephew of Jeremiah Day. Professor of Greek at Western Reserve, 1872–80, and at Yale, 1880–1907. Chairman of managing committee, American School at Athens, 1887–1901; president, Archaeological Institute of America, 1903–07. Author of, among other books, *Life in the Homeric Age* (1907).

SEYMOUR, THOMAS HART (*b Hartford, Conn., 1807; d. Hartford, 1868*), lawyer, Mexican War soldier. Congressman, Democrat, from Connecticut, 1843–45; governor of Connecticut, 1850–53; U.S. minister to Russia, 1854–58. A leader of the Connecticut Peace Democrats.

SEYMOUR, TRUMAN (*b. Burlington, Vt., 1824; d. Florence, Italy, 1891*), Union major general. Graduated West Point, 1846; served with artillery in Mexican War and against Seminoles. As brigade and later division commander during the Civil War, Seymour executed the decisive enveloping movement at the battle of South Mountain, and at Antietam led the advance of Hooker's corps in opening the battle. In continuous service thereafter, he was distinguished as a soldier but unaggressive in promotion of his own ambitions. He retired in 1876.

SEYMOUR, WILLIAM (*b. New York, N.Y., 1855; d. Plymouth, Mass., 1933*), actor, stage director, theater manager. Son-in-law of Edward L. Davenport. He was for many years associated with productions of Charles Frohman.

SHABONEE (*b. possibly near Maumee River, Ohio, ca. 1775; d. Grundy Co., Ill., 1859*), Potawatomi chief. An associate of Tecumseh, 1807–14, he later became a good but unrewarded friend of the settlers.

SHAFER, HELEN ALMIRA (*b. Newark, N.J., 1839; d. Wellesley, Mass., 1894*), educator. Graduated Oberlin, 1863. Professor of mathematics at Wellesley *post* 1877, she succeeded to the presidency of the college, 1888. She completely remodeled the curriculum, altered requirements for admission, and added many new courses of study.

SHAFROTH, JOHN FRANKLIN (*b. Fayette, Mo., 1854; d. Denver, Colo., 1922*), lawyer. Removed to Colorado, 1879. Congressman, Republican, Silver Republican, and Democrat, 1895–1904, he supported the Reclamation Act, a woman's suffrage amendment, and the abolition of lame-duck sessions. Democratic governor of Colorado, 1909–13, he forced adoption of the direct primary, initiative, and referendum. As U.S. senator, 1913–19, he supported President Wilson in the main, but clashed with him on conservation; his Senate speech, Mar. 21, 1914, is the classic statement of the western viewpoint of that subject.

SHAFTER, WILLIAM RUFUS (*b. Kalamazoo Co., Mich., 1835; d. near Bakersfield, Calif., 1906*), soldier. In service with the Union army, 1861–65, he received brevet of brigadier general of volunteers and the Medal of Honor for gallantry at Fair Oaks. Remaining in the army, he rose to colonel, 1st U.S. Infantry, 1879, and was made brigadier general, 1897. On outbreak of the war with Spain, he was promoted major general of volunteers. In command of the expeditionary force against Santiago de Cuba, he landed at Daiquiri, June 22, 1898, and took Santiago on July 17 in a campaign which was widely criticized because of high American mortality from malaria and yellow fever. Much of the criticism of Shafter may be more justly charged to the nation's general unpreparedness and ignorance of tropical diseases. Retiring from active service as brigadier general, 1899, he was advanced to the grade of major general retired, 1901.

SHAHAN, THOMAS JOSEPH (*b. Manchester, N.H., 1857; d. 1932*), Roman Catholic clergyman, educator. Educated at Sulpician College of Montreal and at the American College and the Propaganda in Rome, he was ordained, 1882; he studied later also at the universities of Paris and Berlin. Professor of church history, Roman law, and patrology at Catholic University, Washington, D.C., *post* 1891; rector of the university, 1909–28. He was consecrated titular bishop of Germanicopolis, 1914. A voluminous writer and an able executive, he was a founder and an editor of the *Catholic Encyclopedia* (1907–13).

SHAHN, BENJAMIN ("BEN") (*b. Kovno, Lithuania, 1898; d. New York, N.Y., 1969*), painter and graphic artist. Immigrated to the United States in 1906; attended New York University, City College of New York, National Academy of Design, Art Students League, Sorbonne, and Académie de la Grande Chaumière. Achieved wide acclaim with a series of paintings (1932) on the Sacco-Vanzetti case. Worked for several government agencies, 1934–43, creating paintings or murals for such buildings as the Social Security Building in Washington, D.C. While employed by the Farm Security Administration (1935–38), he took 6,000 photos portraying rural hardship; in 1942–43 designed posters for the Office of War Information. Taught at Boston Museum of Fine Arts and Brooklyn Museum Art School (1947–50); named Norton Professor of Poetry at Harvard (1956). He had several one-man shows and a major retrospective (1947) at the Museum of Modern Art. Foremost among the social-realist artists, he used art as a weapon for political and social change.

SHAIKEWITZ, NAHUM MEIR *See* SCHOMER, NAHUM MEIR.

SHAKALLAMY *See* SHIKELLAMY.

SHALER, NATHANIEL SOUTHGATE (*b. Newport, Ky., 1841; d. 1906*), Union soldier, geologist, educator. A favorite pupil of Agassiz, Shaler took a B.S. degree at Lawrence Scientific School, 1862. Returning to his alma mater after Union army service, he was assistant to Agassiz in paleontology; *post* 1868, he served as lecturer and professor of paleontology and geology. He was also dean of Lawrence Scientific School from 1891 until his death. As a teacher, he was concerned more with awakening the minds of his students than with imparting information; as dean, he revivified Lawrence and toward the end of his tenure fought its merger with Massachusetts Institute of Technology. A man of very wide interests, Shaler served also as state geologist of Kentucky, as a member of many Massachusetts state commissions, as a consultant in mining ventures, and as a supervising official of the U.S. Geological Survey. He was a prolific writer on many

subjects, scientific and otherwise, displaying exceptional powers of observation and imagination.

SHALER, WILLIAM (*b. Bridgeport, Conn., ca. 1773; d. Havana, Cuba, 1833*), sea captain. Friend and partner of Richard J. Cleveland. Shaler held a number of U.S. consular offices, of which the most notable was the post of U.S. consul general at Algiers, 1815–28. He had previously served as U.S. commissioner with Stephen Decatur (1779–1820) in the arbitrary negotiation of the U.S.–Algiers treaty of 1815. He was author of *Sketches of Algiers* (1826).

SHANNON, FRED ALBERT (*b. Sedalia, Mo., 1893; d. Wickenburg, Ariz., 1963*), historian and art teacher. Attended Indiana State Teachers College and Indiana University (Ph.D., 1924). Taught at Iowa Wesleyan (1919–24), Iowa State Teachers (1924–26), Kansas State College of Agriculture (1926–39), and Illinois (1939–61). His first major work, *The Organization and Administration of the Union Army, 1861–1865* (1928), was a vividly written series of essays. *Economic History of the People of the United States* (1934) displayed his sympathies for the common man. He was part of the group that planned the nine-volume *Economic History of the United States*; his own volumes were *American Farmers' Movements* (1957) and *The Centennial Years* (1967).

SHANNON, WILSON (*b. Mount Olivet, Ohio Territory, 1802; d. 1877*), lawyer, public official. Democratic governor of Ohio, 1838–40 and 1842–44; inept and tactless U.S. minister to Mexico, 1844–45; undistinguished congressman from Ohio, 1853–55. Commissioned governor of Kansas Territory, August 1855, he became confidential with the Missouri party and accused the Free State group of a secret conspiracy to resist the laws. On outbreak of the so-called Wakarusa War in November, he was able to persuade both factions to disband their forces, but when guerrillas again assembled before the town of Lawrence in May 1856, he refused to intervene and contented himself after the pillaging of the town with a proclamation ordering armed bands to desist. On the invasion of the territory by James H. Lane (1814–66) and his army in August and the consequent attacks on proslavery areas, Shannon again played the role of peacemaker and effected a settlement. His resignation anticipated by an order for his removal, August 1856, he resumed the practice of law, becoming in time a leading member of the Kansas bar.

SHAPLEY, HARLOW (*b. Nashville, Mo., 1885; d. Boulder, Colo., 1972*), astronomer. Graduated University of Missouri (M.A., 1911) and Princeton University (Ph.D., 1913) and became a researcher at the Mount Wilson Observatory in California (1913–21), where he developed a method to measure stellar distances from the brightness of pulsating stars. In a controversial and landmark theory, he proposed that the earth's sun was a minor star on the outskirts of the Milky Way Galaxy. He was director of the Harvard College Observatory (1921–52) and transformed the facility into a leading research center. He also championed cooperation with Russian intellectuals and helped launch the United Nations Education, Scientific, and Cultural Organization (UNESCO).

SHARKEY, WILLIAM LEWIS (*b. Holston Valley, East Tenn., 1798; d. Jackson, Miss., 1873*), lawyer, jurist. Removed to Mississippi as a young man: began practice at Warrenton, 1822. Chief justice, state court of errors and appeals, 1832–51. As president of Nashville Convention, 1850, he opposed Southern extremist efforts to dominate that body and up to 1861 was probably the most active antisecessionist in the state of Mississippi. Appointed provisional governor, June 1865, he served until the fall of that year. He was then chosen U.S. senator, but was denied his seat when Congress repudiated President Johnson's Reconstruction plan.

SHARP, DALLAS LORE (*b. Haleyville, N.J., 1870; d. Hingham, Mass., 1929*), educator, Methodist clergyman, naturalist. Author of *Wild Life Near Home* (1901) and some 20 more popular works on nature study, including *A Watcher in the Woods* (1903) and *Beyond the Pasture Bars* (1914).

SHARP, DANIEL (*b. Huddersfield, England. 1783; d. near Baltimore, Md., 1853*), Baptist clergyman. Highly influential in his principal pastorate at the Third Baptist Church, Boston, Mass., 1812–53.

SHARP, JOHN (*b. Clackmannanshire, Scotland, 1820; d. 1891*), Mormon pioneer and bishop, railroad contractor. Came to America, 1848; settled in Salt Lake City, 1850; served as superintendent of the church quarries. Principal subcontractor under Brigham Young in construction of Union Pacific roadbed from Echo Canyon to Ogden, he later undertook other contracts and developed the Utah Central Railroad, of which he was president *post* 1873.

SHARP, KATHARINE LUCINDA (*b. Elgin, Ill., 1865; d. Lake Placid, N.Y., 1914*), librarian. Graduated Northwestern University, 1885; New York State Library School, 1892. Director, Department of Library Science, Armour Institute (later at University of Illinois), 1893–1907; librarian, University of Illinois, 1897–1907. Author of *Illinois Libraries* (1906–08).

SHARP, WILLIAM GRAVES (*b. Mount Gilead, Ohio, 1859; d. Elyria, Ohio, 1922*), lawyer, industrialist. As congressman, Democrat, from Ohio, 1909–14, he became ranking member of Committee on Foreign Affairs; he was U.S. ambassador to France, 1914–19.

SHARPE, HORATIO (*b. near Hull, England, 1718; d. England, 1790*), British soldier, colonial governor of Maryland. 1753–69. Appointed governor, probably through family influence, he served as royal commander in chief during the French and Indian War, until replaced by Braddock. Defending the interests of Lord Baltimore, he quarreled with the legislature over its decision to tax the proprietor's revenue, though he opposed the retaliatory measure of quartering troops in Annapolis. Credited by some with first suggesting the Stamp Act, he warned the ministry that parliamentary taxation could be enforced only by troops. By 1760 he reached agreement with Virginia concerning the disputed boundary of the two colonies. Removed as governor in 1769, he returned to England in 1773.

SHARPLES, JAMES (*b. England, ca. 1751; d. New York, N.Y., 1811*), portrait painter, inventor. Came to America, 1793; worked as an itinerant painter through New England states and the South; settled in Philadelphia, 1796, and resided thereafter there or in New York except for the years 1801–09 when he returned to England. Noted for his ability to catch a likeness, he made many portraits of distinguished Americans, including George Washington and his wife, and of important foreign visitors. For his work in America he used pastels on a thick gray paper of soft grain. Because of the ability of his wife and children to duplicate his work in copies, there has been much confusion over authentication of works from his own hand.

SHARPLESS, ISAAC (*b. Chester Co., Pa., 1848; d. 1920*), Quaker leader and historian, educator. Graduated Harvard, 1873. Began a lifelong service at Haverford College as instructor in mathematics, 1875; president of Haverford, 1887–1917. He was one of

the most eminent U.S. exponents of the small, efficient liberal arts college.

SHARSWOOD, GEORGE (*b. Philadelphia, Pa., 1810; d. 1883*), jurist. Judge of the district court of Philadelphia, 1845–68, he was president judge *post* 1848. Elevated to the state supreme court, he served until his retirement in 1882, and was chief justice *post* 1879. Noted for his learning, promptness of decision, and sound judgment, Sharswood was also a prolific legal writer and professor of law and dean of the law school at University of Pennsylvania.

SHATTUCK, AARON DRAPER (*b. Francestown, N.H., 1832; d. Granby, Conn., 1928*), portrait and landscape painter. Brother-in-law of Samuel Colman.

SHATTUCK, FREDERICK CHEEVER (*b. Boston, Mass., 1847; d. 1929*), noted Boston physician. Son of George C. Shattuck (1813–93); brother of George B. Shattuck. Jackson Professor of clinical medicine, Harvard Medical School, 1888–1912.

SHATTUCK, GEORGE BRUNE (*b. Boston, Mass., 1844; d. 1923*), Boston physician. Son of George C. Shattuck (1813–93); brother of Frederick C. Shattuck. Visiting physician for many years at Boston City Hospital, Shattuck was influential in establishing the Massachusetts State Board of Health, 1869, the first in the United States. He was editor in chief, *Boston Medical and Surgical Journal*, 1881–1912.

SHATTUCK, GEORGE CHEYNE (*b. Templeton, Mass., 1783; d. 1854*), physician, philanthropist. Father of George C. Shattuck (1813–93). Graduated Dartmouth, 1803; M.B., 1806; M.D., University of Pennsylvania, 1807, the leading physician of his time in Boston, Shattuck engaged in many philanthropies, including endowment of a professorship of anatomy at Harvard Medical School, foundation of the Shattuck lectures of the Massachusetts Medical Society, and assistance to authors such as James Thacher and John J. Audubon.

SHATTUCK, GEORGE CHEYNE (*b. Boston, Mass., 1813; d. 1893*), physician, philanthropist. Son of George C. Shattuck (1783–1854); father of Frederick C. and George B. Shattuck. Graduated Harvard, 1831; M.D., Harvard Medical School, 1835. During three years' postgraduate study in Europe he was influenced principally by P. C. A. Louis. Shattuck's report of studies differentiating typhoid from typhus fever, read in Paris, 1838, and published in America, 1840, was one of the early, important contributions to the subject. Practicing with his father in Boston, *post* 1840, he gave much of his time to the improvement of medical education; with Oliver W. Holmes, Henry I. Bowditch, and James Jackson (1777–1867), he was a founder of the Boston Society of Medical Observation and succeeded Holmes as visiting physician to Massachusetts General Hospital, 1849. As professor at Harvard Medical School, and as dean *post* 1864, he woke the school out if its lethargy, extended the teaching into hospitals, and introduced clinical conferences. A leading Episcopal layman, he founded St. Paul's School, Concord, N.H., 1855.

SHATTUCK, LEMUEL (*b. Ashby, Mass., 1793; d. 1859*), merchant, statistician. Interested from an early period in the provision of precise vital statistics, Shattuck was a founder of the American Statistical Association, 1839, and of the New England Historic Genealogical Society. He was influential also in securing a state law requiring an effective system of registry of births, marriages, and deaths, 1842. Shattuck's census of the city of Boston, 1845, contained many innovations, and his services as consultant in the federal census of 1850 resulted in a marked advance in the amount and quality of information recorded. His *Report* (1850) as chairman of the commission to make a sanitary survey of Massachusetts was a milestone in the development of public health works; in it he anticipated almost all the public health measures later put into practice.

SHAUBENA *See* SHABONEE.

SHAUCK, JOHN ALLEN (*b. near Johnsville, Ohio, 1841; d. Columbus, Ohio, 1918*), jurist. Ohio circuit court judge, 1884–94; state supreme court judge, 1894–1913. A stern conservative, he held that it was the duty of courts to declare void all acts of state legislatures which were nongovernmental in nature even though not forbidden by constitutional provision.

SHAUGHNESSY, CLARK DANIEL (*b. St. Cloud, Minn., 1892; d. Santa Monica, Calif., 1970*), football coach. Attended Minnesota (B.A., 1914). Coached at Tulane (1915–28), Loyola of the South (1928–32); Chicago (1933–39); Stanford (1940–41), which won the 1941 Rose Bowl; Pittsburgh (1942–46); and Maryland (1947). Coached the professional Washington Redskins (1946) and Los Angeles Rams (1947–51) and was a technical adviser and vice president for the Chicago Bears. Most of his success was predicated on the use of the T formation.

SHAW, ALBERT (*b. present Shandon, Ohio, 1857; d. New York, N.Y., 1947*), journalist, reformer. B.A., Iowa (now Grinnel) College, 1879; Ph.D., Johns Hopkins University, 1884. Editorial writer, *Minneapolis Tribune*, 1884–91. Editor and publisher, *Review of Reviews*, 1892–1937.

SHAW, ANNA HOWARD (*b. Newcastle-upon-Tyne, England, 1847; d. Moylan, Pa., 1919*), physician, Methodist minister, woman suffrage and temperance reformer. Friend and associate of Susan B. Anthony, Shaw was a practiced orator and able publicist; she was president, National American Woman Suffrage Association, 1904–15.

SHAW, CLAY L. (*b. Kentwood, La., 1913; d. New Orleans, La., 1974*), businessman. As managing director of the International Trade Mart in New Orleans (1949–56), Shaw was able to supply information to the Central Intelligence Agency. In 1967 he was arrested, with New Orleans district attorney Jim Garrison alleging that Shaw, using the alias Clay Bertrand, conspired with Jack Ruby and Lee Harvey Oswald in the 1963 assassination of President John F. Kennedy; after a sensational trial in 1969, Shaw was acquitted.

SHAW, EDWARD RICHARD (*b. Bellport, N.Y., 1850; d. 1903*), educator. Graduated Lafayette College, 1881; Ph.D., New York University, 1890. Helped found pioneer school of education at New York University, 1890; served it as dean, 1894–1901.

SHAW, ELIJAH (*b. Kensington, N.H., 1793; d. 1851*), pioneer minister of the Christian Connection. An editor of the *Christian Journal*.

SHAW, HENRY (*b. Sheffield, England, 1800; d. St. Louis, Mo., 1889*), merchant. Succeeded in business in St. Louis, 1819–40. Advised by Asa Gray, George Englemann, and others, he established a garden for the scientific study of plants at St. Louis, 1857–60. Opened to the public, 1860, it was endowed by its founder as the Missouri Botanical Garden and continues to hold high rank among world botanical institutions.

SHAW, HENRY WHEELER (*b. Lanesboro, Mass., 1818; d. Monterey, Calif., 1885*), humorist. Better known by pseudonym "Josh Billings." Author of hundreds of once-popular bucolic aphorisms

phrased in grotesque misspellings, Shaw was author of *Josh Billings, His Sayings* (1865) and a number of similar collections. His best work is in *Josh Billings' Farmer's Allminax*, published yearly from 1869 until 1880.

SHAW, HOWARD VAN DOREN (*b. Chicago, Ill., 1869; d. Baltimore, Md., 1926*), architect. Graduated Yale, 1890. Studied architecture at Massachusetts Institute of Technology and worked in office of William LeB. Jenney. Worked in a highly personal style, largely in the Middle West, where he became probably the best regarded practitioner of domestic and noncommercial architecture.

SHAW, JOHN (*b. Mountmellick, Ireland, 1773; d. Philadelphia, Pa., 1823*), naval officer, merchant mariner. Made brilliant record in command of schooner *Enterprise*, 1799–1800, as destroyer of French privateers. Prepared naval force in lower Mississippi to frustrate Aaron Burr's intrigues, 1807; after mainly shore service in the War of 1812, commanded the squadron stationed off Algiers to protect American interests, 1815–17.

SHAW, JOHN (*b. Annapolis, Md., 1778; d. at sea, 1809*), physician, naval surgeon, poet.

SHAW, LAWRENCE TIMOTHY ("BUCK") (*b. near Mitchelville, Iowa, 1899; d. Menlo Park, Calif., 1977*), football coach. Graduated Notre Dame University (1922), where he played football for Knute Rockne and was selected an All–American (1921). He became a coach for the University of Nevada (1922–24, 1925–29), North Carolina State (1924), and University of Santa Clara (1929–43), where he turned a losing football team into a national power. He moved into professional football as the first coach of the San Francisco 49ers (1946–54) and returned to college football as the Air Force Academy's first football coach (1955–58). He was back with the pros in 1958, as head coach of the Philadelphia Eagles (1958–60); he retired after the Eagles won the league championship (1960) and was voted NFL Coach of the Year. Inducted into Professional Football Hall of Fame (1960) and National College Football Hall of Fame (1972).

SHAW, LEMUEL (*b. Barnstable, Mass., 1781; d. 1861*), Massachusetts legislator and jurist. Father-in-law of Herman Melville. Graduated Harvard, 1800; studied law in Boston under David Everett. Practicing in Boston *post ca.* 1804, he became known as an adviser in important commercial enterprises; he drew up the first charter of the city, 1822. As chief justice of Massachusetts, 1830–60, he made much law on such matters as waterpower, railroads, and other public utilities; probably no other state judge has so deeply influenced commercial and constitutional law throughout the United States. The strength of his opinions lay in the entire solidity of their reasoning. Thorough and systematic, he had a remarkable ability to charge juries so that they understood the exact questions at issue before them.

SHAW, LESLIE MORTIER (*b. Morristown, Vt., 1848; d. Washington, D.C., 1932*), banker. Removed to eastern Iowa, 1869. Republican governor of Iowa, 1898–1902. Shaw's championing of the gold standard during the campaign of 1896 and his services as permanent chairman of the International Monetary Convention, 1898, led to his appointment as U.S. secretary of the treasury in 1902. He resorted to unprecedented expedients for dealing with stringency of credit, such as liberalizing security and waiving reserve requirements for government bank deposits, artificially stimulating gold importation, and regulating note issues by executive decree. A firm believer in high tariff protection and domestic laissez-faire, he retained office until 1907, despite President Theodore Roosevelt's uneasiness about him.

SHAW, MARY (*b. Boston, Mass., 1854; d. New York, N.Y., 1929*), actress. Made debut with Boston Museum Stock Co., 1879–80. A hardworking intellectual performer, she played ably in support of Helena Modjeska, Julia Marlowe, and other stars, but rarely won commercial success in her own vehicles. Among her own productions were Ibsen's *Ghosts* (produced, 1899 and later) and G. B. Shaw's *Mrs. Warren's Profession*, in which she appeared in New York, October 1905 and on later occasions.

SHAW, NATHANIEL (*b. New London, Conn., 1735; d. New London, 1782*), merchant, Revolutionary patriot. Naval agent for Connecticut, and agent and prize master for the Continental Congress *post* 1775.

SHAW, OLIVER (*b. Middleboro, Mass., 1779; d. Providence, R.I., 1848*), musician, composer. Organist of the First Congregational Church at Providence *post* 1807, he composed sacred music anticipatory of the work of Lowell Mason, but was equally important for his teaching and interest in the betterment of church music. His best known hymn tunes were "Taunton," "Bristol," and "Weybosset."

SHAW, PAULINE AGASSIZ (*b. Neuchâtel, Switzerland, 1841; d. 1917*), philanthropist, educational and social pioneer. Daughter of J. L. R. Agassiz. Gave early support to Boston kindergartens, to the manual-training movement during its experimental period, and to the Vocation Bureau of Boston for its pioneer work in vocational guidance, 1908–17.

SHAW, SAMUEL (*b. Boston, Mass., 1754; d. near Cape of Good Hope, 1794*), Revolutionary officer, merchant. Served with distinction in the Revolution as an artilleryman, for most of the war acting as aide-de-camp to General Henry Knox. Supercargo on the *Empress of China*, first American vessel to Canton, 1784–85, he served as first U.S. consul to China *post* 1786.

SHAW, THOMAS (*b. Philadelphia, Pa., 1838; d. Hammonton, N.J., 1901*), machinist, inventor. Patented almost 200 devices, including gas meters, pressure gauges, hydraulic pumps, engine governors, and iron and steel processes; among these, his springlock nut washer, 1868; his pile driver, 1868, 1870; and the Shaw gas tester, 1886–90, were outstanding.

SHAW, (WARREN) WILBUR (*b. Shelbyville, Ind., 1902; d. near Peterson, Ind., 1954*), automobile racer. Won the Indianapolis 500 in 1937, 1939, and 1940; national champion, 1937, 1939. President and general manager of the Indianapolis Speedway after the track was reopened after World War II. Killed in plane crash.

SHAW, WILLIAM SMITH (*b. Haverhill, Mass., 1778; d. Boston, Mass., 1826*), lawyer. Nephew of Abigail Adams. Helped found the Anthology Society, 1805; built up collections of the Boston Athenaeum as librarian, 1807–22.

SHAWN, EDWIN MEYERS ("TED") (*b. Kansas City, Mo., 1891; d. near Lee, Mass., 1972*), dancer and choreographer. After touring as a ballroom dancer, he established the dance company Denishawn (1914–30) with Ruth St. Denis. In the 1920's the troupe toured extensively, winning acclaim for its eclectic programming and international dance influences, and Shawn opened dance schools around the country. In the 1930's he established a new touring company based at his Massachusetts farm, Jacob's Pillow. In his choreographed works, such as *Kinetic Molpai* (1935), he explored ethnic, labor, war, and religious themes and pioneered male involvement in modern dance.

SHAYS, DANIEL (*b. probably Hopkinton, Mass., ca. 1747; d. Sparta, N.Y., 1825*), Revolutionary soldier, insurgent. A brave and popular officer of the 5th Massachusetts Regiment, he resigned from the army, 1780, and settled in Pelham, Mass., being subsequently elected to various town offices. The acute economic depression which soon followed the peace of 1783 created grievances throughout the rural districts, particularly with reference to foreclosure for debt. On the failure of the legislature to help, the people of western Massachusetts resorted to force to compel legislative action, and Shays's prominence in this movement has caused his name to be given to the whole uprising. On Aug. 29, 1786, the insurgents prevented the sitting of the courts of common pleas and general sessions; the leaders, then fearing that indictments would be brought against them, moved to prevent the sitting of the supreme court at Springfield on Sept. 26. Militiamen under General William Shepard defended the court. A committee of which Shays was chairman drew up resolutions that the court should be allowed to sit, provided it dealt with no case involving indictments concerning insurgents or debts; on agreement, both the militia and the insurgents disbanded and court adjourned. The legislature of Massachusetts continuing to give offense, the insurgents rose again in January 1787 and moved against the arsenal at Springfield but were defeated by state troops under General Benjamin Lincoln. Pursuing the insurgents westward, Lincoln caught up with Shays's men at Petersham on the night of Feb. 2, 1787, and completely routed them. Shays fled to Vermont. At first condemned to death, he was pardoned in June 1788 and some time afterward removed to New York State. A man of little education and not much ability, he was honest and firmly convinced of the justice of his cause.

SHEA, JOHN DAWSON GILMARY (*b. New York, N.Y., 1824; d. Elizabeth, N.J., 1892*), historian, editor. Graduated Columbia Grammar School, 1837; was a Jesuit novice, 1848–52. Dedicating his life to the writing of American Catholic history, he received few material rewards for work of outstanding ability which won him many scholarly honors. Among his books of permanent value were *Discovery and Exploration of the Mississippi Valley* (1852), *History of the Catholic Missions Among the Indian Tribes of the United States* (1854) and the monumental *History of the Catholic Church in the United States* (1886–92); he was also editor of a number of works on Indian linguistics, of many additional Jesuit relations, and of an English translation of Charlevoix's *History and General Description of New France* (1866–72).

SHEAN, ALBERT (*b. Dornum, near Hannover, Germany, 1868; d. New York, N.Y., 1949*), actor. Stage name of Albert Schoenberg. Uncle of the Marx Brothers. Came to United States with parents *ca.* 1876. Burlesque and vaudeville comedian *post* 1884; teamed with Ed Gallagher and famous act of "Gallagher and Shean," 1910–14 and 1920–25, scoring greatest success in the second of these partnerships. Subsequent to the breakup of the team, Shean developed a solid reputation on stage and in films as an able and sensitive character actor.

SHEAR, THEODORE LESLIE (*b. New London, N.H., 1880; d. Newbury, N.H., 1945*), classical archaeologist. B.A., New York University, 1900; M.A., 1903; Ph.D., Johns Hopkins University, 1904. Studied also at American School of Classical Studies at Athens, and at University of Bonn. Taught Greek and Latin at Barnard College, 1906–10; moved to Columbia University as associate in classical philology, 1910, and thereafter spent much of his time in archaeological excavation. Appointed lecturer in the Department of Art and Archaeology at Princeton, 1920, he became professor of classical archaeology in 1928. He is espe-

cially remembered for his direction of large-scale excavations on various sites in ancient Greece, notably at Sardis, Corinth, and the Athenian Agora.

SHEARMAN, THOMAS GASKELL (*b. Birmingham, England, 1834; d. Brooklyn, N.Y., 1900*), lawyer, economist. Came to America as a boy. Employed by David D. Field to work with him on the civil code, 1860, Shearman became a partner of Field, 1868, and served as immediate legal adviser to James Fisk and Jay Gould during the Erie Railroad "war." Withdrawing from the partnership, 1873, Shearman continued to act as counsel for Gould and ably defended Henry Ward Beecher during his famous trial. Shearman was also counsel for a number of banks and railroads and for James J. Hill. By nature a reformer, he continued Field's work in pressing for codification of the law, argued for free trade, and in 1887 suggested the name "single tax" as definition of the measures proposed by Henry George, to which he had become a convert. He was author of *Natural Taxation* (1895).

SHECUT, JOHN LINNAEUS EDWARD WHITRIDGE (*b. Beaufort, S.C., 1770; d. 1836*), physician, botanist, novelist. Practiced in Charleston, S.C., *post ca.* 1790; studied medicine under David Ramsay.

SHEDD, FRED FULLER (*b. New Boston, N.H., 1871; d. Southern Pines, N.C., 1937*), journalist. After early editorial training on the *Haverhill* (Mass.) *Evening Gazette* and the *Boston Herald*, he served on the staff of the *Philadelphia Bulletin, post* 1911, and was its editor in chief, 1921–37.

SHEDD, JOEL HERBERT (*b. Pepperell, Mass., 1834; d. Providence, R.I., 1915*), hydraulic and sanitary engineer, inventor.

SHEDD, JOHN GRAVES (*b. near Alstead, N.H., 1850; d. Chicago, Ill., 1926*), merchant, philanthropist. Removed to Chicago, 1872, to enter employ of Field, Leiter & Co. as salesman. Rising rapidly in the firm, he became a partner of Marshall Field & Co., 1893, and served as its president, 1906–22.

SHEDD, WILLIAM AMBROSE (*b. Mount Seir, Persia, 1865; d. Sain Kala, Persia, 1918*), Presbyterian clergyman. The son of missionary parents, Shedd graduated from Marietta College, 1887, and from Princeton Theological Seminary, 1892. Serving thereafter as a missionary in Persia, he was active in relief work there during World War I.

SHEDD, WILLIAM GREENOUGH THAYER (*b. Acton, Mass., 1820; d. New York, N.Y., 1894*), Congregational and Presbyterian theologian. Graduated University of Vermont, 1839; Andover Theological Seminary, 1843. A professor at Union Theological Seminary, New York City, 1862–93, he was author of *Dogmatic Theology* (1888, 1894), a cogent defense of conservative Calvinism, and of a number of other books.

SHEEAN, JAMES VINCENT (*b. Pana, Ill., 1899; d. Arolo, Italy, 1975*), journalist and writer. Attended University of Chicago (1916–20), became a reporter for the *New York Daily News*, and served as a foreign correspondent for the *Chicago Tribune* (1922–25). His dispatches to American news syndicates detailed some of the great events of the era, including the 1927 revolution in China, the Spanish civil war (1936–39), the Nazi bombing of London (1940–41), and the assassination of Mahatma Gandhi (1947). Sheean's reflective and personal writing style influenced a generation of journalists.

SHEEDY, DENNIS (*b. Ireland, 1846; d. Denver, Colo., 1923*), cattleman, merchant, capitalist. Came to America as an infant;

removed to Lyons, Iowa, 1858. Active as a trader, miner, and freighter throughout the West, he was a rancher in Nevada, Texas, Nebraska, and Colorado, 1870–84. Foreseeing the end of the free range, he sold out his cattle interests and engaged in banking, smelting, and other activities in Colorado.

SHEELER, CHARLES R., JR. (*b. Philadelphia, Pa., 1883; d. Dobbs Ferry, N.Y., 1965*), artist and photographer. Trained at the Philadelphia School of Industrial Art (1900–03) and Pennsylvania Academy (1903–06). Six of his works were chosen for the 1913 Armory Show in New York, and one-man shows of his work were held at various galleries in the 1920's. A commercial photographer since 1912, he specialized in architecture during 1923–32. He was commissioned by Ford Motor Company to photograph their River Rouge Plant (1927) and his "portraits of machinery" further established his reputation. *Fortune* magazine commissioned six canvases on the theme of "Power" (1939–40). Was photographer-in-residence at the Metropolitan Museum of Art, 1942–55; during the 1950's he used his camera to interpret the architecture of Rockefeller Center and the United Nations.

SHEEN, FULTON JOHN (*b. El Paso, Ill., 1895; d. New York City, 1979*), clergyman, author, and radio and television preacher. Graduated College and Seminary of St. Viator in Illinois (B.A., 1917; M.A., 1919) and completed studies at Seminary of St. Paul in Minnesota; he was ordained a Catholic priest in 1919. He pursued graduate studies at Catholic University of America (S.T.B. and J.C.B., 1920); University of Louvain, Belgium (Ph.D., 1923); and Pontifical Athenaeum Angelico in Rome (S.T.D., 1924), then joined the faculty at Catholic University (1926–1950). A compelling evangelist and exceptional public speaker, he appeared regularly on the radio program "Catholic Hour" (1930–52), which drew a worldwide audience of millions, and conducted the first televised religious service (1940). In 1950 he was appointed national director of the Society for the Propagation of the Faith and consecrated a bishop; in 1951 he was named auxiliary to the archbishop of the New York diocese. His "Life Is Worth Living" television series (1952–57) reached 20 million viewers, followed by "The Bishop Sheen Program" (1961–68). In 1966 he was appointed bishop of Rochester, N.Y., and retired in 1969.

SHEFFIELD, DEVELLO ZELOTES (*b. Gainesville, N.Y., 1841; d. Peitaiho, North China, 1913*), Union soldier, Presbyterian clergyman. Missionary to China, *post* 1869, he was active in educational work and in the translation of the Bible into classical Chinese.

SHEFFIELD, JOSEPH EARL (*b. Southport, Conn., 1793; d. New Haven, Conn., 1882*), merchant, financier, philanthropist. Successful as a dry-goods and naval stores merchant in New Bern, N.C., and as a cotton exporter in Mobile, Ala., 1813–35, he entered the fields of canal and railroad finance, in which he was equally successful. He was a principal benefactor of the scientific department of Yale. Given separate status in 1854, it was renamed Sheffield Scientific School in his honor, 1861.

SHEIL, BERNARD JAMES (*b. Chicago, Ill., 1886; d. Tucson, Ariz., 1969*), Roman Catholic bishop. Attended St. Viator's College and Seminary; ordained in 1910. After serving at Chicago's Holy Name Cathedral, he was named curate at St. Mel's in that city. Joined the staff of the chancery office (1923) and rose rapidly in the administration of the Chicago archdiocese. In 1924 he was consecrated an auxiliary bishop and titular bishop of Pege and was named vicar general of the archdiocese in 1928. Became a leader in liberal Catholic social action and supported non-Communist labor organizers in the 1930's. Served as pastor of

St. Andrew's parish in Chicago, 1935–66; appointed titular archbishop of Selge (1959).

SHELBY, EVAN (*b. Tregaron, Wales, 1719; d. 1794*), frontier soldier, trader, landowner. Father of Isaac Shelby. Immigrating to America *ca.* 1734, he resided in Franklin Co., Pa., and, *post* 1739, in western Maryland. An officer of rangers in the French and Indian War, he was particularly distinguished in the Forbes campaign against Fort Duquesne, 1758. Removing to southwestern Virginia *ca.* 1773, he commanded the Fincastle Co. in Dunmore's War and at the close of the battle of Point Pleasant, October 1774, held the chief field command. Engaged against the Indians during the Revolution, he served later in the North Carolina legislature and was militia brigadier general of the Washington District of that state. He negotiated a truce with John Sevier in the troubles over the insurgent "State of Franklin," March 1787, and later declined the governorship of Franklin. Strong, blunt, fearless, and noted for truth-telling, he was prompt to act aggressively in any enterprise in which he engaged.

SHELBY, ISAAC (*b. near North Mountain, present Washington Co., Md., 1750; d. Kentucky, 1826*), soldier. Son of Evan Shelby. Removing to the Holston region of southwestern Virginia *ca.* 1773, he served under his father as a lieutenant in Dunmore's War, and in 1775 visited Kentucky as a surveyor for the Transylvania Co. During the Revolution he acted as commissary of supplies for militia detailed to frontier posts and also for the Continental army in its western field operations. A member of the Virginia legislature, colonel of the militia of Sullivan Co., N.C., and activist in patenting Kentucky lands, he joined Charles McDowell in operations against Tory forces in the South Carolina backcountry, 1780. He played a prominent part at King's Mountain and at Cowpens. After further military activity in 1781 and subsequent service in the North Carolina legislature, he removed to Kentucky, 1783, where he took part in achieving independence and statehood and was in 1792 a member of the convention which drafted the first Kentucky constitution. As first governor of Kentucky, 1792–96, he guided the state through a difficult formative period, holding it fast to the Union, despite contrary schemes and conspiracies. Retiring to private life, he emerged as governor again in 1812 and prosecuted vigorously the war against Great Britain. He led in person the Kentucky volunteers in W. H. Harrison's invasion of Canada, which resulted in British defeat at the battle of the Thames, October 1813. Offered the secretaryship of war by President Monroe in March 1817, he declined because of age. A man of great physical hardiness, Shelby was also an able executive and a wise judge and handler of men.

SHELBY, JOSEPH ORVILLE (*b. Lexington, Ky., 1830; d. Adrian, Mo., 1897*), Confederate soldier. Settled in Missouri, 1852, where he engaged in business. Commissioned a Confederate captain, 1861, he rose to the rank of brigadier general in the course of the Civil War, mainly operating as a cavalry leader in Arkansas and Missouri under General Sterling Price. Renowned for personal courage and mastery of cavalry tactics, he led his men into Mexico, July 1865, where their offer to assist Maximilian was rejected. He later returned to Missouri.

SHELDON, CHARLES MONROE (*b. Wellsville, N.Y., 1857; d. Topeka, Kans., 1946*), Congregational clergyman, author. Graduated Brown University, 1883; B.D., Andover Theological Seminary, 1886. Principal ministry at Central Congregational Church, Topeka, Kans., 1889–1919. Author of many inspirational works and editor in chief of the *Christian Herald*, 1920–25, he is remembered as the writer of *In His Steps* (1897), a novel that ranks among the all-time best-sellers.

SHELDON, EDWARD AUSTIN (*b. near Perry Center, N.Y., 1823; d. 1897*), educator, school superintendent in Oswego and Syracuse, N.Y. An advocate of free public schools, Sheldon was responsible for opening the Oswego Primary Teachers' Training School, the first city school of its kind in the United States, May 1861. He served it most successfully as principal, 1862–97.

SHELDON, EDWARD STEVENS (*b. Waterville, Maine, 1851; d. Cambridge, Mass., 1925*), philologist, lexicographer. Brother of Henry N. Sheldon. A specialist in Romance philology, in which he held a chair at Harvard, 1894–1921.

SHELDON, HENRY NEWTON (*b. Waterville, Maine, 1843; d. 1926*), jurist. Brother of Edward S. Sheldon. Judge of Massachusetts Superior Court, 1894–1905; of Massachusetts Supreme Judicial Court, 1905–15. Noted for legal scholarship and good judgment.

SHELDON, MARY DOWNING *See* BARNES, MARY DOWNING SHELDON.

SHELDON, WALTER LORENZO (*b. West Rutland, Vt., 1858; d. 1907*), Ethical Culture leader in St. Louis, Mo., *post* 1886.

SHELDON, WILLIAM EVARTS (*b. Dorset, Vt., 1832; d. 1900*), educator, leader in progressive educational movements. Principal of several public high schools in Massachusetts, Sheldon was president of the National Education Association, 1887.

SHELDON, WILLIAM HERBERT (*b. Warwick, R.I., 1898; d. Cambridge, Mass., 1977*), psychologist. Graduated Brown University (B.A., 1918), University of Colorado (M.A., 1923), and University of Chicago (Ph.D., 1926; M.D., 1933). He was director of the constitution clinic at Columbia University College of Physicians and Surgeons (1946–58); in 1951–55 was a director of research, Biological Humanics Foundation in Cambridge, Mass., and clinical professor of medicine and director of constitution clinic at University of Oregon Medical School; and in 1955 became a research associate at the Institute of Human Development at University of California at Berkeley. His book *The Varieties of Human Physique* (1940) discusses the classification system he developed that correlated constitutional types (endomorph, mesomorph, ectomorph) and personality characteristics.

SHELEKHOV, GRIGORIĬ IVANOVICH (*b. Rylsk, Russia, 1747; d. Irkutsk, Siberia, 1795*), Russian merchant, fur trader. Father-in-law of N. P. Rezanov. Founded first Russian colony in America, on Kodiak Island, 1784; helped establish Russian dominion over Alaska.

SHELLABARGER, SAMUEL (*b. Washington, D.C., 1888; d. Princeton, N.J., 1954*), novelist, biographer, and educator. Studied at Princeton (B.A., 1909) and Harvard (Ph.D., 1917). Taught at Princeton (1919–23; 1927–29). Essentially a Victorian novelist, Shellabarger's early works were critically successful, but failed commercially. He wrote several mysteries under the pseudonym John Esteven. From 1938 to 1946, he was the headmaster of the Columbus (Ohio) School for Girls. While there, he published more novels under the name Peter Loring. Best remembered for the best-selling novels *Captain from Castile* (1945), *Prince of Foxes* (1947), *The King's Cavalier* (1950), and *Lord Vanity* (1953).

SHELTON, ALBERT LEROY (*b. Indianapolis, Ind., 1875; d. near Batang, China, 1922*), Disciples of Christ clergyman. Medical missionary in western China and Tibet, 1903–22.

SHELTON, EDWARD MASON (*b. Huntingdonshire, England, 1846; d. Seattle, Wash., 1928*), agriculturist. Came to America as a boy. Graduated Michigan Agricultural College, 1871. Professor of agriculture, Kansas State Agricultural College, 1874–90; government agricultural adviser in Australia, 1890–99; thereafter practiced horticulture in the state of Washington.

SHELTON, FREDERICK WILLIAM (*b. Jamaica, N.Y., 1815; d. 1881*), Episcopal clergyman. A rector for many years in New York State and Vermont, Shelton was author of, among other books, *The Trollopiad* (1837), a satire in verse, and of a number of sketches in the style of Washington Irving which he contributed to the *Knickerbocker* magazine, 1838–45.

SHEPARD, CHARLES UPHAM (*b. Little Compton, R.I., 1804; d. 1886*), mineralogist. Lecturer in science at Yale, South Carolina Medical College, and Amherst. His important collection of minerals and meteorites was acquired by Amherst.

SHEPARD, EDWARD MORSE (*b. New York, N.Y., 1850; d. Lake George, N.Y., 1911*), lawyer, political reformer. Ward of Abram S. Hewitt. Graduated College of the City of New York, 1869. Outstanding as counsel to the New York Rapid Transit Commission and to the Pennsylvania Railroad, Shepard devoted much of his time to reform of the New York Democratic organization from within, to the advocacy of civil service reform, and to the improvement of City College.

SHEPARD, FRED DOUGLAS (*b. Ellenburg, N.Y., 1855; d. Turkey, 1915*), physician, medical missionary to Turkey *post* 1882. An outstanding teacher and practitioner of medicine, Shepard died while combating an epidemic of typhus at Aintab.

SHEPARD, JAMES EDWARD (*b. Raleigh, N.C., 1875; d. Durham, N.C., 1947*), educator. Graduated in pharmacy, Shaw University, 1894. Engaged in various business and civic activities before service as field superintendent, International Sunday School Association, 1905–10. In 1910 he founded the National Religious Training School and Chautauqua to provide short, adult education courses for black ministers and teachers. This school, which he served as president until his death, was successively accredited as a state normal school, 1923, as the first state-supported liberal arts college for blacks, 1925, and is presently North Carolina Central University.

SHEPARD, JAMES HENRY (*b. Lyons, Mich., 1850; d. St. Petersburg, Fla., 1918*), chemist. B.S., University of Michigan, 1875, where he also did graduate work. Taught at South Dakota State College of Agriculture and was also director of its experiment station; won international reputation for researches on bleached flour and food adulterants.

SHEPARD, JESSE *See* GRIERSON, FRANCIS.

SHEPARD, SETH (*b. Brenham, Tex., 1847; d. 1917*), jurist. Long active in Texas Democratic politics, he was appointed justice of the court of appeals of the District of Columbia, 1893, and served until 1917; he was chief justice *post* 1905.

SHEPARD, THOMAS (*b. Towcester, England, 1605; d. Cambridge, Mass., 1649*), New England theologian. A graduate of Emmanuel College, Cambridge, England, Shepard was silenced for nonconformity by Archbishop Laud, 1630. Removing to Boston, Mass., October 1635, he became pastor at Newtown (Cambridge). An orthodox Calvinist, he was active in the 1637 condemnation of the Antinomians; he defined Congregationalism as a middle ground between Brownism and Presbyterian polity. Concerned with education, he proposed a plan for the support

of poor students; he also projected a plan of church government which was finally realized in the synod of 1647. A tireless preacher and writer, he was author of a number of tracts and books, including *These Sabbaticae* (1649) and the very popular *The Sincere Convert* (1641). His diary was first published in *Three Valuable Pieces* (1747) and issued as his *Autobiography* in 1832.

SHEPARD, WILLIAM (*b. Westfield, Mass., 1737; d. Westfield, 1817*), Revolutionary officer. Colonel of the 3rd Continental Infantry, he distinguished himself at the battle of Pell's Point, 1776. As major general of Massachusetts militia, 1786–87, he played an important part in the defense of Springfield against the insurgents during Shays's Rebellion. He served as congressman, Federalist, from Massachusetts, 1797–1803.

SHEPHERD, ALEXANDER ROBEY (*b. Washington, D.C., 1835, d. Batopilas, Mexico, 1902*), builder, politician, mine owner. As "boss" of District of Columbia and its territorial governor, 1873–74, he was largely responsible for the improvement of the capital city, although his financial recklessness and unscrupulous methods led to a congressional investigation and a change in the District's type of government.

SHEPHERD, WILLIAM ROBERT (*b. Charleston, S.C., 1871; d. Berlin, Germany, 1934*), historian. Graduated Columbia, 1893; Ph.D., 1896. Taught at Columbia all his life, becoming Seth Low professor of history, 1926. An expert in Latin American history and affairs, he was author of, among other books, *Historical Atlas* (1911) and *Atlas of Medieval and Modern History* (1932).

SHEPLEY, ETHER (*b. Groton, Mass., 1789; d. 1877*), Maine lawyer and jurist. U.S. senator, Democrat, from Maine, 1833–36, Shepley was a vigorous supporter of Andrew Jackson. Appointed judge of the Maine Supreme Court, 1836, he became chief justice, 1848, and retired at the close of 1855.

SHEPLEY, GEORGE FOSTER (*b. Saco, Maine, 1819; d. 1878*), lawyer. Son of Ether Shepley. Practiced in Bangor and Portland, Maine; was U.S. attorney for Maine, 1848–49 and 1853–61. Colonel commanding the 12th Maine Volunteers, Shepley became military commandant at New Orleans, La., May 1862, and in the next month was promoted brigadier general and made governor of Louisiana. An associate of Benjamin F. Butler (1818–93), he shares with him the responsibility for whatever dishonesty there may have been in the army administration of New Orleans. Assigned to command in eastern Virginia, May 1864, he became military governor of Richmond after the fall of that city. *post* 1869, he was circuit judge of the U.S. court in Maine.

SHEPPARD, JOHN MORRIS (*b. near Wheatville, Tex., 1875; d. Washington, D.C., 1941*), lawyer, politician. B.A., University of Texas, 1895; LL.B., 1897; Master of Laws, Yale, 1898. Elected to fill his father's unexpired term as a member of Congress, 1902, he was a progressive Democrat in matters of policy and an able critic of the Republican party. Chosen to succeed J. W. Bailey in the U.S. Senate, 1913, he served until his death. Although he was an ardent supporter of President Woodrow Wilson's liberal program, he became best known as the author of the 18th (Prohibition) Amendment, which he continued to advocate after its repeal. He was Senate sponsor of the 1921 Sheppard-Towner Act, providing federal aid for maternal and infant health care, and a consistent favorer of help for farmers during the 1920's. A backer of most New Deal legislation, he himself sponsored the Federal Credit Union Act of 1934. He was the active and effective chairman of the Senate Committee on Military Affairs at the time of his death.

SHEPPARD, SAMUEL EDWARD (*b. Hither Green, Kent, England, 1882; d. Rochester, N.Y., 1948*), chemist. B.Sc., University College, London, 1903; D.Sc., 1906. Worked with Charles E. K. Mees in research in photographic processes; was coauthor with Mees of *Investigations on the Theory of the Photographic Process* (1907). With the aid of an 1851 Exhibition Scholarship, Sheppard continued his research in photochemistry at Marburg University in Germany and at the Sorbonne in Paris. At both institutions he studied the sensitizing action of dyes. He was the first to apply spectrophotometry to differentiating true and colloidal solutions. In 1910 he joined the photographic manufacturing firm of Wratten and Wainwright in Croydon, Surrey. Two years later he entered the School of Agriculture at Cambridge University in pursuit of an earlier interest in agricultural chemistry. The following year Sheppard joined the new Kodak Research Laboratory at Rochester, N.Y., as a colloid and physical chemist. He was to remain with the Kodak Laboratory until his retirement in 1948.

Sheppard's work can be grouped into nonphotographic and photographic categories. In the former, one of his notable contributions was the development of colloidal fuels during World War I. In 1921 he turned his attention to the electroplating of rubber and rubber compounds; his patents and processes were consolidated with those of others in the American Anode Co. Sheppard also developed concepts on the relationship between chemical constitution and colloidal behavior. In the photographic field he was responsible for elucidating the theory of the photographic process. In his first five years at the Kodak Laboratory, he was mainly concerned with the physicochemical properties of gelatin, the medium that contains the sensitive materials in photography. His research on the factors determining photographic sensitivity in silver halide–gelatin "emulsions" won him immediate recognition. Sheppard's later research dealt with a wide range of matters, including photovoltaic effects (the electrical response of silver halide to light), the physicochemical properties of film supports, the nature of development and of dye sensitizing, and absorption of dyes to crystals and their absorption spectra in relation to the resonance structure of the dyes. Alone or with coauthors he published nearly 200 scientific papers and nine books, beginning with *Photo-Chemistry* (1914), and took out more than 60 patents.

SHERIDAN, PHILIP HENRY (*b. Albany, N.Y., 1831; d. Nonquitt, Mass., 1888*), Union soldier. Raised in Somerset, Ohio, Sheridan graduated from West Point with the class of 1853. Assigned to the infantry, he served on frontier duty along the Rio Grande and in the Northwest. Promoted captain, he began Civil War service in the quartermaster department and was on H. W. Halleck's staff. Appointed colonel of the 2nd Michigan Cavalry, May 1862, he was raised to brigadier general in a little over a month for his victory at Booneville, Mo. His subsequent career was brilliant. Commanding infantry, he was successful at Perryville; at Stone River he practically saved the army of Rosecrans, for which he was made major general of volunteers, December 1862. Distinguished also at Chickamauga and at Missionary Ridge, he rose to high favor with U. S. Grant, who gave Sheridan command of all the cavalry of the Army of the Potomac. His brilliant and decisive raids on Confederate communications around Richmond in May 1864 caused great alarm and apprehension in the Confederate capital. In August, as commander of the Army of the Shenandoah, he effectively carried out Grant's orders to destroy all supplies in the valley. His army was surprised and almost routed at Cedar Creek on Oct. 9, while he was 20 miles away at Winchester, but he made his famous ride to the battlefield in time to rally his troops and to snatch victory from defeat. He was promoted to major general in the regular service, November 1864. Early in 1865 he severed Lee's communications with the

South, turned the flank of the Confederate army, and forced Lee to begin the retreat to Appomattox. In the final operations of the war, Sheridan's troops cut off Lee from any further withdrawal and the Confederate surrender followed.

Sheridan administered the military division of the Gulf *post* 1865, and in 1867 was appointed military governor of Louisiana and Texas. His severely repressive measures in the interests of Reconstruction, though supported by Grant, incurred the disapproval of President Andrew Johnson. Transferred to the department of the Missouri, Sheridan compelled the hostile Plains Indians to settle upon their reservations. Promoted lieutenant general, March 1869, he commanded the division of the Missouri; in 1870–71 he visited the German armies during the Franco-Prussian War. Succeeding W. T. Sherman as commander in chief of the army, 1884, he received the highest military rank, that of general, on June 1, 1888. A few days before his death, he completed his *Personal Memoirs* (1888). Sheridan was a short man of unprepossessing bearing, but endowed with a magnetic personality and a sincere concern for the welfare of his troops. Cool and self-possessed in battle, he was a dashing and brilliant leader of men, who acted according to two rules: to take the offensive whenever possible, and to wring the last possible advantage from a defeated army.

SHERMAN, ALLAN (*b.Allan Copelon, Chicago, Ill., 1924; d. Los Angeles, Calif., 1973*), singer and comedy writer. Attended University of Illinois (1941–44), moved to New York City (1945), and was a gag writer for radio and television shows; in 1951 he helped launch the top-rated game show "I've Got a Secret." In 1962 he recorded the highly successful folk parody album *My Son, the Folksinger*, which poked fun at his Jewish ethnicity with such songs as "Seltzer Boy." In 1963 he released the million-selling single "Hello Muddah, Hello Faddah."

SHERMAN, FORREST PERCIVAL (*b. Merrimack, N.H., 1896; d. Naples, Italy, 1951*), naval officer. Graduated from the U.S. Naval Academy, 1917. A naval aviator, Sherman became captain of the carrier *Wasp* in 1942; the ship was sunk by the Japanese in the Pacific in 1942. Sherman then became chief of staff to Admiral John Towers in 1942; in 1943, head of the staff for the War Plans Division for Admiral Nimitz, commander in chief of the Pacific Fleet. As such, Sherman had "perhaps more influence on the strategy of [the Pacific] theater and its overall direction than any other air admiral." After the war, he commanded the Sixth Task Fleet in the Mediterranean. In 1949, he became chief of naval operations with the rank of full admiral.

SHERMAN, FRANK DEMPSTER (*b. Peekskill, N.Y., 1860; d. New York, N.Y., 1916*), poet, architect, mathematician, genealogist.

SHERMAN, FREDERICK CARL (*b. Port Huron, Mich., 1888; d. San Diego, Calif., 1957*), naval officer. Studied at the U.S. Naval Academy; commissioned in 1912. Through World War I Sherman had submarine and destroyer assignments. In 1936 he became a naval aviator. At the outbreak of World War II he was commander of the carrier *Lexington*, which saw battle at Rabaul, New Guinea, and the Battle of the Coral Sea in 1942. As commander of the Carrier Division 2 on board the *Enterprise*, Sherman saw action in the Solomon Islands; as commander of Division I, he saw action in the battles of Leyte Gulf, the Philippines, Iwo Jima, and Okinawa. He retired from the navy in 1947 with the rank of full admiral. Considered one of the ablest of commanders in World War II, Sherman contributed greatly to the concept of naval air tactics.

SHERMAN, HENRY CLAPP (*b. Ash Grove, Va., 1875; d. Rensselaer, N.Y., 1955*), food chemist. Studied at Maryland Agricul-

tural College and at Columbia University (Ph.D., 1897). Taught at Columbia from 1899 to 1946. His research concerned the properties, activities, and purification of the digestive enzymes; the efficiency of proteins in the human diet; the protein requirements of man; the vitamin requirements of man; and man's need for calcium. His work on Vitamin D brought discovery of ways to induce and control rickets. President of the American Institute of Nutrition (1931–33, 1943–44); president of the American Society of Biological Chemists (1926). Wrote *Chemistry of Food and Nutrition* in 1911.

SHERMAN, JAMES SCHOOLCRAFT (*b. Utica, N.Y., 1855; d. 1912*), lawyer, businessman, politician, vice president of the United States. Congressman, Republican, from New York, 1887–91 and 1893–1909. A "regular," Sherman was not identified with important measures, preferring to give his time to parliamentary management, in which he was gifted. He was regarded as second only to Thomas B. Reed as presiding officer in the House. He served as U.S. vice president, 1909–12.

SHERMAN, JOHN (*b. Dedham, England, 1613; d. 1685*), Puritan clergyman, mathematician. Immigrated to Massachusetts Bay, 1634. Renowned as a preacher, he ministered at Watertown, Mass., and at Wethersfield and other Connecticut settlements. Appointed pastor at Watertown, 1647, he remained in that post for the rest of his life. He was an occasional lecturer on mathematics at Harvard and held many honorary positions at the college.

SHERMAN, JOHN (*b. Lancaster, Ohio, 1823; d. 1900*), statesman. Brother of William T. Sherman. Admitted to the bar, 1844, Sherman entered politics as a Whig and later became a hard-driving, effective worker for the rising Republican party. Elected to Congress from Ohio, 1854, he served in the House until 1861 when he became U.S. senator. Leaving the Senate in 1877, he was U.S. secretary of the treasury until 1881, when he regained his Senate seat and occupied it until 1897.

Sherman's moderate utterances on slavery and his party loyalty in Congress aided his rise to the chairmanship of the House Ways and Means Committee, 1859. As a senator, he served with realistic ability on the Finance Committee, becoming its chairman in 1867. Balked in his natural caution and conservatism by wartime necessity, he helped to give greenbacks the status of legal tender, but led in planning the national banking system, 1863, and advocated unsuccessfully a program of economy and rigorous taxation. Although favoring personally a moderate Reconstruction policy, his substitute for Thad Stevens' drastic military Reconstruction plan was hardly less rigorous. He voted for most of the Radical program, and although expressing sympathy for President Johnson, he voted to convict him. After the war, he dominated national financial policy. Privately opposed to the strong tide of inflationist sentiment, he was swayed by it. Thus, while seeing in the cancellation of greenbacks the most direct route to specie resumption, he opposed McCulloch's currency contraction policies of 1886–68. He believed that resumption was necessary to safeguard the national credit, but felt that it must be undertaken when political conditions permitted. His work on the Funding Act of 1870 reduced the burden of public interest and helped restore national credit. In 1873 he was largely responsible for the mint-reform bill which ended the coinage of silver dollars and was denounced as the chief agent of the "Crime of '73." Two years later he yielded his own excellent resumption plan for funding greenbacks in favor of the substitute scheme of George F. Edmunds.

Sherman's preeminence in financial matters caused President Hayes to appoint him secretary of the treasury in 1877. Ignoring the inflationist outcry, he strengthened the resumption act by

declaring that he was empowered to issue bonds after, as well as before, resumption. He also convinced the bankers that the government would redeem its bonds in gold, thereby enhancing national prestige. The political difficulties of Hayes's administration, a depression, and the clamor for "free silver," all made it hard for him to attain his main purposes—the resumption of specie payments and the funding of the public debt. Humiliated by a congressional resolution declaring government bonds payable in silver, he was able to take advantage of divisions among the inflationists to defeat their extreme objectives. The Bland-Allison Act of 1878 stipulated only the limited coinage of silver, rather than free coinage. Encouraged by some favorable developments in trade, Sherman made his final preparations carefully, so that by Jan. 2, 1879, specie payments were smoothly resumed. As the end of his cabinet service approached, the United States stood firmly on the gold standard and the resumption policy was an admitted success.

In 1880, 1884, and 1888 Sherman sought the Republican presidential nomination, but his lack of popular appeal and strong inflationist opposition militated against him. During his second period of service in the Senate, his most significant contributions were his share in the Antitrust and Silver Purchase acts of 1890. Appointed U.S. secretary of state, 1897, he defended his antiexpansionist views when the cabinet decided for war with Spain, and resigned in protest. Prior to his resignation, he betrayed a growing loss of memory which incapacitated him for much beyond routine operations.

Economically, Sherman's point of view was that of the conservative creditor; politically, he understood very well the radical debtor psychology of his constituents. He carefully studied the attitudes of the Middle West and helped to stamp national legislation with the influence of that section.

SHERMAN, ROGER (*b. Newton, Mass., 1721 o.s.; d. 1793*), lawyer, merchant, Connecticut colonial legislator and jurist, statesman. Settled in New Milford, Conn., 1743; resided in New Haven, *post* 1761. Serving, in addition to his many other public offices, as judge of the superior court of Connecticut, 1766–89, Sherman belonged to the conservative wing of the Revolutionary party; he was, however one of the first to deny the supremacy of Parliament in American affairs. Active in committee work in the Continental Congress, 1774–81 and 1783–84, he was a member of the committee appointed to draft the Declaration of Independence (which he signed) and of the committee on the Articles of Confederation. Described by John Adams as "an old Puritan, as honest as an angel and as firm in the cause of American Independence as Mount Atlas," Sherman fought attempts to weaken government credit by fiat currency or excessive loans and urged frequent levying of high taxes by Congress and by the states. Perhaps the most influential figure in Congress toward the end of the Revolution, he was hopeful that the Confederation might be strengthened and entered the Constitutional Convention, 1787, still disposed to patch up the old scheme of government. Soon aware of the need for creating a new system, he introduced the "Connecticut Compromise" in June 1787; he also favored an executive dominated by the legislature and made a stand for election of congressmen and senators by the state legislatures. A signer of the Constitution, he took a prominent part in the campaign for its ratification and contributed letters in support of it to the *New Haven Gazette* under the pseudonym "A Countryman," November and December 1787. Elected to Congress, 1789, he opposed amendments to the Constitution, urged use of western lands to extinguish the national debt, favored sale of public lands to settlers rather than speculators, and voted for Hamilton's measure for assumption. He served as U.S. senator from Connecticut, 1791–93. Illustrating at its best the Puritan combination of piety and a desire to succeed in practical

affairs, he was honored by contemporaries for his ability and integrity, although his personal awkwardness and rusticity of manner were also remarked.

SHERMAN, STUART PRATT (*b. Anita, Iowa, 1881; d. near Dunewood, on Lake Michigan, 1926*), literary critic, educator. Graduated Williams, 1903; took Ph.D. at Harvard, 1906, where he was influenced by Irving Babbitt. Taught English at Northwestern University; headed Department of English at University of Illinois, which he made one of the strongest in the Middle West. A frequent contributor to the *Nation*, 1908–18, he was in critical sympathy with its editor, Paul Elmer More. Author of *Matthew Arnold: How to Know Him* (1917), he applied Arnold's principles to the chief contemporary writers in his *On Contemporary Literature* (1917). In his belief that contemporary American writers had gone astray through failure to understand the national ideal, he became a standard-bearer of tradition against the modernist Crocean critics of the early 1920's, but later shifted his position to a greater sympathy with his opponents. *post* 1924, he was editor of the literary supplement of the *New York Herald Tribune*. Among his later books were *Americans* (1922), *Points of View* (1924), and *Critical Woodcuts* (1926).

SHERMAN, THOMAS WEST (*b. Newport, R.I., 1813; d. Newport, 1879*), soldier. Graduated West Point, 1836. Assigned to the artillery, he served in the campaigns against the Florida Indians and rendered conspicuous service as a battery commander in the Mexican War. After frontier duty largely in Minnesota and Kansas, he held brigade and division command during the Civil War in the Union army, distinguishing himself particularly in command of land forces at the taking of Port Royal, S.C., and Fernandina, Fla., 1861; also in the expedition against Port Hudson, La., May 1863. He retired as major general, 1871.

SHERMAN, WILLIAM TECUMSEH (*b. Lancaster, Ohio, 1820; d. New York, N.Y., 1891*), Union soldier. Brother of John Sherman (1823–1900). Losing his father as a young boy, Sherman was raised in the family of Thomas Ewing (1789–1871). On graduation from West Point, 1840, he was assigned to the artillery. He spent his leisure time in the study of law and in travel in the South. He saw little active service during the Mexican War, in which he was employed mainly as adjutant to Philip Kearny, Richard B. Mason, and Persifor F. Smith. In May 1850, he married Ellen Ewing, daughter of his guardian. Resigning his army commission, 1853, he was unsuccessful in a banking venture and as a lawyer in Leavenworth, Kans., but was very successful as superintendent of a military college at Alexandria, La., 1859–61.

Regarding, as he did, the Union and the Constitution with almost religious fervor, he also loved the South and its people; he considered it a duty to end the contest between the North and South as quickly and ruthlessly as possible, with the proviso that the peace terms be as lenient as the war was stern. Appointed colonel of the 13th Infantry, May 1861, he was assigned to brigade command in July and shared in the disaster of first Bull Run. Transferred to Kentucky as brigadier general of volunteers, he took on the thankless job of trying to hold that state in the Union with little more than raw home guards to work with. Anxiety preyed upon his mind, he overestimated the difficulties of his position, and his quarrels with the press over breaches of security encouraged newspapermen to report that Sherman's mind was giving way. Superseded, he was received at headquarters with suspicion and coldness. Joining U. S. Grant's army with a division of volunteers, he took prominent part in the battle of Shiloh and the advance to Corinth and was promoted major general of volunteers, May 1862. In July, Grant sent Sherman to Memphis, Tenn., where Sherman suppressed guerrillas, put civil authority on a firm basis, and made a push at Vicksburg, Miss.,

which was rendered hopeless when Grant's communications were cut and he had to withdraw from his part in the operation. Grant reorganized his forces and, with Sherman commanding the XV Corps, carried through the amphibious campaign which resulted in the surrender of Vicksburg on July 4, 1863.

On Grant's subsequent advance to supreme command in the West, Sherman was given command of the Army of the Tennessee. He participated in the relief of Chattanooga and Knoxville and destroyed the Confederate base at Meridian, Miss., in January 1864. Sherman succeeded to supreme command in the West after Grant's promotion to commander in chief of all the armies. By the combined plan of 1864, General George Meade was to advance against General R. E. Lee and Richmond, while Sherman advanced early in May against General J. E. Johnston and Atlanta. Concentrating about 100,000 men at Chattanooga, Sherman forced Johnston back to the Allatoona Pass–Kenesaw Mountain line, and then back to Peachtree Creek, by several flanking maneuvers. He swung around Atlanta and opened a siege, cutting the railroads to Montgomery and Macon. On Sept. 1, General Hood, who had replaced Johnston, evacuated Atlanta. Sherman, who had been promoted to major general in the regular army, ordered the removal of the civilian population from the city. With Grant's approval, he began the famous "march to the sea" through Georgia on Nov. 15. His purpose was to break the resistance of the South by cutting off the supply of its armies, for Georgia was the only untouched source of supply. His army lived off the country, destroying war supplies, public buildings, railroads, and manufacturing shops. By bringing the war home to the civilian population, Sherman believed that it could be terminated quickly; for his deliberate exploitation of this principle he has been called the first modern general. His activities made him the center of a bitter controversy, but he urged that it was better to destroy goods rather than life, that wanton destruction was prevented insofar as possible, and that there was no serious personal violence to noncombatants. It is obvious, however, that discipline in his army was not strict enough. After occupying Savannah on Dec. 21, 1864, he marched northward through the Carolinas, causing even more destruction than in Georgia. He occupied Columbia, S.C., and burned it, forced the evacuation of Charleston and then moved on Raleigh, N.C. Eight days after Lee's surrender on Apr. 9, 1865, General J. E. Johnston, Confederate commander in the Carolinas, surrendered to Sherman. The terms granted were liberal, but the Washington government, enraged by the assassination of Lincoln, repudiated them.

After the war Sherman commanded the Division of the Mississippi, aiding the construction of the transcontinental railway and controlling Indian hostility. In 1866 he was promoted to lieutenant general and was sent on a diplomatic mission to President Juarez of Mexico, as part of the pressure exerted on France for withdrawal of support to Maximilian. Three years later Sherman became general commanding the army and held the position until his retirement in 1883. He rejected repeated attempts to draw him into politics, especially in the Republican convention of 1884, when his positive veto prohibited a move for his nomination for the presidency. His *Memoirs* were first published in 1875.

SHERRY, LOUIS (*b. probably St. Albans, Vt., 1856; d. 1926*), restaurateur. Opened his first restaurant and confectionery at 38th St. and Sixth Ave., New York City, 1881. Removing to two successive locations on Fifth Ave. and Park Ave., he was highly successful as host and caterer to the wealthy.

SHERWIN, THOMAS (*b. Westmoreland, N.H., 1799; d. 1869*), educator. Graduated Harvard, 1825. As principal of the English High School, Boston, Mass., 1837–69, Sherwin made it the lead-

ing educational institution of its grade in the United States; he was active also in the establishment of the Massachusetts Institute of Technology.

SHERWOOD, ADIEL (*b. Fort Edward, N.Y., 1791; d. St. Louis, Mo., 1879*), Baptist clergyman, educator. Graduated Union, 1817. Removing to Georgia, 1818, he was active in the ministry there and as a teacher in several institutions; he was president of Shurtleff College, 1841–46, and later of Masonic and Marshall colleges.

SHERWOOD, ISAAC RUTH (*b. Stanford, N.Y., 1835; d. 1925*), journalist, Union soldier. Editor of a number of Ohio newspapers at various times, Sherwood served as congressman, Republican, from Ohio, 1873–75, but was refused renomination because of his greenback sympathies. As congressman, Democrat, from Ohio, 1907–21 and 1923–25, he was an aggressive advocate of veterans' pensions and an opponent of U.S. entry into World War I.

SHERWOOD, KATHARINE MARGARET BROWNLEE (*b. Poland, Ohio, 1841; d. 1914*), journalist, reformer. Wife of Isaac R. Sherwood.

SHERWOOD, MARY ELIZABETH WILSON (*b. Keene, N.H., 1826; d. New York, N.Y., 1903*), author. A prolific contributor to newspapers and periodicals and the writer of a number of books, Sherwood was principally renowned for her manuals of social life and etiquette, which were as popular as they were conservative.

SHERWOOD, ROBERT EMMET (*b. New Rochelle, N.Y., 1896; d. New York, N.Y., 1955*), writer and government official. Studied at Harvard University. Wrote book reviews for *Scribner's Magazine* and movie reviews for *Life*; wrote several screenplays and plays including *Idiot's Delight* (1936), *Abe Lincoln in Illinois* (1938), and *There Shall Be No Night* (1940) — all of which won the Pulitzer Prize. He wrote the screenplay, *The Best Years Of Our Lives* in 1946; the film won nine Academy Awards. In 1948 he published his book *Roosevelt and Hopkins: An Intimate History*, which also won the Pulitzer Prize. Sherwood wrote presidential addresses for President Roosevelt and served as director of the Overseas Branch of the Office of War Information from 1942 to 1944.

SHERWOOD, THOMAS ADIEL (*b. Eatonton, Ga., 1834; d. California, 1918*), jurist. Son of Adiel Sherwood. Judge of the Missouri Supreme Court, 1872–1902, was a strict constructionist and opponent of federal encroachment on state powers, but also an earnest defender of civil liberty and a proponent of both administrative and procedural judicial reform.

SHERWOOD, WILLIAM HALL (*b. Lyons, N.Y., 1854; d. Chicago, Ill., 1911*), pianist, teacher, composer. A pupil of William Mason (1829–1908) and others in America, he studied also with distinguished masters in Europe, including Franz Liszt. One of the first Americans to play with great European orchestras, he devoted himself to teaching and to concert work in America *post* 1876. He founded the Sherwood Music School in Chicago.

SHICK CALAMYS See SHIKELLAMY.

SHIELDS, CHARLES WOODRUFF (*b. New Albany, Ind., 1825; d. Newport, R.I., 1904*), Presbyterian and Episcopal clergyman, educator. Graduated College of New Jersey (Princeton), 1844; Princeton Theological Seminary, 1847. A professor of philosophy and history for many years at Princeton, Shields devoted his life to the reconciliation of science with religion and to the reunion of Protestantism.

SHIELDS, FRANCIS XAVIER ("FRANK") (*b. New York, N.Y., 1909; d. New York, N.Y., 1975*), tennis player. A national junior champion (1927–28), he joined the men's tennis circuit and was ranked in the U.S. top ten eight times, achieving number-one status in 1933, when he won nine tournaments. He ceased full-time playing in 1934; in 1951 he was the nonplaying captain of the U.S. Davis Cup team. Enshrined in the International Tennis Hall of Fame (1964).

SHIELDS, GEORGE HOWELL (*b. Bardstown, Ky., 1842; d. St. Louis, Mo., 1924*), Missouri Republican politician and jurist.

SHIELDS, GEORGE OLIVER (*b. Batavia, Ohio, 1846; d. New York, N.Y., 1925*), journalist, author, pioneer in the conservation of wildlife.

SHIELDS, JAMES (*b. Altmore, Ireland, 1806; d. Ottumwa, Iowa, 1879*), soldier, politician. Immigrated to America *ca.* 1826; settled in Kaskaskia, Ill., where he studied and practiced law. As an Illinois legislator and state auditor, he helped correct that state's chaotic finances; he was judge of the Illinois Supreme Court, 1843–45. After brief service as commissioner of the U.S. General Land Office, he volunteered for the Mexican War and won a brevet of major general for gallantry in action. Resigning an appointment as governor of Oregon Territory, he served as U.S. senator, Democrat, from Illinois, 1849–55. Removing to Minnesota Territory, he did much to stimulate Irish settlement there and was U.S. senator from Minnesota, 1858–59. Removing to California and then to Mexico, he returned to the United States on the outbreak of the Civil War and was appointed brigadier general of volunteers, August 1861. Winning credit for his leadership at Kernstown and Port Republic, he resigned his commission, March 1863, and became a California railroad commissioner. Reentering politics in Missouri, 1866, he served in the legislature and as a railroad commissioner and finally as U.S. senator, Democrat, from Missouri, January–March 1879.

SHIELDS, JOHN KNIGHT (*b. near Bean's Station, Tenn., 1858; d. near Bean's Station, 1934*), Tennessee jurist. An irreconcilable isolationist and conservative as U.S. senator, Independent Democrat-Republican, 1913–25.

SHIELDS, THOMAS EDWARD (*b. near Mendota, Minn., 1862; d. 1921*), Roman Catholic clergyman, educator. Slow to develop mentally, Shields was ordained, 1891, after a rigorous course in self-education and graduation from St. Thomas Seminary; he received a Ph.D. in biology from Johns Hopkins, 1895. After teaching and pastoral work in St. Paul, Minn., he became an instructor at Catholic University, Washington, D.C., 1902, and was raised to professor of education and psychology, 1909. Constantly crusading against stereotypes in religious and general education, he was author of a number of books and founder of the *Catholic Educational Review*, which he edited *post* 1911. He was founder also of the Sisters College as an affiliated school of the university, 1911, and an innovator in providing summer courses for teaching sisters.

SHIKELLAMY (*b. Shamokin, Pa., 1748*), Oneida chief. Father of James Logan (*ca.* 1725–80). A sympathetic intermediary between the frontier whites and the Iroquois, he was influential in negotiating the treaties of 1736 and 1744 which greatly favored the Iroquois at the expense of the Delaware and Shawnee.

SHILLABER, BENJAMIN PENHALLOW (*b. Portsmouth, N.H., 1814; d. Chelsea, Mass., 1890*), journalist, humorist, printer. Edited the important weekly the *Carpetbag*, 1851–53, to which Artemus Ward and Mark Twain sent their first contributions. Creator of the character of "Mrs. Partington," Shillaber served as chief connecting link between the old school of American humor, which preceded the Civil War, and the new. Among his separately published works were *Life and Sayings of Mrs. Partington* (1854), *Knitting-Work* (1859), *Partingtonian Patchwork* (1872), and the "Ike Partington" juveniles.

SHINN, ASA (*b. New Jersey, 1781; d. Brattleboro, Vt., 1853*), Methodist clergyman, reformer. A founder of the Methodist Protestant church, 1830.

SHINN, EVERETT (*b. Woodstown, N.J., 1876; d. New York, N.Y., 1953*), painter and illustrator. Studied at the Pennsylvania Academy of Fine Arts. Member of the "Philadelphia Four" who formed the nucleus of a new wave of urban realism in American art; and of the dissident group, "the eight," who protested the academic strictures of art at the turn of the century. Theatrical in his style, his paintings include *The Docks, New York City* (1901) and *London Hippodrome* (1903). He did many illustrations for *Harper's Magazine*, and painted many murals, including those in the Oak Room at the Plaza Hotel in New York City. Elected to the American Academy of Arts and Letters in 1951.

SHIPHERD, JOHN JAY (*b. near Granville, N.Y., 1802; d. Olivet, Mich., 1844*), Congregational home missionary. Founder, with Philo P. Stewart and others, of Oberlin College, 1833.

SHIPLEY, RUTH BIELASKI (*b. Montgomery County, Md., 1885; d. Washington, D.C., 1966*), career civil servant. Joined the U.S. Patent Office in 1903; later worked in the Records Division of the State Department. As special assistant to second assistant secretary of state Alvey Adee (1919–21), she became one of the most able of her generation of bureaucrats. Appointed chief of the Passport Division in 1928, she turned it into a model of efficiency; upgraded passport fraud investigations, and her operatives later nabbed Communist party leader Earl Browder and Nazi spy Gunther Rumrich. After 1939, she was charged with preventing foreign travel rather than facilitating it; she invalidated all old passports, and with few exceptions, denied citizens passports to belligerent countries and combat zones. After the war her influence reached to the granting of visas and immigration; following passage of the McCarran Internal Security Act (1950), which gave the secretary of state the authority to deny passports to members of Communist oganizations, she took over the task of dealing with such cases and was criticized for blatant political bias. She retired in 1955.

SHIPMAN, ANDREW JACKSON (*b. Springvale, Va., 1857; d. 1915*), lawyer, Slavic scholar, philanthropist. Graduated Georgetown University, 1878. An able and successful lawyer in New York City, he maintained a lifelong interest in the welfare of Salvic immigrants, particularly in the religious rights of Catholics of the Eastern Rite.

SHIPP, ALBERT MICAJAH (*b. Stokes Co., N.C., 1819; d. Cleveland Springs, N.C., 1887*), Methodist clergyman, educator. Graduated University of North Carolina, 1840, where he taught history, 1849–59. President of Wofford College, 1859–75, and professor of exegetical theology at Vanderbilt, 1875–85.

SHIPP, SCOTT (*b. Warrenton, Va., 1839; d. 1917*), Confederate soldier, educator. Graduated Virginia Military Institute, 1859. After service in the West Virginia and Romney campaigns, 1861, he became commandant of cadets at VMI, 1862, and led his men into the field on five occasions; the famous charge of the cadets against the Union forces at New Market, May 1864, was made under his command. Resuming his work at VMI at the end of the war, he was promoted to its superintendency, 1890, and served in this capacity until 1907.

SHIPPEN, EDWARD (*b. Methley, England, 1639; d. Philadelphia, Pa., 1712*), Merchant, Pennsylvania colonial legislator. Immigrated to Boston, Mass., 1668. Joining the Society of Friends *ca.* 1671, he was severely persecuted until his removal to Philadelphia *ca.* 1694. Holder of many high provincial offices, he was mayor of Philadelphia, 1701–03, and acting governor of Pennsylvania, April 1703–February 1704.

SHIPPEN, EDWARD (*b. Philadelphia, Pa., 1728/9; d. Philadelphia, 1806*), jurist. Great-grandson of Edward Shippen (1639–1712); father-in-law of Benedict Arnold. A moderate Loyalist during the Revolution, Shippen held a number of judicial posts *post* 1784. An associate justice of the Pennsylvania Supreme Court, 1791–99, he was chief justice, 1799–1805.

SHIPPEN, WILLIAM (*b. Philadelphia, Pa., 1736; d. Philadelphia, 1808*), physician, medical educator. Great-grandson of Edward Shippen (1639–1712); cousin of Edward Shippen (1729–1806). Graduated College of New Jersey (Princeton), 1754. Studied medicine with his father and in London and at the University of Edinburgh, where he received the M.D. degree, 1761. Successful in practice in Philadelphia *post* 1762 and as a teacher of anatomy and midwifery, he was appointed professor of surgery and anatomy at the College of Philadelphia, 1765. During the Revolution, he served under various titles as director of several divisions of the Continental army hospital service. He was chief of the medical department of the Continental army, 1777–81, succeeding John Morgan, who charged him with bad faith. He was later court-martialed for alleged financial irregularities in office, but acquitted. A member of the staff of the Pennsylvania Hospital, 1778–79 and 1791–1802, he held the chair of anatomy, surgery, and midwifery at University of Pennsylvania *post* 1791.

SHIPSTEAD, HENRIK (*b. Burbank Township, Minn., 1881; d. Alexandria, Minn., 1960*), politician. Studied at Northwestern University School of Dentistry. Elected to the U.S. Senate on the Farmer-Labor ticket in 1922; he served in the Senate until 1946, switching to the Republican party in 1940. An ardent populist and isolationist, Shipstead served on the Senate Foreign Relations Committee, opposing U.S. involvement in the United Nations and wanting to limit U.S. defense commitments to the Western Hemisphere.

SHIRAS, GEORGE (*b. Pittsburgh, Pa., 1832; d. Pittsburgh, 1924*), jurist, U.S. Supreme Court justice. Brother of Oliver P. Shiras. Graduated Yale, 1853. Associate justice, U.S. Supreme Court, 1892–1903, he was widely criticized (perhaps unjustly) for his part in the nullification of the federal income tax statute in April 1895.

SHIRAS, OLIVER PERRY (*b. Pittsburgh, Pa., 1833; d. 1916*), jurist. Brother of George Shiras. Admitted to the Iowa bar, 1856, after graduation from Ohio University and Yale Law School, he practiced in Dubuque. As U.S. judge for the northern Iowa district, 1882–1903, he excelled in equity cases and enunciated, 1894, the concept of a national common law subject to independent application by the federal courts irrespective of state interpretation.

SHIRLAW, WALTER (*b. Paisley, Scotland, 1838; d. Madrid, Spain, 1909*), genre, portrait, and mural painter. Came to America as a child. Beginning his career as a bank-note engraver, he studied in Chicago and was a student in Munich, Germany, 1870–77. While in Germany, he painted his two best pictures, *Toning the Bell*, 1874, and *Sheep-Shearing in the Bavarian Highlands*, 1876. Returning to America, he became first president of the Society of American Artists, taught at the Art Students League

in New York City and achieved a fair degree of professional success. His mastery of design may be studied in his ceiling painting *The Sciences*, in the Library of Congress, Washington, D.C.

SHIRLEY, WILLIAM (*b. Preston, Sussex, England, 1694; d. Roxbury, Mass., 1771*), colonial official, lawyer. Immigrated to Boston, Mass., 1731. As judge of admiralty and later advocate general, he upheld the imperial view of business matters, laboring faithfully to enforce the trade acts. Critical of Governor Jonathan Belcher's policies, Shirley succeeded Belcher as governor of Massachusetts in May 1741. Adroitly settling the land-bank controversy, Shirley persuaded the Massachusetts General Court to make appropriations for defense of the colony and had affairs in a good state of preparation by the time war was declared with the French in 1744. Aware of the economic importance of the French fortress of Louisburg on Cape Breton Island, he matured plans to capture it, despite discouragement from the English government; he won support of the General Court for the enterprise, in which the other New England colonies cooperated. The taking of weakly defended Louisburg in June 1745 proved to be the one great English victory of the war. From 1749 to 1753 Shirley participated in the negotiations held in Paris concerning the boundary line between French North America and New England. With the outbreak of the French and Indian War, which he had foreseen, he was appointed major general and given command of the campaign against Niagara. After General Braddock's death in July 1755, he succeeded to the supreme command of British forces on the American continent. Though his military plans were sound, they were unsuccessful, largely because of bickering among the colonies and their failure to lend adequate support. On the failure of the Niagara expedition, Shirley's enemies accused him of mismanagement, and suspicion was aroused in England that he was guilty of treasonable activity. Summoned to England early in 1756, he was threatened with court-martial, but charges were dropped for lack of evidence. Meantime, he had been removed as governor of Massachusetts. Named governor of the Bahama Islands, 1761, he resigned in 1767. As an executive Shirley showed ability and tact and became one of the most personally popular of colonial governors. Careless in his management of public finance, he was of unimpeachable personal integrity. More than any other contemporary governor, he had a broad grasp of the whole imperial problem.

SHOBONIER *See* SHABONEE.

SHOLES, CHRISTOPHER LATHAM (*b. Mooresburg, Pa., 1819; d. 1890*), printer, journalist, inventor. Removing to Wisconsin *ca.* 1837, Sholes engaged in politics, held political appointments, and was editor of several Wisconsin newspapers, including the *Milwaukee News* and the *Milwaukee Sentinel*. Holder of a number of patents for mechanical devices, he devoted most of his life *post* 1867 to the perfection of the typewriter. Granted a basic patent, 1868, he patented improvements, 1871, but on failing to raise the means for making and marketing his machine, he sold his rights to the Remington Arms Co., March 1873. He continued to improve his typewriter until 1878, turning over his results to the Remington Co.

SHONTS, THEODORE PERRY (*b. Crawford Co., Pa., 1856; d. 1919*), railroad executive. Able president of a number of midwestern railroads; chairman, second Isthmian Canal Commission, 1905–07; president, Interborough Rapid Transit Co., New York City, *post* 1907. An efficient, adaptable manager.

SHOOK, ALFRED MONTGOMERY (*b. near Winchester, Tenn., 1845; d. Nashville, Tenn., 1923*), industrialist. As superintendent

and general manager of the Tennessee Coal, Iron & Railroad Co., 1868–1901, Shook became a master of all phases of iron manufacture, greatly enlarged the business, and directed the company's engagement in steel manufacture at Ensley, near Birmingham, Ala. The opening of his company's steelworks in 1899 began a new era in southern industrial development.

SHOR, BERNARD ("TOOTS") (*b. Philadelphia, Pa., 1903; d. New York City, 1977*), saloonkeeper. Attended Drexel Institute and Wharton School of Business and moved to New York City in 1930. Street tough and confident, he worked at various speakeasies as greeter, bouncer, and occasional bookmaker and in 1940 opened Toots Shor's, a showcase for entertainers, athletes, and sportswriters and hangout for his famous friends. He sold the lease for the restaurant for $1.5 million in 1959, and the next year ground was broken for another Toots Shor's, which went bankrupt in 1971.

SHOREY, PAUL (*b. Davenport, Iowa, 1857; d. Chicago, Ill., 1934*), classicist. Graduated Harvard, 1878. After attending the universities of Leipzig and Bonn and the American School at Athens, he received a Ph.D. from Munich in 1884. Professor of Latin and Greek at Bryn Mawr, 1885–92, he went to the University of Chicago as professor of Greek and served as head of the department, 1896–1927. An erudite and unusually effective teacher, he made his greatest contribution to scholarship in the field of Platonic studies; a founder of *Classical Philology*, he was its editor, 1908–34. Among his numerous books and monographs, *What Plato Said* (1933) is outstanding. Impatient with modern pedagogical methods, Shorey was a stout opponent of current prejudices against the classics in education.

SHORT, CHARLES (*b. Haverhill, Mass., 1821; d. New York, N.Y., 1886*), classical philologist. Graduated Harvard, 1846. After service as teacher and headmaster in several academies, he was president of Kenyon College, 1863–67. Succeeding Henry Drisler as professor of Latin at Columbia, 1867, he remained in that post for the rest of his life.

SHORT, CHARLES WILKINS (*b. Woodford Co., Ky., 1794; d. near Louisville, Ky., 1863*), physician, educator, botanist. Nephew of William Short; grandson of John C. Symmes. Graduated Transylvania University, 1810; M.D., University of Pennsylvania, 1815; made private studies with Caspar Wistar (1716–1818). Teacher and dean at Transylvania and later at the Medical Institute of Louisville, he is remembered principally as a collector and classifier of plants from the little-explored country west of the Alleghenies.

SHORT, JOSEPH HUDSON, JR. (*b. Vicksburg, Miss., 1904; d. Alexandria, Va., 1952*), journalist. Worked for many newspapers before joining the Associated Press in 1931; assigned to Washington, he remained there until 1941. From 1943 to 1950 he was a member of the Washington bureau of the *Baltimore Sun*. Appointed as presidential press secretary by President Truman in 1950, he covered many events for the president including the Korean War and the firing of General Douglas MacArthur.

SHORT, LUKE (*b. Frederick Dilley Glidden, Kewanee, Ill., 1908; d. Aspen, Colo., 1975*), writer. Graduated University of Missouri (B.A., 1930) and in 1935 began earning a reputation as the author of cleverly plotted and well-written Western novels. In the late 1930's he wrote fourteen novels of Western pulp fiction; in the 1940's he released the mainstream and highly regarded works *Gunman's Chance* (1941) and *High Vermilion* (1948), and several of his books, including *Ramrod* (1943) and *Station West* (1947), were made into films.

SHORT, SIDNEY HOWE (*b. Columbus, Ohio, 1858; d. 1902*), electrical engineer, educator. Inventor of numerous important devices for arc-lighting and electric traction systems.

SHORT, WALTER CAMPBELL (*b. Fillmore, Ill., 1880; d. Dallas, Tex., 1949*), army officer. B.A., University of Illinois, 1901. Commissioned in U.S. Army, 1902; began service with 25th Infantry at Fort Reno, Okla. Served in Alaska and on Mexican punitive expedition, 1916–17; served with 1st Division in France during World War I and was decorated for forward reconnaissance work and for efficiency in training machine-gun units. After various peacetime assignments in which he rose to brigadier general, 1936, and divisional command, 1939, he was recognized as one of the army's best training specialists. In 1941 he took charge of the army's Hawaii department with rank of lieutenant general. Relieved of duty after the Japanese attack on Oahu, Dec. 7, 1941, he was accused of negligence by many at that time, but presented a reasonable public defense of his actions in hearings before an investigating committee of Congress, early in 1946.

SHORT, WILLIAM (*b. Surry Co., Va., 1759; d. 1849*), diplomat, planter, landowner. Graduated William and Mary, 1779. A founder of Phi Beta Kappa, Short served on the executive council of Virginia, 1783–84, and thereafter as Thomas Jefferson's private secretary and secretary of legation in Paris. Becoming chargé d'affaires, 1789, he served with ability until 1792 when he was appointed U.S. minister at The Hague. Named as joint commissioner with William Carmichael to negotiate a treaty with Spain, he went to Madrid in February 1793. Superseded by Thomas Pinckney, he loyally cooperated with Pinckney in securing the Pinckney Treaty, signed October 1795. Disappointed in his professional ambitions, he amassed a large fortune. He died probably in Philadelphia, Pa.

SHORTER, JOHN GILL (*b. Monticello, Ga., 1818; d. 1872*), jurist, Alabama legislator. An enthusiastic secessionist and strong supporter of Jefferson Davis, Shorter served in the provisional Confederate Congress, and was governor of Alabama, 1861–63.

SHOTWELL, JAMES THOMSON (*b. Strathroy, Ontario, Canada, 1874; d. New York, N.Y., 1965*), historian and internationalist. Attended University of Toronto and Columbia (Ph.D., 1903), taught history at the latter, 1905–42. He was an organizer and first chairman of the National Board for Historical Service following U.S. entry into World War I and accompanied President Woodrow Wilson to the Paris Peace Conference (1919). After the war he agreed to edit the 152-volume *Economic and Social History of the World War*. He became director of the Carnegie Endowment's Division of Economics and History (1924) and was president of the League of Nations Association (1935–39). In 1945 he became chairman of the consultants to the U.S. delegation to the United Nations Conference and became president of the Carnegie Endowment for International Peace (1949–50).

SHOUP, FRANCIS ASBURY (*b. Laurel, Ind., 1834; d. Columbia, Tenn., 1896*), Confederate brigadier general and artillerist, Episcopal clergyman, educator. Graduated West Point, 1855. Chief of artillery under Generals J. E. Johnston and John Hood in the Atlanta campaign, Shoup took orders after the war and was professor of mathematics at the University of Mississippi and at the University of the South.

SHOUP, GEORGE LAIRD (*b. Kittanning, Pa., 1836; d. Boise, Idaho, 1904*), businessman, Union soldier, Colorado and Idaho pioneer. Helped found Salmon, Idaho, 1866, where he made his home. Long active in Republican politics, he was territorial governor and governor of Idaho, 1889–90, and first U.S. senator from the state, 1891–1901.

SHOUSE, JOUETT (b. Woodford County, Ky., 1879; d. Washington, D.C., 1968), U.S. congressman. Attended University of Missouri (1895–98). In 1911 he became involved in Kansas politics and won a state senate seat (1912). As a U.S. congressman (1914–18), he was a member of the Banking and Currency Committee and active in developing the Federal Farm Loan Act (1916). Defeated for reelection in 1918, he became assistant secretary of the treasury, devoting his attention to the War Risk Bureau; resigned in 1920. Remained active in Kansas Democratic politics and led the Kansas delegation to the 1920 and 1924 national conventions; became chairman (1929) of the Executive Committee of the Democratic National Committee. He served his connections with the Democratic party in 1932 and became more and more conservative. President of the American Liberty League (1934–40), an isolationist organization; later vigorously endorsed the campaigns of Thomas Dewey (1948) and Richard Nixon (1960).

SHOWERMAN, GRANT (b. Brookfield, Wis., 1870; d. Madison, Wis., 1935), classicist. Graduated University of Wisconsin, 1896; Ph.D., 1900. Professor at Wisconsin for the greater part of his life, he was expert in the history, literature, and art of Rome and an outspoken exponent of classical culture. Among his many books were *Eternal Rome* (1924) and *Rome and the Romans* (1931).

SHRADY, GEORGE FREDERICK (b. New York, N.Y., 1837; d. 1907), surgeon, medical journalist. M.D., College of Physicians and Surgeons, New York, 1858. Holder of many New York hospital staff appointments, he was a skillful, conservative operator, specializing mainly in plastic surgery. He made his principal contribution to medicine as editor of the *American Medical Times*, 1860–64, and of the *Medical Record*, 1866–1904, championing reforms in medical education and practice. He was father of Henry M. Shrady.

SHRADY, HENRY MERWIN (b. New York, N.Y., 1871; d. 1922), sculptor. Son of George F. Shrady. Mainly self-taught save for some technical instruction from Karl Bitter, Shrady did his finest work on the memorial group to General U. S. Grant, in Union Square, Washington, D. C. Winner of the competition for this work, 1902, he labored on it until 1922 and died two weeks before it was dedicated.

SHREVE, HENRY MILLER (b. Burlington Co., N.J., 1785; d. St. Louis, Mo., 1851), steamboat captain. Raised on the Pennsylvania frontier, Shreve began trading journeys by keelboat down the Monongahela and Ohio to the West, 1799. Initiator of the fur trade between St. Louis and Philadelphia via Pittsburgh, 1807, he then entered the lead trade between the upper Mississippi and New Orleans. Becoming a stockholder in the steamboat *Enterprise*, 1814, he freighted supplies for Andrew Jackson's army from Pittsburgh to New Orleans in the vessel and in May 1815 brought it successfully up to Louisville, Ky. He established the practicability of steam navigation on the Mississippi and Ohio route with his second steamboat, the *Washington*, 1816–17, and later broke the Fulton-Livingston monopoly which had been asserted against his operations in legal proceedings. As U.S. superintendent of western river improvements, 1827–41, Shreve designed the first steam snagboat and removed the famous Red River raft. Shreveport, La., was named for him.

SHREVE, THOMAS HOPKINS (b. Alexandria, Va., 1808; d. Louisville, Ky., 1853), journalist. Removing to Cincinnati, Ohio, ca. 1830, he was associated there with such literary pioneers as William D. Gallagher and James H. Perkins; with Gallagher, he edited the *Cincinnati Mirror*, 1831–36. Active in business as well, he published essays and poems in the *Western Messenger*, the *Western Literary Journal*, the *Western Monthly Magazine*, the *Knickerbocker*, and others. He served as assistant editor of the *Louisville Daily Journal*, 1842–53.

SHUB, ABRAHAM DAVID (b. Vilna, Russia, 1887; d. Miami Beach, Fla., 1973), Yiddish journalist. After participation in the 1905–06 revolution in Russia as a Menshevik (Social Democrat), he was forced to flee the country in 1907, settling in New York City, where he was an editor and reporter for several newspapers, including the *Jewish Daily Forward* (1924–60). In 1948 he wrote a noted biography of Lenin, and from 1956 to 1971 he wrote Russian-language tracts for Radio Liberty.

SHUBERT, LEE (b. Shirvinta, Russia, 1873[?]; d. New York, N.Y., 1953), theatrical producer. Immigrated to the U.S. in 1883. With his brothers Samuel and Jacob, Lee Shubert began a career in theater ownership and production; by 1900, the brothers were producing plays in a leased theater in New York. In 1905 Lee Shubert became president of the Shubert Theatrical Corp. Over the next decade the Shubert brothers came to dominate American theatrical management and production; by 1925 they owned six London theaters, owned or controlled thirty-five New York theaters, and controlled seventy-five percent of all theater tickets sold, as well as owning many theaters in other American cities. The company suffered greatly during the Great Depression and underwent antitrust suits from the federal government. Shubert's last production of a play was in 1954; his earlier productions included Romberg's operettas, many reviews, and the play *Street Scene*, Elmer Rice's Pulitzer Prize winner of 1929. A theater in New York bears the Shubert name.

SHUBRICK, JOHN TEMPLER (b. Bull's Island, S.C., 1788; d. 1815), naval officer. Brother of William B. Shubrick. Appointed midshipman, 1806, he had an extraordinarily eventful career, serving in major actions aboard the *Constitution*, the *Chesapeake*, the *Hornet*, and the *Guerrière*. Returning home from Algiers, 1815, in command of the *Epervier*, he was lost at sea.

SHUBRICK, WILLIAM BRANFORD (b. Bull's Island, S.C., 1790; d. 1874), naval officer. Brother of John T. Shubrick. Appointed midshipman, 1806, he served for a time under Capt. James Lawrence and was shipmate with James Fenimore Cooper. Promoted lieutenant, 1813, he served aboard the *Constellation* and the *Constitution*, 1813–15. After some 30 years of routine ship and shore duty, he served on the Pacific Coast during the Mexican War. Chairman of the lighthouse board, 1852–71, he is chiefly remembered for his command of the expedition sent to settle difficulties with Paraguay, 1858–59. Retired as flag officer, 1861, he was raised to rear admiral (retired), 1862.

SHUCK, JEHU LEWIS (b. Alexandria, Va., 1812; d. Barnwell Court House, S.C., 1863), Baptist clergyman. Missionary to China, 1836–45 and 1847–51. He later served as a missionary among the Chinese in California.

SHUEY, EDWIN LONGSTREET (b. Cincinnati, Ohio, 1857; d. 1924), educator, advertising man, director of factory welfare work. Author of *Factory People and Their Employers* (1900).

SHUEY, WILLIAM JOHN (b. Miamisburg, Ohio, 1827; d. 1920), clergyman of the United Brethren in Christ. Able and energetic in the service of his church as minister, missionary, publishing agent, 1865–97, and seminary manager.

SHUFELDT, ROBERT WILSON (b. Red Hook, N.Y., 1822; d. Washington, D.C., 1895), naval officer. Appointed midshipman, 1839, he resigned, 1854, to engage in the merchant service and

during the early years of the Civil War was consul to Cuba and a special agent to Mexico. Recommissioned commander, November 1862, he served with ability at sea and in miscellaneous postwar duties until 1878. The great achievement of his career was his negotiation of a treaty with China, 1882, which established diplomatic relations, extraterritoriality, and commercial privileges for the United States. He retired as rear admiral, 1884.

SHULL, GEORGE HARRISON (*b. Clark County, Ohio, 1874; d. Princeton, N.J., 1954*), plant geneticist. Studied at Antioch College, and the University of Chicago (Ph.D., 1904). Professor of botany and genetics at Princeton University, 1915–42. Responsible for the development of the hybridization of corn, 1908–09. By the beginning of World War II this development had increased American corn production by 20 percent. His methods of cross breeding were applied to other crops such as rice and wheat, and are said to be the most significant development in twentieth-century agriculture.

SHULZE, JOHN ANDREW (*b. Berks Co., Pa., 1775; d. Lancaster, Pa., 1852*), Lutheran clergyman, businessman, Pennsylvania legislator. Grandson of Henry M. Mühlenberg. As Democratic governor of Pennsylvania, 1823–29, he promoted canal construction and public elementary education.

SHUMLIN, HERMAN ELLIOTT (*b. Atwood, Colo., 1898; d. New York City, 1979*), theatrical producer and director. After writing for the show business papers *New York Clipper* (1921–24) and *Billboard* (1924–25), he began producing plays. His first success was *The Last Mile* (1930); he made his directorial debut with the Broadway production of *Grand Hotel* (1930) and later directed *Kiss Them for Me* (1945). Other successful stage productions were *The Children's Hour* (1934), *The Little Foxes* (1939), *The Male Animal* (1940), *The Corn Is Green* (1941), *Watch on the Rhine* (1941), for which he directed the movie version (1943), and *Inherit the Wind* (1955).

SHUNK, FRANCIS RAWN (*b. Trappe, Pa., 1788; d. 1848*), educator, lawyer, public official. Restored Pennsylvania's financial credit and opposed concessions to corporate business interests as Democratic governor, 1845–48.

SHURTLEFF, NATHANIEL BRADSTREET (*b. Boston, Mass., 1810; d. 1874*), physician, antiquary. Democratic mayor of Boston, 1868–70. A thorough and conscientious editor of original Massachusetts records, he was author of A *Topographical and Historical Description of Boston* (1871).

SHURTLEFF, ROSWELL MORSE (*b. Rindge, N.H., 1838; d. New York, N.Y., 1915*), animal and landscape painter.

SHUSTER, GEORGE NAUMAN (*b. Lancaster, Wis., 1894; d. South Bend, Ind., 1977*), author and college president. Graduated University of Notre Dame (1915) and attended University of Poitiers in France and Columbia University. He became chairman of the English Department at Notre Dame, taught at St. Joseph's College for Women (1925–35), and became an editor of *Commonweal* (1925–37). In *The Catholic Spirit in America* (1927), he attempted to differentiate the "Catholic intellect" from the "American intellect." He was acting president (1939) and president (1940–60) of Hunter College in New York City, then the largest public women's college in the world, and director of the Carnegie Endowment for International Peace (1954–64).

SHUSTER, W(ILLIAM) MORGAN (*b. Washington, D.C., 1877; d. New York, N.Y., 1960*), financier, lawyer, and publisher. Studied at Columbia University. Collector of customs in the Philippines,

1901–06; secretary of public instruction, 1906–09. A friend of President Taft, Shuster was asked to journey to Persia and help that nation out of its financial difficulties and reorganize the financial structure. In 1911 Shuster arrived in Teheran and began his work, which soon became embroiled in conflicts between British and Russian interests. After causing some military fighting and a possible international crisis between the two nations, he was dismissed and returned to Washington. In 1915 Shuster became president of Century, a publishing firm, later Appleton-Century (1933) and, still later, Appleton-Century-Crofts (1948). He was chairman of the board from 1952 until his death.

SHUTE, SAMUEL (*b. London, England, 1662; d. England, 1742*), British soldier. Shute's administration as colonial governor of Massachusetts Bay and New Hampshire extended from 1716 to 1727 and was one of the stormiest endured by any royal governor. Constantly at odds with the assembly over fiscal matters and questions of legislative privilege, he returned to England, 1723, to complain of his grievances and seek redress. As he was about to return to Massachusetts in the spring of 1727, his commission was vacated.

SIAMESE TWINS *See* CHANG AND ENG.

SIBERT, WILLIAM LUTHER (*b. Gadsden, Ala., 1860; d. near Bowling Green, Ky., 1935*), military engineer. Graduated West Point, 1884. Commissioned in the engineers, he performed extensive river and harbor improvement work and distinguished himself in reconstruction of Philippine railways, 1899–1900. He supervised construction of the Atlantic Division of the Panama Canal, 1908–14. Promoted major general, May 1917, he organized the Chemical Warfare Service for the army in World War I.

SIBLEY, GEORGE CHAMPLAIN (*b. Great Barrington, Mass., 1782; d. near St. Charles, Mo., 1863*), Indian agent, explorer. Son of John Sibley; grandson of Samuel Hopkins (1721–1803). Served as factor and Indian agent at Fort Osage, Mo., 1808–26; explored the Grand Saline in present Oklahoma, 1811; was one of the commissioners to mark Santa Fe Trail from Council Grove to the Mexican boundary, 1825.

SIBLEY, HENRY HASTINGS (*b. Detroit, Michigan Territory, 1811; d. 1891*), fur trader, Minnesota pioneer. Settled at Mendota, 1834. Influential among the Sioux. He was delegate to Congress from Wisconsin Territory, 1848, and promoted the organization of Minnesota Territory, 1849, serving as its delegate, 1849–58. He was first governor of the state of Minnesota, 1858–60, elected as a Democrat. Commanding the Minnesota forces during the Sioux uprising of 1862, he relieved the frontier posts and fought the battle of Wood Lake. During 1863–64, he commanded punitive expeditions against the Sioux in the Dakota region, and in 1865–66 was one of the commissioners to negotiate peace treaties with the Sioux. Removing to St. Paul, Minn., he concerned himself with private business thereafter, but remained an important and influential figure in the life of the state.

SIBLEY, HIRAM (*b. North Adams, Mass., 1807; d. Rochester, N.Y., 1888*), businessman, promoter. A pioneer in the telegraph industry, he early reached the conclusion that there were too many small companies and that consolidation was demanded; in association with Ezra Cornell, he formed the Western Union Telegraph Co. (chartered 1856), which he served as president until 1866. An earnest advocate of a transcontinental telegraph line, he undertook the project first on his own account and amalgamated it with the Western Union in 1864. After his retirement

from Western Union affairs, 1869, he invested in railroads and in agricultural enterprises with great success. He was one of the incorporators of Cornell University and a benefactor to it and to the University of Rochester.

SIBLEY, JOHN (*b. Sutton, Mass., 1757; d. 1837*), physician, Indian agent, Louisiana politician and planter. Father of George C. Sibley. Removed to Louisiana, 1802; served as contract surgeon to the U.S. Army at Natchitoches, 1803–05, and as Indian agent for Orleans Territory and Louisiana, 1805–14. He later prospered as a planter and salt manufacturer. His official reports to Governor Claiborne and to President Jefferson are important sources of information regarding Louisiana.

SIBLEY, JOHN LANGDON (*b. Union, Maine, 1804; d. 1885*), librarian. Graduated Harvard, 1825; Harvard Divinity School, 1828. Assistant librarian of Harvard, 1825–26 and 1841–56; librarian, 1856–77. He is remembered principally as author of the *Biographical Sketches of Graduates of Harvard University* (1873–85), covering the lives of graduates through the class of 1689.

SIBLEY, JOSEPH CROCKER (*b. Friendship, N.Y., 1850; d. near Franklin, Pa., 1926*), oil refiner. Congressman, Democrat-Populist-Prohibitionist, from Pennsylvania, 1893–95; congressman, Democrat, 1899–1901, and Republican, 1901–07. In addition to his activities in business and politics, he was an agriculturist and a stockbreeder.

SICALAMOUS *See* SHIKELLAMY.

SICARD, MONTGOMERY (*b. New York, N.Y., 1836; d. Westernville, N.Y., 1900*), naval officer. Graduated U.S. Naval Academy, 1855. Distinguished as an ordnance expert, he developed the modern high-power naval guns installed before the war with Spain. Promoted rear admiral, 1897, he was superseded as commander of the North Atlantic Squadron because of medical reasons, March 1898, and retired for age later in that year.

SICKELS, FREDERICK ELLSWORTH (*b. Gloucester Co., N.J., 1819; d. 1895*), engineer. Patented first successful drop cutoff for steam engines devised in the United States, 1842; patented a steam-steering apparatus for ships, 1860, which failed to receive any financial support for its exploitation.

SICKLES, DANIEL EDGAR (*b. New York, N.Y., 1819; d. New York, 1914*), lawyer, Union major general, diplomat. Studied law under Benjamin F. Butler (1795–1858); was admitted to the bar, 1846. Active in politics as a Democrat, he served as New York City corporation counsel, as secretary of the U.S. legation at London, as a New York State senator, and as a congressman from New York, 1857–61. A spectacular figure in Washington, D.C., he killed the son of Francis S. Key in a duel, 1859, winning acquittal with an innovating plea of temporary mental aberration. Raising the New York Excelsior Brigade, 1861, he led it as brigadier general and was promoted major general early in 1863. Commanding the III Corps, he was an important factor in the Chancellorsville campaign and stopped Stonewall Jackson's advance. Criticized for a controversial maneuver at Gettysburg, July 2, 1863, he found his military career in the field at an end and served on diplomatic missions and as a military administrator until the end of 1867. Retiring from the army, 1869, he was a vigorous but undiplomatic U.S. minister to Spain, 1869–73. After living for a time abroad, he returned to New York, where he held state appointments, and served again in Congress, 1893–95.

SIDELL, WILLIAM HENRY (*b. New York, N.Y., 1810; d. New York, 1873*), civil engineer, Union brevet brigadier general. Graduated West Point, 1833. Performed effective service as provost and recruiting officer in Kentucky and Tennessee, 1861–65.

SIDIS, BORIS (*b. Kiev, Russia, 1867; d. Portsmouth, N.H., 1923*), psychopathologist. Came to America, 1887. Graduated Harvard, B.A., 1894; Ph.D., 1897; M.D., 1908. Author of *The Psychology of Suggestion* (1898), an attempt to explain the nature of the subconscious; *Psychopathological Researches: Studies in Mental Dissociation* (1902); *The Psychology of Laughter* (1913), and other works.

SIDNEY, MARGARET *See* LOTHROP, HARRIET MULFORD STONE.

SIEBER, AL (*b. Baden, Germany, 1844; d. near Globe, Ariz., 1907*), soldier, scout. Came to America as a child; was raised in Pennsylvania and Minnesota. After Civil War service with the Union army, he went to the Far West, 1866, settling in Arizona *ca.* 1868. Winning repute as a leader in organizing the settlers to defend themselves against Indian attack, he was engaged, 1871, as an army scout. In command of the famous Apache scouts under General George Crook, he soon became recognized as the outstanding scout and Indian fighter of the Southwest. After service under a number of department commanders, he was discharged, 1890, by the agent of San Carlos Reservation for denouncing unfair treatment of the Apache, and engaged thereafter in construction work. Trusted absolutely by his men, he could match them in endurance and trail skills; he possessed a high sense of honor and was utterly fearless.

SIGEL, FRANZ (*b. Sinsheim, Germany, 1824; d. New York, N.Y., 1902*), Union soldier, editor. An associate of Friedrich K. F. Hecker in the Baden insurrection, 1848, Sigel acted for a short time as minister of war in the revolutionary government of Baden and, on the collapse of the movement, fled first to Switzerland and then to England. Immigrating to America, 1852, he worked as a teacher and interested himself in the New York militia. Resident in St. Louis, Mo., when the Civil War broke out, Sigel became colonel of the 3rd Missouri Infantry, May 1861, and rose to divisional command during the struggle to hold Missouri in the Union. Promoted major general of volunteers, March 1862, he was transferred to the eastern theater of the war and was prominent as a corps commander until the spring of 1863. Considered unaggressive by the Washington authorities, he was removed from field command in the summer of 1864. Resigning his commission in May 1865, he worked as an editor of German-language newspapers in Baltimore, Md., and New York City, held several political appointments in New York, and was prominent as a lecturer. Although his military career was comparatively undistinguished, his prompt, ardent espousal of the Union cause united the German population of the North solidly behind the Union.

SIGERIST, HENRY ERNEST (*b. Paris, France, 1891; d. Pura, Switzerland, 1957*), medical historian. Immigrated to the U.S. in 1932. Studied at the University of Zurich (M.D., 1917), and at the Leipzig Institute for the History of Medicine, where he taught from 1925 to 1932. From 1932 to 1947 he taught at Johns Hopkins Institute of the History of Medicine. Major works include *Amerika und die Medizin* (1933), *Socialized Medicine in the Soviet Union* (1937), and the monumental *History of Medicine*, only one volume of which he was able to complete in 1951. A pioneer in the field of medical history, Sigerist was a believer in social problems and their solution as part of the responsibilities

of modern medicine. Founded the *Bulletin of the History of Medicine* in 1933.

SIGMAN, MORRIS (*b. Costesh, Bessarabia, Russia, 1881; d. Storm Lake, Iowa, 1931*), labor leader, officer of the International Ladies' Garment Workers' Union.

SIGOURNEY, LYDIA HOWARD HUNTLEY (*b. Norwich, Conn., 1791; d. Hartford, Conn., 1865*), poet, essayist. Conventional and imitative, Sigourney held high reputation in her own time and was called "the American Hemans." She was author of 67 books whose theme, for the most part, was death.

SIGSBEE, CHARLES DWIGHT (*b. Albany, N.Y., 1845; d. 1923*), naval officer. Graduated U.S. Naval Academy, 1863. Distinguished principally for his services as a scientist and inventor, Sigsbee was associated with Alexander Agassiz in deep-sea explorations, principally in the Gulf of Mexico, and developed a number of devices which practically revolutionized deep-sea sounding and dredging. Chief hydrographer to the Navy Department, 1893–97, he was commissioned captain, March 1897, and was in command of the battleship *Maine* when it was blown up in the harbor of Havana, February 1898. During the war with Spain, he commanded the *St. Paul*; in 1905 he commanded the squadron which brought back the body of John Paul Jones to America. He retired as rear admiral, 1907.

SIKES, WILLIAM WIRT (*b. Watertown, N.Y., 1836; d. Cardiff, Wales, 1883*), journalist, consular officer, folklorist. Husband of Olive Logan.

SIKORSKY, IGOR IVANOVICH (*b. Kiev, Russia, 1889; d. Easton, Conn., 1972*), aeronautical engineer. Attended Russian Naval Academy in St. Petersburg (1903–06) and the Kiev Polytechnic Institute (1907–10) and began designing helicopters and airplanes; his two-passenger plane set a speed record in 1911 and his first transport was used for reconnaissance in World War I. In 1919 he immigrated to New York City, where he continued with aeronautical design. In 1928 he became a U.S. citizen and sold his first seaplane to Pan American Airways; for the next ten years Pan Am pioneered long-distance transport with Sikorsky planes, including the S-40 or *American Clipper* (1931). In 1938 he returned to helicopter design, and his R-4 (1939) was the only helicopter used by U.S. military forces in World War II. The S-51 (1945) was the first helicopter used for commercial transport (1950) and the S-61 became the first helicopter to fly across the Atlantic nonstop (1967).

SILCOX, FERDINAND AUGUSTUS (*b. Columbus, Ga., 1882; d. Alexandria, Va., 1939*), forester, labor relations counsel, conservationist. Chief of the U.S. Forest Service, 1933–39.

SILKWOOD, KAREN GAY (*b. Longview, Tex., 1946; d. Cimarron, Okla., 1974*), nuclear-plant worker and union activist. Hired in 1972 as a laboratory analyst by Kerr–McGee Nuclear Corporation, a manufacturer of plutonium pellets and rods in Cimarron, she was elected to the local union's negotiating committee. In 1974, after she began documenting safety violations and careless handling of plutonium at the plant, she was killed in a mysterious car crash while bringing evidence of the plant's coverup of safety violations to a *New York Times* reporter.

SILL, ANNA PECK (*b. Burlington, N.Y., 1816; d. Rockford, Ill., 1889*), educator. A pioneer in the education of women, she was a founder of the present Rockford College, 1849–51, and principal, 1851–84.

SILL, EDWARD ROWLAND (*b. Windsor, Conn., 1841; d. Cleveland, Ohio, 1887*), poet, educator. Raised in Ohio. Graduated Yale, 1861. Professor of English, University of California, 1874–82. A poet of metaphysical doubt and perplexity, Sill voiced a humane idealism in a simple classical style. Author of *The Hermitage and Other Poems* (1868), *The Venus of Milo and Other Poems* (1883), and *The Poems of Edward Rowland Sill*, a collected edition (1902).

SILLIMAN, BENJAMIN (*b. present Trumbull, Conn., 1779; d. New Haven, Conn., 1864*), chemist, geologist, naturalist. Graduated Yale, 1796. After studying law under Simeon Baldwin and David Daggett, he was admitted to the bar, 1802, but in September of that year accepted appointment to the professorship of chemistry and natural history at Yale. He retired in 1853 as professor emeritus with a reputation as the most prominent and influential scientific mind in America.

In order to prepare himself for his professorship, he made special studies for two years at the medical school in Philadelphia, worked in the laboratory of Robert Hare, and received much valuable advice on the teaching of science from Dr. John Maclean. He began his work at Yale in April 1804 with the first course of lectures in chemistry ever given there. While traveling abroad in 1805, he became the intimate friend of Sir Humphry Davy, Sir David Brewster, Dr. John Murray, and Dr. Thomas Hope and grew deeply interested in geology. He was able, by 1813, to begin a full course of illustrated lectures in mineralogy and geology, utilizing the famed mineral collection of his friend George Gibbs, which the college later purchased. Silliman acted as a leading member of the committee to organize Yale Medical School, opened in 1813. *Post* 1808, he won wide acclaim as a lecturer on science to the public in New Haven, New York, and other cities; lectures on geology before the Boston Society of Natural History, 1835, were especially notable. In 1839–40 he was invited to deliver the first series of Lowell Institute lectures; few series of scientific lectures ever aroused greater interest, and Silliman justly regarded them as the crowning success of his professional life. Realizing the need for advanced study and laboratory work in the sciences, and aided by his son Benjamin (1816–85) and by his son-in-law, James D. Dana, he persuaded Yale College to establish in 1847 the Department of Philosophy and the Arts, under which the natural and physical sciences could be studied intensively. From this modest beginning grew the Yale Scientific School, later called the Sheffield Scientific School.

In 1818 he had founded *The American Journal of Science and Arts*, devoted to the publication of original papers, notices, and reviews in the broad field of the natural and physical sciences. Under his management, it became one of the world's great scientific journals and brought him wide recognition; it is one of his most enduring monuments. In addition to editing two texts on chemistry and geology, he published his own excellent *Elements of Chemistry* (1830–31) and contributed numerous articles to scientific journals. He investigated gold deposits in Virginia and coal in Pennsylvania, and directed an investigation for the government on sugar culture. A member of the American Philosophical Society *post* 1805, he was elected in 1840 first president of the Association of American Geologists, forerunner of the American Association for the Advancement of Science. In 1863 he became an original member of the National Academy of Sciences.

Silliman exerted a profound influence on collegiate education by establishing science as a study on a basis of equality with the older disciplines. A sincerely religious man, he believed that to study science was to learn of the wonderful manifestations of God in the natural world, which it was man's duty to interpret reverently and by which it was his privilege to improve the condi-

tions of his life. This combination of a superior scientific mind with deep religious conviction enabled him to exert so great an influence in the interests of science on a generation that itself was dominated by strong religious convictions.

SILLIMAN, BENJAMIN (*b. New Haven, Conn., 1816; d. New Haven, 1885*), chemist. Son of Benjamin Silliman (1779–1864). Graduated Yale, 1837. Began teaching as an assistant to his father, whom he succeeded as professor of chemistry at Yale, 1853; he taught also at the University of Louisville, 1849–54. In association with his father and later with his brother-in-law, James D. Dana, he was an editor of the *American Journal of Science, post* 1838. Author of several textbooks and a number of monographs on chemistry and mineralogy, he frequently acted as consultant on chemical and mining problems. In this capacity he made, 1855, a major contribution to the petroleum industry by showing that petroleum was essentially a mixture of hydrocarbons and that it could be separated, by fractional distillation and simple means of purification, into a series of distillations making up about 90 percent of the whole. He discovered the chief uses which were to be made of petroleum products for the next 50 years and outlined the principal methods of preparing and purifying those products.

SILLS, MILTON (*b. Chicago, Ill., 1882; d. Santa Monica, Calif., 1930*), actor. A forceful stage actor and a motion-picture star *post* 1916, he helped organize the Academy of Motion Picture Arts and Sciences.

SILOTI, ALEXANDER ILYITCH (*b. near Kharkov, Russia, 1863; d. New York, N.Y., 1945*), pianist, conductor. Cousin of Sergei Rachmaninoff. Graduated Moscow Conservatory, 1881; studied at Weimar with Franz Liszt, 1883–86. Winning fame as a concert artist, he was also renowned as a conductor; between 1903 and 1917 he organized and conducted in St. Petersburg the Siloti Concerts, introducing new works by contemporary composers, including Scriabin, Schoenberg, Stravinsky, Prokofiev, Ravel, Falla, and Enesco. Director of the Maryinsky Opera at the time of the Russian Revolution, he left Russia to reside for a time in England and Belgium. In 1922 he came to the United States, joining the faculty of the Juilliard School, New York City, 1924; from them until his retirement in 1942, he devoted his principal energies to teaching and editing.

SILSBEE, NATHANIEL (*b. Salem, Mass., 1773; d. Salem, 1850*), merchant mariner, shipowner, Massachusetts legislator. Congressman, Democratic-Republican, 1817–21, and U.S. senator, 1826–35, he was influential in maritime legislation and was chairman, Senate Committee on Commerce, 1833–35.

SILVER, ABBA HILLEL (*b. Sirvintus, Lithuania, 1893; d. Cleveland, Ohio, 1963*), rabbi and Zionist leader. Came to New York in 1902; attended University of Cincinnati and Hebrew Union College; ordained in 1915. From 1917 until his death he led "The Temple," the Tifereth Israel Reform congregation in Cleveland. Wrote several books, including *A History of Messianic Speculation in Israel* (1927), *Religion in a Changing World* (1930), and *The World Crisis and Jewish Survival* (1941); a collection of his Zionist speeches, *Vision and Victory*, appeared in 1949. Starting in the 1930's he spent more and more time involved in Zionist affairs; he was cochairman of the American Zionist Emergency Council (1943–44) and president of the World Zionist Organization (1947–48). After the establishment of the state of Israel in 1948, he was forced out of the Zionist leadership.

SILVER, GRAY (*b. White Hall, Va., 1871; d. 1935*), West Virginia farmer and legislator, spokesman for farm groups. Orga-

nized the nonpartisan farm bloc which dominated legislative activities of the 67th Congress, 1921–23.

SILVER, THOMAS (*b. Greenwich, N.J., 1813; d. New York, N.Y., 1888*), civil engineer, inventor. His marine engine governor, covered by patents between 1855 and 1866, was adopted for use by most of the naval authorities of the world, though not by the United States.

SILVERHEELS, JAY (*b. Harold Jay Smith, Six Nations Indian Reserve, near Brantford, Ontario, Canada, 1919; d. Woodland Hills, Calif., 1980*), actor. A Mohawk Indian named for his blinding speed as one of Canada's greatest professional lacrosse players, he worked as a film extra and had his first major screen role in *Captain from Castile* (1947); from 1940 to 1970 he was the leading actor playing Native American roles. He costarred as Tonto, the Indian companion, in the popular television series "The Lone Ranger" (1949–57). His other major film roles were in *Broken Arrow* (1950), *The Lone Ranger* (1956), *True Grit* (1970), and *The Man Who Loved Cat Dancing* (1973). In 1963 he founded the Indian Actors Workshop in Hollywood.

SILVERMAN, JOSEPH (*b. Cincinnati, Ohio, 1860; d. New York, N.Y., 1930*), rabbi. Graduated University of Cincinnati, 1883; Hebrew Union College, 1884; D.D., 1887. After serving in Texas for a short time, he became junior rabbi at Temple Emanu-El, New York City, 1888. Elected rabbi, 1897, he became emeritus in 1922. A liberal in religion, he was active in community affairs and became a strong supporter of Zionism toward the end of his life.

SILVERMAN, SIME (*b. Cortland, N.Y., 1873; d. Los Angeles, Calif., 1933*), editor and publisher of *Variety post* 1905. The success of this notable theatrical paper was owing entirely to Silverman's honesty, devotion to work, and imaginative editing. Much present-day slang originated in its pages.

SILVERS, LOUIS (*b. Brooklyn, N.Y., 1889; d. Hollywood, Calif., 1954*), composer and conductor. He composed the song "April Showers" for Al Jolson in 1921 (for the Broadway show, *Bombo*). Remembered for his compositions for films, Silvers wrote the music for *The Jazz Singer* (1927) which was the first all-talking motion picture, starring Al Jolson. Other films include *It Happened One Night* (1934) and *One Night of Love* (1934), which won Silvers an Academy Award.

SIMKHOVITCH, MARY MELINDA KINGSBURY (*b. Chestnut Hill, Mass., 1867; d. New York, N.Y., 1951*), settlement worker and housing reformer. Studied at Boston University, Radcliffe College, the University of Berlin, and Columbia University. Founded the settlement house, Greenwich House, in New York in 1902; head resident until 1946. The house became an important focal point for community life in the area of Greenwich Village, included John Dewey on the educational committee, and sheltered such figures as Frances Perkins, who became the first woman cabinet member. President of the National Federation of Settlements, 1917; vice-chairman of the N.Y. City Housing Authority, 1934–48. Convinced Secretary of the Interior Harold Ickes to include federal housing in the public works projects of the New Deal.

SIMMONS (SZYMANSKI), ALOYSIUS HARRY (*b. Milwaukee, Wis., 1903; d. Milwaukee, 1956*), baseball player. One of baseball's greatest outfielders and batters, Simmons played from 1924 to 1932 for the Philadelphia Athletics under the management of Connie Mack. His lifetime batting average was .334; his 1,827 runs batted in was the tenth best in baseball history. After 1932, he played for the Chicago White Sox and other teams before

becoming a coach. He was elected to the Baseball Hall of Fame in 1953.

SIMMONS, EDWARD (*b. Concord, Mass., 1852; d. Baltimore, Md., 1931*), mural painter. A boyhood companion of H. D. Thoreau. He graduated from Harvard, 1874, and as a student of painting at the Boston Museum of Fine Arts was influenced by William Rimmer. Studied and worked in France and England, 1879–91, then returned home to execute a number of murals in public buildings and private residences. His murals were strong and direct, but lacked originality in composition and execution.

SIMMONS, FRANKLIN (*b. present Webster, Maine, 1839; d. Rome, Italy, 1913*), sculptor. A resident principally of Rome *post* 1867, he was author of many portrait busts, public monuments, and ideal figures, which at their best displayed power and a simple grace.

SIMMONS, FURNIFOLD MCLENDEL (*b. near Polloksville, N.C., 1854; d. near New Bern, N.C., 1940*), lawyer, politician. Graduated Trinity College (later Duke University), 1873. Congressman, Democrat, from North Carolina, 1887–89. Simmons gradually established himself in control of the Democratic state machine *post* 1892 and employed "white supremacy" tactics and propaganda to recapture the radical whites who had been drawn away from the party by the Populists. U.S. senator from 1900 to 1930, Simmons continued to control North Carolina politics and maintained a parochial ultraconservative attitude toward legislation, except in matters which might assist the interests of North Carolina. Seniority and hard work as a committee member earned him national influence; however, a general restiveness under his control was aggravated by his opposition to Alfred E. Smith, 1928.

SIMMONS, GEORGE HENRY (*b. Moreton-in-Marsh, Gloucestershire, England, 1852; d. Chicago, Ill., 1937*), physician, medical editor and executive. Came to America, 1870, settling in the Middle West. M.D., Hahnemann Medical College, 1882. Contributed to raising medical education standards as secretary (later general manager) of the American Medical Association and editor of the association's *Journal*, 1899–1924.

SIMMONS, JAMES STEVENS (*b. Newton, N.C., 1890; d. Hartford, Conn., 1954*), bacteriologist, army medical officer, and university administrator. Studied at Davidson College, the University of North Carolina, the University of Pennsylvania (M.D., 1915), George Washington University (Ph.D., 1934), and at Harvard (Ph.D., 1939). U.S. Army Medical Reserve Corps (1917–46). During World War II, assigned to the Office of the Surgeon General of the Army, where he developed and directed a successful program to safeguard the health of American fighting men. Promoted to brigadier general in 1943. As a member of the National Research Council (1941–46) he researched the first widespread use of DDT to control the spread of insect-borne diseases. Dean of the Harvard School of Public Health (1946–54).

SIMMONS, ROSCOE CONKLING MURRAY (*b. Monroe County, Miss., 1878; d. Chicago, Ill., 1951*), orator, journalist, and politician. Studied at Tuskegee Institute. A black active in Republican politics, Simmons became columnist for the black newspaper the *Chicago Defender* in 1913, helping to make that paper, through his travels and orations, the largest black newspaper in the country. Chairman of the colored speaker's bureau of the Republican National Committee in the 1920's. Seconded the nomination of President Hoover at the national convention in 1932. Feature writer for the *Chicago Tribune* during the 1940's.

SIMMONS, THOMAS JEFFERSON (*b. Hickory Grove, Ga., 1837; d. 1905*), Confederate officer, Georgia legislator and jurist. A principal factor in the restoring of Georgia finances during the last years of Reconstruction, Simmons was elected to the state supreme court, 1887, became chief justice in 1894, and continued in that post until his death.

SIMMONS, WILLIAM JOSEPH (*b. Harpersville, Ala., 1880; d. Atlanta, Ga., 1945*), promoter, founder of the revived Ku Klux Klan. After riding circuit in rural Alabama and northern Florida as a minister of the Methodist Episcopal Church, South, 1899–1912, he left the ministry and became a successful organizer for various fraternal orders. On Thanksgiving night, 1915, atop Stone Mountain, near Atlanta, Ga., he held a ceremony at which he announced a formal revival of the post-Civil War secret society dedicated to the preservation of public morality and white supremacy. The new Ku Klux Klan made little progress, however, until 1920 when an Atlanta firm of publicity agents took over and devised for it a creed of militant opposition to Catholics, Jews, blacks, immigrants, bootleggers, and modernist theologians—among other categories. The Klan then grew at an astonishing rate, spreading into every part of the nation and engaging in numerous acts of terrorism. Simmons' power as "Imperial Wizard" dwindled as the society expanded. In 1924, after a legal struggle with various state leaders, he resigned from the Klan and surrendered all copyrights on Klan literature and paraphernalia in exchange for a cash settlement and the deed to the "palace" he occupied in Atlanta.

SIMMS, RUTH HANNA MCCORMICK (*b. Cleveland, Ohio, 1880; d. Chicago, Ill, 1944*), politician, rancher. Daughter of Marcus A. Hanna; niece of James F. Rhodes. Married Joseph M. McCormick, 1903 (deceased 1925); married Albert G. Simms, 1932. Early associated with progressivism and midwestern agrarian liberalism, and an effective lobbyist for labor reforms and woman suffrage, she was essentially a partisan Republican "regular." Delighting in her self-described role of "first woman ward politician," she served on state and national Republican committees, organized a network of active women's Republican clubs throughout Illinois, and in 1928 was elected congressman-at-large from Illinois on a platform of "no promises and no bunk." She thus became the first woman in the United States to win a statewide election. Defeated in her candidacy for the U.S. Senate, 1930, she devoted herself thereafter principally to her personal business, removing after her second marriage to New Mexico.

SIMMS, WILLIAM ELLIOTT (*b. near Cynthiana, Ky., 1822; d. 1898*), lawyer, Mexican War and Confederate soldier. Congressman, Democrat, from Kentucky, 1859–61. He abandoned his early neutral position and served as Confederate senator from Kentucky, 1862–65.

SIMMS, WILLIAM GILMORE (*b. Charleston, S.C., 1806; d. Charleston, 1870*), novelist, man of letters. Educated in public and private schools in his native city, he was at first apprenticed to a druggist, but studied law and was admitted to the bar, 1827. He wrote and published a good deal of verse and contributed articles to periodicals and newspapers; as editor of the Charleston *City Gazette* he took a vigorous, unpopular stand against nullification. In 1832, after the death of his wife and other private difficulties, he removed to the North, where, in New York, he formed a permanent friendship with William Cullen Bryant and wrote a crime story, *Martin Faber* (1833). On its favorable reception by the public, he followed it with *Guy Rivers* (1834) and *The Yemassee* (1835). As he did not feel at home in the North, he returned to Charleston.

Marrying the daughter of a Barnwell Co. plantation owner, 1836, he had much to do with the management of his father-in-law's property. He continued active as a writer, producing, among other books, *Richard Hurdis* (1838), *Border Beagles* (1840), *Beauchampe* (1842); his best work of this period was *The Partisan* (1835), *Mellichampe* (1836), and *The Kinsmen* (1841, later titled *The Scout*). Possessed of a strong bent toward public affairs and a warm local patriotism, Simms turned his pen to the defense of slavery, but more particularly to the upbuilding of a distinctively Southern image. By saving slavery, as he saw it, the South would be preserved in its essential quality. He undertook to do whatever a man of letters could do for South Carolina by compiling a history and a geography of the state, by delivering orations, and by writing biographies of figures either distinctively Southern or filled with the qualities which he believed to be those of his section. From 1842 to 1850 Simms wrote comparatively little fiction; he then issued *Katharine Walton* (1851), *The Sword and the Distaff* (1853, later titled *Woodcraft*), *The Forayers* (1855), *Eutaw* (1856), *Charlemont* (1856), *The Classique of Kiawah* (1859), and others. Ruined materially by the Civil War, during which he gave his sympathies entirely to the South, Simms could do nothing to restore himself and his defeated section but edit *The War Poetry of the South* (1867), busy himself with journalism, and write bad serials for magazines.

SIMON, RICHARD LEO (*b. New York, N.Y., 1889; d. North Stamford, Conn., 1960*), publisher. Studied at Columbia University. Founded, with Max Lincoln Schuster, the firm Simon and Schuster in 1924. The firm concentrated on publishing best-sellers; many "how-to" books were ordered by the publishers, and writers complied. Simon published books that reflected his interests such as music, bridge, and photography. In 1939, he published *A Treasury of Art Masterpieces* which became a model for art books in America. Simon wrote a column for *Publishers Weekly* entitled "From the Inner Sanctum" (1926–35). In 1939 the partners founded Pocket Books, Inc., and were instrumental in opening up the lucrative paperback market. In 1944, the firm was sold to Marshall Field Enterprises, with Simon remaining as executive; he retired in 1957.

SIMONDS, FRANK HERBERT (*b. Concord, Mass., 1878; d. Washington, D.C., 1936*), journalist, commentator on military events of World War I.

SIMONS, ALGIE MARTIN (*b. North Freedom, Wis., 1870; d. New Martinsville, W.Va., 1950*), socialist theorist, journalist, and politician; personnel management expert; medical economist. B.L., University of Wisconsin, 1895. Edited a number of socialist publications, 1899–1916; author of *Packingtown* (1899), a vivid description of Chicago stockyard conditions, and of *Social Forces in American History* (1911), the first Marxist attempt at an explanation of the American past. *Post* 1918, he was engaged in industrial personnel management and as an economist for the American Medical Association.

SIMONS, HENRY CALVERT (*b. Virden, Ill., 1899; d. Chicago, Ill., 1946*), economist. B.A., University of Michigan, 1920; graduate study of Columbia University and University of Chicago. Taught at the University of Iowa, 1920–27, and the University of Chicago, 1927–46. With Frank H. Knight, a major factor in formation of the Chicago school of economists. Author of, among other works, *Personal Income Taxation* (1938).

SIMONTON, CHARLES HENRY (*b. Charleston, S.C., 1829; d. Philadelphia, Pa., 1904*), Confederate officer, South Carolina legislator, lawyer. Judge, U.S. district court of South Carolina, 1886–93; circuit court of appeals (4th Circuit), 1893–1904.

SIMONTON, JAMES WILLIAM (*b. Columbia Co., N.Y., 1823; d. Napa, Calif., 1882*), journalist, Washington correspondent, newspaper publisher. General agent of the Associated Press, 1867–81, he was instrumental in exposing some of the corruption of President Grant's administration.

SIMPSON, ALBERT BENJAMIN (*b. Bayview, Prince Edward Island, Canada, 1843; d. 1919*), Presbyterian clergyman, independent evangelist. Founded the Christian Alliance, 1887 (*post* 1897, the Christian and Missionary Alliance), of which he served as president and general superintendent.

SIMPSON, CHARLES TORREY (*b. Tiskilwa, Ill., 1846; d. Miami, Fla., 1932*), naturalist, U.S. National Museum official, authority on mollusks.

SIMPSON, EDMUND SHAW (*b. England, 1784; d. New York, N.Y., 1848*), actor, manager. Made American debut at the Park Theatre, New York City, October 1809; became acting manager of the Park, 1812, and a partner in that theater *ca.* 1818. Successful for a number of years as manager and director. Simpson became sole lessee upon the death of Stephen Price, 1840, at a time when, for a number of reasons, the enterprise was tottering. After eight years of dogged struggle, he gave up his interest to others for a small annuity.

SIMPSON, EDWARD (*b. New York, N.Y., 1824; d. Washington, D.C., 1888*), naval officer. Son of Edmund S. Simpson. An ordnance expert and veteran of the Mexican and Civil wars, Simpson held many important commands and retired as rear admiral, 1886.

SIMPSON, JAMES HERVEY (*b. New Brunswick, N.J., 1813; d. St. Paul, Minn., 1883*), soldier, explorer. Graduated West Point, 1832. Commissioned in the artillery, he transferred to the topographical engineers, 1838, and was engaged up to the Civil War in important survey work in the West and Southwest and also in Minnesota. After field service in the early days of the Civil War, he served as chief engineer, Department of the Ohio, 1862–63, and was in general charge of fortification and engineering projects in Kentucky, 1863–65, receiving the brevet of brigadier general. Chief engineer, Department of the Interior, 1865–67, he undertook general direction and inspection of the Union Pacific Railroad as well as of all government wagon roads and was promoted colonel, March 1867. Subsequently he engaged actively in engineering work in the South and the Middle West. Simpson was author of a number of interesting reports of great historical value, including *Report from the Secretary of War . . . of the Route from Fort Smith, Ark., to Santa Fe, N.Mex.* (1850) and *Journal of a Military Reconnaissance from Santa Fe, N.Mex., to the Navajo Country* (1852).

SIMPSON, JERRY (*b. Westmoreland Co., New Brunswick, Canada, 1842; d. Wichita, Kans., 1905*), farmer, rancher, politician. After working as a Great Lakes sailor, brief service in the Union army, and a short residence in Porter Co., Ind., Simpson settled in Kansas *ca.* 1879. Losing his savings and harassed by mortgages after the collapse of the boom times in Kansas, he drifted from the Republican party by various stages into the Populist movement and represented the seventh Kansas district in the U.S. House of Representatives, 1891–95. Reelected with Democratic help, he served again 1897–99. Called "Sockless Jerry," he combined with the Populist doctrine a belief in the single tax. Although he delivered few speeches and proposed few bills in Congress, he directed his sharp, shrewd wit at insincerity and what he considered false doctrine. His belief in simple democracy and monetary reform were the two consistent threads through his career.

SIMPSON, JOHN ANDREW (*b. near Salem, Nebr., 1871; d. Washington, D.C., 1934*), farm leader, lawyer, Oklahoma legislator. Advocated legislation to guarantee cost of production plus reasonable profit to farmers for products consumed in the home market; also favored low farm-mortgage refinancing and free coinage of silver.

SIMPSON, MATTHEW (*b. Cadiz, Ohio, 1811; d. 1884*), Methodist clergyman, educator. President, present DePauw University, 1939–48, Simpson was elected bishop, 1852, and as a strong antislavery proponent became a friend and counselor of Salmon P. Chase, Edwin Stanton, and President Lincoln. He was public speaker of rare effectiveness and the most influential Methodist of his day in the United States.

SIMPSON, MICHAEL HODGE (*b. Newburyport, Mass., 1809; d. Boston, Mass., 1884*), capitalist, manufacturer, inventor of machinery for carpet-making and wool-burring.

SIMPSON, STEPHEN (*b. Philadelphia, Pa., 1789; d. Philadelphia, 1854*), periodical editor, reformer. Edited the *Portico*, Baltimore, Md., 1816–17; coproprietor of the *Columbian Observer*. A strong supporter of Andrew Jackson and the first man to run for Congress on a labor ticket in the United States, he was author of, among other books, *The Working Man's Manual: A New Theory of Political Economy on the Principle of Production the Source of Wealth* (1831). In this work he contended that labor should receive the whole of its production, denounced fund holders and land monopolists, and advocated political divisions according to economic allegiance.

SIMPSON, WILLIAM DUNLAP (*b. Laurens District, S.C., 1823; d. 1890*), lawyer, South Carolina legislator, Confederate soldier and congressman. Democratic lieutenant governor of South Carolina, 1876–78; governor, 1878–80. Chief justice of South Carolina, 1880–90. Competent but not brilliant.

SIMPSON, WILLIAM KELLY (*b. Hudson, N.Y., 1855; d. 1914*), laryngologist. Associated with Joseph O'Dwyer in his work on intubation. Professor of laryngology, New York College of Physicians and Surgeons, 1904–14; served on many hospital staffs.

SIMS, CHARLES N. (*b. Fairfield, Ind., 1835; d. Liberty, Ind., 1908*), Methodist clergyman. Graduated present DePauw University, 1859. After an active ministry and a brief term as president of Valparaiso College, he served with great ability as chancellor of Syracuse University, 1881–93.

SIMS, JAMES MARION (*b. Lancaster Co., S.C., 1813; d. 1883*), gynecologist. Graduated South Carolina College, 1832; Jefferson Medical College, 1835. Settling in Mount Meigs, Ala., he attained his first local fame by urging an abdominal incision for an abscess after consultants had dismissed the patient with a diagnosis of cancer. Removing to Montgomery, Ala., 1840, he next won attention by the complete rectification of a cleft palate. Called to treat a woman in labor, June 1845, he found that impaction and extensive sloughing had resulted in a large bladder fistula which would render the patient unfit for all social relationships and which was considered incurable. Convinced that he could cure this and similar troubles by a new technique which accident had suggested to him, he began a long, drawn-out series of operations performed under the most difficult conditions. Successful in the late spring of 1849 with three patients, owing mainly to silver sutures which he had devised and to his own unparalleled skill, he wrote the history of his vesicovaginal fistula operation in full recognition of its importance and published it in the *American Journal of the Medical Sciences*, January 1852. Removing to New York City, 1853, he continued to perform fistula operations, instructed his fellow surgeons in his methods, and brought about institution of the Woman's Hospital, 1855. Removing to Europe for a rest, 1861, he was received everywhere with high praise and honor, performed a number of successful operations, and after a brief visit to America returned to Paris to practice, July 1862–1865. His *Clinical Notes on Uterine Surgery* (1866) was a factor in formation of the nascent specialty of gynecology. Resident principally in New York City after the Civil War, he performed volunteer service in France during the Franco-Prussian War, 1870. In 1876 he was president of the American Medical Association. His autobiography, *The Story of My Life*, appeared posthumously, 1884.

SIMS, WILLIAM SOWDEN (*b. Port Hope, Ontario, Canada, 1858; d. Boston, Mass., 1936*), naval officer, naval reformer. Son of Alfred W. Sims, an American civil engineer, and Adelaide (Sowden) Sims of Port Hope, he spent his youth in the United States and graduated from Annapolis, 1880. Six years at sea and a year of language study in Paris were followed by six more years at sea, including two on the China Station during the Sino-Japanese War; he then spent three years as naval attaché in France and, briefly, in Russia. His voluminous reports from Europe showed his awareness of the comparative backwardness of the U.S. Navy. By 1901 he was bombarding the Navy Department with problems of ship design and gunnery, enthusiastically advocating the new British technique of continuous-aim firing, and committing an insubordinate act by writing directly to President Theodore Roosevelt about the "very inefficient condition of the Navy." Ordered to Washington as inspector of target practice, 1902, he also served *post* 1907 as the president's naval aide. These were fruitful years for the naval reformers. By the end of the Roosevelt administration, American gunnery was second to none, and criticism of ship design and of navy bureaucracy had provoked congressional investigations, with, however, inconclusive results. In 1910 Sims made an effusively pro-British speech at the Guildhall in London, for which he was publicly reprimanded by President Taft. He served with distinction as commander, Atlantic Destroyer Flotilla, and as president, 1917, of the Naval War College. He won promotion to rear admiral, 1917, and to vice admiral, 1918, and was named commander, U.S. Naval Forces in European Waters, June 1918. Promoted full admiral in December, he spent the war in London supervising America's extensive overseas naval activity. Still agitating for Navy Department reorganization, Sims refused a decoration for wartime service. Retiring in 1922, he continued through speeches and articles to press for processes of reform. He later championed naval aviation and crusaded for legislation to keep America out of war. In the wider sense this highly competent officer represented the Progressive and muckraking movements, improbably situated within a military environment.

SIMS, WINFIELD SCOTT (*b. New York, N.Y., 1844; d. Newark, N.J., 1918*), inventor. First to apply electricity to torpedo propulsion, Sims also invented a pneumatic field gun, several dynamite guns, and a number of other ordnance devices.

SINCLAIR, HARRY FORD (*b. Wheeling, W. Va., 1878; d. Pasadena, Calif., 1956*), oil producer. Studied briefly at the University of Kansas. Sinclair became an oil broker in 1903; by 1905, he invested in the rich Kiowa Pool in Oklahoma. By 1916, he had founded one of the giants in American industry, the Sinclair Oil and Refining Company. The company prospered; in the 1920's, Sinclair was involved in the Teapot Dome Scandal and was called before a Senate investigating Committee. He later stood trial along with ex-secretary of the interior, Albert Fall. Sinclair refused to testify before the Senate and at his trial. While never convicted of the bribery charges brought against him, he did

serve nine months in prison for contempt of court and of the Senate. An intensely private man, Sinclair retired from active life in his company in 1954.

SINCLAIR, UPTON BEALL, JR. (*b. Baltimore, Md., 1878; d. Bound Brook, N.J., 1968*), journalist and novelist. Attended City College of New York (B.A., 1897) and Columbia. In his earliest writings he exhibited the fluency of pen that enabled him to become one of the most prolific and widely read authors in American literary history. He joined the Socialist party in 1902; with Jack London he helped found the Intercollegiate Socialist Society in 1905. He was also an unsuccessful Socialist candidate for Congress and the California governorship in the 1920's and 1930's. The best of his early novels was *Manassas* (1904). *The Jungle* (1906) was an immediate and sensational best-seller; it depicted the lives of packinghouse workers and the unsanitary conditions in the meat-processing industry. With that work he became a "muckraker"; other muckraking books include *The Moneychangers* (1908), *King Coal* (1917), and *Oil!* 1927). He began a series of nonfiction works on the effects of capitalism in America seen from the socialist standpoint with *Profits of Religion* (1918). In 1940 he published the first of the eleven-volume Lanny Budd series; the third volume, *Dragon's Teeth* (1942), won a Pulitzer Prize. *What Didymus Did* (1954) was his farewell to fiction writing. His autobiography was published in 1962.

SINGER, CHARLES H. (*b. Bayonne, N.J., 1903; d. Sibley, Va., 1972*), communications expert. In the 1920's he worked as a wireless operator on passenger steamships and installed radio communications between Bayonne Police Headquarters and its patrol cars. He went to work for WOR radio station in New York City as an engineer. After World War II he helped design the station's new television facilities. In 1955 he became vice-president and director of operations at Page Communications Engineers, a subsidiary of Northrop Corporation that constructed and operated the long-distance communication systems of the U.S. military. In the 1960's he helped Page Communications install and maintain an undersea cable communications network to support the U.S. military in Vietnam.

SINGER, ISAAC MERRIT (*b. Pittstown, N.Y., 1811; d. Torquay, England, 1875*), inventor. Developed the first practical domestic sewing machine (patented 1851, with improvement patents thereafter until 1863) and brought it into general use through the manufacturing company which he founded and headed until 1863.

SINGER, ISRAEL JOSHUA (*b. Bilgoray, Poland, 1893; d. New York, N.Y., 1944*), Yiddish novelist, journalist. Brother of Isaac B. Singer. Son of a Hasidic rabbi, he rebelled against his religious and cultural traditions yet never could discover any values to replace them; in his work, he gives artistic expression to this sense of alienation and to the struggles which he observed and underwent. After a troubled career in Russia and Poland, he came to the United States in 1934. He was author of, among other works, *Yoshe Kalb* (1933, entitled in English *The Sinner*); *The Brothers Ashkenazi* (1936); *East of Eden* (1939); and *The Family Carnovsky* (1943). One volume of an unfinished autobiography, *Of a World That Is No More*, was published posthumously in 1946 (English translation, 1970).

SINGERLY, WILLIAM MISKEY (*b. Philadelphia, Pa., 1832; d. Philadelphia, 1898*), journalist. Editor-publisher of the *Philadelphia Record* (originally the *Public Record*) post 1877; Democratic political leader of Pennsylvania.

SINGLETON, ESTHER (*b. Baltimore, Md., 1865; d. Stonington, Conn., 1930*), editor, music critic. Author of, among other books,

The Furniture of Our Forefathers (1900) and *Social New York Under the Georges* (1902).

SINGLETON, JAMES WASHINGTON (*b. Frederick Co., Va., 1811; d. Baltimore, Md., 1892*), Illinois lawyer, Civil War peace projector. Congressman, Democrat, from Illinois, 1879–83.

SINNOTT, EDMUND WARE (*b. Cambridge, Mass., 1888; d. New Haven, Conn., 1968*), botanist and geneticist. Attended Harvard (Ph.D., 1913), taught at Harvard Forestry School and Bussey Institution (1914–15), Connecticut Agricultural College (1915–28), Barnard (1928–39), and Columbia (1939); at Yale, beginning in 1940, he was Sterling Professor of Botany and director of the Osborn Botanical Laboratory, March Botanical Gardens, and, during 1946–56, the Sheffield Scientific School. Although a botanist, he approached the study of plants as a morphologist. In the 1920's and 1930's he published a series of articles that define how genes affect the shape of fruit, particularly squash. He became one of the leading plant geneticists in the United States and coauthored a book that became a standard work, *Principles of Genetics* (1925).

SIRINGO, CHARLES A. (*b. Matagorda Co., Tex., 1855; d. Hollywood, Calif., 1928*), cowboy, detective. Author of *A Texas Cowboy* (1885) and *A Cowboy Detective* (1912).

SISLER, GEORGE HAROLD ("GORGEOUS GEORGE") (*b. Manchester, Ohio, 1893; d. St. Louis, Mo., 1973*), baseball player. Graduated University of Michigan (1915) and signed with the St. Louis Browns. In 1922 he batted .420, the third highest percentage in baseball history, and won the league's Most Valuable Player award. In 1924–27 he was a player-manager with the Browns, then was sold to the Washington Senators (1927) and Boston Braves (1928). He finished his major league career with the Braves in 1930. Elected to Baseball's Hall of Fame in 1939.

SISSLE, NOBLE LEE (*b. Indianapolis, Ind., 1889; d. Tampa, Fla., 1975*), lyricist, singer, and bandleader. Attended DePauw University (1913) and Butler University (1914–15). After jobs as a bandleader and vocalist in Indianapolis and Baltimore, he settled in New York City in 1916 with the James Reese Europe Clef Club Society, the first black musical organization in New York, and began writing lyrics with pianist and composer Eubie Blake. In 1921 he and Blake collaborated on *Shuffle Along*, the first successful black Broadway show. Sissle wrote the lyrics for such hit songs as "I'm Just Wild About Harry" and "Honeysuckle Time." The next Sissle–Blake collaboration was for *Chocolate Dandies* (1924). He formed his own band in 1928 and toured Europe and the United States and was in residence at Billy Rose's Diamond Horseshoe in New York in 1938–42 and again in 1945 to the mid-1950's.

SITTING BULL (*b. on Grand River, S. Dak., 1834[?]; d. 1890*), Hunkpapa Sioux chief, medicine man. His camp in the buffalo country became the rallying point for Sioux, Cheyenne, and Arapaho Indians hostile to the whites; by the spring of 1876 he had gathered a force estimated at from 2,500 to 4,000 men. When General George A. Custer made his disastrous attack on the consolidated Indian village at the Little Bighorn in June, Sitting Bull did no fighting, but spent the time in "making medicine." Driven with his band across the Canadian border by the end of 1876, he surrendered at Fort Buford in 1881 and was settled on the Standing Rock Reservation. Arrested by Indian policemen for his part in the Messiah agitation, he was shot and killed in the fight that followed.

SIZER, NELSON (*b. Chester, Mass., 1812; d. 1897*), phrenologist. Pupil of J. G. Spurzheim; associated in practice with Orson

Fowler and S. R. Wells; president, American Institute of Phrenology.

SKAGGS, MARION BARTON (*b. Aurora, Mo., 1888; d. San Francisco, Calif., 1976*), grocer. In 1915 he bought his father's tiny Idaho grocery and by 1926 he owned 428 stores in ten western states. One of the pioneers of retail grocery chains, Skaggs key to success was building volume sales by taking only a small profit. In 1926 he merged his stores with the Safeway grocery chain. By 1931 the revitalized Safeway Stores, Inc., owned 3,527 stores. He resigned as chairman of Safeway Stores in 1941.

SKANIADARIIO (*b. Ganawaugus, N.Y., ca. 1735; d. Onondaga, N.Y., 1815*), Seneca sachem, religious leader. Claiming revelation from the Creator of Life, he propounded a new religion for the Iroquois called the Gaiwiio.

SKENANDOA (*b. 1706[?]; d. near Oneida Castle, N.Y., 1816*), Oneida chief. Converted to Christianity by Samuel Kirkland. During the Revolution, he helped keep the Oneida and Tuscarora from joining the British and later persuaded many members of these tribes to join the Americans.

SKENE, ALEXANDER JOHNSTON CHALMERS (*b. Fyvie, Scotland, 1837; d. 1900*), pioneer gynecologist. Came to America, 1856. M.D., Long Island College Hospital, 1863; served there for many years as teacher, dean, and president; was consultant to a number of hospitals; practiced in Brooklyn, N.Y. A founder and president of the American Gynecological Society and the International Congress of Gynecology and Obstetrics, he was author of more than 100 medical papers and of a number of books. His discovery, 1880, of what are now called Skene's urethral glands gave him an international reputation and an assured place in the history of gynecology. He also is known to have devised 31 surgical instruments.

SKIDMORE, LOUIS (*b. Lawrenceburg, Ind., 1897; d. Winter Haven, Fla., 1962*), architect. Attended Bradley Polytechnic in Illinois and Massachusetts Institute of Technology (1920–24). In 1929 he prepared drawings for the Chicago centennial celebration and was made chief of design of the fair, even though no design of his had yet been built. He succeeded in coordinating the design work to create the first coherent statement of modern architecture in the United States. In 1936 he opened an office in Chicago with his brother-in-law, Nathaniel Owings; John Merrill joined the firm in 1939, and Skidmore, Owings and Merrill began an innovative architectural practice. Skidmore headed the New York office, which had the bulk of the work and the prestige clients; its projects included designs for the 1939 New York World's Fair; the Fort Hamilton Veteran's Hospital (1939); the Community of Oak Ridge, Tenn., for the Manhattan Project (1942–45); Lever House in New York City (1952), and the U.S. Air Force Academy at Colorado Springs (1954–64). Skidmore retired in 1955 and was awarded the Gold Medal of the American Institute of Architects (1957).

SKILLERN, ROSS HALL (*b. Philadelphia, Pa., 1875; d. Philadelphia, 1930*), laryngologist, professor of laryngology in Medico-Chirurgical College of Philadelphia and University of Pennsylvania.

SKINNER, AARON NICHOLS (*b. Boston, Mass., 1845; d. Framingham, Mass., 1918*), astronomer. Associated with the U.S. Naval Observatory, 1870–1909.

SKINNER, ALANSON BUCK (*b. Buffalo, N.Y., 1886; d. near Tokio, N.Dak., 1925*), anthropologist, ethnologist. Associated with American Museum of Natural History, 1907–13; later with Milwaukee Museum and with Heye Foundation. Authority on material culture of Algonquian Indians and of Siouan tribes in contact with them.

SKINNER, CHARLES RUFUS (*b. Union Square, Oswego Co., N.Y., 1844; d. Pelham Manor, N.Y., 1928*), journalist. New York legislator and congressman. In state education department *post* 1886, he was state superintendent of public instruction, 1895–1904. He held several other state appointments thereafter, and was legislative librarian, 1915–25.

SKINNER, CORNELIA OTIS (*b. Chicago, Ill., 1901; d. New York City, 1979*), actress, playwright, and author. Attended Bryn Mawr College, studied in Paris at the Sorbonne, and received classical theater training in Europe. She made her Broadway debut in *Will Shakespeare* (1923) and performed all the roles in *Edna, His Wife* (1938), had the title role in *Candida* (1935), and appeared in *Major Barbara* (1946), *The Searching Wind* (1944), and *Lady Windemere's Fan* (1946). She used her widely known monologue technique on network radio in the 1930's and wrote scripts for the prime-time radio serial "William and Mary." She had an easy, conversational writing style, and her sketches appeared in the *New Yorker, Harper's Bazaar,* and *Ladies' Home Journal.* Her books include the best-selling book *Our Hearts Were Young and Gay* (1942) with Emily Kimbrough and *Madame Sarah* (1967). Her essays were collected in *Tiny Garments* (1932), *That's Me All Over* (1948), and *Bottoms Up* (1955). Her greatest critical success was her monodrama *Paris '90,* which opened on Broadway in 1952 and in which she portrayed fourteen characters in fin de siècle Paris. Her last Broadway triumph was her production of *The Pleasure of His Company* (1958).

SKINNER, HALCYON (*b. Mantua, Ohio, 1824; d. 1900*), inventor of carpet-weaving machinery, notably a power loom for moquette carpets (patented 1877).

SKINNER, HARRY (*b. Perquimans Co., N.C., 1855; d. Greenville, N.C., 1929*), lawyer, North Carolina legislator. Congressman, Populist, from North Carolina, 1895–99. Claimed that his ideas formed basis of "subtreasury" plan for agricultural price-fixing as advocated by Populists.

SKINNER, JOHN STUART (*b. Calvert Co., Md., 1788; d. Baltimore, Md., 1851*), lawyer, public official, agricultural editor and writer. Companion of Francis Scott Key during bombardment of Fort McHenry, September 1814, he subsequently arranged to have "The Star-Spangled Banner" first printed. In 1819 he founded the *American Farmer,* the first continuous, successful agricultural periodical in the United States, which he published until 1830. In 1829 he started the *American Turf Register and Sporting Magazine,* the first magazine devoted to the improvement of American Thoroughbred horses. From 1845 to 1848 he edited the *Farmer's Library* in New York, and then established in Philadelphia *The Plough, the Loom, and the Anvil,* which he edited until his death. A member of leading agricultural organizations, he was an outstanding agricultural publicist.

SKINNER, OTIS (*b. Cambridge, Mass., 1858; d. New York, N.Y., 1942*), actor. While he worked as Hartford correspondent for the New York *Dramatic News* and editor of the *Hartford Clarion,* his thoughts constantly reverted to the theater. In 1877 a letter of recommendation from the showman P. T. Barnum, an acquaintance of his father's, helped Skinner obtain a position as "utility" actor. During his first season he played 92 roles. He spent the next season, 1878–79, with the more prosperous Walnut Street Theatre stock company in Philadelphia. In 1880 he played minor roles with a company formed around Edwin Booth, who became his revered friend and teacher. From 1881 to 1884 Skin-

ner acted with Lawrence Barrett, but he left Barrett's troupe and toured with the comedy company of Augustin Daly. Barrett, as Booth's business manager, engaged Skinner for second leads in the combined tour of Booth and the Polish tragedienne Helena Modjeska, 1889–90.

In 1894 Skinner managed his own company, and over the next few years he enjoyed many successes in Shakespearean plays and 19th-century favorites. His most noteworthy appearances during this period were in *His Grace de Grammont* (1894); *Villon the Vagabond* (1895), written by Skinner and his brother Charles; *Hamlet* (1895); Sheridan's *The Rivals* (1899), on tour with Joseph Jefferson; *Prince Otto* (1900), Skinner's first New York success as a star; a revival of *Francesca da Rimini* (1901); a season of classic comedies with Ada Rehan (1903); and a poetic French drama, *The Harvester* (1904).

By 1904 Skinner was an established star on Broadway and in "the provinces." That year he went under the management of Charles Frohman, who presented him in Henri Lavedan's *The Duel* (1906) and in *The Honor of the Family* (1907), in which Skinner scored one of his biggest hits as the villain. After appearing as a hammy old actor in *Your Humble Servant* (1910), he went on to his greatest triumph, *Kismet* (1911). He played *Kismet* for three years (in New York and on tour) and made two films of the play. He continued his stardom as a deaf philanthropist in Jules Eckert Goodman's *The Silent Voice* (1914), as a lovable Italian organgrinder in *Mister Antonio* (1916), as a bullfighter in *Blood and Sand* (1921), as Sancho Panza in the play of that name (1923), and as Falstaff in the Players Club revival of *Henry IV* (1926) and in the 1927 production of *The Merry Wives of Windsor* by Minnie Maddern Fiske. In the 1930's Skinner went on tour with Maude Adams, playing Shylock to her Portia, and appeared in several classic revivals presented by the Players. He retired from the stage in 1940. He was the father of the actress and author Cornelia Otis Skinner.

SKINNER, THOMAS HARVEY (*b. Harvey's Neck, N.C., 1791; d. New York, N.Y., 1871*), Presbyterian clergyman, professor of homiletics at Andover and Union Theological seminaries. An advocate of the "new school," he promoted broader theological views and closer interdenominational relations.

SKINNER, WILLIAM (*b. London, England, 1824; d. 1902*), silk manufacturer. Immigrated to America, 1843; did business at Holyoke, Mass., *post* 1874 after making start near Williamsburg, Mass., *ca.* 1874 after making start near Williamsburg, Mass., *ca.* 1849. Produced high-quality "Skinner's satin" lining.

SKOURAS, GEORGE PANAGIOTES (*b. Skourohorion, Greece, 1896; d. New York, N.Y., 1964*), theater executive. Arrived in the United States in 1911. Beginning in 1914 he and his brothers Charles and Spyros purchased entertainment properties in St. Louis, and by 1926 the Skouras chain included thirty-seven St. Louis–area theaters. Prior to the stock-market crash of 1929, the brothers had sold Skouras Brothers Enterprises to Warner Brothers, which became owner of one of the top theater circuits. Warners hired the brothers to head different divisions of its theater operations; George moved to New York City as general manager of the eastern section. In 1931 he became president of the new Skouras Circuit of fifty theaters in New York City area; in 1952 he was president of the United Artists Theatre Circuit. He founded the Magna Theatre Corporation (1953); its first product, *Oklahoma!* (1955), was shot in Todd-A-O and lost $4 million; he then guided Magna through the lucrative leasing of the Todd-A-O process to Twentieth Century-Fox for its highly profitable *South Pacific* (1958). He retired as head of Magna in 1963.

SKOURAS, SPYROS PANAGIOTES (*b. Skourahorian, Greece, 1893; d. Rye, N.Y., 1971*), motion-picture executive. Immigrated to the United States in 1910 and with his brothers purchased a St. Louis nickelodeon hall in 1913; by 1926 they owned movie theaters in several Midwestern cities. During the 1930's, Spyros, as head of Fox Metropolitan Theaters, directed Fox's merger with Twentieth Century movie studios. After 1942 Skouras was president of Twentieth Century–Fox, during which time he led a spirited battle against the television industry, including an unsuccessful campaign to prevent the sale of films to television. He oversaw the creation of such noted films as *The Keys of the Kingdom* (1947), *All About Eve* (1950), and *The Diary of Anne Frank* (1959). He also introduced movie screen innovations, such as CinemaScope, which produced pictures superior to small-screen televisions. Skouras was forced to resign his position in 1962, partly because of the hugely over-budget film *Cleopatra*.

SLADE, JOSEPH ALFRED (*b. near Carlyle, Ill., ca. 1824; d. Virginia City, Mont., 1864*), freighter, wagon-train boss, stagecoach division agent, "bad man." Hanged by vigilantes.

SLADE, WILLIAM (*b. Cornwall, Vt., 1786; d. Middlebury, Vt., 1859*), lawyer, editor, public official, politician. Elected to Congress as Democrat in 1830, he served for 12 years and in that time became a Whig; he was a fierce opponent of slavery and a high-tariff advocate. As governor of Vermont, 1844–46, he reorganized the public school system. He served thereafter as agent of the Board of National Popular Education.

SLAFTER, EDMUND FARWELL (*b. Norwich, Vt., 1816; d. Hampton, N.H., 1906*), Episcopal clergyman, scholar. Graduated Dartmouth, 1840. Active in pastoral work and as an official of the American Bible Society, he was a valued member and officer of the New England Historic Genealogical Society and of the Prince Society (president, 1880–1906). He edited four Prince Society monographs, including *Voyages of Samuel de Champlain* (1878–82).

SLATER, JOHN CLARKE (*b. Oak Park, Ill., 1900; d. Sanibel Island, Fla., 1976*), physicist. Graduated University of Rochester (B.A., 1920) and Harvard University (M.A.; Ph.D., 1923). In 1924 he researched the emission and absorption of energy in atoms at Cavendish Laboratory in England and collaborated with Niels Bohr and Hans Kramers on "The Quantum Theory of Radiation" (1924), which followed Slater's idea that a radiation field guided the light quanta. He taught at Harvard (1924–30), Massachusetts Institute of Technology (1930–66), and University of Florida at Gainesville (1964–76). His most important paper, "The Theory of Complex Spectra" (1929), introduced determinantal wave functions for system of many electrons (Slater determinants). He was also renowned for this textbooks: *Introduction to Theoretical Physics*, with N. H. Frank (1933); *Microwave Transmission* (1942); *Modern Physics* (1955); and *Quantum Theory of Molecules and Solids* (1963–74).

SLATER, JOHN FOX (*b. Slatersville, R.I., 1815; d. 1884*), cotton and woolen manufacturer, philanthropist. Founded John F. Slater Fund for black education, 1882.

SLATER, SAMUEL (*b. Belper, England, 1768; d. 1835*), founder of the American cotton-spinning industry. Apprenticed in 1782 to Jedediah Strutt, a partner of Richard Arkwright in development of cotton-manufacturing machinery, Slater immigrated by stealth to America in 1789. Having studied and memorized all details of making textile machinery (whose exportation from England was then forbidden by law), he contracted with Almy and Brown of Rhode Island to reproduce Arkwright's machine for that firm; in 1793 they built their first factory in Pawtucket under

the firm name of Almy, Brown and Slater. In 1798 he formed a family partnership known as Samuel Slater & Co. and undertook a variety of highly successful mill operations in Rhode Island, Connecticut, and Massachusetts.

SLATTERY, CHARLES LEWIS (*b. Pittsburgh, Pa., 1867; d. Boston, Mass., 1930*), Episcopal clergyman, author. Consecrated co-adjutor bishop of Massachusetts, 1922; succeeded to the see, 1927. Made his principal contribution as pastor and scholar, in particular as chairman of commission to revise the Book of Common Prayer.

SLAUGHTER, PHILIP (*b. Culpeper Co., Va., 1808; d. 1890*), Episcopal clergyman, historian. Author of a number of Virginia parish histories and monographs.

SLEEPER, JACOB (*b. Newcastle, Maine, 1802; d. Boston, Mass., 1889*), merchant, philanthropist. One of the three founders of Boston University, 1869.

SLEMP, CAMPBELL BASCOM (*b. Turkey Cove, Lee County, Va., 1870; d. Knoxville, Tenn., 1943*), lawyer, politician. Chosen to complete his father's unexpired term as a Republican member of Congress from Virginia, 1907, he won reelection to seven consecutive terms. He voted consistently with the "Old Guard" of his party, and was one of its most influential southern members. He served as presidential secretary to President Calvin Coolidge, 1923–25.

SLICER, THOMAS ROBERTS (*b. Washington, D.C., 1847; d. New York, N.Y., 1916*), Unitarian clergyman. Principal pastorate at All Souls Church, New York City, *post* 1897. A prominent preacher and writer, he was best known as a militant leader of civic reform.

SLICHTER, LOUIS BYRNE (*b. Madison, Wis., 1896; d. Los Angeles, Calif., 1978*), geophysicist. Graduated University of Wisconsin (B.A., 1917; Ph.D., 1922) and worked for the Submarine Signal Corporation (1922–24). With Max Mason he created a consulting firm (1924) that provided geophysical prospecting advice to mineral companies. He taught at California Institute of Technology (1930–31) and Massachusetts Institute of Technology (1931–45) and organized the Institute of Geophysics at the University of California at Los Angeles (1947–62). Slichter's research involved detection of subsurface structures and measuring the electrical conductivity of the earth's crust. He coauthored the groundbreaking paper "The Theory of the Interpretation of Seismic Travel–Time Curves in Horizontal Structures" (1932).

SLICHTER, SUMNER HUBER (*b. Madison, Wis., 1892; d. Boston, Mass., 1959*), economist. Studied at the University of Munich, Germany, at the University of Wisconsin, and at the University of Chicago (Ph.D., 1918). Taught at Cornell in the 1920's and at Harvard Business School from 1930. Believing that academic economists could have an important influence on the nation's economy, Slichter wrote *Union Policies and Industrial Management* in 1941, published by the Brookings Institution. Other books include *The Impact of Collective Bargaining on Management* (1960). Associate chairman of the Advisory Council on Social Security to the Senate Finance Committee (1947–48). President of the American Economic Association, 1941.

SLIDELL, JOHN (*b. New York, N.Y., 1793; d. Cowes, England, 1871*), lawyer, Louisiana politician, diplomat, Confederate agent. Brother of Alexander S. Mackenzie; brother-in-law of Matthew C. Perry. Graduated Columbia, 1810. Removing to New Orleans, La., 1819, he practiced successfully and entered politics as a Jackson Democrat. As congressman, 1843–45, he advocated tariff reductions, except for tariff on sugar; in the election of 1844, he helped secure a majority for Polk in Louisiana by maneuvering a "floater" vote. Appointed U.S. commissioner to Mexico to adjust Texas boundary and purchase New Mexico and California, 1845, he returned unsuccessful. As U.S. senator from Louisiana, 1853–61, he favored repeal of the Missouri Compromise and, as James Buchanan's campaign manager in 1856, materially promoted both his nomination for the presidency and election. During the first three years of the administration, he was the power behind the throne and recommended numerous cabinet and diplomatic appointments. He favored the Lecompton Constitution for Kansas, bitterly opposed Stephen A. Douglas, and supported the Breckinridge-Lane ticket in 1860. Breaking with Buchanan after the dismissal of John B. Floyd from the War Department, Slidell was chosen to represent the Confederacy in France and was apprehended with James M. Mason in the celebrated "*Trent* affair." He performed creditably enough at Paris, but was distrusted by other Confederate agents and won little more than lip service from Napoleon III. After the Civil War, he resided in Paris until the fall of the empire.

SLIPHER, VESTO MELVIN (*b. Mulberry, Ind., 1875; d. Flagstaff, Ariz., 1969*), astronomer. Attended Indiana (Ph.D., 1909). Began his career with the Lowell observatory in Flagstaff while attending college, becoming director in 1926 and retiring in 1954. His first task at the observatory was to install a new spectrograph; he discovered that the diffuse nebula in the Pleiades shone solely by reflected starlight, indicating the existence of interstellar dust. His most significant work involved the study of the velocity and rotation of spiral nebula; by 1912 he had obtained several exposures of the Andromeda nebula (M31) and announced in 1913 that the nebula was approaching earth at 300 kilometers per second. Over the next eighteen months, he calculated the radial velocities of fourteen other nebulae, finding that most were receding from the earth at velocities as great as 1,000 kilometers per second.

SLOAN, ALFRED PRITCHARD, JR. (*b. New Haven, Conn., 1875; d. New York, N.Y., 1966*), industrialist and philanthropist. Attended Brooklyn Polytechnic and Massachusetts Institute of Technology. In 1898 his father and an associate purchased the Hyatt Roller Bearing company and put Sloan in charge. He convinced the Olds Motor Company to use his bearing in the still-experimental horseless carriage; in 1916 he sold the company to William Durant, founder of General Motors, and received his share in United Motors stock, a collection of parts and accessories firms that supplied GM's several companies. Sloan was put in charge of United, and when it was incorporated into GM (1918), he became a member of the GM Executive Committee. He became president of GM (1923–37), then chairman (until 1946). By creating an administrative structure that became a model for the management of large-scale industrial enterprise, he transformed GM and the auto industry. He also developed the industry's first systematic trade-in policies; by 1929 GM surpassed its competitor Ford; by 1940 it was the largest motor vehicle manufacturer in the world. In the 1920's, with the demand for autos low, he embarked on a strategy of diversification; GM's success with the production of diesel locomotives made the steam locomotive obsolete in less than two decades. After 1946 he concentrated on philanthropy. He set up the Alfred P. Sloan, Jr., Foundation, which financed the Sloan-Kettering Institute for Cancer Research, and at MIT the Center for Advanced Engineering Study and the Fund for Basic Research in the Physical Sciences.

SLOAN, GEORGE ARTHUR (*b. Nashville, Tenn., 1893; d. New York, N.Y., 1955*), business executive, civic leader, music patron. LL.B., Vanderbilt University (1915). 1919–22, assistant to the chairman of the American National Red Cross, specializing in Chinese relief. President and chairman of the board of the Cotton and Textile Institute (1932–35); chairman of the Consumer Goods Industries Committee under the NRA. Commissioner of Commerce for New York after 1940; after World War II, chairman of the board of trustees of the International Chamber of Commerce. President of the Metropolitan Opera Association, 1940. Helped bring about the repeal of the federal admissions tax in 1951, saving the Met great sums of money.

SLOAN, HAROLD PAUL (*b. Westfield, N.J., 1881; d. Camden, N.J., 1961*), Methodist clergyman, editor, and author. Attended University of Pennsylvania and Crozer and Drew (B.D., 1908) seminaries; ordained in the Methodist Episcopal Church in 1908. Pastor of Haddonfield Methodist Church in New Jersey (1924–33) and Wharton Methodist Church in Philadelphia (1941–53). He was the principal leader of the fundamentalist defense of the faith, but he rejected the term "fundamentalism" and disassociated himself from the premillenialism of organized fundamentalism, disavowed biblical literalism, and upheld the legitimacy of higher criticism. He personally rejected evolution, but felt that Christianity and evolution were compatible. In the late 1920's he grew increasingly alienated within Methodism by his attacks on the acceptance by liberal Methodists of naturalistic and behavioristic philosophy. Author of *The Child and the Church* (1916), *Historic Christianity and the New Theology* (1922), and *The Apostle's Creed* (1930); editor of Methodism's leading newspaper, the *New York Christian Advocate* (1936–41).

SLOAN, JAMES FORMAN (*b. Bunker Hill, Ind., 1874; d. Los Angeles, Calif., 1933*), jockey, popularly known as "Tod," Adopting a special seat whereby he revolutionized modern race-riding, Sloan became principal rider for William C. Whitney and the most celebrated jockey of the late 19th century. Riding principally in Europe *post* 1897, he was ruled off the turf in 1901 by the English Jockey Club.

SLOAN, JOHN FRENCH (*b. Lock Haven, Pa., 1871; d. Hanover, N.H., 1951*), painter, printmaker. A member of the "Philadelphia four," a group of modernist painters, and, later of the famous Ashcan school, a New York group of painters of urban scenes who dissented from the academic approach to art at the turn of the century. Their paintings, exhibited at the famed Armory Show in 1913, were influential in forming the school of realism in American art of the 1920's and 1930's, and influenced such painters as Edward Hopper and George Bellows. Sloan wrote *Gist of Art* (1939). His style was realistic and depicted scenes from everyday urban life. The painting *Dust Storm* was purchased by the Metropolitan Museum of New York in 1921.

SLOAN, MATTHEW SCOTT (*b. Mobile, Ala., 1881; d. New York, N.Y., 1945*), public utilities executive. B.S., Alabama Polytechnic Institute, 1901; M.S., 1902. After work with the General Electric Co. and its subsidiary, the Electric Bond and Share Co., he went in 1917 with the Consolidated Gas Co., New York City. This company, which controlled electric power distribution in the city through four subsidiary companies, was notoriously inefficient and dominated by local politicians. Successful in effecting reforms in administration and in modernizing plants while president of the Brooklyn Edison Co., 1919–28, he was chosen president and operating head of the several companies supplying power in and around New York when they were combined (later to be reorganized as Consolidated Edison Co.). After four years of struggle to achieve for the whole system what he

had accomplished in Brooklyn, he made some progress in solving the technical problems involved; he was defeated, however, by labor and economic problems incident to the Great Depression and by pressure from the political enemies he had made. He was forced to resign in 1932. From 1934 to 1945 he was president and chairman of the board of the Missouri-Kansas-Texas Railroad and its related lines.

SLOAN, RICHARD ELIHU (*b. Preble Co., Ohio, 1857; d. Phoenix, Ariz., 1933*), lawyer, Arizona legislator and jurist. Republican governor of Arizona Territory, 1901–12.

SLOAN, SAMUEL (*b. Lisburn, Ireland, 1817; d. Garrison, N.Y., 1907*), railroad executive. Brought to America as an infant. After a successful career as a commission merchant in New York City, Sloan entered the railroad field as a director of the Hudson River Railroad, 1855, was chosen its president, and directed its rapid rise until 1864. As president of the Delaware, Lackawanna & Western Railroad, 1867–99, he transformed that road from a limited "coal road" into a profitable handler of general freight and passenger traffic.

SLOAN, TOD *See* SLOAN, JAMES FORMAN.

SLOANE, ISABEL CLEVES DODGE (*b. Detroit, Mich., 1896; d. West Palm Beach, Fla., 1962*), racehorse owner and dog breeder. Her Brookmeade Stable in Virginia had its best year in horse racing in 1934, when it won more money than any other stable; its horse Cavalcade won the Kentucky Derby; and for the first time a woman headed the Thoroughbred-owner's list. In 1949 she was named outstanding breeder of the year by the New York Turf Writers Association; she also headed the owners' list in 1950. Her horse Sword Dancer was Horse of the Year in 1959. Brookmeade Kennels in Syosset, N.Y., did pioneering work with schnauzers and basset hounds, taking best of both breeds at the 1928 Westminster show.

SLOANE, WILLIAM MILLIGAN (*b. Richmond, Ohio, 1850; d. Princeton, N.J., 1928*), educator, historian. Graduated Columbia, 1868; Ph.D., Leipzig, 1876. Served as research assistant to George Bancroft, 1873–75; taught at Princeton and at Columbia, where he was Seth Low professor of history. Author of, among other books, *Life of Napoleon Bonaparte* (serialized in *Century Magazine*, published as book, 1896).

SLOAT, JOHN DRAKE (*b. near Goshen, N.Y., 1781; d. Staten Island, N.Y., 1867*), naval officer. Appointed midshipman, 1800; served in merchant marine, 1801–12, and on frigate *United States* in War of 1812. Received first command (schooner *Grampus*), 1823, and cruised against West Indian pirates; subsequently performed routine sea and shore services. Chosen commander of Pacific Squadron, 1844. He received secret and confidential orders dated June 1845 while based at Mazatlán, Mexico, directing what action he should take in the event of declaration of war by Mexico. Receiving word on June 7, 1846, that the Mexicans had invaded Texas, he sailed for California and arrived at Monterey on July 2. Five days later, overruling opinion of the U.S. consul there, Sloat landed a detachment and proclaimed the U.S. annexation of California; a little later he sent an officer to take possession of San Francisco. Turning over command to Commodore Robert F. Stockton on July 23, he returned to Washington. His conduct of affairs in the Pacific was both criticized and warmly commended. Put on the reserve list, 1855, he was promoted commodore, 1862, and rear admiral on the retired list, 1866.

SLOCUM, FRANCES (*b. Warwick, R.I., 1773; d. near present Peru, Ind., 1847*), Indian captive. Made prisoner near Wyoming,

Pa., 1778, she was adopted by a Delaware Indian family, married in the tribe, and refused offers to return to her white relatives.

SLOCUM, HENRY WARNER (*b. Delphi, N.Y., 1827; d. New York, N.Y., 1894*), Union major general. Graduated West Point, 1852. Resigned from the army, 1856, to engage in the practice of law at Syracuse, N.Y. Appointed colonel, 27th New York Infantry, May 1861, he was soon promoted to brigadier general of volunteers and in July 1862 was promoted major general. An able division and corps commander, Slocum performed outstanding service at Chancellorsville and Gettysburg. He was later active in the campaigns in Tennessee, commanded the district of Vicksburg early in 1864, and with his troops was first to enter Atlanta. Thereafter he commanded the XIV and XX Corps under W. T. Sherman (later known as the Army of Georgia). Practiced law in Brooklyn, N.Y., *post* 1866, and was congressman, Democrat, from New York, 1869–73 and 1883–85.

SLOCUM, JOSHUA (*b. Wilmot Township, Nova Scotia, Canada, 1844; d. at sea, ca. 1910*), mariner, lecturer. Sailed around the world alone in the sloop *Spray*, 1895–98. Author of *Sailing Alone Around the World* (1900) and various periodical writings.

SLOCUM, SAMUEL (*b. Canonicut Island, Newport Co., R.I., 1792; d. Pawtucket, R.I., 1861*), manufacturer. Inventor of, among other devices, a machine for sticking pins in paper so as to package them effectively for sale (patented 1841).

SLOSS, JAMES WITHERS (*b. Mooresville, Ala., 1820; d. 1890*), Alabama industrialist, railroad operator. Associated with H. F. De Bardeleben in development of coal and iron industry in the Birmingham district.

SLOSS, LOUIS (*b. Bavaria, 1823; d. San Rafael, Calif., 1902*), California capitalist, philanthropist. Immigrated to America, 1845; removed to California, 1849. Successful as a broker, leather merchant, and partner and official of the Alaska Commercial Co., Sloss engaged in systematic philanthropies and was an active supporter of almost every charity in San Francisco.

SLOSSON, EDWIN EMERY (*b. present Sabetha, Kans., 1865; d. Washington, D.C., 1929*), chemist, educator, writer of popular works on the sciences.

SMALL, ALBION WOODBURY (*b. Buckfield, Maine, 1854; d. Chicago, Ill., 1926*), sociologist. Graduated Colby College, 1876; Ph.D., Johns Hopkins, 1889. A teacher of history and political economy at Colby, 1881–88, he served Colby as president, 1889–91, and in 1892 became head of the Department of Sociology at University of Chicago, the first department of its kind. He served also as dean of the College of Liberal Arts there, and from 1904 until his retirement in 1924 was dean of the graduate school. Small was founder of the *American Journal of Sociology*, which he edited, 1895–1926. He was author of a number of books, which include *General Sociology* (1905) and *Between Eras: From Capitalism to Democracy* (1913).

SMALL, ALVAN EDMOND (*b. Wales, Maine, 1811; d. 1886*), homeopathic physician. Practicing and teaching at first in Pennsylvania, he removed to Chicago, Ill., 1856, where he was professor, dean, and president of the Hahnemann Medical College.

SMALLEY, EUGENE VIRGIL (*b. Randolph, Ohio, 1841; d. St. Paul, Minn., 1899*), journalist. Associated *post* 1883 with the advertising department of the Northern Pacific Railroad, he edited *The Northwest Illustrated Monthly Magazine*.

SMALLEY, GEORGE WASHBURN (*b. Franklin, Mass., 1833; d. London, England, 1916*), journalist, lawyer. Graduated Yale, 1853. After an outstanding career as war correspondent for the *New York Tribune*, November 1861–October 1862, Smalley served on the New York staff of the paper. As correspondent at the Austro-Prussian War, 1866, he sent what were probably the first of all cabled news dispatches, and in 1867 organized a London bureau for the coordination of all European news. Scoring a series of journalistic triumphs with the help of his correspondents during the Franco-Prussian War, 1870, he remained in charge of the *Tribune*'s European correspondence until 1895; he then served as U.S. correspondent of the London *Times*, 1895–1905.

SMALLS, ROBERT (*b. Beaufort, S.C., 1839; d. Beaufort, 1915*), black Union soldier, South Carolina politician. Smalls performed valuable service during the Civil War. He served in the legislature and was congressman, Republican, from South Carolina, 1875–79 and 1882–87.

SMALLWOOD, WILLIAM (*b. Charles Co., Md., 1732; d. Prince George's Co., Md., 1792*), Revolutionary soldier, Maryland colonial legislator. Commissioned colonel of the Maryland battalion, January 1776, Smallwood, who had had military experience during the French and Indian War, trained his command so effectively that the Maryland Line won high repute for valor through all the campaigns of 1776–77. Promoted major general, September 1780, he served with credit at Camden. Disliked for his constant complaints over lack of promotion and for his offensive attitude toward foreign officers, Smallwood performed his greatest service in the war as a drill master, a raiser of men and supplies, and a military administrator. He was governor of Maryland, 1785–88.

SMART, DAVID ARCHIBALD (*b. Omaha, Nebr., 1892; d. Chicago, Ill., 1952*), magazine publisher and promoter. Self-educated, Smart founded the David A. Smart Publishing Co. in Chicago in 1921; the first magazine of the company was *Gentlemen's Quarterly*; in 1933, he brought out the first edition of *Esquire: The Magazine for Men*. The magazine became successful and featured such writers as Ernest Hemingway, F. Scott Fitzgerald, H. L. Mencken, and John Dos Passos. The Magazine *Coronet* appeared in 1936 and became the nation's leading newsstand publication. Smart broke new ground in publishing standards, often running stories and articles (and cartoons) that were considered sexually and thematically bold for the time.

SMART, JAMES HENRY (*b. Center Harbor, N.H., 1841; d. 1900*), educator. After winning a reputation as an administrator of school systems in Indiana *post* 1865, he built up Purdue University and directed its emphasis toward engineering while he was president, 1883–1900.

SMEDLEY, AGNES (*b. Osgood, Mo.[?], 1894; d. Oxford, England, 1950*), journalist, propagandist for the Chinese Communist movement. Raised in Trinidad, Colo. After a grimly deprived childhood, adolescence, and early adult life during which she strove to educate herself, she had come to reject not only capitalism but all constituted authority, red or white. *Post* 1919, she resided mainly abroad. Her books on Chinese subjects contain little value to the historian, but her writings in general provide insight into the mentality of the American left wing in the 1930's and 1940's. She was author also of a fictionalized autobiography, *Daughter of Earth* (1929, rev. ed. 1935).

SMEDLEY, WILLIAM THOMAS (*b. Chester Co., Pa., 1858; d. Bronxville, N.Y., 1920*), portrait painter, illustrator. Expert in portraying the social characteristics of the genteel class.

SMIBERT, JOHN (*b. Edinburgh, Scotland, 1688; d. Boston, Mass., 1751*), painter. After employment as a coach-painter and as a copyist of pictures for dealers, he visited Italy, 1717–20, where he acquired a feeble Venetian technique and a facility at "face painting" in the grand manner; he also met at this time George Berkeley, later bishop of Cloyne. Practicing for a time as a portrait painter in London, Smibert accompanied Berkeley to Newport, R.I., 1729, as potential professor of art in Berkeley's proposed Bermuda college. Remaining in America after the failure of the project and Berkeley's return home, Smibert settled in Boston early in 1730 and, before the end of his professional career, painted likenesses of the "best" people in the Bay Colony. Despite his success in his profession, he found it necessary to earn additional income by conducting an art shop in his house in which he sold paints, brushes, prints, and copies of pictures in European galleries. He furnished the designs for Faneuil Hall (built 1742) and gave up painting *ca.* 1748 because of failing eyesight. Smibert's work is often awkward but important because of his precise and often grim records of New England worthies and because it served as an early link between the art of Europe and that of the colonies.

SMILEY, ALBERT KEITH (*b. Vassalboro, Maine, 1828; d. near Redlands, Calif., 1912*), educator. Graduated Haverford, 1849. Coproprietor with his brother of the celebrated Lake Mohonk resort in Ulster Co., N.Y., *post* 1870. A member of the Board of Indian Commissioners, 1879–1912, Smiley instituted the Lake Mohonk Conferences on Indian affairs in 1883 and another series of conferences for discussions of world peace, 1895.

SMILLIE, GEORGE HENRY (*b. New York, N.Y., 1840; d. Bronxville, N.Y., 1921*), landscape painter. Son of James Smillie; brother of James D. Smillie. Studied with his father and with James M. Hart.

SMILLIE, JAMES (*b. Edinburgh, Scotland, 1807; d. Poughkeepsie, N.Y., 1885*), engraver. Father of George H. and James D. Smillie. Settled in New York City, 1830. Assisted by Robert W. Weir and A. B. Durand, he became a successful banknote engraver and engraved the works of some of the leading figure painters and landscapists of his time. Among his important works were the series of plates after Thomas Cole's *Voyage of Life* and *The Rocky Mountains* after a painting of Albert Bierstadt.

SMILLIE, JAMES DAVID (*b. New York, N.Y., 1833; d. New York, 1909*), engraver, etcher. Son of James Smillie; brother of George H. Smillie. Studied with his father, with whom he collaborated in much of his work until 1864. Unsatisfied thereafter to confine his efforts to the mechanical phases of engraving, he employed himself in etching, dry point, aquatint, mezzotint, and lithography, and was foremost in the movement to promote painter-etching as an art. His work displayed technical mastery and great versatility.

SMILLIE, RALPH (*b. Pennsylvania, 1887; d. Essex Fells, N.J., 1960*), civil engineer. Studied at Yale and Columbia. From 1919 until 1927, he was the design engineer for the construction of the Holland Tunnel connecting New York and New Jersey. From 1933 to 1945 he worked on the construction of the Lincoln Tunnel for the Port of New York Authority, and from 1945 to 1950, he was chief of the New York Triborough Bridge and Tunnel Authority, completing work on the Brooklyn-Battery Tunnel. He retired and opened his own consulting firm in 1950.

SMITH, ABBY HADASSAH (*b. Glastonbury, Conn., 1797; d. 1878*), woman's rights advocate. Refusing, with her sister Julia Evelina Smith (1792–1886), to pay taxes unless given the right to vote, 1873, she continued to resist in this manner until her death, despite repeated sale of her livestock and other property for delinquent taxes. The sisters and their troubles gave publicity and an added impetus to the cause of woman's rights.

SMITH, ALBERT HOLMES (*b. Philadelphia, Pa., 1835; d. 1885*), obstetrician, gynecologist, advocate of recognition of women in medicine. Graduated University of Pennsylvania, 1853; M.D., 1856. Practiced in Philadelphia; devised the Smith-Hodge pessary and other obstetrical instruments.

SMITH, ALBERT MERRIMAN (*b. Savannah, Ga., 1913; d. Alexandria, Va., 1970*), journalist. Attended Oglethorpe University. Became a staff correspondent for United Press, first covering assignments in the South (1936–41), then as White House correspondent. He also wrote a column for UPI, "Backstairs at the White House," covering personal aspects of White House life. Accompanied presidents on many domestic and overseas trips, including Roosevelt's wartime conferences and the 1960 Kennedy-Khruschev summit. Author of five books on the presidency, including *Thank You, Mr. President* (1946). Won the Pulitzer Prize for his coverage of the Kennedy assassination. Awarded the Presidential Medal of Freedom (1969).

SMITH, ALEXANDER (*b. Edinburgh, Scotland, 1865; d. Edinburgh, 1922*), chemist. Taught at University of Chicago, 1894–1911; headed Department of Chemistry at Columbia University, 1911–19. Distinguished himself in physical chemistry; made important studies on the forms of sulfur and on vapor-pressure measurements at comparatively high temperatures.

SMITH, ALFRED EMANUEL (*b. New York, N.Y., 1873; d. New York, 1944*), politician, public official. The first Roman Catholic to be nominated for the presidency of the United States, Smith was born on the lower East Side of New York; his father was of German and Italian descent, his mother of Irish stock. At 14, a month before completing the eighth grade, he dropped out of school to work as an errand boy for a trucking firm. At 18 he became general clerk for Feeney and Co., a wholesale commission house in the Fulton Fish Market area. He changed jobs again at 20, this time working in a boiler manufacturing plant in Brooklyn.

In 1894 Smith opposed the man chosen by Tammany boss Richard Croker as the 4th District's congressional nominee. The insurgents failed to elect their own man, but helped defeat the Tammany candidate, and the vote in their district also helped elect as mayor a Republican reform candidate, William L. Strong. Early in 1895 Smith was appointed process server for the commissioner of jurors. In 1903 he was chosen as the Democratic nominee for state assemblyman. Nomination was equivalent to election, but Smith conducted an energetic campaign. Untrained in the law or in parliamentary procedure, he was at first ignored by both the Republican majority and the Tammany leaders, who instructed him how to vote but did not take him into their counsel. But slowly he learned assembly politics and state government. He was appointed to the Insurance Committee in 1906, a year of insurance company scandals, but he attracted little notice in the assembly until 1907, when, as a member of a special committee to revise the New York City charter, he defended home rule and the rights of the city's "plain people." In 1911, after a Democratic election sweep, Smith was selected by Charles F. Murphy, the head of Tammany, as majority leader of the assembly and chairman of the Ways and Means Committee. He became Speaker of the assembly in 1913.

In these years of his political emergence, Smith's energies were directed both to protecting the interests of Tammany and to achieving a variety of progressive reforms. He supported home rule for New York City (a favorite progressive issue), a state con-

servation department, and improvements in workmen's compensation. Indeed, the last issue would preoccupy Smith during most of his political career. Perhaps the most important single event in Smith's development as a reformer was the 1911 Triangle Shirtwaist Co. fire, a New York City disaster which took 146 lives, most of them working girls and women. His bill to establish a factory-investigating commission quickly passed the assembly, and the commission launched a statewide series of surveys and on-the-spot investigations of factory conditions. As its vice-chairman, Smith was thrown into a close working relationship with a remarkable group of independent and sometimes brilliant social workers and reformers. The commission's work continued until 1915, and Smith sponsored much of the social legislation it recommended. These reforms perhaps constitute Smith's greatest political achievement.

In 1915 he was elected to a two-year term as sheriff of New York City, and two years later won easy election as president of the board of aldermen. By 1918 the most popular man in the New York Democratic party, supported by Tammany, upstate politicians, and independent reform groups, Smith was the logical Democratic candidate for governor. Urging a broad reorganization of the state government, economy measures, and social legislation, especially the regulation of hours and wages for women and children, Smith won by only 15,000 votes.

The 1919–21 gubernatorial term set the pattern for Smith's later incumbencies. Most jobs went to deserving Democrats, but a few major appointments demonstrated the new governor's independence: a well-qualified Republican became the patronage-rich highway commissioner, and Frances Perkins, an independent, was appointed to the State Industrial Commission. Applying himself to crisis situations in city housing and milk distribution, two issues basic to tenement dwellers, Smith supported the temporary extension of wartime rent controls, tax incentives for the construction of low-cost housing, and price fixing of milk by a state commission. Normally prolabor, he utilized the State Industrial Commission to mediate labor differences, as in the Rome, N.Y., copper strike of 1919, when Frances Perkins initiated public hearings that led to negotiations and eventual recognition of the union. In a time of political reaction, Smith vetoed several antisedition bills that would have severely curtailed the civil liberties of Socialists. In 1923, during his second term, he pardoned an Irish revolutionary, Jim Larkin, imprisoned under the state sedition law; granted clemency to the Communist Benjamin Gitlow; and signed a bill virtually outlawing the Ku Klux Klan in the state. He supported the League of Nations; Wilsonianism evidently awakened in him an interest in international affairs that persisted into the 1920's.

In 1920, with an anti-Democratic current running nationally, Smith lost his bid for reelection by 75,000 votes. During the next two years, while serving as board chairman of the United States Trucking Corporation, he kept in close touch with politics. He was renominated in 1922, and in his campaign he again emphasized such welfare and reform issues as a 48-hour week, governmental reorganization, conservation, and the creation of a public hydroelectric power authority. His personal popularity, the continued support of his heterogeneous coalition, and a national business depression identified with the Republicans gave him a record plurality over the incumbent governor. Two more successful gubernatorial campaigns followed in 1924 and 1926.

In 1924 Smith was himself the most important Democratic leader in the state, and was thus freed from dependence upon bosses and machines. He supported James J. ("Jimmy") Walker for mayor of New York in 1925, but he did not reward Tammany heavily with political spoils. His welfare program included state support for low-cost housing projects, bond issues to develop an extensive park and recreation system, more funds for state education, and support for the State Labor Department in enforcing safety requirements and administering workmen's compensation. In short, in a decade little known for reform politics, Smith played an almost classic progressive role.

Smith's position and his record made him a serious presidential contender. Smith had strong support in the states with the largest electoral votes, but the 1924 Democratic convention was torn apart by a conflict between the rural-dry-Protestant forces and the urban-wet-Catholic representatives of the Northeast, and Smith withdrew after prolonging a deadlock. In April 1927 the *Atlantic Monthly* published an article by Charles C. Marshall, a prominent Episcopal layman, suggesting a basic conflict between Smith's loyalty to the Roman Catholic church and his allegiance to the U.S. Constitution. Smith's immediate reaction to Marshall's largely legalistic argument was, "I know nothing whatsoever about papal bulls and encyclicals." By 1928 Smith's candidacy could not be denied, and on the first ballot the Houston convention nominated him for the presidency. The campaign that followed has usually been interpreted as a victory for bigotry and narrow-minded rural prohibitionism. Yet, with Republican prosperity then reaching its zenith, the Democratic cause was all but hopeless. Smith and his running mate, Senator Joseph T. Robinson of Arkansas, received only 15 million votes to Herbert Hoover's 21.4 million; the electoral count was 444 to 87.

His hoped-for return to influence in Albany following Franklin D. Roosevelt's somewhat unexpected gubernatorial victory in 1928 was thwarted by Roosevelt's desire for independence. Instead, Smith entered business as president of the Empire State Building Corporation; he also served as chairman of a trust company. As he settled in a Fifth Avenue apartment and was lionized by New York's social and business circles, his conservatism hardened, and he drifted into an acrimonious feud with Roosevelt. Late in 1931, probably in an attempt to forestall Roosevelt, he launched an ill-organized campaign for the presidential nomination. He labeled "demagogic" Roosevelt's plea in April 1932 for the "forgotten man at the bottom of the economic pyramid," and throughout the next two years he expressed similar views in a monthly column of political opinion in the *New Outlook*, which he also served as editor. In the mid-1930's his close association with the moneyed classes and his genuine alarm at the New Deal led Smith to an active role in the right-wing, anti-Roosevelt American Liberty League. Smith's opposition to the Democratic ticket in 1936 and 1940 was largely ineffectual. Moreover, even in the private realm tranquility was not to be his. The stock-market crash had left two of his sons, a nephew, and several close friends deeply in debt, and Smith assumed heavy obligations on their behalf. The Empire State Building, completed in 1931, remained largely unoccupied, and only extreme efforts prevented bankruptcy. The approach of World War II partially mended the breach between Smith and Roosevelt. Smith supported the president's 1939 Neutrality Act amendments and actively backed the lend-lease program. Soon the two men were exchanging pleasantries, and Smith twice visited informally at the White House.

SMITH, ALFRED HOLLAND (*b. near Cleveland, Ohio, 1863; d. 1924*), railroad executive. President, New York Central Railroad, 1914–24.

SMITH, ANDREW JACKSON (*b. Bucks Co., Pa., 1815; d. 1897*), Union major general. Graduated West Point, 1838. Commissioned in the 1st Dragoons, Smith performed his early service mostly in the West. Becoming chief of cavalry under General Henry W. Halleck early in the Civil War, he served as such through the Corinth campaign and was appointed brigadier general of volunteers, March 1862. His important but unspectacular

service, 1863–65, was highlighted by his defeat of General N. B. Forrest at Tupelo, Miss., 1864. Resigning from the army, 1869, he held several public offices at St. Louis, Mo.

SMITH, ARCHIBALD CARY (*b. New York, N.Y., 1837; d. Bayonne, N.J., 1911*), marine painter, naval architect. Designed well over a hundred yachts, of which the most notable were the *Vindex* (1871), *Mischief* (1879), *Meteor* (1902), and *Resolute* (1903).

SMITH, ARTHUR HENDERSON (*b. Vernon, Conn., 1845; d. Claremont, Calif., 1932*), Congregational clergyman. Missionary to China, 1872–1925. Author of a number of books, which included *Chinese Characteristics* (1890) and *China in Convulsion* (1901).

SMITH, ASA DODGE (*b. Amherst, N.H., 1804; d. Hanover, N.H., 1877*), Presbyterian clergyman, educator. Graduated Dartmouth, 1830; Andover Theological Seminary, 1834. A pastor in New York City, 1834–63, Smith served as president of Dartmouth College, 1863–77. He rebuilt the prestige of that institution and was responsible for the establishment of the Thayer School of Engineering and the New Hampshire College of Agriculture. A tactful and ultraconservative administrator, Smith was not particularly happy in matters of finance.

SMITH, ASHBEL (*b. Hartford, Conn., 1805; d. Tex., 1886*), physician, statesman, Confederate officer. Graduated Yale, 1824; M.D., 1828. Practicing at first in North Carolina, he removed to Texas, 1837, and became surgeon general of the Texas Republic. Texas minister to England and France, 1842–44, he became secretary of state of the Republic in February 1845 and negotiated with Mexico the Smith-Cuevas Treaty, acknowledging Texan independence. Cited during the Civil War for gallantry at Shiloh and Vicksburg, he later served actively in the defense of Texas. A leader in all educational movements in the state after the Civil War, he undertook the reorganizing of the University of Texas *post* 1881. He was author of *Reminiscences of the Texas Republic* (1876) and other works.

SMITH, AZARIAH (*b. Manlius, N.Y., 1817; d. Aintab, Armenia, 1851*), Presbyterian clergyman, medical missionary in Asiatic Turkey *post* 1843. Cousin of Judson Smith.

SMITH, BENJAMIN ELI (*b. Beirut, Syria, 1857; d. New Rochelle, N.Y., 1913*), editor. Son of Eli Smith. Managing editor of *The Century Dictionary and Cyclopedia* under William D. Whitney, 1882–94; editor in chief of the *Dictionary* and cognate enterprises, 1894–1911.

SMITH, BENJAMIN MOSBY (*b. Powhatan Co., Va., 1811; d. 1893*), Presbyterian clergyman. Professor at Union Theological Seminary, Virginia, *post* 1855.

SMITH, BESSIE (*b. Chattanooga, Tenn., 1894; d. near Clarksdale, Miss., 1937*), blues singer. An outstanding influence on jazz music, she achieved her greatest popularity between 1923 and 1929. Her singing had casual but great strength and a heartbreaking earthiness.

SMITH, BETTY (*b. Elisabeth Wehner, New York City, 1896; d. Shelton, Conn., 1972*), novelist. Attended University of Michigan at Ann Arbor (1921–22, 1927–31) and studied playwriting at the Yale School of Drama. She rose to fame with the novel *A Tree Grows in Brooklyn* (1943), which drew on her experiences as a youth and explored tenement family life in Brooklyn before World War I. She wrote three additional novels: *Tomorrow Will Be Better* (1948), *Maggie–Now* (1958), and *Joy in the Morning* (1963).

SMITH, BRUCE (*b. Brooklyn, N.Y., 1892; d. Southampton, N.Y., 1955*), police consultant and criminologist. Studied at Wesleyan University and Columbia (LL.B., 1916). Became the most prominent American authority on police administration and director of the Institute of Public Administration. Investigated police departments of New Orleans, St. Louis, and New York City. Most lasting contribution was the introduction of crime statistics, *The Uniform Crime Reports* first published in 1930. Wrote *Police Systems in the United States*.

SMITH, BUCKINGHAM (*b. Cumberland Island, Ga., 1810; d. New York, N.Y., 1871*), lawyer, diplomat, Florida Unionist, antiquarian. Smith is remembered particularly as an Americanist who stimulated study in the early history of Florida and the regions nearby. Among his many books and collections of documents were *The Narrative of Alvar Nuñez Cabeça de Vaca* (1851) and *The Narratives of the Career of Hernando de Soto in the Conquest of Florida, As Told by a Knight of Elvas* (first published as a whole, 1866).

SMITH, BYRON CALDWELL (*b. Island Creek, Ohio, 1849; d. Boulder, Colo., 1877*), philologist, educator.

SMITH, CALEB BLOOD (*b. Boston, Mass., 1808; d. Indianapolis, Ind., 1864*), lawyer. Studied law with Oliver H. Smith; began practice in Indiana, 1828. As an Indiana legislator *post* 1832, he promoted internal improvement projects; as congressman, Whig, from Indiana, 1843–49, he directed his principal efforts against annexation of Texas and war with Mexico. Later a leader in Indiana Republican politics, Smith seconded Lincoln's nomination at Chicago, 1860. U.S. secretary of the interior, 1861–62, he served thereafter as U.S. district judge from Indiana.

SMITH, CHARLES ALPHONSO (*b. Greensboro, N.C., 1864; d. Annapolis, Md., 1924*), educator. Friend and biographer of O. Henry. Graduated Davidson College, 1884; Ph.D., Johns Hopkins, 1893. Taught English at Louisiana State University, 1893–1902; at University of North Carolina, 1902–09; at University of Virginia, 1909–17; at U.S. Naval Academy, 1917–24. A gifted, enthusiastic teacher and student of folklore.

SMITH, CHARLES EMORY (*b. Mansfield, Conn., 1842; d. Philadelphia, Pa., 1908*), journalist, diplomat. As editor of the Philadelphia *Press post* 1880, Smith enjoyed great political influence. He was U.S. minister to Russia, 1890–92, and U.S., postmaster general, 1898–1901.

SMITH, CHARLES FERGUSON (*b. Philadelphia, Pa., 1807; d. Savannah, Tenn., 1862*), Union soldier. Graduated West Point, 1825. Instructor and commandant of cadets at West Point, 1829–42, he received three brevets for gallant conduct in the Mexican War. After service in the Midwest and West and considerable administrative duty, he became brigadier general of volunteers, 1861. He was promoted major general, March 1862, for his decisive assault on Fort Donelson, which lodged federal troops within the defenses and was the immediate cause of the fort's surrender.

SMITH, CHARLES FORSTER (*b. present Greenwood Co., S.C., 1852; d. Racine, Wis., 1931*), classical philologist. Brother of James P. Smith. Taught at Williams College, Vanderbilt University, and University of Wisconsin. In addition to contributions to classical journals, he translated Thucydides for the Loeb Classical Library.

SMITH, CHARLES HENRY (*b. Lawrenceville, Ga., 1826; d. Cartersville, Ga., 1903*), journalist, humorist, Confederate soldier. Author of a number of sketches marked by genial satire and rustic philosophy, which he published under the pseudonym "Bill Arp."

SMITH, CHARLES HENRY (*b. Hollis, Maine, 1827; d. Washington, D.C., 1902*), Union major general, lawyer. An able but unspectacular cavalry commander with the Army of the Potomac, 1861–65, he returned to the regular service in 1866 and retired as colonel, 1891.

SMITH, CHARLES PERRIN (*b. Philadelphia, Pa., 1819; d. Trenton, N.J., 1883*), New Jersey politician, editor, genealogist.

SMITH, CHARLES SHALER (*b. Pittsburgh, Pa., 1836; d. St. Louis, Mo., 1886*), bridge engineer. Early associated with Albert Fink, Smith became a division engineer for the Louisville & Nashville Railroad and during the Civil War served as a Confederate captain of engineers. In 1866 he entered partnership with Benjamin H. and Charles H. Latrobe in the Baltimore Bridge Co. Smith produced his greatest engineering achievement in the Kentucky River bridge built for the Cincinnati Southern Railroad, 1876–77. The cantilever which he employed for this work had no precedent anywhere in the world but soon became the dominant type for long-span construction. His Lachine Bridge over the St. Lawrence River near Montreal, begun in 1880, was for many years the only continuous bridge of importance in America.

SMITH, CHARLES SPRAGUE (*b. Andover, Mass., 1853; d. 1910*), educator, professor of German at Columbia University. Founded the People's Institute at Cooper Union, New York City, 1897, as a community center for working-class education.

SMITH, CHAUNCEY (*b. Waitsfield, Vt., 1819; d. Cambridge, Mass., 1895*), lawyer. Successful as counsel to the Bell Telephone Co. in the great patent litigation of 1878–96.

SMITH, COURTNEY CRAIG (*b. Winterset, Iowa, 1916; d. Swarthmore, Pa., 1969*), educator. Attended Harvard (Ph.D., 1944) and Merton College, Oxford, as a Rhodes Scholar (1938–39). Taught at Princeton (1946–53) and was president of Swarthmore College and American secretary of the Rhodes Scholarships (both 1953–69). He sought to improve Swarthmore by appointing faculty members with intellectual power and "character." He also challenged the students to reach his standards of intellect, character, and deportment; he was responsible for an increase in the number of black students, but was strongly committed to a system of merit. He reduced teaching loads, built a modern science center, and secured an excellent library.

SMITH, DANIEL (*b. Stafford Co., Va., 1748; d. Sumner Co., Tenn., 1818*), Revolutionary soldier, Tennessee official. Made the first map of Tennessee, published in Carey's *General Atlas for the Present War* (1794); wrote *A Short Description of the Tennessee Government* (1793). U.S. senator from Tennessee, 1798 and 1805–09.

SMITH, DANIEL B. (*b. Philadelphia, Pa., 1792; d. Germantown, Pa., 1883*), pharmacist, philanthropist. Long in business in Philadelphia, Smith was associated with establishment of Philadelphia College of Pharmacy, 1822, and served as its president, 1829–54. He was chosen first president of the American Pharmaceutical Association, 1852. From 1834 until 1846 he taught moral philosophy and chemistry at Haverford.

SMITH, DAVID EUGENE (*b. Cortland, N.Y., 1860; d. New York, N.Y., 1944*), educator, historian of science, Ph.B., Syracuse University, 1881; Ph.M., 1884; Ph.D., 1887. Taught mathematics at State Normal School, Cortland, N.Y., and at State Normal College, Ypsilanti, Mich.; principal, State Normal School, Brockport, N.Y., 1898–1901. Professor of mathematics, Teachers College, Columbia University, 1901–26. Author or coauthor of a number of widely used elementary and secondary school textbooks; active in U.S. mathematical associations, and in the International Commission on the Teaching of Mathematics. Instrumental in founding of the History of Science Society and its first president, 1927, he assembled a notable collection of rare books and manuscripts and of ancient mathematical and astronomical instruments. His best-known historical works were *Rara Arithmetica* (1908) and *History of Mathematics* (1923–25).

SMITH, DAVID ROLAND (*b. Decatur, Ind., 1906; d. Bennington, Vt., 1965*), sculptor. Attended Ohio University and Art Students League. First tentative experiments in sculpture (1931–34) were made with coral, wood, and metal, but he did not commit himself to sculpting until 1935, when he began a period of intensive experimentation in various styles derived chiefly from cubism and constructivism. Much of his sculpture of the 1930's uses human or other recognizable references, but very little expresses direct social commentary. His work of the 1940's shows a tendency toward larger pieces and more complex imagery, with an intensely felt and sometimes highly elaborate private symbolism. Two examples are *Home of the Welder* (1945) and *The Cathedral* (1950). He abandoned that style in the 1950's and by mid-decade achieved a commanding reputation among artists and critics of the avant-garde; a retrospective exhibit was held at the Museum of Modern Art in 1957. His work of the 1960's is characterized by a growing monumentality of scale and form; there are more and larger nonobjective arrangements of planes and cursive forms, culminating in the "Cubi," "Zig," and "Wagon" series.

SMITH, EDGAR FAHS (*b. York, Pa., 1854; d., Philadelphia, Pa., 1928*), chemist. Graduated present Gettysburg College, 1874; Ph.D., Göttingen, 1876. Taught at University of Pennsylvania, Muhlenberg College, and Wittenberg College. Headed Department of Chemistry, University of Pennsylvania, 1892–1920, and served as provost, 1911–20. Smith and his pupils at Pennsylvania carried out a great number of investigations into methods of electrochemical analysis, in which he was a pioneer; also investigated atomic weight determinations, compounds of the rarer metals, and complex salts of various inorganic acids. His research on tungsten led to its extensive use in scientific and artistic work. He was author of, among other books, *Electro-Chemical Analysis* (1890).

SMITH, EDMUND KIRBY *See* KIRBY-SMITH, EDMUND.

SMITH, EDMUND MUNROE (*b. Brooklyn, N.Y., 1854; d. 1926*), educator. Nephew of Henry B. Smith. Graduated Amherst, 1874; LL.B., Columbia Law School, 1877; D.C.L., Göttingen, 1880. A teacher of history and political science at Columbia *post* 1880, Smith was professor of Roman law and comparative jurisprudence there, 1891–1924. From its establishment in 1886, he was for many years managing editor of the *Political Science Quarterly*. He was author of, among other studies, *The Development of European Law* (1928) and *A General View of European Legal History* (1927).

SMITH, EDWARD HANSON (*b. Vineyard Haven, Mass., 1889; d. Falmouth, Mass., 1961*), U.S. Coast Guard officer and oceanographer. Graduated from Coast Guard Academy and was commissioned an ensign in 1913; later attended Harvard (Ph.D.,

1934). Assigned to the International Ice Patrol in the North Atlantic in 1920. Commanded the *Marion* expedition to the iceberg-producing areas of Greenland (1928), the most comprehensive oceanographic survey undertaken by the U.S. government. Promoted to rear admiral (1942). As commander of Task Force 24 of the Atlantic Fleet (1943), he was in charge of rescue ships on D day. Commandant of the Third Coast Guard District and captain of the port of New York (1945). Retired in 1950 and became director of Woods Hole Oceanographic Institution, until 1956.

SMITH, ELI (*b. Northford, Conn., 1801; d. Beirut, Syria, 1857*), Congregational clergyman. Father of Benjamin E. Smith. Missionary in the Near East for most of his life *post* 1826, Smith, with H. G. O. Dwight, was largely responsible for establishment of the American mission at Urumiah.

SMITH, ELIAS (*b. Lyme, Conn., 1769; d. 1846*), clergyman, healer. Rejecting the Calvinistic system held by the Baptists, he also denied the doctrine of the Trinity and founded a fundamentalist Bible church of his own at Portsmouth, N.H., *ca.* 1800. In 1818 he became a Universalist, but renounced that mode of thought in 1823. He was founder of the *Herald of Gospel Liberty*, September 1808, the first weekly religious newspaper published in the United States, which served as organ of the so-called Christian Connection. He was author of a number of controversial pamphlets and of several volumes of sermons and hymns.

SMITH, ELIHU HUBBARD (*b. Litchfield, Conn., 1771; d. New York, N.Y., 1798*), physician, editor, author. Graduated Yale, 1786; studied medicine with his father and with Benjamin Rush. As a student in Philadelphia, he became a friend of Charles B. Brown; as a practicing physician at Wethersfield, Conn., 1791–93, he was associated with the so-called Hartford Wits. A contributor to the *Echo* and editor of the earliest anthology of American poetry, *American Poems* (1793), he then settled in New York City, where he practiced until his death during a yellow fever epidemic. During his stay at New York, he was host to the Friendly Club, made up of, among others, William Dunlap, Samuel L. Mitchill, James Kent, and Samuel Miller (1769–1850). He projected the first American medical journal, the *Medical Repository*, and was coeditor of it, 1797–98. Just before his death he was planning to issue a literary magazine and review in association with Charles B. Brown.

SMITH, ELIZA ROXEY SNOW *See* SNOW, ELIZA ROXEY.

SMITH, ELIZABETH OAKES PRINCE (*b. North Yarmouth, Maine, 1806; d. North Carolina, 1893*), novelist, lyceum lecturer, woman's rights reformer. Married Seba Smith, 1823. A contributor to popular periodicals.

SMITH, ELLISON DURANT (*b. "Tanglewood," near Lynchburg, S.C., 1864; d. "Tanglewood," 1944*), cotton planter, politician. Known as "Cotton Ed" Smith. Graduated Wofford College, 1889. Deeply affected by the ideology of the southern agrarian protest movement of the 1890's, he waged a lifelong battle against high tariffs, Wall St., big business, and hard money. Elected as a Democrat to the U.S. Senate, 1908, he represented South Carolina until his defeat in 1944; he died a few weeks before his last term expired. A consistent critic of the Taft Republicans and a reliable supporter of President Woodrow Wilson's policies, he opposed the tariff and fiscal policies of the Harding, Coolidge, and Hoover administrations and was an early backer of Franklin D. Roosevelt. Although he became chairman of the Senate Agricultural Committee, he had little influence in shaping the New Deal farm program and believed that the WPA, NRA, and other federal agencies for relief of the Great Depression threatened the South's social and economic structure. *Post* 1935, he was openly hostile to the administration and indulged in uncharacteristic tirades in the Senate against blacks; he opposed the regulation of wages and hours of labor, fought against the judiciary- and executive-reorganization bills of 1937, and in the World War II period was against selective service, lend-lease, and other wartime policies.

SMITH, ERASMUS DARWIN (*b. De Ruyter, N.Y., 1806; d. 1883*), jurist. As judge, New York Supreme Court, 1855–77, Smith tended to uphold legislative acts whenever possible and was unsympathetic in both law and equity cases toward artificial rules. His upholding of the Legal Tender Act as incident to the war powers of Congress, 1863, was said to be equal to a victory in the field for the cause of the Union. His best-known decision was in *People* v. *Albany & Susquehanna R.R.*, in which he settled the main point involved in the "Erie War."

SMITH, ERMINNIE ADELLE PLATT (*b. Marcellus, N.Y., 1836; d. 1886*), geologist, ethnologist. Authority on the language, customs, and myths of the Iroquois Indians.

SMITH, ERWIN FRINK (*b. Gilberts Mills, N.Y., 1854; d. Washington, D.C., 1927*), botanist, bacteriologist. Graduated University of Michigan, 1886; Sc.D., 1889. Thereafter, as a member of the scientific staff of the U.S. Department of Agriculture, he was a leader in development of the science of plant pathology and was unequaled in that field. He was author of a number of monographs and books, of which *Bacteria in Relation to Plant Diseases* (1905–14) was outstanding.

SMITH, EUGENE ALLEN (*b. Washington, Ala., 1841; d. Tuscaloosa, Ala., 1927*), geologist. Graduated University of Alabama, 1862; Ph.D., Heidelberg, 1868. Taught at universities of Mississippi and Alabama; was state geologist of Alabama, 1873–1927.

SMITH, FRANCIS HENNEY (*b. Norfolk, Va., 1812; d. Lexington, Va., 1890*), soldier, educator. Graduated West Point, 1833. Superintendent, Virginia Military Institute, 1840–89. Smith attacked the classical type of education prevalent in the antebellum South and emphasized a utilitarian approach.

SMITH, FRANCIS HOPKINSON (*b. Baltimore, Md., 1838; d. New York, N.Y., 1915*), engineer, artist, writer. Great-grandson of Francis Hopkinson. Successful in all three of his professions, Smith is remembered particularly for his best-selling works of fiction, which were marked by his own sunny temperament and by his special gift for observation of local color. Among his many books, *Colonel Carter of Cartersville* (1891) is outstanding; *The Fortunes of Oliver Horn* (1902) is in part autobiographical.

SMITH, FRANCIS MARION (*b. Richmond, Wis., 1846; d. Oakland, Calif., 1931*), capitalist. In 1872, at Columbus, Nev., he and his partner, William Tell Coleman, discovered in Teel's Marsh colemanite, from which borax is derived. These mines soon became the world's chief source of borax. The partners organized the Pacific Coast Borax Co. and succeeded in controlling the borax market for a long period. Later Smith acquired colemanite deposits in Death Valley, Calif. From there the product was hauled by mules to Mojave, Calif., and the "20-mule team" became a familiar borax trademark.

SMITH, FRANK LESLIE (*b. Dwight, Ill., 1867; d. Dwight, 1950*), businessman, banker, Illinois politician. Congressman, Republican, from Illinois, 1919–21. Chairman, Illinois Commerce Commission, 1921–26. He was denied admission to the U.S. Senate after election in November 1926, and appointment to fill out an unexpired term in December of the same year, on grounds

that his victory in the primary had been gained by fraud and unlawful campaign expenditures.

SMITH, FRED BURTON (*b. near Lone Tree, Iowa, 1865; d. White Plains, N.Y., 1936*), lay evangelist, reformer, YMCA official.

SMITH, GEORGE (*b. Aberdeenshire, Scotland, 1806; d. London, England, 1899*), banker. Principally resident in America *ca.* 1834–60. Smith profited by the boom in Chicago, Ill., land values in 1835 and 1836. By influence in the Wisconsin legislature, he succeeded in evading antibanking laws by winning a charter for his Wisconsin Marine & Fire Insurance Co., 1839. Under a clause in this charter Smith was able to conduct a general banking business, of which Alexander Mitchell was the active manager. After making enormous profits, the company became a state bank in 1853. The rapid economic expansion of Wisconsin and Illinois in the 1840's would not have been possible without the trustworthy credit provided by Smith's company.

SMITH, GEORGE ALBERT (*b. Salt Lake City, Utah, 1870; d. Salt Lake City, 1951*), youth leader and leader of the Mormon Church. Studied briefly at the University of Deseret (later University of Utah). Worked with the Young Men's Mutual Improvement Association; general superintendent (1921–35). Member of the Council of the Twelve Apostles, the Mormon administrative body, from 1903 until his death. President of the Mormon Church (1945). He expanded Mormon programs to help American Indians and provided church property as a site for a state institute for the blind.

SMITH, GEORGE HENRY (*b. Knoxville, Tenn., 1873; d. Maplewood, N.J., 1931*), journalist, author of humorous juvenile stories.

SMITH, GEORGE OTIS (*b. Hodgdon, Maine, 1871; d. Augusta, Maine, 1944*), geologist. B.A., Colby College, 1893; Ph.D., Johns Hopkins University, 1896. A staff member of the U.S. Geological Survey *post* 1896, he served as its director, 1907–30, and was chairman of the Federal Power Commission, 1930–33.

SMITH, GERALD BIRNEY (*b. Middlefield, Mass., 1868; d. 1929*), theologian. Nephew of Judson Smith. Taught at the divinity school of University of Chicago. An empiricist, he bent his efforts "to find a vital religion which should not rest upon authoritative dogma" and sought to give his students a method of critical thinking rather than a body of conclusions.

SMITH, GERALD L. K. (*b. Pardeeville, Wis., 1898; d. Arkansas, 1976*), minister, political organizer, and publisher. Graduated Valparaiso University (B.A., 1918) and became pastor of Kings Highway Christian Church, Shreveport, La. (1929–33). As a paid organizer for Sen. Huey Long's political machine, he organized clubs for Long's Share Our Wealth Society (1934). After a failed bid for the Republican nomination for the U.S. Senate (1942), he moved to far-right politics and founded the anti-Semitic and anti-Communist political-religious journal *The Cross and the Flag*. He also founded the America First party (1943), which became the Christian Nationalist party (1946), then the Christian Nationalist Crusade (1948). He only polled a few thousand votes each time he ran for president (1944, 1948, 1956) but was effective in direct-mail solicitations for money and became a millionaire.

SMITH, GERRIT (*b. Utica, N.Y., 1797; d. New York, N.Y., 1874*), reformer. Grandson of James Livingston; son of Peter Smith. Devoting his large fortune to what he considered the good of mankind, he experimented with systematic charity on a large scale. He also advocated strict Sunday observance, vegetarianism, total abstinence from liquor, reform of dress, prison reform, and woman's suffrage. Joining the antislavery movement in 1835, he became one of the best-known abolitionists in the United States and a backer of the aid societies for Kansas. A supporter of the use of force against proslavery adherents in Kansas, he backed John Brown enthusiastically, but later denied complicity in Brown's plot. During the Civil War he wrote and spoke in support of the Union cause, and in the Reconstruction period advocated moderation toward the Southern whites and supported black suffrage.

SMITH, GILES ALEXANDER (*b. Jefferson Co., N.Y., 1829; d. 1876*), Union major general. Brother of Morgan L. Smith. Distinguished himself particularly in command of the 2nd Division, XVII Corps, at the battle of Atlanta, July 1864.

SMITH, GUSTAVUS WOODSON (*b. Georgetown, Ky., 1822; d. New York, N.Y., 1896*), civil and military engineer, Confederate major general. Graduated West Point, 1842. After serving as actual commander of the army engineers during the Mexican War, Smith taught engineering at West Point and after his resignation from the army, 1854, was employed in important civil engineering work. Appointed major general in the Confederate army, 1861, he succeeded to command of Confederate forces in the Peninsular campaign between the wounding of General A. S. Johnston and General R. E. Lee's arrival. Resigning in 1863 after a series of quarrels with President Jefferson Davis, he returned to arms in June 1864 as major general of Georgia militia with the Army of Tennessee.

SMITH, HAMILTON (*b. near Louisville, Ky., 1840; d. Durham, N.H., 1900*), mining engineer, authority on hydraulics.

SMITH, HANNAH WHITALL (*b. Philadelphia, Pa., 1832; d. Iffley, England, 1911*), author, religious interpreter, reformer. Mother of Logan P. Smith.

SMITH, HAROLD BABBITT (*b. Barre, Mass., 1869; d. 1932*), electrical engineer, educator. M.E., Cornell University, 1891. Taught electrical engineering at University of Arkansas and Purdue; established and headed electrical engineering department at Worcester Polytechnic Institute, 1896–1931. A pioneer in electrical engineering education, Smith was also prominent as an industrial consultant and carried on extensive research in dielectric phenomena and electric stress distribution.

SMITH, HAROLD DEWEY (*b. near Haven, Kans., 1898; d. Culpepper, Va., 1947*), public administrator. As director of the federal Bureau of the Budget, 1939–46, he was forced to assume great additional responsibilities during World War II, which he did his best to handle with nonpartisan objectivity. On his resignation in mid-1946, he became vice president of the World Bank; in December 1946 he became its acting head.

SMITH, HARRY ALLEN (*b. McLeansboro, Ill., 1907; d. San Francisco, Calif., 1976*), journalist, humorist, and author. Began his career as a reporter for the *Huntington Press* in Indiana (1923–25), then spent twenty years as an itinerant newspaperman. He worked for the *Denver Post* (1927–29), United Press (1929–34), and the *New York World–Telegram* (1936) as rewrite man, feature interviewer, and composer of humorous articles. His book *Low Man on a Totem Pole* (1941) was a best-selling collection of interviews, autobiographical sketches, and trivia, and he began writing "The Totem Pole," a daily syndicated column for the United Feature Syndicate. Some of his thirty-seven books include the best-sellers *Lost in the Horse Latitudes* (1944), *Rhubarb* (1946), and *The Pig in the Barber Shop* (1958).

SMITH, HARRY BACHE (*b. Buffalo, N.Y., 1860; d. Atlantic City, N.J., 1936*), operetta and musical comedy librettist, book collector. Raised in Chicago, Ill. Author of book and lyrics for a great number of successful shows, which included *Robin Hood* (music by Reginald de Koven), *The Fortune Teller* (music by Victor Herbert), *Gypsy Love* (music by Franz Lehar), and the *Ziegfeld Follies* of 1907, 1908, 1909, 1910, and 1912.

SMITH, HARRY JAMES (*b. New Britain, Conn., 1880; d. near Murrayville, British Columbia, Canada, 1918*), playwright, novelist. Author of a number of comedies of manners, of which *Mrs. Bumpstead-Leigh* (1910–11) and *A Tailor-Made Man* (1917) were the most successful.

SMITH, HENRY AUGUSTUS MIDDLETON (*b. Charleston, S.C., 1853; d. 1924*), South Carolina jurist, local historian.

SMITH, HENRY BOYNTON (*b. Portland, Maine, 1815; d. New York, N.Y., 1877*), Presbyterian clergyman. Professor of church history and later of theology at Union Theological Seminary, 1850–74. A representative of liberal orthodoxy, he edited the *American Theological Review*, 1859–74, and was the translator of several German theological works.

SMITH, HENRY JUSTIN (*b. Chicago, Ill., 1875; d. Evanston, Ill., 1936*), newspaper editor. Associated with the *Chicago Daily News*, 1899–1924, Smith returned to it as managing editor in 1926 and remained in that post until his death. Encourager of many later prominent journalists and writers who made their start under him, he was author of a number of books, including *Chicago: The History of Its Reputation* (with Lloyd Lewis, 1929) and *Oscar Wilde Discovers America* (1936).

SMITH, HENRY LOUIS (*b. Greensboro, N.C., 1859; d. Greensboro, N.C., 1951*), university president. Studied at Davidson College and the University of Virginia, Ph.D. in physics, 1891. President of Davidson College (1891–1912); during his tenure, the faculty, physical plant, student body, endowment, and annual income of the college approximately doubled. 1912–1930, president of Washington and Lee University. As president, Smith expanded the university, reestablished the school of journalism, and raised the admission requirements. Published *This Troubled Century* (1947).

SMITH, HENRY PRESERVED (*b. Troy, Ohio, 1847; d. Poughkeepsie, N.Y., 1927*), Presbyterian clergyman, biblical scholar. Brother of Richmond Mayo-Smith. A pioneer in the introduction of German higher criticism, he was suspended from the ministry after trial in November 1892 by the Presbytery of Cincinnati. He later taught at Amherst College and at Meadville Theological School, and was librarian at Union Theological Seminary, 1913–25. He was author of a number of books, including *A Critical and Exegetical Commentary on the Books of Samuel* (1899), *Samuel, Old Testament History* (1903), and *The Religion of Israel* (1914).

SMITH, HEZEKIAH (*b. Hempstead, N.Y., 1737; d. 1805*), Baptist clergyman. Pastor at Haverhill, Mass., *post* 1766, he frequently undertook missionary journeys into New Hampshire and Maine and served as a Revolutionary War chaplain. An associate with James Manning in the founding of Rhode Island College (Brown University), he devoted much of his time to the development of that institution.

SMITH, HIRAM (*b. Tinicum, Pa., 1817; d. 1890*), agriculturist. Removed to Sheboygan Falls, Wis., 1847, where he developed one of the outstanding dairy farms of the state. As a regent of the University of Wisconsin, he was responsible for establishment of the first U.S. dairy school there, 1890.

SMITH, HOKE (*b. Newton, N.C., 1855; d. 1931*), lawyer, newspaper publisher, Georgia politician. As U.S. secretary of the interior, 1893–96, Smith was an advocate of conservation of western natural resources and supported President Cleveland's effort to maintain the gold standard. A leader of liberal and reform elements in Georgia, Smith returned to politics in 1906, urging more effective control of the railroads and of elections, wherein fraud had been so great as to amount to disfranchisement of blacks. In his first term as governor, July 1907–July 1909, he accomplished more in extending the scope of social control in Georgia than any other governor in recent times; under his leadership, the assembly inaugurated the good-roads movement, established a department of commerce and labor, uprooted the convict-lease system, and curbed the state's public utilities companies. After a second brief term, July–November 1911, Smith became U.S. senator, Democrat, and served until 1921. His prime interest as a senator was in furthering the cause of education, especially vocational education. He disagreed with President Woodrow Wilson on a number of issues, particularly on the matter of the League of Nations. Throughout his long career he played an important part in the civic development of Atlanta, Ga.

SMITH, HOLLAND MCTYEIRE (*b. Hatchechubbee, Ala., 1882; d. San Diego, Calif., 1967*), Marine Corps officer. Attended Alabama Polytechnic and University of Alabama Law School. Commissioned a second lieutenant in 1905, and in 1906 was assigned to the first of various posts around the world. In France as a captain (1917–18), he became assistant operations officer with I Corps, First Army, and won the Croix de Guerre. Served with the occupation army in Koblenz, Germany, until 1919. Assistant Marine Corps commandant and director of operations and training (1937–39). Named assistant commandant in 1939 and promoted to brigadier general. Commander of the First Marine Brigade, Fleet Marine Force (1940); the First Marine Division (1941); all Marine Corps forces in the Central Pacific (1943–44); and Fleet Marine Force, Pacific (1944). Named commanding general of the Marine Training and Replacement Command in San Diego (1945–46), promoted to general, and retired.

SMITH, HOMER WILLIAM (*b. Denver, Colo., 1895; d. New York, N.Y., 1962*), physiologist. Attended University of Denver and Johns Hopkins (D.Sc., 1921). Chairman of the Department of Physiology, University of Virginia (1925–28) and professor at and director of the physiological laboratories at New York University College of Medicine (1928–61). His pioneer studies of the kidney and its function first involved refinement of the concept of renal clearance. Two of his books have had a profound influence in medicine: *The Physiology of the Kidney* (1937) and *The Kidney: Structure and Function in Health and Disease* (1951). Awarded the Presidential Medal of Freedom (1948), Lasker Award (1948), and Passano Award (1954) for his research.

SMITH, HORACE (*b. Cheshire, Mass., 1808; d. 1893*), inventor, arms manufacturer. In partnership with Daniel B. Wesson, he developed a revolver using a central-fire metallic cartridge (patented 1859, 1860), which was manufactured for the Union army in the Civil War and enjoyed large sales abroad.

SMITH, HORATIO ELWIN (*b. Cambridge, Mass., 1886; d. New York, N.Y., 1946*), professor of French. Graduated Amherst College, 1908; Ph.D., Johns Hopkins Chicago, 1912. Taught at Yale, 1911–18; at Amherst, 1919–25. Headed Romance language department, Brown University, 1925–36; headed French section

of Romance language department, Columbia University, 1936–46. Editor of *Romantic Review*, 1937–46. Author of, among other works, *Masters of French Literature* (1937).

SMITH, HORTON (*b. Springfield, Mo., 1908; d. Detroit, Mich., 1963*), professional golfer. In 1928–29 began a meteoric rise to international recognition, winning eleven tournaments, including the French Open; then played on the U.S. Ryder Cup team for a decade. Won the Masters Tournament in 1934 and 1936 and continued to win tournaments through the 1930's. As president of the Professional Golfers' Association (1951–53) helped liberalize PGA policy with respect to black players. Elected to the PGA Hall of Fame (1958).

SMITH, HOWARD WORTH ("JUDGE") (*b. Broad Run, Va., 1883; d. Alexandria, Va., 1976*), U.S. congressman. Graduated University of Virginia (LL.B., 1903) and practiced law in Alexandria (1922) and judge of Sixteenth Circuit of Virginia (1928). Elected as a Democrat to U.S. House of Representatives (1930–66), he initially supported Franklin Roosevelt's New Deal but opposed the National Industrial Recovery Act, "court-packing" plan, and Fair Labor Standards Act. The Smith Act of 1940 criminalized speech that urged insubordination or disloyalty in the military. As chairman of the House Rules Committee (1955–66), he exercised power by refusing to schedule hearings on bills he opposed, including civil rights legislation. His amendment to Title VII, which banned discrimination in employment on the basis of race, color, religion, or national origin, added the word "sex."

SMITH, ISRAEL (*b. Suffield, Conn., 1759; d. 1810*), lawyer. Raised in Vermont, Smith served in the Vermont legislature and was congressman, Democratic-Republican, from Vermont, 1791–97 and 1801–03; U.S. senator, March 1803–October 1807. He then became governor of the state for a single term.

SMITH, JAMES (*b. Northern Ireland, ca. 1719; d. Pennsylvania, 1806*), lawyer. Came to York Co., Pa., as a boy. Admitted to the bar, 1752. A backcountry leader during the Revolutionary era; member of the Continental Congress in 1776 and 1777; signer of the Declaration of Independence. A vigorous states' righter, he held but few political posts after his service in Congress and engaged chiefly in the practice of law.

SMITH, JAMES (*b. present Franklin Co., Pa., ca. 1737; d. 1814*), frontiersman, soldier, Kentucky pioneer. Author of *An Account of the Remarkable Occurrences in the Life and Travels of Col. James Smith, During His Captivity with the Indians, in the Years 1755, '56, '57, '58 & '59* (1799).

SMITH, JAMES (*b. Newark, N.J., 1851; d. Newark, 1927*), businessman, Democratic boss of New Jersey. Served as U.S. senator from New Jersey, 1893–99, without distinction; forced nomination of Woodrow Wilson for governor of New Jersey, 1910.

SMITH, JAMES ALLEN (*b. Pleasant Hill, Mo., 1860; d. 1924*), political scientist. Graduated University of Missouri, 1886; received Ph.D. at University of Michigan, 1894, after submitting a brilliant, controversial dissertation on the theory of money. In 1897 he became professor of political science at the University of Washington, remaining there until his death. His best-known work, *The Spirit of American Government* (1907), profoundly influenced Theodore Roosevelt, Robert La Follette, and many of the leading Progressives. Repeatedly denounced as a radical, he was in fact a Jeffersonian Democrat.

SMITH, JAMES FRANCIS (*b. San Francisco, Calif., 1859; d. Washington, D.C., 1928*), soldier, lawyer, jurist. Graduated Santa Clara College, 1877. Commanded 1st California Volunteer Infantry in the Philippines, 1898; rose to rank of brigadier general and served as military governor of several subdistricts in the Philippines. After holding a number of high official positions in the administration of the islands, 1900–06, he served with great ability, and success as governor general, 1906–09. He was a judge, U.S. court of customs appeals, 1910–28.

SMITH, JAMES MCCUNE (*b. New York, N.Y., 1813; d. Williamsburg, N.Y., 1865*), physician. The son of slave parents who had been emancipated, Smith graduated from the University of Glasgow, 1835, received his M.D. degree from Glasgow in 1837, and, after studying in clinics in Paris, France, returned to practice medicine in New York City. His chief claim to remembrance, however, rests upon his services, which were numerous and varied, on behalf of blacks. His writings show a high degree of scholarship.

SMITH, JAMES PERRIN (*b. near Cokesbury, S.C., 1864; d. 1931*), paleontologist, geologist. Brother of Charles Forster Smith. Graduated Wofford College, 1884; M.A., Vanderbilt, 1886; Ph.D., Göttingen, 1892. Taught at Stanford *post* 1893; made special study of ammonite group; served as geologist in U.S. Geological Survey, 1906–24.

SMITH, JAMES YOUNGS (*b. Groton, Conn., 1809; d. 1876*), cotton manufacturer, philanthropist. Republican governor of Rhode Island, 1863–66.

SMITH, JEBEDIAH STRONG (*b. Bainbridge, N.Y., 1798; d. near Cimarron River, Santa Fe Trail, 1831*), fur trader, explorer. Smith made the journeys on which his fame rests in the period 1826–30. Investigating the practicability of penetrating the Oregon country from California, he left Great Salt Lake in August 1826, passed through the territory of the Ute, Paiute, and the Mohave, and entered California from the desert in November. Restrained from any movement north by the governor of California, he proceeded east and north to the valley of King's River, where, in February 1827, he tried to cross the mountains and failed. He then moved north to the American River and with two companions crossed the mountains in May, making his way to Salt Lake over the unrelieved desert. Retracing his previous year's route from Salt Lake to Mission San Gabriel, he wintered in the Sacramento Valley; in April 1828 he headed northwest and in June reached the seacoast at the mouth of the Klamath River. After a hard journey to the Willamette, he reached Fort Vancouver, where Dr. John McLoughlin entertained him until March 1829. Smith then made his way on ground familiar to him to the rendezvous at Pierre's Hole. Retiring from the Rocky Mountain trade, he entered the Santa Fe trade and was killed on the trail by Comanche Indians. He was the first explorer of the Great Basin and the first American to make his way into California from the east and out of California from the west.

SMITH, JEREMIAH (*b. Peterborough, N.H., 1759; d. Dover, N.H., 1842*), lawyer. Congressman, Federalist, from New Hampshire, 1791–97. After service as U.S. attorney for the New Hampshire district, as a New Hampshire judge of probate, and as U.S. circuit judge, he was chief justice of New Hampshire, 1802–09. During this period he did more for the improvement of the jurisprudence of the state than any other man. After a single unsatisfactory term as Federalist governor of New Hampshire, 1809–10, he served again as chief justice, 1813–16. Retiring to private life, he was an associate counsel with Daniel Webster and Jeremiah Mason in celebrated Dartmouth College Case.

SMITH, JEREMIAH (*b. Exeter, N.H., 1837; d. St. Andrews, New Brunswick, Canada, 1921*), jurist, teacher of law. Son of Jeremiah

Smith (1759–1842). Justice, New Hampshire Supreme Court, 1867–74; Story professor of law, Harvard, 1890–1910.

SMITH, JEREMIAH (*b. Dover, N.H., 1870; d. 1935*), lawyer, financial expert. Son of Jeremiah Smith (1837–1921). Practiced in Boston, Mass., *post* 1896. Successfully reorganized finances of Hungary under supervision of League of Nations, 1924–26; served as counsel to American financial experts in formulation of the "Young Plan."

SMITH, JOB LEWIS (*b. Onondaga Co., N.Y., 1827; d. 1897*), physician. Brother of Stephen Smith. Graduated Yale, 1849; M.D., New York, College of Physicians and Surgeons, 1853. Author of one of the earliest American books to deal with the diseases of children as a specialty, Smith became one of America's leading pediatricians and was professor of the diseases of children at Bellevue Hospital Medical College, 1876–96.

SMITH, JOEL WEST (*b. East Hampton, Conn., 1837; d. Middletown, Conn., 1924*), educator of the blind.

SMITH, JOHN (*b. Willoughby, Lincolnshire, England, 1579/80; d. London, England, 1631*), adventurer, explorer, author. Apprenticed to a merchant, he soon left to seek adventure on the Continent and fought against the Turks in Transylvania. A prisoner and slave for some time among the Turks, he escaped, experienced further adventures, and returned to England, probably in 1604. Sailing with the colonists of the Virginia Co. of London late in 1606, he landed with them at Jamestown, 1607. During the troubled early days of the colony, Smith showed himself at his best in the expeditions he made among the Indians to procure food; taken prisoner on one of these trips, he was, according to his story in his *Generall Historie* (1624), condemned to death and saved by the intercession of Pocahontas. The story has been long in controversy, but there is nothing inherently improbable in it. Returning to Jamestown in January 1608, he found personal enemies in command of the turbulent colony and was arrested and condemned to be hanged. On the arrival, however, of Capt. Christopher Newport with new settlers from England, Smith was released and restored to a place in the colonial council, from which he had been ousted. Much more interested in exploring than in the administration of Jamestown, he settled down to governing the colony when elected president in the autumn of 1608. In October 1609, after much wrangling about authority, Smith returned to England, where he severely criticized the Virginia Co. and its methods. Despite the spectacular nature of his brief career in Virginia, his substantial contributions to the later founding of New England are possibly of more importance. Sent to New England by London merchants in March 1614, he brought back a valuable cargo of fish and furs and emphasized the value of the fisheries, continuing to the end of his life to proclaim the favorable prospects of New England for settlement. Among his numerous writings, *The True Travels, Adventures, and Observations of Captaine John Smith* (1630) and the *Generall Historie of Virginia, New-England, and the Summer Isles*, already cited, are considered the most important. His *Map of Virginia* (1612) and *Description of New England* (1616) were primary contributions to cartography.

SMITH, JOHN (*b. possibly Virginia, ca. 1735; d. present St. Francisville, La., ca. 1824*), Baptist clergyman, merchant. U.S. senator from Ohio, Democratic-Republican, 1803–07, Smith is best known for his association with Aaron Burr in the latter's western projects.

SMITH, JOHN AUGUSTINE (*b. Westmoreland Co., Va., 1782; d. 1865*), physician. Graduated William and Mary, 1800; received his medical education in London. A member of the first faculty of New York College of Physicians and Surgeons *post* 1807, he became president of the College of William and Mary, 1814. Returning to New York in 1825 after a most unsatisfactory tenure, he resumed his old duties as professor at the College of Physicians and Surgeons and, as its president *post* 1831, succeeded in broadening and improving the curriculum. He retired in 1843.

SMITH, JOHN BERNHARD (*b. New York, N.Y., 1858; d. 1912*), lawyer, entomologist. Appointed entomologist of the New Jersey state agricultural experiment station, 1889, he made his principal contribution in discovery of the breeding habits of the salt-marsh mosquito and the later institution of that insect's control. He served as professor of entomology, Rutgers College, 1889–1912.

SMITH, JOHN BLAIR (*b. Pequea, Pa., 1756; d. Philadelphia, Pa., 1799*), Presbyterian clergyman, educator. Nephew of Samuel Blair; brother of Samuel S. Smith. The leader of Presbyterian thought in Virginia in his time, he served as president of Hampden-Sydney College, 1779–89, and was made first president of Union College, 1795.

SMITH, JOHN COTTON (*b. Sharon, Conn., 1765; d. 1845*), lawyer, Connecticut legislator. A sturdy Calvinist and conservative, he served in Congress, sat on the state bench, and, as Federalist governor of Connecticut, 1813–17, was the last representative of the old "Standing Order" to hold the governor's chair. An opponent of the War of 1812, he urged Connecticut representation in the Hartford Convention and was an enemy of reform and of liberal revision of the Connecticut Charter.

SMITH, JOHN COTTON (*b. Andover, Mass., 1826; d. 1882*), Episcopal clergyman, author. Rector of the Church of the Ascension, New York City, *post* 1860. Active in support of foreign missions, reconciliation of theology and science, church union, and the solution of social problems, he was also a pioneer advocate of model housing and tenement-house reform.

SMITH, JOHN EUGENE (*b. Canton of Berne, Switzerland, 1816; d. Chicago, Ill., 1897*), soldier. Brought to America as an infant, Smith learned the jeweler's trade, which he followed in St. Louis, Mo., and Galena, Ill. Appointed colonel, 45th Illinois Infantry, July 1861, he rose to brigade and division command for brilliant services in the western campaigns and at Savannah, Ga. Commissioned colonel, 27th Infantry, regular army, in 1866, he served on the frontiers and helped quell the Sioux outbreak under Spotted Tail.

SMITH, JOHN GREGORY (*b. St. Albans, Vt., 1818; d. 1891*), railway organizer and executive, lawyer, Vermont legislator. Republican governor of Vermont, 1863 and 1864.

SMITH, JOHN JAY (*b. Burlington Co., N.J., 1798; d. Germantown, Pa., 1881*), editor, librarian. Grandnephew of Richard Smith; father-in-law of Hannah W. Smith; father of Lloyd P. Smith. Librarian of the Library Co. of Philadelphia, 1829–51; editor of *Waldie's Select Circulating Library* and briefly of *Littell's Museum*.

SMITH, JOHN LAWRENCE (*b. near Charleston, S.C., 1818; d. 1883*), chemist, mineralogist, authority on organic chemistry and meteorites.

SMITH, JOHN MERLIN POWIS (*b. London, England, 1866; d. New York, N.Y., 1932*), biblical scholar. Immigrated to Iowa, 1883. Ph.D., in Semitics, University of Chicago, 1899. After serving as assistant to William R. Harper, Smith taught at University of Chicago *post* 1908 and was also editor of the *American Journal*

of Semitic Languages. He was author of a number of important works on Hebrew and on the Old Testament.

SMITH, JOHN ROWSON (*b. Boston, Mass., 1810; d. 1864*), painter. Son of John Rubens Smith. Employed as a painter of stage scenery, he produced a number of scenic panoramas which were exhibited on tour through the United States and in Europe. These included panoramas of Boston, the conflagration of Moscow, and the Mississippi Valley. The last of these has been credited with greatly stimulating immigration.

SMITH, JOHN RUBENS (*b. London, England, 1775; d. New York, N.Y., 1849*), engraver, painter, drawing master. Son of John Raphael Smith, an eminent English mezzotinter; father of John Rowson Smith. Immigrated to America *ante* 1809. As a teacher in Boston, Philadelphia, and New York, he was reputed able but quarrelsome; he engaged in a number of controversies with contemporary artists.

SMITH, JONAS WALDO (*b. Lincoln, Mass., 1861; d. New York, N.Y., 1933*), civil engineer, water-supply expert. Graduated Massachusetts Institute of Technology, 1887. Associated with Clemens Herschel in developing water supplies of Paterson, Passaic, and other New Jersey communities. Appointed chief engineer of the Aqueduct Commission of New York City, 1903, and of the New York Board of Water Supply, 1905, Smith performed the most important work of his life in creating and later extending the system for bringing water from the Catskill Mountains to New York City.

SMITH, JONATHAN BAYARD (*b. Philadelphia, Pa., 1742; d. 1812*), Philadelphia merchant, Revolutionary patriot and soldier, Continental congressman. Father of Samuel H. Smith.

SMITH, JOSEPH (*b. Hanover, Mass., 1790; d. 1877*), naval officer. Appointed midshipman, 1809; served with credit in War of 1812 and the war with Algiers. Held a number of important sea and shore commands, notably that of chief of the Bureau of Navy Yards and Docks, 1846–69; headed the naval board which decided on building the *Monitor*. Promoted rear admiral on the retired list, 1862.

SMITH, JOSEPH (*b. Sharon, Vt., 1805; d. Carthage, Ill., 1844*), Mormon prophet. While resident in Palmyra, N.Y., he experienced a series of visions, 1820–23, whereby he was led to believe that God had selected him to restore the church of Christ. In September 1827 he was permitted to take from their hiding place near Manchester, N.Y., certain golden plates which recorded the story of the "true" church on the American continent following its migrations from Jerusalem. After translating the history by miraculous means, he published the result at Palmyra in July 1830 as *The Book of Mormon*. Before its publication, Smith had founded the Church of Jesus Christ of Latter-Day Saints at Fayette, N.Y., April 1830, but the extraordinary growth of the sect did not begin until Sidney Rigdon became associated with it. A cooperative society ruled by an ecclesiastical oligarchy, Mormonism was a system excellently adapted to success on the far frontier, but it brought its members into continual conflict with neighbors in the communities they occupied during Smith's lifetime. Removing first to Kirtland, Ohio, 1831, and later to Missouri, 1838, Smith and his flock came in 1839 to Commerce, Ill., which Smith renamed Nauvoo. After five years of prosperity, during which Smith enjoyed power, publicity, and worship, he made formal announcement of his candidacy for the presidency of the United States, Feb. 15, 1844. However, the scandal of his business affairs, the general unpopularity of his sect, and the discovery by local non-Mormons of the practice of polygamy (foreshadowed *ca.* 1831, declared as revelation July 1843)

brought about an uprising against the Mormons on the part of their neighbors. Smith and his brother were arrested and put in jail at Carthage, Ill., whence they were taken on June 27, 1844, and shot. He was the father of, among other children, Joseph Smith (1832–1914) and the uncle of Joseph F. Smith.

SMITH, JOSEPH (*b. Kirtland, Ohio, 1832; d. 1914*), Mormon prophet. Son of Joseph Smith (1805–44). President of the Reorganized Church of Jesus Christ of Latter-Day Saints *post* 1860; opposed polygamy, denying that his father had preached or practiced it.

SMITH, JOSEPH FIELDING (*b. Far West, Mo., 1838; d. 1918*), sixth president of the Utah branch of the Mormon Church. Nephew of Joseph Smith (1805–44). His chief contribution was the strengthening of the Mormon organization and the fostering of more friendly relations with non-Mormons.

SMITH, JOSEPH FIELDING (*b. Salt Lake City, Utah, 1876; d. Salt Lake City, 1972*), tenth president of the Church of Jesus Christ of Latter-day Saints. The grandnephew of the founder of the Mormon Church, Joseph Smith, he began a lifetime career in the church historian's office in 1902. In *Essentials in Church History* (1922), which became a standard text in Mormon education, Smith examined church history through scriptural themes. Excerpts from his sermons and extensive writings were published in *Answers to Gospel Questions* (1954–66). In 1970 he became president of the Mormon church.

SMITH, JUDSON (*b. Middlefield, Mass., 1837; d. 1906*), educator. Uncle of Gerald B. Smith. Graduated Amherst, 1859; Oberlin Theological Seminary, 1863. Ordained a Congregational minister, 1866, Smith taught Latin and history at Oberlin, and in 1884 became a secretary of the American Board of Commissioners for Foreign Missions.

SMITH, JULIA EVELINA *See* SMITH, ABBY HADASSAH.

SMITH, JUNIUS (*b. Plymouth, Conn., 1780; d. New York, N.Y., 1853*), lawyer, merchant, "father of the Atlantic liner." Organized British & American Steam Navigation Co., 1836, to undertake establishment of regular transatlantic steamship service. The voyage of this company's vessel *Sirius* in 1838 was the first of its kind, beating the *Great Western* to New York by a few hours. Competition from the Cunard line and the loss of a new vessel, the *President*, brought Smith's company to an end *ca.* 1842.

SMITH, JUSTIN HARVEY (*b. Boscawen, N.H., 1857; d. Brooklyn, N.Y., 1930*), historian, publisher, educator. Graduated Dartmouth, 1877. Taught modern history at Dartmouth, 1899–1908. Author of, among other books, *The Annexation of Texas* (1911) and *The War with Mexico* (1919), for which he was awarded the Pulitzer Prize and other honors.

SMITH, LILLIAN EUGENIA (*b. Jasper, Fla., 1897; d. Atlanta, Ga., 1966*), writer, editor, and civil rights advocate. Attended Piedmont College, Peabody Conservatory, and Columbia Teachers College. As music director at an American Methodist mission school in Huchow, China (1922–25), she embraced Chinese concepts of respect for human dignity, which gave her new perspectives on the South's social system. In 1935 launched the magazine *Pseudopodia*, devoted to southern issues; it used literary, cultural, and psychological criticism to indict caste and class in the South; it ceased publication in 1945. Her first novel, *Strange Fruit* (1944), depicting an ill-fated interracial love affair, was an immediate best-seller; it was declared obscene by the U.S. Post Office, which refused to allow it through the mails, but Eleanor Roosevelt got a White House order lifting the ban.

Joined the Congress of Racial Equality, and in 1948–49 wrote a regular column for the *Chicago Defender*, in which she pressed for the abolition of segregation. Her second book, *Killers of the Dream* (1949), labeled racists as morally and psychologically unbalanced and evoked strong criticism from white southerners. Its companion volume was *The Journey* (1954). *Our Faces, Our Words* (1964), her last book, is a pictorial essay on the nonviolent civil rights movement.

SMITH, LLOYD LOGAN PEARSALL (*b. Millville, N.J., 1865; d. London, England, 1946*), author. Scion of a Quaker family, young Smith would have led the unruffled life of the son of a manufacturer had his father not experienced an ecstatic conversion to the Higher Life evangelical movement and become, with his wife, an international revivalist. When disillusionment with evangelical Christianity returned the family to their origins in Germantown, Pa., Smith entered the Quaker Penn Charter school, after which he attended Haverford College, 1881–84, and Harvard, 1884–85. He abandoned the family business in 1888 after a trial year and followed his sister Mary to England, entering Balliol College, Oxford, where he found in Walter Pater's aestheticism a way to reconcile his skepticism with his capacity for passionate attachment. The pursuit of artistic perfection became his lifelong concern. Smith persisted in his interest, moving first to Paris, where he met Whistler and produced a volume of stories entitled *The Youth of Parnassus* (1895), and then to a cottage in England. He published a few of his essays in *The Golden Urn* (1897–98) with his sister Mary and Bernard Berenson, later her husband, but waited until 1920 to assemble a collection, entitled *Trivia*. It was followed by *More Trivia* (1922) and the aphoristic *Afterthoughts* (1931); the three were united in *All Trivia* (1933) and supplemented in 1945 by *Last Words*.

Brought by his polished writing and his work on *The English Language* (1922) to the attention of the poet Robert Bridges, he joined with Bridges and others to form in 1913 the Society for Pure English, formally launched in 1919. Directing his sharpest attacks in his many tracts for the society against those who had confused pedantry with purity, compromising thereby the vitality and simplicity of the language, he presented numerous essays collected in his *Reperusals and Re-Collection* (1936). He enjoyed his greatest success with his autobiography, *Unforgotten Years* (1939). He was close to George Santayana, with whom he collaborated on *Little Essays* (1920), and to Henry James.

SMITH, LLOYD PEARSALL (*b. Philadelphia, Pa., 1822; d. 1886*), librarian, publisher, editor. Son of John Jay Smith, whom he succeeded as librarian of the Library Co. of Philadelphia, 1851. He was the first editor of *Lippincott's Magazine*, 1868–69, and the author of *On the Classification of Books* (1892), which was a pioneer discussion of that subject.

SMITH, LUCY HARTH (*b. Roanoke, Va., 1888; d. Lexington, Ky., 1955*), schoolteacher and administrator. Studied at Hampton Institute, Kentucky State College, and the University of Cincinnati (M.Ed., 1943). Teacher and principal at Booker T. Washington Elementary School in Lexington, Ky., from 1917 until her death. Only woman to serve as the president of the Kentucky Negro Education Association; regional vice president of the American Teachers' Association. Named one of the five outstanding black citizens of Kentucky by the *Louisville Defender* 1945. Smith traveled widely lecturing on black history and traditions. Her address on black music was published in the *Journal of Negro History* (1935).

SMITH, MARCUS (*b. New Orleans, La., 1829; d. Paris, France, 1874*), actor, better known as Mark Smith. Son of Solomon F. Smith. Superior in supporting roles, notably as an interpreter of old English gentlemen.

SMITH, MARGARET BAYARD (*b. 1778; d. Washington, D.C., 1844*), society leader, author. Daughter of John B. Bayard; wife of Samuel H. Smith. Writer of several novels and a contributor to the periodicals of her time, Smith is remembered for her letters, which form a record by a keen observer of social and political events from Jefferson's time to the administration of W. H. Harrison. Edited by Gaillard Hunt, they were published as *The First Forty Years of Washington Society* (1906).

SMITH, MARTIN LUTHER (*b. Danby, N.Y., 1819; d. Savannah, Ga., 1866*), Confederate major general. Graduated West Point, 1842. Helped plan and construct fortification of New Orleans and Vicksburg; served at various times as chief engineer of the Army of Northern Virginia and the Army of Tennessee.

SMITH, MELANCTON (*b. Jamaica, N.Y., 1744; d. New York, N.Y., 1798*), lawyer, merchant, Revolutionary patriot. Active in ferreting out Tories in New York, 1775–80, he served in the Continental Congress, 1785–88, and rendered his most conspicuous service as an Antifederalist debater in the New York convention for ratification of the U.S. Constitution.

SMITH, MELANCTON (*b. New York, N.Y., 1810; d. Green Bay, Wis., 1893*), naval officer. Grandson of Melancton Smith (1744–98). Entering the navy, 1826, he performed a variety of sea and shore duties up to the time of the Civil War, in which he won repute as a grim and dogged fighting commander. He served under Farragut in the campaign against New Orleans, 1862, and at Port Hudson, 1863. During 1864 he operated on the James River, and commanded a gunboat flotilla during efforts to destroy the ram *Albemarle*, May–June 1864. He was later commended for his part in the attacks against Fort Fisher. Promoted rear admiral, 1870, he retired, 1871.

SMITH, MERIWETHER (*b. Essex Co., Va., 1730; d. Essex Co., 1794*), Revolutionary patriot, Virginia legislator and congressman. Able, but erratic.

SMITH, MILDRED CATHARINE (*b. Smethport, Pa., 1891; d. King's Point, N.Y., 1973*), editor. Graduated Wellesley College (B.A., 1914; M.A., 1922) and in 1920 was hired as an assistant editor at *Publisher's Weekly*. She became editor in chief (1959–67) and worked aggressively to improve the quality of the trade journal. She solicited articles by experts on the publishing industry and expanded the magazine's book review section.

SMITH, MILTON HANNIBAL (*b. Greene Co., N.Y., 1836; d. Louisville, Ky., 1921*), railroad official. Associated principally with the Louisville & Nashville *post* 1866, he served as its chief executive, 1882–1921, under various titles. He made his road one of the more important transportation factors in the United States.

SMITH, MORGAN LEWIS (*b. Mexico, N.Y., 1821; d. Jersey City, N.J., 1874*), Union brigadier general. Brother of Giles A. Smith. Held brigade, division, and, for a brief time, corps command under U. S. Grant and W. T. Sherman, 1861–64; commanded District of Vicksburg, 1864–65. Celebrated for coolness under fire and for a remarkable ability to instill discipline and morale in raw troops.

SMITH, NATHAN (*b. Rehoboth, Mass., 1762; d. New Haven, Conn., 1829*), physician, medical educator. After apprenticeship to several physicians in Vermont, where he was raised, Smith began practice at Cornish, N.H., 1787. Realizing the inadequacy of his training, he studied at Harvard with John Warren and

Benjamin Waterhouse, 1789–90, and then returned to his practice. Still unsatisfied with his education and desiring to teach, he made further studies in Europe, 1796–97, and in 1797–98 began work as professor of medicine at Dartmouth. In addition to his teaching he practiced generally in the area. Exasperated at lack of support of the medical school from the state legislature, he removed to Yale, where he became professor of the theory and practice of medicine, surgery, and obstetrics, 1813. In high repute as surgeon and teacher, he was one of the earliest to perform ovariotomy and in other ways showed an ability and resourcefulness which were unsurpassed in his day. The importance of his work for succeeding generations is to be found in the fresh and original manner in which he attacked problems in medicine and surgery, his essentially modern concept of disease, his distaste for theorizing, and his emphasis on the need for accurate observation. Among his writings *Practical Essay on Typhous Fever* (1824) has classic stature.

SMITH, NATHAN (*b. Woodbury, Conn., 1770; d. Washington, D.C., 1835*), lawyer. Brother of Nathaniel Smith. Active in the fight to disestablish Congregationalism in Connecticut, Smith held several judicial offices in the state and was U.S. senator, Whig, from Connecticut, 1832–35.

SMITH, NATHAN RYNO (*b. Cornish, N.H., 1797; d. Baltimore, Md., 1877*), surgeon, teacher of anatomy and surgery. Son of Nathan Smith (1762–1829). M.D., Yale, 1823. Taught at University of Vermont, at Jefferson Medical College, and at University of Maryland. Invented a new instrument for lithotomy; was a pioneer in extirpation of the thyroid gland.

SMITH, NATHANIEL (*b. Woodbury, Conn., 1762; d. 1822*), Connecticut jurist. Brother of Nathan Smith (1770–1835). Congressman, Federalist, from Connecticut, 1795–99; judge, state superior court, 1806–19. Attended Hartford Convention, 1814.

SMITH, OLIVER (*b. Hatfield, Mass., 1766; d. 1845*), businessman. Uncle of Sophia Smith. Bequeathed his very large fortune to several charitable enterprises under a will which was contested by his heirs at law. After a notable legal battle in which Rufus Choate and Daniel Webster were of counsel, the will was sustained. Among its present beneficiaries are the Smith Agricultural School and Northampton (Mass.) School of Technology.

SMITH, OLIVER HAMPTON (*b. Bucks Co., Pa., 1794; d. Indianapolis, Ind., 1859*), lawyer. Began practice at Versailles and Connersville, Ind., 1820. After service as a legislator and as prosecuting attorney, he was congressman, Democrat, from Indiana, 1827–29. As U.S. senator, Whig, from Indiana, 1837–43, he became chairman of the committee on public lands and was a leader in evolving a federal land policy in the interest of the actual settlers.

SMITH, ORMOND GERALD (*b. New York, N.Y., 1860; d. 1933*), publisher. Headed the firm of Street & Smith, publishers of dime novels and popular fiction, *post* 1887.

SMITH, PERSIFOR FRAZER (*b. Philadelphia, Pa., 1798; d. Fort Leavenworth, Kans., 1858*), soldier. Graduated College of New Jersey (Princeton), 1815. Removing to Louisiana, 1819, he practiced law in New Orleans and was active in the militia, serving in the Seminole War campaigns of 1836 and 1838. Commissioned colonel, U.S. Army, May 1846, he served with great distinction in the Mexican War as brigade commander under Zachary Taylor and during Scott's campaign against Mexico City. Breveted major general, he commanded several departments in the West, 1848–58. He was commissioned brigadier general, reg-

ular army, 1856. Gallant and efficient, he was noted particularly for the implicit trust which his men gave him.

SMITH, PETER (*b. near Tappan, N.Y., 1768; d. Schenectady, N.Y., 1837*), landowner. Father of Gerrit Smith. For a brief time a partner of John Jacob Astor in the fur trade, Smith acquired large tracts in Oneida and Onondaga counties, N.Y., by lease and purchase from the Indians.

SMITH, PRESERVED (*b. Cincinnati, Ohio, 1880; d. Louisville, Ky., 1941*), historian. Son of Henry Preserved Smith; nephew of Richmond Mayo-Smith. B.A., Amherst College, 1901; M.A., Columbia University, 1902; Ph.D., 1907. Granted a seven-year fellowship by Amherst, he studied in Berlin and Paris, but was incapacitated by tuberculosis, 1913–18. After lecturing at Harvard and Wellesley, he was appointed professor of history at Cornell University, 1922, a post he held until his death. He was author of, among other books, *Life and Letters of Martin Luther* (1911), *The Age of the Reformation* (1920), *Erasmus* (1923), and *History of Modern Culture* (1930–34).

SMITH, RALPH TYLER (*b. Granite City, Ill., 1915; d. Alton, Ill., 1972*), lawyer and politician. Graduated Illinois College (B.A., 1937) and Washington University Law School (LL.B., 1940). After service as a naval officer in World War II, he established a law practice in Alton, Ill., where he became active in Republican party politics. He served in the Illinois House of Representatives (1955–69), then was appointed to fill a vacant seat in the U.S. Senate (1969–70), where he vigorously supported President Richard Nixon's policies on the Vietnam War, welfare reform, and revenue sharing with the states.

SMITH, RICHARD (*b. Burlington, N.J., 1735; d. Natchez, Miss., 1803*), lawyer, land speculator. Smith's diary as a member of the Continental Congress from New Jersey, 1774–76, supplies much information not available from official sources concerning the proceedings in Congress. Another of his journals, covering his explorations of a tract of land which he owned on the upper Susquehanna River, was published as *A Tour of Four Great Rivers* (1906).

SMITH, RICHARD PENN (*b. Philadelphia, Pa., 1799; d. near Philadelphia, 1854*), lawyer, author, playwright. Grandson of William Smith (1727–1803). Author of 20 plays (1825–35), of which 15 were performed. Most of his work represented translations or adaptations from works by French and English authors; *The Deformed* (1830) and *Caius Marius* (1831) are considered his best works. He was author also of a novel, *The Forsaken* (1831), and of a number of tales, sketches, and verses.

SMITH, RICHARD SOMERS (*b. Philadelphia, Pa., 1813; d. 1877*), soldier, educator. Graduated West Point, 1834. Taught mathematics, drawing, and engineering at a number of schools, including West Point, 1840–55; Cooper Union; and the U.S. Naval Academy. Served in Union army, 1861–63; was president of Girard College, 1863–67.

SMITH, ROBERT (*b. possibly Glasgow, Scotland, ca. 1722; d. 1777*), Philadelphia architect and builder. Designed and built Nassau Hall at College of New Jersey (Princeton), 1754; St. Peter's Church, Philadelphia, 1758; also other Philadelphia churches. Planned obstructions in the Delaware River below Philadelphia for defense of that city, 1775–76. Smith handled the contemporary Georgian style with admirable dignity but tended to excessive plainness.

SMITH, ROBERT (*b. Worstead, England, 1732 o.s.; d. 1801*), Revolutionary patriot and chaplain, Episcopal clergyman. Came

to Charleston, S.C., 1757, as assistant minister of St. Philip's Church; becoming rector, 1759, he continued so until his death. He was consecrated first bishop of South Carolina, 1795.

SMITH, ROBERT (*b. Lancaster, Pa., 1757; d. 1842*), lawyer, Maryland legislator. Brother of Samuel Smith, U.S. secretary of the navy, 1801–09, Smith ran his office with fair efficiency, although greatly criticized by Albert Gallatin. A member of the Senate cabal which included his brother, W. B. Giles, and Michael Leib, Smith continued his feud with Gallatin while acting as U.S. secretary of state, 1809–11. Forced to resign by President Madison, whose policies on commercial restrictions he opposed, Smith retired to private life.

SMITH, ROBERT ALEXANDER C. (*b. Dover, England, 1857; d. Southampton, England, 1933*), railroad and public utilities promoter, capitalist. As dock commissioner of New York City, 1913–17, Smith developed and provided for construction of the Hudson River piers, which greatly improved New York's standing among world seaports.

SMITH, ROBERT BARNWELL See RHETT, ROBERT BARNWELL.

SMITH, ROBERT HARDY (*b. Camden Co., N.C., 1813; d. Mobile, Ala., 1878*), Alabama lawyer, member of the provisional Confederate Congress. Took active part in framing the permanent constitution of the Confederacy.

SMITH, ROBERT SIDNEY (*b. Bloomington, Ill., 1877; d. near Harvard, Ill., 1935*), comic-strip artist. Credited with being the first to use continuity in a comic strip, Smith began his successful "Andy Gump" series in 1917.

SMITH, ROSWELL (*b. Lebanon, Conn., 1829; d. New York, N.Y., 1892*), lawyer. publisher. Associated in publication of *Scribner's Monthly* with Josiah G. Holland, Charles Scribner, and Richard W. Gilder *post* 1870, he became sole proprietor, 188. Thereafter, the periodical was known as the *Century*. Smith also proposed publication of *St. Nicholas* magazine, 1873, and conceived the idea of *The Century Dictionary*. He directed the publication activities of the Century Co. until his death.

SMITH, RUSSELL (*b. Glasgow, Scotland, 1812; d. Glenside, Pa., 1896*), painter. Came to America as a boy. Specialized *post* 1833 in painting scenery for theaters and opera houses.

SMITH, SAMUEL (*b. Carlisle, Pa., 1752; d. Baltimore, Md., 1839*), soldier, statesman. Brother of Robert Smith (1757–1842). Served throughout the Revolution and won particular distinction for commanding defense of Fort Mifflin, 1777. Growing wealthy in land speculation, he entered politics, serving as congressman from Maryland, 1793–1803; at first a Federalist, he soon became a supporter of Jefferson. Elected to the U.S. Senate, 1803, he remained a senator until 1815. During the War of 1812, as major general he headed the force which defended Baltimore. Returning to the House of Representatives, 1816, he served until December 1822, when he resigned to fill out a vacancy in the U.S. Senate. Reelected in 1826, he held office until 1833. A forceful debater, intelligent and ambitious, he made his influence felt both on the floor of Congress and behind the scenes, where he was much given to intrigue. One of the leaders in opposing the nomination of James Madison for the presidency, he also led the faction which fought Albert Gallatin as secretary of the treasury and obstructed Gallatin's financial program in Congress. Later, although he favored equalization of tariff duties, he fought bitterly against Henry Clay's "American system" and even suggested in 1832 that the Union be divided at the Potomac in order to

escape it. His most constructive work was done in securing recovery of trade with the British West Indies, 1830.

SMITH, SAMUEL FRANCIS (*b. Boston, Mass., 1808; d. Boston, 1895*), Baptist clergyman, poet. Graduated Harvard, 1829. Author of the national hymn "America," which he wrote at the request of Lowell Mason, 1832.

SMITH, SAMUEL HARRISON (*b. Philadelphia, Pa., 1772; d. Washington, D.C., 1845*), journalist, banker. Son of Jonathan B. Smith; husband of Margaret B. Smith. Graduated University of Pennsylvania, 1787. Edited the *National Intelligencer*, official organ of the Jefferson administration, 1800–10; president, Washington Branch, Bank of the United States, 1828–36.

SMITH, SAMUEL STANHOPE (*b. Pequea, Pa., 1750; d. 1819*), Presbyterian clergyman, educator. Brother of John Blair Smith, Graduated College of New Jersey (Princeton), 1769. After pastoral work and missionary activity in western Virginia and periods of teaching at Princeton and at Hampden-Sydney, he became professor of moral philosophy at Princeton, 1779–1812. As acting president, 1795–1802, and as president, 1802–12, he contributed much to the physical and intellectual advancement of the college. Long interested in natural science himself, he raised money for scientific apparatus and called John Maclean to the college, 1795, to give the first undergraduate courses in chemistry and natural science in the United States. Although a popular teacher and preacher, he was subjected to much hostile criticism because of his supposed liberalism.

SMITH, SEBA (*b. Buckfield, Maine, 1792; d. 1868*), journalist, political satirist. Graduated Bowdoin, 1818. Husband of Elizabeth O. P. Smith. Founded *Portland Courier*, 1829, first daily paper to be issued in Maine, in which his celebrated "Major Jack Downing" letters appeared *post* January 1830. At first critical of the state legislature, Smith extended his satire to the administration and policies of President Andrew Jackson. Immediately popular and widely reprinted and imitated, the letters were published in book form as *The Life and Writings of Major Jack Downing of Downingville* (1833). Smith's rather mild ridicule of national leaders and party platforms is in contrast to the pointed wit of the "Jack Downing letters" written by Charles Augustus Davis, whose imitations of Smith's work received wide circulation. The creation of this Yankee type must, however, be credited to Seba Smith alone. After the success of Jack Downing, he held a number of editorial positions and was author of several other books, including 'Way Down East (1854) and a second series of Downing letters published as a book in 1859 under the title *My Thirty Years Out of the Senate*. The new pattern which he set for American humor was carried on by, among others, James Russell Lowell, Finley P. Dunne, and Will Rogers.

SMITH, SOLOMON FRANKLIN (*b. Norwich, N.Y., 1801; d. 1869*), comedian, theater manager, lawyer. Father of Marcus Smith. Better known as Sol Smith, he led a roaming life, 1818–35, associated at times with the itinerant companies of Samuel Drake and Noah M. Ludlow. At Mobile, Ala., 1835, he became junior partner with Ludlow in a theatrical firm which became one of the most important in the West. Operating theaters in St. Louis, Mo., Mobile, and New Orleans, the firm was successful until 1853, when it was dissolved. Thereafter Smith practiced law in St. Louis and served in the state convention which kept Missouri from secession.

SMITH, SOPHIA (*b. Hatfield, Mass., 1796; d. 1870*), founder of Smith College. Niece of Oliver Smith. Bequeathed her large fortune for the founding of Smith at the suggestion of the Congregational minister at Hatfield, John Morton Greene.

SMITH, STEPHEN (*b. near Skaneateles, N.Y., 1823; d. Montour Falls, N.Y., 1922*), surgeon, pioneer in public health. Brother of Job L. Smith. M.D., New York College of Physicians and Surgeons, 1851. An expert conservative surgeon and author of several valuable textbooks, Smith is remembered principally for his drafting of the Metropolitan Health Law for New York City, 1866, which became the basis of civic sanitation in the United States. He served as commissioner of the New York City Board of Health, 1868–75, and helped organize the American Public Health Association, 1871, of which he was first president.

SMITH, THEOBALD (*b. Albany, N.Y., 1859; d. 1934*), medical scientist. Ph.B., Cornell University, 1881; M.D., Albany Medical College, 1883. Organized Department of Bacteriology at present George Washington University, 1886, and taught there until 1895; taught also at Harvard Medical School, 1895–1915, and directed Massachusetts Board of Health pathological laboratory over the same period. Directed Department of Animal Pathology at the Rockefeller Institute for Medical Research *post* 1915. Smith, with Daniel E. Salmon, made important studies in the cause and prevention of swine plague; Smith later (1898–1902) wrote far-reaching studies on the relation between bovine and human tuberculosis. Between 1884 and 1893, Smith made classic investigations of Texas fever among cattle and showed for the first time how parasites may act as vectors of disease from animal to animal; he also made the first recorded observation of allergy. Author of more than 224 published works and studies, he ranks in American medical history in a place comparable to that of Pasteur in France and Koch in Germany.

SMITH, THEODATE LOUISE (*b. Hallowell, Maine, 1859; d. 1914*), genetic psychologist. Graduated Smith College, 1882; Ph.D., Yale, 1896; studied also at Clark University, where she was research assistant to Granville S. Hall., 1902–09. She was author of the interpretative *The Montessori System in Theory and Practice* (1912).

SMITH, THOMAS ADAMS (*b. Essex Co., Va., 1781; d. Saline Co., Mo., 1844*), soldier. Nephew of Meriwether Smith. Commissioned lieutenant of artillery, 1803, he served in command of infantry during War of 1812, rising to rank of brigadier general, 1814. Appointed commander of the territories of Missouri and Illinois, 1815, he resigned from the army, 1818, and was appointed receiver of public monies at Franklin, Mo. Resigning in 1826, he became a planter and a leader in Missouri public affairs. Fort Smith, Ark., was named in his honor.

SMITH, THOMAS VERNOR (*b. Blanket, Tex., 1890; d. Hyattsville, Md., 1964*), philosopher, political scientist, and politician. Attended University of Texas, Texas Christian, and University of Chicago (Ph.D., 1922). Taught at Texas Christian (1915–17), University of Texas (1919–21); University of Chicago (1921–48); and Syracuse University (1948–56). Published three books in 1934: *Beyond conscience, Creative Sceptics,* and *Philosophers Speak for Themselves*. Elected to the Illinois State Senate (1934) and U.S. Congress (1938–40), on the Democratic ticket. Director of education for the Allied Control Commission in Italy (1944) and director of democratization for German prisoners of war.

SMITH, TRUMAN (*b. Roxbury, Conn., 1791; d. 1884*), lawyer. Nephew of Nathan Smith (1770–1835) and of Nathaniel Smith. Graduated Yale, 1815. Congressman, Whig, from Connecticut, 1839–43 and 1845–49, he was among the first Whig party leaders to promote Zachary Taylor's candidacy in 1848 and directed Taylor's campaign. As U.S. senator, 1849–54, he described the sectional crisis of the time as a matter requiring scientific settlement on the basis of the climate and topography of the regions into which it was proposed to extend slavery. In other legislative matters he followed the predominant views of his party and section.

SMITH, URIAH (*b. West Wilton, N.H., 1832; d. Battle Creek, Mich., 1903*), Seventh-Day Adventist leader and editor, wood engraver.

SMITH, WALTER BEDELL (*b. Indianapolis, Ind., 1895; d. Washington, D.C., 1961*), soldier and diplomat. Enlisted in the Indiana National Guard (1910); was commissioned a first lieutenant in the Regular Army in 1920. Advanced in rank slowly; he did not become a major until 1939. During interwar period he served with the Bureau of Military Intelligence and had staff assignments in various posts. Taught at the Infantry School (1935–37), where he caught the attention of Gen. George C. Marshall, who called him to Washington in 1939 to help build up the army. Promotions now came rapidly; by 1943 he was a lieutenant general and in 1951 a full general. In 1942 he was named secretary of the Joint Chiefs of Staff and U.S. secretary of the Combined Chiefs of Staff; became Gen. Dwight Eisenhower's chief of staff (1942–45). Ambassador to Russia (1946–49); commander of the First Army (1949); director of the Central Intelligence Agency (1950–52); and undersecretary of state (1953–54).

SMITH, WALTER INGLEWOOD (*b. Council Bluffs, Iowa, 1862; d. Council Bluffs, 1922*), Iowa jurist. As congressman, Republican, from Iowa, 1900–11, he was an outstanding member of the Appropriations Committee; *post* 1911, he was judge, U.S. circuit court of appeals (8th Circuit).

SMITH, WILLIAM (*b. Newport-Pagnell, England, 1697; d. 1769*), jurist. Father of William Smith (1728–93). Immigrated to New York, 1715. Graduated Yale, 1719; studied law at home and at Gray's Inn. Practicing in New York City, Smith identified himself with the radical Presbyterian faction in provincial politics and was associated with leading cases seeking to curb the governor's prerogative. With James Alexander, he defended Rip Van Dam against claims of William Cosby, 1733, and also defended John Peter Zenger, 1735. Disbarred for criticism of Judge James DeLancey and an associate, Smith was readmitted to practice, 1737. He served as provincial attorney general, 1751, was a member of the Provincial Council, 1753–67, and was associate justice of the New York Supreme Court, 1763–69. Associated with the founding of the first New York public school, 1732, he was an incorporator of the College of New Jersey and a vigorous protester against the establishment of King's College (Columbia) under Anglican auspices.

SMITH, WILLIAM (*b. Aberdeen, Scotland, 1727; d. Philadelphia, Pa., 1803*), Episcopal clergyman, educator. M.A., University of Aberdeen, 1747. Immigrating to New York, 1751, he worked as a tutor on Long Island until 1753, during which time he wrote and published his plan for a college entitled *A General Idea of the College of Mirania* (1753). Invited by Benjamin Franklin and Richard Peters to associate himself with the Philadelphia Academy, he settled in Philadelphia in May 1754 and was the dominant influence in the academy's affairs until the Revolution. He taught logic, rhetoric, and natural and moral philosophy and, with Francis Alison, drew up a new charter, 1755, which established the academy on a collegiate basis. In the next year, Smith presented to the trustees a curriculum which was one of the most comprehensive educational schemes devised for any American school or college up to that time. An ambitious man, he made his influence felt in all the affairs of the province

of Pennsylvania. Active in providing schools for the education of German immigrants, he favored the appointment of an American bishop and labored to that end; a leading supporter of the proprietary interest, he incurred Franklin's bitter enmity. During the French and Indian War he condemned the assembly for failure to adopt aggressive military measures and published several pamphlets on the subject; he established in 1757 *The American Magazine and Monthly Chronicle* to support the interest of the British crown and of the Penn family. Arrested for libel, 1758, as a result of his association with William Moore (1699–1783), he was twice confined and jailed but later vindicated after an appeal to the king. Meanwhile, he had been provost of the College of Philadelphia since 1755 and had been very successful as a fundraiser for the institution.

At the request of Henry Bouquet and from facts supplied by him, Smith prepared *An Historical Account of the Expedition Against the Ohio Indians in 1764* (1765), which remains an important historical source; he was also active in other intellectual activities, particularly the affairs of the American Philosophical Society. An opponent of the Stamp Act, Smith continued to oppose individual British measures, but was quite out of sympathy with independence and in a notable sermon preached before Congress, June 1775, and later in several pamphlets signed "Candidus," called for a liberal reconciliation with Great Britain. After a number of difficulties with the patriots and the voiding of the charter of the College of Philadelphia, November 1779, by the Pennsylvania Assembly, Smith withdrew to Chestertown, Md., where he established a school later known as Washington College. One of the leaders in the organization of the Protestant Episcopal church, he is said to have suggested its name; he failed, however, to attain the bishopric to which he aspired. On the restoration of the charter of the College of Philadelphia by the assembly, 1789, Smith resumed his position as provost, keeping it until 1791. Despite high positions which he held and the honors which he received, he never enjoyed the highest respect and confidence of his contemporaries, who variously described him as artful, haughty, self-opinionated, hypocritical, and bad-mannered. With all his faults, he was yet one of the ablest, most versatile, and most influential Pennsylvanians of his day. His service to what is now the University of Pennsylvania was incalculable, and in his editorship of the *American Magazine* he encouraged a notable group of young literary men, including Francis Hopkinson, Thomas Godfrey, and James Sterling.

SMITH, WILLIAM (*b.* New York, N.Y., 1728; *d.* Quebec, Canada, 1793), New York jurist, Loyalist, historian. Son of William Smith (1697–1769). Graduated Yale, 1745. After admission to the New York bar, 1750, he established himself as a leading practitioner in partnership with William Livingston; with Livingston, he published the first digest of the colony statutes in force, 1752. Counsel in very many important cases, Smith was, with his partner and with John Morin Scott, a contributor to the *Independent Reflector* and the *Occasional Reverberator*; with them, he was author also of a defense of William Shirley entitled *A Review of the Military Operations in North America* (1757). His chief literary contribution was *The History of the Province of New-York from the First Discovery to the Year M.DCC.XXXII* (London, 1757; repr. with additions, New York, 1829). An important continuation of this work still remains in manuscript. A justice of the province *post* 1763 and a councillor *post* 1767, he was a leader of the popular party and a founder of the Whig Club. However, he shifted to a "fence-sitting" role and refused commitment to either side after the outbreak of the Revolution. Although he was consulted in the drafting of the New York State constitution, he refused in 1777 to take the oath of allegiance to the state, withdrawing to New York City, which was in British hands. Appointed chief justice of New York, 1779, he never ac-

tually served, since the city was under military control. Removing to England, 1783, he immigrated to Canada, 1786, as chief justice, an office which he held until his death.

SMITH, WILLIAM (*b.* probably Aberdeen, Scotland, ca. 1754; *d.* New York or Connecticut, 1821), Episcopal clergyman, educator. Came to America *ante* 1785. A learned but unsuccessful man, Smith's chief claim to remembrance is that he contributed the "Office of Institution of Ministers" to the Episcopal Book of Common Prayer.

SMITH, WILLIAM (*b.* possibly North Carolina, ca. 1762; *d.* Huntsville, Ala., 1840), lawyer, statesman, South Carolina legislator and jurist. U.S. senator from South Carolina, 1816–23 and 1826–30. A Jeffersonian Democrat of the strictest sort, Smith was a lifelong defender of states' rights and slavery and an opponent of banks, internal improvements, tariffs, and capitalism. Allied with William H. Crawford in national politics, he won the enmity of John C. Calhoun, whom he detested. Disapproving of nullification, which he thought a remedy worse than the disease, he was refused reelection in 1830 and thereafter was identified with the Union party. *Post* 1833 he resided in Louisiana and Alabama and was a member of the legislature of the latter state.

SMITH, WILLIAM (*b.* King George Co., Va., 1797; *d.* near Warrenton, Va., 1887), lawyer, mail-coach operator, Virginia legislator and congressman. Democratic governor of Virginia, 1846–49 and 1864–65. He served with distinction as a Confederate brigadier general, in particular at Antietam and Fredericksburg.

SMITH, WILLIAM ANDREW (*b.* Fredericksburg, Va., 1802; *d.* Richmond, Va., 1870), Methodist clergyman, educator. President of Randolph-Macon College, 1846–66; of Central College, Missouri, 1868.

SMITH, WILLIAM EUGENE (*b.* Wichita, Kans., 1918; *d.* Tucson, Ariz., 1978), photographer. He sold his first photograph to the *Wichita Eagle* in 1934 and attended the University of Notre Dame (1936–37) and the New York Institute of Photography. He worked for *Newsweek* (1937) and began supplying photos (1939) to *Life* magazine and *Collier's*. He was a war correspondent for *Flying* magazine and returned to *Life* in 1944, covering major operations in Pacific and setting new standards in front-line photography. His work for *Life* in 1947–54, including "Country Doctor" and "Spanish Village," raised the picture essay to a new level of excellence. His widely acclaimed book *Minamata* (1975) documented the tragic effects of industrial pollution.

SMITH, WILLIAM FARRAR (*b.* St. Albans, Va., 1824; *d.* Philadelphia, Pa., 1903), Union soldier, engineer. Graduated West Point, 1845, where he was assigned to teach mathematics. After hard service as brigade and division commander in the Army of the Potomac, Smith was author, with William B. Franklin, of an address of complaint to President Lincoln after the defeat at Fredericksburg. Transferred, he displayed extraordinary engineering skill in maintaining Union communications in the Chickamauga-Chattanooga campaigns, 1863, and was reappointed major general, March 1864. In constant controversy thereafter over credit for the opening of the "cracker-line," Smith went east with U.S. Grant. After participating in the action at Cold Harbor, he was once more moved to complain about the policies of his superiors and was relieved of command after failure in leading the attack on Petersburg in June 1864.

SMITH, WILLIAM HENRY (*b. Montgomeryshire, Wales, 1806; d. probably San Francisco, Calif., 1872*), actor, stage manager. Came to America, 1827, to make his debut at the Walnut Street Theatre, Philadelphia. Active thereafter in support of the elder Booth and with the Boston Museum company; during his latter years he was connected with the California Theatre, San Francisco.

SMITH, WILLIAM HENRY (*b. Austerlitz, N.Y., 1833; d. Lake Forest, Ill., 1896*), journalist, public official. General manager *post* 1882 of the combined New York Associated Press and Western Associated Press.

SMITH, WILLIAM LOUGHTON (*b. South Carolina, ca. 1758; d. 1812*), lawyer, pamphleteer. Son-in-law of Ralph Izard. Congressman, Federalist, from South Carolina, 1789–97, U.S. minister to Portugal, 1797–1801. A heavy speculator in government securities, Smith vigorously supported Hamilton's policy of assumption. He was author of several pamphlets in support of Federalism and attacking Thomas Jefferson, among which was *The Politicks and Views of a Certain Party, Displayed* (1792). He was also author, under the name "Phocion," of a series of letters in the *Charleston Daily Courier*, 1806, which defended the British point of view on topics then in dispute.

SMITH, WILLIAM NATHAN HARRELL (*b. Murfreesboro, N.C., 1812; d. 1889*), North Carolina legislator and jurist, Confederate congressman. Chief justice of the North Carolina Supreme Court *post* 1878.

SMITH, WILLIAM RUSSELL (*b. Russellville, Ky., 1815; d. 1896*), Alabama lawyer, legislator, and congressman. Raised in Alabama, Smith was active in politics, at first as a Whig and later as a Know-Nothing. Congressman from Alabama, 1851–57, he served in the Confederate House of Representatives, 1861–65. He wrote widely on legal and other subjects.

SMITH, WILLIAM SOOY (*b. Tarlton, Ohio, 1830; d. 1916*), civil engineer, Union brigadier general. Graduated West Point, 1853. Made first American use of pneumatic process for sinking foundations *ca.* 1859; later developed and improved the process. An expert in foundation work and bridge construction, he was one of the first to advocate carrying piers of high buildings down to rock and was foundation expert on early all large buildings constructed in Chicago, 1890–1910. He was father of Charles Sooysmith.

SMITH, WILLIAM STEPHENS (*b. New York, N.Y., 1755; d. Lebanon, N.Y., 1816*), Revolutionary soldier, lawyer, diplomat. As aide to Washington, he supervised evacuation of New York City by the British, 1783. Secretary of legation in London, 1785–88, he married Abigail, daughter of the then American minister, John Adams, 1786. Returning to the United States, he plunged heavily into land speculation and politics, held several federal offices, dabbled in South American filibustering activities, and was congressman, Federalist, from New York, 1813–16.

SMITH, WILLIAM WAUGH (*b. Warrenton, Va., 1845; d. 1912*), Confederate soldier, educator. President of Randolph-Macon College and of Randolph-Macon Woman's College and chancellor of the Randolph-Macon System of academies, Smith worked out new standards of secondary education for boys and of higher education for women which markedly influenced southern education.

SMITH, WINCHELL (*b. Hartford, Conn., 1871; d. 1933*), playwright, stage director. Rose to prominence as coproducer with Arnold Daly of a series of plays by George Bernard Shaw, 1904.

An able theater craftsman, he was author of the stage version of *Brewster's Millions, The Fortune Hunter,* and *The Only Son.* The rest of his highly successful work was done in collaboration. Smith is also notable as creator of the fictitious "George Spelvin," a name to represent an actor who doubles in a part.

SMITH, XANTHUS RUSSELL (*b. Philadelphia, Pa., 1839; d. Edgehill, Pa., 1929*), painter of historical subjects and battles. Son of Russell Smith.

SMOHALLA (*b. ca. 1815; d. 1907*), Indian medicine man and prophet. Chief of the Wanapum, a small tribe which lived around Priest Rapids in present Yakima Co., Wash., Smohalla founded the so-called Dreamer religion *ante* 1872. He taught that Indians alone were real people and that the whites, the blacks, and the Chinese had been created to punish the Indians for their apostasy from ancient custom.

SMOOT, REED OWEN (*b. Salt Lake City, Utah, 1862; d. St. Petersburg, Fla., 1941*), businessman, apostle of the Church of Jesus Christ of Latter-Day Saints, politician. Raised in Provo, Utah. Graduated Brigham Young Academy (later University), 1879. Joining his father in extensive business enterprises, he amassed a considerable fortune; in 1900 he was ordained an apostle of his church, a position second only to its presidency. One of the earliest in Utah to become a member of the Republican party, he was elected to the U.S. Senate by the legislature in January 1903 and consistently reelected, serving until 1933. Named to the Senate Finance Committee in 1909, and its chairman, 1923–33, he was an indefatigable worker with a passion for economy and a magisterial grasp of facts and figures. A leading member of the standpat Republican group, he fought for efficiency in government, lower taxes, and high tariffs; he was cosponsor of the protectionist Smoot-Hawley Tariff Act of 1930. Defeated in the Democratic landslide of 1932, he returned to Utah and gave his full time to church affairs.

SMYTH, ALBERT HENRY (*b. Philadelphia, Pa., 1863; d. Germantown, Pa., 1907*), educator. Professor of English at Central High School, Philadelphia, Pa., *post* 1886. Smyth won recognition as a Shakespeare scholar, as the author of several useful essays in literary criticism on American subjects, and, in particular, as editor of the *Writings of Benjamin Franklin* (1905–07), which he undertook with the cooperation of the American Philosophical Society.

SMYTH, ALEXANDER (*b. Rathlin Island, Ireland, 1765; d. Washington, D.C., 1830*), lawyer, soldier. Came to Virginia as a child. Commissioned brigadier general, U.S. Army, 1812; attempted an invasion of Canada (at Black Rock, above Buffalo, N.Y., November 1812) which failed of success. He later served as a Virginia legislator and as a congressman, Democrat, from Virginia, 1817–25 and 1827–30.

SMYTH, EGBERT COFFIN (*b. Brunswick, Maine, 1829; d. 1904*), Congregational clergyman. Son of William Smyth; brother of Newman Smyth. Graduated Bowdoin, 1848; Bangor Theological Seminary, 1853. Brown professor of ecclesiastical history at Andover Theological Seminary *post* 1863, he was also a lecturer on pastoral theology, and was president of the faculty, 1878–96.

SMYTH, HERBERT WEIR (*b. Wilmington, Del., 1857; d. Bar Harbor, Maine, 1937*), Hellenist. Graduated Swarthmore, 1876; also attended Harvard, and received Ph.D. at Göttingen, 1884. Taught at Johns Hopkins, Bryn Mawr, University of California, and American School of Classical Studies in Athens; professor of Greek at Harvard, 1901–25. Author of outstanding studies in

grammar, he is perhaps best known for *The Greek Melic Poets* (1900, 1906).

SMYTH, JOHN HENRY (*b. Richmond, Va., 1844; d. 1908*), lawyer, educator. Son of a slave father and a free black mother, Smyth was educated in Philadelphia, where he attended the Pennsylvania Academy of Fine Arts, taught school for a while, and considered studying for the stage under Ira Aldridge. Graduated from Howard University, 1872, he practiced law, engaged in Republican politics, and served as U.S. minister to Liberia, 1878–85. In 1897, he secured establishment of the Virginia Manual Labor School and headed it, 1899–1908.

SMYTH, JULIAN KENNEDY (*b. New York, N.Y., 1856; d. White Sulphur Springs, W. Va., 1921*), minister and official of the Church of the New Jerusalem.

SMYTH, NEWMAN (*b. Brunswick, Maine, 1843; d. New Haven, Conn., 1925*), Congregational clergyman. Son of William Smyth; brother of Egbert C. Smyth. Graduated Bowdoin, 1863; served in Union army; graduated Andover Theological Seminary, 1867. After holding pastorates in Maine and Illinois, he became pastor of the First Church, New Haven, Conn., 1882. Author of a number of liberal theological treatises, he was active in movements for church reunion. His nomination for the chair of theology at Andover in 1881 precipitated the well-known Andover controversy.

SMYTH, THOMAS (*b. Belfast, Ireland, 1808; d. 1873*), Presbyterian clergyman, author. Came to America, 1830; was minister and pastor at Second Presbyterian Church, Charleston, S.C., 1832–70.

SMYTH, WILLIAM (*b. Pittston, Maine, 1797; d. 1868*), mathematical textbook writer. Father of Egbert C. and Newman Smyth. Graduated Bowdoin, 1822. Beginning at Bowdoin as instructor in Greek, 1823, he was professor of mathematics there *post* 1828.

SNEAD, THOMAS LOWNDES (*b. Henrico Co., Va., 1828; d. New York, N.Y., 1890*), Missouri lawyer, Confederate officer. Practiced in New York City *post* 1866. Author of *The Fight for Missouri* (1886) and other studies of the Civil War.

SNELL, BERTRAND HOLLIS (*b. Colton, N.Y., 1870; d. Potsdam, N.Y., 1958*), businessman and politician. Studied at Amherst College. The owner of a paper and lumber company in upstate N.Y., Snell was elected as a Republican to the U.S. Congress in 1915; he served until his retirement in 1939. In the House, he was chairman of the House Rules Committee during the 1920's and House minority leader during the 1930's. An ardent foe of the New Deal, he was in favor of government spending for construction of the St. Lawrence Seaway in his own district.

SNELLING, HENRY HUNT (*b. Plattsburg, N.Y., 1817; d. St. Louis, Mo., 1897*), librarian, journalist. Son of Josiah Snelling; brother-in-law of George P. Putnam. Employed by E. & H. T. Anthony, dealers in photographic supplies, 1843–57, Snelling was author of *The History and Practice of the Art of Photography* (1849), a pioneer work. He founded and edited the *Photographic and Fine Art Journal*. A constant experimenter with photographic processes, he invented the enlarging camera, 1857, and at about the same time devised a ray filter.

SNELLING, JOSIAH (*b. Boston, Mass., 1782; d. Washington, D.C., 1828*), soldier. Commissioned as first lieutenant, 1808, and soon promoted captain, Snelling was made prisoner at Detroit during the War of 1812; after being exchanged, he took part in the Niagara campaign. Promoted colonel of 5th Infantry, 1819, he saw through to completion the building of Fort St. Anthony, adjacent to the present cities of St. Paul and Minneapolis. He remained in command there until 1828, the virtual ruler of a remote community completely isolated from civilization. The fort's name was changed to Fort Snelling in 1825.

SNELLING, WILLIAM JOSEPH (*b. Boston, Mass., 1804; d. Chelsea, Mass., 1848*), journalist. Son of Josiah Snelling. Author of, among other works, the verse satire *Truth: A New Year's Gift for Scribblers* (1831) and *Tales of the Northwest* (1830).

SNETHEN, NICHOLAS (*b. Glen Cove, N.Y., 1769; d. Princeton, Ind., 1845*), Methodist clergyman, a founder of the Methodist Protestant church.

SNIDER, DENTON JAQUES (*b. near Mt. Gilead, Ohio, 1841; d. St. Louis, Mo., 1925*), educator, philosopher. A disciple of William T. Harris and Henry C. Brokmeyer. Snider was one of the original members of the St. Louis Philosophical Society and, as a brilliant popular lecturer, did much to carry the idealism of the St. Louis movement to the intellectually starved cities of the Middle West. He was author of a number of critical works, of which those on Shakespeare and Goethe were possibly the best.

SNOW, CARMEL WHITE (*b. Dalkey, Ireland, 1887; d. New York, N.Y., 1961*), editor and fashion authority. Joined *Vogue* in 1921 as assistant fashion editor and was made American editor in 1929. Became fashion editor of *Harper's Bazaar* (1932) and made the magazine a "fortress of fashion opinion." As editor of *Harper's* (1935–57), she changed the magazine into a literary as well as fashion medium. She attended all the Paris showings and is generally credited with bringing Christian Dior and Balenciaga to prominence in America.

SNOW, EDGAR PARKES (*b. Kansas City, Mo., 1905; d. Eysins, Switzerland, 1972*), journalist. Attended University of Missouri Journalism School (1925–26) and in 1928 began work in Shanghai as an advertising manager and reporter for the *China Weekly Review*. He wrote *Red Star Over China* (1937), a noted early account of the Chinese Communist movement. He returned to the United States in 1941 as an associate editor for the *Saturday Evening Post* and was its chief war correspondent in Russia. During the McCarthy era in the 1950's he was accused as a Chinese Communist sympathizer and blacklisted by American newspapers and publishers. He resettled in Switzerland and published in European journals.

SNOW, ELIZA ROXEY (*b. Becket, Mass., 1804; d. 1887*), Mormon leader and hymnist. Sister of Lorenzo Snow; polygamous wife of Joseph Smith, and later of Brigham Young.

SNOW, FRANCIS HUNTINGTON (*b. Fitchburg, Mass., 1840; d. Delafield, Wis., 1908*), educator, naturalist. An original faculty member of the University of Kansas, Snow specialized in entomology both as teacher and as state entomologist. He served as chancellor of the university, 1890–1901.

SNOW, JESSIE BAKER (*b. Nantucket, Mass., 1868; d. Great Neck, N.Y., 1947*), civil engineer, expert in compressed-air tunnel work. B.S., Union College, 1889. Served as supervisor or consultant on most tunnel construction for subways and under neighboring waterways, New York City, 1904–43. As chief engineer, Board of Transportation, New York City, was responsible for consolidation of subway lines after municipal ownership and for razing elevated railway structures.

Snow, John Ben (*b. Pulaski, N.Y., 1883; d. Colorado Springs, Colo., 1973*), businessman. Graduated New York University School of Commerce (1904) and began his lengthy career with F. W. Woolworth in 1906 as a stockroom clerk, soon advancing to store manager. He transferred to England where he became superintendent of buyers in 1920. Through personal investments in Woolworth, he retired a multimillionaire in 1936. Between 1908 and 1948 Snow helped purchase a chain of newspapers as a silent partner and financial backer of newspaperman Merritt Speidel. By 1948 Speidel Newspapers owned the *Iowa City Press–Citizen*, the *Reno Gazette*, and the Visalia Newspapers, among other papers.

Snow, Lorenzo (*b. Mantua, Ohio, 1814; d. 1901*), fifth president of the Utah branch of the Mormon Church. Brother of Eliza R. Snow.

Snow, William Freeman (*b. Quincy, Ill., 1874; d. Bangor, Maine, 1950*), public health administrator, leader in the social hygiene movement. B.A., Stanford University, 1896; M.A., 1897. M.D., Cooper Medical College, San Francisco, Calif., 1900. Taught hygiene at Stanford, 1902–09; secretary and executive officer, California State Board of Health, 1909–13. Director of American Social Hygiene Association *post* 1913. President, National Health Council, 1927–34.

Snowden, James Ross (*b. Chester, Pa., 1809; d. Hulmeville, Pa., 1878*), numismatist, lawyer, Pennsylvania official. Director of U.S. Mint at Philadelphia, 1854–61.

Snowden, Thomas (*b. Peekskill, N.Y., 1857; d. 1930*), naval officer. Graduated Annapolis, 1879. Promoted rear admiral, 1917, after able, unspectacular service, he commanded a squadron of the battleship force of the Alantic Fleet through World War I and served with great ability as military governor of Santo Domingo, 1918–21.

Snyder, Edwin Reagan (*b. Scottdale, Pa., 1872; d. San Jose, Calif., 1925*), educator, educational administrator, specialist in vocational training.

Snyder, Howard McCrum (*b. Cheyenne, Wyo., 1881; d. Washington, D.C., 1970*), army physician. Received his M.D. from Jefferson Medical College (1905), then worked as an army contract surgeon at Fort Douglas, Utah; he was commissioned a first lieutenant in the medical corps of the Regular Army (1908) and held various assignments in the Philippines and United States (1909–17). During the 1920's he served at Fort Leavenworth, Kans., and the U.S. Military Academy. A medical adviser with the National Guard Bureau (1936–40), he pioneered cartilage surgery for the treatment of football injuries and supervised the training and facilities of National Guard medical personnel. Named assistant inspector general in 1940 and retired in 1945, but was recalled to active duty to serve as Dwight D. Eisenhower's personal physician (1945–48, 1951–60).

Snyder, John Francis (*b. Prairie du Pont, Ill., 1830; d. Virginia, Ill., 1921*), physician, Confederate soldier, archaeologist.

Snyder, Simon (*b. Lancaster, Pa., 1759; d. 1819*), businessman, Pennsylvania legislator. A Jeffersonian Democrat, he served as governor of Pennsylvania, 1808–17, the first representative of German descent and of the backcountry farming class to be elected to that office.

Sobeloff, Simon E. (*b. Baltimore, Md., 1894; d. Baltimore, 1973*), lawyer and judge. Graduated University of Maryland School of Law (1915) and interspersed private practice with public service until his appointment as U.S. Attorney for the District of Maryland (1931–34). He also served as Baltimore city solicitor (1943–47) and chief judge for the Maryland Court of Appeals (1952–54). As U.S. solicitor general (1954–56), he gained notoriety for refusing to argue a case against a public health official who had been discharged for alleged ties to the Communist party. From 1956 until his death, he served on the U.S. Court of Appeals for the Fourth Circuit. While on the federal bench, he wrote several major opinions upholding school desegregation.

Sobolewski, J. Friedrich Eduard (*b. Königsberg, East Prussia, 1808; d. 1872*), musician, author, composer. Immigrated to Milwaukee, Wis., 1859. Conductor, St. Louis Philharmonic, 1860–66. His opera *Mohega* produced in Milwaukee, October–November 1859, was probably the first operatic treatment of an episode from the American Revolution.

Sokolsky, George Ephraim (*b. Utica, N.Y., 1893; d. New York, N.Y., 1962*), author. Because of his early radical sympathies, left for Russia in 1917 and then wrote for Englishlanguage papers in Russia and China, 1917–31, and edited the *Far Eastern Review*. His knowledge of China enabled him to write for the *New York Times* (1931–33) and *New York Herald-Tribune* (1931–40). He also became a prominent spokesman for capitalism and wrote the column "These Days" for the *New York Sun* (1940–50). He promoted the cause of political conservatism through speeches and radio appearances, and his book *The American Way of Life* (1939) defended American capitalism against the attacks of consumer interests. He supported Sen. Joseph McCarthy's anti-Communist crusade and blamed the Truman administration for the triumph of the Chinese Communists.

Soldan, Frank Louis (*b. Frankfurt am Main, Germany, 1842; d. St. Louis, Mo., 1908*), educator. Immigrated to America, 1863. Beginning as a teacher in the St. Louis public school system, 1868, he rose through a number of important assignments to be superintendent of instruction, 1895–1908. An able administrator, he also lectured frequently and was associated with William T. Harris and others in St. Louis cultural affairs.

Soley, James Russell (*b. Roxbury, Mass., 1850; d. 1911*), educator, lawyer, writer. Graduated Harvard, 1870. Appointed professor of ethics and English at Annapolis, 1871. He served as head of the department of English studies, history and law, 1873–82, supervised publication of Civil War naval records, 1882–90, and was commissioned in the naval corps of professors of mathematics, 1876–90. Resigning his commission, 1890, he served as assistant secretary of the navy until 1893 and practiced law thereafter in New York City. He was author of a number of books on naval history.

Solger, Reinhold (*b. Stettin, Prussia, 1817; d. 1866*), scholar, lecturer, German revolutionary. Immigrated to Roxbury, Mass., 1853. Aided in securing support of German-Americans in the East for the Union cause.

Solis-Cohen, Jacob da Silva See Cohen, Jacob da Silva Solis.

Solomons, Adolphus Simeon (*b. New York, N.Y., 1826; d. Washington, D.C., 1910*), businessman, bookseller, philanthropist. Solomons was an inaugurator of a great number of charitable institutions, among them the American Red Cross, Mount Sinai and Montefiore hospitals in New York City, and the Jewish Theological Seminary of America.

Somers, Richard (*b. Somers Point, N.J., 1778; d. harbor of Tripoli, 1804*), naval officer. Volunteering to take the ketch *In-*

trepid as a fireship into the harbor of Tripoli, Somers was killed in the premature explosion of the vessel, Sept. 4, 1804.

SOMERVELL, BREHON BURKE (*b. Little Rock, Ark., 1892; d. Ocala, Fla., 1955*), army engineer and business executive. Graduated West Point (1914). Studied at the U.S. Army Engineering School (1922), the Command and General Staff School (1923), and at the Army War College (1926). Worked on various army engineering projects in Mexico and during World War I in action in France. As a lieutenant colonel on detached duty, he was chief of the WPA in New York City from 1936 to 1940, overseeing such projects as the construction of La Guardia Field. During World War II, as commanding general of the Services of Supply of the Operations Division under George C. Marshall; he was, in effect, Marshall's principal logistics adviser and operator. Retired a full general in 1946. President of the Koppers Co., a holding company in Pittsburgh, from 1946.

SONNECK, OSCAR GEORGE THEODORE (*b. Jersey City, N.J., 1873; d. 1928*), musician, librarian, historian. After extensive study in Germany, where he had been brought up, Sonneck returned to America, 1899, and thereafter became the principal scholar of American musical life in colonial and revolutionary times. As chief of the music division, Library of Congress, 1902–17, he made it one of the leading music libraries in the world. Among his most important books are *Early Concert-life in America* (1907), *The Star Spangled Banner* (1914), *Early Opera in America* (1915), and *Miscellaneous Studies in the History of Music* (1921). *Post* 1917 he worked for, and was an official of, the Schirmer music publishing company.

SONNICHSEN, ALBERT (*b. San Francisco, Calif., 1878; d. near Willimantic, Conn., 1931*), war correspondent, advocate of consumer's cooperatives.

SON OF MANY BEADS (*b. near Glenwood, N.Mex., ca. 1866; d. Ramah, N.Mex., 1954*), Navaho philosopher, leader, educator, and singer-curer. A Navaho schooled in the ceremonial intricacies of the Blessing Way and in the traditions and customs of the tribe, Son of Many Beads became famous among archaeologists and anthropologists who studied the Navahos, as the leading interpreter of the Navaho code of ethics. In 1951, Kluckhohn, an anthropologist, introduced Son of Many Beads to philosopher John Ladd, whose resulting book, *The Structure of a Moral Code* (1957) illuminates both Western and Navaho ethics through a detailed comparison of the two. Son of Many Beads became an important liaison for whites who wanted to learn from the Navaho.

SOOYSMITH, CHARLES (*b. Buffalo, N.Y., 1856; d. 1916*), civil engineer. Son of William S. Smith. Graduated Rensselaer Polytechnic Institute, 1876. Expert in foundation problems, he introduced to the United States the "freezing" process for excavation in unstable soils.

SOPHOCLES, EVANGELINUS APOSTOLIDES (*b. Tsangarada, Thessaly, ca. 1805; d. Cambridge, Mass., 1883*), classicist. Immigrated to Massachusetts ca. 1828. Teacher and professor of Greek at Harvard *post* 1842. Sophocles was author of a number of important works on Greek morphology, syntax, and cognate subjects, of which the most important was possibly his *Greek Lexicon of the Roman and Byzantine Periods* (1870).

SORENSEN, CHARLES (*b. Copenhagen, Denmark, 1881; d. Bethesda, Md., 1968*), automobile executive. Came to the United States in 1884. Began a forty-year career with the Ford Motor Company in 1904, becoming a vice president and member of the board in 1941. He helped work out the system of the moving

assembly line at Ford (1909–13) and assisted Henry Ford and others in the design of the Model A of 1928. During World War II he was occupied with building and operating the Willow Run plant for the manufacture of B-24 Liberators; he was the scapegoat for the disappointing performances at the plant and resigned in 1944. He became president and vice-chairman of Willys-Overland, then retired in 1953.

SORGE, FRIEDRICH ADOLPH (*b. Bethau bei Torgau, Saxony, 1828; d. Hoboken, N.J., 1906*), socialist labor leader. Immigrated to New York City, 1852, where he worked as a music teacher. Active in radical activities in America *post* 1858, he came to be considered the authoritative American representative of Karl Marx.

SORIN, EDWARD FREDERICK (*b. Ahuillé, France, 1814; d. 1893*), Roman Catholic clergyman, educator. Ordained 1838, Sorin entered the Congregation of the Holy Cross, 1840, and immigrated to the neighborhood of Vincennes, Ind., as a missionary, 1841. Removing to a site near South Bend, Ind., 1842, he began to build a college there which was chartered in January 1844 as Notre Dame University; he served as president until 1865. He was also responsible for the establishment in the United States of the Sisters of the Holy Cross and in 1865 founded *Ave Maria* magazine. Elected superior general of his congregation, 1868, he supervised its activities in France, Canada, and Bengal, as well as in the United States.

SOTHERN, EDWARD ASKEW (*b. Liverpool, England, 1826; d. London, England, 1881*), actor. Father of Edward H. Sothern. Immigrating to America, 1852, he became associated *post* 1858 with the role of Lord Dundreary, in the play *Our American Cousin*, which he made the archetype of the British "silly ass."

SOTHERN, EDWARD HUGH (*b. New Orleans, La., 1859; d. New York, N.Y., 1933*), actor. Son of Edward A. Sothern. A leading man in Daniel Frohman's company at the New York Lyceum Theatre *post* 1886, Sothern built up a brilliant reputation as a light comedian and romantic actor in cloak-and-sword dramas; he was outstanding as Rudolf in *The Prisoner of Zenda*. From 1904 to 1907, under the management of Charles Frohman, he acted chiefly in Shakespeare with Julia Marlowe; these productions, carefully staged, were enormously popular. Among other plays in which he was successful were *The Sunken Bell*, *If I Were King*, and *When Knighthood Was in Flower*. He was author of an autobiography, *The Melancholy Tale of Me* (1916).

SOTHERN, JULIA MARLOWE *See* MARLOWE, JULIA.

SOTO, HERNANDO DE *See* DE SOTO, HERNANDO.

SOUCHON, EDMOND (*b. Opelousas, La., 1841; d. 1924*), surgeon, anatomist, sanitarian. After making his early medical studies in Paris, France, he returned to New Orleans and graduated, 1867, from the medical department of University of Louisiana (later Tulane). Professor of anatomy and clinical surgery at Tulane, 1885–1908, he was the author of outstanding monographs on aneurisms and shoulder dislocations.

SOULÉ, GEORGE (*b. Barrington, N.Y., 1834, d. 1926*), mathematician, pioneer in business education in the South. President of Soulé College, New Orleans, La., 1856–1926.

SOULE, JOSHUA (*b. Bristol, Maine, 1781; d. Nashville, Tenn., 1867*), Methodist clergyman and bishop, author of the constitution of the Methodist Episcopal church, 1807.

SOULÉ, PIERRE (*b. Castillon-en-Couserans, France, 1801; d. 1870*), Louisiana legislator and jurist, diplomat. Educated in France, Soulé was exiled for participation in republican plots, 1825, and came to Baltimore, Md., in October of that year. After travel in the interior of the United States, he settled in New Orleans, La., where he succeeded as a legal practitioner, orator, and financier. Active in Democratic politics, he served briefly as U.S. senator frm Louisiana early in 1847, and was elected for a full term with Whig support in 1848. As senator, he succeeded J. C. Calhoun as leader of the states' rights wing of the Southern Democrats, but, except for oratory, achieved no outstanding distinction. Appointed U.S. minister to Spain, April 1853, he made one error after another in his endeavors to secure acquisition of Cuba and resigned in December 1854 after the fiasco of the Ostend Manifesto. In this matter he was in fact a scapegoat for errors of the administration. Although opposed to secession, he went with his state, 1860, but was prevented by President Jefferson Davis' hostility from rising to any position of prominence in the Confederacy.

SOUSA, JOHN PHILIP (*b. Washington, D.C., 1854; d. Reading, Pa., 1932*), brandmaster, composer. Conductor of the U.S. Marine Band, 1880–92, and thereafter successful as conductor of his own band on concert tours, Sousa composed more than a hundred marches of outstanding merit. He was composer also of ten comic operas and a number of works in other musical forms. Among his best-known march tunes were "Washington Post March" (1889), "High School Cadets" (1890), "Semper Fidelis" (1888) and "Stars and Stripes Forever" (1897).

SOUTHACK, CYPRIAN b. *London, England, 1662; d. Boston, Mass., 1745*), mariner, pioneer New England cartographer. Came to Boston, 1685; served on coast guard duty against pirates and privateers; commanded the Province Galley in Benjamin Church's expedition against Maine and Nova Scotia, 1704. Issued charts of Boston harbor, the St. Lawrence River, the English colonies from the Mississippi's mouth to the St. Lawrence, and the New England seacoast; author of *New England Coasting Pilot* (ca. 1720).

SOUTHALL, JAMES COCKE (*b. Charlottesville, Va., 1828; d. 1897*), Virginia journalist, author. Edited the *Richmond Enquirer*, 1868–74; wrote *The Recent Origin of Man* (1875) and other works.

SOUTHARD, ELMER ERNEST (*b. South Boston, Mass., 1876; d. New York, N.Y., 1920*), neuropathologist, social psychiatrist. Graduated Harvard, 1897; M.D., 1901. Taught neuropathology at Harvard *post* 1904, becoming professor, 1909. As first director, Boston Psychopathic Hospital, 1912–19, he developed psychiatric social work as a profession and provided a program of training for such workers.

SOUTHARD, LUCIEN H. (*b. presumably Sharon, Vt., 1827; d. Augusta, Ga., 1881*), musician, composer, Union soldier. First director, music conservatory of the Peabody Institute, Baltimore, Md., 1868–71; composer of, among other works, an opera, *The Scarlet Letter* (1855).

SOUTHARD, SAMUEL LEWIS (*b. Basking Ridge, N.J., 1787; d. Fredericksburg, Va., 1842*), jurist, statesman. Associate justice, New Jersey Supreme Court, 1815–20; U.S. senator, Democrat, from New Jersey, 1821–23. As U.S. secretary of the navy, 1823–29, he advocated a naval academy, thorough charting of the coasts, and a more intelligent location of naval bases. He also acted ad interim as secretary of the treasury, March–July 1825, and as secretary of war, May–June 1828. Becoming a Whig, Southard served as attorney general of New Jersey and was governor of that state, 1832–33. Reelected to the U.S. Senate, he served from 1833 to 1842 and strongly opposed the policies of Andrew Jackson.

SOUTHGATE, HORATIO (*b. Portland, Maine, 1812; d. Astoria, N.Y., 1894*), Episcopal clergyman. A missionary and missionary bishop in Turkey, 1840–50, he later held a number of appointments as rector in Boston, New York City, and elsewhere. A moderate High Churchman, he was author of, among other works, a novel, *The Cross Above the Crescent* (1878).

SOUTHMAYD, CHARLES FERDINAND (*b. New York, N.Y., 1824; d. 1911*), lawyer. Beginning the study of law at the age of 12, Southmayd soon became proficient and served for some years as a partner of Alexander S. Johnson. He is particularly remembered as the "office" member of the celebrated firm of Evarts, Southmayd & Choate (formed 1851, Joseph H. Choate joining it ca. 1858). Southmayd's brief in the case of *Pollock v. Farmers' Loan and Trust* is said to have resulted in the Supreme Court's ruling against the income tax as imposed in the Wilson-Gorman Act.

SOUTHWICK, SOLOMON (*b. Newport, R.I., 1773; d. 1839*), printer, Albany (N.Y.) journalist, New York official.

SOUTHWORTH, EMMA DOROTHY ELIZA NEVITTE (*b. Washington, D.C., 1819; d. Georgetown, D.C., 1899*), novelist. Encouraged to write by John G. Whittier (to whom she suggested the story that later became the poem of Barbara Frietchie), Southworth was author of more than 60 sentimental and melodramatic novels, many of which appeared as serials in the *New York Ledger*. Among her works were *The Hidden Hand* (1859), *The Fatal Marriage* (1869), and *The Maiden Widow* (1870).

SOWER, CHRISTOPHER (*b. Laasphe, Germany, 1693; d. Germantown, Pa., 1758*), printer, publisher. Father of Christopher Sower (1721–84). Immigrated to Pennsylvania, 1724. Active *post* 1738 as a printer and publisher of German-language books and newspapers, Sower undertook his most ambitious task in issuing the Bible in German, 1743. Except for John Eliot's Indian version, this was the first American edition of the Bible.

SOWER, CHRISTOPHER (*b. Laasphe, Germany, 1721; d. Methacton, Pa., 1784*), printer, publisher, bishop of the Dunkers (German Baptist Brethren). Son of Christopher Sower (1693–1758). Brought to Pennsylvania by his parents, 1724, he succeeded to his father's publishing business, 1758. A political supporter of the proprietary party, he suffered considerable persecution and loss of property during the Revolution.

SOWER, CHRISTOPHER (*b. Germantown, Pa., 1754; d. Baltimore, Md., 1799*), printer, publisher, Loyalist. Son of Christopher Sower (1721–84); grandson of Christopher Sower (1693–1758). After seizure and condemnation of the family property, August 1778, Sower endeavored to establish Loyalist associations in Pennsylvania; he worked out of the British base in New York. Removing to England, 1783, he returned to America in 1785 as deputy postmaster general and king's printer of the province of New Brunswick.

SOYER, MOSES (*b. Borisoglebsk, Russia, 1899; d. 1974*), painter. Settled in New York City after his family was banished from Russia in 1912. Studied at the National Academy of Design School (1916–20), and, except for a few landscapes and still lifes, his paintings focused on the human form, usually people in a reflective or melancholy mood. He had a one-man show at Neuman's Art Circle Gallery in New York (1928); his portraits *Joseph Stella* (1943) and *Abraham Walkowitz* (1944) are among his memorable paintings.

SPAATZ, CARL ANDREW ("TOOEY") (*b. Boyertown, Pa., 1891; d. Washington, D.C., 1974*), military officer and aviator. Graduated U.S. Military Academy (1914) and earned his wings in 1916. In 1929 he set an endurance record by staying aloft for seven days in the famous *Question Mark* flight. As an air force commander during World War II, he developed air tactics from the theory of strategic bombing, which called for aggressive bombing of enemy industrial sites; directed the air campaigns over Nazi-occupied Europe in 1942; and oversaw the atomic bomb strikes against Japan. He became the first chief of staff of the U.S. Air Force (1946–48).

SPAETH, ADOLPH (*b. Esslingen, Württemberg, 1839; d. Philadelphia, Pa., 1910*), Lutheran clergyman, author. Came to America, 1864, as assistant minister, St. Michael's and Zion's Church, Philadelphia; served later at St. Johannis Church and as a professor of New Testament exegesis in Philadelphia Lutheran Theological Seminary.

SPAETH, JOHN DUNCAN (*b. Philadelphia, Pa., 1868; d. Wayne, Pa., 1954*), educator. Studied at the University of Pennsylvania and the University of Leipzig (Ph.D., 1892). Preceptor at Princeton (1905–11); professor of English (1911–35); president of the University of Kansas City (Mo.) (1935–38). Wrote *Old English Poetry: Translations into Alliterative Verse With Introductions and Notes* (1921), an authoritative work on the subject which went into several printings.

SPAETH, SIGMUND (*b. Philadelphia, Pa., 1885; d. New York, N.Y., 1965*), musicologist. Attended Philadelphia Music Academy, Haverford, and Princeton (Ph.D., 1910). Music editor or reporter for several newspapers and magazines, including *New York Evening Mail* (1914–18), *Boston Transcript* (1919–20), *McCall's* (1931–33), *Esquire* (1934), *Literary Digest* (1937–38), and *Music Journal* (1955–65). Published more than thirty books, including the widely read *The Common Sense of Music* (1924) and *The Art of Enjoying Music* (1933). In the late 1920's he began giving expert testimony in major music plagiarism cases, usually speaking for the defense. His radio program "At Home with Music" was cited by the Peabody Awards Committee (1949, 1950).

SPAHR, CHARLES BARZILLAI (*b. Columbus, Ohio, 1860; d. at sea in English Channel, 1904*), editor, economist, reformer.

SPAIGHT, RICHARD DOBBS (*b. New Bern, N.C., 1758; d. 1802*), North Carolina legislator, Revolutionary patriot. Nephew of Arthur Dobbs. Antifederalist governor of North Carolina, 1792–95; congressman, 1798–1801. Never a narrow partisan, he frequently voted independently of his party.

SPALDING, ALBERT (*b. Chicago, Ill., 1888; d. New York N.Y., 1953*), violinist. A friend of Saint-Saëns, Spalding was the first American violinist to achieve a major international reputation. American debut 1908 at Carnegie Hall with the New York Symphony led by Damrosch. He was the first American to sit on jury examinations at the National Conservatory of Music in Paris in 1923, and was invited to play at the Beethoven Centennial Festival in Hamburg in 1927. Taught at Juilliard (1933–1944).

SPALDING, ALBERT GOODWILL (*b. Byron, Ill., 1850; d. Point Loma, Calif., 1915*), professional baseball player, merchant. An outstanding pitcher with Harry Wright's Boston team and with the Chicago National League Club, Spalding was a founder, 1876, and for many years president of A. G. Spalding & Brothers, manufacturers of sporting goods.

SPALDING, CATHERINE (*b. Charles Co., Md., 1793; d. Louisville, Ky., 1858*), founder and mother superior of the Sisters of Charity of Nazareth, established in Bardstown, Ky., January 1813. Sister Catherine was for many years the guiding spirit of her community. She also established educational and charitable institutions in Louisville and elsewhere in Kentucky.

SPALDING, FRANKLIN SPENCER (*b. Erie, Pa., 1865; d. Salt Lake City, Utah, 1914*), Episcopal clergyman, missionary bishop of Utah, 1904–14. A prison reformer, a prohibitionist, and a pacifist he was known outside his own communion as "the socialist bishop."

SPALDING, JOHN LANCASTER (*b. Lebanon, Ky., 1840; d. 1916*), Roman Catholic clergyman. Nephew of Martin J. Spalding. Educated at Mount St. Mary's Seminary, Cincinnati, Ohio, and at Rome and Louvain. Bishop of Peoria, Ill., 1877–1908, he was associated with liberal movements in the church and was a prime factor in the founding of Catholic University of America. A prolific and profound writer on social, educational, and philosophical problems.

SPALDING, LYMAN (*b. Cornish, N.H., 1775; d. Portsmouth, N.H., 1821*), physician, surgeon. Studied medicine with Nathan Smith (1762–1829). M.B., Harvard, 1797. Practiced in Portsmouth, N.H., 1799–1812; taught at, and was president of, the College of Physicians and Surgeons of the Western District of New York, Fairfield, N.Y., 1813–16. Spalding's greatest achievement was his founding of the U.S. Pharmacopoeia (1820).

SPALDING, MARTIN JOHN (*b. Rolling Fork, Ky., 1810; d. 1872*), Roman Catholic clergyman. Uncle of John L. Spalding. Educated at Bardstown (Ky.) Seminary and at Rome, where he was ordained, August 1834, he then did pastoral work in Kentucky and won repute as a lecturer and writer. Consecrated coadjutor bishop of Louisville, 1848, he succeeded to that see, 1850. A zealous administrator and builder of educational and charitable institutions, he proved a courageous leader during the Know-Nothing riots, 1855. He was one of the promoters of the North American College in Rome and of the American College at Louvain. Steadfastly neutral during the Civil War, he became archbishop of Baltimore, 1864, serving until his death. He took a leading part in the Vatican Council, 1870, where he was a strong supporter of papal infallibility.

SPALDING, THOMAS (*b. Frederica, Ga., 1774; d. Darien, Ga., 1851*), planter, Georgia legislator and congressman. Among the first to introduce sea-island cotton into the South, he was the first to grow sugar cane and to manufacture sugar in Georgia.

SPALDING, VOLNEY MORGAN (*b. East Bloomfield, N.Y., 1849; d. Loma Linda, Calif., 1918*), botanist. Graduated University of Michigan, 1873; Ph.D., Leipzig, 1894. Taught at Michigan, 1876–1904. Steadfast advocate of a rational policy of forest conservation, Spalding directed his interest in later years to ecology and the life relations of desert plants.

SPANGENBERG, AUGUSTUS GOTTLIEB (*b. Klettenberg-Hohenstein, Germany, 1704; d. Berthelsdorf, Saxony, 1792*), bishop and director of missions of the Moravian church. During the American periods of his very active career (at various times, 1735–62), he was the driving force in organization of Moravian work. Among his other achievements, he set up the "Economy" congregation at the Bethlehem, Pa., settlement and supervised the Moravian settlement in North Carolina, 1754–62.

SPANGLER, EDWARD *See* BOOTH, JOHN WILKES.

SPANGLER, HENRY WILSON (*b. Carlisle, Pa., 1858; d. 1912*), engineer, educator. Graduated from engineer course, U.S. Naval Academy, 1878. Taught engineering at the University of Pennsylvania *post* 1881, and at the end of his career, head of the Department of Mechanical and Electrical Engineering there. He was author of standard textbooks on thermodynamics and other engineering subjects.

SPARGO, JOHN (*b. Stithians, England, 1876; d. Old Bennington, Vt., 1966*), socialist, reformer, museum director, and historian. Worked as a Methodist lay preacher in the 1890's and by 1899 was a well-regarded socialist intellectual. Immigrated to the United States in 1901. His best-selling *The Bitter Cry of the Children* (1906) was influential in the passage of child-labor and widows' pension laws. He wrote seven more books on socialism, notably *Karl Marx, His Life and Work* (1909). The socialism he espoused during those years was grounded in a faith in universal suffrage and democratic politics and remarkably tolerant of capitalist reforms. He resigned from the Socialist party in 1916, and by the mid-1920's had repudiated socialism and become a Republican. Founded and headed the Bennington Historical Museum (1926–54) and was president of the Vermont Historical Society (1926–38).

SPARKS, EDWIN ERLE (*b. near Newark, Ohio, 1860; d. 1924*), educator, historian, pioneer in university extension courses. President, Pennsylvania State College, 1908–20.

SPARKS, JARED (*b. Willington, Conn., 1789; d. Cambridge, Mass., 1866*), editor, historian. Graduated Harvard, 1815. After studying divinity and serving as science tutor at Harvard, 1817–19, Sparks was minister of the First Independent Church (Unitarian) of Baltimore, Md., 1819–23. His installation there occasioned the celebrated sermon by William Ellery Channing defining the precise position of the Unitarians. Successful as proprietor and editor of the *North American Review*, 1823–29, he became a leading social and literary figure in the Boston group which included Prescott, Ticknor, and the Everett. Meanwhile, he had undertaken collection and publication of *The Writings of George Washington* (1834–37) and published *The Life of Gouverneur Morris* (1832), *The Works of Benjamin Franklin* (1836–40), and *The Diplomatic Correspondence of the American Revolution* (1829–30); he was also editor and a contributor to *The Library of American Biography* (ser. 1, 1834–38). These formidable sets of printed letters and documents sold well and were pioneer works of their kind. However, Sparks's editorial methods were bad inasmuch as he treated historical documents as if they had been articles submitted to his magazine and used his editorial pencil entirely too freely. He was influenced thereto by a desire to spare the feelings of the descendants of great men and of those who had lent him documents. Famous and well off, he became McLean professor of history at Harvard in 1839. Although he began his work by setting forth an excellent and innovating plan for historical studies, he trained no disciples and his professorship proved a false dawn of the study of modern history in American universities. Chosen president of Harvard, 1849, he attacked the elective system of study in his inaugural address, proposing to substitute definite alternative programs for indiscriminate groupings of course units. The effect, however, was a reaction toward the rigidly prescribed course and the conditions prevalent at Harvard before the reforms associated with George Ticknor. Unhappy as president, Sparks resigned, 1853, and devoted his time thereafter to collecting material for a projected history of the Revolution, which was never written. Faulty as his methods may have been, his energetic search for original documents and his skill in selecting and annotating them, to say nothing of his success in getting them published, gave the American public a new conception of their history.

SPARKS, WILLIAM ANDREW JACKSON (*b. near New Albany, Ind., 1828; d. St. Louis, Mo., 1904*), lawyer, Illinois legislator. Congressman, Democrat, from Illinois, 1875–83, Sparks performed his most notable public service as commissioner of the General Land Office, 1885–87. Despite the hostility of Congress and the press, he succeeded in effecting extensive reforms.

SPARROW, WILLIAM (*b. Charlestown, Mass., 1801; d. Alexandria, Va., 1874*), Episcopal clergyman, educator. Principal and chief teacher of the theological seminary instituted at Worthington, Ohio, by Bishop Philander Chase, 1826, Sparrow was actual administrative head of the school as it developed into Kenyon College and Gambier Theological Seminary. Accepting a professorship in the Virginia Theological Seminary, 1841, he soon became dean and served there until his death. He was an evangelical Low Churchman.

SPAULDING, CHARLES CLINTON (*b. Columbus County, N.C., 1874; d. Durham, N.C., 1952*), insurance executive, bank president. Self-educated, Spaulding joined the newly founded North Carolina Mutual Life Insurance Co. in 1898. A black company, the North Carolina Mutual became the largest black business in the nation by the 1920's, expanding into banks, building and loan associations, and fire insurance companies. Spaulding became president of the company in 1923, and president of the Mechanics and Farmers Bank in 1922.

SPAULDING, EDWARD GLEASON (*b. Burlington, Vt., 1873; d. Princeton, N.J., 1940*), neorealist philosopher. B.S., University of Vermont, 1894; M.A., Columbia, 1896; Ph.D., Bonn, 1900. Taught at College of the City of New York, 1900–05. On the staff of Princeton University thereafter, he was named McCosh professor of philosophy, 1936. Author of, among other works, *The New Rationalism* (1918), in which he called for the development of a constructive realism upon the basis of modern logic and science.

SPAULDING, ELBRIDGE GERRY (*b. Cayuga Co., N.Y., 1809; d. 1897*), Buffalo, N.Y., banker. A Whig congressman from New York, 1849–51, he returned to Congress as a Republican, 1859–63. Member of a subcommittee of the Committee on Ways and Means, he introduced into the House a bill for issuance of legal-tender treasury notes payable on demand, which became law, Feb. 25, 1862, and authorized the issue of the famous "greenbacks."

SPAULDING, LEVI (*b. Jaffrey, N.H., 1791; d. Uduvil, Ceylon, 1873*), Congregational clergyman. Missionary to Ceylon *post* 1820; distinguished as educator and Tamil linguist.

SPAULDING, OLIVER LYMAN (*b. Jaffrey, N.H., 1833; d. Georgetown, D.C., 1922*), lawyer, Union officer, government official. Special agent, U.S. treasury at Detroit, Mich., 1875–90; assistant secretary, U.S. treasury, 1890–93, 1897–1903; special agent, U.S. treasury in Washington, *post* 1903. Leading U.S. authority on customs law and administration.

SPEAKER, TRIS E. (*b. Hubbard, Tex., 1888; d. Lake Whitney, Tex., 1958*), baseball player. One of baseball's greatest hitters and fielders, Speaker finished his career standing third on the all-time list with 3,515 hits, sixth with 223 triples, and seventh with a .344 lifetime batting average. He played with the Boston Red Sox from 1907 to 1915; with the Cleveland Indians from 1915 to 1926, manager from 1919, and with the Philadelphia Athletics and Washington Senators for one year each. After retirement, he

became a radio baseball announcer. Elected to the National Baseball Hall of Fame in 1937.

SPEAKS, OLEY (*b. Canal Winchester, near Columbus, Ohio, 1874; d. New York, N.Y., 1948*), singer, composer. Composed more than 200 songs and hymns, of which three attained great popularity: "On the Road to Mandalay" (1907, to words by Rudyard Kipling), "Morning" (1912), and "Sylvia" (1914).

SPEAR, CHARLES (*b. Boston, Mass., 1801; d. Washington, D.C., 1863*), Universalist clergyman. An opponent of capital punishment, he devoted himself to assistance of discharged prisoners; he was author of *Essays on the Punishment of Death* (1844), *A Plea for Discharged Convicts* (1846), and editor of the periodical *The Prisoners' Friend.*

SPEAR, WILLIAM THOMAS (*b. Warren, Ohio, 1834; d. Columbus, Ohio, 1913*), jurist. Graduated Harvard Law School, 1859; was law partner of Jacob D. Cox. Judge of the common pleas court, 1878–85, and of the Ohio Supreme Court, 1885–1912, he was considered one of the ablest and most conscientious of any who served on the Ohio bench.

SPECK, FRANK GOULDSMITH (*b. Brooklyn, N.Y., 1881; d. Philadelphia, Pa., 1950*), ethnologist, student of American Indian languages and cultures. B.A., Columbia University, 1904; M.A., 1905; Ph.D., University of Pennsylvania, 1908. Staff member, University Museum, University of Pennsylvania, 1908–11; taught anthropology at Pennsylvania *post* 1911 (chairman of anthropology department *post* 1925). Author of, among other works, *Naskapi: Savage Hunters of the Labrador Peninsula* (1935) and *Penobscot Man* (1940).

SPEED, JAMES (*b. Jefferson Co., Ky., 1812; d. near Louisville, Ky., 1887*), lawyer, Kentucky legislator. An uncompromising Union man, he was a principal adviser of Abraham Lincoln on Kentucky affairs. Appointed U.S. attorney general, 1864, he went along with the president's policy of moderation toward the Southern states until Lincoln's death, when he developed a strange fascination for the Radical policy. Favoring military commissions to try the Lincoln conspirators and other persons not protected by parole, he was an early advocate of black suffrage and a sharp critic of President Andrew Johnson. After his resignation, 1866, he was prominent in Radical Republican activities, but later altered his opinions and supported Grover Cleveland in 1884. He was party to the controversy with Joseph Hold over the alleged recommendation for mercy in the case of Mrs. Surratt.

SPEER, EMMA BAILEY (*b. Pottstown, Pa., 1872; d. Bryn Mawr, Pa., 1961*), association administrator. Attended Bryn Mawr (1888–90). An active volunteer for the Young Women's Christian Association (1898–1910), she was president of its National Board (1915–32). Under her leadership the YWCA helped young women cope with a changing world by providing residences, recreation, and practical education. She combined several programs for teen-age girls into the Girl Reserves (1918). During World War I she devoted herself to the cause of young women, particularly those who moved to cities seeking employment. She continued to be active in YWCA until the 1950's.

SPEER, EMORY (*b. Culloden, Ga., 1848; d. Macon, Ga., 1918*), jurist. After serving as Georgia solicitor general, 1873–76 Speer was elected to Congress as an independent Democrat and served, 1879–83. Affiliating with the Republicans in his second term, he was appointed a federal judge for the southern district of Georgia, 1885, and held that position until his death. He was also dean of the law school of Mercer University *post* 1893. He

wrote pioneer decisions in many cases involving expansion of federal powers; his opinions in general were noted for lucidity and literary excellence, the most outstanding being *U.S. v. Greene and Gaynor.*

SPEER, ROBERT ELLIOTT (*b. Huntingdon, Pa., 1867; d. Bryn Mawr, Pa., 1947*), Presbyterian churchman and lay leader, foreign missions administrator. B.A., College of New Jersey (Princeton University), 1889; attended Princeton Theological Seminary, 1890–91. Secretary of Board of Foreign Missions of the Presbyterian Church in the USA, 1891–1937.

SPEER, WILLIAM (*b. New Alexandria, Pa., 1822; d. Washington, Pa., 1904*), Presbyterian clergyman. Organized first Presbyterian mission work in Canton, China, 1846–50. Later worked among Chinese immigrants to California, chiefly in San Francisco, and was secretary of the board of education of the Presbyterian church, 1865–76.

SPEIR, SAMUEL FLEET (*b. Brooklyn, N.Y., 1838; d. Brooklyn, 1895*), physician, Civil War surgeon. Graduated medical department, University of the City of New York (New York University), 1860; did European postgraduate study in ophthalmology and otology. Long a leader of the medical profession in Brooklyn, he was author of the notable *The Use of the Microscope in the Differential Diagnosis of Morbid Growths* (1871).

SPEISER, EPHRAIM AVIGDOR (*b. Skalat, Galicia, Austria-Hungary [now in the Soviet Union], 1902; d. Elkins Park, Pa., 1965*), archaeologist. Came to the United States in 1919, then attended University of Pennsylvania and Dropsie College (Ph.D., 1924). A concurrent Guggenheim fellowship (1926–28) and professorship at the American School of Oriental Research in Baghdad (1926–27) launched his career as an authority on the Sumerian, Akkadian, Babylonian, and Assyrian languages and the cultures of ancient Mesopotamia. Worked for the Office of Strategic Services as chief of the Near East section of the Research and Analysis Branch during World War II. Taught at the University of Pennsylvania (1931–65) and published *Mesopotamian Origins* (1930), *Introduction to Hurrian* (1941), and *The United States and the Near East* (1947).

SPELLMAN, FRANCIS JOSEPH (*b. Whitman, Mass., 1889; d. New York, N.Y., 1967*), Roman Catholic clergyman. Attended Fordham, the seminary for the Archdiocese of Boston, North American College in Rome, and the Urban College of Propaganda; he was ordained a priest in 1916. He first did parish work in Roxbury, Mass. (1916–18), then was assigned to the chancery staff (1922–25) and named archivist of the archdiocese (1924). In 1925 he accompanied a group of Boston pilgrims to Rome, where he developed friendships with prominent people, including Eugene Pacelli, later Pope Pius XII. In 1931 he smuggled Pope Pius XI's letter condemning fascism out of Italy to Paris, where it was printed and distributed by the Associated Press. Consecrated titular bishop of Sila (1932) and named auxiliary bishop of Boston (1932–39). In 1939 he was named archbishop of New York and vicar for the armed forces of the United States, using his dual position to gain national influence. During World War II he mobilized the Catholic war effort and became a symbol of Catholic patriotism. He was named a cardinal in 1946. Although frequently seen as the most powerful prelate in America, he never quite dominated the American hierarchy. He continually worked for the establishment of full diplomatic relations between the United States and the Holy See, and opposed the decreasing lack of censorship of American films; in a rare address from the pulpit, he struck out against the release of the film *Baby Doll* (1956). Socially, politically, and theologically, he was a con-

servative, but at Vatican II he was elected to the presidency of the council. After the council he became the object of increasing criticism for his stance in favor of U.S. involvement in the Vietnam War. He was perhaps the most powerful American Catholic churchman in the nation's history.

SPENCE, BRENT (*b. Newport, Ky., 1874; d. Fort Thomas, Ky., 1967*), U.S. congressman. Attended University of Cincinnati (LL.B., 1895); admitted to the Kentucky bar (1895). Elected to kentucky State Senate (1904–08), later served as city solicitor of Newport (1916–24). U.S. congressman (1930–63); made chairman of the Committee on Banking and Currency in 1943, a position he held except for two Republican-led Congresses. A Democrat, he supported almost all New Deal and Fair Deal measures. Advocated requiring banks to divest themselves of real estate, insurance, and all nonbanking interests. Supported the International Monetary Fund, International Bank for Reconstruction and Development, and helped establish the Small Business Administration.

SPENCER, AMBROSE (*b. Salisbury, Conn., 1765; d. 1848*), New York legislator and jurist. Brother-in-law of DeWitt Clinton. Graduated Harvard, 1783. Admitted to the bar in New York, 1788, he served in the legislature as a Federalist, 1793–98, and as a Democratic-Republican, 1798–1802. From 1800 to 1820 Spencer was almost undisputed dictator of politics in New York State and, with DeWitt Clinton, dominated the scene by ruthless exploitation of the spoils system. Appointed judge of the state supreme court, 1804, he remained there until 1823, serving as chief justice *post* 1819. Dissatisfaction with his autocratic manner and his autocratic power found expression through Martin Van Buren in the constitutional convention, 1821, when extensive amendments were passed which limited Spencer's power. His great ability as a jurist has been obscured by the fury of his political activities; his dissents often gave first expression to what later became accepted doctrine in New York courts. He guided New York jurisprudence along lines he thought it should follow, and somewhat in the manner of John Marshall and Theophilus Parsons, he created judicial law largely by the sheer force of his own reasoning and authority. He was father of John C. Spencer.

SPENCER, ANNA GARLIN (*b. Attleboro, Mass., 1851; d. 1931*), journalist, independent clergyman, educator, woman's rights and peace reformer.

SPENCER, CHRISTOPHER MINER (*b. Manchester, Conn., 1833; d. Hartford, Conn., 1922*), machinist, inventor. Patented the Spencer self-loading, or repeating, rifle, 1860, which was immediately adopted by the U.S. government and used extensively in the Civil War. Patented a breech-loading gun, 1862, and a magazine gun, 1863. Successful in the manufacture of dropforgings, he continued to work on inventions and patented, September 1873, a machine for turning metal screws automatically which included the automatic turret lathe. As this feature was overlooked by the patent attorney who made the application, Spencer could never claim patent rights to it. Organizing with others the Hartford Machine Screw Co., 1876, he laid the foundation of a very large industrial enterprise in Hartford, but later withdrew from it and in 1893 organized the Spencer Automatic Machine Screw Co. at Windsor, Conn.

SPENCER, CORNELIA PHILLIPS (*b. Harlem, N.Y., 1825; d. Cambridge, Mass., 1908*), author. Principally distinguished *post* 1866 for her efforts to rehabilitate the University of North Carolina.

SPENCER, ELIHU (*b. East Haddam, Conn., 1721; d. 1784*), Presbyterian clergyman. Brother of Joseph Spencer; grandfather of John and Thomas Sergeant; cousin of David and John Brainerd. Held principal pastorates at Elizabethtown, N.J., and Trenton, N.J. An ardent Revolutionary patriot, he was chaplain in the French and Indian War and the Revolution.

SPENCER, JESSE AMES (*b. Hyde Park, N.Y., 1816; d. 1898*), Episcopal clergyman, educator, author. A Broad Churchman, Spencer held a number of pastoral and teaching posts in New York and New Jersey. He was appointed custodian of the Standard Bible of the Church, 1883.

SPENCER, JOHN CANFIELD (*b. Hudson, N.Y., 1788; d. Albany, N.Y., 1855*), lawyer, New York official and legislator. Son of Ambrose Spencer. Graduated Union College, Schenectady, 1806. Admitted to the bar, 1809, in Albany, N.Y., he practiced in Canandaigua, N.Y., and with the help of his father rose rapidly in his profession and in politics. One of the ablest lawyers of his day, he served with John Duer and B. F. Butler on the committee to revise the New York statutes, 1827, and in 1829 was special prosecuting officer in the investigation of the murder of William Morgan. Joining the Whig party *ca.* 1838, he was appointed U.S. secretary of war, 1841, and served until March 1843; then appointed U.S. secretary of the treasury, he resigned in May 1844 because of opposition to the annexation of Texas. His son, Philip, suffered execution for attempted mutiny aboard the USS *Somers*, 1842, while serving under Alexander S. Mackenzie.

SPENCER, JOSEPH (*b. East Haddam, Conn., 1714; d. East Haddam, 1789*), Connecticut legislator and official, Revolutionary soldier. Brother of Elihu Spencer; cousin of David and John Brainerd. A militia officer *post* 1747, Spencer served in the colonial wars and was chosen brigadier general of Connecticut forces, 1775. Passed over in June of that year for promotion to major general in the Continental service, he left the army. Later reconciled, he served through the siege of Boston and in the New York campaign and was promoted major general, August 1776. Resigning 1778, he later served in the Continental Congress and in the Connecticut Assembly.

SPENCER, PITMAN CLEMENS (*b. Charlotte Co., Va., 1793; d. Petersburg, Va., 1860*), surgeon, lithotomist.

SPENCER, PLATT ROGERS (*b. East Fishkill, N.Y., 1800; d. Geneva, Ohio, 1864*), calligrapher, creator of the Spencerian handwriting. Developed his characteristic hand, a sloping, semiangular style with many embellishments, *ante* 1820. He issued copybooks *ca.* 1855 and thereafter brought out a whole series of textbooks.

SPENCER, ROBERT (*b. Harvard, Nebr. 1879; d. New Hope, Pa., 1931*), painter. Studied at National Academy of Design, New York, and at New York School of Art; worked with William M. Chase and Robert Henri.

SPENCER, SAMUEL (*b. Columbus, Ga., 1847; d. near Lawyers, Va., 1906*), railway engineer. Son-in-law of Henry L. Benning. After service with the Baltimore & Ohio Railroad and other roads, including a brief presidency of the B. & O., he became railway expert for Drexel, Morgan and Co. and played an important part in the Morgan railroad reorganizations. He was highly efficient and successful as president of the Southern Railway, 1894–1906.

SPERRY, ELMER AMBROSE (*b. Cortland, N.Y., 1860; d. Brooklyn, N.Y., 1930*), engineer. Mainly self-taught, Sperry was first successful in developing and manufacturing improved dynamos and arc lamps and founded the Sperry Electric Co. at Chicago, Ill., 1880. In 1888 he organized a company to manufacture an

electrically driven undercutting punching machine for soft-coal mining; he subsequently perfected a continuous chain undercutter and also electric mine-locomotives. Founding another company, 1890, for manufacture of his patented electric street-railway cars, he operated this concern with success until 1894 when he sold it and his patents to the General Electric Co. He was next engaged, 1894–1900, in manufacture of electric automobiles of his own design and his patented storage battery for their operation. In 1900 he established at Washington, D.C., a research laboratory wherein, with an associate, he evolved the socalled Townsend process for manufacture of caustic soda from salt and developed the chlorine process for recovering tin from scrap. Sperry's most distinctive inventions, however, were those which put to practical use the principle of the gyroscope. He began work on this project *ca.* 1896, and through long, expensive investigation successfully combined electrical and mechanical elements into gyroscopic compasses and stabilizers for ships and airplanes. His first compass was tried out on the USS *Delaware* at Brooklyn Navy Yard, 1910, and shortly after adopted by the U.S. Navy and by steamship lines generally. In 1918 he produced his high-intensity arc searchlight and, at his death, had just completed a device for detecting flaws in railroad rails. He was the holder of more than 400 patents and the recipient of many scientific honors.

SPERRY, NEHEMIAH DAY (*b. Woodbridge, Conn., 1827; d. New Haven, Conn., 1911*), contractor, businessman, Know-Nothing and Republican politician. Dominating Republican politics in Connecticut *post* 1856, Sperry served in Congress, 1895–1911, where he was an ardent protectionist. He also served as postmaster of New Haven, 1861–86 and 1890–94.

SPERRY, WILLARD LEAROYD (*b. Peabody, Mass., 1882; d. Cambridge, Mass., 1954*), clergyman, theologian, and essayist. Studied at Olivet College, Mich., as a Rhodes Scholar at Oxford University, and at Yale (M.A., 1908). From 1925 to 1953, he was professor and dean of the Harvard Divinity School. During his tenure, he liberalized the school's admissions policies to include students from a wide variety of denominations. He wrote *Religion in America* in 1946 at the request of Cambridge University Press as part of its series on American life and institutions.

SPEWACK, SAMUEL (*b. Bachmut, Russia, 1899; d. New York City, 1971*), writer. Attended Columbia University (1916–18) and became a reporter, then a foreign correspondent (1922–26), for the *New York World*. In the 1920's he and his wife, Bella Cohen, began writing stage comedies. Their major works, which included *Boy Meets Girl* (1935), *Miss Swan Expects* (1939), and *My Three Angels* (1953), won acclaim for their fast-paced and madcap comedy. The Spewacks won a Tony award for the hit musical *Kiss Me, Kate* (1948). The duo also composed twenty screenplays, including *My Favorite Wife* (1940). Spewack was also a novelist, publishing three mysteries under the pseudonym A. A. Abbott.

SPEYER, JAMES JOSEPH (*b. New York, N.Y., 1861; d. New York, 1941*), financier, philanthropist. Scion of a great German Jewish banking family, he was raised in Frankfurt am Main and attended schools there. In 1885 he joined the New York City branch of the family firm, Speyer and Co., becoming senior partner, 1899. Active in underwriting and distributing railroad securities and bonds of foreign governments, the firm ranked as one of the leading international banking houses of the time up to 1914. Adversely affected by its German connections on the outbreak of World War I and by the postwar fall in railroad stocks, Speyer and Co. declined in importance; the rise of the Nazis in Germany was the final blow. James Speyer formally retired in 1938

and the American firm was liquidated in 1939. His many philanthropies included the University Settlement, Teachers College, the Provident Loan Society, the Museum of the City of New York, and various political reform groups.

SPICKER, MAX (*b. Königsberg, Germany, 1858; d. 1912*), musician, conductor, composer. Came to New York City, 1882, after a successful career in Europe. Conductor of the Beethoven-Männerchor, 1882–88; director, Brooklyn Conservatory of Music, 1888–95; headed theory department, New York National Conservatory, 1895–1907; director of music, Temple Emanu-El, 1898–1910.

SPIER, LESLIE (*b. New York, N.Y., 1893; d. New Mexico, 1961*), anthropologist. Attended City College of New York and Columbia (Ph.D., 1920). Taught at University of Washington (1920–27, 1929–30), Yale (1933–39), and University of New Mexico (1939–55). Editor of *American Anthropologist* (1934–38) and the *Southwestern Journal of Anthropology* (1944–61). He was in the field for part of every year during 1916–35, studying North American Indians; his *Havasupai Ethnography* (1928) served as a model of ethnographic description, and *The Sun Dance of the Plains Indians* (1921) remains a classic of the historical method of anthropology.

SPIERING, THEODORE (*b. St. Louis, Mo., 1871; d. Munich, Germany, 1925*), violinist, conductor, music teacher. Studied in Cincinnati, Ohio, with Henry Schradieck; at Berlin with Joseph Joachim. Appreciated more in Europe than in America, Spiering organized and directed the Spiering Quartet, 1893–1905, taught for some years in Chicago, Ill., and was concertmaster of the New York Philharmonic, 1909–11, under Gustav Mahler.

SPILLMAN, WILLIAM JASPER (*b. Lawrence Co., Mo., 1863; d. 1931*), agricultural economist. Graduated University of Missouri, 1886. After serving on staff of Washington State College, Spillman acted for many years as an expert in the U.S. Department of Agriculture. He was also professor of commercial geography at Georgetown University, 1922–31. An innovator in development of scientific farm management, he was author of *Balancing the Farm Output* (1927).

SPILSBURY, EDMUND GYBBON (*b. London, England, 1845; d. New York, N.Y., 1920*), mining engineer, metallurgist. Trained in Belgium and Germany, Spilsbury came to America, 1870. Practicing for many years as a consultant, he was responsible for introduction of a number of European processes into the United States.

SPINGARN, ARTHUR BARNETT (*b. New York City, 1878; d. New York City, 1971*), civil rights attorney. Graduated Columbia University (B.A., 1897; M.A., 1899; LL.B., 1900). He joined the National Association for the Advancement of Colored People (NAACP) shortly after its formation in 1909 and became a driving force in the association's legal activities. Spingarn argued the cases *Nixon v. Herndon* (1927) and *Nixon v. Condon* (1932), which established the unconstitutionality of the Texas all-white primary. As president of the NAACP Legal Defense and Education Fund (1940–57), he lobbied unsuccessfully for a federal antilynching law and oversaw the seminal case of *Brown v. Board of Education* (1954).

SPINGARN, JOEL ELIAS (*b. New York, N.Y., 1875; d. New York, 1939*), literary critic, reformer. Graduated Columbia, 1895; Ph.D., 1899. Strongly influenced by George E. Woodberry, Spingarn taught comparative literature at Columbia, 1899–1911. A man of many talents, activities, and enthusiasms, he was perhaps the leading American exponent of the principles of Be-

Spink

nedetto Croce. He also interested himself in politics (liberal Republican), in the culture of flowers, and in securing justice for blacks. Among his books were *History of Literary Criticism in the Renaissance* (1899) and *Creative Criticism* (1917).

SPINK, JOHN GEORGE TAYLOR (*b. St. Louis, Mo., 1888; d. Clayton, Mo., 1962*), baseball publicist. Succeeded his father as publisher of *Sporting News*, a St. Louis-based weekly journal of baseball news, in 1914. Called the "Bible of Baseball," by 1942 the paper boasted a weekly circulation of 100,000 copies. Ancillary publications include *Sporting Goods Dealers* and yearbooks of baseball facts and statistics, including the *Baseball Register*, first published in 1940. After the postwar rise of rival sports and leisure publications, the paper became a lively tabloid and extended coverage to other sports.

SPINNER, FRANCIS ELIAS (*b. German Flats, N.Y., 1802; d. 1890*), banker. Congressman, antislavery Democrat, from New York, 1855–57, he served as a Republican, 1857–61. Honest and able as U.S. treasurer, 1861–75, his employment of young women in his department during the Civil War is said to have established the status of women in the civil service.

SPITZKA, EDWARD ANTHONY (*b. New York, N.Y., 1876; d. Mount Vernon, N.Y., 1922*), anatomist, criminologist. Son of Edward C. Spitzka. M.D., New York College of Physicians and Surgeons, 1902. Taught anatomy at Jefferson Medical College *post* 1906. Author of notable studies on the human brain, Spitzka edited the 18th American edition of Gray's *Anatomy* (1910).

SPITZKA, EDWARD CHARLES (*b. New York, N.Y., 1852; d. 1914*), neurologist, psychiatrist. Father of Edward A. Spitzka. Graduated medical department, University of the City of New York (New York University), 1873; made postgraduate studies in Leipzig and Vienna. Practiced in New York City *post* 1876 and gained nationwide reputation as a medicolegal expert in cases involving insanity; he also made many contributions to knowledge of the anatomy of the nervous system.

SPIVAK, CHARLES DAVID (*b. Krementchug, Russia, 1861; d. 1927*), physician, author. Came to America 1882; worked at first as a laborer in New York and New Jersey. M.D., Jefferson Medical College, 1890. An authority in the field of gastroenterology, he taught for many years at the medical school of the University of Denver and was founder of the Jewish Consumptives' Relief Society, 1904. From 1904 until his death he acted as secretary and gastroenterologist to the society's sanatorium near Denver, Colo.

SPOFFORD, AINSWORTH RAND (*b. Gilmanton, N.H., 1825; d. 1908*), bookseller, journalist. Appointed assistant in the Library of Congress, 1861, he became chief librarian, 1864, and directed the affairs of the library until 1897. Reverting then to the position of assistant, he continued in that post until his death. During his tenure the library made extraordinary progress.

SPOFFORD, HARRIET ELIZABETH PRESCOTT (*b. Calais, Maine, 1835; d. Deer Island, Maine, 1921*), author. Encouraged to write by Thomas W. Higginson, Spofford enjoyed a successful career as a miscellaneous writer, romantic novelist, and verse writer, 1860–1910.

SPOONER, JOHN COIT (*b. Lawrenceburg, Ind., 1843; d. New York, N.Y., 1919*), lawyer. Successful as counsel for railroads, Spooner was U.S. senator, Republican, from Wisconsin, 1885–91 and 1897–1907. Winning notice in his first term as an able debater and brilliant parliamentarian, he became a national figure during his second period in the Senate, sharing with Nelson W. Aldrich, W. B. Allison, and Orville H. Platt the confidence of Presidents McKinley and Roosevelt. A counselor rather than a leader in Republican politics, he belonged to the "stalwart" wing of the Wisconsin Republicans and was a principal target for attacks by the reform element. The decline of his faction in the state and the election of Robert M. La Follette as his colleague brought about Spooner's resignation. Thereafter he practiced law in New York City.

SPOONER, LYSANDER (*b. Athol, Mass., 1808; d. 1887*), lawyer, antislavery advocate, reformer. Author of, among other books, *Unconstitutionality of Slavery* (1845, 1847) and *Essay on the Trial by Jury* (1852).

SPOONER, SHEARJASHUB (*b. Orwell, Vt., 1809; d. Plainfield, N.J., 1859*), dentist, promoter of art. Author of, among other works, *A Biographical and Critical Dictionary of Painters, Engravers, . . .* (1853).

SPORN, PHILIP (*b. Folotwiner, Austria, 1896; d. New York City, 1978*), expert in electric utility engineering, economics, and marketing. Immigrated to the United States and became a citizen in 1907. Graduated Columbia University (1917), worked for Crocker–Wheeler Manufacturing Company (1917–19), and joined American Gas and Electric Company as a protection engineer (1920), becoming chief engineer (1933) and president (1947–61). He introduced innovations in the generation, transmission, and distribution of electricity; changed the company name to American Electric Power; and increased AEP's generating plant capacity. In 1961 he was appointed full-time chairman of the AEP System Development Committee, which focused on new forms of energy generation.

SPOTSWOOD, ALEXANDER (*b. Tangier, 1676; d. Annapolis, Md., 1740*), lieutenant governor of Virginia. Entering the British army, he fought in the War of the Spanish Succession, and in 1710 was appointed lieutenant governor of Virginia, under the nominal governor, the earl of Orkney. He undertook his new duties with a vigor rather disconcerting to a people inclined to reduce governmental activity to a minimum. He sought to regulate the fur trade, to maintain an enlightened Indian policy, to encourage actual settlers as opposed to mere land speculators, and to require inspection of tobacco designed for export or for use as legal tender. This last policy led to a violent quarrel with the House of Burgesses, 1715, particularly with two prominent members of his council, William Byrd and Philip Ludwell, who had little taste for the additional labors the governor thrust upon them. A struggle for power between the governor and the council ensued and harmony was not restored until 1720. From his arrival in Virginia, Spotswood was actively identified with the problems of the frontier. He made a number of explorations westward, of which the most famous was in 1716. He also attempted to protect the colony from Iroquois raids by establishing compact communities of friendly Indians, powerful enough to resist attack and convenient for the work of missionary and schoolmaster; he negotiated a treaty with the Iroquois whereby they were to keep north of the Potomac and west of the Blue Ridge. During the closing years of his administration his attitude toward colonial self-assertion mellowed perceptibly. Doubtless due in part to the conviction that it was futile to contend against what amounted to a Virginia nationalism, the change was natural in one who had decided to make America his permanent home. Removed from office in 1722, he engaged in the mining and smelting of iron. When war with Spain broke out in 1739, he set about to recruit a colonial regiment and was appointed major general of a proposed expedition against Cartagena. He died in the midst of his preparations for this service.

Spotted Tail (*b. near Fort Laramie, Wyo., ca. 1833; d. 1881*), a head chief of the Lower Brulé Sioux. Uncle of Crazy Horse. Rising in tribal authority as a warrior, he opposed Red Cloud at the Fort Laramie council, 1866. He was a singer of the treaty of April 1868 providing for withdrawal of Indian opposition to railroad building and acceptance of a reservation in present South Dakota. Later removing to a reservation in northwestern Nebraska, he continued friendly to the whites and resisted efforts to bring his tribe to war in 1876. Sharp, witty, and affable in manner, he was considered one of the most brilliant of the Sioux leaders.

Spottswood, Stephen Gill (*b. Boston, Mass., 1897; d. Washington, D.C., 1974*), clergyman and civil rights leader. Graduated Albright College (B.A., 1917) and Gordon School of Theology (Th.D., 1919) and became a minister in the African Methodist Episcopal (AME) Zion Church. He pastored several churches, including the pastorate in Washington, D.C. (1936–52), before becoming bishop of the entire AME Zion Church in 1952. In the 1940's, as a branch president of the National Association for the Advancement of Colored People (NAACP), he spearheaded campaigns against discriminatory racial practices in Washington, D.C. In 1961 he was elected chairman of the NAACP board of directors. He lobbied for civil rights legislation and federal intervention in the murder of civil rights workers in Mississippi (1964), spoke out prominently against what he viewed was President Richard Nixon's hostility toward African Americans, and challenged the "black power" activists.

Sprague, Achsa W. (*b. Plymouth Notch, Vt., ca. 1828; d. 1862*), spiritualist, medium, mental healer.

Sprague, Charles (*b. Boston, Mass., 1791; d. 1875*), banker, poet. Author of a number of odes and other minor poems which were published in a collected edition (1841).

Sprague, Charles Arthur (*b. Lawrence, Kans., 1887; d. Salem, Oreg., 1969*), newspaper editor and governor of Oregon. Graduated from Monmouth College (1910). Purchased the weekly *Journal-Times* of Ritzville (1915), a one-third interest in *Corvallis* (Oreg.) *Gazette-Times* (1925), and two-thirds interest in *Oregon Statesman* (1929), long the most influential paper in the state capital. As editor and publisher of the *Statesman* for the next forty years, he gained a national reputation as an articulate spokesman for small-town values, fiscal conservatism, and internationalism. As governor (1938–42) he improved the state's employment services, launched vocational-training programs to aid the jobless, modernized the school system, reduced the state debt by $12 million, and balanced the budget while increasing social welfare services. An early conservationist, he set up regulations for logging operations to ensure sustained-yield management of its forests. Described as the "conscience of Oregon," he was also an outspoken defender of civil liberties.

Sprague, Charles Ezra (*b. Nassau, N.Y., 1842; d. New York, N.Y., 1912*), banker, Union soldier. Long employed by the Union Dime Savings Bank in New York City, he was its president, 1892–1912. One of the first to qualify as a certified public accountant, he was a leading spirit in establishment of the New York University School of Commerce, where he taught accountancy. He was author of a number of textbooks in accountancy and finance.

Sprague, Frank Julian (*b. Milford, Conn., 1857; d. 1934*), engineer, inventor. Graduated Annapolis, 1878. After naval service, 1878–83, during which he devoted himself to problems in electrical development, he joined the staff of Thomas A. Edison for a brief period, and then organized the Sprague Electric Railway & Motor Co. Winning repute in 1887 for adaptation of a constant-speed motor devised by him to use in street-railway service at Richmond, Va., he achieved rapid success. In 1892 he formed the Sprague Electric Elevator Co., which became part of the Otis Elevator Co. His system of "multiple unit" control for trains made up of motor cars was first tried out in 1897 and later generally adopted for subway, elevated, and suburban service. He was also a pioneer in design and production of miniature electric power units suitable for machine tools, printing presses, dentist's drills, and laborsaving conveniences in the home.

Sprague, Homer Baxter (*b. South Sutton, Mass., 1829; d. 1918*), educator, Union soldier. Graduated Yale, 1852. After holding a number of important teaching and administrative posts in New York, Connecticut, and Massachusetts, Sprague served as president of Mills College, 1885–87, and of the University of North Dakota, 1887–91. He was founder of the Martha's Vineyard Summer Institute, 1879, said to be the first general summer school in the United States.

Sprague, Kate Chase (*b. Cincinnati, Ohio, 1840; d. Washington, D.C., 1899*), political hostess. Daughter of Salmon P. Chase; wife of William Sprague (1830–1915).

Sprague, Oliver Mitchell Wentworth (*b. Somerville, Mass., 1873; d. Boston, Mass., 1953*), economist and professor. Studied at Harvard University (Ph.D., 1897). Taught at Harvard (1899–1905); at the Imperial University in Tokyo (1905–08); professor at the Harvard School of Business Administration (1913–41). From 1930 to 1933, he was chief economic advisor to the Bank of England, and also counseled the heads of the German Reichsbank, the Austrian Kreditsbank, the Bank of France, and the Bank for International Settlements. One of President Roosevelt's "brain trusters," Sprague was influential in government circles, but resigned in 1933 over differences in ways to achieve economic recovery. Wrote *Recovery and Common Sense* in 1934. President of the American Economic Association (1937).

Sprague, Peleg (*b. Duxbury, Mass., 1793; d. Boston, Mass., 1880*), jurist. After serving in the first Maine legislature, 1821–22, and as congressman and U.S. senator from Maine, 1825–35, he found his true vocation when appointed U.S. district judge for Massachusetts, 1841. Sprague was outstanding on the bench until his retirement in 1865, despite constant weakness of the eyes which ended in total blindness. His decisions included a definitive statement on the doctrine of treason and the powers of the federal government to punish treason, March 1863.

Sprague, William (*b. Cranston, R.I., 1773; d. Cranston, 1836*), textile manufacturer, lumber merchant, stockbreeder.

Sprague, William (*b. Cranston, R.I., 1830; d. Paris, France, 1915*), textile manufacturer, Union soldier, politician. Grandson of William Sprague (1773–1836); husband of Kate C. Sprague. An inheritor of great wealth, he advanced easily in politics and was Democratic governor of Rhode Island, 1860–61. After Civil War service, he was reelected governor, 1862, but resigned to become U.S. senator from Rhode Island, serving 1863–75. Considered irresponsible by many of his constituents, almost beggared in the panic of 1873, and divorced in 1882 under scandalous circumstances, he lived in retirement *post* 1883.

Sprague, William Buell (*b. Hebron, Conn., 1795; d. Flushing, N.Y., 1876*), Congregational clergyman, autograph collector, biographer. Held pastorates at West Springfield, Mass., and Albany, N.Y. Author of, among other works, lives of Timothy

Dwight and Jedidiah Morse and of *Annals of the American Pulpit* (1857–69).

SPRECHER, SAMUEL (*b. Washington Co., Md., 1810; d. San Diego, Calif., 1906*), Lutheran clergyman, educator. President of Wittenberg College, 1849–74, he taught theology and philosophy there until 1884, thereafter bearing the title of professor emeritus.

SPRECKELS, CLAUS (*b. Lamstedt, Hannover, Germany, 1828; d. San Francisco, Calif., 1908*), sugar manufacturer, capitalist. Came to America, 1846; removed to San Francisco, 1856. Organized the California Sugar Refinery, 1867; held for many years a virtual monopoly of sugar manufacture and sale on the Pacific Coast; fought the Sugar Trust, 1888–89. Spreckels was also active in public utilities and in development of the sugar industry in Hawaii.

SPRECKELS, JOHN DIEDRICH (*b. Charleston, S.C., 1853; d. Coronado, Calif., 1926*), sugar merchant, capitalist. Son of Claus Spreckels.

SPRECKELS, RUDOLPH (*b. San Francisco, Calif., 1872; d. San Mateo, Calif., 1958*), industrialist and reformer. A bank founder and sugar industrialist, Spreckels was instrumental, along with San Francisco editor, Fremont Older, and muckraker Lincoln Steffens, in breaking the corrupt political ring of Abraham Ruef. The San Francisco Graft Prosecution (1906–10) successfully destroyed the political machine of the Union Labor Party whose officials were convicted of accepting bribes and payoffs from public utilities. Ruef went to prison, and Spreckels returned to private industry.

SPRING, GARDINER (*b. Newburyport, Mass., 1785; d. New York, N.Y., 1873*), Presbyterian clergyman. Son of Samuel Spring. Graduated Yale, 1805. After a brief practice of law, he attended Andover Theological Seminary and was called to the pastorate of the Brick Presbyterian Church, New York City, 1810, as colleague to John Rodgers (1727–1811). A thorough Calvinist and a conservative, he remained at the Brick Church until his death, building up a strong congregation and taking a commanding position in the life of New York City.

SPRING, LEVERETT WILSON (*b. Grafton, Vt., 1840; d. Boston, Mass., 1917*), Congregational clergyman, educator. Author of *Kansas: The Prelude to the War for the Union* (1885), the first nonpartisan account of the Kansas struggle. Served as Morris professor of rhetoric at Williams College, 1886–1909.

SPRING, SAMUEL (*b. Uxbridge, Mass., 1746 o.s.; d. 1819*), Congregational clergyman. Father of Gardiner Spring. Pastor at Newburyport, Mass., 1777–1819. Spring was identified with the "Hopkinsian" wing of the church and was a man of great influence. He was one of the founders of Andover Theological Seminary and of the American Board of Commissioners for Foreign Missions.

SPRINGER, CHARLES (*b. Louisa Co., Iowa, 1857; d. 1932*), lawyer, New Mexico cattleman and Republican politician. Brother of Frank Springer.

SPRINGER, FRANK (*b. Wapella, Iowa, 1848; d. 1927*), lawyer, paleontologist. Removing to New Mexico, 1873, he became one of the leading lawyers of that territory and state. Among other important cases in which he served as counsel was the case of the celebrated Maxwell Land Grant, which he fought in the U.S. courts for some 30 years and finally won. In association with Charles Wachsmuth, Springer did outstanding work in the study of fossil crinoids, publishing a series of volumes which have been called "the most magnificent monographs on invertebrate paleontology published in the United States."

SPRINGER, REUBEN RUNYAN (*b. Frankfort, Ky., 1800; d. 1884*), wholesale grocery merchant, financier, philanthropist. Remembered as a patron of music and art and as a benefactor of the Catholic church, he was largely responsible for providing his home city of Cincinnati, Ohio, with a music hall and a college of music.

SPRINGER, WILLIAM MCKENDREE (*b. New Lebanon, Ind., 1836; d. 1903*), lawyer, judge in Indian Territory. Congressman, Democrat, from Illinois, 1875–95, he was active on many committees and served as chairman of the committees on claims, territories, elections, ways and means, banking and currency. He introduced bills under which Washington, Montana, and the Dakotas were admitted into the Union as states. A strict parliamentarian, he seemed often more interested in the rules of procedure than in the issues involved.

SPROUL, ALLAN (*b. San Francisco, Calif., 1896; d. Kentfield, Calif., 1978*), banker. Graduated University of California at Berkeley (B.S., 1919) and was hired by the Federal Reserve Bank of San Francisco (1920) to head the Division of Analysis and Research. He joined the Federal Reserve Bank of New York (1930), where he was assigned to the foreign department, then became a vice-president (1936) and president (1941). He disagreed with the Department of Treasury's subordination of the Federal Reserve System's monetary powers and with provisions of the proposed International Monetary Fund but was a strong supporter of the World Bank. He considered inflation one of the worst dangers to the nation and criticized the influence of "monetarists." He left the bank in 1956 and became a director of American Trust Company (later merged with Wells Fargo Bank), a director of Wells Fargo and Company (1969), and a director of Kaiser Aluminum and Chemical Corporation (1957–68).

SPROUL, ROBERT GORDON (*b. San Francisco, Calif., 1891; d. Berkeley, Calif., 1975*), university president. Graduated University of California (B.S., 1913). Began his forty-four-year career with the University of California in 1914 as a cashier, rising to vice-president and comptroller in 1925 and president in 1929. He oversaw the dynamic growth of the state's higher education system; by the end of his tenure in 1959, enrollment had risen from 19,000 to 47,000. Generally a popular administrator, he became embroiled in a bitter controversy in the late 1940's when he supported a loyalty oath that was intended to identify Communist sympathizers; the oath was ruled unconstitutional in 1956.

SPROUL, WILLIAM CAMERON (*b. Octoraro, Pa., 1870; d. near Chester, Pa., 1928*), manufacturer, businessman. Republican governor of Pennsylvania, 1919–23, he actively promoted highway construction and reorganized several branches of the state government, but was criticized for his handling of the steel strike of 1919.

SPROULE, WILLIAM (*b. Co. Mayo, Ireland, 1858; d. San Francisco, Calif., 1935*), railroad executive. Immigrated to America ca. 1876. Entering employ of the Southern Pacific Railroad, 1882, he rose to post of freight traffic manager by 1898. Associated with other companies, 1906–11, he returned to the Southern Pacific as president, serving 1911–28.

SPROULL, THOMAS (*b. near Lucesco, Pa., 1803; d. 1892*), Reformed Presbyterian clergyman, educator. Pastor of the Old

School Church at Allegheny (North Pittsburgh), Pa., 1834–68; taught thereafter at Allegheny Theological Seminary.

SPRUANCE, RAYMOND AMES (*b. Baltimore, Md., 1886; d. Pebble Beach, Calif., 1969*), naval officer. Graduated from U.S. Naval Academy (1906) and circled the globe aboard the *Minnesota* as part of the Great White Fleet (1907–09). In Great Britain in 1917 to study fire-control techniques while serving as electrical officer at the New York Navy Yard. With the Office of Naval Intelligence (1928–29) and taught at the Naval War College (1931–32, 1935–37). Advanced to rear admiral in 1939 and assumed command of the Tenth Naval District in Puerto Rico (1940–41), then was transferred to the Pacific to command a division of heavy cruisers; he participated in the first carrier raids of the Pacific war (1942) and relieved Adm. William Halsey as commander of one of two carrier task forces assigned to stop the Japanese fleet. Took command of the Central Pacific Force, later designated the Fifth Fleet (1943), and directed the capture of numerous Pacific Islands. Made full admiral in 1944, he assumed command of the Pacific Fleet after Japan's surrender. President of the Naval War College (1946–48) and ambassador to the Philippines (1952–55).

SPRUNT, JAMES (*b. Glasgow, Scotland, 1846; d. 1924*), businessman, philanthropist, local historian. Immigrated to North Carolina as a boy; resident in Wilmington *post* 1854. One of the largest exporters of cotton in the country, Sprunt was active in civic affairs and was author of a number of valuable historical monographs, among them *Tales and Traditions of the Lower Cape Fear, 1661–1896* (1896) and *Chronicles of the Cape Fear River* (1914). He gave much financial assistance to Presbyterian church work and to hospitals.

SPURR, JOSIAH EDWARD (*b. Gloucester, Mass., 1870; d. Winter Park, Fla., 1950*), mining geologist. B.A., Harvard 1893; M.A., 1894. As staff member, Minnesota Geological Survey, he made the first geological map of the Mesabi iron range. While associated with U.S. Geological Survey, 1894–1906, he headed first expedition to Alaska, 1896, and reported on Yukon gold fields. Served as chief geologist, American Smelting and Refining Co., 1906–08. After conducting a private consulting practice, and service during World War I as chairman of the federal committee on mineral needs and resources, he was editor of *Engineering and Mining Journal*, 1919–27. He was author of two controversial treatises: *The Ore Magmas* (1923) and *Geology Applied to Selenology* (1944–49).

SQUANTO (*d. Chatham Harbor, Mass., 1622*), Pawtuxet Indian. Kidnapped at Pawtuxet (Plymouth) in 1615 by an English sea captain, he was sold in Spain as a slave. Escaping to England, he lived for a time in London. While serving as a pilot in an English expedition to the New England coast, 1619, he escaped and made his way home to Pawtuxet only to find himself the sole surviving member of his tribe. Introduced by Samoset to the Pilgrims, March 1621, he took Edward Winslow to Massasoit and acted as interpreter in concluding the treaty of Plymouth between that chief and the Pilgrims. He also showed the newcomers how to set corn and where to fish. After he had made himself obnoxious to the Indians by exploiting his friendship with the English, and notably by sounding a false alarm of impending treachery on the part of Massasoit that chief demanded that the Pilgrims give him up for punishment. He later made his peace with Massasoit. In November 1622 he served as guide and interpreter on Bradford's expedition around Cape Cod.

SQUIBB, EDWARD ROBINSON (*b. Wilmington, Del., 1819; d. Brooklyn, N.Y., 1900*), physician, pharmacist, manufacturing chemist. M.D., Jefferson Medical College, 1845. A U.S. Navy surgeon, 1847–57, he established in 1852 a laboratory for preparation of high-grade pharmaceuticals for service use which he directed until 1857. Establishing his own manufactory in Brooklyn, N.Y., 1858, he continued to do pioneer work in manufacture of pure pharmaceuticals and was a leader in independent chemical research; he was also an authority on the *U.S. Pharmacopoeia*.

SQUIER, EPHRAIM GEORGE (*b. Bethlehem, N.Y., 1821; d. Brooklyn, N.Y., 1888*), journalist, archaeologist, diplomat. Considered in his time an authority on Central America, Squier held a number of consular and diplomatic posts in Latin America. He was coauthor with Edwin H. Davis of *Ancient Monuments of the Mississippi Valley* (1847) and author of *Aboriginal Monuments of the State of New York* (1851).

SQUIER, GEORGE OWEN (*b. Dryden, Mich., 1865; d. Washington, D.C., 1934*), soldier, engineer. Graduated West Point, 1887; Ph.D., Johns Hopkins, 1893. An expert in cable and radio communication, Squier did much important early experimental work in wireless telephony and multiple telephony; he was also a student of military aviation. He served as chief signal officer, U.S. Army, with the rank of major general, 1917–23.

SQUIERS, HERBERT GOLDSMITH (*b. Madoc, Canada, 1859; d. London, England, 1911*), soldier, diplomat. Outstanding as chief of staff in defense of legations at Peking, China, during the Boxer Rebellion, 1900; handled successfully the difficult post of U.S. minister to Cuba, 1902–05.

SQUIRE, WATSON CARVOSSO (*b. Cape Vincent, N.Y., 1838; d. Seattle, Wash., 1926*), lawyer, Union soldier, capitalist. Son-in-law of Philo Remington. Settling in Seattle, Wash., 1879, he was Republican governor of Washington Territory, 1884–87, and U.S. senator from the state of Washington, 1889–97.

STACY, WALTER PARKER (*b. Ansonville, N.C., 1884; d. Raleigh, N.C., 1951*), jurist and labor arbitrator. Studied at the University of North Carolina. Served on the Supreme Court of North Carolina from 1920 to 1951; chief justice (1925–51). Appointed by presidents Coolidge, Hoover, Roosevelt, and Truman to be a mediator on various labor boards specializing in railroad labor affairs, Stacy served with distinction. In 1932, headed a commission for the rewriting and modernizing of the Constitution of North Carolina.

STAFFORD, JEAN (*b. Covina, Calif., 1915; d. White Plains, N.Y., 1979*), novelist and short-story writer. Graduated University of Colorado (B.A., M.A., 1936). Attained overnight celebrity with her first novel, *Boston Adventure* (1944). Her second novel, *The Mountain Lion*, was published in 1947, and she began a long association with the *New Yorker*. Her story "In the Zoo" won the O. Henry Prize (1955) and her *Collected Stories* (1969) won a Pulitzer Prize (1970).

STAGER, ANSON (*b. Ontario Co., N.Y., 1825; d. Chicago, Ill., 1885*), telegraph pioneer. Associated with the Western Union Telegraph Co. *post* 1856, he served as its general superintendent and later as superintendent of its Central Division; he was chief of U.S. military telegraphs, 1861–66. Leading western representative of the Vanderbilt interests, he helped found the Western Electric Manufacturing Co. and served as its president until shortly before his death.

STAGG, AMOS ALONZO (*b. West Orange, N.J., 1862; d. Stockton, Calif., 1965*), football coach. Attended Yale (B.A., 1888), Yale Divinity School, and International YMCA College at

Springfield, Mass. Became director of physical culture and athletics at University of Chicago (1892), where he remained for fortyone years. An acknowledged leader in the development of football and most of its phases, he is credited with creating dozens of plays, formations, and strategies that have become standard, including the T formation and the forward pass. He originated the huddle, numbered uniforms, and lighted practice fields. His Chicago teams had five undefeated seasons and won six Western Conference (Big Ten) titles; the 1905 team was ranked first in the country. Became head coach at College of the Pacific (1933–46) and was named coach of the year in 1943. Became offensive coach at Susquehanna College (1947–53), then advisory coach at Stockton Junior College (1953–60). Elected to the Football Hall of Fame (1951) as both player and coach.

STAHEL, JULIUS (*b. Szeged, Hungary, 1825; d. 1912*), Union major general, U.S. consular officer, insurance executive. Veteran of the Hungarian revolution of 1848, Stahel immigrated to New York City, 1856. A volunteer at the outbreak of the Civil War, he rose to division command of cavalry and was awarded the Congressional Medal of Honor for gallantry in the Shenandoah Valley, June 1864.

STAHLMAN, EDWARD BUSHROD (*b. Güstrow, Germany, 1843; d. 1930*), railroad official, newspaper publisher. Came to America as a boy; settled in Nashville, Tenn., 1863. Becoming owner-publisher of the *Nashville Banner*, 1855, he built it into one of the best-known crusading journals in the South.

STAHR, JOHN SUMMERS (*b. near Applebachsville, Pa., 1841; d. 1915*), Reformed clergyman, educator. Graduated Franklin and Marshall College, 1867; studied theology under John W. Nevin. Taught *post* 1868 at his alma mater and was its president, 1890–1909. A linguist and a prolific writer in German and English, he was the last of the master exponents of the Mercersburg philosophy.

STALEY, CADY (*b. Montgomery Co., N.Y., 1840; d. Minaville, N.Y., 1928*), civil engineer, educator, sanitation expert. An able teacher and president of faculty at Union College and at the Case School of Applied Science.

STALLINGS, LAURENCE TUCKER (*b. Macon, Ga., 1894; d. Whittier, Calif., 1968*), writer. Attended Wake Forest (B.A., 1916). Severely wounded in France in 1918, his leg was amputated in 1922 and during his recuperation he wrote his autobiographical novel *Plumes* (1924). He became book reviewer for the *New York World* and collaborated with Maxwell Anderson on the play *What Price Glory?*, which was an instant success on stage in 1924; he achieved additional success with the film *The Big Parade* (1925). He worked for the *New York Sun* (1931) and adapted Ernest Hemingway's *A Farewell to Arms* to the screen (1932); he also worked on the films *Too Hot to Handle* (1938), *Northwest Passage* (1940), *A Miracle Can Happen* (1948), and *She Wore a Yellow Ribbon* (1949). Published *The Doughboys* (1963), a widely read history of U.S. participation in World War I.

STALLO, JOHANN BERNHARD (*b. Sierhausen, Oldenburg, Germany, 1823; d. 1900*), lawyer, philosopher of science, diplomat. Immigrated to America, 1839; practiced law in Cincinnati, Ohio, *post* 1849. An outstanding political liberal, he served as U.S. minister to Italy, 1885–89. Among his books and writings was the influential *The Concepts and Theories of Modern Physics* (1882).

STANARD, MARY MANN PAGE NEWTON (*b. Westmoreland Co., Va., 1865; d. Richmond, Va., 1929*), historian. Wife of William G. Stanard. Author of, among other works, *Colonial Virginia* (1917) and *Richmond, Its People and Its Story* (1923).

STANARD, WILLIAM GLOVER (*b. Richmond, Va., 1858; d. 1933*), editor, antiquarian. Husband of Mary M. P. N. Stanard. Secretary, Virginia Historical Society, and editor, *Virginia Magazine of History and Biography*, 1898–1933.

STANBERY, HENRY (*b. New York, N.Y., 1803; d. New York, 1881*), lawyer. Raised in Ohio. Law partner of Thomas Ewing, 1824–31. Practiced thereafter in Lancaster, Columbus, and Cincinnati, Ohio, and was in the first rank of the Ohio bar. A Whig and later a Republican, he served as U.S. attorney general, July 1866–March 1868. His able service as President Andrew Johnson's chief counsel during Johnson's impeachment cost him further political advancement.

STANCHFIELD, JOHN BARRY (*b. Elmira, N.Y., 1855; d. 1921*), lawyer. Graduated Amherst, 1876; studied law with David B. Hill, whose partner he became. Active in Democratic politics in New York State, he was celebrated as a courtroom pleader in a number of sensational cases, which included the trials of F. A. Heinze, Harry K. Thaw, and the Gould and Guggenheim family lawsuits.

STANDERREN, ANN LEES *See* LEE, ANN.

STANDISH, BURT L. *See* PATTEN, GILBERT.

STANDISH, MYLES (*b. possibly Lancashire, England, ca. 1584; d. Duxbury, Mass., 1656*), Pilgrim father and military captain. A soldier of fortune in the Low Countries, he was hired by the Pilgrims to accompany them on the *Mayflower*, 1620. The only one with practical experience in camping, he was their mainstay in the first explorations of Cape Cod, and was one of the small party who made the first landing at Plymouth. He handled relations with the Indians expertly, designed and superintended the erection of a fort, and devised measures for defense. In 1625 he was sent to England to negotiate with the Merchant Adventurers and the Council for New England. There is no historical basis for the story of John Alden's proposal to Priscilla on Standish's behalf. He was a cofounder of Duxbury, 1631.

STANDLEY, WILLIAM HARRISON (*b. Ukiah, Calif., 1872; d. San Diego, Calif., 1963*), naval officer and diplomat. Graduated from U.S. Naval Academy (1895). Rising to prominence in the navy, he became chief of naval operations in 1933. His major task was to convince Congress of the need for modernizing and replacing ships in the midst of the Great Depression. Represented the United States at the naval disarmament conferences in 1934–35. Retired from the navy in 1937 and became naval adviser to President Franklin Roosevelt in 1939. Returned to active duty in 1941 and became a member of the Production Planning Board. U.S. ambassador to the Soviet Union (1942–43), then served with the Office of Strategic Services (1944–45).

STANFORD, AMASA LELAND (*b. Watervliet, N.Y., 1824; d. Palo Alto, Calif., 1893*), railroad builder. Admitted to the bar in New York State, 1848, he began practice at Port Washington, Wis., that same year. Encouraged by his brothers who had prospered as storekeepers in California, he removed there in 1852. After engaging in merchandising with some success in Placer County and at Sacramento, he was elected Republican governor of California in 1861. His success was due to his personal popularity and to his strong Union and Republican convictions, for he had had no opportunity to distinguish himself in public service. In

1863 he was not renominated, and he held no other public office until his election as U.S. senator in 1885. His chief task as governor was to hold California in the Union, and this he accomplished satisfactorily. He also approved several public grants to the transcontinental railroad — the enterprise which brought him wealth and upon which his reputation chiefly rests. Interested in the project by Theodore D. Judah's promotional activity, he subscribed money to finance the surveys which proved the feasibility of the proposed railroad line; he also helped finance organization of the Central Pacific Railroad in June 1861. As governor he signed four acts affording considerable assistance to the new enterprise. He had no scruples about taking official action where his private interests as railroad president were engaged, or he overcame such as may have occurred to him by reflecting upon the public importance of a railroad connection with the East. He was president and director of the Southern Pacific Co., 1885–90, and director of the Southern Pacific Railroad. At all times he was a shareholder in, and contributor to, the resources of the construction companies which built the railroads. The Central Pacific was built almost entirely with, or on the security of, public funds, so that Stanford and his friends risked less of their own capital in the undertaking than has sometimes been supposed.

From the great personal fortune he amassed, he was able to indulge his tastes in matters not strictly connected with his business. He maintained extensive vineyards and a large ranch where he bred fine racing stock. Out of his desire to raise a fitting memorial to his son, who died at the age of 15, grew Leland Stanford, Jr., University, founded in 1885. Entirely opposed to interference with the railroad business by public bodies, he asserted the railroad's right to protect itself by political action when attacked. Thus, he accepted election as U.S. senator in 1885, but he found himself in a field for which he had no proper training and for which his abilities were inadequate. It is not too much to say that his legislative record shows lack of interest or lack of capacity, probably both. His senatorship satisfied his vanity and increased his prestige in California, but it did not add to his reputation.

STANFORD, JOHN (*b. Wandsworth, England, 1754; d. 1834*), Baptist clergyman, humanitarian. Immigrated to America, 1786. Held pastorates in New York City and Providence, R.I., until 1801; thereafter preached in Baptist churches in New York, New Jersey, Pennsylvania, and Connecticut without a fixed pastorate. Appointed chaplain of the New York State Prison, 1812, he devoted his attention to the establishment of special reform institutions for youthful prisoners.

STANFORD, LELAND *See* STANFORD, AMASA LELAND.

STANG, WILLIAM (*b. Langenbrücken, Baden, Germany, 1854; d. 1907*), Roman Catholic clergyman, educator. Served as curate, pastor, and chancellor of the diocese in Rhode Island, 1878–95 and 1899–1904, acting in the interim as vice-rector of the American College in Louvain. He was bishop of Fall River, Mass., 1904–07.

STANLEY, ALBERT AUGUSTUS (*b. Manville, R.I., 1851; d. Ann Arbor, Mich., 1932*), musician, educator. Professor of music, University of Michigan, 1888–1932, emeritus *post* 1921. He was author of a symphony and a number of choral compositions.

STANLEY, ANN LEE. *See* LEE ANN.

STANLEY, AUGUSTUS OWSLEY (*b. Shelbyville, Ky., 1867; d. Washington, D.C., 1958*), lawyer and politician. Studied at Centre College in Danville, Ky. Elected to the U.S. Congress as a Democrat (1903–15). In the House, the Stanley Committee's

investigation of the U.S. Steel Corp. (1911–12), led to major regulations included in the Clayton Antitrust Act of 1914. From 1915 to 1919, Stanley was governor of Kentucky. In 1919, he was elected to the U.S. Senate as an antiprohibitionist. He served until 1924 when he was defeated. After some years in private law practice, he was appointed to the International Joint Commission which regulated American-Canadian waters; chairman from 1933; retired in 1954.

STANLEY, DAVID SLOANE (*b. Cedar Valley, Ohio, 1828; d. 1902*), soldier. Graduated West Point, 1852. A cavalry officer, Stanley served with ability on the western frontier. As major general of volunteers during the Civil War, he held corps command in the Mississippi and Tennessee campaigns and on Sherman's march through Georgia. Reverting in rank to colonel in the regular army, he showed himself a master in handling Indians while on service in the Yellowstone area and in Texas, 1866–92. He retired as regular brigadier general, 1892.

STANLEY, FRANCIS EDGAR (*b. Kingfield, Maine, 1849; d. 1918*), inventor, manufacturer. A portrait photographer, he organized with his brother a company for manufacture of dry plates according to his own formula, which he conducted successfully and sold to the Eastman interests, 1905. Meanwhile, having become interested in steam automobiles, he had begun early in 1897 a series of experiments which resulted in the production in that year of the first steam motorcar to be successfully operated in New England. In 1898 he began manufacture of the cars, but soon sold out to other interests. Repurchasing, 1902, their patents from what had become the Locomobile Co., Stanley and his brother organized the Stanley Motor Carriage Co., which they continued to operate until 1917.

STANLEY, HAROLD (*b. Great Barrington, Mass., 1885; d. Philadelphia, Pa., 1963*), investment banker and securities expert. Attended Yale (B.A., 1908). Joined the New York City bond house of J. G. White and Company (1910), then Guaranty Trust Company (1915), becoming vice president of the bond department (1916). Attracted Wall Street attention as a leading authority on the bond market and became a partner in J. P. Morgan and Company (1928). In 1935, with William Ewing and Henry S. Morgan, formed the independent bond house of Morgan, Stanley and Company, and became president of the new firm; he retired in 1955 but remained a limited partner.

STANLEY, HENRY MORTON (*b. Denbigh, Wales, 1841; d. London, England, 1904*), journalist, explorer. Brought up in an English workhouse and by unfeeling relatives, Stanley was known as John Rowlands until his adoption in December 1859 by Henry Morton Stanley, a New Orleans, La., merchant. After Civil War service in the Confederate army and in the Union army and navy, Stanley discovered his true vocation when he became a traveling newspaper correspondent, 1866. His early dispatches from the campaign of General W. S. Hancock against the western Indians brought him commissions from the *New York Herald*, 1868; his reports from Abyssinia, Crete, and Spain further established his reputation as a gifted correspondent. Sent by James Gordon Bennett (1841–1918) to find the Scottish missionary David Livingstone in the unexplored heart of Africa, he set off from Zanzibar in March 1871. After many hardships he discovered Livingstone in the native village of Ujiji on Nov. 10 and spoke a greeting which has passed into history: "Dr. Livingstone, I presume?" After further explorations in company with Livingstone along the northern shore of Lake Tanganyika, Stanley returned to London, where he was met with disbelief in his discoveries and much social scorn; however, he was soon vindicated after investigation of the proofs which he had brought back.

On further expeditions, 1874–77, he made geographical studies of central Africa which were of the greatest importance, including exploration of the headwaters of the Nile, a complete survey of Lake Tanganyika, and a traverse of the Congo River. Between 1879 and 1884 he worked in the Congo, establishing 22 stations along the river, putting steamers in operation on it, and building roads; the Congo Free State was formed on the basis of his work. Thereafter he continued his restless, roving career in Africa and made lecture tours around the world until the failure of his health *ca.* 1899. First among African explorers by reason of the extent of his geographical discoveries, Stanley also possessed the vision and organizing ability of a pioneer. He believed that he was furthering Livingstone's fight against slavery by introducing European commerce to darkest Africa. A man of strong moral feeling, he was greatly disappointed over the later developments in the Congo, which he described as "a moral malaria." Generally successful in his dealings with the native peoples whom he encountered, he was completely lacking in tact at home in England and America; a lonely man, he was introspective and self-absorbed. He was author of a number of books descriptive of his travels and explorations; his unfinished *Autobiography* was published in 1909.

STANLEY, JOHN MIX (*b. Canandaigua, N.Y., 1814; d. Detroit, Mich., 1872*), painter. Apprenticed to a wagon maker as a boy, he removed to Detroit, 1834, where he painted portraits and landscapes. Resident in Chicago and Galena, Ill., 1838–39, he began painting portraits of the Indians near Fort Snelling. Between 1842 and 1852 he traveled widely in the West, painting wherever he went, and giving several exhibitions of Stephen W. Kearny to California. Much of his spirited, accurate work, of the greatest possible value to students of history and ethnology, was deposited in the Smithsonian Institution in 1852 and destroyed by fire there, 1865. In 1853 he served as artist of the U.S. expedition for exploration of the Pacific Railroad route from St. Paul, Minn., to Puget Sound.

STANLEY, ROBERT CROOKS (*b. Little Falls, N.J., 1876; d. Staten Island, N.Y., 1951*), metallurgist. Studied at Stevens Institute of Technology and at Columbia School of Mines. Employed by the Orford Copper Company, Bayonne, N.J. (1904–17). There he discovered and patented the white nickelcopper alloy Monel, used as roofing for Pennsylvania Station in New York. From 1918 to 1949, he was employed by International Nickel Company; vice president (1918–22); president (1922–49); chairman of the board, 1949 until his death. Stanley was responsible for the widespread peacetime uses of nickel, in particular by the automobile industry.

STANLEY, WENDELL MEREDITH (*b Ridgeville, Ind., 1904; d. Salamanca, Spain, 1971*), virologist. Graduated Earlham College (B.S., 1926; M.S., 1927) and University of Illinois (Ph.D., 1929) and joined the Rockefeller Institute for Medical Research in New York City (1931). In his research on a tobacco crop virus, for which he received the Nobel Prize in chemistry (1946), he employed innovative laboratory techniques to isolate the compound in its protein form, which was a landmark breakthrough in the understanding of previously mysterious viral agents. In 1945 he developed a partially effective influenza vaccine. He directed a virus research laboratory at the University of California from 1948 until his retirement.

STANLEY, WILLIAM (*b. Brooklyn, N.Y., 1858; d. Great Barrington, Mass., 1916*), electrical engineer. Devised the multiple system of alternating-current distribution (patented 1887); in collaboration with others, worked out the "S.K.C." system of longdistance transmission of alternating current. Among his many other inventions were condensers, two-phase motors, generators, and an alternating-current watt-hour meter.

STANLY, EDWARD (*b. New Bern, N.C., 1810; d. San Francisco, Calif., 1872*), lawyer. Congressman, Whig, from North Carolina, 1837–43. Stanly was an extreme nationalist and a leader of his party in the House. After service in state offices and in the North Carolina legislature, he returned to Congress, 1849–53. Removing to California, 1854, he was successful in legal practice in San Francisco. Convinced that the secession of North Carolina from the Union had been the result of Democratic trickery, he accepted appointment by President Lincoln as military governor of the state in May 1862. He quickly discovered that his hope of restoring a civil government loyal to the Union was an illusion. Opposed to emancipation, he resigned in January 1863 and returned to California

STANSBURY, HOWARD (*b. New York, N.Y., 1806; d. Madison, Wis., 1863*), soldier, civil engineer, explorer. Grandson of Joseph Stansbury. Entered the U.S. Army, July 1838, as lieutenant of topographical engineers. Among the many surveys which he undertook, the most outstanding was his expedition to the Great Salt Lake region, 1849, on which James Bridger acted as one of the guides. His report of this expedition was issued first as *Senate Executive Document 3, 32 Congress* (1852). It was several times reprinted, and is a classic of western Americana.

STANSBURY, JOSEPH (*b. London, England, 1742; d. New York, N.Y., 1809*), Loyalist agent, merchant, satirist. Immigrated to Philadelphia, Pa., 1767. Transmitted Benedict Arnold's first proposals of treason to British headquarters and served thereafter as go-between for Arnold and the British. His witty satires were collected in *The Loyal Verses of Joseph Stansbury and Doctor Jonathan Odell* (edited, Winthrop Sargent, 1860).

STANTON, EDWIN MCMASTERS (*b. Steubenville, Ohio, 1814; d. Washington, D.C., 1869*), lawyer, public official. Admitted to the bar, 1836, he practiced at first in Cadiz and Steubenville, Ohio, and later in Pittsburgh, Pa., and Washington, D.C. Able and energetic, he soon won success; his work as counsel for the State of Pennsylvania (1849–56) against the Wheeling & Belmont Bridge Co., gave him a national reputation, and his masterly defense work in *McCormick v. Manny* deeply impressed one of his associates, Abraham Lincoln. Though his practice was chiefly in civil and constitutional law, he demonstrated in his defense of Daniel E. Sickles that he was no less gifted in handling criminal suits. In 1858, as special counsel for the U.S. government in combating fraudulent land claims in California, he won a series of notable victories. His services in this connection were the most distinguished of his legal career and won him the appointment of U.S. attorney general, December 1860. Although he disapproved of slavery, he accepted the Dred Scott decision and contended that all laws constitutionally enacted for the protection of slavery should be rigidly enforced. He had supported Breckinridge's candidacy for the presidency in 1860 in the belief that the preservation of the Union hung on the forlorn hope of his election.

During the early months of Lincoln's administration, Stanton, now in private life, was utterly distrustful and critical of the president and his cabinet. When Simon Cameron was removed from office in 1862, however, Stanton took his place as secretary of war. His appointment was well received as presaging a more honest and efficient management of War Department affairs and a more aggressive prosecution of the war. The department was reorganized, personnel increased, contracts investigated, those tainted with fraud revoked, and their perpetrators prosecuted. Stanton also put himself in active touch with generals, governors,

and the congressional Committee on the Conduct of the War. Becoming impatient with General G. B. McClellan's slowness in achieving tangible results, Stanton joined with other members of the cabinet in seeking to have him deprived of any command. Quickness of decision, mastery of detail, and vigor in execution were among Stanton's outstanding characteristics as a war administrator, and he became annoyed when subordinates proved deficient in these qualities. He was frequently accused of meddling with military operations and was probably guilty of it on many occasions. His severe censorship of the press was also a source of much criticism in newspaper circles, and his exercise of the power of extraordinary arrest was often capricious and harmful. Soldiers and civilians alike found him arrogant, irascible, and often brutal and unjust.

At the request of President Andrew Johnson, Stanton retained his post after Lincoln's death and ably directed the demobilization of the Union armies. At the same time, he entered upon a tortuous course with respect to Reconstruction and related problems, which brought him into serious conflict with the president. It was soon suspected that Stanton was out of sympathy with the administration and was intriguing with the rising opposition. From the summer of 1865 onward, upon nearly every issue, he advised a course of action which would have played into the hands of the Radicals and which fostered a punitive Southern policy. By the beginning of August 1867, President Johnson could no longer tolerate his mendacious minister and was satisfied that Stanton had indeed plotted against him in the matter of Reconstruction legislation and had encouraged insubordination on the part of the commanders of the military districts. When called upon to resign, Stanton refused to do so until Congress reassembled, contending that the Tenure of Office Act had become law by its passage over the presidential veto. Dismissed in February 1868, he declared that he would not give up his post until expelled by force and was supported by the Senate. When the impeachment charges against President Johnson failed, Stanton accepted the inevitable and resigned the same day, May 26, 1868. He accepted President U.S. Grant's appointment to the U.S. Supreme Court, 1869, but death overtook him before he could occupy his seat. His defects of temperament and the disclosures of his amazing disloyalty and duplicity in his official relations detract from his stature as a public man, although his abilities as lawyer and administrator remain unquestioned. Whether he was motivated by egotism, mistaken patriotism, or a desire to stand well with the congressional opposition is difficult to determine.

STANTON, ELIZABETH CADY (*b. Johnstown, N.Y., 1815; d. New York, N.Y., 1902*), reformer, leader in the woman's rights movement. Daughter of Daniel Cady; granddaughter of James Livingston; cousin of Gerrit Smith. Married Henry B. Stanton, 1840, and insisted on omission of the word "obey" from the ceremony. Much influenced by Lucretia C. Mott, she joined with Mott and others in holding the celebrated women's rights convention at Seneca Falls, N.Y., 1848. *Post* 1851 she was closely associated in suffrage work with Susan B. Anthony, planning campaigns, appearing before legislative and congressional committees, and delivering speeches. President of the National Woman Suffrage Association, 1869–90, she also served as president of the National American Woman Suffrage Association subsequent to a merger of those organizations. Coauthor with Anthony of *History of Woman Suffrage* (1881–86), she was author also of many contributions to periodicals and newspapers and of an autobiography, *Eighty Years and More* (1898).

STANTON, FRANK LEBBY (*b. Charleston, S.C., 1857; d. 1927*), Georgia journalist, poet. Conducted one of the first newspaper columns in the *Atlanta Constitution* from 1889. He published a number of volumes of his poems, among them, *Up from Georgia* (1902) and *Little Folks Down South* (1904).

STANTON, FREDERICK PERRY (*b. Alexandria, Va., 1814; d. Stanton, Fla., 1894*), lawyer. Removing to Tennessee, 1835, he served as congressman, Democrat, from the Memphis district, 1845–55. As chairman of the Committee on Naval Affairs *post* 1849, he advocated useful reforms; in his last term he was chairman of the judiciary committee. Proslavery in his general opinions, he served as secretary and acting governor of Kansas Territory, March–May 1857, and as secretary thereafter until 1858, save for another brief period as acting governor after the resignation of Robert J. Walker. Although he apportioned delegates to the Lecompton Convention under an inequitable and incomplete census because of lack of experience, he and Walker later tried to ensure a fair vote for members of a legislature. After his removal from office for attempting to provide a referendum on the Lecompton Constitution, he became a Free-Soiler.

STANTON, HENRY BREWSTER (*b. Griswold, Conn., 1805; d. New York, N.Y., 1887*), lawyer, journalist, reformer, antislavery agent. Husband of Elizabeth Cady Stanton. Author of, among other books, *Random Recollections* (1887).

STANTON, RICHARD HENRY (*b. Alexandria, Va., 1812; d. 1891*), Kentucky congressman, jurist, legal writer.

STANWOOD, EDWARD (*b. Augusta, Maine, 1841; d. Brookline, Mass., 1923*), journalist, historian. After holding editorial posts on Maine and Boston, Mass., newspapers, Stanwood was for many years *post* 1883 managing editor and editor of the *Youth's Companion*. He was author of *A History of Presidential Elections* (1884), *American Tariff Controversies in the Nineteenth Century* (1903) and *James Gillespie Blaine* (1905).

STAPLES, WALLER REDD (*b. Stuart, Va., 1826; d. Montgomery Co., Va., 1897*), lawyer, Confederate congressman. Judge of the Virginia Supreme Court of Appeals, 1870–82, he gave his most notable opinion in the Coupon Case, 1878, which led to the forming of the Readjuster party and the partial repudiation of the state debt. Staples' dissenting opinion was later upheld. He served as a co-compiler of *The Code of Virginia* (1887).

STAPLES, WILLIAM READ (*b. Providence, R.I., 1798; d. 1868*), Rhode Island jurist, historian. Author of, among other works, *Annals of the Town of Providence* (1843) and *Rhode Island in the Continental Congress* (Reuben A. Guild, ed., 1870).

STARBUCK, EDWIN DILLER (*b. Bridgeport, now part of Indianapolis, Ind., 1866; d. 1947*), psychologist. B.A., Indiana University, 1890; M.A., Harvard, 1895; Ph.D., Clark University, 1897. Taught education at Stanford University, 1897–1903, and at Earlham College, 1904–06; professor of philosophy at State University of Iowa, 1906–30, and at University of Southern California, 1930–43. Author of *The Psychology of Religion* (1899), a pioneering work; innovator in character education.

STARIN, JOHN HENRY (*b. Sammonsville, N.Y., 1825; d. New York, N.Y., 1909*), freight agent. Operated *post* 1859 a general agency for the transport of freight around New York City by a system of lighters and tugs, which included his later invention of the car float. Owner and operator of the largest "harbor marine" in the United States, he also owned and operated passenger and freight lines on Long Island Sound.

STARK, EDWARD JOSEF (*b. Hohenems, Austria, 1858; d. 1918*), cantor, composer of synagogue music. Came to America as a boy; received musical education in New York City and abroad.

Practicing his profession in Brooklyn, N.Y., and San Francisco, Calif., he was author of music which, by its successful combination of traditionalism and modernism, was particularly adapted for Reform Jewish temples.

STARK, HAROLD RAYNSFORD (*b. Wilkes–Barre, Pa., 1880; d. Washington, D.C., 1927*), admiral. Graduated U.S. Naval Academy (1903) and his first major assignment was aboard the gunboat *Newport* (1904–06). He moved through a series of choice positions in the battleship-oriented navy and became chief of the staff of the Battle Fleet destroyer force (1928–30). In 1939 he became chief of naval operations with the rank of full admiral. In 1940, on the eve of World War II, Stark devised the strategic plan that called for the Allies to defeat Germany before defeating Japan. He served as the commander of U.S. naval forces in Europe during the war and retired in 1946.

STARK, JOHN (*b. Londonderry, N.H., 1728; d. 1822*), colonial and Revolutionary soldier. Saw extensive service with Rogers' Rangers in French and Indian War, attaining captaincy. Appointed colonel of a New Hampshire regiment on outbreak of the Revolution, he distinguished himself at Bunker Hill, on the retreat from Canada, 1776, and at Trenton and Princeton. Resigning his commission, March 1777, because Congress promoted junior officers over his head, he returned to the field as brigadier general, commanding New Hampshire troops for the defense of Vermont. He defeated a Hessian and Tory force at Bennington, August 1777, and later helped to effect Burgoyne's surrender by blocking his line of retreat. Promoted brigadier general in the Continental service, October 1777, he served with Gates in Rhode Island, 1779, participated in the battle of Springfield, N.J., 1780, and acted on the board of officers appointed to try Major André. He retired with the brevet of major general in 1783.

STARK, LLOYD CROW (*b. near Louisiana, Mo., 1886; d. St. Louis, Mo., 1972*), nurseryman and governor. Graduated U.S. Naval Academy (1908) but resigned from the navy in 1912 to become an executive at his family's firm, Stark Brothers Nurseries and Orchards, the largest nursery in the nation. With the help of the Kansas City political machine of boss Thomas Pendergast, he was elected governor of Missouri (1937–41), but broke Pendergast's political power during his tenure. Following a failed 1940 bid to unseat incumbent U.S. senator Harry Truman, Stark returned to the nursery business.

STARK, LOUIS (*b. Tibold Daracz, Hungary, 1888; d. New York, N.Y., 1954*), newspaper correspondent. Immigrated to the U.S. in 1890. Studied at the N.Y. Training School for Teachers. Reporter for the *New York Times* (1917–51); member of the editorial board (1951–54). Head of the labor correspondents of the Washington D.C. bureau (1933). Covered many significant New Deal legislative and executive programs, including the establishment of the NRA; also covered the split in the AFL which formed the CIO in 1935. Won the Pulitzer Prize for national reporting in 1942.

STARKS, EDWIN CHAPIN (*b. Baraboo, Wis., 1867; d. 1932*), ichthyologist. An authority on the osteology of fishes, Starks served on a number of important field expeditions under David S. Jordan, Charles H. Gilbert, and others. His principal academic post was at Stanford University, where he was curator of zoological collections *post* 1901. He retired as associate professor in the year of his death.

STARR, ELIZA ALLEN (*b. Deerfield, Mass., 1824; d. Durand, Ill., 1901*), author, lecturer on art. Settling in Chicago, Ill., *ca.* 1856, she became one of the first art teachers there and wrote and illustrated a number of books, devotional in character.

STARR, FREDERICK (*b. Auburn, N.Y., 1858; d. Tokyo, Japan, 1933*), anthropologist. Graduated Lafayette College, 1882; Ph.D., 1885. After teaching at a number of schools, he organized the work in anthropology at the University of Chicago, 1892, and in 1895 became associate professor there. He served as sole teacher of his subject until 1923. Author of a number of books and studies, he is chiefly remembered for the wide interest he created in anthropology through his teaching.

STARR, LOUIS (*b. Philadelphia, Pa., 1849; d. 1925*), physician, pediatrician. M.D., University of Pennsylvania, 1871. Author of *Hygiene of the Nursery* (1888), one of the first popular expositions of the subject.

STARR, MERRITT (*b. Ellington, N.Y., 1856; d. 1931*), corporation lawyer. Practiced in Chicago, Ill., *post* 1882; was active in Winnetka, Ill., civic affairs.

STARR, MOSES ALLEN (*b. Brooklyn, N.Y., 1854; d. 1932*), neurologist. Graduated Princeton, 1876; M.D., New York College of Physicians and Surgeons, 1880; made postgraduate studies in Heidelberg and Vienna. Taught at New York Polytechnic, 1884–89; was professor of mental and nervous diseases, New York College of Physicians and Surgeons, 1889–1915. An American pioneer in cerebral localization, he did valuable work on brain tumors. He was author of a great number of special articles on neurological subjects and of several books, including *Atlas of Nerve Cells* (1896) and *Organic and Functional Nervous Diseases* (1903). He was particularly noted as a teacher.

STARRETT, LAROY S. (*b. China, Maine, 1836; d. St. Petersburg, Fla., 1922*), engineer, architect, builder, financier. A partner and officer in Thompson-Starrett Co., engaged in skyscraper and factory construction, he was later associated with the George A. Fuller Co. and with Starrett Brothers and Eken. Completely oblivious to all city-planning values except the financial, he was essentially an executive and neither a designer nor a man of thought.

STARRETT, PAUL (*b. Lawrence, Kans., 1866; d. Greenwich, Conn., 1957*), builder. Studied briefly at Lake Forest University. A supervisor with the Fuller Company (1897–1922), Starrett was the builder of such notable American buildings as the Flatiron Building (1902), Pennsylvania Station (1906–10), General Post Office (1913), Metropolitan Life Insurance Tower (1909), and the Plaza Hotel (1907) — all in New York City. He founded his own firm in 1922 and constructed such buildings as the McGraw Hill Building (1931) and the Empire State Building (1931).

STARRETT, WILLAIM AIKEN (*b. Lawerence, Kans., 1877; d. Madison, N.J., 1932*), engineer, architect, builder, financier. A partner and officer in Thompson-Starrett Co., engaged in skyscraper and factory construction, he was later associated with the George A. Fuller Co. and with Starrett Brothers and Eken. Completely oblivious to all city-planning values except the financial, he was essentially and executive and neither a designer or a man of thought.

STATLER, ELLSWORTH MILTON (*b. Somerset Co., Pa., 1863; d. New York, N.Y., 1928*), hotel owner and operator. Began his career as a bellboy in the McClure House, Wheeling, W.Va., and achieved success through his cardinal rule, "The guest is always right." At his death his hotel properties were the most extensive owned by one man.

STAUFFER, DAVID MCNEELY (*b. Richland, Pa., 1845; d. Yonkers, N.Y., 1913*), civil engineer, editor, collector of prints and autographs. Author of *American Engravers upon Copper and Steel* (1907), the standard work in its field.

STAUGHTON, WILLIAM (*b. Coventry, England, 1770; d. Washington, D.C., 1829*), Baptist minister, educator. Came to America, 1793; held pastorates in Burlington, N.J., and Philadelphia, Pa. Helped establish Columbian College (present George Washington University); served as its president, 1822–29.

STAYTON, JOHN WILLIAM (*b. Washington Co., Ky., 1830; d. Tyler, Tex., 1894*), jurist. LL.B., Louisville University, 1856. Removed to Texas, 1856; served in the Confederate cavalry, 1861–65. Associate justice, Texas Supreme Court, 1881–88, he served as chief justice thereafter until his death.

STEAGALL, HENRY BASCOM (*b. Clopton, Ala., 1873; d. Washington, D.C., 1943*), lawyer, politician. Congressman, Democrat, from Alabama, 1914–43. A member of the bipartisan "farm bloc" during the 1920's, he frequently attacked Republican claims of national prosperity on the ground that farmers had no share in it. Named chairman of the House Banking and Currency Committee, 1930, he sought to cooperate with President Hoover in reviving the economy and had an important role in shaping the economic programs of the New Deal. He insisted on preserving the independence of state banks from the Federal Reserve System by provisions in the Glass-Steagall Act of 1933 and, with other inflationists, forced the Silver Purchase Act of 1934 on an unwilling administration. A cosponsor of the Wagner-Steagall National Housing Act of 1937, he grew increasingly skeptical of legislation exclusively benefiting labor and the urban poor and concentrated on agricultural issues in the last years of his career. During World War II he extended the number of basic crops to be subsidized (the "Steagall commodities"), and forced President Roosevelt to accept a bill providing that no price ceiling of less than 110 percent of parity would be placed on farm products.

STEARMAN, LLOYD CARLTON (*b. Wellsford, Kans., 1898; d. Northridge, Calif., 1975*), aviator and aircraft designer. Attended Kansas State Agricultural College (1917–18) and was hired by E. M. Laird, a commercial airplane company, in 1919, after which he was involved with several firms as an aircraft designer. In 1927 he formed Stearman Aircraft in Wichita, Kans., the first of several of his aircraft design and manufacturing companies. His most famous plane design was the Model 75 Kaydet, also known as the Stearman Trainer, which was the training airplane for U.S. pilots during World War II. His last position was with Lockheed Aircraft as a design specialist (1955–68).

STEARNS, ABEL (*b. Lunenberg, Mass., 1798; d. San Francisco, Calif., 1871*), California pioneer, stockraiser. Immigrated to Mexico *ca.* 1826; settled in Los Angeles, Calif., 1833. Joined in revolutions in favor of J. B. Alvarado, 1836, and against Manuel Micheltorena, 1844–45; remained neutral in hostilities during U.S. seizure of California.

STEARNS, ASAHEL (*b. Lunenberg, Mass., 1774; d. 1839*), lawyer. Cousin of Abel Stearns. Graduated Harvard, 1797. Practiced in present Lowell, Mass., and in Charlestown, Mass., served also in the legislature and as congressman for a single term, 1815–17. Professor of law, Harvard Law School, 1817–29, Stearns was author of *A Summary of the Law and Practice of Real Actions* (1824). Relatively unsuccessful as a law professor, he was an able lawyer and was a commissioner under Charles Jackson in making the first real revision of the Massachusetts statutes (adopted 1835).

STEARNS, EBEN SPERRY (*b. Bedford, Mass., 1819; d. 1887*), educator. Brother of William A. Stearns. Graduated Harvard, 1841. First president, State Normal School, Nashville, Tenn., *post* 1875, and chancellor of the University of Nashville, he proved himself an efficient administrator and was tireless in trying to raise educational standards in the South.

STEARNS, FRANK BALLOU (*b. Berea, Ohio, 1878; d. Cleveland, Ohio, 1955*), inventor and manufacturer. Studied briefly at Case School of Applied Science (now Case Institute of Technology). Founder of the F.B. Stearns Co. in 1898, makers of the Stearns-Knight cars; the company introduced the internal combustion engine in 1912. Stearns left the company in 1918 and concentrated on improvements in the diesel engine; he obtained sixteen patents and sold the engine to the Navy Department in 1935.

STEARNS, FRANK WATERMAN (*b. Boston, Mass., 1856; d. Boston, 1939*), dry-goods merchant. Partner in R. H. Stearns and Co., Boston, Mass., *post* 1880; resigned as president, 1919, retaining chairmanship of the board. Friend and backer of Calvin Coolidge.

STEARNS, FREDERIC PIKE (*b. Calais, Maine, 1851; d. 1919*), civil engineer, hydraulics expert. Planned improvement of Charles River Basin. As engineer for Massachusetts Board of Health, he designed and saw to completion the metropolitan water supply of Boston and its vicinity *ca.* 1895–1907. He later served as a consultant for many other municipal water supply projects and for the Panama Canal.

STEARNS, GEORGE LUTHER (*b. Medford, Mass., 1809; d. New York, N.Y., 1867*), abolitionist, manufacturer. A leader in the movement that put Charles Sumner in the U.S. Senate, he played a great part in the rise of the Republican party in Massachusetts. A friend and patron of John Brown, he financed Brown's proposed raid into Virginia and after his capture attempted his rescue. During the Civil War he recruited black troops for the Union army.

STEARNS, HAROLD EDMUND (*b. Barre, Mass., 1891; d. Hempstead, N.Y., 1943*), journalist, social critic. An expatriate in Paris, France, during the 1920's, he expressed the post–World War I alienation of many intellectuals in *America and the Young Intellectual* (1921) and in a symposium that he edited in 1922 entitled *Civilization in the United States*. Returning to the United States in 1932, he summed up the realities of the expatriate flight from responsibility in several books, including *The Street I Know* (1935, an autobiography) and *America: A Re-Appraisal* (1937).

STEARNS, HENRY PUTNAM (*b. Sutton, Mass., 1828; d. 1905*), physician, psychiatrist, Union army surgeon. Superintendent of Hartford (Conn.) Retreat for the Insane *post* 1874.

STEARNS, IRVING ARIEL (*b. Rushville, N.Y., 1845; d. Wilkes-Barre, Pa., 1920*), mining engineer. Graduated Rensselaer Polytechnic Institute, 1868. Managed coal interests of the Pennsylvania Railroad, 1885–97; made radical improvements in processes of mining and preparing anthracite coal. Thereafter he headed several coal and iron companies until his retirement from business, 1905.

STEARNS, JOHN NEWTON (*b. New Ipswich, N.H., 1829; d. Brooklyn, N.Y., 1895*), temperance reformer, author of much temperance propaganda.

STEARNS, OLIVER (*b. Lunenberg, Mass., 1807; d. Cambridge, Mass., 1885*), Unitarian clergyman. Nephew of Asahel Stearns. Graduated Harvard, 1826; Harvard Divinity School, 1830. After

holding pastorates in Northampton and Hingham, Mass., he served as president of Meadville (Pa.) Theological School, 1856–63, and as professor at Harvard Divinity School, 1863–70. Appointed dean of that school on its reorganization, 1870, he served until 1878 and taught systematic theology and ethics. He was author of several interesting publications asserting that the progressive development of Christian doctrine is the story of intuitive reason interpreting revelation, but safeguarded against private error by an intention to seek truth in the light of the church.

STEARNS, ROBERT EDWARDS CARTER (*b. Boston, Mass., 1827; d. Los Angeles, Calif., 1909*), naturalist, early student of California fauna. Author of a number of articles on molluscan systematics and distribution. He served as paleontologist to the U.S. Geological Survey (appointed 1884) and as assistant curator of mollusks in the U.S. National Museum.

STEARNS, SHUBAL (*b. Boston, Mass., 1706; d. 1771*), Baptist clergyman. Brother-in-law of Daniel Marshall. Ordained, 1751, Stearns immigrated first to Virginia and then to Sandy Creek, N.C., where he served as pastor of the Separate Baptist church *post* 1755. He won high repute as a preaching evangelist in the Carolinas, Georgia, and Virginia.

STEARNS, WILLIAM AUGUSTUS (*b. Bedford, Mass., 1805; d. Amherst, Mass., 1876*), Congregational clergyman, educator. Brother of Eben S. Stearns. Graduated Harvard, 1827. After a long, successful pastorate at Cambridgeport, Mass., he was president of Amherst College, 1854–76.

STEBBINS, HORATIO (*b. South Wilbraham, Mass., 1821; d. Cambridge, Mass., 1902*), Unitarian clergyman. Graduated Harvard, 1848; attended Harvard Divinity School. After serving churches in Fitchburg, Mass., and Portland, Maine, Stebbins succeeded Thomas S. King as pastor of the Unitarian Church in San Francisco, Calif., 1864. For 35 years thereafter he was a force in the development of the state, particularly in its educational progress; he was a leader in the foundation of the University of California, Stanford University, and Lick Observatory. He resigned his pastorate, 1900.

STEBBINS, RUFUS PHINEAS (*b. South Wilbraham, Mass., 1810; d. Cambridge, Mass., 1885*), Unitarian clergyman. Cousin of Horatio Stebbins. Graduated Amherst, 1834; attended Harvard Divinity School. Pastor at Leominster, Mass., 1837–44, he became first president of the Meadville (Pa.) Theological School and served in that post until 1856. Thereafter he held various pastorates in Massachusetts and New York and served as president of the American Unitarian Association.

STECK, GEORGE (*b. Cassel, Germany, 1829; d. New York, N.Y., 1897*), piano manufacturer. Immigrated to New York City, 1853.

STEDMAN, EDMUND CLARENCE (*b. Hartford, Conn., 1833; d. New York, N.Y., 1908*), stockbroker, poet, critic. Son of Elizabeth C. D. S. Kinney. Author of a number of technically meritorious but imitative poems, Stedman exercised great influence on American letters of his period through his critical works and anthologies, among them, *Poets of America* (1885), *A Victorian Anthology* (1895), and *An American Anthology* (1900).

STEEDMAN, CHARLES (*b. Santee, S.C., 1811; d. Washington, D.C., 1890*), naval officer. On active service, principally at sea, *post* 1828, he retired as rear admiral, 1873. Remaining loyal to the Union during the Civil War, he served chiefly on blockade duty off the southeast coast and commanded the *Ticonderoga* during both attacks against Fort Fisher.

STEEDMAN, JAMES BLAIR (*b. Northumberland Co., Pa., 1817; d. 1883*), printer, Union major general, Ohio Democratic politician. Won his greatest distinction in the battle of Chickamauga, where he commanded a division of Granger's corps which came to the rescue of General George H. Thomas after the rest of the army had been swept away. He was active in journalism and civic affairs in Toledo, Ohio, *post* 1869.

STEELE, DANIEL (*b. Windham, N.Y., 1824; d. Milton, Mass., 1914*), Methodist clergyman, educator. Held a number of Massachusetts pastorates and was a strong reformer and a leader in Methodism. Professor of languages in Genesee College, 1862–69, and its acting president, 1869–71, he served briefly as professor of philosophy, vice president, and acting chancellor, 1871–72, after Genesee had become Syracuse University.

STEELE, FREDERICK (*b. Delhi, N.Y., 1819, d. San Mateo, Calif., 1868*), soldier. Graduated West Point, 1843. Commanded infantry with credit in Mexican War; *post* 1848, served in California, Minnesota, Nebraska, and Kansas. During the Civil War he rose to division command in Union army and the rank of major general of volunteers. Immediately after the surrender of Vicksburg, he was charged with completing the conquest of Arkansas, which he accomplished within a few months. He failed in an effort to assist General N. P. Banks in the Red River campaign, March–April 1864.

STEELE, JOEL DORMAN (*b. Lima, N.Y., 1836; d. 1886*), educator, author of science textbooks, Union soldier. Principal of the Elmira (N.Y.) Free Academy, 1866–72.

STEELE, JOHN (*b. Salisbury, N.C., 1764; d. 1815*), businessman, landowner. Congressman, independent Federalist, from North Carolina, 1789–93; comptroller of U.S. treasury, 1796–1802. Opposed to any extension of presidential or judicial powers.

STEELE, WILBUR DANIEL (*b. Greensboro, N.C., 1886; d. Essex, Conn., 1970*), writer. Attended University of Denver (B.A., 1907), Boston Museum School of Fine Arts, and Art Students League. His first story, "On the Ebb Tide," was published in *Success Magazine* (1910); other stories then appeared in *Atlantic Monthly*, *Scribner's Magazine*, and *Harper's*. His first story collection was *Land's End* (1918). Nine stories reappeared in the annual *Best Stories* volumes, 1915–26; during 1919–33 he received the O. Henry Memorial Award twelve times. His second collection of stories was *The Shame Dance* (1923). His novels include *Storm* (1914); *Isles of the Blest* (1924); and *Taboo* (1925), which treats the theme of incest, as did his story "When Hell Froze," which won first prize in Harper's 1925 Short Story Contest. Wrote the hit Broadway mystery-comedy *Post Road* (1935). During 1938 only a trickle of his works sold to mass-market magazines, and the novels he wrote after that were not well received.

STEENDAM, JACOB (*b. the Netherlands, 1616; d. Netherlands Indies, ca. 1672*), merchant, first poet of New Netherland. Resident on Long Island and in New Amsterdam, 1652–ca. 1662.

STEENWIJCK, CORNELIS VAN *See* STEENWYCK, CORNELIS.

STEENWYCK, CORNELIS (*b. probably Haarlem, the Netherlands, date unknown; d. New York, N.Y., 1684*), colonial merchant. Came to New Amsterdam, 1651, as mate of a trading vessel. Prospering as a merchant, he held a number of civic posts under the Dutch rule and was a signer of the articles by which New Netherland was surrendered to the English. Mayor of New York, 1668–70, he became a member of Governor Francis Lovelace's council, continued influential during the brief restoration

of Dutch rule, and survived the second English seizure of the colony sufficiently well to serve again as mayor of New York City, 1682–83. A wealthy man, he was reputed the best-dressed, most polite, and most popular man in the New York of his time.

Steers, George (*b. Washington, D.C., 1820; d. 1856*), naval architect. Trained in his father's New York City shipyard, Steers introduced revolutionary changes in hull design. He was particularly renowned as builder of the famous yacht *America*, which he sailed in the memorable race of Aug. 22, 1851, around the Isle of Wight.

Stefansson, Vilhjalmur (*b. Arnes, Manitoba, Canada, 1879; d. Hanover, N.H., 1962*), Arctic explorer. In 1880 his family moved to Dakota territory. Attended University of North Dakota and Harvard (M.A., 1903). Spent the summers of 1904 and 1905 on archaeological expeditions to Iceland for the Peabody Museum and was selected a teaching fellow for the polar regions at Harvard (1905). Persuaded officials of the American Museum of Natural History to finance an Arctic expedition, with additional support from the Canadian government (1908–11), spending three years among the Eskimos of eastern Alaska. A second exploration was sponsored by the Canadian government to the Beaufort Sea and Coronation Gulf (1913–18). His two most influential books are *The Friendly Arctic: The Story of Five Years in Polar Regions* (1921) and *The Northward Course of Empire* (1922). During World War II he was a government consultant on Arctic matters.

Steffens, Lincoln (*b. San Francisco, Calif., 1866; d. Carmel, Calif., 1936*), journalist, reformer. Reared in a prosperous family, Steffens graduated from the University of California, Ph.B., 1889, and made various studies in Germany, England, and France. After reportorial and editorial work on the New York *Evening Post* and the New York *Commercial Advertiser*, 1892–1901, he joined the staff of *McClure's Magazine* and found his true métier as writer of muckraking articles exposing civic corruption (collected as *The Shame of the Cities*, 1904). Continuing his investigations, he published *The Struggle for Self-Government* (1906) and *Upbuilders* (1909), in which he cited evidence of substantial reform gains achieved and expressed a growing belief in the need for firm leadership. Associated with Edward A. Filene in Boston reform efforts, 1909, he became convinced that exposure of evil was not enough to bring about reform and began to look about for some single principle as a solution. Disappointed in his belief in the Golden Rule, in his efforts to negotiate a settlement of the case of the McNamara brothers, and in his personal life as well, he sought a new panacea in violent social upheaval. From 1917 until his death, he was increasingly a partisan of the Soviet Union. *Post* 1929 he felt that Russia offered the only practical solution for the problems of progress and power. His *Autobiography* (1931), although manifestly self-serving in numerous passages, was written with skeptical humor and questioned social processes in a manner relevant to the Great Depression.

Stehle, Aurelius Aloysius (*b. Pittsburgh, Pa., 1877; d. Pittsburgh, 1930*), Roman Catholic clergyman, Benedictine. Archabbot of St. Vincent Archabbey, 1920–30, he was founder of the Catholic University at Peking, China, 1924.

Steichen, Edward Jean (*b. Luxembourg, 1879; d. West Redding, Conn., 1973*), photographer. Came to the United States with his family in 1881 (naturalized 1900), studied at the Milwaukee Arts Students League (1894–98), and in 1902 founded with Alfred Stieglitz the Photo–Secession Gallery, an organization dedicated to photography as an art form. His early photographs, which resembled the impressionist paintings of the era, were displayed by museums beginning in the 1910's. During this period he also created noted photographic portraits of luminaries. In 1923 he plunged into the consumer and fashion boom and became chief photographer for *Vogue* and *Vanity Fair*. During World War II he worked in photographic units and produced one his most memorable photographs, an infrared image of the flight deck of the USS *Lexington*. In 1947–62 he was director of photography at the Metropolitan Museum of Modern Art in New York City. His most famous photographic exhibition was "The Family of Man" (1955).

Stein, Evaleen (*b. Lafayette, Ind., 1863; d. 1923*), poet, writer of children's stories.

Stein, Gertrude (*b. Allegheny, Pa., 1874; d. Neuilly-sur-Seine, France, 1946*), author. Her earliest memories were of Vienna, where her father, Daniel Stein, moved for business reasons in 1875, and then Paris. Her mother, Amelia (Keyser) Stein, figured only remotely in Gertrude's preadolescence. The family returned to America in 1879, settling the next year in Oakland, Calif. At Radcliffe College, which she attended from 1893 to 1897 (B.A., 1898), Gertrude's primary interest was the psychology of William James; his theory of consciousness forms the basis of her thought. To prepare for a career in psychology, she entered Johns Hopkins Medical School in 1897. Her research on the brain was solid, but she failed final examinations and preferred traveling abroad to retaking them. After a period in London at the British Museum systematically reading English narratives from the Elizabethans to the present, she joined her brother Leo in Paris in 1903 at 27 rue de Fleurus. Although he was never to succeed in translating his aesthetic intellections into tangible achievement, Leo was among the first to recognize the genius of postimpressionist painters. He and Gertrude began to cover their walls with masters of the Paris school, which Leo expounded to the uninitiated who streamed through their soon-famous flat. In her friendships, especially with Pablo Picasso, Juan Gris, and Francis Picabia, Gertrude promoted modern art.

Gertrude Stein's earliest fiction, *Q.E.D.*, completed in 1903, first appeared posthumously in 1950 under the title *Things As They Are*. Supposedly "forgotten," it was more probably withheld because of its homoeroticism. In "Melanctha," the last of three long stories published in 1909 as *Three Lives*, the central love affair is between a black doctor and a mulatto girl. Often cited as a minor classic, its racial clichés justified or denied, "Melanctha" is stylistically original but at the expense of fictional reality as created in the cruder *Q.E.D.* The book *The Making of Americans* (1925), probably written between 1903 and 1911, marked a stage in Stein's development parallel to cubism in its incorporation of random events and the process of completion itself. *Tender Buttons* (1914) was her work most resembling verbal collage. From this book onward, narrative, with its assumption of a causal ordering of events, mostly disappears.

Although in middle life she was still largely unpublished, Stein was sought after as a savant of the new. Her lectures given at Cambridge and Oxford in 1926 and published as *Composition As Explanation* represent one of her earliest efforts to elucidate her practice and formulate theoretical principles. Other important efforts are *Lectures in America* and *Narration* (both 1935) and *What Are Masterpieces* (1940). Through her influence on Sherwood Anderson and, more significantly, on Ernest Hemingway, she made a decisive contribution to modern American literature and prose style. Leo having left in 1913, and with Alice B. Toklas from 1909 as her companion and amanuensis, she enjoyed a Johnsonian eminence in her salon, where the roster of visitors was an index to the distinguished artists and intellectuals of her time. She created her own legend in *The Autobiog-*

raphy of Alice B. Toklas (1933), using the persona of her friend to write about herself in a communicable style. The next year her esoteric opera *Four Saints in Three Acts*, with music by Virgil Thomson, was premiered with fanfare in Hartford, Conn., and moved to New York City. Of the other dramatic works produced with some critical success, the most notable are the ballet *A Wedding Bouquet* (1937), *Yes Is for a Very Young Man* (1946), and the opera *The Mother of Us All* (1947), in collaboration with Virgil Thomson.

After 30 years, Stein returned to America for a triumphant lecture tour in 1934. Her reacquaintance with the country led to insights into American character and landscape in *The Geographical History of America* (1936). Although she courted public success and effectively used her grasp of modern publicity techniques, being a headlined celebrity disturbed her sense of identity, as she revealed in *Everybody's Autobiography* (1937). Throughout World War II she lived in seclusion with Alice Toklas in occupied France. *Wars I Have Seen* (1945), beginning with the Spanish-American, had immediate journalistic appeal in its account of daily life during her last war.

STEIN, LEO DANIEL (*b. Allegheny, Pa., 1872; d. Settignano, Italy, 1947*), art critic, author. Brother of Gertrude Stein. Unable either to accept his limitations or to capitalize on his talents, he tried successively to be a historian, a scientist, a painter, and a writer. He achieved a critical success at last with his book *Appreciation: Painting, Poetry, and Prose* (1947), but he is remembered particularly as an early and discriminating collector of modern painting.

STEINBECK, JOHN ERNST, JR. (*b. Salinas, Calif., 1902; d. New York, N.Y., 1968*), writer. Attended Stanford, but did not pursue a degree. With the publication of *The Pastures of Heaven* (1932), *To a God Unknown* (1933), and the stories collected in *The Long Valley* (1938), he defined his primary subject matter — farm life in an enclosed California valley. He remained largely unknown until *Tortilla Flat* (1935). The three great novels of his midcareer were *In Dubious Battle* (1936), *Of Mice and Men* (1937), and *The Grapes of Wrath* (1939), which won a Pulitzer prize and established his reputation as a major American writer. Following U.S. entry into World War II, he worked without pay for several government agencies, writing *The Moon Is Down* (1942) and, for the Army Air Corps, the nonfictional *Bombs Away*. Became a correspondent for the *New York Herald-Tribune* (1943) and was sent to the Mediterranean. In 1945 *Cannery Row* appeared, and then he worked on the script and filming of *The Pearl* (1948). Other works include *The Wayward Bus* (1947), *Burning Bright* (1950), *East of Eden* (1952), *The Winter of Our Discontent* (1961), and *Travels with Charley* (1962). He was awarded the Nobel Prize for literature in 1962. In 1966 he was in Vietnam as a correspondent for *Newsday*; his support for the Vietnam War alienated him from the liberal intellectual community. Few American writers have been the source of as much controversy. More of his works are on lists of books banned by schools and libraries than any other writer, but many of his novels are commonly taught in schools and colleges; *The Grapes of Wrath* remains one of the major American novels of the twentieth century.

STEINER, BERNARD CHRISTIAN (*b. Guilford, Conn., 1867; d. 1926*), educator, librarian, historian. Son of Lewis H. Steiner. Graduated Yale, 1888; Ph.D., Johns Hopkins, 1891. Taught at Williams College; was librarian of Enoch Pratt Free Library, Baltimore, Md., 1892–1926. He was author of a great number of monographs and books on the history of Maryland and Connecticut and on the history of education in America; he was also editor of Volumes 18 and 36–45 of the *Archives of Maryland*.

Among his books, *Life and Correspondence of James McHenry* (1907), *Life of Reverdy Johnson* (1914), and *Life of Roger Brooke Taney* (1922) were of particular value.

STEINER, LEWIS HENRY (*b. Frederick, Md., 1827; d. 1892*), physician, librarian. Father of Bernard C. Steiner. A practicing physician and teacher of medicine, 1849–84, he served thereafter as first librarian of the Enoch Pratt Free Library of Baltimore, Md.

STEINER, MAX(IMILIAN) RAOUL WALTER (*b. Vienna, Austria, 1888; d. Los Angeles, Calif., 1971*), film music composer. Studied at the Imperial Academy of Music in Austria at age thirteen and was a pupil of Gustav Mahler. He came to the United States in 1917 (naturalized 1920) and became an orchestrator and conductor of Broadway musicals. In 1930 he started writing original film scores for Hollywood movies. His rich symphonic scoring established a standard. Among his numerous credits were scores for the films *King Kong* (1933), *The Informer* (1935), *Casablanca* (1938), *Gone With the Wind* (1939), and *A Summer Place* (1959).

STEINERT, MORRIS (*b. Scheinfeld, Bavaria, 1831; d. 1912*), optician, merchant, collector of musical instruments. Immigrated to America *ca.* 1856; made his home in New Haven, Conn., *post* 1861. Founded Mathushek Piano Co. and New Haven Symphony Orchestra; donated his important collection of rare instruments to Yale University.

STEINHARDT, LAURENCE ADOLPH (*b. New York, N.Y., 1892; d. near Ottawa, Ontario, Canada, 1950*), lawyer, diplomat. After attending private schools, Steinhardt entered Columbia University, from which he received the B.A. degree in 1913 and the M.A. and LL.B. in 1915. He was admitted to the New York bar the following year. During World War I he served in the army field artillery and as a sergeant on the provost marshal general's staff. In 1920 he joined his uncle's law firm, Guggenheimer, Untermyer and Marshall. A liberal Democrat, Steinhardt became interested in politics and in 1932 joined the preconvention presidential campaign committee of Franklin D. Roosevelt. Following Roosevelt's election Steinhardt accepted an appointment in 1933 as U.S. minister to Sweden. He was the youngest chief of a diplomatic mission, and he negotiated one of the administration's first reciprocal trade agreements. He was named ambassador to Peru in 1937, and his efforts impressed Secretary of State Cordell Hull, who two years later recommended Steinhardt's appointment as ambassador to the Soviet Union.

Steinhardt arrived in Moscow on the eve of the Nazi-Soviet Nonaggression Pact of 1939. Grasping well the realities of Soviet policies, he stressed the solidarity of the agreement with Berlin and maintained that, for the time being at least, the two nations could not afford to quarrel. After the fall of France to the Germans in 1940, the United States sought to improve Soviet-American relations by granting unilateral concessions, despite Steinhardt's repeated warnings that America's prestige would be harmed by not demanding a quid pro quo. As the anticipated improvement in relations did not occur, Washington moved closer to Steinhardt's policy of reciprocity during the spring of 1941. Shortly after Pearl Harbor he was sent as ambassador to neutral Turkey, where he helped influence that country's decision not to fulfill its trade commitment with Germany.

Late in 1944 Roosevelt named Steinhardt ambassador to Czechoslovakia. After the announcement in 1947 of the Marshall Plan for the rebuilding of Europe, he successfully urged Washington to delay action on the Czech government's loan application until the campaign ended and American claims in Czechoslovakia were settled. As the Czech elections approached, Steinhardt saw the Communists' popularity declining, but he

misjudged the party's ability, abetted by Moscow, to effect the coup d'état that took place in February 1948. In the summer of 1948 President Harry S. Truman appointed Steinhardt ambassador to Canada. Election to high office in New York State was Steinhardt's greatest ambition, although during his diplomatic career he did not court publicity. Early in 1950, while flying to New York to attend a political dinner, he was killed in a plane crash.

STEINITZ, WILLIAM (*b. Prague, Czechoslovakia, 1836; d. New York, N.Y., 1900*), champion chess player of the world, 1866–94. An American citizen *post* 1884, he wrote extensively on chess and was author of *The Modern Chess Instructor* (1889, 1895).

STEINMAN, DAVID BARNARD (*b. New York, N.Y., 1886; d. New York, 1960*), engineer. Studied at the City College of New York and at Columbia University (Ph.D., 1911). The designer of many of the world's most famous and spectacular bridges, Steinman taught at the University of Idaho from 1910 to 1915 before returning to New York to collaborate with Gustav Lindenthal in designing the Hell Gate Bridge over the East River in New York (1917). Other bridges designed through his company, Steinman, Boyton, Fronquist, and London, include the George Washington Bridge (1931), the Sidney Harbor Bridge in Australia (1932), the Thousand Islands International Bridge (1938), and the Mackinac Strait Bridge (1957).

STEINMETZ, CHARLES PROTEUS (*b. Breslau, Germany, 1865; d. 1923*), mathematician, electrical engineer. Deformed from birth, he showed brilliance and a great capacity for study at the University of Breslau, which he attended, 1883–88. Having engaged in socialist journalism there, he was obliged to flee Germany to avoid arrest and never received the doctor's degree for which he had completed his work. Immigrating from Switzerland to the United States, 1889, he worked for Rudolf Eickemeyer, who before long established him in an experimental laboratory of his own.

Given the task of calculating and designing an alternating-current commutator motor, and wishing to calculate the hysteresis loss, he derived the law of hysteresis mathematically from existing data. He followed this with an elaborate series of tests to prove the law and simplify its application. In 1892, he read two papers on the subject before the American Institute of Electrical Engineers which at once established his reputation. His further studies of alternating electric current led him to develop a mathematical method of reducing alternating-current theory to a basis of practical calculation. His symbolic method is now universally used, although it required a process of elucidation by him in several books before it was generally understood. His third and last great research undertaking had to do with lightning. He began a systematic study of the general equation of the electric current and of "transient electrical phenomena," as lightning is scientifically called. This work culminated in 1921 with dramatic experiments yielding man-made lightning in the laboratory. In addition to his work as consulting engineer for the General Electric Co., 1894–1923, he was professor of electrical engineering and electrophysics at Union University, Schenectady, N.Y. He received numerous honors, patented a great number of inventions, and wrote several books, including *Theory and Calculation of Transient Electric Phenomena and Oscillations* (1909) and *Theory and Calculation of Alternating Current Phenomena* (5th ed., 1916).

STEINMEYER, FERDINAND *See* FARMER, FATHER.

STEINWAY, CHRISTIAN FRIEDRICH THEODORE (*b. Seesen, Germany, 1825; d. Brunswick, Germany, 1889*), piano manufacturer.

Son of Henry E. Steinway; brother of William Steinway. Resident in America, 1865–70, he made extensive experiments in application of modern science to the problems of piano-building.

STEINWAY, HENRY ENGELHARD (*b. Wolfshagen, Germany, 1797; d. New York, N.Y., 1871*), piano manufacturer. Father of Christian F. T. and William Steinway. Immigrated to New York City, 1851. Started his own business under his original name, Steinweg, 1853; introduced innovating square piano with overstrung strings and a full cast-iron frame, 1855. Thereafter he undertook the manufacture of grand pianos and uprights and built Steinway Hall (formally opened, 1867), which became a center of New York musical life.

STEINWAY, WILLIAM (*b. Seesen, Germany, 1835; d. New York, N.Y., 1896*), piano manufacturer. Son of Henry E. Steinway; brother of Christian F. T. Steinway. Immigrated to America with his family, 1851. Concerned mainly with the financial and sales departments of Steinway & Sons, he was a patron of music and won international standing for his firm by inducing foreign artists to play Steinway pianos. President of the firm, 1876–96, he was active also in civic affairs and was chairman of the New York City commission which planned the first subways.

STEJNEGER, LEONHARD HESS (*b. Bergen, Norway, 1851; d. Washington, D.C., 1943*), zoologist. Graduated in arts, 1870, philosophy, 1872, and law, 1875, University of Kristiania. Came to the United States, 1881, and, with help of Spencer F. Baird, was appointed to staff of the National Museum, Smithsonian Institution. Head curator of the museum's Department of Biology *post* 1911, he made substantial contributions to knowledge of the taxonomy and geographical distribution of North American and other birds, reptiles, and amphibians.

STELLA, JOSEPH (*b. Muro Lucano, near Naples, Italy, 1877; d. New York, N.Y., 1946*), painter. Came to the United States, 1896; studied for brief periods at Art Students League, New York City, and with William M. Chase. His drawings of immigrants (*Outlook* magazine, 1905) and of the persons and physical milieu of miners and steelworkers (Pittsburgh Survey in *Charities and the Commons*, 1908) rank among the best figure drawings ever produced in the United States. A student in Italy and France, 1909–12, he gave up his "old master" technique and was influenced by fauvism, cubism, and especially futurism. On his return to the United States, his semiabstract *Battle of Lights, Coney Island*, 1913, won him a leading place in the avant-garde. His most creative period followed World War I (*The Gas Tank*, 1918; *Brooklyn Bridge*, ca. 1919; *New York Interpreted*, 1920–22). He spent most of 1922–34 in Italy and France, abandoning abstraction for a primitivizing style. The few paintings of real merit which he did in the last decade of his life were produced on Barbados in 1938.

STELZLE, CHARLES (*b. New York, N.Y., 1869; d. New York, 1941*), Presbyterian clergyman. During apprenticeship as a machinist, he was distressed at the widening gap between workingmen and the church, and devoted himself to a special mission, interpreting the labor movement to the church and the church to working people. Ordained in 1900, was supported in his work by the Board of Home Missions and made a significant contribution to the spread of the Social Gospel movement; he was author of, among other works, *Christianity's Storm Center: A Study of the Modern City* (1907) and the founder of New York City's Labor Temple, 1910. In face of mounting conservative criticism, he resigned his special ministry in 1913 and set up an office and staff to undertake survey, publicity, and promotional services on behalf of social and religious causes.

Stengel, Alfred (*b. Pittsburgh, Pa., 1868; d. Philadelphia, Pa., 1939*), pathologist, medical educator. M.D., University of Pennsylvania, 1889; studied also at Berlin, Vienna, and London. A teacher of medicine at Pennsylvania *post* 1893, he served also as vice president of the university for medical affairs, 1931–39. As president of the American College of Physicians, 1925–27, he brought about its complete reorganization and made it the outstanding organization of internists in America.

Stengel, Charles Dillon ("Casey") (*b. Kansas City, Mo., 1890; d. Glendale, Calif., 1975*), baseball manager. Between 1912 and 1925, Stengel played major league baseball with moderate success as an outfielder for the Brooklyn Dodgers, Pittsburgh Pirates, Philadelphia Phillies, New York Giants, and Boston Braves. He managed in the minor leagues (1925–32) and returned to the majors as coach (1932–34) and manager (1934–36) for the Dodgers. He also managed the Braves (1938–43) before becoming manager of the New York Yankees in 1949. Stengel led the club to nine pennants and two World Series championships (1956, 1958). He was fired in 1960 at the age of seventy. In 1962 he became manager of the newly organized New York Mets; a hip fracture led to his retirement in 1965. Inducted into Baseball Hall of Fame in 1966.

Stephens, Alexander Hamilton (*b. Wilkes, later Taliaferro, Co., Ga., 1812; d. Atlanta, Ga., 1883*), statesman, lawyer. Half brother of Linton Stephens. Orphaned at an early age; graduated University of Georgia, 1832; began practice of law at Crawfordville, Ga., 1834. After effective service in the Georgia legislature *post* 1836 as an associate in the faction headed at various times by William H. Crawford and George M. Troup, he entered the U.S. House of Representatives as a Whig, 1843. His first notable speech was made at the beginning of 1845 on the Texas question. Annexation, he said, while tending to lessen the prosperity of the cotton states already in the Union, would give the South a greatly needed political weight and thus preserve a proper balance between the different sections of the nation. However, the next year, he denounced the sending of troops to the Rio Grande and the precipitation of war with Mexico. Deprecating the Democratic project of expansion, 1847, he censured the Wilmot Proviso, saying that if its policy were pursued, the Union must give place to a prospect of desolation, carnage, and blood. Growing more alarmed at what he considered the progressive erosion of states' rights and constitutional safeguards, he defied the North in August 1850 by stating, "Whenever this Government is brought in hostile array against me and mine, I am for disunion — openly, boldly and fearlessly, for revolution . . . seven millions of people fighting for their rights, their homes and their hearth-stones cannot be easily conquered." However, when Henry Clay's compromise measures were enacted, he hastened to Georgia to endorse the Union-saving legislation, provided that Congress and the North maintained it in letter and spirit. To improve the prospect of intersectional peace, he launched with Robert Toombs and Howell Cobb the Constitutional Union party, but the project collapsed for lack of support.

Rejecting Winfield Scott, the Whig candidate for president in 1852, Stephens abandoned the Whig party and shifted to the Democrats; he heartily denounced the Know-Nothing movement. Supporting the Kansas-Nebraska Act, he acted as House floor manager in its behalf. Convinced that the bill was admirable, he was proud of his maneuvers which resulted in its enactment. His essential concern, often and sincerely proclaimed, was the preservation of Southern security within a placid Union of all the states. In 1859 he gave up his seat in Congress, but continued his interest in politics. In the campaign of 1860, he preferred the candidacy of R. M. T. Hunter, but supported Stephen A. Douglas. When Lincoln was elected, Stephens advised a policy of watchful waiting, with readiness for drastic action if Lincoln or Congress invaded Southern rights or violated the Constitution. At the convention summoned by the Georgia legislature which met in January 1861, he declared that he opposed "the policy of immediate secession," but if the majority voted for secession he would accept their decision. As a delegate to the convention of Southern states held at Montgomery, he proposed the formation of a union on the model of the United States. Under the quickly devised Provisional Constitution, Jefferson Davis was elected president of the Confederate States of America and Stephens vice president, February 1861.

As vice president, Stephens lent a hand in affairs where he could, but gradually drifted into the position of leader of the opposition. He disapproved of many of Davis' policies, and his fondness for principles, scruples, and constitutional restraint made him an unhappy member of a wartime government. War itself was keenly distressing to him, particularly the sufferings of the wounded and prisoners on both sides. Sent in 1865 to Hampton Roads as one of three commissioners to negotiate a peaceful settlement with Lincoln and W. H. Seward, he found that the maintenance of Confederate independence would be impossible. Shortly after the termination of the war he was arrested by federal troops, but was later released on parole. Elected to the U.S. Senate in 1866, he was excluded from that body along with all others from the "rebel" states.

In the Reconstruction period Stephens counseled self-discipline, patience, and forbearance from recrimination, and recommended support for President Johnson's policies. In hearings before a congressional committee on Reconstruction, he declared that Georgia acquiesced in the abolition of slavery but opposed granting the suffrage to blacks, and he denied the constitutional power of the federal government to impose conditions precedent to restoration of the late Confederate states to their functions in the Union. Congress proceeded with its drastic program, and Stephens accepted a publisher's invitation to write A *Constitutional View of the Late War Between the States* (published 1868, 1870). It is a tedious rationalization, obscuring the historic problem of slavery by refinements of doctrine on the sovereignty of the states. Dull as the book may be to readers in the 20th century, it was a sensation in its day, evoking attacks by Northern and Southern champions of causes upon which it impinged. In 1872 Stephens was elected to the House of Representatives and served for a decade. In 1882, after resigning from Congress, he was elected governor of Georgia but died a few months after inauguration.

Stephens, Alice Barber (*b. near Salem, N.J., 1858; d. Rose Valley, Pa., 1932*), illustrator. Studied at School of Design for Women, Philadelphia, Pa., where she later taught; worked under Thomas Eakins at Pennsylvania Academy. Excelled in pictures of quiet scenes and incidents from classical fiction, characterized by simplicity and technical assurance.

Stephens, Ann Sophia (*b. Derby, Conn., 1813; d. Newport, R.I., 1886*), editor, author. A prolific writer for the periodicals of her time, Stephens served in editorial capacities on the *Ladies' Companion, Graham's Magazine,* and *Peterson's Magazine.* She is particularly notable as author of the first of the celebrated Beadle "dime novels" — *Malaeska* (1860).

Stephens, Charles Asbury (*b. Norway Lake, Maine, 1844; d. Norway Lake, 1931*), author of juvenile stories, experimenter in biology.

Stephens, Edwin William (*b. Columbia, Mo., 1849; d. Columbia, 1931*), editor-publisher of the *Columbia Herald,* 1870—

1905, commercial printer. Chairman, Missouri State Capitol commission (completed 1918).

STEPHENS, HENRY MORSE (*b. Edinburgh, Scotland, 1857; d. 1919*), educator, historian. Graduated Balliol College, Oxford, B.A., 1882; studied also at Lincoln's Inn and at universities of Bonn and Paris. After achieving distinction in England as writer, librarian, and teacher, he served as professor of modern European history at Cornell University, 1894–1902, and was thereafter head of the Department of History at University of California. A rigorously scientific historian, he was author of, among other books, *History of the French Revolution* (1886, 1891). He was successful in obtaining for the University of California the collection of works relating to Spanish colonization and to the Pacific Coast which was gathered by H. H. Bancroft.

STEPHENS, JOHN LLOYD (*b. Shrewsbury, N.J., 1805; d. New York, N.Y., 1852*), lawyer, steamship and railroad promoter, traveler, author. After publishing several books on his travel in eastern Europe and the Near East, he investigated the Maya ruins in Honduras, Guatemala, and Yucatan, 1839–40, accompanied by an English artist, Frederick Catherwood, who was experienced in archaeology. Stephens aroused interest in the early Central American cultures by his *Incidents of Travel in Central America, Chiapas, and Yucatan* (illustrated by Catherwood, 1841). Returning for more intensive study of the subject in 1841, they published another collaborative work, *Incidents of Travel in Yucatan* (1843).

STEPHENS, LINTON (*b. near Crawfordville, Ga., 1823; d. Georgia, 1872*), Georgia legislator and jurist. Confederate soldier. Half brother of Alexander H. Stephens. A Whig legislator, he aided his half brother, Robert Toombs, and Howell Cobb in organizing the Constitutional Union party; he later returned to the Whigs and was a Democrat *post* 1856. After the Civil War he practiced law and refused to reenter politics, but militantly opposed Reconstruction.

STEPHENS, URIAH SMITH (*b. near Cape May, N.J., 1821; d. Philadelphia, Pa., 1882*), pioneer labor leader. A tailor by trade, he helped organize the Garment Cutters' Association of Philadelphia, 1862. Upon its dissolution in 1869, he and others founded the Noble Order of the Knights of Labor. The order, in which Stephens served for a time as "grand master workman," was based on the principles of secrecy, union of all trades, education, and cooperation. Stephens conceived of the Knights of Labor not simply as a trade union but as a nucleus for building a cooperative commonwealth. After a bitter struggle between Stephens and Terence V. Powderly, the principle of secrecy in the order was repudiated, 1881.

STEPHENSON, BENJAMIN FRANKLIN (*b. Wayne Co., Ill., 1823; d. Rock Creek, Ill., 1871*), physician, Union army surgeon, founder of the Grand Army of the Republic at Decatur, Ill., Apr. 6, 1866.

STEPHENSON, CARL (*b. Fayette, Ind., 1886; d. Ithaca, N.Y., 1954*), medievalist. Studied at DePauw University and at Harvard University (Ph.D., 1914); further study at the University of Ghent (1924). Taught at several universities including the University of Wisconsin (1920–30), and Cornell University (1930–54). An expert in the development of English urban settlements in the Anglo-Saxon period, he published *Borough and Town* (1933). A textbook was *Medieval History* (1935), which went into its fourth printing in 1962.

STEPHENSON, ISAAC (*b. Maugerville, New Brunswick, Canada, 1829; d. Marinette, Wis., 1918*), lumberman, politician. Re-moved to Milwaukee, Wis., 1845; settled at Marinette, 1858; was thereafter connected with many industrial operations in the Menominee River valley. A Republican member of the Wisconsin legislature and a congressman, 1883–89, he turned against the machine and financed Robert M. La Follette's campaign for governor, 1900. Elected U.S. senator, 1907, in succession to John C. Spooner, he was reelected in 1908. Attacked for his lavish expenditure of money in the campaign by both La Follette and the Progressives and also the "regular" Republicans, he was confirmed in his seat nevertheless and served out his term.

STEPHENSON, JOHN (*b. Co. Armagh, Ireland, 1809; d. New Rochelle, N.Y., 1893*), streetcar builder. Came to New York City as a child; was apprenticed to a coachmaker. Designed and built the first omnibus made in New York, 1831; also designed and built the first car for the first street railway in the world (Fourth Avenue line, New York & Harlem Railroad), 1832.

STEPHENSON, NATHANIEL WRIGHT (*b. Cincinnati, Ohio, 1867; d. 1935*), journalist, educator, historian. Taught principally at College of Charleston, 1903–20, and at Scripps College, 1927–35. Author of several novels, three successful textbooks in American history, and, among other historical studies, *An Autobiography of Abraham Lincoln* (1926) and *Nelson W. Aldrich* (1930). An able, thorough, and judicious writer, Stephenson was not distinguished for originality of research.

STERETT, ANDREW (*b. Baltimore, Md., 1778; d. 1807*), naval officer. Entered navy as a lieutenant, 1778; served as executive officer and first lieutenant of the *Constellation*, 1799–1800. Commanding the schooner *Enterprise*, he fought a brilliant engagement against a Tripolitan polacca in the Mediterranean, August 1801.

STERKI, VICTOR (*b. Solothurn, Switzerland, 1846; d. 1933*), physician, conchologist. Immigrated to America, 1883; practiced in New Philadelphia, Ohio. Made exhaustive studies of the smaller mollusks, in particular, the *Sphaeriidae*.

STERLING, GEORGE (*b. Sag Harbor, N.Y., 1869; d. San Francisco, Calif. 1926*), poet. Friend and disciple of Ambrose Bierce.

STERLING, JAMES (*b. Dowrass, Ireland, 1701[?]; d. Kent Co., Maryland, 1763*), Anglican clergyman, colonial customs official. Came to America, 1737; held several rectorships in Maryland. Author of *The Rival Generals* (1722), *The Parricide* (1736), and several volumes of lyric poetry before his immigration, Sterling expressed his conviction that the greatness of Britain was bound up with the development of its American colonies in a long poem *An Epistle to the Hon. Arthur Dobbs*. Written in Maryland, 1748, it was published in London and Dublin, 1752. A group of his later poems appeared in the *American Magazine*, 1757.

STERLING, JOHN WHALEN (*b. Blackwalnut, Pa., 1816; d. Madison, Wis., 1885*), educator. A graduate of the College of New Jersey (Princeton), 1840, and Princeton Theological Seminary, 1844, he became professor of mathematics, natural philosophy, and astronomy at University of Wisconsin in 1849. For some years he served as acting chancellor, dean, and vice-chancellor. In 1869 he was appointed vice president of the university and held the office until his death. Because of his devoted service, he is regarded as the chief builder and the guiding spirit of the university in its early years.

STERLING, JOHN WILLIAM (*b. Stratford, Conn., 1844; d. Grand Metis, Quebec, Canada, 1918*), lawyer, philanthropist. Graduated Yale, 1864; Columbia Law School, 1867. Employed in New York City office of David D. Field, he shortly became a junior

partner in the firm of Field & Shearman, and was associated in the practice of law with Thomas G. Shearman, 1873–1900. Counsel for Jay Gould, James Fisk, and other sensational clients, he acted also for the defense in the celebrated suit of Theodore Tilton against Henry Ward Beecher. Long active in a most lucrative corporation practice, Sterling left his estate to Yale University, providing thereby for erection of the Sterling Memorial Library and a number of other buildings. The receipt of this estate doubled Yale's resources.

STERLING, ROSS SHAW (*b. near Anahuac, Chambers Co., Tex., 1875; d. Fort Worth, Tex., 1849*), oilman, public official. President of Humble Oil Co. (later Humble Oil and Refining Co.), 1911–22; chairman of the board, 1922–25. A convinced "dry" and rigid advocate of honest government, he entered politics in opposition to the Texas dynasty of James E. Ferguson and his wife, "Ma" Ferguson. After serving with great ability as chairman of the Texas Highway Commission, 1926–30, he won the Democratic nomination for governor and was elected. Despite his honest intentions and public spirit, he could not cope with the double problems of the depression and ruinous overproduction in the East Texas oil field. Defeated in the 1932 primary by Ma Ferguson, he returned to private business.

STERN, BILL (*b. Rochester, N.Y., 1907; d. Rye, N.Y., 1971*), sports announcer. Began his career in 1925 with a Rochester, N.Y., radio station and began covering sports for NBC in 1934. He launched the TV sports talk show "The Bill Stern Sports Review" in 1937 and the "Colgate Sports Newsreel" in 1939, a fifteen-minute spirited and entertaining sports information show that combined fact with fiction and ran nightly until 1951.

STERN, JOSEPH WILLIAM (*b. New York, N.Y., 1870; d. Brightwaters, N.Y., 1934*), songwriter, music publisher. Author of, among other songs, with Edward B. Marks, his partner, "The Little Lost Child" (1894) and "My Mother Was a Lady" (1896). Became leading publishers of current hits *post* 1896.

STERN, KURT GUENTHER (*b. Tilsit, Germany, 1904; d. London, England, 1956*), biochemist. Studied at the Friedrich-Wilhelms University in Berlin (Ph.D., 1930). Immigrated to the U.S. in 1935. Taught at Yale University (1935–42); at the Overly Biochemical Research Foundation (1942–44); and at Brooklyn Polytechnic Institute (1944–56). Stern's work included study of the influences of heavy metals on the proteolytic action of tissue extracts on proteins; attempts at unraveling the Pasteur reaction (unsuccessful); and successful attempts to clarify the chemical and physical characteristics of catalase enzymes.

STERN, OTTO (*b. Sohrau, Upper Silesia, Germany, 1888; d. Berkeley, Calif., 1969*), physicist and physical chemist. Attended universities of Freiburg, Munich, and Breslau (Ph.D., 1912). Became an unpaid assistant to Albert Einstein in Prague, then accompanied him to Zurich as an unsalaried lecturer at Eidgenössische Technische Hochschule. In 1914 he transferred to the University of Frankfurt, but was drafted into the German army with outbreak of World War I. After the war he resumed his post at Frankfurt (until 1921) and began a series of investigations based on a dormant molecular-beam method, developing the technique into one of the most powerful research tools of modern physics; it was for the results of the series of experiments performed with this technique that he received the Nobel Prize for physics in 1943. His first experiment was the direct measurement of the distribution of the velocities in a gas at low temperature. His next result showed that individual atoms behave in a discontinuous or "jerky" manner instead of smoothly or continuously. At the University of Rostock (1921), the University of Hamburg (1922–33), and Carnegie Institute of Technology (1933–45), where he established a molecular-beam laboratory. He retired in 1945.

STERNBERG, CONSTANTIN IVANOVICH (*b. St. Petersburg, Russia, 1852; d. Philadelphia, Pa., 1924*), baron, pianist, composer, teacher. Having achieved a brilliant European reputation, he made a concert tour of the United States, 1880–81. He settled there in 1886, becoming an American citizen. He conducted the Sternberg School of Music in Philadelphia, Pa., *post* 1890; among his pupils were Olga Samaroff, Robert Armbruster, and George Antheil.

STERNBERG, GEORGE MILLER (*b. Hartwick Seminary, Otsego Co., N.Y., 1838; d. Washington, D.C., 1915*), bacteriologist, epidemiologist. M.D., New York College of Physicians and Surgeons, 1860. Appointed assistant surgeon, U.S. Army, May 1861, he was made prisoner at first battle of Bull Run, but escaped and participated in the early stages of the Peninsular campaign. Contracting typhoid, he passed the remainder of his Civil War service on hospital duty. After the war he served until 1879 at a number of army posts. While at Fort Barrancas, Fla., 1872–75, he noted the efficacy in treating yellow fever of removing inhabitants from an infected environment and successfully applied the method at the fort. Two articles in the *New Orleans Medical and Surgical Journal* (1875, 1877) gave him status as an authority upon that disease. On duty with the Havana Yellow Fever Commission, 1879–80, he studied its nature and the natural history of its cause; this involved microscopical examination of blood and tissues of yellow fever patients. In these investigations he was one of the first to employ the newly discovered process of photomicrography. In 1881 he reported that the so-called *Bacillus malariae* had no part in the causation of malaria. In the same year, simultaneously with Pasteur, he announced his discovery of the pneumococcus. He was the first in the United States to demonstrate the plasmodium of malaria, 1885, and the bacilli of tuberculosis and typhoid fever, 1886. His interest in bacteriology naturally led to an interest in disinfection; scientific disinfection had its beginning with his work and that of Koch.

Named surgeon general of the army with the rank of brigadier general in 1893, his nine years' tenure of that office saw the establishment of the Army Medical School, the organization of the Army Nurse Corps and the Dental Corps, the creation of the tuberculosis hospital at Fort Bayard, and of many general hospitals during the Spanish-American War. In 1898 he set up the Typhoid Fever Board, and in 1900, the Yellow Fever Commission. He was the first American bacteriologist to bring the fundamental principles and technique of the new science within the reach of American physicians. In 1892 he published *A Manual of Bacteriology*, the first exhaustive treatise on the subject published in the United States.

STERNE, MAURICE (*b. Libau, Latvia, 1878; d. Mount Kisco, N.Y., 1957*), artist. Studied at the National Academy of Design. The son of Jewish immigrants who came to the U.S. in 1889, Sterne won a grant to study in Paris in 1904. He was influenced by Cézanne and knew many leading art figures, including Gertrude Stein and Max Weber. After travel to Egypt, India, and Bali, Sterne had produced a great deal of work that brought him acclaim in America. In 1918, he founded an art school in Anticoli, Italy. Sterne's work is considered academic and conventional, though many pieces hang in major galleries throughout the world. In 1935, he was commissioned to paint murals for the library of the Department of Justice. In 1929, he was president of the Society of American Painters, Sculptors, and Engravers.

STERNE, SIMON (*b. Philadelphia, Pa., 1839; d. 1901*), lawyer, civic reformer. LL.B., University of Pennsylvania, 1859. Practiced in New York City *post* 1860, eventually specializing in cases involving common carriers. Secretary of the Committee of Seventy, which overthrew the Tweed Ring, he served on a number of commissions to secure improvement in New York State legislation and drafted a large body of legislation designed to regulate the activities of railroad companies. In the course of his practice, he secured important additions to the common law of New York with respect to the liability of railroad companies for obstructing passage of light and air, the responsibility of carriers to handle freight during a strike, and the analogy between telephone service and that rendered by a common carrier.

STERNE, STUART *See* BLOEDE, GERTRUDE.

STERRETT, JAMES MACBRIDE (*b. Howard, Pa., 1847; d. 1923*), Episcopal clergyman, philosopher. Professor of philosophy at Seabury Divinity School, Minnesota, 1882–92; at Columbian (present George Washington) University, 1892–1909. Rector and associate rector at All Souls', Washington, D.C., *post* 1911. An adherent of the "St. Louis school" headed by William T. Harris, he devoted his thought to the philosophical principles which underlie the intellectual aspect of religion. By his several books and his teaching he helped give idealism a better standing in relation to the empirical pragmatic trend so pronounced in his time.

STERRETT, JOHN ROBERT SITLINGTON (*b. Rockbridge Baths, Va., 1851; d. 1914*), archaeologist. Attended University of Virginia, 1868–71; studied at Leipzig, Berlin, and Munich, where he received the Ph.D., 1880. After service as professor of Greek at Miami University, University of Texas, and Amherst, he headed the Greek department at Cornell *post* 1901. His numerous published works include the data of his explorations and research in Asia Minor and Babylonia. Among other achievements, he identified the sites of scores of important ancient cities, among them the Lystra of St. Paul's travels.

STETEFELDT, CARL AUGUST (*b. Holzhausen, Germany, 1838; d. Oakland, Calif., 1896*), metallurgist. Came to America, 1863. Invented and developed the Stetefeldt furnace, since superseded but in its time marking an advance in reducing sulphide ores containing gold and silver by the chlorination process.

STETSON, AUGUSTA EMMA SIMMONS (*b. Waldoboro, Maine, ca. 1842; d. 1928*), Christian Science leader. Successful in developing Christian Science work in New York City *post* 1886, Stetson was formally excommunicated by Mary Baker Eddy in November 1909.

STETSON, CHARLES AUGUSTUS (*b. Newburyport, Mass., 1810; d. Reading, Pa., 1888*), hotel proprietor. Manager and host of the Astor House, New York City, 1838–68.

STETSON, CHARLES WALTER (*b. Tiverton Four Corners, R.I., 1858; d. Rome, Italy, 1911*), portrait painter, landscapist.

STETSON, FRANCIS LYNDE (*b. Keeseville, N.Y., 1846; d. 1920*), lawyer. Graduated Williams, 1867; Columbia Law School, 1869. Expert in the organization and reorganization of corporations, Stetson became the personal counsel of J. Pierpont Morgan and, as such, took a leading part in creation of the U.S. Steel Corporation and other Morgan promotions. Active in Democratic politics, he was a friend and adviser of Grover Cleveland. He is to be credited with suggesting Cleveland's "sound money" policy; as Morgan's counsel, he attended the 1895 meeting at the White House at which the Morgan-Belmont syndicate offered to sell gold to the government to stem the drain on U.S. gold reserves. An extreme economic conservative, he joined with Joseph H. Choate and others in opposing the federal income-tax amendment to the Constitution.

STETSON, HENRY CROSBY (*b. Cambridge, Mass., 1900; d. at sea, 1955*), geologist. Studied at Harvard (M.A., 1926). Taught at the Harvard Museum of Comparative Zoology (1927–55); worked at the Woods Hole Oceanographic Institution (1931–55). A specialist in paleontology and marine geology, Stetson devoted his life to research in these fields. He proposed theories on the nature of the continental shelves, maintaining that they were the products of sedimentation.

STETSON, JOHN BATTERSON (*b. Orange, N.J., 1830; d. De Land, Fla., 1906*), hat manufacturer. Opened a one-man hat factory in Philadelphia, Pa., 1865, which grew through provision of a high-quality product into a vast industrial plant. Long a generous donor to Baptist churches and charities, Stetson was principal benefactor of the present John B. Stetson University at De Land.

STETSON, WILLIAM WALLACE (*b. Greene, Maine, 1849; d. probably Auburn, Maine, 1910*), educator, public school administrator. Introduced extensive and constructive reforms as superintendent of Maine schools, 1895–1907.

STETTINIUS, EDWARD REILLY (*b. Chicago, Ill., 1900; d. Greenwich, Conn., 1949*), corporation executive, public official. Son of Edward R. Stettinius (1865–1925). An Episcopalian, he considered becoming a minister, but was persuaded by John Lee Pratt, vice president of General Motors, to apply his humanitarian ideals to a business career. He began as a stockroom clerk at GM's Hyatt roller-bearing division and soon rose to employment manager. In 1926, as special assistant to Pratt, he instituted one of the automobile industry's first group insurance plans. He became assistant to GM president Alfred P. Sloan, Jr., in 1930 and, a year later, vice president in charge of industrial and public relations. In 1934 Stettinius moved to the U.S. Steel Corporation as a vice president, and the following year he became chairman of the board.

President Franklin D. Roosevelt appointed him to the Industrial Advisory Board in 1933 and chairman of the War Resources Board in 1939. The following year he was placed on the new National Defense Advisory Commission, at which point he resigned from U.S. Steel to devote full time to government service. He became director of priorities of the Office of Production Management in January 1941 and, nine months later, administrator of lend-lease.

In September 1943, Roosevelt appointed Stettinius undersecretary of state and charged him with the task of reorganizing the State Department. On Dec. 1, 1944, after the resignation of the ailing Cordell Hull, Stettinius was named secretary of state. His most notable contributions as secretary of state centered on his vigorous efforts to establish the United Nations. As undersecretary he had headed the American delegation to the seminal Dumbarton Oaks Conference in 1944. In February 1945 he accompanied Roosevelt to the Yalta Conference with Churchill and Stalin, at which it was decided to call a conference in San Francisco at the end of April to form the new organization. Stettinius subsequently attended the Inter-American Conference in Mexico City, which resulted in the Act of Chapultepec, which laid the foundation for the Organization of American States in 1948.

President Truman, who did not fully share Roosevelt's confidence in Stettinius, accepted his resignation as secretary of state at the close of the San Francisco Conference, but appointed him

chairman of the U.S. delegation to the United Nations Preparatory Commission and, in January 1946, chairman of the American delegation to the first session of the UN General Assembly, as well as American representative on the Security Council. He resigned in June of that year.

STETTINIUS, EDWARD RILEY (*b. St. Louis, Mo., 1865; d. Locust Valley, N.Y., 1925*), industrialist. Acting for J. P. Morgan & Co., Stettinius supervised contracts for, and production of, the war supplies purchased in the United States by the Allies, 1915–17. He continued his work after the entry of the United States into World War I, acting first as surveyor general of purchases and as an assistant secretary of war, 1918–19. Thereafter he was with the Morgan firm until his death.

STEUBEN, FRIEDRICH WILHELM LUDOLF GERHARD AUGUSTIN, BARON VON (*b. Magdeburg, Germany, 1730; d. Steuben, Oneida Co., N.Y., 1794*), baron, soldier. Son of a lieutenant of engineers in the army of Frederick William I of Prussia, Steuben spent his early childhood in Russia, where his father served for several years in the army of the Czarina Anne. Entering the officer corps of the Prussian army, he served with credit through the Seven Years' War as an infantry officer and later on the staff; he became a general staff officer, 1761, and soon thereafter was promoted captain. After a diplomatic mission to Russia, 1762, he served at the royal headquarters as one of the aides-de-camp to the king. His specific training for the experience in general staff duties, a military agency then little known outside Prussia, equipped him peculiarly for his career in the American Revolution. Discharged for obscure reasons from the army in the spring of 1763, he took employment as chamberlain at the court of the prince of Hohenzollern-Hechingen in 1764. There he attained the rank of baron. Financial difficulties caused him to seek employment in 1776, first with the French, then with the margrave of Baden, and finally, 1777, in the American army. In letters from Benjamin Franklin and others to Washington, he was introduced as a lieutenant general in the service of Prussia, although his actual rank was that of captain.

Well received in America because of the prestige of his supposed rank and his declaration that he wished no immediate compensation and would stake his fortunes upon the success of the Revolution, Steuben reported in February 1778 to Washington at Valley Forge. Prevailed upon to serve as acting inspector general and to undertake the training of the army, he was immediately successful. This involved serious difficulties, since he had to act through interpreters. He prepared brief drill instructions which were issued to the regiments from time to time as the drills progressed. He formed a model company of 100 selected men and undertook its drill in person. Progress of this company under his skilled instruction made an immediate appeal to the imagination of the whole army and drill became the fashion. In consequence, Washington recommended his regular appointment as inspector general with the rank of major general on Apr. 30. Thereafter, the Continental army proved itself, battalion for battalion, the equal in discipline of the best British regulars.

During the winter of 1778–79, Steuben prepared his *Regulations for the Order and Discipline of the Troops of the United States*, which became the military bible of the Continental army. He grew steadily in Washington's confidence; he was consulted upon all questions of strategic and administrative policy, and performed all of the essential functions of a modern general staff. In the autumn of 1780, when General Nathaniel Greene was sent to the Carolinas, Steuben accompanied him to assist in reorganizing the southern army. Greene, realizing that most of his replacements and supplies came from Virginia, left Steuben in command in that state. His efforts to make Virginia a base of supply for Greene's army were thwarted to a large extent by British forces, and with his limited troops, Steuben could offer slight resistance. Greene, however, appreciated Steuben's difficulties and acknowledged that his support had been indispensable to the success of the Carolina campaign. When Lafayette took command in Virginia in April 1781, Steuben served under his orders; at Yorktown, Steuben commanded one of the three divisions of the besieging army. In 1783 he assisted Washington in preparation of a plan for the future defense of the United States and in the arrangements for demobilizing the Continental army. When Washington relinquished command of the army, he deliberately made it his last official act to write a letter commending Steuben's invaluable services to the United States throughout the war. After retirement from the army, Steuben, a citizen of the United States since 1783, resided in New York and became one of the most popular figures in the social life of the city and state. In converting the American army into an effective and highly disciplined military force, he performed an essential service that none of his contemporaries in America was qualified to perform.

STEUBEN, JOHN (*b. Ukraine, Russia, 1906; d. Flemington, N.Y., 1957*), labor leader. Immigrated to the U.S. in 1923. In the early 1930's, Steuben became a full-time organizer for the Steel and Metal Workers Industrial Union, an affiliate of the Trade Union Unity League, the Communist-led union federation established in 1929. In 1936, he became an organizer for the Steel Workers Organizing Committee, which was actively trying to organize the Bethlehem, Republic, Inland, and Youngstown steel companies. The attempt ended in violence, and Steuben was purged because of his Communist affiliation. Steuben served in World War II, and was editor of the *March of Labor* from 1950 to 1954.

STEUER, MAX DAVID (*b. Homino, present Czechoslovakia, 1870[?]; d. Jackson, N.H., 1940*), lawyer. Came to New York City as a child. LL.B., Columbia Law School, 1893. Practicing in New York City *post* 1893, he became one of the outstanding trial lawyers of his time, skillful alike in commercial and criminal cases. Possessed of an unusual capacity for grasping a case as a whole, as the sum of all its parts, he also had great technical skill as a cross-examiner and was most dangerous when apparently checkmated.

STEVENS, ABEL (*b. Philadelphia, Pa., 1815; d. San Jose, Calif., 1897*), Methodist clergyman, editor. Author of *The History of the Religious Movement of the Eighteenth Century, Called Methodism* (1858–61) and *The History of the Methodist Episcopal Church in the United States* (1864–67), which take high rank among denominational histories.

STEVENS, ALEXANDER HODGDON (*b. New York, N.Y., 1789; d. 1869*), surgeon. Brother of John A. Stevens (1795–1874). Graduated Yale, 1807. Studied medicine with Edward Miller; M.D., University of Pennsylvania, 1811; studied also in London and Paris. Professor of surgery at present Rutgers and at New York College of Physicians and Surgeons, he was president of the latter institution, 1843–55. He maintained a large practice in New York City and held many honorary appointments.

STEVENS, ASHTON (*b. San Francisco, Calif., 1872; d. Chicago, Ill., 1951*), drama critic. Critic and writer for the Hearst paper *San Francisco Examiner* (1897–1906); for the *Chicago Examiner*, from 1910 until his death. A witty, restrained reviewer, Stevens was considered by many to be the dean of American theater reviewers.

STEVENS, BENJAMIN FRANKLIN (*b. Barnet, Vt., 1833; d. Surbiton, England, 1902*), bookman, antiquarian. Brother of Henry

Stevens. Editor of a number of reprints of rare works and manuscripts of Americana.

STEVENS, CLEMENT HOFFMAN (*b. Norwich, Conn., 1821; d. 1864*), Confederate brigadier general. Grandson of Peter Fayssoux. Designed armored battery on Morris Island, Charleston, S.C. Recklessly gallant, he was mortally wounded near Peachtree Creek in the campaign against Atlanta, Ga.

STEVENS, DORIS (*b. Omaha, Nebr., 1892; d. New York, N.Y., 1963*), suffragist and feminist leader. Graduated from Oberlin (1911). Joined the suffrage crusade and became a member of the Congressional Union for Woman Suffrage (1914), which became the National Woman's Party in 1916. She was arrested for picketing the White House in 1917 and served three days of a sixtyday sentence; wrote *Jailed for Freedom* (1920) about the militant suffrage effort. Chaired the NWP's International Relations Committee (1923–29); led an NWP delegation to the Sixth Pan-American Conference (1928) to lobby for equal rights, which led to the creation of the Inter-American Commission of Women (which she chaired 1928–39); and was a member of the Women's Consultative Committee on Nationality for the League of Nations (1931–36). Later became an ardent champion of Sen. Joseph McCarthy.

STEVENS, EDWIN AUGUSTUS (*b. Hoboken, N.J., 1795; d. Paris, France, 1868*), engineer, financier. Son of John Stevens, whose business affairs he managed in great part; brother of Robert L. Stevens. Organized the Camden & Amboy Railroad, 1830, and managed it with great success until his death. Began experiments in construction of an armored or ironclad warship ca. 1814, which came to fruition in his vessel *Stevens Battery* 40 years later, but failed of acceptance by the government. He left land and money for the establishment of Stevens Institute of Technology in Hoboken.

STEVENS, EMILY (*b. New York, N.Y., 1882; d. New York, 1928*), actress. Cousin of Minnie Maddern Fiske. Adept in the performance of roles of beautiful and alluring women, she played for a number of years with her cousin's companies and scored her first great success in *The Unchastened Woman*, New York, 1915. She later won acclaim for her performance in *Fata Morgana*, 1924.

STEVENS, GEORGE BARKER (*b. Spencer, N.Y., 1854; d. 1906*), theologian. Graduated University of Rochester, 1877; Yale Divinity School, 1880; Ph.D., Syracuse, 1883; D.D., Jena, 1886. Professor of New Testament criticism, Yale Divinity School, 1886–95, and professor of systematic theology thereafter, he was author of a number of books which were concerned chiefly with the reinterpretation of religious truth in the light of modern scholarship.

STEVENS, GEORGE COOPER (*b. Oakland, Calif., 1904; d. Beverly Hills, Calif., 1975*), motion-picture director. In 1921 started a Hollywood career as a cameraman at Hal Roach studios, where he began directing films in 1930. Between 1933 and 1943, he directed for several studios; his films included several box-office hits, including *Swing Time* (1936), *Gunga Din* (1939), and *Woman of the Year* (1942). During World War II he headed the famous Special Motion Picture Coverage Unit and documented the horrors of the Dachau concentration camp. He cofounded Liberty Pictures, which released *It's a Wonderful Life* (1946). Liberty merged with Paramount in 1949, and Stevens directed such notable films as *A Place in the Sun*, for which he won an Oscar as best director (1951), and *Shane* (1953), which received an Oscar for photography. Stevens received the Irving Thalberg Academy Award for a lifetime of cinematic achievement in 1954.

He won his second director's Oscar for *Giant* (1956) and also directed *The Diary of Anne Frank* (1959) and *The Greatest Story Ever Told* (1965).

STEVENS, GEORGE WASHINGTON (*b. Utica, N.Y., 1866; d. 1926*), educator, journalist. Revolutionized museum practice as director of the Toledo (Ohio) Museum of Art, 1903–26. Under his guidance the Toledo Museum was the first to enter on a policy of art education for all people, the first to maintain a free school of design, and among the first to give music an equal rank with the other arts.

STEVENS, HARRY MOZLEY (*b. London, England, 1855; d. New York, N.Y., 1934*), and **STEVENS, FRANK MOZLEY** (*b. London, 1880; d. New York, N.Y., 1965*), sports concessionaires and caterers. Starting with a concession to sell baseball scorecards at the Columbus, Ohio, park in 1887, Harry obtained other concessions over the next four years, including the New York Giants Polo Grounds in 1894, where he also sold snack food to fans. After 1900 he began selling peanuts, soda pop, and hot dogs. He built an army of hirelings to sell his food and expanded his enterprise into a profitable catering industry, catering to patrons of hotels, indoor shows, exhibitions, conventions, recetracks, and other public entertainments. Frank succeeded his father as head of Harry M. Stevens, Inc., having thirty-eight years experience with the firm. Although by the 1960's the firm had only two baseball concessions left, in 1962 it was estimated that it served about 30 million customers.

STEVENS, HENRY (*b. Barnet, Vt., 1819; d. London, England, 1886*), bookman. Brother of Benjamin F. Stevens. A pioneer in the collection of rare Americana, Stevens was also an authority on the bibliographical history of the English Bible. He was author of, among other works, *Recollections of Mr. James Lenox* (1886).

STEVENS, HIRAM FAIRCHILD (*b. St. Albans, Vt., 1852; d. 1904*), lawyer, Minnesota legislator. Removed to St. Paul, Minn., 1879, where he practiced until his death. A leader in starting the St. Paul College of Law, 1900, he served as its president thereafter.

STEVENS, ISAAC INGALLS (*b. Andover, Mass., 1818; d. Chantilly, Va., 1862*), soldier. Graduated West Point, 1839. Commissioned in the engineers, he served ably on fortification work in New England and was on General Winfield Scott's staff in the war with Mexico, winning brevets for gallantry in the capture of Mexico City. Executive assistant, U.S. Coast Survey, 1849–53, he showed high administrative talent; resigning from the army, he served as governor, Washington Territory, 1853–57. During this period he acted as director of exploration for the northern route of the Pacific Railway surveys. His term as governor was a controversial one since his Indian treaty policy brought about a number of uprisings among the tribes in the territory. Although much criticized, he was elected territorial delegate to Congress and served from March 1857 until the opening of the Civil War. Appointed colonel, 79th New York Volunteers, he was promoted, brigadier general, September 1861, and major general, July 1862. He was killed in battle.

STEVENS, JOHN (*b. New York, N.Y., 1749; d. Hoboken, N.J., 1838*), engineer, inventor. Grandson of James Alexander; father of Edwin A. and Robert L. Stevens. Graduated King's College (present Columbia), 1768. After Revolutionary War services, principally as a collector of money in New Jersey for the Continental army, he served as surveyor general for the eastern division of New Jersey, 1782–83, and then turned to the development of an estate in and around what is presently Hoboken,

N.J. About 1788 his attention was drawn to the work of John Fitch and James Rumsey in the development of the steamboat; thereafter until his death he devoted himself to advancement of mechanical transport on water and on land. Concentrating on the use of steam, he began to work out designs of boilers and engines unique for the time. In 1791, having helped to bring about the framing of the act of 1790 establishing the first patent laws, he was among the first dozen citizens to receive U.S. patents; his inventions included an improved vertical steam boiler and an improved Savery-type steam engine, both intended for boat propulsion. He associated himself *ca.* 1797 with Nicholas I. Roosevelt and Robert R. Livingston in the project of building a steam engine and boat. Livingston obtained the exclusive privilege of steamboat operation on the waters of New York State, and with this incentive the partners set to work with added vigor. An experimental boat, the *Polacca*, proved unsuccessful in trials on the Passaic River, but experiments were continued and in 1800 a definite 20-year partnership agreement was consummated. Shortly after, Stevens became consulting engineer for the Manhattan Co., organized to furnish an adequate water supply to New York City. He convinced the directors that steam pumping engines should be used, and installed equipment of his own design, but it was not efficient, and a Boulton & Watt type of engine was later substituted. In 1803, after further experimentation, he secured a patent for a multitubular boiler. In the following year his small twin-screw steamboat *Little Juliana* traveled back and forth across the Hudson. Spurred to greater effort, Stevens determined to inaugurate an adequate steam ferry system between Hoboken and New York, and to operate a regular line of steamboats on the Hudson between New York and Albany. Before his *Phoenix* was completed, however, Fulton's *Clermont* made its successful voyage in 1807 to Albany and return. The achievement discouraged Stevens, since it was made under a monopoly granted to Livingston and Fulton, and he still considered himself bound by the earlier agreement with Roosevelt. He also had come to believe that any monopoly was unconstitutional. Restricted by law from using the Hudson River, he sent the *Phoenix* to Philadelphia in 1809. It made the trip successfully and is considered the first seagoing steamboat in the world. Thereafter, plying between Philadelphia and Trenton, it served as a unit in the cross-state transportation system which was controlled and managed by Stevens' sons.

About 1810, he began giving greater attention to adaptation of the steam engine as motive power for railways. He induced the New Jersey Assembly in February 1815 to create a railway company. Eight years later, the Pennsylvania legislature authorized a railway company and empowered Stevens to build it. The necessary funds, however, could not be raised, although in 1825 he designed and built an experimental locomotive and operated it on a circular track on his estate in Hoboken to prove the feasibility of the scheme. This was the first American-built steam locomotive, though it was never used for actual service on a railroad. Stevens also proposed an armored navy, bridging the Hudson from New York to Hoboken, a vehicular tunnel under the Hudson, and an elevated railway system for New York City.

STEVENS, JOHN AUSTIN (*b. New York, N.Y., 1795; d. New York, 1874*), banker. Brother of Alexander H. Stevens; father of John A. Stevens (1827–1910). President of the Bank of Commerce, New York City, 1839–66.

STEVENS, JOHN AUSTIN (*b. New York, N.Y., 1827; d. Newport, R.I., 1910*), financier, author. Son of John A. Stevens (1795–1874). Founded the *Magazine of American History*, which he edited, 1877–81; author of *Colonial Records of the New York Chamber of Commerce* (1867), *The Burgoyne Campaign* (1877), *Albert Gallatin* (1884), and other works.

STEVENS, JOHN FRANK (*b. near West Gardiner, Maine, 1853; d. Southern Pines, N.C., 1943*), civil engineer, railroad executive. Graduated State Normal School, Farmington, Maine, 1872. Removed to Minneapolis, Minn., 1873, where an engineer uncle helped him secure work as a rodman for the city engineer. Deciding to make a career in railroad work in 1875, he subsequently worked for the Sabine Pass & Northwestern Railroad; the Denver & Rio Grande Railroad; the Chicago, Milwaukee & St. Paul Railroad, 1881–82 and 1885–86; the Canadian Pacific Railroad, 1882–84; and beginning in 1886, the Duluth, South Shore & Atlantic Railroad.

Stevens next worked briefly as assistant engineer of the Spokane Falls & Northern Railway, where he gained valuable knowledge of the Pacific Northwest, and then began an important association with the Great Northern Railway and its president, James J. Hill. Hill was building an unsubsidized transcontinental railroad through the northernmost tier of states, and one of Stevens' first assignments was to explore the route west from Havre, Mont. He established the feasibility of the now famous Marias Pass, which provided the key passage across the Continental Divide. Sent next to Washington to explore the Columbia River and the Cascades for the final route down the western slopes of the Divide, he located another important pass, later named Stevens Pass, near Lake Wenatchee.

When the Pacific extension was completed in 1893, Stevens became assistant chief engineer on the Great Northern, with which he remained intermittently until 1903. During these years he supervised the planning and construction of more than a thousand miles of new track, much of it in Minnesota. Stevens left the Great Northern in 1903 to become chief engineer (in 1904, second vice president) of the Chicago, Rock Island & Pacific Railway. The following year he was named to the federal Philippine Commission, to head its railroad building program. Before he could serve, however, Secretary of War William Howard Taft named Stevens, on Hill's suggestion, as chief engineer of the Isthmian Canal Commission.

When Stevens arrived at the Canal Zone in the early part of 1906, he found conditions chaotic. Drawing on his years of railroad experience, Stevens immediately set about reorganizing the work force and engineering staff. He also accepted the theory of the mosquito as the vector for yellow fever and malaria and aided Col. William C. Gorgas, head of the sanitation department, in implementing adequate sanitary and health measures. Construction was under way late in 1906, but Stevens, frustrated by political maneuvering in Washington, resigned a few months later.

Upon returning to the United States, Stevens became vice president of the New York, New Haven & Hartford Railroad, but in 1909 he accepted an offer to rejoin Hill in the building of a southward extension of the Hill lines from the Columbia River through central Oregon, the first step toward a connection with San Francisco; the new line was successfully completed in 1911. He then moved to New York City, where for several years he was a private consultant.

In 1917 Stevens was appointed by President Wilson as chairman of an advisory commission of American railway experts to study the Russian railway system. He went to Siberia later in 1917 as head of a second American commission, the Russian Railway Service Corps, and began reorganizing the Trans-Siberian and Chinese Eastern railways. In 1919 he was named president of the Technical Board of the Inter-Allied Railway Commission, an international body set up to supervise railways in those parts of Siberia and Manchuria where Allied troops were stationed. Upon his return to the United States in 1923, he became a member of the board of directors of the Baltimore & Ohio Railroad.

STEVENS, JOHN HARRINGTON (*b. Brompton Falls, Quebec, Canada, 1820; d. 1900*), Minnesota pioneer, agricultural editor.

After service in the Mexican War, Stevens settled *ca.* 1849 on a claim on the west banks of the Mississippi at the Falls of St. Anthony. His house was the first dwelling erected in the present city of Minneapolis.

STEVENS, JOHN LEAVITT (*b. Mount Vernon, Maine, 1820; d. Augusta, Maine, 1895*), journalist, diplomat. Associated with James G. Blaine on the *Kennebec Journal* of Augusta, Maine. Stevens served as U.S. minister to Paraguay, Uruguay, Norway, and Sweden between 1870 and 1883. As minister resident to Hawaii and later as envoy extraordinary, 1889–93, he played a prominent part in the 1893 rebellion whereby Queen Liliuokalani was dethroned and a provisional government under Sanford B. Dole was installed.

STEVENS, ROBERT LIVINGSTON (*b. Hoboken, N.J., 1787; d. Hoboken, 1856*), engineer, naval architect, inventor. Son of John Stevens; brother of Edwin A. Stevens. Assistant to his father in his steam propulsion experiments, he helped in the design and construction of the steamboat *Phoenix*, 1808, and with Moses Rogers took it on its pioneer sea voyage from New York to Philadelphia, 1809. Recognized in time as a leader in naval architecture, he designed and had built more than 20 steamboats and ferries which incorporated his successive inventions. Among these were the method of installing knees of wood and iron inside the ship's frame, a "cam-board" cutoff for steam engines, and balanced poppet valves. He also devised an improved type of walking beam, introduced a forced-draft firing system under boilers, and was first to perfect a marine tubular boiler. The split paddle wheel, "hog-framing" for boats, and the present type of ferry slip were also his inventions. He played an important part in managing the family transportation business in New Jersey and was president and engineer *post* 1830 of the Camden & Amboy Railroad, for which he designed the T-rail, the hook-headed spike, and other rail devices. In November 1831, at the throttle of the locomotive *John Bull*, he inaugurated the first steam railway service in New Jersey at Bordentown. *Post* 1815, he worked for many years on problems of ordnance and the armoring of warships.

STEVENS, THADDEUS (*b. Danville, Vt., 1792; d. Washington, D.C., 1868*), lawyer, political leader. Lame and sickly from birth, Stevens grew up in the semifrontier atmosphere of Peacham, Vt., and early developed a strong sympathy for the poor and an intense dislike of caste in any form. Graduating from Dartmouth, 1814, he studied also at the University of Vermont. Beginning the study of law in Vermont, he continued his studies while teaching in an academy at York, Pa., and began practice at Gettysburg, Pa., 1816, engaging also *post* 1826 in the manufacture of iron. Seeing much of the slavery system as it operated in nearby Maryland, he became an extreme hater of the institution and defended numerous fugitive slaves without fee. Entering politics as a violent opponent of Andrew Jackson, he first became prominent at the Anti-Masonic Convention in Baltimore, Md., 1831, where he delivered a notable speech condemning secret orders. As a member of the Pennsylvania House, elected on the Anti-Masonic ticket, 1833–41, he became known as a brilliant advocate for the extension of free public education and as a defender of the protective tariff. At his retirement from the legislature, he was recognized as one of the strongest men in his state. Removing to Lancaster, Pa., 1842, he devoted himself for a while to his legal practice.

Elected to Congress on the Whig ticket, 1848, he took a leading place among the Free-Soilers, setting his face against any compromise with slavery in the territories and denouncing that institution as a national curse and crime with fierce invective. Disgusted with Whig moderation, he left Congress in March

1853. Playing a vigorous part in formation of the Republican party in Pennsylvania, he was reelected to Congress, 1858. Denouncing slavery and pleading for a protective tariff, he also warned the South to secede at its peril and called upon President Buchanan to exert the full federal authority against those who were flouting the national government. Passed over for a cabinet post on President Lincoln's election, he became chairman of the House Ways and Means Committee and exerted wide authority over measures dealing with the prosecution of the Civil War. Though in matters of finance he loyally supported the administration, his ideas of policy diverged sharply from Lincoln's, and he was a constant thorn in the side of the administration on matters concerning the conduct of the war. By 1864 he had become so far committed to stern measures as to speak of the necessity to exterminate the "rebels" and to desolate the South. He laid down the rule that the South was outside the Constitution and that the law of nations alone would limit the victorious North in determining the conditions of Southern restoration. He considered the Wade-Davis bill an inadequate measure for Reconstruction and was probably secretly hostile to Lincoln's 1864 candidacy. His almost fanatical fight to maintain Republican party supremacy in the government was motivated by economic as well as political considerations.

After Lincoln's assassination, Stevens prepared to give battle to Andrew Johnson on the question of reducing the South to a "territorial condition." To Stevens, it was a "conquered province"; he would make it choose between black suffrage and reduced representation. When Congress met in December 1865, a joint committee on Reconstruction was appointed on his motion; as chairman of the House group, Stevens was the dominant member of the committee. The first open rupture with President Johnson came in February 1866 on the Freedmen's Bureau bill, which Stevens belligerently pushed and Johnson vetoed. Stevens succeeded in passing the Civil Rights Act and a revised Freedmen's Bureau Act over Johnson's veto, and in April 1866 the joint committee reported the 14th Amendment, which Congress adopted. A sweeping Republican victory in the congressional elections of 1866 gave Stevens the whip-hand over Johnson and the South. The first use he made of his triumph was to impose military Reconstruction and the 15th Amendment upon the South. When Johnson removed Edwin M. Stanton as U.S. secretary of war early in 1868, Stevens reported an impeachment resolution based on the president's supposed disregard of the Tenure of Office Act. Although a member of the committee to draft articles of impeachment and one of the managers to conduct the case before the Senate, Stevens took little part in the trial itself.

Shortly after Johnson's acquittal, Stevens died. An intense partisan, his career was marred by a harsh and vindictive temper, which in his last years made him frankly vengeful toward the South. His policy aroused fierce resentment, accentuated racial antagonism, cemented the Solid South, and postponed for many decades any true solution of the race problem. Had tolerance been added to his character, he might have been a brilliant, instead of a sinister, figure in American history.

STEVENS, THOMAS HOLDUP (*b. Charleston, S.C., 1795; d. probably Washington, D.C., 1841*), naval officer. Father of Thomas H. Stevens (1819–96). Appointed midshipman, 1809, he won distinction on the Niagara frontier in the War of 1812 and commanded the sloop *Trippe* in the battle of Lake Erie. He later served in a variety of ship and shore commands and was promoted captain, 1836.

STEVENS, THOMAS HOLDUP (*b. Middletown, Conn., 1819; d. Rockville, Md., 1896*), naval officer. Son of Thomas H. Stevens (1795–1841). Appointed midshipman, 1836. During the Civil

War he served with great credit in blockade and other duties along the eastern coast and was the commander of the desperate night boat attack, Sept. 8, 1863, on Fort Sumter. He was later active in Union operations in the Gulf of Mexico. Promoted rear admiral, 1879, he retired, 1881.

STEVENS, WALLACE (*b. Reading, Pa., 1879; d. Hartford, Conn., 1955*), poet. Studied at Harvard, graduating in 1900, and at the New York University Law School (LL.B., 1903). Considered one of the twentieth century's major poets, Stevens never led the publicized life of a successful artist. He worked for the Hartford Accident and Indemnity Co. from 1916 until his death. From 1914 to 1922, he wrote poems for the magazines *Poetry* and *Others*. These poems were published by Alfred A. Knopf in 1923 under the title of *Harmonium*. The volume was reprinted in 1931, establishing Stevens as a leading poet of his generation. From 1923 to 1930, he wrote little. Volumes during the 1930's include *Ideas of Order* (1935), *Owl's Clover* (1936), and *The Man With the Blue Guitar* (1937). Other volumes include *Parts of the World* (1942), *Notes Toward a Supreme Fiction* (1942), *Esthetic du Mal* (1945), *Three Academic Pieces* (1947), *Transport to Summer* (1947), and *The Auroras of Autumn* (1950), which won the National Book Award. His *Collected Poems* (1954) won a second National Book Award, and in 1955, he won the Nobel Prize. After his death, the volume, *Opus Posthumous* was issued in 1957.

STEVENS, WALTER HUSTED (*b. Penn Yan, N.Y., 1827; d. Veracruz, Mexico, 1867*), Confederate brigadier general, military engineer. Graduated West Point, 1848. Served at various times as chief engineer, Army of Northern Virginia; supervised building of defenses of Richmond.

STEVENS, WILLIAM ARNOLD (*b. Granville, Ohio, 1839; d. 1910*), New Testament scholar. Graduated Denison University, 1862; studied also at Harvard, Newton Theological Institution, Leipzig, and Berlin. Taught Greek at Denison; was professor of New Testament interpretation at Rochester Theological Seminary, 1877–1910. A scholarly theological conservative, he was author of, among other books, *A Harmony of the Gospels for Historical Study* (1894).

STEVENS, WILLIAM BACON (*b. Bath, Maine, 1815; d. 1887*), Episcopal clergyman, historian, physician. Brother-in-law of Henry Coppée. Assistant bishop of Pennsylvania, 1862–65, he succeeded to the see. He was instrumental in the founding of Lehigh University and was author of a number of scholarly works on religious and historical subjects, among them, *A History of Georgia from Its First Discovery* (1847, 1859).

STEVENSON, ADLAI EWING (*b. Christian Co., Ky., 1835; d. Chicago, Ill., 1914*), lawyer, U.S. vice president. Removed to Bloomington, Ill., 1852. Began practice of law at Metamora, Ill., 1858; practiced in Bloomington *post* 1868. Congressman, Democrat, from Illinois, 1875–77 and 1879–81, he served without particular distinction but made many friends. As first assistant postmaster general, 1885–89, he performed with extraordinary tact his unpleasant task of removing Republican postmasters to make way for deserving Democrats. As vice president of the United States, 1893–97, he presided gracefully over the Senate and did not embarrass the administration by pressing his well-known "soft money" views. In the campaign of 1900 he was William J. Bryan's running mate, and in 1908 ran unsuccessfully for the governorship of Illinois.

STEVENSON, ADLAI EWING, II (*b. Los Angeles, Calif., 1900; d. London, England, 1965*), politician and government official. Attended Princeton, Harvard Law, and Northwestern Law School (J.D., 1926); became a law clerk in the conservative Republican firm of Cutting, Moore and Sidley in Chicago. He then went to work for the Agricultural Adjustment Administration (1933), became chief attorney for the Federal Alcohol Control Administration (1934), rejoined his law firm and was made partner (1935), and was elected to the Chicago Council on Foreign Relations (1935). He became principal attorney for Secretary of the Navy Frank Knox, serving as speech writer and administrative assistant (1941–44). In 1945 he became special assistant to Secretary of State Edward Stettinius, Jr., his major task being to improve the public image of the State Department. He accompanied Stettinius to London for the Preparatory Commission of the United Nations (1945) and headed the delegation to the early General Assembly sessions of the UN. As governor of Illinois (1948–52) he achieved many improvements in state government, such as removing state police from political patronage, doubling aid to public schools, and launching the state's biggest roadbuilding program. His Democratic presidential campaign in 1952 raised American political thinking to a high plane, and his campaign speeches became best-selling books at home and abroad. After his overwhelming defeat by Dwight D. Eisenhower, he devoted himself to rejuvenating the Democratic party; he played an important part in the successful campaign to elect a Democratic Congress in 1954. The Democratic candidate for president again in 1956, he raised issues that the Eisenhower administration had either ignored or handled inadequately; he advocated the suspension of nuclear testing in the atmosphere, reduction of tensions with the Soviet Union, end of the draft, and increased assistance to underdeveloped countries through the UN. Becoming the conscience of American politics, he urged Americans to live up to their ideals, spoke of the pressing necessity of improving race relations, and decried the destruction of natural resources for private profit. After his defeat, he was a prime mover in the founding of the Democratic Advisory Council, which became an effective instrument for issuing policy statements. As ambassador to the UN (1961–65), he wanted to make this organization the center of U.S. foreign policy, a concept not acceptable to presidents John Kennedy or Lyndon Johnson. Repeated crises marked his tenure at the UN, requiring almost constant negotiations on his part: the Bay of Pigs; the Cuban missile crisis; UN forces in the Congo, on Cyprus, and on the Egypt-Israeli border; the wrangle with Portugal over its control of African colonies; the question of admitting Communist China to the UN; white racism in Rhodesia and South Africa; and the quest for disarmament. He died during UN Secretary General U Thant's overtures to the United States, Soviet Union, and Hanoi to discuss peaceful solutions to the Vietnam War.

STEVENSON, ANDREW (*b. Culpeper Co., Va., 1784; d. Albemarle Co., Va., 1857*), lawyer, Virginia legislator. Nephew of Lewis Littlepage. Congressman, Democrat, from Virginia, 1821–34, he was a member of the influential "Richmond Junto" and Speaker of the House, 1827–34. A Unionist during the nullification controversy, he later was a supporter of Martin Van Buren and served as U.S. minister to Great Britain, 1834–41. He was essentially a machine politician; his career lacks the stamp of a strong personality.

STEVENSON, CARTER LITTLEPAGE (*b. near Fredericksburg, Va., 1817; d. Caroline Co., Va., 1888*), Confederate major general, civil engineer. Nephew of Andrew Stevenson. Graduated West Point, 1838. Served principally in the western campaigns of the Civil War; commanded the right of the Confederate lines during the siege of Vicksburg. Taken prisoner there, he was later exchanged and fought in the Atlanta and Carolina campaigns.

STEVENSON, JAMES (*b. Maysville, Ky., 1840; d. New York, N.Y., 1888*), ethnologist, explorer. Employed in government engineering work *post* 1856, he became a member of the U.S. Geological Survey of the territories under Ferdinand V. Hayden, with whom he made explorations of the Missouri, Columbia, and Snake rivers; in 1871 he took an active part in the survey of the Yellowstone region. He climbed to the summit of the Grand Teton, 1872, and is believed to have been the first white man to do so. Continuing in the survey under the directorship of John W. Powell, he was in the service of the Bureau of Ethnology *post* 1879. Becoming interested in Indian language and customs, he collected a great deal of material on the Pueblo Indians and their former settlements, including large collections of culture material both ancient and modern, which he catalogued in bureau reports and which constitute a valuable and, in most respects, unique contribution to science.

STEVENSON, JOHN JAMES (*b. New York, N.Y., 1841; d. New Canaan, Conn., 1924*), geologist. Graduated present New York University, 1863; Ph.D., 1867. After teaching at West Virginia University and working on the geological surveys of Ohio and Pennsylvania and the Wheeler surveys in the West, he was professor of geology at New York University, 1881–1909. He was particularly interested in stratigraphic problems and those relating to coal.

STEVENSON, JOHN WHITE (*b. Richmond, Va., 1812; d. Covington, Ky., 1886*), lawyer, Kentucky legislator. Congressman, Democrat, from Kentucky, 1857–61, he was a moderate Confederate sympathizer during the Civil War. Elected lieutenant governor of Kentucky, 1867, he became governor in September of that year and served with ability and sanity until 1871. As U.S. senator, 1871–77, he was a close adherent of Jeffersonian principles.

STEVENSON, MATILDA COXE EVANS (*b. San Augustine, Tex., ca. 1850; d. 1915*), ethnologist. Wife and professional associate of James Stevenson. Author of an encyclopedic study on the Zuni Indians (*Twenty-third Annual Report of the Bureau of American Ethnology*, 1901–02, published 1904) and other important works in her field.

STEVENSON, SARA YORKE (*b. Paris, France, 1847; d. 1921*), archaeologist. Raised and educated abroad, she resided in Philadelphia, Pa., *post ca.* 1867. Author of a number of papers on Egyptian archaeology and other subjects, she helped establish the Museum of the University of Pennsylvania and was literary editor of the Philadelphia *Public Ledger*, 1908–21.

STEWARD, IRA (*b. New London, Conn., 1831; d. Plano, Ill., 1883*), labor leader, proponent of eight-hour-day legislation. A believer in labor solidarity and an ultimate socialistic state, Steward, with George E. McNeill and George Gunton, joined with leading American members of the Marxian International Workingmen's Association to form the International Labor Union, 1878, for organization of unskilled laborers. In the realm of theory, Steward held that shorter hours of labor developed leisure-time wants and hence a demand for higher wages. Increased wages in turn would compel introduction of better techniques, which would make mass production possible. Mass production, to be stable, would need mass purchasing powers which must be protected against the down-drag of the unemployed by progressive shortening of hours of labor in accordance with an index of unemployment. Ultimately, the workers would be able to buy the capitalists out and so inaugurate socialism.

STEWARDSON, JOHN (*b. Philadelphia, Pa., 1858; d. near Philadelphia, 1896*), architect. Studied in Paris; was partner with Walter Cope *post* 1886. Primarily an artist, Stewardson specialized in English Gothic; his work at University of Pennsylvania, Bryn Mawr, and Princeton had great influence for good on American educational-building design.

STEWART, ALEXANDER PETER (*b. Rogersville, Tenn., 1821; d. Biloxi, Miss., 1908*), Confederate lieutenant general, educator. Graduated West Point, 1842. An artillery officer, Stewart rose to divisional command in the western campaigns of the Civil War and in the Atlanta campaign; at the end of the war, he was the commander of the Army of Tennessee. He was chancellor of the University of Mississippi, 1874–86.

STEWART, ALEXANDER TURNEY (*b. Lisburn, Ireland, 1803; d. 1876*), merchant. Immigrated to New York City *ca.* 1820; opened a small lace shop in New York, 1823. A canny observer of fashion and the market, he prospered in his own trade and made good profits by sale of stock bought at auction during the panic of 1837. By 1850 he had the largest dry-goods establishment in the city (operating in his own building at Broadway and Chambers St., built 1846), and in 1862 he opened at Broadway and Ninth St. what was then the largest retail store in the world. Profiting also by Civil War contracts, he acquired numerous other interests in the United States and abroad. Purchasing always for cash, he was a strict disciplinarian of his employees and his wage policy was poor even for his time. Garden City, N.Y., was built up by him as a "model town" for persons of moderate means.

STEWART, ALVAN (*b. South Granville, N.Y., 1790; d. 1849*), lawyer, abolitionist. Settled in Utica, N.Y., *ca.* 1832, where he practiced. Founder and first president of New York Anti-Slavery Society, he won by his vivid, erratic speeches the title of "humorist" of the antislavery movement. He advanced the argument that, since slaves were deprived of their freedom without due process, the institution of slavery was unconstitutional. With William L. Garrison, he was responsible for dissension in the national antislavery movement, 1840, and was presiding officer at the convention which organized the Liberty party.

STEWART, ANDREW (*b. Fayette Co., Pa., 1791; d. 1872*), lawyer, Pennsylvania legislator and official. Congressman, Democrat and National Republican, from Pennsylvania, 1821–29 and 1831–35; congressman, Whig, 1843–49. Ardent in support of protection and internal improvements, he was called "Tariff Andy."

STEWART, ARTHUR THOMAS ("TOM") (*b. Dunlap, Tenn., 1892; d. Nashville, Tenn., 1972*), attorney and U.S. senator. Graduated Emory College and Cumberland University (LL.B.) and became Tennessee attorney general in 1925; he was the lead prosecutor in the Scopes "Monkey Trial," which convicted John Scopes for teaching Darwin's theory of evolution in violation of a state law. A conservative Democrat, he was appointed in 1938 to the vacant U.S. Senate seat from Tennessee but lost his election bid in 1942.

STEWART, CHARLES (*b. Philadelphia, Pa., 1778; d. Bordentown, N.J., 1869*), naval officer. Trained in the merchant service, he was commissioned lieutenant, U.S. Navy, 1798, and in 1800 made a very successful cruise in command of the schooner *Experiment*. Capturing two armed French vessels and recapturing a number of American merchantmen, he also provided convoy protection. After further distinguished service in the troubles with the Barbary states, 1802–06, he was commissioned captain. He won further fame during the War of 1812, notably as commander of the *Constitution* from December 1813 to the end of the war. In varied service thereafter, he was made senior flag officer, 1859, and in 1862 became rear admiral on the retired

list. He was the grandfather of Charles Stewart Parnell, the eminent advocate in the British Parliament of Irish home rule.

STEWART, DONALD OGDEN (*b. Columbus, Ohio, 1894; d. London, England, 1980*), humorist, playwright, and screenwriter. Graduated Yale University (1916). *Vanity Fair* published his early parodies of contemporary writers, collected in *A Parody Outline of History* (1921). His attempt at more serious satire, *Aunt Polly's Story of Mankind* (1923), was a critical failure, and he returned to a whimsical style in *Mr. and Mrs. Haddock Abroad* (1924). His next book, *The Crazy Fool* (1925), led to work as a screenwriter for MGM, where he completed *Mr. and Mrs. Haddock in Paris, France* (1926). His play *Rebound* (1929) was voted one of the ten best of 1929–30. He returned to screenwriting in 1929; his scripts included *The Prisoner of Zenda* (1937), *The Philadelphia Story*, which won him an Oscar (1940), and *Keeper of the Flame* (1942). His leftist sympathies drew the attention of the House Un-American Activities Committee, and he was blacklisted in 1950.

STEWART, EDWIN (*b. New York, N.Y., 1837; d. South Orange, N.J., 1933*), naval officer. Brother of John A. Stewart. Joining the U.S. Navy, September 1861, as assistant paymaster, he was associated with the business and supply activities of the service thereafter until his retirement, 1899. Largely instrumental in effecting the reform of naval purchase procedures and their centralization in a bureau of supplies and accounts, he was appointed paymaster general with rank of commodore, 1890, and retired as rear admiral. He distinguished himself particularly in his handling of navy supply problems during the Spanish-American War.

STEWART, ELIZA DANIEL (*b. Piketon, Ohio, 1816; d. Hicksville, Ohio, 1908*), schoolteacher, temperance advocate. Formed Woman's League in Osborne, Ohio, 1873, the first organization in the Women's Christian Temperance Union movement, and was a leader in the rapid extension of the work.

STEWART, GEORGE NEIL (*b. London, Ontario, Canada, 1860; d. Cleveland, Ohio, 1930*), physiologist. Raised in Scotland. Educated at University of Edinburgh, he received, among other degrees, M.A., 1883; D.Sc., 1887; and M.D., 1891. He also worked at Berlin on electrophysiology and was one of the group of investigators who worked at Cambridge under Sir Michael Foster. Stewart's investigations were chiefly on the velocity of blood flow, on temperature regulation, and on the cardiac nerves. Coming to America in 1893 as an instructor at Harvard, was professor of physiology at Western Reserve University, 1894–1903, and served as head of the Department of Physiology at the University of Chicago, 1903–07. *Post* 1907 he was director of the H. K. Cushing Laboratory of Experimental Medicine at Western Reserve. While in America, Stewart continued his investigations on circulation time and on the electric conductivity of the blood and hemolysis as an approach to the problem of cell permeability. From 1910 to 1915 he devised and applied a calorimetric method of measuring the blood flow suitable for clinical use. In association with J. M. Rogoff, he worked on the epinephrine output of the adrenal glands, 1916–23, and investigated the course of the removal of these glands, 1924–27, establishing the efficiency of extracts of adrenal cortex in clinical use.

STEWART, HUMPHREY JOHN (*b. London, England, 1854; d. San Diego, Calif., 1932*), organist, composer. Settled in San Francisco, Calif., 1886; was organist to a number of churches; served as municipal organist of San Diego *post* 1915.

STEWART, JOHN AIKMAN (*b. New York, N.Y., 1822; d. New York, 1926*), banker. Brother of Edwin Stewart. Planned organization of U.S. Trust Co., N.Y., 1852–53, and served as its president, 1864–1902, thereafter becoming chairman of the board. As senior trustee of Princeton University, he served as president pro tempore of Princeton, 1910–12.

STEWART, JOHN GEORGE (*b. Wilmington, Del., 1890; d. Washington, D.C., 1970*), architect of the U.S. Capitol. Attended University of Delaware (honorary B.S., 1958). Worked in his father's construction firm from 1911, becoming president in 1929; under his supervision the firm restored the original du Pont black powder plant at Hagley, Del., and constructed the museum house for Henry F. du Pont at Winterthur, Del. U.S. congressman (1934–37), then returned to the construction business. Was chief clerk of the Senate Committee on the District of Columbia (1947–51), then was named architect of the Capitol in 1954. Under his direction the new Senate (Dirksen) Office Building (1955–58) and the Rayburn House Office Building (1955–65) were built and the east front of the Capitol was extended (1958–60). The American Institute of Architects issued formal criticisms of his Capitol Hill work and projects, since many American architects had converted to modernism, and Stewart represented the old order of classical and traditional aesthetics.

STEWART, PHILO PENFIELD (*b. Sherman, Conn., 1798; d. Troy, N.Y., 1868*), Congregational missionary, inventor. Cofounder with John J. Shiperd of Oberlin College; received patent for his invention of the "Oberlin stove," 1834, which he deeded to that institution.

STEWART, ROBERT (*b. Sidney, Ohio, 1839; d. Sialkot, Punjab, India, 1915*), United Presbyterian clergyman, missionary to India.

STEWART, ROBERT MARCELLUS (*b. Truxton, N.Y., 1815; d. St. Joseph, Mo., 1871*), lawyer, Missouri legislator and railroad promoter. Anti-Benton Democrat governor of Missouri, 1857–61. Taking a middle ground on the secession issue at first, Stewart upheld the Crittenden Compromise, but later took a strong stand for the Union.

STEWART, WALTER WINNE (*b. Manhattan, Kans., 1885; d. New York, N.Y., 1958*), economist. Studied at the University of Missouri and taught there from 1913 to 1916, and at Amherst College from 1916 to 1922. Stewart was appointed director of the Division of Analysis and Research of the Federal Reserve Board in 1922; he served until 1926, when he joined the investment house of Case, Pomeroy and Company in New York. He was the first economic advisor to the Bank of England, 1928–30. From 1930 to 1938, he was chairman of the board of Case, Pomeroy and Company, and from 1938, he was professor of economics at the Institute for Advanced Study in Princeton, N.J. From 1953 to 1955, he served on President Eisenhower's Council of Economic Advisors.

STEWART, WILLIAM MORRIS (*b. Galen, N.Y., 1827; d. 1909*), lawyer. Raised in Ohio, he attended Yale College, 1848–50. Removing to California, 1850, he engaged in mining, studied law, and was admitted to practice, 1852. Author of the first rules and regulations for quartz mining in Nevada Co., 1853, he entered a law-partnership in San Francisco, 1854, with Henry S. Foote, whose daughter he married. Removing to Nevada, 1859, he came to the fore through his energy and knowledge of mining law; successful as counsel for the original claimants to the Comstock Lode, he was thereafter retained by some of the largest mining companies in the West. Chairman of the judiciary committee of the Nevada constitutional convention, he served as U.S.

senator, Republican, from Nevada, 1864–75. Instrumental in securing passage of the mining laws of 1866 and 1872. He advocated President Andrew Johnson's impeachment and voted for his conviction, and in 1869 was author of the 15th Amendment to the Constitution in the form in which it was finally adopted. Reelected to the U.S. Senate, 1887, he served continuously until 1905. Perhaps the first member of either House of Congress to propose federal aid for reclamation of arid lands in the West, but he directed his efforts mainly toward the remonetization of silver. His successful campaigns in 1893 and 1899 were conducted as a member of the Silver party. As senior counsel for the Roman Catholic prelates of California, he presented one of the winning arguments before the Hague Court in the controversy with Mexico over the Pious Fund, 1902. A lifelong friend and adviser of Leland Stanford, he was one of the first trustees of Stanford University.

STEWART, WILLIAM RHINELANDER (*b. New York, N.Y., 1852; d. New York, 1929*), capitalist, philanthropist. Appointed a commissioner of the New York State Board of Charities, 1882, he served the board as president, 1894–1903 and 1907–23. He organized the New York State Conference of Charities and Corrections, 1900, and a like New York City conference, 1910. He engaged also in many personal philanthropies and much civic work.

STICKNEY, ALPHEUS BEEDE (*b. Wilton, Maine, 1840; d. St. Paul, Minn., 1916*), lawyer, railroad builder. Removed to Minnesota, 1862; settled in St. Paul, 1869. Associated with a number of railroads as counsel and manager, he is remembered particularly for his connection with the Chicago Great Western and its antecedent lines. His original ideas on railroad finance and operation were set forth in his book *The Railway Problem* (1891).

STIEGEL, HENRY WILLIAM (*b. near Cologne, Germany, 1729; d. Charming Forge, near Womelsdorf, Pa., 1785*), ironmaster, glassmaker, known as "Baron" von Stiegel. Immigrated to Philadelphia, Pa., 1750; settled near Brickerville, Lancaster Co., Pa., *ca.* 1752. Acquired an iron manufactory, 1758, which he expanded and named Elizabeth Furnace; there he made all sorts of iron castings, including stoves, soap kettles, and sugar-making equipment and became by 1760 one of the most prosperous ironmasters in the country. In 1762 he laid out and promoted the town of Manheim, Lancaster Co.; there, early in 1764, he began building a glass factory, which by 1767 was in full operation and which was supplemented in 1769 by a second factory. The works produced, in addition to window and sheet glass, the beautiful Stiegel glassware now eagerly sought by collectors. A spendthrift and overambitious in business ventures, Stiegel began to suffer hard times in 1772 and by 1774 was obliged to sell his properties, becoming a bankrupt.

STIEGLITZ, ALFRED (*b. Hoboken, N.J., 1864; d. New York, N.Y., 1946*), photographer, art gallery proprietor, art patron. Son of German Jewish immigrant parents; brother of Julius Stieglitz. Raised in New York City. His father took the family to Germany in 1881. Alfred first enrolled at the Karlsruhe Realgymnasium and then, in 1882, entered the Technische Hochschule in Berlin as a student of mechanical engineering, but was diverted from this subject by a course he had elected in photochemistry taught by Hermann Wilhelm Vogel. Thereafter, Stieglitz gave most of his attention to photochemistry and photography, continuing his studies from 1887 to 1890 at the University of Berlin.

When Stieglitz returned to New York after eight years of study and travel in Europe, his father supported him in the photoengraving business, which he operated for five years without any great enthusiasm. Because Stieglitz had few customers, he was able to spend much of his time taking and exhibiting photographs. In the 1890's he became a frequent exhibitor in American and international photographic exhibitions and the editor of two influential journals, the *American Amateur Photographer*, 1893–96, and *Camera Notes*, 1897–1902, the organ of the Camera Club of New York.

Growing dissatisfied with the conservative policies of the Camera Club of New York, Stieglitz organized, in 1902, the Photo-Secession, a group of photographers who were sympathetic to his advanced ideas about creative "pictorial photography." To serve the ideals of the Photo-Secession, he established a quarterly magazine, *Camera Work*, which he issued from 1903 to 1917. From 1903 to 1905 he used *Camera Work* as his primary medium to promote the Photo-Secession. In 1905, however, he and his friend Edward Steichen discussed the prospect of converting the top floor of 291 Fifth Avenue, New York City, into a gallery for the Photo-Secession group. They agreed to work together on this project, and with Stieglitz' financial backing, Steichen redecorated three rooms to form the Little Galleries of the Photo-Secession, usually known simply as "291." The galleries opened in November 1905, with a show of photographs, and for more than a year the rooms were dedicated exclusively to the art of photography. But early in 1907 Stieglitz staged the first in a series of exhibitions of paintings, drawings, and sculptures; nonphotographic art gradually overshadowed photographic exhibitions, and in a year, 291 had become the most advanced center for the fine arts in America. Stieglitz here presented the first American exhibitions of such noted modern European artists as Matisse, 1908; Henri Rousseau, 1910; Cézanne, 1911; Picasso, 1911; Picabia, 1913; and Brancusi, 1914. It is safe to say that American painting would not have developed as it did without the exhibitions at 291. In his work as a gallery director lies much of Stieglitz' historical importance.

Stieglitz established himself quite early in his career as a vocal philosopher of art. Believing generally in progressive causes, he was antiacademic and antidescriptive in his views. By 1917, after 14 years of intense activity, he seemed to have exhausted himself. He closed the gallery in that year, and no further issues of *Camera Work* were published. His association with Georgia O'Keeffe, beginning in 1916, helped to renew his creative life. This talented painter, whom he married on Dec. 11, 1924, served as a model for a series of superb photographic portraits. Although Stieglitz closed 291 in 1917, his battle for modern art was not over. He continued to sell paintings and promote his circle of artists at the Intimate Gallery, 1924–29, and at An American Place, 1929–46.

STIEGLITZ, JULIUS (*b. Hoboken, N.J., 1867; d. Chicago, Ill., 1937*), chemist. Brother of the photographer Alfred Stieglitz. Ph.D., University of Berlin, 1889. A teacher of chemistry at University of Chicago *post* 1892 and chairman of the department, 1915–33, Stieglitz made important researches in four major fields of organic chemistry: molecular rearrangements, homogeneous catalysis, the theory of indicators, and stereochemistry in organonitrogen compounds. He is considered one of the founders of physicoorganic chemistry and was author of the important *The Elements of Qualitative Chemical Analysis* (1911). He played an important role in overcoming the lack of synthetics from Germany during World War I and served later as an adviser to the Chemical Foundation.

STIGLER, WILLIAM GRADY (*b. Newton, Indian Territory [now Oklahoma], 1891 d. Stigler, Okla., 1952*), congressman. Studied at Northeastern State College and the University of Oklahoma. Admitted to the bar in 1920; further study at the University of Grenoble, France, while serving with the U.S. Army during World War I. Part Choctaw Indian, Stigler was the national at-

torney for the tribe (1937–44). Elected to the Congress as a Democrat (1944–52). Served on the House Appropriations Committee and the Agricultural Appropriations Subcommittee; a champion of the rights of the American Indians.

STILES, CHARLES WARDELL (*b. Spring Valley, N.Y., 1867; d. Baltimore, Md., 1941*), medical zoologist, public health expert. Attended Wesleyan University, 1885–86; decided to continue his studies in Europe. After a few months in Paris and Göttingen, Stiles studied for two years at the University of Berlin. He then moved to the University of Leipzig to concentrate on zoology with Rudolph Leuckart. He received his Ph.D. degree in 1890. After an additional year spent at Robert Koch's laboratory in Berlin, at the Austrian Zoological Station in Trieste, at the Collège de France, and at the Pasteur Institute, Stiles returned to the United States in 1891 to begin work in Washington as principal zoologist in the Bureau of Animal Industry of the Department of Agriculture. In 1895 he was chosen a member of the five-man International Commission on Zoological Nomenclature, of which he subsequently served as secretary, 1898–1936.

At the Bureau of Animal Industry he investigated livestock disease caused by filth-ridden slaughterhouses in country towns. Stiles also became the focal point of the bureau's concern with trichinosis in pork. In 1900 and 1901, at the request of Representative Rudolph Kleberg, he went to Texas to investigate losses of cattle, sheep, and goats owing to parasitic worms. In 1902 Stiles transferred to the Hygienic Laboratory of the U.S. Public Health and Marine Hospital Service, where for the next 30 years he was chief of the division of zoology. He was also professor of medical zoology at Georgetown University from 1892 to 1906 and special lecturer in the subject at the Johns Hopkins University, 1897–1937.

Stiles's most dramatic and far-reaching contributions to public health were in connection with hookworm disease. In 1902 he discovered a variety of hookworm indigenous to the western hemisphere which he named *Uncinaria americana*, or *Necator americana*. In 1908 and 1909, as an expert on President Roosevelt's Country Life Commission, he was able to interest Walter Hines Page, Wallace Buttrick, and Frederick T. Gates in the problem of hookworm disease in the South. The result was the formation in 1909 of the Rockefeller Sanitary Commission, which conducted an extensive and highly successful campaign against hookworm disease through rural sanitation and education.

Stiles also investigated the health of cotton mill workers, mine sanitation, and other public health problems. Following World War I he directed experiments on soil pollution, which demonstrated how fecal matter and bacteria were spread by groundwater. An even larger project was his publication, with Albert Hassall, of the *Index-Catalog of Medical and Veterinary Zoology*. Their preparation of the first four volumes (1902–20) of this work, together with a series of supplemental *Key Catalogs* (of insects, parasites, protozoa, crustacea, and arachnoids), was a continuing task from the 1890's until the mid-1930's. After his formal retirement in October 1931, he continued some helminthological work at the Smithsonian Institution and taught zoology at Rollins College in Florida for several winters.

STILES, EZRA (*b. North Haven, Conn., 1727 o.s.; d. New Haven, Conn., 1795*), Congregational clergyman, scholar, educator. Graduated Yale, 1746. After further study of theology, he was licensed to preach, 1749, and in the same year appointed tutor at Yale. During his six years in this position he became noted as a public orator; he also engaged in electrical experimentation at the instance of his friend and correspondent Benjamin Franklin. Troubled in mind for some years as to the truth of Christian dogma, he made a long, patient study of the Bible and of Christian evidences before accepting ordination and installation as

pastor of the Second Church of Newport, R.I., 1755. Extremely conscientious in his ministerial duties, he maintained a number of outside activities and a voluminous correspondence with outstanding people at home and abroad. Librarian of the Redwood Library, Newport, 1756–76, he was an ardent antiquarian, a very competent orientalist, and a scientific experimenter. Recognized as probably the most learned man in New England, he was made a member of the American Philosophical Society, 1768; meanwhile, in 1763, he had played an important part in the founding of Rhode Island College (present Brown University). He was a strong advocate of American rights and liberties and a supporter of the Revolution. Removing from Newport in March 1776, he lived in several towns before he accepted the offered presidency of Yale College, March 1778. Stiles carried Yale through a difficult period with reasonable success, teaching Hebrew, ecclesiastical history, philosophy, scientific subjects, and, for a time, theology, in addition to doing his administrative work. The most notable event of his administration was a change in the college charter whereby several of the state officials were made members of the corporation ex officio and certain financial aid from the state was secured. Although Stiles wrote much, he published very little. His manuscripts, edited by Franklin B. Dexter, have yielded two posthumous works of historical importance: *The Literary Diary of Ezra Stiles* (1901) and *Extracts from the Itineraries . . . of Ezra Stiles* (1916).

STILES, HENRY REED (*b. New York, N.Y., 1832; d. 1909*), physician, genealogist, local historian. Among his valuable studies of the history of early New England and New York were *The History of Ancient Windsor, Connecticut* (1859) and *A History of the City of Brooklyn* (1867–70). Intermittent in his practice of medicine, he conducted a sanitorium at Lake George, N.Y., *post* 1888.

STILL, ANDREW TAYLOR (*b. Jonesville, Va., 1828; d. Kirksville, Mo., 1917*), farmer, Union soldier, founder of osteopathy. Raised in Missouri, he resided in Kansas, 1853–75, where he entered on the practice of medicine and worked out his theory that "all the remedies necessary to health exist in the human body. . . they can be administered by adjusting the body in such condition that the remedies may naturally associate themselves together . . . and relieve the afflicted." Returning to Missouri, 1875, he settled at Kirksville, Mo., in 1892. In that year he incorporated the American School of Osteopathy, thereafter teaching at the school, writing, and practicing.

STILL, CLYFFORD (*b. Grandin, N. Dak., 1904; d. Baltimore, Md., 1980*), painter. Graduated Spokane University (B.A., 1933) and Washington State College (M.A., 1935), where he taught fine arts (1935–41). His paintings in the 1930's and 1940's were dark and cryptic; he held a Romanticist ideal of an artist's work transcending his culture. His first one-man exhibit was at the San Francisco Museum of Art (1943). He also taught at Richmond Professional Institute (1943); California School of Fine Arts (1946), where he initiated a world-renowned graduate program; and, beginning in 1951, at Hunter College and Brooklyn College. During the 1950's he produced his most praised works, compositions of color and nonrepresentational forms. He had one-man shows at the Betty Parsons gallery in New York (1947, 1950, 1951) and contributed works to the 1952 exhibition "Fifteen Americans" at the Museum of Modern Art in New York.

STILL, WILLIAM (*b. Burlington Co., N.J., 1821; d. Philadelphia, Pa., 1902*), black leader, reformer. Settling in Philadelphia, 1844, he became a clerk of the Pennsylvania Society for the Abolition of Slavery, 1847, remaining in that post until *ca.* 1861 when he went into business. Very active in the work of assisting

runaway slaves to freedom, he was author of *The Underground Railroad* (1872), one of the best accounts available of that operation. Until the end of his life Still continued active in promoting the welfare of his race through legislation and charitable activity, displaying courage and independence.

STILL, WILLIAM GRANT, JR. (*b. Woodville, Mass., 1895; d. Los Angeles, Calif., 1978*), composer. Attended Wilberforce University (1911–15) and Oberlin College (1917–18) and became a band member and arranger with W. C. Handy in New York City. He studied at the New England Conservatory of Music and began composing full-time in the mid-1920's, including chamber music (*From the Land of Dreams*, 1924), full-orchestra pieces (*Darker America*, 1924), and the ballet *La Guiablesse* (1927); his most famous work was *Afro–American Symphony* (1931). He was the first black to conduct a major American orchestra (Los Angeles Philharmonic, 1936) and first black arranger-conductor for a white radio orchestra, for the show "Willard Robison and His Deep River Orchestra" (1935). His ballet *Troubled Island* (1938), with libretto by Langston Hughes, was produced by New York City Opera (1949). In 1961 he won a contest for a work dedicated to the United Nations (*The Peaceful Land*).

STILLÉ, ALFRED (*b. Philadelphia, Pa., 1813; d. Philadelphia, 1900*), physician. Brother of Charles J. Stillé. M.D., University of Pennsylvania, 1836; studied also in Europe principally in Paris, France. Professor of the theory and practice of medicine, University of Pennsylvania, 1864–83, he received numerous professional honors. Author of *Elements of General Pathology* (1848), the first American book on the subject; he was also coauthor with John M. Maisch of the *National Dispensatory* (1879).

STILLÉ, CHARLES JANEWAY (*b. Philadelphia, Pa., 1819; d. Atlantic City, N.J., 1899*), educator, historian. Brother of Alfred Stillé. Graduated Yale, 1839. Outstanding worker for the U.S. Sanitary Commission during the Civil War. Accepted appointment in 1866 as professor of English in the University of Pennsylvania. As provost of the university, 1868–80, he showed unusual qualities as an educational leader and executive, arousing community interest in the university and opening new departments — among them, science, 1872; music, 1877; and dentistry, 1878. Removal of the university to its present site was accomplished by Stillé, and he secured a considerable extension of its endowment. Among his numerous books, *The Life and Times of John Dickinson* (1891) may be mentioned.

STILLMAN, JAMES (*b. Brownsville, Tex., 1850; d. New York, N.Y., 1918*), banker, capitalist. Raised in Connecticut and in New York City. A protégé of Moses Taylor, Stillman prospered first as a cotton trader, expanding his interests gradually into other industries. Named president of the National City Bank, 1891, he held that office until 1909 and was thereafter chairman of the board. Under his management the bank took a foremost place in serving the great industrial and financial combines that flourished at the end of the 19th century and in the first decade of the 20th; it had close contacts with the Standard Oil financiers headed by H. H. Rogers and William Rockefeller.

STILLMAN, SAMUEL (*b. Philadelphia, Pa., 1737 o.s.; d. Boston, Mass., 1807*), Baptist clergyman. Held principal pastorate at First Baptist Church, Boston, 1765–1807; was named among original trustees of Rhode Island College (present Brown University), 1764. Active and influential in the affairs of his denomination, he was noted as a preacher. His election sermon before the General Court, 1779, contained an interesting argument for the necessity of inserting a bill of rights in the constitution of Massachusetts and for separation of church and state.

STILLMAN, THOMAS BLISS (*b. Plainfield, N.J., 1852; d. 1915*), chemist, expert in water-and milk-supply problems. B.S., Rutgers, 1873; studied also in Germany. Noted as a consultant for industry, he also taught at Stevens Institute of Technology, where he was professor of analytical chemistry, 1886–1902, and head of the chemistry department, 1902–09. Author of *Engineering Chemistry* (1897) and of a number of articles in scientific journals. He held many patents for manufacturing processes and experimented in production of synthetic foods.

STILLMAN, THOMAS EDGAR (*b. New York, N.Y., 1837; d. France, 1906*), lawyer, specialist in admiralty and corporation law. Helped establish new principles of American maritime law in cases of the *Scotland*, the *Pennsylvania*, and the *Atlas*; in later years devoted much time to corporation management.

STILLMAN, WILLIAM JAMES (*b. Schenectady, N.Y., 1828; d. Surrey, England, 1901*), landscape painter, journalist, diplomat. A close friend of the celebrated English critic John Ruskin, Stillman had a varied career which included service as U.S. consul at Rome, 1862–65, and in Crete, 1865–68. Settling in London, England, he was employed for many years as a London *Times* special correspondent.

STILWELL, JOSEPH (*b. Palatka, Fla., 1883; d. San Francisco, Calif., 1946*), army officer. Raised in Yonkers, N.Y. Graduated West Point, 1904. Served for two years with 12th Infantry in the Philippines. Save for later regimental duty there and in Monterey, Calif., 1911–13, he spent the rest of the decade before World War I at West Point as an instructor. Upon promotion to captain, 1916, Stilwell joined the American Expeditionary Forces in France in December 1917. He played a major role in organizing G-2 operations for the American offensive at Saint-Mihiel, winning the Distinguished Service Medal and promotion to the temporary rank of colonel. His first postwar assignment was as the army's first language officer in China. The duty took him to Peking, 1920–23, where he learned to speak Chinese. After attending the army's Infantry and Command and General Staff schools, at Fort Benning and Leavenworth, he returned to China, 1926–29, as battalion commander and later executive officer of the 15th Infantry, an American regiment stationed in Tientsin as a result of the Boxer Rebellion. His third China duty came in 1935–39, when he returned as U.S. military attaché.

From 1929 to 1933 Stilwell served as chief of the tactical section at the Infantry School, Fort Benning, Ga., under the direction of Col. George C. Marshall. At the Infantry School his unsparing and often acid critiques earned him the nickname "Vinegar Joe." In 1939 Marshall picked Stilwell for one of his first two promotions to brigadier general. By the time of Pearl Harbor, he had commanded the 3rd Infantry Brigade in Texas, 1939; the 7th Division in California, 1940; and the III Corps, 1940–41. He had been promoted to major general, September 1940. In February 1942 he was appointed commanding general of U.S. Army forces (at this time only air units) in the China-Burma-India theater, chief of staff to Generalissimo Chiang Kai-shek of China, and supervisor of lend-lease in the area.

Arriving at his new post in early March 1942, Stilwell took up the defense of Burma. When Burma fell to the Japanese, he lead an endangered remnant of 114 men on a 140-mile march across the mountains to India. He encountered further frustration in his subsequent program to train Chinese troops in India. His command status was further complicated in mid-1943 when, besides his other titles, he became deputy supreme Allied commander in Southeast Asia under Britain's Admiral Lord Louis Mountbatten. Yet Stilwell doggedly pressed construction of the Ledo Road (afterward named for him), which eventually linked up with the Burma Road to provide a land supply route from

India to China; and in the first seven months of 1944 Stilwell led Chinese troops in the successful battle to retake northern Burma. But Stilwell's most enduring frustration was his long struggle to bring about a reform of the Chinese army, an effort doomed by the resistance of Chiang. Stilwell's persistence and his unconcealed contempt for the generalissimo caused three attempts by Chiang to bring about his recall. Although President Roosevelt sometimes wavered, Marshall, as chief of staff, steadfastly stood by Stilwell.

In 1944, when a renewed Japanese offensive in China made the situation desperate, Roosevelt, persuaded by Marshall, officially requested that Stilwell be appointed to command the Chinese armed forces. This proposal precipitated the final crisis, which culminated in Stilwell's recall in October 1944. His last command was of the 6th Army in charge of the Western Defense Command. Before his death, he was awarded the Combat Infantryman Badge, usually reserved for the enlisted foot soldier who has proved himself under fire. He had previously received the Distinguished Service Cross for action in Burma and the Legion of Merit for high command.

STILWELL, SILAS MOORE (*b. New York, N.Y., 1800; d. New York, 1881*), lawyer, banking reformer. New York legislator. Responsible as an assemblyman for passage of the Stilwell Act, 1831, abolishing imprisonment for debt in New York.

STILWELL, SIMPSON EVERETT (*b. Tennessee, 1849; d. Cody, Wyo., 1903*), army scout, peace officer. Raised in Missouri and Kansas, he became an army scout at Fort Dodge, 1867. While operating out of Fort Wallace with Maj. G. A. Forsyth's company in September 1868, Stilwell eluded a hostile Indian cordon to bring relief when the company was surrounded on the Arikaree Fork of the Republican River by Cheyenne and Sioux under Chief Roman Nose. He continued to serve irregularly as a scout under Custer, Miles, Mackenzie, and other army officers until 1881. He served thereafter as a deputy marshal at various places in Oklahoma.

STIMPSON, WILLIAM (*b. Roxbury, Mass., 1832; d. Ilchester, Md., 1872*), naturalist. Encouraged in his studies by Augustus A. Gould and J. L. R. Agassiz, he served as naturalist to the North Pacific Exploring Expedition, 1852–56, and spent a number of years thereafter in classifying the material gathered in that time. His collections and works were destroyed in the Chicago fire of October 1871, together with much other scientific material which had been loaned to him for comparative study. He was author of many papers on mollusca and crustacea published mainly by the Smithsonian Institution.

STIMSON, ALEXANDER LOVETT (*b. Boston, Mass., 1816; d. Glens Falls, N.Y., 1906*), expressman. Author of, among other works, *History of the Express Companies: and the Origin of American Railroads* (1858).

STIMSON, FREDERIC JESUP (*b. Dedham, Mass., but possibly New York City or Dubuque, Iowa, 1855; d. Dedham, 1943*), lawyer, diplomat, author. A.B., Harvard, 1876; LL.B., 1878. Practiced in Boston, Mass., specializing in railroad law; was in partnership for a time with Francis C. Lowell and A. Lawrence Lowell. Originally a Republican, he became a mugwump and eventually a Democrat; he was an advocate of justice for the American Indian and for labor, an anti-imperialist, and opposed to governmental interference with individual liberty and property rights. In addition to a number of books on legal subjects, he was author of works of fiction (under pseudonym "J.S. of Dale"), including *Guerndale* (1882) and *King Noanett* (1896).

STIMSON, HENRY LEWIS (*b. New York, N.Y., 1867; d. "Highhold," Huntington, N.Y., 1950*), lawyer, statesman. Son of Lewis A. Stimson. A.B., Yale, 1888. Attended Harvard Law School, 1888–90. In 1891 he entered the law firm of Root and Clarke. Stimson started his exploration of politics in something smaller than a ward, an election district, and in time worked his way up to a seat on the powerful New York County Republican Committee. In 1899 he and Bronson Winthrop started their own partnership. They remained together for the rest of their lives. In 1906 Theodore Roosevelt appointed Stimson U.S. attorney for the Southern District of New York. Insufficiently staffed and badly managed at the time, the office was totally reconstructed by Stimson in the next two years. By his work in the Southern District, which ended in 1909, he gave one of the earliest demonstrations that the power of large corporations could be sensibly controlled by the action of a determined government.

His service as district attorney stirred up his concern over the dislocations produced in the society by the excesses of corporate enterprise. In 1910 he was persuaded to run for governor, in the hope that he might be able to put some of his ideas in effect from Albany. In the election, running behind most of his ticket, he was soundly defeated. In the following year, President William Howard Taft appointed him secretary of war. For two years thereafter he struggled to make a modern army out of a force that still was preparing itself. First, he obtained a "tactical reorganization" of the troop units. He also resolved the ancient immobilizing conflict between the staff and line. He left the War Department in 1913, but he returned to the army in 1914, to take an active part in the effort to prepare the country for the conflict. A persistent advocate of universal military service, he applied for active duty in 1917. That same year, he went to France as a lieutenant colonel in the field artillery to fight along the Chemin des Dames in Lorraine. In 1927, Stimson was sent to Nicaragua by President Calvin Coolidge. In a month of negotiation, he arranged a peace between two factions that were at civil war, but the day after he left the country, fighting broke out and continued for half a decade. In the next year, Coolidge sent Stimson to the Philippines as governor general. There, amid a population that was earnestly seeking independence, he sought to stabilize the precarious economy and restore the confidence of the people. But on his departure, agitation for independence began again, and in a few more years the great aim was actually achieved.

Stimson came home in 1929 to become secretary of state in President Herbert Hoover's cabinet. In each month of his tenure, it seemed, matters went from bad to worse. There was first the worldwide economic depression, and as the principal creditor, the United States had a considerable role to play. But nothing that was done by either Stimson or Hoover served to bring more than temporary relief; conditions steadily deteriorated. Then there was the effort to reduce tensions between nations by readjusting the structure of international armaments. At the London Naval Conference of 1930, Stimson was the principal negotiator for the United States; as such, he can be given much credit for the resulting agreement, which seemed on paper to eliminate "further naval competition" among the chief signatories. There was also the problem of how to get the Japanese out of Manchuria, which they had entered on Sept. 18, 1931; but the Japanese remained there, unresponsive alike to Stimson's structures and a later condemnatory finding by the League of Nations.

In 1933 Stimson returned to private life. When in 1939 World War II came, he spoke out increasingly for the support by all moral and material means of those nations opposing Germany and Italy. In June 1940 he was appointed the secretary of war by President Franklin Roosevelt. For the next five years he devoted

himself to the discharge of the affairs of this office. In his first 15 months in office he surrounded himself with able, energetic, purposeful men and established a harmony of civil and military interests within the War Department that was without parallel in the direction of an American armed force in time of war.

The decisions that interested Stimson most had to do with military matters. In the first year of the war he tried to use radarequipped army planes to assist in the fight against the German submarines. In this effort he was thwarted by the resistance of the navy. Stimson also did everything he could to convince Roosevelt and Churchill of an early landing in Europe from British bases. His objective was postponed by the landings in North Africa, but fulfilled in June 1944. Late in the war much of his time was taken up with the activities surrounding the development and manufacture of the atom bomb.

In those closing months of the war he searched increasingly for postwar settlements that would give some promise of extended peace, and in 1945 urged that the United States, England, and Russia share the secret of the atom so that they could act with a common sense of power and responsibility to stabilize by mutual action the postwar world. Soon after the coming of the peace, on Sept. 21, 1945, his seventy-eighth birthday, he retired.

STIMSON, JULIA CATHERINE (*b. Worcester, Mass., 1881; d. Poughkeepsie, N.Y., 1948*), leader in nursing. Niece of Lewis A. Stimson. B.A., Vassar, 1901. Graduated New York Hospital Training School for Nurses, 1908. Superintendent of nurses, Harlem Hospital, New York City, 1908–11; director of social service at hospitals of Washington University Medical School, St. Louis, Mo., 1911–13; directed training school for nurses at Washington University, 1913–17. Active also in Red Cross work, she served in France at No. 12 General Hospital, near Rouen, 1917–18, and at Paris, where, as World War I ended, she was appointed director of the Nursing Service of the American Expeditionary Forces. On her return to the United States, 1919, she served as dean of the Army School of Nursing until 1933 and as superintendent of the Army Nurse Corps until 1937. Chairman of the Nursing Council on National Defense, 1940–42, she returned to active army duty in 1942–43 as a recruiter of nurses. After full commissioned rank was authorized for nurses, she was promoted colonel on the retired list.

STIMSON, LEWIS ATTERBURY (*b. Paterson, N.J., 1844; d. Shinnecock Hills, N.Y., 1917*), surgeon. Graduated Yale, 1863; M.D., Bellevue Hospital Medical School, 1874. Practiced in New York City. Taught at medical college of the University of the City of New York (present New York University), 1883–98. Instrumental in founding Cornell University Medical College, he was professor of surgery there, 1898–1917. Author of *A Practical Treatise on Fractures and Dislocations* (1899), a classic in the subject, and other works.

STINE, CHARLES MILTON ATLAND (*b. Norwich, Conn., 1882; d. Wilmington, Del., 1954*), industrial chemist. Studied at Gettysburg College and Johns Hopkins University (Ph.D., 1907). Worked for E.I. du Pont de Nemours and Co. (1907–45); chemical director from 1924; member of the board of directors and vice president from 1930. One of the first organic chemists employed in American industry, Stine convinced the Du Ponts of the necessity of pursuing basic research in industry. He helped develop the first commercial TNT in the U.S., did extensive work in explosives and dyes, and directed the research that led to the discovery of nylon. Stine was the first du Pont official concerned with the atomic energy project, which was the company's largest single undertaking of World War II.

STINESS, JOHN HENRY (*b. Providence, R.I., 1840; d. 1913*), lawyer. Union soldier, expert in canon law. Judge, Rhode Island Supreme Court, 1875–1904, serving for four years as chief justice.

STIRLING, LORD WILLIAM *See* ALEXANDER, WILLIAM.

STITH, WILLIAM (*b. Charles City Co., Va., 1707; d. Williamsburg, Va., 1755*), Anglican clergyman, educator, historian. B.A., Queen's College, Oxford, 1727/8. Appointed master of the grammar school at William and Mary, 1731, he served also as chaplain to the House of Burgesses. Rector of Henrico Parish, Henrico Co., 1736–1751/2, he was qualified as president of the College of William and Mary on Aug. 14, 1752, and served in that post uneventfully until his death. He is principally remembered for his *History of the First Discovery and Settlement of Virginia* (1747), the earliest important secondary account of the colony and one which has influenced most subsequent interpretations of the history of Virginia under the London Co.

STITT, EDWARD RHODES (*b. Charlotte, N.C., 1867; d. Bethesda, Md., 1948*), navy surgeon, educator. B.A., University of South Carolina, 1885. M.D.; University of Pennsylvania, 1889. Commissioned assistant surgeon, U.S. Navy Medical Corps, he spent much of 1890 serving in the eastern Atlantic and the Mediterranean. His interest in diseases of the tropics led to his selection as a medical member of the commissions formed to recommend possible routes for a canal across the isthmus of Central America.

In his first 20 years in the navy, Stitt spent all his available free time acquiring as much information as possible about tropical medicine and bacteriology. In 1902 he was appointed head of the departments of bacteriology, chemistry, and tropical medicine at the Navy Medical School, Washington, D.C. For the next 18 years, with the exception of two duty tours in the Philippines, he remained at the school. During this time he wrote two major books: *Practical Bacteriology, Hematology, and Animal Parasitology* (1908) and *Diagnostics and Treatment of Tropical Diseases* (1914). After 1916 he was made commanding officer of the Navy Medical School, and for his service in that capacity during World War I he won the Navy Cross. In 1917 he was promoted to the rank of rear admiral. In 1928 Stitt became inspector general of medical activities, West Coast, a position he held for the next two and a half years. Finally, on Aug. 1, 1931, he was obliged to retire from active duty.

STOBO, ROBERT (*b. Glasgow, Scotland, 1727; d. place unknown, ca. 1772*), soldier. Immigrated as a young man to Virginia. As a merchant, enjoyed patronage of Governor Dinwiddie. A captain in the Virginia militia, he was with George Washington at Fort Necessity, 1754, and was made a hostage. Escaping from prison in Quebec, he reached the British forces at Louisburg in the spring of 1759 and served ably in the expedition against Quebec. Commissioned captain in the 15th Regiment of Foot, he was in service until about 1770, at which time his name disappeared from the Army List. The *Memoirs of Major Robert Stobo* appeared posthumously in London (1800).

STOCK, FREDERICK AUGUST (*b. Jülich, near Cologne, Germany, 1872; d. Chicago, Ill., 1942*), orchestra conductor. A protégé of Theodore Thomas, he joined the Chicago Symphony Orchestra as a viola player, 1895. Succeeding Thomas as conductor, 1905, except for August 1918 to February 1919, he served until his death. Through special programs, children's concerts, and encouragement of musical education in the public schools, he made the orchestra an integral part of the community; it dominated the musical life of the Midwest by its brilliant perfor-

mances and a repertory more catholic and extensive than that of any other American orchestra of his day.

STOCKARD, CHARLES RUPERT (*b. Stoneville, Miss., 1879; d. 1939*), biologist, anatomist. Graduated Mississippi A. & M. College, 1899, 1901; Ph.D., Columbia, 1907. A teacher at Cornell University Medical College *post* 1907, he became professor in 1911 and head of the anatomical laboratories. A lifelong student of the relative effects of environmental and hereditary factors upon the development of animals, Stockard was a codiscoverer of the method of timing the reproductive cycle of the female which later led to discovery of the ovarian hormones. Managing editor, *American Journal of Anatomy*, 1921–38, he served as president of the board of scientific directors of the Rockefeller Institute for Medical Research, 1935–39.

STOCKBRIDGE, HENRY (*b. Baltimore, Md., 1856; d. 1924*), jurist. Son of Henry S. Stockbridge; nephew of Levi Stockbridge. Prominent in Baltimore civic and legal affairs, he served as a judge of the supreme bench of Baltimore, 1896–1911, and as a judge of the Maryland Court of Appeals, 1911–23.

STOCKBRIDGE, HENRY SMITH (*b. North Hadley, Mass., 1822; d. Baltimore, Md., 1895*), lawyer, Maryland legislator. Brother of Levi Stockbridge; father of Henry Stockbridge. Originally a Whig, he early became a Republican and was a strong Unionist during the Civil War. A leader in the constitutional reform which abolished slavery in Maryland, he was active in support of black rights.

STOCKBRIDGE, HORACE EDWARD (*b. Hadley, Mass., 1857; d. Atlanta, Ga., 1930*), agricultural chemist and editor, educator. Son of Levi Stockbridge. Graduated Massachusetts Agricultural College, 1878; Ph.D., Göttingen, 1884. Taught at Massachusetts Agricultural College and in Japan; president of North Dakota Agricultural College, 1890–94. Associated with Florida Agricultural College, 1897–1902, he was editor of the *Southern Ruralist* and the *Southern Farm and Dairy*.

STOCKBRIDGE, LEVI (*b. Hadley, Mass., 1820; d. Amherst, Mass., 1904*), agriculturist, educator. Father of Horace E. Stockbridge; brother of Henry S. Stockbridge. Mainly self-educated and a pioneer in agricultural experiment, he served at various times in the Massachusetts legislature and was a member of the state board of agriculture. A shaper of the curriculum at Massachusetts Agricultural College *post* 1867, he served there as professor of agriculture, 1869–80, and was president of the college, 1880–82. His investigations dealt primarily with plant feeding, and he published the first formulas for fertilizers for specific crops.

STOCKDALE, THOMAS RINGLAND (*b. Greene Co., Pa., 1828; d. Summit, Miss., 1899*), lawyer, Confederate soldier. Removed to Mississippi, 1856. As congressman, Democrat, from Mississippi, 1887–95, he employed a unique argument against tariffs, pointing out that much of the burden of protection fell upon blacks in agricultural work.

STÖCKHARDT, KARL GEORG (*b. Chemnitz, Saxony, 1842; d. St. Louis, Mo., 1913*), Lutheran clergyman. Disapproving of the state church in Saxony, Stöckhardt immigrated to St. Louis, Mo., where he served as pastor, 1879–1913, and as a professor in Concordia Theological Seminary. He had a strong influence on the teaching and preaching of the Missouri Synod.

STOCKTON, CHARLES G. (*b. Madison, Ohio, 1853; d. Buffalo, N.Y., 1931*), physician, specialist in internal medicine. M.D., University of Buffalo, 1878. Successful as a practitioner and consultant in Buffalo and as a professor *post* 1887 at his alma mater.

STOCKTON, CHARLES HERBERT (*b. Philadelphia, Pa., 1845; d. Washington, D.C., 1924*), naval officer. Graduated U.S. Naval Academy, 1865. A specialist in international law, Stockton retired as rear admiral, 1907, after long and varied service. First delegate at the Declaration of London Conference, 1908–09; served without salary as president of George Washington University, 1910–18.

STOCKTON, FRANK RICHARD (*b. Philadelphia, Pa., 1834; d. Washington, D.C., 1902*), author. Trained as a wood engraver. Stockton contributed to the *Riverside Magazine for Young People* the stories which were collected as *Ting-a-Ling Tales* in 1870; he was thereafter employed mainly as an editor and writer. Assistant editor of *St. Nicholas Magazine*, 1873–81, he was at the same time a frequent contributor to *Scribner's Monthly* and the *Century*. The popular success of *Rudder Grange* (1879) encouraged him to live entirely by his writing. Stockton's many novels and stories were worked out of a vein of absurd invention which he had discovered that he possessed and which the public liked. However circumstantial he might be in his stories, his imagination dealt with a world of cheerful impossibility, and his tales are in effect loose-knit comic operettas. Among them may be mentioned *The Casting Away of Mrs. Lecks and Mrs. Aleshine* (1886), *The Dusantes* (1888), *The Adventures of Captain Horn* (1895), and such classic short stories as "The Lady or the Tiger?" (first appearance, *Century Magazine*, November 1882) and "The Transferred Ghost" (1882). In addition to his fiction, Stockton was author of several volumes of local history, including *Buccaneers and Pirates of Our Coasts* (1898).

STOCKTON, JOHN POTTER (*b. Princeton, N.J., 1826; d. 1900*), lawyer, New Jersey politician and official. Son of Robert F. Stockton. Elected U.S. senator, Democrat, from New Jersey, March 1865, he became the center of a famous controversy over his right to be seated, which terminated adversely for him a year later. Elected to the U.S. Senate again, 1869, he served through 1875 and was New Jersey attorney general, 1877–97.

STOCKTON, RICHARD (*b. Princeton, N.J., 1730; d. Princeton, 1781*), lawyer, New Jersey provincial legislator, Revolutionary patriot. Father of Richard Stockton (1764–1828). Graduated College of New Jersey (Princeton), 1748; studied law under David Ogden. Successful in practice, he served as a provincial councillor, 1768–75, and was regarded as a moderate in his opposition to crown policy. Elected to the Continental Congress, June 1776, he heard the closing debate on the Declaration of Independence, of which he was a signer; he also served on several important congressional committees in the summer and fall of 1776. Betrayed to the British by Loyalists late in the year, he was imprisoned at Perth Amboy and New York. In shattered health on his release, he returned to find his estate, "Morven," pillaged. He remained an invalid until his death.

STOCKTON, RICHARD (*b. near Princeton, N.J., 1764; d. near Princeton, 1828*), lawyer, farmer, politician. Son of Richard Stockton (1730–81). U.S. senator, Federalist, from New Jersey, 1796–99; congressman, Federalist, 1813–15. Conspicuous in opposition to the War of 1812. He approved highly of the U.S. Constitution, but felt that it had not been improved by a single one of its amendments. He was the father of Robert F. Stockton.

STOCKTON, ROBERT FIELD (*b. Princeton, N.J., 1795; d. 1866*), naval officer. Son of Richard Stockton (1764–1828). Appointed midshipman, 1811, he served with credit under Commodore John Rodgers in the War of 1812; he also distinguished himself

later in the war with Algiers and on duty in the Mediterranean, 1816–20. After further duty in suppressing slave traders and pirates, he engaged in private business while on furlough, 1828–38. Promoted captain, 1838, and returning to active service, he interested himself in application of steam power in the U.S. Navy and was commander of the USS *Princeton*, 1843–45.

As war with Mexico was imminent, he was ordered to proceed in USS *Congress* to the Pacific and reinforce the U.S. squadron there. When he arrived at Monterey, Calif., July 1846, war had already begun. Relieving Commodore J. D. Sloat on July 23, he began military operations for the seizure of California. Entering Los Angeles in August, he issued a proclamation declaring California a territory of the United States and organized a civil and military government, assuming for himself the title of governor and commander in chief. Forced to abandon further ambitious plans because of the recapture of Los Angeles by the Mexicans, he joined with the forces of General S. W. Kearny early in January 1847, repossessed Los Angeles and ended the war on California soil. Superseded soon thereafter, he resigned from the navy, May 1850. As U.S. senator, Democrat, from New Jersey, 1851–53, he urged several naval reforms, including the abolition of flogging.

STOCKTON, THOMAS HEWLINGS (*b. Mt. Holly, N.J., 1808; d. Philadelphia, Pa., 1868*), Methodist clergyman, notable pulpit orator.

STOCKWELL, JOHN NELSON (*b. Northampton, Mass., 1832; d. 1920*), mathematical astronomer. Raised in Ohio, Stockwell was mainly self-educated and came to notice first as editor of an almanac. Employed as a computer with the U.S. Coast Survey and the U.S. Naval Observatory; taught at Case School of Applied Science, 1881–88. His chief contributions, made over a period of 70 years, dealt with the theory of the moon's motion and with the computation of eclipses.

STODDARD, AMOS (*b. Woodbury, Conn., 1762; d. near present Maumee, Ohio, 1813*), lawyer, soldier. An artilleryman in the Revolution, Stoddard returned to the U.S. Army in 1798 after practicing law and service as a Massachusetts official and legislator. Commissioned captain in the 2nd Artillery, 1798, he was promoted major, 1807, and died during the siege of Fort Meigs. Meanwhile, he had served as first civil and military commandant of Upper Louisiana, 1804, receiving the cession of that territory early in March and acting as governor until the end of September. He was author of *Sketches, Historical and Descriptive, of Louisiana* (1812).

STODDARD, CHARLES WARREN (*b. Rochester, N.Y., 1843; d. 1909*), author. Removed to San Francisco, Calif., 1855; published verses in the *Golden Era*, 1861–63, which were collected in *Poems* (Bret Harte, ed., 1867). Converted to Catholicism, 1867, he traveled widely during the succeeding 20 years and was for a short time secretary to Mark Twain in London. After teaching English for a time at Notre Dame and Catholic universities, he lived in Monterey, Calif., *post* 1906. As a writer he is remembered chiefly for *South-Sea Idyls* (1873).

STODDARD, DAVID TAPPAN (*b. Northampton, Mass., 1818; d. Seir, Persia, 1857*), Congregational clergyman. Nephew of Arthur and Lewis Tappan. Missionary among the Nestorians in Persia, 1843–48 and 1851–57.

STODDARD, ELIZABETH DREW BARSTOW (*b. Mattapoisett, Mass., 1823; d. New York, N.Y., 1902*), novelist, poet. Married Richard H. Stoddard, 1851. Encouraged by her husband, she became a contributor to periodical publications of her day. She wrote fiction praised for its realism by Nathaniel Hawthorne and others, although she lacked skill in plotting and her work showed a morbid strain. Among her books were *The Morgesons* (1862), *Two Men* (1865), and *Temple House* (1867).

STODDARD, JOHN FAIR (*b. Greenfield, N.Y., 1825; d. Kearny, N.J., 1873*), educator, mathematician, author of a number of superior textbooks in mathematics.

STODDARD, JOHN LAWSON (*b. Brookline, Mass., 1850; d. near Meran, Tyrol, Austria, 1931*), lecturer, writer. Highly successful as a travel lecturer, he was author of, among other books, the *John L. Stoddard's Lectures* (1897–98, with later supplements).

STODDARD, JOHN TAPPAN (*b. Northampton, Mass., 1852; d. Northampton, 1919*), chemist. Nephew of David T. Stoddard. Graduated Amherst, 1874; Ph.D., Göttingen, 1877. Taught physics and chemistry at Smith College *post* 1878 and was chairman of Department of Chemistry there *post* 1897.

STODDARD, JOSHUA C. (*b. Pawlet, Vt., 1814; d. Springfield, Mass., 1902*), inventor, apiarist. Invented and patented, 1855, a steam calliope which he later manufactured; also devised and patented hayraking machines (1861, 1870, and 1871).

STODDARD, RICHARD HENRY (*b. Hingham, Mass., 1825; d. New York, N.Y., 1903*), poet, critic, editor. Husband of Elizabeth D. B. Stoddard. An iron moulder by trade, Stoddard won reputation as a writer *post* 1845 and did much worthy, if derivative and ephemeral, work. Personally popular among writers of his time, he achieved an important position in criticism, and with his wife turned his home into a center of New York literary life. Among his numerous volumes of collected verse, *Poems* (1851), *Abraham Lincoln: An Horatian Ode* (1865), and *Poems* (1880) may be cited.

STODDARD, SOLOMON (*b. Boston, Mass., 1643; d. Northampton, Mass. 1728/9*), Congregational clergyman. Grandfather of Jonathan Edwards (1703–58) and progenitor of a long line of distinguished persons. Graduated Harvard, 1662; was first librarian of Harvard, 1667–74. Pastor at Northampton, Mass., *post* 1672, Stoddard accepted the Half-Way Covenant and introduced in his church *ante* 1677 the practice called "Stoddardeanism," which allowed many of the privileges of full church membership to professing Christians even when they were not certain they were in a state of grace. Although most of the churches in western Massachusetts accepted Stoddard's view, his grandson, Jonathan Edwards, rejected it and was therefore dismissed from his pastorate at Northampton, in which he had succeeded Stoddard.

STODDARD, THEODORE LOTHROP (*b. Brookline, Mass., 1883; d. Washington, D.C., 1950*), author, foreign policy student, publicist of nativism. Son of John Lawson Stoddard, B.A., Harvard, 1905; M.A., 1910; Ph.D., 1914. Also studied law at Boston University and was admitted to Massachusetts bar, 1908. Achieved contemporary reputation for four books and numerous articles on race relations, which dramatized the theories of Madison Grant and other white supremacists and proponents of eugenics. The first and most successful of his books was *The Rising Tide of Color* (1920).

STODDARD, WILLIAM OSBORN (*b. Homer, N.Y., 1835; d. Madison, N.J., 1925*), author, inventor. Graduated University of Rochester, 1858. As editor of an Illinois newspaper, 1858–60, Stoddard was a strong supporter of Abraham Lincoln, whom he served as secretary, 1861–63. He was author of over a hundred books, among them, *Inside the White House in War Times* (1890) and 76 excellent stories for boys.

STODDART, JAMES HENRY (*b. Barnsley, England, 1827; d. Sewaren, N. J., 1907*), actor. Immigrated to New York City, 1854; was associated with the companies of James W. Wallack, Laura Keene, Joseph Jefferson, and Albert M. Palmer. His most successful role was in Maclaren's *Beside the Bonnie Briar Bush* from 1901.

STODDART, JOSEPH MARSHALL (*b. Philadelphia, Pa., 1845; d. Elkins Park, Pa., 1921*), editor, publisher. First American publisher and representative in America of Gilbert and Sullivan and of Oscar Wilde.

STODDERT, BENJAMIN (*b. Charles Co., Md., 1751; d. 1813*), Revolutionary soldier, merchant. Served with great ability as first secretary of the U.S. Navy, 1798–1801. Supervised plans for new vessels; established and located navy yards

STOECKEL, CARL (*b. New Haven, Conn., 1858; d. Norfolk, Conn., 1925*), philanthropist, patron of music. Originated and sponsored the Norfolk Music Festival, presented, 1900–23.

STOEK, HARRY HARKNESS (*b. Washington, D.C., 1866; d. Urbana, Ill., 1923*), mining engineer, editor, educator. Organized Department of Mining Engineering at University of Illinois, which he headed, 1909–23. Wrote a number of technical articles on coal mining which changed that occupation from a rule-of-thumb trade to an engineering science; maintained lifelong interest in vocational education of miners.

STOESSEL, ALBERT FREDERIC (*b. St. Louis, Mo., 1894; d. New York, N.Y., 1943*), violinist, conductor, composer. Studied at Hochschule für Musik, Berlin, 1910–13; made debut as solo violinist with Blüthner Orchestra in Berlin, November 1914. American debut with St. Louis Symphony, November 1915. After World War I army service, he made concert tours and served as assistant to Walter Damrosch in direction of the New York Oratorio Society; in 1921 he succeeded Damrosch as director. Stoessel also directed the music at Chautauqua (*post* 1928) and was director of the Worcester (Mass.) Music Festival *post* 1925. He organized and directed the music department at New York University, 1923–30, and headed the orchestra and opera department at Juilliard Graduate School, New York City, *post* 1927. In addition to these duties, he appeared as guest conductor with leading symphony orchestras and composed, among other works, and opera *Garrick* (1936).

STOEVER, MARTIN LUTHER (*b. Germantown, Pa., 1820; d. Philadelphia, Pa., 1870*), educator. Principal of the Academy at Gettysburg, 1842–51; professor of history and Latin, Gettysburg College, 1844–70. Secretary for a number of years of the General Synod, Evangelical Lutheran Church, he was an editor of the *Evangelical Review*, 1857–61, and sole editor, 1862–70.

STOKES, ANSON PHELPS (*b. New York, N.Y., 1838; d. New York, 1913*), merchant, banker, civic reformer. Brother of William E. D. and Olivia E. P. Stokes.

STOKES, ANSON PHELPS (*b. Staten Island, N.Y., 1874; d. Lenox, Mass., 1958*), educator and clergyman. Studied at Yale University and the Episcopal Theological Seminary in Cambridge, Mass. Secretary of Yale University from 1899 to 1921, where he was instrumental in shaping Yale into an international center of learning of the highest standards. From 1924 to 1938, Stokes was the canon residentiary of the National Cathedral (Episcopal) in Washington, D.C. An outspoken critic of the practice of racial bigotry, Stokes was a trustee of Tuskegee Institute. After retirement, he wrote a monumental study, *Church and State in the United States* (1950), regarded as essential for understanding religion in America.

STOKES, CAROLINE PHELPS *See* STOKES, OLIVIA EGLESTON PHELPS.

STOKES, FREDERICK ABBOT (*b. Brooklyn, N.Y., 1857; d. New York, N.Y., 1939*), publisher. Became partner in White & Stokes, 1881; later published over imprint of White, Stokes & Allen; Frederick A. Stokes & Brother; and Frederick A. Stokes Co.

STOKES, ISAAC NEWTON PHELPS (*b. New York, N.Y., 1867; d. Charleston, S.C., 1944*), architect, housing reformer. Son of Anson P. Stokes. Following his graduation from Harvard in 1891, Stokes acceded to his father's demand that he enter the banking business. But after two years he decided to study architecture, enrolling first at Columbia University and then in 1894 at the École des Beaux Arts in Paris. He returned to the United States in 1897, and that year, with John Mead Howells, submitted the winning design for the University Settlement building. Encouraged by this success, the pair opened an architectural office in Manhattan, a partnership which lasted until 1917. Among their more noteworthy designs were the Baltimore Stock Exchange, the headquarters for the American Geographical Society in New York, and the Bonwit Teller department store in New York.

In 1898 Stokes helped organize the Charity Organization Society's Tenement House Committee. He was chiefly responsible for the preparation of the committee's tenement architecture competition and exhibition, which led in 1900 to the establishment by Governor Theodore Roosevelt of the New York State Tenement House Commission. Appointed to the commission in 1901, Stokes focused on the city's ubiquitous dumbbell tenements. Though Stokes helped set minimum standards for air, light, and sanitation, he soon lost faith in this type of legislation. Convinced that detailed codes inhibited the architectural experimentation necessary for the development of low-cost housing, Stokes resigned in 1912 from the Tenement Housing Committee because of its emphasis on restrictive legislation. He now believed that the solution to the housing problem lay entirely in the development of more economical designs; thereafter, as president, 1911–24, and secretary, 1924–37, of the Phelps-Stokes Fund, which had been established by Caroline Phelps Stokes in 1911, he concentrated on technical problems to lower the cost of construction.

Beginning in 1908, when his historical imagination was fired by the Hudson-Fulton celebration in New York, Stokes collected prints of old Manhattan as a hobby. Eventually his collection took the form of the monumental published compilation *The Iconography of Manhattan Island, 1498–1909* (6 vols., 1915–28), a full record of the physical evolution of the island.

STOKES, MAURICE (*b. Pittsburgh, Pa., 1933; d. Cincinnati, Ohio, 1970*), basketball player. Attended St. Francis College (B.A., 1955), where he achieved stardom on the basketball court; he was named to the All-American Basketball team in his sophomore, junior, and senior years. He was a first-round choice of the Rochester Royals in 1955 and was chosen NBA Rookie of the Year. In his second season the Royals moved to Cincinnati, and he led the NBA in rebounds. A serious fall in his third season (1958) left him in a coma for six months, after which he was paralyzed and confined to a wheelchair.

STOKES, MONTFORT (*b. Lunenburg Co., Va., 1762; d. Fort Gibson, Indian Territory, 1842*), planter, North Carolina public official and legislator. Uncle of Joseph M. Street. U.S. Senator, Democrat, from North Carolina, 1816–23; governor of North

Carolina, 1830–32; U.S. Indian commissioner and agent, 1833–42.

Stokes, Olivia Egleston Phelps (*b. New York, N.Y., 1847; d. Washington, D.C., 1927*), philanthropist. Sister of Anson P. and William E. D. Stokes. Active in many charitable activities with her sister, Caroline P. Stokes; chief patron of the Phelps-Stokes Fund, which Caroline had endowed prior to her death in 1909.

Stokes, Rose Harriet Pastor (*b. Russian Poland, 1879; d. Frankfurt am Main, Germany, 1933*), agitator. Immigrated to America as a young girl; married a son of Anson P. Stokes, 1905; was long associated with left-wing Socialist and Communist activity.

Stokes, Thomas Lunsford, Jr. (*b. Atlanta, Ga., 1898; d. Washington, D.C., 1958*), journalist. Studied at the University of Georgia. Stokes left Georgia in 1920 to assume a position as reporter for United Press in Washington. In 1933, he became Washington correspondent for the New York *World Telegram*, and in 1936, he became a national correspondent for the Scripps-Howard Newspaper Alliance. In 1938, though a backer of Roosevelt, Stokes investigated charges of political use of the Works Progress Administration in Kentucky. He uncovered widespread corruption. His stories led to a Senate investigation that resulted in the passing of the Hatch Act in 1938 and won Stokes the Pulitzer Prize for journalism. Stokes continued to write his columns until retirement.

Stokes, William Earl Dodge (*b. New York, N.Y., 1852; d. New York, 1926*), capitalist, real estate operator. Brother of Anson P. and Olivia E. P. Stokes.

Stokowski, Leopold Anthony (*b. London, England, 1882; d. Nether Wallop, Hampshire, England, 1977*), conductor and composer. Studied organ, theory, and composition at the Royal College of Music (1895–1900) and graduated Queen's College, Oxford (B.M., 1903). He was hired as organist for St. Bartholomew's Church in New York City (1905–08). He made his first appearances as a conductor in Paris (1908) and London (1909). He became music director and conductor for the Cincinnati Symphony Orchestra (1909–12), conductor and music director for the Philadelphia Orchestra (1912–36); he was naturalized in 1915. He brought international renown to both himself and the Philadelphia Orchestra. An early advocate of orchestral recordings, he made his first with the Philadelphia Orchestra in 1917 and his last in 1977 at age ninety-five; he became expert in acoustics and recording techniques. He was also music director for the Disney film *Fantasia* (1941). He founded and conducted the New York Symphony Orchestra (1944), was principal conductor of the Houston Symphony Orchestra (1955–60), and cofounder of the American Symphony Orchestra (1962). At age ninety he conducted the London Symphony Orchestra (1972).

Stolberg, Benjamin (*b. Ninich, Germany, 1891; d. New York, N.Y., 1951*), labor journalist. Immigrated to the U.S. in 1908. Studied at George Washington University, Harvard University, and the University of Chicago (M.A., 1919). A socialist, Stolberg was labor reporter for the *Nation*, the *New Republic*, and *The New York Evening Post*; after 1933, he supported himself entirely as a free-lance journalist. An ardent critic of the New Deal and the CIO, Stolberg was anti-Stalin, favoring instead the thinking of Leon Trotsky; he was a member of the commission of inquiry, headed by John Dewey, that exonerated Trotsky in 1937. Wrote *Economic Consequences of the New Deal* in 1935.

Stone, Abraham (*b. Russia, 1890; d. New York, N.Y., 1959*), physician and birth control activist. Attended New York University (M.D., 1912). A urologist, he practiced in New York as well as taught at the New School for Social Research and other institutions. In 1921, he attended with his wife, Hannah, the First International Birth Control Congress in New York and met Margaret Sanger. He and his wife, who was a gynecologist, devoted much of their lives to educating the public about birth control. He was director of the Margaret Sanger Research Center from 1941. Books include *A Marriage Manual* and *Practical Birth-Control Methods*. Stone was vice president of the Planned Parenthood Federation and of the International Planned Parenthood Federation.

Stone, Amasa (*b. Charlton, Mass., 1818; d. 1883*), capitalist, railroad builder. Brother-in-law of William Howe; father-in-law of John Hay and Samuel Mather. A carpenter by trade, Stone prospered as holder of the rights to the Howe truss bridge. Contracting with others to build the Cleveland Columbus & Cincinnati Railroad in 1849, he became its superintendent and president and made his residence in Cleveland. He played a great part in the industrial development of the Cleveland area. As managing director of the Lake Shore & Michigan Southern, he cooperated with the Rockefeller interests by allowing them preferential shipping rates. He was a principal benefactor of Western Reserve University.

Stone, Barton Warren (*b. near Port Tobacco, Md., 1772; d. Hannibal, Mo., 1844*), frontier evangelist, leader in the Christian denomination in Kentucky and Ohio.

Stone, Charles Augustus (*b. Newton, Mass., 1867; d. New York, N.Y., 1941*) and **Webster, Edwin Sibley** (*b. Roxbury, Mass., 1867; d. Newton, Mass., 1950*), electrical engineers, founders of the firm of Stone & Webster. The two men first met in 1884, when taking the entrance examinations for the Massachusetts Institute of Technology. Upon graduating in 1888, they planned to go into partnership as electrical engineers. After their plan was discouraged, Stone worked first as an assistant to Elihu Thomson at the Thomson Electric Welding Co. of Lynn, Mass., and then as the agent for the C & C Motor Co. in Boston. Webster spent several months touring Europe, and then worked at Kidder, Peabody & Co. Yet their idea persisted, and in November 1889, Stone and Webster launched a consulting engineering company in Boston.

Their first major project provided New England with one of its earliest high-voltage power transmission facilities. During the next few years they built small electric light plants, reported on the operations of existing facilities, and gained support for their laboratory by testing electrical materials. During the depression of 1893, electrical manufacturers had taken securities of operating power companies in partial payment for equipment. In the panic that followed, banks demanded reduction on loans to manufacturers, and General Electric had to run unseasoned and unsalable securities over to a syndicate, which engaged Stone & Webster to examine and report upon them. On the advice of the elder J. P. Morgan, they invested in one of the most promising of the properties, the Nashville (Tenn.) Electric Light and Power Co. They later gained a controlling interest in the Nashville company, extended and developed it, and within a few years sold it for a staggering profit. Until 1905 they were the only partners, but by 1913 their were seven.

Meanwhile, the need for capital to improve and extend the utilities they managed had led the partners to establish, in 1902, a securities department to act as fiscal agent in floating securities for the utility companies under their management. In 1906 they formed the Engineering Corporation to systematize design and

construction and to relate these to management and finance. The Massachusetts Institute of Technology had the firm build the limestone-faced buildings of its new campus on the Charles River esplanade, 1913–15. In 1913 the company also completed construction of the Keokuk hydroelectric station at Des Moines Rapids on the Mississippi River.

In 1920 the partnership was incorporated in Massachusetts; Webster became vice-chairman in 1930 and succeeded to the chairmanship after Stone's death in 1941. Subsidiary firms were set up to manage the company's various functions; in 1927, Stone, Webster & Blodget (later Stone & Webster Securities Corporation), to handle securities sales; in 1928, Stone & Webster Engineering Corporation, to assume the engineering and construction work; and in 1929, the Stone & Webster Service Corporation, to take over the development and operation of public utility properties.

Despite changes in the organization of the firm, Charles Stone and Edwin Webster in their later years saw their company continue to provide services along the lines they had established. Both served on the executive committee of MIT for many years and were directors of numerous organizations.

STONE, CHARLES POMEROY (*b. Greenfield, Mass., 1824; d. New York, N.Y., 1887*), Union brigadier general. Blamed and imprisoned for the Union defeat at Ball's Bluff, Oct. 21, 1861, he was later exonerated and served in the Port Hudson and Red River campaigns. He served in the Egyptian army, 1870–83, becoming chief of staff and lieutenant general.

STONE, DAVID (*b. near Windsor, N.C., 1770; d. Wake Co., N.C., 1818*), planter, lawyer, North Carolina governor and jurist. Congressman, Democratic-Republican, from North Carolina, 1799–1801; U.S. senator, 1801–07 and 1813–14. Lost prestige with the electorate during his second term as senator for opposing administration measures for the War of 1812.

STONE, DAVID MARVIN (*b. Oxford, Conn., 1817; d. Brooklyn, N.Y., 1895*), editor, publisher. Associated with the New York *Journal of Commerce* from 1849, he became its editor in chief in 1866 and held that post until 1893. He was also president of the New York Associated Press, 1869–*ca.* 1894.

STONE, EDWARD DURELL (*b. Fayetteville, Ark., 1902; d. New York City, 1978*), architect. Attended University of Arkansas (1920–23), Harvard University (1926), and Massachusetts Institute of Technology (1927) and studied in Europe (1927–29). He was employed by Schultze and Weaver (1929) and helped design the interior of the Waldorf–Astoria Hotel in New York City. He next worked on Rockefeller Center, creating the interior of Radio City Music Hall. He opened Edward Durell Stone and Associates in New York City (1936), and with Philip Goodwin completed his first major building, the Museum of Modern Art (1937). In the 1940's he became committed to the International Style. Major commissions included the El Panama Hotel in Panama City (1946), which incorporated cantilevered balconies; a prizewinning design for the American Embassy in New Delhi, India (1954), which employed grillwork as a protective screen; the National Geographic Society's headquarters in Washington, D.C. (1964), which floats on a two-story base with overhang; the General Motors Building in New York City (1964–68); and the John F. Kennedy Center for Performing Arts in Washington, D.C. (1971).

STONE, ELLEN MARIA (*b. Roxbury, Mass., 1846; d. Chelsea, Mass., 1927*), Congregational missionary in Bulgaria, 1878–1902. Her seizure and captivity by brigands, 1901–02, attracted worldwide attention.

STONE, GEORGE WASHINGTON (*b. Bedford Co., Va., 1811; d. Montgomery, Ala., 1894*), jurist. Raised in Tennessee; admitted to the Alabama bar, 1834. Judge of Alabama circuit court, 1843–49; associate justice, Alabama Supreme Court, 1856–65 and 1876–84. *Post* 1884 he served as chief justice, at first by appointment and afterward by election. An earnest advocate of judicial reform, Stone labored to raise the standards of his court, which had been demoralized by war and Reconstruction.

STONE, HARLAN FISKE (*b. Chesterfield, N.H., 1872; d. Washington, D.C., 1946*), lawyer, chief justice of the United States. Attended Massachusetts Agricultural College; graduated Amherst College, 1894. While teaching science at the high school in Newburyport, Mass., he became interested in the law and entered Columbia Law School, New York City, 1895. After graduation in 1898, Stone combined law school teaching at Columbia with a clerkship in the firm of Sullivan and Cromwell. A year later he shifted to Wilmer and Canfield. He resigned his professorship in March 1905 for a full-time partnership at Wilmer and Canfield. In 1906, however, he accepted an invitation to return as professor and dean at Columbia, with the understanding that he would enjoy freedom in choosing the law faculty. Soon the authoritarian president and the staunchly independent dean clashed. Again, Stone resigned, evoking a concerted drive by students, faculty, and trustees on his behalf. The upshot was his unanimous appointment as dean, effective July 10, 1910. The years 1910–16 were marked by efforts to raise academic standards and improve the curriculum. Stone himself set an example by continuing to teach, write, and maintain a nominal law practice at Wilmer, Canfield, and Stone. As a practicing lawyer, his career was brief—1905–10 and about six months in 1923–24. In later years, he rated his teaching more enduring than anything he did as a judge.

An Anglophile and strong interventionist, Stone anxiously observed the course of World War I. He lamented his ineligibility for active service, but doubted the wisdom of coerced conformity at the cost of conscience. His essay "The Conscientious Objector" (1919) is recognized as a classic. Stone resigned as dean on Feb. 21, 1923. On Apr. 1, 1924, President Coolidge named Stone attorney general. In trying to brighten the tarnished Justice Department, Stone's primary goal was recruitment of personnel unsullied by alliance with the underworld. William J. Burns was dismissed as head of the Federal Bureau of Investigation and replaced by 29-year-old J. Edgar Hoover on Dec. 19, 1924. Eliminating political plums for congressional protégés, accustomed to serving as counsel for the government in cases before the Supreme Court, Stone revived the tradition of arguing cases himself. He campaigned for Coolidge in 1924, and was nominated to the Supreme Court on Jan. 5, 1925. Stone was overwhelmingly confirmed on Feb. 5, 1925, and sworn in on Mar. 2. The ideas Stone expounded in a series of lectures (later published as *Law and Its Administration*, 1915) at Columbia University have been regarded as conservative, even reactionary. But when, as a Supreme Court justice, he harshly attacked judicial distrust of social legislation, he was hailed as a liberal. The notion, vigorously advanced in certain quarters, that Holmes and Brandeis were the "pacemakers" and Stone a sort of judicial "me-too" is not borne out by the record. Without minimizing the contributions of Holmes and Brandeis, Stone was the one who, in both the old Court (before 1937) and the new (after 1937), carried the Holmes-Brandeis tradition to fulfillment.

In *United States* v. *Carolene Products Co.* (1938), Stone suggested in the text of the opinion that the Court would not go so far as to say that no economic regulation would violate constitutional restraints, but he did indicate that henceforth the Court's role in this area would be strictly confined. Attached to this proposition is what is considered to be the most famous footnote in

the Court's history, suggesting special judicial scrutiny in three areas: legislative encroachment on 1st Amendment freedoms; government action impeding or corrupting the political process; and official conduct adversely affecting the rights of racial, religious, or national minorities.

Stone considered judicial review to be one of the auxiliary precautions envisioned by the founding fathers against abuse of power. He believed that unless the Court invokes its authority to preserve the rights deemed fundamental, especially the crucial preliminaries of the political process — speech, press, assembly — no free government can exist. On June 2, 1941, Chief Justice Hughes resigned at the age of 79. Speculation concerning Hughes's successor centered on Attorney General Robert H. Jackson and Associate Justice Stone. The choice of Stone seemed a fitting reward for the uphill battle he had waged, despite his strong misgivings, on behalf of the New Deal's constitutionality. Refuting the charge that he made party loyalty the primary qualification for appointment to the Supreme Court, Roosevelt passed over his popular attorney general and sent Stone's name to the Senate on June 12, 1941. Stone's chief justiceship, however, was unimpressive. The bench Stone headed was the most frequently divided, the most openly quarrelsome in history.

As chairman of the board of trustees of the National Gallery, Stone played an important role in expanding its collections and rescuing European art treasures during World War II. He also served on committees of the Smithsonian Institution and the Folger Library. Stone's charm made him a favorite companion of President Hoover, with whom he sometimes went fishing; he was also a member of the intimate group known as the Medicine Ball Cabinet.

STONE, HORATIO (*b. Jackson, N.Y., 1808; d. Carrara, Italy, 1875*), sculptor, physician, Union army surgeon

STONE, JAMES KENT (*b. Boston, Mass., 1840; d. 1921*), educator, Roman Catholic clergyman, Passionist. Son of John S. Stone. Graduated Harvard, 1861. After service in the Union army, he became a teacher of Latin at Kenyon College, took orders in the Protestant Episcopal church and was president of Kenyon, 1867. President of Hobart College, 1868–69, he resigned and became a Catholic in December 1869. Joining the Paulists, he was ordained in the Catholic priesthood, 1872, but withdrew in 1876 to join the more severe Congregation of the Passion, wherein he took the name in religion of Father Fidelis. Thereafter he achieved high distinction in his order, holding a number of administrative offices and founding its work in South America.

STONE, JOHN AUGUSTUS (*b. Concord, Mass., 1800; d. Philadelphia, Pa., 1834*), playwright, actor. Author of a number of plays and adaptations which are no longer extant, he wrote his most important play, *Metamora*, for Edwin Forrest. It was first produced at the Park Theatre, N.Y., December 1829, and provided Forrest with one of his most popular parts.

STONE, JOHN MARSHALL (*b. Milan, Tenn., 1830; d. Mississippi, 1900*), politician, Confederate officer. As Democratic governor of Mississippi, 1876–82 and 1890–96, Stone reorganized the state government on the basis of control by whites, tempered the extravagances of the recent carpetbag administrations, and, in his second administration, provided for the perpetuation of white control by the provisions of the 1890 state constitution. He served briefly before his death as president of Mississippi A. and M. College (present Mississippi State). He was an able administrator and of high personal character.

STONE, JOHN SEELY (*b. West Stockbridge, Mass., 1795; d. Cambridge, Mass., 1882*), Episcopal clergyman, educator. Father of James K. Stone. An eloquent preacher and a leader in the evangelical school, he held a number of pastorates, taught theology in the Philadelphia Divinity School, 1862–67, and was dean and professor of theology at Episcopal Theological School, Cambridge, Mass., 1867–76.

STONE, JOHN STONE (*b. Dover, Va., 1869; d. San Diego, Calif., 1943*), telephone and radio engineer. Son of Charles Pomeroy Stone. Studied at School of Mines, Columbia University, 1886–88, and at Johns Hopkins University, 1888–90. Worked in Boston laboratory of American Bell Telephone Co.; unsuccessful in attempt to manufacture and market his own inventions; was associate engineer at large for American Telephone and Telegraph Co., 1920–34. A pioneer in radio telegraphy and telephony, unlike most of the other pioneer experimenters, he was a theoretician who relied almost wholly on mathematical analysis to test the validity of his concepts. His system of loosely coupled tuned circuits for radio transmission and reception (patented 1902) anticipated Marconi's similar system; the priority was established by the U.S. Supreme Court shortly after Stone's death. He made important contributions also in the field of high-frequency wire transmission and to shortwave and ultrahigh-frequency radio.

STONE, JOHN WESLEY (*b. Wadsworth, Ohio, 1838; d. Lansing, Mich., 1922*), lawyer, jurist. Removed to Michigan ca. 1856. Held state and federal offices in Michigan; served as a state circuit judge; was congressman, Republican, from Michigan, 1877–81. Elected to the state supreme court 1909, he served with ability until his death.

STONE, LUCY (*b. near West Brookfield, Mass., 1818; d. Dorchester, Mass., 1893*), reformer, pioneer in the woman's rights movement. Graduated Oberlin, 1847. An ardent abolitionist, she lectured widely on this subject *post* 1848, losing no opportunity at the same time to lecture on the inferior position of her sex. She led in calling the first national woman's rights convention, Worcester, Mass., 1850. On her marriage to Henry B. Blackwell, 1855, she gained notoriety by insistence on keeping her maiden name as a symbol of equality. Thereafter, with the aid of her husband, she continued and extended her labors and helped form the American Woman Suffrage Association, which concentrated on gaining the suffrage by states. With her husband, she edited the *Woman's Journal* from 1872.

STONE, MELVILLE ELIJAH (*b. Hudson, Ill., 1848; d. New York, N.Y., 1929*), journalist. Coproprietor, *Chicago Daily News*, 1875–88, he sold out his interest to his partner, Victor F. Lawson, and after several years of travel, engaged for a while in banking. On becoming general manager of Associated Press of Illinois, 1893, he secured exclusive right for use of Reuter's news in the United States and continued to head the Associated Press after its reorganization in New York, 1900, until his retirement, 1921. A man of constructive mind, executive powers, and engaging personality, he fostered the cooperative principle on which the Associated Press was based, kept its news free of partisanship and bias, and opposed sensationalism. He was also active in persuading official European news sources to deal fairly with American correspondents and played a part behind the scenes in settlement of the Russo-Japanese War by treaty at Portsmouth, N.H., 1905.

STONE, ORMOND (*b. Pekin, Ill., 1847; d. Clifton Station, Va., 1933*), astronomer. Brother of Melville E. Stone. Director of Cincinnati Observatory, 1875–82; of University of Virginia McCor-

mick Observatory, 1882–1912. Founded *Annals of Mathematics,* 1884.

STONE, RICHARD FRENCH (*b. near Sharpsburg, Ky., 1844; d. Indianapolis, Ind., 1913*), physician. Author of, among other works, *Biography of Eminent American Physicians and Surgeons* (1894, 1898).

STONE, SAMUEL (*b. Hertford, England, 1602; d. Hartford, Conn., 1663*), Puritan clergyman. Immigrated to Massachusetts with Thomas Hooker and John Cotton, 1633. Removing to the Connecticut settlement, he selected the site of Hartford, negotiated its purchase from the Indians and settled there, 1636. After Hooker's death in 1647, he remained sole minister of the church at Hartford until his own death. Although his idea of church government approached Presbyterianism more than Independency, he was steadfastly supported by a majority of his congregation.

STONE, THOMAS (*b. Charles Co., Md., 1743; d. Alexandria, Va., 1787*), lawyer, planter, Maryland legislator. As member of the Continental Congress for the greater part of the period 1775–78, he was a signer of the Declaration of Independence and did important work on the committee which framed the Articles of Confederation.

STONE, WARREN (*b. Saint Albans, Vt., 1808; d. New Orleans, La., 1872*), physician, surgeon. M.D., Berkshire Medical Institution, Pittsfield, Mass., 1831. In practice at New Orleans *post ca.* 1833, he served on the staffs of several hospitals, founded one of the earliest private hospitals in the United States, 1839, and taught at the Medical College of Louisiana (later Tulane), 1834–72. During the Civil War, he was surgeon general of Louisiana. Among his professional achievements were the first resection of part of a rib to secure permanent drainage in cases of empyema, the first successful cure for traumatic vertebral aneurism by open incision and packing, and the first use of silver wire for ligation of the external iliac.

STONE, WARREN SANFORD (*b. near Ainsworth, Iowa, 1860; d. Cleveland, Ohio, 1925*), trade-union official. Headed Brotherhood of Locomotive Engineers, 1903–25. Led in struggle to secure better wages and shorter hours by dealing with railway managers through regional groups, thereby finishing one contest before taking up another; favored cooperative ownership of railways and independent political action by labor.

STONE, WILBUR FISK (*b. Litchfield, Conn., 1833; d. Denver, Colo., 1920*), Colorado pioneer and jurist. Raised in the Midwest; removed to Nebraska, 1859, and to Colorado, 1860. Holder of both federal and state offices, he was active in railroad promotion. From 1877 until 1889 he was judge of the state supreme court and of the criminal court of Denver, and from 1891 until 1904 he sat on a unique court appointed to determine Spanish and Mexican land titles in the Southwest.

STONE, WILLIAM (*b. Northamptonshire, England, ca. 1603; d. Charles Co., Md., ca. 1660*), planter, Maryland colonial official. Immigrated to Virginia *ante* 1628. Appointed proprietary governor of Maryland, 1648, he was engaged in a continuous struggle with the Puritan element of the colony, which climaxed in his defeat in the battle of the Severn, Mar. 25, 1655.

STONE, WILLIAM JOEL (*b. Madison Co., Ky., 1848; d. 1918*), lawyer. Congressman, Democrat, from Missouri, 1885–91, and a moderate reformer, he served with tact and ability as governor of Missouri during the troubled period 1893–97. U.S. senator from Missouri *post* 1903, he was a disciple of William J. Bryan

and an orthodox Democratic partisan; however, on becoming chairman of the Foreign Relations Committee, 1914, he invited criticism by his steadfast opposition to the U.S. involvement in World War I.

STONE, WILLIAM LEETE (*b. New Paltz, N.Y., 1792; d. New York, N.Y., 1844*), journalist. After experience on a number of newspapers and periodicals, he became a proprietor of the *New York Commercial Advertiser*, 1821. He was an influential Federalist editor, but is remembered principally for his efforts to arouse interest in the preservation and historical use of the state archives and for several of his works in local history, including *Life of Joseph Brant* (1838), *Life and Times of Red Jacket* (1841), and *Border Wars of the American Revolution* (1843).

STONE, WILLIAM LEETE (*b. New York, N.Y., 1835; d. 1908*), journalist. Son of William L. Stone (1792–1844); nephew of Francis Wayland. Graduated Brown, 1858. Editor and compiler of a number of valuable source works on the history of the American Revolution, notably on the Saratoga campaign.

STONE, WILLIAM OLIVER (*b. Derby, Conn., 1830; d. Newport, R.I., 1875*), portrait painter. Studied with Nathaniel Jocelyn. A prolific and successful portraitist of prominent persons; worked in New York City *post* 1854.

STONE, WITMER (*b. Philadelphia, Pa., 1866; d. Philadelphia, 1939*), naturalist, museum curator and director. Associated *post* 1888 with Academy of Natural Sciences in Philadelphia; editor, *The Auk*, 1912–36. Author of, among other works, *Bird Studies at Old Cape May* (1937), regarded as one of the best all regional bird books.

STONEMAN, GEORGE (*b. Busti, N.Y., 1822; d. Buffalo, N.Y., 1894*), soldier. Graduated West Point, 1846. A cavalryman, he served mainly in the Southwest prior to the Civil War. Chief of cavalry, Army of the Potomac, under General George B. McClellan, he was assigned to command the 1st Division, III Corps, and succeeded to command of the corps as major general, November 1862. When General Joseph Hooker took command of the Army of the Potomac, he put Stoneman in charge of the separate corps of cavalry. While in this post Stoneman made a famous raid toward Richmond, Va., April–May 1863, as part of the Chancellorsville campaign. Transferred to the western armies, he commanded the cavalry corps of the Army of the Ohio in the Atlanta campaign, but suffered defeat and capture at Clinton, Ga., early in August 1864. Exchanged, he returned to duty, making another cavalry raid with considerable success into southwestern Virginia in December 1864 and later acting in cooperation with Sherman in the Carolinas. After his retirement from the army for disability, 1871, he settled near Los Angeles, Calif. As Democratic governor of California, 1883–87, he opposed the increasing power of the railroads in state affairs and in business, and favored legislation encouraging irrigation projects.

STONG, PHIL(IP DUFFIELD) (*b. Pittsburg, Iowa, 1899; d. Washington, Conn., 1957*), author. Studied at Drake University and Columbia University. Author of forty books, two anthologies, and many magazine stories and articles. Stong's best-known work was *State Fair* (1932), a novel which was filmed three times. Other works include *Week-End* (1935) and *Career* (1936, filmed 1939). Children's books include *The Hired Man's Elephant* (1939), which won the *New York Herald Tribune* Award in 1939.

STORER, BELLAMY (*b. Cincinnati, Ohio, 1847; d. Paris, France, 1922*), lawyer, diplomat. Nephew of David H. Storer. Graduated Harvard, 1867; law school of Cincinnati College, 1869. Married Maria Nichols, widow of George W. Nichols,

1886. Congressman, Republican, from Ohio, 1891–95, he helped William McKinley in the campaign of 1896 and was appointed U.S. minister to Belgium, 1897. Becoming U.S. minister to Spain, 1899, he successfully handled problems incident to the Spanish-American War, and in 1902 was made U.S. ambassador at Vienna. Popular and successful, he was summarily removed in March 1906 after a dispute with President Theodore Roosevelt.

STORER, DAVID HUMPHREYS (*b. Portland, Maine, 1804; d. Boston, Mass., 1891*), Boston obstetrician, naturalist, collector of rare fishes and shells. Graduated Bowdoin, 1822; Harvard Medical School, 1825; served apprenticeship with John C. Warren (1776–1856). As a practitioner and as a teacher at Harvard Medical School (dean, 1854–64), he did much to advance obstetrics in the United States; he was also regarded as expert in medical jurisprudence. He was father of Francis H. and Horatio R. Storer and uncle of Bellamy Storer.

STORER, FRANCIS HUMPHREYS (*b. Boston, Mass., 1832; d. Boston, 1914*), chemist. Son of David H. Storer; brother of Horatio R. Storer. Studied at Lawrence Scientific School; served as assistant to Josiah P. Cooke, and was chemist with U.S. North Pacific exploring expedition, 1853–54. Chemist of the Boston Gas Light Co., *ca.* 1858–71, he was associated also in research projects with Charles William Eliot, with whom he collaborated on several textbooks and whose sister he married. On Eliot's appointment to the presidency of Harvard, 1869, he appointed Storer professor of agricultural chemistry at the Bussey Institution. Becoming dean of the institution, 1871, he held both posts until 1907. During this period he performed important research on soils, fertilizers, forage crops, cereals, vegetables, and other products, publishing the results in the *Bulletin of the Bussey Institution*. He was author also of *Agriculture in Some of Its Relations with Chemistry* (1887) and various manuals and textbooks.

STORER, HORATIO ROBINSON (*b. Boston, Mass., 1830; d. Newport, R.I., 1922*), gynecologist, numismatist. Son of David H. Storer; brother of Francis H. Storer. Graduated Harvard, 1850; M.D., Harvard Medical School, 1853; studied also in Paris, London, and Edinburgh. Among the early American specialists in gynecology, he wrote and lectured extensively against abortion. After his retirement from practice, 1872, he became a world authority on medallions of medical interest and a notable collector of them.

STOREY, MOORFIELD (*b. Roxbury, Mass., 1845; d. Lincoln, Mass., 1929*), lawyer. Graduated Harvard, 1866. As assistant to Charles Sumner, 1867–69, he was closely connected with the attempt to impeach President Andrew Johnson. Winning an international reputation in the practice of commercial law in Boston *post* 1871, he became a crusader against political corruption, attacking Benjamin F. Butler and James G. Blaine, and leading the Mugwump Republicans during the presidential campaign of 1884. An anti-imperialist and a defender of the rights of blacks and Indians, he wrote prolifically in support of his opinions. Earnest and courageous, he won little gratitude or popularity by his activity.

STOREY, WILBUR FISK (*b. near Salisbury, Vt., 1819; d. Chicago, Ill., 1884*), journalist. Gaining experience on newspapers in New York, Indiana, and Michigan, he made the *Detroit Free Press* one of the leading Democratic newspapers in the West as co-owner and owner, 1853–61. Purchasing the *Chicago Times*, 1861, he was its active head until 1878, making it one of the most prosperous of the Chicago dailies despite a brief suppression for alleged "copperhead" proclivities in 1863 and the destruction of its plant in 1871. Not a writer, but rather a directing executive, Storey emphasized the importance of news and attacked men and issues with vigor and fearlessness.

STORROW, CHARLES STORER (*b. Montreal, Canada, 1809; d. Boston, Mass., 1904*), engineer. Born of American parents and raised in Boston and in Paris, France, Storrow graduated from Harvard, 1829. He studied engineering with Loammi Baldwin and in Paris. Construction engineer and manager, Boston & Lowell Railroad, 1832–45, he then became engineer for the Essex Co. and, as such, planned, laid out, and built the industrial town of Lawrence, Mass. He was father of James J. Storrow.

STORROW, JAMES JACKSON (*b. Boston, Mass., 1837; d. Washington, D.C., 1897*), lawyer. Son of Charles S. Storrow; grandson of James Jackson. Graduated Harvard, 1857. Devoting himself to patent law, he was associated with Chauncey Smith in the long litigation over validity of the Bell Telephone patents, showing himself a master in clear analysis of evidence. He was author of the brief on behalf of Venezuela, 1895–96, which brought about British consent to submit the boundary controversy to arbitration.

STORRS, RICHARD SALTER (*b. Longmeadow, Mass., 1787; d. Braintree, Mass., 1873*), Congregational clergyman. Pastor, First Church, Braintree, 1811–73, he was a conspicuous defender of orthodoxy and active in home missionary work. He was father of Richard S. Storrs (1821–1900)

STORRS, RICHARD SALTER (*b. Braintree, Mass., 1821; d. Brooklyn, N.Y., 1900*), Congregational clergyman. Son of Richard S. Storrs (1787–1873). Pastor, Church of the Pilgrims, Brooklyn, N.Y., *post* 1846, he was active in Brooklyn's civic, philanthropic, and cultural affairs, and won great popularity as a lyceum lecturer.

STORY, ISAAC (*b. Marblehead, Mass., 1774; d. Marblehead, 1803*), poet, miscellaneous writer. Cousin of Joseph Story. A contributor to the *Farmer's Museum* and the *Columbian Centinel* and other papers, he was author of essays modeled on Joseph Dennie's "Lay Preacher" papers and of a number of satirical and serious poems. His best-known verses were published in *A Parnassian Shop . . . By Peter Quince, Esq.* (1801).

STORY, JOSEPH (*b. Marblehead, Mass., 1779; d. Cambridge, Mass., 1845*), lawyer, jurist, U.S. Supreme Court justice. Father of William W. Story. Graduated Harvard, 1798; studied law in office of Samuel Sewall, later chief justice of the supreme court of Massachusetts. Began practice at Salem, Mass., 1801. Although he was an avowed follower of Jefferson in a Federalist community, he did well in his profession and was elected to the state legislature, where, among other reforms, he made an unsuccessful effort to establish a state court of chancery. He served briefly as a member of Congress, 1808–09, opposing administration policies on the Embargo of 1807 and naval affairs. Reelected to the Massachusetts legislature, he served as Speaker of the House in January and May 1811. On Nov. 18, 1811, he was appointed an associate justice of the U.S. Supreme Court.

Supreme Court judges at this time also exercised circuit court jurisdiction, and Story's circuit took in Maine, New Hampshire, Massachusetts, and Rhode Island. A pioneer in outlining and defining the field of admiralty law for the United States, by his decisions first put the admiralty jurisdiction of the federal courts on a sound basis. Many of his opinions are still impressive for their breadth of learning, but in some there is a tendency to range beyond the facts and law necessary for judgment in a particular case. However, not a few of his opinions had important legal and constitutional results. His opinion in *Martin v. Hunter's Lessee* (1816) has been called the keystone of the arch of federal

judicial power, holding as it did that appellate jurisdiction of the Supreme Court could rightfully be exercised over the state courts. In the case of the *Thomas Jefferson,* Story's opinion allayed a mounting feeling in some of the inland states that the federal courts were menacing state common-law jurisdiction over inland waters. Story spoke for the court in the case of the *Amistad,* a slaverunner, holding that the human cargo should be freed and sent back to Africa; he also wrote the opinion in the Girard will case. Daniel Webster considered Story's ablest opinion his dissent in *Charles River Bridge* v. *Warren Bridge,* in which he upheld the sanctity of contracts. The facts disprove the often-quoted charge that Story was dominated by John Marshall, whom he failed to succeed as chief justice, in part because Andrew Jackson disliked him and considered him dangerous.

Together with the vast amount of work he performed on the bench, Story was professor of law at Harvard, *post* 1829, and may be regarded in a very real sense as a founder of the Harvard Law School. The method of teaching which he devised later resulted in his famous *Commentaries* on bailments, the Constitution, conflict of laws, equity jurisprudence and pleading, agency, partnership, and bills and notes, which were published in quick succession between 1832 and 1845. He was author also of a number of other legal treatises and, by his writing, has provided an example of industry and legal scholarship hardly to be equaled. The success of the *Commentaries* was widespread and immediate and provided the author of a handsome income and an international reputation. Together with Chancellor James Kent, Story will be remembered as the founder of the equity system in the United States. He drew up the rules of equity practice for the U.S. Supreme Court and the circuit courts in 1842, and among his *Commentaries* those on equity jurisprudence and pleading remain outstanding. A Unitarian, a great lover of conversation, poetry, and music, his favorite novelist was Jane Austen.

STORY, JULIAN RUSSELL (*b. Walton-on-Thames, England, 1857; d. Philadelphia, Pa., 1919*), portrait painter. Son of William W. Story.

STORY, WILLIAM EDWARD (*b. Boston, Mass., 1850; d. 1930*), mathematician. Graduated Harvard, 1871; Ph.D., Leipzig, 1875. After teaching at Harvard and at Johns Hopkins, where he was associated with J. J. Sylvester, Story was professor of mathematics at Clark University, 1889–1921.

STORY, WILLIAM WETMORE (*b. Salem, Mass., 1819; d. Vallombrosa, Italy, 1895*), sculptor, author. Son of Joseph Story. Graduated Harvard, A.B., 1838; LL.B., 1840. Practiced law with, among others, his brother-in-law, George T. Curtis, and wrote two long-standard legal textbooks; devoted himself in his spare time to painting, sculpting, and music. After completing a statue of his late father for Mount Auburn Cemetery and also composing his father's biography, he settled in Rome, Italy, 1856, and thereafter devoted his chief efforts to sculpture and travel in Europe. He revisited his own country only occasionally. Intimate friend of Robert and Elizabeth Barrett Browning, Nathaniel Hawthorne, and many other distinguished literary and artistic figures, Story led a happy life but one of artistic unfulfillment. His approach to his conceptions was fundamentally intellectual and deficient in intensity. Among his numerous books, *Roba di Roma* (1862) may still be read as an outstanding appreciation of the spirit of Italy.

STOTESBURY, EDWARD TOWNSEND (*b. Philadelphia, Pa., 1849; d. Chestnut Hill, Pa., 1938*), banker. Entering employ of Drexel & Co. as a clerk, 1866, he rose in successive promotions to senior partner, 1904. Partner also in Drexel's New York City affiliate, the then J.P. Morgan & Co., he was active in the railroad reorganizations and securities underwriting which were responsible for the success of both firms.

STOTT, HENRY GORDON (*b. Orkney Island, 1866; d. probably New Rochelle, N.Y., 1917*), electrical engineer. Came to America, 1891. As engineer for Buffalo (N.Y.) Light & Power Co., he constructed its conduit system and major power plant; *post* 1901 he superintended power plants and transmission lines for the Manhattan Railway Co. and the Interboro Rapid Transit, New York City.

STOUFFER, SAMUEL ANDREW (*b. Sac City, Iowa, 1900; d. New York, N.Y., 1960*), sociologist, statistician. Educated at Morningside College, Iowa; Harvard University, and the University of Chicago (Ph.D., 1930). Taught at the University of Chicago (1930–31 and 1935–46), at the University of Wisconsin (1932–35), and at Harvard University (1946–60). Stouffer was a reformist in purpose and empiricist in approach, insisting on verified evidence for the advancement of social science and the solution of social problems. He introduced and developed the system of sample surveys for the gathering of social data. From 1941 to 1946, he directed the Research Branch Information and Education Division of the U.S. Army, gathering social data on over half a million servicemen. Stouffer was chairman of the joint committee of the National Research Council and the Social Science Research Council, for which he did a survey in 1954 on the effects of McCarthyism.

STOUFFER, VERNON BIGELOW (*b. Cleveland, Ohio, 1901; d. Cleveland, 1974*), restaurateur and businessman. Graduated University of Pennsylvania (B.A., 1923) and opened a lunch counter in Cleveland, emphasizing strict standards for efficiency and service, which helped him develop a successful restaurant chain that featured home-style food. In 1954 he expanded profitably into the frozen food business. By 1967, when he sold his company to Litton Industries, the Stouffer Foods Corporation owned forty-six restaurants and had annual revenues of $80 million. He was also owner of baseball's Cleveland Indians (1966–72).

STOUGHTON, EDWIN WALLACE (*b. Springfield, Vt., 1818; d. New York, N.Y., 1882*), lawyer. Practiced in New York City *post* 1840; won reputation in patent suits, including the Goodyear rubber, the Wheeler & Wilson sewing machine, and Corliss steam-engine cases. Originally a War Democrat, he became a Republican and served on the commission which investigated the Louisiana vote in the election of 1876; he later spoke in behalf of the Republican position before the Electoral Commission. He was U.S. minister to Russia, 1877–79.

STOUGHTON, WILLIAM (*b. probably England, 1631; d. Dorchester, Mass., 1701*), colonial official. Graduated Harvard, 1650; M.A., New College, Oxford, 1653. Ejected from his Oxford fellowship, 1660, he returned to Massachusetts, 1662, where he held a number of offices and became a political henchman of Joseph Dudley. Named lieutenant governor of the colony, 1692, under Sir William Phips, he became acting governor, 1694, and except for a brief period, 1699–1700, continued to head the government until his death. As chief justice of oyer and terminer during the Salem witchcraft cases, 1692, he was largely responsible for the tragic aspect they assumed, because of his insistence on the admission of "spectral evidence" and by his overbearing attitude.

STOUT, REX TODHUNTER (*b. Noblesville, Ind., 1886; d. Brewster, N.Y., 1975*), author. Began writing fiction for magazines in 1912 and in 1916 helped launched the Educational Thrift Service, a business that enrolled students in savings plans. After the stock market crash depleted much of his wealth, he ventured

into mystery writing, primarily works that included his eccentric and brilliant detective Nero Wolfe; Stout eventually sold over forty-five million copies of the Wolfe mystery novels.

STOVALL, PLEASANT ALEXANDER (b. Augusta, Ga., 1857; d. Savannah, Ga., 1935), Georgia journalist and legislator, diplomat. Graduated University of Georgia, 1875. Editor, Savannah Press from 1891; U.S. minister to Switzerland, 1913–20.

STOW, BARON (b. Croydon, N.H., 1801; d. 1869), Baptist clergyman, editor. A powerful evangelical preacher, he held his principal pastorates at the Second Baptist Church, Boston, Mass., 1832–48, and at the Rowe Street Baptist Church, 1848–67.

STOWE, CALVIN ELLIS (b. Natick, Mass., 1802; d. 1886), educator. Graduated Bowdoin, 1824. Taught at Dartmouth, Lane Theological Seminary, Bowdoin, and Andover Theological Seminary; author of a celebrated Report on Elementary Instruction in Europe (1837). Husband of Harriet E. B. Stowe.

STOWE, HARRIET ELIZABETH BEECHER (b. Litchfield, Conn., 1811; d. Hartford, Conn., 1896), author. Daughter of Lyman Beecher; sister of Catharine E., Edward, and Henry Ward Beecher; wife of Calvin E. Stowe. A true member of her family in her earnestness, intelligence, and devotion to the antislavery cause, Stowe developed an early taste for writing. She was influenced in choosing an antislavery subject for her pen by current discussions of the Fugitive Slave Law and also by her brother Edward and his wife. While tending her newly born seventh child, she began work on what was to be Uncle Tom's Cabin, or Life Among the Lowly, which was first published as a serial in the National Era, June 5, 1851–Apr. 1, 1852; it was brought out as a book in two volumes by John P. Jewett on Mar. 20, 1852. Within a year of publication the sales of the book had mounted to 300,000; however, Stowe received surprisingly little remuneration for her work. She, as well as her novel, became the center of violent controversy, and she was attacked on the grounds of inaccuracy, literary quality, and motive. As a picture of American manners, however, Uncle Tom's Cabin deserves high rank and at times its style rises to eloquence. The influence of her work in England and on the Continent was very great, winning enormous favor for the antislavery cause. Exceedingly industrious as a writer, she continued to pour forth a steady stream of fiction, despite distractions of family life, trips to Europe, and the like. Over nearly 30 years she wrote, on the average, almost a book a year, including Dred: A Tale of the Great Dismal Swamp (1856), The Minister's Wooing (1859), and Oldtown Folks (1869), which is considered perhaps the richest and raciest of her works. It has been lately said of her that "as the historian of the human side of Calvinism she tempered dogma with affection" and also "the creative instinct was strong in her but the critical was wholly lacking."

STRACHEY, WILLIAM (b. fl. 1606–18), first secretary of the Virginia colony, historian. A grantee under the second charter to the London Co. of Virginia, he sailed for that colony, 1609, with Sir Thomas Gates, reaching Jamestown after shipwreck, 1610; he returned to London late in 1611. His fame rests principally on his letter of 1610 descriptive of the colony (first printed by Samuel Purchas in his Pilgrimes, 1625, but previously circulated in manuscript), on his production of the first written code of laws for Virginia, and on The Historie of Travaile Into Virginia Britannia (written in 1613). This last work is the most ably written of the contemporary accounts of the region and is a highly authoritative and valuable historical source. It was first printed and published in 1849.

STRAIGHT, WILLARD DICKERMAN (b. Oswego, N.Y., 1880; d. Paris, France, 1918), diplomat, financier. Son-in-law of William C. Whitney. Graduated in architecture, Cornell University,, 1901. After working in the Chinese customs service and as a newspaper correspondent, he held consular offices in the Far East and served briefly in the U.S. Department of State. He then served as a representative of various banking groups in China, 1909–12. Thereafter resident in the United States, he engaged in promoting American capital investments in foreign countries. With his wife he financed publication of the weekly The New Republic (1914).

STRAIN, ISAAC G. (b. Roxbury, Pa., 1821; d. Aspinwall, present Colón, Panama, 1857), naval officer, explorer. Conducted exploration of the Isthmus of Darien, 1853, which determined impracticability of a ship-canal route there.

STRANAHAN, JAMES SAMUEL THOMAS (b. Peterboro, N.Y., 1808; d. Saratoga, N.Y., 1898), capitalist. Assisted Gerrit Smith in promotion of his Oneida Co., N.Y., properties; was successful as a railroad contractor in New Jersey. Post 1844, transferring his activities to Brooklyn, N.Y., he developed the Atlantic Basin there, invested in the East River ferries, and came to be known as a principal civic leader. He was largely responsible for the creation of Brooklyn's Prospect Park and for the consolidation of Brooklyn into the city of New York.

STRAND, PAUL (b. New York City, 1890; d. Orgeval, France, 1976), photographer and filmmaker. Influenced by the contemporary masters exhibited at Alfred Stieglitz's Photo–Secession Gallery and developed a protégé-mentor relationship with Stieglitz. In the 1910's Strand created photographic abstractions through extreme close-ups, odd camera angles, unusual croppings, and an interplay of light, shadow, line, and form, as in "Abstractions, Bowls" and "Abstraction, Porch Shadows." Leaving the abstract, he took an innovative series of candid street portraits, exhibited in 1916. He became a free-lance cinematographer (1922–32), then resumed his personal photography in 1932. In 1937 he formed a cooperative filmmaking company, Frontier Films, which made documentaries emphasizing the need to fight for social equality and civil liberties, including Native Land (1942), which dealt with union busting and violation of civil liberties. Disenchanted with a perceived repressive political and social climate in the United States, he went into self-imposed exile in France (1950).

STRANG, JAMES JESSEE (b. Scipio, N.Y., 1813; d. Voree, Wis., 1856), Mormon leader, founder of the sect known by his name.

STRANGE, MICHAEL (b. New York, N.Y., 1890; d. Boston, Mass., 1950), actress, writer. Christened Blanche Oelrichs. Married Leonard M. Thomas, 1910 (divorced, 1919); John Barrymore, 1921 (divorced, 1928); Harrison Tweed, 1929 (divorced, 1942).

STRATEMEYER, EDWARD (b. Elizabeth, N.J., 1862; d. Newark, N.J., 1930), juvenile fiction writer, creator of the "Rover Boys" and other series.

STRATEMEYER, GEORGE EDWARD (b. Cincinnati, Ohio, 1890; d. Orlando, Fla., 1969), U.S. Army and Air Force officer. Graduated from the U.S. Military Academy (1915) and the Army War College (1939). Earned his Air Force wings in 1917, and in 1920 was transferred to the Army Air Service. In 1941 he became executive officer for the Chief of Air Corps and, in 1942, chief of the Air Staff. In August 1943 he was assigned to the China-Burma-India Theater; his responsibilities included command of the Tenth Air Force in India-Burma and the theater's Air Service

Command; supply and maintenance of the Fourteenth Air Force; protection of the Hump route to China; and coordination of Air Transport Command's theaterwide operations. Was also air adviser to the theater's commander, Gen. Joseph Stilwell. Became deputy commander of the American and British air forces in 1943 and exercised operational control of all Southeast Asia Command air forces. In the spring of 1945 he was given command of all U.S. air forces in the China theater. During the Korean War, he persuaded Gen. Douglas MacArthur, Far East commander, to extend U.S. air operations into North Korea, and within a month his air forces, with navy carriers and Marine Corps aviation, had driven the North Korean air force from the skies. He retired in 1951.

STRATON, JOHN ROACH (*b. Evansville, Ind., 1875; d. Clifton Springs, N.Y., 1929*), Baptist clergyman, fundamentalist leader, sensational preacher. Held pastorates in Chicago, Ill., Baltimore, Md., and Norfolk, Va.; *post* 1918 was pastor of Calvary Baptist Church, New York City.

STRATTON, CHARLES SHERWOOD (*b. Bridgeport, Conn., 1838; d. Middleboro, Mass., 1883*), midget, the celebrated "General Tom Thumb" of P. T. Barnum's museum.

STRATTON, SAMUEL WESLEY (*b. Litchfield, Ill., 1861; d. 1931*), physicist. B.S., University of Illinois, 1884. Taught mathematics and physics at Illinois; assistant professor of physics, University of Chicago, 1892–1901. After preparing the plan of a proposed Bureau of Standards, 1900, he drafted the bill authorizing the establishment of the bureau and won acceptance for the bill which was passed in 1901. As first director of U.S. Bureau of Standards, 1901–23, he made it a great research center and secured for it an international reputation. He served as president, Massachusetts Institute of Technology, 1923–30.

STRATTON-PORTER, GENE *See* PORTER, GENE STRATTON.

STRAUS, ISIDOR (*b. Otterberg, Rhenish Bavaria, 1845; d. at sea, aboard the Titanic, 1912*), merchant, philanthropist. Brother of Nathan and Oscar S. Straus. Immigrated with family to Georgia, 1854. Prospered in crockery and glassware business; with brother Nathan, became owner of R. H. Macy and Co., New York City, 1896, developing it subsequently into the largest department store in the world. He also developed the Brooklyn, N.Y., store of Abraham & Straus. An enthusiastic Democrat, he served briefly in Congress and twice refused nomination for mayor of New York City.

STRAUS, JESSE ISIDOR (*b. New York, N.Y., 1872; d. New York, 1936*), merchant, diplomat. Son of Isidor Straus; nephew of Nathan and Oscar S. Straus. Associated with the family business of R. H. Macy & Co. *post* 1896, he took over its supervision in 1912 and acted as its president *post* 1919. An active Democrat, Straus served with success as U.S. ambassador to France, 1933–36. He was a benefactor of New York University and Harvard.

STRAUS, NATHAN (*b. Otterberg, Rhenish Bavaria, 1848; d. New York, N.Y., 1931*), merchant, philanthropist. Brother of Isidor and Oscar S. Straus. Immigrated to Georgia with his family, 1854. A partner in the family crockery and glassware business, and later associated with his brother Isidor in the ownership of R. H. Macy and Co., Nathan Straus is particularly remembered as a pioneer in public health, a strong supporter of Zionism, and an active worker in innumerable campaigns for the relief of primary needs to which he devoted a great part of his fortune. During the last 15 years of his life he concentrated his efforts on supplying educational and social agencies for relief in Palestine.

STRAUS, OSCAR SOLOMON (*b. Otterberg,, Rhenish Bavaria, 1850; d. New York, N.Y., 1926*), lawyer, diplomat. Brother of Isidor and Nathan Straus. Immigrated with his family to Georgia, 1854. Graduated Columbia, 1871; Columbia Law School, 1873. *Post* 1881 a partner in the family crockery and glassware business, he is chiefly remembered as a diplomat. Prominent in the Democratic party, he served as U.S. minister to Turkey, 1887–89, 1898–1900, and 1909–10, distinguishing himself each time by his tact and success in negotiation. In 1902 he was appointed a member of the Hague Court and was subsequently reappointed in 1908, 1912, and 1920. He was U.S. secretary of commerce and labor, 1906–09, having become at this time a progressive Republican because of opposition to William J. Bryan. At the Paris Peace Conference, 1918–19, he continued a lifelong career of activity in behalf of his fellow Jews by striving to provide for safeguarding of the rights of Jewish minorities in Europe.

STRAUS, PERCY SELDEN (*b. New York, N.Y., 1876; d. New York, 1944*), department store executive, philanthropist. Son of Isidor Straus; brother of Jesse I. Straus. A.B., Harvard, 1897. Associated *post* 1897 with the family firm of R. H. Macy and Co., New York City, he was its president, 1933–39. An expert in the technique of store management, he was among the first in industry to use objective testing in the hiring and placement of employees and a leader in the introduction of formal training programs for clerks and executives.

STRAUS, ROGER W(ILLIAMS) (*b. New York, N.Y., 1891; d. Liberty, N.Y., 1957*), industrialist. Studied at Princeton University. The husband of Gladys Guggenheim, Straus entered the Guggenheim interests by becoming the family's representative at the American Smelting and Refining Co. before World War I. After the war, he became assistant to the president of the company, and president himself in 1941. Straus diversified the company by developing independent processing capabilities. In 1928, he helped found and finance the National Conference of Christians and Jews.

STRAUS, SIMON WILLIAM (*b. Ligonier, Ind., 1866; d. New York, N.Y., 1930*), banker. President S. W. Straus & Co., 1898–1928. Promoted building of skyscrapers; originated financing of building projects by sale of real estate bonds, 1909.

STRAUSS, JOSEPH BAERMANN (*b. Cincinnati, Ohio, 1870; d. Los Angeles, Calif., 1938*), bridge engineer, C.E., University of Cincinnati, 1892; assistant to Ralph Modjeski, 1899–1902. Originated and developed the Strauss trunnion bascule bridge and the Strauss lift bridge. Designer and builder of well over 400 bridges of all types, including his important modifications of the bascule, he is best known as chief engineer for the Golden Gate Bridge at San Francisco (completed 1937).

STRAUSS, LEWIS LICHTENSTEIN (*b. Charleston, W.Va., 1896; d. Culpeper, Va., 1974*), government official. After serving as personal secretary to Herbert Hoover in the Food Administration during World War I, he joined a Wall Street investment firm. In 1946 he was named a member of the newly formed Atomic Energy Commission, where he was an influential supporter of the hydrogen bomb. As chairman of the AEC (1953–58), he lobbied successfully to increase the business sector's involvement in hydroelectric energy. He also became embroiled in the controversy concerning AEC official J. Robert Oppenheimer, whom Strauss opposed as an alleged Communist sympathizer. In 1958 the Senate rejected his nomination as secretary of commerce.

STRAVINSKY, IGOR FYODOROVICH (*b. Oranienbaum, Russia, 1882; d. New York City, 1971*), composer. The son of wealthy Russian landowners, he earned a degree in jurisprudence from

the University of St. Petersburg in 1901, after which he trained with composer Nikolai Rimsky–Korsakov and began composing. He composed for the Russian ballet and collaborated with Serge Diaghilev on *The Firebird* (1910), *Petrouchka* (1911), and *The Rite of Spring* (1913), all considered masterpieces of modern music. Stravinsky lived in exile from Russia after the Bolshevik Revolution. He settled in France before he became a U.S. citizen in 1945. In the interwar period he began a neoclassical phase of composition. Drawing on eighteenth-century musical structures, he developed works that emphasized precision, symmetry, and clarity. *Symphony of Psalms* (1930) and the opera *The Rake's Progress* (1951) were among his distinguished works. After 1945 Stravinsky toured as a conductor and made numerous recordings of his works. During this period he made another daring musical shift, entering a phase of dodecaphony, composing *Canticum Sacrum* (1950).

STRAWBRIDGE, ROBERT (*b. near Carrick-on-Shannon, Ireland, date unknown; d. near Towson, Md., 1781*), Methodist preacher. Immigrated between 1759 and 1766 to Maryland where he was the first apostle of Methodism, preaching in his home colony and also in neighboring Virginia, Delaware, and Pennsylvania.

STRAWN, JACOB (*b. Somerset Co., Pa., 1800; d. Illinois, 1865*), farmer, livestock dealer. Active *post* 1831 as a grazer and fattener of cattle on pasture tracts in Morgan, Sangamon, and LaSalle counties, Ill.

STRAWN, SILAS HARDY (*b. near Ottawa, Ill., 1866; d. Palm Beach, Fla., 1946*), corporation lawyer, businessman. Practiced in Chicago, with firm of Winston, Strawn, Black, and Towner; held office in local, state, and national bar associations and in U.S. Chamber of Commerce.

STREET, ALFRED BILLINGS (*b. Poughkeepsie, N.Y., 1811; d. 1881*), lawyer, poet, librarian of the New York State Library.

STREET, AUGUSTUS RUSSELL (*b. New Haven, Conn., 1791; d. New Haven, 1866*), businessman. Graduated Yale, 1812. A notable benefactor of Yale, Street endowed professorships in ecclesiastical history, modern languages, and the arts; he was also donor of Street Hall and endowed, in part, the Yale School of Fine Arts.

STREET, JOSEPH MONTFORT (*b. Lunenburg, Co., Va., 1782; d. near present Agency City, Iowa, 1840*), frontier journalist, Indian agent. Nephew of Montfort Stokes. Edited controversial Federalist *Western World* in Frankfort, Ky., in 1806–07, and for a time thereafter; on losing libel suit brought against him by Harry Innes, 1812, he removed to Shawneetown, Ill., where he was active in local politics. Appointed agent to the Winnebago tribe, he sought unsuccessfully to protect his wards from encroaching settlement and from frauds.

STREETER, GEORGE LINIUS (*b. Johnstown, N.Y., 1873; d. Gloversville, N.Y., 1948*), embryologist. Graduated Union College, 1895. M.D., College of Physicians and Surgeons, Columbia University, 1899. To prepare himself for practice in the diseases of the nervous system he studied in Germany, 1902–03, with the anatomist Ludwig Edinger at Frankfurt and the embryologist Wilhelm His at Leipzig. Strongly attracted by embryological research, upon his return to the United States, Streeter gave up the practice of medicine and joined the Department of Anatomy of the Johns Hopkins University School of Medicine, 1904. He was assistant professor of anatomy at the Wistar Institute, Philadelphia, 1906–07. He was professor of human anatomy at the University of Michigan, 1907–14, where he continued work on the development of the human brain, nerves, and auditory

system. His chapter on the development of the major structures of the brain in the *Handbook of Human Embryology*, edited by Franz Keibel and Franklin P. Mall (1910), remains the most authoritative account of this complicated subject.

In 1914 Streeter joined the Department of Embryology of the Carnegie Institution of Washington, located at the Johns Hopkins Medical School, as a research associate; three years later he became director. During his directorship its publications filled 22 volumes of the *Contributions to Embryology of the Carnegie Institution*, one of the most distinguished American scientific publications. A notable early publication was a set of charts (in *Contributions to Embryology*, Vol. 2, 1920) relating the principal dimensions of human embryos and fetuses to their developmental age. This is still the standard quantitative record of human prenatal growth. Streeter participated with Chester H. Heuser and Carl G. Hartman in a masterly study of the early embryology of the rhesus monkey, 1925–41. He contributed also to the pathology of the embryo and fetus, notably by a revolutionary explanation of defects in which the loss of a limb (intrauterine amputation) or similar damage is associated with adhesions of the amnion at the site of injury. After his retirement in 1940, Streeter devoted himself to the compilation of a series of papers entitled "Developmental Horizons in Human Development" (1942–51), a descriptive and pictorial classification of the stages of embryonic development.

Streeter was elected to the National Academy of Sciences, 1931, and the American Philosophical Society, 1943. He was also a fellow of the Royal Society of Edinburgh, 1928. He was president of the American Association of Anatomists, 1926–28.

STRIBLING, THOMAS SIGISMUND (*b. Clifton, Tenn., 1881; d. Florence, Ala., 1965*), novelist and short-story writer. Attended Southern Normal College, Florence Normal College, and University of Alabama Law School (LL.B., 1905). Wrote fiction for Sunday-school magazines and adventure stories for such magazines as *Youth's Companion* and *American Boy* until 1917. His first novel, *Birthright*, was serialized in *Century Magazine* (1921–22) and gained wide attention; it was one of the first novels by a southerner to treat racial problems in a serious way. The novel *Teeftallow* (1926) firmly established his reputation. His most ambitious work was a trilogy: *The Forge* (1931); *The Store* (1932), which won the Pulitzer Prize in 1933; and *The Unfinished Cathedral* (1934). He frequently published short stories in the *Saturday Evening Post*, 1935–42, and mysteries in *Ellery Queen*, after 1945.

STRICKLAND, WILLIAM (*b. Philadelphia, Pa., ca. 1787; d. Nashville, Tenn., 1854*), architect, engineer, engraver. Studied under Benjamin H. Latrobe. An outstanding exponent of the Greek revival in America, he designed a number of Philadelphia buildings, including the U.S. Custom House, 1819; the Bank of the United States, completed 1824 (later the Custom House); and the Merchants' Exchange, 1834. At the time of his death he was engaged on the state capitol at Nashville, Tenn. Concurrently with his architectural work, he engaged in engineering work for the Chesapeake and Delaware Breakwater and made several railroad surveys.

STRINGFELLOW, FRANKLIN (*b. Culpeper Co., Va., 1840; d Louisa Co., Va., 1913*), Episcopal clergyman, chief of scouts in the Army of Northern Virginia, 1864–65.

STRINGHAM, SILAS HORTON (*b. Middletown, N.Y., 1797; d. Brooklyn, N.Y., 1876*), naval officer. Appointed midshipman, 1809. Served in War of 1812 on frigate *President*; served against Algiers and in suppression of slave trade; commanded *Ohio* in Mexican War. Commodore in 1861, he was a valued adviser of

Gideon Welles and, as commander of the Atlantic blockade fleet, planned and executed the expedition against forts at Hatteras Inlet, N.C., August 1861. Irked by criticism, he requested release in September; promoted rear admiral, 1862, he commanded the Boston navy yard until 1865.

STRINGHAM, WASHINGTON IRVING (*b. Yorkshire Center, present Delevan, N.Y., 1847; d. Berkeley, Calif., 1909*), mathematician. Graduated Harvard, 1877, influenced by Benjamin Peirce. Ph.D., Johns Hopkins, 1880. Author of a number of professional papers of high quality, he was professor of mathematics, University of California, 1882–1909.

STRITCH, SAMUEL ALPHONSUS (*b. Nashville, Tenn., 1887; d. Rome, Italy, 1958*), Roman Catholic prelate. Studied at St. Gregory's Preparatory Seminary and at the American College in Rome; he earned doctorates in philosophy (1906) and theology (1910) and was ordained on special dispensation from Pope Pius X in 1910. Consecrated bishop of Toledo, Ohio, he served there from 1921 to 1930; from 1930 to 1940, he was archbishop of Milwaukee; and, from 1940 to 1958, Archbishop of Chicago. In 1946, he became a Cardinal. In 1958, shortly before his death, he was appointed pro-prefect of the Sacred Congregation for the Propagation of the Faith in the Rome Curia, the first American to head a Rome Curia department. Remembered for his work with the poor, especially during the Depression years, Stritch was often called the Cardinal of the Poor.

STROBEL, CHARLES LOUIS (*b. Cincinnati, Ohio, 1852; d. Chicago, Ill., 1936*), civil engineer, specialist in steel-framed structures. As consultant for Burnham & Root and for Adler & Sullivan, he helped devise the steel-skeleton construction of many early skyscrapers. Active in standardization of the design and manufacture of steel structural shapes, he was originator of the Z-bar and designer of standard I-beam sections. He was author of *A Pocket Companion . . . to the Use of Wrought Iron for Engineers, Architects and Builders* (1881).

STROBEL, EDWARD HENRY (*b. Charleston, S.C., 1855; d. Bangkok, Thailand, 1908*), diplomat. Entering the U.S. diplomatic service, 1885, as secretary of legation at Madrid, Spain, he held posts thereafter at Washington, D.C., and in Ecuador and Chile. Appointed Bemis professor of international law, Harvard Law School, 1898. Became a general adviser to the then Siamese government with rank of minister plenipotentiary, 1903, and effected numerous reforms before his death.

STROHEIM, ERICH VON *See* VON STROHEIM, ERICH.

STROMME, PEER OLSEN (*b. Winchester, Wis., 1856; d. 1921*), Lutheran clergyman, Norwegian-American journalist and author.

STRONG, ANNA LOUISE (*b. Friend, Nebr., 1885; d. Beijing, China, 1970*), radical journalist and lecturer. Attended Oberlin, Bryn Mawr, and University of Chicago (B.A. from Oberlin, 1905). Moved to New York City in 1909, and her circle of radical and bohemian friends widened to include most of the city's left-wing intellectuals. In Seattle in 1916 she made friends with unionists and members of the Industrial Workers of the World. She began to write for the IWW's *Seattle Daily Call*, then for the *Seattle Union Record*, a paper run by the Seattle branch of the American Federation of Labor. She traveled to Moscow in 1921 to report on the Soviet famine. During 1921–49 she traveled often to Russia and China and recounted events in those countries in such works as *China's Millions* (1928) and *The Soviets Conquer Wheat* (1931). Also wrote an autobiography, *I Change Worlds! The Remaking of an American* (1935). Founding

editor of the *Moscow Daily News*, an English-language paper (1930–46); she was arrested in Moscow in 1949 and expelled "for spying activities." In 1957 she moved to China, her chief activity being the writing of the newsletter *Letters from China* (1961–70).

STRONG, AUGUSTUS HOPKINS (*b. Rochester, N.Y., 1836; d. 1921*), Baptist clergyman, theologian. Graduated Yale, 1856; Rochester Theological Seminary, 1859. Pastor, First Baptist Church, Haverhill, Mass., 1861–65; First Baptist Church, Cleveland, Ohio, 1865–72. President and professor of biblical theology, Rochester Theological Seminary, 1872–1912; thereafter, president emeritus. Author of, among other works, *Systematic Theology* (1886, 1907–09) and *Philosophy and Religion* (1888). Influenced his onetime parishioner John D. Rockefeller in founding a university under Baptist auspices, an idea which eventuated in refounding of University of Chicago.

STRONG, BENJAMIN (*b. Fishkill-on-Hudson, N.Y., 1872; d. New York, N.Y., 1928*), banker. Official in Bankers' Trust Co., New York; first governor, Federal Reserve Bank of New York, 1914–28.

STRONG, CALEB (*b. Northampton, Mass., 1745; d. Northampton, 1819*), lawyer, Federalist statesman, Massachusetts legislator and official. Graduated Harvard, 1764; studied law under Joseph Hawley; was admitted to Massachusetts bar, 1772. Served on committee for drafting Massachusetts constitution, 1779. Represented Massachusetts in Constitutional Convention of 1787, advocating annual elections of representatives and choice of a president by Congress and making the successful motion that the House alone should originate money bills, although the Senate might amend them. U.S. senator from Massachusetts, 1789–96, he formed, with Oliver Ellsworth and Rufus King, the bulwark of the administration in the Senate. As Federalist governor of Massachusetts, 1800–07, he was responsible, fair-minded, and an able administrator; during his second period as governor, 1812–16, he was in continuous opposition to the national administration and the War of 1812. He approved both the calling of the Hartford Convention in December 1814 and its subsequent report.

STRONG, CHARLES AUGUSTUS (*b. Haverhill, Mass., 1862; d. Fiesole, Italy, 1940*), psychologist, philosopher. Son of Augustus H. Strong; son-in-law of John D. Rockefeller. Graduated University of Rochester, 1884; A.B., Harvard, 1885; studied also in Germany. Influenced by William James and George Santayana. Strong taught briefly at Cornell, Clark, and University of Chicago; he was lecturer in psychology, Columbia University, 1896–1903, and professor of psychology, 1903–13. Author of a number of books, he belonged to the group known as the critical realists.

STRONG, CHARLES LYMAN (*b. Stockbridge, Vt., 1826; d. 1883*), mining engineer. First superintendent of Gould & Curry mine at Virginia City, Nev. (Comstock Lode), 1860–64.

STRONG, ELMER KENNETH, JR. ("KEN") (*b. West Haven, Conn., 1906; d. New York City, 1979*), baseball player and football player and coach. Graduated New York University (1929), where he won national renown as a baseball player and an All-American football player. He played with farm teams of the New York Yankees (1929–30) and Detroit (1931), but a wrist injury ended his baseball career. He began his football career with the Staten Island Stapletons (1929–32), then joined the New York Giants (1933–36; 1939–40). In 1933 he tied for the NFL lead in scoring and helped the Giants win the NFL championship. In 1936 he signed with the New York Yankees in the short-lived American Football League, then became a placekicking special-

ist with the Giants (1944–47). After working in public relations, he returned to the Giants as a kicking coach (1962–65). Elected to the Pro Football Hall of Fame (1967).

Strong, Harriet Williams Russell (*b. Buffalo, N.Y., 1844; d. near Whittier, Calif., 1926*), horticulturist, civic leader. Wife of Charles L. Strong. Raised in California. Pioneered in California walnut industry; was an early advocate of flood control for irrigation; patented device for impounding debris and water in hydraulic mining, 1893.

Strong, James (*b. New York, N.Y., 1822; d. Round Lake, N.Y., 1894*), biblical scholar, businessman. Professor of exegetical theology, Drew Theological Seminary, 1868–93. A learned, conservative scholar.

Strong, James Hooker (*b. Canandaigua, N.Y., 1814; d. Columbia, S.C., 1882*), naval officer. Appointed midshipman, 1829. Distinguished for Civil War service as commander of USS *Monongahela*, notably at Mobile Bay, August 1864, where he put the Confederate ram *Tennessee* out of action. He retired as rear admiral, 1876.

Strong, James Woodward (*b. Brownington, Vt., 1833; d. Northfield, Minn., 1913*), Congregational clergyman, educator. Brother of William B. Strong. President, Carleton College, 1870–1903.

Strong, Josiah (*b. Naperville, Ill., 1847; d. 1916*), Congregational clergyman, social reformer. A pioneer, with Washington Gladden and Walter Rauschenbusch, in the Social Gospel movement. Strong was author of two influential books, *Our Country* (1885) and *The New Era* (1893), analyzing the social and economic ills of his day and calling for the creation of an ideal society upon earth. Founder of the League for Social Service (later the American Institute for Social Services), 1898, he initiated the Safety First movement and was active participant in the establishment of the Federal Council of Churches.

Strong, Moses McCure (*b. Rutland, Vt., 1810; d. Mineral Point, Wis., 1894*), surveyor, lawyer, Wisconsin legislator and official. Settled at Mineral Point, 1836.

Strong, Richard Pearson (*b. Fortress Monroe, Va., 1872; d. Cambridge, Mass., 1948*), public health physician, educator, expert on tropical medicine. Ph.B., Sheffield Scientific School, Yale, 1893; M.D., Johns Hopkins, 1897. Served as assistant surgeon, U.S. Army, during Spanish-American War, from 1899 to 1901 he established and directed the work of the Army Pathological Laboratory and served as president of the Board for the Investigation of Tropical Diseases in the Isthmus of Panama. In 1901 he went to the Philippines. Leaving the army while in Manila, he became director of the Biological Laboratories Bureau of Science, 1901–13; professor of tropical medicine at the College of Medicine and Surgery at University of the Philippine Islands, 1907–13, and chief of medicine at the Philippine Islands General Hospital, 1910–13.

Strong joined the faculty of medicine of Harvard University in 1913 as the first professor of tropical medicine, a post he held until his retirement in 1938. During these years he led numerous expeditions to study tropical diseases in their natural habitat. Many publications by Strong and his associates resulted from these expeditions, notably his monograph on onchocerciasis in Africa and America in 1934 and his two volumes in Liberia. In 1938 he assumed responsibility for the foremost textbook in his field, Edward Stitt's *Diagnosis and Treatment of Tropical Disease*, which he rewrote after his retirement from Harvard.

In 1915 Strong directed the Rockefeller Institute's expedition to Serbia to combat a typhus epidemic. Joining the American Expeditionary Forces in 1917 as a member of the chief surgeon's staff, he and his group demonstrated that trench fever was transmitted by a louse. Rejoining the Medical Reserve Corps as a colonel in 1941, he served as director of tropical medicine at the Army Medical School in Washington through World War II.

Strong, Theodore (*b. South Hadley, Mass., 1790; d. 1869*), mathematician, educator. Graduated Yale, 1812. Professor of mathematics and natural philosophy at Hamilton College, 1816–27; at Rutgers College, 1827–61.

Strong, Walter Ansel (*b. Chicago, Ill., 1883; d. 1931*), journalist. Associated *post* 1905 with the *Chicago Daily News*, he served as its publisher, 1925–31. He was active also in many national publishing organizations and in local civic affairs.

Strong, William (*b. Somers, Conn., 1808; d. 1895*), jurist, U.S. Supreme Court justice. Graduated Yale, 1828. Admitted to the Philadelphia, Pa., bar, October 1832, he began practice in Reading, Pa. Congressman, Democrat, from Pennsylvania, 1847–51; outstanding justice, Pennsylvania Supreme Court, 1857–68. Appointed associate justice of the U.S. Supreme Court, 1870, he was concerned with Joseph P. Bradley in the 1871 reversal of a previous Supreme Court decision which had held the Legal Tender Act of February 1862 unconstitutional. This action led to the charge that President Grant, by appointing Strong, had "packed" the Court in order to ensure such a decision. Strong's position, however, was wholly consistent with his previous record and views on the subject. Until his resignation, December 1880, he remained a power on the Supreme Court bench and generally regarded as one of the truly great judges of the Court. He has been compared for integrity of character to John Jay.

Strong, William Barstow (*b. Brownington, Vt., 1837; d. Los Angeles, Calif., 1914*), railroad official. Brother of James W. Strong. Transformed the Atchison, Topeka & Sante Fe Railroad into a system of national importance as its general manager *post* 1877 and its president, 1881–89.

Strong, William Lafayette (*b. Richland Co., Ohio, 1827, d. 1900*), merchant. Removed to New York City, 1853, where he became wealthy in the dry-goods business. An ardent Republican, he served as reforming mayor of New York City, 1894–97. Appointed Theodore Roosevelt police commissioner.

Strother, David Hunter (*b. Martinsburg, Va. [now W.Va.], 1816; d. Charles Town, W.Va., 1888*), Union soldier, author, illustrator. A valued contributor to *Harper's New Monthly Magazine*, he produced a number of illustrated articles dealing with life in Virginia which were collected as *Virginia Illustrated, by Porte Crayon* (1857). He was author and illustrator of other superior magazine series which were not reprinted. A Unionist, he served on staff duty throughout the Civil War, receiving brevet of brigadier general at its close. He was U.S. consul general at Mexico City, 1879–85.

Strubberg, Friedrich Armand (*b. Cassel, Germany, 1806; d. Gelnhausen, Germany, 1889*), novelist, physician. Resident in frontier America, 1826–29 and *ca.* 1840–54, he used his experiences in Texas and Arkansas as materials for more than 50 volumes of fiction, written in German under the pen name "Armand."

Strudwick, Edmund Charles Fox (*b. near Hillsboro, N.C., 1802; d. Hillsboro, 1879*), physician, surgeon. M.D., University

of Pennsylvania, 1824. The best type of "country doctor," he practiced at Hillsboro *post* 1826.

STRUNSKY, SIMEON (*b. Vitebsk, Russia, 1879; d. Princeton, N.J., 1948*), journalist, essayist. Brought at age seven to the United States by Jewish immigrant parents, he grew up on New York City's Lower East Side. A.B., Columbia College (University), 1900. Employed first as an encyclopedia editor, he was a member of the editorial staff of the *New York Evening Post*, 1906–24 (chief editorial writer *post* 1920), and editorial writer and columnist on the *New York Times*, 1924–48. A humorist and a prose stylist, he was author of, among other books, *The Patient Observer and His Friends* (1911), *Belshazzar Court* (1914), and *No Mean City* (1944).

STRUVE, GUSTAV (*b. Munich, Bavaria, 1805; d. Vienna, Austria, 1870*), publicist, revolutionary agitator. Union soldier. A lawyer and jurist in his native Germany, he was active in the events which led up to the Revolution of 1848 and was associated with F. K. F. Hecker and Franz Sigel in the abortive republic of Baden. Resident in the United States, 1851–63, he wrote without much success, edited the socialist periodical *Die sociale Republik*, and worked for cooperation of labor groups in New York and Philadelphia. A 19th-century disciple of Rousseau and Robespierre, he combined noble intentions with opinionated impracticability.

STRUVE, OTTO (*b. Kharkov, Russia, 1897; d. Berkeley, Calif., 1963*), astronomer. Attended Kharkov University and then, after arriving in the United States in 1921, University of Chicago (Ph.D., 1923). Joined the Yerkes Observatory of the University of Chicago in 1921, becoming director in 1932 and editor of the *Astrophysical Journal*. He mastered observing techniques in spectroscopic stellar astronomy, but rapidly advanced into modern astrophysics. He drafted a plan whereby the universities of Chicago and Texas joined forces in the construction of McDonald Observatory (1935–36) in west Texas. Chairman of the Department of Astronomy at the University of California at Berkeley (1950–59), then director of the National Radio Astronomy Observatory in West Virginia (1959–62). His many projects included spectroscopic observations of double stars and studies of novae, surface brightness of bright and dark nebulae, and general radiation of the interstellar medium.

STRYKER, LLOYD PAUL (*b. Chicago, Ill., 1885; d. New York, N.Y., 1955*), attorney. Studied at Hamilton College. Called "the most celebrated American criminal lawyer since Clarence Darrow," by the *New York Times*, Stryker won fame for his work in two trials: the defense of James J. Hines, a Tammany Hall leader indicted for conspiring to protect an illegal daily lottery who was prosecuted by district attorney Thomas E. Dewey, and the defense of Alger Hiss in his first perjury trial. Both men were later convicted, but Stryker's defense gained him a national reputation. He wrote *Courts and Doctors* (1932) and *The Art of Advocacy* (1954).

STRYKER, MELANCTHON WOOLSEY (*b. Vernon, N.Y., 1851; d. Rome, N.Y., 1929*), Presbyterian clergyman, hymnologist. President of Hamilton College, 1892–1917, he improved that institution in all departments, procuring large additions to its funds.

STUART, ALEXANDER HUGH HOLMES (*b. Staunton, Va., 1807; d. 1891*), lawyer, Virginia legislator. Son of Archibald Stuart. Graduated University of Virginia, 1828. A follower of Henry Clay, he served in the U.S. Congress, 1841–43. As U.S. secretary of the interior, 1850–53, he proved himself a successful organizer of his department. Active in the Know-Nothing party, he opposed secession as long as opposition was practicable. He was

prevented by age from taking any active part in the Civil War, but was sympathetic with his section. After the war he played a large part in securing restoration of home rule to Virginia. He was rector of the University of Virginia, 1876–82 and 1884–86, and served for some years as a trustee of the Peabody Fund.

STUART, ARCHIBALD (*b. near Staunton, Va., 1757; d. 1832*), Revolutionary soldier, Virginia legislator and jurist. Father of Alexander H. H. Stuart. For many years a prominent leader of the conservative wing of Virginia Democratic-Republicans, he was judge of the general court of Virginia, 1800–32.

STUART, CHARLES (*b. Jamaica, British West Indies, 1783; d. Lake Simcoe, Canada, 1865*), abolitionist, mentor of Theodore D. Weld. Settled in Canada *ca.* 1814. Author of, among other antislavery tracts, *The West India Question* (1832), a widely circulated and influential statement of abolitionist principles.

STUART, CHARLES BEEBE (*b. Chittenango Springs, N.Y., 1814; d. Cleveland, Ohio, 1881*), engineer, Union soldier. Active in New York State railroad construction, 1833–49; proposed railway suspension bridge over Niagara River below the Falls (completed 1855); supervised construction of navy dry docks, 1849–53. Thereafter a successful businessman and consulting engineer, he was author of, among other works, *The Naval and Mail Steamers of the United States* (1853) and *Lives and Works of Civil Military Engineers of America* (1871).

STUART, CHARLES MACAULAY (*b. Glasgow, Scotland, 1853; d. La Jolla, Calif., 1932*), Methodist clergyman, educator, editor. Energetic and successful president of Garrett Biblical Institute, 1911–24.

STUART, ELBRIDGE AMOS (*b. near Greensboro, N.C., 1856; d. Los Angeles, Calif., 1944*), businessman, cattlebreeder. Raised in Indiana. Cofounder, president, 1899–1932, and chairman of the board, 1932–44, of the Carnation Co., producers of milk products "from contented cows."

STUART, FRANCIS LEE (*b. Camden, S.C., 1866; d. Essex Falls, N.J., 1935*), civil engineer, specialist in railroad and transportation problems.

STUART, GILBERT (*b. North Kingstown Township, Kings [later Washington] Co., R.I., 1755; d. Boston, Mass., 1828*), painter. Growing up in Newport, R.I., Stuart early showed talent for drawing and, *ca.* 1769, became pupil of a Scottish artist, Cosmo Alexander, then working in Newport. Traveling to Edinburgh with Alexander, who died there in August 1772, Stuart failed in an attempt to support himself by his art and is said to have worked his way home in 1773 or 1774 on a collier bound for Nova Scotia. After busying himself at home in painting and the study of music, he sailed for London in June 1775 as conditions in pre-Revolutionary America were adverse to the practice of art as a profession. After about a year of privation, he wrote to Benjamin West (1738–1820) asking help; receiving an immediate, friendly response, he became West's pupil and later (probably summer 1777) became a member of his household and remained with him for nearly five years. By 1781 he had become an exhibitor at the Royal Academy exhibitions, and his work was attracting favorable notice from London critics. In 1782 his *Portrait of a Gentleman Skating* brought him prominently before the public and he received many commissions.

By 1787, Stuart had become one of the leading portrait painters of London, sharing honors with J. Reynolds, G. Romney, and Gainsborough. He was also living in a very lavish style and, because of his lifelong unconcern with business details, came in danger of imprisonment for debt. Accordingly, he left England

for Ireland, probably early in the summer of 1787, and scored success all over again in Dublin. Here, too, however, he lived injudiciously, fell in debt, and late in 1792 or early in 1793 sailed for New York City hopeful of making enough money to pay off his English and Irish creditors. He also had in mind to make a fortune by painting portraits of George Washington and to profit through the sale of prints of a Washington portrait. After practicing in New York, he removed to Philadelphia in November 1794, and opened a studio on the southwest corner of Fifth and Chestnut streets. As always immediately successful in securing commissions from leaders of intellect and fashion, he completed in Philadelphia a brilliant series of portraits of women, and there painted his first two life portraits of Washington. The first, a bust showing the right side of the face and known as the Vaughan Type, was painted in the late winter of 1795. Beginning in April 1796, Washington sat for Stuart for a second life portrait, a life-size standing figure showing left side of face and with right hand outstretched, which is known as the Landsdowne Type. Stuart removed to Germantown, Pa., in the summer of 1796 and during the early fall made a third life portrait of the president, a bust showing the left side of the face, eyes front. This is the well-known "Athenaeum Head," unfinished as to the stock and coat; it is highly idealized.

Stuart followed the seat of government to Washington in 1803. He opened a studio there at F and Seventh streets and there painted Jefferson, Madison, Monroe, and many other contemporary leaders. Removing to Boston, Mass., in the summer of 1805, he lived there for the remainder of his life. Successful as usual, he was overrun with commissions, but chronically out of money owing to his indifferent business habits. *Post* 1825, although symptoms of paralysis developed in his left arm, he continued to paint, but with difficulty.

Stuart had in his manners much of the formality of the old school, yet his dress was usually disordered, and he took snuff from a tin box holding perhaps half a pound, which he used up in a single day. A witty man with a keen sense of the ridiculous, he was celebrated for his gifts as a talker and for his extensive knowledge of the art masters of all ages, on whom he could discourse with great charm and learning. A procrastinator, he would only paint when in the mood, was quick to take offense, and impatient of any criticism of his work. Benjamin West is quoted as having said, "It's no use to steal Stuart's colors; if you want to paint as he does you must steal his eyes." Stuart's mastery of the use of what may be called transparent color gave his portraits their lifelike and luminous effect, and it is this quality which ranks them supreme among American portrait paintings.

STUART, GRANVILLE (*b. Clarksburg, Va. [now W.Va.], 1834; d. Missoula, Mont., 1918*), Montana pioneer. Raised in Illinois and Iowa. After prospecting in California, September 1852–June 1857, Stuart, on a return journey east with some companions, turned north before reaching Great Salt Lake and entered Beaverhead Valley in present Montana. Proceeding to Deer Lodge Valley in spring 1858, Stuart and a brother, with others, found gold. After further prospecting and varying success he settled permanently in Deer Lodge Valley, 1867, took a leading part in community affairs, and served in the territorial council and legislature. He organized and managed the stock-raising firm of Davis, Hauser and Stuart Co., 1879, and was successful for a time in operations of the Judith Basin. Overstocking of the range and losses in the winter of 1886–87 brought the firm to disaster. He served thereafter as state land agent, as U.S. minister to Uruguay and Paraguay, and as librarian of the Butte city library. A student and an observer, he was instrumental in founding many of the civic and cultural organizations in Montana. He was author of *Montana As It Is* (1865), and his journals, together with those of

his borther James, were published in part as *Forty Years on the Frontier* (1925).

STUART, HENRY ROBSON *See* ROBSON, STUART.

STUART, ISAAC WILLIAM (*b. New Haven, Conn., 1809; d. Hartford, Conn., 1861*), local historian, orator. Son of Moses Stuart.

STUART, JAMES EWELL BROWN (*b. Patrick Co., Va., 1833; d. Richmond, Va., 1864*), soldier. Graduated West Point, 1954. Commissioned in the cavalry, he served briefly in Texas. He was in Kansas with the 1st Cavalry for the most part of 1855–61, rising to rank of captain. Resigning from the U.S. Army on learning of the secession of Virginia, he was commissioned lieutenant colonel of Virginia infantry, May 10, 1861, and captain of Confederate cavalry, May 24, 1861. At the first battle of Bull Run, he protected the Confederate left with the 1st Virginia Cavalry and contributed to the victory. Promoted brigadier general, September 1861, he brought his cavalry command to high efficiency and showed himself outstanding in outpost duty. His spectacular sweeps around the Union army during the fighting in northern Virginia won him General R. E. Lee's praise as the "eyes of the army"; skillful though not original in tactics, he was defective in strategic sense, but had the rare gift of winning the goodwill of men as dissimilar as Stonewall Jackson and Longstreet. Dressed like a beau and always alive to the dramatic, Jeb Stuart was often accused by other officers (some of them in his own corps) of selfish disregard of the achievements of subordinates, of consciously parading himself for admiration, and of claiming credit that belonged to others. However, he confounded his critics at Fredericksburg and held the line of the Rappahannock with much skill during the winter of 1862–63. He was also extremely effective in the Confederate victory at Chancellorsville, commanding the II Corps after the wounding of Stonewall Jackson and the incapacitation of A. P. Hill. Meanwhile, he had been promoted major general and confirmed in that grade, September 1862.

The Gettysburg campaign represents the most disputable chapter in Stuart's career. Expected to play his usual role of screening the army's movements and collecting information and provisions, he engaged in a raid which achieved little in itself and which left Lee groping in the dark at a time when accurate information of the enemy was of the essence. Although he rejoined the main Confederate army on the Afternoon of July 2 and was ceaselessly active through the rest of the campaign, it has been asserted that he cost Lee the victory by his actions. This matter is still a subject of controversy. Thereafter he served with ability and zeal at his principal task of keeping his commander informed of hostile movements and engaged in a number of lesser battles, very often employing his cavalrymen as infantry. He covered with skill Lee's operations subsequent to Grant's crossing of the Rapidan, May 4, 1864, but was mortally wounded a week later as he endeavored to intercept General P. H. Sheridan's drive on Richmond at Yellow Tavern.

STUART, JOHN (*b. Scotland, ca. 1700; d. Pensacola, Fla., 1779*), colonial Indian agent. Immigrated to America *ca.* 1748; settled in South Carolina. Superintendent of Indian affairs for the southern district *post* 1762, Stuart fled to Florida, 1775, after his arrest was ordered by the South Carolina assembly on the charge of attempting to incite the Catawba and the Cherokee in the British interest. Thereafter until his death he strove to raise Loyalist companies and secure Indian cooperation with the British, but died under censure for his failures and for the enormous amount of money he had spent.

STUART, JOHN LEIGHTON (*b. Hangchow, China, 1876; d. Washington, D.C., 1962*), missionary, university president, and ambassador. Son of missionary parents, arrived in the United States in 1887. Attended Hampden-Sidney College (1893–96; D.D., 1913) and Union Theological Seminary; ordained a Presbyterian minister in 1902. Settled in the Hangchow area of China in 1904 as professor at Nanking Theological Seminary (1908–19). Wrote *Essentials of New Testament Greek in Chinese* (1916) and a *Greek-Chinese-English Dictionary of the New Testament* (1918). Became the first president of Yenching University in Beijing in 1919; when Japan invaded China in 1937 and captured the capital, he refused to fly the flag of the puppet government and in 1939 was interned by the Japanese in a house in Beijing; he was freed in 1945 and resumed the presidency of the university. Appointed U.S. ambassador to China in 1946, but returned to the United States in 1949. Wrote his memoirs, *Fifty Years in China* (1954).

STUART, JOHN TODD (*b. near Lexington, Ky., 1807; d. 1885*), Illinois lawyer, legislator, and congressman. Cousin of Mary Todd Lincoln. Practiced law in Springfield, Ill., *post* 1828. Friend, political mentor, and first law partner (Springfield, Ill., 1837–41) of Abraham Lincoln, he remained an old-line Whig and opposed the Republican party. Although a strong Unionist, he actively opposed Lincoln's administration, whose emancipation policy he decried.

STUART, MOSES (*b. Wilton, Conn., 1780; d. 1852*), Congregational clergyman, educator, biblical scholar. As professor at Andover Theological Seminary, 1810–48, he was outstanding for insistence on investigation of German scholarly literature and was author of some 40 books and monographs. He was the father of Issac W. Stuart and the father-in-law of Austin Phelps.

STUART, ROBERT (*b. Callander, Perthshire, Scotland, 1785; d. Chicago, Ill., 1848*), fur trader. Immigrated to Canada, 1807; through Wilson P. Hunt, became partner in J. J. Astor's Pacific Fur Co., 1810. Sailing in that year on the *Tonquin* to the Columbia River, he was active in affairs of the Astoria colony; he journeyed eastward overland, 1812–13, with Ramsay Crooks and others over what was largely a new route. He later served as a traveling agent for Astor in the East and as Crooks's assistant at Mackinac, succeeding him *ca.* 1820 and remaining as head of the American Fur Co. for the upper Great Lakes region until 1834. Settling in Detroit, Mich., 1835, he engaged in business and civic affairs and was superintendent of Indian affairs for Michigan, 1841–45. His journal of the journey from Astoria appears in *The Discovery of the Oregon Trail* (P. A. Rollins, ed., 1935); it was summarized in Washington Irving's *Astoria*.

STUART, ROBERT LEIGHTON (*b. New York, N.Y., 1806; d. 1882*), sugar refiner, philanthropist. A generous benefactor to Presbyterian institutions and charities.

STUART, RUTH MCENERY (*b. Marksville, La., 1849; d. 1917*), short-story writer, editor. Raised in New Orleans, which was her principal residence until her removal to New York City *ca.* 1892. Her stories and sketches, published in more than 20 volumes after periodical publication, were humorous, sentimental, and optimistic; however, she was the first to describe the post–Civil War black in his own social environment, and possessed an extraordinary skill in rendering dialect.

STUB, HANS GERHARD (*b. Muskego, Wis., 1849; d. St. Paul, Minn., 1931*), Lutheran clergyman, celebrated principally for his services in merging several synods into the Norwegian Lutheran Church of America, 1917. He served as president of this new body, 1917–25, and was emeritus thereafter.

STUBBS, WALTER ROSCOE (*b. near Richmond, Ind., 1858; d. Topeka, Kans., 1929*), railroad contractor, Kansas legislator, stockman. Raised in Douglas Co., Kans. Progressive Republican governor of Kansas, 1909–13, he failed of further political advancement after his support of Theodore Roosevelt, 1912.

STUCK, HUDSON (*b. London, England, 1863; d. Fort Yukon, Alaska, 1920*), Episcopal clergyman. Came to America, 1885; was employed at first as a public school principal in Texas. Ordained, 1892, he held several rectorates in Texas; *post* 1904 he served as archdeacon of the Yukon. Author of several books descriptive of his travels and his mission work, he was one of the party which made the first complete ascent of Mount McKinley, 1913.

STUCKENBERG, JOHN HENRY WILBRANDT (*b. Bramsche, Hannover, Germany, 1835; d. London, England, 1903*), Lutheran clergyman, educator, sociologist. Immigrated to Pittsburgh, Pa., as a child; was raised in Cincinnati, Ohio. Graduated Wittenberg College, B.A., 1857; theology degree, 1858; studied also at universities of Halle, Göttingen, Tübingen, and Berlin. Held pastorates in several midwestern states and was pastor of the American Church in Berlin, Germany, 1880–94. A pioneer in the field of sociology, he was author of a number of studies, of which *Sociology, the Science of Human Society* (1903) was outstanding.

STUDEBAKER, CLEMENT (*b. Pinetown, Pa., 1831; d. 1901*), wagon and carriage manufacturer. Raised in Ashland Co., Ohio. Established with a brother the firm of H. & C. Studebaker at South Bend, Ind., 1852, which became the largest manufacturer of horsedrawn vehicles in the world. In 1897 he began experiments with self-propelled vehicles, and the company began their manufacture soon after his death.

STUHLDREHER, HARRY A. (*b. Massillon, Ohio, 1901; d. Pittsburgh, Pa., 1965*), college football player, coach, and athletic director. Attended Notre Dame (B.A., 1924), where he played football under coach Knute Rockne. One of the members of the "Four Horsemen" backfield, his Notre Dame teams won two national championships, had an undefeated season in 1924, and won the 1925 Rose Bowl game against Stanford. Named to Walter Camp's 1924 All-America team. Was football coach and athletic director at Villanova (1925–36), then at the University of Wisconsin (1936–50), after which he joined the industrial relations division of the United States Steel Company.

STURGES, PRESTON (*b. Chicago, Ill., 1898; d. New York, N.Y., 1959*), playwright, film director, and producer. Sturges was educated in Europe, served in the U.S. Army during World War I, and worked in his family's cosmetic firm before turning to writing. His first play, *Strictly Dishonorable* (1929) was a hit on Broadway; after other plays, Sturges went to Hollywood as a screenwriter. Films include *Diamond Jim* (1935), *If I Were King* (1939), and *The Great McGinty* (1940), which Sturges also directed and which won an Academy Award for the best screenplay.

STURGIS, RUSSELL (*b. Baltimore, Md., 1836; d. New York, N.Y., 1909*), architect, critic. Graduated present College of the City of New York, 1856; studied in office of Leopold Eidlitz and at Munich. Practiced in association with Peter B. Wight, 1863–68, and by himself until about 1880. A competent architect in the Greek revival and Victorian Gothic styles, he was more celebrated as a connoisseur and Ruskinian critic of art and architecture. As writer in the *Nation* and *Scribner's Magazine* and author of a number of books, he was perhaps the most important single factor in the artistic reawakening of the American

people in the early years of the 20th century. His most ambitious work was A *History of Architecture* (1906–15, left unfinished).

STURGIS, SAMUEL DAVIS (*b. Shippensburg, Pa., 1822; d. St. Paul, Minn., 1889*), soldier. Graduated West Point, 1846. After service in the Mexican War, he performed duty in the West with the 1st Dragoons and the present 4th Cavalry. Commanding at Fort Smith, Ark., 1861, he brought off his troops in safety, together with most of the government property at the post, although menaced by hostile militia. He succeeded General Nathaniel Lyon in command at the battle of Wilson's Creek. Promoted brigadier general, August 1861, he commanded Union cavalry divisions for the rest of the Civil War, particularly distinguishing himself at Antietam, but suffering a severe defeat at Guntown, Miss., June 1864.

STURGIS, WILLIAM (*b. Barnstable, Mass., 1782; d. Boston, Mass., 1863*), Boston merchant in the China trade, Massachusetts legislator. Author of *The Oregon Question* (1845).

STURTEVANT, BENJAMIN FRANKLIN (*b. Norridgewock, Maine, 1833; d. Jamaica Plain, Mass., 1890*), inventor and manufacturer of shoemaking machinery. Patented a rotary exhaust fan, 1867, which he adapted for use in pressure blowers, ventilating fans, pneumatic conveyors, and the like, thereby virtually creating a new industry.

STURTEVANT, EDWARD LEWIS (*b. Boston, Mass., 1842; d. 1898*), agricultural scientist. Graduated Bowdoin, 1863; M.D., Harvard Medical School, 1866. Developed an experimental farm near South Framingham, Mass., where he made important studies of the physiology of milk and of the history of edible plants. First director, New York Agricultural Experiment Station at Geneva, 1882–87, he outlined broad plans of operation, which were largely followed in other stations established under the Hatch Act. He was author of a number of books and monographs.

STURTEVANT, JULIAN MONSON (*b. Warren, Conn., 1805; d. Jacksonville, Ill., 1886*), Congregational clergyman, educator. Graduated Yale, 1826. A member of the "Yale Band" pledged to further religion and education in the West, he taught *post* 1830 at Illinois College and served it as president 1844–76.

STUTZ, HARRY CLAYTON (*b. Ansonia, Ohio, 1876; d. Indianapolis, Ind., 1930*), automobile manufacturer, machinist. As engineer and manager of the Marion Motor Car Co., 1906–10, he designed for it the first "underslung" pleasure car. In 1911, he became a partner in the Ideal Motor Car Co., organized to manufacture a car designed by Stutz. In 1913 he consolidated this company with another under the name of the Stutz Motor Car Co. and served as president until 1919. His automobile gained its greatest reputation in the period 1913–19. *Post* 1919 he engaged principally in the manufacture of taxicabs and airplane engines.

STUYVESANT, PETRUS (*b. Friesland, the Netherlands, date given variously from 1592 to ca. 1610; d. New York, N.Y., 1672*), colonial governor and statesman. After early military service and a term as governor of Curaçao and adjacent islands (during which he lost his right leg subsequent to an expedition against the island of St. Martin), he was commissioned director general of New Netherland, July 28, 1646. Sailing from the Texel on Christmas Day, 1646, he stopped first at Curaçao and thence went on to New Amsterdam, arriving May 11, 1647, "like a peacock, with great state and pomp." Active and able, he set himself to promote good order in the colony by somewhat stern measures; he promoted intercolonial relations with the English, drove the Swedes from the Delaware, increased commerce, and set his face resolutely against assertions of the popular will in government. Despite his efforts, the people of New Amsterdam won independent municipal government in February 1653 after making a "remonstrance" to the States-General. Much to his disgust, Stuyvesant was obliged to surrender New Netherland to the English in the late summer of 1664 and thereafter withdrew from public affairs. After journeying to the Netherlands, 1665, to defend his official conduct, he returned to New York, where he lived on his farm until his death.

SUBLETTE, WILLIAM LEWIS (*b. Lincoln Co., Ky., 1799[?]; d. Pittsburgh, Pa., 1845*), fur trader, merchant. One of five brothers conspicuous in the early fur trade, he removed with his family to St. Charles, Mo., *ca.* 1818. He joined the expedition of William H. Ashley to the Rocky Mountains, 1822. He was with Ashley in the Arikara fight, June 1823, and served under Col. Henry Leavenworth in the attack on the Arikara villages in August. In his own business financed by Ashley, Sublette made a fortune, and, with Jedediah S. Smith and another partner, finally bought Ashley out. They continued to trade successfully as a firm until 1832, when Sublette formed a partnership with Robert Campbell which continued for some ten years; their principal trading posts were on the Platte at the mouth of the Laramie and on the Missouri near Fort Union.

SUGIURA, KANEMATSU (*b. Tsushima-shi, Japan, 1892; d. White Plains, N.Y., 1979*), biochemist and cancer research pioneer. Came to the United States in 1905 (U.S. citizen, 1953), became an assistant chemist at Harriman Research Laboratory (HRL) at Roosevelt Hospital in 1911, and began studying chemotherapy of cancer in 1912. Graduated Polytechnic Institute of Brooklyn (B.S., 1915) and Columbia University (M.A., 1917). As an associate chemist at HRL, he and his colleagues were committed to developing drug therapies for cancer. He became a chemist at Memorial Hospital for Cancer and Allied Diseases (1917–47), a research chemist fellow at New York University–Bellevue Hospital College of Medicine (1923–31), and a member of Memorial Sloan–Kettering Institute for Cancer Research (1947–62). His early research sought to identify specific carcinogens and investigated uses of X rays in treating cancer. His later work focused on chemotherapeutic properties of compounds, and his research resulted in practical advances in patient care.

SULLAVAN, MARGARET (*b. Norfolk, Va., 1909; d. New Haven, Conn., 1960*), actress. Studied at the E. E. Clive Dramatic School in Boston. Sullavan worked first for the University Players Guild where she met and married Henry Fonda. Her Broadway debut was *A Modern Virgin* (1931) and was followed by a series of bad plays but good personal reviews. In 1933, she took over a role in *Dinner at Eight* which won her a contract with Universal Pictures. Her first film won her stardom, *Only Yesterday*. Other films include *Three Comrades* (1938), *The Shining Hour* (1938), *The Shop Around the Corner* (1940), and *Back Street* (1941). Other Broadway roles include *Stage Door* (1936), *The Voice of the Turtle* (1942), considered her best role, and *Sabrina Fair* (1953).

SULLIVAN, ED(WARD) VINCENT (*b. New York City, 1901; d. New York City, 1974*), television variety show host and newspaper columnist. Began his career as a sportswriter for several New York City newspapers, made an unsuccessful bid for an acting career in Hollywood, and, after hosting a Harvest Moon Ball at Madison Square Garden in 1947, was hired to host "Toast of the Town," a television variety show that featured entertainment acts and profiles of show business personalities. Sullivan emerged as the leading figure both on and off screen for the popular broadcast, which was renamed "The Ed Sullivan Show" in 1956. Sullivan

broke ground by hiring African–American entertainers and spot-
lighting celebrities from the arts, including opera singers and
ballet dancers. He also established the practice of paying per-
formers' fees. The show was canceled in 1971.

SULLIVAN, GEORGE (*b. Durham, N.H., 1771; d. Exeter, N.H.,
1838*), lawyer, New Hampshire legislator and congressman. Son
of John Sullivan. Graduated Harvard, 1790. A Federalist, he op-
posed President Madison's foreign policies and the War of 1812.
As New Hampshire attorney general, 1815–35, he served with
ability but was said to rely too little on his preparation and too
much upon his oratory.

SULLIVAN, HARRY STACK (*b. Norwich, N.Y., 1892; d. Paris,
France, 1949*), psychiatrist. M.D., Chicago College of Medicine
and Surgery, 1917. Best known for his work with schizophrenics,
his theory of interpersonal relations, and his labors to bring about
a fusion of psychiatry and social science.

SULLIVAN, JAMES (*b. Berwick, District of Maine, 1744; d. prob-
ably Boston, Mass., 1808*), lawyer, Massachusetts patriot, legis-
lator and jurist. Brother of John Sullivan; father of William Sul-
livan. Practicing at first in Maine and *post* 1783 in Boston, Mass.,
he became one of the most prominent lawyers in the state and
was a leader of the Democratic-Republicans there. A promoter
of historical studies, he was author of several legal and historical
treatises and served as governor of Massachusetts, 1807–08. Dur-
ing his term he engaged in a celebrated controversy with Tim-
othy Pickering over the Embargo of 1807.

SULLIVAN, JAMES EDWARD (*b. New York, N.Y., 1860; d. 1914*),
journalist, publisher, athlete. A zealot for the preservation of am-
ateurism in sports, he was a founder of the Amateur Athletic
Union of the United States, 1888, and American director of the
Olympic Games.

SULLIVAN, JAMES WILLIAM (*b. Carlisle, Pa., 1848; d. Carlisle,
1938*), printer, trade unionist, advocate of the initiative and ref-
erendum. For many years a trusted lieutenant of Samuel Gom-
pers in the American Federation of Labor.

SULLIVAN, JOHN (*b. Somersworth, N.H., 1740; d. Durham,
N.H., 1795*), Revolutionary general, statesman. Brother of James
Sullivan; father of George Sullivan. An able if somewhat litigious
lawyer, generous, oversensitive, and a born political organizer,
he was early engaged on the patriot side in the American Revo-
lution. A New Hampshire delegate to the First Continental Con-
gress, September–December 1774, he returned home to lead in
the seizure of Fort William and Mary in Portsmouth harbor.
After taking his seat in the second Continental Congress, he
received appointment as brigadier general, June 1775. Serving
through the siege of Boston, he was ordered to join the forces
retreating from Canada after Montgomery's defeat at Quebec; he
succeeded to their command on the death of General John
Thomas. Superseded by General Horatio Gates in July 1776, he
offered his resignation, but withdrew it and was promoted major
general in August. Taken prisoner at the battle of Long Island,
he was exchanged after serving as the bearer of Lord Howe's
peace overtures to Congress and rejoined the American army in
West-chester Co., N.Y. He shared in the retreat across New Jersey
in the late fall of 1776, led the right column at Trenton, and
pursued the British at Princeton. Embroiled with Congress be-
cause of his protests against undue favor given newly arrived for-
eign officers, he found his conduct in various engagements
through 1777, including the battle of the Brandywine, called into
question, but after investigation he was exonerated. He always
had the strong support of George Washington. Once again un-
fortunate in his operations around Newport, R.I., in the summer

of 1778, principally because of the failure of support from a
French fleet, Sullivan was highly successful in a punitive expe-
dition through western Pennsylvania and New York against the
Iroquois Indians in the spring and summer of 1779, in associa-
tion with General James Clinton. His health impaired, he re-
signed from the army, November 1779. Thereafter, he served
briefly in Congress, was a New Hampshire legislator and attorney
general, and was president (governor) of New Hampshire, 1786–
87 and 1789. Appointed U.S. district judge for New Hampshire,
1789, he held that post until his death.

SULLIVAN, JOHN FLORENCE See ALLEN, FRED.

SULLIVAN, JOHN LAWRENCE (*b. Boston, Mass., 1858; d. West
Abington, Mass., 1918*), pugilist, the "Great John L." Defeated
the American champion Paddy Ryan by a knockout in the ninth
round at Mississippi City, Miss., Feb. 7, 1882; dominated the
American prize ring for the next decade; ended his career in
defeat by James Corbett, Sept. 7, 1892.

SULLIVAN, LOUIS HENRI (*b. Boston, Mass., 1856; d. Chicago,
Ill., 1924*), architect. Attended course in architecture at Massa-
chusetts Institute of Technology under William R. Ware, 1872–
73, but was irked by academic study; admired work of Henry H.
Richardson; was encouraged by Richard M. Hunt. Removed to
Chicago, where he worked for a time in office of William Le B.
Jenney; studied at the École des Beaux arts, Paris (atelier Vau-
dremer), 1874–75. Returning to Chicago, he won a reputation
in several offices as a skillful draftsman, and in 1879 began to
work with Dankmar Adler, becoming a partner in May 1881.
The firm of Adler and Sullivan rose rapidly, but there is little in
Sullivan's work done at this time to back his claim that he at-
tempted a radical departure from contemporary work. However,
on the completion of the Auditorium Building, Chicago, 1886–
90, the firm received international recognition, not only for a
demonstrated mastery of the problem of acoustics but for a def-
inite break with tradition so far as the interior design was con-
cerned. Accepting with enthusiasm the revolutionary principle
of skeleton construction as demonstrated by Holobird and
Roche, Sullivan then designed a series of important buildings
expressing his own principles. Notable among these are the
Wainwright Building, St. Louis, Mo.; the sensational Transpor-
tation Building at the World's Fair of 1893; and the Gage Build-
ing, Chicago. After the death of Adler in 1900, Sullivan's oppor-
tunity to do work on a large scale ceased and his material fortunes
declined, yet he continued to fight for his major principle that
"form follows function." In his writings and in what work he did,
he stressed the essentially modern function of the skyscraper and
the proper form for its expression, attacking the triumphant
eclecticism of the post-1893 period. Known as the founder of the
"Chicago school," Sullivan is father of modernism in architec-
ture and more than any man helped to make the skyscraper
America's greatest contribution to the art. His style of architec-
tural ornament, although too personal and complicated for pop-
ular acceptance, was a distinct contribution, and he will be re-
membered also for the philosophy he set forth in *The
Autobiography of an Idea* (1924).

SULLIVAN, LOUIS ROBERT (*b. Houlton, Maine, 1892; d. 1925*),
physical anthropologist. Author of a number of important studies
of race, describing geographical distribution and physical char-
acteristics of anthropological types.

SULLIVAN, MARK (*b. Avondale, Pa., 1874; d. Avondale, Pa.,
1952*), journalist. Studied at West Chester Normal School and
Harvard University (LL.B., 1903). A noted "muckraker," Sullivan
was a journalist for *Collier's Weekly* from 1906 to 1917; editor

from 1914. From 1919 to 1923 he was Washington correspondent for the *New York Evening Post*. From 1923 until his death he wrote a syndicated column for the *New York Tribune* (later the *Herald-Tribune*). A personal friend of Herbert Hoover, Sullivan was a champion of the nineteenth-century ideals of individualism; he saw the New Deal as a threat to these ideals and became increasingly conservative in his political views. Wrote *Our Times*, a popular history of the United States from 1900 to 1925.

SULLIVAN, TIMOTHY DANIEL (*b. New York, N.Y., 1862; d. near Eastchester, N.Y., 1913*), politician, known as "Big Tim." A saloonkeeper and vaudeville entrepreneur, Sullivan raised himself to leadership of the Tammany Democracy in New York City's Third Assembly District and was uncrowned king of the lower East Side, 1892–1912. An efficient organizer of graft and a magnetic machine boss, Sullivan played a strong role in New York State politics, 1900–10. He served as congressman, Democrat, from New York, 1903–07.

SULLIVAN, WILLIAM (*b. Biddeford, Maine, 1774; d. 1839*), lawyer, Massachusetts legislator. Son of James Sullivan. Author of, among other works, *Familiar Letters on Public Characters and Public Events* (1834; repr., 1847, as *The Public Men of the Revolution*).

SULLIVAN, WILLIAM HENRY (*b. Port Dalhousie, Canada, 1864; d. 1929*), lumberman. Organized and directed, *post* 1906, the vast lumbering operations and factory complex at Bogalusa, La.; helped build lumber industry in Louisiana along intelligent and conservationist lines.

SULLIVANT, WILLIAM STARLING (*b. Franklinton, Ohio, 1803; d. 1873*), botanist, bryologist. Graduated Yale, 1823. Among his several pioneering and important works, his *Icones Muscorum* (1864) is considered outstanding; he also assisted in the amplification of Gray's *Manual*, 1856, and was associated in studies with Leo Lesquereux and others. His contribution to Gray's *Manual*, also published separately, laid the foundation for subsequent bryological studies in the United States.

SULLY, DANIEL JOHN (*b. Providence, R.I., 1861; d. Beverly Hills, Calif., 1930*), cotton speculator, dominant in the New York City market, 1902–04.

SULLY, THOMAS (*b. Horncastle, Lincolnshire, England, 1783; d. Philadelphia, Pa., 1872*), painter. Came to America, 1792; was raised in Charleston, S.C. Encouraged in his artistic tastes by Charles Fraser and by his elder brother, Lawrence Sully, a painter of miniatures. He removed to Virginia *ca.* 1799 and lived and studied with his brother in Richmond and Norfolk until 1803. In May 1801, Thomas Sully painted his first miniature portrait from life and continued to work industriously, but with little remuneration, until his removal to New York City in November 1806. There, with the aid of Thomas A. Cooper, Sully received a number of profitable commissions. Encouraged by a brief interview with Gilbert Stuart at Boston in 1807, Sully went to Philadelphia and made that city his permanent home in 1808. Although much of his early work ranks among his best, he was dissatisfied with his own skill. With the aid of friends, he visited England, July 1809–March 1810. There, Benjamin West (1738–1820) suggested that he make a serious study of anatomy and osteology, which Sully did; he also made the acquaintance of Sir Thomas Lawrence and the Kemble family of actors. After his return to Philadelphia he attempted several historical subjects and grew in reputation as a portraitist. After the deaths of Charles W. Peale, 1827, and Gilbert Stuart, 1828, Sully had no formidable rivals in his art. When he made a second visit to England,

1837, and painted the young Queen Victoria, he reached the summit of his fame, receiving a number of commissions from distinguished English people and achieving also a social success. During his career he produced more than 2,600 works. Although occasionally his draftsmanship was defective, he was always a master of color and his works have a characteristic warmth and beauty. Sometimes called "the Sir Thomas Lawrence of America," he was especially happy in delineation of women and children, yet some of his portraits of men, such as that of Dr. Samuel Coates, are marked by an admirable firmness.

SULZBERGER, ARTHUR HAYS (*b. New York, N.Y., 1891; d. New York, 1968*), newspaper publisher. Attended Columbia (B.S., 1913). In 1917 he married the daughter of *New York Times* publisher Adolph S. Ochs and began work with the *Times* in 1918 as assistant to the executive manager with unspecified duties. By the late 1920's he had worked his way up to a vice-presidency. His role in managing the paper grew in the 1930's, and he succeeded Ochs as president of the company and publisher of the paper in 1935. Under his leadership the *Times* experienced gradual and steady change and improvement in news coverage, newspaper content, and technical progress. In his twenty-five years as publisher, the advertising linage more than tripled, daily circulation increased by 40 percent, and Sunday circulation nearly doubled. After retiring as publisher in 1961, he became chairman of the board.

SULZBERGER, CYRUS LINDAUER (*b. Philadelphia, Pa., 1858; d. New York, N.Y., 1932*), textile merchant, leader in Jewish affairs, philanthropist.

SULZBERGER, MAYER (*b. Heidelsheim, Germany, 1843; d. Philadelphia, Pa., 1923*), jurist, Hebrew scholar. Cousin of Cyrus L. Sulzberger. Came as a child to Philadelphia, where he practiced law *post* 1865 after study in office of Moses A. Dropsie. He served as judge of the court of common pleas, 1895–1916, and was president judge *post* 1902. He was also active in Jewish welfare work and the promotion of higher Jewish learning.

SULZER, WILLIAM (*b. Elizabeth, N.J., 1863; d. New York, N.Y., 1941*), lawyer, politician. Attended Cooper Union; admitted to New York bar, 1884. A member of Tammany Hall, he represented an East Side district in the state assembly, 1890–94, serving as Speaker, 1893, and minority leader the following year. During nine terms in the House, Sulzer compiled a creditable record of support for progressive measures, including the graduated income tax and direct election of U.S. senators. As chairman of the House Foreign Affairs Committee after 1910, he opposed American intervention in Mexico and was responsible for the resolution abrogating the 1832 treaty of commerce with Russia. He advocated Cuban independence and supported the Boers' struggle in South Africa.

Although a product of Tammany Hall, Sulzer was a reformer independent enough to be opposed by the machine in one of his congressional races. When Tammany boss Charles F. Murphy finally accepted him as the organization's choice for governor in 1912, he campaigned as the "unbossed" candidate; after he won he promised that he would be "his own" governor, "the people's governor." As governor, Sulzer irritated Murphy by denying patronage to Tammany and by ordering investigations which revealed vast corruption, inefficiency, and maladministration in state departments. Resentful legislators, seeking to discredit him, uncovered evidence that he had diverted unreported campaign contributions to speculation in the stock market. Impeachment proceedings began, and on Oct. 17, 1913, in his tenth month as governor, Sulzer was found guilty.

Sulzer was again elected to the state assembly, this time for one term on the Progressive ticket. Defeated in the Progressive gubernatorial primary in 1914, he ran unsuccessfully as the American-Prohibition candidate. His political career ended ingloriously in 1916 when the Prohibitionists refused to make him their presidential candidate and he declined the American party nomination.

SUMMERALL, CHARLES PELOT (*b. Blount's Ferry, Fla., 1867; d. Washington, D.C., 1955*), soldier and educator. Graduated West Point in 1888. Saw action in the Spanish-American War, the Philippines, the Boxer Rebellion, and in France during World War I. An expert on the uses of artillery, Summerall made important contributions in the uses of these weapons. As commander of the Hawaiian Dept., he was criticized by Col. William Mitchell; later, Summerall sat on the court-martial of Mitchell Appointed chief of staff by President Coolidge, 1926–30. Retired a four-star general in 1930. From 1931 to 1953, president of The Citadel, a military college in South Carolina, making that institution into one of the leading military colleges in the nation.

SUMMERFIELD, ARTHUR ELLSWORTH (*b. Pinconning, Mich., 1899; d. West Palm Beach, Fla., 1972*), postmaster general. After careers in real estate, the oil business, and auto sales, he became active in Michigan Republican politics, supporting Wendell Willkie's 1940 presidential campaign and Dwight Eisenhower's presidential nomination at the 1952 Republican National Convention. As postmaster general (1953–60) he effectively instituted decentralized management methods in the postal service but failed to reduce the agency's perennial operating deficits. He vigorously opposed the mail distribution of pornography and in 1958 banned D. H. Lawrence's *Lady Chatterley's Lover*, though the policy was later overturned by a court decision.

SUMMERS, EDITH *See* KELLY, EDITH SUMMERS.

SUMMERS, GEORGE WILLIAM (*b. Fairfax Co., Va., 1804; d. Charleston, W.Va., 1868*), lawyer, Virginia legislator and congressman. Originally a Whig, he was an active Unionist and strong opponent of secession.

SUMMERS, THOMAS OSMOND (*b. near Corfe Castle, Dorsetshire, England, 1812; d. Nashville, Tenn., 1882*), Methodist clergyman, editor. Immigrated to New York, N.Y., 1830. After ministry, 1835–40, in Maryland, he became a founder of the Texas and Alabama conferences and was secretary to the 1844 convention at Louisville, Ky., which organized the Methodist Episcopal Church, South. He served thereafter as secretary of its conferences until his death. He was dean and professor of systematic theology at Vanderbilt University, 1876–82.

SUMMERSBY, KATHLEEN HELEN ("KAY") (*b. County Cork, Ireland, 1908; d. Long Island, N.Y., 1975*), military aide. After working as a model and film extra in London, she joined the British Auxiliary Corps in 1942 and was assigned as the driver and confidential secretary for General Dwight Eisenhower. She became a close confidant and aide to Eisenhower and traveled extensively with the general during the war. In 1944 Eisenhower arranged for her commission as a second lieutenant in the U.S. Women's Army Corps. She became a U.S. citizen in 1950 and worked as a fashion consultant and costume designer for television, stage, and film productions.

SUMNER, CHARLES (*b. Boston, Mass., 1811; d. Washington, D.C., 1874*), statesman. Son of an independent-minded antislavery lawyer and Massachusetts public official, Charles Sumner attended Boston Latin School, 1821–26, and Harvard College, 1826–30; at Harvard Law School, 1831–33, he was the pupil and friend of Joseph Story. Reacting against practical politics and finding the routine of legal practice little to his liking, he became a lecturer in the Harvard Law School, a contributor to the *American Jurist* and a reviser of legal textbooks. Francis Lieber and William E. Channing exercised a profound influence upon him. During two years of travel and observation in Europe *post* 1837, he learned French, German, and Italian and became acquainted with many literary and political figures; he also studied European governments and jurisprudence. Ambitious for distinction on the intellectual side of his profession, he produced an annotated edition of Vesey's *Reports of Cases . . . in the High Court of Chancery* (1844–45).

He reached a turning point in his career when he delivered the Boston Independence Day oration in 1845. Powerful of voice and skillful in oratory, he denounced war and, although bringing considerable odium on himself, discovered at the same time that he could thrill and sway great audiences. For years thereafter he was a successful lyceum lecturer. Loudly championing peaceful arbitration in public disputes and denouncing the Mexican War, he increased the antipathy of the conservative Whigs of Boston toward him, but was elected to the U.S. Senate by a coalition of Free-Soilers and Democrats, taking his seat, Dec. 1, 1851. Although the compromise measures of the previous year had apparently been accepted as final, Sumner rose toward the end of his first session to arraign the Fugitive Slave Law in a tremendous speech, Aug. 26, 1852, and moved an amendment that no allowances be permitted for expenses incurred in executing the law. The Southern senators heaped angry derision upon the amendment, and it received only four votes in its favor. Sumner, however, continued outspoken in opposition, particularly to the Kansas-Nebraska Act, which brought him into greater disfavor with the Boston press and society. In the debate on the right of petition, Southern senators charged Sumner with repudiating his oath of office and urged his expulsion, but could not muster the requisite two-thirds vote for this. Sumner's answer was that he had sworn to support the Constitution as he understood it, and his courage won admirers for him. Boldly denouncing the Know-Nothing party and scorning its support, he had a large part in organization of the Republican party.

During the hot debate in the Senate over the struggle for Kansas, Sumner delivered his famous "crime against Kansas" speech, May 20, 1856, denouncing the Kansas-Nebraska Act as "in every respect a swindle" and arraigning Andrew P. Butler and Stephen A. Douglas in bitter terms, thrilling antislavery forces throughout the North. Two days later he was assaulted at his desk in the Senate by Preston S. Brooks of South Carolina, a kinsman of Senator Butler. Seriously injured, Sumner went abroad in search of health and did not return to the Senate for three and a half years. Meantime, he had been reelected by almost unanimous vote of the Massachusetts legislature. Announcing his determination to assault American slavery all along the line, he set forth in a speech "the barbarism of slavery" (delivered during the debate on the bill for the admission of Kansas) a social, moral, and economic attack on the institution as well as a political one; widely distributed, the speech had great influence in the presidential election of 1860.

During the months following Lincoln's victory, Sumner refused to support the Crittenden Compromise. In October 1861, at the Massachusetts Republican convention, he became the first statesman of prominence to urge emancipation and thereafter never ceased to press for it. Appointed chairman of the Senate Committee on Foreign Relations, 1861, he rendered invaluable service to the Union in many ways, notably in effecting a peaceful solution of the problems raised by the seizure of Mason and Slidell and in bringing about the defeat or suppression of Senate resolutions which would have involved the United States in war

with France and Great Britain. As early as the second year of the Civil War, he began a struggle to secure absolute equality of civil rights for all United States citizens. In February 1862, he announced the extravagant doctrine that the seceding states had abdicated all their rights under the Constitution and remained insistent that initiation and control of Reconstruction should be by Congress, not by the president.

During the administration of President Andrew Johnson, Sumner and Thaddeus Stevens headed, respectively, in the Senate and the House opposition to Johnson's Reconstruction policy. Sumner's persistence led the Senate to add to the requirements for readmission of seceded states the insertion in their constitution of a provision for equal suffrage for blacks and whites. Prominent in the move to impeach President Johnson, Sumner descended to lurid and furious invective and showed himself at his worst in the opinion which he filed in support of his vote for conviction.

Antipathetic to President U.S. Grant, Sumner became antagonistic soon after the new administration began. Among other clashes, the most violent developed over the president's project of acquiring Santo Domingo. Sumner's committee brought in an adverse report on treaties negotiated by Grant's personal envoy, 1869. The administration retaliated against Sumner's friends and by bringing about his demotion from the chairmanship of the Foreign Relations Committee. The administration was influenced in this action also by fears that Sumner's excessive views on U.S. claims against Great Britain for wartime losses might jeopardize plans already under way for settlement of these claims. Among other legislation which Sumner introduced before his sudden death was a bill (introduced in session beginning December 1872) which provided that the names of Civil War battles should not be perpetuated in the Army Register or placed on regimental colors, an irenic gesture which brought him official censure.

Unlike Abraham Lincoln, Charles Sumner outlived his best days; his later years brought domestic sorrows, illness, and ceaseless struggle over problems of Reconstruction. Through many years in the Senate he strove for "absolute human equality" and judged every man and every measure by reference to that goal, becoming progressively intolerant not only of opposition but even of dissent. Diligent in the routine work of a senator, he commanded respect in discussions of money and finance, the tariff and copyright; he also introduced an intelligent bill for civil service reform. His great work, however, was not in the framing of laws but rather in the kindling of moral enthusiasm and the overthrow of injustice. A major force in the struggle that put an end to slavery, he also attempted to hold in check barbarous attempts at retaliation during wartime and maintained peace with European nations when war with them would have meant the end of the Union.

SUMNER, EDWIN VOSE (*b. Boston, Mass., 1797; d. Syracuse, N.Y., 1863*), soldier. Commissioned lieutenant in infantry, 1819; appointed captain in 1st Dragoons, 1833. Served on the frontier and in the Mexican War with great credit; was for a time military commandant of New Mexico. Promoted colonel, 1st (present 4th) Cavalry, 1855, he campaigned along the Oregon Trail and was commander at Fort Leavenworth, 1856, acting with discretion to keep order during the struggle for Kansas. He assumed command of the Department of the West, 1858, with headquarters at St. Louis, Mo. A loyal Union man, Sumner accompanied the president-elect to Washington, D.C., 1861, and during the Civil War rose to rank of major general of volunteers for gallant service at Fair Oaks. He commanded the right grand division at Fredericksburg, but was soon after relieved of duty with the Army of the Potomac at his own request.

SUMNER, FRANCIS BERTODY (*b. Pomfret, Conn., 1874; d. La Jolla, Calif., 1945*), zoologist. B.S., University of Minnesota, 1894; Ph.D., Columbia University, 1901. Taught biology at College of the City of New York, 1899–1906; directed laboratory of U.S. Fish Commission at Woods Hole, Mass., 1903–11; naturalist on the Bureau of Fisheries marine research ship *Albatross,* 1911–13. Associated thereafter with Scripps Institution at La Jolla, he became professor of biology there in 1926. Made important researches in the biology of fishes; demonstrated by breeding experiments with field mice that the accumulation of minor adaptive characteristics was a major factor in the evolution of the various geographic races.

SUMNER, INCREASE (*b. Roxbury, Mass., 1746; d. Roxbury, 1799*), jurist. Graduated Harvard, 1767; began practice of law at Roxbury, 1770. A Massachusetts legislator during the Revolution, he was appointed a justice of the Supreme Judicial Court of Massachusetts, 1782, winning repute as an able judge and a warm supporter of the new national government. Federalist governor of Massachusetts, 1797–99, he followed middle-of-the-road policy, allayed partisan bitterness, and gave special attention to improving the state's military defenses.

SUMNER, JAMES BATCHELLER (*b. Canton, Mass., 1887; d. Buffalo, N.Y., 1955*), biochemist. Studied at Harvard University (Ph.D., 1914). Around 1915, joined the faculty of Cornell University Medical College at Ithaca, N.Y.; full professor from 1929. Discovered that enzymes were proteins; successfully isolated the enzyme urease in 1926. Awarded the Nobel Prize for chemistry in 1946. Retired from Cornell in 1955.

SUMNER, JETHRO (*b. Nansemond Co., Va., ca. 1733; d. Warren Co., N.C., 1785*), planter, Revolutionary brigadier general. Fought in French and Indian War; removed to North Carolina, 1764. Among the foremost of North Carolina patriots in the Revolution, he distinguished himself in the defense of Charleston, 1776, with Washington's army in the campaigns of 1777–78, and in the defense of North Carolina against Cornwallis' invasion, 1780. He was also outstanding at the battle of Eutaw Springs, 1781.

SUMNER, WALTER TAYLOR (*b. Manchester, N.H., 1873; d. Portland, Oreg., 1935*), Episcopal clergyman. Attracted nationwide attention for activities in behalf of reform and social betterment as a minister in Chicago, 1904–15. Active and public-spirited bishop of Oregon, 1915–35.

SUMNER, WILLIAM GRAHAM (*b. Paterson, N.J., 1840; d. Englewood, N.J., 1910*), educator, social scientist. Graduated Yale, 1863. After study abroad in preparation for the ministry, he returned home and was tutor at Yale, 1866–69. Ordained priest of the Protestant Episcopal church, 1869, he remained in the ministry until 1872, also helping to establish, and editing, *The Living Church.* Because his interests turned increasingly to social and economic questions, he accepted the chair of political and social science at Yale in 1872 and spent the remainder of his life at that institution. A man of prodigious industry, he made his influence felt widely beyond the university, serving as a New Haven alderman and as a member of the Connecticut Board of Education. He wrote extensively, expressed his views on public questions, and engaged in extended research into the origin of social institutions which ranks him among the foremost students in this field. Skilled in all the social sciences, he had a working knowledge of at least a dozen languages.

A respected teacher and a most effective one, he made everyday affairs his textbook for the examination of social facts and principles. Rebelling against the conservatism of Yale, he labored

against opposition to broaden the curriculum. Through public addresses and periodical essays he carried on a warfare against economic and political evils, treating practically every social question of his day in an unsentimental and critical fashion. He was an outstanding advocate of a sound monetary system and opposed all inflationary expedients, yet he also fought protectionism. Deploring the agitation against "big business" and regarding the evolution of the trusts as a natural phenomenon, he opposed with vigor any government interference upon the industrial field, maintaining that state remedies would be worse than the disease. He believed that social conditions can be improved, but only by scientific procedure carried on by thoroughly informed individuals. In his use of the term "the Forgotten Man" in an 1883 lecture, he meant the self-supporting person who has to bear the cost of political bungling and social quackery. Finding himself less and less satisfied by the traditional boundaries of political economy and political science, he became preoccupied with the concept of a general science of society which should incorporate religion, marriage customs, and all other examples of the human experience which might provide the facts for a scientific induction. Attempting a treatise on this subject, he became convinced that he must begin it with an analysis of custom and from this conviction developed his classic book *Folkways* (1907). His data and outline for the projected treatise appeared as *Science of Society* (reclassified and revised by Albert G. Keller, 1927). Sumner was author also of a number of other books on banking, finance and currency, three biographies, and several volumes of essays.

SUMNERS, HATTON WILLIAM (*b. Boons Hill, Tenn., 1875; d. Dallas, Tex., 1962*), lawyer and U.S. congressman. Admitted to the Texas bar in 1897; elected county attorney (1900–02, 1904–06) and U.S. congressman (1912–46). He was named to the Judiciary Committee in 1918; he appeared in four cases before the Supreme Court as spokesman for Congress and managed the impeachment trials of three federal judges (1926–36). A Democrat, he tolerated the New Deal in its early years, but was a central participant in defeating President Franklin Roosevelt's "court-packing" plan.

SUMTER, THOMAS (*b. near Charlottesville, Va., 1734; d. near Statesburg, S.C., 1832*), Revolutionary officer, South Carolina partisan leader and legislator. After military experience in the campaigns of Braddock and Forbes and in fighting against the Cherokee, he settled as a storekeeper near Eutaw Springs, S.C., ca. 1765. A provincial congressman and for a time lieutenant colonel in the Continental service, he is remembered principally for his leadership of partisan troops against British and Tory forces in the Carolinas, 1780 and 1781–82. Feared by the enemy and called the "Gamecock of the Revolution," he played a role whose importance was out of all proportion to the small numbers he commanded. His campaigns were of material assistance to the later American victory at Yorktown.

SUNDAY, WILLIAM ASHLEY (*b. Ames, Iowa, 1862; d. 1935*), evangelist, popularly known as "Billy" Sunday. A member successively of the Chicago White Sox and the Pittsburgh and Philadelphia teams, 1883–91; he was associated thereafter until 1896 with activities of the Chicago YMCA and was assistant to the evangelist J. Wilbur Chapman. Beginning his independent career, 1896, he was ordained by the Chicago Presbytery, 1903. Soon becoming widely known, he held meetings in the largest cities of the United States. A vivid and unconventional preacher, he proclaimed a crude version of ultraconservative evangelical theology and instituted the practice of "hitting the sawdust trail," so called from the fact that the floors of the places in which he preached were covered with sawdust. Earnest and sincere, he preached the divine wrath rather than divine love.

SUNDERLAND, ELIZA JANE READ (*b. near Huntsville, Ill., 1839; d. Hartford, Conn., 1910*), educator, reformer. Active generally for human betterment, especially the promotion of temperance, the improvement of education, and the advancement of women, during long residences in Chicago, Ill., and Ann Arbor, Mich.

SUNDERLAND, LA ROY (*b. Exeter, R.I., 1804; d. 1885*), abolitionist. Originally a Methodist clergyman, but later a "faddist" and finally an infidel, he was responsible for organization of the first antislavery society in the Methodist church and was the first editor of *Zion's Watchman,* 1836.

SURRAT, JOHN H. *See* BOOTH, JOHN WILKES.

SURRAT, MARY *See* BOOTH, JOHN WILKES.

SUSANN, JACQUELINE (*b. Philadelphia, Pa., 1921; d. 1974*), author. Moved to New York City in 1936 and was an unsuccessful actress on Broadway. She collaborated on the play *Lovely Me* (1946), after which she worked as a radio talk-show host. In 1966 Susann rose to stardom with the publication of her novel *Valley of the Dolls,* a racy story of drugs, sex, and avarice in show business. The novel, which sold more than 20 million paperback copies, drew on her experience in Hollywood. She explored similar topics in the later novels *The Love Machine* (1969) and *Once Is Not Enough* (1973).

SUTHERLAND, EARL WILBUR, JR. (*b. Burlingame, Kans., 1915; d. Miami, Fla., 1974*), biomedical scientist. Graduated Washburn College (1937) and Washington University Medical School (M.D., 1938) and began his academic career at Washington University; he later held positions at Case Western Reserve University, Vanderbilt University, and the University of Miami. In 1953 he discovered the compound cyclic adenosine monophosphate (cAMP). In pathbreaking research during the 1960's, he elaborated on cAMP's crucial role as a regulator of metabolic functions in living organisms, for which he won the Nobel Prize in physiology or medicine (1971).

SUTHERLAND, EDWIN HARDIN (*b. Gibbon, Nebr., 1883; d. Bloomington, Ind., 1950*), sociologist, criminologist. Graduated Grand Island (Nebr.) College, 1904; Ph.D., University of Chicago, 1913. Taught sociology at William Jewell College, University of Illinois, University of Minnesota, University of Chicago; professor of sociology and chairman of that department, Indiana University, 1935–50. Author of *Criminology* (1924, and subsequent editions), *The Professional Thief* (1937), and *White Collar Crime* (1949).

SUTHERLAND, GEORGE (*b. Stony Stratford, Bucking-hamshire, England, 1862; d. Stockbridge, Mass., 1942*), lawyer, justice of the U.S. Supreme Court. His father was a Mormon convert who immigrated in 1863 to Utah. Young George left school at the age of 12, but in 1879 entered the new Brigham Young Academy in Provo. He left the academy in 1881 to take a job for the contractors building the Denver & Rio Grande Western Railroad, but the next year enrolled as a law student at the University of Michigan. Within a year he was admitted to the Michigan bar and to that of Utah.

For three years Sutherland practiced law in Provo with his father; he then entered a partnership with other young attorneys. Although an Episcopalian, he acted as counsel for the Mormon church. In politics he first joined the non-Mormon Liberal party and was its candidate for mayor of Provo in 1890; but by 1892, when he ran unsuccessfully for territorial delegate to Congress,

he had become a Republican. In 1893 he moved to Salt Lake City, where he joined a leading law firm and rose rapidly through railroad and other corporate cases. With the admission of Utah to the Union in 1896, he was elected to the first state senate, 1897–1901, and in 1900 to Utah's sole congressional seat. He did not seek reelection, but returned to Utah in 1903 and, by speaking at patriotic and civic gatherings, began to muster support for a seat in the U.S. Senate. In January 1905 he won the first of two consecutive terms.

Despite his basic conservatism, as senator Sutherland yielded to the progressive sentiments of the day and supported much of Theodore Roosevelt's reform program. Defeated for reelection in the Democratic year of 1916, Sutherland took up law practice in Washington, D.C. He was president of the American Bar Association in 1916–17. During the presidential campaign of 1920 he was a prominent adviser to his friend and former Senate colleague Warren G. Harding. Sometimes called "the Colonel House of the Harding administration," Sutherland served as chairman of the advisory committee for the Washington Arms Conference, 1921.

On Sept. 5, 1922, Harding appointed Sutherland to the Supreme Court. He was often aligned with the Court's other conservative justices in effective opposition to federal and state regulatory legislation and appeals under the Bill of Rights. Yet he occasionally took positions that were surprising for their liberality. During the 1920's many of Sutherland's opinions reflected his commitment to the limitation of political authority, as well as to the survival of "dual federalism," the balance between state and federal power. He led the majority that found unconstitutional much of the legislation of Franklin D. Roosevelt's New Deal and curtailed the activities of New Deal agencies. On Jan. 6, 1938, six months after the defeat of President Roosevelt's plan to enlarge the Supreme Court, Sutherland announced his retirement.

SUTHERLAND, JOEL BARLOW (*b. Clonmel, N.J., 1792; d. 1861*), physician, lawyer, Pennsylvania legislator. Congressman, Democrat, from Pennsylvania, 1827–37. Brilliant but shallow, he began as an enthusiastic Jacksonian but became a protectionist.

SUTHERLAND, RICHARD KERENS (*b. Hancock, Md., 1893; d. Washington, D.C., 1966*), army officer. Attended Yale (B.A., 1916). Served on the Mexican border in a federalized National Guard unit, then became a second lieutenant in the Regular Army. Joined the Second Infantry Division in France in 1918, and tours of duty during 1919–37 included various school, troop, and staff assignments. From 1938 to 1946, when he retired, he was closely associated with Gen. Douglas MacArthur, becoming his chief of staff in 1939. He oversaw MacArthur's staff activities during the latter's various commands and acted as liaison between MacArthur and senior field officers. In 1943 Sutherland coordinated the rapid buildup of Southwest Pacific Area forces, but he and MacArthur had an angry clash at Tacloban and they were never close again, although he continued to serve as chief of staff for MacArthur's new commands: U.S. Army Forces, Pacific, and Supreme Commander for the Allied Powers, Japan.

SUTRO, ADOLPH HEINRICH JOSEPH (*b. Prussia, 1830; d. San Francisco, Calif., 1898*), mining engineer. Immigrated to America, 1850; settled in San Francisco, 1851. Established quartz-reducing mill in Nevada, 1860, where he conceived idea of driving a tunnel into Mount Davidson from Carson River to the Comstock Lode as a more efficient means of transporting men and materials to and from the mines. After great difficulty in securing financing, Sutro brought the tunnel to completion, 1878; it proved immediately and immensely profitable. Selling out his interest, 1879, he returned to San Francisco, where he made profitable real estate investments and served as Populist mayor, 1894–96.

SUTTER, JOHN AUGUSTUS (*b. Kandern, Baden, 1803; d. Washington, D.C., 1880*), soldier, California colonizer. Officially a Swiss citizen, Sutter immigrated to America, 1834, journeyed to St. Louis, Mo., and in 1835 and 1836 accompanied trading parties to Santa Fe. Removing overland to Oregon, 1838, he reached California by way of Honolulu, Hawaii, and Sitka, Alaska, on July 1, 1839. Receiving large grants from the Mexican governor of California, he set up the colony of Nueva Helvetia on the American River at its junction with the Sacramento. Virtual sovereign ruler of his domain, he assisted early American settlers in his neighborhood. After the conquest of California by the United States he seemed secure in his fortunes, but discovery of gold on his estate, Jan. 24, 1848, marked the beginning of his ruin. Squatters settled upon his lands, his herders and workmen deserted the colony, and by 1852 he was bankrupt. He spent the rest of his life fruitlessly petitioning Congress for redress.

SUTTON, WILLIAM FRANCIS, JR. ("WILLIE") (*b. Brooklyn, N.Y., 1901; d. Spring Hill, Fla., 1980*), bank robber. After charges of theft beginning at age ten, he was charged with murder in 1921 but fled and changed his identity. Arrested on charges of murder and robbery in 1923, he was found not guilty and began planning a career as a bank robber, learning to circumvent burglar alarms and to break locks and open safes. He was arrested for breaking into a bank in 1926, paroled in 1929 and arrested again for bank robbery. He escaped from Sing Sing Prison (1932), Eastern State Penitentiary (1945), and Holmesburg Prison (1947). In 1952 he received a sentence of thirty years in prison (1952) but received an early release in 1969; he spent a total of thirty-three years in prison and estimated he stole almost $2 million from banks and merchants.

SUTTON, WILLIAM SENECA (*b. Fayetteville, Ark., 1860, d. Austin, Tex., 1928*), Texas educator.

SUZZALLO, HENRY (*b. San Jose, Calif., 1875; d. Seattle, Wash., 1933*), educator. Graduated Stanford University, 1899; Ph.D., Columbia, 1905. Taught in San Francisco public school system, at Stanford, and at Teachers College, Columbia, where he was professor of educational sociology. As president, University of Washington, 1915–26, he successfully coordinated the services of the university with the needs of the state. After supervising preparation of the report of the National Advisory Committee on Education (published 1931), which led to reforms in government educational services, he served as president of the Carnegie Foundation for the Advancement of Teaching, 1930–33. He was author also of a study of higher education in the state of California (1932).

SVENSON, ANDREW EDWARD (*b. Belleville, N.J., 1910; d. Livingston, N.J., 1975*), writer. Graduated University of Pittsburgh (B.A., 1932) and earned a teaching certificate from Montclair State Teachers College in 1933. In 1933–48 he was a reporter for the *Newark Star Eagle* and *Newark Evening Post*, then joined Stratemeyer Syndicate, publisher of children's books, as a writer and editor; he was made a partner in the syndicate in 1961. Svenson contributed to several book series, including the Hardy Boys and Tom Swift, Jr.

SVERDRUP, GEORG (*b. near Bergen, Norway, 1848; d. Minneapolis, Minn., 1907*), Lutheran theologian, educator. Professor of theology, Augsburg Seminary, Minneapolis, 1874–1907. An opponent of state-dominated churches, he championed congregationalist ideas.

Swain, Clara A. (*b. Elmira, N.Y., 1834; d. Castile, N.Y., 1910*), pioneer woman medical missionary in India, 1869–76 and 1879–85. A graduate of the Woman's Medical College, Philadelphia, 1869, she worked in India under Methodist auspices.

Swain, David Lowry (*b. Buncombe Co., N.C., 1801; d. 1868*), lawyer, North Carolina legislator and jurist. Whig governor of North Carolina, 1832–35, he pressed for tax reform and improved public education; he also induced the legislature to call the constitutional convention of 1835, at which he favored every liberal reform proposed. A constructive figure of the first rank, he did not believe in secession, but accepted it as a necessity and later advised President Andrew Johnson on plans of reconstruction. As president of the University of North Carolina *post* 1835, he built up that institution financially and scholastically, kept it open during the Civil War by heroic efforts, and until his death continued his efforts in its behalf. Appointed state agent for the collection of historical material, 1854, he began the work which resulted years later in the publication of the North Carolina *Colonial and State Records*.

Swain, George Fillmore (*b. San Francisco, Calif., 1857; d. Holderness, N.H., 1931*), engineer. B.S., Massachusetts Institute of Technology, 1877. Teacher of civil engineering at MIT *post* 1881, he served as professor and head of the department, 1887–1909; he was McKay professor of civil engineering at Harvard, 1909–29. A well-known consultant on engineering projects, he had a profound influence on methods of teaching and of interpreting technology in the practice of structural engineering.

Swain, James Barrett (*b. New York, N.Y., 1820; d. 1895*), journalist, New York Republican politician and officeholder.

Swallow, George Clinton (*b. Buckfield, Maine, 1817; d. Evanston, Ill., 1899*), geologist. Graduated Bowdoin, 1843. As state geologist, Swallow made important surveys in Missouri, 1853–61, and in Kansas, 1865. He was professor of agriculture at University of Missouri, 1870–82, and later a journalist in Montana.

Swallow, Silas Comfort (*b. near Wilkes-Barre, Pa., 1839; d. 1930*), Methodist clergyman, reformer. Holder of many pastoral charges in central Pennsylvania, he was a bitter and persistent enemy of the Republican machine in that state. As presidential nominee of the Prohibition party, 1904, he polled better than a quarter-million votes.

Swan, James (*b. Fifeshire, Scotland, 1754; d. Paris, France, 1830*), Massachusetts legislator and official speculator. Immigrated to Boston, 1765. Removing to France, 1787, with the help of Lafayette he won contracts to furnish the French with marine stores. In 1795, by a complicated series of transactions and as agent for the French Republic, he transformed the American foreign debt outstanding to France into a domestic one at considerable profit to himself. Failing in later French mercantile ventures, he remained in debtor's prison in Paris, 1808–30, refusing to permit his debt to be paid, because he considered it unjust.

Swan, Joseph Rockwell (*b. Westernville, N.Y., 1802; d. Columbus, Ohio, 1884*), Ohio jurist, legal writer, abolitionist. Celebrated for a classic opinion on state and federal court jurisdiction in the case of *Ex Parte Bushnell*; author of among other works, *A Treatise on the Law Relating to the Powers and Duties of Justices of the Peace . . . in the State of Ohio* (1837).

Swan, Timothy (*b. Worcester, Mass., 1758; d. Northfield, Mass., 1842*), composer and compiler of psalms. Author of, among other music, the very popular "China," composed in 1790 and first publicly sung in 1794.

Swank, James Moore (*b. Westmoreland Co, Pa., 1832; d. Philadelphia, Pa., 1914*), statistician. Associated in a managerial capacity with the American Iron and Steel Association, 1873–1912, he was an outstanding propagandist for protection.

Swann, Thomas (*b. Alexandria, Va., ca. 1806; d. 1883*), lawyer, businessman. Rose to prominence as able president of Baltimore & Ohio Railroad, 1848–53, extending the line to the Ohio River. Know-Nothing mayor of Baltimore, 1856–60. Swann was a strong Unionist during the Civil War, and Union party governor of Maryland, 1866–68. Opposing Radical Reconstruction, he succeeded in restoring the franchise to former Southern sympathizers. Congressman, Democrat, from Maryland, 1869–79, he rose to be chairman of the Committee on Foreign Relations, thereafter retiring to his estate near Leesburg, Va.

Swanson, Claude Augustus (*b. near Danville, Va., 1862; d. near Criglersville, Va., 1939*), lawyer, statesman. Graduated Randolph-Macon College, 1885; LL.B., University of Virginia, 1886. As congressman, Democrat, from Virginia, 1893–1906, he fought to secure rural free delivery service and was an able member of the House Ways and Means Committee. A progressive and successful governor of Virginia, 1906–10, he became U.S. senator in the latter year and served until 1933. A consistent supporter of Woodrow Wilson's policies and a "big navy" advocate, he was active also on the Senate Foreign Relations Committee. He was U.S. secretary of the navy, 1933–39, continuing his support of the navy although hampered by ill health.

Swanton, John Reed (*b. Gardiner, Me., 1873; d. Newton, Mass., 1958*), anthropologist and folklorist. Studied at Harvard University (Ph.D., 1900). Member of the staff of the Bureau of American Ethnology, Smithsonian Institution, 1900–44. An expert on American Indians, especially on the Southeast, Swanton conducted mostly field work, collecting records, artifacts, and legends from his sources. Not an anthropological theorizer, he was content to let his materials speak for themselves. Works include *Myths and Tales of the Southeastern Indians* (1929), *Indians of the Southeastern United States* (1946), and *Source Material on the History and Ethnology of the Caddo Indians* (1942).

Swartwout, Samuel (*b. Poughkeepsie, N.Y., 1783; d. New York, N.Y., 1856*), merchant, speculator, politician. A close associate of Aaron Burr (1756–1836), Swartwout delivered the famous cipher letter from Burr to James Wilkinson, October 1806, which produced such a strong impression of Burr's treason. Arrested as an accomplice, he served as an important witness against Burr. Later an active supporter of Andrew Jackson, he was collector of the Port of New York, 1829–38, achieving notoriety for misappropriation of more than a million dollars of public money.

Swasey, Ambrose (*b. Exeter, N.H., 1846; d. Exeter, 1937*), mechanical engineer, manufacturer, philanthropist. With W. R. Warner, entered machine-tool manufacturing business, 1880, in Chicago, removing to Cleveland, Ohio, 1881. Successful specialists in manufacture of hand-operated turret lathes, Warner and Swasey achieved greatest distinction for a sideline, the making of precision astronomical and other scientific instruments.

Swayne, Noah Haynes (*b. Frederick Co., Va., 1804; d. New York, N.Y., 1884*), jurist, U.S. Supreme Court justice. Father of

Wager Swayne. Reaching high rank at the Ohio bar *post* 1823, he was appointed justice of the U.S. Supreme Court, 1862, and served until 1881. A satisfactory judge but not a brilliant one, he gave his principal opinions in *Gelpcke v. City of Dubuque* and *Springer v. U.S.* He was regarded as the most nationalistic-minded member of the Court in his time.

SWAYNE, WAGER (*b. Columbus, Ohio, 1834; d. 1902*), Union major general, lawyer. Son of Noah H. Swayne. Winner of the Medal of Honor for gallantry at Corinth, Miss., October 1862, Swayne did valuable service in Alabama with the Freedmen's Bureau. He was later successful in the practice of law in New York City in partnership with John F. Dillon and others.

SWEENEY, MARTIN LEONARD (*b. Cleveland, Ohio, 1885; d. Cleveland, Ohio, 1960*), lawyer and politician. Studied at Baldwin-Wallace College (LL.B., 1914). Elected to the House of Representatives, 1931–42. A Democrat and supporter of Roosevelt, Sweeney was pro-labor but was not a New Dealer. He was known for his ardent isolationism; was against Lend-Lease and did not want America involved in the war. Re-elected many times without party endorsement, Sweeney was defeated in 1942 and returned to private law practice in Cleveland.

SWEENY, PETER BARR (*b. New York, N.Y., 1825; d. Lake Mahopac, N.Y., 1911*), lawyer, politician. Considered the guiding intelligence of the Tweed Ring in New York City *ca.* 1861–71.

SWEENY, THOMAS WILLIAM (*b. Co. Cork, Ireland, 1820; d. Astoria, N.Y., 1892*), Union brigadier general, Fenian leader of the ill-starred raid on Canada in 1866.

SWEET, JOHN EDSON (*b. Pompey, N.Y., 1832, d. Syracuse, N.Y., 1916*), mechanical engineer, educator. Headed the Straight Line Engine Co. *post* 1880; received John Fritz Medal, 1914, for pioneer work in construction and development of highspeed steam engines.

SWENSON, DAVID FERDINAND (*b. Kristinehamn, Sweden, 1876; d. Lake Wales, Fla., 1940*), philosopher. Came to America as a child. Graduating University of Minnesota, 1898, he taught philosophy and psychology there until the end of his life. He was noted as the pioneer American authority on work of Søren Kierkegaard and as a sharp, effective critic of current symbolic logics.

SWENSSON, CARL AARON (*b. Sugargrove, Pa., 1857; d. Los Angeles, Calif., 1904*), Swedish Lutheran clergyman, educator. Long associated with the congregation at Lindsborg, Kans., he was instrumental in founding Bethany College there, 1881.

SWETT, JOHN (*b. near Pittsfield, N.H., 1830; d. near Martinez, Calif., 1913*), California public school administrator, opponent of political influence in the schools.

SWIFT, GUSTAVUS FRANKLIN (*b. near Sandwich, Mass., 1839; d. 1903*), meatpacker. Established himself in Chicago, Ill., as a cattle buyer, 1875; sought to avoid waste by shipping already dressed beef to eastern markets, 1877. Conceived of the railroad refrigerator car as aid to year-round shipping. A pioneer in development of by-products from animal parts previously thrown away, Swift extended his business successfully to foreign markets; before his death, Swift & Co. (incorporated 1885) was capitalized at $25 million.

SWIFT, JOHN FRANKLIN (*b. Bowling Green, Mo., 1829; d. Japan, 1891*), lawyer, California legislator. Practiced in San Francisco, Calif., *post* 1857; was outstanding as an opponent of monopolistic corporations. A U.S. commissioner, 1880, to negotiate modifications of the Burlingame Treaty with China, he was later counsel for California in sustaining constitutionality of the Chinese Exclusion Act, 1888. U.S. minister to Japan, 1889–91.

SWIFT, JOSEPH GARDNER (*b. Nantucket, Mass., 1783; d. Geneva, N.Y., 1865*), military engineer. Brother of William H. Swift. Graduated West Point, 1802, in the first class. Chief engineer of the U.S. Army, 1812–18, he resigned because of conflict over appointment of Simon Bernard and worked there-after on railroad and harbor improvement projects. An engineer of distinction, he exerted influence over George W. Whistler, William G. McNeill, and other, younger professionals.

SWIFT, LEWIS (*b. Clarkson, N.Y., 1820; d. Marathon, N.Y., 1913*), astronomer, businessman.

SWIFT, LINTON BISHOP (*b. St. Paul, Minn., 1888; d. New York, N.Y., 1946*), social welfare administrator. Practiced law in St. Paul, 1910–17; following service in France during World War I, decided to devote himself to social work. After experience in St. Paul and in Louisville, Ky., 1920–25, he removed to New York City as executive secretary of the Family Service Association of America. In this position, which he held for the rest of his life, he was chief spokesman for a federation of 230 family welfare agencies in the United States and Canada. Throughout his career he insisted on a differentiation of social work from both psychiatry and social activism.

SWIFT, LOUIS FRANKLIN (*b. Sagamore, Mass., 1861; d. Chicago, Ill., 1937*), meatpacker. Son of Gustavus F. Swift. Official of Swift & Co. *post* 1885 and its president, 1903–31. With aid of brothers, he made the firm one of the world's greatest food processing and distributing businesses. He also pioneered in employee-welfare activities.

SWIFT, LUCIUS BURRIE (*b. Orleans Co., N.Y., 1844; d. 1929*), lawyer, civil service reformer. Practiced in Indianapolis, Ind., *post* 1879; edited and published the *Civil Service Chronicle*, 1889–96.

SWIFT, WILLIAM HENRY (*b. Taunton, Mass., 1800; d. New York, N.Y., 1879*), soldier, engineer. Brother of Joseph G. Swift. Attended West Point, 1813–18; accompanied Stephen H. Long to the Rocky Mountains and was commissioned in the artillery, 1819. After employment in railroad and canal work, he was made captain of topographical engineers, 1838, and was principal assistant in the topographical bureau at Washington, D.C., 1843–49. Resigning from the army, he was successively president of the Philadelphia, Wilmington & Baltimore and the Massachusetts Western railroads, a director of many corporations, and a financial adviser of Baring Brothers.

SWIFT, ZEPHANIAH (*b. Wareham, Mass., 1759; d. Warren, Ohio, 1823*), Connecticut legislator and jurist. Congressman, Federalist, from Connecticut, 1793–97; secretary to Oliver Ellsworth on mission to France, 1800. Author of the first American law text, *A System of the Laws of the State of Connecticut* (1795, 1796), he was a judge of the state superior court, 1801–19, serving for a time as chief justice. Deprived of office as a Federalist, he retired to legal researches and writing.

SWING, DAVID (*b. Cincinnati, Ohio, 1830; d. Chicago, Ill., 1894*), Presbyterian and independent clergyman. Pastor, Fourth Church, Chicago, *post* 1866, he was cited for heresy, 1874, and served *post* 1875 as minister of Chicago's Central Church.

SWING, RAYMOND EDWARDS (GRAM) (*b. Cortland, N.Y., 1887; d. Washington, D.C., 1968*), foreign correspondent and news

commentator. Attended Oberlin and became a cub reporter for the *Cleveland Press* in 1906; for the next six years he worked for newspapers in Ohio and Indiana. In Berlin in 1912, he became foreign correspondent for the *Chicago Daily News*. In 1919 he became correspondent for the *New York Herald* in Berlin, and was admitted to Moscow in 1921. In 1922 he became London correspondent for the *Wall Street Journal* and during 1924–33 was with the foreign-news service of the *Philadelphia Public Ledger* and the *New York Post*. He returned to Washington to write for the *Nation, London News-Chronicle,* and Britain's *Economist.* In 1935–45 he was the American end of a weekly exchange of broadcasts with Britain undertaken by the BBC. During World War II the exchange became one between two Americans, Swing and London-based Edward R. Murrow. In 1951 he became the first political commentator for Voice of America, then joined Murrow in writing the latter's daily radio commentaries until 1959, when he returned to Voice of America. He retired in 1963.

SWINTON, JOHN (*b. near Edinburgh, Scotland, 1829; d. Brooklyn, N.Y., 1901*), journalist, social reformer. Brother of William Swinton. Raised in Canada; worked as journeyman printer in the South and Middle West *post* 1853; was active in freestate movement in Kansas, 1856. Employed by the *New York Times* and *Sun* from *ca.* 1860, Swinton was an outstanding labor sympathizer and edited *John Swinton's Paper,* 1883–87.

SWINTON, WILLIAM (*b. near Edinburgh, Scotland, 1833; d. Brooklyn, N.Y., 1892*), journalist, educator. Brother of John Swinton. Resident in the United States *post ca.* 1863, he served as Civil War correspondent for *New York Times,* wrote several books about the war, and in 1869 became professor of English, University of California. Resigning in 1874 because of differences with Daniel C. Gilman, Swinton became a successful writer of school textbooks.

SWISSHELM, JANE GREY CANNON (*b. Pittsburgh, Pa., 1815; d. Swissvale, Pa., 1884*), teacher, antislavery and woman's rights reformer. Founded and edited the *Pittsburgh Saturday Visiter* (1847–57), the *St. Cloud Visiter,* the *Reconstructionist* (Washington, D.C.), and other waspishly written journals.

SWITZER, MARY ELIZABETH (*b. Newton Upper Falls, Mass., 1900; d. Washington, D.C., 1971*), federal social services administrator. Graduated Radcliffe College (B.A., 1921) and received her first civil service job in the Department of the Treasury in 1923. She joined the Public Health Service in 1935 and was appointed in 1950 as director of the Office of Vocational Rehabilitation, overseeing dramatic increases in federal spending on rehabilitation programs. In 1967 she became administrator of the Social and Rehabilitation Service within the Department of Health, Education, and Welfare and was active in drafting legislation to reduce the number of welfare recipients by putting welfare mothers to work. She retired in 1970.

SWITZLER, WILLIAM FRANKLIN (*b. Fayette Co., Ky., 1819; d. Columbia, Mo., 1906*), Missouri legislator and journalist. Editor of the *Missouri Statesman,* 1842–85, he was active in Democratic politics, supported the Union during the Civil War, and subsequently held several federal offices. One of the best-informed men of his time in the history of his state, he published, among other works, *Early History of Missouri* (1872).

SWOPE, GERARD (*b. St. Louis, Mo., 1872; d. New York, N.Y., 1957*), engineer and business executive. Studied at the Massachusetts Institute of Technology: Swope began working with Western Electric in 1895; in 1919 he was International General Electric's first president; in 1922 he became president of General

Electric. Remembered as an organizational genius, Swope's main accomplishments included reorganizing Western Electric's foreign interests and, later, those of General Electric; during World War I, he overhauled the Army Supply Service. Along with Owen D. Young, Swope was associated with the "new capitalism," especially with corporate welfare and employee representation programs, mass marketing of durables, and the recognition of managerial responsibility to workers, customer, and the industry as a whole. The famous "Swope Plan" of 1931 was adopted by the National Industrial Recovery Act of 1933. He retired from General Electric in 1939, but returned during World War II.

SWOPE, HERBERT BAYARD (*b. St. Louis, Mo., 1882; d. New York, N.Y., 1958*), newspaper editor. After working as a reporter for several midwestern and New York papers, Swope joined the Staff of the *New York World* in 1909. He was executive editor from 1920 to 1928. At the *World,* Swope's reporting won the Pulitzer Prize (the first for reporting) in 1917 for a series of articles on Germany before and during World War I. As executive editor he introduced the concept of the "Op Ed" page, now widely used by leading papers. Influential in politics, Swope was a backer of Al Smith in 1928, and later supported Roosevelt.

SYDENSTRICKER, EDGAR (*b. Shanghai, China, 1881; d. New York, N.Y., 1936*), social and economic investigator, public health statistician. Brother of Pearl S. Buck. Author of, among other works, *Conditions of Labor in American Industries* (with W. J. Lauck, 1917) and *Health and Environment* (1933).

SYDNOR, CHARLES SACKETT (*b. Augusta, Ga., 1898; d. Biloxi, Miss., 1954*), historian. Studied at Hampden-Sydney College and Johns Hopkins University (Ph.D., 1923). Taught at Hampden-Sydney College, 1923–36; at Duke University, 1936–54; chairman of the history department from 1952; dean of the Graduate School of Arts and Sciences from 1952. An expert in southern history, his works include *Slavery in Mississippi* (1933) and volume 5 in the *History of the South,* entitled *The Development of Southern Sectionalism, 1819–1848,* in 1948.

SYKES, GEORGE (*b. Dover, Del., 1822; d. Fort Brown, Tex., 1880*), Union major general. Graduated West Point, 1842. An excellent tactician on the defense, Sykes commanded the V Corps at Gettysburg, defending the Round Tops successfully, but suffering criticism for his failure to counterattack.

SYLVESTER, FREDERICK OAKES (*b. Brockton, Mass., 1869; d. 1915*), painter, art teacher. Employed in the St. Louis, Mo., public school system, 1892–1914, he produced many highly regarded canvases of scenes on the Mississippi River.

SYLVESTER, JAMES JOSEPH (*b. London, England, 1814; d. probably Oxford, England, 1897*), mathematician, educator. A brilliant student at St. John's College, Cambridge, 1831–33 and 1836–37, he was barred as a Jew from taking his degree or receiving a fellowship. Professor of natural philosophy at University College, London, 1837–41. He taught mathematics at the University of Virginia, 1841–42, but because of problems of discipline resigned and returned to London. Engaged there in actuarial work, 1844–56, he also studied law; he was professor of mathematics, Royal Military Academy at Woolwich, 1855–70. Invited to serve as professor of mathematics at Johns Hopkins University, 1876, he brought there a reputation as one of the greatest mathematicians of his time and an infectious eagerness for intellectual endeavor. Setting new standards for mathematical research in America and inspiring scores of students, he acted also as editor of the *American Journal of Mathematics,* 1878–84. Resigning his chair, December 1883, he became Savilian pro-

fessor of geometry at Oxford, in which position he remained for the rest of his life. He devoted his attention as a scholar to the theory of numbers; to higher algebra; and to the theory of invariants, a subject in which he was recognized as preeminent. Many of his contributions to learned journals were issued in a collected edition, edited by H. F. Baker (1904–12).

SYLVIS, WILLIAM H. (*b. Armagh, Pa., 1828; d. 1869*), labor leader. An official of an iron-moulders' union, organized in Philadelphia, Pa., 1855, he signed the call for the first convention of the Iron-Moulders International Union, Philadelphia, 1859. His address at the convention became the preamble to the constitution of the new union, of which he was elected treasurer, 1860, and president, 1863. Active in calling the Labor Congress at Baltimore, Md., 1866, he was elected president of the National Labor Union, 1868. An opponent of strikes in theory, in practice he led some of the first great struggles of the American trade unions. Although he urged affiliation with the First International, he was influenced more personally by the English cooperative movement.

SYMES, JAMES MILLER (*b. Glen Osborne, Pa., 1897; d. Feasterville, Pa., 1976*), railroad executive. Began his career with the Pennsylvania Railroad (PRR) as a clerk and car tracer in 1916 and rose through the company, becoming vice-president of operations in 1947, executive vice-president in 1952, president in 1954, and chairman of the board in 1959. He implemented modernization programs; urged regulatory reform, especially in flexibility for setting rates; and championed industry consolidation through mergers. In 1957 he proposed the merger of PRR with New York Central (which did not take place until 1968). He retired from PRR in 1963.

SYMMES, JOHN CLEVES (*b. Southold, N.Y., 1742; d. Cincinnati, Ohio, 1814*), Revolutionary patriot, New Jersey legislator and jurist, Ohio pioneer. Becoming interested in western colonization as a member of Congress from New Jersey, 1785–87, Symmes applied for a large tract between the two Miamis on the Ohio. In October 1788 he was given a definite contract for 1 million acres, the so-called Miami Purchase. Early in 1789 he founded a settlement at North Bend, but was unable to make collections for sales of his land in time to meet the payments due under his contract with the government. Aided by Jonathan Dayton and Elias Boudinot, he received a patent in September 1794 for the acreage which he had actually paid for. A persevering man with qualities of leadership, he was also exceedingly careless as a businessman and lost control of much of his property; however, he had planted an important colony. Its chief settlement, Cincinnati, was perhaps the most important military and commercial outpost in the early West.

SYMONS, GEORGE GARDNER (*b. Chicago, Ill., 1865; d. Hillside, N.J., 1930*), landscape painter specializing in winter scenes.

SYMONS, THOMAS WILLIAM (*b. Keeseville, N.Y., 1849; d. Washington, D.C., 1920*), military engineer. Graduated West Point, 1874. Served on survey expeditions under George M. Wheeler, 1876–79, and with the Mississippi River Commission and other government agencies; had charge of construction of the Buffalo, N.Y., breakwater; advocated construction of New York State Barge Canal.

SYMS, BENJAMIN (*b. probably England, ca. 1591; d. Virginia, ca. 1642*), Virginia planter. Resident in Virginia *post* 1624, Syms executed a will on Feb. 12, 1634/5 bequeathing property for establishment of a free school, thus becoming probably the first inhabitant of any North American colony to provide the means for such a purpose.

SYNG, PHILIP (*b. Cork, Ireland, 1703; d. 1789*), Philadelphia silversmith. Grandfather of Philip S. Physick. Immigrated to Maryland, 1714; was established in Philadelphia by 1720. An outstanding craftsman, Syng was a member of Benjamin Franklin's Junto, an electrical experimenter, and an original trustee of the College of Philadelphia (later University of Pennsylvania).

SZELL, GEORGE (*b. Budapest, Austria-Hungary, 1897; d. Cleveland, Ohio, 1970*), orchestra conductor. Conducted for the first time in 1913 with the Vienna Konzertvereins-Orchester in Bad Kissingen. Engaged as a conductor at the Berlin Royal Opera (1915–17), Municipal Theater in Strassburg (1917–18), German Opera in Prague (1919–21), Darmstadt Court Theater (1921–22), Municipal Theater in Düsseldorf (1922–24), and Berlin State Opera (1924–29). His first American concert was with the St. Louis Symphony Orchestra (1930). He fled to Western Europe in 1937 and simultaneously served as conductor for the Scottish Orchestra in Glasgow and the Residentie Orchestra in The Hague (1937–39). In 1939 he became a teacher at the Mannes School of Music and a director of an opera workshop at the New School for Social Research, both in New York City. Appeared with Toscanini's NBC Symphony Orchestra in 1941, and debuted with the Metropolitan Opera in 1942, where he remained until 1946. Appeared with the New York Philharmonic (1943–70) and became music director of the Cleveland Orchestra (1946–70).

SZILARD, LEO (*b. Budapest, Hungary, 1898; d. La Jolla, Calif., 1964*), physicist. Attended Budapest Institute of Technology, Technische Hochschule at Charlottenburg, and University of Berlin (Ph.D., 1922). He collaborated with Albert Einstein in developing a pumping system for liquid metals and filed a patent (1928) for a prototype cyclotron, or particle accelerator. Fled to England in 1933 and during 1934–38 initiated research on the problem of controlling and sustaining an artificial chain reaction. At Columbia in 1935 it became clear to him that a controlled nuclear chain reaction could become the basis for a bomb of enormous destructive force. He joined forces with Enrico Fermi in 1939, and they persuaded Einstein to write to President Franklin Roosevelt on the probability of developing nuclear weapons. He was a leading member of the Manhattan Project; at the University of Chicago, he and Fermi directed construction of a uranium-graphite reactor, which in 1942 sustained the first controlled nuclear reaction. Became a U.S. citizen in 1943. After the war he and Fermi received patent rights to the world's first nuclear fission reactor. When the war ended he became more concerned about control of atomic energy in the postwar world and lobbied for the creation of the Atomic Energy Commission. His endeavors to achieve international arms control were mostly negated by the Cold War; but one result of his efforts was the Pagwash Conference on Science and World Affairs, a disarmament forum.

SZOLD, BENJAMIN (*b. Nemiskert, Hungary, 1829; d. Berkeley Springs, W.Va., 1902*), rabbi. A moderate in his religious views and an outstanding scholar, he served as rabbi of Congregation Oheb Shalom, Baltimore, Md., 1859–92, and was thereafter emeritus.

SZOLD, HENRIETTA (*b. Baltimore, Md., 1860; d. Jerusalem, Palestine [now Israel], 1945*), Zionist leader. Daughter of Benjamin Szold. Taught at a private school in Baltimore; helped found, 1889, and managed an evening school for immigrants; aided her father in his research and writing; made a public espousal of Zionism, 1895. Editor of the Jewish Publication Society, 1893–1916. A member of the executive council of the Federation of American Zionists *post* 1899, she became its sec-

retary and displayed unusual executive and public-speaking abilities. In 1912 she founded and became president of Hadassah, serving as president until 1926 and as honorary president thereafter. In 1920 she left for Palestine to help Isaac M. Rubinow in the administration of the American Zionist Medical Unit. Elected a member of the newly formed Jewish Agency Executive in Jerusalem, 1929, and elected in 1931 to the national council sanctioned under the British mandate, she was responsible for education and health programs and instituted a modern system of social service. In 1933 she was appointed director of the Youth Aliya Bureau and took a leading role in the rescue of European Jewish children and their settlement in Palestine. A democrat and a pacifist, she advocated Arab-Jewish binationalism; for her, there was no necessary antagonism between Jewish hopes and Arab rights.

SZYK, ARTHUR (b. *Łodz, Russian Poland, 1894; d. New Canaan, Conn., 1951*), miniaturist and cartoonist. Studied at the Académie Julien in Paris. Immigrated to the U.S. in 1937. Remembered for his miniature book illustrations, Szyk's works include the *Song of Songs* (1917), *The Last Days of Shylock* (1931), *George Washington and His Times* (1931) — the originals of which President Roosevelt had hung in the White House — and *The Arabian Nights* (1952). During World War II Szyk published many anti-Nazi political cartoons.

T

TABB, JOHN BANISTER (*b. Amelia Co., Va., 1845; d. 1909*), Confederate dispatch carrier, Roman Catholic clergyman, poet. A convert to Catholicism, 1872, Father Tabb was ordained in December 1884, and taught at St. Charles' College, Md., thereafter for the rest of his active life. His work, epigrammatic and somewhat cryptic, appeared in *Poems* (1894), *Lyrics* (1897), and other volumes. Calling himself an "unreconstructed rebel," he had a rich and paradoxical nature.

TABER, JOHN (*b. Auburn, N.Y., 1880; d. Auburn, 1965*), lawyer, U.S. congressman. Attended Yale University (B.A., 1902) and New York Law School in Albany, from which he graduated in 1904. Began his congressional career in 1923 when he was elected to the House of Representatives. A conservative Republican, Taber was a leading anti-New Dealer during the 1930's. After the 1946 elections he became chairman of the Appropriations Committee, as well as the first chairman of the Joint Congressional Committee on the Budget. These two positions made him one of the most influential members of government. Such was his zeal for fiscal conservatism that the expression "Taberizing" became a synonym for dismissal or cutback. His chairmanship of the Appropriations Committee ended in 1949, by which time he claimed to have saved the federal government over $6 billion. He regained the chairmanship briefly (1953–54), and continued to serve in the House until 1963.

TABOR, HORACE AUSTIN WARNER (*b. Holland, Vt., 1830; d. Denver, Colo., 1899*), prospector, mineowner, merchant. One of the "rushers" to Pike's Peak in 1859. Tabor, a storekeeper, grubstaked the discoverers of the Little Pittsburgh Mine (1878) of which he became a one-third owner. Prosperous for a time, he spent the returns of the great silver lode with a lavish hand; among other benefactions he built an opera house at Leadville, Colo., and Tabor Grand Opera House in Denver. At first he invested in real estate, but soon turning to less conservative operations, he was brought to bankruptcy by the decline in the price of silver and the crash of 1893. His second wife was the celebrated "Baby Doe."

TAFT, ALPHONSO (*b. Townshend, Vt., 1810; d. California, 1891*), lawyer. Father of Charles P. and William H. Taft. Graduated Yale, 1833. Successful at the bar in Cincinnati, Ohio, *post* 1839, he was interested also in railroad development in the Middle West and in Cincinnati traction lines. Judge of the Cincinnati superior court, 1865–72, he served briefly as U.S. secretary of war in 1876 and as U.S. attorney general, 1876–77. Politically a conservative, originally a Whig and later a Republican, he was U.S. minister to Austria-Hungary, 1882–84, and to Russia, 1884–85.

TAFT, CHARLES PHELPS (*b. Cincinnati, Ohio, 1843; d. 1929*), lawyer, publisher, philanthropist. Son of Alphonso Taft; half brother of William H. Taft. Graduated Yale, 1864; LL.B., Columbia, 1866; studied also at Heidelberg and at the Sorbonne. In the practice of law in Cincinnati, 1869–79, he acquired a controlling interest in the Cincinnati *Times*, 1879. He consolidated it in 1880 with the *Star*. Editor and ultimately sole proprietor, he built the *Times-Star* into a profitable newspaper property, made notable contributions to the aesthetic life of Cincinnati, and played a large part in shaping the career of William H. Taft.

TAFT, HENRY WATERS (*b. Cincinnati, Ohio, 1859; d. New York, N.Y., 1945*), lawyer, civic leader, philanthropist. Son of Alphonso Taft; brother of William H. Taft; half brother of Charles P. Taft. B.A., Yale, 1880. Admitted to New York bar, 1882, he became a partner in the firm of Strong & Cadwalader, 1899 (*post* 1914, Cadwalader, Wickersham & Taft).

TAFT, LORADO ZADOC (*b. Elmwood, Ill., 1860; d. Chicago, Ill., 1936*), sculptor. Graduated University of Illinois, 1879; attended École des Beaux Arts, Paris, France, 1880–83. The outstanding "art missionary" of his time, Taft lectured widely, served on city, state, and federal fine arts commissions, and worked unceasingly for public school art education. He wrote *History of American Sculpture* (1903), *Modern Tendencies in Sculpture* (1921), and hundreds of articles. At the Chicago Art Institute (1886–1906), he pioneered in new methods of instruction. A competent and essentially conservative sculptor, he was one of the early workers in group composition and monumental fountains ("Columbus Fountain," 1912, Washington, D.C.; "Thatcher Memorial Fountain," 1917, Denver; "Fountain of the Great Lakes," 1913, "Fountain of Time," 1922, both Chicago).

TAFT, ROBERT ALPHONSO (*b. Cincinnati, Ohio, 1889; d. New York, N.Y., 1953*), lawyer, politician. Graduated from Yale University and Harvard Law School, 1913. During World War I, served under Herbert Hoover for the U.S. Food Administration and worked on relief programs in Europe. Entered Ohio politics, becoming the Republican speaker of the assembly in the Ohio legislature, 1925. The son of President William Howard Taft, he was a conservative advocate of big business, an isolationist, and an outspoken critic of Roosevelt and the New Deal, which he termed socialistic. Served in the U.S. Senate, 1938–53. Tried unsuccessfully to win the Republican nomination for the presidency, 1940.

By 1944, Taft was the leading Republican in the Senate and an influential spokesman for the bipartisan conservative bloc that ruled Capitol Hill. For the next eight years he was one of the most powerful senators in modern American history. Author of the Taft-Hartley Act, which placed curbs on union abuses, he emerged as a leading contender for the presidency; he was defeated in 1948 by Thomas E. Dewey and in 1952 by Eisenhower. He, while a defender of Senator Joseph McCarthy, was against the Marshall Plan and NATO, and opposed the U.N. At the end of his career, he was known as "Mr. Republican."

TAFT, WILLIAM HOWARD (*b. Cincinnati, Ohio, 1857; d. Washington, D.C., 1930*), lawyer, jurist, president and chief justice of the United States. Son of Alphonso Taft; half brother of Charles

P. Taft. Graduated Yale, 1878; Cincinnati Law School, 1880. A large, good-natured young man with a tendency toward sloth, Taft early showed a weakness for procrastination which he never quite overcame. Entering Republican party politics, he served as assistant prosecutor of Hamilton County, his first public office, but in 1882, after appointment as collector of internal revenue for Cincinnati, resigned because he refused to conform to the prevalent spoils system. Resuming the practice of law, he became judge of the superior court of Ohio in March 1887. Happy in his work as a jurist, he served until 1890, attracting unwelcome labor criticism for his exhaustive opinion in the case of *Moores & Company* v. *The Bricklayers' Union, No 1*. Appointed U.S. solicitor general, he assumed office in February 1890 and served with great credit until March 1892 when he became a federal circuit court judge.

A man of scholarly tastes and abilities, Taft found his new post ideal, but continued to win the enmity of organized labor for rulings in major cases. Although his own position on the right of labor to organize was in advance of the existing legal opinion of the day, he refused to win an easy popularity by seeking for reasons to support illegal acts by labor, especially in matters of attempted boycotts. Taft, however, ruled in favor of labor in cases involving attempts of employers to evade responsibility for negligence; in the Addyston Pipe Case, 1898, he ruled that a combination of manufacturers was in restraint of trade and enjoined them. He became president of the Philippine Commission, 1900, resigning from the bench at the request of President William McKinley. He served as civil governor of the islands, 1901–04, devoting himself with great tact and energy to the solution of several thorny problems which were legacies of the Spanish-American War and the insurrection, and also to the improvement of the economic status of the Philippines. Accepting office as U.S. secretary of war, 1904, at the request of President Theodore Roosevelt, he soon became a close adviser of the president whose impulsive qualities he balanced with his own easygoing conservatism. He became in effect the "trouble shooter" of the administration. His nomination for the presidency on the Republican ticket in 1908 was owing to his unusual talents as administrator and conciliator and also to Roosevelt's backing; Taft, however, had to be urged to run, as he stated that he had no taste for the office.

After his election over William Jennings Bryan by an electoral vote of 321 to 162, he took office in March 1909 and was troubled and harassed almost from the start. Taft's troubles were owing to certain specific mistakes but principally to his erroneous belief that the Republican party could continue in power without giving ground to its liberal wing. He was also hampered by his stolid, plodding honesty of purpose; he had no part of his predecessor's genius for guiding and (when he chose) confusing public opinion. Bringing unpopularity on himself by his courageous attempt to secure tariff revision (which Roosevelt had zealously refrained from attempting), he then found himself threatened by the insurgents in his own party such as Senators LaFollete, Dolliver, Borah and others, and by the growing strength of the Democratic party which won the House in November 1910. At odds with his sponsor, Theodore Roosevelt, because of a number of incidents, notably Roosevelt's resentment over the dismissal of Gifford Pinchot, Taft turned more and more to the conservative members of his cabinet and his party. Despite this, he proposed and achieved "trust-busting" and other reform activities much more efficiently than Roosevelt. Renominated at Chicago in June 1912 by a convention whose behavior threw Roosevelt into opposition as a candidate of the Bull Moose party, Taft received only 8 electoral votes in the election of 1912 as against 88 for Roosevelt and 435 for Woodrow Wilson.

Unique among presidents in that he did not want the office and surrendered it gladly, Taft retired to Yale in March 1913 as Kent Professor of Constitutional Law. Named chief justice of the United States in June 1921, he achieved his heart's desire. In many ways his work as administrator and reformer of the Supreme Court's procedure was more important than any of his decisions; among the best of his accomplishments was the so-called Judges' Bill, February 1925. Generally conservative in his decisions, he made his most important dissent in the case of *Adkins* v. *Children's Hospital* (261 U.S., 525), holding that a minimum wage law for women was constitutional because sweatshop wages did just as much to impair health and morals as did long hours. In so far as Taft sanctioned control of commerce and industry, his decisions show that he believed that supervision by the federal government was superior to that by the states, but he was, in contrast, an advocate of broad federal powers under the commerce clause of the Constitution. One of his most important contributions to constitutional law is said to have been his ruling in *Myers* v. *U.S.* (272 U.S., 52) sustaining the presidential power to remove executive officers. A coordinator and conciliator all his life rather than an advocate, Taft was not a leader of judicial thought in the sense that Justice O. W. Holmes or Justice Brandeis was a leader. Retiring from the bench, February 1930, because of ill health, he died a month later.

TAGGARD, GENEVIEVE (*b. Waitsburg, Wash., 1894; d. New York, N.Y., 1948*), poet. Raised in the Hawaiian Islands, where her parents were missionaries; graduated University of California at Berkeley, 1920; removed to New York City, where she was associated with the *New Masses* and a variety of left-wing causes; taught at Mt. Holyoke College (1929–30), Bennington College (1932–35), and Sarah Lawrence College (1935–46).

TAGGART, THOMAS (*b. Co. Monaghan, Ireland, 1856; d. Indianapolis, Ind., 1929*), Indiana politician, hotel proprietor, banker. Immigrated to America as a child. Long a power in state and national Democratic politics, he served with ability as mayor of Indianapolis, 1895–1901, and was U.S. senator from Indiana, March–November 1916.

TAGLIABUE, GIUSEPPE (*b. Como, Italy, 1812; d. Mt. Vernon, N.Y., 1878*), instrument maker. Settled in New York, N.Y., 1831, after apprenticeship in the family business of thermometer making. For years he supplied instruments used by the U.S. Geodetic Survey; he also patented improvements on the hydrometer, a mercurial barometer, and other scientific devices.

TAIT, AUTHUR FITZWILLIAM (*b. near Liverpool, England, 1819; d. Yonkers, N.Y., 1905*), landscape and animal painter. Immigrated to New York, N.Y., 1850. A skillful academic painter, Tait produced many pictures which had wide contemporary circulation as popular lithographs and are of present value as documents of phases of the life of his time.

TAIT, CHARLES (*b. Louisa Co., Va., 1768; d. Alabama, 1835*), lawyer. Cousin of Henry Clay. Admitted to the Georgia bar, 1795, he practiced in association with William H. Crawford and was a prominent figure in the faction which opposed the Yazoo sales. U.S. senator, Democrat, from Georgia, 1809–19, he was untiring in efforts on behalf of the navy, and aided in formation of Alabama as a territory and its later admission to the Union. Removing to Claiborne, Ala., 1819, he served as U.S. judge of the district of Alabama, 1820–26. He was also known for his scientific accomplishments.

TAKAMINE, JOKICHI (*b. Takaoka, Japan, 1854; d. 1922*), chemist, industrialist. Graduated University of Tokyo, 1879; studied at Glasgow University. Headed Japanese patent bureau and also

division of chemistry in Japanese department of agriculture. Resident *post* 1890 in the United States and long associated with Parke, Davis & Co., Takamine developed the starch-digesting enzyme known as takadiastase and in 1901 succeeded in isolating adrenalin from the suprarenal gland. Among other industries, he aided in the development in Japan of dyes, aluminum, the electric furnace, and nitrogen fixation.

TALBOT, ARTHUR NEWELL (*b. Cortland, Ill., 1857; d. Chicago, Ill., 1942*), civil engineer, engineering educator. B.S., Illinois Industrial University (later the University of Illinois), 1881. Taught engineering at University of Illinois, 1885–1926 (professor of municipal and sanitary engineering *post* 1890); a pioneer in application of scientific research to engineering, in particular to railway construction and the use of reinforced concrete.

TALBOT, EMILY FAIRBANKS (*b. Winthrop, Maine, 1834; d. Holderness, N.H., 1900*), teacher, philanthropist. Wife of Israel T. Talbot. Was active in promoting organizations of university women and higher education for women.

TALBOT, ETHELBERT (*b. Fayette, Mo., 1848; d. Tuckahoe, N.Y., 1928*), Episcopal clergyman. Consecrated missionary bishop of Wyoming and Idaho, 1887, he served with ability until 1897, recounting his experiences in *My People of the Plains* (1906). Bishop of central Pennsylvania, 1898–1904, he continued as bishop of Bethlehem (after the division of the original diocese) until 1927. He was presiding bishop of the Protestant Episcopal Church, 1924–26.

TALBOT, FRANCIS XAVIER (*b. Philadelphia, Pa., 1889; d. Washington, D.C., 1953*), Roman Catholic priest, writer. Studied at Woodstock (Md.) College. A Jesuit, Talbot prepared at the Society of Jesus at St. Andrew-on-the-Hudson; ordained in 1921. As literary editor for the Catholic weekly *America*, 1924–44, and editor in chief of *America* and *Catholic Mind*, 1936–44, he introduced leading Catholic writers and thinkers and was responsible for broad coverage of poetry, literature, and drama. President of Loyola College, Baltimore, 1947–50. Author of several books about Catholic missionaries and contributor to the *Encyclopaedia Britannica*.

TALBOT, HENRY PAUL (*b. Boston, Mass., 1864; d. 1927*), chemist. Graduated Massachusetts Institute of Technology, 1885; studied organic and physical chemistry at Leipzig (Ph.D., 1890). Taught *post* 1890 at the Massachusetts Institute of Technology, rising to head of department of chemistry and chemical engineering, 1902, and acting as dean of students, 1921–27.

TALBOT, ISRAEL TISDALE (*b. Sharon, Mass., 1829; d. Hingham, Mass., 1899*), physician. Husband of Emily F. Talbot. A leader in homeopathic medicine, he was appointed dean and professor of surgery at Boston University School of Medicine on its establishment, 1873.

TALBOT, JOHN (*b. Wymondham, England, 1645; d. Burlington, N.J., 1727*), Anglican clergyman. Assistant to George Keith on missionary travels in America, Talbot arrived in Boston, Mass., 1702. Rector of St. Mary's Church, Burlington, N.J., *post* 1704, he made numerous trips to England on behalf of an American episcopate and engaged in many controversies both in America and England. Losing his missionary status because of alleged disaffection toward the government, 1724, he was described by a defender as "a man universally beloved, even by the dissenters."

TALBOT, SILAS (*b. Dighton, Mass., 1751; d. New York, N.Y., 1813*), Revolutionary soldier, naval officer. Trained in the merchant service, he was commissioned captain in the Continental

Army, 1775, was at the siege of Boston, and later commanded a fireship in the attempt to burn the British warship *Asia* at New York. Prominent in the defense of the Delaware River forts and in the 1778 Rhode Island campaign, he was made captain, Continental Navy, 1779, but put to sea in an unsuccessful privateer, was captured and underwent many hardships. A farmer after the war in New York State, he was chosen captain in the reorganized navy, 1794, and superintended building of the frigate *President*. He resigned from the navy, September 1801, after service as commander of the Santo Domingo station.

TALBOTT, HAROLD ELSTNER (*b. Dayton, Ohio, 1888; d. Palm Beach, Fla., 1957*), business executive, government official. Studied at Yale University. A member of the "Dayton group" of industrialists, Talbott was active in the aviation industry, organizing the Wright Aeroplane Co. before World War I, and from 1932, chairman of the board of the North American Aviation concern. Involved in the campaigns of Wendell Willkie, Thomas Dewey, and Eisenhower. Secretary of the air force, 1952–55; resigned over alleged conflicts of interest.

TALCOTT, ANDREW (*b. Glastonbury, Conn., 1797; d. Richmond, Va., 1883*), soldier, engineer. Graduated West Point, 1818. After varied service he resigned his commission, 1836, and served as chief engineer of a number of railroads. He undertook his most important work in locating and building the railroad from Veracruz to the city of Mexico, 1857–67. He devised the so-called "Talcott's method" of determining terrestrial latitudes.

TALCOTT, ELIZA (*b. Vernon, Conn., 1836; d. Kobe, Japan, 1911*), Congregational missionary to Japan *post* 1873.

TALCOTT, JOSEPH (*b. Hartford, Conn., 1669; d. 1741*), Connecticut colonial legislator, soldier, and jurist. Governor of Connecticut, 1724–41, he was the first of the colony's governors to have been native born.

TALIAFERRO, LAWRENCE (*b. King George Co., Va., 1794; d. Bedford, Pa., 1871*), soldier. Indian agent at Fort Snelling (Minn.), 1819–39, he set himself to keep peace between the Sioux and their enemies the Chippewa and other neighbors, an endeavor in which he was often successful because the Indians trusted him. He engaged, however, in almost constant strife with the traders whose efforts to bribe or oust him failed.

TALIAFERRO, WILLIAM BOOTH (*b. Gloucester Co., Va., 1822; d. "Dunham Massie," Gloucester Co., Va., 1898*), lawyer, farmer, Confederate major general. Won high reputation as one of Stonewall Jackson's lieutenants; served with great ability in the defense of Charleston, S.C., *post* 1863. As a Virginia legislator, 1874–79, he opposed repudiation of the state debt.

TALLMADGE, BENJAMIN (*b. Brookhaven, N.Y., 1754; d. Litchfield, Conn., 1835*), Revolutionary officer, businessman. Graduated Yale, 1773. In service as a major during most of the Revolution, Tallmadge won distinction as a field officer (notably in the capture of Fort St. George, Long Island, November 1780) and as principal director of Washington's secret service, 1778–83. Congressman, Federalist, from Connecticut, 1801–17, he served on many committees and was for a time chairman of the military affairs committee. He was a son-in-law of William Floyd.

TALLMADGE, JAMES (*b. Stanford, N.Y., 1778; d. New York, N.Y., 1853*), lawyer, New York politician and militia officer. As congressman, Democrat, from New York, 1817–19, he introduced in February 1819 an amendment to the Missouri admission bill which was designed to prohibit further introduction of

slaves into that state and to provide for gradual emancipation of those born there after admission. The amendment precipitated a nationwide controversy. Lieutenant governor of New York, 1825–27, he concerned himself thereafter with nonpolitical activities and was a founder of the present New York University.

TALMADGE, CONSTANCE (*b. Brooklyn, N.Y., 1900; d. Los Angeles, Calif., 1973*), silent film star.Following the lead of her elder sister, Norma, Constance got her first show-business job in 1914 as an extra at the Vitagraph Motion Picture Studio in Brooklyn; her big break came when she was in D. W. Griffith's *Intolerance* (1916). Her talents as a comedienne made her a leading Hollywood star through the 1920's, appearing in some seventy films, including *Her Night of Romance* (1924) and *Her Sister from Paris* (1925). She never played in the talkies, retiring from the screen in 1929.

TALMADGE, EUGENE (*b. Forsyth, Ga., 1884; d. Atlanta, Ga., 1946*), lawyer, politician. LL.B., University of Georgia, 1908. Following a year of law practice in Atlanta, where he made excellent political connections, Talmadge moved to Ailey in Montgomery County. In 1912 the family moved to Telfair County, where for the next fourteen years he engaged in farming and the law. His only involvement in politics during these years was on the local level; as solicitor for the McRae city court (1918–20) and as county attorney (1920–23).

Talmadge began his statewide political career in 1926 when he defeated the "machine" candidate for the office of commissioner of agriculture. He was reelected in 1928 and 1930, but his tenure was marked by controversy. In 1932 he was elected governor, after defeating a field of nine in the Democratic primary; he was reelected two years later. Talmadge took office as governor at the same time that Franklin D. Roosevelt became president. Delighted at first by the Democratic sweep and Roosevelt's leadership, he gradually became a bitter foe of the New Deal. The chief objects of his attack were agricultural policies of acreage and poundage reduction and the WPA minimum-wage level. Determined to consolidate his authority, he suspended the entire Public Utilities Commission (1933) and declared martial law to "subjugate" the Highway Commission (1933). A determined foe of organized labor, Talmadge called out the National Guard to break strikes during attempts to unionize the state's textile mills in 1934. By 1936 he was solidly in the "stop-Roosevelt" camp, and called a "Grass Roots" convention at Macon, Ga., which formed the "Constitutional Jeffersonian Democratic" party and nominated Talmadge for president. The movement soon collapsed, and the fiasco, together with his opposition to the Agricultural Adjustment Act, temporarily cost Talmadge the support of the farmers. Ineligible to run again in 1936 for governor, he made an unsuccessful attempt to unseat incumbent U.S. Senator Richard B. Russell, Jr. A similar attempt against Walter G. George in 1938 also failed. Between 1936 and 1940 Talmadge practiced law in Atlanta, continued to run his farms, and published the *Statesman*, a weekly newspaper that he founded in 1932.

Talmadge was returned to the governor's chair in 1940. He wisely refrained from attacking Roosevelt, but embroiled himself in a feud with the University of Georgia while attempting to return a political favor. The episode was largely responsible for Talmadge's defeat by Ellis G. Arnall when he ran for a four-year term in 1942. He was nonetheless again elected governor in 1946; but before assuming office he died.

TALMADGE, NORMA (*b. Jersey City, N.J., 1897; d. Las Vegas, Nev., 1957*), film actress. First appeared in *The Household Pest* (1910), in which only the back of her head was seen. Her first lead was in *Under the Daisies* (1913). Her reputation was estab-

lished in *The Battle Cry of Peace* (1915). Founded her own film company and appeared in *Panthea* (1917), *Smilin' Through* (1922), *Secrets* (1924), and *Kiki* (1926). Retired from films in 1930, having failed to make the transition from silent films to talkies. Second in popularity only to Mary Pickford, Talmadge was considered an accomplished actress.

TALMAGE, JAMES EDWARD (*b. Hungerford, England, 1862; d. 1933*), geologist, Mormon theologian. Immigrating to Utah as a boy, he was educated at the present Brigham Young University, Lehigh, Johns Hopkins, and Illinois Wesleyan. Professor of geology, University of Utah, he served as its president, 1894–97. Appointed an Apostle, 1911, he occupied himself in the service of the Mormon Church thereafter.

TALMAGE, JOHN VAN NEST (*b. Somerville, N.J., 1819; d. Boundbrook, N.J., 1892*), Dutch Reformed missionary to China, 1847–89. Brother of Thomas De W. Talmage.

TALMAGE, THOMAS DE WITT (*b. near Boundbrook, N.J., 1832; d. 1902*), Dutch Reformed clergyman, lecturer. Brother of John Van N. Talmage. Achieving notice for his sensational style of preaching while pastor of the Second Church in Philadelphia, Pa., 1862–69, he was called to the Central Presbyterian Church, Brooklyn, N.Y., and there drew the largest audiences of any contemporary minister in America. His sermons preached in the Brooklyn Tabernacle, which was built specially for him, were published in some 3,500 newspapers each week. Pastor in Washington, D.C., 1894–99, he devoted himself thereafter to conducting the *Christian Herald*.

TALVJ. *See* ROBINSON, THERESE ALBERTINE LOUISE VON JAKOB.

TAMARKIN, JACOB DAVID (*b. Chernigov, Russia, 1888; d. Washington, D.C., 1945*), mathematician. Graduated University of St. Petersburg, 1910; taught there, and also at the School of Communications, and the Electro-Technical School; spent 1920–22 at the University of Perm; returned to his professorships at St. Petersburg (Petrograd). A Menshevik, he had to flee Russia in 1924 and came to the United States, 1925. After two years as visiting lecturer at Dartmouth College, he joined the faculty of Brown University (professor *post* 1928) and brought Brown's mathematics department to a front-rank position. His early research was in number theory and boundary value problems; he was one of the contributors to the theory of functional analysis and did much to make the new theory appreciated.

TAMARÓN, PEDRO (*b. La Guardia, Spain, date uncertain; d. Bamoa, Sinaloa, Mexico, 1768*), Mexican ecclesiastic. Immigrating to Venezuela when quite young, he was named bishop of Durango, Mexico, 1758. His diary of his episcopal tours to the most remote provinces of his diocese includes a valuable record of New Mexico in 1760.

TAMIRIS, HELEN (*b. New York, N.Y., 1903; d. New York, 1966*), dancer, choreographer. She studied Italian ballet with Rosina Galli and Russian ballet with Michel Fokine, then performed with several theatrical companies. One of the leaders of the revolt against traditional dance, Tamiris abandoned mimed stories, theatricality, and atmospheric staging. In her School of the American Dance (1929), she emphasized the innate ability of each student to be expressive, but developed no identifiable style of her own. She helped form the Dance Repertory Theatre (1930–31). Formed her Group and created the *Walt Whitman Suite* (1934), *Cycle of Unrest* (1935), and *Momentum* (1936). Choreographed works for the Federal Dance Theater, 1936–39; choreographed, staged, and directed dances in eighteen Broad-

way musicals (1945–57), receiving an Antoinette Perry Award for *Touch and Go* (1948). With husband Daniel Nagrin she formed the Tamiris-Nagrin Dance Company (1960–63).

TAMIROFF, AKIM (*b. Baku, Russia, 1899; d. Palm Springs, Calif., 1972*), actor. Admitted to the Moscow Art Theater in 1919; he came to the United States on a tour with the group in 1923 and decided to remain. In Hollywood, he played supporting roles as Chinese, Greek, French, Spanish, and Russian characters, notably the brutal Chinese warlord in *The General Died at Dawn* (1936). Throughout the 1940's and 1950's he brought vitality to an assortment of nasty or flamboyant characters in films, including *The Great McGinty* (1940), *For Whom the Bell Tolls* (1943), *Touch of Evil* (1958), and *Lord Jim* (1966).

TAMMANY, (*fl. 1683–1698*), Delaware Indian chief. A legendary figure in Pennsylvania history, he is known principally in tradition and by presence of his name on several documents and in minutes of conferences. Not a principal chief of his tribe, he was believed to be a strong friend of the white settlers. As years went by, he was gradually invested with the noblest attributes and came to be regarded as a symbol of American resistance to British tyranny and to aristocracy in general.

TAMMEN, HARRY HEYE *See* BONFILS, FREDERICK GILMER.

TANDY, CHARLES DAVID (*b. Brownsville, Tex., 1918; d. Texas, 1978*), entrepreneur and manufacturer. Graduated Texas Christian University (1940), attended Harvard Graduate School of Business, and became vice-president of his father's wholesale leather goods business (1947). He he renamed the firm the Tandy Leather Company in 1950 and began opening retail outlets, positioning stores in low-rent locations. He acquired Radio Shack (1963), a small chain of consumer electronics stores, and by 1973 Tandy Corporation had 2,800 outlets. His key to success was to spot profitable new products, such as CB radios and personal microcomputers, and to turn around losing products.

TANEY, ROGER BROOKE (*b. Calvert Co., Md., 1777; d. Washington, D.C., 1864*), jurist, statesman. Brother-in-law of Francis S. Key. Descended through his mother from the old Catholic landed aristocracy of Maryland, Taney graduated from Dickinson College, 1795, was admitted to practice law in 1799, and served as a Federalist legislator, 1799–1800. Practicing in Frederick, Md., 1801–23, he attained considerable professional success. Breaking with the leading Federalists in 1812 over the conduct of the war with England, he became a leader of the faction called the "Coodies," and exerted a liberal influence as a state senator, 1816–21. Removing to Baltimore, Md., 1823, he soon became recognized as a leader at the bar. A master of procedural technicalities, he had a simple, direct style of delivery which was highly effective in contrast to contemporary florid eloquence. A supporter of Andrew Jackson *post* 1824, he served as attorney general of Maryland, 1827–31, and in July 1831 was appointed attorney general of the United States, assuming also for a short time the duties of secretary of war. In the controversy over the renewal of the charter of the second Bank of the United States, Taney, who from experience as counsel to a state bank had concluded that definite limitations should be put on the national Bank's powers, opposed rechartering and helped draft President Jackson's veto message. After Jackson's reelection, 1832, and the revelation of the Bank's activities during the campaign, Taney with others advised the president to withdraw government deposits from the Bank of the United States and place them in selected state banks. Appointed U.S. secretary of the treasury, September 1833, to implement this policy, he did so, setting up a system of government depositories which continued to function

despite the opposition of all the friends of the Bank. Far from being the pliant instrument of the president, Taney was actually putting into effect long-held opinions of his own; however, the enmity of the friends of the Bank in the Senate effected his retirement to private life in June 1834.

Rejected in January 1835 as a nominee for an associate justiceship of the U.S. Supreme Court, Taney was confirmed over Whig opposition as chief justice in March 1836. His appointment reversed certain trends which are characterized as the work of his predecessor, John Marshall. Speaking for the majority in *Charles River Bridge v. Warren Bridge* (36 U.S., 420), Taney held that rights not specifically conferred by a corporation charter could not be inferred from the language of the document. "While the rights of private property are sacredly guarded," he declared, "we must not forget that the community also have rights, and that the happiness and well being of every citizen depends on their faithful preservation." However, this decision did not mean that Taney meant to devitalize the obligation of the contract clause of the Constitution or that his decisions would always be uncompromisingly against corporations. In *Bank of Augusta v. Earle* (38 U.S., 519) he asserted the important principle that although a state might specifically exclude from its borders the corporations of other states, the courts, in the absence of specific legislation to that effect, would observe the rule of comity and hold that it had not done so. In effect Taney stood for a modification of the assumption that unchecked centralization of federal power and unqualified judicial benevolence toward private wealth and power always work for the good of the country. Taney felt that the commerce clause of the Constitution should be interpreted narrowly when the issue involved a mere arbitrary use to defeat state laws; he opposed use of the Constitution to prevent state regulation where regulation otherwise would not exist. He apparently had little sympathy for the laissez-faire regime which was being enforced upon the states under color of Constitutional necessity. Yet in dealing with the extension of admiralty laws to inland waters and the jurisdiction of federal courts over cases arising there, he asserted a breadth of federal power which had not been claimed even by Marshall.

Taney had been brought up in a Southern agrarian atmosphere and, although he personally assisted in several plans for the amelioration of slavery he was convinced that white and black could not satisfactorily live together in large numbers as equals. He was also convinced that the solution of the problem was to be arrived at only by the people who were in immediate contact with it, and not by emotional Northern abolitionism. In general he believed that the courts should scrupulously guard the sovereignty of the states from federal encroachment because that part of the population dominated by Northern culture and interests was gaining rapidly over the population of the South and must in time come to control the federal government without reference to the principles of the Constitution. Accepting the challenge which circumstances presented to him in the case of *Dred Scott v. Sandford* (60 U.S., 393), he consented to discuss in his opinion several sectional issues which might easily have been avoided. He argued that a black could not possess the rights of citizenship which entitled him to sue in a federal court, and that the lower court, in the case at hand, had erred in taking jurisdiction. Since doubt had been expressed, however, as to whether this phase of the question of jurisdiction could now legitimately be determined by the Supreme Court, he sought to strengthen his position by another argument in proof of the contention that the lower court had been in error in taking jurisdiction. It was admitted that Dred Scott had been born a slave. Taney sought to demonstrate that he was still a slave and that he had not, as contended, become free because of residence in territory made free by act of Congress—because Congress had

never had the constitutional power to exclude slavery from the territories. Thus, under cover of a discussion of jurisdiction, Taney ruled on questions which were basic in the bitter controversy between North and South. Attacked with extreme bitterness by Republicans and Abolitionists for deciding, as they said, unnecessarily that Congress had no such power and attacked also for what were called his *obiter dicta*, Taney found that his well-meant attempt to protect the Southern culture against Northern aggression had hastened rather than retarded the ultimate downfall of the South. He wrote two other major opinions on sectional issues: the masterly analysis of the relations between the state and national governments in *Ableman v. Booth* (62 *U.S.*, 506); and also the defense of the rights of civilians in wartime contained in *Ex parte Merryman* (*Federal Cases* No. 9,487). He had a complete lack of sympathy with the national government in the conduct of the Civil War and believed that force should not have been used to prevent the South from leaving the Union. Hence it was that when he died he was scorned by the war-frenzied masses. His character and motives have come more and more to be understood, however, and he is regarded today as a great chief justice.

TANGUAY, EVA (*b. Marbleton, Quebec, Canada, 1878; d. Hollywood, Calif., 1947*), singer, vaudeville star. First sang her trademark song, "I Don't Care," in *The Chaperones*, a 1903 musical show. A headliner in vaudeville, 1906–*ca.* 1925, she owed her success primarily to her brash, publicity-wise personality, and a flouting of conventions that foreshadowed the attitudes of succeeding generations of women.

TANNEBERGER, DAVID (*b. Berthelsdorf, Saxon Lusatia, 1728; d. York, Pa., 1804*), organ builder. Immigrated to Bethlehem, Pa., 1749. He worked there and in its neighborhood for the remainder of his life, building organs for use in such distant points as Albany, N.Y., Salem, N.C., and Baltimore, Md.

TANNER, BENJAMIN (*b. New York, N.Y., 1775; d. Baltimore, Md., 1848*), engraver. Brother of Henry S. Tanner. Worked in Philadelphia, Pa., *post* 1799, where he was for a time partner with Francis Kearny and Cornelius Tiebout in banknote engraving.

TANNER, BENJAMIN TUCKER (*b. Pittsburgh, Pa., 1835; d. 1923*), bishop of the African Methodist Episcopal Church, 1888–1908.

TANNER, EDWARD EVERETT, III (*b. Evanston, Ill., 1921; d. New York City, 1976*), writer. Attended Art Institute of Chicago and adopted the pseudonyms Patrick Dennis and Patrick Tanner. After 1945 he worked in advertising until he became promotion manager of the magazine *Foreign Affairs* (1951–56), then drama critic at the *New Republic* (1957–71). Under the name Virginia Rowans he published four novels, including *Oh, What a Wonderful Wedding* (1953), and the best-selling *Guestward Ho!* and *The Loving Couple* (both 1956). His best-known book, *Auntie Mame* (1955), was one of twelve published under the pseudonym Patrick Dennis; the book brought him acclaim and wealth by its adaption for Broadway (1956), as a motion picture (1958), and as the musical *Mame* on screen and the Broadway stage. Another of his popular novels as Patrick Dennis was *Little Me* (1961), which was adapted for Broadway (1962).

TANNER, HENRY OSSAWA (*b. Pittsburgh, Pa., 1859; d. Paris, France, 1937*), painter. Son of Benjamin T. Tanner. Studied under Thomas Eakins at Pennsylvania Academy of the Fine Arts. A black, Tanner worked in the United States without success, eking out a bare living as a photographer. A student in Paris, France, under Benjamin Constant and J. P. Laurens, 1891, he made his home abroad thereafter and won prestige as a painter on religious themes.

TANNER, HENRY SCHENCK (*b. New York, N.Y., 1786; d. New York, 1858*), cartographer, statistical geographer. Brother of Benjamin Tanner. Author of a number of maps, atlases, guide books and geographical compendia, Tanner was principally notable for his *A New American Atlas* (five parts, 1818–23), a work of extraordinary merit which was founded on primary source material. In 1829 he published a map of the United States, 64 by 50 inches in size, on the scale of about 32 miles to the inch, practically twice as detailed as Melish's map of 1816.

TANNER, JAMES (*b. Richmondville, N.Y., 1844; d. Washington, D.C., 1927*), Union soldier, pension lobbyist, known as "Corporal Tanner." Inept U.S. commissioner of pensions, March–August 1889.

TANSILL, CHARLES CALLAN (*b. Fredericksburg, Tex., 1890; d. Washington, D.C., 1964*), historian. Attended Catholic University of America (B.A., 1912; M.A., 1913; Ph.D., 1915) and Johns Hopkins University (Ph.D., 1918). Joined the Department of History at American University in Washington as assistant professor (1919) and was promoted to full professor two years later. His most influential book, *America Goes to War* (1938), challenged the orthodox view that the United States entered World War I solely to defend its neutral rights. Tansill was a fine scholar and popular teacher, but his isolationism and anti-British bias prompted him to praise Hitler, and he was forced to resign his professorship at American University in 1937. Later he taught at Fordham University (1939–44) and Georgetown University (1944–58). After World War II he became obsessed with anticommunism and served as an adviser to Sen. Joseph Mc-Carthy.

TAPPAN, ARTHUR (*b. Northampton, Mass., 1786; d. New Haven, Conn., 1865*), New York City silk merchant, Abolitionist. Brother of Benjamin and Lewis Tappan. Founded *New York Journal of Commerce*, 1827; aided free church movement of Charles G. Finney; assisted Kenyon College, Oberlin College, Auburn Theological Seminary. Helped support William L. Garrison's *Liberator* from 1830; active in launching the *Emancipator*, 1833; first president, American Anti-Slavery Society, from which he withdrew, 1840, to help form American and Foreign Anti-Slavery Society. Convinced that slavery could be destroyed under the Constitution by political action, he supported the Liberty Party and helped establish the *National Era*. Oblivious of threats and unpopularity, he was a major financier of the abolitionist movement.

TAPPAN, BENJAMIN (*b. Northampton, Mass., 1773; d. Steubenville, Ohio, 1857*), Ohio legislator and jurist, antislavery leader. Brother of Arthur and Lewis Tappan; father of Eli T. Tappan. Studied law with Gideon Granger; settled in present Portage Co., Ohio, 1799; practiced in Ravenna and Steubenville, and was later a partner of Edwin M. Stanton. A Jacksonian Democrat, he opposed slavery but was not an Abolitionist; he served as U.S. senator from Ohio, *post* 1838. He refused to follow instructions of the Whig legislature to oppose Texas annexation, 1845, yet he was active in free-soil affairs and cast his last presidential vote for Frémont, 1856.

TAPPAN, ELI TODD (*b. Steubenville, Ohio, 1824; d. 1888*), lawyer, educator. Son of Benjamin Tappan. Taught mathematics at Ohio University; president of Kenyon College, 1869–75; lifelong champion of common schools.

TAPPAN, EVA MARCH (*b. Blackstone, Mass., 1854; d. Worcester, Mass., 1930*), teacher, author of anthologies, text-books and stories for children.

TAPPAN, HENRY PHILIP (*b. Rhinebeck, N.Y., 1805; d. probably Switzerland, 1881*), Congregational clergyman, philosopher. Graduated Union, 1825; Auburn Theological Seminary, 1827. Taught at University of the City of New York, 1832–37. As president, University of Michigan, 1852–63, he strove to give that institution a university status according to ideas expressed in his *University Education* (1851).

TAPPAN, LEWIS (*b. Northampton, Mass., 1788; d. Brooklyn, N.Y., 1873*), merchant, Abolitionist. Brother of Arthur and Benjamin Tappan. Proprietor of *New York Journal of Commerce,* 1828–31. Established "the Mercantile Agency," 1841, the first commercial-credit rating agency in the United States; retired from business, 1849, to devote himself to antislavery work and other humanitarian labors. As did his brother Arthur, Lewis Tappan repudiated William L. Garrison when the latter proposed to attach other reforms to the abolition cause; he took a leading part in the American and Foreign Anti-Slavery Society and later in the Abolition Society.

TAPPEN, FREDERICK DOBBS (*b. New York, N.Y., 1829; d. Lakewood, N.J., 1902*), banker. President of the Gallatin National Bank (1868–1902), he was invariably chosen by the other New York banks as dictator-chairman to direct their united policy in times of financial panic.

TAPPER, BERTHA FEIRING (*b. Christiania, Norway, 1859; d. Boston, Mass., 1915*), painter, music teacher. Graduated Leipzig Conservatory of Music, 1878. Immigrating to America 1881, she played with the Kneisel Quartet and was an outstanding teacher at the New England Conservatory of Music and at the New York City Institute of Musical Art.

TARBELL, EDMUND CHARLES (*b. West Groton, Mass., 1862; d. New Castle, N.H., 1938*), painter. Trained as a lithographer, he studied at the Museum of Fine Arts, Boston, and in Paris under Boulanger and J. J. Lefebvre. Teacher of drawing and painting at the Boston Museum, 1889–1913, he was one of the group known as "The Ten" *post* 1898, and was celebrated for his solid craftsmanship, particularly in portraits of outstanding men. He was principal, Corcoran School of Art, Washington, D.C., 1918–26.

TARBELL, FRANK BIGELOW (*b. West Groton, Mass., 1853; d. New Haven, Conn., 1920*), archaeologist. Graduated Yale, 1873; Ph.D., 1879. Among the first American to achieve distinction in classical archaeology, he taught Greek at Yale and Harvard, served as director and secretary of the American School at Athens, and was professor of archaeology at the University of Chicago, 1893–1918.

TARBELL, IDA MINERVA (*b. Hatch Hollow, near Wattsburgh, Pa., 1857; d. Bridgeport, Conn., 1944*), writer. Graduated Allegheny College, 1880. Interested in biology, she discovered that science offered no such opportunity for a woman, and she took a post as preceptress at a seminary in Poland, Ohio. She found her teaching burdens oppressive and left at the end of two years. Returning to Meadville, Pa., she went to work in the editorial offices of the *Chautauquan* and found her calling as a journalist in an environment heady with aspirations to improvement. In 1891 she departed for Paris, where she divided her time between lectures at the Sorbonne, research at the Bibliothèque Nationale on the role of women in the French Revolution, and writing topical columns for a group of midwestern American newspapers. The editor S. S. McClure found her in Paris in 1892 and thus began a connection with *McClure's Magazine* that lasted for twelve years. On her return to the United States in 1894 McClure hired Tarbell to write a serial biography of Napoleon Bonaparte. The success of the Napoleon series led her next to Abraham Lincoln, a subject she revered and one to which she would return repeatedly over the next forty years.

In 1901, spurred on by the creative enthusiasm of McClure, she set to work on the most important assignment of her career, her famous inquiry into the oil interests of John D. Rockefeller. The project lasted five years, ran to nineteen articles in *McClure's*, and appeared as a two-volume history in 1904. What began as a careful exposure of the oil trust as a national economic fact ended as a studied ethical indictment of corporate arrogance, dishonesty, and secret privilege. The age of muckraking journalism produced no document more substantial than *The History of the Standard Oil Company*.

In 1906 the staff at *McClure's* blew apart in controversy over S. S. McClure's ambitious managerial policies and erratic personal behavior. Tarbell was intimately involved in the struggle against him. The dispute ended in her resignation and departure, along with John S. Phillips, Ray Standard Baker, and Lincoln Steffens. This group, soon joined by Finley Peter Dunne and William Allen White, promptly acquired control of the *American Magazine,* where by the end of 1906 Tarbell had launched her major series on the tariff.

The limits of her reformist zeal were revealed in her journalistic inquiry into the status of women. Sensitive to criticism of her failure to support the suffrage cause, she privately characterized the movement as "part of what seems to me the most dangerous fallacy of our times — and that is that we can be saved morally, economically, socially by laws and systems." The judgment reflected her growing distrust of politics and group militance as ways to human progress. To her mind the suffragists shared with the urban boss and the trade union leader a mistaken reliance on coercion to get what they wanted. She was more sympathetic with the settlement house work and peace activities of Jane Addams.

Henry Ford helped convert her to welfare capitalism, or what she called "the Golden Rule in Industry." From 1912 to 1915 she traveled widely to examine factory conditions, and was awestruck by Ford's mass-production methods, his wage policy, and his "sociological" treatment of his work force. Similarly, she came to place great confidence in the scientific management plans of Frederick W. Taylor as an antidote for industrial strife and inefficiency. Once more her conclusions startled some who had tagged her as a radical muckraker and who felt her newfound faith in corporate "fair play" was platitudinous. After she ended her connection with the *American Magazine* in 1915, Tarbell remained a prolific writer and lecturer.

TARBELL, JOSEPH (*b. probably Massachusetts, ca. 1780; d. Washington, D.C., 1815*), naval officer. Appointed midshipman, 1798, he served in the naval war with France, and also with distinction in the attacks on Tripoli in 1804. On June 20, 1813, as commander of a gunboat flotilla, he engaged three British frigates indecisively in Hampton Roads. He was promoted captain, 1813.

TARBOX, INCREASE NILES (*b. East Windsor, Conn., 1815; d. West Newton, Mass., 1888*), Congregational clergyman, genealogist. A founder and an original editor (1849–51) of the *Congregationalist,* he served as secretary of the American Education Society, 1851–84.

TARKINGTON, BOOTH (*b. Indianapolis, Ind., 1869; d. Indianapolis, 1946*), novelist, playwright. Christened Newton Booth Tar-

kington. Nephew of Newton Booth. His ambition was to become a writer and an illustrator, and he cultivated both skills at Phillips Exeter Academy, Purdue University (1890–91), and Princeton University (1891–93). For five years he made little progress as a free-lance writer and illustrator. In 1899 he published his successful first novel, *The Gentleman From Indiana*; followed it the next year with the popular historical romance *Monsieur Beaucaire*; and was launched on a career as novelist and playwright. His books ultimately totaled more than forty-five.

Tarkington's great public and critical successes belonged to the decade 1914–24, when he wrote his best-known books of childhood and adolescence, *Penrod* (1914), *Penrod and Sam* (1916), *Seventeen* (1916), and *Gentle Julia* (1922); his two Pulitzer Prize novels, *The Magnificent Ambersons* (1918) and *Alice Adams* (1921); and two other mature novels, *The Turmoil* (1915) and *The Midlander* (1924). A 1921 *Publishers' Weekly* poll of booksellers named him the most significant of contemporary authors. In a *Literary Digest* contest in 1922 he was voted the greatest living American writer, and a *New York Times* poll of the same year put him on a list of the ten greatest contemporary Americans. Tarkington's work, however, has ill survived the test of time; half a century later, his serious novels were scarcely read at all and even his juvenile entertainments were out of favor.

Tarkington wrote some twenty plays, including such successes as *The Man From Home* (first performed in 1907), *The Country Cousin* (1917), and *Clarence* (1919). A number of these plays Tarkington wrote in collaboration with Harry Leon Wilson; for *The Country Cousin* his coauthor was Julian Street. Even in the best of his novels, the fine *Alice Adams*, Tarkington takes up a position above and slightly to the right of his characters, and as he manipulates them, however gently, one detects the strings of the puppet master.

TARR, RALPH STOCKMAN (*b. Gloucester, Mass., 1864; d. Ithaca, N.Y., 1912*), geologist, geographer. Studied at Lawrence Scientific School, Harvard, and worked under Alpheus Hyatt and Spencer F. Baird, and with the U.S. Geological Survey. Taught geology at Cornell University *post* 1892; headed department of physical geography *post* 1906. Author of a number of widely used textbooks and coauthor of *Alaskan Glacier Studies* (1914), he made important contributions to glaciology.

TASHRAK *See* ZEVIN, ISRAEL JOSEPH.

TASHUNCA-UITCO *See* CRAZY HORSE.

TATE, GEORGE HENRY HAMILTON (*b. London, England, 1894; d. Morristown, N.J., 1953*), mammalogist. Immigrated to the U.S. in 1912. Studied at Columbia University, B.S., 1927, and the University of Montreal, Ph.D., 1938. Staff member of the American Museum of Natural History from 1921, associate curator of mammals, 1942; curator of mammals, 1946. An expert on South American mammals and on Asian and Australian wildlife, he published *Mammals of the Pacific World* (1945) and *Mammals of Eastern Asia* (1947).

TATE, (JOHN ORLEY) ALLEN (*b. Winchester, Ky., 1899; d. Sewanee, Tenn., 1979*), poet, essayist, and literary critic. Attended Vanderbilt University (B.A., 1923), where he was a member of the informal discussion group known as the Fugitives, a group that espoused the New Criticism school of literary theory. During the 1920's he was a free-lance writer and reviewer for the *New York Herald Tribune*, *Nation*, and *New Republic* and wrote many of his best poems, collected in *Mr. Pope and Other Poems* (1928). In the 1930's and 1940's he produced his most celebrated poems, including "Sonnets of the Blood" (1931), "Winter Mask" (1943), and "Seasons of the Soul" (1944). He occupied the chair

of poetry at the Library of Congress (1934–44) and was poet-in-residence at Princeton (1939–42), editor of the *Sewanee Review* (1944–46), and professor at the University of Minnesota (1951–68). The essays "The Angelic Imagination" and "The Symbolic Imagination" (both 1951) illustrate the overtly theological nature of his criticism. He won the Bollingen Prize for Poetry in 1956.

TATE, JOHN TORRENCE (*b. Lenox, Iowa, 1889; d. Minneapolis, Minn., 1950*), physicist. B.S., University of Nebraska, 1910; M.A., 1912. Ph.D., University of Berlin, 1914. Taught physics at University of Nebraska; and at University of Minnesota, 1916–50 (professor *post* 1920). An outstanding teacher and active in professional associations; managing editor of *Physical Review*, 1926–50; helped found American Institute of Physics and served as its chairman, 1936–39. Dean of College of Science, Literature, and the Arts, University of Minnesota, 1937–44. Chief of Division 6 (on subsurface warfare), National Defense Research Committee, 1941–45. His research work at Minnesota developed out of his interest in electron collision and ionization phenomena first stimulated by Franck at Berlin; studies by him and his students led to the refinement of such precision experimental techniques as those of mass spectroscopy and yielded much specific information on the structure and internal force fields of numerous gaseous molecules and compounds.

TATHAM, WILLIAM (*b. Hutton-in-the-Forest, England, 1752, d. near Richmond, Va., 1819*), civil engineer, geographer. A brilliant but eccentric man, Tatham lived for long periods *post* 1769 in Virginia and on the North Carolina and Tennessee frontiers, engaging in a bewildering number of occupations. He was author of, among other works, *A Topographical Analysis of the Commonwealth of Virginia* (1791). He made a pioneer survey of Atlantic Coast from Cape Fear to Cape Hatteras *post* 1805, was the friend and correspondent of Thomas Jefferson, and collaborated with Robert Fulton in the field of canalization.

TATLOCK, JOHN STRONG PERRY (*b. Stamford, Conn., 1876; d. Northampton, Mass., 1948*), medievalist, educator. B.A., Harvard, 1896; M.A., 1897; Ph.D., 1903. Taught English at University of Michigan, 1897–1901, 1903–15. Professor of English at Stanford University, 1915–25; at Harvard, 1925–29; and at University of California at Berkeley, 1929–46. Among his major publications were *The Development and Chronology of Chaucer's Works* (1907); *A Concordance to the Complete Works of Geoffrey Chaucer*, etc. (1927; with A. G. Kennedy); and *The Legendary History of Britain: Geoffrey of Monmouth's Historia Regum Britanniae and Its Early Vernacular Versions* (1950).

TATTNALL, JOSIAH (*b. near Savannah, Ga., 1795; d. Savannah, 1871*), naval officer. Appointed midshipman, 1812, he served aboard the *Constellation* and was in the engagement at Craney Island, Va., June 1813. Assigned to the *Epervier*, he was in the war with Algiers, 1815. Thereafter until the war with Mexico he engaged in routine duties, rising to the rank of commander; during that war he engaged in the operations on the east coast of Mexico and was promoted to captain, 1850. Although opposed to secession, he was loyal to his native state and in March 1861 was commissioned captain in the Confederate Navy, commanding the naval defenses of Georgia and South Carolina. He succeeded Franklin Buchanan as commander in Virginia waters, March 1862. On the abandonment of Norfolk, he again commanded the Georgia naval defense, particularly at Savannah.

TATUM, ART (*b. Toledo, Ohio, 1910; d. Los Angeles, Calif., 1956*), jazz pianist. Blind in one eye, Tatum began his career as a child star on a radio program. In 1932, he became singer Ade-

laide Hall's accompanist; traveled with her to New York, where he made his first recordings and played in leading nightclubs. Played at clubs in Chicago, returning to New York in 1943 with his own jazz trio. He continued to give concerts and play in clubs until his death. Greatly influenced by Fats Waller, Tatum's intricate and varied style is considered by many to be the greatest of jazz piano.

TATUM, EDWARD LAWRIE (*b. Boulder, Colo., 1909; d. New York City, 1975*), biochemist and geneticist. Graduated University of Wisconsin (B.A., 1931; M.S., 1932; Ph.D., 1934). As a research associate at Stanford University, he teamed up with Dr. George Wells Beadle; in 1940 the two undertook studies of biochemical mutations in the pink bread mold *Neurospora crassa*, studies that greatly influenced the future of genetics as the first assertion of what would later be known as the "one gene, one enzyme" theory. Tatum headed the new department of biochemistry at Stanford in 1956 and in 1957 left for New York City to become a professor at the Rockefeller Institute of Medical Research. In 1958 the work of Tatum and Beadle was recognized with the Nobel Prize in physiology or medicine, shared jointly with Joshua Lederberg.

TAUBER, MAURICE FALCOLM (*b. Norfolk, Va., 1908; d. New York City, 1980*), librarian and consultant. Graduated Temple University (B.S., 1930; M.Ed., 1939), Columbia University (B.S., 1934), and University of Chicago Graduate Library School (Ph.D., 1941). He worked at Temple's library in the acquisitions and cataloging departments (1931–38), becoming head of the Catalog Department in 1935 and an authority in library technical services. He was an instructor and chief of cataloging at the Chicago Graduate Library School (1941–44) and professor at Columbia University School of Library Service (1944–76). He wrote the encyclopedic textbook *Technical Services in Libraries* (1954) and was editor of the journal *College and Research Libraries* (1948–62). An early champion of the centralization of library technical services, he argued for adoption of the Library of Congress cataloging system over Dewey classification and helped lay the foundation for library automation.

TAUSSIG, FRANK WILLIAM (*b. St. Louis, Mo., 1859; d. Cambridge, Mass., 1940*), economist. Son of William Taussig. Educated at Harvard (A.B., 1879; Ph.D., 1883; LL.B., 1886); served there, 1882–1935, as a profoundly influential teacher of economics. As editor of the *Quarterly Journal of Economics*, 1896–1937, though essentially conservative, he introduced many new and unorthodox writers. He served as first chairman of the federal Tariff Commission, 1917–19, and as a member of the Paris Peace Conference. His writings include a famous textbook *Principles of Economics* (1911), *Tariff History of the United States* (1888), *Wages and Capital* (1896), *Inventors and Money Makers* (1915), *International Trade* (1927), and, with C. S. Joslyn, a sociological study of American business leaders (1932).

TAUSSIG, FREDERICK JOSEPH (*b. Brooklyn, N.Y., 1872; d. Bar Harbor, Maine, 1943*), gynecologist, advocate of legalized abortion. B.A., Harvard, 1893. Graduated Washington University Medical School, St., Louis, Mo., 1898. Practiced in St. Louis; professor of clinical obstetrics and gynecology, Washington University Medical School *post* 1911. Author of, among other works, *Abortion, Spontaneous and Induced: Medical and Social Aspects* (1936).

TAUSSIG, JOSEPH KNEFLER (*b. Dresden, Germany, 1877; d. Bethesda, Md., 1947*), naval officer. Cousin of F. W. Taussig. Born abroad of American parents from St. Louis, Mo. Graduated U.S. Naval Academy, 1899. Wounded while on duty in Boxer Rebellion, China; commanded first division of destroyers to go overseas in World War I (May 1917). Opposed policies of Franklin D. Roosevelt (then assistant secretary of the navy), 1919. On duty at Naval War College (except for three years in commands at sea), 1920–31, he rose to rank of rear admiral. Held high staff positions, 1931–36, but only minor assignments thereafter until retirement, 1941. Recalled to active duty, 1943, he served until 1946 as chairman of the naval clemency board.

TAUSSIG, WILLIAM (*b. Prague, Bohemia, 1826; d. St. Louis, Mo., 1913*), physician, businessman, civic leader. Immigrated to America, 1847; practiced medicine in and near St. Louis, Mo., *post* 1850. Turning to the banking profession, 1866, he served as manager, and later president, of the company organized to bridge the Mississippi River at St. Louis and of its successor companies until his retirement in 1896.

TAWNEY, JAMES ALBERTUS (*b. near Gettysburg, Pa., 1855; d. Excelsior Springs, Mo., 1919*), lawyer, Minnesota legislator. Settled in Winona, Minn., 1877. Congressman, Republican, from Minnesota, 1893–1911, he rose to the chairmanship of the committee on appropriations and was one of the clique, along with Joseph G. Cannon, John Dalzell, and others, which dominated the House for a number of years. He was a consistent protectionist and orthodox Republican.

TAYLOR, ALFRED ALEXANDER (*b. Happy Valley, Tenn., 1848; d. near Johnson City, Tenn., 1931*), lawyer, Tennessee legislator and Congressman. Brother of Robert L. Taylor. Republican governor of Tennessee, 1921–23, he attributed his political success and that of his brother to the fact that "We played the fiddle, were fond of dogs, and loved our fellow men."

TAYLOR, ARCHIBALD ALEXANDER EDWARD (*b. Springfield, Ohio, 1834; d. Columbus, Ohio, 1903*), Presbyterian clergyman. An Old School minister, he held pastorates in Kentucky, Iowa, the District of Columbia, and Columbus, Ohio; he also served as president of University of Wooster, 1873–83.

TAYLOR, BAYARD (*b. Kennett Square, Pa., 1825; d. Germany, 1878*), traveler, author, diplomat. A printer by trade, Taylor attracted the notice of Rufus W. Griswold and was encouraged by him to publish *Ximena* (1844), a first volume of verse. Commissioned by several periodicals and newspapers (including the N.Y. *Tribune*) to contribute letters descriptive of his travels, he spent two years in Europe and on his return published the successful *Views Afoot* (1846). Thereafter until 1860 he continued to travel and tell about his travels and also lectured widely. He represented to the home-keeping Americans of that time an enviable adventurer's image. Among his numerous books of this period, *Eldorado* (1850) still has value as an early picture of California. During the Civil War he served for a time as Washington correspondent for the N.Y. *Tribune*, and was U.S. secretary of legation at St. Petersburg, Russia, 1862–63. Subsequent to his return he continued to pour out hackwork and labored on his translation of Goethe's *Faust* (published, 1870–71). Meanwhile, increasingly ambitious for reputation as poet and man of letters, he published a great quantity of mediocre verse and three undistinguished novels. Immensely renowned in his own time, the brilliant activity of his life blinded people to the low quality of his actual achievement. Appointed U.S. minister to Germany, 1870, he died late in that year at his post. His outstanding work, his translation of *Faust*, has been extravagantly praised for its fidelity but it is, when all is said and done, a rendering in second-rate English verse.

TAYLOR, BENJAMIN FRANKLIN (*b. Lowville, N.Y., 1819; d. Cleveland, Ohio, 1887*), journalist, lecturer, poet. Associated

with the Chicago *Daily Journal*, 1845–65, he won national reputation for his realistic Civil War battle reports. A collected edition of his popular verses was published in 1886.

TAYLOR, BERT LESTON (*b. Goshen, Mass., 1866; d. Chicago, Ill., 1921*), newspaper columnist. Employed principally on newspapers in Chicago, Ill., *post* 1899, he was author of the "A Line o' Type or Two" column which set a standard for such work that has been the inspiration and despair of many other journalists. He was noted also as a writer of highly polished satirical verse.

TAYLOR, CHARLES ALONZO (*b. Greenfield, Mass., 1864; d. Glendale, Calif., 1942*), dramatist. Author of blood-and-thunder melodramas (e.g., *The Queen of the White Slaves; The Child Wife*). Married Laurette Taylor, 1901, whose first successful vehicle was *From Rags to Riches* (1903), which he wrote for her.

TAYLOR, CHARLES FAYETTE (*b. Williston, Vt., 1827; d. Los Angeles, Calif., 1899*), orthopedic surgeon. M.D., University of Vermont, 1856. In practice in New York City, 1857–*ca*. 1882, Taylor devised a method for eventual cure of the spinal lesion known as Pott's disease by giving protection to the diseased vertebrae through the principle of fixed points for adequate support. He also devised many other appliances for chronic bone, joint, and muscle lesions, and was instrumental in establishing the New York Orthopedic Dispensary.

TAYLOR, CHARLES HENRY (*b. Charlestown, Mass., 1846; d. 1921*), Union soldier, journalist. Publisher of the *Boston Daily Globe, post* 1873, Taylor successfully developed his paper as a reflection of New England life and thought.

TAYLOR, CHARLOTTE DE BERNIER (*b. Savannah, Ga., 1806; d. Isle of Man, 1861*), entomologist. Daughter of William Scarbrough. A naturalist rather than a laboratory scientist, she was author of a number of early and important articles stressing the agricultural significance of entomological studies. These appeared principally in *Harper's New Monthly Magazine* during the late 1850's.

TAYLOR, CREED (*b. probably Cumberland Co., Va., 1766; d. 1836*), Virginia legislator and jurist, law teacher. Political sponsor of John Randolph of Roanoke. Conducted *post* 1821 at "Needham," his Cumberland Co. estate, a law school at which many Virginia attorneys received their training and which was recommended by Thomas Jefferson, James Madison, and John Marshall.

TAYLOR, DAVID WATSON (*b. Louisa Co., Va., 1864; d. Washington, D.C., 1940*), naval officer, naval constructor. Graduated Randolph Macon College, 1881; U.S. Naval Academy, 1885; made advanced studies at Royal Naval College, Greenwich, England. An early advocate of the need of scientific research in naval architecture, Taylor designed and constructed the navy's experimental model basin and remained in charge of it from 1899 until 1914 when he was appointed chief naval constructor. Promoted rear admiral in 1916, he retired from active duty, 1923, but continued active in naval aviation research and ship design. He was author of *The Speed and Power of Ships* (1910) in which he proposed the "standard series method" of estimating propulsion power. He supervised the naval building program during World War I and was one of the pioneers in development and production of naval aircraft of all types.

TAYLOR, EDWARD (*b. Leicestershire, England, ca. 1645; d. 1729*), Puritan clergyman, poet. Immigrated to Boston, Mass., 1668. Graduating from Harvard, 1671, he served as minister at Westfield, Mass., until his death. He was a strict supporter of the Congregational way. Writing in the style of the early 17th-century "concettist" poets of England, Taylor produced a number of poems marked by intensity, metrical variety and skill, and freshness of imagery—all in all perhaps the finest single poetic achievement in America before the 19th century. His works remained in manuscript virtually unknown until 1937; they were first published as *The Poetical Works of Edward Taylor* (edited by T. H. Johnson, 1939) and have received much subsequent critical attention.

TAYLOR, EDWARD THOMPSON (*b. Richmond, Va., 1793; d. Boston, Mass., 1871*), mariner, peddler, Methodist clergyman. Known as "Father Taylor." Minister of the Boston (Mass.) Seamen's Bethel *post* 1830, Father Taylor was reputed one of the greatest American preachers of his generation. The sermon of Father Mapple in Herman Melville's *Moby Dick* is a portrayal of Taylor's manner and method. He was highly respected for his charitable character and noted for his epigrams; he described Daniel Webster as the "best bad man he ever knew."

TAYLOR, FRANCIS HENRY (*b. Philadelphia, Pa., 1903; d. Worcester, Mass., 1957*), museum director. Studied at the University of Pennsylvania, the Sorbonne, the universities of Paris and Florence, and at Princeton. Director of the Worcester Art Museum in Massachusetts, 1931–39 and 1955–57. Director of the Metropolitan Museum of Art in New York, 1939–54. An innovative museum director, Taylor introduced the techniques of modern display and community participation in museum affairs. Instituted international loan programs for the Metropolitan after World War II. Author of *The Taste of Angels* (1948).

TAYLOR, FRANK BURSLEY (*b. Fort Wayne, Ind., 1860; d. Fort Wayne, 1938*), geologist, specialist in glacial history of the Great Lakes region.

TAYLOR, FRANK WALTER (*b. Philadelphia, Pa., 1874; d. Ogdensburg, N.Y., 1921*), book and magazine illustrator, painter, portraitist.

TAYLOR, FRED MANVILLE (*b. Northville, Mich, 1855; d. Pasadena, Calif., 1932*), economist. Graduated Northwestern University 1876; Ph.D., University of Michigan, 1888. Taught economics at Michigan, 1892–1929. An authority on currency and banking, he was author of the influential *Principles of Economics* (1911, and subsequent editions).

TAYLOR, FREDERICK WINSLOW (*b. Germantown, Pa., 1856; d. Philadelphia, Pa., 1915*), mechanical engineer, inventor, efficiency expert. Learned trades of pattern maker and machinist; graduated M.E., Stevens Institute of Technology, 1883. Noted for design and construction of large machines and for his joint discovery of the Taylor-White process of heat treatment of tool steel. Taylor evolved over years of observation a theory that by scientific study of every operation in a manufacturing plant, a fair and reasonable estimate of the production capacities of both man and machine could be made. Application of the data found would, he felt, abolish the antagonism between employer and employee and thus bring about increased efficiency. In addition, he worked out a system of analysis, classification, and symbolization to be used in the study of every type of manufacturing organization. Applying his theory with success for, among other clients, the Bethlehem Steel Co., he devoted his life *post* 1901 to expounding his principles. He published *The Principles of Scientific Management* in 1911 and was author of a number of technical papers.

TAYLOR, GEORGE (*b. probably northern Ireland, 1716; d. 1781*), ironmaster, Pennsylvania colonial legislator. Immigrated

to Pennsylvania *ca.* 1736; operated furnaces in Bucks Co., Pa., *post ca.* 1754. A moderate radical, he served as member of the Continental Congress, July 1776–*ca.* February 1777. He was a signer of the Declaration of Independence.

TAYLOR, GEORGE BOARDMAN (*b. Richmond, Va., 1832; d. Rome, Italy, 1907*), Baptist clergyman. Son of James Barnett Taylor. Served as a Baptist missionary in Italy *post* 1873.

TAYLOR, GEORGE WILLIAM (*b. Philadelphia, Pa., 1901; d. Philadelphia, 1972*), educator, public administrator, and industrial relations authority. Graduated Wharton School of Economics (B.A., 1923; M.B.A., 1926; Ph.D. 1929) and became associate professor of labor relations. One of the pioneering academics who mediated contractual disputes between unions and management, he became an adviser to the National Fair Labor Standards Administration in 1937 and vice-chairman (later chairman) of the National War Labor Board in 1942. Taylor's work as chairman of New York governor Nelson Rockefeller's Advisory Committee on Public Employment Relations led to passage of the Taylor Law (1967), which guaranteed public employees the right to join unions and bargain collectively and also penalized unions for participating in strikes.

TAYLOR, GRAHAM (*b. Schenectady, N.Y., 1851; d. Ravinia, Ill., 1938*), Dutch Reformed and Congregational clergyman, civic reformer. After ministerial and teaching experience elsewhere, he served as head of the department of Christian sociology at Chicago Theological Seminary, 1892–1924; he was also founder of the Chicago Commons, a settlement house, 1894. In the fall of 1903, with Charles R. Henderson, he offered the first course for social workers in Chicago which developed through various changes of title into the Graduate School of Social Service Administration at the University of Chicago.

TAYLOR, HANNIS (*b. New Bern, N.C., 1851; d. 1922*), lawyer, scholar. Practiced at Mobile, Ala., 1870–92, and in Washington, D.C., *post* 1898; able U.S. minister to Spain, 1893–97; author of *The Origin and Growth of the English Constitution* (1889, 1898).

TAYLOR, HARRY (*b. present Tilton, N.H., 1862; d. Washington, D.C., 1930*), soldier. Graduated West Point, 1884. Chief engineer of the AEF in France, 1917–18, he planned port facilities, bases, and training camps, supervised their construction, and took over operation of necessary French railroads, all with remarkable efficiency and speed. He also planned and constructed water systems, electrical supply, and roads for frontline troops. Promoted major general, 1924, he retired in 1926 as chief of engineers of the U.S. Army.

TAYLOR, HENRY OSBORN (*b. New York, N.Y., 1856; d. New York, 1941*), historian. B.A., Harvard, 1878. LL.B., Columbia Law School, 1881. Studied Roman law at University of Leipzig. Admitted to the New York bar, 1884, he devoted himself to scholarship and was author among other works of *The Classical Heritage of the Middle Ages* (1901) and *The Mediaeval Mind* (1911).

TAYLOR, JAMES BARNETT (*b. Barton-upon-Humber, England, 1804; d. Richmond, Va., 1871*), Baptist clergyman. Father of George B. Taylor. Brought to New York, N.Y., as an infant, he was raised in Virginia; he held pastorates *post* 1826 in or near Richmond. He was active in mission work and in the movement to establish Richmond College.

TAYLOR, JAMES BAYARD See TAYLOR, BAYARD.

TAYLOR, JAMES MONROE (*b. Brooklyn, N.Y., 1848; d. 1916*), Baptist clergyman. Graduated University of Rochester, 1868; Rochester Theological Seminary, 1871. As president of Vassar College, 1886–1914, he strove for a proper endowment, carried a heavy teaching load, improved the faculty, and was largely responsible for setting and maintaining high academic standards.

TAYLOR, JAMES WICKES (*b. Starkey, N.Y., 1819; d. Winnipeg, Canada, 1893*), lawyer, journalist, government official. Practiced law in Cincinnati, Ohio, and St. Paul, Minn.; served as special U.S. treasury agent, 1859–69; was effective U.S. consul at Winnipeg, 1870–93.

TAYLOR, JOHN (*b. Fauquier Co., Va., 1752; d. 1835*), Baptist preacher, farmer. Organized and served churches in the Virginia frontier settlements; removed to Kentucky, 1783, where he continued his work. Author of *A History of Ten Baptist Churches* (1823), a fine picture of religion on the frontier.

TAYLOR, JOHN (*b. either Orange or Caroline Co., Va., 1753; d. Caroline Co., 1824*), Revolutionary soldier, Virginia legislator, agriculturist, political philosopher. Generally known as "John Taylor of Caroline." Raised by his cousin Edmund Pendleton, he attended the College of William and Mary, read law in Pendleton's office, and was licensed to practice in 1774. He married a daughter of John Penn, 1783.

Early identified with the democratic group led by Thomas Jefferson, Taylor was prominent in forwarding land legislation for the advantage of actual settlers and favored a wider franchise and a more equal system of representation. He opposed the Federal Constitution, along with Patrick Henry and George Mason, on the ground that the rights of the individual and of the states were not sufficiently protected by it; he later roundly condemned Alexander Hamilton's financial measures. In December 1798 he introduced into the Virginia legislature the famous resolutions in support of the doctrine of delegated powers and the right of states to interpose in cases of "deliberate, palpable and dangerous exercise of other powers." U.S. senator from Virginia, 1792–94, 1803, and 1822–24, he remained a strong supporter of Jefferson and Jeffersonian principles both as public man and as writer. Among his numerous pamphlets, books, and contributions to newspapers, his *An Inquiry into the Principles and Policy of the Government of the United States* (published, 1814, first conceived in 1794) deserves rank among the two or three historic contributions to political science produced in the United States. In this work he denied the existence of a natural aristocracy, and condemned the idea of a permanent debt with taxes and a banking system to support it. He proposed shortening terms of both president and senators and checking their patronage. He contended that the American government was one of divided powers, not classes and that its agents were responsible to the people alone; in a later work he denied validity of appeals from state courts to the U.S. Supreme Court. In 1820 and 1822 he launched powerful attacks against the right of Congress to dictate to Missouri on the question of slavery, and also against the protective tariff system. His important contributions to scientific agriculture were collected in *The Arator* (1813). Champion of local democracy and state rights, he was one of America's greatest philosophers of agrarian liberalism.

TAYLOR, JOHN (*b. Milnthorpe, Westmoreland, England, 1808; d. Kaysville, Utah, 1887*), journalist, Mormon Apostle. Third president of the Utah branch of the Mormon Church, 1880–87.

TAYLOR, JOHN LOUIS (*b. London, England, 1769; d. Raleigh, N.C., 1829*), North Carolina jurist, legal writer. Justice of the

state superior court, 1798–1818 (chief justice *post* 1811); chief justice, state supreme court, 1819–29.

TAYLOR, JOHN W. (*b. Charlton, N.Y., 1784; d. Cleveland, Ohio, 1854*), lawyer, New York legislator, antislavery leader. Congressman, National Republican and later Whig, from New York, 1813–33; speaker of the House, 1820–21, 1825–27. Seconded James Tallmadge's amendment to the Missouri bill. Delivered early antislavery speeches in Congress (1819–21) in support of his proposal prohibiting introduction of slavery into territories north of 36°30'.

TAYLOR, JOSEPH DEEMS (*b. New York, N.Y., 1885; d. New York, 1966*), composer, author, editor, music critic. Attended New York University (B.A., 1906). Created one of his most celebrated works, *Through the Looking Glass,* in 1917. He was a humor columnist for the *New York Press,* the music critic of the *New York World* (1921–25), the editor of *Musical America* (1927–29), and the music critic of the *New York American* (1931–32). Wrote music for the Broadway theater and four operas: *The King's Henchman* (1927), *Peter Ibbetson* (1931), *Ramuntcho* (1942), and *The Dragon* (1958). Broadcast a series of radio talks on opera and was intermission commentator (1936–43) for national broadcasts of the New York Philharmonic Orchestra. Books include *Of Men and Music* (1937), *The Well-Tempered Listener* (1940), *Music to My Ears* (1949), and *Some Enchanted Evenings: The Story of Rodgers and Hammerstein* (1953). Served as president of American Society of Composers, Authors, and Publishers, 1942–48, and as a director of the society, 1933–66.

TAYLOR, JOSEPH WRIGHT (*b. Monmouth Co., N.J., 1810; d. 1880*), physician, leather merchant. Founded Bryn Mawr College, purchasing land for it in 1878 and supervising construction of buildings *post* 1879; virtually the whole of his estate was left to the college.

TAYLOR, LAURETTE (*b. New York, N.Y., 1884; d. New York, 1946*), actress. Christened Loretta Cooney. Married Charles Alonzo Taylor, 1901, and acted in his melodramas until 1908; divorced him, 1910. After attracting favorable notices in mediocre Broadway plays, she rose to stardom in *Peg O' My Heart,* 1912, written especially as a vehicle for her by John Hartley Manners whom she married. Unfortunately the public insisted on her appearance in similar parts, and her efforts to break her image as a "lovable" personality failed of financial success although critics applauded them. At a low personal and professional ebb after Manners died in 1928, she made a triumphant comeback in 1945, presenting one of the great performances in American theatrical history as Amanda Wingfield in Tennessee Williams' *The Glass Menagerie.*

TAYLOR, MARSHALL WILLIAM (*b. Lexington, Ky., 1846; d. New Orleans, La., 1887*), Methodist clergyman, editor of *Southwestern Christian Advocate* and other church publications.

TAYLOR, MOSES (*b. New York, N.Y., 1806; d. 1882*), banker, capitalist. Starting as an importer and sugar broker, he became president of the City Bank, N.Y., 1855. *Post* 1857, he owned a controlling interest in the Delaware, Lackawanna & Western Railroad. Active also in many other public utilities, he was treasurer of the first Atlantic Cable Co.

TAYLOR, MYRON CHARLES (*b. Lyons, N.Y., 1874; d. New York, N.Y., 1959*), financier, diplomat. Graduated from Cornell University, LL.B., 1894. Practiced law in New York before becoming a financier. Gained directorships of the First National Bank of New York, the New York Central, and the Atchison, Topeka,

and Santa Fe. Chairman of the finance committee of U.S. Steel, 1927–32. As chairman of the board, 1932–38, guided the company through periods of low production; in 1937, he signed a labor contract with the CIO—making U.S. Steel the first great steel company to do so. An ardent supporter of the New Deal, Taylor was appointed special representative with ambassadorial rank to the Vatican in 1939. The position occasioned great controversy from parties afraid of church ties. Forced to leave Rome in 1942; returned in 1944 and served until 1949.

TAYLOR, NATHANIEL WILLIAM (*b. New Milford, Conn., 1786; d. New Haven, Conn., 1858*), theologian, educator. Graduated Yale, 1807; studied theology with Timothy Dwight whom he served as secretary. Installed as minister of the First Church, New Haven, 1812, he was appointed Dwight Professor of Didactic Theology at Yale Divinity School, 1822, and continued in this post until the end of his life. A bold, original thinker, Taylor broke through the confines of the orthodox Calvinism of his day, asserting that the freedom of the will to choose is a reality and consists in the power to distinguish between motives. To induce men to turn from evil, an appeal must be made to man's natural desire for happiness which, in a regenerated mind, becomes identical with an unselfish love of God. Debate over Taylor's opinions became a principal theological reason for the disruption of the Presbyterian Church in 1838.

TAYLOR, RAYNOR (*b. England, ca. 1747; d. Philadelphia, Pa., 1825*), musician. Immigrating to America, 1792, and settling soon afterwards in Philadelphia, Taylor produced a number of entertainments featuring burlesques and parodies also known as "olios." He also composed hymns, songs, and music for the theater.

TAYLOR, RICHARD (*b. near Louisville, Ky., 1826; d. New York, N.Y., 1879*), Louisiana sugar planter and legislator, Confederate lieutenant general. Son of Zachary Taylor. Commanding at various times under T. J. Jackson in the Valley, under Lee before Richmond, and in Louisiana, Mississippi, and Alabama, Taylor performed his most notable service in stopping General N. P. Bank's Red River campaign in April 1864 by decisive battles against odds at Pleasant Hill and Sabine Crossroads. He surrendered the last Confederate Army east of the Mississippi at Citronelle, Ala., May 4, 1865. Author of the important *Destruction and Reconstruction* (published 1879).

TAYLOR, RICHARD COWLING (*b. England, 1789; d. Philadelphia, Pa., 1851*), geologist. Immigrated to America, 1830, after winning high professional repute in England. Taylor made numerous surveys of the Pennsylvania coal regions and of many other mineral districts, ranging from Canada to Central America. He was author of the monumental *Statistics of Coal* (1848).

TAYLOR, ROBERT (*b. Spangler Arlington Brugh, Filley, Nebr., 1911; d. Santa Monica, Calif., 1969*), actor. Attended Doane College and Pomona College (graduated in 1933). He was given the name Robert Taylor by Louis B. Mayer, head of Metro-Goldwyn-Mayer (MGM). Taylor stayed with MGM from 1934 until 1958, a record for a major star to remain with one studio. He became a star in 1935 with *Magnificent Obsession.* Other films included *Small Town Girl* (1936), *Camille* (1937), *A Yank at Oxford* (1938), and *Waterloo Bridge* (1940). In the late 1940's his box office appeal waned, and he was thereafter cast in expensive costume dramas such as *Quo Vadis* (1951). He left MGM to form his own company, Robert Taylor Productions, appearing in eleven films, 1959–67. Starred in the television series "The Detectives" (1959–61), and served as host, narrator, and occasional star of "Death Valley Days."

TAYLOR, ROBERT LOVE (*b. Happy Valley, Tenn., 1850; d. 1912*), lawyer, lyceum lecturer, politician. Brother of Alfred. A. Taylor. Outstanding as a conciliator and a reformer of local abuses, he served as Democratic governor of Tennessee, 1887–91 and 1897–99. U.S. senator, 1907–12. A favorite of the plain people, he was unpopular with the party leaders who could not control him.

TAYLOR, ROBERT TUNSTALL (*b. Norfolk, Va., 1867; d. Baltimore, Md., 1929*), physician. B.A., Johns Hopkins, 1889; M.D., University of Virginia, 1891. In large part responsible for creation of the orthopedic department in University of Maryland medical school, he taught there until his death; he was also responsible for the founding and growth of the present Kernan Hospital and Industrial School, Baltimore.

TAYLOR, SAMUEL HARVEY (*b. Londonderry, N.H., 1807; d. Andover, Mass., 1871*), educator. Graduated Dartmouth, 1832; Andover Theological Seminary, 1837. Principal, Phillips Academy, Andover, 1837–71. A stern, able Puritan.

TAYLOR, STEVENSON (*b. New York, N.Y., 1848; d. New York, 1926*), marine engineer, machinery designer. Established high standards for the American Bureau of Shipping as president, 1916–26; served as president of the Webb Institute of Naval Architecture *post* 1899.

TAYLOR, THEODORE ROOSEVELT (**"HOUND DOG"**) (*b. Natchez, Miss., 1917; d. Chicago, Ill., 1975*), blues guitarist and singer. Raised in the Mississippi Delta, he moved to Chicago in 1942, where he brought his unique blues style to virtually every club on the city's South Side. From 1951 until his death he performed throughout the United States at colleges and universities, major clubs, and such concert venues as Avery Fisher Hall. In 1971 his first effort on the Alligator label, *Beware of the Dog*, included such popular tunes as "Let's Get Funky" and "Freddie's Blues."

TAYLOR, WILLIAM (*b. Rockbridge Co., Va., 1821; d. Palo Alto, Calif., 1902*), Methodist clergyman and evangelist. After traveling and preaching literally all over the world, 1847–84, he was elected missionary bishop for Africa in which post he served until 1896. Developed "Pauline" system of self-supporting missions.

TAYLOR, WILLIAM CHITTENDEN (*b. San Francisco, Calif., 1886; d. Corning, N.Y., 1958*), industrial chemist. Graduated from the Massachusetts Institute of Technology, B.S., 1908. A chemist with the Corning Glass Works, 1908–54, Taylor became director of manufacturing and engineering in 1947. Contributed to the transformation of the glass industry from a hand-blown to a totally automated industry. Instrumental in introducing and developing borosilicate glass, marketed in 1915 by Corning under the Pyrex trademark. It revolutionized not only home baking, but all of industry and was used in laboratories, in electronics, and for the construction of the 200-inch mirror of the Mt. Palomar Observatory.

TAYLOR, WILLIAM LADD (*b. Grafton, Mass., 1854; d. 1926*), book and magazine illustrator.

TAYLOR, WILLIAM MACKERGO (*b. Kilmarnock, Scotland, 1829; d. New York N.Y., 1895*), Congregational clergyman. Coming to America, 1871, he served as pastor of Broadway Tabernacle, New York City, 1872–92, and ranked as a preacher with Richard S. Storrs and Henry W. Beecher.

TAYLOR, WILLIAM ROGERS (*b. Newport, R.I., 1811; d. Washington, D.C., 1889*), naval officer. Son of William V. Taylor. Appointed midshipman, 1828. After service in Mexican War, he engaged in ordnance work at Washington. Promoted captain, 1862, he commanded blockade vessels off Charleston, S.C., and was captain of USS *Juniata* in the first attack on Fort Fisher, December 1864. Promoted rear admiral, 1871, he retired, 1873.

TAYLOR, WILLIAM VIGNERON (*b. Newport, R.I., 1780; d. Newport, 1858*), naval officer. Father of William R. Taylor. Supervised rigging and arming of Oliver H. Perry's squadron before battle of Lake Erie, September 1813; served as sailing master of flagship *Lawrence* in the battle. Promoted captain, 1841, he commanded USS *Ohio* in the Mexican War. He was put on the reserved list, 1855.

TAYLOR, ZACHARY (*b. Montebello, Orange Co., Va., 1784; d. Washington, D.C., 1850*), soldier, president of the United States. Father of Richard Taylor. Nicknamed "Old Rough and Ready." Raised in Kentucky, he was appointed first lieutenant in the 7th Infantry in 1808, was promoted captain in 1810, and in 1812 won brevet of major for defense of Fort Harrison, Indiana Territory, against Indians. During the War of 1812 he assisted in defense of the frontier from Indiana to Missouri. Appointed lieutenant colonel of the 4th Infantry, 1819, he performed arduous but uneventful service on the Southwestern and Western frontiers until 1832 when he was promoted colonel and given command of the 1st Regiment stationed at Fort Crawford (Prairie du Chien). He commanded regular troops under General Henry Atkinson in the Black Hawk War and was brevetted brigadier general for his defeat of the Seminoles at Lake Okeechobee, December 1837. Unsuccessful in a two-year campaign against the Seminoles, he returned to the Southwest, 1840, where he served at Fort Gibson and Fort Smith, Ark.

Ordered to Fort Jesup on the Louisiana frontier, 1844, he prepared for action that might be necessary in view of the annexation of Texas. Collecting an army of about 4000 men at Corpus Christi, he advanced to the Rio Grande early in 1846 and established a base at Point Isabel and entrenchments opposite Matamoros. On May 8, 1846, he met the Mexicans at Palo Alto and defeated them principally with artillery; he was again successful the following day at Resaca de la Palma. Despite distrust of him in Washington, Taylor was promoted major general by brevet and designated commander of the Army of the Rio Grande. With about 6,000 men, half regulars and half volunteers, he moved against Saltillo in September, attacking Monterey on September 21. After three days of skirmishing, the Mexican army asked for and received an eight weeks' armistice which brought Taylor more criticism from Washington. Taylors' letters attacking the administration for lack of support increased the tension between him and President Polk. Evading cooperation with General Winfield Scott, Taylor disobeyed orders to remain on the defensive and advanced southward, defeating the Mexicans under Santa Anna at Buena Vista, Feb. 22–23, 1847, and so ending the war in the northern provinces. Taylor ascribed most of his success against superior Mexican forces to his regular artillery. At the end of the war he had achieved a great personal popularity.

A lifelong Whig in his opinions, he was a logical candidate for the presidential nomination of that party in 1848. Endorsed by Thurlow Weed and J.J. Crittenden, he asserted that he would accept nomination only if the people drafted him, that he would not be the candidate of a party, nor would he reach the place through any agency of his own. Too outspoken to please the politicians, Taylor expressed himself on many issues, urging in particular that the executive office should return to its proper position of a coordinate government branch. He also expressed dislike for extremists on the subject of slavery, both in the North and South. Nominated on the first ballot at the Whig Convention in Philadelphia, June 1848, over Henry Clay, Winfield

Scott, and Daniel Webster, he expressed the politics he proposed to implement in the so-called second "Allison" letter, once again promising a nonpartisan administration. Successful in November over Lewis Cass, the Democratic candidate, Taylor delivered a noncommittal inaugural address expressive of basic Whig principles. His cabinet was harmonious and industrious but inferior. Headed by John M. Clayton of Delaware as secretary of state, it made no effort to conciliate a fractious and sensitive Congress. Dissension soon sprang up among party leaders, and although Taylor had declared for nonpartisanship, he concluded by May 1849 that all offices must be filled with his own partisans. Before his nomination he had described the Wilmot Proviso as negligible, but it now became apparent that Taylor would not veto the Proviso should a bill containing it be presented to him. Hoping to prevent sectional agitation of the question of the further extension of slavery (which he had assured the North would not take place), he encouraged California and New Mexico to apply for statehood, recommending in his message to Congress, December 1849, that both be admitted to the Union if they presented governments which were republican in form. Southern representatives led by Alexander H. Stephens filibustered to prevent a vote on the admission of California and to insist on the combination into a single measure of all proposals affecting the Mexican cession. Facing the open hostility of the Southern Whigs for his plan to admit California and New Mexico and also for his hostile attitude toward Texas, Taylor remained obstinate despite threats of secession. He died before the separate legislative acts which were devised to alleviate the situation and which are known as the Compromise of 1850 were passed. His brief experience with foreign relations was not particularly happy; the most significant achievement of the administration was the Clayton-Bulwer Treaty.

Lacking political skills and experience, Taylor displayed practical wisdom, common sense, and resolution of purpose during his brief public career; these, however, were not enough for the kind of leadership demanded by the crisis of 1850.

TAZEWELL, HENRY (*b. Brunswick Co., Va., 1753; d. Philadelphia, Pa., 1799*), Virginia legislator and jurist, Revolutionary patriot. Father of Littleton W. Tazewell. Probably the most popular Virginian of his day, he served his state as U.S. senator, Democratic-Republican, 1794–99.

TAZEWELL, LITTLETON WALLER (*b. Williamsburg, Va., 1774; d. Norfolk, Va., 1860*), lawyer, Virginia legislator, statesman. Son of Henry Tazewell. A pupil of George Wythe, he graduated from the College of William and Mary, 1791, and was licensed to practice law, 1796. An individualist, of high intellectual powers but cold and lacking in human sympathy, Tazewell enjoyed a great contemporary reputation but has left no lasting mark on history. In principle an anti-Federalist, he opposed as legislator many important policies of Jefferson's administration and later opposed the War of 1812. As U.S. senator, 1824–32, he led in opposition to President J. Q. Adams, but after supporting Andrew Jackson for the presidency, opposed Jackson's coercion policy as strongly as he opposed nullification. Elected governor of Virginia, 1834, he resigned in March 1836.

TCHELITCHEW, PAVEL (*b. Moscow, Russia, 1898; d. Rome, Italy, 1957*), painter, stage designer. A leader of the "neoromantic" school of the 1920's and 1930's, Tchelitchew had one-man shows in London and Paris, before his first show in New York in 1934. Immigrated to the U.S. in 1938. Important paintings include *Phenomena* (1936–38) and *Hide and Seek* (1940–42). His ballet designs include works for Balanchine, Diaghilev, and others: *Ode* (1929), *L'Errante* (1933), *Ondine* (1939), and *Balustrade* (1941).

TEAGARDEN, WELDON LEO ("JACK") (*b. Vernon, Tex., 1905; d. New Orleans, La., 1964*), trombonist, bandleader. Started playing the trombone at the age of seven. During 1921–27 played with several bands, including Peck Kelley's Bad Boys and Doc Ross' Jazz Bandits. Moved to New York (1927) where he became one of the most highly regarded trombonists in white jazz. Played in Paul Whiteman's orchestra (1933–38). The popularity of swing induced him to form "Jack Teagarden and His Orchestra," which he led 1939–46. Performed in the film *Birth of the Blues* with Bing Crosby (1941) and made many recordings. Played with Louis Armstrong's All Stars, 1947–51, then appeared with his own All Stars until 1956.

TEALL, FRANCIS AUGUSTUS (*b. Fort Ann, N.Y., 1822; d. Bloomfield, N.J., 1894*), printer, journalist. A learned and conscientious proofreader, he did outstanding work on the *American Cyclopaedia* and on the *Century Dictionary*.

TEASDALE, SARA (*b. St. Louis, Mo., 1884; d. New York, N.Y., 1933*), lyric poet. Author, among other volumes, of *Sonnets to Duse* (1907), *Flame and Shadow* (1920), and *Dark of the Moon* (1926).

TECUMSEH, (*b. probably near present Oldtown, Ohio, ca. 1768; d. near present Thamesville, Ontario, Canada, 1813*), Shawnee chief. Brother of Tenskwatawa, the Prophet. A brave warrior, remarkable for humanity and trustworthiness, Tecumseh and his brother and their followers were forced by pressure of white settlers into present Indiana, 1808. They settled on the Wabash near the mouth of the Tippecanoe at a place later known as Prophet's Town. Tecumseh there developed a program of action that threatened to stop westward movement of American settlement. He maintained that no Indian land sale or cession could be valid without consent of all the tribes assembled, since the Indians owned land in common. He pointed out also that the United States had given an implied assent to this point of view under the treaty of Greenville in 1795. Seeking to combine the tribes into a confederacy to prevent further land cessions and to reform abuses which contact with the whites had brought, he visited widely among the tribes and brought more and more of them under his influence. His program was not necessarily a warlike one; he hoped that (if unmolested by the whites) his people might in time adapt to civilization and escape decadence. Led to expect help by the British officials in Canada who wished to see an Indian buffer state set up in the Old Northwest, Tecumseh defied Governor W. H. Harrison at Vincennes in August 1810. While absent in the south on a speaking tour, Tecumseh's chance of success was lost by the action of his brother, the Prophet, who allowed himself to be tricked into the battle of Tippecanoe, November 1811. Commissioned brigadier general by the British, Tecumseh fought in the War of 1812 with great courage and fell at the battle of the Thames.

TEDYUSKUNG (*b. in vicinity of Trenton, N.J., ca. 1700; d. Wyoming, Pa., 1763*), Delaware chief, largely responsible with Christian F. Post for British success at Fort Duquesne, 1758.

TEEPLE, JOHN EDGAR (*b. Kempton, Ill., 1874; d. New York, N.Y., 1931*), chemist, educator, practicing chemical engineer. Among his many achievements in designing and directing chemical plants was his notable success in developing potash production at Searles Lake, Calif., *post* 1919. He is credited with building up the American potash industry almost single-handed.

TEGGART, FREDERICK JOHN (*b. Belfast, Ireland, 1870; d. Berkeley, Calif., 1946*), librarian, historian, sociologist. Settled near San Diego, Calif., 1889. B.A., Stanford University, 1894. Librarian at Stanford, at San Francisco's Mechanics Mercantile

Library, and at Bancroft Library, University of California. A teacher of history at California *post* 1905, he became associate professor in 1916; in 1919 he founded the department of social institutions at Berkeley, which he headed until academic retirement, 1940. He was author of a number of books and articles on his theory of a science of society, which was to be based on concrete historical materials employed free of the conventionalized framework of unilinear, narrative, history writing. His major effort to apply his theories of comparative history and change was his book *Rome and China* (1939).

TELFAIR, EDWARD (*b. Scotland, ca. 1735; d. 1807*), merchant, Georgia colonial legislator, Revolutionary patriot. Came to Virginia *ca.* 1758; settled in Georgia *ca.* 1766, identifying himself with the city of Savannah and its trade. Member of the Continental Congress, 1777–83, he also held a number of state appointments. Elected governor of Georgia for 1786, he acted with vigor in dealing with the Indians and in the boundary dispute with South Carolina. As governor of Georgia, 1791–94, he was in conflict with the federal government, in particular over the case of *Chisholm v. Georgia*. He brought about by his actions the passage of the Eleventh Amendment. He was also reckless in his dealings with the state's public lands.

TELLER, HENRY MOORE (*b. Allegany Co., N.Y., 1830; d. Denver, Colo., 1914*), lawyer. In practice *post* 1861 at Central City, Colo., he became a leading figure in that territory and served as U.S. senator, Republican, 1877–82. After appointment as U.S. secretary of the interior, 1882–85, he returned to the Senate and served there until 1909. He was elected for his first two terms as a Republican, the third as an Independent Silver Republican, and the fourth as a Democrat. Outspoken as an advocate of silver remonetization, he tended more and more (as his career proceeded) to align himself with the weaker groups in society and to support woman's suffrage, income taxes, and government regulation of big business. The Teller Resolution which pledged the United States to an independent Cuba was named for him. He strongly opposed United States policy in the Philippines (1899–1902) as well as President Theodore Roosevelt's policy toward Panama.

TEMPLE, OLIVER PERRY (*b. near Greenville, Tenn., 1820; d. 1907*), Knoxville, Tenn., lawyer and Unionist, author.

TEMPLE, WILLIAM GRENVILLE (*b. Rutland, Vt., 1824; d. Washington, D.C., 1894*), naval officer. Appointed midshipman, 1840. Performed valuable Civil War service on Union blockade duty and was recommended for promotion for conduct in both attacks on Fort Fisher, December 1864 and January 1865. Retired as rear admiral, 1884.

TEMPLETON, ALEC ANDREW (*b. Cardiff, Wales, 1910; d. Greenwich, Conn., 1963*), pianist, musical satirist. Attended the Royal Academy of Music (licentiate degree, 1931) and the Royal College of Music (1932–34). Blind from birth, Templeton was a musical prodigy who created his first musical composition by the age of four. At eleven, he was employed by the British Broadcasting Company to present a musical program that remained popular for twelve years. Made his American debut in 1935 and decided to remain in the United States, becoming a naturalized citizen in 1941. Got his own national network radio show, "Alec Templeton Time" in 1939, and achieved fame chiefly for his home improvisation of operatic themes and on-the-spot creation of melodies. His compositions include *Concertina Lirico* (1942) and *Gothic Concerto* for piano and orchestra (1954).

TEN BROECK, ABRAHAM (*b. Albany, N.Y., 1734; d. 1810*), New York colonial legislator, Revolutionary soldier. Brother-in-law of

Philip Livingston. Albany County judge, 1781–94; mayor of Albany, N.Y., 1779–83, 1796–99.

TEN BROECK, RICHARD (*b. Albany, N.Y., 1812; d. near Menlo Park, Calif., 1892*), horseman. Early a partner of William R. Johnson in racing on Southern tracks, he was the owner, among other horses, of Lexington, Prioress, and Starke. He was the first (1856) American horseman to race successfully on the English turf.

TENÉ-ANGPÓTE See KICKING BIRD.

TENNENT, GILBERT (*b. Co. Armagh, Ireland, 1703; d. Philadelphia, Pa., 1764*), Presbyterian clergyman. Son of William Tennent (1673–1746); brother of William Tennent (1705–77). Immigrated to America as a boy. Assisted father at newly established "Log College"; was ordained at New Brunswick, N.J., 1726; was friendly with and influenced by Theodorus J. Frelinghuysen. A zealous evangelical, Tennent soon became known as a vivid preacher, and with his clerical associates in the New Jersey area prepared the way for the Great Awakening. Intimate of George Whitefield in 1739–40, he continued with great force in New England and elsewhere, and attacking his conservative Presbyterian associates with great virulence as religious formalists. Reproved by the Synod of 1741 for disregarding its authority and for other disturbing actions, Tennent and members of the New Brunswick Presbytery withdrew and caused a division of the Presbyterian Church which lasted 17 years. During his later years as pastor in Philadelphia he showed evidence of regret for his earlier contentiousness and worked for a reunion of the Presbyterian Church.

TENNENT, JOHN (*b. England, ca. 1700; d. place unknown, ca. 1760*), physician. Active in Virginia *ca.* 1725–39, he was author of *Essay on the Pleurisy* (Williamsburg, Va., 1735), an enthusiastic account of his experience in the therapeutic use of rattlesnakeroot.

TENNENT, WILLIAM (*b. Ireland, 1673; d. Neshaminy, Pa., 1746*), Presbyterian clergyman, founder of the "Log College." Father of Gilbert and William Tennent (1705–77). Immigrated to Philadelphia, Pa., *ca.* 1717. Pastor at Neshaminy, Pa., *post* 1726, where he trained for the ministry and filled with his own evangelical spirit an outstanding group which included his sons and also Samuel Blair and Samuel Finley. He erected his famous "Log College," 1736. At his death, its supporters united with others in organizing the College of New Jersey.

TENNENT, WILLIAM (*b. Co. Armagh, Ireland, 1705; d. Freehold, N.J., 1777*), Presbyterian clergyman. Son of William Tennent (1673–1746); brother of Gilbert Tennent. Pastor at Freehold, N.J., *post* 1733, he was a friend of George Whitefield, a promoter of revivals, and celebrated as a peacemaker and counselor.

TENNEY, CHARLES DANIEL (*b. Boston, Mass., 1857; d. Palo Alto, Calif., 1930*), Congregational clergyman, missionary and educator in China, U.S. consular and diplomatic official in China.

TENNEY, EDWARD PAYSON (*b. Concord, N.H., 1835; d. 1916*), Congregational clergyman, educator. President of Colorado College, 1876–84.

TENNEY, TABITHA GILMAN (*b. Exeter, N.H., 1762; d. Exeter, 1837*), novelist. Author, among other works, of *Female Quixotism* (1801), a satire on the prevailing literary taste of her time, and

in particular on the American fondness for foreign romantic sentimentality.

TENNEY, WILLIAM JEWETT (*b. Newport, R.I., 1811; d. Newark, N.J., 1883*), editor. Graduated Yale, 1832. A convert to Catholicism, Tenney was an important member of the staff of D. Appleton & Co., 1853–83. He served as editor of *Appleton's Annual Cyclopaedia* (1861–83) and collaborated on Jefferson Davis's *Rise and Fall of the Confederate Government* (1881).

TENSKWATAWA (*b. present Oldtown, Ohio, ca. 1768; d. place unknown, possibly Kansas, ca. 1834*), Shawnee Indian, known as "The Prophet." Brother of Tecumseh whose plans for an Indian confederacy he upset by allowing himself to be maneuvered into the battle of Tippecanoe, November 1811. He was known to his contemporaries as a vain, boastful man who gave a false impression of ability and power.

TERESA, MOTHER (*b. Ireland, ca. 1766; d. Georgetown, D.C., 1846*), founder of the Visitation Order in the United States. Name in religion of Alice Lalor. Immigrated to Philadelphia, Pa., 1795, where with two friends she lived in an unofficial religious community under the direction of Father Leonard Neale. Removing with her community to Georgetown, D.C., 1799, she conducted a school. In December 1816, she and her associates took vows as Visitation nuns.

TERHUNE, ALBERT PAYSON (*b. Newark, N.J., 1872; d. Pompton Lakes, N.J., 1942*), author. Son of Mary V. H. Terhune. B.A. Columbia University, 1893. On staff of New York *Evening World*, 1894–1916. Author of a great number of magazine short stories and serials, but achieved reputation for stories about dogs, in particular collies. These were collected in *Lad, a Dog* (1919) and later volumes.

TERHUNE, MARY VIRGINIA HAWES (*b. Dennisville, Va., 1830; d. New York, N.Y., 1922*), author, writer on household management. Better known as "Marion Harland," she was author among many other works of *Common Sense in the Household* (1871), one of the most successful books of its kind.

TERMAN, LEWIS MADISON (*b. Johnson County, Ind., 1877; d. Palo Alto, Calif., 1956*), psychologist. Studied at Central Normal School, Danville, Ind., and at Clark University, Ph.D., 1905. Taught at Stanford University, 1910–43; chairman of the psychology department from 1922. Author of the Stanford-Binet intelligence test, which he standardized for use in this country. President of the American Psychological Association and member of the National Academy of Sciences. Author of *The Measurement of Intelligence* (1916) and *Genetic Studies of Genius* (1925–56).

TERRELL, EDWIN HOLLAND (*b. Brookville, Ind., 1848; d. San Antonio, Tex., 1910*), lawyer. Practiced in San Antonio, Texas *post* 1877. Active in Texas Republican politics, he served as U.S. minister to Belgium, 1889–93.

TERRELL, MARY ELIZA CHURCH (*b. Memphis, Tenn., 1863; d. Annapolis, Md., 1954*), civil rights advocate, feminist. Graduated from Oberlin College, 1884. The daughter of slaves, Mary Terrell helped form the National Association of Colored Women in 1896 and was its first president. A charter member of the NAACP and the first black woman to serve on the Washington, D.C., school board, 1895–1901. Published *A Colored Woman in a White World* (1940), with foreword by H. G. Wells. In 1953, she won a civil rights suit before the Supreme Court.

TERRY, ALFRED HOWE (*b. Hartford, Conn., 1827; d. New Haven, Conn., 1890*), lawyer, soldier. Commissioned colonel of the 2nd Connecticut Militia, 1861, he soon became colonel of the 7th Connecticut Volunteers and was promoted brigadier general in April 1862. After outstanding service in the operations against Charleston, S.C., 1863, and those against Richmond and Petersburg, Va., 1864, he commanded in the attacks against Fort Fisher, N.C., December 1864–January 1865, achieving success in concert with fleet action under Adm. D. D. Porter. Promoted brigadier general in the regular army, January 1865, and major general of volunteers three months later, he remained in service after the Civil War. During the Indian troubles in the Dakotas in the 1870's, he commanded that Department. Becoming involved in controversy over the Custer Massacre (June 1876), Terry refused to make a statement with respect to Custer's conduct, preferring to accept criticism rather than create an issue. Promoted major general, 1886, he retired in 1888. A student of the science of war, Terry was also noted for his ability to work harmoniously with others.

TERRY, DAVID SMITH (*b. Todd Co., Ky., 1823; d. Lathrop, Calif., 1889*), Mexican War and Confederate soldier, California jurist and political leader. Raised in Texas, Terry settled in California, 1849, where he practiced law and was active in Know-Nothing party activities. He became a judge of the California supreme court in 1855, and was raised to chief justice in 1857. Affiliated *post* 1859 with the Gwin Democrats, he engaged David Broderick in a duel, Sept, 13, 1859, which resulted in Broderick's death. Prior to the duel, Terry had resigned judicial office. Returning to California, 1869, after service in the Confederate Army and a short exile in Mexico, Terry resumed practice of law. He was shot dead by a bodyguard of Justice Stephen J. Field whose life Terry had threatened after the rendering of a judgment adverse to him.

TERRY, ELI (*b. East Windsor, Conn., 1772; d. Plymouth, Conn., 1852*), inventor, pioneer clock manufacturer. Set up first clock factory in America at Plymouth, Conn., *ca.* 1800; became partner of Seth Thomas and another, 1807. Devised popular "pillar scroll top" wood clock, 1814; also built brass clocks of high quality, and tower clocks.

TERRY, MARSHALL ORLANDO (*b. Watervliet Center, N.Y., 1848; d. Coronado, Calif., 1933*), physician, Florida real-estate developer. As surgeon general of New York State National Guard, he made a valuable critical study of care of New York troops in federal camps at the time of the Spanish-American War, with special reference to the high incidence of typhoid fever.

TERRY, MILTON SPENSER (*b. Coeymans, N.Y., 1840; d. Los Angeles, Calif., 1914*), Methodist clergyman, educator. Advocated the higher criticism as head of department of Hebrew and Old Testament and professor of Christian doctrine at the Garrett Biblical Institute, *post* 1884.

TERRY, PAUL HOULTON (*b. San Mateo, Calif., 1887; d. New York City, 1971*), animator. Worked as a reporter and photographer and in 1915 completed his first cartoon, "Little Herman." He joined the studio of animator John Randolph Bray, where Terry introduced his popular character Farmer Al Falfa. In 1921 he cofounded a company that produced the animated series "Aesop's Film Fables" and in 1929 formed a partnership with fellow animator Frank Moser to produce sound cartoons called "Terrytoons." In 1936 he bought out Moser and introduced popular series characters such as Mighty Mouse (1942) and Heckle and Jeckle (1946). In 1955 he sold his studio and his stock of some 1,100 animated shorts to CBS.

TESLA, NIKOLA (*b. Smiljan, Croatia [then part of Austria-Hungary], 1856; d. New York, N.Y., 1943*), inventor, electrical engineer. As a child Tesla had shown a precocious talent for mental arithmetic and a fascination with mechanical problems. He entered the Joanneum at Graz, at the age of nineteen, and during the next four years acquired a sound knowledge of mathematics, physics, and mechanics — as well as a brief fondness for gambling, billiards, and chess. In 1879 he enrolled in the philosophical faculty of the University of Prague, but his father's death required him to become self-supporting and he left without a degree.

While at Graz, Tesla had become preoccupied with the problem of eliminating the useless sparks produced at the commutators and brushes of early direct-current electric motors. During his years in Budapest he conceived the idea of the spatially rotating electric field to make possible the efficient use of alternating-current electricity, a principle that underlies the design of all later polyphase induction motors. His attempts to exploit his invention in Europe proved unsuccessful, and in 1884 he sailed to New York, armed with a letter of introduction to Thomas A. Edison, who rejected Tesla's ideas but gave him a job designing directcurrent components. Tesla resigned in 1885 after a disagreement over compensation. He then formed a company to develop an arc lamp for streets and factories, but he was eased out of the company.

Tesla then formed his living by day labor, but by 1887 he had formed the Tesla Electric Company and had set up a laboratory to develop his idea for an alternating-current motor. He sold his patents for a polyphase induction motor to George Westinghouse and joined the staff of the Westinghouse Company. He resigned after a year because of conflicts with the company's engineers and because he realized that for creative work he required complete independence.

The next few years were a period of great affluence for Tesla. His work on arc lights, which produced an objectionable hum at low frequencies, led him to become interested in the generation of high-frequency currents. He constructed machines with output frequencies up to 25,000 cycles per second. Although similar machines were to play a part in the development of radiotelegraphy, he foresaw their limitations and turned his attention to other high-frequency circuits and components, of which the Tesla coil, a resonant air-core transformer, is the best known. He also designed or conceived apparatus for the high-frequency heating of dielectrics, which anticipated diathermy and induction heating. His high-frequency devices brought him worldwide scientific fame and made him a social celebrity. After his mother's death he resolved to withdraw from social life and to concentrate on what he believed to be his true destiny, the discovery of new scientific principles, and he adopted an increasingly solitary and eccentric pattern of living.

The 1893 Chicago World's Fair buildings and grounds were illuminated by means of his polyphase alternating-current system and the following year he received honorary doctorates from Columbia and Yale. In 1896 Tesla saw one phase of his work come to impressive fruition with the completion of the Niagara Falls project: the world's first hydroelectric generating plant and a network for transmitting and distributing the electric power, both in Niagara Falls and in Buffalo, twenty-two miles away. The project used Tesla's polyphase alternating-current system, his greatest achievement. Tesla forecast the possibility of transmitting electricity without wires, not merely for communication but as a means of sending large amounts of power from one place to another. In 1897 he successfully demonstrated his wireless communications system over a distance of twenty-five miles. His methods were not well conceived, and radio ultimately developed along quite different lines.

In 1898 Tesla patented and then built a model of a radio-controlled ship, the ancestor of all remotely guided craft. The next year he built and successfully tested a high-voltage transmission system and experimented with the production of artificial lightning. In the last four decades of his life Tesla experienced increasing poverty and produced few realizable ideas, although he continued to conceive startling new devices. In spite of his genius, his personality imposed severe handicaps. In 1912, despite his need for funds, he refused to be corecipient with Edison of the Nobel Prize in physics. Because others had consistently exploited his work, Tesla increasingly concealed the details of his new concepts and insisted on working in complete independence. As he gradually withdrew from society he developed a fondness for pigeons, which he fed in the New York parks and harbored in his hotel room.

Tesla remained in the public eye for many years and made several predictions of remarkable prescience. Besides his earlier forecast of radio, a prediction he made in 1917 described several features of pulsed radar nearly twenty years before it was realized, although Tesla suggested electromagnetic propagation through water, not through air. Tesla's predictions were not invariably fulfilled; a careful study of his later writings would doubtless reveal more bad guesses than good. On his seventy-eighth birthday, he announced that he had invented a powerful "death ray," but the claim was never substantiated.

Tesla was granted more than a hundred patents, but his fame rests almost entirely on the discoveries he made before he was thirty-six. A complete recluse in his later years, he was almost wholly dependent on a yearly gift of $7,200 from the Yugoslavian government.

TESTUT, CHARLES (*b. France, ca. 1818; d. New Orleans, La., 1892*), Louisiana journalist, physician, poet. Active in French-language journalism in New Orleans *post ca.* 1844; indefatigable founder of unsuccessful newspapers.

TEUBER, HANS-LUKAS ("LUKE") (*b. Berlin, Germany, 1916; d. off Virgin Gorda, British Virgin Islands, 1977*), neuropsychologist and educator. Attended University of Basel (1935–39) and Harvard University (Ph.D., 1947). In 1944 he became a U.S. citizen and joined the U.S. Naval Reserve (1944–46), where he worked with neurologist Morris B. Bender and published several papers with Bender on brain injury. He became a research associate at New York University College of Medicine (1947) and professor in the department of psychiatry and neurology; head of the NYU–Bellevue Medical Center psychophysiological laboratory (1947–61); and professor and head of the psychology department at Massachusetts Institute of Technology (1961–78). He developed now-standard tests to evaluate tactile, auditory, and visual functioning in order to reveal neurological impairment or deficit. He also served on the editorial boards of *Journal of Comparative and Physiological Psychology* (1956–68) and *Journal of Psychiatric Research* (1961–64).

TEUSLER, RUDOLF BOLLING (*b. Rome, Ga., 1876; d. Japan, 1934*), surgeon, Episcopal medical missionary. Worked in Japan *post* 1900; founded St. Luke's Hospital, Tokyo; was pioneer in public-health methods in Japan.

TEVIS, LLOYD (*b. Shelbyville, Ky., 1824; d. San Francisco, Calif., 1899*), lawyer, capitalist. Removed to California, 1849. Entered law and business partnership with James Ben Ali Haggin, 1850, at Sacramento; moved office to San Francisco, 1853. Identified with some of California's greatest business undertakings, Tevis was an early projector of telegraph lines, a promoter of the Southern Pacific Railroad and briefly its president, an organizer of the Pacific Express Co., and president of Wells, Fargo & Co.,

1872–92. He was a partner in mining ventures with, among others, George Hearst and Marcus Daly.

THACHER, EDWIN (*b. De Kalb, N.Y., 1839; d. New York, N.Y., 1920*), civil engineer, bridge constructor. Graduated Rensselaer Polytechnic Institute, 1863. Invented Thacher cylindrical slide rule, 1881; devised the "Thacher bar" used in reinforced concrete construction.

THACHER, GEORGE (*b. Yarmouth, Mass., 1754; d. Biddeford, Maine, 1824*), lawyer. Settled at Biddeford, Maine, 1782. Congressman from the District of Maine, Federalist, 1789–1801; associate judge, Massachusetts Supreme Judicial Court, 1801–24.

THACHER, JAMES (*b. Barnstable, Mass., 1754; d. Plymouth, Mass., 1844*), physician, Revolutionary Army surgeon, historian. Author, among other works, of the valuable A *Military Journal during the American Revolutionary War* (1823, and many subsequent editions) and of the *American Medical Biography* (1828), a chief source book for the medical history of his time.

THACHER, JOHN BOYD (*b. Ballston Spa, N.Y., 1847; d. Albany, N.Y., 1909*), businessman, New York State public servant, book collector.

THACHER, PETER (*b. Salem, Mass., 1651; d. Milton, Mass., 1727*), Congregational clergyman, theologian. Graduated Harvard, 1671; held principal pastorate at Milton *post* 1681.

THACHER, PETER (*b. Milton, Mass., 1752; d. Savannah, Ga., 1802*), Congregational clergyman, Revolutionary patriot. Great-grandson of Peter Thacher (1651–1727). Graduated Harvard, 1769. Held pastorates in Malden, Mass., and at Brattle Street Church, Boston, Mass.; served as chaplain to the General Court *post* 1776. An outstanding orator on the patriot side, he was a founder of the Massachusetts Historical Society, 1790–91.

THACHER, SAMUEL COOPER (*b. Boston, Mass., 1785; d. Moulins, France, 1818*), Unitarian theologian. Son of Peter Thacher (1752–1802). Graduated Harvard, 1804. A friend and pupil of William E. Channing (1780–1842), he served as pastor of the New South Church, Boston, Mass., *post* 1811.

THACHER, THOMAS ANTHONY (*b. Hartford, Conn., 1815; d. 1886*), classicist. Graduated Yale, 1835. Taught at Yale *post* 1838, becoming eventually professor of Latin and performing much of the work which a modern dean would do. Active in the administration of the college, he and Theodore D. Woolsey were the first advocates at Yale of graduate instruction in nontechnical fields; he played a larger part in the building of modern Yale than any of his contemporaries there.

THACHER, THOMAS DAY (*b. Tenafly, N.J., 1881; d. New York, N.Y., 1950*), lawyer, jurist, civic leader. Grandson of Thomas A. Thacher. B.A., Yale, 1904; attended Yale Law School. Admitted to the New York bar, 1906, he entered the office of his father's firm, Simpson, Thacher & Bartlett, and became a partner, 1914. He devoted a great part of his time to municipal reform and public service. Among the posts he held were U.S. district court judge, Southern District of New York (1925–30); solicitor general of the U.S. (1930–33); New York City corporation counsel, 1943; justice of the New York State Court of Appeals, 1943–48.

THALBERG, IRVING GRANT (*b. Brooklyn, N.Y., 1899; d. Santa Monica, Calif., 1936*), motion picture producer and studio executive. Began career as secretary to Carl Laemmle *ca.* 1918 and rose to be head of studio of Universal Pictures Corp. Associated with Louis B. Mayer *post* 1923, he headed the production department of the subsequent Metro-Goldwyn-Mayer studio, 1924–32, thereafter limiting his activity because of progressive ill health. He was noted for his skill in casting and taste in production.

THANET, OCTAVE See FRENCH, ALICE.

THATCHER, BENJAMIN BUSSEY (*b. Warren, Maine, 1809; d. Boston, Mass., 1840*), lawyer, philanthropist, advocate of African colonization as solution of slavery question. Author, among other works, of *Indian Biography* (1832), the first work of its kind to seek accuracy in handling the subject.

THATCHER, GEORGE See THACHER, GEORGE.

THATCHER, HENRY KNOX (*b. Thomaston, Maine, 1806; d. Boston, Mass., 1880*), naval officer. Grandson of Henry Knox. Appointed midshipman, 1823; rose to commodore, 1862. After service on the North Atlantic blockading squadron, 1863–64, he was commended for his part as a division commander under Adm. David D. Porter in the reduction of Fort Fisher, N.C., December 1864–January 1865. He succeeded Adm. D. G. Farragut in command of the West Gulf blockade squadron, January 1865, and aided in the reduction of Mobile, Ala. He retired as rear admiral, 1868.

THATCHER, MAHLON DANIEL (*b. New Buffalo, Pa., 1839; d. 1916*), pioneer Colorado merchant and banker. Removed to Pueblo, Colo., 1865, where with his brother he ran a general store. Turning to professional banking, 1871, he founded the First National Bank of Pueblo, of which he was president *post* 1889. Active in stock-raising and other businesses, he came in time to have holdings in nearly forty banks.

THATCHER, ROSCOE WILFRED (*b. Chatham Center, Ohio, 1872; d. Amherst, Mass., 1933*), agricultural chemist. Graduated University of Nebraska, 1898. Conducted experiment stations and taught at Washington State College and University of Minnesota; served as director, New York State agricultural experiment station, 1921–27; president, Massachusetts Agricultural College, 1927–32.

THAW, HARRY KENDALL (*b. Pittsburgh, Pa., 1871; d. Miami Beach, Fla., 1947*), notorious character. Married Evelyn Nesbit, April 1905. Shot and killed Stanford White, June 25, 1906; escaped death penalty on grounds of insanity.

THAW, WILLIAM (*b. Pittsburgh, Pa., 1818; d. Paris, France, 1889*), Pennsylvania capitalist, freighting and transportation executive. Benefactor of the present University of Pittsburgh.

THAXTER, CELIA LAIGHTON (*b. Portsmouth, N.H., 1835; d. Appledore, Isles of Shoals, N.H., 1894*), poet. Mother of Roland Thaxter. Author, among other works, of *Poems* (1872), *Among the Isles of Shoals* (1863), and *Driftweed* (1879).

THAXTER, ROLAND (*b. Newtonville, Mass., 1858; d. 1932*), botanist. Son of Celia L. Thaxter. Graduated Harvard, 1882; Ph.D., 1888. Taught cryptogamic botany at Harvard, 1891–1919. Renowned as a research scholar, he specialized in mycology, publishing many excellent studies. His greatest work is his *Contribution Towards a Monograph of the Laboulbeniaceae* in *Memoirs of the American Academy of Arts and Sciences* (1896–1931).

THAYER, ABBOTT HANDERSON (*b. Boston, Mass., 1849; d. Monadnock, N.H., 1921*), painter. Grandson of Gideon F. Thayer. Early skilled as a painter of animals, he attended art classes in Boston and New York and studied in Paris, France, at the atelier of J. L. Gérôme. Returning to New York City, 1879, he was

chosen president of the Society of American Artists. In 1901 he was elected an Academician, but at about that time he removed to New Hampshire and adopted a hermitlike habit of life. Winner of many important distinctions, Thayer painted varied subjects and in varied techniques but ideal figures and landscapes supplied his masterpieces. Chief among these are "Caritas" in the Boston Museum of Fine Arts and "Winter Sunrise, Monadnock" in the Metropolitan Museum, New York City. Idealizing women, Thayer realized his figures on the canvas directly and sincerely, and originality was the very basis of his style. He was free from the control of French technique. Almost mystically conscious of his artistic mission, he tried to make visible the beauty of spirit he saw in a person or natural object. To gain monumentality he exaggerated light and shadow and placed his colors in large, simple masses. His color range was limited but his whites — sometimes luminous, sometimes flat, but always suggestive. A large part of his later career was taken up with experiments in the protective coloration of animals and the promotion of what is called "Thayer's Law" of coloration.

THAYER, ALEXANDER WHEELOCK (*b. South Natick, Mass., 1817; d. 1897*), lawyer, journalist, U.S. consular officer. Author of the standard biography of Ludwig van Beethoven, first published in Berlin (Volume 1, 1866; Volume 2, 1872; Volume 3, 1879) and issued in an English version, edited by Henry E. Krehbiel, in 1921.

THAYER, AMOS MADDEN (*b. Mina, N.Y., 1841; d. 1905*), Union soldier, Missouri jurist. Admitted to the bar in St. Louis, Mo., 1868. Judge of the St. Louis circuit court, 1876–87, he served as federal judge for the eastern district of Missouri, 1887–94, and as federal circuit judge for the eighth circuit *post* 1894. He delivered notable opinions in cases involving the law of conspiracy in 1897 and 1903; the second of these in *U.S. v. Northern Securities Company* had great economic significance.

THAYER, ELI (*b. Mendon, Mass., 1819; d. 1899*), Massachusetts educator, legislator, and congressman. Principal of the Oread Collegiate Institute, Worcester, Mass. Thayer originated and was principal promoter of the New England Emigrant Aid Co., chartered, February 1855, as a means of financing organized freesoil immigration to Kansas.

THAYER, EZRA RIPLEY (*b. Milton, Mass., 1866; d. 1915*), legal educator. Son of James B. Thayer; brother of William S. Thayer. Graduated Harvard, 1888; Harvard Law School, 1891. Practiced with Boston law firm of Louis D. Brandeis and with other firms. Dean, Harvard Law School, 1910–15.

THAYER, GIDEON FRENCH (*b. Watertown, Mass., 1793; d. Keene, N.H., 1864*), Massachusetts educator, businessman. Grandfather of Abbott H. Thayer. Founded Chauncy-Hall School in Boston, Mass., 1828.

THAYER, JAMES BRADLEY (*b. Haverhill, Mass., 1831; d. Cambridge, Mass., 1902*), legal educator. Father of Ezra R. and William S. Thayer. Graduated Harvard, 1852; attended Harvard Law School, 1854–56. Practiced in Boston; served as editor (with Oliver W. Holmes, Jr.) of Kent's *Commentaries* (12th edition, 1873). Professor at Harvard Law School *post* 1874, he cooperated with C. C. Langdell, J. C. Gray, and James B. Ames in promoting the case system of study. A prolific writer of treatises and textbooks, he became recognized as a leading scholar in constitutional law and the law of evidence.

THAYER, JOHN (*b. Boston, Mass., 1758; d. Limerick, Ireland, 1815*), Roman Catholic clergyman. A convert to Catholicism, 1783, Thayer studied theology in Paris where he was ordained,

1787. Returning to Boston, Mass., 1790, he worked there with dedicated but tactless zeal. Replaced as pastor in 1792, he served courageously as a roving missionary through the New England towns, in Virginia, and on the Kentucky frontier until 1803 when he retired to work in Ireland.

THAYER, JOHN MILTON (*b. Bellingham, Mass., 1820; d. Lincoln, Nebr., 1906*), lawyer, Union major general. Settled in Omaha, Nebr., 1854, where he practiced law and was commissioned first brigadier general of the territorial militia. After distinguished service in the Western campaigns of the Civil War, he was U.S. senator, Republican, from Nebraska, 1867–71. An active Radical, he did his best work in Indian Affairs. Governor of Wyoming Territory, 1875–79, he returned to Nebraska and served as Republican governor of that state, 1887–92.

THAYER, JOSEPH HENRY (*b. Boston, Mass., 1828; d. 1901*), Congregational clergyman, New Testament scholar. Graduated Harvard, 1850; Andover Theological Seminary, 1857. Taught sacred literature at Andover, and at Harvard Divinity School where he was Bussey Professor of New Testament, 1884–1901. Editor-reviser of *Greek-English Lexicon of the New Testament* (adapted from Grimm and Wilke, 1887).

THAYER, NATHANIEL (*b. Lancaster, Mass., 1808; d. Boston, Mass., 1883*), financier, philanthropist, benefactor of Harvard.

THAYER, SYLVANUS (*b. Braintree, Mass., 1785; d. Braintree, 1872*), military engineer, educator. Graduated West Point, 1808. Called the "Father of the Military Academy," Thayer served at West Point as superintendent, 1817–33. He instituted many needed reforms and established an efficient organization for military and academic training including an able and distinguished faculty. From 1833 until his retirement as brevet brigadier general, 1863, he was engineer in charge of fortifications at Boston Harbor entrance and of the improvement of harbors on the New England coast. He established (1867) and endowed the Thayer School of engineering at Dartmouth.

THAYER, THOMAS BALDWIN (*b. Boston, Mass., 1812; d. Roxbury, Mass., 1886*), Universalist clergyman. Pastor in Lowell, Mass., 1833–45, 1851–59; in Boston, Mass., 1859–67. Editor, *Universalist Quarterly*, 1864–86.

THAYER, TIFFANY ELLSWORTH (*b. Freeport, Ill., 1902; d. Nantucket, Mass., 1959*), novelist, actor, advertising scriptwriter. Acted in the Midwest, 1918–22, before becoming an advertising copywriter in New York in 1926. The first of his more than twenty novels, *Thirteen Men* (1930), was a bestseller. His works were described as smutty, and he never achieved critical success. Other works include *Call Her Savage* (1931), *An American Girl* (1933), and *The Old Goat* (1937). Published the first three volumes of a projected series on the Italian Renaissance, *Mona Lisa: The Prince of Taranto* (1959).

THAYER, WHITNEY EUGENE (*b. Mendon, Mass., 1838; d. Burlington, Vt., 1889*), organist, music teacher, composer.

THAYER, WILLIAM MAKEPEACE (*b. Franklin, Mass., 1820; d. Franklin, 1898*), Congregational clergyman. Author of a number of "rags-to-riches" biographies which included *The Poor Boy and Merchant Prince* (1857), *The Bobbin Boy* (1860), and *The Pioneer Boy and How He Became President* (1863).

THAYER, WILLIAM ROSCOE (*b. Boston, Mass., 1859; d. Cambridge, Mass., 1923*), journalist, editor, historian. Graduated Harvard, 1881; M.A., 1886. Editor, *Harvard Graduates' Magazine*, 1892–1915. Author of *The Dawn of Italian Independence* (1893)

and the outstanding *Life and Times of Cavour* (1911), among other works.

THAYER, WILLIAM SYDNEY (*b. Milton, Mass., 1864; d. Washington, D.C., 1932*), physician. Son of James B. Thayer; brother of Ezra R. Thayer. Graduated Harvard, 1885; Harvard Medical School, 1889. After further study in Berlin and Vienna, he served on the staff of Johns Hopkins Hospital under William Osler; he later became professor of clinical medicine in Johns Hopkins Medical School and professor of medicine and physician-in-chief to the hospital. He made numerous contributions to knowledge of the circulatory system and investigated the condition of blood in leukemia, typhoid fever, and malaria.

THÉBAUD, AUGUSTUS J. (*b. Nantes, France, 1807; d. New York, N.Y., 1885*), Roman Catholic clergyman, Jesuit educator. In America *post* 1838, he held various teaching and administrative appointments at institutions of his order in Kentucky, New Jersey, New York, and Canada; he was three times rector of the present Fordham University. Distinguished as a preacher and lecturer, he made studies of immigration and social problems and wrote widely for Catholic magazines.

THEOBALD, ROBERT ALFRED (*b. San Francisco, Calif., 1884; d. Boston, Mass., 1957*), naval officer. Graduated from the U.S. Naval Academy, 1907; commissioned in 1908. Following routine assignments through World War I, Theobald became a popular instructor at the Naval War College and, in 1924, head of the Postgraduate School. Served on the staff of the War Plans Division, 1931–35, and by 1940 was an admiral in command of a destroyer flotilla that was destroyed at Pearl Harbor. Commander of the North Pacific Forces (1942); because of friction between commanders of other branches of the armed forces, he was reassigned to the Boston Navy Yard in 1943. Author of *The Final Secret of Pearl Harbor* (1954), which accused Roosevelt of purposely failing to alert the fleet because he wanted the U.S. in the war.

THEOBALD, SAMUEL (*b. Baltimore, Md., 1846; d. 1930*), ophthalmologist. Grandson of Nathan R. Smith, by whom he was raised. M.D., University of Maryland, 1867; studied also in Vienna and London. Practicing in Baltimore *post* 1871, he was founder of the Baltimore Eye, Ear, and Throat Charity Hospital and professor of his specialty at Johns Hopkins School of Medicine. Among other contributions, he invented lachrymal probes and introduced use of boric acid in ophthalmology.

THEUS, JEREMIAH (*b. probably Switzerland, ca. 1719; d. 1774*), painter. Immigrated *ca.* 1739 to Orangeburg Co., S.C.; by 1740 had begun his successful career as portraitist in Charleston. Painter of many men and women of the Southern colonies, he was celebrated for true if somewhat stiff and formal likenesses.

THIERRY, CAMILLE (*b. New Orleans, La., 1814; d. Bordeaux, France, 1875*), Louisiana poet. In part of black ancestry, Thierry resided in France *post* 1855. His popular poems were published in collected form at Bordeaux as *Les Vagabondes* (1874).

THILLY, FRANK (*b. Cincinnati, Ohio, 1865; d. 1934*), philosopher, educator. Graduated University of Cincinnati, 1887; studied also at Berlin and Heidelberg. Taught philosophy at Cornell, University of Missouri, and Princeton; professor at Sage School, Cornell, *post* 1906. Dean, College of Arts and Sciences, Cornell, 1915–21. Adhered in principle to the so-called tradition of idealism.

THOBURN, ISABELLA (*b. St. Clairsville, Ohio, 1840; d. Lucknow, India, 1901*), Methodist missionary and educator. Sister of James M. Thoburn. Associated in mission work with Clara A. Swain, she conducted schools in India, 1870–80, 1882–86, and *post* 1891.

THOBURN, JAMES MILLS (*b. St. Clairsville, Ohio, 1836; d. Meadville, Pa., 1922*), Methodist clergyman. Brother of Isabella Thoburn. Missionary in India for the greater part of the years 1859–88; missionary bishop for India (later Southern Asia), 1888–1908; acknowledged missionary leader in his denomination.

THOMAS, ALLEN (*b. Howard Co., Md., 1830; d. Waveland, Miss., 1907*), lawyer, Louisiana planter, Confederate brigadier general. U.S. minister to Venezuela, 1895–97.

THOMAS, AMOS RUSSELL (*b. Watertown, N.Y., 1826; d. Philadelphia, Pa., 1895*), homeopathic physician. Taught anatomy in Philadelphia Academy of the Fine Arts, 1856–70. Professor of anatomy, Hahnemann Medical College of Philadelphia, 1867–95. He served also as dean of the college *post* 1874.

THOMAS, AUGUSTUS (*b. St. Louis, Mo., 1857; d. Nyack, N.Y., 1934*), dramatist. Author or adapter of nearly seventy plays. Thomas was a master of conventional stage technique and the painstaking use of local color, but displayed little dramatic interest in what lay below the surface of his situations. His work was important in its day in helping to free the American stage from bondage to Europe and in regularizing and professionalizing the craft of dramatist in America. Outstanding among his plays were *Alabama* (produced, 1891), *In Mizzoura* (1893), *Arizona* (1899), *The Witching Hour* (1907), *As a Man Thinks* (1911), and *The Copperhead* (1918).

THOMAS, CALVIN (*b. Lapeer, Mich., 1854; d. 1919*), German scholar. Graduated University of Michigan, 1874. Taught Germanic studies at Michigan and at Columbia University. An authority on Goethe, he produced a remarkable edition of *Faust* (1892–97) and was author of *Goethe* (1917), along with many other scholarly contributions in his field.

THOMAS, CHARLES SPALDING (*b. near Darien, Ga., 1849; d. Denver. Colo., 1934*), lawyer. Removed to Denver, Colo., 1871, where he won success in practice and was a partner of Thomas M. Patterson for a number of years. A nonconformist in politics as in other matters, he was elected governor of Colorado by the Silver Fusionists in 1898, serving until 1901. As U.S. senator, Democrat, 1913–21, he opposed the League of Nations, the soldiers' bonus, and what he considered extreme demands by both capital and labor.

THOMAS, CHRISTIAN FRIEDRICH THEODORE (*b. Esens, Germany, 1835; d. Chicago, Ill., 1905*), musician. Immigrated to New York City, 1845. Pupil of his father, Thomas early won reputation as a violinist. He was elected to the Philharmonic Society, 1854, and in the next year joined William Mason (1829–1908) in the first of the long famous series of Mason-Thomas chamber music concerts given at Dodworth's Hall. First conducting at the N.Y. Academy of Music, December 1860, Thomas entered on a new career as a kind of musical missionary, taking a series of orchestras on tours under his direction and developing the taste for symphonic music in the United States. Throughout a career filled with practical difficulties, he showed himself a shrewd program maker, seeking to elevate public taste progressively and gradually rather than immediately. He served as conductor of the Chicago Symphony Orchestra, 1891–1905. Often a storm center because of his artistic integrity, he was an important figure in the growth of American culture.

THOMAS, CYRUS (*b. Kingsport, Tenn., 1825; d. 1910*), ethnologist, entomologist, pioneer in Mayan studies, authority on the Mound Builders.

THOMAS, DAVID (*b. Pelham, Mass., 1762; d. Providence, R.I., 1831*), Revolutionary soldier, New York State politician. Congressman, Democratic-Republican, from New York, 1801–08, and treasurer of New York State, 1808–10, 1812, he was a prominent supporter of DeWitt Clinton. Indicted and acquitted for attempted bribery of a legislator, 1812, he retired from politics and removed to Rhode Island.

THOMAS, DAVID (*b. Glamorganshire, Wales, 1794; d. Catasauqua, Pa., 1882*), iron manufacturer. An expert in the hotblast method of smelting iron ore, Thomas came to Pennsylvania, 1839, and constructed the first American anthracite iron manufacturing plant at Catasauqua, Pa. (operational, July 1840).

THOMAS, EDITH MATILDA (*b. Chatham, Ohio, 1854; d. 1925*), poet, editor. Resident in New York City *post* 1887, she was author, among other works, of *A New Year's Masque* (1885), *Lyrics and Sonnets* (1887), and *The Flower from the Ashes* (1915). Her remote, unimpassioned, classical verses were marked by painstaking craftsmanship.

THOMAS, ELBERT DUNCAN (*b. Salt Lake City, Utah, 1883; d. Honolulu, Hawaii, 1953*), political scientist, politician. Studied at the University of Utah, A.B., 1906, and the University of California. Professor of history and political science at the University of Utah, 1924–32. Democratic senator from Utah, 1932–50. A liberal, Thomas was an administration spokesman, championing the New Deal, the formation of the U.N., and labor rights, Urged retainment of the Japanese emperor after World War II to prevent anarchy. High commissioner of the U.S. Trust Territory of the Pacific Islands, 1951–53.

THOMAS, FRANCIS (*b. near Petersville, Md., 1799; d. 1876*), lawyer, Maryland legislator. Congressman, Democrat, from Maryland, 1831–41, he was chairman of the judiciary committee, an able and eloquent parliamentarian, and a friend and defender of Andrew Jackson. As governor of Maryland, 1841–44, he preserved the state from repudiation of its debt. Retiring from politics because of a personal scandal, he emerged at the outbreak of the Civil War as a strong Unionist; while congressman, 1861–69, he supported the extreme Radicals. He was U.S. minister to Peru, 1872–75.

THOMAS, FREDERICK WILLIAM (*b. Providence, R.I., 1806; d. Washington, D.C., 1866*), journalist, author, friend and correspondent of Edgar Allan Poe.

THOMAS, GEORGE (*b. Antigua, British West Indies, ca. 1695; d. London, England, 1774*). Appointed deputy governor of Pennsylvania and the Lower Counties, he served from 1738 until 1747. In bitter controversy with the Assembly over financial and military affairs for the greater part of his term, he was successful in his dealings with the Indians. Advised by Conrad Weiser, he secured the neutrality of the Iroquois, thus permitting settlement of the back country.

THOMAS, GEORGE ALLISON (*b. on the Onondaga Reservation, south of Syracuse, N.Y., 1911; d. Syracuse, 1960*), Onondaga Indian chief and spiritual leader. Promoted Iroquoian culture and the spiritual welfare of the Iroquois's Six Nations for much of his life. Succeeded his father as chief and spiritual leader in 1957. Led protests against the St. Lawrence Seaway (1954–59), the Niagara Power Project (1957–61), and the Kinzua Dam (1957–66) because Iroquois lands were expropriated for their construction.

THOMAS, GEORGE CLIFFORD (*b. Philadelphia, Pa., 1839; d. Philadelphia, 1909*), banker, philanthropist. Partner in Jay Cooke's banking house, 1866–73, he was active *post* 1883 in Drexel & Co. and its Morgan affiliates.

THOMAS, GEORGE HENRY (*b. Southampton Co., Va., 1816; d. San Francisco, Calif., 1870*), soldier. Graduated West Point, 1840; was commissioned in the 3rd Artillery. Served in the Florida War, in several Southern garrisons and throughout Taylor's campaign in the war with Mexico. Instructor in artillery and cavalry at West Point, 1851–54. Promoted to major, 1855, he was assigned to the 2nd (later the 5th) Cavalry, a regiment officered by men almost all of whom rose to high rank, both Union and Confederate, during the Civil War. He served with this unit in Texas and on exploration duty until 1860. Remaining loyal to the Union, Thomas commanded a brigade in the opening operations in the Shenandoah Valley, 1861, rising to brigadier general in August. Commanding the 1st Division, Army of the Ohio, he won a decisive action at Mill Springs, January 1862, and later took part in Buell's advance to Nashville and to Pittsburg Landing. Promoted major general, April 1862, he commanded the right wing of Halleck's army in the march against and capture of Corinth. Reassigned to Buell's army, he served during the campaign against Bragg in Kentucky; he was second in command to Buell in the Perryville operations in October. Under Rosecrans, Thomas commanded the XIV Army Corps at Stone River, and in the Tullahoma campaign of June and July 1863. In September, Thomas reached his highest pitch of fame at the battle of Chickamauga, maintaining the field with his corps despite the rout of the rest of the Union forces. After General U.S., Grant ordered concentration of federal forces on Chattanooga, Thomas succeeded Rosecrans in command of the Army of the Cumberland, holding Chattanooga under great difficulties until Grant was ready to undertake a general offensive. In the battle that followed, Thomas was in general command during the seizure of Lookout Mountain and Missionary Ridge (November 1863).

Thomas's Army of the Cumberland made up over half of General W. T. Sherman's force during the Atlanta campaign and was constantly engaged; units of it were first to enter Atlanta. While Sherman was marching to the sea with his main force, Thomas was designated to command a new army, based in Nashville, which would oppose Confederate forces under General John Hood in the West. After a delaying action, the federal field force took position at Franklin, Tenn., checked Hood's advance there on Nov. 30, 1864, and then withdrew into Nashville. Although Grant insisted on an immediate offensive by Thomas, the latter refused to move until he was ready. When he did attack (December 15–16), he vindicated his judgment by crushing Hood's army so severely that it played no further important part in the war. Promoted major general in the regular army for this victory, he also received the thanks of Congress. He remained in command in the Nashville area for the rest of the war and for a few years after it. In June 1869, he assumed command of the Division of the Pacific at San Francisco. Studious, deliberate but decided in action, Thomas was respected by his superiors and loved by his subordinates. General U.S. Grant said of him that his military dispositions were always good and that he could not be driven from a point he was given to hold.

THOMAS, ISAIAH (*b. Boston, Mass., 1749 o.s.; d. Worcester, Mass., 1831*), printer, historian of the press. After apprenticeship to a Boston printer (Zechariah Fowle), and early journeyman work in Halifax, Nova Scotia, and Charleston, S.C., he became

Fowle's partner in July 1770. Establishing the *Massachusetts Spy*, a fearless and successful Whig newspaper, in that same year, he soon bought out his partner. Removing his printing establishment to Worcester, Mass., April 1775, he continued to publish his newspaper and served as official printer for the patriots of the colony. Despite difficulties, by the end of the Revolutionary War his business was on a firm footing. The leading book and periodical publisher of his day, he conducted branches of his business in Boston, Newburyport, Baltimore, Albany, and in other towns. Notable for good typography, he published more than 400 books which included a folio Bible, a number of school textbooks, reprints of the best English literature of his day, and the first edition of *The Power of Sympathy* (1789), attributed to William H. Brown and the first novel by a native American. He was also famous for a long list of children's books, among them the first American issues of *Mother Goose's Melody* (1786) and *The History of Little Goody Two-Shoes*, and illustrated editions of the *New England Primer*. He was publisher also of the *Royal American Magazine*, 1774–75, and of the *Massachusetts Magazine*, 1789–96. Retiring from personal control of his business, 1802, he devoted the rest of life to scholarship. His *History of Printing in America* (1810) is still a recognized authority on the subject. In 1812 he founded and incorporated the American Antiquarian Society of which he became first president.

THOMAS, JESSE BURGESS (*b. Shepherdstown, present W. Va., 1777; d. Mount Vernon, Ohio, 1853*), lawyer, Indiana and Illinois politician. Removing to Indiana Territory *ca.* 1803, he served as speaker of the territorial legislature, 1805–08. As territorial delegate to Congress, 1808–09, he worked successfully to secure independent territorial status for Illinois. Federal judge in Illinois, 1809–18, he was president of the Illinois constitutional convention, 1818, and served as U.S. senator, Democrat, from the state of Illinois, 1818–29. During the debate over the admission of Missouri, 1820, he introduced an amendment prohibiting slavery north of the line 36°30' except for the area of the proposed state of Missouri. This was embodied in the "Missouri Compromise."

THOMAS, JESSE BURGESS (*b. Illinois, 1832; d. Brooklyn, N.Y., 1915*), Baptist clergyman. Brooklyn, N.Y., pastor; professor of church history at Newton Theological Institution. Grandnephew of Jesse B. Thomas (1777–1853).

THOMAS, JOHN (*b. Marshfield, Mass., 1724; d. near Chambly, Canada, 1776*), physician, Revolutionary major general. Practiced at Kingston, Mass., served as military surgeon in French and Indian War, also as soldier. Commissioned general officer of Massachusetts troops, February 1775, he was elected brigadier general of Continentals, June 1775. Commanded at Roxbury during siege of Boston, 1775–76; commanded occupation of Dorchester Heights, March 1776. Promoted major general and ordered to command in Canada after the failure of Montgomery, he died of smallpox on the retreat from Quebec.

THOMAS, JOHN CHARLES (*b. Meyersdale, Pa., 1891; d. Apple Valley, Calif., 1960*), baritone. Studied at the Peabody Conservatory of Music. Appeared in light opera; made his opera debut in 1925 at the Washington Opera. Appeared in *Salome* at the San Francisco Opera, 1930; and Metropolitan Opera debut in *La Traviata*, 1934. Made numerous recordings; made farewell concert tour in 1952–53.

THOMAS, JOHN JACOBS (*b. Ledyard, N.Y., 1810; d. Union Springs, N.Y., 1895*), pomologist. Brother of Joseph Thomas. A pioneer fruit grower and nurseryman in central New York, he was editor of several agricultural papers, and an outstanding as-

sociate editor of the *Country Gentleman*, 1853–94. Inventor of several farm implements, among them the smoothing harrow. Author of *The Fruit Culturist* (1846, expanded edition, 1849) which marks the beginning of systematic pomology in America.

THOMAS, JOHN PARNELL (*b. John Parnell Feeney, Jr., Jersey City, N.J., 1895; d. St. Petersburg, Fla., 1970*), businessman, U.S. congressman. Attended the University of Pennsylvania (1914–16) and New York University Law School (1916–17). Joined the Paine Webber Company after World War I and stayed there until 1941. In 1920 he changed his name from Feeney to Thomas in the belief he would achieve greater recognition and business under his mother's maiden name. In 1936 he won the first of six successive terms in the U.S. House of Representatives where he specialized in ferreting out Communists and liberals. He became chairman of the House Un-American Activities Committee (HUAC) after the elections of 1946. Under his leadership HUAC investigated the movie industry in 1947 and conducted the Hiss-Chambers hearings in 1948. Indicted for padding his congressional payroll (1948), he resigned from the House in 1950 and served nearly nine months in prison before being paroled by President Truman.

THOMAS, (JOHN WILLIAM) ELMER (*b. near Greencastle, Ind., 1876; d. Lawton, Okla., 1965*), politician, businessman. Attended Central Normal College (teaching certificate, 1897) and De-Pauw University (Ph.D., 1900). Moved to the Oklahoma Territory in 1900 where he practiced law and worked for a real estate company. Elected senator to Oklahoma's first legislature (1907). A leader in the state Democratic party, he was elected to the House of Representatives in 1922 and served two terms. Elected to the U.S. Senate in 1926, he supported the interests of farmers and the free coinage of silver. Was reelected to the Senate in 1932, 1938, and 1944, but was narrowly defeated for his party's nomination in 1950.

THOMAS, JOHN WILSON (*b. near Nashville, Tenn., 1830; d. Nashville, 1906*), Tennessee railroad executive, President of the Nashville, Chattanooga & St. Louis Railway *post* 1884.

THOMAS, JOSEPH (*b. Ledyard, N.Y., 1811; d. Philadelphia, Pa., 1891*), physician, lexicographer, educator. Brother of John J. Thomas. Compiler and editor of a number of reference books for J. B. Lippincott and Co. Long associated with Swarthmore College, he was an authority in his day on etymology and pronunciation.

THOMAS, LORENZO (*b. New Castle, Del., 1804; d. Washington, D.C., 1875*), soldier. Graduated West Point, 1823. A staff officer for many years, Thomas became adjutant general of the U. S. Army in 1861, ranking as brigadier general. Criticized as inadequate, he was relieved in March 1863 and assigned to other duties. Reappointed adjutant general in February 1868, he lost reputation for his foolish actions as *ad interim* secretary of war during contest for control of the War Department between President Andrew Johnson and Edwin M. Stanton.

THOMAS, MARTHA CAREY (*b. Baltimore, Md., 1857; d. Philadelphia, Pa., 1935*), educator. Niece of Hannah W. Smith. Graduated Cornell, 1877. Studied Greek at Johns Hopkins with Basil Gildersleeve and made further philological and linguistic studies abroad, winning her doctorate at University of Zurich, 1882. Appointed dean and professor of English at Bryn Mawr, 1884, she influenced the formation of its curriculum and served as its president, 1894–1922. Active in the fight for woman's suffrage and for international peace, she was also a successful fund-raiser for the Johns Hopkins Medical School, giving her assistance on condition that women be admitted there.

THOMAS, NORMAN MATTOON (*b. Marion, Ohio, 1884; d. Huntington, N.Y., 1968*), reformer, socialist. Attended Bucknell University, Princeton University (B.A., 1905), and Union Theological Seminary (B.D., 1911). An ordained Presbyterian minister, Thomas joined the Socialist party in 1918. In 1917 he helped establish the Civil Liberties Bureau, which later became the American Civil Liberties Union. Became head of the Socialist party in 1 1926. Every four years during 1928–48 he ran for the presidency of the United States. As a pacificst, Thomas ardently opposed U.S. entry into World War I and World War II; after Pearl Harbor, however, he gave "critical support" to the war effort. Spoke out against the interning of Japanese-Americans and the dropping of the atomic bomb on Japan. Worked tirelessly to promote world peace through international cooperation and eloquently defended unpopular people and causes throughout his life.

THOMAS, PHILIP EVAN (*b. Montgomery Co., Md., 1776; d. Yonkers, N.Y., 1861*), Baltimore merchant, banker. Active in securing the charter for the Baltimore and Ohio Railroad, 1827, Thomas became its first president. He resigned in 1836 after the road had reached Harpers Ferry and its chief mechanical problems had been resolved under his direction.

THOMAS, PHILIP FRANCIS (*b. Eastern, Md., 1810; d. 1890*), lawyer, Maryland legislator and congressman. Democratic governor of Maryland, 1847–50; U.S. secretary of the treasury, 1860 (for one month). A Confederate sympathizer, he was denied the post–Civil War seat in the U.S. Senate to which he had been chosen.

THOMAS, RICHARD HENRY (*b. Baltimore, Md., 1854; d. Baltimore, 1904*), physician, Quaker minister, author. Developed and preached an interpretation of Christianity which met challenges of contemporary science and higher criticism.

THOMAS, ROBERT BAILEY (*b. Grafton, Mass., 1766; d. West Boylston, Mass., 1846*), founder, editor, and publisher of the *Farmer's Almanack*, 1792–1846.

THOMAS, ROLAND JAY (*b. East Palestine, Ohio, 1900; d. Muskegon, Mich., 1967*), labor organizer. Attended Wooster (Ohio) College (1919–21). Took a welding job at a Detroit Chrysler auto plant (1929), and in 1934 was elected employee representative of his plant to the Automobile Labor Board. Two years later he became plant president and overall vice-president of the Automotive Industrial Workers of America, an independent union that joined the UAW in 1936. Made a UAW vice-president (1937), he was placed in charge of all bargaining with the Chrysler Corporation. Elected UAW-CIO president, 1939. In 1941 under his leadership UAW successfully organized the Ford Motor Company. Defeated by Walter Reuther for the UAW presidency in 1946, Thomas was active in the CIO for the rest of his career.

THOMAS, SETH (*b. Wolcott, Conn., 1785; d. Plymouth, present Thomaston, Conn., 1859*), pioneer clock manufacturer. Joined Eli Terry and another in partnership at Plymouth, Conn., 1807; began clock production on his own, 1812; purchased manufacturing rights for Terry's shelf clock, 1814. Organized Seth Thomas Clock Co., 1853.

THOMAS, THEODORE *See* THOMAS, CHRISTIAN FRIEDRICH THEODORE.

THOMAS, THEODORE GAILLARD (*b. Edisto Island, S.C., 1831; d. Thomasville, Ga., 1903*), obstetrician, gynecologist. Graduated Medical College of South Carolina, 1852; studied also in Paris and Dublin. Practiced in New York City *post* 1855; professor of obstetrics (later of gynecology) at N.Y. College of Physicians and Surgeons, 1865–90. Inventor of many surgical instruments, he originated, among many other new techniques, the operation of laparoelytrotomy and suggested and used an incubator as early as 1867. He was author of the classic *Practical Treatise on the Diseases of Women* (1868).

THOMAS, WILLIAM ISAAC (*b. Russell County, Va., 1863; d. Berkeley, Calif., 1947*), sociologist. B.A., University of Tennessee, 1884; Ph.D., 1886. Studied at Göttingen and Berlin, 1888–89. Professor of English, Oberlin College, 1889–95. Redirecting his interests, he became one of the first graduate students in the department of sociology, University of Chicago, and was awarded the doctorate, 1895. He then taught sociology at University of Chicago until 1918 (professor *post* 1910), when he was arrested for violation of the Mann Act and dismissed. Thereafter, he was engaged primarily in research projects sponsored by private organizations, and occasional visiting university appointments. His core concerns in his work were social control and the process of social change; his achievement in linking theoretical and empirical research set a model for subsequent sociological investigations. His principal book was his comparative study, *The Polish Peasant in Europe and America* (1918–19).

THOMAS, WILLIAM WIDGERY (*b. Portland, Maine, 1839; d. 1927*), lawyer, U.S. consular office, Maine legislator. Helped establish Swedish settlement in Aroostook Co., Maine, 1870. He was U.S. minister to Sweden and Norway, 1883–85, 1889–94, and 1897–1905.

THOMES, WILLIAM HENRY (*b. Portland, Maine, 1824; d. 1895*), mariner, journalist, California pioneer, Boston (Mass.) publisher. Author of a number of tales of the "dimenovel" variety, and of the vivid and accurate work on pioneer California entitled *On Land and Sea* (1883).

THOMPSON, ALFRED WORDSWORTH (*b. Baltimore, Md., 1840; d. Summit, N.J., 1896*), landscape, figure, and historical painter.

THOMPSON, ARTHUR WEBSTER (*b. Erie, Pa., 1875; d. Pittsburgh, Pa., 1930*), civil engineer, railroad and utilities executive. Associated with the Baltimore and Ohio, 1899–1919, he was president of the Philadelphia Co., 1919–26, and of the United Gas Improvement Co. thereafter.

THOMPSON, BENJAMIN (*b. Woburn, Mass., 1753; d. Auteuil, France, 1814*), scientist, philanthropist, better known as "Count Rumford." Early apt at mathematics and drafting, he was apprenticed to a merchant in Salem, Mass., 1766, but gave much of his time to reading, and scientific experimentation and discussion with Loammi Baldwin (1744–1807). After studying medicine and teaching school for a short time, he married a wealthy widow, 1772. By exercising his lifelong gift for promoting his own interests, he rose high in favor of Governor Wentworth of New Hampshire. Ambivalent in his sympathies at the outbreak of the Revolution, he definitely chose the British side in the fall of 1775. After the British evacuation of Boston, he removed to England, where he again exercised his art of pleasing the great, was appointed to a sinecure and became a fellow of the Royal Society, 1779. Commissioned a British lieutenant colonel for service in America, 1781, he engaged in action near Charleston, S.C., March 1782; he then served on Long Island until late spring 1783 when he returned to England and was put on half pay. Touring in Europe, he entered the service of the Elector of Bavaria in which he was made major general, councilor of state, and head of the war department. Already holder of a British knighthood, he was made a Count of the Holy Roman Empire,

1791. Famous for his efficient reforms in Bavaria, he returned to England, 1795, where he published the first volume (1796) of his *Essays, Political, Economical, and Philosophical*. He introduced improvements in heating and cooking equipment, and established (1796) a fund for the Rumford Medal of the Royal Society and the Rumford prize of the American Academy of Arts and Sciences. Returning to Bavaria as head of the council of regency, he performed important diplomatic services and supervised the department of police. Refused recognition as Bavarian minister to Great Britain, 1798, he remained for a time in London where, at his suggestion, The Royal Institution was incorporated in January 1800. He personally supervised construction of its building and secured for it the services of Humphry Davy. After helping plan the Bavarian Academy of Arts and Sciences, 1801, he settled permanently on the continent of Europe, 1802, and in 1805 married the widow of Lavoisier, the chemist, from whom he later separated. Continuing the scientific investigations he had long conducted on the transmission of heat, the absorption of moisture by various substances and the like, he developed a calorimeter and photometer, made improvements in lamps and illumination, and in his essay *Of the Excellent Qualities of Coffee* (1812) described the drip coffee pot. He contributed papers to the meetings of the Institute of France and to the Royal Society, and in 1802 published *Philosophical Papers* (projected as a two-volume work of which only one volume was issued). He is remembered best as a tireless encourager of scientific and humanitarian activities, and for his demonstration by experiment that a hot body cooling in air loses much of its heat by radiation, also that heat is a mode of motion.

THOMPSON, CEPHAS GIOVANNI (*b. Middleboro, Mass., 1809; d. New York, N.Y., 1888*), painter. Brother of Jerome B. Thompson; brother-in-law of Anna C. O. Mowatt. A successful portraitist and social figure in New York City *post* 1837, he became an intimate friend of Nathaniel Hawthorne while resident in Rome, Italy, 1852–59.

THOMPSON, CHARLES OLIVER (*b. East Windsor Hill, Conn., 1836; d. Terre Haute, Ind., 1885*), engineer. Graduated Dartmouth, 1858. Introduced shop practice in engineering teaching at present Worcester Polytechnic Institute while principal, 1868–82. President, Rose Polytechnic Institute *post* 1883.

THOMPSON, DANIEL PIERCE (*b. Charlestown, Mass., 1795; d. 1868*), lawyer, Vermont historical novelist. Raised in frontier Vermont, Thompson graduated from Middlebury College, 1820, and practiced law in Montpelier *post ca.* 1823. Active in politics as successively a Democrat, a member of the Liberty party, and a Republican. He was author of a number of novels of romantic adventure of which *The Green Mountain Boys* (1839) and *Locke Amsden* (1847) are considered the best.

THOMPSON, DAVID (*b. London, England, 1770; d. Canada, 1857*), fur trader, explorer, geographer. Served for many years *post ca.* 1785 as a Hudson's Bay Company apprentice and surveyor in western Canada, retiring from field service in 1812. Publication (1916) of some of his journals and field notes have won him recognition as one of the greatest land geographers of the English race. Among his achievements were the survey of the most northerly source of the Mississippi (1798), discovery of the source of the Columbia River (1807) and a survey of the Columbia from source to mouth (1811).

THOMPSON, DAVID P. (*b. Cadiz, Ohio, 1834; d. 1901*), contractor, banker, Oregon legislator and public official. Removed to Oregon, 1853. Beginning his career as a U.S. deputy surveyor, he prospered in numerous enterprises and was a leader of the Republican party in Oregon. Among other public offices, he was mayor of Portland, 1879 and 1881.

THOMPSON, DENMAN (*b. near Girard, Pa., 1833; d. West Swanzey, N.H., 1911*), actor, playwright. Star of one of the best-known and most successful dramas to appear on the American stage, *The Old Homestead*. Developed from a brief sketch which was first produced in Pittsburgh, Pa., 1875, the play was expanded first to three acts (produced as *Joshua Whitcombe*, Chicago, Ill., 1877) but did not appear in its final and most successful form until the production of April 1886 at Boston, Mass.

THOMPSON, DOROTHY (*b. Lancaster, N.Y., 1893; d. Lisbon, Portugal, 1961*), journalist. Attended the Lewis Institute (A.A., 1912) and Syracuse University (B.A., 1914). In 1920 she sailed to Europe where she became a highly successful journalist. In 1925 she was named to head the Berlin bureau of the *New York Evening Post* and the *Public Ledger*. Married novelist Sinclair Lewis in 1928. Expelled from Germany in 1934 because of her anti-Nazi sentiments, she returned to the United States. Beginning in 1936 she wrote a thrice-weekly public-affairs column, "On the Record," for the *New York Herald Tribune*; it was eventually carried by 170 newspapers. Moved to the Bell Syndicate after the presidential elections of 1940. In 1941 she founded the Ring of Freedom to prepare the United States for war and became the second president of Freedom House, a liberal internationalist organization. She and Lewis were divorced in 1942, but she wrote a tribute to him in a highly praised article in *Atlantic Monthly* (November 1960). After World War II she supported the cause of Palestinian Arabs and anti-Zionist organizations.

THOMPSON, EDWARD HERBERT (*b. Worcester, Mass., 1856; d. Plainfield, N.J., 1935*), explorer, archaeologist, U.S. consular official in Mexico. A pioneer scientific investigator of Mayan antiquities, Thompson is associated in particular with the work done at Chichen-Itza.

THOMPSON, EGBERT (*b. New York, N.Y., 1822; d. Washington, D.C., 1881*), naval officer. Nephew of Smith Thompson. Appointed midshipman, 1837. After service with the Wilkes Exploring Expedition, 1838–42, and aboard the brig USS *Somers* at the time of the famous alleged mutiny, Thompson engaged in routine duty up to the Civil War, during which he was engaged principally in service with the Union flotillas on the Mississippi River. He was balked of advancement because of alleged tardiness in supporting land operations after running the Confederate batteries at Island No. 10 with the gunboat *Pittsburg*, April 1862. He was retired as captain in 1874.

THOMPSON, HUGH MILLER (*b. Londonderry, Ireland, 1830; d. Jackson, Miss., 1902*), Episcopal clergyman. Came to America as a boy. Held a number of pastorates in the Midwest, in New York City, and in New Orleans, La. Editor, *American Churchman*, 1860–71, he subsequently edited the *Church Journal*. Elected coadjutor bishop of Mississippi, 1882, he became diocesan bishop, 1887, and served until 1902.

THOMPSON, HUGH SMITH (*b. Charleston, S.C., 1836; d. New York, N.Y., 1904*), educator. Nephew of Waddy Thompson. Brilliantly successful as South Carolina superintendent of education, 1877–82, he served efficiently as Democratic governor of that state, 1882–86. Subsequently an assistant secretary of the U.S. treasury and a member of the civil service commission, he was comptroller of the New York Life Insurance Co., 1892–1904.

THOMPSON, JACOB (*b. Leasburg, N.C., 1810; d. Memphis, Tenn., 1885*), lawyer. Removed to Mississippi, 1835. Congress-

man, Democrat, from Mississippi, 1839–51, he was for a time chairman of the committees of public lands and Indian affairs. Efficient as U.S. secretary of the interior, 1857–61, he resigned because of his states' rights views. Serving in the Confederate Army until the fall of Vicksburg, he fomented trouble in Canada *post* 1864 as a secret Confederate agent. After a brief post–Civil War exile in Europe, he returned to America and settled permanently in Memphis.

THOMPSON, JAMES MAURICE (*b. Fairfield, Ind., 1844; d. Crawfordsville, Ind., 1901*), Confederate soldier, civil engineer, lawyer, authority on archery. Author, among other works, of the best-selling historical romance *Alice of Old Vincennes* (1900).

THOMPSON, JEREMIAH (*b. Rawdon, Yorkshire, England, 1784; d. New York, N.Y., 1835*), merchant, shipowner. Organizer (1817, with Benjamin Marshall and others) of regular American packet-ship sailings between New York and Liverpool.

THOMPSON, JEROME B. (*b. Middleboro, Mass., 1814; d. Glen Gardner, N.J., 1886*), painter. Brother of Cephas G. Thompson. He won success as a painter of rustic scenes and other subjects which were widely reproduced by lithography.

THOMPSON, JOHN *See* THOMSON, JOHN.

THOMPSON, JOHN (*b. present Peru, Mass., 1802; d. 1891*), broker, commercial publisher, banker. President, First National Bank, New York City, 1863–77; cofounder of the Chase National Bank, New York City, 1877.

THOMPSON, JOHN BODINE (*b. Readington, N.J., 1830; d. Trenton, N.J., 1907*), Reformed Church clergyman, educator, liberal theologian.

THOMPSON, JOHN REUBEN (*b. Richmond, Va., 1823; d. New York, N.Y., 1873*), editor, poet. Edited *The Southern Literary Messenger*, 1847–60. While assistant secretary of Virginia during the Civil War, he helped edit *Richmond Record* and *Southern Illustrated News* and also contributed to the *Index*, spokesman of the Confederacy in England. After the war he served as literary editor of the N.Y. *Evening Post*. His collected poems were first published in 1920.

THOMPSON, JOSEPH PARRISH (*b. Philadelphia, Pa., 1819; d. Berlin, Germany, 1879*), Congregational clergyman, editor. Father of William G. Thompson. Held principal pastorate at Broadway Tabernacle, New York City, 1845–71; helped edit the *Independent*, 1848–62; was a leader in home missionary work.

THOMPSON, JOSIAH VAN KIRK (*b. near Uniontown, Pa., 1854; d. Uniontown, 1933*), Pennsylvania coal operator, banker.

THOMPSON, LAUNT (*b. Queens Co., Ireland, 1833; d. Middletown, N.Y., 1894*), sculptor. A pupil of Erastus D. Palmer, Thompson was celebrated in his time for his ideal medallion heads and for portrait busts and statues.

THOMPSON, LLEWELLYN E. ("TOMMY"), JR. (*b. Las Animas, Colo., 1904; d. Bethesda, Md., 1972*), career diplomat. Graduated University of Colorado (1928) and became a Foreign Service officer in 1929. He held diplomatic posts in Ceylon and Geneva, then in 1941 was sent to Moscow as second secretary and consul; he remained at the embassy throughout the Nazi siege of 1941–42. He held posts in London (1944), Rome (1950), and Vienna (1952) and was named ambassador to Moscow in 1957. In 1962 he returned to Washington as ambassador at large and was instrumental in the resolution of the 1962 Cuban missile crisis. His expertise in U.S.–Soviet affairs led to his second ap-

pointment (1966) as ambassador to Moscow, where he served until 1969.

THOMPSON, MALVINA CYNTHIA (*b. Bronx, N.Y., 1893; d. New York, N.Y., 1953*), personal secretary. As secretary and companion to Eleanor Roosevelt, 1932–53. Thompson edited columns, advised, and traveled with the first lady. A constant companion, she often issued statements to the press in Mrs. Roosevelt's name.

THOMPSON, MARTIN E. (*b. place uncertain, ca. 1786; d. Glen Cove, N.Y., 1877*), architect. Described in the 1816 New York City directory as a carpenter, he designed (1822–23) the second Bank of the United States on Wall Street, New York City, and also the remarkable Merchants" Exchange (1824), destroyed in the great fire of 1835. Briefly a partner of Ithiel Town, Thompson became a convert to the Greek Revival Style. Little or nothing of the work which he did subsequently has survived in New York City, although it is supposed by some that he was the architect of the dignified houses built in the northern part of Greenwich Village, 1840–60.

THOMPSON, MAURICE *See* THOMPSON, JAMES MAURICE.

THOMPSON, OSCAR LEE (*b. Crawfordsville, Ind., 1887; d. New York, N.Y., 1945*), journalist, music critic. Nephew of James Maurice Thompson. Edited newspapers in Seattle and Tacoma, Wash.; removed to New York City, 1919, to join staff of *Musical America*, of which he was editor, 1936–43. Concurrently, he served as music critic successively of the New York *Evening Post*, *Times*, and *Sun*. He was author, among other books, of *Practical Music Criticism* (1934) and *The International Cyclopedia of Music and Musicians* (1939).

THOMPSON, RICHARD WIGGINTON (*b. Culpeper Co., Va., 1809; d. Terre Haute, Ind., 1900*), lawyer, Whig and Republican politician, Indiana legislator. Resident in Indiana *post ca.* 1832, Thompson remained continuously active in politics and was throughout his life a figure of controversy. Secretary of the navy, 1877–81, he was frequently attacked for unethical conduct.

THOMPSON, ROBERT ELLIS (*b. near Lurgan, Ireland, 1844; d. Philadelphia, Pa., 1924*), Reformed Presbyterian clergyman, educator. Immigrated to Philadelphia as a boy. Graduated University of Pennsylvania, 1865; taught social science there, 1871–92, and was first dean of Wharton School of Finance, 1881–83. A follower of Henry C. Carey, he was author of, among other books, *Social Science and National Economy* (1875) and *Protection to Home Industry* (1866). He represents in his career the unsuccessful struggle of the national economic optimists against the rising tide of reformers, mainly socialists, who preached class cleavage instead of a harmony of economic interests. *post* 1894 he served with great success as president of the Philadelphia Central High School.

THOMPSON, ROBERT MEANS (*b. Corsica, Pa., 1849; d. Fort Ticonderoga, N.Y., 1930*), naval officer, lawyer, financier. Graduated U.S. Naval Academy, 1868; Harvard Law School, 1874. Successful in practice and as an official of the International Nickel Co., Thompson was a benefactor of the Naval Academy and the first president of the American Olympic Association

THOMPSON, SAMUEL RANKIN (*b. South Shenango, Pa., 1833; d. New Wilmington, Pa., 1896*), educator and physicist. Pioneer in public educational organization and normal school work in Nebraska, Pennsylvania, and West Virginia.

THOMPSON, SEYMOUR DWIGHT (*b. Will Co., Ill., 1842; d. East Orange, N.J., 1904*), Union soldier, Missouri jurist. Principal ed-

itor, *American Law Review, post* 1883, he was distinguished chiefly for his many widely read legal treatises which included A *Treatise on Homestead and Exemption Laws* (1878), A *Treatise on the Law of Trials* (1889), and *Commentaries on the Law of Private Corporations* (1895–99).

THOMPSON, SLASON (*b. Fredericton, N.B., Canada, 1849; d. Lake Forest, Ill., 1935*), journalist. A newspaper editor of wide experience and one of the first important industrial press agents in the United States, Thompson is remembered particularly as the friend, publisher, and biographer of Eugene Field.

THOMPSON, SMITH (*b. Amenia, N.Y., 1768; d. Poughkeepsie, N.Y., 1843*), jurist. Graduated College of New Jersey (Princeton), 1788; studied law under James Kent. Allied by marriage with the Livingston family, he was appointed a justice of the New York supreme court, 1802, and was made chief justice, 1814. U.S. secretary of the navy, 1819–23, he accepted appointment as an associate justice of the U.S. Supreme Court and served, 1823–43. One of the group which had already begun to pull away from John Marshall's strong nationalism, he dissented in *Brown* v. *Maryland* (1827) and in the same year helped overrule Marshall in *Ogden* v. *Saunders*; he later (1830) dissented from Marshall's decision in *Craig* v. *Missouri*. Although personally a bitter opponent of slavery, he upheld the federal Fugitive Slave Act. The most notable case in which Thompson spoke for the Court was *Kendall* v. *U.S.* (1838). His opinion in this case contained a paragraph vigorously rejecting the theory attributed to Andrew Jackson that the president, under his power to see that laws are faithfully executed, may enforce his own interpretation of the Constitution by extending protection to subordinates when they violate acts of Congress or mandates of the courts. This paragraph delivered orally was expunged from the written opinion at the request of the attorney general who denied that the theory had been urged in argument.

THOMPSON, STITH (*b. Bloomfield, Ky., 1885; d. Columbus, Ind., 1976*), folklorist. Attended Butler University in Indianapolis and graduated University of Wisconsin (B.A., 1909), where he became interested in folklore and the oral literature of North American Indians; University of California (M.A., 1912); and Harvard University (Ph.D., 1914). He taught at University of Texas (1914–18), Colorado College (1918–20), University of Maine (1920), and Indiana University (1921–55); he became dean of the Indiana Graduate School (1947–50). Known as the "Dean of American Folklore," he legitimized the study of folklore as a university discipline and turned Indiana University into a world center for folklore studies. He produced the standard reference work on folklore, *Motif–Index of Folk–Literature* (1935).

THOMPSON, THOMAS LARKIN (*b. present Charleston, W. Va., 1838; d. Santa Rosa, Calif., 1898*), California editor and congressman. Removed to California, 1855, where he was active in journalism and Democratic politics. Tactful and efficient as U.S. minister to Brazil, 1893–97.

THOMPSON, WADDY (*b. Pickensville, S.C., 1798; d. Tallahassee, Fla., 1868*), lawyer, South Carolina legislator. Uncle of Hugh S. Thompson; brother-in-law of Andrew and Pierce M. Butler. An ardent nullifier, he was congressman, Whig, from South Carolina, 1835–41, and served with success as U.S. minister to Mexico, 1842–44. Too honest to trim sails to the popular breeze, disapproving the war with Mexico and doubting the expediency of secession, he retired to private life.

THOMPSON, WILEY (*b. Amelia Co., Va., 1781; d. near Fort King, Fla., 1835*), Georgia soldier and legislator, Indian agent.

Congressman, Democrat, from Georgia, 1821–33, he rose to chairmanship of the military affairs committee and was a bitter opponent of protection. Approving Andrew Jackson's Indian removal policy, he accepted appointment as agent to supervise removal of the Seminoles under treaties of Payne's Landing and Fort Gibson. Beginning work, 1834, Thompson was opposed by a group of chiefs under Osceola's leadership and in 1835 attempted to remove Osceola and other chiefs. Overruled by President Jackson and condemned as tyrannical by the press, he made further efforts to break Osceola's power but was ambushed and slain by the chief and some of his followers.

THOMPSON, WILL LAMARTINE (*b. Beaver Co., Pa., 1847; d. New York, N.Y., 1909*), song writer and hymnist. Composer of "Softly and Tenderly Jesus Is Calling."

THOMPSON, WILLIAM (*b. Ireland, 1736; d. Carlise, Pa., 1781*), Revolutionary brigadier general. Commanded Pennsylvania riflemen (1st Continental Infantry) at siege of Boston. Made prisoner at attack on Three Rivers, Canada, June 1776, he was paroled and later exchanged for Baron Riedesel.

THOMPSON, WILLIAM BOYCE (*b. Virginia City, Mont., 1869; d. 1930*), mine operator, financier. Founded present Boyce Thompson Institute for Plant Research, 1919.

THOMPSON, WILLIAM GILMAN (*b. New York, N.Y., 1856; d. 1927*), physician. Son of Joseph P. Thompson; nephew of Daniel C. Gilman. Graduated Yale, 1877; M.D., N.Y. College of Physicians and Surgeons, 1881. Practiced in New York City; taught at medical schools of present New York University and Cornell University; served as director of the Loomis Laboratory *post* 1888. Best known for his work in reeducation in connection with war and industrial diseases, he was the founder of the N.Y. Reconstruction Hospital.

THOMPSON, WILLIAM HALE (*b. Boston, Mass., 1867; d. Chicago, Ill., 1944*), politician, demagogue. He attended a select preparatory school in Chicago until he was fourteen when he left for the West and worked as a ranch hand. He spent the winters in Chicago attending a business college. His wealthy family brought him a 3,800-acre ranch in Nebraska, but he returned to Chicago on the death of his father. He devoted most of his time to sporting pasttimes until 1899 when he ran for and was elected alderman. His political career was undistinguished, and he returned to private life and his sporting pursuits until 1915 when he was elected mayor. His administration was run by political boss Fred Lundin, who encouraged Thompson to run for the senate in 1918. He was defeated in the primary but was narrowly reelected mayor in 1919. He launched a large program of public works. Race riots and the indictment of his mentor Lundin for fraud caused his withdrawal from politics. He returned to politics in 1927 and with the support of Al Capone was elected mayor. He then embarked on a campaign to purge "pro-British" elements from the school board and school libraries of books favorable to Britain. He became the object of nationwide ridicule, and his alleged gangland connections cost him reelection in 1931. Isolationist, xenophobic, he was perhaps the most famous of America's urban demagogues.

THOMPSON, WILLIAM OXLEY (*b. Cambridge, Ohio, 1855; d. 1933*), Presbyterian clergyman. Graduated Muskingum College, 1878; Western Theological Seminary, 1882. President, Miami University, Oxford, Ohio, 1891–99; Ohio State University, 1899–1925.

THOMPSON, WILLIAM TAPPAN (*b. Ravenna, Ohio, 1812; d. Savannah, Ga., 1882*), journalist, humorist. Founder and editor of

the *Savannah Morning News*, 1850–82. Author, among other works, of a series of humorous letters originally published in a Georgia periodical and later collected as *Major Jones's Courtship* (1843), *Major Jones's Chronicles of Pineville* (1843), and *Major Jones's Sketches of Travel* (1848).

THOMPSON, ZADOCK (*b. Bridgewater, Vt., 1796; d. Burlington, Vt., 1856*), educator, naturalist, mathematician. Author, among other works, of *History of Vermont, Natural, Civil and Statistical* (1842).

THOMSON, CHARLES (*b. Co. Derry, Ireland, 1729; d. near Philadelphia, Pa., 1824*), Philadelphia teacher and merchant. Secretary of the Continental Congress, 1774–89. Came to America as a boy; prospered in trade and was active in Pennsylvania provincial politics. Described as "the life of the cause of liberty" in Philadelphia, Thomson performed his task of minuting the birth records of the nation with fidelity and zeal. Disappointed in not receiving office under the new federal government, he retired to his estate, 1789, and devoted many years to biblical scholarship and translation.

THOMSON, EDWARD (*b. Portsea, England, 1810; d. Wheeling, W. Va., 1870*), physician, Methodist clergyman. Came to America as a boy; was raised in Ohio. First president, Ohio Wesleyan University, 1842–60, he was active also as an editor and in mission work. Elected bishop, 1864, he served until his death.

THOMSON, EDWARD WILLIAM (*b. Toronto, Canada, 1849; d. Boston, Mass., 1924*), Union soldier, Canadian and American journalist, poet.

THOMSON, ELIHU (*b. Manchester, England, 1853; d. Swampscott, Mass., 1937*), scientist, inventor. Came to America as a child. Graduated Philadelphia Central High School, 1870; taught chemistry, physics, and electricity there, 1870–76, and began a partnership with Edwin J. Houston. Their success in devising an efficient and salable arc-lighting system led to the formation (1883) of the Thomson-Houston Electric Co. at Lynn, Mass., with Thomson as chief engineer. The company soon dominated the industry. In 1892 it merged with the Edison General Electric Co. to form the General Electric Co. Thomson, remaining in Lynn as a consultant, pursued investigations in many fields; he obtained nearly 700 patents. The foremost scientist in the electrical manufacturing field, he was one of the first to recognize the importance of research to industrial progress.

THOMSON, FRANK (*b. Chambersburg, Pa., 1841; d. Merion, Pa., 1899*), railroad executive. Associated *post* 1858 with the Pennsylvania Railroad, he served as assistant to Thomas A. Scott during the Civil War in directing military transport. Elected president of the Pennsylvania, 1897, he served until his death.

THOMSON, JOHN (*b. Petersburg, Va., 1776; d. 1799*), lawyer, orator, political writer. A leader among Virginia Jeffersonians and close friend of John Randolph of Roanoke.

THOMSON, JOHN (*b. Fochabers, Scotland, 1853; d. Brooklyn, N.Y., 1926*), patent attorney, inventor. Came to America as an infant; was raised in Wayne Co., N.Y. Obtained basic patent for disk water meter, December 1887; held a number of other patents for improvements in watchmaking, printing presses, and zinc refining. Headed the Thomson Meter Co.

THOMSON, JOHN EDGAR (*b. Delaware Co., Pa., 1808; d. Philadelphia, Pa., 1874*), civil engineer, railroad executive, financier. A pioneer in railroad engineering, he served with the Georgia Railroad, 1832–47, and won high reputation for his work on the grades of the Pennsylvania Railroad, 1847–54. Elected president of the road, 1852, Thomson purchased a variety of lines projected by the state of Pennsylvania (1857), and by consolidation of other lines west of Pittsburgh extended his system to Chicago. In 1870–71 the Pennsylvania Co., one of the first of the holding companies, was created to control these additional parts of the system. Continuously engaged up to the time of his death in important projects that were to render the Pennsylvania safe from competitive attack, Thomson also insisted on high standards of operating practice.

THOMSON, MORTIMER NEAL (*b. Riga, N.Y., 1831; d. New York, N.Y., 1875*), journalist, humorist, known as "Q. K. Philander Doesticks." Author, *post* 1854, of humorous letters vivid with slang and terse, vigorous phrases which appeared first in the *Detroit Daily Advertiser*, the *New York Tribune*, and the N.Y. *Spirit of the Times*. Thomson served as a staff reporter for the *Tribune* during the Civil War and afterwards continued his successful career as a humorous lecturer.

THOMSON, SAMUEL (*b. Alstead, N.H., 1769; d. Boston, Mass., 1843*), botanic physician, originator of the "Thomsonian system" of treatment by vegetable remedies and the vapor bath.

THOMSON, WILLIAM (*b. possibly Pennsylvania, 1727; d. Sweet Springs, Va., 1796*), Revolutionary soldier. Raised in South Carolina, Thomson traded with the Indians, was an indigo planter, and was active in civic affairs and the militia. During the Revolution he rendered his greatest service at Fort Moultrie in June 1776, when, with his Rangers, he blocked the British attempt to land on Sullivan's Island.

THOMSON, WILLIAM MCCLURE (*b. Spring Dale, Ohio, 1806; d. Denver, Colo., 1894*), Presbyterian clergyman, missionary in Syria. Author, among other books, of the widely selling *The Land and the Book* (1858, enlarged edition in 1880–85), a work which greatly increased knowledge of Palestine in English-speaking countries.

THORBURN, GRANT (*b. near Dalkeith, Scotland, 1773; d. New Haven, Conn., 1863*), seedsman, author. Immigrated to New York City, 1794. Beginning trade as a seedsman *ca.* 1803, he issued the first American seed catalogue, 1812. After the Scottish novelist John Galt told his life story in *Lawrie Todd* (1830), Thorburn assumed that title as a pen name for his numerous contributions to newspapers and magazines.

THOREAU, HENRY DAVID (*b. Concord, Mass., 1817; d. Concord, 1862*), essayist, poet, transcendentalist. Thoreau most resembled his Scotch maternal ancestors; on his father's side, the family derived from the Isle of Jersey and remotely from the French city of Tours. Delighting as a boy in hunting, fishing, and country sports, the young Thoreau took a passionate interest in nature; during his early maturity his journal entries on the subject were characterized by the ecstasy of pantheism, but in later life his observations became more objective and scientific. As an undergraduate at Harvard, 1833–37, he entered little into college life, went to chapel in a green coat "because the rules required black" and solaced himself in the college library with the writings of the 17th century English poets. He began keeping a journal in 1834 and continued the practice until the end of his life. At college he was particularly influenced by Edward T. Channing and Jones Very. After graduation he taught in the Concord town school and helped his father in what had become the family industry of pencil making; with his brother John he conducted a private school at Concord, 1838–41.

In September 1839, he and his brother made a thirteen-day voyage down the Concord River and up the Merrimack, immortalized later by Henry in his first book. After the closing of their school because of John's bad health, Henry lived for two years with R. W. Emerson, so beginning their long friendship; he also began meeting the group now known as the Transcendental Club and became acquainted with F. H. Hedge, A. Bronson Alcott, James F. Clarke, George Ripley, Margaret Fuller, and Elizabeth P. Peabody. While employed as a tutor on Staten Island, N.Y., in the home of William Emerson from spring 1843 to spring 1844, he came to know William H. Channing, Lucretia Mott, Henry James, Sr., and Horace Greeley, meanwhile seeking unsuccessfully to sell articles to the magazines.

Between July 4, 1845, and Sept. 6, 1847, he lived in a small house on Emerson's land on the northwest shore of Walden Pond, Concord, which he regarded as a retreat suitable for philosophic meditation and the practice of a simple, healthy life. During the summer of 1845 he was arrested for nonpayment of poll tax as a gesture of "civil disobedience" in protest against slavery and the Mexican War. After one night in jail he was released, the tax being paid by one of his aunts; the incident underlay his essay "Resistance to Civil Government" (later called "Civil Disobedience") first published in Elizabeth Peabody's *Aesthetic Papers* (1849) and retold in *Walden*. Thoreau regarded his two-year experiment in simple living as a success since it gave him leisure to think and write. On coming back to Concord village and his father's house in the autumn of 1847, he brought with him the first draft of his book *A Week on the Concord and Merrimack Rivers*, notes on life and literature gleaned from his journals and strung on a thread of narrative. He brought back also new journals to be used in the preparation of *Walden* six years later. He resided in Emerson's house through 1848 and published *Week on the Concord* at his own risk in the spring of 1849. Slightly over 200 copies were sold, and in 1853 three-quarters of the original thousand copies came back to the author. Early in 1849 he returned to live in his father's house and resided there during the rest of his life, participating in the family business and sharing in its delightful social life. Late in 1849 he toured Cape Cod, in 1850 he spent a week in Canada and in 1853 went on his second journey into Maine. From these expeditions derive in part his *Excursions* (1863), *The Maine Woods* (1864), *Cape Cod* (1865), and *A Yankee in Canada* (1866), all posthumous.

Between 1847 and 1851 he took keen delight in daily walks about Concord and thought of himself happily as a poet. However, he grew involved in the slavery question once again in October 1851, and showed a growing distrust also of the rising New England industrialism with its concomitant problems of labor. These new concerns and his new critical attitude are found in *Walden, or Life in the Woods* (finished during 1853 and published Aug. 9, 1854). Seemingly parochial in its comment on the society of Concord, it had universal social criticism in it and struck blows at all the superficialities of society and government. At first blush a harmless study of nature, it was at once disarming and devastating. Subsequent to *Walden*'s publication, Thoreau's life was anticlimactic and he became more the scientific observer than the poet of nature. He made his last trip to Cape Cod in 1855 and a last journey to Maine in 1857. Tuberculosis began to ravage him. Among friends whom he made in this period were John Brown of Osawatomie (met in Emerson's house, March 1857) and Walt Whitman whom he had met in New York the previous autumn. Thoreau's life burned out in a great enthusiasm, the defense of John Brown after his arrest in October 1859. He was the first American to make public utterance in defense of Brown, speaking at Concord on October 30 and in Boston on November 1. To him the John Brown affair was a touchstone which had tested and exposed the true nature of the American government.

Thoreau made a long journey to Minnesota seeking health in the spring of 1861, but returned home weaker than when he had left; his last days were spent feverishly editing manuscripts which he left for his sister, Sophia, to publish. The posthumous books already mentioned were drawn from this huge mass of manuscript material. His journal which had already served as quarry for himself was later the source for *Early Spring in Massachusetts* (1881), *Summer* (1884), *Winter* (1888), and *Autumn* (1892). Collected editions of his work were published in 1894 and 1906.

Thoreau's influence upon later literature, both English and American, is due in great part to his effective, usually staccato, although often poetically rhythmic, style. His ideas were presented with the pith and force of a man who is more concerned with incisive thought than with sustained argument and cares more for his sentences than for his essays as a whole. He is a master of the single vivid image. At his best, he is among the finest of American prose writers, but he is most impressive when he is read in excerpts. Of all his books, only *Walden* is really organized; the other books are material from his Journals, either padded out with reflections or left in their original leanness. His observations of nature are characterized not so much by their accuracy as by a tension that gives them at their best a splendid force, for he was always deeply perceptive of spirit manifest in form. *Walden* is his greatest achievement. It is a complete report of an experiment in thinking and living whose purpose is to argue for true values against false and to show that civilized man can escape the evils of competition and be independent of commercialism and industrialism. Although Thoreau has been called anarchistic or antisocial, it would be more accurate to describe him as one who, urging conscience above government and determined to rely upon himself before relying upon others, proposed to obey a set of laws which he regarded as more fundamental than those enforced by his particular state. His essay on civil disobedience is a classic of individualism in its inevitable conflict with government, but by no means proposes to do away with fundamental laws whose existence supports what is noblest and most worthily human. Essentially a man of letters with a touch of the prophet, Thoreau belongs with Walt Whitman as one who having put his own definition upon morality exhorted to the moral life. Both men are at the heart of the persistent American tradition of perfectibility, although Thoreau leans to the pessimistic, Whitman to the optimistic view of the matter.

THOREK, MAX (*b. Hungary, 1880; d. Chicago, Ill, 1960*), surgeon. Immigrated to the U.S. in 1897. Studied at the University of Chicago, and at Rush Medical College, M.D., 1904. Founded the American Hospital (now the Thorek Hospital and Medical Center) in Chicago, 1911. A controversial figure, Thorek was interested in mammoplasty, surgical reconstruction of the female body, and gonadal transplantation. Author of *The Human Testis* (1924) and *Plastic Surgery of the Breast and the Abdominal Wall* (1942). Founded the International College of Surgeons in Geneva in 1935.

THORNDIKE, ASHLEY HORACE (*b. Houlton, Maine, 1871; d. 1933*), educator, scholar. Brother of Edward L. and Lynn Thorndike. Graduated Wesleyan University, 1893; Ph.D., Harvard, 1898. Taught English at Boston University, Western Reserve, and Northwestern; professor of English, Columbia, 1906–33. An authority on the Elizabethan drama, he was author, among other works, of *Tragedy* (1908), *Shakespeare's Theatre* (1916), and *English Comedy* (1929). He was coeditor of "The Tudor Shakespeare," 1913–15.

THORNDIKE, EDWARD LEE (*b. Williamsburg, Mass., 1874; d. Montrose, N.Y., 1949*), educational psychologist. Brother of Ashley H. and Lynn Thorndike. B.A., Wesleyan University, 1895. B.A. Harvard, 1896; M.A., 1897. Influenced by William James, he began graduate work in psychological pioneering in the use of animals for psychological research. In 1897–98 a fellowship brought Thorndike to Columbia, where he worked primarily under James McKeen Cattell and Franz Boas; he derived from both a lifelong interest in the quantitative treatment of psychological data. He completed work for the doctorate in 1898 with his thesis, "Animal Intelligence," which inaugurated the scientific study of animal learning and laid the foundation for a dynamic psychology emphasizing stimulus-response connections (known as "S-R bonds") as the central factors in all learning. After a year at the College for Women of Western Reserve University, Thorndike came to Teachers College, Columbia University, in 1899 as instructor in genetic psychology and remained there for the rest of his life, earning the title adjunct professor in 1901, professor in 1904, and professor emeritus in 1941.

From the beginning, Thorndike's work was precise, systematic, and original; and it quickly came to symbolize his generation's commitment to developing a true science of education. Out of his experiments came a new theory of learning and a series of "laws" founded on that theory. The theory maintained that learning involves the joining of a specific stimulus to a specific response through a neural bond, so that the stimulus regularly calls forth the response. From this followed Thorndike's primary law of learning, the "law of effect," namely, that a satisfactory outcome of any response tends to "stamp out" the bond or connection. Thorndike was able to avoid the age-old problem of defining mind by simply eliminating it as a separate entity. He also discarded the biblical, Rousseauean, and Lockean views of human nature arguing that human nature is nothing more or less than a mass of "original tendencies" in man, as these are subsequently modified by learning. He emphasized activity as the basic pedagogical principle. His work lent strong support for more individualized and utilitarian approaches to education and thus served the cause of reformers who were seeking to introduce greater flexibility into education.

Thorndike may well have been the most influential educational theorist of the early twentieth century. He developed some of the earliest and most widely used American tests of aptitude and achievement. He prepared a series of arithmetics, and his *Teacher's World Book* (1921) was the foundation for the most important series of school readers to appear between the two world wars. (He also compiled a set of dictionaries for school use.) More generally, his laws of learning led to a fundamental rethinking of the entire school curriculum and affected everything from organization of course content to techniques for appraising student progress. His studies of adult learning, after 1925, opened up the field of adult education.

THORNDIKE, ISRAEL (*b. Beverly, Mass., 1755; d. Boston, Mass., 1832*), Revolutionary privateersman, merchant, Massachusetts legislator. An early participant in post–Revolutionary American trade with the Orient.

THORNDIKE, LYNN (*b. Lynn, Mass., 1882; d. New York, N.Y., 1965*), medieval historian, historian of science. Attended Wesleyan University (B.A., 1902) and Columbia (M.A., 1903; Ph.D., 1905). Taught at Northwestern University (1907–09) and Western Reserve University (until 1924) before accepting a professorship of history at Columbia University in 1924; he remained at Columbia for twenty-six years, training many American medievalists at his seminar. His *History of Medieval Europe* (1917; second revision 1949) was, in its earliest form, one of the most popular textbooks of its day. But his international reputation rests chiefly on A *History of Magic and Experimental Science* (1923–58), a masterly eight-volume exploration of the relationship between magic and science. Other major contributions to medieval scholarship include A *Catalogue of Incipits of Mediaeval Scientific Writings in Latin* (1937; rev. and enl., 1963). He helped organize the History of Science Society in 1924 and was elected to the Mediaeval Academy of America in 1926.

THORNE, CHARLES ROBERT (*b. New York, N.Y., ca. 1814; d. San Francisco, Calif., 1893*), actor, theatrical manager. Father of Charles R. Thorne (1840–1883).

THORNE, CHARLES ROBERT (*b. New York, N.Y., 1840; d. New York, 1883*), actor. Son of Charles R. Thorne (*ca. 1814–1893*). Popular for many years in heroic roles in domestic melodrama.

THORNTON, DANIEL I. J. (*b. Hall County, Tex., 1911; d. Carmel Valley, Calif., 1976*), rancher and politician. Attended Texas Technological College (1930–31) and University of California at Los Angeles (1932). He established a profitable ranching operation in Springerville, Ariz. (1937), and the Thornton Hereford Ranch in Gunnison, Colo. (1941), where he bred Thornton Triumphant cattle. He was elected as a Republican to the Colorado state senate (1948–50) and became the youngest governor in the nation (1950–54), promoting conservative fiscal policies and tourism and lobbying for highway construction. He lost his bid for the U.S. Senate (1956) and his attempt to win the primary nomination for a seat in the U.S. House of Representatives (1958). He was appointed special ambassador to Paraguay (1958). In 1961 he closed the Gunnison Ranch and retired from all business in 1974.

THORNTON, HENRY WORTH (*b. Logansport, Ind., 1871; d. New York, N.Y., 1933*), railroad executive. Efficient in management of several American railroads and of the Great Eastern Railway of England. Thornton served with great ability in the British military transport service during World War I and was the directing genius and president of the Canadian National Railways, 1922–32.

THORNTON, JESSY QUINN (*b. near Point Pleasant, present W. Va., 1810; d. Salem, Oreg., 1888*), lawyer, Oregon pioneer. Removed to Oregon, 1846; was associated with Joseph L. Meek in urging (at Washington, D.C., 1848) the establishment of a territorial government for Oregon. Author of *Oregon and California in 1848* (1849).

THORNTON, JOHN WINGATE (*b. Saco, Maine, 1818; d. Scarboro, Maine, 1878*), Boston lawyer, historian, antiquary. A founder of the New England Historic Genealogical Society and of the Prince Society, he had a part in the rediscovery of the manuscript of Bradford's history "Of Plimoth Plantation" and obtained the Trelawny papers for the Maine Historical Society. He was author, among other works, of *The Landing at Cape Ann* (1854) and *The Pulpit of the American Revolution* (1860).

THORNTON, MATTHEW (*b. Ireland, ca. 1714; d. Newburyport, Mass., 1803*), physician, Revolutionary patriot, New Hampshire legislator. Came to America as a boy. Began to practice medicine in Londonderry, N.H., ca. 1740. Prominent in pre-Revolutionary activity and president of the New Hampshire provincial congress of 1775. Thornton continued active as legislator and jurist during the Revolution. Elected to the Continental Congress, 1776, he was a signer of the Declaration of Independence; he served about one year.

THORNTON, WILLIAM (*b. Jost van Dyke, V.I., 1759; d. Washington, D.C., 1828*), architect, inventor, public official. Studied

medicine at Edinburgh and Aberdeen. Coming to America, 1787, he became a citizen and a resident of Philadelphia, Pa. An architect by avocation, he was associated with John Fitch in steamboat experimentation and was designer in 1789 of the Library Company of Philadelphia building on Fifth St. He is remembered chiefly as the successful competitor for the design of the U.S. Capitol, Washington, D.C., and for his defense of the design against the efforts of other architects and structural superintendents to alter it. He was also designer of the "Octagon House (1798–1800) in Washington, of Tudor Place in Georgetown, D.C., and of Brentwood in the District of Columbia, all of which show a plastic and spatial variety and mastery rarely found in America before their time. Pavilion VII at the University of Virginia was built from a sketch by Thornton. Appointed superintendent of patents, 1802, he served in that post until his death. Among other activities in which he engaged were the education of the deaf, the work of the American Colonization Society and the liberation of the Spanish colonies in South America.

THORNWELL, JAMES HENLEY (*b. Marlboro District, S.C., 1812; d. Columbia, S.C., 1862*), Presbyterian clergyman, educator. A teacher at South Carolina College for the greater part of the years 1837–51, he served as its president, 1851–55. Thereafter, professor of theology at the Presbyterian Seminary at Columbia, he was a leading spirit in organization of the Presbyterian Church in the Confederate States.

THORP, JOHN (*b. probably Rehoboth, Mass., 1784; d. North Wrentham, Mass., 1848*), machinist. Obtained first patent in March 1812 for a hand and water loom; patented a power loom, October 1816. In November and December 1828 he received the basic patents for the continuous method of spinning, covering improvements in spinning and twisting cotton, now called "ring spinning." He also patented a netting machine (1828) and a narrow fabric loom (1829).

THORPE, JAMES FRANCIS (*b. Prague, Indian Territory [now Oklahoma], 1888; d. Lomita, Calif., 1953*), athlete. Studied at Carlisle Indian School in Pennsylvania. Considered by many to be the greatest football player and one of the greatest athletes in modern history. Played football for Carlisle, 1908–09, helping that college defeat the University of Pennsylvania and Harvard. Won four out of five possible events at the 1912 Olympics but, because of his having played professional baseball, was disqualified as an Olympic athlete and returned his honors. Played on the New York Giants baseball team, 1913–16. Helped found the National Football League, 1922.

THORPE, ROSE ALNORA HARTWICK (*b. Mishawaka, Ind., 1850; d. San Diego, Calif., 1939*), poet, author of children's books. Her most celebrated work "Curfew Must Not Ring Tonight" was first published in the Detroit (Mich.) *Commercial Advertiser*, 1870; a collection of her poems was published in 1912.

THORPE, THOMAS BANGS (*b. Westfield, Mass., 1815; d. New York, N.Y., 1878*), artist, humorist. Resident in Louisiana ca. 1836–53, Thorpe won reputation as a painter of prairie life and as a portraitist. *Post* 1853 he resided principally in New York City, contributed to periodicals, and held public offices. He is remembered particularly today for his realistic sketches in prose of Southern frontier life; of these the most important was the "Big Bear of Arkansas," first published in the N.Y. *Spirit of the Times*, Mar. 27, 1841. A tall tale, and the first great piece of genuinely "Western" humor, it appeared in book form in the anthology edited by William T. Porter, *The Big Bear of Arkansas* (1845). Other specimens of his work were collected in *Mysteries of the*

Backwoods (1846) and *The Hive of the Bee-Hunter* (1854). Thorpe was author also of a number of works of contemporary journalistic appeal.

THRASHER, JOHN SIDNEY (*b. Portland, Maine, 1817; d. Galveston, Tex., 1879*), journalist, adventurer. Noted as a proslavery protagonist of the purchase of Cuba, Thrasher was also concerned in several attempts at armed intervention there, among them the activities of John A. Quitman in 1852 and after.

THROOP, ENOS THOMPSON (*b. Johnstown, N.Y., 1784; d. 1874*), lawyer, New York jurist and politician. Uncle of Montgomery H. Throop. Elected lieutenant governor of New York (Democrat) 1828, he became acting governor in March 1829 and after election in 1830 held the post until 1833.

THROOP, MONTGOMERY HUNT (*b. Auburn, N.Y., 1827; d. Albany, N.Y., 1892*), lawyer, legal writer. Nephew of Enos T. Throop and also of Ward Hunt. Partner at various times of his uncle Hunt and of Roscoe Conkling, Throop was a strong Democrat and opposed coercion of the South during Reconstruction. Chairman of a commission to revise the New York statues, he was principal author of the 1877 *Code of Civil Procedure* and thereafter devoted most of his time to legal authorship.

THULSTRUP, BROR THURE (*b. Stockholm, Sweden, 1848; d. New York, N.Y., 1930*), artist, illustrator. After military training and service in Sweden and with the French Foreign Legion, he immigrated to Canada in the Early 1870's, but soon removed to the United States where he was successful for many years as a painter of military subjects.

THUMB, TOM *See* STRATTON, CHARLES SHERWOOD.

THURBER, CHARLES (*b. East Brookfield, Mass., 1803; d. Nashua, N.H., 1886*), teacher, inventor, manufacturer. Received a U.S. patent in August 1843 for a hand printing machine which was the first invention that approximated the modern typewriter.

THURBER, CHRISTOPHER CARSON (*b. Norwich, Conn., 1880; d. Greece, 1930*), social worker. Performed heroic service for the Near East Relief organization in Turkey and Greece *post* 1921.

THURBER, GEORGE (*b. Providence, R.I., 1821; d. Passaic, N.J., 1890*), botanist, horticulturist. Served as botanist on Mexican Boundary Survey, 1850–53; editor, *American Agriculturist*, 1863–85. One of the earliest exponents of agricultural botany, he was a specialist in study of the grasses.

THURBER, JAMES GROVER (*b. Columbus, Ohio, 1894; d. New York, N.Y., 1961*), writer, cartoonist. Attended Ohio State University. Began his journalistic career as a reporter on the Columbus *Evening Dispatch* (1920). In 1927 he met E. B. White, who introduced him to *New Yorker* editor Harold Ross, and Thurber then joined the magazine's staff. In 1929 White and Thurber collaborated on *Is Sex Necessary?*. This was followed by *The Seal in the Bedroom* (1932), a book of Thurber cartoons, and *My Life and Hard Times* (1933). Further establishing his reputation as an illustrator and humorist were "The Secret Life of Walter Mitty" (*New Yorker*, March 18, 1939), *Fables for Our Time* (1940), and *My World — and Welcome to It* (1942). Later in his career he experimented with fantasy and fairy tale, as typified by *The 13 Clocks* (1950) and *The Wonderful O* (1957). In 1960 he appeared on Broadway in *A Thurber Carnival*, based on his literary sketches and cartoon captions.

THURBER, JEANNETTE MEYER (*b. New York, N.Y., 1850; d. Bronxville, N.Y., 1946*), patron of music. Founded National Con-

servatory of Music, 1885; American Opera Company, 1886. Sought to secure federal support for the Conservatory as a national institution.

Thure De Thulstrup *See* Thulstrup, Bror Thure.

Thurman, Allen Granberry (*b. Lynchburg, Va., 1813; d. Columbus, Ohio, 1895*), lawyer, Ohio jurist. Studied law with his uncle William Allen (1803–1879), and with Noah H. Swayne. Long active in Democratic politics in Ohio, he served in the U.S. House of Representatives, 1845–47, and was chief justice of the supreme court of Ohio, 1854–56. Opposing federal interference in the question of slavery in the territories, he was a leader of the "Peace Democrats" during the Civil War although an opponent of the doctrine of secession. Serving as U.S. senator, 1867–79, he was a partisan Democrat of the school of Jefferson, a valuable member of the judiciary committee and chairman of that committee in the 46th Congress. He is best remembered as author of the Thurman Act relating to the Pacific railroads; he ran unsuccessfully for vice president on the Democratic ticket, 1888.

Thursby, Emma Cecilia (*b. Brooklyn, N.Y., 1845; d. New York, N.Y., 1931*), singer, voice teacher. One of the first American singers to win international fame and a noted interpreter of Mozart, she was teacher, among others, of Geraldine Farrar.

Thurston, Howard (*b. Columbus, Ohio, 1869; d. Miami, Fla., 1936*), magician. Influenced in choice of his profession by example of Alexander Herrmann, Thurston played for many years with trifling success until a triumphant engagement at Tony Pastor's theater in New York City, 1899. Attractive in his personality and a fine showman who contrived his effects regardless of expense, Thurston was a leading performer in vaudeville, 1908–30, thereafter playing principally in motion-picture theaters.

Thurston, Lorrin Andrews (*b. Honolulu, Hawaii, 1858; d. 1931*), lawyer, Hawaii official. Grandson of Lorrin Andrews. A leader in the movement to overthrow the native Hawaiian government and annex the islands to the United States, Thurston drafted the 1893 proclamation of the provisional government and headed the commission sent to Washington to secure annexation. He was prominent thereafter in industry and the tourist business and was owner-editor of the *Honolulu Advertiser*.

Thurston, Robert Henry (*b. Providence, R.I., 1839; d. Ithaca, N.Y., 1903*), engineer, educator. Son of Robert L. Thurston. Graduated Brown, 1859. Rose to rank of first assistant engineer, U.S. Navy, during Civil War service; headed department of natural and experimental philosophy, U.S. Naval Academy, 1866–71. Devised pioneer four-year course of instruction in mechanical engineering (including both a mechanical laboratory and shop courses) which became basis for curriculum at Stevens Institute of Technology where he served as professor of mechanical engineering, 1871–85. Developer of further innovating courses and techniques of instruction, he was author also of textbooks (notably *The Materials of Engineering*, 1883–84), manuals, and technical papers in many fields. Director of Sibley College, Cornell University, 1885–1903, he worked tirelessly to develop the college and its department of experimental engineering; he himself taught the courses in thermodynamics and steam engineering.

Thurston, Robert Lawton (*b. Portsmouth, R.I., 1800; d. 1874*), pioneer manufacturer of steam engines. Father of Robert H. Thurston. Partner, *post* 1830, in the Providence Steam Engine Co. and successor firms, he was first manufacturer of engines to employ the Sickels "drop cut-off" and to build a standard form of expansion steam engine.

Thurstone, Louis Leon (*b. Chicago, Ill., 1887; d. Chapel Hill, N.C., 1955*), psychologist. Graduated from Cornell University and the University of Chicago, Ph.D., 1917. Taught at the Carnegie Institute of Technology, 1915–24; and at the University of Chicago, 1924–52. Established a psychometric laboratory in 1930. President of the American Psychological Association, 1932–33. A specialist in developing and applying mathematical means of measuring mental activity, Thurstone developed many tests for the army and the American Council of Education. At Chicago, he worked on the measurement of intelligence, approaching it as a problem in multiple correlation. Wrote *The Vectors of Mind* (1935) and *Multiple-Factor Analysis* (1947). Also did work in the measurement of mental stimulation. Founded a psychometric laboratory at the University of North Carolina, 1952.

Thwaites, Reuben Gold (*b. Dorchester, Mass., 1853; d. Madison, Wis., 1913*), journalist, librarian, editor. Removed to Wisconsin, 1866. Managing editor of the *Wisconsin State Journal*, 1876–86, he became a friend and protégé of Lyman C. Draper who recommended him in 1886 for the post of secretary of the Wisconsin State Historical Society. Taking office in 1887, he built up the Society's manuscript collections (in 1891 adding the Draper Manuscripts) and generally made the Society a great center for historical research. During his tenure he produced a yearly volume of the Society's *Proceedings* and a biennial volume of *Collections* and did a vast amount of other editorial work. Among projects supervised by him were the *Jesuit Relations and Allied Documents* (73 vols., 1896–1901), *Original Journals of the Lewis and Clark Expedition* (8 vols., 1904–05), *Early Western Travels* (32 vols. of annotated reprints, 1904–07). He was author also of a number of works including *France in America* (1905) and *Wisconsin* (1908).

Thwing, Charles Franklin (*b. New Sharon, Maine, 1853; d. Cleveland, Ohio, 1937*), Congregational clergyman, educator. Graduated Harvard, 1876; Andover Theological Seminary, 1879. Presided ably over great expansion of Western Reserve University while president, 1890–1921, establishing schools of law, dentistry, pharmacy, applied social science and also a graduate school in liberal arts. He also affiliated the university with the city in developing the Cleveland School of Education. He was a prolific writer on educational and historical subjects.

Thye, Edward John (*b. Frederick, S. Dak., 1896; d. near Northfield, Minn., 1969*), governor of Minnesota, U.S. senator. Attended the American Business College (1914–16). A farmer for his entire life, Thye achieved statewide political prominence in 1938 when Harold Stassen, the governor of Minnesota, appointed him deputy commissioner of agriculture. He was elected Minnesota's lieutenant governor in 1942, succeeding Stassen as governor when the latter resigned to serve in the Navy in 1943. Thye was elected to a full term as governor in 1944; in 1947 he was elected to the U.S. Senate, serving there until 1959, but always remaining close to his farm roots. He was defeated for a third term in the Senate by Eugene J. McCarthy.

Tibbett, Lawrence Mervil (*b. Bakersfield, Calif., 1896; d. New York, N.Y., 1960*), baritone. American-trained, Tibbett made his Metropolitan Opera debut in 1923 in *Boris Godunov*; received tremendous acclaim in 1925, substituting in the role of Ford in Verdi's *Falstaff*. Sang with the Metropolitan until 1950, performing 559 times. A superb singer, Tibbett was one of the first Americans to achieve an international reputation. Helped

found the American Guild of Musical Artists in 1936; president, 1940–52; honorary president, 1952–60.

TIBBLES, SUSETTE LA FLESCHE *See* BRIGHT EYES.

TIBBLES, THOMAS HENRY (*b. Washington Co., Ohio, 1838; d. Omaha, Nebr., 1928*), journalist, social reformer, friend of the Indians, Populist leader.

TICHENOR, ISAAC (*b. Newark, N.J., 1754; d. Bennington, Vt., 1838*), lawyer, Vermont legislator and jurist. U.S. senator, Federalist, from Vermont, 1796–97. Served with tact and intelligence as governor of his state, 1797–1807, 1808–09. Once again U.S. senator, 1815–21, he played no prominent part in national affairs.

TICHENOR, ISAAC TAYLOR (*b. Spencer Co., Ky., 1825; d. Atlanta, Ga., 1902*), Baptist clergyman, Confederate chaplain, educator. Held principal pastorate in Montgomery, Ala.; first president, Alabama State Agricultural and Mechanical College, 1872–82; secretary, Southern Baptist Home Missionary Board.

TICKNOR, ELISHA (*b. Lebanon, Conn., 1757; d. Hanover, N.H., 1821*), Boston, Mass., educator and merchant. Father of George Ticknor. Urged improvement in public school system, especially establishment of free schools for children under 7 years of age.

TICKNOR, FRANCIS ORRAY (*b. Fortville, Ga., 1822; d. 1874*), physician, poet. Long in practice in rural Georgia, Ticknor was author of a number of poems including the Confederate heroic ballad "Little Giffen" and possibly "The Barefooted Boys." An incomplete collected edition of his work appeared as *Poems of Frank D. Ticknor, M.D.* (ed. Kate M. Rowland, 1879).

TICKNOR, GEORGE (*b. Boston, Mass., 1791; d. Boston, 1871*), educator, author. Son of Elisha Ticknor. Graduated Dartmouth, 1807. A man of independent means, Ticknor abandoned practice of the law for a career as a scholar. Between 1815 and 1819 he traveled widely in Europe, calling on leading scientists, scholars, and men of letters and pursuing formal studies mainly at the University of Göttingen. One of the first students from the United States to attend German institutions of learning for the expressed purpose of obtaining a university training more advanced than that to be had at home, Ticknor at first devoted himself to Greek philology. On appointment to the Smith professorship of French and Spanish at Harvard with an added professorship of *belles letters* (accepted by him, November 1817), he made special studies in France, Italy, and Spain. In August 1819 he was inducted into the professorship which he was to hold until 1835. A leader in efforts to broaden the stereotyped curriculum at Harvard, he proposed a division of the college into departments which would handle related subjects of study. He succeeded, however, only in making this method of organization official for his own modern language courses and resigned in favor of Henry W. Longfellow. After further travel in Europe and a long process of research, he published in 1849 his classic *History of Spanish Literature*, the first truly scholarly survey ever produced of the whole range of Spanish letters and a seminal work in later Hispanic studies. He was an active benefactor of the Boston Public Library and was author also of a number of other books, but his reputation rests on his pioneer work in Spanish literature.

TICKNOR, WILLIAM DAVIS (*b. Lebanon, N.H., 1810; d. Philadelphia, Pa., 1864*), publisher. Cousin of George Ticknor. Headed the leading New England publishing firm of its time (in which James T. Fields early became a junior partner) known successively as Allen and Ticknor (1832–33), William D. Ticknor and Co. (1833–49), Ticknor, Reed and Fields (1849–54), and Ticknor and Fields. Publisher of the *Atlantic Monthly* and of many of the leading contemporary writers of England and America. Ticknor was a close friend of Nathaniel Hawthorne.

TIDBALL, JOHN CALDWELL (*b. Ohio Co., present W. Va., 1825; d. 1906*), Union major general of volunteers by brevet. Graduated West Point, 1848. An artillery expert, he served principally with the Army of the Potomac during the Civil War and showed outstanding skill in management of artillery in support of cavalry as well as in siege work. He retired as colonel, regular army, 1889.

TIEBOUT, CORNELIUS (*b. New York, N.Y., 1777; d. New Harmony, Ind., ca. 1832*), line and stipple engraver. Apprenticed to a goldsmith in New York City, Tiebout received training in London, 1793–96. After working in New York City, 1796–99, he removed to Philadelphia where he remained active until about 1825 and was in partnership, 1817–22, with Benjamin Tanner and Francis Kearny in banknote engraving. In 1826, he removed with William Maclure to New Harmony, where he taught in the community school.

TIEDEMAN, CHRISTOPHER GUSTAVUS (*b. Charleston, S.C., 1857; d. Buffalo, N.Y., 1903*), professor of law, writer of legal treatises and textbooks. Taught at University of Missouri and present New York University; dean, University of Buffalo Law School, 1902–03.

TIERNAN, FRANCES CHRISTINE FISHER (*b. Salisbury, N.C., 1846; d. Salisbury, 1920*), novelist, author. Devoted to the Confederacy and to her Catholic religion, she was author of some fifty now-forgotten novels including *Valerie Aylmer* (1870, under pseudonym of Christian Reid) and *Carmela* (1891).

TIERNEY, RICHARD HENRY (*b. Spuyten Duyvil, N.Y., 1870; d. New York, N.Y., 1928*), Roman Catholic clergyman, Jesuit, journalist. Liberal and aggressive editor of the weekly *America*, 1914–25.

TIFFANY, CHARLES LEWIS (*b. Killingly, Conn., 1812; d. Yonkers, N.Y., 1902*), jeweler. Opened a stationery and notion store in New York City, 1837, which through successive partnerships became the famous Tiffany & Co., 1853. Thenceforward until his death he was considered leader of the jewelry trade in America.

TIFFANY, KATRINA BRANDES ELY (*b. Altoona, Pa., 1875; d. New York, N.Y., 1927*), civic worker, social reformer. Daughter-in-law of Louis C. Tiffany. Graduated Bryn Mawr, 1897. A leader in charitable work, the suffrage movement, and the New York League of Women Voters.

TIFFANY, LOUIS COMFORT (*b. New York, N.Y., 1848; d. New York, 1933*), painter, glassmaker, philanthropist. Son of Charles L. Tiffany. Studied with George Inness and Samuel Colman; later studied in Paris. Organized Society of American Artists, 1877, with John La Farge, Augustus Saint-Gaudens, and others. Possessed of an oriental love of color, he began experiments with stained glass, 1875, and devised a process of his own for production of what he called "Favrile glass" which brought him great popular reputation. His largest work in this medium was the curtain for the National Theatre, Mexico City; he was also a designer of jewelry, rugs, and textiles and a patron of other artists.

TIFFANY, LOUIS MCLANE (*b. Baltimore, Md., 1844; d. 1916*), surgeon. Grandson of Louis McLane. M.D., University of Maryland, 1868; studied in office of Nathan R. Smith. A teacher at Maryland, 1869–1902, he was a pioneer in many fields; he is

credited with performing the first nephrolithotomy in America and the first successful gastroenterostomy in Baltimore (October 1892). For many years he dominated surgical thought and practice in Maryland.

Tiffin, Edward (*b. Carlisle, England, 1766; d. probably Chillicothe, Ohio, 1829*), physician, Ohio legislator and jurist, public official. Immigrated to present Jefferson Co., W. Va., 1784; attended Jefferson Medical College, Philadelphia, Pa.; removed to Chillicothe, Ohio, 1798. A leader of Ohio (Democrat) Republicans, he served as the first governor of Ohio, 1803–06, and as U.S. senator, 1807–09. As commissioner of the General Land Office, 1812–14, he brought order out of its chaotic records and surveys. Thereafter until death, he served as surveyor general of the Northwest.

Tigert, John James (*b. Louisville, Ky., 1856; d. Tulsa, Okla., 1906*), clergyman of the Methodist Episcopal Church, South, educator and editor.

Tigert, John James (*b. Nashville, Tenn., 1882; d. Gainesville, Fla., 1965*), professor, U.S. commissioner of education, and university president. Attended Vanderbilt University (B.A., 1904) and Oxford University (B.A. in jurisprudence, 1907; M.A., 1915). The grandson of the first president of Vanderbilt, Tigert began his academic career as professor of philosophy and psychology at Central College in Fayette, Mo. (1907). Became president of Kentucky Wesleyan College (1909), then joined the University of Kentucky as professor of philosophy and psychology (1911). Appointed U.S. commissioner of education in 1921, the youngest man to have held that office. In 1928 became president of the University of Florida at Gainesville, a post he held for nineteen years. Under Tigert, the university conferred its first Ph.D. degrees (1934). His greatest curriculum innovation was creating the General College to provide general arts and sciences instruction for all freshmen and sophomores.

Tikamthi *See* Tecumseh.

Tilden, Samuel Jones (*b. New Lebanon, N.Y., 1814; d. Yonkers, N.Y., 1886*), lawyer, statesman. Acquainted as a boy with Martin Van Buren, Silas Wright, William L. Marcy, and other Democratic leaders of the time, Tilden grew up in frail health and received a somewhat sporadic formal education. He attended Yale for one term in 1834 and then attended the University of the City of New York (present New York University) but concerned himself mainly for several years with writing political treatises for newspapers in support of Van Buren's policies. After attending the law school of the University of the City of New York, 1838–41, and simultaneously clerking in the office of John W. Edmonds, he was admitted to the bar and began practice in New York City, 1841. He soon became a commanding figure in the New York Democracy and a leader of the free-soil opposition group called "Barnburners." Divorced from practical leadership in the party because of the resultant split of the Democratic factions, he turned his energies to the development of his law practice and was conspicuously successful in many complex cases, showing a peculiar genius for railroad reorganization and refinancing. In this way, and through acquisition of mining interests, he laid the foundation of his later enormous fortune.

Tilden opposed Lincoln's election and disapproved of the Civil War from the beginning, but at the declaration of war advised E. M. Stanton to call out immediately the full military strength of the North and so crush the rebellion by a swift stroke. Thereafter, he encouraged the Democratic party in its "constitutional opposition" to the powerful centralized Washington government. He favored President Andrew Johnson's liberal policy of Reconstruction. As chairman of the New York State Democratic committee, 1866–74, he performed the great service of ousting William M. Tweed and his "ring," leading the battle for adequate legislation with which to fight the situation in New York City and aiding in the production of the necessary judicial proof. He was responsible also at this time for reforming and purifying the state judiciary. As governor of New York, 1875–77, he continued his efforts for reform, brought about a substantial reduction in state taxes and expenses, and broke the so-called "Canal ring," a bipartisan group of thieving politicians who had battened on the repair and extension of the state canal system.

Having fired the imagination of the country by his reform activities, he was nominated by the Democrats for the presidency at St. Louis, Mo., June 1876; Thomas A. Hendricks ran with him for vice president. After a campaign of exceptional bitterness, Tilden received a majority of the popular vote, but lost the election when the doubtful states of Oregon, Louisiana, South Carolina, and Florida were claimed by the Republican managers for their candidate, Rutherford B. Hayes. A controversy followed which was resolved by creation of an Electoral Commission containing a majority of one in favor of the Republicans. By a strict party vote, the Commission declared in favor of Hayes's claim. Tilden acquiesced in the decision only as an escape from a renewal of civil war. Remaining to the end of his life a significant figure in national politics, Tilden left the bulk of his estate in trust for establishment of a free library for New York City. Unimpressive in appearance and plagued through life by ill health, Tilden was secretive and dilatory, yet he possessed great power of concentration when he chose, had a marvelous memory and was indebted for his success to intellect rather than personality.

Tilden, William Tatem ("Big Bill"), II (*b. Philadelphia, Pa., 1893; d. Los Angeles, Calif., 1953*), tennis player. Studied at the University of Pennsylvania. Won the U.S. championship seven times and in 1920 was the first American to win the men's singles at Wimbledon; won again in 1921 and 1930. As a professional player, Tilden continued to dominate the sport. He wrote a syndicated column and appeared in several films and stage plays. Persecuted as a homosexual, he served two prison terms in the 1940's and died penniless. In 1949, the Associated Press named him the greatest tennis player of the first half of the twentieth century.

Tileston, Thomas (*b. Boston, Mass., 1793; d. New York, N.Y., 1864*), printer, merchant, shipowner, financier. Removing to New York City, 1818, he entered the successful shipping partnership of Spofford & Tileston. President of the Phoenix Bank, 1840–64, he was also a founder (1829) and director of the Atlantic Insurance Co.

Tilghman, Edward (*b. Wye, Md., 1750/51; d. Philadelphia, Pa., 1815*), lawyer. Cousin of William and Tench Tilghman. Practicing in Philadelphia *post* 1774, he was a powerful advocate and was recognized as an authority in the field of contingent remainders and executory devices.

Tilghman, Matthew (*b. Queen Anne Co., Md., 1718; d. Talbot Co., Md., 1790*), landowner, Maryland colonial legislator and jurist, Revolutionary patriot. Headed Maryland delegation to Continental Congress, September 1774–December 1776; served as president of the Annapolis convention in August 1776 which drafted the first state constitution.

Tilghman, Richard Albert (*b. Philadelphia, Pa., 1824; d. 1899*), chemist. Grandson of Edward Tilghman. Graduated University of Pennsylvania, 1841; gained practical experience in lab-

oratory of James C. Booth. His paper "On the Decomposing Power of Water at High Temperatures" (*Proceedings, American Philosophical Society*, IV, 1847) was the first systematic study of hydration. Employed for much of his time in Scotland and England, he was the developer of many industrial processes including those for manufacture of potassium dichromate, for the manufacture of paper pulp by sulphite process, and for the "sand blast" process for shaping objects out of hard, brittle materials.

TILGHMAN, TENCH (*b. Talbot Co., Md., 1744; d. Baltimore, Md., 1786*), merchant, Revolutionary soldier. Grandson of Tench Francis; brother of William Tilghman; cousin of Edward Tilghman. Trusted and able aide-de-camp to General George Washington, August 1776–83. He rose to rank of lieutenant colonel and was selected to carry the news of the surrender of Cornwallis to the Continental Congress.

TILGHMAN, WILLIAM (*b. Talbot Co., Md., 1756; d. Philadelphia, Pa., 1827*), Maryland legislator. Pennsylvania jurist. Brother of Tech Tilghman; grandson of Tench Francis; cousin of Edward Tilghman. Graduated College of Philadelphia, 1772; read law in office of Benjamin Chew. A Loyalist during the Revolution, he served 1788–93 in the Maryland Assembly and Senate. Removing to practice in Philadelphia, 1793, he held several Pennsylvania judicial appointments before becoming chief justice of the Pennsylvania supreme court, 1806. He served in this post until his death.

TILGHMAN, WILLIAM MATTHEW (*b. Fort Dodge, Iowa, 1854; d. Cromwell, Okla., 1824*), outstanding peace officer in Kansas and Oklahoma *post* 1877.

TILLICH, PAUL (*b. Starzeddel, East Prussia, Germany [now in Poland], 1886; d. Chicago, Ill., 1965*), theologian, philosopher. Attended the University of Berlin, the University of Breslau (Ph.D., 1910), the University of Breslau (Ph.D., 1910), and the University of Halle (licentiate in theology, 1912). Son of a Lutheran pastor, Tillich was ordained a minister of the Evangelical Lutheran Church in 1912. Served as field chaplain on the western front (1914–18), an experience that transformed both his theology and his life. In his first public lecture on his own thought before the Kant Society (1919), he introduced his now-famous dictum: "Religion is the substance of culture; culture is the form of religion." Was associate professor of theology at the University of Marburg (1924), professor of philosophy and religious studies at Dresden's Institute of Technology (1924–29), and professor of philosophy at the University of Frankfurt (1929–33). His first book, *The Religious Situation* (1925), challenged Karl Barth's exclusion of cultural problems from theology, while his second, *The Socialist Decision* (1933), so provoked the Nazis that he was suspended from the University of Frankfurt. In December 1933 he came to the United States, becoming a U.S. citizen in 1940. Visiting lecturer in philosophy at Columbia University and visiting professor of theology at Union Theological Seminary. His twenty-two years at Union saw the publication of some of his most significant English works: *The Protestant Era* (1948), the *Courage to Be* (1952), and volume I of the *Systematic Theology* (1951). In 1955 Tillich was appointed to Harvard as university professor. Here he published volume II of the *Systematic Theology, Existence and the Christ* (1957), a work that aroused concern about his orthodoxy. Upon retiring from Harvard (1962), he became Nuveen Professor of Theology at the University of Chicago Divinity School. The third volume of *Systematic Theology*, cumulatively his greatest contribution to theology, appeared in 1963. An unrivaled "major mentor" of systematic theologians, Tillich was probably the most famous American theologian of the century.

TILLMAN, BENJAMIN RYAN (*b. Edgefield Co., S.C., 1847; d. 1918*), farmer, politician. A blunt, irascible, unmannerly representatively of rural interests in his state *post* 1885, he forced South Carolina to undertake a system of agricultural education, served as Democratic governor, December 1890–1894, and was for many years complete master of South Carolina politics. Organizing an uprising of the farmers against the long-powerful aristocratic element, he dictated a new constitution for the state in 1895, meanwhile equalizing taxes, reapportioning legislative representation, and virtually disfranchising the blacks. He also implemented the powers of the state railroad commission, increased expenditures for public education, and established a public monopoly (1893) over the sale of liquor. Elected U.S. senator, 1894, he served until his death and won national notoriety as an extreme champion of southern agrarianism, becoming known as "Pitchfork Ben." A violent and unscrupulous enemy of Presidents Cleveland and Theodore Roosevelt, he was exposed by the latter as a user of influence in land purchases, and his power in South Carolina declined. His most constructive act as a senator was the steering of the Hepburn Bill through the Senate. A defender of the use of force in disfranchising the black and an advocate of repeal of the Fifteenth Amendment, Tillman grew more conservative as his personal ambitions were gratified.

TILNEY, FREDERICK (*b. Brooklyn, N.Y., 1875; d. Oyster Bay, N.Y., 1938*), neurologist. Graduated Yale, 1897; M.D., Long Island College Hospital, 1903; Ph.D., Columbia, 1912. Taught at N.Y. College of Physicians and Surgeons *post* 1915. Medical director, Neurological Institute, 1935–38.

TILSON, JOHN QUILLIN (*b. Clear Branch, Tenn., 1866; d. New London, N.H., 1958*), lawyer, politician. Studied at Carson-Newman College and at Yale University, LL.B., 1893. Practiced law and participated in Connecticut state politics. Republican Congressman, 1909–13, and 1915–31; majority leader, 1925–31. Author of *Manual of Parliamentary Law and Procedure* (1935).

TILTON, EDWARD LIPPINCOTT (*b. New York, N.Y., 1861; d. Scarsdale, N.Y., 1933*), architect. Designed U.S. immigrant station on Ellis Island (completed, 1900); was especially notable for contributions to modern public library design.

TILTON, JAMES (*b. Kent Co., Del., 1745; d. near Wilmington, Del., 1822*), army surgeon. Graduated College of Philadelphia, B.M., 1768, and M.D., 1771. A regimental and hospital surgeon during the Revolution, he served also as surgeon general of the U.S. Army, 1813–15. He was author of two important treatises: *Economical Observations on Military Hospitals* (1813) and *Regulations for the Medical Department* (1814).

TILTON, JOHN ROLLIN (*b. Loudon, N.H., 1828; d. Rome, Italy, 1888*), landscape painter. Resident in Italy *post* 1852; he specialized in pictures of places famous for their historical associations.

TILTON, THEODORE (*b. New York, N.Y., 1835; d. Paris, France, 1907*), journalist. Managing editor of the *Independent*, a Congregationalist journal, 1856–70, he was a close associate of Henry Ward Beecher and prominent in the antislavery movement and as a post—Civil War Republican partisan. At first attempting to suppress knowledge of alleged adulterous relations between his wife and Beecher, he brought suit against the minister. The trial began Jan. 11, 1875, in Brooklyn, N.Y., lasted 112 trial days, and resulted in a hung jury and a division of public opinion over Beecher's culpability that still persists. Ruined in fortune and reputation, Tilton left the United States, 1883, never to return.

TILYOU, GEORGE CORNELIUS (*b. New York, N.Y., 1862; d. 1914*), amusement park owner and inventor. Laid out Coney Island's famous "Bowery"; founded Steeplechase Park, 1897. Tilyou originated most of the fun-devices used in his enterprises.

TILZER, HARRY VON (*b. Detroit, Mich., 1872; d. New York, N.Y., 1946*), composer and publisher of popular songs. Born Harry Gumm, son of German Jewish parents; adopted his mother's maiden name (with an added "Von"), *ca.* 1887. After work as a tumbler in the circus, in a traveling repertory company, and in burlesque, he came to New York City, 1892, and began writing songs for vaudeville performers. His first great success was "My Old New Hampshire Home" (1898); two years later, he wrote and published "A Bird in a Gilded Cage," which won him wealth and fame. Perhaps his most productive year was 1905, when he wrote (among others) "On a Sunday Afternoon," "Down Where the Wurzburger Flows," "Wait 'til the Sun Shines, Nellie," and "Where the Morning Glories Twine Around the Door." Later successes were "I Want a Girl Just Like the Girl That Married Dear Old Dad" (1911) and "That Old Irish Mother of Mine" (1920).

TIMBERLAKE, GIDEON (*b. Charlottesville, Va., 1876; d. St. Petersburg, Fla., 1951*), physician, urologist. Studied at the University of Virginia, M.D., 1902, and at Johns Hopkins University. Taught at the University of Maryland Medical School, 1910–17. Persuaded the army to establish a school of urology; became chief of the department of urology at Walter Reed Hospital in Washington. Left the University of Maryland in 1926 and entered private practice in Greenville, S.C. and in St. Petersburg, Fla., 1928.

TIMBERLAKE, HENRY (*b. Hanover Co., Va., 1730; d. London, England, 1765*), soldier. Served in French and Indian War; was distinguished for mission (accompanied by Thomas Sumter) to the Cherokees, November 1761–62. Accompanied Outacity and two warriors to England on state visit, 1762. Author of a valuable volume of *Memoirs* (London, 1765) recording his war experiences and observations of the customs and ceremonies of the Cherokee.

TIMBY, THEODORE RUGGLES (*b. Dutchess Co., N.Y., 1822; d. Brooklyn, N.Y., 1909*), inventor. Filed a *caveat*, January 1843, covering a revolving gun turret for use on land or water, a device unrecognized until used by John Ericsson as a feature of his first *Monitor*, 1861–62.

TIMKEN, HENRY (*b. near Bremen, Germany, 1831; d. San Diego, Calif., 1909*), wagon maker, manufacturer. Immigrated to Missouri as a boy. Patented a successful carriage spring, 1877, which he manufactured with profit; patented the Timken tapered roller bearing, June 1898.

TIMM, HENRY CHRISTIAN (*b. Hamburg, Germany, 1811; d. Hoboken, N.J., 1892*), musician, conductor. Immigrated to New York City, 1835. An accomplished organist and pianist, he was an early member of the New York Philharmonic Society and its president, 1848–63.

TIMME, WALTER (*b. New York, N.Y., 1874; d. St. Petersburg, Fla., 1956*), physician, neurologist, endocrinologist. Graduated from the City College of New York and Columbia University, 1897. Member of the staff of the Neurological Institute of New York, 1910–37; professor of clinical neurology at Columbia University, 1929–37. First publicly described the Timme syndrome in 1918: ovarian and adrenal insufficiency leading to compensatory hypopituitarism. Founded and was first president of the Association for Research in Nervous and Mental Diseases, 1920.

TIMON, JOHN (*b. Conewago, Pa., 1797; d. 1867*), Roman Catholic clergyman, Vincentian. Ordained, 1825, at St. Louis, Mo., he served in the missions of the Southwest, held administrative posts in his Order, and came to be one of the best-known priests in the Mississippi Valley. Consecrated first bishop of Buffalo, N.Y., 1847, he served with great ability until his death. He was especially noted for his interest in charitable and educational institutions.

TIMOTHY, LEWIS (*b. France or Holland, date unknown; d. Charleston, S.C., 1738*), printer. Immigrated to Philadelphia, Pa., October 1731. First an employee and later a partner of Benjamin Franklin, Timothy conducted a printing business at Charleston, 1734–38, as successor to Franklin's former partner there. His publication *The Laws of the Province of South-Carolina* (1736) was the most ambitious production of the South Carolina colonial press.

TIMROD, HENRY (*b. Charleston, S.C., 1828; d. Columbia, S.C., 1867*), educator, poet. The most gifted Southern poet of his time (with exception of Sidney Lanier), Timrod possessed high artistic integrity and a crystalline style. He surpassed most of his poetical contemporaries in knowledge of his craft, in taste, and in sheer lyrical power, despite the restricted range and the small body of his production. A lifelong friend of Paul H. Hayne and a literary associate of William G. Simms, he brought out a small collection of his poems in 1860, which was lost sight of in the coming of civil war. The passionate war poems which brought him notice as the "laureate of the Confederacy" showed a ripening of his powers; however, after discharge from the Confederate Army because of his incipient tuberculosis, he suffered one calamity after another and was reduced to abject poverty. Despite his misfortunes, he continued to compose, producing what is perhaps his most perfect composition, the "Magnolia Cemetery Ode," shortly before his death. In 1873 his friend Hayne edited *The Poems of Henry Timrod*, prefacing them with a sympathetic memoir of the author. In his ideals, his fancy, his spirituality, and his high-mindedness, Timrod was characteristic of the finest qualities of his section; it is an irony of American literature that so gentle a spirit should have been the outstanding poet of the Confederacy at war.

TINCKER, MARY AGNES (*b. Ellsworth, Maine, 1831; d. Dorchester, Mass., 1907*), novelist, teacher. A convert to Catholicism, 1851, she contributed to periodicals and was author of 11 novels and books of sketches; among them the most popular was *Signor Monaldini's Niece* (1879). Her work received much contemporary praise.

TINGEY, THOMAS (*b. London, England, 1750; d. Washington, D.C., 1829*), naval officer. Trained in the British navy and later a merchant captain, he resided in the United States *post* 1783. Made captain in the U.S. Navy, September 1798, he served with credit during the naval war with France and in 1800 was appointed to lay out and command the new Washington, D.C., navy yard. He remained in charge of this yard under various titles until his death. Thomas T. and Tunis A. M. Craven were his grandsons.

TINGLEY, KATHERINE AUGUSTA WESTCOTT (*b. Newbury, Mass., 1847; d. Sweden, 1929*), theosophical leader.

TINKHAM, GEORGE HOLDEN (*b. Boston, Mass., 1870; d. Cramerton, N.C., 1956*), politician. Graduated from Harvard, 1894. Practiced law and participated in Massachusetts state politics. As a Republican Congressman, 1915–43, he was a strict isolationist, a foe of Prohibition, a staunch supporter of civil rights, and an opponent of the New Deal.

TIOMKIN, DIMITRI (*b. Poltava, Ukraine, 1894; d. London, England, 1979*), composer and pianist. Studied piano and composition at the Saint Petersburg Conservatory and escaped Russia in 1920. He continued his studies in Berlin and performed with the Berlin Philharmonic before moving to Paris in 1924. He came to New York City in 1926 with virtuoso Mickel Kariton in a two-piano act. He made his recital debut at Carnegie Hall (1927); it included "Quasi Jazz," his first significant musical composition. He provided original accompaniment for such films as *Devil May Care* and *Lord Byron on Broadway* (both 1930), and wrote the scores for *Lost Horizon* (1937), *Mr. Smith Goes to Washington* (1939), and *It's a Wonderful Life* (1947). He became a U.S. citizen in 1937 and made his conducting debut at the Hollywood Bowl in 1938. As the leading composer for Hollywood films, he received Academy Awards for the song ("Do Not Forsake Me, Oh, My Darlin'") and score of *High Noon* (1952) and for the title song of *The High and the Mighty* (1954). Other famous Tiomkin scores include those for *Strangers on a Train* (1951), *Giant* (1956), and *The Guns of Navaronne* (1961).

TIPTON, JOHN (*b. Baltimore Co., Md., 1730; d. near Jonesboro, Tenn., 1813*), Virginia legislator, Revolutionary soldier, frontier politician. Uncle of John Tipton (1786–1839). Removed to Watauga settlements, 1783. A bitter opponent of John Sevier, he served *post* 1793 in the Tennessee legislature.

TIPTON, JOHN (*b. Sevier Co., Tenn., 1786; d. Logansport, Ind., 1838*), Indiana soldier, legislator, and land speculator. Nephew of John Tipton (1730–1813), U.S. senator, Democrat, from Indiana, 1831–39.

TISHMAN, DAVID (*b. New York City, 1889; d. New York City, 1980*), real estate developer and businessman. Graduated New York University Law School (1909) and joined his father's real estate business, Julius Tishman and Sons, which he developed into New York City's most successful owner-builder of luxury apartment buildings during the 1920's; he became vice-president (1912–28), president (1928–48), and chairman (1948–76), and renamed the company Tishman Realty and Construction in 1928. He pioneered modernization of residential holdings and led the renaissance of real estate development by constructing lucrative office towers, including one at Park Avenue and Fifty-seventh Street, which was the first office building north of Grand Central Terminal and the first in the world to feature central air-conditioning, and Tishman headquarters at 666 Fifth Avenue. The management of construction of the World Trade Center in the 1960's created a glut of office space in the city, and the loss of over $70 million in the 1970's with the office building at 1166 Sixth Avenue led to the sale of the Construction and Research division and the company name and logo to Rockefeller Center Corporation (1976).

TISQUANTUM *See* SQUANTO.

TITCHENER, EDWARD BRADFORD (*b. Chichester, England, 1867; d. 1927*), experimental psychologist. B.A., Brasenose College, Oxford, 1890; Ph.D., Leipzig, 1892; D.Sc., Oxford, 1906. Taught psychology at Cornell *post* 1892; was author of *Experimental Psychology* (1901–05), a milestone in the progress of that science. Leader of the "structuralist" school, he opposed the fashionable rage for applied psychology, educational psychology, and mental testing that threatened to obliterate study of the science in its pure form in America.

TITCOMB, JOHN WHEELOCK (*b. Farmington, N.H., 1860; d. Hartford, Conn., 1932*), fish culturist, conservationist.

TITTLE, ERNEST FREMONT (*b. Springfield, Ohio, 1885; d. Evanston, Ill., 1949*), Methodist clergyman. B.A., Ohio Wesleyan, 1906. B.D., Drew Theological Seminary, 1908. Ordained in 1910, he held several pastorates in Ohio before serving in France as a YMCA secretary during World War I. From 1918 until his death, he was pastor of the First Methodist Episcopal Church of Evanston, Ill. A preacher of great distinction, he became the recognized leader of Methodism's liberal ministers. He was dedicated to the social gospel, an absolute pacifist, a foe of racial discrimination, and an incisive critic of unfettered capitalism.

TOBANI, THEODORE MOSES (*b. Hamburg, Germany, 1855; d. Jackson Heights, N.Y., 1933*), composer of semiclassical music. Came to America as a boy. His most popular work "Hearts and Flowers," long in use as incidental music to pathos in the theater, was first published as a piano piece, 1893.

TOBEY, CHARLES WILLIAM (*b. Roxbury, Mass., 1880; d. Bethesda, Md., 1953*), politician. Self-educated. New Hampshire state senator, 1924–28; governor, 1928–30; U.S. Congressman (Republican), 1932–38; U.S. Senator, 1938–53. At first an ardent nationalist and isolationist, Tobey became a backer of more internationalist positions. He opposed the policies of Senator Joseph McCarthy, supported many of the programs of Truman, and was a backer of Eisenhower.

TOBEY, EDWARD SILAS (*b. Kingston, Mass., 1813; d. Brookline, Mass., 1891*), Boston merchant, capitalist. Prominent in many organizations for public safety, welfare, and the propagation of religion.

TOBEY, MARK (*b. Centerville, Wis., 1890; d. Basel, Switzerland, 1976*), artist. Took classes at Art Institute of Chicago and moved to New York City (1911), where he became a fashion illustrator at *McCall's* magazine. His skill as a caricaturist and charcoal portraitist led to his first one-man show in 1917. He became an adherent of the Baha'i faith (1918), which influenced his work with aesthetic principles that emphasized unity in a visual sphere. He moved to Seattle, Wash., in 1922, where he discovered his personal vision of cubism. His one-man shows in Chicago and New York (1928) included his major works of the period, including *Odalisque, Man Scratching Himself*, and *Middle West*. He was artist-in-residence at Dartington Hall, Devonshire, England (1930–38), and developed his distinctive non-objective painting style, "white writing," as in the works *Tundra* (1944) and *Written Over the Plains* (1950). His landscape paintings are typified by *White Night* (1942). There are major collections of his works at the Museum of Modern Art and Metropolitan Museum in New York City.

TOBIAS, CHANNING HEGGIE (*b. Augusta, Ga., 1882; d. New York, N.Y., 1961*), civic and religious leader, YMCA executive. Attended Paine College (B.A., 1902) and Drew Theological Seminary (B.D., 1905). Ordained a minister in the Colored Methodist Episcopal Church (1900). In 1911 he became student secretary of the International Committee of the Young Men's Christian Association (YMCA) and senior secretary of the colored men's department in 1923. Served as director of Paine College, the National Association for the Advancement of Colored People, the Council on Race Relations, and many other groups. Became the first black director of the Phelps-Stokes Foundation (1946–53). In 1946 President Harry S Truman appointed him to the Committee on Civil Rights. He was one of the authors of *To Secure These Rights* (1947), the committee's report, which many consider a major document on the treatment of minority groups.

Tobin, Austin Joseph (*b. Brooklyn, N.Y., 1903; d. New York City, 1978*), career government official. Graduated Holy Cross College (B.A., 1925) and Fordham Law School (LL.B., 1928) and joined the Port Authority of New York (1927) as a law clerk, then was appointed assistant attorney (1928) and real estate attorney (1930), responsible for land condemnation work. As assistant general counsel (1935), he defended the Port Authority against private suits and against Internal Revenue Service efforts to tax salaries and bonds. He also led a nationwide campaign (1938–42) to block Roosevelt administration attempts to strip government bonds of their tax-exempt status. As executive director of Port Authority (1942–72), he oversaw such new projects as the Newark, La Guardia, and Idlewild (now Kennedy) airports; truck, bus, and marine terminals; an expanded regional highway system; and construction of the World Trade Center, the world's largest office center.

Tobin, Daniel Joseph (*b. County Clare, Ireland, 1875; d. Indianapolis, Ind., 1955*), labor leader. Immigrated to the U.S. in 1889. Affiliated with Boston Local 25 of the Team Drivers' International Union (1900). Helped found the International Brotherhood of Teamsters, Chauffeurs, Warehousemen and Helpers of America (IBT), 1903; president, 1907–52. American Federation of Labor executive treasurer, 1917–28; member of the AFL executive council and vice president of the building trades department from 1933. Chairman of the Labor Bureau of the Democratic National Campaign Committee, 1932–44.

Tobin, Maurice Joseph (*b. Roxbury, Mass., 1901; d. Scituate, Mass., 1953*), politician. Studied briefly at Boston College. Democratic member of the Massachusetts House of Representatives, 1926–28; mayor of Boston, 1937–44; governor of Massachusetts, 1944–46. As governor, he introduced a bill that ended discrimination in employment practices based on race, creed, color, and national origin. As secretary of labor, 1948–52, Tobin set up the Federal Safety Council in the Bureau of Labor Standards (1950), supported an increase in the minimum wage law, and strengthened child labor regulations.

Tod, David (*b. near Youngstown, Ohio, 1805; d. 1868*), lawyer, coal and iron operator, railroad executive. Son of George Tod with whom he studied law. Removed *ca.* 1802 to chairman, Democratic presidential convention of 1860, after withdrawal of Caleb Cushing; was Union party governor of Ohio, 1862–64. Refused secretaryship of the U.S. treasury, 1864.

Tod, George (*b. Suffield, Conn., 1773; d. near Youngstown, Ohio, 1841*), jurist. Brother of John Tod; father of David Tod. Graduated Yale, 1795; studied law under Tapping Reeve. Removed to Youngstown, Ohio, 1800. Served as state supreme court judge, 1806–10, establishing by decision in 1809 the doctrine of judicial review in Ohio. After two terms in the legislature and War of 1812 military service, he was presiding judge of the 3rd district circuit court of appeals, 1816–29.

Tod, John (*b. Suffield, Conn., 1779; d. Bedford, Pa., 1830*), lawyer, Pennsylvania legislator and jurist. Brother of George Tod with whom he studied law. Removed *ca.* 1802 to Bedford, Pa., where he practiced with success; served as a congressman, Democrat, 1821–24. As chairman of the House committee on manufactures, he strove for higher tariffs and extension of the protective list.

Todd, Charles Stewart (*b. near Danville, Ky., 1791; d. Baton Rouge, La., 1871*), lawyer, War of 1812 soldier, diplomat. Son of Thomas Todd; son-in-law of Isaac Shelby. Appointed U.S. diplomatic agent in Columbia, 1820, Todd handled U.S. affairs there during a critical period with great integrity and tact; he was U.S. minister to Russia, 1841–45.

Todd, Eli (*b. New Haven, Conn., 1769; d. Hartford, Conn., 1833*), physician. An American pioneer in the humane and intelligent treatment of mental illness and alcoholism, he was superintendent of the Connecticut Retreat at Hartford, 1824–33.

Todd, Henry Alfred (*b. Woodstock, Ill., 1854; d. New York, N.Y., 1925*), Romance philologist. Graduated College of New Jersey (Princeton), 1876; studied at Paris, Berlin, Rome and Madrid; Ph.D., Johns Hopkins, 1885. Taught at Johns Hopkins and at Stanford; professor Romance philology, Columbia University, 1893–1925. A founder and editor of *Modern Language Notes* (1886) and an organizer of the Modern Language Association (1883), he was editor of a number of Old French works and in 1909 helped found the *Romantic Review*.

Todd, John (*b. Rutland, Vt., 1800; d. Pittsfield, Mass., 1873*), Congregational clergyman. A Calvinist of the school of Jonathan Edwards, he held his principal pastorate at the First Church in Pittsfield, and was author of a number of once-popular books including *The Student's Manual* (1835).

Todd, Mabel Loomis (*b. Cambridge, Mass., 1856; d. Hog Island, Maine, 1932*), author. Undertaking to prepare the poems of Emily Dickinson for publication *ca.* 1886, she was editor (with Thomas W. Higginson) of *Poems* (first series, 1890; second series, 1891) and was sole editor for the third series of *Poems* (1896). She was also collector and editor of the *Letters of Emily Dickinson* (1894). A conscientious editor, she endeavored, not always with success, to keep Higginson from "correcting" what the poet had written; alienation from the Dickinson family *post* 1895 prevented her from completing her work as planned.

Todd, Mike (*b. Minneapolis, Minn., 1909; d. Grants, N. Mex., 1958*), theatrical and motion picture producer. Worked as a builder and real estate operator before becoming radio writer and vaudeville producer. Produced *The Hot Mikado* (1939), *Star and Garter* (1942), *Something for the Boys* (1943), *Mexican Hayride* (1944), and *Up in Central Park* (1945). The main founder of the cinematic process called Cinerama; later developed, along with the American Optical Company, the process called Todd-AO, used for *Oklahoma* and Todd's own *Around the World in 80 Days*, winner of the Academy Award for best film, 1956.

Todd, Sereno Edwards (*b. near Lansingville, N.Y., 1820, d. near Orange, N.J., 1898*), journalist, agriculturist, author of works on systematic and economical farm management.

Todd, Thomas (*b. near Dunkirk, Va., 1765; d. 1826*), lawyer, Kentucky public official and jurist. Father of Charles S. Todd. Removed to Danville, Ky., 1786, where he made his home with Harry Innes and studied law. Judge of the state court of appeals, 1801–06, and chief justice, 1806–March 1807, he rendered many opinions basic to Kentucky land law. Appointed associate justice of the U.S. Supreme Court, March 1807, he served until his death. A consistent supporter of John Marshall in cases involving constitutional doctrine (except in the Dartmouth College case), he devoted most of his time and strength to traveling the western circuit. His judgment, especially on cases involving land laws was highly regarded by his colleagues.

Todd, Thomas Wingate (*b. Sheffield, England, 1885; d. Cleveland, Ohio, 1938*), anatomist, physical anthropologist. Educated at Manchester University (England), he also taught there until 1912. Todd served thereafter as professor of anatomy at the medical school of Western Reserve University and as director of

its Hamann Museum of comparative anthropology and anatomy. He was a pioneer in growth studies based on skeletal development.

TODD, WALTER EDMOND CLYDE (*b. Smithfield, Ohio, 1874; d. Rochester, Pa., 1969*), ornithologist, museum curator. Attended college for a few weeks in 1891 but withdrew to accept an apprenticeship in the Division of Ornithology and Mammalogy in the Department of Agriculture. In 1899 he became curator of birds at the Carnegie Museum in Pittsburgh, an association that lasted seventy years. As curator, he classified large collections of neotropical birds in the museum's collections. In 1901 he made the first of eighteen expeditions to northern Canada — the resulting *The Birds of the Labrador Peninsula and Adjacent Regions: A Distributional List* appeared in 1943. In 1940 he published his exhaustive *Birds of Western Pennsylvania.*

TODMAN, WILLIAM SELDEN ("BILL") (*b. New York City, 1916; d. New York City, 1979*), television producer. Graduated Johns Hopkins University (B.S., 1938) and New York University (B.A., 1941) and became a writer and producer for WABC radio in New York City (1941–43) and writer for the "Treasury Salute" radio dramas (1945–46). In 1946 he teamed up with Mark Goodson to form Goodson–Todman Productions, which delivered packaged programs to networks or advertisers. Their first collaboration was the "Winner Take All" radio quiz program, bought by CBS (1946); the show pioneered standard game-show techniques. Goodson–Todman moved into television broadcasting with the award-winning panel show "What's My Line?" (1950–67). Other successful television game shows were "I've Got a Secret," "Password," and "The Price Is Right." In the 1960's they produced and filmed the television dramas "The Rebel," "Branded," and "The Richard Boone Show."

TOKLAS, ALICE BABETTE (*b. San Francisco, Calif., 1877; d. Paris, France, 1967*), writer. Attended the music conservatory at the University of Washington, and after 1897 was the housekeeper of an extended household of her grandparents. Journeyed to Paris in 1907 where she met Gertrude Stein and became her secretary. Their salon was one of the centers of intellectual life in Paris for nearly four decades. With the publication of Stein's *The Autobiography of Alice B. Toklas* (1933), both women became celebrities. After Stein's death in 1946, Toklas launched her own writing career; her first published book was *The Alice B. Toklas Cookbook* (1954), with its famous recipe for hashish fudge. In *What Is Remembered* (1963), she recalled her early days in San Francisco and Seattle and her life in Paris.

TOLAND, HUGH HUGER (*b. Guilder's Creek, S.C., 1806; d. San Francisco, Calif., 1880*), surgeon. Graduated in medicine from Transylvania University, 1828; made special studies in Paris, France, 1830–33. Practiced in Columbia, S.C., until 1852 when he removed to California. Widely known for his skill in lithotomy and plastic surgery, he founded Toland Medical College in San Francisco, 1864, and served as its professor of surgery until his death. In 1873 he placed the institution unconditionally in charge of the University of California, of which it became a part.

TOLLEY, HOWARD ROSS (*b. Howard County, Ind., 1889; d. Alexandria, Va., 1958*), agricultural economist. Graduated from Indiana University, 1910. Active in government agricultural offices from 1915, Tolley worked for the Bureau of Agricultural Economics, 1923–30, and was director, 1938–46. Known as the "soil wizard," Tolley directed the Giannini Foundation for Agricultural Economics at the University of California, 1930–36; was the assistant administrator of the Agricultural Adjustment Administration; and chief of the Program Planning Division,

1933–35. The author of the quota system for planting specific crops and of federal cash grants to farmers for restricting the planted acreage, Tolley was a leader in shaping the agricultural policies of the nation as they exist today. Tolley worked in organizing food and agricultural programs at the U.N. and was head of the Ford Foundation office in Washington, 1951–54.

TOLMAN, EDWARD CHACE (*b. West Newton, Mass., 1886; d. Berkeley, Calif., 1959*), psychologist. Graduated from the Massachusetts Institute of Technology, B.S., 1911, and Harvard University, Ph.D., 1915. Taught at Northwestern University, 1915–18, and at the University of California at Berkeley, 1918–54. Through a series of experiments with white rats, Tolman laid the foundations for the interest in cognitive psychology that became prominent in the U.S. after his death. Author of *Purposive Behavior in Animals and Men* (1932).

TOLMAN, HERBERT CUSHING (*b. South Scituate, Mass., 1865; d. Nashville, Tenn., 1923*), Greek and Indo-Iranian scholar, Episcopal clergyman. Graduated Yale, 1888; Ph.D., 1890. Taught at University of Wisconsin and University of North Carolina; was professor of Greek at Vanderbilt, 1894–1923, and dean of its College of Arts and Sciences, 1913–23.

TOLMAN, RICHARD CHACE (*b. West Newton, Mass., 1881; d. Pasadena, Calif., 1948*), physical chemist, mathematical physicist. Upon graduation from M.I.T. in 1903, Tolman studied at the Technische Hochschule in Berlin and then at an industrial chemical laboratory at Crefeld. He returned to M.I.T. as a graduate student and shortly thereafter joined Arthur Amos Noyes's new Research Laboratory of Physical Chemistry. He received the Ph.D. in 1910. Tolman taught briefly at the University of Michigan and the University of Cincinnati. With Earl Osgerby he made a series of measurements on the electromotive force produced by the acceleration of electrolytes. With T. Dale Stewart, he made the first laboratory determination of the inertial mass of electrons in metals (1916).

In the closing days of World War I Tolman served as chief of the Dispersoid Section of the Chemical Warfare Service. At the close of the war he joined the Fixed Nitrogen Research Laboratory (associate director, 1919–20; director, 1920–22), supervising research in the chemistry of nitrogen pentoxide, the cyanamide and arc process of nitrogen fixation, the separation of helium from natural gases, the theory of catalysis, and the rate of chemical reaction. He also worked on a modified method of measuring the mass of the electric carrier in conductors. In 1922 he joined the faculty of the new California Institute of Technology as professor of physical chemistry and mathematical physics. Tolman became dean of the graduate school as well (1922–46).

Starting from first principles in statistical mechanics, Tolman analyzed completely the problem of accounting for the rate at which chemical reactions occur. His theoretical treatment of monomolecular thermal and photochemical reaction rates underscored the need to clarify the meaning of the loosely defined concept of the energy of activation. This done, Tolman turned to the decomposition of nitrogen pentoxide as a check on the thencurrent proposed mechanisms of chemical reaction. He showed that the simple radiation theory of reaction did not adequately account for known rates of reaction. These studies reveal Tolman's consuming interest in using statistical mechanics in dealing with quantum mechanical phenomena. His *Principles of Statistical Mechanics* (1938) remains a classic in its field.

From its inception in 1905, Tolman followed closely the development of relativity theory and its application to the problems of cosmology. With Gilbert N. Lewis he published the first American account of Einstein's special theory of relativity (1909).

This early interest led to a series of studies on the applications of the general theory to the overall structure and evolution of the universe. His pioneering work on the thermodynamics and behavior of radiation in nonstatic cosmological models of the universe drew public attention, because it challenged the pessimistic view required by classical thermodynamics. In particular, he derived relativistic expressions for the first two laws of thermodynamics and found that reversible processes could take place both at a finite rate and without increase in entropy. In his comprehensive treatise *Relativity, Thermodynamics, and Cosmology* (1934), Tolman presented the model of a universe expanding and contracting rhythmically.

During World War II he served on the National Defense Research Committee, as scientific adviser on the Manhattan Project, and as adviser to the Combined Policy Committee.

TOME, JACOB (*b. York Co., Pa., 1810; d. 1898*), Maryland merchant, banker, philanthropist. Founded Tome School for Boys at Port Deposit, Md. (incorporated 1889, opened 1894).

TOMKINS, FLOYD WILLIAMS (*b. New York, N.Y., 1850; d. 1932*), Episcopal clergyman. A zealous evangelical preacher, he performed his most notable work as rector of the Church of the Holy Trinity, Philadelphia, Pa., 1899–1932.

TOMLIN, BRADLEY WALKER (*b. Syracuse, N.Y., 1899; d. New York, N.Y., 1953*), painter. Studied at Syracuse University, B.A., 1921, and the L.C. Tiffany Foundation in Oyster Bay, L.I. Until 1939, his work was largely realistic, consisting mainly of idealized portraits; he then painted cubistic still lifes. After 1945, influenced by Jackson Pollock, Robert Motherwell, and Philip Guston, his style became completely abstract. Works include *Number 20* (1949) and *Number 9* (1950), New York Museum of Modern Art; *Number 1* (1952), Whitney Museum of Art; *Number 2* (1952–53), Hirshhorn Museum and Sculpture Garden, Washington, D.C. Although he never received great public recognition, Tomlin is considered a leader in the abstract school of painting.

TOMLINS, WILLIAM LAWRENCE (*b. London, England, 1844; d. Delafield, Wis., 1930*), teacher of music. Came to America, 1870. Achieving distinction in America as conductor of the Apollo Club, Chicago, Ill., *post* 1875, he later was notably successful in training children for choral singing and as an instructor of public school music teachers. His system became known as "The Tomlins Idea."

TOMLINSON, EVERETT TITSWORTH (*b. Shiloh, N.J., 1859; d. Elizabeth, N.J., 1931*), Baptist clergyman and missionary executive. Author of over 100 historical stories for boys, including *Three Colonial Boys* (1895), *The Fort in the Forest* (1904), and *Mad Anthony's Young Scout* (1908).

TOMOCHICHI (*b. possibly Apalachicola, in present Alabama, ca. 1650; d. Georgia, 1739*), Creek Indian chief. Leader of a few Creek and Yamassee, he settled at Yamacraw on the Savannah River *post* 1721, where he resided when the first Georgia colonists landed in 1733. Signer of a formal treaty with James E. Oglethorpe, May 1733, he helped negotiate a treaty with the other Creek tribes and accompanied Oglethorpe to England on a visit, 1734.

TOMPKINS, ARNOLD (*b. near Paris, Ill., 1849; d. Menlo, Ga., 1905*), educator, leader in normal school work. Author of *The Philosophy of Teaching* (1893), *The Philosophy of School Management* (1895), and other works once widely used in teacher training schools.

TOMPKINS, DANIEL AUGUSTUS (*b. Edgefield Co., S.C., 1851; d. Montreat, N.C., 1914*), engineer. Graduated Rensselaer Polytechnic Institute, C.E., 1873. After training with Alexander L. Holley and John Fritz in steel and iron making, he began practice in Charlotte, N.C., 1882. Preaching the gospel of northern industrial development to the South, he promoted, designed, and built cottonseed-oil mills throughout the South, and by speeches and newspaper articles popularized the concept that manufactures must supplement agriculture in the section. He next waged a successful campaign in favor of his plan for community financing and founding of cotton manufacturing plants. Realizing that the economic recovery of the South required improved education, he helped found textile schools in both the Carolinas and in Mississippi and Texas. Author of a number of books and pamphlets, he was also chief owner for many years of the *Charlotte Daily Observer* which served him as a means of propagating his ideas.

TOMPKINS, DANIEL D. (*b. Scarsdale, N.Y., 1774; d. Staten Island, N.Y., 1825*), lawyer, New York legislator. Graduated Columbia, 1795. Beginning practice in New York City, he was elected to Congress as a (Democrat) Republican in 1804 but resigned almost at once to accept appointment as a justice of the New York supreme court. Elected governor of New York, 1807, he served through 1817. His administration was marked by liberal and popular reform measures in the school system, the militia and in the criminal code, and also by the complete abolition of slavery in the state. Handicapped during the War of 1812 by lack of money and a hostile Assembly as well as by the incompetence of the U.S. command, he handled the defense of the state as successfully as any man could have done, pledging his personal credit for much of the necessary money. He served as vice president of the United States, 1817–25, without particular distinction. For many years he was DeWitt Clinton's most able antagonist in New York State politics.

TOMPKINS, SALLY LOUISA (*b. Mathews Co., Va., 1833; d. Richmond, Va., 1916*), philanthropist. Fitted up and maintained the Robertson Hospital for Confederate wounded in Richmond, 1861–65. Commissioned captain in the Confederate service, September 1861, she was the only woman ever to receive such an honor and was known to the end of her life as "Captain Sally."

TOMPSON, BENJAMIN (*b. present Quincy, Mass., 1642; d. 1714*), teacher, physician. Graduated Harvard, 1662. Taught at present Boston Latin School, also in Charlestown, Braintree and Roxbury. Author of a number of topical poems which were published as broadsides and in *New Englands Crisis* (Boston, 1676; also as *New-Englands Tears for Her Present Miseries*, London in the same year).

TONDORF, FRANCIS ANTHONY (*b. Boston, Mass., 1870; d. Washington, D.C., 1929*), Roman Catholic clergyman, Jesuit, seismologist. A professor of the sciences principally at Georgetown University *post* 1904, he founded the seismological observatory at Georgetown and served it as director, 1909–29.

TONE, (STANISLAS PASCAL) FRANCHOT (*b. Niagara Falls, N.Y., 1905; d. New York, N.Y., 1968*), actor. Attended Cornell University (B.A., 1927). Originally intending to teach, Tone instead succumbed to a passion for the theater. He made his Broadway debut in 1928 and played his first starring role in *Green Grow the Lilacs* (1931). In 1932 he made his screen debut in *Wiser Sex;* the same year he was signed to a five-year contract by Metro-Goldwyn-Mayer (MGM). He turned in one of his best performances in Paramount's *The Lives of a Bengal Lancer* (1935) and was nominated for an Academy Award as best actor for his role

in *Mutiny on the Bounty* (1935). After his MGM contract expired in 1939, Tone returned to the New York stage, occasionally freelancing as a film actor.

TONER, JOSEPH MEREDITH (*b. Pittsburgh, Pa., 1825; d. Cresson, Pa., 1896*), physician. Graduated Vermont Medical College, 1850; M.D., Jefferson Medical College, 1853. A leading practitioner in Washington, D.C., *post* 1855, he was best known as a medical historian and as the collector of a remarkable library of American medical history which he presented to the Library of Congress. He was the author of *The Medical Men of the Revolution* (1876) among other books, and editor of the early journals of George Washington.

TONTY, HENRY DE (*b. probably Paris, France, 1650; d. near present Mobile, Ala., 1704*), explorer, soldier. Cousin of Daniel Greysolon Duluth; son of the originator of the Tontine form of life insurance. Known as "Iron Hand" because of an artificial right hand with which he had replaced one lost in service with the French army. Tonty became lieutenant to Robert Cavelier, Sieur de la Salle, in 1678, and accompanied La Salle to Canada. He was his chief's principal assistant in the exploration of the Great Lakes and the Illinois country. He commanded at Fort Crèvecoeur, 1680, escaping with great difficulty with five companions after the Iroquois raid on that post. Going first to Green Bay and then to Michilimackinac, he rejoined La Salle at the latter place in June 1681. Cobuilder with La Salle of Fort St. Louis on the Illinois, he joined his chief in the spring of 1682 for the famous exploration of the Mississippi River and the claiming of the Mississippi Valley for France. Left in charge in Illinois, Tonty made an unsuccessful attempt to find La Salle in 1686, and even as late as March 1689 was still unaware of La Salle's death. On learning of it in September of that year, he attempted to find the colonists which La Salle had left in lower Louisiana but was unsuccessful. In 1700, after a decade of able, honest management of the Illinois settlements, he joined the new colony made by Pierre le Moyne, Sieur d'Iberville, near the mouth of the Mississippi, and for the last four years of his life gave valuable service to Louisiana. A great explorer and an able administrator, he succeeded where La Salle failed, was respected and trusted by the Indians and by the settlers, and was particularly noted for his courtesy and consideration. He wrote two brief memoirs of his experiences, one covering the years 1678–83, the other covering the years 1678–91, which remained unpublished until late in the 19th century. Earlier publications credited to him are considered spurious.

TOOLE, EDWIN WARREN (*b. Savannah, Mo., 1839; d. Helena, Mont, 1905*), lawyer. Brother of Joseph K. Toole. Removed to Denver, Colo., 1863, and thence to Montana Territory where he settled in Virginia City; in 1865 he moved to Helena which was thereafter his home. An outstanding lawyer with a varied practice, he is particularly remembered for his representation of the state of Montana in *Barden* v. *Northern Pacific Railroad* (154 U.S., 288–349) which maintained the state's right to mineral lands reserved in the Congressional grant of land to the railroad. He was also successful in defending constitutionality of the "apex" law.

TOOLE, JOSEPH KEMP (*b. Savannah, Mo., 1851; d. 1929*), lawyer, Montana legislator. Brother of Edwin W. Toole. Removed to Helena, Mont., 1869; became his brother's law partner, 1872. Territorial delegate to Congress from Montana, Democrat, 1885–89, he was influential and active in the movement for statehood and was a member of the 1889 convention that drafted the Montana constitution. Elected first governor of the state of Montana, he served November 1889–January 1893 and January 1901–April 1908. A successful administrator, he fostered public education and supported many political and social reforms.

TOOMBS, ROBERT AUGUSTUS (*b. Wilkes Co., Ga., 1810; d. Washington, Ga., 1885*), lawyer, planter, Georgia statesman and legislator. Friend and associate of Alexander H. Stephens. Graduated Union College, 1828. Displaying high ability as a Whig member of the Georgia legislature, Toombs was elected to Congress and took his seat at the close of 1845. A careful student of public finance and robustly eloquent, he soon became popular and influential. Shocked out of his faith that the welfare of the South would be safe in Whig hands by the events which led to the crisis of 1850, he became a leader in the aggressive defense of his section. However, he was satisfied with the Compromise finally adopted and with Alexander H. Stephens and Howell Cobb canvassed Georgia to procure its ratification. He then led in the launching of the Constitutional Union party, pledged to maintain the Compromise measures. After dissolution of the party because of lack of response in other states, he reluctantly joined the Democrats. As U.S. senator, 1853–61, he approved the Kansas-Nebraska Act. He sought to end the ensuing disorders by an 1856 bill of his own providing for prompt admission of Kansas with whatever constitution a new convention might adopt after a thoroughly policed election of delegates. His bill was adopted by the Senate but died in the House. Convinced that control of the government by the Republicans would menace the security of the South, Toombs strove for harmony among the Democrats; after the split in 1860 he supported the Breckinridge ticket. Upon the failure of the Crittenden Compromise which he supported, he publicly urged secession and resigned from the Senate. Author of the address which the Georgia secession convention adopted to justify its acts, he was chosen one of the Georgia delegates sent to launch a Southern confederacy at Montgomery, Ala. Accepting the office of Confederate secretary of state with some reluctance, he discovered that his excellent advice on financial and other matters was little regarded. Growing contemptuous of Jefferson Davis, he resigned and took command in July 1861 of a brigade on the Virginia front. Restless under the defensive policy of his superiors, he censured their inaction and was disliked by them. Wounded at Antietam where his brigade held the stone bridge, Toombs demanded promotion and on its refusal resigned his commission. Thereafter he continued to criticize the government, especially its continued reliance upon credit, and served briefly in arms during Sherman's advance against Atlanta. Briefly a fugitive at the end of the Civil War, he returned home in 1867 and rebuilt a large law practice. Between 1867 and 1880 he fought to overthrow the rule of the Radicals. He dominated the constitutional convention of 1877 which repudiated the carpetbag bonds, curbed black suffrage, improved the judiciary, and provided for the control of corporations.

TOPLIFF, SAMUEL (*b. Boston, Mass., 1789; d. 1864*), dealer in foreign news. Operated Merchants' Reading Room and associated news-gathering services at Boston, 1814–42.

TORBERT, ALFRED THOMAS ARCHIMEDES (*b. Georgetown, Del., 1833; d. at sea, off Florida coast, 1880*), soldier, diplomat. Graduated West Point, 1855. After frontier service with infantry he became colonel, 1st New Jersey Volunteers, September 1861. Following extensive service with the Army of the Potomac, he was promoted brigadier general, 1862. As a cavalry division commander *post* April 1864, Torbert served with great ability under General Philip Sheridan, winning particular honors at the battles of Winchester and Cedar Creek.

TORRENCE, FREDERICK RIDGLEY (*b. Xenia, Ohio, 1874; d. New York, N.Y., 1950*), poet, editor, playwright. Attended Miami University and Princeton. Friend of Edwin Arlington Robinson, Robert Frost, and William V. Moody. Poetry editor of the *New Republic* (1920–33). Author of *The House of a Hundred Lights* (1899), *Hesperides* (1925), and *Poems* (1941); also of dramas in verse and prose, of which the most important were three one-act plays of black life published as *Plays for a Negro Theatre* (1917).

TORRENCE, JOSEPH THATCHER (*b. Mercer Co., Pa., 1843; d. Chicago Ill., 1896*), engineer, Chicago iron manufacturer and businessman.

TORREY, BRADFORD (*b. Weymouth, Mass., 1843; d. Santa Barbara, Calif., 1912*), ornithologist, editor. A faithful and accurate field observer, Torrey was author of *A Rambler's Lease* (1889), *The Foot-path Way* (1892), and other volumes of essays on birds; he served also as editor of the journal of Henry D. Thoreau (Walden edition, 1906).

TORREY, CHARLES CUTLER (*b. East Hardwick, Vt., 1863; d. Chicago, Ill., 1956*), Bible scholar, Semitist. Studied at Bowdoin College, at Andover Theological Seminary, and at the University of Strassburg, Ph.D., 1892. Taught at Andover Seminary, 1892–1900; professor at Yale University, 1901–32. Founded and was the first director of the American School of Archaeology in Jerusalem, 1900–01. Works include controversial interpretations of texts and theological results of the Scriptures and biblical history: *Ezra Studies* (1910), *Pseudo-Ezekiel and the Original Prophecy* (1930), and *The Jewish Foundation of Islam* (1933).

TORREY, CHARLES TURNER (*b. Scituate, Mass., 1813; d. Maryland, 1846*), Congregational clergyman, anti-Garrison abolitionist.

TORREY, JOHN (*b. New York, N.Y., 1796; d. New York, 1873*), botanist, chemist. Inspired with interest in science by Amos Eaton, Torrey graduated M.D., N.Y. College of Physicians and Surgeons, 1818. In medical practice in New York City, Torrey maintained his interest in mineralogy and botany, and served as reporter and classifier of plant specimens sent to him by a long series of government-sponsored Western exploratory expeditions. He was professor of chemistry, mineralogy and geology at West Point, 1824–27, and professor of chemistry at N.Y. College of Physicians and Surgeons, 1827–55; concurrently with his New York professorship he taught chemistry and natural history at the College of New Jersey (Princeton). On his retirement from teaching, he served for the rest of his life as U.S. assayer in New York City. Torrey's great contribution was in pioneer work on the findings of the aforesaid government exploring expeditions (thereby first describing many plants native to North America) and by his lifelong encouragement of young botanists, including Asa Gray. He was also largely instrumental in establishing the New York Botanical Garden. Among his many books and monographs are the following: *A Catalogue of Plants . . . Within Thirty Miles of the City of New York* (1819); *A Flora of the Northern and Middle Sections of the United States* (1823); *A Compendium of the Flora of the Northern and Middle States* (1826); *Flora of North America* (with Asa Gray, seven parts, 1838–43); *Flora of the State of New York* (1843); and contributions to the official reports of almost every important survey expedition between 1820 and 1860.

TOSCANINI, ARTURO (*b. Parma, Italy, 1867; d. New York N.Y., 1957*), conductor. Graduated from the Parma Conservatory (1885). Made professional conducting debut conducting *Aida* in Rio de Janeiro (1886) substituting for an ill conductor. Conducted the world premieres of Leoncavallo's *I Pagliacci* (1892) and Puccini's *La Bohème* (1896). Principal conductor at La Scala, Milan (1898–1903 and 1906–08); artistic director (1920–29). Introduced many operas by German, French, and Russian composers; led the world premiere of Puccini's *Turandot* (1926). Associate conductor of the New York Philharmonic (1927–33) and musical director (1933–36). As conductor of the NBC Orchestra (1937–54), elevated it into one of the best orchestras of its day.

Toscanini was a literalist, determined to carry out every demand of a score as strictly and meticulously as he could. Fortunately, he lived in the age of musical recordings and many of his interpretations are preserved.

TOTTEN, GEORGE MUIRSON (*b. New Haven, Conn., 1809; d. 1884*), engineer. A specialist in canal and railroad work, he served for many years *post* 1850 as chief engineer of the Panama Railroad and was an adviser to the French company which first attempted the Panama Canal.

TOTTEN, JOSEPH GILBERT (*b. New Haven, Conn., 1788; d. 1864*), military engineer. Nephew of Jared Mansfield. Graduated West Point, 1805. Highly effective as chief engineer on the Niagara frontier, War of 1812, he served thereafter in coast defense and river and harbor improvement work. Promoted colonel, he became chief engineer of the U.S. Army and inspector of West Point in 1838, holding both posts until his death. During the Mexican War he planned the operations at Veracruz. Thereafter he won high repute in lighthouse work, and during the Civil War as brigadier general supervised the defensive works around Washington, D.C.

TOU, ERIK HANSEN (*b. near Stavanger, Norway, 1857; d. Napoleon, S.Dak., 1917*), Lutheran clergyman. Immigrated to Minneapolis, Minn., 1881. A graduate of Augsburg Seminary, 1886 and 1889, he served as a missionary in Madagascar, 1889–1903.

TOUCEY, ISAAC (*b. Newtown, Conn., 1792; d. Hartford, Conn., 1869*), lawyer, Connecticut legislator and public official. Congressman, Democrat, from Connecticut, 1835–39; governor of Connecticut, 1846–47; U.S. attorney general, June 1848–March 1849. As U.S. senator, 1852–57, he condemned the "higher law" theory of W. H. Seward and was a supporter of the Kansas-Nebraska bill. During his term as U.S. secretary of the navy, 1857–61, he was criticized for a sympathetic attitude toward the South but conducted his department with efficiency and economy.

TOULMIN, HARRY (*b. Taunton, England, 1766; d. Alabama, 1823*), clergyman, educator, jurist. Immigrating to America with Joseph Priestley, 1794, he served briefly as president of Transylvania University, and was secretary to the Commonwealth of Kentucky, 1796–1804. As secretary, he compiled several collections of Kentucky laws. Appointed judge of the superior court for the eastern district of Mississippi Territory, 1804, he opposed filibusters into Spanish territory; he strove to thwart the designs of Aaron Burr (1807) and the later activities of Reuben Kemper. Retaining his judgeship until 1819 he did much to straighten out the land claims in the region, was prominent in the convention that formed the constitution for Alabama, and was editor of *The Statues of the Mississippi Territory* (1807) and *A Digest of the Territorial Laws of Alabama* (1823).

TOULMIN, HARRY THEOPHILUS (*b. Mobile Co., Ala., 1838; d. Toulminville, Ala., 1916*), Confederate officer, Alabama jurist. Grandson of Harry Toulmin. Alabama state circuit judge, 1874–82; U.S. district judge, southern district of Alabama, 1887–1916.

TOUMEY, JAMES WILLIAM (*b. Lawrence, Mich., 1865; d. 1932*), forester, teacher. Graduated Michigan Agricultural College, 1889. Taught botany at Michigan Agricultural College and University of Arizona, taught at Yale School of Forestry *post* 1900 and served as its dean, 1910–22.

TOUREL, JENNIE (*b. Vitebsk, Belorussia, 1900; d. New York City, 1973*), singer and voice teacher. Her family fled Russia in 1918 and settled in Paris, where she studied voice from an early age. A mezzo-soprano with a wide range, she made her Paris debut at the Opéra Russe and her American debut at the Chicago Civic Opera during the 1930–31 season. She first sang her most famous role, Carmen, at the Opéra–Comique in Paris in 1933. Her career at New York's Metropolitan Opera was brief (1944–47). She became a U.S. citizen in 1946 and frequently collaborated with conductor-composer Leonard Bernstein. She taught voice at the Juilliard School from 1963 until her death.

TOURGÉE, ALBION WINEGAR (*b. Williamsfield, Ohio, 1838; d. Bordeaux, France, 1905*), Union soldier, lawyer, North Carolina carpetbag jurist, U.S. consular officer. Author of a number of books, he is remembered chiefly for his novel *A Fool's Errand* (1879), an early literary picture of Reconstruction.

TOURJÉE, EBEN (*b. Warwick, R.I., 1834; d. Boston, Mass., 1891*), musician. Cofounder (1867) of the New England Conservatory of Music.

TOUSARD, ANNE LOUIS DE (*b. Paris, France, 1749; d. Paris, 1817*), French army artillery officer. An active and efficient aide to Lafayette, 1777–78, Tousard later had a colorful career in Santo Domingo and during the first years of the French Revolution. Immigrating to America *ca.* 1793, he was reinstated in the U.S. Army, 1795, and performed useful service as engineer and artillery officer until 1802 when he returned to France. He served as a French consular officer in several America cities, 1805–16.

TOUSEY, SINCLAIR (*b. New Haven, Conn., 1815; d. New York, N.Y., 1887*), news agent. Merged his own news agency and book distribution business with other similar companies into the American News Co., 1864, which he served as president until his death.

TOWER, CHARLEMAGNE (*b. Philadelphia, Pa., 1848; d. Philadelphia, 1923*), lawyer, financier. Graduated Harvard, 1872. U.S. minister to Austria-Hungary, 1897–99; U.S. ambassador to Russia, 1899–1902; U.S. ambassador at Berlin, 1902–08.

TOWER, ZEALOUS BATES (*b. Cohasset, Mass., 1819; d. Cohasset, 1900*), soldier, engineer. Graduated West Point, 1841. Won distinction in the Mexican War for skill in reconnoitering as an engineer on staff of General Winfield Scott. Helped organize defenses of Fort Pickens, Fla., 1861. As Union brigadier general of volunteers, he commanded a brigade with distinction until his serious wounding at the second battle of Bull Run. After brief service as superintendent of West Point, he performed brilliantly as engineer in charge of the field defenses of Nashville, Tenn., his work proving of great service to General George Thomas in the destruction of General Hood's Confederate army (December 1864).

TOWERS, JOHN HENRY (*b. Rome, Ga., 1885; d. New York, N.Y., 1955*), naval aviator. Graduated from the U.S. Naval Academy, 1906. A pioneer in aviation, Towers volunteered for flight training in 1911; in 1912, he set a record for flight endurance. In the battle to win acceptance by the navy of air power, Towers was often involved in squabbles. During the 1930's, he became a key figure in the fleet air modernization as the country anticipated World War II. Worked at the Bureau of Aeronautics as assistant chief, 1938, and chief, 1939–42. In 1942, he became a vice admiral and Commander Air Force Pacific Fleet, developing the fleet's aviation logistics and tactics. As deputy fleet commander for Admiral Nimitz, 1944, Towers played a key role in victory over Japan. After retirement as a full admiral in 1947, he became an assistant vice president of Pan American World Airways.

TOWLE, GEORGE MAKEPEACE (*b. Washington, D.C., 1841; d. Brookline, Mass., 1893*), Boston journalist, lecturer, and author.

TOWLER, JOHN (*b. Rathmell, Yorkshire, England, 1811; d. Orange, N.J., 1889*), educator. Came to America, 1850; taught at Hobart College and was dean of Geneva Medical College; was also in the U.S. consular service. Editor of *Humphrey's Journal of Photography*, 1862–70, he was author of a number of technical photographic manuals, including the important *The Silver Sunbeam* (1864).

TOWN, ITHIEL (*b. Thompson, Conn., 1784; d. New Haven, Conn., 1844*), architect. Studied in Boston, Mass., with Asher Benjamin. His first important work was the Center Church on New Haven Green; he was next commissioned (1814) to design and build Trinity Church, also on the Green at New Haven. His reputation established, he designed many more public buildings in a number of cities, including the New York Custom House on Wall St. and the state capitols in Indianapolis, Ind., and Raleigh, N.C. He entered partnerships with Martin E. Thompson (1827–28) and Alexander J. Davis (*ca.* 1829–43). Patentee of a truss bridge (1820), he was thereafter celebrated also as a bridge builder. A collector of books on architecture and the fine arts and author of various miscellaneous pieces, he was a founder of the National Academy of Design.

TOWNE, BENJAMIN (*b. Lincolnshire, England, date unknown; d. Philadelphia, Pa., 1793*), printer, journalist. Appeared as a journeyman printer in Philadelphia, 1766. Opening a press of his own, 1774, he published the *Pennsylvania Evening Post*, 1775–84, the first evening newspaper printed in Philadelphia and the only newspaper that continued to be published in that city throughout the Revolutionary War.

TOWNE, CHARLES ARNETTE (*b. Oakland Co., Mich., 1858; d. Tucson, Ariz., 1928*), lawyer. In practice at Duluth, Minn., 1890–1901, and thereafter in New York City, Towne was a Republican congressman from Minnesota, 1895–97. Becoming recognized as leader of the Silver Republicans, he was chairman of their national committee, 1897–1901, and closely associated with William J. Bryan. He served as congressman, Democrat, from New York, 1905–07.

TOWNE, CHARLES HANSON (*b. Louisville, Ky., 1877; d. Earlville, N.Y., 1949*), editor, essayist. Attended College of the City of New York. Held editorial positions successively on *Cosmopolitan* magazine, *Smart Set* (1901–07), *The Delineator, Designer, McClure's Magazine* (1915–20), and *Harper's Bazaar* (1926–29).

TOWNE, HENRY ROBINSON (*b. Philadelphia, Pa., 1844; d. New York, N.Y., 1924*), engineer, manufacturer. Son of John H. Towne. Joined with Linus Yale, 1868, in manufacture of locks at Stamford, Conn.; served as president of Yale Lock Mfg. Co. and its successor corporation, 1868–1916, and was thereafter chairman of its board. Towne was also the pioneer builder of cranes in the United States.

TOWNE, JOHN HENRY (*b. Pittsburgh, Pa., 1818; d. Paris, France, 1875*), engineer, heavy machinery builder, philanthropist. Father of Henry R. Towne. Endowed Towne Scientific School, University of Pennsylvania.

TOWNLEY, ARTHUR CHARLES (*b. Browns Valley, Minn., 1880; d. Makoti, N.Dak., 1959*), political organizer. A farmer in Beach, N.Dak., Townley helped organize and found the Nonpartisan League, 1915; the group espoused the state control to help the farmers and endorsed candidates. The League succeeded in electing the state governor in 1916 and had a clean sweep of the state offices the following year. The group spread to Minnesota and was the father of the Farmer-Labor party. Townley lost all influence in 1921–22, when the League folded because of internal dissension.

TOWNS, GEORGE WASHINGTON BONAPARTE (*b. Wilkes Co., Ga., 1801; d. Macon, Ga., 1854*), lawyer, Georgia legislator and congressman. As Democratic governor of Georgia, 1847–51, he secured amelioration of the slave code, adoption of the *ad valorem* system of taxation, and completion of the Western and Atlantic Railroad; he also worked to improve public education. Becoming an extreme "fire eater" by 1849, he opposed the Wilmot Proviso and called the convention which adopted the "Georgia platform," later the position taken by the entire South on further invasion of states' rights.

TOWNSEND, EDWARD DAVIS (*b. Boston, Mass., 1817; d. Washington, D.C., 1893*), soldier. Grandson of Elbridge Gerry. Graduated West Point, 1837. Originally an artilleryman, Townsend served for many years in the adjutant general's department, heading it as adjutant general 1862–80 (formal appointment in 1869) with extraordinary tact and efficiency. Collection of material for *War of the Rebellion: Official Records* was owing to him.

TOWNSEND, FRANCIS EVERETT (*b. Fairbury, Ill., 1867; d. Los Angeles, Calif., 1960*), physician. Graduated from Omaha Medical College, 1899. Moved to California in 1919, where he practiced in obscurity and great financial deprivation. Conceived his Old Age Revolving Pension Plan, 1933, designed to distribute $200 per month to every citizen over the age of sixty; the money had to be spent within thirty days to bolster the economy. The plan grew in appeal, and Townsend became a national hero. He joined forces with other reformers in the Union Party. The political force of his plan was felt in Washington, but was undermined by Roosevelt's Social Security Act (1935). Convicted of contempt of Congress, 1937, for refusing to answer questions; President Roosevelt commuted the sentence.

TOWNSEND, GEORGE ALFRED (*b. Georgetown, Del., 1841; d. New York, N.Y., 1914*), journalist, Civil War correspondent. Distinguished for vivid reportorial work for the *New York Herald* and the New York *World*, 1861–65, and also for his work as a Union propagandist in England, he contributed a wise and often satirical series of Washington letters to a great number of newspapers, 1867–ca. 1907. This Washington correspondence appeared under the signature of "Gath" and although mainly occupied with politics often dealt with the social life of the time. Among his many books, a novel *The Entailed Hat* (1884) ranks as the best.

TOWNSEND, JOHN KIRK (*b. Philadelphia, Pa., 1809; d. Washington, D.C., 1851*), ornithologist. Traveled to Oregon, 1834, on an expedition with Nathaniel J. Wyeth; visited Hawaii, 1835; served as post surgeon at Fort Vancouver, 1835–36. Described Oregon birds in *Journal of the Academy of Natural Sciences of Philadelphia* (1837, 1839); supplied material on mammals of Oregon and elsewhere for picturing by J. J. Audubon and John Bachman in *Viviparous Quadrupeds of North America* (1845–49). Author

of *Narrative of a Journey across the Rocky Mountains to the Columbia River* (1839) and *Ornithology of the United States of America* (one part, 1840; now one of the rarest works on this subject).

TOWNSEND, LUTHER TRACY (*b. Orono, Maine, 1838; d. Brookline, Mass., 1922*), Union soldier, Methodist clergyman. A popular apologist for traditional evangelical theology, he taught church history, classic languages, and theology at present Boston University School of Theology, 1868–93.

TOWNSEND, MARY ASHLEY (*b. Lyons, N.Y., 1832; d. Galveston, Tex., 1901*), New Orleans, La., journalist and poet.

TOWNSEND, MIRA SHARPLESS (*b. Philadelphia, Pa., 1798; d. Philadelphia, 1859*), philanthropist. Founded the Rosine Association and Home for reform of fallen women (Philadelphia); also founded the Temporary Home, a transient residence for unemployed women and destitute children.

TOWNSEND, ROBERT (*b. Albany, N.Y., 1819; d. off the China coast, 1866*), naval officer. Appointed midshipman, 1837. After both army and navy service in the Mexican War, he resigned from the navy, 1851. Returning to the service during the Civil War, he rose to rank of commander on Atlantic blockade duty and in operations *post* 1863 on the Mississippi River. Promoted captain, 1865, he commanded the *Wachusett* of the East India squadron.

TOWNSEND, VIRGINIA FRANCES (*b. New Haven, Conn., 1836; d. Arlington, Mass., 1920*), teacher, magazine editor, writer of popular stories for girls.

TOWNSEND, WILLARD SAXBY, JR. (*b. Cincinnati, Ohio, 1895; d. Chicago, Ill., 1957*), labor leader. Studied at the University of Toronto and the Royal College of Science in Toronto. Organized and was first president of the International Brotherhood of Red Caps, 1936, renamed the United Transport Service Employees (1940). In 1942, Townsend was the first black to obtain a seat on the executive council of the CIO. Appointed to the Committee to Abolish Racial Discrimination, 1942. Earned a degree from the Blackstone Law School, 1951.

TOY, CRAWFORD HOWELL (*b. Norfolk, Va., 1836; d. 1919*), orientalist, educator. Graduated University of Virginia, 1856; studied also in Berlin. Taught biblical interpretation at Southern Baptist Seminary, 1869–79; was Hancock Professor of Hebrew and Oriental languages at Harvard, 1880–1909. Author, among other scholarly studies, of *Introduction to the History of Religions* (1913).

TRACY, BENJAMIN FRANKLIN (*b. near Owego, N.Y., 1830; d. 1915*), lawyer, New York legislator, Union brigadier general by brevet. An able U.S. attorney for the New York eastern district, 1866–73, he later served as one of defense counsel for Henry Ward Beecher and briefly as a judge of the New York court of appeals. U.S. secretary of the navy, 1889–93, he instituted a number of reforms in administration and began work on rebuilding a powerful naval force of the most modern type.

TRACY, JOSEPH (*b. Hartford, Vt., 1793; d. Beverly, Mass., 1874*), Congregational clergyman, editor. Secretary of the Massachusetts Colonization Society, 1842–74, and director of the American Colonization Society *post* 1858, he was active in the founding of Liberia College and made other outstanding contributions to the colonization movement.

Tracy, Nathaniel (*b. present Newburyport, Mass., 1751; d. Newbury, Mass., 1796*), merchant, Revolutionary patriot. Uncle of Charles and Patrick T. Jackson, and of James Jackson (1777–1867). Graduated Harvard, 1769. Operated privateers and merchant vessels out of Newburyport, 1775–83; after initial success he was reduced to virtual bankruptcy through loss of a number of vessels and other business misfortunes.

Tracy, Spencer Bonaventure (*b. Milwaukee, Wis., 1900; d. Beverly Hills, Calif., 1967*), actor. Attended Ripon College (1921–22) and the American Academy of Dramatic Arts (1922–23). Originally intending to become a doctor, Tracy decided to become an actor after appearing in Ripon's dramatic productions. His first speaking part on Broadway was in *A Royal Fandango* (1923), but he did not achieve a critical and popular breakthrough until 1930, in *The Last Mile*. His performance attracted the attention of film director John Ford, who cast him in *Up the River* (1930), a comedy about prison life. Fox signed Tracy to a five-year contract in 1931, releasing him in 1935. Immediately thereafter he signed with Metro-Goldwyn-Mayer, where he was cast in the three roles that raised him to stardom: *San Francisco* (1936), *Fury* 1936), and *Libeled Lady* (1936). He received his first Academy Award as best actor for *Captains Courageous* (1937) and his second for *Boys Town* (1938). In 1941 he began a professional and personal association with Katharine Hepburn; they made nine films together. His later films include *Father of the Bride* (1950), *The Old Man and the Sea* (1958), *Inherit the Wind* (1960), and *Judgment at Nuremberg* (1961). He received two Oscars and nine best-actor nominations; to many of his contemporaries, he was the greatest screen actor of his generation.

Tracy, Uriah (*b. present Franklin, Conn., 1755; d. Washington, D.C., 1807*), lawyer, Connecticut legislator and official. Congressman, Federalist, from Connecticut, 1793–96; U.S. senator, 1796–1807. A shrewd partisan politician.

Traetta, Filippo. *See* Trajetta, Philip.

Train, Arthur Cheney (*b. Boston, Mass., 1875; d. New York, N.Y., 1945*), lawyer, author. A.B., Harvard, 1896; LL.B., Harvard Law School, 1899. Assistant district attorney, New York County, New York City, 1901–08 and 1913–15, he won reputation as a skillful prosecutor and gained the experience that he employed in his best remembered stories—the courtroom adventures of lawyer "Ephraim Tutt," an ideal character embodying the virtues of Robin Hood, Abraham Lincoln, and Uncle Sam. Mr. Tutt appeared for the first time in a story in the *Saturday Evening Post*, June 1919, and in some eighty stories thereafter. *Mr. Tutt at His Best* (1961, with an introduction by Judge Harold Medina) is a representative selection.

Train, Enoch (*b. probably Weston, Mass., 1801; d. Saugus, Mass., 1868*), Boston merchant, shipowner. Father of Adeline D. T. Whitney. Established a line of sailing packets between Boston and Liverpool, 1844; commissioned a number of vessels from Donald McKay. Made notable success by importing Irish immigrants *post* 1846, serving also as an immigrant agent and banker.

Train, George Francis (*b. Boston, Mass., 1829; d. New York, N.Y., 1904*), Boston merchant, shipowner, champion of eccentric causes.

Trajetta, Philip (*b. Venice, Italy, ca. 1776; d. probably Philadelphia, Pa., 1854*), musician, composer, Italian revolutionary. Resided and worked in a number of American cities *post* 1799; composed operas, oratorios, and cantatas.

Trammell, Niles (*b. Marietta, Ga., 1894; d. North Miami, Fla., 1973*), pioneer network radio and television executive. Attended University of the South in Sewanee, Tenn. (1914–17) and joined the army with the onset of World War I. In 1923 he became a West Coast commercial representative in the traffic department of RCA in San Francisco and by 1929 had risen to the position of vice-president of the Central Division of NBC (part of RCA) in Chicago. Under his leadership, 1,000 of the 1,800 NBC radio programs being broadcast each month originated in the Chicago office, including such hits as "Fibber McGee and Molly" and "Amos 'n' Andy." Trammell was dubbed the "father of the soap opera" for popularizing daytime dramas sponsored by soap manufacturers. He transferred to New York in 1939 and became network president (1940–49) and chairman (1949–52). He became president of Biscayne Television Corporation in Miami in 1952 and a business consultant to television and radio concerns in 1962.

Trask, James Dowling (*b. Astoria, L.I., N.Y., 1890; d. Chicago, Ill., 1942*), pediatrician, medical researcher. Ph.B., Yale, 1913. M.D., Cornell Medical College, 1917. After World War I service with U.S. Army Medical Corps, he worked at Rockefeller Institute, New York City, 1919–21, on determination of the cause of measles; thereafter, he taught at Yale Medical School and carried out important studies on pneumonia, scarlet fever, and streptococcal infections. Appointed to two commissions of the U.S. Army's epidemiological board, 1941, he contracted a fatal disease while investigating an outbreak of streptococcal infection at Chanute Field, Illinois.

Traubel, Helen (*b. St. Louis, Mo., 1899; d. Santa Monica, Calif., 1972*), operatic soprano. Began studying voice at the age of thirteen in St. Louis with Louise Vetta–Karst. She made her concert debut with the St. Louis Symphony Orchestra in 1924 but did not debut at New York's Metropolitan Opera until 1937. After appearing there in 1939 as Sieglinde in Wagner's *Die Walküre*, she remained a principal Wagnerian soprano at the Met until the early 1950's. Thereafter the immensely popular singer continued to pursue her diverse musical interests, including recitals, concerts, and appearances in the film *Deep in My Heart* (1954) and the Broadway musical *Pipe Dream* (1955).

Traubel, Horace L. (*b. Camden, N.J., 1858; d. Bon Echo, Ontario, Canada, 1919*), journalist. A close friend of Walt Whitman, Traubel served as one of his literary executors and was author of *With Walt Whitman in Camden* (1906–14), a valuable diary of his association with the poet beginning March 1888. He was also active in the American Socialist movement and edited a monthly paper, the *Conservator*, 1890–1919.

Trautwine, John Cresson (*b. Philadelphia, Pa., 1810; d. Philadelphia, 1883*), engineer, mineralogist. Trained in office of William Strickland, Trautwine was employed mainly in railroad work in the United States until 1844. Between 1849 and 1853 he worked on surveys for the Panama Railroad in association with George M. Totten and explored the Isthmus of Panama in search of a possible route for an interoceanic ship canal. He was author, among other works, of the celebrated *Engineers' Pocket Book*, first published in 1871.

Travers, Jerome Dunstan (*b. New York, N.Y., 1887; d. East Hartford, Conn., 1951*), amateur golfer. Dominated American amateur golf from 1907 to 1915. Won the U.S. Amateur in 1907, 1908, 1912, and 1913. Won the U.S. Open in 1915. One of the first members of the Golf Hall of Fame, 1940.

TRAVIS, WALTER JOHN (*b. Maldon, Australia, 1862; d. Denver, Colo., 1927*), champion amateur golfer of the United States, 1900, 1901, 1903; British amateur champion, 1904.

TRAVIS, WILLIAM BARRET (*b. near Red Banks, S.C., 1809; d. The Alamo, San Antonio, Tex., 1836*), lawyer, leader in the Texas revolution. Raised in Alabama, Travis removed to Texas, 1831, where he practiced first at Anahuac and later at San Felipe. Active in local politics and in opposition to Mexican rule, Travis was commissioned lieutenant colonel of cavalry late in 1835. Ordered to reinforce the Alamo which the Texans had taken, he assumed joint command of the post with James Bowie, Feb. 13, 1836, and was in full command subsequent to Feb. 24. He died with his men in the final massacre.

TRAYLOR, MELVIN ALVAH (*b. Breeding, Ky., 1878; d. Chicago, Ill., 1934*), banker, lawyer. Beginning his career in Texas, he was active in Chicago banking circles *post ca.* 1914 and held the presidency of the First National Bank *post* 1925. A liberal man, he was active in drought relief and other civic affairs and represented the United States in the organization of the Bank for International Settlements.

TRAYNOR, HAROLD JOSEPH ("PIE") (*b. Framingham, Mass., 1899; d. Pittsburgh, Pa., 1972*), baseball player. Began his professional career in 1920 with the Boston Red Sox affiliate in Portsmouth, Va., then was sold to the Pittsburgh Pirates. One of the great third basemen in baseball history, he had a record 2,291 put-outs and a lifetime batting average of .320 in his 1,941-game career (1920–37). He became player-manager of the Pirates in 1934. An injury ended his playing career, but he remained as manager until 1939 and then as a scout; in 1944 he became a Pittsburgh radio sports commentator. Inducted into the Baseball Hall of Fame in 1948.

TREADWELL, DANIEL (*b. Ipswich, Mass., 1791; d. Cambridge, Mass., 1872*), inventor, Rumford Professor at Harvard. Apprenticed to a silversmith, he gave much of his time to experiments with machinery and patented a power printing press (March 1826) which became widely used in book and newspaper printing. Between 1831 and 1835 he secured basic patents for a hemp-spinning machine which attained worldwide use. A popular lecturer on the steam engine and other practical subjects, he also devised a system of turnouts for railroad operation and a method of manufacturing steel cannon out of rings welded together and reinforced by bands. Internationally honored, he was active in many learned societies.

TREAT, ROBERT (*b. Pitminster, England, ca. 1622; d. Milford, Conn., 1710*), Connecticut colonial official. Settled at Wethersfield, Conn., by 1639, he soon removed to Milford and by 1653 was deputy from Milford to the General Court. A holder of various town offices, he actively opposed absorption of New Haven Colony by Connecticut and was leader of the group from New Haven which settled Newark, N.J. He represented Newark in the East Jersey Assembly, 1667–72. Returning to Milford, he was active in military affairs, commanding the Connecticut troops operating against King Philip, 1675, and in later Indian skirmishes. Elected deputy governor of Connecticut, 1676, he advanced to the governorship in 1683 and held that office until 1687. After the overthrow of Andros's government, 1689, Treat became governor again and served until 1698, maintaining the conservative traditions of the colony. He was deputy governor, 1698–1708.

TREAT, SAMUEL (*b. Portsmouth, N.H., 1815; d. Rochester, N.Y., 1902*), Missouri jurist, teacher of law. Removing to St. Louis, Mo., 1841, he became influential in Democratic politics

and was judge of the St. Louis court of common pleas, 1849–57. Appointed U.S. district judge for eastern Missouri, 1857, he served until 1887 and was one of the organizers of the law school at Washington University. He was expert in admiralty law.

TREAT, SAMUEL HUBBELL (*b. Plainfield, N.Y., 1811; d. 1887*), Illinois jurist. Admitted to the New York bar, 1834, he removed to Springfield, Ill., where he soon had an extensive practice. State circuit court judge, 1839–41, and state supreme court judge, 1841–55, he served thereafter as U.S. judge for the southern district of Illinois. He was coeditor and annotator of *The Statutes of Illinois* (1858).

TREE, LAMBERT (*b. Washington, D.C., 1832, d. New York, N.Y., 1910*), lawyer, diplomat. Practiced in Chicago, Ill., *post* 1855; served as a reforming judge of Cook Co. circuit court, 1870–75. A Democrat, he was U.S. minister to Belgium, 1885–88, and U.S. minister to Russia briefly in 1888.

TRELEASE, WILLIAM (*b. Mount Vernon, N.Y., 1857; d. Urbana, Ill., 1945*), botanist. B.S., Cornell University, 1880; made graduate studies at Harvard, receiving the S.D. degree in 1884. Taught botany at University of Wisconsin, 1881–85; headed Shaw School of Botany, Washington University, St. Louis, Mo., and was director of the Missouri Botanical Garden, 1889–1912. Professor of botany, University of Illinois, 1913–26. Author of some three hundred papers and extensive monographs, marked by unusual bibliographic thoroughness.

TREMAIN, HENRY EDWIN (*b. New York, N.Y., 1840; d. 1910*), Union officer, New York City lawyer and legal editor. Medal of Honor winner for gallantry at Resaca.

TREMAINE, HENRY BARNES (*b. Brooklyn, N.Y., 1866; d. Washington, D.C., 1932*), manufacturer of mechanical musical instruments, developer of the player piano. President, Aeolian Co., 1898–1930.

TRENCHARD, STEPHEN DECATUR (*b. Brooklyn, N.Y., 1818; d. 1883*), naval officer. Appointed midshipman, 1834. Served throughout the Civil War principally on blockade duty; won particular distinction in the second attack on Fort Fisher. Commissioned captain, 1866, he retired as rear admiral, 1880.

TRENHOLM, GEORGE ALFRED (*b. Charleston, S.C., 1807; d. Charleston, 1876*), cotton broker, South Carolina legislator, financier. Rendered important but unspectacular aid to the Confederacy through financial relations abroad and blockade running. Confederate secretary of the treasury, June 1864–65.

TRENT, WILLIAM (*b. probably Philadelphia, Pa., 1715; d. Philadelphia, ca. 1787*), Indian trader, land speculator. In partnership with George Croghan, *ca.* 1749–*ca.* 1755. Trent along with others suffered loss from French and Indian raids along the Ohio in 1754 and later during Pontiac's uprising, 1763. In compensation, he and his associates, including Samuel Wharton and George Morgan, got from the Iroquois a grant of a tract along the upper Ohio known as "Indiana," Accompanying Wharton to England, 1769, he remained there until 1775, endeavoring to obtain royal confirmation of this grant and of another larger project known as Vandalia. Failing to do so, he returned home and continued to present unsuccessful memorials to the Virginia Assembly and to Congress in the hope of securing validation of title.

TRENT, WILLIAM PETERFIELD (*b. Richmond, Va., 1862; d. Hopewell Junction, N.Y., 1939*), educator, historian. Graduated University of Virginia, 1883; A.M., 1884. Made postgraduate

studies in history at Johns Hopkins where he was deeply influenced by Herbert B. Adams. As professor at University of the South, Sewanee, Tenn., 1888–1900, he changed his field from history to literature, and in 1900 began a long career at Columbia University as professor of English literature, Barnard College. Professor also in the graduate school of the university, he remained active in teaching until 1927. A prodigious worker, Trent was editor of a number of texts and author of many books. Among his early works, his *William Gilmore Simms* (1892) was condemned by southern critics for its unfair criticism of the environment in which Simms lived and wrote. A principal editor of the *Cambridge History of American Literature* (1917–21) and editor-in-chief of the Columbia edition of *The Works of John Milton* in the earlier stages of its development, Trent devoted many years of research to a monumental work on Daniel Defoe which remains unpublished. As a teacher he insisted always on appreciation of literature for its own sake subordinating philology and literary history to aesthetic understanding.

TRESCA, CARLO (*b. Sulmona, Italy, 1879; d. New York, N.Y., 1943*), labor agitator, journalist. A revolutionary activist in the 19th-century, romantic tradition, he came to the United States in 1904. Associated at various times with the socialists, the communist anarchists, the I.W.W., and the communist wing of the socialists, he was a consistent and truculent enemy of totalitarianism *post ca.* 1937. A man with many enemies, he was murdered on January 11, 1943, as he left his office in New York City; his murderer was never discovered.

TRESCOT, WILLIAM HENRY (*b. Charleston, S.C., 1822; d. Pendleton, S.C., 1898*), lawyer, South Carolina Confederate legislator, U.S. diplomatic agent, historian. After winning repute as a public speaker and for a number of valuable historical works which included *The Position and Course of the South* (1850), *Diplomacy of the Revolution* (1852), and *The Diplomatic History of the Administrations of Washington and Adams* (1857), he was appointed assistant U.S. secretary of state, 1860. On South Carolina's secession in December of that year, he resigned but stayed in Washington until February 1861 as unofficial adviser of the South Carolina authorities, playing an important part in the negotiations over the Charleston forts and endeavoring to postpone a crisis by preventing reinforcements of the forts by the federal government. After valuable services to the Confederacy, he worked *post* 1865 in Washington as South Carolina agent for recovery of lands seized and taxes levied under the direct tax act of Congress. He also served as a special diplomatic agent of the United States in missions to China, Chile, and Mexico.

TREVELLICK, RICHARD F. (*b. St. Mary's, Scilly Islands, England, 1830; d. Detroit, Mich., 1895*), ship's carpenter, seaman, labor leader. Immigrating to New Orleans, La., 1857, and settling in Detroit, 1861, he became president of the ship carpenters' and caulkers' union and also first president of the Detroit Trades' Assembly. He was president of the National Labor Union, 1869, 1871–72. In 1868, at his own expense, he led one of the first successful labor lobbies, pushing an eight-hour-day act for federal mechanics and laborers through Congress; he also upheld the unpopular idea of abolishing the color line in unions. Active in the Greenback party and convinced of the need for combined industrial and political labor activity, he was one of the first great labor agitators of America.

TRILLING, LIONEL (*b. New York City, 1905; d. New York City, 1975*), author and critic. Graduated Columbia University (B.A., 1925; M.A., 1926; Ph.D., 1938) and spent virtually all his academic career at Columbia, where he held successive faculty appointments from 1931 until his death. He was the embodiment of the New York intellectual and, with Edmund Wilson and F. R. Leavis, dominated the critical world of midcentury America. His works include *Freud and the Crisis of Our Culture* (1955), *The Opposing Self* (1955), *A Gathering of Fugitives* (1956), *The Liberal Imagination* (1958), and *Beyond Culture: Essays on Literature and Learning* (1965). He also served on the editorial boards of the *Kenyon Review* and the *Partisan Review*.

TRIMBLE, ALLEN (*b. Augusta Co., Va., 1783; d. Hillsboro, Ohio, 1870*), agriculturist, Ohio legislator. Raised near Lexington, Ky.; settled in present Highland Co., Ohio, 1805. Acting governor of Ohio, 1822. National Republican governor of Ohio, 1826–30, he was a supporter of Henry Clay's policies and continued after retirement to be an active Whig.

TRIMBLE, ISAAC RIDGEWAY (*b. Culpeper Co., Va., 1802; d. Baltimore, Md., 1888*), soldier, engineer. Raised in Kentucky. Graduated West Point, 1822. Resigning from the army, 1832, he engaged in railroad surveys and management, and was general superintendent of the Baltimore and Potomac Railroad, 1859–61. Commissioned Confederate brigadier general, he served with distinction under Ewell and T. J. Jackson in the Army of Northern Virginia, notably at the second battle of Bull Run in which he was seriously wounded. Commissioned major general, 1862, he was again badly wounded at Gettysburg and taken prisoner. He was not exchanged until just before Appomattox.

TRIMBLE, ROBERT (*b. Augusta Co., Va., 1777; d. Paris, Ky., 1828*), Kentucky jurist. Studied law under George Nicholas and James Brown; practiced at Paris, Ky., *post* 1800. An outstanding lawyer of his section, he was U.S. district judge for Kentucky, 1817–26. Appointed a justice of the U.S. Supreme Court, 1826, he served until his untimely death, supporting John Marshall on constitutional doctrine in most cases but differing with him in *Ogden* v. *Saunders* (12 *Wheaton*, 121), wherein Trimble wrote one of his ablest opinions.

TRIPP, BARTLETT (*b. Harmony, Maine, 1842; d. Yankton, S.Dak., 1911*), jurist, diplomat. Practiced in Dakota Territory *post ca.* 1869; presided over first territorial constitutional convention, 1883; chief justice, territorial supreme court, 1885–89. As U.S. minister to Austria-Hungary, 1893–97, he secured Austrian consent to a ruling that its administrative officers must accept American passports as *prima facie* evidence of America citizenship. He was chairman of the Samoan commission, 1899.

TRIPP, GUY EASTMAN (*b. Wells, Maine, 1865; d. New York, N.Y., 1927*), industrialist. An associate and officer of Stone & Webster, 1897–1911, he became chairman of the board of Westinghouse Electric & Manufacturing Co. in 1912 and held that post until his death. During World War I, as brigadier general he gave important assistance to the chief of ordnance, U.S. Army.

TRIPPE, JOHN (*b. Dorchester Co., Md., 1785; d. Havana, Cuba, 1810*), naval officer. Appointed midshipman, 1799, he is particularly remembered for his single combat with a Tripolitan ship captain during a boarding mission off Tripoli, Aug. 3, 1804.

TRIST, NICHOLAS PHILIP (*b. Charlottesville, Va., 1800; d. Alexandria, Va., 1874*), diplomat, lawyer. Attended West Point; studied in law office of Thomas Jefferson whose granddaughter, Virginia Jefferson Randolph, he later married. A man of high integrity, Trist served as U.S. consul to Havana, Cuba, 1833–41. Appointed chief clerk of the U.S. State Department, 1845, he went as special agent to negotiate a treaty of peace with Mexico, 1847. Exceeding his instructions, he was recalled in November 1847, possibly as part of a U.S. government maneuver to exact severer terms. Trist, however, considered it his duty to proceed

with the work and on Feb. 2, 1848, signed a treaty in strict compliance with his original instructions, thereby ending his diplomatic career.

TRISTANO, LEONARD JOSEPH ("LENNIE") (*b. Chicago, Ill., 1919; d. Jamaica, Queens, N.Y., 1978*), jazz pianist and composer. Began playing piano by age four, when his eyesight began to fail. Completely blind by age nine, he studied piano, drums, and wind instruments at a state school for the blind and attended the American Conservatory of Music in Chicago (1938–43). He taught advanced students at Christiansen School of Popular Music, insisting, despite conventional wisdom, that jazz could be taught but believing that the heart of jazz was improvisation. He moved to New York City in 1946, recorded with a trio of piano, guitar, and bass, and played with major musicians, including Charlie Parker, Max Roach, and Charles Mingus. He created the Lennie Tristano Sextet (1948), opened the Lennie Tristano School of Music (1951–56), formed Jazz Records (1951), and led groups at the Half Note nightclub (1958–65). His sound was characterized by long, intricate ensemble figures, use of counterpoint, and an emphasis on melody that flowed freely over bar lines, creating the effect of polymeter.

TROLAND, LEONARD THOMPSON (*b. Norwich, Conn., 1889; d. California, 1932*), psychologist, scientist, inventor. B.S., Massachusetts Institute of Technology, 1912; Ph.D., Harvard, 1915. A teacher of psychology at Harvard, 1916–29, and noted for his researches in physiological optics, Troland was chief engineer and director of research for the Technicolor Motion Picture Corp. *post* 1918. He invented and perfected the modern multicolor process for colored motion pictures in all its details.

TROOST, GERARD (*b. Bois-le-Duc, Holland, 1776; d. Nashville, Tenn., 1850*), geologist. Educated at the universities of Leyden and Amsterdam, Troost practiced as a pharmacist and served in the Netherlands army; he traveled in Europe making collections of minerals for the King of Holland, 1807–09. Sailing from Paris, Troost arrived in America early in 1810. Resident in Philadelphia, Pa., 1810–25, he established a pharmaceutical and chemical laboratory; a founder of the Academy of Natural Sciences in Philadelphia, 1812, he served it for five years as its first president. Joining William Maclure, Thomas Say, Robert D. Owen, and others in the community at New Harmony, Ind., 1825, he removed in 1827 to Nashville, Tenn., and was professor of sciences at the University of Nashville, 1828–50. He was also state geologist of Tennessee *post* 1831.

TROTT, BENJAMIN (*b. probably Boston, Mass., ca. 1770; d. probably Baltimore, Md., ca. 1841*), portrait painter, miniaturist. Trott was self-taught save for experience gained making miniatures after the portraits of Gilbert Stuart. His best work (done *ca.* 1805) is excelled only by that of Malbone and is distinguished by fine clear color, a talent for characterization, elimination of any but the most necessary costume details, and a characteristic elongation of the neck line and collar.

TROTT, NICHOLAS (*b. England, 1662/63; d. Charleston, S.C., 1739/40*), colonial jurist and official. Came to Charleston, S.C., in May 1699 as attorney general of that part of the Province of Carolina which lay south and west of Cape Fear. An English lawyer of great learning (not to be confused with Nicholas Trott, governor of the Bahamas, his cousin), he became a member of the Commons House and its speaker and was an aggressive leader of the ruling faction in the province until *ca.* 1720. Appointed chief justice, 1702/03, he continued to claim that office as late as 1729. He was author, among other works, of *The Laws of the Province of South Carolina* (1736).

TROUP, GEORGE MICHAEL (*b. McIntosh's Bluff, on Tombigbee River, present Alabama, 1780; d. Montgomery Co., Ga., 1856*), lawyer, Georgia legislator. Graduated College of New Jersey (Princeton), 1797. Congressman, Democratic-Republican, from Georgia, 1807–15, he opposed the Yazoo claims and recharter of the federal bank; he was a consistent supporter of the Jeffersonian program. U.S. senator, 1816–18, he was Crawford Democrat governor of Georgia, 1823–27, in which time he vigorously defended the rights of the state to Creek lands in defiance of President John Q. Adams. Again U.S. senator, 1829–33, he upheld the right of nullification but considered it unwise; he urged legislative action and southern nonconsumption as remedies against tariff pressures from Washington. After his formal retirement from political office, he continued active as a strong states' rights Democrat.

TROUP, ROBERT (*b. probably New York, 1757; d. New York, N.Y., 1832*), Revolutionary soldier, New York jurist and land agent. Interested in land speculation *post* 1794, he was successful as agent for the Pulteney interests in western New York State, 1801–32, and closely connected with settlement of the Genesee country.

TROW, JOHN FOWLER (*b. Andover, Mass., 1810; d. Orange, N.J., 1886*), printer, bookseller, publisher. In business in New York City *post* 1833, he is best remembered for his publication of *Trow's New York City Directory*, post *ca.* 1852.

TROWBRIDGE, AUGUSTUS (*b. New York, N.Y., 1870; d. Taormina, Sicily, 1934*), physicist. Attended Columbia University; Ph.D., Berlin, 1898. Taught physics at universities of Michigan and Wisconsin; was professor of physics at Princeton, 1906–33. An able administrator and research scholar in the field of radiation, he was dean of the graduate school at Princeton, 1928–32.

TROWBRIDGE, EDMUND (*b. Cambridge, Mass., 1709; d. Cambridge, 1793*), jurist. Graduated Harvard, 1728. Massachusetts attorney general, 1749–67, he served as judge of the superior court from 1767 until the Revolution with great ability and impartiality. A moderate conservative and an expert in real property law, he presided over the Boston Massacre trial with fairness and courage. Among his pupils in the law were Theophilus Parsons and Francis Dana, his nephew.

TROWBRIDGE, JOHN (*b. Boston, Mass., 1843; d. Cambridge, Mass., 1923*), physicist, educator. S.B., Lawrence Scientific School, Harvard, 1865. A teacher of physics at Harvard and Massachusetts Institute of Technology for many years, he was Rumford Professor of Science, 1888–1910, and director of the Jefferson Physical Laboratory. A proponent of original research by students, Trowbridge was largely responsible for modernizing methods of teaching science at Harvard and development of improved laboratory facilities there. He was author of a number of research papers in spectrum analysis and the conduction of electricity through gases.

TROWBRIDGE, JOHN TOWNSEND (*b. Monroe Co., N.Y., 1827; d. Arlington, Mass., 1916*), journalist, novelist, poet. Author of a number of works of which the most popular and successful were stories for older boys.

TROWBRIDGE, WILLIAM PETIT (*b. Troy, N.Y., 1828; d. New Haven, Conn., 1892*), engineer, educator. Graduated West Point, 1848. Engaged for a number of years in coast survey work and geodetic surveys, he performed valuable services for the Union Army during the Civil War, taught engineering at Yale, 1871–77, and thereafter was professor of engineering in the School of Mines, Columbia University.

TROYE, EDWARD (*b. near Geneva, Switzerland, 1808; d. Georgetown, Ky., 1874*), Artist whose paintings (*post* 1835) of celebrated American blood horses have much historical and artistic value.

TRUDE, ALFRED SAMUEL (*b. New York, N.Y., 1847; d. 1933*), lawyer. Removed to Chicago, Ill., *ca.* 1864; practiced there *post* 1871; one of the most successful trial lawyers of his time in both civil and criminal cases.

TRUDEAU, EDWARD LIVINGSTON (*b. New York, N.Y., 1848; d. Saranac Lake, N.Y., 1915*), physician, pioneer in tuberculosis research. After early education in France and study at Columbia College, Trudeau graduated at New York College of Physicians and Surgeons, 1871. Stricken with pulmonary tuberculosis, 1873, he moved to the Adirondacks where he lived quietly until 1880 when he resumed medical practice in that region. His work led him to the study of both early diagnosis of tuberculosis and the cure of tubercular patients. In 1884 he founded what became Trudeau Sanatorium, the first American institution of its type; he also built a laboratory (eventually the Saranac Laboratory) where the first tuberculosis immunity experiments in America were performed.

TRUE, ALFRED CHARLES (*b. Middletown, Conn., 1853; d. 1929*), leader in agricultural education. Brother of Frederick W. True. Educated at Wesleyan and Harvard, True taught classic languages for some years before joining the staff of the office of experiment stations, U.S. Department of Agriculture, 1889. He became director of the office in 1893 and expanded its function greatly, supervising research and publication in agricultural education, home economics, irrigation and drainage, and also directing experiment stations in the territories. True's influence was furthered by leadership in what became the Association of Land Grant Colleges and Universities.

TRUE, FREDERICK WILLIAM (*b. Middletown, Conn., 1858; d. 1914*), zoologist. Brother of Alfred C. True. *Post* 1881 an executive of the Smithsonian Institution and ultimately curator of the National Museum, he combined administrative functions with scholarly research on whales and other mammals.

TRUEBLOOD, BENJAMIN FRANKLIN (*b. Salem, Ind., 1847; d. 1916*), educator, professional pacifist worker. Secretary, American Peace Society, 1892–1915.

TRUETT, GEORGE WASHINGTON (*b. near Hayesville, N.C., 1867; d. Dallas, Tex., 1944*), Southern Baptist clergyman. Ordained, 1890. Graduated Baylor University, 1897. Principal pastorate at First Baptist Church, Dallas, 1897–1944. A great preacher and revivalist.

TRUMAN, BENJAMIN CUMMINGS (*b. Providence, R.I., 1835; d. Los Angeles, Calif., 1916*), journalist, federal official, author. A brilliant Civil War correspondent, he observed conditions in the South, 1865–66, reporting them in letters to the *New York Times* and also in *Senate Exec. Doc. No. 43*, 39th Congress, 1st Session.

TRUMAN, HARRY S. (*b. Lamar, Mo., 1884; d. Kansas City, Mo., 1972*), thirty-third president of the United States. In his youth lived with his family on his maternal grandmother's farm near Grandview, Mo., as well as in Independence, Mo., and in Kansas City, where he worked as a bank clerk (1903–06). He volunteered for service in World War I (1917) and was elected a first lieutenant in the Kansas City regiment that he had organized and that entered federal service as the 129th Field Artillery. Promoted to captain, he took over Battery D and led his men through hard action in the Battle of the Meuse–Argonne in September–November 1918. After the war, he became a partner in a Kansas City haberdashery, but the business collapsed three years later. With the help of Thomas J. Pendergast, boss of Kansas City's political machine, Truman was elected county judge (county commissioner) in 1922 and held several county executive posts over the next decade. Elected in 1934 to the U.S. Senate, he became an expert in transportation issues, cosponsoring the Civil Aeronautics Act of 1938, which regulated airlines until the 1970's, and the Wheeler–Truman Transportation Act of 1940, which sought to bring fair competition among the railroad, barge, and trucking industries. He was reelected to the Senate after a close primary race (1940) and achieved prominence with the Truman Committee, which investigated widespread fraud in military contracts. He was the vice-presidential candidate on the ticket for President Franklin D. Roosevelt's successful bid for a fourth term (1944). He became president when Roosevelt died on Apr. 12, 1945, during the final stages of World War II.

Truman announced Germany's surrender on May 8, 1945, and allowed preparations to continue for the detonation of a nuclear test device in New Mexico on July 16. He scheduled a Big Three meeting with Winston Churchill and Joseph Stalin at Potsdam on July 17, ensuring Soviet entrance into the war against Japan. Truman ordered the atomic bombing of Hiroshima and Nagasaki on August 6 and 9, respectively, which killed 120,000 Japanese; he later maintained that more American and Japanese lives were saved by ending the war. (Japan surrendered on August 14.) In the postwar years the Truman administration initiated the Marshall Plan (1947), a multibillion-dollar program to support economic recovery in Western Europe; announced the Truman Doctrine (1947), a statement of principle that the United States would support any nation threatened by Soviet Communism; and allied the United States militarily with Western European nations in the North Atlantic Treaty Organization (1949). Truman staged an upset victory over New York governor Thomas E. Dewey in the 1948 election but soon was accused of cronyism and, in the tirades of the Red-baiting Senator Joseph McCarthy, of harboring Communists within his administration.

TRUMBAUER, HORACE (*b. Philadelphia, Pa., 1868; d. Philadelphia, 1938*), architect. Began his own practice in Philadelphia, 1892; became preferred architect for activities of Peter A. B. Widener and his financial allies, the Elkins family. Working principally in the style of the French Renaissance, he excelled in persuading his clients that their magnificent incomes could find best expression in magnificence of building. His firm's work is best represented in Philadelphia and New York and the areas about those cities, but it was also responsible for the plans for the entire campus of Duke University at Durham, N.C. Among the designers whose work contributed to Trumbauer's success were Frank Seeburger, William O. Frank, and Julian Abele.

TRUMBO, (JAMES) DALTON (*b. Montrose, Calif., 1905; Los Angeles, Calif., 1976*), screenwriter and novelist. Attended University of Colorado (1924–25), University of California, Los Angeles (1926), and University of Southern California (1928–30). He sold his first screenplay, *Jealousy*, to Columbia Pictures in 1934. His first novel was *Eclipse* (1935), and his third novel, *Johnny Got His Gun*, was made into a critically acclaimed film using Trumbo's script (1971). From 1935 to 1945 he worked on twenty-one films, including *A Man to Remember* (1938) and *Thirty Seconds over Tokyo* (1944). He also wrote stories for such national magazines as *Vanity Fair*, *McCall's*, and *Saturday Evening Post* and for the left-wing publications *The New Masses* and *Masses and Mainstream*. By 1945 he was one of the highest-paid writers in Hollywood but was named as a subversive, investigated by the House Un–American Activities Committee (1947), and found

guilty of contempt of Congress for refusing to give any information about his politics. He entered federal prison in June 1950 and was released in April 1951. Placed on a Hollywood blacklist of suspected Communist sympathizers, he was unable to work under his own name. His screenplay *The Brave Bulls*, credited to "Robert Rich," won an Academy Award (1957), and he was able to resume writing under his own name. His later screenplays include *Spartacus* and *Exodus* (both 1960), *Hawaii* (1966), *The Fixer* (1968), and *Papillon* (1973).

TRUMBULL, BENJAMIN (*b. Hebron, Conn., 1735; d. 1820*), Congregational clergyman, historian. Pastor *post* 1760 at North Haven, Conn., he is remembered for his valuable chronicle of Connecticut history from the beginnings to 1764 (first volume, 1797; extended edition, 1818).

TRUMBULL, HENRY CLAY (*b. Stonington, Conn., 1830; d. Philadelphia, Pa., 1903*), Congregational clergyman, Union chaplain in Civil War, Sunday School missionary and writer. Brother of James H. Trumbull.

TRUMBULL, JAMES HAMMOND (*b. Stonington, Conn., 1821; d. Hartford, Conn., 1897*), Connecticut public official, bibliographer, philologist. Brother of Henry C. Trumbull. Historian of New England Indians, particularly those of Connecticut; edited Connecticut colonial records; catalogued library of George Brinley.

TRUMBULL, JOHN (*b. Westbury, Conn., 1750 o.s.; d. Detroit, Mich., 1831*), poet, Connecticut jurist. Descendant of Solomon Stoddard; second cousin of John (1756–1843), Jonathan (1740–1809), and Joseph Trumbull. Passed Yale entrance examination at age of 7 but did not in fact matriculate until 13. As student, he was critical of a curriculum which neglected *belles lettres* in favor of theology, linguistics, and mathematics. Achieving more than local reputation for poems both satirical and classic and for prose essays, he graduated in 1767 but continued his studies at Yale and was awarded the M.A., 1770. While a Yale tutor, 1772–73, he composed and published a satire on college studies, *The Progress of Dulness*; he was also author of a series of essays published under pen name "The Correspondent" in *The Connecticut Journal* (1770 and 1773). Removing to Boston, Mass., 1773, he continued legal studies under John Adams and published a poem on national affairs. *An Elegy on the Times* (1774). He practiced law at New Haven, Conn., 1774–77, and *post* 1781 at Hartford. Meanwhile he had written the first canto of his *M'Fingal* which was published early in 1776 bearing a 1775 imprint; after the Revolution he divided this canto into two and wrote two additional ones, publishing the entire work for the first time at Hartford, 1782. A Hudibrastic, loose narrative of the troubles of a Tory squire, the poem constitutes a comprehensive review of the blunders of pro-British leaders, and took rank *post* 1783 as an important contribution to American literature; it was the most popular American poem of its length before Longfellow's *Evangeline*. Although regarded as literary leader of the "Hartford Wits," 1785–1800, Trumbull did little to sustain his reputation and showed an increasing interest in law and politics. A strong Federalist, he held state office and served in the legislature; he was judge of the state superior court, 1801–19, and judge of the state supreme court of errors, 1808–19. *The Poetical Works of John Trumbull*, a collected edition, appeared in 1820.

TRUMBULL, JOHN (*b. Lebanon, Conn., 1756; d. New York, N.Y., 1843*), painter of the Revolution. Son of Jonathan Trumbull (1710–85); brother of Jonathan (1740–1809) and Joseph Trumbull; second cousin of John Trumbull (1750–1831).

Showed early talent for drawing, but was given little opportunity for study, either during years at Harvard (graduated 1773) or during intermittent military service in the Revolution. At one time an aide-de-camp of George Washington, Trumbull resigned his commission in 1777. He served as a volunteer in the Rhode Island campaign, 1778, but devoted the years 1777–79 mainly to the study of art in Boston. In 1780 he went abroad, settling in England where he became a pupil of Benjamin West. Imprisoned on suspicion of treason and released, he went to Amsterdam and there painted a full-length portrait of Washington which was engraved and published (1781) as the first authentic likeness of the General issued in Europe. Returning to America, he engaged in commercial activities but in 1783 was back in West's London studio. Here he produced his first paintings of the Revolution, *The Battle of Bunker Hill* and the *Death of General Montgomery in the Attack of Quebec* (completed, 1786). Engravings were arranged for, though not published for twelve years.

The years 1786–89, spent in London mainly, were his most productive. He began his 8 years' labors on his *Declaration of Independence*, the most important visual record of the heroic period of American history. (Of its 48 portraits, 36 were from life, the rest from portraits by others or from memory; 13 signers were not represented and 4 non-signers were included.) Other paintings of this period include the *Surrender of Lord Cornwallis at Yorktown* and *Capture of the Hessians at Trenton*. Declining Thomas Jefferson's offer of the post of private secretary in the American Legation in Paris, he returned to America, 1789. He painted portraits, took records of "heads" for his planned historical compositions, and solicited subscriptions for engravings, but the results did not meet his expectations. As John Jay's private secretary, 1793–94, he was successful in diplomatic duties connected with Jay's Treaty; he was unsuccessful in prosecution of various commercial ventures on his own account, 1795–97. Appointed a commissioner to oversee execution of the seventh article of Jay's Treaty, he served with distinction, 1796–1804.

Trumbull married an Englishwoman in 1800 and returned with her to America in 1804, settling in New York City where he had indifferent success as a painter and art dealer. A rapid painter, he averaged five sittings to a head for which he charged $100. His style had deteriorated from disuse, however, and commissions were infrequent; in 1808 he returned to London where he was no more fortunate. In 1815 he was back in New York and two years later secured a congressional commission, over the opposition of many younger painters, to do four panels on Revolutionary subjects for the Rotunda of the U.S. Capitol at Washington. D.C. These heavy-handed, chalky, oversized reworkings of his earlier masterful paintings were unsuccessful despite seven years' effort. Other troubles were added to a steady decline in reputation and income. In 1824 his wife died. In 1826 the founding of the National Academy of Design by S. F. B. Morse and others deprived Trumbull of influence he had wielded as president of the American Academy of Fine Arts. A serious financial crisis was probably averted in 1832 by a military pension and the establishment of the Trumbull Gallery at Yale, the earliest art museum in America connected with an educational institution, which took over the artist's unsalable pictures. In his prime, Trumbull was handsome and courtly, frank and abstemious, excitable and exceedingly sensitive. As an old and disappointed man he became irritable and uncompromising. He published his *Autobiography* in 1841.

Far as he is from America's greatest painter, he is an important part of the national cultural heritage. His 250 to 300 faithful representations, drawn from life, of the principal actors and actions of the Revolution make him the chief, the most prolific, and the most competent visual recorder of that heroic time.

TRUMBULL, JONATHAN (*b. Lebanon, Conn., 1710; d. 1785*), merchant, Connecticut legislator and jurist. Father of John (1756–1843), Jonathan (1740–1809), and Joseph Trumbull. Graduated Harvard, 1727. A candidate for the ministry, he became his father's business associate when his elder brother died, 1731. His commercial ventures flourished for many years, but in 1766 he suffered a reverse for reasons not entirely clear. Meanwhile he had entered politics. First elected to the Connecticut Assembly in 1733, he served in that body or as assistant in the Council almost continually until 1766. In that year Trumbull became deputy governor, holding concurrently the post of chief justice of the superior court. In 1769 he was named governor by the Assembly (and served until his retirement in 1784). A constant supporter of colonial rights, he was the only colonial governor to take the radical side when the Revolution began. During the war Trumbull's chief contribution lay in making Connecticut a principal source of supplies for Washington's army. Though he and Washington frequently differed over details, Washington subsequently acknowledged the great importance of Trumbull's services. When the war ended, Trumbull's expressed wish for a stronger central government made him unpopular in Connecticut; this and other political complications caused his voluntary retirement.

TRUMBULL, JONATHAN (*b. Lebanon, Conn., 1740; d. 1809*), merchant, Connecticut legislator, Revolutionary soldier. Son of Jonathan Trumbull (1710–85); brother of John (1756–1843) and Joseph Trumbull. Graduated Harvard, 1759. Paymaster of the forces, New York department, Continental Army, 1775–78; first comptroller of the U.S. treasury, November 1778–April 1779; secretary to General George Washington, 1781–83. Congressman, Federalist, from Connecticut, 1789–94; was chosen speaker of the House in October 1791. U.S. senator, March 1795–June 1796, he resigned to become deputy governor of Connecticut. He succeeded to the governorship, December 1797, and was annually reelected to that post for the remainder of his life. He refused to employ the Connecticut militia in enforcement of the Embargo, 1809.

TRUMBULL, JOSEPH (*b. Lebanon, Conn., 1737; d. Lebanon, 1778*), merchant, Connecticut legislator, Revolutionary soldier. Son of Jonathan Trumbull (1710–85); brother of John (1756–1843) and Jonathan Trumbull (1740–1809). Graduated Harvard, 1756. Serving as commissary general of Connecticut troops at the siege of Boston, he showed so much efficiency that Congress at General George Washington's request appointed him commissary general of the Continental Army with the rank of colonel, July 1775. Bringing order out of chaos, he served with great ability until his resignation in 1777 over a proposal by Congress to reorganize his department. "Few armies if any," wrote Washington, "have been better and more plentifully supplied than the troops under Mr. Trumbull's care."

TRUMBULL, LYMAN (*b. Colchester, Conn., 1813; d. Chicago, Ill., 1896*), Illinois jurist. Grandson of Benjamin Trumbull. Began practice of law in Belleville, Ill., 1837. Originally a Democrat, he became a Republican after election to the U.S. Senate (1854) as a Free-Soiler. He had Abraham Lincoln's support. As senator, he opposed Douglas on Kansas. He helped Lincoln during the Civil War but resisted executive encroachments on congressional authority. After aiding the Radicals against President Andrew Johnson, he opposed impeachment and later Radical actions as legally excessive. He gave support to Horace Greeley as a Liberal Republican before retiring from the Senate, 1873. He was counsel for Samuel J. Tilden in the contest over the 1876 election. An able statesman and scholarly constitutionalist, he missed fame because of a colorless personality.

TRUTEAU, JEAN BAPTISTE (*b. Montreal, Canada, 1748; d. St. Louis, Mo., 1827*), Indian trader, explorer. Schoolmaster in St. Louis *post* 1774; leader and diarist of exploring expedition on upper Missouri, 1794–95.

TRUXTUN, THOMAS (*b. near Hempstead, N.Y., 1755; d. Philadelphia, Pa., 1822*), naval officer, merchant mariner. A successful privateersman during the Revolution, he took out the first Philadelphia ship to China, the *Canton*, in 1786. Made captain in the U.S. Navy, 1794, he published several important service manuals. During the naval war with France, as commodore of a squadron operating in the West Indies, he served aboard the *Constellation*, winning actions against the French frigates *Insurgente* and *La Vengeance*, 1799–1800. Energetic and a strict disciplinarian, he set high and enduring standards for the young navy.

TRUXTUN, WILLIAM TALBOT (*b. Philadelphia, Pa., 1824; d. Norfolk, Va., 1887*), naval officer. Grandson of Thomas Truxtun. Appointed midshipman, 1841, he saw extensive service at sea up to the Civil War. During that conflict he held several commands on Atlantic blockade duty, winning the commendation of Adm. D. D. Porter. Engaged in navy-yard administration *post-bellum*, he retired as commodore, 1886.

TRYON, DWIGHT WILLIAM (*b. Hartford, Conn., 1849; d. 1925*), landscape painter, art teacher. Self-taught, Tryon worked first in the manner of John F. Kensett or William T. Richards. After study and work abroad, 1876–81 (principally in France under a disciple of Ingres), he achieved his own mature manner. Conservative in style, refined but somewhat lacking in color, Tryon's work won the admiration of Homer Martin and J. A. M. Whistler for its quality of exquisiteness and its rendering of tiny differences of tone at dusk. He painted few pictures but took great pains with them and sold them well; Charles L. Freer was a principal patron and friend. Tryon was visiting professor of art at Smith College, 1885–1923.

TRYON, GEORGE WASHINGTON (*b. Philadelphia, Pa., 1838; d. Philadelphia, 1888*), businessman, conchologist. Long active in Academy of Natural Sciences of Philadelphia; author of a number of studies on mollusks, and of the *Manual of Conchology, Structural and Systematic* (12 vols., 1879–88).

TRYON, WILLIAM (*b. Surrey, England, 1729; d. London, England, 1788*), colonial governor. After an early career in the British army, Tryon was appointed lieutenant governor of North Carolina in 1764. He became governor in 1765 and was involved immediately in the crises caused by deteriorating colonial-British relations. He strongly supported the naval and customs officers during the Stamp Act controversy, but lacking military force was unable to compel compliance with the law. When the Regulator movement broke out in the frontier counties, 1768, he restored order by force and a drastic riot act, culminating his exertions with a crushing military defeat of the Regulators at the Alamance in 1771. Transferred to the governorship of New York, 1771, he encountered frontier disturbances in the Vermont area, caused by conflicting claims between New York and New Hampshire, and also difficulties over land purchases from the Mohawk Valley Indians. Returning from an official trip to England (April 1774–June 1775), he found the Revolution in progress and his civil functions necessarily limited. Active in his preferred role of soldier, he performed his chief feats of arms in raids upon Connecticut which were successful in destroying supplies and in diverting some of Connecticut's energies from support of Washington's army to home defense. Illness ended his career in

1780 and forced his return to England. Loyal to the Crown and prone to use force, Tryon was an able if somewhat vain administrator.

TSCHERINOFF, MARIE VAN ZANDT *See* VAN ZANDT, MARIE.

TUBMAN, HARRIET (*b. Dorchester Co., Md., ca. 1821; d. Auburn, N.Y., 1913*), fugitive slave, Abolitionist, leading figure in the Underground Railroad. Author of memoirs issued as *Scenes in the Life of Harriet Tubman* (1869); revised and reissued in 1886 as *Harriet the Moses of Her People.*

TUCK, AMOS (*b. Parsonfield, Maine, 1810; d. 1879*), lawyer. Practiced in Exeter, N.H., *post* 1838. Congressman, independent Democrat-Whig, from New Hampshire, 1847–53, he acted with Joshua R. Giddings and John G. Palfrey as a nucleus of antislavery sentiment and was influential in the formation of the Republican party. He was naval officer for Boston district, 1861–65.

TUCKER, ALLEN (*b. Brooklyn, N.Y., 1866; d. New York, N.Y., 1939*), architect, painter. Graduated Columbia, 1888. While a draftsman with Richard M. Hunt, he studied painting at the Art Students League, 1891–95; the teacher who most influenced him was John H. Twachtman. Devoting all his effort to painting *post* 1904, he developed his style from impressionism into an expressionism at first influenced by Van Gogh. The work of the final decade of his life was marked by a vigorously personal maturity of style best observed in *The Pale Horse* (1928), *The Review* (1931), and a *Crucifixion* (1936).

TUCKER, BENJAMIN RICKETSON (*b. South Dartmouth, Mass., 1854; d. Monaco, 1939*), radical reformer. Attended Massachusetts Institute of Technology, 1870–73. Converted to individualist anarchism, 1872, through Josiah Warren and others, he became an authority on the work of Pierre Joseph Proudhon. He is remembered principally for his publication *Liberty*, issued regularly at Boston, 1881–92, and at New York, 1892–1908. At first an organ for publicizing the views of European anarchists in general, *Liberty* in its later days came more and more to reflect the outlook of Max Stirner.

TUCKER, GEORGE (*b. Bermuda, 1775; d. Albemarle Co., Va., 1861*), political economist, author. Removed to Virginia as a boy. There he studied and practiced law and served in the state legislature before election to Congress as a Democrat, 1819–25. In 1825 he became professor of moral philosophy at the University of Virginia, probably at the suggestion of James Madison, whom he knew intimately. During twenty years at Virginia he produced, among other works, his *Life of Thomas Jefferson* (1837). Based on extensive research and many conferences with Madison, this was an impartial and on the whole a successful contribution to early American history. Tucker's more important writings were in economics, among them, *The Laws of Wages, Profits and Rent Investigated* (1837) and *The Theory of Money and Banks Investigated* (1839). After his retirement from Virginia in 1845, he continued his scholarly activities, beginning a four-volume *History of the United States* and producing *Political Economy for the People* in 1859. Although a pragmatist in insisting that economic scholarship should lead to recommendations for public policy, Tucker was a conservative and pessimistic adherent of classical French and English economics, apparently learning nothing from the prodigious economic developments going on around him, or from such contemporaries as Henry C. and Matthew Carey. Admiring Adam Smith, he disagreed with David Ricardo in many details. He was impressed with Malthus's principle of population and used it as a basis for predicting the eventual extinction of slavery as unprofitable. His opposition to slavery was unmistakable but his criticism was never outspoken,

ranging from discreetly academic statements to strong but anonymous ridicule. It dwindled to mere feeble mention in his work published on the eve of the Civil War.

TUCKER, GILBERT MILLIGAN (*b. Albany, N.Y., 1847; d. Albany, 1932*), editor of the *Country Gentleman*, 1897–1911. Son of Luther Tucker.

TUCKER, HENRY HOLCOMBE (*b. near Camak, Ga., 1819; d. Atlanta, Ga., 1889*), lawyer, Baptist clergyman. Grandson of Henry Holcombe. A professor at Mercer University, and its president, 1866–71, he was chancellor of the University of Georgia, 1874–78. Thereafter he was proprietor and editor of the *Christian Index.*

TUCKER, HENRY ST. GEORGE (*b. "Matoax," Chesterfield Co., Va., 1780; d. Winchester, Va., 1848*), Virginia legislator, congressman and jurist. Son of St. George Tucker; brother of Nathaniel B. Tucker (1784–1851); half brother of John Randolph of Roanoke (1773–1833); father of John R. (1823–97) and Nathaniel B. Tucker (1820–90). Virginia chancery judge, 1824–31; president of supreme court of appeals of Virginia, 1831–41; professor of law, University of Virginia, 1841–45. Author, among other works, of *Commentaries on the Laws of Virginia* (1836–37).

TUCKER, HENRY ST. GEORGE (*b. Winchester, Va., 1853; d. Lexington, Va., 1932*), lawyer, legal educator. Son of John R. Tucker (1823–97). Congressman, Democrat, from Virginia, 1889–97, 1922–32. A liberal during his first service in Congress, *post* 1922 he was an ardent exponent of states' rights and a strict constructionist, opposing the social and economic legislation of that period.

TUCKER, HENRY ST. GEORGE (*b. Warsaw, Va., 1874; d. Richmond, Va., 1959*), Episcopal minister and bishop. Studied at the University of Virginia and at the Theological Seminary of Virginia, D.D., 1899. Missionary to Japan, 1899–1923. Became bishop of Virginia, 1927; presiding bishop of the Protestant Episcopal Church of America, 1941; president of the Federal Council of the Churches of Christ in America, 1942. Retired in 1946.

TUCKER, JOHN RANDOLPH (*b. Alexandria, Va., 1812; d. Petersburg, Va., 1883*), naval officer. Appointed midshipman, 1826, he rose after extensive general service to rank of commander, 1855. Entering the Confederate service, 1861, he commanded the Charleston Squadron and was promoted captain, 1863. Forming his crews into a naval brigade on evacuation of Charleston in February 1865, he distinguished himself with his command at the battle of Sailor's Creek in April. He served for a time after the war as rear admiral in the Peruvian navy.

TUCKER, JOHN RANDOLPH (*b. Winchester, Va., 1823; d. 1897*), lawyer, teacher of law, Virginia official and congressman. Son of Henry St. G. Tucker (1780–1848); brother of Nathaniel B. Tucker (1820–90); father of Henry St. G. Tucker (1853–1932). A strict-constructionist states' rights logician, he advocated tariff reform, the repeal of the internal revenue system, and sound money. He was eminently successful in his practice of law, serving in such diverse actions as the trial of Jefferson Davis and the case of the Chicago anarchists before the U.S. Supreme Court.

TUCKER, LUTHER (*b. Brandon, Vt., 1802; d. Albany, N.Y., 1873*), printer, agricultural journalist. Proprietor of *Rochester Daily Advertiser* (N.Y.), 1826–39; established *Genesee Farmer*, 1831, which he merged with the *Cultivator* in 1839. In 1846 he established the *Horticulturist*; edited by Andrew J. Downing, it became an outstanding journal. Beginning issue of the *Country*

Gentleman, 1853, he consolidated it with his *Cultivator,* 1866, thereafter publishing under the title *Cultivator and Country Gentleman.* Leader and model of agricultural journalists in his time, he was succeeded as editor-proprietor by his sons, 1873; among them was Gilbert M. Tucker.

TUCKER, NATHANIEL BEVERLEY (*b.* "*Matoax,*" *Chesterfield Co., Va., 1784; d. Winchester, Va., 1851*), professor of law, southern rights publicist. Son of St. George Tucker; brother of Henry St. G. Tucker (1780–1848); half brother of John Randolph of Roanoke (1773–1833). Professor of law at College of William and Mary *post* 1834, he reflected in his numerous letters, books, and lectures the theories of his colleague Thomas R. Dew. A lifelong advocate of secession and aristocratic government, he was author, among other works, of *George Balcombe* (published anonymously, 1836) and *The Partisan Leader* (1836, but bore fictitious date of 1856). The second of these titles attempted a fictional prophecy of what would follow as a result of the Jacksonian policies and was reprinted as propaganda by both sides during the Civil War.

TUCKER, NATHANIEL BEVERLEY (*b. Winchester, Va., 1820; d. 1890*), planter, journalist, Confederate agent. Son of Henry St. G. Tucker (1780–1848); brother of John R. Tucker (1823–97).

TUCKER, RICHARD (*b. Rubin Ticker, Brooklyn, N.Y., 1913; d. Kalamazoo, Mich., 1975*), operatic tenor. Entered the fur business as a salesman after high school, and his earliest professional singing engagements were as a cantor. After studies with the tenor Paul Althouse he made his operatic debut with the small Salmaggie Opera Company (1941). He joined the Metropolitan Opera in 1944, at first specializing in lyric roles and then taking on heavier parts as his voice matured. For three decades he remained a star at the Met.

TUCKER, ST. GEORGE (*b. Port Royal, Bermuda, 1752 o.s.; Nelson Co., Va., 1827*), Revolutionary soldier, Virginia jurist. Father of Nathaniel B. (1784–1851) and Henry St. G. Tucker (1780–1848); stepfather of John Randolph of Roanoke (1773–1833). Judge of the general court of Virginia and professor of law in the College of William and Mary, he was elected to the state supreme court of appeals, 1803, and served until 1811. Appointed U.S. district judge for Virginia, 1813, he resigned shortly before his death. He was author of a number of works, notably an annotated edition of *Blackstone's Commentaries* (1803), one of the most important law texts of its day. His minor poetry included *The Probationary Odes of Jonathan Pindar* (2 pts., 1796), once attributed to Philip M. Freneau.

TUCKER, SAMUEL (*b. Marblehead, Mass., 1747; d. Bremen, Maine, 1833*), merchant mariner, naval officer. Commanded army warships *Franklin* and *Hancock,* 1776, capturing valuable prizes off Boston. As captain in the navy *post* March 1777, he commanded frigate *Boston* and performed important services until capture of the vessel at Charleston, S.C., 1780. Retiring from active naval service, 1781, he sailed for a while on merchant ships and later became a farmer.

TUCKER, SOPHIE (*b. somewhere on a road leading to the Baltic Sea, Russia, 1887; d. New York, N.Y., 1966*), singer, actress. Arrived in the United States as a newborn, with her mother; entered show business in 1906. A headliner in vaudeville, Tucker amused audiences around the country with songs like "There's Company in the Parlour, Girls, Come on Down." In 1914 she "played the Palace," the epitome of success for vaudeville performers. She toured England, 1922 and 1924, and was a sensation. At the Palace in 1928 she was billed as "The Last of the Red Hot Mamas," a title that remained with her for the rest of her career. When vaudeville faded in popularity, she performed at nightclubs and for television. She established the Sophie Tucker Foundation (1945) and the Sophie Tucker Chair of Theater Arts at Brandeis University (1955).

TUCKER, STEPHEN DAVIS (*b. Bloomfield, N.J., 1818; d. London, England, 1902*), printing machinery inventor. Associated with R. Hoe & Co. *post* 1834, he retired as its senior partner, 1893.

TUCKER, WILLIAM JEWETT (*b. Griswold, Conn., 1839; d. 1926*), Congregational clergyman, educator. Graduated Dartmouth, 1861; Andover Theological Seminary, 1866. Distinguished for development of sociology courses at Andover and for settlement work in Boston, Mass., Tucker was a figure in the socalled "Andover controversy," 1886–92. As president of Dartmouth, 1893–1909, he strengthened the college, reforming many archaic attitudes, reorganizing finances, and modernizing the plant.

TUCKERMAN, BAYARD (*b. New York, N.Y., 1855; d. 1923*), scholar, writer. Author, among other works, of *Life of General Lafayette* (1889), *William Jay and the Constitutional Movement for the Abolition of Slavery* (1894), and *Life of General Philip Schuyler* (1903). Editor of *Diary of Philip Hone* (1889).

TUCKERMAN, EDWARD (*b. Boston, Mass., 1817; d. Amherst, Mass., 1886*), botanist, leading authority on American lichenology. Brother of Frederick G. Tuckerman. B.A., Union College, 1837; B.A., Harvard, 1847; also studied at Harvard Law and Divinity schools and at Upsala in Sweden. Professor of botany, Amherst College, *post* 1858. Author of many studies of lichens including his principal work, *Genera Lichenum* (1872).

TUCKERMAN, FREDERICK (*b. Greenfield, Mass., 1857; d. 1929*), comparative anatomist, naturalist. Son of Frederick G. Tuckerman.

TUCKERMAN, FREDERICK GODDARD (*b. Boston, Mass., 1821; d. Greenfield, Mass., 1873*), poet. Father of Frederick Tuckerman; brother of Edward Tuckerman.

TUCKERMAN, HENRY THEODORE (*b. Boston, Mass., 1813; d. New York, N.Y., 1871*), critic, essayist. Nephew of Joseph Tuckerman; cousin of Edward and Frederick G. Tuckerman. Author of a number of works, once widely read, which were typical of the romantic approach to travel, literature, and art. He produced several books of lasting value which include *Book of the Artists: American Artist Life* (1867) and *America and Her Commentators* (1864).

TUCKERMAN, JOSEPH (*b. Boston, Mass., 1778; d. Havana, Cuba, 1840*), Unitarian clergyman, philanthropist. Uncle of Edward, Frederick G., and Henry T. Tuckerman. Pastor in Chelsea, Mass., 1801–26, he was an original member of the Anthology Society; removing to Boston, 1826, he began a city mission for the poor which served as a model for similar institutions in England and France.

TUCKEY, WILLIAM (*b. Somersetshire, England, ca. 1708; d. Philadelphia, Pa., 1781*), organist, choirmaster, composer. Developed choir of Trinity Church, New York City, *post* 1753; conducted first American rendering of Handel's *Messiah* in New York, 1770. Author of a number of original compositions of which only the hymn called "Liverpool" survives.

TUDOR, FREDERIC (*b. Boston, Mass., 1783; d. Boston, 1864*), businessman. Brother of William Tudor. Conceived idea of ship-

ping ice from Boston to tropical cities *ca.* 1804; made first shipment to Martinique, 1806. Thereafter, with great ingenuity and complete ruthlessness, he developed his trade to worldwide proportions.

Tudor, William (*b. Boston, Mass., 1779; d. Rio de Janeiro, Brazil, 1830*), merchant, Massachusetts legislator, U.S. consular officer, author. Brother of Frederic Tudor. Founder and first editor (1815–17) of the *North American Review;* helped found Boston Athenaeum. A keen critic of contemporary manners, he was author, among other works, of *Letters on the Eastern States* (1820), *The Life of James Otis* (1823), and *Gebel Teir* (1829, anonymously).

Tufts, Charles (*b. present Somerville, Mass., 1781; d. 1876*), farmer, brickmaker, Universalist leader. Donated land for the building site of Tufts College, 1852.

Tufts, Cotton (*b. Medford, Mass., 1732; d. Weymouth, Mass., 1815*), physician, Revolutionary patriot. Nephew of John Tufts. Graduated Harvard, 1749. After study of medicine with a brother, began practice in Weymouth, 1752. A close friend of John Adams, Tufts was long associated with scientific, cultural, and political affairs in Massachusetts.

Tufts, James Hayden (*b. Monson, Mass., 1862; d. Berkeley, Calif., 1942*), philosopher. Graduated Amherst College, 1884. B.D., Yale Divinity School, 1889. Ph.D., University of Freiburg, 1892. Taught philosophy at University of Michigan, 1889–91; at University of Chicago, 1892–1930 (chairman of the department *post* 1905). Shared in the rise of the "Chicago School" of instrumentalist philosophy; made contributions to pragmatic moral theory; active in civic and social reform. Coauthor with John Dewey, of *Ethics* (1908); author, among other books, of *America's Social Morality* (1933). Editor, *International Journal of Ethics*, 1914–34.

Tufts, John (*b. Medford, Mass., 1689; d. Amesbury, Mass., 1752*), Congregational clergyman. Minister in West Newbury, Mass., 1714–38. Notable for influence exerted upon American music by his *A Very Plain and Easy Introduction to the Art of Singing Psalm Tunes* (*ca.* 1715) which was considered "a daring and unjustifiable innovation" and aroused much controversy.

Tugwell, Rexford Guy (*b. Sinclairville, N.Y., 1891; d. Santa Barbara, Calif., 1979*), economist, political adviser, and governor of Puerto Rico. Attended Wharton School of Economics (B.S., 1915; M.B.A., 1916) and taught at Wharton (1915–17), University of Washington (1917–18), and Columbia University (1920–37). He visited Soviet Russia in 1927 and published a positive view of Communist accomplishments in *Soviet Russia in the Second Decade* (1928); he was critical of the Hoover administration's handling of Great Depression in *Mr. Hoover's Economic Policy* (1932). As assistant secretary (1932) and under secretary (1934–36) of agriculture, he was a proponent of deficit spending to end the Great Depression and sought funds to relocate farmers to better land. He was chairman of New York City's Planning Commission (1938), chancellor of University of Puerto Rico (1941), governor of Puerto Rico (1941–46), professor of political science (1946–57) at the University of Chicago and director of its Institute of Planning (1946–50), and senior fellow at the Center for the Study of Democratic Institutions, Santa Barbara (1959–79). He was an outstanding memorialist of the New Deal, as demonstrated in his works *The Democratic Roosevelt* (1957) and *Roosevelt's Revolution* (1977).

Tulane, Paul (*b. near Princeton, N.J., 1801; d. Princeton, 1887*), New Orleans, La., merchant, philanthropist. Successful

in trade and real estate operations in New Orleans, 1822–73, Tulane donated property whose income made possible the conversion of the University of Louisiana, a state institution, into the independent Tulane University, 1884.

Tully, William (*b. Saybrook Point, Conn., 1785; d. Springfield, Mass., 1859*), physician. Graduated Yale, 1806; studied medicine with, among others, Nathan Smith (1762–1829) and Eli Ives. In practice thereafter in many locations, Tully was considered the most learned and scientific physician of his time in New England. An authority on *Materia medica*, he was a prolific writer on medical topics and a teacher for many years at the medical school at Castleton, Vt., and at Yale.

Tumulty, Joseph Patrick (*b. Jersey City, N.J., 1879; d. Baltimore, Md., 1954*), politician. Graduated from St. Peter's College, 1899. Adviser to Woodrow Wilson in his gubernatorial campaign in New Jersey, 1910. As secretary to Wilson, 1913–21, Tumulty advised on both domestic and foreign affairs, losing favor with his support of anti-Prohibitionists. Retired to private law practice in Washington, D.C.

Tunnell, Emlen (*b. Bryn Mawr, Pa., 1925; d. Pleasantville, N.Y., 1975*), football player. Attended University of Toledo and University of Iowa and became a professional football player in 1948, becoming the first black player (a defensive safety) for the New York Giants (1948–59). He also played with the Green Bay Packers 1960–61 before retiring as a player and becoming a scout for both the Giants and Packers. He was also the first African American to become a full-time coach in the National Football League (as defensive assistant coach for the Giants, 1965) and the first to be inducted into the Football Hall of Fame (1967).

Tunney, James Joseph ("Gene") (*b. New York City, 1897; d. Greenwich, Conn., 1978*), heavyweight boxing champion. Won his first professional fight as a 140-pound in 1915. He boxed as a marine with the American Expeditionary Forces in France and won the AEF's light heavyweight championship (1918). He won the U.S. light heavyweight title in 1922 and lost it later that year, the only loss of his career. He fought heavyweight champion Jack Dempsey and won the title in 1926. A rematch in 1927 created the most famous moment in boxing history. Tunney commanded the first six rounds but was knocked down in the seventh. Dempsey refused to go immediately to a neutral corner, leading to six-second delay in the referee's count, the so-called "long count." Tunney rose on the count of nine-fifteen seconds after knockdown-won the final three rounds, and retained the championship. Tunney retired after defending the title once more (1928). Boxing had made him a millionaire, and he made a second fortune as corporate executive.

Tupper, Benjamin (*b. Stoughton, Mass., 1738; d. 1792*), Revolutionary officer, Massachusetts legislator, Ohio pioneer. Associated with Rufus Putnam in formation of the Ohio Company, he went with the original settlers to Marietta, 1788, and was practically sole administrator of local justice along the Muskingum until his death.

Tupper, Henry Allen (*b. Charleston, S.C., 1828; d. 1902*), Baptist clergyman, Confederate chaplain. Corresponding secretary, Board of Foreign Missions, Southern Baptist Convention, 1872–93.

Turell, Jane (*b. Boston, Mass., 1708; d. Medford, Mass., 1735*), poet. Daughter of Benjamin Colman. Her religious verses and others appeared in *Reliquiae Turellae* (Boston, 1735; published under another title in London, 1741).

TURKEVICH, LEONID IERONIMOVICH *See* LEONTY, METRO-POLITAN.

TURNBULL, ANDREW (*b. Scotland, ca. 1718; d. Charleston, S.C., 1792*), colonizer, physician. Securing a grant in East Florida, 1766, he endeavored unsuccessfully to develop the colony of New Smyrna by settlement of Greek, Italian, and Minorcan immigrants. He was the father of Robert J. Turnbull.

TURNBULL, ROBERT JAMES (*b. New Smyrna, Fla., 1775; d. 1833*), South Carolina planter, writer. Son of Andrew Turnbull. Obsessed by fears of national consolidation under the doctrine of implied constitutional power, he advocated the compact theory of the Union and extreme state sovereignty. He took a leading part in the nullification convention of 1832, writing its *Address.* Author, among other works, of *The Crisis: or, Essays on the Usurpations of the Federal Government* (1827, originally published in *Charleston Mercury* over pen name "Brutus"), he strongly influenced the thinking of Robert B. Rhett.

TURNBULL, WILLIAM (*b. Philadelphia, Pa., 1800; d. 1857*), soldier, engineer. Grandson of Charles Nisbet. Graduated West Point, 1819. Long active in topographical and other engineering work, he is particularly remembered for his design and construction of the Potomac Aqueduct, and for his services as chief topographical engineer on General Winfield Scott's staff during the Mexican War.

TURNER, ASA (*b. Templeton, Mass., 1799; d. Oskaloosa, Iowa, 1885*), Congregational clergyman, educator. Brother of Jonathan B. Turner. A home missionary in Illinois and Iowa, Turner promoted establishment of numerous churches and several colleges and academies, including Illinois College at Jacksonville and Iowa College at Davenport.

TURNER, CHARLES YARDLEY (*b. Baltimore, Md., 1850; d. New York, N.Y., 1918*), mural painter.

TURNER, DANIEL (*b. probably Richmond, S.I., N.Y., 1794; d. Philadelphia, Pa., 1850*), naval officer. Appointed midshipman, 1808, he commanded the *Caledonia* in the battle of Lake Erie, September 1813. After a long and varied career on sea and land, he was promoted captain, 1835. His last post was as commandant at Portsmouth navy yard.

TURNER, EDWARD (*b. Fairfax Co., Va., 1778; d. near Natchez, Miss., 1860*), Mississippi legislator and jurist. Raised in Kentucky, he settled in Mississippi, 1801, where he prospered in the law. He also held a number of judicial posts including chief justice of the supreme court and chancellor, and was a member of the committee that drafted the first Mississippi constitution. A practical, hardworking man, he was distinguished for his integrity and good manners.

TURNER, EDWARD RAYMOND (*b. Baltimore, Md., 1881; d. 1929*), historian. Graduated St. John's College, Annapolis, 1904; Ph.D., Johns Hopkins, 1910. Professor at University of Michigan, Yale, and Johns Hopkins, he devoted his research to English constitutional history. Author of, among other works, *The Privy Council of England, etc.* (1927–28) and *The Cabinet Council of England, etc.* (1930–32).

TURNER, FENNELL PARRISH (*b. Danielsville, Tenn., 1867; d. Santa Cruz, Calif., 1932*), missionary executive. Secretary, Student Volunteer Movement for Foreign Missions, 1897–1919; secretary for missionary education, Methodist Episcopal Church, 1928–30.

TURNER, FREDERICK JACKSON (*b. Portage, Wis., 1861; d. Pasadena, Calif., 1932*), historian. Educated at University of Wisconsin, A.B., 1884; M.A., 1888. Ph.D., Johns Hopkins, 1890. Assistant professor of history, University of Wisconsin, 1889–91; professor of history, 1891–92; professor of American history, 1892–1910. Professor of history, Harvard, 1910–24. Familiar from his college days with the unique archival materials collected by Lyman C. Draper and housed in the Wisconsin State Historical Society, Turner was attracted to a scientific investigation of American life at its beginnings; he never strayed far from this theme. Invited to present a brief paper at a meeting of the American Historical Association to be held at the Chicago World's Fair, he assembled data for an essay on "The Significance of the Frontier in American History" which he read on July 12, 1893. First printed in *Proceedings of the State Historical Society of Wisconsin . . . 1893* (1894), it was reprinted in the *Annual Report of the American Historical Association* (1894). In this essay he set forth a new hypothesis and opened a new period in the interpretation of the history of the United States. Beyond this important seminal study Turner wrote little, concentrating his energies on his classroom and university work.

Turner's frontier hypothesis was an attempt to account for the fact that emigrants to the United States from western Europe and their descendants had brought into being a nation so variant from any of those from which they came. He accounted for this on the ground that people who came from an environment in which they were unable to own land into an open continent where there was little to impede their free access to good land were thereby subjected to an influence unusual in history and perhaps formative in shaping American culture. Many of Turner's followers who took up his hypothesis dogmatically went far beyond their master in applying it. Turner himself was content to point out the possibility that human nature in a free environment might behave differently from the same nature under social and economic pressure; that equality of opportunity might have something to do with democracy in politics; that isolation on a new frontier might encourage the survival of the robust and the opinionated; that the necessity of repeatedly setting up social and governmental institutions brought about a "laboratory process' in which nonessentials dropped out while tested principles survived; and finally that the relationship between frontiersmen and government led naturally to an intense nationalism. He also pointed out that by 1893 the influence of the frontier was about to terminate. He regarded the frontier less as a place than as a continuous process sweeping the continent, and regarded the region where it might be temporarily operating as a section with aspects and interests deriving from its cultural state. For the rest of his creative life Turner tested his hypothesis, applying it at times to microscopic examination of limited regions and periods, and trying at other times to reconcile it with larger views of American development.

TURNER, GEORGE (*b. Edina, Mo., 1850; d. Spokane, Wash., 1932*), lawyer. Practiced in Alabama, 1870–85; led Republican party in Alabama. Appointed a justice of the supreme court of Washington Territory, 1885, he resigned in 1888 and began practice in Spokane. Successful in mine development and reputed an able constitutional lawyer, Turner served as U.S. senator from Washington, 1897–1903; he was elected on a fusion ticket made up of Silver Republicans, Democrats, and Populists. He later served as a member of the Alaska Boundary Tribunal and as counsel for the United States in a number of actions before international commissions.

TURNER, GEORGE KIBBE (*b. Quincy, Ill., 1869; d. Miami, Fla., 1952*), journalist, editor, author. Graduated from Williams College (B.A., 1890). As a writer for *McClure's Magazine*, 1906–

16, Turner was one of the most effective muckrakers of the time. He concentrated on municipal government and his articles on political support of the white slave traffic led to passage of the socalled Mann Act in 1910. His many novels include *The Last Christian* (1914) and *Red Friday* (1919).

TURNER, HENRY MCNEAL (*b. near Abbeville, S.C., 1834; d. Windsor, Ontario, Canada, 1915*), bishop of the African Methodist Episcopal Church. The first black to be appointed an army chaplain (1863), Turner was active in Georgia Republican politics during Reconstruction. He was bishop of his church for Georgia, 1880–92, and for many years chancellor of Morris Brown College in Atlanta.

TURNER, JAMES MILTON (*b. St. Louis Co., Mo., 1840; d. Ardmore, Okla., 1915*), black leader, educator. An important figure in Missouri Republican politics, he was a benefactor of present Lincoln University and served ably as U.S. minister resident and consul general to Liberia, 1871–78.

TURNER, JOHN WESLEY (*b. near Saratoga, N.Y., 1833; d. St. Louis, Mo., 1899*), Union soldier, St. Louis, Mo., businessman. Graduated West Point, 1855. Served as chief of artillery, chief commissary, and chief of staff at various times in many theaters of the Civil War, rising to rank of brevet major general. He was outstanding as a division commander in the Army of the James and chief of staff in that army, 1864–65.

TURNER, JONATHAN BALDWIN (*b. Templeton, Mass., 1805; d. Jacksonville, Ill., 1899*), educator, agriculturist. Graduated Yale, 1833. Taught at Illinois College, 1833–47, serving for the most part as professor of rhetoric. An early leader in the movement for public schools in Illinois, he was largely responsible for the free school law of 1855 and the establishment of the first normal school in Illinois in 1857. Between 1850 and 1867 he conducted a remarkable campaign for establishment of a state university which would be supported by congressional appropriation of public lands. Through Turner's urgings, the Illinois legislature of 1867 took advantage of the Morrill Act to establish the present University of Illinois.

TURNER, JOSIAH (*b. Hillsboro, N.C., 1821; d. near Hillsboro, 1901*), lawyer, North Carolina legislator and editor. As editor of the Raleigh *Sentinel*, 1868–76, he worked to discredit and defeat the carpetbag government of North Carolina, displaying a singleminded gift for ridicule and sarcasm.

TURNER, NAT (*b. Southampton Co., Va., 1800; d. Jerusalem, Va., 1831*), black preacher and leader. A precocious child, Nat Turner received the rudiments of an education and early developed a fanatical religious conviction that he had been chosen to lead his fellow slaves out of bondage. Settling upon Aug. 21, 1831, as the great day of deliverance, he and some associates plotted a slave insurrection; as a first step they murdered Nat Turner's master and all his family. Securing arms and horses and enlisting other slaves, they killed in all 51 white persons in a single day and night. However, the rebellion collapsed at the first sign of armed resistance and on August 25 Nat Turner went into hiding. Discovered by accident six weeks later, he was at once tried and hanged. This revolt, following closely on slave insurrections in the West Indies, sent a profound shock through the slaveholding states and brought about a great increase in severity of the slave codes, it also dealt a death blow to the flourishing emancipation movement in the South.

TURNER, RICHMOND KELLY (*b. East Portland, Oreg., 1885; d. Monterey, Calif., 1961*), naval officer. Attended the U.S. Naval Academy (1904–08). After a series of assignments on air, land,

and sea, in which he steadily advanced in his naval career, Turner became director of war plans in the Office of Naval Operations (1940–42). He was promoted to rear admiral (1941). In 1942 he headed the amphibious forces in the attack on Guadalcanal and Tulagi and soon became an expert in this complex type of warfare. Later he presided over the invasions of many Japanese-held islands, most notably Okinawa, where more than 1,000 ships were under his command. Promoted to vice admiral in 1944 and admiral in 1945, he ended the war as commander of amphibious forces, Pacific Fleet. He retired in 1947.

TURNER, ROSS STERLING (*b. Westport, N.Y., 1847; d. Nassau, Bahamas, 1915*), painter, teacher of art. Associated in his studies at Munich with Frank Duveneck and other young American artists, he was also familiar with Whistler at Venice. *Post* 1882 a popular teacher of art in the Boston, Mass., area, Turner was distinguished as a watercolorist and as one of the few modern exponents of the art of illumination of manuscripts.

TURNER, SAMUEL HULBEART (*b. Philadelphia, Pa., 1790; d. New York, N.Y., 1861*), Episcopal clergyman, educator. Professor of biblical learning and interpretation at General Theological Seminary, New York City, *post* 1822, he was also professor of Hebrew at Columbia for many years *post* 1830. A conservative scholar both in his teaching and his writings, he was moderately opposed to the contemporary influence of the Oxford Movement.

TURNER, WALTER VICTOR (*b. Epping Forest, England, 1866; d. Wilkinsburg, Pa., 1919*), engineer. Came to America, 1888, as a textile expert. Taking employment with the Santa Fe Railroad, 1897, he became an expert on air brakes; *post* 1903 he directed engineering operations for the Westinghouse Air Brake Co. and won the reputation of being the foremost pneumatic engineer in the world. Among his more than 400 patents, the "K" triple valve (patented, October 1904) and his later electropneumatic brake were outstanding contributions to transportation efficiency.

TURNER, WILLIAM (*b. Kilmallock, Ireland, 1871; d. Buffalo, N.Y., 1936*), Roman Catholic clergyman, educator. Graduated Royal University of Ireland, 1888; studied at North American College, Rome; was ordained, 1893. A seminary professor at St. Paul, Minn., 1894–1906, he became professor of logic and the history of philosophy at Catholic University of America, and also editor of the *American Ecclesiastical Review* and other learned journals. Consecrated bishop of Buffalo, N.Y., 1919, he served there until his death, continuing his scholarly interests as far as his administrative duties permitted. He was author of, among other works, an outstanding *History of Philosophy* (1903).

TURNEY, PETER (*b. Jasper, Tenn., 1827; d. Winchester, Tenn., 1903*), lawyer, Tennessee secessionist and Confederate soldier. Justice of Tennessee supreme court, 1870–93; chief justice, 1886–93. Conservative Democratic governor of Tennessee, 1893–97.

TURPIN, BEN (*b. New Orleans, La., ca. 1869; d. Santa Monica, Calif., 1940*), slapstick comedian. Raised in New York City; roamed the country for some five years as a hobo; entered show business as a burlesque and vaudeville comedian in Chicago, Ill., ca. 1891. Toured for many years in the stage character of "Happy Hooligan." Entering the movies ca. 1907, and capitalizing on his cross-eyed appearance and on his skill as a clownacrobat, he was by 1914 one of Essanay Studio's leading comics. Under the direction of Mack Sennett at the Keystone Studio in California, Turpin reached his height of fame in comedy-parodies of contemporary starring vehicles.

TUTHILL, WILLIAM BURNET (*b. New York, N.Y., 1855; d. 1929*), architect. Studied in office of Richard M. Hunt; began practice, 1877, in New York City. Principally celebrated for building Carnegie Hall, New York City (1891, in association with Dankmar Adler and Louis H. Sullivan), Tuthill also designed a number of other buildings on a broadly eclectic basis. The acoustic success of Carnegie Hall led him to be called in as consultant for many churches and concert halls.

TUTTLE, CHARLES WESLEY (*b. Newfield, Maine, 1829; d. 1881*), astronomer, lawyer, antiquarian. An assistant at the Harvard Observatory, 1850–54, Tuttle made his most important contribution to science by explaining the "dusky" ring of Saturn. A successful Boston lawyer *post* 1856, he was author of a number of scholarly articles on New England history and of *Capt. John Mason* (1887).

TUTTLE, DANIEL SYLVESTER (*b. Windham, N.Y., 1837; d. St. Louis, Mo., 1923*), Episcopal clergyman. Graduated Columbia, 1857; General Theological Seminary, New York, 1862. Missionary bishop of Montana, with jurisdiction in Utah and Idaho, 1867–86, he served thereafter as bishop of Missouri. *Post* 1903 he was presiding bishop of his church.

TUTTLE, HERBERT (*b. Bennington, Vt., 1846; d. Ithaca, N.Y., 1894*), journalist, educator, historian. Graduated University of Vermont, 1869. After employment on the *Boston Daily Advertiser* as a correspondent in Washington, D.C., and in Paris, France, he was Berlin correspondent of the London *Daily News*, 1873–79. Encouraged by Andrew D. White, Tuttle began an academic career as lecturer in international law at University of Michigan and Cornell, 1880–83. *Post* 1883 he taught the history of politics and modern European history at Cornell. Among other works he was author of an unfinished *History of Prussia* (1884, 1888, 1896).

TUTWILER, HENRY (*b. Harrisonburg, Va., 1807; d. Greene Springs, Ala., 1884*), educator. Graduated University of Virginia, 1829. Professor of ancient languages, University of Alabama, 1831–37. Headed Greene Springs School for Boys, 1847–84, an institution unusual in its time for its emphasis on the sciences and its respect for the individual student.

TUTWILER, JULIA STRUDWICK (*b. Greene Springs, Ala., 1841; d. Birmingham, Ala., 1916*), Alabama educator, social reformer. Daughter of Henry Tutwiler. Studied at Vassar; tutored by faculty at Washington and Lee; spent three years in advanced study in France and Germany. A teacher in Alabama *post* 1876, she was responsible for founding of Alabama Normal College, and was its co-principal and principal, 1883–1910. Through her efforts vocational training for women was established in Alabama, 1896.

TWACHTMAN, JOHN HENRY (*b. Cincinnati, Ohio, 1853; d. Gloucester, Mass., 1902*), painter. Studied drawing at Ohio Mechanics' Institute and at University of Cincinnati; went to Munich with Frank Duveneck, 1875, and studied there and at Venice until 1878. After a brief stay in America, he painted, studied, and traveled abroad until 1884. Thereafter he resided principally in New England and was for many years an instructor of the antique class at the Art Students League, New York. Twachtman's work falls into three distinct periods. His early work (1875–81) is characterized by strong contrast of values in subdued variations of brown and black, by vigorous brush work, and by direct rendering from nature. His second period is marked by a reaction against the dark tones of the Munich tradition; the color is in variations of silver grays and greens, the pigment is applied thinly with a delicate but precise technique and the composition is restricted to very simple themes. *Post* 1889 his work shows the obvious influence of impressionism. From subdued hues the color changes to the higher key of sunlight or the ethereal and pallid harmony of winter landscape. He seems striving for the sensitive rather than the striking and for the subtle rather than the obvious, displaying a mastery of nuance. He openly declared the decorative intention of his work at this time. Twachtman found his interest in the expressive organization of form and the harmonic relation of line and color; his art therefore relates to the doctrine of Whistler; his appreciation of light and color is owing to Monet.

TWAIN, MARK *See* CLEMENS, SAMUEL LANGHORNE.

TWEED, BLANCHE OELRICHS *See* STRANGE, MICHAEL.

TWEED, HARRISON (*b. New York, N.Y., 1885; d. New York, 1969*), lawyer, bar association officer. Attended Harvard (B.A., 1907) and Harvard Law School (LL.B., 1910). After service as a captain in World War I, he joined one of the predecessor firms to Milbank, Tweed, Hadley, and McCloy, where he remained as a partner for the rest of his life, drafting wills and trust agreements and administering estates. He became chairman of the legal aid committee of the Association of the Bar of the City of New York (1932), and zealously espoused the cause of providing competing legal services for all. He served as president of the Legal Aid Society of New York (1936–45) and of the National Legal Aid and Defender Association (1949–55). In 1945 he was elected president of the New York City bar association, which he transformed into a strong force for public service. In 1947 he became president of the American Law Institute (ALI) and chairman of the ALI-American Bar Association joint committee on continuing legal education. He was interim president of Sarah Lawrence College for a year (1959–60). In 1963 became co-chairman of the Lawyers' Committee for Civil Rights Under Law.

TWEED, WILLIAM MARCY (*b. New York, N.Y., 1823; d. New York, 1878*), saddler, bookkeeper, political boss. Rising in New York City politics through his influence as officer of a volunteer fire company (Americus No. 6), Tweed was elected an alderman, 1851. Among aldermanic associates who were known in their time as "The Forty Thieves," Tweed soon displayed a capacity for grafting which rendered further honest toil unnecessary for him. He served as congressman, Democrat, from New York, 1853–55, but found that he preferred municipal politics. Defeated for alderman in 1855, Tweed, with Peter B. Sweeny and Richard B. Connolly (later his chief partners in the "Tweed Ring"), set up a faction in Tammany Hall to oppose Fernando Wood. Successful in disposing of Wood, Tweed secured membership for himself on several key boards and commissions, had his friend Sweeny nominated for district attorney, and placed other allies in strategic positions. Made chairman of the Democratic central committee of New York County, 1860, he maneuvered another satellite, A. Oakey Hall, into the district attorney's post and was thereafter dictator of his party in New York.

Reaching out his tentacles of graft in every direction and levying toll on all who did business with the city or in the city, Tweed was doubtless a millionaire by 1867. In 1868 he practically secured control of New York State by dictating the nomination of John T. Hoffman as governor. Tweed, elected a state senator in 1867, ran everything from his seven-room hotel suite in Albany; it was there in 1869 that the members of his "Ring" decided that all bills thereafter rendered against New York City and County must be 50 percent. fraudulent. The proportion was later raised to 85 percent. Bogus naturalization of immigrants and repeating at elections were now carried to hitherto unknown lengths. Tweed was also a partner with Jay Gould and James Fisk

in the plundering of the Erie Railroad. By this time *Harper's Weekly*, with Thomas Nast as cartoonist, began a campaign against Tweed and his friends and against the new (1870) city charter which riveted the rule of the "Ring" more firmly on the city. In September 1870 the *New York Times*, directed by George Jones, began attacks on Tweed. In the spring of 1871 two discontented county officials turned over to the *Times* proofs of the swindling by the "Ring." The evidence was published in July, and in September at a mass meeting in Cooper Union a Committee of Seventy was formed to take action. This committee, made up of prominent citizens including Samuel J. Tilden, was prompt to act. By December, Tweed had been arrested and Sweeny and others had fled the jurisdiction. Convicted at his second trial in November 1873, Tweed was sentenced to twelve years in prison and a fine, but the sentence was reduced by the court of appeals. Rearrested in January 1875 on leaving prison, Tweed escaped from custody late in the year and went to Spain. Returned to America in November 1876 by Spanish officials, Tweed was committed to prison until he made payment under a judgment in a civil suit brought to recover the 'Ring's" thefts. After giving extensive testimony about many of his crooked transactions, he died in jail. The amount which the "Tweed Ring" stole from the city has been variously estimated at between $30 million and $200 million.

TWICHELL, JOSEPH HOPKINS (*b. Southington, Conn., 1838; d. 1918*), Congregational clergyman. Graduated Yale, 1859; Andover Theological Seminary, 1865. Pastor, Asylum Hill Church, Hartford, Conn., *post* 1865, he was a leader in the city's religious and civic affairs and a member of the literary group that included Charles D. Warner, the Stowes, and Mark Twain. He was Mark Twain's companion on the trip described in *A Tramp Abroad* and one of the humorist's most intimate friends.

TWIGGS, DAVID EMANUEL (*b. Richmond Co., Ga., 1790; d. 1862*), soldier. Rose to rank of major in War of 1812; promoted lieutenant colonel of the 4th Infantry, 1831, and colonel of the 2nd Dragoons, 1836. Distinguished for dogged perseverance and bravery rather than intelligence while serving under both General Zachary Taylor and General Winfield Scott in the Mexican War, he rose to brigadier general and brevet major general. In command of the Department of Texas at the outbreak of the Civil War, he surrendered all the forces and stores under his control to the Confederate General McCulloch and was dismissed from the U.S. Army. Made a Confederate major general, May 1861, he was given command of the district of Louisiana. Too old to take the field, he resigned and soon died, probably near Augusta, Ga.

TWINING, ALEXANDER CATLIN (*b. New Haven, Conn., 1801; d. New Haven, 1884*), engineer, astronomer, educator. Graduated Yale, 1820. Taught at Yale and at Middlebury College, Vermont; served for many years as a consulting engineer to railroads. His most important invention was an application of the absorption process for the manufacture of ice on a commercial scale (patented 1853).

TWITCHELL, AMOS (*b. Dublin, N.H., 1781; d. Keene, N.H. 1850*), pioneer New Hampshire surgeon. Graduated Dartmouth, 1802; studied medicine with Nathan Smith (1762–1829). Practiced principally at Keene, N.H., performing many operations with exceptional skill. In 1807 he tied the carotid artery with success; he was also one of the first in the United States to perform extensive amputations for malignant disease, tracheotomy, and trephining of the long bones for suppuration.

TYDINGS, MILLARD EVELYN (*b. Havre de Grace, Md., 1890; d. near Havre de Grace, 1961*), lawyer, U.S. Senator. Attended Maryland Agricultural College (B.S., 1910) and the University of Maryland (LL.B., 1913). Elected to the Maryland House of Delegates (1916), the Maryland State Senate (1922), and the U.S. House of Representatives (1924). Elected in 1926 to the U.S. Senate where he achieved prominence as a conservative Democratic opponent of President Franklin D. Roosevelt's New Deal. He bitterly opposed Roosevelt's plan to pack the Supreme Court in 1937. After World War II Tydings battled for nuclear disarmament. In 1950, as chairman of a special Senate Foreign Relations Committee subcommittee, he labeled Sen. Joseph R. McCarthy's charges of Communist influence on American foreign policy "contemptible." A McCarthy-backed candidate defeated Tydings' bid for a fifth term in 1950.

TYLER, BENNET (*b. Middlebury, Conn., 1783; d. 1858*), Congregational clergyman, educator. Graduated Yale, 1804. Pastor in South Britain, Conn., 1808–22; president of Dartmouth College, 1822–28. Pastor in Portland, Maine, until 1834 when he became president and professor of theology at present Hartford Theological Seminary. An ardent conservative Calvinist, Tyler opposed the innovations of Nathaniel W. Taylor and the "New Divinity," holding throughout his career to the Calvinist system as modified by Jonathan Edwards and later by Timothy Dwight. He resigned his presidency of the seminary in 1857.

TYLER, CHARLES MELLEN (*b. Limington, Maine, 1832; d. Scranton, Pa., 1918*), Congregational clergyman, Union Army chaplain, educator. Graduated Yale, 1855. Professor of history and philosophy of religion at the Sage School, Cornell University, 1891–1903, and emeritus thereafter.

TYLER, DANIEL (*b. Brooklyn, Conn., 1799; d. New York, N.Y., 1882*), soldier, industrialist. Attended West Point and was commissioned lieutenant of artillery, 1819; studied later at the artillery school at Fortress Monroe, Va., and in the French army artillery school at Metz. Exposed shoddy conditions at Springfield Arsenal, 1830–32. Resigning from the army, 1834, he began a highly successful career as engineer and financier of railroads and canals both North and South. Commissioned Union brigadier general, 1861, Tyler commanded a division during the first Bull Run campaign, but through his failure to attack at the proper time must bear some of the blame for the disaster of that battle. His later Civil War career was not notable. In association with Samuel Noble he began exploitation of the iron deposits of eastern Alabama, 1872, and was largely responsible for successful operations at Anniston thereafter.

TYLER, GEORGE CROUSE (*b. Circleville, Ohio, 1867; d. Yonkers, N.Y., 1946*), theatrical manager and producer. A printer by trade, he worked in various capacities in and out of the theater before forming a partnership with Theodore A. Liebler (Liebler and Company), 1897, for play production. Thanks to Tyler's flair and Liebler's financing, the firm produced or managed over 300 superior attractions in New York City and on tour before its bankruptcy in 1914; among their successes were *The Christian* (1898); tours by Mrs. Patrick Campbell, Eleonora Duse, Madame Réjane, and the Abbey Theatre Company; and their management of Arnold Daly's Shaw productions. Tyler staged some of his most elaborate shows while manager of the New Theater (Century), 1911–14. After a period of producing plays with the backing of Klaw and Erlanger, he became an independent manager in 1918; outstanding Tyler productions before his last (*For Valor*, 1935), were *Clarence* (1919); an early version of O'Neill's *Anna Christie; Dulcy* (1921, the first collaboration of Marc Connelly

and George S. Kaufman); Gordon Craig's *Macbeth* (1928); and a series of all-star revivals.

TYLER, JOHN (*b. York Co., Va., 1747; d. Charles City Co., Va., 1813*), Revolutionary patriot, Virginia legislator and jurist. Father of John Tyler (1790–1862). Studied law with Robert C. Nicholas. A friend of Thomas Jefferson and a follower of Patrick Henry, Tyler held a number of judicial posts in Virginia and was active in the House of Delegates where he served for a time as speaker. An opponent of the Federal Constitution, he became an ardent Democratic-Republican. Elected governor of Virginia, 1808, he held that post until 1811 when he became U.S. judge for the district of Virginia.

TYLER, JOHN (*b. Charles City Co., Va., 1790; d. 1862*), lawyer, Virginia legislator, president of the United States. Son of John Tyler (1747–1813); father of Robert Tyler. Educated at College of William and Mary; read law with his father; began practice *ca.* 1809. Elected to the House of Delegates, 1811, he served until 1816, loyally supporting the Madison administration and indicating a preference for strict constuctionism. A man of great charm and a gifted speaker, Tyler was elected to the U.S. Congress as a Democrat in 1816 and served until 1821. He favored revocation of the charter of the Bank of the U.S., voted against Calhoun's "bonus bill" for internal improvements, against a protective tariff, and against adoption of the Missouri Compromise in 1820. Consistent in opposition to the slave trade, he trusted to time and climate for the abolition of the whole institution of slavery. He supported William H. Crawford for president in the campaign of 1824 and had little use for Andrew Jackson. As governor of Virginia, 1825–27, he strove for the development of roads and schools. Elected to the U.S. Senate, 1827, as an anti-Jackson Democrat, he voted against the "tariff of abominations," 1828, and supported Jackson for the presidency as a choice of evils. Although he approved Jackson's opposition to the recharter of the Bank of the U.S., he supported the resolutions which condemned the president for removing federal deposits. Personally opposed to nullification, Tyler considered Jackson's nullification proclamation a violation of the Constitution and cast the single vote recorded in the Senate against the Force Bill. However, it was he who first formulated a plan of conciliation and brought Calhoun and Clay together to agree upon the compromise tariff of 1833. A member of the southern states' rights group in Congress which acted with the National Republicans within the now-forming Whig party, Tyler did not accept the nationalist doctrines of Clay and his following. Reelected to the Senate, 1833, he resigned in 1836 in protest against direction by the Virginia legislature to vote for expunging the resolutions censuring Jackson for removal of the Bank deposits. Losing the contest for a Senate seat to William C. Rives in 1839, Tyler was nominated for the vice presidency on the Whig ticket with William H. Harrison, 1840. Elected, he succeeded Harrison who died within a month of inauguration and became president by right of succession, the first ever to do so.

Henry Clay and the Whig nationalists were soon at odds with the president on matters of fundamental principle although Tyler had retained Harrison's cabinet as a gesture of conciliation. A crisis between the president and the Whigs was brought on by the bank question. Tyler had made it clear that he would not sanction a measure which permitted a national bank to establish branches in the states without their previous consent, and he had devised a plan known as the "exchequer system" which would have avoided this difficulty. Congress passed a bill chartering a U.S. bank along lines desired by Clay, and Tyler promptly vetoed it. A revised bill was presented and passed which Tyler also vetoed. At Clay's urging, the original cabinet then resigned with the exception of Daniel Webster, the secretary of state. A president without a party, Tyler nevertheless made a remarkable record as administrator and negotiator. He was responsible for a reform and reorganization of the navy which included encouragement of scientific work; he ran the government with a minimum of waste and extravagance. He brought the Seminole War to an end, and withheld federal interference from Dorr's Rebellion in Rhode Island. A treaty was negotiated with China which opened the doors of the Orient for the first time, and the Monroe Doctrine was enforced in the cases of Texas and Hawaii. The greatest achievements of Tyler's administration were the negotiation of the Webster-Ashburton treaty and the annexation of Texas, in which the president played an inconspicuous but considerable part.

Although he was supported for reelection in 1844 by a strong element in many states, he withdrew his name in favor of James K. Polk and retired to private life in Virginia. On the outbreak of the Civil War he proposed a convention of the border states to consider compromises which might save the Union, and acted as chairman of the convention which was called for this purpose by the Virginia Assembly and met in Washington, February 1861. A member of the Virginia secession convention, Tyler declared for separation after all compromise measures had failed. He served in the provisional Congress of the Confederacy and was elected to the Confederate House of Representatives but died before he could take his place. An intelligent, approachable, courteous man, Tyler has failed of his due because of a lack of appreciation among historians for a record of courageous consistency and integrity.

TYLER, LYON GARDINER (*b. Charles City Co., Va., 1853; d. Charles City Co., Va., 1935*), lawyer, educator, Virginia legislator, historian. Son of John Tyler (1790–1862). A.B., University of Virginia, 1874; A.M., 1875. A representative of Richmond in the House of Delegates, he sponsored bill reopening College of William and Mary, 1888, and served thereafter as its president until 1919. Author, among other works, of *Parties and Patronage in the United States* (1891); *History of Virginia, Federal Period* (1924); and *The Cradle of the Republic* (1900).

TYLER, MOSES COIT (*b. Griswold, Conn., 1835; d. Ithaca, N.Y., 1900*), Congregational and Episcopal clergyman, reformer, educator, historian. Raised in Detroit, Mich., Tyler attended the University of Michigan and graduated from Yale, 1857. After a few years in the ministry and a period of ardent preoccupation with reform movements (including a crusade for physical culture), he became professor of English at the University of Michigan, 1867, and taught there with success until 1881. He then became professor of American history at Cornell University, the first man to hold such a post in the country. Among other activities, he introduced German methodology into graduate instruction and helped found the American Historical Association (1884). He was generally recognized as a leader in the cause of "critical" as opposed to "patriotic" history. Tyler's permanent reputation is owing to his authorship of *A History of American Literature during the Colonial Time, 1607–1765* (1878), a biography of *Patrick Henry* (1887), *The Literary History of the American Revolution, 1763–1783* (1897), and *Three Men of Letters* (1895). Based on profound research of an original nature and written with clarity and sanity, Tyler's histories of literature in the colonial period have become by common consent the standard account of early American literary development.

TYLER, RANSOM HUBERT (*b. Franklin Co., Mass., 1815; d. Fulton, N.Y., 1881*), lawyer, New York jurist. Author of *American Ecclesiastical Law* (1866) and a number of subsequent texts and treatises on various aspects of civil law which were valuable for their wealth of material but poorly organized.



TYLER, ROBERT (*b. Charles City Co., Va., 1816; d. Montgomery, Ala., 1877*), lawyer, politician, editor. Son of John Tyler (1790–1862) whom he served as private secretary, 1841–44. Thereafter he took a leading part in Philadelphia politics and became a political friend of James Buchanan, influencing Virginia support of Buchanan at the convention of 1856. Removing to the South at the outbreak of the Civil War, Tyler served as register of the Confederate Treasury, and was editor *post* 1867 of the Montgomery (Ala.) *Mail and Advertiser.*

TYLER, ROBERT OGDEN (*b. Hunter, N.Y., 1831; d. Boston, Mass., 1874*), soldier. Nephew of Daniel Tyler. Graduated West Point, 1853. Commissioned in the artillery, he served against the Indians on the frontiers. Appointed colonel, 1st Connecticut Heavy Artillery, September 1861, he served his guns with great distinction during the Peninsular campaigns and was promoted brigadier general, November 1862. At Gettysburg he commanded the artillery reserve which was so effective in stopping Pickett's charge. Serving as infantry, his artillerymen distinguished themselves at Spotsylvania and Cold Harbor. Reverting to lieutenant colonel in the Regular Army, he served in a number of capacities and died as a belated result of war wounds.

TYLER, ROYALL (*b. Boston, Mass., 1757; d. Brattleboro, Vt., 1826*), playwright, novelist, jurist. Graduated Harvard, 1776; studied law with Francis Dana. After brief service in the Revolution, began practice of law, 1780, in present Portland, Maine. A successful lawyer in Boston, 1785–91, and thereafter in Vermont where he held, among other public offices, the post of chief justice of the supreme court, 1807–13, Tyler is remembered principally as author of *The Contrast.* This play, produced April 1787 in New York City and immediately successful, was the first comedy to be written by a native American and produced by a professional company. A satire on city affectation, *The Contrast* contained the character "Jonathan," the prototype of a long succession of stage Yankees. Tyler was author also of a comic opera, *May Day in Town* (produced in New York City, May 1787), and several other plays which have not survived in print. In 1794 he entered into a literary mock-partnership with Joseph Dennie, writing prose and verse under the pseudonym of "Spondee" for various publications. The best of these are contained in *The Spirit of the Farmer's Museum* (1801). He was author also of a picaresque novel *The Algerine Captive* (1797) and of the *Yankey in London* (1809).

TYLER, ROYALL (*b. Quincy, Mass., 1884; d. Paris, France, 1953*), historian, League of Nations official, United Nations official. Studied at Harrow and Oxford. Served in the U.S. delegation to the Versailles Peace Conference, 1919, and on the Reparations Commission, 1919–23. Appointed to the Financial Committee of the League of Nations, 1924, and served in Budapest as deputy commissioner general for Hungary, 1924–28. Tyler was also a member of the Greek Refugee Settlement Committee, 1927, and financial adviser to the Hungarian government, 1932–38. During World War II, he worked for the League of Nations in Geneva. Served in Beirut as chief financial adviser to U.N. Economic Survey mission, 1949.

TYLER, SAMUEL (*b. Prince Georges Co., Md., 1809; d. Georgetown, D.C., 1877*), lawyer, writer. An authority on pleading and procedure. Author, among other works, of *Memoir of Roger Brooke Taney* (1872), an authorized biography and a useful source.

TYLER, WILLIAM (*b. Derby, Vt., 1806; d. 1849*), Roman Catholic clergyman. A convert to Catholicism, Tyler studied theology with Benedict J. Fenwick and at Montreal. Ordained 1829, he served as curate in Boston and as a missionary through New England. Consecrated first bishop of Hartford, Conn., 1844, he established his see at Providence, R.I., where he erected a cathedral and laid sound foundations for his church in an unfriendly region.

TYLER, WILLIAM SEYMOUR (*b. Harford, Pa., 1810; d. 1897*), Congregational clergyman, educator. Graduated Amherst, 1830. Professor of classics at Amherst, 1836–93 (*post* 1847 Williston Professor of Greek), Tyler served as president of the trustees of several schools including Mount Holyoke and Smith colleges. He was author, among other works, of *The History of Amherst College* (1873, 1895).

TYNDALE, HECTOR (*b. Philadelphia, Pa., 1821; d. Philadelphia, 1880*), glass merchant, authority on ceramics, Union major general by brevet. Tyndale was particularly outstanding as a soldier at the battles of Antietam and Missionary Ridge.

TYNG, EDWARD (*b. Boston, Mass., 1683; d. Boston, 1755*), merchant, outstanding officer in the colonial Massachusetts navy. Cruised with success against French and Spanish privateers, 1741–44; later commanded frigate *Massachusetts.*

TYNG, STEPHEN HIGGINSON (*b. Newburyport, Mass., 1800; d. Irvington-on-Hudson, N.Y., 1885*), Episcopal clergyman. Graduated Harvard, 1817; studied theology with Alexander V. Griswold. Held pastorates in Maryland and in Philadelphia, Pa., rector of St. George's Church, New York City, 1845–78. A dogmatic Low Churchman, Tyng was considered one of the greatest preachers of his time and was one of the first Episcopal clergyman to stress the importance of Sunday Schools.

TYSON, GEORGE EMORY (*b. Red Bank, N.J., 1829; d. Washington, D.C., 1906*), whaling captain. Assistant navigator and very capable second-in-command under Charles F. Hall on the *Polaris* expedition to the Arctic, 1871–73. Hero of a remarkable six-months' drift on an ice floe.

TYSON, JAMES (*b. Philadelphia, Pa., 1841; d. 1919*), physician. Graduated Haverford College, 1861; M.D., University of Pennsylvania, 1863. After Civil War service as surgeon, he practiced in Philadelphia. A teacher of various medical subjects at Pennsylvania *post* 1868, he held the chair of medicine there, 1899–1910, and for several years was dean of medical faculty. A staff member of many hospitals, he was author of a number of successful texts.

TYSON, JOB ROBERTS (*b. in or near Philadelphia, Pa., 1803; d. 1858*), Philadelphia lawyer, reformer. An authority on the history of Pennsylvania, he was instrumental in providing for the printing of the Pennsylvania, Archives and did pioneer service in criticizing the exaggerated claims made by the New England historians for their section as the primary source of American freedom.

TYSON, LAWRENCE DAVIS (*b. near Greenville, N.C., 1861; d. Philadelphia, Pa., 1929*), soldier, lawyer, Tennessee legislator and publisher. Graduated West Point, 1883; LL.B., University of Tennessee, 1894. Served in frontier campaigns, 1883–91, and in the Spanish American War. As brigadier general, National Army (commissioned 1917), he commanded the 59th Brigade of the 30th Division in France during its outstanding service in breaking the Hindenburg line, 1918. Publisher thereafter of the Knoxville *Sentinel*, he was active in Democratic politics and served as U.S. senator from Tennessee, 1925–29. He was interested also in coal companies and textile mills.

TYSON, STUART LAWRENCE (*b. Pennllyn, Pa., 1873; d. New York, N.Y., 1932*), Episcopal clergyman, author, lecturer. Graduated Nashota House, Wisconsin, 1895; studied for a number of years at Oxford, England, from which he received the degrees of M.A., B.D., and D.D. Returning to America, 1907, he taught at Western Theological Seminary and the University of the South and served later on the staffs of several New York churches. Moving from an early conservative position, Tyson became an aggressive liberal and modernist; in 1925 after a divorce he left the Episcopal Church and entered the Congregational ministry, presiding thereafter over a Summit, N.J., church composed principally of Unitarians. He was particularly notable during his later career for his defense of clergymen accused of heresy.

TYTUS, JOHN BUTLER (*b. Middletown, Ohio, 1875; d. Cincinnati, Ohio, 1944*), inventor. B.A., Yale, 1897. After working in his family's paper mill, and for a bridge builder, he became interested in steelmaking and in 1904 took a job as laborer in the Middletown, Ohio, plant of the American Rolling Mill Company (Armco). He thus learned steelmaking firsthand. Remembering the machines that produced an unending sheet of paper, Tytus began to study the possibility of designing analogous machinery for the steel industry.

Tytus took on increasing responsibilities in the operation of Armco, which before World War I was beginning various expansion programs. In 1906 he became superintendent of the company's new plant in Zanesville, Ohio; and in 1909, as operations chief at Middletown, he planned a new mill in that city. Meanwhile, he continued to work at designing a continuous process. Armco's acquisition in 1921 of blast furnaces and open hearth furnaces gave Tytus his opportunity. His revolutionary plant began operation in January 1924. The continuous mill won almost immediate acceptance within the steel industry.

U

UDDEN, JOHAN AUGUST (*b. Uddabo, Sweden, 1859; d. Tex., 1932*), geologist. Came to America as a child; was raised in Minnesota. Graduated Augustana College, 1881; M.A., 1889. A teacher at Augustana, 1888–1911, and associated thereafter with the Bureau of Economic Geology of the University of Texas, Udden was eminent as a research geologist and was author of many important papers in his field. His investigations included stratigraphic and areal geology, till in the upper Mississippi Valley, clastic sediments, and related subjects. He was one of the first in America to stress the value of seismograph observations for locating geologic structure and devised a pioneering technique for examining subsurface material. His work in Texas contributed much to the economic development of that state.

UHLER, PHILIP REESE (*b. Baltimore, Md., 1835; d. 1913*), entomologist, librarian of the Peabody Institute. A world authority on entomology specializing in *Hemiptera*, Uhler taught at Harvard, 1864–67, and was associate in natural history at Johns Hopkins, 1876–1913.

ULLOA, ANTONIO DE (*b. Seville, Spain, 1716; d. probably Spain, 1795*), Spanish naval officer, colonial administrator. Celebrated for several reports on conditions in Spanish America (1748–49) which were translated into other languages and widely read, Ulloa became governor of Louisiana in 1766. Given no support by his government and obliged to let the last French governor of the province continue to rule it in the name of the Spanish king, he was recalled in 1768 in the midst of a Creole uprising and was succeeded by Alejandro O'Reilly.

ULMER, EDGAR GEORG (*b. Vienna, Austria, 1904; d. Woodland Hills, Calif., 1972*), film director, producer, and screenwriter. Studied architecture at the Vienna Academy of Arts and Sciences and worked as an actor and set designer at the Burg Theatre. In the 1920's he assisted such directors as F. W. Murnau and Fritz Lang and directed his first feature film, *Menschen am Sonntag* (*People on Sunday*), in 1929, with screenwriters Billy Wilder and Fred Zinnemann. He moved to Hollywood in 1930 and directed several movies, including *The Black Cat* (1934), *Bluebeard* (1944), *Strange Illusion* (1945), and *Detour* (1946).

ULRICH, EDWARD OSCAR (*b. Cincinnati, Ohio, 1857; d. Washington, D.C., 1944*), geologist, paleontologist. His work with fossils at the Cincinnati Society of Natural History, and with the Illinois and Minnesota geological surveys, brought him in 1900 a permanent appointment with the U.S. Geological Survey. He was soon recognized as the Survey's leading stratigrapher, and became the principal authority on the early Paleozoic formations and fossils in the eastern United States.

UNANGST, ERIAS (*b. Easton, Pa., 1824; d. Hollidaysburg, Pa., 1903*), Lutheran clergyman. Missionary in India for the greater part of the years 1858–95.

UNCAS (*b. ca. 1588; d. ca. 1683*), sachem of the Mohegan Indians. Son-in-law of Sassacus, chief sachem of the Pequot, against whom he lead a number of rebellions. On his final revolt the Pequot territory was divided, and Uncas became ruler of the western part, called Moheag, his tribe becoming known as the Mohegans. He courted the favor of the English, and in May 1637, with the Narragansett, joined them in a war against the Pequot. Known during his career for being untrustworthy and dissolute. He appears to have been tolerated by the English in Connecticut and Massachusetts because of his enmity to the Narragansett, and because his presence served as a divisive force among the other Indian tribes.

UNDERHILL, FRANK PELL (*b. Brooklyn, N.Y., 1877; d. New Haven, Conn., 1932*), pharmacologist, toxicologist. Graduated Yale, 1900; Ph.D., 1903. Taught thereafter at Yale, serving as professor of pathological chemistry, 1912–18, of experimental medicine, 1918–21, and of pharmacology and toxicology *post* 1921. His early researches dealt with the physiologic action of proteins and tartrates, and with the effects of chemical substances on the behavior of sugars, salts and water within the body. He was active in organization of the U.S. Army Chemical Warfare Service and made investigations of the effects of lethal gases on the animal body. He also investigated the effects of fluid administration in treating burns and made studies of pellagra.

UNDERHILL, JOHN (*b. probably Warwickshire, England, ca. 1597; d. Oyster Bay, N.Y., 1672*), colonial military leader, magistrate. Trained as a soldier in the Netherlands, Underhill moved to Boston, 1630, as captain and organizer of the Massachusetts Bay militia. Associated with the Connecticut forces in the defeat of the Pequot, 1637, he was disfranchised and discharged from military service by Massachusetts in that same year because of his alliance with the Antinomian. In England during the winter of 1637–38, he published *Newes from America* (1638), a classical account of the Pequot troubles. On his return to Boston he was banished in September 1638 and fled to Dover, N.H., where he secured the governorship and opposed the claims of Massachusetts upon the region. Losing support at Dover, he returned to Massachusetts where he made a public confession of various crimes, 1640, but was considered insincerely repentant and was excommunicated. In September 1640, however, he was reinstated in the church and in the following year his sentence of banishment was repealed. He now moved to Stamford, Conn., which he represented in the assembly of New Haven, 1643. Soon afterwards, being employed by the Dutch to fight Indians, he moved to Long Island where he held office; in 1653 he denounced Peter Stuyvesant's government for its unjust taxation and dealings with the Indians. In the same year, commissioned as a privateer at Providence, he seized the property of the Dutch West India Company at Hartford. After helping reduce the New Amsterdam Dutch to English control, 1664–65, he held several public offices under the English government of New York before retiring from public life, 1666/67.

UNDERWOOD, BENJAMIN FRANKLIN (*b. New York, N.Y., 1839; d. Westerly, R.I., 1914*), Union soldier, journalist, freethinker.

One of the earliest and most zealous American supporters of the theory of evolution, Underwood lectured widely on this and other subjects. He wrote a number of pamphlets which expressed his philosophic position, roughly that of orthodox materialism. *Post* 1897 he was editor of the *Quincy* (Ill.) *Journal*, retiring in 1913.

UNDERWOOD, FRANCIS HENRY (*b. Enfield, Mass., 1825; d. Edinburgh, Scotland, 1894*), lawyer, author, consular official. Conceiving the idea of a magazine which should enlist the literary forces of New England in a crusade against slavery, 1853, he was successful in persuading Phillips, Sampson & Co. to undertake the project in 1857. It was issued as the *Atlantic Monthly* (first issue, November 1857), but Underwood was relegated to the routine post of editorial assistant to James Russell Lowell. Subsequent to his leaving the *Atlantic* in 1859, he engaged in a number of activities before his service as U.S. consul at Glasgow, Scotland, 1886–89, and at Leith *post* 1893. A talented man, he contributed much to the fame of others but won little credit for himself. As Francis Parkman observed, he was "neither a Harvard man nor a humbug" and so was a victim of his own merit.

UNDERWOOD, FREDERICK DOUGLAS (*b. Wauwatosa, Wis., 1849; d. New York, N.Y., 1942*), railroad executive. Associated *post* 1867 with the Chicago, Milwaukee & St. Paul Railroad, the Soo Line, and the Baltimore & Ohio successively, he achieved his greatest success in rehabilitating the Erie Railroad. As president of the Erie, 1901–26, he made it an efficient and profitable freight-service road, a strong competitor of the larger Eastern trunk lines.

UNDERWOOD, HORACE GRANT (*b. London, England, 1859; d. Atlantic City, N.J., 1916*), Dutch Reformed clergyman. Presbyterian missionary to Korea *post* 1885.

UNDERWOOD, JOHN CURTISS (*b. Litchfield, N.Y., 1809; d. Washington, D.C., 1873*), lawyer. A planter in Clarke Co., Va., *post* 1839, Underwood was a Free-Soiler in politics and was virtually driven from Virginia for his attacks on slavery during the presidential campaign of 1856. A Republican officeholder during the Civil War, he became a U.S. district court judge in Virginia, 1864. In this capacity he asserted the right of the United States to confiscate property of persons in rebellion and treated Jefferson Davis with great harshness during and after Davis's indictment for treason at Norfolk, Va., 1866. He presided over the Virginia constitutional convention which met at Richmond, December, 1867.

UNDERWOOD, JOHN THOMAS (*b. London, England, 1857; d. Wianno, Mass., 1937*), typewriter manufacturer. Brother of Horace G. Underwood. Came to America 1873, and engaged with his father in the pioneer manufacture of typewriter supplies. Purchasing the rights to the Wagner "front-stroke" typewriting machine (patented, 1893), Underwood marketed the first typewriters under his own name in 1897. His product was superior in design to its competitors and was soon highly successful.

UNDERWOOD, JOSEPH ROGERS (*b. Goochland Co., Va., 1791; d. 1876*), Kentucky legislator and jurist. Grandfather of Oscar W. Underwood. Practiced at Glasgow, Ky., 1813–23, and at Bowling Green thereafter. Justice, Kentucky court of appeals, 1828–35; congressman, Whig, from Kentucky, 1835–43; U.S. senator, 1847–53. An orthodox Whig in his political opinions and actions, he supported Southern views on slavery short of secession. A Unionist during the Civil War, he became a Democrat, 1864, and was instrumental in reorganizing that party in Kentucky.

UNDERWOOD, LORING (*b. Belmont, Mass., 1874; d. 1930*), landscape architect. Graduated Harvard, 1897; studied at Bussey Institution and in Paris. Practiced his profession in Boston, Mass., *post* 1900. Author of *The Garden and Its Accessories* (1906).

UNDERWOOD, LUCIEN MARCUS (*b. New Woodstock, N.Y., 1853; d. Redding, Conn., 1907*), botanist. Graduated Syracuse University, 1877; Ph.D., 1879. Taught at Illinois, Wesleyan, Syracuse, De Pauw, and Alabama Polytechnic; professor of botany, Columbia, 1896–1907. Authority on ferns and hepaticae. Took leading part in initiating (1905) publication of the *North American Flora*.

UNDERWOOD, OSCAR WILDER (*b. Louisville, Ky., 1862; d. 1929*), lawyer, statesman. Grandson of Joseph R. Underwood. Admitted to the bar, 1884, after study at the University of Virginia. Practiced briefly in Minnesota; removed to Birmingham, Ala. Congressman, Democrat, from Alabama, 1895–96 and 1897–1915; U.S. senator, 1915–27. A man of high character and unflagging industry, Underwood made a lifelong study of the tariff and was a strong opponent of tariffs for protection. He served as Democratic floor leader in the House, 1911–15, and was chairman of the ways and means committee. A supporter of W. H. Taft's reciprocity program, Underwood at the same time took the lead in revising many tariff schedules downward; when the legislation advanced by him was vetoed by President Taft, the outstanding issue of the campaign of 1912 was created. Underwood showed such conspicuous ability in Congress that he was among the leading contenders for the Democratic presidential nomination in 1912 and again in 1924. A loyal supporter of President Woodrow Wilson, Underwood efficiently carried out Wilson's legislative program. His work in framing the tariff bill which bears his name, and in support of the Federal Reserve Act, was especially noteworthy. In the Senate *post* 1915 he continued his support of Wilson's policies, although in the fight over the League of Nations he was of the opinion that the president should have agreed to certain mild reservations. His uncompromising hostility to the Ku Klux Klan and to national prohibition alienated the South and cost him presidential nomination by the Democrats in 1924. A devout follower of Thomas Jefferson, he was strongly averse to all extensions of the federal authority.

UNTERMEYER, LOUIS (*b. New York City, 1885; d. Newton, Conn., 1977*), anthologist, editor, and poet. Retired from his family's jewelry business in 1923 and began his writing career as a music and poetry critic. He was a cofounder of *Seven Arts* magazine and poetry editor of *American Mercury* (1934–37); poet-in-residence at the University of Michigan (1939–40); poetry consultant at the Library of Congress (1961–63); and for a quarter century the chair of the Pulitzer Prize poetry jury. Committed to changing the belief that poetry was too highbrow for mass audiences, he helped popularize the art form in a series of successful anthologies, including *A Treasury of Great Poems* (1955) and *The World's Great Stories* (1964). His most famous collection, *The Golden Treasury of Poetry* (1959), became a common household volume. He also edited anthologies on various subjects, including limericks, food, and short stories.

UNTERMYER, SAMUEL (*b. Lynchburg, Va., 1858; d. Palm Springs, Calif., 1940*), lawyer. Graduated Columbia Law School, 1878. Celebrated during his early career as a trial lawyer in important suits of every type, he grew wealthy as an organizer of large industrial combinations. Moved by growing doubts about the virtues of the corporate combinations he had helped to create, he slowly became known as an enemy of corporate abuses. In 1911 he delivered a series of addresses calling for government action to break up or regulate the trusts. During 1912–13 he

served without pay as counsel to the Pujo investigation instituted by Congress to look into the operations of the leading financiers of the country. The recommendations of the Pujo Committee contributed to passage of the Federal Reserve Act, the Federal Trade Commission Act, and the Clayton Anti-Trust Act; in each of these Untermyer had some part. He served again without pay as counsel to the New York Joint Legislative Committee on Housing, 1919–20, investigating conspiracies to profiteer in the building trades; thereafter, he devoted much time, without compensation, to New York City transit problems. An early advocate of a graduated income tax and of public ownership of public utilities, he was a lifelong Democrat and an ardent supporter of the New Deal. In Jewish matters he was a moderate Zionist.

UPCHURCH, JOHN JORDAN (*b. Franklin Co., N.C., 1820; d. Steelville, Mo., 1887*), railroad mechanic. Founder of the Ancient Order of United Workmen, 1868, a lodge which began as an opponent of trade unions and strikes and which became in time the prototype for subsequent fraternal benefit societies.

UPDEGRAFF, DAVID BRAINARD (*b. Mount Pleasant, Ohio, 1830; d. Mount Pleasant, 1894*), Quaker preacher, editor. Considered an innovator and a controversial figure within the Society of Friends, he represented an intense form of evangelical thought and practiced a dramatic style of preaching.

UPDIKE, DANIEL (*b. North Kingstown, R.I., ca. 1693; d. Newport, R.I., 1757*), lawyer. Attorney general of Rhode Island, 1722–32, 1743–57; attorney general for Kings Co., R.I., 1741–43.

UPDIKE, DANIEL BERKELEY (*b. Providence, R.I., 1860; d. Boston, Mass., 1941*), scholar-printer. His incomplete formal education was acquired in private schools in Providence. After a winter as an assistant in the Providence Athenaeum, he went to Boston in 1880 to the publishing firm of Houghton, Mifflin & Company. His first published work (except for a few anonymous articles in the *Atlantic Monthly*) was *On the Dedications of American Churches* (1891). In 1892 he collaborated with Bertram Grosvenor Goodhue in designing and decorating an edition of the Book of Common Prayer.

In 1893 he struck out on his own as a "typographic adviser." This was the beginning of the Merrymount Press, a name adopted in 1896. The variety and ingenuity of his designs is best seen in the many books that he privately printed for his Boston friends, and in the work that he did for the Club of Odd Volumes, the Grolier Club, and the Limited Editions Club. His masterpiece is the folio edition of the 1928 revision of the Book of Common Prayer that he completed in 1930 for J. Pierpont Morgan.

During the years 1911–16 Updike gave a course at the Harvard Business School on the technique of printing that he eventually recast into the two scholarly volumes of *Printing Types, Their History, Forms, and Use* (1922). He also published an autobiography, *Notes on the Merrymount Press & Its Work* (1934).

UPHAM, CHARLES WENTWORTH (*b. St. John, N.B., now Canada, 1802; d. Salem, Mass., 1875*), Unitarian clergyman, Massachusetts legislator, historian. Graduated Harvard, 1821. Minister in Salem, Mass., 1824–44. After engaging in politics as a Whig and later a Republican, 1848–61, Upham turned to historical research producing, among other works, his *Salem Witchcraft* (1867). He is considered the prototype of "Judge Pyncheon" in *The House of the Seven Gables* by Nathaniel Hawthorne.

UPHAM, SAMUEL FOSTER (*b. Duxbury, Mass., 1834; d. 1904*), Methodist clergyman. A popular and witty preacher as pastor of a number of New England churches, Upham was professor of practical theology at Drew Theological Seminary, 1881–1904.

UPHAM, THOMAS COGSWELL (*b. Deerfield, N.H., 1799; d. New York, N.Y., 1872*), Congregational clergyman, metaphysician. Graduated Dartmouth, 1818; Andover Theological Seminary, 1821. Professor of philosophy at Bowdoin College, 1824–67, he was author, among other books, of *A Philosophical and Practical Treatise on the Will* (1834), an original contribution to modern psychology.

UPHAM, WARREN (*b. Amherst, N.H., 1850; d. St. Paul, Minn., 1934*), glacial geologist, archeologist. Graduated Dartmouth, 1871. After employment on the geological surveys of New Hampshire and Minnesota and service with the U.S. Geological Survey, he was librarian-secretary of the Minnesota Historical Society, 1895–1914, and the society's archeologist thereafter. His principal field in science was glacial geology, and his best-known monograph is "The Glacial Lake Agassiz" (*U.S. Geological Survey Monographs*, Vol. 25, 1896). After changing his major field to archaeology and history *ca.* 1905, he published a number of important essays on the history of Minnesota and its area.

UPJOHN, RICHARD (*b. Shaftesbury, England, 1802; d. Garrison, N.Y., 1878*), architect. Trained as a cabinet-maker, Upjohn Immigrated to America, 1829, and settled in New Bedford, Mass., 1830. At first a draftsman and teacher of drawing, he began to practice as an architect and removed to Boston, Mass., 1834, where he worked with Alexander Parris. In 1837 he completed St. John's Church, Bangor, Maine, his first Gothic church. Chosen architect for the new Trinity Church, New York City, he removed to New York in 1839; Trinity Church, begun in 1841 and consecrated in 1846, won him immediate fame. Upjohn did a great deal of important work, making a careful and sensitive use of the precedents of English Gothic; his influence in the United States was in many ways similar to the contemporary influence in England of Pugin. Among his outstanding buildings were the Church of the Pilgrims, Brooklyn, N.Y.; St. Paul's in Brookline, Mass.; and his own favorite work, Trinity Chapel on W. 25th St., New York City. He also designed a number of houses and civic buildings. He was a founder and first president of the American Institute of Architects, 1857–76, and many famous architects were trained in his office or worked for him.

UPJOHN, RICHARD MICHELL (*b. Shaftesbury, England, 1828; d. Brooklyn, N.Y., 1903*), architect. Son of Richard Upjohn. Came to America as a child. Trained in his father's office, he practiced with him *post* 1853 and exercised a growing influence on the elder man's design. Although he designed a great number of churches, his work was less dominantly ecclesiastical than his father's. His most famous building was the State Capitol at Hartford, Conn. (1885), for which drawings were begun in 1872.

UPSHAW, WILLIAM DAVID (*b. Coweta County, Ga., 1866; d. Glendale, Calif., 1952*), writer, politician, evangelist. Studied briefly at Mercer College. Democratic Congressman from Georgia, 1918–26. An ardent Prohibitionist, Upshaw was against the rights of blacks and was an avowed anti-Communist; failed to win reelection because of his connections with and defense of the Ku Klux Klan. Presidential candidate of the Prohibition party, 1932. Vice president of the Southern Baptist Convention in the late 1930's. Vice president of Linda Vista Baptist College and Seminary in San Diego, 1949–52.

UPSHUR, ABEL PARKER (*b. Northampton Co., Va., 1791; d. aboard battleship Princeton, 1844*), Virginia legislator and jurist. A judge of the Virginia supreme court, 1826–41, he associated himself in politics with the extreme states' rights proslavery group. U.S. secretary of the navy, 1841–43, he succeeded Daniel Webster as U.S. secretary of state. He was killed by the explosion

of a gun on the *Princeton* while cruising on the Potomac. A strong conservative, Upshur was opposed to numerical majorities, democratic conceptions, and the nationalistic theory of the Constitution; he rejected almost entirely the natural rights philosophy.

UPSHUR, JOHN HENRY (*b. Eastville, Va., 1823; d. Washington, D.C., 1917*), naval officer. Nephew of Abel P. Upshur. Entering the navy as midshipman, 1841, he retired as rear admiral, 1885, after varied world-wide service which included the Union North Atlantic blockade.

UPTON, EMORY (*b. near Batavia, N.Y., 1839; d. San Francisco, Calif., 1881*), Union soldier, expert in tactics. Graduated West Point, 1861. Commissioned in the artillery, Upton had a notable career during the Civil War, serving in the infantry and cavalry as well as his own arm and participating in a great number of engagements. He won promotion to brigadier general on the field of Spotsylvania, May 1864, and held divisional command at the battle of Winchester in September. In April 1865 he led in the capture of Selma, Ala., and its arsenal. He was an outstanding commandant of cadets at West Point, 1870–75, and was author of a system of infantry tactics which bears his name. An incomplete but important work by him was published as *The Military Policy of the United States* (ed. J. P. Sanger, 1904).

UPTON, GEORGE BRUCE (*b. Eastport, Maine, 1804; d. Boston, Mass., 1874*), merchant, capitalist, Massachusetts Whig legislator. Author of a public letter (March 23, 1870) charging the British with being responsible for Confederate commerce raiders and with having operated them in the Civil War.

UPTON, GEORGE PUTNAM (*b. Roxbury, Mass., 1834; d. Chicago, Ill., 1919*), journalist, music critic. Associated with Chicago, Ill., newspapers *post* 1855, Upton served on the staff of the *Chicago Daily Tribune* for 57 years *post* 1861. His local reputation was established by his writings as a music critic under the pseudonym "Peregrine Pickle"; he was author also of a number of books in the field of musicology.

UPTON, WINSLOW (*b. Salem, Mass., 1853; d. 1914*), astronomer, meteorologist. Graduated Brown, 1875; M.A., University of Cincinnati, 1877. Professor of astronomy at Brown, 1883–1914, and director of the Ladd Observatory, 1890–1914.

URBAN, JOSEPH (*b. Vienna, Austria, 1872; d. New York, N.Y., 1933*), architect, stage designer. Worked principally in the United States *post* 1911; introduced the new stage art of Europe to this country and to a great degree made possible the introduction of "modern" design concepts. Employing a style which owed much to the Secessionists and to *art nouveau*, he designed furniture, motor cars, clubs and public buildings, as well as the settings for the *Ziegfeld Follies* for which he was famous.

U'REN, WILLIAM SIMON (*b. Lancaster, Wis., 1859; d. Portland, Oreg., 1949*), political reformer. After a rootless childhood in Nebraska, Colorado, and Wyoming, he left home at age seventeen to work in the mines of Colorado and later became a blacksmith in Denver, attending business college at night. He read law for two years and in 1881 was admitted to the bar. In 1888, ill with tuberculosis, he went to Hawaii, where he worked on a sugar plantation. He then settled in Oregon. After reading Henry George's *Progress and Poverty* he became a convert to the single tax. In 1893 he helped organize and became the secretary of a joint committee on direct legislation, and embarked on a campaign to pledge candidates for the legislature to vote for the initiative and referendum.

U'Ren had meanwhile helped organize the Populist party in Oregon and was secretary of its state committee. In 1896 he was elected to the Oregon house of representatives. In 1902 the initiative and referendum amendment was ratified by popular vote. U'Ren then moved toward the next step in the series of measures that became known as the "Oregon System." In 1903 he organized the Direct Primary Nomination League to secure the nomination of candidates for office by primary election. The direct-primary amendment passed in 1904. It included a provision that in effect made possible the direct election of U.S. senators.

In 1905 U'Ren organized the People's Power League. League measures that were enacted included recall of state officers, a corrupt practices law, and one prohibiting railroads from giving free passes. Woodrow Wilson, earlier critical of direct democracy, allowed himself to be tutored by U'Ren on its principles after his election as governor of New Jersey in 1910. U'Ren felt the time was ripe to enact the single tax, and in 1914 ran for governor as an independent; but he and the single tax were soundly defeated.

URSO, CAMILLA (*b. Nantes, France, 1842; d. New York, N.Y., 1902*), violinist. Came to America as a child prodigy, 1852; played on concert tours with Henriette Sontag and Marietta Alboni. Outstanding in concert work, 1862–95, she devoted her last years to teaching.

USHER, JOHN PALMER (*b. Brookfield, N.Y., 1816; d. Philadelphia, Pa., 1889*), lawyer. Began practice in Terre Haute, Ind., 1840. Early active in the Republican party, he became assistant U.S. secretary of the interior *ca.* February 1862 and was appointed head of the department, January 1863. Resigning in May 1865, he removed to Lawrence, Kans., and became chief counsel for the Union Pacific Railroad, a post which he held for the rest of his life.

USHER, NATHANIEL REILLY (*b. Vincennes, Ind., 1855; d. probably Potsdam, N.Y., 1931*), naval officer. Nephew of John P. Usher. Graduated U.S. Naval Academy, 1875. Promoted rear admiral in 1911 after varied service which included the Greely Relief Expedition and command of the torpedo boat *Ericsson* in the Spanish-American War, he performed outstanding service as commandant of the Brooklyn Navy Yard during the period of World War I. Owing principally to his energy and organizing ability, the Port of New York was able to ship the greater part of all supplies and 80 percent of all the men that the United States sent to France. On his retirement, 1919, he was described as a principal factor in the successful incorporation of the Naval Reserve into the regular machine of the naval service.

UTLEY, FREDA (*b. London, England, 1898; d. Washington, D.C., 1978*), author, lecturer, and journalist. Graduated King's College of London University (B.A., 1923) and Westfield College of London University (M.A., 1926), and attended the London School of Economics (1926–28). She joined the British Communist party in 1927, and in 1930 she and her Soviet husband moved to Moscow, where she worked for the Institute for World Economics and Politics. Her husband died in 1938 in the Gulag and she fled to England. She traveled to China that year as war correspondent for the *London News Chronicle*, which enabled her to write the book *China at War* (1939). In 1940 she moved to the United States and emerged as a prominent anti-Communist writer and spokesperson. Utley wrote the autobio-

graphical *The Dream We Lost: Soviet Russia Then and Now* (reprinted as *Lost Illusion*, 1948) and the best-selling *The China Story* (1951), an attack on American supporters of Communist China. She collaborated with Sen. Joseph McCarthy and other anti-Communist politicians during the Red Scare of the early 1950's.

UTLEY, GEORGE BURWELL (*b.* Hartford, Conn., 1876; *d.* Pleasant Valley, Conn., 1946), librarian. Ph.B., Brown University, 1899. Held library posts in Hartford, Baltimore, Md., and Jacksonville, Fla.; effectively guided development of American Library Association as its executive secretary, 1911–20; librarian of the Newberry Library, Chicago, Ill., 1921–42.

V

VACA, ALVAR NÚÑEZ CABEZA DE *See* NÚÑEZ CABEZA DE VACA, ALVAR.

VAIL, AARON (*b.* L'Orient, France, 1796; *d.* Pau, France, 1878) U.S. state department official. Secretary of legation at London, England, 1831–32, he served as chargé d'affaires, 1832–36, with great success. While chief clerk of the U.S. State Department, 1838–40, he acted on numerous occasions as secretary of state; he was chargé d'affaires at Madrid, Spain, 1840–42.

VAIL, ALFRED (*b.* Morristown, N.J., 1807; *d.* Morristown, 1859) telegraph pioneer. Cousin of Theodore N. Vail. Graduated University of the City of New York, 1836. Became associated with Samuel F. B. Morse as constructor of instruments, 1837, and aided in financing early telegraph experiments. As chief assistant to Morse *post* 1843, Vail received the famous first test message "What hath God wrought!" at Baltimore, Md., May 24, 1844.

VAIL, ROBERT WILLIAM GLENROIE (*b.* Victon, N.Y., 1890; *d.* Albuquerque, N. Mex., 1966), librarian, bibliographer, historian. After receiving a B.A. from Cornell (1914), started his career at the New York Public Library where he became interested in completing a bibliographic record (initiated in the 1850's) of all the titles in American history and literature. World War I and other employment, including his editorship of the final twelve volumes of the *Memorial Edition of the Works of Theodore Roosevelt*, interrupted his work on the bibliography, but he returned to the New York Public Library as its coeditor (1928). In 1930 he was appointed sole editor and completed *Bibliotheca Americana* in 1936 while working as librarian for the American Antiquarian Society. Served as director of New-York Historical Society (1944–60) where he discovered the original document authorizing the Louisiana Purchase.

VAIL, STEPHEN MONTFORT (*b.* Union Vale, N.Y., 1816; *d.* Jersey City, N.J., 1880), Methodist clergyman, U.S. consular official, educator. Graduated Bowdoin, 1838; Union Theological Seminary, New York City, 1842. Professor of Hebrew at Methodist Biblical Institute, Concord, N.H., 1847–69. A vigorous advocate of theological training for Methodist clergymen and an active abolitionist.

VAIL, THEODORE NEWTON (*b.* near Minerva, Ohio, 1845; *d.* Baltimore, Md., 1920), telephone and utilities executive. Cousin of Alfred Vail. Raised in New Jersey where he became a telegrapher; resided in Iowa and Nebraska, 1866–73. Entering service of the Post Office Department, Vail devised a number of improvements in the railway mail service. He became assistant general superintendent of that service, 1874, and general superintendent, 1876. At the urging of Gardiner G. Hubbard, he became general manager of the new Bell Telephone Co. in 1878. When he resigned in 1887 he had been responsible for organizing the expanding telephone system into a series of efficient companies properly financed, and he had provided for future technical development and more economical manufacture of telephone apparatus. He had also arranged for a long-distance telephone system by connecting numerous operating companies, for which purpose he had incorporated the American Telephone & Telegraph Co., 1885. Retiring for several years to a Vermont farm, he engaged between 1894 and 1907 in financing and developing vast utility projects in Argentina. Chaotic conditions in the telephone industry followed on the expiration of the Bell patents in 1893 and 1894, and the Bell Company directors persuaded Vail to reenter the telephone industry, electing him president of the American Telephone & Telegraph Co., May 1907. By a policy of cooperation with the independent telephone companies, he achieved a second unification of the industry; meanwhile he pushed forward scientific research and technical improvement. In January 1915 the first transcontinental telephone line was opened, and in the same year telephone engineers under John J. Carty developed radio telephone into a practical means of communication. In 1919 Vail resigned the presidency of the American Telephone & Telegraph Co., becoming chairman of the Board of Directors.

VAILLANT, GEORGE CLAPP (*b.* Boston, Mass., 1901; *d.* Devon, Pa., 1945), archaeologist. Graduated Harvard, 1922; Ph.D., 1927. Associated with the American Museum of Natural History, New York City, *post* 1927, he made a series of excavations in the Valley of Mexico which, with subsequent studies, placed Mexican archaeology on a firm scientific footing and corrected earlier theories of the duration of the preclassic period. His major work, *The Aztecs of Mexico*, was published in 1941, and in that same year he became director of the University Museum, University of Pennsylvania. During 1943–44, he served as senior cultural relations officer in the U.S. embassy in Peru.

VALACHI, JOSEPH MICHAEL (*b.* New York City, 1904; *d.* El Paso, Tex., 1971), racketeer. Dropped out of junior high school, latched onto the Mafia as an enforcer, and joined the crime family headed by Charles ("Lucky") Luciano. In 1959 he was sentenced on a narcotics conviction; while in prison, he murdered another inmate but escaped the death penalty by agreeing to testify before Sen. John L. McClellan's Senate Subcommittee on Crime Investigations. During the 1963 televised hearings, he gave graphic testimony about the organization of the Mafia and helped make organized crime a priority for law enforcement agencies.

VALENTINE, DAVID THOMAS (*b.* East Chester, N.Y., 1801; *d.* New York, N.Y., 1869), New York City official, antiquarian. Clerk of the common council of New York, 1842–68, Valentine is particularly remembered for his supervision and publication of the *Manual of the Corporation of the City of New York* (1841–67) which included with the customary statistical information a vast amount of pictorial and documentary historical material of the greatest interest. The *History of the City of New York* (1853), which bears his name, was chiefly the work of W. I. Paulding.

VALENTINE, EDWARD VIRGINIUS (*b. Richmond, Va., 1838; d. Richmond, 1930*), sculptor. Studied in Paris with Thomas Couture and François Jouffroy, and in Berlin with August Kiss. Executed a number of portrait busts of Southern leaders, including the figure of Robert E. Lee for the Lee Mausoleum at Washington and Lee University.

VALENTINE, MILTON (*b. near Uniontown, Md., 1825; d. 1906*), Lutheran theologian, educator. A teacher *post* 1866 at the Lutheran Theological Seminary, Gettysburg, Pa., and a vigorous defender of General Synod Lutheranism, he served as president of the seminary, 1868–84.

VALENTINE, ROBERT GROSVENOR (*b. West Newton, Mass., 1872; d. 1916*), public official, founder of the profession of industrial counselor. Graduated Harvard, 1896. Retiring from business, 1904, he served as assistant to Francis E. Leupp and was head of the U.S. Indian Office, 1909–12. Becoming a consulting adviser to corporations, labor unions, and public officials *post* 1912, Valentine devised a system of "industrial audits" which would bear the same relation to the social health of an industry or community that a financial audit bore to its solvency.

VALLANDIGHAM, CLEMENT LAIRD (*b. New Lisbon, Ohio, 1820; d. 1871*), lawyer, Ohio legislator, politician. Of Southern stock, Vallandigham idealized the Southern character; he strove for the suppression of Abolitionists and a return to Jeffersonian states' rights principles. As congressman, Democrat, from Ohio, 1858–63, he denounced sectionalism on both sides, opposed disunion sentiment and, although disliking the popular sovereignty views of Stephen A. Douglas, supported him for the presidency in 1860. Proclaiming that the Southern "fire-eaters" would vanish if the Republican party were destroyed, he expressed his intention never to vote as a congressman for any measure in support of a civil war. His strong and able opposition to all measures for national defense proposed in the House brought him the intense hatred of the Republicans. Many Northerners were sympathetic with his pleas for restoration of peace and freedom of speech. After his defeat for reelection to Congress, 1862, he was regarded as a leader of the Peace Democrats or "Copperheads" in his section. For defiance of General A. E. Burnside's General Order Number 38 (1863), Vallandigham was arrested in Dayton, Ohio, and tried in Cincinnati for treason. He was condemned to imprisonment in Boston harbor, but President Lincoln shrewdly banished him to the Confederacy. Running the blockade, he made his way to Windsor, Canada. Defeated in a candidacy for governor of Ohio, 1863, he returned to his native state in June 1864. His influence in the framing of the national Democratic platform helped bring about a Democratic defeat in November. Thereafter he continued active in politics but failed of election to office. Shortly before his death he was instrumental in beginning the movement of reconciliation which took shape later in the Liberal Republican party.

VALLEJO, MARIANO GUADALUPE (*b. Monterey, Calif., 1808; d. Sonoma, Calif., 1890*), soldier, California politician. Supported J.B. Alvarado in the rebellion that led to proclamation of a free California, 1836; on estrangement from Alvarado, made himself a semi-independent chief at Sonoma. A powerful agent in securing submission of California to the United States, Vallejo was elected to the constitutional convention of 1849 and to the first state senate.

VALLENTINE, BENJAMIN BENNATON (*b. London, England, 1843; d. New York, N.Y., 1926*), journalist, playwright. Immigrated to New York City, 1871. A founder of *Puck*, 1877, he served as its managing editor until 1884, contributing the "Fitznoodle" letters which remain his principal achievement.

VALLIANT, LEROY BRANCH (*b. Moulton, Ala., 1838; d. Greenville, Miss., 1913*), lawyer, Confederate officer. Judge of the circuit court of St. Louis, Mo., 1886–98; judge of Missouri supreme court, 1898–1912.

VAN, BOBBY (*b. Robert Stein, New York City, 1930; d. Los Angeles, Calif., 1980*), actor and dancer. First appeared on stage at age four with his vaudevillian parents and as an adult performed as a trumpeter, comic, and dancer in the Catskill Mountains resort area; he made his Broadway debut in the revue *Alive and Kicking* (1950). In the 1950's his skilled and energetic dance routines were showcased in various Hollywood film musicals, including *Skirts Ahoy* (1952), *Small Town Girl* (1953), and *Kiss Me Kate* (1953). He returned to Broadway in a revival of *On Your Toes* (1954) and had critically acclaimed performances in the revival of *No, No, Nanette* (1971) and the title role in *Dr. Jazz* (1975). He also hosted television game shows and choreographed several Miss America pageants.

VAN ALLEN, FRANK (*b. Dubuque, Iowa, 1860; d. Melur, Madura, India, 1923*), Congregational clergyman, medical missionary in India *post* 1888. Built and administered an outstanding hospital in Madura City.

VAN ALSTYNE, FANNY CROSBY *See* CROSBY, FANNY.

VAN AMRINGE, JOHN HOWARD (*b. Philadelphia, Pa., 1835; d. Morristown, N.J., 1915*), educator. Graduated Columbia, 1860. Taught mathematics at Columbia *post* 1860, resigning in 1910 as professor emeritus. A unique figure in the history of Columbia and a promoter of its alumni association, he served as dean of the college *post* 1894 and as acting president of Columbia University, 1899.

VAN ANDA, CARR VATTEL (*b. Georgetown, Ohio, 1864; d. New York, N.Y., 1945*), journalist. Attended Ohio University at Athens, Ohio; rose from printer to editor on Cleveland newspapers; was night editor of Baltimore *Sun*, 1886–88, and of *New York Sun*, 1893–1904. As managing editor of the *New York Times*, 1904 until retirement in 1925 (retaining the title, however, until 1932), he had charge of the newsroom and it was his skill, intuitive sense of news values, and capacity for leadership that won the *Times* its reputation as the foremost news operation in the country.

VAN BEUREN, JOHANNES (*b. Amsterdam, the Netherlands, ca. 1680; d. New York, N.Y., 1755*), physician. A pupil of Boerhaave, Van Beuren came to New York *ca.* 1702 and built up a large practice both in the city and in the town of Flatbush on Long Island. Appointed first medical director of the New York almshouse hospital, 1736, he held the position until his death. This hospital was the beginning of the present Bellevue Hospital.

VAN BRUNT, HENRY (*b. Boston, Mass., 1832; d. Milton, Mass., 1903*), architect. Graduated Harvard, 1854; studied in office of Richard M. Hunt. After Civil War service, formed a partnership with William R. Ware, 1863–83. Working *post* 1883 under firm name of Van Brunt & Howe, he designed a great number of Western railroad stations, shops, and houses. The firm became the most important architectural organization west of Chicago and was domiciled in Kansas City, Mo. Van Brunt was an eclectic. His most important contribution to architecture was in his writings, of which some appear in *Greek Lines and Other Architectural Essays* (1893).

VAN BUREN, JOHN (*b. Kinderhook, N.Y., 1810; d. at sea en route to New York from England, 1866*), lawyer, New York politician and official. Son of Martin Van Buren, he was known as "Prince John." Constantly active in politics in his father's interest *post* 1834, he was influential in organizing the "Barnburners" and espoused free-soil doctrines with evangelistic fervor. Later returning to more moderate views, he supported popular sovereignty in Kansas, denounced Lincoln for precipitancy in calling for troops, and in 1864 supported George B. McClellan for president.

VAN BUREN, MARTIN (*b. Kinderhook, N.Y., 1782; d. Kinderhook, 1862*), lawyer, president of the United States. Father of John Van Buren. After serving as law clerk to William P. Van Ness, he practiced at Kinderhook *post* 1803, handling the cases of small landholders and becoming an adherent of the Clinton-Livingston faction among the Democratic Republicans. Attorney general of New York, 1816–19, and a state senator, 1812–20, he gradually turned against his early political associates in his rise to leadership in Democratic state politics. His wit and charm combined with a clear, realistic intelligence in effecting his rise. His enemies thought him hypocritical, intriguing, and selfish. He was, indeed a political manipulator, but he was honest and serious in both private and public relations and steadfast in his adherence to principle and faithful public service. At the state constitutional convention, 1821, he brought extreme radicals and conservatives together in successful opposition to the old Council of Appointment, thereby securing a distribution of the power to appoint state officers among local authorities, the legislature, and the governor.

Elected to the U.S. Senate, February, 1821, by the "Bucktail" faction, he continued to have a deep interest in New York politics and headed the influential "Albany Regency" which included W. L. Marcy, Benjamin F. Butler (1795–1858), and others. Formidable in their solidarity, Van Buren and his group were sincere as well as shrewd and faithfully performed the duties of the important offices they obtained. A supporter of William H. Crawford for president, 1824, he opposed the movement which gave John Q. Adams the presidency and remained in opposition to Adams's policies throughout that president's term. By 1828 he was a leading supporter of Andrew Jackson and assumed an important role in the campaign of that year. Elected governor of New York, he resigned the office to become Jackson's secretary of state in 1829 and the most influential member of the Jackson cabinet. He urged on the administration the introduction of the political spoils system which had been operated with such success by the Albany Regency. Wholly in Jackson's confidence, Van Buren resigned his post, April 1831, in a move which enabled the president to effect a reorganization of his cabinet and thus eliminate the supporters of John C. Calhoun. His appointment as U.S. minister to Great Britain was refused confirmation by the Senate in January 1832, whereupon he accepted nomination for vice president. He had done well as secretary of state, displaying unusual tact and high administrative ability. In addition to other achievements he settled the old dispute over the West Indian trade between Great Britain and the United States, secured an agreement with France for the payment of claims dating back to the Napoleonic wars, negotiated a favorable trade treaty with Turkey, and made an attempt to buy Texas from Mexico.

Following his nomination for the vice presidency, he aided Jackson in defeating a bill to recharter the Bank of the United States and joined in the president's opposition to nullification. Contrary to opinion, he did not disagree with Jackson over removal of the government's Bank deposits, but he was doubtful about the expediency of their removal at that time. A fair and able presiding officer of the Senate during his vice presidency,

he was nominated for the presidency in May 1835 at Baltimore, Md., as Jackson's protégé.

Elected on a platform of opposition to recharter of the Bank, opposition to distribution of the Treasury's surplus, and opposition to improvement of rivers above ports of entry, he also conveyed the impression that his distaste for the extension of slavery did not extend to any meddling with the right of slave-holding states to control the institution within their boundaries. Striving throughout his term to hold together the Northern and Southern wings of his party, he was much plagued by Abolitionist agitators as well as by those who would compel them to silence. But his chief problems were economic. During the panic of 1837 he held to Jackson's specie circular and properly said that the panic was the result of over-expansion of credit and rashness in business. Determined to divorce the "money power" from the federal government, he urged establishment of an independent Treasury and recommended withholding of the distribution of the Treasury surplus to the states, suggesting a temporary issue of Treasury notes to meet the pressing needs of government. His foresighted efforts were generally unsuccessful and alienated conservative Democrats, especially in New York and Virginia, while at the same time he was denounced by the Whigs for his heartlessness in not undertaking measures of relief. In foreign affairs he continued his wise policy of conciliation during troubles with Canada and Mexico. Despite an enlightened and able administration, he could not maintain popular approval in the face of the prevailing bad times and was overwhelmingly defeated by William H. Harrison in the campaign of 1840.

In retirement he continued to be a leading Democrat but made public announcement that he would take no step to secure another nomination. In the well-known "Hammet letter" of April 1844, he courageously said that the annexation of Texas would mean war with Mexico and that he saw no need for immediate action; this stand probably cost him the Democratic nomination in 1844. Bitter opposition to President James K. Polk soon developed in New York State, and the introduction of the Wilmot Proviso in 1846 provided a rallying point for discontent and for the antislavery feeling that had been steadily increasing. Author in part of the address of the "Barnburner" Democrats in the New York legislature, February 1848, Van Buren accepted the Free-Soil party nomination for the presidency that summer. Although like many Northern Democrats he had grown impatient with the "salvocracy," he accepted the nomination reluctantly and ran unsuccessfully although his candidacy helped to defeat Lewis Cass. After supporting the 1850 compromise measures, he returned to the Democrats in 1852 to find himself successively disillusioned by Pierce and Buchanan. Shocked deeply by the Civil War, he expressed himself confident in the abilities of Abraham Lincoln but died in the summer of 1862 despondent over the situation of the Union armies.

VAN BUREN, WILLIAM HOLME (*b. Philadelphia, Pa., 1819; d. New York, N.Y., 1883*), physician, surgeon. Descendant of Johannes Van Beuren; son-in-law of Valentine Mott. M.D., University of Pennsylvania, 1840. After service as army surgeon, Van Buren practiced in New York City *post* 1845. A member of the staff of Bellevue and other hospitals, he taught in the medical department of the University of the City of New York, 1851–66, and was thereafter professor of surgery in Bellevue Hospital Medical College.

VANCE, AP MORGAN (*b. Nashville, Tenn., 1854; d. Louisville, Ky., 1915*), orthopedic surgeon. M.D., University of Louisville, 1878. Practicing in Louisville *post* 1881, he was the first exclusive practitioner of surgery in Kentucky. His greatest contribution was his improvement of the operation of osteotomy for correction of

deformity of long bones in the extremities; he also improved the procedure of tenotomy for the treatment of congenital clubfoot.

VANCE, ARTHUR CHARLES ("DAZZY") (*b. Orient, Iowa, 1891; d. Homosassa Springs, Fla., 1961*), baseball pitcher. Began his pitching career with Superior and Red Cloud in the Nebraska League in 1912. Played with minor league teams until 1922 when he was traded to the Brooklyn Robins. For seven consecutive seasons he led the National League in strikeouts, and ended his career with 2,045. His best year was 1924, when he led the league with 28 victories, 262 strikeouts and a 2.16 earned run average. That year he won fifteen consecutive games. First winner of the National League's Most Valuable Player Award (1924). Traded to St. Louis Cardinals (1933), but returned to Brooklyn where he pitched the 1935 season before retiring. He left baseball with 197 wins, 140 losses, and a 3.24 earned run average. Elected to Baseball Hall of Fame (1955).

VANCE, HAROLD SINES (*b. Port Huron, Mich., 1890; d. Washington, D.C., 1959*), industrialist, executive, government official. Began his career as a mechanic's assistant for the Everitt-Metzger-Flanders Co. in 1910; in 1912, the company was absorbed by the Studebaker Corporation. Became vice president in charge of manufacturing in 1926; chairman of the board in 1933; and president, 1948–52; the company merged with Packard in 1954. Served as a consultant to the Office of Defense Mobilization, 1952–55, and as a member of the Atomic Energy Commission, 1955–59.

VANCE, LOUIS JOSEPH (*b. Washington, D.C., 1879; d. New York, N.Y., 1933*), popular novelist. Author, among other works, of *The Brass Bowl* (1907), *The Lone Wolf* (1914), and many magazine serials.

VANCE, VIVIAN (*b. Vivian Roberta Jones, Cherryvale, Kans., 1912; d. Belvedere, Calif., 1979*), actress. Studied with William Inge in Independence, Kans., and moved to New York City to pursue an acting career. She became Ethel Merman's understudy and had her breakthrough role on Broadway in *Hooray for What!* (1937); she later starred in the Broadway hit *Let's Face It* (1941). During the run of *The Voice of the Turtle* (1945) in Chicago, she had a nervous breakdown and did not return to the stage until 1951. In the 1950's Vance played Ethel Mertz in the hit television series "I Love Lucy." She won an Emmy in 1954 for her performances as the frumpy and humorous neighbor of Lucy Ricardo, played by Lucille Ball. In the 1960's Vance costarred with Ball in the "The Lucy Show."

VANCE, ZEBULON BAIRD (*b. Buncombe Co., N.C., 1830; d. Washington, D.C., 1894*), lawyer, Confederate soldier, politician. Entered politics as a Whig. On the dissolution of that party he became a Know-Nothing; as congressman from North Carolina, 1858–61, he supported Union measures. Winning reputation as a masterly stump speaker for the Bell-Everett ticket, 1860, he continued to campaign against secession until Lincoln's call for troops whereupon he reversed his position. As a Conservative party governor of North Carolina, 1862–65, he was often at odds with the Confederate government at Richmond, although he pressed the Confederate war effort with as much zeal as the disturbed and unwillng attitude of North Carolina would permit. He tried in vain to explain to President Davis that his execution of conscription laws was not willful obstruction but was dictated by a regard for legality and realism. Opposing the efforts of W. W. Holden to make peace by separate state action, Vance held North Carolina to the support of a cause which many of its citizens felt was now contrary to their real interests. After a brief imprisonment, 1865, he was released on parole and resumed practice of law. As Democratic governor, 1877–79, he stimulated railroad enterprises, agriculture, and industry, improved the public schools, and repudiated the fraudulent state bonds issued during the Reconstruction period. His regime marked the beginning of a new era in North Carolina. Elected to the U.S. Senate, 1879, he served there until his death and was for many years minority leader on the finance committee. He opposed the internal revenue system as a source of political corruption, and during Cleveland's two administrations opposed the president on civil service reform and on the money question.

VAN CORTLANDT, OLOFF STEVENSZEN (*b. probably the Netherlands, 1600; d. New York, 1684*), merchant. Came to New Amsterdam, March 1638, as a soldier of the Dutch West India Company. Successful as a trader and purchaser of real estate, he held many public offices including those of city treasurer (1657, 1659–61, and 1664) and burgomaster (mayor) (1655–60 and 1662–63). Rated at his death as the fourth richest person in the colony, he was founder of one of the most prominent families in the American colonies and father, among other children, of Stephanus Van Cortlandt.

VAN CORTLANDT, PHILIP (*b. New York, N.Y., 1749; d. Croton, N.Y., 1831*), landowner, New York legislator, Revolutionary officer. Son of Pierre Van Cortlandt. Colonel of the 2nd New York Regiment in the Revolution, he served principally in New York State and cooperated effectively with the Sullivan-Clinton expedition, 1779. He received brevet of brigadier general, 1783, for conspicuous bravery at Yorktown. As congressman from New York, 1793–1809, he was a loyal Democratic-Republican and punctilious in performance of his committee duties.

VAN CORTLANDT, PIERRE (*b. New York, N.Y., 1721; d. Croton, N.Y., 1814*), landowner, New York colonial legislator, Revolutionary patriot and soldier. Grandson of Stephanus and father of Philip Van Cortlandt. Presided over New York constitutional convention, 1777. Elected lieutenant governor, 1777, he served until 1795 as a loyal follower of George Clinton (1739–1812). He was a regent of the University of the State of New York, 1784–95, and a patron of the work of the early Methodists.

VAN CORTLANDT, STEPHANUS (*b. New Amsterdam, 1643; d. 1700*), merchant, colonial official. Son of Oloff S. Van Cortlandt. An officer in the colonial militia and a councilor of the province *post* 1674, he was appointed first native-born mayor of the City of New York, 1677, a position to which he was again appointed in 1686–87. Mistreated by Jacob Leisler and forced to flee for his life during Leisler's usurpation of the New York government, he returned to the Council under Governor Henry Sloughter and, with the support of Frederick Philipse and Nicholas Bayard, vigorously pressed Leisler's prosecution on the charge of treason. Associated throughout his career with several of the provincial courts, he became a judge of the supreme court, 1691, and was raised to the post of chief justice a month before his death. He was an important adviser to the provincial governors on Indian relations. A large purchaser of Indian land tracts and a patentee of province lands, he erected his holdings into the manor of Cortlandt by royal patent dated June 17, 1697.

VAN CURLER, ARENT (*b. Nykerk, the Netherlands, 1620; d. Perro Bay, Lake Champlain, N.Y., 1667*), colonial trader and official. Came to New Netherland *ca.* 1638 as a clerk at Rensselaerswyck; soon became *commis*, or resident manager. Famous for his enduring influence over the Indian tribes in the province, Van Curler made the first settlement of Schenectady and was the rescuer of Father Isaac Jogues. A humane man and a peace-

maker, he was long remembered by the Indians who called all subsequent governors of New York "Corlaer" in memory of him.

VAN DAM, RIP (*b. Fort Orange, present Albany, N.Y., ca. 1660; d. 1749*), New York merchant, colonial politician. Roused to political activity by actions of the Jacob Leisler party, Van Dam became a member of the governor's Council in 1702 and served until 1736. As president of the Council he became acting governor of the province, 1731, and for 13 months received the salary of the office. Refusing to divide this salary with Governor William Cosby on the new governor's arrival, Van Dam lost a law suit to Cosby and was suspended from the Council in November 1735. He refused to recognize his removal in March 1736 until dispatches from England certified to the validity of George Clarke's appointment as president of the Council. Thereafter he took part in the struggle for popular rights and against prerogative, acting as a leader in this movement with William Smith and James Alexander.

VAN DEGRAAFF, ROBERT JEMISON (*b. Tuscaloosa, Ala., 1901; d. Boston, Mass., 1967*), physicist, inventor. Studied at the Sorbonne (1924) and was awarded a Rhodes Scholarship at Oxford (1925) where he got a B.S. degree in physics (1926) and a Ph.D. (1928). Invented the Van de Graaff generator, a device that accelerates electrons, protons, or heavier atomic nuclei to high energies (1931). The machine is considered one of the classic "atom smashers." During World War II Van de Graaff directed a project to develop X-ray machines for the nondestructive testing of naval ordnance. Formed a corporation to manufacture a more compact and powerful Van de Graaff accelerator in 1946. In 1960, he resigned his professorship at the Massachusetts Institute of Technology, a position he had held since 1934, to devote all his time to developing the commercial applications of his invention.

VANDEGRIFT, ALEXANDER ARCHER (*b. Charlottesville, Va., 1887; d. Bethesda, Md., 1973*), marine general. Attended University of Virginia (1906–08) and entered the Marine Corps as a second lieutenant in 1909. He served in Latin America, the Caribbean, and China (1912–37) and became a brigadier general in 1940. In August 1942 he led the operation to seize Tulagi and Guadalcanal; for months his meager forces struggled against both the Japanese and the climate, until reinforcements finally allowed him to extend his lines. In 1943 he returned to Washington to become marine commandant, a position he held until his retirement in 1947, having become the first marine officer on active duty to hold four-star rank.

VAN DEMAN, ESTHER BOISE (*b. South Salem, Ohio, 1862; d. Rome, Italy, 1937*), archaeologist. Graduated University of Michigan, 1891; Ph.D., University of Chicago, 1898. Taught Latin at Wellesley, Mount Holyoke, and Goucher. *Post* 1906 she worked at the American School in Rome. Projected methods of determining the date of ancient building construction; published a preliminary study of her work in *American Journal of Archaeology*, 1912.

VANDENBERG, ARTHUR HENDRICK (*b. Grand Rapids, Mich., 1884; d. Grand Rapids, 1951*), journalist, U.S. senator. Studied at the University of Michigan. Appointed to the Senate, 1928, and served, as a Republican, until his death. Opposed most New Deal legislation and was one of the most effective of the die-hard isolationists. On the Senate Foreign Relations Committee from 1929, he became chairman in 1946. During World War II, abandoned his isolationist position and helped draft the Connally Resolution providing for U.S. membership in the future United Nations. Subsequently became a leading proponent of the United Nations and was instrumental in rallying Republican support in the Senate. Appointed to the delegation to the U.N. Conference on International Organization in San Francisco, 1945, and helped draft Articles 51–54 of the Charter, which allowed for regional defense agreements; was instrumental in securing Senate ratification of the Charter, 1945. Appointed delegate to the first two U.N. General Assemblies, 1946–47. Was adviser to Secretary of State James F. Byrnes at the Big Four foreign ministers' conferences in Paris and New York.

Became a chief advocate of a bipartisan foreign policy; helped persuade the Senate to approve the Marshall Plan, and drafted the Vandenberg Resolution, 1948, which became the basis for the U.S. leadership in the formation of the North Atlantic Treaty Organization.

VANDENBERG, HOYT SANFORD (*b. Milwaukee, Wis., 1899; d. Washington, D.C., 1954*), aviator, soldier. Graduated from West Point, 1923. Served in the Army Air Service, 1924–34; graduated from the Army War College, 1939. Chief of staff of the Twelfth Air Force (1942), charged with supporting the North African campaign. Commanded the Ninth Air Force (1944), which gave air support to General Omar Bradley's advance into Germany. Chief of staff of the newly created U.S. Air Force 1948–53, which during his tenure bore the brunt of the Berlin airlift, the Korean War, and the expansion of the force into a major defense arm.

VANDENHOFF, GEORGE (*b. Liverpool, England, 1813; d. Brighton, England, 1885*), actor, lawyer, public reader. Made his American debut at New York City's Park Theater, 1842, as Hamlet. Toured extensively in the United States and England until 1858, when he undertook practice of law in New York City, but continued his popular public readings from the works of classic writers. Vandenhoff was a scholarly actor with a restrained, elevated style.

VAN DEPOELE, CHARLES JOSEPH (*b. Lichtervelde, Belgium, 1846; d. Lynn, Mass., 1892*), scientist, inventor. Immigrated to America, 1869, settling in Detroit, Mich., where he became a successful manufacturer of church furniture and at the same time continued his early experimental interest in electricity. He developed an improved arc-lighting system, 1870–79, and in 1880 tested an electric tramcar on which he had been working since 1874. In September 1883 at Chicago, he gave the first practical demonstration of a spring-pressed under-running trolley; in November 1885 his overhead current feed system was put into operation in South Bend, Ind. After success in developing his trolley-car system, he sold his patents to the Thomson-Houston Electric Co. in 1888 and became electrician of that company. In all, he filed 444 applications for patents, of which some 249 were granted to him under his own name. In addition to his electric railway patent (October 1883) and his patent for an overhead conductor (August 1885) were the following: a carbon commutator-brush which revolutionized motor construction (1888); an alternating-current reciprocating engine (1889); a multiple-current pulsating generator (1890) and a telpher system in the same year; a coal-mining machine (1891); and a gearless electric locomotive (1894). He also made experiments in electric refrigeration.

VANDERBILT, AMY (*b. Staten Island, N.Y., 1908; d. New York City, 1974*), author, columnist, designer, and expert on etiquette. Attended the Institute Heubi in Lausanne, Switzerland, and Packer Collegiate Institute in Brooklyn, N.Y., and studied journalism at New York University (1926–28). She worked in publishing, advertising, and public relations in the 1930's and 1940's and in 1952 published *Amy Vanderbilt's Complete Book of Eti-*

quette, which gained immediate acceptance as the modern guide to social behavior. Her later books include *Amy Vanderbilt's Everyday Etiquette* (1956) and *Amy Vanderbilt's Complete Cookbook* (1961).

VANDERBILT, ARTHUR T. (*b. Newark, N.J., 1888; d. 1957*), lawyer, jurist. Studied at Wesleyan University and Columbia University Law School, LL.B., 1912. Taught at New York University Law School, 1914–48, dean from 1943. Vanderbilt was a leading legal reformer, chairing the New Jersey Judicial Council (1930–40) and the National Conference of Judicial Councils (1933–37). President of the American Bar Association, 1937. Chief Justice of the New Jersey Supreme Court, 1948–57.

VANDERBILT, CORNELIUS (*b. Port Richmond, N.Y., 1794; d. 1877*), financier, steamship and railroad promoter. Father, among other children, of William H. Vanderbilt; grandfather of Cornelius (1843–99), George W., and William K. Vanderbilt. Began business *ca.* 1810 as a freight and passenger ferryman between Staten Island and New York City. Taking advantage of expanded opportunities during the War of 1812, he built up a small fleet of schooners for the Hudson River and coastal trade but disposed of his sailing ships in 1818 to become a ferry captain in the employ of Thomas Gibbons. A strong and tough ally to Gibbons in his fight against the steam-navigation monopoly which existed in New York waters, Vanderbilt turned what was a losing venture into a profitable one within a year. After fighting Gibbons' battles and expanding his business for some 11 years, Vanderbilt entered the steamboat business on his own, 1829. With characteristic zest for conflict, he fought for a share of the Hudson River trade by cutting prices and for the first time came into conflict with a later antagonist, Daniel Drew. His opponents finally paid him to withdraw from competition for ten years, and he then set up lines running on Long Island Sound to Providence and Boston. As he took pleasure in making his ships fast, safe, and comfortable, he did much to promote an advance in steamboat design.

A wealthy man by 1846 "Commodore" Vanderbilt, as he had come to be known, was loud and coarse in speech — a big, bumptious, hardheaded man who was at the same time courageous, constructive, frank, and faithful to a bargain once he had made it. He was also a man of broad vision for his time. When traffic to California reached important proportions with the 1849 gold rush, he conceived the idea of starting a line of his own via Nicaragua to California. He constructed a fleet of new steamers to make the first part of the journey from New York to Nicaragua, and also built roads and other installations in that country to facilitate the overland part of the journey. His aggressive competition reduced the length of time for the New York-San Francisco trip and also greatly reduced the passenger fare. While on an extensive vacation during 1853 he committed the management of his Nicaragua line to Charles Morgan and Cornelius K. Garrison. During his absence they manipulated the stock and secured control of the company; later, as Vanderbilt struggled to win it back, Morgan and Garrison persuaded the filibuster William Walker, who was then temporarily in control of the Nicaraguan government, to void Vanderbilt's operating charter and issue a new one to them. Rising to the challenge, Vanderbilt thereupon set about to oust Walker, which he succeeded in doing early in 1857. Once again in control of his line, he bludgeoned the Pacific Mail Steamship Co. into buying it out. He then entered competition for the Atlantic trade against the Cunard and Collins lines. This, however, was an unprofitable venture.

Vanderbilt had begun buying stock of the New York & Harlem Railroad in 1862; in 1863 he induced the New York City council to let him extend the line by streetcar tracks to the lower part of the city. He also took over the presidency of the road. When Daniel Drew, with the aid of members of the council, attempted a "bear raid" on the stock of the company, Vanderbilt outwitted him and forced a settlement by which many of the plotters were ruined. At about this time he put his son William H. Vanderbilt into the post of vice president of the Harlem Railroad, and thereafter his son was his closest aide. The Harlem's competitor, the Hudson River Railroad, was then acquired, and Vanderbilt sought permission of the New York legislature to combine the two. Again Daniel Drew plotted a raid, this time by legislative bribery, and again the old Commodore was victorious over his enemies. By careful management and by following his lifelong policy of improving the equipment and service of his lines, he presently had them on a paying basis. After another financial and political struggle in which Drew was involved, he succeeded in gaining control of the New York Central in 1867, improved it, and by 1872 had consolidated three inefficient roads into a single excellent line. Meanwhile Drew, Jay Gould, and James Fisk, by a series of spectacular and reprehensible maneuvers, had defeated his attempt to control the Erie Railroad in 1868.

By the addition to his holdings of the Lake Shore & Michigan Southern Railroad (1873) and the Michigan Central and Canada Southern roads (1875), Vanderbilt created one of the great American systems of transportation. During the last years of his life he exerted a strong, stabilizing influence on national finance. He engaged in no philanthropies until late in his life when he gave $1 million to Vanderbilt University (previously Central University) at Nashville, Tenn., of which he is regarded as the founder.

VANDERBILT, CORNELIUS (*b. near New Dorp, N.Y., 1843; d. New York, N.Y., 1899*), financier, philanthropist. Son of William H. Vanderbilt; grandson of Cornelius Vanderbilt (1794–1877); brother of George W. and William K. Vanderbilt. A favorite of his grandfather, he became assistant treasurer of the New York & Harlem Railroad *ca.* 1867 and served as its president from 1886 until his death. *Post* 1885 he acted as the head of the Vanderbilt family and was the director, with his brother William K. Vanderbilt, of its investments. A conscientious worker and a director of many corporations, he was a trustee and benefactor of the N.Y. College of Physicians and Surgeons, of Columbia University, of the N.Y. General Theological Seminary, and of many other public institutions.

VANDERBILT, CORNELIUS, JR. ("NEIL") (*b. New York City, 1898; d. Miami Beach, Fla., 1974*), journalist and publisher. Born into the highest echelon of society, he was educated privately in the United States and Europe. Volunteered for the army in World War I and saw action in France; graduated the War College in Washington, D.C. (1919); and subsequently served in the reserves and National Guard. In 1919 he became a cub reporter at the *New York Herald* and was soon covering the White House for the *New York Times*. In 1922 he launched the *Illustrated Daily News* in Los Angeles and the *Illustrated Daily Herald* in San Francisco, but both soon failed. During the Great Depression he wrote sensitive stories about destitute populations and became an ardent New Dealer; his criticism of the superrich caused his name to be removed from the New York Social Register in 1937.

VANDERBILT, GEORGE WASHINGTON (*b. near New Dorp, N.Y., 1862; d. Washington, D.C., 1914*), capitalist, agriculturist, forestry pioneer. Son of William H. Vanderbilt; grandson of Cornelius Vanderbilt (1794–1877); brother of Cornelius (1843–99) and William K. Vanderbilt. Studious and caring little for finance, he built up a very large property in the vicinity of Asheville, N.C., where he planned and built the finest country home in America,

working with Richard M. Hunt and Frederick L. Olmsted. At his estate, which he named "Biltmore," he practiced scientific farming and stockbreeding, founded and conducted the Biltmore Nursery, and also founded the Biltmore School of Forestry. Gifford Pinchot was his first superintendent of forests. The stimulus which his example gave to agricultural reforms in the South has been called beyond estimate.

VANDERBILT, GLORIA MORGAN (*b. Lucerne, Switzerland, 1904; d. Los Angeles, Calif., 1965*), socialite. Daughter of an American career diplomat, Gloria Morgan and twin Thelma became society's darlings when newspaper columnist "Cholly Knickerbocker" chronicled their activities. In 1923 Gloria consolidated her social celebrity by marrying Reginald Claypoole Vanderbilt, twenty-four years her senior. Gave birth to a daughter, Gloria, in 1924. Following her husband's death in 1925, Gloria Morgan Vanderbilt, "the world's most beautiful widow," became the toast of two continents but neglected her child. In 1934, after a sensational trial, the courts awarded custody of the girl to Vanderbilt's sister-in-law, Gertrude Vanderbilt Whitney. In 1958 Gloria and Thelma wrote of their past in *Double Exposure.*

VANDERBILT, GRACE GRAHAM WILSON (*b. New York, N.Y., 1870; d. New York, 1953*), society leader. Privately educated, Grace Wilson married the heir to the New York Central Railroad, Cornelius Vanderbilt III, in 1896. Succeeded Mrs. Astor as New York social arbiter; famous for her parties in Newport; entertained European nobility as well as several presidents.

VANDERBILT, WILLIAM HENRY (*b. New Brunswick, N.J., 1821; d. New York, N.Y., 1885*), financier, railroad executive. Son of Cornelius Vanderbilt (1794–1877); father of Cornelius (1843–99), George W., and William K. Vanderbilt. Alienated for some years from his father, he was returned to favor *ca.* 1863 after he had achieved success on his own as a farmer and railroad executive. Appointed to high positions in the Vanderbilt railroads, he served as his father's principal aide until *ca.* 1876, showing great ability in management, in the improvement of track and equipment, in regulating rates, and in conciliating labor. After the death of his father, William Henry Vanderbilt became president of all the affiliated New York Central network corporations. Within a few years he bought control of the Chicago & Northwestern and a large interest in the Cleveland, Columbus, Cincinnati & Indianapolis Railroad. He also exercised effective control over the New York, Chicago & St. Louis line and in 1885 leased the West Shore. Like his father a constructive man who prized efficiency, he greatly improved his properties and increased his own fortune. Recognizing the unpopularity of unified and monopoly control, he disposed in 1879 of a large block of his own shareholdings in the roads. He designed all his railroad presidencies in May 1883, ordering that members of the family should be chairmen of the boards of directors thereafter, but that presidents should be practical, working executives. Temperate and simple in his personal habits, he was fond of horses and driving, and made a number of philanthropic benefactions during his lifetime.

VANDERBILT, WILLIAM KISSAM (*b. near New Dorp, N.Y., 1849; d. Paris, France, 1920*), capitalist, sportsman. Son of William H. Vanderbilt; grandson of Cornelius Vanderbilt (1794–1877); brother of Cornelius (1843–99) and George W. Vanderbilt. An executive in the family railroads *post ca.* 1869 and, with his brother Cornelius, for many years a manager of the family investments, William K. Vanderbilt voluntarily permitted the executive direction of the New York Central system to pass the Rockefeller-Morgan-Pennsylvania combination in 1903. He continued, however, as a board member of many railroads until his death and aided in increasing the size of the Vanderbilt fortune. An enthusiastic yachtsman and turfman, he was also active in the affairs of the Metropolitan Opera and in theatrical matters, and was a collector of paintings.

VANDERBURGH, WILLIAM HENRY (*b. Vincennes, Ind., ca. 1798; d. on an affluent of the Jefferson River, present Montana, 1832*), fur trader. Worked for Missouri Fur Co. *post ca. 1818;* was later a partner in the American Fur Co. and in charge of the Rocky Mountain trappers *post ca.* 1828. Ambushed and killed by Blackfeet Indians while on a trapping expedition.

VAN DER DONCK, ADRIAEN (*b. Breda, North Brabant, the Netherlands, 1620; d. New Netherland, ca. 1655*), colonist, lawyer. Studied law at the University of Leyden. Came to America as *schout* (justice officer) at Rensselaerswyck, 1641. Dismissed from office *ca.* 1644 because of enmity of Arent Van Curler, he remained in the colony and established a settlement at the present site of Yonkers, N.Y. Appointed secretary of the Board of Nine Men, 1649, he wrote the famous "Remonstrance" of 1650, which set forth the people's grievances against their rulers, and was one of three men sent to The Hague to present it to the States-General. This gained him the enmity of Peter Stuyvesant. Detained at home by the government, he wrote the description of New Netherland entitled *Beschrijvinge van Nieuvv Nederlant* (written in 1653, published 1655 at Amsterdam). He returned to America late in 1653 with permission to give legal advice but not to appear before the courts since there was no lawyer in the colony competent to contend with him.

VANDERGRIFT, JACOB JAY (*b. Allegheny, Pa., 1827; d. Pittsburgh, Pa., 1899*), riverboat captain. Settling at Oil City, Pa., early in 1861, he became a shipper of oil and later a dealer. In association with John Pitcairn and others, he established the Imperial Refinery, 1872. Although not the builder of the first oil pipe line, he is said to have been the first to make one profitable. With Pitcairn he also laid what was probably the first natural gas line of any importance.

VANDERGRIFT, MARGARET *See* JANVIER, MARGARET THOMSON.

VAN DER KEMP, FRANCIS ADRIAN (*b. Kampen, the Netherlands, 1752; d. 1829*), clergyman, Dutch revolutionary leader, scholar. Long a friend and correspondent of John Adams, Van der Kemp immigrated to New York, 1788, settling first near Kingston and later by Oneida Lake. At the request of DeWitt Clinton, he translated the Dutch colonial records of New York into English.

VANDERLIP, FRANK ARTHUR (*b. near Aurora, Ill., 1864; d. New York, N.Y., 1937*), journalist, banker, public official. Entering journalism as city editor of his hometown newspaper, he went to the *Chicago Tribune*, 1889, where he soon rose to be financial editor. Associate editor of *The Economist* (Chicago, Ill., 1894–97), he further developed his reputation as a financial authority, and was appointed (1897) private secretary to Lyman J. Gage, U.S. secretary of the treasury. Soon becoming an assistant treasury secretary, he won national repute handling the Spanish War loan of 1898. Joining the National City Bank of New York in 1901 as vice president, he brought that institution into the investment field, developed foreign and domestic branches, and, as president, 1909–19, made the bank the largest in the United States. He maintained a lifelong interest in public affairs, denouncing the scandals of the Harding administration, opposing the growing isolationism of the United States, and advocating abandonment of the gold standard, 1933.

VANDERLYN, JOHN (*b. Kingston, N.Y., 1775; d. Kingston, 1852*), historical and portrait painter. Patronized by Aaron Burr, Vanderlyn took his first lessons in drawing from Archibald Robertson and later studied under Gilbert Stuart. A student in Paris, 1796–1801, he returned briefly to America. Between 1803 and 1815 he worked in Europe where, at Rome, he met and became a friend of Washington Allston. His painting *Marius Amid the Ruins of Carthage* (Rome ca. 1806) made a great stir and he received a number of honors abroad. His *Ariadne* of 1812 made a greater sensation than the *Marius*. After his return to New York in 1815 Vanderlyn painted a number of portraits of eminent men, engaged in a controversy with John Trumbull over the paintings for the rotunda of the U.S. Capitol, and executed panoramas of Paris, Versailles, Athens, and Mexico for exhibition. His popularity early waned and he died in poverty.

VAN DER STUCKEN, FRANK VALENTIN (*b. Fredericksburg, Tex., 1858; d. Hamburg, Germany, 1929*), musical composer, conductor. Raised in Belgium, he studied music in Antwerp and Brussels and at Leipzig. Winning repute abroad, he succeeded Leopold Damrosch as conductor of the Arion Society chorus (1884–95) and appeared frequently as an orchestral conductor. *Post 1895* he was conductor of the Cincinnati Symphony Orchestra and director of the Cincinnati Conservatory until 1907 and 1903 respectively. *Post 1908* he resided principally in Europe. Early in his conducting career he adopted a policy of presenting all-American programs at which the works of American musicians were played exclusively.

VANDER VEER, ALBERT (*b. Root, N.Y., 1841; d. 1929*), Union Army surgeon, medical educator. M.D., Columbia College (present George Washington University), 1863. A practitioner in Albany, N.Y.; taught at Albany Medical College, 1869–1915, and served as dean, 1897–1904. He was a regent of the University of the State of New York, 1895–1927, and its chancellor, 1921–22.

VANDERWEE, JOHN BAPTIST (*b. Antwerp, Belgium, 1824; d. Baltimore, Md., 1900*), educator, provincial of the Xaverian Brothers. Known in religion as Brother Alexius, he joined the Xaverian Brothers, 1845, and helped establish the congregation in England, 1848. Sent to America, 1872, he was named provincial of the congregation in 1875. From beginnings of desperate poverty he labored to extend the work of the Brothers, building several schools and colleges, and conducting St. Mary's Industrial School in Baltimore which served as a model to later institutions for the training of boys.

VAN DEVANTER, WILLIS (*b. Marion, Ind., 1859; d. Washington, D.C., 1941*), lawyer, justice of the U.S. Supreme Court. He attended Indiana Asbury (later DePauw) University, 1875–78, and the Cincinnati Law School, LL.B., 1881. He then practiced law in his father's office in Marion for three years.

In July 1884 Van Devanter moved to Cheyenne, Wyo., where he was drawn into public service and Republican politics. He served as commissioner to revise the Wyoming statutes (1886), Cheyenne city attorney (1887–88), as a member of the territorial legislature and chairman of its judiciary committee (1888), and as chief justice of Wyoming (1889–90). Thereafter his political involvement was chiefly as a party manager. His strenuous efforts for William McKinley in 1896 came to the attention of Mark Hanna, and with McKinley's accession to the presidency, Van Devanter entered federal office. In 1897 he became assistant attorney general in charge of Indian and public lands cases. Theodore Roosevelt raised him in 1903 to a judgeship on the federal circuit court of appeals. William Howard Taft made him associate justice of the Supreme Court in 1911.

Van Devanter's outlook was formed on the last frontier. He believed in property rights, in "economic freedom," and in the philosophy that that government governs best which governs least. A consummate lawyer and subtle negotiator, he wielded an important influence. Among Van Devanter's opinions, a number, such as *Evans v. Gore* and *Indian Motorcycle Company v. United States* have been overridden. But the judgment upholding the Federal Employers' Liability Act speaks in more modern tones. Other notable opinions were *National Prohibition Cases*, sustaining the constitutionality of the Eighteenth Amendment; *Pennsylvania v. West Virginia*, applying the commerce clause of the Constitution to prevent a state from reserving its natural resources for use exclusively in its internal commerce; *McGrain v. Daugherty* affirming the Congressional power to investigate; and *New York ex. rel. Bryant v. Zimmerman et al.*, upholding a state statute under which the Ku Klux Klan was required to disclose its membership. An opinion displaying Van Devanter's mastery of the law affecting the Supreme Court's jurisdiction is *Dahnke-Walker Milling Company v. Bondurant*. One of his rare dissents, *Herndon v. Lowry*, argued the validity under the Fourteenth Amendment of a conviction of a black Communist organizer for violating a Georgia anti-insurrection statute.

Van Devanter was a firm member of the group of five justices who declared key New Deal measures unconstitutional. He announced his retirement when the Senate Judiciary Committee was voting on the "court packing" bill, thus probably contributing to the bill's defeat.

VAN DE VELDE, JAMES OLIVER (*b. near Termonde, Belgium, 1795; d. Natchez, Miss., 1855*), Roman Catholic clergyman, Jesuit. Recruited for the American missions by Charles Nerinckx, 1817, he was ordained in 1827. Ordered to St. Louis University, 1831, he served there as vice president (1833) and as president (1840–43). Vice provincial of Missouri, 1843–48, he fostered the Jesuit missions of the Far West. Consecrated bishop of Chicago, 1849, he had a brief and unhappy tenure and was transferred at his own request to the diocese of Natchez, 1853.

VAN DE WARKER, EDWARD ELY (*b. West Troy, present Watervliet, N.Y., 1841; d. 1910*), Union Army surgeon, gynecologist. M.D., Albany Medical College, 1863. Practiced with great success at Syracuse, N.Y., *post 1870*.

VAN DINE, S. S. See WRIGHT, WILLARD HUNTINGTON.

VAN DOREN, CARL CLINTON (*b. Hope, Ill., 1884; d. Torrington, Conn., 1950*), literary critic, biographer. B.A., University of Illinois, 1907. In September 1908 Van Doren left home to attend Columbia University, Ph.D., 1911. He became an influential figure as literary editor (1919–22) of the *Nation*. The "new," "modern" writers were now coming into their own, and Van Doren was one of their great supporters and was a great friend to writers he admired. He was not a bold or venturesome critic, and all his life thought of himself as a novelist *manqué*. Yet his most successful narrative writing was his best-selling biography of Benjamin Franklin (1938), which won the Pulitzer Prize. Van Doren was a superb professional writer, gifted, yet never quite fulfilled. He was an indispensable part of American literary opinion in the vital years after World War I, which saw the triumph of modern American literature.

VAN DOREN, EARL (*b. near Port Gibson, Miss., 1820; d. Spring Hill, Tenn., 1863*), soldier. Graduated West Point, 1842. As an infantry officer, he served with credit in the war with Mexico and against the Seminole Indians (1849–50); thereafter he served with the then 2nd Cavalry in Texas and Indian Territory.

Resigning from the army, 1861, he was appointed brigadier general of Mississippi troops and rose to major general in the Confederate army in the same year. Commander of the trans-Mississippi district, 1862, he was defeated at Pea Ridge in March, and later at Corinth, Miss., after transfer there. In charge of the cavalry during the defense of Vicksburg, he made a brilliant raid on Holly Springs in December 1862, effectively crippling General Ulysses S. Grant's projected campaign. He was shot and killed by a personal enemy while in camp.

VAN DOREN, IRITA BRADFORD (*b. Birmingham, Ala., 1891; d. New York, N.Y., 1966*), literary editor. In 1912 married Carl Van Doren, who went on to become a prominent literary critic and biographer. Joined editorial staff of the *Nation* where her husband was literary editor in 1919, succeeding him as book editor in 1923. Became literary editor of the *Herald Tribune* (1926) and won recognition as a leading literary figure and editor during her thirty-seven years of running the paper's literary supplement. Was divorced in 1935 and in 1937 became romantically involved with Wendell L. Wilkie, the Republican candidate for president in 1940. Collaborated with him on his best-selling *One World* (1943). Retired from the *Herald Tribune* (1963), then was literary consultant to the William Morrow publishing company.

VAN DOREN, MARK ALBERT (*b. Hope, Ill., 1894; d. Torrington, Conn., 1972*), literary critic and poet. Graduated Columbia University (B.A., 1914; M.A., 1915; Ph.D., 1920) and joined the English faculty at Columbia, where he became a full professor in 1942 and remained until his retirement in 1957. In 1920 he began a long association with *The Nation* as a book reviewer, literary editor (1924–28) and movie critic (1935–38). He produced some sixty books of poetry, fiction, and criticism and edited or collaborated on two dozen more. His poetry is dominated by nostalgic, pastoral imagery; among his best-known titles are *A Winter Diary* (1935), *The Mayfield Deer* (1941) and *The Country Year* (1946); his *Collected Poems* (1939) received the Pulitzer Prize in 1940. In later years he also turned to the theater, publishing verse plays, such as *Three Plays* (1966), which collects *Never, Never Ask His Name; A Little Night Music;* and *The Weekend That Was.* Among his two dozen books of literary commentary and criticism are *Shakespeare* (1939), for many years a standard introductory text to the plays; *The Private Reader* (1942); and *Introduction to Poetry* (1951), which has been widely used at the secondary and college level.

VAN DRUTEN, JOHN WILLIAM (*b. London, England, 1901; d. Indio, Calif., 1957*), playwright. Became a U.S. citizen in 1944. Studied at the University College School and the University of London, LL.B., 1923. Taught English law and legal history at University College, Wales, 1923–26. His first produced play, *Young Woodley,* opened on Broadway in 1925. Other works include *Leave Her to Heaven* (1940), *The Voice of the Turtle* (1943), *I Remember Mama* (1944), *Bell, Book and Candle* (1950), and his dramatization of Isherwood's Berlin stories, *I Am a Camera* (1951). Films include *Night Must Fall* (1937) and *Gaslight* (1944). Directed *The King and I* (1951).

VAN DYCK, CORNELIUS VAN ALEN (*b. Kinderhook, N.Y., 1818; d. 1895*), medical missionary, Arabic scholar, author of scientific textbooks in modern Arabic. A graduate of Jefferson Medical College in 1839, he served in Syria and Lebanon, 1840–65 and 1867–95. A master of the Arabic language, he continued and completed the translation of the Bible into Arabic which had been begun by Eli Smith.

VAN DYKE, HENRY (*b. Germantown, Pa., 1852; d. Princeton, N.J., 1933*), Presbyterian clergyman, author, educator, diplomat.

Brother of Paul Van Dyke. Graduated Princeton, 1873; Princeton Theological Seminary, 1877. Pastor at Newport, R.I., 1879–83; minister of Brick Presbyterian Church, New York City, 1883–99, 1902, 1911. Murray Professor of English Literature, Princeton University, 1899–1923, thereafter emeritus. U.S. minister to the Netherlands and Luxembourg, 1913–16. An eloquent preacher and able administrator, Van Dyke was as competent as he was versatile. Active in the fight against political corruption while a New York pastor, he stood for a positive evangelical Christianity during the doctrinal controversies that shook the Presbyterian Church of his time. Equally versatile as a writer, Van Dyke's outdoor essays are in the tradition of Thoreau, Burroughs, and Muir, although his deep religious faith pervades his work at all times. Although changing standards of taste have diminished his reputation, he was master of a lucid style beautifully adapted to his purposes. Among his principal books are *The Poetry of Tennyson* (1899); *Little Rivers* (1895); *Fisherman's Luck* (1899); *The Story of the Other Wise Man* (1896); *The First Christmas Tree* (1897); *The Blue Flower* (1902); and *Out-of-doors in the Holy Land* (1908).

VAN DYKE, JOHN CHARLES (*b. New Brunswick, N.J., 1856; d. New York, N.Y., 1932*), art critic, educator. Grandson of Theodore Strong. A librarian at the New Brunswick Theological Seminary *post* 1878, Van Dyke was also a lecturer on art at Rutgers College, and served as professor of the history of art there, 1891–1929. Author of a number of careful, scholarly works on art and also of several distinguished volumes of nature study (such as *The Desert*, 1901, and *The Mountain*, 1916), Van Dyke was possessed of an almost microscopic acuteness of vision. He employed this in effecting a severe and controversial revision of attributions to the artist in his *Rembrandt and His School* (1923).

VAN DYKE, JOHN WESLEY (*b. near Mercersburg, Pa., 1849; d. Philadelphia, Pa., 1939*), oil company executive. Associated with various Standard Oil companies, 1873–1911, he was president of the Atlantic Refining Co., 1911–27, and chairman of the board until his death. Among his patented inventions were mechanical improvements for the sulfur-eliminating process devised by Herman Frasch, and improvements on railroad tank cars. Probably his most important invention (developed with W. W. Irish) was the tower still which enabled refiners to improve the separation of fractions, to eliminate some refining processes, and to reduce costs.

VAN DYKE, NICHOLAS (*b. New Castle, Del., 1738; d. New Castle Co., Del., 1789*), lawyer, Delaware legislator. Father of Nicholas Van Dyke (1770–1826). A moderate Whig *post* 1774, he served in the Continental Congress, 1777–82, but was more interested in his work as a Delaware councilor. While president (governor) of Delaware, 1783–86, he strove to improve commerce and to put the state finances on a sound basis.

VAN DYKE, NICHOLAS (*b. New Castle, Del., 1770; d. New Castle, 1826*), lawyer, statesman. Son of Nicholas Van Dyke (1738–1789); brother-in-law of Kensey Johns (1759–1848). A moderate in politics like his father, he served as attorney general of Delaware, 1801–06, and as a Federalist congressman, 1807–11. A U.S. senator, 1817–26, he voiced the traditional states' rights sentiments, and although personally opposed to slavery, refused to vote against the admission of Missouri on the ground that Congress had no authority to impose restrictions on slavery.

VAN DYKE, PAUL (*b. Brooklyn, N.Y., 1859; d. Washington, Conn., 1933*), historian. Brother of Henry Van Dyke. Graduated Princeton, 1881; Princeton Theological Seminary, 1884. A Presbyterian pastor for some years at Geneva, N.Y., and at North-

ampton, Mass., he was an instructor in church history at Princeton Seminary, 1889–92, and professor of modern history in Princeton University, 1898–1928. His most important book, *Catherine de Medicis* (1922), won international recognition as a history of the religious wars in France.

VANE, SIR HENRY (*b. probably Debden, Essex, England, 1613; d. London, England, 1662*), Puritan statesman. Immigrated to Massachusetts, 1635. Attempted with Hugh Peter to reconcile the factions of former governors John Winthrop and Thomas Dudley. Elected governor of Massachusetts, May 1636, he served with tact and energy, but his career was soon wrecked by his support of Anne Hutchinson during the great controversy over her religious opinions. At the election of 1637 he sailed for England. An honest and generous man, he was later outstanding during the struggle of King and Parliament in England. He was instrumental in securing the condemnation of the Earl of Strafford and Archbishop Laud, but he had no part in the trial and condemnation of King Charles I, and after the dissolution of the Long Parliament he retired from public life. Excepted from the act of indemnity at the Restoration, he was tried for treason, found guilty, and executed.

VAN FLEET, WALTER (*b. Piermont, N.Y., 1857; d. Miami, Fla., 1922*), physician, naturalist, horticulturist. M.D., Hahnemann Medical College, 1880. Taking up plant breeding as his main vocation, 1891, he gave distinguished service as an expert in the bureau of plant industry, U.S. Department of Agriculture, *post* 1909. His work covered a wide range and included experiments on production of nonblighting chestnuts and the development of many new varieties of plants. He is most famous for his work with the rose, especially the climbing and pillar varieties.

VAN HISE, CHARLES RICHARD (*b. Fulton, Wis., 1857; d. Milwaukee, Wis., 1918*), geologist, educator. Graduated in engineering, University of Wisconsin, 1879; Ph.D., 1892. Taught metallurgy and mineralogy at Wisconsin *post* 1879 and was professor of geology, 1892–1903; he also served with the U.S. Geological Survey. He was president of the University of Wisconsin *post* 1903. Trained in geology under Roland D. Irving, he collaborated with Irving in much research work for the Geological Survey, and was coauthor of several monographs on the iron-bearing districts of the Lake Superior region; he later collaborated with C. K. Leith in the writing of several more general treatises on the subject. As president of the university he developed its research activities and its extension department and engaged actively in public service. He contributed to the conservation movement what has been called its most valuable book, *The Conservation of Natural Resources in the United States* (1910). He was later an enthusiastic supporter of the League of Nations concept.

VAN HOOK, WELLER (*b. Greenville, Ind., 1862; d. Coopersville, Mich., 1933*), Chicago, Ill., surgeon and medical teacher. Did pioneer work in surgery of the genitourinary tract; devised *ante* 1896 the Van Hook-Mayo operation for correction of hypospadias and the repair of epispadias.

VAN HORN, ROBERT THOMPSON (*b. East Mahoning, Pa., 1824; d. Kansas City, Mo., 1916*), Union soldier, journalist, Missouri legislator. Trained as a printer, he removed to Kansas City, 1855, where he was editor-publisher of the *Journal* (published daily, 1858–79). Originally a conservative Democrat, he became a Republican at the outbreak of the Civil War and served as a loyal partisan in Congress, 1865–71, 1881–83, and 1895–97. Several times mayor of Kansas City, he played a leading role in making that place the principal railroad center west of Chicago.

VAN HORNE, WILLIAM CORNELIUS (*b. Will Co., Ill., 1843; d. Montreal, Canada, 1915*), railroad executive. Starting as a telegraph operator with the Illinois Central Railroad *ca.* 1857, he rose by outstanding merit to the superintendency of the Chicago, Milwaukee & St. Paul Railroad. Impressing James J. Hill with his abilities during an 1880 controversy, Van Horne was recommended by Hill to the directors of the Canadian Pacific Railway as the man best qualified to supervise its construction. He began work at Winnipeg at the end of 1881 and carried the project through to completion in 1886. President of the Canadian Pacific, 1888–99, thereafter he developed important railroads in Cuba and Guatemala. A naturalized citizen of Canada *ante* 1890, he was knighted, 1894.

VAN ILPENDAM, JAN JANSEN (*b. Leyden, the Netherlands, ca. 1595; d. probably Amsterdam, the Netherlands, 1647*), Dutch colonial official. Commissary at Fort Nassau on the Delaware *ca.* 1637–45. Opposed English efforts to settle on the Schuylkill, 1641, and on the Delaware, 1644.

VAN LENNEP, HENRY JOHN (*b. Smyrna, Asiatic Turkey, 1815; d. Great Barrington, Mass., 1889*), Congregational clergyman. Graduated Amherst, 1837. Missionary in Turkey, 1839–69; author, among other works, of *Travels in Little-Known Parts of Asia Minor* (1870).

VAN LENNEP, WILLIAM BIRD (*b. Constantinople, Turkey, 1853; d. Philadelphia, Pa., 1919*), surgeon. Son of Henry J. Van Lennep. Graduated Princeton, 1876; Hahnemann Medical College, 1880; made postgraduate studies in London, Paris, and Vienna. A faculty member of Hahnemann College *post* 1886 and dean *post* 1910.

VAN LOON, HENDRIK WILLIAM (*b. Rotterdam, the Netherlands, 1882; d. Old Greenwich, Conn., 1944*), author, illustrator. Came to the United States, 1902. A.B., Cornell University, 1905. Ph.D., University of Munich, 1911. Failing to gain a foothold in the academic world, he became an itinerant lecturer on modern European history, illustrating his talks with maps and sketches which he made as he was speaking. After publishing five books with comparatively little success, he became a best-selling author in 1921 with *The Story of Mankind*, addressed to a juvenile audience, and followed up his first success with similar generalized, panoramic narratives about the Bible, the lives of great men, the story of geography, and the arts. His anecdotal style, personal approach to his subjects, and the drawings with which he illustrated his books brought him popularity and prestige with a loyal and large body of admirers, if not with scholars.

VAN METER, JOHN BLACKFORD (*b. Philadelphia, Pa., 1842; d. Baltimore, Md. 1930*), Methodist clergyman, educator. Associated with John F. Goucher in founding Woman's College of Baltimore (president Goucher); served there as a faculty member, 1888–1914, and as dean, 1892–1910. Largely responsible for the educational policy of the college, he served it also as acting president, 1911–13.

VAN NAME, ADDISON (*b. Chenango, N.Y., 1835; d. New Haven, Conn., 1922*), philologist, librarian. Brother-in-law of Josiah W. Gibbs (1839–1903). Graduated Yale, 1858. Appointed librarian of Yale, 1865, he served until his retirement as emeritus, 1905. He built up the collection of Oriental literature and supervised the library during a period of extraordinary growth.

VAN NESS, WILLIAM PETER (*b. Claverack, Columbia Co., N.Y., ca. 1778; d. 1826*), politician, jurist. Graduated Columbia, 1797; studied law in office of Edward Livingston. Began practice in New York City, 1800, as protégé of Aaron Burr. A loyal fol-

lower of Burr in politics, Van Ness defended his patron in *An Examination of the Various Changes Exhibited against Aaron Burr* (1803, under pseudonym "Aristides") and served him as second in his duel with Alexander Hamilton, 1804. Subsequently an associate of Martin Van Buren, he served as U.S. judge for the Southern District of New York, 1812–26. He was coeditor of the annotated *Laws of the State of New York* (1813) and wrote several other works.

VAN NEST, ABRAHAM RYNIER (*b. New York, N.Y., 1823; d. New York, 1892*), Dutch Reformed clergyman. After holding several New York pastorates he resided abroad, 1863–78, and organized American chapels in Paris, Rome, Florence, and Geneva. Returning to the United States, he was pastor of Third Reformed Church of Philadelphia, Pa., 1878–83.

VAN NOSTRAND, DAVID (*b. New York, N.Y., 1811; d. 1886*), bookseller, publisher, student of military engineering. Opened a New York City bookstore *ca.* 1848, specializing in books on military and naval science. Venturing into publishing, he made his firm the largest American publishers of scientific, technical, and military works, also issuing for many years *Van Nostrand's Engineering Magazine.*

VAN OSDEL, JOHN MILLS (*b. Baltimore, Md., 1811; d. Chicago, Ill., 1891*), carpenter, architect. Employed by William B. Ogden to plan and erect a house for him in Chicago, 1837, Van Osdel removed to Chicago and has the honor of being that city's first professional architect. He was particularly active in the restoration of the city after the great fire of 1871.

VAN QUICKENBORNE, CHARLES FELIX (*b. Peteghem, East Flanders, 1788; d. Portage des Sioux, Mo., 1837*), Roman Catholic clergyman. Jesuit. Assigned to the Jesuit Maryland mission, 1817, he taught at Georgetown and served as professor at the seminary at Whitemarsh. He was renowned for charitable service among the poor and especially the blacks. Named first superior of the Missouri Province, 1823, he instituted its work at Florissant; in 1828 he established St. Louis College, later incorporated as St. Louis University. A zealous missionary among the Osage, Potawatomi, Kickapoo, and other tribes, he traveled extensively through Missouri, Illinois, and Iowa, and served as the pioneer of Catholicism on those frontiers. He was also responsible for the training of such celebrated Jesuits as Christian Hoecken, Pierre De Smet, and Peter Verhaegen.

VAN RAALTE, ALBERTUS CHRISTIAAN (*b. near Zwartsluis, the Netherlands, 1811; d. 1876*), nonconformist Dutch Reformed clergyman. Founded Dutch settlement at Holland, Mich., 1847, and served as its preacher and physician.

VAN RENSSELAER, CORTLANDT (*b. Albany, N.Y., 1808; d. Burlington, N.J., 1860*), Presbyterian clergyman. Son of Stephen Van Rensselaer. Graduated Yale, 1827. Rendered conspicuous service as corresponding secretary and chief executive officer of the Presbyterian Board of Education, 1846–60, furthering the development of parochial schools, Presbyterian academies, and synodical colleges.

VAN RENSSELAER, MARIANA GRISWOLD (*b. New York, N.Y., 1851; d. New York, 1934*), art critic, author. A leader and expositor of the new interest in art that was current in the educated America of the 1880's and 1890's, Van Rensselaer wrote a number of books which included *American Etchers* (1886), *Henry Hobson Richardson and His Works* (1888, the first important monograph on a modern American architect), and *English Cathedrals* (1892). Her best-known work is her authoritative *History of the City of New York in the Seventeenth Century* (1909).

VAN RENSSELAER, MARTHA (*b. Randolph, N.Y., 1864; d. 1932*), teacher, home economist. An early leader in the education of country women, particularly through her extension work at Cornell University *post* 1900.

VAN RENSSELAER, NICHOLAS (*b. Amsterdam, North Holland, 1636; d. 1678*), Dutch Reformed and Anglican clergyman. Son of the first patroon of the Manor of Rensselaer, he became a close associate of Charles II of England during the king's exile on the continent of Europe. In England *post* 1662, he received Anglican orders and came to New York with Sir Edmund Andros who tried to force him on the congregation at Albany as minister. Rejected, he complained to the governor and the dispute was brought before the Council, September–October 1675. On his promise to conform to the rites of the Dutch Church, he was finally installed at Albany but was deposed by the governor, 1677.

VAN RENSSELAER, SOLOMON (*b. Rensselaer Co., N.Y., 1774; d. 1852*), soldier, public official. Entered U.S. Army as cornet of cavalry 1792; served under Anthony Wayne, 1794, and was wounded at Fallen Timbers; honorably discharged as major, 1800. Appointed aide-de-camp to his cousin General Stephen Van Rensselaer, 1812, he commanded the advance party of militia at Queenstown, Canada, Oct. 13, 1812, and was severely wounded while successfully carrying out his part of the operation. As congressman, probably Federalist, from New York, 1819–22, he opposed the Missouri Compromise. He was postmaster at Albany, N.Y., 1822–39 and 1841–43.

VAN RENSSELAER, STEPHEN (*b. New York, N.Y., 1764; d. 1839*), soldier, New York legislator, eighth patroon of the Manor of Rensselaer. Grandson of Philip Livingston. Graduated Harvard, 1782. Married Margaret, daughter of General Philip Schuyler, June 1783. A Federalist legislator, 1789–95, and lieutenant governor of New York, 1795–1801, he ran unsuccessfully for governor against George Clinton in the latter year. Thereafter at various times a member of the New York legislature and an active improver of his great estates, he was called on in 1812 (as a major general in the New York militia) to command the entire northern frontier of the state. Assembling a force based at Lewiston, he was hampered by the refusal of General Alexander Smyth of the regular army to take orders from him. Venturing to attack Queenstown, Canada, in October 1812 without Smyth's support, he suffered a severe defeat and resigned his command. As congressman from New York, 1823–29, he cast the deciding vote for John Q. Adams, 1825, when the choice of a president was thrown into the House of Representatives. Van Rensselaer's chief services to New York were economic and educational. He was an early advocate of a canal to connect the Hudson with the Great Lakes and served on both Erie Canal commissions; he was president of the second *post* 1825. He was instrumental in creating the state's first board of agriculture and paid the costs of the first state geological survey by Amos Eaton. He established in 1824–26 the present Rensselaer Polytechnic Institute and gave generously to other educational institutions.

VAN SANTVOORD, GEORGE (*b. Belleville, N.J., 1819; d. East Albany, N.Y., 1863*), lawyer, New York legislator. A proponent of the civil law as against the "churlish and exclusive spirit" of the common law. Author, among other works, of *A Treatise on the Principles of Pleading in Civil Actions under the New-York Code* (1852) and *Sketches of the Lives . . . of the Chief Justice of the United States* (1854).

VAN SCHAACK, HENRY CRUGER (*b. Kinderhook, N.Y., 1802; d. 1887*), antiquarian, lawyer. Son of Peter Van Schaack. Author, among other works, of a life of his father (1842) which was the

first attempt to present a justificatory memoir of a Tory in the Revolution.

VAN SCHAACK, PETER (*b. near Kinderhook, N.Y., 1747; d. Kinderhook, 1832*), lawyer, Loyalist. Graduated King's College (Columbia), 1766; studied law with William Smith (1728–93). A member of several pre-Revolutionary New York committees of protest against the British government's treatment of the colonies, he attempted to maintain neutrality after the outbreak of fighting. His several refusals to take the oath of allegiance to the State of New York caused him to be banished to England in 1778. Returning to Kinderhook, 1785, he was readmitted to the bar but took no active part in politics.

VAN SCHAICK, GOOSE (*b. Albany, N.Y., 1736; d. Albany, 1789*), Revolutionary patriot and soldier. An officer in the New York provincial militia *post* 1756, he was commissioned colonel of the 1st New York Regiment at the outbreak of the Revolution, and saw constant service during the war in defense of New York's northern and western frontiers. His most famous exploit was a punitive expedition against the Onondaga tribe (April 1779) which was preliminary to the better-known campaign of General John Sullivan later that summer.

VAN SLYKE, LUCIUS LINCOLN (*b. Centerville, N.Y., 1859; d. 1931*), agricultural chemist. Graduated University of Michigan, 1879; Ph.D., 1882. Chief chemist, New York State agricultural experiment station, Geneva, N.Y., 1800–1929; professor of dairy chemistry, Cornell University, 1920–29. He is remembered for pioneer work in dairy chemistry which included basic research on the chemical constituents of milk and their relation to one another. His researches on milk casein led to improvement on cheese-making and were of immense scientific value in contributing to knowledge of the nature and behavior of colloids.

VAN SWERINGEN, MANTIS JAMES (*b. Wooster, Ohio, 1881; d. 1935*), real estate operator, railroad manager, and speculator. Working in close partnership with his brother, Oris P. Van Sweringen, he developed the suburb of Shaker Heights, Cleveland, Ohio, *post* 1900. The brothers later acquired stock control of a vast railroad system, which at its peak included the Nickel Plate, the Chesapeake & Ohio, the Erie, the Pere Marquette, and the Missouri Pacific railroads. In 1935 their holding company pyramid showed signs of weakening, and after the death of the brothers their empire disintegrated.

VAN TWILLER, WOUTER (*b. Gelderland, present the Netherlands, ca. 1580; d. ca. 1656*), colonial official. Nephew of Kiliaen Van Rensselaer, the first patroon of Rensselaerswyck. Arrived at New Amsterdam, 1633, as director general of New Netherland. His foresighted desire to build up the agricultural potential of the colony, rather than produce an immediate profit by trade, was thwarted by a lack of colonists and by the enmity of David P. De Vries and Everardus Bogardus. Popular with the Indians because of his just treatment of them, he was relieved of his post by Willem Kieft in 1637. Returning to the Netherlands, 1639, he justified his actions before the West India Company and was later a manager of his uncle's properties.

VAN TYNE, CLAUDE HALSTEAD (*b. Tecumseh, Mich., 1869; d. 1930*), educator, historian. Graduated University of Michigan, 1896; Ph.D., University of Pennsylvania, 1900. A professor of history at Michigan *post* 1903 and later head of the department of history there, Van Tyne was a stimulating and exacting teacher. He was author, among other scholarly publications, of *The Loyalists in the American Revolution* (1902), *The Causes of the War of Independence* (1922), and *The War of Independence,*

American Phase (1929) for which he was awarded a Pulitzer Prize.

VANUXEM, LARDNER (*b. Philadelphia, Pa., 1792; d. Bristol, Pa., 1848*), geologist. Graduated École des Mines, Paris, 1819. Taught chemistry at South Carolina College. Made geologic surveys in Mexico, New York, Ohio, Kentucky, Tennessee, and Virginia; made studies also of the Third District iron- and salt-bearing formations for the New York State Geological Survey *post* 1836. Author of *Geology of New York, Part III* (1842), he was instrumental in effecting a uniform system of nomenclature for American geology, a cooperative task which led to the later founding of the American Association for the Advancement of Science.

VAN VECHTEN, ABRAHAM (*b. Catskill, N.Y., 1762; d. 1837*), lawyer, Federalist New York legislator, and public official. Studied law with John Lansing; was first lawyer admitted to practice under the New York constitution, 1785; practiced in Albany, N.Y. Held leading position at New York constitutional convention, 1821. Gave notable opinion in *Gibbons v. Ogden* (9 *Wheaton*, 1) in which he was sustained by Chief Justice Marshall.

VAN VECHTEN, CARL (*b. Cedar Rapids, Iowa, 1880; d. New York, N.Y., 1964*), music and dance critic, novelist, photographer. Attended the University of Chicago (Ph.B., 1903), then moved to New York in 1906 and worked as music and arts critic for the *New York Times* and *New York Press*. Met Gertrude Stein (1913) and championed her work for decades, serving as her literary executor after her death. Books of essays hailing works of experimental composers and artists he considered neglected include *Music After the Great War* (1915), *In the Garret* (1919), and *Red* (1925). Also wrote seven novels during 1922–30. Turned to documentary photography in the 1930's; his first show was part of the "Leica Exhibition" in New York City in 1935. Personal reminiscences include *Sacred and Profane Memories* (1932) and *Fragments from an Unwritten Autobiography* (1955).

VAN VLECK, EDWARD BURR (*b. Middletown, Conn., 1863; d. Madison, Wis., 1943*), mathematician. A.B., Wesleyan University, 1884; did graduate work at Johns Hopkins, 1885–87; Ph.D., University of Göttingen, 1893. Taught at University of Wisconsin, 1893–95; at Wesleyan, 1895–1906. Professor of mathematics, University of Wisconsin, 1906–29, and for many years chairman of the department. A conscientious teacher, clear and meticulous in his presentation, he showed the profound influence of his mentor, Felix Klein, in his own mathematical work, especially in its earlier period. This was typified by a broad approach to problems, using both analytical and geometrical methods, together with a keen sense for the relationship between different fields.

VAN VLECK, JOHN HASBROUCK (*b. Middletown, Conn., 1899; d. Cambridge, Mass., 1980*), Nobel laureate physicist. Graduated University of Wisconsin and Harvard University (Ph.D., 1922) and served most of his career on the Harvard faculty (1922–23; 1934–69). A pioneering theorist in quantum physics, he discovered the general theory of magnetic (and electric) susceptibilities in gases. He elaborated his findings in the classic *Theory of Electric and Magnetic Susceptibilities* (1932). He also contributed to advancements in molecular spectroscopy and assisted in the development of magnetic resonance techniques by Harvard scientists. He shared the Nobel Prize for physics in 1977.

VAN WINKLE, PETER GODWIN (*b. New York, N.Y., 1808; d. Parkersburg, W. Va., 1872*), lawyer. Removed to Parkersburg as a young man and practiced law there *post* 1835. Prominent in the creation of the present State of West Virginia, he had much

to do with the framing of its constitution (1861–62) and was a member of its first legislature. U.S. senator, Republican, from West Virginia, 1863–69, he showed courage and independence, especially in his refusal to vote for conviction of President Andrew Johnson.

Van Wyck, Charles Henry (*b. Poughkeepsie, N.Y., 1824; d. Washington, D.C., 1895*), lawyer, Union brigadier general, New York and Nebraska legislator. Congressman, Republican, from New York, 1859–63, 1867–71, he removed to the vicinity of Nebraska City, Nebr., 1874. In the Nebraska legislature, and as U.S. senator, 1881–87, he was a supporter of tariff reform, railroad regulation, protection of the public lands, and direct popular election of senators. He was active in the Farmer's Alliance and in the Populist movement in Nebraska.

Vanzetti, Bartolomeo *See* Sacco, Nicola.

Vardaman, James Kimble (*b. near Edna, Tex., 1861; d. 1930*), lawyer, newspaper editor, politician. Raised in Mississippi, he rose in politics and was speaker of the Mississippi House, 1894. Denied nomination for the governorship by the ruling clique in the Mississippi Democratic party, he managed by his powers as a stump speaker to establish popularity with the poor-white farming group and fractured his party along class lines. Among other arguments, he asserted that the education of the black person was threatening white supremacy. Elected governor, he served 1904–08. Although charged with extending the spoils system, he attacked the custom of leasing out state convicts to private employers. As U.S. senator, 1913–19, he opposed President Wilson's war policies and was one of the "little group of willful men" who filibustered against the Armed Neutrality Bill. He was defeated in the election of 1918 after a specific request for his ouster was made by the president to the Mississippi voters.

Vardill, John (*b. New York, N.Y., 1749; d. probably England, 1811*), Anglican clergyman, British spy. A graduate of King's College (Columbia), 1766, and later a tutor there, he was elected professor of natural law, 1773. Meantime he had come into public notice for essays he had written in connection with the controversy between William Livingston and Thomas B. Chandler over an American episcopate. He was author also of essays signed "Poplicola" against the nonimportation agreement, 1773. Ordained at London in April 1774, he was elected assistant minister of Trinity Church, New York, in December, but remained in England and continued writing for periodicals in defense of the government. Between 1775 and 1781 he was a Crown agent spying on American sympathizers in England. His greatest feat was in securing the theft from Silas Deane of the whole confidential correspondence between the American commissioners and the French Court from March to October 1777.

Vare, William Scott (*b. South Philadelphia, Pa., 1867; d. Atlantic City, N.J., 1934*), contractor, Pennsylvania legislator and official. Established with aid of his brothers a Republican political machine in Philadelphia which by 1917 dominated that city. A congressman, 1912–23, 1923–27, Vare climaxed his career in the primary elections of 1926 when he was successful candidate for the Republican nomination to the U.S. Senate. Rejected by the Senate after a special senatorial committee investigation for expenditures in the primary, Vare continued active in politics and aided in the nomination of Herbert Hoover for the presidency, 1928. Although he maintained his organization largely by spoils and political charity, he was a man of high personal reputation and throughout his career opposed child labor and supported liberal social reform bills.

Varela y Morales, Félix Francisco José María de la Concepción (*b. Havana, Cuba, 1788; d. St. Augustine, Fla., 1853*), Roman Catholic clergyman, Cuban patriot, author. An educational reformer as professor of philosophy at the College of San Carlos in Havana, Varela was a liberal in politics and served as a delegate from Cuba to the Spanish Cortes, 1822–23. Fleeing to New York on the return of the absolute monarchy in Spain, 1823, he served until 1851 as an exemplary pastor at various churches in New York City. He was twice named an administrator of the diocese and was a vicar general *post* 1839.

Varèse, Edgard (*b. Paris, France, 1883; d. New York, N.Y., 1965*), composer. Studied music in Paris (at the Schola Cantorum, Paris Conservatory, and Conservatoire de Musique et Dèclamation). First public performance of his work took place in Berlin in 1910. Came to the United States in 1915. Helped found the International Composers' Guild (ICG) in 1921; during his six years with the ICG he conducted works by the most advanced composers of the day and presented his own new pieces: *Offrandes* (1921), *Hyperprism* (1922), *Octandre* (1923), *Integrales* (1924), and *Arcana* (1925–27). Became a U.S. citizen in 1927. While in Paris, 1928–32, he completed *Ionisation* (1931). *Ecuatorial* (1934) was the first piece in which he used an electronic instrument. Interpolated taped sounds into an orchestral work, *Déserts*, first performed in 1954 in Paris.

Varick, James (*b. near Newburgh, N.Y., ca. 1750; d. 1828*), Methodist clergyman. A founder of the African Methodist Episcopal Zion Church, 1799, Varick was chairman of the committee which drew up a discipline after secession of his church from the Methodist Episcopal organization, 1820. Elected bishop in 1822, he served as such until his death.

Varick, Richard (*b. Hackensack, N.J., 1753; d. Jersey City, N.J., 1831*), Revolutionary soldier, public official. Military secretary to General Philip J. Schuyler; deputy commissary general of musters, 1776–80; aide to General Benedict Arnold at West Point, 1780. Cleared of any complicity in Arnold's treason, Varick was selected by General Washington as secretary to arrange, classify, and copy all headquarters records of the Continental Army; he completed his task in 1783 with the greatest skill and success. Appointed recorder of New York City, 1784, he worked with Samuel Jones on the codification of the New York statutes (published 1789). Speaker of the New York Assembly, 1787–88, and state attorney general, 1788–89, he served as Federalist mayor of New York City, 1789–1801.

Varnum, James Mitchell (*b. Dracut, Mass., 1748; d. Marietta, Ohio, 1789*), lawyer, Revolutionary soldier. Brother of Joseph B. Varnum. Commissioned colonel of the 1st Rhode Island Infantry (9th Continental), he was promoted brigadier general, February 1777, and conducted a gallant though unsuccessful defense of Forts Mercer and Mifflin on the Delaware River. He later took part in the campaigns around Newport, R.I., and was made commander of the Department of Rhode Island early in 1779. Elected to the Continental Congress, 1780, he served at intervals until 1787. A director of the Ohio Company, Varnum was appointed U.S. judge for the Northwest Territory and took up duties at Marietta, Ohio, June 1788.

Varnum, Joseph Bradley (*b. Dracut, Mass., 1750/1; d. 1821*), Revolutionary soldier, Massachusetts legislator. Brother of James M. Varnum. Congressman, Anti-Federalist, from Massachusetts, 1795–1811, he favored a militia as against a standing army, opposed building naval vessels, and was an early opponent of slavery and the slave trade; he served as speaker of the House, 1807–11. U.S. senator, 1811–17, he was associated with the "war

hawks" of the Southwest and was a strong supporter of the War of 1812. In 1813 he was president *pro tempore* of the Senate and acting U.S. vice president.

VASEY, GEORGE (*b. near Scarborough, England, 1822; d. Washington, D.C., 1893*), physician, botanist. Immigrated to central New York State as a child. Removed to northern Illinois, 1848, where he practiced his profession and continued botanical studies of the regional flora. After accompanying John W. Powell on an exploring expedition to Colorado, 1868, he served in several posts before his appointment (1872) as botanist of the U.S. Department of Agriculture and curator of the U.S. National Herbarium. A distinguished specialist on grasses, he published several outstanding monographs on this subject.

VASILIEV, ALEXANDER ALEXANDROVICH (*b. St. Petersburg, Russia, 1867; d. Washington D.C., 1953*), Byzantine scholar. Studied at the University of St. Petersburg, Ph.D., 1902. Taught at the university, 1912–25. Immigrated to the U.S. in 1925. Professor at the University of Wisconsin, 1925–39. Lectured at Columbia University and at Oberlin College; senior scholar at the Dumbarton Oaks Center for Byzantine Studies, 1944–53. Introduced the study of Byzantine culture to the U.S. Author of *Justin the First* (1950) and *History of the Byzantine Empire* (1917–25; English translations, 1928–29).

VASSALL, JOHN (*b. Stepney, Middlesex Co., England, 1625; d. 1688*), colonist, merchant. Immigrated to New England as a boy; was a resident of Scituate, Mass. With an English cousin and others he attempted establishment of a colony at Cape Fear in present North Carolina, 1664. After the failure of the colony, 1667, he removed first to Virginia and later to Jamaica, B.W.I., where he prospered in trade. His great-grandson was the builder of the "Craigie-Longfellow" house in Cambridge, Mass.

VASSAR, MATTHEW (*b. East Tuddingham, England, 1792; d. Poughkeepsie, N.Y., 1868*), brewer, merchant. Came to America as a small boy; was successful as a brewer and in other enterprises at Poughkeepsie, N.Y. Founder of Vassar College.

VATTEMARE, NICHOLAS MARIE ALEXANDRE (*b. Paris, France, 1796; d. Paris, 1864*), ventriloquist, impersonator. Made U.S. debut at the Park Theater, New York City, October 1839. Impressed by the number of duplicate books and art objects in libraries and museums, he evolved the idea of an exchange system for which he won some support in Europe and enthusiastic aid in the United States. Between 1841 and 1851 his system was successful, and his propaganda resulted in the establishment of several free libraries and museums, including the Boston Public Library.

VAUCLAIN, SAMUEL MATTHEWS (*b. Port Richmond, Pa., 1856; d. Rosemont, Pa., 1940*), locomotive manufacturer. Associated *post* 1883 with the Baldwin Locomotive Works, he served as president of the company, 1919–29, and thereafter as chairman of the board. One of the world's leading authorities on locomotive design and inventor of a number of important improvements in locomotives, he ran his business autocratically and fought against any attempt at labor organization.

VAUDREUIL-CAVAGNAL, PIERRE DE RIGAUD, MARQUIS DE (*b. Canada, 1704; d. Paris, France, 1778*), Canadian soldier and public official. Winning honors as a soldier, as governor of Trois Rivières, and as governor of the colony of Louisiana in 1743–53, he was then appointed governor of Canada. Taking up his duties, June 1755, he found the colony on the brink of war with England. Allowing himself to be drawn into the corrupt ring of politicians that surrounded the intendant Bigot, he refused sup-

port to Montcalm who had been sent to conduct the war for France; he has been held responsible for the defeat on the Plains of Abraham, September 1759. A year later he capitulated at Montreal and, by so doing, cost France her last chance to hold Canada. Arriving in France, December 1760, he was arrested and thrown into the Bastille; at his trial he was acquitted of dishonesty and pensioned. Jealous of better soldiers than himself, he talked more than was prudent and failed to check the corruption that went on all around him.

VAUGHAN, BENJAMIN (*b. Jamaica, British West Indies, 1751; d. Hallowell, Maine, 1835*), lawyer, physician, merchant, diplomat, agriculturist. Brother of Charles Vaughan. An active propagandist for the American cause during the Revolution, Vaughan was employed in confidential matters by the Earl of Shelburne. He was co-editor with Benjamin Franklin of the latter's *Political, Miscellaneous and Philosophical Pieces* (1779). He did his most important work in connection with the Anglo-American peace negotiations of 1782, helping to promote confidence between the American commissioners and Shelburne and to reconcile conflicting points of view. In 1789 he published *A Treatise on International Trade*, a plea for free trade. He was sympathetic with the French Revolution and fled to France during an official investigation of the activities of English political enthusiasts, May 1794. Imprisoned by the French, he was later released and retired to Switzerland. Removing to Hallowell, Maine, 1796, he remained retired from active politics but was a correspondent and adviser of the first six presidents and a member of many scientific and literary societies. He published a second collection of Franklin's works in London, 1793, and was probably author of much work which still remains unidentified.

VAUGHAN, CHARLES (*b. London, England, 1759; d. Hallowell, Maine, 1839*), merchant. Brother of Benjamin Vaughan. Immigrated to New England, 1785. He then engaged in a long and generally unsuccessful attempt to improve the "Kennebec Purchase" in Maine of which his maternal grandfather, Benjamin Hallowell, had been an original proprietor; in this effort he built a settlement just below Augusta at Hallowell and tried to establish a seaport at Jones Eddy near the mouth of the Kennebec. Establishing himself as a merchant in Boston, 1791, he was a promoter, with Charles Bulfinch and William Scollay, of Boston's first brick block, the Franklin or Tontine Crescent. Later bankrupted, he retired to Hallowell where he devoted himself to the development of Maine agriculture.

VAUGHAN, DANIEL (*b. near Killaloe, Ireland, ca. 1818; d. Cincinnati, Ohio, 1879*), astronomer, mathematician, chemist. Immigrated to America, 1840; served as a tutor and schoolmaster in Kentucky and in Cincinnati, Ohio. Celebrated as a lecturer on scientific subjects, he was made a fellow of the American Association for the Advancement of Science for his work in experimental physiology. In 1852 he anticipated by many years the demonstration made by J. E. Keeler of the nature of the rings of Saturn. A gentle genius, he died in poverty.

VAUGHAN, THOMAS WAYLAND (*b. Jonesville, Tex., 1870; d. Washington, D.C., 1952*), geologist, paleontologist, oceanographer. Studied at Tulane University and Harvard, Ph.D., 1903. A leader in the study of coral and the larger Foraminifera, Vaughan was affiliated with the U.S. National Museum as custodian of the madreporarian corals, 1903–23, and as a paleontologist, 1936–47. Worked at the Dry Tortugas biological laboratory of the Carnegie Institution of Washington, 1907–18. Wrote *The Recent Madreporaria of the Hawaiian Islands and Laysan* (1907). Studied the coastal plains of the U.S. and became an authority on American Tertiary stratigraphy. Headed the Scripps Institu-

tion in La Jolla, Calif., 1924–36, turning that institution into a leading marine laboratory.

VAUGHAN, VICTOR CLARENCE (*b. near Mt. Airy, Mo., 1851; d. Richmond, Va., 1929*), biochemist, hygienist, medical teacher. M.S., University of Michigan, 1875; Ph.D., 1876; M.D., 1878. For many years a lecturer and professor at Michigan, he served as director of the hygienic laboratory, 1887–1909, and as dean of the medical school, 1891–1921. While dean he put Michigan in a prominent place in the movement to elevate American medical education. After studying at Berlin with Robert Koch, Vaughan and an associate set up one of the earliest laboratories in the United States for the systematic teaching of bacteriology. His work upon ptomaines with F. G. Novy influenced improvement of methods of food preservation. He developed early in his career the interest in public health and education of the public in preventive medicine for which he is best known. Among his many writings were the classic *Report on the Origin and Spread of Typhoid Fever in the U.S. Military Camps* (1904) and *Epidemiology and Public Health* (1922–23) of which he was coauthor.

VAUX, CALVERT (*b. London, England, 1824; d. New York, N.Y., 1895*), landscape architect. Came to America, 1850, as assistant to Andrew J. Downing at Newburgh, N.Y.; removed to New York City *ca.* 1857. Submitted winning design for New York's Central Park in collaboration with Frederick L. Olmsted, 1857; was associated in practice with Olmsted for a number of years, their work including Prospect Park in Brooklyn, N.Y., and South Park in Chicago, Ill. Vaux was landscape architect to the New York City department for parks, 1881–83 and 1888–95.

VAUX, RICHARD (*b. Philadelphia, Pa., 1816; d. 1895*), lawyer, public official. Son of Roberts Vaux. Practicing in Philadelphia *post* 1839, Vaux held a number of local and federal offices. Carrying out his father's theories of penology, he served as a governor of the Eastern Penitentiary, 1839–92, and was president of its board *post* 1852.

VAUX, ROBERTS (*b. Philadelphia, Pa., 1786; d. Philadelphia, 1836*), philanthropist. Son-in-law of Thomas Wistar; father of Richard Vaux. Associated throughout his life with almost every worthy public and private activity for social welfare in Philadelphia, he was a leader in creation of the free public school system, was active in hospital work and the work of learned societies, advocated temperance, and was outstanding as a prison reformer. He drafted legislation for administration of the Eastern Penitentiary and was an advocate of separate confinement of prisoners.

VAWTER, CHARLES ERASTUS (*b. Monroe Co., present W. Va., 1841; d. 1905*), Confederate soldier, educator. Graduated Emory and Henry College, 1866, and taught mathematics and Hebrew there, 1868–78. Built, organized, and headed the Miller Manual Labor School of Albemarle Co., Va., *post* 1878; promoted development of industrial education in the nation's public schools; aided J. M. McBryde in shaping policies of Virginia Polytechnic Institute.

VEATCH, ARTHUR CLIFFORD (*b. Evansville, Ind., 1878; d. Port Washington, N.Y., 1938*), geologist. Attended Indiana and Cornell universities. Began professional career with the Louisiana State Geological Survey; served with U.S. Geological Survey, 1902–10; worked thereafter for various corporations and as a consultant. Specialist in the geology of petroleum and the direction of foreign oil explorations.

VEAZEY, THOMAS WARD (*b. Cecil Co., Md., 1774; d. Cecil Co., 1842*), Maryland legislator, planter. Whig governor of Maryland,

1836–38; directed a reform of state constitution by amendments, 1836.

VEBLEN, OSWALD (*b. Decorah, Iowa, 1880; d. Brooklin, Me., 1960*), mathematician. Studied at the State University of Iowa and at the University of Chicago, Ph.D., 1903. Taught at Princeton University, 1905–32, and at the Institute for Advanced Study, 1932–50. Responsible for assembling the faculty of the Institute, Veblen also helped to relocate many foreign scholars after Hitler's rise to power. Author of *Introduction to Infinitesimal Analysis* (1907), *Analysis Situs* (1922), *Invariants of Quadratic Differential Forms* (1927), and *Geometry of Complex Domains* (1936).

VEBLEN, THORSTEIN BUNDE (*b. Cato Township, Manitowoc Co., Wis., 1857; d. Palo Alto, Calif., 1929*), economist, social theorist. Raised in a Minnesota farm community made up mainly of Norwegian immigrants, Veblen graduated from Carleton College, 1880. Carrying on graduate studies under great difficulties at Johns Hopkins and at Yale, he was granted the doctorate of philosophy at Yale in 1884 but returned to a Minnesota farm when he found that no teaching post was available. After seven miserable years as a farmer he obtained a special fellowship at Cornell University through the aid of J. Laurence Laughlin, 1891, and in the same year published his first essay, "Some Neglected Points in the Theory of Socialism" (*Annals of the American Academy of Political and Social Science*, November 1891), which contained many germs of his later theories.

Following Laughlin to the University of Chicago, Veblen taught political economy there, made private studies of anthropology and psychology, and was managing editor of the *Journal of Political Economy* (University of Chicago, 1895–1905). He achieved overnight prominence on publication in 1899 of *The Theory of the Leisure Class* into which he poured all the acidulous ideas and fantastic terminology that had been simmering in his mind for years. It was a savage attack upon the business class and their pecuniary values, half concealed behind an elaborate screen of irony and polysyllabic learning. *The Theory of Business Enterprise* (1904) contained Veblen's basic economic theory and dealt with the effects of the machine process, the nature of corporate promoting, the use of credit, the distinction between industry and business, and the influence of business ideas and pressures upon law and politics. Obliged to leave Chicago for reasons of personal conduct, he became associate professor at Leland Stanford, 1906, but further difficulties with women brought about his departure in December 1909. While lecturer at the University of Missouri, 1911–18, he brought his course in "Economic Factors in Civilization" to its classic form. Viewing all history and all cultures, the course was omniscient and rambling; his classroom manner was casual and inarticulate. The content of this course is most nearly approximated in his *The Instinct of Workmanship* (1914) which stresses the thesis that proper craftsmanship, an instinct deeply ingrained in man since savage times, has been thwarted throughout history by the piling up of predatory and pecuniary institutions.

Removing to New York City, 1918, he became first an editor of the *Dial* and then, in 1919, a member of the faculty of the New School for Social Research. To this period belong his more revolutionary writings. In *An Inquiry into the Nature of Peace* (1917) Veblen described patriotism and business enterprise as useless to the community at large and as the principal obstructions to a lasting peace; in *The Higher Learning in America* (1918) he leveled a bitter and direct attack on the conduct of universities by businessmen. In *The Vested Interests and the State of the Industrial Arts* (1919) he pointed out with savagery that the aim of business was to maximize profits by restricting or sabotaging production, and defined a vested interest as "a marketable right to get something for nothing." In *The Engineers and the*

Price System (1921) he sketched out a technique of revolution through organization of a soviet of technicians who would take over and carry on the productive processes of the nation. Greatly lionized by liberal intellectuals, he declined gradually both in health and mental powers. Six months before his death he remarked that "Naturally there will be other developments right along, but just now communism offers the best course that I can see." Veblen's thinking does not fall easily into the accepted categories of liberalism and radicalism; his intellectual attitudes and methods are those of liberalism, but his criticism of capitalist society is, at least in its implications, revolutionary. Relatively unaffected by other American writers, he drew his material largely from European sources. His influence was crucial in weakening the hold of neoclassical theory, but his most powerful effect was on economic opinion and policy. He was in no small measure responsible for the trend toward social control in an age dominated by business enterprise.

VEDDER, EDWARD BRIGHT (b. New York, N.Y., 1878; d. Washington, D.C., 1952), physician, army officer. Studied at the University of Rochester and the University of Pennsylvania, M.D., 1902. Graduated from the Army Medical College, 1904. Specialist in tropical medicines and diseases; studied beriberi and scurvy, contributing to the discovery, by others, that ascorbic acid is a vitamin. Chief of medical research of the Edgewood, Md., Arsenal, 1922–25; studied the effects of chemical warfare. Commandant of the Army Medical College, 1930–31. Professor of experimental medicine at George Washington University, 1933–42.

VEDDER, ELIHU (b. New York, N.Y., 1836; d. Rome, Italy, 1923), figure and mural painter, illustrator. Began study of art by himself as a boy; worked for a time with Tompkins H. Matteson. Resided in Florence, Italy, and elsewhere in Europe, 1856–61; *post* 1867 made his home in Rome. Vedder's workmanship is heavy and his color is not remarkable, but his work has rare imaginative power; in his penetration of the realm of abstract ideas he ranks with Albert P. Ryder. Among his best works are his outstanding illustrations for the Rubáiyát of Omar Kháyyam (1884).

VEDDER, HENRY CLAY (b. DeRuyter, N.Y., 1853; d. 1935), Baptist clergyman, journalist, and church historian. Served on staff of the *Examiner*, a leading Baptist newspaper in New York, 1876–94; professor of church history, Crozer Theological Seminary, 1895–1926. Author of a number of works on the history of his own sect and on Christianity in general which were marked by a strong social approach.

VEILLER, LAWRENCE TURNURE (b. Elizabeth, N.J., 1872; d. New York, N.Y., 1959), social worker, housing expert. Studied at the City College of New York. One of the nation's first housing experts, Veiller, under the auspices of the Charity Organization Society of New York, established the Tenement House Committee in 1898 and directed it until 1907. Founded the National Housing Association (1911) and was director, 1911–36. Opposed to public financing of housing, Veiller sought to improve American housing through legislation. His legislative efforts led to the passage of the New York State Tenement House Law of 1901 and the Standard Zoning Law of the U.S. Department of Commerce in 1921. Works include *Housing Reform: A Hand Book for Practical Use in American Cities* (1910).

VENABLE, CHARLES SCOTT (b. Prince Edward Co., Va., 1827; d. 1900), mathematician, Confederate soldier, educator. Graduated Hampden-Sydney, 1842; studied also at University of Virginia. Professor of mathematics at Hampden-Sydney and later at South Carolina College, he served in the Civil War as aide on the staff of General Robert E. Lee. He was professor of mathematics at University of Virginia, 1865–96, and was largely responsible for the development there of schools of applied chemistry and engineering, astronomy, biology, and agriculture.

VENABLE, FRANCIS PRESTON (b. Prince Edward Co., Va., 1856; d. 1934), educator. Son of Charles S. Venable. Graduated University of Virginia, 1879; Ph.D., Göttingen, 1881. Professor of chemistry at the University of North Carolina *post* 1881; president of the university, 1900–14. A frequent contributor to learned journals; author of a number of books on chemical subjects.

VENABLE, WILLIAM HENRY (b. near Waynesville, Ohio, 1836; d. 1920), educator, textbook writer. Taught English in Cincinnati, Ohio, schools *post* 1862. Author of *Beginnings of Literary Culture in the Ohio Valley* (1891).

VENUTI, GIUSEPPE ("JOE") (b. Philadelphia, Pa., 1903; d. Seattle, Wash., 1978), jazz violinist and bandleader. Early in his career he formed a duo with jazz guitarist Eddie Lang and performed with several top jazz men as a soloist until he joined the Paul Whiteman Orchestra in 1929. From the mid–1930's until 1943, he led his own big band and also appeared with such musicians as Red Nichols and Jimmy and Tommy Dorsey. He also performed on live radio, including regular stints on Bing Crosby's programs. In the late 1960's and into the 1970's, he gave well-received performances at music festivals, including the Colorado Jazz Party (1967–76), the Newport Jazz Festival, and the London Jazz Exposition.

VERBECK, GUIDO HERMAN FRIDOLIN (b. Zeist, the Netherlands, 1830; d. Tokyo, Japan, 1898), Dutch Reformed clergyman. Immigrated to America, 1852. Ordained, 1859, he served thereafter as a missionary and public official in Japan.

VERBECK, WILLIAM (b. Nagasaki, Japan, 1861; d. 1930), educator, inventor, New York State militia officer. Son of Guido H. F. Verbeck. Headmaster, St John's School, Manlius, N.Y., *post* 1888; pioneer in the Boy Scout movement.

VERBRUGGHEN, HENRI (b. Brussels, Belgium, 1873; d. Northfield, Minn., 1934), violinist, conductor. Director of the Minneapolis Symphony Orchestra, 1922–32.

VERENDRYE, PIERRE GAULTIER DE VARENNES, SIEUR DE DRYE See LA VERENDRYE, PIERRE GAULTIER DE VARENNES, SIEUR DE.

VERHAEGEN, PETER JOSEPH (b. Haecht, Flanders, 1800; d. St. Charles, Mo., 1868), Roman Catholic clergyman, Jesuit. Came to America, 1821, to enter novitiate at Whitemarsh, Md. Accompanied band of Jesuits led by Charles Van Quickenborne to Missouri, 1823. Ordained, 1825, he became rector of the present St. Louis University, 1829. Named superior of the Indian missions, 1836; became provincial of the Maryland Province of the Society of Jesus, 1844. President of St. Joseph's College, Bardstown, Ky., 1847–50. Thereafter a pastor at St. Charles, Mo.

VERITY, GEORGE MATTHEW (b. East Liberty, Ohio, 1865; d. Middletown, Ohio, 1942), steel manufacturer. President, American Rolling Mill Company (Armco), *post* 1899; backed John B. Tytus's plan for a continuous mill; was a pioneer in welfare capitalism, and active in many projects involving the health, education, and recreation of his employees and the community.

VERMILYE, KATE JORDAN See JORDAN, KATE.

VERNON, SAMUEL (*b. Narragansett, R.I., 1683; d. 1737*), silversmith. Cousin of Edward Winslow (1669–1753). Produced work notable for craftsmanship, novelty, and variety of design at his shop in Newport, R.I.; engraved first Rhode Island bank bills. Served as a Rhode Island legislator and judge *post* 1729.

VERNON, WILLIAM (*b. Newport, R.I., 1719; d. 1806*), merchant. Son of Samuel Vernon. Active in the "triangular trade" out of Newport and in privateering. Performed invaluable work for the infant American Navy as a member of the so-called Eastern Navy Board during the Revolution.

VEROT, JEAN MARCEL PIERRE AUGUSTE (*b. Le Puy, France, 1805; d. St. Augustine, Fla., 1876*), Roman Catholic clergyman, Sulpician. Came to Maryland, 1830. A teacher at St. Mary's Seminary and a pastor in Maryland, he was named vicar-apostolic of Florida *ca.* 1858. Identified with the cause of the Confederacy during the Civil War, he was transferred to the see of Savannah, Ga., 1861, with Florida continued under his care. Active after the war in restoration of his diocese, he disinterestedly returned to Florida, 1870, becoming bishop of St. Augustine when it was made a see.

VERPLANCK, GULIAN CROMMELIN (*b. New York, N.Y., 1786; d. New York, 1870*), lawyer, New York legislator, author. Grandson of William Samuel Johnson. Graduated Columbia, 1801; studied law with Josiah O. Hoffman. Practicing in New York City *post* 1807, he organized (with Issac Sebring and Richard Varick) the Washington Benevolent Society as a Federalist answer to the Tammany Society. A principal with Hugh Maxwell in the Columbia College commencement riot of 1811, Verplanck became an enemy of De Witt Clinton who had presided over his trial and conviction. Among the products of the pamphlet war in which both men engaged, Verplanck was responsible for *A Fable for Statesmen and Politicians* (1815) and *The State Triumvirate* (1819). A professor in the General Theological Seminary, New York City, 1821–24, he was author of *Essays on the Nature and Uses of the Various Evidences of Revealed Religion* (1824), one of the earliest American works influenced by the Scottish school of common-sense philosophy. Congressman, Democrat, from New York, 1825–33, he was chairman of the ways and means committee, 1831–33, and was chiefly instrumental in obtaining the 1831 law improving authors' copyrights. Becoming estranged from the Democrats, he lost in a run as Whig candidate for mayor of New York City, 1834. As a state senator, 1838–41, he outlined plans for reform of the judiciary system which had effect in the state constitutional changes of 1846 and 1868. Editor of a scholarly edition of Shakespeare's plays (1847), he was editor also of the *Talisman* (in association with Robert C. Sands and William Cullen Bryant, 1828–30). Some of his thoughtful and learned essays were collected in *Discourses and Addresses on Subjects of American History, etc.* (1833).

VERRILL, ADDISON EMERY (*b. Greenwood, Maine, 1839; d. Santa Barbara, Calif., 1926*), zoologist. B.S., Lawrence Scientific School, Harvard, 1862. While an undergraduate, assisted J. R. L. Agassiz, Alpheus Hyatt, and N. S. Shaler. Taught zoology at Yale, 1864–1907; taught also in the Sheffield Scientific School, and at University of Wisconsin (1868–70). Wide-ranging in his interests and investigations, he performed the greater part of his work in the study of marine invertebrates. A patient, painstaking investigator, he held firmly to a belief in the value of taxonomical work as a basis for scientific investigations. Among his many collateral activities were work (1871–87) with the U.S. Commission of Fish and Fisheries, the curatorship of the Peabody Museum at Yale, and an editorship of the *American Journal of Science* (1869–1920).

VERRILL, ALPHEUS HYATT (*b. New Haven, Conn., 1871; d. Chiefland, Fla., 1954*), author, illustrator, naturalist, explorer. Studied at the Yale School of Fine Arts. Illustrator of the natural history section of *Webster's International Dictionary*, 1896. Invented the autochrome process of natural-color photography, 1902. Under the auspices of the Museum of the American Indian, Heye Foundation, New York, he explored much of the ancient civilations of the Western Hemisphere and did studies of wildlife and fauna.

VERWYST, CHRYSOSTOM ADRIAN (*b. Uden, the Netherlands, 1841; d. Bayfield, Wis., 1925*), Roman Catholic clergyman, Franciscan, Indian linguist. Came to America as a boy; was raised in Wisconsin. Ordained, 1865. He served as a missionary in the Lake Superior region for many years and was an authority on the language of the Chippewa.

VERY, JONES (*b. Salem, Mass., 1813; d. Salem, 1880*), poet, transcendentalist. Graduated Harvard, 1836. Encouraged by Elizabeth P. Peabody and R. W. Emerson, Very produced a number of sonnets (first published in the *Western Messenger*, March–April 1839; later published in *Essays and Poems*, 1839) which received wide contemporary praise and were distinguished by sincere religious emotion.

VERY, LYDIA LOUISA ANN (*b. Salem, Mass., 1823; d. Salem, 1901*), teacher, poet. Sister of Jones Very. Author, among other works, of *Poems* (1856) and *An Old-fashioned Garden* (1900).

VESEY, DENMARK (*b. ca. 1767; d. Charleston, S.C., 1822*), rebel. Purchasing his freedom in 1800, Vesey (a mulatto) prospered as a carpenter in Charleston. Between the years 1818–22 he laid the foundation for an uprising of slaves against their masters by quoting scripture with powerful effect, identifying the black slaves with the Israelites. He interpreted the debate over the Missouri Compromise to mean that blacks were being held by their masters in defiance of law. Exempt from slave restrictions, he carried his message to the plantations from the Santee to the Euhaws. His conspiracy was betrayed to the city authorities in June 1822, and he was tried, convicted on the testimony of informers, and hanged. The true extent of his conspiracy is not known for he and his aides died without making any revelations.

VESEY, TÉLÉMAQUE See VESEY, DENMARK.

VESEY, WILLIAM (*b. Braintree, Mass., 1674; d. New York, N.Y., 1746*), Anglican clergyman. Graduated Harvard, 1693. Ordained by the bishop of London, 1697, he served thereafter with great ability as rector of Trinity Church, New York City, until his death. An extreme conservative, he engaged in many controversies with the royal governors over the rights vested in Trinity and its rector.

VEST, GEORGE GRAHAM (*b. Frankfort, Ky., 1830; d. Sweet Springs, Mo., 1904*), lawyer, Missouri legislator. Removed to Missouri, 1854. Elected to the Missouri legislature, 1860, he was author of the "Vest Resolutions" denouncing coercion of the South, and was probably the author of the "Ordinance of Secession" adopted by the Southern wing of the legislature at Neosho, fall of 1861. A member of the Confederate Congress, 1862–65, he resumed practice of law in Missouri after the Civil War. His career as U.S. senator, Democrat, from Missouri, 1879–1903, was characterized by a disinclination to recognize new developments and new issues in American life, and by outstanding opposition to high protective tariffs. He was a leading exponent of the theory that it was unconstitutional for the United States to hold and govern Spanish territory permanently as colonies after cession *post* 1898.

VETCH, SAMUEL (*b. Edinburgh, Scotland, 1668; d. England, 1732*), colonial soldier, trader. Immigrating to Central America, 1698, as captain in the military force accompanying the Scotch colony at Darien, he came to New York in 1699 after the failure of the venture. Marrying the daughter of Robert Livingston, 1700, Vetch engaged in the Indian trade out of Albany, N.Y. He moved to Boston *ca.* 1702, where he traded with Acadia and Canada and was tried and fined in 1706 by the General Court for furnishing arms and ammunition to the French and Indians. Appealing the case in England, he won favor by suggesting to the authorities there a plan for conquering the French in America. In it he proposed an attack on Montreal by way of Lake Champlain and a complete investment of Quebec by land and sea. Dispatched by the Whig ministry in March 1709 to carry out this enterprise, Vetch was given powers to enlist colonial assistance from Pennsylvania northward and was accompanied by Francis Nicholson as a volunteer assistant. Mustering three New England regiments at Boston while at the same time Nicholson prepared a force with boats to proceed up Lake Champlain, Vetch was ready to execute his plan early in the summer but an expected British auxiliary force failed to appear and the scheme was dropped. On the arrival of British aid late in 1710, however, Nicholson was able to make an easy conquest of Port Royal and Acadia, and Vetch was appointed military governor of Annapolis Royal and Nova Scotia. Taking a part in the 1711 expedition against Canada, he shared in the disaster which befell the English forces at the mouth of the St. Lawrence River. Pursued by the enmity of Nicholson, who was civil governor of Nova Scotia, Vetch fled to England in 1714. He succeeded in displacing Nicholson in January 1715 only to lose his place two years later. After further misfortunes he died in debtor's prison.

VETHAKE, HENRY (*b. British Guiana, 1792; d. Philadelphia, Pa., 1866*), economist. Came to America as a boy. Graduated Columbia, 1808. Taught mathematics and philosophy at a number of institutions; was a professor and an official at the University of Pennsylvania, 1836–59. An orthodox classical economist, he opposed practically every form of governmental interference in economic life, also trade unions and statutory shortening of hours of labor. Author of *The Principles of Political Economy* (1838, 1844).

VEZIN, HERMANN (*b. Philadelphia, Pa., 1829; d. London, England, 1910*), actor. Made debut at the Theatre Royal, York, England, 1850, and remained active on the British stage until his death. Scholarly and intellectual in his impersonations, he had a somewhat formal manner of delivery.

VIBBARD, CHAUNCEY (*b. Galway, N.Y., 1811; d. Macon, Ga., 1891*), railroad executive, capitalist. Rose to post of general superintendent of the Utica & Schenectady Railroad, 1836–49; prepared the first railroad timetable ever followed in New York State; increased the comfort of passenger travel and was an innovator in use of safety appliances. Urged Erastus Corning to take the lead in creating the consolidation of small lines which was known as the New York Central, of which Vibbard was general superintendent, 1853–65. After Civil War service in Congress and as a railroad expert, he devoted his time to various private business interests.

VICK, JAMES (*b. Chichester, England, 1818; d. Rochester, N.Y., 1822*), printer, seedsman, publisher. Immigrated to America, 1833; settled in Rochester, N.Y. 1856, where he edited the *Genesee Farmer* and the *Rural New Yorker*. An importer and producer of seeds for his own amusement *post* 1848, he began to sell them by mail. He made this activity his principal business *post* 1862. As a merchant of flower seeds and as publisher of an annual catalogue and also a magazine, Vick exercised great influence on the horticulture of the United States. Among the products of his crossbreeding were the white double phlox, the fringed petunia, white gladiolus, and others.

VICKERY, HOWARD LEROY (*b. Bellevue, Ohio, 1892; d. Palm Springs, Calif., 1946*), naval officer, director of merchant marine shipbuilding during World War II. Graduated U.S. Naval Academy, 1915. M.S. in naval architecture, Massachusetts Institute of Technology, 1921. Assigned to naval construction and repair work; was director of shop, supply, and transportation work for government of Haiti (1925–28), and technical adviser on shipping to the governor general of the Philippines (1929–33). As assistant to Adm. Emory S. Land on the U.S. Maritime Commission *post* 1937, and vice chairman of the Commission, 1942–45, he was responsible for all U.S., maritime construction preceding and during World War II. Under his innovative supervision, the moribund shipbuilding industry of the 1930's became the world's fastest, most efficient, and foremost producer of vessels. By the time of his resignation for reasons of health as vice admiral (December 1945), some seventy shipyards turned out almost 40 million gross tons of vessels, including the famous Liberty and Victory ships.

VICTOR, FRANCES FULLER (*b. Oneida Co., N.Y., 1826; d. Portland, Oreg., 1902*), author. Sister-in-law of Orville J. Victor. Removed to Oregon, 1865, where she became the most competent authority on the region of the Pacific Northwest and its history. She was a member for a number of years of H. H. Bancroft's staff and wrote a great part of the histories of Oregon, Washington, Idaho, Montana, Nevada, Colorado, and Wyoming which appeared under his name. She was author also of Volumes 6 and 7 of the *History of California* (1890).

VICTOR, ORVILLE JAMES (*b. Sandusky, Ohio, 1827; d. Hohokus, N.J., 1910*), author, publisher. Married Metta Victoria Fuller, sister of Frances F. Victor, 1856, and was thereafter associated with a number of New York publishing houses specializing in the production of cheap popular books and magazines. For many years he was chief editor of the enterprises of Erastus F. Beadle and is regarded as the editorial projector of the American dime novel (1860).

VIDOR, FLORENCE COBB (*b. Houston, Tex., 1895; d. Pacific Palisades, Calif., 1977*), actress. Discovered by director King Vidor, she married Vidor and moved to Hollywood in 1915 and was featured in silent films for numerous studios. She appeared in numerous light comedies and starred in the historical romances *The Eagle of the Sea* (1926) and *Barbara Frietchie* (1924). After an unsuccessful appearance in the talkie *Chinatown Nights* in 1929, Vidor retired from cinema.

VIEL, FRANÇOIS ÉTIENNE BERNARD ALEXANDRE (*b. New Orleans, La., 1736; d. France, 1821*), Roman Catholic clergyman, Oratorian. Educated in France, Viel was the first native-born Louisianian to take holy orders and taught for many years at the Academy of Juilly. A parish priest in Louisiana, 1792–1812, he returned to France to aid in the reestablishment of the Oratorians. He was a classical Latin scholar of the highest distinction, and a poet.

VIELE, ARNOUT CORNELISSEN (*b. New Amsterdam, 1640; d. ca. 1704*), trader, Indian interpreter and negotiator. Skilled in Indian languages and oratory, Viele was highly effective as a diplomat to the Iroquois and other tribes *post* 1680. He helped extend the New York colony's trade into the country north of the Great Lakes and to the southwest.

VIELE, EGBERT LUDOVICUS (*b. Waterford, N.Y., 1825; d. 1902*), soldier, engineer. Graduated West Point, 1847; served in the Mexican War and on the southwest frontier. Resigning his commission, 1853, he worked as a civil engineer in New York City, and was chief engineer of the New York Central Park, 1856–57; in 1860 he was engineer of Prospect Park, Brooklyn. After Civil War service with the Union Army as brigadier general of volunteers, 1861–63, he resumed engineering practice in New York. He made a plan for the "Arcade" railway, a precursor of the later subways, *ca.* 1868, and was author of a *Topographical Atlas of the City of New York* (1874). One of his sons was educated in France and attained distinction there as a poet under the name Francis Vielé-Griffin.

VIERECK, GEORGE SYLVESTER (*b. Munich, Germany, 1884; d. Holyoke, Mass., 1962*), writer, propagandist. Came to the United States in 1897 and began a lifetime of work on newspapers and magazines. Published his first volume of poetry in 1904; graduated from the College of the City of New York (B.A., 1906). Staff member and editor of several German–language publications. During World War I served as an apologist for German politics. Suspected of receiving money to aid Germany's war effort, he was vilified as a traitor, but was not formally prosecuted. He continued as a controversial journalist, interviewing, among others, Adolf Hitler (1923). During the 1930's he defended the Nazi regime. Arrested for violating the Foreign Agents Registration Act (1941), he was sentenced to prison in 1943. Released in 1947, he wrote two novels and a memoir of his prison years, *Men Into Beasts* (1952).

VIGNAUD, HENRY (*b. New Orleans, La., 1830; d. near Paris, France, 1922*), journalist, diplomat, historian. Taken prisoner while serving as a Confederate soldier, 1862, he escaped to Paris and never returned to the United States. After working with the Confederate mission to France under John Slidell, and service for a number of years in various occupations, he was appointed second secretary of the U.S. legation in Paris, 1875. He was promoted to first secretary, 1885. Until his retirement in 1909 he was an indispensable member of the Paris mission. He was distinguished also for his researches into the career of Columbus and for studies of aboriginal America and of the earliest European contacts with America.

VIGO, JOSEPH MARIA FRANCESCO (*b. Mondoví, Piedmont, Italy, 1747; d. Vincennes, Ind., 1836*), soldier, Merchant. Came to Louisiana in youth as a member of a Spanish regiment; prospered in the fur trade and gained influence with French settlers and Indians. Established headquarters at St. Louis, 1772. Shares credit with George Rogers Clark for conquest of the Northwest in 1778–79, because of information, personal influence, and financial aid which he put at Clark's disposal.

VILAS, WILLIAM FREEMAN (*b. Chelsea, Vt., 1840; d. 1908*), statesman. Raised in Madison, Wis., where he was admitted to the bar, 1860; won professional distinction as a law teacher and official of University of Wisconsin and as reviser of the state statues. A leader in the Democratic party and a counselor and friend of Grover Cleveland, Vilas served as postmaster general, March 1885–January 1888, and as U.S. secretary of the interior, January 1888–March 1889. U.S. senator from Wisconsin, 1891–97, he retired to private life in Madison and was active thereafter in rebuilding the University of Wisconsin.

VILLAGRÁ, GASPAR PÉREZ DE (*b. Puebla de los Angeles, Spain, ca. 1555; d. at sea, en route to Guatemala, 1620*), Spanish soldier and colonial official. An officer in Juan de Oñate's expedition to New Mexico, 1598, he served subsequently at various times in New Mexico until *ca.* 1608. Villagrá was author of *Historia de la Nueva Mexico* (Alcalá de Henares, 1610), an epic poem which lauds Oñate's achievements in 1598–99. It has the distinction of being the first published history of any American commonwealth.

VILLARD, FANNY GARRISON *See* VILLARD, HELEN FRANCES GARRISON.

VILLARD, HELEN FRANCES GARRISON (*b. Boston, Mass., 1844; d. Dobbs Ferry, N.Y., 1928*), reformer. Daughter of William L. Garrison; wife of Henry Villard. Among the many philanthropies and social reforms to which Villard lent her services were woman suffrage, pacifism, and the work of the National Association for the Advancement of Colored People.

VILLARD, HENRY (*b. Speyer, Rhenish Bavaria, 1835; d. Dobbs Ferry, N.Y., 1900*), journalist, railway promoter, financier. Educated in Germany, Villard changed his name from Ferdinand H. G. Hilgard before immigrating to America, 1853; this move was dictated by disagreement with his father over the younger man's republican sympathies. Settling eventually in Illinois, he studied English and, as a special correspondent for the New York *Staats-Zeitung*, reported the Lincoln-Douglas debates and made the acquaintance of Abraham Lincoln. Becoming correspondent for the *Cincinnati Commercial*, he covered the Pike's Peak gold rush, and later the Republican convention at Chicago, 1860. After Lincoln's election he became correspondent at Springfield, Ill., for the *New York Herald*.

A Civil War correspondent for the *Herald* and also the *New York Tribune*, 1861–63, he organized a news agency to compete with the New York Associated Press, 1864. Secretary of the American Social Science Association, 1868–71, he then traveled abroad to restore his health. Becoming a member of a committee of bondholders of the Oregon & California Railroad in Germany, 1873, he went to Oregon in 1874 as their representative and there perfected a plan for efficient operation of that railroad and other local transportation agencies. He became president of the Oregon & California, and of the Oregon Steamship Co., 1876. Named the receiver of the Kansas Pacific Railway, 1876, he achieved an important financial success and laid the foundation of his later fortune. With the idea of building a railway empire in the Far Northwest, he organized with associates the Oregon Railway & Navigation Co., 1879, and built a road eastward from Portland, Oreg., along the south bank of the Columbia River. His plan was to make this line the Pacific Coast outlet for any Northern transcontinental road which might be built, so concentrating the trade of the Northwest in Portland. Clashing with the Northern Pacific, whose objective was an outlet on Puget Sound, Villard with his supporters bought a controlling interest in the Northern Pacific. He was made president, 1881, and completed its line in 1883. His control of transportation in the Northwest did not last long, as a huge deficit forced Villard's resignation from the presidency early in 1884. In 1893 he ended his connections with Northwest transportation. Meanwhile, however, he had helped found the Edison General Electric Co. and had acquired a controlling interest in the New York *Evening Post*. The most important railway promoter in the United States between 1879 and 1883, Villard displayed fairness and breadth of view in dealing with the people of the region which his railroad served. As newspaper proprietor, he permitted complete independence of policy to such editors as Horace White, E. L. Godkin, Carl Schurz, and his son O. G. Villard.

In 1866 he married Helen Frances Garrison, the daughter of W. L. Garrison.

VILLARD, OSWALD GARRISON (*b. Wiesbaden, Germany, 1872; d. New York, N.Y., 1949*), editor, reformer, author. Son of Henry Villard; grandson of William Lloyd Garrison. Born while his parents were on a trip abroad, he was raised in New York City and Dobbs Ferry, N.Y. Received B.A., Harvard, 1893; M.A., 1896. His apprenticeship on the *Philadelphia Press* was cut short at the urging of his father, and he joined the elder Villard's *New York Evening Post* in May 1897. The *Post* came out in opposition to war with Spain, the first of three major Villard stands against involvement in war. Villard was also against U.S. involvement in World War I and World War II. His consistent pacifism cost him the newspaper, but he retained the other Villard-controlled publication, the *Nation*, and proceeded to develop it into what was probably the foremost liberal voice of the 1920's and 1930's. Villard's pacifism led to loss of control of the *Nation* also and social ostracism from his family.

Villard had supported woman's rights as early as his Harvard days, and another area of lasting interest was the status of the blacks in the United States. He prepared the call for a national interracial conference as observance of Lincoln's centennial in 1909. Out of that meeting of black and white social critics and reformers came the organization of the National Association for the Advancement of Colored People. Villard criticized Booker T. Washington and W.E.B. Du Bois; but he worked with virtually every black leader to remove racial discrimination. As chairman of the National Association for the Advancement of Colored People, he obtained an interview with Woodrow Wilson at which he proposed the appointment of a national commission to study black education, health, housing, employment, income, legal rights, and civic participation. Wilson was seemingly sympathetic but found himself "absolutely blocked by the sentiment of Senators." He became increasingly critical of Wilson as a result.

In 1915 Villard went to Washington as the *Evening Post's* capital correspondent and sought to arrest the drift toward war with editorials, cartoons, and interpretive news reports. Liberal issues in which Villard became involved over the years seemed limitless in number, but the subject on which he was preeminently qualified was the press, and he spoke as both high-level practitioner and informed observer in editorials, columns, magazine articles, books, and lectures. His views, presented in part in *Newspapers and Newspaper Men* (1923) were expanded in *The Disappearing Daily* (1944) and in his autobiography, *Fighting Years* (1939). Three of Villard's books were about Germany: *Germany Embattled* (1915), *German Phoenix* (1933), and *Within Germany* (1940). In *Prophets True and False* (1928) he sketched and evaluated twenty-seven public figures of the time; he was the owner of the *Nautical Gazette* from 1918 to 1935, and he founded *Yachting* magazine in 1907.

VILLERÉ, JACQUES PHILIPPE (*b. near New Orleans, La., 1761; d. 1830*), planter. An efficient and conscientious governor of Louisiana, 1816–20, he was the first Creole to hold that position.

VINCENNES, FRANÇOIS MARIE BISSOT, SIEUR DE (*b. Montreal, Canada, 1700; d. on headwaters of Tombigbee River, present Mississippi, 1736*), French colonial soldier and official. Son of Jean B. B. de Vincennes. At request of the governor of Louisiana, Vincennes built a fort in 1731 or 1732 on the site of the Indiana city that now bears his name.

VINCENNES, JEAN BAPTISTE BISSOT, SIEUR DE (*b. Canada, 1668; d. site of present Ft. Wayne, Ind., 1719*), French colonial soldier, explorer. Father of François M. B. de Vincennes. Commanded among the Miami Indians, 1696; accompanied Henry de Tonty to the West, 1698. Principal factor in keeping the Miami Indians loyal to France.

VINCENT, FRANK (*b. Brooklyn, N.Y., 1848; d. Woodstock, N.Y., 1916*), world traveler, collector of Orientalia. Author, among other works, of *The Land of the White Elephant* (1874).

VINCENT, GEORGE EDGAR (*b. Rockford, Ill., 1864; d. New York, N.Y., 1941*), educator, sociologist, foundation executive. Son of John Heyl Vincent. B.A., Yale, 1885. Associated with his father thereafter in the work of the Chautauqua Institution, he served as its president, 1907–15. Ph.D., University of Chicago, 1896; taught there from 1895 to 1911. In 1900, he became dean of the junior colleges at Chicago, and in 1907 dean of the faculties of arts, literature, and science. His success as an administrator led to his appointment as president of the University of Minnesota in 1911. Serving until 1917, he reanimated the professional schools and gave full support to development of graduate study in the arts and sciences. From 1917 to 1929, when he retired, he was president of the Rockefeller Foundation.

VINCENT, JOHN CARTER (*b. Seneca, Kans., 1900; d. Cambridge, Mass., 1972*), diplomat. Graduated Mercer University in Georgia (1923) and was accepted into the Foreign Service; he was assigned first to Changsha, China, then to Mukden, in Japanese-occupied Manchuria. Though critical of Chiang Kai-shek, during World War II Vincent played a key role in the Wallace Mission, which reported that America must continue to back Chiang despite doubt about his ability to stay in power while faced with a Communist revolution. After the war, along with other high-ranking diplomats who had served in China, Vincent was held responsible by U.S. conservatives for "losing" China to the Communists. After five loyalty hearings and appearances before Senate and House committees, he was asked to resign in 1953.

VINCENT, JOHN HEYL (*b. Tuscaloosa, Ala., 1832; d. 1920*), Methodist clergyman and bishop, educational leader. Introduced uniform Sunday School lessons in Chicago, Ill., 1864, an innovation later followed in Protestant Sunday Schools throughout the world. Founded, 1874, a national training institute for Sunday School teachers at Lake Chautauqua, N.Y., in association with Lewis Miller; out of this developed the so-called Chautauqua movement for popular education. Vincent's plan of prescribed readings over a four-year term mark the beginning of directed home study and correspondence schools in America. A tolerant man, widely read, Bishop Vincent became the advocate of an intellectual and spiritual evangelism which relied on education rather than emotion.

VINCENT, MARVIN RICHARDSON (*b. Poughkeepsie, N.Y., 1834; d. Forest Hills, N.Y., 1922*), Methodist and Presbyterian clergyman. Graduated Columbia, 1854. Professor of sacred literature, Union Theological Seminary, New York, 1887–1916. Author, among other works, of *Word Studies in the New Testament* (1887–1900).

VINCENT, MARY ANN (*b. Portsmouth, England, 1818; d. Boston, Mass., 1887*), actress. Made American debut at Boston, November 1846. As a member of the stock company of the Boston Museum *post* 1852, Mrs. Vincent became its leading comedienne and later its leading old lady. A Boston institution, she is commemorated by a hospital founded there in her memory and by the Vincent Club which raises funds for the hospital's support by annual amateur theatricals.

VINER, JACOB (*b. Montreal, Canada, 1892; d. Princeton, N.J., 1970*), economist. Attended Harvard (M.A., 1915; Ph.D., 1922), then became leading figure in the University of Chicago economics department; promoted to full professorship at the age of thirty-four. In *Canada's Balance of International Indebtedness,*

1900–13 (1923), he was one of the first to subject balance-of-payments theory to an empirical test. Other important works include *Studies in the Theory of International Trade* (1937), *The Customs Union Issue* (1950), and *International Trade and Domestic Development* (1952). Also an authority on the social philosophy of Adam Smith. Moved to Princeton in 1946. Served as special assistant to the U.S. Treasury (1934–39) and as consultant to the State Department (1943–52).

VINSON, FRED(ERICK) MOORE (*b. Louisa, Ky., 1890; d. Washington, D.C., 1953*), lawyer, politician. Studied at Kentucky Normal College and Centre College in Danville, Ky., LL.B., 1911. As Democratic member of Congress, 1924–29 and 1931–38, Vinson was an expert on federal taxation and a New Deal "regular" who supported Roosevelt's major policies. Member of the House Ways and Means Committee. Associate justice of the U.S. Circuit Court of Appeals for the District of Columbia, 1938–43. Director of the Office of Economic Stabilization, 1943–45. As secretary of the treasury, 1945–46, oversaw the negotiations of the British loan and lend-lease settlements; supervised the beginnings of the International Bank for Reconstruction and Development and the International Monetary Fund.

Chief justice of the U.S. Supreme Court, 1946–53. Three major themes characterized Vinson's judicial career: a reliance on precedent and a refusal to "make law" where precedent was unclear; deference to the government when the issue of government power was in question; and a corollary tendency to justify alleged governmental infringements of individuals' civil liberties.

Vinson's three opinions on race relations all spoke for a unanimous court. Upheld governmental power over individual claims in more than 80 percent of civil liberties cases involving state governments and more than 90 percent involving the federal government. In two major cases involving the rights of American Communists to proselytize, Vinson upheld government encroachments on free speech, supporting the Taft-Hartley Act's anticommunist affadavit requirements and the Smith Act's antifree-speech provisions. Vinson enthusiastically supported presidential authority to intervene in the economy and upheld presidential power to seize industry in alleged emergencies. In 1953, he voted with the majority against a stay of execution for the Rosenbergs in an extraordinary special session.

Vinson's approach as chief justice was to avoid public controversy, to seek a low profile, and to minimize the Supreme Court's role as a policy-making and power body. He proved to be neither the intellectual nor the social leader of the Court, and did not in any major sense control its direction.

VINTON, ALEXANDER HAMILTON (*b. Providence, R.I., 1807, d. Philadelphia, Pa., 1881*), Episcopal clergyman, physician. Brother of Francis Vinton. M.D., Yale, 1828. A rector in Boston, Philadelphia, and New York, he was prominent in the evangelical group of his church and ranked among its leading preachers.

VINTON, FRANCIS (*b. Providence, R.I., 1809; d. Brooklyn, N.Y., 1872*), soldier, Episcopal clergyman. Brother of Alexander H. Vinton. Graduated West Point, 1830. Resigning from the army, 1836, he was ordained deacon, 1838, and advanced to priest, 1839. An ardent evangelical and a fluent preacher, he ministered with zeal and success in several Rhode Island parishes and also in Brooklyn, N.Y., and at Trinity Church, New York City. He was professor of canon law in the General Theological Seminary, New York, 1869–72.

VINTON, FRANCIS LAURENS (*b. Fort Preble, Portland Harbor, Maine, 1835; d. Leadville, Colo., 1879*), Union soldier, mining engineer. Nephew of Alexander H. and Francis Vinton. Graduated West Point, 1856; studied at École des Mines, Paris,

France, 1856–60. Rising to brigade command in the Civil War, he received disabling wounds in the battle of Fredericksburg. First professor of civil and mining engineering at Columbia School of Mines, 1864–77, he was thereafter a consulting engineer in Colorado.

VINTON, FREDERIC (*b. Boston, Mass., 1817; d. 1890*), librarian. Graduated Amherst, 1837. As assistant librarian, Boston Public Library, 1856–65, he aided in preparation of its printed catalogues; as first assistant librarian, Library of Congress, 1865–73, he continued his specialization in catalogue work. First full-time librarian of the College of New Jersey (Princeton), 1873–90, he produced for it a subject catalogue in 1884 which was considered one of the most scholarly and useful publications of the sort up to that time. He was one of the founders of the American Library Association, 1876.

VINTON, FREDERIC PORTER (*b. Bangor, Maine, 1846; d. Boston, Mass., 1911*), portrait painter. Encouraged by William M. Hunt. Studied drawing at Lowell Institute; studied also in Paris under Léon Bonnat and J. P. Laurens. Practiced his art with great success in Boston *post* 1878, specializing in portraits of men.

VINTON, SAMUEL FINLEY (*b. South Hadley, Mass., 1792; d. Washington, D.C., 1862*), lawyer. Began practice in Gallipolis, Ohio, *ca.* 1816. Congressman, National Republican and Whig, from Ohio, 1823–37, 1843–51, he was at various times a member of committees on public lands, roads, canals, and the judiciary; he was chairman of the ways and means committee during the war with Mexico. Vinton was especially interested in the survey and sale of public lands so as to prevent speculation; also in internal improvements, in the imposition of a protective tariff and the proper apportionment of representatives. He opposed the annexation of Texas and any direct tax for prosecution of the war with Mexico. He reported out the bill providing for establishment of the U.S. Department of the Interior, February 1849.

VISSCHER, WILLIAM LIGHTFOOT (*b. Owingsville, Ky., 1842; d. Chicago, Ill., 1924*), journalist, actor. Starting in journalism as secretary to George D. Prentice, he served, 1875–95, as editorial writer for some of the most important Western newspapers and was author of much journalistic verse.

VITALE, FERRUCCIO (*b. Florence, Italy, 1875; d. 1933*), landscape architect. Came first to America as military attaché to the Italian embassy, 1898. After resignation from the army and study of landscape architecture, he practiced that profession in New York City *post* 1904. Designer of many private estates, towns, and suburbs, he worked to strengthen the position of his profession as one of the fine arts.

VIZCAÍNO, SEBASTIÁN (*b. Spain, ca. 1550; d. ca. 1628*), merchant, explorer. Went to Mexico *ca.* 1585. Engaged in the China trade, he lost a good part of his fortune when the galleon *Santa Ana* was destroyed off Lower California, 1587. Commissioned by the viceroy of New Spain, he sailed from Acapulco in June 1596 for an exploration of the Gulf of California. This expedition was fruitless, but a voyage undertaken in 1602 to explore the outer coast of California as far as Cape Mendocino was more successful. Leaving Acapulco on May 5, 1602, Vizcaíno explored the coast of Lower California and reached San Diego Bay in November; in mid-December he discovered Monterey Bay. He reached Cape Mendocino on Jan. 12, 1603, missing San Francisco Bay in the bad weather. Returning southward he arrived at Mazatlán, Feb. 18, 1603. This expedition, the first to make a scientific exploration of the west coast, furnished the first maps of that coast and did much to explode the myth of the Northwest Passage.

VIZETELLY, FRANK HORACE (*b. London, England, 1864; d. New York, N.Y., 1938*), lexicographer, etymologist. Member of a family which had been engaged in the printing trades and journalism in England ever since 1725, he came to New York City, 1891, and was associated with the staff of Funk & Wagnalls thereafter until his death. His principal work was done on the various editions of the *Standard Dictionary of the English Language*. He was author also of a column in the *Literary Digest*, which dealt with the complications of grammar, usage, and word derivations, and provided the material for nearly a dozen books on these subjects.

VLADECK, BARUCH CHARNEY (*b. near Minsk, Russia, 1886; d. New York, N.Y., 1938*), Socialist and Jewish leader. Coming to America, 1908, he undertook lecture tours for three years and became manager of the Philadelphia edition of the New York *Jewish Daily Forward* in 1912. A leader in the American Socialist party, he became the *Forward's* city editor, 1916, and moved to New York. An opponent of the Communist wing of the Socialist party *post* 1919, he was associated in party affairs with Louis Waldman. Appointed a member of the New York City Housing Authority, 1934, he began, after election to the city council, one of the first municipal slum-clearance projects in the United States. Vladeck's career is interesting as an example of the transformations wrought by American institutions on a European-shaped radicalism.

VLADIMIROFF, PIERRE (*b. St. Petersburg, Russia, 1893; d. New York, N.Y., 1970*), ballet dancer. Graduated from Imperial School of Ballet in St. Petersburg (1911). In 1912 joined Sergei Diaghilev's Ballets Russes for its tour of western Europe. As premier danseur at the Maryinsky Theater (from 1915) he created roles in Fokine's *Francesca da Rimini* and *Eros*. His repertoire also include *Paquita*, *Raymonda*, and *Giselle*. Escaped from Russia in 1920 and joined Diaghilev's company in 1921 but left the following year. Joined Anna Pavlova's company in 1928 and danced as her partner. After her death in 1931 he stopped performing. Taught at the School of American Ballet in New York City (1934–67), providing a link to the Russian tradition of pure classical dance.

VOGRICH, MAX WILHELM KARL (*b. Hermannstadt, Transylvania, 1852; d. New York, N.Y., 1916*), pianist, composer. Came to America, 1878. Toured the country as accompanist to August Wilhelmj and was also associated with Eduard Reményi. A resident in New York, 1886–1902 and 1914–16, he composed much music in various forms and was an adviser to the publishing firm of G. Schirmer.

VOLCK, ADALBERT JOHN (*b. Augsburg, Bavaria, 1828; d. Baltimore, Md., 1912*), dentist, caricaturist. Immigrated to America, 1849. A graduate of the Baltimore College of Dental Surgery, 1852, he practiced with success in Baltimore, but is principally remembered as author of a series of caricatures favorable to the South under the pseudonym "V. Blada." The most important collection of his work is *Confederate War Etchings* (n.d.) and *Sketches from the Civil War in North America* (1863, bearing a possibly false London imprint).

VOLK, LEONARD WELLS (*b. Wellstown, present Wells, N.Y., 1828; d. Osceola, Wis., 1895*), sculptor. Removed to St. Louis Mo., 1848, where he taught himself drawing and modeling. Aided by Stephen A. Douglas, he studied in Rome, Italy, 1855–57, and thereafter practiced his art in Chicago, Ill. He organized the first art exhibition held there (1859) and was a founder of the Chicago Academy of Design, 1867. He produced the colossal Douglas monument at Chicago, statues of Lincoln and Douglas in the Illinois State Capitol, and other portraits of Lincoln which are valuable historic mementos. His talent lay in faithful portraiture.

VOLSTEAD, ANDREW JOHN (*b. near Kenyon, Minn., 1860; d. Granite Falls, Minn., 1947*), lawyer. Attended St. Olaf College; graduated Decorah (Iowa) Institute, 1881; admitted to Minnesota bar, 1884. Congressman, Republican, from Minnesota's 7th District, 1903–23. As chairman of the House Judiciary Committee, 1919, he personally drafted the Volstead Act to enforce the 18th Amendment and became for most Americans the personification of prohibition. In fact his legislative record was on the whole progressive; he was especially proud of his authorship of the Capper-Volstead Act (1922) which exempted farmers' cooperatives from the antitrust laws. Opposed to big business, big labor, and every kind of monopoly, he supported woman's suffrage, a federal antilynching law, and other liberal measures.

VON BRAUN, WERNHER. *See* BRAUN, WERNHER VON .

VON HOLST, HERMANN EDUARD *See* HOLST, HERMANN EDUARD VON .

VON KÁRMÁN, THEODORE *See* KÁRMÁN, THEODORE (TODOR) VON .

VON MOSCHZISKER, ROBERT (*b. Philadelphia, Pa., 1870; d. Philadelphia, 1939*), jurist. Admitted to the Philadelphia bar, 1896, he won reputation as an assistant district attorney, and as judge of the court of common pleas in Philadelphia Co., 1903–09. Elected an associate justice of the Pennsylvania supreme court, 1909, he became chief justice in 1921 and resigned in 1930.

VON NEUMANN, JOHN (*b. Budapest, Hungary, 1903; d. Princeton, N.J., 1957*), mathematician, physicist, economist. Studied at the University of Berlin; the Technische Hochschule in Zurich, Ph.D., 1926; and the University of Budapest, Ph.D., 1926. Immigrated to the U.S. in 1930; taught at Princeton University, 1930–33; member of the Institute for Advanced Study, 1933–57. Began to study and work on atomic weapons in 1940; advisor to the U.S. Department of Defense and chairman of the nuclear weapons committee of the U.S. Air Force. Worked at Los Alamos (1943-45), where his ideas of using converging shock waves to detonate the nuclear explosive proved decisive. Made important contributions to the advancement of computers. Member of the U.S. Atomic Energy Commission, 1954–57. A founder of econometrics.

VON NOH, ROBERT WILLIAM (*b. Hartford, Conn., 1858; d. Nice, France, 1933*), portrait and landscape painter. An able and conscientious craftsman, he was a teacher, among others, of W.J. Glackens and Maxfield Parrish.

VON RUCK, KARL (*b. Constantinople, Turkey, 1849; d. 1922*), physician. M.D., University of Tübingen, 1877; M.D., University of Michigan, 1879. After practice at Norwalk, Ohio, he began a specialization in tuberculosis and founded the Winyah Sanitorium, Asheville, N.C., 1888. By long laboratory research and clinical application, he produced (1912) an anti-tuberculosis vaccine which was widely used in treatment of the disease, although designed primarily for the protective immunization of those exposed to tuberculous infection. Though he was in constant controversy with his fellow-workers in the field, his work and many of his ideas have received general acceptance.

VON STERNBERG, JOSEF (*b. Vienna, Austria-Hungary, 1894; d. Los Angeles, Calif., 1969*), motion-picture director. Came to the

United States in 1901 and settled with his parents in New York City. After World War I, worked as a cutter, editor, title writer, and assistant director in New Jersey, New York, Austria, and England before moving to Hollywood in 1923. In 1924 he wrote, produced, and directed *The Salvation Hunters*, chosen by one critic as one of the ten best films of the year. During 1927–35 directed fourteen films for Paramount—including *The Last Command* (1928), starring the eminent German actor Emil Jannings. At Jannings' behest, a German production company with ties to Paramount engaged von Sternberg to film *The Blue Angel* (1930), his most famous film and the first of seven pictures in which he established Marlene Dietrich as the screen's ultimate *femme fatale*. After leaving Paramount in 1935, he made a few films and spent most of the 1950's and 1960's teaching and appearing at retrospectives of his work around the world.

VON STROHEIM, ERICH (*b. Vienna, Austria, 1885; d. Maurepas, Seine-et-Oise, France, 1957*), film director, actor. Studied at the Mariahilfe Military Academy. Immigrated to the U.S. in 1909. An extra in D. W. Griffith's *The Birth of a Nation*; became an assistant to director John Emerson and also acted in Griffith's *Intolerance* and *Hearts of the World*. Directed, wrote, and appeared in *Blind Husbands* (1918). Directed and acted in *Foolish Wives* (1922), his first lavish spectacle. *Greed* (1924), released in a truncated version, was a failure but is now considered his finest work. Other films include *The Wedding March* (1928) and *Queen Kelly*. Von Stroheim failed to make the transition as a director from silent to sound films. He returned to acting, most notably in *Great Gabbo* (1929), in Jean Renoir's *Grand Illusion* (1938), in which he gave an unforgettable performance as a disabled German soldier. Often cast as the quintessential German or Prussian officer, he played Rommel in *Five Graves to Cairo* in 1943. His greatest performance was in *Sunset Boulevard* (1950), in which he played opposite Gloria Swanson as her ex-director who was now her butler.

Remembered for his realism and frank treatment of sex, Von Stroheim broke much important ground for the art of cinema. His films were poetic and had a touch of surrealism that prompted director Sergei Eisenstein to cite him as "The Director."

VON TEUFFEL, BLANCHE WILLIS HOWARD *See* HOWARD, BLANCHE WILLIS.

VON WIEGAND, KARL HENRY (*b. Hesse, Germany, 1874; d. Zurich, Switzerland, 1961*), foreign correspondent. Immigrated with his family to Iowa when he was a year old. Began journalistic career in 1899 in Arizona, thereafter moving to California, where he covered the 1906 San Francisco earthquake. After he began working in Europe for United Press (1911), except for brief visits, he never lived in the United States again. World War I made his by-line famous. Moved to the Pulitzers' *New York World* in 1915 and thence in 1917 to the Hearst newspapers where he became chief foreign correspondent, retaining the title until his death. He never wrote a book and his reputation has proved to be quite evanescent.

VOORHEES, DANIEL WOLSEY (*b. Butler Co., Ohio, 1827; d. Washington, D.C., 1897*), lawyer. Raised in Indiana, he settled in practice at Terre Haute, 1857. Opposed equally to abolition and secession, he served as congressman, Democrat, from Indiana, 1861–66, and was a virulent critic of administration policies. After a second term in the House of Representatives, 1869–73, he was U.S. senator from Indiana, 1877–97. At first a typical Democrat of his era in his ideas, he became less strictly agrarian and supported President Grover Cleveland in the various questions that divided the Democrat party during Cleve-

land's terms. As chairman of the committee on finance, he led the fight for repeal of the Sherman silver purchase act, 1893. He was unrivaled as a stump speaker.

VOORHEES, EDWARD BURNETT (*b. Minebrook, N.J., 1856; d. 1911*), agriculturist. Graduated Rutgers, 1881. Assistant chemist of the New Jersey State Experiment Station, 1883–88, at which time he became chief chemist. Professor of agriculture at Rutgers, 1890–1911. Director, New Jersey Experiment Station *post* 1893. Founded short agricultural courses for working farmers. Author of *Fertilizers* (1898) and many other works.

VOORHEES, PHILIP FALKERSON (*b. New Brunswick, N.J., 1792; d. Annapolis, Md., 1862*), naval officer. Appointed midshipman, 1809. While commanding frigate *Congress* September 1844, as reprisal for Argentine attacks on an American brig, he captured the entire Argentine squadron which was blockading Montevideo. Court-martialed for his action, June 1845, he was at first suspended from duty, but was reinstated by President Polk in 1849.

VOORSANGER, JACOB (*b. Amsterdam, the Netherlands, 1852; d. San Francisco, Calif., 1908*), rabbi. Came to America, 1873. After occupying several pulpits in the East and in Texas, he served at Temple Emanu-El, San Francisco, *post* 1886. He was professor of Semitic languages and literature, University of California *post* 1894. A moderate member of the reform school of Judaism, he was a gifted journalist and in time was considered the foremost rabbi on the Pacific Coast. He was chairman of relief during the San Francisco earthquake and fire of 1906.

VOPICKA, CHARLES JOSEPH (*b. Dolni Hbity (Bohemia), Austria-Hungary, 1857; d. Chicago, Ill., 1935*), brewer, diplomat. A leader among the Czechs in Chicago, he was active in civic matters there. He served as U.S. minister to Romania, Serbia, and Bulgaria, 1913–20, representing the interests of many of the warring nations as well as those of the United States, and strongly concerning himself with the welfare of prisoners of war.

VORIS, JOHN RALPH (*b. Franklin, Ind., 1880; d. Duarte, Calif., 1968*), minister and social reformer. Received B.D. from the University of Chicago's School of Divinity (1906). Exchanged pastoral for social work after responding to an urgent request to administer programs for army recruits during World War I. During and after the war he served as general secretary of the YMCA, as director of the Inter-church World Movement, and as an officer for the Near East Relief Program. He co-founded the Save the Children Foundation in 1932, guiding it until his retirement in 1952. Thereafter, he formed Seniors in Philanthropic Service. Honored by British and French foreign governments for his international relief work.

VORSE, MARY HEATON (*b. New York, N.Y., 1874; d. Provincetown, Mass., 1966*), author, journalist, labor activist. A prolific writer for popular magazines, she specialized in sketches of family life. Although she published several books of fiction in addition to her magazine work, she is chiefly remembered for her work on behalf of organized labor. Her reporting of labor's crucial struggles, as well as books like *Men and Steel* (1920) and *Labor's New Millions* (1938), helped make organized labor and the right to strike part of American life. Her last major article, on union corruption on the New York City waterfront, appeared in *Harper's* in 1952. In addition, she helped found the Provincetown Players, which revitalized the American theater in the early twentieth century.

VOSE, GEORGE LEONARD (*b. Augusta, Maine, 1831; d. Brunswick, Maine, 1910*), engineer, specialist in railroads. Professor of

civil engineering, Bowdoin, 1872–81; Massachusetts Institute of Technology, 1881–86. Author of *Handbook of Railroad Construction* (1857), *Manual for Railroad Engineers and Engineering Students* (1873), and a number of other useful works.

VOUGHT, CHANCE MILTON (*b. New York, N.Y., 1890; d. Southampton, N.Y., 1930*), aircraft designer and manufacturer. Studied engineering at Pratt Institute, New York University and University of Pennsylvania. Learned to fly *ca.* 1910 under instruction of the Wright brothers. Designed and built an advanced training plane for the British in World War I, 1914. As chief engineer of the Wright Company, he produced the Model V military biplane, 1916. Forming his own company, 1917, he made it in very short time an outstanding factor in the aircraft industry, developing new designs practically alone and directing their realization in the shop. Among his designs were the Vought VE-7 (1919), the Vought UO-1 (1922–25) and the Vought O2U Corsair. Vought worked above all for tactical flexibility in naval aircraft and maintained unsurpassed standards of workmanship. He merged his firm in the United Aircraft & Transport Corp., 1929, but continued to head the Chance Vought unit until his death.

VROOM, PETER DUMONT (*b. Somerset Co., N.J., 1791; d. Trenton, N.J., 1873*), lawyer, New Jersey legislator. Graduated Columbia, 1808. Democratic governor and chancellor of New Jersey, 1829–32, 1833–36; congressman, 1839–41. U.S. minister to Prussia, 1854–57. An opponent of secession, he was a member of the futile peace conference which met at Washington, February 1861. He was reporter of the New Jersey supreme court, 1865–73.

W

WABASHA (*b. probably near present Winona, Minn., ca. 1773; d. ca. 1855*), Mdewakanton Sioux chief. First prominent through conferences with Zebulon M. Pike on upper Mississippi, 1805; was conspicuous at council at Prairie du Chien, August 1825; supported Americans during Black Hawk War, 1832. A wise, honorable, and prudent chief, Wabasha won general respect and was a skillful orator.

WACHSMUTH, CHARLES (*b. Hanover, Germany, 1829; d. probably Burlington, Iowa, 1896*), paleontologist. Came to America, 1852; settled in Burlington, Iowa, *ca.* 1854. Prospering in the grocery business, he retired in 1865 and devoted his time to collecting and studying fossils. After a brief period of work with Louis Agassiz in Cambridge, Mass., he returned to Burlington and worked in a general partnership with Frank Springer *post* 1873. Attempting a personal critical examination of all the collections of crinoids throughout the world, Wachsmuth and Springer continued work until the former's death when it was carried on alone by Springer. They were authors of *North American Crinoidea Camerata* (1897) and a number of other memoirs.

WACKER, CHARLES HENRY (*b. Chicago, Ill., 1856; d. 1929*), brewer, real estate operator, city planner. Chairman of the Chicago Plan Commission, 1909–26, he was a principal factor in the improvement and beautification of that city.

WADDEL, JAMES (*b. Newry, Ireland, 1739; d. near Gordonsville, Va., 1805*), Presbyterian clergyman. Immigrated to southeast Pennsylvania as an infant; was educated in Samuel Finley's "Log College." Pastor in Northumberland and Lancaster counties, Va., 1762–77; pastor of congregations at Tinkling Spring and Staunton, Va., 1777–85. Established a number of churches in Orange, Louisa, and Albemarle counties.

WADDEL, JOHN NEWTON (*b. Willington, S.C., 1812; d. Birmingham, Ala., 1895*), Presbyterian clergyman, educator. Son of Moses Waddel. Graduated present University of Georgia, 1829. Removed to Alabama, 1837, and thence to Mississippi where he established Montrose Academy, 1842, and took a leading part in founding University of Mississippi at Oxford. A teacher at the University of Mississippi and pastor, 1848–57, he served as teacher and president at the Presbyterian College, La Grange, Tenn., until the Civil War when he became a chaplain in the Confederate Army. A leader in organization of the Southern Presbyterian Church, 1861, he held numerous high official positions in that church. Chancellor of University of Mississippi, 1865–74; of Southwestern Presbyterian University, 1879–88.

WADDEL, MOSES (*b. present Iredell Co., N.C., 1770; d. Athens, Ga., 1840*), Presbyterian clergyman, teacher. Father of John N. Waddel. Educated by James Hall; graduated Hampden-Sydney, 1791. Conducted schools in Columbia Co., Ga., and Willington, S.C., where he educated among others John C. Calhoun, William H. Crawford, Hugh S. Legaré, George McDuffie, A. B.

Longstreet, and James L. Petigru. President of Franklin College (present University of Georgia), 1819–29.

WADDELL, ALFRED MOORE (*b. Hillsboro, N.C., 1834; d. 1912*), lawyer, Confederate soldier. A moderate conservative and an opponent of post–Civil War sectionalism as congressman, Democrat, from North Carolina, 1871–79. He was a leading citizen of Wilmington, N.C., and its mayor, 1899–1905.

WADDELL, HUGH (*b. Lisburn, Ireland, ca. 1734; d. 1773*), North Carolina colonial soldier and legislator. Immigrated to North Carolina, 1754, where he became clerk of the council of Governor Arthur Dobbs. Built and commanded at Fort Dobbs on the Rowan County frontier, 1755–57; served as major commanding three companies in the expedition of John Forbes against Fort Dunquesne, 1758; defended Fort Dobbs against Indian attacks, 1760. A principal leader in the colony's defiance of the Stamp Act, he yet remained on good terms with Governor Tryon and helped pacify the back country during the Regulator troubles, 1771.

WADDELL, JAMES IREDELL (*b. Pittsboro, N.C., 1824; d. Annapolis, Md., 1886*), Confederate naval officer. Great-grandson of Hugh Waddell. Appointed midshipman, 1841, he served with credit during the Mexican War and in routine naval duties until 1862 when he resigned and was commissioned lieutenant in the Confederate Navy. After shore service, 1862–March 1863, he went to Paris, and in October 1864 took command at the Madeira Islands of the Confederate raider *Shenandoah*. Thereafter, until he learned in August 1865 of the Confederate defeat, he made havoc among the New England whaling ships in the Pacific. Fearing treatment as a pirate, he surrendered the *Shenandoah* in Liverpool, England, on November 6, still flying the only Confederate flag that ever sailed round the world.

WADDELL, JOHN ALEXANDER LOW (*b. Port Hope, Ontario, Canada, 1854; d. New York, N.Y., 1938*), civil engineer. Graduated Rensselaer Polytechnic Institute, 1875. After work in Canada as a government draftsman and several years of teaching at Rensselaer, he was professor of civil engineering at the Imperial University of Tokyo, 1882–86. In practice at Kansas City, Mo., 1886–*ca.* 1920, and thereafter in New York City, he became one of the best-known bridge engineers in the United States, and was designer or consultant on many of the major bridge construction operations in his time. His most important contribution was an originator of the modern vertical-lift bridge. Although European developments anticipated his, Waddell independently invented and successfully introduced the large-scale high-clearance vertical-lift bridge, the first of his many structures of this type being the South Halsted Street Bridge, Chicago, Ill., 1893.

WADE, BENJAMIN FRANKLIN (*b. near Springfield, Mass., 1800; d. Jefferson, Ohio, 1878*), lawyer, Ohio legislator, and jurist. Removed to Andover, Ohio, 1821. Admitted to the Ohio bar *ca.* 1827, he attained a successful practice in partnerships with J. R.

Giddings and R. P. Ranney. President-judge, third state judicial circuit, 1847–51, he was elected to the U.S. Senate by the Whigs in the Ohio legislature and served, 1851–69. Rough in manner, coarse and vituperative in speech, yet intensely patriotic, he became a leader of the antislavery group in Congress, a close cooperator with Simon Cameron and Zachariah Chandler in resisting Southern aggressions. A Republican *post* 1856, he voted against the Crittenden Compromise and on the outbreak of the Civil War became one of the most belligerent men in Congress. A sharp critic of General George B. McClellan, he was one of those who set up the Committee on the Conduct of the War, and as its chairman made it a violently partisan agency. Working closely with the secretary of war, E. M. Stanton, Wade, like other of the Radical Republicans, seemed incapable of understanding President Lincoln and deplored his cautious conservative policies. He himself favored drastic measures against the South, including confiscation of the property of Confederate leaders and the emancipation of their slaves, nor was he burdened with constitutional scruples. Finding Lincoln's policy of Reconstruction (announced in December 1863) particularly obnoxious, he and Henry W. Davis tried to counteract it by the so-called Wade-Davis bill; on its veto by the president in July 1864 they issued the fierce claim of congressional supremacy known as the Wade-Davis Manifesto. Previous to this, Wade had joined with others in planning to replace Lincoln with Salmon P. Chase, yet he supported Lincoln in the closing weeks of the campaign of 1864. At first believing that he and his group could bend President Andrew Johnson to support of their measures, Wade later turned on him and his policies. *Post* December 1865, along with Charles Sumner, Thaddeus Stevens, and others, he waged a persistent campaign against Johnson and seemed ready to resort to any extremity in order to carry through the congressional program. Chosen president *pro tempore* of the Senate, March 2, 1867, he would, according to the custom of that time, have succeeded to the presidency in the event of Johnson's removal. In the ensuing impeachment of Johnson, Wade voted for the president's conviction, despite the fact that he was an interested party. He was so expectant of success that he began the selection of his cabinet before the impeachment trial was ended. Thwarted by Johnson's acquittal and failing of reelection to the Senate, Wade resumed the practice of law in Ohio.

WADE, DECIUS SPEAR (*b. near Andover, Ohio, 1835; d. near Andover, 1905*), lawyer. Nephew of Benjamin F. Wade. As chief justice of Montana, 1871–87, he shared in the formulation of the mining and irrigation law of that state and was a member of the commission which drafted the state code adopted by the legislature in 1895.

WADE, JEPTHA HOMER (*b. Romulus, N.Y., 1811; d. 1890*), portrait painter, financier. Organized and built a number of Midwest telegraph lines *post* 1847 which were consolidated with those of Royal E. House, 1854. After a further combination into the Western Union Telegraph Co., 1856, Wade served the new company as general agent, and was president, 1866–67. He was organizer also of the California State Telegraph Co. and the Pacific Telegraph Co. *Post* 1867 he engaged in varied businesses in Cleveland, Ohio.

WADE, JEPTHA HOMER (*b. Cleveland, Ohio, 1857; d. Thomasville, Ga., 1926*), financier, philanthropist. Grandson of Jeptha H. Wade (1811–1890). An incorporator of the Cleveland Museum of Art, 1913, he was its president *post* 1920, and also one of its most liberal benefactors. He was a large contributor to many charities.

WADE, MARTIN JOSEPH (*b. Burlington, Vt., 1861; d. Los Angeles, Calif., 1931*), Iowa jurist and Democratic congressman. LL.B., University of Iowa, 1886; taught law there. Justice of the state district court, 1893–1902; U.S. district judge, southern district of Iowa, 1915–27.

WADSWORTH, ELIOT (*b. Boston, Mass., 1876; d. Washington, D.C., 1959*), financier, philanthropist, and government official. Studied at Harvard (B.A., 1898). Combined a lifelong connection with the Red Cross and government activity. Vice-chairman of the War Council during World War I, assistant secretary of the Treasury (1921–26); Loyalty Review Board, Civil Service Commission (1950–53). Member of the Harvard Board of Overseers for twelve years, becoming president in 1929.

WADSWORTH, JAMES (*b. Durham, Conn., 1768; d. Geneseo, N.Y., 1844*), landowner, community builder. Graduated Yale, 1787. As agent with his brother for the Phelps-Gorham Purchase in western New York State, James Wadsworth removed to the neighborhood of the Genesee River, 1790, and settled near the present town of Geneseo. Acquiring large quantities of land and prospering both as land agents and agriculturists, the Wadsworths had unequaled influence in the development of the Genesee country. Except for business, James Wadsworth's chief interest was in public education.

WADSWORTH, JAMES SAMUEL (*b. Geneseo, N.Y., 1807; d. Virginia, 1864*), lawyer, landowner. Son of James Wadsworth. Volunteering as an aide to General Irvin McDowell, 1861, he was commissioned brigadier general of volunteers in August. After two years spent in gaining experience in handling and training men, he took command of the 1st Division, I Corps, December 1862. Highly effective in the Union victory of Gettysburg, Wadsworth was appointed commander of the 4th Division of the V Corps, 1864. He died of wounds received on the second day of the battle of the Wilderness.

WADSWORTH, JAMES WOLCOTT, JR. (*b. Geneseo, N.Y., 1877; d. Washington, D.C., 1952*), politician and farmer. Dominant force in New York State Republican politics for 25 years. Graduated Yale University (1898). Served New York State Assembly (1904–10); U.S. Senate (1914–26). Chairman, Senate Military Affairs Committee; author of National Defense Act of 1920. Lost senate seat to Robert F. Wagner because of anti-Prohibitionist stand. Elected to House of Representatives (1933–51). Ardent opponent of New Deal. Principal architect of National Selective Service Act of 1940. As a member of the House Rules Committee, was a mainstay of the coalition of southern Democrats and Republicans that blocked much of Truman's Fair Deal legislation.

WADSWORTH, JEREMIAH (*b. Hartford, Conn., 1743; d. Hartford, 1804*), merchant mariner, Connecticut legislator, Revolutionary soldier. Grandson of Joseph Talcott. Outstanding as commissary general, at first to the Connecticut forces, and then to the Continental Army, 1778–79, Wadsworth served briefly as a Federalist in Congress where he was a strong advocate of assumption. A man of varied business interests, he was a founder of the Bank of North America, a director of the U.S. Bank, and president of the Bank of New York.

WADSWORTH, PELEG (*b. Duxbury, Mass., 1748; d. Hiram, Maine, 1829*), schoolmaster, farmer, trader, Revolutionary general. Grandfather of Henry Wadsworth Longfellow and Samuel Longfellow. Graduated Harvard, 1769. As engineer officer, 1775, he laid out the American lines at Roxbury and Dorchester Heights during siege of Boston. Briefly aide to Artemas Ward, he then saw service at New York and in 1778 in Rhode Island. He

was second-in-command of the ill-fated American attack on Castine, Maine, 1779. Removing to present Portland, Maine, *ca.* 1782, he was a congressman from that district, 1793–1807.

WAESCHE, RUSSELL RANDOLPH (*b. Thurmont, Md., 1886; d. Bethesda, Md., 1946*), Coast Guard officer. Attended Purdue University; graduated U.S. Revenue Cutter Service cadet school (forerunner of U.S. Coast Guard Academy), 1906. After formation of U.S. Coast Guard, 1915, he served in a number of line and staff capacities, at sea and on land, before his appointment as commandant in 1936 with rank of rear admiral. As commandant, he streamlined the administration of the service, upgraded its educational facilities, and presided over its expansion during World War II to a multi-purpose force of more than 171,000 men and women. He was promoted to admiral in 1945.

WAGENER, JOHN ANDREAS (*b. Sievern, Hanover, Germany, 1816; d. Walhalla, Oconee Co., S.C., 1876*), businessman, South Carolina legislator, Charleston civic leader. Settled in Charleston S.C., 1833, where he led in movements for the economic and social improvement of German immigrants to that state.

WAGGAMAN, MARY TERESA MCKEE (*b. Baltimore, Md., 1846; d. 1931*), writer of fiction, principally for Catholic magazines.

WAGNER, CLINTON (*b. Baltimore, Md., 1837; d. Geneva, Switzerland, 1914*), laryngologist. M.D., University of Maryland, 1859. An outstanding medical officer in the U.S. Army, 1859–69, he was cited for notable services at Gettysburg where he established a field hospital near Little Round Top. Practicing his speciality in New York City *post* 1871, he became known as a surgeon of extraordinary technical skill and a brilliant teacher; he established the Metropolitan Throat Hospital, the first U.S. special hospital of its kind, and was founder of the New York Laryngological Society, 1873. First professor of laryngology at New York Post-Graduate Medical School, he was author of a number of studies, including the pioneer *Habitual Mouth-Breathing* (1881).

WAGNER, JOHN PETER ("HONUS") (*b. Mansfield, (now Carnegie), Pa., 1874; d. Carnegie, Pa., 1955*), baseball player. Played for the Pittsburgh Pirates from 1900 to 1917; coach from 1933 to 1951. Beginning in 1897, Wagner hit .300 or better in seventeen consecutive seasons; led the National League in hitting in 1900, 1903, 1904, 1906–09, and 1911, a record that still stands. A shortstop, Wagner was elected as one of the first members of the National Baseball Hall of Fame in 1936. One of the greatest players of all time, he was also one of the most popular.

WAGNER, ROBERT FERDINAND (*b. Nastätten, Germany, 1877; d. New York, N.Y., 1953*), politician. Immigrated to the U.S., 1896. After studying at the City College of New York (1898) and New York Law School (1900), Wagner became a Tammany politician. He served ably in the New York State Assembly and Senate, championing safety standards in industry, child labor statutes, and the minimum wage. Elected to the First District Supreme Court in 1918, and to the U.S. Senate as a Democrat (1926–53).

As a senator, Wagner was a leader in social legislation and a strong backer of Franklin D. Roosevelt and the New Deal. He sponsored and had a major role in drafting the National Industrial Recovery Act, Social Security legislation, the Railroad Retirement Act, and bills for unemployment insurance, low-cost public housing, and federal health programs. In 1935, the "Wagner Act"—the National Labor Relations Act which created the National Labor Relations Board (NLRB)—had a profound impact on the nation's working classes. He supported the formation

and recognition of the State of Israel in 1948; his last major legislative achievement was the Public Housing Act of 1949.

WAGNER, WEBSTER (*b. Palatine Bridge, N.Y., 1817; d. Spuyten Duyvil, N.Y., 1882*), carpenter, New York Republican legislator. Designed and operated sleeping-cars and drawing-room cars for operation on the New York Central Railroad *post* 1858; was involved for years in litigation with G. M. Pullman.

WAGNER, WILLIAM (*b. Philadelphia, Pa., 1796; d. Philadelphia, 1885*), merchant, philanthropist. Apprenticed to Stephen Girard; engaged in business on his own account, 1818. Retiring, 1840, he devoted himself to studies in geology and mineralogy and founded the Wagner Free Institute of Science, 1855.

WAHL, WILLIAM HENRY (*b. Philadelphia, Pa., 1848; d. 1909*), scientific journalist, metallurgist. Graduated Dickinson College, 1867; Ph.D., Heidelberg, 1869. Principally distinguished as secretary of the Franklin Institute and as editor *post* 1882 of its *Journal*. The most important of his contributions to science was his discovery and application of aluminum as an energetic oxidizing agent for creation of high temperatures in metallurgical operations, the basis of what is known as the "thermit process."

WAIDNER, CHARLES WILLIAM (*b. near Baltimore, Md., 1873; d. 1922*), physicist. A.B., Johns Hopkins, 1896; Ph.D., 1898. Headed the division of heat and thermometry, National Bureau of Standards, *post* 1901; established standard scale of temperature in collaboration with others. Participated anonymously in many of the important activities of his division.

WAILES, BENJAMIN LEONARD COVINGTON (*b. Columbia, Co., Ga., 1797; d. Mississippi, 1862*), surveyor, planter, scientist. Made extensive studies of the plant and animal life and the soil and fossils of Mississippi; supplied information and specimens of the natural history of his region to many individual scientists and to institutions.

WAINWRIGHT, JONATHAN MAYHEW (*b. Walla Walla, Wash., 1883; d. Ft. Sam Houston, Tex., 1953*), military officer. Graduated West Point, 1906. After serving in various posts in the First Cavalry (seeing action in the Philippines) he was sent to France during World War I. Commander of the Philippine Division (1941). Remembered for his valiant leadership during the Japanese invasion, Wainwright was forced to surrender his forces to the Japanese at the battles of Bataan and Corregidor. He was a prisoner of war from 1942 to 1945, when he was rescued by parachutists and brought to Tokyo in time to witness the Japanese surrender on the USS *Missouri*. Promoted to four-star general, Wainwright was given command of the Fourth Army.

WAINWRIGHT, JONATHAN MAYHEW (*b. Liverpool, England, 1792; d. New York, N.Y., 1854*), Episcopal clergyman. Grandson of Jonathan Mayhew. Graduated Harvard, 1812. After his ordination in 1817, he served as minister in Hartford, Conn., and Boston, Mass., but was principally identified with Grace Church and Trinity Parish, New York City. His consecration as bishop of New York, 1852, ended a long controversy in the diocese caused by doctrinal differences and the suspension of Bishop B. T. Onderdonk. A founder of the present New York University, he was active also as a writer and was chief working member of the committee which prepared the standard edition of the *Book of Common Prayer*.

WAINWRIGHT, JONATHAN MAYHEW (*b. New York, N.Y., 1821; d. off Galveston, Tex., 1863*), naval officer. Son of Jonathan M. Wainwright (1792–1854). Appointed midshipman, 1837. After varied sea and shore service, he began duty in the Civil War with

the Atlantic Blockading Squadron. Given command (1862) of the *Harriet Lane*, he played a leading role in the reduction of the Confederate forts on the lower Mississippi and the taking of New Orleans. He was killed in action defending his ship against boarders after the recapture of Galveston.

WAINWRIGHT, RICHARD (*b. Charlestown, Mass., 1817; d. Donaldsonville, La., 1862*), naval officer. Appointed midshipman, 1831; served mainly with the U.S. Coast Survey and on ordnance duty until the Civil War. Commanded the USS *Hartford*, flagship of Admiral Farragut, at the taking of New Orleans and later in the passage of the batteries at Vicksburg.

WAINWRIGHT, RICHARD (*b. Washington, D.C., 1849; d. Washington, 1926*), naval officer. Son of Richard Wainwright (1817–1862). Graduated U.S. Naval Academy, 1868. Performed a variety of duties, notably with the hydrographic office, the U.S. Coast Survey, and the bureau of navigation until 1896 when he became chief of intelligence. Appointed executive officer of the USS *Maine*, 1897, he helped in recovery of the bodies and in preliminary examinations of the ship's hull after its sinking in Havana harbor, Feb. 15, 1898. In command of the USS *Gloucester* (formerly J. P. Morgan's yacht *Corsair*), he performed brilliantly in the battle of Santiago Bay, July 3, 1898, attacking and destroying the Spanish ships *Furor* and *Pluton* and helping in the rescue of Admiral Cervera and other of the Spanish seamen. He retired as rear admiral, 1911.

WAIT, SAMUEL (*b. White Creek, N.Y., 1789; d. Wake Forest, N.C., 1867*), Baptist clergyman. Active *post* 1827 in the organization of the Baptists in North Carolina, he raised funds for the Wake Forest Manual Labour Institute and served as its principal *post* 1834. On its becoming Wake Forest College, 1838, Wait was its president until 1846; he was also president of Oxford Female College, 1851–56.

WAIT, WILLIAM (*b. Ephratah, N.Y., 1821; d. Johnstown, N.Y., 1880*), lawyer. Studied law in office of Daniel Cady; was admitted to the New York bar, 1846. Wait is principally remembered for his legal writings, including a number of useful compilations and manuals of procedure. Among his works were *The Law and Practice in Civil Actions* (1865); *A Table of Cases Affirmed, Reversed, or Cited* (1872, one of the earliest manuals for quick search); *The Practice at Law, in Equity, and in Special Proceedings, etc.* (1872–80, a standard authority on New York adjective law); and *A Treatise upon Some of the General Principles of the Law* (1877–79, a topical digest which was in effect a *corpus juris* for students of that day).

WAIT, WILLIAM BELL (*b. Amsterdam, N.Y., 1839; d. 1916*), educator of the blind. Graduated Albany Normal College, 1859. Starting as superintendent of the New York Institution for the Blind in New York City, 1863, he remained in the service of the Institution until his death. A leader in advancing education of the blind to the status of a profession and in the provision of full intellectual development for blind students, Wait was inventor of the New York Point System (a variant of Braille), 1868, and other learning devices.

WAITE, HENRY MATSON (*b. Toledo, Ohio, 1869; d. Washington, D.C., 1944*), civil engineer, public administrator. Grandson of Morrison R. Waite. B.S., Massachusetts Institute of Technology, 1890. Employed in railroad maintenance and supervision, 1890–1900, chief engineer, Clinchfield Coal Corporation, 1909–12; chief engineer of Cincinnati, Ohio, 1912–14; efficient city manager of Dayton, Ohio, 1914–18. After World War I service in Europe, he practiced in New York City until 1927, when he became chief of planning and construction for the Cincinnati

Union Terminal. On its completion in 1933, he served for a year as deputy administrator of the federal Public Works Administration; from 1934 to 1937, he directed a regional unemployment survey in Cincinnati. Thereafter until his death, he combined private practice with a variety of advisory public service appointments.

WAITE, MORRISON REMICK (*b. Lyme, Conn., 1816; d. 1888*), jurist. Graduated Yale, 1837. Admitted to the Ohio bar, 1839, he practiced *post* 1850 at Toledo, becoming a recognized authority in the law of real estate and the status of legal titles. Active in Whig and Republican politics, he was a leader in his locality in support of the Union cause during the Civil War. After serving, 1871–72, with Caleb Cushing and William M. Evarts, as American counsel in the Geneva Arbitration, he became president of the Ohio constitutional convention of 1873. Named and confirmed as chief justice of the United States, January 1874, he immediately assumed a large share of the work of the U.S. Supreme Court and in his 14 years of tenure gave the Court's opinion in more than a thousand cases. He contributed substantially to clarification of Reconstruction legislation and the constitutional amendments arising our of the Civil War. He reaffirmed the doctrine of the Slaughterhouse Cases in *Minor v. Happersett*. Upholding the right of a state to deny the vote to women, he held that suffrage was not a privilege of U.S. citizenship and that the Fourteenth Amendment did not add to the privileges and immunities of citizens. In *U.S. v. Reese* he demolished the Radical plan of protecting the black by direct federal action, holding sections three and four the Civil Rights Act of May 31, 1870, unconstitutional. In *U.S. v. Cruikshank*, he held that the Fourteenth Amendment did not authorize Congress to legislate affirmatively for the protection of civil rights and did not add to the rights of one citizen against another. In *Munn v. Illinois*, he upheld the power of the state to regulate the charges of grain elevators and public warehouses—businesses that were "clothed with a public interest." Here and in other Granger cases the Court upheld state laws fixing maximum rates on all railroads operating within the state, and by its action profoundly affected the course of American social and economic development. The due process clause was narrowly interpreted while the power of the states was necessarily enlarged. However, it was Waite himself who laid the foundation for the modern interpretation of due process as a limitation on state power. He issued a famous dictum in *Stone v. Farmers Loan and Trust Co.*: "From what has been said it is not to be inferred that this power . . . of regulation is itself without limits . . . It is not a power to destroy . . . The State cannot do that which . . . amounts to a taking of private property . . . without due process of law." Upon this and other dicta rested the decision of the rate cases in 1890 after Waite's death, which made the Supreme Court the final judge in matters of rates. His interpretation of the contract clause constitutes another major contribution to constitutional development. In various decisions he modified profoundly the decision of the doctrine of vested rights as established in the Dartmouth College Case and indicated his willingness to allow the states to exercise wide regulatory power over corporate enterprises in matters pertaining to the "public interest." He strongly upheld the power of Congress to regulate commerce and broadened the sense of that term to include the transfer of intangibles such as telegraphic communications. He scanned very closely the claims of individuals as against the state, even interpreting the Bill of Rights strictly. A skillful and courteous administrator, Waite possessed a style which was eminently judicial, terse, vigorous, and clear. Among other quotable dicta was his statement that "No legislature can bargain away the public health or the public morals."

WAKELEY, JOSEPH BURTON (*b. Danbury, Conn., 1809; d. New York, N.Y., 1875*), Methodist clergyman. Author, among other contributions to the history of early Methodism, of *Lost Chapters Recovered* (1858) and *The Bold Frontier Preacher* (1869).

WAKSMAN, SELMAN ABRAHAM (*b. Novaya Priluka, Ukraine, 1888; d. 1973*), microbiologist and Nobel laureate. Attended Rutgers College (B.S., 1915; M.S., 1916) and the University of California at Berkeley (Ph.D., 1917). Spent most of his professional life at Rutgers, becoming professor of soil microbiology (1929–40), professor of microbiology and chairman of the Microbiology Department (1940–58), and director of the Rutgers Institute of Microbiology (1949–58). In the 1940's and 1950's, he and his colleagues isolated nearly twenty compounds with antibiotic activity toward disease-producing microbes, including streptomycin, which proved effective in controlling the previously uncontrollable tuberculosis organisms. This discovery brought him the 1952 Nobel Prize for medicine or physiology.

WALCOT, CHARLES MELTON (*b. London, England, ca. 1816; d. Philadelphia, Pa., 1868*), actor, dramatist. Father of Charles M. Walcot (1840–1921). Immigrated to Charleston, S.C., *ca.* 1837. Celebrated *ca.* 1840–60 as a light and eccentric comedian and as the author of a number of topical burlesques.

WALCOT, CHARLES MELTON (*b. Boston, Mass., 1840; d. New York, N.Y., 1921*), actor. Son of Charles M. Walcot (*ca.* 1816–1868). Made debut at Charleston, S.C., 1858. Played with companies of Edwin Booth, Laura Keene, and Charlotte Cushman; appeared with his wife *post* 1863 in a number of stock companies, including that of the Walnut Street Threatre, Philadelphia, Pa. They joined the Lyceum Company in New York City, 1887, and remained with it until about the turn of the century.

WALCOTT, CHARLES DOOLITTLE (*b. New York Mills, Oneida Co., N.Y., 1850; d. 1927*), paleontologist. Early interested in the collection of fossils and minerals, Walcott was employed by James Hall (1811–98), the New York State geologist, 1876. He was appointed a field assistant with the U.S. Geological Survey, 1879. Gradually advancing in rank with the Survey, he became chief geologist, 1893, and succeeded John W. Powell as director, 1894. Serving in this post until 1907, he developed and strengthened the Survey along lines already laid down, also taking an active part in the work which led to the establishment of the U.S. Forest Service and the Bureau of Mines. As secretary of the Smithsonian Institution, *post* 1907, he handled its affairs with high executive ability and was influential in founding the Freer Gallery, the Carnegie Institution, the National Research Council, and the National Advisory Committee for Aeronautics. Continuing his field work along with his administrative tasks, he was author of 222 papers of which 110 dealt with the Cambrian formations. Among these works, the most considerable was his *Cambrian Brachiopoda* (1912). The most striking of his field discoveries was that of the Middle Cambrian Burgess shale of British Columbia.

WALCOTT, HENRY PICKERING (*b. Hopkinton, Mass., 1838; d. Cambridge, Mass., 1932*), physician. Graduated Harvard, 1858; M.D., Bowdoin, 1861. After further studies in Vienna and Berlin, he practiced in Cambridge, Mass. Chairman of the Massachusetts State Board of Health, 1886–1915, he widened the Board's influence by giving it advisory power over public water supplies, sewerage, and the protection of the purity of inland waters. He was chairman of the commission which recommended the building of the Charles River Basin, 1893, and planned the metropolitan water supply system of Boston. The most important man in the field of public health in his day, he expressed in his annual reports germinal ideas which have deeply influenced the public health movement in America.

WALD, LILLIAN D. (*b. Cincinnati, Ohio, 1867; d. Westport, Conn., 1940*), public health nurse, settlement house founder. Graduated New York Hospital 1891; studied also at Women's Medical College, New York City. Asked to organize a course of instruction in home nursing for immigrant families on New York's lower East Side, 1893, she soon discovered at first hand the need for reform of conditions under which the immigrants were living. Going to live with an associate in an East Side tenement, she secured financial support from a number of benefactors, notably Jacob H. Schiff, and founded the Nurses' Settlement (*post* 1895 at 265 Henry St.). The settlement house and visiting nurse services which were developed at Henry St. were pioneering innovations. Miss Wald largely originated the concept of public health nursing and the public school nursing system. At her suggestion, several life insurance companies undertook nursing service for their policyholders. Visiting the sick in their homes had revealed many social needs which Wald moved to meet; these included instruction in cooking and sewing, programs in music and art, and the organization of clubs for boys' and girls' recreation. She was also influential in efforts to obtain better housing, to regulate sweatshops, and to abolish child labor. Declining health caused her to retire as head worker at Henry St. 1933.

WALDEN, JACOB TREADWELL (*b. Walden, N.Y., 1830; d. Boston, Mass., 1918*), Episcopal clergyman, author. A rector at various times in Philadelphia, Pa., Indianapolis, Ind., Boston, Mass., and Minneapolis, Minn., he aided in the liberalizing movement by which the broad church group evolved.

WALDEN, JOHN MORGAN (*b. near Lebanon, Ohio, 1831; d. 1914*), Free-soil journalist in Illinois and Kansas, Methodist clergyman. Active in the Cincinnati Conference, 1858–68; able executive of the Western Methodist Book Concern *post* 1868; elected bishop, 1884. Worked for the improvement of the condition of blacks.

WALDERNE, RICHARD (*b. Alchester, Warwickshire, England, ca. 1615; d. Cochecho, present Dover, N.H., 1689*), pioneer. Immigrated to New England, *ca.* 1640. Settled at present Dover, N.H., where he engaged in lumbering and Indian trade and filled at various times practically all important local offices. Member of the Massachusetts General Court, 1654–74 and 1677; appointed to the president's Council of New Hampshire, 1860. Killed by Indians in reprisal for treacherous seizure of refugee tribesmen and their subsequent sale into slavery.

WALDO, DAVID (*b. Clarksburg, present W. Va., 1802; d. Independence, Mo., 1878*), physician, banker, merchant. Removed to Missouri, 1820, and to Taos in present New Mexico *ante* 1829. Becoming a citizen of Mexico, 1830, he amassed a great fortune in the Santa Fe trade, and served as a captain in the regiment commanded by A. W. Doniphan during the Mexican War. Maker and loser of several fortunes in the overland trade, Waldo later executed provision contracts for the U.S. Army and engaged in banking.

WALDO, SAMUEL (*b. Boston, Mass., 1695; d. near present Bangor, Maine, 1759*), merchant, capitalist, land speculator. Attempted for many years to develop wild lands on the Maine coast between the Muscongus and Penobscot rivers (known *post ca.* 1731 as the Waldo Patent). Served as brigadier general and second-in-command of the Massachusetts forces in the Louisburg campaign of 1745. At first a close friend and associate of William Shirley, he had become a bitter enemy of Shirley by the 1750's.

WALDO, SAMUEL LOVETT (*b. Windham, Conn., 1783; d. New York, N.Y., 1861*), portrait painter. Mainly self-taught, Waldo met with his first success in Charleston, S.C., 1804–06. In England, 1806–09, he settled in New York City on his return, where he worked diligently, *post* 1820 in partnership with William Jewett. The firm produced a great number of excellent if somewhat literal likenesses.

WALDO, SAMUEL PUTNAM (*b. Pomfret, Conn., 1779; d. Hartford, Conn., 1826*), lawyer, miscellaneous writer. Author of a number of biographies of great contemporaries in which his formula was a pound of rhetoric to an ounce of fact. Compiled the very popular *Journal Comprising an Account of the Loss of the Brig Commerce . . . by Archibald Robbins* (1817).

WALDRON, RICHARD See WALDERNE, RICHARD.

WALES, JAMES ALBERT (*b. Clyde, Ohio, 1852; d. 1886*), cartoonist. Trained as a wood engraver, he began to draw political cartoons for the *Cleveland Leader*; removing to New York, N.Y., 1873, he worked, among other papers, for *Frank Leslie's Illustrated Newspaper*. Resident for a short time in London, he became a staff member of *Puck*, 1877, and established his reputation by a series of full-page political portraits entitled "Puck's Pantheon." Less vindictive in satire than Thomas Nast but more of a realist than Joseph Keppler, Wales had a decided gift for portraiture.

WALES, LEONARD EUGENE (*b. Wilmington, Del., 1823; d. Wilmington, 1897*), jurist. Associate justice, Delaware superior court, 1864–84; U.S. judge for the district of Delaware, 1884–97.

WALGREEN, CHARLES RUDOLPH (*b. near Galesburg, Ill., 1873; d. Chicago, Ill., 1939*), pharmacist, drugstore chain founder. Organized C. R. Walgreen & Co. in Chicago, 1909. A leader in modernization of the drugstore, he popularized the lunch counter, open-display merchandising, and attractive decoration in his shops.

WALKE, HENRY (*b. Princess Anne Co., Va., 1808; d. Brooklyn, N.Y., 1896*), naval officer. Raised in Ohio. Appointed midshipman, 1827. Evacuated Union garrison and others from Pensacola Navy Yard, January, 1861, after its seizure by the South. In service with Foote's flotilla on the upper Mississippi, 1861–63, he won high distinction as captain of the *Carondelet* in the actions at Fort Henry and Fort Donelson. His most celebrated exploit was the running of the batteries at Island No. 10, an operation which he alone favored in the preliminary council, volunteered for, and executed successfully on the night of Apr. 4, 1862. He was later conspicuous in engagements with Confederate forces above Fort Pillow and in a running fight with the ram *Arkansas* in the Yazoo River, July 15. Commanding the ironclad *Lafayette*, he shared in the reduction of Vicksburg. He was later active against Confederate raiders in the Atlantic. Promoted rear admiral, 1870, he retired, 1871.

WALKER, ALEXANDER (*b. Fredericksburg, Va., 1818; d. Fort Smith, Ark., 1893*), New Orleans lawyer and journalist. Removed to New Orleans, La., 1840; edited and managed at various times the Democratic *Jeffersonian*, the *Daily Delta*, the *New Orleans Times*, the *Herald*, and the *Daily Picayune*. A firm believer in "manifest destiny," he was one of the supporters of the filibuster William Walker, and backed the expedition of General Narciso Lopez to Cuba, 1851.

WALKER, AMASA (*b. Woodstock, Conn., 1799; d. 1875*), Boston businessman, Massachusetts legislator and congressman, economist. Father of Francis A Walker. Especially interested in the monetary system, he was author of, among other works, *The Nature and Uses of Money and Mixed Currency* (1857) and *The Science of Wealth* (1866).

WALKER, ASA (*b. Portsmouth, N.H., 1845; d. Annapolis, Md., 1916*), naval officer. Graduated U.S. Naval Academy, 1866. An expert navigator, he was author of *Navigation* (1888), long used as a textbook at the Naval Academy. Walker commanded the USS *Concord* under Admiral Dewey at the battle of Manila Bay, winning high commendation. Commissioned rear admiral, 1906, he retired, 1907.

WALKER, MADAME C. J. See WALKER, SARAH BREEDLOVE.

WALKER, DAVID (*b. Wilmington, N.C., 1785; d. 1830*), black leader. A free black, Walker traveled widely in the South as a youth, and was established as a clothing dealer in Boston, Mass., *ante* 1827. He is best known as author of *Walker's Appeal* (1829 and later editions) in which he called upon blacks to rise against their oppressors if the slaveholders refused to let their victims go. At the same time he pleaded with the slaveholders to repent of their past actions for fear of God's wrath. A violent reaction to this pamphlet was immediate in the South, and a price was set on the author's head.

WALKER, DAVID (*b. present Todd Co., Ky., 1806; d. 1879*), jurist, Arkansas legislator. Cousin of David S. Walker. Settled in Fayetteville, Ark., *ca.* 1831. Justice, supreme court of Arkansas, 1848–67, 1874–78. Originally opposed secession as president of Arkansas convention, 1861, but followed the general sentiment in his state after bombardment of Fort Sumter.

WALKER, DAVID SHELBY (*b. near Russellville, Ky., 1815; d. Tallahassee, Fla., 1891*), jurist, Florida legislator. Cousin of David Walker (1806–79). Removed to Tallahassee, 1837. Register of public lands and *ex-officio* state superintendent of schools, 1850–59, he was influential in securing passage of the basic school law of 1853. Justice, Florida supreme court, 1859–65, he opposed Florida secession and confined himself to judicial duties during the Civil War. As governor of Florida, 1866–67, he opposed bringing immigrants to Florida, contending that the blacks had the right to furnish the labor supply. He ranks generally among the best of his state's governors. He served as judge of the second state judicial *circuit post* 1879.

WALKER, FRANCIS AMASA (*b. Boston, Mass., 1840; d. 1897*), lawyer, Union soldier, educator, economist. Son of Amasa Walker. Graduated Amherst, 1860. Rising from private to brevet brigadier general in the Civil War, he became a deputy to David A. Wells, commissioner of the revenue, 1869, and chief of the Bureau of Statistics. He reorganized the Bureau along scientific lines and struggled to free it from dependence upon political appointments and special interests. His experience in superintending the census of 1870 without adequate authority was useful to him later as superintendent of the tenth census (1879–81), for which he appointed his own staff of tellers and in which he established his reputation as a statistician. Meanwhile he had served as commissioner of Indian affairs, November 1871–December 1872, with great ability, and, as professor of political economy in Sheffield Scientific School of Yale, 1873–81, had become a leading figure in a new inductive and historical school of economics.

Of first importance was his attack upon the wages-fund theory. He showed that wages were not wholly dependent upon the amount of preexisting capital, but also, and more particularly, upon the current productivity of labor. According to his theory of distribution, which aroused controversy, interest was regulated by a general principle of supply and demand, the profits of the

entrepreneur were like rent, and the laborer was left "as the residual claimant to the remaining portion of the product." He believed competition to be the fundamental basis of economic life but recognized that perfect competition is not attained in practice. He defined money to include bank notes and everything serving as a medium of exchange. He asserted that the government had the right to declare irredeemable paper legal tender, adding that governments were not yet wise enough to avoid over-issue and effectively exposing the inflation fallacy. He held throughout his life to the doctrine of international bimetallism and lectured widely in its behalf. Opposed to any blind acceptance of *laissezfaire*, he advocated a limited reduction of hours of labor from fourteen to ten for increased efficiency; he thought unemployment was due chiefly to the effects of worldwide division of labor. Relations between labor and capital seemed to him in 1888 to have reached an equilibrium which could not be disturbed without threat to the public welfare. His influence extended into England (markedly), Italy, and France, but not far into Germany, and as a theoretical economist he stood higher abroad than at home. A freetrader, he was attacked by other freetraders because he was willing to concede that the protectionists had at least a claim to a hearing.

As president of Massachusetts Institute of Technology, 1881–97, he won public recognition for technical education and extended the physical plant of the Institute. Among the educational reforms which he championed were an insistence on the laboratory method in order to maintain the interest of students of mechanical trend as well as those of retentive memory, and also the inclusion of studies in history and political science in technical schools. He opposed absorption of the Institute by Harvard because he believed that technical schools should maintain a separate identity in order to keep free of the arrogance of the classical disciplines. He was author, among other works, of *The Indian Question* (1874), *The Wages Question* (1876), *Money* (1878), *Land and Its Rent* (1883), and *International Bimetallism* (1896).

WALKER, FRANK COMERFORD (*b. Plymouth, Pa., 1886; d. New York, N.Y., 1959*), lawyer and government official. Grew up in Butte, Mont. Studied at Gonzaga University and at Notre Dame (LL.B., 1909). After practicing law in Butte and serving in state legislature, Walker moved to New York. Became active in Democratic politics in 1928. A backer of Roosevelt and a strong fund raiser among Catholics for the president, he was appointed treasurer of the Democratic National Committee in 1932; chairman 1943–44. Director, National Emergency Council (1933–35). Postmaster general (1940–45). Tenure marked by censorship of *Esquire* magazine as being obscene, which was overturned by the courts. Public career based on personal loyalty to Roosevelt rather than a dedication to politics.

WALKER, GILBERT CARLTON (*b. Cuba, N.Y., 1832; d. New York, N.Y., 1885*), lawyer. After practice in Owego, N.Y., and Chicago, Ill., he removed to Norfolk, Va., 1865, where he engaged in business and banking. After the Virginia constitutional convention of 1867, he helped to secure federal approval of the new constitution without a provision for disfranchisement of Confederates who had held office under the United States. Elected governor of Virginia as a "Conservative" Republican with Democratic support, he served from 1869 through 1874. Successful in restoring Virginia to the Union and in enforcement of law and order, he pursued a fiscal policy which was unworkable and by which, it was believed, he profited personally. His funding of the state's debt was done on very hard terms, and Virginia's interests in transportation companies were diverted to private hands. After service in Congress, 1875–79, he returned to New York State.

WALKER, HENRY OLIVER (*b. Boston, Mass., 1843; d. Belmont, Mass., 1929*), painter. Studied in Paris, France, under Léon Bonnat, 1879–82; worked in Boston, 1883–89; removed to New York City *ca.* 1889. A portraitist and painter of ideal figures, he made a special mark as a muralist. His *Joy and Memory* and *Lyric Poetry* in the Library of Congress are among the most decorative of the many mural works there. He painted other effective works for the Massachusetts State House and the Appellate Court House, New York City.

WALKER, JAMES (*b. present Burlington, Mass., 1794; d. Cambridge, Mass., 1874*), Unitarian clergyman. Graduated Harvard, 1814. Pastor, Harvard Church, Charlestown, Mass., 1818–39; Alford Professor of Natural Religion, etc., Harvard, 1839–53; president of Harvard, 1853–60. A man of erudite but not original mind, he derived almost his entire thought from the Scotch Realists and was the preeminent expounder of the metaphysics of early 19th-century Unitarianism — a common-sense rationalism combined with a simple piety and a lofty ethical tone. His administration of Harvard was competent but uneventful.

WALKER, JAMES BARR (*b. Philadelphia, Pa., 1805; d. Wheaton, Ill., 1887*), Presbyterian and Congregational clergyman, antislavery journalist in Ohio and Illinois. Author of *The Philosophy of the Plan of Salvation* (published anonymously, 1841), a widely popular treatise on Christian apologetics. Professor of philosophy and belles lettres, Wheaton College, Wheaton, Ill., 1870–84.

WALKER, JAMES JOHN (*b. New York, N.Y., 1881; d. New York, 1946*), lawyer, politician, son of a lumberyard owner who was active in local Democratic politics. An indifferent and undisciplined student, he dropped out of the College of St. Francis Xavier (New York City) after a year and out of business school after three months. He enrolled at the New York Law School in 1902 and graduated two years later, but almost a decade passed before he became a member of the New York bar. He spent the intervening time in Tin Pan Alley, grinding out lyrics for popular ballads. In 1905 he scored a minor success with the lyrics for "Will You Love Me in December as You Do in May?" On Apr. 11, 1912, he married Janet Frances Allen, a musical comedy singer and vaudeville performer.

At thirty Walker quit songwriting for politics. His style and values, however, remained those of a man who had started out in show business, and he continued to frequent the world populated by celebrities and characters of the type chronicled by Damon Runyon. In 1909 Walker received the Democratic nomination for the safe state assembly seat from Greenwich Village. He was elevated to the state senate in 1914 and was leader of his party in that body from 1921 to 1925. In 1925 Al Smith and other party leaders picked Walker as an attractive contrast to the blundering incumbent mayor of New York. Walker won the election by more then 400,000 votes. Four years later he won reelection by an even wider margin against Fiorello La Guardia.

Walker introduced many innovations in New York City but the major reason for his popularity was that he embodied qualities that so many of his contemporaries admired during the Jazz Age. An official investigation began to uncover graft and incompetence in his administration, and in 1931 the legislature appointed a committee to investigate the city government in general. Walker failed to give a satisfactory explanation of either the chaos of his administration or the unorthodoxy of his personal finances. His resignation on Sept. 1, 1932, ended one of the more colorful careers in American politics.

WALKER, JOHN BRISBEN (*b. near Pittsburgh, Pa., 1847; d. 1931*), iron manufacturer, rancher, journalist. As publisher and editor of the *Cosmopolitan Magazine*, 1889–1905, he made it

one of the leading American illustrated magazines of that time. Of a restless and adventurous turn of mind, he engaged in political activity and urged economic and other reforms. An enthusiast for aviation, automobiles, and good roads, he offered a prize in 1896 for the automobile showing the greatest speed, safety, and ease of operation at low cost which was won by the Duryea car. In 1898 he bought the Stanley Automobile Co. and began the manufacture of Locomobile steam cars.

WALKER, JOHN GRIMES (*b. Hillsboro, N.H., 1835; d. near Ogunquit, Maine, 1907*), naval officer. Nephew of James W. Grimes. Graduated U.S. Naval Academy, 1856; rose to rank of commander for his Civil War service under Adm. D. D. Porter in Mississippi River operations. Recognized as the most influential officer in the navy during his later career, he was chief of the Bureau of Navigation, 1881–89, held important sea commands, and was in charge of the North Pacific Squadron, 1894, during establishment of the Hawaiian Republic. Retired as commodore, 1897, he served as president of the Isthmian Canal Commission, 1899–1904. He headed the reorganized Commission which administered the Canal Zone until 1905.

WALKER, JONATHAN HOGE (*b. near Hogestown, Pa., 1754; d. Natchez, Miss., 1824*), lawyer. Father of Robert J. Walker. Began practice in Northumberland Co., Pa., 1790, where he was an associate in politics of Robert Whitehill and Thomas Cooper. President judge of the fourth Pennsylvania district, 1806–18; U.S. judge, district of western Pennsylvania, *post* 1818.

WALKER, JOSEPH REDDEFORD (*b. probably Virginia, 1798; d. Contra Costa Co., Calif., 1876*), trapper, explorer, guide. Raised in Roane Co., Tenn.; removed to vicinity of Independence, Mo., 1819. After trading and trapping out of Independence, he joined Bonneville's company which left Fort Osage for the mountains, May 1832. In July 1833, from the Green River rendezvous, he set off westward, first to Great Salt Lake, then to the Humboldt River, and on to what has since been known as Walker Lake. Scaling the Sierra Nevada with great difficulty, he and his group reached Monterey, Calif. in November, and were probably the first whites to cross the Sierra from the East, and also, it is believed, the first to see the Yosemite Valley. On his return east in February 1834, Walker crossed the mountains farther south by what is now known as Walkers Pass and rejoined Bonneville in the present Utah in the early summer. Remaining in the mountains for some nine years, he joined J. B. Chiles' emigrant company at Fort Bridger, August 1843, and led a part of it by way of Walkers Pass to the coast. Overtaking John C. Frémont's second expedition on its return journey, he accompanied it to Bent's Fort. He was the guide to Frémont's third expedition (1845–46) to California. Resident for a short time in Jackson Co., Mo., he reached California among the first of the Forty-niners. He led a company to Arizona 1861, an discovered rich placers on the site of present Prescott, 1862. His knowledge of the geography of the West was outstanding.

WALKER, LEROY POPE (*b. Huntsville, Ala., 1817; d. Huntsville, 1884*), Alabama lawyer, legislator, and jurist. Identified with the secessionist wing of the Democratic party by 1860, he was chairman of the Alabama delegation to his party's convention of that year at Charleston, S.C., and as such announced the withdrawal of the delegation. He was delegate also to the Richmond convention and was sent by the Alabama secession convention as special commissioner to induce Tennessee to secede. Recommended by W. L. Yancey, he was appointed Confederate secretary of war, February 1861. Utterly inexperienced, he resigned in September and served thereafter in several area commands and as judge of a military court until 1865.

WALKER, MARY EDWARDS (*b. Oswego, N.Y., 1832; d. near Oswego, 1919*), physician. Certified by Syracuse Medical College, 1855, Dr. Walker was a lifelong campaigner for woman's rights. Early in her career she adopted men's dress. After service in the Union Army medical corps, 1861–65, she practiced in Washington, D.C. She was principally famous as a lecturer in favor of dress reform, woman suffrage, the abolition of capital punishment, and other reforms, but her consuming egotism is said to have alienated similarly-minded persons.

WALKER, PINKNEY HOUSTON (*b. Adair Co., Ky., 1815; d. 1885*), jurist. Admitted to the Illinois bar, 1839. A judge of the Illinois circuit court, 1853–58, he served thereafter as a justice of the state supreme court. He was chief justice, 1864–67 and 1874–75. Author during his judicial career of about 3000 opinions, he was known for integrity, fairness, and clarity of reasoning. Among his most important opinions were *Starkweather* v. *American Bible Society* and *Ruggles* v. *People*. He concurred in the opinion in *Munn* v. *Illinois*.

WALKER, REUBEN LINDSAY (*b. Logan, Va., 1827; d. Virginia, 1890*), Confederate brigadier general, civil engineer. Greatgrandson of Thomas Walker. Graduated Virginia Military Institute, 1845. Served throughout the Civil War without a day's leave of absence, principally in command of the artillery of A. P. Hill's division (later corps). After the war he engaged in farming and in railroad and contracting work.

WALKER, ROBERT FRANKLIN (*b. Florence, Mo., 1850; d. Jefferson City, Mo., 1930*), Missouri legal official and jurist. As judge of the supreme court of Missouri *post* 1912, he did his most important work in criminal appeals and tactfully mitigated the older Missouri doctrine that all error presumes prejudice against the defendant.

WALKER, ROBERT JOHN (*b. Northumberland, Pa., 1801; d. Washington, D.C., 1869*), lawyer, public official. Son of Jonathan H. Walker. Admitted to the bar in Pittsburgh, Pa., 1821, he soon became a leader of the Democratic party in the state, but removed to Natchez, Miss., 1826. Successful in practice and as a land speculator, he posed as the friend of the squatter and small farmer and was a follower of Andrew Jackson. As U.S. senator from Mississippi, 1836–45, he was identified with the anti-Bank and repudiating party in his state. He spoke often in favor of preemption, lower land prices, and the independent treasury plan; he opposed distribution of the surplus, the protective tariff, and abolition. His service as senator is chiefly memorable for his activities in connection with the annexation of Texas. He was author of the resolution of January 1837 calling for recognition of Texan independence, and was one of President Tyler's foremost allies in efforts to add Texas to the Union, 1843–45.

Walker appears to have been at the center of the manipulations which resulted in the rejection of Martin Van Buren and the nominations of James K. Polk, 1844. After drafting the compromise resolutions which resolved the Senate deadlock over annexation of Texas, February 1845, he became secretary of the treasury. A hardworking secretary, he secured establishment of the independent treasury system for handling public money and financed the conduct of the Mexican War on favorable terms and without scandal. His report of 1845 on the state of the finances became a classic of free-trade literature and remains a very able state paper. He also established the government warehousing system for the handling of imports, and was mainly responsible for creation of the Department of the Interior in 1849. An advocate of seizure of the whole of Mexico, 1847, Walker is believed to have lobbied for the rejection of the Trist treaty, February 1848.

Between 1849 and 1857 Walker lived in Washington, D.C., attending to his speculative interests. Appointed governor of Kansas Territory, March 1857, he had an understanding with President Buchanan that the bonafide residents of Kansas should choose their social institutions by a fair vote. His inaugural address contained the thesis that climatic conditions would be the ultimate determinant of the location of slavery and aroused a storm of protest in the South. Despite his attempts to conciliate the freestate party in Kansas and his own conviction that Kansas would be free state, he failed in his attempts to settle the Kansas difficulties because of the failure of the administration to support him. He resigned in December 1857 when he was unable to persuade Buchanan that the so-called ratification of the Lecompton Constitution was unacceptable. Himself a Free-soiler as early as 1849 and said to have freed his slaves in 1838, Walker was a Unionist in the Civil War and was active in the sale in Europe offederal bonds. After the war he aided in putting the Alaska purchase bill through Congress and was hopeful of annexing Nova Scotia to the United States.

WALKER, SARAH BREEDLOVE (*b. Delta, La., 1867; d. Irvington-on-Hudson, N.Y., 1919*), pioneer black businesswoman, philanthropist. Known throughout later life as Madame C. J. Walker. Educated in public night schools of St. Louis, Mo., Mrs. Walker discovered in 1905 the formula of a hair preparation for blacks which she sold by mail with great success. Settling her business in Indianapolis, Ind., 1910, she manufactured various cosmetics and maintained a training school for agents and beauty culturists. One of her most original ideas was the organization of her agents into clubs for business, social, and philanthropic purposes. She willed two-thirds of her estate to educational institutions and charities.

WALKER, SEARS COOK (*b. Wilmington, Mass., 1805; d. Cincinnati, Ohio, 1853*), mathematician, astronomer. Brother of Timothy Walker (1802–56). Graduated Harvard, 1825. Founded one of earliest astronomical observatories in the United States, 1827, in connection with the Philadelphia High School. Associated *post* 1845 with the U.S. Naval Observatory, Washington, D.C., and with the U.S. Coast Survey, he made important researches in the orbit of the planet Neptune, 1847. He originated the telegraphing of transits of stars and application of the graphic registration of time-results to the registry of time-observations for general astronomical purposes.

WALKER, STUART ARMSTRONG (*b. Augusta, Ky., 1880; d. Beverly Hills, Calif., 1941*), playwright, theatrical producer, film director. Graduated in engineering, University of Cincinnati, 1903. Devoted to the theater from boyhood, he worked for David Belasco as actor, play reader, and director, 1909–14, and for a year as director for Jessie Bonstelle. Eager to make imaginative drama of high quality available to people in every part of the nation, he organized the "Portmanteau Theater" (1915–17), an innovative traveling repertory company, which expressed the best elements in the "little theater" movement's challenge to the mediocrity of the commercial stage. In 1917, he became resident director of the Indianapolis Repertory Company; from 1922 to 1931, he directed the Cincinnati Repertory; in both posts, he continued his previous success in experimental theater and the training of young actors. Thereafter, he was employed as screen writer, acting coach, and director in Hollywood.

WALKER, THOMAS (*b. King and Queen Co., Va., 1715; d. present Albermarle Co., Va., 1794*), physician, soldier, explorer. Studied medicine at Williamsburg, Va., and practiced in Fredericksburg. Joined company of land speculators who explored the southern end of the valley of Virginia, 1748; became chief agent for Loyal Land Company, 1749. Explored westward in 1750 to examine land claims, becoming first white man to have made a recorded expedition to the Kentucky country (as established by his journal, published 1888). Commissary general to Virginia troops serving under George Washington, 1755, he was charged with misconduct for entering partnership with Andrew Lewis in the supply business. Acted as guardian for Thomas Jefferson. Represented Virginia at treaty of Fort Stanwix, 1768; thereafter took important part in Revolutionary movement. A member of the executive council of Virginia and of the House of Delegates, he was typical of the men of action who explored and exploited the early frontier.

WALKER, THOMAS BARLOW (*b. Xenia, Ohio, 1840; d. 1928*), Minnesota lumber magnate, founder of the Walker Art Gallery, Minneapolis.

WALKER, TIMOTHY (*b. Woburn, Mass., 1705; d. Concord, N.H., 1782*), Congregational clergyman. Father-in-law of Benjamin Thompson. Graduated Harvard, 1725. Pastor in present Concord, N.H., 1730–82. He acted as agent for the settlers there in securing a Crown decision which validated their titles to the lands after transfer of the township from Massachusetts to New Hampshire sovereignty. To this end he traveled to England in 1753, 1755, and 1762.

WALKER, TIMOTHY (*b. Wilmington, Mass., 1802; d. Cincinnati, Ohio, 1856*), Ohio lawyer, legal writer, jurist, and law teacher. Brother of Sears C. Walker. Practiced and taught law in Cincinnati *post* 1831. Author of the influential *Introduction to American Law* (1837), a statement of the elementary principles of American jurisprudence.

WALKER, WALTON HARRIS (*b. Belton, Tex., 1889; d. near Seoul, Korea, 1950*), army officer. Graduated West Point, 1912; commissioned in infantry. Served with distinction in World War I; during the 1920's, graduated from the Field Artillery School, the Infantry School, and the Command and General Staff College, Also during the 1920's, he served as instructor at the Infantry and Coast Artillery schools and as a tactical officer at West Point. From 1930 to 1933 he was on railroad patrol in Tientsin, China. After a series of promotions and commands in the United States, Walker became head of the XX Corps, which entered combat in France in August 1944. Walker's troops captured Angers, Chartres, and Rheims. After crossing the Rhine, the so-called Ghost Corps captured Kassel and liberated Buchenwald. In the Korean War, Walker further distinguished himself and commanded all ground troops. Driving into North Korea he captured the capital, Pyongyang. He was killed in a jeep accident.

WALKER, WILLIAM (*b. Nashville, Tenn., 1824; d. Trujillo, Honduras, 1860*), adventurer, greatest of American filibusters. Graduated University of Nashville, 1838; M.D., University of Pennsylvania, 1843; after studying law, was admitted to the bar in New Orleans, La. Failing to succeed as lawyer and journalist, he removed to California, 1850, where he practiced at Marysville. Invading the Mexican province of Lower California with an armed expedition, 1853, he proclaimed himself president of an independent republic there, but was forced to return to the United States. He was acquitted after trial for violation of the neutrality laws. Invited by the leader of a revolutionary faction in Nicaragua, Walker led a small, armed band there in 1855. With the help of the Accessory Transit Co., an American concern, he seized control of Nicaragua and, after recognition of his regime by the United States in May 1856, had himself inaugurated as president. Ambitious to unite the Central American republics into a single military empire, he planned an interoceanic

canal and attempted to reintroduce African slavery. Undertaking to double-cross Cornelius Vanderbilt in a struggle for control of the Accessory Transit Co., he was driven from his presidency after a coalition of neighboring republics was formed against him with Vanderbilt's aid. Returning to the United States, 1857, he attempted an invasion of Nicaragua late in the year, but was arrested on landing by Commodore Hiram Paulding of the U.S. Navy and sent back to the United States. Arrested by British authorities after a landing in Honduras, 1860, he was condemned to death by a court-martial of Honduran officers and shot. A small man, extremely shy and reticent, he was yet able to maintain iron discipline and something like personal devotion among his desperate followers. He was author of *The War in Nicaragua* (1860).

WALKER, WILLIAM HENRY TALBOT (*b. Augusta, Ga., 1816; d. near Atlanta, Ga., 1864*), soldier. Graduated West Point, 1837. Commissioned in the infantry, he served in the Florida Indian War and in the Mexican War. Badly wounded at Molino del Rey, 1847, he undertook minor duties and went on sick leave for a great part of the time until 1860 when he resigned his commission. In service mainly with Georgia state troops, 1861–63, he entered the Confederate service as a brigadier general and was appointed major general, January 1864. Active in the western campaigns, he was with the Army of Tennessee during the northern Georgia campaign and was killed in a sortie out of Atlanta.

WALKER, WILLIAM JOHNSON (*b. Charlestown, Mass., 1790; d. 1865*), physician, financier. A successful practitioner at Charlestown *post* 1816, he accumulated a large fortune in railroad and manufacturing stocks which he devoted to the endowment of Amherst, Tufts College, the Boston Society of Natural History, and Massachusetts Institute of Technology.

WALKER, WILLISTON (*b. Portland, Maine, 1860; d. 1922*), church historian. Graduated Amherst, 1883; Hartford Theological Seminary, 1886; Ph.D., Leipzig, 1888. Taught church history at Hartford, 1889–1901; at Yale, 1901–22. Provost of Yale *post* 1919. A teacher of great ability, Walker made his major contributions to scholarship in the field of New England Congregational history; he was actively concerned in work for Christian unity and for missions.

WALLACE, CHARLES WILLIAM (*b. Hopkins, Mo., 1865; d. Wichita Falls, Tex., 1932*), educator, Shakespeare scholar. Graduated University of Nebraska, 1898; did graduate work at Nebraska and at University of Chicago; Ph.D., Freiburg im Breisgau, 1906. Taught English at University of Nebraska *post* 1901. Applied proceeds of successful work as oil operator in Texas to furtherance of research in history of the early English stage.

WALLACE, DAVID (*b. Pennsylvania, 1799; d. Indianapolis, Ind., 1859*), lawyer. Father of Lewis Wallace. Raised on Ohio and Indiana frontiers. Graduated West Point, 1821. Admitted to the Indiana bar, 1824, he succeeded in practice and was one of the Whig leaders in Indiana. Lieutenant governor, 1831–37, and governor of Indiana, 1837–40, he lost the state millions in money through procuring loans for public improvements from Eastern speculators. Whig congressman, 1841–43, he returned to the practice of law in Indianapolis and died while a judge of the court of common pleas.

WALLACE, HENRY (*b. near West Newton, Pa., 1836; d. 1916*), United Presbyterian clergyman, editor and writer on agricultural subjects. Father of Henry C. Wallace. A pastor in Illinois and Iowa, 1863–76, he took up farming as a way of recovering his health and soon entered agricultural journalism. With his son, he began publishing *Wallace's Farmer*, 1895, and was its editor

until his death. He was president of the National Conservation Congress, 1910.

WALLACE, HENRY AGARD (*b. Orient, Iowa, 1888; d. Danbury, Conn., 1965*), agricultural scientist, editor, government official, and politician. Attended Iowa State (B.S., 1910). Experimented with various strains of corn and produced the first hybrid corn suitable for commercial use; wrote for and edited *Wallace's Farmer*, a family-owned newspaper, assuming the editorship in 1921. U.S. secretary of agriculture (1932–40), concentrating on drafting and securing approval of legislation to assist farmers; he implemented the domestic allotment plan, whereby farmers were eligible to receive support payments for decreasing output; authorized paying cotton and hog farmers for plowing up 10 million acres of growing cotton and for slaughtering 6 million pigs (1933); promoted efforts to find markets abroad for American goods; and staunchly advocated reciprocal trade agreements to lower trade barriers and increase world commerce. The institution of support payments for crop control, soil conservation, food stamp distribution, and government-operated warehouses for storing surpluses helped alleviate the distress of farmers during the Great Depression. Elected vice president (1940) and made goodwill tours to Mexico, Latin America, Soviet Asia, and China. His appeals for responsible American leadership to foster lasting peace and global prosperity in the postwar world commanded wide attention. His pronouncements about postwar policies made him the leading spokesman for liberal opinion in the country and a target for conservatives. President Franklin Roosevelt's tepid endorsement of him for a second term in 1944 doomed his chances for renomination. Named secretary of commerce after the election, he called for extension of the 1934 Trade Agreements Act as one way to promote international economic cooperation and world peace and supported federal programs to provide full employment and higher standards of living. He became increasingly outspoken in calling for U.S. policies to ease tensions with Russia, including economic assistance as well as international control of atomic energy. A public uproar in response to one of his speeches prompted President Harry Truman to dismiss him in 1946. By late 1947 his views had alienated him from the overwhelming majority of Americans, including most liberals.

WALLACE, HENRY CANTWELL (*b. Rock Island, Ill., 1866; d. Washington, D.C., 1924*), agricultural journalist. Son of Henry Wallace; father of Henry A. Wallace. Graduated Iowa State Agricultural College, 1892. Associated with his father in publishing *Wallace's Farmer post* 1895, he became its editor, 1916. As U.S. secretary of agriculture, 1921–24, he emphasized that department's role in the adjustment of production to the needs of consumption, and opposed transfer of its marketing functions to the Department of Commerce. He was a champion of conservation, supported the principles of the McNary-Haugen Bill, established the bureau of agricultural economics and the bureau of home economics in his department, and inaugurated radio market reports.

WALLACE, HORACE BINNEY (*b. Philadelphia, Pa., 1817; d. Paris, France, 1852*), lawyer, literary, art, and legal critic. Brother of John W. Wallace. Graduated College of New Jersey (Princeton), 1835. Author of a novel *Stanley, or the Recollections of a Man of the World* (issued anonymously, 1838), and of two collections of critical and philosophical essays published posthumously. Editor, with J. I. C. Hare, of J. W. Smith's *A Selection of Leading Cases*, and also of *Select Decisions of American Courts* (1847, revised in 1857 as *American Leading Cases*). Auguste Comte recognized Wallace as his leading American disciple.

WALLACE, HUGH CAMPBELL (*b. Lexington, Mo., 1863; d. Washington, D.C., 1931*), financier, diplomat. Identified *post* 1887 with the commercial development of Tacoma, Wash., Wallace became one of the most influential financiers of the Northwest and was a leader of the Democratic party in that region. A trusted adviser to President Woodrow Wilson, he served as U.S. ambassador to France, 1919–21, exercising considerable private influence after the withdrawal of the American delegation to the Peace Conference.

WALLACE, JOHN FINDLEY (*b. Fall River, Mass., 1852; d. Washington, D.C., 1921*), civil engineer, outstanding executive of Midwestern and Western railroads. First chief engineer of the Panama Canal, 1904–05, he continued as such after reorganization of the Canal Commission in April 1905, but resigned in June of that year because of inadequate authority given him and thereby precipitated a bitter controversy. He later served as president of Westinghouse, Church, Kerr & Co. and was an officer and consultant for many other concerns.

WALLACE, JOHN HANKINS (*b. Allegheny Co., Pa., 1822; d. 1903*), cattle breeder, expert on the trotting horse. Published *Wallace's American Stud Book*, 1867; began publication of *Wallace's Year-Book of Trotting and Pacing*, 1886; also published *Wallace's Monthly*, a magazine devoted to the interest of the trotting horse. Author of *The Horse of America* (1897).

WALLACE, JOHN WILLIAM (*b. Philadelphia, Pa., 1815; d. 1884*), legal scholar, author. Brother of Horace B. Wallace. Graduated University of Pennsylvania, 1833; studied law with his father and with John Sergeant. Librarian of the Law Association of Philadelphia, 1841–60. Succeeded his brother as coeditor of *American Leading Cases* and edited a number of other legal compilations; was author of *The Reporters, Chronologically Arranged* (1844). He served as reporter of the U.S. Supreme Court, 1863–75. He was president of the Historical Society of Pennsylvania, 1868–84.

WALLACE, LEWIS (*b. Brookville, Ind., 1827; d. Crawfordsville, Ind., 1905*), lawyer, Indiana legislator, Union soldier, diplomat, author. Son of David Wallace, he was commonly known as "Lew" Wallace. A student of law under his father, he served briefly in the Mexican War and began practice of law in Indianapolis, Ind., 1849. Resident in Crawfordsville *post* 1853, he became adjutant general of Indiana and colonel of the 11th Regiment, 1861. Promoted brigadier general in September, and major general in March 1862 after the capture of Fort Donelson, he won the enmity of General H. W. Halleck who twice attempted to bar him from a command. Among Wallace's outstanding exploits during the Civil War were his saving of Cincinnati, Ohio from capture in 1863 by Confederate General E. Kirby-Smith; also his holding action against Confederate General Jubal Early at the Monocacy, July 1864, for which he was highly commended by General Grant. After the war he spent some time in Mexico and then returned to practice law at Crawfordsville. Republican governor of New Mexico, 1878–81; U.S. minister to Turkey, 1881–85. Wallace is best remembered as a man of letters and as author of, among other books, *The Fair God* (1873), a story of the conquest of Mexico; *Ben Hur* (1880), which had extraordinary success; and of *The Prince of India* (1893). A man of simple, democratic tastes, he disliked the law, had no aptitude for politics, and was disinclined to the military life except when his country required his services. Art, music, and literature were his most vital interests.

WALLACE, LURLEEN BURNS (*b. Tuscaloosa, Ala., 1926; d. Montgomery, Ala., 1968*), governor of Alabama. Graduated from the Tuscaloosa Business College (1942). In 1943 she married George Wallace, who was elected to the state legislature in 1946 and became governor of Alabama in 1962. Forbidden by Alabama's constitution from succeeding himself in office, he asked his wife to run. Lurleen Wallace was elected governor in 1966, becoming only the third woman to be elected a governor in the United States. She proceeded to carry on her husband's programs, which included maintaining segregated public schools. Poor health cut short her tenure in office.

WALLACE, WILLIAM (*b. Manchester, England, 1825; d. 1904*), wire manufacturer, inventor. Immigrated to America as a boy. Established firm of Wallace & Sons with his father and brothers, 1848, locating their plant at Ansonia, Conn., 1850. With Moses G. Farmer, he constructed dynamos based on Farmer's patent of 1872, one of which was used to light the Centennial Exhibition at Philadelphia, 1876. His firm built dynamos for use with the plate-carbon arc lamp, patented by Wallace, December 1877, and believed to be the first commercial arc light made in the United States. Wallace was the first to demonstrate operation of arc lights in series. He also constructed an electroplating plant at Ansonia.

WALLACE, WILLIAM ALEXANDER ANDERSON (*b. near Lexington, Va., 1817; d. near Devine, Tex., 1899*), frontiersman, popularly known as "Bigfoot." Removed to Texas, 1837. As private in a ranger company under John C. Hays, 1840–44, he fought on the Salado and was taken prisoner in the futile Mier expedition. After further service as a ranger and with the Mounted Rifle Volunteers in the Mexican War, he raised a company of volunteers for frontier service under his own command, 1850. A legendary figure in Texas history, he sallied out from his Medina River farm time and again with a hastily gathered band of neighbors to protect life and property from Indian raiders. He was also responsible for the delivery of the mail between San Antonio and El Paso. He had no sympathy with the Civil War and took no part in it.

WALLACE, WILLIAM JAMES (*b. Syracuse, N.Y., 1837; d. Jacksonville, Fla., 1917*), jurist. LL.B., Hamilton College, 1857. U.S. district judge, northern district of New York, 1874–82; U.S. judge, second circuit court, 1882–91; presiding judge, circuit court of appeal, second circuit, 1891–1907.

WALLACE, WILLIAM ROSS (*b. Lexington or Paris, Ky., 1819; d. New York, N.Y., 1881*), lawyer, poet. Practiced in New York City *post* 1841; was a friend of Samuel Woodworth, G. P. Morris, and other New York literati, and of Edgar A. Poe whose memory he defended against John Neal. A frequent contributor to the periodicals of the day, he was author of *The Battle of Tippecanoe* (Cincinnati, 1837) and of *Meditations in America* (1851), which contains his best-known work. He was author of the famous lines, "And the hand that rocks the cradle, Is the hand that rules the world."

WALLACK, HENRY JOHN (*b. London, England, 1790; d. New York, N.Y., 1870*), actor. Brother of James W. Wallack (ca. 1795–1864); father of James W. Wallack (1818–1873). Made American debut at Baltimore, Md., 1819, and was known thereafter as a versatile player in a most extensive repertoire, both in America and in England.

WALLACK, JAMES WILLIAM (*b. London, England, ca. 1795; d. New York, N.Y., 1864*), actor. Brother of Henry J. Wallack; father of Lester Wallack. Made American debut at the Park Theatre, New York City, as Macbeth, September 1818, after achieving early success on the British stage. An actor of the school of J. P. Kemble, he played with a nervous, exuberant vitality; he alter-

nated appearances between several American cities and England. The most distinguished member of a notable theatrical family, he was manager of the National Theatre in New York, 1837–39, and of the old Brougham's Lyceum in New York, 1852–61. With his son Lester, he opened the third of the Wallack theaters in New York City at Broadway and 13th St., 1861.

WALLACK, JAMES WILLIAM (*b. London, England, 1818; d. near Aiken, S.C., 1873*), actor. Son of Henry J. Wallack; nephew of James W. Wallack (*ca. 1795–1864*). Came to America as an infant; made stage debut in Philadelphia, Pa., 1822. After learning his trade at the Bowery Theater, New York City, and with English provincial companies, he became leading juvenile with his uncle's company, 1837, and for many years played with success both in America and England. *Post* 1855 he remained in the United States. At his best in tragedy or romantic drama, he joined his cousin Lester Wallack's stock company, 1865, and scored one of his greatest successes in the part of Fagin in *Oliver Twist*, 1867.

WALLACK, JOHN LESTER *See* WALLACK, LESTER.

WALLACK, LESTER (*b. New York, N.Y., 1820; d. near Stamford, Conn., 1888*), actor, dramatist. Son of James W. Wallack (*ca. 1795–1864*). Educated in England and trained in the English provincial theatres, he made his American debut at the Broadway Theatre, New York City, 1847; in 1848 he made a sensation in the part of Don César de Bazan, and also as Edmond Dantès in *The Count of Monte Cristo*. Soon becoming the matinee idol of New York in comic or romantic parts, he assisted his father in the management of the Wallack theatres and was their actual manager *post* 1861. After a great run of success in his own plays and others, he opened the new Wallack Theatre at Broadway and 30th St., New York City, 1882, which he managed until his retirement, 1887.

WALLENDA, KARL (*b. Magdeburg, Germany, 1905; d. San Juan, P.R., 1978*), high-wire walker, or funambulist. Learned acrobatic skills as a child while performing with his family's traveling circus act. He formed a European high-wire troupe, the Great Wallendas, in 1925 and two years later introduced his daring stunts to U.S. audiences for the Ringling Brothers and Barnum and Bailey Circus. In 1946 Wallenda, seeking ever more exciting stunts, showcased a high-wire seven-man pyramid. Two members of his troupe were killed during a mishap in 1962. Wallenda set the world high-wire distance record by walking a wire 1,800 feet long across King's Island, Ohio, in 1974. He fell to his death during a stunt in San Juan.

WALLER, EMMA (*b. England, ca. 1820; d. New York, N.Y., 1899*), actress. Made American debut at Walnut Street Theatre, Philadelphia, Pa., October 1857, as Ophelia to her husband's Hamlet. Thereafter, often with her husband as her principal associate, she starred as an emotional actress throughout the United States for some twenty years. After her retirement she gave public readings and was a teacher of elocution.

WALLER, FATS. *See* WALLER, THOMAS WRIGHT.

WALLER, FREDERIC (*b. Brooklyn, N.Y., 1886; d. Huntington, N.Y., 1954*), inventor, motion picture producer, and manufacturer. Developed first automatic printer and timer for motion pictures, and first optical printer. Inventor of Cinerama. Released first commercial Cinerama picture, *This Is Cinerama*, in 1952. Won an Academy Award for his invention in 1954.

WALLER, JOHN LIGHTFOOT (*b. Woodford Co., Ky., 1809; d. Louisville, Ky., 1854*), Baptist clergyman. Engaged in controversy with Alexander Campbell. Edited *Baptist Banner and Western Pioneer*; founded *Western Baptist Review* (later called *Christian Repository*), 1845. A capable and militant leader under whom the Baptists in Kentucky made notable advances in education and missionary work.

WALLER, THOMAS MACDONALD (*b. New York, N.Y., ca. 1840; d. Ocean Beach, Conn., 1924*), lawyer, Connecticut legislator and official. Democratic mayor of New London, Conn., 1873–79; governor of Connecticut, 1883–85. U.S. consul general at London, England, 1885–89. Uncompromising leader of the "Gold Democrats" in Connecticut, 1896–1900.

WALLER, THOMAS WRIGHT (*b. New York, N.Y., 1904; d. near Kansas City, Mo., 1943*), musician, composer, jazz pianist. Known as "Fats" Waller. Child of a musical family, he was a professional at age fifteen and attracted the attention and assistance of established Harlem jazz musicians such as James P. Johnson. By 1922, he was recording for the Okeh label and had begun to compose, which he did with remarkable ease and speed. His first big success was "Ain't Misbehavin" (1929). More important musically than his hit songs were his many piano solos. Despite his public image as a humorous entertainer, he was a deeply committed musician; he continually developed his art, studying with Carl Bohm at the Juilliard School and briefly with Leopold Godowsky. After 1934, he spent most of his professional time on the road, touring in the United States, the British Isles, and continental Europe, maintaining a crushing schedule without regard to his failing health. He died on a train, en route from Hollywood to New York.

WALLER, WILLARD WALTER (*b. Murphysboro, Ill., 1899; d. New York, N.Y., 1945*), sociologist. B.A., University of Illinois, 1920. M.A., University of Chicago, 1925. Ph.D., University of Pennsylvania, 1929. Taught at University of Nebraska, Pennsylvania State College, and Barnard College; drew on personal experience for iconoclastic views of the social psychology of marriage and the family.

WALLGREN, MON(RAD) C(HARLES) (*b. Des Moines, Iowa, 1891; d. Olympia, Wash., 1961*), U.S. representative, senator, and governor. Elected U.S. congressman from Washington State (1933–40); his greatest legislative achievement was a bill to create Olympic National Park. U.S. senator (1941–44) who investigated national defense contracts and uncovered defects in aircraft engines and Liberty ships. Governor of Washington (1945–48); enacted the nation's most liberal unemployment compensation law. Chairman of the Federal Power Commission (1950–51).

WALLING, WILLIAM ENGLISH (*b. Louisville, Ky., 1877; d. Amsterdam, the Netherlands, 1936*), Socialist, labor reformer. Grandson of William H. English. Graduated University of Chicago, 1897. Devoting his energies to the labor movement *post ca.* 1900, Walling was a founder of the National Women's Trade Union League, 1903, and presided over a series of meetings (*ca.* 1908) out of which grew the National Association for the Advancement of Colored People. He was a sympathizer with contemporary Russian revolutionary movements and opposed the conservative element in the Socialist party, 1909. In 1917 he supported entry of the United States into World War I and was critical of the Socialist pacifists. After the war he worked full-time for the American Federation of Labor. The conservatism of his later career was brought about largely by the anti-libertarian character of the Communist revolutions.

WALLIS, SEVERN TEACKLE (*b. Baltimore, Md., 1816; d. 1894*), lawyer. Graduated St. Mary's College, Baltimore, 1832; studied

law in office of William Wirt. A Whig in early life, he became a Democrat upon the disintegration of the Whig party, but remained, above all, a reformer, never surrendering his personal independence of opinion. Considered for many years the leader of the Maryland bar, he exercised a strong influence in Baltimore and in the state and was an eloquent speaker. Sympathetic with the Confederacy but opposed to secession, he argued against the doctrine of military necessity in 1861, and was imprisoned for 14 months. His letters to the press during the campaign of 1875, when he supported the Reform ticket, are among the choicest of Maryland polemics.

WALN, NICHOLAS (*b. Fair Hill, near Philadelphia, Pa., 1742; d. 1813*), lawyer, Quaker preacher. Cousin of Robert Waln (1765–1836). Withdrawing from the practice of law, *ca.* 1772, he gave himself up thereafter to the service of the Society of Friends in which he exercised a great influence both here and abroad. He took a leading part in the proceedings of Meeting in its handling of the "Free Quakers" at the time of the Revolutionary War.

WALN, ROBERT (*b. Philadelphia, Pa., 1765; d. 1836*), merchant, textile and iron manufacturer. Cousin of Nicholas Waln; father of Robert Waln (1794–1825). Active as a Federalist in the Pennsylvania legislature, and as a member of Congress, 1798–1801, he became an ardent protectionist and was identified with the high tariff acts of 1816, 1824, and 1828. He was author of *An Examination of the Boston Report* (1828), which was considered a crushing and final argument against the free traders. An orthodox Quaker, he entered into the controversy with Elias Hicks.

WALN, ROBERT (*b. Philadelphia, Pa., 1794; d. Providence, R.I., 1825*), businessman. Son of Robert Waln (1765–1836). A contributor to current periodical literature; editor of Volumes III through VI of Sanderson's *Biography of the Signers to the Declaration of Independence* (1823–24); author of *The Hermit in America* (1819, 1821) and other satires.

WALSH, BENJAMIN DANN (*b. London, England, 1808; d. near Rock Island, Ill., 1869*), businessman, entomologist. A fellow and M.A. of Trinity College, Cambridge, England, Walsh immigrated to Henry Co., Ill., *ca.* 1838, where he engaged in farming and was later a lumber dealer in Rock Island. Retiring from business, *ca.* 1858, he devoted the rest of his life to entomology, publishing a number of excellent papers in which his breadth of knowledge and accurate prophesy of the future of economic entomology were outstanding. He was the first to show that American farmers were planting crops in ways which facilitated the multiplication of insects, and was among the first to suggest introduction of foreign parasites for the control of pests. In 1868, with Charles V. Riley, he founded and edited the *American Entomologist*. An associate of Charles Darwin in England, he attacked the anti-evolutionary views of Agassiz and Dana.

WALSH, BLANCHE (*b. New York, N.Y., 1873; d. Cleveland, Ohio, 1915*), actress. Entering her profession in the company of Marie Wainwright, 1889, she played with most of the principal American stock companies of her time and took over in 1899 the repertory of Sardou plays in which Fanny Davenport had long starred. She made the greatest success of her career as Maslova in the dramatization of Tolstoy's *Resurrection*, 1903.

WALSH, DAVID IGNATIUS (*b. Leominister, Mass., 1872; d. Boston, Mass., 1947*), lawyer, politician. A.B., Holy Cross College, 1893. LL.B., Boston University, 1897. Rising in Massachusetts Democratic politics by ability as an orator and by refusal to identify himself with the Boston bosses of his party, he was elected governor of Massachusetts in 1913 and 1914, the first non-Yankee to serve as the state's chief executive. Aided by a coalition of Democrats, Progressives, and working-class Republicans in the legislature, he instituted a number of reforms, including improvement of the labor code and inauguration of state-supported university extension courses for wage-earning students. As U.S. senator, 1919–25 and 1927–47, he opposed the League of Nations but was otherwise liberal in his views during the 1920's and the earlier years of the New Deal. He opposed Franklin D. Roosevelt's Supreme Court reform bill, his acceptance of a third term, and all the moves that brought the United States closer to involvement in World War II. He was defeated for reelection in 1946.

WALSH, EDMUND ALOYSIUS (*b. Boston, Mass., 1885; d. Washington, D.C., 1956*), Roman Catholic clergyman, educator, and author. Novitiate of the Society of Jesus, student at Woodstock College, at the Universities of Dublin and London, and at Georgetown University (Ph. D., 1920). Dean of the Georgetown University College of Arts and Sciences from 1918, vice president from 1924. Founded School of Foreign Service in 1919 (regent until 1952) and Institute of Languages and Linguistics in 1949. In 1922, Walsh led a Papal delegation to oversee famine relief in Russia and as Vatican representative for the Church's interests; he returned an ardent anticommunist. In 1945–46, he was civilian consultant to the American counsel at the Nuremberg trials. Works include *Total Power* (1949) and *Total Empire* (1951). Widely influenced American foreign policy through his lectures, writings, and the school that he founded.

WALSH, EDWARD AUGUSTINE ("BIG ED") (*b. Plains, Pa., 1881; d. Pompano Beach, Fla., 1959*), baseball player. Pitcher for the Chicago White Sox, 1906–17, Walsh was a successful practitioner of the spitball. Won 194 games for the White Sox, forty of them in the 1908 season. His earned run average of 1.82 was a record.

WALSH, FRANCIS PATRICK (*b. St. Louis, Mo., 1864; d. New York, N.Y., 1939*), lawyer, public official. Raised in Kansas City, Mo., Walsh was admitted to the Missouri bar, 1889, and quickly became an outstanding trial lawyer. Associated with many reform movements in Kansas City, he served with ability as chairman of the U.S. Commission on Industrial Relations, 1913–18, doing much to arouse public sympathy for labor's side in industrial disputes. Active also in work for preservation of civil liberties, he was counsel for Tom Mooney during the long litigation over Mooney's conviction for murder. *post* 1919 he acted as counsel for many labor organizations in important cases. A worker for Irish freedom and for a number of liberal causes, he served as chairman of the New York State Power Authority after his removal to New York City *ca.* 1928, and with his friend George W. Norris was influential in shaping Franklin D. Roosevelt's ideas on public power. First president of the National Lawyers Guild, he resigned in protest over its failure to take a position against Communist dictatorships.

WALSH, HENRY COLLINS (*b. Florence, Italy, 1863; d. Philadelphia, Pa., 1927*), journalist, explorer, magazine editor. Grandson of Robert Walsh.

WALSH, JAMES ANTHONY (*b. Cambridge, Mass., 1867; d. Maryknoll, N.Y., 1936*), Roman Catholic clergyman. Attended Boston College and Harvard; ordained, 1892, after study at St. John's Seminary, Brighton, Mass. Interested in foreign missions from his seminary days, he worked for the establishment of an American foreign mission society and with Thomas F. Price founded the Catholic Foreign Mission Society of America (Maryknoll)

which received official approval, June 1911. Elected Maryknoll's first superior general, 1929, Father Walsh became a bishop, 1933. Before his death, the mission activities of Maryknoll had extended to China, Korea, Japan, Manchuria, the Philippines, and Hawaii.

WALSH, MICHAEL (*b. near Cork, Ireland, ca. 1815; d. New York, N.Y., 1859*), printer, journalist, politician. Immigrated to America as a child. Resident in New York City *post* 1839, he recruited the young laboring men of the city into the Spartan Association as a workingman's protest against Tammany control of the local Democratic organization. Through the efforts of this association the organized gang became a new feature in political practice. Continuing his efforts on behalf of labor, Walsh founded a paper, the *Subterranean*, 1843, and briefly collaborated with George H. Evans in the National Reform program. When the New York Democrats split over the free-soil controversy, Walsh joined the Hunker faction, denouncing the Abolitionists who neglected the wage slaves of the North for the cause of the black. After service in the New York legislature and a single term in Congress (1853–55), he gradually fell into intemperance.

WALSH, RAOUL (*b. New York City, 1880; d. Simi Valley, Calif., 1980*), motion-picture actor and director. Worked in the West as a cowboy and began his acting career playing horsemen in silent films for New York City studios. Moving to Los Angeles in 1910, he launched a prolific directing career that would span over fifty years. He made his first films for the Biograph Company with D. W. Griffith, including directing *Life of General Villa* (1913) and appearing in Griffith's *The Birth of a Nation* (1915). He later directed the noted silent films *The Thief of Baghdad* (1924) and *What Price Glory?* (1926) for Fox studios. Signing with Warner Brothers in 1939, Walsh directed several classic gangster films, including *High Sierra* (1941). His directing credits include Westerns, comedies, and period pieces. He is best remembered for *They Drive by Night* (1940), *They Died with Their Boots On* (1941), *Colorado Territory* (1949), and *The Tall Men* (1955).

WALSH, ROBERT (*b. Baltimore, Md., 1784; d. Paris, France, 1859*), journalist, man of letters. Attended St. Mary's College, Baltimore, and the present Georgetown University; studied law with Robert G. Harper; traveled and studied in France and the British Isles, and for a while served as secretary to William Pinkney. Returning to the United States, 1809, he served as editor of a number of reviews and miscellanies, and in 1811 founded the first American quarterly, *The American Review of History and Politics*. He was professor of English, University of Pennsylvania, 1818–28. Among his books, which were influential in their time, were *A Letter on the Genius and Dispositions of the French Government* (1810); *An Appeal From the Judgments of Great Britain Respecting the United States of America* (1819); and *Didactics: Social, Literary and Political* (1836). Settling permanently in Paris, 1837, he founded there what was probably the first American salon and was U.S. consul general, 1844–51.

WALSH, THOMAS (*b. Brooklyn, N.Y., 1871; d. Brooklyn, 1928*), poet, critic, editor. Graduated Georgetown University, 1892; Ph.D., 1899. Distinguished as a student and translator of Hispanic literature, Walsh engaged also in general editorial work, and was assistant editor of the *Commonweal*, New York City, 1924–28. A selection of his original poems and translations appeared in 1930; he was editor of the *Hispanic Anthology* (1920) and of *The Catholic Anthology* (1927, 1932).

WALSH, THOMAS JAMES (*b. Two Rivers, Wis., 1849; d. on a train en route to Washington, D.C., 1933*), lawyer, statesman.

LL.B., University of Wisconsin, 1884. Beginning practice in Dakota Territory, he removed to Helena, Mont., 1890, where he won a reputation in copper litigation and as a constitutional lawyer. He was U.S. senator, Democrat, from Montana, 1913–33. Invariably on the liberal side in debates, he advocated woman suffrage and the child-labor amendment, and also the protection of farm organizations and trade unions from suit under the Sherman Act. He was a loyal follower of the policies of President Woodrow Wilson. His greatest fame derived from his services as counsel and director of the investigation of leases of naval oil reserves in Wyoming and California to private individuals, an investigation brought about by a resolution introduced in the Senate by Robert M. LaFollette, April 1922. After 18 months' study of the evidence, Walsh began public hearings in October 1923 and disclosed with calm precision and unemotional clarity the whole sordid story of Teapot Dome and Elk Hills. The leases were in consequence voided and the public officials responsible for them were discredited. Selected as U.S. attorney general in the cabinet of President F. D. Roosevelt, Walsh died suddenly before Roosevelt's inauguration.

WALSH, THOMAS JOSEPH (*b. Parkers Landing, Pa., 1873; d. South Orange, N.J., 1952*), Roman Catholic clergyman. Studied at St. Bonaventure College (B.A., 1896) and Seminary (ordained, 1900). Secretary to the bishop of Buffalo (1900–15) and chancellor (1900–18). Received doctorates in theology and canon law from Apollinaris Seminary in Rome (1908). Bishop of Trenton, N.J., 1918–28; of Newark, N.J., 1928–37. In 1937 he was appointed archbishop of the archdiocesan see of New Jersey. Known as the Bishop of Charity and Education, Walsh helped found the Mount Carmel Guild while in Buffalo (and which he transplanted to all his later assignments); the Guild was organized to aid immigrants and the needy. He helped found Caldwell College and stimulated the growth of Seton Hall University.

WALTER, ALBERT G. (*b. Germany, 1811; d. Pittsburgh, Pa., 1876*), surgeon. M.D., University of Königsberg; studied also in Berlin and in London. Immigrated to America, *ca.* 1835, and practiced in Pittsburgh, Pa., *post* 1837. An American pioneer in orthopedic surgery and a versatile general surgeon, Walter performed an epoch-making laparotomy for the relief of a ruptured bladder, January 1859. He was author, among other medical writings, of *Conservative Surgery . . . in Cases of Severe Traumatic Injuries of the Limbs* (1867).

WALTER, BRUNO (*b. Berlin, Germany, 1876; d. Beverly Hills, Calif., 1962*), conductor. First conducted with several German opera companies and state theaters, in Hamburg, Breslau, Berlin, and Munich; became musical director of the Berlin Municipal Opera (1925–29) and director of the Leipzig Gewandhaus Orchestra (1929–33), then moved to Austria. He conducted in Europe and the United States until 1936, when he became principal conductor and artistic adviser for the Vienna State Opera. Immigrated to America in 1939, having made his debut with the New York Symphony in 1923; he made his Metropolitan Opera debut in 1941. He was a guest conductor with several U.S. orchestras, but mainly for the New York Philharmonic, serving as its musical adviser and principal conductor from 1947 to 1949.

WALTER, EUGENE (*b. Cleveland, Ohio, 1874; d. Hollywood, Calif., 1941*), journalist, playwright. Author of a number of "well made" plays, of which *Paid in Full* (1908) and *The Easiest Way* (1909) were outstanding successes. In the latter of these, his use of an unhappy ending in which vice triumphed over virtue won him extravagant contemporary acclaim as a great realist, an "American Ibsen." After 1929, he worked as a contract writer for movie studios.

WALTER, FRANCIS EUGENE (*b. Easton, Pa., 1894; d. Washington, D.C., 1963*), U.S. congressman and lawyer. Attended Lehigh, George Washington, and Georgetown Law School (LL.B., 1919). U.S. congressman from Pennsylvania, 1933–63; his main specialties while in Congress after World War II were immigration laws and investigations of un-American activities. As chairman of the Judiciary Subcommittee on Immigration and the Immigration and Naturalization Subcommittee, he backed laws that retained quotas favoring northern European countries and limiting the number of immigrants from most other countries. Became chairman of the House Un-American Activities Committee, 1955; his search for Communist infiltration covered the fields of entertainment, education, religion, and government.

WALTER, THOMAS (*b. Roxbury, Mass., 1696; d. Roxbury, 1725*), Congregational clergyman. Nephew of Cotton Mather. Assistant pastor at Roxbury *post* 1718, he engaged in a controversy with John Checkley, but is principally remembered as author of *The Grounds and Rules of Musick Explained* (1721). This was an effort, scientifically and artistically conceived, to correct the "horried medley of confused and disorderly sounds" which passed for singing in the New England churches.

WALTER, THOMAS (*b. Hampshire, England, ca. 1740; d. South Carolina, 1789*), planter, botanist. Immigrated to eastern South Carolina as a young man. Author of a work of lasting scientific importance—*Flora Caroliniana* (London, 1788), the first tolerably complete account of the flora of any definite portion of eastern North America in which an author used the so-called binomial system of nomenclature.

WALTER, THOMAS USTICK (*b. Philadelphia, Pa., 1804; d. 1887*), architect. A master bricklayer, Walter studied architecture under William Strickland and others at the Franklin Institute. After entering practice in 1830, he designed the Moyamensing Prison, Philadelphia, and also Girard College (1833), which marked the climax and at the same time sounded the knell of the Greek Revival in America. He had charge of the extension of the U.S. Capitol at Washington, 1851–65, adding the wings of the present structure, the dome, and also projecting a center extension. Among his other works in Washington were the completion of the Treasury Building begun by Robert Mills, St. Elizabeth's Hospital, and the design for the interior of the State, War, and Navy Building. He also assisted Nicholas Biddle in the design of "Andalusia" and designed churches, banks, and private houses in Philadelphia, Baltimore, Richmond, and elsewhere. He helped organize the American Institute of Architects, 1857, and served as its president, 1876–87.

WALTERS, ALEXANDER (*b. Bardstown, Ky., 1858; d. 1917*), bishop of the African Methodist Episcopal Zion Church. An active minister *post* 1877 in a number of cities throughout the United States, he became pastor of "Mother Zion" in New York City, 1888, and was elected bishop, 1892. He was an organizer of the Afro-American League and later president of the National Afro-American Council. He was author of *My Life and Work* (1917).

WALTERS, HENRY (*b. Baltimore, Md., 1848; d. New York, N.Y., 1931*), capitalist, art collector. Son of William T. Walters, whom he assisted and succeeded in the development of the Atlantic Coast Line Railroad and other large operations. Adding extensively to his father's collections of art, he established the Walters Art Gallery and bequeathed it, with an endowment, to the City of Baltimore.

WALTERS, WILLIAM THOMPSON (*b. Liverpool, Pa., 1820; d. 1894*), merchant, railroad executive, art collector. Father of Henry Walters. Played an important part in the railroad development of the South by consolidating a number of small roads and coordinating their service. After the interruption of his plans by the Civil War, Walters renewed his activities when efficient through service by rail to the North was demanded by development of truck farming in eastern North Carolina and Virginia. In 1889 he incorporated the holding company, later known as the Atlantic Coast Line Co., which, under his son, became the means of effecting consolidation of roads from Washington to Florida and the Gulf ports, and also to Memphis and St. Louis. He was an eager collector of objects of art and a patron of artists; he was also a breeder of fine stock and brought the Percheron horse to America.

WALTHALL, EDWARD CARY (*b. Richmond, Va., 1831; d. Washington, D.C., 1898*), Confederate major general, lawyer. Raised in Mississippi where he began practice at Coffeeville, 1852. An officer of unusual bravery and steadiness, he fought with tenacity at Chickamauga, at Lookout Mountain, and at Missionary Ridge where his brigade covered the Confederate retreat. After sharing in the fighting about Atlanta, he served under Hood in Tennessee. A friend of Lucius Q. C. Lamar, he helped overthrow the Carpetbag government in Mississippi, and was U.S. senator, Democrat, 1885–94, 1895–98. Like Lamar, he was an advocate of conciliation and strove to lessen sectional animosity.

WALTHALL, HENRY BRAZEAL (*b. Shelby Co., Ala., 1878; d. Monrovia, Calif., 1936*), motion picture actor. Grandnephew of Edward C. Walthall. A successful stage player, Walthall was persuaded to try the new medium of motion pictures by David W. Griffith ca. 1909. His greatest role while under Griffith's direction was that of Benjamin Cameron in *The Birth of a Nation*, 1915. A leader in the effort to produce motion pictures that would attract educated audiences, he failed to thrive after leaving Griffith ca. 1915 and faded from notice until the coming of talking pictures gave him the chance of a new start.

WALTHER, CARL FERDINAND WILHELM (*b. near Waldenburg, Saxony, 1811; d. St. Louis, Mo., 1887*), Lutheran clergyman. Immigrated to America, 1839; settled as pastor in Perry Co., Mo. With three associates, he founded a school at Altenburg in December 1839 which was moved to St. Louis, 1850, and became Concordia Theological Seminary. Pastor in St. Louis *post* 1841, he became professor of theology in Concordia Seminary, 1850. Meanwhile, in 1844 he issued the first number of *Der Lutheraner*, and was organizer of the Missouri Synod which he served as president, 1847–50, 1864–78. Walther dominated every activity in the synod and directed it with strict efficiency. An exponent of confessional Lutheranism, he engaged in a number of controversies with other theologians in which he displayed immense learning, considerable intolerance, and a strong belief in his own inerrancy. His influence has been greater than that of any other American Lutheran clergyman of the 19th century.

WALTON, GEORGE (*b. near Farmville, Va., 1741; d. "College Hill," near Augusta, Ga., 1804*), lawyer, Revolutionary patriot and soldier. Removed to Savannah, Ga., 1769. Served on Revolutionary committees; was secretary of the Georgia Provincial Congress and president of the Council of Safety. Elected to the Continental Congress, February 1776, he served until 1778 and from 1779 until September 1781. A signer of the Declaration of Independence, he was a member of a number of important committees. He advocated an equal vote for all states and urged that the Indian trade be made a monopoly and that its control be vested in Congress. In January 1777, with George Taylor, he negotiated a treaty with the Six Nations at Easton, Pa. A conservative Whig and opponent of the radicals led by Button Gwin-

nett, he was governor of Georgia from November 1779 to January 1780. Chief justice of Georgia, 1783–89, he was again governor, 1789–90. This second term was marked by the establishment of a new state constitution, the location of the state capital at Augusta, and by pacification of the Creek Indians. He was several times a judge of the superior court of Georgia between 1790 and his death, and was U.S. senator, Federalist, from Georgia, 1795–99.

WALTON, LESTER AGLAR (*b. St. Louis, Mo., 1882; d. New York, N.Y., 1965*), diplomat and journalist. Editor of *New York Age* (1908–14, 1932) and writer for the *New York World* (1922–31) and *New York Herald Tribune* (1931). Publicity director for the National Negro Business League (1926–35) and the black division of the Democratic National Committee during the 1924, 1928, and 1932 presidential campaigns. Appointed envoy extraordinary and minister plenipotentiary to Liberia, 1935–46. Adviser to Liberia's United Nations delegation, 1948–49.

WALWORTH, CLARENCE AUGUSTUS (*b. Plattsburgh, N.Y., 1820; d. 1900*), Roman Catholic clergyman, Paulist. Son of Reuben H. Walworth. Graduated Union, 1838. After beginning the practice of law, he attended the General Theological Seminary, New York City. On becoming a Catholic in 1845, he went with Isaac T. Hecker and J. A. McMaster to study theology at St. Trond in Belgium and entered the Redemptorist Order. Ordained, 1848, he preached as a missionary in England, and returned to America, 1851, where he preached missions until 1858. With Hecker and others he helped found the Congregation of St. Paul the Apostle (Paulists), 1858. After further missionary service, he was pastor at St. Mary's Church, Albany, N.Y. *post* 1866. Among his books is a notable study, *The Oxford Movement in America* (1895).

WALWORTH, JEANNETTE RITCHIE HADERMANN (*b. Philadelphia, Pa., 1837; d. New Orleans, La., 1918*), Southern novelist. Author, among much negligible work, of *Southern Silhouettes* (1887), a series of post–Civil War sketches.

WALWORTH, REUBEN HYDE (*b. Bozrah, Conn., 1788; d. 1867*), jurist. Father of Clarence A. Walworth. Admitted to the New York bar, 1809, he began practice at Plattsburgh. During the War of 1812 he served as adjutant general of the state militia, distinguishing himself in the land battles at Plattsburgh, Sept. 6 and 11, 1814. Congressman, Democrat, from New York, 1821–23, he was circuit judge of the supreme court for the fourth judicial district of New York, 1823–28. Succeeding James Kent as chancellor of New York, 1828, he made important contributions to the system of equity jurisprudence which had been erected by Kent. He filled numerous gaps in the law of evidence and in equity pleading and practice by his decisions; he also added materially to the law relating to injunctions, to arbitration in equity matters, and the adoption of statutes in the Northwest Territory. A number of appeals were taken from his decisions to the court of errors, and in about one-third of these cases he was reversed. Given to biting sarcasm on the bench, he won a host of enemies, and the abolition of the court of chancery under the New York constitution in 1846 has been attributed in great measure to the desire of the bar to retire Walworth to private life. He thus contributed by indirection to an important legal reform, the merger of the courts of law and equity. Upon retirement in 1848, he was Democratic candidate for governor, but lost to Hamilton Fish. He then retired from political life.

WAMBAUGH, SARAH (*b. Cincinnati, Ohio, 1882; d. Cambridge, Mass., 1955*), internationalist and authority on plebiscites. Studied at Radcliffe College (B.A., 1902; M.A., 1916), the University of London School of Economics, and Oxford University. Prepared *Monograph on Plebiscites, With a Collection of Official Documents*, for the Paris Peace Conference (1920). Working for the League of Nations, she was adviser for the plebiscites on the Saar and the free city of Danzig; and for the Peruvian government in administering the Tacna-Arica plebiscite. For the United Nations, she observed elections in Greece (1945–46) and helped arrange plebiscites in Jammu and Kashmir in 1949. First Woman lecturer at the Academy of International Law at The Hague in 1927; also taught at Radcliffe and Wellesley. Wrote and lectured widely on the importance of the League of Nations and the United Nations.

WANAMAKER, JOHN (*b. Philadelphia, Pa., 1838; d. near Philadelphia, 1922*), merchant, pioneer in development of the modern department store. Beginning as an errand boy, he became a salesman of men's clothing. Between 1857 and 1860 he was secretary of the YMCA in Philadelphia, the first paid secretary of that organization. Opening a men's clothing shop in Philadelphia with his brother-in-law, 1861, Wanamaker conducted the business successfully and in 1876, with characteristic showmanship, opened a huge dry goods and clothing store in the former freight depot of the Pennsylvania Railroad at 13th and Chestnut Sts. In March of the next year he inaugurated his "new kind of store," a collection of specialty shops under one roof, with which he had extraordinary success. In 1896 he bought the New York City store of Alexander T. Stewart and continued it as Wanamaker's. An innovator and even a gambler, he began in 1865 a policy of guaranteeing their money back to dissatisfied customers; he was also a master of the art of publicity, notably newspaper advertising. He provided an employee's mutual-benefit association (1881), training classes for clerks, and other educational and recreational features. A consistent Republican, he was U.S. postmaster general, 1889–93. Although he instituted several technical improvements in the Post Office, he was denounced by reformers for his use of the spoils system.

WANAMAKER, LEWIS RODMAN (*b. Philadelphia, Pa., 1863; d. Atlantic City, N.J., 1928*), merchant. Son of John Wanamaker. Graduated College of New Jersey (Princeton), 1886. A member of the Wanamaker firm *post* 1902, and sole owner and director *post* 1922, he was responsible for the emphasis on the sale of antiques and other art objects which became an integral part of the business. A collector of rare musical instruments, he instituted public concerts in both the New York and Philadelphia stores. He was also an enthusiast for aviation and financed several expeditions among the Indian tribes of the West for the purpose of study.

WANAMAKER, REUBEN MELVILLE (*b. North Jackson, Ohio, 1886; d. Columbus, Ohio, 1924*), Ohio jurist, reformer of Ohio criminal jurisprudence.

WANER, PAUL GLEE (*b. Harrah, Okla., 1903; d. Sarasota, Fla., 1965*), baseball player. Began his career in 1924 with the Pacific Coast League, then was purchased in 1925 by the Pittsburgh Pirates for the then-unprecedented sum of $100,000. One of the most successful hitters of doubles in the game, he won the National League batting crown in 1927, 1934, and 1936. Named the National League's most valuable player in 1927. From 1940 to 1944 played as a reserve outfield and pinch hitter for the Boston Braves, New York Yankees, and Brooklyn Dodgers. Elected to Baseball Hall of Fame, 1952.

WANGER, WALTER (*b. Walter Feuchtwanger, San Francisco, Calif., 1894; d. New York, N.Y., 1968*), theater and motion picture producer. Studied at Dartmouth, then worked in New York City

as an assistant to the producer Harley Granville-Barker, and later joined Elisabeth Marbury agency (1915–17). In 1919 was hired by Jesse L. Lasky to be general manager of Paramount Pictures' Long Island studios; supervised all of Paramount's productions (1923–31), became an executive producer at Metro-Goldwyn-Mayer in 1931, then returned to Paramount as an independent producer. In the late 1930's he was with United Artists, and in 1941 he set up his own production company allied with Universal Pictures. He was president of the Academy of Motion Picture Arts and Sciences (1939–45). He produced more than sixty pictures, and his erudition and love of innovation made him a leader in the industry.

WANLESS, WILLIAM JAMES (*b. Charleston, Ontario, Canada, 1865; d. Glendale, Calif., 1933*), Presbyterian medical missionary. Active in service in India, 1889–1930, principally at Miraj, he received knighthood (1928), for extraordinary work as hospital builder and medical teacher.

WANTON, JOSEPH (*b. Newport, R.I., 1705; d. Newport, 1780*), merchant, colonial governor of Rhode Island, 1769–75. A partial sympathizer with the Revolutionary movement in America, he opposed independence and retired from public life shortly after the outbreak of hostilities at Lexington.

WARBASSE, JAMES PETER (*b. Newton, N.J., 1866; d. Woods Hole, Mass., 1957*), surgeon and sociologist. Studied at Columbia College of Physicians and Surgeons (M.D., 1889) and at Göttingen and Vienna. Founder and first president of the Cooperative League of America (1916). An early advocate of socialized medicine. His liberal views, considered radical by his conservative colleagues, often put him at odds with his profession, and he withdrew from medicine to pursue interests in sociology. In 1939, he offered the first course in medical sociology at Long Island College of Medicine. Books include *Surgical Treatment* (1918–19), *Cooperative Democracy* (1923), and *Cooperative Medicine* (1936).

WARBURG, FELIX MORITZ (*b. Hamburg, Germany, 1871; d. New York, N.Y., 1937*), financier, philanthropist. Brother of Paul M. Warburg; son-in-law of Jacob H. Schiff. Came to America, 1894; became partner in Kuhn, Loeb & Co., 1897. Although he was the senior partner of this banking firm at the time of his death, Felix Warburg was primarily a humanitarian and lent his support to innumerable charitable, educational, and cultural organizations. A member of the New York City Board of Education and trustee of a number of schools including Teachers College at Columbia University, he also worked closely with Lillian D. Wald in her settlement work and was a leader in the establishment and management of the Federation for Support of Jewish Philanthropic Societies. Never a Zionist, he became increasingly associated *post* 1917 with the work of the Zionists in relocating displaced Jews and in securing a peaceful settlement of the Arab-Jewish problem in Palestine.

WARBURG, JAMES PAUL (*b. Hamburg, Germany, 1896; d. Greenwich, Conn., 1969*), financier, author, and government official. Moved with his parents to the United States in 1901. Studied at Harvard (B.A., 1917), then worked in several financial corporations. In 1933 joined President Franklin D. Roosevelt's first "brain trust" as a financial adviser, but soon resigned and criticized Roosevelt in a series of books, including *The Money Muddle* (1934), *It's Up to Us* (1934), *Hell Bent for Election* (1935), and *Still Hell Bent* (1936). As a free-lance originator of industrial financing, Warburg made a fortune by helping to find financing for Edwin H. Land, the inventor of the Polaroid process. He became a leading spokesman for the Committee to De-

fend America by Aiding the Allies and wrote *Peace in Our Time* (1940) and *Our War and Our Peace* (1941). During World War II he worked for the Office of Coordinator of Information and the Office of War Information. He became a critic of the Truman Doctrine and the idea of the United States as a global policeman. He opposed containment and favored accommodation with the Soviet Union and Communist China in the interest of peace. In 1961 he was appointed to assist John McCloy, who was forming a new Arms Control and Disarmament Agency and was negotiation with the Soviet Union.

WARBURG, PAUL MORITZ (*b. Hamburg, Germany, 1868; d. New York, N.Y., 1932*), banker. A partner in Kuhn, Loeb & Co., New York City, *post* 1902, Warburg was an authority on the central banking system employed in the principal European countries. After the panic of 1907 he joined with those urging a fundamental reform in the American banking system, and had a large part in the plan for a proposed national reserve association submitted by Senator Nelson W. Aldrich in 1911. Although the Federal Reserve law of 1913 was not wholly to his liking, Warburg served with great ability as a member of the first Federal Reserve Board, 1914–18. Thereafter he devoted himself chiefly to the organization and operation of the International Acceptance Bank. He received nationwide notice in March 1929 because of his plain warning of the disaster threatened by the wild stock speculation of that period; he predicted that unless speculation were brought under control, a general depression would ensue. After the panic of October 1929 and the succeeding commercial depression, he was quick to condemn emotional prophecies of ruin just as vigorously as he had warned against the delusions of the period of speculation. In analyzing the causes of the depression, he stressed the bad effects of efforts to maintain high prices by tariff barriers and other artificial expedients in the face of constantly accelerated mass production. He was the brother of Felix M. Warburg.

WARD, AARON MONTGOMERY (*b. Chatham, N.J., 1843; d. Highland Park, Ill., 1913*), mail-order merchant. As a salesman traveling out of St. Louis, Mo., Ward became aware of the difficulties of people in rural areas who were obliged to sell their own produce at low prices determined by competition, but had to make their own retail purchases at high cost without competition. He then conceived the idea of buying goods in large quantities for cash from the manufacturer and selling for cash by mail to the farmer. He began operations with his partner, G. R. Thorn, in Chicago, Ill., 1872; the firm's first stock was a small selection of dry goods, the first catalogue a single price sheet. By shrewd purchasing and a policy of permitting the return of goods if unsatisfactory, Ward succeeded from the very outset. By 1876 the Montgomery Ward catalogue had 150 pages with illustrations; at the time of his death, annual sales amounted to $40 million. Owing to a prolonged legal battle which he carried on in the Illinois courts, Chicago's lake frontage was preserved as a heritage for the people of that city.

WARD, ARCH BURDETTE (*b. Irwin, Ill., 1896; d. Chicago, Ill., 1955*), sportswriter and promoter. Notre Dame University's first athletic publicity director at the behest of Knute Rockne. Sportswriter for the *Chicago Tribune* from 1925 until his death. From 1937 wrote the column "In the Wake of the News," the oldest continuous sports column in American journalism. Conceived of and founded the all-star baseball series (1933) and the allstar football series (1934).

WARD, ARTEMAS (*b. Shrewsbury, Mass., 1727; d. Shrewsbury, 1800*), storekeeper, Massachusetts colonial legislator, Revolutionary general. Graduated Harvard, 1748. Holder of a number

of offices in Worcester Co., Ward rose to colonel in the provincial militia during the French and Indian War. Active in opposition to royal authority, he became a member of the Council, 1770–74, despite disapproval of the royal governor. A member of the first and second Massachusetts provincial congresses, he took command of the forces besieging Boston, April 1775, and in May was formally commissioned general and commander in chief of Massachusetts troops. Reduced to second-in-command with the rank of major general after the appointment of George Washington to supreme command, he viewed his successor without cordiality and offered his resignation to Congress soon after the fall of Boston, March 1776. He remained, however, in command at Boston after the withdrawal of the main army to New York until relieved by William Heath, March 1777. Thereafter, he served as a councillor of Massachusetts, as a legislator, and as a member of the Continental Congress. As congressman, Federalist, from Massachusetts, 1791–95, he was assigned to committees dealing with military affairs.

WARD, ARTEMUS. *See* BROWNE, CHARLES FARRAR.

WARD, CHARLES ALFRED (*b. Elyria, Ohio, 1883; d. New York, N.Y., 1951*), marine architect. Studied at Webb's Academy and Home for Shipbuilders (now Webb Institute of Naval Architecture), graduating in 1904. Supervisor of early designs of submarines, Ward is remembered for his designs of commercial ships, notably the United States Lines' *America* (1938) and the *United States* (1952), holder of the record of the fastest transatlantic crossing.

WARD, CHARLES HENSHAW (*b. Norfolk, Nebr., 1872; d. New Haven, Conn., 1935*), teacher. A.B., Pomona College, 1896; A.M., Yale, 1899. Taught English at the Taft School, Watertown, Conn., 1903–22. Wrote a number of elementary textbooks of grammar and English and several popular expository works on the sciences.

WARD, CYRENUS OSBORNE (*b. western New York State, 1831; d. Yuma, Ariz., 1902*), machinist, labor journalist, and lecturer. Brother of Lester F. Ward. Author, among other works, of *A Labor Catechism of Political Economy* (1878) and *A History of the Ancient Working People* (1889, later published as *The Ancient Lowly*). He urged working people to refrain from violence and to achieve a socialistic state by political methods.

WARD, ELIZABETH STUART PHELPS (*b. Boston, Mass., 1844; d. 1911*), writer. Daughter of Austin Phelps; granddaughter of Moses Stuart. Married Herbert D. Ward, 1888. Interpreter of the intellectual, oversensitive people of New England and their compulsion to do "the painful right," she was the author of the phenomenally successful *The Gates Ajar* (1869) and of many works of fiction, including *The Silent Partner* (1871), *The Madonna of the Tubs* (1886), and *A Singular Life* (1894).

WARD, FREDERICK TOWNSEND (*b. Salem, Mass., 1831; d. Tzeki, China, 1862*), adventurer, soldier. After a number of years at sea, and in military service with William Walker in Nicaragua and with the French in the Crimea, he appeared in Shanghai, China, 1859. Developing an army of well-drilled Chinese soldiers which came to be called the "Ever Victorious Army," he opposed the Taiping rebels and recaptured Sunkiang. The force later cooperated effectively with the Anglo-French forces near Shanghai and Ning-po. He was mortally wounded in battle. The celebrated British general Charles "Chinese" Gordon later achieved success in quelling the rebellion with the military instrument that Ward had created.

WARD, GENEVIEVE (*b. New York, N.Y., 1838; d. London, England, 1922*), singer, actress. After success in opera in Paris, she made her American debut at the Academy of Music, New York City, November 1862, in *La Traviata* as Violetta. On the failure of her singing voice, she studied for the dramatic stage and played with success at both Drury Lane and the Comédie-Française, 1875–77. Thereafter she was professionally active in the United States and abroad, scoring her greatest success in *Forget-Me-Not* by Herman Merivale. An intellectual player, she was described as of the school of Ristori.

WARD, GEORGE GRAY (*b. Great Hadham, England, 1844; d. New York, N.Y., 1922*), telegrapher, cable engineer. Came to America *ca.* 1876 as U.S. superintendent of a new cable company which broke the existing monopoly of the Anglo-American Telegraph Co. Served as general manager of the Commercial Cable Co. *post* 1884. Ward was primarily responsible for the diplomatic and engineering aspects of the work that resulted in the first cable across the Pacific. It was laid to Honolulu in 1902, to Manila in 1903, and to China and Japan in 1906.

WARD, HARRY FREDERICK (*b. Brentford, England, 1873; d. Palisades, N.J., 1966*), religious educator, author, and social critic. Immigrated to the United States in 1891. Studied at the University of Southern California, Northwestern (B.A., 1897), and Harvard (M.A., 1898). A disciple of the Social Gospel, he was accredited as a Methodist minister in 1902 and served several churches in the Chicago area. In 1907 drafted "The Social Creed of the Churches," a landmark church program for the benefit of the workers. This led to the formation in 1907 of the Methodist Federation for Social Service (later, Social Action). Ward served the federation as editor (1907–11) and general secretary (1911–44). Taught at Boston University's School of Theology (1913–18) and Union Theological Seminary (1918–41). He was chairman of the national board of the American Civil Liberties Union (1920–40) and national chairman of the American League Against War and Fascism (after 1936 the League for Peace and Democracy) (1934–40). His books include *The Labor Movement* (1917), *The New Social Order* (1919), *Our Economic Morality* (1929), *Which Way Religion?* (1931), and *In Place of Profit* (1933).

WARD, HENRY AUGUSTUS (*b. Rochester, N.Y., 1834; d. Buffalo, N.Y., 1906*), naturalist. Assisted in his efforts by the family of James S. Wadsworth, Ward worked under Agassiz at Cambridge, Mass., and later studied at the School of Mines in Paris, France. Professor of natural science in the University of Rochester, 1861–76, he is principally remembered for his founding of Ward's Natural Science Establishment for the preparation and sale of scientific materials to colleges and other institutions. Engaged chiefly in this work *post* 1864, he made a number of outstanding collections, including the natural history exhibit at the World's Columbian Exposition in 1893 which was bought by Marshall Field and was the nucleus of the Field Museum of Natural History.

WARD, HENRY BALDWIN (*b. Troy, N.Y., 1865; d. Urbana, Ill., 1945*), zoologist, parasitologist. Son of Richard Halsted Ward. A.B., Williams College, 1885. After graduate study abroad, in particular at University of Leipzig with Rudolph Leuckart, he entered the graduate school at Harvard (1890) and received the Ph.D. degree in 1892. He taught zoology briefly at University of Michigan, and then at University of Nebraska, 1902–09. As head of the department of zoology, University of Illinois, 1909–33, he established one of the first research laboratories in the United States to offer graduate work in parasitology. In 1914, he founded the *Journal of Parasitology*, which he continued to edit until

1932. Besides his papers on parasites, he was coauthor of *Fresh-Water Biology* (1918, with George C. Whipple).

WARD, HENRY DANA (b. *Shrewsbury, Mass., 1797; d. Philadelphia, Pa., 1884*), reformer, Episcopal clergyman. Grandson of Artemas Ward. Active in the Anti-Masonic movement and party *post* 1828, and in William Miller's Adventist movement, he was ordained to the Episcopal ministry, 1844. Thereafter he devoted most of his time to teaching in New York City and Flushing, N.Y.

WARD, HERBERT DICKINSON (b. *Waltham, Mass., 1861; d. Portsmouth, N.H., 1932*), author. Son of William H. Ward; husband of Elizabeth S. P. Ward.

WARD, JAMES EDWARD (b. *New York, N.Y., 1836; d. Great Neck, N.Y., 1894*), shipowner and operator. Originally a ship chandler and manager of a general freighting business to Cuba, Ward instituted direct passenger and mail service to Havana by steamship, 1877, as the Ward Line. The firm was incorporated, 1881, as the New York & Cuba Mail Steamship Co.

WARD, JAMES HARMON (b. *Hartford, Conn., 1806; d. off Matthias Point, Va., 1861*), naval officer. Appointed midshipman, 1823. One of the most scholarly officers in the service and a recognized authority on ordnance and naval tactics, he was author of *An Elementary Course of Instruction on Ordnance and Gunnery* (1845) and of *A Manual of Naval Tactics* (1859). He served as first commandant of midshipmen at the U.S. Naval Academy, 1845–47. Commanding a flying flotilla which he had proposed for use on Chesapeake Bay and the Potomac River in the Civil War, he silenced Confederate batteries at Aquia Creek, June 1, 1861, and was killed in action about three weeks later.

WARD, JAMES WARNER (b. *Newark, N.J., 1816; d. Buffalo, N.Y., 1897*), teacher. Appointed librarian of the Grosvenor Library in Buffalo, 1874, he served until 1896, and brought the library to a position of eminence.

WARD, JOHN ELLIOTT (b. *Sunbury, Ga., 1814; d. Dorchester, Ga., 1902*), lawyer, Georgia legislator and official. Having held, among other offices, the posts of acting lieutenant governor of the state and mayor of Savannah, he presided over the Democratic Convention at Cincinnati, Ohio, 1856, which nominated James Buchanan. As U.S. minister to China, 1859–60, he was successful in exchanging ratifications of the new American treaty with China and in settling outstanding American claims. Opposed to the secession of Georgia, he took no part in the Civil War. *Post* 1866 he practiced law in New York City.

WARD, JOHN QUINCY ADAMS (b. *near Urbana, Ohio, 1830; d. New York, N.Y., 1910*), sculptor. Began career as student assistant to Henry Kirke Brown *ca.* 1849. Winning notice for bust portraits of Alexander H. Stephens, John P. Hale, and other statesmen in Washington, D.C., 1857–59, he opened a studio in New York City, 1861. His "Indian Hunter" was among the first statues to be placed in New York's Central Park; conceived as a statuette in 1857, it was sited, 1868. Meanwhile, along with "The Freedman" it had been shown in the Paris Exposition of 1867. These works, and also his statue of Matthew C. Perry and his 7th Regiment Memorial in Central Park, showed his characteristic technical mastery, but his finest work was still to come. Winning further fame for his equestrian monument to General G. H. Thomas (1878) and his statue of William G. Simms (1879), he touched the heights in his "Lafayette" (Burlington, Vt.) and his "George Washington" (Wall St., New York City, Sub-treasury Building), both of 1883. Among other outstanding works by Ward were his *Pilgrim*, placed in Central Park, 1885; his *Horace*

Greeley in City Hall Park, New York; the James A. Garfield monument in Washington; and the Henry Ward Beecher Monument, Borough Hall, Brooklyn, N.Y. Ward was at his best in realistic rather than in idealized representation and preferred masculine themes. He was the first native sculptor to create without benefit of foreign training an impressive body of good work. Bringing a primitive Ohio vigor to what he did, he showed himself wholly out of sympathy with the mid-Victorian pseudoclassic ideals fostered in Florence and Rome. In the final decade of his life he produced, among other works, the pediment of the New York Stock Exchange and the equestrian statue of General Hancock, Fairmount Park, Philadelphia, both in collaboration with Paul Bartlett. A generous man, he gave his support to every worthy enterprise in art.

WARD, JOSEPH (b. *Perry Centre, N.Y., 1838; d. 1889*), Congregational clergyman. Graduated Brown, 1865; attended Andover Theological Seminary. Began his ministry at Yankton, Dakota Territory, 1869. Opened a private school there which became the Yankton Academy, 1872, and was eventually made the Yankton High School, earliest in the territory. Principal founder of Yankton College, 1881, he served there as president and professor of philosophy until his death. The education law of South Dakota was almost wholly his work, and he played a great part in keeping the school lands of the territory safe from speculators.

WARD, LESTER FRANK (b. *Joliet, Ill., 1841; d. Washington, D.C., 1913*), Union soldier, sociologist. Brother of Cyrenus O. Ward. Raised in Illinois and Iowa. After Civil War service, he worked in the U.S. Treasury Department at Washington, D.C., 1865–81, meanwhile receiving from Columbian College (present George Washington University) the A.B. degree in 1869, the LL.B. in 1871, and the A.M. in 1872. Joining the staff of the U.S. Geological Survey, 1881, he was appointed geologist, 1883, and paleontologist, 1892. He was professor of sociology at Brown University, 1906–13. Ward made valuable studies in the natural sciences, but he is best known because of his leadership in the field of American sociology. He became a pioneer of evolutionary sociology in the United States through the publication of *Dynamic Sociology* (1883), *Outlines of Sociology* (1898), *Pure Sociology* (1903), and other works in which he sought to give a strongly monist and evolutionary interpretation to social development. He argued that the emotional, willing aspects of the human mind have produced ambitious aspirations for individual and social improvement, and that the intellect, when rightly informed with scientific truth, enables the individual or the social group to plan for future development. The mind will become "telic," enabling mankind to pass from passive to active evolutionary processes, and from natural to human or social evolution. This ability will usher in an age of systematic planning for human progress in which government will stress social welfare and democracy will pass into "sociocracy." Accepting the fact of wide differences in human heredity and racial aptitudes, he argued that latent talent can be called forth by a stimulating social environment and a general education in the sciences. Governments, therefore, should aim to abolish poverty and develop national systems of general education, suited in one aspect for genius, in another, for ordinary minds. He was author also of a "mental autobiography," *Glimpses of the Cosmos* (1913–18).

WARD, LYDIA ARMS AVERY COONLEY (b. *Lynchburg, Va., 1845; d. Chicago, Ill., 1924*), author, Chicago civic leader. Wife of Henry A. Ward.

WARD, MARCUS LAWRENCE (b. *Newark, N.J., 1812; d. 1884*), businessman, philanthropist. Republican governor of New Jersey, January 1866–January 1869; congressman from New Jersey,

1873–75. Established Civil War welfare institutions in Newark; secured passage of reform legislation as governor.

WARD, MONTGOMERY *See* WARD, AARON MONTGOMERY.

WARD, NANCY *(fl. 1776–1781)*, Cherokee leader, known as "Beloved Woman." A resident of Great Echota in present Monroe Co., Tenn., she was a strong advocate of peace and a friend of the white frontier settlers. On several occasions during the Revolution she warned the settlers in the Watauga and Holston valleys in time to save themselves from raids and exercised her tribal right of sparing prisoners.

WARD, NATHANIEL *(b. Haverhill, England, ca. 1578; d. Shenfield, England, 1652)*, lawyer, clergyman, author. A.B., Emmanuel College, Cambridge, 1599; A.M., 1603. After practicing law for some time in England, he entered the ministry *ca.* 1619 and was chaplain to the British merchants at Elbing, Prussia. Returning to England, 1624, he was successively curate of St. James's, Piccadilly, London, and rector of Stondon Massey. Dismissed for nonconformity, 1633, he immigrated to Massachusetts Bay, 1634, and served briefly as a colleague minister at Agawam (Ipswich). Resigning his ministry, he was appointed by the General Court in 1638 to help prepare a legal code for Massachusetts, the first code of laws to be established in New England. According to John Winthrop, these laws (enacted 1641) were composed by Ward. The code was known as the "Body of Liberties" and was in effect a bill of rights, setting one of the cornerstones in American constitutional history. In 1645 Ward completed *The Simple Cobler of Aggawam in America* (London, 1647, under pseudonym "Theodore de la Guard"). The book was a protest against toleration, amusingly digressive and satirical; through it runs the prophecy of Presbyterianism. Ward expressed a strong opposition to "polypiety" in the church; in the state he would restore the old order with king, lords, and commons. Several other works in defense of tradition have been attributed to him. He was minister at Shenfield *post* 1648.

WARD, RICHARD *(b. Newport, R.I., 1689; d. 1763)*, merchant, Rhode Island colonial legislator and official. Father of Samuel Ward (1725–76). Elected deputy governor of Rhode Island, May 1740, he became governor a few months later and continued in office three years. A conservative, he supported colonial defense efforts, unsuccessfully opposed excessive issue of paper money, supported Rhode Island in a boundary controversy with Massachusetts, and protested against invasion of charter rights by the British.

WARD, RICHARD HALSTED *(b. Bloomfield, N.J., 1837; d. 1917)*, physician, microscopist. Graduated Williams, 1858; M.D., N.Y. College of Physicians and Surgeons, 1862. *Post* 1863 he practiced in Troy, N.Y., and taught botany and other scientific subjects at Rensselaer Polytechnic Institute, 1867–92. One of the first to demonstrate by the microscope the difference in cellular structure of blood from various animals, he was also an authority on adulteration of foods and medicines. He perfected a number of accessories for the microscope, notably an iris illuminator for the binocular instrument.

WARD, ROBERT DECOURCY *(b. Boston, Mass., 1867; d. 1931)*, educator, climatologist. Graduated Harvard, 1889; A.M., 1893. Taught physical geography and meteorology at Harvard *post* 1890, becoming professor of climatology, 1910, the first in the United States. Author of *Practical Exercises in Elementary Meteorology* (1899), *The Climate of the United States* (1925), and other works.

WARD, SAMUEL *(b. Newport, R.I., 1725; d. Philadelphia, Pa., 1776)*, farmer, Rhode Island colonial legislator. Son of Richard Ward. Conservative opponent of Stephen Hopkins in pre-Revolutionary politics. Governor of Rhode Island, 1762, 1765, and 1766, Ward signed the charter of the present Brown University, of which he was an original trustee. He vigorously opposed the Stamp Act. Elected a delegate to the First and Second Continental Congresses, Ward served as chairman of the Committee of the Whole, 1775, and proposed the appointment of George Washington as commander in chief of the colonial forces.

WARD, SAMUEL *(b. Westerly, R.I., 1756; d. New York, N.Y., 1832)*, Revolutionary soldier, New York City merchant. Son of Samuel Ward (1725–76); father of Samuel Ward (1786–1839).

WARD, SAMUEL *(b. Warwick, R.I., 1786; d. New York, N.Y., 1839)*, banker. Son of Samuel Ward (1756–1832); father of Samuel Ward (1814–84) and Julia Ward Howe. Became partner in the New York banking house of Prime & Sands, 1808; later became head of the firm, then known as Prime, Ward & King. Prevented repudiation of financial obligations by New York State in the panic of 1837; helped restore specie payments by New York banks in 1838. Helped found and became president of the Bank of Commerce in New York, 1839.

WARD, SAMUEL *(b. New York, N.Y., 1814; d. Pegli, Italy, 1884)*, financier, lobbyist, author. Son of Samuel Ward (1786–1839); brother of Julia Ward Howe; uncle of Francis Marion Crawford. Graduated Columbia, 1831; made studies in France and Germany; worked briefly in his father's banking house of Prime, Ward & King. Having lost his fortune by 1849, he joined the gold rush to California, where he adapted himself with great success to the rough environment. He became the confidant of James R. Keene, who helped him with financial advice. After journalistic and other activities, he lived in Washington, D.C., during the closing years of the Civil War and through the administrations of Andrew Johnson and U. S. Grant, acting as a lobbyist in the employ of financiers and gaining a reputation for the entertainments which he offered to public officials. Among the intimates of the "King of the Lobby," as he was known, were W. H. Seward, Charles Sumner, James A. Garfield, William M. Evarts; he was also a friend of W. M. Thackeray and Henry W. Longfellow. Described as having "a vagueness concerning all points of morality, which would have been terrible in a man less actively good," Ward was author of *Lyrical Recreations* (1865, 1871) and is believed today to have been the author of "The Diary of a Public Man" (*North American Review*, August—November 1879).

WARD, SAMUEL RINGGOLD *(b. Maryland, 1817; d. Jamaica, British West Indies, ca. 1866)*, black abolitionist and orator, Baptist and Congregational clergyman. Agent of the American and the New York State Anti-Slavery societies and of the Anti-Slavery Society of Canada. Spoke extensively and successfully in Great Britain, 1853–54.

WARD, THOMAS *(b. Newark, N.J., 1807; d. 1873)*, physician, poet, playwright. Author of, among other works, *Passaic, a Group of Poems* (1842, under pseudonym "Flaccus") and *War Lyrics* (1865). Produced amateur operettas for charity in a theater attached to his New York City house, 1862–72.

WARD, THOMAS WREN *(b. Salem, Mass., 1786; d. 1858)*, Boston merchant. Becoming American agent for the London, England, banking establishment of Baring Brothers through influence of his friend, Joshua Bates, Ward held that post from 1830 to 1853. Supervising operations which annually involved several million pounds sterling, he was regarded as one of the soundest

financiers in the United States. He succeeded in bringing the firm through the crisis of 1837–42 with unimpaired reputation and credit.

WARD, WILLIAM HAYES (*b. Abington, Mass., 1835; d. 1916*), editor, orientalist. Father of Herbert D. Ward. Graduated Amherst, 1856; Andover Theological Seminary, 1859. Associated in editorial capacities with the *New York Independent*, 1868–1916. One of the earliest Assyriologists in the United States, he became the leading authority in the world on Assyrian and Babylonian seals. An exploring expedition conducted by him, 1884–85, resulted in the uncovering of ancient Nippur, 1888–1900. He was author, among other works, of *The Seal Cylinders of Western Asia* (1910).

WARDE, FREDERICK BARKHAM (*b. Deddington, England, 1851; d. Brooklyn, N.Y., 1935*), actor. Making his American debut in New York at Booth's Theatre, 1874, he subsequently played Shakespearean roles in support of Edwin Booth, Charlotte Cushman, Madame Janauschek, and others. At his death, he represented the last of the old school of tragedians. *Post* 1907 he lectured on Shakespeare and other topics connected with the drama, displaying scholarship and taste.

WARDEN, DAVID BAILIE (*b. near Greyabbey, Ireland, 1772; d. France, 1845*), teacher, diplomat, collector of Americana. A.M., University of Glasgow, 1797. Immigrated to America, 1799, after his arrest for association with the United Irishmen. Becoming a U.S. citizen, 1804, he went to Paris as private secretary to General John Armstrong and was later consul at Paris. After his removal from office, 1814, he spent the rest of his life in France, but gave a great deal of his time to the dissemination of information concerning America. He wa author, among other works, of *On the Origin . . . of Consular Establishments* (1813), *A Statistical, Political and Historical Account of the United States of North America* (1819), and several annotated catalogues of his book collections.

WARDEN, ROBERT BRUCE (*b. Bardstown, Ky., 1824; d. Washington, D.C., 1888*), Ohio jurist and supreme court reporter. Author of biographies of Salmon P. Chase and Stephen A. Douglas.

WARDER, JOHN ASTON (*b. Philadelphia, Pa., 1812; d. 1883*), physician. Associated as a boy with John J. Audubon, François Michaux, and Thomas Nuttall. M.D., Jefferson Medical College, 1836. Practiced in Cincinnati, Ohio, 1837–55. Thereafter a farmer at North Bend, Ohio, he was active in the state and national horticultural and pomological societies as officer and editor. He served as president of the American Forestry Association, 1875–82, and was an organizer of its successor, the American Forestry Congress. Among his books were *Hedges and Evergreens* (1858) and *American Pomology: Apples* (1867).

WARDMAN, ERVIN (*b. Salt Lake City, Utah, 1865; d. 1923*), journalist. Graduated Harvard, 1888. On staff of *New York Tribune*, 1889–95, he was briefly managing editor of *New York Press* and its editor in chief, 1896–1916. He made the paper an aggressive organ of liberal Republicanism and in the late 1890's coined the term "yellow journalism." *Post* 1916 he was publisher of the New York *Sun*. As an editorial writer his chief field was labor economics.

WARE, ASHUR (*b. Sherborn, Mass., 1782; d. 1873*), editor, jurist. Nephew of Henry Ware (1764–1845). Graduated Harvard, 1804; studied law in office of Loammi Baldwin. Removed to Portland, Maine, 1817, mainly to edit the *Eastern Argus*, and was an active force in Maine's home-rule politics and in the Dem-

ocratic party. Becoming Maine's secretary of state, 1820, he served as U.S. district court judge in Maine, 1822–66. He was, in the opinion of Judge Story, perhaps the ablest American authority in the field of maritime law.

WARE, EDMUND ASA (*b. North Wrentham, Mass., 1837; d. 1885*), Congregational clergyman, educator. Graduated Yale, 1863. Appointed superintendent of education for Georgia by General O. O. Howard, 1867, Ware was a founder of Atlanta University (chartered 1867, opened 1869) and served as its president until his death. His idealism and courage were important factors in the university's success.

WARE, HENRY (*b. Sherborn, Mass., 1764; d. Cambridge, Mass., 1845*), Unitarian clergyman, theologian. Graduated Harvard, 1785. Pastor, First Church, Hingham, Mass., 1787–1805. His election as Hollis Professor of Divinity at Harvard in 1805 marked a new era in the history of Congregationalism and gave rise to a controversy between members of the liberal and orthodox parties. In 1820 the liberal Ware engaged in pamphlet argument with Dr. Leonard Woods (1774–1854), known as the "Wood'n Ware Controversy." In 1811 Ware began a course of instruction for ministerial candidates from which developed the Harvard Divinity School (organized, 1816), with Ware as professor of systematic theology and evidences. He resigned as Hollis Professor, 1840, but continued to teach in the Divinity School. He was father of Henry (1794–1843), John, and William Ware.

WARE, HENRY (*b. Hingham, Mass., 1794; d. Framingham, Mass., 1843*), Unitarian clergyman, author. Son of Henry Ware (1764–1845); brother of John and William Ware; father of John F. W. Ware and William R. Ware. Graduated Harvard, 1812. Pastor of the Second Church (Unitarian), Boston, 1817–*ca.* 1829, he served as editor of the *Christian Disciple* and was a leader in the establishment of the American Unitarian Association. He was professor of pulpit eloquence and pastoral care in Harvard Divinity School, *ca.* 1830–42.

WARE, JOHN (*b. Hingham, Mass., 1795; d. 1864*), physician, editor. Son of Henry Ware (1764–1845); brother of Henry (1794–1843) and William Ware. Graduated Harvard, 1813; M.D., Harvard Medical School, 1816. Practicing in Boston, he served as editor of several publications and was author in 1831 of the first important work on *delirium tremens* to appear in America. After succeeding James Jackson as Hersey Professor at Harvard Medical School, 1836, Ware was author of a number of scientific papers which included important discussions of croup and hemoptysis.

WARE, JOHN FOTHERGILL WATERHOUSE (*b. Boston, Mass., 1818; d. Milton, Mass., 1881*), Unitarian clergyman. Son of Henry Ware (1794–1843); half brother of William R. Ware. Principal pastorates at Fall River and Cambridgeport, Mass., and at Church of the Saviour, Baltimore, Md.; pastor of Arlington Street Church, Boston, *post* 1872.

WARE, NATHANIEL A. (*b. Massachusetts or South Carolina, date uncertain; d. near Galveston, Tex., 1854*), land speculator, public official. Secretary of Mississippi Territory, 1815–17, he lived thereafter in a number of places both North and South. He is best remembered for *Notes on Political Economy . . .* (1844, under pseudonym "A Southern Planter"), a work often echoing Henry C. Carey. Ware was a protectionist, almost unique in a Mississippian of that period, and an advocate of a balanced economy for the South.

WARE, WILLIAM (*b. Hingham, Mass., 1797; d. Cambridge, Mass., 1852*), Unitarian clergyman. Son of Henry Ware (1764–

1845); brother of Henry (1794–1843) and John Ware. Graduated Harvard, 1816. Pastor of the first Unitarian Church to be established in New York City, 1821–36, he resigned the ministry and became noted thereafter as an author. Among his works, which were very popular in their time, were *Letters of Lucius M. Piso from Palmyra* (1837, entitled in subsequent editions *Zenobia: or, the Fall of Palmyra*); *Probus: or, Rome in the Third Century* (1838, published afterwards under the title *Aurelian*); *Julian: or, Scenes in Judea* (1841); and *Lectures on the Works and Genius of Washington Allston* (1852).

WARE, WILLIAM ROBERT (*b. Cambridge, Mass., 1832; d. Milton, Mass., 1915*), architect. Son of Henry Ware (1794–1843); half-brother of John F. W. Ware. Graduated Harvard, 1852; S.B., Lawrence Scientific School, 1856; studied in offices of Edward C. Cabot and Richard M. Hunt. Successful in practice in Boston with Henry Van Brunt, Ware and his partner experimented with an atelier for students in their own office, 1863–65. Appointed head of a proposed school of architecture in the Massachusetts Institute of Technology, 1865, Ware studied professional education abroad, and on his return brought with him Eugène Létang to take charge of the work in design at the new school. In 1881 Ware was called to New York to found a school of architecture at Columbia University where he remained until his retirement as professor emeritus, 1903. He may be called the founder of American architectural education in a very real sense. To him the architect was more than a mere technician — he was a an artist, an exponent of a traditional cultural history, and a member of society as a whole. In order to develop the creative side of his students, he borrowed from France the idea of teaching design by projects to be solved under criticism. His ideals of education appear in *An Outline of a Course of Architectural Instruction* (1866) and in a paper "On the Condition of Architecture and of Architectural Education in the United States" (*Papers*, Royal Institute of British Architects, 1866–67). He was author also, among other works, of *Modern Perspective* (1883); *The American Vignola* (1902–06); and *Shades and Shadows* (1912–13).

WARFIELD, BENJAMIN BRECKINRIDGE (*b. near Lexington, Ky., 1851; d. Princeton, N.J., 1921*), Presbyterian clergyman. Grandson of Robert J. Breckinridge. Graduated College of New Jersey (Princeton), 1871; Princeton Theological Seminary, 1876; studied also at University of Leipzig. Professor of New Testament in Western Theological Seminary, Pittsburgh, 1879–87, he was professor of theology at Princeton Seminary thereafter. Editor of the *Presbyterian and Reformed Review* (1890–1903), he was author of some twenty books on biblical and theological subjects. An orthodox Calvinist, he continued without concessions the theological tradition established at Princeton by the Hodges.

WARFIELD, CATHERINE ANN WARE (*b. Natchez, Miss., 1816; d. 1877*), writer. Daughter of Nathaniel A. Ware. Educated in Philadelphia, Pa., and a resident of Kentucky *post* 1833, Mrs. Warfield was author of minor verse and of the novel *The Household of Bouverie* (1860) and much other fiction. Her work was melodramatic and written in a cheerless, pedantic style.

WARFIELD, DAVID (*b. San Francisco, Calif., 1866; d. New York, N.Y., 1951*), actor. After years of playing burlesque and vaudeville, Warfield, known for his dialects, appeared in the David Belasco play *The Auctioneer* in 1900. The role of Simon Levi, a Russian Jewish exile on New York's Lower East Side, became Warfield's stock character. His next play, Belasco and Klein's *The Music Master*, opened in 1904, followed by Belasco's *The Grand Army Man* (1907), *The Return of Peter Grimm* (1911), and the Belasco production of Shakespeare's *The Merchant of Venice*

(1922), in which Warfield played Shylock. He retired from the stage after the failure of the latter. Early investments in Loew's Incorporated made Warfield a millionaire.

WARFIELD, SOLOMON DAVIES (*b. near Mount Washington, Md., 1859; d. 1927*), Maryland manufacturer and financier. Postmaster of Baltimore, Md., 1894–1905. Organized and became president of Continental Trust Co., 1898, which was the agency of his later operations in railroads, public utilities, and cotton manufacturing. Among his successful operations were the organization and reorganization of the Seaboard Air Line Railway, and the merging of Baltimore utilities in the Consolidated Gas, Electric Light & Power Co.

WARING, GEORGE EDWIN (*b. Pound Ridge, N.Y., 1833; d. New York, N.Y., 1898*), agriculturist, sanitary engineer. Studied agricultural chemistry under James J. Mapes; managed Horace Greeley's farm at Chappaqua, N.Y.; drainage engineer of Central Park, New York City, 1857–61. After Civil War service in the Union Army, he managed the Ogden Farm near Newport, R.I., and then engaged as a professional expert in sanitary drainage of houses and towns. He made a notable success as a reforming and efficient streetcleaning commissioner of New York City, 1895–98.

WARING, JULIUS WATIES (*b. Charleston, S.C., 1880; d. New York, N.Y., 1968*), lawyer, federal judge, and civil rights activist. Studied at the College of Charleston (B.A., 1900), then built a thriving law practice in Charleston. Was assistant U.S. attorney (1914–21) and corporate counsel of Charleston (1933–42). In 1938 he directed the senatorial campaign of the notorius racist "Cotton" Ed Smith. While serving as a federal district judge (1942–52), he changed his racial views and handed down a series of liberal civil rights decisions, opposing, for example, the disfranchisement of blacks and segregation in public schools. Ostracized, even by relatives, he moved to New York City following his retirement, lending his hand to many civil rights causes.

WARMAN, CY (*b. near Greenup, Ill., 1855; d. Chicago, Ill., 1914*), railroadman, Colorado journalist. Author of many short stories and novels depicting the romance of the frontier and, in particular, of the pioneer railroads. Among his books were *Tales of an Engineer with Rhymes of the Rail* (1895) and *The Last Spike and Other Railroad Stories* (1906).

WARMOTH, HENRY CLAY (*b. MacLeansboro, Ill., 1842; d. Louisiana, 1931*), Union soldier, lawyer. Opened law office in New Orleans, La., 1865, for practice before military commissions and government departments. Outraged all factions by his attempts to harmonize interests of both blacks and whites while Republican governor of Louisiana, 1868–72. Engaged thereafter in sugar planting and refining near New Orleans.

WARNER, ADONIRAM JUDSON (*b. Wales, N.Y., 1834; d. Marietta, Ohio, 1910*), teacher, Union officer. Settled in Marietta, Ohio, 1865; bought and developed oil and coal lands and built two short-line railroads. A vehement opponent of the demonetization of silver in 1873, he introduced unsuccessful free-coinage bills while congressman, Democrat, from Ohio, 1879–81 and 1883–87. Remaining active in the fight for free silver, he served as president of the American Bimetallic League and later of the American Bimetallic Union. He spent the latter part of his life in industrial activity, for the most part in Georgia.

WARNER, AMOS GRISWOLD (*b. Elkader, Iowa, 1861; d. Las Cruces, N.Mex., 1900*), sociologist. Graduated University of Nebraska, 1885; Ph.D., Johns Hopkins, 1888. Taught economics at Nebraska and at Leland Stanford. Served as superintendent of

charities for District of Columbia, 1891–93. Author of the standard work *American Charities* (1894).

WARNER, ANNA BARTLETT (*b. New York, N.Y., 1827; d. Highland Falls, N.Y., 1915*), author of children's books. Sister of Susan B. Warner.

WARNER, ANNE RICHMOND (*b. St. Paul, Minn., 1869; d. England, 1913*), popular novelist. Resided principally abroad *post* 1901. Author of many magazine serials and other works of fiction, of which the best known were *Susan Clegg and Her Friend Mrs. Lathrop* (1904) and four other books dealing with the same principal character.

WARNER, CHARLES DUDLEY (*b. Plainfield, Mass., 1829; d. Hartford, Conn., 1900*), journalist, essayist. Graduated Hamilton College, 1851. After attempting surveying, general business, and the law, Warner became assistant to Joseph R. Hawley on the Hartford, Conn., *Evening Press*, 1860, and was editor of the paper *post* 1861. After consolidation of the *Press* with the *Hartford Courant*, 1867, Warner remained identified with the *Courant* for the rest of his life. A friend of Mark Twain (with whom he collaborated on *The Gilded Age*, 1873) and other notable literary men of the period, Warner was author of a number of travel books, three novels, and two biographies, but he was at his best in the essay form. *My Summer in a Garden* (1871), *Backlog Studies* (1873), *Being a Boy* (1878), and other collections all bear the impress of the work of Charles Lamb and have something of his mellowness and grace. Warner was also a contributing editor to *Harper's New Monthly Magazine* and was a coeditor of *The Library of the World's Best Literature* (1896–97).

WARNER, EDWARD PEARSON (*b. Pittsburgh, Pa., 1894; d. Duxbury, Mass., 1958*), aeronautical engineer and civil servant. Studied at Harvard University and at the Massachusetts Institute of Technology. In 1919–20 he was chief physicist for the National Advisory Committee for Aeronautics. Warner taught at M.I.T. from 1920 to 1926, when he was appointed assistant secretary of the navy for aeronautics (1926–29). From 1929 to 1934 he was the editor of the magazine *Aviation*. From 1934 to 1935 he was vice-chairman of the Federal Aviation Commission and from 1938 to 1945 he was a member and vice-chairman of the Civil Aeronautics Authority (later Board). After World War II Warner became head of the International Civil Aviation Organization (1947–57), and was instrumental in standardizing flight rules and procedures for international commercial flights. Books include *Airplane Design* (1927).

WARNER, FRED MALTBY (*b. Hickling, Nottinghamshire, England, 1865; d. Orlando, Fla., 1923*), businessman, Michigan legislator. Brought to America as an infant, he was raised in Farmington, Mich. Successful in the cheese-making industry, farming, and banking, he appeared thoroughly conservative in background when elected Republican governor of Michigan in 1904. However, during his term (1905–11) he undertook a sturdy fight for liberal reforms, including a general primary law, heavier taxation and lower rates on railroads, stricter control of public utilities and insurance companies, conservation of natural resources, and curbing of stock manipulation.

WARNER, GLENN SCOBEY ("POP") (*b. Springville, N.Y., 1871; d. Palo Alto, Calif., 1954*), football coach. Football coach at Carlisle Indian School, Pa. (1899–1903; 1907–14). Experimented with new rules and forms of the game including the forward pass, the single wingback attack, and the double wingback formation. With All-American halfback Jim Thorpe on his 1912 team, Warner gained national recognition when the team beat Harvard, Dartmouth, the University of Pennsylvania, and the University of Chicago. From 1914 to 1925 he coached at the University of Pittsburgh; from 1925 to 1932 at Stanford University; and from 1932 to 1939 at Temple University. All of these teams enjoyed great success. Along with Knute Rockne of Notre Dame, he dominated college football coaching.

WARNER, HARRY MORRIS (*b. Krasnosielce, Poland, 1881; d. Bel Air, Calif., 1958*), motion picture executive. Immigrated to the U.S. in the late 1880's. Harry Warner was the financial manager of Warner Brother Pictures, Inc., founded in 1923. A distributing company founded in 1903 by four Warner brothers and a sister, the firm was, by 1930, the second largest film company in Hollywood. Through early expansion into theaters and sound pictures, the company was financially successful from the beginning. Famous for musicals and gangster films. Harry Warner was president of the company from 1923 until 1951 and chairman of the board until his death.

WARNER, HIRAM (*b. Williamsburg, Mass., 1802; d. Atlanta, Ga., 1881*), Georgia jurist and legislator. Chief justice of the state supreme court, 1867–68 and 1872–80.

WARNER, JACK LEONARD (*b. Jack Eichelbaum, London, Ontario, Canada, 1892; d. Los Angeles, Calif., 1978*), motion-picture executive. While in his teens, Warner and his brothers learned the workings of the motion picture industry. After purchasing theaters around the country and producing several silent features, in 1923 they incorporated as Warner Brother Pictures, with Jack as vice-president and production chief. In 1927 Warner Brothers released *The Jazz Singer*, which featured the first spoken words in a commercial movie, and followed with the first all-talking full-length film, *Lights of New York* (1928). During the 1930's Warner Brothers secured contracts with a burgeoning number of talented stars and directors. Warner films included such classics as *Little Caesar* (1930), *42nd Street* (1933), *The Life of Emile Zola* (1937), and *The Adventures of Robin Hood* (1938).

During World War II, Warner Brothers continued its string of successes with *Casablanca* (1942) and *Destination Tokyo* (1943); Jack Warner served in the motion-picture unit of the Army Air Forces and produced several films, including Irving Berlin's *This Is the Army* (1943). In the 1950's, at the height of anti-Communism, he supported the campaign to blacklist "un-American" directors, actors, and other film industry figures. Because of federal antitrust regulations, Warner Brothers separated their production and theater-ownership functions in 1955, after which the company moved increasingly into television production. In 1965 he became president of the merged Warner–Seven Arts Studio; he sold his shares in 1967 and retired from the studio in 1969. He became president of Jack Warner Productions, which produced such films as *My Fair Lady* (1964), *Who's Afraid of Virginia Woolf?* (1966), *Bonnie and Clyde* (1967), and *1776* (1972).

WARNER, JAMES CARTWRIGHT (*b. Gallatin, Tenn., 1830; d. 1895*), industrialist. A prime factor in the revival and modernization of the charcoal iron industry in Middle Tennessee *post* 1868.

WARNER, JONATHAN TRUMBULL (*b. Hadlyme, Conn., 1807; d. California, 1895*), California pioneer and legislator. Employed by Jedediah Smith, 1831, as clerk of a trading expedition to New Mexico, Warner reached Santa Fe early in July; he then joined a trading expedition to California, arriving in Los Angeles in December. Employed for a time by Abel Stearns, he opened a store of his own in 1836. He became a Mexican citizen, 1843, and began acquisition of Warner's Ranch, southeast of Los Angeles, 1844. Later losing the bulk of his property, he yet remained

one of the most widely esteemed of the American pioneers. He was coauthor of *An Historical Sketch of Los Angeles County* (1876).

WARNER, JUAN JOSÉ *See* WARNER, JONATHAN TRUMBULL.

WARNER, LANGDON (*b.* Cambridge, Mass., 1881; *d.* Cambridge, 1955), art historian. Graduated Harvard, 1903. Taught at Harvard, 1915–17, when he became director of the Philadelphia Museum of Art (1919–23). Returned to Harvard where he remained until his death. Offered the first courses in Oriental art in the U.S. The leading Orientalist in the U.S., Warner was technical consultant to General Douglas MacArthur on arts and monuments in occupied Japan. His books include *Japanese Sculpture of the Suiko Period* (1923), *The Long Old Road in China* (1926), *Buddhist Wall Paintings* (1936), and *The Enduring Art of Japan* (1951). Responsible for at least four new departments of Asian art in leading museums and trained a generation of teachers, curators, experts, and collectors.

WARNER, OLIN LEVI (*b.* Suffield, Conn,., 1844; *d.* 1896), sculptor. Originally self-taught, he studied in Paris under Jouffroy and J. B. Carpeaux, *ca.* 1869–1872. He gradually gained fame *post* 1876 as a sculptor of portrait busts which were truly classic in feeling and profound in their interpretation of character. Among his outstanding works were portrait studies of a number of Northwest Indian chiefs including Chief Joseph; William L. Garrison on Commonwealth Avenue, Boston, Mass.; and the figure of Charles Devens in front of the Boston State House. He also designed and modeled the door of the Library of Congress, Washington D.C., entitled "Oral Tradition."

WARNER, SETH (*b.* present Roxbury, Conn., 1743; *d.* Roxbury, 1784), Revolutionary soldier. Removed to Bennington, Vt., 1763, where, with Ethan Allen and others, he resisted assertion of authority over Vermont by the province of New York. During the Revolution he aided Allen and Benedict Arnold in the surprise of Ticonderoga on May 10, 1775, and himself captured Crown Point on the following day. Commanding a regiment of Green Mountain Boys, he served under Montgomery in Canada. In 1777, during the advance of Burgoyne, he commanded the rear guard of St. Clair's army and fought an action at Hubbardton on July 7. The timely arrival of his regiment in the latter part of the battle of Bennington (August 16, 1777) is said to have turned the tide in favor of the Americans.

WARNER, SUSAN BOGERT (*b.* New York, N.Y., 1819; *d.* Highland Falls, N.Y., 1885), novelist. Sister of Anna B. Warner. Author, among other works, of the best-selling *The Wide, Wide World* (1850, under pseudonym "Elizabeth Wetherell") and *Queechy* (1852). Her description of the emotions of her characters (which found expression in tears on almost every page) compensated in the minds of contemporary readers for the absence of action in her stories.

WARNER, WILLIAM (*b.* Shullsburg, Wis., 1840; *d.* 1916), lawyer. Union soldier. In practice in Kansas City, Mo., *post* 1865, he was U.S. attorney for the western district of Missouri, 1882–84, 1898, and 1902–05. Republican congressman from Missouri, 1885–87, 1889–91, and U.S. senator, 1905–11, he was strongly conservative and seldom rose above the level of complacent mediocrity.

WARNER, WILLIAM LLOYD (*b.* Redlands, Calif., 1898; *d.* Chicago, Ill., 1970), social anthropologist. Studied at Berkeley (B.A., 1925), then worked in Australia under Alfred Radcliffe-Brown (1926–29), where his work was one of the earliest efforts to understand the linkages between social-structural and cultural-symbolic phenomena. His dissertation is the classic *A Black Civilization: A Social Study of an Australian Tribe* (1937). At Harvard (1929–35) Warner worked with Elton Mayo on the Hawthorne Western Electric plant and the Yankee City studies. The latter were published in six volumes, 1941–59. He took a position at the University of Chicago in 1935 and became involved with the Committee on Human Development. In 1946 Warner and Mary Gardner formed Social Research, Inc., a consulting firm. While teaching at Michigan State (1959–70), he wrote *The American Federal Executive* (1967), a study of corporate executives.

WARNER, WORCESTER REED (*b.* near Cummington, Mass., 1846; *d.* Eisenach, Germany, 1929), manufacturer. Partner with Ambrose Swasey in making turret lathes and other special machinery, 1881–1911, Warner devoted most of his leisure to astronomy and the engineering of telescopes. Among others which he and Swasey designed, built, and installed were those at the Lick Observatory, the Yerkes telescope, and the 72-inch telescope for the Dominion of Canada.

WARREN, CHARLES (*b.* Boston, Mass., 1868; *d.* Washington, D.C., 1954), constitutional authority and historian. Graduated Harvard Law School, 1892. Appointed assistant U.S. attorney general (1914–18) by Woodrow Wilson; author of the Espionage and Trading With the Enemy Acts of 1917. In private practice in Washington, *post* 1918. His three-volume *The Supreme Court in United States History* (1922) won the Pulitzer Prize for history in 1923, and is often cited by the justices of the court in their rulings and by presidents in their uses of presidential powers.

WARREN, CYRUS MOORS (*b.* West Dedham, Mass., 1824; *d.* Manchester, Vt., 1891), tar-roofing manufacturer, chemist. B.S., Lawrence Scientific School, Harvard, 1855. Studied also in Paris, at Heidelberg under Bunsen, at Munich under Liebig, and elsewhere abroad. Made important researches on the hydrocarbon constituents of tars; developed improved process of "fractional condensation" (*ca.* 1865) which was afterwards applied to study of the hydrocarbons in Pennsylvania petroleum; invented processes of purification for asphalt. Warren's petroleum investigations may be said to mark the beginning of modern exact research in this field.

WARREN, EARL (*b.* Los Angeles, Calif., 1891; *d.* Washington, D.C., 1974), governor of California and chief justice of the United States. Graduated University of California at Berkeley (B.L., 1912; J.D., 1914); served in World War I; then joined the Alameda County district attorney's office (1920). He was elected district attorney (1926), state attorney general (1938), and governor of California (1942), and ran unsuccessfully for vice-president on the ticket headed by Thomas E. Dewey (1948). He was nominated chief justice of the Supreme Court by President Dwight Eisenhower in October 1953 and confirmed by the Senate in March 1954.

The Warren Court made a lasting imprint on American society by shifting the Court's priorities from questions of property rights to civil liberties and by making the courts an active partner in governing the nation. In *Brown v. Board of Education* (1954), public-school racial segregation was found to be unconstitutional under the equal protection clause of the Fourteenth Amendment. Warren used his political skill to forge unanimity among the justices in *Brown* and in all the Warren Court's future racial segregation decisions. Other landmark Warren Court decisions include *Engel v. Vitale* (1962), which outlawed mandatory school prayer; *Griswold v. Connecticut* (1963), which announced a constitutionally protected right to privacy; and *Reynolds v. Sims* (1964), which reapportioned legislative districts in accordance

with the "one man, one vote" formula. Warren also presided over decisions protecting the rights of the accused, including *Mapp v. Ohio* (1961), which prevented prosecutors from using evidence seized in illegal searches; *Gideon v. Wainwright* (1963), which guaranteed indigent defendants the right to an attorney; and *Miranda v. Arizona* (1966), which held that suspects must be apprised of their legal rights.

WARREN, FRANCIS EMROY (*b. Hinsdale, Mass., 1844; d. 1929*), Union soldier, Wyoming pioneer, cattle- and sheep-raiser. Republican governor of Wyoming Territory, 1885–86, 1889–90. Elected first governor of the state of Wyoming, he resigned immediately to become U.S. senator, serving 1890–93 and 1895–1929. He was at various times chairman of the Senate committee on military affairs and of the committee on appropriations; he was particularly interested in the reclamation of arid lands.

WARREN, FULLER (*b. Blountstown, Fla., 1905; d. Miami, Fla., 1973*), politician and governor of Florida. Attended University of Florida and was elected in his senior year to the Florida house of representatives; after one term he enrolled at Cumberland University in Tennessee, receiving a law degree in 1928. Elected governor in 1948, he tightened regulation of the citrus industry and attempted to reform Florida's regressive tax system, but in 1951 he was accused by the U.S. Senate's Crime Investigation Committee of having allowed his office to be used by a crime syndicate "in its successful effort to muscle into Miami Beach gambling." In 1956 he made another (unsuccessful) bid for the governorship.

WARREN, GEORGE FREDERICK (*b. near Harvard, Nebr., 1874; d. probably Ithaca, N.Y., 1938*), agricultural economist. Graduated University of Nebraska, 1897; Ph.D., Cornell University, 1905. *Post* 1906 a teacher of agricultural subjects at Cornell, and ultimately head of the department of agricultural economics there, Warren made his chief contribution by originating farm cost-accounting and by promotion of efficiency through statistical analysis of the income of individual farms and groups of farms. The agricultural surveys introduced at Cornell became the basis of surveys conducted at other land-grant colleges and by the U.S. Department of Agriculture. A frequent adviser to the government both on the state and federal level, he advocated the "commodity" or "compensated" dollar, a government-managed currency whose purchasing power in terms of commodities would be kept uniform by manipulating the price of gold through government purchases of that metal. In October 1933 President F. D. Roosevelt devalued the dollar in accordance with the Warren plan and, though the results failed to live up to Warren's predictions as a remedy for depression, Warren continued for several years to act as a consultant on monetary policy to the Roosevelt administration.

WARREN, GOUVERNEUR KEMBLE (*b. Cold Spring, N.Y., 1830; d. Newport, R.I., 1882*), soldier, engineer. Graduated West Point, 1850. Assigned to the Topographical Engineers. Made surveys in Mississippi River Delta and on other river-improvement projects; assisted A. A. Humphreys as compiler of maps and reports for Pacific Railroad exploration; made maps and reconnaissances in Dakota and Nebraska territories. A gallant and highly effective Union Army brigade, division, and corps commander during the Civil War, he rendered his most distinguished service at Gettysburg, July 1863. Making a reconnaissance of the Union left, he discovered that Little Round Top was undefended and improvised a force for its defense, an action which saved the Union Army from repulse. Commanding the V Corps at Five Forks, April 1, 1865, he clinched the victory but was summarily relieved of command by General P. H. Sheridan. Returning to river and

harbor work, he continued to apply for a board of inquiry into the causes of his relief at Five Forks, but did not receive vindication until after his death.

WARREN, HENRY CLARKE (*b. Cambridge, Mass., 1854; d. 1899*), orientalist, authority on Pali and the sacred books of southern Buddhism.

WARREN, HENRY ELLIS (*b. Boston, Mass., 1872; d. Ashland, Mass., 1957*), inventor. Studied at Massachusetts Institute of Technology (B.S., 1894). Inventor of the synchronous electric clock in 1914. Later devised master clock for General Electric to control power frequencies at generating stations.

WARREN, HENRY WHITE (*b. Williamsburg, Mass., 1831; d. University Park, near Denver, Colo., 1912*), Methodist clergyman. Brother of William F Warren. Pastor in several Massachusetts towns and in Philadelphia, Pa., and New York City. Elected bishop, 1880, he took up residence at Atlanta, Ga., and later in the neighborhood of Denver, Colo. Among his numerous writings was *The Lesser Hymnal* (1875), which he prepared with Eben Tourjée.

WARREN, HERBERT LANGFORD (*b. Manchester, England, 1857; d. 1917*), architect. The son of an American Swedenborgian missionary, Warren came to America in 1876 and studied at the Massachusetts Institute of Technology, 1877–79. He served as assistant in the office of Henry H. Richardson, 1879–84. After practicing for a time, he became an instructor at Harvard in 1893 and the school of architecture there formed itself about him. Elected professor of architecture, 1899, he became first dean of the independent faculty of architecture, 1914. Gifted in the interpretation of great architecture and its principles, he was author, among other works, of *The Foundations of Classic Architecture* (1919, augmented by Fiske Kimball).

WARREN, HOWARD CROSBY (*b. Montclair, N.J., 1867; d. 1934*), psychologist. Graduated College of New Jersey (Princeton), 1889; M.A., 1891; studied also at Leipzig, Berlin, and Munich. Early a believer in a deterministic interpretation of mental processes, he was influenced by Spencer and the psychology of the British Associationists. A teacher of psychology at Princeton *post* 1893, and first chairman of a separate department of psychology *post* 1920, he expressed in his writings and in his textbook *Elements of Human Psychology* (1922) a conservatively behavioristic point of view. He was joint editor of the *Psychological Bulletin*, 1904–34, and editor of the *Psychological Review*, 1916–34.

WARREN, ISRAEL PERKINS (*b. present Bethany, Conn., 1814; d. 1892*), Congregational clergyman. Editor of publications, American Tract Society at Boston, Mass., 1859–70; editor and publisher, the *Christian Mirror* at Portland, Maine, *post ca.* 1876.

WARREN, JAMES (*b. Plymouth, Mass., 1726; d. 1808*), merchant, farmer, Massachusetts legislator. Graduated Harvard, 1745. Married Mercy Otis Warren, 1754. A friend and trusted adviser of John and Samuel Adams, he figured in his own community as an organizer of the radicals and served on the local revolutionary committees. President of the Provincial Congress of Massachusetts, 1775, he became speaker of the state House of Representatives in the new General Court in 1776. Pursued by the enmity of John Hancock, he failed of reelection to the legislature, 1778, and did not return to political power until Shays's Rebellion, 1786, when he plainly showed sympathy to the insurgents. Elected speaker of the Massachusetts House, 1787, he boldly criticized the government's handling of the insurrection and adopted a very unorthodox stand on the question of the currency. He opposed with ability any ratification of the Federal

Constitution without a bill of rights. Defeated as candidate for lieutenant governor, he retired to scientific farming.

WARREN, JOHN (*b. Roxbury, Mass., 1753; d. 1815*), surgeon. Father of John C. Warren (1778–1856). Graduated Harvard, 1771; studied medicine with his brother, Joseph Warren, and with Edward A. Holyoke. After Revolutionary War service, 1775–77, he began practice in Boston, Mass., and was soon the leading surgeon there. His private course of anatomical lectures in 1780–81 led to the establishment of a medical department at Harvard College, November 1782. Warren began service there as professor of anatomy and surgery in 1783. A bold and skillful operator, Warren performed one of the first abdominal operations recorded in America and was a pioneer in amputation at the shoulder joint; he also did much to promote adoption of cowpox vaccination *post* 1800. His most notable contribution to medical literature was A *View of the Mercurial Practice in Febrile Diseases* (1813).

WARREN, JOHN COLLINS (*b. Boston, Mass., 1778; d. 1856*), surgeon. Son of John Warren. Graduated Harvard, 1797; studied medicine with his father and in London, Edinburgh, and Paris. Practiced in Boston *post* 1802. Adjunct professor of anatomy and surgery at Harvard Medical School *post* 1809, he became full professor on the death of his father, serving 1815–47. With James Jackson, he revolutionized medical education and practice and was a prime mover in the erection of the Massachusetts General Hospital. First surgeon in the United States to operate for strangulated hernia, he was operator also in the famous trial of anesthesia by ether at Massachusetts General, Oct. 16, 1846 (the ether administered by W. T. G. Morton). He was author, among other works, of *Surgical Observations on Tumours* (1837), a landmark in the history of this subject.

WARREN, JOHN COLLINS (*b. Boston, Mass., 1842; d. 1927*), surgeon. Grandson of John C. Warren (1778–1856). Graduated Harvard, 1863; Harvard Medical School, 1866. Returning from further study abroad in 1869, he began practice in Boston and soon associated himself with the Harvard Medical School as a teacher of surgery; he was Moseley Professor, 1899–1907. Author, among other works, of *Surgical Pathology and Therapeutics* (1895), a notable accomplishment based on bacteriology. His principal interest was in medical progress and education.

WARREN, JOSEPH (*b. Roxbury, Mass., 1741; d. Breed's Hill, outside Boston, Mass., 1775*), physician, Revolutionary patriot. Brother of John Warren. Graduated Harvard, 1759. Practicing in Boston, Warren became a friend of John Adams and an ardent Whig; he was a member of the North End Caucus and of other revolutionary clubs and committees. He delivered the anniversary speeches of the Boston Massacre in 1772 and 1775, served on the local Committee of Safety, and drafted the "Suffolk Resolves." On Apr. 18, 1775, he sent William Dawes and Paul Revere to warn Hancock and Adams of their danger of capture. Chosen president *pro tempore* of the Provincial Congress, August 23, he was killed rallying troops during the battle of Bunker Hill.

WARREN, JOSIAH (*b. Boston, Mass., ca. 1798; d. Charlestown, Mass., 1874*), musician, inventor, American pioneer of philosophical anarchy. An extreme individualist, he was author, among other works, of *Equitable Commerce* (1846), *True Civilization an Immediate Necessity* (1863), and the posthumous *True Civilization* (1875).

WARREN, LEONARD (*b. New York, N.Y., 1911; d. New York, 1960*), operatic and concert singer. One of the world's greatest Verdi baritones, Warren won the Metropolitan Opera Auditions of the Air in 1938 after studying at the Greenwich House Music School. He then studied in Italy before making his Metropolitan Opera debut in 1939 as Paolo in Verdi's *Simon Boccanegra*. Sang 25 roles at the Metropolitan in 633 performances. Died on the stage at the Metropolitan during a performance of *La Forza del Destino*.

WARREN, LINDSAY CARTER (*b. Washington, N.C., 1889; d. Washington, N.C., 1976*), politician and U.S. comptroller general. Studied at the University of North Carolina at Chapel Hill (1906–08) and its law school (1911–12), founded a law practice, and became involved in state Democratic party politics. He was elected to the U.S. House of Representatives (1925–40), he established a reputation as a talented and influential legislator, rising to acting House majority leader. He generally supported the New Deal and internationalist policies of President Franklin Roosevelt and cosponsored the Reorganization Act of 1939 that consolidated federal government agencies. As comptroller general of the United States (1940–54), he directed the General Accounting Office and instituted an improved accounting program for federal departments. He served in the North Carolina state senate in 1959–62.

WARREN, MERCY OTIS (*b. Barnstable, Mass., 1728; d. 1814*), poet, dramatist, historian. Sister of James Otis; wife of James Warren; aunt of Harrison G. Otis (1765–1848). A talented woman, Mercy Warren became an early laureate of the patriot cause and was later its historical apologist. Among other works, she was author of *The Adulateur* (1773) and *The Group* (1775), satires; and *Poems Dramatic and Miscellaneous* (1790). Her *History of the Rise, Progress and Termination of the American Revolution* (1805) reveals expert knowledge of public affairs and is a caustic analysis of the motives of those "malignants" who opposed American freedom.

WARREN, MINTON (*b. Providence, R.I., 1850; d. Cambridge, Mass., 1907*), classicist. Graduated Tufts College, 1870; did graduate studies at Yale, Leipzig, Bonn; Ph.D., Strasbourg, 1879. Inaugurated Latin Seminary at Johns Hopkins while professor there, 1879–99; taught Latin at Harvard *post* 1899 and was appointed Pope Professor, 1905. A master in the idiom of Latin comedy.

WARREN, SIR PETER (*b. Warrenstown, Ireland, 1703; d. Dublin, Ireland, 1752*), British vice admiral. On duty in America, 1730–47, he made his residence in New York City where he acquired title to the "Warren Farm," now known as Greenwich Village, and bought a large tract in the Mohawk Valley of which his nephew, Sir William Johnson, became manager. In 1731 he married Susannah, sister of James and Oliver De Lancey. In 1745 he cooperated with William Shirley in the attack on Louisburg, Cape Breton Island, later receiving appointment as governor. On May 3, 1747, he was the outstanding hero of the British naval victory over the French off Cape Finisterre. Thereafter, he changed his residence from New York City to London, was knighted, and served in the British Parliament.

WARREN, RICHARD HENRY (*b. Albany, N.Y., 1859; d. South Chatham, Mass., 1933*), organist, composer. Remembered principally as organist at St. Bartholomew's Church and at the Church of the Ascension, both in New York City, 1886–1921.

WARREN, RUSSELL (*b. Tiverton, R.I., 1783; d. Providence, R.I., 1860*), architect. A devotee of the Greek Revival, he designed a number of luxurious houses for ship captains and merchants in Bristol, R.I., ca. 1805–25, and thereafter practiced in Providence. He is said to have devised the Warren truss used in steel bridge construction. Several of his finest productions were erected in

New Bedford, Mass., among them his masterpiece, the J. A. Parker house (1834).

WARREN, SAMUEL PROWSE (*b. Montreal, Canada, 1841; d. 1915*), organist, composer. Held principal posts as organist at Grace Episcopal Church, New York City, 1868–74 and 1876–94, and at the First Presbyterian Church, East Orange, N.J., 1895–1915. His choral settings for the Episcopal service are of very high merit.

WARREN, SHIELDS (*b. Cambridge, Mass., 1898; d. Mashpee, Mass., 1980*), experimental pathologist. Graduated Boston University (B.A., 1918) and Harvard University (M.D., 1923) and joined the faculty at Harvard Medical School in 1925. During the 1930's he produced landmark research on the role of the lymphatic system in the spread of cancer. After the atomic bomb strikes on Japan in 1945, he led a navy medical team that examined the effects of radioactive fallout. In 1947–52 he oversaw the Division of Biology and Medicine for the Atomic Energy Commission and helped fashion federal health policies regarding atomic energy and radiation. Although aware of the deleterious effects of radiation poisoning, Warren, citing his studies in Japan, argued that atomic fallout did not cause widespread birth defects and that antibiotics could treat many infections from radiation effectively. In 1955–63 he was U.S. representative to the United Nations Scientific Committee on the Effects of Atomic Radiation.

WARREN, WILLIAM (*b. Bath, England, 1767; d. Baltimore, Md., 1832*), actor, theatre manager. Father of William Warren (1812–1888). Came to America, 1796, to act with Thomas Wignell's company; played and managed theaters almost exclusively in Baltimore and Philadelphia, Pa. Celebrated for the dignity and rich humor of his "old man" roles. He was founder, through his son and the marriages of his daughters, of a celebrated American theatrical family.

WARREN, WILLIAM (*b. Philadelphia, Pa., 1812; d. Boston, Mass., 1888*), actor. Son of William Warren (1767–1832). Made debut, Oct 27, 1832, at Arch Street Theater, Philadelphia, Pa. After obtaining his professional schooling in a number of migratory troupes and lesser companies, he was associated with the stock company at the Boston Museum from 1847 until his retirement from the stage in 1883. A skillful comedian, whose acting was marked by high intelligence and faithful study, he was also a leading citizen of Boston and the friend, among others, of Oliver W. Holmes, Henry W. Longfellow, and Mr. and Mrs. James T. Fields.

WARREN, WILLIAM FAIRFIELD (*b. Williamsburg, Mass., 1833; d. Brookline, Mass., 1929*), Methodist clergyman, educator. Brother of Henry W. Warren. Graduated Wesleyan University, 1853; studied at Andover Theological Seminary and at the universities of Berlin and Halle. A professor of theology in Germany, 1861–66, he became president of the Boston Theological School, 1867, serving as such until 1873. A founder of Boston University and the guiding spirit in its development, he served it as president, 1873–1903, continuing his work as professor at the theological school throughout his term and as late as 1920. Basing his plan for the university upon a fusion of English emphasis on the humanities grounded in the classics with German thoroughness in research, he also insisted on the maintenance of comparative independence by the professional and technical schools. He was zealous in providing international educational opportunities for the university's students. Under his leadership the theological school was the first to require sociology and the study of missions in the course leading to a degree. He was au-

thor, among many other works, of a celebrated address published in 1886 under the title *A Quest for a Perfect Religion*.

WARRINGTON, ALBERT POWELL (*b. Berlin, Md., 1866; d. Ojai, Calif., 1939*), lawyer, Theosophical leader.

WARRINGTON, LEWIS (*b. Williamsburg, Va., 1782; d. 1851*), naval officer. Appointed midshipman, 1800. In active and varied service thereafter, Warrington is remembered for his victory of Apr. 29, 1814, off Cape Canaveral, when he captured the British brig *Epervier*, himself commanding the sloop-of-war *Peacock*. Post 1842 he was chief of the bureau of yards and docks, briefly secretary of the navy in 1844, and chief of the bureau of ordnance.

WARTHIN, ALDRED SCOTT (*b. Greensburg, Ind., 1866; d. 1931*), clinical pathologist, investigator of syphilis.

WASHAKIE (*b. probably Montana, ca. 1804; d. Fort Washakie, Wyo., 1900*), Shoshone chief. Part Shoshone and part Umatilla, he became chief of the eastern band of Shoshone during the 1840's. Friendly to the whites and of great assistance to the overland immigrants, he ranked high as a warrior in many small defensive wars which he fought against more powerful neighboring tribes. His band, originally ranging over the lower valley of the Green River, was settled on the present Shoshone reservation in the Wind River country at the Fort Bridger council of 1868.

WASHBURN, ALBERT HENRY (*b. Middleboro, Mass., 1866; d. Vienna, Austria, 1930*), lawyer, diplomat. Graduated Cornell University, 1889. Entering the U.S. consular service, he served at Magdeburg, Germany, 1890–93. While private secretary to Henry Cabot Lodge, 1893–96, he studied law and was engaged for some years in federal and private practice, becoming a specialist in customs cases. As U.S. minister to Austria post 1922, he aided in the financial rehabilitation of the country and the restoration of its credit.

WASHBURN, CADWALLADER COLDEN (*b. Livermore, Maine, 1818; d. Eureka Springs, Ark., 1882*), lawyer, land agent, Union major general, industrialist. Brother of Elihu B. Washburne, Israel Washburn, and William D. Washburn. Removing to the West in 1839, he began practice of law at Mineral Point, Wis., 1842, but gradually abandoned the law for banking and land operations. As congressman, Republican, from Wisconsin, 1855–61, 1867–71, he achieved no great prominence, nor was his term as governor of Wisconsin (1872–73) particularly outstanding. Engaging in vast industrial enterprises, he acquired water-power rights at the Falls of St. Anthony (Minneapolis, Minn.), which enabled him to become one of the nation's foremost manufacturers of flour. He was one of the first to adopt the "new process" of milling which created a demand for North-west spring wheat and completely revolutionized the U.S. flour industry. He was an organizer in 1877 of Washburn, Crosby & Co.

WASHBURN, CHARLES GRENFILL (*b. Worcester, Mass., 1857; d. 1928*), lawyer, wire manufacturer, Massachusetts legislator. As congressman, Republican, from Massachusetts, 1906–11, he performed his principal service with the committees on insular affairs and patents and copyrights. His advice to Chief Justice White in 1911 helped establish a reaffirmation by the U.S. Supreme Court of the application of the "rule of reason" to the Sherman Law.

WASHBURN, EDWARD ABIEL (*b. Boston, Mass., 1819; d. New York, N.Y., 1881*), Episcopal clergyman. Principal rectorate at Calvary Church, New York, N.Y., post 1865. Next to Phillips

Brooks, he was in his day the leading representative of broad churchmanship in the Episcopal ministry.

WASHBURN, EDWARD WIGHT (*b. Beatrice, Nebr., 1881; d. 1934*), chemist, educator. B.S., Massachusetts Institute of Technology, 1905; Ph.D., 1908. His paper on the iodometric determination of arsenious acid (1908) was the result of a study of particular significance inasmuch as it prompted the first thermodynamic treatment of "buffer" solutions so important in later work in indicators. He made the first accurate measurement of true transference numbers and of the relative hydration of aqueous ions. Professor of chemistry at the University of Illinois and editor (1922–26) of the *International Critical Tables of Numerical Data: Physics, Chemistry and Technology*, he became head of the division of chemistry at the National Bureau of Standards in 1926. There he initiated a program of thermochemical research, instituted and directed an extensive project on petroleum research, was responsible for the isolation of the first crystals of rubber. In December 1931 he made his most notable discovery—the fractional electrolysis of water with respect to the isotopes of hydrogen.

WASHBURN, ELIHU BENJAMIN *See* WASHBURNE, ELIHU BENJAMIN.

WASHBURN, EMORY (*b. Leicester, Mass., 1800; d. Cambridge, Mass., 1877*), lawyer, Massachusetts legislator. Graduated Williams, 1817. Admitted to the Massachusetts bar, 1821, he practiced principally in Worcester, achieving great success and reputation. After an uneventful term as Whig governor of Massachusetts, 1854–55, he joined the staff of the Harvard Law School and served as Bussey Professor until 1876. He was author of treatises on real property and easements which were greatly valued in their day.

WASHBURN, GEORGE (*b. Middleboro, Mass., 1833; d. 1915*), Congregational clergyman, educator. Graduated Amherst 1855. Son-in-law of Cyrus Hamlin, Washburn became a missionary at Constantinople, Turkey, 1863, and also taught at Robert College. *Post* 1871 he was director and professor of philosophy at Robert; between 1878 and 1903 he served as its president, steadily increasing its enrollment, its physical plant, and its prestige. He was a consultant on Near Eastern affairs to James G. Blaine, John Hay, and President Theodore Roosevelt.

WASHBURN, ICHABOD (*b. Kingston, Mass., 1798; d. Worcester, Mass., 1868*), blacksmith, manufacturer. Partner in a firm which made wool-spinning machinery, 1823–34, Washburn then began the manufacture of wire and became the leader of that industry in the United States; the firm was known as Washburn & Moen *post* 1850. He introduced the galvanized iron telegraph wire once so extensively used, and developed the first continuous method of tempering and hardening wire in 1856.

WASHBURN, ISRAEL (*b. Livermore, Maine, 1813; d. Philadelphia, Pa., 1883*), lawyer. Brother of Elihu B. Washburne, Cadwallader C. and William D. Washburn. Admitted to the Maine bar, 1851–61, he was a leader in the formation of the Republican party in Washington, D.C., and is considered by some to have been the first to suggest the name "Republican." On May 9, 1854, ten weeks after the original meeting at Ripon, Wis., he called a meeting of about thirty anti-slavery representatives in Washington which undertook further steps toward organizing the new party. As governor of Maine, 1861–63, he ranks among the leading war governors of the North. He was collector of the port at Portland, Maine, 1863–78.

WASHBURN, MARGARET FLOY (*b. New York, N.Y., 1871; d. Poughkeepsie, N.Y., 1939*), experimental psychologist. Graduated Vassar, 1891; Ph.D., Cornell, 1894. Taught at Wells College, Sage College, and at University of Cincinnati; headed psychology work at Vassar, 1903–37. Author of *The Animal Mind* (1908) and *Movement and Mental Imagery* (1916), she made Vassar one of the most active psychological centers in America, employing a unique system of collaboration in experimental research between student and professor on problems of feasibly limited scope.

WASHBURN, NATHAN (*b. Stafford, Conn., 1818; d. Stafford Springs, Conn., 1903*), iron founder. Patented an improved cast-iron railroad-car wheel in April 1849 which soon displaced every other pattern of wheel; later that year he founded a firm for the manufacture of the wheel and also textile machinery. During the Civil War, Washburn perfected a process of puddling pig iron whereby he produced a superior gun barrel.

WASHBURN, WILLIAM DREW (*b. Livermore, Maine, 1831; d. Minneapolis, Minn., 1912*), lawyer, mill owner. Brother of Elihu B. Washburne and of Cadwallader C. and Israel Washburn. Graduated Bowdoin, 1854; studied law with his brother Israel and with John A. Peters. Removing to the West, 1857, he settled in Minnesota for the practice of law, served for some time as agent for his brother Cadwallader, and was federal surveyor for Minnesota, 1861–65. Thereafter, a resident of Minneapolis, he engaged in lumbering, real estate operation, and flour manufacture. In 1878, after a brief association with his brother in Washburn, Crosby & Co., he founded the milling firm of W. D. Washburn & Co. He was congressman, Republican, from Minnesota, 1879–85, and U.S. senator, 1889–95, but his principal importance was as a major figure in the financial and business life of his community.

WASHBURNE, ELIHU BENJAMIN (*b. Livermore, Maine, 1816; d. 1887*), lawyer, diplomat. Brother of Cadwallader C., Israel and William D. Washburn. After admission to the Massachusetts bar, he removed to the West, 1840, and settled at Galena, Ill. Moderately successful in practice, he made careful investments in Western lands and became a wheel-horse of the local Whig party. As congressman, Whig and Republican, from Illinois, 1853–69, he was a fierce opponent of lobbyists and treasury raiders, and was one of the first of a long succession of "watchdogs of the treasury" while chairman of the committee on appropriations. Active in furthering the career of Ulysses S. Grant, Washburne was a member of the joint committee on reconstruction and a violent attacker of President Andrew Johnson. Continuing his sponsorship of Grant through the campaign of 1868, he served less than two weeks as U.S. secretary of state, 1869, and was then U.S. minister to France, 1869–77. A capable diplomat, he was the only official representative of a foreign government to remain in Paris throughout the siege and the Commune, 1871; his *Recollections* (1887) contain a valuable account of those exciting days.

WASHINGTON, BOOKER TALIAFERRO (*b. Hale's Ford, Franklin Co., Va., 1856; d. Tuskegee, Ala., 1915*), black educational leader. Born in slavery, he was taken by his mother soon after emancipation to Malden, W. Va., where he worked for a time in a salt furnace. Studying at night and later attending regular classes after his work, he was encouraged by the wife of his employer to fulfill his ambition to attend Hampton Institute. Working his way through Hampton, which he attended, 1872–75, he won the regard of General Samuel C. Armstrong whom he later served as secretary. After graduation in 1875, he taught in a black school at Malden, W. Va., and between 1879 and 1881 had

charge of the night school at Hampton Institute. In May 1881 General Armstrong recommended Washington as principal to a black normal school at Tuskegee, Ala., for which a charter had just been secured. He opened the institution with forty students in a dilapidated shack and thereafter labored incessantly for the good of Tuskegee. Acting on the theory of first things first, he taught his students the dignity of efficient labor and how to live "on the farm off the farm." He also stressed the values of cleanliness and a proper diet. By the time of his death Tuskegee had grown to remarkable strength in plant, endowment, faculty, and reputation. Washington also started many forms of rural extension work and established the National Negro Business League and a number of conferences for self-improvement. In great demand throughout the country as a lecturer, he stressed the necessity of providing an education useful in life, the need of keeping close to nature and of cultivating the respect of one's neighbors. A remarkable address at the Cotton States Exposition, Atlanta, Ga., September 1893, brought him national recognition.

Booker Washington's views were opposed by black intellectuals who felt that he did not sufficiently emphasize political rights and that his stress on industrial education might result in keeping the black in virtual bondage. However, he was more interested in the immediate improvement of his race from a material point of view and in making it worthy of the franchise. He opposed agitation. In view of the general public opinion of his day, which he hoped to influence, he would appear to have adopted the only policy which could be then really effective. A man of high character and devoted to spiritual values, he made a number of memorable observations, including his characteristic saying, "No man, black or white, from North or South, shall drag me down so low as to make me hate him." He was author, among other works, of *The Future of the American Negro* (1899), *Up From Slavery* (1901), *Frederick Douglass* (1907), and *My Larger Education* (1911).

WASHINGTON, BUSHROD (*b. Westmoreland Co., Va., 1762; d. Philadelphia, Pa., 1829*), Revolutionary soldier, lawyer. Nephew of George Washington. Graduated William and Mary, 1778; studied law after the Revolution in the office of James Wilson. A devoted student of the law, he was appointed an associate justice of the U.S. Supreme Court in 1798 and served until his death. Slow of mind, but thorough in reasoning, he excelled as a *nisi prius* judge. Following John Marshall on constitutional matters, he rendered a number of important opinions in admiralty and commercial cases.

WASHINGTON, DINAH (*b. Tuscaloosa, Ala., 1924; d. Detroit, Mich., 1963*), singer and pianist known as the "Queen of the Blues" and "Queen of the Jukeboxes." Beginning at age fifteen, she performed in several Chicago nightclubs. Sang with the Lionel Hampton band, 1943–45, and made her first solo recordings The preeminent female rhythm and blues singer of the day, her more than twenty-five best-selling discs include "Baby Get Lost" (1949), "Cold, Cold Heart" (1951), "Wheel of Fortune" (1952), "Unforgetable" (1952), and, with Brook Benton, "Baby, You've Got What It Takes" (1960). Her biggest hit was a revival of the ballad "What a Diff'rence a Day Makes" (1960).

WASHINGTON, GEORGE (*b. Westmoreland Co., Va., 1732; d. "Mount Vernon," Fairfax Co., Va., 1799*), planter, soldier, first president of the United States. Born on his father's estate which lay between Bridges Creek and Popes Creek and was later known as Wakefield, George Washington was the eldest son of Augustine Washington and his second wife, Mary Ball (1708–1789). He was descended from Lawrence Washington of Sulgrave, Northamptonshire, England, whose descendant John immigrated to Virginia in 1657–58. Augustine Washington lived in Westmoreland until 1735 when he removed to Little Hunting Creek on the Potomac and thence to Ferry Farm in King George County. Augustine died in 1743, and for the next six years George Washington lived with relatives in Westmoreland and the Chotank region, at Ferry Farm, and at Mount Vernon, home of his elder half brother, Lawrence Washington. His principal, if not his only, teachers appear to have been his father and Lawrence; the extent of his mother's influence upon Washington cannot be accurately appraised. His training in mathematics extended to trigonometry and surveying, and he had a natural talent for map-making. His accounts show purchases of books dealing with military affairs, agriculture, history, biography, and a fair number of the outstanding novels of his day such as *Tom Jones* and *Humphry Clinker*. Quotations sprinkled through his correspondence indicate his familiarity with the works of Pope and Addison, and he made extensive use of biblical allusions.

Washington learned the courtly manners and customs of the best English culture at Mount Vernon. Connected by marriage through his half-brother with the Fairfax family, he owed the first important adventure of his career to Lord Fairfax, who permitted him to go along on a survey of Fairfax lands in the Shenandoah, 1748. A year later, appointed county surveyor for Culpeper Co., Washington explored more wild country and received an insight into the importance of land ownership. He interrupted his work to accompany his half-brother to Barbados on a health-seeking voyage. Lawrence Washington returned to Virginia to die in July 1752, bequeathing the Mount Vernon estate in such a way that it shortly became the property of George. Appointed district-adjutant for the southern district of Virginia, 1752, he was soon transferred to that of the Northern Neck and Eastern Shore. His military ambitions, first stimulated during his half-brother's service with Adm. Edward Vernon, were now reawakened. In 1753 he accepted Governor Dinwiddie's appointment to carry an ultimatum to the French forces encroaching on English lands in the Ohio country. This mission, although one of hardship and danger, appealed to Washington as a road to possible honor and glory. Instructed to warn off the French, and to strengthen the friendship of the Six Nations with the English, he left Wills Creek in the middle of November 1753, but on arrival at the forks of the Ohio a week after discovered that the French had withdrawn for the winter. After holding a council at Logstown with certain of the chiefs of the Six Nations at which he accomplished little, he traveled farther into the wilderness to reach the next French post. Arriving at Venango, he was directed by the officer there to carry his message to the commandant at Fort Le Boeuf. Proceeding another hundred miles through winterclogged swamps nearly to the shores of Lake Erie, he reached the fort only to receive in writing a refusal to heed Dinwiddie's ultimatum. Guided by Christopher Gist, he was several times in danger of death on his return journey. His report to the governor was printed as *The Journal of Major George Washington. . .* (1754) and created a stir in England as well as America.

Washington had noted a position at the forks of the Ohio (present site of Pittsburgh) as the best place for an outpost, and the governor had dispatched a small force to forestall the French in building a fort there. Commissioning Washington a lieutenant colonel, Dinwiddie ordered him to reinforce the forks with the militia then assembling at Alexandria. After setting out with 150 men on April 2, 1754, Washington was met on the ways by news that the French had taken the British outpost and renamed it Fort Duquesne. Nevertheless, he advanced to the Ohio Company trading post at Red Stone about forty miles from the forks, and began to build a road which would facilitate the later attempt at recapture which Dinwiddie would be obliged to make. He also fortified a camp (Fort Necessity) at Great Meadows, Pa. Informed by friendly Indians of the approach of the French

scouting party, he marched out to intercept it. On May 27 he surprised and defeated the French party; their leader, Jumonville, was killed. As the French advanced in force out of Fort Duquesne, Washington fell back to Great Meadows since he feared an attack at some less defensible place. After a ten-hour siege of the camp, the French proposed terms which Washington accepted, unwittingly signing an admission that Jumonville had been "assassinated." Dinwiddie's mismanagement of military affairs having left Washington in the position of being commanded by officers junior to himself, he therefore resigned toward the end of the year 1754.

When the British sent an expedition of regular troops under General Braddock against Fort Duquesne in 1755, Braddock offered Washington a post as aide. Falling sick on the march to Duquesne, he rejoined Braddock the day before the action on the Monongahela, during which he strove to carry out Braddock's orders before being swept from the field in the resultant panic after the French and Indians struck. As his appointment as aide ended with the general's death, he returned to Mount Vernon and made ready the militia of his district. Appointed colonel and commander in chief of all Virginia forces in the fall of 1755, he was responsible for the defense of about 300 miles of mountainous frontier with about 300 men. Averaging two engagements with raiding Indians a month, Washington acquired the habit of thinking and acting for the welfare of a people, and also a skill in conducting military operations over an extensive range of territory. His difficulties at this time closely parallel those he was later to meet in the Revolution. In order to settle a dispute over his rank and right to command, Washington rode from Winchester, Va., to Boston, Mass., in 1756. His journey had a secondary but important effect in broadening his viewpoint in respect to the character of the people of the other colonies. Returning to his duty in defense of the frontier, he managed reasonably well despite lack of money, clothes, shoes, powder, and even at times food. His efforts to win the cooperation of Maryland and Pennsylvania in supporting a Virginian attack on Fort Duquesne were unsuccessful. Joining the British expedition under General John Forbes against Fort Duquesne in 1758, Washington commanded the two Virginia regiments with the title of brigadier. His suggestion that the expedition use an open-order method of marching and fighting was ignored by the British officers. The British found, on their approach to Fort Duquesne, November 1758, that it had been abandoned by the French, and Washington resigned soon thereafter from military service.

On Jan. 6, 1759, he married Martha (Dandridge) Custis, a widow, and settled down to the life of a gentleman-farmer at Mount Vernon. He was active in local affairs and a generous contributor to educational organizations. He took a seat in the House of Burgesses, 1759. Appreciative of music and the theatre, he also enjoyed card playing, billiards, horseracing, dancing, fishing, hunting, and, indeed, all the usual sports of a gentleman of his time. However, his pleasant, busy life at Mount Vernon was not without its annoyances, mainly on the head of British commercial restrictions and the sharp practice of the English factors without whose services no Virginia planter could transact business with the English markets. Washington's disillusion with British military efficiency, as evidenced during the campaigns against Fort Duquesne, now revived and merged into a subconscious antagonism against the mother country which had been inspired by senseless difficulties thrown in his way as he endeavored to improve his estates. A faithful attendant at the sessions of the legislature, he clarified his view of the handicaps imposed on America by the British colonial system. At the time of the Stamp Act he expressed the general American attitude toward the claims of Parliament, saying that it "hath no more right to

put their hands into my pocket, without my consent, than I have to put my hands into yours for money." Another major grievance was the British prohibition of colonial paper money. Since the balance of trade was always against them, the colonists required paper money. Acting as agent for the officers and men he had formerly commanded, he traveled down the Ohio and up the Great Kanawha rivers in 1770 to locate the bounty lands allotted to men who had served. This journey revived his interest in the west and provided him with a personal knowledge which was later useful in developing his western land policy when he was president.

Washington supported the device of nonimportation as a check to British political and economic aggression, yet prophesied that blood would be spilt if the British ministers continued to be stubborn. He was one of the burgesses who met in the Raleigh Tavern at Williamsburg on May 27, 1774, after the Assembly had been dissolved by the governor; he signed the proceedings of that important meeting. On July 18 he acted as chairman of a meeting in Alexandria at which the Fairfax Resolutions were adopted. A Virginia delegate to the First Continental Congress, he was also chosen to command the independent militia companies of several Virginia counties. As delegate to the Second Continental Congress beginning May 1775, he served on the committee for drafting army regulations and planning the defense of New York City. Elected to command the American armies, June 15, 1775, as the result of a compromise between the northern and southern factions in Congress, he refused all pay for the employment, asking only that he be reimbursed for necessary expenses.

On taking command of the army at Cambridge, Mass., on July 3, 1775, Washington found it little better than a loosely organized mob of New England militia whose terms of service were to expire at the end of the year or sooner. Hampered in his efforts to obtain legislation for creation of an efficient army by the widespread belief that some accommodation might still be made with the British, he was also thwarted in establishing discipline by a too-democratic spirit among the troops. Scarcity of powder as well as insufficiency of men kept Washington back from any major operation until 1776. At the first opportunity, however, he seized and fortified Dorchester Heights, so threatening the besieged British in Boston with bombardment and putting the British fleet in jeopardy. As a result, the city was evacuated on March 17, 1776.

As it was obvious that the next logical base of operations for the British would be New York City, Washington set out for that place with his army of newly enlisted troops. On his arrival he found that he was partially committed to a plan of defense already mapped out by Major General Charles Lee and others. Faced with the decree that New York must be defended, although the place was virtually indefensible, he was further handicapped by a lack of experienced officers and by the three-to-one superiority which the British soon massed against him. His concept of duty compelled him to obey the orders of Congress, despite his personal opinion of them, and he deferred scrupulously to the views of subordinates in cases where he believed that his knowledge and experience were inadequate. When Sir William Howe, the British commander, chose Long Island as his point of attack, Washington sent a large part of his force to reinforce the defensive works at Brooklyn, meanwhile holding a strong body on Manhattan to oppose a possible attack by the British fleet. After the American forces on Long Island had been outflanked and defeated on Aug. 27, 1776, Washington withdrew the remnant of the forces on Long Island over to Manhattan on the night of Aug. 29, a retreat which is considered a military masterpiece. Following on the British landing at Kips Bay, Sept. 15, Washington was obliged to give up his footing on Manhattan,

retreating to a strong natural position at White Plains, N.Y., where the British were held in a sharp engagement. The fall of Fort Washington and Fort Lee in November resulted from the same misplaced deference to the opinions of his generals which has been noted previously, yet both these disasters were blessings in disguise. They freed Washington and the Continental Army from responsibility for fixed fortifications and made it into a mobile force of maneuver which Washington could handle in accordance with his own ideas. The general principle on which he preferred to wage the war was the avoidance of a general action unless compelled to undertake it by necessity. Until Congress created a permanent army, this was the only way in which inexperienced troops always inferior in numbers to the enemy could survive. Survival was all-important to Washington, for his belief in the moral rightness of the American fight for liberty was based on his sense of the injustice of the British course. Having scrupulously determined on a course of rebellion and a change of allegiance, he considered that any turning back was unthinkable. The fortitude with which he met his difficulties was based upon his faith.

As the British pushed forward into New Jersey, Washington, with a steadily dwindling force, fell back before them, but contrived to give his enemy the impression that they might encounter a strong opposition at any point. After he had apparently taken refuge with an army of barely 5000 men behind the Delaware River, the British settled into winter quarters in a series of outposts along the Delaware at and near Trenton, N.J., and in a line across New Jersey to Amboy.

Meanwhile, as Congress had left Philadelphia and the protection of that city had become relatively unimportant in his judgment, Washington fixed his eye on Morristown, N.J., as the base of operations most threatening to the British. Crossing the Delaware on Christmas night, 1776, he took the outpost at Trenton and captured its Hessian garrison, so dislocating the British arrangements. Finding it impossible to drive to Morristown (as had been his first intention) through failure of two supporting detachments, he returned across the river. A few days later he again crossed into Jersey and began to move northward. After a stubborn engagement at Assunpink Creek, he outwitted the British by a night march and attacked their line at Princeton. Victorious there, he was soon at Morristown, where his position presented such a strategic threat that the British abandoned their whole line and retreated to Brunswick. Meanwhile, Washington had been assigned by Congress a grant of extraordinary powers in order that he might wage war with more efficiency, but was severely criticized when he endeavored to use these powers. However, *post* 1777, he could enlist troops for a period of three years or the duration of the war, and he then began to build a permanent military machine. He continued to be forced to rely upon militia for swelling his forces to a respectable total at times of crisis; this was a constant annoyance to him for he held and expressed a very low opinion of militia troops.

Slowly shaping and disciplining his army at Morristown, he managed to contain the enemy during the spring of 1777 and convinced Sir William Howe that the risk of marching across New Jersey to take Philadelphia was too great. On Howe's transport of his forces to Chesapeake Bay by sea, Washington marched south and on Sept. 11, 1777, engaged the British at Brandywine Creek. Defeated, he refused to withdraw and delayed the British entry into Philadelphia for two weeks. Although he continued to act with great deference to the civil power as expressed by Congress, he complained of a lack of information on political matters. His surprise attack on the British at Germantown, Oct. 3–4, 1777, failed through no fault of plan, damaged the British forces and also Sir William Howe's confidence in himself, and is to be credited with great influence in the decision of France

to aid the United States. During the winter encampment at Valley Forge which followed, a continuing intrigue to supplant Washington in command of the army reached its crisis in the events of the so-called Conway Cabal. The victory of Horatio Gates at Saratoga, Oct. 17, 1777, gave Washington's enemies in Congress a chance to draw invidious comparisons. The whole plot was at bottom a culmination of a continuous effort by Massachusetts ever since 1775 to regain control of the war. The exposure of the Cabal and of Gates's share in it aroused resentments in Congress and effectually destroyed congressional support for Washington's replacement as commander. True to his nature, he did not allow this episode to interfere with more important matters, nor was he troubled by any vulgar desires for popularity. In the spring of 1778 the Continental Army emerged from its trials at Valley Forge, drilled to a high standard of efficiency by Baron von Steuben, and heartened by the news of the French alliance which had come in March. A determining factor in the securing of French support had been the character and purpose of George Washington as certified to Vergennes, the French foreign minister, and to Louis XVI by Gerard, the French acting minister in America. Once convinced by Washington's example that the Americans would not compromise with Great Britain, the French moved effectively.

An early proof that the Continental Army had become efficient and a new demonstration of Washington's skill as a general were provided at the battle of Monmouth, N.J., June 28, 1978. In this battle the Americans struck at the British army as it was retreating from Philadelphia across New Jersey to New York City. Washington turned the confusion brought about by the debatable conduct of General Charles Lee into an obstinate and successful holding action from which the British were glad to make good their withdrawal. A new problem, however, arose in the lethargy which seized upon Congress and the states after the announcement of the French alliance. Lacking troops, supplies, and even powder in the summer of 1779, Washington was unable to make a major move, yet succeeded in mounting an expedition under General John Sullivan into New York State which broke the power of the Six Nations and freed the frontier from Indian warfare. After the arrival of a French army under Rochambeau at Rhode Island in July 1780, Washington was still unable to attempt a major campaign because of his own lack of supplies and men and frankly confessed this fact to the French general. At a conference with Rochambeau in Wethersfield, May 21–22, 1781, it was decided to attempt an attack on New York, and both French and American forces closed in on the northern defenses of that city. The availability of the French West India fleet under Adm. De Grasse providing the chance for a combined operation, Washington changed his plans and determined on a move against Cornwallis in Virginia. Organizing his march with remarkable skill, Washington brought the French and American armies on schedule before Yorktown, Va., where Cornwallis had fortified himself and where he had been cut off from an escape by sea by the French fleet. After a short siege, Yorktown fell and Cornwallis was taken. Rochambeau took his army into winter quarters in Virginia, and Washington led his troops back to the Hudson River, making headquarters at Newburgh.

The states now became even more supine than before, and Washington's arguments for the necessity of a continued effort had no effect. He remained patient while an orgy of profiteering broke out, even to the extent of a clandestine trade with the British, which he and the army were unable to stop. For two more dreary years the war dragged on, although no military events of importance took place. The Continental soldiers were restless because of neglect of their services and lack of pay; their dissatisfaction took form in a proposal to make Washington a

king by military force. Shaken to his depth by the realization that the men on whom he relied were ready to support him in a monstrous treason for personal power, he replied to the proposal on May 22, 1782, with a blast that ended the whole affair. Continuing unrest and a prospect of mutiny were met by him with tact and wisdom; he urged Congress to take action on the petitions addressed by the soldiers and their officers, and also addressed a circular letter to the states, pleading with them for justice to the personnel of the fast-disbanding Continental Army. Revealing how close to his heart was the national principle for which he had fought, he stated that four things were essential to respectable national existence: (1) an indissoluble union of the states under one federal head; (2) a sacred regard to public justice; (3) the adoption of a proper national defense; (4) a spirit of cooperation and the suppression of local prejudices. Hostilities ended on April 19, 1783, the anniversary of the battle of Lexington, and Washington then entered New York City at the head of those troops which still remained in service, just as the British evacuated it. He bade farewell to his officers at Fraunces Tavern and resigned his commission to Congress at Annapolis.

Washington's financial condition at the close of the war was unsatisfactory. Mount Vernon was now not even self-supporting; however, he continued his usual unostentatious charities. During the autumn of 1784 he went on a horseback journey of exploration in the west in furtherance of his favorite project of opening a route to the western country from tidewater Virginia by connecting the Potomac and Ohio rivers. Discouraged by the inefficiency of slave labor, he grew convinced that the gradual abolition of slavery by legislative authority would prevent much future mischief. Although he had more slaves than he could profitably employ, he refused on principle to sell any of them. Absorbed in the management of Mount Vernon and in the affairs of the Potomac Company, he considered himself as a retired man, writing to Lafayette that he would "move gently down the stream of life, until I sleep with my fathers." This philosophic calm was interrupted in 1786 by Shay's Rebellion in Massachusetts, which only added to his conviction that the Articles of Confederation would have to be revised in the interest of a strong central government. Serving as president of the Federal Convention, he lent the great authority of his reputation to its deliberations. Admitting that the Constitution as written had imperfections, he maintained that it was the best obtainable at that time and that, since a workable machinery had been provided for amending it, it should be first adopted and then altered.

Repelling the suggestion that he should be first president when it was made to him, he opposed it wherever he decently could, saying that he had no "wish beyond that of living and dying an honest man on my own farm." He accepted the presidency with diffidence, dreading the possibility that he would appear incompetent. Believing that the success of the Revolution was owing to Providence, and content with the thought that he had played an honorable part in a great popular movement, he was doubtful of his ability to administer a government. Driven by the sense of duty that always actuated him, he accepted the post, although he was compelled to borrow money to pay his traveling expenses to his inauguration, Apr. 30, 1789, in New York City. Declining a salary, he accepted the later offer of Congress of $25,000 annually for expenses; in his case, his expenses exceeded this sum. Cautious in his organization of the governmental machine and his appointment of officials, he faced a number of pressing problems, both domestic and foreign. At home it was essential that the nation be made financially stable and that manufacturing and commerce be encouraged; the retention of military posts in the west by Great Britain constituted the major foreign problem.

Unsympathetic with those divergent theories of government which almost immediately proved the basis of a struggle between Alexander Hamilton and Thomas Jefferson within the circle of his first cabinet, he thought of these differences of opinion as purely personal and as willful obstacles to the task of establishing the government firmly. He could not understand differences on the basis of theory, although he acted with great forbearance toward both Jefferson and Hamilton on the grounds that their talents were essential to success. The gradual emergence of Federalist and Democratic-Republican points of view in government influenced him in his decision to serve a second term. He was strongly influenced by the disturbed foreign situation and adamant in his belief that the European powers must be convinced that Americans acted for themselves and not for others. At first sympathetic with the revolution in France, he grew speedily sick of the excesses which it produced and desired a strict American neutrality as between the French and their principal opponent, Great Britain. Although unopposed in his election to a second term, he was roundly criticized for his neutrality policy and was subjected to an abuse which went beyond the bounds of decency. Continuing firm in his belief that twenty years of peace would make the United States strong enough to bid defiance "in a just cause to any power whatever," he could not comprehend emotional attitudes at home which could put any other problem ahead of this. He gradually came to regard the French sympathizers in the United States as virtual traitors. When, after the recall of the French envoy Edmond Genêt, the political frenzy in the United States subsided, Washington attempted a settlement of United States difficulties with Great Britain by appointing John Jay to negotiate a treaty with the British, 1794. In this same year the resistance to the excise tax in Pennsylvania known as the Whiskey Rebellion seemed to Washington to prove that the same indifference of the states to the national welfare which had plagued him in the Revolution must still be reckoned with. Acting with decision against the rebels, he was heartened by the prompt response of the militia to his call. On the collapse of the rebellion, he again displayed his broad understanding by avoiding any harsh reprisal measures.

Offsetting the optimism brought about by the signing of the Pinckney Treaty, 1795, which secured the navigation of the Mississippi River and established the southern boundary of the United States, came an outburst of criticism over Jay's Treaty. Denounced as a base surrender to the British, it yet seemed to Washington the best treaty that could be obtained at the time, and he withstood the storm of opposition just as he had withstood previous ones, confident of his integrity of purpose and likening the attacks to a cry against a mad dog.

In 1796 he set about to prepare an address which would announce to the people of the United States his determination to retire from public life. His Farewell Address is partly an explanation of his course as president, with main emphasis upon the need for a firm union and a strong central government, and it is also a solemn warning against the spirit of party. Political parties, as Washington had observed them, seemed devoted to a usurpation of power for personal ends and would logically result in a loss of liberty. He urged morality and education as necessities for the people's happiness and prosperity, counseled good faith and justice toward all nations but favors to none, and warned against the wiles of foreign influence. On his retirement from the presidency, the nation was well on the road to international importance. Washington had given it dignity; he had demonstrated its power crushing the Indians in the west (at Fallen Timbers, 1794, the army commanded by Anthony Wayne); he had seen its credit firmly fixed through the efforts and policy of Alexander Hamilton. Treaties with Spain and with Great Britain had amicably settled the questions of navigation on the Mississippi and also the Florida and the eastern boundaries. Having sacrificed his personal inclination throughout his life to his sense

of duty, he now looked forward to a quiet and fruitful old age at Mount Vernon. However, when trouble with France brought about a war situation in 1798, he was brought out of retirement by President John Adams to command a provisional army of defense with the rank of lieutenant general. As changing conditions in France reduced the chance of conflict, Washington never personally commanded the army and allotted a greater and greater part of his time to the management of Mount Vernon. He never brought his farms to the point of efficiency which he had planned, although he did work out a scheme of rotation of crops in his fields. He died on Saturday, Dec. 14, 1799, with high courage. Used to driving himself unsparingly and often beyond his strength, he had neglected a cold which developed into a malignant cynanche trachealis.

WASHINGTON, HENRY STEPHENS (*b. Newark, N.J., 1867; d. 1934*), petrologist. Graduated Yale, 1886; made extensive travels, studying especially the volcanic islands of the Greek and Turkish archipelagoes; Ph.D., Leipzig, 1893. Associated with Joseph P. Iddings, L. V. Pirsson, and W. Cross in formulating a systematic classification of igneous rocks based primarily upon chemical composition; published *Manual of the Chemical Analysis of Rocks* (1904), *Chemical Analyses of Igneous Rocks* (revised edition, 1917). A research worker *post* 1912 at Geophysical Laboratory of the Carnegie Institution of Washington, D.C., he issued a number of publications which established him as the most learned student of igneous rocks of his time.

WASHINGTON, JOHN MACRAE (*b. Stafford Co., Va., 1797; d. at sea, off the mouth of the Delaware River, 1853*), soldier. Graduated West Point, 1817. Commissioned in the artillery, he served principally in Florida and in the South; in 1838–39 he aided General Winfield Scott in the removal of the Cherokee to Oklahoma. After further duty with Scott in quelling disturbances along the Canadian border, he returned to routine duty, 1842. As a battery commander in the Mexican War, he was the chief factor in securing victory at the battle of Buena Vista, Feb. 22, 1847, repelling Mexican attacks on the first day and on the second day holding a key point after a rout of the American militia. He served later as governor of Saltillo and as civil and military governor of New Mexico.

WASHINGTON, KENNETH STANLEY ("THE GENERAL") (*b. Los Angeles, Calif., 1918; d. Los Angeles, 1971*), athlete. Enrolled at the University of California at Los Angeles in 1936 and was on the baseball, football, boxing, and track teams. Excelling in football, he became the first UCLA Bruin to be chosen for the All-American team. A plan to sign him to the Chicago Bears in 1940 was blocked by NFL owners, who maintained a de facto "whites only" policy. He played on semiprofessional teams until 1946, when he signed with the Los Angeles Rams and became the first African American to be signed by any modern major-league sports team. He retired in 1948 at age thirty, his knees beyond rehabilitation.

WATERHOUSE, BENJAMIN (*b. Newport, R.I., 1754; d. Cambridge, Mass., 1846*), physician. Apprenticed in medicine to a Newport physician, he studied also in London and Edinburgh, 1775–78, and at the University of Leyden, 1778–*ca.* 1782. Returning to America, he became professor of the theory and practice of medicine in the medical department of Harvard, 1783. On reading Edward Jenner's 1798 essay on vaccination with cowpox, Waterhouse sent to England for the vaccine and immediately after its receipt (July 8, 1800) tested it successfully on his own son and on another child. Continuing to vaccinate others with cowpox with equally good results, he published *A Prospect of Exterminating the Small Pox* (Aug. 18, 1800). As the news of

his work spread, vaccination was administered improperly by a number of unqualified persons using impure vaccine. A number of people died and there was a general resentment against Waterhouse. After a committee of physicians had investigated the affair and approved Waterhouse's practice, 1802, he continued to publicize vaccination and to insist on maintaining the purity of vaccine. He opposed the moving of the Harvard Medical School from Cambridge to Boston and also the suggestion that the instruction given be more clinical in character. After the failure of his attempt to open a rival medical school and his publication of a number of libels on his colleagues, he was forced to resign from Harvard, 1812. Medical superintendent of New England army posts, 1813–20, he gave considerable time thereafter to general literature as well as the practice of his profession.

WATERHOUSE, FRANK (*b. Cheshire, England, 1867; d. Seattle, Wash., 1930*), capitalist. After immigrating to Canada as a young man, he settled in Tacoma, Wash., *ca.* 1893. Soon removing to Seattle, he became general manager of the Pacific Navigation Co., 1895, and was thereafter highly successful in shipping enterprises and other business interests in the Pacific Northwest.

WATERHOUSE, SYLVESTER (*b. Barrington, N.H., 1830; d. St. Louis, Mo., 1902*), educator, civic leader. Professor of Greek at Washington University, St. Louis, Mo., 1864–1901, he was an outstanding publicist for the Middle West, advocating Mississippi River improvement, encouraging immigration to Missouri, and endeavoring to stimulate trade.

WATERMAN, ALAN TOWER (*b. Cornwall, N.Y., 1892; d. Washington, D.C., 1967*), physicist and federal scientific administrator. Studied at Princeton (B.A., 1913; M.A., 1914; Ph.D., 1916), then taught at the University of Cincinnati. He taught at Yale (1919–48), where much of his work centered on the conduction of electricity through solids. In 1942 he went to Washington to work with the National Defense Research Committee, soon renamed the Office of Scientific Research and Development, which mobilized science and technology for World War II. During the war Waterman was deputy to Karl T. Compton in the Office of Scientific Research and Development. He assisted Compton in directing the development and application of radar from the original British work in that field. Appointed deputy chief of the Office of Field Service in 1943, he succeeded Compton as chief of the Office of Scientific Research and Development (1945–46). Waterman was appointed deputy chief of the Office of Naval Research in 1946 and rose to chief by 1951. He became the first director of the National Science Foundation in 1951, where he made "basic science" the foundation's policy and its public ideology in national politics.

WATERMAN, LEWIS EDSON (*b. Decatur, N.Y., 1837; d. Brooklyn, N.Y., 1901*), book agent, life insurance salesman, inventor. Obtained his first patent for an efficient fountain pen, 1884; established the Ideal Pen Co. in New York to manufacture it. Incorporated his successful business as the L. E. Waterman Co., 1887, and served the firm thereafter as president and manager.

WATERMAN, ROBERT H. (*b. Hudson, N.Y., 1808; d. San Francisco, Calif., 1884*), sea captain. A mate and master aboard packets of the Black Ball line and ships owned by Howland & Aspinwall, Waterman made a series of remarkable passages to China with the *Natchez*, 1842–45. As master of the clipper *Sea Witch*, he made a record run between Hong Kong and New York, 1849. Accepting command of the new clipper *Challenge*, he sailed it from New York to San Francisco in a passage which has frequently been cited as a classic voyage in a "hell ship." An attempted mutiny and the death of several members of the crew

resulted in an attempt to lynch Waterman when he arrived in California, Oct. 29, 1851. Subsequently tried for murder, he was exonerated by the testimony of both crew and passengers.

WATERMAN, THOMAS WHITNEY (*b. Binghamton, N.Y., 1821; d. 1898*), lawyer, writer of digests and legal treatises. Admitted to the bar, 1848, he began practice in New York City, making his residence in Binghamton again *post* 1862. He was author of a great number of works on phases of law which were rapidly changing. Although ephemerally useful and successful, his writings have not noticeably affected the later development of law.

WATERS, DANIEL (*b. Charlestown, Mass., 1731; d. Malden, Mass., 1816*), naval officer. Commanded the schooner *Lee* under John Manley in warfare on British communications off Boston, 1776. Appointed captain in the Continental Navy, March 1777, he commanded several small ships of war on Atlantic cruises and was in command of the Massachusetts ship *General Putnam* in the expedition against Castine, Maine. His most famous exploit came on Dec. 25, 1779, when he defeated the British privateers *Governor Tryon* and *Sir William Erskine* while captain of the Boston privateer *Thorn*.

WATERS, ETHEL (*b. Chester, Pa., 1896; d. Chatsworth, Calif., 1977*), singer, actress, and Christian evangelist. A domestic worker in Philadelphia before launching a career as a singer and dancer in nightclubs on the East Coast and on the vaudeville circuit, she gained notoriety for her renditions of classic blues songs. After hearing her performance of "Stormy Weather" at the Cotton Club in Harlem, Irving Berlin recruited Waters for the hit musical *As Thousands Cheer*. Later, she was the first black actress to star on Broadway in a dramatic role, in *Mamba's Daughters* (1939). Other Broadway roles were in *Cabin in the Sky* (1940) and *The Member of the Wedding* (1950). She appeared in the film version of *Cabin in the Sky* (1943) and in the film *Pinky* (1949), for which she received an Oscar nomination for best supporting actress. In the 1950's she performed in a one-woman show; after 1957 she toured extensively as a singer in the evangelical crusades of Billy Graham.

WATERS, WILLIAM EVERETT (*b. Winthrop, Maine, 1856; d. 1924*), classicist. Graduate Yale, 1878; Ph.D., 1887. An enthusiastic and able teacher of Greek at several schools and colleges, including Chautauqua summer and correspondence courses, he held the presidency of Wells College, 1894–1900. He was associate professor and professor of Greek at New York University, 1901–23.

WATIE, STAND (*b. near site of present Rome, Ga., 1806; d. 1871*), Cherokee leader planter, Confederate brigadier general. Brother of Elias Boudinot (*ca. 1803–1839*). Joined his brother, his uncle Major Ridge, and John Ridge in signing the treaty of New Echota, 1835, whereby the Georgia Cherokee surrendered their lands and removed to what is now Oklahoma. Bitterly attacked for his part in the treaty. Watie later became leader of the minority, or treaty, party of his tribe. Appointed colonel of the Cherokee Mounted Rifles, 1861, he was promoted brigadier general, 1864. During the entire Civil War he was active as a raider and cavalry leader, taking part in many engagements in Indian Territory and along its borders. He was one of the last Confederate officers to surrender (June 23, 1865).

WATKINS, ARTHUR VIVIAN (*b. Midway, Utah, 1886; d. Salt Lake City, Utah, 1973*), U.S. senator. Graduated from Brigham Young University (1906) and Columbia University (LL.B., 1912) and became editor of the *Vernal* (Utah) *Express* (1913), assistant county attorney for Salt Lake County (1913–15), and judge for Utah's Fourth Judicial District (1920–33). In 1946 he was elected to the U.S. Senate, where he maintained an isolationist stance, was one of thirteen senators to vote against the NATO treaty, chaired the Senate committee that recommended the censure of the anti-Communist crusader Joseph McCarthy, and cosponsored the Upper Colorado River Storage Project.

WATKINS, GEORGE CLAIBORNE (*b. Shelbyville, Ky., 1815; d. St. Louis, Mo., 1872*), Arkansas jurist. As chief justice of the Arkansas supreme court, 1852–54, he handed down an early decision holding that the United States had exclusive admiralty jurisdiction over navigable streams (in *Merrick* v. *Avery*, 14 *Ark.*, 370).

WATKINS, JOHN ELFRETH (*b. Ben Lomond, Va., 1852; d. New York, N.Y., 1903*), engineer, museum curator. Built up collections pertaining to the transportation industry at U.S. National Museum, Washington, D.C., 1884–92; curator of mechanical technology and superintendent of buildings of the Museum *post* 1895. Authority on the history of engineering and the mechanical arts.

WATSON, ANDREW (*b. Oliverburn, Scotland, 1834; d. Cairo, Egypt, 1916*), United Presbyterian clergyman. Immigrating to America *ca.* 1848, he was raised near Sussex, Wis. Ordained, 1861, he served thereafter as a missionary in Egypt.

WATSON, ARTHUR KITTRIDGE ("DICK") (*b. Summit, N.J., 1919; d. Norwalk, Conn., 1974*), business executive and diplomat. Graduated Yale University (B.A., 1942). A son of IBM founder Thomas J. Watson, Sr., he started with the company as a salesman and became a director and vice-president of the new IBM World Trade division in 1949, later becoming its president (1954) and chairman (1963). Under his leadership IBM World Trade expanded rapidly in Europe, Asia, Latin America, and the Middle East, with revenues topping $1 billion by 1965. Because of production problems, it became clear he would not succeed his brother Thomas as chairman and CEO of the parent company, although he became its vice-chairman in 1966. Turning to other interests, he served as president of the International Chamber of Commerce (1967–68) and cofounded, with David Rockefeller, the Emergency Committee for American Trade, which opposed protectionism. He resigned from IBM to serve as ambassador to France (1970–72), then returned as a director and member of the executive committee.

WATSON, CHARLES ROGER (*b. Cairo, Egypt, 1873; d. Bryn Mawr, Pa., 1948*), United Presbyterian clergyman, missionary, educator. Child of missionary parents. Graduated Princeton University, 1894; Princeton Seminary, 1899. Ordained in 1900. After a brief pastorate in St. Louis, Mo., he served as corresponding secretary of the United Presbyterian Board of Foreign Missions, 1902–16. He was a founder of Cairo Christian University (American University in Cairo), and its president, 1920–45.

WATSON, DAVID THOMPSON (*b. Washington, Pa., 1844; d. Atlantic City, N.J., 1916*), lawyer. Practiced successfully in Pittsburgh, Pa., *post* 1868. Gained widest prominence as one of counsel for the United States in Alaskan Boundary controversy with Great Britain, 1903.

WATSON, ELKANAH (*b. Plymouth, Mass., 1758; d. 1842*), merchant, promoter, agriculturist. Apprenticed to John Brown (1744–80) of Providence, R.I., *ca.* 1774, he remained in the employ of the Browns after he came of age. Embarking for France to carry money and dispatches to Benjamin Franklin, 1779, he entered business on his own at Nantes, and for a time was very successful. Failing in 1783, he returned to America and made an unsuccessful attempt to raise capital for establishment

of an American canal system. After a second failure in business at Edenton, N.C., he settled in Albany, N.Y., 1789, organized the Bank of Albany, and became a leading citizen of that community. Continuing to urge his plans for canals, he persuaded several prominent New Yorkers to join him in a tour of central New York, 1791, during which he projected a plan for a canal in that region. Retiring from active business *ca.* 1802, he moved to Pittsfield, Mass., where he devoted himself to scientific agriculture. He staged the "Cattle Show" (1810) which preceded incorporation of the Berkshire Agricultural Society, sponsor of the first county fair in America. He thereafter helped make the county fair an American institution. He was author of *Men and Times of the Revolution* (1856).

WATSON, HENRY CLAY (*b. Baltimore, Md., 1831; d. Sacramento, Calif., 1867*), journalist. Trained as a printer and newspaper editor in Philadelphia, Pa., he settled in Sacramento, Calif., 1861, where he became editor of the *Daily Union* and won considerable local fame as an editorial writer during the Civil War. He was author also of a number of historical stories and studies for young people.

WATSON, HENRY COOD (*b. London, England, 1818; d. New York, N.Y., 1875*), journalist, music critic. Immigrated to New York, N.Y., 1841. Founded the *Musical Chronicle*, 1843, which later became the *American Musical Times*; was associated with C. F. Briggs and Edgar Allan Poe on the *Broadway Journal*. Later served as an editor of *Frank Leslie's Illustrated Newspaper* and as music critic for the *New York Tribune*. In 1842 he was one of the group that founded the Philharmonic Society of New York.

WATSON, JAMES CRAIG (*b. near Fingal, Ontario, Canada, 1838; d. 1880*), astronomer. Graduated University of Michigan, 1857. Directed the observatory at Michigan and taught physics there, 1859–79; served thereafter as director of the Washburn Observatory, University of Wisconsin. Discovered 22 asteroids; worked with Benjamin Peirce on lunar theory; was author of *Theoretical Astronomy* (1868), a complete compilation and digest of the theory and method of orbital determination.

WATSON, JAMES ELI (*b. Winchester, Ind., 1864; d. Washington, D.C., 1948*), lawyer, politician. Graduated De Pauw University, 1886. Congressman, Republican, from Indiana, 1895–97, 1899–1909; U.S. senator, 1916–33. A member of the "Old Guard," he labored faithfully in Congress for the railroads, the banks, and the corporations; he supported high tariffs and isolationism and believed in the rigid restriction of immigration. As majority leader in the Senate, he blocked President Hoover's attempt to revise the tariff. A skillful "horse trader," he was gifted principally in the political arts of survival and party loyalty.

WATSON, JAMES MADISON (*b. Onondaga Hill, N.Y., 1827; d. Elizabeth, N.J., 1900*), teacher, textbook salesman, and writer.

WATSON, JOHN BROADUS (*b. near Greenville, S.C., 1878; d. New York, 1958*), psychologist. Studied at Furman University and the University of Chicago (Ph.D., 1903). Taught at the University of Chicago (1903–08) and Johns Hopkins University (1908–20). One of the founders of the school of behaviorist psychology which stressed stimulus-response patterns and objective observation. President (1915), American Psychological Association. Watson was forced to resign from Johns Hopkins because of a scandal surrounding his marriage. Left psychology to work in advertising in New York City until his retirement in 1945.

WATSON, JOHN CRITTENDEN (*b. Frankfort, Ky., 1842; d. Washington, D.C., 1923*), naval officer. Graduated U.S. Naval Academy, 1860. Promoted master, 1861, he was navigating officer in the *Hartford* during the 1862 operations against New Orleans and Vicksburg and the 1863 operations against Port Hudson and Grand Gulf. He later served as flag lieutenant on the staff of Adm. D. G. Farragut. Promoted commodore, 1897, he commanded the North Cuban Blockade Squadron and the Eastern Squadron during the Spanish-American War. Promoted rear admiral, 1899, he retired in 1904.

WATSON, JOHN FANNING (*b. Batsto, N.J., 1779; d. 1860*), businessman, antiquarian. Successively a publisher, a banker, and a railroad executive, Watson is remembered as author of studies of pioneer days in Pennsylvania and New York based on the methodical collection of memories of old inhabitants and authentic documents. Among his works were *Annals of Philadelphia* (1830, and subsequent editions), *Historic Tales of Olden Time* (1832); and *Annals and Occurrences of New York City and State* (1846).

WATSON, JOHN WILLIAM CLARK (*b. Albermarle Co., Va., 1808; d. Holly Springs, Miss., 1890*), lawyer, Mississippi jurist, Confederate senator.

WATSON, SERENO (*b. East Windsor Hill, Conn., 1826; d. Cambridge, Mass., 1892*), botanist. Graduated Yale, 1847. Failing in various occupations, he removed to California, 1867, and found employment as a volunteer aide with Clarence King's exploration of the Great Basin. Soon afterwards he was commissioned to collect plants and secure data regarding them, thus by chance undertaking the work in which he was to attain distinction. His *Botany* (1871), the fifth volume in the report of the King survey, was virtually a flora of the Great Basin and contained phytogeographic material in advance of its time. Settling in Cambridge, Mass., Watson became assistant in the Gray Herbarium, 1873, and was its curator *post* 1874. He was author, among other works, of the *Botany of California* (1876, 1880); *Bibliographical Index to North American Botany* (1878); and of many outstanding monographs. He completed the *Manual of the Mosses* begun by Leo Lesquereux and T. P James, and in 1889, with the assistance of John M. Coulter, revised Gray's *Manual of Botany*.

WATSON, THOMAS AUGUSTUS (*b. Salem, Mass., 1854; d. Passagrille Key, Fla., 1934*), telephone pioneer, shipbuilder. *Post* 1874 he assisted Alexander G. Bell during the experimental period of the telephone, and was given an interest in the business in 1877 on formation of the first telephone organization. He was the first research and technical head of the Bell Telephone Co. Resigning in 1881, he first attempted farming, but soon began to build engines and ships. In 1896 his firm undertook contracts for the USS *Lawrence* and *Macdonough*; these were followed by the Cape Hatteras lightship and the cruiser USS *Des Moines*. Watson's shipyard was incorporated as the Fore River Ship & Engine Co., 1901. In 1904 he resigned, retired from business, and gave himself up to the special interests in geology and literature which he had cultivated during his business career.

WATSON, THOMAS EDWARD (*b. near Thomson, Ga., 1856; d. 1922*), lawyer, politician. Attended Mercer University; began successful career as a criminal lawyer, 1880. Brought early under the personal influence of Robert Toombs and Alexander H. Stephens, Watson entered politics as an agrarian reformer, hostile to the new order in the South and nostalgic for the imagined glories of the period before the Civil War. As a young member of the Assembly, he fought against the Georgia Democratic machine which was dominated by capitalist-industrialists, and entered Congress, 1891, as a supporter of the Farmers' Alliance and a Populist. Introducing many reform bills and supporting advanced labor legislation, he was defeated for reelection in 1892 and 1894, but continued to sway thousands of his followers with

his denunciations of the trusts, capitalist finance, and Democratic policies. Nominated for the vice presidency of the United States by the Populist convention, 1896, he received a very small vote. Embittered, he retired from public life and turned to writing, producing, among other books, biographies of Napoleon and Thomas Jefferson. As the Populist candidate for president in 1904, he polled only a small vote but gained considerable attention from reformers. In 1905 he founded *Tom Watson's Magazine* which featured his reform editorials; he later established *Watson's Jeffersonian Magazine*.

As new issues overshadowed the conflict between industrialists and agrarians, Watson took up and prosecuted a number of sensational crusades against Catholics, Jews, blacks, Socialists, and foreign missionaries. Shifting his followers from one Democratic faction to another, he virtually dictated state politics. He conducted a campaign against American intervention in World War I and against conscription. Although he lost the state presidential primary in 1920, he was elected that same year to the U.S. Senate by a large vote on the same platform, namely, restoration of civil liberties and the defeat of the League of Nations.

WATSON, THOMAS JOHN (*b. East Campbell, N.Y., 1874; d. New York, N.Y., 1956*), business executive. Studied at the Miller School of Commerce, Elmira, N.Y. Founder of the International Business Machines Corporation in 1924; president and chairman of the board until 1956. Watson began his career with the National Cash Register Company in 1895; he served as salesman and sales manager until 1913, when he was convicted on charges of conspiracy in restraint of trade; the conviction was later overturned. He joined the Computing-Tabulating-Recording Co. and became president in 1914; this was the organization that became IBM. During the Depression and the necessary accounting procedures demanded by the expanded bureaucracies of the New Deal programs, Watson and IBM prospered; during World War II, the firm produced about forty military ordnance items; profits went from $41 million in 1939 to $142 million in 1945. Watson emphasized sales and distribution instead of original research and despite IBM's strong research ties with universities Sperry-Rand marketed the first commercial computer. However, IBM — ter Watson had relinquished control to his sons, Thomas Jr., and Arthur — soon gained preeminence in the computer field.

WATSON, WILLIAM (*b. Nantucket, Mass., 1834; d. 1915*), engineer, educator. Graduated Lawrence Scientific School, Harvard, 1857; Ph.D., University of Jena, 1862. While abroad, he collected information on technical instruction which in 1864 was used as basis in planning organization of the Massachusetts Institute of Technology. He served at the Institute as its first professor of mechanical engineering and descriptive geometry, 1865–73. Thereafter he devoted himself to private studies, and was recording secretary of the American Academy of Arts and Sciences, 1884–1915.

WATT, DONALD BEATES (*b. Lancaster, Pa., 1893; d. Lancaster, 1977*), educator. Attended Princeton University and traveled in Mesopotamia (Iraq) as the YMCA secretary with the British-Indian army during World War I. In 1931 he launched an educational program designed to facilitate cross-cultural learning for American and foreign youth; Experiment in International Living called for youngsters to immerse themselves in another culture by living with a foreign family and speaking the native language. Initially with a limited number of students, Watt conducted programs in Europe; he later expanded successfully with programs in Latin America and Africa. The experiment was incorporated in 1943 and codified with written materials. By the 1960's a post-secondary institution, the School for International Training, offered degrees in international studies.

WATTERSON, HARVEY MAGEE (*b. Beech Grove, Tenn., 1811; d. 1891*), lawyer, Tennessee legislator. Father of Henry Watterson. Congressman, Democrat, from Tennessee, 1839–43, and for several years thereafter in the diplomatic service, Watterson became proprietor of the *Nashville Daily Union*, 1849. Removing to Washington, D.C., as editor of the *Washington Union*, 1851, he gave up the post because he would not support administration policy in regard to the repeal of the Missouri Compromise. An opponent of the extension of slavery and of secession, he was a Unionist throughout the Civil War. After the war, he engaged in law practice at Washington, D.C.

WATTERSON, HENRY (*b. Washington, D.C., 1840; d. Jacksonville, Fla., 1921*), journalist, statesman. Son of Harvey M. Watterson. Beginning his career as journalist, 1858, he worked briefly in New York and then became a reporter for the Washington, D.C., *Daily States*. By conviction a Unionist, but a secessionist and Confederate soldier because of sectional sympathies. He became editor of the *Cincinnati Evening Times*, 1865, but withdrew to Nashville, Tenn., 1866. After service on the Nashville *Republican Banner*, he went to Louisville, Ky., to help edit the *Daily Journal* (from November 1868, the *Courier-Journal*). As editor of the *Courier-Journal* from November 1868, Watterson struggled for the restoration of Southern home rule, agitating for complete civil and legal rights for blacks in exchange for the return of the South to its own people. Associated with Carl Schurz, Murat Halstead, and Samuel Bowles, he formed the famous "Quadrilateral" (which later included Whitelaw Reid and Horace White) at the Liberal Republican convention of 1872. A powerful advocate of the candidacy of Samuel J. Tilden for nomination and election, 1876, Watterson served in Congress from the summer of 1876 through part of the winter of 1877 as Tilden's floor leader during the contest that ended with the certification of Hayes.

Never again did Watterson express more than a temporary fealty to any Democratic presidential nominee or White House incumbent. He was editorially critical of Grover Cleveland, and a fiery opponent of William J. Bryan in 1896; his stand against Bryan produced a Republican victory in Kentucky and nearly ruined the standing of his newspaper in that state. As late as 1913 Watterson deplored Bryan's appointment as U.S. secretary of state, assailing him as an impractical dreamer. Before this, however, he had made a national sensation with a series of philippics against Theodore Roosevelt, whom he called a potential dictator. Failing to prevent the nomination of Woodrow Wilson in 1912, Watterson remained critical of Wilson until the issues raised in 1916 by Charles E. Hughes and Theodore Roosevelt ranged him on Wilson's side. He once again parted company with the president over the League of Nations. Selling his control of the *Courier-Journal* in 1918, he retired to private life.

Celebrated as a public speaker and lecturer, Watterson had amazing zest, a great gift for conversation, and the ability to set other editors chattering over what he wrote. He belonged to the time when journalism was personal and editorial writing often had immediate and dynamic effect. He died convinced that civilization was facing a crisis because of prevalent godlessness. He was rendered pessimistic more immediately, however, by the triumph of national prohibition and woman suffrage, championed by those whom for many years he had attacked as "red-nosed angels," "silly-sallies," and "crazyjanes." He was author of, among other books, an autobiography, *Marse Henry* (1919).

WATTERSTON, GEORGE (*b. New York, N.Y., 1783; d. Washington, D.C., 1854*), lawyer, librarian. After practicing law in Hag-

erstown, Md., and Washington, D.C., he served as librarian of Congress, 1815–29, and was thereafter editor of the Washington *National Journal.* He was author of a number of works including novels, poems, guidebooks, statistical digests, and a comedy. He began the movement to build the Washington Monument, 1833, and remained as secretary of the Washington National Monument Society until his death.

WATTS, ALAN WILSON (*b. Chislehurst, England, 1915; d. Mill Valley, Calif., 1973*), Zen Buddhist philosopher. At age twenty wrote *The Spirit of Zen* (1936); attended Seabury–Western Theological Seminary in Evanston, Ill.; and was ordained an Episcopal priest in 1944. He served as chaplain at Northwestern University (1944–50), earning his master of sacred theology degree there in 1948. He left the priesthood in 1950 after a love affair scandal and taught at the American Academy of Asian Studies in San Francisco (1951–57); in 1962 he organized the Society for Comparative Philosophy, which published the *Alan Watts Journal.* The leading Western exponent of Zen Buddhism, he influenced the 1960's counterculture through lectures and twenty-two books, including *The Way of Zen* (1957) and *This Is It* (1960).

WATTS, FRANKLIN MOWRY (*b. Sioux City, Iowa, 1904; d. New York City, 1978*), publisher. Graduated Boston University (B.A., 1925) and was a book buyer in Kansas before working as a sales manager for publishers in New York City beginning in 1932. In 1942 he launched Franklin Watts, Inc., which released a series of popular home reference books and became well known for children's books. Watts released the famous First Book series, which included *The First Flying Book, The First Book of Stones,* and *The First Book of World War II;* by his retirement as president in 1969, he had published some 300 titles in the series. Watts also wrote children's books, including *Let's Find Out about Christmas* (1967).

WATTS, FREDERICK (*b. Carlisle, Pa., 1801; d. Carlisle, 1889*), lawyer, farmer, Pennsylvania jurist and supreme court reporter, railroad executive. As U.S. commissioner of agriculture, 1871–77, he obtained an appropriation for a forestry investigation that was the beginning of the Agriculture Department's division of forestry. Throughout his busy life he engaged in farming and in the activities of state and country agricultural societies.

WATTS, THOMAS HILL (*b. near present Greenville, Ala., 1819; d. Montgomery, Ala., 1892*), lawyer, Alabama legislator, confederate soldier. A Whig and later a Know-Nothing, he was a strong Unionist until Lincoln's election and its alleged threat to state rights. Confederate attorney general, 1862, he was governor of Alabama, 1863–65. During his term he fought against invasion of his state by the North and also opposed encroachments on state rights by the Confederate government at Richmond. After the Civil War, he practiced law in Montgomery.

WATTSON, LEWIS THOMAS See FRANCIS, PAUL JAMES.

WAUGH, BEVERLY (*b. Fairfax Co., Va., 1789; d. Baltimore, Md., 1858*), Methodist clergyman. Elected assistant book agent of the Church, 1828, he became principal book agent, 1832, and served with efficiency and success until 1836 when he was elected bishop. He refused to be influenced in the conduct of his duties by either the proslavery or the antislavery groups among Methodists. After endeavoring to prevent the schism of 1844, he remained identified with the Northern wing of the Church and was senior bishop *post* 1852.

WAUGH, FREDERICK JUDD (*b. Bordentown, N.J., 1861; d. Provincetown, Mass., 1940*), painter. Studied with Thomas Eakins at Pennsylvania Academy of the Fine Arts and in Paris. A versatile artist, Waugh is known principally to the public as a talented marine painter whose many seascapes were marked by picturesque realism.

WAXMAN, FRANZ (*b. Königshütte, Upper Silesia, Germany, [now Chorozów, Poland], 1906; d. Los Angeles, Calif., 1967*), composer and conductor. Studied at the Dresden Music Academy and the Berlin Conservatory. He orchestrated and conducted Friedrich Hollaender's music for *The Blue Angel* (1930). His first major original score was for Fritz Lang's *Liliom* (1933). Moving to Hollywood, Waxman composed an original score for *The Bride of Frankenstein* (1935). He was briefly the music director of Universal studios, where he scored *Magnificent Obsession* (1935). For Metro-Goldwyn-Mayer he did scores for *Captains Courageous* (1937), *Three Comrades* (1938), *Rebecca* (1940), *The Philadelphia Story* (1940), *Dr. Jekyll and Mr. Hyde* (1941), *Suspicion* (1941), *Objective, Burma!* (1945), and *Humoresque* (1947). Waxman received Academy Awards for his scores for *Sunset Boulevard* (1950), and *A Place in the Sun* (1951). His other major works of the 1950's include scores for *The Silver Chalice* (1954), *Rear Window* (1954), *Crime in the Streets* (1956), *Sayonara* (1957), *Peyton Place* (1957), *The Spirit of St. Louis* (1957), and *The Nun's Story* (1959). His concert compositions include the *Carmen* Fantasie (1947), the Sinfonietta for Strings and Timpani (1955), the oratorio *Joshua* (1959), the song cycle *The Song of Terezin* (1965), and an unfinished opera based on his film music for *Dr. Jekyll and Mr. Hyde.*

WAYLAND, FRANCIS (*b. New York, N.Y., 1796; d. 1865*), Baptist clergyman, educator. Father of Francis Wayland (1826–1904). Graduated Union, 1813; was influenced at Andover Theological Seminary by Moses Stuart. Chosen president of Brown University, 1827, he gave that school a dynamic administration until his retirement, 1855. Standards were generally raised; an analytic method of study succeeded the old memorization of textbooks; the curriculum was extended and enriched. He was author of a number of textbooks in moral philosophy, political economy, and other subjects. His reforming views on education were expressed in *Thoughts on the Present Collegiate System in the United States* (1842) and *Report on the Condition of the University* (1850). Instrumental in devising a school system for the city of Providence, R.I., he was author of the plan for free Rhode Island public schools (1828) and served as first president of the American Institute of Instruction, 1830.

WAYLAND, FRANCIS (*b. Boston, Mass., 1826; d. New Haven, Conn., 1904*), lawyer. Son of Francis Wayland (1796–1865). Graduated Brown, 1846; studied law at Harvard. Practiced in Worcester, Mass., until 1857. Thereafter a resident of New Haven, he taught at Yale Law School *post* 1871 and served as dean, 1873–1903. A conservative in legal education, he was responsible for much material progress at the school but damaged its prestige by refusing to adopt modern methods of study as instituted at Harvard by C. C. Langdell and others.

WAYMACK, WILLIAM WESLEY (*b. Savanna, Ill., 1888; d. Des Moines, Iowa, 1960*), journalist and government official. Studied at Morningside College in Iowa (B.A., 1911). Reporter and editor for the *Sioux City Journal* (1911–18). From 1918 until 1946, he was editor (1918–1929), and director of publishing (1931–1946), of the Cowles papers, *The Register* and *Tribune,* in Des Moines. An advocate of reform in agriculture, Waymack wrote against "farm tenancy" during the 1920's and the Depression. An internationalist in a time of national isolation, Waymack gained a national reputation for his editorials. From 1946 to 1948, he was a member of the Atomic Energy Commission. Trustee of

the Carnegie Endowment for International Peace (1941–59); director of the Twentieth Century Fund (1942–60). He also served as director of the Federal Reserve Bank of Chicago.

WAYMAN, ALEXANDER WALKER (*b. Caroline Co., Md., 1821; d. Baltimore, Md., 1895*), bishop of the African Methodist Episcopal Church. Born a freeman, he was mainly self-educated. His principal pastorates until his election as bishop (1864) were in Washington, D.C., and Baltimore. As bishop, he organized and supervised conferences throughout the United States.

WAYMOUTH, GEORGE (*b. Devonshire, England, date unknown; d. place unknown, post 1612*), navigator, explorer. Commanded East India Company's expedition of 1602 in search of the Northwest Passage. Commanded ship *Archangel* on the 1605 voyage of exploration to Virginia sponsored by the Earl of Southampton, Lord Wardour, and Sir Ferdinando Gorges, during which he explored and traded along the coast to present Maine. Captured Indians whom he brought back to England later served as pilots to Martin Pring, George Popham, and other explorers. Waymouth was author of several treatises on navigation and ship-building.

WAYNE, ANTHONY (*b. Waynesboro, Pa., 1745; d. Presque Isle, now Erie, Pa., 1796*), surveyor, tanner, soldier. An active committeeman during the early Revolutionary movement, he served in the provincial assembly, 1775, and was commissioned colonel of a Pennsylvania regiment by Congress, January 1776. Impetuous and brave, he was often at odds with commanding officers but won credit for covering the retreat of Montgomery's army from the mouth of the Sorel to Ticonderoga, 1776. Commissioned brigadier general, February 1777, he joined Washington at Morristown, N.J., and took command of the Pennsylvania line. At Brandywine, September 1777, he held the center of the defense against the British at their main point of crossing; nine days later (September 20), he was surprised and badly defeated at Paoli. In the battle of Germantown (October 4), he led an almost victorious attack but was obliged to fall back when the rest of the American force became confused and retreated. He wintered with Washington at Valley Forge and led the advance attack at Monmouth, June 1778. Leading a separate corps of Continental light infantry, he took the British outpost of Stony Point on the Hudson River, July 1779. When Benedict Arnold tried to surrender West Point, September 1780, Wayne prevented British occupation of that post. At the end of the same year he helped quell a mutiny of the Pennsylvania line and secured from Congress a correction of the grievances that had caused it. Serving under Lafayette in the Yorktown campaign, he further distinguished himself at Green Spring, Va., July 1781. During the next year he campaigned successfully against the Creek Indians in Georgia, negotiating treaties with Creek and Cherokee, 1782–83.

Unsuccessful as a rice planter in Georgia after the Revolution, he engaged in conservative politics both in Pennsylvania and Georgia and was strongly in favor of the new Constitution. After the defeats of Generals Harmar and St. Clair by the confederated Indians of the Wabash and Maumee regions, 1790–91, Washington named Wayne as major general to rehabilitate the American army and move against the Indians. Carefully training and organizing his forces, and employing great tact in denying the British any excuse to lend official aid to the Indians, he won a complete victory at Fallen Timbers (near present Toledo, Ohio), Aug. 20, 1794. Pacification and submission of the Indians was secured by Wayne a year later at the treaty of Greenville, where he convinced them of the hopelessness of further resistance. He died on his return from the occupation of the post at Detroit, surrendered under the terms of Jay's Treaty.

WAYNE, ARTHUR TREZEVANT (*b. Blackville, S.C., 1863; d. 1930*), ornithologist. An indefatigable field worker in South Carolina and Florida. Author, among other works, of *Birds of South Carolina* (1910) and *A List of Avian Species for Which the Type Locality is South Carolina* (1917). Added about 45 birds to fauna of South Carolina; discovered breeding grounds of white ibis, 1922.

WAYNE, JAMES MOORE (*b. Savannah, Ga., ca. 1790; d. Washington, D.C., 1867*), lawyer, Georgia legislator, official and jurist. Graduated College of New Jersey (Princeton), 1808. As congressman, Democrat, from Georgia, 1829–35, he supported President Jackson's major policies and rose to chairmanship of the committee on foreign relations. Appointed a justice of the U.S. Supreme Court, 1835, he served until his death and was particularly effective in cases involving admiralty problems and the acquisition of lands from foreign countries. He was a Unionist in the Civil War.

WAYNE, JOHN (*b. Marion Michael Morrison, Winterset, Iowa, 1907; d. Los Angeles, Calif., 1979*), actor. Attended University of Southern California on an football scholarship and began appearing in bit parts in early Western films. In 1926 he met director John Ford, which led to his first starring role, in *The Big Trail* (1930), after which he appeared in a series of low-budget pictures. He had a notable success in *Stagecoach* (1939) and his career went into high gear with *Red River* (1948); in this performance he showcased the gruff and confident swagger that would be his trademark. Wayne starred in Ford's famed cavalry trilogy, which included *Fort Apache* (1948), *She Wore a Yellow Ribbon* (1949), and *Rio Grande* (1950). He also had a noted role in *The Sands of Iwo Jima* (1949).

In 1944 Wayne was a founding member of the Motion Picture Alliance for the Preservation of American Ideals, an organization dedicated to expelling Communists from the film industry; his political conservatism influenced his decisions on acting roles. A career high point was the film *The Searchers* (1956), in which he portrayed a character representing the dark side of the West. He produced, directed, and starred in the first pro-war major-studio feature on the Vietnam War, *The Green Berets* (1968). He won an Oscar for his performance in *True Grit* (1969). His films in the 1970's included *McQ* (1974) and *Brannigan* (1975), both police dramas, and his last film, *The Shootist* (1976), another Western. Though he was considered by many critics a limited actor, Wayne was a legendary Hollywood star and, for many Americans, an authentic and refreshing symbol of patriotism and masculinity.

WEARE, MESHECH (*b. Hampton Falls, N.H., 1713; d. 1786*), New Hampshire colonial legislator and jurist, Revolutionary patriot. Graduated Harvard, 1735. President of the New Hampshire Council and chairman of the committee of safety, 1776–84; chief justice, 1776–82. Elected president of the state of New Hampshire (governor), 1784, he resigned because of ill health in 1785. He was a cautious, temperate man, influential because of his shrewdness and honesty.

WEATHERFORD, WILLIAM (*b. probably in present Elmore Co., Ala., ca. 1780; d. 1824*), Creek Indian chief, known also as Red Eagle. Roused to war against the whites by the visit of Tecumseh in 1811, he took up arms after Tippecanoe, ignorant that his cause was already hopeless. Responsible for the massacre at Fort Mims, Aug. 30, 1813, he was a leader with Menewa of the force defeated at Horseshoe Bend, 1814. After his surrender to Andrew Jackson, he settled as a planter in Monroe Co., Ala. Accused, possibly falsely, by the whites of extreme personal dissoluteness, he was admitted to be eloquent and courageous.

WEAVER, AARON WARD (*b. Washington, D.C., 1832; d. Washington, 1919*), naval officer. Appointed midshipman, 1848; graduated U.S. Naval Academy, 1854. Served with distinction in Union campaigns on the lower Mississippi River, 1862–64, and with the South Atlantic blockade, 1864–65. Retired as rear admiral, 1893.

WEAVER, JAMES BAIRD (*b. Dayton, Ohio, 1883; d. Colfax, Iowa, 1912*), lawyer, Union soldier, Populist. Raised in Michigan and Iowa; practiced law in Iowa. Volunteering for the Union Army, 1861, he served in the western campaigns and rose to rank of brevet brigadier general. Utterly incorruptible, he held post of internal revenue assessor in Iowa, 1867–73, but lost favor with the Republican party to which he belonged because of his objection to its currency policy and his denunciations of predatory corporations. As a Greenbacker, he was elected to Congress from Iowa, 1878, ran for president in 1880, was defeated for Congress in 1882, but won again in 1884 and 1886. Identifying himself with the Farmers' Alliance, he took a leading part in transforming it into the Populist party. No advocate of unlimited inflation, nor of repudiation of debt, he held to the quantity theory of money and opposed what he considered the systematic efforts of creditors to appreciate the purchasing power of the dollar. As Populist candidate for the presidency, 1892, he campaigned with force and dignity; he received a popular vote of over a million, and 22 electoral votes. An advocate of the fusion of all soft-money forces, he helped bring about Populist endorsement of William J. Bryan in 1896.

WEAVER, PHILIP (*b. North Scituate, R.I., 1791; d. Attica, Ind., ante 1861*), cotton manufacturer. Removed to Spartanburg District, S.C., 1816, where with his brothers and others he set up and operated one of the earliest cotton mills in the region.

WEAVER, WARREN (*b. Reedsburg, Wis., 1894; d. New Milford, Conn., 1978*), mathematician. Graduated University of Wisconsin (B.S., 1916; C.E., 1917; Ph.D., 1921) and taught there (1920–32), after which he served as an administrator for the Rockefeller Institute in New York City (1932–59). He increased significantly the institute's funding of research in experimental and quantitative biology. From 1943 to 1946 he chaired the Applied Mathematics Panel of the National Defense Research Committee. After World War II he organized lectures to educate the public on scientific advancements; they were aired during the intermissions of national radio and television shows. These talks were reinforced by printed material provided to schools, colleges, and churches. He wrote *Lady Luck: The Theory of Probability* (1963), which elaborated on the technical aspects of mathematical theory for the lay public.

WEAVER, WILLIAM DIXON (*b. Greensburg, Pa., 1857; d. Charlottesville, Va., 1919*), electrical engineer, editor of technical journals, organizer of professional societies in his field.

WEBB, ALEXANDER STEWART (*b. New York, N.Y., 1835; d. Riverdale, N.Y., 1911*), soldier, educator. Son of James W. Webb. Graduated West Point, 1855; was commissioned in the artillery. Outstanding in his distinguished Civil War service with the Union Army was his command of the 2nd Brigade, Second Division, II Corps, 1863–64. Webb's brigade occupied the "bloody angle" at Gettysburg and bore the brunt of Pickett's charge. Severely wounded at Spotsylvania, May 1864, he returned to duty the next year as chief-of-staff to General Meade. Resigning with the rank of lieutenant colonel, Regular Army, he served as president of the College of the City of New York, 1869–1902. Serving also as professor of political philosophy, he maintained the standards of the college but made no significant advance in the scope of its work.

WEBB, CHARLES HENRY (*b. Rouse's Point, N.Y., 1834; d. New York, N.Y., 1905*), journalist, Civil War correspondent. Active on California journals, 1863–66, he became a close friend of Bret Harte and of Mark Twain. He founded, and was first editor of, the *Californian*, 1864. Working in New York City *post* 1866, he was the sponsor and publisher of Mark Twain's first book, *The Celebrated Jumping Frog of Calaveras County* (1867). His "John Paul" letters for the *New York Tribune* were collected in 1874 as *John Paul's Book*. He was author also of other parodies and satires.

WEBB, CLIFTON (*b. Indianapolis, Ind., 1893; d. Beverly Hills, Calif.; 1966*), singer, dancer, and actor. Appeared in a number of children's plays, operas, and musical comedies. He became a popular ballroom dancer and established his own private studio. He appeared in *Love o'Mike* (1917), *Listen, Lester* (1918), *As You Were* (1920), *Jack and Jill* (1923), *Meet the Wife* (1923), *Sunny* (1925), *She's My Baby* (1928), *Treasure Girl* (1928), the first *Little Show* (1929), *Three's a Crowd* (1930), *Flying Colors* (1932), *As Thousands Cheer* (1933), *And Stars Remain* (1936), *The Importance of Being Earnest* (1939), *Burlesque* (1939), *The Man Who Came to Dinner* (1940), and *Blithe Spirit* (1942). His early films include *Polly with a Past* (1920), *New Toys* (1925), and *The Heart of a Siren* (1925). In 1944 he began a long career with Twentieth Century—Fox, appearing in *Laura*, which earned him an Oscar nomination for best supporting actor. He also appeared in *The Dark Corner* (1946), *The Razor's Edge* (1946), *Sitting Pretty* (1948), for which he received an Oscar nomination for best actor, *Mr Belvedere Goes to College* (1949), *Cheaper by the Dozen* (1950), *For Heaven's Sake* (1950), *Mr. Belvedere Rings the Bell* (1951), *Dreamboat* (1952), *Titanic* (1953), and *Mister Scoutmaster* (1953).

WEBB, DANIEL (*b. England, ca. 1700; d. 1773*), British soldier. Rising in the regular service to be colonel of the 48th Foot (November 1755), he was selected early in 1756 to command in North America under Lord Loudoun and James Abercromby. A temporary major general after the fall of Oswego, he went up the Mohawk River to make a stand against the expected French attack on the forts there. Stricken with panic by Indian rumors, he destroyed the forts and retreated, leaving the colonists unprotected. As Loudoun had no one else to leave in command in New York during 1757, he continued Webb in his post despite that officer's illness and incapacity. During the siege of Fort William Henry in August he made no attempt at its relief. Recalled in December 1757, he later served with ability in Germany.

WEBB, GEORGE JAMES (*b. near Salisbury, England, 1803; d. Orange, N.J., 1887*), musician, composer. Came to Boston, Mass., 1830; was appointed organist of Old South Church. Associated with Lowell Mason in his educational projects, Webb organized an orchestra at the Boston Academy of Music and was important in other ways in the development of music in Boston.

WEBB, HARRY HOWARD (*b. San Francisco, Calif., 1853; d. Montecito, Calif., 1939*), mining engineer. Associated with the development of gold and diamond mines in South Africa, 1895–1916, he was later active in development of the potash and borax deposits near Death Valley, Calif.

WEBB, JAMES WATSON (*b. Claverack, N.Y., 1802; d. New York, N.Y., 1884*), journalist, diplomat. Father of Alexander S. Webb. Commissioned a second lieutenant in the U.S. Army, 1819, he served principally with infantry in the Midwest, won a reputation as a duellist, and resigned from the army, 1827. Acquiring the

N.Y. *Morning Courier,* he merged the *Enquirer* with it in 1829 and continued to edit the *Courier and Enquirer* until 1861. Originally a Jacksonian, he later was a chief prop of the Whigs and a Free-Soiler. He was effective, if rash, as U.S. minister to Brazil, 1861–69, and gave useful aid to the Union cause by his personal friendship and contact with Napoleon III.

WEBB, JOHN BURKITT (*b. Philadelphia, Pa., 1841; d. Glen Ridge, N.J., 1912*), engineer, educator, inventor. C.E., University of Michigan, 1871; studied also at Heidelberg, Göttingen, Berlin, and Paris. Professor of civil engineering, University of Illinois, 1871–79; professor of applied mathematics, Cornell, 1881–86; professor of mathematics and mechanics, Stevens Institute of Technology, 1886–1908. Invented the floating dynamometer, 1888, and other devices for power measurement.

WEBB, THOMAS (*b. England, ca. 1724; d. Bristol, England, 1796*), British army officer, Methodist preacher. A wounded veteran of the French and Indian War, Webb became a Methodist in England, 1764. Returning to America, 1766, he assisted Philip Embury in preaching to the original New York City congregation of Methodists. He aided in the building of Wesley Chapel, 1768, and continued to evangelize until his return to England at some time during the Revolution.

WEBB, THOMAS SMITH (*b. Boston, Mass., 1771; d. 1819*), printer, founder of the American system of chapter and encampment Masonry. Author of *The Freemason's Monitor* (1797). He was a founder and first president (1815) of the Handel and Haydn Society of Boston.

WEBB, WALTER PRESCOTT (*b. Panola County, Tex., 1888; d. San Antonio, Tex., 1963*), historian. Attended University of Texas (Ph.D., 1932). Appointed instructor to train secondary teachers at University of Texas 1918, remaining at that university as a professor from 1933 until his death. Beginning with his dissertation, he continued research on the Texas Rangers until 1931, when he published the highly acclaimed *The Great Plains,* which argued that the environment of the West caused dramatic alterations in institutions and technology and brought forth the Colt revolver, barbed-wire fences, and windmills. He returned to his first interest and published *The Texas Rangers* (1935). He also wrote *Divided We Stand: The Crisis of a Frontierless Democracy* (1937), an indictment of the corporate structures of the Northeast, and *The Great Frontier* (1952). President of the Mississippi Valley Historical Association (1955) and American Historical Association (1958).

WEBB, WILLIAM HENRY (*b. New York N.Y., 1816; d. New York, 1899*), shipbuilder. Working at his New York City yard on the East River between 5th and 7th Sts., 1843–69, Webb showed remarkable versatility in design and construction of vessels. He designed and built a number of notable packets and pre-clippers, and ranked high among the builders of regular clippers. Among his products were the *Sword Fish* (1851), the *Challenge* (1851), *Young America* (1853), and *Black Hawk* (1857). He also constructed hulls for a number of steamships and was the constructor of the Pacific Mail ships *California, panama, Golden Gate, San Francisco,* and *Yorktown.* Among the warships which he built were the cutter *Harriet Lane* (1857) and several vessels for the Russian and Italian navies. His masterpiece was the ironclad ram *Dunderberg* (1865) which was sold to the French navy and sailed as the *Rochambeau.* He established and endowed Webb's Academy, New York, N.Y. (opened, May 1894).

WEBB, WILLIAM ROBERT (*b. near Mount Tirzah, N.C., 1842; d. Bellbuckle, Tenn., 1926*), Confederate soldier, educator. Graduated University of North Carolina, 1867. Founder (1870) and headmaster of a celebrated preparatory school at Culleoka, Tenn., which he removed to Bellbuckle, 1886.

WEBBER, CHARLES WILKINS (*b. Russellville, Ky., 1819; d. Nicaragua, 1856*), journalist, explorer. After serving in the Texas war for independence, he studied medicine and also theology, but became a journalist in New York City, 1844. He projected several abortive exploring expeditions in the Southwest and in 1855 joined the filibuster commanded by William Walker in Nicaragua. He was killed there in the battle of Rivas. Excelling in the description of wild border life, he was author, among other works, of *Old Hicks the Guide* (1848); *The Gold Mines of the Gila* (1849); *The Hunter-Naturalist* (1851); *Tales of the Southern Border* (1852); and *Wild Scenes and Song Birds* (1854).

WEBBER, HERBERT JOHN (*b. Lawton, Mich., 1865; d. Riverside, Calif., 1946*), plant physiologist. B.S., University of Nebraska, 1889; M.A., 1890. Ph.D., Washington University (St. Louis, Mo.), 1901. Associated with the U.S. Department of Agriculture, 1892–1907, he made notable contributions to the study of citrus fruit culture and cotton breeding. As professor of plant biology (1907–08) and head of the department of experimental plant biology (1908–12) at Cornell University, he undertook important research in corn and timothy. He was director of the Citrus Experiment Station and dean of the Graduate School of Tropical Agriculture, University of California at Riverside, 1912–20; after holding a number of posts elsewhere, he returned to Riverside in 1926 and was professor of subtropical horticulture until 1936 when he was made emeritus.

WEBER, ALBERT (*b. Bavaria, 1828; d. New York, N.Y., 1879*), musician, piano-maker. Came to New York City ca. 1844; began business as a piano manufacturer, 1851. Weber did not create anything new in piano construction, but was a thorough craftsman and made a quality product.

WEBER, GUSTAV CARL ERICH (*b. Bonn, Germany, 1828; d. Willoughby, Ohio, 1912*), physician. Immigrated to America ca. 1849. Graduated Beaumont Medical College, St. Louis, Mo., 1851; made further studies in Vienna, Amsterdam, and Paris. Practiced surgery and taught at several medical schools in Ohio, 1856–70; was professor of clinical surgery and dean of medical department of Wooster University, 1870–81; also dean of medical department, Western Reserve University, 1881–94. U.S. consul at Nuremberg, 1897–1902.

WEBER, HENRY ADAM (*b. Franklin Co., Ohio, 1845; d. Columbus, Ohio, 1912*), chemist. Studied at Otterbein College and in Germany. Chemist, Ohio Geological Survey, 1869–74; professor of chemistry, University of Illinois, 1874–82; professor of agricultural chemistry, Ohio State University *post* 1884. In addition to his academic work, Weber collaborated with M.A. Scovell in the manufacture of sugar from sorghum and was active in the work of the state board of agriculture and the state board of health. He was a pioneer in the national pure-food movement initiated by Harvey W. Wiley.

WEBER, JOSEPH MORRIS (*b. New York, N.Y., 1867; d. Los Angeles, Calif., 1942*), and **FIELDS, LEWIS MAURICE** (b. New York, N.Y., 1867; d. Los Angeles, Calif., 1941), dialect and burlesque comedians, theatrical producers. The famous comedy team met while in school on New York's Lower East Side. They began their collaboration at age nine and after a long apprenticeship had fully developed their act, which consisted of blackface, song-and-dance, dialect, and outrageous slapstick routines. The zenith of their career came with a seven-year series of travesties on more serious plays and musicals. The partnership was dissolved in 1904, but in 1912 they were reunited. Taste had changed, how-

ever, and the two comedians turned their talents to musical comedy, vaudeville, and motion pictures. They retired in 1930.

WEBER, MAX (*b. Bialystok, Russia, 1881; d. Great Neck, N.Y., 1961*), artist. Attended Pratt Institute and taught construction drawing and manual training in Lynchburg, Va., public schools, the University of Virginia (1901–03), and State Normal School in Duluth, Minn. (1903). Studied in Europe (1905–09), including at the Académie Julien in Paris, meeting such influential artists as Henri Rousseau, Henri Matisse, and Pablo Picasso. He became the contact between the Paris school and American modern painting. He was among the pioneers of cubism and futurism and was considered by some as responsible for the entry of American art into the mainstream of twentieth-century art. His first one-man show was at Gallery Haas (1909) and showed at Alfred Steiglitz's Gallery 291 (1911). Taught at the White School of Photography in New York (1914–18) and the Art Students League (1920–21, 1926–27). The Museum of Modern Art honored him in 1930 with a retrospective exhibit.

WEBSTER, ALICE JANE CHANDLER (*b. Fredonia, N.Y., 1876; d. 1916*), author, known as Jean Webster. Graduated Vassar, 1901. A grandniece of Mark Twain, she was author of *When Patty Went to College* (1903) and other Patty stories, and of the extraordinarily successful *Daddy-Long-Legs* (1912).

WEBSTER, ARTHUR GORDON (*b. Brookline, Mass., 1863; d. 1923*), physicist. Graduated Harvard, 1885; Ph.D., University of Berlin, 1890. Taught physics at Clark University *post* 1890, succeeding Albert A. Michelson as head of the department, 1892. His course of lectures on mathematical physics was unsurpassed in scope and thoroughness; at the same time he continued his work in experimental physics. He was outstanding in the development of various gyroscopic instruments and in sound investigations; during World War I he established and conducted a school of ballistics at Clark. He was author, among other works, of *The Theory of Electricity and Magnetism* (1897); *The Dynamics of Particles and of Rigid, Elastic and Fluid Bodies* (1904); and *The Partial Differential Equations of Mathematical Physics* (published posthumously, 1927).

WEBSTER, BEN(JAMIN) FRANCIS (*b. Kansas City, Mo., 1909; d. Amsterdam, The Netherlands, 1973*), jazz musician. Took up the saxophone in 1927 and produced his first well-known recordings (with Bennie Moten) in the early 1930's. He played the "old Negro circuit" in Kansas City and the Southwest with the bands of Fletcher Henderson, Cab Calloway, and others; he joined the Duke Ellington Orchestra in 1939. He moved to New York City in 1943 and accompanied such vocalists as Billie Holiday and Ella Fitzgerald and released a series of "Ben Webster Meets ¼ " albums for Verve Records. In 1964 he emigrated to Europe and played with pickup rhythm sections for the next decade.

WEBSTER, DANIEL (*b. Salisbury, N.H., 1782; d. Marshfield, Mass., 1852*), lawyer, statesman. A boy of delicate health, he early displayed a precocious mind and a strongly emotional nature. While a student at Phillips Exeter in 1796, he made rapid headway with his studies, but was shy and sensitive about his unfashionable clothes and clumsy manners. At Dartmouth, he was outstanding in one of the college debating societies. After his graduation in 1801, he began the study of law in a desultory way, but gave up his studies to teach in the Fryeburg Academy in order to help his elder brother complete a college course. Returning to the study of law, September 1802, he varied the monotony of legal treatises with extensive readings in history and the classics. Removing to Boston, he became a clerk in the office

of Christopher Gore and was admitted to the Boston bar, March 1805. After practicing for a short time at Boscawen, N.H., he removed to Portsmouth in September 1807 and practiced there with distinction until 1816.

A rival of Jeremiah Mason at the bar, he improved his style of speaking by conscious imitation of Mason and also learned from him the importance of a most careful preparation of arguments. Temperamentally a conservative, he had inherited from his father strong Federalist convictions and strove by Fourth of July orations and occasional political pamphleteering to assist the revival of Federalism after the Jeffersonian triumph of 1800. A champion of New England shipping interests, he was author of *Considerations on the Embargo Laws* (1808). A vigorous critic of the national administration for having led the nation into an unjustifiable war, 1812, he renounced the idea of resistance or insurrection, advocating "the peaceable remedy of election." His famous Rockingham Memorial was a forceful statement of his anti-war views.

Webster's national political career began with his election to Congress in 1812. A member of the committee on foreign relations, he introduced a number of resolutions designed to embarrass the administration, eloquently denouncing the government's draft bill and favoring repeal of the Embargo Act. He even suggested the expedient of state nullification of a federal law in the debate over conscription, but continued to repudiate any thought of disunion and advised New Hampshire against sending delegates to the Hartford Convention. Reelected to Congress, 1814, he urged the provision of adequate safeguards for financial stability in any reestablishment of the United States Bank. In discussion of the tariff, he announced himself as opposed to any "hotbed" treatment of manufactures and opposed the high duties of the tariff of 1816. Removing to Boston, August 1816, he devoted himself to legal work. The so-called Dartmouth College case, a suit in which the college trustees sought to defend their rights against acts of the New Hampshire legislature which changed the character of the institution and its governing body, made Webster, in the opinion of many people, the foremost lawyer of the time. Placed in charge of the case before the U.S. Supreme Court, he drew on the notes and briefs of his colleagues for most of his materials, but was himself responsible for their brilliant presentation. On Feb. 2, 1819, the Supreme Court by its decision completely upheld the college and its counsel. Three weeks after his victory, he appeared for the Bank of the United States in *McCulloch* v. *Maryland* and soon thereafter played an important part in three other important constitutional cases, *Gibbons* v. *Ogden*; *Osborn* v. *Bank of the United States*; and *Ogden* v. *Saunders*. He also delivered a number of outstanding orations on public occasions, notably his commemoration of the landing of the Pilgrims, December 1820, and his address at the laying of the cornerstone of the Bunker Hill Monument, June 1825.

Returning to Congress, 1823–27, he was made chairman of the judiciary committee. In April 1824 he challenged Henry Clay's arguments for a protective tariff, attacking the proposed tariff bill and its principles and refusing to vote for it. Although he shared the distrust of the New England Federalists for John Q. Adams, he gave Adams his vote during the contest over the presidency in the House, and influenced others over in the same direction. As party lines reshaped themselves under the new administration, Webster became an increasingly loyal Adams supporter. Elected to the U.S. Senate from Massachusetts, June 1827, he was soon in the thick of the fight over the tariff act of 1828. An associate of the millowners of his state and an investor in the Merrimack Manufacturing Co., he was frank to state that New England must consider protection as a determined national policy. Since the tariff bill with all its "abominations" granted protection to woolens, he supported it and helped accomplish

its passage. Henceforward, he was an aggressive champion of protection.

Webster rose to the height of his oratorical abilities in the famous debate of January 1830 with John C. Calhoun's mouthpiece, Robert Y. Hayne, over the issue of state rights and nullification. Webster declared that the Union, in origin, preceded the states. He insisted that the Constitution was framed by the people not as a compact, but to create a government sovereign within the range of the powers assigned to it, with the Supreme Court as the only proper arbiter of the extent of these powers. Nullification could result only in violence and civil war. He was for "Liberty *and* Union, now and forever, one and inseparable." Webster supported President Jackson in his defiance of the nullifiers, 1832–33. When the "Compromise Tariff" was enacted in March 1833, Webster voted with the opposition.

As soon as all those with a common interest in vested rights began to combine in the Whig party, Webster joined the new coalition. He was further persuaded to oppose President Jackson because of Jackson's war on the Bank of the United States which Webster supported both on principle and as a client. Reelected to the Senate, 1833, he spoke constructively in the debates over the removal of deposits from the Bank and the resolution of censure then adopted by the Senate. Named as the Massachusetts Whig candidate for the presidency, 1836, he received only the electoral vote of his own state. Having given so much of his time and energy to the public, he found himself in a poor financial condition which was aggravated by his ill-timed investments during the 1830's in midwestern lands. Harassed by his creditors, he was saved from disgrace only by the loans of wealthy friends. After the panic of 1837, he returned to the special session of Congress and took a brilliant part in the Whig fight against Van Buren's subtreasury plan; he also clashed with Calhoun over slavery and the right of petition. Reelected to the Senate once again in 1839, he campaigned for William H. Harrison in the presidential race of 1840. Named U.S. secretary of state, he remained in office under President John Tyler after Harrison's death. After the resignation of Tyler's cabinet over the president's veto of Whig measures for reestablishing a United States Bank, Webster, suspicious of Henry Clay's leadership, continued in office in order to bring to a conclusion the negotiations over the boundary of Maine; these he carried through to a successful adjustment in the Webster-Ashburton Treaty of 1842. Eminently successful in the State Department, he conducted negotiations also with Portugal and Mexico and undertook the preliminaries to the opening of diplomatic relations with China. Resigning in May 1843 from the only office which had ever allowed him reasonable satisfaction and scope for his talents, he returned to his law practice.

Reelected to the U.S. Senate once again in 1845, he announced that it was his special business to look to "the preservation of the great industrial interests of this country" from Democratic free-trader propensities. He joined in the Whig policy of condemning the war with Mexico, but held that supplies should be appropriated for the war so long as it was not connected with territorial aggrandizement or the dismemberment of Mexico. In the dispute over the disposition of the territories acquired from Mexico after the war, Webster voted consistently for the Wilmot Proviso, but preferred the "no territory" basis that would prevent a controversy from arising over slavery, which he considered "a great moral and political evil." Once again disappointed of hope for the presidency by the election of Zachary Taylor, he grew alarmed over the sectional controversy which seemed likely to result in a Southern separation. He was also disturbed over the obstacle presented by a continued discussion of slavery to Whig efforts at tariff revision. Increasingly annoyed at the militant intransigence of the Abolitionists and anti-slavery men, he declared himself in favor of Henry Clay's compromise measures. On March 7, 1850, he delivered a famous speech designed to "beat down the Northern and Southern follies now raging in equal extremes." No evil was so great as disunion, he said; there could be no peaceful secession. A congressional prohibition of slavery in the territories was useless since a law of nature had settled that slavery cannot exist in California or New Mexico. Conservatives approved his speech, but the antislavery forces denounced him as a fallen star. Serving once again with skill as U.S. secretary of state, 1850–52, he was denied a presidential nomination, 1852. Repudiating the candidacy of General Winfield Scott, he prophesied the downfall of the Whig party, and died before the election.

Forty years in politics revealed in Webster two seemingly contrasting but naturally allied forces. An eloquent champion of the Union, he was also a special advocate for the new industrial interests then forging to the front in the national economy. In behalf of the masters of capital, he sacrificed the popular following that stood ready to rally around a great democratic chieftain. The logic and eloquence of his oratory, the magnetic quality of his personality, did little to bring him the support of workingmen. A great constitutional lawyer, he found his equals or betters among his contemporaries. His victories were never on a par with his ambitions. Even his personal fortunes failed to bring him any sense of security and life was for him a series of great frustrations. However, no other Northern man left so strong an impress upon the political life of the "middle period" or more substantially contributed to the preservation of the Union in the supreme test of the 1860's.

WEBSTER, EDWIN SIBLEY *See* STONE, CHARLES AUGUSTUS.

WEBSTER, HAROLD TUCKER (*b. Parkersburg, W. Va., 1885; d. Stamford, Conn., 1952*), comic artist. Syndicated political and cultural cartoonist, Webster was the creator of Caspar Milquetoast, one of the best-known of all comic strip characters. The term immediately became part of the language.

WEBSTER, JEAN *See* WEBSTER, ALICE JANE CHANDLER.

WEBSTER, JOHN WHITE (*b. Boston, Mass., 1793; d. 1850*), physician, educator. A teacher of chemistry at Harvard, 1824–49, Webster is principally remembered as the murderer of George Parkman (uncle of Francis Parkman), Nov. 23, 1849. After a sensational trial, Webster was convicted and hanged.

WEBSTER, JOSEPH DANA (*b. Hampton, N.H., 1811; d. Chicago, Ill., 1876*), soldier, engineer. Graduated Dartmouth, 1832. Served as an officer in the topographical engineers, 1838–54, resigning to enter business in Chicago. During the Civil War he served as chief-of-staff to General U. S. Grant in 1862 and part of 1863, rising to rank of brigadier general. In charge of all military railways before, during, and after the Vicksburg campaign, he then became chief-of-staff to General W. T. Sherman. He resigned from the army, 1865, as brevet major general.

WEBSTER, MARGARET ("PEGGY") (*b. New York City, 1905; d. New York City, 1972*), theatrical director and actress. Educated in England, she appeared regularly in commercial London West End plays in the 1920's and in 1933 began to direct amateur productions. In 1937 she directed her first commercial play (Keith Winter's *Old Music*) and a Broadway production of Shakespeare's *Richard II*. Numerous Broadway productions followed, including *Hamlet* (1939) with Maurice Evans, *Othello* (1943) with Paul Robeson, *The Cherry Orchard* (1944), and *Hedda Gabler* (1947). She founded the Margaret Webster Touring Company (1948). In the 1950's she was falsely accused of being a Communist and blacklisted; between 1953 and 1970 she directed mainly in England and off-Broadway.

WEBSTER, NOAH (*b. West Hartford, Conn., 1758; d. New Haven, Conn., 1843*), educator, lexicographer, editor. Graduated Yale, 1778. While teaching at Goshen, N.Y., 1782, he composed an elementary spelling book, Part I of A *Grammatical Institute of the English Language* (Hartford, Conn., 1783), which he supplemented with a grammar (1784) and a reader (1785). In preparing the series, he strove to correct the neglect of the American scene in the then current textbooks, and in the introduction to his speller issued a literary declaration of independence. Of the three books, the speller was the outstanding success and under various titles continued to be issued well into the 20th century. Its use had much to do with the standardization of spelling and, to some degree, of pronunciation in the United States along lines differing somewhat from those that prevailed in England. Neither the reader nor the grammar had the vogue of the speller, but the grammar (Part II of the *Institute*) was interesting because it was based on an objective study of the actual phenomena of English speech. Aroused by piracies of his work, he began an agitation which in time led to provision of American copyright; this activity took him into politics and made him an ardent Federalist. His efforts to promote copyright legislation in the 13 states involved travel over most of the country and drew from him several political pamphlets in support of a strong central government. Encouraged by Benjamin Franklin, he became an advocate of spelling reform, but was unable to effect any substantial changes.

Between 1787 and 1798, he served as editor of several newspapers in New York and was editor of the *American Magazine*, 1787–88. Removing to New Haven, 1798, he gave up journalism for good in 1803. Meanwhile, he had produced a number of interesting works including *The Prompter* (1791, informal essays), several treatises in economics, a work on epidemic diseases which was standard in its time, and much political writing. He edited John Winthrop's *Journal* in 1790, and was author of a pioneer American essay in physical science, *Experiments Respecting Dew* (begun 1790, printed 1809). After issuing a preparatory study, A *Compendious Dictionary of the English Language* (1806), Webster devoted twenty years to a larger work which was published in 1828 under the title *An American Dictionary of the English Language*. It took first place at once among English dictionaries on its merits. In it the author freely recorded non-literary words and based definitions upon the usage of American as well as British writers. In defining a word, he proceeded from what he considered its original or primary meaning and as far as possible derived the other meanings from the primary one. The great weakness of Webster's dictionary lay in its etymologies, but it was on the whole a scholarly achievement of the first order.

WEBSTER, PELATIAH (*b. Lebanon, Conn., 1726; d. 1795*), Congregational clergyman, Philadelphia merchant, political economist. Graduated Yale, 1746. Author of a number of papers urging support of the Revolution by taxation rather than by loans, and suggesting curtailment of paper money issues, Webster later (1791) gathered these studies together in a volume entitled *Political Essays on the Nature and Operation of Money, etc.* His *Dissertation on the Political Union and Constitution of the Thirteen United States* (1783) helped educate the people to the need of a new form of government, and he ably supported the Federal Constitution in several pamphlets published during the struggle in Pennsylvania over its adoption, 1787.

WEBSTER-POWELL, ALMA *See* POWELL, ALMA WEBSTER.

WEDDELL, ALEXANDER WILBOURNE (*b. Richmond, Va., 1876; d. near Sedalia, Mo., 1948*), diplomat, philanthropist. LL.B., George Washington University law school, 1908. A protégé of Maurice F. Egan, Weddell served in the U.S. consular service, 1910–28; as U.S. ambassador to Argentina, 1933–39; and as U.S. ambassador to Spain, 1939–42.

WEED, LEWIS HILL (*b. Cleveland, Ohio, 1886; d. Reading, Pa., 1952*), anatomist and medical administrator. Studied at Yale and Johns Hopkins universities (M.D., 1912). Taught at Johns Hopkins (1914–39); chair of anatomy, (1917); dean of the medical school (1923); director of the medical school (from 1929). From 1939 to 1950, chief of the medical division of the National Research Council of the National Academy of Sciences and vice-chairman of the Office of Scientific Research. Did major medical research for the wartime efforts of the nation. Trustee of the Carnegie Institution of Washington and the Institute for Advanced Study, Princeton.

WEED, THURLOW (*b. Greene Co., N.Y., 1797; d. 1882*), printer, journalist, New York politician and legislator. Began as publisher-editor of upstate New York newspapers supporting DeWitt Clinton, 1817–22; served as editorial writer on the *Rochester Telegraph*, which he purchased, 1825. A supporter of John Q. Adams in 1824, Weed became an active Anti-Mason. Elected to the New York Assembly, 1829, he took over editorship of the *Albany Evening Journal*, March 1830. Becoming a Whig, he fought the dominant "Albany Regency" in his state, drilled his new party through the campaigns of 1834 and 1836, and helped create the Whig victories that made William H. Seward governor of New York in 1838 and W. H. Harrison president in 1840. Although he was charged with dominating Seward, his great personal friend, actually he was content for others to formulate the principles while he secured the votes. He considered bribery and legislative favors legitimate party instruments, but was personally not corrupt. A sincere antislavery man, he had nothing but scorn for Abolitionists and other extremists; while recognizing the power of Horace Greeley, he was dubious about Greeley's efforts at social reform. Discouraged at first by the Whig failures in 1842 and 1844, he early recognized the possibilities of a presidential candidacy by General Zachary Taylor, but was again disappointed in his hopes for Whig unity when Taylor died soon after election. Slow to join the new Republican party, he devoted his energies *post ca.* 1854 to the furtherance of his friend Seward's candidacy for the presidency, but was again unsuccessful. Consulted by Abraham Lincoln during the latter's campaign and after, he had considerable influence on appointments, but was distrustful of Abolitionist influences on Lincoln. Preferring an active War Democrat as Union candidate in 1864, he was held in the Republican ranks because of the nomination of George B. McClellan. As the Radical Republicans gained strength after Lincoln's death, Weed's influence declined. He became editor of the N.Y. *Commercial Advertiser*, 1867, but had to abandon editorial work because of failing health and sight. A generous man, good-natured and charming of manner, Weed was described by Henry Adams as "the model of political management and patient address—a complete American education in himself."

WEEDE, ROBERT (*b. Robert Wiedefeld, Hamilton, Md., 1903; d. Walnut Creek, Calif., 1972*), baritone opera singer. Studied voice at the Peabody Conservatory of Music, the Eastman School of Music, and under Oscar Anselmia in Milan, Italy. He was engaged as the leading baritone at Radio City Music Hall (1933) and debuted at the Metropolitan Opera in 1937. Listed on the Met's roster for ten seasons between 1937 and 1953, he actually sang only twenty-one performances with the company, including his tour de force, *Rigoletto*. He performed and recorded with many other companies and orchestras. In 1956 he originated the lead role of Tony Esposito in Frank Loesser's musical *The Most Happy Fella*.

WEEDEN, WILLIAM BABCOCK (*b. Bristol, R.I., 1834; d. Providence, R.I., 1912*), woolen manufacturer, social historian. Author, among other works, of *Indian Money as a Factor in New England Civilization* (1884) and the *Economic and Social History of New England* (1890).

WEEKS, EDWIN LORD (*b. Boston, Mass., 1849; d. Paris, France, 1903*), painter, specializing in Oriental subjects.

WEEKS, JOHN ELMER (*b. Painesville, Ohio, 1853; d. San Diego, Calif., 1949*), ophthalmologist. Worked as a painter and repairman in a railroad shop; then read medicine with a local physician. M.D., University of Michigan, 1881. Studied at Ophthalmic and Aural Institute (New York City), 1882. After six months' study in Berlin (1885), he began a two-year internship at the Ophthalmic and Aural Institute where he established and taught the first systematic course in bacteriology given in New York City. In 1886, he isolated the causative organism of the acute epidemic conjunctivitis known as "pink eye," thereafter known as the Koch-Weeks bacillus. Maintained a private practice and was surgeon and pathologist at New York Eye and Ear Infirmary (1890–1920). He held teaching appointments at Women's Medical College, New York University, and Bellevue Hospital Medical College.

WEEKS, JOHN WINGATE (*b. near Lancaster, N.H., 1860; d. Lancaster, 1926*), stockbroker. Graduated Annapolis, 1881. Entered brokerage business in Boston, Mass., 1888, becoming a partner in Hornblower & Weeks. Congressman, Republican, from Massachusetts, 1905–13; U.S. senator, 1913–19. U.S. secretary of war, 1921–25. An able, hard-working, orthodox Republican.

WEEKS, JOSEPH DAME (*b. Lowell, Mass., 1840; d. 1896*), technical journalist. Long associated in an editorial capacity with the *American Manufacturer* (Pittsburgh, Pa.), he was responsible for the first wage scale offered by the manufacturers to the Amalgamated Association of Iron and Steel Workers. He subsequently presided over a number of wage conferences and other essays in labor arbitration. He is credited with conducting the experiments that led to the first use of gas in a puddling furnace; he was also responsible for assembly of petroleum, coke, gas, and other statistics for the Census and for various state and federal bureaus.

WEEKS, SINCLAIR (*b. West Newton, Mass., 1893; d. Concord, Mass., 1972*), U.S. secretary of commerce. Graduated Harvard College (1914) and was mayor of Newton, Mass. (1930–36), and chairman of United–Carr Fastener Corporation (1942) and Reed and Barton Corporation (1945). He was treasurer of the Republican National Committee (1941–1944) and chairman of its finance committee (1950–52). He became secretary of commerce in 1953 and was instrumental in the construction of the federal highway system; he resigned in 1958 to serve as a director of the First National Bank of Boston.

WEEKS, STEPHEN BEAUREGARD (*b. Pasquotank Co., N.C., 1865; d. Washington, D.C., 1918*), historian, federal educational official. Graduated University of North Carolina, 1886; Ph.D., 1888. Ph.D., Johns Hopkins, 1891. Author of, among other works, *Southern Quakers and Slavery* (1896) and of the *Index to the Colonial and State Records of North Carolina* (1909–14).

WEEMS, MASON LOCKE (*b. near Herring Bay, Md., 1759; d. Beaufort, S.C., 1825*), Episcopal clergyman, subscription book agent, author. One of the first candidates to receive Anglican ordination for service in the United States (1784), Weems served Maryland parishes, 1784–92. Passionate in his faith in the value of good books, he journeyed (*post* 1794 as agent for Mathew Carey) up and down the Eastern coast from New York to Savannah, acting as book salesman and occasional preacher until his death. Author of a number of moralizing tracts, he is remembered for what may be called his masterpiece, *The Life and Memorable Action of George Washington* (*ca.* 1800), in whose fifth edition (1806) the hatchet and cherry-tree story first appeared in book form.

WEEMS, TED (*b. Pitcairn, Pa., 1901; d. Tulsa, Okla., 1963*), orchestra leader and composer. After playing trombone with Paul Specht's band in the early 1920's, he and his brother Art formed their All-American Band, which went on the road and gravitated toward Chicago, where radio broadcasts helped widen the band's popularity. In the 1930's the band performed on radio with Jack Benny. Their first hit record was "Somebody Stole My Gal" (1924); other successes were "My Gal Sal," "You're the Cream in My Coffee," and "Heartaches" (1938).

WEGMANN, EDWARD (*b. Rio de Janeiro, Brazil, 1850; d. Yonkers, N.Y., 1935*), engineer. C.E., New York University, 1871. He was particularly notable for his thirty years of service with the water-supply system of New York City (1884–1914) during which he made studies for design of the Croton Dam, supervised much of the work on the Croton Aqueduct, and continued in service on the maintenance of the Croton water system. He was author of authoritative works on the design of dams and of *The Water Works of the City of New York: 1658–1895* (1896).

WEHLE, LOUIS BRANDEIS (*b. Louisville, Ky., 1880. d. New York, N.Y., 1959*), lawyer, author, and public servant. Studied at Harvard (LL.B., 1904). Wehle practiced law in Kentucky until World War I, when he joined the legal committee of the General Munitions Board. In June 1917, he was special assistant to the secretary of war, negotiating labor contracts for wartime construction. A personal friend of Franklin D. Roosevelt, during the New Deal he was a member of the White House Conference on Power Pooling. He practiced law in Washington and New York until his death.

WEICKER, LOWELL PALMER (*b. Stamford, Conn., 1903; d. New York City, 1978*), business executive. Graduated Yale University (B.S., 1926). In 1927 joined the pharmaceutical firm E. R. Squibb, which his father partially owned, and became its president in 1941. During World War II he served as an intelligence officer in the Army Air Forces; in the postwar years he directed Squibb's profitable expansion. From 1953 to 1956, he was an assistant secretary general of the North Atlantic Treaty Organization (NATO), in charge of production and logistics, then assumed the presidency of Bigelow–Sanford (1956–68), a prominent rug producer; he returned the company to profitability.

WEIDENMANN, JACOB (*b. Winterthur, Switzerland, 1829; d. 1893*), landscape architect. Trained in Munich, he settled in America *ca.* 1861. Superintendent of parks in Hartford, Conn., 1861–68, he was later employed in a number of important projects, sometimes alone and sometimes in collaboration with Frederick L. Olmsted. He was a pioneer in the modern park type of cemetery.

WEIDENREICH, FRANZ (*b. Edenkoben, Germany, 1873; d. Westwood, N.J., 1948*), physical anthropologist. Studied at universities of Munich, Kiel, and Strasbourg; M.D., Strasbourg, 1898. Professor at University of Heidelberg, 1921–35. His early research was concerned largely with human blood and lymph systems; pursuing the relationships of hematology with various tissue systems, he made the structure, functions, and evolution of the human skeleton his dominant scientific interest. Concerned with the Nazi perversion of anthropological data, he

wrote extensively against racism; he resigned from Heidelberg, 1935. As professor at Peking Union Medical School, 1935–41, he continued the research already begun on the fossil human remains discovered at Chou Kou Tien, producing a series of major studies of Peking Man. He continued his work *post* 1941 at the American Museum of Natural History, New York City.

WEIDIG, ADOLF (*b. Hamburg, Germany, 1867; d. Hinsdale, Ill., 1931*), musician, composer. Studied at the Hamburg and Munich conservatories. Came to America, 1892; played with Chicago Symphony Orchestra as a first violin; taught at American Conservatory of Music, Chicago, *post* 1893. A conservative modernist as a composer, he was author of songs, chamber music, and large orchestral works, notably "Drei Episoden" (*Opus 38, 1908*). He was author also of a treatise, *Harmonic Material and Its Uses* (1923).

WEIDNER, REVERE FRANKLIN (*b. Center Valley, Pa., 1851; d. Tangerine, Fla., 1915*), Lutheran theologian. Graduated Muhlenberg, 1869; Lutheran Theological Seminary, Philadelphia, 1873. Professor of dogmatics, Augustana Seminary, 1882–91; first president, Chicago Lutheran Seminary *post* 1891.

WEIGEL, GUSTAVE (*b. Buffalo, N.Y., 1906; d. New York, N.Y., 1964*), theologian. Attended the Jesuit novitiate at St. Andrew-on-Hudson, Woodstock College, and Pontifical Gregorian University in Rome (S.T.D., 1937); assigned to teach dogmatic theology at Catholic University in Chile, 1937–48; became dean of the theological faculty, 1942–48. In 1948 he became the specialist in Protestant theology for *Theological Studies* and professor of ecclesiology at Woodstock in 1949. A pioneer in the promotion of ecumenism in the United States, he served as a consultant to the Secretariat for the Promotion of Christian Unity, 1960–62. During the Second Vatican Council, 1962–65, he served as interpreter for the English-speaking ecumenical observer-delegates.

WEIGHTMAN, WILLIAM (*b. Waltham, England, 1813; d. 1904*), chemist. Immigrated to America *ca.* 1829; was long associated with Powers & Weightman and its antecedent firms. Weightman was the first to manufacture quinine sulphate and popularize the use of the cheaper alkaloids of cinchona as substitutes. His firm is also credited with introducing and perfecting the manufacture of citric acid in the United States. He was also an extensive holder of real estate in Philadelphia and director of a number of banks.

WEIL, RICHARD (*b. New York, N.Y., 1876; d. Macon, Ga., 1917*), physician. Graduated Columbia, 1896; M.D., New York College of Physicians and Surgeons, 1900; studied also in Vienna and Strasbourg. Teacher of experimental pathology and therapeutics at Cornell Medical College, 1905–15, he became head of the department of experimental medicine, 1916. Working *post* 1906 at the Loomis Laboratory, he gained international reputation in the field of the serology of cancer and general problems of immunity. He established the *Journal of Cancer Research*, 1915, and was its managing editor until his death in military service during World War I.

WEILL, KURT (*b. Dessau, Germany, 1900; d. New York, N.Y., 1950*), musician, composer. Child of Jewish parents who were both musical; studied with Albert Bing, briefly at the Berlin Hochschule für Musik, and with Ferruccio Busoni, 1921–24. His first compositions were in the "modernist" tradition of European art music; his own inclinations, and the success of several operas which he wrote in jazz and other popular idioms, convinced him that he should write for the popular theater. Working in collaboration with Berthold Brecht, he produced a number

of contemporary versions of the traditional German *Singspiel*, satirical, ideologically motivated, and technically adroit; of these, the most celebrated was *The Threepenny Opera* (1928), adapted from John Gay's 18th century satire *The Beggar's Opera*. Fleeing Germany in 1933, he lived for a time in France and in England; in 1935, he came to the United States to write music for Max Reinhardt's production *The Eternal Road*. He was highly successful as a composer of musical shows for Broadway: *Knickerbocker Holiday* (1938); *Lady in the Dark* (1941); *One Touch of Venus* (1943); and *Lost in the Stars* (1949).

WEINBERGER, JACOB (*b. Austria–Hungary, 1882; d. San Diego, Calif., 1974*), lawyer and judge. Arrived in the United States in 1889 and attended the University of Colorado Law School (LL.B., 1904). He moved to Arizona in 1905 and was appointed deputy district attorney of Gila County (1907) and served as a delegate to the Arizona constitutional convention (1910). He was appointed to the San Diego Board of Education (1918) and served as vice-chairman of the California Democratic Central Committee (1939), city attorney (1941), and presiding judge (1944). He was appointed to the U.S. District Court of the Southern District of California (1946) and became San Diego's first resident federal judge in 1949; he retired in 1958 and was appointed senior judge.

WEIR, ERNEST TENER (*b. Pittsburgh, Pa., 1875. d. Philadelphia, Pa., 1957*), business executive. Self-educated. Weir was able to buy a bankrupt tinplate mill in 1905, which by 1918 had become the Weirton Steel Company, and by 1929, with consolidation with other small firms, the National Steel Company, the nation's fifth largest steel manufacturer. Violently opposed to unions and an espouser of right-wing causes, Weir conducted a colorful but losing battle to keep his company out of the hands of the unions; he succumbed in the mid-1930's. In 1940, he became chairman of the Republican National Finance Committee. He was active in his company until his death, uncompromising in his political and economic beliefs.

WEIR, JOHN FERGUSON (*b. West Point, N.Y., 1841; d. Providence, R.I., 1926*), artist. Son of Robert W. Weir; brother of Julian A. Weir. Studied with his father and at the National Academy of Design, New York. Grouped with the "Hudson River School," he painted genre, landscapes, portraits, and flowerpieces; his early studies of industry were important and include his masterpiece, *Forging the Shaft*, now in the Metropolitan Museum of Art. He taught painting and design at Yale *post ca.* 1869 and was first director of the School of Fine Arts at Yale.

WEIR, JULIAN ALDEN (*b. West Point, N.Y., 1852; d. New York, N.Y., 1919*), painter. Son of Robert W. Weir; brother of John F. Weir. Studied with his father, at the N.Y. National Academy of Design, and in the atelier of Gérôme in Paris, was influenced by Bastien-Lepage. He settled in New York City *ca.* 1883 after nearly ten years of intermittent foreign travel and study. Friend of most of the outstanding painters of his time, he was also a wise adviser to art collectors in the purchase of contemporary works. His own early painting is somewhat eclectic, marked by skilled craftsmanship and highly developed technique. Deeply influenced by the French Impressionists, he was not an Impressionist in the limited sense; his art is more directly related to that of Whistler, and to the decorative methods of the Japanese. A versatile craftsman in varied media, he never aspired to the grand manner. His conception was expressed in terms of spatial arrangement, simplification of form, and harmonization of tone. In all his work there is reflected his own restraint, sincerity, and reasonableness, together with subtley of observation and delicacy of feeling. In his ultimate style, the color is subdued, marked by

neutralized hues of closely related values; the form is manifested by a universal lighting that eliminates strong contrasts.

WEIR, ROBERT FULTON (*b. New York, N.Y., 1838; d. 1927*), surgeon. Nephew of Robert W. Weir. Graduated present College of the City of New York, 1854; M.D., N.Y. College of Physicians and Surgeons, 1859. After service with the Union Army, he practiced in New York City where he held a number of hospital appointments. He taught surgery at the College of Physicians and Surgeons, 1883–1903. A brilliant operator, he was notable for work in connection with surgery of the joints and intestines. He was among the first to recognize duodenal ulcer as an entity, and to adopt Lister's method. He also made important modifications of the Murphy button for use in gastroenterostomy.

WEIR, ROBERT WALTER (*b. New Rochelle, N.Y., 1803; d. New York, N.Y., 1889*), painter, teacher. Father of John F. and Julian A. Weir. Mainly self-taught, he was enabled by a patron to make studies in Florence and Rome. Teacher of drawing at the U.S. Military Academy, West Point, 1834–76, he also executed portraits, illustrations, and genre paintings. *The Embarkation of the Pilgrims* in the rotunda of the U.S. Capitol, Washington, D.C., was painted by him, 1836–40. A contemporary critic described him as showing "considerable skill of manipulation and detail, facility of composition, and those composite qualities which make up an accomplished rather than an original man."

WEISENBURG, THEODORE HERMAN (*b. Budapest, Hungary, 1876; d. 1934*), neurologist. Came to the United States as a child. M.D., University of Pennsylvania, 1899. Practiced and taught in Philadelphia; was associated in much of his work with Charles K. Mills. Professor of neurology, Graduate School of Medicine, University of Pennsylvania *post* 1917. A contributor to professional journals, *post* 1920 he was best known as editor of the *Archives of Neurology and Psychiatry.*

WEISER, JOHANN CONRAD (*b. near Herrenberg, Württemberg, 1696; d. Womelsdorf, Pa., 1760*), Indian interpreter and agent. Settled in New York, 1710, where he became expert in the Mohawk language and farmed near Schoharie. On his removal to Tulpehocken, Pa., 1729, he renewed his friendship with the chief, Shikellamy, and was responsible for the Philadelphia conferences (1731 and 1736) which won the Iroquois to the interests of the Penns. He made the Iroquois alliance binding by the treaty of 1742, and in 1743 averted war between the Iroquois and Virginia. Through his influence, the Lancaster Treaty of 1744 marked a shift to the direction of Indian affairs from New York to Pennsylvania and a reduction of the power of Sir William Johnson. With George Groghan, he won over the Western tribes at the treaty of Logstown, 1748, thereby extending Pennsylvania trade to the Mississippi.

Superseded in the formulation of policy *post* 1748, he continued active in local politics and was first president-judge of Berks Co., Pa., 1752–60. Weiser is also celebrated for his religious activities. Born a Lutheran, he became a follower of John P. Miller in the German Reformed Church and formed with Miller a Baptist group, 1735. Baptized by Johann C. Beissel, Weiser removed his family to Ephrata and became a member of the cloister there under the name of Brother Enoch. After several quarrels with Beissel, he ended his connection with Ephrata *ca.* 1743. Thereafter, he was successively a Lutheran again and a member of the Reformed Church. Throughout his early career, he assisted the Moravian missions to the Indians.

WEISS, EHRICH See HOUDINI, HARRY.

WEISS, GEORGE MARTIN (*b. New Haven, Conn., 1894; d. Greenwich, Conn., 1972*), baseball executive. Organized the New Haven Colonials and acquired the city's bankrupt professional team, the Profs, in 1919. He became general manager of the Baltimore Orioles (1929), and was hired by the New York Yankees in 1932 to organize a farm system; by the end of the 1930's it included twenty-one teams, including the Newark Bears, considered the greatest of all minor league teams. In 1947 he became general manager of the Yankees and hired Casey Stengel as manager in 1948. In the 1950's the Yankees won every pennant but two. Dismissed in 1960, Weiss became president of the new New York Mets. He retired in 1966 and was elected to the Baseball Hall of Fame in 1971.

WEISS, JOHN (*b. Boston, Mass., 1818; d. Boston, 1879*), Unitarian clergyman. Pastor at various times in Watertown and New Bedford, Mass., he is remembered principally for his efforts to introduce German literature to New England readers through translations of Schiller and Goethe. He was author also of the *Life and Correspondence of Theodore Parker* (1863).

WEISS, SOMA (*b. Bestercze, Hungary, 1899; d. Cambridge, Mass., 1942*), professor of medicine, researcher in pharmacology and physiology. Studied physiology and biochemistry at Royal Hungarian University, Budapest. Came to United States, 1920. A.B., Columbia University, 1921. M.D., Cornell University Medical School, 1923. After internship at Bellevue Hospital, New York City, he moved to Boston, 1925, as research fellow at Harvard Medical School and assistant at Thorndike Laboratory of Boston City Hospital. There, with associates he made classic studies of velocity of human blood flow and contributed greatly (among other subjects of investigation) to knowledge of pathophysiology of left ventricular failure and acute pulmonary edema, also to relation between cardiovascular disturbances and vitamin deficiencies. Winning rapid advancement at Harvard Medical School, he was appointed Hersey Professor of Physics in 1939, and left the Thorndike Laboratory in that same year to become physician-in-chief at Peter Bent Brigham Hospital.

WEITZEL, GODFREY (*b. Cincinnati, Ohio, 1835; d. Philadelphia, Pa., 1884*), soldier, engineer. Graduated West Point, 1855. After service as engineer in several theaters of the Civil War, he was promoted brigadier general, 1862, and commanded a brigade and provisional division during Union Army operations in Louisiana, 1862–63. Chief engineer of the Army of the James, June–September 1864, he returned to troop duty, commanding first the XVIII and later the XXV Corps. Cited for gallantry at the capture of Fort Harrison, Va., 1864, he was promoted major general and served under General Benjamin Butler in the first expedition against Fort Fisher. His command took possession of Richmond upon its evacuation, April 3, 1865. He was distinguished as a corps commander and for his success with black troops. Returning to the engineer service after the Civil War, he was active in river- and harbor-improvement works of which the most important were the ship canals at the falls of the Ohio and at Sault Sainte Marie, Mich.

WELBY, AMELIA BALL COPPUCK (*b. St. Michaels, Md., 1819; d. Louisville, Ky., 1852*), verse writer. Author of the once-celebrated *Poems* (1845) by "Amelia," a book filled with echoes of her greater contemporaries.

WELCH, ADONIJAH STRONG (*b. East Hampton, Conn., 1821; d. Pasadena, Calif., 1889*), educator. Graduated University of Michigan, 1846. As first principal (1852–65) of Michigan State Normal School at Ypsilanti, he conducted teachers' institutes and aided in organizing the state teachers association. Chosen first president of Iowa State Agricultural College at Ames, he served, 1869–83, and later taught history and psychology there.

A defender of industrial education, he based his courses in agriculture and mechanic arts on study of fundamental and applied sciences. He also encouraged systematic experimentation in stock raising and farm products at his college some seven years before the federal act providing for experiment stations.

WELCH, ASHBEL (*b. Nelson, N.Y., 1809; d. Lambertville, N.J., 1882*), civil engineer. Studied at Albany Academy under Joseph Henry. Associated with the Delaware & Raritan Canal of which he was made chief engineer in 1835, he engaged in a variety of engineering work in the field of transportation and developed a large consulting practice. He aided John Ericsson in designing the *Princeton*, and supervised the naval gunnery experiments begun by Commodore R. F. Stockton. After beginning the work of designing and constructing the Chesapeake & Delaware Canal, he was active *post* 1854 in work with the New Jersey railroads, notably the Camden & Amboy for which he planned what is regarded as the earliest (1865) installation of the block signaling system.

WELCH, CHARLES CLARK (*b. Jefferson Co., N.Y., 1830; d. Jacksonville, Fla., 1908*), Colorado miner, railroad builder, and capitalist.

WELCH, JOHN (*b. Harrison Co., Ohio, 1805; d. Athens, Ohio, 1891*), lawyer, Ohio jurist and legislator, Whig and Republican politician. Justice of the Ohio supreme court, 1865–78; expert in cases involving real property.

WELCH, JOSEPH NYE (*b. Primghar, Iowa, 1890; d. Hyannis, Mass., 1960*), lawyer. Graduated Grinnell College (1914); Harvard Law School (1917). Attended Army Officer Candidate School and served with the legal division of the U.S. Shipping Board. Headed the trial department of the Boston firm of Hale and Dorr. In April 1954 Welch was called to serve as special counsel to the Department of the Army in its confrontation with Senator Joseph R. McCarthy. He had never been politically active but showed his acumen nonetheless. His probing questions, general demeanor, and deft thrusts proved to be the senator's undoing. In 1956 Welch was narrator of a much-praised series of "Omnibus" programs on the constitutional history of the nation. Appearances on other shows followed, and in 1959 he played the judge in the movie *Anatomy of a Murder*.

WELCH, LEO DEWEY (*b. Rochester, N.Y., 1898; d. Cuernavaca, Mexico, 1978*), business executive. Graduated University of Rochester (B.A., 1919), joined National City Bank of New York, and worked in Latin American branches until 1943. In 1944 he joined Standard Oil (New Jersey) as treasurer and shaped the financial strategies that helped the firm capitalize on the business opportunities of the post-World War II international economy; in 1960 he became chairman of the company. In 1963 he was chairman of the Communications Satellite Corporation (COMSAT), a government-sponsored, private-sector corporation charged with creating a world communications satellite system. In 1964, collaborating with telecommunications firms around the world, Welch oversaw the formation of the International Satellite Consortium (INTELSAT). With advances in satellite technology developed by INTELSAT, a global commercial satellite communications system involving sixty-four countries was established in 1968. He retired from active direction of COMSAT in 1965.

WELCH, PHILIP HENRY (*b. Angelica, N.Y., 1849; d. Brooklyn, N.Y., 1889*), journalist, humorist. Employed on the staffs of newspapers in Rochester, N.Y., and Philadelphia, Pa., he was, *post* 1884, a member of the staff of the N.Y. *Sun*. He is remembered principally for anonymous "question and answer" jokes and satires which he contributed to the *Sun* and also to most of the periodicals of his time. He was author of *The Tailor-Made Girl* (1888, reprinted from *Puck*). Some of his characteristic jokes were published posthumously as *Said in Fun* (1889).

WELCH, WILLIAM HENRY (*b. Norfork, Conn., 1850; d. Baltimore, Md., 1934*), pathologist, medical educator. Son of William W. Welch. Graduated Yale, 1870; studied chemistry at Sheffield Scientific School. M.D., N.Y. College of Physicians and Surgeons, 1875. As a student at Strasbourg, Leipzig, and Breslau, 1875–78, he worked with some of the greatest men of the time, among them Ludwig, Julius Cohnheim, Paul Ehrlich, and von Recklinghausen. He also studied briefly in Paris and London. Commencing work as a pathologist in New York, 1878, he was associated with Bellevue Hospital and with the Woman's Hospital until 1883 when he accepted an invitation to become professor of pathology at Johns Hopkins University. After further study in Europe under Koch and his pupils, he organized a pathological laboratory at Johns Hopkins, 1885, heading a group of men which included William T. Councilman, William S. Halsted, and Franklin P. Mall. His work at this time later resulted in the publication of his *Thrombosis and Embolism* (1899). Devoting himself then to the study of diphtheria and pneumonia, he also discovered and described in detail the gas-producing bacillus known by his name, which was the cause of "gas gangrene" in wounded soldiers during World War I. When the Johns Hopkins hospital opened in 1889, he suggested William Osler and William S. Halsted as department heads; later, in the organization of the school of medicine, he was responsible for the choice of Mall and other outstanding men. He himself served as the first dean for several years and founded and edited the *Journal of Experimental Medicine*, 1896–1906.

Influential in determining the character of the Johns Hopkins medical school, he turned his attention *post* 1900 to the general advance of medical education throughout the country. The Rockefeller Institute of Medical Research was founded in a way largely based upon his counsel; *post* 1901, he was chairman of its board of scientific directors. *Post* 1906, he was associated in a similar advisory capacity with the activities of the Carnegie Foundation and was active in many scientific and medical associations. As president of the Maryland board of health, 1898–1922, he was frequently consulted by the Baltimore municipal authorities on matters of public health, and during World War I he served actively with the surgeon general of the army. Throughout all these busy years of administration his interest in the problems of pathology and bacteriology remained intense. Among the topics to which he devoted attention were adaptation in pathological processes, morbid conditions caused by the *aerogenes capsulatus*, and immunity. On the opening of the school of hygiene and public health at Johns Hopkins, 1918, Welch, who had resigned his professorship of pathology, was appointed director. His skill in the choice of men and his profound interest in the work were responsible for the success of this school and its far-reaching influence. He resigned in 1926 and entered upon a third career as professor of the history of medicine which he continued until his retirement in 1931.

His keenness of judgment and extraordinary organizing ability were as effective in his research work as in his work of administration. His fame rests on his appreciation of the significance of the epochal developments in pathology and bacteriology which he had witnessed in Europe, and in his introduction to America, not only of the practical results of his investigations, but of the whole spirit of these medical advances. The consequent reform in American medical education, and the development of public health studies for which he was responsible, set up an influence which was felt and treasured in many other countries as well as the United States.

WELCH, WILLIAM WICKHAM (*b. Norfolk, Conn., 1818; d. Norfolk, 1892*), physician, Connecticut legislator. Father of William H. Welch.

WELD, ARTHUR CYRIL GORDON (*b. Jamaica Plain, Mass., 1862; d. West Point, N.Y., 1914*), musician, composer. Achieved greatest distinction as conductor of musical comedy orchestras and composer of incidental music for the theater. He was musical director for productions of Henry W. Savage.

WELD, THEODORE DWIGHT (*b. Hampton, Conn., 1803; d. Hyde Park, Mass., 1895*), Abolitionist. Raised in western New York State. Influenced by Charles Stuart and Charles G. Finney, Weld worked while a young man as an evangelist and as a temperance speaker. Converted to the antislavery cause by Stuart, he lent his principal efforts to this work *post* 1830; his own first converts to emancipation were Arthur and Lewis Tappan. Commissioned by the Tappans to find a site for a Western theological seminary, Weld traveled widely, 1831–34, advocating antislavery at every opportunity. Among his later converts were James G. Birney, Elizur Wright, Beriah Green, Harriet and Henry Ward Beecher, and Gamaliel Bailey. Organizing students at Lane Theological Seminary and training them as agents for the American Anti Slavery Society, Weld continued to preach emancipation with extraordinary success in the then West and part of New England. In 1838 he married Angelina Grimké.

Post 1836, with an augmented group of agents, he consolidated the antislavery movement throughout the North. He employed anonymous pamphlets and tracts in this work with great effect; most of the tracts were written by himself. When congressional insurgents in the House of Representatives broke with the Whigs on the slavery issue, Weld assisted their leader, John Q. Adams, and actively directed the insurgent movement through the sessions of 1841–43. He then withdrew from public life, but his Washington lobby was continued by Lewis Tappan. The greatest of the Abolitionists, Weld has remained largely anonymous in history, in part owing to his almost morbid modesty. He accepted no office, attended no conventions, published nothing under his own name, and would permit neither his speeches nor his letters to be printed.

WELD, THOMAS (*b. Sudbury, England, 1595; d. London, England, 1660/61*), Puritan clergyman, colonial agent. Deposed for nonconformity as vicar at Terling, Essex, 1631, he immigrated to Boston, Mass., 1632, and became first pastor of the church at Roxbury. Opposed the Antinomians. With John Eliot and Richard Mather, was author of the "Bay Psalm Book" (*The Whole Booke of Psalmes* 1640). Sent to England by the General Court to seek financial aid for the colony, 1641, he was associated in this work with Hugh Peter until Peter's involvement in work of the Parliament. He was coeditor with Peter of *New England's First Fruits* (London, 1643). Weld secured Harvard's first scholarship fund, but failed to prevent issuance of a patent for the Narragansett territory to Roger Williams. Poor bookkeeping and misapplication by the General Court of funds collected led to charges of embezzlement against Weld and Peter; they were later vindicated. Weld, like Peter, became involved in English affairs and was induced by the Presbyterians there to edit with additions John Winthrop's manuscript account of the Antinomian troubles. Publication of this book emphasized Congregational turmoil and put Weld in a bad position from which he recovered by publishing *A Brief Narration of the Practices of the Churches in New England* (London, 1645). Thereafter he was an active supporter of the Commonwealth and an unpopular rector in several parishes until the Restoration.

WELKER, HERMAN (*b. Cambridge, Idaho, 1906; d. Washington D.C., 1957*), lawyer and politician. Studied at the University of Idaho (LL.B., 1929). After practicing law in Idaho and California, Welker entered politics, serving as a Republican in the state legislature in Boise. In 1950 he ran for the U.S. Senate and defeated his opponent, using a "soft on Communism" technique popular in the nation at the time. In the Senate, Welker served on the Internal Security Subcommittee led by Sen. Joseph R. McCarthy. An ardent conservative, he backed McCarthy's persecution of alleged Communists and attempted to halt the censure by the Senate, which led to his being defeated for reelection.

WELLER, JOHN B. (*b. Montgomery, Ohio, 1812; d. New Orleans, La., 1875*), lawyer. Congressman, Democrat, from Ohio, 1839–45. Colonel of Ohio militia in the Mexican War; chairman of commission to run boundary line between Mexico and the United States, 1849–50. Practicing in San Francisco, Calif., *post* 1850, he was U.S. senator, Union Democrat, from California, 1851–57, and governor of California, 1858–60. After service as U.S. minister to Mexico, December 1860–March 1861, he engaged in a variety of activities in various parts of the United States before settling in New Orleans, 1867.

WELLES, (BENJAMIN) SUMNER (*b. New York, N.Y., 1892; d. Bernardsville, N.J., 1961*), diplomat. Attended Harvard (B.A., 1914). Took the Foreign Service exam in 1915 and was assigned as third secretary in the embassy at Tokyo, his principal assignment, 1915–17, was inspection of camps in which German and Austrian prisoners of war were being held. Became second secretary in Buenos Aires, 1917–20; assistant chief of the Division of Latin American Affairs of the State Department, 1920–22; and commissioner to devise plans for the withdrawal of U.S. troops and the military government from the Dominican Republic (accomplished in 1924). Assistant secretary of state in 1933, he was the leading proponent of the Good Neighbor policy. In 1934 he undertook negotiations of a treaty with Panama designed to rectify some of the inequities of the 1903 Canal Treaty. Appointed undersecretary of state in 1937, and, after the outbreak of war in Europe, represented the United States at a special inter-American meeting in Panama, at which a neutrality zone was declared around the continent south of Canada; he also assisted in drafting the Atlantic Charter, 1941. He resigned in 1943.

WELLES, GIDEON (*b. Glastonbury, Conn., 1802; d. 1878*), journalist, Connecticut legislator and official. Attended present Norwich University, 1823–25. Editor of the *Hartford Times*, 1826–36, he was a devoted Jeffersonian Democrat. As a member of the legislature, 1827–35, he led fights against imprisonment for debt, property and religious qualifications for voting, grants of special privilege, and religious tests for witnesses in court. He was the father of Connecticut's general incorporation law which became a model for other states. An adviser and supporter of President Andrew Jackson, Welles held several state offices *post* 1835, and was postmaster of Hartford, 1836–41. He was chief of the bureau of provisions and clothing for the U.S. Navy, 1846–49. Leaving the Democratic party on the slavery question, he helped organize the Republican party and *post* 1856 was a chief political writer for the Republican *Hartford Evening Press*. He also contributed an important series of articles on the slavery question to the *New York Evening Post* and to the *National Intelligencer*. Unsuccessful candidate for the governorship of Connecticut, 1856, he headed Connecticut's delegation to the Republican Chicago convention, 1860.

Welles was U.S. secretary of the navy, 1861–69. Foreseeing the Civil War would be a long one, he reorganized his department and created a navy overnight. Although he was accused of undue deliberateness and extravagance, he succeeded in build-

ing an adequate navy from nothing with surprising speed. No other Civil War enterprise was conducted so economically. When scandals developed in navy affairs, he was the first to investigate them and punish the offenders. No other department was more free from political favoritism. His masterly rebukes of delinquent officers made him enemies but improved the efficiency of the service. Although it is hard to determine how much of the credit for supervision of actual naval warfare belonged to him and how much to Gustavus V. Fox and other officers, Welles supervised matters closely and followed all new developments with intelligence. He was an early sponsor of ironclads and supported John Ericsson in building the *Monitor*. He also encouraged development of heavy ordnance, improved steam machinery, and armored cruisers. The navy under Welles's direction was a very important factor in the crushing of the Confederacy.

His contribution to the general policies of the government was as important as his administration of the Navy Department. He distrusted Edwin M. Stanton and suspected the motives of W. H. Seward, yet he did not intrigue against either. He protested against Salmon P. Chase's depreciation of the currency, 1862–63, opposed the admission of West Virginia as unconstitutional, and deplored the suspension of the writ of *habeas corpus*, 1863. He also had doubts whether immediate universal emancipation might not be as injurious to the freed slaves as to the masters. Contending throughout the war that it was fought against rebellious individuals and not against states, he backed Lincoln's moderate program of Reconstruction and later supported the policy of President Andrew Johnson. Returning to the Democratic party, 1868, he became a Liberal Republican in 1872, and in 1876 not only supported Samuel J. Tilden, but wrote attacks against the decision of the Electoral Commission.

Between his retirement in 1869 and his death he published a number of articles in the *Galaxy* magazine which are important documents on the history of his time; one of these was expanded as *Lincoln and Seward* (1874). He kept a painstaking diary which is a storehouse of data, although in its published form (*Diary of Gideon Welles*, 1911), there was no warning to the reader that it was corrected and revised by the diarist in later years. A New England conscience, a keen sense of duty, and a methodical mind made Welles a dependable public servant. Throughout the stormy days of the Civil War he maintained a poise and calmness that often encouraged, but equally irritated, his associates. Realism and unusual common sense prevented too great disappointment on his part when men fell short of his standards.

WELLES, NOAH (*b. Colchester, Conn., 1718; d. 1776*), Congregational clergyman, Revolutionary patriot. Graduated Yale, 1741. Pastor at Stamford, Conn., 1746–76, he was widely known as an advocate of resistance to British oppression, as a defender of the validity of Presbyterian ordination, and as an opponent of episcopacy. He is now generally credited with the authorship of the anonymous *The Real Advantages Which Ministers and People May Enjoy . . . by Conforming to the Church of England* (1762); he was author also of other works of controversy.

WELLES, ROGER (*b. Newington, Conn., 1862; d. 1832*), naval officer, explorer. Graduated Annapolis, 1884. Served in the North Pacific on the cruise of the *Thetis* under W. H. Emory; made three successive voyages into the Polar regions. In 1891 he ascended the Orinoco River to a point farther than any white man had reached before and brought back an important ethnological collection. Director of naval intelligence during World War I, he was promoted rear admiral, 1919, and retired, 1926.

WELLING, JAMES CLARKE (*b. Trenton, N.J., 1825; d. Hartford, Conn., 1894*), journalist, educator. Graduated College of New Jersey (Princeton), 1844. Literary editor of the *Daily National Intelligencer* of Washington, D.C., 1850–56, he became the chief editor of the newspaper and conducted it as a conservative Unionist organ until 1865. A strong legalist, he questioned the validity of the Emancipation Proclamation and joined his friend Edward Bates in declaring trials by military commissions to be irregular. After short terms as president of St. John's College, Annapolis, Md., and as professor of English at Princeton, he served as president of Columbian College (present George Washington University), 1871–94.

WELLING, RICHARD WARD GREENE (*b. North Kingstown, R.I., 1858; d. New York, N.Y., 1946*), lawyer, political and educational reformer. B.A., Harvard, 1880. Attended Harvard Law School; admitted to New York bar, 1883. Active throughout his life in municipal reform movements and organizations, and in educational efforts to increase the sense of civic responsibility in public school students.

WELLINGTON, ARTHUR MELLEN (*b. Waltham, Mass., 1847; d. 1895*), civil engineer, engineering trade journalist. Author of a classic treatise, *The Economic Theory of the Location of Railways* (1877 and later editions).

WELLMAN, SAMUEL THOMAS (*b. Wareham, Mass., 1847; d. Stratton, Maine, 1919*), engineer, inventor. After directing the building of Siemens regenerative gas furnaces in various parts of the United States, 1867–73, he designed and built the Otis Steel Works of Cleveland, Ohio, where he remained as chief engineer, 1873–89. During this time he began invention of machinery and other equipment for the manufacture of iron and steel for which he was granted nearly 100 patents. Of these, the most outstanding were the electric open-hearth charging machine (ca. 1885) and an electromagnet for handling pig iron and scrap steel (patented, December 1895). *Post* 1890 Wellman was associated as president or chairman of the board with a number of engineering companies specializing in the manufacture of iron and steel.

WELLMAN, WALTER (*b. Mentor, Ohio, 1858; d. 1934*), journalist, aeronaut. Founded *Cincinnati Post*, 1879; was Washington correspondent of *Chicago Herald* and *Record-Herald*, 1884–1911. After several Arctic expeditions by boat and sledge (1894 and 1898–99), he was commissioned in 1906 to attempt a trip to the Arctic by air. He took off for the North Pole from Spitzbergen, September 1907, but was defeated by weather conditions. He made a second abortive attempt in August 1909, but abandoned further efforts to reach the Pole by air after the success of Robert E. Peary. Wellman's most ambitious undertaking was his attempt to cross the Atlantic in the airship *America*, 1910. The *America* was 228 feet long and had a speed of 25 miles an hour; below the hydrogen-filled bag of silk and cotton hung a car of steel tubing, a gas tank, a lifeboat, and an equilibrator which was also a fuel supply. Taking off from Atlantic City, N.J., Wellman and five companions exchanged messages by wireless with the shore (a pioneer feat), but were compelled by motor failure to come down and were rescued some 375 miles off Cape Hatteras after covering a distance of 1008 miles in 72 hours.

WELLMAN, WILLIAM AUGUSTUS (*b. Brookline, Mass., 1896; d. Los Angeles, Calif., 1975*), film director. After dropping out of high school and serving as a pilot with the Lafayette Flying Corps, he began acting in movies and directed his first film, a Western called *The Man Who Won*, in 1923. In 1927 he directed the Academy Award-winning *Wings* (1927). His penchant for gritty realism found expression in the classic *Public Enemy* (1931) with James Cagney. Subsequent films include *A Star Is Born* (1937), *Beau Geste* (1939), and *The Ox–Bow Incident* (1943).

WELLONS, WILLIAM BROCK (*b. near Littleton, Va., 1821; d. Suffolk, Va., 1877*), clergyman, educator, leader of the Christian Connection in the Southern states.

WELLS, DAVID AMES (*b. Springfield, Mass., 1828; d. Norwich, Conn., 1898*), economist. Graduated Williams, 1847; Lawrence Scientific School, 1851. Published *The Annual of Scientific Discovery*, 1850–66; made important improvements in textile manufacture; wrote several popular works on science and science textbooks. Wells came into wide prominence in 1864 through publication of *Our Burden and Our Strength*. In this pamphlet he reassured foreign investors and the people of the North concerning the ability of the government to pay its mounting debts by demonstrating the dynamic character of Northern economic life, stressing its rapid accumulation of capital and constant introduction of labor-saving devices. Chairman of the national revenue commission, 1865–66, he served as a special commissioner of the revenue, 1866–70, and was responsible for setting up the bureau of statistics under Francis A. Walker. Originally a protectionist, Wells was converted to free trade and was to the end of his life a leading advocate of abolition of the tariff. While chairman of the New York State tax commission, 1870–76, he was author of *Local Taxation* (1871), the earliest competent study of the subject. He served later as a receiver and trustee in the reorganization of several railroads including the Erie (1875), and in 1878 became a member of the board of arbitration of the Associated Railways. Wells was author of a large number of books, pamphlets, and articles, each based on a current problem; his chief interests were the tariff, the theory of money and the currency question, and taxation. An expositor of the nature and consequences of the "machine age," he felt that the new economics of production required abolition of protective tariffs in order to furnish wide markets, and he was convinced that industrial depressions, with falling prices, were due not to insufficient circulating media but to sudden and rapid increase in commodities. Some of his best writing was in opposition to fiat money or depreciated monetary standards. He was among the earliest to appreciate the importance of what is now known as "technological unemployment." A foe of the general property tax as applied to intangibles, he accepted the diffusion theory of taxation, and his opposition to the faculty theory led him to fight against income taxes. An out-and-out apostle of *laissez faire*, he missed the later implications of many of the tendencies in American economic life which he discovered and expounded. Among his works were *Robinson Crusoe's Money* (1876, 1896); *True Story of the Leaden Statuary* (1874); *The Silver Question* (1877); *A Primer of Tariff Reform* (1884); and *The Theory and Practice of Taxation* (1900).

WELLS, ERASTUS (*b. near Sacketts Harbor, N.Y., 1823; d. near St. Louis, Mo., 1893*), St. Louis street-railway builder and utilities executive. Active in his city's political and civic life, he was congressman, Democrat, from Missouri, 1869–77 and 1879–81. His principal legislative concerns were the improvement of the Mississippi River and the development of the Southwest. He was ahead of his time in regard to both, however, and few of his projects resulted in legislative action.

WELLS, HARRIET SHELDON (*b. Brooklyn, N.Y., 1873; d. New York, N.Y., 1961*), woman suffragist, Treasurer of the Woman's Suffrage Party of New York City and named chairman of its Woman Voter Subcommittee, 1915. A trusted lieutenant of Carrie Chapman Catt, she and others of the party sought to dissociate themselves from the militant tactics used by zealous suffragists. After New York State enacted woman suffrage (1917), she worked for passage of a federal suffrage amendment.

WELLS, HARRY GIDEON (*b. Fair Haven, Conn., 1875; d. Chicago, Ill., 1943*), pathologist. Ph.B., Sheffield Scientific School, Yale, 1895. M.D., Rush Medical College, 1898. Ph.D., University of Chicago, 1903. Studied also at University of Berlin with Ernst Salkowski and Emil Fischer. Within a decade of his return to Chicago in 1905, he had become the leading U.S. authority on the chemical aspects of pathology and immunology; he also continued his affiliation with the medical faculty of the University of Chicago (begun in 1901), becoming professor of pathology, 1913. He retired in 1940. As director of the Sprague Memorial Institute, Chicago, 1911–40, he stimulated and supported research in many fields, including the chemotherapy of tuberculosis and the role of heredity in cancer. His most notable publication was his classic *Chemical Pathology* (1907).

WELLS, HENRY (*b. Thetford, Vt., 1805; d. Glasgow, Scotland, 1878*), expressman. Began as operator of an express service between Albany and Buffalo, N.Y., ca. 1843; later extended his activities into New England and the Midwest. Removing to New York City, 1846, to handle the eastern and transatlantic phases of the business, he served as president of the American Express Co. (a merger of three older companies), 1850–68. In 1852 he organized Wells, Fargo & Co. under the presidency of Edwin B. Morgan for business to California; in 1857 the California service and the business east of the Missouri were linked by award of the overland mail contract to John Butterfield, who represented Wells, Fargo interests. The company prospered, despite heavy competition, until the completion of the transcontinental railroad. Wells retired after a further consolidation within the American Express Co., 1868, traveled widely, and devoted himself to local affairs in Aurora, N.Y. In 1868 he founded Wells Seminary, the present Wells College.

WELLS, HORACE (*b. Hartford, Vt., 1815; d. New York, N.Y., 1848*), dentist, anesthetist. Successful in practice at Hartford, Conn., *post* 1836, Wells was the teacher, and for a short time a partner, of William T. G. Morton. Interested in the narcotic effects of nitrous oxide inhalation, Wells suggested its use as a pain-deadener in tooth extraction as early as 1840. In December 1844 Wells, with the aid of G. Q. Colton, acted as the subject for a successful nitrous oxide extraction by John M. Riggs, and was taught by Colton how to make and administer the gas. He followed up this early trial by extracting several teeth without pain, and although familiar with the similar effects of ether, discarded its use because he considered nitrous oxide less likely to do injury. Traveling to Boston early in 1845, he was enabled through Morton to speak before a medical class of John C. Warren, but failed in a subsequent exhibition of his process. Wells's claim to discovery of anesthesia first appeared in print in the *Hartford Courant*, Dec. 7, 1846, nearly two months after W. T. G. Morton had demonstrated the use of ether. Claiming priority in the discovery and asserting that he had used ether as well as nitrous oxide in his own experiments, Wells published statements in several journals and in a pamphlet entitled *A History of the Discovery of the Application of Nitrous Oxide Gas, Ether, and Other Vapors, to Surgical Operations* (1847). After the general recognition of the superiority of ether over nitrous oxide in protracted operations, Wells, who had removed to New York City, committed suicide in discouragement.

WELLS, JAMES MADISON (*b. near Alexandria, La., 1808; d. 1899*), planter, Louisiana Unionist. Elected lieutenant governor of Louisiana in February 1864, he succeeded as governor upon the resignation of Michael Hahn in March 1865. He was elected in his own right as a National Democrat the following November. An advocate of general black suffrage, he became unpopular and was threatened with impeachment. Removed from office,

June 1867, by General Philip Sheridan, he continued to be prominent in state politics and was chairman of the Louisiana returning board during the dispute over the election of 1876.

WELLS, JOHN (*b. Cherry Valley, N.Y., ca. 1770; d. New York, N.Y., 1823*), lawyer. Graduated College of New Jersey (Princeton), 1788. Editorial associate of William Coleman on the N.Y. *Evening Post*, he edited *The Federalist*, bringing out the fifth edition of the papers in 1802. *Post* 1804, he shared with Thomas A. Emmet the bulk of the commercial law practice which had hitherto gone to Alexander Hamilton and Aaron Burr; he was frequently engaged as special counsel by the City of New York. His argument in the celebrated case of *Gibbons* v. *Ogden* (1819), that the grant by the State of New York of a monopoly of the navigation of its waters by steam was unconstitutional since Congress alone had the right to regulate commerce, was unsuccessful. However, Daniel Webster and William Wirt, pursuing the same argument on appeal to the U.S. Supreme Court, secured a reversal of the original decision, 1824.

WELLS, ROBERT WILLIAM (*b. Winchester, Va., 1795; d. Bowling Green, Ky., 1864*), Missouri legislator and jurist. State attorney general, 1826–36; U.S. district judge for Missouri (*post* 1857 of the western district only), 1836–64. Interested in legal reform, he opposed jury trial in civil cases and advocated simplification of pleading. He was a Civil War Unionist.

WELLS, SAMUEL ROBERTS (*b. West Hartford, Conn., 1820; d. New York, N.Y., 1875*), tanner, phrenologist, and publisher. Partner with Orson S. Fowler and brother in phrenological publishing firm; faddist reformer.

WELLS, WILLIAM CHARLES (*b. Charleston, S.C., 1757; d. London, England, 1817*), physician, physicist, Loyalist. Apprenticed to Alexander Garden (*ca. 1730–1791*), Wells fled to England on the outbreak of the Revolution and studied at the University of Edinburgh and in London; he took the M.D. degree at Edinburgh, 1780. Resident in America, 1781–84, he practiced thereafter in London, England. His most significant contribution to science was contained in a paper read before the Royal Society, 1813, and published with other papers in *Two Essays: One Upon Single Vision . . . The Other on Dew* (1818) in which Wells assumed a biological evolution of human species and clearly explained the principle of a natural selection in the struggle for existence. Darwin, originally unfamiliar with this essay, acknowledged its importance in the fourth (1866) edition of his own *Origin of Species.*

WELLS, WILLIAM HARVEY (*b. Tolland, Conn., 1812; d. 1885*), educator, writer on English grammar. After an outstanding career in New England as teacher, principal, assistant to Henry Barnard in conducting teachers institutes, and normal-school work, Wells was chosen superintendent of public schools in Chicago, Ill., 1856. There he organized the city's first high school and introduced a graded system of schools with a course of study which was widely imitated throughout the United States. He was author, among other works, of *The Graded School* (1862).

WELLS, WILLIAM VINCENT (*b. Boston, Mass., 1826; d. Napa, Calif., 1876*), merchant mariner, adventurer, California journalist. Great-grandson of Samuel Adams. Author, among other works, of *Walker's Expedition to Nicaragua* (1856), and of the *Life and Public Services of Samuel Adams* (1865). Inclusion of family records in the latter book has maintained its importance as a historical source.

WELSH, JOHN (*b. Philadelphia, Pa., 1805; d. 1886*), Philadelphia merchant, philanthropist. Helped develop Fairmount Park system; managed finances of Philadelphia Centennial Exhibition, 1876. U.S. ambassador at London, 1877–79.

WEMYSS, FRANCIS COURTNEY (*b. London, England, 1797; d. New York, N.Y., 1859*), actor, theater manager. American debut at Chestnut Street Theatre, Philadelphia, Pa., 1822. Wemyss later played with success in New York and was for a time manager in Philadelphia, Pittsburgh, and Baltimore; *post* 1841 he was active in a number of New York City theaters. Conspicuous for good taste and integrity, he helped found and administer the theatrical fund for the benefit of needy actors. He was also editor of a number of volumes of the *Acting American Theatre* and was author of *Twenty-Six Years of the Life of an Actor and Manager* (1847).

WENDE, ERNEST (*b. Millgrove, N.Y., 1853; d. Buffalo, N.Y., 1910*), dermatologist, health official. Brother of Grover W. Wende. M.D., University of Buffalo, 1878; M.D., University of Pennsylvania, 1884; made special studies at Berlin and Vienna. Practiced and taught in Buffalo, N.Y., *post* 1886; won national repute for extensive sanitary reforms as Buffalo health commissioner, 1892–1905.

WENDE, GROVER WILLIAM (*b. Millgrove, N.Y., 1867; d. Buffalo, N.Y., 1926*), physician, dermatologist. Brother of Ernest Wende. M.D., University of Buffalo, 1889; made graduate studies at Pennsylvania and in Prague, Vienna, and Paris. Practiced with his brother; served as professor of dermatology at University of Buffalo; was a staff member of many hospitals. A leader in his specialty and an exceedingly accurate observer, he was author of a number of monographs on the rarer skin diseases.

WENDELL, BARRETT (*b. Boston, Mass., 1855; d. 1921*), educator, man of letters. Graduated Harvard, 1877. Appointed a teacher of English composition at Harvard, 1880, he remained associated with that university thereafter, and was celebrated as a teacher for his powers of generalization, his ready control of the background of events and ideas, and his profuse and well-chosen literary illustrations. In 1898 he became the first teacher at Harvard to offer American literature as an object of systematic study, and *post* 1902 served on several occasions as an exchange professor in England and France. Steadily enlarging his field of thought, he moved gradually into the field of comparative literature, striving in all his work "so to increase our sympathetic knowledge of what we study that we may enjoy it with fresh intelligence and appreciation." Literature was, in his opinion, a vital concern—"the best record that human beings have made of human life." He was author, among other books, of *English Composition* (1891); *Cotton Mather, the Puritan Priest* (1891); *William Shakespeare* (1894); *A Literary History of America* (1900); *The Temper of the Seventeenth Century in English Literature* (1904); *The France of Today* (1907); and *The Traditions of European Literature, from Homer to Dante* (1920).

WENDTE, CHARLES WILLIAM (*b. Boston, Mass., 1844; d. Berkeley, Calif., 1931*), Unitarian clergyman, hymn-writer. Removing to San Francisco, Calif., 1861, he became a protégé of Thomas S. King. A graduate of Harvard Divinity School, 1869, he held a number of ministerial posts, and served as general secretary of the International Council of Liberal Religious Thinkers and Workers, 1900–20. In this capacity he organized a number of foreign congresses in the interest of rational, ethical theism.

WENLEY, ROBERT MARK (*b. Edinburgh, Scotland, 1861; d. 1929*), philosopher, educator. Sc.D., University of Edinburgh, 1891; Ph.D., University of Glasgow, 1895. Succeeding John Dewey in the department of philosophy at University of Michi-

gan, 1896, he taught there the rest of his life. He was author of a number of works setting forth his own particular form of Green-Caird-Bosanquet Hegelianism which included *The Life and Work of George Sylvester Morris* (1917).

WENNER, GEORGE UNANGST (*b. Bethlehem, Pa., 1844; d. New York, N.Y., 1934*), Lutheran clergyman. Graduated Yale, 1865; Union Theological Seminary, 1868. Pastor at Christ Lutheran Church, New York City, 1868–1934. A pioneer in weekday religious education and a liturgical scholar, Wenner was a conservative Lutheran in theology, but a recognized leader in interdenominational enterprises. His sixty-six-year pastorate is possibly the longest on record in the United States.

WENTWORTH, BENNING (*b. Portsmouth, N.H., 1696; d. Little Harbor, N.H., 1770*), merchant, New Hampshire colonial official. Uncle of John Wentworth (1737–1820). Graduated Harvard, 1715. Wentworth labored to make New Hampshire independent of Massachusetts, and was first royal governor of New Hampshire province, 1742–67. A tactless man, determined to uphold the royal prerogative, he engaged in bitter controversies with the Assembly and was roundly criticized for appointing relatives to office and favoring them in grants of land; he was also accused of having grown rich through pre-empting choice land in each township. Other complaints were made of his exercise of the office of surveyor of the King's Woods. However, he gave vigorous support to colonial defense against the French and the province prospered materially under his administration.

WENTWORTH, CECILE DE (*b. New York, N.Y., date uncertain; d. Nice, France, 1933*), portrait painter. A student in Paris of Alexandre Cabanel and Edouard Detaille, Madame Wentworth, as she was known, lived abroad for the greater part of her life and was regarded in France as one of the outstanding portraitists of her time.

WENTWORTH, GEORGE ALBERT (*b. Wakefield, N.H., 1835; d. Dover, N.H., 1906*), teacher, author of textbooks in mathematics. Graduated Harvard, 1858. For many years a teacher at Phillips Exeter Academy, he headed the department of mathematics there *ca.* 1861–91. His outstanding texts included *Elements of Geometry* (1878), *Elements of Algebra* (1881), and *College Algebra* (1888).

WENTWORTH, JOHN (*b. Portsmouth, N.Y., 1737; d. Halifax, Nova Scotia, Canada, 1820*), merchant, landowner. Nephew of Benning Wentworth. Graduated Harvard, 1755. Resident in England, 1763–66, he came to know, among other influential Englishmen, the Marquis of Rockingham, and was appointed an agent for New Hampshire. Succeeding his uncle as governor of New Hampshire, 1767, he served with ability and a sincere desire to further the welfare of his native province; he was particularly active in protecting the integrity of the King's Woods and preventing the private cutting of timber. He was responsible for the survey on which the 1784 map of New Hampshire was based and was a supporter and benefactor of Dartmouth College. As the Revolutionary movement grew in force, he did his best to prevent cooperation between New Hampshire and the other colonies, but was obliged to take refuge in Boston, Mass., 1775. Accompanying the British to Halifax, March 1776, he later lived for a time in England, returning to Halifax, 1783. Becoming lieutenant governor of Nova Scotia (in effect governor), 1792, he held that office until 1808.

WENTWORTH, JOHN (*b. Sandwich, N.H., 1815; d. Chicago, Ill., 1888*), editor. Graduated Dartmouth, 1836; settled in Chicago, Ill., in the same year. Beginning as editor of the weekly *Chicago Democrat*, he soon became its owner and in 1840 started the *Daily Democrat*, which he made the leading paper of the Northwest. As congressman, Democrat, from Illinois, 1843–51, 1854–55, he advocated free homestead legislation and favored Western railway land grants. Leaving the Democratic party over the slavery issue, he was elected mayor of Chicago, 1857, on a Republican Fusion ticket; he was elected again in 1860 and also served as police commissioner during the Civil War. One of Chicago's principal owners of real property and a leading figure in the city's civic life, he served again in Congress as a Republican, 1865–67, where he urged immediate resumption of specie payments.

WENTWORTH, PAUL (*b. date and place of birth unknown, but probably New Hampshire; d. Surinam, Dutch Guiana, 1793*), British spy. Described by Governor John Wentworth of New Hampshire as "my near relation," he was a man of education and talents who made his living principally as a stock jobber and served briefly as New Hampshire agent in London in the early 1770's. Becoming one of the important members of the British secret intelligence on the Continent, he recruited Edward Bancroft for the service and was the agent by which Bancroft's reports were transmitted to the British government. He failed in a bold attempt to halt the treaty negotiations between France and the United States, December 1777–January 1778.

WERDEN, REED (*b. Delaware Co., Pa., 1818; d. Newport, R.I., 1886*), naval officer. Appointed midshipman, 1834. Held varied commands in Civil War including post of fleet captain, East Gulf Squadron, 1864–65. Commanded South Pacific Squadron, 1875–76, retiring as rear admiral, 1877.

WERGELAND, AGNES MATHILDE (*b. Christiania, Norway, 1857; d. Laramie, Wyo., 1914*), historian, educator. Ph.D., University of Zürich, 1890. Immigrated to America, 1890. Chairman, department of history, University of Wyoming, 1902–14.

WERNWAG, LEWIS (*b. Württemberg, Germany, 1769; d. Harpers Ferry, Va., 1843*), pioneer bridge builder. Came to Philadelphia, Pa., *ca.* 1786. Chiefly remembered as a designer and builder of wooden bridges and for early (1811) use of the cantilever. His beautiful "Colossus of Fairmount," built in 1812 across the Schuylkill River at Philadelphia, was the greatest singlearch span (340 feet) then in America. The canal of the Schuylkill Navigation Co. was partially constructed by him in 1817, and the Fairmount water works and dam at Philadelphia were erected in accordance with his plans.

WERTENBAKER, CHARLES CHRISTIAN (*b. Lexington, Va., 1901; d. Ciboure, France, 1955*), author and editor. Studied at the University of Virginia, 1925. Wrote his first novel, *Boojum*, a satire on life at the University of Virginia, in 1928. Correspondent and editor for the Luce publications of *Time* and *Fortune*, 1931–47. Other novels include *Write Sorrow on the Earth* (1947), a novel of the French resistance during World War II; and *The Barons* (1950) and *The Death of Kings* (1954), novels about American corporate power modeled after Luce and his empire.

WERTENBAKER, THOMAS JEFFERSON (*b. Charlottesville, Va., 1879; d. Princeton, N.J., 1966*), historian. Studied at the University of Virginia (B.A., M.A., 1902; Ph.D., 1910). His dissertation, *Patrician and Plebian in Virginia; or The Origin and Development of the Social Classes of the Old Dominion*, was published at his own expense. Wertenbaker taught at Princeton (1910–47). He wrote *Virginia Under the Stuarts* (1914), *The Planters of Colonial Virginia* (1922), *The American People: A History* (1926), *The First Americans, 1607–1690* (1927), *Norfolk: Historic Southern Port* (1931), *The Middle Colonies* (1938), *Torchbearer*

of the Revolution: The Story of Bacon's Rebellion and Its Leader (1940), *The Golden Age of Colonial Culture* (1942), *The Old South* (1942), *Princeton, 1746–1896* (1946), *The Puritan Oligarchy* (1947), *Father Knickerbocker Rebels: New York City During the Revolution* (1948), *Bacon's Rebellion: 1676* (1957), and *Give Me Liberty: The Struggle for Self-Government in Virginia* (1958). Internationally recognized, he taught at the University of Göttingen in 1931 and from the 1940's on received a number of honorary degrees. In 1947 was president of the American Historical Association.

WERTHEIMER, MAX (*b. Prague, Bohemia, 1880; d. New Rochelle, N.Y., 1943*), psychologist, founder of the Gestalt movement. Began his university education at the Charles University, Prague, as a student of law; studied psychology subsequently at Berlin, and at Würzburg, Ph.D., 1904. While working at Frankfurt am Main, he became associated with Kurt Koffka and Wolfgang Köhler, and it was from Frankfurt in 1912 that he published the paper on the perception of movement that marks the official beginning of Gestalt psychology. On the seizure of power in Germany by Hitler, he left his professorship at Frankfurt and moved with his family to Czechoslovakia; in September 1933, he joined the faculty of the New School for Social Research, New York City.

WESBROOK, FRANK FAIRCHILD (*b. Brant Co., Ontario, Canada, 1868; d. Vancouver, British Columbia, Canada, 1918*), pathologist, educator. Graduated University of Manitoba, B.A., 1887; M.D.C.M., 1890; studied also at Cambridge University and at Marburg; received further training at London, Dublin, and Hamburg. Appointed director of laboratories, Minnesota State Board of Health, 1895; became professor of pathology and bacteriology, University of Minnesota Medical School, 1896, and dean, 1906. Won world reputation as coauthor of "Varieties of Bacillus diphtherias" (1900). A leader in medical education and an authority on problems of public health and sanitation, he was chosen president of University of British Columbia, 1913.

WESSELHOEFT, CONRAD (*b. Weimar, Germany, 1834; d. Boston, Mass., 1904*), homeopathic physician, educator. Came to America as a child. M.D., Harvard Medical School, 1856. A founder of Boston University Medical School, 1873, and associated with it until his death, he was professor of materia medica and pathology and therapeutics. Elected president of American Institute of Homeopathy, 1879. Attempted to formulate principles of homeopathy in accordance with modern science. Published his translation of Samuel Hahnemann's *Organon*, 1876; coeditor, *Homoeopathic Pharmacopoeia of the United States* (1914).

WESSELHOEFT, WALTER *See* WESSELHOEFT, CONRAD.

WESSON, DANIEL BAIRD (*b. Worcester, Mass., 1825; d. Springfield, Mass., 1906*), inventor and manufacturer of firearms. Formed partnership with Horace Smith for manufacture of a rim-fire metallic cartridge at Norwich, Conn., 1853; with Smith, patented a pistol (1854) whose entirely new repeating action was later adapted to rifles and was an essential factor in the success of the famous Winchester. Again in partnership with Smith, he developed and manufactured *post* 1857 the Smith & Wesson revolver, the only one made with an open cylinder and using a metallic cartridge. He introduced numerous improvements in it, and *ca.* 1887 devised the "hammerless" safety revolver.

WEST, ALLEN BROWN (*b. Reedsburg, Wis., 1886; d. near Stafford Springs, Conn., 1936*), historian. Graduated Milton (Wis.) College, 1907; was Rhodes scholar at Oriel, Oxford; Ph.D., University of Wisconsin, 1912. Principal teaching post, professor of classics and ancient history, University of Cincinnati *post* 1927. West's particular interest lay in the history of imperial Athens. His studies of the financial records of the Athenian Empire in collaboration with Benjamin D. Meritt instituted a revolution in Greek epigraphic scholarship.

WEST, ANDREW FLEMING (*b. Allegheny, Pa., 1853; d. Princeton, N.J., 1943*), classicist, university official. A.B., College of New Jersey (Princeton), 1874. After teaching Latin in Ohio high schools, he became principal of Morris Academy, Morristown, N.J., 1881. Two years later, he was appointed Giger professor of Latin at Princeton. His role became more and more that of an administrator and educational controversialist than of a teacher. He defended the study of the classics without compromise, and attacked the unrestricted elective system of studies and the assignment of academic credit for study of utilitarian subjects. The aim of education, as he saw it, was to discipline the mental faculties and to develop moral character. In 1913, he suffered curtailment of his extensive powers as dean of the graduate school when it lost its autonomous status. He retired in 1928.

WEST, BENJAMIN (*b. Rehoboth, Mass., 1730; d. Providence, R.I., 1813*), almanac-maker, astronomer. Entirely self-educated, West taught mathematics and astronomy at Rhode Island College (later Brown University), 1788–99. He brought out *The New-England Almanack, or Lady's and Gentleman's Diary* 1765–1781; this, and others which he prepared, achieved an excellent reputation in New England for accuracy. He collaborated with Joseph and Moses Brown on observation of transit of Venus, 1769, and published astronomical papers.

WEST, BENJAMIN (*b. near Springfield, Pa., 1738; d. London, England, 1820*), painter. Showing an early aptitude for art, he was assisted by several local patrons, including William Henry. Removing to Philadelphia, Pa., at the invitation of William Smith (1727–1803), he painted portraits and inn signs, continued to practice and study, and by chance made an independent discovery of the principle of the camera obscura. Journeying to Italy in 1760, apparently the first American to study art there, he attracted wide attention and was aided by the then-celebrated painter Anton Fafael Mengs. After traveling about Italy and making special studies of the work of Titian and Raphael, he arrived in England, August 1763, and remained there until his death.

West's agreeable manners and romantic history won him entrance to the highest English circles; among his friends were Sir Joshua Reynolds, the great Samuel Johnson, Edmund Burke, and Dr. Robert H. Drummond, archbishop of York, who became his most powerful patron. Employing Titianesque colors, delicacy of stroke, and subtlety of blended tone, he marked a departure from the robustness of the English school and his work took the public fancy. Admired and liked by George III, he was extensively patronized by that monarch and by the king's appointment was made a charter member of the Royal Academy, founded 1768. *Post* 1772, when he was appointed historical painter to the king, he devoted almost all his time to executing the king's orders for paintings for the royal palaces, including many portraits of the royal family. In his *Death of Wolfe*, exhibited in the Royal Academy, 1771, he represented his heroes in contemporary military costume, a departure from the classic conventions of the day. After approval of this effort at realism by Sir Joshua Reynolds, the picture brought about a new direction in English historical painting. Succeeding Reynolds as president of the Royal Academy, 1792, West devoted much time to teaching young artists, impressing on them the formation of a good palette, truthfulness of design, and a sound technique. Among his American pupils were Matthew Pratt, Charles W. Peale, Gilbert Stuart, John Trumbull, Robert Fulton, Thomas Sully, S. F. B. Morse,

and Charles R. Leslie. His generosity to young artists was unfailing.

Post 1801, West's favor at court began to decline and he set himself to work upon a series of religious pictures for public sale. One of these, *Christ Healing the Sick* (1801), was among his most successful, and *Christ Rejected* (*ca.* 1815) and *Death on the Pale Horse* (1817) were also much admired. At his death on March 11, 1820, his body lay in state at the Royal Academy, and he was buried with great honor in St. Paul's Cathedral. Fitted to the ideals of his time by character, by training, and by many small personal traits, he was a painter of little genuine power. His works are formal and uninspired. His important position in the history of English and American painting is owing largely to the help and encouragement he gave so freely to other artists. One of the best of his works, *Penn's Treaty with the Indians*, hangs in Independence Hall, Philadelphia.

WEST, FRANCIS (*b. probably Hampshire, England, 1586; d. probably Virginia, 1634*), governor of Virginia. Brother of Thomas, Lord De La Warr. Immigrating to Virginia, 1608, he was one of those who quarrelled with Captain John Smith and in September 1609 deposed him in favor of George Percy and a council, of which West became a member. He succeeded Percy as commander at Jamestown, 1612, was commissioned master of the ordnance, 1617, and became one of the most influential of "ancient planters." Governor of Virginia, 1627–March 1629.

WEST, GEORGE (*b. near Bradninch, Devonshire, England, 1823; d. 1901*), paper manufacturer, New York legislator. Immigrated to America *ca.* 1849; settled, 1861, in Saratoga Co., N.Y. By 1878 he owned nine mills whose total output was estimated to exceed that of any other paper maker in the United States and Europe. Manufacture of manila wrapping and grocer's bags was the basis of his fortune. A thoroughgoing protectionist, he was congressman, Republican, from New York, 1881–83 and 1885–89.

WEST, HENRY SERGEANT (*b. Binghamton, N.Y., 1827; d. Sivas, Turkey, 1876*), missionary physician. M.D., N.Y. College of Physicians and Surgeons, 1850. Served in Northern Armenian (later the West Turkey) Mission of the American Board, 1859–76. Besides engaging in extensive and far-reaching practice, West trained native students and doctors.

WEST, JAMES EDWARD (*b. Washington, D.C., 1876; d. New Rochelle, N.Y., 1948*), lawyer, social worker. Chief executive, Boy Scouts of America, 1911–43; editor of *Boy's Life*, 1922–43. One of the outstanding child welfare workers of the 20th century.

WEST, JOSEPH (*b. England, date unknown; d. New York, ante 1692*), South Carolina colonial official. As agent and storekeeper for the proprietors of Carolina (1669), he commanded the three vessels sent out to make a settlement after the first attempt by John Yeamans failed. Having assisted William Sayle, the first governor, to make a settlement at Albemarle Point on the Ashley, West succeeded Sayle as governor, 1671, and directed the colony through a trying year of scarcity. Superseded by Yeamans, 1672, he returned to the governorship in 1674 and held the post until 1682. During his administration the center of settlement was moved to New Charles Town (late Charleston) at the junction of the Ashley and Cooper rivers. Again removed from office, 1682, he was reinstated in 1684, but left the province the next year.

WEST, MAE (*b. New York City, 1893; d. Los Angeles, Calif., 1980*), actress and playwright. In the early 1910's, West toured with her own vaudeville show; her breakthrough on stage came in the musical comedy *Sometime* (1918), and she gained notoriety for her cool acting manner and daring, sexually suggestive demeanor. In the 1920's West wrote and was featured in several theater plays; her production of *Sex* (1926) was targeted by the Society for the Suppression of Vice. Her most successful play was *Diamond Lil* (1928), in which she offered her most memorable line: "Why don't you come up sometime and see me." West made a successful transition to Hollywood with the hit film *Night After Night* (1931). Several box-office successes followed, including *She Done Him Wrong*, based on her play *Diamond Lil*, and *I'm No Angel* (1933). Her sexual personae elicited strident protests from civic groups who often picketed theaters showing her movies. She continued to star in hit films, including *My Little Chickadee* (1940), though by the late 1940's her film career had declined. West enjoyed a successful Broadway and touring role in her play *Catherine Was Great* (1944).

WEST, OSWALD (*b. Guelph, Ontario, 1873; d. Portland, Oreg., 1960*), politician and lawyer. West entered Oregon politics in 1903 as state land agent. In 1910 he was elected governor and served until 1914. One of that state's most progressive governors, West was an early conservationist, an advocate of women's suffrage (women won the right to vote in Oregon in 1912), and an opponent of capital punishment. He was a member of the Democratic National Committee from 1926 to 1930. He then returned to private law practice.

WEST, ROY OWEN (*b. Georgetown, Ill., 1868; d. Chicago, Ill., 1958*), cabinet member and party leader. Studied at De Pauw University (LL.B., 1890). West practiced law in Chicago and became involved in Republican politics. He was chairman of the Republican State Committee, 1904–14, a member of the National Committee, 1912–16 and 1928–32; and National Committee secretary, 1924–28. In 1928 he was appointed secretary of the interior by President Coolidge. President of the board of trustees of De Pauw University from 1924 to 1950.

WEST, SAMUEL (*b. Yarmouth, Mass., 1730; d. Tiverton, R.I., 1807*), Congregational clergyman, author. Graduated Harvard, 1754. Pastor at Dartmouth (later New Bedford), Mass., 1761–1803. As Revolutionary War chaplain, he deciphered for General George Washington the famous treasonable code letter sent by Dr. Benjamin Church, 1775, to the British at Newport, R.I. Arminian in doctrine, he was author of *Essays on Liberty and Necessity* (1793), the most thorough and persuasive reply to Jonathan Edward's *Freedom of the Will*. West was a member of the committee to frame the Massachusetts constitution and is credited with persuading John Hancock to vote for the Federal Constitution.

WEST, WILLIAM EDWARD (*b. Lexington, Ky., 1788; d. Nashville, Tenn., 1857*), portrait painter. Studied in Philadelphia, Pa., under Thomas Sully. In Europe, 1822–40, he won renown for portraits of Lord Byron and Countess Guiccioli, among other celebrities, and exhibited at the Royal Academy, London, 1826–33. He worked in New York City, 1840–50, and 1852.

WESTCOTT, EDWARD NOYES (*b. Syracuse, N.Y., 1846; d. 1898*), author, banker. Remembered for his best-selling novel *David Harum* (1898), dramatized in 1900 and played by William H. Crane.

WESTCOTT, THOMPSON (*b. Philadelphia, Pa., 1820; d. Philadelphia, 1888*), lawyer, journalist. Despite Philadelphia indifference to Sunday journalism, he successfully edited the strong, independent *Sunday Dispatch* there, 1848–84. He is remembered principally as coauthor with J. T. Scharf of *History of Philadelphia* (1884), the most comprehensive account of the city up to that time.

WESTERGAARD, HARALD MALCOLM (*b. Copenhagen, Denmark, 1888; d. Belmont, Mass., 1950*), civil engineer. Graduated Royal Technical College, Copenhagen, 1911; studied also at universities of Göttingen and Munich. Ph.D., University of Illinois, 1916. Taught theoretical and applied mechanics at Illinois, 1916–36 (professor *post* 1927). Gordon McKay professor of civil engineering at Harvard, 1936; dean of the Graduate School of Engineering, Harvard, 1937–46, returning thereafter to full-time academic and research work. Made notable contributions in the areas of stress analysis, particularly of plates and slabs; was deeply learned in engineering mechanics and the mathematical theory of elasticity.

WESTERMANN, WILLIAM LINN (*b. Belleville, Ill., 1873; d. 1954*), ancient historian. Studied at the University of Nebraska and at the University of Berlin (Ph.D., 1902). Taught at the University of Wisconsin, 1908–20; Cornell University, 1920–23; Columbia University, 1923–48; lectured at the University of Alexandria, 1953–54. An expert on the economics of the ancient world, he published a book-length article, "Sklaverei," in German in 1935; the same material appeared posthumously as *Slave Systems of Greek and Roman Antiquity* (1955).

WESTERN, LUCILLE (*b. New Orleans, La., 1843; d. probably Brooklyn, N.Y., 1877*), actress. A trouper from early childhood with her sister, Helen, she became famous *post* 1863 for emotional acting in roles such as Camille, Lucretia Borgia, Queen Gertrude in *Hamlet*, and Nancy in *Oliver Twist*. A wayward genius, she achieved her effects by temperament rather than art.

WESTERVELT, JACOB AARON (*b. Tenafly, N.J., 1800; d. 1879*), shipbuilder. Apprenticed to Christian Bergh, 1817–20, he was Bergh's silent partner, 1822–35. They built several of the best transatlantic packets of the day at their East River (New York City) yard. Westervelt turned out 247 packets, clippers, steamers, and other vessels before his retirement in 1868. His most important steamships were the 1700-ton *Washington* and *West Point* (1847). During the golden years of clipper construction he built, among others, the N.B. *Palmer*, *Golden Gate*, and *Resolute*. He was Democratic mayor of New York City, 1853–54.

WESTINGHOUSE, GEORGE (*b. Central Bridge, N.Y., 1846; d. New York, N.Y., 1914*), Union soldier, inventor, manufacturer. After service in both the Union Army and Navy, he worked in his father's agricultural implement factory and in October 1865 obtained his first patent for a rotary steam engine. In the same year he patented a device for putting derailed freight cars back on the track and later developed a type of railroad frog. In April 1869 he took out his first air-brake patent, incorporating the Westinghouse Air Brake Co. six months later for its manufacture. He was subsequently awarded more than twenty further patents on the device as its automatic features were developed. This invention was of revolutionary importance as it made high-speed railroad travel safe. Moreover, by making all air-brake apparatus standardized and interchangeable, Westinghouse was one of the first industrialists to apply modern techniques of production. In 1880 he began to purchase signal and interlocking-switch patents which he combined with his own inventions into a complete signal system. Interest in developing electrical control of signals manufactured by his Union Switch & Signal Co. led Westinghouse to a more general interest in electrical processes and inventions and to the organization of the Westinghouse Electric Co. Between 1880 and 1890 he took out more than 125 patents in such diverse fields as air-brakes, signals, natural-gas production and control, and electrical power transmission. He developed a pressure system of transmission for natural gas which effectively reduced accidents. Having learned (1885) of French and German methods of transmitting single-phase alternating currents at high voltage over very small wires, and then, by means of transformers, stepping the current down to lower voltages for local distribution, he purchased test apparatus in Europe and set a team of electrical engineers, including William Stanley, to the task of adapting transformers to American conditions. Late in 1885 the Stanley "shell-type" transformer was ready for manufacture, but the system met with much opposition on the ground that high-tension current transmission was dangerous. In order to employ the new alternating-current system in industry, Westinghouse set his assistants to work on development of an induction motor and a two-phase system satisfactory for both lamps and motors. A successful experiment in the practical use of high-tension transmission was conducted by William Stanley at Great Barrington, Mass., in 1886, where a number of dwellings and shops were lighted; a later successful experiment was conducted in a Pittsburgh suburb. From 1893, in which year the Westinghouse Electric Co. contracted to light the Chicago World's Columbian Exposition and to develop the power of Niagara Falls, down through 1907, the Westinghouse interest flourished, but in 1907 the founder lost control of his companies. On reorganization, he continued as president with greatly limited power until retirement, 1911. He served (1905–10) as a trustee of the Equitable Life Assurance Society in the reorganization of that company. After his retirement, he continued experiments with the steam turbine and reduction gear and with an air-spring for automobiles until the failure of his health in 1913.

WESTLEY, HELEN (*b. Brooklyn, N.Y., 1875; d. Franklin Township, N.J., 1942*), actress. Christened Henrietta Remsen Meserole Manney. Studied at Academy of Dramatic Arts, New York City, and at Emerson School of Oratory, Boston. Married actor John Westley, 1900; divorced, *ca.* 1912. A member of the Washington Square Players, 1915–18; a founder, member of the board of managers, and leading actress of the Theatre Guild, 1918–36; thereafter, highly successful as a character actress in films.

WESTON, EDWARD (*b. near Wolverhampton, England, 1850; d. Montclair, N.J., 1936*), electrical engineer, industrialist. After receiving his medical diploma in England, 1870, he immigrated to New York City. Organizing the Weston Dynamo Electric Machine Co., 1877, he soon became the leading manufacturer of electroplating dynamos in the United States. He failed in efforts to develop an arc-lighting system and an incandescent lighting system, although he made important contributions to the technology of both. He achieved great success as designer and manufacturer of precision electrical measuring instruments *post* 1888.

WESTON, EDWARD HENRY (*b. Highland Park, Ill., 1886; d. Carmel, Calif., 1958*), photographer. Studied at the Illinois College of Photography. One of the earliest of the "straight" photographers, Weston moved to California and in 1911 opened a photography shop in Glendale, specializing in soft-focus pictures of Hollywood celebrities. He changed his style to realism, strongly influenced by Alfred Stieglitz, Paul Strand, and Charles Sheeler. Further experiences in Mexico, where he was influenced by the Mexican painters Orozco, Rivera, and Siquieros, developed his style further. In 1930 and 1931 he had one-man shows in New York and San Francisco. In 1937 he was the first photographer to be granted a Guggenheim Fellowship. In 1946 a major retrospective of his work was held at the Museum of Modern Art in New York. A victim of Parkinson's disease, Weston took his last photograph in 1948.

WESTON, EDWARD PAYSON (*b. Providence, R.I., 1839; d. 1929*), long-distance walker. Made first professional venture in 1867,

walking from Portland, Maine, to Chicago, Ill. (1326 miles) in 26 days. Participated thereafter in many types of walking races, winning the Astley Belt at London, England, 1879. In 1910, he walked from San Francisco to New York in about 70 days.

WESTON, NATHAN AUSTIN (*b. Champaign, Ill., 1868; d. 1933*), economist. B.L., University of Illinois, 1889; Ph.D., Cornell, 1901; studied also at Berlin. Taught at University of Illinois *post* 1900; *post* 1920 he devoted himself entirely to graduate-school teaching. Especially interested in development of the quantity theory of money, he was an outstanding American student of orthodox classical economics.

WESTON, THOMAS (*b. ca. 1575; d. Bristol, England, ca. 1644*), ironmonger, merchant adventurer. Served as agent of the London syndicate which underwrote the sailing of the Pilgrims to Plymouth, 1620; secured the patent for the colony from the Virginia Company and hired the *Mayflower*, but was unable to secure signature of the Separatists to the articles of agreement drawn up by him and Robert Cushman. This document remained unsigned until 1621. Weston later made an attempt to settle at the site of present Weymouth and engaged in trade up and down the New England coast and in Virginia. A roving, resourceful, and generally unsuccessful man, he is of significance only for his connection with the Pilgrims.

WESTON, WILLIAM (*b. probably in or near Oxford, England, ca. 1752; d. London, England, 1833*), civil engineer. Came to America early in 1793 as engineer of Schuylkill and Susquehanna Canal. Planned Middlesex Canal for elder Loammi Baldwin, 1794. At request of George Washington, 1795, reported on locks at Great Falls of Potomac. Served as adviser (1796–97) to Western Inland Lock Navigation Co., New York State, on the precursor of the Erie Canal. In 1799 he made an examination of future New York City water supply; he suggested the Bronx River as source, purification by artificial filters, and use of 24-inch cast-iron water pipe. His deep coffer dam for the "Permanent Bridge," Philadelphia, Pa., was the first in America. He removed to England ca. 1800. Weston commanded large fees and was highly respected by such public figures as Washington, Robert Morris, and Philip Schuyler. He taught native engineers how to design and build lock canals and published, among other reports, *An Account of the Rise, Progress and Present State of the Canal Navigation in Pennsylvania* (1795).

WETHERILL, CHARLES MAYER (*b. Philadelphia, Pa., 1825; d. Bethlehem, Pa., 1871*), chemist. Cousin of Samuel Wetherill (1821–1890). Graduated University of Pennsylvania (where he studied under A. D. Bache and J. F. Frazer), 1845; studied also in laboratory of James C. Booth and Martin H. Boyé and in Paris. Ph.D., University of Giessen, 1848. Published wellknown treatise *The Manufacture of Vinegar* (1860). Appointed chemist of the U.S. Department of Agriculture, 1862, he was the first scientist of the department; his *Report on the Chemical Analysis of Grapes* (1862) was the department's first scientific bulletin. Made studies of munitions for the War Department, 1862 and 1863. As chemist of the Smithsonian Institution, 1863–66, he made an important investigation upon ventilation of the Capitol. Professor of chemistry, Lehigh University, 1866–71.

WETHERILL, SAMUEL (*b. near Burlington, N.J., 1736; d. 1816*), pioneer American manufacturer of white lead and other chemicals, Philadelphia civic leader. He was cut off from the Society of Friends, 1777, for supporting the cause of the colonies and the use of weapons in its defense. He then joined in forming the sect of Free, or Fighting, Quakers before whom he preached regularly until his death.

WETHERILL, SAMUEL (*b. Philadelphia, Pa., 1821; d. Oxford, Md., 1890*), inventor, Union soldier, industrialist. Great-grandson of Samuel Wetherill (1736–1816). Graduated University of Pennsylvania, 1845. Invented (1852) process for deriving white zinc oxide direct from ore; founded Lehigh Zinc Co., 1853. He was the father of John P. Wetherill (1844–1906), inventor of the Wetherill furnace and Wetherill magnetic concentrating process for treatment of refractory ores.

WETZEL, LEWIS (*b. probably Lancaster Co., Pa., 1764; d. probably near Natchez, Miss., 1808[?]*), Indian fighter, scout. Raised near present Wheeling, W. Va. Served on a number of war expeditions, notably against Indian village on site of present Coshocton, Ohio, 1781. An implacable Indian hater.

WEXLER, IRVING (*b. New York, N.Y., 1888; d. Alcatraz Prison, San Francisco, Calif., 1952*), criminal. Under the name of Waxey Gordon, Wexler was a leading bootlegger and trafficker in narcotics during the 1920's and 1930's. Sentenced to a ten-year prison term for income tax evasion, he was released in 1940. Sentenced in 1951 for selling heroin, Wexler died in Alcatraz. He had been brought West to testify at the trial of a nationwide narcotics ring.

WEYERHAEUSER, FREDERICK EDWARD (*b. Rock Island, Ill., 1872; d. St. Paul, Minn., 1945*), lumberman, financier. Assumed control of his family's widespread business interests after his father's death in 1914.

WEYL, HERMANN (*b. Elmshorn, Germany, 1885; d. Zurich, Switzerland, 1955*), mathematician. Studied at the University of Göttingen (Ph.D., 1908). Taught at the Federal Institute of Technology in Zurich, 1913–30; at the University of Göttingen, 1930–33. Immigrated to the U.S. in 1933 and became a member of the Institute for Advanced Study in Princeton, N.J., 1933–55; emeritus after 1951. Published *The Concept of a Riemann Surface* (1913), *Space, Time, Matter* (1918), his account of Einstein's theory of relativity, and *The Classical Groups, Their Invariants and Representations* (1939). Member of the National Academy of Sciences and a fellow of the Royal Society of London.

WEYMOUTH, FRANK ELWIN (*b. Medford, Maine, 1874; d. San Marino, Calif., 1941*), hydraulic engineer. B.S. in civil engineering, University of Maine, 1896. On staff of Isthmian Canal Commission, 1899–1903; associated with U.S. Reclamation Service, 1903–24 (chief engineer *post* 1920). After a few years in private practice, and in irrigation projects for the Mexican government, he crowned his career as chief engineer and general manager of the Colorado River Aqueduct (1929–41).

WHALEN, GROVER ALOYSIUS (*b. New York, N.Y., 1886; d. New York, 1962*), businessman and city official. Attended Packard Commercial College and New York Law School. Began work with Wanamaker Department Store in New York City in 1914, and was general manager, 1924–34. In 1918 he was named secretary to Mayor John F. Hyland and became a member of the New York and New Jersey Bridge-Tunnel Commission (1919–23) and chairman of New York's Board of Purchasing (1919–24). He was also appointed chairman of the Mayor's Committee for the Reception of Distinguished Guests (1919), becoming the city's official greeter. Appointed police commissioner (1928–30) and established the Police Academy and originated a crime-prevention bureau. President of a nonprofit corporation to organize the 1939 World's Fair; he enlisted foreign countries to participate and transformed 1,216 acres of wasteland into a magnificent exhibition grounds. Chairman of Schenley Products (1934–37) and Coty (1941) and president of Transcontinental Industries (1956) and the Fifth Avenue Association (1957).

WHALLEY, EDWARD (*b. Nottinghamshire, England, date unknown; d. probably Hadley, Mass., 1674 or 1675*), regicide. Father-in-law of William Goffe; cousin of Oliver Cromwell. Rose to colonel in English civil war, 1645; answered to Parliament for escape of the King from Hampton Court. As member of High Court of Justice he signed Charles I's death warrant. Appointed major general, 1655; became member of Cromwell's House of Lords. Condemned at the Restoration, he fled to New England with Goffe, 1660, and resided at various places in Massachusetts and Connecticut thereafter.

WHARTON, ANNE HOLLINGSWORTH (*b. Southampton Furnace, Pa., 1845; d. Philadelphia, Pa., 1928*), writer. An authority on genealogy and American colonial social history, she was author of, among other books and articles, *Through Colonial Doorways* (1893), *Heirlooms in Miniature* (1898), *Social Life in the Early Republic* (1902), and *English Ancestral Homes of Noted Americans* (1915).

WHARTON, CHARLES HENRY (*b. St. Mary's Co., Md., 1784; d. Burlington, N.J., 1833*), Episcopal clergyman. Educated in Jesuit schools in France and Belgium; ordained a Catholic priest, 1772. Served as chaplain to Roman Catholics at Worcester, England, where he underwent a change in his religious views. Returning to Maryland, 1783, he published a justification of his conversion to Protestantism, 1784, which was answered by Rev. John Carroll. Thereafter, one of the leading Episcopal clergymen of the United States, he served as rector of St. Mary's Church, Burlington, N.J., 1798–1833.

WHARTON, EDITH NEWBOLD JONES (*b. New York, N.Y., 1862; d. St. Brice-sous-forêt, near Paris, France, 1937*), author. Descended from several families of the small, tightly-knit group which dominated the business and social life of New York City before the Civil War, Edith Jones grew to maturity in a somewhat restricted world which attempted to maintain its stratified codes of behavior and its tradition of elegance against the threats of the new industrialism. Her family circle was predominantly masculine and communicated a masculine temper to her mind. As Henry James, her friend of later years, remarked, in her novels the "masculine conclusion" tended "to crown the feminine observation." Educated by governesses and tutors and by her own wide reading, she resided abroad for long periods with her family and grew fluent in French, German, and Italian. In 1885 she married a wealthy Bostonian, Edward Wharton. The couple divided the year between residence in New York City and Newport, R.I.; later Newport was replaced by Lenox, Mass., where Mrs. Wharton drew about herself a small, distinguished circle of intimates. As her husband began to decline in health, the Whartons spent more and more time abroad in England or Italy; in 1907 they established themselves in Paris. They were divorced in 1913. During World War I, Mrs. Wharton applied her talents for organization and her boundless sympathies to support of the Allied cause and to relief work in France. With Walter Berry, an international jurist and an old friend of her youth who possessed a marked influence over her opinions, she spent much time during and after the war visiting hospitals and serving on many committees. She was the first woman to receive an honorary LL.D. from Yale University (1923) and was the recipient of many other civic and literary honors.

Although she had issued a privately printed volume of verses in Newport, R.I., 1878, Mrs. Wharton did not publish her first book until 1897; it was *The Decoration of Houses* written in collaboration with Ogden Codman, Jr. Her first collection of stories was *The Greater Inclination* (1899). In 1902 she published *The Valley of Decision*, a long historical novel set in 18th-century Italy. However, it was not until *The House of Mirth* appeared in 1905 that Edith Wharton found a wide public and her major subject—the depiction of an individual who wishes to escape from the inhibitions of a rigid society, but is unable to do so because he has been molded beyond change by its values and standards. The tragedy of Lily Bart in this novel is a tragedy of unfulfilled possibilities. As Mrs. Wharton later said of her own purpose in adopting such a subject, "A frivolous society can acquire dramatic significance only through what its frivolity destroys. Its tragic implications lie in its power of debasing people and ideals." Her criticism of society, however, did not blind her to the vulgarities of the "new" people who challenged it. In *The Custom of the Country* (1913) she lashed out at the selfishness and arrogance of a money-dominated society.

In *The Age of Innocence* (1920; awarded the Pulitzer Prize in 1921), she continued her study in depth of the aristocratic-plutocratic struggle at the point of its early beginnings. Under the common title of *Old New York* (1924) she published four novelettes which examine the same theme of values in conflict throughout the latter two-thirds of the 19th century. Of these *The Old Maid* is the best known but is by no means superior to the others in the group, notably *False Dawn*. A group of her later novels published *post* 1925 deal generally with this theme as well. Written in the tradition of George Eliot and Gustave Flaubert and of her American predecessor, Henry James, these novels had in them a prophetic vein and a high moral vision. Other works, while partaking of her central theme, touched the international theme first developed by Henry James—the contrast of foreign and domestic manners. Outstanding examples were *Madame de Treymes* (1907) and *The Reef* (1912); however, where Henry James probed the contrasts in manners ever more deeply on psychological level, Wharton remained close to the actual data she observed. Her two novels of New England, *Ethan Frome* (1911) and *Summer* (1917), are distinct from her other work in background and method, but not in underlying theme. The first, realistic and grim, tells of a large nature harnessed to a mean spirit and doomed to a life of physical and spiritual confinement. The second of these novels is a tightly told story of a girl who cannot rise above her environment, and is an outstanding piece of work. These, together with a briefer tale, "The Bunner Sisters" (in *Xingu*, 1916), illustrate the author's broad sympathies with individuals outside her own environment. She was author, in all, of more than fifty books, including collections of short stories and travel books such as *Italian Villas and Their Gardens* (1904) and *Italian Backgrounds* (1905). She published several collections of her verse and a critical study, *The Writing of Fiction* (1925).

Wharton's writings fall into two distinct periods. Most critics agree that her best work was done during the years preceding 1914 and that her later work is largely an echo of it; a number of reasons have been assigned for this decline in her powers, but none is wholly satisfactory. She was a friend of many distinguished men, among whom may be mentioned Charles E. Norton, Theodore Roosevelt, and Bernard Berenson. The influence upon her work of her friend Henry James has been perhaps exaggerated, although she was in certain respects (choice of theme, moral attitude, interest in technique) one of his disciples. *A Backward Glance* (1934) contains autobiographical material.

WHARTON, FRANCIS (*b. Philadelphia, Pa., 1820; d. Washington, D.C., 1889*), lawyer, Episcopal clergyman, government official, educator. Son of Thomas I. Wharton. Graduated Yale, 1839. Admitted to Pennsylvania bar, 1843. An authority on criminal and international law, he wrote, among other works, *A Treatise on the Criminal Law of the United States* (1846) and *Treatise on the Conflict of Laws* (1872). Professor of history and literature, Kenyon College, 1856–63. Active as a religious writer, editor, and lay preacher, he was ordained in 1862, and served as rector,

St. Paul's Episcopal Church, Brookline, Mass., 1863–71. Professor at Episcopal Theological Seminary, Cambridge, Mass., 1871–81, he was a leader of the Low Church school. Wharton was examiner of claims, legal division, Department of State, *post* 1885. He compiled *A Digest of the International Law of the United States* (1886, 1887; largely incorporated by J.B. Moore in *A Digest of International Law* 1906).

WHARTON, GREENE LAWRENCE (*b. near Bloomington, Ind., 1847; d. Calcutta, India, 1906*), Disciples of Christ clergyman. Missionary in India, 1882–99, 1904–06.

WHARTON, JOSEPH (*b. Philadelphia, Pa., 1826; d. 1909*), manufacturer, philanthropist. Studied chemistry at laboratory of Martin H. Boyé in Philadelphia. As manager of Lehigh Zinc Co. from 1853 to 1863, he was responsible for the first commercially successful production of spelter in the United States. For many years the only producer of refined nickel in America, he succeeded in 1875 in manufacturing a pure, malleable nickel. Wharton exerted strong political influence, particularly as a leading spokesman for a high protective tariff. He was a founder of Swarthmore College and established the Wharton School of Finance at the University of Pennsylvania.

WHARTON, RICHARD (*b. England, date unknown; d. England, 1689*), merchant, promoter. Immigrating to New England early in the Restoration Period (*post* 1660), he associated himself with a group of imperialistic recent settlers and with Puritan descendants who wished monopolistically to expand commerce, invest capital, and develop natural resources. Successive marriages to members of the Higginson and Winthrop families aided his business success. He involved New England in a trade war with the Dutch and urged recapture of New Netherland in order to develop American commerce on a unified plan with the port of New York as center. Advocating a remodeling of government so as to eliminate church power over the state, Wharton was influential in establishing the Dominion of New England, 1686. An importer, owning his own wharves and vessels, he aspired to a landed proprietorship and was associated in the Atherton Company and the Million Purchase; alone, he undertook the large Pejepscot Purchase in Maine. The New England Puritan governments and Governor Edmund Andros disapproved of these large projects, preferring a more democratic distribution of land. While in England to further his projects at court and to build opposition to Andros, he died suddenly, leaving his vast estate bankrupt.

WHARTON, ROBERT (*b. Philadelphia, Pa., 1757; d. 1834*), flour merchant. Half brother of Samuel Wharton. Elected mayor of Philadelphia, 1798, he was re-elected, 1799, and served subsequently, 1806–07, 1810, 1814–18, and 1820–24. An avid sportsman, he was for many years governor of the Schuylkill Fishing Company.

WHARTON, SAMUEL (*b. Philadelphia, Pa., 1732; d. near Philadelphia, 1800*), merchant, land speculator. Half brother of Robert Wharton. Associated *post* 1763 with George Morgan in trading firm of Baynton, Wharton & Morgan. Obtained "Indiana Grant," 1768. In England, 1769, he organized the Grand Ohio Company (Walpole Company) and petitioned for a grant to the proposed "Vandalia" colony of 20,000,000 acres between the Alleghanies and the upper Ohio. The Revolution ended this scheme.

WHARTON, THOMAS (*b. Chester Co., Pa., 1735; d. Lancaster, Pa., 1778*), merchant, Revolutionary patriot. First cousin of Robert and Samuel Wharton. Advocate of Whig policies, he served on the provincial Committee of Safety, 1775, and was president of the Council of Safety, 1776–77. He was in constant touch with General George Washington and was the principal figure in ordering out the Pennsylvania militia and encouraging enlistments. Elected president of the Supreme Executive Council of Pennsylvania, March 1777, he issued bills of credit to carry on the war, passed laws to punish the disloyal, and organized the new state's courts and military defenses.

WHARTON, THOMAS ISAAC (*b. Philadelphia, Pa., 1791; d. 1856*), lawyer, author. Nephew of William Rawle and Samuel Wharton; cousin of Thomas Wharton. Graduated University of Pennsylvania, 1807. Practiced in Philadelphia; was authority on real property and profoundly learned in other legal fields. A member of Joseph Dennie's Tuesday Club and a contributor to the *Port Folio*, he succeeded Washington Irving in 1815 as editor of *Analectic Magazine*. In 1830 he was appointed with William Rawle and Joel Jones to codify civil statute law of Pennsylvania.

WHARTON, WILLIAM H. (*b. Albemarle Co., Va., 1802; d. 1839*), lawyer, leader in Texas revolution. Settled in Texas *ca.* 1828. Wrote petition for repeal of law prohibiting foreign colonization in Texas at San Felipe convention, Oct. 1, 1832. Favored complete separation of Texas from Mexico. Accompanied S. F. Austin and B. T. Archer to the United States on mission for aid and support to Texas revolution, 1835–36. Minister to the United States to negotiate for recognition and annexation of Texas, 1836–37.

WHATCOAT, RICHARD (*b. Quinton, England, 1736; d. Dover, Del., 1806*), Methodist clergyman. Came to New York with Thomas Coke in 1784, at request of John Wesley, to organize American Methodists; was itinerant preacher and elder, and traveling companion of Bishop Asbury on episcopal tours. Elected bishop at the General Conference, 1800.

WHEAT, ZACHARIAH DAVIS ("BUCK") (*b. Bonanza, Mo., 1888; d. Sedalia, Mo., 1972*), baseball player. Signed his first professional contract in 1906 with the Enterprise of the Kansas League and played with Shreveport and Mobile in 1907–08. He joined the Brooklyn Dodgers in 1909 and quickly impressed his teammates with his outstanding hitting and fielding (left field). He went on to establish Dodger career records for most games played (2,322), most hits (2,804), most doubles (464), most triples (171), and most total bases (4,003). Released by the Dodgers in 1926, he played two seasons with the Philadelphia Athletics and minorleague Minneapolis before retiring in 1928. He was inducted into the Baseball Hall of Fame in 1959.

WHEATLEY, PHILLIS (*b. Africa, ca. 1753; d. Boston, Mass., 1784*), poet. A slave, purchased as a child by John Wheatley of Boston, Mass., she rapidly mastered English and read extensively in Greek mythology, Greek and Roman history, and contemporary English poetry. Her verses, influenced by Pope and Gray, won her reputation in Boston and London, and were published as *Poem on Various Subjects, Religious and Moral* (London, 1773).

WHEATLEY, WILLIAM (*b. New York, N.Y., 1816; d. New York, 1876*), actor, theater manager. Made debut with Macready at Park Theater, New York City, 1826; by 1834 had become principal "walking gentleman" at the Park. Active as a player and manager in Philadelphia, Pa., Washington, D.C., and New York, he was most successful at Niblo's Garden, New York, 1862–68, where he presented sumptuous productions of romantic dramas with star actors. In 1866 he introduced the extravagant ballet spectacle to America with his production of *The Black Crook*.

WHEATON, FRANK (*b. Providence, R.I., 1833; d. Washington, D.C., 1903*), soldier. Appointed first lieutenant, 1st U.S. Cavalry, 1855. As lieutenant colonel, 2nd Rhode Island Infantry, he fought at first Bull Run and was cited by General Burnside. Made brigadier general late in 1862, he commanded a brigade in the VI (Sedgwick's) Corps and played a prominent part in the Wilderness campaign, 1864. Commanding a division, he repelled a threatened attack on Washington, D.C., by General J. A. Early, July 1864, and was rewarded by brevet of major general. Successful in the assault on Petersburg, Va., Apr. 2, 1865, he continued in the army after the Civil War and, among other duties, ably commanded the campaign against the Modoc Indians, 1872. He retired as major general, 1897.

WHEATON, HENRY (*b. Providence, R.I., 1785; d. Dorchester, Mass., 1848*), jurist, diplomat, authority on international law. Graduated Brown, 1802. After studying law in his native city, he made a special study of civil law at Poitiers, France, 1805–06. Practicing in Providence, 1806–12, he removed to New York City where he was editor of the *National Advocate*, a (Democrat) Republican newspaper, until 1815. Justice of the New York City marine court, 1815–19, he was also reporter of the U.S. Supreme Court, 1816–27. A member also of the New York Assembly for one term and a commissioner to revise the New York laws (1825–27), he was author of a number of legal works and of a life of William Pinkney. His published reports of the decisions of the U.S. Supreme Court during his incumbency as reporter were distinguished for the excellence and extent of his notes. Appointed chargé d'affaires to Denmark, 1827, he brought about agreement on a treaty of indemnity (signed, March 1830) for seizures of American vessels during the Napoleonic wars which served as the prototype of similar treaties negotiated later with France and Naples. While in Denmark, he learned the language and studied the history of the Scandinavian peoples; in 1831 he published his *History of the Northmen*. Appointed chargé d'affaires at Berlin at the request of the Prussian authorities, March 1835, he was raised in rank to minister to Prussia, 1837, indirectly as a result of publication of his celebrated *Elements of International Law* (1836). In 1844 he secured signature of a treaty however, was rejected by the U.S. Senate. Among other treaties negotiated by Wheaton and put into effect were those providing for the abrogation of taxes imposed on emigrants to the United States from Hanover, Württemberg, Hesse-Cassel, Saxony, Nassau, and Bavaria. Resigning at the request of President Polk, 1846, Wheaton returned to the United States the next year.

Notable as were Wheaton's accomplishments in a number of fields, his most distinguished achievement was his work as an expounder and historian of international law. His *Elements* (previously mentioned) was an immediate success both at home and in Europe and encouraged Wheaton to further literary efforts which included his *History of the Law of Nations in Europe and America* (Leipzig, 1841; New York 1845). He is regarded by competent critics as standing with John Marshall, Judge Story, and Chancellor Kent among the greatest of American legal writers.

WHEATON, NATHANIEL SHELDON (*b. Marbledale, Conn., 1792; d. Marbledale, 1862*), Episcopal clergyman, educator. Graduated Yale, 1814. As rector, Christ Church, Hartford, Conn., 1821–31, he assisted Ithiel Town in design of its new (1827) edifice, said to be first truly Gothic church in America. President, Washington College (present Trinity), Hartford, 1831–37. While rector, Christ Church, New Orleans, 1837–44, he lost his health in heroic ministry during a yellow fever epidemic.

WHEDON, DANIEL DENISON (*b. Onondaga, N.Y., 1808; d. Atlantic City, N.J., 1885*), Methodist clergyman, editor, teacher. Graduated Hamilton College, 1828. Converted by Charles G. Finney. Professor of classics, Wesleyan (Conn.) College, 1833–43. A strong controversialist, he opposed the radical abolitionist movement in his church, but was also opposed to extension of slavery; he defended Wesleyan Arminianism. Professor of logic, rhetoric, and philosophy of history, University of Michigan, 1845–51. Editor, *Methodist Quarterly Review*, 1856–84. Author, among other works, of *Commentaries* on the Bible (1860–1884), which were widely popular.

WHEELER, ANDREW CARPENTER (*b. New York, N.Y., 1835; d. 1903*), journalist, playwright, drama and music critic. Entered journalism on staff of *New York Times* 1857; local editor, *Milwaukee Sentinel*, 1859–62; served as Civil War correspondent. Post ca. 1867, he wrote dramatic criticism under pseudonym "Trinculo" for *New York Leader*; as "Nym Crinkle," his weekly music and drama reviews for the New York *World* attracted wide attention for caustic humor and breadth of information.

WHEELER, ARTHUR LESLIE (*b. Hartford, Conn., 1872; d. Princeton, N.J., 1932*), classical scholar. Graduated Yale, 1893; Ph.D., 1896. Taught classical languages at Yale; headed department of classics at Bryn Mawr, 1900–25; headed department of classics at Princeton thereafter. Made special studies of the types of poetry as they developed in Latin literature, particularly of the Roman elegy.

WHEELER, BENJAMIN IDE (*b. Randolph, Mass., 1854; d. Vienna, Austria, 1927*), educator. Graduated Brown, 1875. Ph.D., Heidelberg, 1885. Professor of philology and Greek, Cornell University, 1886–99; taught also at Brown, American School of Classical Studies in Athens (1895–96), and University of Berlin (1909–10). Through his efforts as president of the University of California, 1899–1919, students and faculty increased four-fold; twenty new departments were added as well as divisions for special research; the summer session, extension division, and material equipment were expanded; and student self-government was instituted. Relieved from active conduct of the university, 1918, because of German sympathies, he retired (1919) as "Professor of Comparative Philology and President Emeritus."

WHEELER, BURTON KENDALL (*b. Hudson, Mass., 1882; d. Washington, D.C., 1975*), U.S. senator. Graduated University of Michigan Law School (1905) and established a practice in Butte, Mont. A Democrat, he was elected to the Montana legislature (1910), appointed U.S. district attorney general (1913), and elected to the U.S. Senate (1922). He became a national figure in 1924 when he charged the U.S. attorney general with failing to prosecute those involved in the Teapot Dome scandal and headed the subsequent Senate inquiry. He led the successful New Deal fight in 1935 to win passage of the Public Utilities Holding Company Act but in 1940–41 became the leading isolationist in Congress, twice releasing information that had the potential of harming U.S. security. Defeated in his 1946 bid for reelection, he practiced corporate law in Washington, D.C., and backed a variety of right-wing causes.

WHEELER, EARLE GILMORE (*b. Washington, D.C., 1908; d. Frederick, Md., 1975*), army officer. Graduated U.S. Military Academy (B.S., 1932) and returned as an instructor in 1940; in December 1941 he entered the Command and General Staff College at Fort Leavenworth, Kans. Appointed chief of staff for the Sixty-third Infantry Division at Camp Van Dorn, Miss., he and the division went to France in December 1944. After assignments in Europe he was made director of the Joint Staff, De-

partment of Defense (1960), designated a full general and deputy commander in chief of the United States European Command (1962), and appointed army chief of staff in October 1962. In July 1964 he became chairman of the Joint Chiefs of Staff, a position he held through the Vietnam War. He retired in 1970.

WHEELER, EVERETT PEPPERRELL (*b. New York, N.Y., 1840; d. 1925*), lawyer, civil service reformer. Cousin of James R. Wheeler. Graduated present College of the City of New York, 1856; LL.B., Harvard, 1859. Admitted to the New York bar, 1861, he practiced there until his death. Specialist in admiralty law, he was a founder of the New York Bar Association, 1869. Devoted to civil service reform and better government, he aided in drafting of revised Pendleton Bill, 1881, and with Edward M. Shepard wrote New York State civil service bill, 1883. He was active in reform politics and in the Citizen's Union which he helped found.

WHEELER, GEORGE MONTAGUE (*b. Hopkinton, Mass., 1842; d. New York, N.Y., 1905*), topographical engineer. Graduated West Point, 1866. Supervised survey of territory west of 100th meridian, 1871–88, commonly known as the "Wheeler Survey." His 14 field trips, 1871–79, in deserts and among mountain peaks entailed hardships which broke Wheeler's health. The survey's definitive *Report* was published in a number of volumes between 1875 and 1889, and Wheeler devoted the years 1879–88 to supervising their publication. He retired in 1888 with major's rank and pay awarded by act of Congress.

WHEELER, (GEORGE) POST (*b. Oswego, N.Y., 1869; d. Neptune, N.J., 1956*), diplomat and writer. Studied at Princeton University (D.Litt., 1893), at the Sorbonne, and the University of Pennsylvania. The first American career diplomat, Wheeler passed his State Department examination in 1906 and was sent as secretary to the embassy in Tokyo, 1906–09; to St. Petersburg, 1909–11; to Rome, 1912–13; and to Tokyo again from 1914 to 1916. He was counselor in London, Madrid, and Rio de Janeiro, and was minister to Albania from 1933 until his retirement in 1934. Books include *Russian Wonder Tales* (1912), *Dragon in the Dust* (1946), and his autobiography, written with his wife, novelist Hallie Rives, *Dome of Many-Colored Glass* (1955).

WHEELER, GEORGE WAKEMAN (*b. Woodville, Miss., 1860; d. Bridgeport, Conn., 1932*), jurist, law reformer. A.B., Yale, 1881; LL.B., 1883. Judge, Connecticut superior court, 1893–1910. In 1910 he was appointed associate justice, supreme court of errors; he served as chief justice, 1920–30. Influential in procuring uniform state bar admission standards. As chairman, Connecticut judicial council, 1927–30, he was mainly responsible for the rule of summary judgment and other innovations.

WHEELER, JAMES RIGNALL (*b. Burlington, Vt., 1859; d. 1918*), classicist, archaeologist. Cousin of Everett P. Wheeler. Graduated University of Vermont, 1880; Ph.D., Harvard, 1885. Studied also at American School of Classical Studies, Athens, 1882, and was closely identified with it for many years. Taught at Johns Hopkins, Harvard, and University of Vermont; professor of Greek literature and archaeology, Columbia University *post* 1895. Dean, faculty of fine arts, Columbia, 1906–11.

WHEELER, JOHN HILL (*b. Murfreesboro, N.C., 1806; d. Washington, D.C., 1882*), lawyer, diplomat, historian, North Carolina legislator and politician. As U.S. minister to Nicaragua, 1854–57, he recognized the insurrectionist government of William Walker, thereby exceeding instructions, and was forced to resign by Secretary of State W. L. Marcy. Wheeler's historical works abound in error, but aroused interest in local history in North Carolina and other Southern states.

WHEELER, JOHN MARTIN (*b. Burlington, Vt., 1879; d. Underhill Center, Vt., 1938*), ophthalmologist. Graduated University of Vermont, 1902; M.D., 1905. Long associated with the New York Eye and Ear Infirmary, he was head of ophthalmic service at New York's Bellevue and Presbyterian hospitals and consultant to a number of other hospitals. A teacher of his specialty at Cornell Medical College and at New York University, he was professor at N.Y. College of Physicians and Surgeons *post* 1928. He directed the Institute of Ophthalmology at Columbia-Presbyterian Medical Center from 1933 until his death. An operator of exquisite dexterity, he was skilled also in the field of plastic surgery.

WHEELER, JOSEPH (*b. near Augusta, Ga., 1836; d. Brooklyn, N.Y., 1906*), soldier. Graduated West Point, 1859; resigned commission, 1861. Colonel, 19th Alabama Infantry, he was given command in July 1862 of the cavalry of the Army of Mississippi. Rising by merit eventually to rank of Confederate lieutenant general, he led all cavalry in the Civil War western theater; he took a most prominent part in the Murfreesboro and Chickamauga campaigns. After Rosecrans's retirement to Chattanooga, Wheeler executed a masterly raid on Union communications. His cavalry provided the main obstacle to Sherman's march to the seas after Atlanta. R. E. Lee bracketed Wheeler with J. E. B. Stuart as one of the two outstanding Confederate cavalry leaders. Congressman, Democrat, from Alabama, 1881–83, 1885–1900, he was ranking Democrat of the ways and means committee; he fought for low tariff, and was instrumental in congressional rehabilitation of Fitz-John Porter. His chief public contribution was untiring advocacy of reconciliation between North and South. Appointed by President McKinley as major general of volunteers in Cuba, 1898, he commanded cavalry in General Shafter's Santiago expedition.

WHEELER, NATHANIEL (*b. Watertown, Conn., 1820; d. Bridgeport, Conn., 1893*), manufacturer, inventor, Connecticut legislator. Manufactured new rotary-hook sewing machine of Allen B. Wilson (patented 1851), adding four-motion feed in 1854. Invented and patented a wood-filling compound (1876, 1878) and a home ventilating system (1883).

WHEELER, ROYALL TYLER (*b. Vermont, 1810; d. Washington Co., Tex., 1864*), jurist. Studied law in Delaware, Ohio. Removed to Texas, 1839. In 1844 he became a district judge. Appointed to the state supreme court, 1845, he became chief justice, 1858. A strong advocate of secession, he upheld and enforced the Confederate conscription law.

WHEELER, SCHUYLER SKAATS (*b. New York, N.Y., 1860; d. New York, 1923*), inventor, engineer, manufacturer. A founder with Francis B. Crocker, 1888 (and president *post* 1889) of the Crocker-Wheeler Co., soon prominent in manufacture of motors. With Crocker, he published *Practical Management of Dynamos and Motors* (1894). He was inventor of an electric fire-engine system, an electric elevator (both patented 1885), and an electric fan.

WHEELER, WAYNE BIDWELL (*b. near Brookfield, Ohio, 1869; d. 1927*), lawyer, professional Prohibitionist. Superintendent, Anti-Saloon League of Ohio, 1904–15; general counsel, Anti-Saloon League of America, *post* 1915, also legislative superintendent. Successfully lobbied for national prohibition; favored extreme measures of enforcement.

WHEELER, WILLIAM (*b. Concord, Mass., 1851; d. 1932*), engineer, educator. Graduated Massachusetts Agricultural College, 1871. Professor of mathematics and civil engineering, Imperial Agricultural College of Sapporo, Japan, 1876–77; president,

1877–80. Began wide consulting practice in Boston, Mass., 1880, and became a national authority on water works.

WHEELER, WILLIAM ADOLPHUS (*b. Leicester, Mass., 1833; d. Boston, Mass., 1874*), lexicographer, bibliographer. Graduated Bowdoin College, 1853. Assisted J. E. Worcester in preparing *Dictionary of the English Language* (1860); supervised unabridged quarto and other editions of the Webster dictionary for Merriam Company. Assistant superintendent, Boston Public Library, from 1868 until his death. Author, among other reference works, of *Dictionary of the Noted Names of Fiction* (1865).

WHEELER, WILLIAM ALMON (*b. Malone, N.Y., 1819; d. 1887*), lawyer, banker, New York legislator. Admitted to the bar, 1845; practiced successfully in Malone, N.Y. Independent Republican congressman from New York, 1861–63, 1869–77, he stood out among his contemporaries as a man of scrupulous integrity. His "Wheeler adjustment" of a Louisiana disputed election, 1874, averted collapse of the state's government. Nominated for the U.S. vice-presidency, 1876, to secure a balance of sectional elements in the party, he was elected and served as a good presiding officer but cared little for the office.

WHEELER, WILLIAM MORTON (*b. Milwaukee, Wis., 1865; d. Cambridge, Mass., 1937*), zoologist, entomologist. Educated at Englemann German Academy, Milwaukee; worked under Henry A. Ward at Rochester, N.Y. Continuing his studies while teaching in Milwaukee, he became a research fellow at Clark University, 1890, where he received the Ph.D., 1892. His "A Contribution to Insect Embryology" (*Journal of Morphology*, 1893) achieved classic status. After teaching at the universities of Chicago and Texas, 1893–1903, he became a curator of invertebrate zoology at the American Museum of Natural History, New York City. In 1908 he became professor of entomology at the Bussey Institution, Harvard, and remained at Harvard until his retirement, 1934. Although most of his more than 450 publications are concerned with insects, a large number deal with problems of evolution, ecology, and behavior; among his books was *Social Life among the Insects* (1923).

WHEELOCK, ELEAZAR (*b. Windham, Conn., 1711; d. 1779*), Congregational clergyman, first president of Dartmouth. Father of John Wheelock. Graduated Yale, 1733. Pastor of Second Church, Lebanon, Conn., 1735–70. A popular emotional preacher during the Great Awakening, he founded a school at Lebanon primarily to convert and educate Indians to be missionaries and teachers for their tribes. Dissatisfied with the progress of the mission work and recruiting, and desiring to enlarge his educational program, Wheelock founded Dartmouth College, Hanover, N.H. (chartered 1769), maintaining it during the Revolutionary turmoil until his death.

WHEELOCK, JOHN (*b. Lebanon, Conn., 1754; d. 1817*), Revolutionary soldier, educator. Son of Eleazar Wheelock. Graduated Dartmouth College, 1771. As president of Dartmouth, 1779–1815, he established salaried professorships, built Dartmouth Hall and a chapel, revived in 1800 the educational program for the Indians, and secured the financing of the college and of Moor's Charity School. The last twelve years of his term were embittered by his struggles with the trustees, resulting in Wheelock's removal and a public controversy. The case was brought before the Supreme Court (*Trustees of Dartmouth College v. Woodward*, 4 Wheaton, 518), and was won for the college in 1819 by Daniel Webster.

WHEELOCK, JOHN HALL (*b. New York City, 1886; d. New York City, 1978*), poet, critic, and editor. Graduated Harvard University (1908), studied at the University of Göttingen (1909) and University of Berlin (1910), and became a clerk in Scribner's Book Store in New York City (1911–26); in 1932 he joined the Scribner publishing firm, remaining until his retirement in 1957. He established his reputation as a poet with the book *The Human Fantasy* (1911) and eventually published fourteen books of poetry. He developed a lyrical and emotive style, and many of his verses touched upon his love for the Atlantic Ocean and eastern Long Island. He won the Bollingen Prize in 1962. As an editor, he worked with such authors as Thomas Wolfe and Marjorie Kinnan Rawlings and introduced the Scribner Poets of Today series, which helped made the careers of poets May Swenson, James Dickey, Louis Simpson, and Joseph Langland.

WHEELOCK, JOSEPH ALBERT (*b. Bridgetown, N.S., Canada, 1831; d. 1906*), editor. Removed to Minnesota Territory, 1850. Edited *St. Paul Daily Press*, 1861–75; edited *St. Paul Daily Pioneer-Press* as an influential Republican paper *post* 1875. Opposed Republican party on Reconstruction and tariff; fought faction led by Ignatius Donnelly. His editorials in the 1890's helped keep Minnesota in the gold ranks.

WHEELOCK, LUCY (*b. Cambridge, Vt., 1857; d. Boston, Mass., 1946*), educator. Founded Wheelock School (later College) for training of kindergarten teachers, 1888, and headed it until 1940. Active in professional and other organizations, she strove to maintain the best aspects of the traditional kindergarten while preserving an open mind with respect to significant current educational theories.

WHEELWRIGHT, EDMUND MARCH (*b. Roxbury, Mass., 1854; d. Thompsonville, Conn., 1912*), architect. Studied architecture at Massachusetts Institute of Technology and in Paris; worked in offices of Peabody & Stearns and McKim, Mead & White. In 1888 he formed a Boston partnership which in 1910 became Wheelwright, Haven and Hoyt. As city architect for Boston, 1891–95, and consultant thereafter, he set a new high level for American municipal architecture. Perhaps his most widely known buildings are the subway entrances at Park St. corner of Boston Common. In 1900 he was chief designer of the Cambridge bridge. Among other works, Wheelwright designed Horticultural Hall (1900) and the Boston Opera House (1908). He sought the monumental, classic solution; stylistically he was catholic, even erratic. His later work tended toward a rational simplicity.

WHEELWRIGHT, JOHN (*b. probably Saleby, Lincolnshire, England, ca. 1592; d. Salisbury, N.H., 1679*), clergyman. B.A., Sidney College, Cambridge, 1614/15; M.A., 1618. For some years vicar of Bilsby (England), he was deprived for nonconformity, 1633, and immigrated to Boston, Mass., 1636. Pastor at Mount Wollaston (now Quincy), Mass., he and John Cotton alone among the clergy supported Anne Hutchinson, Wheelwright's sister-in-law, in the Antinomian controversy. Publicly denouncing the majority (which now included Cotton), 1637, he was disfranchised and banished from Massachusetts colony by the General Court. After organizing a community at present Exeter, N.H., he served there as pastor until Massachusetts asserted jurisdiction, when he removed to present Wells, Maine. Recanting his opinions, 1643, he secured reversal of his sentence in May 1644.

WHEELWRIGHT, MARY CABOT (*b. Boston, Mass., 1878; d. Sutton's Island, Maine, 1958*), anthropologist. With scanty formal education but of independent means, Mary Wheelwright became, at the age of forty, an eminent amateur anthropologist. She founded the Museum of Navajo Ceremonial Art in Santa Fe, N.M., in 1936. Her study of symbolism in primitive religions

around the world was published by the Peabody Museum at Harvard University in 1956.

WHEELWRIGHT, WILLIAM (*b. Newburyport, Mass., 1798; d. England, 1873*), merchant mariner, promoter of Latin American enterprises. Became U.S. consul at Guayaquil in 1824. Removing to Valparaiso *ca.* 1830, he built port facilities, provided gas and water works, and also secured British charter for Pacific Steam Navigation Co. (1840) of which he became chief superintendent. Between 1849 and 1852, he built the first railroad in Chile; in 1850 he gave Chile the first South American telegraph line. He also promoted the Grand Central Argentine Railway (opened 1870), a part of his projected trans-Andean railway (completed, 1910). He created the port of La Plata and completed the railroad linking it with Buenos Aires, 1872.

WHELPLEY, HENRY MILTON (*b. Battle Creek, Mich., 1861; d. Argentine, Kans., 1926*), pharmacist, drug-trade editor, teacher. Graduated St. Louis (Mo.) College of Pharmacy, 1883. Professor of microscopy, 1886–1922, at his *alma mater*; professor of pharmacognosy, materia medica, and physiology, 1915–26; dean, 1904–26. From 1890 to 1909 he also served as professor of these subjects at a number of other Missouri institutions.

WHERRY, ELWOOD MORRIS (*b. South Bend, Pa., 1843; d. Indiana, Pa., 1927*), Presbyterian clergyman. Graduated Princeton Theological Seminary, 1867. Served in missions to India, 1867–89, and 1898–1922. Among other works, he published a monumental *Comprehensive Commentary of the Quran* (1882–84).

WHERRY, KENNETH SPICER (*b. Liberty, Nebr., 1892; d. Washington, D.C., 1951*), politician. Studied at the University of Nebraska and at Harvard University, 1915–16. Elected to the U.S. Senate as a Republican in 1942, he served until his death. An isolationist and conservative, Wherry was opposed to the policies of the New and Fair Deals, all foreign aid, federal aid to education and housing, and the Office of Price Administration. Too conservative to be a party policymaker, he was an efficient party member.

WHETZEL, HERBERT HICE (*b. near Avilla, Ind., 1877; d. Ithaca, N.Y., 1944*), phytopathologist, mycologist. Graduated Wabash College, 1902. Graduate study at Cornell University with George F. Atkinson. Headed department of plant pathology at Cornell *post* 1906, resigning the chairmanship in 1922 to devote himself to his research and teaching as professor. A dynamic and innovative teacher, he concentrated in his early research on practical problems of plant disease control; later, he devoted more and more time to mycology. His researches on the family *Sclerotiniaceae* were a major contribution to the field of plant pathology.

WHIPPLE, ABRAHAM (*b. Providence, R.I., 1733; d. Marietta, Ohio, 1819*), naval officer. Brother-in-law of Stephen and Esek Hopkins. In 1772 he led party which burned British schooner *Gaspée* near Pawtucket, R.I., sometimes regarded as the first overt act of the Revolution. Appointed Rhode Island commodore, 1775, he captured the British frigate *Rose*, first prize taken by an official American vessel. In 1779, commanding flagship *Providence* as commodore of a Continental squadron, he brought back eight East-Indiamen, one of the richest captures of the war. Entrusted with naval defense of Charleston, S.C., 1780, he was made prisoner when the city was taken.

WHIPPLE, AMIEL WEEKS (*b. Greenwich, Mass., 1816; d. Washington, D.C., 1863*), soldier, topographical engineer. Graduated West Point, 1844–49; on survey of boundary between United States and Mexico, 1849–53; and on Pacific Railroad surveys, 1853–56. As chief topographical engineer, he served with Union forces at Bull Run. Promoted brigadier general, April 1862, he was active in the defense of Washington until October when he was assigned command of the third division of the III (Stoneman's) Corps. He was mortally wounded on the second day of Chancellorsville (May 3, 1863).

WHIPPLE, EDWIN PERCY (*b. Gloucester, Mass., 1819; d. Boston, Mass., 1886*), broker, lyceum lecturer, literary critic. Published, among other works, *Essays and Reviews* (1848–49), *Lectures on Subjects Connected with Literature and Life* (1850), *Recollections of Eminent Men* (1887), and *American Literature and Other Papers* (1887) with an introduction by Whittier, his intimate friend. Popular as a lyceum lecturer, he enjoyed a considerable contemporary reputation as a reviewer and critic, exhibiting logical analysis, imagination, discrimination, and sensitive love of beauty.

WHIPPLE, FRANCES HARRIET *See* GREEN, FRANCES HARRIET WHIPPLE.

WHIPPLE, HENRY BENJAMIN (*b. Adams, N.Y., 1822; d. Faribault, Minn., 1901*), Episcopal clergyman, reformer of U.S. Indian system. Ordained priest, 1850; rector, Zion Church, Rome, N.Y., until 1857 except for 1853–54. Built up and administered Holy Communion parish, south side of Chicago, 1857–59. Consecrated first bishop of Minnesota, October 1859, he opposed the U.S. government's Indian policy. During the 1862 uprising of the Minnesota Sioux, which began the series of Indian wars he had predicted, Whipple appealed on behalf of the Indians to the outraged settlers and to President Lincoln who forbade execution of many condemned Sioux. His proposed reforms of the reservation system, and his suggestions of land-ownership by Indians, adequate schools, and inspection, were largely adopted under President Grant. During the next two decades he exposed frauds, built up missions among the Minnesota Chippewa, traveled widely, and made eloquent addresses in America and abroad for support of his work. In 1897 he attended the fourth Lambeth Conference as presiding bishop of the American Church. Author of an autobiography, *Lights and Shadows of a Long Episcopate* (1899).

WHIPPLE, SHERMAN LELAND (*b. New London, N.H., 1862; d. Brookline, Mass., 1930*), Boston, Mass., lawyer. Graduated Yale Law School, 1884. Celebrated as a plaintiff's attorney in personal injury and will cases.

WHIPPLE, SQUIRE (*b. Hardwick, Mass., 1804; d. Albany, N.Y., 1888*), civil engineer, author, inventor. A.B., Union College, 1830. Devised (*ca.* 1846) a widely used truss of trapezoidal form which placed him among American pioneers in development of the pure truss bridge. Whipple's chief contribution to bridge engineering was publication of *A Work on Bridge Building* (1847), the first notable attempt to present the subject on a scientific basis and the first thorough treatment of modern methods of computing stresses and designing parts to meet them.

WHIPPLE, WILLIAM (*b. Kittery, Maine, 1730; d. 1785*), merchant, revolutionary patriot, New Hampshire legislator. Prominent in early provincial congresses and a close associate of John Langdon. Member of the Continental Congress, 1776–79, with interludes for militia commands, he was a signer of the Declaration of Independence. An active committee member, he urged effective naval operations and strong measures against speculators and Tories. He advocated also the spread of the burden of the struggle over the entire people by means of adequate taxation.

He served as a justice, state supreme court, from 1782 until his death.

WHISTLER, GEORGE WASHINGTON (*b. Fort Wayne, Ind., 1800; d. St. Petersburg, Russia, 1849*), soldier, engineer. Father of James A. M. Whistler. Graduated West Point, 1819. Commissioned second lieutenant of artillery, he was assigned to topographical duty. In 1828 he assisted in location and construction of the Baltimore and Ohio Railroads, subsequently supervising construction of other roads. Resigned from army, 1833. As chief engineer, Western Railroad of Massachusetts (now Boston & Albany), 1840–42, he located section between Springfield and Pittsfield through the Berkshires under especially difficult conditions. This resulted in appointment by the Czar of Russia as consulting engineer for a railroad between St. Petersburg and Moscow which was completed in 1850. He also supervised construction of fortifications and docks at Cronstadt, and of the iron bridge of the Neva.

WHISTLER, JAMES ABBOTT MCNEILL (*b. Lowell, Mass., 1834; d. London, England, 1903*), painter, etcher, author. Son of George W. Whistler; nephew of William G. McNeill. A bright boy, somewhat delicate in health but precociously able as a draftsman, Whistler resided in Russia and England, 1843–49. Although his mother was offered a place for him in the Russian imperial school for pages after his father's death, she brought him and her other children back to America in 1849. A West Point cadet, 1851–54, he was dismissed for deficiency in chemistry. "Had silicon been a gas," he is reported to have said, "I would have been a major general." He retained from his military education his insistence upon the point of honor, his erect carriage, and probably his lifelong proclivity for fighting. After a brief engagement as a draftsman of maps in the U.S. Coast Survey at Washington, D.C., during which he learned much about the mechanics of etching, he departed to study in Paris, 1855.

He never returned to his native country probably because he found more congenial conditions of life abroad and friends with whom he was instinctively at home. Entering the atelier of Charles Gleyre, a competent painter in the tradition of Ingres, Whistler conducted himself in dress and manner as a Bohemian of the Bohemians. He had the gift of dramatizing his own every movement and adopted originality as a career, not because he was a *poseur*, but because he couldn't help it; he was invincibly an individual in his life as in his work. Among his friends of this period were many artists later to become famous—among them, George Du Maurier, Henri Fantin-Latour, and Alphonse Legros. Resisting contemporary French art influences with the exception of that of Gustave Courbet, Whistler sought beauty in truth but subjected truth to his very personal conception of beauty. Among his early paintings, *The Music Room*, with its decisively decorative motive, foreshadows the essential Whistler. He published his first group of etchings in Paris, November 1858. His painting *The White Girl*, rejected at the Paris Salon in 1863, later made a sensation in the Salon des Refusés.

After the 1850's, Whistler oscillated between Paris and London, with London becoming more and more the field of his labors. His mother came to live in England, 1863, and it was there that he painted the celebrated portrait of her first shown in 1872 and now in the Louvre. In London, between 1872 and 1877, he painted those other portraits which won him so much reputation—notably his *Carlyle*, and *Miss Alexander*. Also of London ancestry are his *Nocturnes* and the Thames set of etchings. Harshly criticized by John Ruskin for work shown in the Grosvenor gallery exhibition of 1877, Whistler sued the critic (November 1878), winning a nominal verdict. He later described the affair in his book *The Gentle Art of Making Enemies* (1890). The episode served to dramatize the fact that Whistler had cre-

ated something new and strange in art, something beyond the comprehension of the contemporary British mind which had been nurtured on the sentimental "subject" picture or painted anecdote. "Take the picture of my mother," he said, "exhibited at the Royal Academy as an 'Arrangement in Grey and Black.' Now that is what it is. To me it is interesting as a picture of my mother; but what can or ought the public to care about the identity of the portrait?" Again, in regard to one of his Nocturnes, he said "My picture of a 'Harmony in Grey and Gold' is an illustration of my meaning—a snow scene with a single black figure and a lighted tavern. I care nothing for the past, present, or future of the black figure, placed there because the black was wanted at that spot. All that I know is that my combination of grey and gold is the basis of the picture."

Sensitive to the appeal of Japanese art, he acquired from Japan a feeling for pattern as pattern. His admiration for Velásquez was great, but Whistler was by no means a disciple of the great Spaniard. Each painter strove for perfection, which probably explains Whistler's admiration; but each did so in his own specific way. Velásquez was first and last constrained to record the fact before him, but Whistler, although properly regardful of the fact, was constrained to produce a distinctively Whistlerian pattern or "harmony." The many Nocturnes and Symphonies by Whistler do more than even his original and distinguished portraits to bring out the artist's singularity and creative power. He was not a great designer as Raphael was, nor was his craftsmanship equal to that of Velásquez. He gave us no high imaginative conceptions and attempted no emotional interpretation of life. However, he is very rich in sheer beauty, partly through the simplicity characterizing his design and his arrangement of color, and partly through the play of mysterious and elusive feeling. His contribution to art was inimitable. He has had no followers, as he had no predecessors, in painting.

On the other hand, Whistler has had a widespread influence upon etching, and it is a paradox in his career that the draftsmanship which worried him so much when he was using a brush was ever ready to his hand when he used an etcher's needle. He was already a master of line and style in the French set of etchings which date from 1858; the Thames set (1860) discloses the same technical authority and grasp of composition. By the time he went to Venice in the 1870's and in later years, he more and more practiced elimination of intrusive detail, employing a lighter, more broken line in work of great beauty and distinction. His lithographs, as well as his etchings and paintings, express his distinctive artistic qualities and are equally models of conscientious craft. A prodigious worker, absorbed in his art, he often presented himself to the public as a dilettante, discharging airy shafts of wit against critics, artists, functionaries, or any others who appeared to him either bad at their work or scornful of his aesthetic principles. His gifts of sarcasm, as well as his inexhaustible gaiety, are to be found in *The Gentle Art of Making Enemies* (1890) in which he also expresses his philosophy of art. Much of what it contains had already appeared in pamphlets, exhibition catalogues, and letters to the press.

Prosperous *post* 1885, admired and imitated by the rising generation of young artists, he moved a good deal in society and served briefly but effectively as president of the Society of British Artists and of the International Society of Sculptors, Painters and Gravers. Subsequent to the early 1890's, he lived mainly in Rue du Bac, Paris, and gave some of his time to teaching in the short-lived Académie Carmen. After the failure of his health *ca.* 1901, he traveled for a time in Africa and Corsica before returning to London where he died.

WHITAKER, ALEXANDER (*b. Cambridge, England, 1585; d. near Henricopolis, Va., 1616/17*), Anglican clergyman. Came to Virginia as a volunteer minister, 1611. Helped to form and

strengthen Virginia's attitude of welcome toward Puritan ministers and lay people, and to establish the colony's characteristic tradition of low churchmanship. Instructed and baptized Pocahontas in Christian faith. Author of *Good News from Virginia* (1613).

WHITAKER, CHARLES HARRIS (*b. Woonsocket, R.I., 1872; d. Great Falls, Va., 1938*), architectural editor and critic. A strong influence on modern architecture as editor-in-chief of the *Journal of the American Institute of Architects*, 1913–27; author of *Rameses to Rockefeller: The Story of Architecture* (1934).

WHITAKER, DANIEL KIMBALL (*b. Sharon, Mass., 1801; d. Houston, Tex., 1881*), editor, writer. South Carolina planter, lawyer. B.A. Harvard, 1820. Organized, edited, and contributed to Southern periodicals including *Southern Quarterly Review*, New Orleans, La., 1842–47, which encouraged such well-known writers as William G. Simms.

WHITAKER, NATHANIEL (*b. Huntington, N.Y., 1730; d. Hampton, Va., 1795*), Presbyterian clergyman, Revolutionary patriot. Conducted a tour in the British Isles with Samson Occom, 1766, which raised £12,000 for Moor's Charity School for Indians and effected the grant of the Dartmouth College charter, 1769. D.D., St. Andrew's University, 1767. Minister, Third Church, Salem, Mass., 1769–84; Presbyterian Church, Skowhegan, Maine, 1785–90. An ardent patriot, active in practical matters, his fondness for controversy brought him many enemies.

WHITCHER, FRANCES MIRIAM BERRY (*b. Whitesboro, N.Y., 1814; d. Whitesboro, 1852*), author. Her popular humorous sketches satirizing smalltown society appeared in Joseph C. Neal's *Saturday Gazette and Lady's Literary Museum*, 1846–50, and in *Godey's Lady's Book*. They were published as *The Widow Bedott Papers* (1856) and *Widow Spriggins, Mary Elmer, and Other Sketches* (1867).

WHITCOMB, JAMES (*b. Rochester, Vt., 1795; d. New York, N.Y., 1852*), lawyer, Indiana legislator. Father-in-law of Claude Matthews. Raised near Cincinnati, Ohio. Prosecuting attorney at Bloomington, Ind., 1826–29. Commissioner, General Land Office, 1836–41. Established successful law practice at Terre Haute, Ind., 1841. As governor of Indiana (the first Democrat to defeat a Whig), 1843–48, he contributed decisively toward adjustment of staggering indebtedness incurred by previous internal improvements, promoted popular education and developed state benevolent institutions. An ardent supporter of the national administration in war with Mexico. U.S. senator from Indiana, 1849–52. Author of *Facts for the People* (1843), one of the most effective arguments ever written against a protective tariff.

WHITCOMB, SELDEN LINCOLN (*b. Grinnell, Iowa, 1866; d. 1930*), educator, writer. A.B., Grinnell, 1887; A.M., Columbia, 1893. A notable teacher, he was professor of English, Grinnell College, 1895–1905; professor of comparative literature, University of Kansas, 1905–30. Author of poems, essays on nature, and studies in literature which include *Chronological Outlines of American Literature* (1894).

WHITE, ALBERT SMITH (*b. Blooming Grove, N.Y., 1803; d. near Stockwell, Ind., 1864*), lawyer, jurist, railroad builder. Settled in Tippecanoe Co., Ind., 1829. Congressman, Whig, from Indiana, 1837–39; U.S. senator, 1839–45. As congressman, Republican, from Indiana, 1861–63, he introduced a resolution for a plan for gradual indemnified emancipation of slaves in the border states which was supported by President Lincoln. Judge, U.S. District Court for Indiana, 1864.

WHITE, ALEXANDER (*b. Frederick Co., Va., ca. 1738; d. 1804*), lawyer, Virginia legislator. Began practice in Virginia, 1765. Served in state House of Burgesses, 1772; later championed allegedly Loyalist Quakers. In state assembly, 1782–86, 1788, 1799–1801, he was one of James Madison's ablest lieutenants. Successful leader in northwestern Virginia for ratification of U.S. Constitution, 1788. Congressman, Federalist, from Virginia, 1789–93. A commissioner to lay out city of Washington, D.C., 1795–1802.

WHITE, ALEXANDER (*b. Elgin, Scotland, 1814; d. 1872*), pioneer merchant, art collector. Immigrated to America, 1836. Settled in Chicago, Ill., 1837; prospered as merchant in paints, oils, glass, and dyestuffs and *post* 1857 in real estate. His collection of notable European contemporary and American paintings constituted the first private art gallery in Chicago. Sold at auction, New York, 1871, it was considered the best in America at that time.

WHITE, ALFRED TREDWAY (*b. Brooklyn, N.Y., 1846; d. Orange Co., N.Y., 1921*), pioneer in housing reform. Built model tenements in Brooklyn, N.Y., *post* 1876; also Riverside Tower and Homes Building, 1890, and others. His outstanding success spurred enactment of New York's tenement-reform legislation of 1895 and later. Published, among other books, *Better Homes for Workingmen* (1885). As commissioner of city works (appointed 1893), he set new standards of efficiency and economy.

WHITE, ALMA BRIDWELL (*b. Lewis County, Ky., 1862; d. Zarephath, N.J., 1946*), schoolteacher, evangelist, founder of the Pillar of Fire Church.

WHITE, ANDREW (*b. London, England, 1579; d. London, 1656*), Jesuit missionary, "Apostle of Maryland." A proscribed recusant, he was ordained at Douai (now France), ca. 1605, and joined the Society of Jesus, 1609. While a secret priest in England, he corresponded with George Calvert, first Baron of Baltimore, and composed the *Declaratio Coloniae Domini Baronis de Baltimore* (revised and published by Cecil Calvert as *Conditions of Plantation*). Headed mission to Baltimore's immigrant group which sailed on the *Ark* and the *Dove*, landing in the lower Chesapeake, March 25, 1634. Missionary to the white colonists and Indians for ten years, he was author of *Relatio Itineris in Marilandiam*. He arranged a scheme of manors for the support of the Catholic organization in the palatinate. After William Claiborne's Puritan insurrection, 1644, White was shipped in irons to London, tried for treason, and exiled.

WHITE, ANDREW DICKSON (*b. Homer, N.Y., 1832; d. Ithaca, N.Y., 1918*), educator. Graduated Yale, 1853; studied briefly at Paris and Berlin. Served as an attaché to the U.S. legation at St. Petersburg, Russia, 1854–55. After a year of graduate study again at Yale, he became professor of history in the University of Michigan, 1857. While winning distinction as an inspiring and original teacher, he matured his early concept of a state university for New York which would be as scholarly and free as the universities which he had observed in his travels abroad. In writing for help to his friend Gerrit Smith, he described the university of his dream as "excluding no sex or color, battling mercantile morality and tempering military passion . . . it should afford an asylum for science where truth shall be sought for truth's sake." In command of considerable wealth after the death of his father in 1860, he continued to propagandize in favor of his university, but was obliged to seek rest abroad late in 1862.

Returning to America late in 1863, he found that he had been elected *in absentia* to the New York State senate. As chairman of the senate committee on education, 1864, he played a large

part in codifying New York's school laws and creating its new normal schools. Employing the endowment of land given New York under the Morrill Act, together with the benefactions of Ezra Cornell whom he won over to his own plans, White worked with Cornell to draw the charter of a new university at Ithaca, N.Y., which should bear Cornell's name. The educational clauses of the charter were written by White and ensured instruction not only in agriculture and the mechanic arts as the Morrill Act directed, but also provided for instruction in "such other branches of science and knowledge as the trustees may deem useful and proper." After a sharp struggle with rivals the charter was validated, April 1865. The most novel elements in the new institution were: (1) its democracy of studies—the humanities, sciences, and technical arts taught commonly; (2) its parallel courses, open to free choice and leading to varying but equal degrees; (3) its equal rank for modern languages and literatures and for history and political science with classics; (4) its large use of eminent scholars as "nonresident professors;" (5) its treatment of the students as men, not boys.

As Cornell would not go on with the project unless White served as president, White resigned his position at Michigan, and set about gathering a faculty and equipment, reserving the chair of European history for himself. At the opening of the university in 1868, its resident faculty was young, although among the nonresidents were Louis Agassiz and J. R. Lowell, George W. Curtis, James Hall, and Bayard Taylor. In addition to teaching, White busied himself in defending the university and its founder against attacks on its method; he also coped with financial crises brought about by a failure of working capital. He continued to struggle with his burdens until 1885 when he was succeeded as president by Charles K. Adams. Meanwhile, he had spent several years abroad in travel and had served as U.S. minister to Germany, 1879–81; in 1884 he had helped found the American Historical Association, becoming its first president.

After seeking to recruit his health again in travel, 1885–89, he resumed his research work and lectured widely. Among the many honorable posts which he held thereafter were U.S. minister to Russia, 1892–94; U.S. ambassador to Germany, 1897–1902; and a trusteeship of the Carnegie Institution of Washington under the presidency of his old friend Daniel C. Gilman *post* 1902. He considered the greatest event of his diplomatic career his headship of the American delegation to the Hague Conference, 1899. He was author, among other works, of *History of the Warfare of Science with Theology* (1896) and an *Autobiography* (1905).

WHITE, BENJAMIN FRANKLIN (*b. Whitevale, Ontario, 1873; d. Orlando, Fla., 1958*), driver, breeder, and trainer of harness horses. The trainer and driver of more winners of major harness races than anyone in history, White drove in nineteen Hambletonians, winning four; he also won seven Kentucky Futurities, six Matron Stakes, and four Review Futurities. His success earned him the title "Dean of Colt Trainers." Famous horses he trained and drove include Lee Worthy, Volga, Rosalind, and Volo Song.

WHITE, CANVASS (*b. Whitesboro, N.Y., 1790; d. St. Augustine, Fla., 1834*), civil engineer. Benjamin Wright's principal assistant *post* 1818 on Erie Canal construction; was chief expert in designing the locks and their equipment; supervised Glens Falls feeder. Obtained patent for waterproof cement (1820). Chief engineer, Delaware & Raritan Canal, New Jersey, and Lehigh and Union canals in Pennsylvania. Characterized as possessing "the most strict engineering mind . . . of his time."

WHITE, CHARLES ABIATHAR (*b. North Dighton, Mass., 1826; d. Washington, D.C., 1910*), geologist, paleontologist, naturalist, physician. Raised near Burlington, in Territory of Iowa. His large

collections of fossils, including the famous Burlington crinoids, served to introduce his work to James Hall, F. B. Meek, A. H. Worthen, and other geologists of the time. Graduated Rush Medical College, 1864. From 1866 to 1870 he served as Iowa state geologist; he was also professor of geology, Iowa State University, 1867–74. Employed successively, 1875–79, by G. M. Wheeler's survey west of 100th meridian, by J. W. Powell's survey of Rocky Mountain region, and by F. V. Hayden's geological survey of the Territories, he published important reports and paleontological studies. Curator, invertebrate fossils, National Museum, Washington, D.C., 1879–82; organized paleontologic collections. Geologist, U.S. Geological Survey, 1882–92. White's major scientific contributions were in invertebrate paleontology and stratigraphy, particularly of the Mesozoic.

WHITE, CHARLES IGNATIUS (*b. Baltimore, Md., 1807; d. Washington, D.C., 1878*), Roman Catholic clergyman. Ordained to secular priesthood, Notre Dame Cathedral, Paris, France, 1830. Influential and scholarly rector, St. Matthew's Church, Washington, D.C., 1857–78, where he did notable social work. A founder and editor (1842) of *Religious Cabinet* (later *U.S. Catholic Magazine* and *Metropolitan Magazine*, 1853).

WHITE, CHARLES WILBERT (*b. Chicago, Ill., 1918; d. Los Angeles, Calif., 1979*), artist. Because he was influenced by socialism and the Harlem Renaissance early in his career, African–American workers and laborers were his main subjects. During the late 1930's, with the Works Progress Administration, he created the noted mural *Five Great American Negroes* for the Chicago Public Library. In the 1950's, due to his health problems with paint chemicals, he turned to graphics and drawings and explored issues of his African heritage; he honored African–American women as matriarchal figures in such works as *Solid as a Rock* (1954). In 1968 he executed a series of drawings titled *I Have a Dream*, in memory of Martin Luther King, Jr.

WHITE, CLARENCE CAMERON (*b. Clarksville, Tenn., 1880; d. New York, N.Y., 1960*), violinist, composer, and educator. Studied at the Oberlin Conservatory of Music. Taught at the Washington Conservatory of Music, 1903–08; at West Virginia State College, 1924–30; and at the Hampton Institute, 1932–35. Major works include many pieces about black life in America and the Caribbean: *Forty Negro Spirituals* (1927), *Traditional Negro Spirituals* (1940), and the opera *Ouanga* (1932), first performed in 1949. Other works include *Elegy* (1954), *Fantasie* (1954), and *Heritage* (1959), with text by poet Countee Cullen. A major black composer, White's works for violin have been performed by Fritz Kreisler and Albert Spalding, among others.

WHITE, DAVID (*b. near Palmyra, N.Y., 1862; d. Washington, D.C., 1935*), paleobotanist, geologist. B.S., Cornell University, 1886. Associated thereafter with the U.S. Geological Survey, he performed most of his research in the period before 1912, at which time he was made chief geologist of the Survey and became active in the National Academy of Sciences. He was curator of paleobotany, U.S. National Museum, 1903–35. He resigned the post of chief geologist, 1922, to return to research, but his administrative duties continued to be heavy.

In such works as *Fossil Flora of the Lower Coal Measures of Missouri* (1899) and *Flora of the Hermit Shale, Grand Canyon, Arizona* (1929), White brought to his work an unusually keen mind; he was never content with a mere description of fossils, but interpreted them in terms of their chronology and environment, particularly their climatic significance and the part which they took in the foundation of coal and petroleum. His methodology consisted essentially in employment of a much greater precision than had been used by earlier scientists and in the

discrimination of slight differences, particularly if such differences could be shown to occur at different stratigraphic horizons. His success demanded a combination of work in the field with personal office studies of the resulting collections. His method provided a disproof of prevailing opinions on the constitution of the Appalachian coal basin; he was also able to show that coals should be classified according to a standard in which the degree of deoxygenation served as an index of coal evolution; this in turn led to the generalization announced in 1915 (commonly known as the "carbon-ratio" hypothesis) which enables the determination of the rank of a coal, and also limits the extent of liquid and gaseous hydrocarbons. A few years later the economic importance of this brilliant idea was universally recognized in petroleum exploratory work. White's theory, amplified and clarified, was stated in his "Metamorphism of Organic Sediments and Derived Oils" (*Bulletin of the American Association of Petroleum Geologists*, May 1935).

WHITE, EDWARD DOUGLASS (*b. Maury Co., Tenn., 1795; d. New Orleans, La., 1847*), lawyer, planter, political leader. Father of Edward D. White (1845–1921). Studied law in office of Alexander Porter. Congressman, Whig, from Louisiana, 1829–34 and 1839–43. As governor of Louisiana, 1835–39, he effectively vetoed bill to charter Farmers' Bank in panic of 1837.

WHITE, EDWARD DOUGLASS (*b. Parish Lafourche, La., 1845; d. Washington, D.C., 1921*), lawyer, Confederate soldier, planter, jurist. Son of Edward D. White (1795–1847). Left the present Georgetown University to serve in the Confederate Army; studied law after the Civil War with Edward Bermudez. Admitted to the Louisiana bar, 1868, he entered politics and served in the Louisiana senate; he was also a justice of the state supreme court, 1879–80. Early identified with the anti-lottery movement, he was elected to the U.S. Senate as a Democrat and served, 1891–94. Appointed to the U.S. Supreme Court, 1894, he was raised to the post of chief justice, 1910.

During his years on the bench, Justice White wrote opinions in more than 700 cases. It is difficult to characterize his decisions as a whole. He was sometimes found with the so-called liberals as, for example, when he dissented in the case of *Lochner v. New York* (1905) and when he wrote the majority opinion in *Wilson v. New* upholding the Adamson Act. On the other hand, while he concurred in the New York Central case (243 *U.S.*, 188) upholding the New York workmen's compensation act, he dissented in the Mountain Timber Co. case (243 *U.S.*, 219) which upheld the Washington compensation law. Many other examples of an apparent inconsistency could be cited. *Wilson v. New* was probably the most important decision he ever wrote even though the reasoning he employed left much to be desired, but he is doubtless best known for the "rule of reason" laid down in the Standard Oil and the American Tobacco cases (221 *U.S.*, 1, 106) interpreting and applying the Anti-trust Act. He had earlier announced this rule in a dissent. It must be said, however, that by applying the rule he wrote into the law something which Congress had not put there, and that he did it by a sophistical course of reasoning.

An untiring worker, courteous and devoted to the public service, he unwittingly gave an approximation of his own philosophy in a 1916 address on the death of Joseph R. Lamar. It could be said of him, as he said of Lamar, that he appreciated keenly the duty to adjust between conflicting activities so as to preserve the rights of all by promoting the rights of each, and that it was his duty to uphold and sustain the authority of the Union as to the subjects coming within the legitimate scope of its power as conferred by the Constitution. He believed that no thought of expediency, no mere convictions about economic problems, and no personal belief that the guarantees of the Constitution were becoming obsolete should sway his purpose to uphold and protect those constitutional guarantees.

WHITE, EDWARD HIGGINS, II (*b. San Antonio, Tex., 1930; d. Cape Kennedy, Fla., 1967*), U.S. Air Force officer and astronaut. Graduated from the U.S. Military Academy (1952) and received a master's degree from the University of Michigan (1959). He was accepted into the astronaut program by the National Aeronautics and Space Administration in 1962, and he was the pilot on *Gemini IV* in 1965. In 1966 he was named to the crew of the first Apollo flight. With Virgil Grissom and Roger Chaffee he was killed in a fire in the Apollo spacecraft during a preflight ground test.

WHITE, ELLEN GOULD HARMON (*b. Gorham, Maine, 1827; d. St. Helena, Calif., 1915*), Seventh-day Adventist leader. Embracing Advent faith of William Miller in the 1840's, she exerted great influence on Adventists, most of whom accepted her visions and messages as from God. Her husband, Rev. James White, managed Adventist publishing work *post* 1849. They founded the Western Health Reform Institute, Battle Creek, Mich., 1866, and promoted Battle Creek College (founded 1874). Mrs. White also helped found College of Medical Evangelists, Loma Linda, Calif., 1909.

WHITE, EMERSON ELBRIDGE (*b. Mantua, Ohio, 1829; d. 1902*), educator. Influential as editor and proprietor, *Ohio Educational Monthly*, 1861–75; as commissioner of common schools, 1863–65, he codified Ohio school laws. President, Purdue University, 1876–83. Superintendent, Cincinnati, Ohio, public schools, 1886–89. President, among other school organizations, of National Council of Education, 1884, which he helped found. Author of widely used *White's New School Register Containing Forms for Daily, Term and Yearly Records* (1891), and of a number of textbooks.

WHITE EYES, (*d. 1778*), Delaware chief. Became chief sachem of the Delaware nation, 1776. Held his people neutral in early stages of the Revolution because of false representations by agent George Morgan; was deceived into signing treaty with the American states, 1778. Murdered while guiding American troops against Detroit.

WHITE, GEORGE (*b. Charleston, S.C., 1802; d. 1887*), writer, teacher, Episcopal clergyman. Self-educated, White settled in Savannah, Ga., 1823, where he established an academy and night school. He was ordained, 1833. Helped organize Georgia Historical Society, 1839. Published *Statistics of the State of Georgia* (1849), a work of great merit; also an account of the Yazoo Fraud (1852), and *Historical Collections of Georgia* (1854), a classic in Georgia bibliography. Among other church assignments, he served as rector of Calvary Church, Memphis, Tenn., 1859–85.

WHITE, GEORGE (*b. New York, N.Y., 1890; d. Los Angeles, Calif., 1968*), producer, director, actor, librettist, and lyricist. Danced in Bowery saloons, then teamed up with Benny Ryan. They appeared on Broadway in *The Echo* (1910). On his own, White appeared in the 1911 *Ziegfeld Follies, Vera Violetta* (1911), in which he helped to popularize the turkey trot, *The Red Widow* (1912), *The Whirl of Society* (1912), *The Pleasure Seekers* (1913), *The Midnight Girl* (1914), and the 1915 *Ziegfeld Follies*. During 1919–39 White produced thirteen editions of his musical revues called the *Scandals*. He also produced and directed *Runnin' Wild* (1923), in which the Charleston was introduced, *Manhattan Mary* (1927), *Flying High* (1930), *George White's Music Hall Varieties* (1932, 1933), and *Melody* (1933). He wrote, produced, directed, and performed in film versions of

the *Scandals* (1934, 1935, 1945), and he appeared as himself in the film *Rhapsody in Blue* (1945).

WHITE, GEORGE LEONARD (*b. Cadiz, N.Y., 1838; d. Ithaca, N.Y., 1895*), conductor of Jubilee Singers of Fisk University, music teacher, self-educated, White was a choir leader in Ohio. He became instructor of vocal music at Fisk University, Nashville, Tenn., 1867, and subsequently a trustee and treasurer. To help maintain Fisk, White took a choir of his newly emancipated students on highly successful concert tours (1871–78) in America, Great Britain, and the Continent, spreading understanding and respect for the freedmen.

WHITE, HENRY (*b. Maryland, 1732; d. England, 1786*), Loyalist, New York city merchant. Appointed to the Province Council, 1769; opposed Stamp and Townshend acts. Agent and attorney for Governor Tryon, 1774. A signer of the Loyal Address to the Howes, he served the British by equipping Tory provincial regiments and as agent for selling prizes. By Act of Attainder, 1779, his property was confiscated and he later removed to London.

WHITE, HENRY (*b. Baltimore, Md., 1850; d. Pittsfield, Mass., 1927*), diplomat. Son-in-law of Lewis M. Rutherfurd. Began career as secretary, Vienna legation, 1883; was second, then first, secretary in London, 1883–93; Richard Olney's unofficial agent in clearing up Venezuelan dispute. Resuming his London post, 1897, he served brilliantly for eight years under Ambassadors John Hay and Joseph Choate in furthering Anglo-American cooperation. Ambassador to Italy *post* March 1905, and to France, 1907–09, he was President Roosevelt's agent at the Algeciras Conference, 1906, and aided in preventing a warmenacing rupture. Head of American delegation, fourth Pan-American Conference, Buenos Aires, 1910. Appointed by President Wilson to Peace Commission, November 1918, he accompanied Wilson to Paris and strongly advocated America's entrance into the League of Nations. White might be called the first professional American diplomatist.

WHITE, HENRY CLAY (*b. Baltimore, Md., 1848; d. Athens, Ga., 1927*), chemist, educator. Graduated University of Virginia, 1870. Appointed professor of chemistry at University of Georgia, 1872; served as president, Georgia State College of Agriculture and the Mechanic Arts, 1890–1907. State chemist of Georgia, 1880–90, and vice-director, Georgia Experiment Station, 1890–1913. Organized Farmers' Institutes of Georgia.

WHITE, HORACE (*b. Colebrook, N.H., 1834; d. 1916*), journalist, economist. Raised in Beloit, Wis. Reported on Lincoln-Douglas debates, 1858, for *Chicago Tribune*, becoming friend of Lincoln and Henry Villard; was *Tribune's* Washington correspondent, 1861–65, and served as its editor-in-chief, 1865–74. Managed financial and economic policies of *New York Evening Post* and the *Nation* from *ca.* 1883; was editor in chief of the former, 1899–1903, succeeding E. L. Godkin. A free-trader and Manchester-school liberal, he threw himself into the *Evening Post's* opposition to Hawaiian annexation; he also opposed America's attitude in the Venezuelan imbroglio with England (1895), the war with Spain, and the Philippine conquest. His paper's editorial page was one of the most distinguished in American journalism. Author of *Money and Banking* (1985) and other works.

WHITE, HUGH LAWSON (*b. Iredell Co., N.C., 1773; d. near Knoxville, Tenn., 1840*), Tennessee legislator and jurist. Son of James White. Secretary to William Blount, 1793. Judge, superior court of Tennessee, 1801–07. Chosen presiding judge, supreme court of errors and appeals, 1809, he served until 1815. President,

Bank of the State of Tennessee, 1812–27. U.S. senator, Democrat, from Tennessee, 1825–40. A strict constructionist, a Jeffersonian and Jacksonian Democrat, he opposed J. Q. Adam's administration. As chairman of the committee on Indian affairs, he was active in planning for Indian removal westward. President Jackson, to promote Martin Van Buren's political fortunes, attempted to force acceptance of the U.S. secretaryship of war on White, 1831; in refusing, White broke with Jackson. With John Tyler as his running mate and the support of the Whigs, he ran for the U.S. presidency in 1836 and was defeated. He favored Henry Clay for the presidency in 1840 and promised him support after Clay's pledge not to push his nationalist program and to oppose Texas annexation. White resigned from the Senate, January 1840, when instructed by the Tennessee legislature to vote for the subtreasury bill. Strict of conscience, he was entirely disinterested as a public servant.

WHITE, ISRAEL CHARLES (*b. Monongalia Co., present W. Va., 1848; d. Baltimore, Md., 1927*), geologist. Graduated West Virginia University, 1872; studied also at Columbia University. Held chair of geology at West Virginia, 1877–92; from 1897 until his death was superintendent of geological survey of West Virginia which he largely established; was assistant geologist on U.S. Geological Survey, 1884–88. He was author of "Stratigraphy of the Bituminous Coal Field of Pennsylvania, Ohio, and West Virginia" (1891), said to be the foundation for later work in this field. His most important work, ranking him foremost among petroleum geologists of the world, was his "anticlinal theory" of oil and gas, formulated *ca.* 1883. In it he drew the conclusion that a direct relation existed between gas territory and disturbance in rocks caused by their upheaval into arches. Successful dealings in "wildcat" leases proved his theory. His White House address "The Waste of Our Fuel Resources" (May 1908) greatly influenced the subsequent conservation movement.

WHITE, JAMES (*b. Rowan, present Iredell, Co., N.C., 1747; d. Knoxville, Tenn., 1821*), Revolutionary soldier, pioneer, North Carolina and Tennessee legislator. Father of Hugh L. White. Laid out town of Knoxville, Tenn., 1792; directed its defense against Indians, 1793. Served in 1796 convention which drew up Tennessee constitution; supported policies of William Blount and John Sevier; represented Tennessee in first treaty of Tellico, 1798. Made brigadier general, Tennessee militia, in late 1790's; he served in the Creek War, 1813.

WHITE, JAMES CLARKE (*b. Belfast, Maine, 1833; d. 1916*), dermatologist, reformer of medical education. Graduated Harvard, 1853; M.D., Harvard Medical School, 1856; did postgraduate work in Vienna. Adjunct professor of chemistry, Harvard Medical School, 1866–71; held chair of dermatology, 1871–1902. Established with B. J. Jeffries first dermatological clinic in America *ca.* 1860. President, Sixth International Dermatological Congress, 1907.

WHITE, JAMES WILLIAM (*b. Philadelphia, Pa., 1850; d. Philadelphia, 1916*), surgeon. Nephew of Samuel S. White. M.D. and Ph.D., University of Pennsylvania, 1871. Professor of clinical surgery at Pennsylvania, 1887–1900; Barton Professor of Surgery, 1900–11, becoming professor emeritus. Author, with Edward Martin, of *Genito-Urinary Surgery and Venereal Diseases* (1897), his most important work. An editor of *Annals of Surgery*, 1892–1916.

WHITE, JOHN (*fl. 1585–93*), artist, cartographer. Sent by Sir Walter Raleigh to Roanoke Island on the expedition of 1585, White painted a series of sketches in water color depicting the flora and fauna of America as well as the appearance of the native

Indians. These first scientific and careful studies are primary historical sources. They were later adapted in engravings by Theodore de Bry for the 1590 edition of Thomas Hariot's *A Briefe and True Report of Virginia*. It is possible that he was the John White who served as governor of Raleigh's "second colonie," Roanoke, Va., *post* 1587.

WHITE, JOHN BLAKE (*b. near Eutaw Springs, S.C., 1781; d. ca. 1859*), artist, dramatist, lawyer. Studied under Benjamin West, 1800–03. Settled in Charleston, S.C., 1804, where he remained for most of his life. Between 1804 and 1840 he produced historical pictures (four in the U.S. Capitol) and portraits; also painted miniatures. Among his plays were *Foscari* (1806) and *The Triumph of Liberty, or Louisiana Preserved* (1819).

WHITE, JOHN DE HAVEN (*b. near New Holland, Pa., 1815; d. Philadelphia, Pa., 1895*), dentist. Practiced in Philadelphia *post* 1837. Graduated Jefferson Medical College, 1844. Teacher of Thomas W. Evans and Samuel S. White. An organizer of Philadelphia College of Dental Surgery, he was professor of anatomy and physiology and of operative dental surgery and special dental physiology, 1854–56. Author of numerous professional papers.

WHITE, JOHN WILLIAMS (*b. Cincinnati, Ohio, 1849; d. Cambridge, Mass., 1917*), Hellenist. Graduated Ohio Wesleyan, 1868; Ph.D., Harvard, 1877. Taught Greek at Harvard, 1874–1909. Aided President C. W. Eliot in expansion of the college into a university. Broke from older teaching methods by insisting on wide and rapid reading in his courses on Greek authors; was expert in Greek meters. Founded with J. B. Greenough and helped edit the *Harvard Studies in Classical Philology*; with C. E. Norton and W. W. Goodwin, organized Archaeological Institute of America, 1879. Influenced James Loeb; helped establish Loeb Classical Library.

WHITE, JOSEPH MALACHY (*b. New York, N.Y., 1891; d. New York, 1959*), composer and singer. One of the first recording artists and radio singers, White was an Irish tenor. He became famous while performing with the B.F. Goodrich Silvertown Orchestra on radio from 1924 to 1930. Known as "The Silver-Masked Tenor," White sang on radio and in vaudeville until 1943, when his leg had to be amputated because of an accident. Songs he composed include "Maureen Mavourneen," "In Flanders," and "Drifting in the Moonlight."

WHITE, JOSH (*b. Greenville, S.C., 1915; d. Manhasset, N.Y., 1969*), guitarist and folksinger. He also performed as Tippy Barton, Pinewood Tom, and the Singing Christian. From the age of seven wandered the streets of southeastern cities and Chicago, leading a series of blind street singers and learning their songs. He recorded Blind Joe Taggart and Blind Lemon Jefferson. He performed in New York City with Clarence Williams' "Southernaires" and in 1939 formed the Josh White Singers. White appeared on Broadway in *John Henry* (1940), *Blue Holiday* (1945), and *A Long Way from Home* (1948). He recorded and appeared with Leadbelly and became a favorite performer of President Roosevelt, entertaining frequently at the White House. His best-known songs include "Ball and Chain Blues," "Delia," "Hard Times Blues," "Jim Crow Train," "Silicosis Blues," "Uncle Sam Says," and "Welfare Blues." Described as "a pre-Belafonte black sex idol," he was a major contributor to the blues and to American folk music

WHITE, LEONARD DUPEE (*b. Acton, Mass., 1891; d. Chicago, Ill., 1958*), political scientist. Studied at Dartmouth College and at the University of Chicago (Ph.D., 1921). Taught at the University of Chicago, 1920–56, chairman of the political science department, 1940–48. An expert in public administration and the civil service, White was a member of the Committee on Social Trends from 1929. From 1934 to 1936 he was commissioner of the U.S. Civil Service Commission; and from 1939 to 1941 he was a member of Roosevelt's Committee on Civil Service Improvement. Major works include histories of the American civil service and public administration: *The Federalists* (1948); *The Jeffersonians* (1951); *The Jacksonians* (1954); and *The Republican Era, 1869–1901* (1958), which won him the Pulitzer Prize in 1959. President of the American Political Science Association in 1944.

WHITE, MINOR MARTIN (*b. Minneapolis, Minn., 1908; d. Boston, Mass., 1976*), photographer. Graduated University of Minnesota (B.A., 1933) and was hired by the Works Progress Administration in 1938 to photograph Portland (Oregon) architecture. In 1941 he participated in the *Image of Freedom* exhibition at the Museum of Modern Art in New York and had his first one-man show in 1942 in Portland. In 1952 he cofounded the influential photography journal *Aperture*, which he helped edit until his death. He worked at Eastman House in Rochester, N.Y. (1952–55) and taught at the Rochester Institute of Technology (1955–64). In 1959 he had his largest exhibition, *Sequence 13/Return to the Bud*, at Eastman House. In 1965 he began a photography program at the Massachusetts Institute of Technology. He published *Mirrors, Messages, Manifestations* (1969), a compilation of photos and writings. He stressed natural light in his photography, which frequently depicted objects of wood, stone, and other organic substances.

WHITE, PAUL DUDLEY (*b. Roxbury, Mass., 1886; d. Boston, Mass., 1973*), physician and cardiologist. Graduated Harvard College (1908) and Medical School (1911); studied cardiovascular physiology with Dr. Thomas Lewis in London (1913); worked at Massachusetts General Hospital (1919–48); and served on the Harvard faculty (1921–56). The founder of preventive cardiology, White cofounded the American Heart Association (1924), was named executive director of the National Advisory Heart Council in 1949, and was chief consultant to the National Heart Institute (1948–55). He wrote more than 700 articles and twelve books, including *Heart Disease* (1931).

WHITE, PEARL (*b. Greenridge, Mo., 1889; d. Paris, France, 1938*), motion picture actress, star of *The Perils of Pauline* (1914) and other popular serial motion pictures.

WHITE, RICHARD GRANT (*b. New York, N.Y., 1821; d. New York, 1885*), writer. Graduated present New York University, 1839. Won distinction as musical critic of *Morning Courier and New-York Enquirer*. Wrote extensively for *Putnam's Magazine*, *Galaxy*, *Atlantic Monthly*, and London *Spectator*. Author, among other works, of *The New Gospel of Peace* (anonymous, 1863–66), *Words and Their Uses* (1870), and *Studies in Shakespeare* (1886). An acute Shakespeare scholar, he edited *The Works of William Shakespeare* (1857–66). He was father of Stanford White.

WHITE, SAMUEL (*b. Kent Co., Del., 1770; d. Wilmington, Del., 1809*), lawyer. Admitted to the Delaware bar, 1793. U.S. senator, Federalist, from Delaware, 1801 until his death.

WHITE, SAMUEL STOCKTON (*b. Hulmeville, Pa. 1822; d. Paris, France, 1879*), dental supplies manufacturer, dentist. Credited with important improvements in porcelain teeth; also introduced new or improved dental appliances and instruments.

WHITE, STANFORD (*b. New York, N.Y., 1853; d. New York, 1906*), architect. Son of Richard G. White. Worked in firm of Gambrill & Richardson as close associate of H. H. Richardson

post ca. 1872; was associated with Charles F. McKim and W. R. Mead and others in McKim, Mead & White *post* 1880. A friend of Augustus Saint-Gaudens, White designed the pedestal for Saint-Gaudens' statue of Farragut in Madison Square, New York City (unveiled, 1881), for which he received much praise. Operating on the theory that all things intrinsically good can be brought into harmony, White worked with great skill in a number of styles; he planned luxurious city and country houses, designed furniture, ransacked Europe for interior decorations, designed magazine covers, gravestones, and jewelry. The splendid success of McKim, Mead & White was aided by the rapid contemporary increase in wealth in America and the desire of the traveled wealthy for a share in Old World art and culture. White was notably successful among his partners in impressing wealthy clients with a respect for the beautiful even though they might fail to understand it, and was aptly called the protagonist of popular art in New York City. Among the number of churches which he designed, the Judson Memorial in Washington Square, New York City, remains as an example. He was designer also of a number of clubs including the Metropolitan Club, New York City, his supreme achievement in Renaissance architecture. His work has been described as graceful and charming rather than imposing; among his most enduring achievements are the Washington Arch (New York City) and the Prison Ship Martyrs Monument, Brooklyn, N.Y. His business buildings included the one-time Gorham and Tiffany buildings on Fifth Avenue, New York City, and he was the designer (1889) of the original Madison Square Garden. There he met his death, murdered by Harry K. Thaw.

WHITE, STEPHEN MALLORY (b. *San Francisco, Calif., 1853; d. Los Angeles, Calif., 1901*), lawyer. Admitted to the bar, 1874, he began successful practice in Los Angeles, Calif. U.S. senator, Democrat, from California, 1893–99. Favored free coinage of silver, opposed imperialism, and championed the "country" voters against monopolistic aggression. Defeated C. P. Huntington's plans to divert federal funds from San Pedro to harbor site desired by Southern Pacific Railroad.

WHITE, STEPHEN VAN CULEN (b. *Chatham Co., N.C., 1831; d. 1913*), banker, lawyer. Raised in Illinois. Practiced law in Iowa, 1856–64, and was acting U.S. district attorney for Iowa, 1864. Became member of New York Stock Exchange, 1869, where he was soon known as a daring manipulator, especially in shares of Delaware, Lackawanna & Western Railroad. Congressman, Republican, from New York, 1887–89. He was a friend of Henry Ward Beecher and long the treasurer of Plymouth Church.

WHITE, STEWART EDWARD (b. *Grand Rapids, Mich., 1873; d. San Francisco, Calif., 1946*), author. Traveled widely as a child and youth in the wilder parts of the West and Canada, which lent verisimilitude to his action-filled, romantic stories. A lover of adventure and the outdoors, he worked at various times as trapper and lumberjack; in later life, he traveled and explored in East Africa. Among his books (which included novels, travel books, juveniles, and collections of essays and short stories) were: *The Westerners* (1901); *The Blazed Trail* (1902); *Arizona Nights* (1907); his carefully researched fictional history of California in *Gold* (1913); *The Gray Dawn* (1915); *The Rose Dawn* (1920); *The Leopard Woman* (1916); and *The Long Rifle* (1932).

WHITE, THOMAS WILLIS (b. *Williamsburg, Va., 1788; d. New York, N.Y., 1843*), printer. Established successful printing business in Richmond, Va., ca. 1817. Founded (1834) the *Southern Literary Messenger*, of which Edgar Allan Poe was editor, 1835–37.

WHITE, WALTER FRANCIS (b. *Atlanta, Ga., 1893; d. New York, N.Y., 1955*), civil rights leader. Studied at Atlanta University. Member of the NAACP, 1918–55; assistant secretary of the national staff, 1918–31; from 1931, executive secretary. Only one-fourth black and fair-complexioned, White wrote a novel *Flight* (1926) telling of experiences of passing for white. In 1929, he wrote *Rope and Faggot; A Biography of Judge Lynch*, a study of the complex forces behind lynching. Under White's leadership, the NAACP embarked on its most important legal battles: anti-lynching legislation, the press for equality in public conveniences, education, and the professions, and the battle for equality in elections and voting rights. In 1946 he led a delegation to the White House and persuaded President Truman to establish the President's Committee on Civil Rights which led to the controversial civil rights platform in the 1948 Democratic campaign. In 1945 he published *A Rising Wind*, an exposé of discrimination against black soldiers which led to Truman's 1948 executive order desegregating the armed forces. In spite of friction within the NAACP, White remained a leader of the organization until his death.

WHITE, WILLIAM (b. *Philadelphia, Pa., 1748 n.s.; d. Philadelphia, 1836*), Episcopal clergyman. Graduated College of Philadelphia, 1765; ordained deacon in London, England, 1770, and priest, 1772. Principal rectorate at Christ Church, Philadelphia. Largely devised plan for organization of Protestant Episcopal Church in the United States (1785–89) on principle that laity should have an equal part with clergy in all legislation; drafted original constitution of Church and secured its adoption. With William Smith, he was chiefly responsible for the American revision of the Book of Common Prayer. Consecrated bishop of Pennsylvania in England, 1787, he served with tact and ability and was presiding bishop *post* 1796. Noted for active promotion of Sunday School work; trained, among other clergyman, W. A. Muhlenberg and J. H. Hobart. Long chaplain of Congress, he published, among other works, *Comparative Views of the Controversy between the Calvinists and the Arminians* (1817) and *Memoirs of the Protestant Episcopal Church in the United States of America* (1820).

WHITE, WILLIAM ALANSON (b. *Brooklyn, N.Y., 1870; d. Washington, D.C., 1937*), psychiatrist, hospital administrator. M.D., Long Island College Hospital, 1891. Influenced by Boris Sidis while at Binghamton (N.Y.) State Hospital. Superintendent of the present St. Elizabeth's Hospital, Washington, D.C., *post* 1903, he established a psychological laboratory there, developed department of internal medicine, and was an early exponent of psychoanalysis. Under his leadership the hospital became one of the leading centers of psychiatric care and training in the United States. A professor at Georgetown and George Washington universities, he also taught in the army and navy medical schools; he was president of the first International Congress on Mental Hygiene, Washington, D.C., 1930. Among his many publications was *The Outlines of Psychiatry* (1907).

WHITE, WILLIAM ALLEN (b. *Emporia, Kans., 1868; d. Emporia, 1944*), newspaper editor, author. Raised in Eldorado, Kans., son of a physician-druggist, he was accustomed to hear public issues debated at home and so learned a lifelong tolerance for contrary views. Taught to honor the Puritan conscience, he attended Sunday schools and camp meetings, but did not join the Congregational Church until he was an adult. His father died in the midst of financial reverses when White was in high school. He attended the College of Emporia (1884–86) and the University of Kansas, 1886–90, but did not graduate. After a series of newspaper jobs, White borrowed $3,000 in 1895 and bought the daily *Emporia Gazette*. His lively, conversational editorial

style soon made him the most celebrated person in town and his Aug. 15, 1896, editorial entitled "What's the matter with Kansas?" made him nationally famous. Republican editors in Chicago and new York reprinted it, and in the year of the campaign against William Jennings Bryan and free silver, the Republican national chairman, Marcus A. Hanna, distributed more than a million copies over the country. For *McClure's* he wrote a series of boyhood stories later collected as *The Court of Boyville* (1899). A group of fictionalized articles on politics for *Scribner's Magazine*, published in 1901 as *Stratagems and Spoils*, reflected his Republican conservatism.

By 1901 his political outlook had begun to change. On his first trip east, in 1897, he met Theodore Roosevelt, who quickly became his political hero. White began to see a need for government regulation of business and such reforms as the direct primary. He also met S. S. McClure and formed friendships with Lincoln Steffens and Ray Stannard Baker. When in 1906 Steffens, Baker, Ida M. Tarbell, and others took over the *American* magazine, White joined them as an Emporia-based editorial associate. His articles for the *American* and *Collier's* now expounded progressive ideas. In Kansas he worked to build up a reform-minded antirailroad wing of the Republican party. White helped found the National Progressive Republican League in 1911 and was an early supporter of Robert M. La Follette for president. The next year he followed Roosevelt into the Progressive party.

After the Progressive spell broke, White returned, disheartened, to the Republican fold. He praised Wilson's progressivism in 1913, and during the war years he backed the government's control of prices, wages, and the railroads and vigorously supported the League of Nations. A mission to inspect Red Cross services took him overseas in 1917, and in 1919 he reported the Paris Peace Conference

As a member of the platform committee of the Republican national conventions of 1920 and 1928 he sought, with little success, to commit the party to more progressive policies. He supported the unions in the 1922 railroad strike, during which he was briefly under arrest for displaying a pro-union poster in the window of the *Gazette* office. His editorial during the controversy received a Pulitzer Prize. He was an uncompromising foe of the Ku Klux Klan. When in 1924 he could not persuade either candidate for governor of Kansas to oppose the Klan, he ran as an independent, delighting in the opportunity to speak out against intolerance. Yet White shared a small-town dislike of the cities and their way of life that, together with his strong prohibitionism, led him to attack Alfred E. Smith in the campaign of 1928 with a severity that distressed even members of his family.

White's attitude toward the New Deal was ambivalent. He did not wholly trust Franklin D. Roosevelt and criticized many of his specific proposals. White's efforts to liberalize the Republican platform in 1936 were again unsuccessful, and his backing of his fellow Kansan Alfred M. Landon was less than enthusiastic. White was most consistent in his endorsement of Roosevelt's foreign policies. After the outbreak of World War II he became a leading advocate of supplying Britain and France with arms and war materials. For nearly a half-century the sage of Emporia was nationally recognized as a spokesman and interpreter of rank-and-file, first-name, commonsense, God-fearing, good-neighbor, small-town, Main Street America.

WHITE, WILLIAM NATHANIEL (b. Longridge, Conn., 1819; d. 1867), horticulturist, editor. Settled in Georgia, 1847. Authority on pomology, horticulture, and rural economy, he became editor (1863) and owner (1865) of the *Southern Cultivator*. Author of *Gardening for the South* (1856), a standard work.

WHITEFIELD, GEORGE (b. Gloucester, England, 1714 o.s.; d. Newburyport, Mass., 1770), clergyman, evangelist. The son of a tavern keeper, but descended from a line of clergymen, Whitefield as a boy was impetuous and emotional, but his own picture of his youthful depravity is doubtless over-colored. Admitted as a servitor to Pembroke College, Oxford, 1732, he made the acquaintance of Charles and John Wesley. Adopting a rule of life and engaging in charitable activities, he behaved with such fanatical zeal that he became seriously ill late in the spring of 1735. Experiencing a "new birth" at this time, he was filled with a sense of the pardoning love of God and became convinced that such an experience was indispensable to all individuals in search of religious conviction. While recovering from his illness, he converted some of his friends and formed a religious society; he devoted a part of each day to corporal works of mercy. Returning to Oxford, March 1736, he was admitted to deacon's orders in Gloucester Cathedral in June. The powerful effect of his first sermon upon his fellow townsmen was prophetic of the power over audiences which he was to exhibit later. In July he was graduated as B.A. from Oxford and, as the Wesleys were now in Georgia, he became leader of the few Methodists left at the university. Taking every opportunity offered to preach his idea of the "new birth," he soon achieved extraordinary prominence in several provincial cities and in London, incidentally collecting large sums of money for the Georgia mission of the Wesleys and for charity schools. Soon attacked by conservative churchmen, he left for Georgia on Dec. 30, 1737, accompanied by friends, one of whom was James Habersham.

Undiscouraged by the unsatisfactory experiences of the Wesley brothers in Georgia, Whitefield landed at Savannah on May 7; during a four-months' stay, he began services, started several schools, and determined to establish an orphanage. Returning to England in September 1738, he was ordained priest in January 1739, but encountered further bitter opposition at home and was denied use of churches for preaching. Accepting the use of halls and other meeting places, he continued his preaching work, delivering his first open-air sermon on Feb. 17, 1739, to a group of colliers near Bristol; soon he was preaching at many of the public resorts of the London populace. Accused of ignorance and Pharisaism (with considerable justification), he persevered in his work as an itinerant preacher to constantly increasing audiences, and won the patronage of several members of the aristocracy, notably the Countess of Huntingdon.

Departing once again for America, August 1739, he remained there for more than a year, although his parish at Savannah saw little of him. He spent most of his time in further itinerant preaching which awakened religious excitement all the way from Georgia to Massachusetts; encouraged by the Presbyterians and Congregationalists, he was opposed by clergy of the Church of England. Among his supporters among the Presbyterians were William and Gilbert Tennent. During a brief stay in Savannah, he began construction of the orphanage which he had planned, giving it the name Bethesda, but he soon made himself disliked by his general attitude of censoriousness and his abuse of fellow clergymen. Setting out once again to visit the North, he preached with great effect in Philadelphia and in New York; among his triumphs was the securing of a donation for his orphanage from Benjamin Franklin. Summoned before an ecclesiastical court in Charleston, S.C., June 1740, because of irregularities in doctrine and practice, he denied the court's jurisdiction, failed to appear and was suspended, but did not cease his activities. Journeying to New England, he produced there the same great religious awakening that he had already produced in the Middle Colonies. On his leisurely return southward he stopped in many places, visiting Jonathan Edwards at Northampton, Mass., and when in New Brunswick, N.J., persuading Gilbert Tennent to go to Bos-

ton and further the revival which was in progress there. He sailed for England in January 1741, and almost four years elapsed before he was once again in America.

Whitefield had by now become a rigid Calvinist and engaged in a unpleasant controversy with John Wesley. His admirers had built the Tabernacle for him in London, but he continued his wanderings and his field-preaching in all parts of the British Isles. In Wales he was made moderator of the first Calvinistic Methodist Conference. Married in Wales, November 1741, he left England for America with his wife in August 1744, landing at the present York, Maine. Since his first visit to New England, a spirit of opposition to him had arisen in many of the Congregational leaders, foremost among whom was Charles Chauncy (1705–1787). Yet he had strong supporters and his preaching continued to draw large audiences. Removing to Georgia at the end of 1745, he spent part of the next two years there and in evangelistic journeys; in 1748 he went to Bermuda and returned to England during that same summer to become domestic chaplain to the Countess of Huntingdon. He also continued his preaching in London and throughout the British Isles.

His activities in Great Britain were broken by four more visits to America. In 1751–52 he spent some seven months in Georgia and the Carolinas; in 1754–55 he spent about the same period of time on a preaching itinerary that included Philadelphia, New York, Virginia, and parts of New England. Returning in September 1763, he remained until *ca.* 1765, traveling and preaching as always, and also petitioning Georgia for a grant of land for establishment of a college at Bethesda; this failed because of opposition in England. In September 1769 he left England for the last time, arriving in Charleston, S.C., in November, and proceeding to Bethesda. In the spring of 1770 he entered on a most strenuous itinerary, preaching in Pennsylvania, New York, and New England, during which he met his death at Newburyport, Mass.

A man of middle stature, graceful, although somewhat fleshy in his later years, he had a fair complexion and small, keen dark-blue eyes in one of which was a noticeable squint. When speaking, he used many gestures; his voice was strong and musical and his mastery of it was perfect; his histrionic gifts would have made him one of the immortals of the stage and he was a master of pathos. He followed a simple and orderly manner of life. Easily irritated, he was as easily placated. His influence in America, quite apart from that which he exerted in Great Britain, was far-reaching. He stimulated a religious awakening which had already begun and by his preaching added thousands to the churches. The doctrinal discussions which arose in his wake resulted in a definitely American contribution to theology. He gave impetus to education and to philanthropic work. It is fair to say that because he made the denominations intercolonial and encouraged his followers to ignore parish and sectional lines, he made a very real contribution to the creation of a distinct Americanism among the colonies. His work also encouraged limitation of ecclesiastical and political authority and advocated freedom of conscience and individual liberty; his weakening of the Church of England in the South loosened one of the closest links between the colonies and the mother country. In these and other respects the Great Awakening prepared the way for revolution and independence.

WHITEHEAD, ALFRED NORTH (*b. Ramsgate, Isle of Thanet, Kent, England, 1861; d. Cambridge, Mass., 1947*), philosopher. Son of an Anglican clergyman, who had been headmaster of a private school; educated at home until age fourteen, when he was sent to school at Sherborne in Dorset. He was outstanding there in mathematical studies and rugby; in his last year, he was head prefect and captain of games. In 1880 he matriculated at Trinity College, Cambridge (B.A., 1884). In October of that year

he was elected a fellow of Trinity (his dissertation was on Clerk Maxwell's theory of electricity and magnetism) and appointed an assistant lecturer in mathematics, becoming the senior lecturer in 1903. He earned the D.Sc. in 1905.

Whitehead wrote few papers in mathematics, although he taught that subject for thirty-nine years. He was most interested in those newer branches that went beyond the traditional notion of what mathematics was — quaternions, the Boolean algebra of logic, and Grassmann's calculus of extension. The first volume of his *Treatise on Universal Algebra* (1898) secured his election to the Royal Society in 1903. He abandoned a second volume to collaborate with Bertrand Russell on *Principia Mathematica*, which is generally considered one of the great intellectual monuments of all time. In January 1901 Russell secured Whitehead's collaboration on the second volume of his *Principles*. Russell always deplored the tendency of scholars to give him the major credit for *Principia Mathematica*. Most of the work was done by 1909, and the three huge volumes were published in 1910–13. Whitehead began a fourth volume, but he never finished it.

In 1910 Whitehead resigned his lectureship and moved to London. In this year he wrote *Introduction to Mathematics*. University College in 1911 made him lecturer in applied mathematics and mechanics and in 1912 appointed him reader in geometry. In 1914 Whitehead was elected to the chair of applied mathematics at the Imperial College of Science and Technology, where he remained until 1924. If the fourth volume of *Principia Mathematica* had been finished, it would have presented a complete theory of geometry, conceived as the first chapter of natural science. The development of Whitehead's thought went into three books on the foundations of natural science: *An Enquiry Concerning the Principles of Natural Knowledge* (1919), *The Concept of Nature* (1920), and *The Principle of Relativity* (1922).

In a memoir published by the Royal Society in 1906, Whitehead had expressed the classical concept of the material world (as composed of particles occupying points of space at instants of time) and some theoretical alternatives to it. The main purpose of the *Enquiry* was to replace the classical concept, with its unperceivable points and instants, by a coherent set of meanings defined in terms logically derived from the kinds of data and of relationships that are given in every external perception. The *Enquiry* was highly original, but it was too philosophical and the paths to the required definitions were too intricate to influence physicists. His principle of relativity was explored by a few mathematical physicists but could not compete with Einstein's.

Whitehead was more successful with philosophers, and *The Concept of Nature*, a nonmathematical companion to his *Enquiry*, made a great impression. In 1924 Harvard offered him a five-year appointment, as professor of philosophy. Whitehead had made a point of excluding metaphysics from his work on the basic concepts of natural science; now he felt his way into a metaphysical position that would embody that work and satisfy his convictions about value and existence. He emphasized the continuing disastrous effect on Western culture of "scientific materialism." The most striking thing here was Whitehead's appeal to his favorite poets, Wordsworth and Shelley, against the extrusion of values from nature. He held that philosophic theory must not defy, but elucidate, the unsophisticated intuitive experience of mankind and that the deepest expression of these institutions is found in great poetry.

In 1926 Whitehead published *Religion in the Making*. He argued that religion needs a metaphysics and makes its own contribution to metaphysics. His discussions of religious experience and expression and of the use and misuse of dogmas were short and pointed. He attempted a compressed presentation of his metaphysical system at the University of Edinburgh in June

1928. Because of its complexity and the new terminology required, the lectures were a fiasco, but their publication in 1929 was an important event in the history of metaphysics.

The central notion in Whitehead's speculative philosophy was that of a process, or becoming, and it was handled in an original way. No one before Whitehead had produced a full-fledged non-Hegelian theory of process. As Whitehead was aware (although not in detail), some Buddhistic philosophies long ago had made process ultimate; but they sought intuitive, not intellectual, understanding of it. Whitehead's concept of becoming was based on his analysis of an occasion of human experience, considered in its entirety and not as limited to what we are conscious of. In *Symbolism: Its Meaning and Effect* (1927) he argued that a vague, but insistent, perception of casual efficacy underlies all our sensory impressions. In *Process and Reality*, he developed the thesis that an experience is fundamentally a process of absorbing the past and making ourselves different by actualizing some value-potentialities and rejecting others.

In an experience-event, so conceived, consciousness, thought, and sense perception may be absent. The basic pattern could be ascribed to an amoeba and even to the inanimate — not to rocks, but to their molecules or to subatomic particles — by permitting novelty to be negligible or limited to alternation. Whitehead fashioned a conceptual matrix for all levels of existence with his speculative hypothesis: the ultimate units of the entire temporal world ("actual occasions") are becomings, each an individual process of appropriating (prehending) into its perspective the infinity of items ("reality") provided by the antecedent universe of finished becomings and by God, the abiding source of new potentialities. As each becoming is the achievement of an organic unity, Whitehead called his metaphysics "the philosophy of organism." According to it, living things are those organizations of becoming that show a marked degree of coordinated initiative in their reactions to the pressures of their environments, and any object that we meet in everyday life or in science is a group of interdependent series ("societies") of becomings that maintain a certain character for a certain time. The various sciences of course use their own concepts of process; Whitehead's hope was that these (e.g., wave transmission of energy, nutrition, communication) could be placed under his metaphysical theory, in accordance with the special abstractions that each science makes in delimiting its topic, and he made some suggestions toward this end. As for our laws of nature, Whitehead thought it parochial to suppose them eternal; they only express average regularities that prevail in what he called "our present cosmic epoch."

The many principles that appear in Whitehead's formal statement of his speculative hypothesis presuppose three notions implicit in that of becoming: "many," "one," and "creativity." Whitehead tried to fashion and interweave his concepts in such a way as to bridge every traditional dualism. Whitehead would not allow anything in his universe the possibility of existing in independence of other things. His metaphysics is a unified monadology, much richer than Leibniz's.

The originality of Whitehead's theism stems from his way of conceiving of God and the temporal world as mutually dependent and of both as "in the grip of the ultimate metaphysical ground, the creative advance into novelty." This conception of a growing God has become the most favored and most discussed part of Whitehead's metaphysics. In *Adventures of Ideas* (1933) Whitehead used his lifetime of reading in history to bring out the humanistic and sociological side of his philosophy. It was the third and last of his major American books, and the best for most readers.

Whitehead's published writings do not show that his metaphysics was implicit in the work he did while a mathematician; they do exhibit the same imaginative mind seeking, in each area

it dealt with, a precision and a generality beyond that of familiar terms. Whitehead was a speculative thinker — indeed, one of the greatest — with a great respect for facts and a healthy disrespect for their compartmentalization and conventional expression. The rarity of such disrespect in his readers accounts for the frequency with which his philosophical writing is called deliberately obscure. Harvard revised the terms of his appointment and did not retire him until 1937.

WHITEHEAD, WALTER EDWARD (*b. Aldershot, England, 1908; d. Petersfield, England, 1978*), businessman. Worked in the advertising department of General Accident Assurance Company, London (1925–39), and joined the Royal Navy Volunteer Reserve (1937), where he rose to the rank of commander (discharged 1946). He became overseas advertising manager of the Schweppes beverage company (1950) and was named to the board of directors (1952), expanding international sales and arranging for local bottlers in other nations. He came to the United States in 1953 as president of Schweppes (USA) and established a reciprocal bottling agreement with Pepsi-Cola Company, appeared in an advertising campaign that featured Commander Whitehead as the embodiment of British aristocracy, and introduced Schweppes bitter lemon and ginger ale to the United States. He also hosted the radio program "This Is Britain" (1959–61). He became chairman of Schweppes (USA), then director of the merged Cadbury Schweppes (1969–71).

WHITEHEAD, WILBUR CHERRIER (*b. Cleveland, Ohio, 1866; d. at sea, 1931*), bridge expert. Author of *Whitehead's Conventions of Auction Bridge* (1914) and *Auction Bridge Standards* (1921). Contributed a complete tabulation of conventions of play and desirable leads and a complete bidding system. A founder and first president of the Cavendish Club.

WHITEHEAD, WILLIAM ADEE (*b. Newark, N.J., 1810; d. 1884*), historian. Collector of the port of Key West, Fla., 1813–38, and also mayor. A leading organizer of the New Jersey Historical Society, 1845, and its secretary until his death, he published, among other works, *East Jersey Under the Proprietary Governments* (1846); *The Papers of Lewis Morris* (1852); and *Documents Relating to the Colonial History of the State of New Jersey* (1880–85).

WHITEHILL, CLARENCE EUGENE (*b. Marengo, Iowa, 1871; d. New York, N.Y., 1932*), opera singer. Studied in Paris, 1896, at urging of Melba and Campanari. Made debut, 1899, as Friar Lawrence in *Romeo and Juliet* at Théâtre de la Monnaie, Brussels. Leading baritone, Cologne Opera House, 1903–08. Well known for Wagnerian roles, he sang at Metropolitan Opera House, N.Y., 1909–11, 1915–32.

WHITEHILL, ROBERT (*b. Lancaster Co., Pa., 1738; d. near Harrisburg, Pa., 1813*), Pennsylvania legislator and official. Played an important part in drafting the state constitution (1776) and was principal aide of George Bryan. A strong anti-Federalist and democrat, he was one of the group which set up a vehement opposition in the Pennsylvania back country, whose suspicions of central government he reflected in the Pennsylvania convention to ratify the Federal Constitution. Congressman, Democratic-Republican, from Pennsylvania, 1805 until his death.

WHITEHOUSE, FREDERIC COPE (*b. Rochester, N.Y., 1842; d. New York, N.Y., 1911*), lawyer, archeologist. Chiefly interested in Egyptology, he was author, among other writings, of *Lake Moeris: Justification of Herodotus* (1855), *Memorandum on the Raiyan Project and the Action of Her Majesty's Government* (1891), and *The Assuan Reservation and Lake Moeris* (1914).

Devoted many years to promotion of plan for irrigation of lower Egypt by impounding surplus Nile flood-waters.

WHITEMAN, PAUL SAMUEL ("POPS") (*b. Denver, Colo., 1890; d. Doylestown, Pa., 1967*), bandleader. Played with the symphony orchestras in Denver and San Francisco. In 1919 he formed the "original" Paul Whiteman orchestra. In concert in 1924 he performed the number that became most associated with him, *Rhapsody in Blue*, with the composer, George Gershwin, playing the piano part. Known as the "King of Jazz," Whiteman starred in numerous radio programs beginning in the mid-1920's. In 1929 he hired the vocalist Mildred Bailey. In 1943 he became musical director of the Blue Network, later known as the American Broadcasting Company. He was a vice president of the ABC network (1947–55). Also appeared in films and television.

WHITESIDE, ARTHUR DARE (*b. East Orange, N.J., 1882; d. New York, N.Y., 1960*), executive. Studied at Princeton University. As president of National Credit from 1912, Whiteside succeeded in incorporating National Credit, R.G. Dun and the Bradstreet Company, into Dun and Bradstreet, Inc., (1933). He served as president until 1952, and served on the board of directors until his death. The company became the nation's leading credit reporting bureau.

WHITFIELD, HENRY (*b. near London, England, 1597; d. Winchester, England, 1657/8*), nonconformist clergyman, settler. Friend of George Fenwick. Came to New Haven Colony, 1639; returned to England, 1650. Founded, with William Leete and others, the town of Guilford, Conn.; preached to Indians and aided John Eliot in work of conversion. Cotton Mather spoke of the "marvelous majesty and sanctity" of his preaching.

WHITFIELD, OWEN (*b. Jamestown, Miss., 1892; d. Cape Girardeau, Mo., 1965*), Baptist minister and union organizer. Attended Okolona College, and by the 1930's had become pastor of a number of rural churches. Joined the Southern Tenant Farmers Union (1937) and became one of the union's best organizers. In January 1939 he organized a massive roadside demonstration in Missouri to protest mass evictions of croppers and tenant farmers (a device common to the civil rights protests of the 1950's and 1960's). The demonstration did not produce radical changes in farm policy, and he again became minister of several churches.

WHITFIELD, ROBERT PARR (*b. New Hartford, N.Y., 1828; d. Troy, N.Y., 1910*), draftsman, paleontologist. Became chief illustrator, New York State geological survey, 1856; for twenty years, made highly finished drawings of fossils for reports of James Hall. Curator of geology, American Museum of Natural History, New York City, 1877–1909, he identified and classified the James Hall fossil collection and others; prepared and published a catalogue of museum's 8,000 types and figured specimens; helped establish museum's *Bulletin*.

WHITING, ARTHUR BATTELLE (*b. Cambridge, Mass., 1861; d. Beverly, Mass., 1936*), pianist, teacher, composer. Nephew of George E. Whiting. Studied in Boston with William H. Sherwood and George W. Chadwick; in Munich with Josef Rheinberger and Ludwig Abel. Best known for his "university concerts" of chamber music at many Eastern colleges and universities, he was a composer in the classic spirit whose high musical ideals and severity of judgment limited his output of composition. His most admired work was a Fantasy for Piano and Orchestra (1897).

WHITING, CHARLES GOODRICH (*b. St. Albans, Vt., 1842; d. Otis, Mass., 1922*), journalist. Literary editor, *Springfield Repub-*

lican, 1874–1910; associate editor, 1910–19. Author of *The Saunterer* (1886) and *Walks in New England* (1903).

WHITING, GEORGE ELBRIDGE (*b. Holliston, Mass., 1840; d. Cambridge, Mass., 1923*), organist, composer, organ teacher. Head of organ and composition department, College of Music, Cincinnati, Ohio, 1878–82; organist and music director, Church of the Immaculate Conception, Boston, Mass., 1882–1910. Principal instructor of organ, New England Conservatory of Music, 1876–78 and 1882–98.

WHITING, WILLIAM (*b. Concord, Mass., 1813; d. Roxbury, Mass., 1873*), lawyer, public official. Graduated Harvard, 1833; LL.B., 1838. Eminent in his own field of patent law, he served during the Civil War as a special counselor of the U.S. War Department, and as its solicitor, 1863–65. He was author of two useful tracts, *The War Powers of the President, etc.* (1862) and *Military Arrests in Time of War* (1863), together with other works.

WHITING, WILLIAM HENRY CHASE (*b. Biloxi, Miss., 1824; d. Governors Island, N.Y., 1865*), Confederate major general. Graduated West Point, 1845. As chief engineer of General J. E. Johnston's Army of the Shenandoah, he arranged transfer of troops to Manassas, 1861, where he was promoted brigadier general by order of President Davis. At Gaines's Mill the conduct of his division was characterized by General T. J. Jackson as a "matchless display of valor." Assumed command (November 1862) of the military district of Wilmington, N.C., which he guarded for two years, making Cape Fear River the best haven in the South for blockade runners. Developed Fort Fisher into the most powerful defensive work of the Confederacy. Heroically aided Colonel Lamb in defense of Fort Fisher, 1865.

WHITLOCK, BRAND (*b. Urbana, Ohio, 1869; d. Cannes, France, 1934*), writer, diplomat. A journalist in Toledo, Ohio, 1887–90, and in Chicago, Ill., 1891–93, he was admitted to the Illinois bar, 1894. Mayor "Golden Rule" Jones's legal adviser in Toledo, he succeeded Jones as mayor of Toledo (1905–13) on a home-rule, nonpartisan, anti-monopoly platform. Became U.S. minister to Belgium, 1913. Remaining in Brussels after the outbreak of World War I, he helped organize non-resistance and relief projects. Highly honored by the Belgian government, he held advanced rank of ambassador to Belgium, 1919–22. Author of, among other books, *Forty Years of It* (1914), the record of his adventures in liberalism; *Turn of the Balance* (1907), his most considered novel; and *Belgium: A Personal Record* (1919), his best-known work. His fiction is concerned in great part with the technique and problems of justice administration.

WHITMAN, ALBERY ALLSON (*b. Hart Co., Ky., 1851; d. Atlanta, Ga., 1901*), poet, clergyman of African Methodist Episcopal Church. Born in slavery, he was associated with Wilberforce University and was influential in establishing many churches. Author of, among other books, *Leelah Misled* (1873) and *An Idyl of the South* (1901). Whitman's poetry is essentially derivative, yet it is fluent and shows a real, unforced love of nature. He is the most considerable black poet before Paul L. Dunbar.

WHITMAN, CHARLES OTIS (*b. North Woodstock, Maine, 1842; d. Chicago, Ill., 1910*), biologist. Graduated Bowdoin, 1868; Ph.D., Leipzig, 1877. Taught at Imperial University of Japan, Harvard, and Clark; headed zoology department, University of Chicago *post* 1892. Directed Marine Biological Laboratory, Woods Hole, Mass., from its foundation in 1888 until 1908. His main scientific contributions were in embryology, comparative anatomy, taxonomy, evolution, heredity, and animal behavior. Introduced European scientific zoology into America, founding

in 1887 the *Journal of Morphology* and establishing new standards for American scientific publication.

WHITMAN, CHARLES SEYMOUR (*b. Hanover, Conn., 1868; d. New York, N.Y., 1947*), lawyer, politician, public official. Graduated Amherst College, 1890. LL.B., New York University, 1894. Active in New York City Republican politics while he was building a private practice; he was appointed to a place in the corporation counsel's office in 1902 and made a magistrate in 1903. Whitman was the compromise choice for chief of the city's Board of Magistrates in March 1907 and almost immediately set about making headlines by conducting a drive against payoffs to local police by bail bondsmen and the keepers of after-hours saloons. In 1909 he was the successful reform candidate for district attorney of New York County. During this period he established a mutually convenient alliance with Herbert Bayard Swope, a young reporter for the *New York World*. Whitman began to feed Swope stories about what was going on in the district attorney's office, and, in return, Swope headlined Whitman's role as a demon crime fighter. In a sensational investigation into ties between the police and gambling interests touched off by a gangland killing, Whitman successfully prosecuted the alleged killers and was elected governor of New York on the strength of his fame as a crime fighter. Whitman paid little attention to his duties in Albany and trained his sights on the presidency. His defeat by Al Smith in the 1918 governor's race put an end to his political career.

WHITMAN, EZEKIEL (*b. present East Bridgewater, Mass., 1776; d. East Bridgewater, 1866*), jurist, Maine legislator. Admitted to Plymouth Co., Mass., bar, 1799; practiced successfully in New Gloucester, Maine, until 1807, and thereafter in Portland. Congressman, Democrat, from Maine, 1809–11 and 1817–June 1822. Judge, court of common pleas, 1822–41; chief justice, Maine Supreme Court, 1841–48.

WHITMAN, MARCUS (*b. Rushville, N.Y., 1802; d. near present Walla Walla, Wash., 1847*), physician, missionary, pioneer. M.D., College of Physicians and Surgeons at Fairfield, N.Y., 1832. Accompanied Samuel Parker on Oregon reconnaissance for Congregational missions, 1835; in 1836, with Rev. Henry H. Spalding and others, journeyed as missionary to Fort Walla Walla. Opened wagon road between Fort Hall and Fort Boise; established himself at mission at Waiilatpu, while the Spaldings took charge at Lapwai in present Idaho. After early success at missions, dissensions arose and Whitman made his famous "winter ride" east in 1842–43 to settle difficulties at mission headquarters in Boston, Mass. Successful, he returned to Oregon, 1843, accompanying the great immigration of that year. A continuing series of misfortunes at the mission climaxed in the murder of Whitman, his wife, and others by Cayuse Indians.

WHITMAN, ROYAL (*b. Portland, Maine, 1857; d. New York, N.Y., 1946*), orthopedic surgeon. M.D., Harvard Medical School, 1882. After starting practice in Boston, Mass., he went to England in the late 1880's, studied at Cook's School of Anatomy (London), and became a member of the Royal College of Surgeons. As a member of the staff of New York City's Hospital for the Ruptured and Crippled, 1889–1929, he originated several techniques for treatment of disorders of the foot and hip which quickly became standard. Professor also at College of Physicians and Surgeons, Columbia University, and at New York Polyclinic, he exerted important influence through his clinical teaching and through his textbook *A Treatise on Orthopaedic Surgery* (1901, and subsequent editions).

WHITMAN, SARAH HELEN POWER (*b. Providence, R.I., 1803; d. Providence, 1878*), poet. Chiefly remembered as fiancée of Edgar A. Poe, 1848, and the subject of his "To Helen." Praised by Poe and others, her work has grace and sincerity, but little originality or vigor. Author of *Hours of Life and Other Poems* (1853), *Edgar Poe and His Critics* (1860), and *Poems* (1879).

WHITMAN, WALT (*b. West Hills, town of Huntington, N.Y., 1819; d. Camden, N.J., 1892*), poet. Whitman's parents were of predominantly Dutch and English stock, and inclined to Quaker tenets; his father was a farmer and carpenter-builder; his mother, an uneducated woman, but "perfect in understanding and sympathy." The family moved to Brooklyn, N.Y., *ca.* 1823, and there the poet spent a few years in the public schools. In the summers he went visiting in Huntington and in other places on Long Island and was subsequently to believe that the knowledge thus gained of life on farm and seashore was one of the few important influences upon his work. At the age of eleven he was an office boy and an avid reader of the *Arabian Nights* and the works of Sir Walter Scott; in his thirteenth year he became a printer's devil in the office of the *Long Island Patriot*, whence he went to the *Long Island Star*. This was the beginning of a long career on newspapers in which during three decades he was to be identified with a bewildering number of editorial offices. While working as a journeyman compositor in Brooklyn and New York, he made occasional contributions to the papers for which he worked and got his first taste of the theater and the opera. Between 1836 and 1841 he taught in a number of schools on Long Island and edited the *Long Islander* at Huntington in 1838–39. His writings in this and other local papers were conventional and youthfully sentimental; he impressed people at this time as a dreamy, impractical person, indolent, morose, and untidy. According to his own later testimony, he was beginning to read at this time the Bible, Shakespeare, Ossian, the Greek tragic poets, Dante, and others; he was also interested in Democratic politics.

Of the ten or more newspapers or magazines with which Whitman was associated, 1841–48, the most important were the *Democratic Review*, to which he contributed melodramatic stories after the manner of Hawthorne and Poe, and the *Brooklyn Eagle* which he edited, 1846–January 1848. He provided the *Eagle* with an enlightened and well-written editorial page supporting most contemporary reforms. Moving rapidly in the Free-Soil direction on the question of slavery, he was dismissed as editor for protesting against the failure of the Democrats to face the issue of slavery in the new states. The few poems which he published during this period were competent, conventional verse exercises on routine subjects. He was author also of a temperance novel, *Franklin Evans; or, The Inebriate*, issued as an "extra" of the *New World*, 1842. In his leisure hours he made himself familiar with the varied life of New York, sauntering about the streets, haunting the ferries and omnibuses, strolling off to the beaches, and attending the theater and the opera regularly.

Engaged to write for the New Orleans *Crescent*, he spent three months in that city. The romantic legends which have grown up about this stay are doubtful; however, the city charmed him and provided him with new visual experiences. On his return to Brooklyn he resumed journalism, moving like a nomad from paper to paper, editing the *Brooklyn Times*, 1857–59, and publishing a long series of articles on early Brooklyn history in the *Standard*. He also assisted his father in house-building operations.

At about the year 1848, he entered on the period which came to its end and climax with the publication in 1855 of *Leaves of Grass*. The many attempts to analyze the poet's character in terms of these poems have not been particularly successful, and the theory that he passed through some mystical experience shortly before he wrote the twelve poems which make up the

first edition of *Leaves of Grass* is more conjecture than logical deduction. Whitman's sudden full apprehension of himself dates back before 1848. If there was a sudden illumination, it would appear to have been a discovery not of his own nature, which he already knew too well, but of a way in which that nature might be presented to the world and so justified. So far he had managed to be little more than a knockabout journalist in life, which was unsatisfactory to him; also, and more importantly, he had been forced to realize how unlike the rest of the world he was inwardly. He insisted always that his book had no other value than the celebration of himself as an "average man," yet he was anything but average. Early and late his writings testify to his sense of isolation; the theme of separateness is constantly evident. Well before 1850 he must have recognized that his impulses were extraordinary. He has been called autoerotic, erethistic, and homosexual, and some such extremes of nomenclature are necessary to explain certain passages in the "Song of Myself." Although tall and heavy, he was fastidious in his habits and precise in details of his dress, even after he had adopted the rough workmen's clothes which he affected after his return from New Orleans. It is true that love for his own sex is the only kind of love about which he is ever personal or convincing. All this, of course, has nothing to do with his being a great poet, but it has much to do with the state of mind out of which *Leaves of Grass* grew with such slow and conscious effort—an effort made in order that the poet might become an artist and so free himself from the slavery of self-contemplation. It is likely that the immediate influences in this process came through intellectual contact with contemporaries. Goethe's autobiography, the works of Thomas Carlyle and Emerson provided him with an example, and Emerson's work in particular provided him with a style. He learned from Emerson a fundamental lesson, that a man could accept and celebrate himself in cosmic language, transferring his vision from the unique self to the general. He was also encouraged by his then faith in phrenology. Ambitious at this time, and later, to go forth among the American people and astonish them with fresh and forceful utterances, he gave considerable time to the practice of oratory and the planning of lectures; some of the style of his poetry can best be explained in terms of this apprenticeship.

Leaves of Grass was a failure with the public. It was incomprehensible to some readers and shocking to others. Part of the public bafflement may be attributed to Whitman's insistence on being first of all a prophet and only secondly a poet, but the book did strike home here and there. Emerson responded to Whitman's gift of a copy with the famous and generous letter containing the phrase, "I greet you at the beginning of a great career." Thoreau and Bronson Alcott visited Whitman as did William Cullen Bryant, and there were a few favorable reviews, but for the most part the book fell dead from the press despite three rhapsodical reviews of it which Whitman himself wrote for several journals. In 1856 he issued a second edition of *Leaves of Grass* which contained 21 new poems and bore the quotation from Emerson stamped in gold on the cover. This edition was even more unfavorably received, principally because of exploitations of the sexual theme such as "Spontaneous Me." Before the issue of the third edition of 1860, which was published in Boston and contained two new sections, "Children of Adam" and "Calamus," Whitman engaged again in newspaper work and associated with the "Bohemians" who met at Pfaff's rathskeller in New York City. This latest edition of his work contained "Out of the Cradle Endlessly Rocking," one of the high points of the poet's achievement which had previously appeared in the *Saturday Press*. Henceforward, the principal themes which he was to treat were love and death—love as longing and death as the satisfaction of longing. In "Children of Adam" he celebrated

what he called "amativeness," or the love of men and women; in "Calamus" he celebrated what he termed "adhesiveness," or the love of men for men. The edition of 1860–61 sold better than either of the others, and on Whitman's visit to Boston in connection with its printing he met William D. O'Connor, later his greatest champion. However, the Civil War reduced his Boston publishers to bankruptcy and the book became the prey of literary pirates; furthermore, the war itself produced an incalculable effect on Whitman's life, influencing and modifying his every thought and constituting the occasion of his last great burst of poetry.

Journeying to Washington, D.C., in December 1862, in search of a soldier brother who had been wounded with the Union Army in Virginia, Whitman found his brother recovered but saw enough of the misery of war to realize that his life must somehow be involved with it. Residing in Washington and earning a little money by copying documents, he devoted himself to the wounded soldiers in the various hospitals about the city (a work described in *Memoranda During the War*, 1875). He worked entirely on his own, going about the wards to talk with the soldiers or read to them, and bringing gifts of fruit, jelly, and candy; on occasion he would write letters which they dictated to their families; now and then, he assisted at wound-dressing. Through the O'Connor family, with whom he lived, he met Edmund C. Stedman and was sought out in 1863 by John Burroughs. Although he does not appear ever to have met Abraham Lincoln, the president's death, occurring a few weeks after Whitman had secured a clerkship in the Department of the Interior, was the occasion for the poet's masterpiece, "When Lilacs Last in the Dooryard Bloom'd" (printed as a supplement to *Drum Taps*, 1865). Henceforth, Whitman's work is mellower, less egocentric, less raw; henceforth, it makes much of religion and the spiritual problems of society. In successive editions of *Leaves of Grass* the poems are tempered and shorn of excesses. The war and advancing age completed the process in Whitman whereby his private nature was lost sight of in the gray, kindly figure of legend.

Soon dismissed from his position in the Department of the Interior, he was given another post in the attorney general's office. Since he had been dismissed ostensibly because he was the author of a scandalous book, his friends attempted his defense: O'Connor published *The Good Gray Poet* (the first published volume about Whitman) in 1866, and John Burroughs published *Notes on Walt Whitman* (1867), at least half of which was written by Whitman himself. Meanwhile, *Leaves of Grass* was finding European admirers, and an expurgated London edition was issued by W. M. Rossetti in 1868. Publication in England led to the poet's long correspondence and friendship with Mrs. Anne Gilchrist, the widow of William Blake's biographer. Whitman's Washington period came to a close in January 1873 when he suffered a stroke of paralysis and removed to a residence in Camden, N.J. The death of his mother soon thereafter was a blow from which he never recovered; henceforth his life ran gradually downhill. He was dependent for his living upon his brother George, upon the contributions of friends, and upon the sale of his books which he conducted partly from his own house, receiving orders and filling them with his own hand.

Between 1865 and 1873 he had published two new editions of *Leaves of Grass* (1867 and 1871), *Passage to India* (1871), and the prose *Democratic Vistas* (1871). *Democratic Vistas*, written more or less in answer to Carlyle's *Shooting Niagara*, frankly discusses the shortcomings of American democracy and shows that the reference of Whitman's idealism is now to the future in which he still has faith. Constantly at work on revisions, he issued before his death five new editions of *Leaves of Grass* (1876, 1881–82, 1882, 1888–89, 1891–92) and published three collec-

tions which contained new poems: *Two Rivulets* (1876), *November Boughs* (1888), and *Good-Bye, My Fancy* (1891). His war *Memoranda*, already published, was included in *Specimen Days and Collect* (1882–82) which with *Democratic Vistas* represented him in prose until his earlier work began to be republished long after his death. His friends Burroughs and O'Connor were usually within his reach, although he was estranged from O'Connor, 1872–82. Visitors arrived for interviews, many of them from abroad, and as time went on Whitman found himself surrounded by a group of disciples, among them his later literary executor Horace Traubel and Richard M. Bucke, a Canadian physician who wrote the first official biography of Whitman in 1883. The poet's fame continued to grow steadily, although some earlier admirers (notably A. C. Swinburne) lost their enthusiasm. Whitman's tendency to bask in adoration and surround himself with inferior champions is pardonable but pitiable. He mellowed perceptibly as he grew older, especially with respect to his view of other American poets; his mature appraisals of Longfellow, Poe, Bryant, and Emerson are valuable contributions to criticism.

With the passage of years, a saner criticism and a more scientific approach to his biography have improved Whitman's image. The claims originally made for him as a prophet and moralist are less often made, and he is today judged as he should be — as a poet. He has never been popular or accepted by the democracies as he had hoped, nor has he been often imitated by other poets. But as his isolation grows more apparent, it grows more impressive, so that his rank among the poets of his country and his century is higher than it has ever been before. His work survives as certainly the most original work yet done by any American poet. As a maker of phrases, a master of rhythms, a weaver of images — indeed, as an architect of poems — he is often beyond the reach of criticism. His diaries of the war, his prefaces to *Leaves of Grass*, his *Democratic Vistas* are a permanent part of American prose.

WHITMER, DAVID (*b. near Harrisburg, Pa., 1805; d. Richmond, Mo., 1888*), Mormon leader. One of the "The Three Witnesses" to the *Book of Mormon* whose translation was completed in the Whitmer House, 1829. Made president of the "High Council of Zion" to manage Mormon interests in Missouri, 1834; excommunicated, 1838, for so-called neglect of moral and religious obligations to the church. Author of *An Address to All Believers in Christ by a Witness to the Divine Authenticity to the Book of Mormon* (1887), a straightforward account of events at the beginning of Mormonism.

WHITMORE, FRANK CLIFFORD (*b. North Attleboro, Mass., 1887; d. State College, Pa., 1947*), organic chemist. B.A., Harvard, 1911; Ph.D., 1914. Taught at Williams College, Rice Institute, and University of Minnesota; professor of organic chemistry, Northwestern University, 1920–29. Appointed dean of the School of Chemistry and Physics, Pennsylvania State College, 1929, he remained there until his death, becoming research professor of organic chemistry, 1937. His earliest research interests were summed up in his *Organic Compounds of Mercury* (1921); he devoted himself *post* 1929 chiefly to discovering the nature of intramolecular rearrangements of organic molecules, formulating in 1932 an electronic theory of rearrangement that gained wide acceptance. He was author also of *Organic Chemistry* (1937).

WHITMORE, WILLIAM HENRY (*b. Dorchester, Mass., 1836; d. 1900*), merchant, antiquarian. Boston common councilman, 1874–86; appointed a record commissioner, 1875, and city registrar, 1892. Under his supervision many volumes of invaluable local records were edited and issued, and manuscript copies of

vital Boston church records were collected. He was author-editor of a number of works on genealogy and colonial history, including *The Andros Tracts* (1868–74) and the diary of Samuel Sewall. Much of his printed work, although good for its time, requires careful checking.

WHITNEY, ADELINE DUTTON TRAIN (*b. Boston, Mass., 1824; d. 1906*), Daughter of Enoch Train. Author of *Boys at Chequasset* (1862), *Faith Gartney's Girlhood* (1863), *The Gayworthys* (1865); also of the Real Folks Series and collections of verse. Her books for girls dealt largely with New England, her later stories with domestic life.

WHITNEY, ALEXANDER FELL (*b. Cedar Falls, Iowa, 1873; d. Bay Village, Ohio, 1949*), railway brakeman, labor leader. Joined Brotherhood of Railroad Trainmen, 1896; served as chairman of its grievance committee (1901–07), as a vice president (1907–28), and as president of the union *post* 1928. Aggressively liberal in his labor philosophy and devoted to the interests of the rank-and-file, he never hesitated to confront Congress or the president of the United States in defense of what he believed to be legitimate labor claims.

WHITNEY, ANNE (*b. Watertown, Mass., 1821; d. Boston, Mass., 1915*), sculptor, poet. Studied anatomy and modeling with William Rimmer and in Rome, Paris, and Munich. Established studio in Boston, Mass., 1872. Executed, among other portrait busts and ideal figures, the heroic marble statue of Samuel Adams (commissioned *ca.* 1873) in Statuary Hall, U.S. Capital, Washington, D.C.

WHITNEY, ASA (*b. Townsend, Mass., 1791; d. Philadelphia, Pa., 1874*), inventor, manufacturer. Superintendent, Mohawk & Hudson Railroad, *ca.* 1833–39; canal commissioner of New York State, 1839–42. Granted patent for a locomotive steam engine (1840). Removed to Philadelphia, Pa., 1842, and entered partnership with Matthias W. Baldwin; developed sound management system for the firm, also a system of locomotive classification. Resigned, 1846, to work on improvement of cast-iron car wheels (patented, 1847–48). Formed Asa Whitney & Sons, the largest and most successful car-wheel works in America. President, Philadelphia & Reading Railroad, 1860–61.

WHITNEY, ASA (*b. North Groton, Conn., 1797; d. 1872*), dry goods merchant, railroad promoter. Favored and unsuccessfully promoted (1844–51) an American transcontinental railroad from Lake Michigan via the South Pass of the Rockies to the Pacific Ocean. Author of, among other pamphlets, *A Project for a Railroad to the Pacific* (1849).

WHITNEY, CASPAR (*b. Boston, Mass., 1861; d. New York, N.Y., 1929*), journalist, sports writer. Originated idea of the All-American football team, 1889, whose members he and Walter Camp chose together for some ten years. Served as war correspondent in Cuba for *Harper's Weekly*, 1898. Later editor of *Outing* magazine and others, he was correspondent for the *New York Tribune* in Europe, 1917–19, protesting vigorously and practically against wartime censorship regulations.

WHITNEY, CHARLOTTE ANITA (*b. San Francisco, Calif., 1867; d. San Francisco, 1955*), suffragist and political activist. Studied at Wellesley College (1889), President of the California College Equal Suffrage League (1911) and second vice president of the National American Woman Suffrage Association. Member and supporter of the Communist Labor party (renamed the Communist party); she was arrested under the antisyndicalism laws in Oakland 1919 and sentenced to prison; she served only a few days because of health. National chairman of the Commu-

nist party, 1936; Communist candidate for the U.S. Senate from California in 1950.

WHITNEY, COURTNEY (*b. Takoma Park, Md., 1897; d. Washington, D.C., 1969*), army officer. While in the Army Air Corps he studied at the National University in Washington (LL.B., 1923). As a civilian, he established a lucrative law practice in Manila, Philippines. In 1940 he returned to active duty, and in 1943 became the head of the Philippine Regional Section. He soon became General Douglas MacArthur's confidant, and in 1945 moved to Japan with MacArthur and became chief of the Government Section, which was largely responsible for drafting Japan's constitution of 1946. When the Korean War erupted, Whitney was named military secretary of the United Nations Command, headed by MacArthur. He retired as a major general in 1951 to become MacArthur's personal secretary. When the latter became board chairman of Remington Rand in 1952, Whitney was employed as an executive by the firm.

WHITNEY, ELI (*b. Westboro, Mass., 1765; d. New Haven, Conn., 1825*), inventor. Disinclined to study as a boy, he showed a marked proficiency for mechanical work; he made and repaired violins, worked in iron, and at the age of 15 began the manufacture of nails in his father's shop. On making up his mind to acquire a college education (at the age of 18), he taught school to obtain the necessary money and entered Yale in May 1789. Graduating in 1792, he set out for Savannah, Ga., to serve as a tutor while he studied law. Disappointed of the position he had expected, he took up residence on the plantation of General Nathanael Greene's widow in Georgia, began law studies, and showed his appreciation for Mrs. Greene's hospitality by making and repairing all manner of things about the house and the plantation.

During the following winter he learned that many unprofitable areas of land in the South could be made profitable if the green seed cotton which could be raised on them could be cleansed of seeds by some mechanical device. Encouraged by Mrs. Greene, Whitney turned his mind to the problem and within ten days designed a cotton gin and completed an imperfect model. After further experiment, he built by April 1793 a larger, improved machine with which one man could produce fifty pounds of clean cotton a day. Entering into partnership with Phineas Miller, the plantation foreman, to patent and manufacture the new device and also to maintain a monopoly of its use, Whitney obtained his patent, Mar. 14, 1794, but soon found that a monopoly was impossible because of almost universal infringement of his patent by rival machines. Whitney obtained a court decision in his favor in 1807 after a long series of infringement suits; meanwhile Miller had died. On Whitney's application to Congress for a renewal of his patent in 1812, his request was refused. All in all he received practically no return for an invention which let loose tremendous industrial forces in the nation and the world.

Prior to this, on Jan. 14, 1798, he had obtained from the U.S. government a contract to manufacture and deliver 10,000 stand of arms. He proposed to make the guns by a new method, his aim being to make the same parts of different guns (for example, the locks) as much like each other as the successive impressions of a copper-plate engraving. This was perhaps the first suggestion of the system of interchangeable parts which has played so great a part in industrial development and mass production. Raising the necessary capital in New Haven, Conn., he built a factory in present Whitneyville and began design and construction of the machine tools required to carry out his schemes. He worked against great difficulties, having no experienced workmen to aid him and having to make himself practically every tool required. Completing the contract in some eight years instead of two, he nevertheless accomplished all which he had set out to do. Workmen with little or no experience could operate his machinery and turn out the various parts of a musket with so much precision that they were readily interchangeable. In 1812 he received a second contract from the U.S. government for the manufacture of firearms and also a similar contract from the state of New York. Thereafter, his unique manufactory yielded him a just reward.

WHITNEY, GEORGE (*b. Boston, Mass., 1885; d. New York, N.Y., 1963*), banker. Attended Harvard (B.A., 1907). Organized Markoe, Morgan and Whitney, a brokerage house, in 1909, and in 1915 left to join J. P. Morgan and Company, working in the division that was the U.S. purchasing agents for Great Britain and France's massive war purchases. Became a partner in 1919, and in the 1920's worked on several major European reconstruction and currency stabilization loans. Following the 1929 stock market crash, he directed salvage operations for Morgan, and in 1932 headed the bankers' group that devised the financial rescue plan that saved New York City from bankruptcy. When the firm incorporated as a bank and trust company, he served as president and chief executive officer (1940–50), board chairman (1950–55), and then as a director until 1959, when the bank merged to form the Morgan Guaranty Trust Company of New York.

WHITNEY, GERTRUDE VANDERBILT (*b. New York, N.Y., 1875; d. New York, 1942*), sculptor, art patron. Daughter of Cornelius Vanderbilt (1843–99). Married Harry Payne Whitney, 1896. Recognized internationally for her work in sculpture, she is especially remembered for her many efforts to encourage art in the United States and to aid artists less fortunate than herself. These included the establishment of galleries to show and sell the work of innovating artists to whom the conventional galleries were unfriendly (Whitney Studio Club; Whitney Studio Galleries), and the Whitney Museum of American Art (opened in November 1931), which was committed to purchase only the work of living American artists.

WHITNEY, HARRY PAYNE (*b. New York, N.Y., 1872; d. 1930*), financier, sportsman. Son of William C. Whitney (1841–1904), who trained him to he his business successor. Developed silver, lead, and copper interests with Daniel Guggenheim, 1902. Director, Guggenheim Exploration Co., Guaranty Trust Co., and other banking, mining, and railroad concerns. Organizer and captain of American "Big Four" polo team. His polo tactics were adopted by the British and be became one of the few "ten-goal" players. Maintained distinguished racing stables. Financed Whitney South Sea Expedition, 1921–22.

WHITNEY, JAMES LYMAN (*b. Northampton, Mass., 1835; d. Cambridge, Mass., 1910*), bookseller, librarian. Half brother of William D. and Josiah D. Whitney. Graduated Yale, 1856. Chief of catalogue department, Boston Public Library, 1874–99; librarian, 1899–1903. His great contribution to library technique was the building up of the card-cataogue system at Boston. Compiler and editor of *Catalogue of the Spanish Library and of the Portuguese Books Bequeathed by George Ticknor to the Boston Public Library* (1879) and of many other special catalogues.

WHITNEY, JOSIAH DWIGHT (*b. Northampton, Mass., 1819; d. Lake Sunapee, N.H., 1896*), geologist, chemist. Brother of William D. Whitney; half brother of James L. Whitney. Graduated Yale, 1839. Studied chemistry and mineralogy under Benjamin Silliman and Robert Hare; also in Paris, Berlin, and Giessen. Engaged by C. T. Jackson (1847) to aid in survey of mineral lands of northern Michigan, he completed the survey in 1849 and issued its report, 1850–51. In practice as a mining consultant, 1850–55, he served as chemist and mineralogist, 1855–58,

on the geological survey of Iowa; he also investigated lead regions of Wisconsin. As state geologist of California, 1860–74, he undertook an elaborate survey, introducing topographical mapping by triangulation and issuing a number of notable reports, some of which were published at his own expense. Founder of a school of mines at Harvard, 1868, he was Sturgis-Hooper Professor at Harvard from 1875 until his death. He was author, among other writings, of *Metallic Wealth of the United States* (1854), *Auriferous Gravels of the Sierra Nevada of California* (1880), and *Climatic Changes of Later Geological Times* (1882). His work stimulated later scientific study of ore deposits.

WHITNEY, MARY WATSON (*b. Waltham, Mass., 1847; d. 1921*), astronomer, educator. Graduated Vassar, A.B., 1868, A.M., 1872. Succeeded Maria Mitchell as director of Vassar Observatory, 1888–1910, and as professor of astronomy.

WHITNEY, MYRON WILLIAM (*b. Ashby, Mass., 1836; d. Sandwich, Mass., 1910*), oratorio and operatic basso. Considered by critics an unequaled artist in oratorio, Whitney was active as a concert, church, and stage singer, 1852–90.

WHITNEY, RICHARD (*b. Beverly, Mass., 1888; d. Short Hills, N.J., 1974*), banker, investment counselor, and embezzler. Graduated Harvard University and by 1923 was the principal broker for J. P. Morgan and Company. He took over his father's investment business and renamed it Richard Whitney and Company; in 1930 he was elected to the first of five annual terms as president of the New York Stock Exchange. A 1938 investigation revealed that he had borrowed more than $30 million from friends, family, and the accounts in his trust since at least 1926, and he was convicted of misuse of funds; he spent three years and four months in prison.

WHITNEY, WILLIAM COLLINS (*b. Conway, Mass., 1841; d. 1904*), financier, sportsman. Son-in-law of Henry B. Payne; father of Harry P. Whitney. Graduated Yale, 1863; attended Harvard Law School, 1863–64; admitted to the bar, 1865. A success in New York law and politics, he gained the confidence of Samuel J. Tilden, helped in action against the "Tweed Ring," and (1875–82) effectively reorganized the New York City corporation counsel's office. Identified with New York City utilities, notably street-railways, and other large corporate activities, he won great wealth and a prominent place in society. As U.S. secretary of the navy, 1885–89, he fought successfully against outmoded concepts of ship design, modernized procedures, and supported aims of the Naval War College. A member of Grover Cleveland's inner circle, he played a significant role in Cleveland's second nomination and election, 1892, and fought Free Silver at the 1896 Democratic convention. *Post* 1899 he devoted himself to horseracing activities.

WHITNEY, WILLIAM DWIGHT (*b. Northampton, Mass., 1827; d. 1894*), Sanskrit scholar, linguistic scientist. Brother of Josiah D. Whitney; half brother of James L. Whitney. Graduated Williams, 1845. Beginning his career as a natural scientist, he turned to the study of linguistics after a chance reading of Franz Bopp's Sanskrit grammar. After a year's study of Sanskrit at Yale under Edward E. Salisbury (1849), Whitney went to Germany where he continued his studies at Berlin and Tübingen. Elected professor of Sanskrit at Yale, 1854, he remained active there in teaching and research until his death. He devoted himself principally to Sanskrit, linguistic science, modern languages, and lexicography, and his bibliography numbers some 360 titles. Editorauthor of a number of texts and translations in his special field, he did his most important work in his *Sanskrit Grammar* (Leipzig, 1879, later revised and supplemented). His method was essen-

tially descriptive and statistical and marks a transition in the history of Sanskrit study; he subordinated to the technique of modern linguistic science the classifications, rules, and terms of the ancient and medieval Hindu grammarians. His work in linguistics antedated many recent developments, and his books still may serve as a valuable introduction to the science. He had considerable influence upon the modern trend, especially in his recognition of the distinction of linguistic science from philology and in his conception of linguistics as a historical, and not a physical or natural, science. When the Sheffield Scientific School was established, he organized its modern language department and became its head; out of this subsidiary activity grew a long list of publications in modern languages, including series of annotated German texts, a reader and a grammar and a dictionary; also, French and English grammars which show the same clarity and insight that mark his Sanskrit work. The last decade of his life was given largely to *The Century Dictionary* (1889–91), of which he was editor in chief. An outstanding interest in Whitney's life was the American Oriental Society which he served for many years as librarian, editor of publications, and secretary; he was president of the Society, 1884–90. Outstanding among his works (in addition to those already mentioned) are *Language and the Study of Language* (1867), *The Life and Growth of Language* (1875), and *Oriental and Linguistic Studies* (1873, 1874).

WHITNEY, WILLIS RODNEY (*b. Jamestown, N.Y., 1868; d. Schenectady, N.Y., 1958*), chemist and research director. Studied at the Massachusetts Institute of Technology and the University of Leipzig (Ph.D., 1896). Taught at MIT from 1896 to 1904. From 1900 until retirement in 1954, he was associated with the General Electric Company in Schenectady, N.Y., director of the research laboratories from 1904 to 1932, vice president from 1928. Whitney himself held over forty patents and helped in the development of the GEM lamp filament, the modern X-ray tube, and the "gas-filled" lamp.

WHITON, JAMES MORRIS (*b. Boston, Mass., 1833; d. 1920*), Congregational clergyman, educator, author. A popular preacher and able controversialist; held pastorates at Lynn, Mass., 1865–75, and in Newark, N.J., and New York City.

WHITSITT, WILLIAM HETH (*b. near Nashville, Tenn., 1841; d. Richmond, Va., 1911*), Baptist minister, church historian. Accepted chair of ecclesiastical history, Southern Baptist Theological Seminary, Greenville, S.C., 1872; served as president, 1895–99. Precipitated "the Whitsitt controversy" over succession of Baptist churches by article in *Johnson's Universal Encyclopaedia* (1896). Professor of philosophy, Richmond College, Richmond, Va., 1900–10.

WHITTAKER, CHARLES EVANS (*b. Troy, Kans., 1901; d. Kansas City, Mo., 1973*), Supreme Court justice. Graduated University of Kansas City Law School (1924), became a partner with a Kansas City law firm (1930), and was appointed federal district court judge in Kansas City (1954), where he upheld the controversial dismissal of an economics professor who refused to answer U.S. Senate committee questions concerning possible communist affiliations. He was named to the Eighth Circuit Court of Appeals (1956) and sworn in as Supreme Court justice in March 1957. Subscribing to nonpolitical principles of constitutional interpretation, he joined the Court's moderate wing but often sided with conservatives to create a five-man majority. He resigned in March 1962.

WHITTELSEY, ABIGAIL GOODRICH (*b. Ridgefield, Conn., 1788; d. Colchester, Conn., 1858*), editor, author. Sister of Charles A.

and Samuel G. Goodrich. Editor and contributor, *Mother's Magazine*, 1833–47 and 1848–49.

WHITTEMORE, AMOS (*b.* *Cambridge, Mass., 1759; d. West Cambridge, Mass., 1828*), inventor, gunsmith. Patented (1797) a machine for making cotton and wool cards which reduced card manufacture to a series of rapid, entirely automatic operations.

WHITTEMORE, THOMAS (*b.* *Boston, Mass., 1800; d. Cambridge, Mass., 1861*), Universalist clergyman, editor, railroad president, financier, Massachusetts legislator. Editorowner, *Trumpet and Universalist Magazine*, 1828–61.

WHITTEMORE, THOMAS (*b.* *Cambridge, Mass., 1871; d. Washington, D.C., 1950*), archaeologist. Grandson of Thomas Whittemore (1800–61). B.A., Tufts College, 1894. Taught English and the history of art at Tufts; engaged in archaeological excavation in Egypt, 1911–15. Organized a relief program for Russian refugees, 1916, and directed its activities within Russia, 1916–18; thereafter until about 1927, he worked to provide education as well as relief for Russian youths in exile. Taught history of art at New York University, 1927–30. In 1930, he organized the Byzantine Institute as a means of educating the public in the Christian art of the East; his greatest achievement was the uncovering of the mosaics in Santa Sophia and other Byzantine churches in Constantinople.

WHITTIER, JOHN GREENLEAF (*b.* *Haverhill, Mass., 1807; d. Hampton Falls, N.H., 1892*), poet, abolitionist. Raised on a farm, the son of Quaker parents, Whittier improved a limited formal education by wide reading. His earliest attempts at verse were inspired by the work of Robert Burns. Publication of "The Exile's Departure" in the Newburyport *Free Press*, June 1826, brought Whittier to the attention of editor William Lloyd Garrison, who was to be a leading influence in the poet's life. Further publication of poems in the *Free Press* and the *Haverhill Gazette* made Whittier's work widely known in his locality. After a brief time at Haverhill Academy, he became editor with Garrison's help of *The American Manufacturer* (Boston), serving from January 1829 through the summer of that year. This was the first of many editorial positions which he was to hold. Succeeding George D. Prentice as editor of the *New England Weekly Review*, June 1830, Whittier held that post until 1832; meanwhile in February 1831 he published his first book, *Legends of New England in Prose and Verse*. Converted to abolitionism in the spring of 1833, he devoted himself for the next thirty years to the antislavery cause, as a poet and as an active agent, lobbyist, and editor. From March 1838 to February 1840 he edited the *Pennsylvania Freeman*. Sympathetic with the political-action party of the abolitionists to which Garrison was opposed, Whittier became a member of the American and Foreign AntiSlavery Society, and in the fall of 1842 ran for Congress on the Liberty Party ticket. After working as an editor of several minor journals, he became corresponding editor of the *National Era* of Washington, D.C., January 1847, and to it he contributed most of his poems and articles for the next 13 years. He remained active in politics, attacking the administration bitterly for the Mexican War, and in the famous poem "Ichabod" (*National Era*, May 2, 1850) he poured out scorn on Daniel Webster for the "Seventh of March" speech. He encouraged and furthered the career of Charles Sumner and was one of the first to suggest formation of the Republican party.

Whittier's life was uneventful *post* 1861 although his fame as a poet increased by reason of his many contributions to the *Atlantic Monthly* (in the founding of which he had a part) and to the *Independent*. However, he reached the summit of his poetic career in the decade of the 1860's during which appeared *Home Ballads* (1860); *In War Time and Other Poems* (1864, containing

"Barbara Frietchie"); *Snow-Bound* (1866); *The Tent on the Beach* (1867); and *Among the Hills* (1869). In the summer of 1876 he settled in Danvers, Mass., which he made his place of abode almost to the time of his death, with occasional visits to his previous residence at Amesbury which continued to be his legal residence. He was the recipient of numerous honors and was surrounded by friends. Among the more important poetical volumes of his later years were *Miriam and Other Poems* (1871), *The Vision of Echard* (1878), and *At Sundown* (1890).

Whittier sacrificed much and endured much abuse in his devotion to the antislavery cause. He was in general tolerant and keenly sympathetic with all persecuted persons. He had a fine sense of humor and was adept at telling amusing stories. Radical though he might be in his views of slavery, he was extremely conservative on all industrial and economic questions, and as a means of settling economic difficulties recommended simple obedience to the golden rule and saving of money. Greatly admired as a poet in his own day and ranked with Longfellow and Bryant, he is today regarded as possessing mastery only in the poems inspired by the contest over slavery. These appeared in many of the volumes of poems which he issued *post* 1831 and were published collectively under the title *Voices of Freedom* in 1846. The best of his early work will be found in *Lays of My Home and Other Poems* (1843), *Songs of Labor* (1850), *The Chapel of the Hermits* (1853), and *The Panorama and Other Poems* (1856). Many of his religious poems have found a permanent place in the hymnals of various denominations. In spite of the modern exaltation of the merits of his antislavery poems, *Snow-Bound* is still usually considered his masterpiece.

WHITTINGHAM, WILLIAM ROLLINSON (*b.* *New York, N.Y., 1805; d. Orange, N.J., 1879*), Episcopal clergyman. Graduated General Theological Seminary, New York City, 1824. Ordained to priesthood, 1829. Rector of St. Luke's Church, New York, 1831–36; professor of ecclesiastical history, General Theological Seminary, 1836–40. Consecrated bishop of Maryland, 1840, he upheld Union sentiments, 1857–65. A statesman-like and scholarly ecclesiastic, he was highly valued by his contemporaries in the House of Bishops.

WHITTREDGE, WORTHINGTON (*b.* *Springfield, Ohio, 1820; d. Summit, N.J., 1910*), painter. Studied in Europe, 1849–59, principally in Düsseldorf. A landscapist of the Hudson River School, Whittredge painted pictures which, despite their over-emphasis on detail, possess their own individuality and charm. He was Emanuel Leutze's model for Washington in *Washington Crossing the Delaware*.

WHITWORTH, GEORGE FREDERIC (*b.* *Boston, England, 1816; d. 1907*), Presbyterian clergyman, educator. Graduated New Albany Theological Seminary (later McCormick Theological Seminary), 1847. Helped found churches in Portland, Oreg., 1853, and in Olympia, Wash., 1854. Successful as a businessman and civic leader in Seattle, Wash. President of University of Washington, Seattle, 1866–67 and 1875–76. Whitworth College, Spokane, Wash., was named in his honor.

WHORF, BENJAMIN LEE (*b.* *Winthrop, Mass., 1897; d. Wethersfield, Conn., 1941*), chemical engineer, anthropological linguist. B.S., Massachusetts Institute of Technology, 1918. Associated all his life with the Hartford Fire Insurance Company as an expert in industrial fire prevention, his fame rests on his avocational work in linguistic theory. Encouraged by Edward Sapir, he made intensive studies of the Hopi language, and evolved chiefly from this investigation his theory of linguistic relativity; i.e., that the structure of the particular language a person speaks influences his patterns of thought and action.

WHYTE, WILLIAM PINKNEY (*b. Maryland, 1824; d. Baltimore, Md., 1908*), lawyer, Maryland legislator. Grandson of William Pinkney. Admitted to the Maryland bar, 1846. Long active in Democratic politics, an opponent of the Know-Nothings and later a Confederate sympathizer, Whyte served as governor of Maryland, 1872–74. He was U.S. senator, Democrat, from Maryland, 1868–69, 1875–81, and 1906. He also served as mayor of Baltimore, 1881–83; attorney general of Maryland, 1887–91; and city solicitor of Baltimore, 1900–03.

WICKARD, CLAUDE RAYMOND (*b. near Flora, Ind., 1893; d. near Delphi, Ind., 1967*), U.S. secretary of agriculture. Studied at Purdue (B.S., 1915), then took over management of his father's farm. He was elected to the Indiana State Senate in 1932 as a Democrat, and the next year he was called to Washington, D.C., to become an assistant in the Corn-Hog Section of the Agricultural Adjustment Administration. In 1940 he became secretary of agriculture, and in 1942 he took on the added post of food administrator. Was also administrator of the Rural Electrification Administration (1945–53).

WICKERSHAM, GEORGE WOODWARD (*b. Pittsburgh, Pa., 1858; d. New York, N.Y., 1936*), lawyer, public servant. After studying civil engineering and serving briefly as secretary to Matthew S. Quay, he graduated from the law school of the University of Pennsylvania and was admitted to the bar, 1880. In 1883 he joined the firm of Strong and Cadwalader in New York City and became a partner, 1887; he was considered one of the leading corporation experts of the New York State bar. Active in the local Republican party, he was chosen U.S. attorney general, 1909, and over the next four years initiated more actions against the nation's leading corporations under the Sherman Antitrust Law than the preceding administration had begun in seven years. So vigorously did he drive against the trusts that many representatives of industrial and financial circles demanded his resignation. He was one of the closest advisers of President William H. Taft during this period, drew up the original draft of the Mann-Elkins Act, and helped with the corporation tax provision in the Payne-Aldrich Tariff Act. Continuing his interest in public affairs in New York State *post* 1913, he was an internationalist and supported disarmament moves and the World Court. Appointed chairman of the so-called Wickersham Committee, 1929, he undertook an extensive inquiry into the entire federal system of jurisprudence and reported the committee's findings in 14 separate reports. Unfortunately, the major work of the committee was overlooked because of the confusion of its report on the enforcement of the 18th (Prohibition) Amendment.

WICKERSHAM, JAMES PYLE (*b. Chester Co., Pa., 1825; d. Lancaster, Pa., 1891*), educator, Union soldier. Appointed principal, Lancaster County Normal School, Millersville, Pa., 1856; under his administration it became the first state normal school in Pennsylvania 1859. Appointed state superintendent of common schools, 1866, he held that post until 1881; by 1874 he had succeeded in having a school established in every Pennsylvania district. Editor and part owner, *Pennsylvania School Journal*, 1870–81.

WICKES, LAMBERT (*b. Kent Co., Md., 1735[?]; d. at sea, off Newfoundland, 1777*), Revolutionary naval officer. In autumn 1774 he distinguished himself by refusing to ship tea from London in his vessel *Neptune*. Given command of the Continental armed ship *Reprisal*, April 1776, he was victorious in several actions with the British and captured valuable prizes. In October 1776 he carried Benjamin Franklin to France. The *Reprisal* was the first American ship of war and Wickes was the first American naval officer to appear in European waters after the Declaration of Independence.

WICKES, STEPHEN (*b. Jamaica, N.Y., 1813; d. Orange, N.J., 1889*), physician, historical writer. M.D., University of Pennsylvania, 1834. Practiced in Troy, N.Y., and Orange, N.J. Author of, among other works, *History of Medicine in New Jersey, and of Its Medical Men, from the Settlement of the Province to A.D. 1880* (1879). Edited *Transactions of the Medical Society of New Jersey*, 1861–82.

WICKHAM, JOHN (*b. Southold, N.Y., 1763; d. 1839*), lawyer. Began practice in Williamsburg, Va.; removed to Richmond, 1790, where he became celebrated as a pleader. In the case of *Ware v. Fairfax's Hylton* (1793), Wickham's contention that by the U.S. Constitution all treaties were a part of the law of the land and all state legislation inconsistent therewith was invalid was sustained on appeal by the Supreme Court. In 1809 he represented plaintiff in *Hunter v. Fairfax's Devisee*, which established doctrine that the Supreme Court has appellate jurisdiction over decisions of state courts. Wickham's argument, as counsel for the defense, that Aaron Burr had committed no overt act of treason was accepted by Chief Justice Marshall, who so instructed the jury during Burr's celebrated trial, 1807.

WICKLIFFE, CHARLES ANDERSON (*b. near Springfield, Ky., 1788; d. near Ilchester, Md., 1869*), lawyer, Kentucky legislator. Father of Robert C. Wickliffe; cousin of Ben Hardin. Congressman, Democrat, from Kentucky, 1823–33; became chairman, Committee on Public Lands, 1829. Whig lieutenant governor of Kentucky, 1836–39; governor, 1839–40. Postmaster general of the United States, 1841–45. Rejoining the Democrats on the issue of Texas annexation, he later opposed the secession movement and served in Congress, 1861–63, as a Union Whig.

WICKLIFFE, ROBERT CHARLES (*b. Bardstown, Ky., 1819; d. 1895*), lawyer, planter, Louisiana legislator. Son of Charles A. Wickliffe. Removed to Louisiana, 1846. Democratic governor of Louisiana, 1856–60.

WICKSON, EDWARD JAMES (*b. Rochester, N.Y., 1848; d. Berkeley, Calif., 1923*), horticulturist. Graduated Hamilton, 1869. Removing to California, 1875, to join staff of *Pacific Rural Press*, he encouraged founding or reorganizing of state agricultural organizations and taught a variety of subjects in the agricultural school of the University of California. In 1905 he was appointed dean of the school and professor of horticulture, and became director of the university agricultural experiment station, 1907. Author of, among other books, *The California Fruits and How to Grow Them* (1889) and *The California Vegetables in Garden and Field* (1897). Editor in chief, *Pacific Rural Press*, 1898–1923.

WIDENER, GEORGE DUNTON (*b. Philadelphia, Pa., 1889; d. Philadelphia, 1971*), sportsman and philanthropist. Born into one of Philadelphia's oldest and richest families, he began a lifelong association with thoroughbred racing when his silks were registered in 1913; in 1916 he bought Erdenheim Farm outside Philadelphia and bred 100 stakes winners during his career, with earnings in excess of $9 million. He served the Jockey Club as steward (1943), vice-chairman (1947–50), and chairman (1950–64). In support of the humanities, he endowed the Widener Library at Harvard, served as chairman of the board of the Philadelphia Museum of Art (1947–64), and gave financial support to such institutions as the Metropolitan Museum of Art, the Philadelphia Orchestra, and the Saratoga Springs Performing Arts Center.

WIDENER, HARRY ELKINS (*b. Philadelphia, Pa., 1885; d. at sea, aboard the Titanic, 1912*), rare-book collector. Grandson of P. A. B. Widener and William L. Elkins. Graduated Harvard, 1907.

WIDENER, PETER ARRELL BROWN (*b. Philadelphia, Pa., 1834; d. 1915*), financier, philanthropist. After early success as a butcher and Union army meat supplier during the Civil War, he served as Philadelphia city treasurer, 1873–74, in which post he made a large amount of money in fees. *Post* 1875 he was associated with W. L. Elkins and others in street-railway ownership and operation in Philadelphia, Pittsburgh, Baltimore, and Chicago; their properties totaled a greater mileage than any similar syndicate. Widener helped in consolidation of the Philadelphia Rapid Transit Co. and was an organizer of the U.S. Steel Corporation and the American Tobacco Co. He had large investments in many corporations, including the Pennsylvania Railroad Co. Widener's collections of art and Chinese porcelains were considered among the finest in America. He was a generous benefactor to Philadelphia institutions.

WIDFORSS, GUNNAR MAURITZ (*b. Stockholm, Sweden, 1879; d. Grand Canyon, Ariz., 1934*), artist. Studied at Institute of Technology, Stockholm, Sweden, 1896–1900. Settled in the United States, 1921. Called the "painter of the National Parks," he excelled in studies of the Grand Canyon, recording its moods in watercolor and oil. Widforss reproduced nature with remarkable feeling and accuracy.

WIDNEY, JOSEPH POMEROY (*b. Miami Co., Ohio, 1841; d. Los Angeles, Calif., 1938*), physician, civic leader. M.D., Toland Medical College, San Francisco, Calif., 1866. In practice in Los Angeles *post ca.* 1869, he was a principal factor in the development of the Los Angeles area. He helped found the institution chartered in 1880 as the University of Southern California, serving as dean of the medical school and as president of the university itself, 1892–95.

WIECHMANN, FERDINAND GERHARD (*b. Brooklyn, N.Y., 1858; d. 1919*), scientist, author. Chief chemist, Havemeyer and Elder Sugar Refining Co., Brooklyn, N.Y., 1887–1909. Author of, among other books, *Sugar Analysis* (1890).

WIELAND, GEORGE REBER (*b. Boalsburg, Pa., 1865; d. West Haven, Conn., 1953*), paleontologist. Studied at Pennsylvania State College, Göttingen, and Yale (Ph.D., 1900). Associated with the Osborn Botanical Laboratory at Yale (1906–35). Collector and cataloguer of fossils, especially cycadlike plants. Published *American Fossil Cycads* (1906–16) and *Cerro Cuadrado Petrified Forest* (1935), a description of early Mesozoic conifers from Patagonia. Wieland bought land in South Dakota's Black Hills in 1916 and attempted to obtain federal assistance for the preservation of the region as a park for cycadophyte localities; the area was made a national monument in 1922 but was disestablished in 1957. Wieland's ideas are not now the basis for any significant paleobotanical theories.

WIENER, ALEXANDER SOLOMON (*b. Brooklyn, N.Y., 1907; d. New York City, 1976*), physician and educator. Graduated Cornell University (B.A., 1926) and Long Island College of Medicine (M.D., 1930) and began research on human blood groups at Jewish Hospital of Brooklyn, where he devised a method for measuring linkages in human genetics (1932). He established Wiener Laboratories (1934) and worked in the Office of the Chief Medical Examiner of New York City (1938–76). With Karl Landsteiner he codiscovered the Rh factor (1937); he showed that sensitization of Rh-negative people to Rh-positive blood was the chief cause of intragroup hemolytic transfusion reactions. His work led to routine Rh testing of patients and donors before transfusions. With coworkers, he also established the existence of twenty-five different serological specificities. He was on the faculty of the Department of Forensic Medicine at New York University (1939–71) and was instrumental in the compulsory use of blood tests in assault and homicide cases (1952). He wrote more than 500 articles and the standard textbook *Blood Groups and Transfusions* (1935).

WIENER, LEO (*b. Bialystok, Poland, 1862; d. Belmont, Mass., 1939*), Slavic scholar, philologist, cultural historian. A teacher of languages after his immigration to the United States, 1882, he was appointed to the staff of Harvard University through the influence of Francis J. Child and Archibald C. Coolidge, becoming instructor in Slavic languages and literature, 1896. He remained at Harvard, rising through the academic grades and becoming professor emeritus, 1930. In the latter part of his career he abandoned research in the Slavic field and gave much time to investigations of Arabic, Germanic, African, and American Indian culture. He was author of, among other works, *Anthology of Russian Literature* (1902–03) and *History of Yiddish Literature in the Nineteenth Century* (1899).

WIENER, NORBERT (*b. Columbia, Mo., 1894; d. Stockholm, Sweden, 1964*), mathematician. Attended Tufts, Cornell, and Harvard (Ph.D., 1913), and universities of Göttingen and Cambridge (1913–14). Taught at Harvard, University of Maine, and in 1919 joined the Massachusetts Institute of Technology. He began work on integration in function spaces, which led to his greatest achievements, the first of which was differential space. He also studied harmonic analysis, Fourier transforms, and Tauberian theorems, work that established him as a mathematician of the first rank. His 1930 paper "Generalized Harmonic Analysis" was probably his finest contribution. After the outbreak of World War II in Europe, he worked on the control of antiaircraft guns, which led him to investigate the problem of estimating the future position of an airplane on the basis of a finite number of (not perfectly accurate) measurements. His book *Cybernetics* (1948) propelled him to a position of instant fame and popularized several important aspects of communication theory.

WIGFALL, LOUIS TREZEVANT (*b. near Edgefield, S.C., 1816; d. Galveston, Tex., 1874*), lawyer, Texas legislator, Confederate brigadier general. Favored secession of South Carolina, 1844. Settled in Texas, 1848. During crisis of 1849–50, he again declared for separation of South from North. Elected to Texas Senate, 1856, he led "Southern-rights" Democrats. As U.S. senator from Texas, 1860–61, he urged secession, justifying it on the compact theory; he was one of those Southerners whose abstention from voting brought about defeat of the Crittenden Compromise. Remaining in the Senate until March 1861, he aided the Confederacy by confidential advice. Commanded "Texas Brigade" in Virginia, resigning February 1862 to enter Confederate Senate. Bitterly opposed President Jefferson Davis' conduct of the war; led movement making R. E. Davis' conduct of the war; led movement making R. E. Lee general in chief of Confederate armies. After the war he escaped from Galveston, Tex., to England, returning to the United States, 1872.

WIGGER, WINAND MICHAEL (*b. New York, N.Y., 1841; d. 1901*), Roman Catholic clergyman. Studied in Genoa and Rome; ordained, 1865; D.D., University of the Sapienza, Rome, 1869. After holding pastorates in Madison, Summit, and Orange, N.J., he was consecrated third bishop of Newark, N.J., 1881. Notable for work on behalf of German and Italian immigrants.

WIGGIN, ALBERT HENRY (*b. Medfield, Mass., 1868; d. Greenwich, Conn., 1951*), banker. Entering banking after graduation

from high school, Wiggin worked his way up through a succession of jobs in Boston and New York until he became vice president of Chase National Bank (1904); president (1911); chairman of the board (1917); chairman of the governing board (1930–32), when he retired. Wiggin built the Chase into the world's largest bank through a series of mergers (the bank absorbed seven major New York banks) and expansion with the foundation of the Mercantile Trust Co., 1917, and the Chase Securities Corp. After retirement, a Senate investigation disclosed that Wiggin used his position for his own profit. He settled a stockholders suit out of court.

WIGGIN, JAMES HENRY (*b. Boston, Mass., 1836; d. 1900*), Unitarian clergyman, editor. Graduated Meadville Theological School, 1861; ordained, 1862. Held pastorates in Massachusetts, 1861–75. An agnostic by 1881, he devoted himself thenceforth to literary pursuits. The great popularity of Mary Baker Eddy's *Science and Health* dated from his revision (16th ed.), done at her request, 1885. He was associated with Mrs. Eddy for some years thereafter.

WIGGIN, KATE DOUGLAS (*b. Philadelphia, Pa., 1856; d. Harrow, England, 1923*), author, pioneer kindergarten worker. Trained by Emma J. C. Marwedel, she was selected in 1878 to organize in San Francisco the Silver St. Kindergarten, first free kindergarten west of the Rocky Mountains. She established the California Kindergarten Training School, 1880, with Nora A. Smith, her sister and collaborator in teaching and kindergarten writings. Author of, among many other books, *The Birds' Christmas Carol* (1887), typical of her work in its brevity, wide range of characterization, broad humor, and Dickensian pathos; *Polly Oliver's Problem* (1893); and *Rebecca of Sunnybrook Farm* (1903).

WIGGINS, CARLETON (*b. Turner, N.Y., 1848; d. Old Lyme, Conn., 1932*), landscape and animal painter. Studied at National Academy of Design, 1870, and under George Inness. Elected member of the academy, 1906.

WIGGLESWORTH, EDWARD (*b. Malden, Mass., ca. 1693; d. 1765*), educator, theologian. Son of Michael Wigglesworth. Graduated Harvard, 1710; appointed first Hollis professor of divinity at Harvard, 1722. D.D., University of Edinburgh, 1730. A leader among the antievangelical clergy, Wigglesworth's gradual compromise between Arminian and Calvinistic extremes heralded later Unitarianism. Author of, among other works, *A Letter to the Reverend Mr. George Whitefield* (1745) and *The Doctrine of Reprobation Briefly Considered* (1763).

WIGGLESWORTH, EDWARD (*b. Cambridge, Mass., 1732; d. 1794*), educator, theologian. Son of Edward Wigglesworth (*ca. 1693–1765*); grandson of Michael Wigglesworth. Graduated Harvard, 1749. Succeeded his father as Hollis professor of divinity at Harvard, 1765. Author of, among other works, *Calculations on American Population* (1775).

WIGGLESWORTH, EDWARD (*b. Boston, Mass., 1840; d. 1896*), dermatologist. Graduated Harvard, 1861; M.D., Harvard Medical School, 1865; studied in Europe, 1865–70. Practicing in Boston, Mass., he inaugurated and maintained Boston Dispensary for Skin Diseases, 1872–77. Headed Department of Diseases of the Skin, Boston City Hospital, taught at Harvard Medical School.

WIGGLESWORTH, MICHAEL (*b. probably Yorkshire, England, 1631; d. 1705*), Congregational clergyman, author. Father of Edward Wigglesworth (*ca. 1693–1765*). Came to America as a boy. Graduated B.A., Harvard, 1651; served as fellow and tutor at Harvard, 1652–54, and was a fellow *post* 1697. Minister at Malden, Mass., *post ca.* 1655, he also practiced medicine. He was author of, among other works, *The Day of Doom* (1662), a long edificatory poem in ballad meter. Its pictures of the Judgment Day has occasional dramatic flashes and possesses a real if undeveloped poetic power. The work has been criticized for the alleged inhumanity of its theological doctrines; however, *The Day of Doom* is merely a dramatized version of tenets commonly held at the time.

WIGHT, FREDERICK COIT (*b. New London, Conn., 1859; d. 1933*), musician, composer of marches.

WIGHT, PETER BONNETT (*b. New York, N.Y., 1838; d. Pasadena, Calif., 1925*), architect. Graduated present College of City of New York, 1855. Began practice in Chicago, Ill. Won 1862 competition for National Academy of Design building, Fourth Ave. and 23rd St., New York City, notable for Italian Gothic facades. Subsequently he designed the Brooklyn Mercantile Library building and was commissioned to design the Yale School of Fine Arts. Associated with Russell Sturgis, 1863–68. *Post* 1872 his Chicago firm of Drake & Wight (formerly Carter, Drake and Wight) engaged in commercial and domestic work and became a training ground for young architects. Wight devoted himself to development of terra-cotta structural tile, 1881–91. He was responsible for the 1897 Illinois law requiring examination and licensing of architects.

WIGHTMAN, HAZEL VIRGINIA HOTCHKISS (*b. Healdsburg, Calif., 1886; d. Chestnut Hill, Mass., 1974*), tennis champion. Began playing as a child to improve her health and in 1909 swept the women's singles, women's doubles, and mixed doubles at the U.S. National Championships. Graduated University of California at Berkeley (1911) and married in 1912 but did not return to full-scale competition until 1919, when she won the national women's singles title. She began to coach younger women players and initiated the Wightman Cup competition. At the 1924 Olympics in Paris she earned gold medals in women's doubles (with Helen Wills) and mixed doubles (with Dick Williams). She earned a total of forty-five national championships and was inducted into the Tennis Hall of Fame in 1957.

WIGMORE, JOHN HENRY (*b. San Francisco, Calif., 1863; d. Chicago, Ill., 1943*), legal scholar and educator. B.A., Harvard, 1883; M.A. and LL.B., 1887. Practiced in Boston for two years; taught law at Keio University, Tokyo, Japan, 1889–92. Appointed professor of law at Northwestern University, 1893, he was made dean of the law school in 1901 and retained that position until his retirement in 1929. An advocate of the case method of teaching law, he led in the movement to modernize and systematize U.S. legal education. A founder of the *Harvard Law Review*, he became one of the most respected legal writers in the country, publishing the classic *Treatise on the System of Evidence in Trials at Common Law* (1904–05), *Principles of Judicial Proof* (1913), and *A Panorama of the World's Legal Systems* (1928).

WIGNELL, THOMAS (*b. England, ca. 1753; d. Philadelphia, Pa., 1803*), comedian, theatrical manager. Came to America, 1774, to join the American Co. managed by his cousin Lewis Hallam; removed with the company immediately to Jamaica British West Indies. First appeared in the United States, November 1785, with the American Co. at New York. The best comedian seen in America up to that time, he soon became a favorite and was noted for his intelligence and taste. One of his most popular roles was Joseph Surface in Sheridan's *The School for Scandal*. In 1791 he became partner of Alexander Reinagle and opened the Chestnut St. Theatre, Philadelphia, 1794. In 1796

he brought Ann B. Merry and Thomas A. Cooper from England to join the company. The succeeding Philadelphia seasons were the most brilliant of their time. He opened the first theater in Washington, D.C., 1800.

WIKOFF, HENRY (*b. probably Philadelphia, Pa., ca. 1813; d. Brighton, England, 1884*), author, adventurer. Made the grand tour of Europe, 1834–40; was a transatlantic commuter, 1840–50. It was said that no American of the period knew so many European notables or more important unwritten political history. Served in various diplomatic capacities; was ballerina Fanny Elssler's manager, 1840; spent 15 months in jail at Genoa, Italy, for abducting an heiress *ca.* 1852–53. Author of, among other writings, *Napoleon Louis Bonaparte, First President of France* (1849), *My Courtship and Its Consequences* (1855), and *The Reminiscences of an Idler* (1880).

WILBUR, CRESSY LIVINGSTON (*b. Hillsdale, Mich., 1865; d. Utica, N.Y., 1928*), vital statistician. Ph.B., Hillsdale College, 1886; Ph.M., 1889. Appointed chief of Division of Vital Statistics, Michigan State Department of Health, 1893. Chief statistician for vital-statistics, U.S. Census Bureau, 1906–14. In charge of Division of Vital Statistics, New York State Department of Health, 1914–16. Wilbur's outstanding contribution was the fostering of a model vital statistics law that led to establishment of uniform and effective registration in all states.

WILBUR, CURTIS DWIGHT (*b. Boonsboro (now Boone), Iowa, 1867; d. Palo Alto, Calif., 1954*), jurist and government official. Graduated U.S. Naval Academy (1888) but never commissioned. Studied law and began practicing in Los Angeles. Elected to the county court in 1902; appointed to the California Supreme Court in 1918. Appointed secretary of the navy in 1924 by Calvin Coolidge after Teapot Dome scandals. Attempted to build the navy's forces but was hampered by an economy-minded Congress. An advocate of naval air power, he established the first course in aviation at the Naval Academy. Adamantly opposed to a separate air force. Served on Ninth Federal Circuit Court of Appeals in San Francisco (1929–45).

WILBUR, HERVEY BACKUS (*b. Wendell, Mass., 1820; d. Syracuse, N.Y., 1883*), pioneer educator of the retarded, physician. Graduated Berkshire Medical Institution, Pittsfield, Mass., 1843. Established Institute for Idiots at Barre, Mass., *ca.* 1848, the first school of its kind in the United States; was associated with New York State Asylum for Idiots *post* 1851. His system of training became basis for every similar institution in the United States, Canada, and many European countries; he was also an authority on care of the insane. Author of, among other writings, *Aphasia* (1867) and *Report on the Management of the Insane in Great Britain* (1876).

WILBUR, JOHN (*b. Hopkinton, R.I., 1774; d. Hopkinton, 1856*), Quaker preacher, antievangelical leader. Opposed movement led by Joseph J. Gurney; was expelled from Society of Friends, 1843. His followers separated from meeting in 1845. They were popularly known as Wilburites and officially as the New England Yearly Meeting of Friends.

WILBUR, RAY LYMAN (*b. Boonesboro, Iowa, 1875; d. Palo Alto, Calif., 1949*), physician, educator, public official. Raised in Dakota Territory and Riverside, Calif. B.A., Stanford University, 1896; M.A., 1897; M.D., Cooper Medical College, 1899. During his freshman year at Stanford University, he met Herbert Hoover, with whose career he was often intertwined over the next 40 years. After practicing medicine in San Francisco he returned to Stanford as professor and in 1916 became president of the university. He promoted his old friend Hoover as wartime food ad-

ministrator and served as his assistant. At Stanford his reorganization plans for the university were only partially successful because of recalcitrant alumni.

When Hoover became president, Wilbur became his secretary of the interior and served in Washington for four years. As secretary he was moderately conservationist, but was generally opposed to strong government intervention. His chief contribution seems to have been his personal support for Hoover. He returned to Stanford in 1933 and in 1943 became chancellor.

WILBUR, SAMUEL (*b. England, ca. 1585; d. Boston, Mass., 1656*), Rhode Island merchant and colonist. Immigrated to America some time before 1633; was one of the buyers of Boston Common from William Blackstone, 1634. A purchaser and settler of the island of Aquidneck (now Rhode Island), he was a signer of the Portsmouth Compact. He later returned to Massachusetts.

WILCOX, CADMUS MARCELLUS (*b. Wayne Co., N.C., 1824; d. Washington, D.C., 1890*), Confederate major general. Graduated West Point, 1846. Distinguished himself in Mexican War, notably at Chapultepec. Accepted colonelcy, 9th Alabama Infantry, Confederate army, 1861. With General R. E. Lee's army in nearly every great battle, Wilcox was one of the best subordinate commanders of the South. Published *Rifles and Rifle Practice* (1859), first American textbook on the subject.

WILCOX, DELOS FRANKLIN (*b. near Ida, Mich., 1873; d. 1928*), franchise and public utility expert. Ph.D., Columbia, 1896. Chief of Bureau of Franchises, Public Service Commission, New York City, 1907–13; deputy commissioner of Department of Water Supply, Gas and Electricity, New York City, 1913–17; thereafter a consultant on utility problems. Author of, among other works, *Municipal Franchises* (1910–11), *Analysis of the Electric Railway Problem* (1921), *Depreciation in Public Utilities* (1925), and *The Administration of Municipally Owned Utilities* (1931). Revised R. A. Whitten's *Valuation of Public Service Corporations* (1928). Inclined always to the side of the public in controversies.

WILCOX, ELLA WHEELER (*b. Johnstown Center, Wis., 1850; d. Short Beach, Conn., 1919*), writer of inspirational verse. *Poems of Passion* (1883, her first success) was followed by 20 volumes mainly in verse. She wrote a daily poem for a newspaper syndicate and contributed frequent essays to *Cosmopolitan* and other magazines. All her later work shows influence of "New Thought." Defending herself against criticism of sentimentality, she maintained that her poems "comforted" millions.

WILCOX, REYNOLD WEBB (*b. Madison, Conn., 1856; d. 1931*), physician. M.D., Harvard Medical School, 1881. Practiced in New York City. Professor of medicine, New York Post-Graduate Medical School and Hospital, 1886–1908. Edited William Hale-White's *Materia Medica* (1892). Author of, among other works, *Treatment of Disease* (1907). Therapeutic editor of *American Journal of Medical Sciences* for many years.

WILCOX, STEPHEN (*b. Westerly, R.I., 1830; d. Brooklyn, N.Y., 1893*), inventor, engineer. Secured a patent for a safety water-tube boiler with inclined tubes, 1856, and a steam generator, 1867; formed Babcock, Wilson & Co., 1867, with George H. Babcock. The Babcock & Wilcox boiler and stationary steam engine were used in the first central stations (power plants) in America and were of significant value in electric lighting developments.

WILCZYNSKI, ERNEST JULIUS (*b. Hamburg, Germany, 1876; d. Denver, Colo., 1932*), mathematician, educator. Immigrated to America as a child; raised in Chicago, Ill. Ph.D., University of

Berlin, 1897. Taught at universities of California and Illinois; professor of mathematics, University of Chicago, 1914–26. Eminent as a projective differential geometer, a field of geometry he largely created.

WILDE, GEORGE FRANCIS FAXON (*b. Braintree, Mass., 1845; d. 1911*), naval officer. Graduated U.S. Naval Academy, Newport, R.I., 1864. Commanded new steel cruiser *Dolphin* on world cruise, 1886–89; commanded ram *Katahdin* on North Atlantic Patrol, 1898. Commanded cruiser *Boston*, 1898–99, and battleship *Oregon*, 1899–1901, during Philippine Insurrection. Commandant of Philadelphia navy yard, February–May 1904; thereafter at Boston navy yard. Retired as rear admiral, 1905.

WILDE, RICHARD HENRY (*b. Dublin, Ireland, 1789; d. New Orleans, La., 1847*), lawyer, poet. Immigrated to Baltimore, Md., 1797; was raised in Georgia. Became attorney general of Georgia, 1811. Congressman, Democrat, from Georgia, 1815–17 and 1827–35. Traveled extensively in Europe, 1835–40; discovered Giotto's portrait of Dante in the Bargello at Florence, Italy. Removed to New Orleans, La., 1843; was appointed professor of constitutional law, University of Louisiana (present Tulane), 1847. Author of "My Life Is Like the Summer Rose" (composed *ante* 1815), *Conjectures and Researches Concerning . . . Torquato Tasso* (1842), and *Hesperia: A Poem* (1867).

WILDER, ALEXANDER (*b. Verona, N.Y., 1823; d. 1908*), physician, eccentric philosopher. M.D., Syracuse Medical College, 1850. Removed to New York City, 1857, where for 13 years he worked on New York *Evening Post*, becoming financial expert and political journalist. President of the Eclectic Medical College, 1867–77; professor of physiology, 1873–77. Professor of psychology, United States Medical College, 1878–83. Author of, among other books, *New Platonism and Alchemy* (1869), *Vaccination a Medical Fallacy* (1875), and *History of Medicine* (1901).

WILDER, ALEXANDER LAFAYETTE CHEW ("ALEC") (*b. Rochester, N.Y., 1907; d. Gainesville, Fla., 1980*), songwriter and composer. Studied at Eastman School of Music in Rochester, N.Y., and began a career in the early 1930's arranging and composing popular songs in New York City. In 1939 he formed the Alec Wilder Octet, with Wilder on harpsichord and Mitch Miller on oboe. His compositions blended popular song, jazz, and classical elements. In the 1940's he wrote arrangements for big bands and performers, such as Frank Sinatra and Mabel Mercer. His best-known works from the period include "I'll Be Around" and "While We're Young." In the 1950's he composed more serious works, combining big band swing and popular song with classical genres. His celebrated book *American Popular Song: Great Innovators, 1900–1950* (1972) examines 800 songs and led to a weekly radio series showcasing great American songwriters.

WILDER, HARRIS HAWTHORNE (*b. Bangor, Maine, 1864; d. 1928*), zoologist. B.A., Amherst, 1886; Ph.D., University of Freiburg, 1891. Professor of zoology, Smith College *post* 1892. Made important contributions to knowledge of vertebrate anatomy, friction-ridge patterns of the skin, and descriptive anthropology.

WILDER, JOHN THOMAS (*b. Hunter Village, N.Y., 1830; d. Jacksonville, Fla., 1917*), Union brigadier general, industrialist. "Wilder's Lightning Brigade" of Indiana and Illinois volunteers acquitted itself with particular brilliance at Chickamauga, 1863. Resigning from the army, October 1864, Wilder settled in Chattanooga. A developer of Tennessee's natural resources, he founded the Roane Iron Works, 1867, and built at Rockwood one of the first blast furnaces in the South; he was also active in railroad and coal lands development.

WILDER, LAURA INGALLS (*b. Pepin, Wis., 1867; d. Mansfield, Mo., 1957*), author. Self-educated. Wilder began writing novels at the age of sixty-five. Her *Little House* books for children describe life as a pioneer and settler in the American West. *Little House on the Prairie* (1935) and *These Happy Golden Years* (1943) are typical of the books, which have sold over two million copies. In 1974, *Little House on the Prairie* was successfully adapted for a television series.

WILDER, MARSHALL PINCKNEY (*b. Rindge, N.H., 1798; d. 1886*), agriculturist, merchant, Massachusetts legislator. Removed to Boston, Mass., 1825; was known for many years as its chief citizen. A founder of the Constitutional Union party, 1860. Vice president, Massachusetts Institute of Technology, 1865–70, of which he was a founder. President, Massachusetts Horticultural Society, 1840–48. Helped found American Pomological Society, 1848, and was president for 38 years. Helped establish, 1852, and directed Massachusetts Board of Agriculture, and the U.S. Agricultural Society. Led in formation of Massachusetts Agricultural College, one of the first in any state. His proposed reformation in nomenclature of American fruits, 1883, was later adopted. He also developed many important flower and fruit varieties.

WILDER, RUSSELL MORSE (*b. Cincinnati, Ohio, 1885; d. Rochester, Minn., 1959*), medical clinician. Studied at the University of Chicago (Ph.D., 1912), and at Rush Medical College (M.D., 1912). An expert in diabetes and its treatment, Wilder worked at the Mayo Clinic from 1919 to 1950. He was one of the first to use insulin as a treatment for diabetes. In 1921, he published, along with colleagues, *A Primer for Diabetic Patients*, which did much to educate victims of the disease to the possibilities of treatment and to the uses of insulin.

WILDER, THORNTON NIVEN (*b. Madison, Wis., 1897; d. Hamden, Conn., 1975*), playwright and novelist. Graduated Yale (1920) and Princeton (M.A., 1926) universities; while at Princeton he published his first novel, *The Cabala* (1926), and composed his second, *The Bridge of San Luis Rey* (1927), which won a Pulitzer Prize. During the next decade he wrote the novels *The Woman of Andros* (1930) and *Heaven's My Destination* (1934); he also published two collections of short plays, *The Angel That Troubled the Waters* (1928) and *The Long Christmas Dinner* (1931), and taught at the University of Chicago (1931–36). He wrote the screenplays *We Live Again* (1934) and *Shadow of a Doubt* (1943), the Pulitzer Prize–winning stage plays *Our Town* (1938) and *The Skin of Our Teeth* (1942), and the play *The Merchant of Yonkers*, which was slightly revised and retitled as *The Matchmaker* (1957). His later novels include *The Ides of March* (1948) and *The Eighth Day* (1967).

WILDMAN, MURRAY SHIPLEY (*b. Selma, Ohio, 1868; d. Stanford, Calif., 1930*), banker, economist. Ph.D., University of Chicago, 1904. Taught at University of Missouri and Northwestern. As secretary of the National Citizen's League for the Promotion of a Sound Banking System, 1911–12, he contributed to the establishment of the Federal Reserve System. In 1912 he became head of the Department of Economics, Stanford University, and was dean of the school of social sciences *post* 1925. Author of *Money Inflation in the United States* (1905).

WILDT, RUPERT (*b. Munich, Germany, 1905; d. Orleans, Mass., 1976*), astrophysicist and educator. Graduated University of Berlin (Ph.D., 1927) and was a research assistant at the observatory of Bonn University (1928–29) and at University of Göttingen (1930–34). At Göttingen, he accurately theorized that absorption bands in the red spectra of Jupiter and other outer

planets were due to the presence of methane and ammonia. He immigrated to the United States (1935) as a Rockefeller fellow (1935) at the Mt. Wilson Observatory in California. He joined the Institute for Advanced Study, Princeton (1936–42), became an innovator in the study of Jovian planets, and in 1939 discovered why solar gases are more opaque than gases on Earth (negative ions of hydrogen absorb the flow of radiation from inside the sun). During World War II he worked in the Office of Scientific Research and Development and was associate professor of astronomy at the University of Virginia (1942–46). He was on the Yale University faculty (1946–73) and served as president, chairman, and director of the Association of Universities for Research in Astronomy (1958–76).

WILDWOOD, WILL. *See* POND, FREDERICK EUGENE.

WILEY, ALEXANDER (*b. Chippewa Falls, Wis., 1884; d. Philadelphia, Pa., 1967*), studied at Augsburg College, the University of Michigan, and the University of Wisconsin Law School (LL.B., 1907). He practiced law and was district attorney for Chippewa County, Wisconsin (1909–15). He served as a Republican in the U.S. Senate (1939–63), becoming a leader of the party's internationalist wing. Was member of Foreign Relations and Senate Judiciary committees, and U.S. delegate to the United Nations General Assembly (1952–53).

WILEY, ANDREW JACKSON (*b. New Castle Co., Del., 1862; d. Monrovia, Calif., 1931*), irrigation engineer. Graduated Delaware College, 1882. Associated with private irrigation projects in Idaho and Montana *post* 1883, he later extended his field of work over most of the West. Consultant to U.S. Bureau of Reclamation *post* 1902, he worked on practically all major government dam projects of recent times, including the Shoshone, Arrowrock, Roosevelt, and Boulder dams. He was also consultant for other federal departments on the Coolidge and Madden dams, Canal Zone power plant, and the Columbia River Basin and other projects.

WILEY, BELL IRVIN (*b. Halls, Tenn., 1906; d. Atlanta, Ga., 1980*), historian. Graduated Asbury College (B.A., 1928), University of Kentucky (M.A., 1929), and Yale University (Ph.D., 1933) and taught at Mississippi State College for Women (1934–38) and the University of Mississippi (1938). Wiley challenged accepted views of the Civil War and his most influential book was *The Life of Johnny Reb, the Common Soldier of the Confederacy* (1943). During World War II he was staff historian with the Second Army and an assistant historical officer at headquarters, Army Ground Forces. He was a professor of history at Louisiana State University (1946), Emory University (1949), and Oxford University (1965–66). Other works include *The Life of Billy Yank, the Common Soldier of the Union* (1952), *The Road to Appomattox* (1956), *Lincoln and Lee* (1966), and *Confederate Women* (1975).

WILEY, CALVIN HENDERSON (*b. Guilford Co., N.C., 1819; d. Winston, N.C., 1887*), educator, North Carolina legislator. Graduated University of North Carolina, 1840. Effective first superintendent, North Carolina common schools, 1853–65. Established, 1856, and edited *North Carolina Journal of Education*; organized Educational Association of North Carolina; promoted Normal College, 1852–59. Author of, among other works, *The North-Carolina Reader* (1851), a standard text.

WILEY, DAVID (*b. probably Pennsylvania, date uncertain; d. possibly North Carolina, ca. 1813*), Presbyterian clergyman. Graduated College of New Jersey (Princeton), 1788; ordained by presbytery of Carlisle, Pa., 1794. Became principal of Columbian Academy, Georgetown, D.C., 1801. Best remembered as secretary of the Columbian Agricultural Society (organized 1809) and as editor of the *Agricultural Museum* (first number, July 1810), probably the first agricultural journal published in the United States.

WILEY, EPHRAIM EMERSON (*b. Malden, Mass., 1814; d. 1893*), Methodist clergyman, educator. Graduated Wesleyan University, 1837. Professor of ancient languages and literature, 1838–52; president, 1852–79; and treasurer and financial agent, 1886–93, at Emory and Henry College, Virginia. President, Martha Washington College, Virginia, 1881–86. Leader of the Holston Conference, he adhered to the Methodist Episcopal Church, South, after the schism of 1844.

WILEY, HARVEY WASHINGTON (*b. Kent, Ind., 1844; d. Washington, D.C., 1930*), chemist, author, pure-food reformer. M.D., Medical College of Indiana, Indianapolis, 1871; B.S., Harvard, 1873. Professor of chemistry, Purdue University, 1874–83, serving also as state chemist of Indiana. Studied at University of Berlin, 1878. As chief chemist, U.S. Department of Agriculture, 1883–1912, he made a chemical study of sugar and syrup crops and devised new apparatus and procedures for agricultural chemical analyses. His most important work, however, was his campaign against food adulteration and his securing (despite prolonged opposition) of the passage of the Pure Food and Drugs Act, 1906. Thereafter until 1912 he administered the enforcement of the act with tenacity and success. Professor of agricultural chemistry, George Washington University, 1899–1914. Director of Bureau of Foods, Sanitation and Health, *Good Housekeeping*, 1912–30. Successful as a lyceum and Chautauqua lecturer, he was author of, among other books, *Principles and Practice of Agricultural Analysis* (1894–97), *Foods and Their Adulteration* (1907), *History of a Crime Against the Food Law* (1929), and an autobiography (1930).

WILHELMINA (*b. Wilhelmina Behmenburg*), Cullemborg, The Netherlands, 1939; d. Greenwich, Conn., 1980), fashion model and agent. Immigrated to the United States in 1954, enrolled in a Chicago modeling school, and in 1960 launched a seven-year modeling career in Paris; she appeared on nearly 300 magazine covers, including 28 covers of *Vogue*, epitomizing the classical aristocratic look that was the style standard in 1950's and 1960's. She formed Wilhelmina Models (1967), an agency that later represented writers, directors, and performers.

WILKES, CHARLES (*b. New York, N.Y., 1798; d. 1877*), naval officer, explorer. Appointed midshipman, 1818; studied under F. R. Hassler. Appointed to head U.S. Navy Depot of Charts and Instruments, Washington, D.C., 1833. From August 1838 until July 1842, he commanded the flagship *Vincennes* and five other vessels on an extended exploring expedition, surveying the Antarctic coast, the islands of the Pacific Ocean, and the American Northwest coast. *Narrative of the United States Exploring Expedition* (1844) and three of the expedition's scientific reports were his work. In command of *San Jacinto*, he halted the British mail steamer *Trent*, 1861, removing two Confederate agents by force and causing the "*Trent*" affair." Commanding a special squadron in the West Indies and Bahamas against Confederate commerce destroyers, 1862–63, his actions brought protests of neutrality violations. Further conflicts with the Navy Department led to his court-martial, 1864. He was commissioned rear admiral, retired, 1866.

WILKES, GEORGE (*b. New York, N.Y., 1817; d. New York, 1885*), journalist. Cofounded *National Police Gazette*, 1845. Removed to California, 1849, as aide to David C. Broderick, whose fortune he inherited. Bought *Spirit of the Times*, 1856, renaming

it *Porter's Spirit of the Times*; it appeared later as *Wilkes' Spirit of the Times*. Its political articles were influential, and Wilkes reported major Civil War engagements as if they were sporting events. He introduced pari-mutuel betting system to America and promoted famous prizefights. Author of, among other books, *Project for a National Railroad from the Atlantic to the Pacific Ocean* (1845), *The Great Battle Fought at Manassas* (1861), and *Shakespeare from an American Point of View* (1877).

WILKESON, SAMUEL (*b. Carlisle, Pa., 1781; d. Kingston, Tenn., 1848*), boat-builder, contractor, New York legislator. Removed to Lake Erie, near present Westfield, N.Y., 1809. Settling in Buffalo, N.Y., 1814, he engaged successfully in almost all its early business enterprises and constructed an artificial harbor at the mouth of Buffalo Creek for western terminus of the Erie Canal, 1820. Appointed first judge of common pleas, Erie County, 1821; became mayor of Buffalo, 1836. Assisted immigration of freed blacks to Liberia.

WILKIE, FRANC BANGS (*b. West Charlton, N.Y., 1832; d. Norwood Park, Ill., 1892*), journalist. Chief correspondent of *New York Times* in Civil War campaigns in the West and Southwest; assistant editor, *Chicago Times*, 1863–81 and 1883–88. Author of, among other books, *Personal Reminiscences of Thirty-five Years of Journalism* (1891).

WILKINS, ROSS (*b. Pittsburgh, Pa., 1799; d. 1872*), lawyer. Nephew of William Wilkins. Territorial judge of Michigan, 1832–37; U.S. judge, eastern district of Michigan, 1837–70.

WILKINS, WILLIAM (*b. Carlisle, Pa., 1779; d. 1865*), lawyer, businessman. Uncle of Ross Wilkins. President, Bank of Pittsburgh, Pa., 1814–19. President judge, 5th district of Pennsylvania, 1820–24; judge, U.S. district court for western Pennsylvania, 1824–31. U.S. senator, Democratic and Anti-Masonic, 1831–34; U.S. minister to Russia, 1834–36; U.S. secretary of war, 1844–45. A supporter of Andrew Jackson's policies and an expansionist.

WILKINSON, DAVID (*b. Smithfield, R.I., 1771; d. Caledonia Springs, Ontario, Canada, 1852*), inventor, manufacturer. Patented machine for cutting screw threads, incorporating slide rest, 1798. It was widely adopted, particularly in U.S. government firearms manufacture. In 1788–89, he constructed iron parts for Samuel Slater's cotton machinery; he later made patterns and cast wheels and racks for locks of the Charlestown, Mass., canal. Cofounded, ca. 1800, David Wilkinson & Co., iron and textile machinery manufactory, at Pawtucket, R.I. Perfected, among other machines, a mill to bore cannon by waterpower.

WILKINSON, JAMES (*b. Calvert Co., Md., 1757; d. Mexico City, Mexico, 1825*), soldier. Brother-in-law of Clement Biddle. Commissioned a captain in the Continental army, 1776, he served at the siege of Boston, joined Benedict Arnold at Montreal, and accompanied Arnold during the retreat to Albany; in December, he was appointed aide-de-camp to General Horatio Gates. After serving at Trenton and Princeton and a promotion to lieutenant colonel, he rejoined Gates and was appointed deputy adjutant general for the northern department, May 1777. Although he dallied on his way to report the victory at Saratoga to Congress, he was given a brevet of brigadier general and in January 1778 became secretary of the Board of War. A gifted intriguer, he shared in the Conway Cabal against George Washington and was forced to resign his posts. Appointed almost immediately clothier general to the army, he rendered defective accounts and was obliged to give up the assignment in March 1781. He then took up farming in Bucks Co., Pa., and in 1783 was elected to the state assembly.

Engaging in trade westward in 1784, he supplanted George Rogers Clark as a leader in the rapidly growing Kentucky region. The success of two memorials which he wrote advocating immediate separation from Virginia (August 1785) gave him the idea of turning prevalent discontent in the area to his own financial gain. Making approaches through the Spanish authorities in upper Louisiana, he went on a trading voyage to New Orleans, 1787, where he won the favor of Governor Esteban Miró and received an exclusive trading monopoly. He received this in part because he had persuaded the Spaniards that he was working toward disunion in the West. Active in the Kentucky convention of November 1788 as a moderate, he managed to convince Miró that he had achieved much for Spain. On a second journey to New Orleans in the summer of 1789 he composed and presented to the governor a second memorial or report on disunion sentiment and added to it a list of prominent westerners to whom, he suggested, the Spanish government might profitably grant pensions. After receiving a pension himself, together with a so-called loan, he was temporarily upset by a decree of the Spanish government which opened up the river trade on the Mississippi and so rendered his monopoly valueless. Meanwhile, he had also endeavored to worm his way into the confidence of the Yazoo land speculators, only to betray them to the Spaniards. In financial straits because of Kentucky land speculations, he returned to the army, leaving his business affairs to be settled by Harry Innes.

After leading a force of volunteers against the Indians north of the Ohio in March 1791, Wilkinson was commissioned lieutenant colonel in the regular army and in March 1792 was made brigadier general under General Anthony Wayne. A disloyal subordinate to Wayne whom he attempted to discredit, he continued his tenuous connection with the Spaniards and revealed to Baron Carondelet the filibustering activities of George Rogers Clark. In 1796 he took over Detroit from the British, but soon departed for Philadelphia to intensify his lobbying against Wayne. Becoming the ranking officer of the army after Wayne's unexpected death, he returned to Detroit, 1797, where he was extremely unpopular.

Transferred to command on the southern frontier in 1798, he was criticized for his friendship with the Spaniards and for personal land deals and speculations in army contracts. He also schemed to become governor of Mississippi Territory. Following the Democratic-Republican victory of 1800, Aaron Burr helped him keep his place in the army, and Jefferson commissioned him to treat with the various southern Indian tribes, a task that kept him traveling a year and a half. In 1803, after sharing with William C. C. Claiborne the honor of taking possession of the Louisiana Purchase, he invested a great part of a new bribe which he had received from the Spanish boundary commissioner in sugar, and then sailed for New York City. He then began his spectacular relations with Aaron Burr in the so-called Burr Conspiracy. He conferred frequently with Burr in Washington, D.C., during the winter of 1804–05, and again in the following June at the mouth of the Ohio, whence Wilkinson furnished Burr with conveyance to New Orleans and letters of introduction. Public opinion at this time associated the two in a possible invasion of Mexico.

In the spring of 1805, Wilkinson assumed the governorship of Louisiana Territory with headquarters at St. Louis. He was engaged with R. A. Chouteau in the fur trade and at this time dispatched the famous expedition under Zebulon M. Pike to open up a feasible military route to New Mexico. This activity was generally believed to have a connection with the mysterious movements of Burr. Soon as unpopular in St. Louis as he had been at Detroit, he was ordered again to the southern frontier in May 1806 and ultimately removed from the governorship.

Aroused by the threat to himself in Joseph Street's current exposures concerning Burr's purposes, Wilkinson, from his headquarters at Natchitoches, covered himself by warning President Jefferson that a plot was afoot to disrupt the Union and to invade Mexico. He suggested that he should meet this peril by transferring troops to New Orleans. After making these dispositions, he sent a messenger to inform the viceroy of Mexico of the peril of armed invasion which threatened the Spanish dominions and asked for a sum of money for his efforts to avert it. He declared martial law at New Orleans, embargoed vessels, and arrested and imprisoned without regard to law all whom he chose to regard as agents of Burr. Unaware of the hostile reception which Wilkinson had planned, Burr with some 60 men arrived in Mississippi Territory, where he was arrested.

When Burr was put on trial for treason in Richmond, Va., Wilkinson assumed the role of chief witness against him, but narrowly escaped indictment by the grand jury. Suspected by everyone, with the possible exception of Thomas Jefferson, he was deserted by his friends and business associates, caricatured, denounced, and publicly insulted. He was brought before a court of inquiry, which acquitted him after six months of deliberation. President Jefferson now ordered him to New Orleans and empowered him to confer on the way with the Spanish officials at Havana and Pensacola regarding a proposed alliance. Failing in this pioneer attempt at Pan-Americanism, he was once again investigated and in July 1811 was court-martialed by order of President James Madison. The "not guilty" verdict of this court, December 1811, was so worded that the president approved it with regret.

Restored to command at New Orleans, Wilkinson occupied Mobile early in 1813 and later that year was commissioned major general and ordered to the Canadian frontier. There he made a fiasco of the campaign against Montreal. Relieved from regular duty and ordered to Washington, he provoked a quarrel with John Armstrong (1758–1843) which led to yet another inquiry and acquittal, but he was not reinstated in the service. For some years thereafter he lived on a plantation below New Orleans, but Mexico once more claimed his attention in 1821 and he went there in pursuit of a Texas land grant. In time he obtained an option on lands in Texas, but before he could fulfill the conditions of the grant, he died. His *Memoirs of My Own Times*, three confused volumes of documents which are as significant for what they omit as for what they contain, were published in 1816.

WILKINSON, JEMIMA (*b. Cumberland, R.I., 1752; d. 1819*), religious leader. Sister of Jeremiah Wilkinson. Influenced by George Whitefield's sermons and by the example of Ann Lee, she announced, *ca.* 1775, her conviction that her body was inhabited by a prophetic spirit. Assuming the name Public Universal Friend, she preached with great success in her part of Rhode Island and won a number of followers. After considerable opposition and several removes, she founded the colony of Jerusalem in Yates Co., N.Y., 1789–90, presiding over it until her death.

WILKINSON, JEREMIAH (*b. Cumberland, R.I., 1741; d. Cumberland, 1831*), forge-master, farmer, inventor. Brother of Jemima Wilkinson. Perfected a number of devices to expedite his manufacture of wool-cards; drew wire by horsepower *ante* 1776; made first experiments in nail manufacture from cold iron, *ca.* 1776.

WILKINSON, JOHN (*b. Norfolk, Va., 1821; d. Annapolis, Md., 1891*), naval officer *post* April 6, 1861, he was highly successful as commander of the blockade-runners *Giraffe* (later named *Robert E. Lee*), *Chickamauga*, and *Chameleon*. He also led an abortive 1863 attempt to release Confederate prisoners confined on Johnson's Island in Lake Erie. Author of *Narrative of a Blockade-Runner* (1877).

WILKINSON, ROBERT SHAW (*b. Charleston, S.C., 1875; d. 1932*), educator. Son of free black parents, A.B., Oberlin, 1891. Professor of Greek and Latin, State University, Louisville, Ky., 1891–96. Appointed professor of science at State Agricultural and Mechanical College, Orangeburg, S.C., 1896, he served the college as president *post* 1911 with remarkable success. He raised standards in every particular and emphasized a balanced curriculum of industrial and literary instruction.

WILKINSON, THEODORE STARK (*b. Annapolis, Md., 1888; d. Virginia, 1946*), naval officer. Graduated U.S. Naval Academy, 1909. M.S., George Washington University, 1912. Awarded Medal of Honor for leadership in landing at Veracruz, Mexico, 1914. Served in Bureau of Ordnance during World War I; rose to rank of rear admiral in various duties, 1919–41. Director, Office of Naval Intelligence, Oct. 1941–July 1942; commander, Battleship Division 2, Aug. 1942–Jan. 1943; deputy commander, South Pacific Force, Jan.–July 1943; commander, 3rd Amphibious Force, July 1943–45. A leading advocate and practitioner of the "leapfrogging" strategy, whereby U.S. forces in the Pacific theater bypassed and isolated enemy strong points, concentrating on the capture of weaker targets. Promoted vice admiral, 1944.

WILL, ALLEN SINCLAIR (*b. Antioch, Va., 1868; d. New York, N.Y., 1934*), journalist, educator. On *Baltimore Sun* staff, 1889–1912; city editor, 1905–12. Associate editor and editorial writer, *Baltimore News*, 1912–14; news editor, *Philadelphia Public Ledger*, 1914–16; assistant editor, *New York Times*, 1917–24. Director, Department of Journalism, Rutgers University, *post* 1926. Author of, among other works, *Life of Cardinal Gibbons, Archbishop of Baltimore* (1922), and *Education for Newspaper Life* (1931).

WILLARD, DANIEL (*b. North Hartland, Vt., 1861; d. Baltimore, Md., 1942*), railroad executive. From a section hand on the Vermont Central Railroad, Willard rose to a division superintendency on the Minneapolis, St. Paul and Sault Ste. Marie (Soo Line), 1879–99. From 1899 to 1901, he was assistant general manager of the Baltimore & Ohio; from 1901 to 1904, first vice president and general manager of the Erie; from 1904 to 1910, operating vice president of the Chicago, Burlington & Quincy. Returning to the Baltimore & Ohio as president in 1910, he served until 1941, when he became chairman of the board. His rebuilding program produced a major increase in B & O traffic and revenues during the 1920's; during the depression years, his economical management kept the road from receivership. President of the board of trustees of Johns Hopkins University, 1926–41.

WILLARD, DE FOREST (*b. Newington, Conn., 1846; d. Lansdowne, Pa., 1910*), physician, pioneer in orthopedic surgery. Studied under Joseph Pancoast and Samuel D. Gross at Jefferson Medical College; graduated in medicine, University of Pennsylvania, 1867. Taught at Pennsylvania *post* 1867; was clinical professor of orthopedic surgery, 1889–1903, and professor thereafter. General surgeon at the Presbyterian Hospital, Philadelphia, and consultant at many others, he was surgeon in chief of the Widener Memorial Industrial Training School for Crippled Children, which he had helped to plan.

WILLARD, EMMA HART (*b. Berlin, Conn., 1787; d. 1870*), educator. Encouraged by her parents to read widely and to do her own thinking, she attended the district school and Berlin Academy. Becoming a teacher, she was unusually successful as head of the Female Academy, Middlebury, Vt., 1807–09. Opening a

school for girls in her own home at Middlebury, 1814, she experimented with plans for improving female education and proved that such subjects as mathematics and philosophy could be mastered by girls without costing them their health, refinement, or charm. Despite the support of New York's Governor DeWitt Clinton and others, she failed in a pioneer campaign, 1818, for establishment with state aid of schools in which women would be given the same educational advantages as men; she then removed to New York State and in 1821 founded the Troy Female Seminary with the aid of local citizens. As it grew in reputation and influence, she continued her policy of adding higher subjects to the curriculum, especially mathematics. She retired from active management, 1838. Subsequently she worked with Henry Barnard and others for improvement of the common schools. While active at Troy, she evolved new methods of teaching and published widely used textbooks in geography and history. She was author also of a number of mediocre poems, including "Rocked in the Cradle of the Deep."

WILLARD, FRANCES ELIZABETH CAROLINE (*b. Churchville, N.Y., 1839; d. New York, N.Y., 1898*), teacher, reformer. Raised in pioneer Wisconsin. Graduated Northwestern Female College, Evanston, Ill., 1859. Evanston became her permanent home. Joining the temperance crusade, 1874, she was elected president of the National Woman's Christian Temperance Union, 1879. She enlisted her society in the cause of woman's suffrage, helped organize the Prohibition party, 1882, and devoted her life to furthering the cause with tongue and pen. In 1891 she was elected president of the World's Woman's Christian Temperance Union. Temperance, in her opinion, was basically a measure for the protection of home life and therefore an ideal which demanded personal sacrifice.

WILLARD, FRANK HENRY (*b. Anna, Ill., 1893; d. Los Angeles, Calif., 1958*), cartoonist. Studied briefly at the Chicago Academy of Fine Arts. After World War I, Willard settled in New York and by 1923 was producing the cartoon "Moon Mullins," begun for the *New York Daily News*. This strip, along with "Kitty Higgins" insured his fame as a cartoonist. At the time of Willard's death, "Moon Mullins" was appearing in over 250 newspapers.

WILLARD, JAMES FIELD (*b. Philadelphia, Pa., 1876; d. 1935*), historian, medievalist. Graduated University of Pennsylvania, 1898; Ph.D., 1902. Professor and head of the Department of History. University of Colorado *post* 1906. He was author of a number of important studies in medieval history and also edited several volumes of important source materials on the history of the American West.

WILLARD, JOSEPH (*b. Biddeford, Maine, 1738; d. New Bedford, Mass., 1804*), Congregational clergyman, educational leader. Great-grandson of Samuel Willard (1639/40–1707). Graduated Harvard, 1765. Pastor at Beverly, Mass. For many years corresponding secretary and vice president of the American Academy of Arts and Sciences (of which he was a founder, 1780), he was well known for work in astronomy, mathematics, and the classics. President of Harvard, 1781–1804, he repaired ravages of the Revolution, raised entrance requirements, broadened instruction, and founded the medical school.

WILLARD, JOSEPH (*b. Cambridge, Mass., 1798; d. 1865*), lawyer, historian. Son of Joseph Willard (1738–1804); brother of Sidney Willard. LL.B., Harvard Law School, 1820. Clerk, court of common pleas, Suffolk County, *post* 1841. Officer of Massachusetts Historical Society, 1833–64. Author of, among other works, *Sketches of the Town of Lancaster* (1826).

WILLARD, JOSEPH EDWARD (*b. Washington, D.C., 1865; d. New York, N.Y., 1924*), diplomat, lawyer, Virginia legislator. Practiced at Richmond, Va., bar. Gained statewide reputation as soldier in Spanish-American War. Democratic lieutenant governor of Virginia, 1902–06. Served as U.S. ambassador to Spain, 1913–21.

WILLARD, JOSIAH FLINT (*b. Appleton, Wis., 1869; d. 1907*), writer on vagrancy and criminology, better known under the pen name "Josiah Flynt." Nephew of Frances E. Willard. Author of, among other works of sociological value, *Tramping With Tramps* (1899), *The Powers That Prey* (1900), and *The World of Graft* (1901).

WILLARD, MARY HATCH (*b. Jersey City, N.J., 1856; d. New York, N.Y., 1926*), businesswoman, social worker. Established, *ca.* 1890 in New York City, the successful Home Bureau, for supply of food for invalids; later added a trained nurses' registry service. In World War I, led huge emergency movement to supply hospitals on western front with surgical dressings. Associated for many years with State Charities Aid Association of New York.

WILLARD, SAMUEL (*b. Concord, Mass., 1639/40; d. 1707*), Congregational clergyman, controversialist. Son of Simon Willard (1605–76 o.s.). Graduated Harvard, 1659. Pastor of Groton, Mass., 1664–78; of Old South Church, Boston, Mass., *post* 1678. He was conservative in theology, liberal in practice. Like his friends the Mathers, he was an opponent of the methods used in the witchcraft trials, 1692. Vice president of Harvard University, 1700–07, he in fact headed the institution. A voluminous writer, he made one of the best psychic investigations in the literature of the witchcraft delusion (*Massachusetts Historical Society Collections*, 4 ser. VIII, 1868). His *Compleat Body of Divinity* was published in 1726.

WILLARD, SAMUEL (*b. Petersham, Mass., 1775; d. Deerfield, Mass., 1859*), Congregational and Unitarian clergyman, educator, hymnist. Brother of Solomon Willard. Graduated Harvard, 1803. Pastor at Deerfield, Mass., 1807–29. The controversy over his ordination was the first sign in western Massachusetts of the liberal theological opinions which led to Unitarian-Congregational split. As superintendent of Deerfield schools, he wrote and published numerous textbooks, he was author also of hymnals, including the *Deerfield Collection of Sacred Music* (1814).

WILLARD, SIDNEY (*b. Beverly, Mass., 1780; d. 1856*), educator, writer, Massachusetts legislator. Son of Joseph Willard (1738–1804); brother of Joseph Willard (1798–1865). Graduated Harvard, 1798. Hancock professor of Hebrew and Oriental languages at Harvard, 1806–*ca.* 1830; professor of Latin, 1827–31. Established and edited *American Monthly Review*, 1831–33, and was a contributor to, or otherwise associated with, almost all Massachusetts magazine ventures in his time. Mayor of Cambridge, Mass., 1848–50.

WILLARD, SIMON (*b. probably Kent, England, 1605; d. Charlestown, Mass., 1676*), colonist, fur trader. Father of Samuel Willard (1639/40–1707). Cofounder, with Peter Bulkeley, of Concord, Mass., 1635; was one of the leading men on the Merrimac frontier. Represented Concord in the General Court, 1636–54 with exception of 1643, 1647 and 1648; chosen assistant, 1654, he served until his death. Assisted John Eliot among Merrimac tribes, 1646 and afterward. In charge of Merrimac defenses during King Philip's War, his relief of Brookfield, Mass., Aug. 4, 1675, was a notable feat.

WILLARD, SIMON (*b. Grafton, Mass., 1753; d. Roxbury, Mass., 1848*), clockmaker, inventor. Established clock factory at Rox-

bury, Mass., between 1777 and 1780; retired from business, 1839. Built up enviable reputation specializing in church, hall, and gallery timepieces. He is especially renowned for the "Willard Patent Timepiece," or "banjo clock" (patented 1802). President Jefferson was one of his patrons.

WILLARD, SOLOMON (*b. Petersham, Mass., 1783; d. Quincy, Mass., 1861*), sculptor, architect. Brother of Samuel Willard (1775–1859). Executed wood and marble carvings primarily for Boston, Mass., churches and public buildings. His sculpture included the eagle on old Boston Customs House, 1809, and many ship figureheads from *ca.* 1813. Made wooden model of completed U.S. Capitol for Charles Bulfinch. He designed, among other buildings, the Doric U.S. Branch Bank, Boston (1824), and the Boston Court House (1832). Famous chiefly as architect of Bunker Hill Monument, 1825–42, he supervised construction, published *Plans and Section of the Obelisk . . .* (1843) and discovered and worked the Quincy granite quarries.

WILLCOX, LOUISE COLLIER (*b. Chicago, Ill., 1865; d. Paris, France, 1929*), essayist, critic, editor. Sister of Hiram P. Collier. Studied and traveled in Europe; resident in Norfolk, Va., *post* 1887. Editorial writer for *Harper's Weekly* and *Harper's Bazar*; wrote also for the *Delineator*. Member of editorial staff, *North American Review*, 1906–13. Reader and adviser for Macmillan Co., 1903–09; for E. P. Dutton & Co., 1910–17. Translator of contemporary French and German books.

WILLCOX, ORLANDO BOLIVAR (*b. Detroit, Mich., 1823; d. Coburg, Ontario, Canada, 1907*), soldier. Graduated West Point, 1847. First lieutenant of artillery in campaigns against Seminole Indians, 1856–57; commissioned colonel, 1st Michigan Infantry, 1861. Brigadier general of volunteers assigned to Burnside's IX Corps, 1862, he commanded a division, and sometimes the corps, with marked distinction at Antietam, Fredericksburg, and Knoxville, and in campaigns from the Wilderness to Petersburg. Breveted major general of volunteers, 1864, brigadier general and major general in regular army, 1867. Commanded Department of Arizona, March 1878–September 1882, operating notably against the Apache. Commanded Department of Missouri, October 1886–April 1887.

WILLEBRANDT, MABEL WALKER (*b. Woodsdale, Kans., 1889; d. Riverside, Calif., 1963*), lawyer. Attended University of Southern California (LL.B., 1916; LL.M., 1917). Started a private practice and volunteered her services as assistant public defender in police courts. Assistant U.S. attorney general, 1921–29; her major responsibilities included the administration of the Bureau of Federal Prisons, supervision of federal tax cases, and prosecution of cases arising under the National Prohibition Act. By 1925 she was responsible for more than 45,000 criminal prosecutions in the federal courts. Counsel to the Screen Directors' Guild, 1936–57.

WILLET, WILLIAM (*b. New York, N.Y., 1867; d. Philadelphia, Pa., 1921*), artist in stained glass. Studied at New York Mechanics' and Tradesmen's Institute, 1884–85, and under William M. Chase and John La Farge. Resided in Pittsburgh, Pa., *ca.* 1898–1913. Possessing a vivid color sense and high artistic integrity, he challenged popular taste in his speciality after traveling in Europe, 1902. Among his works are the chancel window, Calvary Church, Pittsburgh, 1907; the sanctuary window of West Point Chapel, 1910, called the symbol of a regenerated craft in America; and the great west window, Princeton University Graduate School (1913).

WILLETT, HERBERT LOCKWOOD (*b. Ionia, Mich., 1864; d. Winter Park, Fla., 1944*), Disciples of Christ clergyman, educa-

tor, biblical scholar, B.A., Bethany College, 1886. Ordained, 1890. While engaged in various pastoral activities, he pursued graduate studies at University of Chicago and received the Ph.D., 1896. Joining the staff of the Semitics department at Chicago on completion of his graduate work, he remained there until retirement in 1929 (professor of Oriental languages and literature *post* 1915). He endeavored to popularize liberal biblical scholarship within his own denomination and beyond it, and was widely known as a lecturer. A supporter of ecumenism, he held pastorates in Chicago and Kenilworth, Ill.

WILLETT, MARINUS (*b. Jamaica, N.Y., 1740; d. Cedar Grove, N.Y., 1830*), merchant, Revolutionary soldier. An outstanding Son of Liberty and leader of radical patriots in New York City. After service in Montgomery's invasion of Canada, 1775, he was commissioned lieutenant colonel, 3rd New York Regiment, 1776, commanding at Fort Constitution. As second-in-command under Col. Peter Gansevoort at Fort Schuyler, 1777, he distinguished himself during British attack by Col. Barry St. Leger. He fought under Washington at Monmouth and took part in the Sullivan-Clinton expedition against the Iroquois, 1779. Appointed lieutenant colonel commandant, 5th New York Regiment, 1780. Led regiment of levies on Tryon frontier, 1781, in successful battle of Johnstown. Sheriff of New York City and county, 1784–88 and 1792–96. Obtained treaty with Creek Indians, 1790. Appointed mayor of New York City, 1807.

WILLEY, SAMUEL HOPKINS (*b. Campton, N.H., 1821; d. 1914*), California clergyman, educator. Graduated Dartmouth, 1845; Union Theological Seminary, N.Y., 1848. On behalf of American Missionary Society, he went as minister to Monterey, Calif., 1849. Removed to San Francisco, 1850; established and became pastor of Howard Presbyterian Church, resigning 1862. Helped found College of California, Berkeley, 1855; served as vice president and acting president, 1862–69. Held pastorates in Santa Cruz and Benicia, 1870–89; was president of Van Ness Seminary, 1889–96. Author of, among other historical writings, *Thirty Years in California* (1879) and *A History of The College of California* (1887).

WILLEY, WAITMAN THOMAS (*b. near present Farmington, W.Va., 1811; d. Morgantown, W.Va., 1900*), lawyer, politician. Opposed Virginia's secession, 1861, at state convention, but checked radical movement for immediate West Virginia statehood. U.S. senator from Virginia, July 1861–63, from West Virginia, 1863–71. As senator, he was instrumental in Congress's acceptance of West Virginia's constitution and in ratification of the "Willey Amendment" for gradual abolition of slavery. First a Whig, he became a Republican, 1864. Later, as a Radical Republican, he voted for impeachment of President Andrew Johnson.

WILLIAMS, ALPHEUS STARKEY (*b. Saybrook, Conn., 1810; d. Washington, D.C., 1878*), lawyer, soldier. Practiced in Detroit, Mich., *post ca.* 1837; served in Mexican War; postmaster of Detroit, 1849–53. A Union brigadier general of volunteers, 1861, he commanded a division in the Shenandoah Valley campaign, 1862, and a division of the XII Corps in battle of South Mountain. Lee's famous "lost order" was brought to his headquarters. Succeeding to command of Mansfield's Corps at Antietam, he later led his own division with conspicuous ability at Chancellorsville and Gettysburg. Served with 1st Division of new XX Corps in Army of the Cumberland in Atlanta campaign. Commanded XX Corps in Sherman's march to the sea and during Carolinas campaign. Mustered out, 1866. U.S. minister resident to Salvador, 1866–69. Congressman, Democrat, from Michigan, 1875–78.

WILLIAMS, AUBREY WILLIS (*b. Springville, Ala., 1890; d. Washington, D.C., 1965*), social worker, federal official, and civil rights advocate. Attended Maryville and University of Cincinnati (B.A., 1920). Executive director of the Wisconsin Conference on Social Work, 1922–32, gaining a national reputation as an effective proponent of rationally administered public assistance programs. Field representative for the American Public Welfare Association, 1932–33, to ensure that relief loans from the Reconstruction Finance Corporation reached those in need. A fervent New Dealer, he became deputy administrator of the Works Progress Administration. His outspoken liberalism made his career stormy; he infuriated conservatives by blaming social injustice on "arrogant aggregates of concentrated economic power." Head of the National Youth Administration, 1935–43. Returned to the South and purchased the *Southern Farmer*, a monthly, and continued to be one of the most vigorous white southern spokesmen for civil rights. Became president of the Southern Conference Education Fund in 1947, putting him very much out of step with the white South's determination to preserve segregation.

WILLIAMS, BARNEY (*b. Cork, Ireland, 1823; d. New York, N.Y., 1876*), actor. Stage name of Bernard Flaherty. In 1849, married Maria Pray, with whom he costarred thereafter throughout the United States. Williams was an infectiously humorous entertainer in broad Irish character.

WILLIAMS, BEN AMES (*b. Macon, Miss., 1889; d. Brookline, Mass., 1953*), novelist and short-story writer. Studied at Dartmouth College (1906). Between 1917 and 1941, he published 179 stories, serials, and articles in the *Saturday Evening Post*, and all together, more than 400 pieces in other magazines and journals. His stories usually concerned the people of a fictionalized town, Searsmont, in Maine. Novels include *House Divided* (1947), an epic Civil War novel that became a best seller, *The Strange Woman* (1941), and *Leave Her to Heaven* (1944); the last two were made into successful motion pictures.

WILLIAMS, BERT (*b. New Providence, Bahamas, ca. 1876; d. New York, N.Y., 1922*), comedian, songwriter. Stage name of Egbert Austin Williams. Formed successful vaudeville team with George Walker, 1895. In 1903 they produced the musical comedy *In Dahomey* with an all black cast in New York and London; similar pieces such as *Abyssinia* and *Bandanna Land* followed. Leading comedian in the Ziegfeld Follies *post* 1909, Williams' skits and such songs as "Jonah Man" were often the best things in the show. A pioneer in assuring talented blacks a place in the American theater, he was himself a performer of rare gifts.

WILLIAMS, CATHARINE READ ARNOLD (*b. Providence, R.I., 1787; d. Providence, 1872*), poet, novelist, biographer. Author of, among other works, *Original Poems, on Various Subjects* (1828), *Tales, National and Revolutionary* (1830), and *The Neutral French, or the Exiles of Nova Scotia* (1841), whose theme anticipated Longfellow's *Evangeline*. Her vigorous, didactic books were popular in her day.

WILLIAMS, CHANNING MOORE (*b. Richmond, Va., 1829; d. Richmond, 1910*), Episcopal clergyman. Graduated William and Mary, 1852; Theological Seminary, Alexandria, Va., 1855. Ordained priest, 1857. Sent to Japan, 1859, by board of missions of the Protestant Episcopal church; he supervised erection of the first Protestant church building there. Consecrated in New York, 1866, as bishop of China with jurisdiction in Japan. Named bishop of Tokyo, 1874, he resigned 1889.

WILLIAMS, CHARLES DAVID (*b. Bellevue, Ohio, 1860; d. 1923*), Episcopal clergyman. Graduated Kenyon, 1880; ordained, 1884. Dean of Trinity Cathedral, Cleveland, Ohio, 1893–1906. Consecrated bishop of Michigan, 1906. A liberal, Williams was the leading exponent in his communion of the Social Gospel. He believed the church, by engendering a worldwide fellowship, should help bring about a new social order by proclaiming principles of industrial democracy, not by recommending economic and political programs. Author of, among other books, *The Christian Ministry and Social Problems* (1917), *The Prophetic Ministry for Today* (1912), and *The Gospel of Fellowship* (1923), all of which set forth his social views.

WILLIAMS, CHARLES RICHARD (*b. Prattsburg, N.Y., 1853; d. Princeton, N.J., 1927*), editor, author. Son-in-law of William H. Smith (1833–96). A.B., College of New Jersey (Princeton), 1875. Editor in chief, *Indianapolis News*, 1892–1911. The correctness of style and nicety of language of the *News* set a high standard in the Midwest. Author of, among other books, *The Life of Rutherford Birchard Hayes* (1914); edited Hayes's *Diary and Letters* (1922–26).

WILLIAMS, DANIEL HALE (*b. Hollidaysburg, Pa., 1858; d. Idlewild, Mich., 1931*), surgeon. M.D., Chicago Medical College, 1883. Organized Provident Hospital, Chicago, Ill., 1891, with first black nurses' training school in the United States. Surgeon in chief, Freedmen's Hospital, Washington, D.C., 1893–98. Appointed professor of clinical surgery, Meharry Medical College, Nashville, Tenn., 1899. Performed first successful surgical closure of a wound of the heart and pericardium, 1893; perfected suture for arrest of hemorrhage from the spleen. Charter member of American College of Surgeons, 1913. The most gifted surgeon and most notable black medical man in U.S. history.

WILLIAMS, DAVID ROGERSON (*b. Robbin's Neck, S.C., 1776; d. Williamsburg district, S.C., 1830*), planter, South Carolina legislator, pioneer manufacturer. Congressman, Democratic-Republican, from South Carolina, 1805–09 and 1811–13. Supported the Embargo of 1807, espoused cause of war hawks, and was chairman of House Committee on Military Affairs. Governor of South Carolina, 1814–16. Opposing nullification, he advocated development of southern domestic manufactures and engaged in making cotton yarns, hats and shoes, and cottonseed oil. Opposition to John C. Calhoun was the consuming purpose of his later life.

WILLIAMS, EDWARD THOMAS (*b. Columbus, Ohio, 1854; d. Berkeley, Calif., 1944*), Disciples of Christ clergyman, missionary and diplomat in China, educator. Graduated Bethany College, 1875. Held pastorates in Springfield, Ill., Denver, Colo., Brooklyn, N.Y., and Cincinnati, Ohio. A missionary in China, 1887–96, he left the ministry and became translator at the U.S. consulate general in Shanghai. For the next quarter-century, he served in a number of diplomatic capacities in China and in Washington, D.C., concluding as chief of the Far East division in the U.S. Department of State, 1914–18, and as a consultant at the Washington Conference, 1921. From 1918 until his retirement in 1927, he was Agassiz professor of Oriental languages and literature, University of California, Berkeley. He was author of *China Yesterday and Today* (1923) and *A Short History of China* (1928).

WILLIAMS, EDWIN (*b. Norwich, Conn., 1797; d. New York, N.Y., 1854*), New York City journalist, miscellaneous writer. Author of, among other works, *The Statesman's Manual* (1846–58).

WILLIAMS, EGBERT AUSTIN See WILLIAMS, BERT.

WILLIAMS, ELEAZAR (*b. possibly Sault St. Louis, Canada, ca. 1789; d. Hogansburg, N.Y., 1858*), Episcopal Indian missionary.

A half-breed, he led Oneida chiefs to Green Bay, Wis., 1821, where they negotiated a treaty with the Menominee and Winnebago and were ceded land on the Fox River. In 1822 Williams led a number of Oneida to Wisconsin, becoming their missionary. Repudiated by the Indians, he became well known for hypocrisy, indolence, and desire for notoriety. *Post* 1839 he maintained that he was Louis XVII of France. Published, among other writings, *Good News to the Iroquois Nation* (1813).

WILLIAMS, ELISHA (*b. Hatfield, Mass., 1694; d. Wethersfield, Conn., 1755*), Congregational clergyman, Connecticut colonial legislator. Half brother of Israel Williams. Graduated Harvard, 1711. Gained high repute as teacher in Wethersfield, 1716–19, where he instructed a part of the Yale student body, among them, Jonathan Edwards. Pastor at Wethersfield, 1722–26, he was rector of Yale College, 1726–39. Represented Wethersfield in Connecticut General Assembly, 1717–19, 1740–49, and *post* 1751; several times chosen Speaker. Judge, Connecticut Superior Court, 1740–43. As army chaplain, he was present at capture of Louisburg, Cape Breton Island, 1745. Delegate at Albany Congress, 1754.

WILLIAMS, ELISHA (*b. Pomfret, Conn., 1773; d. probably Waterloo, N.Y., 1833*), lawyer, politician. Admitted to the New York bar, 1793; practiced in Spencertown and Hudson, N.Y.; displayed brilliant oratorical gifts. Elected to New York Assembly for Columbia County, 1800, he served at nine sessions down to 1828. A Federalist leader, he was strongly antidemocratic in the New York constitutional convention in 1821. In 1815 he founded Waterloo, Seneca Co., N.Y.

WILLIAMS, ELKANAH (*b. near Bedford, Ind., 1822; d. Hazelwood, Pa., 1888*), ophthalmologist. M.D., University of Louisville, 1850; influenced by S. D. Gross. Studied in Europe, 1852–55. Returning to Cincinnati, Ohio, 1855, he became the pioneer ophthalmologist in the Midwest. As professor of opthalmology and aural surgery, Miami Medical College *post* 1865, he was first in the United States to hold a chair in this specialty. One of first in America to use the ophthalmoscope.

WILLIAMS, EPHRAIM (*b. Newton, Mass., 1714 n.s.; d. near Crown Point, N.Y., 1755*), colonial soldier. Settled in Stockbridge, Mass., 1739. Commissioned captain, 1745, commanding forts and posts along northern boundary of Massachusetts from Northfield to the New York border. Commissioned colonel of a regiment to aid William Johnson in expedition against Crown Point, 1755, he was killed in ambush while reconnoitering in force with Chief Hendrick. His estate was employed in founding the school which became Williams College.

WILLIAMS, FANNIE BARRIER (*b. Brockport, N.Y., 1855; d. Brockport, 1944*), Afro-American civic leader. Graduated State Normal School, Brockport, 1870; studied also at New England Conservatory of Music and at School of Fine Arts, Washington, D.C. Married S. Laing Williams, a lawyer, 1887, and settled in Chicago, Ill. Having experienced race discrimination for the first time while she was a teacher in the South during the late 1870's, she became a militant and persuasive advocate of equal rights for black people; she made her public debut in 1893 when she delivered a widely acclaimed address before a women's congress at the Chicago World's Fair. During the next ten years, she traveled extensively, speaking to women's clubs and church groups on various aspects of Afro-American life; she also worked to develop an organizational and institutional life in the black community and urged black women to take a leading part in the woman suffrage movement.

WILLIAMS, FRANCIS HENRY (*b. Uxbridge, Mass., 1852; d. Boston, Mass., 1936*), physician. Son of Henry W. Williams. Graduated Massachusetts Institute of Technology, 1873; M.D., Harvard Medical School, 1877. Distinguished in practice in Boston, Mass., and as a faculty member at Harvard Medical School, he is remembered as a pioneer in the use of X rays. Shortly after their discovery by Roentgen in December 1895, Williams began using them to study cases of thoracic lesions, and as early as April 1896 delivered a paper on the use of X rays in medicine, illustrating it with X-ray photographs. He was author of, among other works, *The Roentgen Rays in Medicine and Surgery* (1901). He was also an early experimenter with the therapeutic use of beta rays from radium.

WILLIAMS, FRANK MARTIN (*b. Durhamville, N.Y., 1873; d. Albany, N.Y., 1930*), civil engineer. State engineer and surveyor of New York, 1909–10 and 1915–22, he supervised construction of a barge canal to supersede Erie Canal. Consultant for, among other projects, the Holland Vehicular Tunnel and Sacandaga Reservoir.

WILLIAMS, FREDERICK WELLS (*b. Macao, 1857; d. New Haven, Conn., 1928*), writer, teacher. Son of Samuel W. Williams. Graduated Yale, 1879. Taught Oriental history at Yale, 1893–1925. *Post* 1901 he was associated with Yale-in-China. Author of *The Life and Letters of Samuel Wells Williams* (1889) and *Anson Burlingame and the First Chinese Mission to Foreign Powers* (1912).

WILLIAMS, GAAR CAMPBELL (*b. Richmond, Ind., 1880; d. Chicago, Ill., 1935*), cartoonist. Studied at Art Institute of Chicago; began work on staff of *Chicago Daily News*. Editorial cartoonist, *Indianapolis News*, 1909–21; special cartoonist, *Chicago Tribune* thereafter. Author of the celebrated single-panel series "Just Plain Folks" and the Sunday feature "Among the Folks in History," which were widely syndicated.

WILLIAMS, GARDNER FRED (*b. Saginaw, Mich., 1842; d. 1922*), mining engineer. Graduated College of California, 1865; studied also at Freiberg. Consultant in western mining regions, 1875–83. Manager, under Cecil Rhodes, of De Beers Mining Co., South Africa, 1887–1905. His improved working methods made possible worldwide regulation of diamond prices. Author of *The Diamond Mines of South Africa* (1902).

WILLIAMS, GEORGE HENRY (*b. New Lebanon, N.Y., 1820; d. 1910*), jurist, politician. Iowa district judge, 1847–52; chief justice, Oregon Territory, 1853–57. Leading member of Oregon constitutional convention, 1857; delegate to Union state convention, 1862. As U.S. senator, Republican, from Oregon, 1865–71, he was a member of joint committee on reconstruction; introduced Tenure of Office Act, December 1866, and Military Reconstruction Act, February 1867; voted "guilty" in President Johnson's impeachment trial. He was U.S. attorney general, 1871–75. His nomination as chief justice of U.S. Supreme Court, 1873, was withdrawn after inquiry revealed his connection with Oregon election frauds. He served with Lew Wallace as examiner of the Florida vote, 1876, so "saving the state" for Hayes. He was mayor of Portland, Oreg., 1902–05.

WILLIAMS, GEORGE HUNTINGTON (*b. Utica, N.Y., 1856; d. 1894*), mineralogist, petrologist, teacher. Grandson of William Williams (1787–1850). A.B., Amherst, 1878; Ph.D., Heidelberg, 1882. Taught at Johns Hopkins *post* 1883; professor of inorganic geology, 1891–94. Author of, among other works, *The Greenstone Schist Areas of the Menominee and Marquette Regions of Michigan* (1890, *Bulletin 62* of U.S. Geological Survey).

WILLIAMS, GEORGE WASHINGTON (*b. Bedford Springs, Pa., 1849; d. Blackpool, England, 1891*), Baptist clergyman, Union colonel. Studied law under Alphonso Taft. Born the child of an interracial union. He held federal offices and served in the Ohio legislature following the Civil War. U.S. minister to Haiti, 1885–86. Made critical survey writings of conditions in Congo Free State. Author of, among other writings, *A History of the Negro Troops in the War of the Rebellion* (1888).

WILLIAMS, HARRISON CHARLES (*b. Avon, Ohio, 1873; d. Bayville, L.I., 1953*), utilities executive. Beginning in 1906 with the foundation of the American Gas and Electric Co., Williams built one of the largest financial empires in the nation's history. Through the subsequently outlawed practice of pyramiding, he added to his holdings such companies as Central States Electric Co., the Cleveland Illuminating Co., and the North American Co; under the top holding company, New Empire Corporation, his stock in Central States reached a high of $680 million in 1929; after the Crash, his fortune was reduced. In the 1930's and 1950's, he struggled in endless litigations and antitrust suits under the provisions of the Public Utility Holding Company Act of 1935. In 1952, a $12 million decision was handed down, one of the largest decisions ever brought against an individual; the decision was later reversed and Williams' lawyers settled for $800,000 against his estate in 1959.

WILLIAMS, HENRY SHALER (*b. Ithaca, N.Y., 1847; d. Havana, Cuba, 1918*), paleontologist. Ph.B., Sheffield Scientific School, Yale, 1868; Ph.D., Yale, 1871. Taught paleontology at Cornell University, 1879–92; Silliman professor at Yale, 1892–1904. Returning to teach at Cornell, 1904, he became professor emeritus, 1912. Williams was an authority on the American Devonian and developed the now-common photographic method of fossil illustration. He was also associated with the U.S. Geological Survey from 1883 until his death. Author of, among other works, *Geological Biology* (1895); associate editor of the *Journal of Geology*, 1893–1918, and of *American Journal of Science*, 1894–1918.

WILLIAMS, HENRY WILLARD (*b. Boston, Mass., 1821; d. Boston, 1895*), ophthalmologist. One of the founders of ophthalmology in America, Williams studied in Paris, London, and Vienna, and graduated from Harvard Medical School, 1849. In 1871 he became the first professor of ophthalmology at Harvard Medical School. He was ophthalmologic surgeon, Boston City Hospital, 1864–91. Author of, among other valuable writings, *The Diagnosis and Treatment of the Diseases of the Eye* (1881), the best book of its day on the subject.

WILLIAMS, (HIRAM) HANK (*b. Mt. Olive, Ala., 1923; d. Oak Hill, W.Va., 1953*), songwriter, singer. One of the nation's most famous and talented country and western singer, Hank Williams began recording in Nashville for Sterling Records in 1946. Later, for MGM records, he released such songs as "Lovesick Blues," "Cold, Cold Heart," "Kaw-liga," "Jambalaya," "Half as Much," "Your Cheatin' Heart," and "Take These Chains From My Heart." Williams appeared on the "Grand Ole Opry" and "Louisiana Hayride." He died at the age of twenty-nine from alcohol and drugs.

WILLIAMS, ISRAEL (*b. Hatfield, Mass., 1709; d. Hatfield, 1788*), farmer, land speculator, Massachusetts official, Loyalist. Half brother of Elisha Williams (1694–1755). Active in effecting dismissal of his cousin Jonathan Edwards from Northampton church, 1750. Made colonel of Hampshire Co. militia, 1748; conducted defense of western Massachusetts throughout French and Indian War. Judge, Hampshire Co. court of common pleas,

1758–74; Massachusetts legislator, 1733–73. Lost early paramount influence in his county to his radical cousin Joseph Hawley. The leading Loyalist in western Massachusetts *post* 1774, he was the model for the mobbed Tory squire in Trumbull's *M'Fingal*. As executor of the will of Ephraim Williams, he helped found Williams College.

WILLIAMS, JAMES (*b. Grainger Co., Tenn., 1796; d. Graz, Austria, 1869*), journalist, Confederate diplomat, Tennessee legislator. Aided Confederate propaganda by articles in the London *Times, Standard,* and *Index,* 1861–64; served as Confederate contact with Maximilian of Mexico. He kept John Slidell and James M. Mason posted on his activities, but carried on secret, perhaps more detailed, correspondence with President Jefferson Davis. Author of *Letters on Slavery from the Old World* (1861), enlarged and published in London as *The South Vindicated.*

WILLIAMS, JAMES DOUGLAS (*b. Pickaway Co., Ohio, 1808; d. Indianapolis, Ind., 1880*), farmer, miller, Indiana legislator. As congressman, Democrat, from Indiana, 1875–77, he was chairman of the Committee on Accounts. Insistent on cutting expenses, he became known as "Blue Jeans Williams." Defeating Benjamin Harrison in a famous campaign for governor of Indiana, 1876, he served with ability and independence, 1877–80.

WILLIAMS, JESSE LYNCH (*b. Westfield, N.C., 1807; d. 1886*), civil engineer. Chief engineer, Wabash & Erie Canal, 1832–35 and 1847–76, and of many other transportation projects in Indiana. His report on the Union Pacific to the secretary of the interior, 1862, led to the Crédit Mobilier investigation.

WILLIAMS, JESSE LYNCH (*b. Sterling, Ill., 1871; d. Herkimer Co., N.Y., 1929*), novelist, playwright, editor. Grandson of Jesse L. Williams (1807–86). B.A., Princeton, 1892. Author of, among other fiction and drama, *Princeton Stories* (1895), the Pulitzer Prize play *Why Marry?* (1917), and the novel *She Knew She Was Right* (1930).

WILLIAMS, JOHN (*b. Roxbury, Mass., 1664; d. Deerfield, Mass., 1729*), Congregational clergyman, author. Ordained first pastor at Deerfield, Mass., 1688. Following sacking of the town by French and Indians, 1703/4, he was held captive for two years in Canada. He later prepared with Cotton Mather's help *The Redeemed Captive Returning to Zion* (1707), a testimony of Congregational fortitude against "Popish Poisons." Returned to Deerfield, 1707. Served as chaplain on 1711 expedition against Port Royal and as commissioner to Canada for return of English prisoners, 1713–14.

WILLIAMS, JOHN (*b. London, England, 1761; d. Brooklyn, N.Y., 1818*), satirist, dramatic critic, miscellaneous writer. Under the pseudonym "Anthony Pasquin," he was author of the *Hamiltoniad* (Boston, preface dated 1804), a savage Antifederalist poem, more important for its extensive notes than for its verse. Called "a common libeller" and "polecat," he had been driven in disgrace from England *ca.* 1797 and died destitute in America.

WILLIAMS, JOHN (*b. Surry Co., N.C., 1778; d. Knoxville, Tenn., 1837*), soldier, lawyer, Tennessee legislator. Brother-in-law of Hugh L. White. As colonel of volunteers in War of 1812 he operated against the Seminole in Florida. Colonel, 39th U.S. Infantry in the Creek campaign, he helped bring about Andrew Jackson's victory in battle of Horseshoe Bend, 1814. U.S. senator from Tennessee, 1815–23. Denied renomination because of identification with the Crawford wing of the Democrats, he insisted on running for reelection, thus compelling Jackson to run against him and defeat him in a bitter campaign.

WILLIAMS, JOHN (*b. Old Deerfield, Mass., 1817; d. Middletown, Conn., 1899*), Episcopal clergyman. Graduated present Trinity College, Hartford, Conn., 1835; ordained priest, 1841; while in England, 1840–41, he grew acquainted with the Oxford Movement leaders. President and also Hobart professor of history and literature, Trinity College, 1848–53; chancellor, *post* 1865. In 1851 he was elected bishop coadjutor of Connecticut, succeeding to the see in 1865. Dean and professor of theology and liturgies, Berkeley Divinity School, Middletown, Conn., *post* 1854, presiding bishop of the Protestant Episcopal church *post* 1887.

WILLIAMS, JOHN ELIAS (*b. Merthyr-Tydfil, Wales, 1853; d. Streator, Ill., 1919*), coal miner, industrial mediator. Came to America, 1864; settled in Streator, Ill. Chairman, arbitration board for Hart, Schaffner & Marx and United Garment Workers of America, *post* 1912. One of the first advocates of union-management cooperation, he believed industrial democracy could come through trades organization and continuous collective bargaining; he was instrumental in introducing new devices, including a compromise between closed and open shop called the preferential shop. His procedure and philosophy of mediation created a precedent for board chairmen and influenced so-called progressive unions.

WILLIAMS, JOHN ELIAS (*b. Coshocton, Ohio, 1871; d. Nanking, China, 1927*), Presbyterian missionary to China. Working in China *post* 1899, he helped found, and became vice president of, the University of Nanking, 1911. His murder by a Chinese Communist, 1927, began the "Nanking Incident."

WILLIAMS, JOHN FLETCHER (*b. Cincinnati, Ohio, 1834; d. Rochester, Minn., 1895*), journalist, librarian. Removed to St. Paul, Minn., 1855. Secretary and librarian, Minnesota Historical Society, 1867–93.

WILLIAMS, JOHN FOSTER (*b. Boston, Mass., 1743; d. Boston, 1814*), naval officer. His Revolutionary commands included the state vessels *Republic, Massachusetts,* and *Hazard,* in which he took several prizes, 1778–79, and compelled surrender of British brig *Active,* March 1779. He commanded *Protector,* largest ship in the Massachusetts navy, 1780–81. From 1790 until his death he was captain of the revenue cutter *Massachusetts.*

WILLIAMS, JOHN JOSEPH (*b. Boston, Mass., 1822; d. 1907*), Roman Catholic clergyman. Graduated Sulpician college, Montreal, Canada, 1841; studied theology at St. Sulpice, Paris, where he was ordained, 1845. Named rector of Cathedral of the Holy Cross, Boston, 1855; pastor of St. James Church and vicar general of the diocese, 1857. Consecrated bishop of Boston, 1866, and archbishop, 1875; retired in 1906.

WILLIAMS, JOHN SHARP (*b. Memphis, Tenn., 1854; d. 1932*), planter, lawyer. Educated at universities of the South, Virginia, and Heidelberg. Admitted to the bar, 1877; practiced in Yazoo City, Miss., 1878–93. As congressman, Democrat, from Mississippi, 1893–1909, he became an effective minority leader, 1903. Temporary chairman of the 1904 Democratic National Convention, he upheld conservative views in the fight over the platform and continued to champion moderation in reform through 1912. Entering the U.S. Senate, 1911, after a victory over J. K. Vardaman, he served on the Finance and Foreign Relations committees and consistently supported Woodrow Wilson's policies as president. Disgusted with the trends in public life *post* 1920, he retired in 1923. The most consistent Jeffersonian Democrat of his day, he wrote *Thomas Jefferson, His Permanent Influence on American Institutions* (1913).

WILLIAMS, JOHN SKELTON (*b. Powhatan Co., Va., 1865; d. near Richmond, Va., 1926*), financier, public official. Developed the Seaboard Air Line Railway; served it as president, 1899–1903. Appointed assistant U.S. secretary of the treasury, 1913, he was comptroller of the currency, 1914–21, and an ex officio member of the committee which established the Federal Reserve System. He was also U.S. director of finances and purchases for the railroads, 1917–19. Attacked concentration of banking control "in the hands of a dozen men;" praised Federal Reserve System as means of decentralization; antagonized national banks by charges of usury. His later accusations against the Federal Reserve Board formed basis of congressional investigations which sustained some of the charges. *Post* 1921, he was board chairman of the Richmond Trust Co.

WILLIAMS, JOHN WHITRIDGE (*b. Baltimore, Md., 1866; d. 1931*), physician, obstetrician. M.D., University of Maryland, 1888; studied also in Vienna, Berlin, and Leipzig. Taught at Johns Hopkins *post* 1896, becoming professor of obstetrics and obstetrician in chief to the hospital, 1899. Dean of the Medical School, 1911–23. Author of, among a number of treatises on bacteriology, pathology and obstetrics, an authoritative *Textbook of Obstetrics* (1903).

WILLIAMS, JONATHAN (*b. Boston, Mass., 1750; d. 1815*), merchant, army officer. Sent to London, 1770, to complete business training under his uncle Benjamin Franklin. Employed by commissioners of Continental Congress, 1776, as Nantes agent to inspect arms and supplies, he became unwittingly involved in the controversy between Silas Deane and Arthur Lee. Although vindicated of false charges made by Lee, he left public service, remaining in business in Europe until he returned with Franklin to America, 1785. Williams then settled in Philadelphia as a well-to-do merchant. In 1796 he became associate judge of the court of common pleas and later acquired reputation as scientist. Named by President Jefferson in 1801 as inspector of fortifications and superintendent at West Point with rank of major, he soon became first superintendent of the U.S. Military Academy. Laboring under many handicaps, he resigned, 1803. Reappointed in 1805 as lieutenant colonel of engineers with complete authority over all cadets at the institution, he was now hampered in his efforts to create a first-rate military school by many extra engineering duties which took up most of his time and by the antagonism of Secretary of War, William Eustis. He resigned from the army, 1812, embittered because of failure at West Point and because he was not given command of the New York fortifications. During the War of 1812 he served as brevet brigadier general of New York militia.

WILLIAMS, LINSLY RUDD (*b. New York, N.Y., 1875; d. 1934*), physician. M.D., New York College of Physicians and Surgeons, 1899. Director, Rockefeller Commission for the Prevention of Tuberculosis in France, 1919–22. Directed National Tuberculosis Association, 1922–28; thereafter developed and directed New York Academy of Medicine.

WILLIAMS, MARSHALL JAY (*b. Fayette Co., Ohio, 1837; d. Columbus, Ohio, 1902*), lawyer, Ohio legislator. Judge, Ohio 2nd circuit court, 1884–86, and first chief justice; judge, Ohio Supreme Court, 1887–1902; dean, College of Law, Ohio State University, 1891–93. Conservative in constitutional law, liberal in tort law on questions of negligence and liability.

WILLIAMS, NATHANAEL (*b. Boston, Mass., 1675; d. 1737/8*), physician, schoolmaster. Father-in-law of John Smibert. Graduated Harvard, 1693. Succeeded Ezekiel Cheever as headmaster, Boston Latin School, 1708; resigned from the school, 1733.

WILLIAMS, OTHO HOLLAND (*b. Prince Georges Co., Md., 1749; d. Miller's Town, Va., 1794*), Revolutionary officer. After good service at siege of Boston and with a Maryland-Virginia rifle regiment, he was made prisoner at the fall of Fort Washington, November 1776. Exchanged, January 1778, he began duties as colonel of the 6th Maryland Regiment. Deputy adjutant general under Horatio Gates, 1780, and adjutant under Nathanael Greene; commanded rear guard during Greene's retreat across North Carolina and distinguished himself in battles of Guilford Court House, Hobkirk Hill, and Eutaw Springs. Promoted brigadier general, 1782. Elected naval officer, Baltimore district, 1783; appointed federal collector of the port, 1789.

WILLIAMS, REUEL (*b. present Augusta, Maine, 1783; d. Augusta, 1862*), Maine legislator. Inherited a practice, 1812, including administration of Kennebec Purchase and Bowdoin College timberlands; prospered in many business ventures. In Maine legislature, 1812–29, as a Federalist; 1832 and 1848, as Democrat. U.S. senator, Democrat, from Maine, 1837–43. Actively supported Maine in the boundary dispute, 1832–42. With Thomas Hart Benton, fought against Webster-Ashburton Treaty in 1842.

WILLIAMS, ROBERT (*b. probably England, ca. 1745; d. near Suffolk, Va., 1775*), pioneer Methodist preacher. Appointed as missionary to America, he worked in New York City and Maryland, 1769–71. His reprinting of John Wesley's sermons alerted American Methodists to the value of a religious press. Extending his work to Virginia, he led a great religious revival, 1773; in Petersburg; he organized Brunswick circuit, 1774. Williams was the first Methodist traveling preacher to come to America, the first to publish a book, and the first to settle here.

WILLIAMS, ROGER (*b. London, England, ca. 1603; d. Providence, R.I., 1682/3*), clergyman, president of Rhode Island. A protégé of Sir Edward Coke, Williams was educated at Charterhouse and at Pembroke College, Cambridge (B.A., 1627). He took orders *ante* 1629 and served as chaplain to a Puritan family in Essex; in December 1629 he married Mary Barnard.

Already friendly with John Cotton and Thomas Hooker, Williams took ship aboard the *Lyon* with his wife in December 1630 and was welcomed at first in Massachusetts as "a godly minister." His open criticism of the Puritan system of government soon made him enemies, for he declared that civil government had no power to enforce the religious injunctions of the Ten Commandments. Denied a post as teacher of the church at Salem, he went to Plymouth, and after two years there returned to Salem as assistant minister. In August 1634 he was accepted as full minister at Salem in defiance of the General Court. He continued to work for a more democratic church system, also attacking land claims under the royal charter as a violation of Indian rights and denouncing the oath by which the Massachusetts oligarchy was trying to keep the lower orders of settlers in strict submission. Found guilty on Oct. 9, 1635, of propagating new and dangerous opinions, he was ordered banished by the General Court. Learning that Williams was trying to organize his Salem followers for a colony in Narragansett, the magistrates, who feared the existence of a radical community on their southern border, sent to arrest him. Warned, he escaped and made his way to the friendly Indians at Sowams. After suffering privations, he gathered enough followers to found Providence the earliest Rhode Island settlement, 1636.

Crown skeptical of the claims of the existing churches, he became, 1639, a Seeker — one who accepts no creed, although professing belief in the fundamentals of Christianity. Frontier influences and Williams' own liberalism produced local institutions in Rhode Island which marked a radical advance over the Puritan colonies. Town government was at first a primitive democracy; all heads of families had an equal voice. Heads of families were to share alike in the distribution of land. Religious liberty and complete separation of church and state were provided for. By 1643, four settlements had sprung up in the Narragansett area, and the need of a charter was becoming evident. The Puritan colonies were organizing the New England Confederation and taking steps to end the independent existence of nonconforming settlements. Massachusetts invaded Rhode Island, carried off Samuel Gorton and the Warwick settlers to prison, and began negotiating in London for a Narragansett patent. Williams sailed for England, and with the aid of Sir Henry Vane, circumvented the Bay authorities and secured a patent for the whole area; this charter for the Providence Plantations was issued in March 1644.

While in England, Williams opposed attempts there by the Puritans to establish a national church and a compulsory uniformity. In *The Bloudy Tenent of Persecution* (1644), his most celebrated work, he held that all individuals and religious bodies were entitled to religious liberty as a natural right. He also attacked the undemocratic character of contemporary governments and declared that the foundation of civil power was in the people, who might establish whatever form of government seemed to them "most meete."

After Williams' return to Rhode Island, William Coddington, the dominant figure at Newport, delayed organization of the Rhode Island settlement until 1647; in 1651 he obtained a commission from England splitting the colony and making him governor of Aquidneck for life. Williams traveled to England, accompanied by John Clarke, and succeeded in getting Coddington's commission rescinded. During this second visit Williams continued his propaganda for democracy and religious liberty, publishing among other works *The Bloody Tenent Yet More Bloody* (1652). After his return to Rhode Island, he reunited the colony, became its president, and served three terms; during his presidency Jews and Quakers found a safe harbor in the colony, despite the protests and threats of Massachusetts. The latter years of his life were darkened by controversy and by Indian wars. In 1659 Williams defended the Narragansett tribe against an attempted fraud which would have deprived them of much of their lands, yet during King Philip's War the Narragansett cast in their lot with the other Indians and ended their old-time friendship with the Rhode Island settlements. Williams served as one of the captains in command of the Providence forces during the war and remained active in town affairs to the end of his life. Colonial thinker, religious liberal, and earliest of the fathers of American democracy, he owes his enduring fame to his humanity and breadth of view and to his long record of opposition to privilege and self-seeking.

WILLIAMS, SAMUEL MAY (*b. Providence, R.I., 1795; d. Galveston, Tex., 1858*), Texas pioneer, banker. Became private secretary to Stephen F. Austin, 1824, and a partner in his great colonization project; he kept and preserved the colony's records. *Post* 1834 Williams became unpopular because of land speculations. His mercantile firm of McKinney & Williams (organized 1836) served as financial backer of the Republic of Texas and opened the Commerical and Agricultural Bank, Galveston, 1847, the first chartered bank of Texas.

WILLIAMS, SAMUEL WELLS (*b. Utica, N.Y., 1812; d. 1884*), missionary, diplomat, sinologue. Son of William Williams (1787–1850); father of Frederick W. Williams. Removed to China, 1833. Directed the Canton press for the American Board of Commissioners for Foreign Missions and helped edit the *Chinese Repository*. Accompanied the Perry expedition to Japan as interpreter, 1853–54. Became secretary and interpreter of the

American legation to China, 1856. Associated with the legation until 1876, he helped negotiate treaties. Author of, among other writings, *The Middle Kingdom* (1848, 1883) and *A Syllabic Dictionary of the Chinese Language* (1874). Became professor of Chinese language and literature at Yale, 1877. Williams was the outstanding American sinologist of his time.

WILLIAMS, STEPHEN WEST (*b. Deerfield, Mass., 1790; d. Laona, Ill., 1855*), medical historian. Practiced in Deerfield. Lectured on medical jurisprudence at Berkshire Medical Institution, 1823–31; at Willoughby University, Ohio, 1838–53; at Dartmouth Medical School, 1838–41. Author of, among other works, *A Catechism of Medical Jurisprudence* (1835) and *American Medical Biography* (1845).

WILLIAMS, TALCOTT (*b. Abeih, Turkey, 1849; d. 1928*), journalist. Nephew of Samuel W. Williams. Joined New York *World*, 1873; became night editor. An outstanding political reporter, he was editorial writer for the *Springfield Republican*, 1879–81, and on staff of the Philadelphia *Press*, 1881–1912, becoming associate editor. Became first director, Columbia School of Journalism, 1912; served as professor emeritus *post* 1919. Williams combined cultural courses with practical newspaper training in the curriculum at Columbia and largely originated reporting of scientific news. His greatest contribution to journalism was his ideal of the scholar-journalist.

WILLIAMS, THOMAS HARRY (*b. Vinegar Hill, Ill., 1909; d. Baton Rouge, La., 1979*), historian. Graduated Platteville State Teachers College in Wisconsin (B.Ed., 1931) and University of Wisconsin in Madison (Ph.M., 1932; Ph.D., 1937) and taught at the University of Wisconsin extension division (1936–38), University of Omaha (1938–41), Louisiana State University in Baton Rouge (1941–79), and Oxford University (1966–67). His first book was *Lincoln and the Radicals* (1941), followed by *Lincoln and His Generals* (1952) and *P. G. T. Beauregard: Napoleon in Gray* (1955). He was editor of the Southern Biography Series (1947–78), and his political biographies focused on high command. *Huey Long* (1969) won a Pulitzer Prize and the National Book Award. *The History of American Wars from 1745 to 1918* (1981) was published posthumously.

WILLIAMS, THOMAS SCOTT (*b. Wethersfield, Conn., 1777; d. 1861*), jurist. Connecticut legislator. Nephew of William Williams (1731–1811); son-in-law of Oliver Ellsworth. Studied law under Tapping Reeve and Zephaniah Swift. Congressman from Connecticut, 1817–19; mayor of Hartford, 1831–35. Associate justice, Connecticut Supreme Court of Errors, 1829–34; chief justice, 1834–47. Distinguished for lifelong interest in civic and charitable affairs.

WILLIAMS, WALTER (*b. Boonville, Mo., 1864; d. 1935*), journalist, educator. Distinguished for his editorship of the *Columbia* (Mo.) *Herald*, he was appointed a member of the board of curators of the University of Missouri, 1899, and served as chairman of its executive committee for many years. Becoming first dean of the school of journalism at the University of Missouri, 1908, he organized an educational program which aimed to reproduce as nearly as possible the apprentice experience obtained in a good newspaper office. This school was the first to place journalistic training on a professional level and its plan vastly influenced other schools and departments, as did also Williams' idealistic views on the responsibilities of the press to society. He served also as president of the University of Missouri, 1930–35.

WILLIAMS, WILLIAM (*b. Lebanon, Conn., 1731; d. Lebanon, 1811*), businessman, Revolutionary patriot, signer of the Declaration of Independence, Connecticut official and legislator. Son-in-law of Jonathan Trumbull (1710–85). Graduated Harvard, 1751. Gave heavy financial aid to the Revolutionary movement, helped compose many of Governor Trumbull's state papers. Occupied many Connecticut public offices and was a member of the Continental Congress, 1776–78 and 1783–84; assisted in framing Articles of Confederation and served on the board of war.

WILLIAMS, WILLIAM (*b. Framingham, Mass., 1787; d. Utica, N.Y., 1850*), printer, publisher, soldier. Father of Samuel W. Williams. Became partner in Utica, N.Y., printing firm, 1807, and published many almanacs, music collections, and anti-Masonic books. Managed bookstore which by 1820 was the largest west of Albany, N.Y.; owned, printed, and sometimes edited Utica newspapers, notably the *Patriot* and the *Patrol*.

WILLIAMS, WILLIAM CARLOS (*b. Rutherford, N.J., 1882; d. Rutherford, 1963*), poet and physician. Attended University of Pennsylvania Medical School and interned in New York City (1906–09); he began a general practice in Rutherford in 1910. His first book was a collection of twenty-six poems, entitled *Poems* (1909), printed at his own expense. Wrote numerous essays on the arts, collected in *A Recognizable Image* (1978). The startling range of his achievement is evident in works published in the 1920's: *Kora in Hell: Improvisations* (1920) and *The Great American Novel* (1923), both prose experiments in randomness and discontinuity; *Spring and All* (1923), his most ambitious and successful early books; *The American Grain* (1925), both prose studies of figures in American History; and *A Voyage to Pagany* (1928), a novel. Throughout his career he addressed what he believed to be the American writer's need to discard European precedents. In 1924 he and his wife went to France for six months, where they associated with James Joyce, Ford Madox Ford, Gertrude Stein, Ernest Hemingway, and many other writers and artists. His verse was collected in *The Complete Collected Poems of Williams Carlos Williams, 1906–38* (1939). His major writings of the 1930's were fiction: *The Knife of the Times and Other Stories* (1932) and *Life Along the Passaic River* (1938). His epic poem *Paterson* appeared in five books (1946, 1948, 1949, 1951, 1958); during the years he was writing *Paterson*, he also produced a substantial number of short lyrics — *The Desert Music* (1954) is considered one of his finest long poems. His reputation grew steadily in the last fifteen years of his life; he received the first National Book Award for poetry (1950), the Bollingen Prize (1953), and (posthumously) the Pulitzer Prize in poetry (1963).

WILLIAMS, WILLIAM R. (*b. New York, N.Y., 1804; d. 1885*), Baptist clergyman, author. Practiced law in New York City, 1825–30. Influential, scholarly pastor of Amity St. Baptist Church, New York City, *post* 1832. Helped found Rochester Theological Seminary. Author of, among other writings, *The Conservative Principles in Our Literature* (1844).

WILLIAMS, WILLIAM SHERLEY (*b. probably Kentucky, date uncertain; d. probably north of Taos, N.Mex., 1849*), trapper, guide. Better known as Bill, or Old Bill, Williams. A member of Joseph C. Brown's surveying party which marked Santa Fe Trail, 1825–26. In 1833–34, he was with the California expedition led by Joseph R. Walker; he then trapped the Utah-Colorado country. Set out in 1843 on a two-year journey to the Columbia River, the Great Basin, and Santa Fe; joined the disastrous fourth expedition of John C. Frémont as guide, 1848. Probably killed by Ute. The most eccentric of the "mountain men," Williams has lent his name to numerous western landmarks. The queer jargon which he affected became standard in fictional treatments of the West as true trapper talk.

WILLIAMSON, ANDREW (*b. possibly Scotland, ca. 1730; d. near Charleston, S.C., 1786*), Revolutionary soldier, planter. Came to America as a child. Was influential Whig in South Carolina backcountry. As major of militia, he took part in the 1775 fighting around Ninety-Six and led an expedition against the Cherokee, 1776. Promoted colonel, he commanded South Carolina troops in a second campaign which subdued the Cherokee. Made brigadier general, 1778, he commanded South Carolina militia in Howe's Florida expedition. Accused of treason after the fall of Charleston, 1780, he went into the British lines there and was denounced as "the Arnold of Carolina." He is credited, however, with later supplying Whigs with valuable information through Col. John Laurens.

WILLIAMSON, CHARLES (*b. Balgray, Scotland, 1757; d. at sea, 1808*), British officer, secret agent, New York legislator. As a land promoter in western New York, 1791–1802, he administered and developed for a British syndicate headed by Sir William Pulteney a tract of 1.2 million acres acquired from Robert Morris. He became a citizen and was elected to various offices; he also built roads and bridges and a hotel at Geneva, N.Y. Serving *post* 1803 as a volunteer adviser to the British cabinet on American affairs, he reverted to British citizenship. After an 1806 visit to the United States, he advised a policy directed at overthrow of the "Frenchified" Jeffersonian regime and considered Aaron Burr as a possible agent in this endeavor.

WILLIAMSON, HUGH (*b. West Nottingham, Pa., 1735; d. New York, N.Y., 1819*), physician, statesman, scientist, North Carolina legislator. Graduated College of Philadelphia (University of Pennsylvania), 1757, where he taught mathematics. In 1764 he studied medicine at Edinburgh, London, and Utrecht, receiving M.D. at University of Utrecht. Practicing in Philadelphia, he continued scientific studies. While in England, 1773–76, seeking aid for a proposed school, he obtained by a trick the Hutchinson-Oliver letters from Massachusetts and delivered them to Benjamin Franklin. He also collaborated with Franklin in electrical experiments. Settling in Edenton, N.C., 1777, he built up a large trade with the French West Indies and served as surgeon general of the state troops. Member of the Continental Congress, 1872–85 and 1787–88. At the Federal Convention, 1787, he was the most active North Carolina delegate and played a large part in securing the compromise on representation. He signed the U.S. Constitution and worked for its ratification. After serving in Congress from North Carolina, 1789–93, he devoted the rest of his life to literary and scientific pursuits in New York City. Williamson's work on climate brought him his greatest reputation as a scientist. He showed originality as an economist and was a sound scholar; his historical work was poor. Author of, among other writings, "An Essay on Comets" (1771); "Letters of Sylvius" (*American Museum*, August 1787); and *Observations on the Climate in Different Parts of America* (1811).

WILLIAMSON, ISAAC HALSTED (*b. Elizabethtown, now Elizabeth, N.J., 1767; d. Elizabeth, 1844*), lawyer. Democratic governor and chancellor of New Jersey, 1817–29. Williamson's lasting reputation came through his work in the dual office of chancellor, wherein he increased the dignity and effectiveness of the chancery court and laid the foundations of its unique position in New Jersey. His 1822 code of rules of practice clarified the then confused situation of mortgages.

WILLIAMSON, WILLIAM DURKEE (*b. Canterbury, Conn., 1779; d. Bangor, Maine, 1846*), lawyer, historian, Massachusetts and Maine legislator. Postmaster of Bangor, Maine, 1809–20. Advocated separation of Maine from Massachusetts, 1820. Acting governor of Maine, May–December 1821; congressman, Dem-

ocrat, from Maine, 1821–23. Judge of probate, Penobscot Co., Maine, 1824–40. Author of *History of the State of Maine* (1832; repr., 1839).

WILLIE, ASA HOXIE (*b. Washington, Ga., 1829; d. Galveston, Tex., 1899*), jurist. Removed to Texas, 1846; admitted to the bar, 1849. Elected to the Texas Supreme Court in 1866, he was removed after 15 months by the federal military authorities. Congressman-at-large from Texas, 1873–75; chief justice of Texas Supreme Court, 1882–88.

WILLING, THOMAS (*b. Philadelphia, Pa., 1731; d. Philadelphia, 1821*), banker, Pennsylvania official and legislator. Father of Anne Willing Bingham. Became partner in father's counting-house, 1751; formed Willing, Morris & Co. with Robert Morris, eventually the leading Philadelphia mercantile firm. Engaged in many public activities; elected mayor of Philadelphia, 1763. Justice, Pennsylvania Supreme Court, 1767–77. President of first Provincial Congress of Pennsylvania, 1774; member of second Continental Congress, 1775–76. Voted against Richard Henry Lee's resolution for independence, July 1776. During British occupation declined taking oath of allegiance to the king. President of the Bank of North America, 1781–1807. Supported movement for new constitution of 1787 and Alexander Hamilton's fiscal measures. President, first Bank of the United States, 1791–97.

WILLINGHAM, ROBERT JOSIAH (*b. Beaufort District, S.C., 1854; d. 1914*), Baptist clergyman. Highly effective secretary of the Foreign Mission Board of the Southern Baptist Convention, 1893–1914.

WILLIS, ALBERT SHELBY (*b. Shelbyville, Ky., 1843; d. Honolulu, Hawaii, 1897*), lawyer, Kentucky official, diplomat. Congressman, Democrat, from Kentucky, 1877–87; chairman, Committee on Rivers and Harbors. As envoy extraordinary and minister plenipotentiary to Hawaii, 1893–97, he was unsuccessful in effecting President Cleveland's policy of restoring prerevolutionary status after uprising of 1893.

WILLIS, BAILEY (*b. Idlewild, near Cornwall, N.Y., 1857; d. Palo Alto, Calif., 1949*), geologist. Son of Nathaniel Parker Willis. Took degrees in mechanical and civil engineering, Columbia University, 1878 and 1879. Assisted Raphael Pumpelly in surveys for the tenth federal census and for the projected Northern Pacific Railroad. Associated with U.S. Geological Survey, 1884–1915; headed Department of Geology, Stanford University, 1915–22, and retained close connection with Stanford for the rest of his life. Made important studies in California geology, especially of faulting, seismology, and earthquake hazards. Author of, among other works, *Index to the Stratigraphy of North America* (1912, and collaborated on the accompanying map); *Living Africa* (1930); *A Yanqui in Patagonia* (1947).

WILLIS, HENRY PARKER (*b. Elmira, N.Y., 1874; d. Oak Bluffs, Mass., 1937*), economist, educator. Raised in Racine, Wis. Graduated University of Chicago, 1894; Ph.D., 1897. A teacher at Washington and Lee University, 1898–1905, he served also as editorial writer on the New York *Evening Post* and was briefly Washington correspondent for the New York *Journal of Commerce* and the *Springfield Republican*. He collaborated with J. Laurence Laughlin in *Reciprocity* (1903). Removing to Washington, D.C., 1905, he continued to work as a correspondent and also served as professor of finance at George Washington University until 1912. He then removed to New York City as associate editor of the *Journal of Commerce*. He served as editor in chief of the *Journal*, 1919–31, and was professor of banking at Columbia University *post* 1917. Active as an adviser to con-

gressional committees *post* 1910, Willis helped to draw up the Underwood Tariff Act of 1913 and later contributed to the drafting of the Federal Reserve Act. He was the first secretary of the Federal Reserve Board, 1914–18, and served as the board's director of analysis and research, 1918–22. In his *Journal of Commerce* editorials he called attention to the dangers inherent in the Republican high-tariff policy and in the overextension of credit during the 1920's; he was among the first to foresee a stock-market collapse and a business depression. His chief interest lay in his academic work; at Columbia he organized a banking seminar which played an important role in the university and in the banking life of New York. An old-fashioned political liberal, Willis defended individual and constitutional rights, advocated the competitive enterprise system, and fought against all monopolies, whether in business or labor. He was author of a number of books in the field of banking, including his legislative history entitled *The Federal Reserve System* (1923).

WILLIS, NATHANIEL (*b. Boston, Mass., 1780; d. Boston, 1870*), editor, journalist. Father of Nathaniel P. Willis. Established the *Eastern Argus* at Portland, Maine, 1803, in opposition to the Federalist party; sold the paper, 1809. Removed to Boston, Mass., 1812. Began publication, 1816, of the *Recorder* (*Boston Recorder*), claiming it to be the world's first religious newspaper. *Youth's Companion*, his greatest contribution to journalism, originated as a department in the *Recorder* and appeared in separate covers, 1827. Willis served as editor until 1857.

WILLIS, NATHANIEL PARKER (*b. Portland, Maine, 1806; d. near Tarrytown, N.Y., 1867*), journalist, author. Son of Nathaniel Willis. Won celebrity as a poet while still an undergraduate at Yale; entered journalism on graduation, 1827. As editor of the Boston *American Monthly Magazine*, 1829–31, he posed in print as a dandy and aesthete, attracting envy and criticism, but achieving a reasonable success. Removing to New York City, he became associated with George P. Morris and went abroad as foreign correspondent for the *New-York Mirror*. Resident in Europe until May 1836, he had a great social success, notably in England, but was guilty of considerable indiscretion in the articles which he sent back to the *Mirror* (collected as *Pencillings by the Way*, 1835 and later editions).

Although one of the best paid of American periodical writers after his return to the United States, he also attempted the drama and was author of, among other plays, *Bianca Visconti* (1839; produced in New York, 1837) and *Tortesa* (1839). He continued to write for the *Mirror* and was a cofounder of the weekly *Corsair*, 1839–40, for which he engaged W. M. Thackeray as a correspondent. *Post* 1840 he was associated with G. P. Morris as an editor of the *New Mirror* and the *Evening Mirror* (a daily paper); in 1846 he joined Morris in publication of the *Home Journal*, their final and most prosperous undertaking. A colorful and light-hearted commentator on the day-to-day life of New York City and the nation, Willis was a generous friend to many less fortunate writers, including Edgar Allan Poe, whom he defended against later calumnies. Modern critics have given him a place of importance in the development of the American short story. Among his many books, which were almost wholly made up from his magazine pieces, were (in addition to those already cited) *A l'Abri; or, The Tent Pitch'd* (1839); *Letters from Under a Bridge* (1840); *Dashes at Life with a Free Pencil* (1845); and *Fun Jottings* (1853). He published a number of volumes of his verses, and almost all his works were reprinted in England.

WILLIS, OLYMPIA BROWN *See* BROWN, OLYMPIA.

WILLIS, WILLIAM (*b. Haverhill, Mass., 1794; d. 1870*), historian, lawyer. Portland, Maine, official. Graduated Harvard, 1813.

Became law partner of William Pitt Fessenden, 1835. For 50 years a "subtantial citizen" of Portland, Maine, he was mayor of Portland and president of the Maine Central Railroad. His chief works were *The History of Portland* (1831–33; 2nd ed., 1865) and *A History of the Law, the Courts, and the Lawyers of Maine* (1863). He edited first six volumes of Maine Historical Society's *Collections* (1831–59).

WILLISTON, SAMUEL (*b. Easthampton, Mass., 1795; d. Easthampton, 1874*), philanthropist, businessman. Best known as a promoter of religious and charitable enterprises; founded Williston Seminary, Easthampton, 1841; benefactor of Amherst and Mount Holyoke.

WILLISTON, SAMUEL (*b. Cambridge, Mass., 1861; d. Cambridge, 1963*), lawyer and educator. Attended Harvard Law (LL.B., 1888). Practiced law on and off throughout his life, but found its scholarly aspects more appealing than its practice. Taught at Harvard Law, 1890–1938, proving to be one of the most capable and popular men ever to teach there. Wrote or edited eighteen casebooks and more than fifty articles; his five-volume *Law of Contracts* (1920–22) became the standard text in the field. Served as Massachusetts commissioner for uniform state laws, 1910–29, and prepared a draft stature covering the law of sales that five years later became the Uniform Statute on Sales. After leaving Harvard he taught at the University of Texas and Catholic University in Washington. He returned to Harvard during World War II, and was still an able and popular teacher as an octogenarian.

WILLISTON, SAMUEL WENDELL (*b. Roxbury, Mass., 1852; d. 1918*), paleontologist, physician, dipterist. Graduated Kansas State College, 1872; M.D., Yale Medical School, 1880; Ph.D., Yale, 1885. Employed by Othniel C. Marsh as collector, preparator, and writer, 1873–85; worked in western Kansas, and in dinosaur-bearing beds in Colorado and Montana. Taught anatomy at Yale, 1886–90; taught geology, paleontology, vertebrate anatomy, and physiology at University of Kansas, 1890–1902, serving also for a time as dean of the school of medicine. Headed Department of Vertebrate Paleontology at University of Chicago, *post* 1902. His many papers on the reptiles of the Cretaceous include the classic work on the mosasaurs (in Vol. 4 of *The University Geological Survey of Kansas*, 1898). A pioneer dipterist, he wrote *Manual of North American Diptera* (1908) and was author of, among other works, *American Permian Vertebrates* (1911) and *Water Reptiles of the Past and Present* (1914). W. K. Gregory edited his *Osteology of the Reptiles* (1925). His contributions to paleontology were fundamental and of lasting influence.

WILLISTON, SETH (*b. Suffield, Conn., 1770; d. Guilford Center, N.Y., 1851*), Congregational clergyman, home missionary. Graduated Dartmouth, 1791; appointed to missionary service in New York State by Connecticut Missionary Society, 1798. A follower of Samuel Hopkins (1721–1803), his preaching evoked the revival of 1799–1800 in central and western New York. While pastor at Lisle, N.Y., 1801–10, he continued to preach widely and to establish churches. He removed, 1810, to Durham, N.Y., where he served 18 years as pastor before returning to his missionary travels.

WILLKIE, WENDELL LEWIS (*b. Elwood, Ind., 1892; d. New York, N.Y., 1944*), lawyer, public utility executive, presidential candidate. Both his father and mother were practicing lawyers. In 1913 he received the B.A. degree from Indiana University. To earn money for law school, he next taught history at the Coffeyville, Kans., high school, but in 1914 resigned to take a more

remunerative job as a chemist in a Puerto Rican sugar factory. He entered the Indiana University law school in 1915 and a year later received his LL.B. After graduation he joined his parents' law firm; but on the outbreak of World War I, he volunteered for military duty and gained a commission as first lieutenant. After his discharge from the army in 1919, Willkie joined the legal staff of the Firestone Tire and Rubber Co. He resigned at the end of 1920 to enter a private law firm in Akron. Willkie's firm was counsel for a subsidiary of the Commonwealth & Southern Corporation. In 1933 he became president and chief executive officer, and supplied the company with effective leadership during the Great Depression. He also gained national attention as the most articulate opponent of two New Deal projects—the Public Utility Holding Act and the Tennessee Valley Authority.

Willkie's winning of the Republican presidential nomination at Philadelphia in 1940 was an event unparalleled in American history. A liberal Democrat in early life, he had largely withdrawn from politics after serving as a delegate to the party's disastrous national convention in 1924, and his change of party affiliation in 1939, inspired by his distaste for Roosevelt and his policies, was hardly known even to his friends. Moreover, he did not seriously consider trying for the nomination until early in 1940. He was, however, well known to the business community and had the support of the publishers Henry Luce and John and Gardner Cowles. But it was his personal warmth and magnetism, along with his forthright stand for aid to Britain after the shock of Hitler's easy conquest of western Europe, that created the wave of popular enthusiasm on which he was swept to a sixth-ballot victory.

In the contest with Franklin Roosevelt, who was seeking a third term, Willkie waged a vigorous campaign. He alienated many Republicans by supporting the Selective Service Act and Roosevelt's policy of aid to Britain. At the same time, he accused the president of deliberately leading the country toward war and, on the domestic front, attacked Roosevelt's seeming acceptance of the idea of a closed economy rather than an expanding one, although the issues were sometimes obscured by reckless invective on both sides. Willkie polled a larger popular vote than any other Republican candidate before Eisenhower, but lost in the electoral college by a wide margin.

During the next year Willkie devoted himself to unifying the country behind a policy of increasing military aid to Britain, to which country he paid a dramatic visit during the intense German bombings early in 1941. Again he earned support of Roosevelt's lend-lease proposal, as well as by his continued crusade against isolationism. After Pearl Harbor, Willkie turned to two concerns that dominated the closing years of his life: the creation of an international organization to preserve world peace and the defense of civil liberties, with an increasing emphasis on black rights. His book *One World* (1943) sold millions of copies in a few months. His main theme was the desire of the awakening colonial peoples to join the West in a global partnership based on economic, political, and racial justice.

A related notion, the urgent need for postwar harmony between the United States and the Soviet Union, was in part responsible for his unsparing attacks on the State Department's reliance on former Fascist leaders in French North Africa and Italy. Conservatives in both parties were further enraged when Willkie successfully defended before the Supreme Court a naturalized citizen, William Schneiderman, whose citizenship the Justice Department was trying to revoke because he was an admitted Communist.

Late in 1943 Willkie embarked on a strenuous campaign to win the 1944 Republican presidential nomination, but his hopes were crushed in the Wisconsin primary, and he withdrew from the race.

WILLOUGHBY, WESTEL WOODBURY (*b.* Alexandria, Va., 1867; *d.* Washington, D.C., 1945), political scientist, adviser to the Chinese government. A.B., Johns Hopkins University, 1888; Ph.D., 1891. A founder of political science as a U.S. academic discipline, he taught at Johns Hopkins, 1895–1933; most of his doctoral students became themselves eminent in the field. He was a leader in organizing the American Political Science Association, 1903, and editor of the *American Political Science Review*, 1906–16. During World War I, he served in Peking as constitutional adviser to the Chinese republic, 1916; he counseled the Chinese government on later occasions as well, including service as legal adviser in the League of Nations debate on the Manchuria crisis, 1931.

WILLS, CHILDE HAROLD (*b.* Fort Wayne, Ind., 1878; *d.* Detroit, Mich., 1940), automotive designer, manufacturer, metallurgist. An early associate of Henry Ford in motorcar design, Wills acted as chief engineer and factory manager of the Ford Motor Co. *post* 1903, helping to design every Ford car, including the Model T. Shifting his interest to the study of metals, he adapted vanadium steel and other alloys to Ford use and eventually developed molybdenum steel for use in auto parts subject to stress. Disagreeing with Ford over basic policies, he left the company in March 1919 and began to manufacture the Wills–St. Claire motor car. The new car introduced molybdenum steel, four-wheeled brakes, and other features, and was highly regarded, but production of it was abandoned in 1926 because Wills spent too much time and money on changes.

WILLS, CHILL (*b.* Seagoville, Tex., 1902; *d.* Encino, Calif., 1978), actor. Began a career as a singer and humorist in burlesque and vaudeville and in 1936 began performing in nightclubs. His first film appearances were with his country and western singing group, Chill Wills and the Avalon Boys, in *The Bar 20 Rides Again* (1936) and *Way Out West* (1937). Beginning in 1938, he played supporting roles in Westerns and musicals, performing opposite some of Hollywood's biggest stars; he appeared in *Boom Town* (1940) with Clark Gable and Spencer Tracy, *Meet Me in St. Louis* (1944) and *The Harvey Girls* (1946) with Judy Garland, and *The Alamo* (1960) with John Wayne, for which he received an Oscar nomination for best supporting actor. He is also remembered as the voice of Francis the Talking Mule in a series of comedy films (1950–55). He starred in the television series "Frontier Circus" (1961–62) and "The Rounders" (1966–67) and had a memorable performance in one of his last films, *Pat Garrett and Billy the Kid* (1973).

WILLS, HARRY (*b.* New Orleans, La., 1889[?]; *d.* New York, N.Y., 1958), boxer. Beginning in 1910, Wills officially fought one-hundred and two times, winning sixty-two, forty-five by knock-outs, and losing only eight. A longtime contender for the heavyweight boxing title, Wills was refused a bout with champion Jack Dempsey because Wills was a black. Wills' most important match in terms of earnings and prestige was against Argentinian Luis Angel Firpo in 1924, officially a draw. Wills retired in 1932 and went into the real estate business in New York. He was elected to the Boxing Hall of Fame in 1970.

WILLS, JAMES ROBERT ("BOB") (*b.* near Kosse, Tex., 1905; *d.* Fort Worth, Tex., 1975), bandleader, fiddler, and pioneer of "western swing." Learned fiddling from his father and had his first professional engagement with a traveling medicine show in 1929. His western-swing instrumental style incorporated older, traditional country into a big jazz-band format, a sound he de-

veloped first with the Light Crust Doughboys and later the Texas Playboys. By 1936 records such as "Steel Guitar Rag" and "Trouble in Mind" were outselling those of Gene Autry; his biggest hit, "The New San Antonio Rose," was further popularized when it was recorded by Bing Crosby. He was inducted in the Country Music Hall of Fame in 1968.

WILLSON, AUGUSTUS EVERETT (*b. Maysville, Ky., 1846; d. Louisville, Ky., 1931*), lawyer, politician. Junior partner in Louisville office of John M. Harlan, 1874–79. Unsuccessful Republican candidate for Congress from Kentucky, 1884–92. As governor of Kentucky, 1907–11, he was checkmated by a hostile Democratic legislature and aroused criticism for allegedly partisan executive acts during the night-rider troubles in Kentucky.

WILLYS, JOHN NORTH (*b. Canandaigua, N.Y., 1873; d. 1935*), industrialist. A successful bicycle manufacturer in Elmira, N.Y., he began the sale of Pierce motorcars, 1901, and took over the handling and sale of the entire output of the Overland Co., 1906. Securing control of the Pope-Toledo plant at Toledo, Ohio, he installed the Overland Co. there and produced great numbers of the Willys-Overland between 1908 and 1916. He also invested heavily in concerns making automobile parts. After World War I, the Willys-Overland declined in popularity and faced strong competition; these factors and a strike at the plant, together with Willys' inability to control costs, brought about the liquidation of Willys' overall holding corporation, but left him a principal stockholder and manager of the main manufacturing concern. A heavy contributor to the Republican campaign fund in 1928, he served as U.S. ambassador to Poland, 1930–32, after providentially disposing of his stock in Willys-Overland just before the 1929 crash. He returned to the management of Willys-Overland *post* 1932 as receiver and later president.

WILMARTH, LEMUEL EVERETT (*b. Attleboro, Mass., 1835; d. 1918*), painter, teacher. Studied at Pennsylvania Academy of the Fine Arts, Philadelphia; also at Munich Academy and in Paris under J. L. Gérôme. Began exhibiting genre paintings at the National Academy in New York City, 1866. Taught at the National Academy of Design school, 1870–89; headed it, 1871–87.

WILMER, JAMES JONES (*b. Kent Co., Md., 1749/50; d. Detroit, Mich., 1814*), clergyman. Served as rector of four Maryland parishes, 1779–89. Became leader of Baltimore group which founded in 1792 the first New Church (Swedenborgian) Society in America. Reinstated as Episcopal clergyman, 1799, he held charges in Delaware, Maryland, and Virginia. A chaplain of Congress, 1809–13, he became a U.S. Army chaplain, 1813. Author of, among other writings, *Consolation, Being a Replication to Thomas Paine* (1794) and *The American Nepos* (1805).

WILMER, JOSPEH PÈRE BELL (*b. 1812; d. New Orleans, La., 1878*), Episcopal clergyman. Nephew of William H. Wilmer. Graduated Theological Seminary, Virginia, 1834; ordained, 1838. Served as chaplain, U.S. Navy, 1839–44; rector, St. Mark's Church, Philadelphia, Pa., 1849–61. Consecrated bishop of Louisiana, 1866, he was identified with the High Church party and noted as an orator.

WILMER, RICHARD HOOKER (*b. Alexandria, Va., 1816; d. Mobile, Ala., 1900*), Episcopal clergyman. Son of William H. Wilmer (1782–1827). Graduated Yale, 1836; Theological Seminary, Virginia, 1839. Ministered in rural Virginia parishes, 1840–61; in 1843 was minister, St. James Church, Wilmington, N.C. Consecrated bishop of Alabama, March 1862, he helped organize the Protestant Episcopal Church in the Confederate States, returning to union, 1865. Notable as a preacher, he proved an able administrator during Reconstruction.

WILMER, WILLIAM HOLLAND (*b. Kent Co., Md., 1782; d. 1827*), Episcopal clergyman. Father of Richard H. Wilmer. Ordained, 1808, he became rector of St. Paul's Church, Alexandria, Va., 1812; he was a leader of the convention which effected the election of Bishop R. C. Moore, 1814. Zealous in his denomination's revival in Virginia and in ministerial education, he was appointed a deputy to every meeting of the General Convention from 1814 until his death. Established in Washington, D.C., 1819, the *Theological Repertory*, which he edited until 1826. In 1823, with others, he organized the Theological Seminary at Alexandria, Va. Became president, College of William and Mary, and rector, Bruton Parish, Williamsburg, Va., 1826. Author of, among other works, *The Episcopal Manual* (1815).

WILMER, WILLIAM HOLLAND (*b. Powhatan Co., Va., 1863; d. Washington, D.C., 1936*), ophthalmologist. Son of Richard H. Wilmer. M.D., University of Virginia, 1885; worked with Emil Gruening at Mount Sinai Hospital, New York City; studied also in Europe. Practiced in Washington, D.C., *post* 1889, where he won repute as a diagnostician and surgeon of the highest order and served as professor in the medical school of Georgetown University. *Post* 1925, he directed the Wilmer Ophthalmological Institute at Johns Hopkins until his retirement in 1934. During World War I he directed researches in depth perception, muscular fatigue, and other factors influencing the abilities of flyers.

WILMOT, DAVID (*b. Bethany, Pa., 1814; d. 1868*), lawyer, politician. Congressman, Democrat, from Pennsylvania, 1845–51; U.S. senator, Republican, 1861–63. A leader among the Free-Soilers *post* 1848 and a founder of the Republican party, he served as president judge, 13th judicial district of Pennsylvania, 1851–61. He is principally famous for his addition of the Wilmot Proviso in the bill which appropriated funds for making peace with Mexico, 1846. Passed by the House but defeated in the Senate, the Proviso was intended to impede the growth of Southern power by prohibiting slavery in any territory which might be acquired with the money thus appropriated.

WILSON, ALEXANDER (*b. Renfrewshire, Scotland, 1766; d. Philadelphia, Pa., 1813*), weaver, poet, ornithologist. Immigrating to New Castle, Del., 1794, he engaged in teaching in New Jersey and Pennsylvania. Association with the naturalist William Bartram inspired him to attempt a large-scale study of the birds of the United States. He began at once to observe and to collect specimens, setting himself to learn how to draw and paint them. Engaging Alexander Lawson to prepare engraved plates from his drawings, he devoted ten years to *American Ornithology* (Vol. 1, 1808; Vols. 2–7 published by 1813). George Ord completed the work from Wilson's manuscripts after the author's death and later published two new editions of it. Wilson's reputation rests wholly upon this original and accurate contribution to science. He covered only the eastern United States north of Florida; during the next hundred years, however, only 23 indigenous land birds were added to his list. His *The Foresters* (1805) is a versified account of a walking tour from Philadelphia to Niagara Falls. Wilson's poetry is undistinguished, but the prose essays in his *Ornithology* are outstanding in American nature literature.

WILSON, ALLEN BENJAMIN (*b. Willet, N.Y., 1824; d. Woodmont, Conn., 1888*), inventor. A journeyman cabinet-maker, he patented a sewing machine featuring a double-pointed shuttle, 1850, but sold his interests in the patent to E. Lee & Co. of New York. He then devised a rotary hook and bobbin (patented 1851) as a substitute for the double-pointed shuttle and entered partnership with Nathaniel Wheeler to make and market his improved machine. In 1854 he obtained a patent for a fourmotion feed used on all later machines. Thereafter, he invented cot-

ton-picking machinery and devices for photography and for illuminating-gas manufacture.

WILSON, AUGUSTA JANE EVANS *See* EVANS, AUGUSTA JANE.

WILSON, BIRD (*b. Carlisle, Pa., 1777; d. New York, N.Y., 1859*), Episcopal clergyman, Pennsylvania jurist. Son of James Wilson (1742–98). Ordained priest, 1820; professor of systematic divinity, General Theological Seminary, N.Y., 1821–50; a moderate Anglican. Secretary, House of Bishops, 1829–41. Author of, among other writings, *Memoir of the Life of the Rt. Rev. William White* (1839).

WILSON, CHARLES EDWARD (*b. New York City, 1886; d. Bronxville, N.Y., 1972*), corporate executive. At the age of thirteen went to work in the shipping office of the Sprague Electrical Works, later a General Electric subsidiary, and became president of GE in 1940. He served as executive vice-chairman of the War Production Board (1942–44) and director of the Office of Defense Mobilization (1950–52). He retired from GE in 1952 and joined W. R. Grace Company, where he served as chairman of the board for one year; in 1956 he left to head the People-to-People Foundation.

WILSON, CHARLES ERWIN (*b. Minerva, Ohio, 1890; d. Norwood, La., 1961*), auto executive and secretary of defense. Attended Carnegie Institute (E.E., 1909). An engineer for Westinghouse Electric (1910–21) who designed their first starting motor for autos (1912) and was put in charge of all Westinghouse auto electrical products (1916). Became factory manager of Remy Electric (1921), a subsidiary of General Motors, and a vice president of GM (1928) in charge of the accessory-producing subsidiaries. In 1929 he became vice president for manufacturing with responsibility for approving any proposal for expansion by a GM division or subsidiary. He subsequently assumed charge of labor relations. The settlement of the 1937 strike by the United Auto Workers was historic; it ended the open-shop policy that had dominated the auto industry. He became president of GM in 1941. Through the war years he supervised the enormous volume of military production turned out by GM; by the end of 1943 all GM war contracts were in production and on schedule. In 1952 he was nominated as secretary of defense and was confirmed only after he agreed to sell his GM holdings. He had a stormy term of office (until 1953); he cut the defense budget by $5 billion and the civilian staff by 40,000. He antagonized part of the military establishment by attempting to curtail conventional forces in favor of reliance on massive nuclear retaliation. Even after leaving government, he was attacked as having left the nation exposed to nuclear threats from the Soviet Union by creating a "missile gap."

WILSON, CLARENCE TRUE (*b. Milton, Del., 1872; d. Portland, Oreg., 1939*), Methodist clergyman. Elected president of the Oregon Anti-Saloon League, 1906, he spent his life thereafter in the prohibition movement. Chosen general secretary of the (later-named) Board of Temperance, Prohibition, and Public Morals of the Methodist Episcopal Church, 1910, he gave it an aggressive leadership and, along with men such as Wayne B. Wheeler, was instrumental in securing much church support for national prohibition. After the 18th Amendment had been adopted in 1919, he continued his efforts to secure its full enforcement, giving much time to political action and employing extravagant lobbying and other tactics which brought upon him much bitter criticism.

WILSON, EDITH BOLLING (*b. Wytherville, Va.; d. Washington, D.C., 1961*), wife of President Woodrow Wilson who became one of her husband's most trusted advisers. After Wilson suffered a paralyzing stroke in 1909, she acted as a shield for the president. With the backing of his doctor, no one was allowed to enter the president's sickroom or to communicate with him without her consent. It was charged that she usurped the authority of the presidency, but later evidence shows that she made no policy decisions by herself. After Wilson's death in 1924, she was a mainstay of the Woodrow Wilson Foundation.

WILSON, EDMUND, JR. (*b. Red Bank, N.J., 1895; d. Talcottville, N.Y., 1972*), journalist, historian, and social and literary critic. Graduated Princeton College (1916), worked as a reporter for the *New York Evening Sun*, and served with a hospital unit in France during World War I. After the war he joined the staff of *Vanity Fair*, later working for *The New Republic* and *The Dial*, contributing pieces on books, theater, and ideas. He published *Axel's Castle* (1931), *The American Jitters* (1932), and *The Triple Thinkers* (1938). Among his best-known works of the 1940's are *To the Finland Station* (1940), an intellectual history of the origins of socialism, and *Europe Without Baedecker* (1947), which grew out of a visit to Europe undertaken for *The New Yorker*; he achieved wider notoriety with *Memoirs of Hecate County* (1942), fiction banned for its sexual candor. Later works include *The Scrolls from the Dead Sea* (1955), *A Piece of My Mind* (1956), *Patriotic Gore* (1962), *The Fruits of the MLA* (1968), and *Upstate* (1971).

WILSON, EDMUND BEECHER (*b. Geneva, Ill., 1856; d. New York, N.Y., 1939*), biologist, experimental embryologist and cytologist. Ph.B., Yale, 1878; Ph.D., Johns Hopkins, 1881. A student of William K. Brooks at Johns Hopkins, Wilson spent some time at the universities of Cambridge and Leipzig and worked for almost a year at the Zoological Station at Naples, Italy. After teaching at Williams, Massachusetts Institute of Technology, and Bryn Mawr, he went to Columbia University in 1891 as adjunct professor in the Department of Zoology; he later became full professor and chairman of the department. His monograph on the development of the colonial jellyfish *Renilla* (1883) established him as a scientist, and he became one of the outstanding pioneers of "cell lineage." He then took up the problems presented by the organization of the individual cell, and for a number of years engaged in experiments on various regions of the egg or of different cleavage cells; this aspect of his work was signalized in *The Cell in Development and Inheritance* (1896 and later editions). From 1900 to 1905 his research on germinal localization ran side by side with his investigations of the cellular phenomena that are correlated with artificial parthenogenesis. After 1905 he turned his attention to the problem of sex determination and, in a series of brilliant cytological studies on sex chromosomes, reached the high point of his research labors. He prepared the ground for the sensational series of genetic discoveries made *post* 1910 by Thomas H. Morgan and his associates in the Columbia laboratories.

WILSON, ERNEST HENRY (*b. Chipping Campden, England, 1876; d. near Worcester, Mass., 1930*), botanist. As a plant collector for the Arnold Arboretum, Harvard University, he went to the Far East, Africa, Australia, and New Zealand, 1907–10 and 1914–22, and introduced to cultivation more than a thousand plant species. He became assistant director of the Arnold Arboretum, 1919, and keeper, 1927.

WILSON, FRANCIS (*b. Philadelphia, Pa., 1854; d. 1935*), actor. Began his career *ca.* 1880 as comedian in a number of musical comedies. He became famous in the role of Cadeaux in *Erminie* (1886) and continued as a musical-comedy star until 1904 when he became a "legitimate" actor. His principal vehicle was *The Bachelor's Baby*, which he wrote himself; it opened in Baltimore,

Md., 1909, ran for three years, and made Wilson a fortune. Elected president of Actors Equity Association, 1913, he devoted much of his time to its affairs until 1921 when he resigned as president. The victory of the actors in the famous strike of 1919 was in great measure his victory. Wilson had a genius for friendship; among his many friends were Joseph Jefferson and Eugene Field.

WILSON, GEORGE FRANCIS (*b. Uxbridge, Mass., 1818; d. East Providence, R.I., 1883*), chemical manufacturer, inventor. Established (with Eben N. Horsford) George F. Wilson & Co., later known as the Rumford Chemical Co., at East Providence, R.I., which he headed until his death. Benefactor of Brown University and Dartmouth College.

WILSON, GEORGE GRAFTON (*b. Plainfield, Conn, 1863; d. Cambridge, Mass., 1951*), professor of international law, author, and editor. Studied at Brown University (Ph.D., 1891). Taught at Brown (1891–1907) and at Harvard (1907–36). Professor at the U.S. Naval War College (1900–37). Special counsel to the U.S. Maritime Commission (1941–51). Wrote *Elements of International Law*, an annotated version of Richard Henry Dana's edition of Henry Wheaton's work (1936). Founder of the American Society of International Law and editor of the *American Journal of International Law* (1924–43). Founder of and professor at the Fletcher School of Law and Diplomacy at Tufts University (1933).

WILSON, HALSEY WILLIAM (*b. Wilmington, Vt., 1868; d. Yorktown Heights, N.Y., 1954*), publisher, bibliographer. Studied intermittently at the University of Minnesota. Owned a bookshop in Minneapolis; founded a bibliographical publishing company. Issued the *Cumulative Book Index* (1898); *Readers' Guide to Periodical Literature* (1901), which is the standard periodical index; *Book Review Digest* (1905); and the *Wilson Library Bulletin* (1914). In 1917 his H. W. Wilson Company was transferred to the Bronx, N.Y., and a plant for all aspects of publishing was set up.

WILSON, HARRY LEON (*b. Oregon, Ill., 1867; d. Carmel, Calif., 1939*), novelist, playwright. Began literary career as a contributor to *Puck*, 1887; served on that magazine as assistant to Henry C. Bunner, 1892–96, and as editor in chief, 1896–1902. After writing several serious novels, including *The Spenders* (1902), he achieved in *The Boss of Little Arcady* (1905) for the first time that adroit mingling of burlesque and realism which marked his later work. A collaborator with Booth Tarkington for several years in writing plays (among them the hit *The Man from Home*, 1907), Wilson became a regular contributor of fiction to the *Saturday Evening Post*. Outstanding among his later works were *Bunker Bean* (1913), *Ruggles of Red Gap* (1915), and *Merton of the Movies* (1922).

WILSON, HENRY (*b. Farmington, N.H., 1812; d. Washington, D.C., 1875*), shoemaker, lawyer, Massachusetts legislator and statesman, vice president of the United States. Born Jeremiah Colbath of poverty-stricken parents, he was indentured to a farmer as a boy; he had his name legally changed to Henry Wilson *ca.* 1833. His formal education was never more than meager. With minimum capital, he established a shoe factory which was a moderate success. Elected to the Massachusetts House of Representatives as a Whig in 1840, he served in the state legislature for most of the next 12 years. Disaffected at the 1848 Whig convention because it took no stand on the Wilmot Proviso, he and a small group withdrew and launched the Free Soil party at a Buffalo, N.Y., convention. An ardent opponent of slavery, he edited the *Boston Republican* (the Free Soil organ), 1848–51,

and aligned himself with the American (Know-Nothing) party, mistakenly believing it would be an important force in freedom's cause. When its 1855 convention adopted a platform which was evasive on the slavery issue, he revolted and withdrew, thereby foiling the party's first attempt to control national politics. Elected to fill a Massachusetts vacancy in the U.S. Senate, 1855, he aligned himself with the abolitionists, was vehement in the debate over Kansas, and supported the Republican campaign in 1860. At the outset of the Civil War, he was chairman of the Senate Military Affairs Committee and threw his tremendous energy into the task of framing, explaining, and defending legislative measures necessary for enlisting, organizing, and provisioning a vast army. (*Post* 1852, he had served with his state's militia, attaining a brigadier generalship.) He constantly urged Lincoln to declare emancipation as a war measure, and he shaped the bills which brought freedom to many slaves in the border states before the 13th Amendment was ratified.

After the war, Wilson as senator at first bitterly opposed President Johnson's Reconstruction policy and attitude toward Congress, but he later became more conciliatory. He favored federal legislation to aid education and homesteading in the impoverished South, through which he had made long tours. His name on the Republican ticket as vice presidential candidate in 1872 contributed to its victory, and he made a highly efficient and acceptable presiding officer in the Senate until his death. Independent of mind, he never lost sympathy with the working people and promoted legislation in their behalf.

WILSON, HENRY LANE (*b. Crawfordsville, Ind., 1857; d. Indianapolis, Ind., 1932*), lawyer, diplomat. Brother of John Lockwood Wilson. Practiced in Spokane, Wash., 1884–96. As U.S. minister to Chile, 1897–1904, he was instrumental in averting trouble between Chile and Argentina, 1900. U.S. minister to Belgium, 1905–09. As ambassador to Mexico, 1909–13, he unsuccessfully urged presidents Taft and Wilson to recognize the Huerta government.

WILSON, HENRY PARKE CUSTIS (*b. Workington, Md., 1827; d. Baltimore, Md., 1897*), surgeon, gynecologist. Beginning practice in Baltimore, Md., 1851, he was first in the state to remove uterine appendages by abdominal section and the second to perform successful ovariotomy, 1866. Said to be second in the world to remove an intrauterine tumor by morcellation. Cofounder of Hospital for the Women of Maryland, 1882; consultant at Johns Hopkins and other Baltimore hospitals.

WILSON, HUGH ROBERT (*b. Evanston, Ill., 1885; d. Bennington, Vt., 1946*), diplomat. B.A., Yale, 1906. After study at the École Libre des Sciences Politiques, Paris, and brief service as secretary to the U.S. minister in Lisbon, he returned to the United States, passed the Foreign Service examination, 1911, and was appointed secretary of the U.S. legation in Guatemala, 1912. Thereafter, he held a number of posts before appointment as U.S. minister to Switzerland, 1927. Returning to Washington, D.C., in August 1937, he served briefly as assistant secretary of state and then as U.S. ambassador to Germany, 1938–39 (recalled in November 1938 to protest against Nazi anti-Jewish policies). Resigning from the Foreign Service at the end of 1940, he was with the World War II Office of Strategic Services, 1941–45. Belonging to the "realist" rather than the "messianic" school of U.S. diplomats, he was one of the first career men to achieve ambassadorial rank.

WILSON, JAMES (*b. Carskerdo, Scotland, 1742; d. Edenton, N.C., 1798*), jurist, U.S. Supreme Court justice. Described by James Bryce as "one of the deepest thinkers and most exact reasoners" in the Federal Convention of 1787, and as one whose

works "display an amplitude and profundity of view in matters of constitutional theory which place him in the front rank of the political thinkers of his age." Immigrated to America, 1765. Better educated than most immigrants of the time, he quickly obtained a position as Latin tutor in the College of Philadelphia. After studying law with John Dickinson, he began practice in Reading. Pa., 1768. Soon removing to Carlisle, Pa., he was very successful in cases involving land disputes. By 1773 he had begun borrowing capital for speculative land purchases, a lifelong activity of his.

Active in the early Revolutionary movement, he was elected to the first Continental Congress and distributed to its members his pamphlet *Considerations on the Nature and Extent of the Legislative Authority of the British Parliament* (1774), a work which denied to Parliament the least authority over the colonies. This able statement of the extreme American position was widely read in both England and America. Wilson also spoke to the same effect before the provincial conference of January 1775 and introduced a resolution on the Boston Port Act which presaged the doctrine of judicial review.

From his position on the extreme left in 1774, Wilson moved steadily thereafter to the right. As a Continental congressman, 1776–77, he aided in delaying moves toward independence during June 1776, but on July 2 was one of three out of seven Pennsylvania delegates who voted for independence. Active in executing burdensome committee assignments, he was among the first to urge relinquishment of the claims of the states to western lands, to advocate taxation powers for Congress, and to try to strengthen the national government. He also urged that representation in Congress should be based on free population. However, he fought bitterly against the 1776 Pennsylvania Constitution, a democratic product of the frontier. Leaving Congress in September 1777, he engaged in corporation practice in Philadelphia after a brief stay at Annapolis, Md. Acting as counsel for Loyalists and engaging in privateering and land-jobbing schemes, he widened the breach between himself and the people, and soon became personally unpopular. He served again in Congress, 1782 and 1785–87, but was chiefly concerned with his multiplying business interests. In 1785 he published *Considerations on the Power to Incorporate the Bank of North America*, an able argument in which he foreshadowed John Marshall's doctrine of inherent sovereignty.

Wilson's greatest achievement in public life was his part in the establishment of the U.S. Constitution. With the possible exception of James Madison, no member of the 1787 convention was better versed in the study of political economy, none grasped more firmly the central problem of dual sovereignty, and none was more farsighted in his vision of the future of the United States. Wilson kept constantly in view the idea that sovereignty resided in the people, favoring popular election of the president and of members of both houses of Congress. He clearly stated that the national government was not "an assemblage of States, but of individuals for certain political purposes." He opposed the idea of equal representation in the Senate. He was a member of the committee of detail which prepared the draft of the U.S. Constitution, and after signing it, he fought for its adoption. He was author of the Pennsylvania state constitution of 1790, which represented the climax of his 14-year fight against the earlier democratic constitution. Although he expected appointment as chief justice, he accepted the post of associate justice of the U S Supreme Court, September 1789. Also appointed to the chair of law in the College of Philadelphia, 1789, he delivered a series of lectures in December in which he departed from Blackstone's definitions and, discovering the residence of sovereignty in the individual, postulated as the basis of law the consent of those whose obedience the law requires. He also set forth clearly the implications of the U.S. Supreme Court for judicial settlement of international disputes and for the administration of international law. Commissioned to make a digest of the laws of Pennsylvania, he began the task and also recommended himself to President Washington as being willing and able to establish a body of theoretical principles for future judicial and legislative interpretation of the U.S. Constitution — especially with respect to the problems of federal and state relations. He was unsuccessful in his application, however, as the attorney general urged on the president the impropriety of any single person determining such principles for future guidance. Wilson now plunged further into vast land speculations, involving the Holland Land Co. in unwise purchases, 1792–93, and buying an interest in one of the Yazoo companies, 1795. These and other speculative enterprises in which he engaged brought on him much severe criticism, and he died amid talk of impeachment and while endeavoring to escape from creditors. His most noted decision on the bench was that in *Chisholm* v. *Georgia*, in which he positively affirmed the doctrine that the people of the United States formed a nation.

WILSON, JAMES (*b. Ayrshire, Scotland, 1836; d. 1920*), farmer, Iowa legislator. Settled in Iowa, 1855. Congressman, Republican, from Iowa, 1873–77 and 1883–85; known as "Tama Jim," he was a member of the Agricultural and Rules committees. Appointed professor of agriculture and head of experiment station at Iowa State College, 1891, he helped place instruction on both a scientific and practical basis. As U.S. secretary of agriculture, 1897–1913, he established many new experiment stations and began farm demonstration work in the South; he also began cooperative extension work in agriculture and home economics, promoted world agricultural information, and initiated much helpful legislation.

WILSON, JAMES FALCONER (*b. Newark, Ohio, 1828; d. Fairfield, Iowa, 1895*), lawyer, Iowa legislator. Studied law under William B. Woods; began practice in Iowa *ca.* 1852; was influential delegate in state constitutional convention, 1857. Known as "Jefferson Jim," he was congressman, Republican, from Iowa, 1861–69; as chairman of the House Judiciary Committee, he forwarded the Union program and introduced the original resolution for an abolition amendment. During Reconstruction, he was one of the ablest leaders among the legalistic Radicals. He introduced important amendments to the resolution for repudiation of Confederate debt, an amendment repealing appellate jurisdiction of the Supreme Court under the Habeas Corpus Act of 1867, and the final form of the Civil Rights Act. Advocate of the Pacific railroad, he was a government director of the road under Presidents Grant and Hayes. Attacked for alleged financial improprieties in this connection, he was closely questioned during the House investigations of the railroad, 1873. He was undistinguished as U.S. senator, Republican, from Iowa, 1883–95.

WILSON, J(AMES) FINLEY (*b. Dickson, Tenn., 1881; d. Washington, D.C., 1952*), newspaperman, politician. Studied at Fisk University. A black, Wilson founded, edited, and published the *Washington Eagle* (originally the *Sun*). Joined lodges of the Improved Benevolent and Protective Order of Elks of the World in 1903; was the Grand Exalted Ruler from 1922. Wilson organized and expanded black Elk programs in civil liberties, education, and health. Raised money for legal battles such as the Scottsboro trial. A friend of Franklin D. Roosevelt, he worked for cooperation between the Elks and the National Recovery Administration (NRA). President of the Colored Voters League of America, 1933. Ran unsuccessfully for the New York State Senate as a Republican in 1946.

WILSON, JAMES GRANT (*b. Edinburgh, Scotland, 1832; d. 1914*), editor, Union soldier. Son of William Wilson (1801–60). Came to America as an infant. Removed to Chicago, Ill., 1856, where he edited and published periodicals, including the *Chicago Record*, April 1857–March 1862. Colonel, 4th U.S. Colored Cavalry, 1863; brevetted brigadier general of volunteers, 1865. Settled in New York City, 1865. He was a prolific writer of military and literary biographies and an editor of church and local histories. His most extensive work was as coeditor (with John Fiske) of *Appleton's Cyclopaedia of American Biography* (1886–89; rev. ed., 1898–99).

WILSON, JAMES HARRISON (*b. near Shawneetown, Ill., 1837; d. Wilmington, Del., 1925*), engineer, Union cavalryman, author. Graduated West Point, 1860. Chief topographical engineer on Port Royal expedition; volunteer aide to General G. B. McClellan at South Mountain and Antietam. Named inspector general, Army of Tennessee, 1863, he was active in Vicksburg's siege and capture. Advanced to brigadier general of volunteers, October 1863, he was chief engineer of the Knoxville relief expedition and was made chief of the Washington cavalry bureau, January 1864. Commanding the 3rd Division of General P. H. Sheridan's cavalry corps, Army of the Potomac, he led the advance across the Rapidan, covered General U.S. Grant's passage to the Chicahominy, formed part of Sheridan's first Richmond expedition. Appointed chief of cavalry, Military Division of the Mississippi, with brevet rank of major general, October 1864, he defeated General N. B. Forrest in several engagements, enabling General J. M. Schofield to repulse Confederate General John Hood and contributing to Hood's defeat by General G. H. Thomas at Nashville. On April 2, 1865, Wilson took Selma, Ala., by assault in one of the most brilliant actions of the Civil War. He then moved on through Montgomery, Ala., took Columbus, Ga., and reached Macon, Ga., on April 20. After the war he superintended navigation improvements, resigning from the army in 1870. As senior major general in the Spanish-American War, he served in Puerto Rico and Cuba; in the Boxer Rebellion in China, he was second in command to General A. R. Chaffee. He was advanced to major general, retired, 1915.

WILSON, JAMES SOUTHALL (*b. Bacon's Castle, Va., 1880; d. Charlottesville, Va., 1963*), educator, editor, and author. Attended William and Mary, University of Virginia, and Princeton (Ph.D., 1906). Taught at William and Mary (1906–18) and the University of Virginia (1919–51), where he helped secure the Ingram collection of Edgar Allan Poe memorabilia. Founded (1925) and edited (until 1930) the *Virginia Quarterly*. Prepared an edition of Poe's *Tales* (1927) and wrote *An Appreciation of Edgar Allan Poe* (1923).

WILSON, JOHN (*b. Windsor, England, ca. 1591; d. 1667*), clergyman, verse writer. Immigrated to Massachusetts, 1630. Served the First Church in Boston, Mass., from 1635 until his death, sharing the pulpit with John Cotton until 1652. A spokesman of orthodoxy and a constant counselor of the magistrates, Wilson was zealous for conversion of the Massachusetts Indians and was ranked among the most influential of the Massachusetts clergy.

WILSON, JOHN FLEMING (*b. Erie, Pa., 1877; d. Santa Monica, Calif., 1922*), journalist, author of sea stories.

WILSON, JOHN LEIGHTON (*b. near Salem, S.C., 1809; d. near Salem, 1886*), Presbyterian clergyman. Graduated Columbia (S.C.) Seminary; ordained, 1833. Went to Liberia, 1834; established missions in western Africa at Cape Palmas and Gabon. Returned to America, 1852. Elected secretary of the Board of Foreign Missions, 1853; edited *Home and Foreign Record*, 1853–61; founded *The Missionary*, 1866, which he edited for nearly 20 years. Supervised foreign missions of the Presbyterian Church in the Confederate States of America (later in the United States) *post* 1861; also its home missionary projects, 1863–72. Author of encyclopedic *Western Africa: Its History, Conditions, and Prospects* (1856).

WILSON, JOHN LOCKWOOD (*b. Crawfordsville, Ind., 1850; d. Washington, D.C., 1912*), lawyer, publisher. Brother of Henry L. Wilson. Receiver, federal land office at Colfax, Washington Territory, 1882–87. Republican representative-at-large in Congress from Washington, 1889–95. Promoted Pacific North-west river and harbor development; sponsored effective lieu land bill; secured passage of bill creating Mount Rainier National Park. U.S. senator, 1895–99. In 1899 he purchased a controlling interest in the *Seattle Post-Intelligencer*, which he managed until his death.

WILSON, JOSEPH CHAMBERLAIN (*b. Rochester, N.Y., 1909; d. Albany, N.Y., 1971*), business executive. Graduated University of Rochester (1931) and Harvard University (M.B.A., 1933) and became assistant to the sales manager at the family business, the Haloid Company, which produced a line of papers used to make copies of documents. He became secretary in 1936 and president and general manager in 1946. The next year the firm purchased the commercial rights to a new reproduction process called "electrophotography," which he renamed "xerography," a word derived from the Greek meaning "dry writing." After modest success, in 1960 the newly renamed Xerox Corporation produced a highly successful line of copiers and experienced exponential growth during the 1960's, with revenues of $701 million by 1967; he stepped down as president in 1968 but remained on the board. In 1971 he became chairman of both President Richard Nixon's Committee on Health Education and New York governor Nelson Rockefeller's Steering Committee on Social Problems.

WILSON, JOSEPH MILLER (*b. Phoenixville, Pa., 1838; d. 1902*), civil engineer, architect. Son of William H. Wilson. C.E. Rensselaer Polytechnic Institute, 1858. Engineer of bridges and buildings, Pennsylvania Railroad, 1865–86. Organized Wilson Bros. & Co., consulting civil engineers and architects, 1876. The firm's projects included stations and shops for the Ninth and Third Avenue lines of the New York Elevated Railway and for a number of other railroads; also, buildings for the Drexel Institute, Philadelphia, Pa., and other institutions there. Wilson himself designed and built, among others, the Susquehanna and Schuylkill bridges, the original Broad St. Station in Philadelphia, and the main exhibition building and machinery hall at the Philadelphia Centennial Exhibition, 1876. He did important later consulting work and wrote on scientific and engineering subjects.

WILSON, JOSHUA LACY (*b. Bedford Co., Va., 1771; d. Cincinnati, Ohio, 1846*), Presbyterian clergyman, educator. Father of Samuel R. Wilson. Called to the First Presbyterian Church, Cincinnati, Ohio, 1808, he served there until his death. An "old school" theologian, his defense of Calvinism led him into many controversies; he opposed the "New England theology" and the "Plan of Union" and prosecuted Lyman Beecher for heresy before the presbytery and synod.

WILSON, LOUIS BLANCHARD (*b. Pittsburgh, Pa., 1866; d. Rochester, Minn., 1943*), pathologist, medical educator. Graduated State Normal School at California, Pa., 1886. While teaching high school in St. Paul, Minn., he attended the medical school of the University of Minnesota and received the M.D. degree, 1896. He then became assistant to Frank Wesbrook of the state board of health, who furthered his interest in bacteriology. In

1905, he was invited to join the staff of the Mayo Clinic in Rochester, Minn., to establish laboratories for pathologic and bacteriologic studies. Although he made a number of important contributions to laboratory technique and pathology, he made his most enduring mark as director of the Mayo Graduate School of Medicine, 1915–37.

WILSON, MARIE (*b. Anaheim, Calif., 1916; d.California, 1972*), actress. From her first film, *Stars over Broadway* (1935), through *The Private Affairs of Bel Ami* (1947), she appeared in small parts in nearly two dozen unspectacular films, always typecast, as one reviewer put it, "as the quintessential dumb blonde." In 1947 writer Cy Howard created the "My Friend Irma" series for radio with Wilson in mind for the role of Irma, a scatterbrained secretary. Wilson starred in the radio series (1947–52), the Paramount movie (1949; sequel 1950), and the television series (1952–54).

WILSON, MORTIMER (*b. Chariton, Iowa, 1876; d. New York, N.Y., 1932*), composer, conductor, teacher. Headed theoretical courses, music department, University of Nebraska, 1901–08; revived and conducted the Lincoln Symphony Orchestra. Studied in Leipzig under Max Reger and Hans Sitt, 1908–10. Conducted Atlanta, Ga., symphony orchestra, and directed Atlanta Conservatory of Music, 1913–14. Arranged and wrote music for motion pictures. His compositions included symphonies, suites, sonatas, and numerous short pieces and songs; they displayed fluency and inventiveness in counterpoint.

WILSON, ORLANDO WINFIELD ("WIN," "O. W.") (*b. Veblen, S. Dak., 1900; d. Poway, Calif., 1972*), criminologist and educator. Graduated University of California at Berkeley (1924) and held chief-of-police positions in Fullerton, Calif. (1925–26), and Wichita, Kans. (1928–39); in 1939 he became a consultant to the Public Administration Service, where he surveyed municipal police departments for the purpose of reorganizing them. He joined the faculty of the University of California at Berkeley as full-time professor of police administration (1939–43); he was appointed first dean of the expanded School of Criminology at Berkeley (1950). In 1960–67 he was police superintendent of Chicago, where he implemented a range of reforms.

WILSON, PETER (*b. Banff, Scotland, 1746, d. New Barbadoes, N.J., 1825*), philologist, educator, New Jersey legislator. Educated at University of Aberdeen. Immigrated to New York City, 1763. Principal of Hackensack (N.J.) Academy; of Erasmus Hall Academy, Flatbush, N.Y., *ca.* 1792–1805. Professor of Greek and Latin, Columbia College, 1789–92; of Greek and Latin and Grecian and Roman antiquities, 1797–1820. Wrote treatises on prosody and edited classic texts.

WILSON, ROBERT BURNS (*b. near Washington, Pa., 1850; d. Brooklyn, N.Y., 1916*), painter, poet, novelist. Author of the poem "Remember the Maine" (*New York Herald*, April 17, 1898), which supplied the slogan for the Spanish-American War.

WILSON, SAMUEL (*b. West Cambridge, now Arlington, Mass., 1766; d. Troy, N.Y., 1854*), meatpacker; original of "Uncle Sam" as symbolic figure for the United States. Furnished beef to the army's supply center at Troy, N.Y., during War of 1812. The "U.S." on the casks was humorously defined as standing for "Uncle Sam's" monogram.

WILSON, SAMUEL GRAHAM (*b. Indiana, Pa., 1858; d. Tabriz, Persia, 1916*), Presbyterian clergyman. Missionary to Persia and Armenia *post* 1880. Distinguished as an educator and relief worker among Armenian refugees from Turkey, 1916. Author of, among other works, *Persian Life and Customs* (1895).

WILSON, SAMUEL MOUNTFORD (*b. Steubenville, Ohio, ca. 1823; d. 1892*), lawyer. Admitted to the Ohio bar, 1844; removed to San Francisco, Calif., 1853, after practicing in Galena, Ill. Restricted his work to civil suits; took leading part in nearly all noted California land law cases. Outstanding as counsel for hydraulic mining companies, 1880–86, against farming interests on debris question (*People of California* v. *Gold Run Ditch and Mining Company*). Also in high repute for will cases, notably for his successful defense of David Broderick's will. A fluent, direct speaker, he depended for success on a complete mastery of the matters at issue. He served as chairman of the judiciary committee of the Californian constitutional convention, 1878–79, opposing radical demands of Denis Kearney.

WILSON, SAMUEL RAMSAY (*b. Cincinnati, Ohio, 1818; d. Louisville, Ky., 1886*), Presbyterian clergyman. Son of Joshua L. Wilson. Graduated Princeton Theological Seminary, 1840. Pastor, First Presbyterian Church, Cincinnati, Ohio, 1846–61; First Presbyterian Church, Louisville, Ky., 1865–79. A Southern sympathizer, he opposed the Reconstruction policy of the majority of the "old school" Presbyterian church and drew up the "Declaration and Testimony," adopted by the Louisville Presbytery in protest against the General Assembly's position.

WILSON, SAMUEL THOMAS (*b. London, England, 1761; d. Kentucky, 1824*), Roman Catholic clergyman. Dominican. Ordained priest in Belgium, 1786. Served as vicar provincial of the Dominican community at Bornhem, Belgium, during the French Revolution. A missionary in Kentucky *post* 1805, he was named provincial in 1807 and was responsible for building the Church of St. Rose and College of St. Thomas Aquinas near Springfield, Ky. Founded first American convent of Sisters of the Third Order of St. Dominic, 1822.

WILSON, THEODORE DELAVAN (*b. Brooklyn, N.Y., 1840; d. Boston, Mass., 1896*), ship constructor. Served in Union navy, 1861–63, as ship's carpenter at sea; worked in navy yard at New York, 1863–65. Rose to rank of naval constructor, 1873, after service at Pensacola and Philadelphia yards and as instructor at Annapolis. Chief, Navy Bureau of Construction and Repair, 1882–93, he supervised transition of the navy from wooden vessels to steel, surmounting innumerable problems of material and design.

WILSON, THOMAS WOODROW *See* WILSON, WOODROW.

WILSON, WARREN HUGH (*b. near Tidioute, Pa., 1867; d. New York, N.Y., 1937*), Presbyterian clergyman, educator. Graduated Oberlin, 1890; Union Theological Seminary, New York, 1894. Ph.D., Columbia University, 1908. After studying the operation of new social forces on rural America while a pastor, he became secretary of the Church and Country Life Department of the Presbyterian Board of Missions, 1908, and held that post until his death. His scientific rural surveys in every major region of the United States became standard documents for the developing rural-life movement and exposed the problems and deficiencies of rural education. His chief contributions to rural sociology were the application of the theory of marginal utility to rural social life and, as early as 1919, the development and application of the concept of regionalism to rural social conditions. He taught rural sociology at Teachers College, Columbia, 1914–23.

WILSON, WILLIAM (*b. Loudoun Co., Va., 1794; d. White Co., Ill., 1857*), jurist. Began practice in White Co., Ill., 1817. Justice, Illinois Supreme Court, 1819–24; chief justice, 1824–48. Rendered decision in *Field* v. *State of Illinois ex rel. McClernand*, 1839, in which the governor's power to remove a secretary of state appointed by his predecessor was denied on the ground that

the state constitution did not expressly place any limitation upon the duration of the term of office.

WILSON, WILLIAM (*b. Crieff, Perthshire, Scotland, 1801; d. 1860*), bookseller, publisher. Father of James G. Wilson. Conducted business at Poughkeepsie, N.Y., *post* 1834; author of unoriginal verse, collected in *Poems* (1869).

WILSON, WILLIAM BAUCHOP (*b. Blantyre, Scotland, 1862; d. Savannah, Ga., 1934*), labor leader. Immigrated to Arnot, Pa., as a boy; worked as a miner; was active in early union organization. Secretary-treasurer, United Mine Workers of America, 1900–08. As congressman, Democrat, from Pennsylvania, 1907–13, he was outstanding as chairman of the Committee on Labor. He sponsored investigation of mine safety conditions and influenced organization of federal Bureau of Mines, 1810; in 1912 he secured passage of Seamen's Act, for protection of merchant marine seamen. As first U.S. secretary of labor, 1913–21, he thoroughly reorganized the Bureau of Immigration and Naturalization; developed agencies for mediating and adjusting industrial disputes (probably his most significant work); and set up the U.S. Employment Service.

WILSON, WILLIAM DEXTER (*b. Stoddard, N.H., 1816; d. Syracuse, N.Y., 1900*), Episcopal clergyman, educator. Graduated Harvard Divinity School, 1838. A convert from Unitarianism, 1842, he taught moral and intellectual philosophy at Geneva (later Hobart) Divinity School, 1850–68, and was briefly acting president. Professor of moral and intellectual philosophy, Cornell University, 1868–86, he served also as registrar and was active in university organization and administration. Became dean, St. Andrew's Divinity School, Syracuse, N.Y., 1887.

WILSON, WILLIAM GRIFFITH ("BILL W.") (*b. East Dorset, Vt., 1895; d. Miami, Fla., 1971*), cofounder of Alcoholics Anonymous. Attended Norwich University, served with the Sixty-sixth Coast Artillery in World War I, and after the war broke into Wall Street. The 1929 stock market crash began his long slide into alcoholism, which he began to turn around after discovering the precepts of the Oxford Group, an evangelical movement that stressed personal confession of guilt and restitution-making. Alcoholics Anonymous (AA) began in 1935, when he met another alcoholic, Dr. Robert Holbrook Smith ("Dr. Bob S."), to whom he explained that he could only stay sober by relating his experience with another alcoholic, the basic premise of AA. His books include *Alcoholics Anonymous* (1939) and *Twelve Steps and Twelve Traditions* (1953).

WILSON, WILLIAM HASELL (*b. Charleston, S.C., 1811; d. 1902*), civil engineer. Grandson of William H. Gibbes; father of Joseph M. Wilson. Principal assistant engineer, Philadelphia & Reading Railroad, 1835–36. Engaged in general practice, 1837–57; served as consultant to the Pennsylvania Railroad in westward extensions; appointed resident engineer, Philadelphia & Columbia Railroad, 1857. Given charge of maintenance of way and new construction for the Pennsylvania Railroad "main line" between Philadelphia and Pittsburgh, 1859, he held title of chief engineer, 1862–74. Constructed works of Altoona Gas Co., of which he was president, 1859–71. Headed real estate department of the Pennsylvania Railroad, 1874–84; thereafter, served as president and director of several Pennsylvania-leased railroads.

WILSON, WILLIAM LYNE (*b. Middleway, Va., now W.Va., 1843; d. 1900*), Confederate soldier, lawyer, educator. Graduated Columbian College, Washington, D.C., 1860; LL.B., 1867. Assistant professor of ancient languages. Columbian College, 1865–71. Successfully practiced law in Charles Town, W.Va.,

1871–*ca.* 1883. President, West Virginia University, September 1882–June 1883. As congressman, Democrat, from West Virginia, 1883–95, his most important work was in tariff reform. He supported the Morrison bills and, as a member of the Ways and Means Committee, helped frame the Mills bill. He first reached national prominence in the 1888 debate on this measure. He was a principal opponent of the McKinley bill, 1890. As chairman of the Ways and Means Committee, 1893, he led in framing the Wilson bill; his moderate reform measures were vitiated by Senate amendments in 1894. U.S. postmaster general, 1895–97, he inaugurated rural free delivery and enlarged classified civil service. A staunch believer in the gold standard, Wilson fought the Democratic stampede to free coinage of silver in 1895–96. After the Democratic convention of 1896, he condemned Bryan and was considered for the presidential nomination by the Gold Democrats. He was president of Washington and Lee University, Lexington, Va., *post* 1897.

WILSON, WOODROW (*b. Staunton, Va., 1856; d. Washington, D.C., 1924*), educator, statesman, president of the United States. Christened Thomas Woodrow Wilson, he came of Scottish ancestry and was the son of a Presbyterian minister. In his second year the family removed to Augusta, Ga.; in 1870 Wilson's father became professor at the theological seminary at Columbia, S.C., and pastor of the First Presbyterian Church; in 1874 the family moved to Wilmington, N.C., where the father held a pastorate. The young Wilson was the personal and intellectual companion of his father, acquired much learning at home, and lived a youth largely separated from those of his own age. He retained an indelible impression of the horror produced in him as a child by the Civil War.

After attending Davidson College, 1873–74, he entered the College of New Jersey (Princeton), from which he graduated, 1879. As an undergraduate he was a leader in debating and devoted much study to the lives of British statesmen. Aspiring to a career in public life, he attended the law school of the University of Virginia, where he took more interest in the study of political history than in the formal law courses. In 1882 he began practice of law in Atlanta, Ga., but failed largely because of his repugnance to the purely commercial side of practice. Entering the graduate school of Johns Hopkins, 1883, he worked under Herbert B. Adams, but rebelled against German methods of postgraduate work. However, his newly stimulated literary powers won him a fellowship in the history department, and he published his important *Congressional Government* (1885), a beautifully written analysis of American legislative practice, with emphasis on the evils that come from the separation of the legislative and executive branches of government and from the consequent power of congressional committees. This served also as his thesis for his Ph.D. degree, 1886. In 1885 he married Ellen L. Axson, who was profoundly sympathetic with his ideals and influenced him strongly. After teaching history at Bryn Mawr, 1885–88, and at Wesleyan University, 1888–90, he joined the Princeton faculty as professor of jurisprudence and political economy.

Wilson cared little for scholarly distinction acquired by intensive research; his broad reading and intense intellectual curiosity, however, made him influential among faculty and undergraduates. He was soon a leader of the younger liberals on the faculty. He labored over his literary style and exercised a rigid self-criticism. He also engaged in lecture tours, thereby winning confidence in his ability to interest and dominate general audiences.

Elected president of Princeton, June 1902, he embarked on an already formulated program of academic reform. Convinced that the object of a university is simply and entirely intellectual, he proposed to revolutionize Princeton's attitude toward college life, giving the serious scholar the prestige he had rightly earned and reducing the social and athletic sideshows to a subordinate

place. He undertook a structural reorganization of the university by means of the preceptorial system and the quad plan (providing for more intensive individual instruction and for a democratization of the student body by housing it in small nonexclusive units like the English colleges), and he brought to the faculty a group of new scholars who were prepared to undertake the duties of preceptors to small groups. Wilson hoped to break the hold of the already existing and exclusive undergraduate clubs on the social life of the university, but the quad plan was opposed bitterly, and he was asked by the board of trustees to withdraw this part of his program.

By a stroke of irony this academic defeat served to bring Wilson before the American public as a champion of the underprivileged and as a supporter of democratic principles. However, he received another setback in a controversy which had arisen over the location of the new graduate college. Wilson saw in the refusal of the trustees to give him their entire support a block to the development of his ideal of a democratic coordinated university; he was also disappointed at the manifestation of bitter personal feeling incident to these struggles. At this juncture his early admirer Col. George B. M. Harvey urged Wilson upon the state Democratic organization as an ideal candidate for governor in 1910. The doubtful machine politicians allowed themselves to be persuaded to nominate Wilson; after resigning the presidency of Princeton, October 1910, he was elected governor of New Jersey in November.

Regarded by the machine politicians as a naive theorist and suspected by the reformers as a tool of the machine politicians, he speedily disillusioned both groups. Driving forward reform measures with vigor; by the end of the first session of the legislature he had secured enactment of the most important proposals of his campaign—a primary-election law, an invigorated public utilities act, a corrupt-practices act, and an employers' liability act. New Jersey was now studied by reformers as a practical example of possibilities, and Wilson began to attract national attention. Through the efforts of his friend Col. Edward M. House, who believed that Wilson was a man of genius and a Democrat untouched by "Bryanesque heresies," and also because of the admiration of people in general for the eloquence and power of his public addresses, Wilson was nominated by the Democrats for the presidency at Baltimore, Md., in the summer of 1912.

The political split between Republican progressives and conservatives and the personal quarrel between Theodore Roosevelt and W. H. Taft made the Democratic nomination in 1912 tantamount to election. Wilson was victor in November with 435 electoral votes as against 88 for Roosevelt and 8 for Taft; it was the largest electoral majority ever achieved up to that time, although it represented a popular minority. Wilson presented himself to the public as champion of what he called the "New Freedom." He was to be a conservative reformer, eager to return to the common people an equality of opportunity which had been threatened by the "interests" of industry, finance, and commerce. Distrustful of radical remedies, he believed that the first essential to government at Washington was to render it sensitive to public opinion. His campaign speeches had embodied his program; they were a series of magnificent manifestos and established him as the leader of American liberalism. Aware of the tremendous influence still exercised in the United States by William J. Bryan, Wilson named him secretary of state; the other members of the Wilson cabinet proved to be of more than adequate administrative ability. Determined at the outset to establish a closer working connection between the executive and the legislature, he appeared in person before both houses of Congress in April 1913 to deliver his first message, thus reviving a custom that had lapsed since Jefferson's time. He soon began to use the large Democratic majority in Congress to win extraordinary legislative triumphs; of these, the most important were the Underwood Tariff and the Federal Reserve Act. The third major aspect of his program took form in creation of the Federal Trade Commission and in the Clayton Antitrust Act, which was designed to prevent interlocking directorates and declared that labor organizations should not be held, or construed to be, illegal combinations in restraint of trade. The aim of this legislation was to liberalize the industrial system and to eliminate special privilege, destroy monopoly, and maintain competition. Influential industrialists and the wilder reformers among the Democrats were equally opposed to the president, but he was able to control Congress through judicious use of the political patronage. However, the chief factor in Wilson's early success was his own genius for leading public opinion and mobilizing it against opposition. There were many, however, who said that he was too restless and wanted to go too fast.

Another irony in Wilson's career soon manifested itself. The president, primarily interested in solution of domestic problems, was soon forced to give major attention to international affairs. A determined pacifist, he was to be compelled to lead his country in a great war. Attempting to eliminate the traditional Latin American jealousy of the United States by a policy of goodwill and accommodation, he was thwarted by conditions in Haiti, Central America, and Mexico. Problems occasioned by the Huerta-Carranza struggle in Mexico led to "incidents" and the necessity of military action in defense of United States rights at Tampico and Veracruz. Subsequent to the partial solution of these difficulties by the mediation of Argentina, Brazil, and Chile, a new set of troubles developed because of guerrilla raids across the border into New Mexico. In 1916 Wilson was forced to send a small force under General John J. Pershing across the Mexican border in pursuit of Pancho Villa, and the National Guard was mobilized for protection of the border. He was, however, able to project the essential articles of an agreement to provide for international security of the western hemisphere which forecast the later Covenant of the League of Nations. This matter was discussed with Latin American statesmen, but was soon merged in Wilson's more comprehensive plan for a world organization built upon a similar model. Wilson also engaged in diplomatic efforts through Colonel House to create a closer Anglo-American understanding, which might later be developed by the inclusion of Germany and so end the mutual distrust among nations which was poisoning Europe.

After the sudden outbreak of World War I, the general favor given the cause of the Allies by people of the eastern states was shared by the president; he was determined, however, that this should in no way affect a policy of complete neutrality. Soon, both Allied regulation of neutral maritime trade and the German submarine campaign challenged the neutral policy which Wilson favored. The United States issued a formal protest against Allied maritime control in December 1914, but difficulties with the Allies were at once alleviated by the German decree of February 1915, declaring the waters around the British Isles a war zone and threatening to sink all belligerent merchant ships, with a further intimation that neutral ships might also be sunk. Reacting against such blind destruction of property as was entailed in the German threat, Wilson was further disturbed by the threat to life, for which no adequate compensation could ever be made. On Feb. 10 he warned Germany that destruction of an American vessel or American lives would be regarded as a violation of neutral rights and a matter of strict accountability. Soon "accidents" began to happen. On May 7 the *Lusitania* was sunk; among the victims were 128 Americans. Wilson's firmness in demanding that Germany give up the ruthless submarine campaign led to the resignation of William J. Bryan in June; Bryan saw the danger of war in Wilson's insistence on the preservation of traditional

neutral rights. However, the president's combination of patience and firmness triumphed temporarily. Following the sinking of the *Arabic* in August 1915, the German ambassador to the United States announced his government's promise that passenger liners would not be attacked without warning. A later comprehensive agreement to abandon ruthless submarine warfare was extracted from Germany by the threat of a diplomatic rupture, which Germany hoped to avoid. "My chief puzzle is to determine where patience ceases to be a virtue," Wilson wrote to Colonel House in September 1915. He continued to act, however, on the principle that the people of the United States counted on him to keep them out of the war and that it would be a world calamity if the United States should be actively drawn into the conflict and so deprived of disinterested influence over the peace settlement. His policy toward Germany continued to receive confirmation from Congress right up to the national election of 1916.

At a disadvantage because of domestic dislike of his reform legislation and because of the revived solidarity of the Republican party, Wilson was reelected in November 1916 over the Republican candidate, Charles E. Hughes, by a very narrow margin (277 to 254). Indeed, he at first thought that he had been defeated, and it was not until the full returns from the West came in that Republican majorities in the East were wiped out. He now began to make a determined move for peace, following along lines which he had pursued since the early autumn of 1914, despite constant rebuffs. The failure of the Allies to respond to intimations of a possible settlement from Germany and from Wilson now influenced the Germans to plan resumption of unrestricted submarine warfare; on Jan. 31, 1917, the German government told the United States that its earlier pledges would no longer be observed. Wilson decided immediately to give the German ambassador his passports.

Wilson believed that by upsetting the tentative movements for peace then in progress, however unlikely of success they might be, the Germans had morally condemned themselves. He still refused to believe, however, that a diplomatic rupture meant war. His hand was forced very soon by the publication of the notorious "Zimmermann telegram," suggesting that a German-Mexican-Japanese alliance was in prospect, and by the sinking of more American ships. On April 2, 1917, he appeared before Congress to ask for a declaration of war; the resolution was voted on April 6. It represented an all but unanimous sentiment of the American people, who appeared to share the president's conviction that imperial Germany was an international criminal.

Once the United States was at war, Wilson mustered the full national strength and concentrated on victory. The nation was inadequately prepared for war, yet the president's war leadership was particularly distinguished in that he inspired a general conviction that it was a people's war and that every citizen should make individual sacrifices. He made wise choices of the men who were to occupy vital administrative and military posts, and he let them alone to do their jobs. His own supreme contribution to a victory lay in his formulation of war aims — aims which he had publicized well before the conflict. Embodying the principle of the Monroe Doctrine to the entire world, he demanded a concert of the powers capable of maintaining international peace and the rights of small nations. However, even during the war it became obvious that Wilson's aims were not those of the Allies. Subsequent to the Russian Revolution a restatement of aims became necessary, and on Jan. 8, 1918, the president delivered before Congress the speech of the Fourteen Points. This was not intended as a public international charter but as a diplomatic weapon to meet the Bolshevik drive for peace and to strengthen the morale of the Allied liberals. It contained six general points which repeated ideals already enunciated by Wilson: open di-

plomacy, freedom of the seas, removal of trade barriers, reduction of armaments, impartial adjustment of colonial claims, a league of nations. There were also eight special points dealing with immediate political and territorial problems.

By this speech the president committed himself to participation in the general world problem of preserving the peace and also to an interest in certain local problems peculiar to Europe which might disturb the peace. When the Germans recognized early in the autumn of 1918 that they would be defeated, they seized upon this speech as a general basis of peace negotiations and turned to Wilson as their savior from political and economic annihilation. Although his interchange of notes with the Germans at this point ran counter to public sentiment in the United States and irritated the Allies, it contributed to securing an early armistice by encouraging the existing demand for peace among the German people. When Wilson offered the Allies Germany's acceptance of an armistice on Oct. 23, 1918, the Allies were free to refuse it if they chose. Likewise, although the Germans later complained that they had been lured into a peace without guarantees, they were more than eager at the time to accept the undefined Fourteen Points rather than lose a chance at peace. After compelling the Allied leaders to accept the Fourteen Points by a threat to expose their intransigent attitude to Congress, the president sent Germany a qualified Allied acceptance of the basic conditions of peace and an armistice was signed on Nov. 11, 1918.

Now at the height of his influence, Wilson was the greatest single force in the world, yet the difficulties of capitalizing on the victory were far greater than those which had been involved in winning it. The sense of common interest in war soon evaporated, and Wilson's political ideals could not readily be transplanted to Europe. Also, at this critical moment Wilson made three mistakes. He asked for a heavy Democratic vote in the November elections as a sign of confidence in him and his policies, thus abdicating the national leadership by assuming the role of a party leader; Democratic defeats in the election therefore gave the appearance of a national repudiation. His second mistake lay in his failure to appoint to the Peace Commission a single member who truly represented either the Republican party or the U.S. Senate; he thus forfeited the chance of winning support from his domestic opponents. His third and greatest mistake lay in his decision to attend the Peace Conference in person, since by lowering himself to haggle at the conference table he lost his commanding position as first citizen of the world. He did succeed at the very beginning of the conference in forcing an acceptance of the League of Nations Covenant as an integral part of the treaty of peace. At later sessions he was shaken by the discovery that in their application his principles were sometimes at variance with each other, and he was compelled to compromise — a series of adjustments which left liberals disappointed and the Germans bitter. However, the need for compromise is apparent from the fact that the Allied nationalists were equally disappointed. He could congratulate himself, however, on the adoption of the League of Nations Covenant, through which, as he believed, all errors and omissions could later be rectified.

There now remained the problem of winning the approval of the U.S. Senate for the Versailles Treaty. Wilson had solved many more difficult problems during the negotiations, and there seemed little chance of an upset; public opinion generally favored the League of Nations and cared little about the treaty details. Even Wilson's chief opponent, Senator Henry C. Lodge, hoped only to add amendments or reservations, not to defeat the treaty and the covenant. Even a few conciliatory gestures by the president would have won the two-thirds vote necessary for ratification, but Wilson's attitude was not conciliatory. He would permit no changes, and as opposition developed, his tone be-

came more unyielding. As the debate continued it shifted from the merits of the case to the question of the respective authority of president and Senate and even to personal differences between the president and Senator Lodge, chairman of the Senate Committee on Foreign Relations. Setting forth on Sept. 3, 1919, on a countrywide speech-making tour on behalf of the treaty, the president fell gravely ill at Pueblo, Colo., Sept. 25, and was brought back hurriedly to Washington. He was thereafter incapable of transacting official business. Had Wilson died then, his successor might have made the compromises which the Senate considered necessary for ratification of the covenant; had Wilson recovered sufficiently, he might have made them himself. Isolated from the situation, he could do no more than maintain his earlier position. Despite the efforts of many in both the United States and Europe, the treaty and the covenant were rejected by only seven votes. The rest of his life was spent in invalidism and anticlimax.

Woodrow Wilson was by taste and inheritance designed for a quite life. He was always dependent upon the help and encouragement he received from his domestic circle. Mrs. Wilson died in 1914 and a year later he married Edith B. Galt, who survived him. He never capitalized fully on his personal and intellectual gifts in his public life. To those who worked closely with him he displayed a genial, humorous, and considerate personality, but he was incapable of unbending with men whom he did not like or did not trust. He was handicapped in meeting the simplest problem of political tactics because he carried the attitude of a private citizen into public life; he refused to make many of the sacrifices of taste demanded by the rough game of politics. He was a man of strong prejudices, often ill founded, and he would not yield them; because of this, he alienated important leaders in the world of business and journalism. Although pictured in the public mind at the end of his career as a self-willed and arbitrary egoist, he was actually highly considerate of the feelings and interests of those around him and a man who was unsparing in self-criticism. Sharply sensitive to the sympathies and advice of those for whom he cared, he had little respect for the arguments of personal or political enemies. The public force of his speeches resulted in part from clarity of expression and fine phrasing; they were equally characterized by strong and effective moral fervor. Wilson strove consciously to measure everything by spiritual rather than material values and the great masses of the people recognized this fact. His political philosophy was simple; he was a liberal individualist, insistent upon the rights of unprivileged persons and small nations. Possessed of a noble vision, he was not able to transform that vision into fact, but he will remain in history as an eminent prophet of a better world.

WILTZ, LOUIS ALRED (*b. New Orleans, La., 1843; d. 1881*), businessman, Confederate soldier, Louisiana legislator. An active and able Democratic leader and New Orleans official, Wiltz presided over the legislature as Speaker in 1875 and was elected lieutenant governor, 1876. He served as president of the state constitutional convention, 1879, and was elected governor that same year. He died in office.

WIMAR, CARL (*b. Siegburg, near Bonn., Germany, 1828; d. St. Louis, Mo., 1862*), painter of Indians and the frontier. Immigrated to St. Louis, 1843. Apprenticed to a painter of decorations for carriages and steamboats. Studied in Düsseldorf, 1852–57, with, among others, Emanuel Leutze. On returning to America, Wimar made several trips to the trading posts on the upper Missouri and the Yellowstone to sketch Indians in their natural habitat and gave much attention to details of costume, weapons, and the western scene. Among his outstanding paintings are *Attack on an Emigrant Train* and *Buffalo Hunt by Indians*; his four

historical panels in the St. Louis courthouse were his last work and have been spoiled by inexpert renovation.

WIMMER, BONIFACE (*b. Thalmassing, Bavaria, 1809 d. 1887*), Roman Catholic clergyman, Benedictine. Christened Sebastian Wimmer; ordained priest at Regensburg, 1831; took solemn vows at monastery of Metten, 1833. Influenced by Peter H. Lemke to act on a plan to found a Benedictine monastery in America for ministry to immigrant Germans, he erected St. Vincent's Abbey in Westmoreland Co., Pa., 1946. He was appointed first abbot, 1855, and raised to archabbot, 1883. His foundation marked the beginning of the Benedictine Order in the United States; from it, many other abbeys and priories were established throughout the nation.

WIMSATT, WILLIAM KURTZ (*b. 1907; d. New Haven, Conn., 1973*), professor and literary critic. Graduated Georgetown University (B.A., 1928), Catholic University of America (M.A., 1929), and Yale University (Ph.D., 1939). Beginning in 1939 he spent his entire teaching career at Yale, becoming a full professor in 1955. He was a specialist in eighteenth-century literature; his books include *The Prose Style of Samuel Johnson* (1941) and *The Portraits of Alexander Pope* (1965). He made his greatest mark in literary theory, in such works as *The Verbal Icon* (1954), written with the philosopher Monroe C. Beardsley, and *Literary Criticism: A Short History* (1957), with Cleanth Brooks.

WINANS, ROSS (*b. Sussex Co., N.J., 1796; d. 1877*), inventor, mechanic. Father of Thomas De Kay Winans. Devised, 1828, a model "rail wagon" which had friction wheels with outside bearings, thereby setting the distinctive pattern for railroad car wheels. While engineer of the Baltimore & Ohio, 1829–30, he assisted Peter Cooper with his *Tom Thumb* engine. Employed an improvement of railroad machinery for the Baltimore & Ohio, 1834–60, Winans planned the first eight-wheel car for passenger purposes and is credited with innovating the mounting of a car on two four-wheeled trucks. In 1842, he constructed the *Mud-Digger* locomotive with horizontal boiler, and in 1848, the first powerful "camelback" locomotive. He developed, 1859, with his son, the "cigar-steamer," whose hull shape has been adopted in modern ocean liners.

WINANS, THOMAS DE KAY (*b. Vernon, N.J., 1820; d. Newport, R.I., 1878*), engineer, inventor. Son of Ross Winans. Associated with Joseph Harrison in firm of Harrison, Winans and Eastwick, St. Petersburg, Russia, which supplied locomotives and other rolling stock for the railroad from St. Petersburg to Moscow and cast the iron for the first permanent bridge over the Neva River. Director, Baltimore & Ohio Railroad. Devised, 1859, with his father a cigar-shaped hull for high-speed steamers.

WINANS, WILLIAM (*b. Chestnut Ridge, Pa., 1788; d. Amite Co., Miss., 1857*), Methodist clergyman, outstanding figure in Mississippi Methodism *post* 1820. Championed status quo of Methodist policy and doctrine at General Conferences, 1824–44; actively opposed abolition. At the General Conference, 1844, he defended Bishop J. O. Andrew and was a member of the "Plan of Separation" committee. Elected to General Conferences, Methodist Episcopal Church, South, 1846, 1850, and 1854.

WINANT, JOHN GILBERT (*b. New York, N.Y., 1889; d. Concord, N.H., 1947*), teacher, reform politician, diplomat. Reared in a well to do family, he attended private schools in New York City and St. Paul's School, Concord, N.H. Winant entered Princeton University, but did poorly in his studies. He accepted a standing offer from the rector of St. Paul's School to join its faculty; in 1911 he became an instructor in history there. During his years at St. Paul's he was active in local Republican politics, and in

1916 he was elected to the New Hampshire legislature. He quickly challenged the reactionary Republican politicians and industrial interests that dominated the state. He interrupted his political and academic career in 1917 and joined the American Air Service.

Appointed second vice-rector, he returned to St. Paul's and remained there until 1920, when he won election to the state senate. Two years later, despite a Democratic trend, he was again elected to the lower house. In 1924 he was elected governor, but failed of reelection in 1926. He returned to state politics in 1930 and won reelection as governor (and again in 1932). Winant's reputation as a friend of labor led to his appointment by President Franklin D. Roosevelt in 1934 to head an emergency board of inquiry into a nationwide textile strike.

Upon leaving office in January 1935, Winant, with the help of Roosevelt, was appointed assistant director of the International Labor Organization in Geneva. Within four months, however, Roosevelt brought him back to head the newly created Social Security Board. Spoken of for the Republican presidential nomination in 1936, he was never a serious candidate, and when the party's nominee, Alfred M. Landon, attacked social security, Winant resigned from the Social Security Board so that he could defend the act, thus destroying any future possibility of winning Republican support for a national office. Winant returned to his ILO post in 1937, and two years later became the director. As the European war intensified, he transferred a reduced ILO staff to Canada in mid-1940.

In late 1940 Roosevelt appointed Winant ambassador to the Court of St. James's. Winant was one of the planners of the 1943 Three-Power Foreign Ministers Conference in Moscow, which paved the way for the later summit conference at Teheran. In 1946 he was named by President Truman as the U.S. representative to the Economic and Social Council of the United Nations; he resigned his ambassadorship in March 1946.

WINCHELL, ALEXANDER (*b.* Northeast, N.Y., *1824; d. 1891*), educator, geologist. Brother of Newton H. Winchell. Graduated Wesleyan University, 1847. Held chairs in geology, zoology, and botany at University of Michigan, 1855–73; in geology and paleontology *post* 1879. Director of Michigan state geological survey, 1859–61 and 1869–71. Took advanced stand on evolution and helped reconcile supposed conflict between science and religion. Author of, among other popular works, *Sketches of Creation* (1870), *The Doctrine of Evolution* (1874), *Sparks from a Geologist's Hammer* (1881), and *World Life* (1883).

WINCHELL, HORACE VAUGHN (*b.* Galesburg, Mich., *1865; d. 1923*), geologist, mining engineer. Son of Newton H. Winchell; nephew of Alexander Winchell. Prepared reports and maps of Mesabi range *ante* 1892, predicting its importance. Associated with Anaconda Copper Mining Co *post* 1898, he headed its geological department but also maintained a consultant practice. A leading authority on the "apex law;" did pioneer work in origin of ore deposits. Author of *The Iron Ores of Minnesota* (1891), a standard reference work.

WINCHELL, NEWTON HORACE (*b.* Northeast, N.Y., *1839; d. Minneapolis, Minn., 1914*), geologist, archaeologist. Father of Horace V. Winchell; brother of Alexander Winchell. Graduated University of Michigan, 1866. Minnesota state geologist, 1872–1900; professor of geology, University of Minnesota, 1874–1900. Did valuable geological studies on recession of St. Anthony's Falls, Minneapolis. A founder and editor of the *American Geologist*, 1888–1905. Author of *The Aborigines of Minnesota* (1911).

WINCHELL, WALTER (*b.* New York City, *1897; d. Los Angeles, Calif., 1972*), journalist. Began his career by peddling bits of news and gossip to *Billboard* and the *Vaudeville News*, which hired him in 1922 as a full-time reporter and advertising salesman. Two years later he went to work for the *Evening Graphic* and in 1929 took his column to the *New York Daily Mirror*, where he remained more than thirty years. By 1937 he was one of the most powerful figures in New York. Both his nationally syndicated column and his Sunday night radio program brought the glamour of New York City night life to millions of Depression-era Americans. After World War II, however, Winchell moved politically to the far right, with daily tirades against real and imagined enemies. His radio program was canceled in the mid-1950's, and his syndicated column disappeared when the *Daily Mirror* folded in 1963.

WINCHESTER, CALEB THOMAS (*b.* Montville, Conn., *1847; d. 1920*), teacher, editor of texts in English literature. A.B., Wesleyan University, 1869. Professor of rhetoric and English literature at Wesleyan *post* 1873. Author of, among other works, *Some Principles of Literary Criticism* (1899).

WINCHESTER, ELHANAN (*b.* Brookline, Mass., *1751; d. Hartford, Conn., 1797*), Baptist and Universalist clergyman. Moved in his theology from open-communion Baptist tenets to strict Calvinism; accepted doctrine of universal restoration *ca.* 1787. Preached in London, England, 1787–94, where he made many friends, among them John Wesley and Joseph Priestley. Probably the ablest and the most intellectual of early American Universalists, he was author of a number of books, which included a refutation of Thomas Paine's *Age of Reason*.

WINCHESTER, JAMES (*b.* Carroll Co., Md., *1752; d. Tennessee, 1826*), planter, soldier, Tennessee legislator. After service in the Revolution, he settled in the then Mero District of North Carolina, 1785; as brigadier general of the district, he won fame as an Indian fighter. On admission of Tennessee, 1796, he was elected state senator and Speaker of the Senate. Appointed U.S. brigadier general, 1812, he was surprised and badly defeated by the British on the River Raisin in southeast Michigan, Jan. 22, 1813. Exchanged after imprisonment in Canada, he commanded the Mobile District until 1815. He was a founder of the city of Memphis, Tenn.

WINCHESTER, OLIVER FISHER (*b.* Boston, Mass., *1810; d. New Haven, Conn., 1880*), manufacturer. Invented and patented a new method of shirt manufacture, 1848, in which he was successful at New Haven, Conn. Organized New Haven Arms Co. (later Winchester Repeating Arms Co.), 1857, for manufacture of pistols and rifles under patents of Tyler Henry, D. B. Wesson, and others. Began production of Henry repeating rifle using new rimfire copper cartridge, 1860; it was widely used by state troops during the Civil War, but was not adopted by the federal government. The improvement of a method of loading the magazine through the gate in the frame was made in 1866. Patented features of the Spencer rifle were added later. Winchester also acquired and produced the bolt-action inventions of B. B. Hotchkiss and the single-shot mechanism invented by John M. Browning.

WINCHEVSKY, MORRIS (*b.* Yanovo, Lithuania, *1856; d. 1932*), poet, essayist, miscellaneous writer. Changed name from Lippe Benzion Novachovitch. Resident in London, England, after expulsion as socialist propagandist from Prussia and Denmark, he founded in 1884 the first Yiddish socialist periodical *Der Polischer Yidel*. Immigrating to the United States, 1894, he became the most representative contributor to the Yiddish daily *Forward* after its establishment in 1897; he was associated also with many

other socialist periodicals. His proletarian poems dwell with sympathy on the sordid aspects of the life of laborers.

WINDER, JOHN HENRY (*b. Rewston, Md., 1800; d. Florence, S.C., 1865*), Confederate soldier. Son of William H. Winder. Graduated West Point, 1820. An artilleryman, he won brevet of lieutenant colonel in Mexican War. Appointed Confederate brigadier general, 1861, he held the thankless post of commander of military prisons, at first in Richmond, where he was also provost marshal, and later in Alabama and Georgia. The extent of his responsibility for bad conditions in the Southern prison camps is still in dispute. He was defended by Jefferson Davis, Samuel Cooper, and James A. Seddon. Also, his task was made an impossible one by the refusal of the Northern authorities to continue exchanges and by a general lack of food, clothing, and medicines.

WINDER, LEVIN (*b. Somerset Co., Md., 1757; d. Baltimore, Md., 1819*), farmer, Revolutionary soldier, Maryland legislator. Federalist governor of Maryland, 1813–15. On failure of the federal government to provide adequate defense of Maryland against British attacks in the War of 1812, Winder rallied and equipped the state forces and frustrated the enemy's operations against North Point, Fort McHenry, and elsewhere.

WINDER, WILLIAM HENRY (*b. Somerset Co., Md., 1775; d. Baltimore, Md., 1824*), Baltimore lawyer, soldier. Father of John H. Winder. Served on northern frontier as colonel of infantry, 1812; promoted brigadier general, March 1813. Commanded at battle of Bladensburg, Md., August 1814, and was blamed for the disgraceful defeat there which laid the city of Washington open to spoil by the British. The degree of his responsibility for the defeat is still a matter of dispute.

WINDOM, WILLIAM (*b. Belmont Co., Ohio, 1827; d. New York, N.Y., 1891*), lawyer, politician. Settled in Minnesota, 1855. Congressman, Republican, from Minnesota, 1859–69; voted with the Radicals; was chairman of committee on Indian affairs. Appointed U.S. senator, 1870, he served also 1871–83, interrupted by a term as U.S. secretary of the treasury, March–November 1881. He was probably most notable as a chairman of a special committee on transportation routes to the seaboard. He was also chairman of the Committee on Appropriations, 1876-81, and chairman of the Committee on Foreign Relations *post* 1881. Urged a liberal railroad policy; supported homestead legislation; was a strong nationalist and high-tariff man. He served again with competence as U.S. secretary of the treasury, 1889–91.

WINEBRENNER, JOHN (*b. near Walkersville, Md., 1797; d. Harrisburg, Pa., 1860*), clergyman. Ordained, 1820, by General Synod of the German Reformed Church; dropped from the synod, 1828, because of extravagant revivalistic methods. Founded the General Eldership of the Churches of God in North America, 1830, a sect based on a medley of primitive Methodist and Baptist doctrines.

WINES, ENOCH COBB (*b. Hanover, N.J., 1806; d. Cambridge, Mass., 1879*), prison reformer, educator, Congregational clergyman. Father of Frederick H. Wines. Secretary, Prison Association of New York, *post* 1861. With Theodore W. Dwight, prepared monumental *Report on the Prisons and Reformatories of the United States and Canada* (1867); stimulated widespread movement toward prison reform and encouraged such experimenters as Zebulon R. Brockway at Detroit, Mich. With Franklin B. Sanborn, promoted adaptation of Irish-Crofton system in the United States. Called national prison reform convention at Cincinnati, Ohio, 1870. Secretary of National Prison Association, *ca.* 1870–77.

WINES, FREDERICK HOWARD (*b. Philadelphia, Pa., 1838; d. Springfield, Ill., 1912*), social reformer, Presbyterian clergyman. Son of Enoch C. Wines. Influential secretary, Illinois state board of public charities, 1869–92 and 1896–98. Secretary, National Prison Association, 1887–90. Author of *Punishment and Reformation* (1895), long a standard work. Brought from England the idea of the Kankakee State Hospital plan for care of insane; in early 1890's was among the first to urge use in America of "pathological research" and hydrotherapy. Appointed assistant director of the 12th Census, 1897, he was given major responsibility for *Report on Crime, Pauperism and Benevolence in the United States* (1895–96). Became statistician, Illinois Board of Control, 1909.

WING, JOSEPH ELWYN (*b. Hinsdale, N.Y., 1861; d. Marion, Ohio, 1915*), Ohio farmer, agricultural journalist. Became first strong propagandist for alfalfa culture in central and eastern states. Staff correspondent for the *Breeder's Gazette* from 1898, he lectured widely and was a national figure in agricultural journalism. Author of, among other books, the authoritative *Alfalfa Farming in America* (1909).

WINGATE, PAINE (*b. Amesbury, Mass., 1739; d. Stratham, N.H., 1838*), Congregational clergyman, New Hampshire legislator and jurist. Brother-in-law of Timothy Pickering. Graduated Harvard, 1759. Pastor at Hampton Falls, N.H., 1763–71; *post* 1776, a farmer at Stratham. Delegate to state constitutional convention, 1781; elected to last Congress under the Confederation, 1787. U.S. senator, Federalist, from New Hampshire, 1789–93; U.S. congressman, 1793–95. Opposed Hamilton's funding scheme. As judge of the New Hampshire Superior Court, 1798–1809, he served usefully, although ignorant of legal technicalities and procedure.

WINGFIELD, EDWARD MARIA (*fl. 1586–1613*), soldier. An original grantee of the Virginia charter, 1606, he came with the first settlers and served as president of the Virginia colony, April–September 1607. Removed from office, he was sent back to England in the spring of 1608. Author of "A Discourse of Virginia," a spirited defense of himself and an account of the colony from June 1607 to his departure, first published by Charles Deane in 1860 (*Transactions and Collections of the American Antiquarian Society*, Vol. 4).

WINKLER, EDWIN THEODORE (*b. Savannah, Ga., 1823; d. 1883*), Baptist clergyman, Confederate chaplain, author. Executive secretary, Southern Baptist Publishing Society, 1852–54; edited *Southern Baptist*. Principal pastorates included First Baptist Church, Charleston, S.C., 1854–61, and Citadel Square Baptist Church, Charleston, 1865–72. Editor of *Alabama Baptist*, from 1874. For ten years he was president of Home Missionary Board, Southern Baptist Convention. Deeply interested in the welfare of blacks.

WINLOCK, HERBERT EUSTIS (*b. Washington, D.C., 1884; d. Venice, Fla., 1950*), Egyptologist, museum director. Grandson of Joseph Winlock. B.A., Harvard, 1906. On staff of Metropolitan Museum of Art, New York City, *post* 1906, he served as assistant curator of Egyptian art, 1909–22; associate curator, 1922–29; and curator, 1929–39. Until 1932, he spent the greater part of his time excavating in Egypt; he became director of field work officially in 1928. The most important site at which he worked was the area of Deir al-Bahri on the western side of Thebes; one of his major contributions was the excavation of the royal tombs at Thebes of the periods preceding and following the Middle Kingdom. Concurrently with his Egyptian curatorship, he was director of the Metropolitan Museum, 1932–39.

WINLOCK, JOSEPH (*b. Shelby Co., Ky., 1826; d. Cambridge, Mass., 1875*), astronomer, mathematician. Graduated Shelby College, Kentucky, 1845. Superintendent at various times of the *American Ephemeris*; headed mathematics department, U.S. Naval Academy, 1859–61. Became director, Harvard College observatory and Phillips professor of astronomy, 1866 (later also professor of geodesy), serving in these positions until his death.

WINN, RICHARD (*b. Fauquier Co., Va., 1750; d. Duck River, Tenn., 1818*), Revolutionary soldier, planter, South Carolina legislator. As captain in command, made spectacular defense of Fort McIntosh, Ga., 1777. Served under Thomas Sumter and took distinguished part in skirmish at Fishdam Ford and in the battle of Blackstock. Promoted major general of militia, 1800. Lieutenant governor of South Carolina, 1800–02. Congressman, Democratic-Republican, from South Carolina, 1793–97 and 1803–13. Removed to Tennessee, 1813.

WINNEMUCCA, SARAH (*b. near Humboldt Lake, Nev., ca. 1844; d. Monida, Mont., 1891*), Indian teacher, lecturer. Daughter of a Paiute chief. Mediator between the Paiute and the whites, she served as "guide and interpreter" to General O. O. Howard during the Bannock War of 1878, performing many daring acts. Author of *Life Among the Paiute: Their Wrongs and Claims* (Mary T. P. Mann, ed., 1883).

WINSHIP, ALBERT EDWARD (*b. West Bridgewater, Mass., 1845; d. 1933*), editor, educator, Congregational clergyman. Editor, *Journal of Education*, Boston, Mass., 1886–1933; also edited the *American Teacher* (*post* 1896, the *American Primary Teacher*). Played important part in building National Education Association; was a pioneer in conducting community classes for adult education, 1876–83.

WINSHIP, BLANTON (*b. Macon, Ga., 1869; d. Washington, D.C., 1947*), army officer. B.A., Mercer University, 1889; LL.B., University of Georgia, 1893. Commissioned first lieutenant in Judge Advocate's Department, 1899, after volunteer service in Spanish-American War. Served in Philippines and in Cuba; had charge of civilian administration of Veracruz, Mexico, after 1914 occupation. Commanded 110th Infantry, 28th Division, in Aisne-Marne, St.-Mihiel, and Champagne-Marne actions of World War I. He directed Army Claims Settlement Commission, 1918–19; and was judge advocate of the Army of Occupation in Germany and on the Reparations Commission. He was promoted colonel in 1920. Named judge advocate general with rank of major general, 1931, he retired from active duty in 1933. As governor of Puerto Rico, 1934–39, he reacted to the growing discontent on the island with a strict insistence on public order, which led to controversial acts by the insular police and an attempt on his own life in 1938. Recalled to active duty in World War II, he served until 1944 as coordinator of the Inter-American Defense Board.

WINSHIP, GEORGE PARKER (*b. Bridgewater, Mass., 1871; d. 1952*), bibliographer, librarian. Studied at Harvard University (M.A., 1894). From 1895 to 1915, librarian of the private collection of pre-1800 Americana of John Carter Brown in Providence. Librarian of the Harry Elkins Widener Collection at Harvard, 1915–26. From 1926 to his retirement in 1936, he was assistant librarian of Harvard College in charge of the Treasure Room. An expert in Spanish Americana, he published *The Coronado Expedition* (1896) and *Cabot Bibliography* (1900).

WINSLOW, CAMERON MCRAE (*b. Washington, D.C., 1854; d. Boston, Mass., 1932*), naval officer. Graduated Annapolis, 1875. Commanded cruiser *Nashville's* launches in cable-cutting operation of Cienfuegos, Cuba, 1898; performed extensive staff duty.

Promoted rear admiral, 1911, he commanded successively the 2nd, 3rd, and 1st Atlantic Fleet divisions, 1911–13, and the Special Service Squadron off Mexico, 1914. Commanded the Pacific Fleet, September 1915–July 1916; inspector of Atlantic Coast naval districts, 1917–19. Excelled in navigation and ship handling.

WINSLOW, CHARLES-EDWARD AMORY (*b. Boston, Mass., 1877; d. New Haven, Conn., 1957*), bacteriologist and public health expert. Educated at Massachusetts Institute of Technology (M.S., 1899). Taught at MIT, 1899–1910; College of the City of New York, 1910–14; Yale University, from 1915 until retirement. Curator of public health at the American Museum of Natural History in New York (1910–22). Director of publicity and health education for the New York State Department of Public Health in 1915. First editor of *Journal of Bacteriology* (1916), and of *American Journal of Public Health*, 1944–54. President of the American Public Health Association, 1926. In the 1950's he was consultant to the World Health Organization. Winslow wrote numerous books, articles, and gave countless lectures. A pioneer in public health and preventive medicine, he championed national health insurance, advocated health measures through better housing. Studied the effects of ventilation and bacteriology on health.

WINSLOW, EDWARD (*b. Droitwich, England, 1595; d. at sea, en route from Jamaica, British West Indies, to England, 1655*), Pilgrim father, author. Joined the Separatist congregation at Leiden *ca.* 1617. Sailed on *Speedwell*, 1620, transshipping to *Mayflower*; landed at site of Plymouth, Mass., Dec. 11/21, 1620. Chosen envoy to greet Massasoit, 1621, he made the colonists' first treaty with the Indians. Next to Myles Standish, Winslow was the Pilgrim's most important man in dealing with the Indians throughout his career in America. He became the most active explorer and trader of the colony, setting up valuable posts in Maine, on Cape Ann, at Buzzard's Bay, and on the Connecticut River. In 1629, he was made the colony's agent. He was assistant nearly every year from 1624 to 1646, and governor in 1633, 1636, and 1644. He aided the organization of the New England Confederation and was Plymouth's representative. Active in reorganizing the colonial and local governments, 1636, and in drafting the new code of laws, he was also called on to travel to England on several occasions to defend both Plymouth and the Bay Colony against their enemies at home. Going to England in 1646 to refute the charges of Samuel Gorton, he never returned to Plymouth, but was employed by Cromwell's government on several important missions. Winslow was author of four narratives of explorations in *A Relation or Iournall of the beginning and proceedings of the English Plantation setled at Plimoth in New England* (printed by George Morton, London, 1622) and *Good News . . . at the Plantation of Plymouth . . . Written by E.W.* (1624), the first accounts of the colony and the only contemporary record to be published which had been written in America. He was author also of *Hypocrisie Unmasked by the True Relation of the Proceedings of the Governor and Company of the Massachusetts Against Samuel Gorton* (1646) and *The Glorious Progress of the Gospel Among the Indians in New England* (1649), which led to the founding that year of the Society for the Propagation of the Gospel in New England.

WINSLOW, EDWARD (*b. Boston, Mass., 1669; d. Boston, 1753*), silversmith, Boston public official. Grandnephew of Edward Winslow (1595–1655); cousin of Samuel Vernon.

WINSLOW, EDWARD FRANCIS (*b. Augusta, Maine, 1837; d. Canandaigua, N.Y., 1914*), Union soldier, railroad builder. Removed to Iowa, *ca.* 1856. Served in 4th Iowa Cavalry. Promoted

colonel, July 1863, at Vicksburg, he was chief of cavalry of the XV Corps; his force took Jackson, Miss. Thereafter, he succeeded to command of a cavalry brigade and distinguished himself at Brice's Cross Roads, June 1864. He took part in the expedition against Selma, Montgomery, Columbus, and Macon in the spring of 1865, capturing Columbus by assault. After the Civil War he returned to railroad building, constructing part of the St. Louis, Vandalia & Terre Haute and the St. Louis & South-Eastern. Subsequently he held high executive posts in several midwestern railroads and was president of the New York, Ontario & Western; he was also general manager for a time of the Manhattan Elevated Railway in New York City.

WINSLOW, HUBBARD (*b. Williston, Vt., 1799; d. Williston, 1864*), Congregational clergyman. Brother of Miron Winslow; father of William C. Winslow. Principal pastorate at Bowdoin St. Church, Boston, Mass., 1832–44; conducted Mount Vernon School for Young Ladies, Boston, 1844–53. A frequent contributor to periodicals.

WINSLOW, JOHN (*b. Marshfield, Mass., 1703; d. Hingham, Mass., 1774*), colonial soldier, Massachusetts legislator. Grandson of Josiah Winslow. Began career as captain of a Massachusetts company in the West Indian expedition under Edward Vernon, 1740; subsequently, as a British soldier he served at Cartagena and in Nova Scotia until 1751. Sent to build Fort Western (present Augusta) and Fort Halifax (later Winslow). In 1755, he commanded the New England battalions in the force under Robert Monckton which took forts Beauséjour and Gaspereau. The task of expelling the French inhabitants from Nova Scotia fell largely on Winslow. Assigned to command the provincial army raised in New England and New York, 1756, for the reduction of Crown Point, he cooperated with the British troops, but was held inactive by orders of Lord Loudoun. He never received adequate compensation for his services and continued to the end of his life to put in fruitless claims for pay or preferment to the colonies and to Great Britain.

WINSLOW, JOHN ANCRUM (*b. Wilmington, N.C., 1811; d. Boston Highlands, Mass., 1873*), naval officer. Became midshipman before his sixteenth year. Acquired reputation for gallantry in Mexican War. An abolitionist, he viewed the Civil War as a holy cause and was openly critical of its conduct on the Mississippi, 1862. Promoted captain, July 1862, he was given the USS *Kearsage* and served on patrol from the Azores to the English Channel, 1863–64. Encountering the Confederate cruiser *Alabama* off Cherbourg on June 19, 1864, Winslow won a complete victory and was promoted commodore. Promoted rear admiral, 1870, he commanded the Pacific fleet, 1870–72.

WINSLOW, JOHN BRADLEY (*b. Nunda, N.Y., 1851; d. 1920*), jurist. LL.B., University of Wisconsin, 1875; practiced in Racine, Wis. State circuit court judge, 1883–91; state supreme court justice *post* 1891, becoming chief justice in 1907 by virtue of seniority. An excellent administrator and a profound student of jurisprudence, he won a national reputation for his opinions. His abilities are well represented in *Nunnemacher* v. *State* and in the *Income Tax Cases.* In his greatest opinion, *Borgnis* v. *Falk Co.,* he laid the foundation for much of the so-called progressive legislation in Wisconsin and the nation while dealing with the constitutionality of the workmen's compensation law.

WINSLOW, JOHN FLACK (*b. Bennington, Vt., 1810; d. Poughkeepsie, N.Y., 1892*), industrialist. Associated with Erastus Corning in the firm of Corning & Winslow, 1837–67. In time the largest producers of railroad and other iron in the United States, the firm delegated Alexander L. Holley to purchase the American

rights to the Bessemer steel process, 1863, and began operation of the first Bessemer plant in America at Troy, N.Y., 1865. Winslow manufactured the machinery and iron-plating for the original *Monitor* and also financed the undertaking.

WINSLOW, JOSIAH (*b. Plymouth, Mass., ca. 1629; d. 1680*), colonial soldier and legislator. Son of Edward Winslow (1595–1655). Studied at Harvard, but left without taking a degree. Served as a militia officer; as an assistant, 1657–73; as Plymouth commissioner for the United Colonies, 1658–72. Succeeded Myles Standish as commander in chief of the colony, 1659, after a three-year vacancy of that post. Captured Alexander, the son and successor of Massasoit, 1662, thus ending danger of Indian uprising. Becoming governor of New Plymouth, 1673, he established the first public school there in 1674. Elected commander in chief of the forces of the United Colonies when Indian uprisings began in 1675, he thus became the first native-born commander of an American army and won a decisive battle against the Narragansett, December 1675. He was succeeded by Benjamin Church, the actual effective commander of the force, in February 1676. Liberal and tolerant, Winslow showed his statecraft in his handling of Edward Randolph in 1677, when he converted Randolph from a suspicious investigator into a friend of the Pilgrims. At the time of his death, Winslow was negotiating with the authorities in London to secure a crown charter for Plymouth.

WINSLOW, MIRON (*b. Williston, Vt., 1789; d. Capetown, South Africa, 1864*), Congregational clergyman, educator, translator. Brother of Hubbard Winslow. Missionary at Oodooville, Ceylon, 1819–33, working among the Tamils. Residing in Madras *post* 1836, he was responsible for the final edition of the *Comprehensive Tamil and English Dictionary of High and Low Tamil* (1862) and helped revise the Tamil Bible.

WINSLOW, OLA ELIZABETH (*b. Grant City, Mo., 1885; d. Damariscotta, Maine, 1977*), biographer. Graduated Stanford University (B.A., 1906; M.A., 1914) and University of Chicago (Ph.D., 1922) and taught at the College of the Pacific (1911–14), Goucher College (1914–44), Wellesley College (1944–50), and Radcliffe Summer Seminars (1950–62). Her biography *Jonathan Edwards, 1703–1758* (1940) was awarded a Pulitzer Prize (1944). Other historical and biographical volumes include *Meetinghouse Hill, 1630–1783* (1952); *Master Roger Williams* (1957); *John Bunyan* (1961); *Samuel Sewall of Boston* (1964); and *A Destroying Angel: The Conquest of Smallpox* (1974).

WINSLOW, SIDNEY WILMOT (*b. Brewster, Mass., 1854; d. Beverly, Mass., 1917*), manufacturer, capitalist. Joining Gordon McKay and the Goodyear Co., he formed the United Shoe Machinery Co., 1899, becoming president. Instituted monopolistic lease system for his product, with "typing clause" in contracts. Prominent in New England financial affairs, he was a principal owner of the *Boston Herald* and *Boston Traveller.*

WINSLOW, WILLIAM COPLEY (*b. Boston, Mass., 1840; d. Boston, 1925*), Episcopal clergyman, archaeologist. Son of Hubbard Winslow. Founded and supported the American branch of the Egypt Exploration Fund; procured notable Egyptian collection for Boston Museum.

WINSOR, JUSTIN (*b. Boston, Mass., 1831; d. 1897*), historian, cartographer, librarian. Granted Harvard College degree as of class of 1853; studied in Paris and Heidelberg, 1852–54. A linguist and man of letters, Winsor contributed criticism, poetry, and fiction to periodicals, 1854–68. Librarian, Boston Public Library, 1868–77; he served thereafter as librarian at Harvard College. Winsor was a founder of the *Library Journal* and of the

American Library Association (first president, 1876–85, and 1897). He was editor of *The Memorial History of Boston* (1880–81), characterized as the best work of its kind produced up to that time, and of the *Narrative and Critical History of America* (1884–89), to which he contributed outstanding bibliographies. He was author of, among other writings, *The Reader's Handbook of the American Revolution* (1880), an important bibliographical manual; *Christopher Columbus* (1891); *Cartier to Frontenac* (1894); *The Mississippi Basin* (1895); and *The Westward Movement* (1897).

WINSTON, HARRY (*b. New York City, 1896; d. New York City, 1978*), gem merchant and jeweler. Began work in his father's jewelry business and demonstrated an acumen for identifying gems. He opened his first business, Premier Diamond Company, in 1920 on Fifth Avenue in New York City, and bought shrewdly at auctions and made major estate purchases, removing and re-cutting gems and giving them modern settings. He acquired a reputation as purchaser of large stones in 1930, when he purchased a thirty-nine-carat diamond and a twenty-six-carat ruby. He opened Harry Winston, Inc. (1932) and achieved a world-wide reputation with the purchase for $700,000 of the 726-carat Jonker diamond, cutting the stone into eleven individual stones valued at $2 million. His touring exhibit, called *Court of Jewels* (1949–53), included the 46-carat Hope diamond, 95-carat Star of the East diamond, and 337-carat Catherine the Great sapphire. In 1958 he donated the Hope diamond to Smithsonian Institution (1958).

WINSTON, JOHN ANTHONY (*b. Madison Co., Ala., 1812; d. 1871*), planter, Alabama legislator, Confederate soldier. A leader of Southern-rights Democrats in Alabama, he served as governor, 1853–57. By vetoing state aid to railroads, he saved Alabama from a burden of debt. At the Democratic convention at Charleston, S.C., 1860, he prevented any compromise with Northern Democrats and insisted on withdrawal of the Alabama delegation in accordance with its instructions; during the ensuing presidential campaign, he supported Stephen A. Douglas. Elected U.S. senator for the term 1867–73, he refused to take the oath of allegiance and was denied the post.

WINSTON, JOSEPH (*b. Louisa Co., Va., 1746; d. 1815*), Revolutionary soldier, North Carolina legislator and public official. Cousin of Patrick Henry. Commanded part of right wing of patriot army at battle of King's Mountain, 1780. Congressman, Democratic-Republican, from North Carolina, 1793–95 and 1803–07. Winston (now Winston-Salem), N.C., was named for him.

WINTER, WILLIAM (*b. Gloucester, Mass., 1836; d. 1917*), dramatic critic, historian of the stage, essayist, poet. After beginning his career as a reviewer on the *Boston Transcript*, Winter removed to New York City shortly before the Civil War and served for a time as assistant editor to Henry Clapp, Jr., on the *Saturday Press*. At this time he associated with the bohemian group which met in the cellar of Pfaff's café on Broadway near Bleecker St.; his account of this group in *Old Friends* (1909) is perhaps as accurate as any that exists. While dramatic critic of the *New York Tribune*, 1865–1909, he at first enjoyed a national reputation, but had the misfortune to live into a time in the theater for which he had neither appreciation nor liking. Author of a number of volumes of essays, verse, and critical studies, he is remembered particularly for a series of accurate biographical studies of actors, which include *The Jeffersons* (1881); *Henry Irving* (1885); and *Ada Rehan* (1891). He was an excellent judge of the technicalities of the actor's art. His *Shakespeare on the Stage* (1911–15) is a rec-

ord of the "traditional" interpretations employed by actors in Shakespearean roles, a number of whom Winter had observed.

WINTERHALTER, HUGO (*b. Wilkes-Barre, Pa., 1909; d. Greenwich, Conn., 1973*), arranger, conductor, and composer. Graduated Mt. St. Mary's College, Emmitsburg, Md., and New England Conservatory and began playing saxophone in the 1930's with club bands and in the 1940's with the Tommy Dorsey and Benny Goodman bands. He was a key studio arranger and conductor at RCA Victor (1950–63), where his large string orchestra produced such lush instrumental hits as "Blue Tango." His arrangement of Eddy Heywood's "Canadian Sunset" sold 1.5 million copies in the 1950's.

WINTHROP, FITZ-JOHN *See* WINTHROP, JOHN (1638–1707).

WINTHROP, JAMES (*b. probably Cambridge, Mass., 1752; d. Cambridge, 1821*), scholar, librarian, Massachusetts jurist. Son of John Winthrop (1714–79). Graduated Harvard, 1769. Librarian at Harvard, 1770–87, he was concurrently for a part of this time register of probate for Middlesex Co.; in 1779 he was considered as a successor to his father in the Harvard chair of mathematics and natural philosophy, but was passed over. The next year, he encouraged the students at Harvard in the revolution which deposed President Samuel Langdon. He was a founder of the Massachusetts Historical Society, a miscellaneous writer on a number of subjects, and a judge of common pleas for Middlesex Co. *post* 1791.

WINTHROP, JOHN (*b. Edwardstone near Groton, Suffolk, England, 1587/8, d. Boston, Mass., 1649*), lawyer, colonial statesman, first governor of Massachusetts Bay. Father of John Winthrop (1605/6 –1676). The son of a Suffolk landowner who held the manor of Groton, John Winthrop attended Trinity College, Cambridge, and later studied at Gray's Inn. Early in life he adopted Puritan habits of living. At first successful in the practice of law (he was admitted to the Inner Temple, 1628), he encountered financial difficulties in and after 1629. A Puritan of the type of John Milton, he was much concerned for the future of religion and morals in England. He became interested in the Company of the Massachusetts Bay, which had been chartered in March 1629, and made up his mind, despite family opposition, to immigrate with his immediate family to New England. Entering into the executive work of the new corporation, which was distinguished from earlier colonial ventures by the intention of its settlers to remain permanently in America, he was chosen governor of the proposed colony on Oct. 20, 1629. The decision had already been reached by the Company to transfer itself with its General Court and its charter to America.

Winthrop sailed from Southampton in the *Arbella* on Mar. 22, 1630; he reached John Endecott's settlement at Salem on June 12. From 600 to 700 persons had taken passage in the *Arbella* and other vessels of the little fleet which accompanied it; 200 or 300 more arrived almost simultaneously, and another 1,000 soon afterward. These numbers and the fact that, owing to the transfer of the charter and the Company organization to America, the entire management was local, gave Winthrop a position very different from that held by governors of any of the other early plantations. Soon settling in Boston, which appeared to offer a better site for the center of government of the colony than Charlestown, which had earlier been considered, he threw himself into the work of forming the new community.

The term of governor was one year, and he was elected in 1631, 1632, and 1633. In April 1634, however, at the spring meeting of the General Court, the freemen (that is, the members of the Company) of the town requested to be shown the colony charter. Finding that under the charter the General Court was

the only body entitled to legislate, they wanted to know why some of its powers had been usurped by the leaders or magistrates. They then refused Winthrop's suggestion that the General Court should permanently abrogate some of its powers in order that authority might be concentrated in the hands of the leaders. John Cotton, the principal clergyman in the colony, in a sermon before the General Court, May 14, 1634, declared that a magistrate ought to be reelected continually unless there was sufficient reason that he should not and that officials had a vested interest in their offices. The freemen replied by turning Winthrop out of the governorship and electing Thomas Dudley. Late in 1635, Hugh Peter and Henry Vane began an investigation into the causes of dissent in Massachusetts. Early the next year Winthrop, who had continued to serve as a magistrate, was called before a meeting of investigators, including John Cotton, and was accused of having been too lenient in discipline and judicial decisions. The united clergy of the colony agreeing with this charge, Winthrop promised to adopt a stricter course in future, and so another step was taken toward clerical domination. Also in 1636 the General Court adopted a plan whereby certain magistrates should be chosen for life or good behavior. Winthrop and Dudley allowed themselves to be chosen the first two members of this unconstitutional life council, which was always unpopular and lasted only a few years.

Winthrop, as deputy governor, took a part in the antinomian controversy over the teachings of Anne Hutchinson, which began to rock the colony at about this time. Passion was running so high at the 1637 election that the General Court held its meeting at Newton instead of Boston and elected Winthrop governor in place of Henry Vane. Grown much more narrow and severe since his rebuke by the clergy for leniency, Winthrop executed the law with rigor against the followers of Hutchinson and drove many from the colony. He wrote an account of the controversy, which was incorporated by Thomas Welde in *A Short Story of the Rise, Reign, and Ruine of the Antinomians* (1644). Elected governor again in 1638, Winthrop protected the colony charter from attacks upon it at home in an able letter to the Lords Commissioners for Plantations. Reelected in 1639, he learned at this time of serious financial losses in England which had resulted from the dishonesty of his agent there; for the rest of his life he was in financial straits.

A member of the Court of Assistants, 1640–41, he was again elected governor in 1642. During this term he engaged in the famous controversy over the veto power of magistrates, which led to the separate sitting of the magistrates and the deputies as two houses. Still governor in 1643, Winthrop headed the Massachusetts commissioners for framing the articles for the United Colonies and was first president of the confederation after it was formed. At this time he came under heavy criticism for giving military aid to French officials in Acadia without consulting the General Court. Deputy governor in 1644, he wrote a discourse called "Arbitrary Government Described and the Government of the Massachusetts Vindicated from That Aspersion." It was an attempt to justify the older principles under which the colony had operated and served only to show that Winthrop was losing touch with his people. Regaining his popularity in 1645, however, he was elected governor thereafter annually until his death, although the contentions over Robert Childe and Samuel Gorton, and Winthrop's severity in dealing with them, aroused active opposition to his rule.

A refined and sensitive man, affectionate in his nature, Winthrop lacked aggressiveness. As a writer he had an excellent English prose style, and his journal (published in part as *A Journal of the Transactions and Occurrences in the Settlement of Massachusetts . . . 1630 to 1644*, 1790; supplemented with further manuscript materials, 1825–26) is a sourcebook of the greatest importance. Winthrop had no faith in democracy, believing that, once chosen, representatives should govern according to their own best judgment. His own integrity was always beyond question.

WINTHROP, JOHN (*b. Groton, Suffolk, England, 1605/6 o.s.; d. Boston, Mass., 1676*), lawyer, soldier, colonial statesman. Son of John Winthrop (1587/8–1649). Immigrated to Boston, Mass., 1631. Elected an assistant, 1632, he was one of the founders of Ipswich, 1633. Returning to England late in 1634, he accepted the governorship of the plantation in Connecticut which his father's friends Lord Say and Sele and Lord Brooke were undertaking. Arriving at Boston in October 1635, he sent an advance party to build a fort at Saybrook, the defense of which was entrusted to Lion Gardiner. Winthrop resided in Connecticut from March until autumn of 1636. After settling again at Ipswich, he appears to have moved to Salem in 1639. His father's financial difficulties having put a burden upon him, he began the manufacture of salt and tried to interest English capital in the erection of ironworks. The General Court granted him 3,000 acres of land for the encouragement of iron-making, 1644, and he set up a furnace at Lynn and another at Braintree; in the same year, he was given leave to found a settlement for a similar purpose in Connecticut in the Pequot country (later New London). Retaining his public offices in Massachusetts, he made frequent journeys between the two colonies. Deciding after his father's death in 1649 to remain permanently in Connecticut, he was admitted a freeman of that colony, 1650, and elected an assistant, 1651. While developing ironworks in the New Haven Colony, he was elected chief executive of Connecticut, 1657, and removed to Hartford. Elected lieutenant governor, 1658, he was annually elected governor from 1659 until his death. The most important of his many services to the colony was his mission to England to obtain a charter, 1661–63. Gaining the favor of Charles II, he returned to New England with the most liberal charter that had yet been granted to any colony, making Connecticut almost independent and including within it the former colony of New Haven. One of the most engaging New Englanders of his day and probably the most versatile, he cultivated scientific interests, was skilled in medicine and chemistry, and was elected a member of the Royal Society, 1663—the first member resident in America. He was ahead of his time in his belief that New England's future lay in manufacturing and commerce rather than in agriculture.

WINTHROP, JOHN (*b. Ipswich, Mass., 1638; d. Boston, Mass., 1707*), colonial soldier and official. Son of John Winthrop (1605/6–1676); commonly known as Fitz-John Winthrop. Commissioned in the English parliamentary army, he served in the Scottish campaigns and entered London with General Monk, 1660. Returning from England to Connecticut, 1663, he made his home in New London. He commanded the Connecticut troops which defended Southold, N.Y., 1673, against the Dutch, and served with distinction in the Indian wars of 1675–76. Thereafter spending a large part of his time in Boston, he was appointed to the Governor's Council of Massachusetts by Joseph Dudley in 1686 and served on the council of Sir Edmund Andros. Returning to Connecticut after Andros' defeat, he helped reestablish the government and was elected assistant in Connecticut, 1689. As major general commanding a New York and Connecticut force under orders to invade Canada, 1690, he abandoned the attempt at a point north of Albany on finding himself without the provisions and munitions promised him by Jacob Leisler. Successful in a mission to King William III to request confirmation of the Connecticut charter, 1693, Winthrop was elected governor of Connecticut five years later and reelected annually until his death.

WINTHROP, JOHN (b. Boston, Mass., 1714; d. Cambridge, Mass., 1779), astronomer, physicist, mathematician. Father of James Winthrop; descendant of John Winthrop (1587/8 o.s.– 1649) and John Winthrop (1605/6 o.s.–1676). America's first astronomer and Newtonian disciple, he graduated from Harvard, 1732; LL.D., University of Edinburgh, 1771, and Harvard, 1773. Elected Hollis professor of mathematics and natural philosophy at Harvard, 1738. The results of his forty years' research, mainly in astronomy, were all published in *Philosophical Transactions of the Royal Society.* His other publications include *Relation of a Voyage from Boston to Newfoundland, for the Observation of the Transit of Venus* (1761) and *Two Lectures on the Parallax and Distance of the Sun* (1769). He made a series of sunspot observations, April 19–22, 1739, which were the first in the colony; he also studied transits of Mercury over the sun, April 21, 1740, Oct. 25, 1743, and Nov. 9, 1769. He established at Harvard, 1746, the first laboratory of experimental physics in America and demonstrated with a series of lectures the laws of mechanics, light, heat, and the movements of celestial bodies according to Newtonian doctrines; these lectures were attended by Count Rumford. Winthrop introduced to Harvard's mathematical curriculum the elements of fluxions (differential and integral calculus), 1751. In 1759, he predicted the return of Halley's comet of 1682; he later organized expeditions to Newfoundland for study of transits of Venus. He carried on magnetic and meteorological observations and was the main support of Benjamin Franklin in his theories relative to his electrical experiments. An ardent patriot, he was counselor and friend of Washington, Franklin, and other founders of the Republic.

WINTHROP, ROBERT CHARLES (b. Boston, Mass., 1809; d. 1894), lawyer, Massachusetts legislator, orator. Graduated Harvard, 1828; studied law in office of Daniel Webster. Congressman, Whig, from Massachusetts, 1840–42, 1842–50; Speaker of the House, 1847–49. Appointed to the U.S. Senate on the resignation of Daniel Webster, 1850, he was defeated for reelection by Charles Sumner, 1851, because of alleged reluctance to oppose slavery. He was often called upon for orations and addresses on notable occasions, served for 30 years as president of the Massachusetts Historical Society, and was later in life chairman of the board of the Peabody Education Fund.

WINTHROP, THEODORE (b. New Haven, Conn., 1828; d. Big Bethel, Va., 1861), lawyer, author, Union soldier. Nephew of Theodore D. Woolsey. Graduated Yale, 1848. Engaged in a number of occupations. Traveled in Europe, across the plains, in the Far West, and in Central America. Enlisting in the 7th New York Regiment, 1861, he remained at the front subsequent to his regiment's return after a short term of service and was killed leading the advance in a skirmish on June 10. Winthrop is remembered for a number of books of marked originality, all published posthumously, which enjoyed a great popularity in their time. They include the novels *Cecil Dreeme* (1861) and *John Brent* (1862); also, *The Canoe and the Saddle* (1863) and *Life in the Open Air* (1863).

WINTON, ALEXANDER (b. Grangemouth, Scotland, 1860; d. 1932), pioneer automobile manufacturer. Immigrated to New York City ca. 1880. After working as a marine engine builder and as assistant engineer on an ocean steamship, he settled in Cleveland, Ohio, 1884, where he began a bicycle-repair business. Inventor of a number of improvements in bicycle mechanisms, he began the manufacture of bicycles, 1890, as the Winton Bicycle Co. As early as 1893 he began experimenting in gasoline engine design for automotive use; he built a gasoline motor bicycle, 1895, and completed his first gasoline motorcar, September, 1896. Forming the Winton Motor Carriage Co.,

March 1897, he made a nine-day trip in one of his cars from Cleveland to New York in July of that year—the first reliability run in the history of the American automobile. On Mar. 24, 1898, he sold one of his cars for $1,000, the first sale in America of a gasoline automobile made according to set manufacturing schedules. By the end of 1898 he was successfully producing more cars, all constructed under his patent, granted him September 1898. Energetic and progressive, Winton designed, built, and raced cars both in the United States and abroad; his "Bullet No. 1" established a record of a mile in 52.2 seconds at Daytona Beach, Fla., 1902. *Post* 1904 all his cars were equipped with four-cylinder engines; *post* 1907 all had sixcylinder engines. He was the first in America to experiment with straight-eight-cylinder engines, 1906; as early as 1902 he had designed external and internal brakes on the same brake-drum. Although he gave his major interest *post* 1912 to design and manufacture of diesel engines and other activities, he continued to act as president of his automobile company, maintaining the Winton car in the front rank of American automobiles until February 1924.

WIRT, WILLIAM (b. Bladensburg, Md., 1772; d. Washington, D.C., 1834), lawyer, author. Admitted to the Virginia bar ca. 1792, he began practice in Culpeper Co., Va. After a modest success, he removed to Richmond, Va., ca. 1800; his name first came prominently before the public when he served as counsel for James T. Callender in a famous trial under the Alien and Sedition Acts. After brief service as a chancellor, 1802–03, he removed his residence to Norfolk. His literary career began with the serial publication of *The Letters of the British Spy* in the Richmond *Argus*; published anonymously, they purported to be contemporary observations of an English traveler and were, in fact, shrewd social commentary in essay form. First published as a book, 1803, the letters went through numerous editions. Removing to Richmond, 1806, Wirt appeared for the prosecution in the trial of Aaron Burr and gained much professional prestige. After publication of another series of essays, which did not acquire the popularity of the *British Spy*, Wirt published *Sketches of the Life and Character of Patrick Henry* (1817), his most serious literary effort. Although his material was acquired largely from men who had known Henry, he presented it in a most ornate and stained manner. Also in 1817 he was appointed U.S. attorney general and held that post for 12 consecutive years. He was the first holder of that office to organize its work and to make a systematic practice of preserving his official opinions so that they might serve as precedents. He returned to private life in 1829 on the accession of President Andrew Jackson, but was later an unwilling candidate of the Anti-Masons for the presidency, 1832.

WIRT, WILLIAM ALBERT (b. Markle, Ind., 1874; d. Gary, Ind., 1938), school administrator. Graduated DePauw University, 1898; Ph.D., 1916. A leading exponent of progressive education, he first attracted public attention while superintendent of schools at Bluffton, Ind., 1899–1907. As school superintendent of Gary, Ind., *post* 1907, he devised the "platoon" or "work-study-play" system of organization of activities, which attracted nationwide attention before World War I and was widely copied. Although his specific program did not maintain its popularity, his emphasis on including vocational and recreational subjects in the curriculum has had a lasting effect on American education.

WISE, AARON (b. Erlau, Hungary, 1844; d. New York, N.Y., 1896), rabbi. Immigrated to America, 1874. Rabbi of Temple Rodeph Sholom, New York, an influential, conservatively reformed congregation, *post* 1875. A founder of the Jewish Theological Seminary of New York, 1886. Edited new prayer book,

The Temple Service (1891); editor, New York *Jewish Herald* and *Boston Hebrew Observer*.

WISE, DANIEL (*b. Portsmouth, England, 1813; d. Englewood, N.J., 1898*), Methodist clergyman, editor. Immigrated to America, 1833. Held various Massachusetts and Rhode Island pastorates. Editor, *Sunday School Messenger*, 1838–44; *Zion's Herald*, 1852–56. Corresponding secretary and editor of publications of the Sunday School Union, 1856–72; also editor of the Tract Society *post* 1860. Author of religious works, biographies, and moralistic tales for young people.

WISE, HENRY ALEXANDER (*b. Drummondtown, Va., 1806; d. Richmond, Va., 1876*), lawyer, Confederate general. Congressman, Jacksonian Democrat, from Virginia, 1833–44; chief antagonist of John Quincy Adams in effort to repeal "gag rule" against antislavery petitions. Breaking with President Jackson on the Bank of the United States, Wise went over to the Whigs. A close friend of President John Tyler, he led the Tyler adherents in Congress. U.S. minister to Brazil, 1844–47. An outspoken defender of slavery, he was liberal and progressive in other matters; in the Virginia constitutional convention, 1850–51, he played an important part in securing compromise suffrage and taxation reforms. Influential in transferring the Virginia delegation's support to Franklin Pierce at the Democratic convention of 1852, he helped secure the presidential nomination for Pierce. As Democratic candidate for governor, he conducted an exciting campaign against a Know-Nothing opponent; his victory broke the force of the Know-Nothing wave in the South. As governor, 1856–61, he was active in quelling John Brown's raid and advocated internal improvements. He was largely responsible for James Buchanan's nomination at the Democratic convention, 1856. Delegate to the Virginia convention, 1861, he became a fiery advocate of the Confederacy. Made brigadier general, 1861, he served throughout the Civil War and was promoted major general by General Robert E. Lee, 1865. Wise was one of the last great individualists in Virginia history.

WISE, HENRY AUGUSTUS (*b. Brooklyn, N.Y., 1819; d. Naples, Italy, 1869*), naval officer. Appointed midshipman, 1834. Served with credit in the Mexican War. Appointed assistant in the U.S. Navy Bureau of Ordnance, July 1862, he headed the bureau with great energy and ability, 1863–68. He was author (under pseudonym "Harry Gringo") of a number of books, which included *Los Gringos* (1849) and *Tales for the Marines* (1855).

WISE, ISAAC MAYER (*b. Steingrub, Bohemia, 1819; d. Cincinnati, Ohio, 1900*), rabbi. Studied in Prague and Vienna; named rabbi, 1842. Immigrated to America, 1846. Rabbi of the Jewish congregation, Albany, N.Y., 1846–54; of Bene Yeshurun congregation, Cincinnati, Ohio, *post* 1854. Espoused cause of liberal Judaism; published weekly newspaper, the *Israelite* (later the *American Israelite*). His three great projects were organization of the Union of American Hebrew Congregations, 1873; founding of Hebrew Union College, 1875, which he served as president until his death; organization of the Central Conference of American Rabbis at Detroit, Mich., 1889, of which he was president until his death. In his day the foremost figure in American Jewish religious life, he preached the universalistic interpretation of Judaism and a welding of the spirit of Judaism with the free spirit of America. A prolific writer, he was author of, among other works, *The Cosmic God* (1876), *History of the Hebrews' Second Commonwealth* (1880), and *Reminiscences* (1901).

WISE, JOHN (*b. Roxbury, Mass., 1652; d. 1725*), Congregational clergyman. Graduated Harvard, 1673. Minister of the church at Chebacco in Ipswich, Mass., *post* 1680, he was active and influential in civil and ecclesiastical affairs throughout his life. Having led his fellow townsmen in resistance to a provincial tax levied by Sir Edmund Andros, he was tried and fined in October 1687, but was soon restored to his ministerial post. He served as chaplain of the expedition against Quebec, 1690. In the belief that a movement initiated by the Mathers and others to establish associations of clergy was the beginning of a reactionary revolution, Wise attacked the movement in *The Churches Quarrel Espoused* (1710). In 1717 he published *A Vindication of the Government of New-England Churches*, in which he considered the fundamental ideas of civil as well as religious government from what has been described as a fully democratic point of view. Wise was an extremely forceful and brilliant writer, standing almost alone among the writers of his time for the blending of a racy humor with impassioned earnestness. The two pamphlets were reprinted in 1772 as a body of democratic doctrine suitable for use in the controversy then raging with England.

WISE, JOHN (*b. Lancaster, Pa., 1808; d. by drowning in Lake Michigan, 1879*), balloonist. A scientific aerostatic pioneer, Wise made important contributions to safety of balloons, including the invention of the rip panel. He set a long-distance record of 804 miles in balloon travel, 1859. Author of *A System of Aeronautics* (1850) and *Through the Air* (1873).

WISE, JOHN SERGEANT (*b. Rio de Janeiro, Brazil, 1846; d. near Princess Anne, Md., 1913*), lawyer, politician, Confederate soldier, author. Son of Henry Alexander Wise. Graduated in law, University of Virginia, 1867. Practiced in Richmond; won notoriety for opportunism in politics and as a leader in the William Mahone machine. Congressman-at-large, Republican-Coalition, from Virginia, 1883–85. Removed to New York City, 1888; became leading counsel in important litigation between street railways and other companies; an international authority on law in field of electricity. Author of, among other works, *Diomed* (1897); *The End of the Era* (1899); and *The Lion's Skin* (1905).

WISE, STEPHEN SAMUEL (*b. Budapest, Hungary, 1874; d. New York, N.Y., 1949*), rabbi, Zionist leader, reformer. Son of Aaron Wise. Brought to New York City as a baby. Deciding early in life to enter the rabbinate, he began Jewish studies with his father, continuing them with Alexander Kohut and Gustav Gottheil. Concurrently, he attended the College of the City of New York and in 1892 graduated from Columbia University, to which he had transferred in 1891. He then pursued rabbinic studies with Adolph Jellinek, chief rabbi of Vienna, and received ordination in 1893. On his return to New York City, 1893, he was appointed assistant rabbi at Congregation B'nai Jeshurun and soon assumed full responsibility, at the age of 19. He resumed his graduate studies at Columbia University, Ph.D., 1901.

Wise involved himself in social causes early in his career. In 1895 during a transit strike in Brooklyn, he announced his pro-labor sympathies from the pulpit of B'nai Jeshurun. After he moved to Portland, Oreg., in 1899 to become rabbi of Temple Beth El, his involvement in social justice became a dominant motif in his ministry. Wise achieved national recognition in 1906 when he rebuffed offers to become the rabbi of the prestigious Temple Emanu-El in New York City, after having been refused his demand of a free pulpit. The next year, he founded the Free Synagogue, which served as Wise's principal forum in New York for the next 43 years.

Wise became ever more prominently identified with the cause of labor, and he consistently supported demands for improved working conditions and better pay. In the realm of politics, Wise fought government corruption. Wise's most ambitious attack on the Tammany wigwam came in 1930 with his assault against

Mayor Jimmy Walker, which led to the mayor's resignation. Wise was a cofounder of the National Association for the Advancement of Colored People in 1909 and of the American Civil Liberties Union in 1920. Closer to his Jewish concerns were his battles against the Ku Klux Klan and his support in 1924 and 1926 for liberal immigration laws. Wise made an important contribution to the training of rabbis in 1922 as founder of the Jewish Institute of Religion, which in 1948 was merged with the Hebrew Union College.

The greatest passion of Wise's public life was Zionism. He joined with Richard Gottheil, Harry Friedenwald, and others in 1897 to found the Federation of American Zionists, of which he became honorary secretary. The following year, he attended the Second World Zionist Congress in Basel. Wise made his first trip to Palestine in 1913. The next year, after the outbreak of World War I, he joined with Louis D. Brandeis to found the Provisional Executive Committee for Central Zionist Affairs, which led the fight for Zionism in America, and especially within the American Jewish community. In 1918 Wise was elected president of the newly formed Zionist Organization of America. The following year, he sailed to France as delegate of the American Jewish Congress to lobby for the Jewish cause at the Paris peace conference. In 1921 the Brandeis group of the Zionist Organization of America was defeated in an internal power struggle, but Wise continued his Zionist activities. He was named honorary vice president of the Palestine Development Council that year, and in 1925 he appeared at the Fourteenth Zionist Congress to fight Chaim Weizmann's plans for extending the Jewish Agency for Palestine to include non-Zionists. The same year, he was elected president of the permanent American Jewish Congress, a post he held until his death.

With Hitler's rise to power in 1933, Wise mobilized both Jews and non-Jews to protest against Hitler's anti-Semitic policies. In 1939, as head of the American delegation, Wise attended the Round Table Conference of Jews and Arabs in London (St. James Conference). Having learned in 1942 from the office of the World Jewish Congress in Geneva that Hitler was conducting an all-out campaign to exterminate European Jews, Wise continually railed against the Allied governments, demanding that something be done to save the victims of mass murder. Wise's cochairmanship of the Zionist Emergency Council with Abba Hillel Silver, 1943–46, was marked by constant turmoil. Wise came to the Twenty-second Zionist Congress in 1946, the first postwar meeting, no longer the acknowledged leader of American Zionists.

WISE, THOMAS ALFRED (*b. Faversham, England, 1865; d. New York, N.Y., 1928*), actor, dramatist. Known as Tom Wise. Came to America as a child. A highly competent character actor, he specialized in farce-comedy.

WISLIZENUS, FREDERICK ADOLPH (*b. Königsee, Germany, 1810; d. St. Louis, Mo., 1889*), physician, traveler, author. Immigrated to America, 1835; began practice in rural Illinois. Accompanied a fur-trading party to the Far West, 1839, journeying to the rendezvous on Green River and to Fort Hall, and returning by way of Laramie plains, the Arkansas River, and the Santa Fe Trail to St. Louis. Published an account of the journey as *Ein Ausflug nach den Felsen-Gebirgen* (1840), which was afterward issued in translation. After further practice of medicine in St. Louis in partnership with Dr. George Engelmann, he joined a trading caravan for Santa Fe and Chihuahua in 1846 and made close observations of the fauna, flora, and geology of that region. Joining Alexander W. Doniphan's regiment in March 1847 in Mexico, he returned by way of the Rio Grande and the Mississippi to his home. His account of this adventure appeared in 1848 in *Senate Miscellaneous Document 26, 30 Cong., 1 Sess.,*

and was praised for its scientific observations by Alexander von Humboldt.

WISLOCKI, GEORGE BERNAYS (*b. San Jose, Calif., 1892; d. Milton, Mass., 1956*), anatomist. Studied at Washington University (B.A., 1912), Johns Hopkins University Medical School (M.D., 1916). Taught at Johns Hopkins, 1920–31, Harvard University, 1931–56. An influential experimenter in the fields of placentology and histochemistry, Wislocki published numerous monograms and papers. Member of the National Academy of Sciences and the American Academy of Arts and Sciences.

WISNER, HENRY (*b. Goshen, N.Y., 1720; d. 1790*), farmer, New York legislator, powder manufacturer. Represented Orange Co. in New York Colonial Assembly, 1759–69, and in the first Continental Congress, 1774. A member of the New York Provincial Congress, 1775–77, he served on the committee which drafted the first state constitution and was appointed as a New York delegate to the second Continental Congress, May 1775–May 1777. He served in the state senate, 1777–82. He operated powder mills in Ulster and Orange counties during the Revolution and expedited the laying of chains across the Hudson River to prevent British passage upstream.

WISSLER, CLARK (*b. Wayne County, Ind., 1870; d. New York, N.Y., 1947*), anthropologist. Christened Clarkson Davis Wissler. Graduated Indiana University, 1897; M.A., 1899; Ph.D., Columbia University, 1901. Trained in psychology, he shifted his interest to anthropology through influence of Franz Boas, under whom he served as assistant in ethnology at American Museum of Natural History, 1902–05; he was also assistant and then lecturer in anthropology at Columbia, 1903–09. Succeeding Boas as head of anthropological work at the American Museum in 1905, he remained in charge until his retirement, 1942; in 1931, he became professor of anthropology at Yale. Among his books were *The American Indian* (1917, and later editions); *Man and Culture* (1923), which was important in disseminating anthropological thinking about culture to the other social sciences; and *The Relation of Nature to Man in Aboriginal America* (1926).

WISTAR, CASPAR (*b. Wald-Hilsbach, near Heidelberg, Baden, 1696; d. 1752*), glass manufacturer. Immigrated to Philadelphia, Pa., 1717, where he engaged in brass-button making. He located a factory for manufacture of window and bottle glass in Salem Co., West Jersey, which began work in July 1740. Staffed by Belgian and other foreign glassblowers working on shares, it was one of the earliest successful cooperative ventures in North America and exerted a lasting influence on American glassmaking by providing a technique and tradition of good workmanship. After the Revolution and the failure of the Wistar works, the workmen established glass industries both locally and in New York State and the Middle West.

WISTAR, CASPAR (*b. Philadelphia, Pa., 1761; d. 1818*), physician. Grandson of Caspar Wistar (1696–1752). Studied medicine under John Redman; B.M., University of Pennsylvania, 1782; M.D., Edinburgh University, 1786. Practiced thereafter in Philadelphia; succeeded Benjamin Rush as professor of chemistry in the medical school of the College of Philadelphia (present University of Pennsylvania), 1789; taught chiefly anatomy at University of Pennsylvania *post* 1792. Author of *System of Anatomy* (1811), the first American textbook on that subject, he was also extremely active in the work of the American Philosophical Society (president, 1815–18). The weekly open house which he kept for members of the society and visiting scientists became a tradition which was long continued as the "Wistar Parties." Thomas Nuttall named the wistaria, or wisteria, for him in 1818.

WISTER, OWEN (*b. Germantown, Pa., 1860; d. North Kingstown, R.I., 1938*), author. Grandson of Fanny Kemble. Reared in a markedly intellectual household, Wister graduated from Harvard, 1882, and at first looked forward to a musical career. While a student at Harvard Law School, 1885–88, he spent the summer vacations in the West, and after admission to the Philadelphia bar, 1889, set himself to report the West faithfully in fiction. After publishing a number of short stories, he brought out *The Virginian* (1902), a novel which became the model and high-water mark in cowboy fiction. Realistic in surface details, it is less notable as realism than as a triumphant definition of the cowboy as a folk hero, and was an instant success. Wister was author of a number of other books of no particular importance, including biographies, satires, and farces, and several works on World War I and the tensions which followed it. In domestic politics, Wister was a decided, and even angry, conservative.

WISTER, SARAH (*b. Philadelphia, Pa., 1761; d. Germantown, Pa., 1804*), diarist. Author of a lively journal of everyday events and experiences in the period from Sept. 25, 1777 to June 20, 1778, which illustrates social conditions in and about Philadelphia while the British were occupying that city.

WITHERS, FREDERICK CLARKE (*b. Shepton Mallet, Somersetshire, England, 1828; d. Yonkers, N.Y., 1901*), architect. Trained in London, England, he immigrated to America, 1853, and became in time a partner of Calvert Vaux and F. L. Olmsted, working with them on New York City's Central Park. He practiced alone *post* 1871. In high repute during his lifetime, he worked in a style about halfway between the Gothic revival style of the elder Richard Upjohn and the developed Victorian Gothic of such men as Russell Sturgis. He was the architect of a number of churches and did a considerable amount of work for the City of New York, for which he designed, among other buildings, the Jefferson Market Police Court in Greenwich Village.

WITHERSPOON, ALEXANDER MACLAREN (*b. Bowling Green, Ky., 1894; d. Hampden, Conn., 1964*), educator. Attended Ogden College and Yale (Ph.D., 1923). Taught at Yale for almost forty years. His widely used texts were *A Book of Seventeenth Century Prose* (1929), *The College Survey of English Literature* (1951), and *Seventeenth-Century Prose and Poetry* (1963). On board of editors of *The Complete Prose Works of John Milton* (1943–64).

WITHERSPOON, HERBERT (*b. Buffalo, N.Y., 1873; d. New York, N.Y., 1935*), bass singer, opera manager. Graduated Yale, 1895; studied singing in London, Paris, and Berlin. Made operatic debut with the Castle Square Opera Co.; starred as basso at Metropolitan Opera, New York, 1908–16; devoted himself thereafter to concerts and teaching. Appointed general manager of the Metropolitan Opera, 1935, but died before season began.

WITHERSPOON, JOHN (*b. Yester, near Edinburgh, Scotland, 1723; d. near Princeton, N.J., 1794*), Presbyterian clergyman, educator, statesman. M.A., University of Edinburgh, 1739; D.D., 1743. Notable during his ministry in Scotland as a champion of the so-called Popular party, as a conservative in theology and morals, and as a defender of the traditional rights of the people to choose their own ministers, Witherspoon immigrated to America in 1768 to become president of the College of New Jersey (Princeton). The choice of the New Side school, he held views that were not obnoxious to the Old Side, and his leadership soon healed the factional schism that had existed among the Presbyterians. Thanks to his efforts in great part, the Presbyterian church grew rapidly and was strongly entrenched in the middle colonies and on the frontiers by 1776. He also gave the College of New Jersey a new lease on life, increasing the endowment,

the faculty, and the student body up to the time of the Revolution. He introduced into the curriculum the study of philosophy, French, history, and oratory, and insisted upon mastery of the English language. To his mind, an education should fit a man for public usefulness, and he placed a comparatively low value upon mere scholarship. He decried the philosophy of Berkeley and stood foursquare upon empiricism and "common sense."

Witherspoon engaged actively in the controversy with England, *ca.* 1774, making common cause with his neighbors. As a member of various Revolutionary committees and a delegate to provincial conventions, he helped bring New Jersey into line with the other colonies. Elected to the Continental Congress on June 22, 1776, he boldly upheld and signed the Declaration of Independence, stating that the country was in his judgment "not only ripe for the measure but in danger of rotting for the want of it." Widely influential in Great Britain as well as in America through his writings, he explained the controversy with the mother country in a number of terse and telling written arguments, showing a remarkably clear comprehension of its precise nature. Serving in Congress with a few intermissions from June 1776 until November 1782, he was a useful member of more than a hundred committees; of these, the most important were the Board of War and the Committee on Secret Correspondence (foreign affairs). He was active in the debates on the Articles of Confederation, assisted in organizing the executive departments, and played a foremost part in drawing up the instructions of the American peace commissioners. He opposed the floods of paper money which were issued and the issue of bonds without provision for amortization. His patience, courage, and executive abilities give him high rank among the leaders of the American Revolution.

He spent 1782–94 in endeavoring to rebuild the college at Princeton; however, during his lifetime the institution never fully recovered from the effects of the Revolution. He also served in the New Jersey legislature and was a member of the New Jersey convention which ratified the U.S. Constitution. A leader also in the organization of the Presbyterian church along national lines, he was largely the author of the catechisms, the confessions of faith, the directory of worship, and the form of government and discipline adopted by it. In 1781 in an article on language in the *Pennsylvania Journal*, he coined the term "Americanism."

WITHERSPOON, JOHN ALEXANDER (*b. Columbia, Tenn., 1864; d. 1929*), physician, educator. M.D., University of Pennsylvania, 1887. Taught physiology and medicine at University of Tennessee, *post* 1889. Became professor of medicine and clinical medicine at Vanderbilt University, 1895, serving until his death and laboring to raise standards of medical education.

WITMARK, ISIDORE (*b. New York, N.Y., 1869; d. New York, 1941*), music publisher, composer. Founded, with his brothers Julius and Jay, the firm of M. Witmark & Sons, 1886, publishers and printers of popular music. The firm held a commanding position in the industry and flourished up until the 1920's, when the advent of radio, the decline of vaudeville, and other factors depressed the market for sheet music. In 1928, the firm was sold to the Warner Brothers film studio.

WITTE, EDWIN EMIL (*b. Watertown, Wis., 1887; d. Madison, Wis., 1960*), labor economist. Studied at the University of Wisconsin (Ph.D., 1927); taught there (1920–57), twice chairman of the economics department (1936–41; 1946–53). Published *The Government in Labor Disputes* (1932). Knowledge of the application of economics to government legislation won him President Franklin D. Roosevelt's appointment to head a cabinet-level Committee on Economic Security that formulated the So-

cial Security Act of 1935. President of the American Economic Association in 1956.

WITTHAUS, RUDOLPH AUGUST (*b. New York, N.Y., 1846; d. 1915*), chemist, toxicologist. A.B., Columbia, 1867; studied at the Sorbonne and Collège de France, 1867–69; M.D., University of the City of New York, 1875. Taught at University of the City of New York and at universities of Vermont and Buffalo; professor of chemistry and physics at Cornell University *post* 1898, retiring emeritus in 1911. Won worldwide eminence in legal medicine and as expert witness at murder trials; wrote a number of important books. His greatest achievement was as editor, with T. C. Becker, of *Medical Jurisprudence, Forensic Medicine and Toxicology* (1894–96).

WODEHOUSE, PELHAM GRENVILLE (*b. Guildford, England, 1881; d. Long Island, N.Y., 1975*), novelist and playwright. Raised in Hong Kong and educated in London, he came to America in 1909. In New York he wrote four plays with Guy Bolton, librettos for fourteen musicals, and lyrics for Jerome Kern (including "Bill" from *Showboat*). In 1919 he created his two most famous characters, Bertie Wooster and his manservant, Jeeves, who feature in some fifty short stories and twelve novels, including *The Inimitable Jeeves* (1924) and *Right Ho Jeeves* (1934). Other recurring characters include Psmith (*Psmith in the City*, 1910), Stanley Featherstone Ukridge (*Ukridge*, 1924), and Lord Emsworth of Blandings Castle (*Summer Lightning*, 1929). In 1940, while in France, Wodehouse was caught up by the rapid German advance and interned in a series of camps; in June 1941 he gave five broadcast talks from Berlin, which caused an uproar in wartime Britain.

WOERNER, JOHN GABRIEL (*b. Möhringen, Germany, 1826; d. St. Louis, Mo., 1900*), Missouri legislator, journalist and jurist. St. Louis, Mo., probate judge, 1870–94. Widely known as an authority on probate judicature, he was author of, among other works, *Treatise on the American Law of Administration* (1889) and *A Treatise on the American Law of Guardianship* (1897).

WOFFORD, WILLIAM TATUM (*b. Habersham Co., Ga., 1823; d. near Cass Station, Ga., 1884*), planter, Georgia legislator, Confederate brigadier general, lawyer.

WOLCOTT, EDWARD OLIVER (*b. Longmeadow, Mass., 1848; d. Monte Carlo, Monaco, 1905*), lawyer, politician. Practiced in Colorado *post ca.* 1872; prospered as a railroad lawyer; was a conservative leader of the state Republican party. U.S. senator from Colorado, 1889–1901. Advocated free coinage of silver; opposed federal election bill of 1890 and President Cleveland's Venezuelan message.

WOLCOTT, OLIVER (*b. Windsor, Conn., 1726; d. 1797*), lawyer, Connecticut public official. Son of Roger Wolcott; father of Oliver Wolcott (1760–1833). Graduated Yale, 1747. Removed to Litchfield, Conn., 1751, serving as sheriff there for 20 years. Deputy for Litchfield, 1764, 1767, 1768, and 1770; Connecticut assistant, 1771–86. Judge, Litchfield probate court, 1772–81; judge, county courts in and for Litchfield, 1774–78. A commissioner of Indian affairs for the northern department, he helped settle the Wyoming Valley and New York-Vermont boundary questions. Delegate to the Continental Congress, 1775–83 (with exception of 1779), he signed the Declaration of Independence in October 1776; he was noted in Congress as a man of integrity who spoke his mind but was lacking in political knowledge. As brigadier general, he commanded militia sent to reinforce General Israel Putnam on the Hudson River, 1776; as major general, 1779, he defended Connecticut's seacoast against Tryon's raids. Lieutenant governor of Connecticut, 1787. Helped conclude

1789 treaty to which the Wyandotte surrendered title to the Western Reserve. Conservative Federalist governor of Connecticut, 1796–97.

WOLCOTT, OLIVER (*b. Litchfield, Conn., 1760; d. New York, N.Y., 1833*), lawyer, Connecticut public official, cabinet officer. Son of Oliver Wolcott (1726–97). Graduated Yale, 1778; studied law under Tapping Reeve. Notably successful in Connecticut as reorganizer of the state's financial affairs after the Revolution, he was appointed auditor of the U.S. treasury, 1789. In this capacity he labored over the routine operations of the department to such good effect that Alexander Hamilton recommended him for appointment as comptroller of the treasury, June 1791. Unwavering in his loyalty to Hamilton, who was his close friend also, he succeeded Hamilton as secretary of the treasury, February 1795. Mounting expenditures by the federal government, the spirit of speculation in American commerce, and increasing demoralization of the European money market created grave problems for the treasury; moreover, the Democratic-Republican majority in Congress, under the leadership of Albert Gallatin, were trying to take the initiative in financial matters away from the secretary. Wolcott did not enjoy the quasi-independence in allotting government funds which Hamilton had so cavalierly employed. Although given the confidence of President John Adams, 1797–1800, Wolcott remained subservient to Hamilton's directions and cooperated with Timothy Pickering and James McHenry in intrigues against the Adams administration.

Resigning the secretaryship at the end of the year 1800, he returned to Connecticut a poor man, despite charges by his political enemies that he was guilty of all manner of financial crimes. Removing to New York City *ca.* 1803, he engaged in a number of short-lived business activities and was president of the Bank of America, 1812–14. Settling in Litchfield, Conn., 1815, he occupied himself as a gentleman farmer and promoter of manufacturing in Connecticut. Having become a Democratic-Republican in politics, he was elected governor of Connecticut, 1817, and brought about a political revolution in that state. As governor he succeeded in overthrowing Federalist control of the aristocratic state council; after reelection in April 1818, he presided over a constitutional convention at which a new constitution (which he was influential in drafting) was adopted. The new constitution separated church and state, guaranteed full freedom of conscience, separated the powers of government, and established a more influential executive and an independent judiciary. Able and popular, Wolcott was reelected governor year after year until 1827. During this time he made expert revisions in the tax laws, but failed in efforts to promote state aid for agriculture and industry and other liberal measures.

WOLCOTT, ROGER (*b. Windsor, Conn., 1679; d. 1767*), farmer, businessman, lawyer, Connecticut public official. Father of Oliver Wolcott (1726–97). Assistant, Connecticut colony, 1714–41, with exception of 1718 and 1719; deputy governor of Connecticut, 1741–50; governor, 1750–54. Became judge of the Hartford Co. court, 1721, and of the superior court, 1732; became chief justice of the latter, 1741. As major general, 1745, he was second in command on the expedition which took Louisburg. Author of, among other books, *Poetical Meditations* (1725), the first volume of verse published in Connecticut.

WOLF, GEORGE (*b. Northampton Co., Pa., 1777; d. 1840*), lawyer, Pennsylvania legislator. Began practice in Easton, Pa. As congressman, Democrat, from Pennsylvania, December 1824–29, he supported the protective tariff and other measures to aid American industry. Elected governor of Pennsylvania in 1829, he served six years; he began a revision of the state statute law, reestablished state credit, and secured passage of the free public

school act, 1834, Wolf opposed President Jackson on the second Bank of the United States and fought for renewal of the bank charter. He served as comptroller of the U.S. treasury, 1836–38, and as collector of customs, port of Philadelphia, thereafter.

WOLF, HENRY (*b. Eckwersheim, Alsace, 1852; d. New York, N.Y., 1916*), wood engraver. Immigrated to America, 1871; settled in New York, 1873. Became preeminent in reproduction of paintings by contemporary American artists.

WOLF, INNOCENT WILLIAM (*b. Schmidheim, Rhenish Prussia, 1843; d. 1922*), Roman Catholic clergyman, Benedictine. Immigrated to Brighton, Wis., 1851. Ordained priest, 1866, after studies at St. Vincent Abbey, Latrobe, Pa. Returning to St. Vincent, 1870, after further study in Rome, he taught theology and was successively master of novices, treasurer of the abbey, and prior of the monastery. Elected first abbot of St. Benedict's, Atchison, Kans., 1876, he served actively until 1921.

WOLF, SIMON (*b. Bavaria, 1836; d. Washington, D.C., 1923*), lawyer, philanthropist. Immigrated to America, 1848. Graduated Ohio Law College, Cleveland, Ohio, 1861. Practiced in Washington *post* 1862. Appointed recorder, District of Columbia, 1869; served as civil judge, 1878–81. Won reputation as vigorous champion of civic and religious rights of eastern European Jews. Founder and lifelong president, Hebrew Orphans' Home, Atlanta, Ga.

WOLFE, BERTRAM DAVID (*b. Brooklyn, N.Y., 1896; d. San Jose, Calif., 1977*), political activist and author. Graduated City College of New York (B.A., 1916) and joined the Socialist party in 1917. In 1919 he coauthored "Manifesto of the National Council of the Left Wing of the Socialist Party," participated in formation of the American Communist Party, was indicted under New York's criminal anarchy law, and fled to California. He taught English in Mexico City (1922–25) and received an M.A. degree from the University of Mexico (1925). In 1929 he was an American delegate to the meeting of Communist International (Comintern) in Moscow; allied with anti-Stalinists, he was expelled from the party for refusing to support the Comintern line. He systematically criticized Stalin and eventually repudiated Communism. He received an M.A. in Romance languages from Columbia University (1932), where he was a fellow at the Russian Institute in the early 1950's, and worked for the State Department (1951–54), where he created the Idcological Advisory Unit for Voice of America. He wrote many books, including the highly acclaimed *Three Who Made a Revolution: Lenin, Trotsky, and Stalin* (1948).

WOLFE, CATHARINE LORILLARD (*b. New York, N.Y., 1828; d. New York, 1887*), philanthropist, art patron. Daughter of John D. Wolfe. A munificent benefactor of the Protestant Episcopal church; bequeathed her collection of 19th-century European paintings and an endowment to the Metropolitan Museum of Art, New York City.

WOLFE, HARRY KIRKE (*b. Bloomington, Ill., 1858; d. 1918*), psychologist, educator. Graduated University of Nebraska, 1880; Ph.D., Leipzig, 1886; studied under Wilhelm Wundt. Professor and head of philosophy and psychology department, University of Nebraska, 1891–97; professor of educational psychology, 1906–09; professor of philosophy and psychology again, 1909–18. Served in secondary school and other educational work, 1897–1905.

WOLFE, JOHN DAVID (*b. New York, N.Y., 1792; d. New York, 1872*), hardware merchant, philanthropist. Father of Catharine L. Wolfe. Benefactor of the Protestant Episcopal church,

1841–72, he helped support western dioceses and schools and took an important part in the promotion and support of New York charitable institutions.

WOLFE, THOMAS CLAYTON (*b. Asheville, N.C., 1900; d. Baltimore, Md., 1938*), novelist. The character of Eugene Gant in Wolfe's first novel, *Look Homeward, Angel* (1929), offers a recognizable account of his creator's life up to the age of 20. Product of an unsettled household, Wolfe was directed to literature and encouraged throughout his career by one of his early schoolteachers. While at the University of North Carolina, from which he graduated in 1920, he was encouraged to write by Edwin Greenlaw and others and wrote several plays (*The Return of Buck Gavin*, published 1924; *The Third Night*, published 1938), which were produced by the Carolina Playmakers. A student of playwriting in the famous "47 Workshop" under George P. Baker at Harvard, he received an M.A. in English, 1922. Resolving to dedicate himself to a truthful presentation of life in all its complexity, he gave up writing about Carolina mountaineers and attempted a more comprehensive picture of life in his play *Welcome to Our City* (produced 1923 at Harvard), for which he was unable to achieve professional production. While teaching intermittently at New York University until 1930, he traveled in England, France, and Italy, and was given love, understanding, and financial help by Mrs. Aline Bernstein, a stage designer who became an important influence in his life. After another unsuccessful attempt at the drama (a Civil War play, *Mannerhouse*, published 1948), he turned to prose narrative and began to write an autobiographical novel in a new, energetic, metaphorical style.

After 20 months' labor, he produced a huge manuscript, powerful in cumulative effect, but weakened by digressions and excessive detail. In association with Maxwell Perkins, editor at Charles Scribner's Sons, Wolfe reduced his work to a publishable volume, which appeared in October 1929 as *Look Homeward, Angel* and was enthusiastically reviewed. The author, elated by the praise and burdened by a consciousness of artistic responsibility, next attempted a book which would characterize the restlessness of the modern American and render a sense of the variety and vastness of the American continent. His ideas multiplied until he had in hand a project for a series of novels whose main narrative thread would be his own experiences. Overwhelmed by the bulk of his scheme as his material developed in length and complexity, he was once again assisted by Perkins to reduce his manuscript to order. Perkins divided the work into two separate books and set Wolfe to writing fillers for the narrative gaps in the first of these. Although Wolfe was reluctant to permit issue of the work, it was published in March 1935 as *Of Time and the River*. Parts were magnificent, but as a whole it was uneven and anthology-like in its variety; thousands of sensitive impressions of the whole 20th-century scene served as backdrop to the story of youth's insatiable hunger for life. The critics now began to compare Wolfe to Whitman and Melville. A man of enormous appetites, egoistic as a child, he was one moment elated and the next despondent; now full of goodwill and now overcome with suspicion or anger. After publication of a collection of short stories, *From Death to Morning*, he decided to set aside his six-volume series temporarily while he wrote a different kind of book — a story about an innocent, gullible man discovering the harsh truths of life through disillusionment and trial. As he worked out the narrative, the original grandiose plan was scrapped in favor of a long chronicle about a new hero, George Webber. At this point, he broke off with Maxwell Perkins, in part to show his independence and in part because of a dispute over a libel suit which Wolfe had wanted to fight in court. He did not live to see his new work completed. Out of the vast manuscript which he left behind after his death, three books were fashioned:

The Web and the Rock (1939), *You Can't Go Home Again* (1940), and *The Hills Beyond* (1941).

Thomas Wolfe's books have maintained favor largely because of the richness of his work. As a descriptive writer, he evokes a poetic response with his rhythmical and lyric passages; as a writer of narrative, he achieves at his best the brooding depths of Dostoevski and the vivid portraiture of Dickens. His work is tempered with broad humor which becomes predominantly satirical in his later work. Although his minor figures tend to caricature, his great characterizations display a full range of the strengths and weaknesses of humankind.

WOLFF, KURT AUGUST PAUL (*b. Bonn, Germany, 1887; d. Ludwigsburg, Germany, 1963*), publisher. Established Pantheon Books in 1942, first publishing Charles Péguy's *Basic Verities* (1943); his policy was to publish "books of fine quality which although not designed for a mass audience would nevertheless appeal to a large number of people." During the 1950's several Pantheon books became best-sellers, including Anne Morrow Lindbergh's *Gift from the Sea*, Joy Adamnson's *Born Free*, and Boris Pasternak's *Dr. Zhivago*. After a dispute with associates he resigned in 1960; in 1961 he and his wife arranged with Harcourt, Brace and World to publish Helen and Kurt Wolff Books.

WOLFSKILL, WILLIAM (*b. near Richmond, Ky., 1798; d. near Los Angeles, Calif., 1866*), trapper, California pioneer. After extensive experience as a trapper along the Rio Grande and the Gila, he led a trapping party from Taos, September 1830, which opened a new route to California, approximating what became known as the western part of the Spanish Trail. Settling near Los Angeles, he acquired land and began to develop it as a vineyard in 1838. Becoming wealthy and influential as a rancher and farmer, he introduced the culture of the persimmon and the Italian chestnut and was the first in the area to ship oranges commercially.

WOLFSOHN, CARL (*b. Alzey, Germany, 1834; d. Deal Beach, N.J., 1907*), pianist, teacher, conductor. Came to America, 1854, settling in Philadelphia, Pa. Associated with Theodore Thomas in chamber music recitals *post* 1856. Presented notable recitals of all Beethoven piano sonatas in Philadelphia and in Steinway Hall, New York City, 1863–64. Founded Beethoven Society, 1869; conducted a similar society in Chicago, Ill., 1873–84. Wolfsohn was one of the earliest in America to espouse the cause of Richard Wagner's music.

WOLFSON, ERWIN SERVICE (*b. Cincinnati, Ohio, 1902; d. Purchase, N.Y., 1962*), investment builder and contractor who through the establishment of the Diesel Construction Company and Wolfson Management Corporation became New York City's leading builder by 1960. From 1946 to 1962 he and his firms were associated either as principal investor or general contractor in the construction of over sixty major edifices, including projects for RKO Pictures, NBC studios, and Bankers Trust. The Pan Am Building was the climax of his career (completed in 1963).

WOLFSON, HARRY AUSTRYN (*b. Ostrin, Lithuania, 1887; d. Cambridge, Mass., 1974*), scholar of Hebrew literature and philosophy. Immigrated to New York City (1903), graduated Harvard University (B.A. and M.A., 1912; Ph.D., 1915) and became an instructor at Harvard. He was appointed professor of Hebrew literature and philosophy in 1925 and professor emeritus in 1958. His scholarship established an interfaith community of thought in which the common problems of philosophy overrode theological differences. Along with many seminal articles, he published *The Philosophy of Spinoza* (1934); *Philo: Foundations of Religious Philosophy in Judaism, Christianity, and Islam* (1947);

The Philosophy of the Church Fathers (1956); and, posthumously, *The Philosophy of the Kalam* (1976) and *From Philo to Spinoza* (1977).

WOLHEIM, LOUIS ROBERT (*b. New York, N.Y., 1881; d. Los Angeles, Calif., 1931*), mechanical engineer, mathematician, stage and screen actor. Graduated College of the City of New York, 1903; M.E., Cornell University, 1906. After winning great applause for his performance with the Provincetown Players in Eugene O'Neill's *The Hairy Ape*, 1922–24, Wolheim attained the high point of his career as Captain Flagg in *What Price Glory?* Thereafter, he was engaged principally in motion-picture work as the best delineator of hard-boiled parts.

WOLL, MATTHEW (*b. Luxembourg, 1880; d. 1956*), labor leader. Studied at Lake Forest College of Law (LL.B., 1904). Elected president of the International Photo-Engravers Union of North America in 1906; became eighth vice president and a member of the Executive Council of the American Federation of Labor in 1919. Woll's most outstanding contribution to the labor movement began when he was appointed president of the Free Trade Union Committee in 1944. In Germany Woll worked effectively to prevent infiltration by communists of the labor unions by resisting the dismantling of German industry, by defending the code termination of the German workers, and by calling on United States Government officials to restore a democratic Germany to the family of nations. Decorated by Chancellor Konrad Adenauer in 1953 for his efforts.

WOLLE, JOHN FREDERICK (*b. Bethlehem, Pa., 1863; d. Bethlehem, 1933*), musician. Organist of Moravian Church, Bethlehem, Pa., 1885–1905; of Lehigh University, 1887–1905. Chiefly remembered as founder, 1898, and conductor, Bethlehem Bach Choir; conducted Bach festivals, Lehigh University, 1912–32. Held chair of music, University of California, 1905–11.

WOLMAN, LEO (*b. Baltimore, Md., 1890; d. New York, N.Y., 1961*), economist. Attended Johns Hopkins (Ph.D., 1916). Taught at Hobart, the University of Michigan, Johns Hopkins, the New School for Social Research, and Columbia. Chief of the production statistic section of the War Industries Board (1918) and attached to the Versailles peace mission, his responsibility to prepare memos on the economies of dependent countries. Associated with the Amalgamated Clothing Workers of America, 1920–33. During the New Deal he was chairman of the Labor Advisory Board and a member of the National Labor Board. In 1937 he proposed amendments to the Wagner Act that became part of the Taft-Hartley Act.

WONG, ANNA MAY (*b. Los Angeles, Calif., 1907; d. Santa Monica, Calif., 1961*), actress who came to national attention in the Douglas Fairbanks film *The Thief of Baghdad* (1924). During the 1920's and 1930's, the accepted rule in Hollywood was that ethnic minorities could not rise above the level of menials or stock characters of fun or menace, but Wong was in great demand for films about China or the Orient, appearing in *Mr. Wu* (1927), *Across to Singapore* (1928), *Daughter of the Dragon* (1931), and *Shanghai Express* (1932), her most memorable American performance. In England she appeared in her first stage play, *The Circle of Chalk* (1929), playing opposite Lawrence Olivier, and in such films as *A Study in Scarlet* (1933), a Sherlock Holmes film.

WOOD, ABRAHAM (*fl. 1638–80*), soldier, explorer, Virginia landowner and official. Member of the Virginia Council, 1658–ca. 1680. Maintained a garrison at Fort Henry (Petersburg) *post* 1646; sent out expedition, 1671, which achieved the first recorded passage of the Appalachian Mountains; sent out party,

under James Needham, which traced trail to present Tennessee in 1673 and opened trade with the Cherokee.

WOOD, CASEY ALBERT (*b. Wellington, Ontario, Canada, 1856; d. La Jolla, Calif., 1942*), ophthalmologist. Graduated as Master of Surgery and M.D., 1877, from the medical school of the University of Bishop's College, Montreal. After practicing general medicine in Montreal, in 1886 he began training in diseases of the eye at New York Eye and Ear Infirmary and at Post-Graduate Medical School; he studied also at eye clinics in Berlin, Vienna, Paris, and London. Settling in Chicago, Ill., 1890, he served on the staffs of several hospitals and was professor of clinical ophthalmology at Chicago Post-Graduate, University of Illinois, and Northwestern University. After World War I service, he removed to Palo Alto, Calif., and devoted himself to his avocations, which included research in the mechanism of sight in birds and the assembly of source materials on the history of ophthalmology. He was editor, translator, or author of a number of books on his specialties and a founding member of the American College of Surgeons.

WOOD, CHARLES ERSKINE SCOTT (*b. Erie, Pa., 1852; d. near Los Gatos, Calif., 1944*), army officer, lawyer, author. Graduated West Point, 1874; assigned as second lieutenant to 21st Infantry, he served principally in the Northwest and was aide to General O. O. Howard. After taking the degrees of Ph.B., 1882, and LL.B., 1883, at Columbia University, he resigned from the army and practiced law in Portland, Oreg. Successful in maritime and corporation practice, he also became a crusader for a variety of reform causes and an anarchist. Inclined to literature from his youth, he devoted himself to writing subsequent to his retirement from practice, *ca.* 1918. Of his published works, the best known are *The Poet in the Desert* (1915, with later versions in 1918 and 1929) and *Heavenly Discourse* (1927).

WOOD, CRAIG RALPH (*b. Lake Placid, N.Y., ca. 1901; d. Palm Springs, Fla., 1968*), professional golfer. Joined the professional circuit in the late 1920's. He was a top money winner and member of the U.S. Ryder Cup team during the 1930's, but he failed to win major championships. In 1940 he won the Metropolitan Open with the score of 264, then the world record for a four-round tournament. He won the Masters and U.S. National championships in 1941 and was captain of the U.S. Ryder Cup team in 1942.

WOOD, DAVID DUFFLE (*b. Pittsburgh, Pa., 1838; d. Philadelphia, Pa., 1910*), organist. Blind from childhood and mainly self-taught in music, Wood was an instructor of music at the Pennsylvania Institution for the Instruction of the Blind, Philadelphia, *post* 1862, and principal instructor from 1887 until his death. Organist of St. Stephen's Church, Philadelphia, 1864–1910, he was also choirmaster *post* 1870. He was instructor of organ at the Philadelphia Musical Academy for thirty years. Author of *A Dictionary of Musical Terms, for the Use of the Blind* (1869). A notable interpreter of Bach.

WOOD, EDITH ELMER (*b. Portsmouth, N.H., 1871; d. Greystone Park, N.J., 1945*), housing reformer. B.L., Smith College, 1890. Married Albert N. Wood, a career naval officer, 1893. Convinced by her work in the control and cure of tuberculosis that the disease was an effect of slum conditions, she devoted her life to securing federal support for proper housing. She was vice president of the National Public Housing Conference, which mobilized support for the Wagner-Steagall Act, 1937, and served as consultant to the U.S. Housing Authority, which was set up under that act.

WOOD, EDWARD STICKNEY (*b. Cambridge, Mass., 1846; d. Pocasset, Mass., 1905*), physician, chemist. M.D., Harvard Medical School, 1871; professor of chemistry there from 1876 until his death. Chemist, Massachusetts General Hospital, Boston, Mass. A legal expert in chemistry, he was well known in his time as an expert witness in many trials.

WOOD, FERNANDO (*b. Philadelphia, Pa., 1812; d. Hot Springs, Ark., 1881*), businessman, politician. Entering politics in New York City, 1834, he was active in Tammany Hall and served as a member of Congress, 1841–43. Prospering as a ship chandler and merchant during the California gold rush, he invested his large profits in New York and San Francisco real estate. Meanwhile, he had become a leader of Tammany Hall. Elected mayor of New York City, 1854, and reelected, 1856, he was influential in creating Central Park, but permitted graft to run riot in the city government. During his term of office the city was plagued by the existence of two separate police forces, one under state control, the other under the mayor; consequent confusion over jurisdiction assisted the growth of crime and corruption. Ousted by fellow leaders from Tammany Hall, Wood organized his personal following as the so-called Mozart Hall and through it secured his third election as mayor in 1859. He appeared at the Democratic convention of 1860 at the head of a contesting New York delegation with pro-Southern leanings. Believing that the Union was about to be dissolved, he proposed in January 1861 that New York should become a free city. Defeated for reelection, he denounced the Civil War and advocated peace by conciliation; early in 1863 he joined with C. L. Vallandigham in organizing the Peace Democrats. A New York congressman, 1863–65 and 1867–81, he reflected in his views the dominant banking and mercantile interests of New York, insisting, in opposition to his own Democratic party, upon a sound currency and a tariff for revenue only. He was majority floor leader *post* 1877 and chairman of the Ways and Means Committee. A man of engaging manners, Wood had an uncanny ability to estimate the course of public opinion and a genius for political organization.

WOOD, FREDERICK HILL (*b. Lebanon, Maine, 1877; d. New York, N.Y., 1943*), lawyer. A.B., University of Kansas, 1897; LL.B., 1899. After successful practice as a railroad lawyer in the Midwest, he moved to New York City in 1913 as general attorney of the Southern Pacific Railway. In 1924, he joined the firm of Cravath, Henderson and de Gersdorff (*post* 1928, Cravath, de Gersdorff, Swaine, and Wood). A faithful servant of his corporate clients, he became known as one of the most successful anti-New Deal lawyers in the nation. Among other cases in which he challenged the constitutionality of federal measures was the landmark *Schechter Poultry Corporation* v. *United States*, overturning the National Industrial Recovery Act.

WOOD, GAR(FIELD) ARTHUR (*b. Mapleton, Iowa, 1880; d. Miami, Fla., 1971*), industrialist and powerboat-racing enthusiast. Developed the hydraulic hoist to create the dump truck (1912); in 1922 he incorporated the company that he later named Gar Wood Industries. He designed a powerful high-speed launch in the early 1930's for the navy; the PT boat of World War II was based on a number of Wood's innovations. He devoted much of his life to his passion for speedboats, which he had been manufacturing commercially since 1916. As a racer, he won numerous trophies and held the international motorboat racing record from 1932 to 1937. He sold his stake in Gar Wood Industries in the early 1940's and retired.

WOOD, GEORGE (*b. Chesterfield, N.J., 1789; d. 1860*), lawyer, regarded by contemporaries as the leader of the New Jersey and

New York bar. Graduated College of New Jersey (Princeton), 1808. Studied law under Richard Stockton (1764–1828); began practice at New Brunswick, N.J., 1812. Wood appeared frequently before the U.S. Supreme Court and is of particular importance for his influence in forming the New Jersey law on charitable devises (*e.g., Hendrickson v. Shotwell*). He removed to New York City, 1831. In *Martin v. Waddell*, he expounded the law concerning the right of the sovereign to underwater lands. He was a master of clear and comprehensive statement.

WOOD, GEORGE BACON (*b. Greenwich, N.J., 1797; d. Philadelphia, Pa., 1879*), physician. Uncle of Horatio C. Wood. M.D., University of Pennsylvania, 1818. Professor of chemistry, Philadelphia College of Pharmacy, 1822–35; also professor of materia medica, 1831–35. Wood then became professor of materia medica and pharmacy at University of Pennsylvania; from 1850 to 1860, he served there as professor of the theory and practice of medicine. Attending physician, Pennsylvania Hospital, 1835–59; president, College of Physicians of Philadelphia, 1848 until his death; president, American Philosophical Society, 1859–79. Chairman, National Committee for Revision of U.S. Pharmacopeia, 1850–60. Author of, among other works, *The Dispensatory of the United States* (1833, with Franklin Bache) and *Treatise on the Practice of Medicine* (1847).

WOOD, GRANT (*b. near Anamosa, Iowa, 1892; d. Iowa City, Iowa, 1942*), painter. Influenced in some degree by the style and techniques of the late medieval primitive painters of Germany and Flanders, he produced a body of work expressive of the stern and intense character of his native state. Achieving national prominence, he was a principal figure in the regionalism movement in the arts which flourished during the 1930's. *Post* 1934, he was associate professor of art at the University of Iowa, where he conducted what was in essence a studio class in the European tradition of teaching. Among his best known paintings are: *Woman with Plants* (1929); *American Gothic* (1930); and *Daughters of Revolution* (1932).

WOOD, HENRY ALEXANDER WISE (*b. New York, N.Y., 1866; d. 1939*), inventor, manufacturer. Son of Fernando Wood. Devised and made a series of printing machinery improvements which brought about great changes in the printing of newspapers. Among these were the Autoplate (final patent, 1903), whereby an entire newspaper page was cast in metal, and highspeed press-feeding devices. An early advocate of aviation, he also engaged in propaganda against American entry into the League of Nations and for limitation of immigration.

WOOD, HORATIO CHARLES (*b. Philadelphia, Pa., 1841; d. Philadelphia, 1920*), physician. Nephew of George B. Wood. M.D., University of Pennsylvania, 1862. Professor of botany, University of Pennsylvania, 1866–76; clinical professor of nervous diseases, 1876–1901; professor of materia medica, pharmacy, and general therapeutics, 1876–1906. Worked also as an entomologist. Associated with Philadelphia Hospital (Blockley), 1870–88. Author of approximately 300 papers and 6 books on scientific subjects, including *A Treatise on Therapeutics* (1874) and revisions of his uncle's *Dispensatory of the United States*; edited, among other medical journals, *Therapeutic Gazette*, 1884–1900.

WOOD, JAMES (*b. Greenfield, N.Y., 1799; d. Hightstown, N.J., 1867*), Presbyterian clergyman, educator. Strong adherent of "old school" party. Professor, New Albany (Ind.) Theological Seminary, 1840–51; president, Hanover (Ind.) College, 1859–66.

WOOD, JAMES B. (*b. Mount Kisco, N.Y., 1839; d. Mount Kisco, 1925*), Quaker leader, farmer, horticulturist. Served as presiding

clerk of the New York Yearly Meeting of Friends, 1885–1925, and as clerk of Five Years Meeting, 1907; helped found *American Friend*; wrote on Quaker doctrines and ideals; was a manager of Haverford College and a trustee of Bryn Mawr.

WOOD, JAMES FREDERICK (*b. Philadelphia, Pa., 1813; d. 1883*), Roman Catholic clergyman. A convert to Catholicism in Cincinnati, Ohio, 1836, Wood studied in Rome at the Irish College and at the Propaganda. After ordination in Rome, 1844, he served in Cincinnati. Appointed titular bishop of Antigonia and coadjutor to Bishop J. N. Neumann of Philadelphia, he was consecrated, 1857, and succeeded to full authority in 1860. Became first archbishop of Philadelphia, 1875. An able and somewhat rigorous administrator of his diocese.

WOOD, JAMES J. (*b. Kinsale, Ireland, 1856; d. Asheville, N.C., 1928*), engineer, inventor. Came to America as a boy; was raised in Connecticut. Patented an arc-light dynamo, 1880, which was the first of some 240 electrical and other patents which he took out. These included a floodlighting system which was first used successfully to light the Statue of Liberty, 1885; an internal combustion engine which was installed in the first Holland submarine; and the machines for constructing the main cables on the original Brooklyn Bridge. His later inventions were mainly in the field of alternating-current generators, motors, transformers, and other devices. Becoming a consulting engineer *ca.* 1885, he was chief engineer of the General Electric Co. and later consultant of its Fort Wayne, Ind., works.

WOOD, JAMES RUSHMORE (*b. Mamaroneck, N.Y., 1813; d. New York, N.Y., 1882*), surgeon. Graduated Vermont Academy of Medicine, Castleton, Vt., 1834. Practiced in New York City *post* 1837. A cofounder of Bellevue Hospital, 1847, Wood was a moving spirit in that institution until his death and won fame as a brilliant and successful radical operator. He introduced at Bellevue the first city hospital ambulance service, 1869, and established there the first training school for nurses in the United States, 1873. An organizer of Bellevue Hospital Medical College, 1856, he served it as professor of operative surgery and surgical pathology. Famous for his skill in nerve and bone surgery, he was among the first to cure aneurism by pressure. His collection of postmortem material grew into the Wood Museum, one of the richest collections of pathological specimens in the world.

WOOD, JETHRO (*b. Dartmouth, Mass., or White Creek, N.Y., 1774; d. Cayuga Co., N.Y., 1834*), inventor of plow improvements. Patented a cast-iron plow, 1819, whose design and principles of construction were copied widely throughout the North. The peculiar virtue of the Wood plow lay in the shaping of the moldboard and a combination of good balance, strength, light draft, interchangeability of parts, and cheapness of manufacture.

WOOD, JOHN (*b. Scotland, ca. 1775; d. Richmond, Va., 1822*), political pamphleteer, surveyor and mapmaker. Immigrated to America *ca.* 1800. Served as tutor to Theodosia Burr; worked as a writer in Aaron Burr's interest; was author of, among other political tracts, *The History of the Administration of John Adams* (1802). Associated with the publication of the Frankfort, Ky., *Western World*, 1806; published *A Full Statement of the Trial and Acquittal of Aaron Burr* at Alexandria, Va., 1807. Recommended to the governor of Virginia by Thomas Jefferson, Wood was appointed by the state in 1819 to survey and map each Virginia county, and to execute a general map of the state. By the time of his death, he had supplied all but six of the county charts and had completed, it was believed, a fifth of the general map.

WOOD, JOHN STEPHENS (*b. near Ball Ground, Ga., 1885; d. Marietta, Ga., 1968*), U.S. congressman. Studied at North Geor-

gia Agricultural College and Mercer University (LL.B., 1910) and practiced law in Jasper and Canton. He was Canton city attorney (1915–16), a member of the Georgia House of Representatives (1916–18), solicitor general of the Blue Ridge judicial circuit (1921–26), and superior court judge (1926–31). A Democrat, he served in the U.S. House of Representatives (1933–35, 1945–53). As chairman of the House Un-American Activities Committee, Wood helped broaden the scope of its investigations by probing radio news commentators. He also contributed to the formulation of the Internal Security (McCarran) Act of 1950. Wood was also a member of the House Education and Labor and, briefly, Foreign Affairs committees.

Wood, John Taylor (*b. Fort Snelling, present Minn., 1830; d. Halifax, Nova Scotia, Canada, 1904*), naval officer. Grandson of Zachary Taylor. Graduated Annapolis, 1853. Resigning from the U.S. Navy, 1861, he was commissioned lieutenant in the Confederate navy and served aboard the *Virginia (Merrimack)*. Appointed naval aide to President Jefferson Davis, 1863, he distinguished himself by a series of boat expeditions in the Chesapeake and lower Potomac, raiding and destroying Union vessels. In August 1864 he commanded the steam sloop *Tallahassee* on a raiding expedition from Wilmington, N.C., to Halifax, Nova Scotia, and back, capturing or destroying more than 60 vessels. Promoted captain, February 1865, he accompanied Davis in the retreat from Richmond, but managed to escape through Florida to Cuba. After the war he engaged in the shipping and marine insurance business in Halifax.

Wood, Joseph (*b. Clarkstown, N.Y., ca. 1778; d. Washington, D.C., ca. 1832*), miniaturist, portrait painter. In partnership with John W. Jarvis as maker of *eglomisé* silhouettes, 1804–09; received instruction in miniature painting from Edward G. Malbone. Maintained New York studio until 1812 or 1813; removing to Philadelphia, he exhibited regularly at the Pennsylvania Academy of the Fine Arts until 1817. By 1827, he was established in Washington, D.C.

Wood, Leonard (*b. Winchester, N.H., 1860; d. 1927*), soldier, military surgeon. M.D., Harvard Medical School, 1884. Appointed a contract surgeon in the U.S. Army Medical Corps, he won commendation for service during campaigns against the Apache of Geronimo and was regularly commissioned in 1886. After routine duty in California and the East, he was transferred to Washington, D.C., 1895, where he became physician to President and Mrs. McKinley. A friend of Theodore Roosevelt, he joined with him in organizing the Rough Riders. Wood took command of the unit as colonel and led in the first engagement at Las Guasimas, Cuba, June 1898. He became military governor of Santiago after its surrender. Successful in cleaning up and restoring the city, he was then given charge of the entire province; in December 1899 he was appointed military governor of all Cuba, serving until 1902. A physical giant, extraordinarily energetic and ambitious, Wood was a strong nationalist and no respecter of persons. During his term in Cuba he stabilized the affairs of that island, establishing educational, police, and physical systems and modernizing the administration of justice. He also superintended great advances in sanitation.

As governor of the Moro Province of the Philippines, 1903–06, he pacified the province and brought about a relatively high degree of prosperity there, although criticized for ruthlessness in stamping out local institutions. In August 1903 he had been promoted major general in the regular army. After command of the Philippine Division, 1906–08, he returned home. Chief of staff of the U.S. Army, 1910–14, he supervised the new organization of the War Department, which had been necessitated by the creation of the General Staff in 1903; after an epic contest with conservative bureau heads, Wood was partially successful in organizing the regular army into a coherent force. *Post* 1914 he engaged in development of the civilian training-camp movement and the "preparedness" movement; these activities frequently brought him into conflict with the administration of President Wilson. Although senior officer of the army when the United States entered World War I, Wood was passed over for command either abroad or at home. Following the war he openly sought the Republican nomination for the presidency; he came to the Republican convention at Chicago, 1920, with the largest single following of delegates, but failed of the nomination. Appointed a member of a special mission to the Philippines, 1921, he soon became governor general of the Philippines, serving until 1927 when he returned to the United States for a surgical operation which proved fatal.

Wood, Mary Elizabeth (*b. near Batavia, N.Y., 1861; d. Wuchang, China, 1931*), librarian. Served at Boone College, Wuchang, China, *post* 1904; oversaw erection of Boone Library building, 1910, and founding of Boone Library School, 1920. Promoted China-wide library movement *post* 1923; helped obtain U.S. congressional appropriation for Chinese educational-cultural activities.

Wood, Peggy (*b. Margaret Wood, Brooklyn, N.Y., 1892; d. Stamford, Conn., 1978*), actress and writer. Began her career in the chorus of the Broadway musical comedy *Naughty Marietta* in 1910 and won the lead role in 1916. Other successful roles were in *The Three Romeos* (1911), *Maytime* (1917), and the drama *Candida* (1925). She made her London debut in Noël Coward's *Bitter Sweet* (1929); she also appeared in Coward's *Operette* (1938) and *Blithe Spirit* (1941). She cowrote and played the title part in *Miss Quis* (1937). She made few films, but her memorable performance as Mother Superior in *The Sound of Music* (1965) won an Oscar nomination for best supporting actress. She also appeared in the popular television series "I Remember Mama" (1949–57).

Wood, Reuben (*b. Middletown, Vt., ca. 1792; d. 1864*), jurist. Ohio legislator. Removed to Cleveland, Ohio, 1818. President judge, 3rd common pleas circuit of Ohio, January 1830–February 1833; justice, Ohio Supreme Court, 1833–47. Democratic governor of Ohio, 1850–53. Acting U.S. minister to Chile, 1853–55.

Wood, Robert Elkington (*b. Kansas City, Mo., 1879; d. Lake Forest, Ill., 1969*), army officer and merchant. Graduated from West Point (1900) and served in Panama (1905–15), where he was involved in the construction of the Panama Canal. During World War I he was responsible for all supply services for the American Expeditionary Force. In 1919 he became vice president for merchandising of Montgomery Ward and Company, and in 1924 he joined Sears, Roebuck, and Company. Wood began adding retail stores to the company's mail-order system, and by the time he became president and chief executive in 1928, he had created a nationwide chain of retail stores. When he retired as chairman of the board in 1954, Sears had become the world's largest general merchandise distributor.

Wood, Samuel (*b. Oyster Bay, N.Y., 1760; d. 1844*), bookseller and publisher, philanthropist. Began business in New York City, 1804; organized publishing firm of Samuel Wood & Sons, 1815, later the largest American medical-book publishers. Produced a long series of children's books (earliest imprint, 1806).

Wood, Sarah Sayward Barrell Keating (*b. York, Maine, 1759; d. Kennebunk, Maine, 1855*), novelist. Maine's first fiction writer, she was author of, among other books, *Julia and the Il-*

luminated Baron, a Gothic romance (1800), and *Tales of the Night* (1827).

Wood, Thomas (*b. Smithfield, Ohio, 1813; d. 1880*), surgeon. M.D., University of Pennsylvania, 1839. Practiced in Cincinnati, Ohio, *post ca.* 1845. Taught anatomy and physiology at Ohio College of Dental Surgery and at Medical College of Ohio. A daring and successful operator, he was particularly skillful in treating women's diseases.

Wood, Thomas Bond (*b. Lafayette, Ind., 1844; d. Tacoma, Wash., 1922*), Methodist clergyman. Active as a missionary, mission executive, and educator in Latin America, 1870–1913.

Wood, Thomas John (*b. Mundfordville, Ky., 1823; d. 1906*), soldier. Graduated West Point, 1845. Commissioned in the engineers, he distinguished himself as staff officer under General Zachary Taylor at the Mexican War battles of Palo Alto and Buena Vista. Transferring to the cavalry, he rose to colonel, 1861, after almost continuous frontier service in the West. As brigadier general of Union volunteers, he commanded a division after the spring of 1862 and was outstanding in the battle of Stone's River. At Chickamauga, September 1863, the removal of his division from line permitted the Confederate breakthrough and occasioned a bitter controversy between Wood and General W. S. Rosecrans. Wood's division was highly effective at Missionary Ridge and in the Atlanta campaign. He commanded the IV Corps in the pursuit of General John Hood's broken Confederate army after the battle of Nashville, 1864. Several times badly wounded, he retired for disability as major general, U.S. Army, 1868.

Wood, Walter Abbott (*b. Mason, N.H., 1815; d. Hoosick Falls, N.Y., 1892*), manufacturer and inventor of agricultural implements. Produced the Wood mowers, reapers, and binders at Hoosick Falls *post ca.* 1852; made numerous improvements on mowers and reapers built originally under the John H. Manny patents.

Wood, William (*fl. 1629–35*), author. Immigrating from England to Massachusetts, 1629, Wood probably settled in Lynn; very little is known of his life. He left the colony on Aug. 15, 1633, and on July 7, 1634, his book *New Englands Prospect* was entered in the Stationers' Register in London. The book is an account of New England as the author observed it from 1629 to 1633; the first part is a description of the country and its settlements; the second, a number of observations on the Indians. It is clearly the work of a man with some literary training and is unusual among books of its type for vigor of style and relatively polished form.

Wood, William Burke (*b. Montreal, Canada, 1779; d. 1861*), actor, theatrical manager. Made American debut with the company of Thomas Wignell at Annapolis, Md., 1798. Celebrated as a player in genteel comedy, Wood was identified principally with the Philadelphia theaters in association with William Warren. He was author of *Personal Recollections of the Stage* (1855).

Wood, William Robert (*b. Oxford, Ind., 1861; d. New York, N.Y., 1933*), lawyer, Indiana legislator. Congressman, Republican, from Indiana, 1915–33, he was first famous as one of the most active Republican critics of the administration of President Woodrow Wilson; he was later a most influential figure as chairman of the House Appropriations Committee. His political philosophy reflected a rural background and included a marked suspicion of the "money power." Economy and retrenchment were his watchwords, and his success was owing to hard work and conscientious application to his duties rather than to any intellectual brilliance.

Woodberry, George Edward (*b. Beverly, Mass., 1855; d. Beverly, 1930*), poet, critic, educator. Graduated Harvard, 1877; was influenced there by Henry Adams and Charles E. Norton. Taught English at University of Nebraska, 1877–78 and 1880–82; engaged in writing for *Atlantic Monthly* and *Nation* and other periodicals. As professor of literature (later of comparative literature), Columbia University, 1891–1904, Woodberry was brilliant as a teacher; he also built up a graduate department which transformed the methods of higher instruction in literature and left a deep mark on university teaching in this field throughout the country. After resigning his chair in 1904, he traveled widely, spending part of his time as a sort of itinerant teacher. A prolific writer, he was author of a number of books, including important biographies of Edgar Allan Poe, Nathaniel Hawthorne, and Ralph Waldo Emerson. *The Torch* (1905) contains probably the fullest expression of his philosophy of literature; his poems (he thought of himself essentially as a poet) were issued in a number of small volumes, from which a selection was made by three of his former students in 1933. A lonely and somewhat enigmatic figure, he displayed in his best critical work a subtle intuition of the emotional experience that produced the work of literature with which he was dealing and a deep sense of its relation to the spiritual background of Western man.

Woodbridge, Frederick James Eugene (*b. Windsor, Ontario, Canada, 1867; d. New York, N.Y., 1940*), educator, philosopher. Raised in Michigan. Graduated Amherst, 1889; Union Theological Seminary, New York, 1892. After further study in Berlin, he built up an outstanding philosophy department at the University of Minnesota, 1894–1902; *post* 1902 he was professor of philosophy at Columbia University. A cofounder and for many years editor of the *Journal of Philosophy*, he served also as dean of the graduate faculties of Columbia, 1912–29. A leader of the American "realist" movement, he described his own form of this philosophy as "naive realism" and identified it with the core of Aristotle's metaphysics. He made the *Journal of Philosophy* the chief medium for the attacks of the new pragmatism, realism, and naturalism on the then-dominant school of philosophical idealism.

Woodbridge, John (*b. Stanton, Wiltshire, England, 1613; d. 1695*), colonial magistrate, clergyman. Nephew of Thomas Parker; brother-in-law of Simon Bradstreet. Immigrated to New England, 1634. Public official in Newbury, Mass., 1636–41 (excepting 1639), 1677–79, 1681, 1683–84, and 1690. Helped settle Andover, Mass.; was first pastor of the church at Andover, 1645–47. Removed to England, 1648, returning to Massachusetts, 1663. Assistant minister at Newbury, 1663–70. Conducted a bank of deposit and issue with land and commodities as collateral *post ca.* 1671. Author of *Severals Relating to the Fund . . .* (1681/2), the oldest American tract on currency and banking extant.

Woodbridge, Samuel Merrill (*b. Greenfield, Mass., 1819; d. New Brunswick, N.J., 1905*), Reformed clergyman. Graduated New Brunswick (N.J.) Theological Seminary, 1841. Held New York and New Jersey pastorates, 1841–5. Professor of ecclesiastical history and church government at New Brunswick Seminary, 1857–1901; dean, 1883–88; president of the faculty, 1888–1901. Was also professor of metaphysics and mental philosophy, Rutgers College, 1857–64.

Woodbridge, William (*b. Norwich, Conn., 1780; d. Detroit, Mich., 1861*), lawyer, Ohio and Michigan legislator. Friend of

Lewis Cass; son-in-law of John Trumbull, the poet. Secretary of Michigan Territory, 1814–24; appointed collector of customs at Detroit, 1814. Chosen Michigan's first territorial delegate, 1819; served as territorial judge, 1828–32. Elected Whig governor of Michigan, 1839, he served 14 months, implementing complete program of state rehabilitation. U.S. senator, Whig, from Michigan, 1841–47, he was chairman of the Committee on Public Lands and sponsored measures for internal improvements.

WOODBRIDGE, WILLIAM CHANNING (*b. Medford, Mass., 1794; d. Boston, Mass., 1845*), educator, Congregational clergyman. Graduated Yale, 1811. Edited *American Annals of Education and Instruction* 1831–37; was a pioneer in advocating teaching of physiology and music in common schools and an early American expounder of the Pestalozzian system. Author of *Rudiments of Geography . . . by Comparison and Classification* (1821) and *Universal Geography, Ancient and Modern* (1824), both of which revolutionized presentation of geographical facts in American schools.

WOODBURY, CHARLES JEPTHA HILL (*b. Lynn, Mass., 1851; d. 1916*), industrial engineer, authority on fire prevention. C.E., Massachusetts Institute of Technology, 1873. Became engineer, 1878, and later vice president, Boston Manufacturers Mutual Fire Insurance Co.; assistant engineer, American Telephone & Telegraph Co., 1894–1907; secretary, National Association of Cotton Manufacturers, 1894–1916. Received honors for work on mill construction and formulation of insurance rules for electric lighting.

WOODBURY, DANIEL PHINEAS (*b. New London, N.H., 1812; d. Key West, Fla., 1864*), Union soldier, engineer. Graduated West Point, 1836. Engaged in building Fort Kearny on Missouri River and Fort Laramie, Wyo., 1847–50; supervised construction of Fort Jefferson in the Tortugas and Fort Taylor at Key West. Commissioned brigadier general of volunteers, 1862; commanded engineer brigade, Army of Potomac, in the Peninsular Campaign, constructing siege works, roads, and bridges. Died of yellow fever while commanding Key West district.

WOODBURY, HELEN LAURA SUMNER (*b. Sheboygan, Wis., 1876; d. New York, N.Y., 1933*), social economist. A.B., Wellesley, 1898; Ph.D., Wisconsin, 1908. Appointed industrial expert, U.S. Children's Bureau, 1913, and assistant chief, 1915; studied child labor laws and employment certificate systems. Author of original works on citizenship and the history of women in American industry, and, among others, *Labor Problems* (1905), with Thomas S. Adams. She was one of the first in the American academic world to study and analyze labor problems and did pioneering work in the technique of social legislation administration.

WOODBURY, ISAAC BAKER (*b. Beverly, Mass., 1819; d. Charleston, S.C., 1858*), composer. Editor, *American Monthly Musical Review*. Compiled and edited, among other music books, *Boston Musical Education Society's Collection* (1842) and *Choral* (1845), both with Benjamin F. Baker; *Dulcimer* (1850); *Lute of Zion* (1853); *Cythara* (1854); and *Harp of the South* (1853). Many of his compositions were published, including a popular song, "The Indian's Lament" (1846).

WOODBURY, LEVI (*b. Francestown, N.H., 1789; d. Portsmouth, N.H., 1851*), statesman, jurist, U.S. Supreme Court justice. Studied law with Jeremiah Smith (1759–1842), as well as in Litchfield (Conn.) Law School and in Boston; admitted to the bar, 1812. Associate justice, New Hampshire Superior Court, 1817–23. Elected governor of New Hampshire, 1823, by "Young America" Democrats and Federalists, he served until 1824. Congressman from New Hampshire, 1825, he was chosen Speaker of the House. As U.S. senator, 1825–31 and 1841–45, he supported Democratic measures, served on Commerce, Navy, and Agriculture committees, and was an isolationist and supporter of a mildly protective tariff. As U.S. secretary of the navy, May 1831–June 1834, he reformed rules of conduct and procedure. Appointed U.S. secretary of the treasury, June 1834, he opposed the rechartering of the Bank of the United States and strongly supported President Jackson's bank policy. He favored the independent treasury and warned the country against inflation in 1836. He attempted to popularize use of hard money and urged Congress to use the unprecedented treasury surplus for public works, 1835–36, and for purchase of sound state bonds. He opposed division of the surplus among the states. In the panic of 1837 he perfected a defense against depreciated paper money by which public holders of federal obligations suffered no loss. He was associate justice of the U.S. Supreme Court in 1846–51. He was considered as a Democrat presidential nominee in 1848. Conservative in politics, Woodbury was a party man and a strict constructionist; his personal morals were puritan.

WOODFORD, STEWART LYNDON (*b. New York, N.Y., 1835; d. New York, 1913*), lawyer, Union soldier, diplomat. Admitted to the bar, 1857; practiced in New York City, Republican lieutenant governor of New York, 1867–69; congressman, March 1873–July 1874. Federal district attorney, southern district of New York, 1877–83. As U.S. minister to Spain, 1897–98, he worked with skill but without success to prevent war.

WOODFORD, WILLIAM (*b. Caroline Co., Va., 1734; d. New York, N.Y., 1780*), Revolutionary patriot and soldier. Appointed colonel, 3rd Virginia Regiment, 1775, he defended Hampton and was victorious at Great Bridge. Made colonel, 2nd Virginia Regiment, 1776; promoted brigadier general, 1777. Fought at Brandywine, Germantown, and Monmouth; wintered at Valley Forge. Captured defending Charleston, S.C., 1780, he died as a prisoner of war.

WOODHOUSE, JAMES (*b. Philadelphia, Pa., 1770; d. 1809*), physician, chemist. Graduated present University of Pennsylvania, 1787; M.D., 1792. Studied also with Benjamin Rush. Founded the Chemical Society of Philadelphia, 1792, one of the earliest such societies in the world, and served it as senior president for many years. Becoming professor of chemistry in the University of Pennsylvania, 1795, Woodhouse entered upon a career of research. Among other accomplishments, he gave the most convincing arguments against the doctrine of phlogiston; liberated metallic potassium by original methods; confirmed the anesthetic properties of nitrous oxide gas, 1806; engaged in profound studies of the chemistry and production of white starch; demonstrated the superiority of anthracite over bituminous coal for industrial purposes. Woodhouse was a pioneer in plant chemistry, in the development of chemical analysis, in the elaboration of many industrial processes, and in the use of laboratory methods of instruction in chemistry. Among others who frequented his laboratory were Joseph Priestly, Robert Hare, and the elder Benjamin Silliman.

WOODHULL, ALFRED ALEXANDER (*b. Princeton, N.J., 1837; d. Princeton, 1921*), military surgeon, sanitation expert. Graduated medical department, University of Pennsylvania, 1859. Served in Union army medical corps; was medical inspector, Army of the James, 1864–65. Brevetted lieutenant colonel, 1865, he remained in the army until retirement in 1901. He advanced to brigadier general on the retired list, 1904. Author of, among other writings, the "Surgical Section" of the *Catalogue of the*

United States Army Medical Museum (1866) and *Notes on Military Hygiene for Officers of the Line* (1898–1909).

WOODHULL, NATHANIEL (*b. Mastic, N.Y., 1722; d. 1776*), farmer, soldier. Brother-in-law of William Floyd. Active as a New York assemblyman in protesting crown interference in colonial affairs; served as president of the New York Provincial Congress, 1775. Appointed brigadier general of militia, October, 1775, he was wounded at his headquarters at Jamaica, N.Y., after the battle of Long Island, dying subsequently of ill treatment.

WOODHULL, VICTORIA CLAFLIN (*b. Homer, Ohio, 1838; d. 1927*), adventuress, feminist. Began giving spiritualistic exhibitions with her sister, Tennessee Celeste Claflin (1846–1923), *ca.* 1853; traveled for a time with her family in a medicine and fortune-telling show; worked with her sister as a clairvoyant in Cincinnati, Chicago, and elsewhere in the Midwest. The sisters removed to New York City, 1868, where they won the interest of Cornelius Vanderbilt and made considerable profits in the stock market through his advice. In 1870 they began *Woodhull and Claflin's Weekly*, advocating equal rights for women and free love. Nominated for the presidency by the Equal Rights party in 1872, Victoria went to the polls and made a futile attempt to vote. The Claflin sisters precipitated the greatest sensation of the time by publishing in their *Weekly* on Nov. 2, 1872, the story of the alleged intimacy of Henry Ward Beecher with the wife of Theodore Tilton. Resident in England *post* 1877, both sisters married into respectable English society and became noted for charitable works.

WOODIN, WILLIAM HARTMAN (*b. Berwick, Pa., 1868; d. New York, N.Y., 1934*), industrialist. President of the American Car & Foundry Co. and for many years chairman of the board of the American Locomotive Co., Woodin was a close friend of Franklin D. Roosevelt and supported him for the presidency in 1932. After the election he became one of the inner circle of Roosevelt advisers and was named U.S. secretary of the treasury early in 1933. Woodin addressed himself with great energy and devotion to the task of restoring financial confidence and to carrying out the president's financial and monetary policies; he supervised promulgation of new banking regulations and undertook to stop hoarding of gold. His health failing, he resigned in December 1933.

WOODRING, HARRY HINES (*b. Elk City, Kans., 1887; d. Topeka, Kans., 1967*), governor of Kansas and secretary of war. Worked in banking until 1929. He was Democratic governor of Kansas (1931–33). Following his defeat for reelection in 1933, President Roosevelt named him assistant secretary of war. In 1936 he was given a recess appointment as secretary of war, and the following year the assignment was made permanent. Woodring came into conflict with Roosevelt due to his opposition to providing military equipment to Britain and France. In 1940 Roosevelt asked for, and received, his resignation. Woodring ran unsuccessfully for governor in 1946 and 1956.

WOODROW, JAMES (*b. Carlisle, England, 1828; d. 1907*), Presbyterian clergyman, educator. Uncle of Woodrow Wilson. Came to America as a boy. Graduated Jefferson College, Pennsylvania, 1849; Ph.D., Heidelberg, 1856. Professor of natural science, Oglethorpe University, Georgia, 1856–61. Became professor of science, University of South Carolina, 1869; served as president, 1891–97. Published the *Southern Presbyterian*, 1865–93. His address, *Evolution* (1884), denying any essential conflict between the Bible and science, brought him nationwide attention and aroused a southern church controversy which lasted until 1888. Woodrow's speech in defense of his views before the Synod of

South Carolina, 1884, is one of the most enlightened expositions in Southern ecclesiastical history, but he was removed from his chair at the seminary.

WOODRUFF, CHARLES EDWARD (*b. Philadelphia, Pa., 1860; d. New Rochelle, N.Y., 1915*), ethnologist, army surgeon. M.D., Jefferson Medical College, 1886. During Spanish-American War, served as brigade surgeon under Major General Wesley Merritt in Philippine Islands. Brigade surgeon, 4th Brigade, during Philippine Insurrection, 1902. Author of, among other writings, *The Expansion of Races* (1909) and *Medical Ethnology* (1915).

WOODRUFF, LORANDE LOSS (*b. New York, N.Y., 1879; d. New Haven, Conn., 1947*), biologist. Attended College of the City of New York. B.A., Columbia University, 1901; M.A., 1902; Ph.D., 1905. Taught at Williams College, 1903–07. Instructor at Yale University, 1907–09; assistant professor, 1909–15; associate professor, 1915–22; professor of protozoology, 1922–47. Appointed director of the Osborn Zoological Laboratory at Yale and chairman of the Department of Zoology, 1938, he continued to serve in these positions for the rest of his life. His research publications were numerous; he dealt in particular with the life history and physiology of the ciliated protozoa (mainly with *Paramecium*) and with the history of biology. He was author of, among other books, *Foundations of Biology* (1922).

WOODRUFF, THEODORE TUTTLE (*b. near Watertown, N.Y., 1811; d. Gloucester, N.J., 1892*), inventor. Patented railway-car seat and couch, 1856, and improvements, 1859 and 1860; began manufacture of sleeping cars in Philadelphia, Pa., 1858. Patented a process and apparatus for indigo manufacture, 1872, and a coffee-hulling machine. Later patents include a steam plow.

WOODRUFF, TIMOTHY LESTER (*b. New Haven, Conn., 1858; d. 1913*), merchant, New York politician. Removed to Brooklyn, N.Y., 1881. Republican lieutenant governor of New York, 1897–1903; strengthened Kings County organization of Republican party.

WOODRUFF, WILFORD (*b. Farmington, now Avon, Conn., 1807; d. San Francisco, Calif., 1898*), Mormon leader. Converted to Mormonism at Richland, N.Y., 1833. Removed to Kirtland, Ohio, 1834, and was sent by Joseph Smith to aid distressed Mormons in Missouri. Ordained apostle by Brigham Young, 1839. A member of the first company to enter Great Salt Lake Valley, 1847. Became president of the quorum of the Twelve Apostles, 1880; succeeded to presidency, Utah branch, Mormon church, 1889. One of Mormon's most effective proselyters, his missionary travels covered England, Scotland, Wales, and 23 states and 5 territories of the Union. In 1875 he became Mormon's official historian and recorder; as president, he issued the famous "Manifesto," 1890, in which plural marriage was officially abandoned.

WOODRUFF, WILLIAM EDWARD (*b. Fireplace, N.Y., 1795; d. Little Rock, Ark., 1885*), newspaper publisher. Founder-editor, *Arkansas Gazette*, 1819–38 and 1841–43; established *Arkansas Democrat*, 1846.

WOODS, ALVA (*b. Shoreham, Vt., 1794; d. Providence, R.I., 1887*), Baptist clergyman, educator. Graduated Harvard, 1817; ordained, 1821. President of Transylvania University, Kentucky, 1828–31; of the University of Alabama, 1831–37.

WOODS, CHARLES ROBERT (*b. Newark, Ohio, 1827; d. Ohio, 1885*), soldier. Brother of William B. Woods. Graduated West Point, 1852. Commanded army force aboard *Star of the West* in attempt to relieve Fort Sumter, 1861; appointed colonel, 76th

Ohio Infantry, 1861. For gallant service in Vicksburg campaign, was appointed brigadier general of volunteers, 1863. Led assault on Lookout Mountain; played prominent part at Resaca and Atlanta, 1864; brevetted major general of volunteers in 1865. He served in the West as regular colonel in infantry, 1866–74.

WOODS, JAMES HAUGHTON (*b. Boston, Mass., 1864; d. Tokyo, Japan, 1935*), educator, student of Indian philosophy. Graduated Harvard, 1887; Ph.D., Strassburg, 1896; studied also at Episcopal Theological School in Cambridge, Mass., and at Oxford, Harvard, and the University of Berlin. Taught several subjects intermittently at Harvard. Made special Oriental studies at Kiel, and traveled and studied in India until 1903 when he became a member of the Harvard Department of Philosophy and instructor in the philosophical systems of India. He was professor of philosophy at Harvard, 1913–34, continuing, however, his travels and further studies in Oriental subjects. He was editor and author of texts and translations in his special field.

WOODS, LEONARD (*b. Princeton, Mass., 1774; d. Andover, Mass., 1854*), Congregational clergyman. Father of Leonard Woods (1807–78). Ordained pastor of church at Newbury (now West Newbury), Mass., 1798. A moderate Calvinist, he mediated successfully between the Hopkinsians and the Old Calvinists. He was the first professor of theology at Andover Theological Seminary, 1808–46.

WOODS, LEONARD (*b. Newbury, Mass., 1807; d. Boston, Mass., 1878*), clergyman, educator. Son of Leonard Woods (1774–1854). Graduated Union, 1827; Andover Theological Seminary, 1830. Ordained by Third Presbytery of New York, 1833; was editor, *Literary and Theological Review*, New York City, 1833–36. Called to chair of biblical literature, Bangor (Maine) Theological Seminary, 1836. As president of Bowdoin College, 1839–66, he inspired affection and respect. He was an excellent teacher, was largely responsible for erection of King Chapel, and helped win for the college the reversionary interest in the James Bowdoin estate.

WOODS, ROBERT ARCHEY (*b. Pittsburgh, Pa., 1865; d. 1925*), sociologist, reformer. Graduated Amherst, 1886; studied at Andover Theological Seminary; worked at Toynbee Hall, London, England. Head of Andover House (South End House) settlement, Boston, Mass., *post* 1891. Woods's outstanding contribution to sociology and social work is the concept that the neighborhood or village is the primary community unit and that towns, metropolitan areas, the nation itself, are "federations" of neighborhoods. He organized Boston settlements into a federation, and initiated organization of the National Federation of Settlements, 1911. Author of *English Social Movements* (1891), *The City Wilderness* (1898), the first thoroughgoing study of a depressed area in an American city; *Americans in Process* (1902); and *Neighborhood in Nation-Building* (1923). Coauthor with Albert J. Kennedy of, among others, *The Settlement Horizon* (1922), an authoritative text on the history of American settlements.

WOODS, WILLIAM ALLEN (*b. near Farmington, Tenn., 1837; d. Indianapolis, Ind., 1901*), jurist. Raised in Iowa; admitted to Indiana bar, 1861. Judge, 34th judicial circuit of Indiana, 1873–80; Indiana Supreme Court, 1880–82; U.S. district judge for Indiana, 1882–92; judge of 7th U.S. circuit court *post* 1892. His most widely known case was *United States* v. *Debs*, in which he sentenced the Socialist Eugene V. Debs to prison for violation of an antistrike injunction.

WOODS, WILLIAM BURNHAM (*b. Newark, Ohio, 1824; d. Washington, D.C., 1887*), Ohio Democratic legislator, Union brigadier general, jurist, U.S. Supreme Court justice. Brother of Charles R. Woods. Removed to Alabama, 1866, where he was active in Reconstruction as a Republican. Appointed judge of the U.S. circuit court, 5th circuit, 1869, he removed to Atlanta, Ga. Appointed associate justice of the U.S. Supreme Court, 1880, Woods wrote the opinion in *U.S.* v. *Harris*, determining that protection of black civil rights was not to be found in federal statutes or by federal court indictments. He also wrote the opinion in *Presser* v. *Illinois* and in many patent and equity cases.

WOODSON, CARTER GODWIN (*b. New Canton, Va., 1875; Washington, D.C., 1950*), historian. Child of former slaves, he was largely self-taught until, after working several years in West Virginia coal mines, he attended high school in Huntington. He received the B.Litt., Berea College, 1903. His graduate studies were made (again in periods between various employments) at University of Chicago (B.A. and M.A., 1908) and at Harvard (Ph.D., 1912). From 1909 until 1918, he taught a variety of subjects at the M St. (Dunbar) High School in Washington, D.C. In 1915, he organized the Association for the Study of Negro Life and History, which he headed until his death; he was also editor *post* 1916 of the association's quarterly, *Journal of Negro History*, and, *post* 1937, of the *Negro History Bulletin*. In 1921, he founded Associated Publishers, a firm for the publication of books by and about blacks. His last academic employment was as dean of West Virginia State College, 1920–22; thereafter, he gave his full time to the study and dissemination of black history and the encouragement of black historians. He was author of, among other works, *The Education of the Negro Prior to 1861* (1915); *A Century of Negro Migration* (1918); *The Negro Wage Earner* (1930, with Lorenzo Greene); and a widely used textbook, *The Negro in Our History* (1922, and later editions).

WOODWARD, AUGUSTUS BREVOORT (*b. New York, N.Y., 1774; d. Tallahassee, Fla., 1827*), jurist, political philosopher. Graduated Columbia, 1793. Active in incorporation of city of Washington, 1801–02; was member of its first council. A judge of Michigan Territory, 1805–24, Woodward was the dominant figure in the Michigan court and legislature. He prepared a plan for rebuilding the city of Detroit and compiled *The Laws of Michigan* (1806), known as "The Woodward Code." His *A System of Universal Science* (1816) contained the idea (expanded in 1817 in a legislative act written by him) of the "Catholcpistemiad, or University, of Michigania" (University of Michigan). In 1824 he was appointed to a Florida federal court, where he served until his death. He was a friend and admirer of Thomas Jefferson. Author of, among other works, *Considerations on the Executive Governments of the United States of America* (1809).

WOODWARD, CALVIN MILTON (*b. near Fitchburg, Mass., 1837; d. St. Louis, Mo., 1914*), educator. Graduated Harvard, 1860. Taught geometry at Washington University, St. Louis, Mo.; was dean of its polytechnic school, 1870–96 and 1901–10, and Thayer professor of mathematics and applied mechanics. He accomplished his most important work, however, as originator and director of the St. Louis Manual Training School (opened 1880), which served as model for similar schools in other cities. Author of, among other works, *Manual Training in Education* (1890).

WOODWARD, HENRY (*b. possibly Barbados, British West Indies, ca. 1646; d. ca. 1686*), surgeon, first English settler in South Carolina and a pioneer of English expansion in the lower South. Joined Carolina settlement near Cape Fear, 1664; explored Port Royal, 1666. Acquired important information concerning Indians on northern Florida border and Spaniards in Florida, while a prisoner at St. Augustine. Interpreter and Indian agent with Carolina fleet of 1669–70. On mission to open the interior In-

dian trade for the earl of Shaftesbury, 1674, he effected an alliance with the Westo on the Savannah River. Later he pressed the Carolina trading frontier westward to the towns of the Lower Creek on middle Chattahoochee. By 1686 Woodward had laid a firm foundation for English alliance with the Lower Creek.

WOODWARD, JOSEPH JANVIER (*b. Philadelphia, Pa., 1833; d. Wawa, Pa., 1884*), army medical officer. M.D., University of Pennsylvania, 1853. Practiced in Philadelphia, Surgeon with Army of the Potomac, 1861–62; then assigned to surgeon general's office, Washington, D.C. Prepared medical section of the *Medical and Surgical History of the War of the Rebellion* (1870–88). He was among first to apply photomicrography to use in pathology and was instrumental in improving the photomicrographic camera. Attended President James A. Garfield between his shooting and death, 1881.

WOODWARD, ROBERT BURNS (*b. Boston, Mass., 1917; d. Cambridge, Mass., 1979*), chemist and Nobel laureate. An academic prodigy with an early, advanced knowledge of chemistry, he graduated Massachusetts Institute of Technology (B.S., 1936; Ph.D., 1937) and became a research assistant in organic chemistry at Harvard University, becoming a full professor in 1950 and Donner professor of science (1960–79). His series of publications of data from chemical literature (1941–42) became known as Woodward's rules. In 1944 he synthesized quinotoxine (the basis for quinine) and joined the U.S.–British war effort on the structure and synthesis of penicillin. He reported on the unique structure of the compound ferrocene (1952); formulated the Octant Rule (1961), utilizing optical rotatory dispersion to describe the molecular geometry of ketones; and announced the Woodward–Hoffman Rules (1965), which used wave mechanics to understand the pathways for chemical reactions and to predict spatial arrangement of atoms in organic molecules. He accomplished total synthesis of patulin (1950), cholesterol (1951), cortisone (1951), and other enzymes; his most complex synthesis was for vitamin B12 (1976). He was awarded the Nobel Prize in chemistry (1965) for his contributions to chemical synthesis.

WOODWARD, ROBERT SIMPSON (*b. Rochester, Mich., 1849; d. Washington, D.C., 1924*), engineer, mathematical physicist. C.E., University of Michigan, 1872. Chief geographer, U.S. Geological Survey *post* 1884. Wrote important papers of a geophysical nature on deformations of the earth's surface and on secular cooling of the earth. Put field methods for topographic mapping and primary and secondary triangulation on practical engineering basis. Developed iced-bar apparatus for measuring baselines and for calibrating steel tapes and was first to prove baselines could be measured with sufficient accuracy by means of long steel tapes. Appointed professor of mechanics and mathematical physics, Columbia University, 1893, he shortly thereafter became dean of its College of Pure Science. President, Carnegie Institution of Washington, 1904–20. He was an editor of *Science*, 1884–1924.

WOODWARD, SAMUEL BAYARD (*b. Torrington, Conn., 1787; d. Northampton, Mass., 1850*), mental disease expert. Instrumental in founding Connecticut Retreat for the Insane, Hartford, 1824. Served as superintendent, Massachusetts State Lunatic Asylum, Worcester, 1832–46. Founder and first president, Association of Medical Superintendents of American Institutions for the Insane (American Psychiatric Association).

WOODWARD, WILLIAM (*b. New York, N.Y., 1876; d. New York, 1953*), banker and horseman. Graduated from Harvard Law School, 1901. Joined the Hanover Bank in New York in 1903; vice president, 1904; president, 1910. When the Hanover be-

came the Central Hanover Bank and Trust Company in 1929, Woodward served as chairman of the board until 1933. Owner of the Belair stud farm in Maryland, he bred ninety-two winners of major American stakes races, including two winners of the "Triple Crown," Gallant Fox (1930), Omaha (1935), and the famed Nashua. Active also in British racing, he was a prominent figure in the racing world.

WOODWORTH, JAY BACKUS (*b. Newfield, N.Y., 1865; d. Cambridge, Mass., 1925*), geologist. Studied under Nathaniel S. Shaler at Lawrence Scientific School. B.A., Harvard, 1894, where he served as associate professor of geology, 1912 until his death. He was also assistant geologist, U.S. Geological Survey. Woodworth was a pioneer of seismological studies in relation to geology. He was founder and director of the Harvard seismological station, one of the first in America, 1908–25.

WOODWORTH, SAMUEL (*b. Scituate, Mass., 1784; d. 1842*), printer, journalist, poet. Apprenticed to Benjamin Russell in Boston, Mass., 1800–06. After brief residences in New Haven, Conn., and Baltimore, Md., he settled in New York City, 1809. Engaged throughout his life in a great number of journalistic and literary pursuits, he is remembered principally as the author of "The Bucket" ("The Old Oaken Bucket"). A frequent contributor of poetry to the periodical press over the signature "Selim," he was author of three satires — *New-Haven* (1809), *Beasts at Law* (1811), and *Quarter-Day* (1812) — and of a number of plays, which included the long-popular *The Forest Rose* (1825).

WOOL, JOHN ELLIS (*b. Newburgh, N.Y., 1784; d. Troy, N.Y., 1869*), soldier. Raising a company of volunteers in Troy, N.Y., at the outbreak of the War of 1812, he served in the northern campaigns with gallantry and received the brevet of lieutenant colonel, September 1814, for his conduct at the battle of Plattsburgh, N.Y. Promoted colonel and inspector general of the army, April 1816, he remained in this grade until 1841 when he was promoted brigadier general. After mustering in about 12,000 volunteers at Cincinnati, Ohio, 1846, for service in the war with Mexico, he went to San Antonio, Tex., in August to lead a new command on a march through Chihuahua. Starting thence with a spiritless force of some 1,400 men in September, he crossed 900 miles of hostile country and arrived in Saltillo on Dec. 22. His efficiency and speed of movement were largely responsible for the American victory of Buena Vista; he selected the position and held the Mexicans while General Zachary Taylor went back to Saltillo. He later commanded the Eastern Military Division and the Department of the Pacific. At the opening of the Civil War he saved Fortress Monroe by timely reinforcements. Promoted major general, 1862, he commanded the Middle Department and the Department of the East until his retirement, 1863.

WOOLEY, EDGAR MONTILLION ("MONTY") (*b. New York, N.Y., 1888; d. Saratoga Springs, N.Y., 1963*), director and actor. Graduated Yale (1911) and became drama coach there (1914–17) and assistant professor of drama (1919). His first Broadway success was directing Cole Porter's *Fifty Million Frenchmen* (1920). In the mid-1930's he played numerous bit parts in films, including *Night and Day* (1946). His main claim to fame resulted from his role in the play (1939) and film (1942) of *The Man Who Came to Dinner*. Received an Oscar nomination for best actor for *The Pied Piper* (1942) and for best supporting actor for *Since You Went Away* (1944).

WOOLF, BENJAMIN EDWARD (*b. London, England, 1836; d. Boston, Mass., 1901*), musician, composer, music critic. Came to America as a child. Joined editorial staff of the *Saturday Eve-*

ning Gazette, Boston, Mass., 1871; became publisher and editor, 1892. As music critic of the *Boston Herald,* he was noted for the clarity and severity of his reviews. Author of once-popular plays and light operas, including *Pounce & Co., or Capital vs. Labor* (1882).

WOOLLCOTT, ALEXANDER HUMPHREYS (*b. near Red Bank, N.J., 1887; d. New York, N.Y., 1943*), author, dramatic critic, radio commentator. Ph.B., Hamilton College, 1909. A talented reporter on the *New York Times,* he was made the paper's dramatic critic, 1914; his column, "Second Thoughts on First Nights," was soon popular, and a dispute with the Shubert brothers made him a celebrity. Enlisting in the U.S. Army, 1917, he served in France as a hospital orderly; later, transferred to Paris, he wrote for the service newspaper, *Stars and Stripes.* He resumed his place on the *Times* in the summer of 1919, moved to the *New York Herald,* 1922, and, after a brief period with the New York *Sun,* was critic for the New York *World,* 1925–28. In the 1920's he was one of the wits who made up the famous "Roundtable" at New York's Algonquin Hotel. He turned then to free-lance writing for leading magazines, and in September 1929 made his debut as a radio commentator; *post* 1937, he became known from coast to coast as "The Town Crier." Playing a role obviously modeled on himself, he toured in the Pacific Coast company of *The Man Who Came to Dinner* (1939), by George S. Kaufman and Moss Hart. Despite failing health *post* 1940, he remained active, especially in support of the Allied cause in World War II. Arbitrary, subjective, and given to romantic sentimentality as a critic, he was a gifted maker of phrases who made and broke reputations. His calculated poses and passion for celebrity obscured his native qualities of generosity, patriotism, loyalty, and industry.

WOOLLEY, CELIA PARKER (*b. Toledo, Ohio, 1848; d. Chicago, Ill., 1918*), settlement worker, author. Ordained into the Unitarian fellowship, 1894; held Illinois pastorates. Established and lived in Frederick Douglass Center, a black settlement on Chicago's South Side, 1904–18. Associated with *Unity,* a Chicago religious weekly, *post* 1884. Active in Chicago's cultural and social service circles.

WOOLLEY, JOHN GRANVILLE (*b. Collinsville, Ohio, 1850; d. Spain, 1922*), prohibitionist, lawyer. Active in prohibition movement *post* 1888 as lecturer and editor; Prohibition party presidential candidate, 1900.

WOOLLEY, MARY EMMA (*b. South Norwalk, Conn., 1863; d. West Port, N.Y., 1947*), educator, advocate of woman's rights and world peace. Graduated Wheaton Seminary, 1884. B.A., Brown University, 1894; M.A., 1895. Taught biblical history and literature at Wellesley College, 1895–1900. President of Mount Holyoke College, 1901–37.

WOOLMAN, COLLETT EVERMAN (*b. Bloomington, Ind., 1889; d. Houston, Tex., 1966*), airline executive. Studied at the University of Illinois (B.S., 1912), then worked for the Louisiana State Extension Service. In 1925 he joined the Huff Daland aircraft manufacturing company to sell its crop-dusting services to planters. In 1928 he purchased Huff Daland's dusting operation and founded an independent dusting company, Delta Air Service. The parent company of Delta Air Lines, this firm added passenger service in 1929. Woolman moved Delta's headquarters to Atlanta in 1941, acquired some Douglas DC-3 airplanes, and began a long series of new route acquisitions. Delta pioneered in the operation of such jet aircraft as the DC-8 in 1959 and the DC-9 in 1964.

WOOLMAN, JOHN (*b. Rancocas, West Jersey, 1720; d. York, England, 1772*), tailor, teacher, Quaker leader. Called to the Quaker ministry *ca.* 1743, he embarked on a 30-year series of journeys from North Carolina to New Hampshire and from the northern frontier of Pennsylvania to Yorkshire, England. His ministry was concerned principally with the abolition of slavery; he visited especially the slave-trade centers such as Perth Amboy and Newport. Woolman's writings include his celebrated *Journal* (1774), which won the praise of Charles Lamb, W. E. Channing, and others, and an essay, *Some Considerations on the Keeping of Negroes* (1754).

WOOLSEY, JOHN MUNRO (*b. Aiken, S.C., 1877; d. New York, N.Y., 1945*), jurist. Grandnephew of Theodore Dwight Woolsey. Graduated Yale, 1898. LL.B., Columbia Law School, 1901. Practiced principally admiralty law in New York City until 1929; U.S. district court judge, Southern District of New York, 1929–43. Respected in his profession for his grasp of detail and economy of expression when ruling, he became known to the general public for his decisions permitting the importation of books by Marie C. Stopes, 1931, and the publication and free circulation of James Joyce's *Ulysses,* 1933.

WOOLSEY, MELANCTHON TAYLOR (*b. New York State, 1780; d. Utica, N.Y., 1838*), naval officer. Nephew of John H. Livingston. Entered navy as midshipman, 1800. Served on Great Lakes, 1808–25. In War of 1812 commanded at Sacketts Harbor, and was second in command under Isaac Chauncey. In charge of Pensacola navy yard, 1826–30; commanded Brazil Squadron as commodore, 1832–34.

WOOLSEY, SARAH CHAUNCY (*b. Cleveland, Ohio, 1835; d. 1905*), author. Niece of Theodore D. Woolsey. Wrote under pseudonym "Susan Coolidge." Chiefly remembered as a popular writer of stories for young people; among these are *What Katy Did* (1872), *A Little Country Girl* (1885), and *An Old Convent School in Paris and Other Papers* (1895). Edited, among others, *The Diary and Letters of Frances Burney* (1880) and *Letters of Jane Austen* (1892).

WOOLSEY, THEODORE DWIGHT (*b. New York, N.Y., 1801; d. 1889*), educator, political scientist. Father of Theodore S. Woolsey. Connected by blood with the Dwight and Edwards families (nephew of Theodore Dwight, 1764–1846), he graduated from Yale in 1820. After making theological studies at both Princeton and Yale, he went abroad for further study at Paris, Leipzig, Bonn, and Berlin. Accepting the chair of Greek language and literature at Yale, 1831, he was notably successful as a teacher and as a writer of superior textbooks in his field. Called to the presidency of Yale, 1846, he served until 1871; during his time Yale made greater progress than in any similar period theretofore. Subsequent to his acceptance of the presidency, he had given up teaching Greek and begun giving instruction in history, political science, and international law. He became a recognized authority in the last two subjects both at home and abroad, and was the author of, among other works, the celebrated *Introduction to the Study of International Law* (1860 and many subsequent editions) and *Political Science* (1878). A scholar of extensive and accurate knowledge, he was also a clear-visioned and effective administrator; his dignity and reserve, however, tended to keep people at a distance.

WOOLSEY, THEODORE SALISBURY (*b. New Haven, Conn., 1852; d. New Haven, 1929*), educator. Son of Theodore D. Woolsey. Graduated Yale, 1872; LL.B., Yale Law School, 1876. Professor of international law, Yale Law School, 1878–1911, except

for 1886–90. Author of, among other writings, *America's Foreign Policy* (1898).

WOOLSON, ABBA LOUISA GOOLD (*b. Windham, Maine, 1838; d. Maine, 1921*), writer. Held several teaching positions, including professorship of belles lettres at Mount Auburn Ladies' Institute, Cincinnati, Ohio. Lectured on English literature. Author of, among other books, *Woman in American Society* (1873), with a foreword by her personal friend John G. Whittier.

WOOLSON, CONSTANCE FENIMORE (*b. Claremont, N.H., 1840; d. Venice, Italy, 1894*), author. Grandniece of James Fenimore Cooper. Raised in Cleveland, Ohio. During trips as a young girl through Ohio, Wisconsin, and Mackinac Island, she acquired a thorough knowledge of the lake region. She later traveled widely on the Atlantic seaboard and lived in the Carolinas and Florida, 1873–79. She resided in Europe *post* 1879. Author of, among other regional works, *Castle Nowhere: Lake Country Sketches* (1875); *Rodman the Keeper: Southern Sketches* (1880); *East Angels* (1886); *Jupiter Lights* (1889); and *Horace Chase* (1894). *For the Major* (1883), in many respects her best novel, is a comparatively unlocalized account of village life in the eastern Appalachians. Her collections of European stories, *The Front Yard* (1895) and *Dorothy* (1896), are accounts of Americans projected against the background of an older civilization, in the manner of her friend and critic Henry James.

WOOLWORTH, FRANK WINFIELD (*b. Rodman, N.Y., 1852; d. 1919*), merchant. After a succession of business failures, he opened a prosperous store in Lancaster, Pa., 1879, featuring an array of goods at the fixed prices of five and ten cents. Establishing other stores and absorbing chains of stores run by competitors, he built up the F. W. Woolworth Co. He strove constantly to add articles to his line and to offer at his low price goods which had never been sold at such a figure before; this policy was a principal factor in his success.

WOOSTER, CHARLES WHITING (*b. New Haven, Conn., 1780; d. San Francisco, Calif., 1848*), merchant mariner, War of 1812 privateer, Chilean navy commander in chief, 1822–35. Grandson of David Wooster.

WOOSTER, DAVID (*b. present Huntington, Conn., 1711; d. Connecticut, 1777*), merchant, Revolutionary brigadier general. A practical soldier in the colonial wars *post* 1745, he was appointed a major general of six regiments and colonel of the 1st Regiment by the Connecticut Assembly in 1775. He was made a Continental brigadier general, June 1775. As ranking officer in Canada after General Richard Montgomery's death, he was unsuccessful and was superseded by General John Thomas. Reappointed major general of Connecticut militia in the fall of 1776, he was mortally wounded in the defense of Ridgefield, Conn., during Tryon's raid on Danbury, April 1777.

WOOTASSITE *See* OUTACITY.

WOOTTON, RICHENS LACY (*b. Mecklenburg Co., Va., 1816; d. near Trinidad, Colo., 1893*), trapper, pioneer settler. Raised in Kentucky. Traded and trapped in almost every section of the western fur country, 1836–40; ranched and traded on site of present Pueblo, Colo. *post* 1841. Helped suppress Taos insurrection and participated in battle of Sacramento, 1847. Served as scout with Col. A. W. Doniphan on Chihuahua expedition and with other army expeditions; engaged in freighting. Perhaps best known for building in 1865 a 27-mile road over the roughest portion of the Santa Fe Trail mountain division from Trinidad, Colo., across Raton Pass and down to the Canadian River.

WORCESTER, EDWIN DEAN (*b. Albany, N.Y., 1828; d. New York, N.Y., 1904*), railroad official. Employed by Erastus Corning as chief accountant of the newly consolidated New York Central, 1853, Worcester was associated with that road and its subsequent expansion under the Vanderbilts until his death.

WORCESTER, ELWOOD (*b. Massillon, Ohio, 1862; d. Kennebunkport, Maine, 1940*), Episcopal clergyman. Graduated Columbia, 1886; General Theological Seminary, New York, 1887; Ph.D., Leipzig, 1889. After teaching at Lehigh University and a pastorate in Philadelphia, Pa., he was called to Emmanuel Church, Boston, Mass., 1904, where with the cooperation of physicians he pioneered in the Christian application of psychotherapy, developing what became known as the Emmanuel Movement.

WORCESTER, JOSEPH EMERSON (*b. Bedford, N.H., 1784; d. Cambridge, Mass., 1865*), lexicographer, geographer, historian. Nephew of Noah and Samuel Worcester. Graduated Yale, 1811. From 1817 to 1826, he published geographical gazetteers and works on geography and history used extensively as textbooks. Compiler of, among other dictionaries, the *Comprehensive Pronouncing and Explanatory Dictionary of the English Language* (1830, 1847, 1849; issued in 1855 as *A Pronouncing, Explanatory, and Synonymous Dictionary of the English Language*), containing his linguistic contribution of the "compromise vowel." This work evoked Noah Webster's charge of plagiarism, which Worcester refuted, and initiated the "War of the Dictionaries." In 1831 he assumed an 11-year editorship of *The American Almanac and Repository of Useful Knowledge*. His illustrated quarto *A Dictionary of the English Language* (1860) was the most elaborate and important of all his works. A conservative in lexicography, Worcester held closely to British usage.

WORCESTER, NOAH (*b. Hollis, N.H., 1758; d. Brighton, Mass., 1837*), Congregational and Unitarian clergyman. Brother of Samuel Worcester. Minister of the church at Thornton, N.H., 1787–1810. Editor, *Christian Disciple* (later *Christian Examiner*), 1813–18. His most important contribution was in the promotion of peace; he established and conducted *The Friend of Peace*, 1819–28, and wrote, among other works, *A Solemn Review of the Custom of War* (1814).

WORCESTER, SAMUEL (*b. Hollis, N.H., 1770; d. Brainerd, Tenn., 1821*), Congregational clergyman. Brother of Noah Worcester. Graduated Dartmouth, 1795. Pastor at Fitchburg, Mass., 1797–1802. An inflexible Hopkinsian Calvinist, he was dismissed from his pastorate and became pastor of Tabernacle Church, Salem, Mass., 1803. Involved in famous controversy with William Ellery Channing (1780–1842), 1815. Was a founder, 1810, and corresponding secretary of the American Board of Commissioners for Foreign Missions.

WORCESTER, SAMUEL AUSTIN (*b. Worcester, Mass., 1798; d. present Oklahoma, 1859*), Congregational clergyman. Nephew of Noah and Samuel Worcester, and of Samuel Austin. Graduated Andover Theological Seminary, 1823. Missionary to the Cherokee *post* 1825 in Tennessee and at New Echota, Ga.; translated portions of the Bible into Cherokee; and helped found the *Cherokee Phoenix*. Imprisoned by Georgia, 1831–33, for refusal to quit his mission. Began establishment of important Cherokee Park Hill Mission in Indian Territory, 1835; set up first printing press there. Urged adoption by Cherokee of written language invented by Sequoyah.

WORDEN, JOHN LORIMER (*b. Westchester Co., N.Y., 1818; d. Washington, D.C., 1897*), naval officer. Appointed midshipman, 1834. Commanded original *Monitor* in battle with CSS *Merri-*

mack, March 9, 1862, gaining national renown and promotion to captain, 1863. Commanded monitor *Montauk*, South Atlantic Blockading Squadron, October 1862–April 1863. Made rear admiral, 1872. Superintendent, U.S. Naval Academy, 1869–74, he commanded European Squadron, 1875–77. Retired, 1886.

WORK, HENRY CLAY (*b. Middletown, Conn., 1832, d. Hartford, Conn., 1884*), printer, songwriter. Wrote famous temperance song "Come Home, Father" in 1864; was author, among other Civil War songs, of "Kingdom Coming" (1861), "Babylon Is Fallen!" (1863), "Wake Nicodemus" (1864), and "Marching Through Georgia" (1865). Later, among many other successes, he composed "Grandfather's Clock."

WORK, HUBERT (*b. Marion Center, Pa., 1860; d. Denver, Colo., 1942*), physician, cabinet officer. M.D., University of Pennsylvania, 1885. Practiced in Greeley, Fort Morgan, and Pueblo, Colo. Active in Republican politics, and a member of the party's national committee, 1913–19, he was appointed first assistant postmaster general, 1921. In March 1922, he became postmaster general and instituted more-efficient management methods. Inheriting a department under attack as both corrupt and inefficient, when he took over as U.S. secretary of the interior in March 1923, he centralized its activities, brought in new employees from the business world, and served notice that he was fully in support of the conservation of all natural resources. He reorganized the Reclamation Service and made improvements in the Bureau of Indian Affairs, stressing benefits for the Indians and requesting a broad resurvey of federal Indian policy. He left the Interior Department in July 1928 to direct the successful presidential campaign of Herbert Hoover.

WORK, MILTON COOPER (*b. Philadelphia, Pa., 1864; d. 1934*), lawyer, auction and contract bridge expert. Abandoned Philadelphia law practice, 1917, for bridge lectures and demonstrations; associated with Wilbur C. Whitehead in radio bridge games, 1925–30, and as an editor, *Auction Bridge Magazine*. Developed "artificial two-club game-demand" bid. Author of *Auction Developments* (1913) and other books.

WORKMAN, FANNY BULLOCK (*b. Worcester, Mass., 1859; d. Cannes, France, 1925*), explorer. On expedition to the Himalayas and Karakoram (or Mustagh) Range, she achieved the women's world mountaineering record, 1906. Her books of geographical value include *Algerian Memories* (1895), *Sketches Awheel in Modern Iberia* (1897), *Peaks and Glaciers of Nun Kun* (1909), and *The Call of the Snowy Hispar* (1910).

WORMELEY, KATHARINE PRESCOTT (*b. Ipswich, England, 1830; d. Jackson, N.H., 1908*), author, translator, philanthropist. Sister of Mary E. W. Latimer. Came to America *ca.* 1848. Best known for translations of noted French writers, particularly *The Works of Balzac* (1899–); among her other translations are *Letters of Mlle. de Lespinasse* (1901) and Sainte-Beuve's *Portraits of the Eighteenth Century* (1905). Author of *The Other Side of War* (1889) and *Memoir of Honoré de Balzac* (1892).

WORMELEY, MARY ELIZABETH *See* LATIMER, MARY ELIZABETH WORMELEY.

WORMLEY, JAMES (*b. Washington, D.C., 1819; d. Boston, Mass., 1884*), hotel keeper. Of free black parentage. Steward for the Metropolitan Club, Washington, D.C., *post ca.* 1853, established Wormley's hotel and catering service in Washington *ca.* 1860; won national reputation for cuisine.

WORMLEY, THEODORE GEORGE (*b. Wormleysburg, Pa., 1826; d. 1897*), physician, toxicologist. M.D., Philadelphia College of Medicine, 1849. Professor of toxicology at Capitol University, Columbus, Ohio, 1852–63; at Starling Medical College, Columbus, 1852–77. Held chair of chemistry and toxicology, medical department, University of Pennsylvania *post* 1877. Author of *The Micro-chemistry of Poisons* (1867).

WORTH, JONATHAN (*b. Guilford Co., N.C., 1802; d. Raleigh, N.C., 1869*), lawyer, businessman, North Carolina official and legislator. Studied law under Archibald D. Murphey; began practice at Asheboro, N.C., 1824. In the North Carolina legislature, 1831, he protested nullification, but opposed the Jackson administration later and became a Whig; he opposed the secession movement in the legislature, 1860. Elected state treasurer, 1862, he served until 1865. As governor of North Carolina, 1865–68, he displayed tact and sound judgment. He supported President Johnson and ratification of the new state constitution submitted in 1866; he opposed ratification of the 14th Amendment.

WORTH, WILLIAM JENKINS (*b. Hudson, N.Y., 1794; d. Tex., 1849*), soldier. Commissioned first lieutenant, 23rd Infantry, March 1813, he became aide-de-camp to General Winfield Scott and was commended for bravery at the battles of Chippewa and Lundy's Lane. Remaining in the army after the War of 1812, he served in the artillery and in the Ordnance Department; he was commandant of cadets at West Point, 1820–28. As colonel of the 8th Infantry, he commanded in Florida against the Seminole, 1838, defeating them at the battle of Palaklaklaha. Ordered to join General Zachary Taylor in the Army of Occupation prior to the war with Mexico, he took part in a controversy over rank with General David E. Twiggs. A great part of the credit for victory at Monterey belongs to his successful storming of the heights. Receiving the brevet of major general, he joined General Winfield Scott's army and took part in all the engagements from Veracruz to Mexico City. Narrow and self-centered, he damaged his reputation subsequent to the victory by engaging in intrigues against General Scott who had been his benefactor.

WORTHEN, AMOS HENRY (*b. Bradford, Vt., 1813; d. 1888*), businessman, geologist. Appointed Illinois state geologist, 1858; published seven volumes of *Geological Survey of Illinois* (1866–90). Worthen was a pioneer in classification of the Lower Carboniferous strata.

WORTHEN, WILLIAM EZRA (*b. Amesbury, Mass., 1819; d. 1897*), civil engineer. Graduated Harvard, 1838. Assisted in water supply and hydraulic work in offices of the younger Loammi Baldwin and James B. Francis. Employed by George W. Whistler on Albany & West Stockbridge Railroad. Settled in New York, 1849, engaging in building and mill construction. Worthen was an expert on pumping machinery and drainage; he held many important consultative posts.

WORTHINGTON, HENRY ROSSITER (*b. New York, N.Y., 1817; d. 1880*), hydraulic engineer, inventor. Patented improvements in canal-boat navigation and pumping engines. First proposer and constructor of the direct steam pump, he perfected an ingenious, widely used duplex steam feed pump, 1859, and built the first waterworks engine of this kind, 1860. He also developed a pumping engine that needed no flywheel to carry the piston past the dead point at the end of a stroke.

WORTHINGTON, JOHN (*b. Springfield, Mass., 1719; d. 1800*), lawyer, politician. Father-in-law of Jonathan Bliss and Fisher Ames. For many years king's attorney in western Massachusetts, he was a noted land speculator and was responsible for settlement of Worthington, Mass., 1768. Political dictator of Springfield, Mass., he was its representative in the Massachusetts General

Court almost continuously, 1747–74; his conservatism then ended his influence in colony affairs.

WORTHINGTON, THOMAS (*b. near Charleston, Va., now W. Va., 1773; d. New York, N.Y., 1827*), surveyor, Ohio legislator. Brother-in-law of Edward Tiffin. A leader of the "Chillicothe Junto," which secured Ohio's statehood and the triumph of Jeffersonianism there. U.S. senator from Ohio, 1803–07 and 1811–14, he was influential in matters concerning public lands and the Indian frontier. As governor of Ohio, 1814–18, he suggested social reforms and was responsible for founding the state library.

WOVOKA (*b. near Walker Lake, Nev. ca. 1856; d. 1932*), Indian mystic. A Paiute, he founded the Ghost Dance religion, which swept the Indian country and became important to the white man's political economy during the Messiah agitation of 1890.

WOYTINSKY, WLADIMIR SAVELIEVICH (*b. St. Petersburg, Russia, 1885; d. Washington D.C., 1960*), statistician, economist, public official. Studied at the University of St. Petersburg (1904–08). In 1917 he and his wife Emma fled to Tiflis, Georgia, because of conflicts with the Bolshevik regime. Moved to Berlin, Germany, in 1922, where Woytinsky wrote *Die Welt in Zahlen* (1924–28), a seven-volume set of statistics on the world. As a statistician for German labor unions, he was forced to flee with the rise of Hitler. Immigrated in 1935 to the United States, where he worked for the Central Statistical Board in Washington; also researched for the Social Security Board. His idea of a pay-as-you-go basis for social security was adopted by the government. From 1947 the Woytinskys did research for the Twentieth Century Fund in New York City.

WRAGG, WILLIAM (*b. probably Charlestown, S.C., 1714; d. off coast of the Netherlands, 1777*), lawyer, planter, South Carolina public official. Father-in-law of John Mathews and William L. Smith. Inheritor of the Wragg barony, he was a Loyalist leader; as a member of the South Carolina Assembly, 1763–68; he alone voted against approving action of Stamp Act Congress, 1766. He was a nonsubscriber to the nonimportation agreement, 1769. Banished from the colony, 1777.

WRATHER, WILLIAM EMBRY (*b. Meade County, Ky., 1883; d. Washington, D.C., 1963*), petroleum geologist and federal official. Attended University of Chicago (Ph.D., 1908). Worked for Gulf Oil until 1916, when he became an independent consultant, entering into a partnership with Michael Benedum, a wildcatter, that led to the discovery of the Desdemona field (1918) and the Nigger Creek field (1926). His consulting work was largely the valuation of oil properties for the Internal Revenue Service and investors. He supported the running of each field as a unit to maximize its producing life, contrary to the wasteful practice of the time. Founder (1916) and president (1922–23) of the American Association of Petroleum Geologists and president of the Society of Economic Geologists (1934) and American Institute of Mining and Metallurgical Engineers (1948). Director of the U.S. Geological Survey (1943–56).

WRAXALL, PETER (*b. probably Bristol, England, date unknown; d. New York, N.Y., 1759*), soldier. Came to New York *ante* 1746. Secretary for Indian affairs, New York province, *post* 1752; aide to Sir William Johnson. Author of an outstanding survey of the Indian question, 1755–56 (published in E. B. O'Callaghan, *Documents Relative . . . State of New York*, Vol. 7, 1856).

WRIGHT, BENJAMIN (*b. Wethersfield, Conn., 1770; d. New York, N.Y., 1842*), surveyor, engineer, New York legislator. Senior engineer of the Erie Canal, Wright was in charge of construction of the canal's middle section *post* 1816, and later of its eastern division as well. An able executive, he gathered around him such associates as Canvass White, John B. Jervis, and Nathan S. Roberts. Resigning as the Erie's chief engineer, 1827, Wright was chief engineer of the Chesapeake & Ohio Canal, 1828–31, and of the St. Lawrence Canal, 1833. He was consulting engineer on a number of other canal and railroad projects.

WRIGHT, CARROLL DAVIDSON (*b. Dunbarton, N.H., 1840; d. Worcester, Mass., 1909*), statistician, social economist, public official, Massachusetts legislator. Chief, Massachusetts Bureau of Statistics of Labor, 1873–88. Organized National Convention of Chiefs and Commissioners of Bureaus of Statistics of Labor, 1883; served as president for practically 20 years. First commissioner, U.S. Bureau of Labor, 1885–1905. Chairman, Pullman strike commission, 1894; recorder, anthracite strike commission, 1902. He was also honorary professor of social economics, Catholic University, Washington, D.C., 1895–1904; professor of statistics and social economics, Columbian (later George Washington) University, *post* 1900. Wright was president of the American Statistical Association from 1897 until his death. In 1902 he was chosen first president of Clark College, Worcester, Mass. Author of, among other publications, *The Relation of Political Economy to the Labor Question* (1882) and *The Industrial Evolution of the United States* (1895).

WRIGHT, CHARLES (*b. Wethersfield, Conn., 1811; d. Wethersfield, 1885*), surveyor, teacher, botanical explorer. Graduated Yale, 1835. Initiated important correspondence with Asa Gray of Harvard, 1844, to whom he supplied specimens from the Southwest. Explored and collected in eastern Texas, 1837–45; from San Antonio to El Paso, 1849; in New Mexico and Arizona, 1851–52; and in Cuba, 1856–67. Discovered many new species, described in Gray's "Plantae Wrightianae," and in *Botany of the Mexican Boundary Survey* (1859) and in other works. As botanist, North Pacific Exploring and Surveying Expedition, 1853–56, he made notable collections in China and Japan.

WRIGHT, CHARLES BARSTOW (*b. Wysox, Pa., 1822; d. Philadelphia, Pa., 1898*), financier. Prospered in real estate transactions in neighborhood of Chicago, Ill., 1843–46, and in Philadelphia banking thereafter. Entered directorship, Northern Pacific Railroad, 1870, and was a principal factor in its completion and eventual success. He served as its president, 1874–79.

WRIGHT, CHAUNCEY (*b. Northampton, Mass., 1830; d. 1875*), mathematician, philosopher. Graduated Harvard, 1852. Recording secretary, American Academy of Arts and Sciences, 1863–70. Began publication of a notable series of philosophical essays in the *North American Review*, 1864. Commended by Darwin for essays on arrangements of leaves in plants and genesis of species. A thoroughgoing naturalist, Wright dealt in his most valuable article, "Evolution of Self-Consciousness," with an instrumentalist conception of mental activities which anticipated later trends in thought. He was among the first to introduce methods of British empiricism to America.

WRIGHT, ELIZUR (*b. South Canaan, Conn., 1804; d. 1885*), reformer, actuary. Raised in Tallmadge, Ohio. Graduated Yale, 1826. While a professor at the Western Reserve College, he was enlisted in the antislavery cause by Theodore Weld and served *post* 1833 as secretary of the American Anti-Slavery Society. Resigning in 1839, he became editor of the *Massachusetts Abolitionist*, organ of the conservative opponents of William L. Garrison, but was soon dropped. Unsuccessful in several further attempts as editor of reforming journals, he became widely known as a critic of the financial methods of life insurance companies. Tables published by him enabled life insurance com-

panies for the first time to formulate reserve policies which would render them stable, Wright then lobbied, 1853–58, in the Massachusetts legislature for a law to force all companies doing business in that state to maintain adequate reserves; subsequent to its passage, he was appointed state commissioner of insurance to oversee the new law's enforcement. His efforts at that time and subsequently probably had more to do with the development of sound standards for life insurance than those of any other man in the history of the industry. Ousted from his office in 1866, he became an actuary for several companies, but continued his lobbying for sound insurance legislation and was active in other reform movements.

WRIGHT, FIELDING LEWIS (*b. Rolling Fork, Miss., 1895; d. Rolling Fork, Miss., 1956*), politician and lawyer. Studied at the University of Alabama (LL.B). Served in the Mississippi State Senate and legislature in 1928; elected lieutenant governor in 1943; became acting governor when Governor Thomas Bailey died in 1946; and won election to a full term in 1947. In the 1948 presidential campaign, he and J. Strom Thurmond formed the Dixiecrat party in opposition to the Truman Administration's civil rights platform. Wright ran for vice president, Thurmond for president; the Dixiecrats captured only thirty-nine electoral votes. Wright was defeated in a bid for the governorship in 1955.

WRIGHT, FRANCES (*b. Dundee, Scotland, 1795; d. 1852*), reformer, freethinker. Heiress to a large fortune, she early showed herself a difficult and rebellious child. At the age of 18 she wrote a work which contained in essence the materialistic philosophy that she followed throughout life, *A Few Days in Athens* (1822). Immigrating to New York City, 1818, she made a tour of the northern and eastern states; on her return to England in 1820 she composed her *Views of Society and Manners in America* (1821) which expressed an appreciation of America unusual at that time among Europeans. Returning to the United States, 1824, in company with the Marquis de Lafayette, she visited Thomas Jefferson and James Madison and won their approval for a plan of emancipation for black slaves which she had devised. Investing a large amount of her money in a tract in western Tennessee which she called Nashoba, she attempted to give a practical demonstration of her emancipation theory. Socialist associates within the colony, however, introduced the idea of free love, a point of view which public opinion attached wrongfully to Fanny Wright herself. Coeditor with Robert D. Owen of the *New Harmony Gazette*, she further shocked public sensibilities by appearing as a lecturer in public, attacking religion, the existing system of education, the subjugation of women, and the current state of marriage. In 1829 she settled in New York City, where she published the *Free Enquirer*, also in association with Robert D. Owen. After traveling abroad *ca.* 1830–35, she returned to the United States and continued her writing and lecturing, taking up such causes as birth control and the more equal distribution of property. During her last years, she gave a great deal of time to propaganda for the abolition of the banking system. Frances Wright's fearlessness and initiative contributed to the emancipation of women, although her influence was exerted more by her example than by her doctrines.

WRIGHT, FRANK LLOYD (*b. Richland Center, Wis., 1867; d. Phoenix, Ariz., 1959*), architect. Studied at the University of Wisconsin. Acknowledged widely as one of history's most original, influential, and prolific architects, Wright was never formally trained in his art. From 1888 to 1893 worked as chief assistant to Louis H. Sullivan, the prominent, Chicago-based architect. Wright then became the leader of a group of local architects known as the Prairie School. It was during this period that he developed the principles that were to rule his work. The essence

of these he called organic architecture, a concept of linking people to their surroundings, both natural and man-made, that, he felt, would lead to a democratic organic society. To achieve this, building materials should be used deliberately to show their character and methods of handling. Wright emphasized what he called plasticity, the potential of surfaces of materials — their textures and coloring used as ornamentation — which then are manipulated to mold space, not confine it. Such space was to flow in a continuous, organized way, and became the chief instrument of Wright's art. Of the over 1,000 works designed by Wright, some 400 were constructed.

WRIGHT, GEORGE (*b. New York, N.Y., 1847; d. Boston, Mass., 1937*), professional baseball player, sportsman, merchant. Brother of Henry Wright (1835–95). While shortstop of the Cincinnati Red Stockings, baseball's first professional team, 1869–71, he became the game's first home-run king, making 59 home runs in 52 games in 1869. He later played with Boston of the National League and with Providence. In 1871 he opened a Boston sporting goods store which became Wright & Ditson; he introduced the game of golf in Boston, 1890.

WRIGHT, GEORGE FREDERICK (*b. Whitehall, N.Y., 1838; d. 1921*), geologist, Congregational clergyman. Graduated Oberlin, 1859; Oberlin Theological Seminary, 1862. Held Vermont and Massachusetts pastorates, 1862–81. Presented theory of glacial origin of New England gravel ridges, 1875 and 1876. An expert in glacial geology, he made the first scientific study of Muir Glacier, Alaska, 1886. Professor New Testament language and literature at Oberlin, 1881–92; held chair of harmony of science and religion there, 1892–1907. Editor, *Bibliotheca Sacra*, 1883–1921. Author of, among other works, *The Ice Age in North America* (1889).

WRIGHT, GEORGE GROVER (*b. Bloomington, Ind., 1820; d. 1896*), jurist. Brother of Joseph A. Wright. Chief justice, Iowa Supreme Court, 1855–70. Rigorous in basing decisions on principles, he was a dominant influence on the new state's jurisprudence and formulated Iowa interpretations of domestic relations, libel, contracts, and procedure. As U.S. senator from Iowa, 1871–77, he favored "soft" money and opposed the liquor traffic.

WRIGHT, HAMILTON KEMP (*b. Cleveland, Ohio, 1867; d. Washington, D.C., 1917*), medical scientist. Graduated in medicine, McGill University, Canada, 1895. Worked in neuropathology at Cambridge University; studied at Heidelberg and other continental universities, 1897–98. Established and directed Kuala Lumpur beriberi research laboratory, Straits Settlements, 1899–1903; materially advanced knowledge of beriberi and concluded food was an agent in its transmission. Engaged in research at Johns Hopkins and at various places in the United States and Europe, 1903–08. Appointed to International Opium Commission, 1908; chairman of American delegation, International Opium Conferences, The Hague, 1911 and 1913; was instrumental in preparation of the Harrison Narcotic Law and other federal legislation for drug control.

WRIGHT, HAROLD BELL (*b. near Rome, N.Y., 1872; d. La Jolla, Calif., 1944*), novelist. A minister of the Christian Church (Disciples), 1897–1908, he devoted full time thereafter to writing novels in the hope that he might thereby impress a wider public with his message of simple living according to Christian principles. The 19 books which he published during his lifetime sold more than 10 million copies, although they won no praise from literary critics. Among them were *That Printer of Udell's* (1903); *The Shepherd of the Hills* (1907); *The Calling of Dan Matthews* (1909); and *The Winning of Barbara Worth* (1911).

WRIGHT, HENDRICK BRADLEY (*b. Plymouth, Pa., 1808; d. 1881*), lawyer, Pennsylvania legislator. Chairman, Democratic National Convention, Baltimore, Md., 1844. Congressman, Democrat, from Pennsylvania, 1853–55, 1861–63, and 1877–81. Nominated by the Democrats in 1876 and 1878, his election was due largely to labor and Greenback support. His career was a triumph of demagoguery.

WRIGHT, HENRY (*b. Sheffield, England, 1835; d. Atlantic City, N.J., 1895*), professional baseball player. Came to America as an infant. Brother of George Wright. Organizer, manager, captain, and center fielder of the Cincinnati Red Stockings, first full professional baseball team, 1869–71. Managed National League teams of Boston, 1876–81; Philadelphia, 1884–93; and others.

WRIGHT, HENRY (*b. Lawrence, Kans., 1878; d. Newton, N.J., 1936*), architect, landscape designer, community planner. Raised in Kansas City, Mo. Graduated University of Pennsylvania, 1901. Associated for a number of years with George E. Kessler, a pupil of Frederick L. Olmsted, Wright entered practice for himself in 1909. Carrying on the Olmsted tradition, he designed a number of subdivisions in the St. Louis, Ohio, area showing characteristic sensitivity to community needs and the integration of all necessary private and civic facilities into an orderly pattern. He was coplanner for the New York City Housing Corporation in creating Sunnyside Gardens in Queens County *post* 1923. He introduced even more radical innovations in the design of Radburn, N.J., 1928–29, among them a park at the core of each superblock, forming a broad river of green flowing through the community. Probably the finest example of his art as site planner was the second part of Chatham Village, Pittsburgh, Pa. He was author of a classic document, *A Plan for the State of New York* (1926), the first report of its kind in the United States. *Post* 1923 he persistently attacked the sterile character of zoning, with its tendency toward segregation and architectural monotony.

WRIGHT, HORATIO GOUVERNEUR (*b. Clinton, Conn., 1820; d. Washington, D.C., 1899*), soldier, engineer. Graduated West Point, 1841. Chief engineer at Bull Run of General S. P. Heintzelman's division and later of the Port Royal expedition. Promoted brigadier general of volunteers, September 1861; led successful campaign in Florida, February 1862; appointed to command Department of the Ohio, August 1862. Heading the 1st Division of General John Sedwick's VI Corps after May 1863, he played an important part in the Mine Run campaign. Commissioned major general of volunteers, 1864, he took over the command of the VI Corps at Spotsylvania, fought the Wilderness campaign, and repelled Confederate General Jubal Early's raid on Washington, D.C., July 12, 1864. On Oct. 19, he commanded at Cedar Creek until General P. H. Sheridan's arrival on the field. Wright commanded the Department of Texas, 1865–66. *Post* 1866 he was engaged in important engineering projects, which included the Sutro Tunnel, Nevada, and the completion of the Washington Monument. Promoted through the grades to brigadier general, regular army, and chief of engineers, 1879, he retired, 1884.

WRIGHT, JAMES ARLINGTON (*b. Martins Ferry, Ohio, 1927; d. New York City, 1980*), poet. Graduated Kenyon College (1952), was a Fulbright Scholar at the University of Vienna, and did graduate studies at the University of Washington (M.A., 1954; Ph.D., 1959), under the tutelage of poet Theodore Roethke. He taught at Macalester College in St. Paul and the University of Minnesota before joining the faculty at Hunter College in New York City (1966–80). He gained national attention with his first volume of poetry, *The Green Wall* (1957). He employed carefully crafted traditional and formalistic styles with poems about grief, outcasts, and the downtrodden. *The Branch Will Not Break* (1963) marked a departure from traditional techniques, and deep-image poetry, or poems of emotive imagination, was his style for his next and last works. He received the Pulitzer Prize in 1972 for *Collected Poems* (1971); *This Journey* was published posthumously in 1982.

WRIGHT, JAMES LENDREW (*b. Co. Tyrone, Ireland, 1816; d. Germantown, Pa., 1893*), tailor, labor leader. Came to America as a boy. In 1862, with Uriah S. Stephens, organized the Garment Cutters' Association and served as its president. Wright was also treasurer and cofounder, 1863, of the Philadelphia Trades' Assembly. He was a founder, 1869, of the Noble Order of the Knights of Labor, whose name he devised and of which he was a leading functionary for over two decades.

WRIGHT, JOHN HENRY (*b. Urmia, Persia, 1852; d. Cambridge, Mass., 1908*), Hellenist. A.B., Dartmouth, 1873. Taught at Ohio State, Dartmouth, and Johns Hopkins. Professor of Greek at Harvard *post* 1887; dean, Harvard Graduate School *post* 1895. Editor in chief, *American Journal of Archaeology*, 1897–1906; coeditor, *Classical Review*, 1889–1906. Author of, among other works, *Herondaea* (1893) and *The Origin of Plato's Cave* (1906).

WRIGHT, JOHN JOSEPH (*b. Dorchester, Mass., 1909; d. Cambridge, Mass., 1979*), Roman Catholic cardinal and philosopher. Graduated Boston College (B.A., 1931), attended St. John's Seminary in Brighton, Mass. (S.T.L., 1932) and Pontifical Gregorian University in Rome, Italy (S.T.D., 1939), and was ordained a Roman Catholic priest (1935). He was a professor of philosophy at St. John's Seminary in Boston (1939–44), secretary to the archbishop of Boston (1943–47), auxiliary bishop of Boston (1947–50), bishop of Worcester, Mass. (1950–59), and bishop of Pittsburgh (1959–69); he was elevated to cardinal in 1969. He published *Words in Pain* (1961) and *The Christian and the Law* (1962). Contributed to *Dialogue for Reunion* (1962). His conservative campaign argued for renewed dedication of priests; he opposed liberalism within the church but remained committed to it outside the church, forging ecumenical bonds among Catholic, Jewish, and Protestant leaders, championing civil rights, and calling for a bombing halt during the Vietnam War.

WRIGHT, JOHN KENNETH LLOYD (*b. Oak Park, Ill., 1892; d. La Jolla, Calif., 1972*), architect. Worked with his father, Frank Lloyd Wright, between 1913 and 1917, but after a dispute over wages worked independently in Michigan City, Ind. He received some forty commissions between 1921 and 1947. Such 1930's designs as the House of Steel for Jack Burnham (1933) and the House of Tile for Lowell Jackson (1938) feature different materials in a modernist idiom. In 1947 he settled in Del Mar, Calif., where his work became more informal and more open to nature. Throughout his career he was considered to be in the forefront of modern architecture in the United States.

WRIGHT, JOHN STEPHEN (*b. Sheffield, Mass., 1815; d. Philadelphia, Pa., 1874*), promoter, journalist. Settled in Chicago, Ill., 1832, where he was successful as a real estate operator, 1834–36 and 1846–57. While owner and manager of the *Prairie Farmer*, 1843–57, he promoted western industry and the advantages of Illinois and Chicago in his own paper and in articles for eastern journals. In 1848 he lobbied for a Chicago–Gulf of Mexico railroad. A leader in Illinois education, he built Chicago's first public school building at his own expense, 1835.

WRIGHT, JONATHAN JASPER (*b. Luzerne Co., Pa., 1840; d. Charleston, S.C., 1885*), educator, South Carolina legislator, jurist. Attended Lancasterian University, Ithaca, N.Y.; was first black admitted to the Pennsylvania bar, 1866. Associate justice

of the South Carolina Supreme Court, 1870–77, he was a center of controversy in the South Carolina gubernatorial contest between D. H. Chamberlain and Wade Hampton, 1876.

WRIGHT, JOSEPH (*b. Bordentown, N.J., 1756; d. Philadelphia, Pa., 1793*), portrait painter, die-sinker. Son of Patience L. Wright, who taught him clay- and wax-modeling. Resident in London, England, *ca.* 1772–82, he studied painting with John Trumbull (1756–1843) and Benjamin West. By 1780 he was exhibiting at the Royal Academy, London. Returning to America, 1783, he worked in New York and Philadelphia, executing, among other works, portraits of George Washington, 1783, 1784, and an etching from a sketch in 1790. Appointed first draftsman and die-sinker, U.S. Mint, 1792, he probably designed the first U.S. coins and medals.

WRIGHT, JOSEPH ALBERT (*b. Washington, Pa., 1810; d. Berlin, Germany, 1867*), lawyer, Indiana legislator. Brother of George G. Wright. Congressman, Democrat, from Indiana, 1843–45; governor of Indiana, December 1849–January 1857; U.S. senator, February 1862–January 1863. U.S. minister to Prussia, 1857–61, and from 1865 until his death. Wright, as governor, directed most of his efforts to raising the standard of living and the educational level of Indiana farmers.

WRIGHT, JOSEPH JEFFERSON BURR (*b. Wilkes-Barre, Pa., 1801; d. Carlisle, Pa., 1878*), army medical officer. Appointed assistant surgeon, U.S. Army, 1833. In a long and varied career of field and staff duty, he was outstanding during the Mexican War. He retired as colonel, 1876.

WRIGHT, LUKE EDWARD (*b. Giles Co., Tenn., 1846; d. 1922*), Confederate soldier, Tennessee lawyer. Became vice-governor of the Philippines in 1901, governor in 1904, and governor general in 1905; a strong, competent executive. First U.S. ambassador to Japan, 1906, U.S. secretary of war, 1908–09, he was not retained in office by President W. H. Taft, a circumstance which is said to have contributed to the split between Taft and Theodore Roosevelt.

WRIGHT, MARCUS JOSEPH (*b. Purdy, Tenn., 1831; d. Washington, D.C., 1922*), lawyer, Confederate brigadier general. U.S. government agent for collection of Confederate archives, 1878–1917. Author of, among other works, *Tennessee in the War, 1861–1865* (1908) and *General Officers of the Confederate Army* (1911).

WRIGHT, ORVILLE (*b. Dayton, Ohio, 1871; d. Dayton, 1948*), inventor, pioneer in aviation. Brother of Wilbur Wright. It is impossible to consider the career of Orville Wright apart from that of his brother Wilbur, four years his senior. The gift by their father when they were children of a rubber-band-driven toy *hélicoptère* had stirred their curiosity about the dynamics of flight, but their mature attention was turned to the subject by the gliding successes of the German engineer Otto Lilienthal. They began with the problem of control in the air. Their control system was successfully tested in a small kite-glider in July 1899, and they decided to build a man-carrying glider the next year. As their test grounds they chose the sand dunes and beaches near Kitty Hawk, N.C., where they made thousands of experimental flights with a series of gliders. In 1901 they built a wind tunnel in order to verify and refine the ideas gained in practical gliding. From these data they build a vastly more efficient glider in 1902. The culmination of four and a half years of intensive thought and labor was attained on Dec. 17, 1903, at Kitty Hawk, when Orville made the powered flight of 120 feet.

Orville survived his brother almost 36 years. Until he sold the Wright Co. in 1915, he personally flew and tested improvements on all Wright planes. His last flight as pilot was made in 1918. From 1915 on, he spent much time in his Dayton laboratory. In World War I he was commissioned a major in the U.S. Army and did much work on aircraft design and development. He was director and engineer of the Dayton-Wright Co., connected with U.S. adoption of the British DH-4. For many years he served on the National Advisory Committee for Aeronautics.

WRIGHT, PATIENCE LOVELL (*b. Bordentown, N.J., 1725; d. London, England, 1786*), modeler in wax, Revolutionary spy. Mother of Joseph Wright. Well known in the colonies as a sculptor of wax portraits, she removed to London, *ca.* 1772, where she exhibited historical groups, busts, and life-size figures of contemporary notables and enjoyed success until her death. She sent information of English military plans to Benjamin Franklin at Passy.

WRIGHT, PHILIP GREEN (*b. Boston, Mass., 1861; d. 1934*), teacher, economist, poet. Grandson of Elizur Wright and Beriah Green. Graduated Tufts College, 1884; M.A., Harvard, 1887. Taught mathematics and other subjects, Lombard College, Illinois, 1892–1912; instructed in economics at Williams, 1912–13, and Harvard, 1913–17. On staff of Institute of Economics (later part of Brookings Institution), 1922–31. Author of, among others, important volumes on commercial policy and the tariff, and poems on labor.

WRIGHT, RICHARD NATHANIEL (*b. Roxie, Miss., 1908; d. Paris, France, 1960*), novelist. The son of a sharecropper, Wright received only a ninth grade education. Moved to Chicago in 1927, where he joined the John Reed Club and the Communist Party in 1932. After publishing poems in various magazines, including *Partisan Review*, Wright joined the Federal Writers' Project in 1935 and wrote his first novel, *Lawd Today* (not published until 1963). Moved to New York (1937) and helped edit the magazine *New Challenge* and was Harlem editor of the *Daily Worker*. Published *Uncle Tom's Children* (1938); *Native Son* (1940), which brought him an international reputation; and *Black Boy* (1945). In 1945 Wright traveled to Europe and became involved with the existentialist movement. Settled in France two years later. His final works include *Black Power* (1954), *White Man, Listen!* (1957), and the first novel in an unfinished trilogy, *The Long Dream* (1958). His excellent analysis of modern society and championship of Third World liberation ranks him in importance with Ralph Ellison and James Baldwin.

WRIGHT, RICHARD ROBERT (*b. near Dalton, Ga., 1853; d. Philadelphia, Pa., 1947*), educator, banker. Graduated Atlanta University, 1876. While principal of the elementary school in Cuthbert, Ga., where he had been a slave as a child, he organized farmers' cooperatives for the local black community; in 1878, he called a convention of black teachers and organized the Georgia State Teachers' Association, serving as its first president. In 1880, he established and headed the state's first public high school for blacks in Augusta. From 1891 to 1921, he was president of the State Industrial College in Savannah. Along with his academic duties, he was active in Republican politics up to about 1900 and in commercial dealings (especially Savannah real estate) until his retirement from the college. Removing to Philadelphia, Pa., he opened the Citizens and Southern Banking Co. (chartered in 1926 as the Citizens and Southern Bank and Trust Co.), which, at the time of his death, was regarded as a model of sound and prudent management.

WRIGHT, ROBERT (*b. Queen Annes Co., Md., 1752; d. Queen Annes Co., 1826*), lawyer, Revolutionary soldier, Maryland legislator. U.S. senator, Democratic-Republican, from Maryland,

1801–06; governor of Maryland, 1806–09. Congressman, 1810–17 and 1821–23, he was a member of the Judiciary Committee, 1815–17, and of the Foreign Affairs Committee, 1821–23. Judge of the lower Eastern Shore district court *post* 1823. A consistent supporter of administration policies.

WRIGHT, ROBERT WILLIAM (*b. Ludlow, Vt., 1816; d. Cleveland, Ohio, 1885*), editor, satirist, lawyer. Wright was editor of Democratic newspapers in Waterbury, Hartford, and New Haven, Conn.; New York City; and Richmond, Va., 1856–77. Author of, among other works, political verse satires, satires on local clerical squabbles, and *Life, Its True Genesis* (1880), an anti-Darwinian study.

WRIGHT, SILAS (*b. Amherst, Mass., 1795; d. Canton, N.Y., 1847*), lawyer, New York official, statesman. Graduated Middlebury College, 1815. Admitted to the bar, 1819, he began practice in Canton, N.Y. Throughout his life a nationalist and a Democrat, he served in the New York State Senate, 1824–27, and soon became a member of the directing group of New York Democrats known as the Albany Regency. A lifelong defender of popular rights, he yet held that the people needed the leadership of bosses and an honest use of the spoils system to obtain that strong party unity in which lay their hope in a battle against special privilege. As congressman from New York, 1827–29, he helped frame the Tariff of Abominations of 1828 and took a leading part in defending it; as comptroller of New York, 1829–33, he continued to oppose extension of the state canal system, except when expected revenues promised to reimburse the state. While U.S. senator from New York, 1833–44, he served on a number of important committees and came to hold high rank in the Senate for solid judgment and unselfish service. He was recognized as manager of his friend Martin Van Buren's political interests and employed on behalf of Van Buren his uncannily accurate sense of public opinion. Following Van Buren's election to the presidency, Wright served as chairman of the Senate Finance Committee, 1836–41. He opposed all measures for rechartering the Bank of the United States and opposed distribution of the federal surplus among the states. In the panic of 1837 he urged a complete divorce of federal finance from the banks and much stricter regulation of banking by the states; he also introduced the administration's relief bills and headed the fight for an independent U.S. treasury until victory in 1840. After the accession of President John Tyler, Wright urged a tax-and-pay policy, continuing to oppose distribution of public-land sales income and any increase in the tariff. In 1844 he campaigned for the nomination of Van Buren for the presidency, declining to be a candidate himself. As governor of New York, 1845–47, he acted with even-handed justice to all, thereby alienating all elements of the community; his suppression of violence during the antirent disturbances caused bitter popular feeling and his tax on rent income alienated the landlords. Renominated in 1846, he failed of re-election, but had the satisfaction of seeing many reforms which he had advocated incorporated in the new state constitution of 1846. Honesty, simplicity, and disinterestedness were his outstanding characteristics.

WRIGHT, THEODORE LYMAN (*b. Beloit, Wis., 1858; d. 1926*), teacher. Graduated Beloit College, 1880; M.A., Harvard, 1884; also attended American School of Classical Studies, Athens, 1887. Taught Greek literature and art at Beloit College *post* 1892; produced a series of the Greek dramas in English.

WRIGHT, THEODORE PAUL (*b. Galesburg, Ill., 1895; d. Ithaca, N.Y., 1970*), aeronautical engineer and administrator. Studied at Lombard College (B.S., 1915) and the Massachusetts Institute of Technology (B.S., 1918). While in the navy (1917–21), he worked as a naval aircraft inspector. In 1921 he joined the Curtiss Aeroplane and Motor Company as an engineer; he became chief engineer of the airplane division in 1925. With the formation of the Curtiss-Wright Corporation in 1928, he rose to become vice president and director of engineering in 1937. Wright supervised the design and production of numerous military and commercial aircraft, including the Hawk, Helldiver, Condor, C-46, and Tanager. He joined the National Defense Advisory Commission (1940), became assistant chief of the aircraft section in the Office of Production Management (1941), and served as chairman of the Joint Aircraft Committee, director of the Aircraft Resources Control Office, and member of the Aircraft Production Board of the War Production Board. He was administrator of the Civil Aeronautics Administration (1944–48). In 1948 Wright became vice president for research of Cornell University and president of the Cornell Aeronautical Laboratory. In 1950 he became chairman of the Cornell-Guggenheim Aviation Safety Center. He retired in 1960.

WRIGHT, WILBUR (*b. Millville, near New Castle, Ind., 1867; d. 1912*), aviation pioneer. Wilbur and his brother Orville (born at Dayton, Ohio, 1871) were inseparable partners throughout their lives. As youths, they earned pocket money by selling home-made mechanical toys, later issuing the weekly *West Side News* in Dayton, of which Wilbur was editor. He also wrote on occasion for the *Religious Telescope*, of which his father was editor. Wilbur was the more scholarly and exact-minded of the brothers; Orville was quicker with suggestions, but was inclined to dream. They formed the Wright Cycle Co. *ca.* 1892 and built the "Van Cleve" bicycle, which soon achieved a reputation.

They began thinking about the possibility of flight in 1896, stimulated by the work and writings of Otto Lilienthal, Octave Chanute, S. P. Langley, and other experimenters and theorists. Planning to work on a captive man-carrying glider, they first experimented with kites; in 1899 Wilbur Wright built a model biplane with a wingspread of five feet, which he flew as a kite. From this and other experiments, considerable study of theory, and advice from Chanute, they produced their first glider. Air resistance was reduced by placing the operator in a horizontal position; a front surface gave longitudinal stability and control; lateral balance was obtained by warping the wing extremities to decrease lift on either side, thus supplying a rolling moment at the will of the pilot. Vertical steering was not provided for in the first glider, but the Wrights understood its functions and provided it in their second machine, 1902.

With the advice of the U.S. Weather Bureau, the brothers selected for trial of their glider a strip of sand called Kill Devil Hill, near Kitty Hawk, N.C., and set up camp there in September 1900. Failing in efforts to fly the glider as a kite, they turned to free gliding and were soon operating safely under perfect control in winds of 27 miles per hours, making glides of more than 300 feet. They kept careful tabulation of their findings and concluded that a vertical steering rudder was essential; that the warping of the wing extremities could be relied on for lateral control; that the movement of the center of pressure on a curved wing produced instability; and that calculations based on existing data were in error. It was plain that they would have to find their own correct basic data.

They returned to Dayton, where Orville devised a wind tunnel for further lengthy experiments, testing over 200 wing and biplane combinations to determine accurate values for lift, drag, and center of pressure. In 1902 at Kitty Hawk, they made nearly 1,000 glides in a new glider based on their latest data, and confirmed the accuracy of their findings. They then built a powered machine weighing 750 pounds fully loaded, capable of a 31 mile speed, and with a four-cylinder, twelve horsepower motor they had made. In this new machine on Dec. 17, 1903, Orville made

the first powered flight, which lasted only 12 seconds. Several hours later Wilbur made a flight of 51 seconds, but the machine, forced down by a sudden gust, was so damaged that further flights were impossible.

Despite this serious loss, the Wright brothers built a stronger machine, and on Oct. 5, 1905, at Huffman Field, Dayton, during a 24-mile circuit flight, they solved the equilibrium problem in turning.

Thereafter, despite lack of public encouragement, they abandoned other interests and devoted themselves to constructing a practicable machine. They obtained a patent for a flying machine in 1906. Only after successful negotiations had been conducted with foreign interests did the American government awake to the value of the new device. In late 1907 General James Allen, chief U.S. Army signal officer, opened bids for a "gasless flying machine" to carry two men weighing 350 pounds, with sufficient fuel for 125 miles. The Wrights offered to build a biplane and instruct two operators for $25,000; other bids were accepted, but the Wrights alone completed the contract. Meanwhile, they made highly publicized successful trial flights at Kitty Hawk. Orville, demonstrating the contract plane at Fort Myer, Va. (Sept. 9, 1908), made 57 complete circles at 120-feet altitude, remaining aloft 62 minutes, thus establishing several records simultaneously. On Sept. 17 occurred the most serious accident in the brothers' career, which had been singularly free of them. A stray wire tangled with a propeller blade, and the machine crashed. Orville suffered a fractured thigh and two ribs, and his passenger, Lt. Thomas E. Selfridge, was killed. Fully recovered, Orville completed the official tests eight months later. Meanwhile, in France, Wilbur had been flying at the Hunandrières race course so successfully that he concluded satisfactory arrangements with a French syndicate to manufacture his machine in France. During the 1909 Hudson-Fulton celebration at New York, he made demonstration flights from Governor's Island, around the Statue of Liberty, and up to Grant's Tomb. This led to formation of the American Wright Co., and subsequent negotiations were concluded providing for manufacture of airplanes in England, Germany, Italy, and America.

WRIGHT, WILLARD HUNTINGTON (*b. Charlottesville, Va., 1888; d. New York, N.Y., 1939*), art critic, detective-story writer under pseudonym "S. S. Van Dine." Creator of the fictional detective Philo Vance, whose ostentatiously displayed erudition lent contemporary interest to such books as *The Benson Murder Case* (1926), *The Canary Murder Case* (1927), *The Greene Murder Case* (1928), and others.

WRIGHT, WILLIAM (*b. near Nyack, N.Y., 1794; d. Newark, N.J., 1866*), manufacturer. Cofounder of the saddlery firm of Smith & Wright, Newark, N.J. Mayor of Newark, 1840–43. Congressman, Whig, from New Jersey, 1843–47; U.S. senator, Democrat, 1853–59 and *post* 1863. Chairman, Senate Committee on Manufactures.

WRIGHT, WILLIAM (*b. Ohio, 1829; d. West Lafayette, Iowa, 1898*), journalist, better known under pseudonym "Dan De Quille." Began journalistic career in Iowa; prospected in California and Nevada, 1857–61. Becoming city editor of the Virginia City, Nev. *Daily Territorial Enterprise*, 1861, he held this post for practically the remainder of his life and lived to see the city dwindle into a ghost town and his newspaper cease publication. Mark Twain, his associate on the newspaper in 1862, was his lifelong friend and encouraged Wright to publish his *History of the Big Bonanza* (1877). Late in life, sick and without occupation, he was befriended and helped by John W. Mackay.

WRIGLEY, PHILIP KNIGHT (*b. Chicago, Ill., 1894; d. Elkhorn, Wis., 1977*), businessman and baseball executive. Attended Yale and Stanford universities and joined the family chewing gum company, establishing a gum factory in Melbourne, Australia; he became vice-president (1920), president (1925–61), and chairman (1961–77) of Wrigley Company. In 1934 he became sole owner and president of the Chicago National League Ball Club (Chicago Cubs).

WRIGLEY, WILLIAM (*b. Philadelphia, Pa., 1861; d. Phoenix, Ariz., 1932*), chewing gum manufacturer. A gifted salesman and organizer, Wrigley developed a multimillion-dollar chewing gum business out of a small concern for the manufacture of soap which he started in Chicago, Ill., 1891. After becoming wealthy, he bought a controlling interest in the Chicago National League baseball club and other clubs and was the developer of Santa Catalina Island, off the California coast.

WROSETASATOW *See* OUTACITY.

WU P'AN-CHAO *See* NG, POON CHEW.

WURTZ, HENRY (*b. Easton, Pa., ca. 1828; d. Brooklyn, N.Y., 1910*), chemist, editor. After graduation from College of New Jersey (Princeton), 1848, Wurtz studied chemistry at Lawrence Scientific School, Harvard, and conducted mineral analyses in New York laboratory of Dr. Oliver W. Gibbs. State chemist and geologist, New Jersey geological survey, 1854–56. Conducted research on sodium amalgams for extracting precious metals from their ores, securing patent, 1865. Edited *American Gas Light Journal*, 1868–71. Devised new method of manufacturing fuel gas by alternating action of air and steam upon cheap coal, 1869; took out a number of patents relating to distillation of paraffin hydrocarbons and other chemical products.

WYANT, ALEXANDER HELWIG (*b. Evans Creek, Ohio, 1836; d. New York, N.Y., 1892*), landscape painter. Wyant was an outstanding master of American landscape painting during the latter half of the 19th century. Encouraged by George Inness, 1857, and with the assistance of the elder Nicholas Longworth, he studied in New York and briefly in Germany. He was elected member of the National Academy, 1869, for his *The Upper Susquehanna*. Wyant's early painting is characterized by a photographic fidelity to nature; his middle period is dominated by the environment of the mountains of New York State. His pictures have a thematic conception, an organized unity, and a universal appeal. Mood is transcendent; composition is simple. The rhythmic action is rendered by movement of light and dark sequences related to a fixed point of focal concentration. As a pure naturalist he is unsurpassed; as a poetic tonalist he was master of aerial perspective and atmospheric envelopment. Among his paintings are *The Mohawk Valley* (1866), *An Old Clearing* (1881), *Passing Clouds*, and *Landscape in the Adirondacks*.

WYATT, FRANCIS (*b. Kent, England, 1588; d. Kent, 1644*), baronet. A connection by marriage of Sir Edwin Sandys who gained control of the London Co. in 1619, Wyatt had invested in the company and was designated governor of Virginia, arriving there in October 1621. Forced by the weakness of the London Co. to abandon the prospect of building Virginia into a prosperous community which would serve the ends of mercantilist policy, he rallied the planters and settlers to demand preservation of their liberties after the dissolution of the company in 1624. Continuing in office as the first royal governor of Virginia, he summoned the famous "Convention Assembly" of 1625, which pressed petitions on the home government for the continuation of the liberty of general assembly in the colony. He gave up the governorship in 1626, but succeeded Sir John Harvey as governor

again in 1639. On his return to Virginia he was able to announce that the liberty of general assembly, so long desired, had been confirmed by the royal authority. He was replaced by Sir William Berkeley in 1641.

WYCKOFF, JOHN HENRY (*b.* Tindivanam, East Madras, India, *1881; d.* New York, N.Y., *1937*), physician, medical educator. M.D., Bellevue Hospital Medical College, 1907. After service in the cardiac clinic at Bellevue and military service in World War I, he returned to the clinic *ca.* 1919. In 1927 he was appointed director of the division of Bellevue under supervision of New York College with title of associate professor of medicine. In 1932 he became dean of the University of Medicine and professor. A pioneer in the use of digitalis in the United States, he helped to develop the practice of multiple diagnosis (anatomical, pathological, clinical, etc.) in treating cases of heart disease. He played a leading role in formation of the New York Heart Association.

WYCKOFF, WALTER AUGUSTUS (*b.* Mainpuri, India, *1865; d.* 1908), author, sociologist. B.A., College of New Jersey (Princeton), 1888. Assistant professor of political economy at Princeton *post* 1898. Author of *The Workers: An Experiment in Reality—The East* (1897) and a second part, *The West* (1898).

WYETH, JOHN (*b.* Cambridge, Mass., *1770; d.* Philadelphia, Pa., *1858*), editor, publisher. Cofounder and editor, *Oracle of Dauphin County & Harrisburg* (Pa.) *Advertiser*, 1792–1827, during which time he established a bookstore and general publishing house. Served as first postmaster of Harrisburg, 1793–98, and was active in Harrisburg public affairs.

WYETH, JOHN ALLAN (*b.* Marshall Co., Ala., *1845; d.* 1922), surgeon, medical educator. Graduated medical department, University of Louisville, 1869; M.D., Bellevue Medical School, 1873. Instrumental in organizing New York Polyclinic Hospital and Medical School, 1881, serving as surgeon in chief and subsequently as president until his death. Devised new surgical procedures, including ligation of the external carotid artery and "Wyeth's operation." Author of *A Textbook on Surgery* (1887).

WYETH, NATHANIEL JARVIS (*b.* Cambridge, Mass., *1802; d.* 1856), trader, explorer. Nephew of John Wyeth. Successful with Frederic Tudor in building an important trade in ice to the West Indies, Wyeth is remembered particularly for his attempt to plant an American commercial and agricultural colony in Oregon. Inspired by Hall J. Kelley, Wyeth made his first overland journey to Oregon, 1832–33; nothing concrete resulted from it. Organizing a company for salmon-packing on the lower Columbia and for fur-trading, Wyeth and a party traveled overland again to Oregon in 1834. He was accompanied by Thomas Nuttall and John K. Townsend, the latter of whom published *a Narrative of a Journey Across the Rocky Mountains to the Columbia River* (1839), descriptive of the trip. Wyeth built a small fort named Fort William at the mouth of the Willamette; in present Idaho he built Fort Hall, which became a famous station on the Oregon and California trial. Failing to make progress against the competition of the Hudson's Bay Co., Wyeth returned to the ice business. Although unsuccessful in his primary aim, he succeeded in familiarizing important sections of the eastern population with the facts about Oregon.

WYETH, NEWELL CONVERS (*b.* Needham, Mass., *1882; d. near* Chadds Ford, Pa., *1945*), painter and illustrator. After studying art at the Mechanic Art High School in Boston, he continued his education at the Massachusetts Normal Art School and the Eric Pape School of Art in Boston, and studied with Charles W. Reed. In 1902 Wyeth went to Wilmington, Del., to join the small art school conducted by the famous illustrator Howard Pyle. Winters were spent in the Wilmington studio, summers at nearby Chadds Ford, Pa., in the Brandywine Valley.

In 1904 Wyeth took his small savings and journeyed to a Colorado ranch, where he sketched cowboys, cattle, and the new landscape. When his money was stolen, he got a job as a government mail rider and traveled south to New Mexico. Soon he began to receive commissions from publishing houses for book illustrations, the first of which were published in 1906. Of Wyeth's five children, three became artists; Henriette Zirngiebel (born in 1907), Carolyn Brenneman (1909), and Andrew (1917). Both the coast and the people of Maine became subjects for Wyeth's imagination. The death of a fisherman friend inspired his famous *Island Funeral* and his illustrations for Kenneth Roberts' *Trending into Maine* (1938) were based on a rich store of experience. Of his book illustrations, his work for children reached the widest audience. Beginning in 1911 with Robert Louis Stevenson's *Treasure Island*, he illustrated 18 volumes in Scribner's Illustrated Classics series.

After accepting an initial invitation to paint a mural for a hotel in Utica, N.Y., he went on to paint many others in various parts of the United States. Only during the last two decades of his life did Wyeth find the time to turn to easel painting of his own. His several hundred still lifes, portraits, studies, and landscapes were not well known until after his death. From his son-in-law Peter Hurd he learned to work in egg tempera, and he spent increasing amounts of time with this medium. Wyeth was a member of the National Academy of Design and the Society of Illustrators. He received the gold medal at the Panama-Pacific Exposition in San Francisco, 1915, and the W. A. Clarke Prize of the Corcoran Gallery in Washington, D.C., 1932.

WYLIE, ANDREW (*b.* Washington, Pa., *1789; d. 1851*), educator, Episcopal clergyman, author. Graduated Jefferson College, Pennsylvania, 1810. President, Washington College, 1816–28. First president, Indiana College (later University), 1828 until his death. Introduced "specialization by rotation," or study and mastery of one subject at a time. Also served at Indiana as professor of moral and mental philosophy, political economy, and polite literature.

WYLIE, ELINOR MORTON HOYT (*b.* Somerville, N.J., *1885; d.* New York, N.Y., *1928*), poet, novelist. Great-granddaughter of Morton McMichael; granddaughter of Henry M. Hoyt. A lyric poet of distinction and a writer of novels outstanding for their mannered style and high comic conception, Wylie was remarkable throughout her life for an obsession with the memory and personality of the English poet Percy B. Shelley. Her volumes of poetry included *Incidental Numbers* (1912); *Nets to Catch the Wind* (1921); *Black Armour* (1923); and *Angels and Earthly Creatures* (1929). Her novels included *Jennifer Lorn* (1923); *The Venetian Glass Nephew* (1925); *The Orphan Angel* (1926), a fantasy about Shelley; and *Mr. Hodge and Mr. Hazard* (1928).

WYLIE, PHILIP GORDON (*b.* Beverly, Mass., *1902; d.* Miami, Fla., *1971*), author. Attended Princeton University (1920–23) and joined the staff of the *New Yorker* (1924–27). His early novels, including *Heavy Laden* (1928), *Babes and Sucklings* (1929), and *Gladiator* (1930), are laced with autobiographical sequences, as is *Finnley Wren* (1934), a brilliant analysis of human hypocrisy. His most influential work, *Generation of Vipers* (1942), is a fire-and-brimstone sermon in novel form. Wylie also wrote science fiction, including *When Worlds Collide* (1933), which came from a collaboration with Edwin Balmer. He was an early conservationist; his writing on the subject culminated in *The Magic Animal* (1968).

WYLIE, ROBERT (*b. Douglas, Isle of Man, England, 1839; d. Pont-Aven, France, 1877*), landscape and genre painter. Came to America as a child. Studied at the Pennsylvania Academy, Philadelphia; resided in France *post ca.* 1864, where he was a pupil in Paris of J. L. Gérôme, Thomas Couture, and others. Among the first American artists to discover Brittany and Breton life as subjects, he was largely responsible for the popularity of that region among French artists as well as fellow Americans. An excellent draftsman and a sober colorist, he produced comparatively few works.

WYLIE, SAMUEL BROWN (*b. Moylarg, Ireland, 1773; d. 1852*), educator, Reformed Presbyterian clergyman. M.A., University of Glasgow, 1797. Immigrated to Philadelphia, Pa., 1797. Presumably the first Covenanter to receive American ordination, 1800, he was pastor and cofounder of the Philadelphia congregation, which he served *post* 1803. Professor of Latin and Greek, University of Pennsylvania, 1828–45; vice-provost, 1836–45.

WYLLYS, GEORGE (*b. Hartford, Conn., 1710; d. Hartford, 1796*), Connecticut official. Secretary, colony of Connecticut, pro tempore 1730–34, and in full tenure from 1734 until death. Town clerk of Hartford *post* 1732.

WYMAN, HORACE (*b. Woburn, Mass., 1827; d. Princeton, Mass., 1915*), machinist, inventor. Superintendent of George Crompton's loom works *post ca.* 1861; vice president and consulting engineer, Crompton & Knowles Loom Works, Worcester, Mass., from 1897 until his death. Took out over 200 patents for improvement in process and mechanism of looms and other textile machinery. Among his inventions are a loom-box operating mechanism, 1871; a pile-fabric loom, 1872; processes for fabric weaving in different sizes and colors; the first American "dobby" loom, 1879; and the weft replenishing loom with drop shuttle boxes, 1901.

WYMAN, JEFFRIES (*b. Chelmsford, Mass., 1814; d. Bethlehem, N.H., 1874*), anatomist, ethnologist. Brother of Morrill Wyman. Graduated Harvard, 1833; M.D., 1837. Made curator and lecturer, Lowell Institute, 1840. Became professor of anatomy and physiology, Hampden-Sydney College medical school, Richmond, Va., 1843. Appointed Hersey professor of anatomy, Harvard, 1847. Built up anatomical museum at Harvard, nucleus of present Peabody Museum. Made collecting expeditions to Florida, 1851–52; Surinam, 1856; and South America, 1858. Became curator of department and museum of archaeology and ethnology at Harvard, 1866. President, Boston Society of Natural History, 1856–70. Wyman's most important papers deal with the structure of the gorilla. His monograph on the nervous system of the frog (published by the Smithsonian Institution in 1852–53) and papers on the anatomy of the blind fish of Mammoth Cave (published in the *American Journal of Science* between 1843 and 1854) are also noteworthy. He was considered the leading American anatomist of his time.

WYMAN, MORRILL (*b. Chelmsford, Mass., 1812; d. 1903*), physician. Brother of Jeffries Wyman. Graduated Harvard, 1833; Harvard Medical School, 1837. Practiced for more than 60 years in Cambridge, Mass. Wyman's most effective service to American medical science occurred in 1850. In association with H. I. Bowditch, he improved the operation of thoracentesis, or surgical drainage of the pleural cavity, by substituting a small hollow needle for the large cannula formerly used. This was a landmark in pleurisy treatment. Author of *A Practical Treatise on Ventilation* (1846); a report on ventilators and chimneys (*Proceedings*, American Academy of Arts and Sciences, 1848); and *Autumnal Catarrh: Hay Fever* (1872, with additions, 1876). Adjunct Hersey

professor of theory and practice of medicine, Harvard Medical School, 1853–56. Founded Cambridge Hospital, 1886; served for many years as consulting physician, Massachusetts General Hospital.

WYMAN, ROBERT HARRIS (*b. Portsmouth, N.H., 1822; d. 1882*), naval officer. Appointed midshipman, 1837. Served with credit in Mexican War. During Civil War, served in blockade duty in the Atlantic and commanded the Potomac Flotilla early in 1862. Headed Hydrographic Office at Washington, D.C., 1871–79, and was author of a number of useful publications on navigation. Commissioned rear admiral, 1878, he commanded the North Atlantic Squadron; he died as chairman of the Lighthouse Board.

WYMAN, SETH (*b. Goffstown, N.H., 1784; d. Goffstown, 1843*), burglar. Author of a popular *Life and Adventures* (1843).

WYNN, ED (*b. Isaiah Edwin Leopold, Philadelphia, Pa., 1886; d. Beverly Hills, Calif., 1966*), comedian and actor. Left school at fifteen to join the Thurber-Nasher Repertoire Company. In 1902 he formed a comedy act with Jack Lewis called the "Rah! Rah! Boys." Wynn then went on to become a headliner in Vaudeville. He performed in the 1914 and 1915 *Ziegfeld Follies*, then wrote and produced *Ed Wynn's Carnival* (1920), *The Perfect Fool* (1921), *The Grab Bag* (1924), and *Laugh Parade* (1931). He also appeared in *Manhattan Mary* (1927) and *Simple Simon* (1930). Wynn appeared on radio as the Texaco Fire Chief (1932–35) and returned to Broadway in 1940 in *Boys and Girls Together*. He worked in television, and, prodded by his son, Keenan, took a role in the movie *The Great Man* (1956). Shortly thereafter, he appeared with his son in the television drama *Requiem for a Heavyweight*. His other movies include *Marjorie Morningstar* (1958), *The Diary of Anne Frank* (1959), and *Mary Poppins* (1964).

WYTHE, GEORGE (*b. Back River, Elizabeth City Co., Va., 1726; d. Richmond, Va., 1806*), statesman, professor of law, jurist. Received little formal education, briefly attending College of William and Mary. Admitted to the bar, 1746, he began practice in Spotsylvania Co. Briefly attorney general of Virginia, 1754, while Peyton Randolph was in England, Wythe removed he residence to Williamsburg, Va., 1755. His career really began in 1758 when he became the intimate friend and associate of Governor Francis Fauquier. A member of the House of Burgesses, 1754–55 and 1758–68, he served as clerk of the House, 1769–75. On the announcement of the stamp tax, Wythe maintained the concept (later expounded by Richard Bland) that England and Virginia were coordinate nations united by the crown alone. Wythe drafted the Virginia Resolutions of Remonstrance, which were modified before their adoption by his colleagues in the House. On the approach of the Revolution he wisely recommended the raising of a regular army instead of the use of militia and himself volunteered for service. Sent to the Continental Congress in 1775, he served until the close of 1776. He supported Richard H. Lee's resolution for independence and signed the Declaration. He was probably the designer of the seal of Virginia, adopted 1776. Assigned with Thomas Jefferson and Edmund Pendleton to the task of revising the Virginia laws, he covered the period from the revolution in England, 1688, to American independence; the revision was thorough and intelligent and the various bills embodying it were passed over a period of years subsequent to its submission in 1779. Speaker of the House of Delegates, 1777, he became one of the three judges of the Virginia High Court of Chancery, 1778, and henceforth was known as Chancellor Wythe.

On accepting the chair of law at the College of William and Mary, 1779 (the first chair of law in an American college), Wythe

began that part of his career which perhaps constitutes his greatest service, for he literally charted the way in American jurisprudence and was teacher of, among others later famous, John Marshall. He was a delegate to the Virginia convention which ratified the U.S. Constitution, 1788, but engaged little in debate; in offering the resolution for ratification he emphasized the derivative character of federal power. On reorganization of the state judicial system in 1788, he became sole chancellor, holding this office until 1801, after which he continued to preside over the Richmond district. He resigned his professorship in 1790 and, removing to Richmond, formed a small law school of his own. Among his students was Henry Clay.

As chancellor and ex officio member of the supreme court of appeals, he delivered a significant opinion in the case of *Commonwealth v. Caton*, 1782. An obiter dictum which he made in his concurring opinion was clearly one of the earliest enunciations of the doctrine of judicial review, America's unique contribution to juridical theory; at the time, it was the most complete such statement which had been made. Superbly ethical as an attorney, Wythe refused unjust causes and abandoned any case regarding which he felt he had been misled. Probably the best classical scholar in Virginia, he was widely read in Roman and English law. Opposed to slavery, he emancipated his servants by his will.

Wythe died after drinking coffee poisoned by his grandnephew and heir.

X

XÁNTUS, JÁNOS (b. Csokonya, Somogy Co., Hungary, 1825; d. Hungary, 1894), ornithologist, author. Immigrated to America, 1851; was employed by the Pacific Railroad and U.S. Coast surveys. Made valuable bird collections in California for the Smithsonian Institution, uncovering many new species. His descriptions and catalogues of new species appear in *Proceedings of the Academy of Natural Sciences of Philadelphia* (Vols X–XII, 1859–61). Appointed U.S. consul at Manzanillo, Mexico, he led a scientific research party into the Sierra Madre. Returned to Hungary, 1864; published accounts of his travels.

Y

YALE, CAROLINE ARDELIA (*b. Charlotte, Vt., 1848; d. 1933*), educator. Joined staff of Clarke Institution for Deaf Mutes, 1870; became principal, 1886, emeritus, 1922. Pioneer in use of oral method; established, 1889, and directed normal classes for teacher-training of the deaf. Author of *Years of Building* (1931).

YALE, ELIHU (*b. Boston, Mass., 1649; d. London, England, 1721*), official of the East India Co., philanthropist. After an application made by Cotton Mather for aid to the struggling Collegiate School at Saybrook, Conn., in January 1718, Yale made a gift of various goods to the institution which sold for £562 12s., the largest private contribution made to the college for over a century. At the September commencement, the new building at New Haven and the college were given Yale's name in appreciation.

YALE, LINUS (*b. Salisbury, N.Y., 1821; d. New York, N.Y., 1868*), inventor, manufacturer. Invented the "Yale Infallible Bank Lock" *ca.* 1851; to change the combination, the key's component parts could be separated and reassembled. His "Yale Magic Bank Lock" was an improvement on the first, and was followed by the "Yale Double Treasury Bank Lock," the most notable bank lock operated by keys. About 1862 he began to market the "Monitor Bank Lock," the first dial or combination bank lock, and in 1863 the "Yale Double Dial Bank Lock," whose principles of construction are in general use in America. Between 1860 and 1865 he improved small key locks by devising the "Cylinder Lock," based on the pin-tumbler mechanism of the Egyptians; he obtained patents, 1861 and 1865. Partner with J. H. Towne and H. R. Towne in the Yale Lock Manufacturing Co. (established 1868).

YANCEY, JAMES EDWARD ("JIMMY") (*b. 1894[?]; d. Chicago, Ill., 1951*), jazz musician. Originator of the boogie-woogie piano style, Yancey played professionally until 1925 when he became grounds keeper for the Chicago White Sox baseball club. After World War II there was a revival of his music and he appeared in Chicago clubs and in concert at Carnegie Hall in New York in 1948. His first recordings were made in Chicago in 1939 and 1940: "The Fives" and two vocals, "Death Letter Blues" and "Cryin' in My Sleep."

YANCEY, WILLIAM LOWNDES (*b. Warren Co., Ga., 1814; d. Montgomery, Ala., 1863*), lawyer, Alabama legislator, secessionist. Stepson of Nathan S. S. Beman. Attended Williams College, 1830–33; studied in law office of Benjamin F. Perry at Greenville, S.C. An active Unionist as editor of a Greenville newspaper during the nullification controversy, Yancey removed to Alabama in the winter of 1836–37, where he attempted farming, edited a newspaper at Wetumpka, and practiced law with great success. As a legislator, 1841–44, he was noted as a supporter of representation on the basis of white population only, of a free public school system, and of a nonpolitical state banking system. Elected to Congress in 1844, he served until his resignation on Sept. 1, 1846.

Yancey now resumed the practice of law and began a career of unofficial political action on behalf of Southern independence which transcended party lines. Operating on a narrow but well-defined body of principles, he refused any compromise for the sake of party continuity or for any other reason; contemporary politicians considered him everything from an unwelcome pest to an insufferable firebrand. His body of principles is to be found in the Alabama Platform, written by him, 1848, in answer to the Wilmot Proviso. In brief, the platform demanded a constitution designed to curb the will of the majority and preserve to the states all powers not expressly granted to the federal government, equal rights of citizens and states in the territories, and action by Congress to protect property rights in the territories so long as they remained in territorial status. He presented this simple statement of abstractions to the people of the South on every occasion with an oratorical excellence seldom equaled. After the rejection of his platform by the Democrats in their convention at Baltimore, 1848, he appealed to the people from the decision and in the course of the next 12 years made his platform the Southern creed. In order to arouse the South to the need of a union of all Southern men in a sectional party, he was active in promoting Southern rights associations which would work for the nomination of public office of states' rights men within each party. In 1858 he sought to perfect the system by organizing the League of United Southerners. He traveled widely, delivering hundreds of addresses in support of his views. Dominant in the Democratic party in Alabama as the presidential campaign of 1860 approached, he recommended that if the demands of the South were rejected at the Charleston convention, a "Constitutional Democratic party" should be organized and candidates presented to the people. He furthermore stated that if a Republican president should be elected, then secession should be carried through before his inauguration.

At the Alabama Democratic convention in Montgomery on Jan. 11, 1860, Yancey prepared the Alabama platform of principles — a restatement of the platform of 1848 in line with all that had transpired meantime. The platform also instructed the Alabama delegation to the Charleston convention to present this platform for adoption and to withdraw if it were rejected. At the Charleston convention Yancey delivered the greatest speech of his career in defense of his platform; after its qualified rejection, a majority of the Southern delegates withdrew. When the adjourned convention met later at Baltimore, Md., the supporters of Stephen A. Douglas refused to seat the Yancey delegation from Alabama. Subsequent to this, under Yancey's guidance, the Constitutional Democratic party was organized and nominated John Breckinridge for the presidency. Following the election of Abraham Lincoln, Yancey dominated the proceedings of the Alabama convention and wrote the Ordinance of Secession. A Confederate commissioner in France and England, 1861–62, he served briefly in the Confederate Senate after his return; during this time he fought against the increase of centralized power in the Confederacy just as fiercely as he had fought it in the Union.

YANDELL, DAVID WENDELL (*b. near Murfreesboro, Tenn., 1826; d. Louisville, Ky., 1898*), physician. Son of Lunsford P.

Yandell. Graduated University of Louisville, 1846. Practiced in Louisville; founded the Stokes Dispensary and pioneered in medical education by establishing classes in clinical medicine; was appointed to the chair of clinical medicine at the University of Louisville. During the Civil War he served as medical director, Confederate Department of the West. Professor of clinical surgery, University of Louisville, *post* 1869. Cofounder of *The American Practitioner and News*, which he edited from 1870 until shortly before his death.

YANDELL, LUNSFORD PITTS (*b. near Hartsville, Tenn., 1805; d. Louisville, Ky., 1878*), paleontologist, physician. Father of David W. Yandell. Graduated University of Maryland, 1825. Professor of chemistry and pharmacy, Transylvania University, 1831–37. Held chairs of chemistry and materia medica, and, *post* 1849, physiology, in the medical department, University of Louisville; taught there from 1837 until 1859. Editor of medical journals, and coeditor of *Western Journal of Medicine and Surgery* 1840–55. Made extensive geological and paleontological explorations in the vicinity of Louisville; studied the Ohio falls coral reefs, the Beargrass Creek fossiliferous beds, and Kentucky and Indiana quarries. Discovered and collected numerous fossils. Author of *Contributions to the Geology of Kentucky* (1847), with B. F. Shumard and of many contributions to scientific journals.

YATES, ABRAHAM (*b. Albany, N.Y., 1724; d. 1796*), Revolutionary patriot, public official, Antifederalist pamphleteer. Also known as Abraham Yates, Jr. Chairman, Albany Committee of Correspondence, 1774–76. Headed committee of the convention which drafted New York State's first constitution, 1776–77, and of the committee for putting the new government into operation. State senator, 1777–90. His printed letters and pamphlets are perhaps the ablest exposition of the views of agrarian democrats and of followers of Governor George Clinton. Played role of Antifederalist in Continental Congress, 1787–88. Mayor of Albany from 1790 until his death.

YATES, HERBERT JOHN (*b. Brooklyn, N.Y., 1880; d. Sherman Oaks, Calif., 1966*), motion-picture executive. Cofounded Republic Film Laboratories in 1917. In 1922 he established, and became chairman of, Consolidated Film Industries, which developed into one of the nation's largest producers and developers of motion-picture film. During the 1930's Yates gradually shifted his main interest from film lab services to moviemaking. In 1935 he established Republic Productions in North Hollywood, Calif. Under his leadership Republic quickly became a major producer of movie serials and B-films; among its stars were John Wayne, Gene Autry, and Roy Rogers. Yates sold out his interests in Republic and resigned its chairmanship in 1959.

YATES, JOHN VAN NESS (*b. Albany, N.Y., 1779; d. Albany, 1839*), lawyer, New York official. Son of Robert Yates. Editor of William Smith's *History of New York* (1814) and author of legal works. Democratic-Republican in politics and a partisan of the Clintons, he was New York secretary of state, 1818–26. He was regarded as erratic in character.

YATES, MATTHEW TYSON (*b. Wake Co., N.C., 1819; d. Shanghai, China, 1888*), missionary. Graduated Wake Forest College, 1846. Pioneer Southern Baptist missionary in Shanghai, China, 1847–88.

YATES, RICHARD (*b. Warsaw, Ky., 1815; d. St. Louis, Mo., 1873*), lawyer, Illinois legislator. Congressman, Whig, from Illinois, 1851–55. Opposed to slavery, he then joined the Republican party. As governor of Illinois, 1861–65, he was highly effective in war administration. He gave General U. S. Grant his first Civil War commission and assignments. In 1863, he pro-

rogued the largely Democratic state assembly for passing a resolution urging an armistice and national peace convention. As U.S. senator, 1865–71, Yates was a party regular, favoring vindictive measures against the South, voting for Johnson's impeachment, and supporting the prevailing Radical Republican program.

YATES, ROBERT (*b. Schenectady, N.Y., 1738; d. 1801*), Revolutionary patriot, jurist. Father of John Van N. Yates. Studied law with William Livingston; admitted to the bar at Albany, N.Y., 1760. A radical Whig in the period before the Revolution, he was a member of the Albany Committee of Safety and represented Albany Co. in the four New York provincial congresses. Among other important committee work, he served on the committee which drafted the first New York State constitution. Appointed a justice of the state supreme court, 1777, he was advanced to chief justice in 1790 and resigned the office in 1798. A leader of the Antifederalists, he was a supporter of Governor George Clinton. A delegate from New York to the Federal Convention, 1787, with John Lansing and Alexander Hamilton, he refused further attendance after July 5 on the ground that the Convention was exceeding its powers in attempting to write a new instrument of government. He wrote several series of letters attacking the U.S. Constitution, 1787–88, and voted against ratification of it at the Poughkeepsie, N.Y., convention.

YAWKEY, THOMAS AUSTIN ("TOM") (*b. Thomas Yawkey Austin, Detroit, Mich., 1903; d. Boston, Mass., 1976*), baseball club owner. Studied at Sheffield Scientific School of Yale University (B.S., 1925) and assumed control of his family's far-flung investments. In 1933 he bought the Boston Red Sox franchise for $1 million and devoted the remainder of his life to baseball. He made major renovations at Fenway Park, the team's home; purchased baseball talent from cash-poor teams, spending over $1 million between 1933 and 1937; and developed players in minor league farm system, advancing stars such as Ted Williams. The Red Sox finished second to the Yankees in four of six years (1937–42) and won the pennant in 1946, but finished third or worse in the American League in 1951–67. He idolized and spoiled his players, and critics referred to the team as the self-satisfied country club of baseball. In order to make the Red Sox operation more businesslike, he appointed financial adviser Dick O'Connell as general manager (1965); O'Connell assembled teams that won pennants in 1967 and 1975. Yawkey also served as vice-president of the American League (1956–73). Inducted into the Baseball Hall of Fame posthumously (1980).

YEADON, RICHARD (*b. Charleston, S.C., 1802; d. 1870*), lawyer, editor, South Carolina legislator. Editor of the Unionist *Charleston Daily Courier*, 1832–44. An ardent Whig and antisecessionist up to the Civil War, he supported President Jefferson Davis against opposition of R. B. Rhett. He was a benefactor of the College of Charleston and originated the ordinance establishing Charleston High School.

YEAGER, JOSEPH (*b. possibly Philadelphia, Pa. ca. 1792; d. Philadelphia, 1859*), engraver, publisher. Active in Philadelphia, 1809–45, as line engraver and as portrait etcher; published toy books for children. Became president of Harrisburg and Lancaster Railroad Co., 1848.

YEAMAN, WILLIAM POPE (*b. Hardin Co., Ky., 1832; d. 1904*), Baptist clergyman. Held various pastorates, notably in St. Louis, Mo., 1870–ca. 1879. Secretary, Board of State Missions, General Association of Missouri Baptists, 1884–86. Moderator, General Association of Missouri Baptists, 1877–97; also corresponding secretary. Vice president, Southern Baptist Convention, 1880.

YEAMANS, SIR JOHN (*b. probably Bristol, England, 1610/1; d. 1674*), colonial official. Commissioned governor of Carolina under the proprietors, January 1665, he sailed with the first settlers to the Cape Fear River late in that year, but soon returned to Barbados. After the abandonment of the first settlement, 1667, Yeamans still held the title of governor, but made little effort to serve actively during the second settlement under Joseph West. In 1671 he settled in Carolina and introduced the first slaves there; his claim to be governor was confirmed in 1672 and he then laid out the site of Charles Town on the Ashley River. Unpopular with both people and proprietors, he was discharged by the proprietors, 1674, but word of the change had not yet reached Carolina when Yeamans died.

YEARDLEY, SIR GEORGE (*b. London, England, ca. 1587; d. 1627*), Virginia colonial official. Sailing for Virginia, 1609, he served there several years in a military capacity. Acting governor of Virginia, 1616–17, he was commissioned governor in England and knighted, 1618. He returned to the colony with instructions, important in the history of English colonization, to abolish martial law, to summon the first English colonial representative assembly (over which he presided in 1619), and to amend land tenure terms. Plans to admit numbers of new settlers and establish private plantations ("hundreds") proved failures, primarily because of conditions in the London Co. Retiring, 1621, he was active thereafter as governor and captain of Southampton Hundred plantation and in the colony's affairs. Following dissolution of the London Co., Yeardley went to England in 1625 with important petitions from the "convention" assembly, presenting the needs of the settlers and asking for continuation of their general assembly. Although he failed to secure a definite commitment from the Privy Council on the latter point, the favorable impression he made led to his commission again as governor, 1626. He served until his death.

YEATES, JASPER (*b. Philadelphia, Pa., 1745; d. Lancaster, Pa., 1817*), lawyer, jurist. Studied law under Edward Shippen, 1728–1806. Admitted to the bar, 1765, he practiced successfully in Lancaster, Pa. Active in local politics, Yeates was a moderate Whig and chairman of the Lancaster Co. Committee of Correspondence, 1775. He opposed the Pennsylvania Constitution of 1776; later he was instrumental in ratification of the Federal Constitution at the Pennsylvania convention. Associate justice, Pennsylvania Supreme Court, from 1791 until his death.

YEATMAN, JAMES ERWIN (*b. near Wartrace, Tenn., 1818; d. St. Louis, Mo., 1901*), banker, civic leader, philanthropist. A founder, 1850, and president of the Merchants' National Bank, St. Louis, 1860–95. His most important work was as president of the Western Sanitary Commission, created at St. Louis in 1861. Cooperating with Dorothea Dix, Yeatman organized hospitals, recruited nurses, established homes, and outfitted probably the first railroad hospital cars. He was a generous benefactor of Washington University.

YELL, ARCHIBALD (*b. North Carolina, 1797; d. Buena Vista, Mexico, 1847*), lawyer, soldier. Served under Andrew Jackson in the War of 1812 and against the Seminole in Florida; became a protégé of Jackson. Removed to Little Rock, Ark., ca. 1831; appointed Arkansas territorial judge, 1835. First congressman from Arkansas, 1836–39 and 1845–47, he supported the annexation of Texas and Polk's Oregon policy. As governor of Arkansas, 1840–44, he demanded strong measures for control of the state bank and the real estate bank, recommended a board of internal improvements, and urged agricultural schools based on liberal government donations. As colonel of the 1st Arkansas Volunteer

Cavalry he was killed at the battle of Buena Vista while leading a charge of his troops.

YELLIN, SAMUEL (*b. Mogilev-Podolski, Russia, 1885; d. New York, N.Y., 1940*), decorative metal designer and craftsman. Apprenticed in Europe, he came to America as a young man, settled in Philadelphia, Pa., and was soon made an instructor in wrought-iron work at the Pennsylvania Museum School of Industrial Art. He became an initiator and a leader of the revival of decorative metalwork in the United States during the 1920's and 1930's. Among his more important works are the hand-wrought fixtures at Valley Forge, Pa., Memorial Chapel; the gates of the Harkness Memorial Quadrangle at Yale; decorations at the Hall of Fame, New York City, at the National Cathedral, Washington, D.C., and at the Bok carillon near Lake Wales, Fla. His largest single commission was a pair of gates for the Packard Building, Philadelphia.

YELLOWLEY, EDWARD CLEMENTS (*b. near Ridgeland, Miss., 1873; d. Chicago, Ill., 1962*), federal Prohibition administrator. Joined the Internal Revenue Bureau in 1899. In 1921, after the adoption of the Eighteenth Amendment, Internal Revenue organized a nationwide enforcement unit, and Yellowley was placed in charge of special agents. After success in New York City, he was put in charge of the Chicago office (1925–30), but was stymied by the power of mobster Al Capone. Left Prohibition enforcement in 1930. In 1934 he designed a system for collection of federal liquor taxes that was a model for the rest of the country.

YEOMANS, JOHN WILLIAM (*b. Hinsdale, Mass., 1800; d. Danville, Pa., 1863*), Congregational and Presbyterian clergyman, educator. Graduated Williams, 1824. Attended Andover Theological Seminary, 1824–26; ordained, 1828. President, Lafayette College, Easton, Pa., 1841–44. Among other pastorates, he served at Mahoning Presbyterian Church, Danville, Pa., from 1845 until shortly before his death. Chosen moderator, General Assembly, Old School Presbyterian Church, 1860.

YERGAN, MAX (*b. Raleigh, N.C., 1892; d. Mount Kisco, N.Y., 1975*), missionary, educator, and civil rights activist. Graduated Shaw University, North Carolina (1914). In 1921 he became a YMCA missionary and educator in South Africa, remaining for fifteen years and encouraging the young men there to apply their faith by becoming teachers and leaders. He was appointed (1936) to the chair in Negro history at City College in New York City and organized the Council on African Affairs in 1937. In the 1940's he also served as president of the National Negro Congress, which supported the war effort and called for removal of barriers preventing black participation.

YERGER, WILLIAM (*b. Lebanon, Tenn., 1816; d. 1872*), lawyer. Graduated University of Nashville, 1833. Removed to Jackson, Miss., 1837, where he achieved outstandingly successful law practice. Associate justice, Mississippi Supreme Court, 1851–53. A staunch Whig, he actively opposed secession. Although he remained a Unionist in sympathy, he was a member and, for a time, a president of the state senate during the Civil War. Able member of the Mississippi constitutional convention, 1865.

YERKES, CHARLES TYSON (*b. Philadelphia, Pa., 1837; d. 1905*), financier, traction magnate. Established Philadelphia banking house, 1862; gained reputation as brilliant dealer in municipal securities, 1866. Helped organize Continental Passenger Railway Co., 1875, and was its largest stockholder until 1880. Removed to Chicago, Ill., 1882. In 1886 he was in majority control of all major North Chicago and West Division streetcar companies. Because of devious financial methods, his street-railway enterprises were called the "Chicago traction tangle." Yerkes was

a master of bribery and legislative manipulation. In 1899 he sold his holdings to P. A. B. Widener and W. L. Elkins for approximately $20 million. His unsuccessful attempt to extend his franchises, 1897–99, was largely responsible for introduction of bills for municipal ownership and control of street railways into the state legislature by 1901. He presented Yerkes Observatory at Lake Geneva, Wis., to the University of Chicago, 1892.

YERKES, ROBERT MEARNS (*b. Breadysville, Pa., 1876; d. New Haven, Conn., 1956*), animal psychologist. Studied at Ursinus College and at Harvard University (Ph.D., 1902). Taught at Harvard from 1902 to 1917. Owned and edited, with John R. Watson, the *Journal of Animal Behavior* (1911–19). Commander of the Psychological Corps of the Office of the Army Surgeon General, and chairman of the Research Information Service of the National Research Council in Washington, 1919–24. An early exponent of mental tests, Yerkes became involved in the controversies over army test results and immigration restrictions. From 1924 to 1941 he taught at Yale University, founding the Yale Laboratories of Primate Biology in Florida in 1929, director until 1941. After his retirement, the laboratories were administered by Harvard and Yale and renamed the Yerkes Laboratory of Primate Biology. Books include *The Great Apes* (1929).

YOAKUM, BENJAMIN FRANKLIN (*b. near Tehuacana, Tex., 1859; d. 1929*), promoter, railroad executive. Dominant figure in the St. Louis & San Francisco and Rock Island roads, 1903–13; held responsible for their failure because of extravagant profits by "insiders" during construction.

YOAKUM, HENDERSON (*b. Powell's Valley, Tenn., 1810; d. Houston, Tex., 1856*), lawyer, Tennessee legislator, historian. Graduated West Point, 1832. Removed from Tennessee to Huntsville, Tex., 1845. Principally remembered as author of *History of Texas* (1855), for many years the standard history of the state.

YOHN, FREDERICK COFFAY (*b. Indianapolis, Ind., 1875; d. Norwalk, Conn., 1933*), illustrator, painter. Studied at Art Students League, N.Y., under Henry S. Mowbray. Yohn was a specialist in battle scenes and painted numerous historical subjects. During World War I he painted *America's Answer*, the second official war poster picture.

YON, PIETRO ALESSANDRO (*b. Settimo Vittone, Italy, 1886; d. Huntington, N.Y., 1943*), organist, composer. Studied at conservatories of Milan and Turin; graduated Liceo di S. Cecilia, Rome, 1905. Immigrated to New York City, 1907. Organist and choir director, Church of St. Francis Xavier; and at St. Patrick's Cathedral, New York City, 1927–43. A virtuoso player, he was also a dedicated musician and teacher. His long list of compositions includes oratorios, masses, motets, chamber music, and songs.

YORK, ALVIN CULLUM (*b. Pall Mall, Tenn., 1887; d. Nashville, Tenn., 1964*), soldier. A member of a fundamentalist church, York led a relatively uneventful life until he was inducted into the Army in 1917. Already a crackerjack rifleman, York became a fine soldier, but his religious convictions made him balk at killing others. Eventually satisfied that the Bible permitted killing under certain circumstances, York accompanied his division to France in 1918. During the Meuse-Argonne offensive, he proved himself such a marksman that he killed seventeen Germans with as many shots; then, having run out of bullets, he killed another eight with his pistol. Believing York to be at the head of hundreds, ninety more Germans surrendered. When York and his seven surviving buddies returned to camp, they delivered a total of 132 prisoners to battalion headquarters, and York, "the greatest civilian soldier of the war," became the most renowned doughboy of World War I. He was promoted to sergeant and received the Congressional Medal of Honor and France's Croix de Guerre, among other honors. After the war he helped found the American Legion. He was the subject of *Sergeant York*, a 1941 film with Gary Cooper.

YORKE, PETER CHRISTOPHER (*b. Galway, Ireland, 1864; d. 1925*), Roman Catholic clergyman. Ordained in Baltimore, Md., 1887. S.T.B., Catholic University, Washington, D.C., 1890; S.T.L., 1891. Chancellor of the San Francisco diocese *post* 1894; editor of the *Monitor*. Permanent rector, St. Anthony's Church, Oakland, Calif., 1903–13; rector, St. Peter's Church, San Francisco, 1913–25. Best known as a hard-hitting controversialist, he fought successful campaigns against bigotry on the West Coast. He was an active laborite and ardent Irish nationalist.

YOST, CASPER SALATHIEL (*b. Sedalia, Mo., 1864; d. St. Louis, Mo., 1941*), journalist. Associated *post* 1889 with the *St. Louis Globe-Democrat*, he became editor of the editorial page in 1915. A conservative Republican and deeply religious, he was a pioneer in concern for professional standards among newspapermen. He led in the founding of the American Society of Newspaper Editors and served as its first president, 1922–26. He was author of a number of books, among them *The Principles of Journalism* (1924).

YOST, FIELDING HARRIS (*b. Fairview, W. Va., 1871; d. Ann Arbor, Mich., 1946*), football coach, athletic director. Attended Ohio Normal University (later Ohio Northern). LL.B., West Virginia University, 1897. Football coach at Ohio Wesleyan and at universities of Nebraska, Kansas, and Stanford, 1897–1900, at each of which he led the team to a conference championship. As head coach at University of Michigan, 1901–23 and 1925–27, he produced teams which had eight undefeated seasons and were eight times champions of the "Big Ten." His success was based less on gridiron theory than on skill in player recruitment and in management. His insistence on swift execution of plays on the practice field won him the nickname "Hurry-up." From 1921 through 1941, he was athletic director at Michigan.

YOU, DOMINIQUE (*b. Port-au-Prince, Haiti, or St.-Jean-d'Angély, France, ca. 1772; d. New Orleans, La., 1830*), buccaneer. Associated with Jean Laffite's smugglers at Barataria, La., *post* 1810; held command in Andrew Jackson's artillery defending New Orleans against the British, 1814–15. A legendary figure in Louisiana.

YOUMANS, EDWARD LIVINGSTON (*b. Coeymans, N.Y., 1821; d. 1887*), writer, editor. Brother of William J. Youmans. A popular lecturer on science, 1851–68, Youmans was the chief promoter in America of Herbert Spencer's publications. He was author of, among other works, *A Class-Book of Chemistry* (1851), a standard text; and *Chemical Atlas; or the Chemistry of Familiar Objects* (1854). He edited *The Culture Demanded by Modern Life* (1867), and began the International Scientific Series, 1871. He founded and edited *Popular Science Monthly* (later *Scientific Monthly*), 1872 and after.

YOUMANS, VINCENT MILLIE (*b. New York, N.Y., 1898; d. Denver, Colo., 1946*), composer, theatrical producer. Intended by his parents to study engineering at Yale, he enlisted in the U.S. Navy at the declaration of war in 1917. Assigned to an entertainment unit at Great Lakes Training Station, Youmans was fortunate enough to spend his service years composing musical shows; one joyous song that attracted the navy bandmaster's attention survived to become "Hallelujah!" in *Hit the Deck* (1927). Upon

leaving the service, he went to work for the Harms Music Co. in New York as a "song-plugger."

In 1920 Youmans published his first song and made his first stage contributions for *Two Little Girls in Blue* (1921). The year 1923 saw two Youmans shows; the short-lived *Mary Jane McKane*, and *Wildflower*. Only three years after Youmans' first produced show, he composed the music for *No, No, Nanette*, a fluffball farce that captured the gaiety of the 1920's. *No, No, Nanette* opened in London in March 1925 and in New York that same September. Although *Wildflower* ran longer on Broadway, within months 17 companies were performing *Nanette* around the world.

Oh, Please! (1926) contained one song that has remained popular, "I Know That You Know." As a result, he became his own producer to present *Hit the Deck* (1927), one of Youmans' best scores; it held two hit songs, the jubilant "Hallelujah!" and the sophisticated rhythm ballad "Sometimes I'm Happy." Youmans composed several songs for Florenz Ziegfeld's *Smiles* (1930), although his best effort, "Time on My Hands," was dropped from the show. Youmans himself produced *Through the Years* (1932), a failure whose title song was reputedly the composer's favorite. *Take a Chance* (1932) was his last Broadway contribution, with five Youmans songs supplementing the basic score. The young Ethel Merman shone brightly in the latter show, and the song "Rise 'n' Shine" joined the earlier "Hallelujah!," "Great Day!," and "Drums in My Heart." His final work of any substance was the film score for *Flying Down to Rio* (1933).

YOUMANS, WILLIAM JAY (*b. Milton, N.Y., 1838; d. 1901*), scientific writer, editor. Brother of Edward L. Youmans. Graduated in medicine, University of the City of New York (New York University), 1865. Prepared for publication *The Elements of Physiology and Hygiene* (1868), by Thomas Huxley. Actively associated with *Popular Science Monthly* from 1872, he was sole editor, 1887–1900. Author of *Pioneers of Science in America* (1896); contributed to *Appleton's Annual Cyclopaedia*, 1880–1900.

YOUNG, AARON (*b. Wiscasset, Maine, 1819; d. Belmont, Mass., 1898*), physician, pharmacist, botanist. Studied under Parker Cleaveland at Bowdoin. State botanist of Maine, 1847–49; wrote survey of Mount Katahdin; was a pioneer in afforestation. He served as U.S. consul to Rio Grande do Sul, Brazil, 1863–73.

YOUNG, ALEXANDER (*b. Boston, Mass., 1800; d. Boston, 1854*), Unitarian clergyman, antiquarian. Graduated Harvard, 1820; Harvard Divinity School, 1824. Pastor at New South Church, Boston. Published *Chronicles of the Pilgrim Fathers of the Colony of Plymouth from 1602 to 1625* (1841) and *Chronicles of the First Planters of the Colony of Massachusetts Bay from 1623 to 1636* (1846).

YOUNG, ALFRED (*b. Bristol, England, 1831: d. New York, N.Y., 1900*), Roman Catholic clergyman, musician. Came to America as an infant. Graduated College of New Jersey (Princeton), 1848; M.D., present New York University, 1852. A convert to Catholicism, 1850, he studied theology at St. Sulpice, Paris; he was ordained in Newark, N.J., 1856. Joined Society of St. Paul, 1862. A leader in laymen's retreats and missions for non-Catholics. Founded Paulist Choir, 1873. Promoted Gregorian chant and composed hymnals.

YOUNG, ALLYN ABBOTT (*b. Kenton, Ohio, 1876; d. London, England, 1929*), economist. Ph.D., University of Wisconsin, 1902. Taught at numerous institutions including Stanford, Cornell, Harvard, and the London School of Economics, 1927. Author of *Economic Problems New and Old* (1927).

YOUNG, AMMI BURNHAM (*b. Lebanon, N.H., 1798; d. Washington, D.C., 1874*), architect. Began his career as a builder; was a pupil and assistant of Alexander Parris in Boston, Mass. Architect of Thornton and Wentworth halls at Dartmouth College, 1828–29, he designed Reed Hall there, 1839. He was also architect for the State Capitol at Montpelier, Vt., 1833–36 (later destroyed). Removing to Boston *ca.* 1837, he was busy for about ten years with the construction of the Boston Customs House and did other work in that city and elsewhere. Its powerful design won high praise, and Young was appointed to succeed Robert Mills as architect of federal buildings *ca.* 1850. He continued in federal service until 1862. During his years as architect for the Treasury Department, Young designed a great number of customhouses, federal courthouses, post offices, and marine hospitals, employing in the interest of speed and economy a fruitful standardization of types and rationalized construction method. His most important innovation was the wide use of iron in these buildings. His work for the government ranged from monumental classic edifices like the customhouse at Norfolk, Va., to the Appraiser's Stores at St. Louis, Mo., and San Francisco, Calif., to small classical-revival public buildings in minor eastern towns.

YOUNG, ART (*b. near Orangeville, Ill., 1866; d. New York, N.Y., 1943*), cartoonist, socialist. Raised in Monroe, Wis. Studied at Chicago Academy of Design, Art Students League in New York City, and Académie Julian in Paris; staff artist and cartoonist for newspapers in Chicago and Denver. Removed to New York City, where he made comic drawings for *Life*, *Puck*, and *Judge*, and editorial cartoons for the Hearst newspapers; through the influence of the muckrakers and of radical writers generally, he developed his earlier questionings of capitalism into a full commitment to socialism. He was a contributor to *The Masses* from its first number (January 1911) and to the *Liberator*; he was also Washington correspondent, 1912–17, for *Metropolitan* magazine. From 1919 to 1921, he published his own weekly of art and comment, *Good Morning*. Possessed of a clear, uncluttered style, richly expressive and stripped of nonessentials, he was able to satirize society without becoming either sour or cantankerous; his love of humanity more than balanced his scorn for its follies and failures.

YOUNG, BRIGHAM (*b. Whitingham, Vt., 1801; d. Utah, 1877*), colonizer of Utah, second president of the Mormon church. Young's family belonged to the same class of restless frontier drifters from which Joseph Smith (1805–44) came; as a youth in western New York he resided in several places in the neighborhood of Smith's wanderings. A competent farmer as well as a journeyman house painter, he settled with his first wife in Mendon, N.Y., 1829. A Methodist from the age of 22, Young first read *The Book of Mormon* within a few weeks of its publication; after two years' study, he was baptized at Mendon, April 1832. His conversion to his new faith integrated all his vast energies, and the rest of his life was devoted to building up the Mormon church in highly practical ways.

In July 1833 he led a band of converts to Kirtland, Ohio, and soon thereafter traveled throughout the eastern United States as the most successful of the Mormon missionaries. He was chosen third of the newly organized Quorum of the Twelve Apostles in February 1835, and by 1838, when the Mormons were expelled from Missouri, he had become the senior member of the body. He directed the removal to Nauvoo, Ill., during Joseph Smith's imprisonment. After heading a most successful mission in England, 1839–41, he became the leading fiscal officer of the church at Nauvoo. Electioneering in behalf of Smith's campaign for the presidency of the United States, 1844, he was in Boston when he learned of the prophet's murder. Hurrying back to Nau-

voo, he rallied the shaken church behind the authority of the Twelve Apostles, of whom he was the head.

Having taken command of a church already responsive to authoritarian control and shaped to cooperative effort, he began one of the most successful colonizing endeavors in U.S. history. Obviously the Mormons could not survive in the American social system. With assistance from abroad and from the U.S. government, Young undertook to remove the church to the western wilderness and completed his preparations for the exodus by 1847. On Dec. 5, 1847, he had himself elected president of the church at Winter Quarters, Nebr. Having determined on the valley of Great Salt Lake as the site of Zion, he supervised the migration with great success. He had hoped for a long period of isolation for the Mormon people, but the gold rush to California in 1849 soon upset his expectation and it was ended by the completion of the Union Pacific Railroad during the 1860's. Once in Deseret (the Mormon name for the colony, later changed to Utah by Congress), Young displayed brilliance and genius as a city planner and colonizer. He instituted systems of irrigation which were indispensable to agricultural success and dispatched groups of settlers to occupy fertile valleys throughout the intermountain country, each group supplied with its own quota of mechanics and specialists. Meanwhile, his missionaries were bringing a steady stream of immigrants to the settlements, and Young instituted public works to occupy them while places were being found for them in the agricultural system. The greatest number of converts came from the tenant farmers and the city unemployed of Europe and America.

If Brigham Young was soon nationally infamous as a despot, it was because nothing less than a united effort could preserve his group. Because the first essential was food and agricultural development, he forbade the opening of mines. High freight rates for transport from the East led him to develop home industries, which he supported with a curious blend of the Rochdale Plan and the joint-stock company. His policy, however, gave the church organization financial and industrial interests separate from the people and began a change from cooperation to corporate control which accelerated after Young's death. He met the threat of competition from gentile merchants by organizing Zion's Cooperative Mercantile Institution and similar concerns which kept Mormon money at home. Young's greatest achievement was his transformation of a loose hierarchy into a magnificent fiscal organization for social and economic management. He discountenanced prophecy and similar evangelical gifts, stating that the Kingdom must be built upon earth before it could aspire to any celestial inheritance.

His 20-year struggle with the federal government and occasional local terrorism were political expressions of a social and economic fact. Young was dictator of a society whose methods and ideals were radically different from those of the 19th-century American society which surrounded it. He managed to make the theocracy coextensive with the political state for some years, but after the organization of Utah Territory by Congress in 1850, he was forced to permit the exterior form of government to come increasingly into accord with the American system. Appointed the first governor of the territory, he refused to vacate his office when displaced. Although he yielded to the threat of a U.S. expeditionary force under General A. S. Johnston, 1857, his successors were mere figureheads and Young governed as effectively as before.

Brigham Young had no interest in systematic thought and was impatient of theory; he was perhaps the foremost social pragmatist of his time. His mind worked rapidly and could carry a myriad relevant details about every activity and personality of his church. Ruthless and domineering as a leader, he was in private life a genial, benevolent man who had strong family affections and loved dancing, singing, and the theater. He had a fanatical belief in salvation by labor and abhorred all forms of waste. The number of his wives is variously given from 19 to 27. He had 56 children.

YOUNG, CHARLES AUGUSTUS (*b.* Hanover, N.H., 1834; *d.* Hanover, 1908), astronomer. Grandson of Ebenezer Adams. Graduated Dartmouth, 1853. As professor of natural philosophy and astronomy at Dartmouth, 1866–77, Young engaged in pioneering studies in solar physics with a spectroscope of his own design. He was professor of astronomy at the College of New Jersey (Princeton), 1877–1905, and was author of *The Sun* (1881) and of several astronomy textbooks.

YOUNG, CLARENCE MARSHALL (*b.* Colfax, Iowa, 1889; *d.* Sedona, Ariz., 1973), lawyer, aviation administrator, and airline executive. Graduated Yale Law School (1910); served as a bomber pilot in World War I; and became chief of air regulations in the aeronautics branch of the Department of Commerce (1926) and assistant secretary of commerce for aeronautics (1929). Under his leadership at the Commerce Department, there was a dramatic drop in the accident rate for scheduled airlines. Resigning over budget cuts, he joined Pan American Airways (1934–45; 1950–59), where he developed the infrastructure that in 1935 enabled Pan Am's giant seaplanes to cover the 8,746 miles from San Francisco to Hong Kong.

YOUNG, CLARK MONTGOMERY (*b.* Hiram, Ohio, 1856; *d.* 1908), educator. Ph.B., Hiram College, 1883. Became professor of history and political science, South Dakota University, 1892; was first dean of the college of arts and sciences from 1902 until his death. Active in South Dakota educational progress, he helped draft state school laws and conducted teachers institutes.

YOUNG, DAVID (*b.* Pine Brook, N.J., 1781; *d.* 1852), New Jersey almanac-maker, author. Self-educated. As "David Young, Philom," he published *Citizens' & Farmers' Almanac* (1814) and numerous others until his death. Author of *The Contrast* (1804), a religious poem in blank verse; *The Perusal* (1818), a cosmic, Miltonian poem; *Lectures on the Science of Astronomy* (1821); and *The Wonderful History of the Morristown Ghost* (1826).

YOUNG, DENTON TRUE ("CY") (*b.* Gilmore, Ohio, 1867; *d.* Newcomerstown, Ohio, 1955), baseball player. 1890–99 was pitcher for the Cleveland Spiders; 1900–09 he pitched for the American League team in Boston, playing in the first game of the modern World Series in 1903. Young achieved an unmatched record of 509 wins and 316 losses. One of baseball's greatest pitchers, he retired in 1912. Elected to the National Baseball Hall of Fame in 1937.

YOUNG, ELLA FLAGG (*b.* Buffalo, N.Y., 1845; *d.* 1918), educator. District superintendent, Chicago, Ill., schools, 1887–99. Ph.D., University of Chicago, 1900; professor of education at the university, 1899–1904. Principal, Chicago Normal School, 1905–09, and superintendent, Chicago public school system, 1909–15. She was the first woman president of the National Education Association, 1910.

YOUNG, EWING (*b.* eastern Tennessee, date unknown; *d.* Oregon, 1841), trapper, pioneer. Probably accompanied expedition under William Becknell which opened Santa Fe Trail, 1821, thereafter worked as a trapper out of Taos. In 1829 he led a party which included Kit Carson across the Mojave Desert into California. Returning to Taos, 1831, he joined with David Waldo and others in organizing two expeditions to California. Between 1832 and 1834, he journeyed over a great part of California and to the Colorado River at Yuma. In association with

Hall J. Kelley, he went from Monterey, Calif., to Fort Vancouver, arriving in the fall of 1834 and settling on a farm on the Chehalem. At first shunned because of a false accusation of horse theft, he cleared himself by 1837 and was thereafter a leader in the young Oregon community. He was a man of intelligence, active and scrupulously honest.

YOUNG, GEORGE (*b. near South Boston, Va., 1870; d. New York, N.Y., 1935*), pullman porter, bookseller, bibliophile. Born of black parents who had been slaves, Young educated himself principally in night schools and by wide outside reading. In the course of many years' collecting, he built up an outstanding library of some 9,000 books by or about blacks which is now contained in the New York Public Library system. He was also a lifelong worker for the cultural advancement of blacks.

YOUNG, HUGH HAMPTON (*b. San Antonio, Tex., 1870; d. Baltimore, Md., 1945*), urologist. A.B. and A.M., University of Virginia, 1893; M.D., 1894. After graduate study at Johns Hopkins Hospital, he interned there and then became head of the genitourinary dispensary, 1897. From 1898 until 1942, he taught genitourinary diseases and surgery at Johns Hopkins Medical School (professor of urology *post* 1932); he also carried on a private practice in Baltimore. An eminent pioneer in the development of modern urology, he designed improved versions of the cystoscope and other instruments and invented a number of new instruments and novel surgical procedures. In 1903, he devised a radical operation for total removal of the cancerous prostate gland. Director *post* 1915 of the Brady Urological Institute at Johns Hopkins Hospital, he and associates developed mercurochrome there and pioneered in use of sulfa and other modern drugs for treatment of venereal disease. He was author of more than 350 technical papers and of *Young's Practice of Urology* (1926, with collaborators).

YOUNG, JESSE BOWMAN (*b. Berwick, Pa., 1844; d. Chicago, Ill., 1914*), Union soldier, Methodist clergyman, editor. A.B., Dickinson College, 1868. Held pastorates in Pennsylvania, Missouri, Ohio, and Florida; edited *Central Christian Advocate*, 1892–1900. Author of, among other works, *The Battle of Gettysburg* (1913).

YOUNG, JOHN (*b. Chelsea, Vt., 1802; d. New York, N.Y., 1852*), lawyer, New York legislator. Congressman, Whig, from New York, 1836–37 and 1841–43. As assemblyman from Livingston Co., 1845, he secured passage of the Whig measure calling a convention to revise the state constitution. As Whig and Antirent governor of New York, 1847–49, he alienated conservatives of his party by pardoning imprisoned Antirent rioters and by supporting the Mexican War.

YOUNG, JOHN CLARKE (*b. Greencastle, Pa., 1803; d. 1857*), Presbyterian clergyman, educator. Graduated Dickinson College, 1823; Princeton Theological Seminary, 1827. President, Centre College, Danville, Ky., 1830–57. Became pastor of Danville Presbyterian Church, 1834; organized Second Presbyterian Church for students of the college, 1852. Became moderator of the General Assembly, 1853. An "old school" minister, distinguished for high principles and common sense.

YOUNG, JOHN RICHARDSON (*b. Elizabethtown, Md., 1782; d. 1804*), physician. M.D., University of Pennsylvania, 1803. Author of *An Experimental Inquiry into the Principles of Nutrition and the Digestive Process* (1803), a brilliant anticipation of the work of William Beaumont.

YOUNG, JOHN RUSSELL (*b. Co. Tyrone, Ireland, 1840; d. 1899*), journalist. Came to America as an infant. A reporter on the Philadelphia *Press*, he came to be a favorite of John W. Forney; as war correspondent, 1861, he became famous for an account of the Union defeat at first Bull Run. After serving as managing editor of Forney's newspapers, 1862–65, he became managing editor of the *New York Tribune*, 1866. In 1870 and 1871, he went abroad on confidential missions for the U.S. secretaries of the treasury and of state; in the course of this work, he witnessed the Paris Commune, of which he wrote a brilliant report. An editor of the *New York Herald* from 1872, he worked in London and Paris; in 1877, he accompanied U.S. Grant on a tour around the world. As U.S. minister to China, 1882–85, Young settled many outstanding claims and mediated in the dispute between France and China over Annam; he then resumed work on the *Herald*. He served as Librarian of Congress *post* 1897. Author of *Around the World with General Grant* (1879) and *Men and Memories* (1901).

YOUNG, JOHN WESLEY (*b. Columbus, Ohio, 1879; d. Hanover, N.H., 1932*), mathematician, educator. Graduated Ohio State, 1899; Ph.D., Cornell University, 1904. Taught at Northwestern, Princeton, Illinois, and Kansas universities; at Dartmouth *post* 1911. Editor of the American Mathematical Society *Bulletin*, 1907–25, Coauthor of *Projective Geometry* (1910, 1918); author of *Lectures on Fundamental Concepts of Algebra and Geometry* (1911).

YOUNG, JOSUE MARIA (*b. Shapleigh, Maine, 1808; d. 1866*), Roman Catholic clergyman. A printer-journalist in Maine, Kentucky, and Ohio, he was a convert to Catholicism, 1828. After studies at Mount St. Mary's, Emmitsburg, Md., he was ordained in 1838 and worked in the diocese of Cincinnati, Ohio. Consecrated bishop of Erie, Pa., 1854, he served until his death.

YOUNG, KARL (*b. Clinton, Iowa, 1879; d. New Haven, Conn., 1943*), medievalist, educator. A.B., University of Michigan, 1901. A.M., Harvard, 1902; Ph.D., 1907. Taught English at University of Wisconsin, 1909–23; professor of English (*post* 1938 Sterling professor) at Yale, 1923–43. Author of scholarly works on Chaucer's literary sources and of *The Drama of the Medieval Church* (1933), a definitive corpus of texts with accompanying exposition, interpretation, and evaluation.

YOUNG, LAFAYETTE (*b. near Eddyville, Iowa, 1848; d. Des Moines, Iowa, 1926*), Iowa journalist and legislator. Editor-publisher of the *Des Moines Capital*, 1890–1926. A correspondent in Cuba, 1898, he won the friendship of Theodore Roosevelt and placed Roosevelt's name in nomination for the vice-presidency at the Republican National Convention, 1900. U.S. senator, Republican, from Iowa, 1910–April, 1911.

YOUNG, MAHONRI MACKINTOSH (*b. Salt Lake City, Utah, 1877; d. Norwalk, Conn., 1957*), artist. Studied at the Art Students League in New York and at the Académie Julian in Paris. Remembered for his bronze sculptures and watercolors of the American West, of athletes, and of cowboys and Indians. Young, the grandson of Brigham Young, sculpted the famous Sea Gull monument (1913) and *This Is the Place* sculpture (1947) in Utah. He helped organize the famed Armory Show of 1913. His works can be seen in the Metropolitan Museum of Art, the Whitney Museum of American Art in New York, the American Museum of Natural History, and the Brooklyn Museum, as well as many others across the country.

YOUNG, OWEN D. (*b. Van Hornersville, N.Y., 1874; d. St. Augustine, Fla., 1962*), lawyer, industrialist, political adviser, and diplomat. A lawyer experienced in the electrical industry, Young joined the General Electric Company (GE) as general counsel and vice president in 1913. There he became one of the first

industrialists to recognize the importance of bettering industrial relations within the company and improving GE's image with the public. In 1919, he organized, and became chairman of, the board of the Radio Corporation of America (RCA). In the mid-1920's Young helped found the National Broadcasting Company. In 1922 he became chairman of the board of GE. In 1933 he resigned the chairmanship of RCA because of federal court order forcing him to choose between chairing GE or RCA. Young retired from GE in 1939, returning briefly as chairman during World War II (1942–44). He also enjoyed a career in international diplomacy beginning in the 1920's when he was chief architect of the Dawes Plan (1924) to reconstruct the German economy and reduce reparations payment. He was a close adviser to Franklin D. Roosevelt during the 1932 campaign, but later criticized the New Deal. In 1947 Young served on the Committee on Foreign Aid, which made recommendations on European relief and reconstruction under the Marshall Plan.

YOUNG, PIERCE MANNING BUTLER (*b. Spartanburg, S.C., 1836; d. New York, N.Y., 1896*), Confederate soldier, diplomat. Raised in Georgia. Attended West Point, 1857–61, resigning to enter Confederate artillery. Served with great gallantry in the Virginia campaigns with the cavalry of Cobb's Legion; won commendation for his behavior at Gettysburg and Brandy Station. He was made brigadier general, 1863, and given command of Hampton's brigade. In 1864 he defended Augusta, Ga., against General W. T. Sherman, rising to major general in December. Congressman, Democrat, from Georgia, July 1868–March 1869 and December 1870–March 1875. U.S. consul general at St. Petersburg, Russia, 1885–87; U.S. minister to Guatemala and Honduras, 1893–96.

YOUNG, ROBERT RALPH (*b. Canadian, Tex., 1897; d. Palm Beach, Fla., 1958*), railway executive. Studied briefly at the University of Virginia. After working for E. I. du Pont, 1916, and General Motors, 1922, assistant treasurer, 1928, Young made a fortune in the stock market crash of 1929. He thereafter sought to control railroads with the idea of a true coast-to-coast passenger service. Gained control of the Chesapeake and Ohio in the early 1930's and embarked on a long battle to win the New York Central, something he realized in 1954. But the government and other railroads never cooperated in allowing him to connect his transcontinental system. In one of his recurring bouts of depression, he committed suicide.

YOUNG, SAMUEL HALL (*b. Butler, Pa., 1847; d. near Clarksburg, W. Va., 1927*), Presbyterian clergyman. Ordained in 1878 as a missionary to Alaska, he spent the greater part of his life in service there. He organized the first Protestant and first American church in Alaska at Fort Wrangell, 1879. With John Muir, he explored Glacier Bay and discovered the Muir Glacier. He was also organizer and secretary of the first territorial convention, 1881, and drafted a memorial to Congress asking for better government.

YOUNG, STARK (*b. Como, Miss., 1881; d. Fairfield, Conn., 1963*), drama critic, novelist, playwright. Attended the University of Mississippi (B.A., 1901) and Columbia (M.A., 1902). Faculty member of the University of Texas at Austin where he founded the Curtin Club (1909). In 1914 he founded and edited the *Texas* (later *Southwest*) *Review*, then was an English professor at Amherst College (1915–21). At Amherst he published numerous poems and articles while his play, *At the Shrine*, was published in *Theatre Arts Magazine*. Left his academic career to devote himself fully to the arts as a staff member of the *New Republic* (1922–47) and *Theatre Arts Magazine* (1922–48). His novel, *So Red the Rose*, one of the best-sellers of 1934, brought him widespread acclaim and became a motion picture in 1935.

YOUNG, THOMAS (*b. New Windsor, N.Y., 1731/2; d. Philadelphia, Pa., 1777*), Revolutionary patriot, physician. Began practice of medicine in Amenia, N.Y., 1753; removed to Boston, Mass., 1766, where he was second only to Samuel Adams in pre-Revolutionary activity. Resident in Newport, R.I., 1774–75, he then escaped possible capture by the British by removal to Philadelphia, where he was secretary of the Whig Society. He suggested the name Vermont for the new state proposed by delegates from the New Hampshire grants, 1777. He died while serving as surgeon in a Continental army hospital.

YOUNG, WHITNEY MOORE, JR. (*b. Lincoln Ridge, Ky., 1921; d. Lagos, Nigeria, 1971*), civil rights leader. Graduated Kentucky State Industrial College (1941) and School of Social Work at the University of Minnesota (1947) and worked for the St. Paul Urban League, focusing on improving employment opportunities for African Americans. He became executive director of the Omaha Urban League (1950), dean of the Atlanta University School of Social Work (1954), and executive director of the National Urban League (1960). Under his leadership the league broke new ground by participating in the formation of public policy.

YOUNGDAHL, LUTHER WALLACE (*b. Minneapolis, Minn., 1896; d. Washington, D.C., 1978*), lawyer, judge, and governor. Attended University of Minnesota (1915–16) and graduated Gustavus Adolphus College (B.A., 1919) and Minnesota College of Law (LL.B., 1921). He became assistant city attorney for Minneapolis (1921–24), a judge on the Minneapolis Municipal Court (1930–36), and district judge of Hennepin County (Minneapolis) Court (1936–42). As a Republican governor of Minnesota (1947–52), he enforced the state's laws against gambling and sought improved treatment of the mentally ill in state hospitals. He was appointed federal judge for the U.S. District Court for the District of Columbia (1951–66).

YOUNGER, MAUD (*b. San Francisco, Calif., 1870; d. Los Gatos, Calif., 1936*), woman suffragist, trade unionist. Washington lobby chairman of the Congressional Union for Woman Suffrage (later the National Woman's Party).

YOUNGER, THOMAS COLEMAN (*b. near Lee's Summit, Mo., 1844; d. near Lee's Summit, 1916*), desperado, better known as "Cole" Younger. After service as a Confederate guerrilla, he was active in the gang of bandits reputedly led by Jesse James. Captured with his brothers and others of the gang after their attempt to rob the bank at Northfield, Minn., September 1876, he was tried and sentenced to life imprisonment. Paroled in 1901, he was pardoned early in 1903.

YOUNGS, JOHN (*b. Southwold, England, 1623; d. 1698*), colonial soldier and official. Immigrated to Salem, Mass., 1637; was a settler of Southold, N.Y., ca. 1640. Appointed magistrate and a deputy from Southold to New Haven, 1660, he worked to establish the complete jurisdiction of Connecticut over the Long Island towns and became a member of the Connecticut council, 1664. He aided in the capture of New Amsterdam, 1664, but later led a protest against the newly imposed rule of the duke of York and restored Southold and neighboring towns to Connecticut after the Dutch recaptured New York in 1673. However, he accepted a share in the patent of Southold from the duke of York, 1676, and returned to New York allegiance. In 1681 he drafted a petition to the duke for a representative assembly (first held in New York, October 1683), while serving as the high sheriff of

the country of Yorkshire. He was a member of the Governor's Council of New York *post* 1686.

YOUNT, GEORGE CONCEPCÍON (*b. Dowden Creek, N.C., 1794; d. Caymus Rancho, Calif., 1865*), farmer, trapper, California pioneer. Raised in Missouri. Removing to Santa Fe, 1825, he became a trapper and worked with Ewing Young and others; during 1829, he worked in the northern fur country around the source of the Yellowstone. Influenced by Jedediah S. Smith, he joined William Wolfskill's 1830 expedition to California, arriving in Los Angeles in February 1831. After a period of drifting up and down the coast, he became a Mexican citizen and was given a grant of land in the Napa Valley, 1836, on which he built a fort and began cultivation and improvement. Suffering heavy loss after the American conquest of California, he later recovered much of his property.

YULEE, DAVID LEVY (*b. St. Thomas, Danish West Indies, 1810; d. New York, N.Y., 1886*), lawyer, Florida politician, railroad promoter. Admitted to the Florida bar, 1836, he served as Florida territorial delegate to Congress *post* 1841, and as U.S. senator, Democrat, from Florida, 1845–51, and 1855–61. Originally a leader in the Southern rights movement, he later became much more conservative. One of the earliest railroad promoters in the South, he incorporated the Atlantic & Gulf Railroad, 1853, which he completed after difficulties in 1860; it connected Fernandina, Fla. with Cedar Keys. During the Civil War he devoted his energies to his plantation and to the running of his railroad, successfully preventing seizure of its material by the Confederate authorities for use in repair of other lines.

YUNG, WING (*b. Nam Ping, Pedro Island, near Macao, China, 1828; d. Hartford, Conn., 1912*), educator, Chinese official. Graduated Yale, 1854, the first Chinese alumnus of an American college. Initiated, and served as commissioner of, the Chinese Educational Commission, 1870–81, for placing young Chinese in U.S. educational institutions. Associated with reforming and "Westernizing" movements as a Chinese official, he fled his own country in 1899 and resided in the United States *post* 1902.

Z

ZACH, MAX WILHELM (*b. Lemberg, Austria, 1864; d. 1921*), orchestral conductor, composer. Violist, Boston Symphony Orchestra, 1886–1907; Adamowski String Quartette, 1890–1906. Conductor, St. Louis Symphony Orchestra, 1907–21. His most significant contribution to American music was his advocacy of works by American composers. He wrote marches and waltzes in the Viennese style.

ZACHARIAS, ELLIS MARK (*b. Jacksonville, Fla., 1890; d. West Springfield, N.H., 1961*), naval officer. Began a lifelong study of Japanese language and culture at the U.S. Naval Academy, from which he was graduated in 1912. During his 1920 assignment to Tokyo as naval attaché, he became fluent in Japanese and met many of the men who later directed Japan's war effort during World War II. After serving both in combat and in naval intelligence during World War II, he played a key role in the preparation of psychological operations to induce Japan to surrender unconditionally. Zacharias was awarded a Legion of Merit for the part he took in the Japanese surrender. He retired as a rear admiral in 1946.

ZACHOS, JOHN CELIVERGOS (*b. Constantinople, Turkey, 1820; d. New York, N.Y., 1898*), educator, Union army surgeon, Unitarian clergyman, author, inventor. Brought to America by Samuel G. Howe, 1830. B.A., Kenyon, 1840; studied medicine at Miami University, Ohio, 1842–45. Associated for a number of years with Ohio educational institutions. Curator and teacher of literature and oratory, Cooper Union, New York City, *post* 1871. Patented machine for printing at high reporting speed, 1876. Author of, among other works, *A Sketch of the Life and Opinions of Mr. Peter Cooper* (1876) and *The Phonic Primer and Reader* (1864).

ZAHARIAS, MILDRED ("BABE") DIDRIKSON (*b. Port Arthur, Tex., 1914; d. Galveston, Tex., 1956*), athlete. One of the greatest women athletes of all time, Babe Zaharias broke 4 world records at the 1936 Olympics: in the javelin throw, the 80-meter hurdles (twice), and the high jump. It is as a golfer that she is most remembered. She became the first American woman to win the British Ladies' Amateur Open in 1947. She won 17 consecutive tournaments in 1946–47, and 82 between 1933 and 1953, making her the greatest woman golfer of all time. The Associated Press voted her "Woman of the Year" in 1936, 1945, 1947, 1950, and 1954.

ZAHM, JOHN AUGUSTINE (*b. New Lexington, Ohio, 1851; d. Munich, Germany, 1921*), Roman Catholic clergyman, educator. Graduated Notre Dame University, 1871; entered Congregation of the Holy Cross. Ordained, 1875, he taught at Notre Dame and held administrative posts in his order. Occupied chiefly as a writer *post* 1905, he was author of scientific and theological books, and authoritative texts on South America, sometimes under pseudonym "J. H. Mozans." He was a friend and traveling associate of Theodore Roosevelt.

ZAHNISER, HOWARD CLINTON (*b. Franklin, Pa., 1906; d. Hyattsville, Md., 1964*), conservationist, editor. Attended the Greenville College, Ill. (B.A., 1928) and did postgraduate work at American University and George Washington University in Washington, D.C. After a series of positions with the federal government as an editor, writer, and broadcaster, Zahniser became executive secretary (later executive director) of the Wilderness Society and editor of its magazine, *The Living Wilderness* (1945–64). In the 1950's he successfully led a movement to defeat construction of a dam at Dinosaur National Monument on the Colorado-Utah border. Was instrumental in creating a national wilderness preservation system. He was also an essayist and book editor for *Nature* magazine (1935–59).

ZAKRZEWSKA, MARIE ELIZABETH (*b. Berlin, Germany, 1829; d. 1902*), physician. Immigrated to America, 1853. Aided by Elizabeth Blackwell, she graduated M.D. from Cleveland Medical College, 1856. Founder, and virtual head, of the New England Hospital for Women and Children, 1862–99, she became the outstanding woman physician in New England.

ZAMORANO, AGUSTIN JUAN VICENTE (*b. St. Augustine, Fla., 1798; d. 1842*), military engineer, Mexican official. Executive secretary of California, 1825–36; also commandant of the *presidio* at Monterey, 1831–36. Chiefly remembered as California's first printer. Among his known imprints are letterheads, official broadsides or folders, and four books, including José Figueroa's *Manifesto a la Republica Mejicana* (1835). Military commander of Lower California, 1839–40, he was appointed adjutant inspector of California, 1842, but died soon after reaching San Diego.

ZANE, CHARLES SHUSTER (*b. Cape May Co., N.J., 1831; d. Salt Lake City, Utah, 1915*), jurist. Admitted to the Illinois bar, 1857. Law partner of W. H. Herndon and S. M. Cullom. Illinois circuit judge, 1873–84; chief justice of Utah Territory, 1884–88 and 1889–94. Enforced Edmunds Law against polygamy and related offenses with efficient sternness, yet won respect of the Mormons and protected their legal rights. First chief justice of the state of Utah, 1896–99.

ZANE, EBENEZER (*b. near Moorefield, Va., now W.Va., 1747; d. 1812*), pioneer, land speculator. Established Wheeling, Va., settlement, 1769. A colonel in Dunmore's War, he also played a prominent part in sieges of Fort Fincastle (Fort Henry), 1777 and 1782. He received, 1796, federal grants of land where Zanesville and Lancaster, Ohio, were later laid out, on condition that he blaze a road from Wheeling to Limestone, Ky., before 1797.

ZANUCK, DARRYL FRANCIS (*b. Wahoo, Nebr., 1902; d. Palm Springs, Calif., 1979*), motion-picture producer and screenwriter. He sold his first stories to film studios in 1923, did gagwriting for Charlie Chaplin and others, wrote episodes of the two-reelers *The Telephone Girl* and *The Leatherpusher*. He was hired as a scriptwriter at Warner Brothers (1924) for the Rin–

Tin–Tin series and became an executive producer (1927), general production chief (1929), and chief executive in charge of all production (1931). He produced the first talkie, *The Jazz Singer* (1927). His successful productions include *Little Caesar* (1930), *Public Enemy* (1931), and *I Am a Fugitive from a Chain Gang* (1932). He left Warner in 1933 to cofound Twentieth Century Pictures and had an immediate success with *The Bowery* (1933). He became vice-president and chief of production of the merged Twentieth Century–Fox (1935), which produced Shirley Temple films, Westerns, comedies, children's classics, and director John Ford's *The Grapes of Wrath* (1940) and *How Green Was My Valley* (1941).

Zanuck was the first recipient of the Irving G. Thalberg Award (1937, 1944, 1950), which recognizes consistently creative producers. Other successful films were *The Razor's Edge* (1946), *Miracle on 34th Street* (1947), *Gentleman's Agreement* (1947), and *Twelve O'Clock High* (1950). He introduced the CinemaScope process in *The Robe* (1953). In 1956 he left Twentieth Century–Fox and established DFZ Productions, which produced several war movies, including *The Longest Day* (1962) and *Tora! Tora! Tora!* (1970), and the musical *Hello, Dolly!* (1969). He returned to Twentieth Century–Fox as president (1962–69) and became chairman and chief executive officer (1969–71), reinvigorating the studio with *The Sound of Music* (1965), *Patton* (1970), and *M*A*S*H** (1970). He received best-film Oscars for *How Green Was My Valley, Gentleman's Agreement,* and *All About Eve* (1950).

ZECKENDORF, WILLIAM (*b. Paris, Ill., 1905; d. New York City, 1976*), real estate developer. Attended New York University (1922–25) and became a real estate agent. He was hired to run the property management division of Leonard S. Gans's estate brokerage firm (1926) and became a partner in 1930. He became vice-president of Webb and Knapp in 1938, and his best-known deal was the purchase of land along the East River in 1945, which became headquarters for the United Nations. He became president of Webb and Knapp in 1947 and took part in several large-scale developments, including development of Century City in Los Angeles and Mile High City in Denver. He also hired I. M. Pei as in-house architect (1949) and created a general contracting division for the company's projects (1952). By 1957, the firm's net worth was $75 million, but it was dangerously overextended and forced into bankruptcy in 1965; he was forced to file for personal bankruptcy protection (1968).

ZEILIN, JACOB (*b. Philadelphia, Pa., 1806; d. 1880*), U.S. Marine Corps officer. Attended West Point for several years *post* 1822; entered marines as second lieutenant, 1831. Served in California during Mexican War; also on M. C. Perry's expedition to Japan; was wounded at first Bull Run. First marine officer to attain rank of brigadier general, 1867, he was commandant of the corps, 1864–76.

ZEISBERGER, DAVID (*b. Zauchtenthal, Moravia, 1721; d. Goshen, Ohio, 1808*), Moravian missionary. Immigrating first to Savannah, Ga., he removed to Pennsylvania in 1739. A successful and devoted missionary to the Iroquois and the Delaware tribes, Zeisberger was involved from 1745 until his death in all the complicated politics of the frontier. Invaluable in conferences with the Indians because of his knowledge of their habits and languages, he gave his primary attention to making the Indians useful members of society. He lived about ten years among the Iroquois between 1745 and 1763. He then worked principally with the Delaware, following them as they were pushed westward by the tide of settlement and establishing a Christian Indian settlement in the Tuscarawas Valley, 1771. Here he erected the first church building and schoolhouse west of the Ohio River; within

a few years three similar centers were erected nearby. After the ruin of these Indian settlements during the Revolution, Zeisberger helped establish settlements for Indian converts in what is now Michigan and also at New Salem, Ohio, and Fairfield, Canada.

ZEISLER, FANNIE BLOOMFIELD (*b. Bielitz, Austrian Silesia, 1863; d. 1927*), pianist, teacher. Wife of Sigmund Zeisler; sister of Maurice Bloomfield. Came to America as a child; was raised in Chicago, Ill. A pupil of Bernhard Ziehn and Carl Wolfsohn; studied also with Leschetizky in Vienna. Played with major European orchestras on continental tours, 1893–1912; noted for technique and poetic feeling.

ZEISLER, SIGMUND (*b. Bielitz, Austrian Silesia, 1860; d. Chicago, Ill., 1931*), lawyer. Husband of Fannie B. Zeisler. Immigrated to America, 1883. J.D., University of Vienna, 1883; LL.B., Northwestern University, 1884. Practiced law in Chicago, Ill., *post* 1884. Assistant corporation counsel of Chicago, 1893–94; master in chancery, Cook Co. circuit court, 1904–20.

ZELLERBACH, HAROLD LIONEL (*b. San Francisco, Calif., 1894; d. Honolulu, Hawaii, 1978*), businessman and music and art patron. Attended University of California at Berkeley (1913–15) and University of Pennsylvania (B.S., 1917) and joined the family firm, Zellerbach Paper Company. With his father and brother, he greatly expanded the firm, merging in 1928 with Crown Willamette Paper Company to form Crown Zellerbach Corporation. He was appointed vice-president of Crown Zellerbach, then executive vice-president (1938–56), director (1928–59), and chairman (1957–59). He had a lifelong interest in the arts and public service; he served on several boards, including those of the San Francisco Symphony and San Francisco Performing Arts Center, and was a founding member of the Foundation for the Arts and Humanities (1973).

ZELLERBACH, JAMES DAVID (*b. San Francisco, Calif., 1892; d. San Francisco, 1963*), industrialist, diplomat. Entered the Zellerbach Corporation, founded by his grandfather, as a counterman after graduating from the University of California in 1913. In 1929 Zellerbach Corporation merged with the Crown Willamette Corporation to become Crown Zellerbach, the nation's leading manufacturer of paper and paper products. Zellerbach was its first president; he became chairman in 1938. As a labor expert, he served as vice chairman of the International Labor Organization (1945–48) and headed the Economic Cooperation Administration's mission to implement the Marshall Plan in Italy (1948). From 1956 to the end of the Eisenhower administration was U.S. ambassador to Italy.

ZENGER, JOHN PETER (*b. Germany, 1697; d. New York, N.Y., 1746*), printer, journalist. Immigrated to New York ca. 1710; was apprenticed in 1711 to William Bradford, the pioneer printer of the middle colonies. After a residence in Kent Co., Md., 1719–21, he returned to New York, forming a partnership with Bradford, 1725. He set up in business for himself, 1726, and printed a number of unimportant works in English and Dutch. He brought out Venema's *Arithmetica*, 1730, the first arithmetic text printed in the New York colony.

Backed by Lewis Morris, James Alexander, and William Smith (1697–1769) as editor of a journal which would oppose the administration of Governor William Cosby, Zenger brought an independent and truculent spirit to New York journalism. The first number of his *New-York Weekly Journal* appeared Nov. 5, 1733. Although its major articles were contributed by his backers, Zenger was legally responsible for them as publisher, and he was arrested in the fall of 1734 for alleged libelous statements in the

issues numbered 7, 47, 48, and 49 of the *Journal*. Confined for some ten months before trial, he continued to bring out his paper through the management of his wife. Brought to trial in April 1735 for criminal libel, he appeared to have very little chance. Alexander and Smith, who represented him, were disbarred when they questioned the validity of appointment of two of the judges. However, at the trial in August, Zenger was represented by Andrew Hamilton (d. 1741) of Philadelphia, who overrode the strict construction of criminal libel under common law and pleaded for the right of the jury to inquire into the truth or falsity of the libel. When his argument was cut off by the court, Hamilton appealed to the jury, which responded with a verdict of not guilty. This was the first major victory for the freedom of the press in the American colonies, and the account of the trial, published as *A Brief Narrative of the Case and Tryal of John Peter Zenger* (1736), aroused great interest both in America and in Great Britain. Appointed public printer for the colony of New York in 1737, Zenger was appointed to the same office for New Jersey the following year.

Zentmayer, Joseph (*b. Mannheim, Germany, 1826; d. Philadelphia, Pa., 1888*), inventor, manufacturer. Immigrated to America 1848. Established himself in Philadelphia, 1853, as a scientific instrument-maker. Made a number of improvements in the microscope; invented, 1865, and patented an improved photographic lens.

Zerrahn, Carl (*b. Malchow, Germany, 1826; d. Milton, Mass., 1909*), musician, conductor. Came to the United States, 1848. Conductor, Boston, Mass., Handel and Haydn Society, 1854–96. Directed Harvard Musical Association, 1865–82. Active as conductor of Massachusetts orchestras and music festivals. Taught singing, harmony, and composition at the New England Conservatory of Music, Boston.

Zeuner, Charles (*b. Eisleben, Saxony, 1795; d. probably Camden, N.J., 1857*), composer, organist. Immigrated to America *ante* 1830. Organist, Boston, Mass., Handel and Haydn Society, 1830–39. Author of, among other publications, *Church Music . . . Anthems, Motets, and Chants* (1831); *Organ Voluntaries* (1840); and an oratorio, *The Feast of Tabernacles* (ca. 1832), the first American work of its kind, presented by the Boston Academy of Music, 1837.

Zevin, Israel Joseph (*b. Horki, Mohilev, Russia, 1872; d. 1926*), editor, writer. Best known under pseudonym "Tashrak." Immigrated to New York City, 1889. Associated with *Jewish Daily News* thereafter until his death as a chief contributor, and as editor in chief for a time *post* 1907. He wrote humorous stories depicting immigrant American Jews which were widely popular. Among his books were *Tashrak's beste Erzeilungen* (1910) and *Ale Agodos fun Talmud* (1922).

Ziegemeier, Henry Joseph (*b. Allegheny, Pa., 1869; d. probably Bremerton, Wash., 1930*), naval officer. Graduated Annapolis, 1890. After varied service at sea and staff duty, he was promoted captain, 1916, and commanded the battleship *Virginia*, 1917–19. He had charge of the organization and training of the Naval Reserve Force, 1919–21. Promoted rear admiral, 1922, he died as commandant of the 13th Naval District and the Puget Sound navy yard.

Ziegfeld, Florenz (*b. Chicago, Ill., 1869; d. Hollywood, Calif., 1932*), theatrical producer. Entered show business as promoter of musical features for the Chicago World's Fair, 1893. Acted as manager for Sandow the Strong Man, and for Anna Held, displaying great gifts for publicity. Introduced the musical revue to the United States as *The Follies of 1907* and followed

its success by similar shows produced for more than 20 years. The *Ziegfeld Follies* became noted for lavish beauty of setting and for the attractiveness of its chorus types. Ziegfeld's "glorification of the American girl" was responsible for a change in feminine style of beauty. Despite the lavishness of his productions, he possessed an instinctive taste which held them within bounds. Among other successful shows which he produced were *Sally* (1920), *Show Boat* (1927), and *Bitter Sweet* (1929).

Ziegler, David (*b. Heidelberg, Germany, 1748; d. 1811*), soldier, Ohio pioneer and civic official. Immigrated to Pennsylvania, 1774. Fought in Revolution from Boston siege to Yorktown. Held captain's commission in regular army, 1784–90; major, 1st Infantry, 1790–92. President, Cincinnati, Ohio, council, 1802–04. Appointed first marshal, Ohio district, 1803; Ohio adjutant general, 1807. Ziegler served as surveyor of the port of Cincinnati from 1807 until his death.

Ziegler, William (*b. Beaver Co., Pa., 1843; d. 1905*), businessman. An organizer and official of the Royal Chemical Co., manufacturers of Royal Baking Powder. Patron of North Pole scientific expeditions, 1901 and 1903.

Ziehn, Bernhard (*b. Erfurt, Germany, 1845; d. 1912*), musical theorist, teacher. Immigrated to America, 1868; settled in Chicago, Ill. Ziehn developed the idea of symmetrical inversion of melodic phrases and solved the problem of the unfinished final fugue in J.S. Bach's *Art of the Fugue*. His greatest contribution to the history of music was his monographic demonstration of the spuriousness of the *St. Luke Passion*. He was author of, among other works, *Harmonie- und Modulationslehre* (1888), an epoch-making work on harmonic analysis; *Manual of Harmony* (1907); *Five- and Six-Point Harmonies* (1911); and *Canonical Studies: A New Technic in Composition* (1912).

Ziff, William Bernard (*b. Chicago, Ill., 1898; d. New York, N.Y., 1953*), publisher, author, and editor. Studied at the Art Institute of Chicago before founding an advertising company; in 1923, he became head of a Chicago publishing company, E.C. Auld Co., which in 1933 became the Ziff-Davis Publishing Co. Beginning with *Ziff's Magazine* (later *America's Humor*), the company went on to publish *Flying, Popular Photography, Amazing Stories, Air Adventures,* and *Mammoth Detective*. Ziff's books include *The Rape of Palestine* (1938) and *The Coming Battle of Germany* (1942), a best-seller that argued that the use of air power, long an interest of Ziff's, was the only way to achieve victory over Nazi Germany.

Zilboorg, Gregory (*b. Kiev, Russia, 1890; d. New York, N.Y., 1959*), psychoanalyst and psychiatric historian. Studied at the Faculty of Medicine in St. Petersburg and at Columbia University's College of Physicians and Surgeons. Immigrated to the U.S. in 1919. Zilboorg practiced privately in New York from 1931 and was a charter member of the New York Psychoanalytic Institute (1931). Remembered as a historian of psychiatry, Zilboorg wrote many works in the field: *The Medical Man and the Witch During the Renaissance* (1935), *History of Medical Psychology* (1941), and *Mind, Medicine and Man* (1943). Zilboorg was critical of Freud's view on religion and deplored the lack of a clear synthesis of psychoanalysis, psychiatry, and medicine in the United States.

Zimmerman, Eugene (*b. Vicksburg, Miss., 1845; d. 1914*), Ohio capitalist, railroad official.

Zimmerman, Eugene (*b. Basel, Switzerland, 1862; d. 1935*), cartoonist. Came to America as a child. Encouraged by Joseph Keppler, he began his career on *Puck*; he served as political cartoonist and comic draftsman on the staff of *Judge*, 1885–1913.

Limited in technique, he was a shrewd, humorous observer of human nature and belonged with F. B. Opper to the grotesque or "exaggerated distortion" phase of American graphic humor.

ZIMMERMAN, HENRY ("HEINIE") (*b. Bronx, N.Y., 1896; d. New York, N.Y., 1960*), baseball player. Played for the Chicago Cubs; in 1916 he was recognized as the best third baseman in the National League. That same year he was traded to the New York Giants where he was responsible for the infamous "bone-head" play in the fourth inning of the sixth and final game of the World Series between the Giants and the Chicago White Sox. Ever after known as "the man who chased Eddie Collins across the plate," Zimmerman perpetrated, according to the *New York Times*, "one of the stupidest plays that has ever been seen in a world's series." His career ended in 1919 when he was suspended for having thrown games.

ZINSSER, HANS (*b. New York, N.Y., 1878; d. New York, 1940*), physician, bacteriologist, author. Graduated Columbia, 1899; M.D., Columbia, 1903. Bacteriologist at Roosevelt Hospital, New York City, 1906–10, he also taught that subject at Columbia. After teaching bacteriology and immunology at Stanford University, 1910–13, he returned to Columbia as professor in the College of Physicians and Surgeons until 1923 when he became professor of bacteriology and immunology at Harvard University Medical School. Remaining at Harvard until his death, he engaged in research, particularly on typhus, for which he became widely known. He was author of a number of scientific papers and several important textbooks, but is principally remembered by the public for his *Rats, Lice and History* (1935) and his autobiography, *As I Remember Him* (1940). A leader in development of the science of immunology, he made important investigations into four broad subjects; (1) the nature of antigens and antibodies and the colloid chemical aspects of immunological reactions; (2) the early emphasis on "residue antigens," from the tubercle bacillus and other bacteria (nonprotein substances, particularly proteoses and polysaccharides); (3) studies of *Treponema pallidum*, the spirochete of syphilis; and (4) studies on typhus fever.

ZINZENDORF, NICOLAUS LUDWIG, COUNT VON (*b. Dresden, Saxony, 1700; d. Herrnhut, Saxony, 1760*), Moravian leader and bishop. His career as a whole belongs to German biography, but he played a personal part in American ecclesiastical affairs on a visit to Pennsylvania, December 1741–January 1743. Attempting to work with Henry Antes and others in an effort to unite all Pennsylvania German Protestants in a single association, Zinzendorf held a series of conferences during the first six months of 1742 at various places, but was so mercilessly attacked by Samuel Blair, J. P. Boehm, Gilbert Tennent, and others that he abandoned his plan. He later journeyed among the Indians in the interest of Moravian missions and helped establish Moravian congregations at Bethlehem (which owes its name to him), Nazareth, Philadelphia, Lancaster, and York, Pa., and at New York and on Staten Island.

ZNANIECKI, FLORIAN WITOLD (*b. Swiatniki, Poland, 1882. d. Urbana, Ill., 1958*), sociologist and philosopher. Studied at the Jagiellonian University of Krakow (Ph.D., 1910). In collaboration with American sociologist, W. I. Thomas, Znaniecki traveled to Chicago in 1914 to complete their book, *The Polish Peasant in Europe and America* (5 vols., 1919–1927), which was a landmark in sociology because of its use of personal documents and biograms.

Founded the first department of sociology in Poland at the University of Poznan in 1922. Was forced to flee Hitler in 1939. Taught at the University of Illinois from 1942 to 1950. Works include *Cultural Reality* (1919), *The Method of Sociology* (1934), and *Cultural Sciences, Their Origin and Development* (1952).

ZOGBAUM, RUFUS FAIRCHILD (*b. Charleston, S.C., 1849; d. New York, N.Y., 1925*), illustrator, noted for the vivid realism and the high spirit of his depictions of military actions and army and navy life. Studied at the University of Heidelberg, at the New York City Art Students League, 1878–79, and in Paris under L. J. F. Bonnat, 1880–82.

ZOLLARS, ELY VAUGHAN (*b. near Lower Salem, Ohio, 1847; d. Warren, Ohio, 1916*), educator, Disciples of Christ clergyman, author. Graduated Bethany, 1875. President of, among others, Hiram College, 1888–1902. Established Oklahoma Christian University (Phillips University), chartered 1907, serving it as president and president emeritus until his death.

ZOLLICOFFER, FELIX KIRK (*b. Maury Co., Tenn., 1812; d. near Mill Springs, Ky., 1862*), Tennessee journalist, politician and official, Confederate brigadier general. A vehement states' rights Whig, he edited a number of small newspapers and was notable as editor of the *Nashville Banner*, 1850–52. A power in state politics, he served as a congressman from Tennessee, 1853–59, working for peace and understanding between North and South. Commissioned Confederate brigadier general, 1861, he commanded in East Tennessee and was killed early in January 1862 while moving with his army into Kentucky.

ZOOK, GEORGE FREDERICK (*b. Fort Scott, Kan., 1885; d. Arlington, Va., 1951*), historian, government official, educator. Studied at the University of Kansas (B.A., 1906) and at Cornell University (Ph.D., 1913). Taught at Penn State, 1912–20. After World War I, chief of higher education in the U.S. Bureau of Education, serving until 1925. President of Akron University, 1925–29. In 1933 President Franklin D. Roosevelt appointed him commissioner of education, a post he held for one year. From 1934 on, he was director and president of the American Council on Education. Became the most prominent lobbyist for higher education; supported the growth of junior colleges and vocational training programs; sought federal aid to servicemen; encouraged exchange programs and was responsible in revamping the educational systems of Germany and Japan after the war. United States national commissioner for UNESCO from 1946 to 1951.

ZORACH, WILLIAM (*b. Euberick, Lithuania, 1889; d. Bath, Maine, 1960*), sculptor. Came to the United States in 1893. Studied painting and drawing at the National Academy of Design in New York City during the winters of 1908–10, and decided to continue his studies in Paris (1910–11). Exhibited at the 1913 Armory Show. Increasingly attracted to carving, he "realized that sculpture, not painting, would have to become my lifework . . ." In 1927 he began one of his best-known compositions, *Mother and Child*, later acquired by the Metropolitan Museum of Art. Taught at the Art Students League in New York City, 1929–60. Was the subject of a major retrospective exhibition at the Whitney Museum of American Art in 1959.

ZUBLY, JOHN JOACHIM (*b. St. Gall, Switzerland, 1724; d. Savannah, Ga., 1781*), Presbyterian clergyman, pamphleteer. Immigrated to South Carolina, 1744; removed to Georgia, 1760, to become pastor of the Independent Presbyterian Church at Savannah. A chief spokesman for dissenting groups against what they considered local oppressions, he was also an early champion of colonial rights against the British government. He was author of a number of pamphlets and articles on the difficulties with Great Britain, 1766–75. Chosen a delegate from Savannah to the Georgia provincial congress, he also represented Georgia in

the second Continental Congress, 1775. Opposing a complete break with the mother country, he returned to Georgia, October 1775, where he was arrested as a Loyalist and later banished from the province. He returned to Savannah, 1779, after restoration of the royal authority and continued his pastoral work until his death.

ZUKOFSKY, LOUIS (*b. New York City, 1904; d. Port Jefferson, N.Y., 1978*), poet and critic. Graduated Columbia University (1923) and began writing poetry; "Of Dying Beauty" was published in *Poetry* magazine (1924) and "Poem Beginning 'The'" was published in Ezra Pound's journal *Exile* (1928). In 1928 he finished the first four of twenty-four "movements" of a long experimental work titled "A." He also wrote the brilliant poems "Mantis" and "'Mantis,' An Interpretation" (1934), about the helplessness of the poor, and completed the eighth (1937) and ninth (1939) movements of "A," and also *55 Poems* (1941). He was an instructor of English at Polytechnic Institute of Brooklyn (1947–65) and published his anthology *A Test of Poetry* (1948). During the 1960's he continued work on "A" and published *After I's* (1964) and the first two volumes of *ALL, The Collected Poems* (1965, 1966); the October 1965 issue of *Poetry* was devoted to his work. An unrelenting experimenter, he was regarded as a poet's poet but did not receive widespread public recognition.

ZUKOR, ADOLPH (*b. Ricse, Hungary, 1873; d. Los Angeles, Calif., 1976*), motion-picture executive. Immigrated to United States in 1888; the success of his investment in a New York City penny arcade led to the opening of others along the East Coast. Beginning with the Crystal Hall Theater, he bought several theaters and began showing films. In 1910 he merged most of his theaters into a vaudeville circuit owned by Marcus Loew; as a cost-cutting measure; feature-length films replaced some of the variety acts. In 1912 he bought the rights to the four-reel French production *Queen Elizabeth*, starring Sarah Bernhardt, and premiered it at the Lyceum Theater. He established Famous Players Film Company, and the studio's early successful productions were *The Prisoner of Zenda, Tess of the D'Urbervilles, The Count of Monte Cristo*, and, in 1914, *Tess of the Storm Country*, starring Mary Pickford. In that year he contracted with distributor Paramount Pictures Corporation to provide half of their annual need of 104 films; Famous Players took a major step in making high-quality films of an hour or more in length.

In 1916 he engineered a merger with Feature Pictures Company to form Famous Players–Lasky, with Zukor as president. He gained control of Paramount Pictures in 1917, and in 1919 expanded aggressively in the ownership of theaters. Zukor's films featured Rudolph Valentino, Wallace Reid, Gloria Swanson, and Western star William S. Hart. Paramount compiled record profits by 1930, combining production, distribution, and exhibition, but the Great Depression exposed the reckless manner of the company's vertical expansion. In 1933 Paramount was forced into receivership and emerged from bankruptcy in 1935 with Zukor as chairman. He received a special Academy Award for lifetime contributions to the motion-picture industry (1949).

ZUNSER, ELIAKUM (*b. Vilnius, Russia, 1836; d. 1913*), Yiddish poet. Immigrated to America, 1889; settled in New York City. Celebrated as author-composer of Yiddish folk songs.

ZUPPKE, ROBERT CARL (*b. Berlin, Germany, 1879; d. Champaign, Ill., 1957*), football coach. Immigrated to the United States, 1881. Studied at the University of Wisconsin (Ph.B., 1905). Legendary coach of the Illini of the University of Illinois from 1913 to 1941, Zuppke led his teams to 131 victories, 81 defeats, and 12 ties. Won the national championship in 1914, 1919, 1923, and 1927. As were many of his famous players, Red Grange among them, Zuppke was elected to the National Football Hall of Fame (1951).

ZWICKY, FRITZ (*b. Varna, Bulgaria, 1898; d. Pasadena, Calif., 1974*), astrophysicist. Graduated Eidgenossische Technische Hochschule in Zurich, Switzerland (B.S., 1920; Ph.D., 1922). In 1925 he received a fellowship to work with scientists at the California Institute of Technology, where he was appointed assistant professor of theoretical physics in 1927 and professor of astronomy in 1942, having changed his field of study to astrophysics in 1933. He also became director of research for the Aerojet Engineering Corporation (1943–49), pioneering the development of several different types of jet and propulsion engines. Among his many scientific and technological achievements are his theories concerning neutron stars; his supervision of an international search effort for supernovas; his initiation of a sky survey at the Mt. Palomar and Mt. Wilson observatories, which resulted in the creation of the most comprehensive set of galactic catalogs; and his work in the areas of jet propulsion and rocketry.

OCCUPATIONS INDEX

McCord, David James
McDougall, Alexander
Paine, Thomas
Struve, Gustav

AGRARIAN LEADER (See also
 AGRICULTURAL LEADER,
 AGRICULTURIST, FARM LEADER)
Johnson, Magnus
Lemke, William Frederick

AGRICULTURAL CHEMIST (See also
 AGRICULTURIST, CHEMIST)
Armsby, Henry Prentiss
Atwater, Wilbur Olin
Babcock, Stephen Moulton
Carver, George Washington
Collier, Peter
Frear, William
Hopkins, Cyril George
Jenkins, Edward Hopkins
Johnson, Samuel William
King, Franklin Hiram
Mapes, Charles Victor
Ravenel, St. Julien
Stockbridge, Horace Edward
Thatcher, Roscoe Wilfred
Van Slyke, Lucius Lincoln

AGRICULTURAL ECONOMIST (See also
 ECONOMIST)
Tolley, Howard Ross
Warren, George Frederick

AGRICULTURAL EDUCATOR (See also
 AGRICULTURIST, EDUCATOR)
Babcock, Howard Edward
Davenport, Eugene
Ladd, Carl Edwin

AGRICULTURAL HISTORIAN (See also
 HISTORIAN)
Edwards, Everett Eugene

AGRICULTURAL JOURNALIST (See also
 AGRICULTURIST, JOURNALIST)
Gregory, Clifford Verne
Sanders, James Harvey
Tucker, Luther
Wallace, Henry Cantwell
Wing, Joseph Elwyn

AGRICULTURAL LEADER (See also
 AGRARIAN LEADER, FARM
 LEADER)
Goss, Albert Simon
Haugen, Gilbert Nelson
Lowden, Frank Orren
Newsom, Herschel David

AGRICULTURAL SCIENTIST
Wallace, Henry Agard

AGRICULTURE, COMMISSIONER OF
 (See also AGRICULTURIST)
Le Duc, William Gates
Newton, Isaac, 1800–1867
Pearson, Raymond Allen

AGRICULTURIST (See also
 AGRICULTURAL CHEMIST, EDITOR,
 EDUCATOR, JOURNALIST;
 AGRICULTURE, COMMISSIONER OF;
 AGRONOMIST; ARBORICULTURIST;
 BOTANIC PHYSICIAN; BOTANIST;
 FARM COOPERATIVE LEADER;
 FARMER; FORESTER; GRANGER;
 HORTICULTURIST; NURSERYMAN;
 PLANT BREEDER; PLANTER;
 POMOLOGIST; SECRETARY OF
 AGRICULTURE; SEEDSMAN;
 SILVICULTURIST; SOIL EXPERT;
 SOIL SCIENTIST; SUGAR PLANTER;
 TREE SURGEON; TREE-CARE
 EXPERT; VITICULTURIST)
Allen, Richard Lamb
Bement, Caleb N.
Blalock, Nelson Gales
Bordley, John Beale
Brigham, Joseph Henry
Buel, Jesse
Capron, Horace
Chamberlain, William Isaac
Coker, David Robert
Dabney, Charles William
Eaton, Benjamin Harrison
Ellsworth, Henry Leavitt
Emerson, Gouverneur
Flint, Charles Louis
Furnas, Robert Wilkinson
Gardiner, Robert Hallowell
Garnett, James Mercer
Garst, Roswell ("Bob")
Goodale, Stephen Lincoln
Hazard, Thomas Robinson
Henry, William Arnon
Holmes, Ezekiel
Jarvis, William
Johnson, Benjamin Pierce
Johnston, John
Knapp, Bradford
Knapp, Seaman Asahel
Landreth, David
Leaming, Jacob Spicer
Le Duc, William Gates
L'Hommedieu, Ezra
Loring, George Bailey
Lubin, David
Lyman, Joseph Bardwell
McBryde, John McLaren
Mapes, James Jay
Mason, Arthur John
Miles, Manly
Mitchell, Donald Grant
Montgomery, William Bell
Morton, Julius Sterling
Murphy, Frederick E.
Oemler, Arminius
O'Neal, Edward Asbury, III

Patrick, Marsena Rudolph
Pedder, James
Peters, Richard, 1810–1889
Powel, John Hare
Randall, Henry Stephens
Roberts, Job
Robinson, Solon
Ruffin, Edmund
Shelton, Edward Mason
Smith, Hiram
Stockbridge, Levi
Sturtevant, Edward Lewis
Taylor, John
Todd, Sereno Edwards
Trimble, Allen
True, Alfred Charles
Turner, Jonathan Baldwin
Vanderbilt, George Washington
Vaughan, Benjamin
Voorhees, Edward Burnett
Waring, George Edwin
Watson, Elkanah
Watts, Frederick
Wilder, Marshall Pinckney
Wilson, James

AGRONOMIST (See also
 AGRICULTURIST)
Cobb, Nathan Augustus
Hopkins, Cyril George
Piper, Charles Vancouver
Rosen, Joseph A.

AIRCRAFT DESIGNER
Stearman, Lloyd Carlton

AIR FORCE CHIEF OF STAFF
Spaatz, Carl Andrew ("Tooey")
Vandenberg, Hoyt Sanford

AIR FORCE OFFICER
Brown, George Scratchley
Chennault, Claire Lee
Fairchild, Muir Stephen
Grissom, Virgil Ivan ("Gus")
James, Daniel, Jr. ("Chappie")
O'Donnell, Emmett, Jr. ("Rosy")
Royce, Ralph
Stratemeyer, George Edward
White, Edward Higgins, II

AIRLINE EXECUTIVE (See AVIATION
 EXECUTIVE)

AIRMAIL PIONEER
Henderson, Paul

ALCOHOLICS ANONYMOUS CO-
 FOUNDER
Wilson, William Griffith ("Bill W.")

ALIENIST (See also PHYSICIAN;
 PSYCHIATRIST; PSYCHOANALYST)
Awl, William Maclay
Flint, Austin
Gray, John Purdue
Hamilton, Allan McLane

Astrophysicist (See also
 Astronomer, Physicist)
 Mason, Max
 Rutherfurd, Lewis Morris
 Wildt, Rupert
 Zwicky, Fritz
Athlete (See also **Specific Sports**)
 Blaikie, William
 Brown, Johnny Mack
 Clothier, William Jackson
 Hubbard, Robert C. ("Cal")
 McGrath, Matthew J.
 Metcalfe, Ralph Harold
 Nevers, Ernest Alonzo ("Ernie")
 O'Brien, Robert David ("Davey")
 Owens, James Cleveland ("Jesse")
 Pilkington, James
 Prefontaine, Steve Roland ("Pre")
 Thorpe, James Francis
 Washington, Kenneth Stanley ("The
 General")
 Zaharias, Mildred ("Babe")
 Didrikson
Athletic Coach
 Lapchick, Joseph Bohomiel
Athletic Director
 Allen, Forrest Clare ("Phog")
 Butts, James Wallace ("Wally")
Athletic Trainer
 Murphy, Michael Charles
Atom-Bomb Spy
 Gold, Harry ("Raymond")
Attorney (See **Lawyer**)
Attorney General (Confederate)
 Benjamin, Judah Philip
 Davis, George
 Watts, Thomas Hill
Attorney General (Federal)
 Beck, James Montgomery
 Biddle, Francis Beverley
 Black, Jeremiah Sullivan
 Bonaparte, Charles Joseph
 Brewster, Benjamin Harris
 Cummings, Homer Stille
 Daugherty, Harry Micajah
 Devens, Charles
 Garland, Augustus Hill
 Gilpin, Henry Dilworth
 Gregory, Thomas Watt
 Harmon, Judson
 Hoar, Ebenezer Rockwood
 Kennedy, Robert Francis
 Lee, Charles, 1758–1815
 Legaré, Hugh Swinton
 McGranery, James Patrick
 McGrath, James Howard
 Miller, William Henry Harrison
 Moody, William Henry
 Murphy, Frank
 Olney, Richard

Palmer, Alexander Mitchell
Perlman, Philip Benjamin
Pierrepont, Edwards
Randolph, Edmund, 1753–1813
Speed, James
Stanbery, Henry
Stanton, Edwin McMasters
Stockton, John Potter
Taft, Alphonso
Taney, Roger Brooke
Thacher, Thomas Day
Toucey, Isaac
Wickersham, George Woodward
Williams, George Henry
Wirt, William
Attorney General (State)
 Conner, James
 Gilchrist, Robert
 Johnston, Augustus
 Martin, Luther
 Pringle, John Julius
 Robeson, George Maxwell
 Trott, Nicholas
 Updike, Daniel
Author (See also **Biographer,**
 Critic, Diarist, Dramatist,
 Essayist, Litterateur,
 Novelist, Poet, Writer)
 Abbot, Willis John
 Abbott, Austin
 Abbott, Benjamin Vaughan
 Abbott, Charles Conrad
 Abbott, Edith
 Abbott, Jacob
 Abbott, Lyman
 Acheson, Dean Gooderham
 Acrelius, Israel
 Adair, James
 Adams, Andy
 Adams, Frederick Upham
 Adams, John Coleman
 Adams, Samuel Hopkins
 Ade, George
 Adler, Polly
 Aiken, Conrad Potter
 Akeley, Mary Leonore
 Akers, Elizabeth Chase
 Alcott, Amos Bronson
 Alcott, Louisa May
 Alden, Henry Mills
 Alden, Isabella Macdonald
 Alden, Joseph
 Alexander, Archibald
 Alexander, Edward Porter
 Alexander, Joseph Addison
 Alger, William Rounseville
 Alinsky, Saul David
 Allen, Alexander Viets Griswold
 Allen, Anthony Benezet
 Allen, Ethan

Allen, George
Allen, Joel Asaph
Allen, Joseph Henry
Allen, William
Allen, Zachariah
Allston, Washington
Alsop, Charles
Alsop, Mary O'Hara
Altsheler, Joseph Alexander
Anderson Margaret Carolyn
Anderson, Sherwood
Anderson, Victor Vance
Andrews, Christopher Columbus
Andrews, Roy Chapman
Angle, Paul McClelland
Antin, Mary
Apes, William
Arthur, Timothy Shay
Artzybasheff, Boris
Ashhurst, John
Atkinson, George Wesley
Atwater, Caleb
Audsley, George Ashdown
Austin, Jane Goodwin
Austin, Mary
Austin, William
Azarias, Brother
Babbitt, Irving
Babcock, Maltbie Davenport
Babson, Roger Ward
Bacon, Alice Mabel
Bacon, Delia Salter
Bacon, Edwin Munroe
Badeau, Adam
Bagby, George William
Baird, Samuel John
Baker, Ray Stannard
Baker, William Mumford
Baldwin, Faith
Baldwin, Joseph
Baldwin, Joseph Glover
Baldwin, Loammi
Balestier, Charles Wolcott
Ballou, Hosea
Ballou, Maturin Murray
Bancroft, Aaron
Bancroft, Edward
Banvard, John
Banvard, Joseph
Barbour, Oliver Lorenzo
Bardeen, Charles William
Barnard, Charles
Barnes, Albert
Barr, Amelia Edith Huddleston
Barth, Alan
Bartholow, Roberts
Bartlett, Elisha
Bartlett, Joseph
Barton, Bruce Fairchild
Barton, Robert Thomas

Bates, Arlo
Bates, Katharine Lee
Baum, Lyman Frank
Bausman, Benjamin
Baylor, Frances Courtenay
Beard, Daniel Carter
Beard, James Carter
Beard, Mary Ritter
Beatty, John
Beers, Henry Augustin
Bell, Bernard Iddings
Bell, Charles Henry
Bell, Eric Temple
Bellamy, Edward
Bellamy, Elizabeth Whitfield
 Croom
Benét, William Rose
Benezet, Anthony
Benjamin, Asher
Benjamin, Park
Benjamin, Samuel Greene Wheeler
Bennett, Charles Edwin
Bentley, William
Benton, Thomas Hart
Berg, Gertrude Edelstein
Berger, Meyer
Berkman, Alexander
Berle, Adolf Augustus, Jr.
Biddle, Horace P.
Bidwell, Barnabas
Bierce, Ambrose Gwinett
Bigelow, John
Binkley, Wilfred Ellsworth
Binns, John
Bishop, John Peale
Bixby, James Thompson
Blackmur, Richard Palmer
Blake, John Lauris
Blake, Lillie Devereux
Blake, Mary Elizabeth McGrath
Blanshard, Paul
Bledsoe, Aibert Taylor
Bleyer, Willard Grosvenor
Bloomgarden, Solomon
Bodenheim, Maxwell
Bok, Edward William
Bolton, Sarah Knowles
Bond, Elizabeth Powell
Bonsal, Stephen
Bontemps, Arna Wendell
Booth, Mary Louise
Botta, Anne Charlotte Lynch
Bottome, Margaret McDonald
Botts, John Mmor
Boudin, Louis Boudinoff
Bouton, John Bell
Bouvet, Marie Marguerite
Bowen, Herbert Wolcott
Bowker, Richard Rogers
Boyesen, Hjalmar Hjorth

Boynton, Charles Brandon
Brace, John Pierce
Brachvogel, Udo
Brackenndge, Henry Marie
Brackenridge, Hugh Henry
Brackett, Charles William
Bradford, Alden
Brady, Cyrus Townsend
Bragdon, Claude Fayette
Brierton, John
Briggs, Charles Frederick
Brigham, Amariah
Brightly, Frederick Charles
Bristed, Charles Astor
Bristed, John
Brockett, Linus Pierpont
Bromfield, Louis
Brooks, Elbridge Streeter
Brooks, Noah
Broun, Heywood Campbell
Browder, Earl Russell
Brown, Addison
Brown, Benjamin Frederick
Brown, Margaret Wise
Brown, William Garrott
Brown, William Hill
Browne, John Ross
Browne, William Hand
Brownson, Orestes Augustus
Bruce, Andrew Alexander
Brühl, Gustav
Bryan, Mary Edwards
Bryce, Lloyd Stephens
Bryson, Lyman Lloyd
Buchanan, Joseph Rodes
Buchanan, Scott Milross
Buckminster, Joseph Stevens
Bulfinch, Thomas
Bunce, Oliver Bell
Bunner, Henry Cuyler
Buntline, Ned (**See** Judson,
 Edward Zane Carroll)
Burdick, Usher Lloyd
Burgess, John William
Burgess, Thornton Waldo
Burnap, George Washington
Burnett, Frances Eliza Hodgson
Burnham, Clara Louisa Root
Burrage, Walter Lincoln
Burrilf, Alexander Mansfield
Burroughs, Edgar Rice
Burroughs, John
Burt, Mary Elizabeth
Burton, William Evans
Butler, William Allen
Butterworth, Hezekiah
Byrd, William
Cabell, Nathaniel Francis
Cable, George Washington
Caffin, CharEes Henry

Cahill, Holger
Cain, James Mallahan
Cain, William
Caines, George
Calef, Robert
Calkins, Earnest Elmo
Calkins, Norman Allison
Callimachos, Panos Demetrios
Campbell, John Wood, Jr.
Cannon, Charles James
Capen, Nahum
Carleton, Henry
Carlson, Evans Fordyce
Carnegie, Dale
Carpenter, Edmund Janes
Carpenter, Frank George
Carpenter, George Rice
Carr, John Dickson
Carrington, Henry Beebee
Carroll, Howard
Carruth, Fred Hayden
Carryl, Guy Wetmore
Carter, Robert
Carter, William Hodding, Jr.
Caruthers, William Alexander
Cash, Wilbur Joseph
Castle, William Richards, Jr.
Cather, Willa
Catlin, George
Catton, Charles Bruce
Chadwick, John White
Chamberlam, Nathan Henry
Champlin, John Denison
Chandler, Elizabeth Margaret
Chandler, Raymond Thornton
Charlton, Thomas Usher Pulaski
Chase, Mary Ellen
Cheney, Ednah Dow Littlehale
Cheney, John Vance
Chesebrough, Caroline
Chessman, Caryl Whittier
Chester, George Randolph
Child, Frank Samuel
Child, Lydia Maria Francis
Child, Richard Washburn
Chipman, Daniel
Chopin, Kate O'Flaherty
Church, Benjamin
Church, George Earl
Church, Irving Porter
Clapp, Margaret Antoinette
Clapp, William Warland
Clark, Charles Heber
Clarke, Helen Archibald
Clarke, Mary Bayard Devereux
Clemmer, Mary
Cleveland, Horace William Shaler
Clews, Henry
Clinch, Charles Powell
Clurman, Harold Edgar

Hawthorne, Julian
Hayes, John Lord
Hays, Arthur Garfield
Hazard, Thomas Robinson
Headley, Joel Tyler
Hearn, Lafcadio
Heath, James Ewell
Heilprin, Michael
Heinzen, Karl Peter
Helmuth, William Tod
Helper, Hinton Rowan
Hempel, Charles Julius
Henderson, Peter
Hendrick, Ellwood
Hennepin, Louis
Henningsen, Charles Frederick
Henry, Caleb Sprague
Hentz, Caroline Lee Whiting
Herbermann, Charles George
Herbert, Henry William
Herford, Oliver Brooke
Herrick, Sophia McIlvaine Bledsoe
Herron, George Davis
Higginson, Thomas Wentworth
Hildreth, Richard
Hilgard, Theodor Erasmus
Hill, Frederick Trevor
Hill, Grace Livingston
Hilliard, Henry Washington
Hillis, Newell Dwight
Hillquit, Morris
Hine, Charles De Lano
Hinsdale, Burke Aaron
Hinshaw, David Schull
Hirst, Barton Cooke
Hitchcock, Enos
Hitchcock, Ethan Allen, 1798–1870
Hitchcock, James Ripley Wellman
Hittell, John Shertzer
Hittell, Theodore Henry
Hodges, George
Hodgins, Eric Francis
Hofstadter, Richard
Hogue, Wilson Thomas
Hoisington, Henry Richard
Holcombe, William Henry
Holder, Joseph Bassett
Holland, Edwin Clifford
Holland, Josiah Gilbert
Holley, Alexander Lyman
Hollister, Gideon Hiram
Holmes, George Frederick
Holt, Henry
Hooker, Worthington
Hopkinson, Francis
Hosmer, Hezekiah Lord
Hosmer, James Kendall
Houdini, Harry
Hough, Emerson
House, Edward Howard

Howard, Blanche Willis
Howe, Edgar Watson
Howe, Julia Ward
Hoyt, Henry Martyn
Hubbard, Elbert
Hubbard, Wynant Davis
Hudson, Charles
Hudson, Thomson Jay
Hughes, Henry
Hughes, Rupert
Huneker, James Gibbons
Hunt, Isaac
Hunt, Theodore Whitefield
Hunter, William C.
Huntington, William Reed
Hunton, William Lee
Hurlbert, William Henry
Hurlbut, Jesse Lyman
Husmann, George
Hutchinson, Woods
Hutton, Laurence
Hyde, William De Witt
Ickes, Harold Le Clair
Ide, John Jay
Imlay, Gilbert
Ingersoll, Charles Jared
Ingersoll, Edward
Inglis, Alexander James
Ingraham, Edward Duffield
Ingraham, Joseph Holt
Ingraham, Prentiss
Inman, Henry
Irving, John Treat
Irving, Peter
Irving, Pierre Munro
Irving, Washington
Irwin, William Henry
Isham, Samuel
Jackson, Edward Payson
Jacobi, Mary Cerinna Putnam
James, Marquis
James, Thomas
James, Will Roderick
Jamison, Cecilia Viets Dakin
 Hamilton
Jamison, David Flavel
Janes, Lewis George
Janney, Russell Dixon
Janney, Samuel McPherson
Janvier, Catharine Ann
Janvier, Margaret Thomson
Janvier, Thomas Allibone
Jarves, James Jackson
Jay, John
Jay, William
Jefferson, Thomas
Jenkins, John Stilwell
Jenks, Tudor Storrs
Jewett, Sarah Orne
Johnson, Alexander Bryan

Johnson, Alvin Saunders
Johnson, Franklin
Johnson, Helen Louise Kendrick
Johnson, James Weldon
Johnson, Joseph
Johnson, Osa
Johnson, Richard W.
Johnson, Samuel
Johnson, Samuel William
Johnson, Viriginia Wales
Johnston, Richard Malcolm
Johnston, William Andrew
Joline, Adrian Hoffman
Jones, Alexander
Jones, Amanda Theodosia
Jones, George
Jones, Howard Mumford
Jones, John Beauchamp
Jones, William Alfred
Jordan, William George
Josephson, Matthew
Josselyn, John
Joutel, Henri
Joynes, Edward Southey
Judah, Samuel Benjamin Helbert
Judd, Sylvester
Judson, Edward Zane Carroll ("Ned
 Buntline")
Judson, Emily Chubbuck
Kaempffert, Waldemar Bernhard
Kaye, Frederick Benjamin
Keating, John McLeod
Keating, John Marie
Keener, William Albert
Keller, Helen Adams
Kelley, Edith Summers
Kelley, James Douglas Jerrold
Kellogg, Elijah
Kelly, Aloysius Oliver Joseph
Kelly, Myra
Kemble, Frances Anne
Kennan, George
Kennedy, John Pendleton
Kent, Charles Foster
Kidder, Frederic
Kimball, Richard Burleigh
King, Alexander
King, Clarence
King, Edward Smith
King, Grace Elizabeth
King, Thomas Starr
Kinsey, Alfred Charles
Kirk, John Foster
Kirkland, Caroline Matilda
 Stansbury
Kirkland, Joseph
Kirkman, Marshall Monroe
Kirkus, Virginia
Kirlin, Joseph Louis Jerome
Klingelsmith, Margaret Center

Knapp, Samuel Lorenzo
Knapp, William Ireland
Kneeland, Stillman Foster
Knight, Edward Henry
Knight, Henry Cogswell
Knox, George William
Knox, Thomas Wallace
Kobbe, Gustav
Koebler, Sylvester Rosa
Kohler, Max James
Krapp, George Philip
Krauth, Charles Porterfield
Krehbiel, Henry Edward
Kyne, Peter Bernard
La Borde, Maximilian
La Farge, John
La Farge, Oliver Hazard Perry
Lamb, Martha Joanna Reade Nash
Lambert, Louis Aloisius
Landon, Melville de Lancey
Landreth, David
Lane, Arthur Bliss
Langley, Samuel Pierpont
Lanman, Charles
Larcom, Lucy
Lardner, Ringgold Wilmer
Larned, Josephus Nelson
Larpenteur, Charles
Lathbury, Mary Artemisia
Lathrop, George Parsons
Latimer, Mary Elizabeth Wormeley
Lawson, James
Lawson, John
Lawson, Robert Ripley
Lawson, Thomas Willlam
Lea, Homer
Leach, Daniel Dyer
Leavitt, Dudley
Lee, Eliza Buckminster
Lee, Hannah Farnham Sawyer
Lee, Henry, 1787–1837
Lee, James Melvm
Lee, James Wideman
Leeds, Daniel
Leeser, Isaac
Legler, Henry Eduard
Leigh, William Robinson
Leland, Charles Godfrey
Leonard, Sterling Andrus
Leonard, Zenas
Leopold, Nathan Freudenthal, Jr.
Leslie, Charles Robert
Leslie, Eliza
Lester, Charles Edwards
Levant, Oscar
Levy, Louis Edward
Lewis, Alfred Henry
Lewis, Estelle Anna Blanche
 Robinson
Lewis, Lawrence

Lewis, Orlando Faulkland
Liebling, Abbott Joseph
Liebman, Joshua Loth
Lincoln, John Larkin
Lincoln, Mary Johnson Bailey
Lindsey, William
Linn, William Alexander
Lippincott, Joseph Wharton
Lippincott, Sara Jane Clarke
Littell, William
Little, Arthur Dehon
Livermore, Abiel Abbot
Livermore, Mary Ashton Rice
Lloyd, Henry Demarest
Lockwood, Ralph Ingersoll
Lodge, Henry Cabot
Loeb, Sophie Irene Simon
Logan, Olive
Lomax, Louis Emanuel
London, Jack
Long, John Luther
Longfellow, William Pitt Preble
Longstreet, Augustus Baldwin
Lord, Eleazar
Loring, Frederick Wadsworth
Lossing, Benson John
Lounsbury, Thomas Raynesford
Love, Robertus Donnell
Loveman, Amy
Lowell, James Russell
Lowell, Percival
Lowell, Robert Traill Spence
Lucas, Daniel Bedinger
Ludlow, Fitz Hugh
Ludlow, Noah Miller
Luhan, Mabel Dodge
Lummis, Charles Ftetcher
Lunt, George
Lyman, Albert Josiah
Lyman, Theodore, 1792–1849
Lynch, James Daniel
Lynd, Robert Staughton
Lyon, Harris Merton
Lyttelton, William Henry
MacArthur, Robert Stuart
McBride, Mary Margaret
McCabe, William Gordon
McClure, Alexander Wilson
McClure, Samuel Sidney
McConnel, John Ludlum
McCrae, Thomas
McCullough, Ernest
MacDonald, Betty
McGarvey, John William
McGinley, Phyllis
McGovern, John
McKenney, Thomas Loraine
Mackenzie, Alexander Slidell
Mackenzie, Robert Shelton
Maclay, Edgar Stanton

McLeod, Alexander
McPherson, Edward
McQuillen, John Hugh
MacVicar, Malcolm
Macy, John Albert
Malcolm, James Peller
Malcom, Howard
Mann, Mary Tyler Peabody
Mann, Newton
Mann, William Julius
Mansfield, Edward Deering
Marble, Albert Prescott
Marden, Orison Swett
Margalis, Max Leopold
Marshall, Henry Rutgers
Martin, Anne Henrietta
Martin, François-Xavier
Martin, Frederick Townsend
Martin, John Hill
Martin, Thomas Commerford
Martin, William Alexander Parsons
Martyn, Sarah Towne Smith
Mason, Daniel Gregory
Mason, Francis Van Wyck
Mather, Cotton
Mather, Frank Jewett, Jr.
Mather, Fred
Mather, Increase
Mather, Richard
Mather, Samuel
Mathews, Albert
Mathews, Cornelius
Mathews, William
Matthews, Franklin
Matthews, Joseph Brown
Maxwell, Elsa
Maxwell, Samuel
Mayer, Brantz
Mayes, Edward
Mayhew, Experience
Mayo, Sarah Carter Edearton
Mayo, William Starbuck
Mead, Edwin Doak
Mears, John William
Mease, James
Mechem, Floyd Russell
Meehan, Thomas
Meek, Alexander Beaufort
Meigs, Arthur Vincent
Meigs, Charles Delucena
Meigs, John Forsyth
Mell, Patrick Hues
Mellen, Grenville
Melville, Herman
Mercier, Charles Alfred
Merrill, Stephen Mason
Metcalf, Henry Harrison
Micheaux, Oscar
Mielziner, Moses
Miller, Emily Clark Huntington

Miller, Harriet Mann
Miller, James Russell
Miller, Samuel
Millet, Francis Davis
Mills, Enos Abijah
Minor, Raleigh Colston
Mitchell, Donald Grant
Mitchell, John, d. 1768
Mitchell, Margaret Munnerlyn
Mitchell, Nahum
Moffett, Cleveland Langston
Mollhausen, Heinrich Baldwin
Mombert, Jacob Isidor
Montefiore, Joshua
Moore, Annie Aubertine Woodward
Moore, Frank
Moore, Jacob Bailey
Moore, John Trotwood
Moran, Benjamin
Morford, Henry
Morgan, James Morris
Morley, Christopher Darlington
Morley, Margaret Warner
Morris, Edward Joy
Morris, William Hopkins
Morse, Sidney Edwards
Morse, Wayne Lyman
Morton, Charles Walter
Morton, Nathaniel
Mott, Frank Luther
Moulton, Richard Green
Mowatt, Anna Cora Ogden
Mowrer, Edgar Ansel
Mowry, William Augustus
Mulford, Clarence Edward
Mulford, Elisha
Mullins, Edgar Young
Mumford, James Gregory
Murat, Achille
Murdock, James
Murray, David
Murray, Judith Sargent Stevens
Nadal, Ehrman Syme
Nash, Henry Sylvester
Nash, Simeon
Nason, Elias
Nathan, George Jean
Neal, John
Neely, Thomas Benjamin
Nelson, Henry Loomis
Neuberger, Richard Lewis
Nevin, Alfred
Nevin, Edwin Henry
Newcomb, Harvey
Newman, Samuel Phillips
Newton, Joseph Fort
Nichols, Charles Lemuel
Nichols, Mary Sargeant Neal Gove
Nichols, Thomas Low
Nicholson, Meredith

Niza, Marcos de
Nock, Albert Jay
Nordhoff, Charles
Nordhoff, Charles Bernard
Norris, Mary Harriott
Northen, William Jonathan
Norton, Charles Eliot
Nott, Henry Junius
Nourse, Edwin Griswold
Oberholtzer, Sara Louisa Vickers
O'Brien, Fitz-James
O'Brien, Frederick
O'Callaghan, Jeremiah
O'Connor, William Douglas
Ogg, Frederic Austin
Okey, John Waterman
O'Malley, Frank Ward
O'Neall, John Belton
O'Neill, Rose Cecil
O'Reilly, Henry
Orton, Helen Fuller
Osborn, Henry Stafford
Osgood, Howard
O'Shea, Michael Vincent
Otis, Arthur Sinton
Ott, Isaac
Ottley, Roi
Owen, Robert Dale
Oxnam, Garfield Bromley
Paine, Ralph Delahaye
Paine, Thomas
Paley, John
Pallen, Condé Benoist
Palmer, Horatio Richmond
Palmer, Joel
Palmer, John McAuley
Palmer, John Williamson
Parish, Elijah
Parker, Jane Marsh
Parker, William Harwar
Parton, James
Parton, Sara Payson Willis
Partridge, William Ordway
Paschal, George Washington
Pastorius, Francis Daniel
Patterson, Robert Mayne
Pattie, James Ohio
Pattison, James William
Patton, William
Paulding, James Kirke
Peabody, Andrew Preston
Peabody, Elizabeth Palmer
Pearson, Edmund Lester
Peattie, Donald Culross
Peck, George Washington
Peck, John Mason
Pedder, James
Peloubet, Francis Nathan
Penfield, Edward
Penfield, Frederic Courtland

Penniman, James Hosmer
Pennington, James W. C.
Pentecost, George Frederick
Percy, George
Percy, William Alexander
Perelman, Sidney Joseph
Perkins, Frederic Beecher
Perkins, James Handasyd
Perry, Bliss
Perry, Edward Baxter
Perry, Thomas Sergeant
Peterkin, Julia Mood
Peters, Absalom
Peters, Madison Clinton
Peterson, Charles Jacobs
Peyton, John Lewis
Phelan, James, 1856–1891
Phelps, Almira Hart Lincoln
Phelps, Charles Edward
Phillips, Willard
Phillips, William Addison
Phisterer, Frederick
Pickard, Samuel Thomas
Picket, Albert
Pidgin, Charles Felton
Pierce, Gilbert Ashville
Pierson, Arthur Tappan
Pierson, Hamilton Wilcox
Pike, Albert
Pike, James Shepherd
Pise, Charles Constantine
Pollard, Edward Alfred
Pollard, Joseph Percival
Pollock, Channing
Pond, Enoch
Pond, Frederick Eugene
Pool, Maria Louise
Poore, Benjamin Perley
Porter, Robert Percival
Post, Louis Freeland
Poston, Charles Debrill
Potter, Elisha Reynolds
Powel, John Hare
Powell, Edward Payson
Prang, Mary Amelia Dana Hicks
Pratt, Sereno Stansbury
Preble, George Henry
Prentiss, George Lewis
Prescott, George Bartlett
Preston, Harriet Waters
Preston, Margaret Junkin
Preston, Thomas Scott
Price, William Thompson
Prime, Edward Dorr Griffin
Prime, Samuel Irenaeus
Prime, William Cowper
Proctor, William
Pugh, Ellis
Pulte, Joseph Hippolyt
Putnam, George Haven

Putnam, Nina Wilcox
Putnam, Ruth
Pyle, Howard
Quick, John Herbert
Quincy, Edmund
Quincy, Josiah Phillips
Rains, George Washington
Ramsey, James Gettys McGready
Randall, Henry Stephens
Randolph, Sarah Nicholas
Randolph, Thomas Jefferson
Ravenel, Harriott HorryRutledge
Rawle, Francis, 1846–1930
Raymond, George Lansing
Read, Opie Pope
Redfield, Isaac Fletcher
Redman, Ben Ray
Reed, Earl Howell
Reed, Myrtle
Reed, Richard Clark
Reed, William Bradford
Reese, Heloise Bowles
Reid, Gilbert
Reiersen, Johan Reinert
Remington, Frederic
Remy, Henri
Renwick, James, 1792–1863
Reuterdahl, Henry
Revere, Joseph Warren
Reynolds, Quentin James
Rhodes, Eugene Manlove
Rice, Alice Caldwell Hegan
Rice, Nathan Lewis
Richards, Laura Elizabeth Howe
Richards, Thomas Addison
Richardson, Charles Francis
Richardson, Robert
Richmond, Mary Ellen
Rickert, Martha Edith
Riddle, Albert Gallatin
Rideing, William Henry
Rideout, Henry Milner
Riis, Jacob August
Riley, Benjamin Franklin
Rivers, William James
Roberts, Elizabeth Madox
Roberts, Kenneth Lewis
Robertson, George
Robertson, John
Robertson, Morgan Andrew
Robinson, Charles Mulford
Robinson, Conway
Robinson, Henry Morton
Robinson, Rowland Evans
Robinson, Solon
Robinson, Stillman Williams
Robinson, Therese Albertine Louise
 Von Jakob
Robinson, William Callyhan
Rodenbough, Theophilus Francis

Roe, Edward Payson
Roe, Gilbert Ernstein
Rogers, Clara Kathleen Barnett
Rollins, Alice Marland Wellington
Rölvaag, Ole Edvart
Romans, Bernard
Rombro, Jacob
Roosevelt, Robert Barnwell
Root, Frank Albert
Rorty, James Hancock
Rose, John Carter
Rosenberg, Abraham Hayyim
Rosenthal, Herman
Ross, Alexander
Rowland, Henry Cottrell
Rowlandson, Mary White
Royall, Anne Newport
Ruffner, Henry
Rugg, Harold Ordway
Ruhl, Arthur Brown
Rukeyser, Muriel
Russell, Charles Edward
Russell, Osborne
Ryan, Cornelius John ("Connie")
Rynning, Ole
Sachs, Hanns
Sachse, Julius Friedrich
Sadlier, Mary Anne Madden
Sadtler, Samuel Philip
Sage, Bernard Janin
Salter, William
Salter, William Mackintire
Sanborn, Franklin Benjamin
Sanborn, Katherine Abbott
Sanders, Elizabeth Elkins
Sanders, Frank Knight
Sanderson, John
Sands, Robert Charles
Sangster, Margaret Elizabeth
 Munson
Sarg, Tony
Sargent, Epes
Sargent, John Osborne
Sargent, Lucius Manlius
Sargent, Winthrop, 1825–1870
Saunders, Frederick
Saunders, Prince
Savage, Minot Judson
Sawyer, Lemuel
Schechter, Solomon
Schofield, William Henry
Schroeder, John Frederick
Schultze, Augustus
Schuyler, George Washington
Schuyler, Montgomery
Scidmore, Eliza Ruhamah
Scott, Leroy
Scott, Samuel Parsons
Scott, William Anderson
Scruggs, William Lindsay

Scudder, Horace Elisha
Sears, Edmund Hamilton
Seawell, Molly Elliot
Sedgwick, Catharine Maria
Sedgwick, Theodore, 1780–1839
Sedgwick, Theodore, 1811–1859
Seiss, Joseph Augustus
Selikovitsch, Goetzel
Semmes, Raphael
Seton, Grace Gallatin Thompson
Seton, William
Severance, Frank Hayward
Sewall, Jonathan
Seward, Theodore Frelinghuysen
Shaler, Wilham
Sharp, Dallas Lore
Shecut, John Linnaeus Edward
 Whitridge
Shedd, William Greenough Thayer
Sheen, Fulton John
Sheldon, Charles Monroe
Shelton, Frederick William
Sherwood, Katharine Margaret
 Brownlee
Sherwood, Mary Elizabeth Wilson
Shields, Charles Woodruff
Shields, George Oliver
Showerman, Grant
Shreve, Thomas Hopkins
Shub, Abraham David
Shuey, Edwin Longstreet
Shuster, George Nauman
Sigourney, Lydia Howard Huntley
Sikes, William Wirt
Simpson, James Hervey
Simpson, Stephen
Singleton, Esther
Siringo, Charles A.
Skinner, Cornelia Otis
Skinner, John Stuart
Skinner, Thomas Harvey
Slafter, Edmund Farwell
Sloan, Harold Paul
Sloan, Richard Elihu
Slocum, Joshua
Slosson, Edwin Emery
Smedley, Agnes
Smith, Alexander
Smith, Arthur Henderson
Smith, Charles Alphonso
Smith, Edmund Munroe
Smith, Elias
Smith, Elihu Hubbard
Smith, Elizabeth Oakes Prince
Smith, Francis Hopkinson
Smith, Hannah Whitall
Smith, Harry Allen
Smith, Henry Justin
Smith, James McCune
Smith, James 1737–1814

Morgan, James Dada
Morgan, John Pierpont
Morgan, Junius Spencer
Morrow, Dwight Whitney
Newberry, Walter Loomis
Peabody, George Foster
Perkins, George Clement
Perkins, George Walbridge
Perkins, James Handasyd
Powers, Daniel William
Price, Hiram
Prince, Frederick Henry
Ralston, William Chapman
Reynolds, George McClelland
Riggs, George Washington
Robb, James
Rollins, Frank West
Rosenberg, Henry
Sabin, Charles Hamilton
Salomon, Haym
Sayre, Stephen
Schneider, George
Seligman, Arthur
Seligman, Isaac Newton
Seligman, Jesse
Seney, George Ingraham
Shaw, Leslie Mortier
Smith, George
Smith, Samuel Harrison
Spaulding, Charles Clinton
Spaulding, Elbridge Gerry
Sprague, Charles
Sprague, Charles Ezra
Spreckels, Rudolph
Sproul, Allan
Stanley, Harold
Stevens, John Austin, 1795–1874
Stewart, John Aikman
Stillman, James
Stokes, Anson Phelps
Stotesbury, Edward Townsend
Straus, Simon William
Strong, Benjamin
Taggart, Thomas
Tappens Frederick Dobbs
Taylor, Moses
Thatcher, Mahlon Daniel
Thomas, George Clifford
Thompson, David P.
Thompson, John
Thompson, Josiah Van Kirk
Tome, Jacob
Traylor, Melvin Alvah
Vanderlip, Frank Arthur
Waldo, David
Warburg, Paul Moritz
Ward, Samuel, 1786–1839
Welch, Leo Dewey
Westcott, Edward Noyes
White, Stephen Van Culen

Whitney, George
Whitney, Richard
Wiggin, Albert Henry
Williams, Samuel May
Willing, Thomas
Woodward, William
Wright, Richard Robert
Yeatman, James Erwin

BANK ROBBER
Sutton, William Francis, Jr. ("Willie")

BARITONE (See SINGER)

BASEBALL CLUB OWNER
Comiskey, Grace Elizabeth Reidy
Crosley, Powel, Jr.
O'Malley, Walter Francis
Yawkey, Thomas Austin ("Tom")

BASEBALL COMMISSIONER
Landis, Kenesaw Mountain

BASEBALL EXECUTIVE
Barrow, Edward Grant
Frick, Ford Christopher
Giles, Warren Crandall
Griffith, Clark Calvin
Harridge, William ("Will")
Johnson, Byron Bancroft
McKinney, Frank Edward, Sr.
MacPhail, Leland Stanford ("Larry")
Rickey, Wesley Branch
Weiss, George Martin
Wrigley, Philip Knight

BASEBALL MANAGER
Collins, Edward Trowbridge
Dressen, Charles Walter
Griffith, Clark Calvin
Harris, Stanley Raymond ("Bucky")
McCarthy, Joseph Vincent ("Joe")
McGraw, John Joseph
Mack, Connie
McKechnie, William Boyd
Murtaugh, Daniel Edward ("Danny")
Rolfe, Robert Abial ("Red")
Stengel, Charles Dillon ("Casey")

BASEBALL ORIGINATOR
Doubleday, Abner

BASEBALL PLAYER
Alexander, Grover Cleveland
Anson, Adrian Constantine
Baker, John Franklin
Bender, Charles Albert ("Chief")
Berg, Morris ("Moe")
Bridges, Thomas Jefferson Davis ("Tommy")
Carey, Max George ("Scoops")
Cicotte, Edward Victor
Clemente, Roberto
Cobb, Tyrus Raymond ("Ty")

Cochrane, Gordon Stanley ("Mickey")
Collins, Edward Trowbridge
Combs, Earle Bryan
Crawford, Samuel Earl
Dressen, Charles Walter ("Chuck")
Duffy, Hugh
Easter, Luscious Luke
Foxx, James Emory
Gehrig, Henry Louis ("Lou")
Gibson, Joshua
Goslin, Leon Allen ("Goose")
Griffith, Clark Calvin
Grove, Robert Moses ("Lefty")
Harris, Stanley Raymond ("Bucky")
Hartnett, Charles Leo ("Gabby")
Heilmann, Harry
Hodges, Gilbert Ray
Hooper, Harry Bartholomew
Hornsby, Rogers
Howard, Elston Gene ("Ellie")
Huggins, Milrer James
Johnson, Walter Perry
Kelly, Michael J.
Klein, Charles Herbert ("Chuck")
Lajoie, Napoleon ("Larry")
McGraw, John Joseph
Maranville, Walter James Vincent ("Rabbit")
Marquard, Richard William ("Rube")
Martin, Johnny Leonard Roosevelt ("Pepper")
Mathewson, Christopher ("Christy")
Medwick, Joseph ("Ducky") Michael
Munson, Thurman Lee
Murtaugh, Daniel Edward ("Danny")
O'Doul, Francis Joseph ("Lefty")
Ott, Melvin Thomas ("Mel")
Page, Joseph Francis ("Joe")
Reach, Alfred James
Rice, Edgar Charles ("Sam")
Robinson, John Roosevelt ("Jackie")
Rolfe, Robert Abial ("Red")
Rommel, Edwin Americus ("Eddie")
Rowe, Lynwood Thomas
Rucker, George ("Nap")
Ruth, George Herman ("Babe")
Schalk, Raymond William ("Cracker")
Simmons (Szymanski), Aloysius Harry
Sisler, George Harold ("Gorgeous George")
Speaker, Tris E.
Strong, Elmer Kenneth, Jr. ("Ken")
Traynor, Harold Joseph ("Pie")

Fox, Fontaine Talbot, Jr.
Gibson, Charles Dana
Gillam, Bernhard
Goldberg, Reuben Lucius ("Rube")
Gray, Harold Lincoln
Gropper, William
Gross, Milt
Grosz, George
Hatlo, Jimmy
Held, John, Jr.
Herriman, George Joseph
Hubbard, Frank McKinney
Kelly, Walter ("Walt") Crawford, Jr.
Keppler, Joseph
Kirby, Rollin
McManus, George
Minor, Robert
Morgan, Matthew Somerville
Mullin, Willard Harlan
Nast, Thomas
Newell, Peter Sheaf Hersey
Opper, Frederick Burr
Raymond, Alexander Gillespie
Rogers, William Allen
Smith, Robert Sidney
Szyk, Arthur
Thurber, James Grover
Volck, Adalbert John
Wales, James Albert
Webster, Harold Tucker
Willard, Frank Henry
Williams, Gaar Campbell
Young, Art
Zimmerman, Eugene

CASINO OWNER
Harrah, William Fisk ("Bill")

CATERER (See RESTAURATEUR)

CATHOLIC PACIFIST
Day, Dorothy

CATHOLIC WORKER MOVEMENT COFOUNDER
Day, Dorothy

CATTLEMAN (See also DAIRY HUSBANDMAN, RANCHER, STOCK BREEDER)
Chisum, John Simpson
Goodnight, Charles
Lasater, Edward Cunningham
Littlefield, George Washington
McCoy, Joseph Geating
Mackenzie, Murdo
Renick, Felix
Springer, Charles
Strawn, Jacob

CAVALRY OFFICER
McCoy, Tim

CELLIST
Busch, Hermann
Casals, Pablo

CENSUS DIRECTOR
Kennedy, Joseph Camp Griffith
Merriam, William Rush

CHANCELLOR (STATE)
Harrington, Samuel Maxwell
Livingston, Robert R., 1746–1813
Saulsbury, Willard, 1820–1892
Walworth, Reuben Hyde

CHANDLER
Jackson, William, 1783–1855

CHAPLAIN (See also CLERGYMAN, RELIGIOUS LEADER)
Hunter, Andrew
Jones, David
Jones, George
Munro, Henry

CHEF
Diat, Louis Felix

CHEMIST (See also BIOCHEMIST, SCIENTIST)
Abel, John Jacob
Adkins, Homer Burton
Austen, Peter Townsend
Babcock, James Francis
Bache, Franklin
Bailey, Jacob Whitman
Bancroft, Wilder Dwight
Barker, George Frederick
Baskerville, Charles
Beck, Lewis Caleb
Benedict, Stanley Rossiter
Bolton, Henry Carrington
Boltwood, Bertram Borden
Booth, James Curtis
Boye, Martin Hans
Browne, Charles Albert
Burnett, Joseph
Carothers, Wallace Hume
Chandler, Charles Frederick
Clarke, Frank Wigglesworth
Cooke, Josiah Parsons
Cope, Arthur Clay
Cottrell, Frederick Gardner
Crafts, James Mason
Cutbush, James
Dabney, Charles William
Dana, James Freeman
Dana, Samuel Luther
Day, David Talbot
Debye, Peter Joseph William
Doremus, Robert Ogden
Dorset, Marion
Dow, Herbert Henry
Draper, John William
Drown, Thomas Messinger
Dudley, Charles Benjamin
Duncan, Robert Kennedy
Du Pont, Francis Irénée
Ellis, Carleton
Fieser, Louis Frederick

Folin, Otto Knut Olof
Franklin, Edward Curtis
Freas, Thomas Bruce
Fullam, Frank L.
Genth, Frederick Augustus
Gibbs, Oliver Wolcott
Goessmann, Charles Anthony
Gomberg, Moses
Gorham, John
Grasselli, Caesar Augustin
Green, Jacob
Griscom, John
Guthrie, Samuel
Hall, Charles Martin
Hare, Robert
Harkins, William Draper
Hart, Edward
Hayes, Augustus Allen
Hendrick, Ellwood
Herty, Charles Holmes
Hill, Henry Barker
Hillebrand, William Francis
Hooker, Samuel Cox
Horsford, Eben Norton
Hudson, Claude Silbert
Hunt, Thomas Sterry
Jackson, Charles Thomas
James, Charles
Jarves, Deming
Johnson, Treat Baldwin
Johnston, John
Jones, Harry Clary
Keating, William Hypolitus
Kedzie, Robert Clark
Kharasch, Morris Selig
Kinnicutt, Leonard Parker
Kirkwood, John Gamble
Koenig, George Augustus
Kohler, Elmer Peter
Ladd, Edwin Fremont
Lamb, Arthur Becket
Langley, John Williams
Langmuir, Irving
Latimer, Wendell Mitchell
Lea, Mathew Carey
Leffmann, Henry
Levy, Louis Edward
Lewis, Gilbert Newton
Libby, Willard Frank
Loeb, Morris
Long, John Harper
Mabery, Charles Frederic
Maclean, John
McMurtrie, William
Mallet, John William
Mallinckrodt, Edward, Jr.
Matheson, William John
Matthews, Joseph Merritt
Merrill, Joshua
Metcalfe, Samuel Lytler

Michael, Arthur
Michaelis, Leonor
Midgley, Thomas
Mitchell, John Kearsley
Moore, Richard Bishop
Morfit, Campbell
Morley, Edward Williams
Mulliken, Samuel Parsons
Munroe, Charles Edward
Nef, John Ulric
Nichols, James Robinson
Nieuwland, Julius Arthur
Norris, James Flack
Norton, John Pitkin
Noyes, Arthur Amos
Noyes, William Albert
Noyes, William Albert, Jr.
Onsager, Lars
Ostromislensky, Iwan Iwanowich
Parr, Samuel Wilson
Peckham, Stephen Farnum
Pendleton, Edmund Monroe
Peter, Robert
Phillips, Francis Clifford
Piccard, Jean Felix
Porter, John Addison
Power, Frederick Belding
Prescott, Albert Benjamin
Pugh, Evan
Randall, Wyatt William
Reese, Charles Lee
Reid, David Boswell
Remsen, Ira
Rice, Charles
Richards, Ellen Henrietta Swallow
Richards, Theodore William
Rogers, James Blythe
Rogers, Robert Empie
Sadtler, Samuel Philip
Sanger, Charles Robert
Scovell, Melville Amasa
Seabury, George John
Shepard, James Henry
Sheppard, Samuel Edward
Silliman, Benjamin, 1816–1885
Slosson, Edwin Emery
Smith, Alexander
Smith, Edgar Fahs
Smith, John Lawrence
Squibb, Edward Robinson
Stern, Otto
Stieglitz, Julius
Stillman, Thomas Bliss
Stine, Charles Milton Altland
Stoddard, John Tappan
Storer, Francis Humphreys
Takamine, Jokichi
Talbot, Henry Paul
Taylor, William Chittenden
Teeple, John Edgar

Tilghman, Richard Albert
Tolman, Richard Chace
Torrey, John
Vaughan, Daniel
Warren, Cyrus Moors
Washburn, Edward Wight
Weber, Henry Adam
Weightman, William
Wetherill, Charles Mayer
White, Henry Clay
Whitmore, Frank Clifford
Whitney, Josiah Dwight
Whitney, Willis Rodney
Wiechmann, Ferdinand Gerhard
Wiley, Harvey Washington
Witthaus, Rudolph August
Wood, Edward Stickney
Woodhouse, James
Woodward, Robert Burns
Wurtz, Henry
CHESS PLAYER
Loyd, Samuel
Mackenzie, George Henry
Marshall, Frank James
Morphy, Paul Charles
Pillsbury, Harry Nelson
Rice, Isaac Leopold
Steinitz, William
**CHIEF JUSTICE (STATE) (See also
JUDGE, JURIST, LAWYER, SUPREME
COURT JUSTICE)**
De Lancey, James
Gaines, Reuben Reid
Horsmanden, Daniel
Livermore, Arthur
Lloyd, David
Lowe, Ralph Phillips
Lumpkin, Joseph Henry
Mellen, Prentiss
More, Nicholas
Morris, Lewis, 1671–1746
Morris, Robert Hunter
Morton, Marcus, 1819–1891
Nicholls, Francis Redding Tillon
Read, George
Rusk, Thomas Jefferson
Shippen, Edward, 1728–1806
Simpson, William Dunlap
CHINESE ART SPECIALIST
Ferguson, John Calvin
CHOIRMASTER (See also CONDUCTOR)
Dett, Robert Nathaniel
Tuckey, William
CHOREOGRAPHER
Berkeley, Busby
Bolm, Adolph Rudolphovitch
Champion, Gower
Fokine, Michel
Humphrey, Doris
Limón, José Arcadio

Shawn, Edwin Meyers ("Ted")
Tamiris, Helen
**CHRISTIAN SCIENCE LEADER (See
also RELIGIOUS LEADER)**
Eddy, Mary Morse Baker
Stetson, Augusta Emma Simmons
**CHRONICLER (See also DIARIST,
HISTORIAN)**
Clyman, James
Johnson, Edward
**CHURCH HISTORIAN (See also
HISTORIAN)**
Dubbs, Joseph Henry
Edwards, Morgan
Guilday, Peter Keenan
Jackson, Samuel Macauley
Moffatt, James
Perry, William Stevens
Schaff, Philip
Walker, Williston
Whitsitt, William Heth
CINEMATOGRAPHER
Howe, James Wong
CIRCUS CLOWN (See CLOWN)
CIRCUS PROPRIETOR (See SHOWMAN)
CITY PLANNER
Atterbury, Grosvenor
Bassett, Edward Murray
Bettman, Alfred
Brunner, Arnold William
Ford, George Burdett
Moore, Charles
Nolen, John
Robinson, Charles Mulford
Saarinen, Gottlieb Eliel
Wacker, Charles Henry
Wright, Henry
CIVIC LEADER
Adams, Charles Francis, 1835–1915
Blodgett, John Wood
Breckinridge, Desha
Burlingham, Charles Culp
Chandler, Harry
Clement, Rufus Early
Cutting, Robert Fulton
Dawes, Rufus Cutler
Donovan, John Joseph
Fallows, Samuel
Fortier, Alcé
Foulke, William Dudley
Haskell, Henry Jospeh
Hay, Mary Garrett
Hirsch, Emil Gustav
Jackson, Robert R.
Kirstein, Louis Edward
Lazarus, Fred, Jr.
Lingelbach, Anna Lane
Loring, Charles Morgridge
Marburg, Theodore
Martin, Elizabeth Price

Eaton, Charles Aubrey
Eddy, Daniel Clarke
Edwards, Morgan
Faunce, William Herbert Perry
Fernald, James Champlin
Fosdick, Harry Emerson
Foster, George Burman
Frey, Joseph Samuel Christian
 Frederick
Fuller, Richard
Fulton, Justin Dewey
Furman, James Clement
Furman, Richard
Gale, Elbridge
Gambrell, James Bruton
Gano, John
Gano, Stephen
Garrard, James
Gilmore, Joseph Henry
Going, Jonathan
Goodspeed, Thomas Wakefield
Graves, James Robinson
Gregory, John Milton
Griffith, Benjamin
Hatcher, William Eldridge
Henderson, Charles Richmond
Holcombe, Henry
Holman, Jesse Lynch
Horr, George Edwin
Hovey, Alvah
Howell, Robert Boyté Crawford
Jeter, Jeremiah Bell
Johnson, Franklin
Johnson, Mordecai Wyatt
Johnson, William Bullein
Jones, David
Judson, Edward
King, Henry Melville
King, Martin Luther, Jr.
Lamb, Isaac Wixom
Lane, Tidence
Leland, John
Lightburn, Joseph Andrew Jackson
Lorimer, George Claude
Love, Emanuel King
Lowrey, Mark Perrin
MacArthur, Robert Stuart
McGlothlin, William Joseph
Macintosh, Douglas Clyde
Malcolm, Howard
Manly, Basil, 1798–1868
Manly, Basil, 1825–1892
Manning, James
Marshall, Daniel
Martin, Warren Homer
Massey, John Edward
Mell, Patrick Hues
Mercer, Jesse
Merrill, Daniel
Merrill, George Edmands

Morehouse, Henry Lyman
Morgan, Abel
Morgan, Thomas Jefferson
Moss, Lemuel
Moxom, Philip Stafford
Mullins, Edgar Young
Myles, John
Osgood, Howard
Payne, Christopher Harrison
Peck, John Mason
Pendleton, James Madison
Pentecost, George Frederick
Perry, Rufus Lewis
Potter, Charles Francis
Powell, Adam Clayton, Jr.
Powell, Adam Clayton, Sr.
Rauschenbusch, Walter
Rhees, Morgan John
Rhees, Rush
Rice, Luther
Richmond, John Lambert
Riley, Benjamin Franklin
Riley, William Bell
Robins, Henry Ephraim
Robinson, Ezekiel Gilman
Ross, Martin
Ryland, Robert
Sanders, Billington McCarter
Sears, Barnas
Sharp, Daniel
Sherwood, Adiel
Smith, Hezekiah
Smith, John, *c.* 1735–*c.* 1824
Smith, Samuel Francis
Stanford, John
Staughton, William
Stearns, Shubal
Stillman, Samuel
Stow, Baron
Straton, John Roach
Taylor, George Boardman
Taylor, James Barnett
Taylor, James Monroe
Taylor, John
Thomas, Jesse Burgess
Tichenor, Isaac Taylor
Tomlinson, Everett Titsworth
Tucker, Henry Holcombe
Tupper, Henry Allen
Vedder, Henry Clay
Waller, John Lightfoot
Wayland, Francis, 1796–1865
Whitfield, Owen
Whitsitt, William Heth
Williams, George Washington
Williams, William R.
Willingham, Robert Josiah
Winchester, Elhanan
Winkler, Edwin Theodore
Woods, Alva

Yeaman, William Pope
Campbellite (**See** Disciples of
 Christ)
Catholic (**See** Roman Catholic)
Christian Connection
 Shaw, Elijah
 Smith, Elias
 Wellons, William Brock
Church of England (**See** Anglican)
Church of God
 Michaux, Lightfoot Solomon
Church of the New Jerusalem (**See**
 Swedenborgian)
Congregational
 Abbott, Edward
 Abbott, Jacob
 Abbott, John Stevens Cabot
 Abbott, Lyman
 Adams, Nehemiah
 Alden, Timothy
 Allen, William
 Ament, William Scott
 Andrew, Samuel
 Atkinson, George Henry
 Atkinson, Henry Avery
 Atwater, Lyman Hotchkiss
 Austin, David
 Austin, Samuel
 Backus, Azel
 Bacon, Benjamin Wisner
 Bacon, David
 Bacon, John
 Bacon, Leonard
 Bacon, Leonard Woolsey
 Bailey, Rufus William
 Bancroft, Aaron
 Barnard, John
 Barrows, John Henry
 Bartlett, Samuel Colcord
 Barton, James Levi
 Barton, William Eleazar
 Beecher, Charles
 Beecher, Edward
 Beecher, Henry Ward
 Beecher, Thomas Kinnicut
 Behrends, Adolphus Julius
 Frederick
 Belknap, Jeremy
 Bissell, Edwin Cone
 Blakeslee, Erastus
 Bosworth, Edward Increase
 Boynton, Charles Brandon
 Bradford, Amory Howe
 Brattle, William
 Brown, Charles Reynolds
 Bumstead, Horace
 Burr, Enoch Fitch
 Burton, Asa
 Burton, Marion Le Roy
 Burton, Nathaniel Judson

Baird, Robert
Baird, Samuel John
Baker, Daniel
Baker, William Mumford
Baldwin, Elihu Whittlesey
Barnes, Albert
Beard, Richard
Beattie, Francis Robert
Beatty, Charles Clinton
Beecher, Lyman
Beman, Nathan Sidney Smith
Bishop, Robert Hamilton
Blackburn, Gideon
Blackburn, William Maxwell
Blair, Samuel
Blanchard, Jonathan
Bourne, George
Boynton, Charles Brandon
Brainerd, Thomas
Breckinridge, John, 1797–1841
Breckinridge, Robert Jefferson
Brown, Isaac Van Arsdale
Brown, William Adams
Brownlee, William Craig
Bruce, Robert
Burchard, Samuel Dickinson
Burr, Aaron
Burrell, David James
Bush, George
Caldwell, David
Caldwell, James
Cameron, Archibald
Campbell, William Henry
Carrick, Samuel
Cattell, William Cassaday
Cavert, Samuel McCrea
Chavis, John
Coffin, Henry Sloane
Colman, Benjamin
Converse, James Booth
Corrothers, James David
Cox, Samuel Hanson
Crosby, Howard
Curtis, Edward Lewis
Cuyler, Theodore Ledyard
Darling, Henry
Davidson, Robert
Doak, Samuel
Dod, Albert Baldwin
Dod, Thaddeus
Donnell, Robert
Duffield, George, 1732–1790
Duffield, George, 1794–1868
Duffield, Samuel Augustus
 Willoughby
Dwight, Benjamin Woodbridge
Ewing, John
Field, Henry Martyn
Finley, Robert
Finley, Samuel

Fisher, Daniel Webster
Foote, William Henry
Frey, Joseph Samuel Christian
 Frederick
Frissell, Hollis Burke
Gale, George Washington
Gally, Merritt
Garnet, Henry Highland
Gaut, John McReynolds
Gilbert, Eliphalet Wheeler
Gillett, Ezra Hall
Girardeau, John Lafayette
Goulding, Francis Robert
Green, Ashbel
Green, Jacob
Green, Lewis Warner
Gregory, Daniel Seelye
Hall, Baynard Rush
Hall, Charles Cuthbert
Hall, James, 1744–1826
Hall, John
Hatfield, Edwin Francis
Headley, Phineas Camp
Henry, Robert
Hewat, Alexander
Hickok, Laurens Perseus
Hoge, Moses
Hoge, Moses Drury
House, Samuel Reynolds
Howe, George
Hunter, Andrew
Jackson, Samuel Macauley
Jacobs, William Plumer
Junkin, George
Kellogg, Samuel Henry
Kirk, Edward Norris
Knox, Samuel
Lacy, Drury
Lindley, Daniel
Lindsley, John Berrien
Lindsley, Philip
Linn, John Blair
Lunn, George Richard
Lyon, James
McAfee, John Armstrong
McAuley, Thomas
McBride, F(rancis) Scott
McCalla, William Latta
McCook, Henry Christopher
McCormick, Samuel Black
MacCracken, Henry Mitchell
McDowell, John
McFarland, Samuel Gamble
McGready, James
McIlwaine, Richard
McLeod, Alexander
MacWhorter, Alexander
Makemie, Francis
Marquis, John Abner
Mason, John Mitchell

Mattoon, Stephen
Mears, David Otis
Mears, John William
Miller, James Russell
Miller, John
Miller, Samuel
Mitchell, Edwin Knox
Moorehead, William Gallogly
Morris, Edward Dafydd
Morrison, William McCutchan
Murray, James Ormsbee
Neill, Edward Duffield
Neill, William
Nelson, David
Nevin, Alfred
Nevin, Edwin Henry
Nisbet, Charles
Noble, Frederick Alphonso
Nott, Eliphalet
Osborn, Henry Stafford
Palmer, Benjamin Morgan
Parker, Joel
Parker, Thomas
Parkhurst, Charles Henry
Patillo, Henry
Patterson, Robert Mayne
Patton, Francis Landey
Patton, William
Peck, Thomas Ephraim
Peters, Absalom
Peters, Madison Clinton
Pierson, Arthur Tappan
Pierson, Hamilton Wilcox
Plumer, William Swan
Prentiss, George Lewis
Prime, Edward Dorr Griffin
Prime, Samuel Irenaeus
Purviance, David
Reed, Richard Clark
Reid, William Shields
Rice, David
Rice, John Holt
Rice, Nathan Lewis
Roberts, William Charles
Roberts, William Henry
Robinson, Charles Seymour
Robinson, Stuart
Rodgers, John, 1727–1811
Ruffner, Henry
Ruffner, William Henry
Sanders, Daniel Jackson
Sawyer, Leicester Ambrose
Scott, William Anderson
Simpson, Albert Benjamin
Skinner, Thomas Harvey
Smith, Asa Dodge
Smith, Benjamin Mosby
Smith, Henry Boynton
Smith, Henry Preserved
Smith, John Blair

Smith, Samuel Stanhope
Smyth, Thomas
Speer, Robert Elliott
Spencer, Elihu
Spring, Gardiner
Sproull, Thomas
Stelzle, Charles
Stryker, Melancthon Woolsey
Swing, David
Taylor, Archibald Alexander Edward
Tennent, Gilbert
Tennent, William, 1673–1745
Tennent, William, 1705–1777
Thacher, Peter
Thompson, William Oxley
Thornwell, James Henley
Van Dyke, Henry
Van Rensselaer, Cortlandt
Vincent, Marvin Richardson
Voris, John Ralph
Waddel, James
Waddel, John Newton
Waddel, Moses
Walker, James Barr
Warfield, Benjamin Breckinridge
Whitaker, Nathaniel
Whitworth, George Frederic
Wiley, David
Willey, Samuel Hopkins
Wilson, Joshua Lacy
Wilson, Samuel Ramsay
Wilson, Warren Hugh
Witherspoon, John
Wood, James
Woodrow, James
Woods, Leonard, 1807–1878
Yeomans, John William
Young, John Clarke
Zubly, John Joachim

Protestant Episcopal (**See** EPISCOPAL)

Puritan
Bulkeley, Peter
Cotton, John
Holden, Oliver
Mather, Cotton
Mather, Increase
Mather, Richard
Mayhew, Jonathan
Morton, Charles
Norton, John
Parris, Samuel
Sherman, John, 1613–1685
Stone, Samuel
Taylor, Edward
Weld, Thomas
Whitfield, Henry
Wigglesworth, Michael
Williams, Roger
Wilson, John
Woodbridge, John

Quaker
Chalkley, Thomas
Coffin, Charles Fisher
Comstock, Elizabeth L.
Evans, Thomas
Grellet, Stephen
Hallowell, Benjamin
Hicks, Elias
Hoag, Joseph
Hubbs, Rebecca
Hunt, Nathan
Janney, Samuel McPherson
Jay, Allen
Jones, Sybil
Kelsey, Rayner Wickersham
Mott, Lucretia Coffin
Muste, Abraham Johannes
Owen, Griffith
Pemberton, John
Pugh, Ellis
Sands, David
Savery, William, 1750–1804
Scattergood, Thomas
Scott, Job
Updegraff, David Brainard
Waln, Nicholas
Wilbur, John

Reformed Church in America
Schenck, Ferdinand Schureman
Searle, John Preston
Thompson, John Bodine
Van Nest, Abraham Rynier
Woodbridge, Samuel Merrill

Roman Catholic
Alphonsa, Mother
Andreis, Andrew James Felix
 Bartholomew de
Andrews, Samuel James
Andrews, William Watson
Angela, Mother
Antoine, Père
Ayres, Anne
Barzyndski, Vincent
Bayma, Joseph
Behrens, Henry
Benavides, Alonzo de
Burke, John Joseph
Campbell, Thomas Joseph
Carr, Thomas Matthew
Clarke, Mary Francis
Conaty, Thomas James
Cooper, John Montgomery
Coppens, Charles
Corcoran, James Andrew
Cosby, William
Coughlin, Charles Edward
Curran, John Joseph
Currier, Charles Warren
Cushing, Richard James
Dabrowski, Joseph

Dietz, Peter Ernest
Dougherty, Dennis Joseph
Drumgoole, John Christopher
Du Bois, John
Du Bourg, Louis Guillaume
 Valentin
Duffy, Francis Patrick
Dwenger, Joseph
Elder, William Henry
Elliott, Walter Hacket Robert
Farley, John Murphy
Fenwick, Benedict Joseph
Ffrench, Charles Dominic
Finn, Francis James
Finotti, Joseph Maria
Fitzgerald, Edward
Flanagan, Edward Joseph
Franas, Paul James
Gallagher, Hugh Patrick
Ganss, Henry George
Garrigan, Philip Joseph
Gasson, Thomas Ignatius
Gibbons, James
Gilmour, Richard
Gmeiner, John
Goupil, René
Greaton, Joseph
Guérin, Anne-Thérèse
Guilday, Peter Keenan
Haid, Leo
Hardey, Mother Mary Aloysia
Harding, Robert
Hayes, Patrick Joseph
Hecker, Isaac Thomas
Hennepin, Louis
Hennessy, John
Henni, John Martin
Hessoun, Joseph
Hewit, Augustine Francis
Hubbard, Bernard Rosecrans
Hudson, Daniel Eldred
Hughes, John Joseph
Hurley, Joseph Patrick
Ireland, John, 1838–1918
Johnson, George
Joubert de la Muraille, James
 Hector Marie Nicholas
Judge, Thomas Augustine
Katzer, Frederic Xavier
Keane, James John
Keane, John Joseph
Keller, James Gregory
Kenrick, Francis Patrick
Kenrick, Peter Richard
Kerby, William Joseph
Kirlin, Joseph Louis Jerome
Kohlmann, Anthony
LaFarge, John
Lambert, Louis Aloisius
Lambing, Andrew Arnold

Lamy, John Baptist
Larkin, John
Lee, James Wideman
Levins, Thomas C.
Loras, Jean Mathias Pierre
Lynch, Patrick Neeson
Maas, Anthony J.
McCaffrey, John
McCloskey, John
McCloskey, William George
McElroy, John, 1782–1877
McFaul, James Augustine
McGill, John
McGivney, Michael Joseph
McGlynn, Edward
McGrath, James
McGuire, Charles Bonaventure
McIntyre, James Francis Aloysius
Machebeuf, Joseph Provectus
Maes, Camillus Paul
Malone, Sylvester
Maréchal, Ambrose
Marest, Pierre Gabriel
Marty, Martin
Matignon, Francis Anthony
Meerschaert, Théophile
Merton, Thomas
Messmer, Sebastian Gebhard
Meyer, Albert Gregory
Michel, Virgil George
Miles, Richard Pius
Ming, John Joseph
Moeller, Henry
Molyneux, Robert
Moore, John, 1834–1901
Moosmuller, Oswald William
Moriarity, Patrick Eugene
Morini, Austin John
Mundelein, George William
Neale, Leonard
Nerinckx, Charles
Neumann, John Nepomucene
Nieuwland, Julius Arthur
Nobili, John
O'Brien, Matthew Anthony
O'Callaghan, Jeremiah
O'Callahan, Joseph Timothy
O'Connor, James
O'Connor, Michael
Odenbach, Frederick Louis
Odin, John Mary
O'Gorman, Thomas
Ortynsky, Stephen Soter
Pace, Edward Aloysius
Pardow, William O'Brien
Patrick, John Ryan
Perche, Napoleon Joseph
Phelan, David Samuel
Pise, Charles Constantine
Portier, Michael

Power, John
Preston, Thomas Scott
Price, Thomas Frederick
Purcell, John Baptist
Quarter, William
Quigley, James Edward
Rese, Frederick
Reuter, Dominic
Rigge, William Francis
Riordan, Patrick William
Ritter, Joseph Elmer
Robot, Isidore
Rosati, Joseph
Rosecrans, Sylvester Horton
Rouquette, Adrien Emmanuel
Ryan, Abram Joseph
Ryan, John Augustine
Ryan, Patrick John
Ryan, Stephen Vincent
Saenderl, Simon
Scanlan, Lawrence
Schnerr, Leander
Schrembs, Joseph
Seghers, Charles Jean
Semmes, Alexander Jenkins
Sestini, Benedict
Seton, Robert
Shahan, Thomas Joseph
Sheen, Fulton John
Sheil, Bernard James
Shields, Thomas Edward
Sorin, Edward Frederick
Spalding, Catherine
Spalding, John Lancaster
Spalding, Martin John
Spellman, Francis Joseph
Stang, William
Stehle, Aurelius Aloysius
Stone, James Kent
Tabb, John Banister
Talbot, Francis Xavier
Thébaud, Augustus J.
Tierney, Richard Henry
Timon, John
Tondorf, Francis Anthony
Turner, William
Tyler, William
Van de Velde, James Oliver
Varela y Morales, Félix Francisco
 José María de la Concepción
Verot, Jean Marcel Pierre Auguste
Viel, François Étienne Bernard
 Alexandre
Walsh, Edmund Aloysius
Walsh, James Anthony
Walsh, Thomas Joseph
White, Charles Ignatius
Wigger, Winand Michael
Willlams, John Joseph
Wilson, Samuel Thomas

Wimmer, Boniface
Wolf, Innocent William
Wood, James Frederick
Wright, John Joseph
Yorke, Peter Christopher
Young, Alfred
Young, Josue Maria
Zahm, John Augustine
Russian Orthodox
 Leonty, Metropolitan
Society of Friends (See QUAKER)
Southern Baptist
 Dodd, Monroe Elmon
 Norris, John Franklyn
 Rawlinson, Frank Joseph
 Scarborough, Lee Rutland
 Truett, George Washington
Swedenborgian
 Barrett, Benjamin Fiske
 Brown, Solyman
 Giles, Chauncey
 Mercer, Lewis Pyle
 Reed, James, 1834–1921
 Sewall, Frank
 Smyth, Julian Kennedy
Unaffiliated
 Craig, Austin
 Newton, Joseph Fort
 Spencer, Anna Garlin
Unitarian
 Abbot, Francis Ellingwood
 Alger, William Rounseville
 Allen, Joseph Henry
 Ames, Charles Gordon
 Barnard, Charles Francis
 Barrows, Samuel June
 Bartol, Cyrus Augustus
 Batchelor, George
 Bellows, Henry Whitney
 Bentley, William
 Bixby, James Thompson
 Brazer, John
 Brooks, Charles
 Brooks, Charles Timothy
 Buckminster, Joseph Stevens
 Burnap, George Washington
 Burton, Warren
 Chadwick, John White
 Channing, William Ellery
 Channing, William Henry
 Clarke, James Freeman
 Colman, Henry
 Conway, Moncure Daniel
 Cooke, George Willis
 Cranch, Christopher Pearse
 Crothers, Samuel McChord
 Cummings, Edward
 Dewey, Orville
 Ellis, George Edward
 Emerson, William

Thomas, George Clifford
 (autographic historical material)
Vincent, Frank (antiquities)
Wilson, Ernest Henry (plants)

COLLEGE ADMINISTRATOR
Fulton, Robert Burwell
Geddes, James Lorraine
Keppel, Frederick Paul
Perkins, George Henry
Royster, James Finch
Small, Albion Woodbury

COLLEGE PRESIDENT
Adams, Charles Kendall
Adams, Jasper
Alden, Timothy
Alderman, Edwin Anderson
Allen, William Henry
Ames, Joseph Sweetman
Anderson, Galusha
Anderson, John Alexander
Anderson, Martin Brewer
Andrews, Elisha Benjamin
Andrews, Israel Ward
Andrews, Lorin
Angell, James Burrill
Angell, James Rowland
Atherton, George Washington
Atwood, Wallace Walter
Aydelotte, Frank
Ayres, Brown
Backus, Azel
Bailey, Rufus William
Baker, Hugh Potter
Baker, James Hutchins
Baldwin, Elihu Whittlesey
Ballou, Hosea
Barnard, Frederick Augustus Porter
Barrows, David Prescott
Barrows, John Henry
Bartlett, Samuel Colcord
Bascom, Henry Bidleman
Bascom, John
Bashford, James Whitford
Bass, William Capers
Battle, Kemp Plummer
Baugher, Henry Louis
Beardshear, William Miller
Beecher, Edward
Beman, Nathan Sidney Smith
Bennett, Henry Garland
Benton, Allen Richardson
Bethune, Mary McLeod
Blackburn, Gideon
Blackburn, William Maxwell
Blanchard, Jonathan
Bomberger, John Henry Augustus
Bowman, Isaiah
Bradley, John Edwin
Breckinridge, Robert Jefferson
Bronk, Detlev Wulf

Brown, Elmer Ellsworth
Brown, Francis
Brown, Samuel Gilman
Brownell, Thomas Church
Bryan, John Stewart
Burr, Aaron
Burton, Ernest DeWitt
Burton, Marion Le Roy
Butler, Nicholas Murray
Butterfield, Kenyon Leech
Cain, Richard Harvey
Caldwell, Joseph
Camm, John
Campbell, Prince Lucien
Campbell, William Henry
Candler, Warren Akin
Capen, Elmer Hewitt
Carnahan, James
Carrick, Samuel
Carter, Franklin
Caswell, Alexis
Cattell, William Cassaday
Chadbourne, Paul Anscl
Chandler, Julian Alvin Carroll
Chapin, Aaron Lucius
Chaplin, Jeremiah
Chase, Harry Woodburn
Chase, Thomas
Chauncey, Charles
Cheney, Oren Burbank
Clapp, Charles Horace
Clark, William Smith
Coffman, Lotus Delta
Compton, Karl Taylor
Conant, James Bryant
Cooper, Myles
Corby, William
Cordier, Andrew Wellington
Crafts, James Mason
Cravath, Erastus Milo
Craven, Braxton
Cummings, Joseph
Cutler, Carroll
Daggett, Naphtali
Darling, Henry
Davies, Samuel
Davis, Harvey Nathaniel
Davis, Henry
Day, Jeremiah
Dennett, Tyler (Wilbur)
Dickinson, Jonathan
Dunster, Henry
Durant, Henry
Dwight, Timothy, 1752–1817
Dwight, Timothy, 1828–1916
Dykstra, Clarence Addison
Eaton, Nathaniel
Eisenhower, Dwight D.
Eliot, Charles William
Estabrook, Joseph

Fairchild, George Thompson
Fairchild, James Harris
Farrand, Livingston
Faunce, William Herbert Perry
Ferris, Isaac
Few, Ignatius Alphonso
Fisher, Daniel Webster
Folwell, William Watts
Foster, William Trufant
Fox, Dixon Ryan
Fraley, Samuel
Frank, Glenn
Frelinghuysen, Theodore
Frieze, Henry Simmons
Furman, James Clement
Gambrell, Mary Latimer
Garfield, Harry Augustus
Garland, Landon Cabell
Gates, Caleb Frank
Gates, Thomas Sovereign
Gerhart, Emanuel Vogel
Gilbert, Eliphalet Wheeler
Gilman, Daniel Coit
Glueck, Nelson
Goodell, Henry Hill
Goodnow, Frank Johnson
Goodwin, Daniel Raynes
Goucher, John Franklin
Graham, Edward Kidder
Graves, Zuinglius Calvin
Green, Ashbel
Gregg, John Andrew
Gregory, John Milton
Griffin, Edward Dorr
Griswold, Alfred Whitney
Gummere, Samuel James
Hadley, Arthur Twining
Hadley, Herbert Spencer
Hardenbergh, Jacob Rutsen
Harris, William
Hasbrouck, Abraham Bruyn
Hibben, John Grier
Hickok, Laurens Perseus
Hill, David Jayne
Hill, Thomas
Hinman, George Wheeler
Hoar, Leonard
Holt, Hamilton Bowen
Horrocks, James
Howard, Ada Lydia
Humes, Thomas William
Humphrey, Heman
Huntington, William Edwards
Hutchins, Harry Burns
Hyer, Robert Stewart
James, Edmund Janes
Jessup, Walter Albert
Johns, John
Johnson, Mordecai Wyatt
Johnson, Samuel

Jordan, David Starr
Kephart, Ezekiel Boring
King, Charles
King, Stanley
Kirkland, James Hampton
Kirkland, John Thornton
Knapp, Bradford
Krauth, Charles Philip
Langdon, Samuel
Lathrop, John Hiram
Leverett, John, 1662–1724
Lipscomb, Andrew Adgate
Livermore, Abiel Abbot
Loos, Charles Louis
Lord, Nathan
Low, Seth
Lowell, Abbott Lawrence
McBryde, John McLaren
McCosh, James
McGlothlin, William Joseph
McIlwaine, Richard
McKeen, Joseph
Maclean, John
McNair, Fred Walter
McVey, Frank Lerond
Madison, James
Magill, Edward Hicks
Magnes, Judah Leon
Magoun, George Frederic
Mahan, Asa
Main, John Hanson Thomas
Manning, James
Marquis, John Abner
Marsh, James
Maxcy, Jonathan
Maxwell, William
Mayes, Edward
Mendenhall, Thomas Corwin
Merrill, George Edmands
Middleton, Nathaniel Russell
Miner, Alonzo Ames
Mitchell, Edward Cushing
Moore, Benjamin
Moore, Nathaniel Fish
Moore, Zephaniah Swift
Morgan, Arthur Ernest
Morgan, John Harcourt Alexander
Morrison, Nathan Jackson
Mortimer, Mary
Morton, Henry
Muhlenberg, Frederick Augustus
Neilson, William Allan
Nichols, Ernest Fox
Nisbet, Charles
Northrop, Cyrus
Nott, Eliphalet
Oakes, Urian
Parrish, Edward
Patrick, Mary Mills
Patton, Francis Landey

Payne, Bruce Ryburn
Payne, Daniel Alexander
Pearson, Raymond Allen
Pendleton, Ellen Fitz
Pendleton, William Kimbrough
Porter, Noah
Pott, Francis Lister Hawks
Potter, Eliphalet Nott
Preus, Christian Keyser
Pritchett, Henry Smith
Pugh, Evan
Purnell, William Henry
Pynchon, Thomas Ruggles
Quincy, Josiah, 1772–1864
Rankin, Jeremiah Eames
Raymond, John Howard
Reid, John Morrison
Reinhardt, Aurelia Isabel Henry
Rhees, Rush
Rhoades, James E.
Robinson, Ezekiel Gilman
Runkle, John Daniel
Sadtler, John Philip Benjamin
Sanford, Edmund Clark
Scarborough, William Saunders
Schurman, Jacob Gould
Scott, Austin
Scott, Walter Dill
Seelye, Laurenus Clark
Seip, Theodore Lorenzo
Sewall, Joseph Addison
Seymour, Charles
Shafer, Helen Almira
Sharpless, Isaac
Shepard, James Edward
Shuster, George Nauman
Sims, Charles N.
Smart, James Henry
Smith, Asa Dodge
Smith, John Augustine
Smith, John Blair
Smith, Samuel Stanhope
Smith, William Andrew
Smith, William Waugh
Sparks, Edwin Erle
Sproul, Robert Gordon
Stearns, William Augustus
Stewart, Alexander Peter
Stiles, Ezra
Stith, William
Stockbridge, Horace Edward
Strong, James Woodward
Stryker, Melancthon Woolsey
Stuart, John Leighton
Swain, David Lowry
Tappan, Henry Philip
Taylor, James Monroe
Thatcher, Roscoe Wilfred
Thomas, Martha Carey
Thompson, William Oxley

Thomson, Edward
Thornwell, James Henley
Thwing, Charles Franklin
Tigert, John James, IV
Tyler, Lyon Gardiner
Van Hise, Charles Richard
Venable, Francis Preston
Vincent, George Edgar
Waddel, Moses
Wait, Samuel
Walker, James
Warren, William Fairfield
Wayland, Francis, 1796–1865
Webb, Alexander Stewart
Wheeler, Benjamin Ide
Wheelock, Eleazar
Wheelock, John
White, Andrew Dickson
White, Henry Clay
Whitsitt, William Heth
Wilbur, Ray Lyman
Willard, Joseph
Willard, Samuel
Williams, Walter
Wilson, Woodrow
Woods, Alva
Woods, Leonard
Woolley, Mary Emma
Woolsey, Theodore Dwight
Wylie, Andrew

COLONIAL AGENT

Argall, Sir Samuel
Ashmun, Jehudi
Barnwell, John
Bollan, William
De Berdt, Dennys
Dummer, Jeremiah
Partridge, Richard
Randolph, Edward
Sebastian, Benjamin
Vassall, John
Weld, Thomas

COLONIAL LEADER

Bacon, Nathaniel
Byrd, William
Carter, Robert
Clarke, George
Dinwiddie, Robert
Gayoso de Lemos, Manuel
Habersham, James
Hathorne, William
Holloway, John
Jenifer, Daniel of St. Thomas
Kennedy, Archibald
Minuit, Peter
Moore, John, c. 1659–1732
Newton, Thomas, 1660–1721
Nicholas, Robert Carter
Norris, Isaac, 1671–1735
Nuñez Cabeza De Vaca, Alvar

Cohan, George Michael
Coltrane, John William
Converse, Charles Crozat
Converse, Frederick Shepherd
Cook, Will Marion
Damrosch, Leopold
Damrosch, Walter Johannes
De Koven, Henry Louis Reginald
De Rose, Peter
Dett, Robert Nathaniel
Dresel, Otto
Du Bois, Shirley Lola Graham
Duke, Vernon
Dunham, Henry Morton
Edwards, Julian
Eichberg, Julius
Elman, Harry ("Ziggy")
Emery, Stephen Albert
Engel, Carl
Evans, William John ("Bill")
Fairchild, Blair
Fairlamb, James Remington
Faith, Percy
Farwell, Arthur
Fielding, Jerry
Fisher, William Arms
Foote, Arthur William
Foster, Stephen Collins
Fry, William Henry
Ganss, Henry George
Ganz, Rudolph
Garner, Erroll Louis
Gershwin, George
Gilbert, Henry Franklin Belknap
Gilchrist, William Wallace
Gleason, Frederic Grant
Godowsky, Leopold
Goldbeck, Robert
Goldman, Edwin Franko
Goldmark, Rubin
Gottschalk, Louis Moreau
Grainger, George Percy
Griffes, Charles Tomlinson
Grofé, Ferde
Hadley, Henry Kimball
Hammerstein, Oscar
Harney, Benjamin Robertson
Harris, LeRoy Ellsworth ("Roy")
Hastings, Thomas
Hathaway, Donny
Hays, William Shakespeare
Hemrich, Antony Philip
Hemmeter, John Conrad
Henderson, Ray
Herrmann, Bernard
Hewitt, James
Hoffman, Richard
Hofmann, Josef Casimir
Holyoke, Samuel
Humiston, William Henry

Hunter, Ivory Joe
Ives, Charles Edward
Jackson, George K.
Johns, Clayton
Jones, Lindley Armstrong ("Spike")
Kaiser, Alois
Keller, Mathias
Kelley, Edgar Stillman
Kenton, Stanley Newcomb
Kern, Jerome David
Klein, Bruno Oscar
Koemmenich, Louis
Korngold, Erich Wolfgang
Kreisler, Fritz
Kroeger, Ernest Richard
Landowska, Wanda Aleksandra
Lang, Benjamin Johnson
Law, Andrew
Ledbetter, Huddie ("Leadbelly")
Levant, Oscar
Liebling, Emil
Liebling, Estelle
Loeffler, Charles Martin
Loesser, Frank
Lutkin, Peter Christian
MacDowell, Edward Alexander
Mannes, Leopold Damrosch
Maretzek, Max
Marzo, Eduardo
Mason, Daniel Gregory
Mason, William
Mercer, John Herndon ("Johnny")
Mingus, Charles, Jr.
Mitchell, Nahum
Mitropoulos, Dimitri
Morton, Ferdinand Joseph ("Jelly Roll")
Musin, Ovide
Nabokov, Nicolas
Nevin, Ethelbert Woodbridge
Nevin, George Balch
Newman, Alfred
Niles, John Jacob
Nolan, Bob
Nunó, Jaime
Oehmler, Leo Carl Martin
Oliver, Joseph
Ory, Edward ("Kid")
Osgood, George Laurie
Paine, John Knowles
Palmer, Horatio Richmond
Parker, Charlie ("Bird")
Parker, Horatio William
Parker, James Cutler Dunn
Pease, Alfred Humphreys
Perabo, Johann Ernst
Phillips, Philip
Piston, Walter Hamor
Porter, Cole
Pratt, Silas Gamaliel

Prima, Luigi ("Louis")
Pryor, Arthur W.
Rachmaninoff, Sergei Vasilyevich
Razaf, Andy
Reinagle, Alexander
Riegger, Wallingford
Ritter, Frédéric Louis
Rodgers, Richard Charles
Rogers, Clara Kathleen Barnett
Romberg, Sigmund
Root, Frederic Woodman
Root, George Frederick
Rosenblatt, Joseph
Runcie, Constance Faunt Le Roy
Rybner, Martin Cornelius
Sandler, Jacob Koppel
Schelling, Ernest Henry
Schillinger, Joseph
Schindler, Kurt
Schnabel, Artur
Schoenberg, Arnold
Scott, John Prindle
Selby, William
Shaw, Oliver
Sherwood, William Hall
Silvers, Louis
Sobolewski, J. Friedrich Eduard
Sousa, John Philip
Southard, Lucien H.
Speaks, Oley
Spicker, Max
Stanley, Albert Augustus
Stark, Edward Josef
Steiner, Maximilian Raoul Walter ("Max")
Sternberg, Constantin Ivanovich, Edler von
Stewart, Humphrey John
Still, William Grant, Jr.
Stoessel, Albert Frederic
Stokowski, Leopold Anthony
Stravinsky, Igor Fyodorovich
Swan, Timothy
Taylor, Joseph Deems
Taylor, Raynor
Thayer, Whitney Eugene
Tilzer, Harry Von
Tiomkin, Dimitri
Tobani, Theodore Moses
Trajetta, Philip
Tristano, Leonard Joseph ("Lennie")
Tuckey, William
Van Der Stucken, Frank Valentin
Varèse, Edgard
Vogrich, Max Wilhelm Karl
Waller, Thomas Wright ("Fats")
Warren, Richard Henry
Warren, Samuel Prowse
Waxman, Franz
Webb, George James

Ewing, Thomas
Ferry, Orris Sanford
Fess, Simeon Davidson
Findlay, James
Findley, William
Fitzpatrick, Morgan Cassius
Fitzsimmons, Thomas
Florence, Thomas Birch
Floyd, William
Foot, Samuel Augustus
Fordney, Joseph Warren
Forney, William Henry
Forward, Walter
Foster, Abiel
Foster, Charles
Fowler, Orin
Frye, William Pierce
Galloway, Samuel
Garfield, James Abram
Garrett, Finis James
Gear, John Henry
Gillett, Frederick Huntington
Gillette, Guy Mark
Gilmer, George Rockingham
Gilmer, John Adams
Glynn, Martin Henry
Goldsborough, Charles
Goldsborough, Thomas Alan
Goodenow, John Milton
Green, James Stephens
Green, William Joseph, Jr.
Greenhalge, Frederic Thomas
Greenup, Christopher
Griswold, John Augustus
Groesbeck, William Slocum
Grosvenor, Charles Henry
Hahn, Georg Michael Decker
Hale, Robert Safford
Hamer, Thomas Lyon
Hamilton, William Thomas
Hampton, Wade, 1751–1835
Hancock, John, 1824–1893
Hanson, Alexander Contee, 1786–
 1819
Hardin, Ben
Hardin, John J.
Harding, Abner Clark
Hardwick, Thomas William
Harlan, James
Harris, Wiley Pope
Harrison, Byron Patton
Harrison, Francis Burton
Hartley, Fred Allen, Jr.
Hartley, Thomas
Hasbrouck, Abraham Bruyn
Hastings, William Wirt
Hatch, William Henry
Haugen, Gilbert Nelson
Haugen, Nils Pederson
Havens, James Smith

Hawley, Willis Chatman
Hébert, Felix Edward ("Eddie")
Heflin, James Thomas
Hemphill, Joseph
Henderson, Archibald
Hendricks, Thomas Andrews
Hendricks, William
Hendrix, Joseph Clifford
Hepburn, William Peters
Herbert, Hilary Abner
Herter, Christian Archibald
Hiester, Daniel
Hiester, Joseph
Hillhouse, James
Hilliard, Henry Washington
Hillyer, Junius
Hinds, Asher Crosby
Hitt, Robert Roberts
Hoar, Ebenezer Rockwood
Hoar, George Frisbie
Hoar, Samuel
Hobson, Richmond Pearson
Hoey, Clyde Roark
Hoffman, Clare Eugene
Hoffman, Ogden
Hogan, John
Holman, William Steele
Holmes, Isaac Edward
Hope, Clifford Ragsdale
Hopkinson, Joseph
Houghton, Alanson Bigelow
Houk, Leonidas Campbell
Howard, Benjamin
Howard, Jacob Merritt
Howard, Volney Erskine
Hubbard, David
Hughes, Dudley Mays
Hull, Cordell
Hunt, Carleton
Hunter, Whiteside Godfrey
Hurlbut, Stephen Augustus
Ingersoll, Charles Jared
Ingham, Samuel Delucenna
Iverson, Alfred
Jackson, James, 1819–1887
Jackson, John George
Jackson, William, 1783–1855
James, Ollie Murray
Jenkins, Albert Gallatin
Jensen, Benton Franklin ("Ben")
Johns, Kensey
Johnson, Cave
Johnson, James
Johnson, Magnus
Johnson, Robert Ward
Johnson, Tom Loftin
Jones, Frank
Jones, Jehu Glancy
Jones, John Marvin
Jones, John Winston

Jones, William
Judd, Norman Buel
Kahn, Julius
Keating, Kenneth Barnard
Keifer, Joseph Warren
Keitt, Lawrence Massillon
Kelley, William Darrah
Kelly, John
Kenna, John Edward
Kennedy, John Fitzgerald
Kennedy, Robert Patterson
Kent, Joseph
Key, Philip Barton
Kilbourne, James
King, Austin Augustus
King, John Alsop
King, Thomas Butler
King, William Rufus Devane
Kitchin, Claude
Kitchin, William Walton
Knickerbocker, Herman
Knott, James Proctor
Knutson, Harold
Lacey, John Fletcher
Lacock, Abner
La Guardia, Fiorello Henry
Lane, Henry Smith
Lanham, Frederick Garland
 ("Fritz")
Lattimore, William
Law, John
Lawrence, William, 1819–1899
Leavitt, Humphrey Howe
Lee, William Henry Fitzhugh
Leffler, Isaac
Leffler, Shepherd
Leib, Michael
Lemke, William Frederick
Lenroot, Irvine Luther
Letcher, John
Letcher, Robert Perkins
Lever, Asbury Francis
Levin, Lewis Charles
Lewis, Dixon Hall
Lewis, James Hamilton
Lewis, Joseph Horace
Ligon, Thomas Watkins
Lind, John
Lindbergh, Charles Augustus
Littauer, Lucius Nathan
Littleton, Martin Wiley
Livermore, Arthur
Livermore, Edward St. Loe
Livermore, Samuel, 1732–1803
Lloyd, Edward, 1779–1834
Locke, Matthew
Long, John Davis
Longfellow, Stephen
Loomis, Arphaxed
Loomis, Dwight

Robertson, John
Robinson, Joseph Taylor
Rollins, James Sidney
Rousseau, Lovell Harrison
Rowan, John
Rusk, Jeremiah McClain
Sabath, Adolph J.
Sage, Russell
Saunders, Romulus Mitchell
Sawyer, Lemuel
Schenck, Robert Cumming
Seddon, James Alexander
Sergeant, John, 1779–1852
Sergeant, Jonathan Dickinson
Sevier, Ambrose Hundley
Seybert, Adam
Seymour, Thomas Hart
Shafroth, John Franklin
Shepard, William
Sheppard, John Morris
Sherwood, Isaac Ruth
Shouse, Jouett
Sibley, Joseph Crocker
Sickles, Daniel Edgar
Simms, William Elliott
Simpson, Jerry
Singleton, James Washington
Skinner, Harry
Slemp, Campbell Bascom
Smalls, Robert
Smith, Caleb Blood
Smith, Howard Worth ("Judge")
Smith, Jeremiah, 1759–1842
Smith, Oliver Hampton
Smith, Truman
Smith, Walter Inglewood
Smith, William, 1797–1887
Smith, William Loughton
Smith, William Nathan Harrell
Smith, William Russell
Smyth, Alexander
Snell, Bertrand Hollis
Spaight, Richard Dobbs
Spalding, Thomas
Sparks, William Andrew Jackson
Spaulding, Elbridge Gerry
Speer, Emory
Spence, Brent
Spencer, Ambrose
Spencer, John Canfield
Sperry, Nehemiah Day
Springer, William McKendree
Stanley, Augustus Owsley
Stanly, Edward
Stanton, Frederick Perry
Stanton, Richard Henry
Starin, John Henry
Steagall, Henry Bascom
Steele, John
Stephens, Alexander Hamilton

Stephenson, Andrew
Stephenson, Isaac
Stevens, Thaddeus
Stevenson, Adlai Ewing
Stevenson, John White
Stewart, Andrew
Stigler, William Grady
Stockdale, Thomas Ringland
Stone, David
Stone, William Joel
Storer, Bellamy
Stuart, Alexander Hugh Holmes
Stuart, John Todd
Sullivan, George
Sulzer, William
Summers, George William
Sumners, Hatton, William
Sumter, Thomas
Sutherland, Joel Barlow
Swann, Thomas
Swanson, Claude Augustus
Sweeney, Martin Leonard
Taber, John
Tallmadge, Benjamin
Tawney, James Albertus
Taylor, Alfred Alexander
Thacher, George
Thayer, Eli
Thomas, David
Thomas, Francis
Thomas, John Parnell
Thomas, Philip Francis
Thompson, Jacob
Thompson, Thomas Larkin
Thompson, Waddy
Thompson, Wiley
Throop, Enos Thompson
Thurman, Allen Granberry
Tilson, John Quillin
Tinkham, George Holden
Tod, John
Toucey, Isaac
Towne, Charles Arnette
Towns, George Washington
 Bonaparte
Tracy, Uriah
Troup, George Michael
Trumbull, Jonathan, 1740–1809
Tuck, Amos
Tucker, Henry St. George, 1853–
 1932
Tucker, John Randolph, 1823–1897
Tyson, Job Roberts
Upham, Charles Wentworth
Van Cortlandt, Philip
Van Horn, Robert Thompson
Van Rensselaer, Solomon
Van Rensselaer, Stephen
Verplanck, Julian Crommelin
Vibbard, Chauncey

Vinson, Fred(erick) Moore
Vinton, Samuel Finley
Volstead, Andrew John
Vroom, Peter Dumont
Waddell, Alfred Moore
Wadsworth, James Wolcott, Jr.
Wadsworth, Jeremiah
Wadsworth, Peleg
Walker, Amasa
Walker, Gilbert Carlton
Wallace, David
Wallgren, Mon(rad) C(harles)
Walter, Francis Eugene
Ward, Marcus Lawrence
Warner, Adoniram Judson
Warner, Hiram
Warner, William
Warren, Lindsay Carter
Washburn, Cadwallader Colden
Washburn, Charles Grenfill
Washburn, Israel
Washburn, William Drew
Washburne, Elihu Benjamin
Watson, James Eli
Watterson, Harvey Magee
Weaver, James Baird
Weeks, John Wingate
Welch, John
Weller, John B.
Wells, Erastus
Wentworth, John, 1815–1888
West, George
Wheeler, Joseph
White, Alexander
White, Stephen Van Culen
Whitehill, Robert
Whitman, Ezekiel
Wickliffe, Charles Anderson
Wilde, Richard Henry
Williams, David Rogerson
Willis, Albert Shelby
Wilmot, David
Wilson, James
Wilson, James Falconer
Wilson, William Bauchop
Wilson, William Lyne
Windom, William
Winn, Richard
Winthrop, Robert Charles
Wise, Henry Alexander
Wolf, George
Wood, Fernando
Wood, John Stephens
Wood, William Robert
Wright, Hendrick Bradley
Wright, Joseph Albert
Wright, Robert
Yates, Abraham
Yell, Archibald

Magonigle, Harold Van Buren
Mencken, Henry Louis
Morehouse, Ward
Nathan, George Jean
Parker, Dorothy Rothschild
Poe, Edgar Allan
Pollak, Gustav
Pound, Ezra Loomis
Price, William Thompson
Rahv, Philip
Redman, Ben Ray
Reitzel, Robert
Rittenhouse, Jessie Belle
Seldes, Gilbert Vivian
Stedman, Edmund Clarence
Stoddard, Richard Henry
Sturgis, Russell
Trilling, Lionel
Tuckerman, Henry Theodore
Van Vechten, Carl
Wallace, Horace Binney
Walsh, Thomas
Wheeler, Andrew Carpenter
Wheelock, John Hall
Whitaker, Charles Harris
Willcox, Louise Collier
Williams, John
Woodberry, George Edward
Woollcott, Alexander Humphreys
Zukofsky, Louis

CRYPTOLOGIST
Friedman, William Frederick

CULT LEADER
Jones, Jim

CURATOR (See also MUSEUM DIRECTOR)
Burroughs, Bryson
Fitzpatrick, John Clement
Goodyear, William Henry
Koehler, Sylvester Rosa
Lutz, Frank Eugene
Rau, Charles
Seitz, William Chapin
Steichen, Edward Jean
Todd, Walter Edmond Clyde
Watkins, John Elfreth

CUSTOMS EXPERT
Colton, George Radcliffe
Keith, Sir William
Sterling, James

CYTOLOGIST
Wilson, Edmund Beecher

DAIRY HUSBANDMAN (See also CATTLEMAN)
Alvord, Henry Elijah
Arnold, Lauren Briggs
Hoard, William Dempster

DANCE EDUCATOR
Eglevsky, Andreé Yevgenyevich
Horst, Louis

DANCER
Bailey, Bill
Barton, James Edward
Bolm, Adolph Rudolphovitch
Castle, Irene Foote
Castle, Vernon Blythe
Champion, Gower
Dailey, Dan, Jr.
Duncan, Isadora
Fokine, Michel
Fuller, Loie
Gilbert, Anne Hartley
Gray, Gilda
Humphrey, Doris
Limón, José Arcadio
McCracken, Joan
Murray, Mae
Rand, Sally
Robinson, Bill ("Bojangles")
Rooney, Pat
St. Denis, Ruth
Shaw, Edwin Meyers ("Ted")
Tamiris, Helen
Van, Bobby
Vladimiroff, Pierre
Webb, Clifton

DEAF EDUCATION SCHOLAR
Goldstein, Max Aaron

DEFENSE LAWYER
Leibowitz, Samuel Simon

DEMOCRATIC NATIONAL CHAIRMAN
Bailey, John Moran

DEMOGRAPHER (See also STATISTICIAN)
Lotka, Alfred James

DENDROCHRONOLOGIST
Douglass, Andrew Ellicott

DENTIST (See also PHYSICIAN)
Abbott, Frank
Allen, John
Black, Greene Vardiman
Bonwill, William Gibson Arlington
Brown, Solyman
Buchanan, Edgar
Evans, Thomas Wiltberger
Fillebrown, Thomas
Flagg, Josiah Foster
Garretson, James
Greenwood, John
Harris, Chapin Aaron
Hayden, Horace H.
Howe, Percy Rogers
Hudson, Edward
Hullihen, Simon P.
Kingsley, Norman William
Loomis, Mahlon
McQuillen, John Hugh

Miller, Willoughby Dayton
Morton, William Thomas Green
Owre, Alfred
Parsons, Thomas William
Riggs, John Mankey
Spooner, Shearjashub
Volsk, Adalbert John
Wells, Horace
White, John de Haven

DEPARTMENT STORE EXECUTIVE
Lazarus, Fred, Jr.
Rosenwald, Lessing Julius
Straus, Percy Selden

DERMATOLOGIST (See also PHYSICIAN)
Duhring, Louis Adolphus
Jackson, George Thomas
Pusey, William Allen
Schamberg, Jay Frank
Wende, Ernest
Wende, Grover William
White, James Clarke
Wigglesworth, Edward

DESIGNER (CINEMATOGRAPHIC EQUIPMENT)
Howell, Albert Summers

DESIGNER (COSTUME)
Bernstein, Aline

DESIGNER (FASHION)
Adrian, Gilbert
Carnegie, Hattie
Fogarty, Anne Whitney
Kiam, Omar
Klein, Anne
McCardell, Claire
Norell, Norman
Orry-Kelly
Rosenstein, Nettie Rosencrans

DESIGNER (INTERIOR)
Eames, Charles Ormand, Jr.
Herter, Christian

DESIGNER (SCENIC)
Aronson, Boris Solomon
Bernstein, Aline

DESPERADO (See also BANDIT, BRIGAND, BUCCANEER, BURGLAR, CRIMINAL, OUTLAW, PIRATE)
Bass, Sam
Billy the Kid
Dalton, Robert
James, Jesse Woodson
Mason, Samuel
Slade, Joseph Alfred
Younger, Thomas Coleman

DETECTIVE
Burns, William John
Means, Gaston Bullock
Pinkerton, Allan
Ruditsky, Barney
Siringo, Charles A.

Slidell, John
Smith, Charles Emory
Smith, Walter Bedell
Smith, William Loughton
Smyth, John Henry
Soulé, Pierre
Squier, Ephraim George
Squiers, Herbert Goldsmith
Stallo, Johann Bernhard
Standley, William Harrison
Steinhardt, Laurence Adolph
Stevens, John Leavitt
Stevenson, Andrew
Stillman, William James
Stimson, Frederic Jesup
Storer, Bellamy
Stovall, Pleasant Alexander
Straight, Willard Dickerman
Straus, Jesse Isidor
Straus, Oscar Solomon
Strobel, Edward Henry
Stuart, John Leighton
Swift, John Franklin
Taft, Alphonso
Taylor, Hannis
Taylor, Myron Charles
Tenney, Charles Daniel
Terrell, Edwin Holland
Thomas, Allen
Thomas, William Widgery
Thompson, Llewellyn E.
 ("Tommy"), Jr.
Thompson, Thomas Larkin
Thompson, Waddy
Tod, David
Todd, Charles Stewart
Torbert, Alfred Thomas Archimedes
Tower, Charlemagne
Tree, Lambert
Trescot, William Henry
Tripp, Bartlett
Trist, Nicholas Philip
Turner, James Milton
Vail, Aaron
Van Dyke, Henry
Vaughan, Benjamin
Vignaud, Henry
Vincent, John Carter
Vopicka, Charles Joseph
Wallace, Hugh Campbell
Walton, Lester Aglar
Ward, John Elliott
Warden, David Bailie
Washburn, Albert Henry
Washburne, Elihu Benjamin
Webb, James Watson
Weddell, Alexander Wilbourne
Welles, (Benjamin) Sumner
Wheaton, Henry
Wheeler, (George) Post

Wheeler, John Hill
White, Andrew Dickson
White, Henry
Whitlock, Brand
Wikoff, Henry
Wilkins, William
Willard, Joseph Edward
Williams, Edward Thomas
Williams, James
Williams, John
Williams, Samuel Wells
Willis, Albert Shelby
Wilson, Henry Lane
Wilson, Hugh Robert
Winant, John Gilbert
Woodford, Stewart Lyndon
Wright, Joseph Albert
Young, Owen D.
Zellerbach, James David
DIRECTOR (See also MOTION PICTURE
 DIRECTOR, STAGE DIRECTOR,
 THEATRICAL DIRECTOR)
Blackmer, Sydney Alderman
Brenon, Herbert
Carroll, Leo Grattan
Champion, Gower
Chaplin, Charles Spencer
 ("Charlie")
Clurman, Harold Edgar
Craven, Frank
Crisp, Donald
DeMille, Cecil Blount
Griffith, David Wark
Hampden, Walter
Hart, William Surrey
Hitchcock, Alfred Joseph
Lindsay, Howard
Lubitsch, Ernst
Miller, Gilbert Heron
Mitchell, Thomas Gregory
Muse, Clarence
Nagel, Conrad
Nichols, Dudley
Pemberton, Brock
Perry, Antoinette
Rice, Elmer
Ritchard, Cyril
Rossen, Robert
Schwartz, Maurice Von
Sternberg, Josef
White, George
DIRECTOR OF U.S. MINT (See also
 COMPTROLLER OF CURRENCY)
DeSaussure, Henry William
Linderman, Henry Richard
Ross, Nellie Tayloe
Snowden, James Ross
DISARMAMENT ADVOCATE
Dingman, Mary Agnes

DISK JOCKEY
Freed, Alan J.
DISCOVERER (See also EXPLORER,
 FRONTIERSMAN, GUIDE, PIONEER,
 SCOUT)
Cárdenas, García López de
De Soto, Hernando
Gray, Robert
Ingraham, Joseph
Ponce, Juan de León
DIVER
Patch, Sam
DIXIE CUP CORPORATION FOUNDER
Moore, Hugh Everett
DRAFTSMAN
Sterne, Maurice
DRAMA CRITIC
Allen, Kelcey
Benchley, Robert Charles
Brown, John Mason, Jr.
Gibbs, (Oliver) Wolcott
Hale, Philip
Hammond, Percy Hunter
Kronenberger, Louis, Jr.
Laffan, William Mackay
Mailly, William
Mantle, (Robert) Burns
Moses, Montrose Jonas
Parker, Henry Taylor
Pollard, Joseph Percival
Stevens, Ashton
Winter, William
Young, Stark
DRAMATIST
Adams, Frank Ramsay
Ade, George
Aiken, George L.
Akins, Zoê
Anderson, Maxwell
Arden, Edwin Hunter Pendleton
Arliss, George
Armstrong, Paul
Auden, Wystan Hugh
Bacon, Frank
Baker, Benjamin A.
Bannister, Nathaniel Harrington
Barker, James Nelson
Barnes, Charlotte Mary Sanford
Barry, Philip James Quinn
Bateman, Sidney Frances Cowell
Baum, Lyman Frank
Behrman, Samuel Nathaniel
 ("S.N.")
Belasco, David
Bernard, William Bayle
Biggers, Earl Derr
Bird, Robert Montgomery
Blitzstein, Marc
Boker, George Henry
Boucicault, Dion

ECONOMIST (See also HOME ECONOMIST)

Adams, Henry Carter
Adams, Thomas Sewall
Anderson, Benjamin McAlester
Andrew, Abram Piatt
Andrews, John Bertram
Atkinson, Edward
Ayres, Leonard Porter
Barnett, George Ernest
Bigelow, Eratus Brigham
Blodget, Samuel
Callender, Guy Stevens
Cardozo, Jacob Newton
Carey, Henry Charles
Carey, Mathew
Catchings, Waddill
Chamberlin, Edward Hastings
Clark, John Bates
Clark, John Maurice
Commons, John Rogers
Conant, Charles Arthur
Corey, Lewis
Daniels, Winthrop More
Davenport, Herbert Joseph
Day, Edmund Ezra
Dean, William Henry, Jr.
Del Mar, Alexander
Dew, Thomas Roderick
Douglas, Paul Howard
Dunbar, Charles Franklin
Ely, Richard Theodore
Emery, Henry Crosby
Ensley, Enoch
Fairchild, Fred Rogers
Falkner, Roland Post
Farnam, Henry Walcott
Fetter, Frank Albert
Fisher, Irving
Foster, William Trufant
George, Henry
Goldenweiser, Emanuel Alexander
Gordon, Kermit
Gould, Elgin Ralston Lovell
Gunton, George
Hadley, Arthur Twining
Hamilton, Walton Hale
Hansen, Alvin Harvey
Harris, Seymour Edwin
Haynes, Williams
Hollander, Jacob Harry
Horton, Samuel Dana
Hoxie, Robert Franklin
Jacoby, Neil Herman
James, Edmund James
Jenks, Jeremiah Whipple
Johnson, Harry Gordon
Jordan, Virgil Justin
Kemmerer, Edwin Walter
Knauth, Oswald Whitman

Knight, Frank Hyneman
Laughlin, James Laurence
Leiserson, William Morris
List, Georg Friedrich
Lubin, Isador
Macfarlane, Charles William
McPherson, Logan Grant
McVey, Frank Lerond
McVickar, John
Mayo-Smith, Richmond
Millis, Harry Alvin
Mitchell, Wesley Clair
Moore, Henry Ludwell
Nourse, Edwin Griswold
Olds, Leland
Page, Thomas Walker
Parker, Carleton Hubbell
Pasvolsky, Leo
Patten, Simon Nelson
Perlman, Selig
Perry, Arthur Latham
Persons, Warren Milton
Pitkin, Timothy
Poor, Henry Varnum
Rae, John
Raguet, Condy
Remington, William Walter
Riefler, Winfield William
Ripley, William Zebina
Robinson, Edward Van Dyke
Rogers, James Harvey
Sachs, Alexander
Schoenhof, Jacob
Schultz, Henry
Schumpeter, Joseph Alois
Schwab, John Christopher
Seager, Henry Rogers
Seligman, Edwin Robert Anderson
Shearman, Thomas Gaskell
Simons, Algie Martin
Simons, Henry Calvert
Slichter, Sumner Huber
Spahr, Charles Brazillai
Spillman, William Jasper
Stewart, Walter Winne
Sumner, William Graham
Taussig, Frank William
Taylor, Fred Manville
Thompson, Robert Ellis
Tucker, George
Tugwell, Rexford Guy
Vaughan, Benjamin
Veblen, Thorstein Bunde
Vethake, Henry
Viner, Jacob
Walker, Amasa
Walker, Francis Amasa
Webster, Pelatiah
Wells, David Ames
Weston, Nathan Austin

White, Horace
Wildman, Murray Shipley
Willis, Henry Parker
Wolman, Leo
Woodbury, Helen Laura Sumner
Woytinsky, Wladimir Savelievich
Wright, Philip Green
Young, Allyn Abbott

ECUMENICAL MOVEMENT LEADER

Brown, William Adams
Cavert, Samuel McCrea

ECUMENICAL PIONEER

Mott, John R.

EDITOR

Abbott, Lyman
Adams, Cyrus Cornelius
Adams, William Lysander
Aikens, Andrew Jackson
Alden, Henry Mills
Aldrich, Thomas Bailey
Allen, Frederick Lewis
Allen, Joseph Henry
Allen, Paul
Allen, Richard Lamb
Altsheler, Joseph Alexander
Ameringer, Oscar
Ames, Charles Gordon
Anderson, Margaret Carolyn
Armstrong, Hamilton Fish
Arthur, Timothy Shay
Atwood, David
Bagby, George William
Bangs, John Kendrick
Barron, Clarence Walker
Barrow, Washington
Barrows, Samuel June
Barsotti, Charles
Bartholdt, Richard
Bartlett, John
Bausman, Benjamin
Bayles, James Copper
Benét, William Rose
Benjamin, Park
Bennett, James Gordon
Bidwell, Walter Hilliard
Bigelow, John
Bird, Frederic Mayer
Bird, Robert Montgomery
Blackwell, Alice Stone
Blackwell, Henry Brown
Bledsoe, Albert Taylor
Bliss, Edwin Munsell
Bok, Edward William
Boner, John Henry
Booth, Mary Louise
Botts, Charles Tyler
Boudinot, Elias
Bowen, Henry Chandler
Bowker, Richard Rogers
Bowles, Samuel, 1797–1851

Bowles, Samuel, 1826–1878
Bowles, Samuel, 1851–1915
Brace, John Pierce
Bradwell, Myra
Brainerd, Erastus
Brainerd, Thomas
Brann, William Cowper
Brayman, Mason
Breckinridge, Desha
Breckinridge, William Campbell
 Preston
Brickell, Henry Herschel
Bright, Edward
Brisbane, Arthur
Bronson, Walter Cochrane
Brooks, James Gordon
Browne, Francis Fisher
Bryant, Louise Frances Stevens
Bryant, William Cullen
Buckingham, Joseph Tinker
Burlingame, Edward Livermore
Burr, Alfred Edmund
Burrage, Henry Sweetser
Butts, Isaac
Calverton, Victor Francis
Cameron, William Evelyn
Campbell, Charles
Campbell, John Wood, Jr.
Campbell, Lewis Davis
Canby, Henry Seidel
Cardozo, Jacob Newton
Carruth, Fred Hayden
Carter, John
Carter, Robert
Carter, William Hodding, Jr.
Cary, Edward
Catton, Charles Bruce
Chamberlain, Henry Richardson
Champlin, John Denison
Channing, Edward Tyrrell
Chase, Edna Woolman
Childs, Cephas Grier
Church, William Conant
Cist, Charles
Claiborne, John Francis
 Hamtramck
Clark, Charles Hopkins
Clark, Lewis Gaylord
Clark, Willis Gaylord
Clarke, Helen Archibald
Clarkson, Coker Fifield
Cobb, Frank Irving
Coffin, Robert Peter Tristram
Cohen, John Sanford
Colby, Frank Moore
Colver, William Byron
Cook, Martha Elizabeth Duncan
 Walker
Corcoran, James Andrew
Cornwallis, Kinahan

Costain, Thomas Bertram
Covici, Pascal ("Pat")
Croly, Herbert David
Crooks, George Richard
Croswell, Harry
Crowninshield, Francis Welch
Cunliffe-Owen, Philip Frederick
Dana, Charles Anderson
Dana, Edward Salisbury
Daniels, Josephus
Dart, Henry Paluché
Davenport, Russell Wheeler
Davis, Paulina Kellogg Wright
Davis, Watson
Dawson, Henry Barton
De Bow, James Dunwoody
 Brownson
Deering, Nathaniel
Dell, Floyd James
Dennie, Joseph
De Young, Michel Harry
Dingley, Nelson
Dodge, Mary Elizabeth Mapes
Dole, Nathan Haskell
Doyle, Alexander Patrick
Drake, Benjamin
Drury, John Benjamin
Du Bois, William Edward
 Burghardt
Dunbar, Charles Franklin
Dunning, Albert Elijah
Duyckinck, Evert Augustus
Duyckinck, George Long
Dwight, Henry Otis
Dwight, John Sullivan
Dwight, Theodore
Dymond, John
Edwards, Bela Bates
Elliot, Jonathan
Elliott, Charles
Ellmaker, (Emmett) Lee
Elwell, John Johnson
English, Thomas Dunn
Errett, Isaac
Evans, George Henry
Evans, Thomas
Everett, Alexander Hill
Fanning, Tolbert
Faran, James John
Farley, Harriet
Fauset, Jessie Redmon
Fenno, John
Fernald, James Champlin
Fernow, Berthold
Finley, John Huston
Fiske, Amos Kidder
Fiske, Daniel Willard
Fitzgerald, Thomas
Fitzpatrick, John Clement
Flagg, Azariah Cutting

Fleisher, Benjamin Wilfrid
Florence, Thomas Birch
Flower, Benjamin Orange
Floy, James
Fogg, George Gilman
Folsom, Charles
Ford, Daniel Sharp
Ford, Guy Stanton
Ford, Henry Jones
Forney, Matthias Nace
Foster, Charles, James
Foster, Frank Pierce
Foster, John Watson
Foster, Lafayette Sabine
Francis, Charles Spencer
Francis, John Morgan
Frank, Glenn
Frazer, John Fries
Freneau, Philip Morin
Fuller, Andrew S.
Fuller, Joseph Vincent
Funk, Isaac Kauffman
Gaillard, Edwin Samuel
Gallagher, William Davis
Gambrell, James Bruton
Gernsback, Hugo
Gibbs, (Oliver) Wolcott
Gilder, Jeannette Leonard
Gilder, Richard Watson
Gildersleeve, Basil Lanneau
Giles, Chauncey
Gillis, James Martin
Gilpin, Henry Dilworth
Gitt, Josiah Williams ("Jess")
Glass, Franklin Potts
Glynn, Martin Henry
Godkin, Edwin Lawrence
Godman, John Davison
Godwin, Parke
Goodhue, James Madison
Goodwin, Elijah
Gordon, Laura De Force
Gould, George Milbry
Graham, George Rex
Grasty, Charles Henry
Greeley, Horace
Green, Thomas
Greene, Nathaniel
Gregory, Daniel Seelye
Griffin, Solomon Bulkley
Griswold, Stanley
Grosvenor, Gilbert Hovey
Gruening, Ernest
Gunton, George
Habberton, John
Hackett, Francis
Hahn, Georg Michael Decker
Haines, Lynn
Haldeman-Julius, Emanuel
Hale, Edward Joseph

Moss, Lemuel
Munn, Orson Desaix
Muñoz-Rivera, Luis
Nancrède, Paul Joseph Guérard de
Nast, William
Nathan, George Jean
Neal, John
Nelson, Henry Loomis
Nevin, Alfred
Newcomb, Harvey
Newell, William Wells
Newton, Robert Safford
Ng Poon Chew
Nichols, Clarina Irene Howard
Nichols, Thomas Low
Nicola, Lewis
Nieman, Lucius William
Niles, Hezekiah
Niles, John Milton
Nock, Albert Jay
North, Simon Newton Dexter
Northen, William Jonathan
Norton, Charles Eliot
Oakes, George Washington Ochs
O'Brien, Robert Lincoln
Ogg, Frederic Austin
Older, Fremont
O'Reilly, Henry
O'Reilly, John Boyle
Osborn, Norris Galpin
Otis, George Alexander
Oursler, (Charles) Fulton
Packard, Frederick Adolphus
Packer, William Fisher
Paley, John
Palfrey, John Gorham
Pallen, Condé Benoist
Palmore, William Beverly
Parkhurst, Charles
Passavant, William Alfred
Patterson, Robert Mayne
Patterson, Thomas MacDonald
Paul, Elliot Harold
Payne, John Howard
Peck, George
Peck, Harry Thurston
Pedder, James
Peirce, Bradford Kinney
Peloubet, Francis Nathan
Pendleton, William Kimbrough
Perché, Napoleon Joseph
Perkins, Frederic Beecher
Perkins, George Douglas
Perkins, Maxwell Evarts
Perry, Bliss
Peters, Absalom
Peterson, Charles Jacobs
Peterson, Henry
Phillips, John Sanburn
Pickard, Samuel Thomas

Pierson, Arthur Tappan
Pilcher, Lewis Stephen
Pinckney, Henry Laurens
Pinkerton, Lewis Letig
Pinkney, Edward Coote
Polk, Leonidas Lafayette
Pollak, Gustav
Pomeroy, Marcus Mills
Pond, George Edward
Poore, Benjamin Perley
Potter, William James
Powell, John Benjamin
Pratt, Eliza Anna Farman
Pratt, Sereno Stansbury
Presser, Theodore
Price, Thomas Frederick
Prime, Samuel Irenaeus
Pulitzer, Joseph, Jr.
Purple, Samuel Smith
Putnam, Eben
Quick, John Herbert
Raguet, Condy
Rahv, Philip
Raymond, Henry Jarvis
Raymond, Rossiter Worthington
Redman, Ben Ray
Redpath, James
Reed, David
Reid, Gilbert
Reid, John Morrison
Reiersen, Johan Reinert
Reitzel, Robert
Rémy, Henri
Rhoades, James E.
Rice, Edwin Wilbur
Rideing, William Henry
Ripley, George
Robertson, James Alexander
Robinson, Charles Seymour
Robinson, Stuart
Rombro, Jacob
Rorty, James Hancock
Ross, Charles Griffith
Ross, Harold Wallace
Rothwell, Richard Pennefather
Rowlands, William
Rublee, Horace
Rupp, William
Sanders, Daniel Jackson
Sanger, George Partridge
Sangster, Margaret Elizabeth
 Munson
Saunders, William Laurence
Sawyer, Thomas Jefferson
Saxton, Eugene Francis
Schem, Alexander Jacob
Schnauffer, Carl Heinrich
Schouler, William
Schultze, Augustus
Schuster, Max Lincoln

Schuyler, Robert Livingston
Schwimmer, Rosika
Scott, Harvey Whitefield
Screws, William Wallace
Scudder, Horace Elisha
Scull, John
Seymour, Horatio Winslow
Shattuck, George Brune
Shea, John Dawson Gilmary
Sherwood, Isaac Ruth
Shields, George Oliver
Shreve, Thomas Hopkins
Sizel, Franz
Silverman, Sime
Simpson, Stephen
Singerly, William Miskey
Singleton, Esther
Sloan, Harold Paul
Smalley, Eugene Virgil
Smith, Benjamin Eli
Smith, Charles Perrin
Smith, Edmund Munroe
Smith, Elias
Smith, Elihu Hubbard
Smith, John Augustine
Smith, John Cotton, 1826–1882
Smith, John Jay
Smith, Lillian Eugenia
Smith, Lloyd Pearsall
Smith, Mildred Catharine
Smith, Samuel Francis
Smith, Uriah
Smyth, Albert Henry
Snow, Carmel White
Spahr, Charles Barzillai
Sparks, Jared
Spivak, Charles David
Spooner, Shearjashub
Sprague, Charles Arthur
Stanard, William Glover
Stanwood, Edward
Stauffer, David McNeely
Stedman, Edmund Clarence
Stephens, Ann Sophia
Stephens, Edwin William
Steuben, John
Stevens, Abel
Stoddard, Richard Henry
Stoddart, Joseph Marshall
Stone, David Marvin
Stone, Richard French
Storey, Wilbur Fisk
Stovall, Pleasant Alexander
Street, Joseph Montfort
Stuart, Charles Macaulay
Summers, Thomas Osmond
Swisshelm, Jane Grey Cannon
Talmage, Thomas De Witt
Taylor, Marshall William
Teall, Francis Augustus

Tenney, William Jewett
Thatcher, Benjamin Bussey
Thayer, Thomas Baldwin
Thayer, William Makepeace
Thomas, John Jacobs
Thomas, Robert Bailey
Thompson, John Reuben
Thompson, Joseph Parrish
Thompson, Thomas Larkin
Thompson, William Tappan
Thomson, Edward
Thomson, Edward William
Thrasher, John Sidney
Thurber, George
Thurston, Lorrin Andrews
Thwaites, Reuben Gold
Tigert, John James
Tilton, Theodore
Todd, Henry Alfred
Torrence, Frederick Ridgely
Towne, Charles Hanson
Tracy, Joseph
Trumbull, Henry Clay
Tucker, Gilbert Milligan
Turner, George Kibbe
Turner, Henry McNeal
Turner, Josiah
Tyler, Robert
Underwood, Benjamin Franklin
Untermeyer, Louis
Updegraff, David Brainard
Vanderlip, Frank Arthur
Van Doren, Irita Bradford
Villard, Oswald Garrison
Vizetelly, Frank Horace
Vogrich, Max Wilhelm Karl
Walker, James Barr
Wallace, Henry
Waller, John Lightfoot
Walsh, Henry Collins
Walsh, Michael
Walsh, Thomas
Ward, Cyrenus Osborne
Ware, Ashur
Ware, John
Warner, Charles Dudley
Warren, Israel Perkins
Watson, Henry Clay
Watson, Henry Cood
Watterson, Harvey Magee
Watterson, Henry
Wellington, Arthur Mellen
Wentworth, John, 1815–1888
Wertenbaker, Charles Christian
Wharton, Francis
Whedon, Daniel Denison
Wheelock, John Hall
Wheelock, Joseph Albert
Whelpley, Henry Milton
Whitaker, Charles Harris

Whitaker, Daniel Kimball
White, Charles Ignatius
White, William Allen
White, William Nathaniel
Whitney, Caspar
Whittelsey, Abigail Goodrich
Whittemore, Thomas
Wiggin, James Henry
Willcox, Louise Collier
Williams, Charles Richard
Williams, Jesse Lynch
Willis, Henry Parker
Willis, Nathaniel
Willis, Nathaniel Parker
Wilson, George Grafton
Wilson, James Grant
Wilson, James Southall
Winchester, Caleb Thomas
Winchevsky, Morris
Winkler, Edwin Theodore
Winship, Albert Edward
Wise, Daniel
Woodruff, Lorande Loss
Woodruff, William Edward
Worcester, Noab
Wright, John Stephen
Wright, Marcus Joseph
Wright, Robert William
Wurtz, Henry
Wyeth, John
Yeadon, Richard
Yost, Casper Salathiel
Youmans, Edward Livingston
Youmans, William Jay
Young, Jesse Bowman
Young, Lafayette
Zahniser, Howard Clinton
Zevin, Israel Joseph
Ziff, William Bernard

**EDITOR (AGRICULTURAL) (See also
AGRICULTURIST)**
Aiken, David Wyatt
Brown, Simon
Coburn, Foster Dwight
Gaylord, Willis
Judd, Orange
Myrick, Herbert
Skinner, John Stuart
Stockbridge, Horace Edward
Wiley, David

EDITOR (ANARCHIST)
Goldman, Emma

EDITOR (MAGAZINE)
Bliven, Bruce Ormsby
Brady, Mildred Alice Edie
Goodman, Paul
Kirchwey, Freda
Lorimer, George Horace
Patrick, Edwin Hill ("Ted")
Patterson, Alicia

Sedgwick, Ellery
Woodward, Robert Simpson

EDITOR (MEDICAL)
Ingelfinger, Franz Joseph
Jelliffe, Smith Ely
Simmons, George Henry

EDITOR (NEWSPAPER)
Abbott, Robert Sengstacke
Bingay, Malcolm Wallace
Bovard, Oliver Kirby
Brokenshire, Norman Ernest
Freeman, Douglas Southall
Gauvreau, Emile Henry
Goddard, Morrill
Howard, Joseph Kinsey
Howe, Edgar Watson
Howell, Clark
Johnson, Albert
Lait, Jacquin Leonard (Jack)
McClatchy, Charles Kenny
Ogden, Rollo
Patterson, Eleanor Medill
Pulitzer, Ralph
Reid, Ogden Mills
Shedd, Fred Fuller
Smith, Henry Justin

EDITOR (SCIENCE)
Blakeslee, Howard Walter
Cattell, James McKeen
Woodward, Robert Simpson

**EDUCATOR (See also COLLEGE
PRESIDENT, PROFESSOR, SCHOLAR,
TEACHER)**
Abbot, Benjamin
Abbot, Gorham Dummer
Abbott, Edith
Abbott, Jacob
Adams, Daniel
Adams, Ebenezer
Adams, John
Adler, Felix
Agassiz, Elizabeth Cabot Cary
Aggrey, James Emman Kwegyir
Aiken, Charles Augustus
Akeley, Mary Leonore
Alcott, Amos Bronson
Alcott, William Andrus
Alden, Joseph
Alderman, Edwin Anderson
Aldrich, Charles Anderson
Alexander, Archibald
Alexander, Joseph Addison
Alison, Francis
Allen, Alexander Viets Griswold
Allen, George
Allen, James Edward, Jr.
Allen, William
Allen, Young John
Allinson, Anne Crosby Emery
Allyn, Robert

Coppée, Henry
Coppens, Charles
Cordier, Andrew Wellington
Cox, Samuel Hanson
Craig, Austin
Craighead, Edwin Boone
Crandall, Prudence
Crary, Isaac Edwin
Crooks, George Richard
Crunden, Frederick Morgan
Cubberley, Ellwood Patterson
Curry, Jabez Lamar Monroe
Curtis, Edwards Lewis
Dagg, John Leadley
Darby, John
Davis, John Warren
Dawley, Almena
Day, Edmund Ezra
Day, Henry Noble
Day, James Roscoe
Day, Jeremiah
Dean, Amos
Denny, George Vernon, Jr.
Deutsch, Gotthard
Dewey, Chester
Dewey, John
Dickinson, John
Dickinson, John Woodbridge
Dickson, Leonard Eugene
Dillard, James Hardy
Diman, Jeremiah Lewis
Dimitry, Alexander
Dinwiddie, Albert Bledsoe
Doak, Samuel
Dod, Thaddeus
Dodge, Ebenezer
Donovan, James Britt
Dorchester, Daniel
Dove, David James
Downey, John
Draper, Andrew Sloan
Drinker, Cecil Kent
Drisler, Henry
Drown, Thomas Messinger
Dunham, Henry Morton
Dutton, Samuel Train
Dwight, Benjamin Woodbridge
Dwight, Francis
Dwight, Nathaniel
Dwight, Sereno Edwards
Dwight, Theodore, 1796–1866
Dwight, Theodore Wllliam
Dwight, Timothy
Dyer, Isadore
Dykstra, Clarence Addison
Earle, Edward Mead
Earle, Mortimer Lamson
Earle, Ralph
Eastman, Harvey Gridley
Eaton, Amos

Eaton, John
Edwards, Ninian Wirt
Eigenmann, Carl H.
Eiseley, Loren Corey
Eliot, Charles William
Elliott, William Yandell, III
Elman, Robert
Elvehjem, Conrad Arnold
Emerson, Benjamin Kendall
Emerson, George Barrell
Emerson, Joseph
Emerton, Ephraim
Erdman, Charles Rosenbury
Esbjörn, Lars Paul
Espy, James Pollard
Ewell, Benjamin Stoddert
Fairchild, Fred Rogers
Fairchild, George Thompson
Fairchild, James Harris
Fairfield, Edmund Burke
Fairlie, John Archibald
Fanning, Tolbert
Fay, Sidney Bradshaw
Ferguson, John Calvin
Ferris, Woodbridge Nathan
Fess, Simeon Davidson
Few, William Preston
Fieser, Louis Frederick
Fillebrown, Thomas
Finley, John Huston
Finley, Robert
Finn, Francis James
Finney, Charles Grandison
Fisher, Ebenezer
Fisk, Wilbur
Fiske, George Converse
Fite, Warner
Fitzpatrick, Morgan Cassius
Fleming, Walter Lynwood
Fletcher, Robert
Flexner, Abraham
Follen, Charles
Ford, Guy Stanton
Fortier, Alcée
Foss, Cyrus David
Foster, George Burman
Fowle, William Bentley
Frame, Alice Seymour Browne
Francis, Convers
Frank, Philipp G.
Frazier, Edward Franklin
Frear, William
Friedlaender, Walter Ferdinand
Frissell, Hollis Burke
Fuertes, Estevan Antonio
Furman, Richard
Furst, Clyde Bowman
Gale, George Washington
Galloway, Samuel
Gambrell, James Bruton

Garland, Landon Cabell
Garnet, Henry Highland
Garnett, James Mercer
Garrett, William Robertson
Gasson, Thomas Ignatius
Gates, George Augustus
Gauss, Christian Frederick
Giddings, Franklin Henry
Giesler-Anneke, Mathilde Franziska
Gildersleeve, Virginia Crocheron
Gill, Laura Drake
Gillespie, William Mitchell
Gillett, Ezra Hall
Gilman, Arthur
Gilmer, Francis Walker
Godel, Kurt Friedrich
Going, Jonathan
Goldbeck, Robert
Goodale, George Lincoln
Goodell, Henry Hill
Goodnow, Isaac Tichenor
Goodrich, Annie Warburton
Goodrich, Chauncey Allen
Goodrich, Elizur
Goodspeed, Thomas Wakefield
Gordy, John Pancoast
Goss, James Walker
Gottschalk, Louis Reichenthal
Gove, Aaron Estellus
Grady, Henry Francis
Graham, Evarts Ambrose
Graham, Frank Porter
Gray, John Chipman
Gray, William Scott, Jr.
Green, Lewis Warner
Green, Samuel Bowdlear
Greene, Charles Ezra
Greene, George Washington
Greene, Samuel Stillman
Greener, Richard Theodore
Greenlaw, Edwin Almiron
Greenleaf, Benjamin
Gregg, Alan
Gregory, Charles Noble
Gregory, Daniel Seelye
Gregory, John Milton
Griffis, William Elliot
Grimke, Thomas Smith
Gros, John Daniel
Gross, Charles
Grossmann, Louis
Guerin, Anne-Therese
Guilford, Nathan
Gurney, Ephraim Whitman
Guthe, Karl Eugen
Haagen-Smit, Arie Jan
Haas, Francis Joseph
Haddock, Charles Brickett
Hale, Benjamin
Hall, Arethusa

Leonard, Sterling Andrus
Levermore, Charles Herbert
Lewis, Clarence Irving
Lewis, Enoch
Lewis, Exum Percival
Lewis, Oscar
Lewis, Samuel
Lieber, Francis
Lindeman, Eduard Christian
Lindsley, John Berrien
Lindsley, Philip
Lipman, Jacob Goodale
Listemann, Bernhard
Littlefield, George Washington
Livingston, John Henry
Locke, Alain Leroy
Locke, Bessie
Longcope, Warfield Theobald
Longstreet, Augustus Baldwin
Lord, Asa Dearborn
Lord, Chester Sanders
Loughridge, Robert McGill
Lovell, John Epy
Lovett, Robert Morss
Lowes, John Livingston
Lowrey, Mark Perrin
Lubin, Isador
Luce, Henry Winters
Lutkin, Peter Christian
Lyon, David Gordon
Lyon, Mary
Maas, Anthony J.
McAfee, John Armstrong
MacAlister, James
McAnally, David Rice
McAndrew, William
McAuley, Thomas
McCaleb, Theodore Howard
McCartee, Divie Bethune
McCartney, Washington
McClellan, Henry Brainerd
McClenahan, Howard
M'Clintock, John
McCook, John James
McCormick, Samuel Black
MacCracken, Henry Mitchell
McDonald, James Grover
McDowell, John
McFarland, John Thomas
McFarland, Samuel Gamble
McGarvey, John William
McGuffey, William Holmes
McHale, Kathryn
McIver, Charles Duncan
Mackenzie, James Cameron
McKenzie, Robert Tait
MacLean, George Edwin
Maclean, John
McMurry, Frank Morton
MacVicar Malcolm

Mahan, Dennis Hart
Mahan, Milo
Main, John Hanson Thomas
Malcom, Howard
Manly, Basil, 1798–1868
Manly, Basil, 1825–1892
Mann, Horace
Mann, Mary Tyler Peabody
Mannes, Clara Damrosch
Mannes, David
Marble, Albert Prescott
Marks, Elias
Marshall, James Fowle Baldwin
Martin, Everett Dean
Martin, William Alexander Parsons
Mason, John Mitchell
Maxwell, William Henry
Mayo, Amory Dwight
Meany, Edmond Stephen
Mears, John William
Meigs, John
Meigs, Josiah
Meikle John, Alexander
Mell, Patrick Hues
Mendenhall, Thomas Corwin
Menetrey, Joseph
Mengarini, Gregory
Mercer, Margaret
Merrick, Frederick
Merrill, James Griswold Messer, Asa
Mezes, Sidney Edward
Michel, Virgil George
Michie, Peter Smith
Middleton, Thomas Cooke
Milledoler, Philip
Miller, Emily Clark Huntington
Miller, Kelly
Miller, Leslie William
Miller, Samuel
Millet, Fred Benjamin
Milligan, Robert
Milligan, Robert Andrews
Mills, Cyrus Taggart
Mills, Susan Lincoln Tolman
Miner, Myrtilla
Minor, Benjamin Blake
Minot, Charles Sedgwick
Mitchell, Albert Graeme
Mitchell, Lucy Sprague
Molyneux, Robert
Monis, Judah
Monroe, Paul
Montague, William Pepperell
Mood, Francis Asbury
Moody, William Vaughn
Moore, James, 1764–1814
Moore, Joseph Earle
Morgan, Thomas Jefferson
Morison, Samuel Eliot
Morón, Alonzo Graseano

Morrey, Margaret Warner
Morris, Edward Dafydd
Morris, George Sylvester
Morrison, John Irwin
Morse, Anson Daniel
Morse, Wayne Lyman
Morton, Robert Russa
Mosher, Eliza Maria
Moss, Lemuel
Mott, Frank Luther
Mowry, William Augustus
Mullins, Edgar Young
Munro, William Bennett
Murfee, James Thomas
Murray, David
Muste, Abraham Johannes
Muzzey, David Saville
Nabokov, Nicolas
Nash, Charles Sumner
Nason, Henry Bradford
Neef, Francis Joseph Nicholas
Neill, Edward Duffield
Neill, William
Nelson, David
Nelson, Reuben
Nevin, Edwin Henry
Nevin, John Williamson
Nevins, Joseph Allan
Newlon, Jesse Homer
Newman, Albert Henry
Nicholls, Rhoda Holmes
Nichols, Roy Franklin
Niebuhr, Helmut Richard
Nobili, John
Norris, Mary Harriott
Norsworthy, Naomi
North, Edward
North, Simeon, 1802–1884
Northend, Charles
Northrop, Birdsey Grant
Norton, John Pitkin
Noss, Theodore Bland
Notestein, Wallace
Nott, Henry Junius
Notz, Frederick William Augustus
Noyes, Clara Dutton
Nutting, Mary Adelaide
O'Callahan, Joseph Timothy
Odell, George Clinton Densmore
Ogden, Robert Curtis
O'Gorman, Thomas
Olin, Stephen
Orcutt, Hiram
Orr, Gustavus John
Orton, Edward Francis Baxter
Orton, James
Osborn, Henry Fairfield
O'Shea, Michael Vincent
Overstreet, Harry Allen
Owen, Edward Thomas

Wilson, William Lyne
Wines, Enoch Cobb
Wirt, William Albert
Witherspoon, Alexander Maclaren
Witherspoon, John Alexander
Wolfe, Harry Kirke
Wood, James
Wood, Thomas Bond
Woodbridge, Frederick James Eugene
Woodbridge, William Channing
Woodward, Calvin Milton
Woolsey, Theodore Dwight
Woolsey, Theodore Salisbury
Wright, Jonathan Jasper
Wright, Richard Robert
Wyckoff, John Henry
Wyeth, John Allan
Wylie, Andrew
Wylie, Samuel Brown
Yale, Caroline Ardelia
Yeomans, John William
Yergan, Max
Youmans, Edward Livingston
Young, Clark Montgomery
Young, Ella Flagg
Young, John Clarke
Zachos, John Celivergos
Zollars, Ely Vaughn
Zook, George Frederick

EFFICIENCY EXPERT
Bedaux, Charles Eugene

EGYPTOLOGIST (See also SCHOLAR)
Breasted, James Henry
McCauley, Edward Yorke
Reisner, George Andrew
Selikovitsch, Goetzel
Winlock, Herbert Eustis

ELECTRIC COMPANY EXECUTIVE
Sporn, Philip

ELECTRIC POWER ADMINISTRATOR
Ross, James Delmage McKenzie

ELECTRICAL ENGINEER (See ENGINEER, ELECTRICAL)

ELECTRICIAN (See also ENGINEER, ELECTRICAL)
Farmer, Moses Gerrish
Pope, Franklin Leonard

ELECTROTHERAPIST (See also PHYSICIAN)
Rockwell, Alphonso David

EMBEZZLER
Whitney, Richard

EMBRYOLOGIST (See also BIOLOGIST, PHYSICIAN, ZOOLOGIST)
Mall, Franklin Paine
Streeter, George Linius
Wilson, Edmund Beecher

EMIGRATION AGENT
Mattson, Hans

ENCYCLOPEDIST (See also COMPILER, SCHOLAR)
Heilprin, Michael
Mackey, Albert Gallatin
Schem, Alexander Jacob

ENDOCRINOLOGIST (See also PHYSICIAN)
Timme, Walter

ENGINEER (See also SPECIFIC TYPES)
Allen, Jeremiah Mervin
Allen, John F.
Argall, Philip
Babcock, George Herman
Babcock, OrvilEe E.
Bailey, Frank Harvey
Bailey, Joseph
Ball, Albert
Barnes, James
Barrell, Joseph
Bayles, James Copper
Bell, Louis
Benham, Henry Washington
Benjamin, George Hillard
Black, William Murray
Bogart, John
Bonzano, Adolphus
Boyden, Uriah Atherton
Broadhead, Garland Carr
Burr, William Hubert
Cass, George Washington
Colles, Christopher
Coney, Jabez
Crozet, Claude
Curtis, Samuel Ryan
Daniels, Fred Harris
Davis, George Whitefield
De Lacy, Walter Washington
De Leeuw, Adolph Lodewyk
Dickie, George William
Dod, Daniel
Douglass, David Bates
Dripps, Isaac L.
Dunbar, Robert
Durfee, William Franklin
Durham, Caleb Wheeler
Eads, James Buchanan
Eastman, William Reed
Eckart, William Roberts
Eimbeck, William
Ellicott, Joseph
Emery, Albert Hamilton
Emery, Charles Edward
Ericsson, John
Ernst, Oswald Herbert
Eustis, Henry Lawrence
Field, Charles William
Flad, Henry
Ford, Hannibal Choate
Forney, Matthias Nace
Frasch, Herman

Fuertes, Estevan Antonio
Furlow, Floyd Charles
Gaillard, David Du Bose
Gantt, Henry Laurence
Gardiner, James Terry
Gaskill, Harvey Freeman
Gayley, James
Goethals, George Washington
Graff, Frederick
Greene, Francis Vinton
Grinnell, Frederick
Guthrie, Alfred
Hallidie, Andrew Smith
Hamilton, Schuyler
Harris, Daniel Lester
Haswell, Charles Haynes
Hebert, Louis
Henck, John Benjamin
Hickenlooper, Andrew
Hornblower, Josiah
Humphreys, Andrew Atkinson
Hunt, Alfred Ephraim
Hutton, Frederick Remsen
Jadwin, Edgar
James, Charles Tillinghast
Jervis, John Bloomfield
Jones, William Richard
Judah, Theodore Dehone
Kafer, John Christian
Kármán, Theodore (Todor) Von
Kerr, Walter Craig
Lamme, Benjamin Garver
La Tour, Le Blond de
Latrobe, Benjamin Henry, 1764–1820
Lefferts, Marshall
L'Enfant, Pierre Charles
Léry, Joseph Gaspard Chaussegros de
Lewis, William Gaston
Long, Stephen Harriman
Lucas, Anthony Francis
Ludlow, William
Lundie, John
McCallum, Daniel Craig
Macfarlane, Charles William
Mangin, Joseph François
Marshall, William Louis
Mason, Arthur John
Maxim, Hiram Stevens
Meigs, Montgomery Cunningham
Merrill, William Emery
Miller, Ezra
Millington, John
Mills, Robert, 1781–1855
Mitchell, Henry
Mordecai, Alfred
Moreell, Ben
Morell, George Webb
Morgan, Charles Hill

Engineer (Industrial)

Entrepreneur

Pincus, Gregory Goodwin
("Goody")
Sanders, Harland David ("Colonel"
Tandy, Charles David

EPIDEMIOLOGIST (See also PHYSICIAN)
Carter, Henry Rose
Chapin, Charles Value
Doull, James Angus
Frost, Wade Hampton
Rosenau, Milton Joseph
Sedgwick, William Thompson
Sternberg, George Miller

ESPIONAGE AGENT
Berg, Morris ("Joe")
Gold, Harry ("Raymond")
Powers, Francis Gary

ESSAYIST (See also AUTHOR, WRITER)
Agee, James Rufus
Appleton, Thomas Gold
Auden, Wystan Hugh
Behrman, Samuel Nathaniel
("S.N.")
Bourne, Randolph Silliman
Calvert, George Henry
Colum, Padraic
Crévecoeur, Michel-Guillaume
Jean de
Crothers, Samuel McChord
Dana, Richard Henry
Dennie, Joseph
Douglas, Lloyd Cassel
Downey, John
Emerson, Ralph Waldo
Goodman, Paul
Gregory, Eliot
Guiney, Louise Imogen
Hall, Sarah Ewing
Holley, Marietta
Holmes, Oliver Wendell
Kinney, Elizabeth Clementine
Dodge Stedman
Lazarus, Emma
McKinley, Carlyle
Miller, Henry Valentine
Porter, Katherine Anne
Saltus, Edgar Evertson
Sperry, Willard Learoyd
Story, William Wetmore
Tate, John Orley Allen
Thoreau, Henry David
Tuckerman, Henry Theodore
Warner, Charles Dudley
Willcox, Louise Collier
Winchevsky, Morris
Winter, William

ETCHER (See also ARTIST, ENGRAVER)
Bacher, Otto Henry
Bellows, Albert Fitch
Benson, Frank Weston
Charles, William

Clay, Edward Williams
Dielman, Frederick
Duveneck, Frank
Farrer, Henry
Forbes, Edwin
Garrett, Edmund Henry
Gifford, Robert Swain
Hart, George Overbury
Haskell, Ernest
Koopman, Augustus
Merritt, Anna Lea
Mielatz, Charles Frederick William
Miller, Charles Henry
Moran, Peter
Moran, Thomas
Nicoll, James Craig
Pennell, Joseph
Platt, Charles Adams
Plowman, George Taylor
Reed, Earl Howell
Rix, Julian Walbridge
Smillie, James David
Whistler, James Abbott McNeill
Young, Mahonri Mackintosh

ETHICAL CULTURE LEADER
Coit, Stanton
Elliott, John Lovejoy

**ETHNOLOGIST (See also
ANTHROPOLOGIST)**
Bourke, John Gregory
Churchill, William
Cooper, John Montgomery
Cushing, Frank Hamilton
Dorsey, James Owen
Emerson, Ellen Russell
Farabee, William Curtis
Fewkes, Jesse Walter
Fletcher, Alice Cunningham
Gatschet, Albert Samuel
Gibbs, George
Goddard, Pliny Earle
Hale, Horatio Emmons
Henshaw, Henry Wetherbee
Jones, William
Lowie, Robert Harry
Mallery, Garrick
Mason, Otis Tufton
Matthews, Washington
Mooney, James
Morgan, Lewis Henry
Nott, Josiah Clark
Pilling, James Constantine
Safford, William Edwin
Schoolcraft, Henry Rowe
Skinner, Alanson Buck
Smith, Erminnie Adelle Platt
Speck, Frank Gouldsmith
Stevenson, James
Stevenson, Matilda Coxe Evans
Thomas, Cyrus

Woodruff, Charles Edward
Wyman, Jeffries

ETHNOMUSICOLOGIST
Densmore, Frances

ETIQUETTE AUTHORITY
Post, Emily Price
Vanderbilt, Amy

ETYMOLOGIST
Vizetelly, Frank Horace

EUGENICIST
Davenport, Charles Benedict
Laughlin, Harry Hamilton

**EVANGELIST (See also CLERGYMAN,
RELIGIOUS LEADER)**
Chapman, John Wilbur
Crittenden, Charles Nelson
Dow, Lorenzo
Durant, Henry Fowle
Hammond, Edward Payson
Hayden, William
Ironside, Henry Allan
Jones, Robert Reynolds ("Bob")
Jones, Samuel Porter
McPherson, Aimee Semple
Miller, George
Mills, Benjamin Fay
Moody, Dwight Lyman
Nettleton, Asahel
Pierce, Robert Willard
Rieger, Johann Georg Joseph Anton
Riley, William Bell
Smith, Fred Burton
Stone, Barton Warren
Sunday, William Ashley ("Billy")
Taylor, William
Updegraff, David Brainard
Upshaw, William David
Waters, Ethel
Whitefield, George

**EXECUTIVE (See also BUSINESSMAN,
BUSINESSWOMAN, CAPITALIST,
ENTREPRENEUR, INDUSTRIALIST,
MANUFACTURER, MERCHANT)**
Avery, Sewell Lee
Barton, Bruce Fairchild
Berwind, Edward Julius
Black, Eli
Boeing, William Edward
Braniff, Thomas Elmer
Brookings, Robert Somers
Brownlee, James Forbis
Brush, George Jarvis
Carpenter, John Alden
Clayton, William Lockhart
Copley, Ira Clifton
Cordiner, Ralph Jarron
Davis, Francis Breese, Jr.
Dean, Gordon Evans
Dillingham, Walter Francis
Dittemore, John Valentine

Crocker, Hannah Mather
Doyle, Sarah Elizabeth
Duniway, Abigail Jane Scott
Foster, Abigail Kelley
Gage, Matilda Joslyn
Grant, Jane Cole
Grimké, Angelina Emily
Grimké, Sarah Moore
Harper, Ida Husted
Haskell, Ella Louise Knowles
Hepburn, Katharine Houghton
Hooker, Isabella Beecher
Huntington, Margaret Jane Evans
Kehew, Mary Morton Kimball
Lozier, Clemence Sophia Harned
Martin, Anne Henrietta
Mussey, Ellen Spencer
Nathan, Maud
Park, Maud Wood
Robinson, Harriet Jane Hanson
Schwimmer, Rosika
Sewall, May Eliza Wright
Sill, Anna Peck
Smith, Abby Hadassah
Snow, Eliza Roxey
Stanton, Elizabeth Cady
Stevens, Doris
Stone, Lucy
Terrell, Mary Eliza Church
Walker, Mary Edwards
Zakrzewska, Maria Elizabeth

FENCER
Hewes, Robert

FENIAN LEADER
Devoy, John
O'Mahony, John
O'Neill, John
Roberts, William Randall
Sweeny, Thomas William

FILIBUSTER
Walker, William
Ward, Frederick Townsend

FILM ANIMATOR
O'Brien, Willis Harold
Terry, Paul Houlton

FILM CENSOR
Breen, Joseph Ignatius

FILMMAKER (See also MOTION PICTURE DIRECTOR)
Eames, Charles Ormand, Jr.
Flaherty, Robert Joseph
Hughes, Howard Robard, Jr.
Micheaux, Oscar
Morrison, Jim
Porter, Edwin Stanton
Selig, William Nicholas
Strand, Paul

FINANCIER (See also BANKER, CAPITALIST, STOCKBROKER)
Adams, Charles Francis
Aldrich, Nelson Wilmarth

Aldrich, Winthrop William
Astor, William Vincent
Austell, Alfred
Bache, Jules Semon
Barbour, John Strode
Barker, Jacob
Barker, Wharton
Baruch, Bernard Mannes
Bates, Joshua
Biddle, Nicholas
Borie, Adolph Edward
Brooker, Charles Frederick
Butterfield, John
Calhoun, Patrick
Canfield, Richard H.
Carlisle, Floyd Leslie
Cazenove, Theophile
Cheves, Langdon
Chisolm, Alexander Robert
Chouteau, Pierre
Clews, Henry
Cooke, Jay
Coolidge, Thomas Jefferson
Corbin, Daniel Chase
Craigie, Andrew
Creiar, John
Currier, Moody
Cutting, Robert Fulton
Day, George Parmly
Dillon, Sidney
Duer, William
Dunwoody, William Hood
Durant, William Crapo
Eckels, James Herron
Fair, James Graham
Fairchild, Charles Stebbins
Fessenden, William Pitt
Garrett, Robert
Garrison, Cornelius Kingsland
Garrison, William Re Tallack
Gary, Elbert Henry
Giannini, Amadeo Peter
Gilbert, Seymour Parker
Gilman, John Taylor
Girard, Stephen
Godfrey, Benjamin
Goodwin, Ichabod
Gould, George Jay
Gould, Jay
Green, Henrietta Howland
 Robinson
Green, John Cleve
Griscom, Clement Acton
Guggenheim, Meyer
Hambleton, Thomas Edward
Harding, Abner Clark
Harding, William Procter Gould
Harriman, Edward Roland Noel
Harrison, Charles Custis
Harvie, John

Hatch, Rufus
Hayden, Charles
Hertz, John Daniel
Hill, James Jerome
Holden, Liberty Emery
Holladay, Ben
Hopson, Howard Colwell
Hotchkiss, Horace Leslie
Huntington, Henry Edwards
Inman, John Hamilton
James, Arthur Curtiss
Joy, Henry Bourne
Keep, Henry
Keys, Clement Melville
Kirby, Allan Price
King, James Gore
Knox, John Jay
Lamont, Daniel Scott
Lamont, Thomas William
Lanier, James Franklin Doughty
Lewisohn, Sam Adolph
Lord, Herbert Mayhew
Ludlow, Thomas William
Macalester, Charles, 1798–1873
McGhee, Charles McClung
Mather, Samuel
Matheson, William John
Mellon, Andrew William
Meredith, Samuel
Meyer, André Benoit Mathieu
Mitchell, Alexander
Morgan, John Pierpont
Morgan, Junius Spencer
Morris, Robert, 1734–1806
Murchison, John Dabney
Nettleton, Alvred Bayard
Newhouse, Samuel
Nixon, John, 1733–1808
Park, Trenor William
Peabody, George
Pearsons, Daniel Kimball
Peters Richard, 1810–1889
Phinizy, Ferdinand
Pollock, Oliver
Randolph, Thomas Jefferson
Raskob, John Jakob
Rice, Isaac Leopold
Ripley, Edward Hastings
Roberts, Ellis Henry
Rockefeller, William
Rollins, Edward Henry
Rose, Chauncey
Ryan, Thomas Fortune
Sage, Russell
Salomon, Haym
Sanders, Thomas
Scarbrough, William
Schiff, Jacob Henry
Seligman, Joseph
Shuster, W(illiam) Morgan

Beers, Clifford Whittingham (mental hygiene movement)

Black, James (National Prohibition Party)

Blair, James (College of William and Mary)

Blavatsky, Helena Petrovna Hahn (Theosophical Society)

Bliss, Daniel (Syrian Protestant College)

Boisen, Anton Theophilus (clinical pastoral education movement)

Booth, Ballington (Volunteers of America)

Bowman, John Bryan (Kentucky University)

Buchman, Frank Nathan Daniel (Moral Re-Armament)

Cabell, Joseph Carrington (University of Virginia)

Cabrini, Francis Xavier (Mother Cabrini) (Missionary Sisters of the Sacred Heart)

Cadillac, Antoine de la Mothe (Detroit, Mich.)

Campbell, Thomas (Disciples of Christ)

Cannon, Harriet Starr (Sisterhood of St. Mary)

Champlain, Samuel de (Canada)

Clark, Francis Edward (Young People's Society of Christian Endeavor)

Coit, Stanton (America's first social settlement)

Connelly, Cornelia (Society of the Holy Child Jesus)

Conover, Harry Sayles (Harry Conover Modeling Agency)

Considérant, Victor Prosper (utopian community in Texas)

Cook, George Cram (Provincetown Players)

Cooke, Samuel (Penn Fruit Company)

Cooper, Sarah Brown Ingersoll (kindergartens)

Cornell, Ezra (Cornell University)

Coulter, Ernest Kent (Big Brother Movement)

Crittenton, Charles Nelson (Florence Crittenton Missions)

Cummins, George David (Reformed Episcopal Church)

Cunningham, Ann Pamela (Mount Vernon Ladies' Association of the Union)

Dabrowski, Joseph (S.S. Cyril and Methodius Seminary)

Darling, Flora Adams (patriotic organizations)

Davenport, George (Davenport, Iowa)

Davidge, John Beale (Univ. of Maryland)

Dempster, John (Methodist theological seminaries)

Dodge, David Low (New York Peace Society)

Dole, James Drummond (Hawaiian Pineapple Company)

Donahue, Peter (Union Iron Workers)

Dooley, Thomas Anthony, III (Medical International Corporation Organization, MEDICO)

Dorrell, William (Dorrellites)

Dowie, John Alexander (Christian Catholic Apostolic Church in Zion)

Drexel, Katharine Mary (Sisters of the Blessed Sacrament for Indians and Colored People)

Dufour, John James (Swiss vineyards in America)

Easley, Ralph Montgomery (National Civic Federation)

Eddy, Mary Morse Baker (Christian Science)

Eggleston, Thomas (School of Mines, Columbia Univ.)

Eielsen, Elling (Norwegian Evangelical Church of North America)

Eliot, William Greenleaf (Washington University of St. Louis)

Estaugh, Elizabeth Haddon (Haddonfield home for travelling ministers)

Eustis, Dorothy Leib Harrison Wood (The Seeing Eye)

Evans, John (Northwestern University, Colorado Seminary)

Ewing, Finis (Cumberland Presbyterian Church)

Fee, John Gregg (Berea College)

Few, Ignatius Alphonso (Emory College)

Fillmore, Charles (Unity School of Christianity)

Flanagan, Edward Joseph (Boys Town)

Foster, Thomas Jefferson (International Correspondence Schools)

Francis, Paul James (Society of the Atonement)

George, William Reuben (George Junior Republic)

Goodall, Harvey L. (livestock market paper)

Guérin, Anne-Thérèse (Mother Theodore) (Sisters of Providence of Saint Mary-of-the-Woods)

Hallett, Benjamin (Seamen's Bethels)

Harris, John (Harrisburg, Pa.)

Harris, Paul Percy (Rotary International)

Harvard, John (Harvard College)

Haynes, George Edmund (Urban League)

Hecker, Isaac Thomas (Paulists)

Herr, John (Reformed Mennonites)

Higginson, Henry Lee (Boston Symphony Orchestra)

Hodur, Francis (Polish National Catholic Church in America)

Holmes, Joseph Austin (U.S. Bureau of Mines)

Houghton, George Hendric (Church of the Transfiguration, N.Y.C.)

Hubbard, Gardiner Greene (National Geographic Society)

Huidekoper, Harm Jan (Meadville Theological School)

Huntington, Henry Edwards (Hungington Library and Art Gallery)

Hyde, Henry Baldwin (Equitable Life Assurance Society of the U.S.)

Jackson, Patrick Tracy (cotton factories at Lowell, Mass.)

Jansky, Karl Guthe (science of radio astronomy)

Jenckes, Joseph (Pawtucket, R.I.)

Johnson, Elijah (Liberia)

Jones, Robert Reynolds ("Bob") (Bob Jones University)

Joubert de la Muraille, James Hector Marie Nicholas (Oblate Sisters of Providence)

Juneau, Solomon Laurent (Milwaukee, Wis.)

Kalmus, Herbert Thomas (Technicolor Incorporated)

Keeley, Oliver Hudson (Grange)

Keith, George ("Christian Quakers")

Keith, Minor Cooper (American Fruit Company)

Keppler, Joseph (Puck)

King, John (eclectic school of medicine)

King, Richard (ranch)

Spalding, Catherine (Sisters of Charity of Nazareth)

Spring, Samuel (American Board of Commissioners for Foreign Missions)

Spring, Samuel (Andover Theological Seminary)

Stephenson, Benjamin Franklin (Grand Army of the Republic)

Stewart, Philo Penfield (Oberlin College)

Still, Andrew Taylor (osteopathy)

Taylor, Joseph Wright (Bryn Mawr College)

Teresa, Mother (Visitation Order in U.S.)

Teusler, Rudolf Bolling (St. Luke's Hospital, Tokyo)

Thomas, Isaiah (American Antiquarian Society)

Thomas, Robert Bailey (Farmer's Almanack)

Tonty, Henry de (Mississippi Valley settlements)

Tourjée, Eben (New England Conservatory of Music)

Townley, Arthur Charles (Nonpartisan League)

Townsend, Francis Everett (Old Age Revolving Pension Plan)

Tufts, Charles (Tufts College)

Upchurch, John Jordan (Ancient Order of United Workmen)

Valentine, Robert Grosvenor (industrial counseling)

Van Raalte, Albertus Christiaan (Dutch settlement in Holland, Mich.)

Varick, James (African Methodist Episcopal Zion Church)

Vassar, Matthew (Vassar College)

Vattemare, Nicholas Marie Alexandre (system of international exchanges)

Vincennes, François Marie Bissot, Sieur de (Vincennes, Ind.)

Wade, Jeptha Homer (American commercial telegraph system)

Walgreen, Charles Rudolph (Walgreen drugstore chain)

Werthelmer, Max (Gestalt movement)

Wetherill, Samuel (Free Quakers)

White, Alma Bridwell (Pillar of Fire Church)

White, Thomas Willis (Southern Literary Messenger)

FRATERNAL ORDER LEADER
Davis, James John
Wilson, J(ames) Finley

FREEMASON
Morgan, William
Pike, Albert

FREE-SOILER
Stearns, George Luther

FREE-STATE ADVOCATE
Conway, Martin Franklin
Pomeroy, Samuel Clarke

FREETHINKER
Bennett, De Robigne Mortimer
Underwood, Benjamin Franklin
Wright, Frances

FREIGHTER (See also TRANSPORTER)
Majors, Alexander
Russell, William Hepburn

FRONTIERSMAN (See also DISCOVERER, EXPLORER, GUIDE, PIONEER, SCOUT)
Bridger, James
Burleson, Edward
California Joe
Crockett, David
Dixon, William
Fonda, John H.
Hughes, Price
Kenton, Simon
Lillie, Gordon William
Maxwell, Lucien Bonaparte
North, Frank Joshua
Oñate, Juan de
Shelby, Evan
Wallace, William Alexander Anderson

FROZEN FOOD PROCESS INVENTOR
Birdseye, Clarence

FUNAMBULIST
Wallenda, Karl

FUNDAMENTALIST ADVOCATE
Price, George Edward McCready

FUND RAISER
Jones, John Price

FUR TRADER (See also FUR TRAPPER, MERCHANT, TRADER, TRAPPER)
Ashely, William Henry
Astor, John Jacob
Baranov, Alexander Andreevich
Bent, Charles
Bent, William
Bridger, James
Cerré, Jean Gabriel
Chouteau, Auguste Pierre
Chouteau, Jean Pierre
Chouteau, Pierre
Crooks, Ramsay
Dickson, Robert
Farnham, Russel
Franchère, Gabriel
Gray, Robert
Harmon, Daniel Williams
Henry, Alexander

Hubbard, Gurdon Saltonstall
Kinzie, John
Kittson, Norman Wolfred
La Barge, Joseph
Larpenteur, Charles
Lisa, Manuel
Mackenzie, Donald
Mackenzie, Kenneth
McLeod, Martin
Menard, Pierre
Mitchell, David Dawson
Morton, Thomas
Navarre, Pierre
Ogden, Peter Skene
Pircher, Joshua
Pond, Peter
Pratte, Bernard
Provost, Etienne
Rolette, Jean Joseph
Ross, Alexander
Sarpy, Peter A.
Sibley, Henry Hastings
Stuart, Robert
Sublette, William Lewis
Thompson, David
Vanderburgh, William Henry
Willard, Simon

FUR TRAPPER (See also FUR TRADER, MERCHANT, TRADER, TRAPPER)
Campbell, Robert
Henry, Andrew

GAMBLER
Canfield, Richard A.
Morrissey, John

GANGSTER (See also BOOTLEGGER, CRIMINAL)
Capone, Alphonse ("Al")
Flegenheimer, Arthur
Galante, Carmine
Kelly, Machine Gun (George Kelly Barnes, Jr.)
Madden, Owen Victor ("Owney")

GAS PRODUCER
Gregory, Thomas Barger

GASTROENTEROLOGIST
Ingelfinger, Franz Joseph

GAY RIGHTS ACTIVIST
Milk, Harvey Bernard

GEM MERCHANT
Winston, Harry

GEMOLOGIST
Kunz, George Frederick

GENEALOGIST
Alden, Ebenezer
Banks, Charles Edward
Chester, Joseph Lemuel
Farmer, John
Lapham, William Berry
Putnam, Eben

Hayden, Horace H.
Hayes, Charles Willard
Heilprin, Angelo
Hilgard, Eugene Woldemar
Hitchcock, Charles Henry
Hitchcock, Edward, 1793–1864
Houghton, Douglass
Hunt, Thomas Sterry
Iddings, Joseph Paxon
Irving, John Duer
Irving, Roland Duer
Jackson, Charles Thomas
Jaggar, Thomas Augustus, Jr.
Johnson, Douglas Wilson
Keith, Arthur
Kemp, James Furman
Kerr, Washington Caruthers
King, Clarence
Lawson, Andrew Cowper
LeConte, Joseph
Lesley, Peter
Leverett, Frank
Lindgren, Waldemar
Lucas, Anthony Francis
Lyman, Benjamin Smith
McGee, William John
Maclure, William
Marbut, Curtis Fletcher
Marcou, Jules
Mather, William Williams
Matthes, Francois Emile
Meinzer, Oscar Edward
Merrill, George Perkins
Mitchell, Elisha
Newberry, John Strong
Orton, Edward Francis Baxter
Owen, David Dale
Penrose, Richard Alexander
 Fullerton
Percival, James Gates
Perin, Charles Page
Perkins, George Henry
Pirsson, Louis Valentine
Powell, John Wesley
Price, George Edward McCready
Proctor, John Robert
Prosser, Charles Smith
Pumpelly, Raphael
Ransome, Frederick Leslie
Rice, William North
Roemer, Karl Ferdinand
Rogers, Henry Darwin
Rogers, William Barton
Rubey, William Walden
Russell, Israel Cook
Safford, James Merrill
Salisbury, Rollin D.
Scopes, John Thomas
Scott, William Berryman
Shaler, Nathaniel Southgate

Smith, Erminnie Adelle Platt
Smith, Eugene Allen
Smith, George Otis
Smith, James Perrin
Spurr, Josiah Edward
Stetson, Henry Crosby
Stevenson, John James
Swallow, George Clinton
Talmage, James Edward
Tarr, Ralph Stockman
Taylor, Frank Bursley
Taylor, Richard Cowling
Troost, Gerard
Udden, Johan August
Ulrich, Edward Oscar
Upham, Warren
Van Hise, Charles Richard
Vanuxem, Lardner
Vaughan, Thomas Wayland
Veatch, Arthur Clifford
White, Charles Abiathar
White, David
White, Israel Charles
Whitney, Josiah Dwight
Willis, Bailey
Winchell, Alexander
Winchell, Horace Vaughn
Winchell, Newton Horace
Woodworth, Jay Backus
Worthen, Amos Henry
Wright, George Frederick

GEOMORPHOLOGIST
Bryan, Kirk
Johnson, Douglas Wilson

GEOPHYSICIST
Day, Arthur Louis
Fleming, John Adam
Kennedy, George Clayton
Slichter, Louis Byrne

GIRL SCOUT LEADER
Choate, Anne Hyde Clarke
Low, Juliette Gordon

GLASSMAKER (See also GLAZIER)
Hewes, Robert
Leighton, William
Libbey, Edward Drummond
Stiegel, Henry William
Tiffany, Louis Comfort

GLAZIER (See also GLASSMAKER)
Godfrey, Thomas

GOLDSMITH (See also CRAFTSMAN)
Le Roux, Bartholomew

GOLFCOURSE DESIGNER
Macdonald, Charles Blair

GOLFER
Armour, Thomas Dickson
 ("Tommy")
Hagen, Walter Charles
Little, William
Lawson, Jr.

Macdonald, Charles Blair
Ouimet, Francis Desales
Smith, Horton
Travers, Jerome Dunstan
Travis, Walter John
Wood, Craig Ralph

GOSPEL SINGER
Jackson, Mahalia

GOSSIP COLUMNIST
Hopper, Hedda
Lyons, Leonard
Parsons, Louella Rose Oettinger

GOVERNMENT ADVISER
Elliott, William Yandell, III

GOVERNMENT OFFICIAL (See also PUBLIC OFFICIAL)
Altmeyer, Arthur Joseph
Ames, Joseph Sweetman
Arnold, Thurman Wesley
Ballantine, Arthur Atwood
Bennett, Henry Garland
Bethune, Mary McLeod
Biffle, Leslie L.
Breckinridge, Henry Skillman
Bundy, Harvey Hollister
Bunker, Arthur Hugh
Bush, Vannevar ("Van")
Chapman, Oscar Littleton
Clayton, William Lockhart
Coolidge, Thomas Jefferson
Cooper, William John
Creel, George
Crowley, Leo Thomas
Cutler, Robert
Dennett, Tyler (Wilbur)
Dodge, Joseph Morrell
Dorn, Harold Fred
Early, Stephen Tyree
Finletter, Thomas Knight
Flint, Weston
Fly, James Lawrence
Gaston, Herbert Earle
Haas, Francis Joseph
Hannegan, Robert Emmet
Herrick, Robert Welch
Hill, Arthur Middleton
Hines, Frank Thomas
Hopkins, Harry Lloyd
Hunt, Gaillard
Johnson, Hugh Samuel
Kennedy, Joseph Patrick
Knudsen, William S.
Krug, Julius Albert
Leffingwell, Russell Cornell
Legge, Alexander
Lubin, Isador
McEntee, James Joseph
McHugh, Keith Stratton
Manly, Basil Maxwell
Merchant, Livingston Tallmadge

Merriam, Charles Edward, Jr.
Meyer, Eugene Isaac
Mitchell, William DeWitt
Nelson, Donald Marr
Niles, David K.
Pasvolsky, Leo
Payne, Christopher Harrison
Pelham, Robert A.
Pickens, William
Post, Louis Freeland
Powderly, Terence Vincent
Richberg, Donald Randall
Roche, Josephine Aspinwall
Russell, Charles Wells
Sargent, Frank Pierce
Sherwood, Robert Emmet
Strauss, Lewis Lichtenstein
Talbott, Harold Elstner
Tobin, Austin Joseph
Vance, Harold Sines
Vanderlip, Frank Arthur
Wadsworth, Eliot
Warburg, James Paul
Warner, Edward Pearson
Waterman, Alan Tower
Waymack, William Wesley
Wharton, Francis
Zook, George Frederick

GOVERNOR (ACTING)

Argall, Sir Samuel (Va.)
Blair, John (Va.)
Danforth, Thomas (Mass.)
Evans, John (Pa.)
Hamilton, Andrew, d.1703 (Pa.)
Hamilton, Andrew Jackson (Tex.)
Hamilton, James, 1710–1783 (Pa.)
Lloyd, Thomas (Pa.)
Nelson, William, 1711–1772 (Va.)
Paddock, Algernon Sidney (Nebr.)
Parsons, Lewis Eliphalet (Ala.)
St. Ange de Bellerive, Louis (La.)
Sharkey, William Lewis (Miss.)
Shippen, Edward, 1639–1712 (Pa.)
Stanton, Frederick Perry (Kans.)
Stoddard, Amos (La.)

GOVERNOR (COLONIAL)

Andros, Sir Edmund
Archdale, John
Basse, Jeremiah
Belcher, Jonathan
Bellingham, Richard
Berkeley, Sir William
Bernard, Sir Francis
Botetourt, Norborne Berkeley,
 Baron de
Burnet, William
Burrington, George
Calvert, Leonard
Campbell, Lord William
Clarke, Walter

Clinton, George
Coote, Richard
Copley, Lionel
Cosby, William
Cranston, John
Cranston, Samuel
Cubero, Pedro Rodriguez
Culpeper, Thomas, Lord
Dobbs, Arthur
Dongan, Thomas
Dudrey, Joseph
Dudley, Thomas
Dunmore, John Murray, Earl of
Eden, Robert
Ellis, Henry
Fendall, Josias
Fitch, Thomas
Fletcher, Benjamin
Franklin, William
Gage, Thomas
Gates, Sir Thomas
Gooch, Sir William
Greene, William
Hamilton, Andrew, d. 1703
Harvey, Sir John
Hopkins, Stephen
Hunter, Robert
Hutchinson, Thomas
Hyde, Edward
Johnson, Robert
Johnson, Sir Nathaniel
Johnston, Gabriel
Keith, Sir William
Kieft, Willem
Law, Jonathan
Leete, William
Leverett, John, 1616–1679
Lovelace, Francis
Ludwell, Philip
Lyttelton, William Henry
Markham, William
Martin, Josiah
Mayhew, Thomas
Middleton, Arthur
Miró, Esteban Rodriguez
Moore, James, d. 1706
Moore, Sir Henry
Nicholson, Francis
Nicolls, Richard
Ogle, Samuel
Phips, Sir William
Pierpont, Francis Harrison
Pott, John
Pownall, Thomas
Printz, Johan Bjornsson
Reynolds, John
Rising, Johan Classon
Russwurm, John Brown
Saltonstall, Gurdon
Sharpe, Horatio

Shirley, William
Shute, Samuel
Stone, William
Talcott, Joseph
Thomas, George
Treat, Robert
Trumbull, Jonathan, 1710–1785
Tryon, William
Ulloa, Antonio de
Vane, Sir Henry
Van Twiller, Wouter
Villeré, Jacques Philippe
Ward, Richard
Ward, Samuel, 1725–1776
Wentworth, Benning
Wentworth, John, 1737 N.S.–1820
West, Joseph
Winslow, Josiah
Winthrop, John, 1587/88 O.S.–
 1649
Winthrop, John, 1605/06 O.S.–
 1676
Winthrop, John, 1638–1707
Wolcott, Oliver, 1726–1797
Wolcott, Roger
Wyatt, Sir Francis
Yeamans, Sir John
Yeardley, Sir George

GOVERNOR (GENERAL)

Alvarado, Juan Bautista (Mexican
 California)
Brown, William (Bermuda)
Coddington, William (Aquidneck)
Colton, George Radcliffe (Puerto
 Rico)
Corondo, Francisco Vazquez
 (Nueva Galicia)
Gore, Robert Hayes (Puerto Rico)
Hasket, Elias (Bahamas)
Minuit, Peter (New Sweden)
Muñoz Marín, Luis (Puerto Rico)
Vandreuli-Cavagnal, Pierre de
 Riguad, Marquis de (Canada)
Wright, Luke Edward (Philippines)

GOVERNOR (STATE)

Aandahl, Fred George (N.Dak.)
Abbett, Leon (N.J.)
Adams, Alva (Colo.)
Adams, James Hopkins (S.C.)
Alcorn, James Lusk (Miss.)
Alger, Russell Alexander (Mich.)
Allen, Henry Justin (Kans.)
Allen, Henry Watkins (La.)
Allen, Philip (R.I.)
Allen, William (Ohio)
Allston, Robert Francis Withers
 (S.C.)
Altgeld, John Peter (Ill.)
Ames, Adelbert (Miss.)
Ames, Oliver (Mass.)

Long, Huey Pierce (La.)
Long, John Davis (Mass.)
Lord, William Paine (Oreg.)
Low, Frederick Ferdinand (Calif.)
Lowden, Frank Orren (Ill.)
Lowe, Ralph Phillips (Iowa)
Lowndes, Lloyd (Md.)
Lowry, Robert (Miss.)
Lubbock, Francis Richard (Tex.)
Lucas, Robert (Ohio)
McArthur, Duncan (Ohio)
McCall, Samuel Walker (Mass.)
McClelland, Robert (Mich.)
McClurg, Joseph Washington (Mo.)
McCreary, James Bennett (Ky.)
McCullough, John Griffith (Vt.)
McDaniel, Henry Dickerson (Ga.)
McDonald, Charles James (Ga.)
McDowell, James (Va.)
McEnery, Samuel Douglas (La.)
McGrath, James Howard (R.I.)
McGraw, John Harte (Wash.)
McKay, (James) Douglas (Oreg.)
McKeldin, Theodore Roosevelt
 (Md.)
McLaurin, Anselm Joseph (Miss.)
McLean, Angus Wilton (N.C.)
McMillin, Benton (Tenn.)
McMinn, Joseph (Tenn.)
McNair, Alexander (Mo.)
McNutt, Paul Vories (Ind.)
McRae, Thomas Chipman (Ark.)
Magoffin, Beriah (Ky.)
Magrath, Andrew Gordon (S.C.)
Manning, Richard Irvine, 1789–
 1836 (S.C.)
Manning, Richard Irvine, 1859–
 1931 (S.C.)
Marland, Ernest Whitworth (Okla.)
Marmaduke, John Sappington
 (Mo.)
Marshall, Thomas Riley (Ind.)
Marshall, William Rainey (Minn.)
Martin, Alexander (N.C.)
Martin, John Alexander (Kans.)
Mason, Richard Barnes (Calif.)
Mason, Stevens Thomson (Mich.)
Mathews, Henry Mason (W.Va.)
Mathews, John (S.C.)
Mathews, Samuel (Va.)
Matteson, Joel Aldrich (Ill.)
Matthews, Claude (Ind.)
Mattocks, John (Vt.)
Maybank, Burnet Rhett (S.C.)
Meigs, Return Jonathan (Ohio)
Mellotte, Arthur Calvin (S.D.)
Mercer, John Francis (Md.)
Metcalfe, Thomas (Ky.)
Mifflin, Thomas (Pa.)
Milledge, John (Ga.)

Miller, John (Mo.)
Miller, Nathan Lewis (N.Y.)
Milton, John (Fla.)
Mitchell, David Brydie (Ga.)
Mitchell, Nathaniel (Del.)
Montague, Andrew Jackson (Va.)
Moore, Gabriel (Ala.)
Moore, Thomas Overton (La.)
Morehead, Charles Slaughter (Ky.)
Morehead, James Turner (Ky.)
Morehead, John Motley (N.C.)
Morgan, Edwin Denison (N.Y.)
Morril, David Lawrence (N.H.)
Morrill, Anson Peaslee (Maine)
Morrill, Edmund Needham (Kans.)
Morrill, Lot Myrick (Maine)
Morris, Lewis, 1671–1746 (N.J.)
Morris, Luzon Burritt (Conn.)
Morris, Robert Hunter (Pa.)
Morrow, Edwin Porch (Ky.)
Morrow, Jeremiah (Ohio)
Morton, Levi Parsons (N.Y.)
Morton, Marcus, 1784–1864
 (Mass.)
Morton, Oliver Perry (Ind.)
Moses, Franklin J. (S.C.)
Moultrie, William (S.C.)
Mouton, Alexander (La.)
Murphy, Franklin (N.J.)
Murphy, Frank (Mich.)
Murphy, Isaac (Ark.)
Nash, Abner (N.C.)
Neely, Matthew Mansfield (W.Va.)
Nelson, Knute (Minn.)
Nelson, Thomas (Va.)
Newell, William Augustus (N.J.)
Nicholas, Wilson Cary (Va.)
Nicholls, Francis Redding Tillou
 (La.)
Norbeck, Peter (S.Dak.)
Northen, William Jonathan (Ga.)
Noyes, Edward Follansbee (Ohio)
Oates, William Calvin (Ala.)
O'Daniel, Wilbert Lee ("Pappy")
 (Tex.)
Odell, Benjamin Barker (N.Y.)
O'Ferrall, Charles Triplett (Va.)
Ogden, Aaron (N.J.)
Oglesby, Richard James (Ill.)
Olden, Charles Smith (N.J.)
Olson, Floyd Bjerstjerne (Minn.)
O'Neal, Edward Asbury (Ala.)
O'Neill, C. William ("Bill") (Ohio)
Orr, James Lawrence (S.C.)
Osborn, Chase Salmon (Mich.)
Otermín, Antonio de (N.Mex.)
Owsley, William (Ky.)
Paca, William (Md.)
Pacheco, Romualdo (Calif.)
Page, John (Va.)

Paine, Charles (Vt.)
Palmer, John McAuley (Ill.)
Parker, John Milliken (La.)
Parris, Albion Keith (Maine)
Pattison, John M. (Ohio)
Pease, Elisha Marshall (Tex.)
Peay, Austin (Tenn.)
Peck, George Wilbur (Wis.)
Peñalosa Briceño, Diego Dioniso de
 (N.Mex.)
Pennington, William (N.J.)
Pennington, William Sandford
 (N.J.)
Pennoyer, Sylvester (Oreg.)
Pennypacker, Samuel Whitaker
 (Pa.)
Peralta, Pedro de (N.Mex.)
Percy, George (Va.)
Perkins, George Clement (Calif.)
Perry, Benjamin Franklin (S.C.)
Perry, Edward Aylesworth (Fla.)
Phelps, John Smith (Mo.)
Philipp, Emanuel Lorenz (Wis.)
Pickens, Francis Wilkinson (S.C.)
Pickens, Israel (Ala.)
Pierce, Benjamin (N.H.)
Pillsbury, John Sargent (Minn.)
Pinchot, Gifford (Pa.)
Pinckney, Charles (S.C.)
Pinckney, Thomas (S.C.)
Pingree, Hazen Stuart (Mich.)
Pitkin, Frederick Walker (Colo.)
Pitkin, William, 1694–1769
 (Conn.)
Plaisted, Harris Merrill (Maine)
Plater, George (Md.)
Pleasants, James (Va.)
Pollock, James (Pa.)
Porter, Albert Gallatin (Ind.)
Porter, James Davis (Tenn.)
Pratt, Thomas George (Md.)
Price, Rodman McCamley (N.J.)
Price, Sterling (Mo.)
Proctor, Redfield (Vt.)
Ralston, Samuel Moffett (Ind.)
Ramsey, Alexander (Minn.)
Randall, Alexander Williams (Wis.)
Randolph, Theodore Fitz (N.J.)
Randolph, Thomas Mann (Va.)
Rector, Henry Massey (Ark.)
Reid, David Settle (N.C.)
Reynolds, John (Ill.)
Rice, Alexander Hamilton (Mass.)
Ritchie, Albert Cabell (Md.)
Ritner, Joseph (Pa.)
Roane, Archibald (Tenn.)
Robertson, Thomas Bolling (La.)
Robertson, Wyndham (Va.)
Robinson, Charles (Kans.)
Rockefeller, Nelson Aldrich (N.Y.)

Binkley, Robert Cedric
Bolton, Herbert Eugene
Botsford, George Willis
Bourne, Edward Gaylord
Bouton, Nathaniel
Bowers, Claude Gernade
Boyd, Julian Parks
Boyd, William Kenneth
Bozman, John Leeds
Breasted, James Henry
Brinton, Clarence Crane
Brodhead, John Romeyn
Bronson, Henry
Brown, Alexander
Brown, William Wells
Bruce, Philip Alexander
Buley, Roscoe Carlyle
Burr, George Lincoln
Burrage, Henry Sweetser
Burton, Clarence Monroe
Cabell, James Branch
Cajori, Florian
Callender, Guy Stevens
Campbell, Charles
Campbell, William W.
Carson, Hampton Lawrence
Case, Shirley Jackson
Cathcart, William
Chamberlain, Mellen
Channing, Edward
Charlevoix, Pierre François Xavier
 de
Cheyney, Edward Potts
Chittenden, Hiram Martin
Cist, Henry Martyn
Claiborne, John Francis
 Hamtramck
Clark, Arthur Hamilton
Colcord, Lincoln Ross
Cole, Arthur Charles
Colum, Padraic
Connor, Robert Digges Wimberly
Cooke, John Esten
Coolidge, Archibald Cary
Corwin, Edward Samuel
Corwin, Edwin Tanjore
Crawford, Francis Marion
Cross, Arthur Lyon
Dart, Henry Paluché
Dawson, Henry Barton
Deane, Charles
Del Mar, Alexander
Dennett, Tyler (Wilbur)
Dennis, Alfred Lewis Pinneo
Dennis, James Shepard
DeVoto, Bernard Augustine
Dexter, Franklin Bowditch
Dodd, William Edward
Dodge, Theodore Ayrault
Dos Passos, John Roderigo

Drake, Francis Samuel
Drake, Samuel Adams
Drake, Samuel Gardner
Draper, John William
Draper, Lyman Copeland
Du Bois, William Edward
 Burghardt
Dunlap, William
Dunning, William Archibald
Dupratz, Antoine Simon Le Page
Durrett, Reuben Thomas
Eggleston, Edward
Egle, William Henry
Eliot, Samuel
Elliott, Charles
Ellis, George Edward
Emerton, Ephraim
Engelhardt, Zephyrin
English, William Hayden
Evans, Clement Anselm
Fall, Bernard B.
Farrand, Max
Fay, Sidney Bradshaw
Fernow, Berthold
Field, David Dudley
Filson, John
Finney, Charles Grandison
Fish, Carl Russell
Fisher, George Park
Fisher, Sydney George
Fiske, John
Fleming, Walter Lynwood
Folwell, William Watts
Forbes, Esther
Force, Peter
Ford, Henry Jones
Ford, Paul Leicester
Fortier, Alcee
Fox, Dixon Ryan
Francis, Joshua Francis
Francke, Kuno
Frank, Tenney
Freeman, Douglas Southall
Frothingham, Richard
Fulton, John Farquhar
Gambrell, Mary Latimer
Garrett, William Robertson
Garrison, Fielding Hudson
Gavin, Frank Stanton Burns
Gay, Edwin Francis
Gayarré, Charles Étienne Arthur
Gipson, Lawrence Henry
Goddard, Calvin Hooker
Golder, Frank Alfred
Good, James Isaac
Gordy, John Pancoast
Gottschalk, Louis Reichenthal
Gröbner, August Lawrence
Green, Constance McLaughlin
Greene, Francis Vinton

Greenhow, Robert
Griffin, Martin Ignatius Joseph
Grigsby, Hugh Blair
Gross, Charles
Hall, Hiland
Hamilton, Alexander, 1712–1756
Hammond, Bray
Hammond, Jabez Delano
Hansen, Marcus Lee
Haring, Clarence
Harlow, Ralph Volney
Harrisse, Henry
Hart, Albert Bushnell
Haskins, Charles Homer
Hawks, Francis Lister
Hay, John Milton
Hayes, Carlton Joseph Huntley
Haynes, Williams
Haywood, John
Hendrick, Burton Jesse
Henry, William Wlrt
Hewat, Alexander
Hildreth, Samuel Prescott
Hill, Frederick Trevor
Hoffman, David
Hofstadter, Richard
Holbrook, Stewart Hall
Holmes, Abiel
Holst, Hermann Eduard von
Howard, Joseph Kinsey
Howe, George
Howe, Henry
Howe, Mark De Wolfe
Howe, Quincy
Hubbard, William
Hulbert, Archer Butler
Hunt, Gaillard
Ireland, Joseph Norton
Jacobs, Joseph, 1854–1916
Jameson, John Franklin
Jenkins, Howard Malcolm
Jewett, Clarence Frederick
Johnson, Allen
Johnston, Alexander
Johnston, Henry Phelps
Johnston, Robert Matteson
Jones, Charles Colcock
Jones, Howard Mumford
Jones, Hugh
Kapp, Friedrich
Keeney, Barnaby Conrad
Kelsey, Rayner Wickersham
Knight, Lucian Lamar
Knox, Dudley Wright
Kobbé, Gustav
Körner, Gustav Philip
Krehbiel, Henry Edward
Kuykendall, Ralph Simpson
Labaree, Leonard Woods
Lacy, William Albert

Parr, Samuel Wilson
Parrott, Robert Parker
Patterson, Rufus Lenoir
Paul, William Darwin ("Shorty")
Perkins, Jacob
Perry, Stuart
Pidgin, Charles Felton
Pitts, Hiram Avery
Pope, Franklin Leonard
Porter, Rufus
Potter, William Bancroft
Pratt, Francis Ashbury
Pratt, John
Pratt, Thomas Willis
Prince, Frederick Henry
Pullman, George Mortimer
Rains, George Washington
Ramsay, Erskine
Rand, James Henry
Read, Nathan
Rees, James
Reese, Abram
Reese, Isaac
Reese, Jacob
Renwick, Edward Sabine
Reynolds, Edwin
Reynolds, Samuel Godfrey
Rice, Richard Henry
Riddell, John Leonard
Roberts, Benjamin Stone
Robinson, Stillman Williams
Robinson, William
Rodman, Thomas Jackson
Rogers, Henry J.
Rogers, James Harris
Rogers, John Raphael
Rogers, Thomas
Roosevelt, Hilborne Lewis
Roosevelt, Nicholas J.
Root, Elisha King
Rowland, Thomas Fitch
Rumsey, James
Rust, John Daniel
Sargent, James
Saunders, William Lawrence
Sawyer, Sylvanus
Saxton, Joseph
Schieren, Charles Adolph
Schneller, George Otto
See, Horace
Seiberling, Frank Augustus
Selden, George Baldwin
Sellers, Coleman
Sellers, William
Sergeant, Henry Clark
Sessions, Henry Howard
Shaw, Thomas
Sholes, Christopher Latham
Short, Sidney Howe
Sickles, Frederick Ellsworth

Silver, Thomas
Simpson, Michael Hodge
Sims, Winfield Scott
Singer, Isaac Merrit
Skinner, Halcyon
Slocum, Samuel
Smith, Horace
Spencer, Christopher Miner
Sperry, Elmer Ambrose
Sprague, Frank Julian
Stanley, Francis Edgar
Stanley, William
Starrett, Laroy S.
Stearns, Frank Ballou
Stetefeldt, Carl August
Stevens, Edwin Augustus
Stevens, John
Stevens, Robert Livingston
Stewart, Philo Penfield
Stoddard, Joshua C.
Stoddard, William Osborn
Sturtevant, Benjamin Franklin
Tagliabue, Giuseppe
Taylor, Frederick Winslow
Terry, Eli
Tesla, Nikola
Thomson, Elihu
Thomson, John
Thornton, William
Thorp, John
Thurber, Charles
Timby, Theodore Ruggles
Timken, Henry
Treadwell, Daniel
Troland, Leonard Thompson
Tucker, Stephen Davis
Turner, Walter Victor
Twining, Alexander Catlin
Tytus, John Butler
Van de Graaff, Robert Jemison
Van Depoele, Charles Joseph
Van Dyke, John Wesley
Vauclain, Samuel Matthews
Verbeck, William
Wait, William Bell
Wallace, William
Waller, Frederic
Warren, Cyrus Moors
Warren, Henry Ellis
Warren, Josiah
Washburn, Nathan
Waterman, Lewis Edson
Webb, John Burkitt
Wellman, Samuel Thomas
Westinghouse, George
Wetherill, Samuel
Wheeler, Nathaniel
Wheeler, Schuyler Skaats
Whipple, Squire

Whitney, Asa
Whitney, Eli
Whittemore, Amos
Wilcox, Stephen
Wilkinson, David
Wilkinson, Jeremiah
Wilson, Allen Benjamin
Wilson, George Francis
Winans, Ross
Winans, Thomas De Kay
Wood, Henry Alexander Wise
Wood, James J.
Wood, Jethro
Wood, Walter Abbott
Woodruff, Theodore Tuttle
Worthington, Henry Rossiter
Wright, Orville
Wyman, Horace
Yale, Linus
Zachos, John Celivergos
Zentmayer, Joseph

INVESTMENT COUNSELOR
Whitney, Richard

INVESTMENT EXECUTIVE
Levy, Gustave Lehmann
Paul, Josephine Bay

INVESTOR
Ball, George Alexander

IRONFOUNDER (See also TYPEFOUNDER)
Ames, Nathan Peabody
Foxall, Henry
Leach, Shepherd
Meneely, Andrew
Ogden, Samuel

IRONMASTER (See MANUFACTURER)

IRRIGATION ENGINEER (See ENGINEER, IRRIGATION)

ITALIAN CULTURE PROMOTER
Da Ponte, Lorenzo

JAYHAWKER (See also OUTLAW, VIGILANTE)
Montgomery, James

JAZZ BAND LEADER
Celestin, Oscar ("Papa")
Oliver, Joseph

JAZZ CORNET PLAYER
Celestin, Oscar ("Papa")
Hackett, Robert Leo ("Bobby")

JAZZ CRITIC
Gleason, Ralph Joseph

JAZZ DRUMMER
Catlett, Sidney

JAZZ GUITARIST
Condon, Albert Edwin ("Eddie")

JAZZ MUSICIAN
Armstrong, Louis ("Satchmo")
Jordan, Louis
Mingus, Charles, Jr.

Eastman, Charles Gamage
Eaton, Charles Aubrey
Edes, Benjamin
Eggleston, George Cary
Everett, David
Farago, Ladislas
Farson, Negley
Fessenden, Thomas Green
Field, Joseph M.
Field, Mary Katherine Kemble
Fischer, Louis
Fiske, Harrison Grey
Fiske, Stephen Ryder
Flynn, John Thomas
Ford, Patrick
Forney, John Wien
Foss, Sam Walter
Foster, Thomas Jefferson
Fowler, Gene
Fox, Richard Kyle
Franklin, Fabian
Frederic, Harold
Freeman, Joseph
Frick, Ford Christopher
Fry, William Henry
Fuller, Hiram
Fuller, Sarah Margaret
Gaillard, Edwin Samuel
Gaillardet, Théodore Frédéric
Gales, Joseph, 1761–1841
Gales, Joseph, 1786–1860
Gallico, Paul William
Gannett, Frank Ernest
Gardner, Charles Kitchell
Gardner, Gilson
Garis, Howard Roger
Gaston, Herbert Earle
Gay, Sydney Howard
George, Henry
Gilder, Jeannette Leonard
Gilder, William Henry
Gill, John
Gipson, Frederick Benjamin
Gleason, Ralph Joseph
Goddard, William
Gold, Michael
Goodall, Harvey L.
Goodrich, Frank Boott
Grady, Henry Woodfin
Graham, Philip Leslie
Grant, Jane Cole
Graves, John Temple
Gray, Joseph W.
Greathouse, Clarence Ridgeby
Green, Bartholomew
Green, Duff
Green, Jonas
Greenleaf, Thomas
Grieve, Miller
Griffin, Martin Ignatius Joseph

Griswold, Rufus Wilmot
Grosvenor, William Mason
Grund, Francis Joseph
Gue, Benjamin F.
Guild, Curtis, 1827–1911
Gunther, John
Hale, Charles
Hale, David
Hale, Nathan
Hale, William Bayard
Hall, Abraham Oakey
Hallock, Charles
Hallock, Gerard
Halpine, Charles Graham
Halstead, Murat
Hammond, Charles
Hapgood, Isabel Florence
Harby, Isaac
Hard, William
Hardy, William Harris
Harper, Ida Husted
Harris, Joel Chandler
Harris, Julian La Rose
Harrison, Henry Sydnor
Harvey, George Brinton McClellan
Haskell, Henry Jospeh
Hassard, John Rose Greene
Hassaurek, Friedrich
Hatton, Frank
Hay, John Milton
Hazertine, Mayo Williamson
Heath, Perry Sanford
Heatter, Gabriel
Hecht, Ben
Heinzen, Karl Peter
Hendrick, Burton Jesse
Herbst, Josephine Frey
Hewitt, John Hill
Hibben, Paxton Pattison
Higgins, Marguerite
Hill, Edwin Conger
Hirth, William Andrew
Hitchcock, James Ripley Wellman
Hittell, John Shertzer
Hodgins, Eric Francis
Holbrook, Stewart Hall
Holden, Liberty Emery
Holden, William Woods
Holt, John
Hooper, Lucy Hamilton
Hough, Emerson
House, Edward Howard
Howe, Quincy
Howell, James Bruen
Howey, Walter Crawford
Hudson, Charles
Hudson, Frederic
Hunt, William Gibbes
Hurlbert, William Henry
Ickes, Harold Le Clair

Inman, John
Irwin, William Henry
Isaacs, Samuel Myer
Jackson, Charles Douglas
Jacobs, Paul
James, Edwin Leland
Janvier, Thomas Allibone
Jemison, Alice Mae Lee
Jenks, George Charles
Johnson, Malcolm Malone
Johnston, William Andrew
Jones, Alexander
Jones, Herschel Vespasian
Jones, John Beauchamp
Jones, John Price
Jordan, Thomas
Keating, John McLeod
Keeler, Ralph Olmstead
Kendall, Amos
Kendall, George Wilkins
Kennan, George
Kester, Vaughan
Keys, Clement Melville
King, Edward Smith
King, Henry
Kinney, William Burnet
Kintner, Robert Edmonds
Kiplinger, Willard Monroe
Kirchwey, Freda
Knapp, George
Knox, Frank
Knox, Thomas Wallace
Koenigsberg, Moses
Kollock, Shepard
Krock, Arthur
Kroeger, Adolph Ernst
Laffan, William Mackay
Lamoureux, Andrew Jackson
Lanigan, George Thomas
Lapham, William Berry
Lardner, John Abbott
Lardner, Ringgold Wilmer
Lawson, Victor Freemont
Leggett, William
Leupp, Francis Ellington
Lewis, Alfred Henry
Lewis, Lloyd Downs
Liebling, Abbott Joseph
Link, Theodore Carl
Lippmann, Walter
Lisagor, Peer Irvin
List, Georg Friedrich
Littledale, Clara Savage
Lloyd, Henry Demarest
Locke, David Ross
Locke, Richard Adams
Loeb, Sophie Irene Simon
Logan, Olive
Lomax, Louis Emanuel
Loring, Frederick Wadsworth

Brown, John Mason, Jr.
Burton, Richard Eugene
Buttrick, George Arthur
Chase, Mary Ellen
Coffin, Robert Peter Tristram
Colman, Lucy Newhall
Cook, Flavius Josephus
Cooke, George Willis
Dinwiddie, Edwin Courtland
Dixon, Thomas
Dyer, Louis
Elson, Louis Charles
Erskine, John
Farmer, Fannie Merritt
Field, Mary Katherine Kemble
Fletcher, Horace
Gibbons, Herbert Adams
Gilman, Charlotte Perkins Stetson
Goldman, Emma
Gronlund, Laurence
Hall, Florence Marion Howe
Herron, George Davis
Holmes, Elias Burton
Hubbard, Bernard Rosecrans
Ingersoll, Robert Green
James, George Wharton
James, Henry, 1811–1882
Johnson, John Albert
Keller, Helen Adams
King, Thomas Starr
Krebbiel, Henry Edward
Lease, Mary Elizabeth Clyens
Leipziger, Henry Marcus
Lockwood, Belva Ann Bennett
Logan, Olive
Lord, John
Morris, Robert, 1818–1888
Moulton, Richard Green
Murdoch, James Edward
Nason, Elias
Ng Poon Chew
Nicholson, Meredith
Ogilvie, James
Pattison, James William
Perry, Edward Baxter
Peters, Madison Clinton
Phelps, William Lyon
Pollock, Channing
Rossiter, Clinton Lawrence, III
Salter, William Mackintire
Sanborn, Katherine Abbott
Savage, Minot Judson
Schaeffer, Nathan Christ
Seton, Ernest Thompson
Slocum, Joshua
Slosson, Edwin Emery
Smith, Elizabeth Oakes Prince
Soulé, George
Starr, Eliza Allen
Stoddard, John Lawson

Stone, Ellen Maria
Strong, Anna Louise
Sunderland, Eliza Jane Read
Talmage, Thomas De Witt
Taylor, Benjamin Franklin
Taylor, Robert Love
Towle, George Makepeace
Underwood, Benjamin Franklin
Utley, Freda
Vasiliev, Alexander Alexandrovich
Warde, Frederick Barkham
Whipple, Edwin Percy
Wiley, Harvey Washington
Williams, Fannie Barrier
Winnemucca, Sarah
Winship, Albert Edward
Woolson, Abba Louisa Goold

LEGAL ANNOTATOR
Kirby, Ephraim
Lowery, Woodbury
Rose, Walter Malins

LEGAL PHILOSOPHER
Cahn, Edmond Nathaniel
Llewellyn, Karl Nickerson

LEGISLATOR (See also CONGRESSMAN, SENATOR)
Adams, Robert
Anderson, William
Applegate, Jesse
Ashe, Thomas Samuel
Bacon, John
Beatty, John
Bingham, William
Bouligny, Dominique
Brinkerhoff, Jacob
Brown, John
Buck, Daniel
Clay, Green
Cocke, William
Curtis, Newton Martin
Edwards, Weldon Nathaniel
Elmer, Ebenezer
Elmer, Jonathan
Elmer, Lucius Quintius
 Cincinnatus
Fell, John
Garnett, James Mercer, 1770–1845
Garvin, Lucius Fayette Clark
Goebel, William
Green, Norvin
Grimes, James Wilson
Grose, William
Halderman, John A.
Hale, Eugene
Hamer, Thomas Lyon
Harlan, James
Hart, John
Hill, James
Hill, Richard
Holman, Jesse Lynch

Holmes, Ezekiel
Hooper, Samuel
Hoppin, William Warner
Hornblower, Josiah
Huntington, Jabez
Jenckes, Thomas Allen
Johnson, Chapman
Johnston, Peter
Jones, George Wallace
Lane, Joseph
Leffler, Isaac
Leffler, Shepherd
L'Hommedieu, Ezra
Lord, Otis Phillips
Low, Nicholas
Lowell, John, 1743–1802
Lyon, William Penn
McClure, Alexander Kelly
McCreery, James Work
Maclay, William Brown
Marshall, Thomas
Mason, Thomson
Maxcy, Virgil
Maxwell, David Hervey
Maxwell, George Troup
Memminger, Christopher Gustavus
Mills, Benjamin
Morris, Edward Joy
Munford, William
Nesmith, James Willis
Nisbet, Eugenius Aristides
Northen, William Jonathan
Orr, Jehu Amaziah
Osgood, Samuel
Parker, James
Pendleton, John Strother
Pitney, Mahlon
Pruyn, Robert Hewson
Purviance, David
Raines, John
Raney, George Pettus
Ridgely, Nicholas
Robinson, Henry Cornelius
Rodman, Isaac Peace
Rollins, Edward Henry
Sanford, Nathan
Sedgwick, Theodore, 1746–1813
Seevers, William Henry
Silver, Gray
Spalding, Thomas
Stephens, Linton
Strong, Moses McCure
Stuart, Archibald
Van Wyck, Charles Henry
White, James
Wingate, Paine
Wofford, William Tatum

LETTERING ARTIST
Goudy, Frederic William

Ewing, James Caruthers Rhea
Farmer, Ferdinand
Ferguson, John Calvin
Filton, James
Fiske, Fidelia
Fleming, John
Fletcher, James Cooley
Flint, Timothy
Fout, Pedro
Frame, Alice Seymour Browne
Gallitzin, Demetrius Augustine
Garcés, Francisco Tomás
 Hermenegildo
Garry, Spokane
Gates, Caleb Frank
Gibault, Pierre
Going, Jonathan
Good, Adolphus Clemens
Goodell, William
Goodrich, Chauncey
Gordon, Andrew
Goupil, René
Graessl, Lawrence
Grant, Asahel
Graves, Rosewell Hobart
Greaton, Joseph
Greene, Daniel Crosby
Grube, Bernhard Adam
Guignas, Michel
Gulick, John Thomas
Gulick, Luther Halsey, 1828–1891
Gulick, Sidney Lewis
Hall, Sherman
Hamlin, Cyrus
Happer, Andrew Patton
Harding, Robert
Harpster, John Henry
Hart, Virgil Chittenden
Hawley, Gideon, 1727–1807
Haygood, Laura Askew
Heckewelder, John Gottlieb
 Ernestus
Heiss, Michael
Helbron, Peter
Hepburn, James Curtis
Heyer, John Christian Frederick
Hill, John Henry
Hoecken, Christian
Hoisington, Henry Richard
Holcombe, Chester
Homes, Henry Augustus
Hoover, James Matthews
Hume, Robert Allen
Ingalls, Marilla Baker
Innokentii
Jackson, Sheldon
Jacoby, Ludwig Sigmund
Jessup, Henry Harris
Jogues, Isaac
Jones, George Heber

Jones, John Peter
Jones, John Taylor
Judge, Thomas Augustine
Judson, Adoniram
Judson, Ann Hasseltine
Judson, Emily Chubbuck
Judson, Sarah Hall Boardman
Keith, George
Kellogg, Samuel Henry
King, Jonas
Kino, Eusebio Francisco
Kirkland, Samuel
Kohlmann, Anthony
Lambuth, James William
Lambuth, Walter Russell
Lane, Horace M.
Lansing, Gulian
Lee, Jason
Lefevere, Peter Paul
Lemke, Peter Henry
Lindley, Daniel
Loewenthal, Isidor
Loughridge, Robert McGill
Lowrie, James Walter
Lowrie, Walter
Lowry, Hiram Harrison
Luce, Henry Winters
McCartee, Divie Bethune
MacCauley, Clay
McCord, James Bennett
McCoy, Isaac
McElroy, John
McFarland, Samuel Gamble
McGilvary, Daniel
McKay, David Oman
McKean, James William
McKenna, Charles Hyacinth
Maclay, Robert Samuel
MacSparran, James
Mansell, William Albert
Marquette, Jacques
Martin, William Alexander Parsons
Marty, Martin
Mason, Francis
Mateer, Calvin Wilson
Mayhew, Experience
Mayhew, Thomas, 1593–1682
Mayhew, Thomas, 1621–1657
Mazzuchelli, Samuel Charles
Meeker, Jotham
Meerschaert, Théophile
Membré, Zenobius
Menard, René
Menetrey, Joseph
Mengarini, Gregory
Mills, Cyrus Taggart
Mills, Susan Lincoln Tolman
Morrison, William McCutchan
Mott, John R.
Mudge, James

Murrow, Joseph Samuel
Nash, Daniel
Nassau, Robert Hamill
Nevins, John Livingston
Niza, Marcos de
O'Brien, Matthew Anthony
Occom, Samson
Padilla, Juan de
Palladino, Lawrence Benedict
Palou, Francisco
Parker, Alvin Pierson
Parker, Edwin Wallace
Parker, Peter
Parker, Samuel
Perkins, Justin
Perry, Rufus Lewis
Pierre, Joseph Marie Chaumonot
Pierson, Arthur Tappan
Pierz, Franz
Pond, Samuel William
Poor, Daniel
Post, Christian Frederick
Post, George Edward
Pott, Francis Lister Hawks
Price, Thomas Frederick
Pye, Watts Orson
Raffeimer, John Stephen
Râle, Sébastien
Ravalli, Antonio
Ravoux, Augustin
Rawlinson, Frank Joseph
Reed, Mary
Reid, Gilbert
Reid, John Morrison
Rice, Luther
Richard, Gabriel
Richards, William
Riggs, Elias
Riggs, Stephen Return
Roberts, Issachar Jacob
Robot, Isidore
Ruter, Martin
Ryan, Arthur Clayton
Saenderl, Simon
Savage, Thomas Staughton
Schauffler, Henry Albert
Schauffler, William Gottlieb
Schereschewsky, Samuel Isaac
 Joseph
Schneider, Benjamin
Schneider, Theodore
Scudder, John
Seagrave, Gordon Stifler
Seghers, Charles Jean
Sergeant, John, 1710–1749
Serra, Junipero
Shedd, William Ambrose
Sheffield, Devello Zelotes
Shelton, Albert Leroy
Shepard, Fred Douglas

Patterson, Daniel Todd
Patterson, Thomas Harman
Pattison, Thomas
Paulding, Hiram
Paulding, James Kirke
Pennock, Alexander Mosely
Percival, John
Perkins, George Hamilton
Perry, Christopher Raymond
Perry, Matthew Calbraith
Perry, Oliver Hazard
Phelps, Thomas Stowell
Philip, John Woodward
Pillsbury, John Elliott
Plunkett, Charles Peshall
Poor, Charles Henry
Porter, David
Porter, David Dixon
Pound, Thomas
Pratt, William Veazie
Preble, Edward
Preble, George Henry
Price, Rodman McCamley
Pring, Martin
Pringle, Joel Robert Poinsett
Quackenbush, Stephen Platt
Queen, Walter W.
Raby, James Joseph
Radford, Arthur William
Radford, William
Ramsay, Francis Munroe
Read, Charles William
Read, George Campbell
Read, Thomas
Reeves, Joseph Mason
Remey, George Collier
Revere, Joseph Warren
Reynolds, William
Rhind, Alexander Colden
Ribaut, Jean
Ricketts, Claude Vernon
Ridgely, Charles Goodwin
Ridgely, Daniel Bowly
Ringgold, Cadwalader
Robertson, Ashley Herman
Rodgers, Christopher Raymond
 Perry
Rodgers, George Washington,
 1787–1832
Rodgers, George Washington,
 1822–1863
Rodgers, John, 1773–1838
Rodgers, John, 1812–1882
Rodgers, John, 1881–1926
Roe, Francis Asbury
Rousseau, Harry Harwood
Rowan, Stephen Clegg
Russell, John Henry
Saltonstall, Dudley
Sampson, William Thomas

Sands, Benjamin Franklin
Sands, Joshua Ratoon
Schenck, James Findlay
Schley, Winfield Scott
Schroeder, Seaton
Selfridge, Thomas Oliver
Semmes, Raphael
Shaw, John, 1773–1823
Shaw, Nathaniel
Sherman, Forrest Percival
Sherman, Frederick Carl
Shubrick, John Templer
Shubrick, William Branford
Shufeldt, Robert Wilson
Sicard, Montgomery
Sigsbee, Charles Dwight
Simpson, Edward
Sims, William Sowden
Sloat, John Drake
Smith, Joseph, 1790–1877
Smith, Melancton, 1810–1893
Snowden, Thomas
Somers, Richard
Spruance, Raymond Ames
Standley, William Harrison
Stark, Harold Raynsford
Steedman, Charles
Sterett, Andrew
Stevens, Thomas Holdup, 1795–
 1841
Stevens, Thomas Holdup, 1819–
 1896
Stewart, Edwin
Stockton, Charles Herbert
Stockton, Robert Field
Strain, Isaac G.
Stringham, Silas Horton
Strong, James Hooker
Tabot, Silas
Tarbell, Joseph
Tattnall, Josiah
Taussig, Joseph Knefler
Taylor, David Watson
Taylor, William Rogers
Taylor, William Vigneron
Temple, William Grenville
Thatcher, Henry Knox
Theobald, Robert Alfred
Thompson, Egbert
Tingey, Thomas
Towers, John Henry
Townsend, Robert
Trenchard, Stephen Decatur
Trippe, John
Trott, Nicholas
Truxtun, Thomas
Truxtun, William Talbot
Tucker, John Randolph, 1812–1883
Tucker, Samuel
Turner, Daniel

Turner, Richmond Kelly
Tyng, Edward
Upshur, John Henry
Usher, Nathaniel Reilly
Vickery, Howard Leroy
Voorhees, Philip Falkerson
Waddell, James Iredell
Wainwright, Jonathan Mayhew,
 1821–1863
Wainwright, Richard, 1817–1862
Wainwright, Richard, 1849–1926
Walke, Henry
Walker, Asa
Walker, John Grimes
Ward, James Harmon
Warren, Sir Peter
Warrington, Lewis
Waters, Daniel
Watson, John Crittenden
Weaver, Aaron Ward
Welles, Roger
Werder, Reed
Whipples Abraham
Wickes, Lambert
Wilde, George Francis Faxon
Wilkes, Charles
Wilkinson, John
Wilkinson, Theodore Stark
Williams, John Foster
Winslow, Cameron McRae
Winslow, John Ancrum
Wise, Henry Augustus
Wood, John Taylor
Woolsey, Melancthon Taylor
Wooster, Charles Whiting
Worden, John Lorimer
Wyman, Robert Harris
Zacharias, Ellis Mark
Ziegemeier, Henry Joseph

NAVIGATOR (See also MARINER,
 STEAMBOAT OPERATOR)
Allefonsce, Jean
Amadas, Phllip
Ayala, Juan Manuel de
De Brahm, William Gerard
Gosnold, Bartholomew
Gray, Robert
Hudson, Henry
Ingraham, Joseph
Kendrick, John
Waymouth, George

NAVY BUREAU OF YARDS AND DOCKS
 (U.S.) CHIEF
Moreell, Ben

NAVY SURGEON GENERAL
McIntire, Ross

NAZI PARTY (AMERICAN) LEADER
Rockwell, George Lincoln

NEMATOLOGIST (See also ANATOMIST)
Cobb, Nathan Augustus

Bacheller, Irving
Bailey, (Irene) Temple
Baker, Dorothy Dodds
Basso, (Joseph) Hamilton
Baum, Hedwig ("Vicki")
Beach, Rex
Beer, Thomas
Benét, Stephen Vincent
Bennett, Emerson
Biggers, Earl Derr
Bird, Robert Montgomery
Boyd, James
Boyd, Thomas Alexander
Bradford, Roark Whitney Wickliffe
Brown, Charles Brockden
Buntline, Ned (See JUDSON,
 EDWARD ZANE CARROLL)
Burgess, Frank Gelett
Cabell, James Branch
Cahan, Abraham
Campbell, William Edward March
Catherwood, Mary Hartwell
Chambers, Robert William
Chatterton, Ruth
Churchill, Winston
Clark, Walter Van Tilburg
Cleghorn, Sarah Norcliffe
Clemens, Jeremiah
Clemens, Samuel Langhorne
Cobb, Sylvanus
Cohen, Octavus Roy
Colum, Padraic
Comfort, Will Levington
Cooke, John Esten
Cooper, James Fenimore
Costain, Thomas Bertram
Cozzens, James Gould
Crawford, Francis Marion
Croy, Homer
Cullen, Countee Porter
Curwood, James Oliver
Davis, Rebecca Blaine Harding
Day, Holman Francis
Dell, Floyd James
Donn-Byrne, Brian Oswald
Dos Passos, John Roderigo
Douglas, Lloyd Cassel
Dreiser, Theodore
Dupuy, Eliza Ann
Eggleston, Edward
Eggleston, George Cary
Farrell, James Thomas
Faulkner (Falkner), William
 Cuthbert
Fearing, Kenneth Flexner
Ferber, Edna Jessica
Fitzgerald, Francis Scott Key
Forbes, Esther
Ford, Paul Leicester
Forester, Cecil Scott

Fox, John William
Frederic, Harold
Freeman, Joseph
Fuller, Henry Blake
Garland, Hamlin
Garreau, Armand
Gipson, Frederick Benjamin
Glasgow, Ellen Anderson Gholson
Grant, Robert
Gunter, Archibald Clavering
Hackett, Francis
Hagedorn, Hermann Ludwig
 Gebhard
Harben, William Nathaniel
Hardy, Arthur Sherburne
Harris, Miriam Coles
Harrison, Constance Cary
Harrison, Henry Sydnor
Hawthorne, Nathaniel
Hazelton, George Cochrane
Hemingway, Ernest Miller
Herbert Frederick Hugh
Herbst, Josephine Frey
Hergesheimer, Joseph
Herrick, Robert Welch
Heyward, DuBose
Hirschbein, Peretz
Hobart, Alice Nourse Tisdale
Hoffman, Charles Fenno
Holley, Marietta
Holmes, Mary Jane Hawes
Howells, William Dean
Hughes, James Langston
Huntington, Jedediah Vincent
Hurst, Fannie
Hurston, Zora Neale
Inge, William Motter
Jackson, Charles Reginald
Jackson, Helen Maria Fiske Hunt
Jackson, Shirley Hardie
James, Henry, 1843–1916
Janson, Kristofer Nagel
Johnson, Owen McMahon
Johnston, Mary
Jones, James Ramon
Jordan, Kate
Judson, Edward Zane Carroll ("Ned
 Buntline")
Kantor, MacKinlay
Kelland, Clarence Budington
Kerouac, Jack
Kerr, Sophie
Kester, Vaughan
King, William Benjamin Basil
Koch, Vivienne
La Farge, Christopher Grant
Lennox, Charlotte Ramsay
Lewis, Harry Sinclair
Lewisohn, Ludwig
Lincoln, Joseph Crosby

Lippard, George
Lloyd, John Uri
Lynde, Francis
McCullers, Carson
McCutcheon, George Barr
MacDowell, Katherine Sherwood
 Bonner
McHenry, James
McKay, Claude
Magruder, Julia
Major, Charles
Marquand, John Phillips
Masters, Edgar Lee
Melville, Herman
Miller, Henry Valentine
Mitchell, Isaac
Mitchell, John Ames
Mitchell, Margaret Munnerlyn
Mitchell, Silas Weir
Morley, Christopher Darlington
Motley, Willard Francis
Murfree, Mary Noailles
Norris, Benjamin Franklin
Norris, Charles Gilman Smith
Norris, Kathleen Thompson
O'Connor, Edwin Greene
O'Connor, Mary Flannery
O'Hara, John Henry
O'Higgins, Harvey Jerrold
Oppenheim, James
Patchen, Kenneth
Patten, Gilbert
Paul, Elliot Harold
Phillips, David Graham
Pike, Mary Hayden Green
Poole, Ernest Cook
Porter, Gene Stratton
Porter, Katherine Anne
Post, Melville Davisson
Rawlings, Marjorie Kinnan
Reid, Thomas Mayne
Rice, Elmer
Rinehart, Mary Roberts
Rives, Hallie Erminie
Roche, Arthur Somers
Rowson, Susanna Haswell
Ruark, Robert Chester
Saltus, Edgar Evertson
Sandoz, Mari
Scarborough, Dorothy
Schomer, Nahum Melr
Schorer, Mark
Scoville, Joseph Alfred
Sealsfield, Charles
Sedgwick, Anne Douglas
Sheean, James Vincent
Shellabarger, Samuel
Simms, William Gilmore
Sinclair, Upton Beall, Jr.
Singer, Israel Joshua

Clayton, Joshua
Cochran, John
Cohen, Jacob da Silva Solis
Cohn, Alfred Einstein
Coit, Henry Leber
Cook, Frederick Albert
Cooke, Elisha
Cooke, John Esten
Cooke, Robert Anderson
Copeland, Royal Samuel
Craik, James
Cranston, John
Craven, John Joseph
Crawford, John
Crawford, John Martin
Crumbine, Samuel Jay
Cullis, Charles
Cushny, Arthur Robertson
Cutler, Ephraim
Da Costa, Jacob Mendez
Dalcho, Frederick
Darling, Samuel Taylor
Davis, Charles Henry Stanley
Davis, Edwin Hamilton
Davis, Nathan Smith
Delafield, Francis
Deléry, Franéois Charles
Dercum, Francis Xavier
De Rosset, Moses John
Dewees, William Potts
Dick, Elisha Cullen
Dickson, Samuel Henry
Disbrow, William Stephen
Doddridge, Joseph
Dooley, Thomas Anthony, III
Dorsch, Eduard
Doughty, William Henry
Douglass, William
Drake, Daniel
Dwight, Nathaniel
Dyer, Isadore
Earle, Pliny
Eberle, John
Edder, William
Edes, Robert Thaxter
Edsall, David Linn
Eliot, Charles
Ellis, Calvin
Elmer, Ebenezer
Elmer, Jonathan
Elwell, John Johnson
Elwyn, Alfred Langdon
Emerson, Gouverneur
Emmet, Thomas Addis
Emmons, Ebenezer
Engelmann, George
Evans, George Alfred
Evans, John
Ewell, James
Ewell, Thomas

Faget, Jean Charles
Favill, Henry Baird
Fay, Jonas
Fayssoux, Peter
Finlay, Carlos Juan
Fisher, George Jackson
Fisher, John Dix
Fletcher, William Baldwin
Flick, Lawrence Francis
Flint, Austin, 1812–1886
Flint, Austin, 1836–1915
Foote, John Ambrose
Fordyce, John Addison
Forwood, William Henry
Foster, Frank Pierce
Foster, John Pierrepont Codrington
Francis, John Wakefield
Francis, Samuel Ward
Freeman, Nathaniel
Friedenwald, Aaron
Fuller, Robert Mason
Fussell, Bartholomew
Gale, Benjamin
Gallinger, Jacob Harold
Gallup, Joseph Adams
Garcelon, Alonzo
Garden, Alexander
Gardiner, Silvester
Garnett, Alexander Yelverton Peyton
Garvin, Lucius Fayette Clark
Gerhard, William Wood
Gibbes, Robert Wilson
Gibbons, William
Gilbert, Rufus Henry
Girard, Charles Frederic
Goddard, Paul Beck
Goforth, William
Goldsmith, Middleton
Goldstein, Max Aaron
Goodrich, Benjamin Franklin
Gorham, John
Gorrie, John
Gould, Augustus Addison
Gould, George Milbry
Gradle, Henry
Grant, Asahel
Gray, John Purdue
Green, Asa
Green, Horace
Green, Norvin
Green, Samuel Abbott
Greenhow, Robert
Guernsey, Egbert
Guild, La Fayette
Guiteras, Juan
Guthrie, Samuel
Guttmacher, Alan Frank
Hack, George
Hale, Edwin Moses
Hale, Enoch

Hall, William Whitty
Hamilton, Alexander, 1712–1756
Hamilton, Alice
Hamilton, Allan McLane
Hand, Edward
Harlan, Richard
Harrington, Thomas Francis
Hartshorne, Henry
Haviland, Clarence Floyd
Hawley, Paul Ramsey
Hayes, Isaac Israel
Hays, Isaac
Hempel, Charles Julius
Hench, Philip Showalter
Henderson, Thomas
Henry, Morris Henry
Henshall, James Alexander
Hering, Constantine
Herter, Christian Archibald
Hewes, Robert
Hildreth, Samuel Prescott
Hoagland, Charles Lee
Hoff, John Van Rensselaer
Holcombe, William Henry
Holder, Joseph Bassett
Holten, Samuel
Holyoke, Edward Augustus
Hooker, Worthington
Hoover, Charles Franklin
Hopkins, Lemuel
Horn, George Henry
Horsfield, Thomas
Hosack, David
Hough, Franklin Benjamin
House, Samuel Reynolds
Hubbard, John
Huger, Francis Kinloch
Hunt, Harriot Kezia
Huntington, Elisha
Husk, Charles Ellsworth
Huston, Charles
Hutchinson, James
Hutchinson, Woods
Hyde, James Nevins
Ingals, Ephraim Fletcher
Ives, Eli
Jackson, Abraham Reeves
Jackson, Chevalier
Jackson, David
Jackson, Hall
Jackson, James, 1777–1867
Jackson, James Caleb
Jackson, John Davies
Jackson, Mercy Ruggles Bisbe
Jackson, Samuel
Jacobi, Abraham
Jacobi, Mary Corinna Putnam
James, Edwin
James, Thomas Chalkley
Jameson, Horatio Gates

Pickering, Charles
Pitcher, Zina
Plotz, Harry
Plummer, Henry Stanley
Polk, William Mecklenburg
Porcher, Francis Peyre
Post, George Edward
Pott, John
Potter, Ellen Culver
Potter, Nathaniel
Potts, Charles Sower
Potts, Jonathan
Powell, William Byrd
Prescott, Oliver
Prescott, Samuel
Preston, Ann
Preston, Jonas
Price, George Moses
Price, Joseph
Prime, Benjamin Youngs
Prince, Morton
Pulte, Joseph Hippolyt
Purple, Samuel Smith
Putnam, Charles Pickering
Putnam, Helen Cordelia
Quine, William Edward
Quintard, Charles Todd
Ramsay, David
Ramsey, James Gettys McGready
Ranney, Ambrose Loomis
Rauch, John Henry
Raue, Charles Gottlieb
Ravenel, Edmund
Ravenel, St. Julien
Redman, John
Reed, Walter
Rhoads, Cornelius Packard
Richards, Dickinson Woodruff
Richardson, Charles Williamson
Richardson, Robert
Richmond, John Lambert
Richmond, John Wilkes
Ricord, Philippe
Riddell, John Leonard
Rivers, Thomas Milton
Robertson, Jerome Bonaparte
Robinson, George Canby
Romayne, Nicholas
Roosa, Daniel Bennett St. John
Root, Joseph Pomeroy
Rothrock, Joseph Trimble
Rous, Francis Peyton
Rovenstine, Emery Andrew
Rowland, Henry Cottrell
Rubinow, Isaac Max
Rush, Benjamin
Rush, James
Russ, John Dennison
Russell, Bartholomew
Sachs, Theodore Bernard

Sajous, Charles Euchariste de
 Médicis
Salisbury, James Henry
Salmon, Thomas William
Sappington, John
Sargent, Dudley Allen
Sargent, Fitzwilliam
Sartwell, Henry Parker
Saugrain de Vigni, Antoine
 François
Saulsbury, Gove
Savage, Thomas Staughton
Say, Benjamin
Schöpf, Johann David
Scudder, John Milton
Semmes, Alexander Jenkins
Seybert, Adam
Shattuck, Frederick Cheever
Shattuck, George Brune
Shattuck, George Cheyne, 1783–
 1854
Shattuck, George Cheyne, 1813–
 1893
Shaw, Anna Howard
Shaw, John, 1778–1809
Shecut, John Linnaeus Edward
 Whitridge
Shepard, Fred Douglas
Shippen, William
Short, Charles Wilkins
Sibley, John
Small, Alvan Edmond
Smith, Elihu Hubbard
Smith, James McCune
Smith, Job Lewis
Smith, John Augustine
Smith, Nathan, 1762–1829
Snyder, Howard McCrum
Snyder, John Francis
Spalding, Lyman
Speir, Samuel Fleet
Spivak, Charles David
Squibb, Edward Robinson
Starr, Louis
Stearns, Henry Putnam
Steiner, Lewis Henry
Stephenson, Benjamin Franklin
Stiles, Henry Reed
Stillé, Alfred
Stockton, Charles G.
Stone, Abraham
Stone, Richard French
Stone, Warren
Strong, Richard Pearson
Strudwick, Edmund Charles Fox
Talbot, Israel Tisdale
Taussig, William
Taylor, Joseph Wright
Taylor, Robert Tunstall
Tennent, John

Terry, Marshall Orlando
Testut, Charles
Thacher, James
Thayer, William Sydney
Thomas, Joseph
Thomas, Richard Henry
Thompson, William Gilman
Thomson, Samuel
Thornton, Matthew
Ticknor, Francis Orray
Timberlake, Gideon
Timme, Walter
Todd, Eli
Toner, Joseph Meredith
Townsend, Francis Everett
Trudeau, Edward Livingston
Tufts, Cotton
Tully, William
Turnbull, Andrew
Tyson, James
Van Alben, Frank
Van Beuren, Johannes
Van Buren, William Holme
Van Fleet, Walter
Vedder, Edward Bright
Von Ruck, Karl
Walcott, Henry Pickering
Waldo, David
Walker, Mary Edwards
Walker, Thomas
Walker, William Johnson
Ward, Richard Halsted
Warder, John Aston
Ware, John
Warren, Joseph
Warthin, Aldred Scott
Waterhouse, Benjamin
Weber, Gustav Carl Erich
Weil, Richard
Welch, William Wickham
Wells, William Charles
Werde, Grover William
Wesselhoeft, Conrad
West, Henry Sergeant
White, Charles Abiathar
White, Paul Dudley
Whitman, Marcus
Wickes, Stephen
Widney, Joseph Pomeroy
Wiener, Alexander Solomon
Wilbur, Ray Lyman
Wilcox, Reynold Webb
Wilder, Alexander
Wilder, Russell Morse
Willard, De Forest
Williams, Francis Henry
Williams, John Whitridge
Williams, Linsly Rudd
Williams, Nathanael
Williams, William Carlos

Wistar, Caspar
Witherspoon, John Alexander
Wood, Edward Stickney
Wood, George Bacon
Wood, Horatio Charles
Woodhouse, James
Woodruff, Charles Edward
Woodward, Joseph Janvier
Woodward, Samuel Bayard
Work, Hubert
Wormley, Theodore George
Wright, Joseph Jefferson Burr
Wyckoff, John Henry
Wyman, Morrill
Yandell, David Wendell
Yandell, Lunsford Pitts
Young, Thomas
Zakrgewska, Marie Elizabeth
Zinsser, Hans

PHYSICIST (See also SCIENTIST)
Allison, Samuel King
Alter, David
Ames, Joseph Sweetman
Anthony, William Arnold
Bache, Alexander Dallas
Barker, George Frederick
Barus, Carl
Bauer, Louis Agricola
Bayma, Joseph
Becker, George Ferdinand
Békésy, Georg Von
Bell, Louis
Blair, William Richards
Blake, Francis
Blodgett, Katharine Burr
Boltwood, Bertram Borden
Bowen, Ira Sprague
Boyé, Martin Hans
Brace, Dewitt Bristol
Bridgman, Percy Williams
Briggs, Lyman James
Buckley, Oliver Ellsworth
Bumstead, Henry Andrews
Burgess, George Kimball
Cohen, Jacob da Silva Solis
Compton, Arthur Holly
Compton, Karl Taylor
Condon, Edward Uhler
Davis, Harvey Nathaniel
Davisson, Clinton Joseph
Debye, Peter Joseph William
Duane, William
Eddy, Henry Turner
Einstein, Albert
Farrar, John
Fermi, Enrico
Franck, James
Frank, Philipp G.
Gale, Henry Gordon
Gamow, George

Germer, Lester Halbert
Gibbs, Josiah Willard
Goddard, Robert Hutchings
Goudsmit, Samuel Abraham
Gunn, Ross
Guthe, Karl Eugen
Hall, Edwin Herbert
Hansen, William Webster
Harkins, William Draper
Hastings, Charles Sheldon
Haworth, Leland John
Henry, Joseph
Hess, Victor Franz
Humphreys, Wiliam Jackson
Kármán, Theodore (Todor) von
Langmuir, Irving
Lawrence, Ernest Orlando
Lewis, Exum Percival
Loomis, Elmer Howard
Lyman, Chester Smith
Lyman, Theodore
Maclaurin, Richard Cockburn
Mayer, Alfred Marshall
Mayer, Maria Goeppert
Mendenhall, Charles Elwood
Mendenhall, Thomas Corwin
Michelson, Albert Abraham
Miller, Dayton Clarence
Millikan, Clark Blanchard
Millikan, Robert Andrews
Morley, Edward Williams
Nichols, Edward Leamington
Nichols, Ernest Fox
Nipher, Francis Eugene
Oppenheimer, Julius Robert
Page, Leigh
Pegram, George Braxton
Peirce, Benjamin Osgood
Pfund, August Herman
Pupin, Michael Idvorsky
Richtmyer, Floyd Karker
Rogers, William Auzustus
Rood, Ogden Nicholas
Rosa, Edward Bennett
Rowland, Henry Augustus
Sabine, Wallace Clement Ware
Slater, John Clarke
Stern, Otto
Szilard, Leo
Tate, John Torrence
Thompson, Benjamin
Tolman, Richard Chace
Troland, Leonard Thompson
Trowbridge, Augustus
Trowbridge, John
Van de Graat, Robert Jemison
Van Vleck, John Hasbrouck
Von Neumann, John
Waidner, Charles William
Waterman, Alan Tower

Webster, Arthur Gordon
Wells, William Charles
Winthrop, John
Woodward, Robert Simpson

PHYSIOGRAPHER (See also GEOGRAPHER, NATURALIST)
Campbell, Marius Robinson

PHYSIOLOGICAL CHEMIST (See also CHEMIST, PHYSIOLOGIST)
Mendel, Lafayette Benedict

PHYSIOLOGIST (See also PHYSICIAN)
Allen, Edgar
Auer, John
Bazett, Henry Cuthbert
Békésky, Georg Von
Bowditch, Henry Pickering
Cannon, Walter Bradford
Carlson, Anton Julius
Curtis, John Green
Dalton, John Call
Drinker, Cecil Kent
Dusser de Barenne, Joannes Gregorius
Erlanger, Joseph
Flint, Austin
Gasser, Herbert Spencer
Hecht, Selig
Hemmeter, John Conrad
Henderson, Lawrence Joseph
Henderson, Yandell
Hooker, Donald Russell
Hough, Theodore
Howell, William Henry
Keyt, Alonzo Thrasher
Knowles, John Hilton
Lee, Frederic Schiller
Lining, John
Loeb, Jacques
Lombard, Warren Plimpton
Lusk, Graham
Martin, Henry Newell
Meltzer, Samuel James
Mitchell, John Kearsley
Murphy, Gardner
Osterhout, Winthrop John Vanleuven
Porter, William Townsend
Rachford, Benjamin Knox
Rolf, Ida Pauline
Smith, Homer William
Stewart, George Neil
Troland, Leonard Thompson
Vaughan, Daniel
Weiss, Soma

PIANIST (See also JAZZ PIANIST, MUSICIAN)
Armstrong, Henry Worthington ("Harry")
Baermann, Carl
Bauer, Harold Victor

Beach, Amy Marcy Cheney
Blodgett, Benjamin Colman
Cadman, Charles Wakefield
Casadesus, Robert Marcel
Chotzinoff, Samuel
Cole, Nat ("King")
Dresel, Otto
Duchin, Edward Frank ("Eddy")
Gabrilowitsch, Ossip
Ganz, Rudolph
Godowsky, Leopold
Goldbeck, Robert
Gottschalk, Louis Moreau
Grainger, George Percy
Griffes, Charles Tomlinson
Hanchett, Henry Granger
Henderson, Fletcher Hamilton
Hoffman, Richard
Hofmann, Josef Casimir
Iturbi, José
Jarvis, Charles H.
Joseffy, Rafael
Katchen, Julius
Kenton, Stanley Newcomb
Klein, Bruno Oscar
Landowska, Wanda Aleksandra
Lang, Benjamin Johnson
Levant, Oscar
Lhévinne, Josef
Lhévinne, Rosina
Liebling, Emil
Lopez, Vincent Joseph
Mannes, Clara Damrosch
Mannes, Leopold Damrosch
Mason, William
Mitropoulos, Dimitri
Pease, Alfred Humphreys
Perabo, Johann Ernst
Perry, Edward Baxter
Pratt, Silas Gamaliel
Rachmaninoff, Sergei Vasilyevich
Rockefeller, Martha Baird
Runcie, Constance Faunt Le Roy
Rybner, Martin Cornelius
Samaroff, Olga
Schelling, Ernest Henry
Schnabel, Artur
Sherwood, William Hall
Siloti, Alexander Ilyitch
Sternberg, Constantin Ivanovich,
 Edler von
Stravinsky, Igor Fyodorovich
Tapper, Bertha Feiring
Templeton, Alec Andrew
Tiomkin, Dimitri
Vogrich, Max Wilhelm Karl
Washington, Dinah
Whiting, Arthur Battelle
Zeisler, Fannie Bloomfield

PILGRIM
Alden, John
Allerton, Isaac
Brewster, William
Morton, George
Morton, Nathaniel
Standish, Myles
Winslow, Edward

**PIONEER (See also FRONTIERSMAN,
 GUIDE, SCOUT)**
Atwater, Caleb
Ballard, Bland Williams
Bedinger, George Michael
Belden, Josiah
Birkbeck, Morris
Boone, Daniel
Bozeman, John M.
Brannan, Samuel
Bryant, John Howard
Burnett, Peter Hardeman
Carter, John
Carter, Landon
Chapman, John
Clark, George Rogers
Cleaveland, Moses
Connor, Patrick Edward
Cresap, Thomas
Dale, Samuel
Doddridge, Joseph
Duchesne, Rose Philippine
Dunn, Williamson
Dupratz, Antoine Simon Le Page
Dustin, Hannah
Faribault, Jean Baptiste
Flower, George
Flower, Richard
Folger, Peter
Fry, Joshua
Gaines, George Strother
Gerstle, Lewis
Gibson, Paris
Goodnow, Isaac Tichenor
Gross, Samuel David
Haraszthy de Mokcsa, Agoston
Harrod, James
Henderson, David Bremner
Hillis, David
Hitchcock, Phineas Warrener
Jenkins, John, 1728–1785
Jenkins, John, 1751–1827
Langworthy, James Lyon
Lee, Jason
Logan, Benjamin
Lyon, Matthew
McLeod, Martin
Magoffin, James Wiley
Marsh, Grant Prince
Marsh, John
Mattson, Hans
Mears, Otto

Meeker, Ezra
Meigs, Return Jonathan
Neighbors, Robert Simpson
Nesmith, James Willis
Newell, Robert
Nicholas, George
Overton, John
Palmer, Joel
Peary, Josephine Diebitsch
Piggott, James
Potter, Robert
Pryor, Nathaniel
Putnam, Rufus
Renick, Felix
Rice, Henry Mower
Robertson, James, 1742–1814
Robinson, Charles
Robinson, Solon
Russell, Osborne
Russell, William Henry
Sargent, Winthrop, 1753–1820
Sawyer, Lorenzo
Scholte, Hendrik Peter
Sevier, John
Stearns, Abel
Stevens, John Harrington
Stone, Wilbur Fisk
Stuart, Granville
Symmes, John Cleves
Thornton, Jesse Quinn
Tupper, Benjamin
Walderne, Richard
Warner, Jonathan Trumbull
Warren, Francis Emroy
White, James
Whitman, Marcus
Wilkeson, Samuel
Williams, Samuel May
Wolfskill, William
Young, Ewing
Zane, Ebenezer
Ziegler, David

PIRATE (See also BUCCANEER)
Halsey, John
Ingle, Richard
Kidd, William
Laffite, Jean
Mason, Samuel
Pound, Thomas
Quelch, John

**PISCICULTURIST (See also
 ICHTHYOLOGIST, ZOOLOGIST**
Garlick, Theodatus
Green, Seth
Mather, Fred
Titcomb, John Wheelock

**PLANT BREEDER (See also
 AGRICULTURIST, BOTANIST)**
Burbank, Luther
Coker, David Robert

Dickinson, Emily Elizabeth
Dinsmoor, Robert
Drake, Joseph Rodman
Duganne, Augustine Joseph Hickey
Dugué, Charles Oscar
Dunbar, Paul Laurence
Eastman, Charles Gamage
Eliot, T(homas) S(tearns)
Emerson, Ralph Waldo
Evans, Nathaniel
Eve, Joseph
Fairfield, Sumner Lincoln
Faust, Frederick Shiller
Fearing, Kenneth Flexner
Fenollosa, Ernest Francisco
Ferguson, Elizabeth Graeme
Fessenden, Thomas Green
Field, Eugene
Finch, Francis Miles
Fletcher, John Gould
Foss, Sam Walter
Freeman, Joseph
Freneau, Philip Morin
Frost, Robert Lee
Gallagher, William Davis
Gilder, Richard Watson
Giovannitti, Arturo
Godfrey, Thomas
Gould, Hannah Flagg
Greene, Albert Gorton
Guiney, Louise Imogen
Guthrie, Ramon
Hagedorn, Hermann Ludwig
 Gebhard
Hall, Hazel
Halleck, Fitz-Greene
Halpine, Charles Graham
Hammon, Jupiter
Harris, Thomas Lake
Hartley, Marsden
Hay, John Milton
Hayden, Robert Earl
Hayne, Paul Hamilton
Henderson, Daniel McIntyre
Hewitt, John Hill
Heyward, DuBose
Hillhouse, James Abraham
Hillyer, Robert Silliman
Hirst, Henry Beck
Hoffman, Charles Fenno
Holley, Marietta
Holmes, Daniel Henry
Holmes, Oliver Wendell
Hope, James Barron
Hosmer, William Howe Cuyler
Hovey, Richard
Hubner, Charles William
Hughes, James Langston
Humphreys, David
Humphries, George Rolfe

Imber, Naphtali Herz
Irving, William
Jackson, Helen Maria Fiske Hunt
Janson, Kristofer Nagel
Jarrell, Randall
Jeffers, John Robinson
Jeffrey, Rosa Griffith Vertner
 Johnson
Johnson, Henry
Johnson, Robert Underwood
Kerouac, Jack
Kilmer, Alfred Joyce
Kinney, Elizabeth Clementine
 Dodge Stedman
Kreymborg, Alfred Francis
Krez, Konrad
Lacy, Ernest
Ladd, Joseph Brown
La Farge, Christopher Grant
Lander, Frederick West
Lanier, Sidney
Lathrop, John
Latil, Alexandre
Lazarus, Emma
Leonard, William Ellery
Lindsay, Nicholas Vachel
Linn, John Blair
Linton, William James
Lodge, George Cabot
Longfellow, Henry Wadsworth
Longfellow, Samuel
Lord, William Wilberforce
Lowell, Amy
Lucas, Daniel Bedinger
Lytle, William Haines
McCarroll, James
McGinley, Phyllis
McHenry, James
McKay, Claude
MacKaye, Percy Wallace
MacKellar, Thomas
McKinley, Carlyle
McLellan, Isaac
McMaster, Guy Humphreys
Macy, John
Malone, Walter
Markham, Edwin
Markoe, Peter
Marquis, Donald Robert Perry
Martin, Edward Sandford
Masters, Edgar Lee
Menken, Adah Isaacs
Merrill, Stuart FitzRandolph
Mifflin, Lloyd
Miles, George Henry
Millay, Edna St. Vincent
Miller, Cincinnatus Hiner
Mitchell, Langdon Elwyn
Mitchell, Silas Weir
Moïse, Penina

Monroe, Harriet
Moody, William Vaughn
Moore, (Austin) Merrill
Moore, Marianne Craig
Morris, George Pope
Morrison, Jim
Morton, Sarah Wentworth Apthorp
Munford, William
Muñoz-Rivera, Luis
Nack, James M.
Nash, Frederick Ogden
Newell, Robert Henry
Nicholson, Eliza Jane Poitevent
 Holbrook
Nies, Konrad
Niles, Nathaniel
Oakes, Urian
Oppenheim, James
O'Reilly, John Boyle
Osborn, Laughton
Osborn, Selleck
Osgood, Frances Sargent Locke
Paine, Robert Treat
Parke, John
Parker, Dorothy Rothschild
Parsons, Thomas William
Patchen, Kenneth
Peabody, Josephine Preston
Percival, James Gates
Perry, Nora
Peterson, Henry
Piatt, John James
Piatt, Sarah Morgan Bryan
Pierpont, John
Pinkney, Edward Coote
Plath, Sylvia
Plummer, Jonathan
Plummer, Mary Wright
Poe, Edgrar Allan
Posey, Alexander Lawrence
Pound, Ezra Loomis
Powell, Thomas
Poydras, Julien de Lelande
Preston, Margaret Junkin
Randall, James Ryder
Rankin, Jeremiah Eames
Ransom, John Crowe
Read, Thomas Buchanan
Realf, Richard
Reed, John, 1887–1920
Reese, Lizette Woodworth
Reitzel, Robert
Requier, Augustus Julian
Ricketson, Daniel
Riley, James Whitcomb
Rittenhouse, Jessie Belle
Robinson, Edwin Arlington
Roche, James Jeffrey
Roethke, Theodore Huebner
Rorty, James Hancock

Rose, Aquila
Rosenfeld, Morris
Rouquette, Adrien Emmanuel
Rouquette, Fransois Dominique
Rukeyser, Muriel
Russell, Irwin
Ryan, Abram Joseph
Saltus, Edgar Evertson
Sandburg, Carl August
Sandys, George
Santayana, George
Sargent, Epes
Savage, Philip Henry
Saxe, John Godfrey
Schnautter, Carl Heinrich
Scollard, Clinton
Searing, Laura Catherine Redden
Seeger, Alan
Service, Robert William
Sewall, Jonathan Mitchell
Sexton, Anne Gray Harvey
Shaw, John, 1778–1809
Sherman, Frank Dempster
Shillaber, Benjamin Penhallow
Sill, Edward Rowland
Smith, Samuel Francis
Snow, Eliza Roxey
Spingarn, Joel Elias
Sprague, Charles
Stanton, Frank Lebby
Stedman, Edmund Clarence
Steendam, Jacob
Stein, Evaleen
Sterling, George
Stevens, Wallace
Stoddard, Elizabeth Drew Barstow
Stoddard, Richard Henry
Story, Isaac
Story, William Wetmore
Strange, Michael
Street, Alfred Billings
Sylvester, Frederick Oakes
Tabb, John Banister
Taggard, Genevieve
Tate, John Orley Allen
Taylor, Benjamin Franklin
Taylor, Edward
Teasdale, Sara
Testut, Charles
Thaxter, Celia Laighton
Thierry, Camille
Thomas, Edith Matilda
Thompson, James Maurice
Thompson, John Reuben
Thomson, Edward William
Thoreau, Henry David
Thorpe, Rose Alnora Hartwick
Ticknor, Francis Orray
Timrod, Henry
Torrence, Frederick Ridgely

Townsend, Mary Ashley
Trumbull, John, 1750–1831
Tuckerman, Frederick Goddard
Tuckerman, Henry Theodore
Turell, Jane
Untermeyer, Louis
Van Doren, Mark Albert
Van Dyke, Henry
Villagr , Gasper Pérez de
Wallace, William Ross
Walsh, Thomas
Ward, Thomas
Warfield, Catherine Ann Ware
Warren, Mercy Otis
Wheatley, Phillis
Wheelock, John Hall
Whitman, Albery Allson
Whitman, Sarah Ellen Power
Whitman, Walt
Whitney, Anne
Whittier, John Greenleaf
Wilcox, Ella Wheeler
Wilde, Richard Henry
Williams, Catharine Read Arnold
Williams, William Carlos
Willis, Nathaniel Parker
Wilson, Robert Burns
Wilson, William
Winchevsky, Morris
Winter, William
Woodberry, George Edward
Woodworth, Samuel
Wright, James Arlington
Wright, Philip Green
Wylie, Elinor Morton Hoyt
Young, David
Zukofsky, Louis
Zunser, Eliakum

POGO STICK INVENTOR
Hansburg, George Bernard
POLAR EXPERT
Balchen, Bernt
POLICE COMMISSIONER
Connor, Theophilus ("Bull")
Eugene
POLICE CONSULTANT
Smith, Bruce
POLICE EXECUTIVE
Byrnes, Thomas F.
Curtis, Edwin Upton
POLICE OFFICER
Glassford, Pelham Davis
McGrath, Matthew J.
Ruditsky, Barney
POLITICAL ACTIVIST
Du Bois, William Edward
Burghardt
Harriman, Florence Jaffray Hurst
Lowenstein, Allard Kenneth
Meyer, Frank Straus

Robeson, Paul Leroy
Whitney, Charlotte Anita
Wolfe, Bertram David
POLITICAL ADVISER
Bryan, Charles Wayland
Clay, Lucius DuBignon
Ewing, Oscar Ross
Rosenman, Samuel Irving
Tugwell, Rexford Guy
Young, Owen D.
POLITICAL AIDE
Hinshaw, David Schull
POLITICAL BOSS
Hague, Frank
Kelly, Edward Joseph
Kenny, John V.
Pendergast, Thomas Joseph
Tweed, William Marcy
POLITICAL CARTOONIST
Fischetti, John
Gropper, William
POLITICAL COMMENTATOR
Dunne, Finley Peter
Gillis, James Martin
POLITICAL CRITIC (See also CRITIC)
Howard, Joseph Kinsey
**POLITICAL ECONOMIST (See also
 ECONOMIST)**
Colwell, Stephen
Coxe, Tench
Rawle, Francis, 1662–1726/27
POLITICAL FIGURE
Coughlin, Charles Edward
POLITICAL HOSTESS
Mesta, Perle Reid Skirvin
POLITICAL JOURNALIST
Rovere, Richard Halworth
POLITICAL LEADER
Raskob, John Jakob
Rose, Alex
POLITICAL ORGANIZER
Kohlberg, Alfred
Smith, Gerald L. K.
POLITICAL PHILOSOPHER
Arendt, Hannah
MacIver, Robert Morrison
**POLITICAL REFORMER (See also
 REFORMER)**
Churchill, Winston
Hawkins, Dexter Arnold
Kelly, Edmond
Linton, William James
McClintock, Oliver
MacVeagh, Isaac Wayne
Mitchell, Stephen Arnold
Moskowitz, Belle Lindner Israels
Pinchot, Amos Richards Eno
Roosevelt, Robert Barnwell
Shepard, Edward Morse

Charless, Joseph
Cist, Charles
Crocker, Uriel
Currier, Nathaniel
Dana, John Cotton
Day, Benjamin Henry
Day, Stephen
De Vinne, Theodore Low
Draper, Richard
Dunlap, John
Fleet, Thomas
Fleming, John
Foster, John
Fowle, Daniel
Franklin, Benjamin
Franklin, James
Gaine, Hugh
Gilliss, Walter
Goddard, William
Gordon, George Phineas
Goudy, Frederic William
Green, Bartholomew
Green, Jonas
Green, Samuel
Green, Thomas
Greenleaf, Thomas
Hall, David
Hall, Samuel, 1740–1807
Harper, Fletcher
Harper, James
Haswell, Anthony
Holt, John
Humphreys, James
Jansen, Reinler
Johnson, Marmaduke
Keimer, Samuel
Kneeland, Samuel
Linton, William James
Loudon, Samuer
MacKellar, Thomas
Mecom, Benjamin
Meeker, Jotham
Miller, John Henry
Moore, Jacob Bailey
Munsell, Joel
Nancrède, Paul Joseph Guérard de
Nash, John Henry
Nuthead, William
Parker, James
Parks, William
Pickard, Samuel Thomas
Pomeroy, Marcus Mills
Rivington, James
Robertson, James, b. 1740
Roulstone, George
Rudge, William Edwin
Sholes, Christopher Latham
Sower, Christopher, 1693–1758
Sower, Christopher, 1721–1784
Thomas, Isaiah

Tileston, Thomas
Timothy, Lewis
Towne, Benjamin
Trow, John Fowler
Updike, Daniel Berkeley
White, Thomas Willis
Williams, William
Zamorano, Augustin Juan Vicente
Zenger, John Peter

PRINTMAKER (See also ARTIST, ENGRAVER, ETCHER, LITHOGRAPHER)
Albers, Josef
Calder, Alexander
Ganso, Emil
Sloan, John French

PRISON ADMINISTRATOR
Lawes, Lewis Edward
Lynds, Elam
Pilsbury, Amos

PRISON REFORMER See also PENOLOGIST, REFORMER)
Davis, Katharine Bement
Gibbons, Abigail Hopper
Johnson, Ellen Cheney
Older, Fremont
Osborne, Thomas Mott
Round, William Marshall Fitts
Spear, Charles
Wines, Enoch Cobb

PRIVATEER (See also ADVENTURER, NAVAL OFFICER, NAVIGATOR)
Burns, Otway
Chever, James W.
Fanning, Nathaniel
Green, Nathan
Haraden, Jonathan
McNeill, Daniel
McNeill, Hector
Maffitt, David
Olmsted, Gideon
Peabody, Joseph
Randall, Robert Richard
Ropes, Joseph
Southack, Cyprian

PROBATION OFFICER
Augustus, John

PRODUCER (See also DIRECTOR, FILMMAKER, MOTION PICTURE DIRECTOR, MOTION PICTURE PRODUCER, THEATRICAL MANAGER)
Ames, Winthrop
Belasco, David
Berg, Gertrude Edelstein
Bonstelle, Jessie
Brackett, Charles William
Brady, William Aloysius
Brenon, Herbert
Carroll, Earl

Cohan, George Michael
Cohn, Harry
Conried, Heinrich
Cornell, Katharine
Crouse, Russel McKinley
Daly, John Augustin
DeMille, Cecil Blount
De Sylva, George Gard ("Buddy")
Dillingham, Charles Bancroft
Disney, Walter Elias ("Walt")
Dixon, Thomas
Faversham, William Alfred
Fiske, Harrison Grey
Frohman, Daniel
Gest, Morris
Golden, John
Hampden, Walter
Harrigan, Edward
Harris, Jed
Harris, Sam Henry
Helburn, Theresa
Hurok, Solomon Isaievitch
Janney, Russell Dixon
Johnson, Nunnally Hunter
Klaw, Marc
Laemmle, Carl
Langner, Lawrence
Leiber, Fritz
Liveright, Horace Brisbin
Loew, Marcus
MacArthur, Charles Gordon
McClintic, Guthrie
Mayer, Louis Burt
Miller, Gilbert Heron
Nichols, Dudley
Pemberton, Brock
Pickford, Mary
Rice, Elmer
Ritchard, Cyril
Rose, Billy
Rossen, Robert
Savage, Henry Wilson
Schary, Dore
Schwartz, Maurice
Selig, William Nicholas
Shubert, Lee
Shumlin, Herman Elliott
Taylor, Charles Alonzo
Thalberg, Irving Grant
Tyler, George Crouse
Walker, Stuart Armstrong
Wanger, Walter
White, George
Youmans, Vincent Millie
Ziegfeld, Florenz

PROFESSOR (See also EDUCATOR, SCHOLAR, TEACHER)
Abel-Henderson, Annie Heloise
Adams, George Burton
Adams, Herbert Baxter

Smith, Nathan, 1762–1829
Smyth, Egbert Coffin
Smyth, Herbert Weir
Smyth, William
Sprague, Oliver Mitchell
 Wentworth
Spring, Leverett Wilson
Stephenson, Carl
Sumner, James Batcheller
Tansill, Charles Callan
Tatlock, John Strong Perry
Thacher, Thomas Anthony
Thayer, Ezra Ripley
Thayer, James Bradley
Thorndike, Lynn
Thurstone, Louis Leon
Tiedeman, Christopher Gustavus
Tigert, John James, IV
Timberlake, Gideon
Towler, John
Treadwell, Daniel
Trent, William Peterfield
Tucker, Nathaniel Beverley, 1784–
 1851
Tuttle, Herbert
Tyler, Charles Mellen
Tyler, William Seymour
Van Amringe, John Howard
Vasiliev, Alexander Alexandrovich
Venable, Francis Preston
Vincent, Marvin Richardson
Ward, Robert De Courcy
Ware, Henry, 1764–1845
Warner, Langdon
Webb, John Burkitt
Webster, John White
Weed, Lewis Hill
Weiss, Soma
Wertenbaker, Thomas Jefferson
West, Allen Brown
West, Andrew Fleming
Weyl, Hermann
Wheeler, Arthur Leslie
Willard, James Field
Williams, Edward Thomas
Willis, Henry Parker
Wilson, Bird
Wilson, George Grafton
Wilson, Peter
Wimsatt, William Kurtz
Woodbridge, Samuel Merrill
Woods, James Haughton
Woods, Leonard
Young, Karl

PROHIBITION ADMINISTRATOR
Yellowley, Edward Clements

PROHIBITIONIST (See also REFORMER,
 TEMPERANCE REFORMER)
Carmack, Edward Ward
Fisk, Clinton Bowen

Poling, Daniel Alfred
St. John, John Pierce
Wheeler, Wayne Bidwell
Wilson, Clarence True
Woolley, John Granville

PROMOTER (See also LAND
 PROMOTER, LECTURE PROMOTER,
 PRODUCER, SHOWMAN)
Addicks, John Edward O'Sullivan
Agnew, Cornelius Rea
Andrews, Israel DeWolf
Brady, Anthony Nicholas
Brown, Charlotte Emerson
Collier, Barron Gift
Durant, Henry
Fanning, Edmund
Flagler, Henry Morrison
Gates, John Warne ("Bet-you-a-
 million")
Goerz, David
Goldschmidt, Jakob
Green, Benjamin Edwards
Harrah, Charles Jefferson
Harvey, William Hope
Hatch, Rufus
Holladay, Ben
Holliday, Cyrus Kurtz
Hopkins, Edward Augustus
Hotchkiss, Horace Leslie
Hubbard, Gardiner Greene
Kearns, Jack
Law, Sallie Chapman Gordon
Lawrance, Uriah Marion
Moore, William Henry
Morgan, Anne
Morse, Charles Wyman
Patterson, John Henry
Paul, Alice
Penrose, Spencer
Perkins, Charles Callahan
Rankine, William Birch
Reed, James Hay
Rickard, George Lewis
Ryan, Thomas Fortune
Sanders, George Nicholas
Seiberling, Frank Augustus
Sheedy, Dennis
Sibley, Hiram
Smart, David Archibald
Smith, Junius
Smith, Robert Alexander C.
Thompson, Benjamin
Train, George Francis
Whalen, Grover Aloysius
Wharton, Richard
Wright, John Stephen

PROPAGANDIST (See also AGITATOR,
 REFORMER)
Bergh, Henry
Goldman, Emma

Kelley, Hall Jackson
Lovejoy, Owen Reed
Pomeroy, Marcus Mills
Viereck, George Sylvester

PROSECUTOR
Hogan, Frank Smithwick

PROSPECTOR (See also MINER)
Broderick, David Colbreth
Fair, James Graham
Goold, William A.
La Ronde, Louis Denis, Sieur de
Marshall, James Wilson
Merritt, Leonidas
Osborn, Chase Salmon
Scott, Walter Edward

PROTESTANT MINISTER
Buttrick, George Arthur

PROTESTANT SPOKESMAN
Lyman, Eugene William

PSYCHIATRIC HISTORIAN (See also
 HISTORIAN, PSYCHIATRIST)
Zilboorg, Gregory

PSYCHIATRIST (See also
 PSYCHOANALYST, PSYCHOLOGIST,
 PHYSICIAN)
Anderson, Victor Vance
Babcock, James Woods
Barrett, Albert Moore
Briggs, Lloyd Vernon
Brush, Edward Nathaniel
Burrow, Trigant
Campbell, Charles Macfie
Clevenger, Shobal Vail
Dewey, Richard Smith
Earle, Pliny
Fisher, Theodore Willis
Fromm-Reichmann, Frieda
Gregory, Menas Sarkas
 Boulgourjian
Haviland, Clarence Floyd
Hinkle, Beatrice Moses
Hoch, August
Jones, William Parker
Kempster, Walter
Kerlin, Isaac Newton
Kirby, George Hughes
Little, Charles Sherman
Menninger, William Claire
Meyer, Adolf
Moore, (Austin) Merrill
Nichols, Charles Henry
Ray, Isaac
Rohé, George Henry
Sakel, Manfred Joshua
Salmon, Thomas William
Seguin, Edouard
Southard, Elmer Ernest
Spitzka, Edward Charles
White, William Alanson

Bonfils, Frederick Gilmer
Bonner, Robert
Bowen, Abel
Bowen, Henry Chandler
Bowker, Richard Rogers
Brace, Donald Clifford
Bradford, Andrew
Bradford, Thomas
Bradford, William
Breckinridge, Desha
Brett, George Platt
Brewster, Osmyn
Bridgman, Herbert Lawrence
Brown, James
Bunce, Oliver Bell
Butler, Burridge Davenal
Butler, Simeon
Cameron, Andrew Carr
Capper, Arthur
Carey, Henry Charles
Carey, Mathew
Carter, William Hodding, Jr.
Cerf, Bennett Alfred
Charless, Joseph
Childs, Aphas Grier
Childs, George William
Cist, Charles
Clarke, Robert
Collier, Peter Fenelon
Cook, Robert Johnson
Covici, Pascal ("Pat")
Cox, James Middleton, Jr.
Crocker, Uriel
Currier, Nathaniel
Curtis, Cyrus Hermann Kotzschmar
Day, George Parmly
Delavan, Edward Cornelius
De Young, Michel Harry
Dodd, Frank Howard
Doran, George Henry
Doubleday, Frank Nelson
Doubleday, Nelson
Draper, Margaret Green
Dworshak, Henry Clarence
Ellmaker, (Emmett) Lee
Estes, Dana
Everett, Robert
Field, Marshall, III
Field, Marshall, IV
Fields, James Thomas
Fitzgerald, Thomas
Ford, Daniel Sharp
Francis, Charles Stephen
Funk, Isaac Kauffman
Funk, Wilfred John
Gannett, Frank Ernest
Gernsback, Hugo
Ginn, Edwin
Gitt, Josiah Williams ("Jess")
Glass, Franklin Potts

Godey, Louis Antoine
Gonzales, Ambrose Elliott
Goodrich, Samuel Griswold
Gowans, William
Graham, George Rex
Graham, Philip Leslie
Grasty, Charles Henry
Greenslet, Ferris
Griscom, Lloyd Carpenter
Grosset, Alexander
Guggenheim, Harry Frank
Guinzburg, Harold Kleinert
Gunter, Archibald Clavering
Haldeman-Julius, Emanuel
Harcourt, Alfred
Harding, Jesper
Harding, William White
Harper, Fletcher
Harper, James
Harris, Benjamin
Harris, Julian La Rose
Hart, Abraham
Haynes, Williams
Heard, Dwight Bancroft
Hearst, William Randolph
Helmer, Bessie Bradwell
Hill, David Jayne
Hitchcock, Gilbert Monell
Hobby, William Pettus
Holt, Henry
Houghton, Henry Oscar
Huebsch, Benjamin W.
Humphreys, James
Hunt, Freeman
Jackson, Charles Samuel
Jewett, John Punchard
Jones, George
Judd, Orange
Kenedy, Patrick John
Kiplinger, Willard Monroe
Kirchwey, Freda
Kline, George
Klopch, Louis
Knapp, Joseph Palmer
Kneeland, Samuel
Knopf, Blanche Wolf
Kohlberg, Alfred
Kollock, Shepard
Lange, Louis
Langlie, Arthur Bernard
Lawrence, David
Lea, Henry Charles
Lea, Isaac
Leslie, Frank
Leslie, Miriam Florence Folline
Leypoldt, Frederick
Lippincott, Joseph Wharton
Lippincott, Joshua Ballinger
Littell, Eliakim
Little, Charles Coffin

Liveright, Horace Brisbin
Longley, Alcander
Lothrop, Daniel
Loudon, Samuel
Luce, Henry Robinson
McClurg, Alexander Caldwell
McCook, Anson George
McElrath, Thomas
Macfadden, Bernarr
McGraw, Donald Cushing
McGraw, James Herbert
McIntyre, Alfred Robert
McLean, William Lippard
Macrae, John
McRae, Milton Alexander
Marble, Manton Malone
Marquis, Albert Nelson
Mattson, Hans
Maxwell, William
Melcher, Frederic Gershom
Meredith, Edna C. Elliott
Meredith, Edwin Thomas
Merriam, Charles
Miller, John Henry
Mitchell, Samuel Augustus
Moody, John
Moreau de Saint-Méry, Médéric-
 Louis-Élie
Morwitz, Edward
Mosher, Thomas Bird
Munn, Orson Desaix
Munro, George
Munsey, Frank Andrew
Murphy, John
Myrick, Herbert
Nieman, Lucius William
Norman, John
Norton, William Warder
Oliver, George Tener
Parks, William
Patterson, Alicia
Peterson, Charles Jacobs
Pittock, Henry Lewis
Plimpton, George Arthur
Polock, Moses
Pomeroy, Marcus Mills
Poulson, Zachariah
Prang, Louis
Pulitzer, Joseph, Jr.
Putnam, Eben
Putnam, George Haven
Putnam, George Palmer
Redfield, Justus Starr
Revell, Fleming Hewitt
Rice, Edwin Wilbur
Ridder, Bernard Herman
Ridder, Herman
Rinehart, Stanley Marshall, Jr.
Root, Frank Albert
Rossiter, William Sidney

Drake, Francis Marion
Durant, Thomas Clark
Evans, John
Farnam, Henry
Grant, John Thomas
Holdrege, George Ward
Holliday, Cyrus Kurtz
Joy, James Frederick
Judah, Theodore Dehone
Keith, Minor Cooper
Kerens, Richard C.
Litchfield, Electus Backus
McCoy, George Braidwood
McDonald, John Bartholomew
Martin, William Thompson
Mason, Claibourne Rice
Meiggs, Henry
Mitchell, Alexander
Packer, Asa
Price, Thomas Lawson
Robinson, Albert Alonzo
Rose, Chauncey
Scullin, John
Stanford, Leland
Stickney, Alpheus Beede
Stone, Amasa
Welch, Charles Clark
Winslow, Edward Francis

Railroad Engineer

Cohen, Mendes
Fink, Albert
Pearson, Edward Jones
Schuyler, James Dix
Spencer, Samuel

Railroad Executive

Ashe, William Shepperd
Atterbury, William Wallace
Baer, George Frederick
Baldwin, William Henry
Bernet, John Joseph
Billings, Frederick
Bishop, William Darius
Boorman, James
Borden, Richard
Bridgers, Robert Rufus
Brown, William Carlos
Budd, Ralph
Burrall, William Porter
Callaway, Samuel Rodger
Cameron, James Donald
Cass, George Washington
Cassatt, Alexander Johnston
Clark, Horace Francis
Clement, Martin Withington
Clifford, John Henry
Clough, William Pitt
Colby, Gardner
Corbin, Austin
Corbin, Daniel Chase
Cowen, John Kissig

Depew, Chauncey Mitchell
Devereux, John Henry
Drayton, Thomas Fenwick
Dudley, Edward Bishop
Echols, John
Fink, Aliert
Fish, Stuyvesant
Gadsden, James
Garrett, John Work
Gordon, William Washington
Gould, George Jay
Gowen, Franklin Benjamin
Gray, Carl Raymond
Harahan, James Theodore
Harahan, William Johnson
Harriman, Edward Henry
Harrington, Samuel Maxwell
Harrison, Fairfax
Hayne, Robert Young
Hill, James Jerome
Hine, Charles de Lano
Holden, Hale
Houston, Henry Howard
Hubbard, Thomas Hamlin
Huntington, Collis Potter
Huntington, Henry Edwards
Ingalls, Melville Ezra
Jeffers, William Martin
Jeffrey, Edward Turner
Jewett, Hugh Judge
Johnston, John Taylor
Jones, Frank
King, John Pendleton
Kirkman, Marshall Monroe
Kneass, Strickland
Lord, Eleazar
Loree, Leonor Fresnel
Lovett, Robert Scott
Lucas, James H.
McCullough, John Griffith
McKennan, Thomas McKean
 Thompson
Mahone, William
Markham, Charles Henry
Mellen, Charles Sanger
Merrick, Samuel Vaughan
Messler, Thomas Doremus
Minty, Robert Horatio George
Negley, James Scott
Newman, William H.
Oakes, Thomas Fletcher
Ogden, William Butler
Olyphant, Robert Morrison
Osborn, William Henry
Palmer, William Jackson
Parsons, Lewis Baldwin
Payne, Henry Clay
Pearson, Edward Jones
Perham, Josiah
Perkins, Charles Elliott

Peters, Richard, 1810–1889
Plumbe, John
Poor, John Alfred
Porter, Horace
Preble, William Pitt
Randolph, Epes
Rea, Samuel
Rice, Edmund
Ripley, Edward Payson
Robb, James
Roberts, George Brooke
Sayre, Robert Heysham
Scott, Thomas Alexander
Scott, William Lawrence
Sewell, William Joyce
Shonts, Theodore Perry
Sloan, Samuel
Smith, Alfred Holland
Smith, John Gregory
Smith, Milton Hannibal
Spencer, Samuel
Sproule, William
Stahlman, Edward Bushrod
Stephens, John Lloyd
Stevens, John Frank
Stewart, Robert Marcellus
Strong, William Barstow
Symes, James Miller
Thomas, John Wilson
Thompson, Arthur Webster
Thomson, Frank
Thomson, John Edgar
Thornton, Henry Worth
Underwood, Frederick Douglas
Vanderbilt, William Henry
Van Horne, William Cornelius
Van Sweringen, Mantis James
Vibbard, Chauncey
Wallace, John Findley
Walters, William Thompson
Willard, Daniel
Worcester, Edwin Dean
Wright, Charles Barstow
Yeager, Joseph
Yoakum, Benjamin Franklin
Young, Robert Ralph
Zimmerman, Eugene

Railroad Expert

Adams, Charles Francis
Allen, William Frederick
Reagan, John Henninger

Railroad Owner

James, Arthur Curtiss
Morgan, Charles
Starin, John Henry

Railroad Promoter (See also Promoter)

Ames, Oliver
Andrews, Alexander Boyd
Brewster, James

Myers, Gustavus
Nichols, Clarina Irene Howard
Nichols, Mary Sargeant Neal Gove
Noyes, John Humphrey
Opdykes George
O'Sullivan, Mary Kenney
Parkhurst, Charles Henry
Pennypacker, Elijah Funk
Philips, Martin Wilson
Phillips, Wendell
Pierpont, John
Pillsbury, Parker
Polk, Frank Lyon
Post, Louis Freeland
Poznanski, Gustavus
Price, Eli Kirk
Quincy, Edmund
Quincy, Josiah, 1772–1864
Rambaut, Mary Lucinda Bonney
Rantoul, Robert, 1778–1858
Rantoul, Robert, 1805–1852
Riis, Jacob August
Ripley, George
Rose, Ernestine Louise Siismondi
 Potowski
Rose, John Carter
Russell, Charles Edward
Sanders, Elizabeth Elkins
Saunders, Prince
Scott, Colin Alexander
Scott, Walter
Seidel, George Lukas Emil
Shaw, Albert
Shaw, Anna Howard
Sherwood, Katharine Margaret
 Brownlee
Sims, William Sowden
Smith, Elizabeth Oakes Prince
Smith, Fred Burton
Smith, Gerrit
Smith, Hannah Whitall
Spargo, John
Spencer, Anna Garlin
Spingarn, Joel Elias
Spreckels, Rudolph
Stanton, Elizabeth Cady
Stanton, Henry Brewster
Steffens, Lincoln
Sterne, Simon
Still, William
Stone, Lucy
Straton, John Roach
Sunderland, Eliza Jane Read
Swallow, Silas Comfort
Swisshelm, Jane Grey Cannon
Sylvis, William H.
Thomas, Norman Mattoon
Tutwiler, Julia Strudwick
Villard, Helen Frances Garrison
Villard, Oswald Garrison

Ward, Henry Dana
Warren, Josiah
Weber, Henry Adam
Whipple, Henry Benjamin
White, Alfred Tredway
Wiley, Harvey Washington
Willard, Frances Elizabeth Caroline
Woodhull, Victoria Claflin Woods,
 Robert Archey
Wright, Elizur
Wright, Frances

REGICIDE
Dixwell, John
Goffe, William
Whalley, Edward

REGIONAL PLANNER
Behrendt, Walter Curt
MacKaye, Benton

REHABILITATION MEDICINE PIONEER
Paul, William Darwin ("Shorty")

RELIEF ORGANIZER
Morgan, Anne

RELIGIOUS ACTIVIST
Robins, Raymond

RELIGIOUS LEADER (See also
 ARCHABBOT, ARCHBISHOP,
 BISHOP, CABALIST, CHAPLAIN,
 CHRISTIAN SCIENCE LEADER,
 CLERGYMAN, EVANGELIST, INDIAN
 PROPHET, METAPHYSICIAN,
 MISSIONARY, MYSTIC, REVIVALIST,
 SPIRITUALIST, THEOLOGIAN,
 THEOSOPHIST,
 TRANSCENDENTALIST
Abbott, Benjamin
Adler, Cyrus
Adler, Felix
Albright, Jacob
Antes, Henry
Backus, Isaac
Bowne, John
Coe, George Albert
Coffin, Henry Sloane
Cox, Henry Hamilton
Dittemore, John Valentine
Divine, Father
Drexel, Katharine Mary
Eddy, Mary Morse Baker
Haven, Henry Philemon
Hodur, Francis
Hutchinson, Anne
Ivins, Anthony Woodward
Jones, Abner
McKay, David Oman
Metz, Christian
Middleton, Arthur
Mills, Benjamin Fay
Morris, Anthony, 1654–1721
Norris, Isaac, 1701–1766
Osgood, Jacob

Poznanski, Gustavus
Pratt, Orson
Rapp, George
Russell, Charles Taze
Rutherford, Joseph Franklin
Sharpless, Isaac
Skaniadariio
Smith, George Albert
Smith, Uriah
Thomas, Richard Henry
Tobias, Channing Heggie
Wilkinson, Jemima
Wood, James
Woolman, John

REMONSTRANT
Child, Robert

**REPUBLICAN PARTY NATIONAL
 CHAIRMAN**
Hamilton, John Daniel Miller, II

RESEARCH INSTITUTE EXECUTIVE
Baroody, William Joseph

RESETTLEMENT EXPERT
Rosen, Joseph A.

RESORT OWNER
Grossinger, Jennie

RESTAURANT CRITIC
Hines, Duncan

RESTAURATEUR
Delmonico, Lorenzo
Kohlsaat, Herman Henry
Romanoff, Michael ("Prince Mike")
Sanders, Harland David ("Colonel")
Sardi, Melchiorre Pio Vencenzo
 ("Vincent")
Sherry, Louis
Stevens, Frank Mozley
Stouffer, Vernon Bigelow

RETAILER
Cushman, Austin Thomas ("Joe")
Hughes, Albert William
Ohrbach, Nathan M. ("N.M.")

REVIVALIST (See also EVANGELIST,
 RELIGIOUS LEADER)
Alline, Henry
Finney, Charles Grandison
Kirk, Edward Norris
Wormley, James

REVOLUTIONARY HEROINE (See
 HEROINE)

REVOLUTIONARY LEADER (See also
 PATRIOT, REVOLUTIONARY
 PATRIOT, SOLDIER, STATESMAN)
Benson, Egbert
Carroll, Charles
Chase, Samuel
Drayton, William Henry
Gadsden, Christopher
Hanson, John
Hindman, William
Hobart, John Sloss

Houston, William Churchill
Houstoun, John
Huger, Isaac
Huger, John
Johnston, Samuel
Jones, Willie
Person, Thomas
Scott, John Morin
Sears, Isaac
Tilghman, Matthew

REVOLUTIONARY PATRIOT (See also
 PATRIOT, REVOLUTIONARY
 LEADER, SOLDIER)
Alexander, Abraham
Arnold, Benedict
Arnold, Jonathan
Banister, John
Bartlett, Josiah
Cabell, William
Frelinghuysen, Frederick
Habersham, Joseph
Harvie, John
Howell, Richard
Howley, Richard
Izard, Ralph
Jones, Noble Wymberley
Jouett, John
Lamb, John
Leaming, Thomas
Lewis, Andrew
Lewis, Fielding
Livingston, Robert R., 1718–1775
Marshall, Christopher
Mason, Thomson
Matlock, Timothy
Mercer, James
Milledge, John
Moore, Maurice
Moore, William, 1735–1793
Nicholas, Robert Carter
Nixon, John, 1733–1808
Page, John
Parsons, Samuel Holden
Peabody, Nathaniel
Pendleton, Edmund
Peters, Richard, 1744–1828
Pettit, Charles
Roberdeau, Daniel
Sands, Comfort
Smith, Robert, 1732–1801
Thornton, Matthew
Tyler, John, 1747–1813
Warren, Joseph
Weare, Meshech
Whipple, William
Yates, Abraham
Yates, Robert
Young, Thomas

REVOLUTIONIST (See also AGITATOR,
 INSURGENT, RADICAL)
Hecker, Friedrich Karl Franz
Heinzen, Karl Peter

Lee, Francis Lightfoot
Rapp, Wilhelm
Reed, John, 1887–1920
Sanders, George Nicholas
Wharton, William H.

RHEUMATOLOGIST (See also
 PHYSICIAN)
Hench, Philip Showalter

RHINOLOGIST (See also PHYSICIAN)
Jarvis, William Chapman

RHYTHM-AND-BLUES MUSICIAN
Jordan, Louis

ROAD BUILDER
Mears, Otto
Mullan, John

ROCKET PIONEER
Goddard, Robert Hutchings

ROCKET SCIENTIST
Braun, Wernher von
Ley, Willy

ROENTGENOLOGIST (See also
 PHYSICIAN, RADIOGRAPHER,
 RADIOLOGIST)
Baetjer, Frederick Henry
Brown, Percy
Caldwell, Eugene Wilson
Williams, Francis Henry

ROWING CHAMPION (See also
 OARSMAN)
Kelly, John Brendan

ROWING COACH (See also ATHLETE,
 OARSMAN)
Cook, Robert Johnson
Courtney, Charles Edward

SAILMAKER
Forten, James

SAILOR (See MARINER)

SALOONKEEPER
Shor, Bernard ("Toots")

SALVAGE EXPERT
Merritt, Israel John

SALVATION ARMY GENERAL
Booth, Evangeline Cory

SANITARIAN (See also ENGINEER
 (SANITARY)
Carter, Henry Rose
Freeman, Allen Weir
Gorgas, William Crawford
Harrington, Charles
Harris, Elisha
Jones, Joseph
Jordan, Edwin Oakes
Kedzie, Robert Clark
Logan, Thomas Muldrup, 1808–
 1876
McCormack, Joseph Nathaniel
Magruder, George Lloyd

RICHARDS, ELLEN HENRIETTA
 SWALLOW
Souchon, Edmond

SATIRIST (See also HUMORIST, WIT)
Alsop, Richard
Hopkins, Lemuel
Locke, David Ross
Smith, Seba
Snelling, William Joseph
Wright, Robert William

SAXOPHONIST
Adderley, Julian Edwin
 ("Cannonball")
Gray, Glen

SCENARIST
Beach, Rex

SCHOLAR (See also ARCHAEOLOGIST,
 ASSYRIOLOGIST, CLASSICIST,
 EGYPTOLOGIST, GENEALOGIST,
 GRAMMARIAN, HEBRAIST,
 HELLENIST, LOGICIAN,
 ORIENTALIST, PHILOLOGIST,
 PHILOSOPHER, SEMITIST,
 SINOLOGUE)
Abbot, Ezra
Abbott, Frank Frost
Adams, Jasper
Allen, Frederic de Forest
Allen, William Francis
Anderson, Henry Tompkins
Anthon, Charles
Baylies, Francis
Beck, Charles
Beeson, Charles Henry
Bennett, Charles Edwin
Biddle, Nicholas
Bliss, Tasker Howard
Botta, Vincenzo
Bunche, Ralph Johnson
Carter, Jesse Benedict
Chase, Thomas
Clinton, DeWitt
Coe, George Albert
Cook, Albert Stanburrough
Crane, Thomas Frederick
Cross, Wilbur Lucius
Curme, George Oliver
Currier, Charles Warren
Curtin, Jeremiah
Dargan, Edwin Preston
Davidson, Thomas
Dennison, Walter
D'Ooge, Martin Luther
Dowling, Noel Thomas
Dunbar, (Helen) Flanders
Dyer, Louis
Edgren, August Hjalmar
Eliot, Samuel
Fay, Edwin Whitefield
Felton, Cornelius Conway

Fenollosa, Ernest Francisco
Fletcher, Robert
Frothingham, Arthur Lincoln
Furness, Horace Howard, 1833–1912
Furness, Horace Howard, 1865–1930
Grandgent, Charles Hall
Green, William Henry
Griswold, Alfred Whitney
Gruening, Emil
Hale, William Gardner
Harkness, Albert
Haven, Joseph
Heilprin, Michael
Hirsch, Emil Gustav
Hohfeld, Wesley Newcomb
Holmes, George Frederick
Hudson, Henry Norman
Humphreys, Milton Wylie
Humphries, George Rolfe
Isaacs, Abram Samuel
Jastrow, Morris
Kaufmann, Walter Arnold
Kaye, Frederick Benjamin
Kendrick, Asahel Clark
Knapp, William Ireland
Kohut, George Alexander
Lewis, William Draper
Lincoln, John Larkin
Logan, James, 1674–1751
MacLean, George Edwin
Malter, Henry
Margolis, Max Leopold
Marsh, George Perkins
Mather, Cotton
Matthiessen, Francis Otto
Merrill, Elmer Truesdell
Miller, Perry Gilbert Eddy
Millett, Fred Benjamin
Mills, Lawrence Heyworth
Mitchell, Hinckley Gilbert Thomas
Monis, Judah
Moore, Clement Clarke
Murphy, Henry Cruse
Newell, William Wells
O'Brien, Justin
Perrin, Bernadotte
Perry, Thomas Sergeant
Pinto, Isaac
Platner, Samuel Ball
Prince, Thomas
Richardson, Rufus Byam
Rorimer, James Joseph
Schinz, Atbert
Schofield, William Henry
Schuyler, Eugene
Scott, Samuel Parsons
Shipman, Andrew Jackson
Soldan, Frank Louls

Solger, Reinhold
Sprecher, Samuel
Stiles, Ezra
Sulzberger, Mayer
Tait, Charles
Taylor, Hannis
Thomas, Calvin
Thorndike, Ashley Horace
Tolman, Herbert Cushing
Torrey, Charles Cutler
Trent, William Peterfield
Updike, Daniel Berkeley
Van der Kemp, Francis Adrian
Van Dyck, Cornelius van Alen
Viel, François Étienne Bernard Alexandre
Wallace, Charles William
Wallace, John William
Warren, Minton
Wiener, Leo
Wigmore, John Henry
Wilde, Richard Henry
Woolsey, Theodore Dwight

SCHOLAR (BIBLICAL)
Cone, Orello
Gregory, Caspar Rene
Hackett, Horatio Balch
Kent, Charles Foster
Mead, Charles Marsh
Mitchell, Edward Cushing
Moorehead, William Gallogly
Morgan, Abel
Norton, Andrews
Packard, Joseph
Paton, Lewis Boyles
Riddle, Matthew Brown
Ropes, James Hardy
Rosenberg, Abraham Hayyim
Sanders, Frank Knight
Sawyer, Leicester Ambrose
Smith, Henry Preserved
Smith, John Merlin Powis
Stevens, William Arnold
Strong, James
Stuart, Moses
Thayer, Joseph Henry

SCHOLAR (LAW)
Cook, Walter Wheeler

SCHOOL BUILDING SPECIALIST
Barrows, Alice Prentice

SCHOOLMASTER (See also EDUCATOR, TEACHER)
Coit, Henry Augustus
Dock, Christopher
Gould, Benjamin Apthorp
Gummere, John
Gunn, Frederick William
Keith, George
Ladd, Catherine
Lovell, James

Lovell, John
McCabe, William Gordon
Mazzuchelli, Samuel Charles
Morton, Charles
Nason, Elias
Peter, John Frederick
Pormort, Philemon
Truteau, Jean Baptiste
Williams, Nathanael

SCIENCE ADMINISTRATOR
Merriam, John Campbell
Ritter, William Emerson

SCIENCE HISTORIAN (See also HISTORIAN)
Thorndike, Lynn

SCIENCE REPORTER
Laurence, William Leonard

SCIENTIFIC MANAGEMENT CONSULTANT
Cooke, Morris Llewellyn

SCIENTIST (See also SPECIFIC SCIENCES)
Agassiz, Jean Louis Rodolphe
Alexander, John Henry
Alexander, William Dewitt
Allen, Zachariah
Arnold, Harold DeForest
Birdseye, Clarence
Brashear, John Alfred
Braun, Wernher von
Brewer, William Henry
Bronk, Detlev Wulf
Brooke, John Mercer
Caswell, Alexis
Clark, William Smith
Cleaveland, Parker
Conant, James Bryant
Cooper, Thomas
Dewey, Chester
Drake, Daniel
Dunbar, William
Durant, Charles Ferson
Eaton, Amos
Emerson, Rollins Adams
Eve, Joseph
Ferguson, Thomas Barker
Ferree, Clarence Errol
Folger, Walter
Franklin, Benjamin
Frazer, John Fries
Frazer, Persifor
Gibbes, Robert Wilson
Gillman, Henry
Greely, Adolphus Washington
Greenhow, Robert
Haldeman, Samuel Steman
Hallock, Charles
Hayes, John Lord
Herrick, Edward Claudius
Hewitt, Peter Cooper

Hill, Thomas
Himes, Charles Francis
Humphreys, Andrew Atkinson
Hyer, Robert Stewart
Jefferson, Thomas
Jeffries, John
Lapham, Increase Allen
LeConte, John
Lee, Charles Alfred
Locke, John
Mease, James
Mell, Patrick Hues
Michaelis, Leonor
Minot, George Richards
Mitchill, Samuel Latham
Morton, Henry
Oliver, Andrew
Olmsted, Denison
Palmer, Walter Walker
Peirce, Charles Sanders
Pliny, Earle Chase
Potamian, Brother
Priestley, Joseph
Rhoads, Cornelius Packard
Saugrain de Vigni, Antoine
 François
Schöpf, Johann David
Seybert, Adam
Sheppard, Samuel Edward
Simpson, Charles Torrey
Spillman, William Jasper
Squier, George Owen
Stallo, Johann Bernhard
Thompson, Samuel Rankin
Thomson, Elihu
Totten, Joseph Gilbert
Trowbridge, William Petit
Van Depoele, Charles Joseph
Wailes, Benjamin Leonard
 Covington
Westergaard, Harald Malcolm
Wilder, Russell Morse
Williamson, Hugh
Wright, Hamilton Kemp
SCOUT (See also GUIDE,
 FRONTIERSMAN, PIONEER)
Bailey, Ann
Bridger, James
Burnham, Frederick Russell
Cody, William Frederick
Dixon, William
Grouard, Frank
Hamilton, William Thomas
Hickok, James Butler
Horn, Tom
Kelly, Luther Sage
McClellan, Robert
Navarre, Pierre
North, Frank Joshua
Reynolds, Charles Alexander

Sieber, Al
Stilwell, Simpson Everett
Stringfellow, Franklin
SCREENWRITER (See AUTHOR,
 DRAMATIST, WRITER)
SCULPTOR (See also ARTIST,
 MODELER)
Adams, Herbert Samuel
Akers, Benjamin Paul
Amateis, Louis
Archipenko, Alexander
Aronson, Boris Solomon
Augur, Hezekiah
Bailly, Joseph Alexis
Ball, Thomas
Barnard, George Grey
Bartholomew, Edward Sheffield
Bartlett, Paul Wayland
Bissell, George Edwin
Bitter, Karl Theodore Francis
Borglum, John Gutzon de la Mothe
Borglum, Solon Hannibal
Boyle, John J.
Brackett, Edward Augustus
Brenner, Victor David
Brooks, Richard Edwin
Browere, John Henri Isaac
Brown, Henry Kirke
Bush-Brown, Henry Kirke
Calder, Alexander
Calder, Alexander Stirling
Calverley, Charles
Clarke, Thomas Shields
Clevenger, Shobal Vail
Cogdell, John Stevens
Connelly, Pierce Francis
Crawford, Thomas
Dallin, Cyrus Edwin
Davidson, Jo
Dexter, Henry
Diller, Burgoyne
Donoghue, John
Doyle, Alexander
Duveneck, Frank
Eakins, Thomas
Eckstein, John
Edmondson, William
Elwell, Frank Edwin
Epstein, Jacob
Ezekiel, Moses Jacob
Flannagan, John Bernard
Fraser, James Earle
Frazee, John
French, Daniel Chester
Gabo, Naum
Garlick, Theodatus
Goldberg, Reuben Lucius ("Rube")
Gould, Thomas Ridgeway
Grafly, Charles
Greenough, Horatio

Greenough, Richard Saltonstall
Hart, Joel Tanner
Hartley, Jonathan Scott
Haseltine, James Henry
Hosmer, Harriet Goodhue
Hoxie, Vinnie Ream
Hughes, Robert Ball
Ives, Chauncey Bradley
Jackson, John Adams
Kemeys, Edward
Kingsley, Norman William
Lachaise, Gaston
Launitz, Robert Eberhard Schmidt
 von der
Lebrun, Federico ("Rico")
Lipchitz, Jacques
Lukeman, Henry Augustus
MacDonald, James Wilson
 Alexander
McKenzie, Robert Tait
MacMonnies, Frederick William
MacNeil, Hermon Atkins
Magonigle, Harold Van Buren
Manship, Paul Howard
Martiny, Philip
Mead, Larkin Goldsmith
Mears, Helen Farnsworth
Mestrovic, Ivan
Mills, Clark
Milmore, Martin
Mozier, Joseph
Mulligan, Charles J.
Nadelman, Elie
Newman, Barnett
Ney, Elisabet
Niehaus, Charles Henry
O'Donovan, William Rudolf
Palmer, Erastus Dow
Partridge, William Ordway
Perkins, Marion
Potter, Edward Clark
Potter, Louis McClellan
Powers, Hiram
Pratt, Bela Lyon
Putnam, Arthur
Quinn, Edmond Thomas
Remington, Frederic
Rimmer, William
Rinehart, William Henry
Roberts, Howard
Rogers, John, 1829–1904
Rogers, Randolph
Ruckstull, Frederick Wellington
Rumsey, Charles Cary
Rush, William
Saint-Gaudens, Augustus
Shrady, Henry Merwin
Simmons, Franklin
Smith, David Roland
Sterne, Maurice

Brown, Prentiss Marsh
Bruce, Blanche K.
Bruce, William Cabell
Buckalew, Charles Rollin
Buckingham, William Alfred
Bulkeley, Morgan Gardner
Burnet, Jacob
Burr, Aaron
Burrows Julius Caesar
Burton, Theodore Elijah
Bush, Prescott Sheldon
Butler, Marion
Butler, Matthew Calbraith
Butler, Pierce
Butler, William Pickens
Byrd, Harry Flood
Cabat, George
Caffery, Donelson
Cain, Harry Pulliam
Camden, Johnson Newlon
Cameron, James Donald
Cameron, Simon
Campbell, George Washington
Capper, Arthur
Caraway, Hattie Ophelia Wyatt
Caraway, Thaddeus Horatius
Carlile, John Snyder
Carlisle, John Griffin
Carpenter, Matthew Hale
Carter, Thomas Henry
Case, Francis Higbee
Chamberlain, George Earle
Chandler, John
Chandler, William Eaton
Chandler, Zachariah
Chavez, Dennis
Chesnut, James
Christiancy, Isaac Peckham
Clark, Bennett Champ
Clark, William Andrews
Clarke, James Paul
Clay, Clement Claiborne
Clay, Clement Comer
Clay, Henry
Clemens, Jeremiah
Cobb, Howell
Cockrell, Francis Marion
Cohen, John Sanford
Coke, Richard
Collamer, Jacob
Colt, Le Baron Bradford
Conkling, Roscoe
Connally, Thomas Terry ("Tom")
Cooper, James
Copeland, Royal Samuel
Cordon, Guy
Corwin, Thomas
Costigan, Edward Prentiss
Couzens, James
Crane, Winthrop Murray

Crawford, William Harris
Curtis, Charles
Cutting, Bronson Murray
Daniel, John Warwick
Davis, Cushman Kellogg
Davis, Garret
Davis, Henry Gassaway
Davis, James John
Davis, Jeff
Dawes, Henry Laurens
Dawson, William Crosby
Depew, Chauncey Mitchell
De Wolf, James
Dickerson, Mahlon
Dill, Clarence Cleveland
Dirksen, Everett McKinley
Dodge, Augustus Caesar
Dodge, Henry
Dolph, Joseph Norton
Donnell, Forrest C.
Dorsey, Stephen Wallace
Douglas, Paul Howard
Douglas, Stephen Arnold
Downey, Sheridan
Drake, Charles Daniel
Dryden, John Fairfield
Duff, James Henderson
Du Pont, Henry Algernon
Dworshak, Henry Clarence
Edge, Walter Evans
Edmunds, George Franklin
Edwards, John
Edwards, Ninian
Elkins, Stephen Benton
Ellis, Powhatan
Elmore, Franklin Harper
Engle, Clair William Walter
Eppes, John Wayles
Ewing, Thomas
Fairbanks, Charles Warren
Fall, Albert Bacon
Felch, Alpheus
Felton, Rebecca Latimer
Fenton, Reuben Eaton
Ferris, Woodbridge Nathan
Ferry, Orris Sanford
Ferry, Thomas White
Fess, Simeon Davidson
Field, Richard Stockton
Fitzpatrick, Benjamin
Flanders, Ralph Edward
Fletcher, Duncan Upshaw
Foot, Samuel Augustus
Foote, Henry Stuart
Foraker, Joseph Benson
Foster, Ephraim Hubbard
Foster, Lafayette Sabine
Foster, Theodore
Fowler, Joseph Smith
Francis, John Brown

Franklin, Jesse
Frazier, Lynn Joseph
Frelinghuysen, Frederick
Frelinghuysen, Theodore
Frye, William Pierce
Gaillard, John
Gear, John Henry
George, James Zachariah
George, Walter Franklin
Geyer, Henry Sheffie
Gibson, Paris
Gillett, Frederick Huntington
Gillette, Guy Mark
Glass, Carter
Goldthwaite, George
Goodhue, Benjamin
Goodrich, Chauncey
Gordon, James
Gore, Thomas Pryor
Gorman, Arthur Pue
Graham, Frank Porter
Grayson, William
Green, James Stephens
Green, Theodore Francis
Grimes, James Wilson
Gruening, Ernest
Grundy, Joseph Ridgway
Guffey, Joseph F.
Guggenheim, Simon
Hager, John Sharpenstein
Hale, Frederick
Hamilton, William Thomas
Hamlin, Hannibal
Hammond, James Henry
Hampton, Wade, 1818–1902
Hanna, Marcus Alonzo
Hannegan, Edward Allen
Hanson, Alexander Contee, 1786–
 1819
Hardin, Martin D.
Hardwick, Thomas William
Harlan, James
Harris, William Alexander
Harrison, Byron Patton
Hart, Philip Aloysius
Hastings, Daniel Oren
Hatch, Carl A.
Hawkins, Benjamin
Hawley, Joseph Roswell
Hayden, Carl Trumbull
Hayne, Robert Young
Hearst, George
Heflin, James Thomas
Henderson, John
Henderson, John Brooks
Hendricks, Thomas Andrews
Henry, John, 1750–1798
Hill, Joshua
Hill, Nathaniel Peter
Hindman, William

Bloor, Ella Reeve
Corey, Lewis
Debs, Eugene Victor
DeLeon, Daniel
Ghent, William James
Gronlund, Laurence
Hayes, Max Sebastian
Hillquit, Morris
Hoan, Daniel Webster
Hunter, Robert
London, Meyer
McLevy, Jasper
Mailly, William
Maurer, James Hudson
Mooney, Thomas Joseph
O'Hare, Kate (Richards)
 Cunningham
Russell, Charles Edward
Seidel, George Lukas Emil
Sorge, Friedrich Adolph
Spargo, John
Thomas, Norman Mattoon
Vladeck, Baruch Charney
Walling, William English
Young, Art

SOCIALITE
Belmont, Alva Ertskin Smith
 Vanderbilt
Bingham, Anne Willing
Gardner, Isabella Stewart
Harriman, Florence Jaffray Hurst
Longworth, Alice Lee Roosevelt
McAllister, Samuel Ward
Mackay, Clarence Hungerford
Manville, Thomas Franklyn
 ("Tommy"), Jr.
Paley, Barbara Cushing ("Babe")
Palmer, Bertha Honore
Rublee, George
Smith, Margaret Bayard
Thaw, Harry Kendall
Vanderbilt, Gloria Morgan
Vanderbilt, Grace Graham Wilson

SOCIAL PHILOSOPHER (See also
 PHILOSOPHER)
Fromm, Erich
Herberg, Will
Lindeman, Eduard Christian

SOCIAL PSYCHOLOGIST (See also
 PSYCHOLOGIST)
Cantril, Albert Hadley
Martin, Everett Dean
Overstreet, Harry Allen

SOCIAL REFORMER (See also
 REFORMER)
Addams, Jane
Andrews, John Bertram
Bellanca, Dorothy Jacobs
Blanshard, Paul
Blatch, Harriot Eaton Stanton

Brisbane, Albert
Chapin, Henry Dwight
Collins, John Anderson
Crosby, Ernest Howard
Darrow, Clarence Seward
Dennison, Henry Sturgis
Dietz, Peter Ernest
Dock, Lavinia Lloyd
Dreier, Mary Elisabeth
Fuller, Sarah Margaret
Gillette, King Camp
Gilman, Charlotte Perkins Stetson
Hamilton, Alice
Hazard, Thomas Robinson
Holmes, John Haynes
Jemison, Alice Mae Lee
Jones, Rufus Matthew
Kellogg, Paul Underwood
Lindsey, Benjamin Barr
Longley, Alcander
McBride, F(rancis) Scott
McClure, Samuel Sidney
Mussey, Ellen Spencer
Nathan, Maud
O'Hare, Kate (Richards)
 Cunningham
Owen, Robert Dale
Oxnam, Garfield Bromley
Peck, Lillie
Pinchot, Cornelia Elizabeth Bryce
Poling, Daniel Alfred
Regan, Agnes Gertrude
Robins, Margaret Dreier
Robins, Raymond
Roosevelt, (Anna) Eleanor
Ryan, John Augustine
Simkhovitch, Mary Melinda
 Kingsbury
Strong, Josiah
Swinton, John
Taylor, Graham
Tibbles, Thomas Henry
Tiffany, Katrina Brandes Ely
Voris, John Ralph

SOCIAL RESEARCHER
Bryant, Louise Frances Stevens

SOCIAL SCIENTIST (See also SPECIFIC
 SOCIAL SCIENCES)
Bateson, Gregory
Frank, Lawrence Kelso
Kracauer, Siegfried
Mayo, George Elton
Merriam, Charles Edward, Jr.
Mitchell, Wesley Clair
Sullivan, Harry Stack
Sumner, William Graham

SOCIAL SERVICES ADMINISTRATOR
Switzer, Mary Elizabeth

SOCIAL WELFARE LEADER
Brackett, Jeffrey Richardson
Mack, Julian William
Swift, Linton Bishop

SOCIAL WORKER (See also
 SETTLEMENT WORKER)
Abbott, Edith
Abbott, Grace
Adie, David Craig
Antin, Mary
Balch, Emily Greene
Barrett, Janie Porter
Billikopf, Jacob
Binford, Jessie Florence
Blaustein, David
Bloomfield, Meyer
Bowen, Louise De Koven
Brace, Charles Loring
Breckenridge, Sophonisba Preston
Cabot, Richard Clarke
Cannon, Ida Maud
Carr, Charlotte Elizabeth
Coyle, Grace Longwell
Cratty, Mabel
Devine, Edward Thomas
Dinwiddie, Courtenay
Dodge, Grace Hoadley
Doremus, Sarah Platt Haines
Dyott, Thomas W.
Elliott, John Lovejoy
Glueck, Eleanor Touroff
Hart, Hastings Hornell
Hersey, Evelyn Weeks
Hopkins, Harry Lloyd
Hunter, Robert
Johnson, Alexander
Kelley, Florence
Kober, George Martin
Lathrop, Alice Louise Higgins
Lathrop, Julia Clifford
Lee, Joseph
Lee, Porter Raymond
Lewis, Orlando Faulkland
Loeb, Sophie Irene Simon
Lovejoy, Owen Reed
McDowell, Mary Eliza
McHugh, Rose John
Mason, Lucy Randolph
Park, Maud Wood
Peirce, Bradford Kinney
Perkins, James Handasyd
Perry, Clarence Arthur
Potter, Ellen Culver
Richmond, Mary Ellen
Robertson, Alice Mary
Rubinow, Isaac Max
Schuyler, Louisa Lee
Shuey, Edwin Longstreet
Thurber, Christopher Carson
Veiller, Lawrence Turnure
West, James Edward
Willard, Mary Hatch
Williams, Aubrey Willis

Bonham, Milledge Luke
Bonneville, Benjamin Louis Eulalie
 de
Borland, Solon
Boteler, Alexander Robinson
Bouquet, Henry
Bourke, John Gregory
Bourne, Benjamin
Bowers, Theodore Shelton
Bowie, James
Boyle, Jeremiah Tilford
Boynton, Edward Carlisle
Bradstreet, John
Bragg, Braxton
Bragg, Edward Stuyvesant
Branch, Lawrence O'Bryan
Brannan, John Milton
Bratton, John
Brayman, Mason
Breckenridge, James
Breckinridge, John Cabell
Brodhead, Daniel
Brooke, Francis Taliaferro
Brooke, John Rutter
Brooks, John
Brooks, William Thomas Harbaugh
Brown, Jacob Jennings
Brown, John
Browne, Thomas
Buchanan, Robert Christie
Bucher, John Conrad
Buckland, Ralph Pomeroy
Buckner, Simon Bolivar
Buell, Don Carlos
Buford, Abraham, 1749–1833
Buford, Abraham, 1820–1884
Buford, John
Buford, Napoleon Bonaparte
Burbridge, Stephen Gano
Burleson, Edward
Burnett, Henry Lawrence
Burnside, Ambrose Everett
Burr, Aaron
Bussey, Cyrus
Butler, Benjamin Franklin
Butler, John
Butler, Matthew Calbraith
Butler, Richard
Butler, Walter N.
Butler, William
Butler, William Orlando
Butler, Zebulon
Butterfield, Daniel
Cabell, Samuel Jordan
Cabell, William Lewis
Cadwalader, John
Cadwalader, Lambert
Cameron, Robert Alexander
Camp, John Lafayette
Campbell, William

Canby, Edward Richard Sprigg
Capers, Ellison
Carlson, Evans Fordyce
Carr, Eugene Asa
Carr, Joseph Bradford
Carroll, Samuel Sprigg
Carson, Christopher
Casey, Silas
Cass, Lewis
Caswell, Richard
Cesnola, Luigi Palma di
Chaffee, Adna Romanza
Chalmers, James Ronald
Chamberlain, Joshua Lawrence
Chandler, John
Cheatham, Benjamin Franklin
Chesnut, James
Chetlain, Augustus Louis
Childs, Thomas
Chisolm, Alexander Robert
Christian, William
Church, Benjamin
Churchill, Thomas James
Cilley, Joseph
Cist, Henry Martin
Claghorn, George
Clark, Charles
Clark, William Smith
Clark, William Thomas
Clarke, Elijah
Clarkson, Matthew
Clay, Green
Clay, Joseph
Cleburne, Patrick Ronayne
Clemens, Jeremiah
Cleveland, Benjamin
Clinton, George
Clinton, James
Cobb, David
Cobb, Thomas Reade Rootes
Cochrane, Henry Clay
Cocke, Philip St. George
Cocke, William
Cockrell, Francis Marion
Cofer, Martin Hardin
Colquitt, Alfred Holt
Combs, Leslie
Conger, Edwin Hurd
Conner, James
Connor, Patrick Edward
Cook, Philip
Cooke, Philip St. George
Cooper, Joseph Alexander
Coppée, Henry
Corbin, Henry Clark
Cornell, Ezekiel
Cox, William Ruffin
Crane, John
Crawford, Martin Jenkins
Crawford, Samuel Johnson

Crawford, William
Cresap, Michael
Crittenden, George Bibb
Crittenden, Thomas Leonidas
Croghan, George
Croix, Teodoro de
Crook, George
Crosby, John Schuyler
Crozet, Claude
Cullum, George Washington
Curtis, Newton Martin
Curtis, Samuel Ryan
Custer, George Armstrong
Dale, Samuel
Dale, Sir Thomas
Dana, Napoleon Jackson Tecumseh
Darke, William
Davenport, George
Davidson, John Wynn
Davidson, William Lee
Davie, William Richardson
Davies, Henry Eugene
Davis, George Breckenridge
Davis, George Whitefield
Davis, Jefferson Columbus
Davis, Joseph Robert
Dayton, Elias
Dayton, Jonathan
Dearborn, Henry
Deas, Zachariah Cantey
De Haas, John Philip
De Lacy, Walter Washington
De Lancey, James
De Lancey, Oliver
Delany, Martin Robinson
De Mézières y Clugny, Athanase
Dent, Frederick Tracy
Denver, James William
De Peyster, John Watts
De Trobriand, Régis Denis de
 Keredern
Devens, Charles
Devin, Thomas Casimer
Dibrell, George Gibbs
Dickey, Theophilus Lyle
Dickinson, Philemon
Dickman, Joseph Theodore
Diven, Alexander Samuel
Dix, John Adams
Dodge, Henry
Donelson, Andrew Jackson
Dongan, Thomas
Doniphan, Alexander William
Donovan, William Joseph
Doubleday, Abner
Douglas, Henry Kyd
Douglas, William
Douglass, David Bates
Dow, Henry
Draper, William Franklin

Hazen, Moses
Hazen, William Babcock
Heath, William
Hébert, Louis
Hébert, Paul Octave
Hecker, Friedrich Karl Franz
Heintzelman, Samuel Peter
Henderson, David Bremner
Henderson, Thomas
Henningsen, Charles Frederick
Herbert, Hilary Abner
Herkimer, Nicholas
Heth, Henry
Heyward, Thomas
Hibben, Paxton Pattison
Hickenlooper, Andrew
Hickok, James Butler
Hiester, Joseph
Higginson, Henry Lee
Higginson, Thomas Wentworth
Hill, Ambrose Powell
Hill, Daniel Harvey
Hill, James
Hill, William
Hindman, Thomas Carmichael
Hitchcock, Ethan Allen, 1798–1870
Hitchcock, Henry
Hobson, Edward Henry
Hodes, Henry Irving
Hodges, Courtney Hicks
Hoffman, Wickham
Hogun, James
Hoke, Robert Frederick
Holmes, Julius Cecil
Holmes, Theophilus Hunter
Hood, John Bell
Hooker, Joseph
Hopkins, Samuel, 1753–1819
Hough, Warwick
Houston, Samuel
Hovey, Alvin Peterson
Hovey, Charles Edward
Howard, Benjamin
Howard, John Eager
Howard, Oliver Otis
Howe, Albion Parris
Howe, Robert
Howe, William Wirt
Howze, Robert Lee
Hubbard, Lucius Frederick
Hubbard, Richard Bennett
Hubbard, Thomas Hamlin
Huger, Benjamin
Huger, Francis Kinloch
Hughes, George Wurtz
Hull, William
Humbert, Jean Joseph Amable
Humphreys, Andrew Atkinson
Humphreys, Benjamin Grubb
Humphreys, David

Hunt, Henry Jackson
Hunter, David
Huntington, Jedediah
Hunton, Eppa
Hurlburt, Stephen Augustus
Huse, Caleb
Hyrne, Edmund Massingberd
Imboden, John Daniel
Ingraham, Prentiss
Inman, George
Inman, Henry
Ireland, John, 1827–1896
Irvine, James
Irvine, William
Irwin, George Le Roy
Ives, Joseph Christmas
Izard, George
Jackson, Henry Rootes
Jackson, Thomas Jonathan
Jackson, William, 1759–1828
Jacob, Richard Taylor
Jadwin, Edgar
Jaquess, James Frazier
Jasper, William
Jenkins, Albert Gallatin
Jenkins, John
Jenkins, Micah
Jennings, John
Jesup, Thomas Sidney
Johnson, Bradley Tyler
Johnson, Bushrod Rust
Johnson, Edward
Johnson, James
Johnson, Richard W.
Johnston, Albert Sidney
Johnston, Joseph Eggleston
Johnston, Peter
Johnston, William Preston
Johnston, Zachariah
Jones, Allen
Jones, David Rumph
Jones, John B.
Jones, William
Jordan, Thomas
Kane, Thomas Leiper
Kautz, August Valentine
Kearney, Philip
Kearney, Stephen Watts
Keifer, Joseph Warren
Keitt, Lawrence Massillon
Kelton, John Cunningham
Kemper, James Lawson
Kennedy, John Doby
Kennedy, Robert Patterson
Kershaw, Joseph Brevard
Key, David McKendree
Keyes, Erasmus Darwin
Kilmer, Alfred Joyce
Kilpatrick, Hugh Judson
Kimball, Nathan

King, Rufus
Kirby-Smith, Edmund
Knowlton, Thomas
Kosciuszko, Tadeusz Andrzej
 Bonawentura
Lacey, John
Lacey, John Fletcher
Lafayette, Marie Joseph Paul Yves
 Roch Gilbert du Motier, Marquis
 de
Lamb, John
Lander, Frederick West
Lane, James Henry, 1814–1866
Lane, James Henry, 1833–1907
Lane, Joseph
Lane, Walter Paye
Larrabee, Charles Hathaway
Laurance, John
Laurens, John
Law, Evander McIvor
Lawton, Alexander Robert
Lawton, Henry Ware
Lea, Homer
Leaming, Thomas
Learned, Ebenezer
Leavenworth, Henry
Le Duc, William Gates
Ledyard, William
Lee, Fitzhugh
Lee, George Washington Custis
Lee, Henry ("Light-Horse Harry"),
 1756–1818
Lee, Henry, 1787–1837
Lee, Robert Edward
Lee, Stephen Dill
Lee, William Henry Fitzhugh
Le Gendre, Charles William
Leggett, Mortimer Dormer
L'Enfant, Pierre Charles
Lewis, Andrew
Lewis, Isaac Newton
Lewis, Joseph Horace
Lewis, Morgan
Lewis, William Gaston
Liggett, Hunter
Lightburn, Joseph Andrew Jackson
Lincoln, Benjamin
Livingston, James
Locke, Matthew
Lockwood, James Booth
Logan, John Alexander
Lomax, Lunsford Lindsay
Longstreet, James
Lorimier, Pierre Louis
Loring, William Wing
Lovell, Mansfield
Lowrey, Mark Perrin
Lowry, Robert
Lubbock, Francis Richard
Ludlow, William

Patrick, Marsena Rudolph
Patterson, Robert
Peck, John James
Pelham, John
Pemberton, John Clifford
Peñalosa Briceño, Diego Dionisio
Pender, William Dorsey
Pendleton, William Nelson
Pennypacker, Galusha
Pepperrell, Sir William
Perry, Edward Aylesworth
Pettigrew, James Johnston
Pettus, Edmund Winston
Phelps, Charles Edward
Philips, John Finis
Phillps, William Addison
Phisterer, Frederick
Pickens, Andrew
Pickering, Timothy
Pickett, George Edward
Pierce, William Leigh
Pike, Albert
Pike, Zebulon Montgomery
Pillow, Gideon Johnson
Pinckney, Charles Cotesworth
Pinckney, Thomas
Pitcairn, John
Plaisted, Harris Merrill
Pleasonton, Alfred
Plumb, Preston B.
Poe, Orlando Metcalfe
Polk, Lucius Eugene
Polk, Thomas
Polk, William
Pomeroy, Seth
Pond, Peter
Poor, Enoch
Pope, John
Porter, Andrew
Porter, Fitz-John
Porter, Horace
Posey, Thomas
Potter, James
Potter, Robert Brown
Potts, Benjamin Franklin
Powel, John Hare
Pratt, Richard Henry
Prentiss, Benjamin Mayberry
Prescott, Oliver
Prescott, William
Preston, John Smith
Preston, William
Price, Sterling
Pryor, Nathaniel
Pryor, Roger Atkinson
Pulaski, Casimir
Putnam, Eben
Putnam, George Haven
Putnam, Israel
Putnam, Rufus

Quesnay, Alexandre-Marie
Quimby, Isaac Ferdinand
Quitman, John Anthony
Rains, Gabriel James
Rains, George Washington
Ramsay, George Douglas
Ramsay, Nathaniel
Ramseur, Stephen Dodson
Ransom, Matt Whitaker
Ransom, Thomas Edward
 Greenfield
Raum, Green Berry
Rawlins, John Aaron
Read, Jacob
Reed, James, 1772–1807
Reed, John, 1757–1845
Reed, Joseph
Reno, Jesse Lee
Revere, Joseph Warren
Reynolds, Alexander Welch
Reynolds, John Fulton
Reynolds, Joseph Jones
Richardson, Israel Bush
Richardson, Wilds Preston
Ricketts, James Brewerton
Riley, Bennet
Ripley, Edward Hastings
Ripley, Eleazar Wheelock
Ripley, James Wolfe
Ripley, Roswell Sabine
Roane, John Selden
Roberts, Benjamin Stone
Roberts, Oran Milo
Robertson, Jerome Bonaparte
Robinson, John Cleveland
Robinson, Moses
Rochambeau, Jean Baptiste
 Donatien Vimeur, Comte de
Rockwell, Kiffin Yates
Roddey, Philip Dale
Rodenbough, Theophilus Francis
Rodes, Robert Emmett
Rodman, Isaac Peace
Rodman, Thomas Jackson
Rodney, Thomas
Romans, Bernard
Rosecrans, William Starke
Ross, Lawrence Sullivan
Rosser, Thomas Lafayette
Rousseau, Lovell Harrison
Ruger, Thomas Howard
Ruggles, Timothy
Rusk, Thomas Jefferson
Russell, David Allen
Rutgers, Henry
St. Ange Bellerive, Louis de
St. Clair, Arthur
St. Denis (Denys), Louis Juchereau
 de

St. Lusson, Simon François
 Daumont, Sieur de
St. Vrain, Ceran de Hault de Lassus
 de
Sargent, Henry
Sargent, Winthrop, 1753–1820
Scammell, Alexander
Scharf, John Thomas
Schenck, Robert Cumming
Schnauffer, Carl Heinrich
Schofield, John McAllister
Schriver, Edmund
Schurz, Carl
Schuyler, Peter
Schuyler, Philip John
Scott, Charles
Scott, Robert Kingston
Scott, Winfield
Scudder, Nathaniel
Sedgwick, John
Sedgwick, Robert
Seeger, Alan
Sevier, John
Sewell, William Joyce
Seymour, Truman
Shafter, William Rufus
Shaw, Samuel
Shays, Daniel
Shelby, Evan
Shelby, Isaac
Shelby, Joseph Orville
Shepard, William
Shepley, George Foster
Sheridan, Philip Henry
Sherman, Thomas West
Sherman, William Tecumseh
Sherwood, Isaac Ruth
Shields, James
Shipp, Scott
Shoup, Francis Asbury
Sickles, Daniel Edgar
Sidell, William Henry
Sigel, Franz
Simmons, Thomas Jefferson
Simms, William Elliott
Simonton, Charles Henry
Simpson, James Hervey
Smallwood, William
Smith, Andrew Jackson
Smith, Charles Ferguson
Smith, Charles Henry, 1827–1902
Smith, Daniel
Smith, Francis Henney
Smith, Giles Alexander
Smith, Gustavus Woodson
Smith, James, 1737–1814
Smith, James Francis
Smith, John Eugene
Smith, Martin Luther
Smith, Morgan Lewis

Erlanger, Abraham Lincoln
Fiske, Stephen Ryder
Fleming, William Maybury
Ford, John Thomson
Fox, George Washington Lafayette
Frohman, Charles
Frohman, Daniel
Hallam, Lewis
Hamblin, Thomas Sowerby
Hammerstein, Oscar
Harrison, Gabriel
Haverly, Christopher
Henry, John, 1746–1794
Hodgkinson, John
Hurok, Solomon Isaievitch
Keith, Benjamin Franklin
Klaw, Marc
Lewis, Arthur
Logan, Cornelius Ambrosius
Ludlow, Noah Miller
McVicker, James Hubert
Merry, Ann Brunton
Miller, Henry
Mitchell, William, 1798–1856
Niblo, William
Palmer, Albert Marshman
Pastor, Antonio
Powell, Snelling
Pray, Isaac Clark
Presbrey, Eugene Wiley
Price, Stephen
Proctor, Frederick Francis
Proctor, Joseph
Rankin, McKee
Richings, Peter
Seymour, William
Simpson, Edmund Shaw
Smith, Solomon Franklin
Thorne, Charles Robert
Tyler, George Crouse
Warren, William, 1767–1832
Wemyss, Francis Courtney
Wheatley, William
Wignell, Thomas
Wikoff, Henry
Wood, William Burke

**THEATRICAL PRODUCER (See also
PRODUCER)**
Bloomgarden, Kermit
Harris, Jed
Hayward, Leland
Todd, Mike

**THEOLOGIAN (See also RELIGIOUS
LEADER)**
Apple, Thomas Gilmore
Appleton, Jesse
Beckwith, Clarence Augustine
Bellamy, Joseph
Boisen, Anton Theophilus
Bouquillon, Thomas Joseph

Brown, William Adams
Bruté de Rémur, Simon William
 Gabriel
Bushnell, Horace
Chambers, Talbot Wilson
Cheever, Henry Theodore
Clarke, William Newton
Coit, Thomas Winthrop
Colton, Walter
Corcoran, James Andrew
Curtis, Olin Alfred
Curtiss, Samuel Ives
Dabney, Robert Lewis
David, John Baptist Mary
Dempster, John
Dodge, Ebenezer
Du Bose, William Porcher
Edwards, Jonathan, 1703–1758
Edwards, Jonathan, 1745–1801
Emmons, Nathanael
Erdman, Charles Rosenbury
Evans, Hugh Davey
Everett, Charles Carroll
Fenn, William Wallace
Foster, Frank Hugh
Fritschel, Conrad Sigmund
Fritschel, Gottfried Leonhard
 Wilhelm
Gerhart, Emanuel Vogel
Gillis, James Martin
Girardeau, John Lafayette
Gräbner, August Lawrence
Hall, Charles Cuthbert
Harris, Samuel
Hart, Samuel
Herberg, Will
Heschel, Abraham Joshua
Hodge, Charles
Hoenecke, Gustav Adolf Felix
 Theodor
Hopkins, Mark
Hopkins, Samuel, 1721–1803
Hoye, Elling
Huidekoper, Frederic
Huidekoper, Harm Jan
Jacobs, Henry Eyster
Johnson, Elias Henry
Johnson, Erik Kristian
King, Henry Churchill
Knox, George William
Krauth, Charles Porterfield
Ladd, George Trumbull
Little, Charles Joseph
Lord, David Nevins
McCaffrey, John
Machen, John Gresham
Macintosh, Douglas Clyde
Mathews, Shailer
Monis, Judah
Moore, George Foot

Nevin, John Williamson
Niebuhr, Helmut Richard
Niebuhr, Karl Paul Reinhold
 ("Reinie")
Niles, Nathaniel, 1741–1828
Oftedal, Sven
Park, Edwards Amasa
Parker, Theodore
Patton, Francis Landey
Pieper, Franz August Otto
Prince, Thomas
Raymond, Miner
Richard, James William
Ridgaway, Henry Bascom
Ropes, James Hardy
Schmidt, Friedrich August
Schmucker, Samuel Simon
Seyffarth, Gustavus
Shedd, William Greenough Thayer
Smith, Gerald Birney
Smith, Henry Boynton
Smyth, Newman
Sperry, Willard Learoyd
Stearns, Oliver
Stevens, George Barker
Strong, Augustus Hopkins
Stuckenberg, John Henry Wilbrandt
Sverdrup, Georg
Talmage, James Edward
Taylor, Nathaniel William
Thacher, Peter
Thacher, Samuel Cooper
Tillich, Paul
Tyler, Bennet
Valentine, Milton
Walther, Carl Ferdinand Wilhelm
Watson, Charles Roger
Weidner, Revere Franklin
Weigel, Gustave
Wigglesworth, Edward, 1693–1765
Wigglesworth, Edward, 1732–1794
Woodbridge, Samuel Merrill

**THEOSOPHIST (See also RELIGIOUS
LEADER)**
Judge, William Quan
Tingley, Katherine Augusta
 Westcott
Warrington, Albert Powell

TOBACCONIST
Ginter, Lewis

TOOL BUILDER
Hartness, James

**TOPOGRAPHER (See also
CARTOGRAPHER, MAPMAKER)**
Ogden, Herbert Gouverneur

**TOPOGRAPHICAL ENGINEER (See
ENGINEER, TOPOGRAPHICAL)**

TOXICOLOGIST (See also PHYSICIAN)
Henderson, Yandell
Reese, John James

Clarke, Rebecca Sophia (juvenile)
Cocke, Philip St. George
(agricultural)
Cohen, Octavus Roy (screen)
Cohn, Alfred A. (magazine, screen)
Colburn, Dana Pond (textbook)
Coleman, Lyman (religious)
Colman, Henry (agricultural)
Colum, Padraic (children's books)
Considine, Robert ("Bob") Bernard
(columnist)
Cooke, Philip Pendleton (story)
Cooke, Rose Terry (story)
Cozzens, James Gould
Cullen, Countée Porter (essayist)
Da Ponte, Lorenzo (librettist)
Davenport, Russell Wheeler
Davis, Elmer Holmes (magazine)
Davis, Watson (science)
Deane, Samuel (agricultural)
Dercum, Francis Xavier (medical)
Dickson, David (agricultural)
Dobie, J(ames) Frank
Drinkwater, Jennie Maria (juvenile)
Dunglison, Robley (medical)
Eastman, Max Forrester
Edman, Irwin (philosophy)
Elliott, Charles Burke (legal)
Epstein, Philip G. (screen)
Faulkner (Falkner), William
Cuthbert (short story)
Fauset, Jessie Redmon
Ferguson, Elizabeth Graeme (letter)
Fischer, Louis
Fischer, Ruth
Flandrau, Charles Macomb
(essayist)
Flanner, Janet
Fletcher, Alice Cunningham
(Indian music)
Fletcher, Horace (nutrition)
Frank, Waldo David
Gág, Wanda (Hazel) (juvenile)
Gale, Benjamin (political)
Gardner, Erle Stanley (detective
fiction)
Gaylord, Willis (agricultural)
Genung, John Franklin (religious)
Gilman, Charlotte Perkins Stetson
Gold, Michael
Goldbeck, Robert (music)
Gonzales, Ambrose Elliott (Negro
dialect story)
Gouge, William M. (financial)
Grant, Jane Cole (free-lance)
Greene, Samuel Stillman (textbook)
Greenleaf, Benjamin (mathematical
textbook)
Guest, Edgar Albert (popular verse)
Gulick, John Thomas (evolution)

Hall, Bolton
Halsman, Philippe
Hammett, Samuel Dashiell
(detective fiction)
Hawes, Charles Boardman
(adventure)
Hawks, Howard Winchester
Hazard, Rowland Gibson
(philosophy)
Headley, Phineas Camp (biography)
Heard, Franklin Fiske (legal)
Heaton, John Langdon (editorial)
Hecht, Ben (screen)
Held, John, Jr.
Hemingway, Ernest Miller (short
story)
Hening, William Waller (legal)
Henshall, James Alexander (angling)
Herbert, Frederick Hugh (screen)
Hergesheimer, Joseph (short story)
High, Stanley Hoflund (magazine)
Hilliard, Francis (legal)
Hindus, Maurice Gerschon
Hobart, Alice Nourse Tisdale
Hoffman, Frederick Ludwig
Hoffmann, Francis Arnold
(agricultural)
Horner, William Edmonds
(medical)
Huebner, Solomon Stephen
Hunter, Robert
Hutchinson, Paul (religious
subjects)
Huxley, Aldous Leonard
Jackson, Charles Reginald (short
story)
Jackson, Joseph Henry
Jackson, Shirley Hardie (short story)
James, George Wharton (Southwest)
James, Henry, 1811–1882
(religious)
Jarrell, Randall (essayist)
Jenks, George Charles (dime novel)
Johnson, Joseph French (financial)
Johnson, Nunnally Hunter (screen)
Johnson, Owen McMahon (short
story)
Johnston, Annie Fellows (juvenile)
Jones, Leonard Augustus (legal)
Judson, Frederick Newton (legal)
Kaufman, George S. (screen)
Kellogg, Edward (commercial
reform)
Kent, James (legal)
Kerouac, Jack (essayist)
Kim, Sophie (short story)
Keyes, Frances Parkinson
Klippart, John Hancock
(agricultural)
Kracauer, Siegfried

Kronenberger, Louis, Jr.
Krutch, Joseph Wood
Lahontan, Louis-Armand de Lom
D'Arce, Baron de (travel)
Laimbeer, Nathalie Schenck
(financial)
Lait, Jacquin Leonard (Jack)
(newspaper)
Langdell, Christopher Columbus
(legal)
Lathrop, Harriett Mulford Stone
(juvenile)
Lawrence, William Beach (legal)
Lawson, John Howard (screen)
Leaf, Wilbur Munro (children's
books)
Lease, Mary Elizabeth Clyens
Lee, Gypsy Rose
Lee, Manfred B.
Ley, Willy
Liggett, Walter William
Linton, Ralph (popular)
Livermore, Samuel, 1786–1822
(legal)
Long, Joseph Ragland (legal)
Lowell, John, 1769–1840 (political)
Lowell, Robert Traill Spence, Jr.
McClintock, James Harvey
(historical)
McCord, Louisa Susanna Cheves
(Antebellum South)
McCullers, Carson (short story)
MacDowell, Katherine Sherwood
Bonner (short story)
McFee, William (essayist, novelist)
MacKaye, Percy Wallace (essayist)
Mackey, Albert Gallatin (Masonic)
McNulty, John Augustine (short
story)
McWilliams, Carey
Magruder, Julia (short story)
Mankiewicz, Herman Jacob
(screen)
Martin, Edward Sandford (essayist)
Mathews, William Smythe Babcock
(music)
Merton, Thomas (religious)
Metalious, Grace
Meyer, Agnes Elizabeth Ernst
Meyer, Annie Nathan
Meyer, Frank Straus
Millay, Edna St. Vincent (poetry)
Millington, John (scientific)
Millis, Walter
Minor, John Barbee (legal)
Montgomery, David Henry
(textbook)
Moore, Charles Herbert (fine arts)
Moore, John Weeks (music)

Morley, Christopher Darlington
 (essayist)
Morris, Edmund (agricultural)
Morris, Robert, 1818–1888
 (Masonic)
Morton, James St. Clair
 (engineering)
Moulton, Ellen Louise Chandler
 (juvenile)
Mulford, Clarence Edward
 (magazine)
Murfree, Mary Noailles (short story)
Musmanno, Michael Angelo
Nabokov, Nicolas
Nabokov, Vladimir Vladimirovich
Nichols, Dudley (screen)
Nitchie, Edward Bartlett (lip-
 reading)
O'Connor, Mary Flannery (short
 story)
Odets, Clifford (screen)
O'Hara, John Henry (short story)
Olney, Jesse (textbook)
Oursler, (Charles) Fulton
Paine, Albert Bigelow (light fiction)
Palmer, Alonzo Benjamin (medical)
Parker, Dorothy Rothschild (short
 story)
Parker, Henry Taylor (essayist)
Parker, Richard Green (textbook)
Peabody, Francis Greenwood
 (religious thought)
Pearson, Edmund Lester (crime
 stories)
Peary, Josephine Diebitsch
Peattie, Donald Culross (magazine)
Periam, Jonathan (agricultural)
Perkins, Samuel Elliott (legal)
Perry, Nora (juvenile)
Peterkin, Julia Mood (short story)
Peters, John Charles (medical)
Philips, Martin Wilson
 (agricultural)
Phillips, Thomas Wharton
 (religious)
Pitkin, Walter Boughton
Poe, Edgar Allan (short story)
Pomeroy, John Norton (legal)
Porter, Gene Stratton (nature)
Porter, Katherine Anne (short story)
Porter, William Sydney (short story)
Post, Augustus
Post, Melville Davisson (short story)
Powell, John Benjamin
Pratt, Eliza Anna Farman (juvenile)
Prentiss, Elizabeth Payson (juvenile)
Priestley, Joseph (religious)
Prince, William Robert
 (agricultural)
Proctor, Lucien Brock (legal)

Prouty, Olive Higgins
Pulitzer, Margaret Leech
Pusey, Caleb (Quaker controversial)
Quinan, John Russell (medical)
Ralph, James (political)
Rauschenbusch, Walter (religious)
Ravenel, Henry William
 (agricultural)
Rawle, William Henry (legal)
Redfield, Amasa Angell (legal)
Reed, Elizabeth Armstrong
 (Oriental literature)
Reed, Sampson (Swedenborgian)
Reeve, Tapping (legal)
Reid, Thomas Mayne (juvenile)
Reik, Theodor (psychology)
Repplier, Agnes
Richter, Conrad Michael
Rinehart, Mary Roberts (mystery
 story)
Ritter, Frédéric Louis (music)
Roane, Spencer (political)
Rohlfs, Anna Katharine Green
 (detective stories)
Rombauer, Irma Louise (cookbook)
Rorer, David
Rossen, Robert (screen)
Roulston, Marjorie Hillis
Rumsey, William (legal)
Runyon, Damon (short story)
Sayles, John (legal)
Schary, Dore (screen)
Schofield, Henry (legal)
Schorer, Mark
Schwartz, Delmore David (poetry)
Schwimmer, Rosika
Scudder, (Julia) Vida Dutton
Sergeant, Thomas (legal)
Seton, Ernest Thompson (nature)
Shawn, Edwin Meyers ("Ted")
Sherman, Allan (comedy)
Sherwood, Robert Emmet
 (dramatist)
Short, Luke (novelist)
Shub, Abraham David (Yiddish)
Smith, George Henry (juvenile)
Smith, Lillian Eugenia
Smith, Lloyd Logan Pearsall
 (essayist)
Soley, James Russell (naval)
Spewack, Samuel (screen)
Spooner, Lysander (political)
Sprague, Charles Ezra
 (accountancy)
Stafford, Jean (short story)
Stallings, Laurence Tucker
Stanton, Richard Henry (legal)
Stark, Louis (editorial)
Steele, Joel Dorman (textbook)
Steele, Wilbur Daniel

Steinbeck, John Ernst, Jr.
Stewart, Donald Ogden (screen)
Stilwell, Sitas Moore (financial)
Stockton, Frank Richard (story)
Stoddard, John Fair (textbook)
Stratemeyer, Edward (juvenile)
Stribling, Thomas Sigismund (short
 story)
Strunsky, Simeon (essayist)
Swan, Joseph Rockwell (legal)
Talbot, Francis Xavier
Tanner, Edward Everett, III
 ("Patrick Dennis") (humor)
Tappan, Eva March (juvenile)
Tarbell, Ida Minerva
Taylor, Charles Alonzo
Taylor, John (political)
Terhune, Mary Virginia Hawes
 (household management)
Thomson, John (political)
Thurber, James Grover (humor)
Tiedeman, Christopher Gustavus
 (legal)
Toklas, Alice Babette
Towler, John (photography)
Trumbo, Dalton (screen)
Tyler, Ransom Hubert (legal)
Ulmer, Edgar Georg (screen)
Upshaw, William David
Viereck, George Sylvester
 (magazine, newspaper)
Wahl, William Henry (science)
Wait, William (legal)
Walker, James Barr (religious)
Walker, Timothy, 1802–1856
 (legal)
Wallace, Henry (agricultural)
Ward, Charles Henshaw
Warner, Anna Bartlett (juvenile)
Warner, Anne Richmond (fiction)
Watson, Henry Clay (editorial,
 historical, juvenile)
Watson, James Madison (textbook)
Wentworth, George Albert
 (mathematics textbooks)
Will, Allen Sinclair (biography)
Willard, Josiah Flint (vagrancy,
 criminology)
Williams, Ben Ames (short story)
Williams, Catharine Read Arnold
 (biography)
Wood, Peggy
Wood, Sarah Sayward Barrell
 Keating (fiction)
Wright, Willard Huntington
 (detective fiction)
Youmans, William Jay (scientific)
Zanuck, Darryl Francis (screen)
Zevin, Israel Joseph (story)

BIRTHPLACES—UNITED STATES

ALABAMA

Allen, James Browning
Allen, Viola Emily
Bankhead, John Hollis, 1842–1920
Bankhead, John Hollis, 1872–1946
Bankhead, Tallulah
Bankhead, William Brockman
Belmont, Alva Ertskin Smith
 Vanderbilt
Berry, James Henderson
Birney, David Bell
Birney, William
Black, Hugo Lafayette
Bozeman, Nathan
Brickell, Robert Coman
Bridgman, Frederic Arthur
Brown, Johnny Mack
Brown, William Garrott
Bullard, Robert Lee
Burleson, Rufus Clarence
Camp, John Lafayette
Campbell, William Edward March
Carmichael, Oliver Cromwell
Clay, Clement Claiborne
Clayton, Henry De Lamar
Clemens, Jeremiah
Cole, Nat ("King")
Comer, Braxton Bragg
Connor, Theophilus ("Bull") Eugene
Culberson, Charles Allen
Davis, Mary Evelyn Moore
De Bardeleben, Henry Fairchild
De Priest, Oscar Stanton
Dowling, Noel Thomas
Duggar, Benjamin Minsze
Elder, Ruth
English, Elbert Hartwerl
Ernst, Morris Leopold
Fearn, John Walker
Fitzpatrick, Morgan Cassius
Fleming, Walter Lynwood
Fulton, Robert Burwell
Gaines, Reuben Reid
Glass, Franklin Potts
Gorgas, William Crawford
Grant, James Benton
Graves, David Bibb
Greenway, John Campbell
Gregg, John

Guild, La Fayette
Hall, Paul
Hamilton, Andrew Jackson
Hancock, John
Handy, William Christopher
Harding, William Procter Gould
Hardy, William Harris
Hargrove, Robert Kennon
Heflin, James Thomas
Hitchcock, Ethan Allen, 1835–1909
Hitchcock, Henry
Hobson, Richmond Pearson
Jones, Robert Reynolds ("Bob")
Jones, Samuel Porter
Julian, Percy Lavon
Keller, Helen Adams
Kolb, Reuben Francis
Lambrith, James William
Lile, William Minor
Love, Emanuel King
Lyon, David Gordon
McKellar, Kenneth Douglas
Manly, John Matthews
Mastin, Claudius Henry
Mitchell, Sidney Zollicoffer
Moore, John Trotwood
Morgan, John Hunt
Murphy, Edgar Gardner
Oates, William Calvin
O'Neal, Edward Asbury, 1818–1890
O'Neal, Edward Asbury, III, 1875–
 1958
Owen, Thomas McAdory
Owens, James Cleveland ("Jesse")
Owsley, Frank Lawrence
Parsons, Albert Richard
Pelham, John
Perry, Pettis
Pettus, Edmund Winston
Pou, Edward William
Riley, Benjamin Franklin
Roddey, Philip Dale
Screws, William Wallace
Sibert, William Luther
Simmons, William Joseph
Sloan, Matthew Scott
Sloss, James Withers
Smith, Eugene Allen
Smith, Holland McTyeire

Steagall, Henry Bascom
Tomochichi
Toulmin, Harry Theophilus
Tutwiler, Julia Strudwick
Valliant, Leroy Branch
Van de Graaff, Robert Jemison
Van Doren, Irit Bradford
Vincent, John Heyl
Walker, Leroy Pope
Wallace, Lurleen Burns
Walthall, Henry Brazeal
Washington, Dinah
Watts, Thomas Hill
Weatherford, William
Williams, Aubrey Willis
Williams, (Hiram) Hank
Winston, John Anthony
Wyeth, John Allan

ARIZONA

Devine, Andrew ("Andy")
Douglas, Lewis Williams
Geronimo
Mingus, Charles, Jr.
Patch, Alexander McCarrell

ARKANSAS

Adler, Cyrus
Anthony, Katharine Susan
Barnes, Julius Howland
Baylor, Frances Courtenay
Bennett, Henry Garland
Biffle, Leslie L.
Brady, Mildred Alice Edie
Burns, Bob
Couch, Harvey Crowley
Davis, Jefferson
Dean, Jay Hanna ("Dizzy")
Ellis, Clyde Taylor
Fletcher, John Gould
Gray, Carl Raymond
Haynes, George Edmund
Jordan, Louis
Ladd, Alan Walbridge
Liston, Charles ("Sonny")
MacArthur, Douglas
McClellan, John Little
McRae, Thomas Chipman

Mitchell, Martha Elizabeth Beall
Perkins, Marion
Powell, Richard Ewing ("Dick")
Robinson, Joseph Taylor
Somervell, Brehon Burke
Stone, Edward Durell
Sutton, William Seneca

CALIFORNIA

Aborn, Milton
Abrams, Albert
Acosta, Bertram Blanchard ("Bert")
Adams, Annette Abbott
Aitken, Robert Grant
Allen, Gracie
Alvarado, Juan Bautista
Anderson, Edward ("Eddie")
Anderson, Mary
Andrus, Ethel Percy
Arzner, Dorothy Emma
Ashford, Emmett Littleton
Atherton, Gertrude Franklin (Horn)
Atkinson, Henry Avery
Bacon, Frank
Beatty, Willard Walcott
Belasco, David
Berkeley, Busby
Blinn, Holbrook
Bowes, Edward, J.
Boyd, Louise Arner
Bradley, Frederick Worthen
Brady, William Aloysius
Britton, Barbara
Brownlee, James Forbis
Burton, Clarence Monroe
Chandler, Norman
Cone, Fairfax Mastick
Connolly, Maureen Catherine
Cooper, William John
Corbett, Harvey Wiley
Corbett, James John
Cottrell, Frederick Gardner
De Angelis, Thomas Jefferson
Dorgan, Thomas Aloysius
Doyte, Alexander Patrick
Drury, Newton Bishop
Duncan, Isadora
Engle, Clair William Walter
Erlanger, Joseph
Evans, Herbert McLean
Fay, Francis Anthony ("Frank")
Fisher, William Arms
Ford, Mary
Frost, Robert Lee
Gaxton, William
George, Henry
Getty, George Franklin, II
Gherardi, Bancroft
Giannini, Amadeo Peter
Gilbreth, Lillian Evelyn Moller

Goldberg, Reuben Lucius ("Rube")
Goodman, Louis Earl
Grady, Henry Francis
Guthrie, William Dameron
Hammond, Tohn Hays
Hansen, William Webster
Harrah, William Fisk ("Bill")
Hearst, William Randolph
Heilmann, Harry
Hinkle, Beatrice Moses
Hohfeld, Wesley Newcomb
Hooper, Harry Bartholomew
Hopper, Edna Wallace
Howard, Sidney T. Coe
Hubbard, Bernard Rosecrans
Jackson, Shirley Hardie
Jepson, Willis Linn
Jewett, Frank Baldwin
Johnson, Hiram Warren
Jones, Lindley Armstrong ("Spike")
Keller, James Gregory
Kirchoff, Charles William Henry
Kohlberg, Alfred
Knowland, William Fife
Kuykendall, Ralph Simpson
Kyne, Peter Bernard
Laguna, Theodore de Leo de
Lasky, Jesse Louis
Lawson, Ernest
Lee, Bruce
Leonard, Robert Josselyn
Leonard, Sterling Andrus
Lewis, John Henry
Lindley, Curtis Holbrook
Lockheed, Allan Haines
Lockheed, Malcolm
London, Jack
Lord, Pauline
Lydston, George Frank
Lynn, Diana ("Dolly")
McClatchy, Charles Kenny
McClintock, James Harvey
McClung, Clarence Erwin
McGeehan, William O'Connell
Mack, Julian William
Mackay, Clarence Hungerford
Magnes, Judah Leon
Mather, Stephen Tyng
Matthiessen, Francis Otto
Maxwell, George Hebard
Meusel, Robert William
Meyer, Eugene Isaac
Meyer, Martin Abraham
Mezes, Sidney Edward
Mizner, Addison
Monroe, Marilyn
Morgan, Julia
Moscone, George Richard
Moss, Sanford Alexander
Nevada, Emma

Norris, Kathleen Thompson
O'Brien, Willis Harold
O'Doul, Francis Joseph ("Lefty")
Overstreet, Harry Allen
Oxnam, Garfiel Bromley
Pacheco, Romualdo
Palón, Francisco
Parker, Carleton Hubbell
Patton, George Smith
Peek, Frank William
Phelan, James Duval
Regan, Agnes Gertrude
Reinhardt, Aurelia Isabel Henry
Ripley, Robert LeRoy
Robb, Inez Early Callaway
Roberts, Theodore
Rockefeller, Martha Baird
Roeding, George Christian
Rolph, James
Royce, Josiah
Ruef, Abraham
Sanderson, Sibyl
Sanford, Edmund Clark
Scripps, Robert Paine
Seton, Grace Gallatin Thompson
Smith, James Francis
Spreckels, Rudolph
Sproul, Allan
Sproul, Robert Gordon
Standley, William Harrison
Stafford, Jean
Steffens, Lincoln
Steinbeck, John Ernst, Jr.
Stevens, Ashton
Stevens, George Cooper
Stevenson, Adlai Ewing, II
Suzzallo, Henry
Swain, George Fillmore
Taylor, William Chittenden
Terry, Paul Houlton
Theobald, Robert Alfred
Tibbett, Lawrence Mervil
Toklas, Alice Babette
Vallejo, Mariano Guadalupe
Wanger, Walter
Warfield, David
Warner, William Lloyd
Warren, Earl
Washington, Kenneth Stanley ("The General")
Webb, Harry Howard
White, Stephen Mallory
Whitney, Charlotte Anita
Wightman, Hazel Virginia Hotchkiss
Wigmore, John Henry
Wilson, Marie
Wislocki, George Bernays
Wong, Anna May
Younger, Maud

Zellerbach, Harold Lionel
Zellerbach, James David

COLORADO

Allen, Edgar
Bliss, George William
Byington, Spring
Andrews, Bert
Chaney, Lon
Chapman, John Arthur
Fairbanks, Douglas
Fowler, Gene
Gipson, Lawrence Henry
Gregg, Alan
Herr, Herbert Thacker
Hoagland, Dennis Robert
Holt, Arthur Erastus
Lea, Homer
Leyner, John George
Libby, Willard Frank
MacDonald, Betty
McDonnell, James Smith, Jr.
McHugh, Keith Stratton
McWilliams, Carey
May, Morton Jay
Otis, Arthur Sinton
Parsons, Talcott
Perry, Antoinette
Ross, Harold Wallace
Sabin, lorence Rena
Shumlin, Herman Elliott
Smith, Homer William
Tatum, Edward Lawrie
Thompson, Llewellyn E. ("Tommy"),
 Jr.
Trumbo, James Dalton
Whiteman, Paul Samuel ("Pops")

CONNECTICUT

Abbot, Willis John
Abbott, Frank Frost
Abbott, William Hawkins
Acheson, Dean Gooderham
Adams, Andrew
Adams, John
Adams, William
Adrian, Gilbert
Alcott, Amos Bronson
Alcott, William Andrus
Alexander, Francis
Alford, Leon Pratt
Allen, Edward Tyson
Allen, Ethan
Allen, Ira
Allen, Jeremiah Mervin
Allyn, Robert
Alsop, Richard
Alsop, Stewart Johonnot Oliver
Alvord, Corydon Alexis

Andrews, Charles McLean
Andrews, Israel Ward
Andrews, Lorrin
Andrews, Samuel James
Andrews, Sherlock James
Andrews, William Watson
Arnold, Benedict
Arnold, Harold DeForest
Arnold, Leslie Philip
Atwater, Lyman Hotchkiss
Atwood, Lewis John
Augur, Hezckiah
Austin, David
Austin, Henry
Austin, Moses
Austin, Samuel
Ayer, James Cook
Ayres, Leonard Porter
Babcock, Washington Irving
Backus, Azel
Backus, Isaac
Bacon, Alice Mabel
Bacon, Benjamin Wisner
Bacon, David
Bacon, John
Bacon, Leonard Woolsey
Badger, Oscar Charles
Bailey, Anna Warner
Bailey, Ebenezer
Bailey, John Moran
Baker, Remember
Baldwin, Abraham
Baldwin, Edward Robinson
Baldwin, Frank Stephen
Baldwin, Henry
Baldwin, John
Baldwin, John Denison
Baldwin, Roger Sherman
Baldwin, Simeon
Baldwin, Simeon Eben
Baldwin, Theron
Bangs, Nathan
Banister, Zilpah Polly Grant
Barber, John Warner
Barbour, Clarence Augustus
Barbour, Henry Gray
Barlow, Joel
Barnard, Daniel Dewey
Barnard, Henry
Barnum, Phineas Taylor
Barstow, William Augustus
Bartholomew, Edward Sheffield
Bartlett, Paul Wayland
Batchelor, George
Bates, Theodore Lewis ("Ted")
Bates, Walter
Batterson, James Goodwin
Bayley, Richard
Beach, Moses Yale
Beach, Wooster

Beard, George Miller
Beardsley, Eben Edwards
Beaumont, William
Beecher, Charles
Beecher, Henry Ward
Beecher, Lyman
Beecher, Thomas Kinnicut
Beers, Clifford Whittingham
Begley, Edward James ("Ed")
Belden, Josiah
Bell, Jacob
Bellamy, Joseph
Benedict, David
Benedict, Erastus Cornelius
Bentley, Elizabeth Terrill
Besse, Arthur Lyman
Bidwell, Walter Hilliard
Bingham, Caleb
Birge, Henry Warner
Bishop, Abraham
Bissell, George Edwin
Blakeslee, Erastus
Blatchford, Richard Milford
Blatchford, Samuel
Bliss, Philemon
Boardman, Thomas Danforth
Bolton, Sarah Knowles
Booth, Albert James, Jr.("Albie")
Bostwick, Arthur Elmore
Bouton, Nathaniel
Bowen, Henry Chandler
Bowers, Elizabeth Crocker
Bowles, Samuel, 1797–1851
Bowles, Samuel, 1826–1878
Bowles, Samuel, 1851–1915
Brace, Charles Loring
Brace, John Pierce
Bradley, Frank Howe
Bradley, Stephen Row
Brainard, John Gardiner Calkins
Brainerd, David
Brainerd, Erastus
Brainerd, John
Brainerd, Lawrence
Brandegee, Frank Bosworth
Brandegee, Townshend Stith
Brewster, James
Bristol, William Henry
Brockway, Zebulon Reed
Bromley, Isaac Hill
Bronson, Henry
Brooker, Charles Frederick
Brown, Ethan Allen
Brown, John
Brown, John Newton
Brown, Samuel Robbins
Brown, Solymon
Buck, Daniel
Buck, Dudley
Buckingham, Joseph Tinker

Buckingham, William Alfred
Buckland, Cyrus
Buel, Jesse
Buell, Abel
Bulkeley, Morgan Gardner
Bulkley, John Williams
Bunce, William Gedney
Burleigh, Charles Calistus
Burleigh, George Shepard
Burleigh, William Henry
Burr, Aaron
Burr, Alfred Edmund
Burr, Enoch Fitch
Burr, William Hubert
Burrall, William Porter
Burritt, Elihu
Burton, Asa
Burton, Nathaniel Judson
Burton, Richard Eugene
Bushnell, David
Bushnell, Horace
Butler, John
Butler, Simeon
Butler, Thomas Belden
Cable, Frank Taylor
Calkins, Mary Whiton
Camp, David Nelson
Camp, Hiram
Camp, Walter Chauncey
Candee, Leverett
Capp, Al
Carrington, Henry Beebee
Carter, Franklin
Case, William Scoville
Chamberlain, Jacob
Chamberlain, William Isaac
Chandler, Thomas Bradbury
Chapin, Aaron Lucius
Chapin, Alonzo Bowen
Chauncey, Isaac
Cheney, John
Cheney, Seth Wells
Cheney, Ward
Chester, Colby Mitchell
Chester, Joseph Lemuel
Childs, Richard Spencer
Chipman, Daniel
Chipman, Nathaniel
Chittenden, Martin
Chittenden, Russell Henry
Chittenden, Simeon Baldwin
Chittenden, Thomas
Church, Frederick Erwin
Church, Irving Porter
Clark, Charles Hopkins
Clark, Horace Francis
Clark, Sheldon
Clark, William Thomas
Cleaveland, Moses
Cleveland, Chauncey Fitch

Coan, Titus
Coe, Israel
Coggeshall, George
Coit, Thomas Winthrop
Cole, George Watson
Colt, Samuel
Comstock, Anthony
Cooke, Rose Terry
Copeland, Charles W.
Corbin, Austin
Corning, Erastus
Cowles, Henry Chandler
Cox, Jacob Dolson
Crane, Bob Edward
Crary, Isaac Edwin
Cross, Wilbur Lucius
Croswell, Harry
Curtiss, Samuel Ives
Cushman, George Hewitt
Cutler, Manasseh
Daboll, Nathan
Dana, Edward Salisbury
Dana, Samuel Whittelsey
Danforth, Moseley Isaac
Davenport, Charles Benedict
Davenport, James
Davis, Charles Henry Stanley
Davis, George Whitefield
Day, Henry Noble
Day, Jeremiah
Dean, Sidney
Deane, Silas
De Forest, David Curtis
De Forest, John Kinne Hyde
De Forest, John William
De Koven, Henry Louis Reginald
De Koven, James
Deming, Henry Champion
De Vinne, Theodore Low
Dickinson, Anson
Dickinson, Daniel Stevens
Dike, Samuel Warren
Dillingham, Charles Bancroft
Dixon, James
Dockstader, Lew
Dodd, Thomas Joseph
Dodge, David Low
Dodge, William Earl
Doolittle, Amos
Douglas, Benjamin
Douglas, William
Dow, Lorenzo
Downer, Eliphalet
Dudley, William Russel
Dunbar, Moses
Dunning, Albert Elijah
Durand, William Frederick
Durkee, John
Dutton, Clarence Edward
Dutton, Henry

Dwight, Benjamin Woodbridge
Dwight, Sereno Edwards
Dwight, Theodore, 1764–1846
Dwight, Theodore, 1796–1866
Dwight, Timothy
Dyer, Eliphalet
Eaton, William
Edwards, Henry Waggaman
Edwards, Jonathan, 1703–1758
Eliot, Jared
Ellsworth, Henry Leavitt
Ellsworth, Henry William
Ellsworth, Oliver
Ellsworth, William Wolcott
Emmons, Nathanael
English, James Edward
Falkner, Roland Post
Fanning, Edmund
Fanning, John Thomas
Fanning, Nathaniel
Farnam, Henry Walcott
Farrell, James Augustine
Fayerweather, Daniel Burton
Ferry, Orris Sanford
Fetterman, William Judd
Field, David Dudley, 1781–1867
Field, David Dudley, 1805–1894
Field, Stephen Johnson
Fillmore, John Comfort
Finney, Charles Grandison
Fiske, John
Fitch, John
Fitch, Samuel
Fitch, Thomas
Flagg, George Whiting
Flagg, Jared Bradley
Fleming, William Maybury
Foot, Samuel Augustus
Foote, Andrew Hull
Foote, William Henry
Ford, Gordon Lester
Forward, Walter
Foster, John Pierrepont Codrington
Foster, Lafayette Sabine
Foulois, Benjamin Delahauf
Fryer, Douglas Henry
Gallaudet, Edward Miner
Gallaudet, Thomas
Gallup, Joseph Adams
Gardner, Leroy Upson
Gary, James Albert
Gauvreau, Emile Henry
Gaylord, Willis
Gibbs, Josiah Willard
Gibson, William Hamilton
Giddings, Franklin Henry
Gilbert, William Lewis
Gillett, Ezra Hall
Gillette, Francis
Gillette, William Hooker

Gilman, Charlotte Perkins Stetson
Gilman, Daniel Coit
Gleason, Frederic Grant
Goddard, William
Goodhue, Bertram Grosvenor
Goodrich, Charles Augustus
Goodrich, Chauncey
Goodrich, Chauncey Allen
Goodrich, Elizur, 1734–1797
Goodrich, Elizur, 1761–1849
Goodrich, Samuel Griswold
Goodyear, Charles
Goodyear, William Henry
Gould, Edward Sherman
Gould, George Jay
Gould, James
Graham, John Andrew
Graham, Sylvester
Granger, Francis
Granger, Gideon
Green, Beriah
Green, Thomas
Griffin, Edward Dorr
Griffing, Josephine Sophie White
Griswold, Alexander Viets
Griswold, Matthew
Griswold, Roger
Griswold, Stanley
Grosvenor, Charles Henry
Grow, Galusha Aaron
Guernsey, Egbert
Gunn, Frederick William
Gurley, Ralph Randolph
Hadley, Arthur Twining
Hale, David
Hale, Nathan
Hall, Asaph
Hall, Isaac Hollister
Hall, Lyman
Halleck, Fitz Greene
Hamline, Leonidas Lent
Hammett, Samuel Adams
Hammond, Edward Payson
Hand, Daniel
Harding, Abner Clark
Harris, William Torrey
Harrison, Henry Baldwin
Hart, John
Hart, Samuel
Harvey, Louis Powell
Haskell, Ernest
Hastings, Thomas
Haven, Henry Philemon
Hawley, Gideon, 1727–1809
Hawley, Gideon, 1785–1870
Hayden, Horace H.
Hendrick, Burton Tesse
Herrick, Edward Claudius
Herter, Christian Archibald
Hewit, Augustine Francis

Hickok, Laurens Perseus
Higginson, Nathaniel
Hill, Ureli Corelli
Hillhouse, James
Hillhouse, James Abraham
Hinman, Elisha
Hinman, Joel
Hitchcock, Peter
Hoadley, David
Hoadly, George
Hobart, Iohn Sloss
Hogan, Frank Smithwick
Holbrook, Alfred
Holbrook, Frederick
Holbrook, Josiah
Holcomb, Amasa
Holley, Alexander Lyman
Holley, Horace
Holley, Myron
Hollister, Gideon Hiram
Holmes, Abiel
Holmes, Israel
Hooker, Donald Russell
Hooker, Isabella Beecher
Hopkins, Lemuel
Hopkins, Samuel, 1721–1803
Hosmer, Titus
Hotchkiss, Benjamin Berkeley
Howe, Henry
Howe, John Ireland
Howland, Gardiner Greene
Hubbard, Henry Griswold
Hubbard, Joseph Stillman
Hubbard, Richard William
Hull, Isaac
Hull, William
Humphrey, Heman
Humphreys, David
Hunt, Mary Hannah Hanchett
Hunt, Thomas Sterry
Huntington, Collis Potter
Huntington, Jabez
Huntington, Jedediah
Huntington, Samuel, 1731–1796
Huntington, Samuel, 1765–1817
Hyde, James Nevins
Ingersoll, Jared, 1722–1781
Ingersoll, Jared, 1749–1822
Ingersoll, Simon
Inglis, Alexander James
Ives, Charles Edward
Ives, Chauncey Bradley
Ives, Eli
Ives, Frederic Eugene
Ives, Levi Silliman
Jarvis, Abraham
Jenkins, John, 1728–1785
Jenkins, John, 1751–1827
Jerome, Chauncey
Jesup, Morris Ketchum

Jewett, David
Jewett, William
Jocelyn, Nathaniel
Johnson, Samuel
Johnson, Seth Whitmore
Johnson, Treat Baldwin
Johnson, William
Johnson, William Samuel
Johnston, Josiah Stoddard
Jones, Joel
Judah, Theodore Detton
Keeler, James Edward
Keep, Robert Porter
Kelley, Alfred
Kellogg, Albert
Kellogg, Edward
Kellogg, Martin
Kellogg, William Pitt
Kendall, Edward Calvin
Kensett, John Frederick
Kilbourne, James
King, Dan
Kingsbury, John
Kingsley, James Luce
Kirby, Ephraim
Kirkland, Samuel
Kirtland, Jared Potter
Knight, Jonathan
Ladd Franklin, Christine
Lanman, Charles Rockwell
Lanman, Joseph
Larned, Joseph Gay Eaton
Larrabee, William
Law, Andrew
Law, John
Law, Jonathan
Law, Richard
Leaming, Jeremiah
Leavenworth, Henry
Leavitt, Humphrey Howe
Ledyard, John
Ledyard, William
Lee, Charles Alfred
Leonard, William Andrew
Lester, Charles Edwards
Levermore, Charles Herbert
Lockwood, Ralph Ingersoll
Lockwood, Robert Wilton
Loomis, Arphaxed
Loomis, Dwight
Loomis, Elias
Lord, Daniel
Lord, David Nevins
Lord, Eleazar
Lothrop, Harriett Mulford Stone
Lusk, Graham
Lusk, William Thompson
Lyman, Chester Smith
Lyman, Phineas
Lynds, Elam

Lyon, Nathaniel
McClellan, George, 1796–1847
McGwney, Michael Joseph
MacKaye, Benton
MacLean, George Edwin
McLevy, Jasper
McMahon, Brien
Mallary, Rollin Carolas
Mansfield, Edward Deering
Mansfield, Jared
Mansfield, Joseph King Fenno
Mansfield, Richard
Marble, Danforth
Marks, Amasa Abraham
Marsh, John
Marshall, Daniel
Marvin, Dudley
Mason, Jeremiah
Mason, William
Masson, Thomas Lansing
Mather, Frank Jewett, Jr.
Mather, Samuel Livingston
Mather, William Williams
Mattocks, John
Meigs, Josiah
Meigs, Return Jonathan, 1740–1823
Meigs, Return Jonathan, 1764–1824
Merrilf, Selah
Miller, Emily Clark Huntington
Miller, Oliver
Mills, Samuel John
Miner, Charles
Mitchell, Donald Grant
Mitchell, Elisha
Mitchell, Samuel Augustus
Mitchell, Stephen Mix
Moody, (Arthur Edson) Blair
Morey, Samuel
Morgan, Charles
Morgan, John Pierpont
Morris, Charles
Morris, Luzon Burritt
Morse, Jedidiah
Moses, Bernard
Moulton, Ellen Louise Chandler
Munson, Walter David
Murdock, James
Murdock, Joseph Ballard
Nettleton, Asahel
Newberry, John Strong
Newberry, Oliver
Newberry, Walter Loomis
Newcomb, Charles Leonard
Newman, Alfred
Niles, John Milton
North, Edward
North, Elisha
North, Simeon, 1765–1852
North, Simeon, 1802–1884
Northrop, Birdsey Grant

Northrop, Cyrus
Norton, Charles Hotchkiss
Nott, Abraham
Nott, Eliphalet
Nott, Samuel
Noyes, Walter Chadwick
Occom, Samson
Olmsted, Denison
Olmsted, Frederick Law
Olmsted, Gideon
Olney, Jesse
Ormsby, Waterman Lilly
Osborn, Henry Fairfield
Osborn, Norris Galpin
Osborn, Selleck
Osborne, Thomas Burr
Owen, Edward Thomas
Packer, Asa
Paddock, Benjamin Henry
Paddock, John Adams
Paine, Elijah
Painter, Gamaliel
Palmer, Albert Marshman
Palmer, Elihu
Palmer, Nathaniel Brown
Palmer, William Adams
Parish, Elijah
Park, Roswell, 1807–1869
Park, Roswell, 1852–1914
Parker, Amasa Junius
Parsons, Samuel Holden
Paterson, John
Pease, Calvin
Pease, Elisha Marshall
Pease, Joseph Ives
Peck, Charles Howard
Peck, Harry Thurston
Peck, John Mason
Peck, Tracy
Peet, Harvey Prindle
Peet, Isaac Lewis
Penfield, Frederic Courtland
Percival, James Gates
Perkins, Elisha
Perkins, Frederi Beecher
Perrin, Bernadotte
Peters, Samuel Andrew
Phelps, Almira Hart Lincoln
Phelps, Anson Greene
Phelps, Guy Rowland
Phelps, John Smith
Phelps, Oliver
Phelps, William Lyon
Phillips, Harry Irving
Picket, Albert
Pierpont, John
Pierrepont, Edwards
Piggott, James
Pinchot, Gifford
Pinney, Norman

Pitkin, Frederick Walker
Pitkin, Timothy
Pitkin, William, 1694–1769
Pitkin, William, 1725–1789
Plant, Henry Bradley
Platt, Charles Adams
Platt, Orville Hitchcock
Platver, Samuel Ball
Pond, Peter
Pond, Samuel William
Porter, Arthur Kingsley
Porter, Ebenezer
Porter, Noah
Porter, Peter Buell
Porter, Samuel
Porter, Sarah
Potter, Edward Clark
Potter, Ellen Culver
Potter, William Bancroft
Powell, Adam Clayton, Jr.
Pratt, Bela Lyon
Prentice, Samuel Oscar
Prentiss, Samuel
Preston, Thomas Scott
Prudden, Theophil Mitchell
Purtell, William Arthur
Putnam, Nina Wilcox
Pynchon, Thomas Ruggles
Quintard, Charles Todd
Quintard, George William
Ranney, William Tylee
Raymond, Charles Walker
Raymond, Daniel
Read, John, 1679/80–1749
Redfield, Justus Starr
Redfield, William C.
Reid, Samuel Chester
Remington, Eliphalet
Reynolds, Edwin
Riggs, John Marke
Ripley, James Wolfe
Robbins, Thomas
Robins, Henry Ephraim
Robinson, Edward, 1794–1863
Robinson, Henry Cornelius
Robinson, Solon
Robinson, William Callyhan
Rockwell, Alphonso David
Rogers, John, 1648–1721
Rogers, John Almanza Rowley
Rogers, Moses
Rogers, Thomas
Rogers, William Augustus
Rood, Ogden Nicholas
Root, Erastus
Root, Jesse
Rose, Chauncey
Rosenthal, Toby Edward
Rossiter, Thomas Prichard
Rowland, Thomas Fitch

Ruggles, Samuel Bulkley
Russell, Rosalind
Sage, Bernard Janin
Sage, Henry Williams
Saltonstall, Dudley
Sanford, Elias Benjamin
Sanford, Henry Shelton
Sassacus
Saunders, Prince
Savage, Thomas Staughton
Sawyer, Walter Howard
Scoville, Joseph Alfred
Scranton, George Whitfield
Seabury, Samuel, 1729–1796
Seabury, Samuel, 1801–1872
Sedgwick, John
Sedgwick, Theodore, 1746–1813
Sedgwick, William Thompson
Seelye, Julius Hawley
Seelye, Laurenus Clark
Setchell, William Albert
Seymour, Charles
Seymour, Thomas Hart
Shaler, William
Shaw, Nathaniel
Sheffield, Joseph Earl
Sigourney, Lydia Howard Huntley
Sill, Edward Rowland
Silliman, Benjamin, 1779–1864
Silliman, Benjamin, 1816–1885
Sloan, Alfred Pritchard, Jr
Smith, Abby Hadassah
Smith, Arthur Henderson
Smith, Ashbel
Smith, Charles Emory
Smith, Eli
Smith, Elias
Smith, Elihu Hubbard
Smith, Harry James
Smith, Israel
Smith, James Youngs
Smith, Joel West
Smith, John Cotton, 1765–1845
Smith, Junius
Smith, Nathan, 1770–1835
Smith, Nathaniel
Smith, Roswell
Smith, Truman
Smith, Winchell
Sonnichsen, Albert
Sparks, Jared
Spencer, Ambrose
Spencer, Christopher Miner
Spencer, Elihu
Spencer, Joseph
Sperry, Nehemiah Day
Sprague, Frank Julian
Sprague, William Buell
Stanton, Henry Brewster
Stedman, Edmund Clarence

Steiner, Bernard Christian
Stephens, Ann Sophia
Sterling, John William
Stevens, Clement Hoffman
Stevens, Thomas Holdup, 1819–1896
Steward, Ira
Stewart, Philo Penfield
Stiles, Ezra
Stine, Charles Milton Altland
Stoddard, Amos
Stoeckel, Carl
Stone, David Marvin
Stone, Wilbur Fisk
Stone, William Oliver
Stowe, Harriet Elizabeth Beecher
Stratton, Charles Sherwood
Street, Augustus Russell
Strong, Elmer Kenneth, Jr. ("Ken")
Strong, William
Stuart, Isaac William
Stuart, Moses
Sturtevant, Julian Monson
Sumner, Francis Bertody
Talcott, Andrew
Talcott, Eliza
Talcott, Joseph
Tarbox, Increase Niles
Tatlock, John Strong Perry
Taylor, Nathaniel William
Terry, Alfred Howe
Terry, Eli
Thacher, Thomas Anthony
Thomas, Seth
Thompson, Charles Oliver
Thurber, Christopher Carson
Ticknor, Elisha
Tiffany, Charles Lewis
Tod, George
Tod, John
Todd, Eli
Totten, George Muirson
Totten, Joseph Gilbert
Toucey, Isaac
Tousey, Sinclair
Town, Ithiel
Townsend, Virginia Frances
Tracy, Uriah
Troland, Leonard Thompson
True, Alfred Charles
True, Frederick William
Trumbull, Benjamin
Trumbull, Henry Clay
Trumbull, James Hammond
Trumbull, John, 1750–1831
Trumbull, John, 1756–1843
Trumbull, Jonathan, 1710–1785
Trumbull, Jonathan, 1740–1809
Trumbull, Joseph
Trumbull, Lyman
Tryon, Dwight William

Tucker, William Jewett
Tully, William
Twichell, Joseph Hopkins
Twining, Alexander Catlin
Tyler, Bennet
Tyler, Daniel
Tyler, Moses Coit
Utley, George Burwell
Van Vleck, Edward Burr
Van Vleck, John Hasbrouck
Verrill, Alpheus Hyatt
Vonnoh, Robert William
Wadsworth, James
Wadsworth, Jeremiah
Waite, Morrison Remick
Wakeley, Joseph Burton
Waldo, Samuel Lovett
Waldo, Samuel Putnam
Walker, Amasa
Walworth, Reuben Hyde
Ward, James Harmon
Warner, Jonathan Trumbull
Warner, Olin Levi
Warner, Seth
Warren, Israel Perkins
Washburn, Nathan
Watson, Sereno
Webster, Pelatiah
Weicker, Lowell Palmer
Weiss, George Martin
Welch, Adonijah Strong
Welch, William Henry
Welch, William Wickham
Weld, Theodore Dwight
Welles, Gideon
Welles, Noah
Welles, Roger
Wells, Harry Gideon
Wells, Horace
Wells, Samuel Roberts
Wells, William Harvey
Wheaton, Nathaniel Sheldon
Wheeler, Arthur Leslie
Wheeler, Nathaniel
Wheelock, Eleazar
Wheelock, John
White, William Nathaniel
Whitman, Charles Seymour
Whitney, Asa
Whittelsey, Abigail Goodrich
Wight, Frederick Coit
Wilcox, Reynold Webb
Willard, De Forest
Willard, Emma Hart
Williams, Alpheus Starkey
Williams, Edwin
Williams, Elisha
Williams, Thomas Scott
Williams, William
Williamson, William Durkee

Williston, Seth
Wilson, George Grafton
Winchester, Caleb Thomas
Winthrop, Theodore
Wolcott, Oliver, 1726–1797
Wolcott, Oliver, 1760–1833
Wolcott, Roger
Woodbridge, William
Woodruff, Timothy Lester
Woodruff, Wilford
Woodward, Samuel Bayard
Woolley, Mary Emma
Woolsey, Theodore Salisbury
Wooster, Charles Whiting
Wooster, David
Work, Henry Clay
Wright, Benjamin
Wright, Charles
Wright, Elizur
Wright, Horatio Gouverneur
Wyllys, George

DELAWARE

Bates, Daniel Moore
Bates, George Handy
Bayard, James Asheton
Bayard, Richard Henry
Bayard, Thomas Francis
Beauchamp, William
Bedford, Gunning
Bird, Robert Montgomery
Brown, John Mifflin
Budd, Edward Gowen
Burton, William
Canby, Henry Seidel
Cannon, Annie Jump
Cannon, William
Chandler, Elizabeth Margaret
Clayton, John Middleton
Coit, Henry Augustus
Cummins, George David
Davies, Samuel
Du Pont, Henry
Du Pont, Henry Algernon
Du Pont, Lammot
Du Pont, Pierre Samuel
Emerson, Gouverneur
Evans, Oliver
Fisher, George Purnell
Forwood, William Henry
Garretson, James
Gibbons, James Sloan
Gilpin, Edward Woodward
Gray, George
Harrington, Samuel Maxwell
Howell, Richard
Johns, Clayton
Johns, John
Johns, Kensey
Johnson, Eldridge Reeves

Jones, David
Jones, Jacob
Keating, William Hypolitus
Kollock, Shepard
Lea, Isaac
Learned, Marion Dexter
Lewis, William David
Lord, William Paine
McCullough, John Griffith
Macdonough, Thomas
McKean, Joseph Borden
McKennan, Thomas McKean
 Thompson
McLane, Louis
McLane, Robert Milligan
MacWhorter, Alexander
Marquand, John Phillips
Miller, Edward
Miller, Samuel
Mitchell, Nathaniel
Moore, John Bassett
Newbold, William Romaine
Palmer, William Jackson
Parke, John
Polk, Trusten
Pyle, Howard
Read, John, 1769–1854
Read, Thomas
Ridgely, Nicholas
Rodney, Caesar
Rodney, Caesar Augustus
Rodney, Thomas
Ross, George
Saulsbury, Eli
Saulsbury, Gove
Saulsbury, Willard, 1820–1892
Saulsbury, Willard, 1861–1927
Smyth, Herbert Weir
Squibb, Edward Robinson
Stewart, John George
Sykes, George
Thomas, Lorenzo
Tilton, James
Torbert, Alfred Thomas Archimedes
Townsend, George Alfred
Van Dyke, Nicholas, 1738–1789
Van Dyke, Nicholas, 1770–1826
Wales, Leonard Eugene
White, Samuel
Wiley, Andrew Jackson
Wilson, Clarence True

DISTRICT OF COLUMBIA

Ashford, Bailey Kelly
Baker, William Mumford
Barber, Donn
Beale, Edward Fitzgerald
Bowie, Richard Johns
Brannan, John Milton
Breck, George William

Broderick, David Colbreth
Burke, Billie
Carroll, Samuel Sprigg
Cassidy, Marshall Whiting
Colby, Frank Moore
Considine, Robert ("Bob") Bernard
Cook, Will Marion
Corcoran, William Wilson
Cranch, Christopher Pearse
Craven, Thomas Tingey
Da Costa, John Chalmers
Davis, Benjamin Oliver, Sr.
Davis, Watson
Dimitry, Charles Patton
Dorsey, Anna Hanson McKenney
Drew, Charles Richard
Dulles, John Foster
Ellington, Edward Kennedy ("Duke")
Ewell, Benjamin Stoddert
Ewell, Richard Stoddert
Farrington, Joseph Rider
Fay, Sidney Bradshaw
Fitzpatrick, John Clement
Force, Manning Ferguson
Garrison, Fielding Hudson
Gauss, Clarence Edward
Getty, George Washington
Gibbons, loyd
Gilliss, James Melville
Goldsborough, Louis Malesherbes
Graham, William Montrose
Graves, Alvin Cushman
Hartley, Frank
Hodes, Henry Irving
Hodgson, William Brown
Holly, James Theodore
Hoover, John Edgar
Houston, Charles Hamilton
Hunter, David
Hyatt, Alpheus
Ingersoll, Royal Eason
Janney, Oliver Edward
Johnson, Robert Underwood
Johnston, Eric Allen
Kelser, Raymond Alexander
King of William, James
Lenthall, John
Lewis, Fulton, Jr.
Lipscomb, Andrew Adgate
Lovell, Mansfield
McAuliffe, Anthony Clement
McCormick, Cyrus Hall
McGuire, Joseph Deakins
McLean, Edwar Beale
McNamee, Graham
Magruder, George Lloyd
Manning, Marie
Mason, James Murray
Mattingly, Garrett
Maynard, George Willoughby

District Of Columbia

Meade, Robert Leamy
Nicholson, William Jones
Noyes, Frank Brett
O'Neale, Margaret
Peary, Josephine Diebitsch
Pilling, James Constantine
Pleasonton, Alfred
Plunkett, Charles Peshall
Pollock, Channing
Pratt, Thomas George
Prouty, Charles Tyler
Queen, Walter W.
Ramsay, Francis Munroe
Rawlings, Marjorie Kinnan
Razaf, Andy
Richardson, Charles Williamson
Riggs, George Washington
Rodgers, John, 1881–1926
Schroeder, Seaton
Scott, William Lawrence
Seibold, Louis
Semmes, Alexander Jenkins
Semmes, Thomas Jenkins
Shellabarger, Samuel
Shepherd, Alexander Robey
Shuster, W(illiam) Morgan
Slicer, Thomas Roberts
Sousa, John Philip
Southworth, Emma Dorothy Eliza
 Nevitte
Steers, George
Stoek, Harry Harkness
Swann, Thomas
Towle, George Makepeace
Tree, Lambert
Vance, Louis Joseph
Wainwright, Richard, 1849–1926
Watterson, Henry
Weaver, Aaron Ward
West, James Edward
Wheeler, Earle Gilmore
Willard, Joseph Edward
Winlock, Herbert Eustis
Winslow, Cameron McRae
Wormley, James

FLORIDA

Adderley, Julian Edwin
 ("Cannonball")
Avery, Isaac Wheeler
Bellamy, Elizabeth Whitfield Croom
Bloxham, William Dunnington
Brooke, John Mercer
Broward, Napoleon Bonaparte
Bryan, Mary Edwards
Cochran, Jacqueline
Davis, Edmund Jackson
Drayton, William
Forbes, John Murray
Geiger, Roy Stanley

Holland, Spessard Lindsey
Hurston, Zora Neale
James, Daniel, Jr. ("Chappie")
Johnson, James Weldon
Kirby-Smith, Edmund
McCoy, George Braidwood
McIntosh, John Bailie
Merrill, Charles Edward
Morrison, Jim
Pace, Edward Aloysius
Randolph, Asa Philip
Raney, George Pettus
Smith, Lillian Eugenia
Summerall, Charles Pelot
Turnbull, Robert James
Warren, Fuller
Zacharias, Ellis Mark

GEORGIA

Abbott, Robert Sengstacke
Aiken, Conrad Potter
Alexander, Edward Porter
Allen, Young John
Anderson, George Thomas
Andrew, James Osgood
Andrews, Garnett
Arnold, Richard Dennis
Atkinson, William Yates
Bacon, Augustus Octavius
Baker, Daniel
Barrett, Charles Simon
Barrett, Janie Porter
Bass, William Capers
Battey, Robert
Battle, Cullen Andrews
Benning, Henry Lewis
Benson, William Shepherd
Berry, Martha McChesney
Bibb, William Wyatt
Black, Eugene Robert
Blalock, Alfred
Bleckley, Logan Edwin
Blount, James Henderson
Boudinot, Elias
Boudinot, Elias Cornelius
Bowie, James
Bozeman, John M.
Bulloch, James Dunwody
Butts, James Wallace ("Wally")
Callaway, Morgan
Campbell, Henry Fraser
Campbell, John Archibald
Candler, Allen Daniel
Candler, Asa Griggs
Candler, Warren Akin
Cardozo, Jacob Newton
Carnochan, John Murray
Charles, Ezzard Mack
Chivers, Thomas Holley
Clay, Joseph

Clay, Lucius DuBignon
Clements, Judson Claudius
Clopton, David
Cobb, Andrew Jackson
Cobb, Howell
Cobb, Thomas Reade Rootes
Cobb, Tyrus Raymond ("Ty")
Cohen, John Sanford
Collier, John
Colquitt, Alfred Holt
Cook, Philip
Couper, James Hamilton
Cox, Edward Eugene
Crawford, George Walker
Crawford, Martin Jenkins
Culberson, David Browning
Cumming, Alfred
Curry, Jabez Lamar Monroe
Davis, John Warren
Dawson, William Crosby
Dawson, William Levi
Dickson, David
Divine, Father
Doughty, William Henry
Elliott, Sarah Barnwell
Evans, Augusta Jane
Evans, Clement Anselm
Eve, Paul Fitzsimons
Fannin, James Walker
Fahy, Charles
Felton, Rebecca Latimer
Felton, William Harrell
Few, Ignatius Alphonso
Fitzpatrick, Benjamin
Fletcher, Duncan Upshaw
Folsom, Marion Bayard
Fremont, John Charles
Furlow, loyd Charles
Gaines, Wesley John
Gartrell, Lucius Jeremiah
George, James Zachariah
George, Walter Franklin
Gibbons, Thomas
Gibson, Joshua
Gordon, John Brown
Gordon, William Washington
Goulding, Francis Robert
Grady, Henry Woodfin
Grant, John Thomas
Habersham, Joseph
Hadas, Moses
Hale, William Gardner
Hall, Charles Henry
Hammond, Nathaniel Job
Harben, William Nathaniel
Hardee, William Joseph
Hardwick, Thomas William
Hardy, Oliver Norvell
Harris, Joel Chandler
Harris, Julian La Rose

Harris, William Littleton
Harrison George Paul
Harrison, William Pope
Hartsfield, William Berry
Haygood, Atticus Green
Haygood, Laura Askew
Henderson, Fletcher Hamilton
Herring, Augustus Moore
Herty, Charles Holmes
Hill, Benjamin Harvey
Hill, Walter Barnard
Hillyer, Junius
Hodges, Courtney Hicks
Holsey, Lucius Henry
Hope, John
Hopkins, Isaac Stiles
Houston, John
Howell, Evan Park
Howley, Richard
Hubbard, Richard Bennett
Hudson, Claude Silbert
Hughes, Dudley Mays
Hyer, Robert Stewart
Iverson, Alfred
Jackson, Henry Rootes
Jackson, James, 1819–1887
Jacobs, Joseph, 1859–1929
Johnson, Herschel Vespasian
Johnson, Malcolm Malone
Johnson, Nunnally Hunter
Johnston, Richard Malcolm
Jones, Charles Colcock
Jones, Joseph
Jones, Thomas Goode
Judson, Frederick Newton
Keener, William Albert
Kerneys, Edward
Kilpatrick, William Heard
King, Martin Luther, Jr.
Knight, Lucian Lamar
Lamar, Gazaway Bugg
Lamar, Joseph Rucker
Lamar, Lucius Quintus Cincinnatus
Lamar, Mirabeau Buonaparte
Langworthy, Edward
Le Conte, John
Le Conte, Joseph
Lee, Ivy Ledbetter
Lee, James Wideman
Lincecum, Gideon
Lomax, Louis Emanuel
Long, Crawford Williamson
Longstreet, Augustus Baldwin
Lumpkin, Joseph Henry
McAdoo, William Gibbs
McAllister, Hall
McAllister, Matthew Hall
McAllister, Samuel Ward
McCullers, Carson
McDaniel, Henry Dickerson

McDuffie, George
McGillivray, Alexander
McIntosh, William
McKinley, Carlyle
McKinstry, Alexander
McLaws, Lafayette
Maxwell, Augustus Emmett
Maxwell, George Troup
Mayes, Joel Bryan
Meigs, Montgomery Cunningham
Mell, Patrick Hues, 1814–1888
Mell, Patrick Hues, 1850–1918
Melton, James
Mercer, John Herndon ("Johnny")
Metcalfe, Ralph Harold
Milledge, John
Millis, Walter
Milner, John Turner
Milton, John
Mitchell, Margaret Munnerlyn
Moore, George Fleming
Morehouse, Ward
Muhammad, Elijah
Murrow, Joseph Samuel
Nisbet, Eugenius Aristides
Northen, William Jonathan
O'Connor, Mary Flannery
Odum, Howard Washington
Oemler, Arminius
Ogburn, William Fielding
Osceola
Paschal, George Washington
Peabody, George Foster
Pendleton, Edmund Monroe
Perry, William Flake
Phillips, Ulrich Bonnell
Phinizy, Ferdinand
Pierce, George Foster
Pierce, William Leigh
Pinchback, Pinckney Benton Stewart
Rainey, Gertrude Malissa Nix Pridgett
Ramspeck, Robert C. Word ("Bob")
Riegger, Wallingford
Rivers, Thomas Milton
Robinson, John Roosevelt ("Jackie")
Robinson, Ruby Doris Smith
Root, John Wellborn
Rucker, George ("Nap")
Russell, Richard Brevard, Jr. ("Dick")
St. John, Isaac Munroe
Sanders, Billington McCarter
Saunders, William Lawrence, 1856–
 1931
Scarborough, William Saunders
Sherwood, Thomas Adiel
Shorter, John Gill
Silcox, Ferdinand Augustus
Simmons, Thomas, Jefferson
Smith, Albert Merriman
Smith, Buckingham

Smith, Charles Henry, 1826–1903
Spalding, Thomas
Speer, Emory
Spencer, Samuel
Stallings, Laurence Tucker
Stephens, Alexander Hamilton
Stephens, Linton
Stokes, Thomas Lunsford, Jr.
Stovall, Pleasant Alexander
Sydnor, Charles Sackett
Talmadge, Eugene
Tattnall, Josiah
Taylor, Charlotte De Bernier
Tensler, Rudolf Bolling
Thomas, Charles Spalding
Ticknor, Francis Orray
Tobias, Channing Heggie
Toombs, Robert Augustus
Towers, John Henry
Towns, George Washington Bonaparte
Trammell, Niles
Troup, George Michael
Tucker, Henry Holcombe
Twiggs, David Emanuel
Upshaw, William David
Wailes, Benjamin Leonard Covington
Walker, William Henry Talbot
Ward, John Elliott
Watie, Stand
Watson, Thomas Edward
Wayne, James Moore
Wheeler, Joseph
White, Walter Francis
Willie, Asa Hoxie
Winkler, Edwin Theodore
Winship, Blanton
Wofford, William Tatum
Wood, John Stephens
Wright, Richard Robert
Yancey, William Lowndes

HAWAII

Alexander, William Dewitt
Armstrong, Samuel Chapman
Baldwin, Henry Perrine
Bingham, Hiram
Carter, Henry Alpheus Peirce
Castle, William Richards, Jr.
Dillingham, Walter Francis
Dole, Sanfor Ballard
Gulick, John Thomas
Gulick, Luther Halsey, 1828–1891
Gulick, Luther Halsey, 1865–1918
Hillebrand, William Francis
Kalanianaole, Jonah Kuhio
Lathrop, George Parsons
Patterson, William Allan ("Pat")
Thurston, Lorrin Andrews

IDAHO

Borglum, John Gutzon de la Mothe
Jardine, William Marion
Kamaiakan
Pound, Ezra Loomis
Sacagawea
Welker, Herman

ILLINOIS

Abbott, Emma
Abt, Isaac Arthur
Adams, Cyrus Cornelius
Adams, Frank Ramsay
Adams, Franklin Pierce
Addams, Jane
Alcorn, James Lusk
Alinsky, Saul David
Allison, Samuel King
Arvey, Jacob M.
Atwood, Wallace Walter
Austin, Mary
Ayres, William Augustus
Bacon, Henry
Baker, James
Balaban, Barney
Bancroft, Edgar Addison
Bancroft, Frederic
Barrett, Albert Moore
Barrow, Edward Grant
Barrows, David Prescott
Barton, William Eleazar
Beaupré, Arthur Matthias
Bendix, Vincent
Benny, Jack
Bentley, Arthur Fisher
Bergen, Edgar
Bernays, Augustus Charles
Bestor, Arthur Eugene
Bettendorf, William Peter
Bevan, Arthur Dean
Bickel, Karl August
Black, Greene Vardiman
Black Hawk
Blackstone, Harry
Bliss, Gilbert Ames
Bloom, Sol
Bloomfield, Leonard
Bode, Boyd Henry
Borah, William Edgar
Boring, William Alciphron
Bosworth, Edward Increase
Bovard, Oliver Kirby
Bowen, Louise De Koven
Brann, William Cowper
Breasted, James Henry
Breckinridge, Henry Skillman
Brennemann, Joseph
Brophy, Truman William
Brown, Gertrude foster

Brunswick, Ruth Mack
Bryan, Charles Wayland
Bryan, William Jennings
Bryant, Ralph Clement
Bumstead, Henry Andrews
Burroughs, Edgar Rice
Bush, Lincoln
Calkins, Earnest Elmo
Capps, Edward
Carpenter, John Alden
Chalmers, William James
Chamberlain, Henry Richardson
Chamberlin, Thomas Chrowder
Champion, Gower
Chandler, Raymond Thornton
Chase, (Mary) Agnes Merrill
Coghill, George Ellett
Cohn, Alfred A.
Colton, George Radcliffe
Comiskey, Grace Elizabeth Reidy
Conger, Edwin Hurd
Conover, Harry Sayles
Coolbrith, Ina Donna
Coolidge, Elizabeth Penn Sprague
Copley, Ira Clifton
Coquillett, Daniel William
Correll, Charles James
Cort, Edwin Charles
Costigan, George Purcell
Cozzens, James Gould
Crane, Charles Richard
Crane, Frank
Crothers, Rachel
Crothers, Samuel McChord
Cudahy, Edward Aloysius, Jr.
Cummings, Walter Joseph
Cushman, Vera Charlotte Scott
Daley, Richard Joseph
Danenhower, John Wilson
Davis, Arthur Powell
Davis, Pauline Morton Sabin
Davisson, Clinton Joseph
Dell, Floyd James
Dille, John Flint
Dirksen, Everett McKinley
Disney, Roy Oliver
Disney, Walter Elias ("Walt")
Donaldson, Jesse Monroe
Donoghue, John
Dos Passos, John Roderigo
Doubleday, Neltje de Graff
Downes (Edwin) Olin
Drake, Francis Marion
Dressen, Charles Walter
Dunbar, (Helen) Flanders
Duniway, Abigail Jane Scott
Dunne, Finley Peter
Durkin, Martin Patrick
Duryea, Charles Edgar
Duryea, James Frank

Du Vigneaud, Vincent
Dyer, Louis
Easley, Ralph Montgomery
East, Edward Murray
Eddy, Manton Sprague
Eichelberger, Clark Mell
Elliott, John Lovejoy
Ellsworth, Lincoln
Emmett, Burton
Farrell, James Thomas
Fearing, Kenneth Flexner
Ferris, George Washington Gale
Field, Marshall, III
Finley, John Huston
Firestone, Harvey Samuel, Jr.
Fisher, Henry Conroy ("Bud")
Flower, Benjamin Orange
Forbes, Stephen Alfred
Fox, Virgil Keel
Frankfurter, Alfred Moritz
Fry, James Barnet
Fuller, Henry Blake
Fuller, Loie
Gale, Henry Gordon
Gardner, Gilson
Gary, Elbert Henry
Gates, Caleb Frank
Gates, John Warne
Germer, Lester Halbert
Giancana, Sam ("Mooney")
Gibbs, George
Gilbert, Charles Henry
Giles, Warren Crandall
Gilman, Arthur
Goodman, Kenneth Sawyer
Goodnight, Charles
Goudy, Frederic William
Graham, Evarts Ambrose
Gray, Glen ("Spike")
Gray, Harold Lincoln
Gray, William Scott, Jr.
Greenlaw, Edwin Almiron
Gunther, John
Hale, George Ellery
Hale, Louise Closser
Hallett, Moses
Hammond, Laurens
Hansberry, Lorraine Vivian
Hapgood, Hutchins
Hapgood, Norman
Harbord, James Guthrie
Harlan, James
Harlan, John Marshall
Harridge, William ("Will")
Harrington, Mark Walrod
Harrison, Carter Henry, Jr.
Hart, George Overbury
Hartzell, Joseph Crane
Hathaway, Donny
Hawthorne, Charles Webster

Helmer, Bessie Bradwell
Hemingway, Ernest Miller
Hibben, John Grier
Hickok, James Butler
High, Stanley Hoflund
Higinbotham, Harlow Niles
Hills, Elijah Clarence
Hodge, John Reed
Hoerr, Normand Louis
Hoffman, Paul Gray
Hokinson, Helen Elna
Holmes, Elias Burton
Hood, Clifford Firoved
Horner, Henry
Hovey, Richard
Howard, Charles Perry
Howard, Leland Ossian
Hubbard, Elbert
Humphrey, Doris
Hunt, Haroldson Lafayette
Hunt, Lester Callaway
Huntington, Ellsworth
Huntington, William Edwards
Hurley, Edward Nash
Husk, Charles Ellsworth
Hyde, Charles Cheney
Illington, Margaret
Ingals, Ephraim Fletcher
Jackson, Robert R.
James, Edmund Janes
James, Louis
Jennings, Herbert Spencer
Johnson, Albert
Johnson, Harold Ogden ("Chic")
Jones, James Ramon
Jones, Wesley Livsey
Keane, James John
Keefe, Daniel Joseph
Kelly, Edward Joseph
Kelsey, Rayner Wickersham
Kempff, Louis
Keokuk
Kerner, Otto, Jr.
Kilgallen, Dorothy Mae
Kingsbury, Albert
Kirby, Rollin
Kirkman, Marshall Monroe
Knight, Frank Hyneman
Knowles, John Hilton
Koch, Fred Conrad
Kofoid, Charles Atwood
Kohlsaat, Herman Henry
Krupa, Eugene Bertram ("Gene")
Landis, Jessie Royce
Lardner, John Abbott
Lasswell, Harold Dwight
Lathrop, Julia Clifford
Lawson, Victor Freemont
Lee, John Doyle
Lee, William Granville

Leiber, Fritz
Leiter, Joseph
Lenz, Sidney Samuel
Leonard, Jack E.
Leopold, Nathan Freudenthal, Jr.
Lewis, Dean De Witt
Lillie, Gordon William
Lincoln, Robert Todd
Lindsay, Nicholas Vachel
Lingelbach, Anna Lane
Logan, John Alexander
Loree, Leonor Fresnel
Lowry, Thomas
Lucas, Scott Wike
McAdams, Clark
MacCameron, Robert
McClure, Robert Alexis
McConnel, John Ludlum
McCord, James Bennett
McCormick, Joseph Medill
McCormick, Robert Rutherford
McCoy, Joseph Geating
McCumber, Porter James
McKinley, William Brown
McLaughlin, Andrew Cunningham
Mann, James Robert
Marquis, Donald Robert Perry
Martin, Everett Dean
Martin, Warren Homer
Mason, Francis Van Wyck
Masterson, William Barclay
Maxwell, Lucien Bonaparte
Maycr, Oscar Gottfried
Maytag, Frederick Louis
Meinzer, Oscar Edward
Mendelsohn, Samuel
Micheaux, Oscar
Miller, Perry Gilbert Eddy
Millikan, Clark Blanchard
Millikan, Robert Andrews
Mitchell, James Tyndale
Mitchell, John, 1870–1919
Mitchell, Lucy Sprague
Mitchell, Wesley Clair
Monroe, Harriet
Mooney, Thomas Joseph
Morgan, Helen
Morrison, William Ralls
Motley, Willard Francis
Mowrer, Edgar Ansel
Mulford, Clarence Edward
Munson, Thomas Volney
Nash, Charles Williams
Nevins, Joseph Allan
Newell, Peter Sheaf Hersey
Nicholson, Seth Barnes
Nielsen, Arthur Charles
Norris, Benjamin Franklin
Norris, Charles Gilman Smith
Novy, Frederick George

Nutting, Charles Cleveland
O'Brien, Tustin
Paine, Ralph Delahaye
Palmer, John McAuley
Parkhurst, John Adelbert
Parr, Samuel Wilson
Parrington, Vernon Louis
Parsons, Louella Rose Oettinger
Patten, James A.
Patten, Simon Nelson
Patterson, Alicia
Patterson, Eleanor Medill
Patterson, Joseph Medill
Pearson, Drew
Pearson, Thomas Gilbert
Peattie, Donald Culross
Peek, George Nelson
Pentecost, George Frederick
Perkins, George Walbridge
Poole, Ernest Cook
Post, Charles William
Post, Marjorie Merriweather
Powell, Alma Webster
Powell, Maud
Radford, Arthur William
Rainey, Henry Thomas
Raum, Green Berry
Rawlins, John Aaron
Raymond, George Lansing
Redfield, Robert
Reed, Earl Howell
Reed, Myrtle
Reeves, Joseph Mason
Revell, Fleming Hewitt
Revell, Nellie MacAleney
Rhees, Rush
Richmond, Mary Ellen
Ridgway, Robert
Robertson, Ashley Herman
Robinson, Benjamin Lincoln
Robinson, Edward Van Dyke
Robinson, James Harvey
Rockwell, George Lincoln
Rogers, John Raphael
Rohde, Ruth Bryan Owen
Rosenwald, Julius
Rosenwald, Lessing Julius
Ross, Edward Alsworth
Roulston, Marjorie Hillis
Rowell, Chester Harvey
Ruby, Jack L.
Ruhl, Arthur Brown
Ryan, Robert Bushnell
Sandburg, Carl August
Schalk, Raymond William ("Cracker")
Schneider, Albert
Schroeder, Rudolph William
Schwatka, Frederick
Scott, Harvey Whitefield
Scott, John Adams

Scott, Walter Dill
Scripps, Edward Wyllis
Selig, William Nicholas
Sharp, Katharine Lucinda
Shaw, Howard Van Doren
Sheean, James Vincent
Sheen, Fulton John
Sheil, Bernard James
Sherman, Allan
Short, Luke
Short, Walter Campbell
Sills, Milton
Simons, Henry Calvert
Simpson, Charles Torrey
Skinner, Cornelia Otis
Slade, Joseph Alfred
Slater, John Clarke
Smith, Frank Leslie
Smith, Harry Allen
Smith, Henry Justin
Smith, Ralph Tyler
Smith, Robert Sidney
Snow, William Freeman
Snyder, John Francis
Spalding, Albert
Spalding, Albert Goodwill
Stephenson, Benjamin Franklin
Stettinius, Edward Reilly
Stone, Melville Elijah
Stone, Ormond
Stratton, Samuel Wesley
Strawn, Silas Hardy
Strong, Josiah
Strong, Walter Ansel
Stryker, Lloyd Paul
Sturges, Preston
Sunderland, Eliza Jane Read
Symons, George Gardner
Taft, Lorado Zadoc
Talbot, Arthur Newell
Tanner, Edward Everett, III ("Patrick
　　Dennis")
Teeple, John Edgar
Thayer, Tiffany Ellsworth
Thomas, Jesse Burgess
Thompson, Seymour Dwight
Thurstone, Louis Leon
Todd, Henry Alfred
Tompkins, Arnold
Townsend, Francis Everett
Tristano, Leonard Joseph ("Lennie")
Turner, George Kibbe
Vanderlip, Frank Arthur
Van Doren, Carl Clinton
Van Horne, William Cornelius
Vincent, George Edgar
Wacker, Charles Henry
Walgreen, Charles Rudolph
Wallace, Henry Cantwell
Waller, Willard Walter

Ward, Arch Burdette
Ward, Lester Frank
Warman, Cy
Warmoth, Henry Clay
Waymack, William Wesley
West, Roy Owen
Westermann, William Linn
Weston, Edward Henry
Weston, Nathan Austin
Weyerhaeuser, Frederick Edward
White, Charles Wilbert
Willard, Frank Henry
Willcox, Louise Collier
Williams, Jesse Lynch
Williams, Thomas Harry
Wilson, Edmun Beecher
Wilson, Harry Leon
Wilson, Hugh Robert
Wilson, James Harrison
Wolfe, Harry Kirke
Wright, John Kenneth Lloyd
Wright, Theodore Paul
Wrigley, Philip Knight
Yancey, James Edward ("Jimmy")
Young, Art
Zeckendorf, William
Ziegfeld, lorenz
Ziff, William Bernard

INDIANA

Acker, Charles Ernest
Adams, Andy
Ade, George
Allport, Gordon Willard
Anderson, Edwin Hatfield
Anderson, Margaret Carolyn
Andrew, Abram Piatt
Arvin, Newton
Atterbury, William Wallace
Aydelotte, Frank
Barnes, Charles Reid
Bass, Sam
Beadle, William Henry Harrison
Beard, Charles Austin
Beard, Mary Ritter
Beeson, Charles Henry
Bell, Lawrence Dale
Bement, Charles Sweet
Bennett, Richard
Billings, John Shaw
Blackburn, William Maxwell
Blasdel, Henry Goode
Blue, Gerald Montgomery ("Monte")
Boisen, Anton Theophilus
Booth, Newton
Bowers, Claude Gernade
Bradley, Lydia Moss
Budenz, Louis Francis
Buley, Roscoe Carlyle
Burnside, Ambrose Everett

Caldwell, Otis William
Calkins, Gary Nathan
Capehart, Homer Earl
Carey, Max George ("Scoops")
Catlett, Sidney
Chapman, John Wilbur
Chase, William Merritt
Coffman, Lotus Delta
Condon, Albert Edwin ("Eddie")
Cooper, Henry Ernest
Cooper, Kent
Cope, Arthur Clay
Crawford, Samuel Johnson
Cubberley, Ellwood Patterson
Cuppy, William Jacob (Will)
Curme, George Oliver
Daeger, Albert Thomas
Davis, Adelle
Davis, Elmer Holmes
Davis, Jefferson Columbus
Davis, John Lee
Dean, James Byron
Debs, Eugene Victor
Deemer, Horace Emerson
Denby, Edwin
De Pauw, Washington Charles
Dillinger, John
Dodge, Henry
Doolittle, Charles Leander
Doolittle, Eric
Douglas, Lloyd Cassel
Dreiser, Theodore
Dresser, Louise Kerlin
Du Bois, Shirley Lola Graham
Dunn, William McKee
Eads, James Buchanan
Eggleston, Edward
Eggleston, George Cary
English, William Hayden
Ewing, Oscar Ross
Fazenda, Louise Marie
Fetter, Frank Albert
Fetcher, James Cooley
Flanner, Janet
Fletcher, William Baldwin
Fordney, Joseph Warren
Foster, John Watson
Foster, Robert Sanford
Frick, Ford Christopher
Geer, William Aughe ("Will")
Ghent, William James
Gimbel, Bernard Feustman
Girdler, Tom Mercer
Goode, George Brown
Goudy, William Charles
Green, Norvin
Gresham, Walter Quintin
Gridley, Charles Vernon
Grissom Virgil Ivan ("Gus")
Haan, William George

Hackley, Charles Henry
Haggerty, Melvin Everett
Hale, William Bayard
Hamtrauck, John Francis
Handley, Harold Willis
Hannagan, Stephen Jerome
Harper, Ida Husted
Hawks, Howard Winchester
Hawley, Paul Ramsey
Hay, John Milton
Hay, Mary Garrett
Hay, Oliver Perry
Hays, Will H.
Heath, Perry Sanford
Henderson, Charles Richmond
Herron, George Davis
Hershey, Lewis Blaine
Hibben, Paxton Pattison
Hill, Edwin Conger
Hill, John Wiley
Hodges, Gilbert Ray
Hoffa, James Riddle ("Jimmy")
Holcomb, Silas Alexander
Hollis, Ira Nelson
Holman, William Steele
Hornaday, William Temple
Hovey, Alvin Peterson
Howe, Edgar Watson
Howe, Louis McHenry
Hunter, Robert
Ingram, Jonas Howard
Jaquess, James Frazier
Jessup, Walter Albert
Johnston, Annie Fellows
Jones, Jim
Jones, George Wallace
Juday, Chancey
Julian, George Washington
Kern, John Worth
Kimball, Nathan
Klein, Charles Herbert ("Chuck")
Lane, James Henry
Leavenworth, Francis Preserved
Levinson, Salmon Oliver
Lewis, Lloyd Downs
Lilly, Eli
Lilly, Josiah Kirby
Little Turtle
Loeb, Milton B.
Logan, James Harvey
Lombard, Carole
Lowes, John Livingston
Lynd, Robert Staughton
McCormack, Buren Herbert ("Mac")
McCrary, George Washington
McCutcheon, George Barr
McFarland, John Thomas
McHale, Kathryn
McKinney, Frank Edward, Sr.
McMurry, Frank Morton

McNutt, Paul Vories
McPherson, Smith
McQueen, Terence Stephen ("Steve")
Macy, Jesse
Main, Marjorie
Major, Charles
Marshall, Thomas Riley
Martin, William Alexander Parsons
Mead, Elwood
Meek, ielding Bradford
Mellette, Arthur Calvin
Menninger, Charles Frederick
Miller, Cincinnatus Hiner
Miller, John Franklin
Millis, Harry Alvin
Mills, Anson
Milroy, Robert Huston
Minton, Sherman
Monroe, Paul
Moody, William Vaughn
Mooney, James
Moore, Addison Webster
Moore, Philip North
Morgan, Thomas Jefferson
Morrow, William W.
Morton, Oliver Perry
Nash, Arthur
Nathan, George Jean
Nelson, William Rockhill
New, Harry Stewart
Newlon, Jesse Homer
Newsom, Herschel David
Niblack, Albert Parker
Niblack, William Ellis
Nicholson, Meredith
Nixon, William Penn
Noll, John Francis
Norell, Norman
Noyes, William Albert, Jr.
Ogg, Frederic Austin
Oliphant, Herman
Olsen, John Sigvard ("Ole")
Osborn, Chase Salmon
Pearson, Edward Iones
Pearson, Leonard
Pearson, Raymond Allen
Philipson, David
Phillips, David Graham
Piatt, John James
Plummer, Mary Wright
Porter, Albert Gallatin
Porter, Cole
Porter, Gene Stratton
Pyle, Ernest Taylor
Randall, James Garfield
Record, Samuel James
Reisner, George Andrew
Rice, Edgar Charles ("Sam")
Ridpath, John Clark
Riley, James Whitcomb

Riley, William Bell
Ritter, Joseph Elmer
Rodman, Thomas Jackson
Rose, Joseph Nelson
Rovenstine, Emery Andrew
Runcie, Constance Faunt Le Roy
St. John, John Pierce
Sanders, Harland David ("Colonel")
Schelling, Felix Emanuel
Scott, Fred Newton
Scott, Leroy
Shaw, (Warren) Wilbur
Shelton, Albert Leroy
Shields, Charles Woodruff
Shoup, Francis Asbury
Sims, Charles N.
Sissle, Noble Lee
Skidmore, Louis
Slipher, Vesto Melvin
Sloan, James Forman
Smith, David Roland
Smith, Walter Bedell
Sparks, William Andrew Jackson
Spooner, John Coit
Springer, William McKendree
Stanley, Wendell Meredith
Starbuck, Edwin Diller
Stein, Evaleen
Stephenson, Carl
Stout, Rex Todhunter
Straton, John Roach
Straus, Simon William
Stubbs, Walter Roscoe
Tarkington, Booth
Taylor, Frank Bursley
Terman, Lewis Madison
Terrell, Edwin Holland
Thomas, (John William) Elmer
Thompson, James Maurice
Thompson, Oscar Lee
Thornton, Henry Worth
Thorpe, Rose Alnora Hartwick
Tolley, Howard Ross
Trueblood, Benjamin Franklin
Usher, Nathaniel Reilly
Vanderburgh, William Henry
Van Devanter, Willis
Van Doren, Mark Albert
Van Hook, Weller
Veatch, Arthur Clifford
Voris, John Ralph
Wallace, Lewis
Warthin, Aldred Scott
Watson, James Eli
Webb, Clifton
Wharton, Greene Lawrence
Whetzel, Herbert Hice
Whistler, George Washington
Wickard, Claude Raymond
Wiley, Harvey Washington

Williams, Elkanah
Williams, Gaar Campbell
Willkie, Wendell Lewis
Wills, Childe Harold
Wilson, Henry Lane
Wilson, John Lockwood
Wirt, William Albert
Wissler, Clark
Wood, Thomas Bond
Wood, William Robert
Woolman, Collett Everman
Wright, George Grover
Wright, Wilbur
Yohn, Federick Coffay

IOWA

Adams, Ephraim Douglass
Adams, Henry Carter
Adler, Felix
Alden, Cynthia May Westover
Aldrich, Bess Genevra Streeter
Anson, Adrian Constantine
Baker, Carl Lotus
Ballinger, Richard Achilles
Beer, Thomas
Bell, Frederic Somers
Benson, Oscar Herman
Binford, Jessie Florence
Bingham, Walter Van Dyke
Bliven, Bruce Ormsby
Borg, George William
Botsford, George Willis
Bowen, Thomas Meade
Buckley, Oliver Ellsworth
Buckner, Emory Roy
Budd, Ralph
Burdick, Eugene Leonard
Burton, Marion Le Roy
Byoir, Carl Robert
Campbell, Marius Robinson
Carothers, Wallace Hume
Case, Francis Higbee
Cody, William Frederick
Collier, Hiram Price
Cone, Russell Glenn
Cook, George Cram
Cooley, Edwin Gilbert
Cowles, Gardner
De Forest, Lee
Devaney, John Patrick
Devine, Edward Thomas
Dickinson, Edwin De Witt
Dickson, Leonard Eugene
Eisenhower, Mamie Geneva Doud
Ely, Hanson Edward
Emerson, Oliver Farrar
Evermann, Barton Warren
Gabrielson, Ira Noel
Garretson, Austin Bruce
Garst, Roswell ("Bob")

Gidley, James Williams
Gillette, Guy Mark
Glaspell, Susan Keating
Graff, Everett Dwight
Gregory, Clifford Verne
Hall, James Norman
Hamilton, John Daniel Miller, II
Hawley, James Henry
Hays, Paul R.
Heezen, Bruce Charles
Herbst, Josephine Frey
Hickenlooper, Bourke Blakemore
Hillis, Newell Dwight
Hooper, Jessie Annette Jack
Hoover, Herbert Clark
Hope, Clifford Ragsdale
Hopkins, Harry Lloyd
Hough, Emerson
Hove, Elling
Howard, Edgar
Howard, Joseph Kinsey
Howey, Walter Crawford
Hutton, Levi William
Irwin, Robert Benjamin
Jackson, Clarence Martin
Jensen, Benton Franklin ("Ben")
Kantor, MacKinlay
Keenan, James Francis
Kerby, William Joseph
Knapp, Bradford
Koren, John
Langdon, Harry Philmore
Laughlin, Harry Hamilton
Leahy, William Daniel
Leedom, Boyd Stewart
Leopold, (Rand) Aldo
Leverett, Frank
Lewelling, Lorenzo Dow
Lewis, John Llewellyn
Lunn, George Richard
McGee, William John
McKean, James William
MacNider, Hanford
Mall, Franklin Paine
Martin, Glenn Luther ("Cy")
Maxwell, Elsa
Maxwell, Marvel Marilyn
Meredith, Edna C. Elliott
Meredith, Edwin Thomas
Merriam, Charles Edward, Jr.
Merriam, John Campbell
Miller, Glenn
Mitchell, Stephen Arnold
Morley, Margaret Warner
Mott, Frank Luther
Nagel, Conrad
Noyes, William Albert
Paul, Josephine Bay
Phillips, John Sanburn
Pierce, Robert Willard

Plumb, Glenn Edward
Pritchard, Frederick John
Quick, John Herbert
Read, George Windle
Remey, George Collier
Reno, Milo
Reynolds, George McClelland
Ringling, Charles
Ross, Lawrence Sullivan
Rowe, Leo Stanton
Ruml, Beardsley
Russell, Charles Edward
Russell, Lillian
Ryan, Arthur Clayton
Salter, William Mackintire
Seberg, Jean Dorothy
Shaw, Lawrence Timothy ("Buck")
Sherman, Stuart Pratt
Shorey, Paul
Smith, Courtney Craig
Smith, Fre Burton
Smith, Walter Inglewood
Springer, Charles
Springer, Frank
Stone, Warren Sanford
Stong, Phil(lip Duffield)
Stouffer, Samuel Andrew
Sunday, William Ashley
Tate, John Torrence
Tilghman, William Matthew
Van Allen, Frank
Vance, Arthur Charles ("Dazzy")
Van Vechten, Carl
Veblen, Oswald
Wallace, Henry Agard
Wallgren, Mon[rad] C[harles]
Warner, Amos Griswold
Watts, Franklin Mowry
Wayne, John
Welch, Joseph Nye
Whitcomb, Selden Lincoln
Whitehill, Clarence Eugene
Whitney, Alexander Fell
Wilbur, Curtis Dwight
Wilbur, Ray Lyman
Wilson, Mortimer
Wood, Garfield Arthur ("Gar")
Wood, Grant
Young, Clarence Marshall
Young, Karl
Young, Lafayette

KANSAS

Bemis, Harold Edward
Braniff, Thomas Elmer
Browder, Earl Russell
Capper, Arthur
Chaffee, Adna Romanza
Chaplin, Ralph Hosea
Chrysler, Walter Percy

Clapper, Raymond Lewis
Cobb, Frank Irving
Curry, John Steuart
Curtis, Charles
Douglas, Aaron
Earhart, Amelia Mary
Fisher, Dorothea Frances Canfield
Frank, Tenney
Franklin, Edward Curtis
Friday
Gaylord, Edward King
Gregg, John Andrew
Hadley, Herbert Spencer
Harrington, John Lyle
Hatch, Carl A.
Henderson, Paul
Hinshaw, David Schull
Holmes, Julius Cecil
Inge, William Motter
Johnson, Edwin Carl
Johnson, Hugh Samuel
Johnson, Osa
Johnson, Walter Perry
Johnson, Wendell Andrew Leroy
Keaton, Joseph Francis ("Buster"), V
Kelly, Emmett Leo
Kenton, Stanley Newcomb
Kuhn, Joseph Ernst
Latimer, Wendell Mitchell
Lee, John Clifford Hodges
Livingstone, Belle
McDaniel, Hattie
Marlatt, Abby Lillian
Masters, Edgar Lee
Menninger, William Claire
Mills, Enos Abijah
Moore, Hugh Everett
Murdock, Victor
Nichols, Ernest Fox
O'Hare, Kate (Richards) Cunningham
Parker, Charlie ("Bird")
Parks, Larry
Peabody, Lucy Whitehead
Pemberton, Brock
Pitts, Zasu
Runyon, Damon
Rupp, Adolph Frederick
Schoeppel, Andrew Frank
Slosson, Edwin Emery
Smith, Harold Dewey
Smith, William Eugene
Sprague, Charles Arthur
Starrett, Paul
Starrett, William Aiken
Stearman, Lloyd Carlton
Stewart, Walter Winne
Sutherland, Earl Wilbur, Jr.
Vance, Vivian
Vincent, John Carter
White, William Allen

Whittaker, Charles Evans
Willebrandt, Mabel Walker
Woodring, Harry Hines
Wright, Henry
Zook, George Frederick

KENTUCKY

Adams, William Wirt
Alexander, Barton Stone
Alexander, Gross
Allen, Henry Tureman
Allen, James Lane
Altsherer, Joseph Alexander
Anderson, Richard Clough
Anderson, Robert
Anderson, Victor Vance
Anshutz, Thomas Pollock
Applegate, Jesse
Atchison, David Rice
Baker, Jehu
Barkley, Alben William
Baylor, Robert Emmet Bledsoe
Becknell, William
Bell, James Franklin
Bent, Silas
Berryman, Clifford Kennedy
Birney, James
Birney, James Gillespie
Blackburn, Joseph Clay Styles
Blackburn, Luke Pryor
Blair, Francis Preston
Blair, Montgomery
Bland, Richard Parks
Bledsoe, Albert Taylor
Bloch, Claude Charles
Bjoggs, Lillburn W.
Bolton, Sarah Tittle Barrett
Bowman, John Bryan
Boyle, Jeremiah Tilford
Bradley, William O'Connell
Bramlette, Thomas E.
Brandeis, Louis Dembitz
Breckenridge, Sophonisba Preston
Breckinridge, Desha
Breckinridge, John
Breckinridge, John Cabell
Breckinridge, Robert Jefferson
Brennan, Alfred Laurens
Bristow, Benjamin Helme
Bristow, Joseph Little
Brown, Benjamin Gratz
Brown, John Mason, Jr.
Brown, John Young
Brown, William Wells
Browning, Orville Hickman
Browning, Tod
Buchanan, Joseph Rodes
Buckner, Simon Bolivar, 1823–1914
Buckner, Simon Bolivar, 1886–1945
Buford, Abraham

Buford, John
Buford, Napoleon Bonaparte
Bullitt, Henry Massie
Burbridge, Stephen Gano
Burnam, John Miller
Butler, Burridge Davenal
Butler, William Orlando
California Joe
Canby, Edward Richard Sprigg
Carlisle, John Griffin
Carson, Christopher
Carter, Caroline Louise Dudley
Cawein, Madison Tulius
Chilton, William Paris
Churchill, Thomas James
Clark, Champ
Clay, Cassius Marcellus
Cobb, Irvin Shrewsbury
Cofer, Martin Hardin
Coleman, William Tell
Combs, Earle Bryan
Combs, Leslie
Connelly, Henry
Cooper, Joseph Alexander
Corwin, Thomas
Crittenden, George Bibb
Crittenden, John Jordan
Crittenden, Thomas Leonidas
Crittenden, Thomas Theodore
Croghan, George
Cullom, Shelby Moore
Davies, William Augustine
Daviess, Maria Thompson
Davis, Garrett
Davis, Jefferson
Dickey, Theophilus Lyle
Dinwiddie, Atbert Bledsoe
Doniphan, Alexander William
Drake, Benjamin
Duke, Basil Wilson
Duncan, Joseph
Dunn, Charles
Dunn, Williamson
DuPont, Thomas Coleman
Durbin, John Price
Durrett, Reuben Thomas
Duveneck, Frank
Edwards, Ninian Wirt
Evans, Walter
Everleigh, Ada
Everleigh, Minna
Fagan, James Fleming
Fall, Albert Bacon
Fee, John Gregg
Field, Charles William
Flanagan, Webster
Flexner, Abraham
Flexner, Bernard
Flexner, Jennie Maas
Flexner, Simon

Floyd, John
Ford, John Baptiste
Foster, Ephraim Hubbard
Fowke, Gerard
Fox, Fontaine Talbot, Jr.
Fox, John William
Francis, David Rowland
Frazer, Oliver
Garrard, Kenner
Gholson, Samuel Jameson
Gibson, Randall Lee
Gilliss, Walter
Goldman, Edwin Franko
Goodloe, William Cassius
Gore, Robert Hayes
Gorman, Willis Arnold
Greathouse, Clarence Ridgeby
Green, Benjamin Edwards
Green, Duff
Green, Lewis Warner
Greene, George Sears
Griffith, David Wark
Grimes, Absalom Carlisle
Guthrie, James
Haggin, James Ben Ali
Halderman, John A.
Hall, William Whitty
Hanson, Roger Weightman
Hardin, Charles Henry
Hardin, John J.
Harlan, James
Harlan, John Marshall
Harney, Benjamin Robertson
Harrison, Carter Henry
Harrison, Elizabeth
Harrison, James
Hart, Joel Tanner
Hatch, William Henry
Hauser, Samuel Thomas
Hays, William Shakespeare
Helm, John Larue
Henderson, Yandell
Herndon, William Henry
Hill, Patty Smith
Hines, Duncan
Hines, Walker Downer
Hobson, Edward Henry
Hodgen, John Thompson
Holladay, Ben
Holman, Jesse Lynch
Holt, Joseph
Hood, John Bell
Hume, Edgar Erskine
Hunter, William C.
Ireland, John, 1827–1896
Jackson, Claiborne Fox
Jackson, John Davies
Jacob, Richard Taylor
James, Ollie Murray
Jennings, James Hennen

Johnson, Richard Mentor
Johnson, Richard W.
Johnson, Robert Ward
Johnson, Tom Loftin
Johnston, Albert Sidney
Johnston, William Preston
Jones, William Palmer
Jouett, James Edward
Jouett, Matthew Harris
Kimmel, Husband Edward
King, John Pendleton
Klaw, Marc
Knott, James Proctor
Koch, Frederick Henry
Krock, Arthur
Lane, Henry Smith
Lawson, Leonidas Merion
Lee, Willis Augustus
Lewis, Joseph Horace
Lincoln, Abraham
Lincoln, Mary Todd
Linn, Lewis Fields
Logan, Stephen Trigg
Lorimer, George Horace
Lurton, Horace Harmon
McAfee, Robert Breckinridge
McCalla, William Latta
McCann, William Penn
McClernand, John Alexander
McCormack, Joseph Nathaniel
McCreary, James Bennett
McCreery, Charles
McElroy, John
McElroy, Robert McNutt
McGarvey, John William
McMillan, James Winning
McMillin, Benton
McReynolds, James Clark
Magoffin, Beriah
Magoffin, James Wiley
Majors, Alexander
Marcosson, Isaac Frederick
Marshall, Humphrey
Marshall, Thomas Alexander
Marshall, William Louis
Martin, William Thompson
Masquerier, Lewis
Matthews, Claude
Matthews, Joseph Brown
Maury, Francis Fontaine
Maxey, Samuel Bell
Maxwell, David Hervey
May, Andrew Jackson
Meigs, Return Jonathan
Miller, Henry
Miller, Samuel Freeman
Mills, Robert, 1809–1888
Mills, Roger Quarles
Mitchel, Ormsby MacKnight
Moore, William Thomas

Morehead, Charles Slaughter
Morehead, James Turner
Morgan, Thomas Hunt
Morris, Thomas Armstrong
Morrow, Edwin Porch
Morrow, Prince Albert
Morrow, Thomas Vaughan
Morton, Rogers Clark Ballard
Moss, Lemuel
Nation, Carry Amelia Moore
Nelson, Thomas Henry
Nelson, William, 1824–1862
Niles, John Jacob
Nolan, Philip
Norton, Elijah Hise
O'Fallon, Benjamin
O'Fallon, John
Oglesby, Richard James
O'Hara, Theodore
Palmer, Bertha Honore
Palmer, John McAuley
Pattie, James Ohio
Peay, Austin
Phillips, Lena Madesin
Piatt, Sarah Morgan Bryan
Polk, Willis Jefferson
Pope, John
Pope, Nathaniel
Poston, Charles Debrill
Powell, Lazarus Whitehead
Powell, William Byrd
Powers, Francis Gary
Preston, William
Price, William Thompson
Proctor, John Robert
Purnell, Benjamin
Pusey, William Allen
Rachford, Benjamin Knox
Rector, Henry Massey
Reed, Stanley Forman
Reynolds, Charles Alexander
Reynolds, Joseph Jones
Rice, Alice Caldwell Hegan
Rice, Nathan Lewis
Richardson, Tobias Gibson
Ridgely, Daniel Bowly
Rives, Hallie Erminie
Roark, Ruric Nevel
Roberts, Elizabeth Madox
Robertson, George
Robertson, Jerome Bonaparte
Rogers, James Gamble
Rollins, James Sidney
Rose, Uriah Milton
Rousseau, Lovell Harrison
Russell, William Henry
Rutledge, Wiley Blount
Sanders, George Nicholas
Saunders, Alvin
Scopes, John Thomas

Scott, Hugh Lenox
Scott, Walter Edward
Semple, Ellen Churchill
Shaler, Nathaniel Southgate
Shelby, Joseph Orville
Shields, George Howell
Short, Charles Wilkins
Shouse, Jouett
Simms, William Elliott
Smith, Gustavus Woodson
Smith, William Russell
Spalding, John Lancaster
Spalding, Martin John
Speed, James
Spence, Brent
Springer, Reuben Runyan
Stanley, Augustus Owsley
Stayton, John William
Stevenson, Adlai Ewing
Stevenson, James
Stone, Richard French
Stone, William Joel
Stuart, John Todd
Sublette, William Lewis
Switzler, William Franklin
Tate, John Orley Allen
Taylor, Marshall William
Taylor, Richard
Terry, David Smith
Tevis, Lloyd
Thompson, Stith
Tichenor, Isaac Taylor
Todd, Charles Stewart
Towne, Charles Hanson
Traylor, Melvin Alvah
Underwood, Oscar Wilder
Vest, George Graham
Vinson, Fred(erick) Moore
Visscher, William Lightfoot
Walker, David, 1806–1879
Walker, David Shelby
Walker, Pinkney Houston
Walker, Stuart Armstrong
Wallace William Ross
Waller, John Lightfoot
Walling, William English
Walters, Alexander
Warden, Robert Bruce
Warfield, Benjamin Breckinridge
Watkins, George Claiborne
Watson, John Crittenden
Webber, Charles Wilkins
Wehle, Louis Brandeis
West, William Edward
White, Alma Bridwell
Whitman, Albery Allson
Wickliffe, Charles Anderson
Wickliffe, Robert Charles
Willis, Albert Shelby
Willson, Augustus Everett

Winlock, Joseph
Witherspoon, Alexander Maclaren
Wood, Thomas John
Wrather, William Embry
Yates, Richard
Yeaman, William Pope
Young, Whitney Moore, Jr.

LOUISIANA

Aime, Valcour
Armstrong, Louis ("Satchmo")
Basso, (Joseph) Hamilton
Beauregard, Pierre Gustave Toutant
Bechet, Sidney
Behan, William James
Bermudez, Edouard Edmond
Blanchard, Newton Crain
Bontemps, Arna Wendell
Bouligny, Dominique
Bouvet, Marie Marguerite
Breaux, Joseph Arsenne
Brooks, Overton
Butterworth, William Walton ("Walt")
Cable, George Washington
Caffery, Donelson
Caffery, Jefferson
Cahn, Edmond Nathaniel
Canonge, Louis Placide
Carter, William Hodding, Jr.
Celestin, Oscar ("Papa")
Chouteau, Jean Pierre
Chouteau, René Auguste
Clark, Felton Grandison
Collens, Thomas Wharton
Connelly, Pierre Francis
Cushman, Pauline
Davis, Abraham Lincoln, Jr.
Deléry, François Charles
Dimitry, Alexander
Dugué, Charles Oscar
Edeson, Robert
Elder, Susan Blanchard
Elkin, William Lewis
Ellender, Allen Joseph
Eustis, George
Eustis, James Biddle
Faget, Jean Charles
Farrar, Edgar Howard
Fay, Edwin Whitfield
Fiske, Minnie Maddern
Fortier, Alcée
Foster, Murphy James
Gayarré, Charles Étienne Arthur
Gherardi, Bancroft
Goldman, Mayer C.
Gottschalk, Louis Moreau
Hall, Luther Egbert
Harrod, Benjamin Morgan
Hébert, Felix Edward ("Eddie")
Hébert, Louis

Hébert, Paul Octave
Herriman, George Joseph
Hunt, Carleton
Hunt, Gaillard
Jackson, Mahalia
Janin, Louis
Janvier, Margaret Thomson
Kenner, Duncan Farrar
Kennicott, Robert
King, Grace Elizabeth
Koenigsberg, Moses
La Barge, Joseph
Lafon, Thomy
Latil, Alexandre
Ledbetter, Huddie ("Leadbelly")
Lejeune, John Archer
Leslie, Miriam Florence Folline
Levy, Gustave Lehmann
Lisa, Manuel
Long, Earl Kemp
Long, Huey Pierce
Ludeling, John Theodore
Lynch, John Roy
McEnery, Samuel Douglas
Maestri, Robert Sidney
Marigny, Bernard
Matas, Rudolph
Matthews, James Brander
Menken, Adah Isaacs
Mercier, Charles Alfred
Morgan, James Morris
Morgan, Philip Hicky
Morphy, Paul Charles
Morrison, Delesseps Story
Morton, Ferdinand Joseph ("Jelly Roll")
Mouton, Alexander
Nicholls, Francis Redding Tillou
Oliver, Joseph
Ory, Edward ("Kid")
Osgood, Howard
Oswald, Lee Harvey
Ott, Melvin Thomas ("Mel")
Patterson, Thomas Harman
Pavy, Octave
Perez, Leander Henry
Pope, James Pinckney
Prima, Luigi ("Louis")
Provosty, Olivier Otis
Richardson, Henry Hobson
Roman, André Bienvenu
Rouquette, Adrien Emmanuel
Rouquette, François Dominique
Scarborough, Lee Rutland
Séjour, Victor
Shaw, Clay L.
Smith, Marcus
Sothern, Edward Hugh
Souchon, Edmond
Stuart, Ruth McEnery

Thierry, Camille
Turpin, Ben
Viel, François Étienne Alexandre
Vignaud, Henry
Vileré, Jacques Philippe
Walker, Sarah Breedlove
Wells, James Madison
Wills, Harry
Wiltz, Louis Alfred

MAINE

Abbot, Ezra
Abbot, Gorham Dummer
Abbott, Edward
Abbott, Frank
Abbott, Jacob
Abbott, John Stevens Cabot
Akers, Benjamin Paul
Akers, Elizabeth Chase
Albee, Edward Franklin
Alden, James
Alexander, De Alva Stanwood
Allen, William Henry
Allinson, Anne Crosby Emery
Ames, Adelbert
Anderson, Martin Brewer
Andrew, John Albion
Andrews, George Pierce
Andrews, Israel DeWolf
Bailey, Rufus William
Baker, James Hutchins
Banks, Charles Edward
Barker, Benjamin Fordyce
Barker, Jacob
Barrett, Benjamin Fiske
Bartol, Cyrus Augustus
Bates, Arlo
Bates, James
Beaman, Charles Cotesworth
Bean, Leon Lenwood
Berry, Hiram Gregory
Berry, Nathaniel Springer
Bickmore, Albert Smith
Black, Frank Swett
Blunt, James Gillpatrick
Bogan, Louise Marie
Bond, William Cranch
Boutelle, Charles Addison
Brackett, Edward Augustus
Bradbury, James Ware
Bradbury, William Batchelder
Bradley, Milton
Brannan, Samuel
Brewster, Ralph Owen
Bridges, (Henry) Styles
Brooks, Erastus
Brooks, James
Brooks, Noah
Brooks, Peter Chardon

Brown, Samuel Gilman
Browne, Charles Farrar
Cary, Annie Louise
Cayvan, Georgia
Chadbourne, Paul Ansel
Chamberlain, Joshua Lawrence
Chandler, Peleg Whitman
Chase, George
Chase, Mary Ellen
Cheever, George Barrell
Cheever, Henry Theodore
Clark, Walter Van Tilburg
Clarke, McDonald
Clarke, Rebecca Sophia
Clarkson, Coker Fifield
Cobb, Sylvanus, 1798–1866
Cobb, Sylvanus, 1823–1887
Coburn, Abner
Coffin, Charles Albert
Coffin, Robert Peter Tristram
Colby, Gardner
Cole, Joseph Foxcroft
Colman, Samuel
Cook, Walter Wheeler
Copeland, Charles Townsend
Cross, Arthur Lyon
Cummings, Joseph
Curtis, Cyrus Hermann Kotzschmar
Curtis, Olin Alfred
Cutler, Elliott Carr
Dana, Napoleon Jackson Tecumseh
Daveis, Charles Stewart
Davis, Henry Gassett
Davis, Owen Gould
Davis, Raymond Cazallis
Davis, William Hammatt
Day, Holman Francis
Day, James Roscoe
Deane, Charles
Dearing, John Lincoln
Deering, Nathaniel
Deering, William
Dennison, Aaron Lufkin
Dingley, Nelson
Dix, Dorothea Lynde
Dole, Charles Fletcher
Dow, Lorenzo
Dow, Neal
Drinkwater, Jennie Maria
Dryden, John Fairfield
Dunlap, Robert Pinckney
Eastman, Charles Gamage
Eckstorm, Fannie Hardy
Edes, Robert Thaxter
Elliott, Maxine
Emerson, Ellen Russell
Emerson, George Barrell
Emerson, James Ezekiel
Emery, Henry Crosby
Emery, Lucilius Alonzo

Emery, Stephen Albert
Estes, Dana
Evans, George
Everett, Charles Carroll
Fairfield, John
Farmer, Hannah Tobey Shapleigh
Farrington, Wallace Rider
Felch, Alpheus
Fernald, Charles Henry
Fernald, James Champlin
Fernald, Merritt Lyndon
Fessenden, Francis
Fessenden, James Deering
Fessenden, Samuel
Fillebrown, Thomas
Fisher, Clark
Fisher, Ebenezer
Flagg, Edmund
Flint, Charles Ranlett
Folsom, George
Ford, John
Foster, Benjamin
Freeman, John Ripley
Frye, William Pierce
Fuller, Melville Weston
Gammon, Elijah Hedding
Gannett, Henry
Garcelon, Alonzo
Garman, Charles Edward
George, Gladys
Gerrish, Frederic Henry
Gibson, Paris
Gill, Laura Drake
Ginn, Edwin
Goddard, Henry Herbert
Goddard, Morrill
Goddard, Pliny Earle
Goodale, George Lincoln
Goodale, Stephen Lincoln
Goodwin, Daniel Raynes
Goodwin, Ichabod
Goodwin, John Noble
Gould, George Milbry
Grant, Albert Weston
Grant, Claudius Buchanan
Grant, George Barnard
Greenough, James Bradstreet
Griffin, Eugene
Griswold, William McCrillis
Grover, Cuvier
Grover, La Fayette
Hale, Eugene
Hall, Edwin Herbert
Hamlin, Alfred Dwight Foster
Hamlin, Charles
Hamlin, Cyrus
Hamlin, Hannibal
Harris, George
Harris, Samuel
Hartford, George Huntington

Hartley, Marsden
Hatch, Edward
Hatch, Rufus
Hawkins, Dexter Arnold
Hayes, Edward Carey
Hayes, John Lord
Hill, Frank Alpine
Hill, James
Hillard, George Stillman
Hinds, Asher Crosby
Hitchcock, Roswell Dwight
Holden, Liberty Emery
Howard, Blanche Willis
Howard, Oliver Otis
Howard, Volney Erskine
Howe, Albion Parris
Howe, Lucien
Howe, Timothy Otis
Hubbard, John
Hubbard, Thomas Hamlin
Hughes, Charles Frederick
Hume, William
Hussey, Obed
Ingalls, Melville Ezra
Ingraham, Joseph Holt
Jackson, John Adams
Jewett, Charles Coffin
Jewett, John Punchard
Jewett, Sarah Orne
Johnson, Henry
Johnson, Jonathan Eastman
Jones, Rufus Matthew
Jones, Sybil
Jordan, Edwin Oakes
Kavanagh, Edward
Kellogg, Elijah
Kimball, Sumner Increase
Kimball, William Wirt
King, Henry Melville
King, Horatio
King, Rufus
King, William
Klingelsmith, Margaret Center
Ladd, Edwin Fremont
Lane, Gertrude Battles
Lane, Horace M.
Lapham, William Berry
Larrabee, William Clark
Little, Charles Coffin
Littledale, Clara Savage
Long, John Davis
Longfellow, Henry Wadsworth
Longfellow, Samuel
Longfellow, Stephen
Longfellow, William Pitt Preble
Lord, Herbert Mayhew
Lord, Nathan
Loring, Charles Morgridge
Lovejoy, Elijah Parish
Lovejoy, Owen

Low, Frederick Ferdinand
Lunt, Orrington
Mabery, Charles Frederic
McCulloch, Hugh
McGraw, John Harte
McLellan, Isaac
Magoun, George Frederic
Malcolm, Daniel
Manley, Joseph Homan
Marble, Albert Prescott
Mason, Luther Whiting
Mason, Otis Tufton
Mathews, Shailer
Mathews, William
Maxim, Hiram Stevens
Maxim, Hudson
Mellen, Grenville
Merriam, Henry Clay
Merrick, Samuel Vaughan
Merrill, Elmer Drew
Merrill, George Perkins
Millay, Edna St. Vincent
Mills, Hiram Francis
Mitchell, Edward Page
Moore, Anne Carroll
Morrill, Anson Peaslee
Morrill, Edmund Needham
Morrill, Lot Myrick
Morse, Charles Wyman
Morse, Edward Sylvester
Morse, Freeman Harlow
Morton, Charles Gould
Moses, George Higgins
Mosher, Thomas Bird
Munsey, Frank Andrew
Neal, John
Neal, Josephine Bicknell
Nelson, Charles Alexander
Nichols, Charles Henry
Nichols, George Ward
Noble, Frederick Alphonso
Norcross, Orlando Whitney
Nordica, Lillian
North, William
Noyes, Crosby Stuart
Nye, Edgar Wilson
O'Brien, Jeremiah
O'Brien, Richard
Osgood, Herbert Levi
Packard, Alpheus Spring
Packard, Joseph
Paine, Henry Warren
Paine, John Knowles
Parker, Edwin Pond
Parris, Albion Keith
Parris, Alexander
Parsons, Usher
Parton, Sara Payson Willis
Patten, Gilbert
Peavey, Frank Hutchinson

Pepperrell, Sir William
Perham, Josiah
Perkins, George Clement
Peters, John Andrew
Phelps, Thomas Stowell
Phips, Sir William
Pierce, Edward Allen
Pike, James Shepherd
Pike, Mary Hayden Green
Pingree, Hazen Stuart
Piston, Walter Hamor
Poor, Henry Varnum
Poor, John Alfred
Pratt, William Veazie
Preble, Edward
Preble, George Henry
Preble, William Pitt
Prentiss, Elizabeth Payson
Prentiss, George Lewis
Prentiss, Seargent Smith
Proctor, Frederick Frances
Putnam, George Palmer
Putnam, William Le Baron
Reed, Elizabeth Armstrong
Reed, Thomas Brackett
Richards, Robert Hallowell
Richardson, Charles Francis
Rideout, Henry Milner
Roberts, Kenneth Lewis
Robinson, Edwin Arlington
Rockefeller, Nelson Aldrich
Rogers, Edith Nourse
Rogers, John Rankin
Rowse, Samuel Worcester
Russell, Osborne
Sargent, Dudley Allen
Savage, Minot Judson
Scammon, Jonathan Young
Sewall, Arthur
Sewall, Frank
Sewall, Harold Marsh
Sewall, Joseph Addison
Sewall, Stephen
Sheldon, Edward Stevens
Sheldon, Henry Newton
Shepley, George Foster
Sibley, John Langdon
Simmons, Franklin
Sleeper, Jacob
Small, Albion Woodbury
Small, Alvan Edmond
Smiley, Albert Keith
Smith, Charles Henry, 1827–1902
Smith, Elizabeth Oakes Prince
Smith, George Otis
Smith, Henry Boynton
Smith, Seba
Smith, Theodate Louise
Smyth, Egbert Coffin
Smyth, Newman

Smyth, William
Soule, Joshua
Southgate, Horatio
Spofford, Harriet Elizabeth Prescott
Stanley, Francis Edgar
Stanwood, Edward
Starrett, Laroy S.
Stearns, Frederic Pike
Stephens, Charles Asbury
Stetson, Augusta Emma Simmons
Stetson, Winiam Wallace
Stevens, John Frank
Stevens, John Leavitt
Stevens, William Bacon
Stickney, Alpheus Beede
Storer, David Humphreys
Sturtevant, Benjamin Franklin
Sullivan, James
Sullivan, Louis Robert
Sullivan, William
Swallow, George Clinton
Swanton, John Reed
Talbot, Emily Fairbanks
Thatcher, Benjamin Bussey
Thatcher, Henry Knox
Thomas, William Widgery
Thomes, William Henry
Thorndike, Ashley Horace
Thornton, John Wingate
Thrasher, John Sidney
Thwing, Charles Franklin
Tincker, Mary Agnes
Townsend, Luther Tracy
Tripp, Bartlett
Tripp, Guy Eastman
Tuck, Amos
Tuttle, Charles Wesley
Tyler, Charles Mellen
Upton, George Bruce
Verrill, Addison Emery
Vinton, Francis Laurens
Vinton, Frederic Porter
Vose, George Leonard
Walker, Williston
Washburn, Cadwallader Colden
Washburn, Israel
Washburn, William Drew
Washburne, Elihu Benjamin
Waters, William Everett
Weymouth, Frank Elwin
Whipple, William
White, Ellen Gould Harmon
White, James Clarke
Whitman, Charles Otis
Whitman, Royal
Wilder, Harris Hawthorne
Willard, Joseph
Williams, Reuel
Willis, Nathaniel Parker
Winslow, Edward Francis

Wood, Frederick Hill
Wood, Sarah Saywar Barrell Keating
Woolson, Abba Louisa Goold
Young, Aaron
Young, Josue Maria

MARYLAND

Adams, Thomas Sewall
Alexander, John Henry
Alvey, Richard Henry
Andrews, John
Archer, James J.
Archer, John
Archer, Stevenson
Bachrach, Louis Fabian
Badger, Charles Johnston
Baer, William Stevenson
Baetjer, Frederick Henry
Baker, John Franklin
Bamberger, Louis
Bannister, Nathaniel Harrington
Barber, Edwin Atlee
Barnett, George Ernest
Barney, Joshua
Bartholow, Roberts
Bassett, Richard
Baxley, Henry Willis
Bayard, James Ash(e)ton
Bayard, John Bubenheim
Beach, Sylvia Woodbridge
Beall, James Glenn
Beall, Samuel Wootton
Beatty, Adam
Bonaparte, Charles Joseph
Bonaparte, Elizabeth Patterson
Bonaparte, Jerome Napoleon
Bond, Hugh Lennox
Bond, Shadrach
Bond, Thomas
Bonsal, Stephen
Booth, Edwin Thomas
Booth, John Wilkes
Bordley, John Beale
Boston, Charles Anderson
Bowie, Oden
Bowie, Robert
Bowie, William
Bowles, William Augustus
Bozman, John Leeds
Bradford, Augustus Williamson
Bradford, Edward Green
Breckinridge, William Campbell
 Preston
Brookings, Robert Somers
Brown, George William
Brown, Lawrason
Browne, William Hand
Bruce, David Kirkpatrick Este
Buchanan, Franklin
Buchanan, John

Buchanan, Robert Christie
Buckler, Thomas Hepburn
Burns, William John
Bushman, Francis F. Xavier
Cain, James Mallahan
Calvert, Charles Benedeict
Calvert, George Henry
Calverton, Victor Francis
Campbell, William Henry
Cannon, James
Carmichael, William
Carroll, Charles
Carroll, Daniel
Carroll, John
Carroll, John Lee
Carvalho, Solomon Solis
Casey, Joseph
Caswell, Richard
Chaillé-Long, Charles
Chambers, Ezekiel Forman
Chanche, John Mary Joseph
Chappell, Absalom Harris
Chase, Samuel
Chatard, Francis Silas
Chester, Colby Mitchell
Chew, Benjamin
Childs, George William
Churchman, William Henry
Clark, Charles Heber
Clarke, John Sleeper
Clayton, Joshua
Clayton, Thomas
Cohen, Mendes
Cone, Claribel
Conway, Martin Franklin
Cooke, Ebenezer
Cooper, Ezekiel
Cooper, James
Cooper, John Montgomery
Councilman, William Thomas
Crane, Anne Moncure
Creamer, David
Cresap, Michael
Creswell, John Angel James
Curtis, Alfred Allen
Davidge, John Beale
Davidson, Robert
Davis, David
Davis, Henry Gassaway
Davis, Henry Winter
Davis, Meyer
Deady, Matthew Paul
Decatur, Stephen
Deems, Charles Force
Dew, Thomas Roderick
Dickinson, John, 1732–1808
Dickinson, John, 1894–1952
Dickinson, Philemon
Didier, Eugene Lemoine
Dorsey, James Owen

Douglass, Frederick
Dulany, Daniel
Duvall, Gabriel
Eberle, John
Edwards, Minian
Elder, William Henry
Elliot, Cass
Elliott, Jesse Duncan
Elzey, Arnold
Emory, John
Emory, William Hemsley
Evans, Hugh Davey
Ewing, John
Fenwick, Benedict Joseph
Fenwick, Edward Dominic
Ferguson, William Jason
Few, William
Flynn, John Thomas
Ford, Henry Jones
Ford, John Thomson
Forrest, French
Foxx, James Emory
Francis, Paul James
Franklin, Philip Albright Small
Frazier, Edward Franklin
French, William Henry
Friedenwald, Aaron
Galloway, Joseph
Gantt, Henry Laurence
Garnet, Henry Highland
Garrett, John Work
Garrettson, Freeborn
Geyer, Henry Sheffie
Gibbons, Herbert Adams
Gibbons, James
Gibson, William
Gilmor, Harry
Gist, Christopher
Gist, Mordecai
Glenn, John Mark
Goddard, Calvin Hooker
Goddard, Paul Beck
Godman, John Davidson
Goldsborough, Charles
Goldsborough, Robert
Goldsborough, Thomas Alan
Goldsmith, Middleton
Gordy, John Pancoast
Gorman, Arthur Pue
Gorrell, Edgar Staley
Graves, Rosewell Hobart
Greene, Samuel Dana
Greenwald, Emanuel
Griffith, Goldsborough Sappington
Grove, Robert Moses ("Lefty")
Gruening, Ernest
Guttmacher, Alan Frank
Hambleton, Thomas Edward
Hamilton, William Thomas
Hammett, Samuel Dashiell

Hammond, Charles
Hammond, William Alexander
Handy, Alexander Hamilton
Hanson, Alexander Contee, 1749–1806
Hanson, Alexander Contee, 1786–1819
Hanson, John
Hardey, Mother Mary Aloysia
Hastings, Daniel Oren
Hemmeter, John Conrad
Henry, John
Henshall, James Alexander
Henson, Josiah
Henson, Matthew Alexander
Hesselius, John
Hicks, Thomas Holliday
Hill, Richard
Hindman, William
Hoffman, David
Holiday, Billie
Hollander, Jacob Harry
Hollins, George Nichols
Holt, Henry
Hopkins, Johns
Howard, Benjamin Chew
Howard, John Eager
Howell, William Henry
Howison, George Holmes
Hubner, Charles William
Hughes, Christopher
Hughes, James
Hurst, John Fletcher
Husbands, Hermon
Iddings, Joseph Paxon
James, Thomas
Jenifer, Daniel of St. Thomas
Jewett, Hugh Judge
Johns, Kensey
Johnson, Reverdy
Johnson, Thomas
Jones, Harry Clary
Jones, Hugh Bolton
Jones, John Beauchamp
Kefauver, Grayson Neikirk
Kennedy, John Pendleton
Kent, Joseph
Kerr, Sophie
Key, Francis Scott
Key, Philip Barton
Kirk, Norman Thomas
Kirkwood, Daniel
Kirkwood, Samuel Jordan
Knott, Aloysius Leo
Kolb, Lawrence
Lane, Tidence
Latrobe, Charles Hazlehurst
Lazear, Jesse William
Leaf, Wilbur Munro
Lee, Thomas Sim

Leeds, John
Leiter, Levi Zeigler
Lewis, Estelle Ann Blanche Robinson
Lloyd, Edward, 1744–1796
Lloyd, Edward, 1779–1834
Lockwood, James Booth
Logan, Cornelius Ambrosius
Longcope, Warfield, Theobald
Louis, Morris
McCaffrey, John
McCardell, Claire
McClenahan, Howard
McComas, Louis Emory
McCormick, Lynde Dupuy
McDonogh, John
Machen, John Gresham
McKelden, Theodore Roosevelt
McKenney, Thomas Loraine
Mackenzie, Tohn Noland
McMahon, John Van Lear
Marburg, Theodore
Marden, Charles Carroll
Marriott, Williams McKim
Massey, George Betton
Maus, Marion Perry
Mayer, Alfred Marshall
Mayer, Brantz
Mayor, Alfred Goldsborough
Mencken, Henry Louis
Mercer, Margaret
Miles, George Henry
Miles, Richard Pius
Mills, Benjamin
Mitchell, George Edward
Moore, Henry Ludwell
Morawetz, Victor
Murray, Alexander
Murray, John Gardner
Murray, William Vans
Muse, Clarence
Neale, Leonard
Nelson, Roger
Newcomb, Josephine Louise Le Monnier
Nicholson, James
Nicholson, Joseph Hopper
Nicholson, Samuel
Norris, James Flack
Norris, William
Noyes, Clara Dutton
O'Brien, Frederick
Ord, Edward Otho Cresap
Otis, Elwell Stephen
Oursler, (Charles) Fulton
Paca, William
Painter, William
Palmer, James Croxall
Palmer, John Williamson
Partridge, James Rudolph
Pattison, Robert Emory

Peale, Charles Willson
Peale, James
Peale, Raphael
Pennington, James W. C.
Perdue, Arthur William
Perlman, Philip Benjamin
Peterkin, George William
Pinkerton, Lewis Letig
Pinkney, Ninian
Pinkney, William
Pise, Charles Constantine
Plater, George
Porter, Nathaniel
Post, Emily Price
Potts, Richard
Price, Bruce
Proctor, William
Purnell, William Henry
Quigg, Lemuel Ely
Radcliffe, George Lovic Pierce
Randall, Burton Alexander
Randall, James Ryder
Randall, Wyatt William
Rayner, Isidor
Read, George
Reese, Charles Lee
Reese, Lizette Woodworth
Ricketts, Palmer Chamberlaine
Ricord, Philippe
Ridgaway, Henry Bascom
Ridgely, Charles Goodwin
Riley, Bennet
Rinehart, William Henry
Ringgold, Cadwalader
Roberts, Robert Richford
Robinson, George Canby
Robinson, John Mitchell
Robson, Stuart
Rodgers, George Washington, 1787–1832
Rodgers, John, 1773–1838
Rodgers, John, 1812–1882
Rogers, Henry J.
Rogers, Robert Empie
Rofie, George Henry
Rommel, Edwin Americus ("Eddie")
Rose, John Carter
Rous, Francis Peyton
Royall, Anne Newport
Rumsey, James
Russell, John Henry
Ruth, George Herman (Babe)
Ryan, Abram Joseph
Sachs, Bernard
Sachs, Julius
Sadtler, John Philip Benjamin
Sands, Ben Jamin Franklin
Sappington, John
Saxton, Eugene Francis
Schaeffer, Charles William

Scharf, John Thomas
Schley, Winfield Scott
Schmucker, Samuel Simon
Schroeder, John Frederick
Scott, Irving Murray
Searing, Laura Catherine Redden
Seiss, Joseph Augustus
Sellers, Matthew Bacon
Semmes, Raphael
Shaw, John, 1778–1809
Shelby, Isaac
Shipley, Ruth Bielaski
Sinclair, Upton Beall, Jr.
Singleton, Esther
Skinner, John Stuart
Smallwood, William
Smith, Francis Hopkinson
Sobeloff, Simon E.
Spalding, Catherine
Sprecher, Samuel
Spruance, Raymond Ames
Steiner, Lewis Henry
Sterett, Andrew
Stockbridge, Henry
Stoddert, Benjamin
Stone, Barton Warren
Stone, Thomas
Sturgis, Russell
Sutherland, Richard Kerens
Szold, Henrietta
Tammen, Harry Heye
Taney, Roger Brooke
Theobold, Samuel
Thomas, Allen
Thomas, Francis
Thomas, Martha Carey
Thomas, Philip Evan
Thomas, Philip Francis
Thomas, Richard Henry
Thompson, Alfred Wordsworth
Tiffany, Louis McLane
Tilghman, Edward
Tilghman, Matthew
Tilghman, Tench
Tilghman, William
Tipton, John
Trippe, John
Tubman, Harriet
Turner, Charles Yardley
Turner, Edward Raymond
Tydings, Millard Evelyn
Tyler, Samuel
Uhler, Philip Reese
Valentine, Milton
Van Osdel, John Mills
Veazey, Thomas Ward
Waesche, Russell Randolph
Waggaman, Mary Teresa McKee
Wagner, Clinton
Waidner, Charles William

Wallis, Severn Teackle
Walsh, Robert
Walters, Henry
Ward, Samuel Ringgold
Warfield, Solomon Davies
Warrington, Albert Powell
Watson, Henry Clay
Wayman, Alexander Walker
Weede, Robert
Weems, Mason Locke
Welby, Ameli Ball Coppuck
Wharton, Charles Henry
White, Charles Ignatius
White, Henry
White, Henry Clay
Whitney, Courtney
Wickes, Lambert
Wilkinson, James
Wilkinson, Theodore Stark
Williams, John Whitridge
Williams, Otho Holland
Wilmer, James Jones
Wilmer, William Holland
Winchester, James
Winder, John Henry
Winder, Levin
Winder, William Henry
Winebrenner, John
Wolman, Leo
Wright, Robert
Young, John Richardson

MASSACHUSETTS

Abbot, Benjamin
Abbot, Francis Ellingwood
Abbot, Henry Larcom
Abbot, Joel
Abbott, Austin
Abbott, Benjamin Vaughan
Abbott, Eleanor Hallowell
Abbott, Horace
Abbott, Lyman
Abbott, Samuel Warren
Abrams, Creighton Williams, Jr.
Adams, Abigail
Adams, Abijah
Adams, Brooks
Adams, Charles Baker
Adams, Charles Follen
Adams, Charles Francis, 1807–1886
Adams, Charles Francis, 1835–1915
Adams, Charles Francis, 1865–1954
Adams, Charles R.
Adams, Daniel
Adams, Dudley W.
Adams, Edward Dean
Adams, Edwin
Adams, Eliphant
Adams, Frederick Upham
Adams, Hannah

Adams, Henry Brooks
Adams, Herbert Baxter
Adams, John
Adams, Jasper
Adams, John Coleman
Adams, John Quincy
Adams, Jehemiah
Adams, Samuel
Adams, William Taylor
Agassiz, Elizabeth Cabot Cary
Aiken, George L.
Albro, Lewis Colt
Alden, Ebenezer
Alden, Ichabod
Alden, Timothy
Alden, William Livingston
Aldrich, Charles Anderson
Alger, Cyrus
Alger, Horatio
Alger, William Rounseville
Allen, Alexander Viets Griswold
Allen, Anthony Benezet
Allen, Charles
Allen, David Oliver
Allen, Edward Ellis
Allen, Fred
Allen, Frederick Lewis
Allen, Joel Asaph
Allen, Joseph Henry
Allen, Lewis Falley
Allen, Nathan
Allen, Nathan H.
Allen, Richard Lamb
Allen, Thomas
Allen, William
Allen, William Francis
Alphonsa, Mother
Alvord, Clarence Walworth
Alvord, Henry Elijah
Ames, Charles Gordon
Ames, Edward Raymond
Ames, Ezra
Ames, Fisher
Ames, Frederick Lothrop
Ames, Herman Vandenburg
Ames, James Barr
Ames, James Tyler
Ames, Joseph Alexander
Ames, Nathan Peabody
Ames, Nathaniel
Ames, Oakes, 1804–1873
Ames, Oakes, 1874–1950
Ames, Oliver, 1779–1863
Ames, Oliver, 1807–1877
Ames, Oliver, 1831–1895
Ames, Winthrop
Andrew, Samuel
Andrews, Charles Bartlett
Andrews, George Leonard
Andrews, Joseph

Andrews, Sidney
Andrews, Stephen Pearl
Angell, George Thorndike
Anthony, Susan Brownell
Apes, William
Appleton, Daniel
Appleton, James
Appleton, John
Appleton, Nathaniel Walker
Appleton, Thomas Gold
Appleton, William Henry
Appleton, William Sumner
Apthorp, William Foster
Armsby, Henry Prentiss
Armstrong, George Washington
Armstrong, Henry Worthington
 ("Harry")
Armstrong, Samuel Turell
Ashmun, George
Aspinwall, William
Atherton, George Washington
Atherton, Joshua
Atkinson, Edward
Atkinson, George Henry
Atwater, Caleb
Atwood, Charles B.
Auchmuty, Robert
Auchmuty, Samuel
Augustus, John
Austin, Benjamin
Austin, James Trecothick
Austin, Jane Goodwin
Austin, Jonathan Loring
Austin, William
Avery, John
Babbitt, Irving
Babbitt, Isaac
Babcock, James Francis
Babson, Roger Ward
Bacon, Robert
Badger, Joseph, 1708–1765
Badger, Joseph, 1757–1846
Bailey, Jacob
Bailey, Jacob Whitman
Baker, Benjamin Franklin
Baker, Harvey Humphrey
Baker, Lorenzo Dow
Balch, Emily Greene
Baldwin, Loammi, 1740–1807
Baldwin, Loammi, 1780–1838
Baldwin, William Henry
Ball, Albert
Ball, Thomas
Ballou, Maturin Murray
Bancroft, Aaron
Bancroft, Edward
Bancroft, George
Banks, Nathaniel Prentiss
Barbour, Thomas
Bardeen, Charles William

Barker, Albert Smith
Barker, George Frederick
Barker, Jeremiah
Barker, Josiah
Barlow, Samuel Latham Mitchill
Barnard, Charles
Barnard, Charles Francis
Barnard, Chester Irving
Barnard, Frederick Augustus Porter
Barnard, John
Barnard, John Gross
Barnes, Charlotte Mary Sanford
Barnes, James
Barron, Clarence Walker
Barrows, Alice Prentice
Bartlet, William
Bartlett, Francis Alonzo
Bartlett, John
Bartlett, Joseph
Bartlett, Josiah
Barton, Clara
Bascom, Florence
Bass, Edward
Bassett, William Hastings
Bates, Joshua
Bates, Katharine Lee
Bates, Samuel Penniman
Baylies, Francis
Beach, Alfred Ely
Beach, Moses Sperry
Beale, Joseph Henry
Beckwith, Clarence Augustine
Behrman, Samuel Nathaniel
Belcher, Jonathan
Belknap, Jeremy
Bellamy, Edward
Bellows, Albert Fitch
Bellows, Henry Whitney
Bemis, George
Bemis, Samuel Flagg
Benchley, Robert Charles
Benjamin, Asher
Bennett, Emerson
Benson, Frank Weston
Bent, Josiah
Bentley, William
Berle, Adolf Augustus, Jr.
Bernard, William Bayle
Betts, Samuel Rossiter
Bidwell, Barnabas
Bidwell, Marshall Spring
Bigelow, Erastus Brigham
Bigelow, Frank Hagar
Bigelow, Harry Augustus
Bigelow, Henry Bryant
Bigelow, Henry Jacob
Bigelow, Jacob
Bigelow, William Sturgis
Billings, William
Binney, Amos

Bird, Arthur
Bishop, Elizabeth
Bishop, Robert Roberts
Bitzer, George William
Bixby, James Thompson
Blackmur, Richard Palmer
Blake, Eli Whitney
Blake, Francis
Blake, Lyman Reed
Blanchard, Thomas
Bliss, Cornelius Newton
Bliss, George, 1816–1896
Bliss, George, 1830–1897
Bliss, Jonathan
Blodget, Samuel
Blodgett, Benjamin Colman
Blodgett, Henry Williams
Blowers, Sampson Salter
Blunt, George William
Bocher, Maxine
Boies, Henry Martyn
Boise, Reuben Patrick
Bolles, Frank
Boltwood, Bertram Borden
Bond, George Phillips
Bonham, Milledge Luke
Borden, Lizzie Andrew
Borden, Richard
Borden, Simeon
Bourne, Jonathan
Boutell, Henry Sherman
Boutwell, George Sewall
Bowditch, Henry Ingersoll
Bowditch, Henry Pickering
Bowditch, Nathaniel
Bowdoin, James, 1726–1790
Bowdoin, James, 1752–1811
Bowen, Francis
Bowers, Lloyd Wheaton
Bowker, Richard Rogers
Boyd, John Parker
Boyden, Roland William
Boyden, Seth
Boyden, Uriah Atherton
Boyle, Thomas
Boylston, Zabdiel
Boynton, Charles Brandon
Brackett, Jeffrey Richardson
Bradbury, Theophilus
Bradford, Alden
Bradford, Edward Hickling
Bradford, Gamaliel, 1831–1911
Bradford, Gamaliel, 1863–1932
Bradford, William
Bradish, Luther
Bradley, John Edwin
Brattle, Thomas
Brattle, William
Brazer, John
Breck, Samuel

Breed, Ebenezer
Brennan, Walter
Brewer, Charles
Brewer, Thomas Mayo
Brewster, Osmyn
Brewster, William
Bridgman, Elijah Coleman
Bridgman, Herbert Lawrence
Bridgman, Percy Williams
Briggs, Charles Frederick
Briggs, George Nixon
Briggs, Le Baron Russell
Briggs, Lloys Vernon
Brigham, Amariah
Brigham, Mary Ann
Brightman, Edgar Sheffield
Bromfield, John
Bronson, Walter Cochrane
Brooks, Charles
Brooks, Charles Timothy
Brooks, Elbridge Streeter
Brooks, John
Brooks, Maria Gowen
Brooks, Phillips
Brooks, Richard Edwin
Brown, Addison
Brown, Charlotte Emerson
Brown, Ebenezer
Brown, Henry Billings
Brown, Henry Kirke
Brown, James
Brown, John
Brown, John Appleton
Brown, Mather
Brown, Moses
Brown, Percy
Brown, Ralph Hall
Brown, Simon
Brown, William Hill
Browne, Benjamin Frederick
Browne, Charles Albert
Browne, Herbert Wheildon Cotton
Browne, William
Brownell, Thomas Church
Bryant, Gridley
Bryant, John Howard
Bryant, William Cullen
Bulfinch, Charles
Bulfinch, Thomas
Bull, Ephraim Wales
Bullard, Henry Adams
Bumstead, Freeman Josiah
Bumstead, Horace
Burbank, Luther
Burgess, Edward
Burgess, Frank Gelett
Burgess, George Kimball
Burgess, Neil
Burgess, Thornton Waldo
Burgess, W(illiam) Starling

Burlingame, Edward Livermore
Burnett, Joseph
Burnham, Clara Louise Root
Burrage, Henry Sweetser
Burrage, Walter Lincoln
Burrill, Thomas Jonathan
Burroughs, Bryson
Burt, William Austin
Burton, Harold Hitz
Bush, Vannevar ("Van")
Bushnell, George Ensign
Butler, Ezra
Butler, John Wesley
Butler, Zebulon
Butterick, Ebenezer
Byington, Cyrus
Byles, Mather
Cabot, Arthur Tracy
Cabot, Edward Clarke
Cabot, George
Cabot, Godfrey Lowell
Cabot, Hugh
Cabot, Richard Clarke
Cady, Sarah Louise Ensign
Caldwell, Charles Henry Bromedge
Calhoun, William Barron
Callender, John
Canfield, Richard A.
Capen, Elmer Hewitt
Capen, Nahum
Capen, Samuel Billings
Capen, Samuel Paul
Capron, Horace
Carnegie, Mary Crowninshield
　　Endicott
Carpenter, Edmund Janes
Carter, Elias
Carter, James Coolidge
Carter, James Gordon
Carty, John Joseph
Caiver, Jonathan
Caswell, Alexis
Chadwick, George Whitefield
Chadwick, James Read
Chadwick, John White
Chamberlain, Daniel Henry
Chamberlain, Nathan Henry
Champney, James Wells
Chandler, Charles Frederick
Chandler, Joseph Ripley
Chandler, Seth Carlo
Channing, Edward
Channing, William Ellery
Channing, William Francis
Channing, William Henry
Chapin, Calvin
Chapin, Chester William
Chaplin, Jeremiah
Chapman, Alvan Wentworth
Chapman, John

Chapman, Maria Weston
Chase, Harry Woodburn
Chase, Pliny Earle
Chase, Thomas
Chauncy, Charles
Checkley, John
Cheney, Ednah Dow Littlehale
Chever, James W.
Child, David Lee
Child, Francis James
Child, Lydia Maria Francis
Child, Richard Washburn
Childe, John
Childs, Thomas
Chipman, Ward
Choate, Joseph Hodges
Choate, Rufus
Church, Benjamin
Church, George Earl
Church, Thomas Dolliver
Claflin, Horace Brigham
Claflin, William
Claghorn, George
Clap, Thomas
Clapp, Asa
Clapp, Charles Horace
Clapp, William Warland
Clark, Alvan
Clark, Alvan Graham
Clark, Arthur Hamilton
Clark, Henry James
Clark, John Maurice
Clark, Jonas
Clark, Jonas Gilman
Clark, Joseph Sylvester
Clark, Thomas March
Clark, William Smith
Clarke, Frank Wigglesworth
Clarke, Richard
Clarkson, John Gibson
Cleaveland, Parker
Clement, Edward Henry
Cleveland, Aaron
Cleveland, Horace William Shaler
Cleveland, Richard Jeffry
Cobb, David
Cobb, Elijah
Cobb, Jonathan Holmes
Cobb, Lyman
Cobb, Nathan Augustus
Cobb, William Henry
Cochrane, Gordon Stanley ("Mickey")
Codman, John
Coffin, Charles Fisher
Coffin, Sir Isaac
Coffin, James Henry
Coffin, John
Cogswell, Joseph Green
Colburn, Dana Pond
Colburn, Irving Wightman

Colburn, Warren
Colby, Luther
Cole, Frank Nelson
Coleman, Lyman
Coleman, William
Collins, Edward Knight
Collins, Frank Shipley
Colman, Benjamin
Colman, Henry
Colman, John
Colman, Lucy Newhall
Colt, LeBaron Bradford
Colton, Calvin
Conant, Charles Arthur
Conant, Hannah O'Brien Chaplin
Conant, Hezekiah
Conant, James Bryant
Conboy, Sara Agnes McLaughlin
Coney, John
Congdon, Charles Taber
Conly, Jabez
Converse, Charles Crozat
Converse, Edmund Cogswell
Converse, Fredrick Shepherd
Conwell, Russell Herman
Cook, Clarence Chatham
Cook, Russell S.
Cook, Zebedee
Cooke, Elisha, 1637–1715
Cooke, Elisha, 1678–1737
Cooke, Josiah Parsons
Coolidge, Archibald Cary
Coolidge, Charles Allerton
Coolidge, Julian Lowell
Coolidge, Thomas Jefferson, 1831–1920
Coolidge, Thomas Jefferson, 1893–1959
Cooper, Samuel
Copley, John Singleton
Corbett, Henry Winslow
Corson, Juliet
Corthell, Elmer Lawrence
Cory, Charles Barney
Cowl, Jane
Cox, Lemuel
Coyle, Grace Longwell
Crafts, James Mason
Craigie, Andrew
Cranch, William
Crane, John
Crane, William Henry
Crane, Winthrop Murray
Craven, Frank
Creesy, Josiah Perkins
Crocker, Alvah
Crocker, Hannah Mather
Crocker, Uriel
Cross, Charles Whitman
Crowell, Luther Childs

Crowninshield, Benjamin Williams
Crowninshield, Frederic
Crowninshield, George
Crowninshield, Jacob
Cuffe, Paul
Cullis, Charles
Cummings, Charles Amos
Cummings, E. E.
Cummings, Edward
Cummings, John
Cummins, Maria Susanna
Curley, James Michael
Currier, Nathaniel
Curtis, Benjamin Robbins
Curtis, Charles Pelham
Curtis, Edwin Upton
Curtis, George
Curtis, George Ticknor
Curtis, Moses Ashley
Curwen, Samuel
Cushing, Caleb
Cushing, John Perkins
Cushing, Josiah Nelson
Cushing, Luther Stearns
Cushing, Richard James
Cushing, Thomas
Cushing, William
Cushman, Charlotte Saunders
Cushman, Joseph Augustine
Cushman, Joshua
Cushman, Susan Webb
Cutler, Charles Ammi
Cutler, Ephraim
Cutler, Robert
Cutler, Timothy
Daggett, David
Daggett, Naphtali
Dall, Caroline Wells Healey
Dall, William Healey
Dalton, John Call
Dana, Francis
Dana, James
Dana, Richard
Dana, Richard Henry, 1787–1879
Dana, Richard Henry, 1815–1882
Dane, Nathan
Danforth, Charles
Danforth, Thomas
Darby, John
Davenport, Edward Loomis
Davis, Andrew McFarland
Davis, Arthur Vining
Davis, Charles Harold
Davis, Charles Henry, 1807–1877
Davis, Charles Henry, 1845–1921
Davis, George Breckenridge
Davis, Horace
Davis, John, 1761–1847
Davis, John, 1780–1838
Davis, John Chandler Bancroft

Davis, William Thomas
Dawes, Henry Laurens
Dawes, William
Day, Arthur Louis
Day, Benjamin Henry
Day, Horace H.
Deane, Samuel
De Cost, Benjamin Franklin
De Fontaine, Felix Gregory
Delano Amassa
DeMille, Cecil Blount
Denfield, Louis Emil
Dennie, Joseph
Dennison, Henry Sturgis
Derby, Elias Hasket, 1736–1826
Derby, Elias Hasket, 1761–1799
Derby, Elias Hasket, 1803–18B0
Derby, George Horatio
Derby, Richard
Devens, Charles
Dewey, Chester
Dewey, Orville
Dewing, Thomas Wilmer
Dexter, Franklin
Dexter, Franklin Bowditch
Dexter, Henry
Dexter, Henry Martyn
Dexter, Samuel, 1726–1810
Dexter, Samuel, 1761–1816
Dickinson, Jonathan
Ditson, George Leighton
Ditson, Oliver
Dix, John Homer
Dixon, Joseph
Dixon, Rolan Burrage
Doane, Thomas
Doane, William Craswell
Dodge, Ebenezer
Dodge, Grenville Mellon
Dodge, Mary Abigail
Dodge, Raymond
Dodge, Theodore Ayrault
Dole, James Drummond
Dole, Nathan Haskell
Dorchester, Daniel
Douglas, Paul Howard
Douglas, William Lewis
Downer, Samuel
Downes, John
Dowse, Thomas
Drake, Samuel Adams
Draper, Eben Sumner
Draper, Ira
Draper, William Franklin
Du Bois, William Edward Burghardt
Duchin, Edward Frank ("Eddy")
Dudley, Joseph
Dudley, Paul
Duganne, Augustine Joseph Hickey
Dumaine, Frederic Christopher

Dummer, Jeremiah, 1645–1718
Dummer, Jeremiah, 1679–1739
Dunbar, Charles Franklin
Dunham, Henry Morton
Durant, Henry
Durant, Thomas Clark
Durant, William Crapo
Durfee, William Franklin
Durfee, Zobeth Sherman
Durivage, Francis Alexander
Dwight, Arthur Smith
Dwight, Edmund
Dwight, Francis
Dwight, Harrison Gray Otis
Dwight, John Sullivan
Dwight, Nathaniel
Dwight, Theodore
Dwight, Thomas
Dwight, Timothy
Dwight, William
Dyer, Nehemiah Mayo
Eagels, Jeanne
Eames, Charles
Earle, Alice Morse
Earle, James
Earle, Pliny, 1762–1832
Earle, Pliny, 1809–1892
Earle, Ralph, 1751–1801
Earle, Ralph, 1874–1939
Earle, Thomas
Eddy, Clarence
Eddy, Daniel Clarke
Eddy, Harrison Prescott
Eddy, Henry Turner
Edes, Benjamin
Edmonds, John
Edwards, Bel Bates
Eldridge, Shalor Winchell
Eliot, Charles
Eliot, Charles William
Eliot, Samuel
Eliot, Samuel Atkins
Eliot, William Greenleaf
Elliot, James
Ellis, Calvin
Ellis, George Edward
Elman, Robert
Elson, Louis Charles
Elwell, Frank Edwin
Emerson, Edward Waldo
Emerson, Mary Moody
Emerson, Ralph
Emerson, Ralph Waldo
Emerson, William
Emerton, Ephraim
Emerton, James Henry
Emmons, Ebenezer
Emmons, Samuel Franklin
Endicott, Charles Moses
Endicott, William Crowninshield

English, George Bethune
Erving, George William
Eustis, George
Eustis, Henry Lawrence
Eustis, William
Evans, Charles
Evarts, William Maxwell
Everett, Alexander Hill
Everett, David
Everett, Edward
Ewer, Ferdinand Cartwright
Fairbanks, Erastus
Fairbanks, Thaddeus
Fairchild, Blair
Fairchild, James Harris
Fairchild, Mary Salome Cutler
Fairfield, Sumner Lincoln
Fanning, Alexander Campbell Wilder
Farlow, William Gilson
Farmer, annie Merritt
Farmer, John
Farnham, Russel
Farnum, Franklyn
Farrar, Geraldine
Farrar, John
Faunce, William Herbert Perry
Fay, Jonas
Felt, Joseph Barlow
Felton, Cornelius Conway
Felton, Samuel Morse
Fenn, William Wallace
Fenno, John
Fenollosa, Ernest Francisco
Fewkes, Jesse Walter
Fiedler, Arthur
Field, Cyrus West
Field, Henry Martyn
Field, Marshall
Field, Stephen Dudley
Field, Walbridge Abner
Fields, Annie Adams
Filene, Edward Albert
Fisher, Alvan
Fisher, George Park
Fisher, John Dix
Fisher, Theodore Willis
Fitton, James
Fitz, Henry
Fitz, Reginald Heber
Fitzgerald, John Francis
Fitzpatrick, John Bernard
Flagg, Josia
Flagg, Josiah Foster
Flage, Thomas Wilson
Fletcher, Horace
Flint, Albert Stowell
Flint, Austin, 1812–1886
Flint, Austin, 1836–1915
Flint, Charles Louis
Flint, Timothy

Flower, Lucy Louisa Couzes
Folger, Charles James
Folger, Walter
Follen, Eliza Lee Cabot
Follett, Mary Parker
Foote, Arthur William
Forbes, Esther
Forbes, Robert Bennet
Forbes, William Cameron
Forbush, Edward Howe
Ford, Daniel Sharp
Ford, George Burdett
Foster, Abiel
Foster, Abigail Kelley
Foster, Frank Hugh
Foster, Hannah Webster
Foster, John
Foster, Judith Ellen Horton
Foster, Roger Sherman Baldwin
Foster, Theodore
Foster, William Trufant
Foster, William Z.
Fowle, Daniel
Fowle, William Bentley
Fox, Charles Kemble
Fox, George Washington Lafayette
Fox, Gustavus Vasa
Fox, Harry
Francis, Charles Stephen
Francis, Convers
Francis, Joseph
Frankland, Lady Agnes Surriage
Franklin, Benjamin
Franklin, James
Fraser, Leon
Freeman, James
Freeman, Mary Eleanor Wilkins
Freeman, Nathaniel
French, Alice
French, Edwin Davis
Frieze, Henry Simmons
Frisbie, Levi
Frothingham, Arthur Lincoln
Frothingham, Nathaniel Langdon
Frothingham, Octavius Brooks
Frothingham, Paul Revere
Frothingham, Richard
Frye, Joseph
Fullam, Frank L.
Fuller, Hiram
Fuller, Sarah Margaret
Furness, William Henry
Gannett, Ezra Stiles
Gannett, William Channing
Gardiner, John
Gardner, Erle Stanley
Gardner, Henry Joseph
Gardner, John Lane
Garrison, William Lloyd
Gay, Ebenezer

Gay, Frederick Parker
Gay, Sydney Howard
Gay, Winckworth Allan
Gerry, Elbridge
Gibbs, Josiah Willard
Gibson, Charles Dana
Gifford, Robert Swain
Gifford, Walter Sherman
Gilbert, Henry Franklin Belknap
Gilbert, John Gibbs
Giles, Chauncey
Gill, John
Gillett, Frederick Huntington
Gillis, James Martin
Gilman, Arthur Delevan
Gilman, Caroline Howard
Gilman, Samuel
Gilmore, James Roberts
Gilmore, Joseph Henry
Glidden, Charles Jasper
Glover, John
Goddard, John
Goddard, Robert Hutchings
Godfrey, Benjamin
Goldthwaite, George
Goodell, William
Goodhue, Benjamin
Goodnough, Xanthus Henry
Goodrich, Chauncey, 1759–1815
Goodrich, Chauncey, 1798–1858
Goodrich, Frank Boott
Goodrich, William Marcellus
Goodridge, Sarah
Goodwin, Nathaniel Carll
Goodwin, William Watson
Gordon, George Henry
Gorham, John
Gorham, Nathaniel
Gould, Benjamin Apthorp, 1787–
 1859
Gould, Benjamin Apthorp, 1824–
 1896
Gould, Hannah Flagg
Gould, Thomas Ridgeway
Grafton, Charles Chapman
Grandgent, Charles Hall
Grant, Percy Stickney
Grant, Robert
Graves, William Phillips
Gray, Francis Calley
Gray, Horace
Gray, John Chipman
Gray, William
Greaton, John
Greely, Adolphus Washington
Green, Andrew Haswell
Green, Asa
Green, Bartholomew
Green, Francis
Green, Francis Matthews

Green, Henrietta Howland Robinson
Green, Jacob
Green, John
Green, Jonas
Green, Joseph
Green, Nathan
Green, Samuel Abbott
Green, Samuel Bowdlear
Green, Samuel Swett
Greene, Charles Ezra
Greene, Daniel Crosby
Greene, Roger Sherman
Greene, Samuel Stillman
Greenleaf, Benjamin
Greenleaf, Moses
Greenleaf, Simon
Greenleaf, Thomas
Greenough, Henry
Greenough, Horatio
Greenough, Richard Saltonstall
Greenwood, Isaac
Greenwood, John
Grew, Joseph Clark
Gridley, Jeremiah
Gridley, Richard
Griffin, Solomon Bulkley
Grimes, James Stanley
Grinnell, Frederick
Grinnell, Henry
Grinnell, Joseph
Grinnell, Moses Hicks
Grosvenor, William Mason
Guild, Curtis, 1827–1911
Guild, Curtis, 1860–1915
Guild, Reuben Aldridge
Guilford, Nathan
Guiney, Louise Imogen
Gurney, Ephraim Whitman
Guthrie, Samuel
Hackett, Horatio Balch
Hadley, Henry Kimball
Hague, Arnold
Hague, James Duncan
Hale, Benjamin
Hale, Charles
Hale, Edward Everett
Hale, Enoch
Hale, Lucretia Peabody
Hale, Nathan
Hale, Philip Leslie
Haley, Jack
Hall, Arethusa
Hall, Florence Marion Howe
Hall, Granville Stanley
Hall, James
Hall, Samuel, 1740–1807
Hall, Samuel, 1800–1870
Hall, Willard
Hallett, Benjamin
Hallett, Benjamin Franklin

Hallock, Gerard
Hallock, William Allen
Halsey, John
Hamblin, Joseph Eldridge
Hamlin, Charles Sumner
Hammond, George Henry
Hammond, Jabez Delano
Hammond, James Bartlett
Hanaford, Phoebe Ann Coffin
Hancock, John
Hancock, Thomas
Hapgood, Isabel Florence
Haraden, Jonathan
Harahan, James Theodore
Harding, Chester
Harding, Seth
Hardy, Arthur Sherburne
Harkness, Albert
Harnden, William Frederick
Harrington, Charles
Harrington, Thomas Francis
Harris, Thaddeus Mason
Harris, Thaddeus William
Harris, William
Hart, John Seely
Hasket, Elias
Hassam, Frederick Childe
Hastings, Samuel Dexter
Haven, Erastus Otis
Haven, Gilbert
Haven, Joseph
Hawes, Harriet Ann Boyd
Hawley, Joseph
Hawthorne, Julian
Hawthorne, Nathaniel
Hayden, Charles
Hayden, Charles Henry
Hayden, Edward Everett
Hayden, Ferdinand Vaudiveer
Hayden, Hiram Washington
Hayden, Joseph Shepard
Haynes, John Henry
Hayward, George
Hayward, Nathaniel Manley
Hazeltine, Mayo Williamson
Hazen, Moses
Healy, George Peter Alexander
Heard, Augustine
Heard, Dwight Bancroft
Heard, Franklin Fiske
Heath, William
Hedge, Frederic Henry
Hedge, Levi
Henchman, Daniel
Henderson, Lawrence Joseph
Henry, Caleb Sprague
Henshaw, David
Henshaw, Henry Wetherbee
Hentz, Caroline Lee Whiting
Hepworth, George Hughes

Herne, Chrystal Katharine
Herrick, Robert Welch
Herschel, Clemens
Hersey, Evelyn Weeks
Hewes, Robert
Heywood, Ezra Heivey
Heywood, Levi
Hiacoomes
Hichborn, Philip
Higginson, Stephen
Higginson, Thomas Wentworth
Hildreth, Richard
Hildreth, Samuel Prescott
Hill, Frederic Stanhope
Hill, George Handel
Hill, Henry Barker
Hill, Isaac
Hilliard, Francis
Hitchcock, Charles Henry
Hitchcock, Edward, 1793–1864
Hitchcock, Edward, 1828–1911
Hitchcock, Enos
Hitchcock, James Ripley Wellman
Hoar, Ebenezer Rockwood
Hoar, George Frisbie
Hoar, Samuel
Hobbs, Alfred Charles
Hodges, Harry Foote
Holden, Oliver
Holder, Charles Frederick
Holder, Joseph Bassett
Holland, Clifford Milburn
Holland, Josiah Gilbert
Holmes, Ezekiel
Holmes, John
Holmes, Mary Jane Hawes
Holmes, Oliver Wendell, 1809–1894
Holmes, Oliver Wendell, 1841–1935
Holt, Edwin Bissell
Holten, Samuel
Holyoke, Edward Augustus
Holyoke, Samuel
Homer, Arthur Bartlett
Homer, Winslow
Homes, Henry Augustus
Hooker, Joseph
Hooker, Philip
Hooker, Worthington
Hooper, Samuel
Hooner, William
Hopkins, Edward Washburn
Hopkins, Mark
Horr, George Edwin
Hosmer, Frederick Lucian
Hosmer, Harriet Goodhue
Hosmer, James Kendall
Houghton, Alanson Bigelow
Houghton, George Hendric
House, Edward Howard
Hovey, Charles Mason

Howard, Henry
Howe, Andrew Jackson
Howe, Elias
Howe, Frederick Webster
Howe, George
Howe, Henry Marion
Howe, Mark De Wolfe
Howe, Quincy
Howe, Samuel
Howe, Samuel Gridley
Howe, William
Howe, William F.
Hubbard, Gardiner Greene
Hudson, Charles
Hudson, Daniel Eldred
Hudson, Frederic
Hull, Josephine
Hummel, Abraham Henry
Hunnewell, Horatio Hollis
Hunnewell, James
Hunt, Alfred Ephraim
Hunt, Freeman
Hunt, Harriot Kezia
Hunt, William Gibbes
Huntington, Elisha
Huntington, Frederic Dan
Huntington, William Reed
Hurd, John Codman
Hurd, Nathaniel
Huse, Caleb
Hutchinson, Benjamin Peters
Hutchinson, Charles Lawrence
Hutchinson, Thomas
Hyde, William DeWitt
Ingalls, John James
Ingraham, Joseph
Inman, George
Ireland, Charles Thomas, Jr. ("Chick")
Jackson, Charles
Jackson, Charles Thomas
Jackson, Dunham
Jackson, Helen Maria Fiske Hunt
Jackson, James, 1777–1867
Jackson, Mercy Ruggles Bisbe
Jackson, Patrick Tracy
Jackson, William
Jameson, John Franklin
Jarves, Deming
Jarves, James Jackson
Jarvis, Edward
Jarvis, William
Jefferson, Mark Sylvester William
Jeffries, Benjamin Joy
Jeffries, John
Jenkins, Edward Hopkins
Jenkins, Nathaniel
Jenks, William
Jenney, William Le Baron
Johnson, Allen
Johnson, Ellen Cheney

Johnson, George Francis
Johnson, Howard Deering
Johnson, Joseph French
Johnson, Samuel
Johnston, Thomas
Jones, Abner
Jones, Anson
Jones, Calvin
Jones, Joseph Stevens
Jones, Leonard Augustus
Jordan, Eben Dyer
Judd, Sylvester
Judge, Thomas Augustine
Judson, Adoniram
Judson, Ann Hasseltine
Kalmus, Herbert Thomas
Kehew, Mary Morton Kimball
Kellett, William Wallace
Kelley, Oliver Hudson
Kemp, Robert H.
Kendall, Amos
Kendrick, John
Kennedy, John Fitzgerald
Kennedy, Joseph Patrick
Kennedy, Robert Francis
Kenrick, William
Kerouac, Jack
Kettell, Samuel
Keyes, Erasmus Darwin
Kilby, Christopher
Kimball, (Sidney) Fiske
King, Edward Leonard
King, Edward Smith
King, Jonas
King, Thomas Butler
Kinnicutt, Leonard Parker
Kittredge, George Lyman
Knapp, Philip Coombs
Knapps Samuel Lorenzo
Kneeland, Abner
Kneeland, Samuel, 1697–1769
Kneeland, Samuel, 1821–1888
Kneeland, Stillman Foster
Knight, Austin Melvin
Knight, Frederick Irving
Knight, Henry Cogswell
Knight, Sarah Kemble
Knowles, Lucius James
Knowlton, Charles
Knowlton, Marcus Perrin
Knowlton, Thomas
Knox, Frank
Knox, Henry
Lahey, Frank Howard
Lamb, Arthur Becket
Lamb, Martha Joanna Reade Nash
Lander, Edward
Lander, Frederick West
Lane, George Martin
Lang, Benjamin Johnson

Langdon, Samuel
Langer, William Leonard
Langley, John Williams
Langley, Samuel Pierpont
Larcom, Lucy
Larkin, Thomas Oliver
Lathrop, John
Lawrance, Charles Lanier
Lawrence, Abbott
Lawrence, Amos
Lawrence, Amos Adams
Lawrence, William, 1783–1848
Lawrence, William, 1819–1899
Lawrence, William, 1850–1941
Lawson, Thomas William
Leach, Abby
Leach, Daniel Dyer
Leach, Shepherd
Learned, Ebenezer
Leavitt, Erasmus Darwin
Leavitt, Henrietta Swan
Leavitt, Joshua
Lee, Alfred
Lee, Hannah Farnham Sawyer
Lee, Henry, 1782–1867
Lee, Joseph
Leland, George Adams
Leland, John
Leland, Waldo Gifford
Le Moyne, William J.
Leonard, Charles Lester
Leonard, Daniel
Leonard, George
Leonard, Levi Washburn
Leverett, John, 1662–1724
Lewis, Clarence Irving
Lewis, Gilbert Newton
Lewis, Orlando Faulkland
Lewis, Samuel
Lewis, Winslow
Libbey, Edward Drummond
Lincoln, Benjamin
Lincoln, Enoch
Lincoln, John Larkin
Lincoln, Joseph Crosby
Lincoln, Levi, 1749–1820
Lincoln, Levi, 1782–1868
Lincoln, Mary Johnson Bailey
Lincoln, Rufus Pratt
Lindsey, William
Litchfield, Paul Weeks
Little, Arthur Dehon
Little, George
Livermore, George
Livermore, Mary Ashton Rice
Livermore, Samuel, 1732–1803
Locke, Bessie
Lodge, George Cabot
Lodge, Henry Cabot
Lodge, John Ellerton

Logan, Cornelius Ambrose
Lombard, Warren Plimpton
Longfellow, Ernest Wadsworth
Lord, Otis Phillips
Loring, Charles Harding
Loring, Edward Greely
Loring, Ellis Gray
Loring, Frederick Wadsworth
Loring, George Bailey
Loring, Joshua, 1716–1781
Loring, Joshua, 1744–1789
Lothrop, Alice Louise Higgins
Lothrop, George Van Ness
Lovejoy, Asa Lawrence
Loveland, William Austin Hamilton
Lovell, James
Lovell, John
Lovell, Joseph
Lovering, Joseph
Lovett, Robert Morss
Lovett, Robert Williamson
Low, Abiel Abbot
Low, John Gardner
Lowell, Abbott Lawrence
Lowell, Amy
Lowell, Edward Jackson
Lowell, Francis Cabot
Lowell, Guy
Lowell, James Russell
Lowell, John, 1743–1802
Lowell, John, 1769–1840
Lowell, John, 1799–1836
Lowell, John, 1824–1897
Lowell, Josephine Shaw
Lowell, Percival
Lowell, Ralph
Lowell, Robert Traill Spence
Lowell, Robert Traill Spence, Jr.
Lubin, Isador
Lucas, Frederic Augustus
Lummis, Charles Fletcher
Lunt, George
Lyman, Benjamin Smith
Lyman, Eugene William
Lyman, Joseph Bardwell
Lyman, Theodore, 1792–1849
Lyman, Theodore, 1833–1897
Lyman, Theodore, 1874–1954
Lynde, Benjamin
Lyon, Mary
MacArthur, Arthur
McBurney, Charles
McCarren, Patrick Henry
McCarthy, Charles
McCawley, Charles Laurie
McClure, Alexander Wilson
McCormack, John William
McElwain, William Howe
McIntire, Samuel
McIntyre, Alfred Robert

Mack, Connie
McKay, Gordon
McKenzie, Alexander
MacNeil, Hermon Atkins
McNeill, Daniel
McNeill, George Edwin
McNulty, John Augustine
Macomber, Mary Lizzie
Macy, Josiah
Maier, Walter Arthur
Main, Charles Thomas
Manley, John
Mann, Horace
Mann, James
Mann, Mary Tyler Peabody
Mann, Newton
Manning, Robert
Maranville, Walter James Vincent
 ("Rabbit")
Marble, Manton Malone
March, Alden
March, Francis Andrew
Marchant, Henry
Marciano, Rocky
Marcy, Henry Orlando
Marcy, Randolph Barnes
Marcy, William Learned
Marsh, John
Marshall, Charles Henry
Marshall, James Fowle Baldwin
Martin, Joseph William, Jr.
Mason, Daniel Gregory
Mason, Frank Stuart
Mason, Henry
Mason, Jonathan
Mason, Lowell
Mason, William
Massassoit
Masury, John Wesley
Mather, Cotton
Mather, Increase
Mather, Samuel
Matthews, Nathan
Maxcy, Jonathan
Maxcy, Virgil
May, Samuel Joseph
Mayhew, Experience
Mayhew, Jonathan
Maynard, Charles Johnson
Mayo, Frank
Mayo, Sarah Carter Edgarton
Mead, George Herbert
Mears, David Otis
Mecom, Benjamin
Melcher, Frederic Gershom
Mellen, Charles Sanger
Mellen, Prentiss
Merriam, Charles
Merrick, Edwin Thomas
Merrick, Frederick

Merrick, Pliny
Merrill, Daniel
Merrill, Elmer Truesdell
Merrill, Frank Dow
Merrill, George Edwards
Merrill, Gretchen Van Zandt
Merrill, James Cushing
Merrill, James Grisword
Merrill, Joshua
Meserve, Frederick Hill
Messer, Asa
Metcalf, Theron
Metcalf, Willard Leroy
Meyer, George Von Lengerke
Miles, Henry Adolphus
Miles, Nelson Appleton
Miller, Kempster Blanchard
Miller, William
Miller, William Snow
Millett, Fred Benjamin
Mills, Elijah Hunt
Minot, Charles Sedgwick
Minot, George Richards, 1758–1802
Minot, George Richards, 1885–1950
Mitchell, Albert Graeme
Mitchell, Edward Cushing
Mitchell, Henry
Mitchell, Maria
Mitchell, Nahum
Mitchell, William, 1791–1869
Mixter, Samuel Jason
Montague, Gilbert Holland
Montague, William Pepperell
Moody, Dwight Lyman
Moody, Paul
Moody, William Henry
Moore, Clifford Herschel
Moore, Zephaniah Swift
Moorehead, Agnes
Morgan, Edwin Denison
Morgan, James Dada
Morgan, Junius Spencer
Morgan, Justin
Morison, George Shattuck
Morison, Samuel Eliot
Morris, Robert, 1818–1888
Morse, Henry Dutton
Morse, John Lovett
Morse, John Torrey
Morse, Samuel Finley Breese
Morse, Sidney Edwards
Morton, Marcus, 1784–1864
Morton, Marcus, 1819–1891
Morton, Sarah Wentworth Apthorp
Morton, William James
Morton, William Thomas Green
Moseley, Edward Augustus
Mosely, Philip Edward
Motley, John Lothrop
Mott, Lucretia Coffin

Mudge, Enoch
Mudge, James
Mulliken, Samuel Parsons
Munn, Orson Desaix
Munroe, Charles Edward
Munsell, Joel
Murdoch, Frank Hitchcock
Murphy, Gerald Clery
Murphy, Michael Charles
Murray, Judith Sargent Stevens
Muzzey, David Saville
Myrick, Herbert
Nash, Charles Sumner
Nash, Daniel
Nash, Simeon
Nason, Elias
Nason, Henry Bradford
Neagle, John
Neal, David Dalhoff
Nell, William Cooper
Newell, William Wells
Newman, Henry
Newman, Samuel Phillips
Nichols, Charles Lemuel
Nichols, James Robinson
Nicholson, James William Augustus
Niles, David K.
Nixon, John, 1727–1815
Northend, Charles
Norton, Andrews
Norton, Charles Eliot
Norton, Mary Alice Peloubet
Norton, William Edward
Noyes, Arthur Amos
Noyes, Edward Follansbee
Noyes, George Rapall
Nutting, Wallace
Oakes, Thomas Fletcher
Ober, Frederick Albion
O'Brien, Robert Lincoln
O'Callahan, Joseph Timothy
O'Connell, William Henry
O'Connor, William Douglas
O'Donnell, Kenneth Patrick
O'Gorman, Thomas
Oliver, Andrew, 1706–1774
Oliver, Andrew, 1731–1799
Oliver, Fitch Edward
Oliver, Henry Kemble
Oliver, Peter
Olney, Richard
O'Mahoney, Joseph Christopher
Orne, John
Osborn, William Henry
Osgood, rances Sargent Locke
Osgood, George Laurie
Osgood, Samuel
Osgood, William Fogg
Otis, Bass
Otis, George Alexander

Otis, Harrison Gray
Otis, James
Ouimet, Francis Desales
Packard, Alpheus Spring
Packard, Frederick Adolphus
Packard, Silas Sadler
Page, Charles Grafton
Paine, Albert Bigelow
Paine, Charles Jackson
Paine, Robert Treat, 1731–1814
Paine, Robert Treat, 1773–1811
Paine, Robert Treat, 1835–1910
Paley, Barbara Cushing ("Babe")
Palfrey, John Carver
Palfrey, John Gorham
Palmer, George Herbert
Palmer, Walter Walker
Park, Maud Wood
Parker, Edward Pickering
Parker, Henry Taylor
Parker, Horatio William
Parker, Isaac
Parker, James Cutler Dunn
Parker, John
Parker, Peter
Parker, Richard Green
Parker, Samuel
Parker, Theodore
Parker, Theodore Bissell
Parkhurst, Charles Henry
Parkman, Francis
Parsons, Theophilus, 1750–1813
Parsons, Theophilus, 1797–1882
Parsons, Thomas William
Patten, William
Pattison, James William
Paul, Elliot Harold
Paul, Henry Martyn
Payne, Henry Clay
Payne, William Morton
Payson, Seth
Peabody, Andrew Preston
Peabody, Elizabeth Palmer
Peabody, Endicott
Peabody, Francis Greenwood
Peabody, George
Peabody, Joseph
Peabody, Nathaniel
Peabody, Robert Swain
Pearce, Charles Sprague
Pearson, Edmund Lester
Pearson, Eliphalet
Pearson, Fred Stark
Peck, George Washington
Peck, William Dandridge
Peirce, Benjamin
Peirce, Benjamin Osgood
Peirce, Charles Sanders
Peirce, Cyrus
Peirce, Henry Augustus

Peirce, James Mills
Pelham, Henry
Percival, John
Perkins, Charles Callahan
Perkins, rances
Perkins, George Henry
Perkins, Jacob
Perkins, James Handasyd, 1810–1849
Perkins, James Handasyd, 1876–1940
Perkins, Justin
Perkins, Thomas Handasyd
Perkins, Thomas Nelson
Perley, Ira
Perry, Bliss
Perry, Edward Aylesworth
Perry, Edward Baxter
Perry, Enoch Wood
Perry, Nora
Perry, Walter Scott
Perry, William
Peters, Edward Dyer
Phelps, Austin
Phillips, John
Phillips, Samuel
Phillips, Walter Polk
Phillips, Wendell
Phillips, Willard
Phillips, William, 1750/51–1827
Phillips, William, 1824–1893
Phillips, William Addison
Pickard, Samuel Thomas
Pickering, Edward Charles
Pickering, John
Pickering, Timothy
Pidgin, Charles Felton
Pierce, Benjamin
Pierce, Edward Lillie
Pierce, Henry Lillie
Pierpont, James
Pierson, Abraham
Pike, Albert
Pillsbury, Harry Nelson
Pillsbury, John Elliott
Pillsbury, Parker
Pinkham, Lydia Estes
Plimpton, George Arthur
Plumer, William
Plummer, Jonathan
Poe, Edgar Allan
Pomeroy, Samuel Clarke
Pomeroy, Seth
Pond, Enoch
Pond, George Edward
Pool, Maria Louise
Poole, Fitch
Poole, William Frederick
Poor, Charles Henry
Poor, Daniel
Poor, Enoch
Poore, Benjamin Perley

Pope, Albert Augustus
Pope, Franklin Leonard
Porter, Benjamin Curtis
Porter, David
Porter, Rufus
Potter, Charles Francis
Potter, William James
Pratt, Charles
Pratt, Daniel, 1809–1887
Pratt, Enoch
Pratt, Thomas Willis
Pray, Isaac Clark
Prendergast, Maurice Brazil
Prentice, George Dennison
Presbrey, Eugene Wiley
Prescott, Oliver
Prescott, Samuel
Prescott, William
Prescott, William Hickling
Preston, Harriet Waters
Priest, Edward Dwight
Prince, Frederick Henry
Prince, Morton
Prince, Thomas
Proctor, Joseph
Prouty, Olive Higgins
Putnam, Charles Pickering
Putnam, Eben
Putnam, Frederic Ward
Putnam, Gideon
Putnam, Israel
Putnam, James Jackson
Putnam, Rufus
Quincy, Edmund
Quincy, Josiah, 1744–1775
Quincy, Josiah, 1772–1864
Quincy, Josiah Phillips
Rand, Addison Crittenden
Rand, Edward Kennard
Rand, Edward Sprague
Randall, Samuel
Ranney, Ambrose Loomis
Ranney, Rufus Percival
Rantoul, Robert, 1778–1858
Rantoul, Robert, 1805–1852
Ray, Charles Bennett
Ray, Isaac
Read, Daniel, 1757–1836
Read, Nathan
Reed, David
Reed, James, 1722–1807
Reed, James, 1834–1921
Reed, Sampson
Reed, Simeon Gannett
Reid, Robert
Remond, Charles Lenox
Revere, Joseph Warren
Revere, Paul
Revson, Charles Haskell
Rhoads, Cornelius Packard

Rice, Alexander Hamilton
Rice, Calvin Winsor
Rice, Charles Allen Thorndike
Rice, Luther
Rice, William Marsh
Rice, William North
Rich, Isaac
Rich, Obadiah
Richards, Ellen Henrietta Swallow
Richards, Laura Elizabeth Howe
Richards, William
Richards, Zalmon
Richardson, Albert Deane
Richardson, Maurice Howe
Richardson, Rufus Byam
Richardson, Willard
Richardson, William Adams
Richardson, William Lambert
Richmond, John Lambert
Ricketson, Daniel
Riddell, John Leonard
Riddle, Albert Gallatin
Riddle, George Peabody
Rindge, Frederick Hastings
Ripley, Edward Payson
Ripley, Ezra
Ripley, George
Ripley, William Zebina
Robbins, Chandler
Robinson, Charles
Robinson, Edward, 1858–1931
Robinson, Ezekiel Gilman
Robinson, Harriet Jane Hanson
Robinson, Henry Morton
Robinson, Moses
Robinson, William Stevens
Roche, Arthur Somers
Rockwell, Willard Frederick
Rodgers, John, 1727–1811
Rogers, Edward Staniford
Rogers, Harriet Burbank
Rogers, Henry Huttleston
Rogers, Isaiah
Rogers, John, 1829–1904
Rogers, Mary Josephine
Rogers, Robert
Rozers, William Crowninshield
Rorfe, William James
Rollins, Alice Marland Wellington
Root, Elisha King
Root, Frederic Woodman
Root, George Frederick
Root, Joseph Pomeroy
Ropes, James Hardy
Ropes, Joseph
Ross, Abel Hastings
Rossiter, William Sidney
Rotch, Abbott Lawrence
Rotch, Arthur
Rotch, William

Roulstone, George
Rugg, Arthur Prentice
Rugg, Harold Ordway
Ruggles, Timothy
Russ, John Denmson
Russetl, Benjamin
Russell, Joseph
Russell, William Eustis
Rust, Richard Sutton
Ruter, Martin
Ryder, Albert Pinkham
Sabin, Charles Hamilton
Salisbury, Edward Elbridge
Saltonstall, Gurdon
Saltonstall, Leverett
Samuels, Edward Augustus
Sanders, Daniel Clarke
Sanders, Elizabeth Elkins
Sanders, Thomas
Sanger, Charles Robert
Sanger, George Partridge
Sargent, Aaron Augustus
Sargent, Charles Sprague
Sargent, Epes
Sargent, Fitzwilliam
Sargent, Henry
Sargent, Henry Winthrop
Sargent, John Osborne
Sargent, Lucius Manlius
Sargent, Winthrop, 1753–1820
Sartwell, Henry Parker
Savage, Edward
Savage, James
Savage, Philip Henry
Saville, Marshall Howard
Sawyer, Sylvanus
Scammell, Alexander
Schofield, Henry
Schouler, James
Scudder, Horace Elisha
Scudder, Samuel Hubbard
Sears, Barnas
Sears, Edmund Hamilton
Sears, Isaac
Sears, Richard Dudley
Seccomb, John
Sedgwick, Catharine Maria
Sedgwick, Theodore, 1780–1839
Selfridge, Thomas Oliver
Severance, Frank Hayward
Sewall, Jonathan
Sewall, Jonathan Mitchell
Sexton, Anne Gray Harvey
Shattuck, Frederick Cheever
Shattuck, George Brune
Shattuck, George Cheyne, 1783–1854
Shattuck, George Cheyne, 1813–1893
Shattuck, Lemuel
Shaw, Henry Wheeler
Shaw, Lemuel

Shaw, Mary
Shaw, Oliver
Shaw, Samuel
Shaw, William Smith
Shays, Daniel
Shedd, Joel Herbert
Shedd, William Greenough Thayer
Shepard, William
Shepley, Ether
Sherman, Roger
Short, Charles
Shurtleff, Nathaniel Bradstreet
Sibley, George Champlain
Sibley, Hiram
Sibley, John
Silsbee, Nathaniel
Simkhovitch, Mary Melinda
 Kingsbury
Simmons, Edward
Simonds, Frank Herbert
Simpson, Michael Hodge
Sinnott, Edmund Ware
Sizer, Nelson
Skinner, Aaron Nichols
Skinner, Otis
Smalley, George Washburn
Smith, Cale Blood
Smith, Charles Sprague
Smith, Edward Hanson
Smith, Geral Birney
Smith, Harol Babbitt
Smith, Horace
Smith, Horatio Elwin
Smith, John Cotton, 1826–1882
Smith, John Rowson
Smith, Jonas Waldo
Smith, Joseph, 1790–1877
Smith, Judson
Smith, Nathan, 1762–1829
Smith, Oliver
Smith, Samuel Francis
Smith, Sophia
Snelling, Josiah
Snelling, William Joseph
Snow, Eliza Roxey
Snow, Francis Huntington
Snow, Jessie Baker
Soley, James Russell
Southard, Elmer Ernest
Sparrow, William
Spear, Charles
Spellman, Francis Joseph
Spencer, Anna Garlin
Sperry, Willard Learoyd
Spooner, Lysander
Spottswood, Stephen Gill
Sprague, Charles
Sprague, Homer Baxter
Sprague, Oliver Mitchell Wentworth
Sprague, Peleg

Spring, Gardiner
Spring, Samuel
Spurr, Josiah Edward
Stanley, Harold
Starr, Eliza Allen
Stearns, Abel
Stearns, Asahel
Stearns, Eben Sperry
Stearns, Frank Waterman
Stearns, George Luther
Stearns, HaroEd Edmund
Stearns, Henry Putnam
Stearns, Oliver
Stearns, Robert Edwards Carter
Stearns, Shubal
Stearns, William Augustus
Stebbins, Horatio
Stebbins, Rufus Phineas
Stetson, Charles Augustus
Stetson, Henry Crosby
Stevens, Isaac Ingalls
Stimpson, William
Stimson, Alexander Lovett
Stimson, Frederic Jesup
Stimson, Julia Catherine
Stockbridge, Henry Smith
Stockbridge, Horace Edward
Stockbridge, Levi
Stockwell, John Nelson
Stoddard, David Tappan
Stoddard, Elizabeth Drew Barstow
Stoddard, John Lawson
Stoddard, John Tappan
Stoddard, Richard Henry
Stoddard, Solomon
Stoddard, Theodore Lothrop
Stone, Amasa
Stone, Charles Augustus
Stone, Charles Pomeroy
Stone, Ellen Maria
Stone, James Kent
Stone, John Augustus
Stone, John Sedy
Stone, Lucy
Storer, Francis Humphreys
Storer, Horatio Robinson
Storey, Moorfield
Storrow, James Jackson
Storrs, Richard Salter, 1787–1873
Storrs, Richard Salter, 1821–1900
Story, Isaac
Story, Joseph
Story, William Edward
Story, William Wetmore
Stowe, Calvin Ellis
Strong, Caleb
Strong, Charles Augustus
Strong, Theodore
Sturgis, William
Sturtevant, Edward Lewis

Sullivan, John Lawrence
Sullivan, Louis Henri
Sumner, Charles
Sumner, Edwin Vose
Sumner, Increase
Sumner, James Batcheller
Swan, Timothy
Swift, Gustavus Franklin
Swift, Joseph Gardner
Swift, Louis Franklin
Swift, William Henry
Swift, Zephaniah
Switzer, Mary Elizabeth
Sylvester, Frederick Oakes
Talbot, Henry Paul
Talbot, Israel Tisdale
Talbot, Silas
Tappan, Arthur
Tappan, Benjamin
Tappan, Lewis
Tarbell, Edmund Charles
Tarbell, Frank Bigelow
Tarbell, Joseph
Tarr, Ralph Stockman
Taylor, Bert Leston
Taylor, Charles Alonzo
Taylor, Charles Henry
Taylor, William Ladd
Tenney, Charles Daniel
Thacher, George
Thacher, James
Thacher, Peter, 1651–1727
Thacher, Peter, 1752–1802
Thacher, Samuel Cooper
Thaxter, Roland
Thayer, Abbott Handerson
Thayer, Alexander Wheelock
Thayer, Eli
Thayer, Ezra Ripley
Thayer, Gideon French
Thayer, James Bradley
Thayer, John
Thayer, John Milton
Thayer, Joseph Henry
Thayer, Nathaniel
Thayer, Sylvanus
Thayer, Thomas Baldwin
Thayer, Whitney Eugene
Thayer, William Makepeace
Thayer, William Roscoe
Thayer, William Sydney
Thomas, David
Thomas, Isaiah
Thomas, John
Thompson, Benjamin
Thompson, Cephas Giovanni
Thompson, Daniel Pierce
Thompson, Edward Herbert
Thompson, Jerome B.
Thompson, John

Thompson, William Hale
Thoreau, Henry David
Thorndike, Edward Lee
Thorndike, Israel
Thorndike, Lynn
Thorp, John
Thorpe, Thomas Bangs
Thurber, Charles
Thwaites, Reuben Gold
Ticknor, George
Tileston, Thomas
Tingley, Katherine Augusta Westcott
Tinkham, George Holden
Tobey, Charles William
Tobey, Edward Silas
Tobin, Maurice Joseph
Todd, Mabel Loomis
Tolman, Edward Chace
Tolman, Herbert Cushing
Tolman, Richard Chace
Tondorf, Francis Anthony
Topliff, Samuel
Torrey, Bradford
Torrey, Charles Turner
Tower, Zealous Bates
Townsend, Edward Davis
Tracy, Nathaniel
Train, Arthur Cheney
Train, Enoch
Train, George Francis
Traynor, Harold Joseph ("Pie")
Treadwell, Daniel
Trott, Benjamin
Trow, John Fowler
Trowbridge, Edmund
Trowbridge, John
Tucker, Benjamin Ricketson
Tucker, Samuel
Tuckerman, Edward
Tuckerman, Frederick
Tuckerman, Frederick Goddard
Tuckerman, Henry Theodore
Tuckerman, Joseph
Tudor, Frederic
Tudor, William
Tufts, Charles
Tufts, Cotton
Tufts, James Hayden
Tufts, John
Tupper, Benjamin
Turell, Jane
Turner, Asa
Turner, Jonathan Baldwin
Tyler, Ransom Hubert
Tyler, Royall, 1757–1826
Tyler, Royall, 1884–1953
Tyler, William Seymour
Tyng, Edward
Tyng, Stephen Higginson
Underwood, Francis Henry

Underwood, Loring
Upham, Samuel Foster
Upton, George Putnam
Upton, Winslow
Vaillant, George Clapp
Valentine, Robert Grosvenor
Van Brunt, Henry
Varnum, James Mitchell
Varnum, Joseph Bradley
Very, Jones
Very, Lydia Louisa Ann
Villard, Helen Frances Garrison
Vinton, Frederic
Vinton, Samuel Finley
Wade, Benjamin Franklin
Wadsworth, Eliot
Wadsworth, Peleg
Wainwright, Richard, 1817–1862
Walcot, Charles Melton, 1840–1921
Walcott, Henry Pickering
Waldo, Samuel
Walker, Francis Amasa
Walker, Henry Oliver
Walker, Sears Cook
Walker, Timothy, 1705–1782
Walker, Timothy, 1802–1856
Walker, William Johnson
Wallace, John Findley
Walsh, David Ignatius
Walsh, Edmund Aloysius
Walsh, James Anthony
Walter, Thomas, 1696–1725
Ward, Artemas
Ward, Charles Henshaw
Ward, Elizabeth Stuart Phelps
Ward, Frederick Townsend
Ward, Henry Dana
Ward, Herbert Dickinson
Ward, Robert De Courcy
Ward, Thomas Wren
Ward, William Hayes
Ware, Ashur
Ware, Edmund Asa
Ware, Henry, 1764–1845
Ware, Henry, 1794–1843
Ware, John
Ware, John Fothergill Waterhouse
Ware, William
Ware, William Robert
Warner, Charles Dudley
Warner, Hiram
Warner, Langdon
Warner, Worcester Reed
Warren, Charles
Warren, Cyrus Moors
Warren, Francis Emroy
Warren, Henry Clarke
Warren, Henry Ellis
Warren, Henry White
Warren, James

Warren, John
Warren, John Collins, 1778–1856
Warren, John Collins, 1842–1927
Warren, Joseph
Warren, Josiah
Warren, Mercy Otis
Warren, Shields
Warren, William Fairfield
Washburn, Albert Henry
Washburn, Charles Grenfill
Washburn, Edward Abiel
Washburn, Emory
Washburn, George
Washburn, Ichabod
Waters, Daniel
Watson, Elkanah
Watson, Thomas Augustus
Watson, William
Wayland, Francis, 1826–1904
Webb, Thomas Smith
Webster, Arthur Gordon
Webster, Edwin Sibley
Webster, John White
Webster, Noah
Weeks, Edwin Lord
Weeks, Joseph Dame
Weeks, Sinclair
Weiss, John
Weld, Arthur Cyril Gordon
Wellington, Arthur Mellen
Wellman, Samuel Thomas
Wellman, William Augustus
Wells, David Ames
Wells, William Vincent
Wendell, Barrett
Wendte, Charles William
Wesson, Daniel Baird
West, Benjamin
West, Samuel
Wheeler, Benjamin Ide
Wheeler, Burton Kendall
Wheeler, George Montague
Wheeler, William
Wheeler, William Adolphus
Wheelwright, Edmund March
Wheelwright, Mary Cabot
Wheelwright, William
Whipple, Amiel Weeks
Whipple, Edwin Percy
Whipple, Squire
Whistler, James Abbott McNeill
Whitaker, Daniel Kimball
White, Charles Abiathar
White, Leonard Dupee
White, Paul Dudley
Whiting, Arthur Battelle
Whiting, George Elbridge
Whiting, William
Whiting, William Henry Chase
Whitman, Ezekiel

Whitmore, Frank Clifford
Whitmore, William Henry
Whitney, Anne
Whitney, Asa
Whitney, Caspar
Whitney, Eli
Whitney, George
Whitney, James Lyman
Whitney, Josiah Dwight
Whitney, Mary Watson
Whitney, Myron William
Whitney, Richard
Whitney, William Collins
Whitney, William Dwight
Whiton, James Morris
Whittemore, Amos
Whittemore, Thomas, 1800–1861
Whittemore, Thomas, 1871–1950
Whittier, John Greenleaf
Whorf, Benjamin Lee
Wiggin, Albert Henry
Wiggin, James Henry
Wigglesworth, Edward, 1693–1765
Wigglesworth, Edward, 1732–1794
Wigglesworth, Edward, 1840–1896
Wilbur, Hervey Backus
Wilde, George Francis Faxon
Wiley, Ephraim Emerson
Willard, Joseph
Willard, Samuel, 1639/40–1707
Willard, Samuel, 1775–1859
Willard, Sidney
Willard, Simon
Willard, Solomon
Williams, Elisha
Williams, Ephraim
Williams, Francis Henry
Williams, Henry Willard
Williams, Israel
Williams, John, 1664–1729
Williams, John, 1817–1899
Williams, John Foster
Williams, John Joseph
Williams, Jonathan
Williams, Nathaniel
Williams, Stephen West
Williams, William
Willis, Nathaniel
Willis, William
Williston, Samuel, 1795–1874
Williston, Samuel, 1861–1913
Williston, Samuel Wendell
Wilmarth, Lemuel Everett
Wilson, George Francis
Wilson, Samuel
Winchester, Elhanan
Winchester, Oliver Fisher
Wingate, Paine
Winship, Albert Edward
Winship, George Parker

Winslow, Charles-Edward Amory
Winslow, Edward
Winslow, John
Winslow, Josiah
Winslow, Sidney Wilmot
Winslow, William Copley
Winsor, Justin
Winter, William
Winthrop, James
Winthrop, John, 1638–1707
Winthrop, John, 1714–1779
Winthrop, Robert Charles
Wise, John
Wolcott, Edward Oliver
Wood, Edward Stickney
Wood, Jethro
Woodberry, George Edward
Woodbridge, Samuel Merrill
Woodbridge, William Channing
Woodbury, Charles Jeptha Hill%101
Woodbury, Isaa Baker
Woods, James Haughton
Woods, Leonard, 1774–1854
Woods, Leonard, 1807–1878
Woodward, Calvin Milton
Woodward, Robert Burns
Woodworth, Samuel
Worcester, Samuel Austin
Workman, Fanny Bullock
Worthen, William Ezra
Worthington, John
Wright, Chauncey
Wright, John Joseph
Wright, John Stephen
Wright, Philip Green
Wright, Silas
Wyeth, John
Wyeth, Newell Convers
Wylie, Philip Gordon
Wyman, Horace
Wyman, Jeffries
Wyman, Morrill
Yale, Elihu
Yeomans, John William
Young, Alexander

MICHIGAN

Ament, William Scott
Anthon, John
Atkinson, George Francis
Atterbury, Grosvenor
Avery, Sewell Lee
Bachmann, Werner Emmanuel
Bacon, Leonard
Bagley, William Chandler
Bailey, James Anthony
Bailey, Liberty Hyde
Baker, Ray Stannard
Barrows, John Henry
Beach, Rex

Beal, William James
Bennett, Earl W.
Bigelow, Melville Madison
Binga, Jesse
Birkhoff, George David
Blodgett, John Wood
Boeing, William Edward
Bovie, William T.
Brewer, Mark Spencer
Briggs, Lyman James
Brooks, Alfred Hulse
Brower, Jacob Vradenberg
Brown, Olympia
Brown, Prentiss Marsh
Brucker, Wilber Marion
Brundage, Avery
Bunche, Ralph Johnson
Bundy, Harvey Hollister
Burnett, Leo
Burton, Frederick Russell
Butterfield, Kenyon Leech
Campaw, Joseph
Campbell, Douglas Houghton
Carleton, Will
Catton, Charles Bruce
Cavanagh, Jerome Patrick ("Jerry")
Chaffee, Roger Bruce
Chapin, Roy Dikeman
Chessman, Caryl Whittier
Child. Charles Manning
Church, Frederick Stuart
Cicotte, Edward Victor
Clements, William Lawrence
Cobo, Albert Eugene
Cole, Arthur Charles
Comfort, Will Levington
Cooke, George Willis
Cooley, Thomas Benton
Copeland, Royal Samuel
Corby, William
Corrothers, James David
Corwin, Edward Samuel
Cox, Wallace Maynard ("Wally")
Curtis, Edward Lewis
Curtis, Heber Doust
Curwood, James Oliver
Darling, Jay Norwood ("Ding")
Davenport, Eugene
De Kruif, Paul Henry
De Langlade, Charles Michel
Dennison, Walter
Dewey, Thomas Edmund
Dodge, Joseph Morrell
Drum, Hugh Aloysius
Eaton, Daniel Cady
Elliott, Walter Hackett Robert
Fairchild, David Grandison
Farnsworth, Elon John
Ferber, Edna Jessica
Ferry, Elisha Peyre

Ferry, Thomas White
Flaherty, Robert Joseph
Folks, Homer
Ford, Edsel Bryant
Ford, Henry
Forsyth, Thomas
Frieseke, Frederick Carl
Gauss, Christian Frederick
Gay, Edwin Francis
Geddes, Norman Bel
Gerber, (Daniel) Frank
Gerber, Daniel (Frank)
Grabner, August Lawrence
Graham, Ernest Robert
Green, Constance McLaughlin
Hale, Frederick
Haworth, Leland John
Hayden, Robert Earl
Haynes, Williams
Hill, Louis Clarence
Hodgins, Eric Francis
Howard, Brownson Crocker
Howard, Timothy Edward
Howell, Albert Summers
Hubbard, Henry Guernsey
Hulbert, Edwin James
Humphrey, George Magoffin
Hunt, Henry Jackson
Hupp, Louis Gorham
Hutcheson, William Levi
Ingersoll, Robert Hawley
Ingersoll, Royal Rodney
Irwin, George Le Roy
Jenks, Jeremiah Whipple
Jones, Howard Mumford
Joy, Henry Bourne
Kearns, Jack
Kelland, Clarence Budington
Kellogg, John Harvey
Kellogg, Paul Underwood
Kellogg, Will Keith
Kidder, Alfred Vincent
King, Henry Churchill
Kirchwey, George Washington
Kohler, Max James
Krehbiel, Henry Edward
Lacy, William Albert
Lamb, Isaac Wixom
Lamoureux, Andrew Jackson
Lanman, Charles
Lardner, Ringgold Wilmer
Lemmon, John Gill
Levy, Max
Liggett, Louis Kroh
Lindeman, Edward Christian
Livingston, Burton Edward
Longyear, John Munroe
Lovejoy, Owen Reed
McAndrew, William
McCoy, Tim

McHugh, Rose John
McKinstry, Elisha Williams
Macomb, Alexander
McRae, Milton Alexander
Macy, John Albert
Marsh, Frank Burr
Matthews, Franklin
Mayo, Mary Anne Bryant
Meany, Edmond Stephen
Melchers, Gari
Mesta, Perle Reid Skirvin
Miller, Webb
Moore, Charles
Morton, Paul
Moulton, orest Ray
Muir, Charles Henry
Murphy, Frank
Navarre, Pierre
Nestor, Agnes
Newberry, Truman Handy
Noble, Alfred
O'Brien, Thomas James
Otis, Charles Eugene
Pack, Charles Lathrop
Palmer, Thomas Witherell
Penfield, William Lawrence
Pilcher, Lewis Stephen
Pitkin, Walter Boughton
Pond, Allen Bartlit
Pond, Irving Kane
Potter, Charles Edward
Prall, David Wight
Raby, James Joseph
Roethke, Theodore Huebner
Rolshoven, Julius
Royce, Ralph
Ryan, John Dennis
Ryerson, Martin Antoine
St. John, Charles Edward
Sanderson, Ezra Dwight
Schall, Thomas David
Schippers, Thomas
Scripps, William Edmund
Seager, Henry Rogers
Shafter, William Rufus
Shepard, James Henry
Sherman, Frederick Carl
Sibley, Henry Hastings
Sloane, Isabel Cleves Dodge
Squier, George Owen
Summerfield, Arthur Ellsworth
Taylor, Fred Manville
Thomas, Calvin
Tilzer, Harry Von
Toumey, James William
Towne, Charles Arnette
Vance, Harold Sines
Vandenberg, Arthur Hendrick
Van Tyne, Claude Halstead
Webber, Herbert John

Whelpley, Henry Milton
White, Stewart Edward
Wilbur, Cressy Livingston
Wilcox, Delas Franklin
Willcox, Orlando Bolivar
Willett, Herbert Lockwood
Williams, Gardner Fred
Winchell, Horace Vaughn
Woodward, Robert Simpson
Yawkey, Thomas Austin ("Tom")

MINNESOTA

Bender, Charles Albert ("Chief")
Benton, William Burnett
Bierman, Bernard William ("Bernie")
Bottineau, Pierre
Boyle, Michael J.
Burdick, Usher Lloyd
Burleson, Hugh Latimer
Burnham, Frederick Russell
Butler, Pierce
Carlson, Richard Dutoit
Carruth, Fred Hayden
Conrad, Maximilian Arthur, Jr.
Cooper, Hugh Lincoln
Daniels, Farrington
Densmore, Frances
Dobie, Gilmour
Douglas, William Orville
Dworshak, Henry Clarence
Edwards, Everett Eugene
Farwell, Arthur
Fillmore, Charles
Fitzgerald, Francis Scott Key
Flandrau, Charles Macomb
Frary, Francis Cowles
Fraser, James Earle
Frazier, Lynn Joseph
Frey, John Philip
Fulton, Johnt Farquhar
Garland, Judy
Getty, Jean Paul
Gillespie, Mabel
Goode, John Paul
Griggs, Everett Gallup
Haines, Lynn
Hall, Hazel
Haunt, Alma Cecelia
Hefgelfinger, William Walter ("Pudge")
Hodson, William
Hopkins, Cyril George
Hormel, Jay Catherwood
Johnson, John Albert
Judd, Edward Starr
Kerr, Walter Craig
Knappen, Theodore Temple
Langlie, Arthur Bernard
Lemke, William Frederick
Lewis, Harry Sinclair

Liggett, Walter William
Lindbergh, Charles Augustus, Jr.
Little Crow V
Lloyd, Marshall Burns
Lowden, Frank Orren
McAlexander, Ulysses Grant
McNair, Lesley James
MacPhail, Leland Stanford ("Larry")
Magoon, Charles Edward
Manship, Paul Howard
Mayo, Charles Horace
Mayo, William James
Mich, Daniel Danforth
Michel, Virgil George
Mitchell, William DeWitt
Nevers, Ernest Alonzo ("Ernie")
Olds, Robert Edwin
Olson, loy Bjerstjerne
Oppenheim, James
Pegler, Westbrook
Plowman, George Taylor
Plummer, Henry Stanley
Putnam, Helen Cordelia
Pye, Watts Orson
Ranson, Stephen Walter
Red Wing
Reynolds, Milton
Rothafel, Samuel Lionel
Ryan, John Augustine
Sears, Richard Warren
Shaughnessy, Clark Daniel
Shields, Thomas Edward
Shipstead, Henrik
Swift, Linton Bishop
Todd, Mike
Townley, Arthur Charles
Volstead, Andrew John
Wabasha
Warner, Anne Richmond
White, Minor Martin
Wood, John Taylor
Youngdahl, Luther Wallace

MISSISSIPPI

Allen, George Edward
Bailey, Joseph Weldon
Barry, William Taylor Sullivan
Baskerville, Charles
Battle, Burrell Bunn
Bilbo, Theodore Gilmore
Black, John Charles
Bodenheim, Maxwell
Boggs, Thomas Hale
Boyd, Richard Henry
Brandon, Gerard Chittocque
Burnett, Chester Arthur ("Howlin' Wolf")
Brickell, Henry Herschel
Brough, Charles Hillman
Chamberlain, George Earle

Claiborne, John Francis Hamtramck
Clarke, James Paul
Clayton, William Lockhart
Davis, Joseph Robert
Davis, Varina Howell
Dickinson, Jacob McGavock
Dorsey, Sarah Anne Ellis
Easter, Luscious Luke
Ellington, Earl Buford
Evers, Medgar Wiley
Farish, William Stamps
Faulkner (Falkner), William Cuthbert
Finney, John Miller Turpin
Gailor, Thomas Frank
Gaither, Horace Rowan, Jr.
Galloway, Charles Betts
Garner, James Wilford
Gordon, James
Gore, Thomas Pryor
Gregory, Thomas Watt
Hamer, Fannie Lou
Harris, Nathaniel Harrison
Harris, Wiley Pope
Harrison, Byron Patton
Harrison, James Albert
Howry, Charles Bowen
Hughes, Henry
Humphreys, Benjamin Grubb
Ingraham, Prentiss
Jeffrey, Rosa Griffith Vertner Johnson
Jones, James Kimbrough
Leflore, Greenwood
Littlefield, George Washington
Lomax, John Avery
MacDowell, Katherine Sherwoo
 Bonner
McLaurin, Anselm Joseph
Manning, Vannoy Hartrog
Mayes, Edward
Money, Hernando De Soto
Morton, Ferdinand Quintin
Mullins, Edgar Young
Newlands, Francis Griffith
Nicholson, Eliza Jane Poitevent
 Holbrook
Parker, John Milliken
Percy, William Alexander
Phelan, James
Pitchlynn, Peter Perkins
Pittman, Key
Presley, Elvis Aron
Pushmataha
Putnam, Arthur
Rankin, John Elliott
Read, Charles William
Russell, Irwin
Short, Joseph Hudson, Jr.
Simmons, Roscoe Conkling Murray
Still, William Grant, Jr.
Stockard, Charles Rupert

Taylor, Theodore Roosevelt ("Hound
 Dog")
Van Dorn, Earl
Warfield, Catherine Ann Ware
Wheeler, George Wakeman
Whitfield, Owen
Williams, Ben Ames
Wright, Fielding Lewis
Wright, Richard Nathaniel
Yellowley, Edward Clements
Young, Stark
Zimmerman, Eugene

MISSOURI

Ace, Jane
Alexander, Will Winton
Allen, Forrest Clare ("Phog")
Allison, Nathaniel
Anderson, Benjamin McAlester
Arden, Edwin Hunter Pendleton
Armstrong, Paul
Asbury, Herbert
Baker, Josephine
Baldwin, Evelyn Briggs
Bates, John Coalter
Bates, Onward
Beckwith, James Carroll
Beery, Wallace Fitzgerald
Bent, Silas
Bent, William
Biggers, John David
Blair, Emily Newell
Bliss, Robert Woods
Blow, Susan Elizabeth
Benson, Sally
Benton, Thomas Hart
Biggers, John David
Bogy, Lewis Vital
Bonfils, Frederick Gilmer
Boswell, Connie (Connee)
Boyd, William Kenneth
Boyle, Harold Vincent ("Hal")
Brookhart, Smith Wildman
Buchanan, Edgar
Buchanan, Joseph Ray
Caldwell, Eugene Wilson
Campbell, Prince Lucien
Cannon, Clarence
Caraway, Thaddeus Horatius
Carnegie, Dale
Carver, George Washington
Chetlain, Augustus Louis
Chopin, Kate O'Flaherty
Chouteau, Auguste Pierre
Chouteau, Pierre
Churchill, Winston
Clark, Bennett Champ
Clemens, Samuel Langhorne
Cockrell, Francis Marion
Colby, Bainbridge

Coontz, Robert Edward
Cornoyer, Paul
Craig, Cleo Frank
Craig, Malin
Craighead, Edwin Boone
Creel, George
Crowder, Enoch Herbert
Croy, Homer
Dalton, Robert
Dandy, Walter Edward
Darwell, Jane
Davis, Dwight Filley
Davison, Gregory Caldwell
Dent, Frederick Tracy
De Young, Michel Harry
Dodge, Augustus Caesar
Donnell, Forrest C.
Dooley, Thomas Anthony, III
Eames, Charles Ormand, Jr.
Eliot, T(homas) S(tearns)
Ellis, George Washington
Engelmann, George Julius
Evans, Walker
Evola, Natale ("Joe Diamond")
Field, Eugene
Field, Mary Katherine Keemle
Field, Roswell Martin
Finck, Henry Theophilus
Finn, Francis James
Fletcher, Thomas Clement
Fox, Williams Carlton
Frank, Glenn
Froman, Ellen Jane
Galloway, Beverly Thomas
Goldstein, Max Aaron
Gotshall, William Charles
Grable, Betty
Grant, Frederick Dent
Grant, Harry Johnston
Grant, Jane Cole
Griffith, Clark Calvin
Hammond, Bray
Hannegan, Robert Emmet
Harlow, Jean
Harshe, Robert Bartholow
Hatcher, Robert Anthony
Hearst, George
Hearst, Phoebe Apperson
Hendrix, Eugene Russell
Hendrix, Joseph Clifford
Hewett, Waterman Thomas
Hildreth, Samuel Clay
Holden, Edward Singleton
Holden, Hale
Holt, William Franklin
Horn, Tom
Horst, Louis
Howard, Elston Gene ("Ellie")
Howell, Thomas Jefferson
Hubbard, Robert C. ("Cal")

Hubbard, Wynant Davis
Hubble, Edwin
Hudson, Manley Ottmer
Hughes, Howard Robard
Hughes, James Langston
Hughes, Rupert
Hunt, George Wylie Paul
Hyde, Arthur Mastick
Jackling, Daniel Cowan
James, Jesse Woodson
James, Marquis
Jones, Benjamin Allyn
Joy, Charles Turner
Keith, Arthur
Kimball, Dan Able
Kroeger, Ernest Richard
Kuhlman, Kathryn
Lange, Alexis Frederick
Lear, William Powell
Link, Theodore Carl
Long, Breckinridge
Long, Edward Vaughn
Love, Robertus Donnell
Lunceford, James Melvin ("Jimmie")
McAfee, John Armstrong
McArthur, William Pope
McBride, Mary Margaret
McCausland, John
McClurg, Joseph Washington
McConnell, Ira Welch
McCulloch, Robert Paxton
MacCurdy, George Grant
Macfadden, Berharr
McIntyre, Oscar Odd
McManus, George
Malin, Patrick Murphy
Mallinckrodt, Edward
Mallinckrodt, Edward, Jr.
Marbut, Curtis Fletcher
Marmaduke, John Sappington
Marshall, William Rainey
Marvin, Enoch Mather
Mondell, Frank Wheeler
Moore, Marianne Craig
More, Paul Elmer
Morfit, Campbell
Nelson, Donald Marr
Nelson, Marjorie Maxine
Nicholson, James Bartram
Niebuhr, Helmut Richard
Niebuhr, Karl Paul Reinhold
 ("Reinie")
Noonan, James Patrick
Oakie, Jack
O'Sullivan, Mary Kenney
Pallen, Conde Benoist
Parker, Edwar Brewington
Pendergast, Thomas Joseph
Penney, James Cash ("J.C.")
Pershing, John Joseph

Philips, John Finis
Powell, John Benjamin
Pratte, Bernard
Prentis, Henning Webb, Jr.
Pritchett, Henry Smith
Pryor, Arthur W.
Pulitzer, Ralph
Quayle, William Alfred
Rand, Sally
Rautenstrauch, Walter
Reedy, William Marion
Rickard, George Lewis
Robidon, Antoine
Rombauer, Irma Louise
Ross, Charles Griffith
Ross, Nellie Tayloe
Roth, Lillian
Rubey, William Walden
Russell, Charles Ellsworth ("Pee
 Wee")
Russell, Sol Smith
Rutherford, Joseph Franklin
St. Vrain, Ceran De Hault De Lassus
 de
Sarpy, Peter A.
Sauer, Carl Ortwin
Shafroth, John Franklin
Shannon, Fred Albert
Shapley, Harlow
Shawn, Edwin Meyers ("Ted")
Skaggs, Marion Barton
Smedley, Agnes
Smith, Horton
Smith, James Allen
Smith, Joseph Fielding
Snow, Edgar Parkes
Spiering, Theodore
Spillman, William Jasper
Spink, John George Taylor
Stark, Lloyd Crow
Stengel, Charles Dillon ("Casey")
Stephens, Edwin William
Stettinius, Edward Riley
Stoessel, Albert Frederic
Swift, John Franklin
Swope, Gerard
Swope, Herbert Bayard
Talbot, Ethelbert
Taussig, Frank William
Teasdale, Sara
Thomas, Augustus
Toole, Edwin Warren
Toole, Joseph Kemp
Traubel, Helen
Truman, Harry S.
Turner, George
Turner, James Milton
Vaughn, Victor Clarence
Walker, Robertl Franklin
Wallace, Charles William

Wallace, Hugh Campbell
Walsh, Francis Patrick
Walton, Lester Aglar
Webster, Benjamin ("Ben") Francis
Wheat, Zachariah Davis ("Buck")
White, Pearl
Wiener, Norbert
Williams, Walter
Winslow, Ola Elizabeth
Wood, Robert Elkington
Yost, Casper Salathiel
Younger, Thomas Coleman

MONTANA

Baker, Dorothy Dodds
Beary, Donal Bradford
Braden, Spruille
Brophy, Thomas D'Arcy
Cooper, Gary
Huntley, Chester ("Chet") Robert
Kennedy, George Clayton
Metcalf, Lee Warren
Rankin, Jeannette Pickering
Thompson, William Boyce
Washakie

NEBRASKA

Abbott, Edith
Abbott, Grace
Alexander, Grover Cleveland
Alexander, Hartley Burr
Barrett, Frank Aloysius
Billings, Asa White Kenney
Bright Eyes
Bryson, Lyman Lloyd
Clements, Frederic Edward
Clift, Edward Montgomery
Cloud, Henry Roe
Crawford, Samuel Earl
Dern, George Henry
Dunning, John Ray
Eiseley, Loren Corey
Embree, Edwin Rogers
Etting, Ruth
Fairchild, Fred Rogers
Gibson, Edmund Richard ("Hoot")
Gifford, Sanford Robinson
Gortner, Ross Aiken
Guthrie, Edwin Ray, Jr.
Hayward, Leland
Heald, Henry Townley
Higgins, Andrew Jackson
Hitchcock, Gilbert Monell
Hoagland, Charles Lee
Hollingworth, Leta Stetter
Hunter, Walter David
Janssen, David
Jeffers, William Martin
Johnson, Alvin Saunders

Kiewit, Peter
Leahy, Francis William ("Frank")
Lloyd, Harold Clayton
Malcolm X
Matthews, Francis Patrick
Monsky, Henry
Morton, Charles Walter
Pate, Maurice
Patterson, Richard Cunningham, Jr.
Phillips, Frank
Pound, (Nathan) Roscoe
Red Cloud
Rhodes, Eugene Manlove
Roche, Josephine Aspinwall
Roper, Elmo Burns, Jr.
Rosewater, Victor
Sandoz, Mari
Scott, Allen Cecil
Simpson, John Andrew
Smart, David Archibald
Spencer, Robert
Stevens, Doris
Strong, Anna Louise
Sutherland, Edwin Hardin
Taylor, Robert
Warren, George Frederick
Washburn, Edward Wight
Wherry, Kenneth Spicer
Zanuck, Darryl Francis

NEVADA

Ashurst, Henry Fountain
Lynch, Robert Clyde
McCarran, Patrick Anthony
McLoughlin, Maurice Evans
Martin, Anne Henrietta
Michelson, Charles
Requa, Mark Lawrence
Winnemucca, Sarah
Wovoka

NEW HAMPSHIRE

Abbott, Joseph Carter
Adams, Ebenezer
Adams, Isaac
Akerman, Amos Tappan
Albee, Ernest
Aldrich, Edgar
Aldrich, Thomas Bailey
Allen, Glover Morrill
Andrews, Christopher Columbus
Andrews, Elish Benjamin
Appleton, John
Appleton, Nathan
Appleton, Samuel
Atherton, Charles Gordon
Atwood, David
Bachelder, John
Bailey, Solon Irving

Baker, Osmon Cleander
Ballon, Hosea
Bancroft, Cecil Franklin Patch
Barnabee, Henry Clay
Barody, William Joseph
Barry, John Stewart
Bartlett, Ichabod
Bartlett, Samuel Colcord
Batchelder, John Putnam
Batchelder, Samuel
Beach, Amy Marcy Cheney
Beard, Mary
Belknap, George Eugene
Bell, Charles Henry
Bell, Louis
Bell, Luther Vose
Bell, Samuel
Benton, James Gilchrist
Bissell, George Henry
Blair, Henry William
Blake, John Lauris
Blodget, Samuel
Blunt, Edmund March
Bonton, John Bell
Bridgman, Laura Dewey
Brooks, John Graham
Brown, Charles Rufus
Brown, Francis, 1784–1820
Brown, Francis, 1849–1916
Brown, George
Browne, Daniel Jay
Buckminster, Joseph Stevens
Bundy, Jonas Mills
Burnap, George Washington
Burnham, William Henry
Burton, Warren
Butler, Benjamin Franklin
Cass, Lewis
Chamberlain, Mellen
Champney, Benjamin
Chandler, Harry
Chandler, John
Chandler, William Eaton
Chandler, Zachariah
Chase, Philander
Chase, Salmon Portland
Cheney, Benjamin Pierce
Cheney, Oren Burbank
Cheney, Person Colby
Chickering, Jonas
Cilley, Joseph
Clark, Daniel
Clark, Greenleaf
Clarke, James Freeman
Clifford, Nathan
Cohn, Charles Carleton
Coffin, Lorenzo S.
Cones, Elliott
Corbin, Daniel Chase
Craig Daniel H.

Cram, Ralph Adams
Craven, Tunis Augustus Macdonough
Currier, Moody
Cutler, Carroll
Cutting, James Ambrose
Damon, Ralph Shepard
Dana, Charles Anderson
Dana, James Freeman
Dana, Samuel Luther
Daniels, Fred Harris
Darling, Flora Adams
Davis, Noah
Davis, Phineas
Day, Edmund Ezra
Dearborn, Henry
Dearborn, Henry Alexander Scammell
Dodge, Jacob Richards
Doe, Charles
Donovan, John Joseph
Drake, Francis Samuel
Drake, Samuel Gardner
Durant, Henry Fowle
Durell, Edward Henry
Dutton, Samuel Train
Eastman, Arthur MacArth
Eastman, Enoch Worthen
Eastman, John Robie
Eastman, Timothy Corser
Eaton, John
Eddy, Mary Morse Baker
Ellis, Carleton
Elwyn, Alfred Langdon
Emerson, Benjamin Kendall
Emerson, Joseph
Estabrook, Joseph
Estey, Jacob
Farley, Harriet
Farmer, Moses Gerrish
Farnum, Dustin Lancy
Farrar, Timothy
Ferguson, Samuel
Fessenden, Thomas Green
Fessenden, William Pitt
Fields, James Thomas
Fiske, Amos Kidder
Flanders, Henry
Fletcher, William Asa
Flynn, Elizabeth Gurley
Fogg, George Gilman
Folsom, Charles
Folsom, Nathaniel
Foss, Sam Walter
Foster, Frank Pierce
Foster, John Gray
Foster, Stephen Symonds
French, Daniel Chester
French, William Merchant
 Richardson
Fuller, Levi Knight
Gardner, Helen

Gilman, John Taylor
Gilman, Nicholas
Glidden, Joseph Farwell
Goldthwaite, Henry Barnes
Goodenow, John Milton
Goodhue, James Madison
Gordon, George Phineas
Gould, Augustus Addison
Gove, Aaron Estellus
Greeley, Horace
Greene, Nathaniel
Griffin, Appleton Prentiss Clark
Griffin, Simon Goodell
Grimes, James Wilson
Gunnison, John Williams
Hackett, Frank Warren
Haddock, Charles Brickett
Haines, Charles Glidden
Hale, Edwin Moses
Hale, Horatio Emmons
Hale, John Parker
Hale, Sarah Joseph Buell
Hall, Charles Francis
Hall, George Henry
Hall, Samuel Read
Hall, Thomas Seavey
Harlow, Ralph Volney
Harriman, Walter
Haskell, Ella Louise Knowles
Hill, Joseph Adna
Holmes, Nathaniel
Howard, Ada Lydia
Howland, Alfred Cornelius
Hoyt, Albert Harrison
Hoyt, Charles Hale
Hunton, George Kenneth
Hutchins, Harry Burns
Jackson, Hall
Jewell, Harvey
Jewell, Marshall
Jewett, Clarence Frederick
Jones, Frank
Jones, John Taylor
Jones, Robert Edmond
Joy, James Frederick
Judson, Sarah Hall Boardman
Keith, Benjamin Franklin
Kelley, Hall Jackson
Kendall, George Wilkins
Kent, Edward
Kidder, Frederic
Kimball, Gilman
Kimball, Richard Burleigh
Kinkaid, Thomas Cassin
Knox, Thomas Wallace
Ladd, William
Langdell, Christopher Columbus
Langdon, John
Langdon, Woodbury
Lear, Tobias

Leavitt, Dudley
Leavitt, Mary Greenleaf Clement
Lee, Eliza Buckminster
Little, Charles Sherman
Livermore, Abiel Abbot
Livermore, Arthur
Livermore, Edward St. Loe
Livermore, Samuel, 1786–1833
Locke, John
Long, Stephen Harriman
Lord, John
Lothrop, Daniel
Lovewell, John
Lowe, Charles
Lowe, Thaddeus Sobieski Coulincourt
McKeen, Joseph
Marden, Orison Sweet
Marsh, Sylvester
Martyn, Sarah Towne Smith
Mather, Samuel Holmes
Mathews, William Smythe Babcock
Mead, Edwin Doak
Mead, Larkin Goldsmith
Merrill, William Bradford
Meserve, Nathaniel
Metalious, Grace
Metcalf, Henry Harrison
Miller, Charles Ransom
Miner, Alonzo Ames
Moore, Frank
Moore, George Henry
Moore, Jaco Bailey
Moore, Tohn Weeks
Morril, David Lawrence
Morrison, Nathan Tackson
Mussey, Reuben Dimond
Neal, Joseph Clay
Nelson, Edward William
Nesmith, John
Nichols, Mary Sargeant Neal Gove
Nichols, Thomas Low
Orcutt, Hiram
Ordway, John
Osgood, Jacob
Page, David Perkins
Parker, Francis Wayland
Parker, Joel
Parker, Willard
Parrott, Enoch Greenleafe
Parrott, Robert Parker
Partridge, Richard
Patrick, Mary Mills
Patterson, James Willis
Payson, Edward
Peabody, Oliver William Bourn
Peabody, William Bourn Oliver
Pearl, Raymond
Peaslee, Edmund Randolph
Perkins, George Hamilton
Perry, Arthur Latham

Peters, Absalom
Pickering, John
Pierce, Franklin
Pierce, Tohn Davis
Pike, Nicholas
Pillsbury, Charles Alfred
Pillsbury, John Sargent
Pilsbury, Amos
Plaisted, Harris Merrill
Poor, John
Porter, Fitz-John
Pratt, Daniel, July 20, 1799–May 13,
 1873
Prescott, George Bartlett
Prescott, Samuel Cate
Proctor, Lucien Brock
Quimby, Phineas Parkhurst
Randall, Benjamin
Rankin, Jeremiah Eames
Rice, Georze Samuel
Richards, Charles Herbert
Richardson, William Merchant
Ripley, Eleazar Wheelock
Roberts, Edmund
Rolfe, Robert Abial ("Red")
Rollins, Edward Henry
Rollins, Frank West
Sabine, Lorenzo
Sanborn, Edwin David
Sanborn, Franklin Benjamin
Sanborn, Katherine Abbott
Sanborn, Walter Henry
Sargent, George Henry
Savage, Henry Wilson
Shahan, Thomas Toseph
Shattuck, Aaron Draper
Shaw, Elijah
Shear, Theodore Leslie
Shedd, Fred Fuller
Shedd, John Graves
Sherman, Forrest Percival
Sherwin, Thomas
Sherwood, Mary Elizabeth Wilson
Shillaber, Benjamin Penhallow
Shurtleff, Roswell Morse
Smart, James Henry
Smith, Asa Dodge
Smith, Hamilton
Smith, Jeremiah, 1759–1842
Smith, Jeremiah, 1837–1921
Smith, Jeremiah, 1870–1935
Smith, Justin Harvey
Smith, Nathan Ryno
Smith, Uriah
Spalding, Lyman
Spaulding, Levi
Spaulding, Oliver Lyman
Spofford, Ainsworth Rand
Stark, John
Stearns, John Newton

Stone, Harlan Fiske
Stow, Baron
Sullivan, George
Sullivan, John
Sumner, Walter Taylor
Swasey, Ambrose
Swett, John
Taylor, Harry
Taylor, Samuel Harvey
Tenney, Edward Payson
Tenney, Tabitha Gilman
Thaxter, Celia Laighton
Thomson, Samuel
Ticknor, William Davis
Tilton, John Rollin
Titcomb, John Wheelock
Treat, Samuel
Twitchell, Amos
Upham, Thomas Cogswell
Upham, Warren
Walker, Asa
Walker, John Grimes
Waterhouse, Sylvester
Weare, Meshech
Webster, Daniel
Webster, Joseph Dana
Weeks, John Wingate
Wentworth, Benning
Wentworth, George Albert
Wentworth, John, 1737 N.S.–1820
Wentworth, John, 1815–1888
Wentworth, Paul
Whipple, Sherman Leland
White, Horace
Wilder, Marshall Pinckney
Willey, Samuel Hopkins
Wilson, Henry
Wilson, William Dexter
Wood, Edith Elmer
Wood, Leonard
Wood, Walter Abbott
Woodbury, Daniel Phineas
Woodbury, Levi
Woolson, Constance Fenimore
Worcester, Joseph Emerson
Worcester, Noah
Worcester, Samuel
Wright, Carroll Davidson
Wyman, Robert Harris
Wyman, Seth
Young, Ammi Burnham
Young, Charles Augustus

NEW JERSEY

Abbott, Charles Conrad
Abbott, William A ("Bud")
Abeel, David
Adams, Joseph Alexander
Alexander, Samuel Davies
Allen, William Frederick

Allinson, Francis Greenleaf
Alsop, Mary O'Hara
Apgar, Virginia
Archer, Samuel
Armstrong, George Dod
Armstrong, John
Arnold, Lewis Golding
Bailey, Gamaliel
Bainbridge, William
Baird, Charles Washington
Baldwin, Matthias William
Barber, Francis
Bard, John
Barrell, Joseph
Barrett, Lawrence
Barton, James Edward
Bateman, Newton
Beach, Harlan Page
Berrien, John MacPherson
Berry, Edward Wilber
Bishop, William Darius
Blackford, Charles Minor
Blackwell, Alice Stone
Blair, John Insley
Blakeley, George Henry
Bloomfield, Joseph
Boggs, Charles Stuart
Bourke-White, Margaret
Bourne, Randolph Silliman
Brearly, David
Breckinridge, Aida de Acosta
Brewster, Benjamin Harris
Bristol, Mark Lambert
Brooks, Van Wyck
Bross, William
Brown, George Scratchley
Brown, Isaac Van Arsdale
Buckley, James Monroe
Burlingham, Charles Culp
Burnet, David Gouverneur
Burnet, Jacob
Burnet, William
Burr, Aaron
Butler, Nicholas Murray
Cadwalader, Lambert
Caldwell, Joseph
Campbell, Andrew
Campbell, John Wood, Jr.
Cattell, Alexander Gilmore
Cattell, William Cassaday
Chambers, John
Chapman, Frank Michler
Chase, Edna Woolman
Christie, John Walter
Clapp, Margaret Antoinette
Clark, Abraham
Clark, George Whitefield
Claxton, Kate
Cleveland, Stephen Grover
Coerne, Louis Adolphe

Coit, Henry Leber
Cole, Charles Woolsey
Combs, Moses Newell
Condit, John
Cone, Spencer Houghton
Conte, Richard
Cook, Albert Stanburrough
Cook, George Hammell
Cook, Isaac
Cooke, Robert Anderson
Cooper, James Fenimore
Cooper, Samuel
Corrigan, Michael Augustine
Costello, Lou
Cox, Samuel Hanson
Coxe, Arthur Cleveland
Coxe, John Redman
Coxe, Richard Smith
Craig, Austin
Crane, Jonathan Townley
Crane, Stephen
Crane, William Montgomer
Craven, John Joseph
Darling, Samuel Taylor
Dayton, Elias
Dayton, Jonathan
Dayton, William Lewis
Dennis, Frederic Shepard
Dennis, James Shepard
Dickerson, Edward Nicoll
Dickerson, Mahlon
Dickerson, Philemon
Dickinson, Robert Latou
Dingman, Mary Agnes
Disbrow, William Stephen
Ditmars, Raymond Lee
Doane, George Washington
Dod, Albert Baldwin
Dod, Thaddeus
Dodd, Frank Howard
D'Olier, Franklin
Douglas, Helen Gahagan
Douglass, David Bates
Drake, Alexander Wilson
Drake, Daniel
Duffy, Edmund
Dunlap, William
Dunning, William Archibald
Du Pont, Samuel Francis
Durand, Asher Brown
Durand, Cyrus
Eames, Wilberforce
Edgar, Charles
Edison, Charles
Edsall, David Linn
Edwards, William
Eilshemius, Louis Michel
Elmer, Ebenezer
Elmer, Jonathan
Elmer, Lucius Quintius Cincinnatus

Endicott, Mordecai Thomas
Entwistle, James
Evans, Anthony Walton Whyte
Evans, William John ("Bill")
Ewing, Charles
Fagan, Mark Matthew
Farrand, Livingston
Farrand, Max
Farson, Negley
Fauset, Jessie Redmon
Fay, Edward Allen
Fields, Dorothy
Filed, Richard Stockton
Finley, Robert
Fiske, Haley
Fiske, Stephen Ryder
Flanagin, Harris
Force, Peter
Ford, Jacob
Forman, David
Frank, Waldo David
Franz, Shepherd Ivory
Frazee, John
Frelinghuysen, Frederick
Frelinghuysen, Frederick Theodore
Frelinghuysen, Theodore
Gano, John
Gardner, Charles Kitchell
Garrison, Lindley Miller
Gaul, William Gilbert
Gilbert, Seymour Parker
Gilchrist, Robert
Gilchrist, William Wallace
Gilder, Richard Watson
Gitlow, Benjamin
Godwin, Parke
Goetschius, Percy
Goodrich, Annie Warburton
Goslin, Leon Allen ("Goose")
Grace, Eugene Gifford
Green, Ashbel
Green, Henry Woodhull
Green, John Cleve
Green, William Henry
Greenwood, Miles
Griffith, William
Griggs, John William
Griscom, John
Griscom, Lloyd Carpenter
Griswold, Alfred Whitney
Grundy, Joseph Ridgway
Guggenheim, Harry Frank
Gummere, Francis Barton
Gummere, Samuel James
Gummere, Samuel Rene
Gummere, William Stryker
Hager, John Sharpenstein
Hague, Frank
Hall, Juanita Armethea
Halsey, William Frederick, Jr.

Halsted, George Bruce
Hardenbergh, Henry Janeway
Hare, William Hobart
Harris, Jed
Hart, James Morgan
Hartford, John Augustine
Hartley, Fred Allen, Jr.
Hatfield, Edwin Francis
Henderson, John
Henderson, Thomas
Henderson, William James
Henry, Alexander
Hewes, Joseph
Hewitt, Henry Kent
Higgins, Daniel Paul
Hill, David Jayne
Hill, Ernest Rowland
Hill, Thomas, 1818–1891
Hillyer, Robert Silliman
Hires, Charles Elmer
Hobart, Garret Augustus
Hodge, Archibald Alexander
Hoffman, Josiah Ogden
Hopper, Isaac Tatem
Hornblower, Joseph Coerten
Hornblower, William Butler
Howell, David
Howell, James Bruen
Hubbs, Rebecca
Hunt, Theodore Whitefield
Hunt, Wilson Price
Hutchins, Thomas
Hutchinson, Paul
Imlay, Gilbert
Ivins, Anthony Woodward
Ivins, William Mills
Jackson, Charles Reginald
Jackson, John Brinckerhoff
Jackson, Joseph Henry
Janeway, Edward Gamaliel
Jay, Peter Augustus
Jeffers, William Nicholson
Jennings, Jonathan
Johnson, Elijah
Johnston, Augustus
Jones, Ernest Lester
Kafer, John Christian
Katchen, Julius
Kearney, Francis
Kearney, Lawrence
Kearny, Stephen Watts
Keater, Vaughan
Kelly, Howard Atwood
Kenny, John V.
Kerlin, Isaac Newton
Kerney, James
Kilmer, Alfred Joycen
Kilpatrick, Hugh Judson
Kinney, William Burnet
Kinsey, Alfred Charles

Kinsey, John
Kirkpatrick, Andrew
Klein, August Clarence
Knight, Edward Coleings
Kovacs, Ernie
Kroeber, Alfred Louis
Lafever, Minard
Lake, Simon
Lange, Dorothea
Larned, William Augustus
Lasser, Jacob Kay
Lawrence, James
Leaming, Thomas
Leonard, William Ellery
Lieb, John William
Lindabury, Richard Vliet
Lindsey, John Berrien
Lindsley, Philip
Linn, William Alexander
Lippincott, Joshua Ballinger
Littell, Eliakim
Littell, Squier
Littell, William
Lloyd, Alfred Henry
Longstreet, William
Longworth, Nicholas, 1782–1863
Low, Isaac
Low, Nicholas
Lowenstein, Allard Kenneth
Lozier, Clemence Sophia Harned
Lundy, Benjamin
Lyon, James
McAllister, Charles Albert
McCalla, Bowman Hendry
McCauley, Mary Ludwig Hays
McDowell, John
McEntee, James Joseph
McGraw, Donald Cushing
McIlvaine, Charles Pettit
Maclean, John
McLean, John
McLean, Walter
McMichael, Morton
McMurtrie, Douglas Crawford
McMurtrie, William
Madigan, Laverne
Magie, William Jay
Magonigle, Harold Van Buren
Manning, James
Marin, John (Cheri)
Marshall, James Wilson
Marten, Alexander
Marten, Luther
Mason, John
Matlack, Timothy
Medwick, Joseph ("Ducky") Michael
Meeker, Moses
Messler, Thomas Doremus
Meyer, Frank Straus
Miller, Ezra

Miller, James Alexander
Miller, John
Mills, Benjamin Fay
Mitchell, James Paul
Mitchell, Thomas Gregory
Montgomery, John Berrien
Mooey, James
Moody, John
Moore, Edward Mott
Moore, Ely
Moore, Victor Frederick
Moran, Daniel Edward
Morford, Henry
Morgan, Daniel
Morley, Edward Williams
Morris, Edmund
Morris, Robert, 1745–1815
Mott, Charles Stewart
Mott, Gershom
Murphy, Franklin
Myers, Gustavus
Napton, William Barclay
Neilson, John
Nelson, Oswald George ("Ozzie")
Nelson, William, 1847–1914
Newton, Isaac, 1800–1867
Nichols, Roy Franklin
Nies, James Buchanan
Nixon, John Thompson
Nolan, Bob
Norris, Mary Harriott
Norton, Mary Teresa Hopkins
Noyes, Alexander Dana
Oatman, Johnson
Odell, Jonathan
O'Donnell, Thomas Jefferson
Ogden, Aaron
Ogden, David
Ogden, Francis Barber
Ogden, Samuel
Ogden, Thomas Ludlow
Ogden, Uzal
Olcott, Henry Steel
Opdyke, George
Osborn, Henry Fairfield
Otto, John Conrad
Oxden, Charles Smith
Page, Leigh
Paine, John Alsop
Palmer, James Shedden
Pancoast, Joseph
Parke, Benjamin
Parker, Dorothy Rothschild
Parker, James, c. 1714–1770
Parker, James, 1776–1868
Parker, Joel
Parker, John Cortlandt
Parsons, Frank
Parvin, Theodore Sutton
Patrick, Edwin Hill ("Ted")

Paul, Alice
Pennington, William
Pennington, William Sandford
Periam, Jonathan
Perrine, Frederic Auten Combs
Perrine, Henry
Pettit, Charles
Pike, Zebulon Montgomery
Pincus, Gregory Goodwin ("Goody")
Pitney, Mahlon
Plotz, Harry
Pollak, Walter Heilprin
Post, Louis Freeland
Price, Rodman McCamley
Quinby, Isaac Ferdinand
Ralph, James
Randall, Robert Richard
Randolph, Theodore Fitz
Reed, Joseph
Rellstab, John
Richards, Dickinson Woodruff
Riggs, Elias
Roberts, Nathan S.
Robeson, George Maxwell
Robeson, Paul Leroy
Rovere, Richard Halworth
Rusby, Henry Hurd
St. Denis, Ruth
Salmon, Daniel Elmer
Sayre, Lewis Albert
Scattergood, Thomas
Schary, Dore
Schelling, Ernest Henry
Scovell, Melville Amasa
Scudder, John
Scudder, Nathaniel
Sedgwick, Anne Douglas
Seldes, Gilbert Vivian
Sergeant, John, 1710–1749
Sergeant, Jonathan Dickinson
Shafer, Helen Almira
Sharp, Dallas Lore
Shinn, Asa
Shinn, Everett
Shreve, Henry Miller
Sickels, Frederick Ellsworth
Silver, Thomas
Simpson, James Hervey
Singer, Charles H.
Sloan, Harold Paul
Smith, James, 1851–1927
Smith, John Jay
Smith, Lloyd Logan Pearsall
Smith, Richard
Somers, Richard
Sonneck, Oscar George Theodore
Southard, Samuel Lewis
Stagg, Amos Alonzo
Stanley, Robert Crooks
Stephens, Alice Barber

Stephens, John Lloyd
Stephens, Uriah Smith
Stetson, John Batterson
Stevens, Edwin Augustus
Stevens, Robert Livingston
Stieglitz, Alfred
Stieglitz, Julius
Still, William
Stillman, Thomas Bliss
Stimson, Lewis Atterbury
Stockton, John Potter
Stockton, Richard, 1730–1781
Stockton, Richard, 1764–1828
Stockton, Robert Field
Stockton, Thomas Hewlings
Stratemeyer, Edward
Sulzer, William
Sumner, William Graham
Sutherland, Joel Barlow
Svenson, Andrew Edward
Talmadge, Norma
Talmage, John Van Nest
Talmage, Thomas DeWitt
Taylor, Joseph Wright
Tedyuskung
Terhune, Albert Payson
Thacher, Thomas Day
Thomas, John Parnell
Thompson, John Bodine
Tichenor, Isaac
Tomlinson, Everett Titsworth
Traubel, Horace L.
Tucker, Stephen Davis
Tumulty, Joseph Patrick
Tyson, George Emory
Vail, Alfred
Vanderbilt, Arthur T.
Vanderbilt, William Henry
Van Dyke, John Charles
Van Santvoord, George
Varick, Richard
Veiller, Lawrence Turnure
Voorhees, Edwar Burnett
Voorhees, Philip Falkerson
Vroom, Peter Dumont
Warbasse, James Peter
Ward, Aaron Montgomery
Ward, James Warner
Ward, Marcus Lawrence
Ward, Richard Halsted
Ward, Thomas
Warren, Howard Crosby
Washington, Henry Stephens
Watson, Arthur Kittridge
Watson, John Fanning
Waugh, Frederick Judd
Welling, James Clarke
Westervelt, Jacob Aaron
Wetherill, Samuel
Whitehead, William Adee

Whiteside, Arthur Dare
Willard, Mary Hatch
Williams, William Carlos
Williamson, Isaac Halsted
Wilson, Edmund, Jr.
Winans, Ross
Winans, Thomas De Kay
Wines, Enoch Cobb
Wood, George
Wood, George Bacon
Woodhull, Alfred Alexander
Woollcott, Alexander Humphreys
Woolman, John
Wright, Joseph
Wright, Patience Lovell
Wylie, Elinor Morton Hoyt
Young, David
Zane, Charles Shuster

NEW MEXICO

Beals, Ralph Albert
Bryan, Kirk
Carleton, Henry Guy
Chavez, Dennis
Condon, Edward Uhler
Cushman, Austin Thomas ("Joe")
Dodge, Henry Chee
Glassford, Pelham Davis
Hilton, Conrad Nicholson
Hubbell, John Lorenzo
Lyon, Harris Merton
Martinez, Maria
Montoya, Joseph Manuel
Ouray
Seligman, Arthur
Son of Many Beads

NEW YORK

Abbe, Cleveland
Abbey, Henry
Abernethy, George
Adams, Henry Cullen
Adams, James Truslow
Adams, Samuel Hopkins
Adee, Alvey Augustus
Adler, Elmer
Agate, Alfred T.
Agate, Frederick Styles
Agnew, Cornelius Rea
Agnew, Eliza
Akeley, Carl Ethan
Alden, Isabella Macdonald
Alden, John Ferris
Alden, Joseph
Alden, Raymond MacDonald
Aldridge, Ira Frederick
Alexander, Stephen
Alexander, William
Allaire, James Peter

Allen, Arthur Augustus
Allen, Horatio
Allen, John
Allen, Kelcey
Allerton, Samuel Waters
Allis, Edward Phelps
Allison, Richard
Altman, Benjamin
Amidon, Charles Fremont
Anderson, Alexander
Anderson, Elizabeth Milbank
Anderson, Galusha
Andrews, Charles
Andrews, Edward Gayer
Andrews, William Loring
Angel, Benjamin Franklin
Anthon, Charles
Anthon, Charles Edward
Anthony, Andrew Varick Stout
Anthony, George Tobey
Anthony, John J.
Appleby, John Francis
Appleton, William Worthen
Armour, Philip Danforth
Armstrong, David Maitland
Armstrong, Edwin Howard
Armstrong, Hamilton Fish
Arno, Peter
Arnold, Edward
Arnold, George
Arnold, Isaac Newton
Arnold, Lauren Briggs
Arthony, George ToSey
Arthur, Joseph Charles
Arthur, Timothy Shay
Ashmun, Jehudi
Aspinwall, William Henry
Astor, John Jacob, 1822–1890
Astor, John Jacob, 1864–1912
Astor, William Backhouse
Astor, William Vincent
Astor, William Waldorf
Atkinson, John
Atwater, Wilbur Olin
Auchmuty, Richard Tylden
Auer, John
Augur, Christopher Columbus
Austen, (Elizabeth) Alice
Austen, Peter Townsend
Averell, William Woods
Avery, Benjamin Parke
Avery, Milton Clark
Avery, Samuel Putnam
Ayres, Romeyn Beck
Babbitt, Benjamin Talbot
Babcock, George Herman
Babcock, Howard Edward
Babcock, Maltbie Davenport
Babcock, Stephen Moulton
Bache, Jules Semon

Bacheller, Irving
Bachman, John
Backus, Truman Jay
Bacon, Edward Payson
Bacon, Leonard
Badeau, Adam
Bailey, Florence Augusta Merriam
Bailey, James Montgomery
Bailey, Theodorus
Baker, Benjamin A.
Baker, Frank
Baker, George Augustus
Baker, George Fisher
Baker, La Fayette Curry
Baker, Peter Carpenter
Baker, Sara Josephine
Baker, Walter Ransom Gail
Baldwin, Elihu Whittlesey
Baldwin, Faith
Balestier, Charles Wolcott
Bangs, Francis Nehemiah
Bangs, John Kendrick
Banvard, John
Banvard, Joseph
Barbour, Oliver Lorenzo
Barclay, Thomas
Barker, Alexander Crichlow ("Lex")
Barker, James William
Barlow, Francis Channing
Barlow, John Whitney
Barnes, Albert
Barnes, Mary Downing Sheldon
Barnum, Henry A.
Barrows, Samuel June
Barry, Philip James Quinn
Barry, William Farquhar
Barth, Alan
Barthelmess, Richard
Bartlett, Homer Newton
Bascom, Henry Bidleman
Bascom, John
Bashford, Coles
Bassett, Edward Murray
Batcheller, George Sherman
Baum, Lyman Frank
Bausch, Edward
Baxter, Henry
Bayard, William
Bayles, James Copper
Bayley, James Roosevelt
Beach, Frederick Converse
Beach, William Augustus
Beadle, Erastus Flavel
Beard, James Henry
Beardsgey, Samuel
Beauchamp, William Martin
Beck, John Brodhead
Beck, Lewis Caleb
Beck, Theodric Romeyn
Becker, George Ferdinand

Beebe, (Charles) William
Beecher, Catharine Esther
Beecher, Charles Emerson
Beecher, Edward
Beer, George Louis
Beers, Ethel Lynn
Beers, Henry Augustin
Belknap, William Worth
Bell, Clark
Bell, Isaac
Beman, Nathan Sidney Simth
Bement, Caleb N.
Benedict, Ruth Fulton
Benjamin, George Hillard
Benjamin, Nathan
Benjamin, Park
Bennet, Sanford Fillmore
Bennett, Constance Campbell
Bennett, de Robigne Mortimer
Bennett, Floyd
Bennett, James Gordon
Bennett, Nathaniel
Benson, Eugene
Benton, Allen Richardson
Benton, Joel
Berg, Gertrude Edelstein
Berg, Morris ("Moe")
Berger, Meyer
Bergh, Christian
Bergh, Henry
Bernet, John, Joseph
Bernstein, Aline
Bernstein, Theodore Menline
Bethune, George Washington
Bidlack, Benjamin Alden
Bidwell, John
Bierwirth, John Edward
Bigelow, John
Biggs, Hermann Michael
Billy The Kid (Bonney, William H.)
Birdseye, Clarence
Birge, Edward Asahel
Bishop, Charles Reed
Bishop, Joel Prentiss
Bishop, Nathan
Bissell, Edwin Cone
Bissell, William Henry
Bissell, Wilson Shannon
Bixby, Horace Ezra
Black, Douglas MacRae
Black, Eli
Blackfan, Kenneth Daniel
Blackwell, Antoinette Louis Brown
Blaikie, William
Blair, Austin
Blake, Homer Crane
Blake, William Phipps
Blakelock, Ralph Albert
Blandy, William Henry Purnell
Blashfield, Edwin Howland

Blatch, Harriot Eaton Stanton
Bleecker, Ann Eliza
Bliss, Aaron Thomas
Bliss, Cornelius Newton
Bliss, Eliphalet Williams
Bliss, Porter Cornelius
Block, Paul
Blodget, Lorin
Blodgett, Katharine Burr
Blondell, Joan
Blood, Benjamin Paul
Bloomer, Amelia Jenks
Bloomgarden, Kermit
Bloor, Ella Reeve
Bogardus, James
Bogart, Humphrey DeForest
Bogart, John
Bogue, Virgil Gay
Bohlen, Charles Eustis ("Chip")
Boies, Horace
Boissevain, Inez Milholland
Bolton, Henry Carrington
Bomford, George
Bond, Elizabeth Powell
Bonney, Charles Carroll
Bonstelle, Jessie
Booth, Mary Louise
Borchard, Edwin Montefiore
Borden, Gail
Bottome, Margaret McDonald
Bouch, William C.
Bourne, Edward Gaylord
Bow, Clara Gordon
Bowen, Abel
Bowen, Herbert Wolcott
Bowen, Ira Sprague
Bowles, Jane Auer
Boyle, John J.
Brace, Charles Loring
Brace, Dewitt Bristol
Brace, Donald Clifford
Brackett, Charles William
Braddock, James J.
Bradford, Alexander Warfield
Bradford, Amory Howe
Bradford, William
Bradley, Joseph P.
Brady, Alice
Brady, James Topham
Brady, John Green
Brady, Mathew B.
Bragg, Edward Stuyvesant
Brainard, Daniel
Brainerd, Thomas
Braslau, Sophie
Brayman, Mason
Breese, Sidney
Brevoort, James Renwick
Brewer, William Henry
Brice, Fanny

Bridges, Calvin Blackman
Briggs, Charles Augustus
Brigham, Albert Perry
Bright, Jesse David
Brill, Nathan Edwin
Brinkerhoff, Jacob
Brinkerhoff, Roeliff
Brisbane, Albert
Brisbane, Arthur
Bristed, Charles Astor
Bristol, John Bunyan
Bristow, George Frederick
Britton, Nathaniel Lord
Brodhead, Daniel
Bronk, Detlev Wulf
Brooks, Byron Alden
Brooks, James Gordon
Brooks, Thomas Benton
Broun, Heywood Campbell
Browere, John Henri Isaac
Brown, Elmer Ellsworth
Brown, Frederic Tilden
Brown, Margaret Wise
Brown, Phoebe Hinsdale
Brown, William Adams
Brown, William Carlos
Browne, Irving
Browne, Tunius Henri
Brownell, William Crary
Brownson, Willard Herbert
Bruce, Archibald
Bruce, Edwar Bright
Bruce, Lenny
Brunner, Arnold William
Brush, Edward Nathaniel
Brush, George Jarvis
Bryce, Lloyd Stephens
Buck, Albert Henry
Buck, Gurdon
Buck, Leffert Lefferts
Buck, Philo Melvin
Buckhout, Isaac Craig
Buckley, Samuel Botsford
Budd, Joseph Lancaster
Bulkley, Lucius Duncan
Bullock, Rufus Brown
Bullock, William A.
Bunce, Oliver Bell
Bunker, Arthur Hugh
Bunner, Henry CuyAer
Burchard, Samuel Dickinson
Burdick, Francis Marion
Burke, John Joseph
Burke, Stevenson
Burke, Thomas
Burlin Natalie Curtis
Burlingame, Anson
Burnham, Daniel Hudson
Burr, George Lincoln
Burr, Theodosia

Burrill, Alexander Mansfield
Burroughs, John
Burroughs, John Curtis
Burroughs, William Seward
Burt, John
Bush-Brown, Henry Kirke
Bushnell, Asa Smith
Butler, Benjamin Franklin
Butler, Charles
Butler, Howard Crosby
Butler, Walter N.
Butler, William Allen
Butterfield, Daniel
Butterfield, John
Buttrick, Wallace
Butts, Isaac
Cady, Daniel
Calkins, Norman Allison
Calkins, Phineas Wolcott
Callas, Maria
Calverley, Charles
Cambridge, Godfrey MacArthur
Cameron, Robert Alexander
Campbell, Allen
Campbell, George Washington
Campbell, James Valentine
Campbell, Thomas Joseph
Campbell, William W.
Cannon, Charles James
Cannon, James Graham
Cannon, James Thomas
Cantor, Eddie
Capone, Alphonse
Cardozo, Benjamin Nathan
Carlisle, loyd Leslie
Carll, John Franklin
Carlson, Evans Fordyce
Carpenter, Francis Bicknell
Carpenter, Stephen Haskins
Carr, Eugene Asa
Carr, Joseph Bradford
Carrier, Willis Haviland
Carrington, Elaine Stern
Carroll, Howard
Carryl, Guy Wetmore
Carter, Jesse Benedict
Carter, Robert
Cary, Edward
Cary, Elisabeth Luther
Case, Jerome Increase
Casey, Thomas Lincoln
Casilear, John William
Cassidy, Jack
Cassidy, William
Cassoday, John Bolivar
Castle, Irene Foote
Cavert, Samuel McCrea
Cert, Bennett Alfred
Chaffee, Jerome Bonaparte
Chambers, Robert William

Champlin, John Wayne
Chanfrau, Francis S.
Chapin, Edwin Hubbell
Chapin, James Paul
Chapman, John Jay
Chapman, Victor Emmanuel
Chase, Ilka
Chatterton, Ruth
Cheesman, Forman
Cheney, John Vance
Chesebrough, Caroline
Chevey, Charles Edward
Child, Frank Samuel
Chittenden, Hiram Martin
Choate, Anne Hyde Clarke
Christiancy, Isaac Peckham
Church, John Adams
Church, Pharcellus
Church, William Conant
Churchill, William
Claflin, John
Clark, Grenville
Clark, Lewis Gaylord
Clark, Myron Holley
Clark, Willis Gaylord
Clarke, John Mason
Clarke, Thomas Benedict
Clarke, William Newton
Clarkson, Matthew
Clemmer, Mary
Clifton, Josephine
Clinch, Charles Powell
Clinton DeWitt
Clinton, George
Clinton, James
Clough, John Everett
Clough, William Pitt
Cluett, Sanford Lockwood
Clurman, Harold Edgar
Coakley, Cornelius Godfrey
Cobb, Lee J.
Cochran, Alexander Smith
Cochrane, John
Coe, George Albert
Coffey, James Vincent
Coffin, Henry Sloane
Cogswell, William Browne
Cohen, Felix Solomon
Cohen, Jacob De Silva Solis
Cohen, Meyer Harris ("Mickey")
Cohn, Alfred Einstein
Cohn, Edwin Joseph
Cohn, Harry
Colden, Cadwallader David
Cole, Chester Cicero
Coleman, Charles Caryl
Coleman, John Aloysius
Colfax, Schuyler
Colgate, James Boorman
Collamer, Jacob

Collier, Peter
Collins, Edward Trowbridge
Collins, Guy N.
Colman, Norman Jay
Colombo, Joseph Anthony
Coman, Charlotte Buell
Comstock, George Franklin
Conboy, Martin
Cone, Hutchinson Ingham
Cone, Orello
Conkling, Alfred
Conkling, Roscoe
Cook, lavius Josephus
Cook, Frederick Albert
Cook, James Merrill
Cook, John Williston
Cook, Walter
Cooley, Lyman Edgar
Cooley, Mortimer Elwyn
Cooley, Thomas McIntyre
Cooper, Edward
Cooper, James Graham
Cooper, Peter
Cooper, Sarah Brown Ingersoll
Cooper, Susan Fenimore
Cooper, Theodore
Cooper-Poucher, Matilda S.
Corliss, George Henry
Cornell, Alonzo B.
Cornell, Ezra
Cortelyou, George Bruce
Cortissoz, Royal
Corwin, Edward Tanjore
Couch, Darius Nash
Coudert, Frederic René
Coudert, Frederic René, Jr.
Courtney, Charles Edward
Cowen, Joshua Lionel
Cozzens, Frederick Swartwout
Crabtree, Lotta
Crandall, Charles Henry
Crane, Frederick Evan
Crane, Thomas Frederick
Crapsey, Adelaide
Cravath, Erastus Milo
Crawford, Thomas
Crerar, John
Crimmins, John Daniel
Crittenton, Charles Nelson
Crocker, Charles
Crocker, Francis Bacon
Croly, Herbert David
Cromwell, Gladys Louise Husted
Cromwell, William Nelson
Cropsey, Jaspar Francis
Crosby, Ernest Howard
Crosby, ouny
Crosby, Howard
Crosby, John Schuyler
Crosby, Percy Lee

Cross, Milton John
Croswell, Edwin
Crounse, Lorenzo
Cruger, Henry
Cruger, John
Culbertson, Josephine Murphy
Cullum, George Washington
Cummings, Amos Jay
Cuppia, Jerome Chester
Curran, Thomas Jerome
Curtis, John Green
Curtis, Newton Martin
Curtis, Samuel Ryan
Curtiss, Glenn Hammond
Cutler, James Goold
Cutting, Bronson Murray
Cutting, Robert Fulton
Cuyler, Theodore Ledyard
Daggett, Ellsworth
Dailey, Dan, Jr.
Dakin, James Harrison
Dale, Charles Marks
Dale, Chester
Dale, Maud Murray Thompson
Daley, Arthur John
Daly, Peter Christopher Arnold
Dalzell, John
Dana, Charles Anderson
Dana, James Dwight
Darin, Bobby
Darton, Nelson Horatio
Davidson, Jo
Davidson, Lucretia Maria
Davidson, Margaret Miller
Davies, Arthur Bowen
Davies, Henry Eugene
Davies, Marion Cecilia
Davis, Alexander Jackson
Davis, Andrew Jackson
Davis, Cushman Kellogg
Davis, Francis Breese, Jr.
Davis, Henry
Davis, Jerome Dean
Davis, Katharine Bement
Davis, Matthew Livingston
Davis, Nathan Smith
Davis, Oscar King
Davis, Paulina Kellogg Wright
Davison, George Willets
Dawley, Almena
Day, Clarence Shepard
Day, Dorothy
Day, George Parmly
Day, Luther
Dean, Bashford
Dean, Julia
Deerfoot
De Forest, Alfred Victor
De Forest, Robert Weeks
De Kay, George Colman

Delafield, Edward
Delafield, Francis
Delafield, John
Delafield, Richard
De Lancey, James, 1703–1760
De Lancey, James, 1732–1800
De Lancey, James, 1746–1804
De Lancey, William Heathcote
Delano, Jane Arminda
Delano, William Adams
Delavan, Edward Cornelius
Delawater, Cornelius Henry
DeLee, Joseph Bolivar
De Long, George Washington
Del Mar, Alexander
Deming, Philander
Dempster, John
Depew, Chauncey Mitchell
De Peyster, Abraham
De Peyster, John Watts
De Rose, Peter
De Sylva, George Gard "Buddy"
Devin, Thomas Casimer
Dewey, Melvil
Dewey, Richard Smith
De Wilde, Brandon
Dewing, Maria Richards Oakey
De Witt, Simeon
De Wolfe, Elsie
Dexter, Henry
Dibble, Ray Floyd
Dickinson, Charles Monroe
Dickinson, Donald McDonald
Dickinson, Preston
Dietz, Peter Ernest
Dill, James Brooks
Diller, Burgoyne
Dillon, John Forrest
Dillon, Sidney
Disturnell, John
Diven, Alexander Samuel
Dix, Morgan
Dodge, Grace Hoadley
Dodge, Mary Elizabeth Mapes
Dods, John Bovee
Dolph, Joseph Norton
Donaldson, Henry Herbert
Donn-Byrne, Brian Oswald
Donovan, James Britt
Donovan, William Joseph
Doolittle, James Rood
Doremus, Robert Ogden
Doremus, Sarah Platt Haines
Dorn, Harold Fred
Dorsheimer, William Edward
Doty, Elihu
Doty, James Duane
Doubleday, Abner
Doubleday, Frank Nelson
Doubleday, Nelson

Douglas, Amanda Minnie
Dove, Arthur Garfield
Dowling, Austin
Downing, Charles
Doyle, John Thomas
Drake, Edwin Laurentine
Drake, Francis Ann Denny
Drake, Joseph Rodman
Draper, Andrew Sloan
Draper, Dorothy
Draper, Lyman Copeland
Draper, Ruth
Dreier, Katherine Sophie
Dreier, Mary Elisabeth
Drew, Daniel
Drisler, Henry
Drury, John Benjamin
Dryfoos, Orvil E.
Duane, Alexander
Duane, James
Duane, James Chatham
Duane, William
Dudley, Charles Benjamin
Duer, John
Duffield, Samuel Augustus
 Willoughby
Dulles, Allen Welsh
Dumont, Allen Balcom
Dumont, Margaret
Durant, Charles Ferson
Durante, James Francis ("Jimmy")
Durrie, Daniel Steele
Duryea, Hermanes Barkulo
Duryée, Abram
Duyckinck, Evert Augustus
Dwight, Theodore William
Dyar, Harrison Gray
Earle, Edward Mead
Earle, Mortimer Lamson
Eastman, George
Eastman, Harvey Gridley
Eastman, Joseph Bartlett
Eastman, Max Forrester
Eastman, William Reed
Eaton, Amos
Edebohls, George Michael
Edgerton, Alfred Peck
Edgerton, Sidney
Edman, Irwin
Edmonds, Francis William
Edmonds, John Worth
Edwards, William Henry
Eells, Dan Parmelee
Egleston, Thomas
Ehninger, John Whetten
Eidlitz, Cyrus Lazelle Warner
Ellet, Elizabeth Fries Lummis
Elliot, Daniel Giraud
Elliott, Charles Loring
Ellis, Jo Bicknell

Ellsworth, Elmer Ephraim
Elsberg, Charles Atbert
Ely, Richard Theodore
Embury, Emma Catherine
Emerson, Haven
Emerson, Rollins Adams
Emery, Albert Hamilton
Emery, Charles Edward
Emmet, William Le Roy
Emott, James, 1771–1850
Emott, James, 1823–1884
Engelhard, Charles William
Englis, John
Eno, William Phelps
Epstein, Jacob
Epstein, Philip G.
Erdman, Charles Rosenbury
Erlanger, Abraham Lincoln
Erpf, Armand Grover
Errett, Isaac
Erskine, John
Esterly, George
Evans, Edward Payson
Evans, George Alfred
Fairbank, Calvin
Fairchild, Charles Stebbins
Fairchild, Sherman Mills
Faneuil, Peter
Fanning, Edmund
Fargo, William George
Farley, James Aloysius
Farman, Elbert Eli
Farmer, John
Farnam, Henry
Farnham, Eliza Woodson Burhans
Farrand, Beatrix Cadwalader Jones
Farwell, Charles Benjamin
Farwell, John Villiers
Fassett, Cornelia Adele Strong
Fassett, Jacob Sloat
Fawcett, Edgar
Fay, Theodore Sedgwick
Feis, Herbert
Feke, Robert
Fell, John
Fenner, Burt Leslie
Fenton, Reuben Eaton
Ferguson, William Porter Frisbee
Ferris, Isaac
Ferris, Woodbridge Nathan
Field, Benjamin Hazard
Field, Herbert Haviland
Field, Marshall, IV
Field, Maunsell Bradhurst
Field, Thomas Warren
Fields, Lewis Maurice
Fillmore, Millard
Finch, Francis Miles
Fischetti, John
Fish, Hamilton

Fish, Nicholas
Fish, Stuyvesant
Fisher, George Jackson
Fisher, Harrison
Fisher, Irving
Fisk, Clinton Bowen
Fiske, Bradley Allen
Fiske, Daniel Willard
Fiske, Harrison Grey
Fitch, Asa
Fitch, William Clyde
Fitzgerald, Thomas
Fitzsimmons, James Edward ("Sunny
 Jim")
Flagg, Ernest
Flagg, James Montgomery
Flagler, Henry Morrison
Flagler, John Haldane
Flandrau, Charles Eugene
Flegenheimer, Arthur
Fleischer, Nathaniel Stanley ("Nat")
Fletcher, Robert
Flint, Weston
Florence, William Jermyn
Flower, Roswell Pettibone
Floy, James
Floyd, William
Flynn, Edward Joseph
Folger, Henry Clay
Folwell, William Watts
Fonda, John H.
Foote, Lucius Harwood
Forbes, Edwin
Ford, Hannibal Choate
Ford, Paul Leicester
Ford, Worthington Chauncey
Forman, Celia Adler
Forman, Joshua
Forman, Justus Miles
Forrestal, James Vincent
Forsyth, John
Fosdick, Charles Austin
Fosdick, Harry Emerson
Fosdick, Raymond Blaine
Foshag, William Frederick
Foster, David Skaats
Foulke, William Dudley
Fowler, Frank
Fowler, George Ryerson
Fowler, Orson Squire
Fowler, Russell Story
Fox, Dixon Ryan
Foy, Eddie
Francis, Charles Spencer
Francis, John Morgan
Francis, John Wakefield
Francis, Samuel Ward
Frank, Jerome
Frederic, Harold
Freedman, Andrew

Freer, Charles Lang
Freneau, Philip Morin
Freund, Ernst
Frisch, Frank Francis ("The Fordham
 Flash")
Frissell, Hollis Burke
Frost, Holloway Halstead
Fuertes, Louis Agassiz
Fuller, Andrew S.
Fuller, George
Fuller, George Warren
Fuller, Robert Mason
Fulton, Justin Dewey
Funk, Wilfred John
Furman, Richard
Gage, Lyman Judson
Gage, Matilda Joslyn
Galante, Carmine
Gale, Benjamin
Gale, George Washington
Gallico, Paul William
Gally, Merritt
Galpin, Charles Josiah
Gannett, Frank Ernest
Gano, Stephen
Gansevoort, Leonard
Gansevoort, Peter
Gardiner, James Terry
Gardner, Isabella Stewart
Garfield, John
Garis, Howard Roger
Garrett, Edmund Henry
Garrison, Cornelius Kingsland
Gaskill, Harvey Freeman
Gayler, Charles
Gaynor, William Jay
Gear, John Henry
Gehrig, Henry Louis
Geismar, Maxwell David
Gellatly, John
Genin, John Nicholas
Genung, John Franklin
George, Grace
George, William Reuben
Gerard, James Watson, 1794–1874
Gerard, James Watson, 1867–1951
Gerry, Elbridge Thomas
Gershwin, George
Gibbs, George
Gibbs, Oliver Wolcott, 1822–1908
Gibbs, (Oliver) Wolcott, 1902–1958
Gifford, Sanford Robinson
Gilbert, Eliphalet Wheeler
Gilbert, Grove Karl
Gilbert, Linda
Gilbert, Rufus Henry
Gilder, Jeannette Leonard
Gildersleeve, Virginia Crocheron
Gill, Theodore Nicholas
Gillespie, William Mitchell

Gillet, Ransom Hooker
Gillett, Horace Wadsworth
Gilman, Lawrence
Ginter, Lewis
Gleason, Kate
Gleason, Ralph Joseph
Glueck, Eleanor Touroff
Glynn, Martin Henry
Goddard, Calvin Luther
Goddard, Luther Marcellus
Godey, Louis Antoine
Goethals, George Washington
Goff, Emmet Stull
Goforth, William
Gold, Michael
Golden, John
Goldmark, Henry
Goldmark, Rubin
Goldwater, Sigismund Schulz
Goodell, William
Goodman, Paul
Goodnow, Frank Johnson
Goodrich, Benjamin Franklin
Goodsell, Daniel Ayres
Goodspeed, Thomas Wakefield
Goodwin, Hannibal Williston
Goodyear, Anson Conger
Gorcey, Leo
Gordon, Andrew
Goss, Albert Simon
Gottschalk, Louis Reichenthal
Gould, Jay
Gracie, Archibald
Graham, Charles Kinnaird
Granger, Gordon
Grant, Asahel
Grant, Madison
Grauer, Benjamin Franklin ("Ben")
Graves, Frederick Rogers
Gray, Asa
Gray, Henry Peters
Green, Gabriel Marcus
Green, Seth
Greenbaum, Edward Samuel
Greene, William Cornell
Greenslet, Ferris
Gregg, Willis Ray
Gregory, Charles Noble
Gregory, Daniel Seelye
Gregory, Eliot
Gregory, John Milton
Griffes, Charles Tomlinson
Griffiths, John Willis
Grinnell, George Bird
Grinnell, Henry Walton
Griscom, Ludlow
Griswold, John Augustus
Groesbeck, William Slocum
Grofé, Ferde
Gropper, William

Gross, Charles
Gross, Milt
Groves, Leslie Richard, Jr.
Gue, Benjamin F.
Guggenheim, Marguerite ("Peggy")
Guinzburg, Harold Kleinert
Gunnison, Foster
Guthrie, Alfred
Guthrie, Ramon
Habberton, John
Habersham, Alexander Wylly
Hackett, James Henry
Hadley, James
Hagedorn, Hermann Ludwig Gebhard
Hagen, Walter Charles
Haight, Charles Coolidge
Haight, Henry Huntly
Haines, Daniel
Hall, Abraham Oakley
Hall, Charles Cuthbert
Hall, Fitzedward
Hall, Leonard Wood
Hall, Nathan Kelsey
Halleck, Henry Wager
Hallock, Charles
Halsey, Frederick Arthur
Halsted, William Stewart
Hamilton, Alice
Hamilton, Allan McLane
Hamilton, Charles Smith
Hamilton, Clayton
Hamilton, James Alexander
Hamilton, Schuyler
Hamlin, Emmons
Hamlin, Talbot Faulkner
Hammerstein, Oscar, II
Hammon, Jupiter
Hampden, Walter
Hanchett, Henry Granger
Hand, Augustus Noble
Hand, Learned
Hanna, Edward Joseph
Harcourt, Alfred
Hard, William
Hardenbergh, Jacob Rutsen
Hardie, James Allen
Harland, Henry
Harper, Fletcher
Harper, James
Harper, John Lyell
Harrigan, Edward
Harriman, Edward Henry
Harriman, Edward Roland Noel
Harriman, Florence Jaffray Hurst
Harris, Chapin Aaron
Harris, Charles Kassell
Harris, Ira
Harris, Miriam Coles
Harris, Rollin Arthur
Harris, Sam Henry

Harris, Seymour Edwin
Harris, Stanley Raymond ("Bucky")
Harris, Townsend
Harrison, Fairfax
Harrison, Francis Burton
Hart, Edmund Hall
Hart, Lorenz Milton
Hart, Moss
Hart, Virgil Chittenden
Hart, William Surrey
Harte, Francis Brett
Hartford, George Ludlum
Hartley, Jonathan Scott
Hartness, James
Hartsuff, George Lucas
Harvey, Hayward Augustus
Hasbrouck, Abraham Bruyn
Hasbrouck, Lydia Sayer
Hascall, Milo Smith
Hassard, John Rose Greene
Hastings, Charles Sheldon
Hastings, Serranus Clinton
Hastings, Thomas
Haswell, Charles Haynes
Hatch, John Porter
Haughton, Percy Duncan
Hauk, Minnie
Havemeyer, Henry Osborne
Havemeyer, William Frederick
Haven, Emily Bradley Neal
Havens, James Smith
Haviland, Clarence Floyd
Hawes, Charles Boardman
Hayes, Carlton Joseph Huntley
Hayes, Gabby
Hayes, Patrick Joseph
Hayford, John Fillmore
Hays, Arthur Garfield
Hays, William Jacob
Hayward, Susan
Headley, Joel Tyler
Headley, Phineas Camp
Heaton, John Langdon
Heatter, Gabriel
Hecht, Ben
Hecker, Isaac Thomas
Hedding, Elijah
Heenan, John Carmel
Hegeman, John Rogers
Heintzelman, Stuart
Heinze, Frederick Augustus
Helburn, Theresa
Helm, Charles John
Helpern, Milton
Hemenway, Mary Porter Tileston
Henderson, Ray
Hendrick, Ellwood
Heney, Francis Joseph
Henry, Joseph
Hepburn, Alonzo Barton

Hepburn, Katharine Houghton
Herdic, Peter
Herkimer, Nicholas
Herne, James A.
Herrmann, Bernard
Hess, Alfred Fabian
Hewitt, Abram Stevens
Hewitt, John Hill
Hewitt, Peter Cooper
Heye, George Gustav
Hibbard, reeborn Garrettson
Hicks, Elias
Hicks, John, 1847–1917
Higgins, Frank Wayland
Higginson, Henry Lee
Hin, Davi Bennett
Hill, Frederick Trevor
Hill, George William
Hill, Grace Livingston
Hill, John Henry
Hill, Nathaniel Peter
Hines, James J.
Hinman, George Wheeler
Hirsch, Isaac Seth
Hirth, William Andrew
Hiscock, Frank Harris
Hitchcock, Phineas Warrener
Hitchcock, Raymond
Hoadley, John Chipman
Hoag, Joseph
Hoard, William Dempster
Hobart, Alice Nourse Tisdale
Hodge, William Thomas
Hodges, George
Hoe, Richard March
Hoe, Robert, 1839–1909
Hoff, John Van Rensselaer
Hoffman, Charles Fenno
Hoffman, David Murray
Hoffman, Eugene Augustus
Hoffman, John Thompson
Hoffman, Ogden
Hoffman, Wickham
Hofstadter, Richard
Hogue, Wilson Thomas
Holabird, William
Holcombe, Chester
Holdrege, George Ward
Holland Edmund Milton
Holland Joseph Jefferson
Hollenth, Herman
Hollev, Marietta
Hollick, Charles Arthur
Holliday, Judy
Holmes, Daniel Henry
Holt, Hamilton Bowen
Holt, Luther Emmett
Holt, Winifred
Hone, Philip
Hooker, Elon Huntington

Hoppe, William Frederick ("Willie")
Hopper, DeWolf
Hopper, Edward
Hormel, George Albert
Horsford, Eben Norton
Horton, Edward Everett, Jr.
Hosack, Alexander Eddy
Hosack, David
Hosmer, Hezekiah Lord
Hosmer, William Howe Cuyler
Hotchkiss, Horace Leslie
Hough, Franklin Benjamin
Hough, George Washington
Houghton, Douglass
House, Henry Alonzo
House, Samuel Reynolds
Hovey, Alvah
Howard, George Elliott
Howard, Moe
Howe, Herbert Alonzo
Howe, Julia Ward
Howe, William Wirt
Howell, John Adams
Howland, Emily
Howland, John
Hoxie, Robert Franklin
Hoxie, William Dixie
Hoyt, John Sherman
Hubbard, Lucius Frederick
Huebsch, Benjamin W.
Hughes, Albert William
Hughes, Charles Evans
Hughes, George Wurtz
Hull, Clark Leonard
Hunt, Benjamin Weeks
Hunt, Charles Wallace
Hunt, Ward
Hunt, Washington
Huntington, Daniel
Huntington, Edward Vermilye
Huntington, Henry Edwards
Huntington, Jedediah Vincent
Huntington, Margaret Jane Evans
Hurlbut, Jesse Lyman
Hurley, Roy T.
Husing, Edwar Britt ("Ted")
Hutchins, Robert Maynard
Hutton, Barbara Woolworth
Hutton, Edward Francis
Hutton, Frederick Remsen
Hutton, Laurence
Hyatt, John Wesley
Hyde, Helen
Hyde, Henry Baldwin
Hylan, John Francis
Ingalls, Marill Baker
Ingersoll, Robert Green
Inman, Henry, 1801–1846
Inman, Henry, 1837–1899
Inman, John

Inness, George
Ireland, Joseph Norton
Irving, John Treat
Irving, Peter
Irving, Pierre Munro
Irving, Roland Duer
Irving, Washington
Irving, William
Irwin, Elisabeth Antoinette
Irwin, William Henry
Isaacs, Abram Samuel
Isham, Ralph Heyward
Isham, Samuel
Isherwood, Benjamin Franklin
Ives, Halsey Cooley
Ives, Irving McNeil
Ives, James Merritt
Ives, Joseph Christmas
Jackson, Abraham Valentine Williams
Jackson, Charles Douglas
Jackson, George Thomas
Jackson, James Caleb
Jackson, Mortimer Melville
Jackson, Samuel Macauley
Jackson, Sheldon
Jackson, William Henry
Jacobs, Hirsch
Jacobs, Michael Strauss
Jacobs, Paul
James, Arthur Curtiss
James, Edward Christopher
James, Henry, 1811–1882
James, Henry, 1843–1916
James, Thomas Lemuel
James, William
Janeway, Theodore Caldwell
Jay, Sir James
Jay, John, 1745–1829
Jay, John, 1817–1894
Jay, William
Jelliffe, Smith Ely
Jemison, Alice Mae Lee
Jenkins, James Graham
Jenkins, John Stilwell
Jenks, Tudor Storrs
Jerome, William Travers
Jervis, John Bloomfield
Jewett, William Cornell
Johnson, Alexander Smith
Johnson, Benjamin Pierce
Johnson, Elias Henry
Johnson, Helen Louise Kendrick
Johnson, Sir John
Johnson, Levi
Johnson, Owen McMahon
Johnson, Samuel William
Johnson, Virginia Wales
Johnson, William Woolsey
Johnson, Willis Fletcher
Johnston, Alexander

Johnston, John Taylor
Johnston, Samuel
Joline, Adrian Hoffman
Jones, Amanda Theodosia
Jones, George Heber
Jones, Herschel Vespasian
Jones, John
Jones, Samuel, 1734–1819
Jones, Samuel, 1770–1853
Jones, Thomas
Jones, William Alfred
Jordan, David Starr
Jordan, Virgil Justin
Jordan, William George
Josephson, Matthew
Judah, Samuel
Judah, Samuel Benjamin Helbert
Judd, Gerrit Parmele
Judd, Norman Buel
Judd, Orange
Judson, Edward Zane Carroll
Judson, Egbert Putnam
Judson, Emily Chubbuck
Judson, Harry Pratt
Kaempffert, Waldemar Bernhard
Kaiser, Henry John
Kane, Helen
Kane, John Kintzing
Kaye, Frederick Benjamin
Kearny, Philip
Keating, Kenneth Barnard
Kedzie, Robert Clark
Keeley, Leslie E.
Keene, Thomas Wallace
Keep, Henry
Keith, Minor Cooper
Keller, Arthur Ignatius
Kelley, James Douglas Jerrold
Kellogg, Frank Billings
Kellogg, Samuel Henry
Kelly, John
Kelly, Luther Sage
Kelly, Michael J.
Kelsey, Francis Willey
Kemble, Gouverneur
Kemp, James Furman
Kemper, Jackson
Kenedy, Patrick John
Kent, Charles Foster
Kent, James
Kent, Rockwell
Kenyon, Josephine Hemenway
Keppel, Frederick Paul
Kern, Jerome David
Kernan, Francis
Kert, Charles Foster
Kidder, Daniel Parish
Kilpatrick, John Reed
King, Carol Weiss
King, Charles

King, Edward Skinner
King, James Gore
King, John
King, John Alsop
King, Preston
King, Richard
King, Rufus
King, Stanley
King, Thomas Starr
Kingsley, Calvin
Kingsley, Elizabeth Seelman
Kingsley, Norrnan William
Kinne, La Vega George
Kinney, Elizabeth Clementine
Kip, William Ingraham
Kiphuth, Robert John Herman
Kirchwey, Freda
Kirk, Edward Norris
Kirkland, Caroline Matilda Stansbury
Kirkland, John Thornton
Kirkland, Joseph
Kirstein, Louis Edward
Klein, Anne
Klem, William J. ("Bill")
Knapp, Joseph Palmer
Knapp, Martin Augustine
Knapp, Seaman Asahel
Knapp, William Ireland
Knauth, Oswald Whitman
Knickerbocker, Herman
Knopf, Blanche Wolf
Knox, George William
Knox, John Jay
Kobbé, Gustav
Koch, Vivienne
Kreymborg, Alfred Francis
Kuhn, Walt
Kunz, George Frederick
Ladd, Carl Edwin
Ladd, Kate Macy
La Farge, Christopher Grant
La Farge, John
La Farge, Oliver Hazard Perry
La Guardia, iorello Henry
Lahr, Bert
Laimbeer, Natalie Schenk
Lait, Jacquin Leonard (Jack)
Lake, Veronica
Lamb, John
Lamb, William Frederick
Lamont, Daniel Scott
Lamont, Hammond
Lamont, Thomas William
La Mountain, John
Landon, Melville de Lancey
Lane, Arthur Bliss
Langford, Nathaniel Pitt
Langmuir, Irving
Lansing, Gulian
Lansing, John

Lansing, Robert
Lapchick, Joseph Bohomicl
Lapham, Increase Allen
Larrabee, Charles Hathaway
Lathbury, Mary Artemisia
Lathrop, John Hiram
Law, George
Lawes, Lewis Edward
Lawrence, George Newbold
Lawrence, William Beach
Lawrie, Alexander
Lawson, John Howard
Lawson, Robert Ripley
Lay, John Louis
Lazarus, Emma
Le Clear, Thomas
Le Conte, John Lawrence
Leavitt, Frank Simmons (Man
 Mountain Dean)
Lee, Canada
Lee, Frederic Schiller
Lee, James Melvin
Lee, Luther
Lee, Manfred B.
Lee, Porter Raymond
Lee, William Little
Lefferts, George Morewood
Lefferts, Marshall
Leffingwell, Russell Cornell
Leggett, Mortimer Dormer
Leggett, William
Lehman, Adele Lewisohn
Lehman, Arthur
Lehman, Herbert Henry
Lehman, Irving
Lehman, Robert
Lennox, Charlotte Ramsay
Lenox, James
Le Roux, Charles
Letchworth, William Pryor
Leupp, Francis Ellington
Levenson, Samuel ("Sam")
Levitt, Abraham
Levitt, Arthur
Lewis, Dioclesian
Lewis, George William
Lewis, James
Lewis, Morgan
Lewis, Oscar
Lewis, Taylor
Lewisohn, Sam Adolph
Lexow, Clarence
L'Hommedieu, Ezra
Libman, Emanuel
Liebling, Abbott Joseph
Liebling, Estelle
Lindsay, Howard
Link, Henry Charles
Lintner, Joseph Albert
Lippincott, Sara Jane Clarke

Lippmann, Walter
Litchfield, Electus Backus
Littauer, Lucius Nathan
Littlejohn, Abram Newkirk
Livingston, Edward
Livingston, Henry Brockholst
Livingston, John Henry
Livingston, John William
Livingston, Peter VanBrugh
Livingston, Philip
Livingston, Robert R, 1718–1775
Livingston, Robert R, 1746–1813
Livingston, William
Lloyd, Henry Demarest
Lloyd, James
Lloyd, John Uri
Locke, David Ross
Lockwood, Belva Ann Bennett
Lockwood, Samuel Drake
Loeb, James
Loesser, Frank
Loew, Marcus
Logan, Olive
Lombardi, Vincent Thomas
Longworth, Alice Lee Roosevelt
Loomis, Charles Battell
Loomis, Elmer Howard
Loomis, Mahlon
Loop, Henry Augustus
Lopez, Vincent Joseph
Lord, Asa Dearborn
Lord, Chester Sanders
Lord, William Wilberforce
Lorillard, Pierre
Lossing, Benson John
Lounsbury, Thomas Raynesford
Loveman, Amy
Low, Seth
Low, Will Hicok
Lowery, Woodbury
Luce, Stephen Bleecker
Luckenbach, J(ohn) Lewis
Ludlow, Daniel
Ludlow, itz Hugh
Ludlow, Gabriel George
Ludlow, George Duncan
Ludlow, Noah Miller
Ludlow, Thomas William
Ludlow, William
Luhan, Mabel Dodge
Lynch, James Mathew
Lynde, Francis
Lyon, Caleb
Lyon, Theodatus Timothy
Lyon, William Penn
Lyons, Leonard
Mabie, Hamilton Wright
McAdie, Alexander George
McAlpine, William Jarvis
McArthur, Duncan

McCall, John Augustine
McCarthy, Charles Louis (Clem)
McCloskey, John
McCloskey, William George
McComb, John
McCormick, Richard Cunningham
McCullough, Ernest
McCurdy, Richard Aldrich
MacDowell, Edward Alexander
McEntee, Jervis
McGarrah, Gates White
McGiffert, Arthur Cushman
McGlyn, Edward
McGovern, John
McGraw, James Herbert
McGraw, John Joseph
McIntyre, James Francis Aloysius
MacKaye, James Morrison Steele
MacKaye, Percy Wallace
Mackenzie, Alexander Slidell
Mackenzie, Ranald Slidell
McLaren, William Edward
McLaughlin, Hugh
Maclay, William Brown
McLeod, Hugh
McMaster, Guy Humphreys
McMaster, James Alphonsus
McMaster, John Bach
McMath, Robert Emmet
MacMonnies, Frederick Willin
McQuaid, Bernard John
McVickar, William Neilson
McVicker, James Hubert
Macy, Valentine Everit
Maginnis, Martin
Mahan, Alfred Thayer
Mahan, Asa
Mahan, Dennis Hart
Mallory, Clifford Day
Malone, Dudley Field
Mankiewicz, Herman Jacob
Mann, Louis
Mannes, David
Mannes, Leopold Damrosch
Manning, Daniel
Mantle, (Robert) Burns
Mapes, Charles Victor
Mapes, James Jay
Marbury, Elisabeth
Marcantonio, Vito Anthony
Marcus, Bernard Kent
Marquand, Allan
Marquand, Henry Gurdon
Marsh, Grant Prince
Marsh, Othniel Charles
Marshall, Frank James
Marshall, Henry Rutgers
Marshall, Louis
Marshall, Samuel Lyman Atwood
 ("Sam")

Marshall, William Edgar
Martin, Artemas
Martin, Edward Sandford
Martin, Frederick Townsend
Martin, Homer Dodge
Martindale, John Henry
Marx, Adolf Arthur ("Harpo")
Marx, Herbert ("Zeppo")
Marx, Julius Henry ("Groucho")
Marx, Leonard ("Chico")
Marx, Milton ("Gummo")
Maslow, Abraham H.
Mason, Charles
Mason, John Mitchell
Mason, William Ernest
Mather, Fred
Mathews, Albert
Mathews, Cornelius
Matteson, Joel Aldrich
Matteson, Tompkins Harrison
Mattice, Asa Martines
Mattison, Hiram
Mattoon, Stephen
Maverick, Peter
Maxim, Hiram Percy
Maxwell, Samuel
Maybeck, Bernard Ralph
Mayer, Emil
Mayer, Philip Frederick
Maynard, Edward
Maynard, George William
Mayo, William Starbuck
Mead, James Michael
Meade, Richard Worsam
Meany, William George
Mearns, Edgar Alexander
Mechem, Floyd Russell
Megrue, Roi Cooper
Meiggs, Henry
Melville, George Wallace
Melville, Herman
Mendel, Lafayette Benedict
Meneely, Andrew
Merchant, Livingston Tallmadge
Merck, George Wilhelm
Merriam, Augustus Chapman
Merriam, Clinton Hart
Merriam, William Rush
Merrill, Stuart Fitz Randolph
Merritt, Israel John
Merritt, Leonidas
Merry, William Lawrence
Meyer, Agnes Elizabeth Ernst
Meyer, Annie Nathan
Michael, Arthur
Miles, Manly
Milk, Harvey Bernard
Milledoler, Philip
Miller, Charles Henry
Miller, David Hunter

Miller, Gerrit Smith, Jr.
Miller, Gilbert Heron
Miller, Harriet Mann
Miller, Henry Valentine
Miller, Kenneth Hayes
Miller, Nathan Lewis
Miller, Warner
Miller, William Henry Harrison
Mills, Clark
Mills, Cyrus Taggart
Mills, Darius Ogden
Mills, Lawrence Heyworth
Millspaugh, Charles Frederick
Miner, Myrtilla
Minor, Robert Crannell
Minturn, Robert Bowne
Mirsky, Alfred Ezra
Mitchel, John Purroy
Mitchell, Hinckley Gilbert Thomas
Mitchell, Isaac
Mitchell, John Ames
Mitchell, Margaret Julia
Mitchell, William, 1801–1886
Mitchill, Samuel Latham
Moffat, David Halliday
Moffat, Jay Pierrepont
Moffett, Cleveland Langston
Mollenhauer, Emil
Montgomery, David Henry
Montgomery, Thomas Harrison
Moon, Parker Thomas
Mooney, William
Moore, Benjamin
Moore, Charles Herbert
Moore, Clement Clarke
Moore, Nathaniel Fish
Moore, Richard Channing
Moore, Veranus Alva
Moore, William Henry
Moran, Eugene Francis
Morehouse, Henry Lyman
Morell, George Webb
Morgan, Anne
Morgan, Charles Hill
Morgan, Edwin Barber
Morgan, Edwin Vernon
Morgan, John Pierpont
Morgan, Lewis Henry
Morgenthau, Henry, Jr.
Morrell, Benjamin
Morris, Edward Dafydd
Morris, Gouverneur
Morris, Lewis, 1671–1746
Morris, Lewis, 1726–1798
Morris, Lewis Richard
Morris, Richard
Morris, Richard Valentine
Morris, Robert Hunter
Morris, William Hopkins
Mortimer, Charles Greenough

Morton, Henry
Morton, Julius Sterlinz
Moses, Anna Mary Robertson
 ("Grandma")
Moses, Montrose Jonas
Mosher, Eliza Maria
Moskowitz, Belle Lindner Israels
Mosler, Henry
Moss, Frank
Mostel, Samuel Joel ("Zero")
Mott, James
Mott, John R.
Mott, Valentine
Mount, William Sidney
Muldoon, William
Mulford, Prentice
Mullany, James Robert Madison
Muller, Hermann Joseph
Mulry, Thomas Maurice
Mumford, James Gregory
Mundelein, George William
Munger, Theodore Thornton
Murphy, Charles Francis
Murphy, Henry Cruse
Murphy, John Francis
Murphy, John W.
Murray, David
Murray, Thomas Edward, 1860–1929
Murray, Thomas Edward, 1891–1961
Musica, Philip Mariano Fausto
Myer, Albert James
Nack, James M.
Naish, Joseph Carrol
Nash, Frederick Ogden
Nathan, Maud
Nelson, Henry Loomis
Nelson, Rensselaer Russell
Nelson, Reuben
Nelson, Samuel
Nevins, John Livingston
Newberry, John Stoughton
Newell, Robert Henry
Newhouse, Samuel
Newhouse, Damuel Irving
Newman, Barnett
Newman, Henry Roderick
Newman, John Philip
Newton, Hubert Anson
Newton, Isaac, 1794–1858
Nichols, Ruth Rowland
Nichols, William Ford
Nicoll, De Lancey
Nicoll, James Craig
Nipher, Francis Eugene
Nitchie, Edwar Bartlett
Noble, Gladwyn Kingsley
Norsworthy, Naomi
North, Frank Joshua
North, Frank Mason
North, Simon Newton Dexter

Norton, John Nicholas
Norton, John Pitkin
Nott, Charles Cooper
Nourse, Edwin Griswold
Noyes, Henry Drury
Noyes, La Verne
Noyes, William Curtis
Nye, James Warren
Oakley, Thomas Jackson
Oberholser, Harry Church
Oberndorf, Clarence Paul
O'Brian, John Lord
O'Brien, Edward Charles
O'Brien, Morgan Joseph
O'Conor, Charles
Odell, Benjamin Barker
Odell, George Clinton Densmore
Odenbach, Frederick Louis
O'Donnell, Emmett, Jr. ("Rosy")
Ogden, David Bayard
Ogden, Herbert Gouverneur
Ogden, Rollo
Ogden, William Butler
Ogilvie, John
Olcott, Chauncey
Olcott, Eben Erskine
Olds, Leland
Olmstead, Albert Ten Eyck
Olmsted, Frederick Law
Olyphant, Robert Morrison
O'Malley, Walter Francis
Onderdonk, Benjamin Tredwell
Onderdonk, Henry
Onderdonk, Henry Ustick
O'Neill, Eugene
Oppenheimer, Julius Robert
Ordronaux, John
Orton, Edward Francis Baxter
Orton, Harlow South
Orton, Helen Fuller
Orton, James
Orton, William
Osborn, Laughton
Osborne, Thomas Mott
O'Shaughnessy, Nelson Jarvis
 Waterbury
O'Shea, Michael Vincent
Osterhout, Winthrop John Vanleuven
Otis, Charles Rollin
Otis, Fessenden Nott
Ottley, Roi
Paddock, Algernon Sidney
Page, William
Palmer, Alice Elvira Freeman
Palmer, Alonzo Benjamin
Palmer, Erastus Dow
Palmer, Horatio Richmond
Palmer, Innis Newton
Palmer, Potter
Palmer, Walter Launt

Pardee, Ario
Pardow, William O'Brien
Park, William Hallock
Parker, Alton Brooks
Parker, Arthur Caswell
Parker, Ely Samuel
Parker, Foxhall Alexander
Parker, Jane Marsh
Parker, William Harwar
Parsons, Elsie Worthington Clews
Parsons, John Edward
Parsons, Lewis Baldwin
Parsons, Lewis Eliphalet
Parsons, Samuel Bowne
Parsons, William Barclay
Parton, Arthur
Pastor, Antonio
Paton, Lewis Bayles
Patrick, Marsena Rudolph
Patterson, Daniel Todd
Patterson, Robert Porter
Pattison, Thomas
Paul, William Darwin ("Shorty")
Paulding, Hiram
Paulding, James Kirke
Payne, Henry B.
Payne, John Howard
Payne, Sereno Elisha
Payne, William Harold
Peabody, Josephine Preston
Peck, Charles Horton
Peck, George
Peck, George Record
Peck, George Wilbur
Peck, Jesse Truesdell
Peck, John James
Peck, Lillie
Peckham, George Williams
Peckham, Rufus Wheeler
Peckham, Wheeler Hazard
Peixotto, Benjamin Franklin
Peloubet, Francis Nathan
Pendleton, John B.
Penfield, Edward
Pennoyer, Sylvester
Perelman, Sidney Joseph
Perin, Charles Page
Perkins, George Douglas
Perkins, Maxwell Evarts
Perry, Clarence Arthur
Perry, Stuart
Peters, John Charles
Peters, John Punnett
Phelps, William Franklin
Philip, John Woodward
Phillips, Philip
Picton, Thomas
Pierce, Gilbert Ashville
Pierson, Arthur Tappan
Pierson, Hamilton Wilcox

Piggot, Robert
Pilcher, Paul Monroe
Pintard, John
Pintard, Lewis
Piper, William Thomas
Pirsson, Louis Valentine
Pitcher, Zina
Platt, Thomas Collier
Polak, John Osborn
Polk, Frank Lyon
Pomeroy, John Norton
Pomeroy, Marcus Mills
Pond, James Burton
Pope, John Russell
Porter, Holbrook Fitz John
Porter, Jermain Gildersleeve
Porter, John Addison
Post, Augustus
Post, George Adams
Post, George Browne
Post, George Edward
Post, Isaac
Post, Wright
Pott, Francis Lister Hawks
Potter, Alonzo
Potter, Eliphalet Nott
Potter, Henry Codman
Potter, Horatio
Potter, Louis McClellan
Potter, Platt
Potter, Robert Brown
Pound, Cuthbert Winfred
Powell, Edward Payson
Powell, George Harold
Powell, John Wesley
Powell, William Bramwell
Powell, William Henry
Power, Frederick Belding
Powers, Daniel William
Prang, Mary Amelia Dana Hicks
Pratt, Eliza Ann Farman
Pratt, James Bissett
Pratt, Orson
Pratt, Parley Parker
Pratt, Richard Henry
Pratt, Sereno Stansbury
Pratt, Tadock
Prescott, Albert Benjamin
Pressman, Lee
Price, Stephen
Price, Theodore Hazeltine
Prime, Benjamin Youngs
Prime, Edward Dorr Griffin
Prime, Samuel Irenaeus
Prime, William Cowper
Prince, Le Baron Bradford
Prince, William, *c.* 1725–1802
Prince, William, 1766–1842
Prince, William Robert
Pringle, Henry Fowles

Prinze, Freddie
Prosser, Charles Smith
Provoost, Samuel
Pruyn, John Van Schaick Lansing
Pruyn, Robert Hewson
Pulitzer, Joseph, Jr.
Pulitzer, Margaret Leech
Pullman, George Mortimer
Pumpelly, Raphael
Purdy, Lawson
Purple, Samuel Smith
Putnam, (George) Herbert
Putnam, James Osborne
Putnam, Ruth
Quackenbush, Stephen Platt
Quidor, John
Quitman, John Anthony
Radcliff, Jacob
Raft, George
Rafter, George W.
Raines, John
Ralph, Julian
Rambaut, Mary Lucin Bonney
Rand, James Henry
Randall, Alexander Williams
Randall, Clarence Belden
Randall, Henry Stephens
Randall, Samuel Sidwell
Ranger, Henry Ward
Rankine, William Birch
Raskob, John Jakob
Rathbone, Justus Henry
Rathbun, Richard
Rauschenbusch, Walter
Raymond, Alexander Gillespie
Raymond, Benjamin Wright
Raymond, Henry Jarvis
Raymond, John Howard
Raymond, John T.
Raymond, Miner
Red Jacket
Redfield, Amasa Angell
Redfield, William Cox
Redman, Ben Ray
Reed, Daniel Alden
Reed, Luman
Rees, John Krom
Reeve, Tapping
Reeves, Daniel F.
Reid, Gilbert
Reid, John Morrison
Reid, Ogden Mills
Reid, William Wharry
Reinhardt, Ad
Remington, Frederic
Remington, Philo
Remington, William Walter
Remsen, Ira
Renwick, Edward Sabine
Renwick, Henry Brevoort

Renwick, James, 1818–1895
Reynolds, Julian Sargeant
Reynolds, Quentin James
Rhind, Alexander Colden
Rice, Dan
Rice, Edwin Wilbur
Rice, Elmer
Rice, Thomas Dartmouth
Rice, Victor Moreau
Richards, Charles Brinkerhoff
Richards, Vincent
Richtmyer, Floyd Karker
Rickard, Clinton
Ricketts, James Brewerton
Ridder, Bernard Herman
Ridder, Herman
Ridgway, Robert
Riefler, Winfield William
Riggs, William Henry
Riley, Isaac Woodbridge
Rittenhouse, Jessie Befle
Rives, George Lockhart
Rjobb, William Lispenard
Robert, Christopher Rhinelander
Roberts, Benjamin Titus
Roberts, Ellis Henry
Roberts, Marshall Owen
Robertson, Morgan Andrew
Robertson, William Henry
Robertson, William Schenck
Robins, Margaret Dreier
Robins, Raymond
Robinson, Charles Mulford
Robinson, John Cleveland
Robinson-Smith, Gertrude
Rockefeller, John Davison
Rockefeller, John Davison, 3D
Rockefeller, William
Rockefeller, Winthrop
Rockwell, Norman Perceval
Rodgers, Christopher Raymond Perry
Rodgers, George Washington, 1822–
 1863
Rodgers, Richard Charles
Roe, Edward Payson
Roe, Francis Asbury
Rogers, Henry Wade
Rogers, Randolph
Rogers, Stephen
Rohlfs, Anna Katharine Green
Rolf, Ida Pauline
Romayne, Nicholas
Romer, Alfred Sherwood ("Al")
Rooney, Pat
Roosa, Daniel Bennett St. John
Roosevelt, (Anna) Eleanor
Roosevelt, Franklin Delano
Roosevelt, Hilborne Lewis
Roosevelt, Kermit
Roosevelt, Nicholas J.

Roosevelt, Robert Barnwell
Roosevelt, Theodore, 1858–1919
Roosevelt, Theodore, 1887–1944
Root, Elihu
Root, Frank Albert
Rorty, James Hancock
Rosa, Edwar Bennett
Rose, Billy
Rosenberg, Ethel
Rosenberg, Julius
Rosenfeld, Paul Leopold
Ross, Thomas Joseph
Rossen, Robert
Rousseau, Harry Harwood
Rowland, Henry Cottrell
Rubicam, Raymond
Rudge, William Edwin
Rudkin, Margaret Fogarty
Ruger, Thomas Howard
Rukeyser, Muriel
Rumsey, Charles Cary
Rumsey, Mary Harriman
Rumsey, William
Runkle, John Daniel
Ruppert, Jacob
Russell, David Allen
Russell, Henry Norris
Russell, Israel Cook
Russell, James Earl
Rutgers, Henry
Rutherfurd, Lewis Morris
Sachs, Paul Joseph
Sackett, Henry Woodward
Sage, Margaret Olivia Slocum
Sage, Russell
Salisbury, James Henry
Salmon, Lucy Maynard
Salmon, Thomas William
Salter, William
Saltus, Edgar Evertson
Sampson, William Thomas
Sanders, Charles Walton
Sanders, Wilbur Fisk
Sands, Comfort
Sands, David
Sands, Diana Patricia
Sands, Joshua Ratoon
Sands, Robert Charles
Sanford, Nathan
Sanger, Margaret Higgins
Sangster, Margaret Elizabeth Munson
Satterlee, Henry Yates
Satterlee, Richard Sherwood
Sawyer, Leicester Ambrose
Sawyer, Lorenzo
Saxle, John
Saypol, Irving Howard
Sayre, Reginald Hall
Sayre, Stephen
Schell, Augustus

Schenck, Ferdinand Schureman
Schirmer, Rudolph Edward
Schlesinger, Frank
Schofield, John McAllister
Schoolcraft, Henry Rowe
Schuyler, Eugene
Schuyler, George Washington
Schuyler, James Dix
Schuyler, Louisa Lee
Schuyler, Margarita
Schuyler, Montgomery
Schuyler, Peter
Schuyler, Philip John
Schuyler, Robert Livingston
Schwab, John Christopher
Schwartz, Delmore David
Scollard, Clinton
Scott, John Morin
Scott, John Prindle
Scribner, Charles, 1821–1871
Scribner, Charles, 1854–1930
Scribner, Charles, 1890–1952
Scrymser, James Alexander
Scullin, John
Seabury, George John
Seabury, Samuel
Searle, James
Searle, John Preston
Sedgwick, Arthur George
Sedgwick, Ellery
Sedgwick, Theodore, 1811–1859
Seeger, Alan
Seitz, William Chapin
Seixas, Gershom Mendes
Selden, George Baldwin
Seligman, Edwin Robert Anderson
Seligman, Isaac Newton
Seney, George Ingraham
Sennett, George Burritt
Sergeant, Henry Clark
Serling, Rodman Edward ("Rod")
Sessions, Henry Howard
Seton, Elizabeth Ann Bayley
Seton, William
Severance, Caroline Maria Seymour
Seward, Frederick William
Seward, George Frederick
Seward, Theodore Frelinghuysen
Seward, William Henry
Seymour, George Franklin
Seymour, Horatio
Seymour, Horatio Winslow
Seymour, William
Shaw, Edward Richard
Shea, John Dawson Gilmary
Sheffield, Devello Zelotes
Sheldon, Charles Monroe
Sheldon, Edward Austin
Shelton, Frederick William
Shepard, Edward Morse

Shepard, red Douglas
Sheridan, Philip Henry
Sherman, Frank Dempster
Sherman, James Schoolcraft
Sherwood, Adiel
Sherwood, Isaac Ruth
Sherwood, Robert Emmet
Sherwood, William Hall
Shields, Francis Xavier ("Frank")
Shipherd, John Jay
Shrady, George Frederick
Shrady, Henry Merwin
Shufeidt, Robert Wilson
Sibley, Joseph Crocker
Sicard, Montgomery
Sickles, Daniel Edgar
Sidell, William Henry
Sigsbee, Charles Dwight
Sikes, William Wirt
Sill, Anna Peck
Silverman, Sime
Silvers, Louis
Simon, Richard Leo
Simonton, James William
Simpson, Edward
Simpson, William Kelly
Sims, Winfield Scott
Singer, Isaac Merrit
Skaniadariio
Skinner, Alanson Buck
Skinner, Charles Rufus
Slidell, John
Sloat, John Drake
Slocum, Henry Warner
Smillie, George Henry
Smillie, James David
Smillie, Ralph
Smith, Alfred Emanuel
Smith, Archibald Cary
Smith, Azariah
Smith, Betty
Smith, Bruce
Smith, David Eugene
Smith, Edmund Munroe
Smith, Erasmus Darwin
Smith, Erminnie Adelle Platt
Smith, Erwin Frink
Smith, Gerrit
Smith, Giles Alexander
Smith, Harry Bache
Smith, Hezekiah
Smith, James McCune
Smith, Jedediah Strong
Smith, Job Lewis
Smith, John Bernhard
Smith, Martin Luther
Smith, Melancton, 1744–1898
Smith, Melancton, 1810–1893
Smith, Milton Hannibal
Smith, Morgan Lewis

Smith, Ormond Gerald
Smith, Peter
Smith, Solomon Franklin
Smith, Stephen
Smith, Theobald
Smith, William, 1728–1793
Smith, William Henry, 1833–1896
Smith, William Stephens
Smyth, Julian Kennedy
Snell, Bertrand Hollis
Snelling, Henry Hunt
Snethen, Nicholas
Snow, John Ben
Snowden, Thomas
Sokolsky, George Ephraim
Solomons, Adolphus Simeon
Sooysmith, Charles
Soulé, George
Southmayd, Charles Ferdinand
Spalding, Volney Morgan
Spaulding, Elbridge Gerry
Speck, Frank Gouldsmith
Speir, Samuel Fleet
Spencer, Cornelia Phillips
Spencer, Jesse Ames
Spencer, John Canfield
Spencer, Platt Rogers
Sperry, Elmer Ambrose
Speyer, James Joseph
Spier, Leslie
Spingarn, Arthur Barnett
Spingarn, Joel Elias
Spinner, Francis Elias
Spitzka, EdwardAnthony
Spitzka, Edward Charles
Sprague, Charles Ezra
Squier, Ephraim George
Squire, Watson Carvosso
Stager, Anson
Staley, Cady
Stanbery, Henry
Stanchfield, John Barry
Stanford, L&and
Stanley, John Mix
Stanley, William
Stansbury, Howard
Stanton, Elizabeth Cady
Starin, John Henry
Starr, Frederick
Starr, Merritt
Starr, Moses Allen
Stearns, Irving Ariel
Steele, Daniel
Steele, Frederick
Steele, Joel Dorman
Steinhardt, Laurence Adolph
Steinman, David Barnard
Stelzle, Charles
Sterling, George
Stern, Bill

Stern, Joseph William
Sternberg, George Miller
Stetson, Francis Lynde
Stevens, Alexander Hodgdon
Stevens, Emily
Stevens, George Barker
Stevens, George Washington
Stevens, John
Stevens, John Austin
Stevens, Walter Husted
Stevenson, John James
Stewart, Alvan
Stewart, Edwin
Stewart, John Aikman
Stewart, Robert Marcellus
Stewart, William Morris
Stewart, William Rhinelander
Stiles, Charles Wardell
Stiles, Henry Reed
Stillman, Thomas Edgar
Stillman, William James
Stilwell, Joseph Warren
Stilwell, Silas Moore
Stimson, Henry Lewis
Stoddard, Charles Warren
Stoddard, John Fair
Stoddard, William Osborn
Stokes, Anson Phelps, 1838–1913
Stokes, Anson Phelps, 1874–1958
Stokes, Caroline Phelps
Stokes, Frederick Abbot
Stokes, Isaac Newton Phelps
Stokes, Olivia Egleston Phelps
Stokes, William Earl Dodge
Stone, Horatio
Stone, William Leete, 1792–1844
Stone, William Leete, 1835–1908
Stoneman, George
Straight, Willard Dickermam
Stranahan, James Samuel Thomas
Strand, Paul
Strang, James Jesse
Strange, Michael
Straus, Jesse Isidor
Straus, Percy Selden
Straus, Roger W(illiams)
Street, Alfrc Billings
Streeter, George Linius
Stringham, Silas Horton
Stringham, Washington Irving
Strong, Augustus Hopkins
Strong, Benjamin
Strong, Harriet Williams Russell
Strong, James
Strong, James Hooker
Stryker, Melancthon Woolsey
Stuart, Charles Beebe
Stuart, Robert Leighton
Sullivan, Edward Vincent ("Ed")
Sullivan, Harry Stack

Sullivan, James Edward
Sullivan, Timothy Daniel
Sulzberger, Arthur Hays
Sutton, William Francis, Jr. ("Willie")
Swain, Clara A.
Swain, James Barrett
Swan, Joseph Rockwell
Swartwout, Samuel
Sweeny, Peter Barr
Sweet, John Edson
Swift, Lewis
Swift, Lucius Burrie
Swing, Raymond Edwards (Gram)
Symmes, John Cleves
Symons, Thomas William
Taber, John
Tallmadge, Benjamin
Tallmadge, James
Talmadge, Constance
Tamiris, Helen
Tanner, Benjamin
Tanner, Henry Schenck
Tanner, James
Tappan, Henry Philip
Tappen, Frederick Dobbs
Taussig, Frederick Joseph
Taylor, Benjamin Franklin
Taylor, Graham
Taylor, Henry Osborn
Taylor, James Monroe
Taylor, James Wickes
Taylor, John W.
Taylor, Joseph Deems
Taylor, Laurette
Taylor, Moses
Taylor, Myron Charles
Taylor, Stevenson
Teall, Francis Augustus
Teller, Henry Moore
Ten Broeck, Abraham
Ten Broeck, Richard
Terry, Marshall Orlando
Terry, Milton Spenser
Thacher, Edwin
Thacher, John Boyd
Thalberg, Irving Grant
Thayer, Amos Madden
Thomas, Amos Russell
Thomas, George Allison
Thomas, John Jacobs
Thomas, Joseph
Thompson, Dorothy
Thompson, Egbert
Thompson, Malvina Cynthia
Thompson, Martin E.
Thompson, Smith
Thompson, William Gilman
Thomson, Mortimer Neal
Thorne, Charles Robert, 1814–1893
Thorne, Charles Robert, 1840–1883

Throop, Enos Thompson
Throop, Montgomery Hunt
Thurber, Jeannette Meyer
Thursby, Emma Cecilia
Tiebout, Cornelius
Tierney, Richard Henry
Tiffany, Louis Comfort
Tilden, Samuel Jones
Tilney, Frederick
Tilton, Edward Lippincott
Tilton, Theodore
Tilyou, George Cornelius
Timby, Theodore Ruggles
Timme, Walter
Tishman, David
Tobin, Austin Joseph
Todd, Sereno Edwards
Todman, William Selden ("Bill")
Tomkins, Floyd Williams
Tomlin, Bradley Walker
Tompkins, Daniel D.
Tone, Stanislas Pascal Franchot
Torrey, John
Townsend, Mary Ashley
Townsend, Robert
Tracy, Benjamin Franklin
Trask, James Dowling
Travers, Jerome Dunstan
Treat, Samuel Hubbel
Trelcase, William
Tremain, Henry Edwin
Tremaine, Henry Barnes
Trenchard, Stephen Decatur
Trilling, Lionel
Trowbridge, Augustus
Trowbridge, John Townsend
Trowbridge, William Petit
Trude, Alfred Samuel
Trudeau, Edward Livingston
Truxtun, Thomas
Tucker, Allen
Tucker, Gilbert Milligan
Tucker, Richard
Tuckerman, Bayard
Tugwell, Rexford Guy
Tunney, James Joseph ("Gene")
Turner, Daniel
Turner, John Wesley
Turner, Ross Sterling
Tuthill, William Burnet
Tuttle, Daniel Sylvester
Tweed, Harrison
Tweed, William Marcy
Tyler, Robert Ogden
Underhill, Franklin Pell
Underwood, Benjamin Franklin
Underwood, John Curtiss
Underwood, Lucien Marcus
Untermeyer, Louis
Upton, Emory

Usher, John Palmer
Vail, Robert William Glenroie
Vail, Stephen Montfort
Valachi, Joseph Michael
Valentine, David Thomas
Van, Bobby
Van Buren, John
Van Buren, Martin
Van Cortlandt, Philip
Van Cortlandt, Pierre
Van Cortlandt, Stephanus
Van Dam, Rip
Vanderbilt, Amy
Vanderbilt, Cornelius, 1794–1877
Vanderbilt, Cornelius, 1843–1899
Vanderbilt, Cornelius, Jr. ("Cornelius IV," "Neil")
Vanderbilt, George Washington
Vanderbilt, Grace Graham Wilson
Vanderbilt, William Kissam
Vanderlyn, John
Vander Veer, Albert
Van de Warker, Edward Ely
Van Dyck, Cornelius Van Alen
Van Dyke, Paul
Van Fleet, Walter
Van Name, Addison
Van Ness, William Peter
Van Nest, Abraham Rynier
Van Nostrand, David
Van Rensselaer, Cortlandt
Van Rensselaer, Mariana Griswold
Van Rensselaer, Martha
Van Rensselaer, Solomon
Van Rensselaer, Stephen
Van Schaack, Henry Cruger
Van Schaack, Peter
Van Schaick, Goose
Van Slyke, Lucius Lincoln
Van Vechten, Abraham
Van Winkle, Peter Godwin
Van Wyck, Charles Henry
Vardill, John
Varick, James
Vedder, Edwar Bright
Vedder, Elihu
Vedder, Henry Clay
Verplanck, Julian Crommelin
Vesey, William
Vibbard, Chauncey
Victor, Frances Fuller
Viele, Aernout Cornelissen
Viele, Egbert Ludovicus
Vincent, Frank
Vincent, Marvin Richardson
Volk, Leonard Wells
Vorse, Mary Heaton
Vought, Chance Milton
Wade, Jeptha Homer
Wadsworth, James Samuel

Wadsworth, James Wolcott, Jr.
Wagner, Webster
Wainwright, Jonathan Mayhew, 1821–1863
Wait, Samuel
Wait, William
Wait, William Bell
Walcott, Charles Doolittle
Walden, Jacob Treadwell
Walker, Gilbert Carlton
Walker, James John
Walker, Mary Edwards
Wallace, William James
Wallack, Lester
Waller, Frederic
Waller, Thomas Macdonald
Waller, Thomas Wright
Walsh, Blanche
Walsh, Raoul
Walsh, Thomas
Walworth, Clarence Augustus
Ward, Cyrenus Osborne
Ward, Genevieve
Ward, Henry Augustus
Ward, Henry Baldwin
Ward, James Edward
Ward, Joseph
Ward, Samuel, 1814–1884
Waring, George Edwin
Warner, Adoniram Judson
Warner, Ann Bartlett
Warner, Glenn Scobey ("Pop")
Warner, Susan Bogert
Warren, Gouverneur Kemble
Warren, Leonard
Warren, Richard Henry
Washburn, Margaret Floy
Waterman, Alan Tower
Waterman, Lewis Edson
Waterman, Robert H.
Waterman, Thomas Whitney
Watson, James Madison
Watson, Thomas John
Watterston, George
Wayland, Francis, 1796–1865
Webb, Alexander Stewart
Webb, Charles Henry
Webb, James Watson
Webb, William Henry
Weber, Joseph Morris
Webster, Alice Jane Chandler
Webster, Margaret ("Peggy")
Weed, Thurlow
Weigel, Gustave
Weil, Richard
Weir, John Ferguson
Weir, Julian Alden
Weir, Robert Fulton
Weir, Robert Walter
Welch, Ashbel

Welch, Charles Clark
Welch, Leo Dewey
Welch, Philip Henry
Welles, (Benjamin) Sumner
Wells, Erastus
Wells, Harriet Sheldon
Wells, John
Wende, Ernest
Wende, Grover William
Wentworth, Cecile de
West, Mae
Westcott, Edward Noyes
Westinghouse, George
Westley, Helen
Wexler, Irving ("Waxey Gordon")
Whalen, Grover Aloysius
Wharton, Edith Newbold Jones
Wheatley, William
Whedon, Daniel Denison
Wheeler, Andrew Carpenter
Wheeler, Everett Pepperrell
Wheeler, (George) Post
Wheeler, Schuyler Skaats
Wheeler, William Almon
Wheelock, John Hall
Whipple, Henry Benjamin
Whitaker, Nathaniel
Whitcher, Frances Miriam Berry
White, Alfred Tredway
White, Andrew Dickson
White, Canvass
White, David
White, George
White, George Leonard
White, Joseph Malachy
White, Richard Grant
White, Stanford
White, William Alanson
Whitehouse, Frederic Cope
Whitfield, Robert Parr
Whitman, Marcus
Whitman, Walt
Whitney, Gertrude Vanderbilt
Whitney, Harry Payne
Whitney, Willis Rodney
Whittingham, William Rollinson
Wickes, Stephen
Wickham, John
Wickson, Edward James
Wiechmann, Ferdinand Gerhard
Wiener, Alexander Solomon
Wigger, Winand Michael
Wiggins, Carleton
Wight, Peter Bonnett
Wilder, Alexander
Wilder, Alexander Lafayette Chew ("Alec")
Wilder, John Thomas
Wilkes, Charles
Wilkes, George

Wilkie, Fran Bangs
Willard, Frances Elizabeth Caroline
Willet, William
Willett, Marinus
Williams, Charles Richard
Williams, Fannie Barrier
Williams, Frank Martin
Williams, George Henry
Williams, George Huntington
Williams, Henry Shaler
Williams, Linsly Rudd
Williams, Samuel Wells
Williams, William R.
Willis, Bailey
Willis, Henry Parker
Willys, John North
Wilson, Allen Benjamin
Wilson, Charles Edward
Wilson, Joseph Chamberlain
Wilson, Theodore Delavan
Winant, John Gilbert
Winchell, Alexander
Winchell, Newton Horace
Winchell, Walter
Wing, Joseph Elwyn
Winslow, John Bradley
Winston, Harry
Wise, Henry Augustus
Wisner, Henry
Witherspoon, Herbert
Witmark, Isidore
Witthaus, Rudolph August
Wolfe, Catharine Lorillard
Wolfe, Bertram David
Wolfe, John David
Wolheim, Louis Robert
Wood, Craig Ralph
Wood, Henry Alexander Wise
Wood, James, 1799–1867
Wood, James, 1839–1925
Wood, James Rushmore
Wood, Joseph
Wood, Mary Elizabeth
Wood, Peggy
Wood, Samuel
Woodford, Stewart Lyndon
Woodhull, Nathaniel
Woodruff, Lorande Loss
Woodruff, Theodore Tuttle
Woodruff, William Edward
Woodward, Augustus Brevoort
Woodward, William
Woodworth, Jay Backus
Wool, John Ellis
Woolley, Edgar Montillion ("Monty")
Woolsey, Melancthon Taylor
Woolsey, Theodore Dwight
Woolworth, Frank Winfield
Worcester, Edwin Dean
Worden, John Lorimer

Worth, William Jenkins
Worthington, Henry Rossiter
Wright, George
Wright, George Frederick
Wright, Harol Bell
Wright, William
Yale, Linus
Yates, Abraham
Yates, Herbert John
Yates, John Van Ness
Yates, Robert
Youmans, Edward Livingston
Youmans, Vincent Millie
Youmans, William Jay
Young, Ella Flagg
Young, Owen D.
Young, Thomas
Zimmerman, Henry ("Heinie")
Zinsser, Hans
Zukofsky, Louis

NORTH CAROLINA

Alderman, Edwin Anderson
Allen, George Venable
Allen, William
Ammons, Elias Milton
Andrews, Alexander Boyd
Armistead, Lewis Addison
Arrington, Alfred W.
Ashe, John
Ashe, John Baptista
Ashe, Samuel
Ashe, Thomas Samuel
Ashe, William Shepperd
Atkinson, Henry
Avery, William Waigstill
Aycock, Charles Brantley
Badger, George Edmund
Bailey, Josiah William
Baker, Laurence Simmons
Barden, Graham Arthur
Barringer, Daniel Moreau
Barringer, Rufus
Bassett, John Spencer
Battle, Kemp Plummer
Battle, William Horn
Baxter, Elisha
Baxter, John
Beasley, Frederick
Bell, Henry Haywood
Belo, Alfred Horatio
Bennett, Hugh Hammond
Benton, Thomas Hart
Bickett, Thomas Walter
Biggs, Asa
Bingham, Robert Worth
Bingham, William
Blackmer, Sydney Alderman
Blake, Lillie Devereux
Blalock, Nelson Gates

Bloodworth, Timothy
Blount, Thomas
Blount, Willie
Blue, Victor
Bonner, John Henry
Bragg, Braxton
Bragg, Thomas
Branch, John
Branch, Lawrence O'Bryan
Bridgers, Robert Rufus
Brinkley, John Richard
Brooks, George Washington
Brown, Bedford
Burgevine, Henry Andrea
Burleson, Edward
Burns, Otway
Burton, Hutchins Gordon
Butler, Marion
Bynum, William Preston
Cain, William
Caldwell, Charles
Cambreleng, Churchill Caldom
Cannon, Joseph Gurney
Cannon, Newton
Carr, Elias
Carson, Simeon Lewis
Cheshire, Joseph Blount
Clark, John
Clark, Walter
Clarke, Francis Devereux
Clarke, Mary Bayard Devereux
Clement, Rufus Early
Clewell, John Henry
Clingman, Thomas Lanier
Coffin, Levi
Colton, Elizabeth Avery
Coltrane, John William
Connor, Henry Graves
Connor, Robert Digges Wimberly
Cooley, Harold Dunbar
Cox, William Ruffin
Craven, Braxton
Daly, John Augustin
Daniels, Josephus
Dargan, Edmund Strother
Davis, George
De Mille, Henry Churchill
Denny, George Vernon, Jr.
De Rosset, Moses John
Dick, Robert Paine
Dixon, Thomas
Dobbin, James Cochran
Dodd, William Edward
Donnell, Robert
Doughton, Robert Lee
Dudley, Edward Bishop
Duke, Benjamin Newton
Duke, James Buchanan
Eaton, John Henry
Edwards, Weldon Nathaniel

Elliott, Aaron Marshall
Ellis, John Willis
Fels, Samuel Simeon
Finley, James Bradley
Fitzgerald, Oscar Penn
Forney, William Henry
Fries, Francis
Fuller, Thomas Charles
Gaines, George Strother
Gardner, Oliver Maxwell
Gaston, William
Gatling, Richard Jordan
Gilmer, John Adams
Gould, Robert Simonton
Govan, Daniel Chevilette
Graham, Edward Kidder
Graham, Frank Porter
Graham, William Alexander
Gray, George Alexander
Hale, Edward Joseph
Harnett, Cornelius
Harrell, John
Hawkins, Benjamin
Hawks, Francis Lister
Hawley, Joseph Roswell
Haywood, John
Heineman, Daniel Webster
 ("Dannie")
Helper, Hinton Rowan
Henderson, Archibald
Henderson, James Pinckney
Henderson, Leonard
Henkel, Paul
Hill, Robert Andrews
Hilliard, Henry Washington
Hoey, Clyde Roark
Hoke, Robert Frederick
Holden, William Woods
Holmes, Theophilus Hunter
Holt, Edwin Michael
Hooper, Johnson Jones
Houston, David Franklin
Houston, William Churchill
Howe, Robert
Howell, Robert Boyté Crawford
Hunt, Nathan
Jarvis, Thomas Jordan
Jasper, William
Johnson, Andrew
Johnson, Edward Austin
Johnson, William Ransom
Johnston, Joseph Forney
Jones, Alexander
Jones, Allen
Jones, Willie
Jordan, Benjamin Everett
Kerr, Washington Caruthers
King, William Rufus Devane
Kirby, George Hughes
Kitchin, Claude

Kitchin, William Walton
Koopman, Augustus
Lane, Joseph
Lanier, James Franklin Doughty
Law, Sallie Chapman Gordon
Lewis, Exum Percival
Lewis, William Gaston
Long, James
Loring, William Wing
Luelling, Henderson
Lyon, Francis Strother
Mabley, Jackie ("Moms")
McGilvary, Daniel
McIver, Charles Duncan
McKay, James Iver
McLean, Angus Wilton
McNeill, William Gibbs
Macon, Nathaniel
McRae, Duncan Kirkland
Madison, Dolly Payne
Mangum, Willie Person
Manly, Basil
Manning, Thomas Courtland
Martin, James Green
Means, Gaston Bullock
Mercer, Jesse
Merrimon, Augustus Summerfield
Moore, Alfred
Moore, Bartholomew Figures
Moore, Gabriel
Moore, James, 1737–1777
Moore, Maurice
Moore, Thomas Overton
Mordecai, Alfred
Morehead, John Motley
Murphey, Archibald De Bow
Murphy, James Bumgardner
Murrow, Edward (Egbert) Roscoe
Nash, Frederick
Nicholson, Timothy
Osborn, Charles
Osborne, James Walker
Overman, Lee Slater
Page, Walter Hines
Paine, Robert
Parker, John Johnston
Patterson, Rufus Lenoir
Payne, Bruce Ryburn
Pearson, Richmond Mumford
Pegram, George Braxton
Pender, William Dorsey
Pettigrew, James Johnston
Pickens, Israel
Pickett, Albert James
Polk, James Knox
Polk, Leonidas
Polk, Leonidas Lafayette
Polk, Lucius Eugene
Polk, William
Pool, John

Porter, William Sydney
Potter, Robert
Price, Thomas Frederick
Purviance, David
Rains, Gabriel James
Rains, George Washington
Ramseur, Stephen Dodson
Ransom, Matt Whitaker
Rayner, Kenneth
Reade, Edwin Godwin
Reichel, William Cornelius
Reid, David Settle
Revels, Hiram Rhoades
Reynolds, Robert Rice
Richardson, Edmund
Rivers, Lucius Mendel
Ross, Martin
Royster, James Finch
Ruark, Robert Chester
Saunders, Romulus Mitchell
Saunders, William Laurence, 1835–1891
Sawyer, Lemuel
Schweinitz, Emil Alexander de
Scott, Thomas Fielding
Scott, W(illiam) Kerr
Sellers, Isaiah
Settle, Thomas
Shepard, James Edward
Shipp, Albert Micajah
Simmons, Furnifold McLendel
Simmons, James Stevens
Skinner, Harry
Skinner, Thomas Harvey
Smith, Charles Alphonso
Smith, Henry Louis
Smith, Hoke
Smith, Robert Hardy
Smith, William, 1762–1840
Smith, William Nathan Harrell
Spaight, Richard Dobbs
Spaulding, Charles Clinton
Stacy, Walter Parker
Stanly, Edward
Steele, John
Steele, Wilbur Daniel
Stitt, Edward Rhodes
Stone, David
Strudwick, Edmund Charles Fox
Stuart, Elbridge Amos
Swain, David Lowry
Taylor, Hannis
Thompson, Jacob
Tiernan, rances Christine Fisher
Truett, George Washington
Turner, Josiah
Tyson, Lawrence Davis
Upchurch, John Jordan
Vance, Zebulon Baird
Waddel, Moses

Waddell, Alfred Moore
Waddell, James Iredell
Walker, David, 1785–1830
Warren, Lindsay Carter
Webb, William Robert
Weeks, Stephen Beauregard
Wheeler, John Hill
White, Hugh Lawson
White, James
White, Stephen Van Culen
Wilcox, Cadmus Marcellus
Wiley, Calvin Henderson
Williams, Jesse Lynch
Williams, John
Winslow, John Ancrum
Wolfe, Thomas Clayton
Worth, Jonathan
Yell, Archibald
Yergan, Max
Yount, George Concepcion

NORTH DAKOTA

Aandahl, Fred George
Amlie, Thomas Ryum
Durstine, Roy Sarles
Flannagan, John Bernard
Hunter, Croil
Langer, William
Still, Clyfford

OHIO

Abbey, Henry Eugene
Abel, John Jacob
Adams, William Lysander
Adkins, Homer Burton
Akeley, Mary Leonore
Aldrich, Louis
Alger, Russell Alexander
Allen, Frederic de Forest
Allen, Robert
Allen, William Vincent
Allison, William Boyd
Anderson, Sherwood
Andrews, Chauncey Hummason
Andrews, Lorin
Angell, Ernest
Angle, Paul McClelland
Archbold, John Dustin
Arquette, Clifford
Ashmore, William
Axtell, Samuel Beach
Bacher, Otto Henry
Bacon, Delia Salter
Bailey, Joseph
Baird, Samuel John
Baker, James Heaton
Baker, Oliver Edwin
Ball, Ephraim
Ball, Frank Clayton

Ball, George Alexander
Ballantine, Arthur Atwood
Bancroft, Hubert Howe
Bara, Theda
Barber, Ohio Columbus
Bartlett, Dewey Follett
Barus, Carl
Bauer, Louis Agricola
Beard, Daniel Carter
Beard, James Carter
Beard, Thomas Francis
Beard, William Holbrook
Beardshear, William Miller
Beatty, Clyde Raymond
Beatty, John
Beatty, William Henry
Beavers, Louise
Beck, Johann Heinrich
Bell, Bernard Iddings
Bell, James Madison
Bellows, George Wesley
Bender, George Harrison
Benedict, Stanley Rossiter
Bessey, Charles Edwin
Bettman, Alfred
Beveridge, Albert Jeremiah
Bevier, Isabel
Bickel, Luke Washington
Bickerdyke, Mary Ann Ball
Biddle, Horace P.
Bierce, Ambrose Gwinett
Biggers, Earl Derr
Bingham, Amelia
Binkley, Wilfred Ellsworth
Blum, Robert Frederick
Boardman, Mabel Thorp
Bohm, Max
Bolton, Frances Payne Bingham
Boole, Ella Alexander
Bosworth, rancke Huntington
Boyd, Thomas Alexander
Boyd, William
Bragdon, Claude Fayette
Brett, William Howard
Brice, Calvin Stewart
Brigham, Joseph Henry
Bromfield, Louis
Brooks, William Keith
Brooks, William Thomas Harbaugh
Brough, John
Brown, Carleton
Brown, Clarence James
Brown, Fayette
Brown, George Pliny
Brown, Henry Cordis
Brown, John Porter
Brown, Walter Folger
Brush, Charles Francis
Buchanan, William Insco
Buchtel, John Richards

Buckland, Ralph Pomeroy
Buell, Don Carlos
Burchfield, Charles Ephraim
Burnett, Henry Lawrence
Burns, Raymond Joseph
Burton, Ernest De Witt
Burton, Theodore Elijah
Bush, Prescott Sheldon
Bussey, Cyrus
Butterworth, Benjamin
Byford, William Heath
Callahan, Patrick Henry
Callender, Guy Stevens
Campbell, Lewis Davis
Campbell, William Wallace
Canaga, Alfre Bruce
Canfield, James Hulme
Carney, Thomas
Carpenter, Frank George
Carr, Charlotte Elizabeth
Carr, Wilbur John
Carter, Thomas Henry
Cary, Alice
Cary, Phoebe
Case, Leonard
Cass, George Washington
Catherwood, Mary Hartwell
Chaffee, Adna Romanza
Chamberlain, Charles Joseph
Chamberlain, Joseph Perkins
Chambers, James Julius
Chapin, Henry Dwight
Cherrington, Ernest Hurst
Chester, George Randolph
Christy, David
Christy, Howard Chandler
Cist, Henry Martyn
Clark, Bobby
Clark, Charles
Clarke, John Hessin
Clevenger, Shobal Vail
Cline, Genevieve Rose
Cockerill, John Albert
Coffin, Howard Earle
Coit, Stanton
Colver, William Byron
Commons, John Rogers
Compton, Arthur Holly
Compton, Karl Taylor
Conklin, Edwin Grant
Conover, Obadiah Milton
Cooke, Henry David
Cooke, Jay
Cooper, Elias Samuel
Cooper, Jacob
Cooper, Oswald Bruce
Corbin, Henry Clark
Cordier, Andrew Wellington
Coulter, Ernest Kent
Cowen, John Kissig

Cowles, Edwin
Cox, Georges Barnsdale
Cox, James Middleton
Cox, Kenyon
Cox, James Middleton, Jr.
Cox, Samuel Sullivan
Craig, Winchell McKendree
Crane, Harold Hart
Cranston, Earl
Crapsey, Algernon Sidney
Cratty, Mabel
Cravath, Paul Drennan
Creighton, Edward
Creighton, John Andrew
Crile, George Washington
Crissinger, Daniel Richard
Crocker, William
Crook, George
Crosby, William Otis
Crosley, Powel, Jr.
Crouse, Russel McKinley
Crozier, William
Curtis, William Eleroy
Cushing, Harvey Williams
Custer, George Armstrong
Dahlgren, Sarah Madeleine Vinton
Dandridge, Dorothy Jean
Daniels, Frank Albert
Daniels, Winthrop More
Darrow, Clarence Seward
Daugherty, Harry Micajah
Davis, Edwin Hamilton
Dawes, Charles Gates
Dawes, Rufus Cutler
Day, David Talbot
Day, James Gamble
Day, William Rufus
De Camp, Joseph Rodefer
Dellenbaugh, Fredrick Samuel
Dennison, William
Dickman, Joseph Theodore
Dill, Clarence Cleveland
Dinwiddie, Edwin Courtland
Dittemore, John Valentine
Doherty, Henry Latham
Dorsey, George Amos
Doyle, Alexander
Drake, John Burroughs
Du Bois, Augustus Jay
Dun, Robert Graham
Dunbar, Paul Laurence
Duncan, Donald Franklin
Dwenger, Joseph
Dwiggins, William Addison
Dyer, Rolla Eugene
Dykstra, Clarence Addison
Eaton, Benjamin Harrison
Eaton, Joseph Oriel
Eckart, William Roberts
Eckert, Thomas Thompson

Edison, Thomas Alva
Edwards, Clarence Ransom
Eichelberger, Robert Lawrence
Elkins, Stephen Benton
Elliott, Charles Burke
Ellis, Edward Sylvester
Ellis, John Washington
Ellis, Seth Hockett
Elwell, John Johnson
Emmett, Daniel Decatur
Enneking, John Joseph
Ernst, Harold Clarence
Ernst, Oswald Herbert
Evans, Bergen Baldwin
Evans, John
Evans, Lawrence Boyd
Ewing, Hugh Boyle
Ewing, Thomas
Fairbanks, Charles Warren
Fairchild, George Thompson
Fairchild, Lucius
Fairless, Benjamin F.
Faran, James John
Fenneman, Nevin Melancthon
Ferree, Clarence Errol
Fess, Simeon Davidson
Fieser, Louis Frederick
Finley, Martha Farquharson
Firestone, Harvey Samuel
Fisher, Alfred J.
Fisher, Charles T.
Fisher, Frederic John
Fleming, John Adam
Flickinger, Daniel Kumler
Foraker, Joseph Benson
Fordyce, John Addison
Fosdick, William Whiteman
Foster, Charles
Foster, Randolph Sinks
Fowler, Joseph Smith
Frank, Lawrence Kelso
Franklin, Benjamin
Freas, Thomas Bruce
French, Aaron
Frohman, Charles
Frohman, Daniel
Funk, Isaac Kauffman
Funston, Frederick
Furnas, Robert Wilkinson
Gable, (William) Clark
Gage, Frances Dan Barker
Galbreath, Charles Burleigh
Garey, Thomas Andrew
Garfield, Harry Augustus
Garfield, James Abram
Garfield, James Rudolph
Gavin, Frank Stanton Burns
Gideon, Peter Miller
Gilbert, Cass
Gilliam, David Tod

Gillmore, Quincy Adams
Gish, Dorothy
Glueck, Nelson
Goodrich, Alfred John
Goodwin, Eliiah
Gordon, John Franklin
Granger, Alfred Hoyt
Grant, Ulysses Simpson
Grasselli, Caesar Augustin
Gray, Elisha
Green, William
Greene, Charles Sumner
Greene, Henry Mather
Greer, James Augustin
Grey, Zane
Griffin, Charles
Grose, William
Gross, Samuel Weissell
Grosscup, Peter Stenger
Gunn, James Newton
Gunn, Ross
Gunsaulus, Frank Wakeley
Hall, Charles Martin
Halstead, Murat
Hammond, Percy Hunter
Hanby, Benjamin Russel
Handerson, Henry Ebenezer
Hanna, Marcus Alonzo
Hannegan, Edward Allen
Harding, Warren Gamaliel
Harkness, Edward Stephen
Harmon, Judson
Harper, Robert Francis
Harper, William Rainey
Harris, James Arthur
Harris, Merriman Colbert
Harris, William Logan
Harrison, Benjamin
Hart, Edwin Bret
Hart, Hastings Hornell
Haskell, Charles Nathaniel
Haskell, Henry Jospeh
Hatton, Frank
Hayden, Amos Sutton
Hayes, Charles Willard
Hayes, Max Sebastian
Hayes, Rutherfor Birchard
Hayes, William Henry
Hendricks, Thomas Andrews
Henri, Robert
Henry, William Arnon
Hepburn, William Peters
Herrick, Myron Timothy
Herrick, Sophia McIlvaine Bledsoe
Hickenlooper, Andrew
Hinsdale, Burke Aaron
Hitchcock, Frank Harris
Hitt, Robert Roberts
Hocking, William Ernest
Hodge, Albert Elmer ("Al")

Holloway, Joseph Flavius
Holmes, William Henry
Hooper, Claude Ernest
Hoover, Charles Franklin
Hoover, Herbert William
Hopwood, Avery
Horton, Samuel Dana
Howard, Roy Wilson
Howe, William Henry
Howells, William Dean
Hoyt, John Wesley
Hubbard, Frank McKinney
Hudson, Thomson Jay
Huggins, Miller James
Humiston, William Henry
Hunt, Reid
Hurley, Joseph Patrick
Hurst, Fannie
Hussey, William Joseph
Hyslop, James Hervey
Jackman, Wilbur Samuel
Janis, Elsie
Janney, Russell Dixon
Jay, Allen
Jefferson, Charles Edward
Jeffrey, Joseph Andrew
Jeffries, James Jackson
Johnson, Bushrod Rust
Johnson, Byron Bancroft
Johnson, Franklin
Johnson, George
Johnson, John Butler
Johnston, William Hartshorne
Jones, Lynds
Joyce, Isaac Wilson
Kalisch, Samuel
Keeler, Ralph Olmstead
Keifer, Joseph Warren
Kellor, Frances (Alice)
Kennan, George
Kennedy, Robert Patterson
Kennedy, William Sloane
Kenyon, William Squire
Kerr, John Glasgow
Kester, Paul
Kettering, Charles Franklin
Keyt, Alonzo Thrasher
King, Ernest Joseph
King, Henry
Kingsley, Elbridge
Kinkead, Edgar Benton
Kiplinger, Willard Monroe
Klippart, John Hancock
Knox, Rose Markward
Krapp, George Philip
Kroger, Bernhard Henry
Kronenberger, Louis, Jr.
Kruger, Otto
Kyes, Roger Martin
Kyle, David Braden

Kyle, James Henderson
Ladd, George Trumbull
Lamme, Benjamin Garver
Landis, Henry Robert Murray
Landis, Kenesaw Mountain
Lane, Levi Cooper
Lanston, Tolbert
Latham, Milton Slocum
Latta, Alexander Bonner
Laughlin, James Laurence
Lawrance, Uriah Marion
Lawrence, William, 1819–1899
Lawton, Henry Ware
Lazarus, Fred, Jr.
Leaming, Jacob Spicer
Leavitt, Frank McDowell
Le Duc, William Gates
Leonard, Harry Ward
Lewis, Alfred Henry
Lewis, Charles Bertrand
Liebman, Joshua Loth
Loeb, Louis
Loeb, Morris
Long, John Harper
Long, Perrin Hamilton
Longley, Alcander
Longworth, Nicholas, 1869–1931
Lord, Henry Curwen
Lowe, Ralph Phillips
Lower, William Edgar
Lowry, Hiram Harrison
Lydenberg, Harry Miller
Lytle, William Haines
McBride, (Francis) Scott
McCabe, Charles Cardwell
McClain, Emlin
McConnell, Francis John
McCook, Alexander McDowell
McCook, Anson George
McCook, Edward Moody
McCook, Henry Christopher
McCook, John James
MacCracken, Henry Mitchell
McCulloch, Oscar Carleton
McDill, James Wilson
McDonald, James Grover
MacDonald, James Wilson Alexander
McDonald, Joseph Ewing
McDougal, David Stockton
McDowell, Irvin
McDowell, Mary Eliza
McDowell, William Fraser
McElroy, Neil Hosler
MacGahan, Tanuarius Aloysius
McKinley, William
McPherson, James Birdseye
McPherson, Logan Grant
McVey, Frank Lerond
Main, John Hanson Thomas
Mallory, Frank Burr

Manatt, James Irving
Marquard, Richard William ("Rube")
Marquett, Turner Mastin
Marquis, Albert Nelson
Marvin, Charles Frederick
Mather, Samuel
Matthews, Stanley
Mauchly, John William
Mayo-Smith, Richmond
Meeker, Ezra
Meeker, Jotham
Meeker, Nathan Cook
Mees, Arthur
Mendenhall, Charles Elwood
Mendenhall, Thomas Corwin
Merrill, Stephen Mason
Miller, Dayton Clarence
Miller, Lewis
Miller, Willoughby Dayton
Millikin, Eugene Donald
Mitchell, Edwin Knox
Mitchell, Robert Byington
Moeller, Henry
Moley, Raymond Charles
Monroe, Vaughn Wilton
Montgomery, James
Moore, Clarence Lemuel Elisha
Moore, Eliakim Hastings
Moore, Joseph Haines
Moore, Richar Bishop
Moorehead, William Gallogly
Morgan, Arthur Ernest
Mullin, Willard Harlan
Munson, Thurman Lee
Murphy, Gardner
Mussey, Ellen Spencer
Nash, Henry Sylvester
Nettleton, Alvre Bayard
Nettleton, Edwin S.
Newbrough, John Ballou
Newell, Robert
Newell, William Augustus
Newsam, Albert
Newton, Robert Safford
Nichols, Dudley
Niehaus, Charles Henry
Noble, John Willock
Norris, George William
Norton, William Warder
Notestein, Wallace
Nugent, John Frost
Oalies, George Washington Ochs
Oakley, Annie
O'Daniel, Wilbert Lee ("Pappy")
O'Dwyer, Joseph
Ohlmacher, Albert Philip
Okey, John Waterman
Oldfietd, ("Barney")Berna Eli
Olds, Ransom Eli
Oliver, Charles Augustus

O'Neill, C. William ("Bill")
Opper, Frederick Burr
Osborn, Thomas Ogden
Otis, Harrison Gray
Outcault, Richard Felton
Packard, James Ward
Paine, Byron
Paine, Halbert Eleazer
Pardee, Don Albert
Parker, Isaac Charles
Parker, Samuel Chester
Parsons, Albert Ross
Patchen, Kenneth
Patrick, Hugh Talbot
Patterson, John Henry
Pattison, John M.
Payne, Oliver Hazard
Pease, Alfred Humphreys
Peet, Stephen Denison
Pendleton, George Hunt
Perkins, Charles Elliott
Perrine, Charles Dillon
Peter, Sarah Worthington King
Plumb, Preston B.
Poe, Orlando Metcalfe
Pomerene, Atlee
Porter, Stephen Geyer
Porter, William Townsend
Potts, Benjamin Franklin
Power, Tyrone
Pratt, Donn
Proctor, William Cooper
Pugh, George Ellis
Quantrill, William Clarke
Ralston, Samuel Moffett
Ralston, William Chapman
Ransohoff, Joseph
Rarey, John Solomon
Raymond, Rossiter Worthington
Read, Daniel, 1805–1878
Reed, James Alexander
Reed, Mary
Reeves, Arthur Middleton
Reid, James L.
Reid, Whitelaw
Resor, Stanley Burnet
Rhodes, James Ford
Rice, Felelon Bird
Richards, John Kelvey
Rickenbacker, Edward Vernon
 ("Eddie")
Rickert, Martha Edith
Ricketts, Howard Taylor
Rickey, Wesley Branch
Rigge, William Francis
Rigzs, Stephen Return
Riprey, Roswell Sabine
Ritchey, George Willis
Robinson, Edward Stevens
Rockefeller, John Davison, Jr.

Rogers, William Allen
Root, Amos Ives
Rorimer, James Joseph
Rose, Mary Davies Swartz
Rosecrans, Sylvester Horton
Rosecrans, William Starke
Rosenstiel, Lewis Solon
Ross, Alexander Coffman
Ross, Denman Waldo
Ross, Edmund Gibson
Rourke, Constance Mayfield
Roye, Edward James
Rusk, Jeremiah McClain
Sabine, Wallace Clement Ware
Safford, James Merrill
Safford, William Edwin
Sampson, Martin Wright
Sanders, James Harvey
Schenck, James Findlay
Schenck, Robert Cumming
Schevill, Rudolph
Schlesinger, Arthur Meier
Schuchert, Charles
Scott, Austin
Scott, Samuel Parsons
Scott, William Berryman
Scudder, John Milton
Seiberling, Frank Augustus
Seitz, Don Carlos
Severance, Louis Henry
Seymour, Thomas Day
Shabonee
Shannon, Wilson
Sharp, William Graves
Shauck, John Allen
Shaw, Albert
Sherman, John, 1823–1900
Sherman, William Tecumseh
Sherwood, Katharine Margaret
 Brownlee
Shields, George Oliver
Short, Sidney Howe
Shuey, Edwin Longstreet
Shuey, William John
Shull, George Harrison
Silverman, Joseph
Simms, Ruth Hanna McCormick
Simpson, Matthew
Sisler, George Harold ("Gorgeous
 George")
Skinner, Halcyon
Sloan, Richard Elihu
Sloane, William Milligan
Smalley, Eugene Virgil
Smith, Alfred Holland
Smith, Byron Caldwell
Smith, Henry Preserved
Smith, Joseph, 1832–1914
Smith, Preserved
Smith, William Sooy

Snider, Denton Jaques
Snow, Lorenzo
Spahr, Charles Barzillai
Sparks, Edwin Erle
Speaks, Oley
Spear, William Thomas
Sprague, Kate Chase
Stanley, David Sloane
Stanton, Edwin McMasters
Stearns, Frank Ballou
Stephenson, Nathaniel Wright
Stevens, William Arnold
Stewart, Donald Ogden
Stewart, Eliza Daniel
Stewart, Robert
Stockton, Charles G.
Stone, John Wesley
Storer, Bellamy
Stouffer, Vernon Bigelow
Stratemeyer, George Edward
Strauss, Joseph Baermann
Strobel, Charles Louis
Strong, William Lafayette
Stuhldreher, Harry A.
Stutz, Harry Clayton
Sullivant, William Starling
Swayne, Wager
Sweeney, Martin Leonard
Swing, David
Taft, Charles Phelps
Taft, Henry Waters
Taft, Robert Alphonso
Taft, William Howard
Talbott, Harold Elstner
Tappan, Eli Todd
Tatum, Art
Taylor, Archibald Alexander Edward
Tecumseh
Tenskwatawa
Thatcher, Roscoe Wilfred
Thilly, Frank
Thoburn, Isabella
Thoburn, James Mills
Thomas, Edith Matilda
Thomas, Norman Mattoon
Thomas, Roland Jay
Thompson, David P.
Thompson, William Oxley
Thompson, William Tappan
Thomson, William McClure
Thurber, James Grover
Thurston, Howard
Tibbles, Thomas Henry
Tittle, Ernest Fremont
Tod, David
Todd, Walter Edmond Clyde
Torrence, Frederick Ridgely
Tourgée, Albion Winezar
Townsend, Willard Saxby, Jr.
Twachtman, John Henry

Tyler, George Crouse
Tytus, John Butler
Ulrich, Edward Oscar
Updegraff, Davi Brainard
Vail, Theodore Newton
Vallandigham, Clement Laird
Van Anda, Garr Vattel
Van Deman, Ester Boise
Van Sweringen, Mantis James
Venable, William Henry
Verity, George Matthew
Vickery, Howard Leroy
Victor, Orville James
Voorhees, Daniel Wolsey
Wade, Decius Spear
Wade, Jeptha Homer
Waite, Henry Matson
Wald, Lillian D.
Walden, John Morgan
Wales, James Albert
Walker, Thomas Barlow
Walter, Eugene
Wambaugh, Sarah
Wanamaker, Reuben Melville
Ward, Charles Alfred
Ward, John Quincy Adams
Weaver, James Baird
Weber, Henry Adam
Weed, Lewis Hill
Weeks, John Elmer
Weitzel, Godfrey
Welch, John
Weller, John B.
Wellman, Walter
Wheeler, Wayne Bidwell
White, Emerson Elbridge
White Eyes
Whitehead, Wilbur Cherrier
Whitlock, Brand
Whittredge, Worthington
Widney, Joseph Pomeroy
Wilder, Russell Morse
Wildman, Murray Shipley
Williams, Charles David
Williams, Edward Thomas
Williams, Harrison Charles
Williams, James Douglas
Williams, John Elias
Williams, John Fletcher
Williams, Marshall Jay
Wilson, Charles Erwin
Wilson, James Falconer
Wilson, Samuel Mountford
Wilson, Samuel Ramsay
Windom, William
Wolfson, Erwin Service
Woodhull, Victoria Claflin
Woods, Charles Robert
Woods, William Burnham
Woolley, Celia Parker

Woolley, John Granville
Woolsey, Sarah Chauncy
Worcester, Elwood
Wright, Hamilton Kemp
Wright, James Arlington
Wright, Orville
Wright, William
Wyant, Alexander Helwig
Young, Allyn Abbott
Young, Clark Montgomery
Young, Denton True ("Cy")
Young, John Wesley
Zahm, John Augustine
Zollars, Ely Vaughan

OKLAHOMA

Armstrong, Frank C.
Bayh, Marvella Belle Hern
Berryman, John
Billingsley, John Sherman
Chaney, Lon, Jr.
Clark, Joseph James ("Jocko")
Dunn, Michael
Francis, Kay
Guthrie, Woody
Hamilton, Maxwell McGaughey
Harris, LeRoy Ellsworth ("Roy")
Hastings, William Wirt
Heflen, Van
Hurley, Patrick Jay
Jansky, Karl Guthe
Jones, William
Kerr, Robert Samuel
Kirkwood, John Gamble
Martin, Johnny Leonard Roosevelt
　("Pepper")
Monroney, Almer Stillwell ("Mike")
Owen, Stephen Joseph
Posey, Alexander Lawrence
Robertson, Alice Mary
Rogers, Will
Rushing, James Andrew
Stigler, William Grady
Thorpe, James Francis
Waner, Paul Glee

OREGON

Barbey, Daniel Edward
Bates, Blanche
Cromwell, Dean Bartlett
Cunningham, Imogen
Davenport, Homer Calvin
Gaston, Herbert Earle
Gilbert, Alfred Carlton
Hawley, Willis Chatman
Joseph
Kanaga, Consuelo Delesseps
Keeney, Barnaby Conrad
Latourette, Kenneth Scott

MacDonald, Ranald
McGinley, Phyllis
McIntire, Ross
McKay, (James) Douglas
McNary, Charles Linza
Markham, Edwin
Neuberger, Richard Lewis
Pettengill, Samuel Barrett
Poling, Daniel Alfred
Prefontaine, Steve Roland ("Pre")
Reed, John, 1887–1920
Robinson, Claude Everett
Turner, Richmond Kelly

PENNSYLVANIA

Abbett, Leon
Abbey, Edwin Austin
Abbott, Benjamin
Abernethy, Roy
Acheson, Edward Goodrich
Adams, Randolph Greenfield
Adams, Robert
Addicks, John Edward O'Sullivan
Adlum, John
Agnew, David Hayes
Albright, Jacob
Alcott, Louisa May
Alexander, John White
Alexander, Joseph Addison
Allen, Andrew
Allen, Harrison
Allen, Henry Justin
Allen, Hervey
Allen, Richard
Allen, William
Allibone, Samuel Austin
Alter, David
Anderson, John Alexander
Anderson, Joseph
Anderson, Maxwell
Angela, Mother
Appenzeller, Henry Gerhard
Apple, Thomas Gilmore
Arbuckle, John
Arensberg, Walter Conrad
Armstrong, John
Arnold, Henry Harley
Asch, Morris Joseph
Ashburner, Charles Albert
Ashhurst, John
Ashley, James Mitchell
Ashmead, Isaac
Ashmead, William Harris
Atkinson, William Biddle
Atkinson, Wilmer
Atlee, John Light
Atlee, Washington Lemuel
Awl, William Maclay
Bache, Alexander Dallas
Bache, Benjamin Franklin

Bache, Franklin
Baer, George Frederick
Bailey, Francis
Bailey, Frank Harvey
Bailey, Lydia R.
Baird, Absalom
Bairds Henry Carey
Baird, Henry Martyn
Baird, Robert
Baird, Spencer Fullerton
Baldwin, Joseph
Baldwin, William
Bard, Samuel
Bard, William
Barker, James Nelson
Barker, Wharton
Barnard, George Grey
Barnes, Albert Coombs
Barnes, Joseph K.
Barnum, Zenus
Barrymore, Ethel
Barrymore, Georgiana Emma Drew
Barrymore, John
Barrymore, Lionel
Bartlett, William Holmes Chambers
Bartley, Mordecai
Barton, Benjamin Smith
Barton, John Rhea
Barton, Thomas Pennant
Barton, William Paul Crillon
Bartram, John
Bartram, William
Baugher, Henry Louis
Bausman, Benjamin
Bayard, Samuel
Baziotes, William
Bean, Tarleton Hoffnan
Beasley, Mercer
Beatty, John
Beaumont, John Colt
Beaux, Cecilia
Beaver, James Addams
Beck, James Montgomery
Bedford, Gunning
Bedinger, George Michael
Bell, De Benneville ("Bert")
Bell, James Ford
Bell, James Stroud
Benbridge, Henry
Benner, Philip
Bennett, Caleb Prew
Berger, Daniel
Berkowitz, Henry
Berwind, Edward Julius
Biddle, Anthony Joseph Drexel, Jr.
Biddle, Clement
Biddle, George
Biddle, James
Biddle, Nicholas, 1750–1778
Biddle, Nicholas, 1786–1844

Bigler, John
Bigler, William
Bingham, Anne Willing
Bingham, John Armor
Bingham, William
Binkley, Robert Cedric
Binney, Horace
Bird, Frederic Mayer
Bisphan, David Scull
Black, James
Black, Jeremiah Sullivan
Black, William Murray
Blaine, James Gillespie
Blake, Francis Gilman
Bliss, Philip Paul
Bliss, Tasker Howard
Blitzstein, Marc
Boehm, Henry
Boker, George Henry
Boller, Alfred Pancoast
Bomberger, John Henry Augustus
Boone, Daniel
Booth, James Curtis
Boreman, Arthur Ingram
Borie, Adolph Edward
Borie, Adolphe
Boring, Edwin Garrigues
Boudinot, Elias
Bourke, John Gregory
Bowen, Catherine Drinker
Bowers, Theodore Shelton
Bowman, Thomas
Boyd, James
Brackenridge, Henry Marie
Bradford, William
Brady, Cyrus Townsend
Brashear, John Alfred
Breck, James Lloyd
Breen, Joseph Ignatius
Breese, Kidder Randolph
Brennan, Francis James
Brereton, Lewis Hyde
Brewster, Frederick Carroll
Bridges, Robert
Bright, James Wilson
Brinton, Daniel Garrison
Brinton, John Hill
Brodhead, John Romeyn
Brooke, John Rutter
Brown, Charles Brockden
Brown, David Paul
Brown, Jacob Jennings
Brown, William Henry
Brown, William Hughey
Buchanan, James
Buchman, Frank Nathan Daniel
Buckalew, Charles Rollin
Bucknell, William
Buehler, Huber Gray
Bullard, William Hannum Grubb

Bullitt, William Christian
Burdette, Robert Jones
Burleigh, Henry Thacker
Burnett, Charles Henry
Burpee, David
Burrell, David James
Burrowes, Thomas Henry
Burrows, Julius Caesar
Burrows, William
Burson, William Worth
Butler, Smedley Darlington
Buttz, Henry Anson
Byerly, William Elwood
Cadman, Charles Wakefield
Cadwalader, John, 1742–1786
Cadwalader, John, 1805–1879
Cadwalader, Thomas
Calder, Alexander
Calder, Alexander Stirling
Caldwell, Alexander
Caldwell, David
Calhoun, William James
Cameron, James Donald
Cameron, Simon
Campbell, Bartley
Campbell, James
Campbell, James Hepburn
Carey, Henry Charles
Carnahan, James
Carpenter, Cyrus Clay
Carpenter, Walter Samuel, Jr.
Carr, John Dickson
Carrick, Samuel
Carroll, Earl
Carroll, William
Carson, Hampton Lawrence
Carson, John Renshaw
Carson, Joseph
Carson, Rachel Louise
Carter, John
Case, Leonard
Cassatt, Alexander Johnston
Cassatt, Mary
Cassin, John
Catlin, George
Catron, John
Cattell, James McKeen
Chambers, George
Chambers, Talbot Wilson
Chambers, Whittaker
Chanfrau, Henriett Baker
Chapman, Henry Cadwalader
Chauvenet, William
Cheyney, Edward Potts
Childs, Cephas Grier
Chorpenning, George
Christy, Edwin P.
Cist, Charles
Cist, Jacob
Clark, Walter Leighton

Clark, William Andrews
Clarke, Helen Archibald
Clarke, Thomas Shields
Clay, Albert Thomas
Clay, Edward Williams
Clayton, Powell
Clement, Martin Withington
Clemson, Thomas Green
Cliffton, William
Clothier, William Jackson
Clymer, George
Clymer, George E.
Coates, Florence Earle
Coates, Samuel
Cochran, John
Cochrane, Henry Clay
Coffin, William Anderson
Coggeshall, William Turner
Coleman, Leighton
Collins, Napoleon
Connelly, Cornelia
Connelly, Marcus Cook ("Marc")
Conner, David
Connick, Charles Jay
Connolly, John
Conrad, Frank
Conrad, Robert Taylor
Converse, James Booth
Cook, Martha Elizabeth Duncan
 Walker
Cook, Robert Johnson
Cooke, Morris Llewellyn
Coombe, Thomas
Cooper, William
Cope, Caleb
Cope, Edward Drinker
Cope, Thomas Pym
Cope, Walter
Corbin, Margaret
Corey, William Ellis
Coriat, Isador Henry
Cornstalk
Corse, John Murray
Corson, Hiram
Corson, Robert Rodgers
Cort, Stewart Shaw
Cowan, Edgar
Cox, Hannah Peirce
Cox, Rowland
Coxe, Eckley Brinton
Coxe, Tench
Coxe, William
Coxey, Jacob Sechler
Craig, Thomas
Cramp, Charles Henry
Cramp, William
Crawford, James Pyle Wickersham
Crawford, John Martin
Cresson, Elliott
Cresson, Ezra Townsend

Crooks, George Richard
Crosby, Peirce
Crozer, John Price
Crumbine, Samuel Jay
Cullinan, Joseph Stephen
Cummins, Albert Baird
Cupples, Samuel
Curran, John Joseph
Curry, George Law
Curtin, Andrew Gregg
Cushing, Frank Hamilton
Cutbush, James
Dahlgren, John Adolphus Bernard
Daley, Cass
Dallas, George Mifflin
Darby, William
Darke, William
Darley, Felix Octavius Carr
Darling, Henry
Darlington, William
Davenport, Russell Wheeler
Davidson, William Lee
Davis, Bernard George
Davis, Ernest R. ("Ernie")
Davis, John Wesley
Davis, Noah Knowles
Davis, Rebecca Blaine Harding
Davis, Richard Harding
Davis, Stuart
Davis, William Morris
Davison, Henry Pomeroy
Day, David Alexander
Day, Frank Miles
Deaver, John Blair
De Haren, Edwin Jesse
Deitzler, George Washington
Del Ruth, Roy
Deland, Margaret
Demuth, Charles
Dercum, Francis Xavier
Desha, Joseph
Devers, Jacob Loucks
Dewees, William Potts
Dick, Elisha Cullen
Dickinson, Anna Elizabeth
Diller, Joseph Silas
Dilworth, Richardson
Dock, Lavinia Lloyd
Dodd, Lee Wilson
Dodd, Samuel Calvin Tate
Doddridge, Joseph
Doddridge, Philip
Dolan, Thomas
Donnelly, Eleanor Cecilia
Donnelly, Ignatius
Dorsey, John Syng
Dorsey, Thomas Francis ("Tommy")
Dos Passos, John Randolph
Dougherty, Dennis Joseph
Dougherty, Raymond Philip

Doughty, Thomas
Downey, John
Drew, John
Drexel, Anthony Joseph
Drexel, Joseph William
Drexel, Katharine Mary
Drinker, Cecil Kent
Driscoll, Alfred Eastlack
Dropsie, Moses Aaron
Drown, Thomas Messinger
Duane, William
Dubbs, Joseph Henry
Du Bois, William Ewing
Duff, James Henderson
Duffield, George, 1732–1790
Duffield, George, 1794–1868
Dunlop, James
Dunwoody, William Hood
Durant, Thomas Jefferson
Durham, Caleb Wheeler
Dye, William McEntyre
Eakins, Thomas
Earle, George Howard, III
Eckels, James Herron
Eddy, Thomas
Edge, Walter Evans
Edwards, Richard Stanislaus
Egan, Maurice Francis
Egle, William Henry
Eichholtz, Jacob
Eisenhart, Luther Pfahler
Elder, William
Ellet, Charles
Ellicott, Andrew
Ellicott, Joseph
Ellicott, Washington Lafayette
Ellmaker, (Emmett) Lee
Elman, Harry ("Ziggy")
English, Thomas Dunn
Espy, James Pollard
Eustis, Dorothy Leib Harrison Wood
Evans, Henry Clay
Evans, Lewis
Evans, Nathaniel
Evans, Thomas
Evans, Thomas Wiltberger
Eve, Joseph
Ewing, James, 1736–1806
Ewing, James, 1866–1943
Ewing, James Caruthers Rhea
Eytinge, Rose
Fahnestock, Harris Charles
Fairlamb, James Remington
Falk, Maurice
Farabee, William Curtis
Farquhar, Percival
Faulk, Andrew Jackson
Ferguson, Elizabeth Graeme
Ferrel, William
Ferris, Jean Léon Gérôme

Ffoulke, Charles Mather
Fielding, Jerry
Fields, William Claude
Filson, John
Findlay, James
Fine, Henry Burchard
Fine, John Sydney
Fine, Larry
Finletter, Thomas Knight
Fischer, Louis
Fisher, Clarence Stanley
Fisher, Daniel Webster
Fisher, Frederick Bohn
Fisher, Hammond Edward
Fisher, Joshua Francis
Fisher, Sidney George
Fisher, Sydney George
Fite, Warner
Fitler, Edwin Henry
Flather, John Joseph
Fleisher, Benjamin Wilfrid
Fleming, John
Fletcher, Henry Prather
Flick, Lawrence Francis
Florence, Thomas Birch
Fogarty, Anne Whitney
Folwell, Samuel
Foote, John Ambrose
Force, Juliana Rieser
Ford, Thomas
Forepaugh, Adam
Forney, John Wien
Forney, Matthias Nace
Forrest, Edwin
Forten, James
Foster, Stephen Collins
Foster, Thomas Jefferson
Foulk, George Clayton
Fox, Jacob Nelson ("Nellie")
Fraley, Frederick
Francis, John Brown
Franklin, William
Franklin, William Buel
Frayne, Hugh
Frazer, John Fries
Frazer, Persifor, 1736–1792
Frazer, Persifor, 1844–1909
Frazier, Charles Harrison
Frear, William
Freed, Alan J.
French, Paul Comly
Frick, Henry Clay
Fries, John
Fritz, John
Frost, Arthur Burdett
Fry, William Henry
Fulton, Robert
Furness, Horace Howard, 1732–1790
Furness, Horace Howard, 1794–1868
Furst, Clyde Bowman

Fussell, Bartholomew
Gabb, William More
Gallagher, William Davis
Gallaudet, Thomas Hopkins
Galloway, Samuel
Garman, Samuel
Garner, Erroll Louis
Garrett, Thomas
Gass, Patrick
Gates, Thomas Sovereign
Gayley, James
Geary, John White
Geddes, James
George, Henry
Gerhard, William Wood
Gerhart, Emanuel Vogel
Gibbon, John
Gibbons, Abigail Hopper
Gibbons, William
Gibson, George
Gibson, John
Gibson, John Bannister
Giddings, Joshua Reed
Gihon, Albert Leary
Gilder, William Henry
Gilpin, William
Girty, Simon
Gitt, Josiah Williams ("Jess")
Glackens, William James
Gladden, Washington
Glynn, James
Gobrecht, Christian
Godfrey, Thomas, 1704–1749
Godfrey, Thomas, 1736–1763
Goebel, William
Good, Adolphus Clemens
Good, James Isaac
Good, Jeremiah Haak
Goodman, Charles
Goodyear, Charles
Gordon, Kermit
Gordon, Laura De Force
Gorgas, Josiah
Gostelowe, Jonathan
Goucher, John Franklin
Gouge, William M.
Gowen, Franklin Benjamin
Graff, Frederic
Graff, Frederick
Grafly, Charles
Graham, George Rex
Graham, Joseph
Grant, William Thomas, Jr.
Gratz, Rebecca
Gray, Isaac Pusey
Gray, John Purdue
Graydon, Alexander
Green, Jacob
Green, William Joseph, Jr.
Greener, Richard Theodore

Gregg, Andrew
Gregg, David McMurtrie
Gregory, Casper Rene
Gregory, Thomas Barger
Grier, Robert Cooper
Grierson, Benjamin Henry
Griffin, Martin Ignatius Joseph
Griffis, William Elliot
Griscom, Clement Acton
Gross, Samuel David
Guffey, James McClurg
Guffey, Joseph F.
Guggenheim, Daniel
Guggenheim, Simon
Guggenheim, Solomon Robert
Guilday, Peter Keenan
Gummere, John
Guthrie, George Wilkins
Hagner, Peter
Haid, Leo
Haldeman, Samuel Steman
Haldeman-Julius, Emanuel
Hale, Charles Reuben
Hall, Baynard Rush
Hall, James, 1744–1826
Hall, James, 1793–1868
Hall, John Elihu
Hall, Sarah Ewing
Hall, Thomas
Hallowell, Benjamin
Hallowell, Richard Price
Hamer, Thomas Lyon
Hamilton, Peter
Hammer, William Joseph
Hancock, Winfield Scott
Happer, Andrew Patton
Harbaugh, Henry
Hardin, Ben
Hardin, Martin D.
Harding, George
Harding, Jesper
Harding, William White
Hare, George Emlen
Hare, John Innes Clark
Hare, Robert
Haring, Clarence
Harkins, William Draper
Harlan, Josiah
Harlan, Richard
Harmar, Josiah
Harpster, John Henry
Harrah, Charles Jefferson
Harris, George Washington
Harris, John
Harrison, Charles Custis
Harrison, Gabriel
Harrison, John
Harrison, Joseph
Harrison, Lovell Birge
Harrison, Ross Granville

Harrison, Thomas Alexander
Harrod, James
Harshberger, John William
Hart, Abraham
Hart, Albert Bushnell
Hart, Charles Henry
Hart, Edward
Hart, Philip Aloysius
Hartley, Thomas
Hartranft, Chester David
Hartranft, John Frederick
Hartshorne, Henry
Haseltine, James Henry
Haskins, Charles Homer
Haupt, Herman
Haverly, Christopher
Hay, Charles Augustus
Hayden, William
Hayes, Isaac Israel
Hayes, John William
Hays, Alexander
Hays, Isaac
Hazard, Ebenezer
Hazard, Samuel
Heap, Samuel Davies
Heath, Thomas Kurton
Heintzelman, Samuel Peter
Heinz, Henry John
Helmuth, William Tod
Hemphill, Joseph
Hench, Philip Showalter
Henck, John Benjamin
Hendricks, William
Henrici, Arthur Trautwein
Henry, Andrew
Henry, William
Hepburn, James Curtis
Hergesheimer, Joseph
Hering, Carl
Hering, Rudolph
Herr, John
Herron, Francis Jay
Hershey, Milton Snavely
Hicks, John, 1823–1890
Hiester, Daniel
Hiester, Joseph
Hill, George Washington
Hillegas, Michael
Hillis, David
Himes, Charles Francis
Hires, Charles Elmer, Jr.
Hirst, Barton Cooke
Hirst, Henry Beck
Hise, Elijah
Hittell, John Shertzer
Hittell, Theodore Henry
Hobart, John Henry
Hodge, Charles
Hodge, Hugh Lenox
Hoffman, Clare Eugene

Hogan, John Vincent Lawless
Holliday, Cyrus Kurtz
Holls, George Frederick William
Holmes, David
Holmes, John Haynes
Homer, Louise Dilworth Beatty
Hood, James Walker
Hood, Washington
Hooper, Lucy Hamilton
Hoover, James Matthews
Hopkins, Edward Augustus
Hopkinson, Francis
Hopkinson, Joseph
Hopper, Hedda
Horn, Edward Traill
Horn, George Henry
Horsfield, Thomas
Hoshour, Samuel Klinefelter
Hough, Charles Merrill
Houston, Henry Howard
Howe, Frederic Clemson
Hoyt, Henry Martyn
Hughes, Hector James
Huidekoper, Frederic
Hullihen, Simon P.
Humphreys, Andrew Atkinson
Humphreys, James
Humphreys, Joshua
Humphries, George Rolfe
Huneker, James Gibbons
Hunt, Robert Woolston
Hunter, Andrew
Hussey, Curtis Grubb
Huston, Charles
Hutchinson, James
Ickes, Harold Le Clair
Ingersoll, Charles Jared
Ingersoll, Edward
Ingham, Samuel Delucenna
Ingraham, Edward Duffield
Irvine, James
Irvine, William Mann
Jackson, Abraham Reeves
Jackson, Chevalier
Jackson, David
Jackson, Dugald Caleb
Jackson, Edward
Jackson, Robert Houghwout
Jackson, Samuel
Jacobs, Henry Eyster
Jacobs, Michael
Jadwin, Edgar
Jaggar, Thomas Augustus, Jr.
James Arthur Horace
James, Thomas Chalkley
James, Thomas Potts
Jameson, Horatio Gates
Janvier, Catharine Ann
Janvier, Thomas Allibone
Jarvis, Charles H.

Jayne, Horace Fort
Jeanes, Anna T.
Jeffers, John Robinson
Jefferson, Joseph
Jenkins, Howard Malcolm
Jennings, John
Jessup, Henry Harris
Johnson, John Graver
Johnston, David Claypoole
Johnston, William Andrew
Jones, Benjamin Franklin
Jones, George
Jones, Jehu Glancy
Jones, John Price
Jones, William
Jones, William Patterson
Jones, William Richard
Jordon, John Woolf
Junkin, George
Kagan, Henry Enoch
Kane, Elisha Kent
Kane, Thomas Leiper
Kauffman, Calvin Henry
Kaufman, George S.
Kay, Edgar Boyd
Keagy, John Miller
Keating, John Maric
Keely, John Ernst Worrell
Keen, Morris Longstreth
Keen, William Williams
Keller, Kaufman Thuma
Kelley, lorence
Kelley, William Darrah
Kelly, Aloysius Oliver Joseph
Kelly, George Edward
Kelly, John Brendan
Kelly, Walter ("Walt") Crawford, Jr.
Kelly, William
Kelton, John Cunningham
Kemmerer, Edwin Walter
Kennedy, Joseph Camp Griffith
Kent, William
Kephart, Ezekial Boring
Kephart, Isaiah La Fayette
Kephart, John William
Kier, Samuel M.
King, Samuel Archer
Kintner, Robert Edmonds
Kirby, Allan Price
Kirk, Alan Goodrich
Kirkbride, Thomas Story
Kirkus, Virginia
Kirlin, Joseph Louis terome
Klauder, Charles Zeller
Kline, Frans Josef
Kneass, Samuel Honeyman
Kneass, Strickland
Kneass, William
Knight, Daniel Ridgway
Knight, Jonathan

Knox, Philander Chase
Kohler, Elmer Peter
Kraemer, Henry
Krause, Allen Kramer
Krauth, Charles Philip
Kresge, Sebastian Spering
Kress, Samuel Henry
Kuhn, Adam
Kumler, Henry
Kurtz, Benjamin
Kynett, Alpha Jefferson
Lacey, John
Lacy, Ernest
Lambdin, James Reid
Lambert, Louis Aloisius
Lamberton, Benjamin Jeffer
Lambing, Andrew Arnold
Landis, Walter Savage
Lane, William Carr
Langstroth, Lorenzo Lorraine
Lardner, James Lawrence
La Roche, Rene
Latrobe, Benjamin Henry, 1806–1878
Latrobe, John Hazlehurst Boneval
Lawrence, David
Lawrence, David Leo
Lea, Henry Charles
Lea, Mathew Carey
Lease, Mary Elizabeth Clyens
Le Brun, Napoléon Eugène Henry
 Charles
Leffler, Isaac
Leffler, Shepherd
Leffmann, Henry
Leib, Michael
Leidy, Joseph
Leishman, John G.A.
Leland, Charles Godfrey
Le Moyne, Francis Julius
Lenker, John Nicholas
Leonard, Zenas
Lesley, Peter
Leslie, Eliza
Letterman, Jonathan
Levant, Oscar
Levy, Uriah Phillips
Lewis, Charlton Thomas
Lewis, Edmund Darch
Lewis, Ellis
Lewis, Enoch
Lewis, Isaac Newton
Lewis, Lawrence
Lewis, Wilfred
Lewis, William
Lewis, William Draper
Lick, James
Liggett, Hunter
Lightburn, Joseph Andrew Jackson
Linderman, Henry Richard
Lindley, Daniel

Lindley, Jacob
Linn, John Blair
Linton, Ralph
Lippard, George
Lippincott, James Starr
Lippincott, Joseph Wharton
Little, Charles Joseph
Liveright, Horace Brisbin
Lochman, John George
Locke, Alain Leroy
Locke, Matthew
Lockrey, Sarah Hunt
Logan, Deborah Norris
Logan, George
Logan, James, c. 1725–1780
Long, John Luther
Longacre, James Barton
Love, Alfred Henry
Loy, Matthias
Loyd, Samuel
Lucas, James H.
Luce, Henry Winters
Lukens, Rebecca Webb Pennock
Luks, George Benjamin
Lutz, Frank Eugene
Lybrand, William Mitchell
Lyon, James Benjamin
Macalester, Charles, 1798–1873
MacArthur, Charles Gordon
MacArthur, John Donald
McBride, Henry
McCall, Samuel Walker
McCann, Alfred Watterson
McCartee, Divie Bethune
McCarthy, Daniel Joseph
McCarthy, Joseph Vincent ("Joe")
McCartney, Washington
McCauley, Charles Stewart
MacCauley, Clay
McCauley, Edward Yorke
McCawley, Charles Grymes
McCay, Charles Francis
McCay, Henry Kent
McClellan, George, 1849–1913
McClellan, George Brinton
McClellan, Henry Brainerd
McClellan, Robert
McClelland, Robert
McClintock, Emory
McClintock, John
McClintock, Oliver
McClure, Alexander Kelly
McClurg, Alexander Caldwell
McCormick, Samuel Black
McCoy, Isaac
McCracken, Joan
McCreery, James Work
MacDonald, David John
MacDonald, Jeanette Anna
McDowell, John

McElrath, Thomas
McFadden, Louis Thomas
McFarland, John Horace
McFarland, Samuel Gamble
McFarland, Thomas Bard
Macfarlane, Charles William
McGiffin, Philo Norton
McGill, John
McGranery, James Patrick
McGready, James
McGuffey, William Holmes
McKean, Samuel
McKean, Thomas
McKean, William Wister
McKechnie, William Boyd
McKenna, Joseph
Mackenzie, William
McKim, Charles Follen
McKim, Isaac
McKim, James Miller
McKinley, Albert Edward
McLane, Allan
Maclay, Robert Samuel
Maclay, Samuel
Maclay, William
McLean, Robert
McLean, William Lippard
McMinn, Joseph
McNair, Alexander
McNair, Frederick Valette
MacNair, Harley Farnsworth
McPherson, Edward
McQuillen, John Hugh
MacVeagh, Charles
MacVeagh, Franklin
MacVeagh, Isaac Wayne
Madden, John Edward
Magee, Christopher Lyman
Magill, Edward Hicks
Mailly, William
Malcolm, James Peller
Malcom, Howard
Mallery, Garrick
Man Ray
Manderson, Charles Frederick
Mansfield, Jayne
March, Francis Andrew
March, Peyton Conway
Marchand, John Bonnett
Marland, Ernest Whitworth
Marquis, John Abner
Marshall, Clara
Marshall, George Catlett, Jr.
Marshall, Humphry
Martin, Elizabeth Price
Martin, John Alexander
Martin, John Hill
Mast, Phineas Price
Mateer, Calvin Wilson
Mathews, John Alexander

Mathewson, Christopher
Matthews, Joseph Merritt
Maurer, James Hudson
Mayer, Lewis
Mead, Margaret
Meade, George
Meade, Richard Worsam
Mears, John William
Mease, James
Medary, Milton Bennett
Medary, Samuel
Meigs, Arthur Vincent
Meigs, James Aitken
Meigs, John
Meigs, John Forsyth
Meigs, William Montgomery
Mellon, Andrew William
Mellon, William Larimer
Menjou, Adolphe Jean
Menoher, Charles Thomas
Mercer, Henry Chapman
Mercer, Lewis Pyle
Mercur, Ulysses
Meredith, Samuel
Meredith, William Morris
Merritt, Anna Lea
Mervine, William
Messersmith, George Strausser
Metcalf, Joel Hastings
Metcalf, William
Michener, Ezra
Michler, Nathaniel
Middleton, Thomas Cooke
Midgley, Thomas
Mifflin, Lloyd
Mifflin, Thomas
Milburn, William Henry
Miller, George
Miller, George Abram
Miller, James Russell
Miller, Samuel
Milligan, Robert Wiley
Mills, Charles Karsner
Mitchell, John Hipple
Mitchell, Langdon Elwyn
Mitchell, Silas Weir
Mitchell, Thomas Duche
Mix, Tom
Montgomery, James Alan
Moore, Annie Aubertine Woodward
Moore, George Foot
Moore, James Edward
Moore, Joseph Earle
Moore, William, 1699–1783
Moore, William, 1735–1793
Moorhead, James Kennedy
Moran, Benjamin
Morgan, George
Morgan, George Washington
Morgan, John

Morley, Christopher Darlington
Morley, Sylvanus Griswold
Morris, Anthony, 1766–1860
Morris, Cadwalader
Morris, Caspar
Morris, Edward Joy
Morris, George Pope
Morris, John Gottlieb
Morris, Thomas
Morrison, John Irwin
Morrison, William
Morrow, Jeremiah
Morton, James St. Clair
Morton, John
Morton, Samuel George
Moss, John Calvin
Muhlenberg, Frederick Augustus
Mühlenberg, Frederick Augustus
　　Conrad
Mühlenberg, Gotthilf Henry Ernest
Mühlenberg, Henry Augustus Philip
Mühlenberg, John Peter Gabriel
Mühlenberg, William Augustus
Mulford, Elisha
Murdock, James Edward
Murphy, Dominic Ignatius
Murphy, Isaac
Murray, John, 1737–1808
Murray, Lindley
Murray, Louise Shipman Welles
Murtaugh, Daniel Edward ("Danny")
Musmanno, Michael Angelo
Nancrède, Charles Beylard Guérard
　　de
Nassau, Robert Hamill
Neely, Thomas Benjamin
Negley, James Scott
Neill, Edward Duffield
Neill, John
Neill, Thomas Hewson
Neill, William
Neilson, William George
Nesbit, Evelyn Florence
Nevin, Alfred
Nevin, Edwin Henry
Nevin, Ethelbert Woodbridge
Nevin, George Balch
Nevin, John Williamson
Nevin, Robert Peebles
Newcomer, Christian
Newell, Frederick Haynes
Newton, Henry Jotham
Newton, Richard Heber
Newton, William Wilberforce
Niles, Hezekiah
Nixon, John, 1733–1900
Noah, Mordecai Manuel
Nock, Albert Jay
Nolen, John
Norris, George Washington

Norris, Isaac, 1701–1766
Norris, William Fisher
Noss, Theodore Bland
Oberholtzer, Ellis Paxson
Oberholtzer, Sara Louisa Vickers
Odenheimer, William Henry
Odets, Clifford
Oehmler, Leo Carl Martin
Offley, David
Ogden, Robert Curtis
O'Hara, John Henry
Olds, Irving Sands
Olmsted, Marlin Edgar
O'Malley, Frank Ward
O'Neill, Rose Cecil
Ord, George
O'Reilly, Robert Maitland
Ortle, Godlove Stein
Osborn, Henry Stafford
Osborn, Thomas Andrew
Ott, Isaac
Otto, William Tod
Outerbridge, Alexander Ewing
Outerbridge, Eugenius Harvey
Packard, John Hooker
Packer, William Fisher
Page, Joseph Francis ("Joe")
Palmer, Alexander Mitchell
Palmer, Henry Wilbur
Pancoast, Henry Khunrath
Pancoast, Seth
Park, James
Park, Robert Ezra
Parke, John Grubb
Parker, George Howard
Parkinson, Thomas Ignatius
Parrish, Anne
Parrish, Charles
Parrish, Edward
Parrish, Joseph
Parrish, Maxfield
Parry, Charles Thomas
Parry, John Stubbs
Passavant, William Alfred
Patterson, Morris
Patterson, Robert Mayne
Patton, William
Peale, Anna Claypoole
Peale, Rembrandt
Peale, Sarah Miriam
Peale, Titian Ramsay
Pearse, John Barnard Swett
Peary, Robert Edwin
Peffer, William Alfred
Pemberton, Israel
Pemberton, James
Pemberton, John
Pemberton, John Clifford
Penington, Edward
Penn, John

Penn, Richard
Pennell, Joseph
Pennypacker, Elijah Funk
Pennypacker, Galusha
Pennypacker, Samuel Whitaker
Penrose, Boies
Penrose, Charles Bingham
Penrose, Richard Alexander Fullerton
Penrose, Spencer
Pepper, George Seckel
Pepper, George Wharton
Pepper, William, 1810–1864
Pepper, William, 1843–1898
Pepper, William, III, 1874–1947
Peters, Madison Clinton
Peters, Richard, 1744–1828
Peters, Richard, 1810–1889
Peterson, Charles Jacobs
Peterson, Henry
Pettigrew, Charles
Pettit, Thomas McKean
Pew, John Howard
Pew, Joseph Newton, Jr.
Pfahler, George Edward
Phelps, William Walter
Phillips, Francis Clifford
Phillips, Henry
Phillips, Thomas Wharton
Phipps, Henry
Phipps, Lawrence Cowle
Physick, Philip Syng
Pickens, Andrew
Pickering, Charles
Pippin, Horace
Plumer, William Swan
Polk, Thomas
Polock, Moses
Porter, Andrew
Porter, David Dixon
Porter, David Rittenhouse
Porter, Edwin Stanton
Porter, Horace
Porter, James Madison
Porter, Thomas Conrad
Potts, Charles Sower
Potts, Jonathan
Poulson, Zachariah
Powderly, Terence Vincent
Powdermaker, Hortense
Powel, John Hare
Pratt, Matthew
Pratt, Waldo Selden
Presser, Theodore
Preston, Ann
Preston, Jonas
Preston, Margaret Junkin
Preston, William Campbell
Price, Eli Kirk, 1797–1884
Price, Eli Kirk, 1860–1933
Price, Hiram

Pugh, Evan
Purdue, John
Pyle, Robert
Pyle, Walter Lytle
Quay, Matthew Stanley
Quinan, John Russell
Quinn, Arthur Hobson
Quinn, Edmond Thomas
Raguet, Condy
Ramsay, David
Ramsay, Erskine
Ramsay, Nathaniel
Ramsey, Alexander
Randall, Samuel Jackson
Randolph, Jacob
Rauch, John Henry
Rawle, Francis, 1846–1930
Rawle, William
Rawle, William Henry
Rea, Samuel
Read, Charles
Read, Conyers
Read, John Meredith, 1797–1874
Read, John Meredith, 1837–1896
Read, Thomas Buchanan
Ream, Norman Bruce
Redman, John
Reed, David Aiken
Reed, Henry Hope
Reed, James Hay
Reed, William Bradford
Reeder, Andrew Horatio
Reese, John James
Rehn, Frank Knox Morton
Reick, William Charles
Reid, William Shields
Reilly, Marion
Reinhart, Benjamin Franklin
Reinhart, Charles Stanley
Remington, Joseph Price
Repplier, Agnes
Reynolds, John
Reynolds, John Fulton
Reynolds, William
Rhees, William Jones
Rhine, Joseph Banks
Rhoades, James E.
Rich, Robert
Richards, Theodore William
Richards, William Trost
Richardson, Joseph
Richardson, Robert
Richter, Conrad Michael
Riddle, Matthew Brown
Riddle, Samuel Doyle
Rigdon, Sidney
Rinehart, Mary Roberts
Rinehart, Stanley Marshall, Jr.
Ritner, Joseph
Rittenhouse, David

Roane, Archibald
Robb, James
Roberdeau, Isaac
Roberts, Elizabeth Wentworth
Roberts, George Brooke
Roberts, Howard
Roberts, Job
Roberts, Jonathan
Roberts, Owen Josephus
Roberts, Solomon White
Roberts, William Milnor
Robertson, James Alexander
Robinson, Edward Mott
Rockhill, William Woodville
Rodenbough, Theophilus Francis
Roebling, Washington Augustus
Rogers, Henry Darwin
Rogers, James Blythe
Rogers, John Ignatius
Rogers, Robert William
Rogers, William Barton
Rondthaler, Edward
Rosenau, Milton Joseph
Rosenbach, Abraham Simon Wolf
Rosenbach, Philip Hyman
Ross, Betsy
Ross, James
Rossiter, Clinton Lawrence, III
Rotch, Thomas Morgan
Rothermel, Peter Frederick
Rothrock, Joseph Trimble
Rowan, John
Rowland, Henry Augustus
Rupp, Israel Daniel
Rupp, William
Rush, Benjamin
Rush, James
Rush, Richard
Rush, William
Russell, Charles Taze
Ryan, Harris Joseph
Sachse, Julius Friedrich
Sadtler, Samuel Philip
Samuels, Samuel
Sanderson, John
Sankey, Ira David
Sargent, Winthrop, 1825–1870
Sartain, Emily
Sartain, Samuel
Sartain, William
Savery, William, 1750–1804
Saxton, Joseph
Say, Benjamin
Say, Thomas
Sayre, Robert Heysham
Schadle, Jacob Evans
Schaeffer, Charles Frederick
Schaeffer, David Frederick
Schaeffer, Frederick Christian
Schaeffer, Nathan Christ

Schamberg, Jay Frank
Schmauk, Theodore Emanuel
Schmucker, Beale Melanchthon
Schneider, Benjamin
Schneider, Herman
Schodde, George Henry
Schriver, Edmund
Schwab, Charles Michael
Schweinitz, Edmund Alexander de
Schweinitz, George Edmund de
Schweinitz, Lewis David von
Scott, Robert Kingston
Scott, Thomas Alexander
Scovel, Henry Sylvester
Scull, John
Seaman, Elizabeth Cochrane
See, Horace
Seidel, George Lukas Emil
Seip, Theodore Lorenzo
Sellers, Coleman
Sellers, William
Selznick, David 0.
Sergeant, John, 1779–1852
Sergeant, Thomas
Servoss, Thomas Lowery
Seybert, Adam
Seybert, Henry
Seybert, John
Sharpless, Isaac
Sharswood, George
Shaw, Thomas
Sheeler, Charles R., Jr.
Shippen, Edward, 1728/29–1806
Shippen, William
Shiras, George
Shiras, Oliver Perry
Sholes, Christopher Latham
Shonts, Theodore Perry
Shor, Bernard ("Toots")
Shoup, George Laird
Shulze, John Andrew
Shunk, Francis Rawn
Simpson, Stephen
Singerly, William Miskey
Skillern, Ross Hall
Slattery, Charles Lewis
Sloan, John French
Smedley, William Thomas
Smith, Albert Holmes
Smith, Andrew Jackson
Smith, Charles Ferguson
Smith, Charles Perrin
Smith, Charles Shaler
Smith, Daniel B.
Smith, Edgar Fahs
Smith, Hannah Whitall
Smith, Hiram
Smith, James, 1737–1814
Smith, John Blair
Smith, Jonathan Bayard

Smith, Lloyd Pearsall
Smith, Margaret Bayard
Smith, Mildred Catharine
Smith, Oliver Hampton
Smith, Persifor Frazer
Smith, Richard Penn
Smith, Richard Somers
Smith, Robert, 1757–1842
Smith, Samuel
Smith, Samuel Harrison
Smith, Samuel Stanhope
Smith, Xanthus Russell
Smyth, Albert Henry
Snowden, James Ross
Snyder, Edwin Reagan
Snyder, Simon
Sower, Christopher, 1754–1799
Spaatz, Carl Andrew ("Tooey")
Spaeth, John Duncan
Spaeth, Sigmund
Spalding, Franklin Spencer
Spangler, Henry Wilson
Speer, Emma Bailey
Speer, Robert Elliott
Speer, William
Sproul, William Cameron
Sproull, Thomas
Stahr, John Summers
Stark, Harold Raynsford
Starr, Louis
Statler, Ellsworth Milton
Stauffer, David McNeely
Steedman, James Blair
Stehle, Aurelius Aloysius
Stein, Gertrude
Stein, Leo Daniel
Stengel, Alfred
Sterling, John Whalen
Sterne, Simon
Sterrett, James Macbride
Stevens, Abel
Stevens, Wallace
Stewardson, John
Stewart, Andrew
Stillé, Alfred
Stillé, Charles Janeway
Stillman, Samuel
Stockdale, Thomas Ringland
Stockton, Charles Herbert
Stockton, Frank Richard
Stoddart, Joseph Marshall
Stoever, Martin Luther
Stokes, Maurice
Stone, Witmer
Stotesbury, Edward Townsend
Strain, Isaac G
Strawn, Jacob
Strickland, William
Studebaker, Clement
Sturgis, Samuel Davis

Sullivan, James William
Sullivan, Mark
Sulzberger, Cyrus Lindauer
Susann, Jacqueline
Swallow, Silas Comfort
Swank, James Moore
Swensson, Carl Aaron
Swisshelm, Jane Grey Cannon
Sylvis, William H.
Symes, James Miller
Talbot, Francis Xavier
Tanner, Benjamin Tucker
Tanner, Henry Ossawa
Tarbell, Ida Minerva
Tawney, James Albertus
Taylor, George William
Taylor, Bayard
Taylor, Francis Henry
Taylor, Frank Walter
Taylor, Frederick Winslow
Thatcher, Mahlon Daniel
Thaw, Harry Kendall
Thaw, William
Thomas, George Clifford
Thomas, John Charles
Thompson, Arthur Webster
Thompson, Denman
Thompson, Joseph Parrish
Thompson, Josiah Van Kirk
Thompson, Robert Means
Thompson, Samuel Rankin
Thompson, Will Lamartine
Thomson, Frank
Thomson, Tohn Edgar
Thomson, William
Tiffany, Katrin Brandes Ely
Tilden, William Tatem ("Big Bill")
Tilghman, Richard Albert
Timon, John
Tome, Jacob
Toner, Joseph Meredith
Torrence, Joseph Thatcher
Tower, Charlemagne
Towne, Henry Robinson
Towne, John Henry
Townsend, John Kirk
Townsend, Mira Sharpless
Trautwine, John Cresson
Trent, William
Trumbauer, Horace
Truxtun, William Talbot
Tryon, George Washington
Tunnell, Emlen
Turnbull, William
Turner, Samuel Hulbeart
Tyndale, Hector
Tyson, James
Tyson, Job Roberts
Tyson, Stuart Lawrence
Unangst, Erias

Van Amringe, John Howard
Van Buren, William Holme
Vandergrift, Jacob Jay
Van Dyke, Henry
Van Dyke, John Wesley
Van Horn, Robert Thompson
Van Meter, John Blackford
Vanuxem, Lardner
Vare, William Scott
Vauclain, Samuel Matthews
Vaux, Richard
Vaux, Roberts
Venuti, Giuseppe ("Joe")
Vezin, Hermann
Von Moschzisker, Robert
Wagner, John Peter
Wagner, William
Wahl, William Henry
Walker, Frank Comerford
Walker, James Barr
Walker, John Brisben
Walker, Jonathan Hoge
Walker, Robert John
Wallace, David
Wallace, Henry
Wallace, Horace Binney
Wallace, John Hankins
Wallace, John William
Waln, Nicholas
Waln, Robert, 1765–1836
Waln, Robert, 1794–1825
Walsh, Edward Augustine
Walsh, Thomas Joseph
Walter, Francis Eugene
Walter, Thomas Ustick
Walters, William Thompson
Walworth, Jeannette Ritchie
 Hodermann
Wanamaker, John
Wanamaker, Lewis Rodman
Warden, John Aston
Warner, Edward Pearson
Warren, William, 1812–1888
Waters, Ethel
Watson, David Thompson
Watt, Donald Beates
Watts, Frederick
Wayne, Anthony
Weaver, William Dixon
Webb, John Burkitt
Weems, Ted
Weidner, Revere Franklin
Weir, Ernest Tener
Welsh, John
Wenner, George Unangst
Werdin, Reed
West, Andrew Fleming
West, Benjamin
Westcott, Thompson
Wetherill, Charles Mayer

Wetherill, Samuel
Wetzel, Lewis
Wharton, Anne Hollingsworth
Wharton, Francis
Wharton, Joseph
Wharton, Robert
Wharton, Samuel
Wharton, Thomas
Wharton, Thomas Isaac
Wherry, Elwood Morris
White, James William
White, John De Haven
White, Samuel Stockton
White, William
Whitehill, Robert
Wickersham, George Woodward
Wickersham, James Pyle
Widener, George Dunton
Widener, Harry Elkins
Widener, Peter Arrell Brown
Wieland, George Reber
Wiggin, Kate Douglas
Wikoff, Henry
Wiley, David
Wilkins, Ross
Wilkins, William
Willard, James Field
Williams, Daniel Hale
Williams, George Washington
Williamson, Hugh
Willing, Thomas
Wilmot, David
Wilson Bird
Wilson, Francis
Wilson, John Fleming
Wilson, Joseph Miller
Wilson, Louis Blanchard
Wilson, Robert Burns
Wilson, Samuel Graham
Wilson, Warren Hugh
Winans, Williams
Wines, Frederick Howard
Winterhalter, Hugo
Wise, John
Wistar, Caspar
Wister, Owen
Wister, Sarah
Wolf, George
Wolle, John Frederick
Wood, Charles Erskine Scott
Wood, David Duffle
Wood, Fernando
Wood, Horatio Charles
Wood, James Frederick
Woodhouse, James
Woodin, William Hartman
Woodruff, Charles Edward
Woods, Robert Archey
Woodward, Joseph Janvier
Work, Hubert

Work, Milton Cooper
Wormley, Theodore George
Wright, Charles Barstow
Wright, Hendrick Bradley
Wright, Jonathan Jasper
Wright, Joseph Arbert
Wright, Joseph Jefferson Burr
Wrigley, William
Wurtz, Henry
Wylie, Andrew
Wynn, Ed
Yeager, Joseph
Yeates, Jasper
Yerkes, Charles Tyson
Yerkes, Robert Mearns
Young, Jesse Bowman
Young, John Clarke
Young, Samuel Hall
Zahniser, Howard Clinton
Zeilin, Jacob
Ziegemeier, Henry Joseph
Ziegler, William

PUERTO RICO

Clemente, Roberto
Fernós Isern, Antonio

RHODE ISLAND

Abell, Arunah Shepherdson
Aldrich, Chester Holmes
Aldrich, Nelson Wilmarth
Aldrich, Richard
Aldrich, Winthrop William
Allen, Paul
Allen, Philip
Allen, William Henry
Allen, Zachariah
Alline, Henry
Almy, John Jay
Ames, Samuel
Angell, Israel
Angell, James Burrill
Angell, Joseph Kinnicutt
Angell, William Gorham
Anthony, Henry Bowen
Anthony, John Gould
Anthony, William Arnold
Arnold, Aza
Arnold, Jonathan
Arnold, Richard
Arnold, Samuel Greene
Auchincloss, Hugh Dudley, Jr.
Bacon, Edwin Munroe
Baker, George Pierce
Baldwin, Henry Porter
Ballou, Adin
Bancroft, Wilder Dwight
Bartlett, Elisha
Bartlett, John Russell

Barton, William
Bennett, Charles Edwin
Boss, Lewis
Bourne, Benjamin
Brayton, Charles Ray
Brown, Goold
Brown, James Salisbury
Brown, John
Brown, John Carter
Brown, Joseph
Brown, Joseph Rogers
Brown, Moses
Brown, Nicholas, 1729–1791
Brown, Nicholas, l769–184l
Brown, Obadiah
Brown, Sylvanus
Brownell, Henry Howard
Buffum, Arnold
Bull, William Tillinghast
Burgess, Alexander
Burgess, George
Burrill, James
Butterworth, Hezekiah
Casey, Silas
Chace, Elizabeth Buffum
Chafee, Zechariah, Jr.
Champlin, John Denison
Champlin, Stephen
Channing, Edward Tyrell
Channing, Walter
Channing, William Ellery
Chapin, Charles Value
Church, Benjamin
Clark, John Bates
Clarke, Walter
Clifford, John Henry
Coe, George Simmons
Cohan, George Michael
Collins, John
Colvin, Stephen Sheldon
Cornell, Ezekiel
Cotton, Joseph Potter
Cottrell, Calvert Byron
Crandall, Prudence
Cranston, Samuel
Cross, Samuel Hazzard
Curtis, George William
Davis, Harvey Nathaniel
Dearth, Henry Golden
Decatur, Stephen
De Wolf, James
Diman, Jeremiah Lewis
Dorr, Thomas Wilson
Doyle, Sarah Elizabeth
Duffy, Hugh
Durfee, Job
Durfee, Thomas
Eddy, Nelson
Elder, Samuel James
Ellery, Frank

Ellery, William
Fenner, Arthur
Fenner, James
Fish, Carl Russell
Fish, Preserved
Gardiner, Silvester
Gardner, Caleb
Gibbs, George
Gorham, Jabez
Green, Theodore Francis
Greene, Albert Gorton
Greene, Christopher
Greene, Edward Lee
Greene, Francis Vinton
Greene, George Sears
Greene, George Washington
Greene, Nathanael
Greene, William, 1695/96–1758
Greene, William, 1731–1809
Hackett, Robert Leo ("Bobby")
Hague, Robert Lincoln
Halsey, Thomas Lloyd
Hamlin, William
Hammond, William Gardiner
Harris, Caleb Fiske
Harris, Daniel Lester
Hartnett, Charles Leo ("Gabby")
Hatlo, Jimmy
Haworth, Joseph
Hazard, Augustus George
Hazard, Jonathan J.
Hazard, Rowland Gibson
Hazard, Thomas
Hazard, Thomas Robinson
Herreshoff, James Brown
Herreshoff, John Brown
Herreshoff, Nathanael Greene
Himes, Joshua Vaughan
Hood, Raymond Mathewson
Hopkins, Esek
Hopkins, John Burroughs
Hopkins, Stephen
Hoppin, Augustus
Hoppin, James Mason
Hoppin, Joseph Clark
Hoppin, William Warner
Howe, Mark Anthony De Wolfe
Howe, Mark Antony De Wolfe
Howe, Percy Rogers
Hunter, William
Ide, John Jay
James, Charles Tillinghast
Janes, Lewis George
Jenckes, Joseph
Jenckes, Thomas Allen
Jones, William
King, Charles William
King, Clarence
King, Samuel
King, Samuel Ward

Lad, Joseph Brown
La Farge, Christopher Grant
LaFarge, John
Lajoie, Napoleon ("Larry")
Lippitt, Henry
Little, William Lawson, Jr.
Lomax, Lunsford Lindsay
Luther, Seth
Malbone, Edward Greene
Mauran, John Lawrence
McGrath, James Howard
Melville, David
Mills, Ogden Livingston
Morgan, Morris Hicky
Munro, Dana Carleton
Newel, Stanford
Nicholson, William Thomas
Niles, Nathaniel, 1741–1828
Niles, Samuel
O'Connor, Edwin Greene
Olyphant, David Washington
 Cincinnatus
Palmer, Ray
Park, Edwards Amasa
Patch, Sam
Peckham, Stephen Farnum
Pendleton, Enen Fitz
Perry, Christopher Raymond
Perry, Matthew Calbraith
Perry, Oliver Hazard
Perry, Thomas Sergeant
Perry, William Stevens
Pinchot, Cornelia Elizabeth Bryce
Potter, Elisha Reynolds
Reynolds, Samuel Godfrey
Richmond, John Wilkes
Robinson, Christopher
Rockefeller, Abby Greene Aldrich
Rodman, Isaac Peace
Round, William Marshall Fitts
Russell, Jonathan
Scott, Job
Sheldon, William Herbert
Shepard, Charles Upham
Sherman, Thomas West
Slater, John Fox
Slocum, Frances
Slocum, Samuel
Southwick, Solomon
Sprague, William, 1773–1836
Sprague, William, 1830–1915
Stanley, Albert Augustus
Staples, William Read
Stetson, Charles Walter
Stiness, John Henry
Stuart, Gilbert
Jully, Daniel John
Sunderland, La Roy
Taylor, William Rogers
Taylor, William Vigneron

Tenney, William Jewett
Thomas, Frederick William
Thurber, George
Thurston, Robert Henry
Thurston, Robert Lawton
Tourjée, Eben
Truman, Benjamin Cummings
Updike, Daniel
Updike, Daniel Berkeley
Vernon, Samuel
Vernon, William
Vinton, Alexander Hamilton
Vinton, Francis
Wanton, Joseph
Ward, Richard
Ward, Samuel, 1725–1776
Ward, Samuel, 1756–1832
Ward, Samuel, 1786–1839
Warren, Minton
Warren, Russell
Waterhouse, Benjamin
Weaver, Philip
Weeden, William Babcock
Welling, Richard Ward Greene
Weston, Edward Payson
Wheaton, Frank
Wheaton, Henry
Whipple, Abraham
Whitaker, Charles Harris
Whitman, Sarah Helen Power
Wilbur, John
Wilcox, Stephen
Wilkinson, David
Wilkinson, Jemima
Wilkinson, Jeremiah
Williams, Catharine Read Arnold
Williams, Samuel May

SOUTH CAROLINA

Adair, John
Adams, Joseph Quincy
Aiken, David Wyatt
Aiken, William
Allston, Robert Francis Withers
Allston, Washington
Alston, Joseph
Anderson, David Lawrence
Anderson, Richard Heron
Babcock, James Woods
Baldwin, James Mark
Barnwell, Robert Woodward
Baruch, Bernard Mannes
Bee, Barnard Elliott
Bee, Hamilton Prioleau
Bethune, Mary McLeod
Blease, Coleman Livingston
Bounethean, Henry Brintnell
Boyce, James Petigru
Boyd, Julian Parks
Bratton, John

Brawley, William Hiram
Brooks, Preston Smith
Brown, Albert Gallatin
Brown, Charlotte Hawkins
Brown, Joseph Emerson
Brown, Morris
Brumby, Richard Trapier
Bull, William, 1683–1755
Bull, William, 1710–1791
Bulloch, Archibald
Butler, Andrew Pickens
Butler, Matthew Calbraith
Butler, Pierce Mason
Byrnes, James Francis
Calhoun, John Caldwell
Calhoun, Patrick
Campbell, Josiah A. Patterson
Cannon, Harriet Starr
Capers, Ellison
Capers, William
Cash, Wilbur Joseph
Charlton, Thomas Usher Pulaski
Chestnut, James
Cheves, Langdon
Chisolm, Alexander Robert
Chisolm, John Julian
Clarke, Elijah
Clinton, George Wylie
Cloud, Noah Bartlett
Cogdell, John Stevens
Cohen, Octavus Roy
Coker, David Robert
Coker, James Lide
Conner, James
Corcoran, James Andrew
Crafts, William
Cunningham, Ann Pamela
Davidson, James Wood
Deas, Zachariah Cantey
De Bow, James Dunwoody Brownson
De Leon, Thomas Cooper
De Saussure, Henry William
Dickson, Samuel Henry
Dorr, Julia Caroline Ripley
Drayton, John
Drayton, Percival
Drayton, Thomas Fenwick
Drayton, William
Drayton, William Henry
Du Bose, William Porcher
Elbert, Samuel
Elliott, Benjamin
Elliott, Stephen
Elliott, William
Elmore, Franklin Harper
Evans, Nathan George
Fayssoux, Peter
Ferguson, Thomas Barker
Few, William Preston
Fraser, Charles

Freed, Arthur
Fuller, Richard
Furman, James Clement
Gadsden, Christopher
Gadsden, James
Gaillard, David Du Bose
Gaillard, Edwin Samuel
Gaillard, John
Gambrell, James Bruton
Gambrell, Mary Latimer
Garden, Alexander
Gary, Martin Witherspoon
Gaston, James McFadden
Gayle, John
Gibbes, Robert Wilson
Gibbes, William Hasell
Gibbons, William
Gildersleeve, Basil Lanneau
Girardeau, John Lafayette
Gist, William Henry
Gonzales, Ambrose Elliott
Gorrie, John
Gossett, Benjamin Brown
Graves, John Temple
Gregg, Maxcy
Grimké, Angelina Emily
Grimké Archibald Henry
Grimké, John Faucheraud
Grimké, Sara Moore
Grimké, Thomas Smith
Hagood, Johnson
Hall, Dominick Augustin
Hamilton, James
Hamilton, Paul
Hammett, Henry Pinckney
Hammond, James Henry
Hampton, Wade
Harper, William
Hayne, Isaac
Hayne, Paul Hamilton
Hayne, Robert Young
Hemphill, John
Henry, Edward Lamson
Henry, Robert
Herbert, Hilary Abner
Heyward, DuBose
Heyward, Thomas
Hill, Daniel Harvey
Hill, Joshua
Hitchcock, Thomas
Holbrook, John Edwards
Holland, Edwin Clifford
Holmes, Isaac Edward
Holmes, Joseph Austin
Howell, Clark
Huger, Benjamin
Huger, Daniel Elliott
Huger, Francis Kinloch
Huger, Isaac
Huger, John

Hunt, William Henry
Hurlbert, William Henry
Hurlbut, Stephen Augustus
Hutson, Richard
Hyrne, Edmund Massingberd
Ingraham, Duncan Nathaniel
Ioor, William
Irving, John Beaufain
Izard, Ralph
Jackson, Andrew
Jacobs, William Plumer
Jamison, David Flavel
Jenkins, Charles Jones
Jenkins, Micah
Johnson, Joseph
Johnson, William
Johnson, William Bullein
Johnston, Henrietta
Johnston, Olin DeWitt Talmadge
Johnstone, Job
Jones, David Rumph
Jones, John B.
Just, Ernest Everett
Keitt, Lawrence Massillon
Kellogg, Clara Louise
Kennedy, John Doby
Kershaw, Joseph Brevard
Keyes, Edward Lawrence
Kinloch, Cleland
Kirkland, James Hampton
La Borde, Maximilian
Laurens, Henry
Laurens, John
Law, Evander McIvor
Lawton, Alexander Robert
Lee, Stephen Dill
Lee, Thomas
Legaré, Hugh Swinton
Lever, Asbury Francis
Levin, Lewis Charles
Lipscomb, Abner Smith
Logan, Thomas Muldrup, 1808–1876
Logan, Thomas Muldrup, 1840–1914
Longstreet, James
Loughridge, Robert McGill
Lowndes, William
Lowry, Robert
Lubbock, Francis Richard
Lynch, Thomas, 1727–1776
Lynch, Thomas, 1749–1779
McBryde, John McLaren
McCaleb, Theodore Howard
McCall, Edward Rutledge
McCord, David James
McCord, Louisa Susanna Cheves
McCrady, Edward
McDonald, Charles James
McGowan, Samuel
Mackey, Albert Gallatin
McTyeire, Holland Nimmons

Magrath, Andrew Gordon
Manigault, Arthur Middleton
Manigault, Gabriel
Manigault, Peter
Manly, Basil
Manly, Basil Maxwell
Manning, Richard Irvine, 1789–1836
Manning, Richard Irvine, 1859–1931
Manon, Francis
Marks, Elias
Mathews, John
Maybank, Burnet Rhett
Meek, Alexander Beaufort
Michel, William Middleton
Middleton, Arthur, 1681–1737
Middleton, Arthur, 1742–1787
Middleton, Henry
Middleton, John Izard
Middleton, Nathaniel Russell
Mignot, Louis Remy
Mifies, William Porcher
Miller, Kelly
Miller, Stephen Decatur
Mills, Robert, 1781–1855
Moffett, William Adger
Moïse, Penina
Montgomery, William Bell
Mood, Francis Asbury
Moore, Samuel Preston
Mordecai, Moses Cohen
Moses, Franklin J.
Moultrie, John
Moultrie, William
Murphy, William Sumter
Murray, James Ormsbee
Myers, Abraham Charles
Newman, Albert Henry
Northrop, Lucius Bellinger
Nott, Henry Junius
Nott, Josiah Clark
O'Neall, John Belton
Orr, Gustavus John
Orr, James Lawrence
Orr, John Amaziah
Palmer, Benjamin Morgan
Payne, Daniel Alexander
Peck, Thomas Ephraim
Perry, Benjamin Franklin
Peterkin, Julia Mood
Petigru, James Louis
Philips, Martin Wilson
Pickens, Francis Wilkinson
Pickens, William
Pinckney, Charles
Pinckney, Charles Cotesworth
Pinckney, Henry Laurens
Pinckney, Thomas
Poinsett, Joel Roberts
Porcher, Francis Peyre
Pratt, John

Pringle, Joel Roberts Poinsett
Pringle, John Julius
Rainey, Joseph Hayne
Ravenel, Edmund
Ravenel, Harriott Horry Rutledge
Ravenel, Henry William
Ravenel, St. Julien
Read, Jacob
Requier, Augustus Julian
Rhett, Robert Barnwell
Rice, John Andrew
Richardson, Anna Euretta
Rivers, William James
Robert, Henry Martyn
Roberts, Oran Milo
Rogers, James Harvey
Roper, Daniel Calhoun
Rusk, Thomas Jefferson
Rutledge, Edward
Rutledge, John
Sanders, Daniel Jackson
Scarbrough, William
Shecut, John Linnaeus Edward
 Whitridge
Shepherd, William Robert
Shubrick, John Templer
Shubrick, William Branford
Simms, William Gilmore
Simonton, Charles Henry
Simpson, William Dunlap
Sims, James Marion
Smalls, Robert
Smith, Charles Forster
Smith, Ellison DuRant
Smith, Henry Augustus Middleton
Smith, James Perrin
Smith, John Lawrence
Smith, William Louehton
Spreckels, John Diedrich
Stanton, Frank Lebby
Steedman, Charles
Stevens, Thomas Holdup, 1795–1841
Strobel, Edward Henry
Stuart, Francis Lee
Thomas, Theodore Gaillard
Thompson, Hugh Smith
Thompson, Waddy
Thornwell, James Henley
Tiedeman, Christopher Gustavus
Tillman, Benjamin Ryan
Timrod, Henry
Toland, Hugh Huger
Tompkins, Daniel Augustus
Travis, William Barret
Trenholm, George Alfred
Trescot, William Henry
Trott, Nicholas
Tupper, Henry Allen
Turner, Henry McNeal
Waddel, John Newton

Waring, Julius Waties
Watson, John Broadus
Wayne, Arthur Trezevant
Weils, William Charles
White, George
White, John Blake
White, Josh
Wigfall, Louis Trezevant
Wilkinson, Robert Shaw
Williams, David Rogerson
Willingham, Robert Josiah
Wilson, John Leighton
Wilson, William Hasell
Woolsey, John Munro
Wragg, William
Yeadon, Richard
Young, Pierce Manning Butler
Zogbaum, Rufus Fairchild

SOUTH DAKOTA

Anderson, Clinton Presba
Flanagan, Hallie
Gall
Graham, Philip Leslie
Grass, John
Hansen, Alvin Harvey
Humphrey, Hubert Horatio, Jr.
Lawrence, Ernest Orlando
Lundeen, Ernest
Mundt, Karl Earl
Norbeck, Peter
Sande, Earl
Schmidt, Carl Louis August
Sitting Bull
Thye, Edward John
Wilson, Orlando Winfield ("Win,"
 "O.W.")

TENNESSEE

Adams, John
Agee, James Rufus
Allen, William Joshua
Anderson, James Patton
Anderson, Paul Y.
Andrews, Frank Maxwell
Austell, Alfred
Ayres, Brown
Balch, George Beall
Barksdale, William
Barnard, Edward Emerson
Barrow, Washington
Barton, Bruce Fairchild
Barton, David
Bate, William Brimage
Beard, Richard
Bell, John
Benton, Thomas Hart
Berry, George Leonard
Bewley, Anthony

Bible, Dana Xenophon
Boyd, Lynn
Bradford, Joseph
Bradford, Roark Whitney Wickliffe
Branner, John Casper
Brantley, Theodore
Bridges, Thomas Jefferson Davis ("Tommy")
Brown, John Calvin
Brown, Neill Smith
Brush, George de Forest
Burgess, John William
Burnet, Peter Hardeman
Burnett, Swan Moses
Byrns, Joseph Wellington
Cain, Harry Pulliam
Campbell, Francis Joseph
Campbell, William Bowen
Caraway, Hattie Ophelia Wyatt
Carmack, Edward Ward
Carter, Samuel Powhatan
Catchings, Waddill
Cheatham, Benjamin Franklin
Chisum, John Simpson
Clement, Frank Goad
Collier, Barron Gift
Cone, Moses Herman
Conway, Elias Nelson
Conway, James Sevier
Cooper, (Leon) Jere
Crockett, David
Crump, Edward Hull
Davis, Norman Hezekiah
Davis, Reuben
Dibrell, George Gibbs
Dickson, Earle Ensign
Dodd, Monroe Elmon
Dorset, Marion
Dromgoole, William Allen
Edmondson, William
Elliott, William Yandell, III
Embree, Elihu
Ensley, Enoch
Fanning, Tolbert
Farragut, David Glasgow
Featherston, Winfield Scott
Fenner, Charles Erasmus
Folk, Joseph Wingate
Forrest, Nathan Bedford
Frazer, Joseph Washington
Fuller, Joseph Vincent
Gaisman, Henry Jaques
Garland, Augustus Hill
Garrett, Finis James
Garvin, Lucius Fayette Clark
Gaut, John McReynolds
Geers, Edward Franklin
Gillem, Alvan Cullem
Gilliam, James William ("Junior")

Gilmer, Elizabeth Meriwether ("Dorothy Dix")
Gleaves, Albert
Gordon, George Washington
Green, Alexander Little Page
Gregg, Josiah
Gwin, William McKendree
Hamilton, Walton Hale
Harahan, William Johnson
Harney, William Selby
Harris, Isham Green
Harrison, Henry Sydnor
Haynes, Henry Doyle ("Homer")
Hays, Harry Thompson
Hays, John Coffee
Hillman, Thomas Tennessee
Hindman, Thomas Carmichael
Hogg, James Stephen
Houk, Leonidas Campbell
Houston, George Smith
Howze, Robert Lee
Hull, Cordell
Humes, Thomas William
Humphreys, West Hughes
Inman, John Hamilton
Inman, Samuel Martin
Isom, Mary Frances
Jackson, Howell Edmunds
Jackson, William Hicks
Jarman, Walton Maxey
Jarrell, Randall
Johnson, Cave
Johnson, David Bancroft
Johnson, Mordecai Wyatt
Jones, James Chamberlayne
Jones, Jesse Holman
Kefauver, (Carey) Estes
Kelly, Machine Gun (George Kelly Barnes, Jr.)
Key, David McKendree
King, Austin Augustus
Krutch, Joseph Wood
Lard, Moses E.
Lea, Luke
Levering, Joseph Mortimer
Lindsey, Benjamin Barr
Littleton, Martin Wiley
Loguen, Jermain Wesley
Lowrey, Mark Perrin
McAnally, David Rice
McCulloch, Ben
McFerrin, John Berry
McGhee, Charles McClung
McGill, Ralph Emerson
McGlothlin, William Joseph
McReynolds, Samuel Davis
Malone, Walter
Maney, George Earl
Markham, Charles Henry
Marling, John Leake

Milton, George Fort
Moore, (Austin) Merrill
Moore, Grace
Morgan, John Tyler
Murfree, Mary Noailles
Murrell, John A.
Nelson, David
Newman, William Truslow
Nicholson, Alfred Osborne Pope
Nielsen, Alice
Oconostota
Oldham, Williamson Simpson
Palmore, William Beverly
Peck, James Hawkins
Perkins, Dwight Heald
Perry, Rufus Lewis
Pillow, Gideon Johnson
Poindexter, Miles
Polk, William Mecklenburg
Porter, James Davis
Pritchard, Jeter Connelly
Proctor, Henry Hugh
Ramsey, James Gettys McGready
Randolph, Lillian
Ransom, John Crowe
Raulston, John Tate
Rayburn, Samuel Taliaferro ("Sam")
Read, Opie Pope
Reagan, John Henninger
Reece, Brazilla Carroll
Reed, Richard Clark
Reynolds, Richard Samuel, Sr.
Rice, (Henry) Grantland
Richardson, James Daniel
Richberg, Donald Randall
Ridge, Major
Riis, Mary Phillips
Roane, John Selden
Roberts, Issachar Jacob
Rockwell, Kiffin Yates
Rogers, James Harris
Rose, Edward
Rose, Wickliffe
Ross, John
Sanford, Edward Terry
Scott, William Anderson
Scruggs, William Lindsay
Sequoyah
Sevier, Ambrose Hundley
Sharkey, William Lewis
Shields, John Knight
Shook, Alfred Montgomery
Sloan, George Arthur
Smith, Bessie
Smith, George Henry
Stewart, Arthur Thomas ("Tom")
Stilwell, Simpson Everett
Stone, John Marshall
Stribling, Thomas Sigismund
Stritch, Samuel Alphonsus

Sumners, Hatton, William
Taylor, Alfred Alexander
Taylor, Robert Love
Temple, Oliver Perry
Terrell, Mary Eliza Church
Thomas, Cyrus
Thomas, John Wilson
Tigert, John James, IV
Tilson, John Quillin
Tipton, John
Turner, ennell Parrish
Turney, Peter
Vance, Ap Morgan
Walker, William
Ward, Nancy
Warner, James Cartwright
Watterson, Harvey Magee
White, Clarence Cameron
White, Edward Douglass
Whitsitt, William Heth
Wiley, Bell Irvin
Williams, James
Williams, John Sharp
Wilson, J(ames) Finley
Witherspoon, John Alexander
Woods, William Allen
Wright, Luke Edward
Wright, Marcus Joseph
Yandell, David Wendell
Yandell, Lunsford Pitts
Yeatman, James Erwin
Yerger, William
Yoakum, Henderson
York, Alvin Cullum
Young, Ewing
Zollicoffer, Felix Kirk

TEXAS

Batts, Robert Lynn
Beaty, Amos Leonidas
Blocker, Dan
Buck, Franklyn Howard
Burleson, Albert Sidney
Camp, John Lafayette
Carter, William Samuel
Chennault, Claire Lee
Clark, Tom Campbell
Connally, Thomas Terry ("Tom")
Cordon, Guy
Crawford, Joan
Cullen, Hugh Roy
Dies, Martin
Dobie, J(ames) Frank
Dyer, Isadore
Eberle, Edward Walter
Eisenhower, Dwight David
Ewing, William Maurice
Ferguson, James Edward
Ferguson, Miriam Amanda Wallace
Fly, James Lawrence

Frye, William John ("Jack")
Garner, John Nance
Gibbons, Euell
Gipson, Frederick Benjamin
Graves, William Sidney
Griffin, John Howard
Hirsch, Maximilian Justice
Hobby, William Pettus
Holly, Charles Hardin ("Buddy")
Hornsby, Rogers
House, Edward Mandell
Hughes, Howard Robard, Jr.
Hunter, Ivory Joe
Johnson, Jack
Johnson, Lyndon Baines
Jones, John Marvin
Jones, Richard Foster
Joplin, Janis Lyn
Kendrick, John Benjamin
Key, Valdimer Orlando, Jr.
King, Richard, Jr.
Kleberg, Robert Justus, Jr.
Lanham, Frederick Garland ("Fritz")
Lasater, Edward Cunningham
Lovett, Robert Scott
Mangrum, Lloyd Eugene
Maverick, (Fontaine) Maury
McMillin Alvin Nugent ("Bo")
Mills, Charles Wright
Minor, Robert
Moser, Christopher Otto
Munger, Robert Sylvester
Murchison, Clinton Williams
Murchison, John Dabney
Murphy, Audie Leon
Murray, William Henry David
Newton, Joseph Fort
Neyland, Robert Reese, Jr.
Nimitz, Chester William
Norris, John Franklyn
O'Brien, Robert David ("Davey")
Ochs, Phil
Page, Oran Thaddeus ("Lips")
Parker, Alvin Pierson
Patman, John William Wright
Pool, Joe Richard
Porter, Katherine Anne
Post, Wiley
Quanah
Reese, Heloise Bowles
Richardson, Sid Williams
Richardson, Wilds Preston
Rister, Carl Coke
Ritter, Woodward Maurice ("Tex")
Rosenman, Samuel Irving
Rowe, Lynwood Thomas
Rust, John Daniel
Samaroff, Olga
Scarborough, Dorothy
Scott, Emmett Jay

Shepard, Seth
Sheppard, John Morris
Silkwood, Karen Gay
Siringo, Charles A.
Smith, Thomas Vernor
Speaker, Tris E.
Sterling, Ross Shaw
Stevenson, Matilda Coxe Evans
Stillman, James
Tandy, Charles David
Tansill, Charles Callan
Teagarden, Weldon Leo ("Jack")
Thornton, Daniel I. J.
Van Der Stucken, Frank Valentin
Vardaman, James Kimble
Vaughan, Thomas Wayland
Vidor, Florence
Walker, Walton Harris
Webb, Walter Prescott
White, Edward Higgins, II
Wills, Chill
Wills, James Robert ("Bob")
Yoakum, Benjamin Franklin
Young, Hugh Hampton
Young, Robert Ralph
Zaharias, Mildred ("Babe") Didrikson

UTAH

Adams, Maude
Allen, Florence Ellinwood
Borglum, Solon Hannibal
Borzage, Frank
Browning, John Moses
Cantril, Albert Hadley
Clark, Joshua Reuben, Jr.
Clyde, George Dewey
Dallin, Cyrus Edwin
DeVoto, Bernard Augustine
Eccles, Marriner Stoddard
Farnsworth, Philo Taylor
Gilbert, John
Haywood, William Dudley
Held, John, Jr.
Hines, Frank Thomas
Kahn, lorence Prag
Knight, Goodwin Jess ("Goodie")
McKay, David Oman
Moreell, Ben
Priest, Ivy Maude Baker
Smith, George Albert
Smith, Jospeh Fielding
Smoot, Reed Owen
Thomas, Elbert Duncan
Wardman, Ervin
Watkins, Arthur Vivian
Young, Mahonri Mackintosh

VERMONT

Adams, Alvin
Adams, Charles Kendall

Adams, George Burton
Adams, Herbert Samuel
Aiken, Charles Augustus
Aikens, Andrew Jackson
Ainsworth, Frederick Crayton
Alden, Henry Mills
Allen, Elisha Hunt
Allen, George
Allen, Timothy Field
Alvord, Benjamin
Ames, Joseph Sweetman
Angell, James Rowland
Arthur, Chester Alan
Atkins, Jearum
Austin, Warren Robinson
Babcock, Joseph Weeks
Babcock, Orville E.
Ballou, Hosea
Barber, Amzi Lorenzo
Barrett, John
Barton, James Levi
Bennett, Edmund Hatch
Bentley, Wilson Alwyn
Benton, Josiah Henry
Billings, Charles Ethan
Billings, Frederick
Bingham, Harry
Bingham, Hiram
Blaine, Anita (Eugenie) McCormick
Blanchard, Jonathan
Bliss, Daniel
Bliss, Edwin Elisha
Botta, Anne Charlotte Lynch
Bowen, George
Boynton, Edward Carlisle
Bradley, William Czar
Bradwell, Myra
Brainerd, Ezra
Browne, Francis Fisher
Brownson, Orestes Augustus
Burnham, Sherburne Wesley
Bush, George
Carpenter, Matthew Hale
Chase, Irah
Church, Alonzo
Clark, Charles Edgar
Clark, William Butlock
Closson, William Baxter
Coates, George Henry
Colburn, Zerah
Collins, John Anderson
Colton, Gardner Quincy
Colton, Walter
Colver, Nathaniel
Conant, Alban Jasper
Conant, Thomas Jefferson
Converse, John Heman
Coolidge, Calvin
Dana, Charles Loomis
Dana, John Cotton

Davenport, Herbert Josep
Davenport, Thomas
Dean, Amos
Deere, John
Delano, Columbus
Dewey, George
Dewey, John
Dillingham, William Paul
Dixon, Luther Swift
Dorsey, Stephen Wallace
Douglas, Stephen Arnold
Douglass, Andrew Ellicott
Eaton, Dorman Bridgman
Eaton, Homer
Edmunds, George Franklin
Emmons, George Foster
Evans, Warren Felt
Evarts, Jeremiah
Fairbanks, Henry
Farnham, Thomas Jefferson
Farrar, John Chapman
Field, Fred Tarbell
Fisk, James
Fisk, Wilbur
Flagg, Azariah Cutting
Flanders, Ralph Edward
Fletcher, Calvin
Fletcher, Richard
Foot, Solomon
Frost, Edwin Brant
Gale, Elbridge
Garlick, Theodatus
Gates, George Augustus
Gilmore, Joseph Albree
Going, Jonathan
Goodall, Harvey L.
Goodnow, Isaac Tichenor
Granger, Walter
Grant, Lewis Addison
Graves, James Robinson
Graves, Zuinglius Calvin
Gray, Joseph W.
Green, Horace
Greenleaf, Halbert Stevens
Grinnell, Josiah Bushnell
Griswold, Rufus Wilmot
Hale, Philip
Hale, Robert Safford
Hall, Hiland
Hall, Sherman
Hamilton, Frank Hastings
Hammond, Edwin
Harmon, Daniel Williams
Harris, Elisha
Harvey, George Brinton McClellan
Haselton, Seneca
Haskell, Dudley Chase
Hawkins, Rush Christopher
Hayes, Augustus Allen
Hazen, Allen

Hazen, William Babcock
Herring, Silas Clark
Hitchcock, Ethan Allen, 1798–1870
Hoisington, Henry Richard
Holbrook, Stewart Hall
Holmes, Bayard Taylor
Hopkins, James Campbell
Horton, Valentine Baxter
Houghton, Henry Oscar
House, Royal Earl
Hovey, Charles Edward
Hovey, Otis Ellis
Howard, Jacob Merritt
Howard, William Alanson
Hubbard, Gurdon Saltonstall
Hudson, Henry Norman
Hulbert, Archer Butler
Hunt, Richard Morris
Hunt, William Morris
Ide, Henry Clay
Jackson, William Alexander
James, Edwin
Jameson, John Alexander
Jewett, Milo Parker
Johnson, Edwin Ferry
Johnson, Oliver
Jones, George
Kasson, John Adam
Kendrick, Asahel Clark
Kent, Arthur Atwater
Keyes, Elisha Williams
Kimball, Heber Chase
Kingsley, Darwin Pearl
Knowlton, Frank Hall
Ladd, William Sargent
Lampson, Sir Curtis Miranda
Langdon, William Chauncy
Langworthy, James Lyon
Lawrence, Richard Smith
Lull, Edward Phelps
Lyman, Albert Josiah
Marsh, George Perkins
Marsh, James
Mayo, Henry Thomas
Mead, Charles Marsh
Mead, William Rutherford
Merrill, Samuel
Miller, Jonathan Peckham
Miller, Leslie William
Mills, Susan Lincoln Tolman
Morrill, Justin Smith
Morris, George Sylvester
Morse, Anson Daniel
Morse, Harmon Northrop
Morton, Levi Parsons
Mower, Joseph Anthony
Mozier, Joseph
Newcomb, Harvey
Nichols, Clarina Irene Howard
Niles, Nathaniel, 1791–1869

Noyes, John Humphrey
Olin, Stephen
Otis, Elisha Graves
Paine, Charles
Paine, Martyn
Park, Trenor William
Parker, Edwin Wallace
Parker, Joel
Parkhurst, Charles
Parmly, Eleazar
Partridge, Alden
Peabody, Cecil Hobart
Peabody, Selim Hobart
Pearsons, Daniel Kimball
Peirce, Bradford Kinney
Perkins, Samuel Elliott
Perry, Ralph Barton
Pettigrew, Richard Franklin
Phelps, Charles Edward
Phelps, Edward John
Picknell, William Lamb
Pilkington, James
Plumley, Frank
Poland, Luke Potter
Porter, Russell Williams
Porter, William Trotter
Post, Truman Marcellus
Powell, Thomas Reed
Powers, Hiram
Pratt, Francis Ashbury
Pratt, Silas Gamaliel
Pringle, Cyrus Guernsey
Proctor, Redfield
Prouty, Charles Azro
Ransom, Thomas Edward Greenfield
Redfield, Isaac Fletcher
Rice, Edmund
Rice, Henry Mower
Richardson, Israel Bush
Richmond, Dean
Ripley, Edward Hastings
Rix, Julian Walbridge
Roberts, Benjamin Stone
Robinson, Arbert Alonzo
Robinson, Charles Seymour
Robinson, Rowland Evans
Robinson, Stillman Williams
Robinson, Theodore
Rowell, George Presbury
Rublee, Horace
Russell, William Hepburn
Safford, Truman Henry
Salm-Salm, Agnes Elisabeth Winona
 Leclercq Joy, Princess
Sargent, Frank Pierce
Sargent, James
Sargent, Nathan
Sawyer, Philetus
Sawyer, Thomas Jefferson
Saxe, John Godfrey

Schoff, Stephen Alonzo
Scott, Orange
Seymour, Truman
Shaw, Leslie Mortier
Sheldon, Walter Lorenzo
Sheldon, William Evarts
Sherry, Louis
Slade, William
Slafter, Edmund Farwell
Smith, Chauncey
Smith, John Gregory
Smith, Joseph, 1805–1844
Smith, William Farrar
Southard, Lucien H.
Spaulding, Edward Gleason
Spooner, Shearjashub
Sprague, Achsa W.
Spring, Leverett Wilson
Stevens, Benjamin Franklin
Stevens, Henry
Stevens, Hiram Fairchild
Stevens, Thaddeus
Stoddard, Joshua C.
Stone, Warren
Storey, Wilbur Fisk
Stoughton, Edwin Wallace
Strong, Charles Lyman
Strong, James Woodward
Strong, Moses McCure
Strong, William Barstow
Tabor, Horace Austin Warner
Taft, Alphonso
Taylor, Charles Fayette
Temple, William Grenville
Thompson, Zadock
Todd, John
Torrey, Charles Cutler
Tracy, Joseph
Tucker, Luther
Tuttle, Herbert
Tyler, William
Vilas, William Freeman
Wade, Martin Joseph
Wells, Henry
Wheeler, James Rignall
Wheeler, John Martin
Wheeler, Royall Tyler
Wheelock, Lucy
Whitcomb, James
Whiting, Charles Goodrich
Willard, Daniel
Wilson, Halsey William
Wilson, William Griffith ("Bill W.")
Winslow, Hubbard
Winslow, John Flack
Winslow, Miron
Wood, Reuben
Woods, Alva
Worthen, Amos Henry
Wright, Robert William

Yale, Caroline Ardelia
Young, Brigham
Young, John

VIRGINIA

Abert, John James
Adams, Daniel Weissiger
Adams, James Hopkins
Ainslie, Peter
Alexander, Archibald
Allen, Henry Watkins
Allen, John James
Allen, Thomas M.
Ambler, James Markham Marshall
Ammen, Daniel
Ammen, Jacob
Anderson, Henry Tompkins
Anderson, Joseph Reid
Anderson, Richard Clough
Anderson, William
Archer, Branch Tanner
Archer, William Segar
Armistead, George
Armstrong, Edward Cooke
Armstrong, Robert
Ashby, Turner
Ashley, William Henry
Atkinson, George Wesley
Atkinson, Thomas
Austin, Stephen Fuller
Bagby, Arthur Pendleton
Bazby, George William
Bailey, Bill
Bailey, (Irene) Temple
Baldwin, John Brown
Baldwin, Joseph Glover
Ballard, Bland Williams
Bangs, Frank C.
Banister, John
Barbour, James
Barbour, John Strode, Jr.
Barbour, Philip Pendleton
Barrett, Kate Waller
Barron, James
Barron, Samuel
Barry, William Taylor
Barton, Robert Thomas
Barton, Seth Maxwell
Bates, Edward
Bates, Frederick
Battle, John Stewart
Baylor, George
Bayly, Thomas Henry
Beale, Richard Lee Turberville
Beall, John Yates
Beckwourth, James P.
Bell, Peter Hansborough
Beverley, Robert
Bibb, George Mortimer
Bingham, George Caleb

Binns, John Alexander
Bitter, Karl Theodore Francis
Blackburn, Gideon
Blair, Francis Preston
Blair, John, 1687–1771
Blair, John, 1732–1800
Blanchfield, Florence Aby
Bland, Richard
Bland, Theodorick
Blow, Henry Taylor
Bocock, Thomas Stanley
Borland, Solon
Botts, Charles Tyler
Botts, John Minor
Boyd, Belle
Boyd, David French
Boyd, Thomas Duckett
Boyle, John
Bradford, John
Brannon, Henry
Braxton, Carter
Breckenridge, James
Breckenridge, John
Bridger, James
Broadhead, Garland Carr
Broadus, John Albert
Brodhead, James Overton
Brooke, Francis Taliaferro
Brown, Aaron Venable
Brown, James
Brown, John, 1757–1837
Brown, Samuel
Brownlow, William Gannaway
Bruce, Blanche K.
Bruce, Philip Alexander
Bruce, William Cabell
Bryan, John Stewart
Bryan, Thomas Barbour
Buchanan, Joseph
Buford, Abraham
Bullitt, Alexander Scott
Burns, Anthony
Burrow, Trigant
Butler, William
Byrd, Richard Evelyn
Byrd, William
Cabell, James Branch
Cabell, James Lawrence
Cabell, Joseph Carrington
Cabell, Nathaniel Francis
Cabell, Samuel Jordan
Cabell, William
Cabell, William H.
Cabell, William Lewis
Cain, Richard Harvey
Caldwell, Henry Clay
Caldwell, James
Call, Richard Keith
Camden, Johnson Newlon
Cameron, William Evelyn

Campbell, Charles
Campbell, John Wilson
Campbell, William
Capps, Washington Lee
Carleton, Henry
Carlile, John Snyder
Carlisle, James Mandeville
Carr, Dabney
Carr, Dabney Smith
Carrington, Paul
Carter, Henry Rose
Carter, John
Carter, Landon
Carter, Maybelle Addington
Carter, Robert
Cartwright, Peter
Caruthers, William Alexander
Cary, Archibald
Cary, Lott
Cather, Willa
Chalmers, James Ronald
Chandler, Julian Alvin Carroll
Chapman, John Gadsby
Chapman, Oscar Littleton
Chapman, Reuben
Christian, Henry Asbury
Christian, William
Claiborne, Nathaniel Herbert
Claiborne, William Charles Coles
Clark, George Rogers
Clark, James
Clark, William
Clay, Clement Comer
Clay, Green
Clay, Henry
Clay, Matthew
Clayton, Augustin Smith
Cleghorn, Sarah Norcliffe
Cleveland, Benjamin
Clopton, John
Clyman, James
Cocke, John Hartwell
Cocke, Philip St. George
Cocke, William
Coe, Virginius ("Frank")
Coke, Richard
Coles, Edward
Collier, Henry Watkins
Colquitt, Walter Terry
Colter, John
Colwell, Stephen
Cone, Etta
Conrad, Charles Magill
Conrad, Holmes
Conway, Moncure Daniel
Cooke, John Esten
Cooke, Philip St. George
Cooper, Mark Anthony
Costigan, Edward Prentiss
Crawford, William

Crawford, William Harris
Creath, Jacob
Creighton, William
Cross, Edward
Crump, William Wood
Cutler, Lizzie Petit
Dabney, Charles William
Dabney, Richard
Dabney, Robert Lewis
Dabney, Thomas Smith Gregory
Dabney, Virginius
Dagg, John Leodley
Dale, Richard
Dale, Samuel
Daniel, John Moncure
Daniel, John Warwick
Daniel, Peter Vivian
Dare, Virginia
Dargan, Edwin Preston
Daveiss, Joseph Hamilton
Davidson, John Wynn
Davis, John Staige
Davis, Varina Anne Jefferson
Dawson, John
Dean, William Henry, Jr.
De Lacy, Walter Washington
Denby, Charles
Denver, James William
Dillard, James Hardy
Dinwiddie, Courtenay
Doak, Samuel
Dod, Daniel
Dodge, William De Leftwich
Dowell, Greensville
Dudley, Benjamin Winslow
Dupuy, Eliza Ann
Duval, William Pope
Dyer, Alexander Brydie
Early, John
Early, Jubal Anderson
Early, Peter
Early, Stephen Tyree
Echols, John
Edwards, John, 1748–1837
Ellis, Powhatan
Emmet, Thomas Addis
Eppes, John Wayles
Evans, Robley Dunglison
Ewell, James
Ewell, Thomas
Ewing, Finis
Ewing, Thomas
Ezekiel, Moses Jacob
Fackler, David Parks
Fairfax, Donald McNeill
Fanning, David
Faulkner, Charles James, 1806–1884
Faulkner, Charles James, 1847–1929
Fels, Joseph
Fifer, Joseph Wilson

Fishback, William Meade
Fitzhugh, George
Fleming, Aretas Brooks
Floyd, John Buchanan
Foote, Henry Stuart
Forsyth, John
Franklin, Jesse
Freeman, Allen Weir
Freeman, Douglas Southall
Freeman, Frederick Kemper
Frémont, Jessie Benton
French, Lucy Virginia Smith
Frost, Wade Hampton
Fry, Birkett Davenport
Gaines, Edmund Pendleton
Gaines, John Pollard
Gamble, Hamilton Rowan
Gardener, Helen Hamilton
Garland, Landon Cabell
Garnett, Alexander Yelverton Peyton
Garnett, James Mercer, 1770–1843
Garnett, James Mercer, 1840–1916
Garnett, Muscoe Russell Hunter
Garnett, Robert Selden
Garrard, James
Garrett, William Robertson
Gholson, Thomas Saunders
Gholson, William Yates
Gibbs, James Ethan Allen
Giles, William Branch
Gilmer, Francis Walker
Gilmer, George Rockingham
Gilmer, Thomas Walker
Gilpin, Charles Sidney
Glasgow, Ellen Anderson Gholson
Glass, Carter
Glenn, Hugh
Glover, Samuel Taylor
Goode, John
Gordon, William Fitzhugh
Goss, James Walker
Graham, James Duncan
Graham, John
Grasty, Charles Henry
Grayson, William
Green, James Stephens
Green, William
Greene, Belle Da Costa
Greenhow, Robert
Greenup, Christopher
Griffin, Cyrus
Griffin, Robert Stanislaus
Grigsby, Hugh Blair
Grundy, Felix
Hall, Willard Preble
Hamilton, James
Hammond, Samuel
Hampton, Wade
Hardin, John
Hardy, Samuel

Harper, Robert Goodloe
Harris, John Woods
Harris, William Alexander
Harrison, Benjamin
Harrison, Constance Cary
Harrison, Gessner
Harrison, William Henry
Harvie, John
Hatcher, Orie Latham
Hatcher, William Eldridge
Hay, George
Heath, James Ewell
Henderson, John Brooks
Henderson, Richard
Hening, William Waller
Henley, Robert
Henry, Patrick
Henry, William Wirt
Herndon, William Lewis
Heth, Henry
Hill, Ambrose Powell
Hine, Charles De Lano
Hodges, Luther Hartwell
Hoge, Moses
Hoge, Moses Drury
Holcombe, Henry
Holcombe, James Philemon
Holcombe, William Henry
Holt, John
Hope, James Barron
Hopkins, Arthur Francis
Hopkins, Juliet Ann Opie
Hopkins, Samuel, 1753–1819
Horner, William Edmonds
Hough, Theodore
Hough, Warwick
Houston, Edwin James
Houston, Samuel
Howard, Benjamin
Howard, William Travis
Hubbard, David
Hughes, Robert William
Humphreys, Milton Wylie
Hunter, Robert Mercer Taliaferro
Hunton, Eppa
Imboden, John Daniel
Innes, Harry
Innes, James
Jackson, Charles Samuel
Jackson, John George
James, Edwin Leland
Janney, Eli Hamilton
Janney, Samuel McPherson
Jarratt, Devereux
Jarvis, William Chapman
Jefferson, Thomas
Jenkins, Albert Gallatin
Jenkins, Thornton Alexander
Jesse, Richard Henry
Jesup, Thomas Sidney

Jeter, Jeremiah Bell
Johnson, Ames
Johnson, Chapman
Johnson, Charles Spurgeon
Johnson, Edward
Johnson, Louis Arthur
Johnston, George Ben
Johnston, Joseph Eggleston
Johnston, Mary
Johnston, Peter
Johnston, Zachariah
Jones, Catesby Roger
Jones, Gabriel
Jones, Hilary Pollard
Jones, John William
Jones, John Winston
Jones, Joseph
Jones, Thomas Catesby
Jones, Walter
Jordan, Thomas
Jouett, John
Joynes, Edward Southey
Kalmus, Natalie Mabelle Dunfee
Kean, Jefferson Randolph
Keith, James
Kemper, James Lawson
Kemper, Reuben
Kenna, John Edward
Kenton, Simon
Keyes, Frances Parkinson
Kilgore, Harley Martin
Klipstein, Louis Frederick
Krauth, Charles Porterfield
Lackaye, Wilton
Lacock, Abner
Lacy, Drury
Ladd, Catherine
Lamon, Ward Hill
Lancaster, Henry Carrington
Lane, James Henry
Lane, John
Langston, John Mercer
Lanier, Sidney
Lattimore, William
Laws, Samuel Spahr
Lawson, Thomas
Lay, Henry Champlin
Leathers, Waller Smith
Lee, Arthur
Lee, Charles, 1758–1815
Lee, Fitzhugh
Lee, Francis Lightfoot
Lee, George Washington Custis
Lee, Henry, 1756–1818
Lee, Henry, 1787–1837
Lee, Jesse
Lee, Richar Bland
Lee, Richard Henry
Lee, Robert Edward
Lee, Samuel Phillips

1793

Lee, William
Lee, William Henry Fitzhugh
Leffel, James
Leigh, Benjamin Watkins
Letcher, John
Letcher, Robert Perkins
Lewis, Dixon Hall
Lewis, Fielding
Lewis, James Hamilton
Lewis, John Francis
Lewis, Meriwether
Lewis, William Berkeley
Lewis, William Henry
Ligon, Thomas Watkins
Lindsay, William
Littlepage, Lewis
Logan, Benjamin
Lomax, John Tayloe
Long, Armistead Lindsay
Long, Joseph Ragland
Low, Juliette Gordon
Lukeman, Henry Augustus
Lumpkin, Wilson
Lynch, Charles
Lynch, James Daniel
Lynch, William Francis
McCabe, John Collins
McCabe, William Gordon
McCaw, James Brown
McClurg, James
McCormick, Cyrus Hall
McCormick, Leander James
McCormick, Robert
McCormick, Robert Sanderson
McCormick, Stephen
McDowell, Charles
McDowell, Ephraim
McDowell, James
McDowell, Joseph
McGuire, Hunter Holmes
McIlwaine, Richard
McKee, John
McKinley, John
McKnight, Robert
McNeill, John Hanson
Macrae, John
Madison, James
Magruder, John Bankhead
Magruder, Julia
Mahan, Mito
Mahone, William
Manly, Charles Matthews
Mann, Ambrose Dudley
Manson, Otis Frederick
Marshall, Humphrey
Marshall, James Markham
Marshall, John
Marshall, Louis
Marshall, Thomas
Martin, Thomas Staples

Mason, Claibourne Rice
Mason, George
Mason, John Young
Mason, Lucy Randolph
Mason, Richar Barnes
Mason, Samuel
Mason, Stevens Thomson, 1760–1803
Mason, Stevens Thomson, 1811–1843
Mason, Thomson
Massey, John Edward
Mathews, George
Maury, Dabney Herndon
Maury, Matthew Fontaine
Maxwell, William
Mayo, William Kennon
Meade, Richard Kidder
Meade, William
Meason, Isaac
Meek, Joseph L.
Mercer, Charles Fenton
Mercer, James
Mercer, John Francis
Metcalfe, Samuel Lytler
Metcalfe, Thomas
Mettauer, John Peter
Michaux, Lightfoot Solomon
Mifflin, Warner
Minnigerode, Lucy
Minor, Benjamin Blake
Minor, John Barbee
Minor, Lucian
Minor, Raleigh Colston
Minor, Virginia Louisa
Mitchell, David Dawson
Mitchell, John Kearsley
Moncure, Richard Cassius Lee
Monette, John Wesley
Monroe, James
Montague, Andrew Jackson
Moore, Andrew
Moore, Edwin Ward
Moore, Frederick Randolph
Moore, James, 1764–1814
Moore, Thomas Patrick
Morehead, John Motley
Morgan, William
Morrison, William McCutchan
Morton, Robert Russa
Mosby, John Singleton
Mullan, John
Munford, Robert
Munford, William
Murfee, James Thomas
Murray, Mae
Myers, Jerome
Nash, Abner
Nash, Francis
Neighbors, Robert Simpson
Nelson, Hugh
Nelson, Thomas

Nelson, William, 1711–1772
Neville, John
Neville, Wendell Cushing
Newman, Robert Loftin
Newman, William H.
Newton, John
Newton, Thomas, 1768–1847
Nicholas, George
Nicholas, John
Nicholas, Philip Norborne
Nicholas, Robert Carter
Nicholas, Wilson Cary
Noble, James
O'Donovan, William Rudolf
O'Ferrall, Charles Triplett
Otey, James Hervey
Overton, John
Owen, Robert Latham
Owsley, William
Page, John
Page, Mann
Page, Richard Lucian
Page, Thomas Jefferson
Page, Thomas Nelson
Page, Thomas Walker
Parker, Josiah
Parker, Richard Elliot
Parrish, Celestia Susannah
Patton, John Mercer
Pearce, James Alfred
Peers, Benjamin Orrs
Pelham, Robert A.
Pendleton, Edmund
Pendleton, James Madison
Pendleton, John Strother
Pendleton, William Kimbrough
Pendleton, William Nelson
Penick, Charles Clifton
Penn, John
Penniman, James Hosmer
Pennock, Alexander Mosely
Person, Thomas
Peyton, John Lewis
Pick, Lewis Andrew
Pickett, George Edward
Pickett, James Chamberlayne
Pierpont, Francis Harrison
Pilcher, Joshua
Pleasants, James
Pleasants, John Hampden
Pocahontas
Poindexter, George
Pollard, Edward Alfred
Porter, John Luke
Posey, Thomas
Powell, Adam Clayton, Sr.
Powell, Lucien Whiting
Power, Frederick Dunglison
Pratt, John Lee
Prentiss, Benjamin Mayberry

Preston, John Smith
Preston, William Ballard
Price, Joseph
Price, Sterling
Price, Thomas Lawson
Price, Thomas Randolph
Price, William Cecil
Pryor, Nathaniel
Pryor, Roger Atkinson
Puller, Lewis Burwell ("Chesty")
Puryear, Bennet
Radford, William
Ramsay, George Douglas
Randotph, Alfred Magill
Randolph, Edmund, 1753–1813
Randolph, Edmund, 1819–1861
Randolph, Epes
Randolph, George Wythe
Randolph, Isham
Randolph, Sir John
Randolph, John, 1727 or 1728–1784
Randolph, John, 1773–1833
Randolph, Peyton
Randolph, Sarah Nicholas
Randolph, Thomas Jefferson
Randolph, Thomas Mann
Ravenscroft, John Stark
Reed, Walter
Reid, Ira De Augustine
Reid, Mont Rogers
Renick, Felix
Reynolds, Alexander Welch
Reynolds, William Neal
Rice, David
Rice, John Holt
Richard, James William
Ritchie, Albert Cabell
Ritchie, Thomas
Rives, John Cook
Rives, William Cabell
Roane, Spencer
Roberts, Joseph Jenkins
Robertson, James, 1742–1814
Robertson, John
Robertson, Thomas Bolling
Robertson, William Joseph
Robertson, Wyndham
Robinson, Beverley
Robinson, Bill (Bojangles)
Robinson, Conway
Robinson, John
Robinson, Moncure
Rochester, Nathaniel
Rodes, Robert Emmett
Rorer, David
Ross, Erskine Mayo
Russel, Thomas Lafayette
Ruffin, Edmund
Ruffin, Thomas
Ruffner, Henry

Ruffner, William Henry
Russell, James Solomon
Ryan, Thomas Fortune
Ryland, Robert
Saunders, Clarence
Scott, Charles
Scott, Dred
Scott, Gustavus
Scott, William
Scott, Winfield
Seaton, William Winston
Seawell, Molly Elliot
Sebastian, Benjamin
Seddon, James Alexander
Seevers, William Henry
Sevier, John
Sherman, Henry Clapp
Shipman, Andrew Jackson
Shipp, Scott
Short, William
Shreve, Thomas Hopkins
Shuck, Tohn Lewis
Silver, Gray
Singleton, James Washington
Slaughter, Philip
Slemp, Campbell Bascom
Smith, Benjamin Mosby
Smith, Daniel
Smith, Francis Henney
Smith, Howard Worth ("Judge")
Smith, John, 1735–1824
Smith, John Augustine
Smith, Lucy Harth
Smith, Meriwether
Smith, Thomas Adams
Smith, William, 1797–1887
Smith, William Andrew
Smith, William Waugh
Smythe, John Henry
Snead, Thomas Lowndes
Southall, James Cocke
Spencer, Pitman Clemens
Stanard, Mary Mann Page Newton
Stanard, William Glover
Stanton, Frederick Perry
Stanton, Richard Henry
Staples, Waller Redd
Sterrett, John Robert Sitlington
Stevenson, Andrew
Stevenson, Carter Littlepage
Stevenson, John White
Still, Andrew Taylor
Stith, William
Stokes, Montfort
Stone, George Washington
Stone, John Slow
Street, Joseph Montfort
Stringfellow, Franklin
Strong, Richard Pearson
Stuart, Alexander Hugh Holmes

Stuart, Archibald
Stuart, Granville
Stuart, James Ewell Brown
Sullavan, Margaret
Summers, George William
Sumner, Jethro
Sumter, Thomas
Swanson, Claude Augustus
Swayne, Noah Haynes
Tabb, John Banister
Tait, Charles
Taliaferro, Lawrence
Taliaferro, William Booth
Tauber, Maurice Falcolm
Taylor, Creed
Taylor, David Watson
Taylor, Edward Thompson
Taylor, George Boardman
Taylor, John, 1752–1835
Taylor, John, 1753–1824
Taylor, Robert Tunstall
Taylor, William
Taylor, Zachary
Tazewell, Henry
Tazewell, Littleton Waller
Terhune, Mary Virginia Hawes
Thomas, George Henry
Thomas, Jesse Burgess
Thomas, William Isaac
Thompson, John Reuben
Thompson, Richard Wigginton
Thompson, Thomas Larkin
Thompson, Wiley
Thomson, John
Thornton, Jesse Quinn
Thurman, Allen Granberry
Timberlake, Gideon
Timberlake, Henry
Todd, Thomas
Tompkins, Sally Louisa
Toy, Crawford Howell
Trent, William Peterfield
Trimble, Allen
Trimble, Isaac Ridgeway
Trimble, Robert
Trist, Nicholas Philip
Tucker, Henry St. George, 1780–1848
Tucker, Henry St. George, 1853–1932
Tucker, Henry St. George, 1874–1959
Tucker, John Randolph, 1812–1883
Tucker, John Randolph, 1823–1897
Tucker, Nathaniel Beverley, 1784–1851
Tucker, Nathaniel Beverley, 1820–1890
Turner, Edward
Turner, Nat
Tutwiler, Henry
Tyler, John, 1747–1813
Tyler, John, 1790–1862

Tyler, Lyon Gardiner
Tyler, Robert
Underwood, Joseph Rogers
Untermyer, Samuel
Upshur, Abel Parker
Upshur, John Henry
Valentine, Edward Virginius
Vandegrift, Alexander Archer
Venable, Charles Scott
Venable, Francis Preston
Walke, Henry
Walker, Alexander
Walker, Joseph Reddeford
Walker, Reuben Lindsay
Walker, Thomas
Wallace, William Alexander Anderson
Walthall, Edward Cary
Walton, George
Ward, Lydia Arms Avery Cooney
Warrington, Lewis
Washington, Booker Taliaferro
Washington, Bushrod
Washington, George
Washington, John Macrae
Watkins, John Elfreth
Watson, John William Clark
Waugh, Beverly
Weddell, Alexander Wilbourne
Wellons, William Brock
Wells, Robert William
Wertenbaker, Charles Christian
Wertenbaker, Thomas Jefferson
Wharton, William H.
White, Alexander
White, Thomas Willis
Wilkinson, John
Will, Allen Sinclair
Williams, Channing Moore
Williams, John Skelton
Willoughby, Westel Woodbury
Wilmer, Joseph Pére Bell
Wilmer, Richard Hooker
Wilmer, William Holland
Wilson, Edith Bolling
Wilson, James Southall
Wilson, Joshua Lacy
Wilson, William
Wilson, Woodrow
Winn, Richard
Winston, Joseph
Wise, Henry Alexander
Woodford, William
Woodson, Carter Godwin
Wootton, Richens Lacy
Wright, Willard Huntington
Wythe, George
Young, George

WASHINGTON

Bailey, Mildred
Bartlett, Edward Lewis ("Bob")

Blakeslee, Howard Walter
Buchanan, Scott Milross
Carlson, Chester Floyd
Cayton, Horace Roscoe
Chamberlin, Edward Hastings
Cordiner, Ralph Jarron
Crosby, Harry Lillis ("Bing")
Dean, Gordon Evans
Dennis, Eugene
Fairchild, Muir Stephen
Faust, Frederick Shiller
Garry, Spokane
Hendrix, Jimi
Knox, Dudley Wright
Lee, Gypsy Rose
Leschi
Llewellyn, Karl Nickerson
McClintic, Guthrie
Pangborn, Clyde Edward
Seattle
Smohalla
Taggard, Genevieve
Wainwright, Jonathan Mayhew

WEST VIRGINIA

Allen, James Edward, Jr.
Baker, Newton Diehl
Bent, Charles
Bishop, John Peale
Brooke, Charles Frederick Tucker
Brown, Charles Reynolds
Buck, Pearl Comfort Syden-Stricker
Byrd, Harry Blood
Carpenter, Franklin Reuben
Chadwick, rench Ensor
Cooke, Philip Pendleton
Davis, John William
Delany, Martin Robinson
Dixon, William
Dolliver, Jonathan Prentiss
Douglas, Henry Kyd
Elkins, William Lukens
Fairfield, Edmun Burke
Fisher, Walter Lowrie
Foster, George Burman
Greer, David Hummell
Gregg, William
Hamilton, John William
Harvey, William Hope
Hill, Arthur Middleton
Hines, John Leonard ("Birdie")
Hough, Walter
Hughes, Edwin Holt
Humphreys, Wiliam Jackson
Jackson, Thomas Jonathan
Johnson, Douglas Wilson
Johnston, Frances Benjamin
Lacey, John Fletcher
Lashley, Karl Spencer
Leigh, William Robinson

Lisagor, Peter Irvin
Lowndes, Lloyd
Lucas, Daniel Bedinger
Lucas, Robert
Miller, John
Morrow, Dwight Whitney
Nadal, Ehrman Syme
Neely, Matthew Mansfield
Owens, Michael Joseph
Patrick, Mason Mathews
Payne, Christopher Harrison
Payne, John Barton
Post, Melville Davisson
Rathbone, Monroe Jackson ("Jack")
Reno, Jesse Lee
Reuther, Walter Philip
Robertson, Absalom Willis
Russell, Charles Wells
Sayre, Wallace Stanley
Sinclair, Harry Ford
Strauss, Lewis Lichtenstein
Strother, David Hunter
Tidball, John Caldwell
Vawtor, Charles Erastus
Waldo, David
Webster, Harold Tucker
White, Israel Charles
Willey, Wartman Thomas
Wilson, William Lyne
Worthington, Thomas
Yost, ielding Harris
Zane, Ebenezer

WISCONSIN

Adams, Alva
Altmeyer, Arthur Joseph
Ames, Edward Scribner
Andrews, John Bertram
Andrews, Roy Chapman
Ayer, Edward Everett
Baker, Hugh Potter
Bashford, James Whitford
Billings, Frank
Bishop, Seth Scott
Blaine, John James
Bleyer, Willard Grosvenor
Bloodgood, Joseph Colt
Bolton, Herbert Eugene
Bond, Carrie Jacobs
Briggs, Clare A.
Bryant, Joseph Decatur
Burt, Mary Elizabeth
Cannon, Ida Maud
Cannon, Walter Bradford
Catt, Carrie Clinton Lane Chapman
Chafin, Eugene Wilder
Chapelle, Dickey
Coburn, Foster Dwight
Comstock, George Cary
Comstock, John Henry

Crowley, Leo Thomas
Curtin, Jeremiah
Curtis, Edward Sheriff
Cushing, William Barker
Davies, Joseph Edward
Dawson, Thomas Cleland
Dennett, Tyler (Wilbur)
Dexter, Wirt
Doheny, Edward Laurence
Duffy, Francis Ryan
Egtvedt, Clairmont ("Claire") Leroy
Eklund, Carl Robert
Elvehjem, Conrad Arnold
Esch, John Jacob
Falk, Otto Herbert
Favill, Henry Baird
Fitzpatrick, Daniel Robert
Ford, Guy Stanton
Gale, Zona
Garland, Hamlin
Gasser, Herbert Spencer
Gesell, Arnold Lucius
Gillette, King Camp
Goetz, George Washington
Grabau, Amadeus William
Haas, Francis Joseph
Hansen, Marcus Lee
Hanson, Ole
Harris, Paul Percy
Haugen, Gilbert Nelson
Hazelton, George Cochrane
Hempl, George
Hine, Lewis Wickes
Hoan, Daniel Webster
Hooton, Earnest Albert
Hopson, Howard Colwell
Houdini, Harry
Hoxie, Vinnie Ream
Hubley, John
Huebner, Solomon Stephen
Husting, Paul Oscar
Irving, John Duer
Jones, Lewis Ralph
Kaltenborn, Hans Von
Kelley, Edgar Stillman
King, Franklin Hiram
Kohler, Walter Jodok
Kohler, Walter Jodok, Jr.
Kremers, Edward
Krug, Julius Albert
La Follette, Philip Fox
La Follette, Robert Marion
La Follette, Robert Marion, Jr.
Lambeau, Earl Louis ("Curly")
Leemans, Alphonse E. ("Tuffy")
Legge, Alexander
Lennon, John Brown
Lenroot, Irvine Luther

Lewis, Ed ("Strangler")
Libby, Orin Grant
Lunt, Alfred David, Jr.
Lutkin, Peter Christian
McCarthy, Joseph Raymond
McIntyre, James
McNair, Fred Walter
Macune, Charles William
Mahoney, John Friend
Manville, Thomas Franklyn
 ("Tommy"), Jr.
March, Frederic
Martin, Franklin Henry
Mason, Max
Matheson, William John
Mears, Helen Farnsworth
Merrill, William Emery
Meyer, Albert Gregory
Mitscher, Marc Andrew
Moldenke, Richard George Gottlob
Morse, Wayne Lyman
Murphy, Frederick E.
Murphy, John Benjamin
Murphy, Robert Daniel
Nehrling, Henry
Newell, Edward Theodore
Nieman, Lucius William
Nye, Gerald Prentice
Ochsner, Albert John
Older, Fremont
Pammel, Louis Hermann
Penfold, Joseph Weller
Perkins, James Breck
Persons, Warren Milton
Pfund, August Herman
Philipp, Emanuel Lorenz
Pond, Frederick Eugene
Preus, Christian Keyser
Purdy, Corydon Tyler
Reid, Helen Miles Rogers
Reinsch, Paul Samuel
Rice, Edwin Wilbur
Richmond, Charles Wallace
Ritter, William Emerson
Robinson, Frederick Byron
Roe, Gilbert Ernstein
Romnes, Haakon Ingolf ("H.L.")
Rublee, George
Salisbury, Albert
Salisbury, Rollin D.
Savage, John Lucian ("Jack")
Sawyer, Wilbur Augustus
Schorer, Mark
Schwellenbach, Lewis Baxter
Scidmore, Eliza Ruhamah
Scott, James Wilmot
Sewall, May Eliza Wright
Showerman, Grant

Shuster, George Nauman
Simmons (Szymanski), Aloysius Harry
Simons, Algie Martin
Slichter, Louis Byrne
Slichter, Sumner Huber
Smith, Francis Marion
Smith, Gerald L. K.
Starks, Edwin Chapin
Stromme, Peer Olsen
Stub, Hans Gerhard
Tobey, Mark
Tracy, Spencer Bonaventure
Turner, Frederick Jackson
Underwood, Frederick Douglas
U'Ren, William Simon
Vandenberg, Hoyt Sanford
Van Hise, Charles Richard
Veblen, Thorstein Bunde
Walsh, Thomas James
Warner, William
Weaver, Warren
West, Allen Brown
Wheeler, William Morton
Wilcox, Ella Wheeler
Wilder, Laura Ingalls
Wilder, Thornton Niven
Wiley, Alexander
Willard, Josiah Flint
Witte, Edwin Emil
Woodbury, Helen Laura Sumner
Wright, Frank Lloyd
Wright, Theodore Lyman

WYOMING

Arnold, Thurman Wesley
Downey, June Etta
Downey, Sheridan
Pollock, (Paul), Jackson
Snyder, Howard McCrum
Spotted Tail

STATE NOT SPECIFIED

Attucks, Crispus
Baynham, William
Black, Eli
Glass, Hugh
Grew, Theophilus
Johnson, Robert
Kicking Bird
Plummer, Henry
Pontiac
Powhatan
Squanto
Tammany
Uncas
Vesey, Denmark
Ware, Nathaniel A.

BIRTHPLACES—FOREIGN COUNTRIES

ARGENTINA

Haymes, Richard Benjamin ("Dick")
Parvin, Theophilus

AUSTRALIA

Booth, Agnes
Errol, Leon
Flynn, Errol Leslie
Grainger, George Percy
Henry, Alice
Jacobs, Joseph, 1854–1916
Mason, Arthur John
Mayo, George Elton
Oberon, Merle
Orry-Kelly
Ritchard, Cyril
Robson, May
Travis, Walter John

AUSTRIA

(Including Austria-Hungary)

Baraga, Frederic
Baum, Hedwig ("Vicki")
Berger, Victor Louis
Bloomfield, Maurice
Bodanzky, Artur
Brill, Abraham Arden
Carnegie, Hattie
Conried, Heinrich
Deutsch, Gotthard
Drexel, Francis Martin
Fall, Bernard B.
Fenichel, Otto
Frank, Philipp G.
Frankfurter, Felix
Franzblau, Rose Nadler
Gericke, Wilhelm
Goldberger, Joseph
Grau, Maurice
Grossmann, Louis
Grund, Francis Joseph
Hassaurek, Friedrich
Herbert, Frederick Hugh
Hess, Victor Franz
Katzer, Frederic Xavier
Keppler, Joseph
King, Alexander
Korngold, Erich Wolfgang

Kreisler, Fritz
Landsteiner, Karl
Lang, Fritz
Lazarsfeld, Paul Felix
Lowie, Robert Harry
Lucas, Anthony Francis
Malter, Henry
Muni, Paul
Neutra, Richard Joseph
Ohrbach, Nathan M. ("N.M.")
Ortynsky, Stephen Soter
Pierz, Franz
Pilat, Ignaz Anton
Pollak, Gustav
Pupin, Michael Idvorsky
Raffeiner, John Stephen
Reik, Theodor
Rosenstein, Nettie Rosencrans
Roth, Samuel
Rubin, Isidor Clinton
Sachs, Hanns
Sakel, Manfred Joshua
Schildkraut, Joseph
Schindler, Rudolph Michael
Schnabel, Artur
Schoenberg, Arnold
Schuster, Max Lincoln
Sporn, Philip
Stark, Edward Josef
Steiner, Maximilian Raoul Walter
 ("Max")
Ulmer, Edgar Georg
Urban, Joseph
Von Sternberg, Josef
Von Stroheim, Erich
Weinberger, Jacob
Weisenburg, Theodore Herman
Zeisler, Fannie Bloomfield
Zeisler, Sigmund

BELGIUM

(Including Flanders)

Baekeland, Leo Hendrik
Bouquillon, Thomas Joseph
Brondel, John Baptist
Carondelet, Francisco Luis Hector,
 Baron de
Coppens, Charles
Croix, Teodoro de

De Smet, Pierre-Jean
Hennepin, Louis
Heurotin, Charles
Heurotin, Fernand
Janssens, Francis
Lefevere, Peter Paul
Maes, Camillus Paul
Meerschaert, Théophile
Musin, Ovide
Nerinckx, Charles
Nieuwland, Julius Arthur
Parmentier, Andrew
Rau, Charles
Sauveur, Albert
Seghers, Charles Jean
Van Depoele, Charles Joseph
Vander Wee, John Baptist
Van de Velde, James Oliver
Van Quickenborne, Charles Felix
Verbrugghen, Henri
Verhaegen, Peter Joseph

BERMUDA

Cooke, John Esten
Cooke, John Rogers
Meigs, Charles Delucena
Patton, Francis Landey
Tucker, George
Tucker, St. George

BOHEMIA

Heinrich, Antony Philip
Heller, Maximilian
Herrman, Augustine
Hessoun, Joseph
Janauschek, Franziska Magdalena
 Romance
Levy, Louis Edward
Neumann, John Nepomucene
Prokosch, Eduard
Rosewater, Edward
Steinitz, William
Taussig, William
Vopicka, Charles Joseph
Wise, Isaac Mayer

BRAZIL

Carrère, John Merven
Glover, Townend

Wegmann, Edward
Wise, John Sergeant

BRITISH GUIANA

Benjamin, Park
Holmes, George Frederick
Vethake, Henry

BULGARIA

Arlen, Michael
Zwicky, Fritz

BURMA

Seagrave, Gordon Stifler

CANADA

Anglin, Margaret Mary
Arden, Elizabeth
Avery, Oswald Theodore
Aylwin, John Cushing
Barton, George Aaron
Bassett, James
Beattie, Francis Robert
Becket, Frederick Mark
Belcourt, George Antoine
Benham, Henry Washington
Bensley, Robert Russell
Bingay, Malcolm Wallace
Blake, William Rufus
Blanchet, François Norbert
Blue, Ben
Bowen, Norman Levi
Bowman, Isaiah
Brent, Charles Henry
Brokenshire, Norman Ernest
Brunton, David William
Burk, Frederic Lister
Burrowes, Edward Thomas
Callaway, Samuel Rodger
Carpenter, George Rice
Carson, Jack
Case, Shirley Jackson
Céloron de Blainville, Pierre Joseph de
Cerré, Jean Gabriel
Chisholm, Hugh Joseph
Clark, Francis Edward
Colpitts, Edwin Henry
Comstock, Henry Tompkins Paige
Copway, George
Costain, Thomas Bertram
Coughlin, Charles Edward
Couzens, James
Cox, Palmer
Cuvillier, Louis Mitchell
Creath, Jacob
Creelman, James
Creighton, James Edwin
Crouter, Albert Louis Edgerton

Crowe, Francis Trenholm
Cullen, Thomas Stephen
Cutter, George Washington
Daly, Reginald Aldworth
Dett, Robert Nathaniel
Doran, George Henry
Douglas, James
Doull, James Angus
Dow, Herbert Henry
Dressler, Marie
Dubuque, Julien
Duffy, Francis Patrick
Duncan, Robert Kennedy
Dymond, John
Eaton, Charles Aubrey
Eaton, Cyrus Stephen
Eaton, Wyatt
Faith, Percy
Faribault, Jean Baptiste
Farnsworth, John Franklin
Ferguson, Alexander Hugh
Fergusori, John Calvin
Fessenden, Reginald Aubrey
Finn, Henry James William
Fleming, Arthur Henry
Fortescue, Charles LeGeyt
Fowler, Charles Henry
Fox, Margaret
Franchére, Gabriel
Freeman, James Edwards
Frizell, Joseph Palmer
Gallinger, Jacob Harold
Garrison, William Re Tallack
Gibault, Pierre
Goddu, Louis
Gordon, George Byron
Gould, Elgin Ralston Lovell
Grosset, Alexander
Hackett, James Keteltas
Hambidge, Jay
Harrison, Richard Berry
Hill, James Jerome
Hunton, William Lee
Huston, Walter
Iberville, Pierre Le Moyne, Sieur d'
Ironside, Henry Allan
Irwin, May
Jacoby, Neil Herman
James, Will Roderick
Jamison, Cecilia Viets Dakin Hamilton
Jeffrey, Edward Charles
Johnson, Edward
Johnson, Harry Gordon
Johnston, William Hugh
Johnstone, Edward Ransom
Jolliet, Louis
Juneau, Solomon Laurent
Kelley, Edith Summers
Keys, Clement Melville
Kimball, Dexter Simpson

King, William Benjamin Basil
Kinzie, John
Kirk, John Foster
Kittson, Norman Wolfred
Koyl, Charles Herschel
Kraft, James Lewis
Lane, Franklin Knight
Langford, Samuel
Lanigan, George Thomas
Laramie, Jacques
Larned, Josephus Nelson
La Ronde, Louis Denis, Sieur de
Lear, Ben
Leary, John
Lee, Jason
Léry, Joseph Gaspard Chaussegros de
Lewis, Francis Park
Lillie, Frank Rattray
Livingston, James
Livingstone, William
Lombardo, Gaetano Albert ("Guy")
Lorimier, Pierre Louis
Loucks, Henry Langford
MacArthur, Robert Stuart
McBain, Howard Lee
MacCallum, William George
McCoy, Elijah
McCrae, Thomas
Macdonald, Charles Blair
McKay, Donald
McKenzie, Robert Tait
McLaughlin, James
McLean, Archibald
MacLeod, Colin Munro
McLeod, Martin
McLoughlin, John
McMillan, James
McMurrich, James Playfair
McPherson, Aimee Semple
Mahler, Herbert
Marling, Alfred Erskine
Marsh, Charles Wesley
Marsh, William Wallace
Mason, Walt
Mathewson, Edward Payson
Matthew, William Diller
Medill, Joseph
Menard, Michel Branamour
Menard, Pierre
Mitchell, William, 1832–1900
Morgan, John Harcourt Alexander
Morris, Clara
Morrison, Frank
Moxom, Philip Stafford
Munro, George
Munro, William Bennett
Murphy, William Walton
Murray, James Edward
Naismith, James
Nash, John Henry
Nesmith, James Willis

Newcomb, Simon
Nicholson, Samuel Danford
Norwood, Robert Winkworth
Noyan, Pierre-Jacques Payen de
Nutting, Mary Adelaide
Ogden, Peter Skene
O'Higgins, Harvey Jerrold
Osler, William
Palmer, Daniel David
Palmer, Joel
Pearce, Richard Mills
Phelan, David Samuel
Pickford, Mary
Piper, Charles Vancouver
Price, George Edward McCready
Provost, Etienne
Quigley, James Edward
Rand, Benjamin
Rankin, McKee
Raymond, Harry Howard
Reid, Rose Marie
Riordan, Patrick William
Robinson, Boardman
Rolette, Jean Joseph
Rose, Walter Malins
Ross, James Delmage McKenzie
Rothwell, Richard Fennefather
Ryan, Stephen Vincent
Ryan, Walter D'Arcy
St. Ange De Bellerive, Louis
St. Denis (Denys), Louis Juchereau de
Sandham, Henry
Sauganash
Scherman, Harry
Schofield, William Henry
Schurman, Jacob Gould
Scott, Colin Alexander
Scott, James Brown
Sears, Robert
Sennett, Mack
Shikellamy
Shotwell, James Thomson
Silverheels, Jay
Simpson, Albert Benjamin
Simpson, Jerry
Sims, William Sowden
Slocum, Joshua
Squiers, Herbert Goldsmith
Stefansson, Vilhjalmur
Stephenson, Isaac
Stevens, John Harrington
Stewart, George Neil
Storrow, Charles Storer
Sullivan, William Henry
Tanguay, Eva
Thompson, Slason
Thomson, Edward William
Truteau, Jean Baptiste
Upham, Charles Wentworth
Vaudreuil-Cavagnal, Pierre de Rigaud,
 Marquis de

Vincennes, Jean Baptiste Bissot
Viner, Jacob
Waddell, John Alexander Low
Wanless, William James
Warner, Jack Leonard
Warren, Samuel Prowse
Watson, James Craig
Wesbrook, Frank Fairchild
West, Oswald
Wheelock, Joseph Albert
White, Benjamin Franklin
Williams, Eleazar
Wood, Casey Albert
Wood, William Burke
Woodbridge, Frederick James Eugene

CEYLON

Coomaraswamy, Ananda Kentish
Sanders, Frank Knight

CHILE

Albright, William Foxwell
De Cuevas, Marquis
Murrieta, Joaquin

CHINA

Coulter, John Merle
Howe, James Wong
Lambuth, Walter Russ
Lowrie, James Walter
Luce, Henry Robinson
Lyon, David Willard
Maclay, Edgar Stanton
Ng Poon Chew
Stuart, John Leighton
Sydenstricker, Edgar
Williams, Frederick Wells
Yung Wing

CUBA

Agramonte y Simoni, Aristides

CZECHOSLOVAKIA

(*See also* Bohemia, Moravia, Silesia)

Cermak, Anton Joseph
Cori, Gerty Theresa Radnitz
Gerster, Arpad Geyza Charles
Friml, Charles Rudolf
Hertz, John Daniel
Koller, Carl
Ottendorfer, Oswald
Sabath, Adolph J.
Schumann-Heink, Ernestine
Schumpeter, Joseph Alois
Steuer, Max David
Wertheimer, Max

DENMARK

Bierregaard, Carl Henrik Andreas
Blichfeldt, Hans Frederik

Boyé, Martin Hans
Clausen, Claus Lauritz
Febiger, Christian
Fenger, Christian
Gronlund, Laurence
Hansen, Niels Ebbesen
Hovgaard, William
Isbrandtsen, Hans Jeppesen
Jacobson, John Christian
Jensen, Jens
Jensen, Peter Laurits
Knudsen, William S.
Linde, Christian
Melchior, Lauritz Lebrecht Hommel
Nelson, Julius
Nelson, Nels Christian
Poulson, Niels
Riis, Jacob August
Rybner, Martin Cornelius
Sorensen, Charles
Westergaard, Harald Malcolm

DUTCH GUIANA

Matzeliger, Jan Ernst

EGYPT

Forester, Cecil Scott
Mowbray, Henry Siddons
Watson, Charles Roger

ENGLAND

(Including Channel Islands, Isle of
Man, Isle of Wight, Orkney Islands,
Scilly Isles)

Abel-Henderson, Annie Heloise
Alden, John
Allen, John F.
Allerton, Isaac
Alsop, George
Altham, John
Amadas, Philip
Amherst, Jeffery
Andros, Sir Edmund
Archdale, John
Archer, Frederic
Argall, Sir Samuel
Arliss, George
Asbury, Francis
Asher, Joseph Mayor
Ayer, Francis Wayland
Ayres, Anne
Bache, Richard
Bache, Theophylact
Bacon, Nathaniel
Bacon, Thomas
Bailey, Ann
Baker, Edward Dickinson
Banister, John
Banner, Peter

Barr, Amelia Edith Huddleston
Barradall, Edward
Barrett, George Horton
Bartlett, John Sherren
Bateman, Harry
Bates, Barnabas
Bateson, Gregory
Bauer, Harold Victor
Baxter, William
Bazett, Henry Cuthbert
Beer, William
Bellingham, Richard
Berkeley, John
Berkeley, Sir William
Bernard, John
Bernard, Sir Francis
Bertram, John
Biggs, Edward George Power
Birch, Reginald Bathurst
Birch, Thomas
Birch, William Russell
Birchall, Frederick Thomas
Birkbeck, Morris
Blackstone, William
Blackton, James Stuart
Blackwell, Elizabeth
Blackwell, Henry Brown
Bladen, William
Bland, Thomas
Blennerhassett, Harman
Blitz, Antonio
Bollan, William
Boorman, James
Booth, Ballington
Booth, Evangeline Cory
Booth, Junius Brutus
Booth-Tucker, Emma Moss
Boucher, Jonathan
Bourne, George
Bourne, Nehemiah
Bowler, Metcalf
Bowne, John
Bradford, William, 1589/90–1657
Bradford, William, 1663–1752
Bradstreet, Anne
Bradstreet, Simon
Bradwell, James Bolesworth
Bray, Thomas
Brent, Margaret
Brett, George Platt
Brewster, William
Brierton, John
Bright, Edward
Brightly, Frederick Charles
Brioted, John
Brooks, William Robert
Brophy, John
Brown, Ernest William
Brown, John George
Browne, John
Bulkeley, Peter

Burgis, William
Burnett, Frances Eliza Hodgson
Burrington, George
Burton, William Evans
Buttrick, George Arthur
Byrd, William
Cabot, Charles Sebastian Thomas
Cadman, Samuel Parkes
Caffin, Charles Henry
Calef, Robert
Calvert, Charles
Calvert, George
Calvert, Leonard
Cameron, Andrew Carr
Camm, John
Campbell, Lord William
Campbell, William
Cannon, George Quayle
Carbutt, John
Carr, Benjamin
Carroll, James
Carroll, Leo Grattan
Carteret, Philip
Castle, Vernon Blythe
Catesby, Mark
Chadwick, Henry
Chalkley, Thomas
Chamberlain, Alexander Francis
Chaplin, Charles Spencer ("Charlie")
Chauncy, Charles, 1592–1671/72
Cheetham, James
Cheever, Ezekiel
Child, Robert
Chovet, Abraham
Clagett, Wyseman
Claiborne, William
Clarke, George
Clarke, John
Clay, Joseph
Claypole, Edward Waller
Clayton, John
Clews, Henry
Clinton, George
Cobbett, William
Cockerell, Theodore Dru Alison
Coddington, William
Coghlan, Rose
Cole, Thomas
Cole, Timothy
Colgate, William
Collier, Constance
Collyer, Robert
Colman, Ronald Charles
Comstock, Elizabeth L.
Conant, Roger
Connolly, Thomas H.
Conway, Frederick Bartlett
Cooper, Myles
Cooper, Thomas
Cooper, Thomas Abthorpe
Copley, Lionel

Coram, Thomas
Cornbury, Edward Hyde, Viscount
Cornwallis, Kinahan
Cotton, John
Couldock, Charles Walter
Cowley, Charles
Coxe, Daniel
Cranston, John
Cresop, Thomas
Crisp, Charles Frederick
Crisp, Donald
Croly, Jane Cunningham
Crompton, George
Crompton, William
Crowne, John
Crowne, William
Crunden, Frederick Morgan
Culpeper, Thomas, Lord
Cuming, Sir Alexander
Cummings, Thomas Seirs
Cunliffe-Owen, Philip Frederick
Cushman, Robert
Daft, Leo
Dakin, Henry Drysdale
Dalcho, Frederick
Danforth, Thomas
Davenport, Fanny Lily Gypsy
Davenport, George
Davenport, John
Davey, John
Davidge, William Pleater
Davidson, George
Davie, William Richardson
Dawkins, Henry
Dawson, Francis Warrington
Dawson, Henry Barton
Day, Stephen
Dealey, George Bannerman
De Berdt, Dennys
Delafield, John
De La Warr, Thomas West, Baron
Dennis, Graham Barclay
Dickins, John
Dickson, Thomas
Disston, Henry
Dixwell, John
Dorrell, William
Dove, David James
Dow, Henry
Downing, George
Drake, Samuel
Draper, John William
Dudley, Charles Edward
Dudley, Thomas
Duer, William
Duff, Mary Ann Dyke
Dunglison, Robley
Dunster, Henry
Duranty, Walter
Dyer, Mary
Dyott, Thomas W.

Eaton, Nathaniel
Eaton, Samuel
Eaton, Theophilus
Eddis, William
Eden, Charles
Eden, Robert
Edmunds, Charles Wallis
Edwards, Charles
Edwards, John, 1671–1746
Edwards, Julian
Edwards, Morgan
Edwards, Talmadge
Edwin, David
Eliot, John
Elliot, Jonathan
Elliott, John
Ellis, Henry
Endecott, John
Estaugh, Elizabeth Haddon
Esterbrook, Richard
Evans, Frederick William
Evans, George Henry
Everendon, Walter
Ewbank, Thomas
Fairburn, William Armstrong
Fairfax, Thomas
Fallows, Samuel
Farrer, Henry
Fauquier, Francis
Faversham, William Alfred
Fechter, Charles Albert
Fendall, Josias
Fennell, James
Fenwick, George
Fenwick, John
Field, Robert
Fisher, Clara
Fitzhugh, William
Fitzsimmons, Robert Prometheus
Fleet, Thomas
Fletcher, Benjamin
Fletcher, Robert
Flower, George
Flower, Richard
Folger, Peter
Foster, Charles James
Fox, Gilbert
Foxall, Henry
Francis, James Bicheno
Fry, Joshua
Fry, Richard
Fuller, John Wallace
Gage, Thomas
Gales, Joseph, 1761–1841
Gales, Joseph, 1786–1860
Gardiner, Sir Christopher
Gardiner, Harry Norman
Gardiner, Lion
Gardiner, Robert Hallowell
Gasson, Thomas Ignatius
Gates, Horatio

Gates, Sir Thomas
Gibbs, Arthur Hamilton
Gilbert, Anne Hartley
Gillam, Bernhard
Gilpin, Henry Dilworth
Gladwin, Henry
Glass, Montague Marsden
Godbe, William Samuel
Goffe, William
Gompers, Samuel
Gooch, Sir William
Goodall, Thomas
Gookin, Daniel
Gordon, William
Gorton, Samuel
Gosnold, Bartholomew
Gottheil, Richard James Horatio
Gough, John Bartholomew
Graham, David
Greaton, Joseph
Green, Samuel
Greenhalge, Frederic Thomas
Greenstreet, Sydney Hughes
Grierson, Francis
Grote, Augustus Radcliffe
Guest, Edgar Albert
Gunn, Selskar Michael
Gunter, Archibald Clavering
Gunton, George
Guthrie, Sir Tyrone
Guy, Seymour Joseph
Gwinnett, Button
Haas, Jacob Judah Aaron de
Habersham, James
Hall, Arthur Crawshay Alliston
Hall, Henry Bryan
Hallam, Lewis
Hallidie, Andrew Smith
Hamblin, Thomas Sowerby
Hamilton, Andrew
Hamilton, William Thomas
Harding, Robert
Hardwicke, Cedric Webster
Hare, James H.
Harland, Thomas
Harris, Benjamin
Harris, Joseph
Harris, Maurice Henry
Harris, Thomas Lake
Harrison, Peter
Harvard, John
Harvey, Sir John
Haswell, Anthony
Hathorne, William
Havell, Robert
Haviland, John
Hawks, John
Haynes, John
Haywood, Allan Shaw
Hazelwood, John
Heathcote, Caleb

Heckewelder, John Gottlieb Ernestus
Henningsen, Charles Frederick
Henry, Morris Henry
Herbert, Henry William
Herford, Oliver Brooke
Herring, James
Hewitt, James
Hibbins, Ann
Higginson, Francis
Higginson, John
Hill, John
Hill, Thomas, 1829–1908
Hitchcock, Alfred Joseph
Hoar, Leonard
Hodgkinson, Francis
Hodgkinson, John
Hoe, Robert, 1784–1833
Hoffman, Richard
Hogg, George
Holland, George
Holloway, John
Hollyer, Samuel
Holme, Thomas
Hooker, Samuel Cox
Hooker, Thomas
Hooker, William
Hoover, Herbert Clark, Jr.
Hopkins, Edward
Horlick, William
Hornblower, Josiah
Horrocks, James
Horsmanden, Daniel
Howard, Leslie
Howe, George Augustus, Viscount
Hubbard, William
Hudson, Henry
Hudson, William Smith
Hughes, David Edward
Hughes, Robert Ball
Hull, John
Hunt, Robert
Hutchinson, Anne
Hutchinson, Woods
Huxley, Aldous Leonard
Hyde, Edward
Ingle, Richard
Inskip, John Swanel
Insull, Samuel
Iredell, James
Irene, Sister
Izard, George
Jackson, George K.
Jackson, James, 1757–1806
Jackson, William
Jacobi, Mary Corinna Putnam
James, Charles
James, Daniel Willis
James, George Wharton
Jarvis, John Wesley
Jefferson, Joseph
Jeffery, Edward Turner

Jenckes, Joseph
Jenks, George Charles
Jenks, Joseph
Johnson, Alexander
Johnson, Alexander Bryan
Johnson, Edward
Johnson, Marmaduke
Johnson, Sir Nathaniel
Jones, Alfred
Jones, Hugh
Jones, John Percival
Jones, Noble Wymberley
Jones, Thomas P.
Josselyn, Hugh
Joy, Thomas
Karloff, Boris
Katte, Walter
Kearsley, John
Keene, James Robert
Keene, Laura
Keimer, Samuel
Kemble, Frances Anne
Kempster, Walter
Kilty, William
King, Albert Freeman Africanus
Kingsford, Thomas
Kinnersley, Ebenezer
Klein, Charles
Knight, Edward Henry
Lake, Kirsopp
Lander, Jean Margaret Davenport
Landreth, David
Lane, Sir Ralph
Larkin, John
Latimer, Mary Elizabeth Wormeley
Latrobe, Benjamin Henry, 1764–1820
Laughton, Charles
Laurance, John
Laurel, Stan
Lawley, George Frederick
Lawrence, Gertrude
Lawson, John
Lay, Benjamin
Lechford, Thomas
Lee, Ann
Lee, Charles, 1731–1782
Lee, Richard
Leeds, Daniel
Leete, William
Leipziger, Henry Marcus
Leney, William Satchwell
Lennon, John Winston Ono
Leslie, Charles Robert
Leslie, Frank
Leverett, John, 1616–1679
Levy, Joseph Leonard
Lewis, Arthur
Linton, William James
Locke, Richard Adams
Lorimer, William
Lothropp, John

Lovelace, Francis
Lovell, John Epy
Lucas, Jonathan, 1754–1821
Lucas, Jonathan, 1775–1832
Ludlow, Roger
Ludwell, Philip
Lyttelton, William Henry
McCormick, Anne Elizabeth O'Hare
McDougall, William
McLaglen, Victor
Madden, Martin Barnaby
Madden, Owen Victor ("Owney")
Manners, John Hartley
Manning, William Thomas
Markham, William
Marlowe, Julia
Marshall, Benjamin
Martin, Henry Austin
Martin, Thomas Commerford
Mason, Francis
Mason, George
Mason, John
Mather, Richard
Mathews, Samuel
Matthews, John
Maverick, Samuel
May, Edward Harrison
Mayhew, Thomas, 1593–1682
Mayhew, Thomas, 1621–1657
Mayo, William
Mayo, William Worrell
Meehan, Thomas
Mees, Charles Edward Kenneth
Meiklejohn, Alexander
Mendes, Henry Pereira
Merry, Ann Brunton
Middleton, Henry
Middleton, Peter
Miles, Edward
Miller, Henry
Millington, John
Mitchell, John, d. 1768
Mitchell, Jonathan
Mitchell, William, 1798–1856
Mitten, Thomas Eugene
Molyneux, Robert
Monckton, Robert
Montague, Henry James
Montefiore, Joshua
Moore, John, c. 1569–1732
Moran, Edward
Moran, Peter
Moran, Thomas
More, Nicholas
Morgan, Matthew Somerville
Morley, Frank
Morris, Anthony, 1654–1721
Morris, Elizabeth
Morris, Robert, 1734–1806
Morris, Roger
Mortimer, Mary

Morton, Charles
Morton, George
Morton, Thomas
Moulton, Richard Green
Mowbray, George Mordey
Murray, John, 1741–1815
Muybridge, Eadweard
Myles, John
Needham, James
Nelson, John
Newport, Christopher
Newton, Richard
Newton, Thomas, 1660–1721
Nicholls, Rhoda Holmes
Nichols, Edward Leamington
Nicholson, Francis
Nicolls, Matthias
Nicolls, Richard
Nicolls, William
Noble, Samuel
Nordhoff, Charles Bernard
Norman, John
Norris, Edward
Norris, Isaac, 1671–1735
Norton, John
Nurse, Rebecca
Nuthead, William
Nuttall, Thomas
Oakes, Urian
Ogle, Samuel
Oglethorpe, James Edward
Oldham, John
Owens, John Edmond
Paine, Thomas
Palmer, Joseph
Palmer, William Henry
Paris, Walter
Parks, William
Parris, Samuel
Parry, Charles Christopher
Parton, James
Pasco, Samuel
Payne-Gaposchkin, Cecilia Helena
Pearce, Richard
Pearce, Stephen Austen
Pedder, James
Peirce, William
Pelham, Peter
Pellew, Henry Edward
Penhallow, Samuel
Penington, Edward
Penn, Thomas
Penn, William
Peter, Hugh
Peter, Robert
Peters, Richard
Peters, William Cumming
Phillips, George
Pierson, Abraham
Pike, Robert
Pilmore, Joseph

Pine, Robert Edge
Pinkney, Edward Coote
Pitkin, William, 1635–1694
Pitman, Benn
Pittock, Henry Lewis
Popham, George
Pormort, Philemon
Porter, Robert Percival
Pory, James
Pott, John
Potter, Paul Meredith
Pound, Thomas
Powell, Thomas
Power, Frederick Tyrone
Pownall, Thomas
Priestley, James
Priestley, Joseph
Pring, Martin
Proud. Robert
Pusey, Caleb
Putnam, George Haven
Pynchon, John
Pynchon, William
Quelch, John
Quine, William Edward
Rains, Claude
Randolph, Edward
Randolph, William
Ransome, Frederick Leslie
Rawle, Francis, 1662–1726/27
Rawlinson, Frank Joseph
Reach, Alfred James
Realf, Richard
Reinagle, Alexander
Rennie, Michael
Renwick, James, 1792–1863
Restarick, Henry Bond
Reynolds, John
Richards, Joseph William
Richards, Thomas Addison
Richings, Peter
Rideing, William Henry
Riley, Charles Valentine
Rimmer, William
Rivington, James
Roberts, Brigham Henry
Rogers, Clara Kathleen Barnett
Rolfe, John
Rollinson, William
Rose, Aquila
Rosebury, Theodor
Rowlands, William
Rowlandson, Mary White
Rowson, Susanna Haswell
Ruditsky, Barney
Russell, Annie
Sabin, Joseph
Saltonstall, Richard
Sanderson, Robert
Sandys, George
Sargent, Frederick

Sartain, John
Saunders, Frederick
Savery, William, 1721–1787
Scott, John
Scripps, Ellen Browning
Scripps, James Edmund
Searle, Arthur
Sedgwick, Robert
Seed, Miles Ainscough
Selby, William
Serrell, Edward Wellman
Service, Robert William
Seton, Ernest Thompson
Sewall, Samuel
Sharp, Daniel
Sharpe, Horatio
Sharples, James
Shaw, Anna Howard
Shaw, Henry
Shearman, Thomas Gaskell
Shelton, Edward Mason
Shepard, Thomas
Sheppard, Samuel Edward
Sherman, John, 1613–1685
Shippen, Edward, 1639–1712
Shirley, William
Shute, Samuel
Simmons, George Henry
Simpson, Edmund Shaw
Skinner, William
Slater, Samuel
Smith, John, 1579–1631
Smith, John Merlin Powis
Smith, John Rubens
Smith, Robert, 1732–1801
Smith, Robert Alexander
Smith, William, 1697–1769
Sothern, Edward Askew
Southack, Cyprian
Spargo, John
Spilsbury, Edmund Gybbon
Standish, Myles
Stanford, John
Stansbury, Joseph
Staughton, Willniam
Stevens, Frank Mozley
Stevens, Harry Mozley
Stewart, Humphrey John
Stoddart, James Henry
Stone, Samuel
Stone, William
Story, Julian Russell
Stott, Henry Gordon
Stoughton, William
Stokowski, Leopold Anthony
Strachey, William
Stuck, Hudson
Sully, Thomas
Summers, Thomas Osmond
Sutherland, George
Sylvester, James Joseph

Syms, Benjamin
Tait, Arthur Fitzwilliam
Talbot, John
Talmage, James Edward
Tate, George Henry Hamilton
Tatham, William
Taylor, Edward
Taylor, James Barnett
Taylor, John
Taylor, John Louis
Taylor, Raynor
Taylor, Richard Cowling
Tennent, John
Thompson, David
Thompson, Jeremiah
Thomson, Elihu
Tiffin, Edward
Tingey, Thomas
Titchener, Edward Bradford
Todd, Thomas Wingate
Tomlins, William Lawrence
Toulmin, Harry
Towler, John
Towne, Benjamin
Treat, Robert
Trevellick, Richard F.
Troup, Robert
Tryon, William
Tuckey, William
Turner, Walter Victor
Underhill, John
Underwood, Horace Grant
Underwood, John Thomas
Upjohn, Richard
Upjohn, Richard Michell
Utley, Freda
Vallentine, Benjamin Bennaton
Vandenhoff, George
Van Druten, John William
Vane, Sir Henry
Vasey, George
Vassall, John
Vassar, Matthew
Vaughan, Charles
Vaux, Calvert
Vick, James
Vincent, Mary Ann
Vizetelly, Frank Horace
Wainwright, Jonathan Mayhew, 1792–
 1854
Walcot, Charles Melton, 1816–1868
Walderne, Richard
Wallace, William
Wallack, Henry John
Wallack, James William, 1795–1864
Wallack, James William, 1818–1873
Waller, Emma
Walsh, Benjamin Dann
Walter, Thomas, c. 1740–1789
Ward, George Gray
Ward, Harry Frederick

Ward, Nathaniel
Warde, Frederick Barkham
Warner, Fred Maltby
Warren, Herbert Langford
Warren, William, 1767–1832
Waterhouse, Frank
Watson, Henry Cood
Watts, Alan Wilson
Waymouth, George
Webb, Daniel
Webb, George James
Webb, Thomas
Weightman, William
Weld, Thomas
Wemyss, Francis Courtney
West, Francis
West, George
West, Joseph
Weston, Edward
Weston, Thomas
Weston, William
Whalley, Edward
Wharton, Richard
Whatcoat, Richard
Wheelwright, John
Whitaker, Alexander
White, Andrew
White, John
Whitefield, George
Whitehead, Alfred North
Whitehead, Walter Edward
Whitfield, Henry
Whitworth, George Frederic
Wigglesworth, Michael
Wignell, Thomas
Wirbur, Samuel
Willard, Simon
Williams, John
Williams, Robert
Williams, Roger
Wilson, Ernest Henry
Wilson, John
Wilson, Samuel Thomas
Wingfield, Edward Maria
Winslow, Edward
Winthrop, John, 1587/88–1649
Winthrop, John, 1605/06 o.s.– 1676
Wise, Daniel
Wise. Thomas Alfred
Withers, Frederick Clarke
Wodehouse, Pelham Grenville
Wood, Abraham
Wood, William
Woodbridge, John
Woodrow, James
Woolf, Benjamin Edward
Wormeley, Katharine Prescott
Wraxall, Peter
Wright, Henry
Wyatt, Sir Francis
Wylie, Robert

Yeamans, Sir John
Yeardley, Sir George
Young, Alfred
Youngs, John

ESTONIA

Holst, Hermann Eduard von, 1841–1904
Kahn, Louis I.
Leiserson, William Morris

FINLAND

Nordberg, Bruno Victor
Saarinen, Eero
Saarinen, Gottlieb Eliel

FRANCE

Aca, Michel
Agnus, Felix
Allefonsce, John
Allouez, ClaudeJean
André, Louis
Badin, Stephen Theodore
Bailly, Joseph Alexis
Bedaux, Charles Eugene
Benezet, Anthony
Bernard, Simon
Biard, Pierre
Biddle, Francis Beverley
Bienville, Jean Baptiste le Moyne, Sieur de
Blanc, Antoine
Bonard, Louis
Bonneville, Benjamin Louis Eulalie de
Bouvier, John
Boyer, Charles
Brady, Anthony Nicholas
Brulé, Étienne
Bruté de Rémur, Simon William Gabriel
Bryant, Louise Frances Stevens
Cabet, Étienne
Cadillac, Antoine de la Mothe
Carrel, Alexis
Casadesus, Robert Marcel
Champlain, Samuel de
Chanute, Octave
Chapelle, Placide Louis
Charlevoix, Pierre François Xavier de
Chaumonot, Pierre Joseph Marie
Cheverus, John Louis Ann Magdalen Lefebre de
Clerc, Laurent
Colston, Raleigh Edward
Considérant, Victor Prosper
Cortambert, Louis Richard
Coutard, Henri
Cret, Paul Philippe
Crétin, Joseph

Crèvecoeur, Michel-Guillaume Jean de
Crowninshield, Francis Welch
Crozet, Claude
Dablon, Claude
Dannreuther, Gustav
David, John Baptist Mary
Delmas, Delphin Michael
De Mézières y Clugny, Athanase
Derbigny, Pierre Auguste Charles Bourguignon
De Trobriand, Régis Denis de Keredern
De Vries, David Pietersen
Diat, Louis Felix
Du Bois, John
Duchesne, Rose Philippine
Dugdale, Richard Louis
Duluth, Daniel Greysolon, Sieur
Du Ponceau, Pierre Étienne
Du Pont, Eleuthère Irénée
Du Pont, Victor Marie
Durand, Élie Magloire
Engel, Carl
Esher, John Jacob
Flaget, Benedict Joseph
Forbes, John Murray
Gaillardet, Théodore Frédéric
Garreau, Armand
Genet, Edmond Charles
Girard, Stephen
Gravier, Jacques
Grellet, Stephen
Croseilliers, Médart Chouart, Sieur de
Guérin, Anne-Thérèse
Guignas, Michel
Hallet, Étienne Sulpice
Harrisse, Henry
Herrmann, Alexander
Herter, Christian Archibald
Hite, Jost
Houdry, Eugene Jules
Humbert, Jean Joseph Amable
Hyvernat, Henri
Imbert, Antoine
Jogues, Isaac
Johnston, Robert Matteson
Joubert de la Maraille, James Hector Marie Nicholas
Joutel, Henri
Jumel, Stephen
Kelly, Edmond
Klein, Joseph Frederic
Kohlmann, Anthony
Lachaise, Gaston
Laclede, Pierre
Lafayette, Marie Joseph Paul Yves Roch Gilbert du Motier, Marquis de
Laffite, Jean
Lahontan, Louis-Armand de Lom D'Arce, Baron de

Lamy, John Baptist
Landais, Pierre
Larpenteur, Charles
La Salle, Robert Cavelier, Sieur de
La Tour, Le Blond de
Laudonnière, René Goulaine de
Le Gendre, Charles William
Le Jau, Francis
L'Enfant, Pierre Charles
Le Sueur, Charles Alexandre
Le Sueur, Pierre
L'Halle, Constantin de
Loeffler, Charles Martin
Loos, Charles Louis
Loras, Jean Mathias Pierre
Lucas, John Baptiste Charles
Lufbery, Raoul Gervais Victor
Machebeuf, Joseph Proiectus
Mangin, Joseph François
Manigault, Pierre
Marcow, Jules
Maréchal, Ambrose
Marest, Pierre Gabriel
Marquette, Jacques
Marsh, Reginald
Martin, François-Xavier
Martiny, Philip
Matignon, Francis Anthony
Maurin, Peter Aristide
Mayer, Constant
Mazureau, Étienne
Membré, Zenobius
Ménard, René
Merton, Thomas
Meyer, André Benoit Mathieu
Michaux, André
Michaux, François André
Mielziner, Jo
Mitchell, William
Monteux, Pierre Benjamin
Mowatt, Anna Cora Ogden
Murat, Achille
Nancrède, Paul Joseph Guérard de
Neef, Francis Joseph Nicholas
Nicola, Lewis
Nicolet, Jean
Nicollet, Joseph Nicolas
Nin, Anaïs
Niza, Marcos de
Noailles, Louis Marie, Vicomte de
Noyan, Gilles-Augustin Payen de
Odin, John Mary
Partridge, William Ordway
Pascalis-Ouvrière, Felix
Pauger, Adrien de
Perché, Napoleon Joseph
Perrot, Nicolas
Petri, Angelo
Pinchot, Amos Richards Eno
Pons, Lily
Portier, Michael

Poydras, Julien De Lelande
Prevost, François Marie
Quartley, Arthur
Quesnay, Alexandre-Marie
Radisson, Pierre Esprit
Râle, Sébastien
Ramée, Joseph Jacques
Ravoux, Augustin
Rémy, Henri
Ribaut, Jean
Richard, Gabriel
Ritter, Frédéric Louis
Robot, Isidore
Rochambeau, Jean Baptiste Donatien
 De Vimeur, Comte de
Rosenberg, Paul
Ruckstull, Frederick Wellington
St. Lusson, Simon François Daumont,
 Sieur de
Saint-Mémin, Charles Balthazar Julien
 Fevret de
Saugrain De Vigni, Antoine François
Schussele, Christian
Seguin, Edouard
Seguin, Edward Constant
Sigerist, Henry Ernest
Sorin, Edward Frederick
Soulé, Pierre
Stevenson, Sara Yorke
Testut, Charles
Thébaud, Augustus J.
Timothy, Lewis
Tonty, Henry de
Tousard, Anne Louis de
Tulane, Paul
Urso, Camilla
Vail, Aaron
Vattemare, Nicolas Marie Alexandre
Verot, Jean Marcel Pierre Auguste
Wolf, Henry
You, Dominique

GALICIA

Grossinger, Jennie
Imber, Naphtali Herz
Neumark, David
Sembrich, Marcella
Speiser, Ephraim Avigdor
Zach, Max Wilhelm

GERMANY

(Including Bavaria and Prussia)

Adams, Charles
Adler, Felix
Adler, George J.
Adler, Samuel
Albers, Josef
Ameringer, Oscar
Antes, Henry
Arendt, Hannah

Arents, Albert
Astor, John Jacob
Baade, Wilhelm Heinrich Walter
Baermann, Carl
Balbach, Edward
Balch, Thomas Willing
Bartholdt, Richard
Beck, Carl
Beck, Charles
Behrendt, Walter Curt
Behrens, Henry
Beissel, Johann Conrad
Belmont, August
Bergmann, Max
Berkenmeyer, Wilhelm Christoph
Berliner, Émile
Bieber, Margarete
Bien, Julius
Bierstadt, Albert
Bimeler, Joseph Michael
Blankenburg, Rudolph
Blenk, James Hubert
Bloede, Gertrude
Bluemner, Oscar Florians
Boas, Emil Leopold
Boas, Franz
Boehler, Peter
Boehm, John Philip
Boldt, George C.
Bollman, Justus Erich
Bolza, Oskar
Bonzano, Adolphus
Brachvogel, Udo
Braun, Wernher von
Brentano, Lorenz
Brokmeyer, Henry C.
Brühl, Gustav
Busch, Adolphus
Busch, Hermann
Cammerhoff, John Christopher
 Frederick
Carnap, Rudolf
Carus, Paul
Cornell, Katharine
Damrosch, Walter Johannes
Dancel, Christian
Deindörfer, Johannes
Demme, Charles Rudolph
Detmold, Christian Edward
Dielman, Frederick
Dold, Jacob
Dorsch, Eduard
Dresel, Otto
Dreyfus, Max
Duhring, Louis Adolphus
Eckstein, John
Eichberg, Julius
Eickemeyer, Rudolf
Eigenmann, Carl H.
Eilers, Frederic Anton
Eimbeck, William

Einhorn, David
Einstein, Albert
Eisler, Gerhart
Elsberg, Louis
Engelhardt, Zephyrin
Engelmann, George
Ernst, Max
Ettwein, John
Faber, John Eberhard
Falckner, Daniel
Falckner, Justus
Farmer, Ferdinand
Felsenthal, Bernhard
Fernow, Bernhard Eduard
Fernow, Berthold
Feuchtwanger, Lion
Fink, Albert
Fischer, Emil Friedrich August
Fischer, Ruth
Flad, Henry
Flügel, Ewald
Follen, Charles
Franck, James
Francke, Kuno
Frasch, Herman
Frelinghuysen, Theodorus Jacobus
Frey, Joseph Samuel Christian
 Frederick
Friedlaender, Walter Ferdinand
Fritschel, Conrad Sigmund
Fritschel, Gottfried Leonhard
 Wilhelm
Fromm, Erich
Fromm-Reichmann, Frieda
Ganso, Emil
Ganss, Henry George
Gemünder, August Martin Ludwig
Genth, Frederick Augustus
Genthe, Arnold
Gerstle, Lewis
Giesler-Anneke, Mathilde Franziska
Girsch, Frederick
Gmeiner, John
Goessmann, Charles Anthony
Goldbeck, Robert
Goldschmidt, Jakob
Gottheil, Gustav
Grabau, Johannes Andreas August
Gradle, Henry
Graessl, Lawrence
Graupner, Johann Christian Gottlieb
Grim, David
Gropius, Walter Adolf Georg
Gros, John Daniel
Grossmann, Georg Martin
Grosz, George
Grube, Bernhard Adam
Gruening, Emil
Gunther, Charles Frederick
Guthe, Karl Eugen
Haarstick, Henry Christian

Hack, George
Hagen, Hermann August
Hahn, Georg Michael Decker
Haish, Jacob
Hamilton, Edith
Hammerstein, Oscar
Hansen, George
Hanus, Paul Henry
Hartwig, Johann Christoph
Hasenclever, Peter
Haupt, Paul
Hazelius, Ernest Lewis
Hecker, Friedrich Karl Franz
Heckscher, August
Heinemann, Ernst
Heinrich, Max
Heinzen, Karl Peter
Heiss, Michael
Helbron, Peter
Helffenstein, John Albert Conrad
Helmpraecht, Joseph
Helmuth, Justus Henry Christian
Hempel, Charles Julius
Hendel, John William
Herbermann, Charles George
Hering, Constantine
Herman, Lebrecht Frederick
Herter, Christian
Hertz, Alfred
Heyer, John Christian Frederick
Hilgard, Eugene Woldemar
Hilgard, Julius Erasmus
Hilgard, Theodor Erasmus
Hilprecht, Herman Volrath
Hirsch, Emil Gustav
Hoecken, Christian
Hoen, August
Hocnecke, Gustav Adolf Felix Thedor
Hoffman, Frederick Ludwig
Hoffmann, Francis Arnold
Hofman, Heinrich Oscar
Hofmann, Hans
Horney, Karen Danielssen
Hotz, Ferdinand Carl
Howard, Willie
Husmann, George
Ingelfinger, Franz Joseph
Jacobi, Abraham
Jacoby, Ludwig Sigmund
Jaeger, Werner Wilhelm
Juengling, Frederick
Jungman, John George
Kahn, Albert
Kahn, Gustav Gerson
Kahn, Julius
Kahn, Otto Herman
Kalb, Johann
Kalisch, Isidor
Kallen, Horace Meyer
Kapp, Friedrich
Kaufmann, Walter Arnold

Kautz, August Valentine
Keller, Mathias
Kellerman, Karl Frederic
Kelpius, Johann
Kiehbiel, Christian
Kirchmayer, John
Klein, Bruno Oscar
Kline, George
Klopsch, Louis
Knab, Frederick
Knabe, Valentine Wilhelm Ludwig
Knapp, Herman
Kober, George Martin
Kocherthal, Josua von
Koehler, Robert
Koehler, Sylvester Rosa
Koemmenich, Louis
Koenig, George Augustus
Koffka, Kurt
Kohler, Kaufmann
Kolb, Dielman
Kolle, Frederick Strange
Korner, Gustav Philipp
Kracauer, Siegfried
Kraus, John
Kraus-Boelté, Maria
Krauskopf, Joseph
Krez, Konrad
Krimmel, John Lewis
Kroeger, Adolph Ernst
Kruell, Gustav
Kunze, John Christopher
Kunze, Richard Ernest
Laemmle, Carl
Lange, Louis
Lasker, Albert Davis
Laufer, Berthold
Lederer, John
Leeser, Isaac
Lehmann, Frederick William
Lehmann, Lotte
Leisler, Jacob
Lemke, Peter Henry
Leutze, Emanuel
Lewin, Kurt
Lewisohn, Adolph
Lewisohn, Ludwig
Ley, Willy
Leyendecker, Joseph Christian
Leypoldt, Frederick
Lieber, Francis
Liebling, Emil
Lienau, Detlef
Lilienthal, Max
Lindenkohl, Adolph
Lindheimer, Ferdinand Jacob
List, Georg Friedrich
Listemann, Bernhard
Loeb, Jacques
Loeb, Leo
Loewi, Otto

Lovejoy, Arthur Oncken
Lubitsch, Ernst
Ludwick, Christopher
Maas, Anthony J.
McClellan, George Brinton
Maisch, John Michael
Mann, William Julius
Mansfield, Richard
Marcuse, Herbert
Marwedel, Emma Jacobina Christiana
Maschke, Heinrich
Mattheissen, Frederick William
Melsheimer, Friedrick Valentin
Memminger, Christopher Gustavus
Mendelsohn, Erich (or Eric)
Mergenthaler, Ottmar
Mergler, MarieJosepha
Merz, Karl
Metz, Christian
Meyer, Henry Coddington
Meyerhof, Otto
Michaelis, Leonor
Michelson, Albert Abraham
Mies van der Rohe, Ludwig
Miller, John Henry
Miller, John Peter
Mohr, Charles Theodore
Moldehuke, Edward Frederick
Möllhausen, Heinrich Baldwin
Mombert, Jacob Isidor
Moosmüller, Oswald William
Morgenthau, Hans Joachim
Morgenthau, Henry
Morris, Nelson
Morwitz, Edward
Most, Johann Joseph
Mühlenberg, Henry Melchior
Müller, Wilhelm Max
Munch, Charles
Mundé, Paul Fortunatus
Münsterberg, Hugo
Nast, Thomas
Nast, William
Neidhard, Charles
Nessler, Karl Ludwig
Neuendorff, Adolph Heinrich Anton
 Magnus
Ney, Elisabet
Nicolay, John George
Niedringhaus, Frederick Gottlieb
Niemeyer, John Henry
Nies, Konrad
Noeggerath, Emil Oscar Jacob Bruno
Nordheimer, Isaac
Nordhoff, Charles
Notz, Frederick William Augustus
Oberhoffer, Emil Johann
Ochs, Julius
Oertel, Johannes Adam Simon
Orthwein, Charles F.
Osterhaus, Peter Joseph

Ottendorfer, Anna Behr Uhl
Otterbein, Philip William
Otto, Bodo
Overman, Frederick
Panofsky, Erwin
Pastorius, Francis Daniel
Perabo, Johann Ernst
Peters, Christian Henry Frederick
Phisterer, Frederick
Pieper, Franz August Otto
Piez, Charles
Pollard, Joseph Percival
Post, Christian Frederick
Preetorius, Emil
Priber, Christian
Pulte, Joseph Hippolyt
Pursh, Frederick
Rademacher, Hans
Raht, August Wilhelm
Rapp, George
Rapp, Wilhelm
Rattermann, Heinrich Armin
Rauch, Frederick Augustus
Raue, Charles Gottlieb
Reed, John, 1757–1845
Reichenbach, Hans
Reisinger, Hugo
Reitzel, Robert
Rese, Frederick
Reuling, George
Reuter, Dominic
Rice, Charles
Rice, Isaac Leopold
Rieger, Johann Georg Joseph Anton
Rittenhouse, William
Robinson, Therese Albertine Louise
 Von Jakob
Rock, John
Roebling, John Augustus
Roemer, Karl Ferdinand
Roselius, Christian
Rummel, Joseph Francis
Saenderl, Simon
Sapir, Edward
Schaeberle, John Martin
Schaeffer, Frederick David
Schauffler, William Gottlieb
Scheel, Fritz
Schem, Alexander Jacob
Scheve, Edward Benjamin
Schieren, Charles Adolph
Schiff, Jacob Henry
Schilling, Hugo Karl
Schindler, Kurt
Schindler, Solomon
Schirmer, Gustav
Schmidt, Arthur Paul
Schmidt, Friedrich August
Schmucker, John George
Schnauffer, Carl Heinrich
Schneider, George

Schneider, Theodore
Schneller, George Otto
Schnerr, Leander
Schocken, Theodore
Schoenheimer, Rudolf
Schoenhof, Jacob
Schöpf, Johann David
Schott, Charles Anthony
Schradieck, Henry
Schrembs, Joseph
Schultze, Augustus
Schurz, Carl
Schuttler, Peter
Seidensticker, Oswald
Seligman, Jesse
Seligman, Joseph
Seyffarth, Gustavus
Shean, Albert
Sieber, Al
Sigel, Franz
Sloss, Louis
Sobolewski, J. Friedrich Eduard
Soldan, Frank Louis
Solger, Reinhold
Sorge, Friedrich Adolph
Sower, Christopher, 1693–1758
Sower, Christopher, 1721–1784
Spaeth, Adolph
Spangenberg, Augustus Gottlieb
Spicker, Max
Spreckels, Claus
Stahlman, Edward Bushrod
Stallo, Johann Bernard
Stang, William
Steck, George
Steinert, Morris
Steinmetz, Charles Proteus
Steinway, Christian Friedrich
 Theodore
Steinway, Henry Engelhard
Steinway, William
Stern, Kurt Guenter
Stern, Otto
Stetefeldt, Carl August
Steuben, Friedrich Wilhelm Ludolf
 Gerhard Augustin, Baron von
Stiegel, Henry William
Stock, Frederick August
Stockhardt, Karl Georg
Stolberg, Benjamin
Straus, Isidor
Straus, Nathan
Straus, Oscar Solomon
Strubberg, Friedrich Armand
Struve, Gustav
Stuckenberg, John Henry Wilbrandt
Sulzberger, Mayer
Tannenberger, David
Taussig, Joseph Knefler
Teuber, Hans-Lukas ("Luke")
Thomas, Christian Friedrich
 Theodore

Tillich, Paul
Timken, Henry
Timm, Henry Christian
Tobani, Theodore Moses
Viereck, George Sylvester
Villard, Henry
Villard, Oswald Garrison
Volsk, Adalbert John
Von Wiegand, Karl Henry
Wachsmuth, Charles
Wagener, John Andreas
Wagner, Robert Ferdinand
Wallenda, Karl
Walter, Albert G.
Walter, Bruno
Walther, Carl Ferdinand Wilhelm
Warburg, Felix Moritz
Warburg, James Paul
Warburg, Paul Moritz
Waxman, Franz
Weber, Albert
Weber, Gustav Carl Erich
Weidenreich, Franz
Weidig, Adolf
Weill, Kurt
Weiser, Johann Conrad
Wernawag, Lewis
Wesselhoeft, Conrad
Weyl, Hermann
Wilczynski, Ernest Julius
Wildt, Rupert
Wimar, Carl
Wimmer, Boniface
Wislizenus, Frederick Adolph
Wistar, Caspar
Woerner, John Gabriel
Wolf, Innocent William
Wolf, Simon
Wolff, Kurt August Paul
Wolfsohn, Carl
Zakrzewska, Marie Elizabeth
Zenger, John Peter
Zentmayer, Joseph
Zeuner, Charles
Ziegler, David
Ziehn, Bernhard
Zinzendorf, Nicolaus Ludwig
Zuppke, Robert Carl

GHANA

Aggrey, James Emman Kwegyir

GIBRALTAR

Montrésor, John

GREECE

Anagnos, Michael
Athenagoras I
Benjamin, Samuel Greene Wheeler
Colvocoresses, George Musalas

Hearn, Lafcadio
Mitropoulos, Dimitri
Papanicolaou, George Nicholas
Skouras, George Panagiotes
Skouras, Spyros Panagiotes
Sophocles, Evangelinus Apostolides

GUATEMALA

Sarg, Tony

HONG KONG

Barrie, Wendy
Higgins, Marguerite

HUNGARY

Alexander, Franz Gabriel
Asboth, Alexander Sandor
Beck, Martin
Békésy, Georg Von
Curtiz, Michael
Ditrichstein, Leo
Farago, Ladislas
Fejos, Paul
Fleischmann, Charles Louis
Fox, William
Franklin, Fabian
Goldmark, Peter Carl
Haraszthy de Mokcsa, Agoston
Heilprin, Angelo
Joseffy, Rafael
Kaiser, Alvis
Karfiol, Bernard
Kiss, Max
Kohnt, Alexander
Kohut, George Alexander
Lorre, Peter
Lugosi, Bela
Pal, George
Pulitzer, Joseph
Rapaport, David
Reiner, Fritz
Roheim, Geza
Romberg, Sigmund
Schwimmer, Rosika
Seidl, Anton
Stahel, Julius
Stark, Louis
Szell, George
Szilard, Leo
Szold, Benjamin
Thorek, Max
Von Neumann, John
Weiss, Soma
Wise, Aaron
Wise, Stephen Samuel
Xántus, János
Zukor, Adolph

ICELAND

Cahill, Holger

INDIA

Barrymore, Maurice
Bellew, Frank Henry Temple
Bruce, Andrew Alexander
Chandler, John Scudder
Fullerton, George Stuart
Hazen, Henry Allen
Huber, Gotthelf Carl
Hume, Robert Allen
Judd, Charles Hubbard
Judson, Adoniram Brown
Judson, Edward
Kennelly, Arthur Edwin
Leigh, Vivien
Mansell, William Albert
Oldham, William Fitzjames
Scudder, (Julia) Vida Dutton
Wyckoff, John Henry
Wyckoff, Walter Augustus

INDONESIA

(*See* Java)

IRAN

(*See* Persia)

IRELAND

Adair, James
Adrain, Robert
Alison, Francis
Amory, Thomas
Anthony, Sister
Argall, Philip
Armstrong, George Buchanan
Armstrong, John
Arthur, William
Azarias, Brother
Baird, Matthew
Barnwell, John
Barry, John
Barry, Patrick
Beatty, Charles Clinton
Binns, John
Blair, Samuel
Blair, William Richards
Blake, Mary Elizabeth McGrath
Blakely, Johnston
Bonner, Robert
Boucicault, Dion
Bowden, John
Breen, Patrick
Brenon, Herbert
Bront, George
Brougham, John
Brown, Alexander
Brown, George
Brown, James
Brown, John A.

Browne, John Ross
Bryan, George
Burk, John Daly
Burke, AEdanus
Burke, Thomas
Butler, Pierce
Butler, Richard
Butler, William
Byrne, Andrew
Byrne, John
Byrnes, Thomas F.
Campbell, Alexander
Campbell, Robert
Campbell, Thomas
Carey, Mathew
Carpenter, Stephen Cullen
Carr, Thomas Matthew
Cathcart, James Leander
Cathcart, William
Charless, Joseph
Clark, Daniel
Clarke, Sir Caspar Purdon
Clarke, Joseph Ignatius Constantine
Clarke, Mary Francis
Cleburne, Patrick Ronayne
Coate, Richard
Cockran, William Bourke
Colden, Cadwallader
Colles, Christopher
Collier, Peter Fenelon
Collins, Patrick Andrew
Colum, Padraic
Conaty, Thomas James
Condon, Thomas
Connolly, John
Connor, Patrick Edward
Conway, Thomas
Conwell, Henry
Conyngham, Gustavus
Cosby, William
Cox, Henry Hamilton
Crawford, John
Crawford, John Wallace
Croghan, George
Croker, Richard
Croly, David Goodman
Cudahy, Michael
Cuming, Fortescue
Daly, Charles Patrick
Daly, Marcus
Dalzell, Robert M.
Delany, Patrick Bernard
Devoy, John
Digges, Dudley
Dinsmoor, Robert
Dobbs, Arthur
Donahue, Patrick
Dongan, Thomas
Donlevy, Brian
Donnelly, Charles Francis
Dornin, Thomas Aloysius

Drew, John
Dripps, Isaac L.
Drumgoole, John Christopher
Duane, William John
Dulany, Daniel
Dunlap, John
Egan, Michael
Elliott, Charles
Embury, Philip
Emmet, Thomas Addis
England, John
Erskine, John
Evans, William Thomas
Fair, James Graham
Farley, John Murphy
Feehan, Patrick Augustine
Ffrench, Charles Dominic
Field, Joseph M.
Findley, William
Finley, Samuel
Fitzgerald, Edward
Fitzpatrick, John
Fitzpatrick, Thomas
Fitzsimmons or Fitzsimins, Thomas
Flanagan, Edward Joseph
Flannery, John
Ford, Patrlck
Fox, Richard Kyle
Francis, Tench
Gaine, Hugh
Galberry, Thomas
Gallagher, Hugh Patrick
Gallier, James
Garrett, Robert
Garrigan, Philip Joseph
Gillman, Henry
Gilmore, Patrick Sarsfield
Glennon, John Joseph
Godkin, Edwin Lawrence
Goff, John William
Good, John
Grace, William Russell
Gregg, John Robert
Hackett, Francis
Hall, Bolton
Hall, John
Halpine, Charles Graham
Hamilton, Edward John
Hand, Edward
Harpur, Robert
Haughery, Margaret Gaffney
Heck, Barbara
Hennessy, John
Hennessy, William John
Henry, John, 1746–1794
Henry, John, fl. 1807–1820
Herbert, Victor
Heron, Matilda Agnes
Heron, William
Hill, William
Hoban, James

Hogan, John
Hogun, James
Holland, John Philip
Hopkins, John Henry
Hovenden, Thomas
Hudson, Edward
Hughes, John Joseph
Hunter, Thomas
Hunter, Whiteside Godfrey
Ingham, Charles Cromwell
Inglis, Charles
Ireland, John, 1838–1918
Irvine, William
Johnson, Guy
Johnson, Sir William
Jones, Mary Harris
Jordan, Kate
Judge, William Quan
Julia, Sister
Keane, John Joseph
Kearney, Denis
Keating, John McLeod
Kelley, Eugene
Kelly, Myra
Kennedy, Robert Foster
Kenrick, Francis Patrick
Kenrick, Peter Richard
Keppel, Frederick
Kerens, Richard C.
Kerfoot, John Barrett
Kinsella, Thomas
Knox, Samuel
Laffan, William Mackay
Lane, Walter Paye
Leighton, William
Levins, Thomas C.
Lewis, Andrew
Logan, James, 1674–1751
Loudon, Samuel
Lynch, Patrick Neeson
Lyon, Matthew
Lyons, Peter
Lyster, Henry Francis Le Hunte
McAuley, Jeremiah
McAuley, Thomas
McBurney, Robert Ross
McCaine, Alexander
McCarroll, James
McClure, George
McClure, Samuel Sidney
McCormack, John Francis
McCosh, Andrew James
McCullagh, Joseph Burbridge
McCullough, John
McDonald, John Bartholomew
McElroy, John
McFaul, James Augustine
McGrath, James
McGrath, Matthew J.
McGuire, Charles Bonaventure
McHenry, James, 1753–1816

McHenry, James, 1785–1845
Mackay, John William
McKenna, Charles Hyacinth
Mackenzie, Robert Shelton
McKinly, John
McMahon, Bernard
McManes, James
McNeill, Hector
MacNeven, William James
McNicholas, John Timothy
McNulty, Frank Joseph
McNutt, Alexander
MacSparran, James
McVickar, John
Maginnis, Charles Donagh
Makemie, Francis
Mallet, John William
Malone, Sylvester
Maloney, Martin
Marshall, Christopher
Martin, Henry Newell
Matthews, Washington
Maxwell, William
Maxwell, William Henry
Meagher, Thomas Francis
Milligan, Robert
Milmore, Martin
Minty, Robert Horatio George
Mitchel, John
Montgomery, Richard
Moore, James, d. 1706
Moore, John, 1834–1901
Moriarity, Patrick Eugene
Morrissey, John
Moylan, Stephen
Mulholland St. Clair Augustin
Mulholland William
Mulligan, Charles J.
Murphy, Francis
Murphy, John
Murray, Joseph
Nesbitt, John Maxwell
Niblo, William
O'Brien, Fitz-James
O'Brien, Matthew Anthony
O'Brien, William Shoney
O'Callaghan, Edmund Bailey
O'Callaghan, Jeremiah
O'Connor, James
O'Connor, Michael
O'Dwyer, William
O'Fallon, James
O'Hara, James
O'Leary, Daniel
Oliver, George Tener
Oliver, Henry William
O'Mahony, John
O'Neill, James
O'Neill, John
O'Reilly, Alexander
O'Reilly, Henry

O'Reilly, John Boyle
Orr, Alexander Ector
O'Shaughnessy, Michael Maurice
Owen, William Florence
Paterson, William
Patterson, Robert, 1743–1824
Patterson, Robert, 1792–1881
Patterson, Thomas MacDonald
Patterson, William
Phelan, James
Pollock, Oliver
Porter, Alexander
Potamian, Brother
Potter, James
Power, John
Purcell, John Baptist
Quarter, William
Quill, Michael Joseph
Rainsford, William Stephen
Ramage, John
Read, George Campbell
Rehan, Ada
Reid, Thomas Mayne
Rhea, John
Roach, John
Roberts, William Randall
Robinson, Stuart
Robinson, William
Robinson, William Erigena
Roche, James Jeffrey
Rowan, Stephen Clegg
Russell, Mother Mary Baptist
Ryan, Cornelius John ("Connie")
Ryan, Edward George
Ryan, Patrick John
Sadlier, Denis
Sadlier, Mary Anne Madden
Saint-Gaudens, Augustus
Sampson, William
Savage, John
Scantan, Lawrence
Sewall, William Joyce
Shaw, John, 1773–1823
Sheedy, Dennis
Shields, James
Sloan, Samuel
Smith, James, 1719–1806
Smyth, Alexander
Smyth, Thomas
Snow, Carmel White
Sproule, William
Stephenson, John
Sterling, James
Stewart, Alexander Turney
Strawbridge, Robert
Summorahy, Kathleen Hubu ("Kay")
Sweeny, Thomas William
Syng, Philip
Taggart, Thomas
Teggart, Frederick John
Tennent, Gilbert

Tennent, William, 1673–1745
Tennent, William, 1705–1777
Teresa, Mother
Thompson, Hugh Miller
Thompson, Launt
Thompson, Robert Ellis
Thompson, William
Thomson, Charles
Thornton, Matthew
Tobin, Daniel Joseph
Turner, William
Vaughan, Daniel
Waddel, James
Waddell, Hugh
Walsh, Michael
Warden, David Bailie
Warren, Sir Peter
Wilde, Richard Henry
Williams, Barney
Wood, James J.
Wright, James Lendrew
Wylie, Samuel Brown
Yorke, Peter Christopher
Young, John Russell

ITALY

Adonis, Joe
Amateis, Louis
Andreis, Andrew James Felix
 Bartholomew de
Angeli, Pier
Ascoli, Max
Atlas, Charles S.
Auden, Wystan Hugh
Baccaloni, Salvatore
Barsotti, Charles
Bayma, Joseph
Bellanca, Giuseppe Mario
Bemelmans, Ludwig
Botta, Vincenzo
Boucher, Horace Edward
Brumidi, Constantino
Bruno, Angelo
Cabrini, Francis Xavier
Caruso, Enrico
Cataldo, Joseph Maria
Cesnola, Luigi Palma di
Chiera, Edward
Clevenger, Shobal Vail
Corey, Lewis
Costello, Frank
Crawford, Francis Marion
Da Ponte, Lorenzo
De Luca, Giuseppe
De Palma, Ralph
Di Purdy, Alonso
Dodd, Bella Visono
Dundee, Johnny
Faccioli, Giuseppe
Fermi, Enrico
Finotti, Joseph Maria

FitzgeraJd, Alice Louise Florence
Foresti, Eleutario Felice
Galli-Curci, Amelita
Gambino, Carlo
Gatti-Casazza, Giulio
Genovese, Vito
Giovannitti, Arturo
Hadfield. George
Kino, Eusebio Francisco
Langdon, Courtney
Lebrun, Federico ("Rico")
Legler, Henry Eduard
Luchese, Thomas
Luciano, Charles ("Lucky")
Mackubin, Florence
Martinelli, Giovanni
Marzo, Eduardo
Mazzachelli, Samuel Charles
Mazzei, Philip
Mengarini, Gregory
Morais, Sabato
Morini, Austin John
Nobili, John
Palladino, Lawrence Benedict
Patri, Angelo
Pecora, Ferdinand
Pel, Mario Andrew
Pinza, Ezio
Profaci, Joseph
Ravalli, Antonio
Ricca, Paul
Rosati, Joseph
Sacco, Nicola
Sardi, Melchiorre Pio Vencenzo
 ("Vincent")
Sargent, John Singer
Sestini, Benedict
Seton, Robert
Stella, Joseph
Tagliabue, Giuseppe
Toscanini, Arturo
Trajetta, Philip
Tresca, Carlo
Vanzetti, Bartolomeo
Vigo, Joseph Maria Francesco
Vitale, Ferruccio
Walsh, Henry Collins
Yon, Pietro Alessandro

JAMAICA

Garvey, Marcus Moziah
McKay, Claude

JAPAN

Greene, Jerome Davis
Hartmann, Carl Sadakichi
Hayakawa, Sessue
Kuniyoshi, Yasuo
Landis,, James McCauley
Noguchi, Hideyo

Sugiura, Kanematsu
Takamine, Jokichi
Verbeck, William

JAVA

Norden, Carl Lukas

LATVIA

Bellanca, Dorothy Jacobs
Davidoff, Leo Max
Halsman, Philippe
Moisseiff, Leon solomon
Sterne, Maurice

LITHUANIA

Berenson, Bernard
Berenson, Senda
Bloomgarden, Solomon
Godowsky, Leopold
Goldman, Emma
Hillman, Sidney
Laurence, William Leonard
Lipchitz, Jacques
Myerson, Abraham
Sachs, Alexander
Sack, Israel
Schereschewsky, Samuel Isaac Joseph
Schlesinger, Benjamin
Shahn, Benjamin ("Ben")
Silver, Abba Hillel
Winchevsky, Morris
Wolfson, Harry Austryn
Zorach, William

LUXEMBOURG

Gernsback, Hugo
Steichen, Edward Jean
Woll, Matthew

MARSHALL ISLANDS

Gulick, Sidney Lewis

MEXICO

Font, Pedro
Kiam, Omar
Larrazolo, Octaviano Ambrosio
Limón, José Arcadio
Novarro, Ramon
Oñate, Juan de

MORAVIA

Gödel, Kurt Friedrich
Lindenthal, Gustav
Maretzek, Max
Nitschmann, David
Sealsfield, Charles
Zeisberger, David

NETHERLANDS

Bayard, Nicholas
Behrends, Adolphus Julius Frederick

Block, Adriaen
Boelen, Jacob
Bogardus, Everardus
Bok, Edward William
Burnet, William
Cazenove, Théophile
Covode, John
Cuyler, Theodore
Debye, Peter Joseeh William
De Haas, John Philip
De Lamar, Joseph Raphael
De Leeuw, Adolph Lodewyk
D'Ooge, Martin Luther
Dupratz, Antoine Simon Le Page
Dusser de Barenne, Joannes Gregorius
Dykstra, John
Freeman, Bernardus
Gallitzin, Demetrius Augustine
Goudsmit, Samuel Abraham
Haagen-Smit, Arie Jan
Henny, David Christiaan
Hudde, Andries
Huidekoper, Harm Jan
Isaacs, Samuel Myer
Jansen, Reinier
Kieft, Willem
Krol, Bastiaen Jansen
Kuiper, Gerard Peter
Le Roux, Bartholomew
Mappa, Adam Gerard
Matthes, Gerard Hendrik
Megapolensis, Johannes
Michaëlius, Jonas
Minuit, Peter
Morton, Nathaniel
Muste, Abraham Johannes
Peter, John Frederick
Philipse, Frederick
Romans, Bernard
Scholte, Hendrik Peter
Schrieck, Sister Louise Van Der
Selijns, Henricus
Steendam, Jacob
Steenwyck, Cornelis
Stuyvesant, Petrus
Troost, Gerard
Van Beuren, Johannes
Van Cortlandt, Oloff Stevenszen
Van Curler, Arent
Van Der Donck, Adriaen
Van Der Kemp, Francis Adrian
Van Ilpendam, Jan Jansen
Van Loon, Hendrik Willem
Van Raalte, Albertus Christiaan
Van Rensselaer, Nicholas
Van Twiller, Wouter
Verbeck, Guido Herman Fridolin
Verwyst, Chrysostom Adrian
Voorsanger, Jacob
Wilhelmina

NORWAY

Balchen, Bernt
Barth, Carl Georg Lange
Boyesen, Hjalmar Hjorth
Dahl, Theodor Halvorson
Dietrichson, Johannes Wilhelm
 Christian
Eielsen, Elling
Furuseth, Andrew
Hanson, James Christian Meinich
Haugen, Nils Pederson
Henie, Sonja
Hoyme, Gjermund
Janson, Kristofer Nagel
Johnsen, Erik Kristian
Kildahl, Johan Nathan
Knutson, Harold
Koren, Ulrik Vilhelm
Larsen, Peter Laurentius
Larson, Laurence Marcellus
Lie, Jonas
Lundeberg, Harry
Mallory, Anna Margrethe ("Molla")
 Bjurstedt
Nelson, Knute
Nelson, Nelson Olsen
Oftedal, Sven
Onsager, Lars
Owre, Alfred
Peerson, Cleng
Reiersen, Johan Reinert
Rockne, Knute Kenneth
Rölvaag, Ole Edvart
Rynning, Ole
Stejneger, Leonhard Hess
Sverdrup, Georg
Tapper, Bertha Feiring
Tou, Erik Hansen
Wergeland, Agnes Mathilde

PALESTINE

Hirschensohn, Chaim

PERSIA

Labaree, Leonard Woods
Mitchell, Lucy Myers Wright
Oldfather, William Abbott
Shedd, William Ambrose
Wright, John Henry

PERU

Peñalosa Briceño, Diego Dioniso de

PHILIPPINES

Quezon, Manuel Luis

POLAND

(*See also* Silesia)

Baruch, Simon
Barzynski, Vincent

Belkin, Samuel
Blaustein, David
Dabrowski, Joseph
Damrosch, Leopold
Friedlaender, Israel
Funk, Casimir
Glueck, Sheldon ("Sol")
Goldin, Horace
Goldwyn, Samuel
Gray, Gilda
Gurowski, Adam
Hecht, Selig
Heilprin, Michael
Heschel, Abraham Joshua
Hodur, Francis
Hofmann, Josef Casimir
Jastrow, Joseph
Jastrow, Marcus
Jastrow, Morris
Kosciuszko, Tadeusz Andrzej
 Bonawentura
Krueger, Walter
Landowska, Wanda Aleksandra
Loewenthal, Isidor
London, Meyer
Lotka, Alfred James
Lubin, David
Modjeska, Helena
Modjeski, Ralph
Nadelman, Elie
Neumann, Franz Leopold
Perlman, Selig
Poznanski, Gustavus
Pulaski, Casimir
Radin, Max
Radin, Paul
Rose, Alex
Rose, Ernestine Louise Siismondi
 Potowski
Rosenblatt, Bernard Abraham
Rosenfeld, Morris
Rosenthal, Max
Rubinstein, Helena
Salomon, Haym
Schneiderman, Rose
Schultz, Henry
Schwidetzky, Oscar Otto Rudolf
Singer, Israel Joshua
Stokes, Rose Harriet Pastor
Szyk, Arthur
Warner, Harry Morris
Wiener, Leo
Znaniecki, Florian Witold

PORTUGAL

Benavides, Alonzo de
Cabrillo, Juan Rodriguez
De Kay, James Ellsworth
Lopez, Aaron
Lumbrozo, Jacob
Miranda, Carmen

PUERTO RICO

Fernós Isern, Antonio
Muñoz Marín, Luis

ROMANIA

Bickel, Alexander Mordecai
Bloomfield, Meyer
Covici, Pascal ("Pat")
Culbertson, Ely
Gluck, Alma
Kneisel, Franz
Liebowitz, Samuel Simon
Renaldo, Duncan
Robinson, Edward G.
Schechter, Solomon

RUSSIA

Abel, Rudolf Ivanovich
Adler, Polly
Adler, Sara
Annenberg, Moses Louis
Antin, Mary
Archipenko, Alexander
Aronson, Boris Solomon
Artzybasheff, Boris
Baranov, Alexander Andreevich
Berkman, Alexander
Bernstein, Herman
Billikopf, Jacob
Blavatsky, Helena Petrovna Hahn
Bolm, Adolph Rudolphovitch
Boudin, Louis Boudinoff
Brenner, Victor David
Cahan, Abraham
Carter, Boake
Casanowicz, Immanuel Moses
Chaliapin, Boris Fyodorovich
Chotzinoff, Samuel
Cist, Charles
Cohen, Morris Raphael
Cooke, Samuel
Davidson, Israel
De Seversky, Alexander Procofieff
Dobzhansky, Theodosius Grigorievich
Duke, Vernon
Eglevsky, André Yevgenyevich
Ehrlich, Arnold Bogamil
Elman, Mischa
Enelow, Hyman Gerson
Epstein, Abraham
Fokine, Michel
Freeman, Joseph
Friedman, William Frederick
Gabo, Naum
Gabrilowitsch, Ossip
Gamow, George
Gest, Morris
Goerz, David
Goldenweiser, Alexander
 Alexandrovich

Goldenweiser, Emanuel Alexander
Golder, Frank Alfred
Goldfine, Bernard
Gomberg, Moses
Gordin, Jacob
Guzik, Jack
Halpert, Edith Gregor
Hansburg, George Bernard
Herberg, Will
Hillquit, Morris
Hindus, Maurice Gerschon
Hirschbein, Peretz
Hourwich, Isaac Aaronovich
Hubert, Conrad
Hurok, Solomon Isaievitch
Ïoasaf
Ïnnokentï
Jolson, Al
Kharasch, Morris Selig
Kostelanetz, Andre
Koussevitzky, Olga Naumoff
Koussevitzky, Serge Alexandrovich
Kunitz, Moses
Kuskov, Ivan Aleksandrovich
Lang, Lucy Fox Robins
Launitz, Robert Eberhard Schmidt
 Von Der
Leonty, Metropolitan
Levene, Phoebus Aaron Theodore
Lhévinne, Rosina
Lipman, Jacob Goodale
Loeb, Sophie Irene Simon
Loskiel, George Henry
Margalis, Max Leopold
Mashiansky, Zvi Hirsch
Mayer, Louis Burt
Mears, Otto
Meltzer, Samuel James
Mosessohn, David Nehemiah
Nabokov, Nicolas
Nabokov, Vladimir Vladimirovich
Nazimova, Alla
Osten Sacken, Carl Robert
 Romanovich Von Der
Ostromislensky, Iwan Iwanowich
Paley, John
Pasvolsky, Leo
Piatigorsky, Gregor
Potofsky, Jacob Samuel
Price, George Moses
Rachmaninoff, Sergei Vasilyevich
Rahv, Philip
Revel, Bernard
Rezanov, Nikolai Petrovich
Romanoff, Michael ("Prince Mike")
Rombro, Jacob
Romeike, Henry
Ropes, John Codman
Rosen, Joseph A.
Rosenberg, Abraham Hayyim
Rosenblatt, Joseph

Rosenthal, Herman
Rostovtzeff, Michael Ivanovitch
Rothko, Mark
Rubinow, Isaac Max
Sachs, Theodore Bernard
Sanders, George
Sandler, Jacob Koppel
Sarnoff, David
Saslavsky, Alexander
Schenck, Nicholas Michael
Schillinger, Joseph
Schomer, Nahum Meir
Schwartz, Maurice
Selikovitsch, Goetzel
Shelekhov, Grigorii Ivanovich
Shub, Abraham
Shubert, Lee
Sidis, Boris
Sikorsky, Igor Ivanovich
Siloti, Alexander Ilyitch
Soyer, Moses
Spewack, Samuel
Spivak, Charles David
Sternberg, Constantin Ivanovich Edler
 von
Steuben, John
Stone, Abraham
Stravinsky, Igor Fyodorovich
Strunsky, Simeon
Struve, Otto
Tamarkin, Jacob David
Tamiroff, Akim
Tchelitchew, Pavel
Tiomkin, Dimitri
Tourel, Jennie
Tucker, Sophie
Vasiliev, Afexander Alexandrovich
Vladeck, Baruch Charney
Vladimiroff, Pierre
Vogrich, Max Wilhelm Karl
Waksman, Selman Abraham
Weber, Max
Woytinsky, Wladimir Savelievich
Yellin, Samuel
Zevin, Israel Joseph
Zilboorg, Gregory
Zunser, Eliakum

SCOTLAND

Abercromby, James
Adie, David Craig
Affleck, Thomas
Ainslie, Hew
Aitken, Robert
Alexander, Abraham
Alexander, James
Allan, John
Armour, Thomas Dickson ("Tommy")
Arthur, Peter M.
Auchmuty, Robert
Audsley, George Ashdown

Bain, George Luke Scobie
Barr, Charles
Bell, Alexander Graham
Bell, Alexander Melville
Bell, Eric Temple
Bell, Robert
Bennett, James Gordon
Bishop, Robert Hamilton
Blair, James
Brackenridge, Hugh Henry
Brackenridge, William D.
Brown, William
Brownlee, William Craig
Bruce, George
Bruce, Robert
Buchanan, Thomas
Burden, Henry
Callender, James Thomson
Calvin, Samuel
Cameron, Archibald
Campbell, Charles Macfie
Campbell, George Washington
Campbell, John
Carnegie, Andrew
Clarke, Robert
Craik, James
Crooks, Ramsay
Crosser, Robert
Cushny, Arthur Robertson
Davidson, Thomas
Dickie, George William
Dickson, Robert
Dollar, Robert
Donahue, Peter
Douglass, William
Dow, Alex
Dowie, John Alexander
Dunbar, Robert
Dunbar, William
Duncan, James
Dunmore, John Murray
Dunwiddie, Robert
Eckford, Henry
Elmslie, George Grant
Erskine, Robert
Fairlie, John Archibald
Finlay, Hugh
Fleming, John
Fleming, William
Fleming, Williamina Paton Stevens
Forbes, John, 1710–1759
Forbes, John, d. 1783
Forbes, John, 1769–1823
Forgan, James Berwick
Garden, Alexander
Garden, Mary
Geddes, James Loraine
Gilmour, Richard
Goold, William A.
Gordon, George Angier
Gowans, William

Graham, Isabella Marshall
Graham, James
Graham, John
Grieve, Miller
Hall, David
Hamilton, Alexander
Hamilton, Andrew
Harkness, William
Hart, James MacDougal
Hart, William
Henderson, Daniel McIntyre
Henderson, David Bremner
Henderson, Peter
Hewat, Alexander
Highet, Gilbert
Humphreys, Alexander Crombie
Hunter, Robert
Jamison, David
Johnston, Gabriel
Johnston, John, 1791–1880
Johnston, John, 1881–1950
Johnston, Samuel
Jones, John Paul
Kane, John
Kcith, George
Keith, Sir William, 1680–1749
Keith, William, 1839–1911
Kemp, James
Kemp, John
Kennedy, Archibald
Kennedy, John Stewart
Kidd, William
Laurie, James
Lawson, Alexander
Lawson, Andrew Cowper
Lawson, James
Leiper, Thomas
Lining, John
Livingston, Robert
Lockhart, Charles
Lorimer, George Claude
Loudoun, John Campbell, Earl of
Lowrie, Walter
Lundie, John
Lyall, James
Macalester, Charles, 1765–1832
MacAlister, James
McArthur, John, 1823–1890
McArthur, John, 1826–1906
McCallum, Daniel Craig
McCosh, James
McDougall, Alexander, 1732–1786
McDougall, Alexander, 1845–1923
Macintosh, Douglas Clyde
McIntosh, Lachlan
MacIver, Robert Morrison
Mackay, James
Mackellar, Patrick
Mackenzie, Donald
Mackenzie, George Henry
Mackenzie, James Cameron

Mackenzie, Kenneth
Mackenzie, Murdo
McLaren, John
Maclaurin, Richard Cockburn
Maclean, John
McLeod, Alexander
Maclure, William
McTammany, John
MacVicar, Malcolm
Mantell, Robert Bruce
Matthews, William
Maxwell, Hugh
Melish, John
Mercer, Hugh
Michie, Peter Smith
Minto, Walter
Mitchell, Alexander
Mitchell, David Brydie
Moffat, James Clement
Moffatt, James
Montgomery, Edmund Duncan
Montresor, James Gabriel
Muir, John
Munro, Henry
Murray, Philip
Murray, Robert
Nairne, Thomas
Neilson, William Allan
Nisbet, Charles
Ogilvie, James
Oliver, James
Orr, Hugh
Owen, David Dale
Owen, Robert Dale
Panton, William
Patillo, Henry
Patterson, James Kennedy
Pattison, Granville Sharp
Phillips, William Addison
Phyfe, Duncan
Pinkerton, Allan
Pitcairn, John, 1722–1775
Pitcairn, John, 1841–1916
Rae, John
Ramsay, Alexander
Redpath, James
Reid, David Boswell
Rhind, Charles
Ritchie, Alexander Hay
Robertson, Archibald
Robertson, James, b. 1740
Robertson, William Spence
Ross, Alexander
Russell, William
St. Clair, Arthur
Sandeman, Robert
Saunders, William
Schouler, William
Scott, Walter
Seth, James
Sharp, John

Shirlaw, Walter
Skene, Alexander Johnston Chalmers
Smibert, John
Smillie, James
Smith, Alexander
Smith, George
Smith, Robert, 1722–1777
Smith, Russell
Smith, William, 1727–1803
Smith, William, 1754–1821
Sprunt, James
Stephens, Henry Morse
Stobo, Robert
Stuart, Charles Macaulay
Stuart, John
Stuart, Robert
Swan, James
Swinton, John
Swinton, William
Taylor, William Mackergo
Telfair, Edward
Thomson, John
Thorburn, Grant
Turnbull, Andrew
Vetch, Samuel
Watson, Andrew
Wenley, Robert Mark
White, Alexander
William, Charles
Williamson, Andrew
Williamson, Charles
Wilson, Alexander
Wilson, James, 1742–1798
Wilson, James, 1836–1920
Wilson, James Grant
Wilson, Peter
Wilson, William
Wilson, William Bauchop
Winton, Alexander
Witherspoon, John
Wood, John
Wright, Frances

SIAM

Chang and Eng

SILESIA

Courant, Richard
Damrosch, Frank Heino
Gratz, Barnard
Gratz, Michael
Mannes, Clara Damrosch
Mayer, Maria Goeppert
Pelz, Paul Johannes
Prang, Louis
Reichel, Charles Gotthold
Schwarz, Eugene Amandus

SOUTH AFRICA

Rathbone, Basil

SOVIET UNION

(*See* Russia)

SPAIN

Alemany, José Sadoc
Antoine, Père
Anza, Juan Bautista de
Ayala, Juan Manuel de
Ayllon, Lucas Vasquez de
Bori, Lucrezia
Cárdenas, García Lópéz de
Casals, Pablo
Copley, Thomas
Coronado, Francisco Vásquez
Costansó, Miguel
Cubero, Pedro Rodríquez
De Soto, Hernando
De Vargas, Zapata y Lujan Ponce de
 Leon, Diego
Escalante, Silvestre Velez de
Espejo, Antonio de
Fages, Pedro
Ferrero, Edward
Garcés, Francisco Tomás
 Hermenegildo
Gálvez, Bernardo de
Gayoso de Lemos, Manuel
Iglesias, Santiago
Iturbi, José
Luna y Arellano, Tristan de
Meade, George Gordon
Meade, Richard Worsam
Menéndez, De Aviles Pedro
Miró, Esteban Rodr!quez
Montgomery, George Washington
Moscoso De Alvarado, Luis de
Narváez, Panfilo de
Núñez, Cabeza De Vaca, Alvar
Nunó, Jaime
Ponce de León, Juan
Portolá, Gaspar de
Santayana, George
Tamarón, Pedro
Ulloa, Antonio de
Villagrá, Gaspar Pérez de
Viccaíno, Sebastián

SRI LANKA

(*See* Ceylon)

SURINAM

(*See* Dutch Guiana)

SWEDEN

Acrelius, Israel
Anderson, Mary
Campanius, John
Carlson, Anton Julius
Cesare, Oscar Edward
Dylander, John
Edgren, August Hjalmar
Ericsson, John
Esbjörn, Lars Paul
Fersen, Hans Axel, Count Von
Folin, Otto Knut Olof
Hasselquist, Tuve Nilsson
Hesselius, Gustavus
Johnson, Magnus
Leipzig, Nate
Lind, John
Lindberg, Charles Augustus
Lindberg, Conrad Emil
Lindgren, Waldemar
Lundin, Carl Axel Robert
Mattson, Hans
Norelius, Eric
Ockerson, John Augustus
Printz, Johan Björnsson
Raphall, Morris Jacob
Reuterdahl, Henry
Rising, Johan Classon
Rydberg, Per Axel
Schele De Vere, Maximilian
Schmidt, Nathaniel
Seashore, Carl Emil
Sellstedt, Lars Gustaf
Swenson, David Ferdinand
Thulstrup, Bror Thure
Udden, Johan August
Widforss, Gunnar Mauritz

SWITZERLAND

Agassiz, Alexander
Agassiz, Jean Louis Rodolphe
Ammann, Othmar Hermann
Bandelier, Adolph Francis Alphonse
Bapst, John
Behrend, Bernard Arthur
Bloch, Ernest
Boll, Jacob
Bouquet, Henry
Bucher, John Conrad
Cajori, Florian
Cramer, Michael John
Delmonico, Lorenzo
Dufour, John James
Du Simitière, Pierre Eugène
Faesch, John Jacob
Gallatin, Abraham Alfonse Albert
Ganz, Rudolph
Gatschet, Albert Samuel
Goetschius, John Henry
Gold, Harry ("Raymond")
Graffenried, Christopher
Gratiot, Charles
Guggenheim, Meyer
Gutherz, Carl
Guyot, Arnold Henry
Hailmann, William Nicholas
Hassler, Ferdinand Rudolph
Henni, John Martin
Hoch, August
Kruesi, John
Krüsi, Johann Heinrich Hermann
Lang, Henry Roseman
Lesquereux, Leo
Martel, Charles
Marty, Martin
Menetrey, Joseph
Messmer, Sebastian Gebhard
Meyer, Adolf
Ming, John Joseph
Nef, John Ulric
Olmsted, John Charles
Pfister, Alfred
Piccard, Jean Félix
Pourtalès, Louis François de
Purry, Jean Pierre
Rosenberg, Henry
Schaff, Philip
Schinz, Albert
Schlatter, Michael
Seiler, Carl
Senn, Nicholas
Shaw, Pauline Agassiz
Smith, John Eugene
Sterki, Victor
Theus, Jeremiah
Troye, Edward
Vanderbilt, Gloria Morgan
Weidenmann, Jacob
Wirt, William
Zimmerman, Eugene
Zubly, John Joachim

SYRIA

Adams, Walter Sydney
Bliss, FrederickJones
Bliss, Howard Sweetser
Dennis, Alfred Lewis Pinneo
Smith, Benjamin Eli

THAILAND

(*See also* Siam)

McFarland, George Bradley

TURKEY

Bliss, Edwin Munsell
Bliss, William Dwight Porter
Brewer, David Josiah
Callimachos, Panos Demetrios
Dwight, Henry Otis
Frame, Alice Seymour Browne
Goodell, Henry Hill
Gorky, Arshile
Gregory, Menas Sarkas Boulgourjian
Grosvenor, Edwin Prescott

Grosvenor, Gilbert Hovey
Jackson, Edward Payson
Johnston, Henry Phelps
Rafinesque, Constantine Samuel
Schauffler, Henry Albert
Van Lennep, Henry John
Van Lennep, William Bird
Von Ruck, Karl
Williams, Talcott
Zachos, John Celivergos

VIRGIN ISLANDS

Behn, Sosthenes
Crosswaith, Frank Rudolph
Morón, Alonzo Graseano

WALES

Coke, Thomas
Davies, John Vipond
Davis, James John
Easton, John
Easton, Nicholas
Evans, Evan
Evans, John
Everett, Robert
Gardiner, John Sylvester John
Griffith, Benjamin
Hughes, Price
Jones, Evan William
Jones, Jenkin Lloyd
Jones, John Peter
Jones, Samuel Milton
Langner, Lawrence
Lewis, Francis
Lloyd, David
Lloyd, Thomas
Morgan, Abel
Moxham, Arthur James
Nicholson, John
Owen, Griffith
Plumbe, John

Powell, Snelling
Pugh, Ellis
Rees, James
Reese, Abram
Reese, Isaac
Reese, Jacob
Rhees, Morgan John
Roberts, William Charles
Roberts, William Henry
Shelby, Evan
Smith, William Henry, 1806–1872
Stanley, Henry Morton
Templeton, Alec Andrew
Thomas, David
Williams, John Elias

WEST INDIES

Alarcón, Hernando De
Audubon, John James
Benjamin, Judah Philip
Berg, Joseph Frederic
Currier, Charles Warren
Da Costa, Jacob Mendez
Dallas, Alexander James
D'Avezac, Auguste Geneviève
 Valentin
Davis, John
Du Bourg, Louis Guillaume Valentin
Dyett, Thomas Ben
Finlay, Carlos Juan
Fitzgerald, Desmond
Fletcher, Alice Cunningham
Fraunces, Samuel
Fuertes, Estevan Antonio
Gorringe, Henry Honeychurch
Guiteras, Juan
Hamilton, Alexander
Holland, William Jacob
Hunt, Isaac
Larrínaga, Tulio
Lowndes, Rawlins
Mallory, Stephen Russell

Markoe, Abraham
Markoe, Peter
Martin, Josiah
Mendes, Frederic De Sola
Menocal, Aniceto Garcia
Moore, Sir Henry
Moreau de Saint-méry, Médéric-Louis-
 Élie
Moreau-Lislet, Louis Casimir
 Elisabeth
Muñoz-Rivera, Luis
Pinckney, Elizabeth Lucas
Prud'homme, John Francis Eugene
Redwood, Abraham
Ricord, Frederick William
Roberdeau, Daniel
Russwurm, John Brown
Stuart, Charles
Thomas, George
Thornton, William
Varela y Morales, Félix Francisco José
 María de la Concepción
Vaughan, Benjamin
Williams, Bert
Woodward, Henry
Yulee, David Levy

YUGOSLAVIA

Adamic, Louis
Rodzinski, Artur
Tesla, Nikola

AT SEA

Colcord, Lincoln Ross
Gibson, Walter Murray
Jemison, Mary
Juilliard, Augustus D.
Kirby, J. Hudson
Lathrop, Francis Augustus
McFee, William
Sajous, Charles Euchariste De
 Médicis